THE EYE
OF DUNCAN PHILLIPS

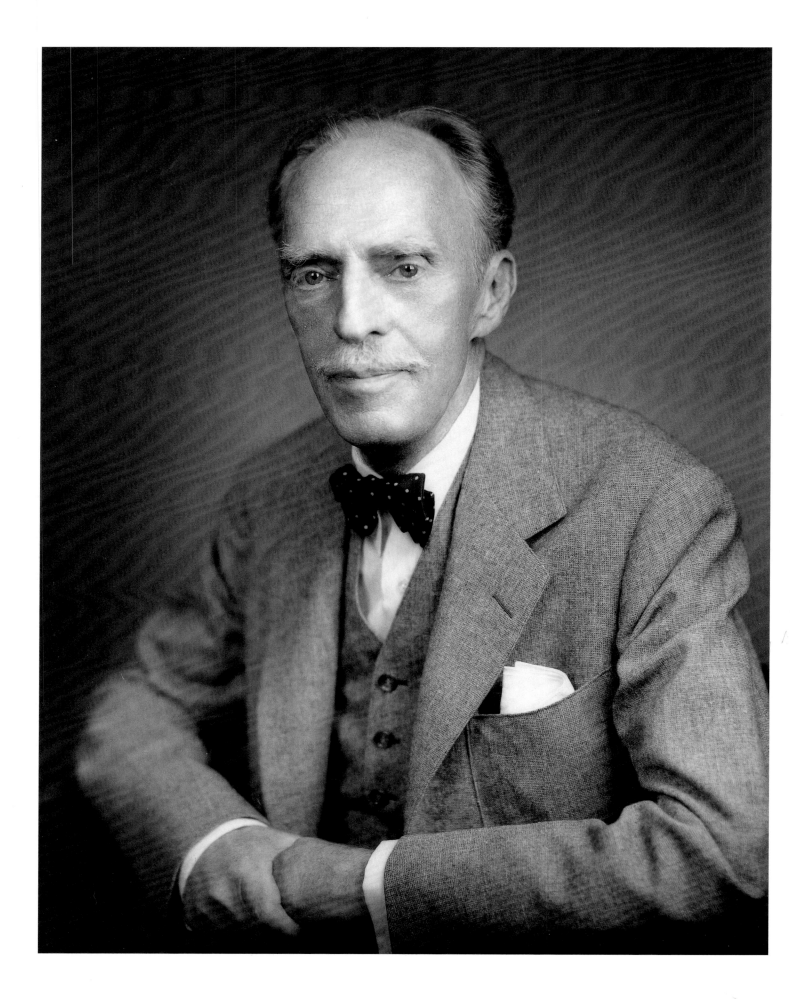

THE EYE
OF DUNCAN PHILLIPS

A Collection in the Making

Editor

ERIKA D. PASSANTINO

Consulting editor

DAVID W. SCOTT

Researchers

VIRGINIA SPEER BURDEN

LESLIE FURTH

GRAYSON HARRIS LANE

LEIGH BULLARD WEISBLAT

THE PHILLIPS COLLECTION WASHINGTON, D.C.

in association with

YALE UNIVERSITY PRESS NEW HAVEN AND LONDON

Published with the assistance of the Getty Grant Program.

Frontispiece: Duncan Phillips, 1940s, Harris & Ewing.

Designed by Bessas & Ackerman.
Set in Minion type by Bessas & Ackerman, Guilford, Connecticut.
Printed in Singapore by CS Graphics.

Library of Congress Cataloging-in-Publication Data
Phillips, Duncan, 1886–1966.
The eye of Duncan Phillips : a collection in the making / Erika D. Passan-
tino, editor ; David W. Scott, consulting editor.
 p. cm.
Includes bibliographical references and index.
ISBN 0-300-08090-5 (alk. paper)
1. Phillips Collection—Catalogs. 2. Art, European—Catalogs. 3. Art,
American—Catalogs. 4. Art—Washington (D.C.) Catalogs. 5. Phillips,
Duncan, 1886–1966—Art patronage. I. Passantino, Erika D. II. Scott,
David W., 1916– . III. Title.
N858.PA87 1999
750'.74'753—dc21 99-15182

A catalogue record for this book is available from the British Library.

The paper in this book meets the guidelines for permanence and durabil-
ity of the Committee on Production Guidelines for Book Longevity of the
Council on Library Resources.

10 9 8 7 6 5 4 3 2 1

CONTENTS

FOREWORD

The history of art museums in America over the course of the past century is one of astonishing success. Nowhere else in the world is it possible to travel from city to city, coast to coast, and consistently encounter collections of such remarkable scale and breadth. But the accelerated pace at which the nation developed its mantle of great institutions—its libraries and universities along with its great museums—is not only a tribute to its persistent sense of optimism. It is also eloquent testimony to a tradition of generosity and public philanthropy that is uniquely American.

This volume documents the accomplishments of a man who played a critical role in defining that tradition. As collector and philanthropist, Duncan Phillips has emerged as a figure of singular significance, a man whose taste and judgment, whose prescient insights and demanding standards merged with a commitment to the public interest in ways that find no equal.

In the essays that follow, Duncan Phillips's extraordinary record as a collector of modern art and its sources is investigated in ways that redefine the conventional "catalogue of the collection." The Phillips Collection is, after all, an unconventional museum formed by a man whose vision arose from deeply felt personal experience and was informed by a lifetime of search and study. Between his youthful encounter with Albert Pinkham Ryder and his conversations with Mark Rothko during the last years of his life, Duncan Phillips became universally recognized as a collector of unique dimensions. Before the great histories of modern art were written, before the major departments of art history were formed, before there was a Museum of Modern Art in New York or a National Gallery in Washington, Duncan Phillips sought out with astonishing success the works of impressionist and modernist masters. He pioneered the collecting of Arthur Dove and the Stieglitz group, and he did it in depth. He shaped our understanding of Braque and Bonnard. He championed the works of Paul Klee long before the museums of Europe.

Those choices may, in retrospect, seem so rational, indeed so inevitable, that we can easily forget they were far from obvious to anyone else. Who else was simultaneously collecting the paintings of

Daumier and Marin, of Chase and El Greco, of Prendergast and Delacroix, of Bacon and Cézanne? And who else collected with such a pointedly public mission, wanting from the start to share with the public the experiences of great works of art in circumstances that were personal and intimate?

It could hardly be more appropriate that, as the twentieth century comes to a close, we are invited to look back on the art of the modern age through the eyes of Duncan Phillips. To no one's surprise, the view is absolutely enchanting.

JAY GATES

Director of The Phillips Collection

PREFACE

I am thrilled that this book can finally be published, through the
good offices of Yale University Press, after some fifteen years in
preparation. It tells an unusual story.

Beginning in 1918, when he conceived the idea of founding an
art museum, and over the next forty-eight years, my father, Duncan
Phillips, was a brilliant, perceptive, impulsive, and enthusiastic col-
lector of nonacademic American and European contemporary art.
From today's perspective it was a pioneering odyssey, highly sig-
nificant in the cultural history of modernism in the United States.
By the time of his death in 1966, he and my mother had given more
than two thousand works of art to the museum that is now known
as The Phillips Collection. In order to appreciate the contents of this
book, which deals with the fruits of that odyssey, we need to con-
sider a few basic facts about the museum's growth and its origins.

Duncan Phillips was born in Pittsburgh in 1886, the grandson
of James Laughlin, a banker and cofounder of the Jones and Laugh-
lin Steel Company. Laughlin's daughter, Eliza, and her husband,
Major Duncan Clinch Phillips, a businessman, lived in a high-
ceilinged house full of academic European and American paintings.

In 1896, after the retirement of Duncan's father and the death of
his grandmother, the Phillips family moved to Washington, D.C.,
persuaded that it had a better climate than Pittsburgh. They bought
property near Dupont Circle and commissioned the Washington
architects Hornblower and Marshall to design a house in the Geor-
gian Revival style. This building, with numerous additions and ren-
ovations between 1907 and the recent ones of 1984 and 1989, now
houses The Phillips Collection.

Entering Yale in 1904, Duncan studied English and agitated for
more courses in the history of art. In an article which appeared in
the *Yale Literary Magazine* in 1907, he compared the "splendid
courses with celebrated instructors" offered to students of literature
with the dearth of instruction in the "sister art of painting." During
the ten years after his graduation in 1908 he became increasingly
involved in writing about art. In a letter to his class secretary for the
History of the Class of 1908, he reported: "I have lived in my home in
Washington . . . devoting much study to the technique of painting
and the history of art. . . . At Madrid, London, and Paris as well as

New York and other cities, I have met and talked with many artists in their studios and gone the round of exhibitions. [In my writing] I have attempted to act as interpreter and navigator between the public and the pictures, and to emphasize the function of the arts as a means for enhancing and enriching living."

This ambition—to act as a sensitive and eloquent interpreter of the painter's language and to share his own delighted understanding of art with an ever-growing audience—became my father's dominant concern and his life work. In 1918, following the deaths of his father and brother within thirteen months, he conceived the idea of founding a museum in their honor: "I would create a Collection of pictures—laying every block in its place with a vision of the whole exactly as the artist builds his monument or his decoration . . . a joy-giving, life-enhancing influence, assisting people to see beautifully."

The Phillips Memorial Gallery was incorporated as a District of Columbia foundation July 23, 1920, and quietly opened to the public in fall 1921 in two rooms of the family residence. Starting with a very small private collection, Duncan Phillips had acquired some 240 paintings by the time of the public opening. The paintings originally purchased, and all those to follow, were chosen not necessarily because they were widely acclaimed, historically significant, or radically innovative, but because they impressed my father as beautiful products of a particular artist's unique vision. His increasingly adventurous taste excluded the academic and faddist but honored "the lonely artist in quest of beauty, the artist backed by no political influence or professional organization."

His collecting proceeded at a wild and wonderful pace during those early years. The Renoir masterpiece *The Luncheon of the Boating Party* was acquired in 1923, Daumier's *The Uprising* and Cézanne's *Mont Sainte-Victoire* in 1925. By 1930, when the entire family house became available for museum use, there were more than six hundred paintings in the collection. By the time of Phillips's death in 1966, he had turned the collection into a magnificent living tribute—not only to his father and brother but to the independent, creative spirit of the many hundred artists represented there.

But in certain ways the museum had not kept pace with its collection. Much needed to be done to improve security, conservation, staff training, climate control, and all the other criteria of a modern art museum. For example, when I became the collection's full-time director in 1978, we had no wholly reliable listing of its complete holdings, and no final decisions had been reached on which works of art constituted its permanent collection. Although the museum had what has proven to be an exceptionally rich trove of Duncan Phillips's notes, published writings, and letters to artists, dealers, and other art world figures, there had been no systematic indexing or analysis of this material.

Publication of this book represents the culmination of a major initiative that we undertook in the early 1980s to record, study, and document the museum's permanent collection of art objects and archival materials. Until then we were in the anomalous and alarming position of possessing a very significant collection of art objects, mostly paintings, which had never been adequately examined, cared for, registered, accessioned, studied, or catalogued. By 1985 we had published *The Phillips Collection: A Summary Catalogue*, with its short catalogue entries and small black-and-white illustrations of all artworks in the permanent collection, and we were beginning preparations for a scholarly catalogue of the collection that would not only provide full documentation of its most important holdings but serve as an interpretive analysis of Duncan Phillips's importance as a writer, collector, and influence on the cultural history of modernism in America.

Full credit for this extensive research and publishing project can be found in Erika Passantino's following preface. Here I simply want to express my personal admiration and gratitude to some of the key players. Thanks first of all to Martha Glenn (formerly Martha Carey) and her assistant Sarah Martin, who launched our research office in 1983, developed the master plan for the entire project, and published our *Summary Catalogue*. They were succeeded in 1986 by research curator Erika Passantino, who skillfully and tirelessly directed the research, writing, and editing of the book for the next eight years and brought the manuscript to its final stages. Erika supervised an excellent research team consisting of Virginia Speer Burden, Leslie Furth, Grayson Harris Lane, and Leigh Bullard Weisblat. We all benefited during those years from the wisdom of Erika's project adviser Dr. David W. Scott, former director of the National Museum of American Art. Other important counsel in many phases of the publication was generously provided by Frances Smyth, editor in chief, National Gallery of Art.

By the time I retired as director of The Phillips Collection in 1992, we were not able to find a publisher prepared to take on a book of this scope, and our search continued over the next six years. I am therefore exceedingly grateful to Yale University Press for taking up the challenge in 1998, and to Johanna Halford-MacLeod, deputy to the director of the collection, for her tireless efforts to bring this important work to publication. Johanna has been assisted by Leigh Bullard Weisblat, former assistant curator and member of the research office, who has returned to the collection during the past year to update and prepare the original manuscript for publication. I am also very grateful to the current director of the collection, Jay Gates, for providing full support to this undertaking since his arrival in June 1998.

Finally, our warmest thanks to the many generous agencies and foundations that provided financial support to our research program. Major support was received over the years from the National Endowment for the Humanities, the National Endowment for the Arts, the Henry Luce Foundation (two grants), the Getty Grant Program, the Marpat Foundation, the L. J. Skaggs and Mary C. Skaggs Foundation, the Brown Foundation, Inc., the John Sloan Memorial

Foundation (also two grants), and especially the Andrew W. Mellon Foundation, from which we received our largest grant. In addition I want to thank the National Endowment for the Humanities for the particular encouragement it gave, which provided the impetus to embark on this project.

I take great pleasure in thinking how astonished and delighted my father would be to see and read this book. During most of his lifelong, painting-by-painting creation of this museum—with only my mother, the artist Marjorie Phillips, as a partner—he was traveling the somewhat lonely road of a trailblazer. I know he would be thrilled, if sometimes amused, to read the analysis of and tributes to his eye, his judgment, and his writings by the illustrious authors of this scholarly catalogue.

LAUGHLIN PHILLIPS
Chairman of the Board of Trustees/
President of The Phillips Collection

EDITOR'S PREFACE

Some time in the early 1920s, Duncan Phillips pondered the purpose of the institution that he had created. What had begun as a memorial to his father and brother had grown into a major collection that might be the nucleus for a national gallery. In 1922 he envisioned this as an "American Prado" that would "hasten the inevitable day when Washington will be the Paris of America and its true and proper art center."

We do not know what caused him to abandon this idea, and if Phillips subsequently struggled for a definition, he soon discovered what his museum was not to be:

A public building with all that the phrase implies and of course one of the leading sights of the city, reared by the munificence of its leading citizens ... to impress upon the public mind a proper sense of the dignity of art as one essential part of the cultural life of any community. ... Wonder and a certain awe are the proper emotions of the visitors on their first visit—wide-eyed ones who know not much about art nor about books, but who realize keenly enough how much there must be in life besides the stock market, the department store, and the moving picture theater. ... If they do not find what they like, they decide that art is not for them. They will not go again until out of town friends need to be impressed with the greatness of their city.

And in this rare case of irony—perhaps a draft for a lecture—Phillips also foresaw the coming of the blockbuster exhibition: "Obviously there must be features of popular interest to attract the crowds. ... Otherwise the attendance figures will show such a falling off that the leading citizens whose munificence helped to rear the edifice might feel that the institution was not functioning properly. Consequently, the museum ... deliberately purchases what people like and the attendance is wonderful; and art flourishes on main street. Now, the Phillips Memorial Gallery ..." and here he sets the tone for his museum: "A home for all the arts, it would be for those who love art and go to it for solace and spiritual refreshment." Late in life, he stated it very precisely: "What I delight to collect ... are the world's wonders of personality—not what can be put into a picture but what cannot be left out—that quintessence of self."

Arthur Dove, detail of
Flour Mill II, see cat. 253

Some time in the future a thorough biography of Duncan Phillips will be written, and yet his life and work were so intricately linked as to be almost one. His personality permeates every aspect of the building, the installations, and the individual purchases. Indeed, in creating this museum, he created a new work of art, and if thanks are due in these acknowledgments—and our gratitude to individuals and institutions who helped make this book possible runs deep—thanks should first be given to the man who dedicated his life and fortune to the task of assembling works of art, exhibiting them, writing about them, and lending substantive support to the artists who created them. The Phillips Collection today is a living legacy to his generosity of spirit, as well as to one family's very American sense of civic responsibility carried on to this very day.

When Laughlin Phillips succeeded his mother, Marjorie Phillips, as the director of the museum, he set out to place the collection in a broader context by formally accessioning the permanent collection and publishing *The Phillips Collection: A Summary Catalogue* as an initial record. This went hand in hand with the renovation of the original building and subsequent expansion of the annex. The final step was the publication of a scholarly survey of the collection so that it might assume its proper place in the history of art. This task called for the establishment of the research office whose early staff, headed by Martha Glenn (formerly Martha Carey) and Sarah Martin confronted an enormous challenge, for Duncan Phillips had cared much for works of art but little for the mechanics of record keeping. With meticulous care and dedication they reviewed six decades of correspondence between Duncan Phillips and artists, scholars, and museum directors around the world; they organized, read, and transferred these records to the Archives of American Art, where their microfilm versions make them available to scholars nationwide. Furthermore, they created a history of exhibitions at the museum; they recorded dates, checklists, and catalogues from 1919 to Phillips's last installation of an Arthur Dove exhibition days before his death in 1966. More than fifteen hundred pieces of manuscript required dating, interpretation, and permanent preservation. These archival documents, enhanced by manuscripts and correspondence that came to the museum after the death of Marjorie Phillips in 1985, are now a treasure of the museum, and the work carried out by members of the research office is acknowledged with gratitude. In 1986, when I took on the task of preparing a survey of the collection, the archives were a formidable foundation, ready to accommodate a large structure.

From the beginning it was clear that this book was not to be a "masterpieces" catalogue but an interpretation of the totality of the collection and an analysis of Phillips's developing taste and understanding. This could become clear only in following the trail of acquisitions, sales, and trades—even if spurred by minor examples. Two distinguished scholars, George Heard Hamilton (for the European works) and David W. Scott (for the American collection),

presided over the selection and determined that chapters should alternately discuss the European and American collections in order to show certain correspondences and harmonies that Phillips had discovered when installing them together. In that regard, it was important to make the exhibition units a core of each chapter, for they reflect the collector's sustained commitment to certain artists.

Once key archival records were computerized and the book's format established, writing could begin in earnest. David Scott continued to advise this project, reading every entry on the American works and bringing his rich experience to bear on every aspect of the catalogue; he may never know how much his wisdom and kindness inspired a new generation of art historians in the research office. Under his guidance, this team of talented young scholars brought dedication, creativity, and enthusiasm to the large task. Cheerful and ever willing, the assistant research curators, Leslie Furth, Grayson Harris Lane, and Leigh Bullard Weisblat, as well as Virginia Speer Burden, the researcher, remained with the project from 1985 to the mid-1990s, together acquiring a store of experience and perspective that became an invaluable resource. They combed thousands of documents from the Library of Congress and archives in New York, Paris, and London, read uncounted rolls of microfilm, wrote entries, gathered materials for scholars, and supervised an army of graduate interns. I feel motherly pride in these scholars and will treasure their friendship forever.

Anyone who has ever worked at The Phillips Collection knows that a special spirit embraces this extended family of artists and scholars brought together by the love of art. A book of this scope, and the endless tasks required of every department to bring it about, surely tested this spirit, and yet all accepted the purpose—to tell the story of The Phillips Collection. This spirit began with the enlightened leadership of Laughlin Phillips, whose support of the project never failed and who understood that an effort on this scale requires time. His memories of his parents' work gave life to many a historical detail; his contribution to this book is immeasurable, and I am grateful for the opportunity to have worked under his guidance. Understanding and support came from colleagues in the curatorial department, Eliza Rathbone and Elizabeth Hutton Turner, who contributed essays and lent their expertise; it became evident when Joseph Holbach and members of his registrar's office had to arrange transfer of hundreds of paintings for photography and conservation. Love for the task could be seen in the meticulous, inch-by-inch inspection of a work's medium and technique by the museum's conservator, Elizabeth Steele, and the consulting paper conservator, Sarah Bertalan, and in the care and talent of the photographer, Edward Owen, who created a luminous, unifying record of the entire collection; it continues with his successor, Peter Harholdt. Dedication to the task was apparent and especially appreciated in the willingness of the chief preparator, Shelly Wischhusen, the installations manager, Bill Koberg, and his former assistant, James

Whitelaw, who moved the priceless works of art under sometimes daunting schedules. We received technical support and encouragement from the librarian, Karen Schneider, who found countless references; the education department, headed by Donna McKee; Penelope deB. Saffer, former director of development, who secured funding; and the museum's former administrators, Elizabeth Griffith, José Tain-Alfonso, and Michael Bernstein.

Our work was immeasurably enhanced by the contribution of individuals who lent their particular talents or advice. Throughout the life of the project, interns and assistants (whose names appear in the Acknowledgments section) spent uncounted hours on research; we hope that their indispensable work was in small part repaid by the training they received. Valued contributions came from Cameron LaClair, Susan B. Frank, Maria Dolores Jiménez-Blanco, Joan Kadonoff, Wendy Kail, Hwaik Lee, Maura K. Parrott, Liza Phillips, Vicky Jennings Ross, and Michelle Lee White. Expert advice and moral support came from Frances Smyth, editor in chief at the National Gallery, a star of the art publishing world, and a dear friend. For a brief time we benefited as well from the wise counsel of the late Sir Lawrence Gowing; we cherish his memory.

Special thanks are due to George Cruger, who read the manuscript several times, lending his elegant prose and editorial skills to the text, giving unity of voice to this large volume. Thanks go as well to Christopher French for his editing of George Heard Hamilton's essay, as well as the listings of Duncan Phillips's writings and the museum's exhibition history. Few projects are fortunate enough to have a contribution from a gifted poet. Jeffrey Harrison helped establish the style guide for the book and inventoried the Foxhall correspondence, a cache of valuable letters that came from the family's residence.

To undertake a catalogue of this scope is an ambitious and exacting enterprise, impossible without the participation of a great many people and institutions. We are indebted to all who supported us—from the generosity and patience of funding agencies to the selfless help of volunteers. In his preface, Laughlin Phillips has acknowledged the support of foundations and funding agencies. To his words should be added thanks to individuals at those foundations and agencies who made a particular difference: Helen Farr Sloan of the John Sloan Memorial Foundation; Marcia Semmel, former director of the Division of Public Programs at the National Endowment for the Humanities; and Neil Rudenstine, at the time director of grants to museums at the Andrew W. Mellon Foundation.

Special funds made possible the participation of various scholars. We are proud to open our book with a perceptive essay by Robert Hughes, who lends his keen insight and special perspective to the place of The Phillips Collection. Further, we were fortunate to have the contribution of experts in areas addressed in individual chapters. Visiting scholars took on entire chapters or supervised the research and writing of entries: David Rosand (Scaggs / Brown Scholar), so ably assisted by Raquel Da Rosa; Richard L. Rubenfeld (Luce Scholar); Kenneth E. Silver (Mellon Scholar), with valued contribution from Elizabeth Peyton; Elizabeth Tebow (Getty Scholar); Ben L. Summerford (Getty Scholar), with the dedicated research of Maura Parrott. Essayists introduce chapters written by members of the research office—William C. Agee and Jane Kallir (Luce), Charles Stuckey and Sarah Wilson (Mellon), and David W. Scott (John Sloan Memorial Foundation). Willem de Looper, for many years the curator at the museum, wrote an essay on the importance of the museum and its collection to Washington artists; only a distinguished painter could have made that particular contribution. Chapters written by staff had the added benefit of specialist-readers who reviewed the text: Christoph Grunenberg, Alain de Leiris, and Elizabeth Prelinger. These experts gave tirelessly of their experience, assuring this book's high level of scholarship.

Finally, this book would not have come about without the trust shown by Yale University Press, especially Judy Metro, senior editor, who recognized the historic significance of publishing the work of one of the university's graduates and lifelong supporters. The burden of preparation for publication fell on current members of The Phillips Collection's staff, whose vision made this publication possible. At great distance from Washington, I appreciate with deep gratitude the long hours and effort this required. I am thankful for the enthusiastic dedication displayed by the current project team, foremost Johanna Halford-MacLeod, deputy to the director; Michael Bernstein, former administrator; Leigh Bullard Weisblat, former assistant curator of the museum, who took on the daunting task of updating the manuscript for publication; and Virginia Speer Burden, who assisted at key moments in this work. Their years of experience and knowledge of the collection have proven invaluable. I am deeply grateful to Jay Gates, director of The Phillips Collection, for his support of the project. We are all grateful to the attorneys David Korn, Denise Madigan, Jonathan Ritter, and Cary Sherman of Arnold & Porter. Stephanie Nealon deserves special thanks for her timely and patient assistance with the electronic stages of the manuscript, and for her technical expertise. Finally, we are grateful to the team of manuscript editors at Yale University Press—Otto Bohlmann, Dan Heaton, Richard Miller, Noreen O'Connor, and Jenya Weinreb—who have caught inconsistencies of style that invariably creep into a book of this size, and who have smoothed out the text. All of us hope that through this book, its essays, entries, and archival material, Duncan Phillips's role as a major force in American aesthetics, philosophy, and patronage will receive due recognition.

ERIKA D. PASSANTINO

This is the record of the youth of an idea, the concept of a small, intimate museum combined with an experiment station—and it marks the first stage of our progress towards the realization of an ideal.

Duncan Phillips
A Collection in the Making (1926)

NOTES TO THE READER

The purpose of this book is to chronicle and interpret the history of Duncan Phillips's activities as a collector and the development of his taste. It contains entries on 191 artists and 411 of 2,396 works of art in The Phillips Collection (TPC). For a complete illustrated list of The Phillips Collection's holdings up to 1985, readers should consult *The Phillips Collection: A Summary Catalogue.*

Organized chronologically, each of the book's eleven chapters addresses a particular aspect of the collection. Within each chapter, an introductory interpretive essay is followed by entries on the artists and works of art. In the case of any artist whose works Phillips collected in depth, creating a grouping he called a unit, an essay on the unit precedes the entries on the individual works. Group essays are identical in form to unit essays but describe groupings that Duncan Phillips did not designate as units or, for some reason, ceased to refer to as units.

Artist entries: The artist entries in each chapter are arranged chronologically by year of birth. Artists born in the same year are listed alphabetically. Each entry is preceded by a short biography of the artist, including information on the artist's first solo exhibition, as well as participation in any major or seminal group exhibitions. The number and type of works by that artist within the collection today are also specified. Within each entry, the works of art are listed in chronological order. Notes to catalogue entries will be found in the back of the book. Initials at the end of each section of text identify the author of that entry. (See Entry Contributors, page 682.)

Titles of works of art: Where possible, these are the original titles conferred by the artist. Foreign titles, if any, and variants follow The Phillips Collection title. The inclusion of variant titles is determined by the significance and frequency of their appearance in publications and museum documents. Titles assigned by Duncan Phillips are indicated by (DP).

Dates of works: Dates considered firm on the basis of artists' inscriptions or other forms of documentation are given without further qualification. A dash between two dates means that the work was begun in one year and worked on continuously into the later year: "1920–22." Dates of works begun in one year, set aside, and

completed in another year are so designated: "1920; completed 1922." Approximate dates, where termini are unknown, are given as ca. (circa): "ca. 1920." Termini, if known, are given: "between 1920 and 1922," "before 1920," or "by 1920." When a more precise date cannot be determined, an estimate or range is given: "late 1920s." Dates of reworkings are noted only when the work was completed in one year, published as a finished work of art, then reworked by the artist at a later date: "1920; reworked 1922."

Media and supports: Technique and medium were established and terminology formulated in consultation with conservation staff. Media are listed first, in sequence of application, and followed by support. For sculpture, the edition and number are included, if known. The base is also included, if integral to the work of art. For photographs, the process is included in the medium line. Finally, if the work has received any significant conservation treatment, then it is discussed either in a note or within the body of the essay. If there is no discussion of conservation, the work's condition is stable.

Measurements: Dimensions given are of the support. For works on paper, the dimensions are of sheet, not image. Where the frame is an integral part of the work of art, it is included in the measurement, with the word "frame." Height precedes width (and depth, in the case of works in relief). Dimensions are first given in inches and are rounded to the nearest one-eighth. The metric measurements were taken independently and are given, in centimeters, within parentheses.

Inscriptions: All artist inscriptions are included. The artist's primary inscription is always given first, along with the standard abbreviation for its location (for example, u.l. for upper left). Secondary inscriptions, usually found on the reverse of works, are given if significant.

Identifying numbers: In addition to the museum's accession number, any other identifying numbers, such as catalogue raisonné numbers, are included with the data on the work of art.

Provenance: The provenance for each work is as inclusive as possible. Gaps in a work's history are so noted: "early history unknown." The date of acquisition is determined by an analysis of three facts: intent of purchase by Duncan Phillips, date of arrival in the collection, and, finally, a bill of sale. When intent to purchase and physical arrival in the collection occurred in the same year, then that is considered the acquisition year, even in cases when the date of the bill of sale is different. When the dealer was not the owner but served as a liaison, the transaction is cited as specifically as possible: "on consignment" means that the artist consigned the work to the gallery; "as agent" means that the dealer acted as an intermediary in the purchase; and finally, "through" signifies that the exact arrangement is unknown.

Notes and references: The major references, TPC sources, and notes for each artist's entry are placed at the end of the book. *Major*

References is a listing of the most significant major sources, published and unpublished, on the artist. It is not a comprehensive list for either the artist or the work of art. *TPC Sources* is a comprehensive listing of all museum sources pertaining to that artist. Some sources are cited by abbreviations. These sources are part of the museum's archives. The museum's official correspondence, from 1920 to 1960, was microfilmed and given to the Archives of American Art and is, therefore, cited within the *Major References* section. Other correspondence in the museum's archives, particularly a group identified as Foxhall, is listed in the *TPC Sources* section.

Appendix: *The Published and Unpublished Writings of Duncan Phillips* is a complete chronological listing of Phillips's writings. Published items are listed first. Unpublished materials that remain undated are assigned a numerical sequence and cited in a separate list that follows the list of dated writings. Gaps in the numerical sequence indicate that formerly undated manuscripts have been dated and moved to the chronological listing of published and unpublished works. Phillips's journals were arranged alphabetically before their dates were established.

The History of Exhibitions at The Phillips Collection contains all exhibitions held at the museum between 1919 and 1999. For shows organized by other institutions, the name of that museum or circulating agency is noted; however, the exhibition is listed under the date of its showing at the Phillips. Sample entry:

PMG.1927.3 "An Exhibition of Expressionist Painters from the Experiment Station." Little Gallery. Mar. 6–Apr. 12. 10 works. Cat. with essay by DP.

The abbreviations refer to the museum's name at the time of exhibition. The year is that in which the exhibition opened. The numeral following the year shows the exhibition's place in the the sequence of that year's exhibitions. An asterisk denotes an exhibition that contains only Phillips works but was held at another institution. In cases where records of an exhibition were discovered after the coding system had been established, the addition is marked in the following manner: PMG.1931.17-A. The following abbreviations are used for the museum's name:

DP Duncan Phillips's private collection (1919–July 1920)
PMAG Phillips Memorial Art Gallery (July 1920–May 1923)
PMG Phillips Memorial Gallery (May 1923–Oct. 1948)
TPG The Phillips Gallery (Oct. 1948–July 1961)
TPC The Phillips Collection (July 1961–present)

Variants not easily noted within the format of the listing are explained in notes.

Other variants: Brackets denote reconstructed titles. For off-site exhibitions, the name of the hosting institution is given. Specific

galleries of The Phillips Collection are indicated only up to 1930, after which the entire residence was converted into a museum and opened to the public. Exhibition dates were derived from catalogues, announcements, reviews, and other records. Uncertain dates are denoted by "ca." or other explanations. Note that during the first two decades of its existence, the museum was closed during the summer months. If a catalogue was not produced, other sources, such as checklists, loan documents, hanging records, or announcements are noted in support of the title, date, and number of works. The authors of introductions and essays are noted where known.

ART AND INTIMACY

ROBERT HUGHES

Everyone who loves early modern art loves The Phillips Collection and envies Washington for having it. The neo-Georgian pile at Twenty-first and Q Streets has grown since the Edwardian days when it was the boyhood home of its founder, Duncan Phillips, who died in 1966 (fig. 1). Parts were tacked onto it to fit its ever-growing collection in 1907, 1920, 1923–24, 1960, and 1984. With the 1989 opening of the Goh Annex, it reached the limit of its expansion (fig. 2). And yet The Phillips has never lost its aedicular quality, its gift of intimacy and unhurried ease in the presence of serious art. Nobody ever feels pressured there or cheated by inflated expectation. It was not made for people with a viewing speed of three miles per hour.

Which is a near-miracle, considering what has happened in some of the great encyclopedic museums of America, like the National Gallery in Washington or the Metropolitan in New York. Unable to handle the vast art audience they helped create, big American museums in the 1980s became, in effect, mass media in their own right. The audience is now too big for the art.

But art does not like a mass audience. Only so many eyes can take in the same painting at the same time. There is a level of crowding beyond which one's sense of the object simply dies. Of course, there are plenty of areas in the big American museums where works of art still can be enjoyed in the silence and relative intimacy that is their due. Only on special occasions do they attain the cultural obscenity of the Louvre or the Uffizi in high tourist season. But the miseries of art-as-mass-spectacle are here, and will not go away.

In contrast are the oases, small and well-loved museums whose scale feels right, where the eye is not crowded and the size of the public does not threaten to burst the institutional seams. They evoke, above all, loyalty and affection. In America, one thinks of the Frick, in New York, with its sublime collection whose unchanging nature one no more resents than the fixity of the North Star, and of The Phillips Collection, which is to early modernism what the Frick is to Old Masters.

Duncan Phillips knew what he wanted: he saw where the big museums were heading. "It is worthwhile," he presciently wrote almost eighty years ago, "to reverse the usual process of popularizing an art gallery. Instead of the academic grandeur of marble halls

Henri Matisse, detail of
Studio, Quai Saint-Michel,
see cat. 109

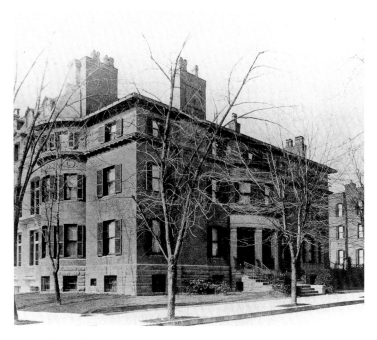

Fig. 1 The Phillips house at 1600 Twenty-first Street, ca. 1900.

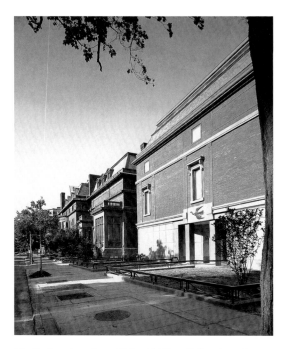

Fig. 2 Exterior view of The Phillips Collection, showing the Goh Annex, 1989.

and stairways and miles of chairless spaces, with low standards and popular attractions to draw the crowds . . . we plan to try the effect of domestic architecture, of rooms small or at least livable, and of such an intimate, attractive atmosphere as we associate with a beautiful home."

The Phillips Collection has changed since its founder's death: how could it not, without dying, too? It is bigger, by nearly nineteen thousand square feet, and puts more stress on conservation and education. It holds focused historical surveys and one-person shows, samplings rather than full retrospectives. But over all this broods continuity. Duncan Phillips's ghost still stalks the corridors of his museum like a benign, bony wading bird. No one would lightly abandon the values he implanted there.

The style was the man. Duncan Phillips was born into a family of Scottish descent, which had made its fortune in Pittsburgh in banking and steel. From his tubular tweeds to his innate belief in the obligations of public service, he was the quintessential eastern WASP (fig. 3). He was brought up in Washington among Tafts and Glovers, and studied English literature at Yale. He was well traveled, rich but not filthy rich, and pomp embarrassed him. He did not collect for "status," because modern art conferred none in Washington seventy years ago, and, in any case, he felt no social insecurities. Still less did he collect for investment, though he had no qualms about selling works out of the collection to trade up.

Like a good Scot, he eschewed the pleasures of the table. When in Paris with his artist wife, Marjorie—his equal partner in forming

the collection (fig. 4)—he would sit down to lunch in temples of belle époque cooking like the Tour d'Argent and stubbornly order two poached eggs and a morsel of bread pudding. His digestion, he said, had been done in by too many hot dogs at Yale.

But Yale had also formed his ambition—as it would for another great Washington collector who was there in 1907, Paul Mellon. Phillips was struck by the "deplorable ignorance and indifference" to art among the students who would move into America's elite. One graduate student he knew declared at dinner that "Botticelli is a wine, a good deal like Chianti only lighter. . . . He was rudely awakened by a sensitive friend to the fact that Botticelli is not a wine but a cheese." Phillips was horrified, as Alfred Barr also would be, by the lack of art history courses in American schools. (What he would have made of the immense, academized, turgid structure of American art education today is anyone's guess.) He wanted to be a dilettante, in the full and proper sense of the word: not a superficial amateur, but a man who took educated pleasure in every field of culture, especially art.

The clue to this growth lay in the writings of Walter Pater, who was as much a cult figure among American student aesthetes at the turn of the century as John Ruskin had been twenty years before or Clement Greenberg would be in the 1960s. Pater's coiling, elegantly nuanced descriptions of works of art, his craving for the exquisite, and above all his belief that the aesthete, "burning with a hard and gem-like flame," could transcend the grossness of material society, struck deep into the intellectual values of young Duncan Phillips's time and class.

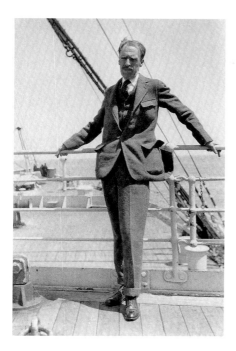

Fig. 3 Duncan Phillips on a transatlantic journey, 1920s.

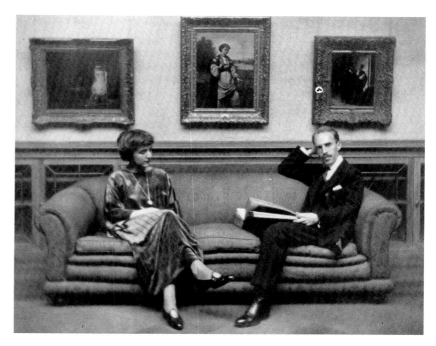

Fig. 4 Marjorie and Duncan Phillips in the Main Gallery of the Phillips Memorial Art Gallery. Photograph by Clara E. Sipprel, ca. 1922. The museum was renamed The Phillips Collection in 1961.

Like many others, including Bernard Berenson and the French critic Henri Focillon, Phillips came to believe that works of art transcend the immediate social and historical conditions of their making, that they form a universal language that can speak to attuned people in any time and place because they are triggers for emotions and feelings that lie deeper than socioeconomic conditioning. Hence their power to please, elevate, stimulate, and provoke reflection. Contemplating them, the viewer becomes a kind of artist.

As Duncan Phillips put it, art is "a joy-giving, life-enhancing influence, assisting people to see beautifully as true artists see." This vision of the "life-enhancing" powers of art was Pater's main legacy to American aesthetes between 1880 and 1914. "Mere" delight—Phillips would never have called it "mere," for it was part of his raison d'être, as it is with all authentic connoisseurs—is out of intellectual fashion today, derided by neo-Marxists and poststructuralists as one of the masks behind which an elite goes about its work of repression.

To art historians who cannot lay eyes on a Matisse still life without spinning lengthy footnotes on the gender-based division of labor in the Nice fruit market in 1931, Duncan Phillips's kind of aestheticism is a fossil. Phillips himself never denied that art reflects society; he knew their reciprocity—as his enthusiasm for Daumier, among others, showed. But he always put disinterested aesthetic awareness before the work of decoding art as a social text. And who could deny that his beliefs have brought more people closer to firsthand art experience than all the socioaesthetic jargon of recent years?

"Life-enhancement" could oppose itself to death and loss. The collection began, in fact, as the Phillips Memorial Art Gallery, a work of *pietas*—a Roman sense of family obligation—to the memory of his father and, especially, his older brother James, who had died at age thirty-four in the Spanish flu epidemic of 1918. Duncan and James had collected pictures jointly until then, and James's death, Duncan wrote later, "forced my hand":

"There came a time when sorrow almost overwhelmed me. Then I turned to my love of painting for the will to live. Art offers two great gifts of emotion—the emotion of recognition and the emotion of escape. Both emotions take us out of the boundaries of self. . . . At my period of crisis I was prompted to create something which would express my awareness of life's returning joys. . . . I would create a collection of pictures—laying every block in place with a vision of the whole exactly as the artist builds his monument or his decoration."

Though born in grief, the collection would eschew the monumental: it would go in the family house and, symbolically, restore the life that house had lost. It opened in three rooms of the Phillipses' home in 1921. Phillips's taste was daring, highly traditional, and somewhat idiosyncratic, all at once. Not for him the premade collection from the *menu touristique* of accepted values. His memorial to the dead was, above all, a product of reflection.

Duncan Phillips was not a "radical" even in his youth. In 1913 he wrote a review dismissing the New York Armory Show—the first North American exhibition of cubism, fauvism, impressionism, and

post-impressionism—as "stupefying in its vulgarity," though later he repented of that, somewhat. Yet one should remember that, although the artists whose work Duncan and Marjorie Phillips collected from the 1920s to the 1950s are long since dead and have become excessively embalmed by history and the market, they were living, problematical creatures with a small audience then.

Few people in 1930 thought of Bonnard as a great painter; even as late as the 1950s there was no shortage of critics writing him off as a *retardataire* impressionist. If the collection now has seventeen Bonnards, it is because Duncan Phillips was almost alone in wanting Americans to see him in depth. But he was no Euro-snob. He stood up for Dove, Marin, Stieglitz, and other American modernists when few private collectors or museums would. His record of sympathy with the American avant-garde was far better than Alfred Barr's. Taste was policy. It was "a cardinal principle," he noted in 1922, "to make the gallery as American as possible, favouring native work whenever it is of really superior quality, as our painting unquestionably is."

Phillips clove to artists—Bonnard, Marin, Stieglitz, Dove—through studio visits and long correspondence. He was not moved by the snobbery that wants to rope in a star painter for the dinner party. The art-star system hardly existed then. Phillips simply wanted to know more about art.

His closest relations were with Arthur Dove, whom he subsidized for some years: there are forty-nine Doves in The Phillips Collection and voluminous letters in the archive. Writing once of ancient Greek vase painting, he mentioned "craftsmen who were also poets in their various plastic ways and who no doubt more truly resembled our modern artists than the great architects and sculptors of the time of Phidias." He thought of modern art as unpretentious in its essence.

Now that taste has been corrupted to the point where few can distinguish scale from size, and "important" means "unmanageably big," one is apt to lose sight of the fact that most of the paintings that changed art history between 1860 and 1950 would fit over a fireplace. Smallness, intimate address, helped distinguish focused art from the shameless inflation of the academy—as it needs to, once again, today.

Phillips knew this and was grateful to the artists who practiced it. With the new and the young, he was cautiously sympathetic. There being no market hysteria, he could wait, reflect, compare, and eventually admit the newcomer—Morris Louis, Kenneth Noland, Mark Rothko, or Philip Guston—to the company of Bonnard's *The Palm* and Matisse's *Studio, Quai Saint-Michel*. After all, it had taken him nineteen years to decide on his first Cézanne still life.

Lawrence Gowing wrote that "a succession of painters, passing through the capital, have learned in the collection the best lessons of their lives." True: The Phillips has always been an artist's museum. One may doubt whether Morris Louis's or Kenneth Noland's work

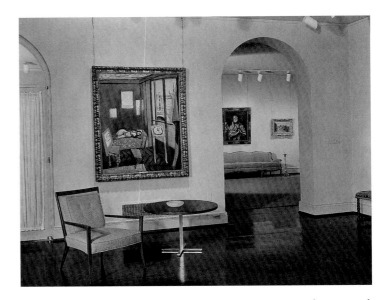

Fig. 5 Annex gallery installed with works by Henri Matisse, El Greco, and Jean-Baptiste-Camille Corot, 1960s.

would have turned out as it did without the radiant example of The Phillips's Bonnards.

When Richard Diebenkorn was a marine at Quantico, he visited The Phillips Collection so regularly that the powerful orthogonal framing of *Studio, Quai Saint-Michel* became the signature of his own work (fig. 5); so it is fitting that Diebenkorn's superb drawing show opened the Goh Annex forty-five years later, and that his retrospective filled the annex in 1998.

When art lovers talk about the paintings that have helped form their sense of quality, one is often struck to find how many hang in the collection. Did Gauguin ever paint a better still life than The Phillips's dusky-red smoked ham, its curve of creamy fat echoed by the sprout-ends of a scatter of pearly onions, floating on its iron table against a deep plane of orange wall? Is there a more audacious gesture anywhere in Bonnard's work than the wide arch of spiky foliage in *The Palm*? Or a Cézanne self-portrait more densely impacted with thought than the one Duncan Phillips bought in 1928 and told his registrar to grab and run with first if there was a fire? How many Matisses carry more messages for future art than his 1916 *Studio, Quai Saint-Michel*? Even those who don't greatly care for Renoir, finding much of his work sugary and repetitious beside the drier pictorial intelligence of a Degas (who is also beautifully represented in the collection), are likely to concur that *The Luncheon of the Boating Party,* painted in 1881 and purchased from Durand-Ruel in 1923 for $125,000, is one of the great paintings of the nineteenth century and the summit of Renoir's pictorial achievement (fig. 6).

This, in a sense, was the world's first museum of modern art, founded in 1921, eight years before the Museum of Modern Art

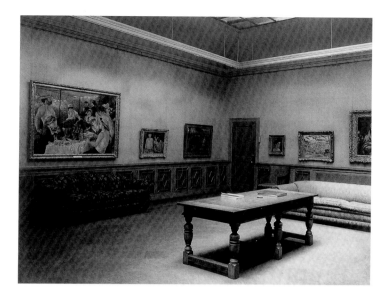

Fig. 6 Main Gallery, late 1920s. On the table is a copy of Duncan Phillips's book *A Collection in the Making,* published December 1926.

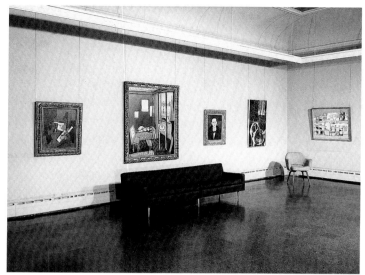

Fig. 7 Main Gallery installed with works by Juan Gris, Henri Matisse, Amadeo Modigliani, Georges Braque, and Nicolas de Staël, 1963.

opened its first show in a Manhattan brownstone. But only in a sense. The collection never set out to define a canon of modernism. It was much more an act of taste than a proposal about art history. What it stressed—and still insists on—is the continuity between past and present.

Phillips had no patience at all with "revolutionary" myths of the avant-garde. He sometimes thought in terms of evolution but was mildly skeptical of progress in art. The eighteenth-century painter Jean-Baptiste-Siméon Chardin, virtuoso of "the richly harmonious envelopment of objects in space," was the ancestor of Georges Braque's late still lifes of the 1930s and 1940s but not their "primitive" ancestor.

In its first stages, The Phillips Collection consisted largely of paintings by French artists like Chardin, Monet, Monticelli, Decamps, and Fantin-Latour and American ones like Whistler, Ryder, Childe Hassam, Twachtman, and Luks. The six great Cézannes and three van Goghs, the matchless late Braques and the Matisses, the Bonnards and the hundreds of works by American modernists—Arthur Dove, John Marin, and so on to Mark Rothko and Philip Guston—were to come later.

Many works seem to have no historical connection to modernism at all—some of them quite extraordinary, like Goya's *The Repentant St. Peter* and the Delacroix portrait of the violinist Paganini, a tallowy wraith whose intensity seems, while you are looking at it, to disclose a whole vista of French romanticism through the dark slot of its surface. Consequently, you never leave the Phillips feeling that a tour of "isms," that schematic labeling of successive movements on which the mass teaching of modern art

has depended for the last fifty years, has been laid out for you. Instead, the clusters of images that come up in room after room have an implied but rarely argued coherence, a sense of "elective affinity" that leads you to ponder what they might have in common and, therefore, what the artists were actually thinking about.

The collection gathered in what Phillips called units. From Twachtman to Nicolas de Staël, he liked to have blocks of five or six representative works by an artist. Then, on the wall, one painter could begin the silent *conversazione* with another. You watch the works talking (fig. 7). The place is set up for association and reverie. Its scholarship has always been impeccable, and Phillips himself was one of the best American critics of his day. But the collection is more dedicated to correspondences and sympathies than to hard chains of art-historical cause and effect. And of course the collection gestures outward, to images it does not contain, to the larger museum in our heads.

To think of Goya and Daumier as belonging together is normal. But it is a quite different thing, while looking at Daumier's *The Uprising,* to grasp a connection between its central figure, a worker in a white shirt shaking his upraised fist, and the white-shirted Madrileño defying the French muskets in Goya's *Third of May.*

None but a fool likes everything, and there were whole strands of modernism to which Duncan Phillips remained indifferent. He was not greatly moved by cubism, finding it—one might guess—too brown and cerebral. Nevertheless, the collection boasts one of Juan Gris's finest works, a 1916 *Still Life with Newspaper.* Phillips ignored most expressionism (too convulsive), and to dada and surrealism he was quite cool, though he bought one Miró, *The Red*

Sun, and accepted one great Schwitters as a gift from the estate of Katherine Dreier. Marcel Duchamp, the father of conceptual art and enemy of the "retinal," could safely be left to the Arensbergs in Philadelphia.

Phillips was in fact the compleat optical collector. He craved color sensation, the delight and radiance and sensory intelligence that is broadcast by an art based on color. Color healed; it consoled; it gave access to Eden. He could not understand—except on the plane of theory—why art should be expected to do anything else.

It had always been so for him, ever since childhood. When Duncan Phillips was four, his parents took him to Europe. In Paris, at the circus, he was terrified into hysterics by the sight of a clown tossing dolls—which the little American boy thought were live babies— into the air. His terror lasted all the way back to the hotel and was only assuaged, Marjorie Phillips wrote in her memoir of her husband, by the sight of a vase of simple flowers in the lobby: blue cornflowers, red poppies, yellow buttercups. "He later remembered how he could not let the bouquet out of his sight and always thought that was his first real aesthetic experience of color." You might say that Phillips's lifetime attachment to color began with a therapeutic instant, one that could be recaptured over and over again, almost at will, in the presence of painting.

He came to see the significance of modern art largely as a narrative of color, of agreeable sense-impression laden with thought. He was not "a modernist," but he immersed himself in modernity as the living form of a tradition that, as he saw it, had begun in cinquecento Venice, among the mysterious reveries of Giorgione: an art of delicately managed emotion, rising from the intersection of culture and nature, in the pastoral mode. (The ideal opener for The Phillips Collection would have been Giorgione's *Tempesta.*)

He hated the laborious or sleeked image: art needed to be fresh in its perception, direct in its touch. He wanted "works which add to my well-being. . . . For me, an artist's unique personality must transcend any imposed pattern which otherwise becomes an academic stencil adaptable to mass production." On Twenty-first Street today, his well-being is still ours.

All of us can acquire eyes wherewith to see the world as the artist see it, variously, selectively, intellectually or emotionally, in full possession of the latent capacity for seeing nature in pictures and pictures in nature.

Duncan Phillips, "A Collection Still in the Making,"
The Artist Sees Differently (1931)

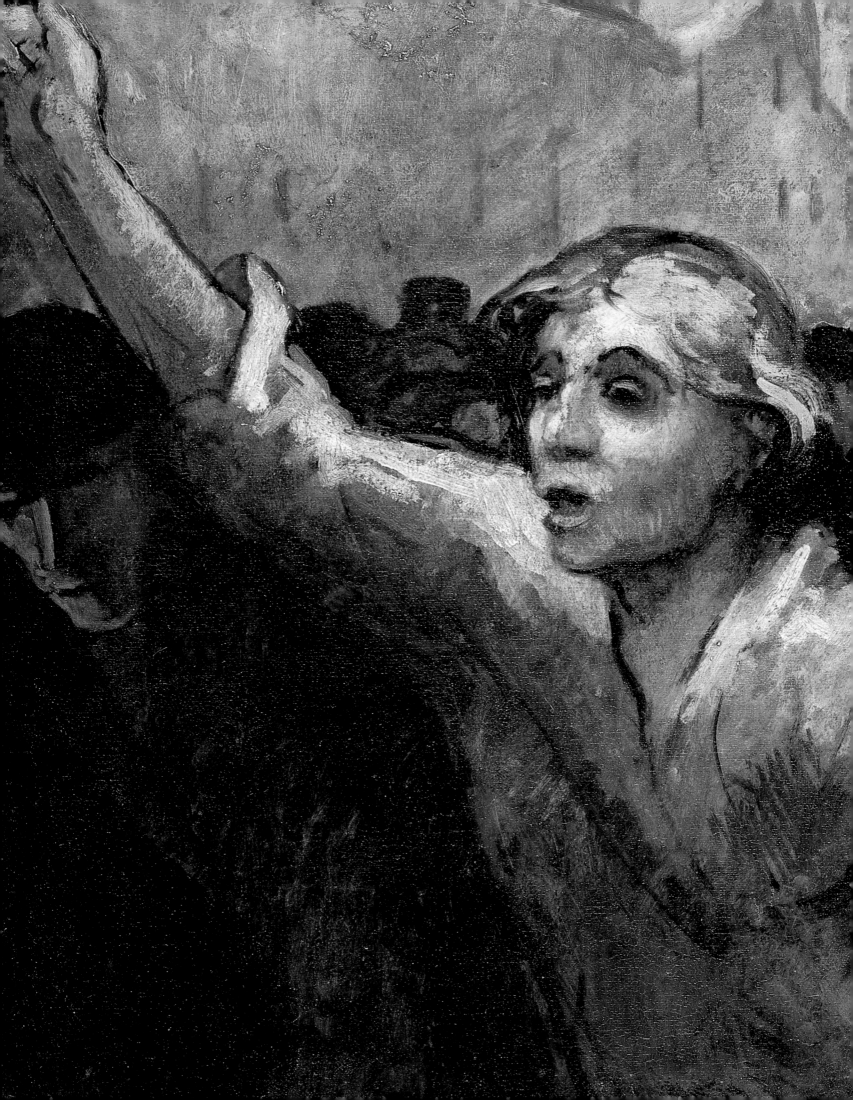

THE EVOLUTION OF A CRITIC

Changing Views in the Writings of Duncan Phillips

DAVID W. SCOTT

One of the most rapid and dramatic changes in the perception of what constitutes "art" took place in the United States early in the twentieth century. For most of us who came to maturity after that revolution in taste, it is difficult to sympathize with the conservatives and reactionaries. And yet, had we been of their generation, our values might well have been similar to theirs, and our struggle to comprehend the new, correspondingly painful. In this connection, the writings of Duncan Phillips are most illuminating, as we find him first embracing art for subject and sentiment, then recoiling in horror at the Armory Show, and finally becoming one of America's early champions of modernism. His essays and appraisals take us graphically and at first hand through his passage from a world whose promise of security and verities was becoming less trusted to a world acknowledging uncertainty and risk, but closer to the twentieth century's experience of reality. A prolific and candid writer, he left a uniquely documented account of the struggle that faced an aesthetically sensitive young man of conservative background in coming to terms with this foreign, threatening, challenging new world.

Phillips's first publication on art dates from 1906; his professional life extended to 1966. The great majority of his writings fall in the first half of his career, from his time at Yale until the thirties, the period of his increasing involvement with art and of his forging and reforging of a personal aesthetic. It was a period of vigorous attempts to establish standards for, and to acquaint the public with, the rapidly changing world of art. In working toward these standards, in the teens and twenties, his first medium was words, supplemented increasingly by exhibitions. His written output was of high quality and astonishing quantity. By the mid-thirties he had found a mature, individual philosophy that took a broad delight in the many-sided world of art and an especial delight in works that frankly appealed to his personal and discriminating taste. He continued to expound this view eloquently but depended less and less on the written word. In his later years he lived this philosophy and acted effectively in the public interest—as collector, museum director, and senior statesman in the arts.

Honoré Daumier, detail of
The Uprising, see cat. 15

Yale, 1904–8

In January 1901, when Duncan Phillips was fourteen, he wrote his mother that "the one study in which my interest, enthusiasm, and ambition is kept alive is English. And as for composition writing, I cannot find the reason for my passionate fondness for this occupation."[1] Fortunately for us, his obsession with writing was to continue and grow, affording an extensive record of his thoughts, feelings, and dreams as he developed as a critic and influential interpreter, collector, and patron of modern art.

We first pick up the thread of this development in the pieces he published in the *Yale Literary Magazine* and the *Yale Courant* during his college years (fig. 8). Although he was a literature major and wrote occasional short stories and essays on English authors, by the end of his junior year he had turned increasingly to essays about art. This fascination with art must have come from young Duncan's personal aesthetic sensibility—a delight in color and visual perception—which was to distinguish his collecting in years to come. At the same time, he entered the world of criticism through the study of literature and initially passed judgments on all the arts on the basis of the same set of values, approaching painting with strong emphasis on subject matter and content. The period was one in which cosmopolitan writers—Henry Adams, Walter Pater, George Moore, James Huneker—were weaving together wide-ranging treatments of literature and visual arts, and for about a decade Duncan was to write in this tradition, while increasingly familiarizing himself with paintings and painters.

He was a romantic, sensitive youth of patrician background, and in his first published essay, "At the Opposite Ends of Art," in June 1905, he made it clear that the literature he loved was youthful, idealistic, and poetic, unaffected by the current influences of science and "sordid realism."[2] We may speculate that he was writing in reaction to a play by Ibsen (then popular in the drama productions at Yale), for he dwells on that playwright in his essay, before concluding by saying of Ibsen, Pindar, and D'Annunzio, "May the spirit of their pessimism, their utter scorn for the law-abiding and the beautiful, never inoculate with the corroding vision of their interesting genius America, land of good hope and moral health." Duncan continued for another decade to rail vehemently against art he found repulsive and disquieting.

In November 1906 he published his first essay on a painter, Camille Corot—the romantic Corot of the nymphs, not the classic master he later chose for permanent collection.[3] Corot's paintings served as the occasion for a literary apology for dreams and dreamers. According to the young Duncan, "all great landscape painters have been dreamers," and Corot achieves "a blending of the romantic and the real by drifting down a stream of dreams," but at the same time "the idealism of Corot was his crowning glory." Again, he introduced what would become recurrent themes in his writing: "Corot, the dreamer and idealist," calls "the jaded toilers of the city

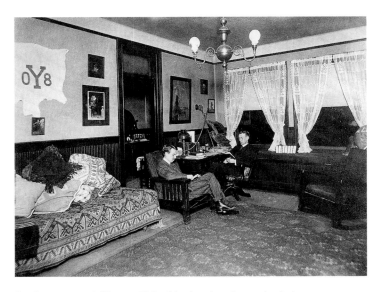

Fig. 8 Duncan Phillips and his older brother, James, in their rooms at Yale. The brothers were very close, and James deferred the start of his university education until Duncan could accompany him. They graduated in 1908.

streets . . . away from their surging, sweating thoroughfares to rest . . . in lonely byways where Nature gives her peace and plenty."

The essay on Corot, like a slightly later one on the Mona Lisa, barely touches on the world of art, but in an essay on the ill-fated painter Marie Bashirtseff we find for the first time a discussion with reflections on the influences of other painters, past and contemporary.[4] Perhaps it was this glimpse into the actual realm of art, together with visits in New York to the Metropolitan Museum and "various sale and loan exhibits," that led to the writing of his most important early piece, "The Need of Art at Yale."[5]

A course in the history of art had previously been offered at the college but was dropped for lack of student interest. Duncan argued for its reinstatement, making suggestions for enrichment, and we see the later art educator foreshadowed. After arguing eloquently for the uplift afforded by the arts, he became specific (although almost apologetic) in defining the role art should play: "the dilettante" needs it to make his life "more exhilarating"; "the arts, after all, serve no higher purpose than to serve as accessories to the joy of living." He ended, on a more eloquent note, with adumbrations of his later concerns for individualism, for the encouragement of artist and critics, and for general public enlightenment: "A wider diffusion of artistic knowledge and instinct would give birth and guidance to dormant individualities of taste, and would not only increase the number of future artists and art critics, but would help to color the lives of the future citizens of the republic, and thus advance the precious cause of the beautiful, in this marvelous breathless modern world, so sadly stained in its cities with excess of printer's ink and factory smoke."

In Phillips's senior year, he wrote three essays for the *Lit*, all bearing on art. In each case he reveals immature judgments he would soon outgrow, together with some longer-lasting biases and lifelong convictions. His essay on "The Problem of Art in Japan" concludes that despite the extraordinary cult of beauty of the Japanese, their literature is "of no lasting worth" and the "arts in general . . . display no impressive evidences of genius."[6] The reason? "Character study, which . . . is the noblest gift of Western Art, is foreign to the Oriental temperament." Needless to say, Phillips soon learned more about the "worth" of Japanese culture, but the test of "character" always remained for him a touchstone in judging all the arts.

Phillips's most ambitious essay of the year was titled "The Nature and Expression of Sentiment."[7] The age, he found, was one of reason and science, not romance, but true sentiment (as distinct from sentimentality) was not dead; it was alive in honor, kindness, patriotism, and sensibility, testifying to "the abiding youth and freshness of the human spirit." The expression of sentiment, he maintained, could be better conveyed through painting and sculpture than through literature, drama, or music; further, sentiment is best expressed not through realism (Jean-Baptiste Greuze, John Everett Millais) but through symbolism (Corot's nymphs, St. Gaudens's Grief, Watts's Hope). Over the next ten to fifteen years, Phillips's receptiveness to symbolism helped lead him to appreciation of Arthur B. Davies and Augustus Vincent Tack, and eventually of abstract art. Frederick Watts, meanwhile, was dropped from his list of favorites.

In a brief essay entitled "Meissonier's Napoleonic Cycle," Phillips came out, uncharacteristically, in the spirited defense of an academic realist because he found the Napoleonic cycle charged with romantic emotion.[8] The essay begins with his first mention of what was to him in 1908 problematic modernism. He observed that critics have "even gone to the extent of tolerating many experiments in Impressionism." The stage was being set for a struggle in comprehension and taste.

A Critic in the Making, 1909–14

During the five years after his graduation from college, Phillips devoted himself to studies amounting to a graduate-level version of the course he had advocated for undergraduates at Yale, which had included an introduction to art criticism. His early essays had not only set his goals but had also expressed the aesthetic attitudes and credos he sought to defend during this period.

In a class report published in 1914, Phillips summed up his first five years since college.[9] His winters, spent in Washington, D.C., had been devoted to study of the technique of painting and the history of art, while in spring and summer he had traveled. "At Madrid, London and Paris as well as New York and other American cities I have met and talked with many artists in their studios and gone the round of exhibitions." He was, he wrote, at work on two forthcoming books on "the function of the arts for enhancing and enriching living": *The Impressionist Viewpoint* and *The Decorative Imagination.* (They were published in 1914 as the two parts of a single volume of essays, *The Enchantment of Art.*)

Phillips's travels during this period were extensive. In 1910 he went with his family to China and Japan, where he and his brother Jim must have seen prints by Hokusai, Hiroshige, and Harunobu. He found that "The Problem with Art in Japan" lessened upon familiarity. Later essays reveal a deep feeling for Oriental art and a recognition of Japan's contribution to European modernism.[10] In 1911, 1912, and 1913 Phillips made trips to Europe, visiting major museums across the continent. He kept extensive journals describing and evaluating artists and paintings in notes that frequently found their way into the essays he wrote during these years. One of his first projects after graduation had been to undertake a paper on the meaning of the term *impressionism,* and in September 1912 he entered the professional ring as an art critic with the publication of "What Is Impressionism?" in *Art and Progress,* the monthly magazine of the American Federation of Arts. He was to continue in 1912 and 1913 with six more art articles in journals—four on contemporary themes and two on Renaissance masters, Giorgione and Titian. As a group, these articles can be viewed as following the path of his college essays, but they showed much wider experience and deeper probing.

His essay "Giorgione, the First Modern Master" is particularly significant.[11] It looks back to Walter Pater, who had found Giorgione the inventor of genre and of a new spirit in art, but it also reveals Phillips as a serious student of art-historical sources and of works examined in situ. Giorgione, for Phillips, represented his cherished individualism finding its first complete expression in painting and thus initiating the modern spirit, "making landscape and light, color and form, symbolically expressive of personal emotions." Phillips had become involved in a study that was to intrigue him for decades and lead to a full-length monograph in 1937.

"Giorgione" was republished in 1914 in *The Enchantment of Art,* along with a number of companion essays which crossed freely between the fields of literature and art.[12] All reflect a comfortable world in which the function of art is to embellish life with beauty, romance, and the vision of dreams. It was only in 1913 that the harmony of this vision was violently threatened by the intrusion of a new modernism, and a new theme appears in a single (and late) essay on this threat, a review of the Armory Show entitled "Revolution and Reactions in Modern Painting."[13]

In this essay Phillips for the first time squarely confronted radical modernism. He had always regarded himself as a "modern"—in sympathy with a fresh, youthful vision—and he was confident that his aesthetics could explain away any difficult works he did not appreciate. In an article written after visiting Joaquin Sorolla, "the lyric poet," in 1912, he compared the Spaniard with Claude Monet,

whose "messy surfaces" so bothered him: "Monet never made us feel . . . that this was the best of all possible worlds."[14] Phillips went on to write that realism did indeed afford one of the approaches to art, but that it became art only when in the service of romance, as he had found in Meissonier's Napoleonic cycle. Monet, who both fascinated and repelled him at this period, became the symbol of his difficulty in accepting the developments of later nineteenth-century French painting, just as Henri Matisse was to symbolize the more radical challenges of the early twentieth century.

Because it was the goal of art to create beauty, it followed, quite simply, that what the young Phillips did not find beautiful he dismissed as inadequate art. (His journal notes on museum visits are full of summary condemnations on these grounds.) Monet he recognized as the leader of a movement that had affected the vision and technique of artists everywhere, often with results that Phillips enjoyed, but "the great Monet . . . cares more . . . for scientific truth than for aesthetic beauty, . . . occasionally . . . capturing, more closely than ever before, fleeting illusions of reality."[15] Phillips knew the work of the French impressionists well and had been struck by them particularly when visiting the home of the dealer Durand-Ruel in 1911. He nevertheless continued in his criticism of Monet in *The Enchantment of Art*, but within five years he purchased a painting by the master and listed it third on a short list of the "15 Best Purchases of 1918–19." By 1926 he recognized Monet as "a poet of light . . . the Columbus of a new continent of art."[16]

As with Monet, so with the term *impressionism*. Its use to designate the art of Monet annoyed Phillips because of his background in literature. For many years he advocated substituting other terms (such as *luminism*), contending that the true meaning of impressionism was quite the opposite in spirit from Monet's "scientific" study of light. A central theme in the first half of *The Enchantment of Art* is the essential role of impressionism as aesthetic perception and impulse in all the arts. The essays in the book begin with a discussion of "The Impressionistic Point of View": "The artist is standing by, watching the world as it passes, appreciating time as it flies, . . . striving to give his sensations and his moods emotional unity in his mind, then artistic unity in his creation—in short, to give definite form to each separate, personal impression."[17] In his second essay, "What Impressionism in Painting Really Means," Phillips concludes that it is "the one true philosophy of all painting, . . . synonymous in equal measure with art itself, which is purely technical, and the motive which makes for art, which is, or should be, inspirational." In the final essay of the book, "Impressionism and the Romantic Spirit," he asserts that both the realist and romanticist "have been impressionists or they have been failures." Moreover, he concluded, the impressionist should be a romanticist because, to quote the critic R. A. M. Stevenson, "the particular triumph of the artist is not simply to convince but to enchant."

In his course through the seventeen essays in *Enchantment*,

Phillips treated many subjects and demonstrated that his five years of travel and study had given him a rich store on which to draw, preparing him for essays on Titian, Tintoretto, Velázquez, and Watteau. He made amends to the Chinese and to the Japanese, who "really founded the modern school of realistic painting represented by the work of Manet, Monet, Renoir and Degas." He had gone to artists' studios. He was familiar with, and appreciated, the paintings of the masters of the Italian Renaissance; of the Spanish, Dutch, and Flemish masters of the seventeenth century; of Chardin, Adolphe Monticelli, Jean-François Millet, Corot, Charles Meryon, Edouard Manet, and Auguste Renoir; and of James Abbott McNeill Whistler, George Inness, Albert Pinkham Ryder, Thomas Wilmer Dewing, Joseph Pennell, Sir Frank Brangwyn, Childe Hassam, Jerome Myers, George Luks, Everett Shinn, and George Bellows. He was constantly searching for the creative individual, for the sources of his "modernism."

This search is reflected in "The City in Painting and Etching," which appeared as an article in *Scribner's* early in 1913 and was reprinted in *Enchantment*.[18] Phillips took a fresh look at New York City and discovered merit in certain views by contemporary painters and something peculiarly American in the new skyscrapers: "One of the most propitious signs of our artistic awakening may be recognized in our new acknowledgement of elements pictorial and even poetic in the modern city. It is difficult for us to relinquish a notion that the world of industry and commerce is an ugly and prosaic one. . . . We begin to see that the city reveals the character of an epoch and the spirit of our modernity is, at least, the most appropriate thing for us to express."

Phillips went on to survey the history of urban landscape and found romance in past views, and he wrote poetically of the work of American contemporaries like Hassam and Myers, only to conclude that "such scenes are as yet too real to yield us illusions. But the sense of their romance will grow." Romantic or not, the art of the New York "realists" was beginning to attract his attention.

Years of Crisis, 1913–18

The period from 1913 to 1918 was marked for Phillips by three crises that in the end changed his outlook and the direction of his life. The Armory Show and the art it introduced squarely challenged his taste and his aesthetic philosophy. The World War brought home to him painful realities that could not be denied by refuge into a world of romance and dreams. Finally, the deaths of his father and brother in 1917 and 1918 brought him near collapse, before he found emotional release in the creation of his Memorial Gallery.

The period was one of growth from youth to manhood. Phillips became an active participant in the world of art, forming all-important friendships in that world, and he brought his wide-ranging interests as an essayist to a focus as a collector and interpreter of paintings, setting foot on the path that led ultimately to his "museum

of modern art and its sources." Upon joining the Century Association in 1917, he formed closer friendships with some of the more liberal representatives of the art community, including Tack, Mahonri Young, Gifford Beal, Allen Tucker, Charles Downing Lay, and the broad-ranging art historian Frank Jewett Mather. At the same time, as a member of the government's Division of Political Publicity, he was hard at work organizing the vast "Allied War Salon," staged in December 1918, and his activities thrust him squarely into the business of exhibiting contemporary art.[19]

From his beginnings as a critic, Phillips considered himself an advocate of "the modern," though dismissing "modernism." He sought out painters like Sorolla, whose work showed freshness and individuality but paid allegiance to "beauty" as he then conceived it. In 1912 he visited a gallery of modern art when in Venice and wrote an article declaring that the three best living French artists were Simon, Cottet, and Ménard.[20] In a journal of the same year he made what was probably his first written reference to Paul Cézanne and the post-impressionists—"a bunch of damned fools."[21]

When he visited the Armory Show in February of 1913, he was overcome with revulsion and rushed from the exhibition. In an article published the following December, he vented his feelings: "As I write, the air of studios in New York is charged with much talk about painting, talk that is full of fanaticism and mystification and real concern for the future of art, all agitated by a recent exposure of crass sensationalism in pictures—an International Exhibition of Modern Art quite stupefying in its vulgarity."[22] Discussing current American art in general, Phillips found its faults to lie in an excess of virtuosity and a "scientific" objectivity stemming from Monet's impressionism, and he concluded: "I really believe that it was a reaction from this excessive objectivity that induced such unbalanced fanatics as Cézanne and Vincent van Gogh to imagine that they saw nature subjectively in cubes and ovals, and the half-savage Gauguin to return to savagery." These were the artists who "initiated the present decadence. . . . Instead of devotion to the great masters of the past . . . these men harked back instead to primitive models. . . . Finally with Matisse the degeneration of this so-called 'expressionism' reached its bottom. . . . This person creates patterns . . . not only crude but deliberately false, and insanely, repulsively depraved. The Cubists are simply ridiculous, Matisse is also poisonous." The article ends with a forecast of a "great Renaissance" in American art, continuing the self-reliant spirit of Inness and Homer and "stimulating in us a deeper appreciation of the glorious privilege of living."

In 1914 several early essays were collected into his first book, *The Enchantment of Art,* and two new articles were published as well. "A Collection of Modern Graphic Art" described works belonging to A. E. Gallatin and charted a course for Phillips's own future collecting: "to collect works of art is good, to collect only what one particularly likes is better, and to collect only such works as mingle agreeably together is to make the best kind of collection."[23] Equally pregnant for the future, but in a very different way, was a review of James Huneker's *The Pathos of Distance* for the *Yale Review.*[24] Huneker's acuteness and broad-ranging sensibility disarmed Phillips, who recognized in him "that rare quality of the critical mind—the ability to perceive that in the house of art there are many mansions, and every single one of them at least interesting." It was as if Phillips had found a key that unlocked a door, though for several years he hesitated to pass through. Eventually, "the many-sidedness of art" became one of his principle critical tenets.

In 1916 Phillips turned to contemporary American art and published essays on four painters: Chase, Ryder, Tack, and Davies. Chase he credited for his record of fighting and winning for American art "the battle for the ancient principle of good painting for its own sake, for the right of the painter to make pictures which shall be primarily pictures and stand or fall, not by reason of their subject, but by reason of their style."[25] But it was not style so much as imagination and romance that attracted him to Ryder, Tack, and Davies. Ryder's "visions of romantic beauty" led Phillips to a lengthy comparison of him to Coleridge in which he drew the line between paintings of poetic imagination and paintings dependent upon poetry. His analysis of Ryder's effectiveness of expression introduced a new formal emphasis for Phillips: the painter's "directness is a quality of plastic design," but it is Ryder's romance that holds his critical attention.[26]

Phillips's admiration for Ryder's work was to play an important role in the forming of his collection. Similarly, his visits to the studios of Tack and Davies, besides leading to significant articles, initiated friendships that were to play critical roles in his understanding of art. Both Tack and Davies were mature painters who were responding to new influences and were going through a period of stylistic exploration. Both men impressed Phillips with their sincerity of purpose and artistic sophistication, and he was challenged to view with sympathy Tack's expressionist brushwork and even some of Davies's cubist forms.

Phillips's article on Tack, "The Romance of a Painter's Mind," appeared in 1916.[27] Tack was a deeply religious man who sought to increase the imaginative and spiritual impact of his work through selection of subject—often symbolic—and rich application of color textures. Passages in such works as *Simon of Cyrene,* 1913–14, verge on abstract expressionist brushwork and intrigued Phillips.[28] He recognized that the paintings were labored and not entirely successful, but to him they were "animated by an idealism which gains in beauty in contrast to the facile . . . materialism of so many other painters of today." His favorites among Tack's paintings, however, were those of a more conventional technique and theme, such as *Court of Romance,* painted by 1914 (acc. no. 1882).

In writing of Davies, Phillips faced a more difficult problem. The dream visions of the artist's earlier work attracted him deeply,

in spite of a certain mannerism, but the limitations of a vision and technique bound too closely to the past had, according to Phillips, led to a restlessness that had "become a dominant motive driving him on to dissipations of experiment. . . . The art of Davies, vulgarized by association with the sensational performances of charlatans, is often a tragic sight to behold." But Davies, who tried patiently to introduce the critic to the mysteries of cubism, exacted a cautious concession that all was not lost, for Phillips paid homage to "a wonderful room in a New York home which owes its wonderfulness to its Davies' decorations [which give it] such sensations of form and hue, of light and volume, as we receive in looking through a prism of multicolored glass." Phillips was at last able to view a cubist work not only without revulsion but with delight, even though it lacked "the old power to stir our emotions" as did "those joyous surprises we found in the sweet capricious fantasies of the earlier pictures."[29]

The influences on Phillips of Tack and Davies, and of other friends and contemporaries of the late teens and twenties, is discussed more fully in Chapter 6. In this connection, Phillips's joining the Century Association in 1917 is of special interest, not only for the range of friendships he formed but also for its leading to an introduction by member Gifford Beal to his niece Marjorie Acker. Miss Acker, whom Phillips married in 1921, was herself an artist and quite at home with the modern movement. Her active involvement in painting and shared enthusiasm for art were to have a strong impact on Phillips.

For all his tentative concession to Davies, Phillips was not ready to change his opposition to modernism. His principal publication on art in 1917 and 1918 was a two-part reaffirmation of his objections to the movement, "Fallacies of the New Dogmatism in Art."[30] His attacks are no less shrill than they were in 1913. He does concede that Cézanne, van Gogh, and Gauguin may be sincere "primitives," but they lead to Matisse, "a deliberate fakir." He had read Roger Fry and Clive Bell and been coached by Davies, but he would have none of their arguments. "Art implies knowledge, taste, selection, skill. We must conclude that the extravagant Modernists are neither worthy to be called artists, nor are they genuinely modern." The basic issue comes down to (barbaric) "primitivism" as opposed to "faith in perfection," and to Phillips "the meaning of the present conflict in Europe is that the two sides [barbarism and idealism] are embattled." Primitivism is akin to "mere pattern making" and the reduction of art to "mere aesthetics unrelated to the emotions of life. . . . Representation is necessary to appeal to our emotion of recognition . . . thereby intensifying our joy in life itself"—the real purpose of art. And Phillips, with his faith in education, envisages making "the knowledge of what representative art really is . . . a part of the compulsory education of every boy and girl, future artists and future appreciators alike."

"Fallacies of the New Dogmatism" was the last of Phillips's wholesale attacks on modernism. In 1918 he changed course from

the career of a critic to that of an incipient museum director, and he was to have the opportunity to put his theories about art collecting and art education into practice. He was eager to do so. He had recently addressed the College Art Association on both the need and an agenda for art education, concluding that "it is positively pathetic that the keen delights of art should be confined to the few, when they could enrich and enlarge the lives of the many. I can hardly wait for the day when there will be wider enlightenment and more comprehending laymen."[31] In his imagination he saw many ways of spreading the light.

A Gallery in the Making, 1918–26

The decision made late in 1918 by Duncan Phillips and his mother to create a memorial art gallery resulted in years of wide-ranging questioning, probing, and planning, leading finally to a gallery unique in concept and of national stature.[32] The making of this gallery, and the implementation of its programs, involved the gathering of a landmark collection and the maturing of its director as a critic. The full story of the creation of the gallery is beyond the scope of this essay, but crucial factors included Phillips's broader understanding of art and acceptance of modernism.

His first step was to begin forming a full-scale collection, and this entailed visiting exhibitions and galleries, establishing ranking orders and priorities, making extensive lists of artists, and collecting biographical information. He seems to have made at least seventy or eighty purchases in 1919 and 1920, with American painters outnumbering foreign artists five or six to one.[33] At the same time, he continued writing. In a journal he wrote drafts of three essays—one on Ryder (a transcription of his 1916 essay, adding a reference to the artist's death), one on Emil Carlsen (a temporary favorite), and one on Julian Alden Weir that anticipated both a paper he was to read at the College Art Association in 1920 and the volume on Weir published in 1922 as Phillips Publication No. 1.[34]

A particularly revealing document, also assignable to 1919, is the proposal Phillips wrote to Harper and Brothers for a book he planned on "Representative American Painters of the New Century."[35] This document clearly reflected his preoccupation with selecting and evaluating representative American painters, and we glimpse his concerns for his planned gallery. He was "now writing a series of short, impressionistic criticisms of contemporary American painters" and collecting photographs of their work. His aim was to introduce to an increasingly curious American public the "work of these living Americans I know intimately because in point of time I am near enough to the men to know from one aesthetic source or another their idiosyncrasies and intentions." It was important to know of the artist's "personality and purpose; how much of his personality is revealed in his painting; how far his painting falls short of his purpose; what manner of mind he has and what sort of a

Fig. 9 McKim, Mead & White, Architects, *Preliminary Study for The Phillips Art Gallery,* May 11, 1922. The intended site is now occupied by the Washington Hilton Hotel.

Fig. 10 Duncan Phillips, Sketch for a new gallery building.

hand; . . . what probably will seem some day the value and significance both of his ideas and of their expression."

Phillips wrote eloquently of the "idea that we are a nation of artists," which he called "a new and fascinating one." He continued: "Far and wide, teachers at schools and colleges, and workers in small museums report the ever increasing appetite of the American public for works of art to study and appreciate." Books were needed on "the art of the present hour, not entirely overlooking the real significance of the widely advertised sensational 'New Movements,' but more seriously concerned with the old, old truths seen by new eyes under the new conditions of our own day." But Phillips did not persuade Harpers that books on contemporary American art were salable; instead, he was urged to write a general history of American painting.[36]

Phillips's subsequent activities focused increasingly on the development of the Memorial Gallery and on publications by the gallery itself. Over the next few years he worked on plans for many and varied publications, often returning to the need for inexpensive booklets. His aim of writing a book of succinct, informative evaluations was finally realized in his *A Collection in the Making* in 1926. Aiming at an effective concision helped him to overcome his early tendency toward wordiness and to develop a "modern" style.

It was probably in 1920 that Phillips, in rapid longhand, filled the back pages of an undated notebook with the earliest surviving program for the Phillips Memorial Art Gallery.[37] The notes come in curious sequence, beginning with "Outline of Suggestions for 2 Volumes to be published by Phillips Memorial Art Gallery." The outline begins by describing an extraordinary series of books, to appear

each May, containing seventeen sections covering all the arts and including original poems, drawings, prints, music, a play, critical reviews of cultural events, and a full account of the museum's activities. The first monograph on a great artist represented in the gallery was to appear in December. The notes continue: "The Herald of Art is one of the titles tentatively suggested for the unique Annual publication—not a magazine but a book—which we propose to devote to the interpretation and illustration of what is considered best in the aesthetic world. The volume is to be compiled and published under the auspices of and prepare the way for The Phillips Memorial Art Gallery which we dream shall be a home for all the arts." There follows a brief description of the "dream" museum, with its theater, library, and galleries, "which will have the character of a beautiful home" (figs. 9 and 10).[38] Phillips then discussed the ways he would exhibit works, by "units" and by interactive mixtures, and continued: "Our hope therefore is that by bringing art to the people in the most attractive way we may be able to make art democratic in relation to the lives of the people who may find in it inspiration and solace without relinquishing our duty to guide them to the heights." The piece ends with the statement that he is turning to the public for advice ("our plans . . . are yet in a plastic state") and also for support, by subscription to the Phillips Publications.[39]

Thus the plans for the gallery and its publications appeared intertwined, and so they continued as they were developed in 1921 and 1922. The longhand "Herald of Art" essay was edited and typed in a slightly expanded version, which included the pledge that "our most enthusiastic purpose would be to reveal the richness of the art

created in our own United States and to stimulate our native artists and afford them encouragement and inspiration."[40] On February 16, 1921, the board of trustees held its second meeting. A Committee on Scope and Plan was created and later broken into seven planning subcommittees, many of which were to examine facets of the general gallery concept first developed in "The Herald of Art."

Late in 1921 the Phillips Memorial Art Gallery was opened to the public, and in 1922 the first two Phillips Publications appeared. After three years, Phillips saw his dream beginning to take shape. Phillips Publication No. 1, on J. Alden Weir, was first published in 1921 by the Century Association.[41] Phillips, who contributed a substantial essay, took over the copyright from the association. Weir, too, had been a member, and six of Phillips's fellow Centurions contributed pieces.

Publication No. 2, on Honoré Daumier, was the first fully to reflect the format of the Phillips series; the central monograph by Phillips was accompanied by a few short essays and many illustrations.[42] The essay on Daumier set a new standard for Phillips, who wrote in a crisper, more direct style and broke new interpretative ground. He concluded with a stirring statement of his own aesthetic code, an eloquent argument for regarding Daumier as the sanest and most humane of realists, as "the very pinnacle of French genius" and the creator of a modern "language which is, in the most profound sense, our universal heritage."

Within both publications Phillips inserted an announcement of his "Plan and Purpose" for the gallery, followed by his plan for "The Phillips Publications." The latter now consisted of two series, the numbered monographs and a number of shorter essays by Phillips "on the art of painters, living and dead, foreign and American," which would give him the opportunity to declare his "faith in and . . . admiration for some living painters" whom he hoped to help "win the fame, esteem and influence they deserve during their lives." The formal monographs were to be on artists represented in the gallery, and Phillips anticipated using the formal publications as sources for reproductions and pamphlet-form essays, to be made available for teaching and study. (There was no mention of "The Herald of Art.")

In 1924, quite suddenly, we find Phillips beginning to come to terms with problems of abstraction and modernism in complete reversal of the stands he took from 1914 to 1918. Unquestionably, this change was the result of his immersion in the New York gallery scene as he built his collection, together with personal contacts he had with such artists as Prendergast, Davies, and Tack. In 1924 he published essays on Prendergast and Davies, held a small exhibition of Tack's latest (and most abstract) paintings, and published a review critical of the conservative stand taken by his friend Royal Cortissoz in his book *American Artists.*

The 1924 Davies essay, with its moderate criticism of Davies's late experiments, stands in sharp contrast to Phillips's 1916 judgment ("The [recent] art of Davies . . . is often a tragic sight to behold").[43] Again, the Prendergast article begins by asserting that the artist "proved that it was possible to be abstract in style and at the same time intimate in self-revelation."[44] The term *abstract* had shed its pejorative associations. The Tack catalogue essay goes farther, as Phillips for the first time pleads the cause for abstraction, leaning on an analogy with music: "People who will go to good music for spiritual nourishment and exultation . . . will yet demand of painting that it be illustrative or imitative and will turn in bewilderment from paintings which seek only to speak to their souls in the same musical way, the way of pure design, the way of ordered and varied rhythms, with organizations of mass and color and line instead of movements of sound. . . . The greatest thing art can suggest is the rhythm of life itself."[45]

Phillips found it a creative adventure to enter into and appreciate this new art, but the values he derived ("we may go either for rest and recreation, or for zest and stimulation; for seeing visions and for dreaming dreams") are described in terms curiously similar to those he used as an undergraduate in defending much more conservative paintings.

From the defense of abstraction Phillips went on, in his review of Cortissoz's *American Artists,* to defend modernism.[46] Although confessing that he himself found "most of modernist painting to date flat and unprofitable," he took the author to task for his conservatism: "Mr. Cortissoz . . . suggests that to see beautifully is not to see differently like the modernists but to see traditionally. . . . [He] really believes that beauty is ecstasy and . . . the self-sufficient reason for all art, he must know that beautiful creations are more likely to be inspired out of fresh and individual intensities of living which seek their own fresh means of expression than out of rearrangements and revisions of the art of the past."

Although Phillips was at the time too conditioned by traditional "beauties" to respond to the freshest of current expressions, he was committed to searching them out, for he believed that "there will emerge a few men of vision with signs and symbols of technical expression in the arts which will be the language of the new age." He was about to find them.

The year 1926 was a historic one for Duncan Phillips both as museum director and as critic. The gallery for the first time presented a schedule of monthly shows, each with a catalogue and essay by Phillips. His collecting continued apace, and with an extended dimension: forming a friendship with Alfred Stieglitz, he acquired works by artists of his "stable"—Marsden Hartley, John Marin, Georgia O'Keeffe, and Arthur Dove—in the process acquiring his first abstractions, Dove's *Golden Storm* and *Waterfall,* both of 1925 (cat. nos. 246 and 247), by an avant-garde painter. Then, in a flurry of activity, he completed and published *Collection in the Making,* the first catalogue of The Phillips Collection, which included introductory essays ("brief estimates") on 105 painters, with 144 illustrations.

In the preface and introductory sections of the catalogue, Phillips described the evolving concept and mission of the gallery. "*This is the record of the youth of an idea, the concept of a small, intimate museum combined with an experiment station*—and it represents the first stage in our progress toward the realization of an ideal."[47] He had taken a venturesome step in acquiring the paintings from Stieglitz and adopting the "experiment station" concept. He suggested several ways in which the gallery was experimental, including its showing paintings in unusual combinations and trying the work of "the lesser and younger men [by] an endurance test." His constant aim was "to interpret beauty in art whatever the manifestation and to gradually popularize what is best, more particularly in modern painting, by novel and attractive methods of exhibition." After railing against the intolerance of both the extreme traditionalist and extreme modernist, he spoke for the best in both schools while conceding that "for yet a little while it may be necessary to stress the tonic qualities of conventionalized simplification and the beneficent properties of abstract form and color." He warned that in the long run all methods of paintings become fashions, and his essential goal was to sponsor the individualist.

Given his long war against French modernism, it comes as a refreshing surprise to read that in reviewing his collection he decried the absence of "a number of brilliant European modernists," including Matisse, Pablo Picasso, and Georges Braque; meanwhile, he intended to encourage "the gallant tentative modern adventures on new trails by buying the works of our American modernists who are not yet fashionable, sensational and overrated." Marin and Dove, among others, were considered for exhibition units.

Phillips closed his introductory sections with a discussion of future plans, in the course of which he returned to his deeply felt concerns for education and the training of critics, but with new emphasis: "We wish to be a post-graduate supplementary school for students who are seriously planning to prepare themselves for art instruction. I can see the time when our Collection might be closed and all our resources devoted to a school for critics."

In 1926 Phillips himself had entered a new field of criticism in the small catalogues for what he termed his "modernist exhibitions," attempting to sort out and evaluate the tendencies of artists in two modernist groups.[48] The first included such artists as Charles Sheeler, Preston Dickinson, and Charles Demuth, who, Phillips wrote, had profited by cubism, adapting it to their modern age and setting, but tended toward excessive intellectualization and objectivity; the second, artists like Max Weber, Dove, Tack, and Hartley, were more lyrical in mood, more spiritual, "allied in a mutual desire to create a fresh and rhythmical language of form and color which will convey their emotions."

The year, for Phillips, was one of discovery and bold reassessments. In a press release dated December 14, 1926, he announced a forthcoming Marin show with the assertion, "The greatest American painter of this period may well be the watercolor virtuoso John Marin."[49] He also announced the purchase of two Bonnard paintings, terming the artist "the greatest living painter"—a characterization reflecting the broadening of Phillips's interests as he began to place the work of the younger Americans within the perspective of the wider horizon of Europeans.

A Critic Still in the Making, 1927–31

In 1929 Duncan Phillips published a short account of the gallery entitled "A Collection Still in the Making."[50] In fact, not only the collection but the gallery, its programs, and its director were still developing significantly. In the five-year period from 1927 to 1931, Phillips acquired an average of more than forty paintings a year. For the 1926–27 season alone, he listed fifty-two acquisitions and began to collect examples of the modern French school, including Braque, Matisse, and Picasso. In the same five-year period he published two books, four *Bulletins*, two issues of the journal *Art and Understanding*, and a number of catalogues and articles. Exhibitions grew in number and size as the Phillips house was expanded and more rooms were converted into galleries. As the gallery grew, its concept evolved: in 1929 Phillips began to refer to it as a "museum of modern art and its sources."[51] It is against this broadening scope of objectives and activities that we must consider Phillips's own growth as a critic during this period.

It seems at first curious that in 1927 Phillips chose to republish his 1914 *Enchantment of Art*, in which he had belittled Gauguin and van Gogh, viciously attacked Matisse, and attempted in lengthy articles to demonstrate that Monet should not be called an impressionist. A close look at the revisions of the new edition, however, reveals significant changes. Nearly a third of the first volume is missing. He cropped and eliminated some essays and substituted others that well represented the sensitive, perceptive insights and eloquence of the youthful critic. The reissued volume, in short, allowed him to preserve the best of his early writing and to include an apology for and review of his changes in taste and perception—a coming to terms with his reversals in judgment.

His six-page introduction is one of Phillips's key essays. He vividly characterizes the strengths and weaknesses of his "youthful exercises in expressive sensibility" and admits that "I liked extravagantly a few painters and writers whom I now consider mediocre and I did scant justice to other painters and writers who now seem to me great artists. . . . Post impressionism had upset my newly acquired and profoundly cherished standards of value."[52] And so, "to the charge of inconsistency I plead guilty, but it does not trouble my conscience. Consistency from youth to middle age is at best a stiff-necked virtue."

In the introduction Phillips included a discussion of his changing concept of impressionism. "I was apparently embattled for the

idea that impressionism means all potentially aesthetic sensibility. . . . What I meant by impressionism is true to a greater extent of what is now called expressionism. In other words, the urge to unburden oneself of beauty applies less to the sensations themselves than to arbitrary and unrepresentative concepts based on sensations." Phillips admitted that he had not previously been prepared mentally "to make room for both subtlety and extreme simplification . . . on the one hand and austere intellectual structure on the other." He had loved rhythm but "did not understand that it must be valued also as . . . the *means* . . . to produce the very emotions which had stirred me to the depths." He had, however, been right in being inspired by "the miracle of truth and the romance of personal visions which prompted me to a book in praise of mingled conviction and enchantment."

Phillips wrote that he republished the book in order to preserve some of his enviable youthful ardor while providing, through inserted dates and revisions, the suggestion of "the gradual unfolding of critical faculties. From desire merely to communicate to others my own special and limited enjoyments I have in due time graduated to a sharpened consciousness of the need for understanding the artist's methods, and an even greater need to open the door of the mind to many different kinds of aesthetic expression."

Phillips's catalogues dating from 1927 included *An Exhibition of Expressionist Paintings from the Experiment Station of the PMG*, a title which reminds us that most of his exhibitions of that year were, in a sense, tests or experiments. He sent to Baltimore an exhibition of "American Themes by American Painters," conceived as a demonstration of the independent character of American art.[53] A gallery exhibition in November, termed "Intimate Decorations, Chiefly Paintings of Still Lifes in New Manners," was revealing in both its essay and content.[54] Phillips wrote that artists were "increasingly using still life not for mere imitation of objects but as a vehicle of personal expression. The expression, to be sure, is not meant to be profound. . . . But decoration is, or should be, an expression of the artist." By the term *decoration* Phillips implied the use of abstract means, and in his essay he once again advised that modernism ran the danger of becoming a mere fashion, so the exhibition was presented in part as a warning. At the same time, it afforded him the opportunity to show some of his recently acquired modernists, including Matisse, Braque, Walt Kuhn, Hartley, O'Keeffe, and—surprisingly—Phillips himself, a truly dedicated experimenter!

Phillips's exhibition for December 1927 was called "Leaders of French Art Today."[55] His catalogue essay began with the assurance that he remained loyal to the cause of American art, which had suffered unjustly in the past. But he had been "sobered into a renewed respect for the apparently continuous mastery exercised by the French in the plastic arts." (In the long run, he assured the reader, America would come into its own, true to itself, and would prevail.) He then launched into a concise account of French modernism that

was fairly well balanced but that betrayed annoyance with the excesses of the early years of the century, including cubism. In evaluating the current artists, he leaned heavily on a distinction by Jan Gordon between "artists driven by an inner urge" and those for whom skill outweighs spirit. Phillips placed Bonnard in the first category and Matisse, Picasso, and Braque in the second—thus sending a signal that although he admired the artists and purchased their paintings, he reserved the right to pass judgment. Then, surprisingly, he paraded the latest work of Andre Derain, in whose new classicism he saw "a sudden emergence . . . from the modernist academy," combined with "a passion of human utterance" that ranked him among the very greatest artists. Phillips still had reservations about modernist art and the stature claimed for its leaders.

The exhibitions of 1928 featured surveys that were more conservative than those of 1927. For "A Survey of French Painting from Chardin to Derain," Phillips wrote an essay which began with a defense of his romantic position against the formalist doctrine just advanced by R. H. Wilenski in *The Modern Movement in Art*.[56] He concluded by closing the loop of the French "modern" development with a tribute to Derain, who had "justified the eclectic experiments" of modernism by assimilating them in a return to classicism. Phillips's two American shows, one of "Old Masters" and the other of "Contemporary American Painting," were relatively conservative.[57] "Contemporary" here meant twentieth-century in spirit rather than modernist, and the Stieglitz group was omitted "for lack of space."

It is tempting to judge Phillips's development as a critic solely by his acceptance of modernism, but this is to do him an injustice. He was quite right in sensing that modernism as a cult had the limitations of academicism and that it was his mission to keep watch for the independents. He was beginning to take special pride in the gallery's open-mindedness and tolerance. This attitude involved broadening his search without lowering his standards and is reflected in his generous review of the "Second Annual Exhibition of the Washington Independents": "It has been sufficiently demonstrated that such exhibitions are not only a necessity if there is to be fair play, but also if undeveloped or neglected talent is worth discovering."[58] Only three years before, in a letter to the same magazine, Phillips had condemned similar "Independents" as encouraging "mediocrity and madness, ignorance and sham."[59]

Phillips's exhibitions for 1929 and 1930 continued to consolidate his position. He displayed the works of Davies, John Graham, and Karl Knaths, as well as the newly completed series of "Decorations" that Tack had prepared for the Music Room. In 1930 an exhibition in the Main Gallery called "Sources of Modern Art"—a term similar to the one Phillips had just hit upon to describe his gallery, Museum of Modern Art and Its Sources—was more a quick survey than an exposition of the theme that was emerging as central to the entire collection.[60]

In his introduction to the reissue of *The Enchantment of Art*, Phillips had warned that he had a book on aesthetics "smouldering at the back of my mind."[61] Sparks from that source glow in essays in two new publication projects: a biannual magazine, *Art and Understanding*, 1929, and a two-volume "de luxe" edition of his essays together with illustrations of the works in the collection, *The Artist Sees Differently*, of 1931. The first was a realization of his long-held dream of a magazine that would both review events at the gallery and also treat broader subjects in art. In the flyer announcing the first issue (November 1929) he wrote, "We believe there is need in this country for an absolutely independent, unprejudiced and disinterested magazine relating art to life, and the present tendencies in art to the traditions and the standards of its historical past. If the public response to *Art and Understanding* in its first year justifies our hope, the magazine will be continued and will appear twice each season." The fall of 1929 was an especially bad time to launch a new venture and to appeal for support. Only two issues appeared.[62]

The lead article in the first number, titled like the magazine "Art and Understanding," set the goal for the publication and sketched Phillips's aesthetic credo. The goal may be summed up as bringing the public and artist closer together by the increase of mutual understanding. He offered advice to artists but out of profound respect for individualism concluded that they must be allowed to be "true to themselves"; the public must be prepared to go more than halfway.[63] Somewhat paradoxically, he saw the potential of art to help bring about a new age ("Art is the greatest unifying . . . force of the universe"), while at the same time declaring that "art is independent of all other activities and . . . has its own pure and disinterested emotional significance." His personal and social idealism led him to conflicting positions; he called for the greatest tolerance for individual differences but also desired six qualities in art: "cultivated sensibility, self reliance, self discipline, tolerant humanity, universality, and essentialism." Such qualities help reconcile art and public, and "since art is synonymous with the proper functioning of human life it is a universal human concern." This relates to his definition of art: "the one method of communication which is also a symbol of life itself, of life with its rhythms and its complexity of independent relations."

In the second issue of *Art and Understanding* we first find the influence of C. Law Watkins, Phillips's longtime friend whom he had recently appointed associate director of education. The two joined in writing "Terms We Use in Art Criticism," which included a clear summary of Phillips's continuing ideas and feelings about *modernist, modernistic, classic,* and *romantic*.[64] In the issue's lead article, "Modern Art, 1930," Phillips surveyed the rapidly changing art scene and reaffirmed his principles.[65] He had been thrilled by the public response to the exhibition "Painting in Paris" at the Museum of Modern Art in New York, but he feared that the new art forms were becoming modish. Matisse and Picasso were fittingly

"leaders attuned to their time," and he conceded Picasso's genius: "The only doubt is in regard to the results of his influence." What Phillips deplored was that the fashion of the time had no taste for "the sensitive lyricist, affected by light and atmospheric colors, using them as instruments of emotional expression." In his view, nonconformists like Bonnard, Marin, and Tack would prove in the future to have been the genuine modernists.

By the end of 1931 Phillips had put in six years of prolific writing and of grudging acceptance of modernism. To be sure, in comments on the individual pictures he had acquired to represent the avant-garde—works by such painters as Matisse, Picasso, Braque, Dove, and Stuart Davis—he often reflected keen appreciation and delight. At the same time, his critical evaluations of the movement betrayed a continuing discomfort, and his two principal publications of the year, *The Artist Sees Differently* and a *Bulletin*, bear this out.

The two volumes of *The Artist Sees Differently* had appeared after some delay. The text consisted mostly of previously published essays, and these, in turn, were repetitive—as Phillips himself confessed—both in thought and expression. The title essay begins with a personal lament that the individuality he adheres to had gone out of fashion, then turns to his main theme: "the artist sees differently from the man of practical behaviour. . . . On his way through the world he really takes time to look at it with rapture and wonder."[66] Phillips cited Roger Fry as supporting this view, which had actually been his own since his college days and was expressed fully in his 1912 essay on "The Impressionistic Point of View."

The *Bulletin* of 1931 had, as its centerpiece, a thirty-six-page essay on "The Modern Argument in Art and Its Answer." Essentially, Phillips repeated his position that predominately formalist modernism is devoid of life; the isolationist aesthetic lacks human relevance. His discussion placed special emphasis on light, which is "synonymous with other universal needs"; therefore, "the most convincing abstractions . . . are the interpretation of material things essentialized and revealed by various degrees of luminosity."[67] His discussion also turned to Helen Parkhurst's *Beauty: An Interpretation of Art and the Imaginative Point of View* and gave new significance to the role of art in "resolving and perhaps unifying the discords or at least the divisions of personality." This led to his conclusion that "if art is a resolver of conflict, then the essential feature of aesthetic emotion should be its happy inclusion of elements which are in themselves contradictory." The concept of art as the resolution of conflict was to appear frequently in later writings.

The Depression and the War, 1929–45

During the period 1929–31 the Memorial Gallery and its programs rounded out dramatically. The staff and collections grew, the building was enlarged and turned over entirely to gallery purposes, exhibitions increased in size and number, and major publications (the

magazine *Art and Understanding* and the two-volume *The Artist Sees Differently*) were produced. By 1931, however, the Depression was taking its toll, and the gallery was forced to curtail hours in 1932–33. Both gallery and director entered a new phase. There were fewer purchases and publications; many exhibitions had no printed catalogue. On the other hand, the gallery had expanded to contain a school (under the directorship of C. Law Watkins, a painter and former Yale classmate of Phillips's), and Phillips himself was much engaged in a variety of public activities, from giving lectures to serving as chairman of the Regional Committee of the Public Works of Art Project. Concurrently, he engaged in a long-term scholarly endeavor that culminated in 1937 with his publication of *The Leadership of Giorgione.*

The season of 1933–34 featured an exhibition entitled "Freshness of Vision: Where the Spirit of the Expression Invents Its Own Means."[68] It was a theme Phillips frequently returned to as a test of an artist's creativity. From the brief catalogue we learn that the exhibition contained groupings in eight galleries plus stairways and halls; both gallery-owned and borrowed works were hung, and rooms were devoted to Tack, Charles Burchfield, and Louis M. Eilshemius, the latter a recent discovery. Phillips was to collect few primitives, but he showed an ongoing enthusiasm for Eilshemius and Henri Rousseau.

The American Magazine of Art for February 1935 contained the first of three installments of Phillips's article "Personality in Art: Reflections on Its Suppression and the Present Need for Its Fulfillment."[69] The subject was one of continuing concern for Phillips, and he treated it frequently in lectures during the following years. He restated and amplified his aesthetic position, without essentially changing it, and he did so in response to impulses coming from two very different sources: John Dewey's recently published *Art as Experience* and Thomas Craven's journalistic attacks on aestheticism and modernism in general.[70] Dewey had reinforced Phillips's own objections to what he had seen as an untenable isolationism in Roger Fry's definitions of aesthetics and pure form. Phillips believed that human personality and expression were suppressed in cubism and formal abstraction. On the other hand, and at the other extreme, personality was also suppressed in the reactionary movement of realism and regionalism that was sweeping the country, championed by Craven.

Because individualism implies differences and complete freedom of choice, no movement—either abstract or realist—could be put off limits. Faced with this apparent paradox, Phillips adopted an answer provided by Dewey, stating that "both abstract and concrete in art are completely justified at those rare moments when art achieves its essential unity: when what is said, Substance, and the manner of saying it, Form, are made one and indivisible in Self, and when the object created is made induplicable and unique, through complete identification with that third factor in the triad—namely the Artist and his inner life." Phillips concluded, "The union in art of both substance and form not only implies personality but is inconceivable without it. Art is the language of personality, and if personality is suppressed, then it follows that art will be suppressed also."[71]

In subsequent writings, Phillips carried this idea further: "Greatness of art occurs when a fusion between the artist and his art is really consummated and when the result conveys at least a hint of universal truth. . . . Great art implies great personality in the artist."[72]

The slightly earlier essay "Personality in Art" ends with an urgent call for the survival of individualism in a threatening age. "Since individualism as an economic phase is almost certainly due for an eclipse, and since collective social planning is already under way, it is the high mission of art today to see to it that personality is not suppressed. Art must be the last stand, as it is the eternal stronghold, of the individual."[73] He was to repeat this call again and again as war threatened and finally became a reality.

"Personality in Art" provided Phillips with a rationale for his personal preferences and evaluations, and it was his last major foray into theoretical aesthetics. It would appear that as he became more secure in his own philosophy, he became less concerned with ranking and condemning artists and more inclined to express frank appreciation for a variety of expressions, concluding that there was no single standard for art.

While writing "Personality in Art" in the mid-1930s, he was also at work on a volume completely detached from the current art wars but equally concerned with individualism. *The Leadership of Giorgione* attempted, by means of sensitive aesthetic probing, to reveal a historical personality and trace the "modern" spirit in art to its source. His starting point was strikingly similar to that of his 1913 essay on the artist as it appeared in *The Enchantment of Art* and in the 1927 reissue of that book. His scholarship, of course, was deeper, and he appraised the artist in the terms of his mid-thirties aesthetic viewpoint, stating that Giorgione "was the first single-minded independent in the history of pictorial art . . . [and] the first proponent of art for art's sake. . . . Giorgione as a sheer painter deserves to rank with the greatest but he was even greater as an artist and as an affirmative non-conformist, as an isolated, inventive phenomenon whose genius for emotional suggestion, conveyed through colors and lines, prophesied the nineteenth and a vital phase of the twentieth century."[74]

In the war-torn world of the 1940s, Duncan Phillips's speeches and writings were understandably involved with the role of the arts in wartime. Concurrently, his active presentation of exhibitions reflected his belief in the importance of the spiritual refreshment art provided a tense and distraught society. Speaking under the shadow of the Battle of Britain in 1940, he declared, "Business as usual? Emphatically no! But art as usual? For as long as we can, yes."[75] He pleaded that "we must see that the Government's assistance to the artists is made permanent, and that it is supplemented by . . . an ever renewed cultivation of the art of understanding and enjoying art.

But we must do more than that. We must see to it that the artist's sincerity is expected from him and that his unique difference of often non-conforming personality is reverenced and welcomed[,] not suppressed."

Appropriately enough, for the 1940–41 season Phillips presented a loan exhibition by Georges Rouault. In his accompanying *Bulletin* article he wrote, "Seen against the fiery background of the second World War, we can read in the paintings and prints of Rouault a sorrowful exposure of human cruelty and a penitential meditation upon the agonizing repetitions of Calvary." Phillips was so deeply affected that he proclaimed Rouault "perhaps the greatest artist now living."[76]

In 1941 Phillips, together with Watkins, presented a major exhibition on "The Functions of Color in Painting.[77] He also found justification for color stridencies in contemporary painting because the "factors of a crisis in civilization are often manifest in a cacophony of color." Picasso's aggressiveness fitted the times: "the terrific force of Picasso's inspired sketch Bull Fight is a dynamic calligraphy."

The war years deepened Phillips's commitment to his long-standing belief in the importance of both individualism and universality. A catalogue essay of 1944, accompanying an exhibition of "The American Paintings in the Phillips Collection," bears this out.[78] An international humanist by education and temperament, he had always enjoyed juxtaposing paintings of different epochs and schools, but during the first years of his gallery he had been especially concerned with advancing the cause of American art. Then, in the later 1920s (as he confesses in the 1944 essay), his eyes were opened to "the distinction of our brilliant French contemporaries," and he became a lifelong internationalist—to the extent that he almost apologized for finally staging an all-American show. However, he stated, few people realized that American art constituted the majority of the collection, and moreover American art was becoming very international by virtue of the artists arriving from Europe. "We are now assimilating world-wide aesthetic ideas."

Summings Up, 1946–66

Duncan Phillips's final twenty years were marked by continued explorations, exhibitions, and acquisitions, but they still may be characterized as a period of summings up. The war had ended, and also an epoch was ending. His writings of the mid- to late 1940s included essays following the deaths of men who had influenced him deeply: C. Law Watkins, Henri Focillon, Arthur Dove, Alfred Stieglitz, and Pierre Bonnard. There followed a period of summaries of the gallery (which was renamed The Phillips Collection in 1961): first, a review and classification of holdings in his extensive catalogue of 1952; then, in magazine articles and television programs, a series of overviews placing the collection squarely on the national stage.

Before Focillon's death, Phillips had come to know the brilliant Frenchman well and admire him greatly. In writing the memorial tribute, Phillips acknowledged Focillon's importance.[79] Later he found that *Life of Forms in Art* had confirmed and expanded his own insights into "the transitional stages of the life of forms" and "the most significant families of artists," themes that had preoccupied him for years.[80]

The introduction to the 1952 catalogue, *The Phillips Collection*, serves as a relaxed and gracious summary of the museum's history and purpose, and of Phillips's philosophy. A catalogue had long been needed, he wrote, but the collection's "formative and malleable" nature had caused him to defer the task. His museum was unique in its mixing periods and nationalities of art in its galleries, "the better to show the universality of art and the continuities of such ancient seeing habits as realism, expressionism and constructivism."[81] As a "museum of modern art" he included his "heroes of evolutionary progress" (the list begins with Giorgione, El Greco, and Chardin, and ends with Picasso, Braque, and Dove). He was "intensely interested . . . in all the functional forms and spatial intervals, the challenging self-sufficiencies and stimulating shocks of art today," but purchased only what he found "sound, sincere and original enough . . . to exhibit as new life springing up from old roots." He freely confessed that his choices were personal: "Encouragement for the lone individual is the hot spot of my endeavors in the world of art and that implies a wide and tolerant acceptance of a many-minded art for a many-minded world, with the reservation that I will buy and exhibit only what I can genuinely respect and enjoy." The resulting collection, he concluded, was "made with enjoyment for the enjoyment of others."

As a collector, his actions fitted his words, and he sought new work that he found personally appealing. In the forties, he discovered and patronized Morris Graves; in the fifties, he found fresh enthusiasm for the work of Theodoros Stamos, Nicolas de Staël, Richard Diebenkorn, and Mark Rothko. Phillips long had been drawn to abstract art that, like Tack's, moved him spiritually, and the abstract-symbolic paintings of Graves struck such a chord. Phillips first came across Graves's work in 1942, during the stressful days of the war, and he perceived in the artist an aspiration "to help in healing the wounds of the war" through an art form that bonded the spirits of the East and the West.[82] Rothko's work affected Phillips similarly: the surfaces and abstracted forms rewarded a deep contemplation. In consultation with the artist he installed his Rothko paintings in a small, chapel-like room, which became the inspiration for Rothko installations elsewhere, including the Rothko Chapel in Houston.

In his last critical writings, Phillips attacked no artists or schools, but he continued to stand firmly by his principles, advocating tolerance for completely free expression but reserving the right to make choices based entirely on his personal responses. In 1953–55 he repeated his beliefs forcefully in articles, a radio talk, and a catalogue foreword. The fullest exposition of his viewpoint came in a 1953 "editorial" entitled "The Critic: Partisan or Referee," appearing in the

Magazine of Art, where he stated that a critic is unqualified "unless, without any need to conceal his personal preferences, he can be tolerant and fair to other points of view than his own."[83] Phillips goes on to say that "there cannot be one standard for all art" and acknowledged, "I am attracted to qualities of contemporary art precisely because they thrill me with refreshing differences from any qualities I have cherished before." Somewhat paradoxically, he then asserts that "the continuity of tradition is my most compelling interest in forming and interpreting a collection of modern art and its sources."

There is a significance in this paradox: Phillips's divergent interests came together in the perceptive taste of the collector-critic: "Rec-

onciliation of opposites is our unfinished business in the modern world, and unification through synthesis is the world's still-distant goal." He looked longingly for the rebirth of the "impressionism" he loved, a "lyrical realism," while proclaiming admiration for "the aesthetic interpretation of the age we live in—even the symbols for the anarchy, the turmoil and the inner tensions." The result, as he realized, was that the unique achievement "of The Phillips Collection is that the diversity of styles, with a chosen standard for what I consider the best of each style, results not in eclecticism . . . but rather in an intimate unity of effect." And, in sum, his unique collection was the signal achievement of the lifelong dedication of an evolving critic.

The true artist needs a friend and the true patron of art has nothing better to give the world than the helping hand he extends to any lonely, lofty life made perilous because a free spirit cannot or will not see eye to eye with the crowd.

Duncan Phillips, "A Collection Still in the Making,"
The Artist Sees Differently (1931)

A COLLECTION IN THE MAKING

GEORGE HEARD HAMILTON

Duncan Phillips seems always to have been interested in art. His childhood memories included the academic paintings in heavy gold frames that hung in his grandparents' Pittsburgh home, remembered at least enough to know he disliked them.

While at Yale, he served as an editor for the *Yale Literary Magazine* and published essays on the arts and literature. His essay on Camille Corot still reads well, and is no worse than papers written by undergraduates who have had the advantage of instruction in art history and criticism, which Yale at that time did not provide.[1] It is doubtful that Phillips had even seen the paintings he discussed with considerable skill. Yale did have a distinguished English department, staffed with professors such as Chauncey Brewster Tinker, John Berdan, and Charlton Miner Lewis; their teaching encouraged Phillips's love of literature and creative writing, as well as an appreciation for the many ways art enhances the beauty he found in life.

In June 1907, at the end of his junior year, he published in the *Lit,* as it was known, a six-page paper calling the authorities to account.[2] "The Need of Art at Yale" is a reasoned plea for the creation of a course in art history that would prepare students for the enjoyment of "this wonderful, beautiful, plentiful world of ours." He also believed that "to know the great pictures and the great sculpture of the ages, not only adds to the pleasures of travel, but is invaluable to the formation of a respectable standard of public taste." These generalities were supported by acute observations, the more remarkable because he could have known very little about the teaching of art history. But he was aware that the student must see original works of art. He also knew that photographs and lantern slides, the art historian's primary tools, "however good, can give in painting no idea of manner, and a but faulty idea of matter."

After graduation in 1908, Phillips returned to Washington to live with his parents and to prepare himself for a life in "literature"[3] (fig. 11). By 1914 he and his brother, Jim (James Laughlin Phillips), had an apartment in New York at 104 East Fortieth Street. Duncan continued to read widely and to study pictures, while his brother, who had been a classmate at Yale, soon became interested in politics. In 1912 James was appointed assistant treasurer of the Republican Party and actively participated in President Taft's unsuccessful cam-

paign for reelection. These were also the years when Duncan Phillips traveled widely, visiting Japan and China with his family in 1910 and spending the summers of 1911–13 in Europe, principally Belgium, England, France, Germany, Italy, and Spain.

During these years Phillips wrote a number of theoretical and critical essays on painting and poetry, and his interests in the two arts became increasingly intertwined. Some of the essays—"Giorgione: The First Modern Master," "Tintoretto," and "Velasquez: 'The Enchanter of Realism'"—are early indications of Phillips's turning to the classical tradition in search of artistic continuity, which he would later call "the sources of modernism."[4] His examination of Jean-Baptiste-Siméon Chardin preceded by seven years his purchase in 1919 of *A Bowl of Plums,* Phillips's first indisputably fine Old Master painting.[5] "The Lyrics of Robert Bridges" indicates that he was aware of contemporary British poetry.[6] Other subjects, such as "George Moore," concerned a man of letters, but one who was also a critic of what he chose to consider "modern art"; this essay allowed Phillips to indulge himself in speculating on the degree to which poetry and painting can be considered interchangeable artistic experiences.[7] The Horatian dictum *Ut pictura poesis* ("as with poetry, so also with painting") was to tantalize Phillips for the next ten years at least and was inextricably a part of his art criticism, expressed as early as 1913 in an essay on Walter Pater: "We must not go to Pater for instruction nor for edification. We must go to him as we go to Giorgione, Chopin, and Debussy for the delicate beauty that will charm and soothe us and gently minister to our passing moods."[8] Music has now been added to the mixture, which if frozen would lead us to Ruskin's definition of architecture. But Ruskin is rarely, if ever, mentioned in Phillips's critical essays. In 1937 he wrote of Giorgione: "It was his destiny to make a unique aesthetic contribution. He invented the painted lyric."[9] A decade later Phillips would acknowledge that in his early years he had too often tried to read a painting as if it were the visual equivalent of poetry or prose, as if the structure of a work of art could be literally re-created in words. In 1946, however, he asked rhetorically, "how much like poetry or music or geometry or pure logic can a painting be without ceasing to be a painting, and is it not so no less with poetry?"[10]

From our vantage point near the end of a century of modern art and modernist criticism, it is tempting to wonder how a young man so obviously left to his own devices created and sustained the vision necessary to build The Phillips Collection. The answer, at least partially, lies in the intensely personal delight with which Phillips responded to encounters with works of art, whether poetry, writing, music, or painting. Similarly, when his responses to art were negative, they could be just as revealing in their intense vehemence. Reacting to the 1913 Armory exhibition, he called Henri Matisse "poisonous," a person who "creates patterns unworthy of the mere ignorance of little children and benighted savages, patterns not only crude but deliberately false, and insanely, repulsively depraved." "The

Fig. 11 Duncan Phillips, ca. 1908, the year he graduated from Yale University.

Cubists," he wrote, "are simply ridiculous," and he termed the exhibition "stupefying in its vulgarity."[11] Despite the agitated nature of this early condemnation, Phillips's love of art (and through art, life) is implicit, if only negatively. This sentiment, that art is one of the essential means of sustaining a moral or spiritual life, is expressed positively in the title, as well as the text, of his collected essays: *The Enchantment of Art: As Part of the Enchantment of Living.*[12]

Duncan and James Phillips had stayed close after their days at Yale, and they shared interests in art which they satisfied by frequenting New York galleries and museums. By 1916 their developing enthusiasm led James to ask their father to set up a fund—he suggested $10,000 annually—for the purchase of art.[13] Although it is difficult to identify with any certainty how many paintings the brothers acquired together before James's death in October 1918, twenty-eight works still in the collection are known to have been acquired before that date.

In 1917 Duncan Phillips was elected to the Century Association in New York, nominated by Augustus Vincent Tuck and Samuel L. Parrish. Founded in 1847 by members of the Sketch Club as a more formal organization of artists who enjoyed sketching during "rambles" in the countryside, "the Century" counted among its members several of the most prominent American artists of the later nineteenth century, among them Winslow Homer, John Singer Sargent, and John La Farge. By the time Phillips was elected, he had met artists such as Gifford Beal, Arthur B. Davies, and Julian Alden Weir, who shared with

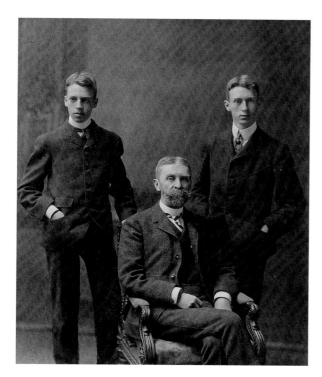

Fig. 12 Duncan and James with their father, Major D. C. Phillips, ca. 1900.

him the technical and formal language of the studio. The list of works by Centurions purchased by Phillips early in his career amounts to some seventy paintings and includes works by Davies, Weir, Beal, William L. Carrigan, Paul Dougherty, Tack, and Robert Spencer.

An early acquisition list entitled "15 Best Purchases of 1918–19" offers a glimpse of Phillips's preferences at the time, after fate had forced him to act on his own; it also shows the didactic intentions that led him to acquire certain European works as examples against which to measure the best in American art.[14] It includes Chardin's *A Bowl of Plums*, Henri Fantin-Latour's *Dawn*, and *The Road to Vétheuil* by Monet. The second section of the list, "15 Best Purchases Since Jan. 1920," includes Pierre Puvis de Chavannes's *The Wine Press* and Fantin-Latour's *Manet in His Studio*. Of the twenty-seven paintings listed, nineteen are by Americans, including three by Weir and two each by George Luks, Albert Pinkham Ryder, Spencer, and John Henry Twachtman. All but one are still part of The Phillips Collection.

The Early Collection, 1918–26

In the introduction to his 1926 book *A Collection in the Making*, Duncan Phillips cites a certain therapeutic value in creating his gallery after the severe trauma of losing two family members in little more than a year (fig. 12): "I incorporated the Phillips Memorial Gallery, first, to occupy my mind with a large, constructive social purpose and then to create a Memorial worthy of the virile spirits of

my lost leaders—my Father, Major D. Clinch Phillips—an upright, high-minded, high-spirited soldier, manufacturer, and citizen, and my brother, James Laughlin Phillips, who was on his way to the heights when death overtook him."[15] Major Phillips died suddenly in 1917, and James died in October of the following year, a victim of the influenza epidemic. At the time of his brother's death, Phillips was already committed to organizing the Allied War Salon for the American Art Galleries, and he threw himself into his work, both to fulfill an obligation and to distract himself from his grief.[16] The exhibition featured 664 entries and was sponsored by a committee that included Charles Dana Gibson, Albert E. Gallatin, and Tack. There is no indication of lenders in the catalogue, but at least two works belonged to Phillips: *Blue Devils on Fifth Avenue* by Luks and *Knitting for Soldiers* by Weir.

By the end of 1920, after a period of intense activity during which he acquired more than seventy works of art, added a skylit gallery over the north wing of his home (now the Main Gallery, fig. 13), and incorporated his museum on July 23, Phillips announced in a newspaper article that, together with his mother, he had conceived the idea of establishing a memorial gallery dedicated to the memory of his father and brother.[17] In order to generate public interest, he exhibited works from his collection—in New York, at the Century Club (May 1919) and Knoedler Gallery (summer 1920), and in Washington at the Corcoran Gallery of Art (March 1920). Very little documentation remains from the small Century exhibition of 1919, but it is safe to say that it reflected Phillips's favorites from the "15 Best Purchases of 1918–19" list.[18] The Washington exhibition was entitled "Selected Paintings from the Collections of Mrs. D. C. Phillips and Mr. Duncan Phillips."[19] Bernardo Bellotto's *A Town Near Venice*, Chardin's *A Bowl of Plums*, Adolphe Monticelli's *As You Like It*, and two works by Fantin-Latour, *Dawn* and *Manet in His Studio*, provided a traditional counterpoint to more recent European paintings, such as Claude Monet's *The Road to Vétheuil* and Ignacio Zuloaga's *Girl of Montmartre* (purchased from the artist during Phillips's 1912 visit to Spain). The remaining fifty-two paintings were all by American artists, and the most contemporary of these were members of The Eight, often known as the Ashcan School. John Sloan's *Clown Making Up*, three paintings by Luks, and Maurice Prendergast's *Autumn* were included, as were six paintings each by Ernest Lawson and Weir. In juxtaposing examples by European masters with works by prominent Americans, Phillips created his own definition of artistic achievement, independent of geography and nationality, and established the essential character of his collection.

Phillips held another exhibition at the Century Association in late fall 1920. Initially consisting of forty-three works (he added two recent purchases before the close of the exhibition), "Selected Paintings from the Phillips Memorial Gallery" illustrated, in Phillips's words, his "enthusiastic purpose" of revealing "the richness of the art created in our United States, to stimulate our native artists and

afford them inspiration."[20] Puvis de Chavannes's *The Wine Press* and John Abbott McNeill Whistler's *Miss Lillian Woakes* were accompanied by two landscapes by Davies, *Along the Erie Canal* and *Springtime of Delight,* as well as the newly acquired Luks portrait, *The Dominican.* Two new Weirs, *Roses* and *An Alsatian Girl,* both acquired in 1920, rounded out the American works. With these exhibitions, Phillips edited his collection and took first steps to formulate his vision of the museum as a collection of contemporary art.

Although he lived in Washington from about 1919 on, Phillips still had a New York residence until 1921, when he rented office space at 21 East Fortieth Street, and he maintained close ties with many members of the Century. This connection to New York is apparent in the list of men and women he proposed for the Advisory Committee on Scope and Plan for the Phillips Memorial Art Gallery.[21] The committee, which seems to have met only twice, existed for the exchange of ideas that would support and encourage the collection's development. Among the twenty individuals invited, five were artists: Marjorie Acker, Beal, Dougherty, Tack, and Mahonri Young. Members of the Century were prominently represented: Frank Jewett Mather Jr., a critic and professor of art history at Princeton University, who remained Phillips's friend for many years; Charles Moore, acting chief of the Division of Manuscripts at the Library of Congress; William Mitchell Kendall, a partner in the architectural firm of McKim, Mead & White; Arthur N. Fuller, Tack's nephew; and John F. Kraushaar and Frank K. M. Rehn, New York dealers who specialized in American art.[22]

Phillips invited six women to hold positions on the committee. In addition to Acker were Mrs. Dwight Clark (whose husband served as treasurer of the gallery) and Dorothy Weir (daughter of J. Alden Weir, who would soon marry Mahonri Young); they were no doubt invited for social as well as artistic considerations. Elizabeth Hudson, a friend of the family, was well known for her charitable work. Leila Mechlin, a Washington critic, was the secretary of the American Federation of Arts, and Katherine Rhoades served as curator at the Freer Gallery of Art. Although several of the artists on his committee enjoyed substantial reputations, none could be considered leading practitioners of modernism, and the spectrum of beliefs and critical ideas, led by Mather and Mechlin, alternated between the poles of moderate and conservative thought.

Phillips had met Acker, a student at the Art Students League in New York, after her uncle, Gifford Beal, sent her an admission card for Phillips's 1920 Century exhibition. They were married October 8, 1921 (figs. 14 and 15). Marjorie Phillips painted throughout her life, and her influence on her husband's appreciation and collecting of art was profound, as he never ceased to acknowledge. She was his closest companion and adviser in the development of what became their collection; she served as associate director, and after her husband's death in 1966 she became the director of The Phillips Collection until her retirement in 1972.

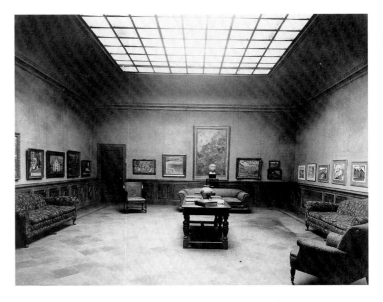

Fig. 13 The Main Gallery of the Phillips Memorial Gallery, 1927.

The Phillips Memorial Art Gallery opened in the family residence, without fanfare, in late fall 1921. On January 3, 1922, Phillips wrote formal letters of announcement to the Washington newspapers, stating that the gallery "will open to the public from February 1st to June 1st on Tuesday, Thursday, and Saturday afternoon."[23] By May 22, Phillips had in his hands a plan and elevation for a new museum, designed by William Mitchell Kendall of McKim, Mead & White. Italianate in character and corresponding closely to Phillips's initial conception of a "memorial," it was rejected as too formal and institutional. Instead, Phillips drew his own vision in a journal, outlining his plan for a new public gallery to be built on a nearby site, where the Washington Hilton Hotel now stands (see fig. 10). Intermingling furniture and art within a series of galleries and alcoves, he envisioned a harmony between the architecture and works of art in each room. This earliest conception of what Phillips would eventually describe as "exhibition units" can be seen in his dedicating entire rooms to individual artists, such as the "Davies Library/Galleries," the "Tack Hallway," and the "Prendergast Library Galleries."[24] Although Phillips still referred to his building plans in 1927, the museum was never built, perhaps because of the enormous sums spent on acquisitions, perhaps because of the oncoming depression; it is also possible that the collector's vision for the museum had changed and that he began to cherish the domestic setting of the family home. In any event, in 1929 Phillips built a new residence at 2101 Foxhall Road, allowing the original mansion to be converted entirely into a museum, thus guaranteeing the intimate character he desired.

During the four years following the museum's opening until

Fig. 14 Duncan Phillips, 1922. Photograph by Clara E. Sipprel.

Fig. 15 Marjorie Acker Phillips, ca. 1920–21. Photograph by Bachrach.

the publication in 1926 of *A Collection in the Making*, Phillips continued to broaden his interests. By the end of 1923, when he made notes for a collection catalogue, he had clearly outgrown many of the attitudes reflected in "15 Best Purchases of 1918–19." The notes, entered in the same journal as the architectural plans, introduce distinctions that would inform Phillips's collecting throughout his life. Such European and American artists as Daumier, Delacroix, Renoir, Whistler, Ryder, and Homer are classified as "Artists of the Past," integral and permanent parts of the collection. A second category lists "paintings by contemporary artists which await the test of time." Phillips concluded his inventory with four pages describing the "Private Collection of Mr. and Mrs. Duncan Phillips and their heirs." This last list, which commences with Ryder's *Desdemona*, includes works by many members of the Century Association, as well as four paintings by Marjorie Phillips.[25] Finally, Phillips records "23 Great Pictures—Watch, then acquire if possible," and lists twenty-six "Pictures slated for release-trade."

Phillips was eager to make acquisitions that would establish his museum's national and international renown, and his purchase in 1923 of Pierre-Auguste Renoir's *The Luncheon of the Boating Party* achieved this aim. Writing to Dwight Clark, Phillips could barely contain his sense of accomplishment: "But the big Renoir deal has gone through with Durand-Ruel and the Phillips Memorial Gallery is to be the possessor of *one of the greatest paintings in the world*."[26] The unquestionably beautiful and important *The Luncheon of the Boating Party* anchored and orchestrated the European collection, consolidating the 1922 purchases of Delacroix's *Paganini*, Manet's

Boy Carrying a Tray, and Daumier's *On a Bridge at Night*. Impressive acquisitions continued with works by El Greco and Puvis de Chavannes in 1923, Courbet in 1924, and John Constable, Gustave Courbet, Honoré Daumier, and Odilon Redon in 1925.

Among the purchases in 1925 was Pierre Bonnard's *Woman with Dog*, which initiated Phillips's lasting love affair with the work of this French artist. But the most important addition of that year was unquestionably Paul Cézanne's *Mont Sainte-Victoire*. By adding this painting to the collection, Phillips began to reconcile his earlier enthusiasm for Alexandre-Gabriel Decamps, René Ménard, and Monticelli with an increasingly comprehensive view of modernism that stretched from the classical ideal of Giorgione to the structural rigor of Cézanne.

In his collecting of American art, Phillips had enthusiastically embraced the work of The Eight long before 1922, the year he purchased two distinguished paintings by Sloan, *The Wake of the Ferry II* and *Six O'Clock, Winter,* as well as works by Luks, Lawson, and Prendergast. Other recognized American masterworks, including Homer's *To the Rescue* and Ryder's *Moonlit Cove,* rounded out his expanding collection. By 1925 Phillips turned to works by younger contemporary American painters like Walt Kuhn, Niles Spencer, and William Zorach and developed an enthusiastic appreciation for the work of Rockwell Kent by acquiring *Azopardo River* and *Mountain Lake—Tierra del Fuego*.[27] However, his most provocative purchases reflected a new awareness of the artists associated with Alfred Stieglitz. Phillips owned Hartley's *After Snow* by 1921, and in 1924 he acquired one of Charles Demuth's most stylishly simplified still lifes,

Eggplant, followed the next year by *Red Chimneys,* an elegant interpretation of the cubism that Phillips had so abhorred in the Armory Show eleven years earlier.

Phillips met Alfred Stieglitz sometime after the famed photographer (equally well known for his passionate support of modernist artists and causes) opened the Intimate Gallery in New York in December 1925. The two men began a friendly relationship that, although briefly marred by a stormy controversy, grew into long and fruitful association.[28] Perhaps it was under the influence of Stieglitz's progressive vision that Phillips embraced American modernism, and the year 1926 can be seen as a watershed for his collecting: *Golden Storm* and *Waterfall* by Arthur Dove; *My Shanty, Lake George* and *Pattern of Leaves* by Georgia O'Keeffe; and *Black River Valley, Grey Sea,* and *Maine Islands* by John Marin. Marin as a painter could express the authenticity of time and place in the American landscape with the same power, authority, and vision that Cézanne had brought to his landscapes of Provence. With O'Keeffe's works, Phillips began the acquisition of what became a distinguished group of six paintings, predominantly early works.

Whether American or European, the works of art purchased in these formative years show that Phillips had expanded the definition of masterpiece to include contemporary art. More important, however, he retained his conviction that although modern art was widely viewed as a radical break with the past, the best contemporary art was rooted in the classic ideal. This may account for his special delight in the paintings of Maurice Stern and André Derain, but it also allowed him to value works by such modern American artists as Dove, Marin, and Charles Sheeler as much as those of Giorgione, Eugène Delacroix, and Cézanne. Furthermore, this change paved the way for his reconciliation with artists whose work he had so violently denigrated earlier: Pablo Picasso and Matisse.

A Collection in the Making

In 1926 Duncan Phillips published the first catalogue of his collection, *A Collection in the Making,* which includes works by 105 artists. The title aptly describes the author's ambitions while only hinting at his emerging commitment to modernism. Phillips made no secret of the fact that his first love was painting, and the catalogue includes only three sculptures.[29]

The text begins with a "more or less autobiographical" statement that sets forth Phillips's belief in the value of art, his plans for the collection, his hope of building a new museum to house it, and his educational program.[30] His "Estimates" (brief evaluations of artists and works of art) suggest that he increasingly viewed painting in formal, or painterly, terms. Statements about Cézanne— "through this structure and equilibrium of tones he built a world, the parts of which function together in an organic rhythm"—show that he no longer viewed art in romantic terms only.[31]

A Collection in the Making was Phillips's first systematic public statement about his collection and a summary of his original purpose: "I would create a collection of pictures—laying every block in its place with a vision of the whole exactly as the artist builds his monument or his decoration."[32] The concept of an expandable but limited core of masterworks was succinctly expressed in his idea for "exhibition units," which would allow viewers to survey the development of an artist's career or permit the study of a particular period.[33] In addition to those already envisioned for entire rooms, Phillips now assembled units of works by Marin, Dove, John Graham, and Karl Knaths, to name a few. Local and regional artists, as well as relatives and staff, were also collected in units but held in the "encouragement collection."

Viewed within the context of Phillips's career as a collector, *A Collection in the Making* illustrates how the process of refining the collection through the sale or exchange of works of art was an integral part of his vision. Except for core masterworks that were at the heart of the collection, Phillips remained flexible and on several important occasions sold or traded paintings in order to acquire works considered essential. Paul Gauguin's *Idyll of Tahiti,* purchased in 1925 and featured in *A Collection in the Making,* was traded in 1936 in partial payment for Goya's *The Repentant St. Peter;* Alfred Sisley's *Banks of the Seine,* purchased in 1921, was given in partial trade for Georges Braque's *The Round Table* in 1934. Other works, for one reason of another, simply did not retain their place in Phillips's changing aesthetic. Courbet's *The Glen at Ornans,* a major purchase in 1920, was given to Yale in 1939. Works by American artists listed in the catalogue, such as Frank W. Benson, Thomas W. Dewing, Daniel Garber, and Henry Lee McFee, did not maintain their initial promise and by 1952, when he published his next major catalogue, were no longer part of the collection.

In light of subsequent trades and deaccessions, it is clear that the approach reflected in *A Collection in the Making* was neither systematically modern nor classical, neither primarily American nor European. Rather, Phillips pursued works that he had determined to be of the highest quality, regardless of origin. Moreover, in many cases he showed amazing prescience in grasping the essential character of an artist's work. Davies, the maverick of The Eight who ignored contemporary subjects in favor of figurative tableaux set in arcadian landscapes, and whose work fulfilled Phillips's early longing for a revival of the romantic idylls of his beloved Giorgione, was represented by at least twelve works by 1926. Ten paintings were still in the Davies unit in 1952, in spite of numerous subsequent purchases and trades.

While Phillips's mature collection stands as a singular statement of modernist sensibilities, it is neither extreme nor narrow in focus. Indeed, Phillips himself may have declared his intentions when he wrote, a few years after *Collection in the Making* was published, that "the Collection is a symbol of tolerance for diversity of taste and opinion and of reverence for human personality and individual expression."[34]

Growth and Consolidation, 1927–39

Throughout the 1920s and 1930s Phillips enriched his holdings, with few exceptions, by acquiring French and American pictures. In 1927 he purchased his first Picasso, *The Blue Room,* and he deepened his commitment to Bonnard by adding five works to the two he already owned. Paintings by two other artists, Derain and Braque, confirmed the quickening pace of his reconciliation with European modernism. Like Bonnard, both of these artists remained abiding passions for Phillips, and Derain became the subject of an essay, "Derain and the New Dignity in Painting," a reconsideration of his earlier dismissal of the artist's work as "the mere magic of paint."[35] Derain's attempts to revive the figural order of the Renaissance appealed to Phillips's classical humanism and corroborates his earlier distaste for the distortion of natural forms (which he still considered extravagant and egotistical) in the work of Matisse and Picasso. Other 1928 acquisitions by European artists included Manet's *Ballet Espagnol,* Cézanne's powerful *Self-Portrait,* and Daumier's *The Strong Man.*

For the American collection, the unit of eight paintings by Ryder was nearly completed in 1928 with two acquisitions: *Dead Bird,* a very small but exquisite example of Ryder's delicate sensitivity, and *Resurrection,* which Phillips would have remembered from the 1913 Armory Show. He also expanded his interest in the Russian émigré Graham (whom he had met the previous year), purchasing eight works to complement the four paintings already in the collection.[36]

In 1927 Alfred H. Barr Jr., who was teaching a pioneering class in modern art at Wellesley College, approached Phillips about using reproductions of works in the collection in his classes. That year Barr also reviewed *A Collection in the Making.*[37] By 1929 both men had become affiliated with the newly established Museum of Modern Art in New York—Barr as its director, Phillips as a member of the board of trustees. In 1935 Phillips was appointed honorary trustee for life, and the friendship between the two men, as well as the working relationship between the two institutions, may have contributed to Phillips's deepening appreciation of the avant-garde, especially Matisse and Picasso. In 1929 Picasso's *Abstraction, Biarritz,* a small exercise in synthetic cubism, was added to the collection from the estate of Arthur B. Davies, while among the notable American paintings purchased that year was Phillips's first work by Milton Avery, *Winter Riders.*[38] In the following year he acquired *Entrance to the Public Gardens in Arles* by van Gogh (an artist whom, along with Cézanne, Phillips had termed an "unbalanced fanatic" in 1914), as well as Juan Gris's *Abstraction* and Braque's *Still Life with Grapes and Clarinet* (indications that Phillips was coming to terms with cubism, at least in its more moderate, lyrical manifestations).

However, after 1930 the economic depression began to have widespread effects on the art market, as well as on the financial stability of the Phillips Memorial Gallery. In 1932, with his resources severely tested, Phillips was forced to close the art school and to limit purchases. While in 1930 he acquired more than seventy works, or more than one a week, in 1931 he reduced this amount by almost half, to thirty-eight.

The economic crisis prompted a proposal by Theodore Sizer, director of the Yale University Art Gallery, to take over the collection. Phillips's response suggests the seriousness of the financial crisis he was facing: "During this depression which has brought our Collection to a standstill, caused us to discontinue temporarily our educational activities, and to open our doors to the public only one day a week, I confess that now your idea is a tempting one." But in the end he decided to persevere: "I felt honored by the renewal of your suggestion that we give the Collection to Yale to be enshrined and carried on in our own manner. . . . Now we have the same reason for preferring to carry on our project here in Washington."[39]

But as the national economy slowly recovered, the tide also turned for Phillips, and by 1937, when he was able to add fifty-two works to the collection, he was approaching the pre-Depression rate of acquisitions. During this difficult period Phillips mostly supported American artists. This heightened concern stemmed in part from his directorship, from 1932 to 1933, of the Baltimore-Washington Regional Committee of the Works Progress Administration, the federal relief agency. Studio House, which opened in 1933, furthered these ideas by offering public classes in criticism, providing studio workspace, and sponsoring sales exhibitions of local and regional artists.

Phillips also managed to buy many important European paintings, in spite of the Depression: for example, in 1931, *Lemons and Napkin Ring,* a horizontal still life by Braque, Bonnard's *Movement of the Street,* and Rouault's *Tragic Landscape.* In 1933 he acquired *Circus Trio* by Rouault and the following year Braque's *The Round Table.* In 1935 he bought Bonnard's *The Terrace;* in 1937, a Daumier crayon and wash drawing, *Plea for the Defense,* and a Picasso oil, *Bullfight;* and in 1938, *The Jester,* a small Picasso bronze, as well as four paintings by Paul Klee. In addition, between 1935 and 1938 Phillips added seventeen works by Dove, among them *Goin' Fishin',* perhaps the artist's best-known collage.

By the close of the decade Phillips was fifty-three years old. He had been committed to the study and appreciation of art since his college days and had been collecting since his early twenties. He had also been presenting exhibitions since he was thirty-three and running an art gallery in his family home since he was thirty-six. What had begun as a "memorial art gallery" had become a museum in every sense of the word, one that featured a splendid collection of paintings, varied educational programs, an art school, and a Sunday-afternoon concert series. After all this time, the museum maintained two of its founder's basic premises: pictures were to be presented in an intimate setting; and visitors were encouraged to see, and by seeing to understand how art is a process as well as an event. Through his ingenuity in finding ways to reveal new aspects of pictures by regularly changing installations, Phillips had made the Phillips Memorial Gallery a place where the visitor would always find surprises.

Commitment to Modernism, 1940–52

With the onset of the Second World War, acquisitions for the museum declined somewhat. Phillips's contributions to the war effort, like his involvement in the 1918 Allied War Salon, were expressed through art. In his essay "The Place of Art in a War-Torn World" he held that "like religion, art is a symbol of what the fight is about, of what must be saved."[40] He concluded that "art in a world at war . . . cannot escape from the truth. . . . Art is a social communicator and a national asset, but never more so than when it is a miracle of personal expression."

During these years he acquired works that supported his philosophy of the inherent continuity between the classical and the modern, including Corot's *View from the Farnese Gardens, Rome,* Delacroix's *Horses Coming Out of the Sea* and *Hercules and Alcestis,* and Braque's *Lemons and Oysters.* As a culmination of his lifelong interest in Daumier, Phillips bought *Advice to a Young Artist* with the intention of presenting it to the National Gallery of Art. Writing to David Finley, the gallery's director, Phillips professed that he "would rather give a Daumier than the work of any other artist because of my deep affection and reverence for this master."[41]

Chaim Soutine, an artist "discovered" by Alfred Barnes in 1922, was represented for the first time with *Return from School After the Storm, Woman in Profile,* and *Windy Day, Auxerre.* Phillips's interest in Soutine reflects his deepening commitment to expressionism, shown also in his enthusiasm for the somber mysticism of Georges Rouault, whose ten works form a unit assembled between 1931 and 1947. He also expanded his commitment to the work of Klee, establishing ultimately a unit of thirteen works. In collecting artists such as Klee and Lyonel Feininger, Phillips acknowledged that those who had worked in central Europe had been lacking in the collection.[42] Soon, however, his purchases also became a way of supporting refugee artists. For example, Oskar Kokoschka's *Prague: View from the Moldau Pier IV,* purchased in 1938, helped ensure the artist's economic survival after Kokoschka and his wife were exiled to England.[43]

Phillips continued to support his favorite American artists with multiple purchases: Dove, Knaths, Marin, and Marsden Hartley. In 1942 *Blue Still Life* became the last purchase of a work by Graham (two later drawings were gifts of the artist), and the Jerome Myers unit was closed the following year with *The Tambourine.*[44] The largest acquisition during the war years was the purchase in 1942 of thirty panels, one-half of the series, from *The Migration of the Negro* by Jacob Lawrence; an exhibition was held soon afterward.[45] Phillips also rounded out his cluster of works by O'Keeffe, adding three paintings to those purchased from Stieglitz in the 1920s.

Aside from an abiding commitment to American art and continued support of local and regional artists, Phillips's concern after the Second World War was the systematic acquisition of French contemporary masterpieces. One of his first postwar acquisitions, in 1950, was a painting by Nicolas de Staël, the first of what was to become an important group. This purchase was followed in 1951 by Pierre Soulages's *July 10, 1950,* and the group was rounded out with the acquisition of Georges Mathieu's *Simon, Comte de Crépy* in 1963.

The 1952 Catalogue

The second published listing and classification of the collection, *The Phillips Collection Catalogue: A Museum of Modern Art and Its Sources,* offers a clear statement of Phillips's ongoing process of augmenting, refining, and integrating his holdings. It is also a curiously selective catalogue that stands as a record of his conception of the classical ideals in modern painting.

While part 1, the larger section, is dedicated to "Permanent Masterpieces," part 2, "The Collection Continued," is reserved for painters, mostly younger artists or members of the staff, who for a variety of reasons were not felt to be ready for full membership in the lineage of established masters. Phillips advised the reader that "many of our important paintings are not illustrated, while a few of those selected for reproduction are included because they are by artists on the staff of the Gallery or closely affiliated with it. Thus we frankly acknowledge the essentially intimate character of the Collection and of its personal associations."[46]

Many works were omitted, and Phillips implied in his introductory comments that future substitutions might occur: in his view, the essential character of the collection remained "formative and malleable."[47] The catalogue designates "favorite artists" with an asterisk, thirty-two in part 1, who are represented by exhibition units, and seven in part 2. This hierarchy, which shows striking parallels with the lists of 1923 and 1924, continues the distinction between what is deemed permanent or temporary.[48] At the end of the book are recent acquisitions, including three contemporary works, Loren MacIver's *The Window Shade,* Willem de Kooning's *Asheville,* and Adolphe Gottlieb's *The Seer,* to take in, somewhat belatedly, abstract expressionism.

The Concluding Years, 1952–66

In 1952 Duncan Phillips was sixty-six, an age often associated with retirement, but he demonstrated the ability to refine and unify his vision throughout the remaining fourteen years of his directorship. Although his daily interactions with the collection were limited by the responsibilities of running a museum, acquisitions were, as always, determined by his personal passions. In this sense, it is important to consider what Phillips chose not to buy. He never held much sympathy for surrealism, and there is no Salvador Dalí, Yves Tanguy, or René Magritte in his collection. There is only one Miró, *The Red Sun,* an early Giorgio de Chirico, and a small André Masson that may have been purchased in 1943 in response to the artist's immigration to America. Moreover, he seems to have had only

pointedly selective interest in the American Scene painters of the 1930s for whom art was a way to examine life in the United States. Even though they were widely celebrated during his lifetime, he bought no works by Thomas Hart Benton, John Steuart Curry, or Grant Wood, but acquired three splendid paintings by Edward Hopper and established a unit of ten works by Charles Burchfield.

Phillips's personal response to art can perhaps be best seen in his appreciation of abstract expressionism (fig. 16). He purchased very few works that match the vigor of de Kooning's *Asheville*. While reacting positively to Mark Rothko and Morris Graves, who phrased a strong mysticism through color fields and lyrical evocation, Phillips remained cool to the more aggressive experiments of Gottlieb and Franz Kline. His sole purchase (in 1958) of a work by Jackson Pollock, *Collage and Oil*, is a delicate collage with oriental overtones that stands apart from the vigorous, revolutionary, and troubling paintings for which he is known. Perhaps the most telling example of Phillips's flexible approach to art is the absence of Marcel Duchamp.

In many ways Phillips's collection is defined by his "favorite artists." His early choices were emotional rather than doctrinaire. He bought what he liked, not what he persuaded himself to think was good. Furthermore, he was not creating a museum reflecting encyclopedic or historic principles, but rather assembling a collection born of two intangible but essential values—pleasure and high artistic achievement—and it becomes evident that he saw these ideals fulfilled most often in compelling harmonies of composition and color. His desire to assemble exhibition units is perhaps most indicative of his complex response to art. The largest units—Dove, Marin, Knaths, and Tack—represent American artists with whom Phillips had long-standing personal relationships. The average for units of European artists is eight works, while American units average almost eleven, many of the larger ones offering a survey of the artist's career. Seventeen Bonnards, painted between 1894 to 1935, and eleven Braques, painted between 1926 and 1952, reflect Phillips's passion for two masters of European modernism, while the Tack unit shows the unique achievement of this American modernist as he reached and then crossed the threshold of abstract art. The continuity between classical and contemporary masters that is at the heart of The Phillips Collection is nowhere more evident than in the carefully conceived Cézanne and Rothko exhibition units. Cézanne's work, which Phillips had dismissed in the teens, grew into a unit that is now one of the cornerstones of the collection. Similarly, many decades later, Rothko's fields of color came to stand for Phillips as the ultimate achievement of abstract expressionism.

It is essential to remember that Phillips had a goal for his collection, and what did not serve that purpose did not remain. This pursuit was not easily defined, and Phillips was not always able to realize it. When he first conceived of a private collection that would

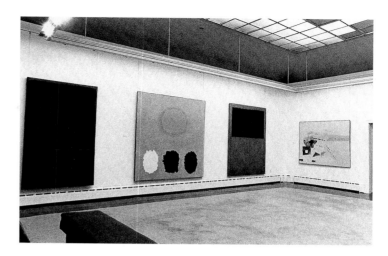

Fig. 16 Main Gallery with works by Adolph Gottlieb, Mark Rothko, and Kenzo Okada, 1963.

double as a public museum, he had to contend with a public prejudiced against modern art and disdainful of American art. The early conservatism that guided his acquisitions was perhaps influenced in subtle ways by the critics and museum visitors of Washington, D.C., of the 1920s and 1930s. What is striking about Phillips's lifelong pursuit of art is that he was so successful at redefining his aesthetic sensibilities. In amassing a collection of more than 1,400 American paintings, Phillips achieved his ambition of creating a museum of American art, and in his last years he hosted or originated exhibitions of Knaths, Avery, Dove, Marin, and Marjorie Phillips. Yet the collection remained profoundly rooted in the art of Europe. Without artists such as Cézanne, Chardin, El Greco, Goya, or van Gogh, in his estimation, there could have never been a Burchfield or Hartley, a Marin or Dove.

Perhaps it is best to recall that every collector of any substance has at least three collections: the one that remains and is known; a second one that got away; and finally, a third that was assembled, the individual pictures carefully pondered, but not kept. But unlike many of the great personal art collections of the twentieth century, the expression of Phillips's aesthetic did not come to a conclusion when he died in 1966; it simply ceased to reflect one man's vision. The subsequent growth of The Phillips Collection, having been (as he wished) placed in others' hands, has been based on the acquisition of works—through gift, purchase, or exchange—that necessarily expand the collection in somewhat different directions from those he would have intended. One of Phillips's greatest gifts was his ability to reject the idea of a finite gathering of objects, each perfect of its own kind, in favor of an organic collection that, even after his death, remains very much a collection in the making.

1 SOURCES OF MODERNISM

DAVID ROSAND

"We need a Giorgionesque or Titianesque picture and something vital from the hand of Tintoretto himself as a source of modern romanticism." This evocation of the great Venetian masters of the Renaissance formed part of the wish list that Duncan Phillips set forth in his introduction to *A Collection in the Making* in 1926.[1] The list itself is indicative of the principles that guided the formation of a collection that, while concentrating on the modern tradition, nonetheless recognized in the earlier history of painting the aesthetic roots of modernism itself.

"The first modern master of the art of painting" for Phillips, as for a previous generation of aesthetes, was Giorgione, whose art, inspired by the naturalizing example of Giovanni Bellini's oil painting, represented a "further emancipation from the restraints of tradition."[2] Although Giorgione's oeuvre is notoriously difficult to define, Phillips felt that he had identified the "single prevailing spirit" that informed all the Venetian's work, a spirit "in which is mingled a knight's love of strong men and fair women, a poet's fondness for dreamy moods detached from the indifferent world, and a painter's passion for colour and for light and shade." In his later monograph on Giorgione, Phillips summed up his "unique aesthetic contribution": "He invented the painted lyric." Clearly inspired by Walter Pater's essay on Giorgione, Phillips perceived in the Renaissance achievement the beginning of a modern sensibility: "As in the more abstract art of music the meaning reaches us subtly, through the senses, and the subject is almost inseparable from the picture form."[3] It was only natural, then, that Phillips should also have been moved by what he called the "mellifluous and meditative music" of Fantin-Latour's painting; his own renaming of the latter's *Bathers* as *Spirit of Dawn* (cat. no. 32) itself represents a kind of interpretive response in a Giorgionesque key.

Phillips's commitment to modernism quite naturally—and, we might say, properly—determined his vision of the art of the more distant past, in which he sought—and found—the sources of the present. As he wrote in his Giorgione essay of 1912, "In their most subjective moods the poetic realists Corot, Inness and Whistler come nearest to the spirit of the Giorgionesque idyll." Evoking that distant spirit and adapting it to a new age, the art of these nineteenth-

Giorgione (?), detail of
The Hour Glass, see cat. 1

century masters confirmed the continuing significance of their Venetian predecessor. Such sentiments suggest more concretely just why the acquisition of a "Giorgionesque" picture was essential to the project of the gallery. Phillips's notion of Giorgione as the inventor of poetry in painting—of painting as poetry—was not new; nor was his insistence on the importance of "the picture form." Already in the sixteenth century itself, as Phillips well knew, Giorgione's achievement was recognized as radical, a liberation of the art of painting from responsibility to values other than those of nature in favor of a direct response in paint to the natural world. In paintings of the school of Giorgione, Phillips, like Pater, "delighted in various anticipations of modern impressionism, in accidental effects of light over lovely landscapes."[4]

A guiding principle of the installations in the gallery— "arrangements" was Phillips's term—was precisely to "bring together congenial spirits among the artists from different parts of the world and from different periods of time," as he wrote, "and I trace their common descent from old masters who anticipated modern ideas." "Thus," he continued, "I demonstrate two things—the antiquity of modern ideas, or, if you prefer, the modernity of some of the old masters, and I prove in our Main Gallery and its union of old masters and modern painters that art is a universal language which defies classification according to any chronological or national order."[5] The collection was predicated on that dynamic relationship between past and present. Fully embracing the dominant values of modern art historiography and criticism, Phillips found continuities of expression in formal structures and in the techniques, the "plastic means," that created such structures. More consciously and deliberately than other institutions, the Phillips Memorial Gallery articulated the values that made possible the modern museum of art.

Phillips was profoundly sympathetic and enthusiastically attentive to the dialogues among the masters that his arrangements were intended to facilitate. Transcending simple chronology, held in genuinely creative tension, the relationships he perceived went both ways: Old Masters looking forward to the present, modern artists reaching back to the past. Thus El Greco, a master resuscitated by modern admirers like Picasso, was for Phillips both "an inspired mystic and the prophet of modern painting who may justly be called the first 'expressionist' in art."[6] Citing Roger Fry, he celebrated the mystic's "'sustained rhythm of design,' every part of his pattern made clear in its relation to every other, his paint made transparent to his idea." Or, to take a less exercised example, Chardin—"this enchanter of realism" whom Phillips linked with his predecessors Velázquez and Vermeer and with his successor Corot—anticipated the painting of the twentieth century, "its acute consciousness of the material world, and its expression of that interest in a language of design, with coordinated shapes, colors,

surfaces, and deep spaces."[7] These words, published a year before Phillips acquired his first Braque still life, prepare us for the richness of the Braque unit of the Collection.

In the masters of the nineteenth century—those poised between past and future, between the grand traditions that had become ossified in the academies and a new sense of imaginative and technical freedom—Phillips found personified the creative tensions that animated his own vision of art history. Delacroix's great achievement, for example, lay less in his pictures than in his example: "a gallant fighter for a return to old artistic principles and for a state of mind open to new aesthetic ideas. He emancipated the art of painting in France from a tyranny of academic dogmatism." This great emancipator stood for a just balance between tradition and innovation. "Delacroix had no sooner left the academic teaching of Guerin than he began to preach and practice a gospel according to Michelangelo, Tintoretto and Rubens. . . . What he did was to resurrect the art of design inherent in the old masters and to emulate their free drawing and emotional color. He was an emancipator of the so-called classic artists from shackles of their own forging and a conservator of the soundest traditions."[8]

In Phillips's view of art-historical conflict, inspired perhaps by the iconography as well as the critical rhetoric of the nineteenth century itself, Delacroix's standard was then picked up by Courbet: "Schooled by Rubens, at war with Raphael, he was destined to be the leader in the second fight of the artists of his time for independence from imposed dogmas." Delacroix's revolutionary gesture could only remain partial, substituting, as it did, "Teutonic glamour and passion for stereotyped Latin models of aesthetic decorum."[9] The danger of replacing a pedantic classicism with a "too literary romanticism" was averted only by the aggressive materialism of Courbet, who moved painting ever closer to its own roots in the substance of this world—and, thereby, closer to the modern.

Less radically than the romantic Delacroix, Corot too was viewed as "a link between the Ancients and the Moderns" by Phillips, who appreciated this gentle painter's sustained commitment to formal values. "Heir of Poussin and Claude in his classic idylls with small figures, Corot is almost like a Greek sculptor in his later figure compositions with their fine contours and rhythmical subordinate lines, their subtle modelling in light and spheric solidity of form."[10] Reaching back to the origins of the classical tradition, Phillips's own critical language is founded firmly in modern formalism. His appreciation of these painters depends on that historical extension, the continuity of past and present.

Phillips had a special interest in Daumier, and in his critical defense of the artist's achievement as a painter he exploited such tensions, expressive as well as formal, evoking both Rembrandt and Michelangelo. The Daumier unit that he built represents an interesting thematic range: from the revolutionary imagery and social

criticism of *The Uprising* and *Three Lawyers* to the professional self-reflexivity of *Two Sculptors* and *Painter at his Easel* (cat. nos. 15, 16, 19, and 20). Committed thus to reality and to art, Daumier comes across in The Phillips Collection as a modern painter indeed.

The historical juxtapositions that Duncan Phillips sought in his collecting and in his arrangements are those that have energized the history of art—the tensions between past and present, between classical form and romantic expression. In his search for the sources of modernism, Phillips recognized one fundamental truth in that history: the artist himself represents the great continuity. And his project intended that The Phillips Collection should contribute to the future of that history by educating new generations of intelligent critics, and, even more important, by inviting creative artists to continue the dialogues sounded on its walls.[11] As the development of his collection so eloquently attests, Phillips's historical vision was an open one.

Giorgione exerted a decisive influence on early sixteenth-century Venetian and later oil painting, yet the known facts of his life are few. Born in Castelfranco in 1477 or 1478, he began his training in the workshop of Giovanni Bellini in Venice. His public commissions included work in the Doge's Palace, 1507–8, and decorations on the facade of the Fondaco dei Tedeschi, 1508. Much of Giorgione's extant oeuvre consists of small paintings for private commissions, including Madonnas and unconventional mythological and allegorical scenes. Among the few works that can be assigned to him with certainty are *Madonna and Child with Saints* (Castelfranco Veneto, cathedral), *The Tempest* (Venice, Accademia), and *Three Philosophers* (Vienna, Kunsthistorisches Museum). The attribution of his late works is complicated by the possible collaboration of Titian, who fell under his spell. Giorgione died in Venice during the plague of 1510. The scarcity of documentation about his career, coupled with the obscure subject matter of his surviving paintings, which often dwell on the harmony between the human and natural realms, led many to romanticize his life, beginning with Vasari's account of 1550. The Phillips Collection owns one painting attributed to Giorgione.

I

Giorgione (?)

The Hour Glass, date unknown

Vecchio con clessidra e giovane musicante
L'Astrologo; Allegory of Time; Old Man with Hourglass and a Woman Playing a Viola; The Astrologer; Chronos und der geigende Engel
Oil on wood panel, 4½ × 7⅝ (11.5 × 19.3)
Unsigned
Acc. no. 0791 (Pignatti no. A 66; Morassi, p. 259)

Early history unknown; Garibaldi Pulszky, Budapest; possibly Galerie S. Lucas, Vienna, 1937; private collection, Lugano (possibly Thyssen); Seligmann, New York; PMG purchase 1939.[1]

The Phillips painting is closely related to two panels in the Museo Civico, Padua, depicting Leda and the Swan and an arcadian idyll.[2] Together the three panels perhaps adorned a piece of furniture. The location of these secularized images within Giorgione's oeuvre is problematic, as is their attribution.[3] Certainly, however, the prominent role played by the landscape setting in evoking a mood of poetic reverie links *The Hour Glass* to pastoral scenes by Giorgione and his circle that were highly prized by a discriminating group of early sixteenth-century Venetian collectors.

It has been suggested that *The Hour Glass* conveys a moralizing message through the invocation of Chronos, or Time, appearing here as an old man in rose-tinted robes wielding an hourglass.[4] Yet the work need not rely on any specific classical references to convey meaning: through a consonance of form and subject matter it evinces an elegiac quality. Two figures are situated in a landscape that encompasses a view of several buildings. Between them is what appears to be a small deer. These various elements are harmonized by the circulating atmosphere suffused with the aura of the late hour. The orange-red sun in the center slips down between two distant blue mountains just as the sand trickles down into the lower chamber of the hourglass; the inevitability of time passing is further evoked by the last penetrant rays of the sun as they lend golden accents to the delicate trees and the rooftops. The youthful figure in white plays a bowed instrument, known as a *lira da braccio*, filling the air with the poignancy of its transitory tones.

Duncan Phillips's introduction to the artist was by way of Walter Pater's famous essay on the School of Giorgione.[5] Although Phillips's early critical writings owe a debt to Pater's aesthetic theories, he later admitted that Pater's approach, which focused on the "miracle" of Giorgione and exhibited an indifference to issues of attribution, left him dissatisfied: "The artist was no mediocrity nor was he a myth. And he was certainly not a Parnassian group collectively inspired. He was a *man,* and one far out ahead of his time. And so, in spite of a dislike for controversy and a disqualification for scholarship, I was forced into a long study of the great leader long ago."[6] What followed were a series of scholarly essays, a monograph (which he considered his best book), lectures, and considerable correspondence with the Renaissance scholar Bernard Berenson.[7] In coming to understand Giorgione and his achievement, Phillips also felt he would be shedding light on the intractable problem of attribution, inasmuch as the artist "did not sign his canvases with his name but with his unique spirit and his unique genius for expressive design."[8]

The Hour Glass was not included in Phillips's Giorgione book of 1937. Aware, however, of Phillips's interest in Giorgione, Paul M. Byk of Seligmann Gallery invited him to see the small panel in 1939.[9] Although Phillips acknowledged that the more firmly drawn figures may have been the work of assistants, he ascribed the painting's conception and design, as well as its diffuse tonal landscape, to Giorgione.[10] A rarity in American collections, it is all the more conspicuous in a museum devoted to modern art.[11] Yet according to Phillips, Giorgione fully merited a place in the collection as the "inventor of romantic landscape as an end in itself, of the easel picture intended for the home."[12] Some modern critics, confronted with the difficulty of deciphering Giorgione's subjects, regarded him as the earliest proponent of the doctrine of art for art's sake. Phillips invoked this idea when he argued that Giorgione's "genius for emotional suggestion, conveyed through colors and lines, prophesied the nineteenth and a vital phase of the twentieth century. He was far closer to the modern painters of abstract lyricism than to the grandiose and prodigiously masterful High Renaissance painters of churchly or worldly preoccupations."[13] For Phillips, however, the true legacy of Giorgione could not be reduced to some specialized aesthetic function; rather it was ultimately based on the artist's ability, vividly apparent in this and other images, to "suggest the richness of the inner life of man in a world of mingled sensuousness and spiritual appeal."[14]

RD-R

EL GRECO (DOMENIKOS THEOTOKOPOULOS; 1541–1614)

Domenikos Theotokopoulos was born in Candia (Iráklion), Crete, in 1541, but little is known about El Greco's early life. He took up his vocation as painter in Crete but around 1568 was in Venice, where he evidently studied the works of Jacopo Bassano, Tintoretto, Titian, and Veronese. Arriving in Rome in 1570, he became part of a circle of learned churchmen and other notables who shared an interest in the classics, literature, and art. El Greco left for Spain in 1577, possibly in the hope of obtaining more commissions than he had received in Italy. He seems to have pinned his hopes on Philip II, who was recruiting painters for the decoration of the Escorial palace near Madrid. Although rejected as a court artist, he secured commissions in Toledo and took up permanent residence there, becoming a citizen in 1589. He developed a highly original style characterized by the elongation of the human figure and flickering brushwork, and he painted mostly for churches and religious orders in and around Toledo. El Greco consciously viewed himself as a learned artist rather than an artisan, and he wrote several treatises on art and architecture. He died in April 1614. Ignored after his death, his reputation was rehabilitated during the mid-nineteenth century. The Phillips Collection owns one painting by El Greco.

2

The Repentant St. Peter, ca. 1600–1605 or later

Las lágrimas de San Pedro
St. Peter in Tears
Oil on canvas, 36⅞ × 29¼ (93.4 × 75.6)
Signed l.l.: *Domenikos Theotokopoulos* [barely visible]
Acc. no. 0851 (Cossío, 1908, nos. 15 and 316; Cossío, 1972, no. 307; Wethey no. 271)

Early history unknown; Guillermo J. de Guillén García, Barcelona, by 1899 and until at least 1906; Ignacio Zuloaga, Zumaya; Ivan Stchoukine, Paris, by 1908; Heilbuth, Copenhagen, by 1920; PMAG purchase through Ehrich Galleries, New York, 1922.[1]

The depiction of saints had a special place in the thematic repertory of the Counter-Reformation, and during his career El Greco painted several pictures of St. Peter in tears.[2] Not only were saints regarded as intercessors between man and Christ, but they were also used in the service of Catholic theology to illustrate the theme of penance and the sacrament of confession. St. Peter, who showed a lapse of faith in denying Christ, was rehabilitated through penitence and prayer. In the present work, which may have been intended as a private devotional image, the same theme is further underlined by the inclusion of a second figure, identified by José López-Rey as Mary Magdalene, who similarly gained salvation through repentance.[3]

Recalling the traditions of Byzantine icon painting, El Greco adopted a close-up view, thereby charging *The Repentant St. Peter* with great feeling. The saint wears a simple blue tunic and a yellow drape, his traditional colors, and is seen against a cave outlined by ivy. His angular body tapers upward, its directional thrust reinforced by the acute configurations of his shoulders, arms, and hands clasped in prayer, as well as by the cropped keys at his waist. His glance is also directed heavenward as he realizes in despair that he has fulfilled Christ's prophecy: "'Before the cock crows, thou shalt deny me thrice.' And he went out, and wept bitterly."[4]

At left, the partly visible image of an angel and the approaching figure of Mary Magdalene with her ointment jar expand the narrative implications of this otherwise iconic image, suggesting Christ's resurrection.[5] So too does El Greco's dramatic depiction of the background sky wedged in between the silhouette of the rock behind Peter and the left edge of the canvas: streaks of light rend the sky, as chalky whites and sulfurous yellows burst into incandescence.

Although he was well aware of the religious milieu in which El Greco worked, Duncan Phillips revealed several decidedly twentieth-century concerns. Following Roger Fry, he revered the artist's "sustained rhythm of design," achieved by "an enlargement of the unit of design, until every mark of the brush, every modulation of color, every swirl of line repeated one insistent rhythm."[6] Phillips, like Fry, also invoked the idea of a kinship between El Greco and Cézanne, attributing Cézanne's "simplifying and unifying formula" to the example of his predecessor: "Cézanne applied Greco's principle of rhythmic coordination to a casual observation of fact."[7]

Significantly, El Greco figured in Phillips's attempt to employ *baroque* as a critical rather than a chronological category: "It is possible to be classic or romantic, realist or abstractionist, impressionist or expressionist in a baroque way. That simply means the way of the *all over pattern*."[8] Nonetheless, Phillips declined to cast the discussion in purely formalist terms. While recognizing the importance of El Greco's stylistic innovations for modern artists, he maintained that El Greco's plastic means were in the service of the artist's own inner life, invoking another twentieth-century notion as he claimed El Greco for expressionism.[9] But returning to a recurrent theme in his own criticism, Phillips insisted that El Greco's emotional expression was ultimately submerged into a classical feeling for order: "As for El Greco, where in the history of art is there a better example of that search for unity and integration which the romantic artist requires to make his passionate utterance intelligible?"[10]

RD-R

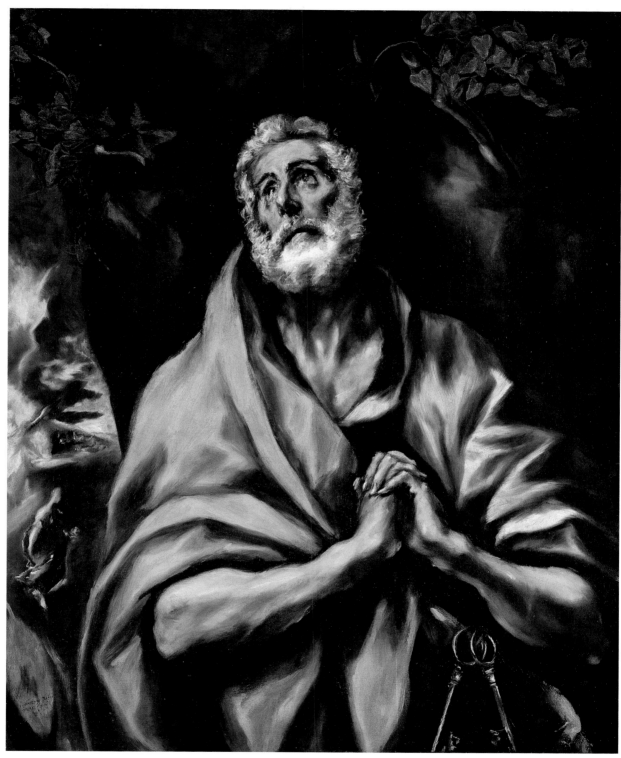

2

JEAN-BAPTISTE SIMÉON CHARDIN (1699–1779)

Jean-Baptiste Siméon Chardin was a painter of humble still-life and genre scenes executed with attention to composition and color that prefigured modernist painting. Born in Paris to a cabinetmaker and his wife November 2, 1699, Chardin may have studied art with Pierre-Jacques Cazes (1718–20) and Noël-Nicolas Coypel (1720–21). In 1724 he joined the Académie de St. Luc and remained a member until 1729. He was admitted to the Académie Royale as a still-life painter in 1728, and he continued working in this academic division until 1733, when he added genre scenes to his repertoire. In 1731 he married Marguerite Saintard, who died in 1735; a son, Jean-Pierre, was born in 1731. Chardin was elected counsellor to the Académie Royale in 1743; the following year he married Françoise Marguerite Pouget. In 1757, two years after Chardin was elected treasurer of the Académie Royale (a post he held until 1766), King Louis XV granted him living quarters in the Louvre palace. The Phillips Collection owns an early still life by Chardin.

3

3

A Bowl of Plums, ca. 1728

Broc de Delft et compotier de fruits
Dish of Plums with Peach and Delft Pitcher; Bowl of Plums,
a Peach and Water Pitcher; Jatte de prunes avec une cerise,
une pêche et un pot à eau
Oil on canvas, 17½ × 22⅛ (44.6 × 56.3)
Unsigned
Acc. no. 0293 (Wildenstein no. 257; Rosenberg no. 38)

Early history unknown; A. H. and J. Roberts Collection by 1913; purchased 1913 by Wildenstein, Paris (Roberts sale, Hôtel Drouot, Paris, Feb. 24–26, 1913, no. 19); DP purchase from Wildenstein, New York, 1919; transferred to PMAG, 1920.[1]

Duncan Phillips ranked Chardin's *A Bowl of Plums* among his outstanding oil paintings, calling it "personal and poetic in spite of its apparent objectivity."[2] When he published an announcement in 1930 advertising the Phillips Memorial Gallery as "A Museum of Modern Art and Its Sources," he illustrated it with *A Bowl of Plums,* thereby establishing his view of Chardin as a precursor of modernism in art. To Phillips, he was one of the first painters to communicate personal expression in his images and to perceive his subjects as compositions of pure color, light, and design, anticipating the vision of the impressionists and Cézanne.[3] *A Bowl of Plums* was frequently displayed in the museum with paintings by modern artists of similar creative temperament. Phillips considered Chardin "the

classic French builder in an architecture of aerial space," believing that his structured compositions and subtle, painterly use of color had more in common with the art of Cézanne, Braque, and Derain than that of artists like Bonnard, who in Phillips's opinion was a subjective "whimsical fantasist," more prone to "seize the fugitive image" than to intellectualize his scenes.[4]

Phillips marveled at the individuality of Chardin's artistic personality within his era.[5] His simple, quiet still lifes and interiors, subjects given a low status in the hierarchy of the Academy, were executed with attention to painterly qualities and light refraction that exceeded that of his French contemporaries.

Although previously dated by Georges Wildenstein to late in the painter's career, *A Bowl of Plums* actually has the characteristics of early Chardin still lifes.[6] The bowl of fruit is set upon an undefined surface that blends into a shadowy background. The tilt of the bowl as well as the placement of the plum, nut, and cherry in the foreground pull the viewer's eye toward the lower left corner. Chardin may have purposefully arranged the composition in this way to decrease emphasis on the brightly lit Delft pitcher that dominates the right half of the

image. The slight compositional tension that results, along with the liberal use of opaque, scumbled paint in the background, are typical of Chardin's early rather than late paintings, which exude more stability and inner radiance.

A Bowl of Plums stands out among the comparatively opulent, dramatic early still lifes for its simplicity and intimacy. Duncan Phillips recognized the artist's appreciation of the feel and character of the painting's modest, everyday objects when he wrote: "In this enchanting *Bowl of Plums* note . . . the 'vraisemblance,' the bloom of the fruits, the interplay and refractions of their colors, the intentionally contrived crackle of the porcelain, the subtleties carried into the most delicate nuance. And yet in all this luminism there is no loss of the character of the objects as color-shapes, and no lack of attention to their existence in an architecture of space. This is still life at its best."[7]

Chardin was sensitive to the design of the composition, and he paid meticulous attention to the surface texture and glowing colors of the objects he represented. Even early in his career he had the ability to manipulate and selectively highlight the elements of a painting in order to convey his personal interpretation of the still life.

GHL

FRANCISCO JOSÉ DE GOYA (1746–1828)

Francisco José de Goya was born in Fuendeto-
dos, Spain, March 30, 1746. Goya began his artis-
tic education in the studio of José Luzan in
Saragossa in 1760 and traveled to Italy in 1770.
The major undertaking of his early career was
the execution of cartoons, mostly rococo idylls,
for the Royal Tapestry Factory of Santa Bárbara.
Goya became a member of the Royal Academy
of San Fernando in 1780 and was named court
painter in 1786. He was promoted to *pintor de
cámara* in 1789, following the accession of
Charles IV. Along with commissioned works,
including candid portraits of the royal family, he
also produced uncommissioned paintings,
drawings, and several series of etchings. The lat-
ter include *Los Caprichos,* 1799, satirizing the
hypocrisy of society, and *Los Desastres de la
Guerra,* 1810, inspired by the atrocities of the
Napoleonic Wars. The well-known paintings
The Second of May, 1808 and *The Third of May,
1808,* both 1814 (Madrid, Prado), commemorate
the rebellion against Napoleon's soldiers. In
1824, following Fernando VII's return to abso-
lutist rule, Goya went into voluntary exile in
Bordeaux, where he continued to produce por-
traits, still lifes, and prints (etchings and litho-
graphs) until his death, April 16, 1828. He exerted
a powerful influence on later generations of
artists, particularly Manet. The Phillips Collec-
tion owns one oil painting, two etchings, and
one drawing by Goya.

4

The Repentant St. Peter, ca. 1820–24

San Pedro arrepentido
Oil on canvas, 28¾ × 25¼ (73.0 × 64.2)
Signed l.r.: *Goya*
Acc. no. 0806 (Gassier-Wilson no. 1641)

Early history unknown; Alejandro Pidal, Madrid, by 1900;
Duc de Trévise, Paris; Trévise sale, Sotheby's, London, July
9, 1936, no. 105, to Spanish Art Gallery, London; PMG pur-
chase, 1936, through Newhouse Gallery, New York.[1]

The Repentant St. Peter was probably painted
just before Goya's departure for Bordeaux in
1824, along with a pendant picture of St. Paul
(private collection, United States).[2] Apostles
figure rarely in Goya's religious output, and it is
not known whether the present work was com-
missioned by a patron or undertaken on the
artist's own initiative.

The Phillips image portrays St. Peter in a
moment of heightened concentration that is
reinforced by the striking simplicity of the com-
position. The half-figure of the saint is posed
against a dark, neutral background; a golden
cloak enfolds his corporeal form and extends its
triangular shape.[3] Emphasizing St. Peter's
intensely private prayer, Goya adds only his
standard attributes, the rock and keys; the latter
serve as visual extensions of the cloak even as
they recall his pastoral powers.[4] Yet the focus is
not on his founding status within the church
but rather on his profound human anguish at
having denied Christ three times. Light falls
from the left on Peter's upturned, sorrowful
countenance, his bluish-gray beard, and his
thick stubby fingers clasped in prayer. As if to
underline his humble origins, the execution is
direct; the paint is applied in a vigorous manner,
and the chromatic scheme is based on blue and
yellow, Peter's traditional colors, with shots of
red in his ruddy face and on his sleeve. The
image's arresting visual and psychological

immediacy reflects the spirit of eighteenth-cen-
tury religious reforms, which eschewed apoc-
ryphal legends in favor of sincere expressions of
religious emotion.[5]

Shortly after deciding to acquire *The Repen-
tant St. Peter,* Duncan Phillips wrote: "For a long
time the Collection has stood in great need of
an example of the art of Goya which is such a
stepping stone between the Old Masters and the
great Moderns."[6] From the moment the work
entered the collection, he never tired of con-
trasting it with El Greco's version (cat. no. 2), a
difference he distilled into two words: "flame"
and "stone."[7] Phillips elaborated:

The expression of personality through Design is
often best revealed by a comparison of the same
subject serving two painters of diametrically differ-
ent temperaments and intentions. El Greco's Repen-
tant Peter was . . . a grand old Byzantine—a
disembodied spirit soaring heavenwards, far above
the mundane emotions of that simple fisherman the
New Testament Peter. Here is a Goya we have
acquired recently, a work of his last period, a
pathetic, poignant picture of a really remorseful,
spiritually shaken but curiously world-shaking old
man. He is grubby, earth-bound, weather-beaten,
strong and solid as a rock. One could well base a
church on him for he is the human unit, the univer-
sal building block.[8]

The place of Goya's canvas in a museum
devoted primarily to the "great Moderns" had to
do with its masterful technique, as it antici-
pated, according to Phillips, "Cézanne's model-
ing by modulations, also his weight and
grandeur."[9] And in keeping with Phillips's larger
purpose, the acquisition was also meant to
inspire living American artists. Marin, who was
very taken by the image, is reported to have said,
"I wish I could tell that old son of a gun what I
think of him for painting that picture! It's like
an old tree: it's so nice and rotten ripe."[10]

RD-R

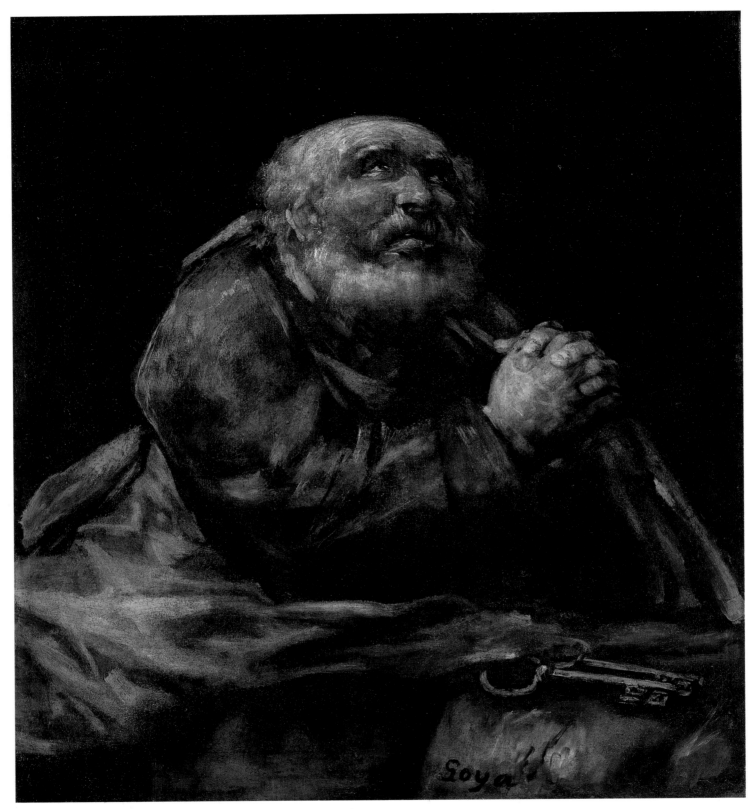

4

JOHN CONSTABLE (1776–1837)

John Constable was born June 11, 1776, in East Bergholt, Suffolk, the son of a well-to-do mill owner. Determined to become a professional painter, Constable went to London, where he entered the Royal Academy Schools in 1799 and exhibited at the Royal Academy for the first time in 1802. In the belief that landscape painting should be based on the direct observation of nature, he subsequently traveled throughout southeastern England and to the Lake District, making countless small preparatory oil sketches outdoors. He also painted sketches on a much grander scale, although these were not regarded as final in his day. Between 1819 and 1825, desiring to make a name for himself, Constable executed and exhibited six large "finished" canvases of scenes along the banks of the river Stour. In 1819, at the age of forty-three, he was elected associate academician, but he had to wait until 1829 to be elected full Royal Academician. His work was highly acclaimed in France, however, where he participated in the Paris Salon of 1824; the *Hay Wain,* 1821 (London, National Gallery), in particular impressed Delacroix, who admired its color and brushwork. The distinction between Constable's various manners of working, the "sketches" and the "finished" paintings for public display, becomes blurred in his late pictures, which are often broadly painted. He died March 31, 1837. The Phillips Collection owns one late work by Constable and one work formerly attributed to him.

5

On the River Stour, ca. 1834–37

A Farmhouse Near the Water's Edge ("On the Stour")
Oil on canvas, 24 × 31 (61.0 × 78.6)
Unsigned
Acc. no. 0330 (Reynolds, 1984, no. 34.76)

Possibly in the collection of Isabel Constable; Dowdeswell Galleries, London, possibly by 1892; Sir Joseph Beecham, London; Beecham sale, Christie's, London, May 3, 1917, no. 7, to Freeman for Sir Thomas Beecham (bought in); sale, Christie's, London, May 10, 1918, no. 89, to Knoedler, New York; Scott and Fowles, New York; PMG purchase 1925.[1]

The landscape of Suffolk furnished the subjects for many of Constable's pictures, holding, as it did, great personal meaning for him. *On the River Stour* depicts the river at a point near Dedham, a locale known to him from his childhood. Following his marriage in 1816, Constable returned only rarely to the Stour Valley, but he nonetheless continued to take up the theme in his studio. The house of Willy Lott, a Suffolk farmer, served as a primary motif, pictorially

Fig. 17 John Constable, *On the River Stour,* photograph of early state. Tate Gallery, London.

and thematically: Lott resided there all his life, and his house became for Constable a symbol of an unchanging and uninterrupted attachment to a place once familiar to him.

Painted during the final years of Constable's life, this oil, along with several others and a watercolor, derives from *The White Horse,* executed in 1819.[2] Constable said of *The White Horse,* "There are generally in the life of an artist perhaps one, two or three pictures, on which hang more than usual interest—this is mine."[3] Graham Reynolds has suggested a more specific reason for Constable's reprise of the theme: his repossession of *The White Horse* in 1829 when his friend Archdeacon Fisher was forced by financial difficulties to sell several works back to him. Reynolds notes that soon after Constable bought back *The White Horse,* he made a pen sketch of the left side of the composition that served as a basis for subsequent variations.[4] These later works were probably intended as studies for a larger exhibition picture that was never completed.[5] The Phillips canvas shares with the other versions from the 1830s the placement of Lott's house on the right, as well as the omission of the barge and white horse included in the 1819 work. In the present work, a man has been placed in the foreground and a boat with a figure situated downriver.

The complicated issue of Constable's late style is here made more difficult by the fact that *On the River Stour* has not come down to us entirely in its original condition. Leslie Parris speculates that although Constable left the work much as we see it today, it was repainted at some time so as to bring it to a more finished and salable state.[6] Significantly, a large sepia photograph (fig. 17), taken at an unknown date when the work was with Dowdeswell Galleries, shows the man in the foreground standing in a well-defined boat against a background consisting of detailed trees, cows, and architecture.[7] According to Parris, the supposed overpaint was removed before the work's entry into the present collection, perhaps returning the canvas to a state closer to the original.[8] On the other hand, it is also possible that the Dowdeswell photograph represents the artist's final statement and that subsequent cleaning has eliminated some original compositional elements; for example, the woman near the house is no longer discernible, and the detail of the man leaning on the pole makes less sense in the absence of the boat. In addition, the sense of three-dimensional illusion seems to have been diminished by the possible removal of dark shadows and other brushwork.[9]

These changes notwithstanding, many of the effects seen today are characteristic of the artist's

5

late style. Building a painterly surface of great variety, he employed a repertoire of energetic strokes, ranging from serpentine lines of underdrawing over brown priming to passages of thick impasto in the foreground. As in other late sketches, he appears to have used a palette knife to create the flickering splinters of white throughout the painting and the man's pole. The overall distribution of color—with the repeated application of flecks of greenish brown, blue, red, and white—carries the eye across the buoyant picture surface.

Duncan Phillips, who called Constable "the founder of modern landscape," paid tribute to the painter's direct engagement with nature: "Never until his time had so much pure nature been set forth in art. He showed that the sun shines, that the wind blows, that water wets, that clouds are living, moving citizens of space, that grass is not brown mud, that air and light are everywhere."[10] And when, shortly after acquiring *On the River Stour,* Phillips confessed that he found the sketches more captivating than the artist's finished canvases, he was not only

responding to the exuberance of the work before him, but was also identifying that aspect of Constable's achievement that he believed was of the greatest historical significance: "'On the River Stour' was created for posterity. It was at least fifty years ahead of its time in its knowledge and full employment of all the emotional capacities of color. It seems daring and dynamic even today and represents the Constable who carries on the tradition of Rubens and who connects it with all that was finest in the painting of the Nineteenth Century."[11]

RD-R

JEAN-AUGUSTE-DOMINIQUE INGRES (1780–1867)

Born August 29, 1780, in Montauban, Jean-Auguste-Dominique Ingres went to Paris in 1797 to study with Jacques-Louis David; he won the Grand Prix de Rome for painting in 1801. In 1806 Ingres left France for Italy, where he stayed for eighteen years. In 1813 he married Madeleine Chapelle, the young cousin of a friend in Rome. Upon Ingres's return to Paris, a painting by him received great acclaim at the 1824 Salon, and his fame grew during the next ten years. Ingres's carefully crafted history paintings earned him enormous prestige, and his portraits are still considered to be among the most accomplished and penetrating of that genre. He received important awards, including the cross of the Legion of Honor, and as a member of the Ecole des Beaux-Arts he gained a large following of students. However, in 1834, stung by negative criticism, he returned to Italy, where he assumed the directorship of the French Academy in Rome. In 1840 Ingres went back to Paris, his work having returned to favor. This period of professional success, however, was marked by personal tragedy: his wife died after a brief illness in 1849. He married Delphine Ramel in 1852. Ingres continued to receive state honors for his contributions to painting, and the 1855 Paris Exposition Universelle featured a room devoted to a retrospective of his oeuvre. He died in Paris, January 14, 1867, and two years later the Musée Ingres was inaugurated in Montauban. The Phillips Collection owns one oil painting by Ingres.

6

The Small Bather, 1826

Baigneuse; La Petite Baigneuse; Bather;
The Small Bathing Woman; Baigneuse vue de dos
Oil on canvas, 12⅞ × 9⅞ (32.7 × 25.0)
Signed and dated l.r.: *Ingres 1826*
Acc. no. 0927 (Wildenstein no. 165; Ternois and Camesasca no. 122a)

Listed in the sale catalogue of E. Blanc, Paris, 1862 (unsold); apparently inherited by Mme Blanc, Paris, by 1870 (sale catalogue); purchased by Baron Mourre, Paris, by 1892 (sale catalogue); sold 1911 through Rosenberg, Paris, to Baron François Hatvany; returned to Rosenberg, New York, 1947; TPC purchase 1948.[1]

The Small Bather is one of several versions of a theme that preoccupied Ingres throughout his long career. The central figure, seen from the back, appears with the same pose, proportions, contours, and headdress of the earlier *Valpinçon Bather,* 1808, as well as the *Interior of a Harem* of 1828, and it materializes for the last time as the

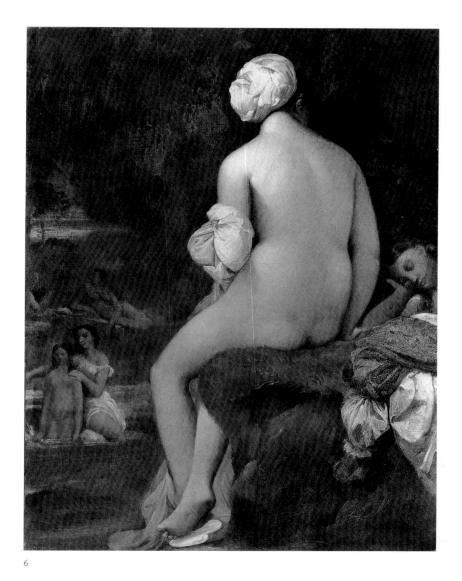

6

mandolin-playing nude in the foreground of *The Turkish Bath,* 1859–64.[2]

Ingres's belief that art should perpetuate tradition rather than break new ground was reaffirmed in this propensity for reworking the same motifs.[3] His admiration for the linearity and precision of Italian Renaissance classicism—especially that of his beloved Raphael—informed his aesthetic choices well into the era of romanticism. Even though viewed as a history painter, whose subjects were themes from mythology and French history, Ingres devoted painstaking attention to the rendering of the single female figure, a motif considered less exalted within the academic hierarchies. Along with his other homages to the female nude, *The Small Bather* represents the painter's personal

delight in creating some of the most sensuous nudes of nineteenth-century French painting. Charles Baudelaire considered these to be among Ingres's most accomplished work.[4]

However, *The Small Bather* is unique in this series and unusual in Ingres's oeuvre for its landscape setting. He admired Nicholas Poussin's classicizing landscapes but was very likely inspired by the examples of Antoine Watteau and Titian in creating this tranquil vision of humanity in harmony with nature.[5] Certainly, the painting recalls the rococo garden-of-love theme so delicately treated by Watteau. It also reflects the fact that Ingres revered Titian for his virtuoso use of color.[6] *The Small Bather*'s landscape undoubtedly owes a great deal to the Venetian Renaissance love of nature,

especially as exemplified by Giorgione.

Duncan Phillips was primarily interested in Ingres's role in the celebrated debate concerning the relative values of line versus color—in which Ingres upheld the supremacy of line and Delacroix favored color. Phillips did not feel the personal affinity for Ingres that he did for other French nineteenth-century artists, such as Delacroix and Daumier. Rather, he valued Ingres's function as an example of classicism, or more precisely, of all that romanticism struggled against as it continued to inform the development of modernism: "The rage of the formalists and purists of painting in our period against what one of them called 'the unusually emotive fragment' exactly corresponds with the aca-demic scorn which the followers of Ingres heaped upon the challenging ideas of Delacroix. 1930 is different from 1830 not in the essentials of the dispute but only in the terms employed."[7]

Phillips's interest in "the assembling of related and contrasting personalities of past and present" was well served by his purchases of works by Ingres and Delacroix, and he saw the former's work very much in relation to the latter's.[8] In 1950 he suggested to Kenneth Clark that he give a lecture at The Phillips Gallery on the two painters: "John [Walker] said you would give us the choice of either a lecture on Henry Moore . . . or else on Ingres *or* Delacroix. My immediate reaction was a preference for the latter but a query—why not Ingres *and* Delacroix? These famous rivals and leaders of two opposed philosophies would make a wonderful double portrait."[9]

Indeed, it was as a foil to Delacroix's painterly expressionism that Phillips valued the stubborn crusader of French academic classicism.[10] For the collector, the rationality and restraint of classicism did not quite express the deeply felt humanity that he valued in and wished upon all artistic creations. *The Small Bather* remains significant in the context of the collection for its role as a pendant to Delacroix. When hung near Delacroix's *Paganini* (cat. no. 10), Ingres's idyll stands in quiet contrast to Delacroix's outpouring of empathy for a musician in the process of creation.

SHL

JEAN-BAPTISTE-CAMILLE COROT (1796–1875)

Born in Paris, July 16, 1796, Jean-Baptiste-Camille Corot was educated at boarding schools in Rouen and Poissy and then apprenticed to drapery shops in Paris. In 1822, with an allowance from his father, Corot was able to study art with two neo-classical landscape painters, working briefly with Achille-Etna Michallon and later Jean-Victor Bertin. His first stay in Italy (1825–28) resulted in many studies of Rome and the surrounding country-side. These studies, intended to be used in the development of formal studio compositions, are valued today for their careful construction and simple tonal values. Upon his return to France, Corot worked in the provinces, spending time with the Barbizon painters. He exhibited at the Salon from 1827, but popular success eluded him for a long time. Corot traveled to England, Holland, and Switzerland, and returned to Italy in 1834 and 1843. As his reputation grew in the 1840s, he was awarded the Cross of the Legion of Honor in 1846 and promoted to officer in 1867. His style changed in the 1850s, when he began painting syl-van landscapes bathed in pearly light, such as *The Dance of the Nymphs,* 1851 (Paris, Musée d'Orsay). Corot's later work also included single female figures. The artist died February 22, 1875, in Ville-d'Avray, at his family's country estate. The Phillips Collection owns four paintings by Corot and one painting attributed to him.

7

View from the Farnese Gardens, Rome, 1826

Rome. Vue prise des jardins Farnèse
Oil on paper mounted on canvas, 9⅝ × 15¼ (24.5 × 40.1)
Unsigned; dated l.r.: *Mars 1826;* red stamp l.l.: VENTE COROT (Lugt no. 461)
Acc. no. 0336 (Robaut no. 65)

Estate of the artist; Corot sale (part 1), Hôtel Drouot, Paris, May 26–28, 1875, no. 17, to Détrimont, Paris, until at least 1905; Quincy Adams Shaw, Boston; Mrs. Malcolm Graeme Houghton, by 1929; Paul Rosenberg, New York; PMG purchase 1942.[1]

After working several years in France, Corot embarked for Italy in 1825, accompanied by the painter Courlandais J. K. Baehr. In Rome he joined a community of foreign artists who con-sidered themselves to be following in the footsteps of the masters of seventeenth-century landscape, Claude and Poussin. Another key figure in this movement was the painter, teacher, and theorist Pierre-Henri de Valenciennes (1750–1819), who had revived the tradition of classical landscape painting and was instrumental in the establish-ment in 1817 of a new Prix de Rome for historical landscape. Corot had been a pupil of two of

Valenciennes's students, Michallon and Bertin; that Corot traveled south to complete his artistic education attests to the fact that he shared the prevailing belief in the cultural and historical authority of Italy. Although the numerous oil sketches he executed during his Italian sojourn have been seen as precursors to impressionist open-air painting, his outdoor work, as Peter Galassi has noted, was itself in keeping with neo-classical values and an integral component of aca-demic instruction. Valenciennes, for example, had recommended sketching from nature as necessary training and preparation for studio work.[2]

View from the Farnese Gardens was created in March 1826, along with two well-known paintings in the Louvre, *The Colosseum from the Farnese Gardens* and *Forum from the Farnese Gardens.* Corot made frequent visits to the Palatine Hill, where he devoted some fifteen painting sessions to the three studies, working on the Phillips sketch in the morning, then turning his attention to the Colosseum at midday and to the Forum in the afternoon. In the present picture Corot com-bined a panoramic view of the city with the more intimate, shaded space of a walled garden in the foreground.[3] He skillfully captured the fresh quality of morning light, imparting definition to the buildings through strongly contrasted areas of sun and shade. In addition to conveying his empirical interest in the effects of light, the work demonstrates the artist's classical feeling for mea-sure and simplicity; in fact, Corot departed from the spontaneous sketch sanctioned by academic authority by introducing a degree of order appro-priate to a more finished work.[4]

The scene is framed by two architectonic trees in the foreground whose verticals are repeated in the cypress trees on the hill at the left and in the short staccato touches of the shuttered windows. Horizontal forms are orchestrated to balance the verticals: a stretch of wall behind a rectangular swath of ground, and a range of purple mountains in the distance. The sense of balance and poise in the design extends to the exquisite color harmony, which is based on the chalky greens of the foliage, the muted pinks of the buildings, and the pale, deli-cate blue of the Roman sky.

For Duncan Phillips, it was the "special dis-tinction of Corot that he combines what is best in naturalism and classicism." For this reason, he was a seminal link between past and modern art: "His trend was ever towards the serenity and symmetry of classic convention yet his was the art which delivered the painters from thralldom to the Greeks and the Romans by showing them that to be classic it is not necessary to be primed with Plutarch but only to be rapturously alive

and aware of the freshness and balance, the form, the order and the rhythm of life."[5]

Corot's reliance on direct observation, com-bined with his instinct for architectural clarity, imbued *View from the Farnese Gardens* with a quality of serenity and equilibrium that evokes the classical past even in the absence of any overtly antique structures, such as are found in the Louvre studies.

RD-R

8

Civita Castellana, 1826 or 1827

Civita Castellana, Plaines et Montagnes
Oil on paper, 9⅛ × 14⅛ (23.2 × 36.2)
Unsigned; red stamp, l.r.: VENTE COROT (Lugt no. 461)
Acc. no. 0333 (Robaut no. 142)

Estate of the artist; Corot sale (part 2), Hôtel Drouot, Paris, May 31–June 2, 1875, no. 271, to Rousset, Paris; inter-mediate history unknown; sale, Parke-Bernet, New York, May 17, 1945, no. 26; PMG purchase from the American British Art Center, New York, 1946.[6]

On May 10, 1826, Corot left Rome for Civita Castellana, in the company of Baehr, and remained there for most of June. He returned the following year, working in the area during September and October 1827, this time accom-panied by Léon Fleury.[7] When selecting sites outside of Rome, Corot and his fellow painters tended to follow certain prescribed routes. The attraction of Civita Castellana, a medieval fortress town, derived in part from its location on the route from the north, which they tra-versed on their way to Rome. They would then return to Civita Castellana on painting excur-sions from Rome.[8]

In the present work, Corot avoided the city's architectural monuments in order to survey the surrounding terrain, with a view of the Sabine Mountains to the east. He adopted a viewpoint near the convent of Santa Chiara, depicting in the foreground a rocky embankment to the left and a grassy mound to the right.[9] Additional details are subordinated by soft, broad brushstrokes that invite the eye to traverse the expansive olive-green and brown plain leading to the mountains in the distance. The massing of clouds on the right counters the rocks in the foreground. If *View from the Farnese Gardens* reveals Corot's ability to strike a delicate balance between qualities of spontaneity and deliberation, this work displays his talent for rendering his immediate impressions of nature. This commitment to visual experience is reflected in his interest in capturing subtleties of lighting and atmosphere.

RD-R

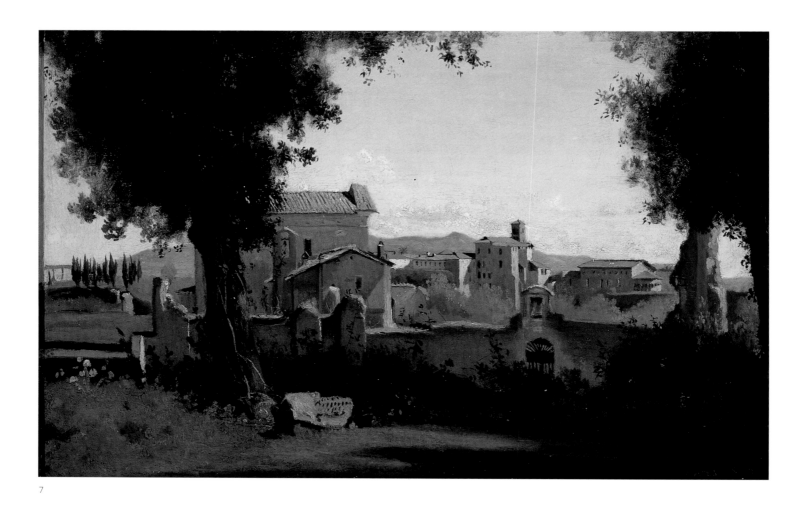

7

8

9

9

Genzano, 1843

Chevrier en vue du village
Oil on canvas, 14⅛ × 22½ (35.8 × 57.1)
Signed and dated l.r.: c. COROT./1843
Acc. no. 0334 (Robaut no. 457bis)

Gift of the artist to Brizard, Paris; sale, Hôtel Drouot, Paris, Jan. 1886, to Closel, Paris; Alfred Robaut, Paris; P. A. Chéramy, Paris, by 1889; Chéramy sale, Paris, Galeries Georges Petit, May 5–7, 1908, no. 131, to Gutmann, Paris; Renan, Paris; Wildenstein, New York, by 1952; TPG purchase 1955.[10]

In 1843, approaching the age of fifty, Corot traveled to Italy for the third and last time. Accompanied by the painter Brizard, he visited the area south of Rome, spending most of his time in the Castelli Romani, where popes and patrician families had constructed their castles and fortified the towns since the Middle Ages. Between June 26 and July 27, Corot worked in the city of Genzano and around Lake Nemi. He painted Genzano from many viewpoints, and the Phillips version is the most significant among them, showing the city from below. In the background, from right to left, are the Cesarini Palace, Santa Maria della Cima, and the Church of the Annunziata.[11] In contrast to the two previous studies, Corot enlivened this work with genre figures, who lend a more human scale and a note of piquant color to the tawny landscape. In the foreground a peasant boy kneels before a goat, and in the middle ground a woman walks along a path, her back to the viewer. The woman's presence is emphasized by her vermilion headcovering, which adds visual weight to the relatively empty left portion of the canvas and neatly balances the composition.

At the outset of his career, Phillips was smitten by Corot's late idylls and his quietly contained female figures.[12] His interest was later to shift to the studies from nature in keeping with the twentieth-century reassessment of and preference for these works. This change in taste also reflects the fact that Phillips, while always responding strongly to romantic imagery, became increasingly sensitive over the years to considerations of composition and treatment.[13] Yet far from portraying Corot's sketches as a uniform group, he was sensitive to the artist's pictorial repertoire and to his increasingly adept handling over time of a variety of coloristic and textural effects:

This famous picture of Genzano ... shows a broader, more painterly touch than the exquisite little studies of the first visit in 1825 when in crystal clear light he built structures as firm as the architecture he depicted. It still reveals Corot's preoccupation of the early years with a harmony of atmospheric colors and a well ordered composition of selected shapes. Now there is added a sensitive suggestion of tactile values and a maturing mastery of the brush.... However much we may respect the pyramidal structure and the unerring register of tonal values, what we prize above all in such a picture is the caress of the canvas and the song that has been sung about the color and the texture of the soil and the remembered quality of the light and the dark accents of the boy and the goats and the sparkling silvery glimpse of the village of Genzano.[14]

Corot's early work in Italy played a decisive role in his artistic development. However, his experience in the French countryside, gained during nearly twenty years between his first and final visits to Italy, made possible this more loosely structured view of *Genzano.* As Phillips noted, Corot's interest in this work lay less in geometry and more in the evocative aspects of color and light, qualities that he was to continue to explore in his poetic Salon landscapes.

RD-R

Born April 26, 1798, at Charenton-Saint-Maurice, near Paris, Eugène Delacroix moved with his family to Marseilles and Bordeaux before returning to Paris in 1806, where he resided until his death. Delacroix received his artistic training in Pierre Guérin's atelier and at the Ecole des Beaux-Arts, exhibiting his first Salon painting, *Dante and Virgil* (Louvre), in 1822. In spring 1825 Delacroix traveled to England. This journey, together with his subsequent excursions—to North Africa, Spain, Belgium, and The Netherlands—profoundly influenced both the subject matter and style of his painting. At the Exposition Universelle in 1855 Delacroix was honored with a retrospective of thirty-six paintings, awarded the Grande Médaille d'Honneur, and made commander of the Legion of Honor; his reputation as the preeminent French romantic painter was well established. Yet his desire to be accepted by the academic elite eluded him until 1857, when, upon his eighth application, he was elected to the Institut de France. Delacroix died a bachelor in his Paris apartment six years later, on August 13, 1863. The Phillips Collection owns three paintings and one charcoal-and-watercolor drawing by Delacroix.

10

Paganini, 1831

Portrait de Paganini
Portrait of Nicolò Paganini; Paganini jouant du violon
Oil on cardboard, 17⅝ × 11⅞ (44.7 × 30.1)
Unsigned and undated
Acc. no. 0487 (Robaut no. 386; Johnson no. 93)

Painted for Achille Ricourt, Paris; Adolphe Hermann, Paris; purchased by Perreau, Paris, 1879 (from Hermann auction); purchased by Boussod, Valadon et Cie., Paris, 1881; purchased by Jules Champfleury, Paris, 1882; purchased by P. A. Chéramy, Paris, 1890 (from Champfleury auction); purchased by Dikran Kélékian, New York, 1908 (from Chéramy auction); PMAG purchase through Kraushaar, New York, 1922 (from Kélékian auction).[1]

Nicolò Paganini (1782–1840), the celebrated Italian violinist, was as renowned for his notorious behavior as he was for his peerless talent. He provided an ideal subject for Delacroix, who once described music as the "sensual delight of the imagination" and likened painting to playing the violin.[2] The portrait, with its abbreviated, spontaneous style so evocative of the virtuoso's frenzied playing, is a consummate reflection of the *romantisme* of Delacroix in particular and the mid-nineteenth century in general.

An amateur fiddler and avid concertgoer, Delacroix was one of many notables who attended Paganini's Parisian debut at the Opéra on March 9, 1831.[3] He painted the Phillips portrait shortly after the performance, and his personalized recollection provides a surprisingly faithful portrayal of the musician. Paganini was only forty-eight at the time of the concert, but according to contemporary accounts his "leanness and lack of teeth [gave] his countenance the expression of a more advanced age."[4] He was "tall and thin, with the pallor of a cadaver, his long black hair reaching his shoulders"; thus his appearance, as Delacroix's likeness indicates, was clearly repellent rather than attractive.[5] Yet Paganini possessed, despite his awkwardness, a curiously charming stage presence: "In the theatre, under the full glare of the lights . . . the effect is nevertheless extraordinary. . . . His clothes flop loosely about his limbs and when he . . . plays, he thrusts his right foot forward and in the rapid passages beats time with it in a most ludicrous manner."[6]

Duncan Phillips knew of Delacroix's *Paganini* when it was owned by Dikran Kélékian.[7] When this collection was auctioned in 1922, Phillips suggested to John Kraushaar that he purchase the painting: "My wife and I expected to get to New York for the Kélékian sale, as I did not wish that collection to be dispersed until after she had seen its treasures. . . . You will no doubt be anxious to acquire the three wonderful examples by Delacroix, especially the 'Paganini.'"[8]

Quite possibly, Phillips's admiration of *Paganini* was kindled by the opinion of Roger Fry, who had recently praised it as a "marvelously intense and imaginative conception" that "makes so eloquent and so passionate an appeal" to the viewer.[9] Additionally, Phillips's patriotism may have been inspired by the solicitation of Hamilton Easter Field, who wrote: "If but one of the masterpieces of the Kélékian collection remains in America through the efforts of THE ARTS, this article and these reproductions [*Paganini* among them] will have brought forth harvest. In any case we shall have broadened the appreciation of many art lovers and we shall have strengthened the love for beauty throughout this land of ours."[10]

Phillips wrote often of the portrait, admiring it primarily because it "is not a characteristic example of Delacroix" but "suggests Daumier, both in its concentrated expression and in its vigorous brushwork."[11] Later, however, he acknowledged the inimitable significance of Delacroix's achievement: "In the little portrait . . . we find all of Daumier's great qualities but also a keener psychological insight. . . . [It is] a tiny soul-portrait."[12]

Paganini is indeed much more than a masterfully painted true-to-life depiction of the virtuoso: its bravura brushstrokes convey the energy and passion of the maestro's performance; it embodies the romantic concept of genius. As Phillips insightfully explained, in *Paganini* we encounter "the soul of the artist, making his confession of faith, of suffering and aspiration."[13]

P H

11

Horses Coming Out of the Sea, 1860

Chevaux sortant de la mer
Homme qui sort de la mer avec les deux chevaux; Chevaux sortant de l'eau; Chevaux sortant du bain; Chevaux Marocains; Chevaux traversant la mer; Horses Emerging from the Sea
Oil on canvas, 20¼ × 24¼ (51.4 × 61.5)
Signed and dated in brown paint, l.r.: *Eug. Delacroix 1860.*
Acc. no. 0486 (Moreau p. 274; Robaut no. 1410; Johnson no. 414)

Painted for the dealer Estienne, Paris; Marquis du Lau, Paris; purchased by Edwards, Paris, 1869 (from Marquis du Lau auction); purchased by Fanien, Paris, 1870 (from Edwards auction); Faure, Paris; purchased by Laurent-Richard, Paris, 1873 (from Faure auction); purchased by Alfred Mame, Tours, 1878 (from Laurent-Richard auction); purchased by Haro, Paris, 1904 (from Mame auction); by 1906, the painting was owned by Mme Esnault-Pelterie, Paris; purchased by Bernheim-Jeune, Paris, 1912; purchased by Troplowitz, Paris, 1913; Baron Denys Cochin, Paris; purchased by Bernheim-Jeune, Paris, 1919 (as agent) for Emil Staub and his wife, Alma Staub-Terlinden, Männedorf, Switzerland); owned by Staub and his wife by 1921; PMG purchase from Staub-Terlinden through Wildenstein, New York, 1945.[14]

Horses Coming Out of the Sea, which Delacroix painted during the last few years of his life, is one of many canvases inspired by his travels to North Africa more than twenty-five years earlier.[15] This exotic journey left an indelible impression on the young Delacroix, and the numerous sketches he made during the excursion provided a rich source of motifs, which he drew upon throughout his career.[16] Delacroix maintained, however, that he created the most successful of these scenes late in life: "I did not begin to do anything passable in my African journey until the moment when I had sufficiently forgotten the small details so as to recall in my paintings only the striking and poetical aspects."[17]

Horses Coming Out of the Sea confirms this assertion: it is a lyrical image of a sun-drenched Mediterranean coastline, enhanced with exotic Arabian horses, turbaned rider, and distant

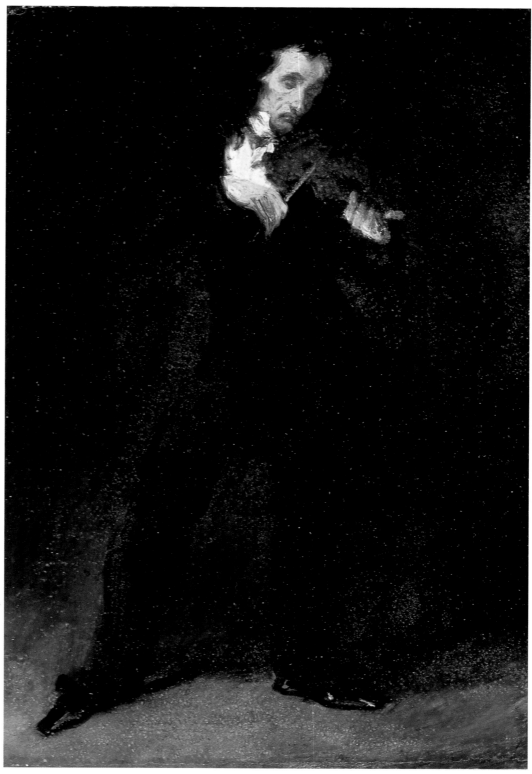

10

Moroccan architecture. The painting's vibrant and luminous color, characteristic of Delacroix's late style and reminiscent of the ambience of North Africa, renders the artist's mellowed recollections all the more palpable.[18]

The painting combines Delacroix's persistent fondness for oriental subjects with another frequently recurring theme in his oeuvre—the horse.[19] In his paintings of equestrian subjects Delacroix aspired to capture the heroic grandeur of the steed, often sacrificing anatomical exactitude for emotional effect.[20] To this end, he usually portrayed nervous and excitable Arabians, whose unkempt manes and tails and dynamic contours proved particularly felicitous for his vigorous baroque compositions.

Like many of Delacroix's late works, *Horses Coming Out of the Sea* is a picturesque genre scene with no conspicuous literary or historical allusions.[21] As Delacroix's reputation became established, he produced fewer grandiose Salon paintings and concentrated on official decorative schemes and easel paintings commissioned by dealers for private collectors.[22] This painting, with its fashionable theme and poetic grace, would certainly have appealed to the purchasing public for whom it was intended.[23]

These qualities also attracted Duncan Phillips when the painting was included in the Delacroix loan exhibition held at the Phillips Memorial Gallery in the winter of 1944–45. He found that the painting embodies "a rare combination of the classic and romantic . . . in one integrated and classic design," and by the end of the show he had decided to purchase it.[24] "For me," Phillips explained, "Delacroix is a perfect example of *controlled energy* in the art of painting, that dynamism of curvilinear design which a disciplined mind keeps curbed and poised and in classic balance, like those splendid horses of his plunging out of the sea."[25]

PH

I I

12

Hercules and Alcestis, 1862

Hercule et Alceste

Hercule ramenant Alceste des Enfers; Hercules bringing back Alcestis from Hades; Hercules brings Alcestis back from the Underworld

Oil on cardboard, 12¾ × 19¼ (32.3 × 48.8)

Signed and dated in dark brown paint, l.c.: *Eug. Delacroix 1862.*

Acc. no. 0485 (Johnson no. 342)

Alluand, Limoges; purchased by Arnold, Tripp, et Cie., Paris, 1888 (from Alluand auction); purchased by Mancini, Paris, 1898; purchased by Gallice, Paris, 1899; purchased by Bernheim-Jeune, Paris, 1900; purchased by Ernest Cronier, Paris, 1902; purchased by George Petit, Paris, 1905 (from Cronier auction; as agent for P. A. Chéramy?); Chéramy, Paris; purchased by Schoeller, New York, 1908 (from Chéramy auction); purchased by Dikran Kélékian, New York, 1913 (from second Chéramy auction, Paris); purchased by Durand-Ruel, New York, 1922 (from Kélékian auction, New York); by 1938, owned by Kélékian; PMG purchase from Kélékian, 1940.[26]

Delacroix's *Hercules and Alcestis* is based on a tragedy by Euripides that recounts the legend of the queen of Pherae who consented to die so that her aged husband Admetus would be granted longer life.[27] Impressed by the compassionate sacrifice and piety of Alcestis, Hercules rescued her from Hades and returned her to earth. Delacroix's painting captures the climactic moment of the episode: Hercules valiantly strides out of the mouth of the underworld and presents the languid body of the queen to her king, who welcomes her on bended knee.

Delacroix first treated this theme in the 1850s, when he was commissioned to decorate the Salon de la Paix in the Hôtel de Ville, Paris.[28] Although this building was destroyed by fire in May 1871, Delacroix's paintings—including the eleven tympanum-shaped lunettes with themes based on the exploits of Hercules—are known from engravings.[29] The Phillips painting is compositionally similar to its prototype but includes additional motifs: in the left background, priests have sacrificed a black sheep on a festooned altar; the left foreground incorporates a still life

12

with amphora, trowel, pitcher, and paten; and the right side of the painting is framed by two fiendish figures peering out from the under-world.[30] Yet more significant than the addition of these auxiliary narrative elements is a subtle transformation that intensifies the sentimental aspects of the drama in the Phillips painting: Admetus no longer gratefully gazes at Hercules but instead tenderly kisses the arm of his beloved queen.

The story of Alcestis was popular in nine-teenth-century France. In 1861, the year before Delacroix painted this scene, Christoph Willibald Gluck's rendition of the tragedy was revived at the Paris Opéra.[31] Perhaps Delacroix attended the performance and was impressed by the poignancy of the tragedy, finding in it an appropriate subject in which his three unswerv-ing passions—theater, music, and painting—could be united.[32]

Hercules and Alcestis is the second Delacroix painting acquired by Duncan Phillips, and it was purchased at a time when he was especially interested in the French masters. Earlier in his collecting career, Phillips had asserted that Delacroix's paintings were "too literary . . . too dependent upon subject for inspiration, like the novels of Scott and the poems of Byron."[33] While *Hercules and Alcestis* is clearly the most "literary" of the three Delacroix paintings in the collection, Phillips was undoubtedly drawn to its dramatic color and energetic composition—attributes synonymous with Delacroix's entire oeuvre. He maintained that Delacroix was "a gallant fighter" for "a state of mind open to new aesthetic ideas" and that he was responsible for resurrecting "the color design and individual expression inherent in the Old Masters."[34]

P H

Alexandre-Gabriel Decamps, a prolific painter of landscape, genre, religious, and oriental scenes, was regarded by many of his contemporaries as one of the foremost romantic artists. Born in Paris on May 3, 1803, Decamps studied briefly with Etienne Bouhot and Abel de Pujol. He soon found buyers for his small pictures, and made his Salon debut in 1827. In 1828 he accompanied the marine painter Ambroise-Louis Garneray to Greece to assist in the painting of a picture commemorating the 1827 battle of Navarino, but he left the expedition to travel for a year throughout Turkey, Albania, and Greece. Although he never returned to the Near East, he painted oriental scenes throughout his career. In 1834 Decamps caused a sensation at the Salon with *La Défaite des Cimbres* (Paris, Louvre), for which he was awarded a medal. Envisioning a career as a history painter, he went to Italy in 1835, but his efforts at ambitious monumental painting did not meet with popular success. Decamps was awarded the rank of chevalier of the Legion of Honor in 1839 and promoted to officer in 1851. Along with Delacroix and Ingres, he was given a retrospective at the Exposition Universelle in 1855 and awarded the coveted Grande Médaille d'Honneur. On August 23, 1860, he died as a result of a riding accident in the forest near Fontainebleau. The Phillips Collection owns one painting by Decamps.

13

Interior of a Turkish Café, 1833 or later

Le Café turc

Oil on canvas, 12¾ × 16 (32.5 × 40.7)

Signed l.r.: *D.C.*

Acc. no. 0477 (Moreau; Mosby no. 465)

Véron, Paris; Véron sale, Hôtel Drouot, Paris, March 17–18, 1858, no. 32; Daniel Cottier, Glasgow; Ichabod T. Williams, New York; Williams sale, Plaza, New York (American Art Association), Feb. 3–4, 1915, no. 74, to James L. Phillips; transferred to PMAG in 1920.[1]

Interior of a Turkish Café reflects the romantic interest in oriental subjects that prevailed during the first half of the nineteenth century and that also engaged artists like Delacroix and Ingres, as well as literary figures.[2] Decamps's attachment to Near Eastern themes was evident from the outset of his career; his *Arabes devant une Maison,* 1823 (Saint-Etienne, Museum), for example, predated his visit to the Orient. When Decamps embarked for the Near East in 1828, he became one of the first European artists to see the region firsthand. Unlike the artists who journeyed there in midcentury in pursuit of documentary realism, Decamps eschewed detailed

13

drawings after nature; rather, according to the contemporary critic Paul Mantz, he absorbed impressions "with his glance rather than with the pencil."[3] Such observations constituted a rich source of inspiration that he was to harvest for the remainder of his career.

Interior of a Turkish Café was painted after Decamps returned to France. A genre scene, it shows a group of standing and seated figures in robes and turbans, assembled before a recess and bathed in liquid semidarkness. The composition is unified by Decamps's heavily worked technique, a characteristic of his style that distinguished it from the polished surfaces of contemporaneous Salon painting.[4]

For many artists who traveled to the Near East, the brilliant and scorching sun was the primary challenge. Eugène Fromentin, a fellow artist and writer who spent time there, felt it necessary to explain Decamps's penchant for Rembrandtesque interiors: "Not able directly to capture the sun, which burns the hands that attempt it, he took a more ingenious detour, and, given the impossibility of suggesting a lot of sunlight with few shadows, he thought that with a lot of shadows he might succeed in producing a bit of sunlight."[5] Indeed, the cavelike dimness of *Interior of a Turkish Café* gives dramatic relief to the shaft of light that enters the room from the right and that is made even more palpable though the use of impasto. At the same time, however, Decamps exploited the shadows in order to create a mood of quiet contemplation and exotic indolence. Fromentin himself had succumbed to the

limpid, colored shadows of the lands of the sun, and another entry from his journal could almost be read as a gloss on the present painting: "Figures float in some kind of blond atmosphere that makes contours disappear." They are rendered immobile, like statues, and "only now and then does a misplaced fold, a gesture, recall life."[6]

Duncan Phillips purchased this work jointly with his brother from the Ichabod T. Williams Collection, which Phillips, then at the beginning of his collecting career, dubbed "one of the most distinguished collections I have seen."[7] Shortly before, Phillips had included Decamps in an essay entitled "Impressionism in Prose." In keeping with his early predilection for romantic, literary themes, much of the text is devoted to writers, but Phillips, in a brief digression, invoked Decamps: "It was the taste for sumptuous backgrounds that sent the painters Delacroix, Decamps, and Fromentin to the Orient. To my mind it is only Decamps who had the Orient in his own soul and was able therefore to bring it back with him on canvas."[8]

Later, Phillips endeavored to characterize the distinctive quality of Decamps's technique in more pictorial terms, claiming that "he was not literary in his romanticism. He was purely and perhaps superficially a sensuous painter."[9] According to Phillips, Decamps laid the "foundations not only for all future romantics who were to use color, as musicians use sounds, for their own sake . . . but also for all the great painters of our day who have devoted their lives to the study of effects of light."[10]

RD-R

HONORÉ DAUMIER (1808–79)

Honoré Daumier was born in Marseilles, February 26, 1808. His father, a glazier with literary ambitions, moved to Paris in 1815 in search of recognition, bringing the rest of the family in 1816. At an early age Daumier worked as an office boy and shop assistant. Under the tutelage of a family friend, Alexandre Lenoir, director of the Musée des Monuments Français, he learned the rudiments of drawing. By 1825 Daumier was apprenticed to the printer Zéphirin Belliard, and in 1830 he joined the staff of *La caricature,* under Charles Phillipon. A lithograph lampooning the bourgeois king Louis-Philippe led to a charge of sedition and six months of imprisonment in 1832. After his release, government censorship forced him to focus his prodigious powers of observation on bourgeois society and manners. The series of cartoons on the swindler Robert Macaire, the law courts, and mythological characters that he contributed to *Le charivari* gained him wide popularity. He also took the plight of the poor as his subject. Although economic necessity forced him to concentrate on lithography, he was also a highly original painter in oil. Daumier died February 11, 1879, at Valmondois in a cottage reportedly given to him by Corot. The collection owns seven oil paintings, forty-eight lithographs, one watercolor, and one drawing by Daumier, as well as one painting formerly attributed to him.

The Daumier Unit

Honoré Daumier occupied the highest place in Duncan Phillips's pantheon of artists. Phillips expressed his admiration when he announced in 1927 that "the principal ambition of my Gallery at present is to make my Daumier Unit second to none and of world wide fame and importance."[1] This goal was pursued over several decades, so that to the works acquired during the early twenties, such as *Three Lawyers,* 1855–57 (cat. no. 16), *On a Bridge at Night,* 1845–48 (cat. no. 14), *The Uprising,* 1848 or later (cat. no. 15), and *Two Sculptors,* 1870–73 (cat. no. 20), Phillips added *The Strong Man,* ca. 1865 (cat. no. 18) in 1928, *Plea for the Defense,* early 1860s (cat. no. 17) in 1937, *The Painter at His Easel,* ca. 1870 (cat. no. 19) in 1944, *To the Street,* 1840s (acc. no. 0382) in 1944, and *The Family,* early 1860s (acc. no. 0375) in 1955.[2] His enthusiasm for the artist also dictated his choice of a gift, *Advice to a Young Artist,* after 1860, to the National Gallery of Art in Washington, D.C., where he hoped it would serve as a bridge between the Old Masters and the moderns.[3] Besides the oil paintings and drawings mentioned above, forty-eight lithographs add further depth to the collection.[4]

The paintings in the collection encompass some twenty-five years of Daumier's work as a painter and embrace a variety of themes, confirming Phillips's view that "many men of special gifts were contained in Daumier."[5] Particularly well represented are subjects from daily life, manifesting Daumier's deep humanity as well as his talents as a satirist. By contrast, subjects from mythology and literature are not found. But it was more than Daumier's strengths as a chronicler of contemporary history that attracted Phillips: he valued Daumier's ability to discover and extract meaning from the drama of ordinary life, a capacity he shared, in Phillips's view, with Michelangelo. Although Daumier's powerfully monumental forms have frequently recalled the example of the Renaissance master, Phillips was thinking of the manner in which both artists, whom he designated "great prophets of painting," were able to "select the significant moments and to mould them into forms of universal symbolism."[6]

According to Phillips, Daumier's plastic means were absolutely essential to the meaning of his works: "To be sure he aspired to interpret modernity, but always through art which is ageless."[7] His compositional strategies and his techniques were always adapted to his subject. If *Three Lawyers* is appropriately "suave and finished," the picture of the woman and child after a day of toil—*On a Bridge at Night*—is simple and unadorned.[8] That Daumier's works defy easy classification was acknowledged by Phillips:

Daumier's material, the drama of the streets, was romantic and so was his rebellion against the authorities in his choice of that material and his protest against the evils of his time and in the life about him. However, in his grand control of his human material and in his humane expression he was superbly classic—always tending to plastic simplification, to functional drawing, modeling and color, to a phrase of pith and moment bereft of meaningless ornament, or flashy virtuosity, to an architectural feeling for line and mass, for balance, projection, recession and proportion. He was romantic then in his intensity and his non-conformity but classic in his exercise of executive poise and power.[9]

For Phillips, the jewel of the unit was *The Uprising.* When this long-forgotten painting appeared on the market, he seized the opportunity to acquire it. His admiration led him to speak of the work in superlatives, and on more than one occasion he referred to it as the "greatest picture in the Collection."[10] Phillips was not alone in his admiration; scholars like Arsène

Alexandre and Frank Jewett Mather hailed the painting, and Phillips always recalled with fondness the talk delivered by Henri Focillon at the Phillips Memorial Gallery on April 18, 1940, in which the French critic described the painting as "a visionary painted by a visionary."[11]

Yet despite the powerful impact of *The Uprising,* its status within Daumier's oeuvre has remained the subject of some debate. The work's uncertain history before its sudden appearance in 1924 and its uneven execution inevitably raise questions. As has been noted, problems of attribution in Daumier are not uncommon: not only did his popularity lead to copies and imitations, but the artist was apt to leave his canvases unfinished, and some were later retouched by others.[12] Phillips's defense of the painting is instructive, however, for it reveals his approach as a collector and critic. While acknowledging that some details were probably later additions, he insisted that "an unfinished masterpiece cannot be left out nor underrated if the heart, the mind and the hand of a great artist at his best have been revealed in the essential part of the picture which carries the emotional expression."[13] Furthermore, the work's "unfinished" state appeared to him to be in perfect harmony with its expressive meaning: "The rough hewn drawing and modelling, bearing down only on crucial contours, this is as it had to be, the only possible equivalent in paint for a malleable, evolutionary world."[14]

But there was a more significant reason for the importance Phillips accorded this painting, bearing on the genesis and purpose of the unit as a whole. During his lifetime, Daumier was able to devote himself only sporadically to painting and sculpture, and for a long time his reputation rested primarily on his superior talents as a draftsman. In 1931 Phillips stated: "As for Daumier I affirmed his importance as a painter in oil and as the greatest and most universal artist of his Century fifteen years ago at a time when textbooks referred to him only as a satirical cartoonist."[15] Phillips hoped to reveal to the public what Daumier had achieved as a painter, and *The Uprising* would play a crucial role, for as he wrote to Focillon: "I think you believe with me that the master's place in history would be diminished without our picture."[16]

Phillips's reflections on other images shed further light on the collection as a whole. In the watercolor *The Connoisseur,* ca. 1860–65, for example, Phillips seems to have found a metaphor for his own mission: "He contemplates in contentment these spoils of the spirit of extraordinary men and he dreams perhaps of how he can communicate to the many who

'have eyes and see not' the ability to appreciate the beautiful, to the end that artists may not be without regard in their own day and without honor in their own country."[17] And in 1929 Phillips wrote of Daumier: "More and more he seems to me a veritable Titan, a symbol in himself and in his art for all that I would have my collection stand for."[18]

RD-R

14

On a Bridge at Night, 1845–48

Femme et Enfant sur un Pont
Le fardeau; Sur un pont pendant la nuit
Oil on wood panel, 10¾ × 8⅜ (27.3 × 21.3)
Unsigned
Acc. no. 0377 (Maison, vol. 1, no. I-9)

Arsène Alexandre, Paris; Alphonse Kann, Paris; Dikran Kélékian, Paris and New York, by 1920; Kélékian sale, Plaza Hotel, New York (American Art Association), Jan. 30–31, 1922, no. 92; PMAG purchase through Kraushaar, New York, 1922.[19]

Duncan Phillips once referred to *On a Bridge at Night* as "one of the most perfect examples of pictorial art purged of all irrelevance." Daumier painted several austere scenes of a woman burdened with a parcel, sometimes laundry, taking a child by the hand.[20]

In the present work his experience as a cartoonist is apparent. Details of appearance and dress are suppressed as the two figures are described with the distinctively expressive outlines of a caricaturist's vocabulary. Daumier's painterly talents are also much in evidence: employing a restricted palette, he skillfully rendered the effects of lamplight falling on the pair and suggested a row of buildings across the Seine. Perhaps having witnessed many such scenes, he sympathetically captured the weary pace of the homeward journey of the two anonymous figures, their shadows cast in the artificial light pointing the way. The silent intimacy between the two is conveyed not only by their joined hands but also by the manner in which their shapes relate to one another: the woman inclines toward the child as she balances the parcel at her side; the child, determined to keep up, leans toward the woman. Whether in lithographs, sculpture, or oil paintings, Daumier's gift for observation extended not only to his subjects' occupations but also to the tone of their daily lives, as is so evident here.

RD-R

14

15

The Uprising, 1848 or later

L'Emeute
Oil on canvas, 34½ × 44½ (87.6 × 113.0)
Signed l.l.: h.D.
Acc. no. 0384 (Maison, vol. 2, no. II-19)

Early history unknown; possibly Henry Bing, Paris; purchased in 1904 from Vigier, Paris, by H. Fiquet, Paris; consigned by Fiquet to Paul E. Cremetti and Leicester Galleries, London, 1924; PMG purchase 1925.[21]

The Uprising was first published by Arsène Alexandre in 1924, when it was on exhibit at the Leicester Galleries in London.[22] Alexandre's enthusiasm, as well as the favorable opinions of Roger Fry and William Burrell, captured the attention of Duncan Phillips.[23] Even those who believe that certain passages were later retouched by another hand have acknowledged Daumier's role in its dramatic conception and accomplished compositional scheme.[24]

The Uprising was possibly inspired by the revolution of 1848, which saw the overthrow of Louis-Philippe's monarchy. To an open competition that same year for a figure symbolic of the new republic, Daumier submitted a sketch showing a majestic female figure seated on a throne, grasping the tricolor in her right hand.[25] He never produced a finished version, but he may have expressed his republican sympathies by recalling the events of 1848 in other paintings, including another called *L'Emeute* (formerly in the collection of H. Rouart, now lost); *A Family on the Barricade* (Prague, National Gallery); and the Phillips picture.[26] Gifted observer though Daumier was, *The Uprising* is much more than the depiction of a specific moment, however; as Henri Focillon noted, "It makes us all breathe a visionary aspect of the 19th century, a street scene full of the mystique of revolutions."[27] Transcending its own time, it held particular resonance for Phillips during the war years of the 1940s.[28]

In *The Uprising* Daumier expressed the fervor of revolution through his manipulation of

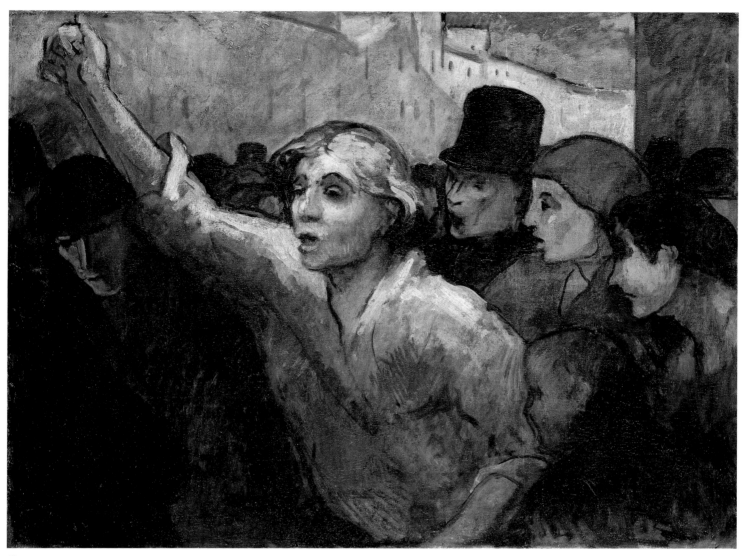

15

compositional and pictorial elements. An insurgent in shirtsleeves incites the mob and conveys its frustration. His illumined arm, diagonally raised, culminates in a fist, but, as Focillon noted, his eyes, though open, do not see: "The regard is directed 'inward.' The rioter is possessed by a dream to which he assembles the crowd."[29] Daumier compressed the crowd by introducing the vertical wall to the right and the dark shadows on the left, massing the figures and thereby heightening the explosive quality of the scene and transforming it, according to Phillips, into a "symbol of all pent up human indignation." The urban background yields as the pack advances, almost of necessity, for the people "are the waves of self rule, of self reliance, the epic movement in the history of freedom."[30]

RD-R

16

Three Lawyers, 1855–57

Trois avocats causant
Trois avocats
Oil on canvas, 16 × 12¾ (40.7 × 32.4)
Signed l.l.: *h. Daumier*
Acc. no. 0381 (Maison, vol. 1, no. I-91)

Geoffroy-Dechaume, Paris, by 1878; Henri Rouart, Paris, by 1888; Rouart sale, Galerie Manzi-Joyant, Paris, Dec. 9–11, 1912, no. 162, to Knoedler, New York; George Blumenthal, New York, 1913; Knoedler on consignment from Blumenthal, 1920; PMAG purchase 1920.[31]

Daumier's fascination with the legal profession is seen in numerous watercolors, drawings, and oils, as well as countless lithographs—including the thirty-nine in the celebrated series *Les Gens de justice,* reproduced in the periodical *Le chari-*

vari from 1845 to 1848. Many critics have speculated that Daumier's dislike of venal lawyers and judges arose from his experience working as an office boy. What is certain is that later, from 1829 to 1831, Daumier's family lived on the rue de la Barillerie, near the law courts, where the young artist would have had the opportunity to observe these same officials.

Three capped and gowned lawyers gather in the hallway of the law courts.[32] They may be former adversaries reliving the drama of a trial just concluded or collaborators genially congratulating each other on a victory. By posing the three dark figures in an intimate group, Daumier reinforced the sense of unity and conspiratorial fellowship. In their arrogance, they are oblivious to the impoverished figure huddled in the shadows at the far left for whom legal proceedings, far from being a matter of intellectual intrigue, may

have devastating consequences. The pale, cold light that filters down from above only adds to the harshness of the scene. Duncan Phillips called attention to the splendid effect created by the dense zones of black, white, and gray: "Especially beautiful are the black gowns and the white walls when daylight falls upon them for an accidental moment of beauty in the midst of cruel bleakness. Velázquez and Terborch never surpassed Daumier in revealing the sensuous colorfulness of luminous blacks and ivory whites, nor are the shadows of Rembrandt more mysterious or marvelous as envelopment for figures."[33]

<div style="text-align: right">RD-R</div>

17

Plea for the Defense, early 1860s

Le défenseur

L'avocat lyrique; La plaidoirie

Wash, pen and ink, and black chalk on paper, 9¼ × 14
(23.5 × 35.5)
Signed l.l.: *h.D.*
Acc. no. 0376 (Maison, vol. 2, no. 664)

Alexis Rouart, Paris, by 1908; Henri Rouart, Paris, by 1923, and until at least 1934; Seligmann (de Hauke), New York; PMG purchase 1937.[34]

Long before acquiring *Plea for the Defense* in 1937, Duncan Phillips reflected on the theme: "None of his satires seem more humane, more earnestly purposeful, than those in which he withers with scorn the contemptuous carelessness of prejudiced judges or the mock emotion of a counsel for the defense, working himself up to actual tears in his appeal on behalf of the innocence of a habitual criminal."[35]

In the present composition, which Daumier varied in several small sketches and watercolors, he exposed the sophistry of the practiced lawyer. The lawyer and the accused man are delineated with deft, sinuous strokes in ink and chalk over wash, while a few vague silhouettes on the left suggest courtroom spectators. The lawyer's exaggerated stance, leaning on one arm and gesturing diagonally back with the other toward his coarse, somewhat timorous client, suggests a performance and recalls a similar pose struck by the barker in *The Strong Man*. A bright spot of light floods the right portion of the scene, as if to underline the histrionic nature of courtroom behavior.

It has been difficult to arrive at a definite chronology of Daumier's drawings and watercolors; datable lithographs have not proven to be a reliable key to dating works in other media. Although *Plea for the Defense* has been associated with the series *Les Gens de justice,* published during the mid- to late 1840s, it more likely dates to the early 1860s.[36]

<div style="text-align: right">RD-R</div>

16

17

18

18

The Strong Man, ca. 1865

Hercule de foire

Une parade de saltimbanques; Le lutteur

Oil on wood panel, 10⅝ × 13⅞ (27.0 × 35.2)

Signed l.l.: *h. Daumier*

Acc. no. 0380 (Maison, vol. 1, no. I-189)

P. A. Aubry, Paris, by 1878; Guyotin, Paris; Alexander Reid, Glasgow; Reid sale, Hôtel Drouot, Paris, June 10, 1898, no. 23; Victor Desfossés, Paris; Desfossés sale, Paris, April 26, 1899, no. 25; Baron Vitta, Paris; sold to Knoedler, New York, March 1928; PMG purchase 1928.[37]

The *Strong Man* is related to two crayon sketches of the barker and a charcoal study of the strongman. In the present work these figures join others to form a complex composition.[38] The subject is a *parade,* or sideshow, in which clowns, musicians, barkers, and strongmen per-form before a theater or tent to solicit customers for the spectacle within. These shows were popular during the eighteenth century in connection with *commedia dell' arte* performances at fairs. By the time Daumier painted most of his parade pictures, in the 1860s, they were no longer a common feature of the Paris scene, although they could still be found in the temporary fairgrounds set up during festivals.[39]

Sharp light illuminates the strongman, whose relatively warm colors set him in striking relief to the subdued gray and blue tones of the rest of the image. His muscular, barrel-chested body contrasts with the backdrop, which consists of flat, rectilinear sections; a pair of legs in the upper left appears to be part of a poster advertising one of the acts. A clownlike barker exhorts the crowd to notice the proud "Her-cules." His stentorian claims are emphasized by his bold gesture and punctuated by his dramati-cally lit hand, in the center of the composition. The spectral faces of the barker and the open-mouthed figures behind him are grotesque, giv-ing the scene an intensely expressionistic quality.

Although Daumier's earlier depictions of parades often lampoon their persistent, frenzied hawking, his works from the 1860s exaggerate to the point that they assume a demonic, night-marish aspect. Paula Hays Harper has suggested that because he was forbidden by censorship laws to caricature French politicians, Daumier may have expressed his dislike of Louis Napoleon and his propaganda machine in more oblique ways. There is reason to believe that the Phillips picture may thus constitute a work of social commentary in which the metaphor of the sideshow is used to condemn the "propa-ganda activities of the Age of the Empire which deftly assessed and manipulated the new politi-cal weapon of the era—public opinion."[40]

RD-R

19

19

The Painter at His Easel, ca. 1870

Le Peintre devant son tableau
Oil on wood panel, 13⅛ × 10⅛ (33.5 × 25.8)
Signed l.l.: *h.D.*
Gift of Marjorie Phillips in memory of Duncan Phillips, 1967
Acc. no. 0378 (Maison, vol. 1, no. I-222)

Dollfus, Paris, by 1878; possibly Paul Rosenberg, Paris, by 1901; Alexander Reid, Glasgow; Sir William Burrell, Glasgow; Burrell sale, Christie's, London, May 16, 1902, no. 141; Alexander Reid, Glasgow; Jules Strauss, Paris; Reid and Lefevre, by 1927; Knoedler (half share from Reid and Lefevre, sold back to Reid and Lefevre); David Cargill Collection, Glasgow; Bignou Gallery, New York; DP purchase for personal collection, 1944; gift of Marjorie Phillips, 1967.[41]

20

Two Sculptors, 1870–73

L'atelier d'un Sculpteur
L'atelier de Clésinger; Amateur et Sculpteur
Oil on wood panel, 10½ × 14 (26.6 × 35.6)
Unsigned
Acc. no. 0383 (Maison, vol. 1, no. I-233)

Uhle, Dresden, by 1904; Durand-Ruel, Paris; Bignou, New York; Kraushaar, New York; PMG purchase 1925.[42]

20

Nineteenth-century art is rich in pictures of artists at work, a subject that gratified a growing popular taste. The theme is also much in evidence in The Phillips Collection. Although Daumier in his lithographs often satirized the Paris art world, the collectors, and the public, in *The Painter at His Easel* he approached the theme of the artist in his studio with deference.[43] Posed before an easel, the painter is shown alone in a sparsely furnished room, the far wall barely distinguishable in the reddish-brown penumbra. His palette and brush seem to be substitutes for his hands. The moment is one of intense concentration; the artist has paused, and the pause itself assumes an almost sacramental aura. Daumier highlighted the figure of the artist, his brush, and the edge of the easel with a white, calligraphic line. Set against a dim background these energetic outlines produce a radiant effect, suggesting the exalted state of the artist in a moment of creative engagement.

Duncan Phillips purchased *The Painter at His Easel* for his personal collection in 1944 but often lent it to the museum.[44] It was formally given to the collection by Marjorie Phillips in 1967. How-

ever, its presence had been anticipated well before it was acquired by Phillips, for a vignette from it had already graced several collection publications, including the 1922 Daumier monograph, where it appears on the cover and title page.

In *Two Sculptors,* two men scrutinize a piece of sculpture, which consists of a pair of half-reclining figures. A silent and poignant exchange appears to be taking place: the attention of the men is riveted on the object before them, while the sculpted figures, depicted from behind, return their fraternal gaze. Furthermore, a plastic aesthetic permeates the work as a whole; indeed, the human figures, no less than their sculpted counterparts, resemble the clay models Daumier himself often executed.[45]

Phillips, who delighted in Daumier's "sculp-

turesque projections of forms in space," envisioned the artist's working process: "In *Two Sculptors* he built the two heads in little planes, seeming to thumb the color as if it were clay and stopping at the moment when the characters revealed themselves."[46] The work also spoke to Phillips's concern with the basic truth of art as personal vision, revealing "two creators working on the same problem from temperamentally different points of view. It is Daumier's version of 'the artist sees differently.'"[47]

The two figures have not been identified with certainty; Maison has suggested that the bearded figure may portray Jean-Baptiste Clésinger (1814–83), a sculptor and painter who shared Daumier's political convictions.

R D - R

GUSTAVE COURBET (1819–77)

Gustave Courbet, one of the great figures of European realism, was born in Ornans, June 10, 1819. While a student at the Collège Royal in Besançon, Courbet arranged to study art with Charles Flajoulot, a former pupil of Jacques-Louis David's. He went to Paris in late 1839 and during the 1840s painted in a romantic idiom, exhibiting at the Salon for the first time in 1844. His gradual turn toward greater naturalism earned him a medal in 1849, and, at the Salon of 1850 his *Stonebreakers* (destroyed at Dresden, 1945) and *A Burial at Ornans* (Paris, Musée d'Orsay) provoked controversy because of their commonplace subject matter and robust technique. When some of his submissions to the Paris World Exposition of 1855 were rejected, he arranged for a private exhibition, the famous Pavilion of Realism. Visits to Belgium, Switzerland, and Germany inspired landscape and hunting scenes. Official recognition returned in the 1860s; in 1870, however, he refused the coveted cross of the Legion of Honor offered by Napoleon III. A committed republican, Courbet was elected president of the general assembly under the Commune in 1871 and was later held responsible for the destruction of the Vendôme column. He was fined and condemned to a prison term of six months, during which time he painted still lifes. In 1873 he fled to Switzerland and took up residence at La Tour-de-Peiltz, near Vevey, where he died December 31, 1877. The Phillips Collection owns three oil paintings and one etching by Courbet.

21

21

Rocks at Mouthier, ca. 1855

Rochers à Mouthier

Les Roches à Ornans; Le Ravin

Oil on canvas, 29¾ × 46 (75.5 × 116.8)

Signed l.l.: *G. Courbet.*

Acc. no. 0342 (Fernier no. 112)

Early history unknown; sale of Félix Gérard Sr., Hôtel Drouot, Paris, Mar. 28–29, 1905, no. 33, to Ambroise Vollard, Paris; Vollard sale, Hôtel Drouot, Paris, May 16, 1908, no. 10; Marquis de Rochecouste, Paris; Sale, Hôtel Drouot, Paris, June 8, 1909, no. 11; Galeries Georges Petit, Paris; Kraushaar, New York; PMG purchase 1925.[1]

The subject of *Rocks at Mouthier* is more precisely identified as the rocks of Hautepierre, a mass of cliffs that overhangs the village of Mouthier-Haute-Pierre.[2] The site is in Courbet's beloved native Franche-Comté, to which he returned often to visit his family and paint the characteristic geological formations. Although this region was experiencing far-reaching changes, including the effects of industrialization, Courbet avoided any signs of human proximity. He seemed interested in the rugged scenery both for the natural drama it contained and as a source of monumental plastic forms.[3]

Courbet made dashing, painterly use of the palette knife to capture the weathered surface of the cliffs: "Try a brush to do rocks like that, rocks that have been eroded by the weather and the rain, which have formed long seams from top to bottom," he once remarked.[4] He added emphatic strokes of white to record the play of bright sunlight across the escarpment. The assertive planar quality of the rocks is relieved, in the foreground, by a more hospitable valley, which abounds in deep-green vegetation and contains a tranquil source of water. A path disappears over the brow of a hill on the left, leading the eye into an open area of blue sky.

In keeping with prevailing attitudes, Duncan Phillips initially minimized Courbet's intellect and learning, identifying him as an unrelenting realist who had earned his place in the history of art by challenging sentimentality and dogma through an instinctual approach to painting.[5] As his appreciation for Courbet's talent grew, his appraisal became more subtle: "In a larger sense, [Courbet] was himself a romantic poet of the type of Walt Whitman, inspired and eloquent in his revelations of the elemental forces of Nature, the immensity of the sea and sky, the structure and sap of the brown old earth and of the fine, fleshy and formidable folk who subsist thereon."[6]

In his assessment of *Rocks at Mouthier*, Phillips again focused on the romantic dimension of Courbet's realism: "This is a close observation of nature but still in the grand manner of the Romantics."[7] The grandeur of this work owes to Courbet's broad, vigorous treatment, to which Phillips was increasingly attracted over the years. During the early 1960s, the painting was exhibited in what Marjorie Phillips dubbed the "Courbet room" on the second floor of the new wing, along with works by Constable, Daumier, Cézanne, and Goya, who painted with similar breadth and simplification.[8]

R D - R

22

The Mediterranean, 1857

La Méditerranée

Oil on canvas, 23⅛ × 35½ (58.8 × 85.6)

Signed l.l.: *Courbet*

Acc. no. 0341 (Fernier no. 219)

Early history unknown; Burton Mansfield, New Haven, by 1919, and until 1924; PMG purchase through Fearon Galleries, New York, 1924.[9]

Courbet first saw the Mediterranean in 1854, when he was the guest of his patron Alfred Bruyas, a wealthy collector from Montpellier. Busy completing portraits and other commis-

22

sions for Bruyas, he seems to have painted only a few seascapes during this visit. The Phillips painting was probably executed during a second visit to this coastal area three years later in 1857.[10]

The sea's many moods exerted a powerful and lasting hold on the artist's imagination. In a letter to Victor Hugo written in 1864, Courbet, perhaps trying to impress the writer with poetic hyperbole, penned: "The Sea! The Sea with her charms saddens me; in her joy she reminds me of a laughing tiger; in her sadness she reminds me of the tears of a crocodile and, in her fury, of

the raging caged monster that cannot devour me."[11] By contrast, the Phillips painting evokes a calmer, more subdued mood, yet the expansive seascape makes a statement no less powerful in its evocation of the romantic sublime.

Courbet created a composition constructed around horizontal parallel bands. The white crests of waves fill the right foreground, while a rock formation rises up on the left to link earth, sea, and sky. The crystalline Provençal light exaggerates the contrasts in the scene, so that the horizon appears as a distinct line dividing

the teal blue sea from the striking yellow-green sky. Clouds looming on the horizon echo the rocks and breaking waves in the foreground. As opposed to the broad treatment of the rest of the work, Courbet included tiny boats on the horizon in the upper right, drawing the eye into the distance. But such ephemeral human activity pales before the grandeur of nature and only emphasizes the physical might of the densely palpable sea. In this work we have a fine example of how Courbet's realistic impulses could coexist with his romantic sensibility.

RD-R

ADOLPHE MONTICELLI (1824–86)

A highly original painter of portraits, still lifes, landscapes, and fantasies, Adolphe Monticelli was born October 14, 1824, in Marseilles of Italian parentage. Monticelli began his training in the local art school before going in 1846 to Paris, where he studied with the academic painter Paul Delaroche and copied paintings in the Louvre, especially works by Giorgione, Rembrandt, and Veronese. He returned to Marseilles around 1848 but resided in Paris intermittently throughout the late 1850s and 1860s. His friends included Delacroix and Narcisse Virgile Diaz de la Peña, whose intense fascination with color he shared. Monticelli's reputation increased during the 1860s, and he applied much of his energy to the creation of *fêtes galantes,* scenes of amorous dalliance and flirtation. After 1870 Monticelli returned to Marseilles, where he painted prolifically and indulged his love of theater and opera. His style became freer as he orchestrated dazzling colors and built up surfaces in rich impasto. Monticelli died in Marseilles June 29, 1886. He exerted a powerful influence on Cézanne, van Gogh, and the fauves, and on the Americans Prendergast and Ryder. The Phillips Collection owns five oils and one painting attributed to the School of Monticelli.

23

23

Woodland Worship, ca. 1872

Oil on wood panel, 17¼ × 29⅝ (45.0 × 75.3)
Signed l.r.: *Monticelli*
Acc. no. 1384

Early history unknown; Mrs. C. L. Atterbury; sale, Plaza Hotel, New York (American Art Association), Feb. 11, 1919, cat. no. 158, to Kraushaar, New York; PMAG purchase 1921.[1]

At a time when his realist and impressionist contemporaries were turning their attention to scenes of everyday life, Monticelli devoted himself to forging an art of imagination and fantasy. During his career he painted hundreds of fêtes galantes, which evoke the pleasure gardens of Antoine Watteau (1684–1721).[2] In so doing, Monticelli continued an early nineteenth-century romantic interest in the eighteenth-century master; furthermore, his fascination with the sensual and fictitious aspects of rococo art were to serve as a bridge to the imaginary visions of Gauguin, Moreau, and Redon at the end of the century.

Woodland Worship shows a gathering of finely dressed figures cavorting in a forest glade. On the left is the arched portal of a temple which no doubt inspired the current title. Dogs at the center and horses tethered to trees at the

right complete the courtly scene. The large cast, theatrical setting, and glittering colors, now somewhat darkened with age, also recall the pageantry that Monticelli so admired in the Venetians.

Duncan Phillips was attracted to Monticelli at the outset of his career, and examples by the artist figured among his earliest acquisitions.[3] Monticelli's pleasure in the materials of his craft and his exploration of chromatic and tonal harmonies prompted Phillips to call him "the most thrilling virtuoso with color music the world has known," and to praise the way he kept his lush gardens, and his court ladies and gallant gentlemen "enveloped in a sensuous lava of jewelled tone."[4] Nonetheless, Phillips's early admiration was tempered by his hesitation to embrace elements of abstract design in Monticelli's imaginary work. It was his belief that the decorative devices and unrestrained, riotous color often obscured the subject, becoming ends in themselves. Phillips wrote in 1914: "No pictorial representation can hope to attain greatness if it disregards such decorative principles as unity of design and harmony of colour. On the other hand no pictorial decoration can safely maintain its legitimacy among the representative arts

if it represents nothing and is expressed merely by abstract colour and line. In so doing it passes into the category of mere ornament."[5] It was perhaps for these reason that Phillips claimed to find greater merit in Watteau, whose work he believed evidenced the "restraint imposed upon the senses by a very fine intellect."[6]

R D - R

24

Bouquet, ca. 1875

Bouquet de Fleurs
Oil on wood panel, 27¼ × 19⅜ (69.2 × 49.3)
Signed c.r.: *Monticelli*
Acc. no. 1381

Alfred Delpiano, Cannes, by 1936; Paul Rosenberg, New York, 1954; TPG purchase 1961.[7]

This harmonious floral arrangement in a blue vase shows evidence of Monticelli's having worked "wet-in-wet"—in other words, applying paint with a loaded brush to still wet layers in order to combine the pigments directly on the canvas. He appears almost to have sculpted the red, orange, and pale yellow blossoms. The tabletop is tilted toward the picture plane,

24

revealing a waxy surface that reflects the deep, unctuous colors. Monticelli allowed the darker tones of the wood underpanel to show through in sections, establishing a warm background that lends further coherence to the composition. The work possesses a concreteness often missing in his escapist fêtes galantes.

Duncan Phillips first saw *Bouquet* in an exhibition at the Rosenberg Gallery in 1954. In his review of this exhibition, Phillips took note of "five gloriously alive flowerpieces, superbly existent in space, their nuance of many colors magically united in resonant tone."[8] His subsequent purchase of a work by Monticelli after a period of many years was prompted by a renewed appreciation of the artist, no doubt encouraged by the examples he encountered at the Rosenberg exhibition. In the same review, Phillips showed himself particularly taken with what he believed was the artist's best work: the more realistic flowers, fruits, landscapes, and portraits. Phillips also rediscovered Monticelli's historical role: "How could we have failed to see that Monticelli at his best, even in his fêtes galantes during the 1870s, is the link connecting the Romanticism of Delacroix with the Expressionism of Van Gogh and with all subsequent Expressionists down to our own day? It was Van Gogh himself who first sensed this truth."[9] In purchasing this flower painting for the collection, Phillips was dramatically able to illustrate the affiliation between Monticelli and van Gogh, for *The Bouquet* exhibits the energetic brushwork and thick layers of impasto that we associate with van Gogh's work in this genre, and that accounts for his fascination with this Provençal artist. Van Gogh proclaimed his indebtedness to Monticelli when he wrote to his brother Theo about his desire to paint the splashes of orange, yellow, and red flowers under the brilliant blue sky of the South, where everything "vibrates like the bouquet of Monticelli which you have."[10]

RD-R

PIERRE PUVIS DE CHAVANNES (1824–98)

Pierre Puvis de Chavannes, an artist of independent vision, strongly influenced the symbolist painters as well as Matisse, Picasso, and the Americans Davies, Glackens, and Prendergast. Puvis de Chavannes was born in Lyons, December 14, 1824. Puvis originally intended to become an engineer, as was the family tradition, but following a visit to Italy in 1847 he decided instead to devote himself to painting. After working for less than a year in the studio of Henri Scheffer in Paris, he made a second trip to Italy in 1848. Puvis first exhibited at the Salon in 1850 but was subsequently refused until 1859. His early work, depicting dramatic subjects in rich colors, was inspired by Delacroix and Théodore Chassériau. In 1861 Puvis won a second-class medal at the Salon for history painting and sold his entry *Concordia,* 1861 (Amiens, Musée de Picardie), to the state. His later works, chiefly murals on canvas, are classical in inspiration, characterized by a rigorous lucidity and a style that employed relatively simplified forms and a cool palette. Puvis executed important mural commissions for museums in Amiens and Marseilles, for the Panthéon and the Sorbonne in Paris, and for the Boston Public Library. He also produced easel paintings, such as *The Poor Fisherman,* 1881 (Paris, Musée d'Orsay). Official awards included the chevalier of the Legion of Honor (1867), officer (1877), and commander (1889). He died in Paris, October 10, 1898. The Phillips Collection owns three oils, one watercolor, and one drawing by Puvis de Chavannes.

25

25

The Wine Press, ca. 1865

Le Pressoir
Oil on canvas, 18½ × 13⅝ (47.0 × 34.6)
Signed l.l.: *P. Puvis de Chavannes*
Acc. no. 1621

Collection of the artist; Catholina Lambert, Paterson, N.J., by 1894; purchased by Durand-Ruel, New York, 1895; Charles H. Tweed, 1896; Ferargil, New York; DP purchase 1920; transferred to PMAG 1921.[1]

Well known for his monumental murals, Puvis de Chavannes once claimed: "The true function of painting is to decorate walls. Apart from this, one should never make paintings any bigger than one's hand."[2] Despite its relatively modest dimensions, *The Wine Press* serves as a reminder that the two genres, mural and easel painting, were nonetheless intimately connected in the work of Puvis.[3] In fact, *The Wine Press* had its source in a motif from his *Ave Picardia Nutrix,* 1861–65, a mural executed for the Musée de Picardie in Amiens. While the Amiens image depicts the production of cider, an occupation typical of that northern region, the present work invokes the general Mediterranean theme of winemaking.[4] Furthermore, *The Wine Press* manifests certain effects that came to be associated with Puvis's mural compositions: a relatively sober color scheme of ashy rose, silvery blue, gray, and indigo; scumbling; and a trellis backdrop that relate the image to the planar surface of the composition.

But compared with the often flat and incorporeal figures in Puvis's murals, the half-draped figures depicted here are hardy and strong, presented in convincing solidity. And although their highly deliberate arrangement within a pyramidal composition mitigates the sense of toil one might expect from a scene of harvest, Puvis generates a feeling of rhythmic continuity by artfully arranging them as if in a relay. The sequence begins at bottom right, where a woman, seated below a yoke of oxen, balances a wooden basket filled with purple grapes. Her gaze directs the viewer's attention to the figure on the far left hoisting a basket. The centermost figure, her back toward us and her hidden glance continuing the leftward motion, seems to have just relinquished the basket that is being emptied by the man at the apex of the pyramid.

The Wine Press is conspicuous for its harmoniously composed arrangement of statuesque figures and its low-keyed, closely valued colors, which together evoke a remote, idyllic Mediterranean past. Puvis's arcadian vision is also evident in the later watercolor *Sacred Grove,* 1883–84 (acc. no. 1619), a study for the mural decoration on the staircase of the Palace of the Arts at Lyons.

RD-R

26

26

Massilia, Greek Colony, ca. 1868–69

Massilia, colonie grècque
Marseille, colonie phocéenne
Oil on canvas, 38⅞ × 57⅞ (98.9 × 147.0)
Unsigned
Acc. no. 1618

Durand-Ruel, Paris; Baron Denys Cochin, Paris; Cochin sale, Galerie Georges Petit, Paris, Mar. 26, 1919, no. 19, to Bernheim-Jeune, Paris; Galerie Barbazanges, Paris; Meyer Goodfriend, New York and Paris; Goodfriend sale, New American Art Galleries, New York (American Art Association), Jan. 4–5, 1923, no. 121, to Kraushaar, New York; PMG purchase 1923.[5]

27

Marseilles, Gateway to the Orient, ca. 1868–69

Marseille, porte de l'Orient
Marseilles, Port of the Orient
Oil on canvas, 38¾ × 57⅝ (98.8 × 146.5)
Unsigned
Acc. no. 1617

See cat. no. 26, noting in addition the different cat. nos.: Cochin sale, Galerie Georges Petit, Paris, no. 20, and Goodfriend sale, New American Art Galleries, New York, no. 122.[6]

In common with a number of other French cities, Marseilles experienced dramatic growth during the Second Empire, and its prosperity was reflected in public projects. In 1862 the city undertook the construction of a municipal museum, the Palais Longchamps. The architect in charge, Henri Espérandieu, was also made responsible in 1867 for the decorative program, consisting of sculpture and painting. At his behest Puvis, who had just completed the decoration at the museum in Amiens, was awarded

the commission for two murals (on canvas) to be placed over the great staircase.[7] In his original submission, Puvis had proposed two works commemorating ancient and modern art in Provence; the former was to depict the construction of a temple to Diana, the latter an episode from the life of the Marseillais sculptor Pierre Puget. The commission he received on October 18, 1867, stipulated, however, that the murals were to depict pagan and Christian Marseilles.[8] Puvis did not altogether adhere to the particulars of the program, inasmuch as the works that he delivered to the city were entitled *Massilia, Greek Colony* and *Marseilles, Gateway to the Orient.*[9] The former, in its depiction of the foundation of Marseilles as a Greek colony, is classical in conception; the latter, inspired perhaps by the recent completion of the Suez Canal, shows the port city as the modern gateway to the East.[10]

The two works in The Phillips Collection are sketches for the larger, final versions in the Palais Longchamps. They conform in all essential elements to the finished works and are known by the same titles. *Massilia, Greek Colony* shows

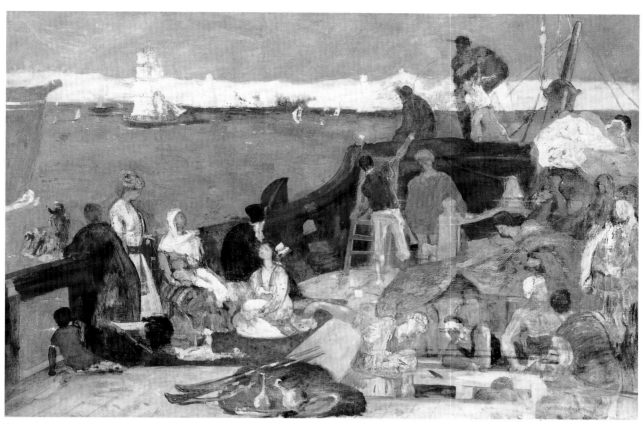

27

clusters of stately figures in classical attire, arranged to suggest the unfolding of daily life in antiquity: a group cooks a fish in the foreground, women display cloth and carry ceramic ware in the middle ground. The sea is visible in the distance. In *Marseilles, Gateway to the Orient* a ship approaches the city, in the distance, gleaming white; the foredeck fills the immediate foreground. As if to convey the idea of a teeming modern-day port, the contrasts here are more emphatic than in *Massilia*. The composition of the figures is less ordered; rather, a heterogeneous assortment of types is represented, comprising, according to Puvis, "the different races of the Levant. An Armenian, a Jew, a Greek, an Arab . . . contemplating the Gallic sea."[11] Blues, reds, yellows, and whites are emphasized so as to enliven the scene. Both sketches, rapidly brushed, show evidence of Puvis's working methods, including pentimenti and incised shapes. *Massilia*, squared for transfer, retains on the left the faint outlines of an architectural structure, a trace perhaps of the artist's earlier idea for a temple to Diana.[12]

Before the final versions were installed and mounted at the Palais Longchamps, they were exhibited at the Paris Salon of 1869. Notwithstanding their rich chromatic effects, the critical response was not favorable; Castagnary spoke for many when he denounced Puvis's "ridiculous colors."[13] Not surprisingly, given his passion for color, it was precisely those prismatic hues equally in evidence in the sketches that appealed to Duncan Phillips: "The sketches for Marseilles, with their deep enchanting blues and opalescent tones, reveal what a wonderful colorist Puvis could be. The exigencies of his fundamental principle for mural painting required however a sacrifice of the sensuous appeal and of light and shade."[14] Indeed, despite Puvis's traditional reputation as a classicist, Phillips insisted that like other gifted artists, Puvis was capable of pursuing many directions at once: "The Puvis of our sketches for the murals in Marseilles shows wistful longings for romantic freedom of color and design in spite of his almost pure architectural attitude."[15] Phillips elaborated on this notion with relish:

The classicist, too, knows his moments of self-questioning. Perhaps he indulges wayward or willful impulse, enjoys evocative suggestion as a change from the pursuit of clear statement, and sensuous color as a holiday when, for a while, he has nothing more to say with incisive or too calmly measured line. In such a mood perhaps Puvis de Chavannes delighted in the subjects for those murals at Marseilles, subjects which permitted him a romantic play of imagination, especially in the preliminary sketches which were done entirely by his own hand and which in no way committed him to irrevocable compositional decisions. He was proud to leave these sketches unfinished with the lines and colors uncertain of their ultimate destinations. . . . For the brief time when these sketches were on his easel he was a searcher for he knew not what, a taster of rare flavors of comingled color, a gleaner after time and its personal memories.[16]

<div align="right">RD-R</div>

EDOUARD MANET (1832–83)

Born to a wealthy Parisian family January 23, 1832, Edouard Manet exhibited an early interest in drawing. In 1848, despite his desire to be an artist, Manet signed on to a merchant vessel bound for Brazil, a choice made in deference to his father. However, after the younger Manet failed to qualify for the Naval Academy upon his return to France in 1849, his father finally consented to his son's studying art. Thus Manet entered the studio of Thomas Couture in September 1850 and remained there as a student for six years, despite repeated conflicts with his teacher. In 1856 Manet set out on his own, renting a studio with another painter and making brief trips to Holland, Germany, Austria, and Italy, where he studied the Old Masters, in particular Rembrandt, Velázquez, and Giorgione. Rejected by the Salon on his first try in 1859, Manet was accepted in 1861, earning his only Salon honor for the next twenty years—an honorable mention for *The Spanish Singer*, 1861 (Metropolitan Museum of Art). Despite that initial success, the Salon of 1863 rejected him, and he turned instead to the Salon des Refusés that year to exhibit *Le Déjeuner sur l'herbe*, 1863 (Louvre). At the 1865 Salon his painting *Olympia*, 1863 (Louvre), created an enormous scandal. Not until 1869 did Manet begin to paint his first plein air scenes, a change partially due to the influence of the impressionist artist Berthe Morisot, who became his sister-in-law in 1874. Despite the high regard the impressionists had for him, Manet refused to participate in their group exhibitions, continuing instead to submit works to the Salon and to hold private exhibitions. After several years of illness, Manet died April 30, 1883; Monet and Emile Zola were among his pallbearers. The Phillips Collection owns an oil painting, a watercolor, and an etching by Manet.

28

Spanish Ballet, 1862

Ballet Espagnol
Spanish Dancers, Danseurs Espagnol
Oil on canvas, 24 × 35⅞ (60.9 × 90.5)
Signed and dated, l.r.: *éd. Manet 62*
Acc. no. 1250 (Rouart/Wildenstein, I, no. 55)

Collection of the artist; purchased 1872 by Durand-Ruel, Paris, for his private collection; PMG purchase 1928.[1]

The *Spanish Ballet* reflects the fascination with Spanish art and culture manifest in Manet's work in the late 1850s and throughout the 1860s. His exploration of these romantic stereotypes reflected the exotic allure of things Spanish that

had been popular in France as far back as the 1830s. In 1862 Manet fell under the spell of a troupe of Spanish dancers from the Royal Theater of Madrid, headed by the veteran and principal dancer Don Mariano Camprubi, who had first excited Paris audiences in 1834 dancing the bolero. Camprubi's company had a successful season at the Paris Hippodrome from August to November 1862, sharing the bill with a group of equestrians. During that period Manet arranged for several of the principal dancers in the troupe to pose for him at the studio of his friend Alfred Stevens.[2] A number of paintings of Spanish themes and entertainers stem from this arrangement, including this painting, which shows the principal dancers from the Royal Theater of Madrid on stage, as if in a performance.

For much of its history, the *Spanish Ballet* has been discussed as if it were a literal record of a scene from the ballet *La Flor de Sevilla*.[3] Indeed, the direct application of paint, in addition to the use of such theatrical artifices as the bouquet in center stage foreground and the unnatural white light to "spotlight" the dancers, give the impression of a straightforward, spontaneous recording of a particular event. That Manet was not interested in transcribing a momentary scene, however, is apparent, not only from his decision to pose the dancers in a studio but also in his combined borrowings from other images to construct the individual figures and the composition. Manet's complex working method, so evident in *Spanish Ballet*, was highly eclectic. He was a collector of images that often functioned as fragments that were combined, in whole or in part, with his life sketches. Consequently, although he worked directly from the models in the studio, he chose to quote his Salon painting *The Spanish Singer*, 1861, in the seated musician on the left and turned to Goya for the pair of caped figures in the left background.[4] The horizontal format is thought to have been adapted from a work at the Louvre formerly attributed to Velázquez and much copied by Manet.[5] Recent scholarship has pointed out that the awkwardness of the dancers' poses, their lack of contrapposto, and their static quality may be related to his recombining parts of poses from a series of 1862 commercial photographs taken in Paris of Camprubi and a female partner.[6]

Although Manet evoked the atmosphere of an actual performance in the painting, he also consciously denied that very spontaneity. In the finished painting, the principal dancer Lola Melea (known to Paris audiences as Lola de Valence) sits on a bench, a perverse denial of her role in the company. Manet enhanced the aw-

wardness of her position by showing her in full frontal view gazing directly out of the picture at the spectator rather than watching her fellow dancers. By its directness, Lola's gaze creates a certain intimacy and tension that engages the viewer as both audience and passive participant. The male dancer next to her (he has been identified as Alemary) stands motionless with feet together and arms fixed in front of him while holding castanets intended to accompany the dancing couple to his left, Mariano Camprubi and Anita Montez.[7] The awkward placement of the figures, paired in a manner that prevents interaction, emphasizes Manet's eclectic borrowing as well as his self-conscious construction and staging in the studio.[8] The entire composition, in fact, is a study in fixed pose and repose, assumed elegance, and imposed awkwardness. Manet's approach was an unsentimental one, in which the figures were manipulated so as to deny them the exotic and romantic qualities normally associated with Spanish dance and music.[9]

The bold and unconventional composition, the use of color, and the elimination of halftones in *Spanish Ballet* were not appreciated by either the public or Manet's critics, even though contemporary criticism was calling for a new art to fit the new order of a modern world.[10] Today we are better able to appreciate his move toward a modernist aesthetic. To begin with, Manet discarded the traditional principles of style and mathematical perspective that had long been held sacred by the academicians. He also abandoned the tradition of disguised brushwork and artful modulation of color and tone from light to dark considered essential for a "finished" academic painting. Instead, he employed bold brushstrokes and abrupt disjunctions of tone and color, stylistic characteristics then associated exclusively with the studio sketch. It has been suggested as well that the loss of halftones in contemporary photographs may have been influential in Manet's developing style.[11] Using black contour to define the dancers in *Spanish Ballet*, Manet simplified their modeling and tonality, allowing his daubs and dashes of fluid color to define the exotic details of the costumes.

His eclectic borrowing from "flat images" such as prints and photographs surely "contributed to the greater flatness of his own works."[12] Perhaps inspired by Goya's *Tauromaquia* prints, Manet divided the canvas into horizontal bands of light and dark that flatten the pictorial space. He immobilized the dancers by freezing them in the glare of a harsh white light. Their implied spatial arrangement in a horizontal plane is contradicted by their relative

28

heights and by the incorrect proportions with which Manet rendered the figures. The stubby physiques and wooden poses of the dancers enhance their peasant or gypsy qualities, in direct contrast to the exoticism of their costumes. At the same time, Manet's emphasis on patterns of form and color in combination with the flatness of the composition gives the painting its uniquely modern flavor.

Duncan Phillips's enthusiasm for this work was born of his recognition that Manet was one of the pivotal sources of modern art.[13] Phillips was particularly interested in the early Manet, and he responded strongly to the romantic and expressionistic qualities of *Spanish Ballet,* as well as to its bold step toward abstraction. He delighted in its unexpected color accents and linear patterning, its "reduced modelling, arbitrary lighting," and its "frieze of figures in one plane."[14]

Setting aside the oft-espoused view of Manet as a traditional link to the doctrine of impressionism, Phillips preferred to champion the early "Spanish" Manet, whom he described as a "significant link in a chain which began with Goya and which [led] to Gauguin and Matisse."[15] For Phillips, the decorative, abstract elements of *Spanish Ballet* were direct links to Matisse, not only in the simple, abstract idiom Matisse later developed, but also in Matisse's evocation of dance as an abstract and decorative pattern unto itself.[16]

<div align="right">SBF</div>

29

Boy Carrying a Tray, 1860–61

L'Enfant portant un plateau

L'Enfant au plateau; Boy with a Tray; Boy with Fruit

Watercolor and gouache over graphite on paper, 8½ × 4½ (21.5 × 11.4)

Signed l.r.c.: *Manet*

Acc. no. 1252 (Rouart/Wildenstein, II, no. 454)

Early history unknown; PMG purchase from Kraushaar Gallery, New York, 1922.[17]

This charming watercolor of a little boy carrying a tray with a carafe and fruit has traditionally been associated with Manet's Velázquez-inspired *Spanish Cavaliers,* an oil painting from 1859 in which the same boy with a tray is found.[18] Scholars are in general agreement that the watercolor was probably not a study for the painting but rather a later work based on it. More than simply a copy of a motif from an earlier painting, however, scholars believe that this watercolor sketch was meant to be the preparatory drawing for an intended etching.[19] Its size, the general outline of the figural motif, and the careful linear details closely match Manet's 1861–62 etching of the same subject.[20] Yet Manet turned this drawing into a finished work by

29

adding watercolor washes to his crisp rendering, restricting the primary color washes to blue and yellow-ocher. The child has soft yellow-ocher hair that is reflected in the yellow-ocher of the fruit and bottle on the tray; he is dressed in dull blue and silhouetted against a gray-blue ground. The overall effect is a luminous one, far removed from the darker tonalities of the original oil painting.

The costume and features of the child in the watercolor closely resemble those of Léon Koëlla-Leenhoff (1852–1927), the boy in Manet's late 1861 painting *Boy with a Sword.* He was the illegitimate son of Suzanne Leenhoff, a Dutchwoman who had been Manet's piano teacher in 1850 and who became his mistress a decade later; they married in 1863.[21] Although Léon was always introduced as Suzanne's younger brother, scholars at times have argued a circumstantial case for Manet's paternity.[22] Nonetheless, it is generally accepted today that Manet was definitely not Léon's father, even though he always treated the boy as if he were his son.[23] Léon was a frequent model for Manet, particularly in the 1860s when he was living with his mother and Manet; he appeared in more of Manet's pictures than any other member of the artist's extended or immediate family.[24] Thus this lovely watercolor, removed from the genre setting of the original painting, can be seen as "a tender and perceptive little portrait" of Manet's stepson.[25]

Changing only the manner of dress, Manet used the same figure of a child carrying a tray in the background of his 1868 painting *The Balcony.*[26] Similar echoes are found in Fantin-Latour's oil sketch, *Manet in His Studio,* 1870, which is also in The Phillips Collection (see cat. no. 31).[27]

<div align="right">SBF</div>

HENRI FANTIN-LATOUR (1836–1904)

Henri Fantin-Latour was born in Grenoble, France, January 14, 1836, the son of the pastel painter Théodore Fantin-Latour and a Russian mother. Fantin moved with his family to Paris in 1841, where he began his artistic training under his father. Accepted at the Petite Ecole de Dessin at the age of fourteen, he studied with the progressive teacher Horace Lecoq de Boisbaudran. He entered the Ecole des Beaux-Arts in 1854 but remained there only briefly, after which he continued to pursue his artistic education while working as a copyist at the Louvre. It was there that Fantin became acquainted with Manet, Morisot, Whistler, and Victoria Dubourg, whom he married in 1876. He first exhibited at the Salon of 1861, and he was also represented in the celebrated Salon des Refusés in 1863. He declined to participate in the impressionist exhibitions, preferring instead to exhibit at the Salon. Fantin won recognition for his group portraits of artists, writers, and musicians of his day, such as *Homage to Delacroix,* 1864, and *A Corner of the Table,* 1872 (both Paris, Musée d'Orsay); he also painted many still lifes, mainly flowers, for patrons in England. At the same time, he executed a series of figure paintings in a more imaginary vein. Deeply moved by the music of Berlioz, Brahms, Schumann, and Wagner, he produced paintings and lithographs inspired by musical themes. Fantin was made chevalier of the Legion of Honor in 1879 and officer in 1900. He died August 25, 1904. The Phillips Collection owns three oil paintings, one drawing, and one lithograph by Fantin.

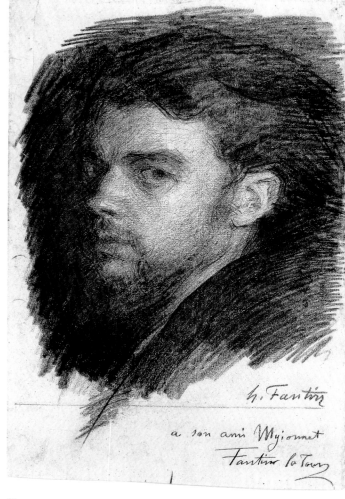

30

30

Self-Portrait, 1861

Fantin à 25 ans

Black chalk on paper, 18⅞ × 12½ (48.0 × 31.6)

Signed l.r.: *h. Fantin;* dedicated l.r.: *a son ami Myionnet/ Fantin la Tour*

Acc. no. 0673 (Fantin-Latour no. 187)

The artist to Florestan Myionnet, Paris; purchased by Fantin from unknown dealer after Myionnet's death in 1872; intermediate history unknown; PMG purchase 1922 or by 1924.[1]

Most of Fantin's self-portraits date from the first phase of his career. When he was later asked about this, he replied in an oft-quoted statement that the artist is "a model who is always ready and who offers all sorts of advantages; he is exact, submissive and one knows him before painting him."[2] It is not unusual for an artist at the beginning of his career to use himself as a model or, as Fantin did, to look to family and close friends for equally available and amenable subjects. Although it is not known whether Fantin ever followed the methods of his teacher Lecoq de Boisbaudran, his practice recalls Lecoq's system of drawing and painting based on a combination of close observation and memory.

The present portrait exhibits a degree of self-dramatization that evokes Rembrandt, an artist whom Fantin greatly admired. Half the face is engulfed in shadow, allowing the artist to experiment with chiaroscuro effects in order to convey a sense of mystery by withholding details of physiognomy. Thickly applied strokes define the area surrounding the face, while a finer network of lines is reserved for the face itself, to model the shapes of the cheekbone, nose, and brow. The keenly observant eye of the artist, his most vital instrument, is near the center, further accentuated by the tremulous lines that encircle it and define the eye socket. Fantin's concentration here on chiaroscuro values presages the next stage of his career: in 1862 he was to begin experimenting with the lithographic medium in his pursuit of an art based more on fantasy.

That Fantin clearly prized this drawing is suggested not only by its indisputably careful modeling but also by its subsequent history. He gave and dedicated it to Florestan Myionnet (1835–72), a member of the circle of friends around Fantin in the early 1860s. Little is known about Myionnet, who may have had literary ambitions; he is mentioned occasionally in Fantin's early correspondence and was included in a preliminary sketch for *Homage to Delacroix,* although he does not appear in the final version.[3] When Fantin discovered the present work at a dealer's after Myionnet's death, he reclaimed it.

RD-R

31

Manet in His Studio, 1870

Manet dans son Atelier
L'Atelier de Manet
Oil on canvas, 11⅝ × 13¾ (29.5 × 34.8)
Signed l.l.: *Fantin*
Acc. no. 0672 (Fantin-Latour no. 425)

Gustave Tempelaere, Paris; Shoukine, Paris; Shoukine sale, Hôtel Drouot, Paris, Mar. 24, 1900, no. 7; John Russell Buckler, London; Buckler sale, Christie's, London, Mar. 10, 1906, no. 79, to Allard Noel; possibly Josef Stransky, New York; Kraushaar, New York, 1917; DP purchase 1920; transferred to PMAG 1920.[4]

This oil sketch celebrating Edouard Manet is a group portrait of an artistic gathering, a type popular during the nineteenth century.[5] This was not the first time Fantin had painted his friend and fellow artist: in 1867 he sent to the Salon a highly elegant portrait of Manet as a dandy, without the attributes of his calling. The Phillips canvas has often been considered a study for *A Studio in the Batignolles,* 1870, which shows Manet at the center of an assemblage of artists and critics.[6] However, it is likely that it is a variant executed after Fantin had started work on the *Batignolles* painting.[7]

In this sketch Manet is seated at his easel, holding a palette, and three figures stand behind him. The two on the right are engaged in conversation, while the one closest to him examines the canvas. Directly to his right is a small boy standing behind a table and holding a tray. He has been identified as Léon Koëlla-Leenhoff, a member of Manet's household and the subject of the Manet watercolor *Boy Carrying a Tray,* 1860–61, in The Phillips Collection (cat. no. 29).

More than a casual illustration of an artist and his friends, *Manet in His Studio* conveys the idea of tradition and pedigree. Recent scholarship suggests that it refers to Manet's debt to, and reverence for, Velázquez through a series of subtle allusions.[8] Manet was a great admirer of the Spanish painter, as he made clear in a letter written to Fantin from Madrid several years earlier.[9] Fantin was familiar as well with pictorial evidence of Manet's regard for Velázquez, for the sketch appears to conflate elements derived from two small paintings by Manet that paid tribute to the Spanish master, one showing him at his easel being observed by two friends, and the other, now in Lyons, showing the detail of a small boy bearing a tray.[10] It is tempting to think that Fantin may also have known Manet's *Boy Carrying a Tray,* mentioned above, which appears to be related to the Lyons painting. Thus "the homage Manet had paid to Velázquez is used as a source of homage to Manet himself."[11] Perhaps Fantin deemed the conceit too complex, for the subject was never developed beyond the sketch.

31

Fantin's invocation of tradition involved not only his choice of models but also his methods. Unlike his contemporaries, who sought to exploit the possibilities of *alla prima* painting, Fantin remained primarily a studio painter, for whom the creation of an ambitious group portrait required thorough preparation. The technique of working from sketches occupied a central role in his artistic practice. *Manet in His Studio* illustrates Fantin's working method: over a white ground he brushed on impastoed white highlights and daubs of pure color—blue, red, and yellow—to create a highly textured, vibrant surface.[12] He avoided this spontaneous manipulation of paint in finished works, in which he achieved a highly polished and anonymous surface through controlled application.

Duncan Phillips claimed to prefer Fantin's sketches to his finished portraits, which he con-

sidered "admirable but tight and a little photographic."[13] Nonetheless, the present sketch provided Phillips with a means of access to what seemed to him the products of a very different artistic sensibility:

Many of Fantin's portraits are at first glance disconcerting in their literal reflection of substantial people as they appear in unobtrusive Parisian daylight. As we observe them more closely we recognize that the illusion is not mechanical but plastic and that there is about them the sympathetic insight of a kindly, philosophical observer who is unafraid of facts. In all the realistic half of his work the vitality of Fantin's pigment discounts the seeming "tightness." Under the surface, so scrupulously worked to remove all trace of method, there is probably the same rich broken impasto which we enjoy in the small sketch "Manet in his Studio."[14]

RD-R

32

32

Dawn, ca. 1883

Baigneuses
Spirit of Dawn
Oil on canvas, 14⅛ × 14¼ (36.2 × 37.8)
Signed l.l.: *Fantin*
Acc. no. 0670 (Fantin-Latour no. 1103)

Tempelaere Gallery, Paris; Kraushaar, New York; DP purchase 1919; transferred to PMAG 1920.[15]

The subject of the bather formed an important category within Fantin's oeuvre. That he was well aware of the importance of this theme stretching back to the Renaissance is borne out by his copies, including one after François Boucher's *Bath of Diana,* 1742, in the Louvre. Many of his original compositions have definite mythological and even musical references.[16] Others, such as the Phillips painting, were generically entitled *Bathers* in Mme Fantin-Latour's 1911 catalogue. In the present painting, however, Fantin's ability to create a hazy, poetic mood prompted Duncan Phillips to assign it the allegorical title *Dawn.*[17]

Two voluptuous women are posed near a source of water, on the right, and against a wooded background. The seated figure is fully draped; she gazes into the distance, away from the viewer. The second woman, seen from behind, is nude, although partly covered by a white veil that she holds in front of her and that cascades to the ground, providing a counterbalance to the inclination of her body. Her gaze draws the viewer's attention to the patch of early morning sky on the left. Fantin created a scene of languorous sensuality in which the figures are in unity with nature, as suggested by the similarity of the flesh tones of the standing figure to the roseate sky.

Such romantic woodland scenes with bathers differ markedly from the images of modern vacationers at resorts favored by Fantin's contemporaries Renoir and Monet. At the same time, Fantin's dreamlike treatment of the theme diverges from his own more precisely rendered still lifes and group portraits. Reflecting on the artist's seemingly contradictory tendencies, realistic and imaginary, Duncan Phillips noted: "Both in lithography and painting he adapted his technique to his subject according to whether he conceived of it in terms of a pellucid and precise prose, or of a mellifluous and meditative music."[18] In *Dawn* the adoption of this second manner results in the soft atmosphere and diffuse definition of forms, enhancing the sense of poetic reverie and leading the viewer into a timeless spiritual realm.[19]

R D - R

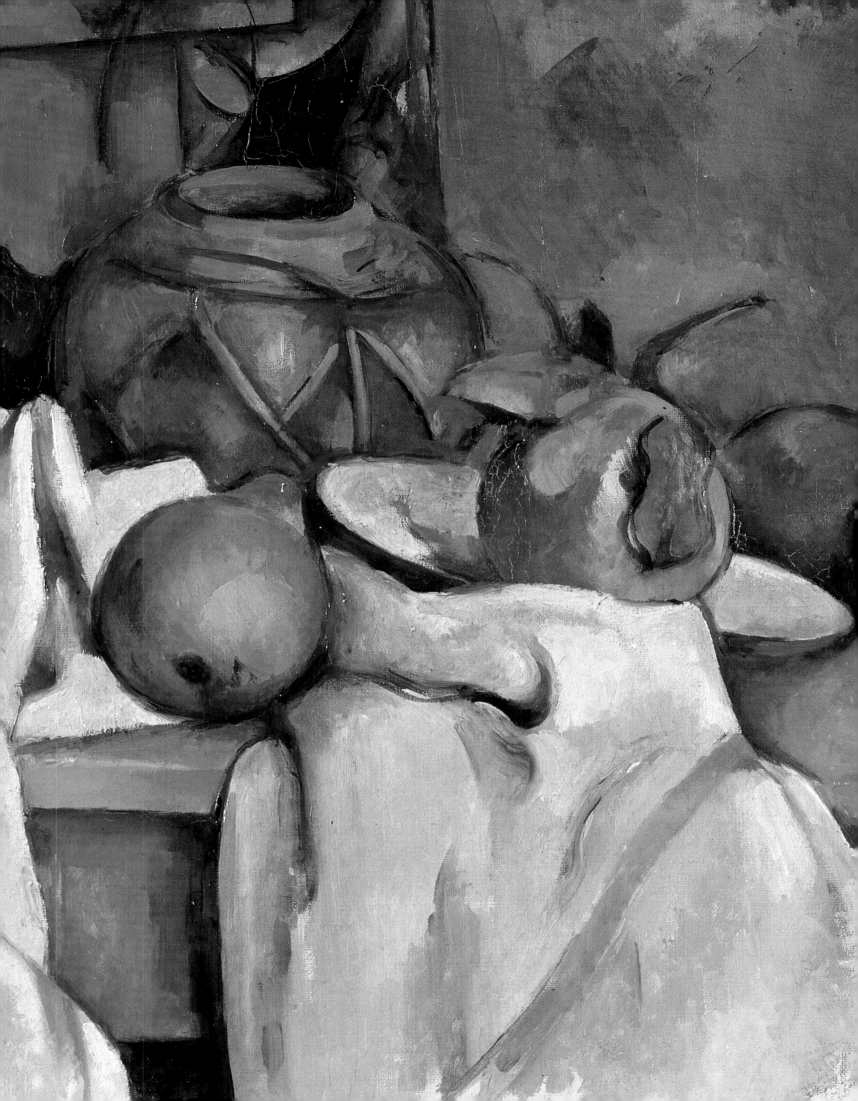

2 FRANCE IN THE LATE NINETEENTH CENTURY

CHARLES STUCKEY

When it came to collecting impressionist and post-impressionist art, Duncan Phillips had plenty of competition, often from collectors as committed as he was to providing museum status for modern art.[1] Around the beginning of the twentieth century, municipal museums mostly disregarded the works of living artists, as exemplified in France in 1893 by the controversial refusal of the Caillebotte bequest of works by Monet, Renoir, and Cézanne to the museum of modern art (Musée du Luxembourg). Reacting against such conservative taste, Phillips and his fellow collectors in the United States and abroad recognized the need to create a new kind of museum or to add special impressionist and modern sections to existing museums. Motivated by far more than mere connoisseurship, their unprecedented philanthropic patronage of modern culture enfranchised debate and education, fundamentally changing the significance of art for museums and their publics.

Not surprisingly, from 1918, when he acquired his first painting by Monet, until 1925, when he acquired the first of six paintings by Cézanne, Phillips's preference was for impressionism rather than post-impressionism. As he had pointed out in 1912, the impressionist mode, predicated on emotional sincerity and truthful observations, reasserted the fundamental values of all great art throughout history. By contrast, for apparently exaggerating and distorting their observations, Cézanne and van Gogh, according to Phillips in 1913, were "damn fools" responsible for the "present decadence" of art.[2] As it would turn out, after roughly a decade of reconsideration, Phillips became obsessed with these "fools," whose works became a cornerstone of his museum's collection.

Although he still intended in 1926 to collect multiple examples of the works of Renoir, Monet, Sisley, and Morisot, Phillips ultimately limited himself to only a single painting by each, as if one well-chosen picture were enough to summarize his or her unique talent. Not until 1959 did he acquire the second painting by Monet to keep in the collection. By that time he had already collected works by Monet's quasi-impressionist (if not post-impressionist) colleagues, Cézanne and Degas, in depth.

His restraint notwithstanding, Phillips found and kept masterpieces by the most orthodox impressionist painters, favoring excep-

Paul Cézanne, detail of
*Ginger Pot with Pomegranate
and Pears,* see cat. 40

tional over typical examples of their works. For example, Monet's *The Road to Vétheuil* (cat. no. 45), nearly half of which is devoted to the dirt surface of an empty, unshaded road leading straight ahead toward a distant picturesque village, is strictly unconventional, altogether lacking the charms associated with classic impressionism. Its rugged simplicity aside, this painting effectively symbolizes the impressionist insistence on the spatial envelope itself as a matrix of light and color. Observed from a few steps back, Monet's picture provides an unprecedented illusion of stereoscopic space. From closer up, however, the dashes of different colors appear disintegrated, as if Monet had no sense at all for making art. By contrast, fastidious refinement is paramount in the later painting by Monet that Phillips acquired in 1959, showing the English Channel from Dieppe (cat. no. 46). Here, in Japanese fashion, Monet created a sense of space by jumping, rather than tunneling, from near to far away. Sparkling with dew, the silhouetted cliff top in the foreground appears like a stage set and consequently recalls the sense of theatricality in the quasi-serial paintings by Monet's mentor Boudin. In these works, fashionably dressed vacationers from Paris assemble on portable chairs like an audience for a drama consisting of the fantasy-like display of light beyond the beach across the Channel. An example of Boudin's modest pioneering paintings of modern life, acquired in the early 1920s (cat. no. 33), remains in the collection as a reminder that the English Channel was something like the geographical cradle of early impressionism.

Not an especially typical work by Sisley, *Snow at Louveciennes* (cat. no. 44), is among his greatest paintings. Exemplifying what might be called the "portraiture" of rural French village life that Pissarro, Cézanne, and Monet perfected as a hallmark of 1870s impressionism, Sisley's snowscape is, along with Monet's *The Road to Vétheuil*, among several paintings included in this section of Phillips's collection that make use of road motifs. Equally evocative of Monet's 1870s impressionism is the upper-left background section of Renoir's painting *The Luncheon of the Boating Party* (cat. no. 50), a 1923 acquisition and the most sensational impressionist work in the collection.[3] It amounts to a composite of landscape, still life, and genre painting, in each of which Renoir was a master: the background riverscape; the table setting in the foreground; and the girl kissing the dog, a premonition of the 1922 Bonnard *Woman with Dog* (cat. no. 102), which Phillips would soon acquire. This extraordinary painting, which has fourteen figures, eighteen hands, and eight hats (six straw ones, in keeping with the countryside vacation setting, and two fine city ones in satin and velvet), amounts all by itself to one of Phillips's units. "It's the only one I need," Phillips reportedly told the rapacious Dr. Barnes, owner of more than a hundred works by Renoir, when asked if this were the *only* one in the collection.[4]

Figure painting was at odds with the premises of orthodox impressionism, which was dedicated to transcribing reality instantaneously without resorting to costumes or poses. Degas and Caille-

botte refused to surrender these conventional means, however, and along with them it was Renoir who most successfully integrated the innovations of impressionism with the traditions of Old Master art. His *Luncheon*, which obviously took weeks to complete from posing sessions with individual models, is a hybrid enterprise, blending the sort of bravura brushwork of impressionism with the scale and attention to detail demanded of museum art in the mid-nineteenth century. More modest by far in scale and complexity, and saturated in pinks and blues like works by the eighteenth-century French masters she deeply admired, the single work by Morisot in Phillips's collection, acquired in 1925 (cat. no. 49), addresses the posing issue in realist art head on. Rather than ask her models to act out some familiar activity from everyday modern life, as Renoir required his models to do for the *Luncheon*, Morisot asked hers to be themselves, that is, to behave like models between posing sessions. Footsore and fatigued, the principal figure symbolizes the behind-the-scenes realities glossed over by would-be realist figure painters, Morisot's close friend Renoir among them.

As if Renoir's *The Luncheon of the Boating Party* summed up not only Renoir's work but all of impressionism, after its acquisition Phillips gradually became obsessed with the post-impressionist masters whom he had once dismissed as "decadent." The turnabout was partly the result of his increasing interest in contemporary artists, ranging from Bonnard, the ultimate heir to Renoir's genius, to American symbolist and abstract artists like Davies who were partisans of post-impressionism. The painting by Redon that Phillips acquired around the same time as the Morisot explicitly transcends the limitations of impressionism (cat. no. 47). The mournful figure emerging like an apparition from an impressionistically rendered bouquet of flowers appears to ponder the sort of verities invisible to objective scientific observation à la Monet. The same year Phillips ventured still further beyond first-generation impressionism, acquiring a Tahitian scene by Gauguin (eventually removed from the collection) and his first painting by Cézanne, *Mont Sainte-Victoire* (cat. no. 39).

Phillips often installed *Mont Sainte-Victoire* adjacent to Monet's *The Road to Vétheuil*, contrasting two distinct ways to render space. Monet had stood like an ordinary traveler in the middle of a road and recorded space as distance along a trajectory from foreground to background, but Cézanne found a special spot off the road from where he noticed the coincidental alignment of overhead branches with the silhouetted ridge of a faraway mountain. Juxtaposed this way, the linked near and far of branch and horizon recall Cézanne's gesture of joining his hands together by overlapping his fingers to demonstrate how a painter must lock together scattered, visible signs of truth, light, and emotion into a tightly resolved pictorial composition.[5]

Only two years after Phillips purchased *Mont Sainte-Victoire*, a superb late version of the same motif was included in the auction of the Quinn collection. But Phillips never attempted to collect impres-

sionist and post-impressionist serial variations. Moreover, he waited until 1955 to acquire a late work by Cézanne, *The Garden at Les Lauves* (cat. no. 43). In this extraordinary painting, Cézanne had returned to the explicit device of an overhanging branch as a structural benchmark from beneath which to gauge all other observations of space. *The Garden at Les Lauves* was the sixth painting by Cézanne to enter The Phillips Collection, thus capping the fullest unit devoted to any impressionist or post-impressionist painter.

The second to be added, in 1928, was Cézanne's *Self-Portrait* (cat. no. 38). In this work, one of his earliest self-images, Cézanne integrated his figure and his surroundings as tightly as he would integrate near and far in his landscapes. Scarcely distinct in color from the neutral background, the painter's jacket is defined by no more than a few rough black lines at the shoulder and lapels. As if to present himself as an essentially thinking, seeing being, Cézanne highlighted only the dome of his bald forehead and his staring eyes. His collar turned up to suggest unposed informality, he sought complete emotional neutrality, masking facial expression as well as gesture. Such neutrality on the part of the observer was essential to Cézanne's headstrong pursuit of ultimate truth.

In 1930 Phillips pursued his first work by van Gogh, a painter on the wish list that he had published in 1926.[6] *Entrance to the Public Gardens in Arles* (cat. no. 52) became the third of the great road paintings in this section of the collection (along with the Monet and the Sisley). This dirt path, painted with little helter-skelter strokes that suggest the footprints of countless strollers, is the setting for what is perhaps the most unconventional of all van Gogh's "portraits." Far up the path, her back turned, as if oblivious to the painter at work in the garden, is his friend and frequent model Augustine Roulin, carrying her infant, Marcelle. With the acquisition of this wonderful picture, the second phase of Phillips's impressionist and post-impressionist collecting effectively came to an end.

The third and final phase started with the acquisition of two small but powerful works by Seurat. Recently redated to 1883–84, the drawing, *Sidewalk Show* (acc. no. 1728), of two clowns and a horse on stage addressing a shadowy audience, scarcely indicated in the foreground, is anti-impressionist in mood, an homage to artificial theatrical lighting of such artists as Toulouse-Lautrec (a master inexplicably overlooked by Phillips), as opposed to the truth-revealing daylight celebrated by the classic impressionists. By contrast, dazzling sunshine is the ultimate subject of the oil by Seurat that Phillips added not long after acquiring this drawing (cat. no. 55). The workman who figures in this small-scale work is breaking stones, according to a title given to it by the organizers of a memorial exhibition held immediately after the painter's premature death. But the figure might just as well be called a gardener: the nature of his task is far less at issue than the stylized brushwork, evidently a premonition of the energetic style that van Gogh would develop a few years later.

Three more masterpieces by Cézanne entered the collection

during the Second World War. The first, a gift from Gifford Phillips, was the sort of great still life that Duncan Phillips had dreamed about obtaining for fifteen years or more. *Ginger Pot with Pomegranate and Pears* (cat. no. 40) has the distinction of being one of the works by Cézanne from Monet's private collection (works that had to be kept out of Monet's sight to save him from bouts of depression with respect to his own work in progress). Including both of Cézanne's prop tables, the taller one with scalloped edges, this painting incorporates two still lifes in one: the one on the left consisting of a scholar's books; the central one consisting of a gardener's freshly picked fruits. Merging interior and out-of-doors themes in this quasi-allegorical way, Cézanne here invented a complex and highly personal form of still life, full of unconventional contrasts. The landscape of farmhouses on a steep hillside road, *Fields at Bellevue* (cat. no. 41), that Phillips acquired in 1940 is as sparse as the still life is rich. As is so often pointed out, the unadorned rural architecture in works like this one makes Cézanne the obvious forerunner of cubism. *Seated Woman in Blue* (cat. no. 42), the stately late portrait acquired in 1946, is perhaps the gem of the entire unit. Her face resigned to the sort of long posing sessions that other sitters for Cézanne complained about, the woman portrayed embodies the reality that Cézanne so often sought to escape in his last years by working on imaginary pictures of nude bathers in a Golden Age. Apparently symbolizing art as a relief from life, the corner of a picture frame visible on the background wall and the bright yellow cover of the novel on the sitter's blue lap are all that challenge her somber mood. With this work, Phillips in effect finally added a "Rembrandt" to his collection.

In every area of The Phillips Collection portraiture emerges as a sort of ultimate form of expression, and among the impressionist and post-impressionist works the obvious counterpart to Cézanne's *Seated Woman in Blue* is a miniature painting by Degas known as *Melancholy* (cat. no. 34). While Cézanne dismissed gesture and expression as inessentials, Degas sought to capitalize on the least shred of such visual data capable of communicating the most emotion. Although limited to only one figure, *Melancholy* is not properly speaking a portrait but rather a genre painting reduced to the barest minimum of detail. Who and where the woman is, and why she acts as she does, are designed to be mysterious and therefore more compellingly realistic. Gesture and facial expression are scarcely indicated. A bit of wrist is the only clue to the figure's gesture. Tucked against the body, it indicates tension, as surely as do the parted lips and lowered eyelids just visible among the shadows surrounding the woman's face. The tension is even manifest in the shaky way that Degas signed his name. With all its red tones, *Melancholy* would seem to have been painted around 1870, when associates accused Degas of being overly theoretical in his approach. Degas's Rembrandtesque obsession with just such dimly lighted subjects, of course, set him apart from his impressionist colleagues.

Women Combing Their Hair (cat. no. 35), acquired shortly before *Melancholy,* is by contrast a laboriously detailed record of female grooming. The real subject matter of this work, however, is the artistic process itself: *Women Combing Their Hair* amounts to a painting of a preparatory drawing, designed to show Degas's obsession with virtuoso technique above and beyond conventional narrative as an ultimate criterion for art. The juxtaposition of images of a single model wearing the same costume for three different poses is by definition a preparatory study, despite the decorative, proto-cinematic narrative qualities inherent in such a subject when treated by an artist of Degas's caliber. Comparable to several other works from the 1870s that seem to show the same figure in a variety of poses and costumes, including the well-known *Portraits in a Frieze* (apparently portraying Mary Cassatt at the Louvre), *Women Combing Their Hair* is the earliest example in Degas's work of what would become a signature theme for him for the rest of his long career: the observation of a woman's private grooming rituals.[7]

Phillips's acquaintance with Sickert, who had known Degas and helped to establish the cult of Degas's studio philosophy, perhaps contributed to his passion for the French master's work. Writing in 1917, Sickert had recorded Degas's subsequently famous remark about heightened candor in art: "I want to observe through a keyhole."[8] The great pastel *After the Bath* (cat. no. 36), added to the Degas unit in 1949, exemplifies this approach, recording, as observed from the rear, a woman's awkward attempt to climb out of her bathtub. Whereas the threefold repetition of the figure in *Women Combing Their Hair* shows a perfectionist's concern for photographic exactitude opposed to the impressionist dogma of transcribing any subject in a single stenographic encounter, in this late work Degas demonstrates his own daunting brand of rapid impressionist style, flourishing his colors in jabs and squiggles the way Monet and Renoir in the 1870s had brushed on paints. No matter how studied such a work was, for Degas the appearance of impressionist instantaneousness became the ultimate goal. If Degas used pastels in *After the Bath* to imitate impressionist oil techniques, in the latest work by him in the Phillips unit, *Dancers at the Bar* (cat. no. 37), he used oils, apparently wiping them on with a cloth or even his bare hands, in imitation of the tones and textures associated with pastels. Posing both models (if this painting does not in fact show a single model posed twice) at the stretching bar with their backs turned to him, Degas translated the figure into an abstract vector of color and shape.

The last works added to the post-impressionist section of the collection, in the early 1950s, include a remarkable, uncharacteristic still life by Gauguin, two late paintings by van Gogh, and a poetic late picture by Monet, *Val-Saint-Nicolas, near Dieppe (Morning)* (cat. no. 46). The surprisingly decorative colors used by Gauguin brought new vigor to a conservative genre of still-life painting previously characterized by the somber harmonies favored by seventeenth- and eighteenth-century still-life masters. The fruity colors of *The Ham* (cat. no. 51) anticipate Gauguin's eventual tropical, so-called primitive aesthetic. A hunk of meat on a plate on a table, with no knife to serve it, is rather savage, and the veins of fat provide a satirical commentary on then-fashionable Art Nouveau taste.

More than anything, it was the decorative sense for color in Gauguin's work that would act as a catalyst for van Gogh's genius during the last three years of his life. The yellow harmonies of *The Road Menders* (cat. no. 53) are evidence of the intimate exchanges between the two leading post-impressionists. Mottled by damp green moss, the old trees along the roadside and their twisting branches might be compared with the ballerinas and their extended arms and legs in Degas's decorative, highly structured late compositions. Of course, the road theme is one that had special appeal for Phillips. Even more intense than his late-1880s paintings, van Gogh's works made during his recuperation at Saint-Rémy and Auvers often appear like failed attempts to conform to mainstream impressionism, as if such conformity would be a sign of good health. For example, in the composition of *House at Auvers* (cat. no. 54), the last painting by van Gogh added to the Phillips unit, the foreground, densely covered with short little strokes to render a deep field swept by wind and light, recalls dozens of compositions by Monet. This similarity, perhaps only coincidental, suggests that Phillips had come full circle, back to where he had begun his appreciation of impressionism immediately after the First World War. The acquisition in 1959 of *Val-Saint-Nicolas near Dieppe (Morning),* hardly the sort of dry scientific exercise in exact observation that Phillips as a young man had associated with the impressionist pioneer, indicated how much the collector had come to understand through decades of studying pictures that celebrate feelings aroused by the sparkle of light.

EUGÈNE-LOUIS BOUDIN (1824–1898)

Noted for his spontaneous, plein air depictions of the fashionable Normandy beaches, Eugène-Louis Boudin was born July 12, 1824, in the seacoast town of Honfleur, France; he and his family moved to nearby Le Havre in 1835. Boudin attended the Ecole des Frères for a year before beginning work with a printer, then a stationer, in 1836. He ran his own stationer's shop from 1844 to 1846, when he decided to paint full-time. In 1851 he received a three-year painting stipend from the city of Le Havre, which enabled him to move to Paris. He returned to Le Havre in 1854 and met Monet there, probably in 1858. The next year he moved back to Paris, and from then on he spent his summers at the Normandy beaches. Boudin first exhibited at the Salon in 1859 and exhibited in the first impressionist exhibition in 1874. In 1881 Durand-Ruel became his dealer. During the 1880s, he began spending summers occasionally in the south of France in addition to his usual Normandy vacations. He died August 8, 1898, in Deauville. The Phillips Collection owns one oil painting by Boudin.

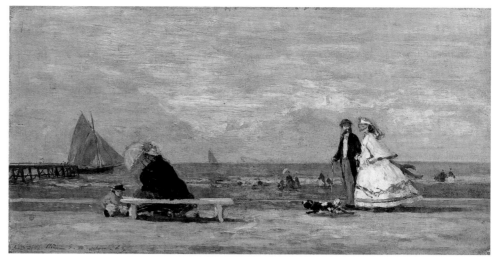

33

33

Beach at Trouville, 1863

Plage de Trouville
Oil on wood panel, 7¼ × 13¾ (18.4 × 34.9)
Signed and dated l.l.: *E. Boudin. 63.;* illegible inscription
l.l.
Acc. no. 0191 (Schmit no. 283)

Early history unknown; Galeries Georges Petit, Paris; PMG purchase 1923.[1]

Boudin painted many beach scenes at Trouville, which is located on the Normandy coast just south of Honfleur, his hometown. Despite its quickly executed appearance, the Phillips painting is probably composed from sketches made on the site; several reworked areas indicate that he carefully contemplated the arrangement of the figures.[2] This work depicts a close-up view of only a few figures, whereas most of his landscapes show crowds of people set deeply in space. The running dog, the woman seated on the bench, and the strolling couple are motifs that reappear in other beach scenes of 1863.[3] The sparseness of detail and simplification of composition compel the viewer to perceive the formal aspects of painting, making it one of Boudin's more abstract pictures.

Duncan Phillips most often exhibited *Beach at Trouville* with paintings by the impressionists and the more avant-garde Cézanne. He interpreted Boudin as a precursor of impressionism, "the link between Constable and Monet" in his establishment of the importance of pure color and light in painting.[4] Admiring the artist's ability to capture the immediacy of strolling beach crowds through freedom of brushstroke and intense color, he wrote: "There was never anything iconoclastic or epoch-making about Boudin's own style of painting. . . . But in his own quiet way he hit upon truths which bolder men used for their foundations. Boudin is an aristocrat of paint and holds high rank in the history of landscape painting."[5]

GHL

HILAIRE-GERMAIN-EDGAR DEGAS (1834–1917)

Edgar Degas, an impressionist whose works bring together the academic tradition of draftsmanship with a keen observation of modern Parisian life, was born in Paris July 19, 1834, the son of a prominent banker. He briefly studied law before entering the Académie des Beaux-Arts in 1855. There he studied with Louis Lamothe, a student of Ingres, and became accomplished at drawing. Between 1856 and 1860 he visited Naples, Rome, and Florence, viewing and copying the works of the Italian Old Masters. In 1858 in Rome, he became friends with the French painter Gustave Moreau. During the early 1860s, he painted large compositions and portraits, and he began showing at the Salon in 1865. Active in organizing the first impressionist exhibition in Paris in 1874, he participated in most of the subsequent impressionist shows. Around 1892 he started working mainly in pastels. At this time he began to experience difficulty with his eyesight. Degas probably suffered from photophobia, and he began working with low light levels in his studio. Late in life he concentrated on collecting paintings, favoring the works of Ingres and Delacroix. He died in Paris September 27, 1917. The Phillips Collection owns three oils, one pastel, and one oil (*l'essense*) on paper.

The Degas Unit

Duncan Phillips's Degas unit displays, in only a few examples, the artist's breadth and versatility. Although Phillips established and expanded this unit during the second half of his collecting years, he admired Degas as early as 1911 and noted in 1922 his desire for a "Race Track Picture" by him.[1] The works he ultimately came to own, however, spanned all Degas's characteristic subjects except for racing scenes. In 1928 he purchased *Ballet Rehearsal,* ca. 1885, which he gave to Yale University in 1952.[2] The remainder of his Degas paintings, all meant to be "fine examples of other periods in [the artist's] career," were acquired during the 1940s: two early figure scenes, *Melancholy,* from the late 1860s, and *Women Combing Their Hair,* ca. 1875–76 (cat. nos. 34 and 35); a mature pastel of a nude bather, *After the Bath,* ca. 1895 (cat. no. 36); and a late oil of the ballet, *Dancers at the Bar,* ca. 1900 (cat. no. 37).[3] In 1983, seventeen years after Phillips's death, the museum was given an oil on paper, *Seated Violin Player,* 1872 (acc. no. 0481), which further strengthened the collection's representation of Degas.[4]

Whereas Phillips acknowledged the association of Degas with the French impressionists, finding him exceptionally talented in his "exquisite play of prismatic colors in evanescent lights," he also admired him for qualities that set him apart from his colleagues.[5] He considered Degas less an advocate of "outward semblance" than his fellow painters and more a follower of the traditional methods of design learned at the Académie des Beaux-Arts.[6] Degas's mastery of the classic line, learned from his Ingres-inspired teacher, Lamothe, resulted in his sensitivity to, and emphasis on, the linear elements of his images, while most of the other impressionists depended on the mingling of colored brushstrokes to define form. Because of his interest in the formal aspects of his scenes, Degas was also more dramatically influenced than the other impressionists by the Japanese print. His compositions were asymmetrical, forms were cut off by the edges of the picture plane, and empty expanses of space were treated as valid entities. These devices resulted in what Phillips called "freaks of Japanese composition and drawing . . . made interesting by the artist's mastery of line and ironical temper."[7] Although the scenes' tilted planes make them appear randomly composed, they are actually the end products of careful organization.

Phillips believed that Degas, who had an "alert and . . . selective, critical intelligence," best evoked, with "Gallic irony, . . . the spectacle of modern life as seen through the modern temperament."[8] This talent depended on the artist's strong powers of observation and his scientific interest in anatomy, psychology, and photography. With honesty and little embellishment, he unhesitatingly portrayed the "emotive fragments" of his fellow Parisians' existence—the awkward poses of dancers, the yawning faces of laundresses, and the bored demeanor of prostitutes.[9] He imbued his scenes with the sophisticated, sometimes jaded atmosphere of his native city.

The expressive nature of Degas's work was heightened by his ingenious manipulation of color and light, in both oil and pastel. Soft light and muted tones add poignancy to an interior scene, bright light and vivid color define the éclat of a bustling city street or racetrack, and glowing light with flaming hues evoke the spectacle of the theater. Because Phillips responded deeply to the emotional sensations elicited in painting, he collected works by Degas that were exceptionally expressive, whether in style or in mood. In fact, except for *Women Combing Their Hair,* which is virtually a figure study, the Degas paintings in The Phillips Collection vibrate with intensity of atmosphere and color. In the subtle, hushed intimacy of *Melancholy* and *After the Bath* and the colorful dynamism of *Dancers at*

the Bar, Degas left the mark of his personal vision. The expressive aspect in his painting was emphasized to a much greater degree by his artistic "descendants." According to Phillips, the "nuance and caprice" of Degas, like those of Bonnard and Vuillard, become ends in themselves.[10] Their subjects are submerged in color, pattern, and mood.

Phillips believed that Degas's individuality stemmed from his duality as an artist: his virtuosity as both a traditionalist and a romantic. His works could be admired both as linear, formal entities in the tradition of Botticelli and Holbein and as incisive images in which a single gesture, pose, or expression evokes mood and, ultimately, the spirit of an era. Phillips summed up his view of Degas's originality in one sentence: "His commentary was invariably as inimitable as his design, and his tone as fine as his drawing."[11]

<div align="right">GHL</div>

34

Melancholy, late 1860s

La Mélancolie

Portrait de jeune femme; Portrait de jeune femme, dit "la Mélancolie"; Femme penchée dans un fauteuil; La Loge; Reflection (DP); *Reflection (La Mélancolie)* (DP)

Oil on canvas, 7½ × 9¾ (19.0 × 24.7)

Signed in white paint, l.r.: *Degas*

Acc. no. 0480 (Lemoisne no. 357)

Dr. Georges Viau, Paris; Wilhelm Hansen, Copenhagen; A. M. Cargill, Glasgow, by 1931; D. W. T. Cargill, Lanark, Scotland, by 1932 and until 1937 or later; Reid and Lefevre Ltd., London; Bignou Gallery, New York; PMG purchase 1941.[12]

Melancholy, a portrait of an unidentified woman, demonstrates Degas's talent for effectively portraying mood in his sitters. The source of the painting's title is unknown, and it has been stated that the artist, in his general preference for depicting "formal calm" over "interior life," would have chosen a neutral title for the work, for example *Portrait of a Young Woman* or *Woman Leaning on a Chair.*[13] At this early point in his career, however, when he was closely examining human nature through portraiture, Degas may have intended melancholic emotion to be a dominant theme.[14]

The artist employed line, color, and light in a simple yet effective manner, in order to emphasize the woman's brooding demeanor. Hugging her body in self-absorption, she is perched on the arm of a chair and leans forward against its back, facing to one side.[15] Her face, positioned off center, is the convergence point for the two

principal lines: the dark, diagonal outline of her shadowed back against the expanse of gestural brushstrokes defining the background wall or screen; and the slightly curved, vertical edge of the chair. Firelight illuminates the woman's features, her dress, and the chair, creating dynamic crimson highlights within the predominantly amber and brown tones. The flickering color around the subject's face, which is framed by a white collar, helps to draw attention to her introspective expression. With these few means, Degas produced a compact, balanced image that evokes quiet intimacy and solemnity, as well as suffering.

Duncan Phillips often hung *Melancholy* in his smaller galleries with other French paintings of similarly intimate themes—for example, Bonnard's *Woman with Dog* (cat. no. 102) and Vuillard's *Woman Sweeping* (cat. no. 108), which perpetuate the contemplative spirit of *Melancholy*.

<div align="right">GHL</div>

34

35

Women Combing Their Hair, ca. 1875–76

Femmes se peignant
Les femmes qui se peignent; La toilette sur la plage; Après le bain
Oil on paper mounted on canvas, 12¾ × 18⅛ (32.4 × 46.2)
Signed in black paint, l.r.: *Degas*
Acc. no. 0482 (Lemoisne no. 376)

The artist to Henri Lerolle, Paris, 1878; Lerolle family collection until at least 1936; private collection by 1937; Carroll Carstairs, New York; PMG purchase 1940.[16]

From the mid-1870s until the end of his career, Degas painted many representations of women brushing, braiding, or drying their hair. As a private, seldom-viewed activity of a woman's daily ritual, the theme captured and held Degas's vigilant attention as a vehicle for myriad figural compositions. His fascination with hair is indicated in his writings, in which he compares its appearance to "the color of gleaming walnut or of hemp, or . . . of horse chestnuts" and praises "its shimmering flow and its lightness, . . . its coarseness and its weight."[17] His paintings reflect his abiding interest in the way a woman's hair falls, glistens, and echoes the curves of her body.

One of Degas's earliest representations of the subject, *Women Combing Their Hair* is unusual for its positioning of the figures in a landscape, not in the privacy of a boudoir. The motif had its roots in representations of the Three Graces in classical art and reappeared in the Renaissance.[18] Degas's contemporaries, such as Renoir,

Puvis de Chavannes, and Cézanne, continued the tradition, although without the literary references so important to Renaissance painting.[19] In his treatment of the theme, Degas avoided idealized or associative trappings, presenting his figures as anonymous, contemporary beings. In Duncan Phillips's words, he saw "woman as a fascinating animal and [drew] her with a detached curiosity and admiration."[20]

Degas probably began *Women Combing Their Hair* as a study sketch but ultimately regarded it as a complete work.[21] Its origin as a sketch is suggested by the ambiguous overlapping of the figures as well as the indistinct, reworked outlines of the chair and incomplete drawing of the figures. The three bathers (actually the same model in different poses) dominate the composition; their white robes present a startling contrast to the tan of the expansive shoreline and serve as an ideal foil to the auburn locks of hair. Arranged horizontally in the manner of Degas's early style, they exist independently, their bodies balanced by the masses of their hair. Their poses reappear frequently in later depictions of bathers. For example, three pastels executed about ten years later each depict

an unclothed model in the pose of the central figure.[22] The intricate yet subtle lines of such early works as *Women Combing Their Hair* became increasingly expressive as Degas's style developed, ultimately becoming in his late creations dynamic, elegant entities in themselves.

<div align="right">GHL</div>

36

After the Bath, ca. 1895

Femme sortant du bain
Woman Leaving Bath
Pastel on paper, 30½ × 33⅛ (77.5 × 84.3)
Unsigned; bears stamp of the Degas sale l.l.
Acc. no. 0478 (Lemoisne no. 1204)

The artist; sold to Ambroise Vollard (private collection) at auction, 1918; Yolande Mazuc, Venezuela; Wildenstein, New York; TPG purchase (from exhibition) 1949.[23]

The motif of a nude bather stepping out of a tub and into the enveloping folds of a towel held open by her maid appears in Degas's oeuvre as early as 1876.[24] The ability to perceive instantaneous, transitional movement had been enhanced by the development of photography,

which could transform such movement into a permanent, easily accessible image. Photography fascinated Degas and sharpened his unfailingly observant eye. When painting bathers, he had his models circulate at will around his studio until they struck a pose that intrigued him.[25] Once such a scene was set, he would continue to repeat and expand on it in all media, including sculpture.

Early versions of the theme from the late 1870s, especially those depicting a rear view of the figure, evoke the awkwardness of the movement and show a robust woman hoisting herself out of the basin. The Phillips pastel, however, executed about twenty years later, exemplifies Degas's enhanced ability to articulate line and color so that they radiate a sense of refined elegance. The model's body, subtly outlined with rubbed touches of black pastel, forms a harmonious, serpentine curve that links the tub, in the lower right, and the towel, which has been thrown over a chair, in the upper left. Although the woman leans heavily on the chair, the curving outline of her body communicates equilibrium as it balances the main elements of the composition. This outline, echoed in the folds of the surrounding drapery, is given all the more definition by its placement against the well-lighted background.[26]

The layers of gold, coral, pink, blue, green, and white in the screen reverberate throughout the composition as the light, emanating from a source above and behind the maid's head, rakes across the scene. The colors are applied in sweeping, frenetic, jagged strokes. The forthright nature of their application increases the work's abstract quality and, by highlighting the shadowy image with touches of intense warmth, heightens the sense of intimacy. In *After the Bath,* color, line, and design are expressively orchestrated to emphasize all the potentially beautiful aspects of the motif.

GHL

37

Dancers at the Bar, ca. 1900

Danseuses à la barre

Oil on canvas, 51¼ × 38½ (130.1 × 97.7)

Signed in orange paint, l.r.: *Degas*

Acc. no. 0479 (Lemoisne no. 807)

The artist; sold at auction, 1918; Ambroise Vollard, Paris; Jacques Seligmann, Paris (private collection), by 1921; sold to Joseph E. Widener at auction, 1921; sold at auction but unclaimed, 1922; Mrs. W. A. Harriman, New York; PMG purchase through Valentine Gallery, New York, 1944.[27]

Degas often depicted dancers in awkward stances within the prosaic settings of rehearsal halls and waiting rooms. Duncan Phillips stated that Degas "tells the truth about toe-dancing,

35

the illusion and the disillusion of it. . . . Instead of thinking of the reality of faeryland, [one] could just about guess the weight of the woman, and we are confident that her legs are aching, and also her back."[28] By choosing to represent behind-the-scenes activity, Degas greatly reduced the emotional distance between him and his subject and discovered more varied figural positions.

The motif of a dancer with her leg propped on a practice bar appears as early as the mid-1870s and continues to around 1900.[29] This work is one of the latest representations. By the time it was painted, Degas had reworked the composition several times in preliminary drawings and pastels, and he had achieved a heightened expressiveness through the use of fiery color, vibrant brushstrokes, and dramatic composition.[30]

Comparison of the most finished pastel with this oil (both were executed around the same time) reveals the versatility of the artist's technique during his mature years.[31] Although freely executed, the pastel conveys stability and lucidity while the oil evokes irrationality and obscurity. The feet of the sturdy dancers in the pastel

are planted firmly on the floor; in the oil, their rubbery limbs twist unnaturally, appear to bear little weight, and slip on the dramatically tilted floor. In Phillips's opinion, Degas "rose above mannerism" in the drawing of the forms.[32] Linear clarity is offset by the patchy film of paint that hovers over the scene, obscuring details of the dancers' outlines and heightening the claustrophobic, oppressive atmosphere. In addition, the intense orange and blue in the Phillips work give it a harsh, artificial glow.

Dancers at the Bar exemplifies Degas's ability, late in his career, to allow the expressive application of medium and color to overtake the rationality of subject and composition. Accurate portrayal is no longer of central importance; the scene has become subjected to the liberating effects of vivid color. Phillips called the painting a "masterpiece [which] in its monumentality . . . is unique among all [Degas's] decorations celebrating . . . dancers. [In its] daring record of instantaneous change at a split second of observation [he] miraculously . . . transformed the incident of swiftly seen shapes in time into a thrilling vision of dynamic forms in space."[33]

GHL

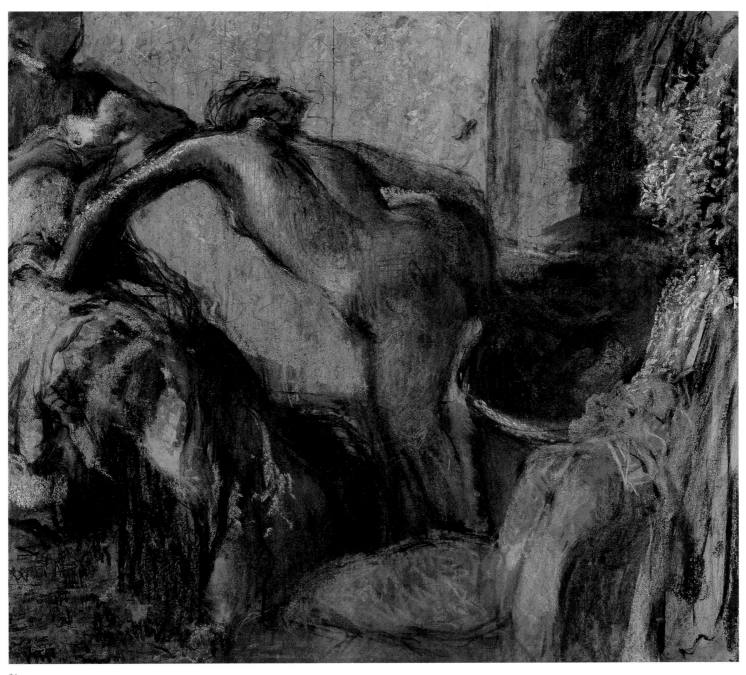

36

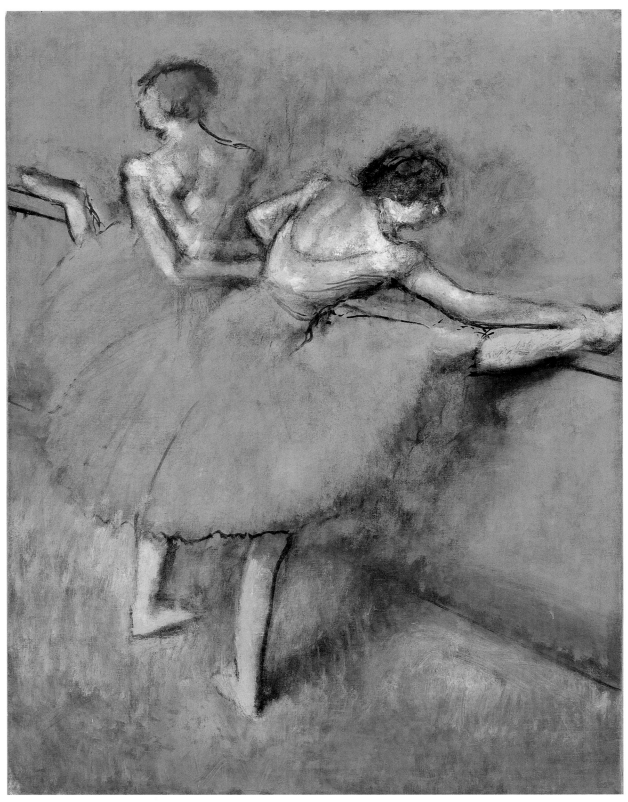

37

PAUL CÉZANNE (1839–1906)

Paul Cézanne linked the classical and traditional aspirations of the nineteenth century with an avant-garde technique and spirit that revealed painting's abstract potential to the twentieth century. Cézanne was born in Aix-en-Provence January 19, 1839, to a family of bankers and land-holders, and his parents envisioned a career in law for their son. While at the Collège Bourbon (now Lycée Mignet) in Aix, he encountered Emile Zola, with whom he established a close friendship that endured until 1886, when Zola's derisive characterization of the artist in his novel *L'oeuvre* precipitated a break. From 1858 to 1861 he studied drawing at the Ecole de Dessin while enrolled in law school to satisfy his father. In 1861 Cézanne finally left for Paris to pursue his passion for art, although he established a lifelong pattern of dividing his time between Aix and Paris. A period of rejection by the academic establishment was followed by some success in the Parisian art world; he worked at the Académie Suisse, met Camille Pissarro and other artists (1861), exhibited at the Salon des Refusés (1863), and found in his friend Zola an advocate in the press. Under the influence of Pissarro and the impressionist circle, Cézanne abandoned his brooding early style and developed an interest in landscape. After being accepted in the Salon of 1882, he attracted increasing notice, mostly from artists, including Gauguin, Monet, and Signac, and worked outdoors with Renoir and Pissarro. In 1886 Cézanne married Hortense Fiquet, the subject of frequent portraits and the mother of his son. Having developed his "classical" style during the 1880s, he reached the pinnacle of his achievement in the 1890s. Ambroise Vollard became his dealer, and he was courted by a coterie of young artists and writers such as Emile Bernard and Joachim Gasquet. Cézanne's last studio in Aix was the center of his life and work in his last productive years, when he was estranged from his wife and became increasingly isolated. He became devoutly religious, and his late work is in many ways a reflection of this deep spirituality, as well as his pioneering creative vision. He died in Aix October 22, 1906. Cézanne is represented in The Phillips Collection by six oil paintings and one lithograph.

The Cézanne Unit

In Duncan Phillips's gradual reckoning with the art of Cézanne lies the chronology of his evolving response to modern art itself. The unit, assembled between 1925 and 1955, represents one of the collector's most sustained and important achievements, the cornerstone of the collection.

It comprises seven works—six oils and one lithograph.[1] While encompassing a broad cross-section of Cézanne's oeuvre, the unit has as its core his late period, esteemed by many scholars as his finest.

Phillips's growing appreciation of Cézanne informed, refined, and educated his eye, while broadening his vision of modern art. His first response to Cézanne and the post-impressionists in 1912 is memorably succinct: "A bunch of damned fools."[2] His distrust sums up late-Victorian training, in which literary, romantic subject matter was prized over formal elements. About six years later, Phillips conceded Cézanne to be "a moderately successful decorator," while still insisting that his images were "both theoretical and awkward—a bad combination."[3] In 1924, writing about Arthur B. Davies's reverence for the French master, he observed more favorably: "It is questionable whether we would overrate the speculative and often stammering Cézanne as we so undeniably do if we did not feel in him . . . a vivid sense like Greco's vast structural symphony."[4]

By 1925, the threatening pictorial distortions of prewar movements, including cubism and fauvism, had lost momentum; thus Phillips's response to Cézanne became more direct as he was able to see him independent of subsequent movements. Phillips wrote to Josef Stransky, the conductor, collector, and sometime agent for Wildenstein Gallery, "Cézanne belongs in our collection by right of his towering genius for decorative abstraction, essential realities in solution," adding, "the portraits and figures seem to me less significant."[5]

Yet in 1925, instead of adding a still life, Phillips made his first purchase a landscape, *Mont Sainte-Victoire* of 1886–87 (cat. no. 39). With its roots in the classical landscape tradition of Claude Lorrain, its chromatic scheme dependent on impressionism, and its unprecedented conception of space through color and volume, it seemed the ideal initiation for the collector and for a generally conservative Washington public.[6] *Mont Sainte-Victoire* became a standard at The Phillips Collection; both the painting and the artist were yardsticks against which newer purchases and later movements were measured. The "intensity" of van Gogh's expressive romanticism in *Entrance to the Public Gardens in Arles,* 1888 (cat. no. 52), was contrasted with the "beneficent harmony" of Cézanne's classicism in this work. The temporal and fragmentary qualities of John Marin's seascapes became evident by direct comparison with *Mont Sainte-Victoire,* which appeared "inevitable, as if determined from the beginning of the world." André Derain

was cited as a disciple, as was Maurice Prendergast, whose "uncompromising" purity and preoccupation with design were said to parallel that of the master. Cézanne and Davies were contrasted as "the lion and the unicorn of modern painting."[7]

By 1926, Phillips acknowledged his desire for a Cézanne unit and was still anxious to have "a monumental still life."[8] Again, this goal was temporarily forestalled. In March 1928, with the encouragement of the art critic and historian Julius Meier-Graefe, who visited the gallery in February, Phillips acquired Cézanne's evocative *Self-Portrait* of 1878–80 (cat. no. 38).[9]

At this time, Phillips's was one of only five museums in the United States that owned Cézannes.[10] His growing reverence, aptly reflected in the purchase of the leonine self-portrait, took on a self-identification in his observations of 1931: "Cézanne, I believe, would not have approved altogether of Picasso. At least, in his ripe maturity he was too devoted a classicist to have tolerated fanaticism when it frankly threatened the sanctity of his museums and traditions and implied infidelity to his beloved Nature. And yet Cézanne, for all his classic conscience, was a romantic adventurer at heart, and there was always something Gothic about him."[11]

In the same essay, Phillips tentatively framed the question that logically follows an exploration of Cézanne's position. Comparing him to both El Greco and Picasso, he asked: "Is he not the logical middle man between the two?"[12] This statement marks an early appreciation of Cézanne the pioneer, as well as Cézanne the classic romantic, and is at the heart of Phillips's conception of his museum as tracing the sources of modernism.

Once convinced of Cézanne's seminal importance, Phillips exalted his oeuvre in lectures and in print, emphasizing his universality and readily espousing the mystical terms of Roger Fry.[13] In one such publication, Phillips betrayed his excitement at the all-embracing breadth of the artist's vision—and surely at his own recently attained appreciation: "It is little wonder then that when once it came to be understood the grandeur of Cézanne's idea conquered the world. What allies Cézanne to the Chinese was his universality and his cosmic consciousness and the impassioned serenity with which he sought for a visual symbol to convey his awareness of the continuity of life."[14]

In 1933 Phillips first displayed interest in an early work by Cézanne, *Still Life with Clock,* ca. 1870.[15] Scrawled in the margins of his catalogue for the "Century of Progress" exhibition in

Chicago, where Phillips had first seen the picture, is his spontaneous response: "It belongs in PMG. Verticals and circles. . . . The abstract quality transcends its objectivity and leads to Braque."[16] In a letter to Stransky, Phillips elaborated: "I could use it in my educational work. . . . It is a link between Manet and Braque."[17] Although *Still Life with Clock* did not become part of the collection, Phillips's appreciation for it indicates his understanding of Cézanne's early work, which he had formerly dismissed as uncouth romanticism.[18]

In the late thirties and in the forties, Phillips's collecting reached its peak: in 1939 *Ginger Pot with Pomegranate and Pears*, 1890–93 (cat. no. 40), the long-sought example in the still-life genre, was acquired as a gift of his nephew Gifford Phillips. Phillips found in this canvas an example of Cézanne's method, "applicable to any subject . . . which is singularly majestic as well as vital."[19] Purchased in the same year was *Harvesters*, ca. 1880, an example in a more naturalistic vein, ultimately given up in 1955 in partial trade for the daring *The Garden at Les Lauves*, ca. 1906 (cat. no. 43).[20] In 1940 *Fields at Bellevue*, 1892–95 (cat. no. 41), was added to the fast-growing unit, suggesting that the period of Cézanne's "constructive stroke" continued to hold special significance for Phillips.

In 1946, still dedicated to augmenting his unit of Cézannes, Phillips chose *Seated Woman in Blue*, 1902–4 (cat. no. 42), over a landscape offered at the same time. He made little comment on the addition of this second portrait; however, its almost permanent display in the gallery attests to his estimation.

Appropriately, the last two purchases date from very late in the artist's career. The 1955 acquisition of *The Garden at Les Lauves* reflects a radical departure; here, Phillips embraced the expressive qualities of Cézanne's last period. His discussion of it, appearing in *Arts Magazine* a year later, expresses extraordinary insight, predating scholarly reevaluation of late Cézanne by twenty years:

In his latest paintings, Cézanne reveals that, after many years of research and discipline . . . he had finally made himself so much the intimate master of his unique method of color construction and color design that he could extemporize with his brushstrokes . . . in an impetuous temperamental freedom. If not the subconscious mind at least the emotional instinct was predominant over the planning intellect. . . . What was expressed was not only his technic but his obsessive conception, his passionate aim to realize with pigments the vitality and organic unity he sensed in nature. . . . The first strokes on a late Cézanne were like the first notes sounded experimentally on a keyboard by a composer starting a symphony and searching for the theme. The shapes of the color patches were decorative units of design each needing its neighbors, each fitting into the shapes of the unfilled areas between.[21]

In comparing the works of Cézanne with such contemporary movements as abstract expressionism, Phillips felt that, through late works such as *The Garden at Les Lauves*, Cézanne had arrived at the same destination first and most thoroughly. In his appraisal, he presaged the views of some scholars, including John Elderfield, who in 1985 found that the "carefully constructed harmonies [of late Cézanne] remain a model for all subsequent modern art."[22]

In 1971, five years after Phillips's death, the fiftieth anniversary of his museum was celebrated with a major traveling exhibition of Cézanne's work—a fitting tribute to both the collector and one of his favorite artists.[23]

L F

38

Self-Portrait, 1878–80

Portrait de l'auteur par lui-même, nu-tête
Portrait de l'artiste; Portrait de Cézanne
Oil on canvas, 23¾ × 18½ (60.4 × 47.0)
Unsigned
Acc. no. 0288 (Venturi no. 290; Rewald no. 383)

Ambroise Vollard, Paris, by 1904; Theodor Behrens, Hamburg, by 1912 and until 1921 or 1922; Leo von Koenig, Berlin-Schlachtersee, by 1923 and until 1927; Rosenberg, Paris and New York; PMG purchase 1928.[24]

Appropriately, the early history of Cézanne's *Self-Portrait* involves some prominent members of the progressive art movements in Europe and the United States. In 1908 Walter Pach, an American artist and critic and an early proponent of Cézanne's work, attempted to interest the Metropolitan Museum of Art in the portrait, but the painting was ultimately deemed "'too modern' for the trustees."[25] Hugo von Tschudi is said to have brought it to the attention of the German collector Theodor Behrens of Hamburg sometime after 1909.[26] Julius Meier-Graefe featured the work in his well-known monograph on the artist; after comparing the portrait with those of Rembrandt's last style, he wrote: "Cézanne's desire for expression here pushed consideration of the modern palette into the background. Dusky dirty tones are sufficient to meet the case. The beard and the hair seem to have been taken from the sea of Courbet, the face has been hammered by strokes of the brush, and the sheer quantity of material used has diminished the eyes. . . . For once his romanticism relaxes the tension of the reins and casts about."[27]

With this acquisition, The Phillips Collection became the first American museum to own a self-portrait by Cézanne, and in 1931 Phillips wrote proudly of Meier-Graefe's assessment of it as one of the finest Cézannes in the world.[28] As did Meier-Graefe, Phillips perceived in this painting a balance of formal restraint and expressive power: "It was about the time when he was becoming a classicist that he painted our famous *Self Portrait*. . . . For ultimate consummation, for working within self-imposed bounds to the end that there shall be no touch of color which is not functional and structural, for restrained, self-contained mastery of material, nothing in the museums can surpass the subtle, solid modelling of that head of an old lion of a man, the pride and loneliness of him so directly conveyed by purely plastic means. In our Collection, notable especially for its colorists, that sombre, swarthy, tawny portrait says the last quiet word about color."[29]

Cézanne painted more than thirty portraits of himself. Although there are no precise analogues to this example, two oils and a drawing bear a close similarity.[30] Perhaps no other work records with such power the penetrating gaze and ruthless scrutiny with which Cézanne fixed his subject. The poet Rainer Maria Rilke described the consuming stare: "Without analyzing or in the remotest degree regarding his expression from a superior standpoint, he represented himself with so much humble objectiveness, with the credulity and extrinsic interest and attention of a dog which sees itself in the mirror and thinks: there is another dog."[31]

For Lawrence Gowing, Cézanne's venerable self-image at thirty-seven contains a note of humor: "The sly, faun-like glint betrays that Cézanne himself remains detached. He secretes the independence, even the wit, to examine the shape which is himself."[32] Lionello Venturi, too, esteemed the portrait "a great masterpiece. . . . In the middle of the bohemian disorder of his suit and hair, the gaze of Cézanne is alive, penetrating, sincere, severe toward himself . . . a look that is the symbol of his personality."[33]

The work recalls Cézanne's disclosure to Renoir that it had taken him thirty years to find out that "painting is not sculpture," and it may represent an intermediary stage in Cézanne's search for an alternative means of evoking plastic form.[34] Gowing asserted that Cézanne's 1875–76 portrait of the collector Victor Choquet was "the example on which Cézanne remodelled his own self-image."[35] The imposing bare head is monumental—almost architectural—in modeled volume and mass. It is the face, built up in heavy impasto into irregular, patchy ridges, that commands attention; it seems to have the substance of flesh. Unblended daubs of paint serve to recall Cézanne's recent work with Pissarro and his absorption of impressionist technique; yet the vigor and intensity of his brushstroke have an expressionistic

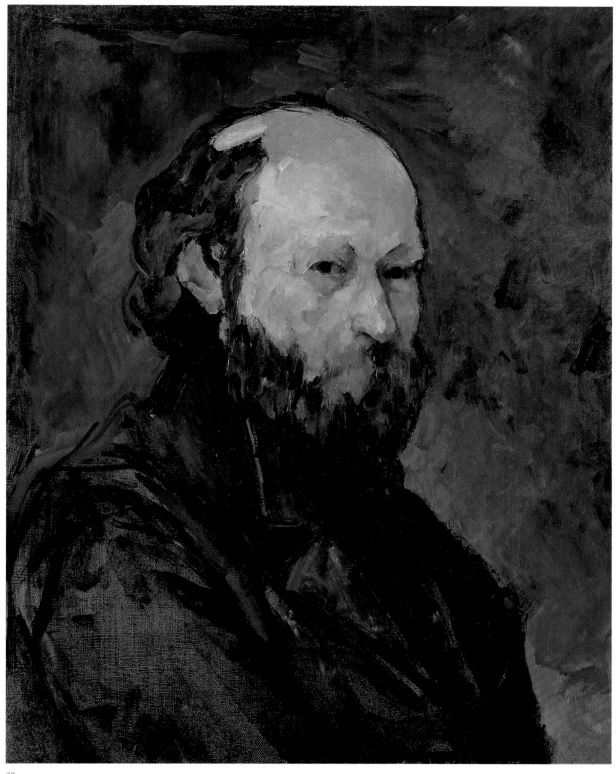

force whose passion and brutality recall his early style. The quiet resolve of Cézanne's stare seems to convey something of his pioneering attitude; in Phillips's words, it "reveals the soul of the artist, defiant in his intellectual isolation."[36]

Cézanne exploited to the full the technical means at his disposal: striations of paint form the beard; a smear of paint, probably applied with the palette knife, defines the hairline; and the toothy weave of the canvas doubles as the coat cloth. This treatment, as well as the mottled color of the face, brings the composition into play with the surface, creating a tension that Cézanne would continue to acknowledge and to reinforce in his later work.

LF

39

Mont Sainte-Victoire, 1886–87

La Montagne Sainte-Victoire au Grand Pin; Vallée de l'Arc Viaduc du chemin de fer
Oil on canvas, 23½ × 28½ (59.6 × 72.3)
Unsigned
Acc. no. 0285 (Venturi no. 455; Rewald no. 598)

Ambroise Vollard, Paris; purchased by Gottlieb Friedrich Reber, Munich, 1913; Rosenberg, Paris and New York; PMG purchase through Wildenstein, New York, 1925.[37]

Phillips's acceptance of Cézanne's eminent ancestry in the Old Masters is signaled by his 1925 purchase of *Mont Sainte-Victoire* and his statement: "Our new masterpieces by Corot, Constable and Cézanne took their place in the Main Gallery as if they had always belonged there in that intimate association with Greco's *Peter*, Chardin's *Still Life*, the groups of Daumiers, Courbets and Chavannes and the great Renoir."[38] In 1931 he conveyed his feeling for the painting in his Trowbridge Lecture: "Perfect equilibrium is established, a beneficent harmony. . . . No touch of the painter's brush fails to function in the sparing application of a few colors, while the canvas is left bare here and there with unerring knowledge of stress and interval, of movement and repose. A symmetry like the Parthenon and a strange solidity are achieved with the simplest means. . . . And so there is life and movement within the architecture of space."[39]

Although the abstract decorative qualities appealed to Phillips, he was attracted equally to Cézanne's sense of place, to the architectural structure of *Mont Sainte-Victoire*, and to the image's origins in the classical tradition of Poussin and Claude Lorrain. By comparison, "abstract art can only make a chart of what is here bewitchingly, profoundly, and naturally revealed."[40]

Cézanne's fascination with Mont Sainte-Victoire stemmed partly from his avowed love for "the conformation of my country," yet it transcended this profound attachment. According to Meyer Schapiro, "He identified with it as the ancients with a holy mountain on which they set the dwelling or birthplace of a god. Only for Cézanne, it was an inner god that he externalized in this mountain peak—his striving and exaltation and desire for repose."[41]

For this version, the artist painted the mountain from Bellevue, his brother-in-law's estate. The vantage point is very close to that shown in two other contemporary versions and identical to a watercolor probably executed earlier.[42] Gowing believes the present work to be "an intermediate stage," which culminated in the more fluidly painted and loosely fused Courtauld canvas. In the Phillips painting, "the handling of the paint and the dry diagonal touch with which the foliage is rubbed in continue the manner of 1886."[43] Gowing elaborated on this observation in 1956: "Now the strokes are rubbed (as they never are before 1885) rapidly and dryly across the canvas, rather than planted solidly on it in full paste: they are in the nature of a summary routine groundwork, in itself incomplete. The emphasis has changed and the character of the mosaic is now different: it is a mosaic of areas whose contours (most characteristically, the lines of horizon and pine branch) are now designed expressly to agree and lie side by side on the surface of the picture." As Joseph Rishel has recently pointed out, the Phillips version is distinguished from contemporaneous views of the mountain by a "rare luminosity," prompting among critics and scholars a special reverence "bordering on the mystical."[44]

The local press's enthusiastic reception of *Mont Sainte-Victoire* must have pleased Phillips. One review reflected an acceptance of his vision for his museum, where exhibitions would eschew divisions of chronology, geography, and ethnicity: "A landscape by Cézanne . . . proves congenial when associated with the works of Monet and of our own Twachtman and Ernest Lawson."[45]

LF

40

Ginger Pot with Pomegranate and Pears, 1890–93

Vase Paillé et fruits sur une table
Pomegranate and Pears; Still Life with Pomegranate and Pears; Pot de Gingembre
Oil on canvas, 18¼ × 21¼ (46.3 × 55.5)
Unsigned
Gift of Gifford Phillips in memory of his father, James Laughlin Phillips, 1939
Acc. no. 0284 (Venturi no. 733; Rewald no. 735)

Possible gift of the artist to Claude Monet, Giverny; Michel Monet, Giverny; inherited by Blanche Monet; purchased by Bernheim-Jeune, Paris, 1929; sold to L'Art Mod-erne (Lausanne branch of Bernheim-Jeune), 1929; purchased by Josef Stransky, New York, 1929; Wildenstein, New York, by November 1936; PMG purchase by Gifford Phillips, 1939, as a gift in memory of his father, James Laughlin Phillips.[46]

The solidity and dignity of this still life recall the luminous arrangements of Chardin, whereas the rich, sonorous hues and symbolic undertones draw on seventeenth-century Dutch compositions. Cézanne repeated this motif in four variants: one other oil and two watercolor studies, each depicting a nearly identical distribution of objects.[47]

The Phillips Collection's monumental oil presents a traditional "window" of rectangular space parallel to the picture surface. The image is organized around the central table; the spatial recession at the left is indicated by the second table, which is piled with books, and the limits of the wall both above and under the table are simply defined. The dominant motifs—the heavily painted, modulated fruits, the ginger pot, and the dishcloth, whose dynamic folds suggest the plasticity of classical drapery—unite the painting in a powerful and harmonious whole. At the precise center is a voluptuously painted pomegranate, made all the more sensual by its curling leaves. The traditional spatial arrangement is somewhat negated by the emptiness of the substantial area of blue wall above the objects. As Theodore Reff points out, the dynamic color modulations on this seemingly flat surface serve to illustrate one of Cézanne's preferred maxims—"bodies seen in space are all convex"—and his insistence that this even applied to "a flat surface like a wall or floor."[48] While the fruit and table retain solidity and monumentality, the objects project ambiguously on each of the composition's edges, where spatial tension is greatest. For example, the volumetric folds of drapery in the upper and lower registers and the uneven stack of books are cut off, creating a tautness in the picture plane.

A variety of technical approaches, mastered by Cézanne in the course of his career, are manifested in this image: the commercially prepared cream-colored ground is left exposed to denote areas of the dishcloth; the lower table, the blue drapery, and the books are treated thinly and sparsely; and heavy impasto imbues the central fruits and nearby shadowy folds of the cloth with weight and texture.[49] Cézanne's adjustments to the composition were revealed by close examination: the central pomegranate was moved to the right; the strap of the ginger pot was lowered; and touches of blue paint around the pears, some of Cézanne's last brushwork, were added in order to suggest space and depth.

Cézanne's chromatic modulations even lend drama to areas of negative space: the black void

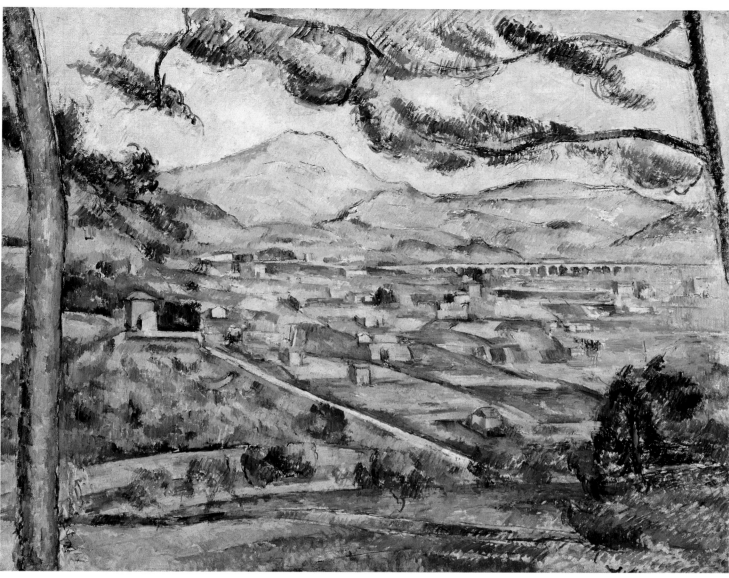

39

under the table vibrates at its edge on meeting the white cloth; the blue wall announces its proximity to the drapery and the pomegranate, with a gradual intensification of hues from gray-blue to violet-blue; and a pool of opulent shadows in orange and blue spills onto the central white plate, reflecting the richly colored surroundings. The muted colors, principally blues and browns rendered in soft light, and the fluid black outlines that sometimes undulate free of the objects they encompass, anticipate Cézannes's still lifes of 1895 and after; these works were to be "at once more sumptuous materially and more symphonic in color and composition than those of the previous decade."[50]

The repertoire of familiar objects—the flowered cloth suspended from above, the ginger pot, and the two tables, one with a scalloped apron—appears in many contemporary works painted in Aix. By contrast, the books are a rare addition; in another still life a skull replaces the stack of books, suggesting a recurring "memento mori" theme.[51]

For Phillips, as for many contemporary collectors and critics, still lifes were the most accessible of Cézanne's works. Having expressed the need for a Cézanne still life as early as 1926, he nonetheless refused several offers, relying strictly on his vision of a work suitable within the context of his growing collection.[52] In his journal, he wrote instructions to himself to "see the great *Still Life* at Stransky's, but hold tenaciously to my position not to make any commitments."[53] After seeing this painting at Wildenstein's in February 1939, Phillips borrowed it for an exhibition before acquiring it through the gift of

Gifford Phillips.[54] This acquisition allowed him to form harmonious groups wherein "the Cézanne Still Life balances our landscape [*Mont Sainte-Victoire*] one on each side of the great Renoir."[55]

The painting's distinguished early history began with Claude Monet. After attending Monet's birthday celebration at Giverny in the fall of 1894, Cézanne left Giverny abruptly. On his return to Aix, he wrote thanking Monet for "the moral support I found in you and which served as a stimulus for my painting."[56] It is possible that the still life entered Monet's collection as a gift, given in commemoration of Monet's birthday or in apology for Cézanne's hasty retreat. A Cézanne still life was noted in Monet's collection at Giverny in 1905 by critic Louis Vauxcelles, who gave a perfunctory description

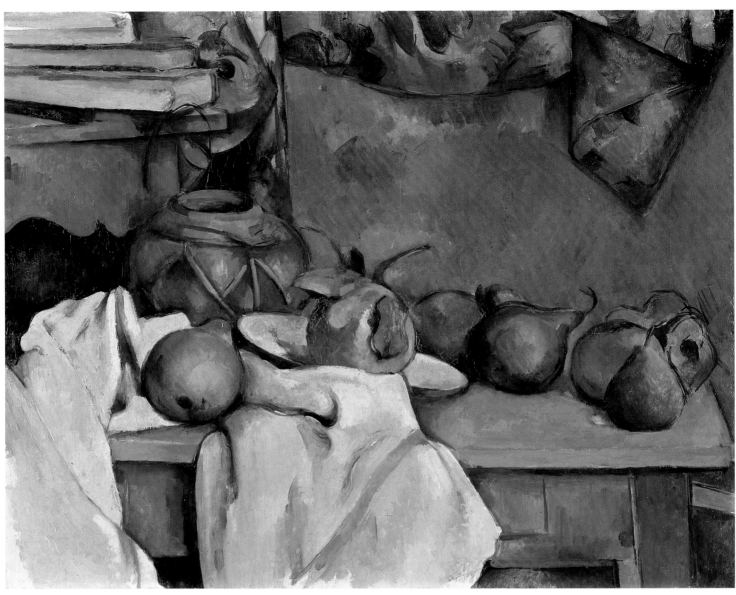

40

consistent with the present image. An undated inventory of Monet's collection held at Wildenstein's also referred to a still life, and Gustave Geffroy's description of the bedroom in 1922 included such a painting, whereas a 1927 inventory did not.[57] By then, the present work may have passed into the collection of the artist's son and daughter-in-law.

LF

41

Fields at Bellevue, 1892–95

Campagnes de Bellevue
Landscape Near Bellevue; Farmhouses Near Bellevue
Oil on canvas, 14¼ × 19¾ (36.1 × 50.1)
Unsigned
Acc. no. 0283 (Venturi no. 449; Rewald no. 717)

The artist (or his son) to Ambroise Vollard, Paris; sold to Egisto Paolo Fabbri, Paris and Florence, Feb. 10, 1900; Marie Harriman Gallery, New York; PMG purchase 1940.[58]

Intimate in scale and lyrical in color, *Fields at Bellevue* depicts the Provençal estate of Cézanne's brother-in-law, Maxime Conil. Overlooking the Arc Valley, near Aix and Mont Sainte-Victoire, it is not far from Jas du Bouffon, the family estate where Cézanne lived and painted until 1899. For this painting and several other landscapes of the period, Cézanne's focus was not east toward the mountain but north to the domestic calm of Bellevue. The house in the foreground is the subject of another larger-scale painting, *Dans la Plaine de Bellevue*, 1885–86, and is the probable site of a third work, *La Plaine de Bellevue*, 1885–87.[59] John

Rewald's description of Bellevue enhances our appreciation for the impact it had on the artist: "Situated on a hill, it dominates the entire wide valley of the Arc to the distant wall of Sainte-Victoire. . . . Here on this hill of Bellevue a landscape spread itself at his feet, rich and firm, harmonious in its lines, soaked in the southern sun."[60]

Lionello Venturi dates *Fields at Bellevue* to 1885–87, contemporary with the landscape series that occupied Cézanne at Gardanne, another Provençal town near Aix. He reasons that in both the Gardanne series (which he considered the culminating point of Cézanne's constructive period) and the Bellevue canvases, "Cézanne knew how to extract solidity and remarkable strength."[61] Indeed, the similarity in subject, and superficially in style, may explain the occasional

identification of *Fields at Bellevue* as *Gardanne*.[62] Lawrence Gowing describes the style at mid-decade as "sharply defined architecture . . . outlined against foliage more dryly and summarily treated" and places the present work beyond this era, in the less brittle and more fluid style of 1892 or before.[63] Rewald's dating roughly corresponds, because he observes in *Fields at Bellevue* "the same clarity as the still life [*Ginger Pot with Pomegranate and Pears*]." Furthermore, the treatment of light and form differs from Cézanne's Gardanne images. Whereas many are dominated by "obsessive tightness" and reductive geometry, *Fields at Bellevue* conveys a greater serenity through softer forms and a looser technique. The light is no longer, as at Gardanne, bleached midday, but instead, in Rewald's words, "the late afternoon . . . when the distance takes on a peculiar sharpness, and the foreground glows under the light of a leisurely disappearing sun."[64] It may have been Cézanne's emotional attachment to this region that infused the painting with a sense of poetry.

The composition, which has the house as its focal point, takes as its central theme the tranquillity of the Aix landscape, accomplished by a blending of architectural and organic forms. This harmony suggests itself in the rhythmically receding planes, each echoing the sloped roofs and angled eaves of the house. The yellow stone seems to fold back into the land from which it was hewn. Some of the structure's starker contours are softened by the surrounding vegetation. Its function as a dwelling is not stressed—doors and windows are almost entirely omitted—but rather it is treated as an abstract cubic form. Texture is subtly evoked: smooth, flat walls are defined by thin washes of yellow paint, and the variegated landscape elements are painted in short, energetic dashes.

Duncan Phillips makes no references to *Fields at Bellevue* in his writings. Although its austere provincial architecture eventually became the first language of cubism, this painting apparently did not affect Phillips's response to the movement; rather, the purchase reinforced his love for the harmonious compositions of Cézanne's classical period.

LF

41

42

Seated Woman in Blue, 1902–4

La Dame au Livre

Femme au Chapeau; La Vieille Femme au Livre; Femme Assise

Oil on canvas, 26 × 19¼ (66.0 × 50.1)

Unsigned

Acc. no. 0287 (Venturi no. 703; Rewald no. 945)

Ambroise Vollard, Paris; Auguste Pellerin, Paris; sold to Bernheim-Jeune, Paris, 1911; repurchased by Vollard, 1911; Wildenstein, London, by 1938; PMG purchase 1946.[65]

In 1939 John Rewald ranked *Seated Woman in Blue* "unquestionably one of the strongest and most complete [portraits] that Cézanne painted during the last years of his life."[66] It shares with *Old Woman with a Rosary*, 1895–96, a humanity, warmth of tone, and somberness of mood, its plasticity rivaling the great still lifes of the last decade.[67] A closely related work, possibly of the same woman posed in the same suit, *Woman in Blue*, 1900–1904, in the Hermitage, possesses similar strengths.

In the present picture, the figure and its background seem to merge in rich tones of orange and blue, complementary colors mediated throughout by greens and browns. Shadowy effects are similarly modulated, whether in the skin tones or on the blank wall behind the sitter, and the artist outlined the forms in thick black paint, lending them a mysterious unity with the dark background.[68]

The treatment of the wall to the sitter's right seems to be a logical progression from that of the earlier *Ginger Pot with Pomegranate and Pears* (cat. no. 40). The energetic parallel strokes along its surface take on a life of their own. Together with the deep brown shadow slanting to the lower right, they are the most intensely gestural touches in the painting. Their activity is balanced by the jutting dashes of deep green and black that model the folds in the dress and by the flickering brown and green defining the drapery folds. The warm light that sweeps diagonally across the left, illuminating the sitter's

flesh and the background textile in gold, suggests late afternoon; yet the dominant feeling of the portrait is of time suspended and of an indeterminate immutable space existing outside the vicissitudes of reality.[69]

The identity of the sitter remains open to scholarly debate. Initially she was thought to be Cézanne's wife, Hortense Fiquet-Cézanne, and indeed Phillips purchased the painting as such.[70] This identification, however, is now widely rejected. In Lawrence Gowing's view, both the lack of resemblance to Madame Cézanne and what he saw as a formal, distant rapport between artist and sitter mitigated this identification.[71] Further, after 1900 Fiquet-Cézanne no longer posed for Cézanne. Françoise Cachin has strengthened the case for the identification of the companion painting *Woman in Blue* as Cézanne's housekeeper Madame Brémond, pointing out that in his late period "Cézanne painted many portraits of . . . the guardians of his old age."[72] Although Cachin also points out subtle disparities in appearance between the present sitter and that in *Woman in Blue*, it is possible that they both represent Madame Brémond; both are posed in the same suit and hat, apparently in the same space.[73] A studio prop seen in other late works is visible in the background of the Phillips painting: a flowered curtain used in many still lifes and other portraits. The yellow book on the sitter's lap recalls the stack of books in *Ginger Pot with Pomegranate and Pears*.

Perhaps the masklike visage of the woman in this portrait, her expression stony and long-suffering, has helped to obscure her identity. Yet, although this portrait and its analogue in Russia have often been viewed as examples of Cézanne's sacrificing of his sitter's individuality entirely to formal considerations, the artist has here imbued his subject with transcendent dignity and humanity, which refute a reading of the portrait as a mere aesthetic arrangement.

The sitter's expression and position evoke the prevalent mood of Cézanne's late portraits, which, according to Theodore Reff, contain "a new note of somberness and mystery, a dark, flickering spirituality reminiscent . . . especially of Rembrandt. . . . The subjects' postures and features so often said to be inexpressive and masklike, speak eloquently of this mood." Citing the present work's deep shadows and volumes, Reff characterizes it as "the most fully Baroque in style of Cézanne's late portraits."[74]

While it was part of Wildenstein's collection in London, the portrait caught the attention of critic Douglas Lord as "evidence of [Cézanne's] complete detachment." For him, the subject's right arm serves as an example of Cézanne's ability to build volume with color, proof that "when color is at its richest, form is at its fullest."[75]

LF

42

43

The Garden at Les Lauves, ca. 1906

Le Jardin des Lauves
Oil on canvas, 25¼ × 31⅞ (65.4 × 80.9)
Unsigned
Acc. no. 0286 (Venturi no. 1610; Rewald no. 926)

Ambroise Vollard, Paris (possibly from estate of Paul Cézanne); Bernheim-Jeune, Paris; Wildenstein, New York; TPG purchase 1955.[76]

In 1901 Cézanne built a studio north of the city of Aix and about twenty kilometers west of Mont Sainte-Victoire. Chosen for its panoramic view of his beloved Provence, this commanding site was the main focus of Cézanne's work until his death in 1906. Dispirited and in failing health, he increasingly turned to painting for spiritual nourishment. Though never mentioned in his letters, *The Garden at Les Lauves* seems to belong to the "constructions after nature, based on methods, sensations and developments suggested by the model" that Cézanne desired to pursue as late as fall 1906. Writing of the torturous slowness of his "researches," Cézanne still reveled in views of "the same subject, seen from a different angle," with which "I could occupy myself . . . for months . . . by leaning once a little more to the right, once a little more to the left."[77]

In this painting, abbreviated horizontal bands locate the geographic features, suggesting an expanding, limitless space. Although the descriptive detail has been reduced to skeletal essentials, several landscape elements are apparent and have been identified by John Rewald: the terrace wall of the studio is the violet band forming the base of the painting; the garden that faces south toward the city of Aix—"not a formal garden but a sloping piece of land with a few bushes and trees"—is indicated by several perfunctory daubs of green in the foreground; and the dark area in the upper left corner represents foliage from a linden tree that overhangs the studio terrace and frames the view.[78] Intriguingly, Cézanne here reused the motif of the overhanging tree seen in *Mont Sainte-Victoire* (cat. no. 39) and other landscapes of his classical period. Whereas in the earlier works the tree defines the foreground plane, now its vague tracings of foliage seem to unite pictorially with the distance, its heavily shadowed mass suggesting a turbulent sky.

Rewald cautions that the exact viewpoint is not entirely clear, because "the view of Aix as I photographed it can be perceived only from the windows of Cézanne's studio on the first floor. The growth of the garden no longer allows a view of the panorama so that it has become impossible to ascertain whether the artist, in his day, could see Aix from his terrace or had to go upstairs as I did." This interpretation of the locale is supported in other renderings of the same view.[79]

The Garden at Les Lauves shares with other late watercolors and oils a thin, diluted paint surface laid on in a series of overlapping, rectangular brushstrokes. Thinned paint appears to have been rubbed on the canvas or wiped away after application.[80] Between these intervals of filmy paint, Cézanne allowed the white ground to denote active areas of the landscape. These voids are suggestive of deep space, and the adjoining color patches can also be found in Cézanne's experiments in watercolor; in fact, this medium may have aided him in "realizing" the luminous and ethereal late landscapes.[81]

The painting resonates with structural solidity and compositional harmony. It seems to be a distilled vision of observations on conveying pictorial space that Cézanne made in a letter to Emile Bernard in 1906: "Lines parallel to the horizon give breadth, that is, a section of nature. . . . Lines perpendicular to this horizon give depth. But nature . . . is more depth than surface."[82] Theodore Reff has noted that much

43

of this powerful sense of order derives from the chromatic scheme, the colors becoming "increasingly cool in successive layers of depth."[83] They seem to culminate around the balanced, soothing area of pink, perhaps a preliminary indication of the Chain d'Etoile mountain range.[84] The undulant brushwork indicating the hanging branches complements the more architectural touches of color applied in clusters below and creates an upward, floating motion in the sky area; turbulent brushwork on the right leads the eye back into the landscape, creating a circular emphasis that adds a baroque element to much of Cézanne's late work.

Initially attracted to the painting's sketchy quality, Phillips referred to it as "an interesting start of a late Cézanne."[85] The interpretation of the work as unfinished, supported by some

scholars, is seen as a diminishment of the artist's achievement by Lawrence Gowing, who believes that Cézanne "reached his own kind of termination" in the vivid color and the skeletal structure of this painting.[86] Cézanne himself describes his new understanding of light and color as the source of his increasingly abstract language. In 1905 he wrote to Emile Bernard, "I, nearly seventy years old, find the color sensations which give us light are the source of abstractions which do not allow me to cover my canvas nor to pursue the delineation of objects where the points of contact are tenuous, delicate; thus my image and picture is incomplete."[87]

Phillips persisted in considering the work unfinished, although he recognized the presence of rigorous structure and the improvisational freedom of handling: "Cézanne reveals . . . he

had finally made himself so much the intuitive master of his unique method of color-construction and color design that he could extemporize with his brush strokes, combining vertical, diagonal, horizontal and semicircular strokes on the same canvas in an impetuous temperamental freedom. . . . The classicist became at the close of his career as he had been at the beginning, an expressionist."[88] Further, Phillips related the work to the abstract expressionist movement, concluding that "even a start as tentative as this *Jardin des Lauves* had already achieved the painterly excitement and sense of adventure to which our best, our most poetic abstract expressionists aspire. In its present state of free intuition and unpremeditated daring it is a symbol of great art in the making."[89]

LF

ALFRED SISLEY (1839–99)

Alfred Sisley was born in Paris October 30, 1839, to a well-to-do English family. During an extended visit to London to learn his father's business, Sisley was exposed to the tradition of English landscape painting and to current art movements, and he returned to France determined to become an artist. In the studio of Charles Gleyre he met Monet, Renoir, and Jean-Frédéric Bazille. Together they traveled to Fontainebleau to paint outdoors; there Sisley formed the foundation of his early style. In 1866 and 1870 he exhibited at the Salon and in 1874 joined the first impressionist exhibition, which was held on the photographer Nadar's premises; he showed with the group on three subsequent occasions. The Franco-Prussian War in 1870 ruined his father financially, caused Sisley financial hardship, and forced him to move to Louveciennes, where he lived from 1871 to 1875. While there, he created works, especially snow scenes, that were marked by their intimacy and emphasis on striking atmospheric conditions. In 1872 Monet and Pissarro introduced Sisley to Paul Durand-Ruel, who gave the artist his first one-person show in 1883; it traveled to Boston, London, Rotterdam, and Berlin with little financial success. His admission to the Société Nationale des Beaux-Arts in 1890 led to some sales and publicity; he exhibited there almost every year for the rest of his life. After 1893 Sisley's energy declined considerably. In 1897 Georges Petit exhibited a retrospective of his work, but it passed relatively unnoticed by critics or collectors. Resigned to obscurity and stricken with throat cancer, Sisley died January 29, 1899. The Phillips Collection holds one oil painting, produced in 1874, the year of the first impressionist exhibition.

44

Snow at Louveciennes, 1874

Jardin à Louveciennes—Effet de neige
Snow Scene; Rouelle—Effet de neige
Oil on canvas, 22 × 18 (55.9 × 45.7)
Signed and dated in black paint, l.r.: *Sisley 74*
Acc. no. 1748 (Daulte no. 146)

Kirkpatrick, London; Zygomalas, Paris; Alexandre Rosenberg, Paris; PMG purchase 1923.[1]

Sisley's *Snow at Louveciennes* captures the silence and serenity of snowfall in a village. It reflects the artist's mature period of the 1870s, when he created his "lightest, most luminous and lyrical paintings."[2] Snow scenes were an ideal motif for impressionists: the softening and blurring of forms and the dense atmosphere required a muted palette to capture the myriad tones of reflected light and the softened contours of the landscape.

Monet attempted snow scenes as early as 1865, preceding both Pissarro and Sisley, and all three painted winter scenes at Louveciennes.[3] Sisley first attempted the theme in Louveciennes, "the cradle of Impressionism," during the winter of 1871–72, and, like both Monet and Pissarro, he approached the same scene in different seasons, from slightly different angles.[4] The path represented here shows the view from the first-floor balcony of Sisley's house overlooking rue de la Princesse and Chemin de l'Etarché. Sisley's conviction that "every picture show[s] a spot with which the artist himself has fallen in love" may explain the sense of intimacy and familiarity. This is enhanced by the implied perspective of pictorial space as contiguous to that of the viewer, illustrating Sisley's belief that "the spectator should be led along the road that the painter indicates to him, and from the first be made to notice what the artist himself has felt."[5]

Sisley rarely created images as vigorously structured and cohesively organized as *Snow at Louveciennes*. The square area of wall serves as the painting's anchoring motif: set off in a bright rust, it frames the small walking figure and is the terminal point of perspective. The fence proceeding from the lower left, and the wall that confines our view at right, converge there as well and turn neatly to the left. The tilt of the stroller's umbrella and the line of the fence echo the slope of the roofs, and even relate to one of the blue gate slats. This strongly defined middle ground also marks the point where the man-made elements are concentrated in a geometric, almost abstract harmony. The architectonic balance gives way in the foreground and, especially, in the sky to the ephemeral lyricism of natural forms, which are enveloped in a soft, heavy snow created with sliding brushstrokes, softened spatial definition, and hazy contours. These elements create a pictorial unity, an image rigorously "closed in upon itself."[6]

Sisley's love of English painting is perhaps reflected in this work's tonal harmonies and textural surface; it also appears in the anecdotal note of the tilted umbrella, and in the artist's poetic sense of place.[7] In 1922 Roger Fry focused on this painting in his review of a Rosenberg Gallery exhibition, where Phillips might first have noticed it: "A little snow scene has that exquisitely tender atmospheric harmony which he alone seized. Like Corot he is an artist of immediate sensibility brought into play by the thing seen."[8]

Phillips's early writings as well as his acquisitions (all subsequently sold or traded) indicate his long-standing interest in Sisley.[9] The painting that Phillips retained for the collection exemplifies the "realm of enchantment" he sought in art during the museum's formative years. In 1926 he wrote, "*Snow at Louveciennes,* with its hush of snowflakes falling over roofs and garden walls, is a lyric of winter, enchanting both in its mood and in its tonality of tenderly transcribed 'values.'"[10]

LF

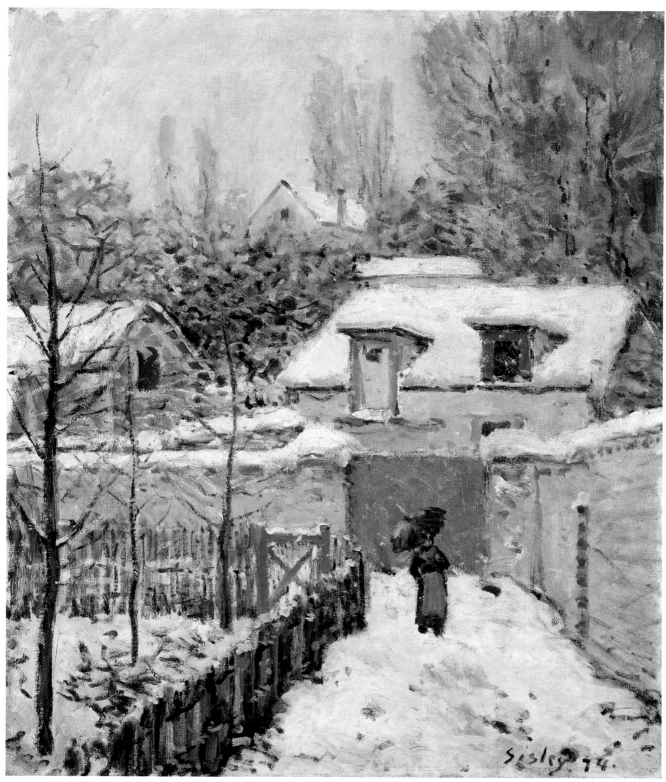

44

CLAUDE MONET (1840–1926)

Claude Monet, the artist most closely identified with impressionism, was born in Paris November 14, 1840. At the age of five Monet moved with his family to Le Havre, where he gained a reputation as a caricaturist. In 1857 he met the plein air painter Eugène Boudin, who became his mentor. In 1859 Monet moved to Paris, where he met Camille Pissarro while studying at the Académie Suisse and later briefly trained under Charles Gleyre (1806–74), at which time he met Bazille, Renoir, and Sisley. In 1865 two of his paintings were accepted to the Salon, but lack of funds forced him to return to his parents' home in Sainte-Adresse, and he spent the remainder of the decade painting scenes of the Normandy coast. For the duration of the Franco-Prussian War (1870–71) he moved to London, where he met his future dealer, Paul Durand-Ruel. Returning to France, he settled in Argenteuil. In 1873 he helped form the first impressionist group and, a year later, became the driving force behind their first exhibition, in which he included five oil paintings and seven pastels. In 1878 Monet and Ernest Hoschedé, one of his first patrons, moved their families to Vétheuil, where they shared a household until 1881. In 1880 Monet was granted his first solo show at the galleries of the periodical *La vie moderne*. The decade of the 1880s proved to be a time of extensive travel, financed by Durand-Ruel. Monet purchased his first home in 1890 at Giverny, where he painted his surroundings: the water lilies, the Japanese bridge, and his garden. In the last two decades of his life, he gradually lost his eyesight. He died December 6, 1926. Monet is represented in The Phillips Collection by two oil paintings.

45

The Road to Vétheuil, 1879

La Route de Vétheuil
Road to the Village, Vétheuil; Le Chemin du village, Vétheuil
Oil on canvas, 23⅜ × 26⅝ (59.4 × 72.6)
Signed l.l.: *Claude Monet*
Acc. no. 1378 (Wildenstein no. 581)

The artist to Durand-Ruel, Paris, 1880; sold in France at unknown date; repurchased by Durand-Ruel from Bernheim-Jeune, 1917; sold to DP for private collection 1918 or 1919; transferred to PMAG 1920.[1]

Monet, the quintessential impressionist, took the depiction of the visible world to its limits through his study of the effects of light and atmosphere on his subjects. *The Road to Vétheuil* is the last of five canvases, executed over a three-year period, depicting the entrance

Fig. 18 *Vétheuil—L'Entrée par la Roche-Guyon*. Postcard, Collection Rodolphe Walter, Wildenstein Institute, Paris.

to Vétheuil from La Roche-Guyon (fig. 18).[2] These works anticipate the 1890s "series" paintings—*Haystacks, Poplars, Rouen Cathedral, Mornings on the Seine*, and *Falaises*—in that they portray the same scene during different seasons and times of day. The Vétheuil paintings differ, however, in that they were not conceived of, or exhibited as, an entity.

In 1878, distraught by lack of sales and mounting debts, Monet relocated his family to Vétheuil, fifty miles northwest of Paris. He found the small rural village to be a haven of solitude where he was free to paint nature directly at the site. When questioned about this habit, Monet gestured to his surroundings and exclaimed, "That's *my* studio!" He remained in Vétheuil for three years, disassociating himself from his impressionist colleagues Degas, Pissarro, and Renoir, with the belief that their "little temple [had] become a dull schoolroom whose doors [were] open to any dauber."[3] Monet lost interest in their shows, participating in the fourth Exhibition of Impressionists (1879) only through the efforts of his friend Gustave Caillebotte, and abstaining from the fifth and sixth (1880 and 1881) exhibitions. When he submitted to the Salon of 1880 in hopes of success, Pissarro and Degas called him a traitor.

At Vétheuil, Monet refined the technique, explored for more than a decade, of rapidly daubing his canvas with "patches of color that correspond to the areas of color he discerns in the natural world before him."[4] The pale pastel

blues and salmons of the late afternoon sky and distant hillside contrast sharply with the darker tonalities of the foreground, creating a harmonious recession into depth by means of color as well as composition. In some background areas the paint is so thinly applied that the weave of the canvas shows through, revealing the medium-brown primed surface with which Monet experimented during the Vétheuil period. In contrast, the foreground is layered with thick paint in varied textures, echoing the canvas weave.

In *The Road to Vétheuil*, Monet invites the viewer into his world; the plain dirt road, leading to the village, passes by his home, which is located in the center of the canvas. Monet paid particular attention to the composition, making it simple, straightforward, and rooted in nature. It resembles a pinwheel divided into triangular sections, each with a different predominant local color, with the main focus on the vanishing point. Monet's agitated brushstroke enlivens the surface and creates a vibrating effect. Yet the pinwheel is subtly interwoven with the horizontal shadows and horizon line and the verticality of the trees, church steeple, and furrows. Together, these elements reinforce the picture plane. But, as Duncan Phillips correctly perceived, they are "submerged in their surroundings and more particularly in their atmospheric envelopment."[5]

Phillips considered Monet a "luminist, the poet of light."[6] In the summer of 1911, he visited

45

46

the Paris apartment of Paul Durand-Ruel and exclaimed: "The walls seemed to shout at me—rather loudly at first but gradually with growing effectiveness of appeal. . . . Renoir, Monet and Degas are especially convincing."[7] Upon his return to the United States, Phillips defined impressionism, which he believed had been misinterpreted, as "the giving of color and form to single, personal impressions." He declared that the term *impressionism* should not be limited to Monet and his colleagues, who represented only "the most recent stage in a gradual and logical development," a statement indicating his search for the sources of modern vision.[8] Phillips again illustrated his point many years later, in a 1942 exhibition entitled "Contrasts in Impressionism," in which he grouped such stylistically diverse artists as Alessandro Magnasco, Monet, and John Marin.[9]

Phillips listed *The Road to Vétheuil* among the fifteen best purchases of 1918–19.[10] In 1959, attesting to his lifelong appreciation of the work, he chose it as an example of how a landscape can depict a fleeting moment and contrasted it with the timeless quality of Cézanne's *Mont Sainte-Victoire* (cat. no. 39). Phillips wrote that Monet "made a science of *color as light* which was one of the great innovations of art history."[11]

46

Val-Saint-Nicolas, near Dieppe (Morning), 1897

Au Val-Saint-Nicolas, près Dieppe (Matin)
On the Cliffs, Dieppe; Sur la falaise, Dieppe
Oil on canvas, 25½ × 39⅜ (64.8 × 99.9)
Signed and dated l.r.: *Claude Monet 97*
Acc. no. 1377 (Wildenstein no. 1466)

The artist to Durand-Ruel, Paris, 1898; purchased by M. Fellion, Paris, at Galerie Charpentier auction, 1955; resold immediately to World House Galleries, New York; TPG purchase 1959.[12]

For Duncan Phillips, who often acquired paintings that were representative examples of an artist's technique, *Val-Saint-Nicolas, near Dieppe (Morning)* was a perfect choice for a Monet landscape, where all of the "individualities of contour . . . [are] lost in the ambience of light."[13] Phillips had searched for such a work for many years. He had purchased and eventually sold four others during the 1920s and 1930s before discovering this one, which he believed to be "one of the most beautiful Monets I have ever seen and to my surprise . . . not sufficiently well known."[14]

In its realistic depiction of nature, *Val-Saint-Nicolas* reflects the northern tradition of European landscape painting on which Monet's art is based.[15] However, Monet rejected the imaginary

landscapes that were popular in fin-de-siècle France, preferring instead to create works that induced an emotional response in the viewer.[16]

Monet's scenes of the Normandy coast from Honfleur to Dieppe, executed over a period of forty years, provide a visual chronology of his artistic development. A native of this area, he returned often to record the precipitous descent of huge cliffs into the sea below. *Val-Saint-Nicolas*, seen from the top of the bluffs above the coast of Hérons looking east toward Dieppe and the Saint-Nicolas Valley, is representative of Monet's Normandy sojourn of 1896 and 1897, during which he painted more than fifty canvases depicting the elemental grandeur of Varengeville, Pourville, and Dieppe.[17] Although these paintings constitute three individual series, Monet exhibited twenty-four of them under the collective title *Falaises,* or *Cliffs,* in 1898.

Unlike earlier examples, where cliffs and beach function as a backdrop for human activity, nature is the sole subject of the *Falaises* series.[18] The intense sunlight drains nearly all color from the far-distant land mass, which is barely visible as a horizontal transition from sea to sky. Monet's enthusiasm for "all of the beautiful movements of the land" at the Saint-Nicolas Valley is here portrayed in the lyrical contour of the cliffs and the sunlit surfaces.[19]

VSB

VSB

ODILON REDON (1840 – 1916)

A painter of imagination and fantasy who captured the interest of the French symbolist literary and artistic circles during the late nineteenth century, Odilon Redon was born April 20, 1840, in Bordeaux and raised on his family's nearby estate, Peyrelebade. After failing the entrance examinations for architecture at the Ecole des Beaux-Arts in 1862 and 1864, Redon studied painting briefly and unhappily with academician Jean-Léon Gérôme in Paris, then trained in etching and lithography with Rodolphe Bresdin in Bordeaux. He first showed at the Paris Salon in 1868. After serving in the Franco-Prussian War in 1870–71, Redon settled in Paris, spending his summers at Peyrelebade. For the next two decades he produced mostly charcoal drawings and black-and-white lithographs, which he called *Les Noirs*. His dreamlike fantasy subjects appealed to the symbolist writers and poets with whom he had become friends during the 1880s— Stéphane Mallarmé, Emile Hennequin, and Joris Karl Huysmans foremost among them. In 1879 he published the first of many lithographic albums, *Dans le rêve*. His first solo show was held in 1881 at the editorial offices of the journal *La vie moderne*. His first major retrospective was held at Durand-Ruel in Paris in 1894. At this point in his career he began working in color, gradually abandoning *Les Noirs* altogether. Forced to sell Peyrelebade in 1897, he summered in St.-Georges-de-Didonne from 1898 to 1908, and at Villa Juliette in Bièvres from 1909 until his death July 6, 1916. The Phillips Collection owns one late oil and three lithographs.

47

Mystery, ca. 1910

Le Mystère
Femme aux fleurs
Oil on canvas, 28¾ × 21⅜ (73.0 × 54.3)
Signed in brick-red paint, l.r.: *ODILON REDON*
Acc. no. 1625 (Berger no. 70; Wildenstein, vol. 1, no. 412)

Madame Redon; Galerie E. Druet, Paris, 1924 (stock no. 10.667); Kraushaar, New York, by 1925; PMG purchase 1925.[1]

Redon's evocative, visionary, and sometimes nightmarish images offer little indication that he was a contemporary of the impressionist painters. Finding the visual objectivity of the impressionists unchallenging and limiting, he preferred to emphasize the unseen, subconscious elements of existence. Accordingly, the symbolist and Nabis painters, who found Redon's mystical interpretations of the essence of life appealing, eventually adopted him as their mentor during the 1890s. Bonnard wrote of his admiration for Redon's "blending of two almost opposite features: a very pure plastic substance and a very mysterious expression."[2]

Redon's style and subjects derive not from caprice but from his intense response to nature, which aroused in him "mental ebullience. . . . I have the need to create, to let myself go to the representation of the imaginary."[3] This temperament, developed during Redon's lonely, daydreaming childhood at Peyrelebade, the family estate, was fueled by his avid reading of works by the symbolist poet Charles Baudelaire, who wrote: "The whole universe is merely a storehouse of images and signs to which fantasy, imagination, assigns place and value; it is a kind of raw material which imagination has to work over and transform."[4] Consequently, from the early, dark *Noirs* to the late, translucent flower pieces, Redon's was an art of curious juxtapositions as well as suggestive subtleties. "His object," John Rewald has observed, "was to exteriorize and communicate his vision rather than to impart a message."[5] Whereas Redon felt indebted to Corot, Delacroix, and most of all Leonardo, his work seems comparable in mystic imagery to that of Gustave Moreau. Redon, however, stripped his art of the older painter's ornate detail and naturalism, expressing his vision through simple form and, in his later oeuvre, pure color.

Mystery was probably painted around 1910, during the last phase of Redon's career, when he had abandoned the velvety blacks of his earlier creations and was working predominantly in color in order to produce more tranquil images;

in other words, "a daemonic symbolism . . . [was] replaced by a magical one."[6] This is one of his many paintings showing a figure's head amid flowers floating against a background of expressive and decorative color. The subtle, modulated blues, roses, and oranges of the background are repeated in the figure's face and hair, which take on the insubstantial, transparent quality of a dream. These colors reappear with greater intensity in the array of flowers—executed with patterned, oriental flair—within the dimly lit aureole in the bottom half of the composition. Color and forms are masterfully orchestrated to create a celestial image.

The otherworldly scene also evokes a state of mind, a dreamlike vision, not outer reality. Redon emphasized the mystical interrelationship of the figure and flowers; painted as fantasy, they become iconic representations of humanity and flora. The figure in *Mystery,* an almost androgynous being, touches its chin in a contemplative gesture that Duncan Phillips read as "intellect meditating on the brief life of flowers."[7] The intangible meaning of the painting lends itself to various interpretations, making the title especially appropriate.[8] As Redon wrote in 1902: "The meaning of mystery is to be always in ambiguity, . . . [to have] forms which will be, or which become according to the state of mind of the beholder."[9]

Redon was admired not only by the younger French artists of the day but also by the American Walter Pach, who arranged for a large group of his works to be exhibited at the 1913 Armory Show. Although Phillips surely saw the images there, he did not publish his opinion of Redon until 1926, when he based an entire exhibition, "Eleven Americans and an Important Work by Odilon Redon," on the association of Redon's aims with those of selected American painters— Dove, Hartley, Kent, Knaths, O'Keeffe, and Tack, among others.[10] He viewed Redon as their "presiding genius" and believed that they were allied in a "mutual desire to create a fresh and rhythmical language of form and color which will convey their emotions." With the newly acquired *Mystery* as the centerpiece of the show, Redon was presented as the father of subjective themes in modern painting, the first artist to "discover . . . the brooding mind of man as a rich vein of raw material for abstract art. . . . He opened an avenue of *escape*."[11] Phillips also recognized Redon's decorative tendencies, writing: "He belongs in a sense to the preciosity of a specific period yet he pointed the way back to ancient art and he stimulates conjecture about the art of the future."[12]

GHL

47

AUGUSTE RODIN (1840–1917)

Auguste Rodin shook the foundations of nine-teenth-century academic sculpture with his naturalistic, dynamic creations. Born in Paris November 12, 1840, Rodin grew up in a devoutly Catholic, working-class family. After failing three times in 1857 to gain entrance to the Ecole des Beaux-Arts, he worked as a commercial decorator to support his family. He studied briefly in 1864 with Antoine-Louis Barye and began working as an assistant in the studio of sculptor Albert-Ernest Carrier-Belleuse. In 1871, after an unsuccessful attempt to join the army during the Franco-Prussian War, Rodin moved to Brussels, where he collaborated on commissions with Carrier-Belleuse and Antoine Van Rasbourg until his return to Paris in 1877. Rodin spent the winter of 1875–76 in Italy, where he was greatly influenced by the works of Michelangelo and Donatello. *The Age of Bronze,* his entry to the 1877 Paris Salon, caused a scandal because it appeared to have been cast from life. Upon its resubmission in 1880, however, it received a third-place medal and was bought by the state. This was followed the same year by a state commission to create bronze portals, the *Gates of Hell,* for the proposed Museum of Decorative Arts in Paris. The project occupied Rodin for the rest of his life but was never finished. Other important commissions received from various institutions throughout his career included the *Burghers of Calais,* 1884–95, for the Municipal Council of Calais, *The Memorial to Victor Hugo,* 1889, for the state, and the *Monument to Balzac,* 1891, for the Société des Gens de Lettres. After 1900 he concentrated on portrait busts and small sculpture. Rodin married his longtime companion, Rose Beuret, in January 1917, and died the following November 17 in Meudon, his home since 1894. The Phillips Collection owns one bronze by Rodin.

48

Brother and Sister, 1890

Frère et Soeur
Bronze, 15 × 7 × 6 ¼ (38.1 × 17.7 × 15.8)
Signed on base l.r.: *A. Rodin;* inside cast: *A. Rodin*
Gift from the estate of Katherine S. Dreier, 1953
Acc. no. 1642

The artist; purchased 1907 by Katherine S. Dreier for her private collection; gift to TPG from the Dreier estate, 1953.[1]

This small bronze statuette explores the delicate relationship between a sister and her baby brother, a variation on the theme of maternal love that appears occasionally in Rodin's oeuvre before 1900.[2] His depictions of mother and child during the 1860s and 1870s reflect his training as a commercial decorator in the rococo tradition: ornate heavy drapery envelops the figures, which twist in exaggerated contrapposto.[3] In contrast, the simple composition and complex emotion of *Brother and Sister* typify Rodin's mature work. The sculpture's endearing subject greatly appealed to the French public, and it became one of his most acclaimed and frequently illustrated groups at the turn of the century.[4]

A sculptor who often repeated motifs, Rodin based the girl's body on a larger version appearing in the marble *Galatea,* ca. 1889, for which one of his favorite models, Madame Abruzzezzi, had posed.[5] The girl is seated, with knees drawn together and lower legs splayed, evoking the awkwardness of young adulthood. Her body, by contrast, exudes strength despite its youthfulness, as her sturdy arms balance an exceptionally large, robust child on her knee. The contours and muscles of both of the figures ripple as if suspended in movement; the effect is enhanced when flickering light enlivens the bronze surface. A comfortable tenderness between sister and brother is conveyed regardless of the girl's pensive, distracted expression.[6] Rodin's intention was not to depict the rapport of a specific brother and sister, but instead to symbolize the unspoken bond between siblings.

Most scholars believe that *Brother and Sister* was created in 1890; more than twenty casts

48

exist, along with marble and plaster versions.[7] Although the number of the Phillips cast is not known, Katherine Dreier stated that "Rodin personally considered [her statuette] the best of those bronze casts made."[8] Duncan Phillips appreciated Rodin as the first modern sculptor to breathe life into his art and to "give shape to life's . . . dramatic many-sidedness." Phillips asserted: "Most sculpture is abstract and static, Rodin's is concrete and dynamic."[9] In 1911 he described Rodin's large sculpture *The Kiss,* ca. 1886, as "a work of inspiration" and expounded upon the artist's ability "to express . . . elemental things directly yet without offense."[10] In Phillips's mind, Rodin's ability to evoke universal human emotion in marble or bronze harked back to the talent of gothic sculptors.[11]

GHL

Berthe Morisot, one of the original French impressionists, painted scenes of women at leisure that reflected her station in life. Born in Bourges, France, January 14, 1841, Morisot moved with her family to Paris in 1852. Beginning around 1857, she and her older sister, Edma, studied art briefly with Joseph Guichard, then with Corot from 1857 to 1860. Morisot first showed at the Salon in 1864. By 1868 she knew Manet and Puvis de Chavannes, who became her lifelong friends. In 1872 Durand-Ruel began selling Morisot's work. The following year she became a charter member of the "Société Anonyme des artistes—peintres, sculpteurs, etc.," whose yearly shows from 1874 to 1886 became known as the Impressionist exhibitions. In 1874 Morisot married Manet's brother, Eugène. Their daughter, Julie, born in 1878, was to become her favorite model. After her husband's death in 1892, Morisot and Julie moved to an apartment on rue Weber in Paris, where the artist died March 2, 1895. The Phillips Collection owns one late oil painting.

49

Two Girls, ca. 1894

Les Deux Fillettes
Jeunes Femmes à leur toilette
Oil on canvas, 25⅝ × 21¼ (65.0 × 54.0)
Black studio stamp l.r.: *Berthe Morisot*
Acc. no. 1390 (Bataille and Wildenstein no. 362; Clairet, Montalant, and Rouart no. 366)

J. Hessel; purchased 1923 by Bernheim-Jeune, Paris; sold 1925 to Kraushaar, New York; purchased 1925 by PMG.[1]

Painted late in Morisot's career, *Two Girls* typifies her many images of young women at home involved in daily routines. Posing in Morisot's rue Weber apartment in Paris, Marthe, a model, prepares to bathe her feet while Jeanne-Marie, another model, daydreams.[2] Both figures reappear in Morisot's *The Coiffure,* 1894, in which Jeanne-Marie, wearing the same robe, is having her hair brushed by the fully dressed Marthe.

Two Girls is executed in pastel colors and with feathery brushstrokes typical of the impressionist technique that Morisot maintained throughout her life. Yet this work reflects her late style. The figures are not blended into the background, as was characteristic of her early work, but have volume and are outlined with broad brushstrokes that set them apart from their surroundings. This practice, and her increasing use of preparatory sketches for her paintings, were adopted from Renoir, a close friend during the last ten years of her life. At the time that *Two Girls* was created, both artists were ardent admirers of Boucher and Rubens and chose to concentrate on the depiction of the figure in intimate compositions that recalled baroque interiors. For Morisot, posing models in her apartment was convenient and ideally suited to this purpose.

The indistinctly rendered surroundings of *Two Girls,* and its studio stamp in lieu of a signature, lead one to speculate that the painting may be unfinished.[3] The interior space is implied by myriad sketchy pink, blue, and gold brushstrokes, highlighted with white, thus lightening the overall palette. The floor of the room tilts down abruptly, and space seems to continue beyond the picture plane, resulting in objects that appear to be floating. Characteristically, Morisot painted from the center outward, leaving the edges of the canvas unpainted in some areas.[4]

Duncan Phillips admired Morisot's intimate boudoir scenes, specifically the "feminine charm in her touch, in the way she caressed pigments into delectable textures and made unusual colors sing."[5] He viewed Morisot as a possible influence on her brother-in-law, Manet, in her accomplished depiction of color and light. Assigning her an important place in the established lineage of French modern art, he observed, "Her line led to Lautrec and her color to Redon and Bonnard—stylists all of them and all painters of the intimate and the idiomatic expression."[6]

GHL

49

PIERRE-AUGUSTE RENOIR (1841–1919)

A painter of colorful, sun-drenched scenes depicting Parisians at leisure, Pierre-Auguste Renoir was born February 25, 1841, in Limoges, France; his family moved to Paris in 1844. In his teens, Renoir was apprenticed to a porcelain painter and decorator, and in 1861 he turned to painting, studying with Charles Gleyre and entering the Académie des Beaux-Arts the following year. He was soon painting with Frédéric Bazille, Sisley, and Monet, with whom he developed the freely executed, brightly colored impressionist style. In 1874 he participated in the first impressionist group exhibition, billed as "Société Anonyme des artistes—peintres, sculpteurs, etc." Around 1876 Paul Durand-Ruel began purchasing his work, and during the 1880s he aroused American collectors' interest in Renoir through his New York branch. After the artist's 1881 trip to Italy, Algeria, and the south of France, his paintings reflected increased interest in drawing, in the female nude, and in the art of the Old Masters. In 1890 he married his longtime companion, Aline Charigot, and from 1898 he spent most of his time outside Paris, in Essoyes and Cagnes. In 1913, his health deteriorating, Renoir took up sculpture, with Richard Guino as his assistant. Renoir died in Cagnes December 3, 1919. In addition to the masterful oil painting *The Luncheon of the Boating Party,* The Phillips Collection owns a bronze sculpture, a late drawing, an etching, and a lithograph by Renoir.

50

The Luncheon of the Boating Party, 1880–81

Le Déjeuner des canotiers

Déjeuner champêtre; Les Canotiers; Un Déjeuner à Bougival; Boating Party at Luncheon

Oil on canvas, 51¼ × 69⅛ (130.0 × 201.0)

Signed and dated l.r.: *Renoir, 1881*

Acc. no. 1637 (Daulte no. 379)

The artist to Durand-Ruel, Paris, 1881; sold to Ernest Balensi, Paris, Dec. 10, 1881; reacquired by Durand-Ruel, 1882; purchased by Paul Durand-Ruel, 1883; ownership transferred back to the gallery 1891; PMG purchase from Joseph Durand-Ruel, July 1923.[1]

Shortly after confirming his purchase of *The Luncheon of the Boating Party,* Duncan Phillips wrote an enthusiastic letter from Paris informing his treasurer of the acquisition: "The Phillips Memorial Gallery is to be the possessor of *one of the greatest paintings in the world. . . .* It will do more good in arousing interest and support for [the Phillips Memorial Gallery] than all the rest of our collection put together. Such a picture creates a sensation wherever it goes."[2] In an affirmation of Phillips's foresight, these statements have proved themselves correct. *The Luncheon of the Boating Party* is undoubtedly among the most visited, commented upon, and memorable paintings in The Phillips Collection.

In spite of Joseph Durand-Ruel's emphatic claims that Renoir's masterpiece was not for sale when it was exhibited with other Renoir works in New York in January 1923, Phillips began negotiations soon thereafter, agreeing to the highest sum yet paid for a Renoir. Because Durand-Ruel had stated publicly that he would allow it to leave France permanently only if it went to a museum, the purchase of a highly esteemed masterpiece lent status and credibility to Phillips's aim of establishing a major museum, not merely a fine private collection.[3]

Phillips might have been aware of the painting as early as 1911, particularly early in his collecting career. In a travel journal of that year he praised the "group of Parisians lunching up the river on a hot holiday" as one of Renoir's "vivacious raptures over modern life." During the same trip, at the Musée du Luxembourg, Phillips saw the earlier *Ball at the Moulin de la Galette,* 1876, a work of a similar theme, and he commented favorably on Renoir's ability to capture the exuberant atmosphere of a dance outdoors in a blur of orchestrated color, swirling figures, and congenial expressions.[4] He later declared that Renoir "was the most French of all painters . . . in his epicurean sensuousness and in his quaint, wholehearted, unhesitating abandon."[5]

Most of the models, all friends of the artist, have been identified.[6] In the right foreground, Angèle, one of Renoir's frequent models, turns her head toward the standing Maggiolo, a journalist. The painter Gustave Caillebotte sits backward in his chair and stares across the table at Aline Charigot, Renoir's future wife, who coos at her terrier, while the burly Alphonse Fournaise Jr., son of the restaurant's owner, leans against the balcony's railing surveying the scene. In the center, Baron Raoul Barbier, a former cavalry officer, is seated with his back to the viewer speaking to the woman resting her elbows on the railing, who is thought to be Alphonsine Fournaise, the daughter of the proprietor. Across the table from Barbier is the actress Ellen Andrée, drinking from a glass. Behind her, the top-hatted Charles Ephrussi, a banker and editor of *Gazette des beaux-arts,* chats with Jules Laforgue, poet, critic, and Ephrussi's personal secretary.[7] Standing in the upper right, Eugène Pierre Lestringuez, an official in the Ministry of the Interior, laughs with Jeanne Samary, a famous actress with the Comédie Française,

while the artist Paul Lhote, a close friend of Renoir, cocks his head.[8] Renoir has immortalized his closest friends to such a degree that the image is "not anecdotal but monumental."[9] Marjorie Phillips was inspired to write: "In the light of time it does not matter much who the figures are. They are every man, all people."[10]

Although *The Luncheon of the Boating Party* is as ambitious as *Ball at the Moulin de la Galette,* a work of similar scale and complexity, it is much more tightly composed, uniting within one image the time-honored compositional traditions of figure painting, still life, and landscape. Renoir used fewer figures than in the earlier work and carefully placed them within the eight-by-ten-foot boundaries of the balcony.[11] In fact, the figures are so densely massed that he had to distort perspective. The intricacy of the composition is further increased by the addition of a lush still life of goblets, wine bottles, and fruit in the foreground. Renoir focused his attention on the position of the figures within their conversational vignettes, weaving a pattern of straying glances. People wearing straw hats are placed at regular intervals around the borders; Charigot, Caillebotte, and Alphonsine Fournaise, with her arms propped on the balustrade, form a triangle that recedes into depth and counters the strong diagonal created by the railing edge and the ascending row of heads. The scene is further unified by the sparkling red, orange, yellow, and blue highlights that flicker throughout the painting.[12] About this tour de force, Phillips declared: "The more difficult the subjects [Renoir] attempted, the more insolently easy the way he mastered them."[13]

The Luncheon of the Boating Party was executed at a transitional stage in the artist's career, when he increasingly stressed the modeling of the human figure and its placement in space. Yet he also retained the sketchy, brightly colored brushstrokes and flickering light of the impressionist style.[14] Phillips recognized this tendency and viewed Renoir's work as "a belated culmination [of] . . . the High Renaissance" sprung from the tradition of the art of Giorgione, Rubens, Titian, and Veronese, as well as the *fêtes galantes* of the rococo painters. Indeed, the painting's sumptuous subject and complicated composition are reminiscent of sections of Veronese's *Marriage Feast at Cana,* which Renoir often admired at the Louvre.[15] By contrast, *The Luncheon of the Boating Party,* in the manner of the impressionists, represents the leisurely life of the middle class, not the aristocracy, reminding one that "the grim Revolution lay between Fragonard and Renoir," causing the latter's work to be

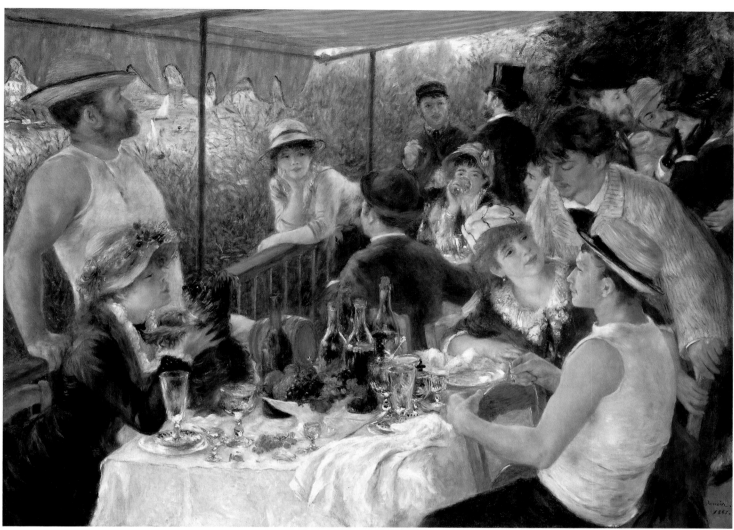

50

"of the people and for the people." Renoir has also added to the "grand manner . . . the impressionist's art of expressing the passing moment in the softness of a woman's dancing glance, the flapping of the striped awning in a fitful breeze, the unity and vivacity of the caressing enveloping light."[16]

Hailed as "one of the most famous French paintings of modern times" when it was first exhibited, *The Luncheon of the Boating Party* was flanked by Sisley's *Snow at Louveciennes* and *Banks of the Seine* at the Phillips Memorial Gallery in December 1923.[17] At the time, Phillips had intentions of forming a unit of Renoir's

works; however, as the painting came to serve its purpose as a magnet attracting to the museum "pilgrims to pay homage from all over the civilized world," Phillips realized that *The Luncheon of the Boating Party* was the only major work by the artist that he would need.[18]

GHL

PAUL GAUGUIN (1848–1903)

Paul Gauguin, whose symbolist style had a profound impact on twentieth-century art, was born in Paris June 7, 1848. Descended from wealthy Spaniards on his mother's side, Gauguin spent a modest youth in Orléans and, following service in the merchant marines and the navy (1865–71), secured a position in Paris as a clerk in a stockbroker's office. In 1873 he married Mette Gad, with whom he had five children. While still involved in his business career, Gauguin began to paint in 1873 and in 1876 exhibited a work for the first time at the Salon. In 1879 he began to associate with the impressionists, the same year they invited him to participate in their fourth impressionist exhibition (1879); he subsequently exhibited in the fifth (1880), sixth (1881), seventh (1882), and eighth (1886) impressionist exhibitions. In 1883 Gauguin began to paint full-time. Late the following year he joined his family in Denmark, returning to Paris by June 1885. He first traveled to Brittany, primarily Pont-Aven, in 1886. In early 1887 he and Charles Laval, a fellow painter, left for a sojourn in Panama and discovered Martinique. He returned to Pont-Aven in February 1888; there Laval and Paul Sérusier painted in his company, and in August he was joined by Emile Bernard (with whom he developed the principles of synthetism). Funded by Theo van Gogh, Gauguin joined Vincent van Gogh in Arles in October 1888, precipitating a brief but fertile artistic collaboration, and by late December he returned to Paris. In November Theo van Gogh organized Gauguin's first solo exhibition at the Boussod and Valadon Gallery, Paris. After a brief stay in Pont-Aven, Gauguin was back in Paris by mid-April 1889 to prepare for the first public exhibition of synthetism, held at the Café Volpini. Immediately following this event, he returned to Brittany, first to Pont-Aven and then by late June to Le Pouldu, where Meyer de Haan painted with him. He continued to travel primarily between Pont-Aven, Le Pouldu, and Paris until he left for Tahiti in April 1891, and except for a visit to France from 1893 to mid-1895, he remained in the South Seas until his death in the Marquesas May 8, 1903. The Phillips Collection contains one work from Gauguin's synthetist period.

51

The Ham, 1889

Le Jambon
Still Life with Ham
Oil on canvas, 19¾ × 22¾ (50.2 × 57.8)
Signed on edge of table, l.r.: *P.Go.*
Acc. no. 0761 (Wildenstein no. 379)

Collection of the artist; purchased by Ambroise Vollard, Paris; sold to Alex Reid and Lefevre, Ltd., London, 1936; pur-

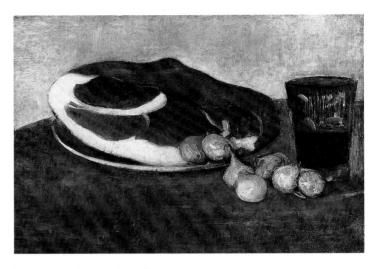

Fig. 19 Meyer de Haan, *Still Life with Ham,* 1889, oil on canvas, 13 × 18¼ in., F.1985.12.P., Norton Simon Foundation, Pasadena, California.

chased by A. Daber, Paris, 1937; Etienne Bignou, Paris, by 1948 and until at least 1950; Maurice Cortot, Paris; sold to Paul Rosenberg and Co., New York, 1951; TPG purchase 1951.[1]

"I like Brittany," Gauguin wrote. "It is savage and primitive. The flat sound of my wooden clogs on the cobblestones . . . is the note I seek in my painting."[2] The rural simplicity of this area of France provided Gauguin with fresh perspectives as he developed his principles of synthetism—seen here in the brilliant and exotic colors, decorative patterns, and spatial complexity of *The Ham.*[3]

The strength of *The Ham*'s composition depends on a tension generated between decorative flatness and implied space. The repeating curves in the composition—in the onions, the crescents of the chainlike design in the background, the oval sweep of the ham, the platter, and the undulating legs of the table—contrast with the alternating vertical stripes of the background. Although these elements give *The Ham* an organic unity evocative of Art Nouveau, Gauguin's subtle assertion of space prevents a purely decorative reading. Patches of pink emerge from the intense orange hue of the background to provide tonal variation, while the subtle use of shadows for modeling, such as those around the platter and on the ham, contradicts the sense of flatness suggested by the patterned background and the upward tilt of the tabletop. The pungent juxtaposition of orange and pink helps emphasize the blood-red color of the meat around which Gauguin keyed his palette. One becomes aware of the presentation of the ham, its plasticity and dissonant rawness, as well as its weight on the platter.

Gauguin's growing concern for plasticity in his forms stemmed partially from Cézanne's example, to which he increasingly turned in 1889. He had admired Cézanne early on, painting with him and Pissarro in 1881, and when commencing a still life was reported to have said "Let's do a Cézanne."[4] An avid collector of Cézanne's work, he was especially fond of *Still Life with Fruit Bowl, Glass and Apples,* ca. 1879–82, which he kept with him until financial considerations forced him to sell it in 1898.[5] In *The Ham,* the highlights and contours of the onions, especially the choice of deep blue to outline them, offer a close comparison to Cézanne's vigorously modeled apples. Gauguin's regular, vertically aligned brushstrokes above the ham and the slight tilt of the tabletop to coincide with the picture plane, thus presenting the platter from both frontal and aerial perspectives, are also reminiscent of the Cézanne still life.[6]

Two other paintings provide further insight into the Phillips work. The subject—a ham on a platter set against a patterned background—may have been inspired by Manet's *Le Jambon,* ca. 1875–78.[7] But Gauguin probably painted his version in the company of Meyer de Haan, whose own rendition of a ham on a platter (fig. 19) is nearly identical to Gauguin's.[8] The differences between the two works are found in the placement of the still life and serve to underscore Gauguin's mastery. De Haan displayed the still life in a fairly realistic manner, with a simple horizontal division of the background that is closer to the Manet, whereas Gauguin expanded the image to include a bistro table placed against a spatially and decoratively complex back-

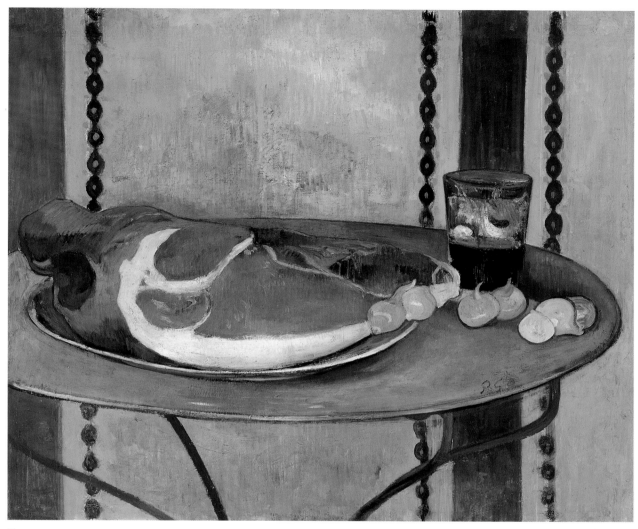

51

ground, blurring the boundary between illusion and reality. This work recalls Gauguin's injunction "Do not paint too much after nature. Art is an abstraction." He added, "Extract it from nature while dreaming in front of it and think more of the creation which will be the result."[9]

In the 1880s Gauguin had become increasingly interested in the surface appearance and texture of his paintings, reflected both in his choice of materials and in his approach.[10] He had been attracted to the "matte finish" and "velvety tone," as described in contemporary accounts, of Pissarro's surfaces, and thus preferred to paint with a lean medium and avoid varnish, according to Jirat-Wasiutynski and Newton.[11] Yet he also liked the "primitive" effect of a rough surface, which he often achieved by letting the weave of the canvas show through. In *The Ham,* however, the textured effect comes from Gauguin's building up layers of paint and

using long, sometimes crosshatched brush-strokes that not only model the forms but also create very slight impasto.[12] Just below the edge of the tabletop there is texture in the paint film that appears to be unrelated to the composition. Perhaps Gauguin made slight revisions to the composition, or he may have painted over the faint start of another composition.[13] The rich, buttery hue of the area above the table is likewise intriguing, and Carolyn Boyle-Turner has speculated that Gauguin may have experimented with wax.[14] Despite the unfortunate later addition of a natural resin varnish that masks many of Gauguin's intended effects, the viewer is still keenly aware of his painting process and of the painting's strong physical and decorative vitality.[15]

Duncan Phillips, who often interpreted a painting by studying its color and design, was most likely drawn to the subtle complexity, deco-

rative forms, and vibrant colors of *The Ham.* Phillips considered Gauguin to be a romantic primitive who looked back with a "wistful yearning for qualities lacking in [his] world."[16] He was, in Phillips's estimate, "a follower of the ideas of human innocence in a wild state proclaimed in writing by Jean Jacques Rousseau."[17] Yet, while Phillips attested to the originality of Gauguin's work, especially "his superb monumental contours and his arabesque of flat, dissonant, decorative color patches," he maintained reservations regarding Gauguin's primitivism, which he believed "led to spurious savagery and to cheap South Sea importations."[18] It was probably because of these concerns that Phillips deaccessioned his earlier, more overtly exotic Gauguin acquisition, *Idyll of Tahiti,* 1902, and then purchased *The Ham,* which he said bore "such a resemblance to the collection and is so much needed as a source of subsequent painting."[19]

LBW

VINCENT VAN GOGH (1853–90)

Vincent Willem van Gogh, a key figure in the development of post-impressionism, was born March 30, 1853, in Groot Zundert, The Netherlands, the eldest of six children. In 1869 van Gogh was employed by the art dealers Goupil and Co. in The Hague, where he began to gather his considerable knowledge of art. After a brief stay in London and Paris, marred by emotional and spiritual turmoil, he decided to become a minister. While an evangelist in the Borinage area of southern Belgium, he made drawings that illustrated the desperate social conditions there. By 1880, however, following repeated rejections by the church hierarchy, he had determined to become an artist. During this period, his brother Theo gradually became his sole means of financial and emotional support. He studied briefly at the Academy of Arts in Antwerp in 1886 but could not tolerate the rigors of academia; yet it was there that he developed technical skill from life drawing. In Antwerp, too, he was exposed to Japanese prints, an encounter that transformed his work. In early 1886 van Gogh moved to Paris, where he soon settled in Montmartre. While studying in the studio of Fernand Cormon, he met Henri Toulouse-Lautrec and Emile Bernard, and later encountered Georges Seurat, Camille Pissarro, and Paul Signac. In the autumn of 1887 he met Paul Gauguin, whom he worshiped until their later estrangement. By February 1888 he left Paris to seek a quieter life in Arles, a move that coincided with his breakthrough into mastery. His desire to found an artist's community was never fulfilled; instead, in the company of Gauguin, van Gogh experienced a severe breakdown in December 1888. This event marked the beginning of mental and emotional crises that had been foreshadowed throughout his unstable life, and led to a stay at a mental hospital at Saint-Rémy in Provence. The voluminous output and unprecedented force of his work in his last two years of life were relatively unacknowledged by public and press. In 1890, after a brief visit to Paris, van Gogh traveled to Auvers-sur-Oise, where he placed himself under the care of Dr. Paul-Ferdinand Gachet, who could not stem the artist's mounting despair. Van Gogh shot himself on July 27, 1890, and died two days later. His career is well represented by five works in The Phillips Collection: a drawing from his Paris sojourn of 1886–87, one oil each from Arles, Saint-Rémy, and Auvers, and a print of Dr. Gachet.

52

Entrance to the Public Gardens in Arles, 1888

L'Entrée du jardin public à Arles
Jardin Public; Public Gardens in Arles
Oil on canvas
28½ × 35¾ (72.3 × 90.8)
Unsigned
Acc. no. 0796 (F-566; H-1585)

Johanna van Gogh-Bonger, Amsterdam; sold April 1907 to Bernheim-Jeune, Paris; possibly sold to Prince de Wagram, Paris, and reacquired by Bernheim-Jeune; purchased 1908 by Carl Sternheim, Munich; Mme Théa Sternheim, Utweil, Switzerland; Sale Théa Sternheim, Amsterdam, 1919; Paul Rosenberg, Paris; Arthur and Alice Sachs, New York, by 1929; purchase through Wildenstein, New York, by PMG 1930.[1]

Entrance to the Public Gardens in Arles is one of a series of thematically related paintings, all standard *toiles de trente,* that van Gogh executed in the south of France between August and October 1888, a period of intense creativity for him.[2] He was probably referring to this painting when he wrote to his brother Theo around October 10, briefly stating that he had finished "a new size 30 canvas . . . another garden."[3]

For several months van Gogh had absorbed the warm Mediterranean atmosphere of Arles, and *Entrance,* remarkable for its strident and saturated colors, its profusion of semiexotic foliage, and its dazzling, shadowless light, conveys the artist's newfound delight in the region. "Everywhere and all over the vault of heaven," he wrote Theo in mid-September, "is a marvelous blue, and the sun sheds a radiance of pure sulphur, and it is soft and as lovely as the combination of heavenly blues and yellows in a Van der Meer of Delft. . . . It absorbs me so much that I let myself go, never thinking of a single rule."[4] Most of the fifteen paintings van Gogh executed that fall represent the formal aspect of the garden on Place Lamartine, some of which are referred to as the *Poet's Garden* series.[5] The Phillips painting depicts the more prosaic side of the park, including its entrance, possibly at a point directly opposite van Gogh's newly rented Yellow House on the north side.[6] His profound sense of place expressed itself in a desire to capture the aesthetics and mood of modern-day Arles while also revealing its ancestry in antiquity and the Renaissance.

The idea of a decorative series based on the two different sides of the garden that once existed on Place Lamartine in Arles evolved slowly from van Gogh's keen desire that his Yellow House and its environs become the site of a new painters' mecca. Continuing in the tradi-

tion of Adolphe Monticelli, a Provençal painter whom he revered, van Gogh envisioned that he, Gauguin, and others would come together there to share inspiration. The entire series of garden paintings seems to have been created in the spirit of Gauguin, as van Gogh anticipated their collaboration. Indeed, paintings of the *Poet's Garden* series were destined for a room that van Gogh hoped would soon be occupied by Gauguin. It has been hypothesized that *Entrance* and the other views of the more "everyday" sections of the park were also intended to serve a decorative function in the house. They share the harmonious colors and ornamental spirit of works meant to be hung and viewed together.[7]

The novelty of van Gogh's first experience of a Mediterranean terrain and culture may well be the major inspiration for this work, an encounter enriched by myriad literary and artistic sources. The casual figures at rest, particularly the standing man, recall his great appetite for the work of Daumier; they also evoke colorful characters in the novels of Emile Zola and Alphonse Daudet, both Provençal writers whom van Gogh mentioned frequently in connection with his observations of Arles and its people. When he wrote to Theo in late September, he described the environs and populace of Arles as "Daumier, absolute Zola."[8]

The man at left reading a newspaper strikes an anecdotal note with his distinctive stance and round straw hat.[9] The recurrence of this figure in van Gogh's art may be a compositional convenience, or it may signify a self-portrait, consciously intended or not, showing him both as a participant in the quotidian life of Arles and in a more suggestive, allegorical role as lover and poet.

The theme of a garden peopled by figures enjoying leisurely pursuits had great favor among the impressionists, and van Gogh himself related it to the work of Manet.[10] The crisp black silhouettes of the Arlesian women, strolling and sitting in the garden, attest to his interest in oriental prints, an influence reinforced by his Paris sojourn of 1886–87.[11] A *japonais* effect can also be detected in the flattening of space through the use of emphatic colors and the contrasting of dense patterning with uniform color areas. The rapid, calligraphic brushwork defining each branch and leaf in black further suggests this influence. Such intensity of treatment is balanced by the general mood of leisure, and from this equilibrium springs the painting's pervasive sense of joie de vivre.[12]

In 1926 Duncan Phillips published a "wish list" that included "examples of the inventive genius of Van Gogh."[13] Four years later, after finding his two first van Gogh purchases unsuit-

52

53

able for the collection, he decided on *Entrance*.[14] For Phillips, van Gogh was "by turns Japanese and Gothic," and his vivid and exultant description of the work conveys much about his own love of expressionism in modern painting: "It is an outcry of the soul, that canvas, a shout of triumph, of joy in the sun, of thanks to God for a brush and some good pigments wherewith to surpass the light of life itself in intensity. How to catch that pulse in nature, the repetition of certain shapes, the wave-like ripples of the heat, the saturated glare of the soil along the garden walk, the pungent, aromatic fragrance, the scintillant, opulent colors, blues and greens, yellows and oranges in full cry under the sun, the trees of many shapes and textures at the depths of which one could plunge and find shelter in the inner recesses of dark, cool shadow."[15] It is fitting that

Phillips hung *Entrance* together with the work of El Greco, whose prophecy he believed van Gogh to have fulfilled.

L F

53

The Road Menders, 1889

Les Paveurs (Boulevard de Saint-Rémy)
Oil on canvas, 29 × 36½ (73.7 × 92.8)
Unsigned
Acc. no. 0799 (F-658; H-1861)

Johanna van Gogh-Bonger, Amsterdam; sold to Paul Cassirer, Berlin, May 1905; sold the same month to Hugo von Tschudi, Berlin; Angela von Tschudi, Munich, as of 1912; Wildenstein, New York, with Rosenberg; purchased by Dorothy Sturges, Providence, R.I., 1930; inherited by Elizabeth Hudson, Syracuse, N.Y., by 1939; PMG purchase 1949.[16]

Van Gogh painted two versions of *The Road Menders* in 1889. The first variant, the final work of many outdoor scenes of that year, was executed in plein air, and the Phillips version, which followed shortly thereafter, was created in the studio.[17] Both works depict the repaving of a street in Saint-Rémy known at the time as the Cours de l'Est. The scene captivated the artist on one of several excursions from the Asylum of Saint-Paul-de-Mausole during the fall and winter of 1889–90. The theme of workers in the landscape had been a prevalent motif of van Gogh's paintings executed in Holland.[18]

On December 7, van Gogh wrote to his brother Theo in Paris, describing the first version: "The last study I have done is a view of the village, where they were at work—under some enormous plane trees—repairing the pave-

ments. So there are heaps of sand, stones and the gigantic trunks—the leaves yellowing and here and there you get a glimpse of a house front and small figures." The Phillips version, which van Gogh called a "copy," followed most likely in mid-December. On January 3, 1890, van Gogh referred to both paintings in a list that accompanied a shipment of paintings sent to Theo: "The big plane trees—the chief street or boulevard of Saint-Rémy, study from nature—I have a copy which is perhaps more finished here."[19]

Throughout his career, van Gogh intermittently followed the academic practice of producing two versions of an image. The two compositions of Saint-Rémy allow a comparison of the first, spontaneous exploration of a subject with a "finished" studio work. Ronald Pickvance notes that van Gogh sent the study in January but kept the present version of *The Road Menders* for four months, until the end of April 1890. He interprets this decision, along with van Gogh's reference to the painting as "perhaps more finished," as indicating the artist's preference for the second canvas.[20]

A photograph of the site taken from a similar vantage point, though dating to some sixty years after the painting, indicates some of the liberties van Gogh took with his subject.[21] The width of the road has been exaggerated, as has the distance between the row of trees and the houses: in reality, their facades run closely parallel to the trees. The houses are represented as flat and symmetrically aligned, although van Gogh's sharply diagonal view of the trees could not have allowed for this effect. These distortions create surface tension and an almost claustrophobic density.

In technique and composition, *The Road Menders* reflects many of the concerns of the Saint-Rémy period. The paler palette contrasts with the brilliant citron of the Arles works, reflecting van Gogh's desire to "begin again with the simpler colors, the ochers for instance," and half-tones that he associated with Delacroix.[22] The sensuous, thickly painted surfaces of the Arles works have evolved at Saint-Rémy into a more varied surface, including both heavy impasto and intervals of bare ground; van Gogh used the white ground of *The Road Menders* to enliven color relationships and to enhance the illusion of depth by juxtaposing it with areas laid in with a loaded brush.[23] Varied dashes of pure color undulate through the trees and vibrate in forceful parallel strokes in the foreground; in some areas, van Gogh applied paint directly from the tube, creating smudges when new pigment came in contact with the still-wet surface. The flamelike brushwork destabilizes the image in spite of the strong vertical axes of the trees, whose textured bark seems to ripple

and beneath which the piles of earth surge into uneven drifts.

The background figures are stylized, frieze-like in their stillness, as if printed from a stamp. The two workers in the road on the left are heavily outlined, while those on the right form a stable triangular grouping. Vigorous crosshatching emphasizes the pile of rocks and the sinuous tree limbs, while other objects are cursorily outlined in diluted browns and blacks and then filled in with color.[24] Passages of white are used to create recurrent highlights in the earth, the tree branches, and on the pile of rocks, and cool tones prevail throughout: slate hues complement the golden-yellow foliage, gray-blue outlines the rocks and cut paving stones, and a strong green highlights the trees; thus van Gogh has achieved a graduated scheme of cool diagonal foreground, lighter middle ground, and warmer upper zone. Typically, he has reversed the traditional sequence of warm foreground colors gradually receding to cooler background hues, thereby creating a vibrant tension of space and color: depth, emphasized by the strong diagonal of the trees, is simultaneously denied by the assertive tones of the background. Pickvance points out that the painting's intervals of bare canvas and heavy impasto create an unevenness that contributes to the strong rhythm of the design.[25]

Van Gogh made drawings and paintings of workers throughout his career, and the poses of the laborers are very close to those in the drawing *Peasants Working*, 1888.[26] In the present work, however, human labor and movement are no longer his overriding concern; the figures are dwarfed by the monumentality of the trees.

Phillips considered van Gogh one of the inventors of the language of modern art and believed that his work flowed out of his romantic and expressive temperament "as a profession of his faith and as an act of love." Phillips found a shared approach to art in the work of van Gogh and Bonnard.[27] In describing the artist's "thwarted evangelism . . . intense subjectivity," and his descent into periodic bouts of madness, Phillips was probably influenced by the prevalent legend of van Gogh's imagery and style arising largely from his emotional illness.[28] Yet, in describing his work as a link between impressionism and expressionism, Phillips also acknowledged van Gogh's deliberate and ambitious artistic intent. His appreciation of a Gothic spirit in van Gogh—especially evident in the expressive, tensile forms of the gnarled trunks in this canvas—demonstrates the broader context in which he and his contemporaries assigned the contribution of van Gogh to an expressionist aesthetic.[29]

Phillips purchased *Road Menders* after having included it in a loan exhibition in the late

1940s; feeling it to be the stronger version of the two Saint-Rémy street scenes, he ranked it "among the best Van Goghs."[30]

LF

54
House at Auvers, 1890

Maison à Auvers
Wheat Fields (DP)
Oil on canvas, 19⅛ × 24¼ (48.5 × 62.8)
Unsigned
Acc. no. 0797 (F-804, H-2018)

Johanna van Gogh-Bonger, Amsterdam; sold to Cassirer Gallery, Berlin, 1907; purchased by Mrs. A. Albert, Wiesbaden, 1907; Caspari Gallery, Munich; Knoedler, London and New York, 1926; sold to Kraushaar, New York, the same year; purchased by Joseph Kerrigan, 1927; Seligmann, New York; Dorothy Sturges, Providence, R.I., 1927; Elizabeth Hudson, Syracuse, N.Y., by 1943; PMG purchase 1952.[31]

Painted in June 1890, six weeks before van Gogh's death, *House at Auvers* is the last of three landscapes mentioned in a letter of June 13 to his sister Wilhelmina. Van Gogh describes it as "nothing but a green field of wheat stretching away to a white country house, surrounded by a white wall with a single tree."[32] The wheat field became a complementary theme to that of the huddled thatched cottages and inviting gardens van Gogh painted of the village Auvers-sur-Oise itself, on the river Oise twenty miles northwest of Paris.

Van Gogh's sojourn in Auvers, May 20 to July 29, 1890, was inspired partly by his desire to return to the north to paint but was largely due to the presence there of Dr. Paul-Ferdinand Gachet. A physician and artist, Gachet encouraged van Gogh, who alluded to his support in his letters; this seems hardly to have been needed, as his prodigious output in Auvers numbered seventy canvases in as many days, several of them portraits of the doctor himself.[33]

The town was known as a haven for such nineteenth-century artists as Daubigny, Corot, Pissarro, Cézanne, and Daumier. From his first day, van Gogh found Auvers "profoundly beautiful; it is the real country, characteristic and picturesque."[34] *House at Auvers* shares with other landscapes of the period a palette of "whites, blues, violets and soft greens" and "a certain unevenness and impetuosity of brushstroke, a simplifying of the composition."[35] Because of its high horizon line and intense concentration on an expanse of land where human presence is peripheral or absent, *House at Auvers* harks back to several landscapes of Arles and Saint-Rémy.[36] At the same time, it may reflect van Gogh's response to the floral, flat designs and high skylines found in Asian art. The integrity of the two-dimensional surface and the compositional

54

format also recall the influence of Seurat.[37] Along with the other northern paintings of van Gogh's last period, the theme of *House at Auvers* further associates it with the vast, open landscapes of the Dutch school.

Van Gogh's desire to express a psychic or spiritual state of flux is mentioned in the letter to his sister of June 13: "I am working a good deal and quickly these days; in so doing I seek to express the desperately rapid passage of things in modern life."[38] Although its base is relatively static and restful, the expanse of field in *House at Auvers* seems to surge rapidly toward its horizon line and the anchoring motif of the house, as if the far distance were being viewed from a passing train. Yet because of the stable, detailed handling of the foreground, in which several stalks of wheat are outlined in black paint, the work seems to illustrate not simply the "rapid passage of things," but how such a passage would be perceived from an isolated, stationary viewpoint. Staccato markings signify the wheat's slant toward the right, as if it were being flat-

tened by a steady wind. The white line of the wall, the narrow band provided for the house and trees, and the black horizontal lines delineating the edges of the field, reinforce the uneasy sense of claustrophobia at the upper reaches of the image, as if the house were on the verge of disappearing from view. The tightness of the upper range juxtaposed with the void of the field creates a characteristic tension.

The fleeting, fragmentary nature of this painting is in marked contrast to the strong sense of stability conveyed by the huge, rooted trees of *The Road Menders,* painted seven months earlier. In *House at Auvers* the earth itself rushes headlong past the distant, peaceful, yet unattainable configuration of house and garden.

The "instantaneous" quality of both viewpoint and brushwork was observed by Pickvance, who found it the "least worked" of the landscapes van Gogh painted that week; the paint is thinly applied overall, and a bare patch of canvas functions as the roof of the smaller dwelling.[39] Less peaceful in mood than other

Auvers works depicting the plain or the village, *House at Auvers* is still almost serene when compared with canvases van Gogh executed a month later of fields under troubled skies.[40]

In 1943 *House at Auvers* entered the collection of Elizabeth Hudson, a family friend of the Phillipses. In 1952 she sold it to The Phillips Gallery, to which, a year later, she sold van Gogh's drawing *Moulin de la Galette,* 1887 (acc. no. 0798). Phillips wrote of the drawing that it "throws light on [his] technical ability and self-discipline" and "would have its own special distinction" in his collection of drawings.[41]

L F

GEORGES SEURAT (1859–91)

Georges Seurat, a painter whose groundbreaking manipulation of color influenced future generations, was born in Paris December 2, 1859. Seurat attended the Ecole des Beaux-Arts for one year (1878), studying with Henri Lehmann, a former pupil of Ingres. In 1884, after exhibiting at the 1883 Salon, he began showing with the Société des Artistes Indépendants, through which he met fellow artist Paul Signac. Soon afterward he developed an optical color theory that manifested itself in his masterpiece, *A Sunday on the Grande Jatte—1884,* 1884–86 (Art Institute of Chicago, Helen Birch Bartlett Memorial Collection, 1926.224). Seurat's career was tragically cut short by a sudden illness at age 31; he died March 29, 1891. The Phillips Collection owns one early oil panel and one drawing by the artist.

55

The Stone Breaker, 1882

Le Casseur de pierres
Casseur de pierres à la brouette; Casseur de pierres à la brouette, Le Raincy
Oil on wood panel, 6⅛ × 9¾ (15.4 × 24.9)
Red stamp l.r.: *Seurat*
Acc. no. 1727 (Dorra and Rewald no. 49; De Hauke no. 100)

The artist; probably Madeleine Knoblock from 1891; Léon Appert, Paris; Félix Fénéon, Paris; Georges Lévy, Paris; Gérard Frères, Paris; purchased by Alex Reid and Lefevre, Ltd., London, 1926; purchased by Leonard Gow, Scotland, 1926; purchased by Reid and Lefevre, London, 1927; purchased by D. W. T. Cargill, Lanark, 1927; to Bignou, New York (in partnership with Reid and Lefevre), 1940; PMG purchase (from Bignou exhibition) 1940.[1]

Painted in Le Raincy, northeast of Paris, *The Stone Breaker* is one of several small oil sketches on panel—called *croquetons*—that Seurat painted between 1880 and 1883, very early in his career. Most of them are compact vignettes of laborers—reapers, gardeners, haymakers, stone breakers—toiling in the sunlit fields and roads of the suburbs around Paris.[2] Seurat's choice of field hands as subject matter reflected the influence of Jean-François Millet; however, unlike Millet, he intended no ideological or emotional commentary on the hardships of peasant life. By objectively depicting the anonymous stone breaker shattering rocks for the road, Seurat shared more with Courbet, who had painted the same subject thirty years earlier.[3] Like Courbet, Seurat deemed the stone breaker worthy of representation without "concocting literature on [the worker's] emotions."[4] While implying empathy for honest workers, Seurat was also concerned with formal issues of composition and contrasts of color and light.

In *The Stone Breaker,* one of his first efforts in oil painting, Seurat employed a dense surface of hatched strokes in bright colors to define and modulate forms—a practice similar to the technique of the impressionist painter Camille Pissarro. Although it is one of his more freely executed works, the painting nevertheless contains studied colors and tones that indicate Seurat's fascination with chromatics and the behavior of light.[5] This interest is revealed in the brightly lit torso of the laborer, silhouetted against the shadowy trees, and the dark outline of the wheelbarrow against the sunny terrain. The central horizontal band of orange and yellow that defines the stones and wheelbarrow is framed on top and bottom by strips of green representing trees and foliage. Each block of color is highlighted with interwoven brushstrokes of complementary colors—the yellows with blues and purples, the greens with red-orange—that heighten the vibrancy and harmony of the image. Seurat had read about this practice in publications on color theory by Charles Blanc and Ogden Rood and had admired it in Delacroix's paintings.[6] *The Stone Breaker* displays the beginnings of Seurat's absorption of scientific aesthetic principles, a discipline that was to manifest itself to an even greater degree in his later works after he established a theory of systematized color and light relationships known as neo-impressionism.[7]

Whereas Duncan Phillips considered some of Seurat's mature works "too faultless," he nevertheless expressed great admiration for their "balanced architecture of forms in space and of contrasted and coordinated lines and colors," comparing them to the art of Piero della Francesca.[8] The two Seurat works that he purchased, *Sidewalk Show,* 1883–84 (acc. no. 1728) and *The Stone Breaker,* represent his judgment that Seurat was a precursor of painters like Matisse and Picasso.[9] His was "a world of strictly aesthetic relations, with values and proportions and a logic independent of the outside world."[10] To Phillips, Seurat's "orchestration with rhythms of line" was one of the "foundations on which the entire edifice of . . . new painting [was] based."[11]

GHL

55

WALTER RICHARD SICKERT (1860–1942)

Walter Richard Sickert, born in Munich May 31, 1860, was the son and grandson of artists on his father's side. From this lineage and his international background came much of Sickert's eccentric and cosmopolitan persona. Educated at King's College School in London, he was discouraged from pursuing a career in art. After modest success on the stage, his second lifelong passion, Sickert turned to painting, entering the Slade School in London in 1881. He met James McNeill Whistler in 1879, becoming his pupil, assistant, and friend until their break in 1897; through the American artist, Sickert received an introduction in 1883 to Degas, with whom he remained friends until the French artist's death in 1917. Sickert summered in or near Dieppe until 1914, living there from 1898 to 1905 and again from 1919 to 1922. In France he garnered notice in the press and among dealers. Several Venetian sojourns (1895–96; 1900; 1901; 1903–4) contributed to the themes and colors of Sickert's paintings. In 1887 or 1888 Sickert became a member of the New English Art Club, a group of progressive artists with whom he remained active until 1917. His first solo exhibition was at Dowdeswell's Gallery in London in 1886. In 1911, together with Spencer Gore and Wyndham Lewis, Sickert founded the Camden Town Group; it later expanded to the London Group, with which Sickert was intermittently affiliated until 1936. Deeply committed to teaching, he directed seven different schools over the course of his career, lectured frequently, and wrote prodigiously for art periodicals and newspapers. In the early twenties he exhibited internationally, showing for the first time at the Carnegie International in 1923. An associate of the Royal Academy since 1924, Sickert was made a full academician ten years later but resigned in 1935. During the thirties he was given several significant solo shows, and his audience continued to expand. Sickert died in Bathampton, England, January 22, 1942. The Phillips Collection owns six oil paintings.

The Sickert Unit

Walter Richard Sickert's varied oeuvre is represented in The Phillips Collection as in few other American museums; in fact, in 1930 Duncan Phillips was the first director of an American museum to acquire a Sickert painting.[1] Five of the paintings were purchased during Sickert's lifetime; the sixth was bequeathed by a friend of the artist. This unit, however, one of three by British artists in the collection, is as remarkable for the works it does not contain as for those it does.[2] The unit contains no bedroom nudes,

music-hall scenes, or "vernacular" landscapes of London, Dieppe, or Venice—the themes for which Sickert is perhaps best known. Yet it does document several landmark moments in his varied and lengthy career, and often shows the artist at his best. His approach to portraiture in the 1890s has been said to reach its zenith in *Portrait of Fred Winter*, ca. 1897–98 (cat. no. 56); his evolving technique in the Camden Town period has been described as having its strongest expression in *Miss Hudson at Rowlandson House*, probably 1910 (acc. no. 1740); out of his handful of still lifes of 1919–20, *The Makings of an Omelette*, 1919 (cat. no. 57), has drawn attention from critics since its first publication; and when exhibited with other recent works in 1932, *Ludovico Magno*, 1930–31 (cat. no. 58), was singled out as the strongest in the show.[3]

At the time of Agnew's "Contemporary British Artists" exhibition in New York in 1929—the first record of Phillips's exposure to Sickert—the collector was initially drawn to a nude subject with striking affinities with Bonnard and to a Bath landscape.[4] His first purchase, *The Makings of an Omelette*, draws on the intimist tradition of Vuillard and Bonnard, whose work Phillips had begun collecting in the late twenties. In 1931 Phillips included Sickert as the only British artist on a list of recently acquired progressive French and German artists.[5] Whereas Sickert's propensity for storytelling and his reliance on studies and drawings firmly separated him from the more spontaneous impressionist approach, his broken brushwork and unblended, freely handled color allied him with post-impressionist movements. Late in the decade Phillips characterized him as having been "influenced by the contemporaneous subjects of Degas and Manet and the intimate charms of Bonnard and Vuillard . . . yet he gives always the London equivalent of the Parisian point of view."[6]

Phillips's interest in Sickert was next in evidence on a visit to the London gallery Arthur Tooth and Sons around 1932. Among the "clever simplifications" upon which Phillips remarked in his diary, he "was most interested in two Sickerts—one an early picture of Venice somewhat in the style of early Bonnard and the other a very recent sketch boldly laid in with broad flat brushmarks of pure color . . . admirably chosen and original in their harmony. . . . The sky was left as bare canvas and yet functioned perfectly in its illusion of luminous void."[7]

Phillips probably relished—and perhaps identified with—Sickert's own contradictory espousal of pure formalism while continuing to create representational, even narrative, paint-

ings. Because Phillips never wrote on this unit and wrote only rarely on the artist himself, his thoughtful discussion of Sickert in an article entitled "Personality in Art" carries significant weight. In it he observed that "Sickert's subjects are apt to be suggestive of stories. . . . But what moves us most . . . is a pleasure of the eye which has nothing to do with the story and the title."[8] Elsewhere he noted that Sickert was "less literary than most English painters" and that "he has never . . . denied himself a lively pleasure in the subjects he paints."[9] His second purchase—a late figure piece, *Victoria and Melbourne*, by ca. 1932–34—underscores Phillips's receptivity to this last, most controversial phase of Sickert's career.[10]

During the 1940s Phillips continued building the Sickert unit within the broader context of the war effort. In the spirit of his involvement with the American British Art Center (1941–49), whose purpose was to aid painters and their families in Great Britain, he sought further purchases of British works, acquiring Sickert's *Ludovico Magno* and *Porte St. Denis* (cat. no. 59) in 1941. He had seen the works in London, probably in 1932, and acquired them with the intention of putting one on the American market.[11] Sickert's later work, though popular with its contemporary British audience, shocked critics with its flagrant borrowing from other media, and it has only recently been reassessed as an important precursor of developments in twentieth-century painting.[12] Sickert's innovations included the undisguised use of photography and graphic sources, and eccentric, off-guard viewpoints of places and people, developments that challenged the nineteenth-century "cult of originality."[13] Phillips, either ignorant of or indifferent to Sickert's declining reputation in England, relied on his sharp instincts in acquiring such works. He acquired an earlier painting, *Portrait of Fred Winter*, from the 1941 American British Art Center exhibition, which he had hosted.

Beginning in the 1930s Phillips often hung Sickert with Whistler, Degas, and Bonnard, highlighting the English artist's affinity with the continental tradition. In 1941 H. S. Ede noted in his catalogue introduction that the April exhibition of British art at the Phillips was "the first opportunity in America of seeing so much of [Sickert's] work."[14] His paintings attracted considerable notice in the press; they were described by one reviewer as "outstanding exceptions" to the predominant malaise.[15] By the 1950s Phillips's preferred context for Sickert was a combination of such British and American modernists as Arthur Dove, Karl Knaths, John

Piper, and Christopher Wood, demonstrating the collector's new approach to Sickert as a "forerunner of modernism."

LF

56
Portrait of Fred Winter, ca. 1897–98

Fred Winter
Oil on canvas, 23½ × 14½ (59.6 × 36.8)
Signed l.l.: *Sickert*
Acc. no. 1742 (Baron no. 94)

Savile Gallery, London, by 1930; sold to Reid and Lefevre, Ltd., London, by 1938; sold to W. Scott and Sons, London, 1939; purchased by the Art Association of Montreal, 1939 (now part of Musée des Beaux-Arts de Montréal); PMG purchase (from exhibition), 1941.[16]

In 1899, not long after painting *Portrait of Fred Winter,* Sickert wrote to a friend, "I see my line. Not portraits."[17] Although Sickert never entirely abandoned portraiture, he favored figure pieces in this period, as exemplified by *Miss Hudson at Rowlandson House.* His caustic remark probably reflected his bitterness at having failed in his attempt to build up a viable portrait business in the 1890s.[18]

While renting a studio at 13 Robert Street, London, in the late 1890s, Sickert produced several portraits of a neighbor, Frederick Winter (1846?–1924), including this bust-length portrait. Winter, a sculptor, served as exhibition secretary of the New English Art Club.[19]

Sickert's biographer characterizes the painting as "the culmination of his portrait style of 1896–98."[20] In technique it reflects the myriad influences on the artist in the late 1890s: painted between visits to Italy, the rich color and painterly surface recall the Venetian school; its thick black outlines and informality reflect the influence of Degas; and the narrow format of the panel harkens back to Sickert's mentor Whistler.[21]

The artist's voyeuristic relish for "characters" is evident in the memoirs of painter and writer William Rothenstein (1872–1945): "[Sickert] delighted in the rough and racy talk of . . . an obscure sculptor called Winter. . . . Through some member of the Court, he obtained an interview with the Prince of Wales. . . . He was getting on splendidly with the Prince, he said, when someone came in and interrupted the talk—'Just,' said Winter—'*when I was chatting him into a bronze*';—a phrase which enchanted Walter."[22]

Winter's apparent bluntness and lack of refinement seem to find expression in Sickert's sketchy, raw technique, which exaggerates the disheveled hair and rough features; yet in the keen gaze Sickert captures a dignity and perspicacity that may attest to his affection for the sitter.[23]

56

Sickert's unique surface quality reflects his commitment to contemporary French movements and justifies his leadership role with other progressive painters in Great Britain. The scumbled handling may also display Sickert's desire to purge Whistler's influence.

During the picture's loan to the museum in 1941, Phillips contacted the owner with an offer, writing, "I was so much impressed by the fine character of this little picture both as portraiture and as good painting."[24]

LF

57
The Makings of an Omelette, 1919

De quoi faire une omelette
Mushrooms
Oil on canvas, 16⅛ × 13 (40.9 × 33.0)
Signed, dated, and inscribed in brown paint, l.l.:
Sickert/Envermeu 1919.
Acc. no. 1739 (Baron no. 376)

The artist to Thomas Agnew and Sons, London and New York, 1929; PMG purchase 1930.[25]

The Makings of an Omelette belongs to the only series of still lifes in Sickert's oeuvre.[26] Just after the First World War, Sickert moved with his second wife, Christine, back to the Normandy coast, settling in Envermeu, a small town east of Dieppe. There he pursued still-life painting in a few tame, domestic canvases celebrating rural gastronomic pleasures. This work draws on a long tradition of still lifes picturing the ingredients and utensils needed for a repast, notably in the art of Chardin; furthermore, it is evocative of French painting of the period, especially the intimist themes of Vuillard and Bonnard.[27]

The Makings of an Omelette may be Sickert's most studied still life. He executed two separate oil paintings and one drawing of its principal elements: the mushrooms appear alone in a canvas and a pencil study, and the eggs are the focus of

57

58

the painting *Take Five Eggs.*[28] Presumably the Phillips painting postdates these works, because it combines the mushrooms and eggs into one composition. Though painted entirely *alla prima,* with no trace of drawing beneath, it presents a complex juxtaposition between the lower and upper register: the off-white preparation layer functions as the mushrooms' pallid color, while thinly applied tones of brown, pink, beige, and gray create outlines and shadows; dry patches of color lend substantiality. The eggs, much more perfunctorily handled, are sketched in smooth curves laid on in serene, fluid, and richly applied brushstrokes.[29] They borrow their color from the ocher background, which gives them a transparent, ghostly quality. Sickert's method may have been to build from a lightly colored base of undiluted paint prepared in two colors heavily blended with whites, as he prescribed in 1918. He might have been referring to *The Makings of an Omelette* when he

observed, "Then in the end, nothing is prettier than the non-coloured spaces semi-transparent and the laboured ones fatter and more opaque."[30]

Sickert departed from the more traditional repertoire of the still-life genre, depicting neither elegant tableware nor ideally rounded, succulent fruits or vegetables, much less a particularly alluring arrangement. The flesh tones of the mushrooms bear a lurid aspect more reminiscent of raw organ meats than vegetables, and the phantomlike eggs are hardly suggestive of food. The objects rest on recessed shelves (or possibly a trolley), in a space we seem to peer into at a peculiar angle.

The inclusion of the glass of wine and the knife underscores the presence of the cook and the function of the provisions after their visual savoring: the mushrooms to be chopped, the eggs broken, the wine to wash down the repast. The provocative title also implies narrative.

On its first-known exhibition in 1929, the painting was associated by one critic with other British works in "brown and ochre," prompting the lament "The consumption of brown paint in England must be enormous."[31] However, it attracted Ralph Flint's notice as "the most provocative canvas shown," and in a predominantly negative critique of British art, Hilton Kramer distinguished it as "a beautiful little still life . . . a picture which, though painted in Sickert's usual palette, is surprisingly light and bright."[32]

The domestic preoccupations reflected in this canvas ended sadly in the summer of 1920, at the death of Sickert's wife. Two years later, Sickert wrote to his sister-in-law, "When Christine was alive, I loved the landscapes there, because they belonged to her, and the still lifes, etc., because they were seen in her house. . . . But I can't bear the sight of those scenes now. They are like still-born children."[33]

LF

59

58

Ludovico Magno, 1930–31

Oil on canvas, 21½ × 30 (54.6 × 76.3)
Signed l.r.: *Sickert*
Acc. no. 1738

The artist to Beaux Arts Gallery, London, 1931; PMG purchase 1941.[34]

59

Porte St. Denis, 1930–31

Paris; Porte St. Denis, Paris
Oil on canvas, 30 × 18¼ (76.3 × 46.4)
Signed in black paint, l.l.: *Sickert*
Acc. no. 1741

The artist to Beaux Arts Gallery, London, 1931; PMG purchase 1941.[35]

These two Paris street scenes show different aspects of the arch of Saint-Denis, a monument constructed in 1672 by Louis XIV to commemorate his victories over Germany.[36] The title *Ludovico Magno* derives from an inscription on the north facade, while *Porte St. Denis* represents the arch from the east. Sickert explored this motif several times; in one work, *The Third Republic,* 1932–33, he again pictured the arch from the north.[37]

These works exemplify Sickert's late style. Richard Shone's description of another late painting could well apply to these images: "A grand salute to the monumental and the everyday, to spontaneity and artifice, to past and future."[38] Sickert's unorthodox approach belied expectations; he seemed to delight in the unusual viewpoint, choosing not to show the dignity and grandeur of the "august site," but instead to capture the urban ambience of the city against the backdrop of its faded past. In so doing, he created seemingly random images with characteristic detachment from his subject. Yet in *Ludovico Magno* Sickert captured in elegant and fluid strokes the sculptural decoration of the arch itself.

Sickert's viewpoint and working process in both paintings were perhaps less casual than they appear, because traces of a grid pattern in pencil on the ground layers of both pictures indicate that he probably scaled up a photograph; Sickert's increasing reliance on photography has been well documented.[39] In *Ludovico Magno* he shows the north facade, where the life of the city encroaches on the base of the monument, rather than the south facade, where the structure is isolated on a plaza. One side of the arch takes up the left half of the image, its solidity balanced on the right by a cluttered array of modern-day ephemera—signs, awnings, and the wares of small shops. Dresses and a uniform hang motionless above a crowded sidewalk.

Sickert employed an arbitrarily cut-off viewpoint, a technique inspired by Degas and possibly suggested by photography. Pedestrians are reduced to bobbing hats, acquiring a disembodied quality suggestive of the personalities of their wearers. Intriguingly, several of Sickert's late paintings include self-portraits in which he signified his persona with a homburg or a fisherman's cap, both of which found their way into the foreground of *Ludovico Magno*.[40] The decorative lettering in the image suggests the distant but pervasive influence of cubism, although here it remains anchored in reality.[41]

Both in color and in composition, Sickert achieved his desired aims: an "economy of means" and "a nonchalance, a looseness, a rapidity, which in themselves are of great beauty."[42] The underdrawing, which he made no attempt to obscure, is more elaborate and detailed than the painted image. The character-istic palette of browns, greens, and gray is enlivened by accents of purple, and the toothy weave of the unvarnished canvas adds texture. The composition, which is tightly held together by the diagonally receding boulevard in the left background and the echoing slant of the awnings at right, overthrows traditional pictorial hierarchy in favor of the random disorder with which the city assails the eye.

On its first exhibition at the Beaux Arts Gallery, critic Cyril Connolly lauded *Ludovico Magno*, finding it substantial and moving, and compared it with the *Echoes*. He wrote: "The colours are light and airy except for the very dark green Homburg in the foreground and a splash of crimson—the Sickert trademark—among the old clothes liturgically flapping their *Sic transit*."[43]

Less dynamic compositionally, *Porte St. Denis* takes as its own daring focus the unadorned side wall of the arch, a pretext for Sickert's treatment of the picture surface. The coarse weave of the canvas and chalky paint, brushed on in small rectangular patches, evoke a texture akin to the stone of the monument while remaining true to the qualities of the painter's materials.[44] The absence of modulation in the buildings recalls black-and-white photography enhanced by Sickert's own memories of the area's theaters, dance halls, and colorful street life; thus these works can be seen as nostalgic evocations of past sojourns abroad. It is also possible that Sickert made a brief visit to Paris in the autumn of 1930.[45]

Phillips had first seen both city scenes in London, probably on his 1932 trip abroad, and kept them in mind until he purchased them eight years later.[46]

LF

EMILE-RENÉ MÉNARD (1862–1930)

A painter of idyllic landscapes inspired by the classical era, Emile-René Ménard was born in Paris April 15, 1862. Ménard, whose father was a painter and art critic, received his training in 1878–79 in the ateliers of Paul Baudry, William Bouguereau, and Rudolf-Heinrich Lehmann; in 1880 he entered the Académie Julian and came under the influence of the artists of the symbolist circle. His uncle, Louis Ménard, a poet and author of *Polythéisme hellénique* (1863) and *Rêverie d'un païen mystique* (1876), encouraged his interest in classicism and introduced him to the Barbizon artists Corot, Daubigny, Narcisse Virgile Diaz de la Peña, Millet, and Théodore Rousseau. Ménard first exhibited with the Salon in 1883 and soon became a member of the Société des Pastellistes Français. He traveled to Sicily in 1898, in the first of many pilgrimages to ancient sites (Greece, 1902; Algeria, 1908; Palestine, 1910; Morocco, 1922; and Egypt, 1925–26). Between 1900 and 1910, Ménard established himself as a mural painter, decorating the Bibliothèque de l'Ecole des Hautes Etudes and the Salle des Actes de l'Ecole de Droit. Later in life his paintings became increasingly academic, and he was elected to the Académie des Beaux-Arts in 1926. He died in Paris January 13, 1930. The Phillips Collection owns one late landscape by Ménard.

60

Gypsies at Sunrise, 1920

Landscape with Figures, Sunrise; Gypsies at Dawn
Oil on canvas, 33½ × 48⅞ (85.0 × 124.1)
Signed in brown paint l.r.: *E. R. Menard*
Acc. no. 1350

The artist; PMAG purchase through Kraushaar, New York, and J. Allard, Paris, 1921.[1]

Although of the same generation as Bonnard, Seurat, and Vuillard, Ménard represents a more conservative trend in French art at the turn of the century. Whereas his landscapes recall the idealized, carefully composed views of the seventeenth-century French artists Claude and Poussin, Ménard's emphasis on mood and lack of didactic meaning kept them from being classified as fully academic. His recurrent theme, the idyllic landscape recalling the innocence and purity of Arcadia, indicates an escapist state of mind that associates him with symbolist artists of the period, Puvis de Chavannes (cat. nos. 25–27), Henri Le Sidaner (acc. no. 1203), and Ker Xavier Roussel (acc. nos. 1696–97). In general, however, Ménard's conservative technique allies him with most French artists, who adhered to traditional styles yet "altered [conventions] significantly to express poetic meaning."[2]

60

Many of Ménard's vast landscapes include imagery and beings from antiquity; others, like *Gypsies at Sunrise,* portray nonspecific figures in scenes that evoke a pastoral mood. Indeed, the subject of gypsy wanderers lends an air of exoticism and mystery to the work. Ménard often enveloped his scenes in the muted light of dawn or dusk to create a melancholic, nostalgic atmosphere. His sensitivity to light and his interest in conveying atmosphere through color reveal the influence of the Barbizon painters, especially Corot. In *Gypsies at Sunrise,* the rusts, yellows, and roses of dawn are carefully and subtly blended in the sky and reflected in the calm water below. They enliven the dark browns of the shadowy foreground terrain and the huddled figures, thereby accentuating the sunrise theme. The horizontal composition and subtle, matte brushstrokes heighten the sense of tranquillity.

Duncan Phillips's enthusiasm for Ménard was at its height in 1912, when he viewed a twilight scene identical in composition to *Gypsies at Sunrise* at the "Tenth International Exhibition of Art" in Venice. He illustrated the painting in a review for *Art and Progress* magazine, in which he wrote:

> The landscape by René Ménard is one of the most beautiful I have ever seen....The last gleam of autumn daylight has flushed the snowy peaks and the serene sky, but the lower hills descending steeply to the water's edge are in all but complete shadow, only a few sunward slopes bronzed by the afterglow. On the sedgy foreground beneath the shelter of a rock, three tired gypsies, wrapped in blankets, are preparing for the night.... From this lyric landscape, speaking so eloquently, so intimately to the spirit, it was with deep reluctance that I moved away.[3]

During a visit to Ménard's Paris studio the same year, Phillips noted that the artist kept on his walls pastel copies of his paintings, including the Venice work.[4] The image, representing a subject that appealed to his romantic sensibility, remained in his mind until 1920, when he apparently commissioned a similar work.[5] The result was *Gypsies at Sunrise,* the same scene but portrayed at a different time of day.

During the second decade of the twentieth century, Ménard's oeuvre represented to the young Phillips the consummate example of his early interpretation of "impressionism," a term he believed should not be limited to Monet's "technique of color spots." Instead, Phillips described it more generally as "the concise expression, through concrete symbols or suggestions, of single, personal impressions, both realistic and romantic."[6] More appreciative of conservative art at the time, Phillips admired Ménard's traditional themes during a time when avant-garde art pervaded France. When he discussed this adherence to tradition with the artist, Ménard "answered with emotion that he was unaffected by the aims and works of others," claiming that "his dream lived deep within."[7] Ménard was Phillips's ideal artist early on; however, as his tastes became more progressive, his enthusiasm for Ménard waned, and he eventually neglected him altogether. Phillips's short-lived yet intense appreciation is reflected in his acquisition of six Ménards between 1916 and mid-1921, and his deaccession of all but two of them by 1924.[8] The following rhapsodic words reflect his high regard of the artist during the years of his strongest admiration: "I saw his ambition to combine . . . serenity of form with Venetian colour and delight in landscape and personal emotion. He is full of charm . . . and one can easily see a deep and tender inner life."[9]

GHL

3 THE AMERICAN VISION

Part I: The American Tradition and American Impressionism

ELIZABETH TEBOW

"I do not collect American paintings just because they are American, but because they are good and often great."[1] With these words, Duncan Phillips proclaimed one of the primary purposes of his collection. Even after broadening his effort to establish a museum not just of American art but of "modern art and its sources," he remained dedicated to making "American art recognized abroad at its true worth . . . part of the main channel and not as a back-water."[2]

When he first began collecting in the second decade of the twentieth century, Phillips lamented that in the writings of European critics and analysts, "if indeed there is any mention of American art at all, they will admit the American birth of Whistler and the American parentage of Sargent [but] consider these men as manifestations of the eclectic, Europeanized character of American art."[3] Even though writers at home had been promoting native artists and seeking to define an American tradition since the late nineteenth century, status-conscious American collectors had, with just a few notable exceptions, favored European masters.[4] It was not until the turn of the century that American paintings began selling at auction for prices as high as those of the Barbizon School and European academic masters, and it was not until the outbreak of the First World War that it became fashionable for American art patrons to add home-grown art to their collections. Phillips found himself in the forefront of what became a movement to recognize the contributions of American painters and to define the essential and enduring qualities of the native tradition.

Rather than seeking to establish a comprehensive survey of styles or movements, Phillips looked for "rivers of artistic purpose" as he assembled his collection of American art.[5] The earliest painting dates to only 1860. Notably absent are genre subjects, sentimental narratives, academic figure studies, and grandiose landscapes in the tradition of the Hudson River School. Their absence may be explained by the negative experience Phillips had at his grandparents' house in Pittsburgh. He vividly recalled "the drawing room containing oil paintings and many of them—'Hudson River School' landscapes and well-drawn, story-telling European pictures in gorgeous gold frames. I was constantly aware of them and more or less fascinated, but none too pleasantly. If my grandmother had made

Thomas Eakins, detail of
Miss Amelia Van Buren, see cat. 69

different choices, I might have found myself earlier, or given hints of my dormant passion for pictorial design so that I could have been better prepared for the work I am here to do."[6]

The first nineteenth-century American painting to enter the collection was a poetic landscape by George Inness. Unlike the Hudson River School paintings, which Phillips described as "hard as steel engravings," Inness's work was loosely painted, richly colored, and expressionistic.[7] He acquired several more Innesses in the twenties, even though by then the artist was, as Phillips put it, "temporarily out of fashion."[8] But to his mind, Inness was both classic and modern, influenced by Europe but true to his own aesthetic vision.

Nineteenth-century American paintings hung in Phillips's museum from the moment it first opened to the public in late 1921. To the Inness were soon added works by Ralph Blakelock, George Fuller, John LaFarge, Robert Loftin Newman, and Albert Pinkham Ryder—all independent and sometimes eccentric artists whose dark, romantic paintings appealed to Phillips's poetic nature and sensitivity to color. His favorite was clearly Ryder, whose works form a unit of considerable distinction. There were also paintings by "the heroes of realism," Eakins and Homer.[9] They, too, represented the spirit of individuality that Phillips admired, and they brought both sophisticated design and emotional complexity to their images of American life. Modifying his initial decision to exclude "Europeanized" artists, he purchased a painting by Whistler, albeit a somewhat atypical portrait that had, along with "his usual fastidious and exquisite vision, an unusual apprehension of the humanity of his sitter."[10] Phillips also expressed regret at not having "an early portrait or genre by Sargent."[11]

With the core of his nineteenth-century collection essentially complete by 1928 and while increasingly focused on contemporary art, Phillips began describing these earlier artists as "leaders of that Renaissance of painting which occurred during the later part of the nineteenth century" and calling them our "Old Masters."[12] Within the next ten years, other institutions dedicated to modern art, including New York's Whitney Museum of American Art and Museum of Modern Art, would follow suit with exhibitions spotlighting the accomplishments of nineteenth-century artists and seeking to define their distinctly American vision.[13]

Along with the so-called Old Masters of American art, Phillips purchased work by painters who had moved beyond the prevailing "tonal character" of the late nineteenth century and become, as he put it, "painters of light and air."[14] These were artists—among them

Childe Hassam, Theodore Robinson, John Henry Twachtman, and J. Alden Weir—who had embraced impressionism in the 1890s. While adopting the bright palette and optical effects of their French predecessors, they were less doctrinaire in their approach and possessed what Phillips called "a spiritual element" and "peculiar charm" in their landscapes, which he considered more in keeping with the American tradition and which appealed to his still somewhat conservative tastes in the twenties. In addition to landscapes, he selected several figural works, including a dark, spatially complex painting by Chase and intimate interiors by the lesser-known painters Helen Turner and Lilian Wescott Hale.[15]

The artist from this period whose works he collected in greatest depth was J. Alden Weir. Although of the same generation as Homer and Eakins and a close friend of Ryder, Weir was still living when Phillips began collecting his work, and he became a cherished friend and respected adviser before his death in 1919. Weir introduced Phillips to the work of Twachtman, the most daring of the American impressionists. Twachtman's exquisite color and the underlying abstraction of his landscape designs helped open Phillips's eyes to a new range of aesthetic possibilities leading to Pierre Bonnard, Augustus Vincent Tack, and many others. In his growth as a connoisseur and collector, Phillips found the American impressionists to be important "connecting links between past and present."[16]

In the thirties, when Phillips was enthusiastically collecting modern art by European and American masters, he added one more artist to his nineteenth-century collection, Louis Eilshemius. Although discovered by Marcel Duchamp and held up as an eccentric, overlooked genius by the avant-garde, Eilshemius, by training and aesthetic outlook, was firmly rooted in the nineteenth century. His moonlights and poetic landscapes were right at home alongside the Blakelocks, Fullers, Innesses, and Ryders that Phillips had collected two decades earlier.

As a group, the nineteenth-century American paintings compose a small but seminal part of The Phillips Collection. In them we see examples of the two great strains of the late nineteenth century, the realist and the visionary, and the coming of age of American art. Here are the works of artists who, while responding to the challenges of Europe, expressed a particularly American vision that would help shape the emergence of modernism in this country. These paintings are also a testament to the foresight and taste of Duncan Phillips and the success of his mission to lift American art out of obscurity.

GEORGE FULLER (1822–84)

Born on a farm in Deerfield, Massachusetts, January 7, 1822, George Fuller began his career as an itinerant portrait painter in northern New York after studying with sculptor Henry Kirke Brown in Albany. Following a brief stay in Boston, where he shared a studio with Thomas Ball and studied at the Boston Artist's Association, Fuller moved to New York in 1847 and took classes at the National Academy of Design. With the exception of a year in Philadelphia and periodic trips to Alabama, Fuller remained in New York painting portraits for the next twelve years. Upon the death of his father in 1859, he returned to Deerfield to take over the family farm. Although forced to put aside his public art career, Fuller continued to draw and paint. In 1860 he spent five months abroad studying not only the Old Masters but also the latest in European art by the Barbizon School painters and the Pre-Raphaelites. In 1876, with his farm failing, Fuller sought out Boston dealers and began exhibiting, becoming successful and admired during the last years of his life. He died on March 21, 1884, in Brookline, Massachusetts. Fuller is represented in The Phillips Collection by seven oil paintings: two nocturnal landscapes, three landscapes with figures, a portrait, and an "ideal head." All but the ideal head were part of the 1959 bequest of Mrs. Augustus Vincent Tack, Fuller's daughter.

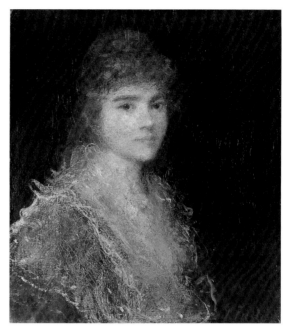

61

61

Ideal Head, 1876–81

Study of Head
Oil on canvas, 24⅛ × 20 (61.2 × 50.8)
Signed l.r.: *G. Fuller*
Acc. no. 0709

Collection of the artist; F. M. Weld, New York; PMG purchase from Macbeth, New York, 1927.[1]

Duncan Phillips purchased *Ideal Head* four years after the Metropolitan Museum of Art's Fuller centennial exhibition. When the painting came on the market, Phillips consulted his friend and adviser Augustus Vincent Tack, author of the essay in the centennial catalogue.[2] Shortly thereafter the painting entered the collection, and Phillips celebrated the acquisition of "an Ideal Head which is perfectly preserved." Describing its art-historical antecedents, he added, "It is an altogether delightful portrait which has been compared by various well-informed critics to Rembrandt, Goya and Gainsborough."[3] Although somewhat darkened by time and discolored varnish, *Ideal Head* still retains much of its original delicacy and charm and is an excellent example of Fuller's work from around 1880.[4]

By the time Fuller resumed exhibiting in the late 1870s after a ten-year hiatus, he had added farm scenes in a Barbizon mood, figurative works with literary allusions, and ideal heads to his repertoire of portraits.[5] After years of obscurity, he was suddenly a huge success, first in Boston, where he showed at the Doll and Richards Gallery, and shortly thereafter in New York. Critics hailed him as America's "Hawthorne in paint," drawing parallels between Fuller's dark, tonalist treatment of rural New England themes and his literary counterpart's evocation of the dark side of America's colonial beginnings, for which America had developed nostalgia following the 1876 Hawthorne centennial.[6] Populated by solitary figures, usually at twilight or in the light of the moon or setting sun, Fuller's landscapes and farm scenes suggest a rural America of magic and romance.[7] A particularly eerie example is *Afterglow,* ca. 1880 (acc. no. 0706), in which a girl, her face given a strange masklike effect by reflected light, pauses in the shadows of a wooded area.[8] Other paintings allude, albeit obliquely, to narrative situations and have seventeenth-century costumes and literary-sounding titles.

Ideal Head, one of more than a dozen works exploring this subject, is a bust-length view of a beautiful young woman set against deep shadow. Her face, framed by a roughly scumbled-in ruffled collar, glows with light. According to Tack, Fuller was especially interested in

suggesting the illusion of depth and having his figures appear to be detached from the surface of the picture plane.[9] This portrait is steeped not only in memories of the colonial period but also in classic art and romantic idealism; added to this are overtones of academic theory and of the nineteenth-century idealization of womanhood. Indeed, Francis Millet, a critic of the time, applauded Fuller for having created "a type of beauty thoroughly natural in its character and individual in its style and one which will live as a representative impression of feminine beauty of the present day. In this type he has combined the choice elements of innocence and simplicity of character and has given us a refined and sweet country maiden, full of health and youthful vigor, and rich in the promise of perfect womanhood."[10]

Shortly after acquiring *Ideal Head,* Phillips included it in an exhibition he called "A Period in Art: Portraits, Ideal Heads and Figures in Praise of Girls and Women," noting in his essay that Fuller's image was from a bygone era when "there was a reserve in feminine dress and demeanor and a certain mystery about sex which made it what we call romantic."[11] By the late thirties, not only had this ideal of womanhood become out of date, but the artist's reputation had faded, as well. Since the 1970s, however, new scholarship in late nineteenth-century American art has revived interest in Fuller, and his work has once again received critical notice and appreciation.

ET

GEORGE INNESS (1825–94)

George Inness was one of America's foremost landscape painters of the late nineteenth century. Born May 1, 1825, on a farm near Newburgh, New York, Inness spent his infancy in New York City and his childhood in Newark, New Jersey. He first studied art in New York with the French landscape painter Régis Gignoux and by 1844 was exhibiting at the National Academy of Design and the American Art Union. In 1850 Inness visited Italy, and in 1851, sponsored by a patron, he spent fifteen months there. After his return to New York, he was elected an associate member of the Academy. In 1853 he traveled to Paris, where he discovered Barbizon landscape painting. After working in New York from 1854 to 1859, he moved to Medford, Massachusetts, and four years later to Eaglewood, New Jersey, where he met the painter William Page, who influenced his new technical experiments with glazing and stimulated his interest in the religious theories of Emanuel Swedenborg. Inness moved back to New York in 1867 and in 1868 was elected to full membership in the Academy. Returning to Europe in 1870, he lived in Rome from 1871 to 1875. Two years later he returned to New York, where he helped found the Society of American Artists. In 1878 he settled in Montclair, New Jersey, but continued to travel and paint in a variety of locations in the eastern and southern United States, Cuba, California, and Mexico. A large retrospective of his work was held in New York in 1884. In 1894 Inness made his last trip abroad, visiting France, Germany, and Scotland, where he died in the village of Bridge of Allan on August 3. A public funeral was held in New York on August 23 at the National Academy of Design. Inness is represented in The Phillips Collection by four landscapes.

62

Lake Albano, 1869

In Italy; Roman Campagna
Oil on canvas, 30⅜ × 45⅜ (77.1 × 115.2)
Signed and dated l.l.: *G. Inness 1869*
Acc. no. 0930 (Ireland no. 465)

The artist to Goupil and Co., Paris and New York, date unknown; purchased by S. M. Nickerson, Boston, 1877; DP purchase through Kraushaar, New York, 1920; transfer to PMAG 1921.[1]

Lake Albano is a particularly fine example of Inness's work at mid-career.[2] The landscape, a sweeping view of a volcanic lake twelve miles south of Rome, features more than forty figures in fashionable clothing and rustic peasant cos-

tumes, and shows a section of Roman aqueduct, a castle, a majestic umbrella pine, and a stand of cypress trees. Curiously, *Lake Albano* is dated 1869, the year before Inness returned to Europe (after a seventeen-year absence) to paint Italian views for an American market.

The Italian countryside held a special attraction for Inness.[3] Preferring what he later called "civilized landscape" to the wilderness, as a young artist he painted landscapes more informed by the classical tradition of Claude than by his Hudson River School predecessors.[4] Trips to Italy in 1850 and 1851 reinforced his interest in the Claudian tradition, whereas exposure to Barbizon painting during a trip to France in 1853 led him to focus more on the expressive qualities of nature. As his style matured, tight drawing and idealized scenes gave way to broader handling and a greater sense of atmosphere, light, and the emotive effects of nature.[5] As Duncan Phillips explained, "The Roman Campagna, with its mellow atmosphere, taught [Inness] to synthesize vastness in unity of light. Thereafter he was equipped to modernize the grand manner of Claude and to apply the methods of Barbizon to American subjects."[6] This synthesis is evident in Inness's paintings throughout the 1860s. In sweeping, panoramic views of locations ranging from the Catskills to the Delaware Valley to the New Jersey countryside, Inness emphasized the dramatic effects of weather and atmosphere rather than the particulars of terrain. He was known to improvise freely and even to fabricate entire compositions from his imagination.[7]

Because of its feeling of vivid, firsthand observation, *Lake Albano* relates more closely to Inness's Italian paintings of the next decade than to the earlier American scenes. His return to Italy in 1870 was undertaken as a commercial venture, with the initial financial backing of the Boston art dealers Williams and Everett. According to the original agreement, Inness was to send back paintings of popular Italian views selected for their appeal to American buyers.[8] Later explaining that "finish is what the picture dealers cry for," he produced scenes that were more detailed and specific than his American views of a few years earlier. Yet, at the same time, Inness avoided falling back on formulas or hackneyed interpretations. Some of his most daring color effects and pictorial compositions date from this sojourn.

Lake Albano also shares with the later paintings "finish," picturesque elements, and some of the more experimental pictorial effects. While retaining the luminosity, classical tranquillity, and deep space of the Claudian tradition, Inness

abandoned Claude's framing devices, leaving the left side of the composition open and updating and enlarging the usual population of a few rustic types to a large gathering of contemporary figures engaged in a variety of activities.

It is tempting to propose that the 1869 date was added erroneously years later and that the painting actually dates from the 1870s. If one assumes the date to be correct, however, perhaps Inness painted *Lake Albano* as a sample for Williams and Everett while negotiating for his trip. But this explanation leaves unresolved questions of visual sources. No Inness preparatory drawings or photographs of the location have surfaced. Nor, apparently, was Albano the subject of pictorial coverage in popular American travel journals in the sixties. Although seventeenth-century engravings and paintings of the area around Albano exist, Inness would not necessarily have had access to them in private collections. If, indeed, the painting was not based on direct visual sources, *Lake Albano* is a wonderful testament to Inness's ability to store up memories and render images that resonate with authenticity and charm.

ET

63

Gray Day, Goochland, 1884

Goochland; Gray Day, Goochland, West Virginia
Oil on wood panel, 18⅛ × 24 (46.0 × 60.9)
Signed and dated l.r.: *G. Inness 1884*
Acc. no. 0929 (Ireland no. 1114)

Purchased by Thomas B. Clarke from Inness executor's sale, 1895; purchased by Peter W. Rouse, Brooklyn, from Clarke sale, 1899; purchased 1917 by Major D. C. Phillips from George Ainslie Galleries, New York; transferred to PMAG 1921.[9]

64

Moonlight, Tarpon Springs, 1892

Oil on canvas, 30 × 45½ (76.2 × 87.6)
Signed and dated 1892 in black paint, l.r.: *G. Inness 1892*
Acc. no. 0931 (Ireland no. 1443)

Charles H. Ault; purchased by Knoedler, New York, 1911; sold to Major D. C. Phillips, 1911; transferred to PMAG, 1921; sold 1928; reacquired for PMG from Knoedler 1939.[10]

A restless, inveterate traveler his entire life, Inness made many extended painting trips to locations in the southern United States in the last decade of his career. Drawn as much by concern for his health as for the natural attractions, he visited Virginia in 1884 and wintered regularly in Florida from 1887 until 1894, the year of

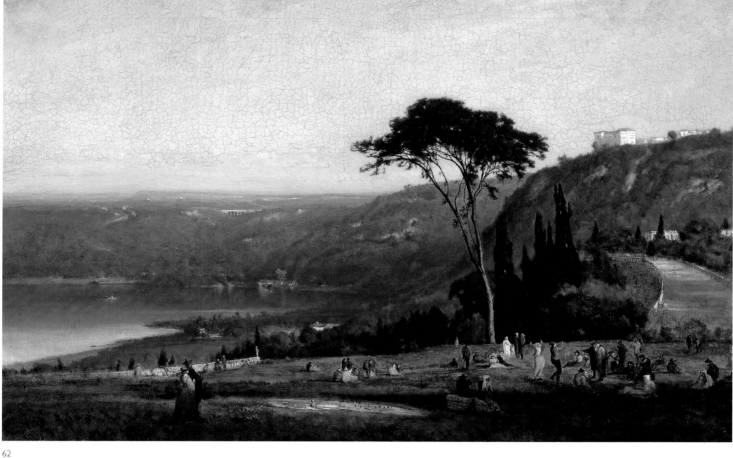

62

his death.[11] Inness made some of his finest late paintings on these trips, among them *Gray Day, Goochland* and *Moonlight, Tarpon Springs.*[12]

The locations he chose were somewhat isolated. Goochland, west of Richmond and about a mile from the James River, was no more than a village whose chief attractions were the county courthouse and jail. Tarpon Springs was a sleepy town on the Florida Gulf Coast that had experienced an influx of Greek sponge fishermen but few, if any, of the tourists who were lured to Florida by accounts of exotic beauty, a benign climate, and the convenience of Henry Flagler's railroads.[13] Inness made only one visit to Goochland and stayed for three months. Why he chose this out-of-the-way place is still a mystery. The timing of the visit, however, from January to mid-March 1884, was probably the result of Inness's decision to avoid the fuss and strain of

the opening of a large retrospective exhibition of his work at the American Art Galleries in New York.[14] His trips to Tarpon Springs were part of a pattern of wintering in rural locations; he set up a relatively permanent household and studio there.

Inness's southern sojourns coincided with the last phase of his career and his achievement of a mature style. As seen in these two works, his paintings from the mid-1880s until his death are characterized by an expressive, loose transcription of nature through broad paint application and subtle color and tonal effects. In *Gray Day, Goochland,* pearly grays and molten pinks warm what would otherwise be a bleak winter scene of an adult and child walking across a field toward a farmhouse nestled in a thin cluster of barren trees. On the one hand, the painting perfectly captures the cool, muted light and the damp but

nippy atmosphere of a Virginia winter. Yet, on the other hand, the blurred forms and deep yet paradoxically indefinite space convey a sense of unreality. By this time it was Inness's practice to sketch out of doors but to execute the final work in his studio, relying on memory and making spontaneous changes.[15] Duncan Phillips described the "musical intensity of his later tonalities, scumbled, scrubbed, and glazed into spiritualized surfaces," adding that Inness "painted landscapes as a form of worship."[16]

The spiritual element in Inness's late landscapes transcended simple pantheism. From the 1860s on, Inness was a devoted follower of Swedenborgianism. Like the vision of the spiritual realm described in the writings of the religion's founder, the eighteenth-century scientist and mystic Emanuel Swedenborg, Inness's landscapes depict a luminous, gloriously hued, and

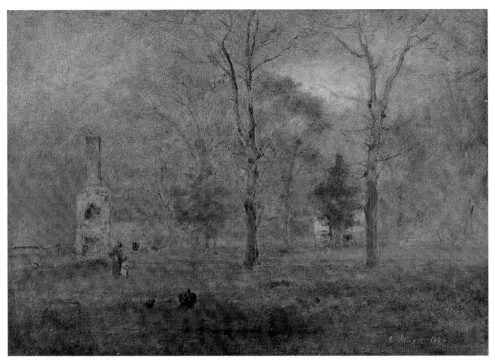

63

64

limitless counterpart to the physical world of matter and substance.[17]

Moonlight, Tarpon Springs, too, reverberates with spiritual intensity. In this and a dozen or so related paintings, Inness avoided the sights most frequently sought out by artists visiting Florida—alligators, palm trees, and lush flowers.[18] Instead, he focused on the more subtle flavor and atmosphere of the northern Gulf Coast, which is known for its tall pine trees, causeways, and short, flat vistas.[19] In *Moonlight,*

Tarpon Springs, the moon and glow of a distant bonfire pick out details in an otherwise dark and shadowy landscape that Phillips poetically described as having "the warm sweet gloom of our fragrant pine groves of the south."[20] A lone woman in a white kerchief, who serves as both a compositional anchor and a poetic accent, enhances the mystery and magic of the night. The figure and atmospheric effects are also reminiscent of the work of the French Barbizon School. In addition, the formal organization of

the picture and the placement and scale of the figure conform to Inness's theories on composition.[21]

As Phillips observed, Inness was "inspired by [his] themes, . . . possessed and acted upon by his subjects."[22] And in the works painted during the travels of his last years, he reached new heights of expressive interpretation of nature through the sensitive manipulation of color, composition, and paint.

ET

JAMES ABBOTT MCNEILL WHISTLER (1834–1903)

James Abbott McNeill Whistler, the American expatriate whose credo "l'art pour l'art" significantly influenced art in the late nineteenth century, was born July 11, 1834, in Lowell, Massachusetts. In 1843 Whistler moved with his family to Russia, where he received his first instruction in art and studied Hogarth's etchings. He entered West Point in 1851 but was dismissed for poor grades and turned briefly to etching topographical maps. He soon left for Paris, where he studied in the atelier of Charles-Gabriel Gleyre. His first series of etchings resulted from a sketching tour of the Rhineland in 1853. In 1859, after having moved to London, he began the Thames etchings, and by the mid-1860s he was incorporating oriental design and tonality in his work. Whistler conceived the "nocturnes"—twilight or evening scenes—but also continued to paint portraits, among which *Arrangement in Grey and Black No. 1: Portrait of the Painter's Mother*, 1871 (Musée d'Orsay, Paris), became one of his first to enter a public collection. After a highly publicized libel suit against John Ruskin in 1878, Whistler declared bankruptcy and left for Venice with a commission from the Fine Arts Society to produce etchings. Throughout the following decades he worked in oil, watercolor, pastel, and printmaking. He married Beatrix Philip Godwin in August 1888. Successful retrospectives in 1889 and in 1892 reestablished his popularity with the British public. He settled briefly in Paris but in 1895 returned to England, where he was elected president of the International Society of Sculptors, Painters and Gravers in 1898. Portraits, printmaking, and finally small oil landscapes and seascapes continued to absorb his energy. His popularity and the demand for his work grew, but the ill health of his wife, and eventually himself, kept him from the studio. He died July 17, 1903, in London. The Phillips Collection owns one oil portrait and one etching.

65

Miss Lillian Woakes, 1890–91

Oil on canvas, 21⅛ × 14⅛ (53.3 × 35.5)
Signed with two butterflies: one as the bow of the blouse and another on the sitter's left shoulder
Acc. no. 2125 (Young no. 393)

Probably commissioned by Dr. Edward G. Woakes, London, who owned the painting until at least 1905; sold to A. J. Sulley and Co., London; purchased by Knoedler, New York, 1911; acquired by Reinhardt Gallery, New York, 1911; resold to Knoedler 1914; acquired by Nathan Allen, Kenosha, Wisc., 1916; returned to Knoedler 1917; purchased by DP 1920; transferred to PMAG 1921.[1]

Characteristic of Whistler is the imperious perfectionism that prompted him, three years after completing the refined and delicate portrait of Miss Lillian Woakes, to wish it altered or destroyed.[2] Even while in progress, the portrait posed difficulties for Whistler; one anonymous report asserts that "at the first sitting he painted quite a fancy head; this was painted out more than twice."[3] Woakes, too, alluded to halting progress: "The portrait was commenced in the Winter of 1890 and sittings continued over four or five months in 1891. . . . At first Whistler said he should want about three sittings. In fact, he had about twenty-five."[4] The expansion of the task from a few hours to several months may have resulted in many adjustments and revisions, which could explain the unusual thickness of the paint in the area of the face. The portrait was probably commissioned by the sitter's father, Edward G. Woakes, who, as senior aural surgeon for London Hospital, may have known Whistler through the artist's brother, also a doctor.[5]

Miss Lillian Woakes is a representative example of Whistler's preferred subject and style in the 1890s, when, according to a family friend, he "was painting excellent 1/2 to 1/3 length portraits," mostly of women and children.[6] These small portrait heads, if not Whistler's most experimental, were nevertheless the product of an era of great personal triumph and professional accomplishment: his recent marriage to Beatrix Godwin was a success; his portrait of Thomas Carlyle was purchased by the Corporation of Glasgow; in March 1890 he had met Charles Lang Freer, who was soon to become his greatest patron; and the same year he published a compilation of correspondence and other writings, *The Gentle Art of Making Enemies*.[7]

An anecdotal account concerning the signing of the painting offers a glimpse of Woakes's tenacious character, as well as the artist's dramatic flair. Whistler intended the large pink bow at her neck to symbolize his butterfly signature, but "when he found that [Woakes] did not appreciate it, he said to his wife: 'Trixie, this makes me sad, very sad!' But to satisfy Woakes's wish for a more obvious signature, he inserted another butterfly on her left shoulder."[8] To the shadowy wings of this second "signature" he added a delicate tendril defining the contour of the sitter's left side.

Although the portrait was given up by Woakes's father several years before his death, public reception of the painting was overwhelmingly favorable. Joseph Pennell, Whistler's first biographer, deemed it "one of the most successful—certainly the most beautiful Whistler

produced after his marriage."[9] It was given the place of honor at one of its earliest public exhibitions in the United States and was praised by one reviewer as follows: "Above enchanting draperies rises the head, soundly modelled and rich in humanity."[10]

In purchasing *Miss Lillian Woakes* in 1920, his first Whistler painting, Duncan Phillips may have been inspired by Freer's 1919 bequest to the nation of his substantial art collection, which included more than three hundred works by Whistler. Freer's collection represented in quantity the graphic work and landscape oils—both the atmospheric and ethereal nocturnes and the highly stylized *Japonais* landscapes with figures.[11] Yet Phillips, whose aesthetic roots were firmly planted in a literary tradition, regarded with distrust the art-for-art's-sake credo espoused by such collectors as Freer and his friend A. E. Gallatin.[12] In selecting this portrait he showed his preference for those aspects of Whistler's work that link him to the realism of Courbet and Degas and that hark back to the naturalism of Velázquez.[13] Phillips appears to have been drawn to the remarkable balance between the artist's purely decorative concern for a harmonious arrangement of color, tonality, and accents and his desire to convey the forthright personality of his subject. Indeed, particularly in the 1930s and 1940s, Phillips often hung the portrait with the works of such French painters as Corot, Degas, and Daumier, artists who in Phillips's view reflected similar pictorial concerns. Only in the 1950s and 1960s did the portrait hang, as is the tradition today, with Whistler's American contemporaries, Eakins, Fuller, Homer, and Inness. In *A Collection in the Making*, as if making a veiled comparison between his Whistler and those on exhibition at the Freer Gallery, Phillips wrote: "*Miss Woakes*, however, is not a mere pretext for a color scheme, and not a Japanese conception of the figure as an arabesque, nor a graceful form enveloped in shadowy air. She is a robust blooming English girl in whose vitality and subtle spirit the artist seems to have forgotten himself, striving only for the plastic 'presence' and for an expression of the 'eternal feminine.'"[14]

LF

65

WINSLOW HOMER (1836–1910)

One of America's great realist painters of the nineteenth century, Winslow Homer was born February 24, 1836, in Boston. When he was six his family moved to then-rural Cambridge, where his strong rapport with nature was established and nourished by his mother, a watercolorist. Apprenticed at the age of nineteen to a commercial lithographer, Homer began a prolific career as an illustrator that took him to the battlefields of the Civil War and continued into the late 1870s. He referred to sketches made at the front when, in 1862, he began to work in oil. In 1865 he was elected to the National Academy of Design in New York. One year later he traveled to Paris, where he stayed barely one year and where the earlier Barbizon painters left more of a mark on his work than the radical impressionists. It was not until 1873, however, that Homer made his first sustained efforts in watercolor, the medium that he was to claim as his own, and by 1875 he was exhibiting with the American Water Color Society of New York. He made a brief sojourn to the bleak Northumberland coast of England in the spring of 1881, settling in Prout's Neck, Maine, in 1883, where he concentrated on capturing humanity's continual struggle against the sea. By the turn of the century Homer rarely depicted the human figure, and by the time of his death on September 29, 1910, nature had become his dominant theme. The Phillips Collection owns two oils and one watercolor by Homer.

66

Girl with Pitchfork, 1867

Oil on canvas, 24 × 10½ (60.9 × 26.6)
Initialed and dated in black paint, l.r.: *W.H.1867*
Acc. no. 0920

The artist's estate; consigned to Macbeth Gallery, New York, 1938; sold to Elizabeth P. Metcalf, Boston, 1939; at John Nicholson Gallery, New York, by Feb. 1946; PMG purchase 1946.[1]

Homer's homage to the French rural ideal, *Girl with Pitchfork,* is an early example of the theme of the heroic agrarian laborer to which he returned intermittently in prints and paintings in his work of ensuing years. The painting was likely created in Picardy, France, in the village of Cernay-la-Ville northeast of Paris.[2] The area's picturesque landscape and peasant inhabitants made it a popular destination for artists, and a small colony had grown up there by the time of Homer's 1866–67 sojourn in France.[3] It has been a matter of scholarly contention whether Homer's trip abroad, occasioned by the Univer-

66

sal Exposition's inclusion of two of his Civil War paintings, was of vital importance in exposing him directly to modern French artistic movements. Yet what seems clear is that Homer's opportunity to view firsthand the Barbizon School works represented at the Exposition—paintings by Jules Breton, and most notably an extensive hanging of Jean-Françoise Millet's work, among others—had an immediate impact on his own paintings in France, including *Girl with Pitchfork*.[4]

Homer depicted a harvester in silhouette in two other works, one a striking image of a man mowing a field with his back to the viewer, the other probably showing the same model and setting as *Girl with Pitchfork*.[5] The economy with which he approached his composition in the Phillips version—narrowing the focus and the picture plane in a strong vertical format in which land and figure and background fields are effectively merged and adjusting light from fierce midday to lyrical twilight—suggests that it was a distillation of the theme of laborer and land explored in the two earlier works.

In 1862 Homer had begun to paint seriously in oils, and art historian Lloyd Goodrich stated: "The only survival of traditional procedure was that he underpainted his earliest pictures in brown monochrome and kept the lights thick and the darks thin."[6] His relative inexperience in the medium may be seen in the uneven, blotchy application of paint in the area of the blouse. Homer here probably retained the brown ground that had served as a foundation for the images in his early works. His propensity for highlighting contours with lines of white paint, probably a technique that carried over from wood engraving, is especially prominent in the present image. In *Girl with Pitchfork* and other works executed during and immediately after Homer's trip to France, this contour is usually accentuated by its juxtaposition with a background of soft and diffuse light.[7]

Girl with Pitchfork remained in the artist's collection and then in his estate until 1938, when it was acquired by a collector from Boston, where Barbizon painting had found its first American audience. Phillips's decision in the late 1940s to augment his collection of Homers by purchasing this early work coincided with an increasing general interest in Homer, as reflected in several exhibitions and publications. Phillips's response probably echoed that of Robert McIntyre, who described the painting as "a lovely dignified thing; there is a kind of classic beauty in its simplicity." In 1940 McIntyre published it in a collotype "to present the best work of its period."[8]

L F

67

67

To the Rescue, 1886

The Rescue
Oil on canvas, 24 × 30 (60.9 × 76.2)
Signed in brown paint, l.l.: HOMER
Acc. no. 0922

Collection of the artist; sold to Thomas B. Clarke, New York, 1896; purchased by Thomas L. Manson Jr., 1899 (Clarke Sale, New York, Feb. 14–17, 1899, no. 210); E. and A. Milch, Inc., New York, 1919; sold to William T. Cresmer, Chicago, Apr. 1919; consigned to Knoedler by 1926; PMG purchase 1926.[9]

With the purchase of *To the Rescue*, Duncan Phillips fulfilled his wish to acquire a "fine oil of the Maine coast" by Homer.[10] He wrote that the work "renounced story and sentiment altogether and let the mighty surf, which breaks tremendously on the rocks, work its will on the observer through the self-effacing agency of his recording brush."[11]

Phillips probably selected this painting for what he termed its "dramatic suggestion," which results in part from pictorial ambiguities, both spatial and narrative.[12] The setting, defined only by an undifferentiated stretch of beach, can be read in two ways: the running figure's position suggests a hill roughly parallel to the picture plane, whereas the striding women seem to walk across it, as if it were a flat promontory overlooking the sea. The sparse narrative avoids all direct description of the rescue mission that is the painting's unseen subject, concentrating instead on three figures rushing to the scene of the shipwreck, isolated against a raging sea. The strength of the painting lies in the chromatic scheme, which is limited to a few tonal values; the severity of the confrontation between human beings and the elements that threaten to engulf them; and the simplified, sketchy quality.

Homer returned to Prout's Neck, Maine, in March 1886, where he began *To the Rescue* during the same month he completed *Eight Bells*, 1886, a work of the same theme and size.[13] Correspondence reveals, however, that he considered the present work an unsuccessful sketch, and six years later it was still in his studio.[14] He wrote to his patron, Thomas Clarke, "The companion to *Eight Bells* that we talked about two years ago—I still have, but found that it was not good enough."[15] Later correspondence between Homer and Clarke indicates that *To the Rescue* remained in Homer's possession until 1896. In October of that year Homer wrote, "I must touch up the sketch a little."[16] He finally sent the painting to the patient Clarke, offering it to him in its unresolved state: "I send today . . . the much talked of Sketch that was made at the time of the *Eight Bells*. . . . I considered on looking at

it that it was much better left as it is than it would be made into a picture by figures in the distance, as it has a tone on it now that the ten years have given it and it also has the look of being made at once and it is interesting as a quick sketch from Nature. . . . I wish it was better, but such as it is I now offer it to you. I would give you this with pleasure, but I know your ideas on that point, so you can send me any time in the next ten years (the time you have so patiently waited) $250.00 in payment for this sketch."[17]

In spite of Homer's description of the painting as "a quick sketch," examination under ultraviolet light reveals that he made several adjustments. Those in the awkward area where Homer daringly allowed the man's dragging left foot to touch the bottom edge of the canvas are the most marked. Other noteworthy changes appear in the center, where black paint was added to sharpen the forms of the women and their billowing clothes, and where brown tones were used to throw into relief the warmest, lightest areas.

The scene described in *To the Rescue* represents a four-part drama of sea and land, and the complementary roles of men and women—the former active, the latter passive. The urgency of the event is expressed only through the tense and uneasy movement of the running man. Homer ultimately returned to the shipwreck theme in a painting of 1896, *The Wreck*.[18] Certainly here the viewer finds the explicit narrative of the tragic accident only hinted at in *To the Rescue*. The three figures on the beach are given a context. The man, himself a fisherman, is part of the community forming the rescue mission, and the women are a pair in the group of anxious observers on the dunes above the sea.

The development and resolution of Homer's use of the shipwreck theme are complex and virtually unexplored. However, studies have revealed a consistent pattern in works that "repeat obsessively the progression from life to death . . . starting with the more ordinary, less dramatic scenes, and gradually progressing toward a depiction of the tragic conclusion, the ultimate moment of death."[19] It is possible that the thematic progression from a scene of relative calm and rote activity, as in *Eight Bells*, to one of tempestuous yet undefined menace, as in the Phillips work, and finally to the more specific drama of death at sea shown in *The Wreck* represents a further illustration of this working process.

Homer again used the awkwardly proportioned running man with rope in hand in his last oil painting, *Driftwood*, 1909.[20] Whereas the man had earlier served both as vertical axis and narrative catalyst, in his reappearance twenty-three years later he embodies a sense of uneasy

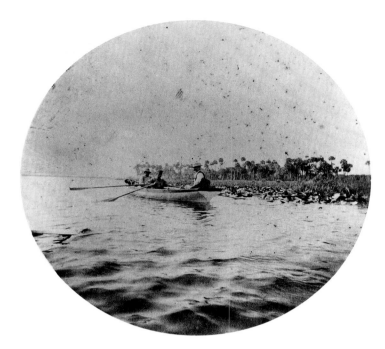

Fig. 20 Winslow Homer and Guides, Homosassa River (?), Florida, photograph, Bowdoin College Museum of Art, Brunswick, Maine.

isolation, both physical and spiritual, thus adding an almost autobiographical meaning to Homer's last image of man confronting a familiar yet unyielding landscape.

LF

68
Rowing Home, 1890
The Return at Sundown; Sunlight on the Sea; Rowing Homeward
Watercolor on paper, 13¾ × 19⅞ (39.9 × 50.5)
Signed and dated l.l.: *Homer 1890*
Acc. no. 0921

The artist to Thomas B. Clarke, New York, 1891; sold to Charles Lang Freer, Detroit (Clarke Sale, cat. no. 220, Feb. 1899, as *Rowing Homeward*); sent to Montross, New York, 1904, and paid for Feb. 1905; J. Alden Weir, New York, by Oct. 1918; consigned to Macbeth, New York, 1918; sold to Duncan Phillips, Dec. 1918; transferred to PMAG 1920.[21]

Rowing Home is one of eleven watercolors executed in 1890, on Homer's second trip to Florida.[22] It was his first visit to Enterprise, at the time a fashionable fishing and boating resort on the Saint Johns River. On February 16, shortly after his arrival, Homer wrote to Thomas B. Clarke, "This is the most beautiful place in Florida. I commence work and play tomorrow—expect to show you something when I return."[23] Homer's serious efforts in watercolor had begun in 1873, and during these southern trips he produced works exuding a

sense of calm and tranquillity, uncomplicated by themes of mortality and man's conflict with nature. Homer's letter to his patron suggests that his immersion in Enterprise's leisure activities was intended not only for refreshment and enjoyment, but also to serve as a catalyst for his work. Further, mindful of Clarke's own dedicated enthusiasm for sporting views, Homer may have hoped to interest the collector in the fishing and boating scenes he went on to produce there.[24]

Rowing Home, an evocative rather than narrative image, was captured in rapid execution with brilliant chromatic effects and spare composition, and has an especially strong emphasis on tranquillity also apparent among the watercolors Homer produced on his various trips to Florida, the Bahamas, Cuba, and the Adirondacks. Nothing disturbs its restful calm. The men in the boat are placed just below the horizon line, reinforcing the lateral emphasis of the picture. The placid nature of the scene is heightened by thin, rhythmically placed waves and by the emphatic wedge of the deeper blue paint describing the skiff. The low vantage point seems to be that of an observer in another boat. The luminosity of the silvery water, contrasting with a darkening sky, suggests that Homer may have referred to a photograph. His studies of light effects in this medium are well documented, particularly in the 1890s in Enterprise.[25] One photograph, known to have been in Homer's possession (fig. 20), reveals the same

68

low vantage point, a similar representation of light on water, and even the same configuration of men in a boat. However, the photograph shows the boat's stern and depicts the far shore as a mass of vertical trees.

Three Men in a Boat, 1890, a painting closely related to *Rowing Home,* includes a faint background of palm trees and fluid reflections, yet the focus is given to the activities of the fishermen.[26] In *Rowing Home* the theme of the return at twilight, with sea and sky awash in color, reflects a lyricism absent from the other work.

It was perhaps the "oriental simplicity" of *Rowing Home* that attracted collector Charles Lang Freer.[27] The illustrious provenance of the watercolor also includes the American impressionist painter J. Alden Weir, from whom Duncan Phillips purchased it in 1918. Eight years later Phillips was still "waiting for a chance to acquire more of the thrilling water colors by Winslow Homer."[28] He reserved for *Rowing Home* a place in modern art, and he delighted in contrasting it with an ancient oriental pictorial approach: "Winslow Homer . . . was uncon-

scious of pure aesthetic inscription when, instinctively, he laid on those suggestive darks over that luminous expanse of Adirondacks lake [*sic*]. The ripples of water in the wake of the oars required a quick simplification of brush stroke. Quickly he wrote it down, just as he saw it. That is the modern as it differs from the ancient calligraphy."[29] The painting was hailed by the New York and Washington press, and the art critic for the *New York Sun* described it as "an instance in which a slight impression reveals much of the man, certainly all his force."[30]

LF

THOMAS EAKINS (1844–1916)

An uncompromising realist whose works and teachings inspired generations of artists, Thomas Eakins was born July 25, 1844, in Philadelphia. Eakins attended Central High School, which was known for its emphasis on science, and from 1862 to 1865 studied at the Pennsylvania Academy of Fine Arts, also attending courses on anatomy at Jefferson Medical College. In 1866 he enrolled at the Ecole des Beaux-Arts in Paris, where he studied under Jean-Léon Gérôme. He traveled to Italy, Germany, Belgium, Switzerland, and Spain before returning to Philadelphia in 1870 and establishing a studio at his family home, 1729 Mount Vernon Street. In 1876, after creating such works as *Portrait of Dr. Gross,* 1875 (Jefferson Medical College of Thomas Jefferson University, Philadelphia), Eakins began to teach at the Pennsylvania Academy School. He was appointed professor of drawing and painting in 1879 and became director in 1882. Two years later he married one of his students, Susan Hannah Macdowell. Eakins continued to teach despite growing opposition to his methods, which included the use of nude models in life classes. After he was forced to resign in 1886, his student supporters retaliated by forming the Art Students League of Philadelphia (1886–93) with Eakins as their instructor. He received a number of honors and awards late in his career. Eakins continued to paint regularly until his health began to fail in 1911. He died June 25, 1916. The Phillips Collection contains one oil portrait from the 1890s.

69

Miss Amelia Van Buren, ca. 1891

Oil on canvas, 45 × 32 (114.3 × 81.2)
Unsigned and undated
Acc. no. 0632 (Goodrich, 1933, no. 263)

Possible gift of the artist to Amelia Van Buren, Detroit, by 1893; PMG purchase from Van Buren, Tryon, N.C., 1927.[1]

After his forced resignation from the Pennsylvania Academy in 1886, Eakins concentrated almost solely on portraiture.[2] Among his finest and most compelling is a portrait of a former student and friend, *Miss Amelia Van Buren.* In this painting, Eakins centered his attention on Van Buren's face and hands, creating through subtle means—deft highlights, distant glance, and relaxed yet tensile hands—an image of great psychological complexity. Her weary head leaning on her curved hand and her other hand resting in her lap, she looks absently toward but not into the strong light that emanates from the left and defines her face and upright hand. Eakins thus reveals Van Buren's character, her quiet

strength and determination. And it is in this manner, through a portrait of the contemplative state of a friend and fellow artist, that Eakins comments on his own grave reflection on his long, tumultuous career.

Eakins often photographed Van Buren, and the results illuminate his continual interest in the expressiveness of her features and figure. The most frequently published photographs were most likely taken after the creation of her portrait and show a youthful, light-haired Van Buren, a striking contrast to her aged appearance in the painting.[3] That this effect was intended on the part of the artist is further suggested by a photograph by Eakins (fig. 21), which is remarkably similar to the painting.[4] Indeed, it probably served as a preparatory or related study.[5] Eakins, who preferred to depict "what the living physiognomy did not yet reflect," aged her soft face and darkly grayed her hair to reveal Van Buren's resilience and strength of character.[6]

The sitter, Amelia Van Buren, is an elusive but fascinating figure. Born in 1856, she was recorded by 1880 as an "artist in color."[7] Her lifelong friendship with the Eakinses undoubtedly began when she took Eakins's life classes at the Pennsylvania Academy in 1884.[8] Van Buren later became interested in photography, an enthusiasm she may have acquired from Eakins. Why she abandoned painting completely is unknown, but she was "determin[ed] to use photography solely as a medium through which to express artistic ideas."[9] Perhaps she was responding to Alfred Stieglitz and his colleagues, who sought to achieve painterly effects through expressive means and struggled to bring respectability to photography as an art form. Van Buren perhaps also found, like many of her female colleagues, that recognition and achievement came more readily through photography.[10]

Van Buren became publicly associated with established artists when she exhibited her work in the Philadelphia Photographic Salons of 1898, 1899, and 1900, which provided recognition to accomplished amateurs, many of whom were women.[11] Van Buren's work was also included in the Philadelphia section of Stieglitz's 1899 Camera Club exhibition in New York (which included work by Eakins), and she was a close friend of Eva Watson-Schütze, an active member of Stieglitz's famed Photo-Secession.[12] In 1900 six of Van Buren's photographs were exhibited at the International Photographic Congress at the Paris Exposition as part of Francis Benjamin Johnston's much publicized exhibition of photographs by women.[13] Van Buren gradually withdrew from these circles, later moving to a small arts community in Tryon, North Carolina, where she died in 1942.

Fig. 21 Thomas Eakins, *Miss Amelia Van Buren,* ca. 1891, platinum print, 3⁵⁄₁₆ × 2⁵⁄₁₆ in., J. Paul Getty Museum, Malibu, California.

Duncan Phillips's interest in Eakins had crystallized by 1926, when he expressed the need for a "powerful and patient transcript of truth by Eakins."[14] Yet the speed with which Phillips acted in acquiring this work may be partially due to the influence of a noted critic and friend, Frank Jewett Mather. Four days after Phillips learned of the possible sale of this portrait, Mather wrote: "I'm glad to see that your plans include such great objective painters as . . . Eakins. At present you are 'long' on subjective and romantic painters."[15] Phillips wrote to Van Buren the following day asking to see the work, and as soon as the painting arrived he included it in his February 1927 Tri-Unit exhibition, even before making Van Buren an offer.[16]

Phillips appreciated Eakins's brilliant sense of color and texture, as well as his respect for the sitter as an individual. He wrote: "This portrait . . . is characterized with the deepest reverence and respect but without so much as a trace of the desire to please the sitter . . . or the public. . . . Her humanity is offered to us in its outer physical manifestation with sincere patient exactitude . . . penetrat[ing] to the spiritual depths instead of glittering on the ornamental surface."[17] Expressing his belief in Eakins's influential place in the history of American art, Phillips stated that "the American old masters pointed the way and they [modern American artists] have followed."[18]

LBW

69

Albert Pinkham Ryder was a nineteenth-century romantic painter whose themes of humanity in the grip of irresistible supernatural forces, expressed in formal designs of uncanny potency, left a lasting impact on subsequent generations of American artists. He was born March 19, 1847, in New Bedford, Massachusetts. His brief education ended with grammar school. Sometime in 1867–68, he moved with his family to New York, where his artistic training began under William E. Marshall, a former student of the French painter Thomas Couture. He continued his studies at the National Academy of Design from 1870 to 1875 (he was elected a full member only in 1906). Until 1887, Ryder exhibited at the Society of American Artists, where he was elected a member in 1877. His early style, characterized by an appealing naturalism of bright, smoothly finished pastoral or animal themes, later gave way to increasingly somber moods both in color and style. In 1875, at Cottier and Co., he participated in an exhibition of artists whose works were rejected from the National Academy of Design. The romantic myth of Ryder as mystic loner arises largely from his later years; his vital social life as a young man included an intense friendship with J. Alden Weir and frequent meetings with a coterie of friends, among whom were Charles de Kay, an early advocate in the press, the poet Charles Erskine Scott Wood, and his dealers, Daniel Cottier and James Inglis. In 1882 Cottier and Inglis guided him on his first of three trips to Europe, where he undoubtedly absorbed much from the Old Masters and current movements, including Corot, the Barbizon painters, Monticelli, and Maris, whom he later met. Collectors of American art, including Thomas B. Clarke of New York, began to purchase his works throughout the late 1880s and 1890s, and Ryder's reputation continued to grow. His oeuvre of the 1890s, considered the culmination of his career, includes haunting marines as well as turbulent scenes from opera and literature. From 1900 until his death the artist produced little, working and reworking his paintings and using eccentric techniques that often resulted in works that today are badly deteriorated. Elected to the National Academy of Design in 1906, and two years later to the National Institute of Arts and Letters, Ryder was well represented and lauded at the Armory Show in 1913. By this time, however, he was suffering from increasingly poor health and failing vision. On March 28, 1917, he died in Elmhurst, New York. He is represented at The Phillips Collection by eight oil paintings.

The Ryder Unit

In the second decade of the twentieth century, the years in which the young Duncan Phillips first launched seriously into art criticism and collecting, both the conservative and the avant-garde factions of the American art scene hailed Albert Pinkham Ryder as one of the greatest of this country's living masters. Studies have revealed that during the reclusive Ryder's lifetime his very personal art was much more widely appreciated than had previously been thought.[1] Since the 1880s his reputation had been growing steadily, and knowledgeable collectors had been seeking out his work for more than twenty years. Leading critics—Charles de Kay, Sadakichi Hartmann, and Roger Fry—published articles about him between 1890 and 1908. His works were frequently reproduced and were included in more than a hundred exhibitions during his lifetime, including a featured showing at the 1913 Armory Show. On that historic occasion, Ryder was accorded a place alongside the founders of French modernism, and Arthur B. Davies, the president of the sponsoring Association of American Painters and Sculptors, escorted the aging artist through the exhibition.

Phillips's first reference to Ryder appeared in his 1914 *Enchantment of Art,* which includes a condemnation of the Armory Show but also his first tribute to Ryder: "My glance fell upon a tiny canvas, unmistakably the work of Albert Ryder. It was almost without color and with only a vague whisper of form, yet I was made to pause for a few moments enchanted by the air of old romance."[2] Phillips was still immersed in literary criticism, and the education of his eye had scarcely begun, but it was to proceed apace.

In 1916 Phillips first directed his criticism squarely toward living American painters, publishing essays on Ryder, Augustus Vincent Tack, Arthur B. Davies, and William Merritt Chase. The Ryder essay reflects serious study of the artist's work and admiration for a number of his pictures. As we might expect, Phillips extolled in Ryder the qualities in art he had most valued up to that time: the sense of dream and romance; a poetic cast, akin to literature but not illustration; a kinship with the Old Masters and with such nineteenth-century artists as Decamps, Monticelli, and Maris; and an independence of vision and style but without the distortions of the modernists. But Phillips also began to recognize formal qualities, noting Ryder's "abstract expression of form through color" and observing that "as we study Ryder we realize that his directness is a quality of plastic design."[3] The study of Ryder surely must have played a role in the development of Phillips's perception of the

formal qualities of art. Ten years later he expressed himself with a mature forcefulness: Ryder was "always superbly plastic with simplification which contains powerful suggestions and persuades us to believe in the reality of his visions. . . . [His] dreams and his designs are absolutely unique and original and they place him among the great artists of all time."[4]

As would be expected, given such admiration, Phillips sought Ryder's paintings eagerly as soon as he began to build his memorial collection in 1919. Undoubtedly his sense of urgency was increased by Ryder's death in 1917 and the accolade bestowed on him by the Metropolitan Museum in its extensive memorial exhibition in 1918. But other collectors were well ahead of him, good works were hard to come by, and both forgeries and altered paintings were all too common. Moreover, as he was to find, prices were skyrocketing. The small *Homeward Bound,* ca. 1893–94 (cat. no. 72), purchased by Frederic Fairchild Sherman in 1919 for $1,000, was passed on to Phillips in 1921 for $12,500. Phillips prized the new acquisition: he ranked *Homeward Bound* ninth in a listing of his eighty best oil paintings in 1921–23.[5]

In the four years from 1919 to 1922 Phillips purchased six pictures ascribed to Ryder, of which only two remain in the collection.[6] Two were deaccessioned without a trace; two were eventually traded for a stronger example; and of the remaining two, *Homeward Bound* and *Fisherman's Huts,* the second is no longer considered an authentic work.[7] In the two following years the collector fared better in his acquisitions: *Desdemona,* mid-1880s to mid-1890s (acc. no. 1703), was an important painting, although it is now in poor condition, and both *Gay Head,* mid-1880s and later (acc. no. 1705), and *Moonlit Cove,* early to mid-1880s (cat. no. 70), have been general favorites. In 1928 he acquired *Resurrection,* ca. 1883–85 (acc. no. 1709), and *Dead Bird,* 1890s (cat. no. 71), which he must have considered a triumph, as *Dead Bird,* like *Moonlit Cove,* had strongly affected him when he wrote his 1916 essay. In 1940, when he acquired, through trade, the large version of *Macbeth and the Witches* (cat. no. 73), he finally rounded out his holdings with a great painting in the artist's late style, after a pursuit of more than twenty years.

The group of Ryders in The Phillips Collection, though considerably smaller than the extensive holdings in the National Museum of American Art, is one of the larger museum collections of Ryders in America and contains significant examples of the artist's different periods and subjects. The dating of Ryder's paintings is of course precarious, depending often on

stylistic conjecture or occasional sightings in his studio while he was subjecting them to extensive revisions.[8] With this caveat, we may ascribe to the Phillips paintings a stylistic and temporal range from the nature-based style of the 1870s and earlier 1880s (*Dead Bird* and *Gay Head*) to the dramatically abstracted and convoluted reworkings of the 1890s and later (*Macbeth and the Witches*). In between fall *Moonlit Cove,* which retains Ryder's simpler and bolder massing of form, and *Desdemona* and *Resurrection,* both begun about the mid-1980s; and *Homeward Bound,* starkly simple in composition but relating to other seascapes of the 1890s.

In its themes, the Phillips group ranges from the nature-based to the imaginatively romantic (*Moonlit Cove*), the open sea (*Homeward Bound*), the biblical (*Resurrection*), and the Shakespearean (*Desdemona* and *Macbeth*). The range of these paintings and the selective process implied suggest that Phillips was concerned with showing not only the artist's stature and quality but also his poetic and expressive scope. The result was distinguished. The assembly of his Ryder unit was one of Duncan Phillips's most notable achievements as a collector.

DWS

70

Moonlit Cove, early to mid-1880s

Moonlight; Moonlight on Beach
Oil on canvas, 14⅛ × 17⅛ (35.9 × 43.5)
Unsigned
Acc. no. 1708

Possibly owned by John Williams; Alexander Morten, New York, by 1911; Marjorie Morten, 1920; on consignment to Rehn Gallery, New York, after 1920; PMG purchase 1924.[9]

Throughout its history, *Moonlit Cove* has been cited as representative of Ryder's mature period. Early critics such as Guy Pène du Bois, Walter Pach, and Duncan Phillips discerned a mood of romantic mystery combined with a faithful rendering of natural forms, which Ryder attained through continual exploration of light, particularly nocturnal effects. The painting's presence in the Armory Show further served to highlight its status as an icon for the American modernists. While *Moonlit Cove* was still in the collection of the wine merchant Alexander Morten, Phillips listed it among the "Paintings Desired for Our Collection."[10] Phillips may have noticed the painting as early as 1911, when it was published in *Scribner's Magazine* with an appreciation by Pach. The critic focused on the "masterly simplicity" of the composition, whose "few and elementary forms are disposed with rare perception of their most effective and just relations."[11] By 1916, when Phillips published his own article on Ryder, he viewed this painting as "one of the

world's great romantic pictures." Intrigued by its narrative suggestion, he found a "luxury of danger" in the shadows of the empty boat and looming cliff.[12] In 1920 Phillips appealed both to Frederic Fairchild Sherman, one of Ryder's patrons, and to the art dealer Frank Rehn, seeking to buy the picture.[13] After its purchase, his enthusiasm was unabated. In 1926, for example, he characterized it as "one of the greatest . . . of all Ryder's marines and landscapes [and] . . . one of the two or three greatest American pictures in our collection."[14]

William Innes Homer believes that the oriental flatness of forms places the painting in the early to mid-1880s, when Ryder is generally believed to have reached the height of his artistic powers.[15] Vestiges of an earlier style—crisp silhouettes and flatly contoured forms—remain in *Moonlit Cove,* but it also shows a new conception in its thin, matte paint application and an austere composition reduced to a few powerfully arranged organic forms.

The composition is based on strikingly juxtaposed shapes: the contours of the moored boat, and the dark mass of the cliff and sky, are arranged in a rhythm whose carefully measured intervals create a tight, interlocking structure, yet its simplicity suggests a random depiction of a scene found in nature. The image culminates in the halo of the moon combined with the attenuated cloud illuminating the cliff's contour. These spare elements, suggestive of a spiritual presence, prompted Pène du Bois to comment on the "deep significances . . . behind the clouds which [Ryder] painted so often as ominous and isolated masses."[16]

The painting's condition, recently judged unstable, reflects Ryder's flawed use of materials and methods. Considerable darkening has occurred owing to the copious amounts of oil he applied to the canvas reverse, and whereas there is overall crazing, the causes of which are not yet fully understood, the sky in particular shows a "sluggish underlayer of not yet dried paint extrud[ing] up out of the cracks as glossy globules."[17]

LF

71

Dead Bird (DP), 1890s

Oil on wood panel, 4⅜ × 10 (11.1 × 25.4)
Unsigned
Acc. no. 1702

Collection of the artist; gift to Mrs. James S. Inglis; Montross Galleries, New York, by 1918; PMG purchase 1928.[18]

Though intimate and small in scale, *Dead Bird* is one of Ryder's most powerful images. It is also a testimony to his masterful draftsmanship, even as it explores a recurrent illusory theme: the

coexistence of the corporeal and the ethereal.

With uncharacteristic directness, Ryder suggests an association with traditional nineteenth-century memento mori images. Such starkly realistic details as the rigidly curled claws, rendered in heavy impasto, and the subtle textural contrasts of plumage and beak, create a moving evocation of suffering and death. Enhancing the mood is a thin veil of paint surrounding the bird; this diaphanous layer of oil was laid on in short, sketchy strokes suggesting rapid, though careful, execution.

Sheldon Keck, noting the painting's unusually good state of preservation and its uncracked surface, claims that the painting was rendered in the "indirect" technique favored by artists from the Renaissance through the nineteenth century, where outline, modeling in light and shade, and color are accomplished separately and systematically. He notes that it was "underpainted with scaled tones of white to umber, over which a glaze of raw sienna has been applied." The ground, which may be a walnut panel from a piece of furniture or a cigar-box lid, is clearly visible.[19]

Duncan Phillips cited *Dead Bird* in his 1916 article on Ryder as an example of the artist's ability to paint directly from nature without a literary context.[20] In a later essay on the transcendent themes and styles represented in the permanent collection, Phillips wrote that *Dead Bird* and *Resurrection,* an associated pair, represented a union of the spiritual and the physical. Commenting on their kinship, he stated: "No lyric ever written on the death of a song bird or for that matter on the mystery of the last sleep as it comes to all has ever surpassed Ryder's tiny picture of a dead canary lovingly laid on a tomb of rock. It is the same soul which reverently conceives of the risen Christ appearing to Mary."[21]

Whereas in his biblical scenes Ryder's approach is imaginative and narrative, in the *Dead Bird* it is spontaneous and direct. Although the bird was often used as a symbol of the soul, the dead bird appeared in the literature and imagery of Ryder's contemporaries as a "lamentation over lost innocence" and lost love. An intriguing parallel arises in a bronze relief by Augustin Préault, *Ophelia,* 1842–76, which Ryder conceivably could have seen in Marseilles, where the relief is still located.[22] The predella-like format of the relief, the curved body of the dead Ophelia, and the enveloping shroud all seem to find an echo in the composition of *Dead Bird.*[23]

Phillips may have seen the painting in the collection of the New York dealer Newman Montross.[24] Montross agreed to sell it with *Resurrection* in November 1927. Early in 1928 they agreed on a price for the two. Phillips hung both in his 1928 "Art Is Symbolical" show. Montross wrote, "As I think of your idea of having

70

the *Resurrection* and the *Dead Bird* to round out as it were your already splendid group, [I] have come to feel that you should have these."[25]

Ryder's painting may have directly inspired Marsden Hartley, who in 1935 produced a similarly isolated image of a lifeless bird, *Portrait of a Sea Dove*, 1935 (Art Institute of Chicago). The theme had a lasting attraction for Phillips, whose collection also contains Henry Varnum Poor's *Dead Crow*, ca. 1943 (purchased in 1944); *Wounded Gull*, 1943, by Morris Graves (bought in 1945); and a 1950 acquisition, Chaim Soutine's *The Pheasant*, 1926–27 (see cat. nos. 298, 364, and 124).[26]

LF

72

Homeward Bound, ca. 1893–94

Oil on canvas mounted on wood panel, 8⅞ × 18 (22.5 × 45.7)

Signed in reddish-brown paint, l.r.: *A. P.* [or *A.*] *Ryder*

Acc. no. 1706

Gift of the artist to Captain John Robinson, London and New York; acquired by Frederic F. Sherman, New York, 1919 (through H. W. Bromhead, Cutts and Co., London); PMAG purchase 1921.[27]

Homeward Bound suggests, in both its title and its composition, an adventure whose safe conclusion is almost at hand. Its theme closely par-

allels those of romantic and symbolist artists and writers of the nineteenth century, such as Delacroix, Redon, and Poe.

In technique fresh and direct, in mood optimistic and almost joyful, this painting has been deemed one of the best and most representative Ryder marines of the 1890s.[28] It was painted as a gift for John Robinson, an English artist and sea captain on whose ship Ryder traveled abroad. The serene mood of *Homeward Bound* no doubt reflects Ryder's enduring friendship with Captain Robinson, whom he had known since 1883. Harold W. Bromhead, an intimate friend of Ryder, wrote that "to the best of [the captain's] recollection Ryder made the voyage with him in

71

72

1893, and it was painted shortly afterwards."[29]

Though small in scale, *Homeward Bound* represents a fusion of pictorial and thematic elements because of the focus on a lone boat, leading one scholar to observe that "Ryder's ships inhabit their pictorial space fully."[30] The upward tilt of the sail gives the image its buoyancy; placed directly in the center of the canvas, it breaks the otherwise continuous horizon line and seems to anchor the composition. The bright line of sun backlighting the cloud at the center right gives a directional push to the composition, further suggesting that the wind and water are propelling the boat toward the still invisible land. In *Homeward Bound*, Ryder brushed on unblended paint in thin, scumbled layers, capturing the sea in a greenish light and showing a brisk wind that breaks the surface of the water into foaming crests and the sky into strata of coursing clouds.

Closely related to the Phillips painting in technique, size, and subject is another small oil called *Marine*, which bears in addition to Ryder's signature the inscription "A mon ami Capt. Robinson."[31] It appears to be a rapid sketch filled in with rough impasto streaks, suggesting that it may have been executed first. Both *Marine* and *Homeward Bound* possess a heightened realism, attesting to Ryder's fascination with, and careful observation of, the sea. They also share the use of pink highlights, an unusual tone that suggests an ebbing light. They differ in that the Phillips work has as its focal point a sailing vessel with two figures, while the sketch shows only the open sea.

Frederic F. Sherman sold the painting with great reluctance, writing to Phillips, "I must confess I had intended to keep that work."[32] Phillips, who appreciated both its realism and its

broader symbolic meaning, wrote that "all of Ryder is in the small marine entitled 'Homeward Bound.' . . . That little boat at the center of the composition, as each of us is at the center of his particular universe, symbolized the soul's adventure as it traverses the vast, uncharted solitude, travelling toward the unknown."[33]

L F

73
Macbeth and the Witches, mid-1890s and later

Oil on canvas, 28¼ × 35¾ (71.7 × 90.8)
Unsigned
Acc. no. 1707

Collection of the artist; acquired by Dr. Albert T. Sanden, New Rochelle, N.Y., by 1917; purchased by Ferargil Galleries, New York, 1924; acquired by Carl Hamilton after 1928 but returned to Ferargil; acquired by the C. Wharton

73

Stork Art Fund for Haverford College, 1930, but returned to Ferargil in 1932; PMG purchase 1940.[34]

Based on act 1, scene 3, of Shakespeare's *Macbeth,* Ryder's *Macbeth and the Witches* engages with the theme of supernatural intervention in human events and the helplessness of humanity in its mortal confrontation with such forces. It appears that, in the face of a contemporary Darwinian worldview and the materialism of the Gilded Age, the aging artist returned to concerns with a moral order as expressed in the power of myth and poetry.[35] In a foreboding scene, Macbeth and Banquo, military leaders of the Scottish king, encounter the three Witches, who prophesy the chain of violent events to come. The turmoil is prefigured in the tortured landscape—the lone tree, looming mountain, and threatening sky.[36]

In his 1918 review, the critic Royal Cortissoz favorably contrasted *Macbeth and the Witches* with the "thousands of Shakespearian illustrations" produced in his day.[37] As in his interpretations of Wagner's operas, Ryder presented a complex image wherein the realms of humanity, nature, and the supernatural powerfully converge. A more recent study stresses Ryder's "atmospheric, introspective and intuitive" interpretations of scenes from Shakespeare.[38] In 1911 Walter Pach published an admiring article on Ryder in which he meticulously described the painting: "We may see [Shakespeare's scene] realized in Ryder's 'Macbeth and the Witches,' in all its dramatic intensity, this weird vision of a night torn by storms. The clouds are swept into tatters, the dark blue of the sky is seen through the rifts. . . . In the darkness, are two little figures of horsemen—like Greek statues for the spirit of their action. . . . At the center of the picture—one of its great surprises and delights—there is a gleam of golden and luminous water."[39]

Ryder approached the same subject in an earlier, smaller painting of this title, begun in the early 1880s.[40] By 1899 or even earlier, he had started the present version for Dr. Sanden, the physician and entrepreneur who was Ryder's principal patron.[41] Sanden's correspondence with Ryder between 1905 and 1913 outlines the artist's slow progress, although Ryder was optimistic in 1899, when he wrote that "the Macbeth . . . more slowly . . . will grow in grandeur and soon have a light and charm that I wish to be in it. . . . I hope to excel anything previous to this."[42] Ryder's neighbor, Charles Fitzpatrick, alleged in his 1917 memoir that the "McBeth [*sic*] picture . . . in the A. T. Sanden collection was taken before [the artist] considered it finished."[43]

The present darkened and cracked surface of the painting, an object lesson in Ryder's unsuccessful experimentation with unorthodox media and methods, impairs a thorough reading and interpretation.[44] Accounts of Ryder's friends, including the painters Weir and Hartley, describe the darkening condition and mistreatment of the painting during Ryder's lifetime.[45] Although one reviewer was still able to comment on its "luxuriantly colored" surface in 1917, Cortissoz criticized its somber hue the next year, writing: "At times he seems to have practically lost control of color, as witness the *Macbeth and the Witches,* in which figures and landscapes are withdrawn into an almost impenetrable penumbra."[46]

Comparison of the work with a photograph published in the Metropolitan Museum's 1918 catalogue (fig. 22) indicates that several changes were made between 1918 and 1924, when a second photograph was taken. They may have been made by a friend of Ryder's, the painter Horatio Walker, who restored Sanden's collection of Ryders in 1924. William Innes Homer has listed

the alterations: "The sky has been repainted, its contours softened and modified, contrasts reduced and new shapes added. In the center, above the distant hills, a whole new cloud form has been invented. . . . Other additions are the rocky outcropping at the left and the backlighting that sets off the contours of the witches, almost in the manner of 1930s cinematography."[47]

The long, arduous creation of *Macbeth and the Witches* typifies the works begun in the mid- to late 1890s. Chronic eye trouble, aggravated by age, further impeded Ryder's progress.[48] Yet, according to his own account, time was needed to achieve the proper spiritual inspiration: "Art is long. The artist must . . . await the season of fruitage without haste, without worldly ambition, without vexation of the spirit. An inspiration is no more than a seed that must be planted and nourished."[49] This almost ritualistic approach may have grown out of Ryder's perhaps unconscious desire to delay separation from his work.

LF

WILLIAM MERRITT CHASE (1849–1916)

Born November 1, 1849, in Williamsburg (now Ninevah), Indiana, William Merritt Chase began to study art at the age of eighteen under a local portrait painter. In 1869 Chase entered the National Academy of Design in New York and in 1872 attended the Royal Academy in Munich, where he studied under Karl von Piloty. He returned to New York to teach at the Art Students League, a position he held until 1896. Suited to teaching by intellect and personality, he began a long and successful career. He traveled abroad regularly, eventually incorporating travel into his teaching career by taking his classes abroad. By 1874 he had acquired his Tenth Street studio, where he taught, painted, and entertained extravagantly. He was elected president of the Society of American Artists in 1885, a post he maintained for the next ten years, and was elected academician of the National Academy of Design in 1890. In 1886 he married Alice Gerson, and the same year the Boston Art Club held his first solo show. He opened a summer school in 1891 on Long Island at Shinnecock, New York, where he firmly established his reputation as a landscape painter. Chase founded the Chase School in 1896, and he taught in Philadelphia at the Pennsylvania Academy of Fine Arts from 1896 until 1909. In 1905 he was elected a member of the impressionist group The Ten. Throughout his career Chase received many honors and awards in the United States and abroad. He died in New York City October 25, 1916. The Phillips Collection owns two of his oil paintings.

74

Hide and Seek, 1888

Oil on canvas, 27 ⅝ × 35 ⅝ (70.2 × 90.5)
Signed l.r.: *Wm. M. Chase*
Acc. no. 0298

The artist to James S. Inglis, after 1890; purchased 1919 at auction by Knoedler, New York; PMG purchase 1923.[1]

Chase returned to New York in 1878 from his studies abroad armed with the dark palette and bravura brushwork of the Munich School. Yet he remained receptive to other influences. By 1886 his work began to show the effects of plein air painting, a technique he had practiced in Holland as early as 1880 but which he would not take up again until several years later, at Shinnecock, New York, where he produced a body of impressionist paintings.[2]

Hide and Seek is a transitional work: whereas its dark colors place it well within the tradition of the Munich School, its broken brushwork and the suggestion of a fleeting moment in time captured by light foreshadow the landscapes that were to come. In this work, Chase has treated the familiar late nineteenth-century theme of children at play more progressively than in his other versions of the same subject matter.[3] Usually noted for his cluttered interiors, in *Hide and Seek* he emphasized economy of object and understatement of color, creating a composition that is at once radical and mysterious. Only four objects are included—a chair, a picture or mirror frame, an oriental curtain, and the door jamb or curtain behind which a young girl is hiding while she watches her playmate.[4] The rapt attention of this child absorbs and instructs the viewer while the second child, delicately positioned on the diagonal, is drawn to the source of light emanating from behind the curtain.

Two influences, *japonisme* and photography, converge in this painting to create a composition that is an anomaly in Chase's oeuvre. In the spirit of japonisme—perhaps inspired by Whistler—Chase has decentralized the picture, raised the horizon line, and defied the laws of gravity. The picture or mirror on the wall slides upward beyond the canvas edge, the empty chair floats unanchored, and the girl hovers before the light. The intense white of the girls' dresses and the slash of peacock blue on the sleeve, chair, and curtain are further allusions to Whistler.[5] It has been noted that *Hide and Seek* "anticipated [the] compositional format" of the Shinnecock landscapes, creating the "same flat, upward-slanting plane" that Chase used in them.[6]

The second influence, photography, supports the unusual cropping in the lower-left corner and the surprising expanse of space that dominates this picture. Abandoning a traditional compositional scheme in favor of one that suggests the accidental moment, Chase adopted for himself photography's intimacy and immediacy of expression. By reputation quick-witted and curious, Chase knew of the substantial gains of Eadweard Muybridge and their mutual colleague, Thomas Eakins, in the use of the camera, and its effect on art.[7] J. Carroll Beckwith, an artist and friend of Chase's, noted in his diary on February 2, 1888: "I went down to Chases [*sic*] to see the Muybridge photographs Sunday."[8] That Chase had in his possession examples of Muybridge's photographs early in 1888 verifies the painter's interest in the new

form at the same time he was working on *Hide and Seek.* The daring cropping of the child in the foreground suggests Degas, a serious student of Japanese prints and an amateur photographer himself, who had studied closely the work on motion carried out by Muybridge.[9] As it might be in a photograph, Chase's cropped figure is sharply defined; the rest of the painting is slightly out of focus.

In subject, and to a lesser extent composition, *Hide and Seek* also reflects the influence of both Velázquez's *Las Meninas* (1656) and Sargent's *The Daughters of Edward D. Boit* (1882), which also reflects the impact of the Spanish master's painting.[10] Although children are the focal point of all three compositions, *Hide and Seek* is not a portrait; indeed, the children remain unidentified.[11] Chase raised the horizon line, thus placing himself at the eye level of the children, a significant shift of emphasis from observation to empathy. Moreover, Chase retrieved Velázquez's strong vertical in the form of the door jamb in the left foreground, and obscured, even more than Sargent, his source of light, veiling it literally with an oriental curtain.[12]

Several journal notations indicate that Duncan Phillips knew Chase personally.[13] In a farewell article written after Chase's death in 1916, Phillips praised Chase for fighting the battle of "good painting for its own sake, for the right of the painter to make pictures which shall be primarily pictures and stand or fall, not by reason of their subject, but by reason of their style."[14] In December 1918 Phillips purchased his first work by Chase, *Outskirts of Madrid,* 1882, and his interest was likely renewed early in 1923, when Chase's work was exhibited at the Corcoran Gallery of Art, for he made inquiries about *Hide and Seek* soon thereafter.[15] Phillips admired Chase as an American teacher who brought the cause of art home at a time when expatriatism was in vogue. It was this commitment to the native soil, Phillips believed, "which made possible the present and future of American painting."[16]

W K

THEODORE ROBINSON (1852–96)

Long considered the first American impressionist, Theodore Robinson was born July 3, 1852, in Irasburg, Vermont; he spent most of his childhood in the rural Midwest, predominantly Evansville, Wisconsin. Robinson's formal art education began at the Art Institute of Chicago (1869–70) and continued at the National Academy of Design in New York (1874–76), where he was one of the founders of the Art Students League. In 1876 he journeyed to Paris and entered the atelier of the academician Carolus-Duran but later moved to the Ecole des Beaux-Arts to study with Jean-Léon Gérôme. The following year he studied briefly with Benjamin Constant, and the Salon accepted one of his paintings. Robinson moved to Venice in the fall of 1879; there he became a friend of Whistler, who had a great influence on him. He returned to the United States in December of that year and began to work as a mural painter for public and private buildings in New York and Boston. By spring 1884 Robinson had earned enough money to return to France. With Paris as his home base, he traveled often to such surrounding locales as Barbizon and Dieppe, as well as to Holland. After a brief visit to Giverny in 1887, he returned to that village every spring and summer for the next five years, becoming good friends with Monet. In late 1892 he returned to New York, where he renewed friendships with Twachtman and Weir. To supplement his income, he began teaching during the summers in Napanoch, New York, and later in a succession of teaching positions in New Jersey. In February 1895 Macbeth Gallery in New York gave him his first solo exhibition. He died April 2, 1896, during an acute attack of asthma, an illness that had plagued him his entire life. The Phillips Collection owns two oil paintings by Robinson.

75

Giverny, ca. 1889

View of Giverny; Giverny Landscape
Oil on canvas, 16 × 22 (40.6 × 55.9)
Unsigned
Acc. no. 1640 (Baur no. 89)

Artist to John Gellatly, New York, date unknown; DP purchase through Rehn Gallery, New York, 1920; transferred to PMG 1924.[1]

76

Two in a Boat, 1891

Oil on canvas adhered to cardboard, 9⅜ × 13¼ (23.8 × 34.8)
Signed and dated in red paint, l.r.: *Th. Robinson—1891*
Acc. no. 1641 (Baur no. 229)

The artist; Macbeth Gallery, New York, by 1913; purchased by George D. Pratt, Feb. 26, 1913; Rehn Gallery, New York, by 1919; DP purchase 1920 for the personal collection; transferred to PMG 1924.[2]

In 1887 the first wave of American artists arrived at Giverny, a small village seventy miles northwest of Paris where Claude Monet lived and painted. Among them was Theodore Robinson, a young artist who had spent four years steeping himself in the rigors of academic training, which stressed strong line, structured composition, and tonal values. In Giverny and Paris, Robinson and his colleagues were deeply affected by the work of the impressionists. In response, Robinson lightened his palette, loosened his brushwork, and placed greater emphasis on replicating the effects of light and atmosphere. Nevertheless, he retained aspects of his academic training and his admiration for the realist tradition of Homer and Eakins, and he never totally embraced the new influence.[3] To the American eye, though, his works epitomized the French style. When he exhibited seven of his Giverny paintings at the Society of American Artists in 1889, a critic wrote, "Mr. Theodore Robinson is one of those who have really gained a good deal by study of impressionistic methods."[4] By 1891 he was considered the preeminent impressionist in America, as another critic wrote: "His technique is the more novel, and to frequenters of picture exhibitions will suggest that of Monet, Pissarro and a majority of other French Impressionists. . . . Over a more or less careful drawing they place a mosaic of small touches of pure color, depending on distance to make them blend and harmonize."[5] The Phillips canvases, *Giverny* and *Two in a Boat,* represent Robinson's major themes: landscape and figure composition.

Painted during his third summer in the village, *Giverny* is a prototypical example of the technique that earned Robinson his reputation in America. From the vantage point of a hillside overlooking the Seine valley, he adjusted his easel to paint several views of the rural landscape. The strong composition and strict delineation of architectural elements in *Giverny* hark back to Robinson's academic training, whereas the bright violet-and-green palette and deft, summary treatment of the light-dappled foliage betray his exposure to impressionism. The underlying structure of *Giverny,* though less pronounced, is similar to that of another view of this location, *Bird's Eye View: Giverny, France,* 1889.[6] In both paintings, Robinson emphasized parallel diagonal lines that radiate to the left of the picture plane and terminate at the horizon line near the top of the canvas. William Gerdts likens the effect to a "half-open fan."[7]

Although Robinson preferred to execute his landscapes in plein air, he created his figure compositions with the aid of preliminary studies—usually photographs of carefully staged compositions that he had begun to take in the early 1880s.[8] "Painting directly from nature is difficult," he noted. "As things do not remain the same, the camera helps to retain the picture in your mind."[9] Robinson viewed the photograph as a means to capture exactly the world around him; the convenience of being able to work in his studio (he suffered from severe asthma) and the financial benefit of reducing the number of hours spent with a model appealed to him as well. Even when Robinson adopted aspects of impressionism in the late 1880s, he continued to use photographs as preliminary studies for his figure compositions because, as John I. H. Baur noted, "impressionism for him . . . meant superimposing a visual, coloristic and atmospheric realism on the older linear and descriptive kind."[10]

Two in a Boat, painted during his 1891 summer at Giverny, represents two women reading while lounging in a skiff floating on the Seine or Epte River. The scene retains the spontaneous freshness and lively brushwork of his pure landscapes, despite the carefully staged composition. The relationship between *Two in a Boat* and the photograph from which it derived (fig. 23) offers a vivid example of Robinson's painting process.[11] He lightly scored the photograph and the canvas with graphite and sketched in the composition, using the grid as a measure. The grid and underdrawing are visible throughout, because Robinson's pink primed canvas was left exposed in many areas, particularly in the lines defining the interior of the occupied boat and

75

76

Fig. 23 Theodore Robinson, *Two in a Boat*, albumen print, 1985.1.1. © Terra Museum of American Art, Chicago.

the figures. The painting differs slightly from the photograph: Robinson excluded a fourth boat to the starboard side of the skiff and the branch falling diagonally from the top left corner; furthermore, the photograph's strong contrast has been replaced by an overall tone of violet and green. Robinson later questioned his use of photographs: "I just don't know why I do this—partly curiosity to see what results—but partly I fear because I am in N.Y. where other men are doing this—it is in the air."[12]

Robinson appears to have been pleased with *Two in a Boat,* because he included it in the Society of American Artists' 1895 annual exhibition and in his one-person exhibition at Macbeth's later that year. It was also one of five Robinsons lent to the 1913 Armory Show, where he and Twachtman represented American impressionism, their paintings hanging in one of the large center rooms alongside works by Ryder and Whistler, who by this time were considered to be American "old masters."[13] Duncan Phillips, however, was only mildly enthusiastic about *Two in a Boat;* when he purchased it in 1920, he wrote the dealer Frank Rehn that he was "interested also in the little oil of the Girls in the Boat but really want[ed] an important Robinson if you get a hold of one."[14] The following month Phillips purchased *Giverny,* paying nearly five times the amount paid for *Two in a Boat.* Collecting the artist's work primarily between 1919 and 1922, Phillips thought of Robinson as a "gifted colorist. . . . His instrument of expression was color and his palette was as individual as that of any painter of his time. He used the broken tones of Monet but refined the method and made it subtle and sensuous. He was more like Renoir than Monet. One hue required another, the red and blue touches making a violet in perfect accord with the modulated greens. . . . Robinson is . . . one of the most attractive personalities and talents of the Impressionist movement."[15]

VSB

Julian Alden Weir, a leading American impressionist, was born at West Point, New York, August 30, 1852. He was the son of Robert Weir, instructor of drawing at the U.S. Military Academy at West Point, and half-brother of John Weir, first director of the art program at Yale University. He took art classes at the National Academy of Design before traveling to Paris in 1870 to study under Jean-Léon Gérôme. After trips to Holland and Spain between 1873 and 1877, Weir returned to New York and took a studio in the Benedick building at Washington Square East. On a second trip to Europe in 1880, Weir won an honorable mention at the Paris Salon; he also purchased two Manet paintings, a Rembrandt, and a Bastien-Lepage on behalf of American collectors. At the time of his marriage to Anna Dwight Baker in 1883, he acquired a farm in Branchville, Connecticut, where he summered regularly; among his guests was Albert Pinkham Ryder. Made a member of the National Academy of Design in 1886, Weir was also a founding member of the Society of American Artists, the Tile Club, and, in 1898, the artists' group The Ten. Weir painted a mural for the "World's Columbian Exposition" of 1893. The recipient of numerous honors in his last years, including the presidency of the National Academy from 1905 to 1917, Weir died December 8, 1919, in New York. He is represented in The Phillips Collection by fourteen oil paintings, one etching, and one wood engraving.

The Weir Unit

Julian Alden Weir was held in high esteem by Duncan Phillips. A friend and fellow member of the Century Association—an exclusive men's club for artists and writers in New York—Weir was one of the first artists whose works Phillips acquired, and he was also a respected adviser who exerted a subtle but important influence on the evolving taste of the collector.[1] When they met around 1915, Weir was at the height of his career and the recipient of many honors.[2] He had impeccable credentials, enjoyed a wide and diverse circle of friends, and produced art of great appeal while also championing originality and experimentation.

Weir's *Pan and the Wolf,* ca. 1907 (cat. no. 80), was purchased by James Phillips in 1916, the year the brothers began their joint collecting venture. The painting's mythological theme was unusual for Weir, but its poetic mood and echoes of Corot suited the still conservative taste of the Phillipses. The year of the purchase, Duncan Phillips wrote his first piece on Weir, praising him for his idealism and asserting that he was

one of the most important landscape painters in the United States since Inness.[3] Phillips added two Connecticut landscapes to the nascent collection in 1917: *After the Ride,* ca. 1903 (cat. no. 79), and *The Fishing Party,* ca. 1915 (cat. no. 81). Both works display the charm and sensitivity that Weir typically brought to even his most vigorous studies of the effects of atmosphere and light—to Phillips's mind, qualities that distinguished the best of American art as it developed a national character. As he later explained, Weir and his fellow American impressionist, John Henry Twachtman, were "able to apply Monet's method to American subjects, and to carry it on with modifications which would make it more adaptable to individuality of expression and more amenable to beauty . . . [and] to surpass their French masters by making their method more flexible and more spiritual, while retaining all the truth and all the vitality."[4]

Upon James Phillips's death in 1918, collecting took on new purpose and momentum for Duncan. Weir's paintings, along with works by his friends Hassam, Ryder, Twachtman, and Whistler, became cornerstones for Phillips's plans for a memorial museum that would spotlight the accomplishments of American artists.[5]

Like Duncan Phillips, Weir was a tireless promoter of American art and artists, often securing purchases and shows for his friends.[6] Yet he also had close ties to Europe, especially France, and encouraged his fellow American artists to learn from, and compete with, their transatlantic counterparts. A decade earlier, acting as agent for and adviser to the New York collector Erwin Davis, Weir had brought two of the first Manets to America—*Woman with Parrot,* 1867, and *Boy with Sword,* 1861.[7] Phillips described these paintings as "monuments to the wisdom of Weir . . . [that] have exerted a powerful influence in the development of American art."[8] In 1893 Weir and Twachtman had a joint exhibition concurrently with a show of paintings by Monet and Albert Besnard at the American Art Galleries in New York. Phillips, inspired by Weir's example, was able to see the continuities and affinities that connected old and new, European and modern, and he began to hang his American paintings alongside European counterparts and precursors, including Corot, Manet, Monet, Puvis de Chavannes, and Renoir.

When Weir died in 1919, Duncan Phillips contributed paintings to the Century Association's memorial exhibition. In his essay for the memorial volume published two years later, he praised Weir for his openness to new ideas: "Although a member of the National Academy since 1885, and president of that body from 1915–1917, he was

nevertheless an adventurous spirit himself, open-minded and sympathetic in regard to the adventures of the younger man, and frankly opposed to the tyranny of traditions and to all dogmatic intolerance."[9] However, Weir was not entirely open-minded about European influence, nor did he show much enthusiasm for modern art in 1912 when he declined an appointment to head the newly formed Association of American Painters and Sculptors, a position that was to direct plans for the 1913 Armory Show. Arthur B. Davies, who was appointed in his stead, proceeded to bring together in this landmark exhibition a significant cross-section of recent European modern art and to do just what many of Weir's circle had feared—overshadow the more conservative-looking work of the Americans.

Late in the second decade of the twentieth century, Phillips also championed originality and independence, but like Weir, his open-mindedness did not yet extend to more recent, radical developments. In an unpublished essay on Weir from 1919–24, Phillips complained about Davies going "weird ways following a tantalizing mirage" but added, "Alden Weir was as impervious to this hyper-estheticism as to pseudo-classicism, and today he is out of sympathy with all abnormal and affected attitudes."[10] Within a decade, however, that attitude would change, and Phillips would become a champion of the avant-garde.

Phillips continued to add to his collection of Weirs. By 1920 he had acquired examples of his figure painting, purchasing *Knitting for Soldiers,* 1918 (acc. no. 2075), in 1918 and *An Alsatian Girl,* 1890–99, in 1920 (acc. no. 2070). In addition to the poetic delicacy that Weir brought to his portraits of women, *Knitting for Soldiers* appealed to Phillips because of its patriotic theme.[11] Although prevented by delicate health from serving in the military, Phillips was deeply involved in the war effort, and he praised Weir's "affectionate tribute to the American woman in the war."[12] Between 1917 and 1921 Phillips added seven landscapes to the collection. In two of them—*The High Pasture,* 1899–before 1902 (cat. no. 78), and *Woodland Rocks,* 1910–19 (acc. no. 2084)—Weir used bold patterns, flattened space, and vigorous brushwork in a style comparable to the work of the post-impressionists.

Weir was the first subject of Phillips's planned series of books on art. Originally published by the Century Association in 1921, *Julian Alden Weir, an Appreciation of His Life and Works* became Phillips Publication No. 1 when Phillips acquired the copyright in 1922.[13] In a format that he followed for a subsequent book on Davies, Phillips wrote the introductory chapter, and fel-

low artists, friends, and critics contributed the remaining chapters, creating a personal yet balanced overview of the artist and his work.[14] Phillips's sense of loss at the death of a revered friend sets the tone of the book, which also contains astute appraisals of Weir's place in history.[15]

Shortly before the memorial volume was published, Phillips acquired several more works to give greater depth to the emerging Weir unit. Among them were two still lifes from the 1880s, *Roses,* 1883–84 (cat. no. 77), and *Grapes, Knife and Glass,* ca. 1880 (acc. no. 2073). Although eclipsed by his later impressionist landscapes, Weir's still lifes represented an important phase in his career. Phillips astutely observed that "collectors are proud today if they have kept the luscious paintings of roses arbitrarily relieved against dark backgrounds, which they probably acquired without due appreciation of their historical importance. These things possess so delicious and unctuous a pigment, so charmingly rendering their subjects with especial regard to richness of tone and texture, that they would make Weir sure of a reputation as a painter's painter even if he had not gone on to greater achievements."[16]

By the end of the 1920s, Phillips considered his Weir unit complete; he even sold off a landscape, *Building a Dam at Setauket,* ca. 1908, in 1925.[17] His interests had changed, having been shaped in part by Davies's more radical tastes and sparked at last by the Parisian and American avant-garde. He never lost his appreciation for Weir, however, and continued to show his paintings and include him in essays on art even after the artist's reputation faded to near oblivion.[18] Phillips's faith was rewarded in the 1950s when scholars and general audiences rediscovered Weir and acknowledged him as a major figure in the American impressionist movement.

ET

77

Roses, 1883–84

Oil on canvas, 35¼ × 24¾ (89.5 × 62.9)
No signature visible
Acc. no. 2081

Early history unknown; PMAG purchase from Frank Rehn, New York, 1920.[19]

In the 1880s, after his return from academic study abroad and before embracing impressionism, Weir painted numerous still lifes. *Roses,* typical of his larger works in this genre, is vertical in format and has a dark background from which emerge two delicate ceramic vases holding numerous flowers in full bloom. The flowers are dropping their petals onto a reflective tabletop.

Still-life painting, especially flower subjects, had grown in popularity in the United States

since the 1860s. In addition to providing artists with challenging studio subjects, still lifes also had a decorative appeal (prompting an accompanying market in chromolithography). Cottier and Inglis, Weir's dealers at the time, specialized in decorative art as well as paintings. Weir concentrated on still lifes as commercial ventures and as a means to explore formal issues.

Roses reflects several European influences, including the illusionistic approach of François Bonvin, leader of a group of French painters who admired Chardin; at the same time, it recalls the dark manner of seventeenth-century Dutch painting revived by the Munich School and the broad, painterly effects of Manet.[20] The fragile, almost melancholy mood of Weir's *Roses* also suggests a debt to the American painter John La Farge, whose aesthetically refined watercolor still lifes of the seventies led the way for Weir and many of his contemporaries, including Childe Hassam and Abbott Thayer.[21]

Weir's choice of flowers and props for his still lifes suggests that his motives were more than simply aesthetic. He had a rich variety of symbolic traditions to draw from, including the rose as a symbol of Mary in sixteenth-century Italian religious painting, the memento mori theme of seventeenth-century Dutch art, and the association of flowers with womanhood in the Victorian era. In *Roses,* Weir recalled the Renaissance tradition by including a sculptural relief of the Madonna and Child behind the flowers, barely visible in the shadows. Once thought to be a Donatello, it is now identified as a reproduction of the *Virgin and Infant Jesus* by Andrea della Robbia (Academy of Fine Arts, Florence)—probably a plaster cast such as those used in art schools.[22] The sculpture enhances the devotional aspect of the rose image.

Lacking a market for easel paintings of traditional religious subjects, Weir was able to elevate the humble subject of still life to a higher level in *Roses* and convey a sense of gentle piety.[23] As Duncan Phillips observed, "Weir's *Roses* is another dark picture more or less influenced by Munich in color and brush work. The spirit, however, is not that of virtuosity. This still life is as solemn as a prayer."[24] This religious sensibility can be traced to Weir's childhood; daily prayers were led by his father, who painted a mural in the cadet chapel at West Point (where he taught drawing) and designed a Gothic revival church, the Chapel of the Holy Innocents, in Highland Falls.[25] Weir's brother John, also an art teacher, frequently ruminated on religious topics in his writings.

Although his still lifes were in great demand, Weir painted few of them after the 1880s, turning his attention instead to the challenge of landscape painting and French impressionism.

ET

78

The High Pasture, 1899–before 1902

The Pasture
Oil on canvas, 24⅛ × 33½ (61.3 × 85.1)
Signed and inscribed l.l. to l.c.: *J. Alden Weir; To my friend Br*[illeg.] *with affection from J. Alden Weir.*
Acc. no. 2074

Early history unknown; PMAG purchase from Rehn Gallery, New York, 1920.[26]

The High Pasture sums up Weir's mature approach to landscape painting, in which he used bold pictorial effects to capture both a visual impression and his intense feelings before nature. It shows his farm near Branchville, Connecticut, where he summered regularly after 1883.[27] Like Monet's beloved Giverny, Weir's farm was an enduring source of inspiration. Duncan Phillips noticed how Weir "could suddenly become absorbed and fascinated by the momentary effect of a long familiar and unremarkable scene. I am thinking of what Weir found so paintable in the mere corner of a high pasture, just a bit of sunshine playing along a stone wall and over a well-worn foot path, and a silvery, green tree outspread against a warm blue sky. The design of the picture I discovered later to be original and delightful, but my first pleasure was that of recognition."[28]

Although celebrated as an American impressionist, Weir had a negative reaction when he first encountered impressionism in Paris in the 1870s. Describing the first works he saw as "worse than a Chamber of Horrors," he initially maintained an allegiance to the more conservative Barbizon School and the approach of his friend and mentor, Jules Bastien-Lepage.[29] When he began to depict the impressionistic effects of light and atmosphere in the late 1880s, he retained, like most of his American colleagues, a predilection for structured compositions and solid forms. He also tended to moderate his color to a narrow tonalist range, reflecting the influence of Whistler.[30]

By the late 1890s, Weir had changed his approach. In place of muted color and hazy, atmospheric effects, he substituted intense hues, active brushwork, and bold patterns in the manner of Twachtman (see cat. nos. 82–84). The new expressiveness of Weir's landscapes also suggested the influence of Ryder, who was a frequent visitor to the farm, and whose *Weir's Orchard,* ca. 1890, shares with *The High Pasture* a low vantage point, bright color, and short, stitchlike brushwork.[31]

Weir, who entertained many guests at his Connecticut home, wrote a now nearly illegible dedication to one of his friends on *The High Pasture.* A likely candidate for the dedication, although unconfirmed by supporting documen-

77

78

tation, is J. Appleton Brown.[32] A Boston painter and fellow member of the Society of American Artists, Brown spent part of the summer of 1899 at Branchville, fishing and painting along with Weir and his older brother, John. As Weir's daughter, Dorothy Young, recounted, Weir and Brown "shared an almost pantheistic feeling for the world of nature."[33] Brown, the more conservative of the two, was still somewhat indebted to the Barbizon tradition, and he sought Weir's advice and benefited from his encouragement. *The High Pasture* can thus be seen as both a souvenir of companionable painting sessions in the Connecticut countryside and an example of Weir's new approach to landscape painting, in which he moved beyond impressionism to the bolder design elements of post-impressionism.

ET

79

After the Ride, ca. 1903

Two Friends; A Girl and a Donkey; Visiting Neighbors
Oil on canvas, 24⅜ × 34⅛ (61.9 × 86.7)
Signed in brown paint, l.r: *J. Alden Weir*
Acc. no. 2083

Whitney Richards, New York, 1916; DP purchase from Macbeth Gallery 1917; transferred to PMAG 1920.[34]

After the Ride depicts Weir's youngest daughter, Cora, with the family donkey, Ned Toodles.[35] Duncan Phillips, impressed by its fresh, unaffected charm, wrote that "this picture is first and last just a vivid glimpse of the real world at Branchville, Connecticut, and of a little girl who had a good time with that particular donkey, and who used to tie on to that particular rustic fence which her daddy had noticed took on just that grayish violet tone at the hour of the sun-flecked green midday."[36] Throughout his career, Weir took special delight in painting members of his family, especially his daughters by his first wife, Anna, who had died following the birth of Cora in 1892.[37] Weir usually painted children in bucolic outdoor settings, creating images that are tender and idyllic without being overly sentimental.

Weir's approach to figure painting changed significantly over the course of his career, from his early, more tradition-bound portraits to later works influenced by Manet and Japanese art.

Except when figures were just small accents within the larger landscape setting, as in *The Fishing Party* (cat. no. 81), Weir was usually unwilling to sacrifice solid form and the identities of his sitters to the impressionist effects of light and atmosphere. Even when he experimented with asymmetrical compositions and decorative designs, he preferred an approach indebted to his early French mentor, Jules Bastien-Lepage, combining plein air lighting effects with solidly modeled, academically correct figures. *After the Ride* is something of an exception. Here the figure of Cora becomes a part of the sun-flecked landscape, her features obscured by the bright summer light, her white dress reflecting the colors of the surrounding grass and trees. The vigorous pattern of repeated horizontal and vertical brushstrokes creates a rich surface, while the figures of the donkey and Cora anchor the composition in depth.[38] The painting is charming in its subject and at the same time somewhat detached; it is both the childhood vignette described by Phillips and a rigorous study of texture and light.[39]

ET

79

80

Pan and the Wolf, ca. 1907

Oil on canvas, 34 × 24 (86.3 × 60.9)
Signed l.l.: *J. Alden Weir*
Acc. no. 2079

Purchased by James L. Phillips from the artist through
Macbeth Gallery, New York, 1916; transfer to PMAG 1921.[40]

Pan and the Wolf was described in an early
review as one of the artist's favorite and most
unusual paintings, revealing his "intense love for
light and atmospheric effects."[41] Although typi-
cal of Weir's late landscapes because of its feath-
ery brushstrokes and rich, silvery color, it was
unusual for Weir for its mythological subject.[42]
By the standards of most turn-of-the century
classically inspired art, Weir's image is quite sub-
tle. Pan, the Greek god of the woods and fields,
is represented as a herm statue that is barely vis-
ible in the half-light of a forest clearing. He plays
his pipes to an audience of one—a wolf stand-
ing transfixed by the sound.

Pan and the Wolf dates from the last period
of Weir's career, by which time he had assimi-
lated a variety of stylistic sources, including
Japanese printmaking and French impression-
ism. As Duncan Phillips observed, however, the
painting was in keeping with Weir's tendency to
"unconsciously express the reticent idealism
which guides and guards the matter-of-fact
materialism of America."[43] He also saw that
despite a foray into impressionism, Weir's paint-
ing continued to be tempered by the earlier Bar-
bizon tradition. As Phillips put it, "The artist
seems to have said to himself, 'now, suppose I
try a classic landscape as Corot would have
painted had he lived a little longer.'"[44] More than
just Corot, however, *Pan and the Wolf* recalls the
larger pastoral landscape tradition dating back
to Claude and the Greek poets, with the Con-
necticut countryside interpreted as a modern-
day arcadia.

Weir was not alone in envisioning an arca-
dian American landscape. His longtime friend
Ryder, whose inspirations ranged from mythol-
ogy and the Bible to Shakespeare and Wagner,
painted nature with the sensitivity of a classical
poet, his scenes reverberating with the same pas-
toral spirit as *Pan and the Wolf*.[45] Weir's col-
league in The Ten, Hassam, also began
introducing classical imagery to his landscapes
about this time, indicating a resurgence of
romanticism in the United States that can be
seen in part as a reaction to the earthshaking
events of the First World War and the emer-
gence of new, radical philosophies of art.[46]

Although Phillips eventually accepted and
promoted the modern art that eclipsed Weir's
romanticism, he never lost his appreciation for
Weir and his contributions as an American
landscape painter. The admiration was mutual.
As a token of their friendship and artistic associ-
ation, Weir presented Phillips with a personally
inscribed wood engraving of *Pan and the Wolf*.[47]

ET

80

81

81

The Fishing Party, ca. 1915

Oil on canvas, 28 × 23⅛ (71.1 × 58.7)
Signed in dark brown paint l.l.: *J. Alden Weir*
Acc. no. 2072

Acquired from the artist by Major Duncan Clinch Phillips through the Corcoran Gallery of Art, 1917; transfer to PMAG 1921.[48]

Whereas his friends and fellow American impressionists Hassam and Twachtman traveled widely and painted a variety of landscapes, Weir stayed close to home in the last three decades of his career. In addition to cherishing the companionship of his family, Weir enjoyed visits by friends and was a generous and amiable host. Among his regular guests were his beloved "Pinkie"—Albert Pinkham Ryder—and Twachtman, who eventually bought property in Connecticut as well (see cat. no. 83). *The Fishing Party* depicts a group enjoying an outing on a bright summer day. As Duncan Phillips described it, "The sun under which we stand seems to silver the ferny fore-

ground, the sky so subtly modulated in key from the horizon up, and in the distant woods beyond the open fields across a little bridge pass the white-clad figures of friends going a-fishing. If one only could hear the hum of insect life and of incidental, unimportant human voices, the sensation of any sunny summer day on a farm would be complete."[49]

Knowing that Weir was an avid fisherman, Phillips devoted an entire chapter to this subject in his monograph on Weir. The chapter was written by Harald de Raasloff, a civil engineer and fellow member of the Century Association who had struck up a friendship with Weir when they joined a fishing club in the Pocono Mountains in 1889. De Raasloff, who was also a guest at Branchville, said that Weir "knew the English streams almost as well as those of his native land." De Raasloff also observed that "the country around Branchville is very 'paintable,'" and he added that "on the way to the fishing place Weir was all 'artist,' pointing out to me the manifold beauties of the landscape."[50]

Interestingly, Weir rarely painted fishing

scenes. *Return of the Fishing Party,* 1906, is the only other known painting dealing with his favorite hobby.[51] In both works, fishing is secondary to the landscape and the lighthearted mood, and the figures are small and indistinct—a mere blur of festive summer clothing and fishing poles seen off in the distance. Phillips wrote that both paintings "are very lovely landscapes with figures enveloped in silvery sunshine, but they are for connoisseurs of rare beauty—not for the sportsman. He was fond of telling stories, but not on canvas. I do not remember a single story-telling picture from his hand."[52]

Phillips was right, because even as an art student in Paris and while under the spell of Jules Bastien-Lepage in the 1870s, Weir rarely incorporated anecdote or narrative in his works. The influence of impressionism in the 1890s reinforced his already essentially nonnarrative approach.

ET

JOHN HENRY TWACHTMAN (1853–1902)

Born in Cincinnati August 4, 1853, John Henry Twachtman was the son of German immigrants. As a young man he worked decorating window shades (as had his father, Frederick); at the same time, he took night classes at the Ohio Mechanics Institute. After enrolling at the McMicken School of Design (which later became the Art Academy of Cincinnati), Twachtman studied with John Duveneck, who had recently returned from Munich. Duveneck urged him to enroll in the Royal Academy of Fine Arts in Munich, which he did in 1875. During his European stay, Twachtman accompanied Duveneck and Chase on a painting trip to Venice. Back in Cincinnati in 1878, he exhibited with the newly formed Society of American Artists in New York; he was elected a member the following year. In 1879 Twachtman met and began a lifelong friendship with J. Alden Weir. After marrying a Cincinnati woman in 1881, he took a wedding trip to Europe, where he met Jules Bastien-Lepage and joined Weir and his brother John on a painting expedition to Holland and Belgium. Between 1883 and 1885 he studied, traveled, and worked in France, meeting Childe Hassam, Willard Metcalf, and Theodore Robinson in Paris. In 1889 Twachtman began teaching at the Art Students League, and with the profits from a cyclorama he had painted with Arthur B. Davies in Chicago, he purchased a home in Connecticut near Weir's farm. Among other awards, Twachtman received a silver medal at the "World's Columbian Exposition" in Chicago in 1893 and a gold medal at the 1894 Buffalo Academy of Fine Arts annual exhibition. In 1897 he and Weir withdrew from the Society of American Artists and formed The Ten, a group of American painters. He spent the summers of 1900 and 1901 in Gloucester, Massachusetts, where he died suddenly August 8, 1902. The Phillips Collection contains four oil paintings and two pastels by Twachtman.

82

The Emerald Pool, ca. 1895

In Yellowstone Park

Oil on canvas, 25 × 25 (63.5 × 63.5)

Signed l.r.: *J. H. Twachtman*

Acc. no. 1982 (Hale no. 772)

Collection of the artist until 1902; sold to Stanford White, New York, 1903; PMAG purchase from Ferargil Gallery, New York, 1921.[1]

The Emerald Pool is one of a series of paintings Twachtman made during a trip to Yellowstone National Park in September 1895. The trip was sponsored by Major William Wadsworth of Buffalo, who, having admired Twachtman's scenes of Niagara Falls in the collection of another Buffalo resident, Charles Carey, wanted the artist to paint the falls at Yellowstone. Twachtman produced more than ten paintings, including four scenes of waterfalls that Wadsworth acquired; among the additional paintings were scenes of canyons and hot springs, including *The Emerald Pool,* which remained in the artist's possession until his death in 1902.[2]

In both the Niagara and Yellowstone works, Twachtman departed radically from the traditional approach to depicting America's scenic wonders. Instead of detailed and theatrical panoramas such as those by Albert Bierstadt and Thomas Moran, members of the previous generation of Yellowstone painters, Twachtman created more intimate, close-up views characterized by the loose, gestural brushwork and pastel palette of impressionism. His sense of awe and wonder before nature's spectacle was not less than that of the earlier artists, however. In a letter to Major Wadsworth from Yellowstone, Twachtman declared "the scenery . . . fine enough to schock [*sic*] any mind." Twachtman added, "We have had several snowstorms and the ground is white—the canyon looks more beautiful than ever. The pools are more refined in color but there is much romance in the falls and the canyon."[3]

The Yellowstone works date from the same period—the mid-1890s—when Twachtman painted many of his best-known scenes of brooks and pools on the grounds of his farm near Greenwich, Connecticut. It was at this time that his adaptation of French impressionist theory evolved into a mature, personal style. In depicting both familiar terrain in his own backyard and more exotic locales such as Yellowstone, Twachtman tended to focus on a single feature within a small area, such as a pool or falls, and to paint it again when the seasons changed. Influenced by Whistler's tonalist approach, Twachtman painted many winter scenes, keying his palette to the saturated white of snow, ice, and heavy atmosphere.[4] Although somewhat limited in tonal range, *The Emerald Pool* is more colorful than his Greenwich winter scenes; the snow in the clear mountain air in late summer shimmers with reflected accents of violet, yellow, and pink against the rich blue-green of the pool and the distant mountain range. Like many of his paintings from the 1890s, it has a square format, a high horizon, and an interplay of patterns and shapes influenced by Japanese design.[5]

Along with daring pictorial effects, Twachtman's landscape resonates with lyrical power and personal expression. Duncan Phillips described it as being in the "oriental tradition of self-effacing, mystical, spiritualized naturalism," adding that while impressionism sought "the evanescent," Twachtman's art "proclaimed its faith in the invisible and the eternal."[6] Phillips held Twachtman in high esteem, appreciating his skills as a colorist, responding to the poetry of his vision, and acknowledging his role as a forerunner of modern painting. He also maintained that *The Emerald Pool* could hold its own with the work of the French master Monet, and he hung the two together for years.[7] It must have been especially gratifying for the collector when another artist he greatly admired, Pierre Bonnard, singled out *The Emerald Pool* as his favorite American painting on a visit to the gallery in 1926.[8]

ET

83

Summer, late 1890s

Oil on canvas, 30 × 53 (76.2 × 134.6)

Signed l.r.: *J. H. Twachtman*

Acc. no. 1986 (Hale no. 605a)

Collection of the artist until 1902; purchased by Knoedler, New York, 1917; DP purchase from Macbeth 1919; transferred to PMAG 1921.[9]

Summer was painted on property in Greenwich, Connecticut, that Twachtman purchased in 1889–90 after being hired to teach at the Art Students League in New York. Twachtman had been a frequent visitor to Weir's Connecticut farm, and he seized the opportunity to live near his friend and within commuting distance of New York City. Over the next ten years, he found a seemingly inexhaustible source of inspiration on this seventeen-acre farm, which included a brook, a pond, and an old farmhouse that he gradually enlarged and improved.

In his numerous paintings of these familiar landmarks, Twachtman captured the changing effects of seasons and weather; most, like *Summer,* have titles referring to the time of year. During the early nineties Twachtman—like many of his contemporaries, including Weir—experimented with atmospheric effects in reaction to exhibitions of French impressionist art in New York. His contact with Theodore Robinson, who returned to New York from a lengthy stay with Monet at Giverny in late 1892, may have contributed to this new approach.[10] But it was tempered by other influences, including Whistler's tonalism and Twachtman's own

82

poetic work in pastel. The Phillips Collection's *Winter*, early 1890s, for example, has uniform, muted tonalities, vaporous, mist-shrouded forms, and a mood of hushed stillness.[11]

By the end of the nineties, when he painted *Summer,* Twachtman was introducing more vivid color. Abstract design still played an important part—seen here, for example, in the intersecting lines of rooftops, road, and hillside, as well as in the bold green-and-yellow pattern of grass in the foreground. Rather than breaking up color with short, choppy strokes like the French impressionists, Twachtman laid in broad areas, often with lighter colors over a darker ground, and with brushwork ranging from thin scumbles to rich impasto. Although he painted out of doors, Twachtman was known to rework canvases back in the studio and to use experimental techniques to achieve unusual surface textures.[12]

In such paintings as *Summer,* Twachtman's work took on a new intensity and vigor, which Phillips later described as "impressionism carried to the heights of spiritual expression."[13] Because of his experimental approach to design, paralleling in interesting ways the more radical developments of post-impressionism in Europe, Twachtman did not enjoy much financial success or public recognition during his lifetime.[14] Yet it was this very independence and nascent modernity that Phillips admired the most when he began collecting Twachtman's work late in the second decade of the twentieth century. His enthusiasm for Twachtman, encouraged initially through his contact with Weir, was reinforced by his friendship with Augustus Vincent Tack, who had studied with Twachtman, and it continued to grow as he became more involved with modern art.[15] By the early twenties, he was planning a Twachtman Room to display the "nuance of color in the work of this great master" against a backdrop of oriental pottery and antique glass.[16]

ET

83

84

My Summer Studio, ca. 1900

My Autumn Studio (DP)

Oil on canvas, 30⅛ × 30⅛ (76.4 × 76.4)

Unsigned; stamped in red, l.l.: *"Twachtman Sale"*

Acc. no. 1984 (Hale no. 602)

Collection of the artist until 1902; sold to Cottier and Co., New York, at the 1903 estate sale; collection of Mrs. John E. (Gertrude) Cowdin, city unknown; collection of Alexander Morten, New York; sold at 1919 Inglis-Morten-Lawrence sale to C. W. Kraushaar, New York; DP purchase 1919; transferred to PMAG 1921.[17]

My Summer Studio dates from the last years of Twachtman's life, when he summered in Gloucester, Massachusetts. In contrast to the muted, tonalist palette of such Greenwich paintings as *Winter,* early 1890s, *My Summer Studio* has a wide range of vivid color, including warm strokes of orange and yellow laid over deeper, cooler blues and purples. The tendency toward simplification of form and abstraction takes on a new boldness here and is enhanced by the picture's square format and varied and vigorous brushwork. The subtle lyricism of a single motif in nature is replaced by a boisterous complexity of images. Rocks, vegetation, and the studio building, which juts out over a promontory, establish a more structured composition.[18]

Several factors, including the environment of Gloucester itself, contributed to the changes in Twachtman's painting. Both a busy commercial fishing port and a picturesque resort, Gloucester had attracted artists for years, from Fitz Hugh Lane in the 1860s to Homer in the 1890s, and by the turn of the century it boasted a thriving artists' colony.[19] In contrast to the quiet retreat and the intimate, self-contained vista that Twachtman's Greenwich property afforded, Gloucester had a bustling dock, varied architecture, ships, and numerous natural landmarks, which the artist explored extensively. In addi-

tion, by late summer the Gloucester landscape already took on the vivid hues of autumn that Twachtman captured here, prompting the alternate title *My Autumn Studio,* by which it was known for years. The Gloucester experience affected Twachtman in another way, as well. Preceding him there in the 1890s was his old friend and mentor John Duveneck. Twachtman had long since abandoned his teacher's dark style, which he had followed during his Cincinnati days. But, as Richard Boyle has noted, his return to a more vigorous gestural approach coincided with, and was probably inspired by, his renewed contact with Duveneck at Gloucester.[20]

Twachtman's use of a square format for *My Summer Studio* dates back to the early nineties and relates to his interest in Japanese art and his experiments with composition and design. As William Gerdts has noted, although many of his contemporaries experimented with the square format, emphasizing the flat picture plane over the traditional rectilinear illusion of space, Twachtman used it the most frequently and creatively.[21]

In *My Summer Studio,* Twachtman achieved a striking synthesis of old and new, bringing together the bravura manner of his early Munich training, impressionist optical effects, vivid color, and an innovative composition.

ET

84

CHILDE HASSAM (1859–1935)

Childe Hassam was a leading American impressionist painter and printmaker. The son of a prosperous hardware merchant and antique collector from Dorchester, Massachusetts, Hassam (christened Frederick Childe Hassam) was born October 17, 1859. In his early artistic career, he studied drawing, made commercial lithographs for a wood engraver in Boston, and created illustrations for such magazines as *Harper's* and *The Century*. Between 1877 and 1879, Hassam attended evening classes at the Boston Art Club, studied briefly with William Rimmer at the Lowell Institute, and took private lessons from the painter Ignaz Gaugengigl. At the age of twenty-four, he visited Great Britain and the Continent for two months. In 1886 he moved to Paris, where he studied at the Académie Julian under Gustave Boulanger and Jules Lefèbvre. He returned to New York in 1889. Hassam made trips to Europe on two subsequent occasions between 1897 and 1910, visiting Pont-Aven and, on the final trip, points in southern Spain. Back in New York in late 1897, he resigned from the Society of American Artists, with which he had been associated since 1890, and cofounded The Ten with J. Alden Weir and John Twachtman. In 1915, influenced in part by the work of his friend Weir, Hassam began experimenting with etching and, two years later, lithography. In 1920, having summered at various seaside resorts since 1882, he established a permanent summer studio in East Hampton, Long Island. During the remaining fifteen years of his life, he continued to exhibit regularly, enjoying national recognition and receiving numerous awards and honors. He died in East Hampton August 27, 1935. The Phillips Collection owns two oil paintings and a watercolor by the artist.

85

Washington Arch, Spring, 1890

Oil on canvas, 27⅛ × 22½ (68.9 × 57.1)
Signed in blue paint, l.r.: *Childe Hassam;* dated in black paint, l.r.: *1890*
Acc. no. 0897

Purchased from the artist by Macbeth, New York, 1919; PMAG purchase 1921.[1]

A prolific artist and enthusiastic traveler, Hassam painted a variety of outdoor locations: picturesque coastal towns in the Northeast such as Appledore, Newport, and Gloucester; Pacific Northwest sites in California and Oregon; and such cities as New York, Boston, and Paris. Duncan Phillips at one time owned seven works by Hassam, including several beach scenes and a figure in an interior. Eventually he sold or gave away more than half of them.[2]

Washington Arch, Spring is an example of one of Hassam's most celebrated and distinctive themes—the city.[3] Like the French impressionists, Hassam enjoyed the challenge of capturing the bustling activity of the street as well as the charm of tree-lined avenues. Even in his early career, before embracing impressionism, he painted city scenes in which light and atmospheric effects played an important part.[4] By the 1880s he was using a higher-keyed palette and looser brushwork to paint the spectacle of Paris boulevards.[5] When he began making paintings and etchings of New York upon his return from Europe in 1889, Hassam saw a place of comparable beauty and excitement in the fashionable neighborhoods along Fifth Avenue and at Washington Square.[6] As he asserted in an interview, "the thoroughfares of the great French metropolis are not one whit more interesting than the streets of New York. There are days here when the sky and atmosphere are exactly those of Paris, and when the squares and parks are every bit as beautiful in color and grouping."[7] In focusing on the more elegant side of New York life, Hassam equated the city physically with the picturesque capitals of Europe, while also, as Phillips explained, reflecting its "awakening cosmopolitanism of the Nineties."[8]

By depicting the arch on Washington Square, Hassam made the analogy to Paris even more apparent. Designed by Stanford White and erected to commemorate the one hundredth anniversary of George Washington's inauguration, the Washington Arch was a source of great civic pride.[9] Hassam's residence at 95 Fifth Avenue was just north of the square, so he was able to watch the progress of the arch's construction, first as a temporary wooden structure, finished in 1889, followed by a permanent marble arch completed in 1892.

Hassam chose a vantage point at street level, partially blocked by trees; the arch could be seen in the distance at the end of the oblique angle of Fifth Avenue. Although he employed an asymmetrical composition and a light palette, as favored by his French impressionist predecessors, Hassam, like most of his American counterparts, preferred not to sacrifice structure and solid form to the fragmenting effects of broken color.[10] He still sought the momentary and fleeting, however, saying that he "never tired of observing [people] in every-day life, as they hurry through the streets on business or saunter down the promenade on pleasure."[11] Hassam included several pedestrians in *Washington Arch,* along with a street cleaner and a horse-drawn carriage. He remained a detached observer, however, focusing on the larger, overall view and, in Phillips's words, maintaining a sense of "unruffled equanimity."[12] For all the bustle and change, Hassam ignored the New York of tenements and commerce and painted a genteel, sunny, picturesque world.

ET

85

LOUIS MICHEL EILSHEMIUS (1864–1941)

Louis Eilshemius was an eccentric American painter who captured the interest of the avant-garde in the early twentieth century. Born February 4, 1864, in North Arlington, New Jersey, to wealthy German and French immigrants, Eilshemius briefly attended Cornell University but left to study art, first in New York at the Art Students League and privately with Robert C. Minor, then in Paris at the Académie Julian. Back in New York by 1887, Eilshemius moved into a brownstone on East 57th Street, where he lived for the rest of his life while maintaining studios at various locations in New York, including the Holbein Studio Building. After being accepted into two juried shows at the National Academy of Design in the late 1880s and exhibiting his work at New York's Salmagundi Club, Eilshemius grew increasingly frustrated in his attempts to gain the recognition he thought he deserved. Efforts as a playwright, poet, writer of fiction, and lyricist proved equally unsuccessful. In the late 1890s and early 1900s he traveled extensively throughout Europe, North Africa, the United States, and the South Seas. Upon his return to New York he began exhibiting strange behavior, printing self-aggrandizing handbills giving himself such titles as "Grand Parnassian and Transcendental Eagle of the Arts" and writing voluminously to newspapers and art magazines criticizing other artists and praising himself. Eilshemius was catapulted to unexpected notoriety when Marcel Duchamp praised work he had seen at the "Society of Independent Artists First Annual Exhibition" in 1917. Two one-person shows sponsored by the Société Anonyme followed in 1920 and 1924. He had more than twenty-five solo shows between 1932 and 1941, including Valentine Dudensing's two major retrospectives in 1932 in New York. Confined to a wheelchair after an accident in 1932, Eilshemius died December 29, 1941, in New York. The Phillips Collection owns twenty oil paintings and two pencil drawings by Eilshemius.

The Eilshemius Unit

Duncan Phillips began collecting the work of Louis Eilshemius in the late twenties after the eccentric and long-neglected artist had attracted the attention of the New York avant-garde. Following the lead of Katherine S. Dreier, whose Société Anonyme had given Eilshemius his first major exhibitions in 1920 and 1924, Phillips continued to acquire Eilshemius's works during the next decade, at the same time that he was beginning to collect modern art in earnest.[1] Although the circumstances and sincerity of Marcel Duchamp's "discovery" of Eilshemius remain questionable, Phillips's appreciation was clearly genuine and understandable: in addition to Eilshemius's appeal as a neglected independent artist, he was a sensitive colorist and, in his romantic interpretation of landscapes and figures, an heir to several of Phillips's favorite nineteenth-century painters, most notably Corot and Inness.[2]

The first Eilshemius painting to enter the collection was the lyrical landscape *Samoa*, 1907 (cat. no. 88), which Phillips purchased from the Valentine Gallery in 1927. He hung it alongside the work of Eilshemius's American contemporaries and immediate predecessors, saying, "Eilshemius should hang with Homer, Eakins, Ryder to make an American group of four masterpieces of complete originality and freedom from foreign influence."[3] Yet it was not until the next show at the Valentine Gallery, in 1932, that Phillips became enthusiastic about collecting Eilshemius's work in depth; he added two intimate studies of women in interiors and a dramatic vignette, entitled *The Rejected Suitor* (cat. no. 89).[4] The following year he purchased several landscapes from Eilshemius's travel paintings, including another Samoan subject, *Twilight in Samoa*, ca. 1907 (acc. no. 0656); an early Adirondack scene depicting the simple delights of childhood; and a souvenir of one of the artist's visits to France.[5]

In 1933 Phillips exhibited these six paintings, the core of his nascent Eilshemius unit, in an exhibition titled "The Freshness of Vision in Painting." Including two loans from the Stephen Clark collection, it coincided with a show in an adjoining gallery of watercolors by Charles Burchfield.[6] In his catalogue essay, Phillips compared Eilshemius to the "unskilled folk painters of America . . . unaffectedly, spontaneously simple and naive in manner."[7] At the same time, by showing his work with a successful contemporary artist, Phillips tacitly aligned him with modern expression. He continued to spotlight Eilshemius through the years, in 1937 with a loan exhibition of drawings and watercolors from the Valentine Gallery; in 1959 with a show of forty works that originated at the Artists' Gallery in New York; and with loans of paintings from the collection to other museums.

Between 1936 and 1939 Phillips added six more paintings, all landscapes, ranging from picturesque Hudson River views to a dramatic moonlit scene, *The Dream* (acc. no. 0643). In 1939 he wrote a review of William Schack's biography of Eilshemius, *And He Sat among the Ashes*, praising the author for "telling Eilshemius's story and settling his account with the world."[8]

By the forties the Eilshemius unit was complete after the addition of three more paintings, among them one of the artist's magical and richly colored city views, *New York Roof Tops*, 1908 (acc. no. 0648), and three pencil sketches, including the delicate early study *Street in Village Near Biskra*, ca. 1896 (acc. no. 0652). The unit covered a wide range of the artist's prodigious and varied output, with one exception: Phillips never purchased any of Eilshemius's quirky, awkward, sexually explicit nudes.[9] In fact, Phillips shared the opinion of other Eilshemius admirers that the artist's huge body of work, which included carefully crafted works along with sloppy daubings, was in need of thorough editing, and he suggested a "big bonfire . . . of his cheapest and craziest things."[10]

Although Eilshemius faded from the public eye in the late fifties and sixties, by the late seventies, as a result of the scholarly work of Paul Karlstrom and exhibitions at major museums, including the Hirshhorn Museum and Sculpture Garden, his work was the object of renewed interest.[11] He was also featured again at The Phillips Collection: in a special installation in the main building in 1973; as part of the threefold 1976 American exhibition; and in the 1982 "Appreciations: Louis Eilshemius" show.

ET

86

Approaching Storm, 1890

Oil on cardboard, 22⅜ × 26⅞ (57.4 × 67.6)
Signed in paint, l.l.: *Elshemius;* dated in pencil, l.l.: *1890*
Acc. no. 0637 (Karlstrom, 1973, no. 39)

Early history unknown; PMG purchase from Kleeman Galleries, New York, 1937.[12]

87

Adirondacks: Bridge for Fishing, 1897

Oil on canvas, 18 × 34⅞ (45.7 × 88.5)
Signed l.r.: *Elshemius*
Acc. no. 0640 (Karlstrom no. 140)

Purchased from the artist through Valentine Dudensing, New York, 1933.[13]

Approaching Storm and *Adirondacks: Bridge for Fishing* are among the many landscape paintings Eilshemius made of American locations he visited on numerous sketching trips in the 1880s and 1890s. Returning to the favorite haunts of the Hudson River School painters—the Adirondacks, the Delaware Water Gap, and the shores of the Hudson River—Eilshemius painted in a style influenced by his first teacher, Robert Minor, and the French Barbizon School. Duncan Phillips said that Eilshemius's landscapes

86

possessed the "lyrics of light and color and per-
fect atmospheric values which are worthy of
comparison with George Inness and even Corot,
especially the early Corot." In addition, he noted
the artist's tendency to use a tonalist approach,
describing his landscapes as "blonde . . . with
their pearly skies, their thinly and directly
painted woodland dells or translucent open
spaces, their dark and slender trees, and their
tiny little people, usually ladies and children."[14]

Although Eilshemius's landscapes fit within
the tradition of late nineteenth-century Ameri-
can painting, they still betray an eccentric vision
that anticipates modern expression. A sunny,
nostalgic view of pastoral America, *Adirondacks:
Bridge for Fishing* resembles a contemporaneous
landscape by Arthur B. Davies, *Along the Erie
Canal,* 1890 (cat. no. 178), the tiny figures in a
bright, "picture-perfect" world giving it a
quaintly old-fashioned quality, or what Phillips

described as "rural romanticism."[15] Yet its lim-
ited, yellow-saturated palette washes out details
and compresses the space, creating the effect of
a simple child's image and emphasizing the two-
dimensional design elements.

Approaching Storm, by contrast, is ominous
and has eerie colors and intense contrasts of
light and dark. The stormy atmosphere and
surging, swaying forms of the landscape set up a
threatening scenario for the tiny figures running
about. The psychological tensions and emo-
tional expressiveness of the painting separate it
from the landscape traditions that had initially
influenced Eilshemius. Phillips saw Eilshemius's
paintings as a bridge between old and new, and
as possessing the expressive power of El Greco
and van Gogh, prefiguring the "improvisations
on nature" of Bonnard and Marin, and antici-
pating the "subjective abstraction" of Dove and
Tack.[16]

88

Samoa, 1907

Apia, Samoa

Oil on cardboard, 23¼ × 27 (59.0 × 68.5)

Signed and dated l.r.: *Elshemius 1907*

Acc. no. 0650 (Karlstrom, 1973, no. 161)

The artist to Valentine Gallery, New York, ca. 1927; PMG
purchase 1927.[17]

In September 1901 Eilshemius arrived in Apia,
Samoa. In the course of a two-month stay he
produced many pencil and watercolor sketches.
Yet not until 1907, five years after his return
home, did he begin to translate them into oils.
As demonstrated by such paintings as *Samoa,* in
which a native woman stands prominently in
the foreground, Eilshemius was as taken with
the people of the islands as he was with their
exotic surroundings. In this work he emphasized

ET

87

the woman's face by placing it between the areas of light and shadow on the mountain in the background. In contrast to the much looser and freer technique used for the landscape, particularly the palm fronds on the right, the brushwork on the face is exceptionally fine, betraying Eilshemius's academic training and creating the effect of a portrait likeness. It also reveals his attitude toward his subject: Samoa is seen as a romantic, foreign setting, but its people are individuals.[18]

Eilshemius's trip to Samoa and other South Sea islands calls to mind those of other city-dwelling artists such as Gauguin and John La Farge, both of whom also traveled to the South Pacific.[19] Eilshemius was attracted by the exotic, romantic setting, and perhaps by what he saw as a more permissive society. But he was not influenced stylistically by these artists, nor by their decision to travel there. Before his association with the Société Anonyme in 1917, Eilshemius was quite isolated from, and even hostile toward, prevailing "modernist" tendencies in painting. The primitivism of his later years (really only hinted at in the Samoan works) did not necessarily grow out of his contact with Samoan culture but instead emerged from his own peculiar vision.

Samoa appealed to Duncan Phillips's love of a naive immediacy, but it did not fall prey to the amateurish primitivism and "bad taste" he would ascribe to later paintings.[20] Henry McBride described the Samoan paintings he saw in 1924 as "lyric," and he detected in them "a real and contagious lilt."[21] Phillips expressed a similar sentiment in 1933 when he wrote, "The *Samoan Twilight* quietly affirmed its poetry of suggestion and perfect spatial value."[22] The careful spatial construction he admired is also evident in *Samoa*. Eilshemius made the visual transition from the woman to the landscape by placing various details in the middle distance—such as the log and small figure at water's edge. He also had her leaning against a dark fence, which stands out against the light areas of mountain and shore. The result is that while her

figure is relatively large in scale, it does not dominate the composition but instead complements the landscape effectively.

Phillips could also place *Samoa* in the landscape tradition of the French Barbizon School. As he explained: "Those earliest works of Eilshemius were, in some ways, very like early Corot. The skies are sensitive and subtly painted with delicate skill and the values are so beautiful in relation to pattern as they are true in regard to space."[23]

AO

89

The Rejected Suitor, 1915

Oil on illustration board, 20¼ × 30¼ (51.5 × 76.9)
Signed l.r.: *EilshemiuS;* dated l.l.: *1915*
Acc. no. 0649 (Karlstrom no. 497)

PMG purchase from Valentine Gallery, New York, 1932.[24]

The Rejected Suitor is one of several works Eilshemius painted around 1915 that resemble theatrical tableaus. Duncan Phillips said that it was like "an unchangeably perfect scene in a grim and dismal play by Ibsen."[25] Its theatrical quality is enhanced by the device of the "self-made frame," Eilshemius's painted border, which encloses the scene like a proscenium arch.[26] As Paul Karlstrom has noted, these theatrical subjects coincide with a shift in Eilshemius's style from more traditional representation to "artifice and unreality."[27] Using a dark palette in which browns and deep reds predominate, Eilshemius painted figures and settings with a broad, almost caricature-like simplicity. He also stopped using canvas and began painting on scraps of cardboard and cigar-box lids.

It was late works such as *The Rejected Suitor* that garnered for Eilshemius the label of primitive when he was plucked from obscurity by Duchamp and compared to the French "naif," Henri Rousseau.[28] In contrast to Rousseau, however, Eilshemius had received fairly extensive academic training, and he took issue with the primitive label, complaining that "among the

critics' pronouncements I always see the words primitive and naive. Now I am neither. I am the true artist—who shirks to represent mere commonplace matter, but upholds the dictum of Diamonides [*sic*] that a painting should be a silent poem."[29] Phillips noticed an underlying sophistication of design in *The Rejected Suitor,* which features the repetition of ovals, the juxtaposition of horizontal and vertical elements, and "modulations of darks and lights—warmer and cooler areas within the melancholy tone and the dominant shapes."[30] He also concluded that in such works Eilshemius "reveals the fact that now and then he could achieve in that last period a unique and intense expressionism of design and tone—in which laughter and despair are fused with a smouldering passion."[31]

In addition to being a prolific painter, Eilshemius was the author of numerous poems, short stories, songs, novels, and plays.[32] But at this time he was as unsuccessful in getting his plays produced and finding commercial publishers for his writing as he was in gaining recognition for his art, and he seems to have found an outlet for his narrative imagination in painting dramatic vignettes. Whereas *The Rejected Suitor* could have derived from a production he had seen or one of his own plays, it may have been based on personal experience. Phillips suggested that "it is perhaps a memory of a deep personal hurt, of a rankling humiliation in that musty room."[33] In his youth, Eilshemius had had several unhappy romantic encounters that became the subjects of love poems and fanciful reminiscences. In one instance, the mother of the object of his affections would not allow her daughter to become involved with Eilshemius because he was an artist.[34] Although he claimed to have had dalliances with freewheeling artists' models and exotic Samoan women, Eilshemius never married. He appears to have had naive, awkward relationships with women that were reflected in the sexual tension, ambivalence, and bittersweet intimacy of his depictions of them.

ET

88

89

3 THE AMERICAN VISION

Part II: Duncan Phillips and the American Popular Tradition

JANE KALLIR

If The Phillips Collection as a whole reflects a particularly heroic moment in the early history of modern art, its holdings of "popular" or "folk" art represent an equally seminal phase in the appreciation of that genre. Although Duncan Phillips's acquisitions of folk art were not extensive or comprehensive, they are all the more remarkable for their focus and time-proven quality. Not only did Phillips buy with an almost unerring sureness of eye, but he did so at a time when few were especially interested in the field.

Although Henri Rousseau's paintings were exhibited at Alfred Stieglitz's Gallery 291 as early as 1910, and again in the 1913 Armory Show, full-blown appreciation of the "naive" in art did not develop in the United States (or, for that matter, Europe) until after the First World War.[1] It was then that modern art first began to gain wider acceptance, and with the appreciation of modernism's challenge to academicism came a growing interest in artists who, like Rousseau, had of necessity worked outside the academic tradition. The various terms—none of them entirely satisfactory—that were coined to describe this type of art often involved interpretations of the circumstances that had kept the artists in question apart from mainstream Western culture. "Naive" (the designation most often applied to Rousseau) and "primitive" (possibly the most common adjective used for this purpose in the 1940s and 1950s) both had pejorative connotations, implying, respectively, intellectual deficiency and innate barbarism. "Folk" and "popular" were more neutral and had democratic associations particularly appealing to Americans, but "folk" also suggested connections with a crafts tradition that seemed to exclude easel painting, and "popular" came a bit too close to commercial art and mass entertainment. Despite the drawbacks of each of these terms, most have survived to this day, with "folk" generally being the current label of choice.[2]

By whatever name, nonacademic art flourished in the United States as it did in few other nations. Americans had an awareness of European fine arts and crafts traditions that inspired concerted attempts at emulation, but a network of museums, schools, and communications capable of linking the United States to those traditions did not develop until the twentieth century. Geographic isolation thus encouraged American artists to develop ad-hoc solutions

Horace Pippin, detail of
Domino Players, see cat. 95

and, in the process, to evolve a vigorous native folk-art culture. Consequently, the search to find American equivalents to Rousseau yielded bounteous results. The first pioneering exhibitions of American folk art—at New York's Whitney Studio Club in 1924, at the Newark Museum in 1930, and at the Museum of Modern Art, New York, in 1932—focused on nineteenth-century examples. Not until 1938 did the Museum of Modern Art follow up with a presentation of contemporary folk art, "Masters of Popular Painting." By this time, Duncan Phillips had already evidenced a firm commitment to the modern naive, having secured two Rousseaus, *Notre Dame,* 1909 (cat. no. 97), and *The Pink Candle,* 1905–8 (acc. no. 1695), and a John Kane, *Across the Strip,* 1929 (cat. no. 93), in 1930.

The Kane acquisition, coming shortly after the Pittsburgh housepainter's 1927 debut at the Carnegie International and five years before he received proper gallery representation, appears particularly farsighted.[3] It was, among other things, the first museum acquisition of a work by the artist. Considering Phillips's fondness for drawing parallels between American and European art, it is probably no coincidence that Kane—hailed upon his discovery as "the American Rousseau"—joined the collection the same year as the Frenchman. It was undoubtedly also for this reason that Phillips in 1931 purchased Arnold Wiltz's *Along the Seine,* 1928 (acc. no. 2135), almost shocking in its resemblance to Rousseau's *Notre Dame.* Nevertheless, it is clear that the decision to buy the Kane was based on no mere intellectual whim but on a profound attraction to the painting in question. *Across the Strip,* a depiction of the street where Kane lived, may have appealed to Phillips because he was himself a native of Pittsburgh, and he went out of his way to win for himself "that particular picture," even raising the price when the artist balked at his initial offer.[4] Evincing a view that has been confirmed by most critics in the more than six decades since, Phillips apparently felt that Kane's Pittsburgh cityscapes exemplified the artist's greatest strengths. It was with some misgivings that, in 1938, he supplemented *Across the Strip* with a smaller figural work, *Blowing Bubbles,* 1931 (acc. no. 1960), thereby bringing Kane's other principal subject type to the museum.[5]

Phillips's pursuit of Anna Mary Robertson ("Grandma") Moses (fig. 24) was equally forward-thinking and equally dogged. In 1941, following the artist's highly successful debut at New York's Galerie St. Etienne, an exhibition of her work was sent to the Whyte Gallery in Washington, D.C. Because the painting that Phillips acquired from this exhibition, *The Old House at the Bend of the Road,* 1940 or earlier, was apparently always kept in the Phillips family's private collection, it cannot really be cited as the first museum acquisition of a Grandma Moses.[6] That distinction was not earned until 1942, when The Phillips Collection bought *Cambridge Valley,* 1942, from the American British Art Center in New York.[7] In the early 1940s, as Moses gained assurance and practice as a painter, her style developed quickly, and Phillips's next purchase, *McDonell Farm,* 1943 (cat.

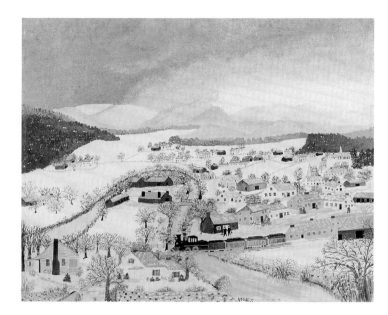

Fig. 24 Grandma Moses and Dorothy Moses at The Phillips Gallery, 1949. Photograph by Otto Kallir. © Grandma Moses/Properties Company, N.Y.

Fig. 25 Grandma Moses, *Hoosick Falls in Winter,* 1944, oil on hardboard, 19¼ × 23¾ in., The Phillips Collection, Washington, D.C., acc. no. 1392. © Grandma Moses/Properties Company, N.Y.

no. 94), far surpassed *Cambridge Valley* in tonal complexity and compositional originality, in effect making the earlier work superfluous to the collection. For a brief period in 1944, Phillips consigned *Cambridge Valley* to the Galerie St. Etienne, but it was not until 1949 that he succeeded in deaccessioning it, as a partial exchange for the collection's most famous Moses, *Hoosick Falls [New York] in Winter,* 1944 (fig. 25). Once again, it took persistence to snare the picture: Otto Kallir, the founder and director of the Galerie St. Etienne, had originally slated *Hoosick Falls in Winter* for a special Moses study collection, but recognizing that The Phillips Gallery would provide

an equally suitable home for the work, he eventually yielded to Phillips's pleas. With *Hoosick Falls in Winter* the collection now had a snow and a summer landscape, both masterful works from what many consider Moses's signature period, and with these Phillips judged his holdings of the artist complete.

Phillips's systematic method of refining and completing the collection is also evident in his choice of works by Horace Pippin. In 1943 Phillips bought *Domino Players,* 1943 (cat. no. 95), arguably one of the artist's finest works; however, his second acquisition, in 1945, *Victorian Interior II,* 1945, did not, upon closer scrutiny, make the grade.[8] In 1946 he convinced Edith Halpert, director of New York's Downtown Gallery, to take *Victorian Interior II* in trade for *The Barracks,* 1945 (cat. no. 96), noting that the former was "not unlike the work of other primitives the world over," whereas the latter offered a "very intimate expression of Negro thought and imagination" and exemplified the artist's "unique vision."[9] Indeed, it may be said that, as with his Moses holdings, Phillips's Pippins represent the two most important strains of the artist's work: home life and the First World War. Thus, with the acquisition of *The Barracks,* Phillips felt no need to pursue the artist's work further.

By the late 1940s, Phillips had conscientiously assembled representative works by three of the four most important American folk painters of the early twentieth century (only Morris Hirshfield is, curiously, lacking). By comparison, however, his approach to nineteenth-century folk art was much more haphazard. One reason for this may be that the vast majority of early American folk art—the so-called limner portraits—did not appeal to him at all. Indeed, John Bradley's *The Cellist,* 1832 (cat. no. 91), is the collection's only "face painting" (a somewhat derogatory expression that Phillips seems to have used to allude to the theory—now largely disproved—that limners appended individualized faces to stock bodies).[10] A "theorem" painting on velvet, of flowers and a butterfly (purchased in 1940 but no longer in the collection), displayed an affinity with Braque's still lifes that was probably more in line with Phillips's desire to trace the "sources of modern art."[11] Phillips's attraction to trompe l'oeil paintings, such as Victor Dubreuil's *Five Dollar Bill,* 1885 (acc. no. 0606), and John Frederick Peto's *Old Time Card Rack,* 1900 (cat. no. 92), may likewise have resulted from a perceived relationship to the cubists' "found object" collages, as well as a more generalized awareness of modernism's redefinition of the object in art.[12] Of all the nineteenth-century American folk paintings in the collection, however, only Edward Hicks's *The Peaceable Kingdom,* 1845–46 (cat. no. 90), with its sure command of form and profound spiritual content, really qualifies as a masterpiece.

The diffuseness of The Phillips Collection's early American folk art holdings bespeaks not so much uncertainty on Phillips's part as the ambiguity that plagues the genre as a whole (and that is reflected in the diversity of terms used to describe it). Bradley, while presumably self-taught, was a professional portrait painter, whereas the creator of the "theorem" was in all likelihood a schoolgirl. Dubreuil and Peto probably would not, today, even be classified as folk artists, although the Dubreuil, particularly, has a certain charming crudeness that argues convincingly for its inclusion in this group. The fact is that the boundaries between folk art and academicism often blurred in the nineteenth century, especially as self-taught artists, through practice and imitation, gradually developed more technical polish. Bradley, for example, became much more academic and, from the folk connoisseur's point of view, much less interesting shortly after painting *The Cellist,* whereas The Phillips Collection's *Peaceable Kingdom,* like all Hicks's later versions of the subject, reveals a proficiency that can hardly be termed primitive.

What Duncan Phillips prized most about folk art was the way it unself-consciously duplicated some of the same discoveries that modernists had made more deliberately. When Phillips, in speaking of Rousseau, noted that "instinct can arrive at the same goal as intellect," he (knowingly or not) echoed Wassily Kandinsky's description of "the great realism" (that is, naive art) and "the great abstraction" as "two roads that lead finally to one goal."[13] More seemingly original, if never fully articulated, was Phillips's idea of linking the playfulness of naive painting with the content-free aspirations of contemporary "art for art's sake."[14] Nonetheless, he was careful to point out that by appropriating only the forms of naive (as well as tribal) art and ignoring its content, the modernists risked producing empty "neo-primitives" without "either sense or flavor."[15]

As folk art has acquired increasing stature as an entity in its own right, it is easy to forget the extent to which its discovery was dependent on the kinship that such artists as Picasso and Kandinsky felt with Rousseau and his self-taught colleagues. It is also easy to forget that the reputations of Kane, Pippin, and many others of their kind were established through early support from such pinnacles of modernism as the Whitney Museum of American Art and the Museum of Modern Art, which not only regularly exhibited contemporary naïves but acquired substantial quantities of their work for their permanent collections.[16] More specialized institutions such as the Museum of American Folk Art have done much to increase our knowledge and understanding of folk art on its own terms, but one cannot help wondering whether, by segregating it from its modernist counterparts, this trend has not also somehow diminished the work. The problem, as Duncan Phillips realized, is that a great deal of folk art does not measure up, and issues of quality can become submerged when examples are dealt with in quantity.[17] That there are, however, folk masterpieces that can stand proudly beside the greatest paintings of this century is a principal lesson of The Phillips Collection—and indeed, one of the principal lessons of modern art.

EDWARD HICKS (1780–1849)

Edward Hicks was born April 4, 1780, in Attleborough (now Langhorne), Pennsylvania, to a family that suffered financial losses during the Revolutionary War. After his mother died when he was eighteen months old, Hicks was raised by a Quaker family named Twining, who gave him religious instruction. At age thirteen Hicks was apprenticed to the Tomlinson brothers, coachmakers in Attleborough, where he spent the next seven years learning the trade. After a short-lived attempt to start his own business and a severe illness, Hicks joined the Society of Friends at Middletown Meeting and moved to Milford (now Hulmville), Pennsylvania, in 1801 to work as a coachmaker and painter of coaches, signs, furniture, and other household objects. He married Sarah Worstall in 1803. Hicks became a devoted follower of the Quaker religion and was soon recognized as a minister himself. He set out on his first of many preaching trips in 1811. Also that year he and his family moved to Newtown, Pennsylvania. Although religion was the dominating force in his life, Hicks continued to paint, except for a brief interval (1813–15) when he worked as a farmer. In 1820, the same year he began easel painting, Hicks visited his cousin Elias Hicks, whose ideological differences from many Quakers resulted in a deep schism in the religion in 1827. Edward Hicks joined his cousin's Hicksite movement, and the controversy is reflected in several of his canvases with the biblically inspired theme of "the peaceable kingdom," of which there are more than sixty versions. Hicks died August 23, 1849, in Newtown, Pennsylvania. The Phillips Collection possesses one late painting.

90

The Peaceable Kingdom, 1845–46

Oil on canvas, 24⅛ × 32⅛ (61.2 × 81.6)
Signed on reverse: *Painted by Edward Hicks in the 66th year of his age*
Acc. no. 0904

Early history unknown; collection of M. J. Strauss, a New York banker; purchased by Edith Halpert for the Downtown Gallery, New York, 1938; PMG purchase 1939.[1]

This version of *The Peaceable Kingdom,* a motif Hicks treated in approximately sixty canvases, was created four years before his death. The inspiration was a passage from the Book of Isaiah, 11:6–8, which was imaginatively poeticized by Hicks himself early in the evolution of the series:

> The wolf did with the lambkin dwell in peace
> His grim carnivorous nature there did cease
> The leopard with the harmless kid laid down
> And not one savage beast was seen to frown.
> The lion with the fatling on did move
> A little child was leading them in love . . .[2]

The painting shares with other late examples of *The Peaceable Kingdom* a new sensitivity to the natural world, and direct observation plays a significant role; indeed, a series of realistic landscapes of his hometown and environs occupied Hicks throughout much of this period. Whereas earlier versions were emblematic assemblages of animals and landscape elements, Hicks now turned his interest away from the purely metaphysical to the formal, giving his images a new ease and unity, reflective, perhaps, of his own increasingly spiritual outlook. Even the anthropomorphic expressions of the animals—particularly the leopard, which may be a self-portrait—project a gentle air, replacing the agitated ferocity of earlier *Kingdom*s.[3] In this period Hicks seemed to revel in a recently developed assurance in depicting spatial recession and atmospheric effects. A sense of realism prevails, apparent in the highlight on the ox's back and the dappled shadows on the leopard and his companions. The light of a hazy afternoon, suggested by white flecks of paint applied to the contours of the forms, permeates the scene, and pictorial harmony triumphs over literal interpretation of the text.[4] Hicks also displayed a new sensitivity in choosing a placid horizontal format; the landscape dominates the figures, and interlocking forms are placed in triangular groupings within the overall design, a wide-based triangle.

In spite of the unprecedented sophistication of the composition, Hicks continued to incorporate forms from popular graphic sources: the grouping of the lioness with her playful cubs, the torque of the bear's head, and the commanding stance of the lion are all direct quotations from contemporary prints, as are the scene of William Penn signing the treaty with the Indians and the delicate profile of the Delaware Water Gap closing off the background.[5]

The unusually quiet mood of the Phillips version of *The Peaceable Kingdom* may reflect Hicks's contrition for an impulsive outburst that he had made in a local Friends' meeting; it may also suggest a premonition of his own approaching demise.[6] As if at last achieving a balance between the allegorical and the natural, Hicks here united these elements in a landscape where the spirit of Isaiah's prophecy is captured as much in narrative detail as in its mood of tranquillity. The present version shares with other late renditions of the theme Hicks's "tender sweep of . . . line, the delicate touch of . . . brush and especially the harmonies of . . . color [that] join in a mellow, all-embracing glow of profound serenity."[7]

LF

90

JOHN BRADLEY (ACTIVE 1831–47)

John Bradley is known to have painted portraits in New York from the 1830s to the 1840s. He may have been the John Bradley of unlisted profession who arrived from Ireland on the *Carolina Ann* in August 1826. Bradley's earliest known works date from 1831, and the first painting that definitely places the artist in the United States is a portrait of 1832 representing the New York merchant Asher Androvette.[1] This and subsequent portraits of the mid-1830s depict residents of Staten Island (then Richmond Island). New York City directories from 1836 to 1847 list Bradley as a "portrait and miniature painter" in an area that now includes Houston Street.[2] Most of his known paintings are dated and signed "I. Bradley" or "J. Bradley," with the less antiquated *J* appearing in signatures from about 1836 on; many are also inscribed "from Great Britton." Bradley's earliest style indicates the influence of British portrait traditions, whereas subsequent works, generally more academic in technique and weaker in spirit, show an American vernacular: bust-length or half-length portraits in larger scale with greater naturalism but fewer details. After 1847 Bradley ceased to appear in the New York directories; no works are known beyond this date. The Phillips Collection owns one early portrait.

91

The Cellist, 1832

Oil on canvas, 17¾ × 16 (44.4 × 40.6)
Signed and dated in black paint, l.r.: *I.Bradley Delin.1832*
Acc. no. 0195

Early history unknown; purchased from Philadelphia dealer W. N. Griscom by the Downtown Gallery, New York, 1937; PMG purchase (from exhibition) 1938.[3]

Upon its first known showing in 1938 at the Downtown Gallery in New York, John Bradley's portrait of a cellist was deemed the undisputed gem of the show.[4] Listed in the catalogue as "found in Pennsylvania," *The Cellist* was said to have been formerly owned by a Philadelphia musician who acquired it in exchange for a rare violin.[5]

By 1945 the painting's significance had been confirmed by Jean Lipman, who observed that "I. Bradley will live in the history of American art as the great primitive painter of *The Cellist*."[6] The portrait's crisp lines, jewel-like tones, and abundance of anecdotal description give the figure unusual appeal and vitality. Because of its meticulous attention to detail, *The Cellist* owes much to the eighteenth-century *portrait d'apparat,* the "conversation piece," which was filled with a multitude of identifying attributes.[7]

Until the recent discovery of *Woman Before a Pianoforte* and *Young Boy Feeding Rabbits,* both of 1831, *The Cellist* alone represented Bradley's early style.[8] Neither efforts to identify the sitter nor extensive analysis of costume, objects, and background represented in the painting yield conclusive proof of whether the picture was created in Great Britain or the United States. The three early pictures as a body, however, do appear to be a product of Bradley's native land, sharing with each other the small scale, myriad anecdotal details, and miniaturized full-length format of sitter and surroundings reminiscent of the portrait d'apparat. Moreover, *The Cellist* was sold to Edith Halpert as an example of "the English school" by its previous owner.[9]

Bradley rendered the musician's striking features—piercing blue eyes, wavy hair, and gaunt face—with characteristic faithfulness. The cellist's status as a man of means as well as a musician is made explicit, yet the homelike setting, the combination of pianoforte and cello, and the hymn book on the piano could suggest an amateur as readily as a professional.[10] Further enticing clues are the black lapel pin, the meticulously rendered gold chain, and the two objects on the bench—possibly a kerchief and a pitch pipe or resin applicator. Most important, the sheet music is legible enough to be identified and played.[11] It is *Mildred Court,* written by W. J. White of Saint Albans in northern London and published ca. 1820. Little is known about the composer, save that he wrote and published music through the 1820s; there is no evidence that he came to the United States (where Bradley would have been working in 1832) or that he played the cello. Thus he is an unlikely candidate for the subject of the portrait. The hymn, possibly the sitter's favorite, refers to Saint Mildred's Church, London, and was no doubt intended to reflect his devout nature.[12]

Typical of autodidactic painters, and certainly of Bradley, are the figure's awkward proportions: an impossibly long right arm rests on a knee whose attenuation defies anatomy; the minuscule feet, clad in black slippers, are no doubt intended to convey the musician's gentility, as is the exaggerated slenderness of his form. Bradley's unusual technique of highlighting the contours of forms to give them greater volume is evident in the area of the sitter's right knee and arm. His trademark addition of white highlights, however, has here been eschewed (or perhaps not yet developed); instead, the paler brown ground shows through, bringing out the somberly hued figure in its equally subdued surroundings. Typical of Bradley's portraits—and indeed of early portraiture in general—are tonal values limited to brown, white, and black, enlivened only by such accents as the ubiquitous red-tasseled curtain and green-figured carpet.

The Cellist was "discovered" in 1938 in a private collection by Edith Halpert, director of the Downtown Gallery. She added the painting to the 1938 exhibition, and by the time the show was sent on to Washington, the painting was published as belonging to The Phillips Memorial Gallery. Duncan Phillips, who had a strong appreciation of music, must have responded to its musical theme as well as to the delightful composition; perhaps he also saw the distant resemblance with Paganini as depicted by Delacroix (cat. no. 10). He hung the painting in the company of works by other painters whom he felt shared Bradley's "primitive" vision, such as Henri Rousseau and Edward Hicks.

LF

91

JOHN FREDERICK PETO (1845–1907)

Born in Philadelphia May 21, 1854, John Frederick Peto was raised by his maternal grandmother. Nothing is known of Peto's early years except that he played the cornet in the city's Fire Department Band. He is first listed in the 1876 Philadelphia directory as a painter residing on Chestnut Street, in a favorite neighborhood of that city's artists. Although he studied briefly at the Pennsylvania Academy of Fine Arts in 1878, he is described as self-taught in their exhibition listings. While still living in Philadelphia, Peto befriended William Harnett, whose influence on his composition and iconography was so strong that later it became a simple matter to forge Harnett's name onto Peto's canvases to fetch more money. A master of trompe l'oeil images of bulletin boards, racks, and doors, Peto was obsessed with worn and shabby objects, and thus his paintings did not appeal to popular nineteenth-century tastes. He never received the public acclaim and support that Harnett did. In June 1887 Peto married Christine Pearl Smith, and to earn money he began to commute to Island Heights, New Jersey, where he played the cornet at camp revival meetings; by 1889 he had settled there permanently, and his career as an artist began to decline. Beset by poverty, family problems, and ill health, Peto died in Island Heights November 23, 1907.[1] The Phillips Collection owns one painting by Peto.

92

Old Time Card Rack, 1900

Old Reminiscences; Old Souvenirs

Oil on canvas, 30 × 25 (76.2 × 64.1)

Signed and dated by unknown hand in black paint, l.r.: WMH (monogram) ARNETT 1900; inscribed by the artist on stretcher in black paint, l.l.: OLD TIME CARD RACK/J.F. PETO/0[?] 1900 ISLAND HEIGHTS N.J.

Acc. no. 1939

The artist to Earle's Gallery, Philadelphia (on consignment?), before 1902; intermediate history unknown; Downtown Gallery, New York, by 1939; on approval (from exhibition) and purchased for PMG (as a Harnett), 1939.[2]

Trompe l'oeil painting, traceable to antiquity and revived in the Renaissance, flourished in the hands of such American artists as Raphaelle Peale, William Harnett, and Peto. A pragmatic and almost documentary illusionism informed the genre in its revival in the United States, where typically literal-mindedness and utilitarianism contradicted the sensuality, cryptic symbolism, and memento mori themes common to the Dutch school.[3] Yet echoes of the *vanitas* canon, the underlying implication that the world's riches are in vain, dominated Peto's pictures. His images became increasingly mysterious, poignant, and enigmatic. *Old Time Card Rack* reflects this trend and substantiates Peto's unique position in American nineteenth-century painting. Rack paintings, a seventeenth-century Flemish tradition, simulated a wooden bulletin board strung with ribbons or strings behind which letters and notes could be slipped for easy reference. Early in his career Peto painted such racks for Philadelphia businesses with letters and notes relating specifically to the patron.[4]

The early history of *Old Time Card Rack*—including its transformation into a signed William Harnett—remains largely a mystery. An inscription by Peto on the reverse, discovered only in 1980, reveals that it was executed in Island Heights, New Jersey, in 1900. The only other clues to the painting's history before 1939 are a label found on its reverse and a letter offering this painting for sale in 1930.[5] Without listing the artist's name or date, the label states the gallery's name and address, "Earle's Gallery at 816 Chestnut Street, Philadelphia," and "*Old Reminiscences,* No. 67, Price: $4,000.00." Most revealing is the high price. Peto, virtually unknown during his lifetime, could not have commanded such a fee. Because Earle's Gallery had moved to a different Chestnut Street address by 1903, the label's date can be narrowed to between 1900 and 1902 unless the old label was retained for a time. Therefore, the forgery, undoubtedly perpetrated for monetary gain, occurred quite early in the painting's life, at a time when Peto himself lived several hours away in Island Heights.[6]

In 1939 Duncan Phillips purchased this painting as a work of William Harnett (1848–92) from Edith Halpert, who had been largely responsible for the "rediscovery" of Harnett in the twentieth century. In spite of her attempts to link Harnett (and American trompe l'oeil still life in general) to surrealism or cubism, Phillips's response seems to have been direct and visual rather than cerebral or theoretical, for in 1949 he received the news of the reattribution to Peto with equanimity. Through his assistant, Elmira Bier, he answered an inquiring colleague that "he bought the painting because he liked it, and not because it was a Harnett."[7]

Old Time Card Rack was reattributed to Peto by Alfred Frankenstein, art critic for the *San Francisco Chronicle*. Frankenstein singled out this work as critical to his reattribution of numerous works to Peto, asserting that it "plays an essential, not to say crucial, role in the story."[8] Frankenstein built his case on several factors: the posthumous dating of two works (Harnett died in 1892); technical data, including obscured or painted-over inscriptions by an unknown hand (including the ones on this painting, although Peto's inscription on the reverse was not discovered until 1980); the representation of objects known to have belonged to Peto; and stylistic comparisons of both artists' work. The posthumous dating had been explained by modern appreciators "as a little surrealistic *jeu d'esprit* on [the artist's] part," but Frankenstein considered this opinion an imposition of twentieth-century values on the work of a nineteenth-century artist.[9] Laboratory studies indicated traces of the original Peto signature and date in the lower-left corner of the painting's front, which had been scraped away and overpainted. Similar traces—though very faint—appeared beneath Harnett's name and address on the envelope depicted in the painting.[10] Frankenstein further established the stretcher to be of a type used frequently by Peto but never by Harnett. The oval reproduction of Lincoln pictured in *Old Time Card Rack* has the same slight tear at its top as one found in Peto's Island Heights studio. Finally, Frankenstein's stylistic analysis (and that of Lloyd Goodrich, in the same year) at last repudiated the contention that Harnett had painted in two distinct styles, establishing Peto's as a soft, impressionistic, fuzzy style and Harnett's as one that was hard-edged and linear.[11]

Duncan Phillips was probably attracted by the somber monumentality of the composition. The painting achieves stability through an underlying triangular framework, the base of which is formed by the stray, unreadable page at the lower right and the fragmented edges of the torn green card at the left. The objects and the rack itself act as abstract elements, interweaving and overlapping in a series of subtle planar and coloristic links and directing the eye to the most intense color-note in the painting: the high-keyed yellow of the envelope. From there, the yellowed image of Lincoln leads back down into the composition. John Wilmerding theorizes that the Lincoln portrait, which was also included in about twelve more of these last rack pictures, evokes both the postwar malaise of Peto's generation and the deeply personal tragedy of his own father's recent death.[12] The almost funereal starkness of *Old Time Card Rack* contrasts markedly with the anecdotal clutter of many of Peto's earlier rack pictures.[13] The worn, tattered objects in this painting—pages of unreadable text, gutted labels, note fragments, closed envelopes, and the faded photograph—defy straightforward decoding. Even the occasional name or phrase, such as the prominently placed "Proprietor" on the brown envelope or the barely visible "JONES" on the faded card, confound through lack of context. Perhaps Peto intended them to represent an elegy of the human presence reduced to its discarded incidentals.

LF

92

JOHN KANE (1860–1934)

In his art and life, John Kane invites comparison with another naive yet passionate artist, the great French primitive Henri Rousseau. Born John Cain in Scotland of Irish parents August 19, 1860, Kane left school at the age of nine to enter the mines. His stepfather sent for him from the United States, and Kane dug coal in the South for two years, earning a reputation as a rowdy but hard-working laborer. In Alabama he began to draw rough landscapes, memories of slate drawings he had done in Scotland. Homesickness caused him to join his family in the North, and by 1890 he was at work paving the streets of Pittsburgh and McKeesport, Pennsylvania. A train accident at the age of thirty-one severed his left leg beneath the knee, forcing him to work temporarily as a watchman. Eventually he recovered sufficiently to hold a job painting freight cars, and he often sketched landscapes on the cars before covering them with paint later in the same day. For a short while he also enlarged and tinted photographs for mining families. The death of an infant son catapulted him into a cycle of drinking and despair, which in turn caused long periods of absence and wandering during which he worked as an itinerant house painter and carpenter. By the end of the First World War Kane was again in Pittsburgh, where he spent the remainder of his life. In 1927 he entered the Carnegie International Exhibition and sold a canvas, but he remained unaffected by either critical praise or money. He remained equally unfazed by a controversy in the early 1930s concerning his having created portraits by painting over photographs. Late in life, he took great pride in having been almost seventy when he painted his last house, at which point he was still able to climb the scaffolding. He died of tuberculosis in Pittsburgh August 10, 1934. The Phillips Collection owns two paintings by Kane.

93

Across the Strip, 1929

Old Pittsburgh (DP)

Oil on canvas, 32¼ × 34¼ (81.9 × 86.9)

Signed and dated in white paint, l.r.: *JOHN KANE/1929*

Acc. no. 0959 (Arkus no. 121)

PMG purchase from the artist (through Carnegie International Exhibition), 1930.[1]

A poor area of Pittsburgh known popularly as the Strip and described by an anonymous social reformer as one of the city's "gravest social problems" became Kane's home in 1929.[2] Henceforth, the city's industrial landscape became the focus of his work. Although many sites have been identified, the exact location (or locations) from which Kane painted *Across the Strip* is difficult to determine because the buildings, including Kane's former dwelling, were razed in the 1970s. One reviewer's claim that Kane's front porch served as the vantage point is attractive but unconfirmed.[3] Kane may have followed his usual practice of sketching multiple views on site and arriving at a composite in his studio.[4] Kane described the area in his autobiography, in a section entitled "I Move to the Strip": "It is a poor district but an interesting one. All about are produce yards, wholesale places for food. There is life and activity, stir and bustle. The Pennsylvania Railroad comes right in along Liberty Avenue and makes one side of the strip, for above it is a high bluff. The Allegheny River makes the other border and it is lined with produce yards and storehouses. Across the river is the Heinz pickle works and the many factories and mills of the North Side. There was plenty to see and draw. I made good use of it in my art work."[5]

In this painting Kane lovingly depicted his neighborhood and its environs in minute detail. It derives its vitality from the evidence of human labor that is catalogued with energetic concentration: each brick and shingle gives testimony to Kane's firsthand knowledge of the trades at which he earned his livelihood for sixty-six years. He included broken windows, nesting birds, crumbling brick, women putting out laundry, and the calligraphy of commercial signs, which he could not possibly have read from his distant vantage point. Today these signs are a faithful record of Pittsburgh's dominant industries and enterprises: Heinz, P. R. Butler Co., and Pittsburgh Maid Bread. His practice of including portraits of friends and neighbors in his paintings invites speculation: Is the prominent profile of the bread man a self-portrait, and is the solid woman by the doorway Kane's wife?

Kane's all-embracing eye incorporated several views at once, compressing and adjusting them—like the stacked perspectives of a miniaturized pop-up diorama—to create a single dense composition with a color scheme restricted to shades of rust and green.[6] From this careful process of assembly flows the strength and unity of the finished work and its dominant theme: Kane's beloved city. This democratically additive vision, the hallmark of his style, places him squarely within the American folk tradition.

Upon seeing this painting at the Carnegie International, the critic Henry McBride pronounced Kane a poet and added that the painting "in some way . . . touches the heart. In fact it was the only picture in the whole collection that did give me that stir of the pulses that Emily Dickinson said is the true test of poetry."[7] McBride was not alone in noticing the painting. Attracted to what he termed "the honesty of [Kane's] point of view and the quaint charm of his unconscious style," Duncan Phillips purchased *Across the Strip* from its public premiere, making The Phillips Memorial Gallery the first museum to own a Kane painting. At its first Washington showing, Phillips, whose own family was from Pittsburgh, changed its title to *Old Pittsburgh* and exhibited it as an example of "Pictorial Language of the People, Direct and Spontaneous." Phillips went so far as to compare Kane's *Across the Strip* with Picasso's *Small Abstraction,* claiming that "instinct had arrived at the same goal as sophisticated intellect."[8]

LF

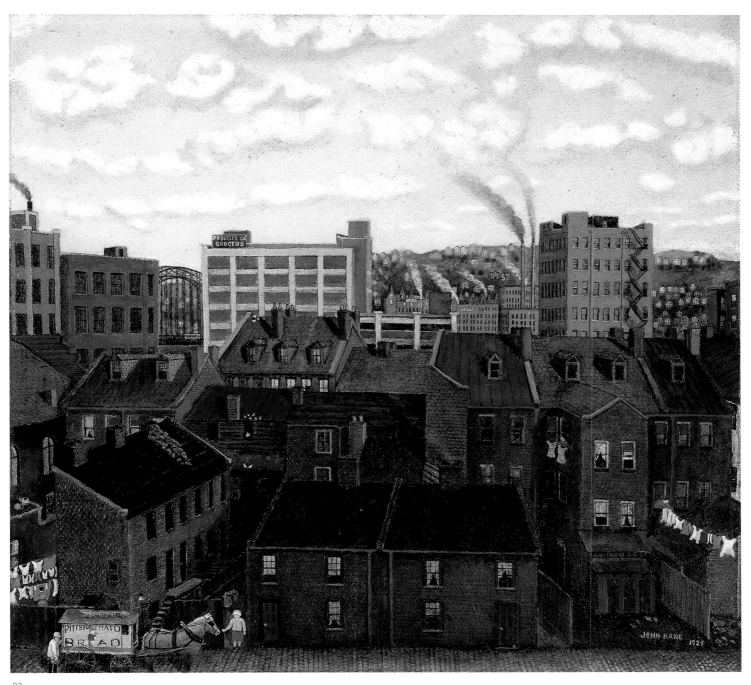

93

Born in Greenwich, in upstate New York, September 7, 1860, Anna Mary Robertson received little formal education and spent her girlhood working on her parents' farm. At the age of twelve she left home to cook, clean, and care for neighboring families. In 1887 she married a farmer, Thomas Salmon Moses, and moved with him to Staunton, Virginia. There she continued her life of hard work and eventually gave birth to ten children, five of whom survived. Eighteen years later the Moses family returned north to run a dairy farm at Eagle Bridge, New York. Not until the death of her husband in 1927 did Moses begin to paint in earnest. She came to painting through embroidered yarn pictures; when arthritis curtailed her sewing, her sister suggested she try oil painting. Although her early works relied on illustrated books and prints, she gradually developed her own sense of color and design. Her range of subject matter was narrow—the farm life she had always loved—but she was a master of it. After first showing her paintings at county fairs, Moses exhibited several works in a local store in 1938, where they were seen by New York City collector Louis J. Caldor. By 1940 she had had her first solo show at the Galerie St. Etienne, New York, and Gimbel's department store displayed her works at Thanksgiving time. Her popularity spread even further when her first Christmas cards were issued in 1946. She was befriended by presidents, awarded two honorary doctorates, and became the recipient of many accolades during her lifetime. Moses died December 13, 1961, at the age of 101 in Hoosick Falls, New York. The Phillips Collection owns two paintings.

94

94

McDonell Farm, 1943

Oil on hardboard, 24 × 30 (60.9 × 76.2)
Signed in black paint, l.r.: MOSES; artist's inscription on reverse (concealed by new backing): *Painted December 1943*
Acc. no. 1393 (K313)

The artist to Galerie St. Etienne, New York, 1944; PMG purchase 1944 (from exhibition).[1]

McDonell Farm was one of the paintings Moses selected for commentary in her book *Grandma Moses: American Primitive*. The passage describes not the painting but farm life itself, as if the artist were seeking to create a parallel for her visual description of the rural ideal. She was inspired by the children's nursery rhyme "Old MacDonald Had a Farm" (misspelled in her title).[2] The myriad clusters of people at work, children at play, and animals in the pasture are dominated by one of her most muted and poetic landscapes. Moses culled her sources for the vignettes and figural groupings from popular media, such as magazine illustrations, greeting cards, and advertisements.[3] She traced the contours of figures and buildings and incorporated them into her compositions, carefully saving the clippings for future use.[4]

Grandma Moses's intuitive balancing contrasts—greens and browns, figural groupings and empty space, abstract pure color and narrative detail—are unusually sensitive in this lyrical landscape. The strength of design and gentleness of tone are probably the qualities that attracted Phillips. In 1949 he added another work to the collection, *Hoosick Falls in Winter*, 1944 (see fig. 25), from her solo exhibition at his museum. That same year President Truman presented her with an award from the Women's National Press Club, and on that occasion the artist visited the show (see fig. 24).[5]

LF

HORACE PIPPIN (1888–1946)

Horace Pippin, a self-taught African-American painter, was born February 22, 1888, in West Chester, Pennsylvania. At the age of three Pippin moved with his family to Goshen, New York, where he attended a segregated one-room school. When he was ten years old, he answered a magazine advertisement and received a box of crayons, paint, and two brushes. In 1903 Pippin left school to support his ailing mother, and after her death in 1911 he moved to Paterson, New Jersey, where he worked at packing and crating pictures and furniture; he later worked as an iron molder. He enlisted in the army in 1917. Seriously wounded in France, where he received the French Croix de Guerre, he left the army in 1919 with a crippled right arm. Pippin married in 1920 and returned to West Chester; by 1929 he had begun to produce burned-wood panels. In 1931 he completed an oil painting about the war, a therapeutic expression that provided an outlet for his memories and acted as a catalyst for his career. He was the first African American to have paintings accepted by the West Chester County Art Association, and his importance was noted by its president, the scholar and collector Christian Brinton, as well as by the painter and illustrator N. C. Wyeth. Pippin became known in the region, and in 1939 the Robert Carlen Galleries of Philadelphia became his dealer. In 1940 Pippin received his first formal instruction in art when he was invited to attend lectures at the Barnes Foundation in Merion, Pennsylvania, but his attendance was sporadic and brief. Among his most renowned works are his three paintings of John Brown, the abolitionist. Later he created a series of paintings based on the Bible and on the work of Edward Hicks. Pippin died July 6, 1946, in West Chester. The Phillips Collection owns two paintings from the end of his career.

95

Domino Players, 1943

Dominoes

Oil on composition board, 12¼ × 22 (32.3 × 55.8) [irreg.]
Signed and dated l.r.: H. PIPPIN./1943.
Acc. no. 1573

The artist to Robert Carlen Gallery, Philadelphia; PMG purchase through the Downtown Gallery, New York, 1943.[1]

Shortly after acquiring this painting, Duncan Phillips wrote to Edith Halpert of the Downtown Gallery: "The [purchase of the] Pippin 'Dominoe [sic] Players' is certainly no mistake and in this case the wisdom of my immediate

Fig. 26 Dr. Albert Barnes and Horace Pippin in front of Pippin's *Domino Players* on the occasion of the painting's first exhibition at the Pyramid Club, Philadelphia, 1943. Photograph by John Mosley. Charles L. Blockson Afro-American Collection, Temple University, Philadelphia.

decision was confirmed on receipt of the picture."[2] The artist himself was aware of the special position this painting had in his oeuvre; at its initial showing at the Pyramid Club in Philadelphia, he hoped to bring it to the attention of Dr. Albert Barnes, who was to speak at the opening (fig. 26). Barnes did not buy the work, although it won first prize.[3]

The intimate interior setting of *Domino Players* is characteristic of Pippin. He explored this theme in a series of paintings that shows this kitchen, and a matriarchal figure usually dominates the scene. He drew on memories of his own childhood, of family members and friends at their everyday activities—caring for children, praying, quilting, smoking, playing games—and created a portrait of African-American family life in the era before the Second World War.[4]

Pippin placed two members of his family in the center of activity. The one at the right may represent his mother, Christine, wearing a polka-dotted blouse, while a woman who may be Pippin's grandmother smokes her pipe and observes the game of dominoes.[5] The dominoes spill toward the family matriarch, a former slave who claimed to have witnessed the hanging of John Brown in 1859.[6] The dominoes build a wall—woman to woman, generation to generation. The boy, perhaps Pippin himself or his

younger brother, John, appears lost in contemplation. He is the only male member of this group, placed protectively between two strong women. The cold whites, grays, and blacks of the barren room are complemented by the colors of the quilt and the vibrant reds placed strategically throughout the painting. Visual tension is achieved by the slight tilt of the solid horizontals of the floor and table, even as the strong verticals of the doorway, window frames, and walls reestablish the stability of the picture's composition and provide a firm vertical support for the figures.

The serenity of the scene and the Sunday evening demeanor are disturbed by the exaggerated size of the sharp open scissors on the blood-red scrap of cloth, the ferocious teethlike flames of the coal fire, and even the tongues of red flame in the oil lamps. All are presented as disproportionate signs of danger, as only a child would perceive them.

Many of the objects in *Domino Players* appear in two other interiors also painted in 1943, *Saying Prayers* and *Sunday Morning Breakfast*, and are also found in later paintings, although the shelf is rendered differently in each case.[7] Pippin's attention to detail and his love of decoration—seen here in the shelf's design pattern—are the only notes of elegance in the unadorned environment. The doorways, the

95

partially shaded window, the coal-burning stove, and the coal bucket and shovel appear with little variation in two later paintings, *Saturday Night Bath* and *Christmas Morning Breakfast*.[8] The matriarch's broken chair in *Domino Players* is in virtually the same position in *Sunday Morning Breakfast*. These two paintings, and even *Saturday Night Bath,* indicate the importance of the day of rest in the lives of people whose existence was dominated by hard work. In these works Pippin has caught the long quiet hours of all childhood Sundays. Despite these similarities in theme and content, however, *Domino Players* stands out for its emphasis on the family group, whose members here loom larger and appear more united and intimate than in any other Pippin interior.

<div align="right">WK</div>

96

The Barracks, 1945

Oil on canvas, 25¼ × 30 (64.1 × 76.2)
Signed l.r.: *H. Pippin*
Acc. no. 1452

The artist to Downtown Gallery, New York, by Nov. 1945; PMG purchase (from Whitney exhibition) 1946.[9]

In exchanging an elaborate still life, *Victorian Interior,* for this painting, Duncan Phillips showed a preference for the somber monotones and "restrained colors, black, white, gray, with touches of red" found in this picture.[10] Though vastly different in mood from *Domino Players, The Barracks* shares with that painting a strong abstract design and an evocative sense of place—two qualities dear to Phillips. Both pictures are a synthesis of memory distilled into images of great power.

In *The Barracks* Pippin drew on memories of the First World War, the theme that prompted him to begin drawing in 1917–18.[11] In March 1917 Pippin joined the New York State 15th National Guard, an African-American unit that became the 369th Infantry Regiment when it was incorporated into the U.S. Army. Pippin's entire war experience abroad centered in France. He was wounded and returned to New York in January 1919, yet it was not until 1945 that this crowded, claustrophobic memory of the animal-like existence of war surfaced. Where another artist might have approached the loss of identity that accompanies military service with a bird's-eye view of numerous soldiers in formation, Pippin

96

was selective. By including a few individual soldiers arranged on a grid, he evoked the painful quashing of identity that war brought on. Moreover, the painting also serves as a poignant reminder of segregation even in the face of battle. As Judith Wilson states, Pippin's "forties war-related canvases condemn the hypocrisy of a segregated nation playing the role of international guardian of freedom."[12]

That this is one of Pippin's most carefully composed paintings is evidenced by the fact that he executed the theme in two versions.[13] Furthermore, the placement of figures, scale, color, and form undergo changes in the Phillips work, and these adjustments belie the apparently intu-

itive ease and immediacy of composition suggested by the strength and simplicity of his finished works.

By including an ashen floor in the foreground, Pippin both softened and lightened this painting. This area appears to be lit by an unseen source much stronger than the candle-light by which the men work or read, perhaps a result of Pippin's method of working at night under a two-hundred-watt bulb and thus presenting sharper contrasts.[14] The eerie light, and the wide perspective that interrupts the sense of spatial continuity, detach the scene from the viewer's space, evoking a universal image of the forlorn monotony of soldiers' lives in wartime.

<div align="right">LF</div>

4 MODERNISM IN FRANCE

Part I: Bonnard, Matisse, and the School of Paris

ELIZABETH HUTTON TURNER

At the core of Duncan Phillips's understanding of modernism was a reverence for painters whose mastery of color had the power to evoke great emotion. When Phillips spoke of color, he meant "expressive" color, which he defined variously as "color not applied to, but identical with form," color not "limited and local" but as "the direct instrument of painting."[1]

Starting with Bonnard, Phillips explored a range and depth of color through the School of Paris that would become the signature of his collection. Remarkably, in 1925, more than eight years after he set out to collect modern art, he was still lacking works by Bonnard, as well as Braque, Derain, Dufy, and Rouault. Equally remarkable is that this omission was corrected in a feverish span of twelve months of buying and selling in 1927. Why was he so late in coming to the School of Paris? What shift in taste accompanied his arrival?

Phillips's initial omission had been deliberate, reflecting a prejudice against the Parisian avant-garde that he had held since his visit to Paris in 1912 at the time of the cubist challenges at the Salon des Indépendants. He had also witnessed, even reviewed, New York's Armory Show in 1913 and soon after published a wholesale rejection of it.

Faced for the first time with abstraction and revolutionary new forms, Phillips saw only artists who had given themselves over to bloodless theories and ideas. He singled out Matisse, whom he saw as the leader and supreme theorist of the entire lot, for his "exploitation of . . . primitive . . . patterns not only crude but deliberately false." Perhaps most damning in Phillips's eyes was the perception that the Parisian avant-garde had cut itself off from the history of styles—particularly the gains of nineteenth-century artists whom he believed had begun to convey "beauty in modern life" through their "mastery of simplification and synthesis."[2]

Predictably, Phillips's earliest selections never ventured far from the realm of representation. In 1925 the lineup in his Main Gallery went from Courbet, Daumier, and Davies to an adjacent wall of El Greco, Kent, Lawson, Ryder, Sloan, and Twachtman. Implicit in such an arrangement was Phillips's developing canon of modernism, which ascribed "great rivers of artistic purpose" to both historical and contemporary works.[3] One might legitimately ask, as Phillips no doubt did, what Matisse and those who had once composed his band of

Pierre Bonnard, detail of *The Palm,* see cat. 104

fauves would add to a combination of romantic and realistic artists known for relatively somber palettes. Yet one painting on the north wall of Phillips's Main Gallery would soon suggest new alternatives.

Renoir's *The Luncheon of the Boating Party,* 1881 (cat. no. 50), had been an abiding presence in the Main Gallery for almost two years. It remained Phillips's stunning but singular tribute to an artist whom he saw as "the modern Titian." At that time he little suspected that Renoir, the good gray genie of the nineteenth century, "the colorist who cannot rest from color," would soon invite the very French radicals Phillips had most sought to avoid.[4] The collector, like most Americans in the early twenties, had no hint of the shifting ambitions of the prewar avant-garde.

In 1914 the great cataclysm of war had indeed disrupted the avant-garde, sending them away from Paris or leaving them on their own to establish new priorities that were only beginning to surface in 1916. In what Gertrude Stein called "a changed Paris," looking to the past became a prescription for choosing a future direction. Classicism in this context did not signify a particular style but inferred a kind of serious or mature intent clearly separate from avant-garde antics. Referring broadly to a "French School" that was built on "the daring innovations of French painters through the nineteenth century," the critic Guillaume Apollinaire exhorted his compatriots "to go beyond the most audacious experiments of contemporary art in order to rediscover the simplicity and freshness of the first principles of art."[5]

In 1916 and 1917, as if laying claim to their inheritance as colorists, Matisse and Bonnard traveled south on separate occasions to seek out Renoir, then a fragile octogenarian in Cagnes. From that point on, a luminism inspired by Mediterranean light would dominate their work. It was as if they picked up a lost thread of something that had been overlooked in the flurry of avant-garde revolt: the significance of color. But they found that the public taste had shifted toward more radical expressions. Bonnard later recalled: "When my friends and myself wanted to pursue the researches begun by the Impressionists and to attempt to develop them, we tried to go farther than their naturalistic impressions of color. . . . But the march of progress has speeded up, the public was ready to accept Cubism and Surrealism before we had reached the goal we had set ourselves. We found ourselves so to speak hanging in mid air."[6]

As early as the fall of 1923, the dealers Paul Rosenberg and Walter Fearon showed Phillips examples of the "new Matisse." Even though this exposure to contemporary French painting was enticing, he was content to survey what he suspected was the latest French fashion away from the New York art market, at the 1925 Carnegie International Exhibition in Pittsburgh. Here, indeed, a contemporary French painting struck him like a revelation, though it was not the one anticipated by his dealers. Bonnard's *Woman with Dog,* 1922 (cat. no. 102), stood out "like a jewel," and he cabled the museum director, asking him to put the painting on hold. Twelve telegram exchanges later, he had convinced Bernheim Jeune, Bonnard's gallery, to let him pull the painting from the tour.

Never had Phillips seen such a combination of ecstatic and evanescent color in a twentieth-century work. He wanted its effect to register immediately in his collection. Something in Bonnard's hypnotic commingling of figuration and color took Phillips back to Renoir. Perhaps he found the shadow of Renoir's beloved Aline and her tousled pup in Bonnard's rendering of his companion Marthe and her pet. In any event, soon after the purchase he wrote of the two artists' shared genius for color: "What [Bonnard] has done is to carry his observations of the evanescent, especially of the movements and comminglements of color in light and shade, to hitherto undreamed subtleties of suggestion. He is the true descendant of the sensuous Renoir, but more sophisticated, less robust and normal."[7]

The coincidence of Bonnard's postwar rebirth as an impressionist and Phillips's maturing understanding of formalism unlocked a new aesthetic door for his collection. Bonnard's color—his seductive high-keyed distortions and transformations, his luscious vermilion and violet, which are so different from Renoir but equally "alive" or inventive—was irresistible to Phillips. Bonnard's iridescent, atmospheric color hugged the edges of representation and abstraction. It enveloped and celebrated everyday modern life, then, spreading like an opalescent stream, it liberated Bonnard's inner vision. Phillips identified this new color with both the historical purposes of the works in his Main Gallery and the new formal challenges of modernism.

After arriving at this understanding, Phillips came to see "the continuity of great tradition in French art," accepting Bonnard and his contemporaries as descendants of "an old family" that had renewed itself.[8] Within a year of his first purchase, almost certainly with Matisse's new Persian arabesques in mind, Phillips wrote that Bonnard "prepared the mind of the twentieth century for even greater freedom of sensation than the impressionists had made possible and announced the coming of influences no longer Greek but Oriental."[9]

When he acquired in 1926 Matisse's *Anemones with a Black Mirror,* 1919, Phillips bridged the "short span" leading from Bonnard's evocative sensations to demonstrative color.[10] He must have appreciated that in the hands of a lesser artist the daring, dark oval mirror would have ruptured rather than unified the daubed clusters of red and blue flowers. Indeed, Renoir's great accolade for Matisse had concerned the color black. "How do you do it?" Renoir asked him. "If I were to put a black like that in a painting, it would stick right out."[11] And yet Phillips remained restive in Matisse's "plastic universe," maintaining that for him the painting "just misses ecstasy."[12] Although Phillips wanted the analytical light and systematic color of Matisse's contemporary painting from Nice to serve as a counterpoint to Bonnard's instinctive design, the right example always eluded him.

At this time, Phillips may have been the only major American collector with any hesitancy about Matisse and yet with great enthusiasm

for Bonnard. He observed that whereas the first was "breathlessly followed and acclaimed," the second was denounced as "a false prophet of escape from the hard facts of modern life." Faced with these criticisms, Phillips diagnosed America's sensibility for color as "underdeveloped."[13]

Although in 1927 Phillips may have been the first American museum director to mount a survey of contemporary French paintings, his selections over the next decade took a particular and peculiar turn away from the mainstream. He almost completely missed surrealism and neoplasticism and focused on Bonnard and three other colorists in the School of Paris—Georges Rouault, Raoul Dufy, and Chaim Soutine.

In 1931 Phillips's initial preference was for a Rouault landscape of 1930, where dark-blue diagonals engulf the conflict of the protagonists and rising streaks threaten to snuff out the yellow-orange sun. Moved by this arrangement of color, Phillips renamed the painting *Tragic Landscape* (acc. no. 1676). Rouault's late oils, purchased in the late 1930s, had weighty stretches of saturated color that were added layer upon layer, providing an equally resonant vision of pathos that spoke to the growing discomfort of a generation facing the shadows of yet another war in Europe.

Concurrently, Phillips turned to Dufy for an opposing tone. For Phillips, Dufy was the supremely uncomplicated extrovert—the *boulevardier* out and about, covering the social circuit from the Paris Opera to Versailles, from the regatta at Joinville to the race courses at Epsom. Phillips celebrated Dufy's spontaneity and exuberance, and saw technical virtuosity underlying the artist's seemingly simple renderings. He wisely distinguished Dufy's bright prismatic color from impressionism, a popular analogy of critics at the time. Citing the counterpoint of calligraphic line and ambient tone, he looked instead to the precedent of the Japanese printmaker Hokusai.[14] In 1944 Phillips brought out and exhibited Dufy, like some stored and treasured wine, to celebrate "liberated France."[15]

In 1940, when the reality of war closed Europe off from America, Phillips associated French painting with a more vulnerable, expressive vision relying heavily on Soutine's anxious impressions from the French countryside. In the summer of 1939 Soutine's lush paint and spiraling brush described the journey of two small, shrouded children bracing against the wind as they rush out of a towering gray-green forest, down the road to L'Isle-sur-Serein, a route that would offer little hope of escape for Soutine when Hitler's military turned westward. Phillips's first purchase, *Return from School After the Storm*, ca. 1939 (cat. no. 127), was among the last of Soutine's works to make it out of Europe. Phillips continued to draw closer to the more vividly grotesque aspects of Soutine's vision. His last purchase, *The Pheasant*, ca. 1926–27 (cat. no. 124), is the earliest Soutine in the collection. The bird's withered form, blue-black in the neck with rivulets of red, recalls the time when Soutine walked Parisian markets in search of the perfect ripe and rotting fowl for his dead-bird series. Here indeed are the pure applications of fauve color that Phillips, the young poet, had found

distasteful and crude at the time of the 1913 Armory Show. A little more than a generation later, he found something masterful in this painting of an attenuated carcass writhing with strokes of color.

Remarkably, also in the 1940s and after many trades, Matisse finally came to rest in the collection, not in a retrospective moment of exuberant Nice-inspired color but in a revealing moment of reckoning from 1916, when the artist was reordering his pictorial priorities. In *Studio, Quai Saint-Michel* (cat. no. 109), the austere black line that Matisse once used to describe free-flowing arabesques now marks the floor and metes out the walls and window in a narrow, slightly vertical pocket of studio space where the artist's model, empty canvas, and chair await him. The tonality of all his color is so evenly matched that the red of the couch and the blue of the water and sky do not compete with the yellow-brown-gray of the interior. The critic John Russell once ascribed something penitential to this studio overlooking the Palace of Justice.[16] Certainly at this moment Matisse recanted whatever distractions of color may have previously kept his attention from concerns of pictorial light and space.

The pictorial suggestions of the French window and its vista in Matisse's painting indeed found a companion in Bonnard's *The Open Window*, 1921 (cat. no. 101), which Phillips had owned since 1930. Both works bring to the artist's space a sense of time and depth from the world outside. Phillips saw this most clearly when he wrote that Bonnard "with his brush opens a window" on a "new world of soaring wings in space and of subconscious life explored."[17] Whereas Matisse's black lines work to combine or perhaps balance the differing suggestions of interior and exterior realms, Bonnard melded the warm and cool tones of daylight and closeted shadow, creating a daydreamlike atmosphere. Bonnard's sleeper reclines in a hot steamy room of yellow, orange, and violet. The blue cat leaps, catching the tone of the window shade, which stands askew before the brilliant lavender sky and the vaporous, leafy green-yellow canopy. While Bonnard achieved unity of surface by way of great fields of simultaneous color and scumbled paint obscuring boundaries, Matisse achieved it via a point and counterpoint of the intuited lines that create them.

Although some would mark him tardy, Phillips believed that he had arrived just in time, referring to this moment as "a period of great painting."[18] The experiments for which the avant-garde had banded together in the past seemed only a preparation for future personal expressions and, eventually, grand summations destined to have the scope and scale of masterworks. Who was the greatest modernist? Referring to Bonnard at The Phillips Collection, Matisse once told Phillips, "He is the best of us all."[19] It was Phillips's great insight to insist on the modernity of Bonnard's mature style while others in America were dismissing him as anachronistic. Indeed, the legacy of Phillips's collection is shared with Bonnard, whose color still has the power to inspire future challenges and, yes, to enchant. As Bonnard himself promised in his journal in 1946: "I should like to present myself to the young painters of the year 2000 with the wings of a butterfly."[20]

HENRI ROUSSEAU (1844–1910)

Henri Rousseau's naive style of painting garnered notoriety and prompted emulation among the Parisian avant-garde, earning him a place in nascent modernism. Rousseau was born May 21, 1844, in Laval, France. While working in an attorney's office in Angers, the young Rousseau was found guilty of petty theft, and to induce the judge to lighten his sentence, Rousseau enlisted in the Fifty-first Infantry Regiment. Contrary to rumor, he was never sent to a foreign country but spent his military service in France. Upon his discharge he entered the Paris municipal toll service as a *gabelou* (toll collector), a job requiring him to wander the streets and quays of Paris. His earliest artistic activities date from 1877. Within eight years, he had derived his own self-taught style, although an introduction from a friend brought him advice from Adolphe-William Bouguereau, Léon Bonnat, and Jean-Léon Gérôme. When his works were refused at the Salon, he paid the twenty-five francs necessary to permit him to hang canvases at the Indépendants exhibition. By 1885 his superiors at the toll service placed him in locations where he could paint. In 1893 he retired, determined to paint full time, and thereafter his life was a continual struggle against poverty. By 1894 the critics attacked his work so severely and unrelentingly that even the Indépendants wavered in their support. He was successfully defended, however, by Toulouse-Lautrec, Alfred Jarry, and later by the poet and critic Guillaume Apollinaire. Placement of a painting in the fauve gallery of the Salon d'Automne of 1905 resulted in much attention. Although financial success eluded him, he began to enjoy popularity among the avant-garde: Robert and Sonia Delaunay praised and supported him and acquired many of his paintings; Picasso held a fête in his honor; and Kandinsky created a Rousseau cult in the Blaue Reiter circle. Nevertheless, he died impoverished and alone September 4, 1910, in Paris. He is represented in The Phillips Collection by two oil paintings.

97

Notre Dame (DP), 1909

Vue prise du quai Henri IV, Paris; Vue de L'Ile Saint-Louis prise du Quai Henri IV
Oil on canvas, 12⅞ × 16⅛ (32.7 × 40.9)
Signed and dated in black paint, l.r.: *H. Rousseau/1909*
Acc. no. 1694 (Certigny no. 285; Vallier no. 228a)

Possibly owned by Wilhelm Uhde, Paris; Robert and Sonia Delaunay, Paris and Madrid, before 1911 and until at least 1922; Paul Guillaume, Paris, 1927; Valentine Gallery, New York; PMG purchase 1930.[1]

With *Notre Dame* Rousseau seems to have commemorated his view of himself as an artist, as well as his nationality and love for Paris. By including a solitary black-clad figure with walking stick, he may have created a miniature image of himself: "He inhabits his paintings the way we inhabit our dreams."[2] The painting conveys an atmosphere of quiet nostalgia: the spire of Sainte-Chapelle and the towers of Notre Dame, suffused in a soft, eerie light, seem to hold the rapt attention of the lonely figure. The simple composition and clear colors are typical refinements of Rousseau's late oeuvre and recall the work of Corot, whom he admired.

A related sketch, probably created in plein air, preceded the more studied Phillips work.[3] In a photograph of Rousseau in his studio (fig. 27), this sketch is seen on a wall. Its "slatey blues and greens [and] fastidious touches of black [which] might almost have been done by Manet" show Rousseau's ability to capture the perceptual, while the finished work signals his choice to emphasize the conceptual.[4] Apparently blocked in with haste, the sketch seeks to convey the masses—buildings, bridge, boat, quay—and eschews detail. The final work underscores Rousseau's commitment to the high finish of the academic painters.

Notre Dame may have been based on photographic images as well as the sketch, but Rousseau probably also relied on his memories of years of wandering and working on the quays of Paris, filtering the scene through his own poetic vision and thus infusing the picture with a characteristically dreamlike, timeless atmosphere.[5] An early advocate of Rousseau described this ambience as one of "vesperial melancholy in which the mast of the barge and the steeple of Notre Dame answer each other across the river."[6]

The painting shows Rousseau's interest in geometric forms and attention to detail. The triangular form of the boat and its jutting mast are echoed by the church towers and spire; the quay, bridge, and distant skyline are composed of soothing horizontals. His interest in repetition

Fig. 27 *Rousseau in His Studio,* photograph, Musée Picasso, Paris. © Photo R.M.N.-Spadem.

of forms and shapes can be seen in the receding rings along the quay, the rows of black rectangles that denote windows, and the toothlike silhouettes of the chimneys. As in the sketch, colors are subdued, but Rousseau added chromatic variations of black, eggshell white, dense green with highlights, and, in the flag, an accent of saturated red.

Rousseau's concept of himself as a realist did not preclude his taking liberties: the progression into spatial depth along the quay is nullified by the calligraphic signature, which asserts the picture plane; a tree inexplicably grows out of the water beyond the bridge, the trunk giving needed emphasis to the lone figure on the quay and allowing Rousseau to create a verdant frame for the white facades on the Ile Saint-Louis; the buttresses of the cathedral resemble a series of gables, which seem to protrude from the structure.

Notre Dame, which was once in the collection of the artists Robert and Sonia Delaunay, both early champions of Rousseau, takes a modest place in the history of Rousseau's powerful influence on artists and critics. Delaunay's own

97

work betrays his love for the older artist: the quay, docked boat, bridge, and Paris rooftops are quoted in the left background of Delaunay's masterpiece *The City of Paris,* 1910–12.[7]

The painting was certainly known to Kandinsky.[8] One German critic, reviewing the 1912 Berlin Secession, noted its "conscious stylization" and found its "simplification of flat shapes reminiscent of the martyr tablets of Upper Bavaria."[9] The similarity of Rousseau's work to folk art and his sophisticated eye for

abstract patterning were both at the heart of the German enthusiasm for him in this period.[10] Notre Dame also seems to have inspired the composition and style of *Along the Seine,* 1928, by Arnold Wiltz, a German immigrant who came to the United States in 1913. The Wiltz painting was purchased by Duncan Phillips the year after *Notre Dame* entered the collection.[11]

Phillips's appreciation of Rousseau apparently developed well after the artist's first U.S. exhibition, Alfred Stieglitz's Gallery 291 in 1910.

He purchased both this work and *Pink Candle* (acc. no. 1695) in 1930, and on their inaugural exhibition took special note of *Notre Dame* as "a beautiful example of inspired primitive directness and instinctive felicity for design and color harmony."[12] Although Rousseau's influence had already begun to wane in the United States, these purchases coincided with Phillips's growing enthusiasm for American and European naive painters.[13]

LF

PIERRE BONNARD (1867–1947)

Pierre Bonnard's luminous eulogies to everyday life are rooted in early symbolist fantasy and expressed in abstract compositions of rich color harmonies. Bonnard was born in Fontenay-aux-Roses, October 3, 1867, growing up both there and in the family's country home in the Dauphiné region. Educated in Paris, he attended the Académie Julian and earned his law degree in 1888. Beginning in 1889 he studied at the Ecole des Beaux-Arts with Vuillard and Roussel. Encounters with Maurice Denis, Paul Sérusier, and Félix Vallotton precipitated the founding of the Nabis (or prophets), who coalesced around the symbolist theories of Gauguin and the poet Stéphane Mallarmé. Inspired by Japanese art, Bonnard focused on intimate domestic themes. He first exhibited at the Salon des Indépendants in 1891 and continued to show there intermittently until his death. Theater designs, illustrations for the avant-garde periodical *La revue blanche,* and his first one-person exhibition at Durand-Ruel in 1896 were among his early successes. Ambroise Vollard commissioned several series of prints and illustrations starting in 1899. Normandy and Mediterranean landscapes gradually replaced Paris scenes in Bonnard's oeuvre; they often included his lover Marthe Boursin, whom he married in 1925, the same year he purchased a home in Le Cannet, above Cannes. His first exhibition in New York took place in 1928, and a landmark retrospective was held at the Art Institute of Chicago in 1938. During the war years, Bonnard lived and painted almost exclusively in Le Cannet and began a regular correspondence with his friend Matisse, returning to Paris only in 1945 and 1946 to attend exhibitions of his work. He died at Le Cannet January 23, 1947. The Phillips Collection owns seventeen oils, five drawings, and nine prints.

The Bonnard Unit

Late in life, Duncan Phillips wrote that "our very personal collection of [Bonnard's] work is in itself a recognized memorial to his genius. . . . With us Bonnard is at home."[1] Phillips's accumulation between 1925 and 1954 of the largest and most diverse collection of Bonnard's paintings in the United States was one of his most resolute and enthusiastic acts as a collector, and his writings on the artist are voluminous.

The annual Carnegie International series of exhibitions in Pittsburgh played a prominent role in Phillips's developing appreciation of Bonnard. In 1925 he made a purchase of two paintings from Bernheim-Jeune that had been in Carnegie International exhibitions: *Early Spring,* 1908 (cat. no. 99), and *Woman with Dog,* 1922 (cat. no. 102). In September of the following year, Bonnard visited the museum after having served as juror of the International. Phillips recalled being engaged by Bonnard, and in a subsequent letter the artist wrote to the collector: "I am touched by the interest you take in my painting despite its great flaws—I am always striving to improve my style, and I am not indifferent to the fact that the like-minded support my efforts."[2] A surge of acquisitions followed Bonnard's visit—five in 1927 alone. These early purchases, each painting a testament to Bonnard's interest in conveying simplicity, informality, and innocence, led Phillips to observe in 1927: "Bonnard is a poet in the intimacy of all life."[3]

In the late twenties and early thirties, Phillips built up his unit of Bonnard's latest work, including the Mediterranean masterpieces *The Riviera,* ca. 1923, and *The Palm,* 1926 (cat. nos. 103 and 104), and the monumental interior with a view of a landscape, *The Open Window,* 1921 (cat. no. 101). By 1931 Phillips pronounced Bonnard, along with Marin, his favorite artist.[4] Continuing to collect his work for the next thirty years (but at a slower pace), Phillips purchased his last picture by Bonnard in 1952.

Phillips gave Bonnard his first one-person museum exhibition in America in 1930 and his first two solo shows of drawings in the United States seven years later.[5] Of the nine group exhibitions in the United States that included Bonnard before 1930, six were held at the Phillips. Since then, Bonnard has been the focus of thirteen one-person exhibitions at the museum, and his paintings have figured in permanent installations throughout its history.

Whereas Phillips's receptivity to Cézanne, Matisse, and Picasso required lengthy contemplation and sometimes skeptical critiques, his response to Bonnard was intuitive and instantaneously adulatory. Bonnard's themes hinge on the joy of vision, the essence of Phillips's own approach to art. The artist's often classical subjects are cloaked in romantic atmosphere; a mood of domesticity and informality emanates from the most monumental canvases, and his evanescent color expresses delight in the visual world. This blend of subjective, personal sensation, expressionistic design, and classical motifs fulfilled Phillips's craving for an art of enchantment, for a transforming and enthralling aesthetic experience, for art inspired by a love of life, which would remain shrouded in tradition. "Once a man is initiated into such rapturous vision," he wrote in 1929, "the earth can never be the same for him again."[6]

Bonnard's vision also appealed to Phillips because he ardently desired to preserve the intimate quality of his museum, a concept that had emerged in the early 1920s. He compared Bonnard to Chardin: "As Chardin, Pierre Bonnard was fond of the intimacy of the bourgeois home, of the joy of every day life."[7]

Always resistant to extremes of pure emotion or the "cold sophistication" of pure formalism, Phillips was particularly attracted to Bonnard's mature work, in which the fusion of emotion, plastic structure, and resonant color results in poetic expression tempered by design. "He can use discipline," Phillips pointed out in 1931, "and it saves him from real danger. . . . In *The Open Window* there would be too much richness . . . of color and too much curve and complexity of form if it were not for that rectangular severity . . . made by the window."[8]

Throughout the thirties, Phillips augmented the unit by buying works of the first two decades of the century, such as *Narrow Street in Paris,* ca. 1897 (cat. no. 98), *Movement of the Street,* ca. 1907 (acc. no. 0168), and *The Terrace,* 1918 (cat. no. 100). By 1937, his delight in the adroitly arranged *japonais* graphics of Bonnard's post-Nabi style prompted the purchase of four whimsical drawings of animals and insects; fifteen years later, lithographs from the masterful, often witty series on Parisian life, *Quelques aspects de la vie de Paris* of 1899, entered the collection.[9]

Several gaps existed in the Bonnard unit; for example, with the exception of *Nude in an Interior,* ca. 1935 (acc. no. 0171), the nude subject is virtually absent.[10] Also missing is an example of the very late work. Around 1948 Phillips appealed to Wildenstein's to procure for him *The Circus Horse* (begun 1936, completed 1946). Bonnard had given it to Charles Terrasse, his nephew, who declined to sell but offered it on long-term loan in 1965.[11] The absence of an important still life was resolved in 1987 with the gift of the sumptuous *Bowl of Cherries,* 1920 (acc. no. 1987.4.4).

Ultimately, Bonnard was for Phillips the symbol of the artist-hero, the "peintre-enfant" isolated against the tide, creating from love and intuition rather than rationality.[12] In the mid-twenties, in opposition to critics championing the cubist "collective," Phillips rallied to the defense of such figure painters as Bonnard, Dufy, and Matisse. He defended Bonnard because of his roots in nature, his naive vision, and his denouncement of theory.[13] Furthermore, in 1929 Phillips championed Bonnard as a standard-bearer who had ushered the French tradition into the modern era; in appealing to the Harvard Society of Contemporary Art to

include Bonnard in their School of Paris exhibition, he wrote: "[Bonnard] is emphatically a contemporary master rather than a left over Impressionist. He carries on the great tradition of French painting as no other painter, with the possible exception of Derain, is doing."[14]

In addition to seeing Bonnard as heir to oriental, Dutch, and Venetian traditions, Phillips also pointed to him as the "bridge between Impressionism and Expressionism." That Bonnard approached abstraction yet never let go entirely of the visible world was a vital factor in Phillips's allegiance. Both he and Marin, Phillips observed in 1931, "are nature poets in an age that boasts that it has finished with nature for art."[15]

In his first Bonnard exhibition, Phillips emphasized the personal nature of Bonnard's themes and his traditional style. In surveys of the twenties and thirties, he exhibited him with Renoir, Monet, Cézanne, Matisse, and Braque, or contrasted him with his American contemporaries, Twachtman, Prendergast, Marin, and Tack.

In 1949, two years after Bonnard's death, Phillips published his culminating statement on the artist, asserting the enduring power of his work: "[Bonnard's] . . . latest expressionist phase of the ever recurring romanticism of our universal human need is as significant a revelation of our times as Cubism and far closer to the fundamentally emotional core of art."[16]

LF AND MJ-B

98
Narrow Street in Paris, ca. 1897

Rue Etroite de Paris; Rue Tholozé
Oil on cardboard, 14⅝ × 7¾ (37.0 × 19.6)
Signed l.r.: *Bonnard*
Acc. no. 0170 (Dauberville, vol. 1, no. 156)

Probably from the artist to Jos Hessel, Paris, until at least 1930; [possible intermediate owner]; PMG purchase from Carroll Carstairs Gallery, New York, 1937.[17]

Narrow Street in Paris recalls Gustave Geffroy's praise for Bonnard at the time of his first solo exhibition in 1896: "No one better captures the look of the street, the colored patch seen through the Parisian mist, the passing silhouettes, a young girl's frail grace . . . the evanescent faces of the street, born and vanished in an instant."[18]

The painting depicts the view from Bonnard's apartment high above the medieval rue Tholozé in Montmartre. The window view was to become an increasingly prominent motif for Bonnard, but in this early work he chose only to imply its presence, allowing it to dictate the image's boundaries. The result was a detached and arbitrarily composed "slice of life redolent of Parisian ambience."[19]

Bonnard's naturalistic handling of the scene relates to the impressionists Caillebotte, Monet, and Pissarro; yet his expressive silhouettes and anecdotal whimsy reveal his efforts to reach beyond their dispassionate recording of city life, which he saw as slavishly dependent on nature and lacking in imaginative color and composition.[20]

While seldom overtly anecdotal, Bonnard's scenes reveal keen, often comical observation: here, for example, a vendor staggers under his load while a chic Parisienne passes him; in the background, a cyclist rides past the richly colored window of a butcher shop. The ironic detachment implicit in such early work recalls the instantaneous quality of photography, while the characteristic wit may owe something to the plays of Alfred Jarry and even to contemporary cartoons.[21]

Like Degas, Monet, and Vuillard, Bonnard found inspiration in Japanese prints, a debt apparent in the high horizon, vertical format, heightened tonal contrasts, and flattening of space in the painting. The owner of at least one nineteenth-century Japanese city scene, Bonnard was known as the "Nabi très Japonard" (very Japanese Nabi).[22] The restricted palette and ocher accents may owe something to Gauguin's Brittany works and to Bonnard's own prolific production in lithography, especially a group executed between 1895 and 1898, *Quelques aspects de la vie de Paris;* Bonnard virtually repeated this scene in a lithograph for that series.[23]

This painting may have been commissioned by Jos Hessel, a writer, collector, and cousin of the Bernheim-Jeune family of art dealers, who loved the culture and street life of Paris. Bonnard did treat the theme of a city panorama in a triptych for Hessel, and it is possible that this painting was a study for its right panel.[24]

Duncan Phillips appreciated the influence of Japanese prints on Bonnard's early work; it "taught him how to . . . subordinat[e] the figure to its setting, displaying the little joys of everyday in a way purely decorative."[25]

LF

99
Early Spring, 1908

Les Pensées; La Campagne Fleurie; Printemps Précoce; Premier Printemps
Oil on canvas, 34¼ × 52 (86.9 × 132.0)
Signed and dated (erroneously) by the artist in ocher-brown paint, l.l.: *Bonnard/1910*
Acc. no. 0161 (Dauberville, vol. 2, no. 508)

Purchased from Bonnard by Bernheim-Jeune, Paris, Feb. 20, 1909; [intermediate owner by at least 1923]; PMG purchase 1925.[26]

100
The Terrace, 1918

"Ma Roulotte" à Vernonnet
Le Jardin sauvage; La Grande Terrasse
Oil on canvas, 62¾ × 98¼ (159.0 × 249.0)
Signed on the balustrade in blue paint, c.l.: *Bonnard*
Acc. no. 0177 (Dauberville, vol. 2, no. 941)

The artist to Bernheim-Jeune, Paris, 1919; PMG purchase 1935.[27]

The northern landscapes of Bonnard's early years, such as *Early Spring,* prophesy the majesty of his late Mediterranean canvases, while encompassing Nabi echoes, classical grandeur, and the allure of Bonnard's native northern France. As Bonnard's provincial sojourns lengthened after 1900, the countryside's lush beauty became the leitmotif for his entire oeuvre. The love of nature that he had formed at the family home in the Dauphiné region found expression in the motif of the garden.

Whereas the garden is wild, profuse, and engulfing in *The Terrace,* in *Early Spring* the human presence is everywhere in evidence—in the carefully turned flower beds, the stone gateway, and the distant house. These elements tame the natural world and impose a linear geometry upon it. Less prevalent in Bonnard's oeuvre, and yet woven into this cultivated landscape, is the motif of people at work, for example, the woman bearing a cart of flowers and what appears to be a farmer plowing fields in the distance.

Bonnard masterfully transformed the theme of spring's tender beginnings into a decorative, unusually constructed composition in which the view does not recede but clings flatly to the picture surface. A flower bed gives way to a small expanse of lawn, which in turn is interrupted by a small thicket, where Bonnard's oriental vision is borne out in a sinuous tangle of budding branches; beyond this enclosed area are a road, an immense field, and distant hills. The entire scene is delineated by a high horizon line.[28]

The border of crisp tulips, the stone wall, and other features of civilization segment the composition—this geometry is countered by the play of sinuous arabesques formed by the trees. A newfound radiance of color is also apparent: overlaid on the predominant tones of luminous gray-green are impressionistic daubs that accent the flowers; an impulsive, somewhat random use of lime green seems to give a passing nod to fauvism.[29]

Phillips admired Bonnard's "discovery of the subtle relation between a season and a state of mind. . . . [His] color suggest[s] the restlessness, the strange blend of ecstasy and melancholy which makes us more . . . aware of growing things in April than any other time of the year."[30] Following his illustrations for two

98

99

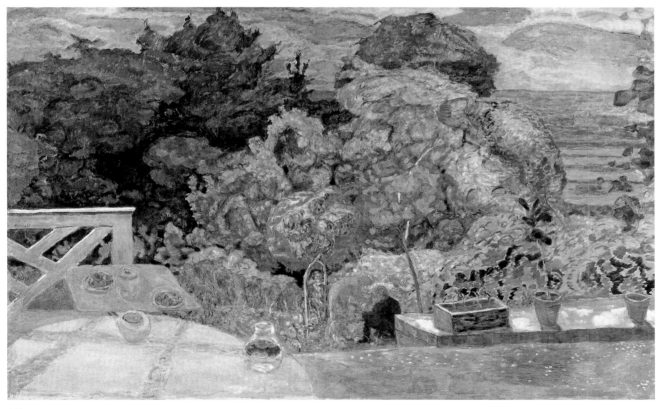

100

books, *Parallèlement*, 1899–1900, and *Daphnis et Chloé*, 1902, Bonnard's figures had gained in plasticity and mass, a development evident in the form of the woman in *Early Spring*.[31] The classical, idealized quality of this figure recalls the sculptures of his friend Maillol, while the frolicking children are reminiscent of the cherubs and nymphs with which Bonnard populated several other Normandy landscapes of the period.[32] At the same time that the picture suggests a specific time and place—the figures are in contemporary dress, the flowers are recognizable as tulips, pansies, and apple blossoms, and the scene possesses Normandy's characteristic segmented fields, silvery light, and scudding clouds—it also hints at Arcadian or allegorical subjects. In one scholar's estimation, *Early Spring* could be a "meditation" on spring, encompassing themes of childhood innocence, death, and regeneration.[33]

During his 1926 visit to Phillips's museum, Bonnard wanted "to change a whole area" in *Early Spring,* much to the alarm of Duncan and Marjorie Phillips. Marjorie Phillips, herself a painter, claimed not to have paints at hand; however, the artist did find the means to sign the painting and to give it the erroneous date of 1910.[34]

The monumental breadth and scale of a second northern landscape, *The Terrace,* invite comparison with the grand murals of nineteenth-century France and with the more recent decorations of Monet.[35] The picture was painted at "Ma Roulotte" (my gypsy wagon), as Bonnard called his home in Vernonnet in the Seine valley. Recalling Poussin are the crepuscular light, panoramic view, and allusion to the insignificance of humanity before the expansive mystery of nature. Yet the traditional theme of humanity in nature, and particularly the garden, serves to accentuate Bonnard's innovative vision, which encompassed an intimate, dreamy sensibility and infused the work with personal expressiveness. By including the table still life, Bonnard suggested an at-home quality, and he further personalized *The Terrace* by selecting a vantage point behind the table so that the viewer could easily imagine the artist himself enjoying the view.

Beyond the horizontal axis created by the terrace line is a cultivated clearing, which gives way to the amorphous shapes of the trees of an engulfing forest, thus creating a sequence from the cultivated domain to the wilderness.[36] In the clearing, Bonnard placed a couple (a rare occurrence in his oeuvre), whose bending poses are echoed by the slim tree trunks behind them.[37] An element of both humor and menace arises from the juxtaposition of these spindly, domesticated trees and the frail potted plants with the burgeoning foliage behind.[38] The trees seem to

crouch and loom in the gathering nocturnal shadows, while the couple, oblivious to these billowing, slightly sinister forms, remain absorbed in gardening.

The fluid, expansive composition of *The Terrace* betrays Bonnard's technique of tacking unstretched canvas straight to the wall and allowing the composition to define its own limits. The paint medium is very lean, and the loose, broadly painted forms were quickly and directly filled in. The sole labored area is the charged space where the glass vase and the table edges converge; several changes are visible in the blue underpainting.[39] The shimmering violet-green palette and the arabesques of the massed forms recall Bonnard's neighbor and mentor, Monet. The cool palette is intensified with a scattering of pink accents.

The Terrace, Phillips's last purchase of a monumental canvas by Bonnard, was kept on view almost constantly between 1935 and 1942; the collector usually hung it with a cross-section of French and American paintings by such artists as Chardin, Derain, Dove, and Spencer.

L F

101

The Open Window, 1921

Soleil d'avril; La Fenêtre ouverte

Oil on canvas, 46½ × 37¾ (118.0 × 96.0)

Signed in orange paint, l.r.c.: *Bonnard*

Acc. no. 0172 (Dauberville, vol. 3, no. 1062)

Acquired from the artist by Bernheim-Jeune, Paris, 1922; sold to Georges Bésnard, Paris, by at least 1924; Jacques Seligmann and Co., New York, 1930; PMG purchase 1930.[40]

A leitmotif in Bonnard's painting, the open-window theme is masterfully interwoven in this canvas with the artist's main subject: the ever-changing relationship of color and light.[41] The window, symbol of divinity in Renaissance painting, had been reclaimed by the German romantics as a "secular metaphor for the imagination" and revived by modern artists to designate the canvas as an imaginary pictorial realm paralleling, rather than imitating, nature.[42]

The setting, Bonnard's home "Ma Roulotte," appears in numerous paintings.[43] The high vantage point suggests a view from the sitting room on the second floor. A figure—perhaps Marthe, Bonnard's companion—lounges on a chair at the right; though clumsily formed, her figure was planned from the painting's inception, but the cat was later altered to show its paw touching the woman. One preliminary drawing lacks figures, focusing instead on the window view, while three others show variations on the room, the figure, and the window view itself.[44]

The Open Window typifies Bonnard's desire to "show all one sees upon entering a

room . . . what the eye takes in at the first glance."[45] In it, he re-created the magical process by which light, space, and form are perceived, first as abstract elements and only afterward as recognizable objects or entities. The painting sustains the symbolist view that form and color are the bearers of poetic feeling, and echoes symbolist themes of man's existence and relationship to the world, such as Mallarmé's evocation of the window as "an aggressive yet fading frame, sole bond to the sky of this world-abandoned dwelling."[46]

"To begin a picture," Bonnard once told a friend, "there must be an empty space in the centre."[47] The focal point of this painting is indeed the void of the window. The architectonic composition recalls Bonnard's hard-won revelation, nine years earlier, that he had been sacrificing form to color. Here, symphonic, vibrant hues soften the painting's structure without compromising it.[48]

The aggressively colored interior contrasts with the mysterious shadows of the violet-green foliage and blue sky outdoors. Languidly playing with the cat, Marthe blends into this torpid atmosphere; her figure is drastically cropped and her presence thus further marginalized. Bonnard dazzlingly juxtaposed the geometric human world—painted in enveloping, expanding red-orange and bright green—with the cool, inviting world of nature, which is distant and closed off by the window frame, seeming to promise a paradise just beyond our range of vision. The window is yet more inviting as the sole exit from the interior, made claustrophobic by the coloration and slanting foreground.

In spite of the contrast between interior and landscape, the embroidered flowers on the chair at the left and the flowers in the vase suggest an indoor-outdoor correspondence. The diagonal formed by the tree line is carried into the room through the angle of Marthe's blue chair. The color of the chair echoes the sky, the violet of the shadows in the trees are repeated in the seat at left, and gray-green highlights are scattered throughout—creating an almost musical accord that is sharpened by the black of the window shade. Whereas in Matisse's treatment of the window view the vista either forms a contiguous space with the interior or invades the artist's habitat, in Bonnard's composition the bond—and contrast—between exterior and interior creates the core of mystery and spiritual longing that pervades the work.[49]

Bonnard's practice of composing from pencil notations rather than directly from the subject freed him from representing nature slavishly and allowed him to develop profound pictorial harmonies faithful to his inner vision. He began with thin washes on a white ground, adding scumbled areas for greater opacity, and reserved

101

the heaviest impasto for the foliage. He also left the white ground exposed in scattered areas to evoke a sense of light and incised the canvas to create the flower designs on the chair at left. To achieve an overall juxtaposition of vibrant hues, he allowed underpainting of harmonious tones to show through the layers; the chairs, for example, were originally an ocher color, which is still visible beneath the overpainting in both.

After *The Riviera,* the present work was Phillips's most prized Bonnard painting, one in which he saw Bonnard's genius revealed: "This unusually geometric and stately example," he wrote, " . . . is almost Persian in its luscious color but ever so delicate and sensitive in its modulations. . . . There is logic enough in the structure and balance . . . to please every follower of Cézanne and any devotee of Matisse, but there is also the rapture of an ever self-renewing, youthful spirit."[50]

Compositions such as *The Open Window* hover on the edge of abstraction; the painting has been cited as a forerunner of the luminous color fields of Mark Rothko and the central voids of Jules Olitski, Morris Louis, and Sam Francis.[51]

The window view also dominates *Nude in an Interior* of ca. 1935 (acc. no. 0171), a later acquisition showing Marthe at her toilette, the only 1930s Bonnard in the collection. In that image, Marthe's figure and surroundings dissolve in luminous atmosphere, indicating the expressionist direction of Bonnard's late painting; yet the composition is held in place by the architectural forms.

LF

102

Woman with Dog, 1922

Femme tenant un Chien
Oil on canvas, 27¼ × 15⅜ (69.1 × 39.0)
Signed in orange-white paint, u.r.: *Bonnard*
Acc. no. 0179 (Dauberville, vol. 3, no. 1156)

The artist to Bernheim-Jeune, Paris, Nov. 1923; PMG purchase (from exhibition) 1925.[52]

Woman with Dog characterizes the era of the early twenties, when simplicity, sculptural form, and carefully balanced color relationships distinguished Bonnard's work. The painting has been reproduced often throughout its history, beginning in November 1923, when Waldemar George singled it out in his review of the Salon d'Automne as one of Bonnard's finer paintings. Virtually an emblem of the museum, it has appeared repeatedly in Phillips publications.

Depicting Bonnard's lover, Marthe, holding the family dog, this melancholy portrait is a descendant of the traditional French domestic interior. Bonnard first used this motif in his Nabi period of the 1890s. His comparatively limited work in portraiture usually features women or children with their heads bowed in concentration over the table, a sewing project, or a pet, their features subsumed in the pervasive color and light. Bonnard worked from memory with the aid of pencil sketches.[53]

Whereas Bonnard often celebrated Marthe's sensuous, womanly qualities in a series of radiant nudes, he also depicted her as here, clothed and with boyishly short hair, where she appears poignantly innocent and youthful. In this canvas, the mood of sadness is emphasized by the solemn gaze of the dachshund, and it has been asserted that Marthe's habitual melancholy demeanor in portraits of this era (1917–25) was brought about in part by her failing health, as well as by a difficult period in her relationship with Bonnard. Thus this portrait may reflect the painful lack of communion between the sitter and the artist at the time.[54]

Marthe's vermilion shirt, which appears in several portraits, offsets the solemn ambience. Its bright, saturated color contrasts strikingly with her mottled, densely worked features and the deftly drawn dog.[55] The plasticity of this figure betrays the influence of Degas and Renoir, yet it reflects the intimacy and lyricism of Bonnard's vision throughout his career. The simple background and table arrangement—spare horizontals and verticals in tonal harmonies of gray-blue and brown—further constrict the cagelike space. In the foreground still life, reminiscent of Cézanne, the bowls cannot logically share the space implied behind the bottle. This tensile arrangement further directs the viewer's attention to the figure and dog.

Bonnard worked with lean washes of paint, abrading areas of the background wall and the dog's snout to allow the white ground to show through. The more built-up area of Marthe's face and hair have a dry, pastel-like quality.[56] Phillips first hung the painting with other "intimate impressionists" in 1926; he might have had it in mind when he wrote five years later that "in his more confiding revelations of his personal moods . . . his joys in the intimacies of the home . . . his loving caress of colors pressed from the very vintage of his inner life, he [Bonnard] is more truly of the family of Renoir."[57]

LF

103

The Riviera, ca. 1923

La Côte d'Azur; Grand paysage du Midi; Southern France (DP)
Oil on canvas, 31⅛ × 30⅜ (79.0 × 77.0)
Signed in brown paint, l.r.: *Bonnard*
Acc. no. 0175 (Dauberville, vol. 3, no. 1173)

Claude Anet, Paris; de Hauke and Co., Paris and New York, 1928; PMG purchase 1928.[58]

104

The Palm, 1926

La Palme
Oil on canvas, 45 × 57⅞ (114.3 × 147.0)
Signed and dated in gray paint, l.r.: *Bonnard 26*
Acc. no. 0174 (Dauberville, vol. 3, no. 1342)

The artist to Félix Fénéon, Paris, date unknown; de Hauke and Co., New York, 1928; PMG purchase (from exhibition) 1928.[59]

Bonnard's first impression of the Mediterranean coast was "an experience akin to the thousand and one nights; the sea, the yellow walls, the reflections which are as colored as the light effects." Yet he found the southern light alien at first, writing, "I can't paint here; there are no colors." But by seeking a vantage point from the shadows, as he did in *The Palm,* he found that the brilliance could come alive, the nuances of color animated by the deep shades of the foreground.[60]

The view of Cannes and the surrounding hills formed the matrix of Bonnard's landscapes from the twenties onward, recalling Cézanne's preoccupation with Mont Sainte-Victoire in Provence. Bonnard worked in southern France for part of almost every year, by 1922 favoring Le Cannet, the village above Cannes. *The Riviera* and *The Palm,* among others in the late oeuvre, reflect his love of the region.[61] The vistas of both paintings do not have the elastic perspective characteristic of earlier works, but instead invite the eye through a legible expanse to nearly unbroken horizons.[62]

The broken brushwork forms luxuriant masses of opalescent foliage akin to the work of Monet and Renoir. Yet, especially in *The Riviera,* the abrupt juxtaposition of foreground and deep space creates stark spatial distinctions that vibrate against each other in the manner of Cézanne; for example, the nearby bushes sparkle in sharp sunlight against the hazy blue middle ground of trees and distant atmosphere. In this way Bonnard imposed compositional structure on his impressionistic technique, thereby solving the problem he continually posed to himself: how to create form from color and light.[63]

The flat shape denoting the foreground in *The Riviera* takes the eye upward; this device, in combination with the foliage's subtle textural variations, recalls the patterning of Bonnard's Nabi years. A lyric expressiveness infuses the pallid sky, the scattered light, and the ethereal view of the mountains. Bonnard's work in gouache and watercolor, begun in earnest in 1925, may have influenced the blurred forms and softened washes of paint in late works such as this one.

The Riviera was included in Bonnard's first one-person gallery exhibition in the United States,

102

103

where Phillips saw it. Though at first more attracted to *The Palm*, he borrowed *The Riviera* on approval; ultimately he found its charms so irresistible that he asked César de Hauke to negotiate its purchase in Paris, lest its owner, Claude Anet, change his mind when he saw it again.

The Palm exemplifies Bonnard's mature achievement, in which his gifts as a colorist and draftsman, and his genius for transposing poetic expression into plastic arrangement, were in full flower. In this classical Mediterranean idyll in the tradition of Poussin and Cézanne, Bonnard sought to revive the pastoral tradition for the twentieth century, a task that had been pursued by Derain, Picasso, and others.

The Palm is a luminous elegy on the process of seeing as revelation and sensual delight. A panoramic view of buildings and gardens unfolds from behind a spray of palm fronds and lush vegetation; characteristically, Bonnard framed the scene as if the viewer were experiencing it directly.[64] A woman (probably Marthe) proffers fruit, calling to mind biblical themes or allegories of the seasons in classical mythology. Her blurred, shadowy form renders her an apparition, perhaps a mythical enchantress personifying the seductions of nature.

Bonnard used the faceted surfaces and shifting angles of the rooftops to create a cityscape that vibrates with nacreous, dappled color and ebullient light. The vibrancy of the color scheme, owed in part to the saturated hues, stems mainly from Bonnard's astute juxtaposition of complementary oranges and blues. The far distance is punctuated by a high-rise building bathed in light, as were the palaces and temples in the landscapes of Poussin. Yet Bonnard's screen of arching palm fronds binds these rectilinear color patches to the surface, creating a rhythmic, tapestry-like design.

In both paintings, the intermingled color and light are perhaps the outstanding features, and they were central to Phillips's response. *The Palm* was the earliest of four monumental landscapes by Bonnard to enter the collection, and Phillips considered it "one of Bonnard's most important canvases."[65] He wrote in 1928: "The Palm is Bonnard in his most sumptuous mood . . . an exultant paean on light . . . the visual and emotional thrill of coming suddenly out of a house into a blaze of sunshine . . . a glory of luminous radiance and chromatic splendor which makes it impossible to observe in detail what is sensed rather than seen against the brilliance . . . a cool tone in refreshing contrast to all the glow of molten color. It is in the land which gave to the world the spiritualized naturalism of Twachtman that such an art should inspire our lyricists to do for America what Bonnard has done for France."[66]

LF

104

EDOUARD VUILLARD (1868–1940)

Edouard Vuillard's domestic interiors radiate, through their muted patterns, an aura of intimacy and tranquillity. Born November 11, 1868, in Cuiseaux (Saône-et-Loire), Vuillard moved with his family to Paris in 1877. He attended the Ecole des Beaux-Arts from 1886 until 1888, when he entered the Académie Julian. There he met Pierre Bonnard and became a member of the newly founded group of Nabis, which included Bonnard, Denis, Ibels, Ranson, Roussel, Sérusier, and Vallotton. Vuillard was given his first one-person exhibition in 1891 at the offices of the new arts journal *La revue blanche*. Increasingly admired for the decorative patterns of his paintings, he received commissions for mural decorations from the families Desmarais (1892) and Vaquez (1896). In 1899 he had his first show at the Bernheim-Jeune Gallery, directed by Jos Hessel, whose wife became one of his foremost patrons and closest friends. After 1900 Vuillard's style became more naturalistic as he concentrated on society portraits, still lifes, and mural commissions (Comédie des Champs-Elysées, 1912–13, and Palais de Chaillot, 1937). From 1917 to 1924 he spent time both in Paris and at the Hessels' house at Vaucresson. Vuillard died June 21, 1940, at La Baule in Brittany. The Phillips Collection owns four Vuillard works, all dating from the 1890s.

The Vuillard Unit

Edouard Vuillard's interiors of the 1890s, three of which are in The Phillips Collection (*Interior, The Newspaper,* and *Woman Sweeping*), represent the artist at the height of his early style, which was based on the Nabi ideal of celebrating color and pattern over perspective and subject, and which drew inspiration from Japanese art and the synthetist ideas of Gauguin's circle at Pont Aven.[1] Although never a vocal member of the Nabis, Vuillard created works strongly reflecting its influence.

In his interiors, Vuillard usually depicted relatives or friends at his home, creating images that became the foundation for his personal manner of interpreting space, pattern, and color. Depth is generally undefined except for the overlapping of objects, and the boundaries of the objects themselves are subordinated to the format of the composition. Selected edges are extended into striking vertical and horizontal bands that create rich, impastoed fields. Vuillard's design and color do not rely on dramatic contrasts, however; his is an art of subtleties and nuances.

In spite of his attention to formal elements, Vuillard created a mood of intimacy and com-

fort, revealing with each brushstroke his profound sensitivity toward his subject. Duncan Phillips recognized this tendency when he wrote that "his every touch reveals him. His personality finds its consummation in what we call 'paint quality,' the indefinable visual joy of a distinguished painted surface made identical with a distinguished personal vision. . . . It reveals spiritual essence in material substance."[2]

The skill of communicating emotion, called "sensibility" by Phillips, is what most attracted the collector to Vuillard's work. He admired the artist's ability to break away from the standard maxims of Nabi theory to create an individual style. "Vuillard knows there is a soul in a house and in a room," he wrote, "and in all material things which people live with and love."[3] He often displayed his Vuillard interiors in the entrance hall and front rooms of his museum so that their intimate theme would complement the domestic setting.

GHL

105

Interior, 1894

Intérieur
Oil on cardboard mounted to canvas, 10¼ × 20⅛ (26.1 × 51.1)
Signed in dark red paint, l.l.: *E. Vuillard*
Acc. no. 2013

Galerie Georges Moos, Geneva; Carroll Carstairs Gallery, New York; TPG purchase 1954.[4]

Interior, which depicts the artist's mother in the dining room of their residence at 342 rue Saint-Honoré in Paris, represents Vuillard at his most abstract.[5] The sketch for the painting, 1894, is characterized by abbreviated outlines and lack of detail.[6] It reveals Vuillard's overriding interest—sparked by the influence of Japanese prints and Nabi theory—in composition rather than definition of form. The door frame and wall moldings function as a grid, and the outlines of objects are ambiguous, almost obscured.

The compositional elements of the painting, including the variously textured designs representing the wall covering, paneling, and fabrics, are painted over a loosely executed brown underpainting that is visible at the edges of the forms. Vuillard scraped back both paint and cardboard, emphasizing the tactile qualities of his textured brush and revealing a lighter tone in the cardboard where the upper layer was removed.[7]

Madame Vuillard has her back to the viewer and is hunched over a table, perhaps involved in a dressmaking project.[8] Her cool-blue dress,

defined by a series of thickly painted, vertical stripes, serves as a formal element that stabilizes the dominant green-and-rust expanse of the wall. It also balances the acutely foreshortened doorway on the left in which a dark figure appears to stand in shadow. The subject of this painting, however, is not only Madame Vuillard and the intimacy of her surroundings, but also the visual relationships—of color, pattern, and abstract forms.

GHL

106

Nurse with a Child in a Sailor Suit, 1895

Nounou avec enfant en sailor
Nounou et enfant en costume marin; Nurse and Child
Oil on cardboard, 9⅝ × 9⅞ (24.3 × 25.2)
Signed and dated in black paint, l.r.: *E. Vuillard/95*
Acc. no. 2015

Alfred Sutro; J. Hessel, Paris; purchased 1935 by M. Knoedler and Co., New York; PMG purchase (from exhibition) 1939.[9]

This small oil is similar in both subject and style to the nine *Jardins publics* panels Vuillard completed in 1894 for the dining room of Alexandre Natanson, cofounder in 1891 of the arts magazine *La revue blanche*.[10] The subject of the works, nannies and children at leisure in the park, was accessible to Vuillard, who at the time lived on rue Saint-Honoré, close to the Tuileries gardens.

Both this painting and the related decorations reflect the strong influence of Japanese woodblock prints, which had been reproduced and praised in *La revue blanche*.[11] The painting presents a high horizon and a tilted expanse of terrain against which strategically placed figures appear to float. Vuillard treated shadows on the ground, and even the areas of exposed cardboard, as individual decorative forms. The scene recedes along the vertical axis created by the foreground tree, and such elements as the chair and tree are dramatically cut off by the edges of the picture plane; these stylistic devices could have been inspired by photography. The tree's midsection, which Vuillard apparently labored over with multiple layers of yellow, gray, and brown paint, dominates the foreground; visually, it might correspond to the hinge of a Japanese screen.[12] While employing a painterly technique of textured strokes and low impasto, Vuillard managed to flatten the scene into an all-encompassing decorative entity in which the figures are merely part of the whole.

GHL

105

106

107

The Newspaper, 1896–98

Le Journal

Femme lisant; La Lecture; Madame Vuillard lisant le journal, Rue Truffaut; The Journal

Oil on cardboard, 12¾ × 21 (32.2 × 53.3)

Signed in black paint, u.r.: *Vuillard;* inscription in black crayon on backing, u.c.: *Hessel*

Acc. no. 2014

Jos Hessel by 1908; Félix Fénéon, Paris; Seligmann, New York; sold to PMG 1929.[13]

108

Woman Sweeping, between 1899 and 1900

Femme balayant dans un intérieur

La Femme qui balaie; Woman Sweeping in a Room

Oil on cardboard, 17⅜ × 18⅝ (44 × 47.3)

Signed l.r.: *E. Vuillard*

Acc. no. 2016

Louis Bernard-Goudchaux, Paris, by 1908; purchased 1916 by Bernheim-Jeune, Paris; sold to Josse Bernheim, Paris, 1918; sold to Seligmann, New York, 1938; PMG purchase (from exhibition) 1939.[14]

These works show Madame Vuillard absorbed in daily routines. In *The Newspaper,* she relaxes with her paper in the sunny salon of the home she shared with her son at 342 rue Saint-Honoré; in *Woman Sweeping,* she cleans the dining room of 28 rue Truffaut, to which they moved in 1899.[15] Because her face is obscured, as it is in most paintings depicting her, the viewer concentrates less on the personality of the subject than on the intimate domestic scene.

As in earlier works, Vuillard used stippled layers of richly textured paint to achieve a flat, ornamental pattern; however, he began to perceive his interior scenes more realistically. *The Newspaper* and *Woman Sweeping* are less flat, more three-dimensional, and objects are more

readily recognizable, delineated, and substantial. In *The Newspaper,* the corner of the room, on the left, is represented by a thin, black vertical line that seems to interrupt the continuous floral design of the wall covering; no shading or perspective suggests foreshortening. A ray of sunshine striking the table behind Madame Vuillard is represented as a flat triangle of bright red color. Similarly, the table covering in *Woman Sweeping* is seen as an efflorescent field that only peripherally follows the curves of the table. Vuillard set off the figure of his mother, especially in *Woman Sweeping,* by slightly altering the configuration of the patterns surrounding her form. This tendency toward greater realism prevailed in later work, partly because of Vuillard's naturally conservative temperament and partly because he lost contact with many of his avant-garde colleagues from *La revue blanche* (the magazine ceased publication in 1902).

GHL

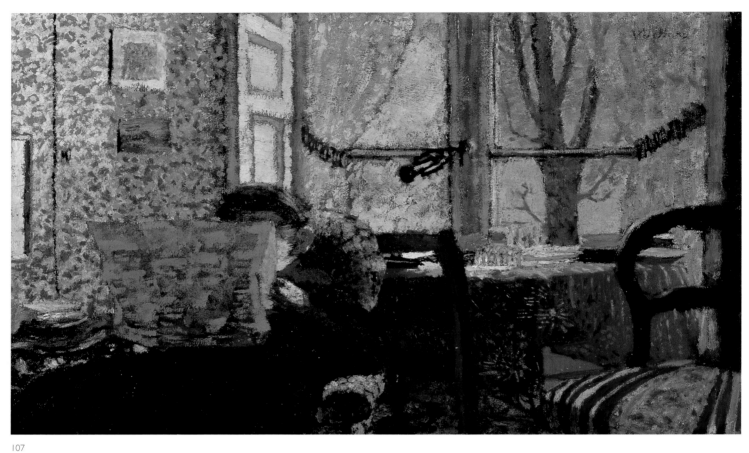

107

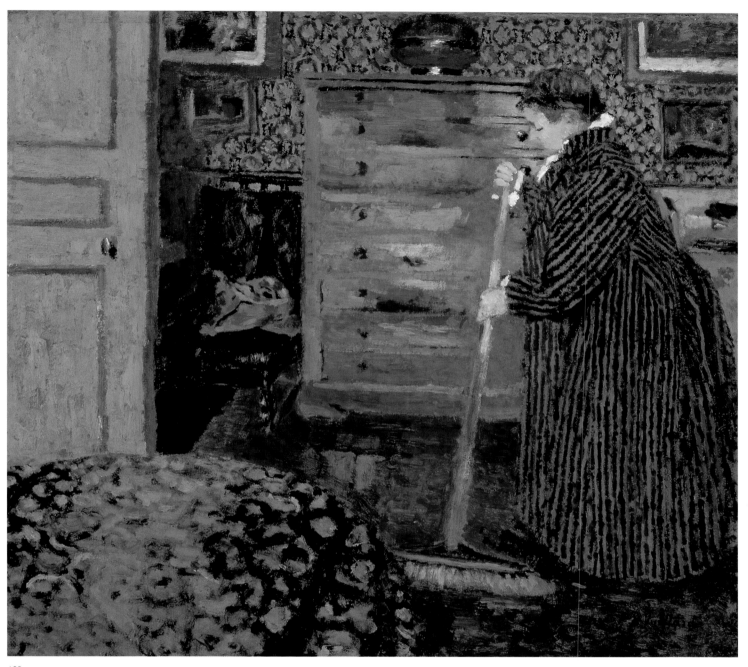

108

HENRI MATISSE (1869–1954)

With boldly colored canvases mediating between abstraction and representation, Henri Matisse forged a modernist language of unprecedented spiritual power and material richness. He was born at Le Cateau-Cambrésis, France, December 31, 1869. He was the son of a grain merchant, and his initial metier was law, but upon discovering painting he dedicated himself to art. He first studied at the Académie Julian with the academician Adolphe Bouguereau, then with the symbolist Gustave Moreau at the Ecole des Beaux-Arts, where he met Henri Manguin, Albert Marquet, and Georges Rouault. The Salon accepted his work in 1896 and the next year elected him an associate member. Early recognition came largely from American and Russian collectors, such as Gertrude and Leo Stein, the Cone sisters of Baltimore, and the Moscow collector Sergei Shchukin. His renown in France took root in 1904, when he was discovered by Ambroise Vollard, and in 1905 at the Salon d'Automne, where as a member of the fauves he stirred the Paris art scene along with his associates Derain and Vlaminck. In 1908 Matisse published his landmark article on his philosophy of art in *La grande revue,* and he opened a private art school in Paris the same year. Following a sojourn in Morocco in 1911, Matisse sought out the Mediterranean light each winter, and from 1917 to 1954 he spent increasingly long periods in Nice. Matisse's serene, ornamental work brought him international honors, including the Chevalier of the Legion of Honor in 1925 and the Carnegie International Prize in 1927. At that time he renewed earlier explorations of sculpture, lithography, and theater and mural design. Beginning in the 1930s, he worked in textile design and book illustration, and in spite of a debilitating illness his work continued to gain in sophistication and impact, especially in his hallmark cutouts and collages. Matisse was the first living artist to be given a retrospective at the Salon d'Automne (1945), and in one of his last major undertakings he decorated the Dominican Chapel in Vence, creating murals, stained glass, and designs for the vestments. He died in Vence November 3, 1954. The Phillips Collection contains three drawings and two oils by Matisse.

The Matisse Group

Duncan Phillips's first reaction to Henri Matisse was one of moral outrage. In 1914 Phillips indicted Cézanne, Gauguin, and van Gogh for rejecting the "Greek standard of form, the Venetian standard of colour," and "Dutch surface quality." He also condemned the modern exploitation of primitive, Gothic, and Far Eastern art, and contended that "in Matisse the degeneration of . . . expressionism reached its bottom. . . . [He] creates patterns unworthy of . . . little children and benighted savages, patterns not only crude but deliberately false and at times insanely depraved."[1] By 1927, however, Phillips's receptivity to post-impressionism and in particular to Cézanne had considerably altered his vision, and Matisse's work had become part of the collection. In that year, he issued a slightly milder judgment and annotated it with a retraction: "I feel that I should atone for my own rash expression of blind prejudice against this artist by reprinting one of the more unfortunate passages from my early writings. Now I am ready to recognize in Matisse a daring and lucid agitator for direct decorative expression and luminous chromatic experiment. . . . He must be acknowledged as the brilliant descendant of a great Oriental tradition. . . . He is one of those rare artists who dare to create an abstract style which corresponds with their crystal-clear mental conceptions and with their exhilarating visual sensations."[2]

Phillips's softened attitude coincided with Matisse's sensuous, decorative oeuvre of the Nice period and the intensive collecting of Matisse's work in the United States during the 1920s. Between 1926 and 1928, Phillips briefly owned several works from this serene period.[3]

In 1930, after having served on the jury of the Carnegie International, Matisse visited The Phillips Memorial Gallery, where he was especially drawn to the American paintings on view. Remarking on the sizable unit of Bonnard's work in the collection, he assured Phillips that the small representation of his own painting in the museum was an appropriate ratio, observing that Bonnard "was the best of us all."[4]

By the 1930s Phillips favored Matisse's earlier, more austere and more rigorously plastic approach, and he purchased *Le torse de plâtre, bouquet de Fleurs,* 1919.[5] He wrote of Matisse's "brilliant craftsmanship," yet hesitated over his emotional detachment and "cold sophistication."[6] Therefore, it seems appropriate that Phillips achieved his first lasting satisfaction with Matisse in the unusually expressive and poignant *Studio, Quai Saint-Michel,* 1916 (cat. no. 109).[7] Interestingly, the picture's geometric simplification, primitivism, and reliance on both Persian and African art constitute an approach that Phillips had renounced earlier.

The late work is represented by the stridently colored and starkly composed *Interior with Egyptian Curtain,* 1948 (cat. no. 110), purchased in 1950, and *Head of a Girl,* 1946 (acc. no. 1303), a simple yet masterful drawing purchased seven years later.[8] Volumetric and boldly brushed, the drawing displays the artist's mastery for depicting form and space in the most economical means. These final purchases indicate Phillips's growing commitment to a bold, direct vocabulary of abstracted forms, and his discerning eye for Matisse's more original and potent images.

LF

109

Studio, Quai Saint-Michel, 1916
L'Atelier du quai Saint-Michel
The Studio
Oil on canvas, 58¼ × 46 (147.9 × 116.8)
Unsigned
Acc. no. 1307

Walther Halvorsen, July 1918; purchased by H. C. Coleman (Herbert Kullmann), Manchester, 1920; acquired by David Tennant for the Gargoyle Club, London, 1929; sold in 1939 to Douglas Cooper, London, who sold it the same year to Kenneth Clark, London; acquired by Pierre Matisse Gallery, New York; PMG purchase 1940.[9]

An austere and somber early work, *Studio, Quai Saint-Michel* reflects Matisse's successful integration of tradition, abstract styles—most notably cubism—and his own highly personal and lyrical expression.[10] The painting's architectonic severity, restrained tones, and aura of melancholy convey an uncharacteristic ambivalence and gravity. This solemnity may stem from the war, which deeply affected the artist, and perhaps from the exhaustive self-searching required to transform his work from the more decorative mode to the subsequent denuded, skeletal style.[11] Matisse would later say it was "a difficult watershed for me. . . . I was virtually alone in not participating in the others' experiment—Cubism . . . [which] did not speak to my deeply sensory nature, to the great lover that I am of line, of the arabesque, those bearers of life."[12]

In this painting, Matisse addressed several of his most deeply felt themes: the artist's studio (including the picture within a picture), the artist and his model, and the open window. Painted during the dark winter months, the work depicts Matisse's studio at 19 Quai Saint-Michel, in the heart of Paris. The view from the window encompassed the Seine, a bridge, the Palace of Justice, and the spire of Sainte-Chapelle rising behind it.[13] Matisse's Italian model of the period, Lorette, reclines on a sofa in the background.[14] In 1914 Matisse had depicted his studio from an almost identical viewpoint in *Interior with a Goldfish Bowl,*

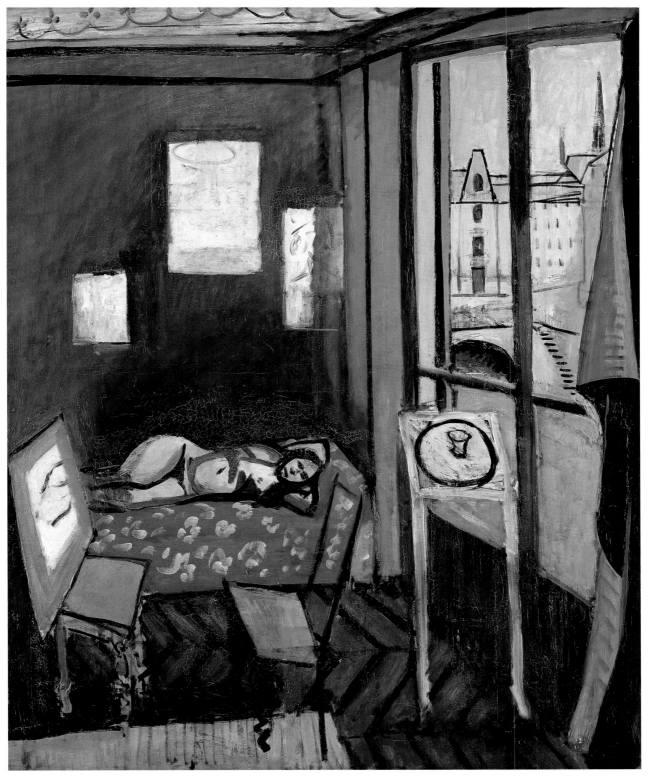

109

embellishing the image with a bowl of fish, a curving plant, a decorative balcony railing, and the echoing arch of a bridge bustling with street life.[15] In the Phillips picture, he added the model, omitted the wrought-iron railing that adorned almost every other depiction of the studio, and left out other curvilinear elements.

Whereas the studio theme had found expression among artists since antiquity, it was pursued with renewed vigor after Courbet revived it with his monumental allegory *The Artist's Studio* in 1855.[16] The motif was favored by Cézanne and other post-impressionists. With a penchant for self-reference that was virtually obsessive, Matisse gave it new intensity and complexity.[17]

Matisse may have looked to Corot for inspiration, because a curious parallel exists between the present work and Corot's *L'Atelier, Jeune Femme en robe de velours noir* of 1870, a work of somber introspection in which paintings hang on the studio walls in a filmy light and are vaguely defined in a bleached, ghostly monochrome.[18] In both the Matisse and the Corot, the dusky interior light is offset by vivid red, a color each artist associated with the female figure. Indian art may have inspired the tensely balanced plasticity and two-dimensionality of Matisse's composition, which are heightened by the geometric elements and the sensual nude.

The picture-within-a picture motif had played a major role in Matisse's art since 1906. At times, depictions of his own work nourished new paintings. Except for the unfinished picture on the chair that serves as a makeshift easel, the pallid works depicted here cannot be identified with any certainty.[19] As such, they reverse the overpowering confidence expressed in an earlier work, *The Red Studio*, 1911, where the paintings not only are recognizable but also are the concrete accents that contrast with its otherwise abstracted character.[20] In *Studio, Quai Saint-Michel* muddy pentimenti enhance the phantomlike effect of the paintings, which seem to hover between the tangible and the intangible, thus heightening the permeable aspect of the space.

Two chairs, a table, and the three pictures on the wall cordon off the nude model—the painting's most sensual and vital element. Her remoteness is enhanced by her position in the darkest part of the painting (also the lowest, given the artificially high viewpoint, as if from a ladder). Her distance is further reinforced by her masklike features, suggesting sleep. Matisse used a nearly identical pose in *Lorette Reclining*, late 1916–spring 1917, and in 1913 he had claimed, "I only make studies from models, not to use in a picture—but to nourish myself, to strengthen my knowledge; and I never work from a previous sketch or study, but from memory."[21]

In *Studio, Quai Saint-Michel* the presence of

the artist is implied by the unfinished picture propped on the chair facing the painter's vacant seat, thus broadening the theme to include the relationship between artist and model, the static and desolate atmosphere perhaps representing Matisse's emotions at the time.[22] In a subsequent work, *The Painter in His Studio*, 1917, he intensified the mood, including himself in the form of a store dummy. These two works, along with the earlier, more buoyant *Interior with a Goldfish Bowl*, form a triptych that is comparable to the Moroccan triptych. That this correspondence is intentional is clear from the identical frames and dimensions, and the similar color schemes, of the three paintings.[23]

Like many of Matisse's works from 1913 to 1917, *Studio, Quai Saint-Michel* bears evidence of cracks from extensive reworking, notably in the shadowed area above the model. The resulting dense, labored surface attests to Matisse's evolving approach and expresses the ambivalence pervading the image.[24]

When asked about the open-window theme, Matisse replied, "For me space is one unity from the horizon right to the interior of my workroom. . . . The wall with the window does not create two different worlds."[25] In fact, in this work a harmony of spare geometry unites both: the bridge's round arch is echoed in the circular table, the fold of the curtain, and the model's hip. The spare rectilinear grid created by the window is echoed in repeated geometric relationships that contain the various color fields.[26] Yet the clear, cool light of the outdoors contrasts markedly with the warmer tones inside. The strips of pastel green and peach that separate the interior and exterior views underscore the wintry tenor of the city and the sallow, grayish hue of the nude.

The composition's abstracted form and mysterious tension recall Jack Flam's observation that "the pictorial field of Matisse remained ambiguously situated between perceptual and conceptual, continu[ing] to have the immediacy of the one and the abstract force of the other. . . . Matisse has learned from Cézanne not only to look at the relationships between things but also in the interstices between things—in those intermittent moments when existence is poised at the edge of a vast emptiness that is perceived not only in the world around us but at the very center of our being."[27]

The painting, while in the Coleman collection in Manchester, made an impression on Roger Fry. Kenneth Clark, its last private owner, later remembered it as "a most troublesome picture to have in the house."[28] Its influence in the United States has found its most notable homage in the work of Richard Diebenkorn, who visited The Phillips Collection while stationed in Washington during the Second World

War, and for whom "no painting had greater impact" in the 1940s.[29]

In the present work, all Matisse's motifs merge and overlap, as if in discourse on the ambiguities of nature, reality, and art; the picture-within-a-picture theme, created by the panoramic view of Paris and the paintings on the wall, highlights the imaginary nature of the painting. The carefully placed curtain offsets both the window view and our own view into the studio, further emphasizing this duality.[30]

L F

110

Interior with Egyptian Curtain, 1948

Intérieur au rideau égyptien; Le Rideau égyptien

Oil on canvas, 45¾ × 35⅛ (116.3 × 89.2)

Signature and date incised on curtain, l.r.: *Matisse 48*

Acc. no. 1305

TPG purchase from the artist through Pierre Matisse Gallery, New York, 1950.[31]

Interior with Egyptian Curtain brings a vibrant energy to the window motif. Painted while Matisse was beginning to develop the synchronized line and color of his paper cutouts, it is considered by many scholars the culminating statement of his final oil series. Indeed, Matisse may never have surpassed this work's inextricable unity of painting and drawing. The curtain is a Middle Eastern appliquéd textile owned by the artist at the time; its freely cut forms and bright colors nourished both the two-dimensional design of this painting and the paper cutouts. The year 1948, an intensely productive one for Matisse, saw his first designs for the Dominican Chapel in Vence and the feverish work in cutouts. The dynamism of this painting seems to be a metaphor for the prolific risk-taking of his eightieth year. It celebrates not only the Mediterranean springtime but also, perhaps, the artist's longing for renewal and vigor.[32]

The luminous energy of the work derives in part from the play of primary colors, which are set, like enamel, onto black fields. Lawrence Gowing observed that "the light it radiates is the vibration generated by oppositions of colour. . . . The virility is extraordinary: at last Matisse is wholly at ease with the fierce impulse." He summarized, "In [the painting] the interaction of colour epitomized the energetic force of light."[33]

The predominance of black in *Interior with Egyptian Curtain* suggests the saturation, rather than absence, of light; furthermore, dark areas connote both positive and negative form, substance and shadow.[34] In fact, traces of ocher, red, and blue appear under various passages of black paint in the curtain; whether Matisse changed his mind or intended to layer color underneath

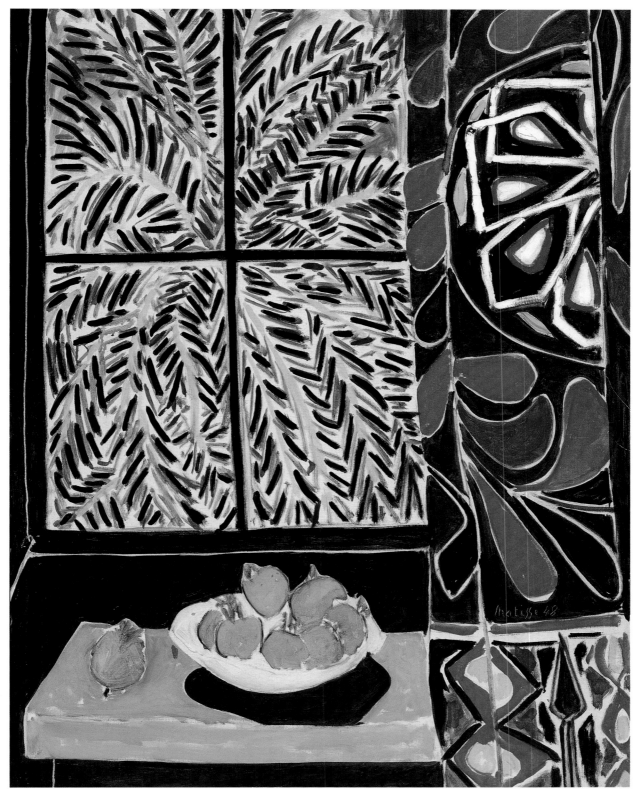

110

to warm these areas is uncertain. In any event, he emphasized the picture's flat, decorative qualities by applying a lean paint layer on finely woven linen canvas, incising lines around the window, and exposing passages of ground.[35] Only the thick white bands in the curtain stand out from the design.

The painting's abstracted objects, stripped of all illusionistic embellishment, indicate the direction of Matisse's art since the 1930s. According to Jack Flam, Matisse was "moving from the description of objects . . . to the evocation of objects by signs . . . from images based on what is directly seen and felt, to . . . what is recollected and thought," and he created a shorthand for ideas as much as objects that can be traced to the philosopher Henri Bergson.[36] Thus the idea of growth takes form in the spiraling vine design on the curtain as much as it does in

the palm outdoors; its explosive branches, barely contained in the window frame, seem to expand in all directions.[37] Matisse's recurrent symbolism in his late painting, though radically simplified, originated in traditional motifs. The pomegranate, the palm, and the spiraling vine refer to fertility, longevity, and creative energy, respectively. Life-giving light, signified by pure lines of yellow paint, pours through the window; the pomegranates seem to absorb and reflect it. Finally, the curtain, with its swirl of primitive patterns and anchoring spear motif, combines male and female allusions, resolving them in a rhythmic, dizzying dance. By Matisse's own standard—that "the importance of an artist is to be measured by the number of new signs he has introduced into the language of art"—the era of *Interior with Egyptian Curtain* revolutionized the twentieth century's visual idiom.[38]

The painting's most serene passage, the still life, mediates the active designs around it. An interval of soothing pastels, it derives much from the cutouts; passages of exposed white canvas around the fruit and bowl render them weightless, while the jagged contours of the fruit deny volume. Yet the still life anchors the image, both technically and thematically: the receding angle of the tabletop and heavy shadow, the painting's sole illusionistic devices, lend depth and weight to the composition's base. This stability is well suited to the time-honored theme of still life in Western art.

Interior with Egyptian Curtain is a further resolution of themes brought out in Duncan Phillips's earlier acquisition, *Studio, Quai Saint-Michel*. Each reflects a climactic period of restless experimentation and discovery in Matisse's career.

L F

GEORGES ROUAULT (1871–1958)

Georges Rouault was a deeply religious artist who worked in solitude much of his life. Born in Paris May 27, 1871, Rouault was the son of a woodworker and spent his youth developing the skills of a craftsman; he left school at the age of fourteen to work for a stained-glass artist. After attending evening classes at the Ecole des Arts Décoratifs, he soon developed an interest in painting, and in 1890 he enrolled at the Ecole des Beaux-Arts; there he studied under Gustave Moreau, together with the future fauve painters Henri-Charles Manguin, Albert Marquet, and Matisse. Moreau quickly adopted Rouault as his favorite pupil and became a seminal figure in Rouault's life and art. When Moreau died in 1898, he left instructions that Rouault be named curator of his artistic estate—what became the Musée Moreau—giving Rouault the financial security he needed to devote himself fully to his work. Other important artists whose work had a lasting impact on Rouault include Cézanne, Daumier, and Rembrandt. As his style developed, Rouault's art proved more akin in spirit to that of the German expressionists than the fauves, although he participated in their first Salon d'Automne exhibition in 1905 and in several of their subsequent shows. In 1917 Ambroise Vollard became Rouault's dealer, and through his commissions Rouault illustrated several books over the next two decades. On Serge Diaghilev's invitation, Rouault also designed sets and costumes for the Ballets Russes production of *The Prodigal Son* in 1929. At various points in his career Rouault enjoyed close relationships with writers, such as Jacques Maritain and Léon Bloy, who shared his devout religiosity. By the late 1920s his art had finally begun to gain recognition in France and by 1930 was being exhibited abroad. Rouault died February 13, 1958. The Phillips Collection owns eight oil paintings, one a recent gift, and eighteen works on paper.

The Rouault Unit

George Rouault was inspired by his profound Catholic faith and his empathy for human suffering. He shared with the German expressionists a fascination with Gothic art, especially the work of Matthias Grünewald, and is quoted as having said, "My real life is back in the age of the cathedrals."[1] This sentiment is reflected in his art, which presents images of society's oppressed and its oppressors in generalized, almost archetypal figures.[2] Through pictures of tragic souls—prostitutes, clowns, judges, Christ—and through symbolic landscapes, Rouault challenged the faith and justice of his peers. He rejected the decorative trends of con-

temporary Parisian art circles and instead created paintings of great emotional intensity that alienated many in his prospective audience. Rouault achieved this intensity through a distinctive use of black outline, rich colors, and thick application of paint—features possibly derived from his years as a stained-glass artist and his infatuation with Gothic art.

Rouault worked in isolation and enjoyed little public acclaim until fairly late in his career.[3] In the early 1930s Duncan Phillips developed a keen interest in Rouault's art and began to acquire his works as a unit. He described him as "a Gothic artist" belonging to "the great tradition of Rembrandt and Daumier," though "more preoccupied, as were the men of the Middle Ages, with sinister backgrounds and the besetting of sin."[4] Attracted to the artist's representations of "man's inhumanity to man" and his bold use of color, Phillips commended Rouault's "multi-colored and dynamic incandescence which is his equivalent for the Divine light, in men and in the creative universe."[5]

All but one of the pictures now in The Phillips Collection were purchased between 1930 and 1940 (the exception is *Verlaine*, ca. 1939; cat. no. 114). In fact, museum records show that ten other paintings by Rouault were bought and sold between 1930 and 1955, ranging in subject matter from landscapes to circus figures and judges. In 1939, eager to expand his Rouault collection, Phillips purchased five works, among them *Bouquet No. 1* and *Bouquet No. 2*, both ca. 1938, and the famous *Three Judges*, 1913, now in the Museum of Modern Art in New York.[6] Today the Rouault unit reflects the artist's favorite motifs and techniques.

Circus Trio, 1924 (cat. no. 111), is the earliest Rouault in the collection and one of the first purchases. It exemplifies the artist's lifelong fascination with circus iconography.[7] The portfolio of prints *Cirque de l'étoile filante*, 1938, and the lithograph *Self-Portrait*, 1926, demonstrate the artist's facility with printmaking, which he explored extensively in his commissions for Vollard during the 1920s and 1930s.[8] *Afterglow, Galilee*, before 1930 (acc. no. 1669), *Tragic Landscape*, 1930 (acc. no. 1676), and *Yellow Christ*, ca. 1937 (cat. no. 113), document the transition from his early apocalyptic depictions of nature to his serene late works.[9] *Christ and the High Priest*, ca. 1937 (cat. no. 112), provides an example of Rouault's turn to overtly religious iconography in the middle of his career. It also illustrates his late technique of painting borders around his subjects, framing them as if to stress their containment on the canvas, a device also evident in the collection's two decorative bouquets. *Ver-*

laine, acquired in 1947 and one of Phillips's last Rouault purchases, is a fine example of the artist's portraiture.[10]

Phillips was clearly pleased with his Rouault unit of works, writing to Daniel Wildenstein in 1953: "We already have Rouault magnificently represented with some masterpieces and a fairly extensive representation of his work in figures, religious subjects, landscapes and flowers."[11] Touched by Rouault's deeply personal style, Phillips had collected a unit of works by an artist he believed to be "among the titans of art, one of the greatest of the builders and the visionaries of painting."[12]

AV

111

Circus Trio, 1924

Trio de Cirque
Les Clowns
Oil on paper, 29½ × 41½ (74.9 × 105.4)
Signed u.r.: *G. Rouault*
Acc. no. 1673 (Dorival and Rouault no. 903)

Early history unknown; PMG purchase from Pierre Matisse Gallery, New York, 1933.[13]

Central to the unit as an example of one of Rouault's prevalent themes, *Circus Trio* displays the somber tones of Rouault's mid-career. The circus figures, which first appeared around 1903, are rooted in the spirit of the small traveling circuses that visited the suburban Paris of his childhood.[14] Rouault was intrigued by the contrast between the clown's "scintillating" costume and ostensibly happy demeanor, and his private life "of *infinite sadness,*" which he saw reflected in all people: "I saw quite clearly that the 'clown' was me, was us, nearly all of us. . . . We are all *more or less* clowns."[15] For Rouault the clown was a symbol of human weakness and vulnerability, of false hopes and unfulfilled dreams.

In *Circus Trio* a male clown is flanked by two circus girls, or *écuyères.*[16] They display a solemn and resigned expression, unlike the playful circus characters of the 1940s, or those of the early years of the century in which Rouault's angrier judgment of human nature is revealed through loose, frenetic brushwork. The painting's muted greens, blues, and reds distinguish Rouault's style from the bright paintings of his fauve peers and also differ from the Byzantine colorism of the later works.[17]

The three-figure composition is not unusual in Rouault's art.[18] The juxtaposition of the circus girls with the clown, however, is a distinctive feature of this painting, because men and women were generally kept separate in Rouault's

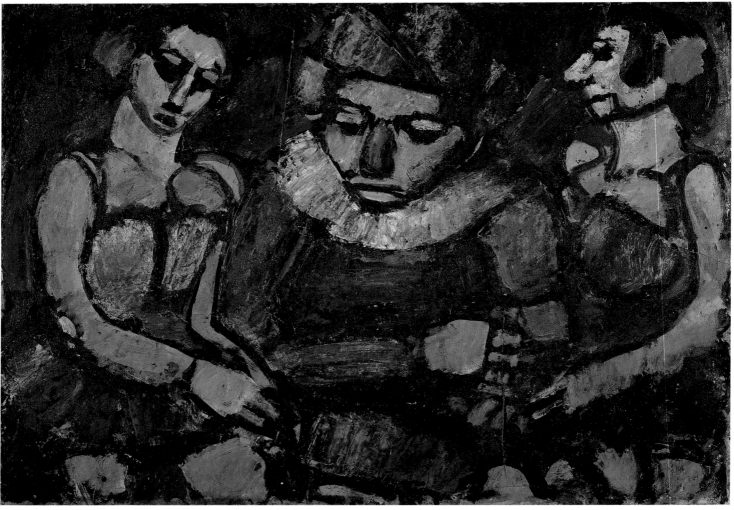

111

world. He tended to portray solitary characters in settings devoid of background, and even in those rare compositions including more than one figure, the characters seldom show signs of communication.[19] This is apparent in *Circus Trio*, where modeling is absent and thick black contours define the basic features and clothing of the figures, creating a strong aura of sadness. The frontal pose of the central clown, the three-quarter view of the female clown on the left, and the harsh profile of the one on the right contribute to the painting's tense atmosphere, as the characters seem to bend in order to fit into the confines of the picture space. The cropping of the figures, and the framing element of the women's arms on either side—foreshadowing Rouault's later device of painting borders directly onto his canvases—heighten the sense of confinement and isolation.

Rouault's so-called stained-glass technique of black outline was crucial to both his painting and his graphic art. It confirms his drawing skills, which were often overlooked in favor of his genius for color. *Cirque de l'étoile filante*, a collection of etchings and aquatints, illustrates his use of the outline technique in his graphic work.[20] Duncan Phillips noted, "Strictly speaking, the heavy black lines in Rouault's mature style are totally different from the leading in cathedral halls which was functional. . . . In Rouault the lines are a structural part of the design and of the emotional and symbolical color."[21] This is evident in *Circus Trio* in the way lines are used to set the characters apart from one another emotionally while joining them spatially. In the tradition of Watteau's *Gilles*, *Circus Trio* displays the contrast between the clown who warms the hearts of spectators and the spirit of the man hidden beneath the makeup.[22]

AV

112

Christ and the High Priest, ca. 1937

Christ et le Docteur
Christ and the Pharisee (DP)
Oil on canvas, 18⅞ × 12⅞ (47.9 × 32.7)
Bears inscription (possibly by the artist) on canvas reverse, u.c.: *G-Rouault/Christ et/Docteur*
Acc. no. 1672 (Dorival and Rouault no. 1548)

PMG purchase from Bignou Gallery, New York, 1940.[23]

Originally entitled *Christ et le Docteur*, this picture exemplifies Rouault's work of the 1930s, when he painted numerous pictures of Christ's Passion that were intended to symbolize the suffering of men and the agony endured by Christ for the sins of all people. Rouault infused these paintings with religious fervor. He frequently represented Christ with other figures, as in several pictures entitled *Christ et le Docteur*,

in which the character of the doctor seems to act as a generic malevolent figure confronting Christ.[24] Generally, few iconographic clues are provided to help identify the figures.

Christ and the High Priest conveys a striking emotional intensity that recalls Rouault's interest in Grünewald and Gothic art in general. The tension between the figures is heightened by the focused view of their interaction within the thick borders to the right and below; by framing the figure of Jesus so that he appears to lean on a windowsill, Rouault reinforced the image of a captive or confined Christ.[25] The two figures fill the lower half of the canvas and are set against a light impastoed background. Thick red strokes highlight the upper left corner, and black contours define the figures and their faces, serving particularly to accentuate the harshness of the priest's features. Bold strokes of red and gold give the painting the rich, textured appearance for which Rouault is best known.

As indicated by his final choice of title, Phillips interpreted this painting as the scene following Christ's arrest, when he is taken before the Sanhedrin tribunal and charged with blasphemy by the High Priest. The painting effectively communicates the tension between the two men by means of the enclosed setting and the contrast in demeanor: the priest or doctor, seen in profile, is shown in a confrontational pose, while Christ, seen from the front, has the almond-shaped face and downcast eyes typical of Rouault's figures of the 1940s.[26]

The unsettling mood evident in much of Rouault's work led many of his contemporaries to ignore its artistic merit. His lifelong friend and correspondent André Suarès wrote to him: "What is least known about you is without doubt this desire to turn a religious feeling into lasting beauty, even though it may seem horrible and scandalous to the Pharisees. The Academy is the Pharisee's temple of Art."[27] Late in the artist's career, however, his impassioned style began to be appreciated. The sincerity of his religious convictions caused him to become known as a painter of sacred art, a label he personally rejected.[28] Rouault often refused to give interviews because he resented being asked to explain his art, which he felt was beyond verbal definition and should speak for itself.

Duncan Phillips admired these troubling images and their "jewelled incrustations."[29] In discussing *Christ and the High Priest*, Phillips noted Rouault's obsession with sin and human suffering, and how these themes were accentuated by his technique, likening his heavy impasto to Cézanne's use of the palette knife. He also observed: "In *Christ and the High Priest* we see the inquisitorial personage ablaze with power and pomp, with vermillion and gold, yet unable to impress the humble son of God. At its

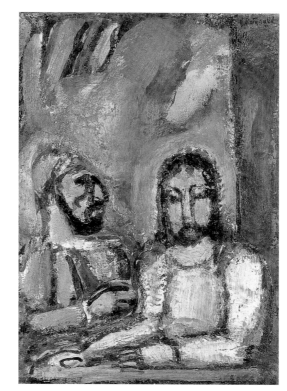

112

inner core Rouault's art is motivated by the early Christian belief in the blessed ministry of suffering."[30]

AV

113

Yellow Christ, ca. 1937

Still Waters; Beside Still Waters
Oil on paper mounted on canvas, 10 × 12¼ (25.4 × 31.1)
Signed l.r.: *G. Rouault*
Acc. no. 1675 (not in Dorival and Rouault)

The artist to Pierre Matisse Gallery, New York, 1939; PMG purchase 1939.[31]

Yellow Christ, which derives its title from Christ's yellow garment, is one of Rouault's late tranquil landscapes. It documents Christ's life as a man and sets a tone of spiritual serenity that implies his divine character. The picture conveys a peaceful, almost sacred quality and has a strong affinity to Gauguin's famous symbolist picture *Yellow Christ,* 1889. Rouault saw that painting at Vollard's gallery around 1900 and is said to have been moved by its "profound truth."[32] It inspired him to discover a way to depict his own vision of religion through art, and the use of yellow to define Christ's figure may have been meant as an allusion to him as "the light of the world." At the same time, it may have been his personal tribute to Gauguin.

Nature was a constant source of inspiration to Rouault, for he believed that by observing it closely he would be able to blend the worlds of "reality and imagination."[33] His earliest landscapes are loosely constructed, often dark images of the natural world, which led his friend Suarès to advise him in 1913: "I wish that . . . you should increasingly seek in your painting of landscapes, its transparency and luminous clarity. To my mind you could succeed in what has not been achieved for a very long time: the religious landscape," and he continued by writing that not since Rembrandt had a painter succeeded in painting mystic landscapes.[34] Through religious landscapes Rouault could communicate his faith. Color and iconography enabled him to create an extraordinary mood. Exposure to Cézanne had encouraged him to use color and color relationships to build three-dimensional form on canvas, a technique that is particularly evident in his landscapes.[35] The colors of *Yellow Christ* are more opaque than in earlier turbulent scenes, and strokes of juxtaposed color, rather than line alone, define the setting and the figures.

The composition bears a notable resemblance to Puvis de Chavannes's *The Poor Fisherman* of 1881 in that the religious theme is almost hidden, not identified by clear iconographic references.[36] In both pictures the central figure stands in a boat at sea; Puvis's is a young fisher-

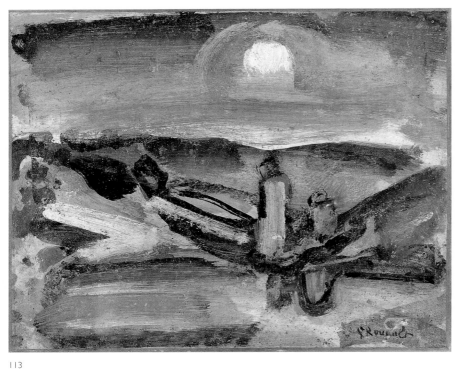

113

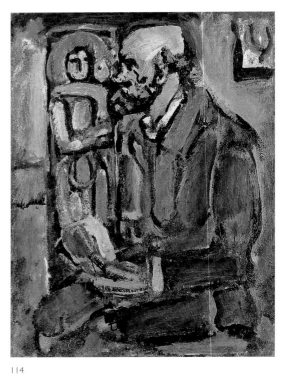

114

man who prays while his wife is seated holding an infant. His tattered clothes and meek expression add social commentary to the barely suggested religious theme. In Rouault's version, the standing figure is identified as the Son of God only through the glowing yellow cloak that gives a sense of mystical light emanating from within.

Duncan Phillips, who had described Rouault's earlier interpretations of nature as "revelations either of scientific analysis or of expressive frenzy," recognized the serenity of this later work.[37] *Yellow Christ* so impressed him that he renamed it *Still Waters* in order to draw attention to the scene's distinctive stillness.

AV

114

Verlaine, ca. 1939

Verlaine à la Vierge; Grand Portrait d'Homme

Oil on canvas, 39¾ × 29⅛ (100.9 × 73.9)

Possible monogram l.r.: *G. R.*

Acc. no. 1677 (Dorival and Rouault no. 2169)

Purchased by Pierre Matisse Gallery, New York, from Gallery Pétridès, Paris, 1947; PMG purchase 1947.[38]

The subject of this painting is Paul Verlaine (1844–96), a prominent poet in the decadent and symbolist circles of late nineteenth-century Paris. While in his late twenties, Verlaine left his family to live with the controversial young poet Arthur Rimbaud (1854–91). Their stormy relationship ended in 1873 when Verlaine shot Rimbaud in the wrist. During his subsequent imprisonment, Verlaine experienced a religious awakening that he went on to immortalize in his poetry.

In light of Rouault's own religious convictions, it is not surprising that in *Verlaine* he chose to portray the poet holding a symbol of his Christian faith: an effigy of the Madonna and Child. In his famous poem *Sagesse,* 1881, Verlaine had written of "ma mère Marie" and "l'enfant unique," and these passages may have inspired Rouault in conceiving this portrait. By including the Madonna and Child, he was able to allude to Verlaine's religious sensibilities in a way that was in keeping with the symbolist aesthetic, which emphasized suggestion rather than overt description.

Through his compositional style—which Duncan Phillips described as "breath-taking vertical architecture of towering, luminous blocks"—Rouault reinforced the vertical format. Thick brushstrokes, rich with color, create the likeness remarkably similar to that recorded in lithographs and oil studies, which, however, show only the poet's head in profile.[39] The dark outlines framing the luminous red, yellow, and white "blocks" define the figure of Verlaine in a manner reminiscent of stained-glass windows and further heighten the expressive power of the image.[40]

Phillips, who treasured the work, was impressed by its religious focus. He wrote to Pierre Matisse: "The importance of that sacred image on the same plane with the head of the man bears out the idea that it is a moving expression of the poet's yearning for a religious regeneration at the end of his life."[41]

AV

RAOUL DUFY (1877–1953)

Raoul Dufy's mature oeuvre consists of works of a colorful calligraphic and decorative exuberance, in which he treated lighthearted themes or classical motifs. Dufy was born June 3, 1877, in Le Havre, France, into a large family whose consuming passion was music. In 1892 he began training as a draftsman at the Ecole Municipale des Beaux-Arts, where he met Braque and Othon Friesz. He won a scholarship to study in Paris at the Ecole des Beaux-Arts, where under Léon Bonnat he developed a style of cautious impressionism. In 1906 Dufy had his first one-person show at the Berthe Weill Gallery, Paris, where he exhibited throughout his career. Financial hardship prompted him to explore media other than painting, including woodcut, lithography, mural and theater design, and textile printing. Sojourns to the Mediterranean and a trip to Morocco in the 1920s resulted in a new luminosity in his painting, and he added watercolor to his repertoire. Gradually his reputation reached abroad, and in 1931 he was awarded a Carnegie International Prize for a landscape. His first one-person museum exhibition in the United States was at the San Francisco Museum of Art in 1939. An extended visit to the United States from 1950 to 1951 was accompanied by a traveling exhibition, reinforcing his worldwide reputation. The steady onset of crippling arthritis impaired his work, however, and he died March 23, 1953. The Phillips Collection owns four oils and six works on paper.

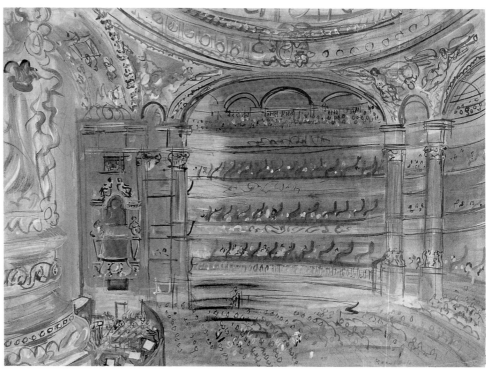

115

115

The Opera, Paris, early 1930s

L'Opéra de Paris

Interior, Paris Opera

Gouache on paper, 19¾ × 25¼ (50.2 × 64.0)

Signed in lavender tempera, l.r.: *Raoul Dufy*

Acc. no. 0613 (Guillon-Laffaille, vol. 2, 1982, no. 1616)

Early history unknown; PMG purchase from Nierendorf Gallery, New York, 1939.[1]

In 1905, deeply affected by Matisse's painting *Luxe, calme et volupté,* 1904, Dufy began his lifelong exploration of color and line, joining the fauve pursuit of a freer technique that liberated both elements from descriptive function.[2] Subsequent study of Cézanne and work with Braque brought greater structure to his compositions. His undemanding subject matter and apparent technical facility have sometimes led critics and scholars to question his importance; recent scholarship, however, has reassessed his post-fauve work. Dufy's watercolor oeuvre, begun in earnest about 1922, is represented in the collection by *Seaside Motifs* (acc. no. 0616), and his later work in gouache by *The Opera, Paris.* These pictures demonstrate his adroit, fluid handling of both media.

The ornate trappings of the Paris Opera are treated with a fanciful note through Dufy's exuberantly delicate style. The subject reflects his habitual theme of the pleasures of public life. Dufy composed rapidly, building on a thin-toned layer of paint and working wet into wet. His intuitive feeling for sculptural and architectural form, enhanced by a 1922–23 sketching trip to Italy, is given full range in the sumptuous interior.[3] The brisk, expressive calligraphy describing the decorations in the upper reaches of the hall, the tiers filled with a schematically rendered audience, and the slashing bows of the musicians in the pit seem to evoke the rhythmic swell and staccato of music itself. Dufy's formal treatment—disengagement of line and form from color—dominates the anecdotal aspect of the image, and the vast sense of space renders massive what is in reality a compact interior. The opulent tones of gold and red in *The Opera, Paris* are experienced as spontaneous evocations of pure light and space. Febrile, vibrating lines play over the areas of translucent color that are suspended behind the drawing, as seen in the gold highlights of the dome and the spans, as well as the blue wash of the floor area; they echo each other like recurring themes in a musical composition.

As early as 1930, Duncan Phillips had written of the "skill and bravura" of Dufy's painting, and of the keen understanding of the "narrow path of technical discipline" that lay behind Dufy's finesse.[4] *The Opera, Paris* was shown in the 1941 Phillips exhibition "The Functions of Color" in a grouping that included Burchfield, Davis, Knaths, and Marin; it was intended to demonstrate "Calligraphic Color and Color in Calligraphy." Phillips likened Dufy's work to both oriental art and French impressionism, because of the "ornamental continuity of the lines" and its "form-dissolving prismatic light."[5] In the next two years, Phillips added six more Dufys, including *Hôtel Sube,* 1926, *Seaside Motifs,* and architectural and sporting themes of the thirties.[6]

Recalling her meeting with the artist in 1937, Marjorie Phillips remarked on Dufy's great wit and charm.[7] Duncan Phillips, finding his "refreshing Gallic work" especially appropriate to "this period when France is in the process of being liberated," hosted Dufy's second one-person exhibition in an American museum in 1944.[8] The show was enthusiastically received by the press, and the selection of loans and acquisi-

tions was viewed as "a happy choice" that showed to great advantage Dufy's "colorful, high-keyed, light and airy" work.[9] Two subsequent one-person shows of Dufy followed in 1948 and 1949, and in 1951 the artist organized a traveling exhibition of his watercolors created during his sojourn in the United States, which was also shown at The Phillips Gallery.[10]

LF

116

The Artist's Studio, 1935

L'Atelier de L'Impasse de Guelma
L'Atelier de l'Artiste
Oil on canvas, 47 × 68⅞ (119.1 × 149.5)
Signed and dated in purple paint, l.l.: *Raoul Dufy 1935*
Acc. no. 0608 (Laffaille, vol. 3, 1976, no. 1184)

Bignou Gallery, Paris and New York, by 1936; PMG purchase 1944.[11]

The theme of the artist's studio was not new to Dufy in 1935; his first example dates to 1909. In the 1930s, however, he painted numerous monumental canvases, sometimes including nude models or self-portraits, of his studio at l'Impasse de Guelma, which he maintained from 1911 until his death. *The Artist's Studio* is considered the most successful of the series.[12]

Here, the room bears the mark of Dufy's work as decorator, designer, and artist: the walls were painted cerulean blue to his specifications; he designed the flowered textile on the left wall; and the paintings, most identifiable, are his.[13] Whereas for Matisse the theme of the studio was occasion for laying bare the creative process, for Dufy it represented a joyful evocation of the painter's environment. For both artists, this theme was a statement of their intoxication with art as much as with life. Matisse and Dufy share a preoccupation that complements the central theme of the studio: the window and the interplay of indoor and outdoor light and space.[14]

This work's sophisticated juxtaposition of even blocks of color and ornate calligraphic patterning recalls Dufy's ventures into fabric design and woodcut; the seeming transparency of the walls bears out Duncan Phillips's characterization of Dufy as a painter who "shuns solidity as only another illusion." The subtle handling is enhanced by the finely woven canvas, upon which the pristine, thinly painted image seems to float.[15]

The reclining nude, a quotation from Titian, has been identified as the one from Dufy's *Nu allongé sur une draperie*.[16] The nude also recalls Dufy's affinities with the French rococo artists Boucher and Fragonard, whereas the seascape prompts association with Claude Lorrain. A pervading eighteenth-century refinement is suggested in the undulation of the picture frame and furnishings, but it is offset in the stark simplicity of the windows. The vista of the Paris sky, fleeting clouds, and sharply angled facades is framed in vertical window strips that flood the room with light. The space at left, enclosed in rectangles, appears tight and compressed. A duality is established between the artist's finite production, framed and inanimate, its limits fixed, and the sky, in continuous flux and evolution, kinetic and animate, virtually bursting the bounds of the window frame. In this painting, poised between the two spaces is a work in progress, a classical nude whose absence of color bestows a neutrality that is reinforced by the figure's generalized rendering. The artist's presence is suggested by his palette and portfolio, as well as by the paintings on the walls.

The colors—warm rose and brown at the left and a cool wash of blue bathing the area around the windows—enhance the thematic contrast. Local accents of red and green, used principally for the paintings, remain muted and are dominated by the interplay of pink and blue; thus the work reflects Dufy's postwar style of "graceful arabesques, sonorous colors and . . . decorative two-dimensionality."[17]

On its first exhibition in London, the painting was singled out for its color harmonies and striking light. The last Dufy painting to enter the collection, *The Artist's Studio* was highlighted by the local press as "indicative of [Dufy's] serious side . . . which he has seldom surrendered to."[18]

LF

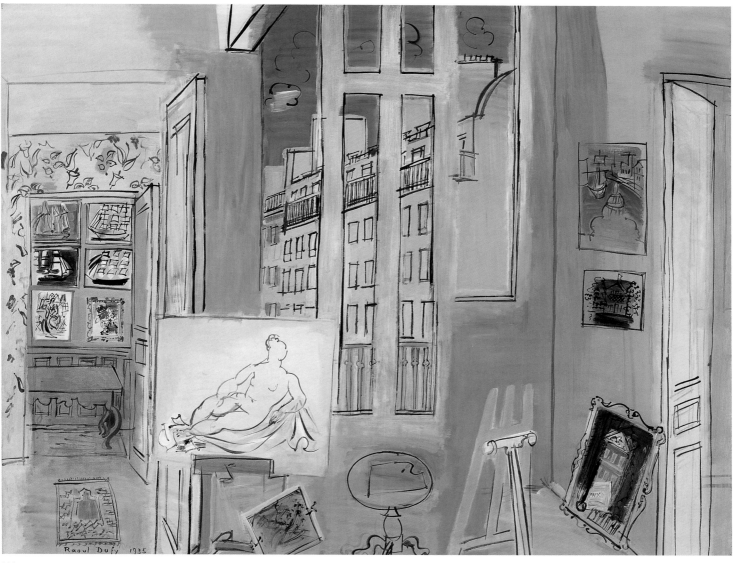

116

ANDRÉ DERAIN (1880–1954)

André Derain was a leader of the French avant-garde who later became the standard-bearer of the return to the classical tradition. Derain was born June 17, 1880, in Châtou, to a prosperous family. In 1898 he went to Paris and enrolled at the Académie Camillo, where he studied along-side Matisse and was taught intermittently by the symbolist Eugène Carrière. Derain introduced Matisse to his friend Maurice de Vlaminck, and together these artists spearheaded the revolution of form and color that earned them the name *les fauves* (the wild beasts), rocking Paris with their 1905 exhibition at the Salon des Indépendants. The dealer Ambroise Vollard was purchasing Derain's work by 1905, and Daniel-Henry Kahnweiler became his dealer in 1907. At about this time, Derain came into contact with the cubist work of Braque and Picasso and began to find inspiration in medieval and primitive art. With the outbreak of the First World War, he was drafted; after five years' service he resumed his career as an artist, drawing on classicism. Paul Guillaume, who was to become Derain's dealer in 1923, hosted his first one-person show in 1916. By 1922 Derain was regularly exhibiting internationally, and in 1928 the Carnegie International honored one of his crystalline still lifes with first prize. The 1940s saw his reputation declining, because of both a controversial visit to Nazi Germany and what his critics saw as a waning of his artistic powers; after the Second World War, Derain focused increasingly on landscapes and the nude. In 1954, after he had suffered a stroke, a car accident hastened his death on September 8. The Phillips Collection represents Derain with four oil paintings and two charcoal drawings.

117

Mano, the Dancer, between 1924 and 1928

Mano, la danseuse
Oil on canvas, 36¼ × 29 (92.0 × 73.6)
Signed l.r.: *Derain*
Acc. no. 0501 (Kellermann, vol. 2, no. 1067)

The artist to de Hauke, New York, by 1928; PMG purchase 1928.[1]

Derain's pivotal role in European modernism included anticipating Matisse's fauve explorations, being among the first in the avant-garde to acquire African art, and inspiring Braque's early cubist palette and sculptural approach.[2] Derain illustrated the first literary works of both Apollinaire and Breton, although Breton dismissed the artist after his subsequent shift to a classical style.[3]

117

In his search for classical values, Derain studied past masters, and *Mano, the Dancer* alludes both to Watteau's performers and to Manet's simply composed, loosely painted figures.[4] Further, Derain had created decor and costumes for the ballet in 1916 and 1919, sparking a period of sustained focus on commedia dell'arte themes.[5] "Theater," he wrote, "is the manifestation of a human archetype made up of the individual or the actor and all the individuals and the spectators. . . . The creation of a superhuman type is the supreme end of art."[6] The imposing size, generalized features, and somewhat mannered pose of Derain's model, Mano (who might have been a dancer with the Ballets Russes or an artist's model posing in costume), indeed evoke a universal "type" as well as a specific individual.

Derain began to experiment with a textured, frescolike background in 1922, handling the paint with increasing looseness throughout the 1920s.[7] In *Mano,* perhaps inspired in part by lithography, he juxtaposed two techniques: black lines and sharp angles, thinly applied, to define the facial features and give contour to the body; and blurred, feathery taches of rubbed-on paint, picked out in low relief, throughout the costume and the green background, to soften the composition.[8] The model's hands blend into her massive arms, and the dress merges into the background. Radiating lines suggest an energy emanating from the woman herself. The area of her torso and waist, emphasized by her framing arms, contains the composition's warmest tones, recalling Derain's dictum that "light has to emanate from the picture. The real subject of the picture is to create light, the only medium of painting."[9]

The subdued palette of jade-green, cream, and pearly flesh tones, and the wistful expression and tilted head, lend this painting an air of melancholy reminiscent of Watteau's subjects. The painting inspired Phillips's immediate enthusiasm, and he purchased it on sight. For him, it "reveal[ed] Derain's position in the direct line of the French classic tradition."[10] The press, too, was overwhelmed; a "storm of applause" ensued, including reproduction on the cover of *Art Digest* on March 2, 1929, and the declaration of one critic that "no finer Derain has ever come to this country and only the great landscape *Southern France* . . . is even comparable to it." The art historian Walter Pach sent Phillips a congratulatory letter on its purchase, counting it as "the greatest piece of painting in recent times."[11]

Walt Kuhn was partly responsible for bringing Derain before the American public in the Armory Show in 1913, and Phillips praised the dignified realism he felt both artists had in common.[12] Yet despite his initial reverence for *Mano, the Dancer,* Phillips, perhaps reacting to Derain's waning reputation, tried to sell the painting in 1943.[13] By contrast, Phillips never lost his enthusiasm for the small, subtly luminous *Head of a Woman,* 1927 or later (acc. no. 0498), acquired the year before *Mano.* Upon its first exhibition at the museum, Phillips wrote that "the glow of color is poignant in its emotion and universal in its symbolism."[14]

LF

118

Southern France, between 1925 and 1927

Paysage de Province
(Landscape) Southern France
Oil on canvas, 29⅞ × 36⅝ (75.9 × 93.0)
Signed in brown paint, l.r.: *Derain*
Acc. no. 0502 (Kellermann, vol. 2, no. 589)

The artist to unknown dealer, probably in Paris; Reinhardt, New York; PMG purchase (from exhibition) 1927.[15]

A revival of classicism in Europe in the 1920s, particularly in France, stemmed partly from the purifying effect of Cézanne and a renewed appreciation for Chardin and French neoclassical painters, especially Ingres. The trend was fomented by a nationalism born of the First World War. The roots of the style can be found in the 1900–1905 work of Derain, Picasso, Matisse, and artists of the Mediterranean, who often worked in this manner while simultaneously experimenting with more innovative styles.[16] In the 1920s, after a brief involvement with the cubists and an exploratory foray into primitive Gothic imagery, Derain resumed his neoclassical style, even while his contemporaries pursued new directions.

The idyllic Provençal view of *Southern France,* which appears in two other paintings, portrays terraced fields and olive groves crowned by a characteristic hilltop village.[17] The work demonstrates Derain's commitment to the French tradition, reflecting the clarity, economy, and fluidity of classicism; precedents can be found in Poussin, Claude Lorrain, and, as Phillips discovered, "Corot of the . . . clear Italian landscapes." Such traditional structure is also the basis of the work of Cézanne, with whom Derain shared "the same disciplined passion for isolated, essentialized form."[18] The mountainous, light-filled regions of the Mediterranean—exemplifying the idealized Arcadian landscape—cast a particularly seductive spell.[19] Derain's annual travels included sojourns at Lecques, Ciotat, Saint-Cyr, Sanary, Saint Maximin, Bandol, Olières, and Cassis. These visits, as well as a 1921 stay in Italy, served to reinforce his delight in the light and landscape of the area.

Through the direct study of nature, Derain brought to life the pastoral theme; his choice of setting allowed him the distant vantage point and broad horizon of classical landscape.[20] The balanced proportions, spatial clarity, and color scheme of brown foreground, green middle ground, and blue background hark back to both Dutch and French landscape traditions; yet the composition's almost primitive simplicity and freshness set Derain apart from them. For instance, the overall thin layer of paint was rubbed down or diluted, especially in the land mass at the left, and incisions were made with a sharp tool. These incised areas create textures that are masterfully adapted to the various forms: undulant, curling strokes suggest a middle ground of full, leafy trees, and horizontal washes evoke the barren earth of the foreground. For Derain, harmonies of form and color were central to atmospheric effects; building from a warm beige imprimatura, he balanced somber tones with passages of pale color, accented the foreground and distance with deep green, and used subtle whites to soften the olive trees, highlight the receding hillside, and suffuse the sky with light.[21]

Southern France was praised in the press as showing "the peace and dignity of a mature talent."[22] In describing Derain's technique in 1929, Duncan Phillips could have been referring to this painting: "His colors . . . are now deep and resonant and steeped in light. . . . He places linear accents and dark contours in his compositions, crisply . . . in a kind of Occidental calligraphy fused with his French plastic power."[23]

Phillips most admired Derain's style of the late 1920s and avoided his fauve and cubist periods.[24] Like many collectors and critics, he was immediately attracted to Derain's "return to order," finding it to be a release from artistic and political turmoil.[25] His consecutive purchases of *Head of a Woman* and *Mano, the Dancer* confirmed his commitment to the artist.

Phillips installed his Derain paintings with those of Renoir, the later School of Paris, and such American naturalists as Maurice Sterne, thus highlighting Derain's versatility and far-reaching influence. In 1928 he observed of *Southern France:* "In this picture we see . . . all the phases of his preparation . . . the simplified, colorful foreground of the Fauve period—then the classic middle distance, sombre and solid as Courbet, and above, a vibrant plane of brilliant sky worthy of the Impressionists. . . . Curiously enough, the result is unity and a grand serenity."[26]

LF

118

MAURICE UTRILLO (1883–1955)

Maurice Utrillo's images of the outreaches of Montmartre and other urban sites have become icons of early twentieth-century bohemian Paris. Born December 26, 1883, in Paris, to the artist Suzanne Valadon and most likely the Catalan artist Miguel Utrillo y Molins, Utrillo grew up in the milieu of his mother, who was friend and model to Renoir, Puvis de Chavannes, and Degas, among others. After Utrillo's hospitalization for alcoholism and attempted suicide at age eighteen, his mother encouraged him to take up painting. Abandoning his education, Utrillo created a significant body of impressionist-influenced landscapes, and soon his work had a small following in Montmartre, where paintings often served as barter for a bottle of wine. He attracted the notice of the dealer Louis Libaude (pseudonym Lormel), and the Salon d'Automne represented his work for the first time in 1909. Undeterred by rejection from the Ecole des Beaux-Arts, he produced his strongest work during his "white period," earning the admiration of such avant-garde artists as Derain and Picasso and writers Elie Faure, Paul Gallimard, and Octave Mirbeau. In 1912 Utrillo showed with Cézanne, Delaunay, Derain, Matisse, and Picasso, and he participated in the Salon des Indépendants for the first time; the following year he had a one-person show at Galerie Eugène Blot. After 1915 Utrillo began his "coloristic" period; his prodigious output included 1,200 paintings during the First World War. A 1919 showing of early work earned him great prestige. His growing success was compromised, however, by his poor health, and he was hospitalized numerous times for alcoholism and severe depression. Named Chevalier of the Legion of Honor in 1928, by the late 1930s Utrillo finally achieved international stature with European and American exhibitions, including a retrospective at the Salon d'Automne in 1948. In spite of a late marriage and renewed commitment to his religious faith, his health deteriorated, and on November 5, 1955, after receiving the Médaille d'Or de la Ville de Paris, Utrillo died of pneumonia. The Phillips Collection owns two oil paintings from the critically acclaimed white period.

119

119

Abbey of Saint-Denis, ca. 1908

Basilique de Saint-Denis
Oil on canvas, 28⅜ × 19⅝ (72.7 × 49.8)
Signed in black paint, l.l.: *Maurice Utrillo, V,*
Acc. no. 1994 (Pétridès no. 83)

Possibly from the artist to Louis Libaude, Paris; Galerie Defrenne, Paris, by 1936; Theodore Schempp, Brodhead, Wisc., by 1939; PMG purchase 1940.[1]

120

Place du Tertre, 1911

Oil on cardboard, 21⅜ × 28⅞ (54.4 × 73.3)
Signed in black paint, l.l.: *Maurice. Utrillo. V.*
Acc. no. 1995

Possibly from the artist to Louis Libaude, Paris; Dr. Raeber, Basel; Jacques Lindon, Gallery of Modern Art, Inc., New York; PMG purchase 1953.[2]

Beginning around 1909–10, Utrillo entered what became known as his white period, an interval of productivity and relative contentment unprecedented in his career. Both *Abbey of Saint-Denis* and *Place du Tertre* are products of this era, the first from the beginning of this period and the second a classic example of the style.

Utrillo almost never worked from nature after about 1909, and both views probably derive from postcards. The artist revisited each subject in several closely related paintings, and, indeed, both churches and street scenes are frequent subjects in his oeuvre.[3] The *Abbey of Saint-Denis* depicts one of France's most imposing Gothic cathedrals, situated north of Paris in the town of Saint-Denis, and the street scene shows the Place du Tertre, a square in Montmartre, the bohemian quarter of the city, which Utrillo frequented.[4]

The Abbey of Saint-Denis is situated between the suburb of Montmargny, where Utrillo lived, and Montmartre, where he went on his trips to Paris. Thus the monument would have been well known to the artist, whose body of work included a generous number of paintings of churches. The legend of its namesake, St. Denis, holds that he was beheaded in Montmartre and walked with his head in his hands to the site of the cathedral, which was built in the twelfth and thirteenth centuries to commemorate his martyrdom. Distinguished for centuries

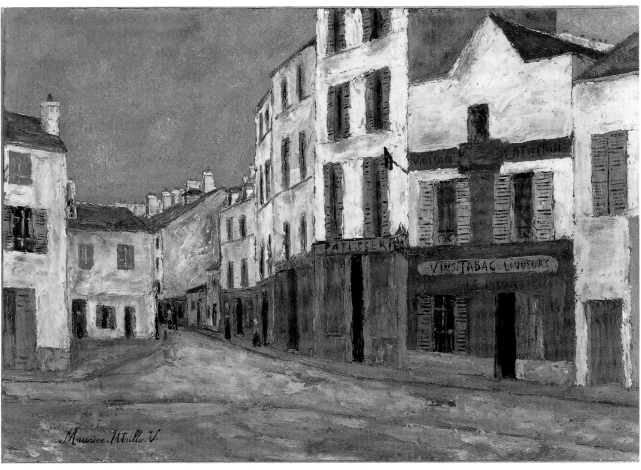

120

as the burial place of French monarchs, the church became a prototype for early Gothic architecture. Utrillo's admirer and fellow artist Maurice de Vlaminck found a spiritual solace in Utrillo's cathedral paintings and observed that they emitted "a mystic power . . . the love of creation rising toward its creator."[5]

In this image, Utrillo concentrated on the strangely asymmetrical west entrance, which has a mixture of Romanesque and Gothic elements. Utrillo's attempt to match the texture of the colored stone and the "patinas of the ancient facade" in paint resulted in a thick and heavily impastoed canvas.[6] For Phillips the tactile effects succeeded. He described the "rugged relief" of Utrillo's surfaces as having "a scintillation which simulated the stone of cathedral facades."[7]

Through its restricted palette and almost deserted setting, *Place du Tertre* creates an atmosphere not of bohemian gaiety or rustic charm but of solitude and eerie quiet. The characteristically tight composition derives from the

geometry of rectangles indicating doors, windows, and houses. The curving perspective creates a closed view and an unsettling claustrophobia that is heightened by the lack of foliage. Utrillo's preoccupation with walls, which prompted one critic to describe him as a mason, serves as an ideal vehicle for his love of rich, heavy paint, which he often mixed with unorthodox materials.[8] Over a rudimentary sketch, Utrillo laid heavy layers of opaque paint with the palette knife and brush, joining each rectangular area squarely to neighboring passages with a craftsman's love of precision. In the more impressionistic sky, only the brush was used. Appropriately, Utrillo's support is thick, unprimed cardboard, which is harder and less permeable than canvas. Textural unity and tonal harmony prevail, linking the chain of houses and attuning the mottled tans and grays of the sky to those of the sandy road. This fluency of hue, and the black accents, are reminiscent of Sisley and Pissarro, whom Utrillo greatly

admired.[9] Utrillo embellished the scene with signs for wine and tobacco and for one of his favorite bars, Maison Catherine. The nuanced colors of the central structures recall the observation that "Utrillo's white takes all tones, drinks all light . . . passes from hot to cold, matte to glossy, banality to the sublime."[10]

Phillips became interested in Utrillo's work around 1926, and from the beginning his efforts centered around finding both secular and church views of the white period. He acquired *Suburbs in Snow* around 1926 and added a painting of a public square in 1939, but ultimately he retained only the present works.[11] Providing Washington, D.C., with a rare opportunity to view Utrillo's best-known period in depth, Phillips held a large one-person exhibition in 1953.[12] For Phillips, the white period was the high point of Utrillo's career, "when there was enough personal expression and painterly distinction in his work to justify his reputation as a master."[13]

LF

AMEDEO MODIGLIANI (1884–1920)

Born in Leghorn (Livorno), Italy, July 12, 1884, Amedeo Modigliani was the youngest and much cherished son of an impoverished Jewish family. Modigliani was stricken with numerous debilitating illnesses throughout his childhood, and he was therefore permitted to study art, first locally with Guglielmo Micheli and later in Florence and Venice. In 1906 he moved to Paris, where the experimental fervor and freedom of the times were conducive to his development as a painter and sculptor. It seemed, however, that for Modigliani artistic order could be born only from personal turmoil, and his ready acceptance by the *peintres maudits* (the "accursed painters," publicly scorned and personally ill fated) fulfilled this need. In these early years he became the archetypal drunken, violent painter whose pictures, in their order and serenity, defied the chaos and anguish of their creator's life. The influence of Cézanne and Toulouse-Lautrec is most apparent in his early Parisian work; the overwhelming presence of Picasso seemed to obsess and distress him. By 1907 he had found his first patron, Dr. Paul Alexandre, who had a profound influence on his life until the beginning of the First World War. In 1908 and 1909 Modigliani exhibited at the Salon des Indépendants. Although well known as a formidable draftsman, he was still deeply involved with sculpture and worked under the powerful influence of Brancusi, with whom he studied briefly. By 1914 he began to concentrate on drawing and painting, and after a brief cubist period from 1915 to 1916, he developed his mature style, rooted in a classical vocabulary. By 1916 Léopold Zborowski had become his dealer and friend. One year later, his one-person show at the Galerie Berthe Weill was closed by the police, and five pictures of nudes were ordered removed from the dealer's window. Beginning in 1917 Modigliani experienced great growth as an artist, and he had a brief period of recovery from ill health in 1919. His self-destructive tendencies increased, however, causing him not to take proper care of himself when he fell ill. He died in Paris January 24, 1920. The Phillips Collection owns one oil painting, one ink drawing, and two pencil studies.

121

Elena Povolozky, 1917

Elena Pavlowski; Helena; Elena
Oil on canvas, 25½ × 19⅛ (64.6 × 48.5)
Signed in black paint, l.r.: *Modigliani;* inscribed in black paint, u.l.: ELENA
Acc. no. 1369 (Pfannstiel no. 189; Parisot, vol. 2, no. 7/1917)

Probably in the collection of Hélène Bernier Povolozky, Paris; possibly owned by Maurice Laffaille, Paris; acquired by Pierre Matisse 1947 or 1948; PMG purchase 1949.[1]

In his 1917 portrait of Hélène Joséphine Bernier Povolozky (1882–1979), Modigliani harmoniously combined elegant line and melancholy spirit with his by-then-expert technical facility. The cool palette and strong plastic modeling of the face through color modulation signal Modigliani's mastery of the lessons of Cézanne; the mood of wistful sadness, characteristic of the late portraits, shows him at the height of his powers.

Povolozky came to Paris from Reims to pursue her own career as an artist, which brought her into contact with the expatriate artists of prewar Montparnasse, including Modigliani, Picasso, and Soutine.[2] In 1911 she met and married a Russian émigré, Jacques Povolozky, a bookstore and gallery owner in Saint-Germain. They played an active role in the Parisian art world and hosted exhibitions of many avant-garde artists. A loyal and generous friend, Mme Povolozky provided both Modigliani and Soutine with food and money and frequently received them in her home. In return, Modigliani gave her this portrait, which may have been executed in a studio rented from Modigliani's dealer, Léopold Zborowski.

According to the sculptor Jacques Lipchitz, a friend of the artist, Modigliani almost always finished works in one session and required, at least initially, the presence of the sitter.[3] A fluidly drawn preparatory sketch of this subject shows Povolozky in an almost three-quarter view (fig. 28). The tighter, more detailed approach in the Phillips work suggests that it was created after the other version, a rare instance in which the artist closely copied a subject.

Fig. 28 Amedeo Modigliani, *Elena*, 1917, pencil, 17 × 10⁵⁄₁₆ in., Perls Galleries, N.Y.

According to her niece and a neighbor, Giselle Tubert, Povolozky's outlook was tinged with an underlying pessimism, which betrays itself here in her grave gaze. Yet Jean Cocteau (whose portrait Modigliani painted in 1917) observed that the artist "reduced us all to . . . the vision within him . . . whereby [he] portrays his own image—not the physical appearance, but the mysterious lineaments of his genius."[4]

The painting reflects the humanist tradition of Modigliani's native Italy. The focus on the human form and spirit, the opulent flesh tones and somewhat mannered proportions, and the Hellenized inscription recall the art of classical antiquity or the Renaissance; indeed, the lettering hovering over her head, the delineation of

eyes and mouth, and the sloping shoulders are reminiscent of Mediterranean figures found in mosaics and trecento painting, "primitif" imagery that was venerated in Paris at that time.[5] It is even possible that the faintly drawn, hairlike tendrils emanating from the left side of Povolozky's wistfully tilted head are abbreviated references to a Botticelli Venus.

The chromatic arrangement, in which dark blues and browns contrast sharply with delicate flesh tones, may owe something to Picasso, specifically his 1906 portrait of Gertrude Stein.[6] This effect focuses attention on the sitter's face and is further enhanced by the narrow triangle of her white shirt, which directs the eye upward to the elongated neck and volumetric contours of the face, and ultimately to the eyes; asymmetrical, heavily browed, and outlined, they seem to focus on opposing worlds—her left inward, and right outward—reinforcing their dual function as "windows of the soul" and as the means by which we absorb the visual world.[7] Perhaps to convey this duality with greater clarity, Modigliani substituted crystalline blue for the actual color of her eyes—deep brown.

Modigliani's subtle use of cubist distortion may contribute to the disconcerting effect of the sitter's features, which are rendered as if examined from different viewpoints: the eyes, close together and frontal, are reminiscent of profile views on Greek vase painting; the nose is symmetrical and flattened, without volume; and the lips, chin, and jawline are out of alignment.[8] Although her face is delicately and simply drawn, the subtleties in the contouring of Elena's high forehead and broad cheekbones were achieved through the technique of painting wet into wet and using a rich oil medium brushed on in textured brushstrokes.[9] This strong interest in surface texture is also signaled by the artist's use of the butt of the brush to scrape incisions into the sitter's hair. His gift for creating plastic form was enhanced by his experience as a sculptor, as well as by his ceaseless drawing.

The blunt, unadorned sweep of Povolozky's short hair, and the mannish coat and bow tie, compete with her feminine features, delicate skin, and rosebud lips, creating an image of her "as an early garçonne," a popular style among women in the bohemian circles of wartime Paris.[10] It was by all accounts a faithful representation of the sitter.

LF

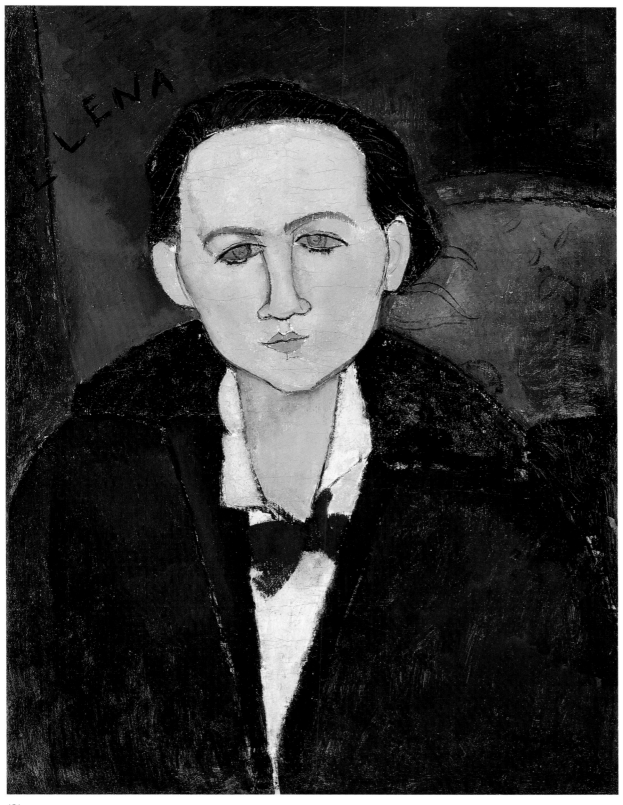

121

MARC CHAGALL (1887–1985)

Marc Chagall's luminous dream-memories of Russia were unique images in their time, yet in them he anticipated surrealism and sparked a new commitment to expressionism. On July 7, 1887, Chagall was born in Vitebsk, Russia. In 1908, after working with a photographer and studying briefly with the painter Jehouda Pen, he received a scholarship at the progressive Swanseva School, where he worked in the studio of Leon Bakst. A grant from a patron enabled Chagall to go to Paris, and in 1911 or 1912 he settled in the apartment building known as La Ruche, a haven of artists of the period. The patronage of the poet Apollinaire gained him his first one-person show at Der Sturm gallery in Berlin in 1914. His influence on the expressionists was great, and they claimed him as one of their own, but Chagall preferred artistic independence and never committed himself to their ranks. Returning to Vitebsk after the October Revolution of 1917, he helped to found the Academy of Fine Arts, but by 1920 he had resigned in protest against the rigid creed imposed by Kasimir Malevich and other suprematists. Chagall then left for Moscow, where his love of the theater emerged in a series of mural paintings for the new Jewish theater. In 1923 he returned to Paris, sojourning for several months in Berlin on the way. Once in France, the dealer Ambroise Vollard commissioned him to execute the drawings for a limited edition of Gogol's *Dead Souls,* and later to illustrate the Bible and the fables of La Fontaine. Chagall took French nationality in 1937 but fled to New York in 1941 to escape the Nazi invasion. There he designed sets for the opera, and the Museum of Modern Art held a retrospective in 1946. When he returned to Paris two years later, Chagall concentrated on religious themes, championing tolerance through his own ecumenical imagery. His career as a theater designer culminated in the 1960s with the unveiling of his ceiling painting for the Paris Opera in 1964 and his two murals for Lincoln Center in New York in 1966. In a long, productive career, Chagall was rewarded with countless retrospectives and honors. He died in Saint-Paul-de-Vence, France, March 28, 1985. The Phillips Collection owns one gouache.

122

The Dream, 1939

Le Rêve
Gouache on paper, 20½ × 26¼ (52.1 × 67.8)
Signed in blue gouache, l.c. to l.r.: *ChAgAll/MArc*
Acc. no. 0290 (Meyer no. 671)

Collection of the artist probably until 1941; Pierre Matisse Gallery, New York, by 1942; PMG purchase 1942 (from exhibition).[1]

In *The Dream,* Chagall explored youthful love and village life. His imagery is a tapestry of motifs from a multitude of sources and memories: the Old and New Testaments, remembrances of Russia, and his own imagined landscape of a promised land. The suspension of narrative logic harkens back to Russian folkloric and Hasidic culture, as well as to medieval painting; its compositional principles draw on Byzantine pictorial structure, which informs the use of light, color, and space, and cubist overtones, visible in the repeating geometric forms of the landscape.[2] The year 1939 was a turbulent one for Chagall, for he and his family were forced to take refuge in the countryside after war was declared.[3] Despite this upheaval, it was a turning point in Chagall's development, ushering in a new cohesiveness and order—qualities that infuse *The Dream* with underlying harmony. The village theme, usually included as a vignette in this era, has here become the primary motif.

Echoes of Chagall's biblical studies for earlier illustrations and his extensive travel bear fruit in *The Dream.* A Palestinian landscape is mingled with motifs from Vitebsk, merging the artist's vision of the past with a land of future and hope. Folkloric allusions in the setting—the floating cock and the hovering angel—are overlaid with Venetian color; the expressive forms recall the work of early Renaissance masters. Chagall recalls Rembrandt's painting *The Jewish Bride* in his depiction of the poignant encounter and tender gestures of the lovers.[4] Their mood extends throughout the central landscape, where the angel, in Western dress, proffers a blessing with a sign of affirmation; the tiny building with a cupola on the hill reinforces this spiritual aura.[5] In the foreground, the interior scene is warm white, and brown tones suggest a separate light source. To the right is an architectural motif often found in Chagall's work: a narrow house with a sign above the door, recalling his apprenticeship as a sign painter. Although the lettering here is somewhat indistinct, it is possibly the Russian word for "shop."[6] Alternatively, Alfred Werner has suggested that *The Dream* is

an Annunciation scene and that the house, which has "Laz" above the door, could be a reference to a hospital.[7]

Chagall's lovers, often portrayed as weightless, ecstatic beings set amid a swirl of saturated colors, usually suggest sensual love. The mood in the present work, however, is more spiritual in its reflection of conjugal love, apparent in the serene harmony between the lovers, an interpretation underscored by the sonorous hues of blue and green.

Possibly executed while Chagall was in hiding, *The Dream* contains echoes of anxiety; whereas a sense of personal happiness and fulfillment pervades the foreground, a series of dark peaks beyond the village suggest cataclysmic forces that threaten to engulf the scene. The title itself, shared by several works of the late 1930s, may suggest a desire to escape the increasing turmoil.[8] This new depth of feeling may indicate Chagall's response to the rapidly deteriorating political situation in Europe and Russia; indeed, James Johnson Sweeney saw the artist's 1930s imagery as replete with "forebodings of evil or warnings of impending disaster."[9]

A master with color and with the gouache medium, Chagall imparted a sense of warmth with a raw-sienna imprimatura.[10] He built up the composition methodically, first blocking in shapes in thin, fluid layers of paint, then applying heavier paint to define forms. He used a loaded, dry brush to create texture, which is complemented by the heavily textured surface of the paper. They help imbue both the architecture and the figures with volume. The dream elements—the landscape, angel, rooster, flowers, and the man on the bed (perhaps the dreamer himself)—are fused with a resonant blue full of nocturnal mystery, and the scene is illuminated with a transcendent green-gold light.

Chagall's presence in the United States from the summer of 1941 until 1948, at just the point when he was achieving artistic skill, furthered his gradual acceptance here. Phillips's recognition of Chagall's mastery through acquisitions and his 1942 exhibition of the artist placed him in the vanguard of American collectors; this recognition coincided with Phillips's eloquent writings on the threat of war.[11] His Chagall exhibition, the first solo show of the artist's work in a U.S. museum, opened in the fall of 1942, the same year as the Soutine exhibition and his first purchases of Soutine's foreboding landscapes. In the context of political upheaval, Phillips may well have appreciated *The Dream*'s allusion to the sanctity and security of the individual being as threatened by amorphous, malevolent forces.

LF

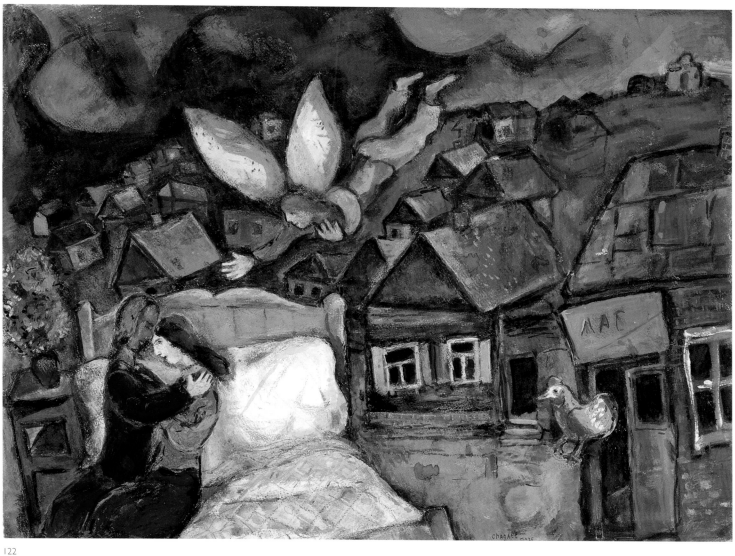

122

JOAN MIRÓ (1893–1983)

Nourished on the independent Catalan spirit as well as the surrealist poetry and automatic drawing of bohemian Paris, Joan Miró spawned a liberated language of form that altered the course of modern art. Miró was born in Barcelona, April 20, 1893. He attended a commercial school, then was permitted to study under the French-trained painter Modesto Urgell and at the Escola d'Art of Francesc Galí in Barcelona. He had his first taste of French avant-garde art at the 1912 exhibition of cubist, fauve, and impressionist art at Galeries Dalmau, the location of his first exhibition six years later. Initially gravitating toward still life, Miró evolved into a painter of hyper-realistic portraits and Catalan landscapes; his native land was an abiding force in his work. Upon his arrival in Paris in 1920, he was introduced to the Paris art world by Picasso, a family friend, and soon traveled in the literary and artistic circles of Tristan Tzara, Max Jacob, and other luminaries. His first one-person exhibition in Paris took place in 1921 at the Galerie La Licorne. In 1925 Miró met André Breton, Louis Aragon, and Paul Eluard and forged a lasting, if somewhat detached, link with the surrealists. He participated in the 1920 Salon d'Automne's tribute to Catalan painters and began to create inventive combinations of Old Master paintings, Catalan landscapes, and his own hallucinatory imagery. His quasi-abstract language, which he also translated into sculpture, ceramics, printmaking, and textiles, brought him early popularity in the United States; his first one-person show there was in 1930, and he was soon thereafter represented by Pierre Matisse. In 1940, with the invasion of France, Miró returned to Spain. He made four visits to the United States in the late 1940s to carry out mural commissions in Cincinnati and Cambridge. Miró's thirty subsequent years of inexhaustible productivity sustained his international recognition and influence. He died in Palma de Mallorca, Spain, December 25, 1983. The Phillips Collection owns one oil painting.

123
The Red Sun, 1948

Le Soleil Rouge
Oil and gouache on canvas, 36⅛ × 28⅛ (91.7 × 71.4)
Signed, dated, and inscribed in black paint on canvas reverse: *Miró/1948/LE SOLEIL ROUGE*
Acc. no. 1365 (Dupin no. 720)

The artist to Pierre Matisse Gallery, New York; TPG purchase 1951.[1]

The art and culture of Miró's native Catalonia were powerful forces in his painting and are reflected in both the playful effervescence and the dramatic intensity of his radical forms.[2] Added to this inspiration were the influences he was exposed to in Paris: the poetry of the Parisian symbolists and surrealists, and the example of Klee and the structural discipline of the cubists. This confluence nurtured a singular style at once earthy and spiritual, sensual and ethereal, but universal in expression. For Miró, this aspect was all important; he felt that painting ought "to rediscover the sources of human feeling."[3]

Further influences had come to play upon the restless imagination of Miró by the 1940s, when his preoccupation with music and with the nocturnal sky brought a lasting sense of mystery and contemplative awe to his work. Miró's illustrations for Paul Eluard's poems, for which he was inspired by a Japanese woodcut artist, may have contributed to the calligraphic effect of the heavy black "signs proliferating in his imagery."[4] A new interest in poetic titles emerged in the late 1940s, a lyric suggestiveness possibly inspired by illustrations for writings of Eluard and Tzara. Several works from 1948 share the theme and motifs of this painting.[5] In addition, Miró had been overwhelmed by the urban scene of New York, where he had reestablished contact with Calder, Tanguy, and Duchamp, and had met Pollock. In fact, the raw mien of abstract expressionism may have been a source for the renewed excitement with materials that he referred to in an interview in the late 1940s, given shortly before executing *The Red Sun*.[6]

After his first American sojourn in October 1947, and before his spring trip to Paris, Miró worked feverishly in Barcelona, where he completed fourteen medium-sized canvases, *The Red Sun* among them.[7] His poetic imagery—whimsical, stirring, and sometimes terrifying—achieved a monumental lyricism in works such as this one. Over a lustrous field of filmy blue, Miró placed several familiar elements: two red orbs and at least two "personages," one with a

bowed head at right, the other whose head is the floating "sun." Miró intensified the drama of the scene by framing it within an oval wash of black gouache. His renewed exhilaration with materials may be read in the bold gestural skein of black paint forming the axis of this image. He poured on whipped or beaten oil medium in which air bubbles had formed, resulting in the "pitted, cratered surface" of the central black elements, which contrast with the thin gouache washes of blue and black, creating a sophisticated textural counterpoint.[8] Miró's working process here also recalls his comment on the role of accident in his work of 1947–48: "I even used some spilled blackberry jam . . . as a beginning; I drew carefully around the stains and made them the center of the composition."[9]

The painting's enigmatic space exists as a highly tactile, ornamental pattern, on the one hand, and a shallow field for the silhouetted "characters," on the other. Miró's "contrapuntal" approach informs his technique and imagery; he juxtaposed abstract and painterly elements—the heavily impastoed drip and the yellow emanation at the right—with figurative and linear motifs—the anthropomorphic figure, the droll visage of the sun, and the hypnotically gazing earthbound head at the composition's base.[10] Each color finds its echo elsewhere, and compositional equilibrium ultimately dominates Miró's unbridled fantasy. The humorous forms and high-keyed primary colors are tempered by the somber, tarry blacks and may derive from Miró's own ambivalent nature, which he described as "actually pessimistic. When I work, I want to escape this pessimism." The note of humor and irony corresponds to Miró's perception of a person as a "marionette who must never be taken too seriously."[11]

The Red Sun embodies qualities Maurice Raynal extolled in his 1948 salute to Miró, seeing in him "the religion of a child filled with wonder at tiny details you alone have divined—a sign language incredibly rich in invention, never calculated, innocently cruel, just what we expect of a child who has never succeeded in growing old."[12] Its resonant, meditative quality, its forceful plastic unity, and the absence of erotic suggestion may have appealed to Duncan Phillips, who wished to "have Miró well-represented in the Collection as we go to press with the Catalogue [of 1952]." Phillips observed to Pierre Matisse at the time of the purchase that the painting signaled "a new phase of Miró's work, but one which I find goes better in our collection [than] his more characteristic style."[13]

LF

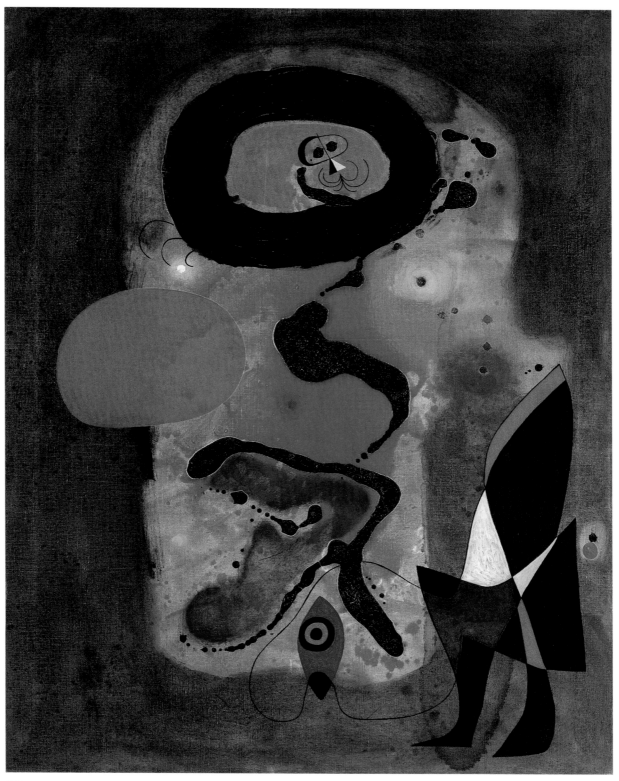

123

CHAIM SOUTINE (1893 – 1943)

An expressionist painter, Chaim Soutine was born in 1893 into a poor Jewish family in Smilovitchi, Lithuania. In 1913, after studies in Minsk and at the School of Fine Arts in Vilna, he journeyed to Paris, where he studied at the Ecole des Beaux-Arts. During this time he came in contact with Archipenko, Chagall, and Zadkine. He befriended Modigliani and was supported by the dealer Léopold Zborowski. In 1918 Soutine visited Venice and Cagnes-sur-mer with Modigliani and from 1919 to 1922 worked in the Pyrenees. He returned to Paris with more than two hundred canvases, many of which he destroyed. Recognition by the American collector Albert Barnes in 1922–23 brought renown and financial security. His first one-person exhibition was held in Paris in 1927, and through his friendship with longtime patrons Marcellin and Madeleine Castaing he met Cocteau and Sartre. Soutine's first U.S. showings were in 1935 in New York and Chicago. In 1937 he met Gerda Groth, a German refugee, with whom he traveled to Civry-sur-Serein. With his health deteriorating from severe stomach ulcers, he lived in locales outside Paris, in hiding from the Nazis, from 1939 on. After suffering an ulcer attack, he died in Paris August 9, 1943. Four oil paintings by Soutine are in The Phillips Collection.

124

124

The Pheasant, ca. 1926 – 27

Le faisan

Dead Pheasant; Pheasant

Oil on canvas, 12¼ × 29¾ (31.1 × 78.6)

Signed l.l.: *Soutine*

Acc. no. 1775 (Tuchman et al., vol. 1, no. 112)

From the artist to Nicolas Karjinsky, Paris; acquired by Maurice Laffaille, Paris, ca. 1948; on consignment with Pierre Matisse Gallery, New York, ca. 1948; TPG purchase 1951.[1]

Duncan Phillips's first purchases of Soutine date to the final years of the artist's life. By 1943 Soutine's vision was increasingly appreciated in the United States. However, Phillips's one-person exhibition of his work in January 1943—Soutine's first museum presentation in this country—received mixed reviews. One conservative Washington critic deemed the pictures "thoroughly repellent," grouping Soutine with the "repulsive painters."[2] Nonetheless, Phillips sustained his commitment to Soutine, who for him represented "the nervous agitation of the modern mind in a period of social conflict and war."[3]

The Pheasant, Phillips's last acquisition, is part of a series of still lifes of dead animals, fowl, and rabbits that Soutine painted in and around

1926–27.[4] Other works share this composition, in which a dead bird is isolated against a white cloth.[5] In earlier works Soutine had depicted twisted and seemingly still-writhing fowl hanging from hooks or prone on cloths. Pointing out the great restraint and peacefulness with which these later horizontally arranged paintings of birds were approached, Esti Dunow has observed, "The image of death is now more static and restrained. We see [death's] after-effects rather than [the] struggle with life."[6] Representing Soutine's most sophisticated approach to the theme, the Phillips version is characterized by the juxtaposition of white with blended reds, oranges, and browns; the contrast between stillness and agitation, both compositionally and thematically; and the tautness of spatial arrangement.

In the early 1920s Soutine sought inspiration from the still lifes of the Old Masters, specifically the skate paintings of Chardin and the beef carcasses of Rembrandt and Goya.[7] Toward the mid- to late 1920s Soutine developed his own approach to the genre, adding symbolic and ritualistic meaning derived from his roots in the shtetls, the Jewish settlements of Eastern Europe. As Maurice Tuchman notes, this subject may relate to Jewish tradition in an ancient rite of Yom Kippur, the Jewish Day of Atonement. A scapegoat was sacrificed for a collective symbolical absolution; in shtetl culture fowls, rather than the goat of antiquity, symbolically assumed the sins of the community.[8]

Soutine's early years of poverty and deprivation, and his severe stomach ulcers later in life, caused him to react ambivalently toward food—"food as good and life-giving and food as painful and illness-provoking"—and this conflict is present in his images of decaying, raw, or

otherwise inedible food.[9] His tireless quest for the properly decayed fowl, which had to be "emaciated just the right way, with just the right tone of blue in its neck, and with particular feather colouration," is well documented.[10]

Duncan Phillips's purchase of *The Pheasant,* which coincided with the Museum of Modern Art's Soutine exhibition in 1950–51, reflects his persistent attraction to the romantic theme of the dead bird, which can be traced in earlier acquisitions of works by Ryder, Poor, and Graves (see cat. nos. 71, 298, and 364).

LF

125

Woman in Profile, ca. 1937

Femme de profil

Profile (DP); *Woman's Profile*

Oil on canvas, 18⅜ × 10⅞ (46.6 × 27.6)

Signed l.r.: *C. Soutine*

Acc. no. 1778 (Tuchman et al., vol. 2, no. 165)

Collection of the artist; Madame Castaing, probably from artist; sold to Carroll Carstairs Gallery, New York, by 1940; PMG purchase 1943.[11]

The sitter has been identified as Mme Tennent, wife of a doctor who treated Soutine's ulcers. Refugees from Vienna, the couple had stopped in Paris en route to the United States, when Dr. Tennent examined Soutine and projected that he had only five or six years to live. Tennent's prescribed regimen, however, was so successful that, to show his gratitude, Soutine painted his wife's portrait. According to Gerda Groth, Soutine's lover during this period, "This canvas, executed with brio (in an afternoon, if I am not mistaken), depicts Mme Tennent in profile."[12] If Soutine gave the portrait

125

to his sitter, it must have been refused, because the painting ultimately came into the possession of Madeleine Castaing, Soutine's friend and patron from 1927 until his death. One critic's wry pronouncement of the painting as "an arresting portrait for which no woman would be grateful" perhaps explains why it did not become part of the sitter's collection.[13]

As early as 1940, Duncan Phillips was eager to have a portrait by Soutine in his museum; his interest centered on the iconic uniformed figures of the 1920s.[14] Indeed, almost half of the twenty-three works he borrowed for his 1943 Soutine exhibition were figure paintings; after the exhibition he found *Woman in Profile* indispensable and purchased it (along with *Windy Day, Auxerre*), subsequently hanging it with an "interesting group of twentieth century masters" that included Chagall, Matisse, Picasso, and Rouault.[15] Its acquisition reflects Phillips's stated commitment to acquiring works that represent various hallmark periods and preoccupations of an artist's career. It is highly representative of the period during the 1930s when Soutine selected as his subjects "simpler people . . . [in] the less assertive shades of household clothing."[16] Marcellin Castaing compared Soutine's figure style after 1930 with archaic Greek sculpture in its achievement of "classical balance. . . . Think of the dense, plastic sense, the vibrant precision in the admirable *Woman's Profile*."[17]

Soutine's enthusiasm for the work of the Old Masters, as well as Courbet, is reflected in the portrait's "filmy" paint application.[18] Nevertheless, it also betrays the agitated, nervous energy associated with Soutine in its frenetic brushwork: the strands and dabs of thin paint highlight the hair and face; the green paint of the woman's dress overflows in a long drip of paint down her left side. The portrait seems to contain all that is characteristic of the genre in Soutine's work of the thirties. "Even in these subdued figures," one scholar has written of this period, "there is a certain feverish pulse and anxious stirring under the surfaces. The quiet of the faces does not create harmony, but reveals some undercurrent of tension. The pinched features and averted eyes reinforce this sense of anxiety."[19]

LF

126

Windy Day, Auxerre (DP), ca. 1939

Paysage d'automne

Jour de vent à Auxerre; Windy Day (DP?); *Group of Trees at Civry*

Oil on canvas, 19¼ × 28⅝ (48.8 × 72.7)

Unsigned

Acc. no. 1777 (Tuchman et al., vol. 1, no. 166)

Carroll Carstairs Gallery, New York, by 1940; PMG purchase 1943.[20]

126

127

Return from School After the Storm, ca. 1939

Retour de l'école après l'orage

Children Before a Storm (DP); *Return from School*

Oil on canvas, 18⅛ × 19¾ (46.0 × 50.1)

Signed l.r.: *C. Soutine*

Acc. no. 1776 (Tuchman et al., vol. 1, no. 174)

Carroll Carstairs, New York, by 1940; PMG purchase 1940 (probably from Carstairs exhibition).[21]

In the summer of 1939 Soutine painted scenes in and around the village of Civry-sur-Serein, not far from Auxerre—including *Windy Day, Auxerre* and *Return from School After the Storm*. His companion, Gerda Groth, recounts in her memoirs: "The road to l'Isle-sur-Serein was lined with tall poplars. . . . Soutine painted several pictures of that road. One of these is the painting to which the Phillips Gallery . . . has given the title *Windy Day, Auxerre*, though in fact it shows the road . . . which he painted under a stormy sky."[22] The theme and figures of *Return from School* are almost identical to, but show a telescoped view of, those in *Windy Day*.

With the onset of the Second World War in September 1939, Soutine and Groth, as foreigners, were forbidden to leave Civry, although Soutine secured a permit to return to Paris for medical reasons. They went into hiding, living in Paris and surrounding areas, in constant fear of deportation by the Nazis (indeed, Groth was

deported to a concentration camp from Paris in spring 1940). Letters reveal Soutine's emotional and physical distress around this time. No substantial proof exists that either *Windy Day* or *Return from School* was painted after the couple had gone underground, but the artist's anxiety seems to be foreshadowed in these scenes, where turbulent forces buffet nature and vulnerable children.[23] According to Groth, Soutine read the newspaper religiously throughout the summer of 1939, "striving to discover between the lines the secret of an impending future full of danger."[24] In spite of his growing anxiety, he declined an invitation to come to the United States in 1940.[25]

The stand of trees that is the focus of both paintings appears in at least three other oils of the period, one of which (*Group of Trees at Civry*, 1939) is thought to have served as a sketch for *Windy Day, Auxerre*.[26] The brighter tones and more unified composition of the Phillips version suggest a greater resolution of the theme. Both works bear out the characterization of this late period as containing a uniquely lyrical, narrative, and nostalgic strain, a personal quality enhanced by the frequency with which small children appear. This tendency can also be detected in the palette, which in both paintings is dominated by blues, greens, and grays, although in the case of *Windy Day* a lurid, slashing red recedes into a background accent. The grandeur of both compositions prevails despite

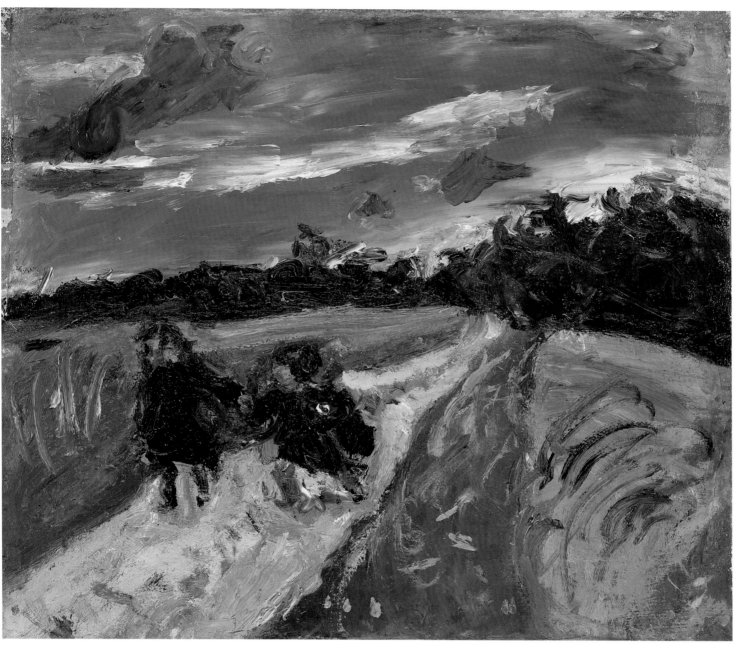

127

the presence of the characteristic spiraling, frenetic brushwork. Jeannette Lowe, who critiqued its first exhibition in New York, considered *Windy Day* to be one of the "magnificent landscapes, felt in huge, strong rhythms."[27] Indeed, Soutine composed this last group of landscapes with a sense of structure often absent in examples from earlier periods.[28]

Return from School, the first Soutine purchased by Phillips, is among the earliest Soutines purchased by a U.S. museum, second only to the extensive acquisitions of Alfred Barnes in the early 1920s. Deeply troubled by the turn of political events in Europe in the early 1940s, Phillips saw in Soutine's painting a "cataclysmic upheaval as if he had a premonition of our world's agony of total

war."[29] Phillips's vision of the late landscapes, such as *Return from School*, has been borne out by later scholars, including Esti Dunow, who finds that "these children start to symbolize a kind of innocence and cohesion in the face of impending overpowering forces, analogous to Soutine's own feelings of vulnerability."[30]

LF

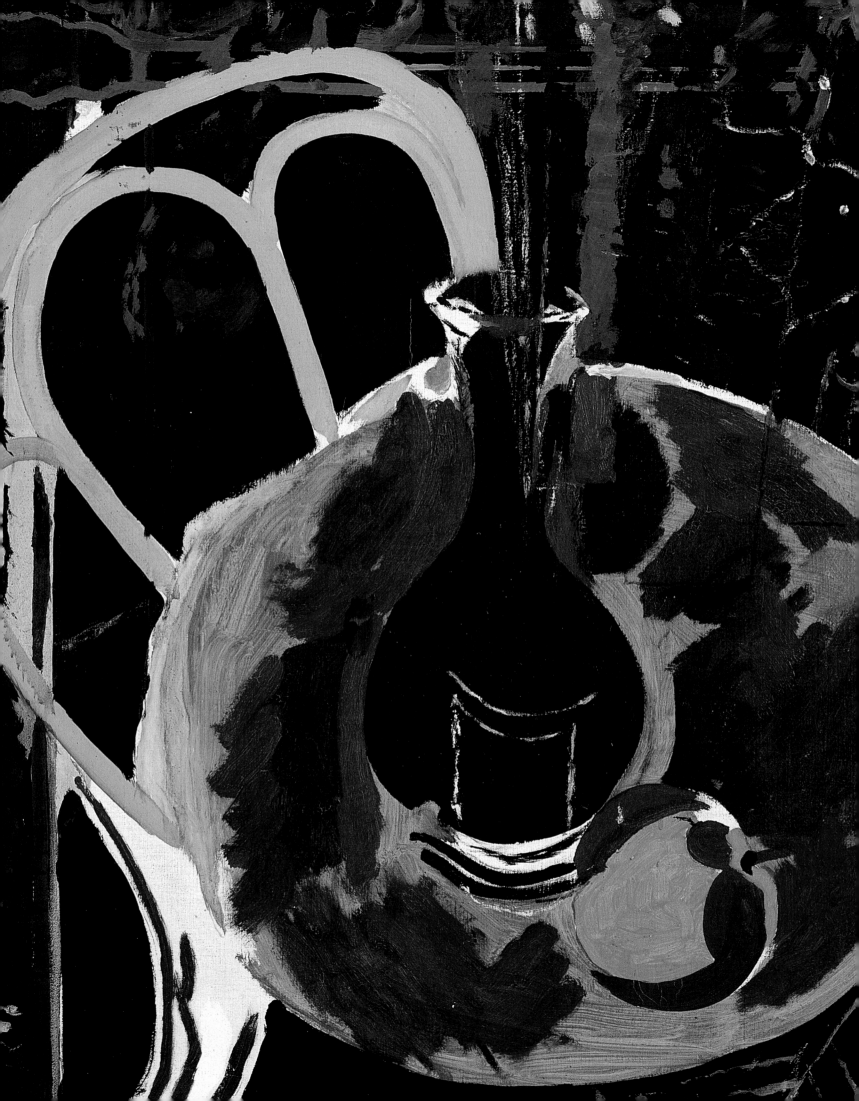

4 MODERNISM IN FRANCE

Part II: Braque, Picasso, and Other Cubists

KENNETH E. SILVER

Cubism was Duncan Phillips's "other," the exception that proved the rule of his overriding taste for lush, intensely colored, sensual painting. Aside from the remarkable representation of the work of Georges Braque, Parisian cubism is a minor aspect of The Phillips Collection's holdings. Indeed, were it not for Phillips's decades-long commitment to collecting Braque's work, we might overlook altogether the role that cubism, and high modernism more generally, played in the development of Phillips's thinking and in the formation of his museum. But this would be a mistake, for the status of cubism was constantly on his mind as he worked his way through the literature on modernism; it was a crucial issue in his published art criticism and theory; and it eventually was the movement with which he had to come to grips in order that his abiding love for Braque's art might be sustained and nurtured. Phillips took his role as museum founder and collector too seriously to ignore what was arguably, during the years of his most significant collecting, the most important and visible movement in art.

The numbers alone tell us a great deal: in terms of purchases for the collection, Phillips bought eleven oil paintings and one gouache by Braque between 1927 and 1953, all except one of which could be termed cubist; nine works by Picasso, only three of which are cubist; two cubist oil paintings by Juan Gris; one cubist still life by La Fresnaye; two cubist works by Villon; and one cubist painting by Marcoussis. From the Katherine Dreier gift in 1953 came another cubist Marcoussis and a cubist relief by Raymond Duchamp-Villon. That is to say, whereas Phillips felt passionately about and collected with equal ardor the work of Bonnard, Rouault, Marin, Klee, Graham, Dove, Tack, Rothko, and Renoir—the artists, represented by more than two hundred works, to whom The Phillips Collection owes its renown—his commitment to the cubists extended only to Braque. Why is this? What was it about the movement whose very name has been considered synonymous with modernism that kept Phillips at a distance? And how did it come to pass that despite these feelings Phillips came to include Braque—who, along with Picasso, invented cubism—among his chosen few?

We should keep in mind that Phillips's collection, like any other, evolved over time, in this case with an initial commitment to Amer-

ican art and a subsequent transfer of allegiance to French painting. His Pauline "conversion," on route to his own aesthetic Damascus, was marked by the purchase from Durand-Ruel in 1923 of Renoir's *Luncheon of the Boating Party*. The picture put Phillips and his new gallery on the cultural map, just as definitively as it opened a window for Phillips onto the richness of French art in general. Phillips had written as early as 1913 that Renoir embodied the spirit of France: "As Camille Mauclair expressed it—'The race speaks through Renoir.' He was the most French of all painters. . . . Renoir inherited the racial taste and talent for expressing his own pleasant sense of life's vivacity."[1] In the terms in which Phillips conceptualized culture, the relation between French and American painting had to be confronted head-on: "The reaction has set in and today we are told about the supremacy of American painting until we come to think that this must be approximately true." And later he continued: "I wish I could believe that it is true and that the lead in painting has passed from France to the United States. Unfortunately I cannot persuade myself that this change has come as yet."[2] As he went on to explain, in the course of his efforts on behalf of American art—"doing my bit," as he put it—he could not help but glance over at contemporaneous work on the other side of the Atlantic: "And I am sobered into a renewed respect for the apparently continuous mastery exercised by the French in the plastic arts. If we are truly patriotic, we cannot afford to deprive our own countrymen of the benefits of being contemporaries of Matisse, Maillol, Bonnard, Vuillard, André, Picasso, Derain, Braque, and Segonzac. To enter a room where the finest work of these Leaders of French Art is displayed together is to realize that we are privileged to live in an era of great painting."[3] Painting in France, then, was both a source of pleasure and a challenge to the American product.

What he valued in French art, apart from the sheer visceral pleasure it afforded him, was this glimpse of "continuous mastery," the panorama of tradition constantly in renewal: "The continuity of the great tradition in French art is the pride of the best French painters. They seem to realize that a tradition, like an old family, must constantly renew itself with the body and soul of each new age."[4] Phillips was very much a man of his time and of his class; what he saw in French art was a kind of mirror of himself within the context of his own great American family. We can safely assume that renewing the Phillips clan in the new age in which he found himself was part of his endeavor in founding the Phillips Memorial Art Gallery.

But even if in 1927—the year he bought his first Braque, *Plums, Pears, Nuts and Knife*, 1926 (cat. no. 136), and his first Picasso, the great, early *Blue Room*, 1901 (cat. no. 131)—Phillips could write with such ease and sweep about the glories of French art, things were already not so clear cut in his mind, and they became only more complicated in the ensuing years. The problem was modernism in general, cubism in particular, and Picasso as the incarnation of both. To begin with, Phillips believed, not without reason, that the French were hostile to cubism—"the late and unlamented Cubism," as Phillips himself wrote in 1927—the movement that had been born and bred in their midst.[5] In 1928 he referred to cubism as a "less enjoyable interruption" in the story of French art, and as being "never wholly congenial to the French taste for synthesis, structure, and style."[6] The next year he quoted Clive Bell, from his book *Since Cézanne*, not only on the "profoundly un-French spirit of Picasso" but also, more broadly, on cubism: "'For the French have never loved Cubism. How should they love anything so uncongenial to their temperament? How should that race which, above all others, understands and revels in life, approve of aesthetic fanaticism?'"[7]

As had been the case for so many observers, Phillips feared that cubism was part of a larger, more dangerous attack on the freedom of the individual, an "aesthetic fanaticism" that would also submerge all that he felt was best in liberal, bourgeois culture: "Ours is an age which knows what it likes and what it wants and which does not particularly prize nor see how it can use individualism," he wrote in *The Artist Sees Differently*. "Standards in art, based too often on commercial success and mere technical skill, are set up by academies of both the conservative and rebel camps. . . . All-powerful is the mind of the majority or of that organized minority of fanatical reformers or shrewd, self-seeking opportunist[s] who so often [prevail] over it."[8] To his credit, Phillips's trepidations about the loss of individualism were nonpartisan: both the Right of the numbing status quo and the Left of the engulfing insurgents were to be defended against. In the attitude of the "insurgents" he saw a profoundly misguided and wholesale rejection of the past. "What has kept me from complete sympathy with the doctrines of the modern movement in art," he wrote, "[are] the intolerance of the preceding period and the claim that there has been a cleavage, a sudden and revolutionary break with the link which connects the present with the past."[9] This claim struck at the heart of Phillips's effort to make clear the historical connections between works of art, periods in history, and peoples. Rupture—as a value in and of itself—was unthinkable to him; both his desire to build a collection of great art and his written campaign on its behalf were predicated on his belief in the restorative power of tradition. Although he conceived of tradition in the liberal understanding of the term, of a "tradition of the new," it was nonetheless continuity—a profound sense of connectedness—that he sought in the history of art.

Phillips's acceptance, however provisional, of modernism's deeply historical aspect, of its appropriateness as a new expression of age-old truths, and of its *necessity* as an instrument of renewal account for his willingness to open the collection to cubism. "Modernist art is not a revolution," he wrote. "It has evolved, like every other period, in a logical and gradual way. Its roots are deep in the remote past. Not since antiquity have the artists been so disciplined in theory to conform to the philosophy, the science, the tempo, and the very textures of the world around them."[10] Again, we find

Phillips projecting himself (as we all do) onto the "raw" material of observation; this evolutionary representation of culture, of an art spirit both ancient and new, was the very model of the traditional yet open-minded twentieth-century man Phillips himself was endeavoring to embody.

But this should not lead us to imagine that Phillips's ideas about cubism were idiosyncratic. In fact, in the late twenties and early thirties his opinions were shared by many artists and critics. This historicized view of modernism was the prevailing one in postwar Paris, at the moment of cubism's "synthetic" phase.[11] Rather than confronting cubism as an alien presence, as a shockingly unanticipated phenomenon, Parisian commentators by that point were familiar enough with the movement to represent it as an appropriate expression of a new "classic" age, as the "synthetic" culmination of earlier disruption. Paul Dermée, André Salmon, Waldemar George, and so many other Parisian writers of the twenties saw cubism as Phillips was endeavoring to, as an emanation of an ancient spirit of order, reason, and control. Gris wrote to his dealer in 1921: "Well, now I believe that the quality of an artist derives from the quantity of the past he carries in him," and Braque, destined to be Phillips's preferred cubist, wrote: "The pre-classic style is a style of rupture; the classic style is a style of development."[12] Phillips himself wrote in 1930: "The generalizing view has supplanted the particularizing. Synthesis has replaced analysis."[13]

That is to say, Phillips's entry onto the modern art scene, although still precocious for an American, was nonetheless belated in terms of Parisian developments: by the twenties Parisian art and art criticism were already more conservative and retrospective than they had been previously. Paris was equipped to offer Phillips a far more congenial modernism than would have been the case in the early years of cubism. And this was as true of the work as it was of its interpretation. Synthetic cubism—the art of modernist "development"—had replaced analytic cubism—the art of modernist "rupture." Braque's art of the twenties was one of the prime examples of the far more "classical" and traditional turn that art had taken within the cubist camp, and Phillips—who wanted an art at once old and new—felt especially drawn to it.

Step by step Phillips was discovering what he could value in cubism and what he could not abide. For instance, he did not like its mechanistic aspect, which he saw not only as cold, but as anti-individualistic as well: "Especially I resent the idea that the art of an age of machinery should itself be mechanical."[14] As a result the art of Léger, whom Phillips considered the quintessential "mechanical" cubist, was never to enter the collection. Nor did he care for cubist art that was too difficult to decipher: "Perhaps I shall never fully understand the hieroglyphics of Cubism at its most abstract," he admitted in 1929, the year he bought Picasso's cubist *Abstraction, Biarritz* (fig. 29) of 1918 (which is not really abstract) and the year before he bought his superb little Gris *Abstraction* (cat. no. 147) of

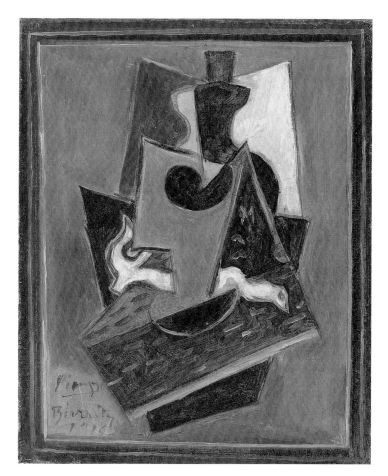

Fig. 29 Pablo Picasso, *Abstraction, Biarritz,* 1918, oil on canvas, 14¼ × 10¾ in., The Phillips Collection, Washington, D.C., acc. no. 1553. Photograph by Edward Owen.

1915 (which is not really abstract either).[15] Yet he was intent on not turning his back on the modern world altogether. "We are living in a complex period," he explained, "when the artists are acutely conscious of their background and their need for simplicity. They are intensely anxious to be at one with the age and to express themselves in musical, pictorial and decorative language, as much attuned to it as the words of common speech. The adventurous zest of the Twentieth Century, its noise, its speed, its elimination of waste, its organization of effort, its emphasis upon system and its perpetual desire for innovation and invention, these characteristics inspire the artists no less than the concrete aspects of the modern world and the new materials employed in its service."[16]

The *spirit* of modernity—simplicity, organization, efficiency, creativity—not its raw data, was Phillips's touchstone for modern inspiration. "Undeniably Picasso and Chirico are logical equivalents in art for the age which has produced Freud, Einstein, and Spengler. As everyone knows who has studied the history of art as an evolution, the leaders of the advance are always attuned to the spirit of investigation of their time."[17] Again, it is spirit rather than matter

that Phillips valued. Indeed, if we sense in this emphasis on spirit a trace of the secular humanist's nostalgia for more conventional forms of belief, it is with good reason. At least twice we find Phillips invoking Christianity. "Christianity was built around the individual and his spiritual needs," he wrote in 1931.[18] And in 1935, after a discussion of John Dewey's analysis of modern society's lack of unifying concerns, he wrote: "Once upon a time there was such a bond. It was known as Christianity.... It must be acknowledged that what was meant to be a religion of humanity, and of inspiration to personal fulfillment in love and service, became institutionalized and all but destroyed by dogma.... And it is possible for the universal language of art to make the ideals of Christ and Christian emphasis upon the worth of human personality 'the unifying spiritual bond and the profound communal inspiration' which would not only raise the standard of art but save the world from itself."[19]

After all was said and done, it was "human personality" as manifested in art—whether that art be the romantic modernity of postimpressionism or the classicized modernity of cubism—that compelled Phillips. Not surprisingly, then, once he had accepted cubism as an important expression of the modern spirit, it was to the movement's inventors, Picasso and Braque, that he was drawn. Picasso's name is invoked often in Phillips's writing, and he was interested enough in the art of "King Pablo," as he called him, to purchase nine examples of it.[20] Yet only three of these works are cubist, and all are very small in scale (Phillips did consider buying the *Three Musicians*, which eventually went to the Museum of Modern Art).[21] And it becomes clear in reading Phillips on Picasso why he could never give unqualified support to the towering artistic figure of the century. Although he admitted that Picasso was a genius, he always doubted his sincerity: Picasso's art and, we sense lurking behind this, Picasso the man (such as Phillips would have known him by way of criticism, journalism, and gossip) were simply too protean.[22]

The very qualities that made Picasso so dazzling to others made him a disturbing figure to Phillips, although the language he used to describe him was more or less the lingua franca of Picasso criticism of the era. In 1929 he wrote of Picasso as "an eclectic and an incorrigible experimentalist. How this young virtuoso has bewildered the modern world with his fascinating feats ... ranging all the way from romantic subjects in rich colors to geometric abstractions in monochrome! He reveals in his own career, the restless complex, insistent, modern mind, so eager for new sensations, so avid of influences, so gifted with cleverness and craft and culture, so insatiable in research!"[23] Two years later he wrote that Picasso was an "acrobat" and a "conjurer," both images perhaps suggested by the characters in the ballet *Parade* of 1917.[24] Apart from Phillips's fears that Picasso was performing sleights of hand, that he was unmanageable, that his art might even be overwhelming in his museum of familial artistic expressions, there is also a sense that Picasso was simply too

much an outsider for the Washingtonian's liking. He wrote of Picasso as a foreigner to France and French culture, of his "Gothic" tastes tempered by Parisian Latinism, of his "Moorish" roots.[25] The artist's aura was a little heady, a bit too pungent and overly exotic for Phillips's embrace.

But Braque was another story altogether, the perfect fulfillment of Phillips's idea of the consummate modern artist, and—it becomes obvious—of a sensibility with which he powerfully identified. He was also Picasso's antithesis: Phillips's representation of Braque is constructed, numerous times, by means of what Picasso is not. In 1927 he stated: "Picasso invented Cubism and tired of it. Braque was more faithful and made the practice a thing of exquisite taste, of standardized conventions, of French style."[26] In 1928 he maintained that while Picasso was "largely responsible" for cubism, "Braque has refined Cubism into a characteristic French style."[27] And in 1935 he wrote: "Architectonic abstraction—not in its whimsical feats of necromancy as in Picasso, but in its more logical consummation as in Braque—is based on plan and purpose put into effect through objective means."[28] This was the year after Phillips had acquired Braque's *The Round Table*, 1929 (cat. no. 140), which he chose in preference to Picasso's *Three Musicians*, both of which he had seen in a show of works from Paul Rosenberg's collection; he may well have been thinking of Braque's majestic still life as the kind of "logical consummation" he preferred to the "whimsical feat of necromancy" represented by Picasso's brilliant costumed trio.

Almost from the first Phillips recognized in Braque an artist after his own heart, an artist of "restraint and austerity.... It has been his function to refine."[29] Compared to Matisse, for instance, he found that "Braque is a more aristocratic type, endowed with a more unusual sensibility" and commented, in the same vein: "Sometimes there is a great decorator, a man of true genius, who wears these garments as if he had been born to them. Such a man is Braque, a distinguished designer if there ever was one, whose every caprice of manner is courtly, who wears formal dress with the distinguished ease and the charming grace one likes to associate with aristocracy in sport clothes."[30] For Phillips, then, Braque was a model of fidelity, refinement, and austerity—an aristocratic Modern. And he was a shining example of the French "race": "He belongs to the family of great French painters who mastered their instruments because they were born to them."[31] In his article "Personality in Art" of 1935, Phillips tells us what we have been sensing all along, that Braque "rescued" cubism for him, that it is owing to Braque that cubism is justified, not the other way around:

The critics who see in Cubism a fanatical theory make no distinction between collective group-dogma and individualized achievements within the group.... Out of it came one artist who used it to create for himself a personal and a racial style which was a fine product of his period and a kind of quintessence of its functionalism. Abstraction was

not for Braque an escape from life but a poem in praise of its interesting and often exquisite relations even in an age of impersonal formula and organization. He wanted to be of his own age and he had to find his own unique place in it. Although he belonged to a group and shared his ideas and material with many other men, still his personality was unique.[32]

Of course, the Braque who Phillips describes is the "personality" he sees manifested in his art, the artist embodied in the series of Apollonian still-life paintings, and several other works, in The Phillips Collection. Most of these date from the second half of the twenties, a moment in which Braque relaxed the cerebral approach of his earlier cubism in favor of a more recognizable, more intentionally classical idiom. In their myriad fruits and utensils, their repeated goblets and white linens, their musical instruments, chair rails, and *fruits de mer,* Phillips saw a vision of balance, clarity, restraint, and breeding that he could find nowhere else in cubism. These descendants of Chardin's still lifes were, in a way, a proof for Phillips that even in the midst of the most unpromising terrain he could find an oasis of calm and an affirmation of all he valued most. It is a testimony to just how much these painted witnesses meant to Duncan Phillips that Braque's image of a bird in flight—now schematized into the museum's symbol—watches over The Phillips Collection as it enters the new millennium.

JACQUES VILLON [GASTON DUCHAMP] (1875–1963)

Jacques Villon was born Gaston Duchamp July 31, 1875, in Damville, a Norman town near Rouen. The pseudonym he later adopted derived in part from the medieval poet François Villon, whose writing he admired. It was with his grandfather Emile Nicolle that Villon first studied engraving. While pursuing a law degree in Paris, he began publishing illustrations in such well-known journals as *L'assiette au beurre, Gil Blas,* and *Le rire.* After giving up law to devote himself entirely to his art, Villon took up oil painting around 1904. Until 1910, however, he primarily made prints and drawings. Beginning in 1911, Villon and his brother Raymond Duchamp-Villon were hosts to weekly meetings at their studios in Puteaux in the outskirts of Paris, where ideas concerning cubism were exchanged among such participants as Gleizes, Léger, and Villon's youngest brother, Marcel Duchamp. Interested as much in light and color as in form, Villon worked during the years preceding the First World War in a style he called "impressionistic cubism." In 1912 he exhibited with the artist group Section d'Or in Paris, and the following year he participated in the New York Armory Show. After the war, Villon gradually found his own direction in painting, refusing to take part in artistic trends of the day. His work became increasingly abstract, and color continued to play a critical role. Starting in 1934, abstract landscapes figured importantly in his production, and he began to receive the public recognition that had earlier eluded him. He received attention in New York through the efforts of Walter Pach, who arranged several exhibitions in the late twenties and early thirties. He did not receive his first big Paris exhibition, however, until 1944 at the gallery of Louis Carré, who also gave Villon his first contract. After the Second World War Villon received various awards for his painting and printmaking, and in 1961, at the age of eighty-five, he was given a major retrospective at the Galerie Charpentier. Villon died in Puteaux June 9, 1963. The Phillips Collection's four oil paintings and one etching span Villon's career.

128

Machine Shop, 1913

L'Atelier de mécanique
Oil on canvas, 28⅞ × 36⅜ (73.3 × 92.5)
Signed and dated l.l.: *Jacques Villon/13*
Acc. no. 2008

The artist to Walter Pach, 1914; Brummer Gallery, New York, 1914; PMG purchase (from exhibition) 1928.[1]

The critical role of the machine in modern life and its implications in the content and production of art were topics frequently discussed by the artists who gathered weekly at Villon's studio in Puteaux. So it is not at all surprising that Villon made machinery the subject of several paintings in the years just preceding the First World War. The Phillips Collection's *Machine Shop* is one of these. Large in scale, the painting has a rich, expressively brushed surface that suggests the drive and energy of the machinery it depicts. In its original French title, *L'Atelier de mécanique,* the allusion to the relation between the machine and art is made clear by the double meaning of *atelier* as an artist's "studio" and an industrial "shop."

Villon's interest in machines and their modern resonances stemmed from personal experience as well. In 1913 he worked for a short time in a machine shop in Asnières. It is also significant that, as a boy, Villon's favorite book was Alphonse Daudet's *Jacques* (titled after its hero, whose name Villon adopted for himself).[2] Published in 1876, it presents a harsh view of the industrial age, revealing the horrors experienced by the young Jacques, who works in an engine room. Daudet describes the machines as seen through the boy's eyes: "Set in motion by steam they seemed to him the personification of malevolent beasts lying in wait for him as he passed, and ready to seize him, rend and cut him to pieces. Cold and motionless, they seemed to him still more menacing, as they stood with gaping jaws, their claws extended, all their instruments of destruction, motionless, concealed, they wore the air of glutted, satiated cruelty."[3]

Although Villon's painting hardly presents such a savage or menacing image, it does indeed depict a world devoid of human presence. The domination of the machine over human beings is communicated through the absence of any clear space that a person might occupy. A sense of density and impenetrability is achieved through the literal crowding of various machine parts, as well as through the use of cubist techniques that destabilize the pictorial illusion of real space. Although diagonal lines in the top half of the painting produce a sense of spatial recession, the radical tilt of the shop floor, created through a patchwork of geometric planes, makes it difficult to imagine that workers could keep their footing among these whirring machines.

The brilliant colors in *Machine Shop,* however, mitigate the impression that the space we are shown is inimical to human life. Indeed, we can easily identify, both mentally and sensually, with the sense of energy, movement, and excitement conveyed here. Despite the absence of windows, Villon imbued the scene with qualities of light and atmosphere more commonly associated with plein air painting. In so doing, he reminded us that technology is only a tool designed to use and amplify the effects of natural laws and forces, and that it need not diminish our humanity.

In view of the daubing technique employed in areas of this picture, most notably in the foreground, and the rich array of complementary colors, Villon's characterization of himself as the "impressionist of cubism" seems apt. This particular composition is cubist only insofar as individual forms and areas of space are defined by basic geometric shapes. Later versions of this theme, such as The Phillips Collection's *Little Machine Shop,* 1946 (acc. no. 2007), make use of cubist grids constructed according to the Golden Section. Across these grids faceted forms are distributed, distilling into two dimensions the potent forces that a machine shop brings into play.

EP

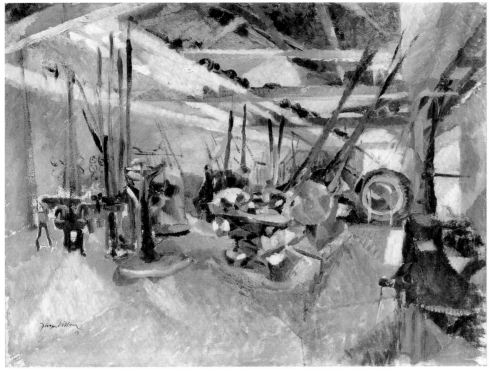

128

129

The Grain Does Not Die, 1947

Le Grain ne meurt

Oil on canvas, 24⅞ × 55¼ (63.3 × 140.5)

Signed l.l.: *Jacques Villon;* inscribed on reverse, u.l.: *LE GRAIN NE MEURT/Jacques Villon/47*

Acc. no. 2006

Louis Carré and Co., Inc., New York; PMG purchase (from exhibition) 1949.[4]

In 1940 Villon and his wife, Gabrielle, left Puteaux for an extended sojourn, traveling first to Bernay and then on to La Brunié (Tarn), in the south of France. Villon found himself entranced by the peace of this pastoral setting. Having excluded nature from his art for years, he was suddenly inspired to make countless sketches of his surroundings and to paint landscapes: "I drew and measured and painted. I used these studies and drawings as the basis for landscapes. . . . The trees and houses, sky and earth were caught up in a play, a sort of enchantment, and exuded a vitality that only needed to be expressed."[5]

The Grain Does Not Die is one of a series of harvest scenes Villon developed years later from the sketches made at La Brunié. The title is likely a reference to a biblical verse that André Gide had used earlier to title his novel of the same name.[6] Villon began the series in 1946, producing both paintings and graphic works. In choosing the harvest as subject, he was participating in a long, if interrupted, tradition of painting that celebrates humanity's relationship with the land and with the earth's bounty, which is cultivated through a combination of sweat and knowledge. The paintings of Le Nain and Millet, as well as the more recent works of Albert Gleizes, come to mind as part of this tradition.[7] The harvest is part of a cycle that is eternal, and in its representation here a kind of classicism—one based on order, repetition, and timeless truths—is evoked. It is understandable that in this period of recovery from the devastating effects of the Second World War a traditional faith in the land as the source of regeneration would find expression in such paintings.[8] New to the tradition of agricultural landscapes but true to his own time is Villon's evocation of machinery. The strong diagonals and the energetic rhythm of contrasting, faceted planes of color suggest the speed and efficiency of a threshing machine. This apparent revival of Villon's interest in machines and their implications was heralded the previous year with *The Little*

Machine Shop. But what distinguishes *The Grain Does Not Die* is its remarkable synthesis of themes: rural landscape and technological progress. Whereas some of the impressionists had recorded the incursion of industry upon the outlying suburbs of Paris, Villon presented, albeit in a more abstract formal language, a view of the transformation, through technology and the demands of industry, of even the most rural parts of the country.[9]

Like the impressionists, whom he greatly admired, Villon was concerned with capturing the fleeting qualities of light and color. But structure was also crucial to him, and so he organized the play of color according to classical ideals of order and balance. Like the science and technology of agriculture implicit in the subject of *The Grain Does Not Die,* Villon's compositional design establishes control over the natural world it depicts. The yield in this case is a field of lines and color for our aesthetic delectation.

As he did with Braque, Duncan Phillips admired the manner in which Villon developed cubist principles into a personal idiom in these late paintings, where structure and lyricism went hand in hand. It is for that reason, presumably, that he chose *Abstract Composition,* 1932 (acc. no. 2005), when offered works from Katherine S. Dreier's personal collection in 1953.[10] In general, he preferred the darker paintings to those that were extremely blonde and high in key.[11] In *The Grain Does Not Die* Villon employed a great deal of black paint, both as an independent color and as a wash over other colors, thereby reducing their pitch. This particular work by Villon was one of Phillips's favorites. Having referred to *The Little Machine Shop* as an "important masterpiece" in a letter of 1956 to Marcel Duchamp, Phillips called *The Grain Does Not Die* an "even finer late example," reporting that in its role as an overmantel in his own home it had become "more or less of a fixture."[12]

EP

129

RAYMOND DUCHAMP-VILLON (1876–1918)

Raymond Duchamp-Villon was a self-taught sculptor who in a tragically short career produced a body of work notable for its dynamic abstraction and architectonic structure. Born Pierre-Maurice-Raymond Duchamp November 5, 1876, in Damville, near Rouen, he later added "Villon," the name his artist brother Jacques had taken. After four years of medical studies in Paris, Duchamp-Villon was forced to give them up when he fell ill with rheumatic fever. During his convalescence, he became serious about sculpting and determined to make it his profession. In 1902 he exhibited his first sculpture at the Salon de la Société Nationale des Beaux-Arts, and beginning in 1905 he was a regular exhibitor at the Salon d'Automne, showing expressively modeled works in the manner of Rodin. In 1907 Duchamp-Villon moved to the Parisian suburb of Puteaux to set up a studio next to that of his brother Jacques Villon. Between 1911 and the outbreak of the First World War a group of artists gathered weekly at the studios of Duchamp-Villon and his brother to discuss the aesthetic theories associated with cubism. The ideas generated in these meetings had a profound impact on Duchamp-Villon's sculpture, which became increasingly abstract although it continued to be based on human and animal forms. In 1914 he completed the plaster of *Horse* (cast posthumously), a forceful emblem of the industrial age and an important contribution to the developing machine aesthetic. When war was declared that same year, Duchamp-Villon enlisted as a junior medical officer, destined never to return to his career as a sculptor full time. After contracting typhoid fever in 1916, he died October 7, 1918. The Phillips Collection owns one polychrome plaster relief from 1916.

130

Gallic Cock, 1916

Coq

Cock; Rooster

Polychrome plaster relief on wood support, 17½ × 14¾ × 2¾ (44.4 × 37.4 × 6.9)

Unsigned

Gift from the estate of Katherine S. Dreier, 1953

Acc. no. 0607

The artist to John Quinn, New York, through Walter Pach, Jan. 1918; Quinn estate, 1924–27; purchased by Katherine S. Dreier, West Redding, Conn., 1927; gift from Dreier estate 1953.[1]

130

Gallic Cock is one of the few sculptures created by Raymond Duchamp-Villon during the First World War. He made it while convalescing from typhoid fever at Mourmelon, where he was asked to design a portable theater for entertaining the troops at the front. *Gallic Cock* was conceived as an architectural medallion to be prominently placed within the scheme of the design. Derived from emblematic tradition, the rooster has the attribute of the rising sun and is the traditional heraldic symbol of France. Ironically, the patriotism expressed in this symbolism was what had prompted Duchamp-Villon's enlistment in the military, which ultimately cost him his life and fulfillment as a sculptor.[2]

The geometric stylization of *Gallic Cock* recalls the architectural decorations that Duchamp-Villon and André Mare had collaborated on between 1911 and 1913: projects, such as the *Maison Cubiste,* that combined sculpture, painting, and the decorative arts.[3] During this period Duchamp-Villon made many bas-reliefs of animal motifs that were intended for use as architectural medallions. He conceived them in a schematically modified manner in order to create fluid, stylized designs.

In contrast to some of these earlier medallions, which in their extreme geometric reduction approached pure abstraction, *Gallic Cock* is iconographically quite legible. We see before us a rooster of regal bearing, his wings partially spread like a mantle.[4] One talon rests on the orb of the sun, which radiates its golden rays behind him, creating a striated and textured field that visually complements the bird's raised geomet-

ric form. Duchamp-Villon deliberately minimized the degree of abstraction in the interest of his army audience, most of whom were not familiar with recent avant-garde developments. In a letter to Walter Pach, he offered an explanation: "I am writing to you from the hospital where I have been for thirty-five days with fever. . . . I sent to New York a medallion made under circumstances which it will be necessary to explain to the public. . . . It is an ornament for a theater erected at the front to amuse the soldiers. I could not push the abstraction too far without risk of being misunderstood."[5] Evidently Duchamp-Villon assumed that a more sophisticated cross-section of people would be viewing the work in New York and that, without an explanation, they might judge it an insufficiently advanced work for an artist of avant-garde reputation.

Although there are several versions of *Gallic Cock* in plaster and bronze, the work now in The Phillips Collection is the original plaster model, painted and framed with a wooden support. It is also the one Duchamp-Villon sent to New York in 1917. His worry about its reception, however, appears to have been unjustified. In fact, its fate could hardly have been better. It was purchased by John Quinn, a collector whose keen and sustained interest in Duchamp-Villon helped to enlarge the artist's reputation in the United States.[6] Upon receiving the news of Duchamp-Villon's death in October 1918, Quinn immediately commissioned three bronze casts of the plaster medallion as a memorial.[7] In the interest of preserving the artist's original vision, Quinn had them painted in exact duplication of the plaster. One of these is now in the collection of the Hirshhorn Museum and Sculpture Garden, Washington, D.C.

In many respects the *Gallic Cock* was an adumbration of trends that came to characterize avant-garde activity in postwar Paris. The theatrical context for which it was created attracted many other artists in the period after the First World War: Picasso, Braque, and Gris each designed sets and costumes for Diaghilev's ballets. Musical and dramatic productions by Satie, Cocteau, and Stravinsky were also designed by artists.[8] Just as Duchamp-Villon had felt compelled to modify the degree of abstraction in *Gallic Cock,* these artists engaged in theatrical collaborations that tended to create designs more traditional than modern.[9] By invoking Latinate themes and images such as the commedia dell'arte, they stressed the classical heritage of France, sounding a patriotic spirit similar to that expressed by Duchamp-Villon's heraldic rooster.

EP

PABLO PICASSO (1881-1973)

The most renowned and prodigious artist of the twentieth century, Pablo Ruiz Picasso was also one of the most versatile, equally inventive and accomplished as a painter, sculptor, printmaker, ceramicist, and book illustrator. Born in Málaga October 25, 1881, Picasso first studied drawing and painting under his father, an art instructor. In 1895 he was admitted with advanced standing to the School of Fine Arts in Barcelona, and soon he was exhibiting paintings and publishing illustrations in avant-garde journals. Picasso had his first Paris exhibition at the Galerie Vollard in 1901, the year that marked the beginning of his Blue Period, in which he produced melancholic paintings of people at the margins of society. Between 1904 and 1908 he lived in Montmartre, meeting artists and writers such as Georges Braque and Guillaume Apollinaire. After his Rose Period of 1905-6, Picasso developed a style of bold geometries in which he manifested his interest in both archaic and African art. New ways of treating volume and space were revealed in his *Demoiselles d'Avignon*, 1907. The independent formal experiments of both Picasso and Braque led to the emergence of cubism, which the two artists developed jointly through its analytic and early synthetic phases. Following the First World War Picasso worked alternately in a constructive cubist manner and in a more naturalistic neoclassical style. The biomorphism and distortions of surrealism are evident in his paintings of the thirties, the most famous of which is *Guernica*, first shown at the 1937 World's Fair and later included in the Picasso retrospective at the Museum of Modern Art in 1940. Picasso spent the last decades of his life in the south of France in the villa he had bought in 1948. Prolific as ever, he produced sculptures in various media in addition to paintings in which he frequently quoted the subjects and compositions of such Old Masters as Velázquez and Delacroix. On April 8, 1973, Picasso died in Mougins at the age of ninety-two. The Phillips Collection owns six oil paintings (three of which are recent gifts), two bronzes, five prints, and a watercolor drawing.

131

The Blue Room, 1901

Le Tub; La Toilette; Early Morning
Oil on canvas, 19⅞ × 24¼ (50.4 × 61.5)
Signed l.l.: *Picasso*
Acc. no. 1554 (Zervos 1 no. 103; DB no. VI,15)

Wilhelm Uhde, Paris, by 1908; Etienne Bignou, Paris, date unknown; Alfred Gold, Berlin, date unknown; sold to Alex Reid, Glasgow, 1926; sold to Alex Reid and Lefevre Ltd., London, 1926; purchased Wildenstein, New York, June 1927; PMG purchase 1927.[1]

In the fall of 1901, during his second stay in Paris, Picasso painted *The Blue Room,* a haunting work that embodies a transitional moment in his evolving style. Having arrived in Paris in May, he was given an exhibition at the Galerie Vollard in June. In a laudatory review, the critic Félicien Fagus called the artist "a brilliant newcomer" but cautioned that his passionate and facile experimentation with other artists' styles deprived him of his own: "One sees that Picasso's haste has not yet given him time to forge a personal style."[2] Picasso's debt to a variety of artists is still very much evident in *The Blue Room.* In fact, in many respects it reads as a summation of turn-of-the-century Parisian aesthetics because of its references to Degas, Toulouse-Lautrec, Puvis de Chavannes, symbolism, and post-impressionism. Yet the manner in which he synthesized these borrowed elements, bathing the composition in a unifying blue atmosphere, signals the beginning of a period in which he created a style indisputably his own.

The paintings of Picasso's Blue Period (1901-4) generally depict poor and socially marginalized individuals set in somber, blue-toned spaces saturated with a mood of sorrow and despair. *The Blue Room* retains the rich surface and detailed attention to surroundings that had been characteristic of earlier works, but unlike them it depicts a scene of great intimacy. The space is a private one in which the emotional state of a solitary individual seems to suffuse the entire room. What we are shown is in fact Picasso's own studio in which a woman stands alone, unaware of our gaze, absorbed in the private ritual of bathing.

This subject recalls the numerous paintings and pastels of Degas.[3] But whereas Degas delighted primarily in the formal possibilities of his models' intimate poses and the sensuality of their opalescent skin, Picasso made the limp, awkwardly arched form of the woman's body—so reminiscent of El Greco in its languid distortion—a powerful instrument of psychological expression. The contrast of her leaden pose with the lithe dancing figure in the Toulouse-Lautrec poster *May Milton,* 1895, hanging on the rear wall, makes the melancholic mood of the scene seem all the more poignant. That Picasso himself was pleased with the effects of this pose is evident from the number of times he quoted it in subsequent works.[4] This mannered, exaggerated way of presenting a figure, employed in conjunction with an increasingly monochromatic, blue palette, remained the principal means through which Picasso made interior states of mind the

implicit subject of his Blue Period paintings.

Although quite poor at this time, Picasso did not skimp in his application of paint.[5] The surface of *The Blue Room* is thick and highly textured. Most of the forms are outlined in dark colors, a technique that emphasizes their two-dimensional silhouettes. Picasso was already playing on the tension between depth and surface design in other ways as well. Whereas several objects—such as the pitcher and the flower pot—are shown foreshortened in fairly plausible perspective, others—such as the tub, the pail, and the tabletop—are tilted forward, toward the picture plane, disturbing the impression of spatial recession.

Duncan Phillips purchased *The Blue Room,* his first Picasso, in 1927, passing over the artist's recent production in favor of a work he had created some twenty-five years earlier. Phillips preferred the emotional resonance, sonorous tones, and Gothic sensibility of Picasso's earlier work to what he perceived as the austerity of formal research that defined the cubist paintings. In 1929 Phillips expressed his admiration for *The Blue Room:* "Ours is a succulent, sumptuous little picture. Enjoying its strange, heady color we cannot resist a sharp regret that he could not have worked for at least ten years in so rich a vein. The design is rhythmical and in spite of the realism of the bed and the early morning light the distortion and unreality of the figure are appropriate to a scene which is already more of a Hispano-Moresque pattern than a picture."[6]

Phillips had aspired to augment his collection with another early Picasso, and in 1928 he wrote to Josef Stransky at the Wildenstein Galleries about his interest in a painting of acrobats he had seen reproduced in *The Dial.*[7] Although he was prepared to part with several fine paintings by other artists in order to obtain "one of the finest, if not the finest Picassos in existence," the transaction was never made.[8] In 1929, however, he did purchase *Abstraction, Biarritz,* 1918 (see fig. 29). It was not until 1952 that Phillips was able to satisfy his desire for another early Picasso, acquiring an unusual painting, *Still Life with Portrait,* 1906, for his private collection.[9]

EP

132

The Jester, 1905

Pierrot
Bronze; height: 16⅛ (40.9)
Signed rear, lower edge: *Picasso*
Acc. no. 1559 (Zervos 1 no. 148)

Ambroise Vollard, 1905; Alfred Flechtheim, Berlin, date unknown; purchased by Buchholz Gallery, New York, date unknown; PMG purchase 1938.[10]

131

Although known first and foremost as a painter, Picasso was an accomplished and innovative sculptor as well, represented in The Phillips Collection by *The Jester* and by *Head of a Woman,* 1950 (acc. no. 1558). In the early part of the twentieth century there emerged a number of artists who could be characterized as painter-sculptors and whose very lack of academic training in carving or modeling frequently functioned as a de facto license to challenge traditional conventions.[11] In the process, sculpture was defined increasingly as an autonomous art form, like painting, free of didactic public functions and architectural contexts.[12] But if the central concern of modernism was to define the essential nature of each art, Picasso distinguished himself over the course of his career as a painter-sculptor by his abiding interest in exploring the potential interrelationship of the two.[13]

Picasso's earliest sculptures tended to mirror the subjects and moods of his Blue Period and Rose Period paintings. *The Jester* is a sculptural rendition of one of the many circus performers that populate the artist's paintings of the same year. At that time Picasso frequently attended the Médrano Circus in Montmartre, where he would slip behind the scenes to get a sense of backstage life.[14] It was this more private realm of the performers' lives that he depicted in his paintings of harlequins and acrobats, revealing

their quiet dignity and tender intimacies. In *The Jester* the amusing antics and expressions characteristic of the performer's on-stage persona are absent, and we glimpse instead a poignant image of a sensitive young man, paradoxically tragic beneath his quintessentially comic cap.

The Jester is an amalgam of academic convention and subtle subversion. Because the portrait bust had enjoyed a long, venerable tradition usually associated with great historical figures, the use of this sculptural genre to depict an anonymous jester, a circus clown belonging to the margins of society, has a parodic quality about it. Simultaneously Picasso ennobled the jester and mocked the conventional subjects associated with this form. Themes that play on the identity of kings and clowns had been present in literature at least as far back as the Middle Ages. In 1896, less than ten years before Picasso sculpted his jester, Alfred Jarry had written *Ubu roi,* a play whose title character was a grotesque incarnation of an absurd and ignoble king, oblivious to his own perversions of power. A friend and admirer of Jarry, Picasso may have had Ubu in mind when creating his *Jester,* although he chose to emphasize the noble aspect of the clown rather than the foolish excesses of the king.

Stylistically, the example of Rodin is very much evident in *The Jester,* particularly in the painterly treatment of its surface. The alternation of low bumps and shallow depressions disperses the light, animating the subject and allowing for a shift of mood according to the degree of illumination. The psychological intensity that results from this expressively modeled surface is consistent with Picasso's manifest concern for making the formal articulation of his painted figures express interior states of mind. Not until several years later would Picasso make the formal qualities of his sculpture his primary concern and create works independent of mimetic description and psychological expression. This development occurred in tandem with the evolution of his cubist paintings and collages.

EP

132

133

Studio Corner, 1921

Un Coin d'atelier

Gouache and watercolor on paper, 8¼ × 10⅝ (20.9 × 27.0)
Signed and dated in gray and black paint, l.l.: *9-1-21— Picasso*
Acc. no. 1561 (Zervos 4 no. 241)

Early history unknown; Valentine Gallery, New York, date unknown; PMG purchase 1930.[15]

In spite of a steady stream of negative criticism during the First World War, cubism survived as

a viable pictorial practice among many avant-garde artists into the 1920s. What had been cast as disintegrative and subversive by the swelling ranks of anti-modernist polemicists came to occupy, strangely enough, a secure position in the cultural mainstream in the years following the war.[16] In part this phenomenon can be explained by the emergence of dada, which by virtue of its nihilistic spirit and extremism rendered cubism's transgressions tame in comparison, pushing it closer to the center of Parisian culture.[17] In addition, cubism itself was substantially altered in the postwar period, having shifted from an "analytic" orientation to a "synthetic" one. Picasso's gouache-and-watercolor drawing *Studio Corner* exemplifies the synthetic approach, which reflected not only a change in style but also a changed ideological climate.

Traditionally, the seeds of this shift from analytic to synthetic cubism have been identified in the practice of collage, which occupied Picasso and Braque in 1912 and 1913. The visual correspondence between collage and subsequent cubist paintings, in which forms are described through an accumulation of discrete geometric planes, is clear. Historically, however, the term *synthetic* was not invoked in critical discourse until the war years and after, when its significance entailed more than mere stylistic description. As Kenneth Silver has persuasively demonstrated, *synthesis* became a privileged rhetorical term in all areas of postwar social and cultural activity, connoting such values as collectivity, construction, and clarity.[18]

Whereas Picasso objected strenuously to the evolutionary and hierarchical model implicit in the analytic-synthetic formulation, the paintings he produced in the years immediately following the war clearly participated in the conservative and classicizing trends of prevailing avant-garde practice. In addition to a synthetic cubist idiom, Picasso worked in a naturalistic, neoclassical style, which invoked traditional Latinate subjects such as characters of the commedia dell'arte and large nude or partially clad female figures. In his remarkable facility for alternating between styles, Picasso presented himself paradoxically as both a part of, and apart from, his times. According to Silver, "In making us concentrate on his artistic prowess, on his unique ability to be both the most traditional artist and the most gifted creator of new forms, Picasso removes himself from the group aspects of both Cubist and neo-classical aesthetics."[19] This protean creative power was perhaps most dramatically revealed in the summer of 1921, when Picasso painted his closely related yet stylistically polarized *Three Musicians* and *Three Women at a Spring.*

Earlier that same year Picasso painted *Studio Corner.* With a fluency similar to his ability to

work in more than one style, he was switching among a variety of media, proving himself adept in them all. Between 1918 and 1921, however, he worked more consistently in gouache and watercolor than at any other time in his career. Picasso had become increasingly conversant with these media during the war years, when canvas and oil paints were in short supply, but it was by choice rather than necessity that he reserved gouache and watercolor for his synthetic cubist compositions. These media were eminently suited to this idiom, as they enabled Picasso to construct elaborate and ordered compositions without sacrificing a sense of spontaneity.[20]

Studio Corner is one of several gouache-and-watercolor drawings executed in January 1921 in which elements of the artist's work environment serve as subjects. The chair and guitar combination in the right foreground had been the focus of three drawings done six days earlier in which the various parts were isolated and presented as an assemblage of flat, irregularly shaped planes.[21] In similar fashion, Picasso here combined a frontal view of a chair's back and front legs, a bird's-eye view of the chair caning, and the squared-off shape of a guitar resting on its side. He added a cupboard and a number of abstract planes, which, while suggestive of walls, floor, and corners, work to emphasize the flat surface of the picture plane. Yet by arranging a sequence of overlapping elements beginning with the guitar and ending with the cream-colored plane at left, Picasso established the idea of recession, so that a tension exists between the conceptual and visual information we perceive. Using a palette of brown, ocher, white, gray, and black, he seemed to have been alluding to the

133

color schemes of his analytic cubist works while treating form and volume in an altogether different manner.

<div style="text-align: right">EP</div>

134

Bullfight, 1934

Courses de taureaux

Oil on canvas, 19⅝ × 25¾ (49.8 × 65.4)

Signed and dated l.l.: *Picasso/Boisgeloup, 27 juillet XXXIV*

Acc. no. 1555 (Zervos 8 no. 218)

Early history unknown; Valentine Gallery, New York, date unknown; TPG purchase 1937.[22]

During the summer of 1934, between June and September, Picasso was preoccupied with the theme of the bullfight, producing a large series of paintings, drawings, and etchings devoted to the subject. The return to this theme, which he had first treated in 1900, seems to have been prompted by a trip to Barcelona the previous summer. In September 1933, soon after this sojourn, Picasso produced a few bullfight paintings in which the most salient features of the 1934 series were already present: a sweeping arena framing the moment of impact between a white horse and dark bull. The emphasis on the event's dramatic and violent climax distinguishes these paintings from the earlier works, as well as from bullfight scenes by Goya and

Manet, who tended to feature quieter scenes before or after the moment of conflict.

The Phillips Collection's *Bullfight* was painted in Picasso's studio in Château Boisgeloup, France, July 27, 1934. Like the other paintings in the series, it is an expressively abstracted depiction of a lanced bull savagely goring a frightened horse, which rears up on its hind legs and arches its neck in anguish.[23] A picador and toreador are also present, but their forms seem slight and inconsequential next to the principal drama between horse and bull. Indeed, all anecdotal detail is suppressed in the interest of focusing the viewer's attention on this passionate and violent encounter. The spectators are nothing but generalized flecks of color above the pink and red wall of the ring. The abbreviations and distortions of the animal and human forms at the heart of the composition function as vehicles of raw energy and intense emotion.

In Picasso's hands the drama of the bullfight becomes symbolic of the clash of opposing forces that constitutes the drama of life itself. The horse and bull represent any number of polarities: good and evil, innocence and experience, victim and aggressor, purity and corruption, woman and man, and so on. The sexual analogy is particularly explicit: the lustful bull penetrates the virginal white horse, whose loss is symbolized by a torrent of blood spilling from

the wound. Whereas the bull is synonymous with cruelty and brutality, it is also associated with creativity. It is not difficult to see Picasso in the role of the bull, as his inexhaustible creativity often destroyed established artistic conventions. The tremendous sense of energy and vitality contained in this scene of imminent death captures the paradoxical nature of creative expression.

Although appreciative of such paradoxes, Picasso was neither celebrating violence nor advocating aggression. It is true that in a series of etchings depicting the minotaur, the classical creature who was half man and half bull, Picasso often made the beast seem gentle and devoid of malice. But, as here, he later cast the bull as the vicious perpetrator of inexcusable atrocities. In 1937 he incorporated the bull and horse into his celebrated mural-scaled painting *Guernica,* one of the most powerful anti-war statements in art.[24] The screaming horse at the center of the composition is surrounded by images of terror-stricken individuals with whom we, as viewers, sympathize. The bull stands dispassionately in the upper left, unaffected by the horrific effects of his unthinking brutality.

In contrast to the dark and somber palette that Picasso would later use in *Guernica,* in *Bullfight* he indulged in a wide range of vivid, exuberant colors. The dynamism of the composition is as much a function of Picasso's skillful play of color as of line. In 1941 Duncan Phillips included this painting in an exhibition entitled "The Functions of Color in Painting," placing it in the category "Dynamic Color."[25] Earlier he had written the following about *Bullfight:* "This abstraction is vividly expressive of the light and excitement of a bull fight in the Spanish sun. It is a composite of Picasso's life extending from his racial background to his latest emotions in the bull pen of Europe today. Symbolical clashes of color and a swirl of ferocious lines mark this new Baroque with the special significance of an aesthetic dictator's impetuous and ruthless calligraphy."[26] Although Phillips tended to be critical of Picasso's virtuoso displays of technical and stylistic genius, and often found them lacking in personal expression, he evidently felt that in *Bullfight* the artist had poignantly captured the fury and emotional intensity of the drama of life and death. It was as though Picasso's own "impetuous" and "ruthless" qualities had found their perfect vehicle of expression in the wild spectacle of the bullfight.

<div style="text-align: right">EP</div>

134

GEORGES BRAQUE (1882–1963)

In a long and prolific career, Georges Braque established himself as one of the twentieth century's most important painters, an innovator and consummate craftsman whose committed exploration of cubist principles yielded both cerebral and sensuous effects. On May 13, 1882, Braque was born in Argenteuil to a family of *peintres-décorateurs*. At the age of twenty, after a two-year apprenticeship—first in Le Havre, where his family had moved, then in Paris—he began full-time study in the fine arts. Passing through impressionist and fauvist styles, he became increasingly concerned with volume and structure, taking the work of Cézanne as his model. Together with Picasso, Braque engaged in a rigorous analysis of form, developing the radical pictorial language of cubism, which remains the most seminal innovation in twentieth-century painting. In 1912 Braque created the first of his papiers collés, initiating what would become a lifelong concern for the tactile depiction of space. Wounded in the First World War, Braque resumed painting in 1917, classicizing and naturalizing the cubist vocabulary. During the 1920s he divided his time between small, decorative still lifes and large, complex canvases produced in series. The rich, velvety textures of these works gave way in the 1930s to leaner, drier paintings with vibrant colors and bold patterns. In the 1940s and 1950s Braque undertook two ambitious series, *Billiard Tables* and *Studios,* in which a new visionary quality emerged. During his lifetime Braque had numerous museum exhibitions, including a large retrospective in Cleveland and New York in 1949, and he was the first living artist to have his works shown at the Louvre. In 1948 he received first prize at the Venice Biennale, and in 1951 he was awarded the Légion d'Honneur. When Braque died on August 31, 1963, funeral services were held in front of the Louvre. The Phillips Collection's Braque unit comprises thirteen oil paintings, one watercolor, one silkscreen, and one color aquatint.

The Braque Unit

Duncan Phillips's estimation of Georges Braque as one of the twentieth century's master painters is reflected in the size and scope of the Braque unit he assembled. The collection's holdings represent roughly thirty years of Braque's artistic career, with a special emphasis on his still lifes from the 1920s. Phillips's dedication to collecting Braque's work was testimony to his commitment to celebrate the continuous mastery of French modernist painters, as well as to his emerging preference for a particular strain of

European modernism whose distinguishing quality was personal vision rather than dogma.

In 1927 Phillips purchased his first painting by Braque: *Plums, Pears, Nuts and Knife,* 1926 (cat. no. 136). The acquisition reflected a recent decision to augment the collection with examples of contemporary French painting. This sudden shift in orientation away from an emphasis on American art demonstrated not only his more informed understanding of French modernism but also his sympathetic response to the stylistic shifts that had occurred in avant-garde painting during and after the First World War.[1]

In the ten-year interval between his publication in 1917 of an essay titled "Fallacies of the New Dogmatism in Art" and his first purchase of a painting by Braque, Phillips radically reformulated his position with regard to many of the modernist idioms he had previously derided.[2] In the essay cubism was singled out as a primary manifestation of "the obscure malady which has produced in our day and generation debased aesthetic standards." His characterization of cubist practices typified the prevailing attitudes of consternation and condescension with which American audiences viewed this new stylistic development: "A characteristic cubist canvas looks as if anyone of us in an absent-minded way had been making all kinds of zig-zags and criss-crosses on a bare surface, jumbling the forms and inextricably confusing the outlines."

A more benign attitude is reflected in the essay "The Many Mindedness of Modern Painting," published in the fall of 1929, in which his description of cubist inventions emphasizes qualities of discipline, structure, and simplification.[3] But it is also clear that his revised opinion about the earliest formal innovations of the cubist painters was significantly informed by his greater appreciation of subsequent developments, which, while clearly dependent on cubist principles, modified them to different, often less distorted visual effects. In his catalogue essay accompanying an exhibition of contemporary French art, Phillips credited Braque with having "made the practice [of cubism] a thing of exquisite taste, of standardized conventions, of French style."[4] Ten years later Phillips was still content to view cubism as a necessary means toward even greater ends: "All the experiments of Cubism are justified by the emergence of this great master of design [Braque] who now takes his place in history among the French masters of the Classic tradition."[5]

Braque's work satisfied three of Phillips's principal criteria of value: classicism, personal vision, and continuity with tradition. Each of these qualities implied and reinforced the oth-

ers. Personal vision did not mean a radical departure from traditional values, but rather an individual way of seeing that both drew upon conventional ideals and developed them in new directions befitting the times: "The continuity of the great tradition in French art is the pride of the best French painters. They seem to realize that a tradition, like an old family, must constantly renew itself with the body and soul of each new age. Otherwise the end is in sight. A tradition in art simply means the heritage of qualities which deserve not only to endure but to develop."[6] We may then understand that the structural clarity and refined lyricism of Braque's postwar still lifes revealed to Phillips a strong personal sensibility, while they also recalled the still lifes of such earlier artists as Chardin and Cézanne.

The classicism Phillips saw in Braque's work had to do not only with this continuation of French tradition, but also with Braque's own evolution and consummate control of his artistic skills. In Phillips's view Braque's prewar analytic cubism was in effect the archaic period of his later, more resolved postwar classicism. His still lifes of the twenties were infused with the "classic qualities of taste, logic and balance which the French take pride in, century after century."[7] In addition to admiring his classical, indeed "timeless," designs, Phillips delighted in Braque's use of subtle color harmonies and the sensuous immediacy of his textured surfaces.

Between 1927 and 1934 Phillips acquired six paintings of his Braque unit, all of which had been painted in the 1920s, the decade Phillips judged Braque to be at the pinnacle of his powers. He proceeded according to his passions, but with a keen eye for selecting works that were compatible and complementary. *Lemons, Peaches and Compotier,* 1927 (cat. no. 137), entered the collection as a loosely brushed, tactile counterpart to the more linear and restrained *Plums, Pears, Nuts and Knife.* In contemplating the purchase of *Still Life with Grapes and Clarinet,* 1927 (cat. no. 139), Phillips imagined how it might work as part of a "triptych": "I . . . decided that I could make a beautiful wall with my two long panels to the right and left of this handsome canvas as a center."[8] He went to considerable lengths to acquire this comparatively costly work and thus complete the vision he had in mind.

The "lyricism of pure aesthetic relations" that Phillips admired in these still lifes perhaps found its grandest expression in *The Round Table,* 1929 (cat. no. 140), a monumental canvas he considered the climax of this great period.[9] Phillips first saw this work in 1934 at an exhibi-

tion of Paul Rosenberg's collection of paintings by Braque, Matisse, and Picasso; he was captivated by both *The Round Table* and Picasso's *Three Musicians*, 1921.[10] Phillips put all his energy into acquiring of *The Round Table*, leaving the pursuit of the Picasso to Alfred Barr. Employing a musical metaphor to describe the purely formal effects of nonnarrative painting, Phillips called the colors, planes, and lines in *The Round Table* "the instruments for an orchestral symphony."[11]

Braque's somewhat ornate and vividly colored still lifes of the 1930s seem not to have interested Phillips, who preferred his structurally solid and subtly toned compositions. These qualities resurfaced in many of the paintings Braque produced during the Second World War. *The Washstand*, 1944, acquired in 1948 (cat. no. 141), has a taut structure and suggestive textures that recall the classical sensuality of the 1920s still lifes Phillips loved so well.

In 1953, the same year Phillips received Braque's *Music*, 1914, as part of a gift from Katherine S. Dreier's estate, the New York dealer Theodore Schempp presented a selection of Braque's recent paintings, including some from his *Billiard Tables* and *Studios* series.[12] Not since the 1920s had a period of Braque's work elicited such an enthusiastic response from Phillips. Very quickly he resolved to buy *The Shower* and *The Philodendron*, both 1952 (cat. nos. 142 and 143), two paintings very different from one another in both scale and style. *The Philodendron* is representative of the spatial and psychological intensity of Braque's late interiors, whereas *The Shower* is an early example of his expressionistic experiments in the landscape genre. Finally, in 1958 Phillips attended a Braque exhibition at the Maeght galleries in Paris, where he was awestruck by one of the artist's last *Studio* paintings. If not for its prohibitively high price, it too would have been added to the collection.[13]

During the last decade of his life Braque often depicted birds in his paintings. When planning the museum wing that opened in 1960, Phillips sought and received Braque's permission to have a bas-relief made after one of the artist's bird designs. The powerfully simple silhouette of a bird in flight, executed in brown granite by Pierre Bourdelle, was placed over the front door of the annex, where to this day it watches over all who come and go. In 1966, shortly before his death, Phillips acquired *Bird*, 1956 (acc. no. 0209), a work of almost awkward simplicity which reminds one that the beauty of painting is its ability to let the imagination soar. In 1990 the collection was given a splendid wartime still life titled *Pewter Pot and Plate of Fruit*, 1944 (acc. no. 1990.1.1), which reveals a more elevated mood than that of *The Washstand*.[14]

The Phillips Collection is unique among museums of modern art in that it contains more works by Braque than by Picasso. Phillips was well aware that Picasso was generally regarded as the greater artist, but he was convinced that Braque would better stand the test of time: "Although Picasso's range has been far wider and his influence far greater and although his is perhaps the most indisputable genius, time may rank the mellowed craftsmanship and enchanting artistries of the reserved Frenchman higher than the restless virtuosities and eccentric innovations of the spectacular Spaniard."[15] Whether Phillips's speculation proves right is really of little consequence. The preferences that are so clearly reflected in the composition of his collection require no vindication or validation by future generations. Rather, it is the good fortune of these generations to have before them a living record of one man's vision of what mattered most in modern art and the art of his day.

E P

135

Pitcher, Pipe and Pear, 1924

Poires, pommes, pipe et pot
Fruits, pot et pipe; Still Life with Pipe; Pitcher and Fruit
Oil on plywood panel, 13⅜ × 16⅞ (33.9 × 42.9)
Signed in black paint, l.r.: *G Braque*
Acc. no. 0215 (Valsecchi and Carrà no. 243)

The artist to Paul Rosenberg, Paris; Mrs. E. R. Workman, London, probably 1924; purchased by Reid and Lefevre, London, 1928; sold to Kraushaar, New York, 1928; PMG purchase 1929.[16]

136

Plums, Pears, Nuts and Knife, 1926

Fruits et couteau
Poires, pêches, verre et couteau; Fruits, verre, couteau; Fruits and Knife; Plums, Knife and Walnuts; Plums, Nuts and Knife
Oil on canvas, 9 × 28¾ (22.8 × 73.0)
Signed and dated in black paint, l.l.: *G Braque/26*
Acc. no. 0216 (Valsecchi and Carrà no. 314)

The artist to Paul Rosenberg, Paris; PMG purchase through Durand-Ruel, New York, 1927.[17]

137

Lemons, Peaches and Compotier, 1927

Compotier, citron et pommes
Compotier et fruits; Oysters, Lemons and Peaches; Peaches and Lemons
Oil on canvas, 8⅞ × 28⅞ (22.5 × 73.3)
Signed and dated in black paint, l.r.: *G Braque/27*
Acc. no. 0212 (Valsecchi and Carrà no. 355)

The artist to Paul Rosenberg, Paris; Reinhardt, New York, date unknown; PMG purchase 1928.[18]

138

Lemons and Napkin Ring, 1928

Pichet, citrons, serviette sur une table
Serviette, pichet et citrons; Pichet, citrons, serviette; Pitcher, Lemons and Napkin Ring
Oil and graphite on canvas, 15¾ × 47¼ (40.0 × 120.0)
Signed and dated in gray paint, l.l.: *G Braque/28*
Acc. no. 0210 (Valsecchi and Carrà no. 243)

The artist to Paul Rosenberg, Paris; Paul Rosenberg, Paris and Wildenstein, New York; purchased by the Valentine Gallery, New York, 1930; PMG purchase 1931.[19]

Braque's still lifes of the 1920s are exquisite expressions of a finely wrought balance between structure and sensuousness. Their sober compositional solidity combined with rich plays of tone and texture appeal equally to the mind and the senses. For Braque the space of still life was preeminently tactile, and for him one measure of artistic success was the degree to which the painter rendered that quality of space palpable: "It is not enough to make people see what we paint. We must also make them want to touch."[20] By virtue of their heightened aspect of tactility, these still lifes of the twenties are strikingly different from Braque's prewar cubist compositions, which have a far more cerebral appeal.

It is customary to discuss Braque's still lifes of this period in terms of their increased naturalism. Compared with those executed in the idiom of analytic cubism, they are more immediately legible, filled as they are with easily recognizable forms. But this heightened naturalism did not entail a total return to illusionism. Although the individual forms of fruit and tableware are depicted with a greater sense of their physical substance and three-dimensionality than the earlier works, they are never set in a space we could construe as an illusionistic extension of our own. Instead, they are paradoxically compressed within a thin shelf of space bounded by radically tilted background planes and the picture plane itself.

The tension established between the suggestion of substance and the perception of spatial compression compels an awareness of two distinct yet interdependent dimensions of the paintings' "reality": the representational and the literal. The modernist impulse to assert the object status of the painting itself is very much present in these works. For Braque the emphatic presentation of a painting's intrinsic properties was of paramount importance: "The objective is not to care about *reconstituting* an anecdotal fact but about *constituting* a pictorial fact."[21] We are constantly reminded that what we see are forms disposed upon a two-dimensional surface. That the coloristic and textural qualities of these

135

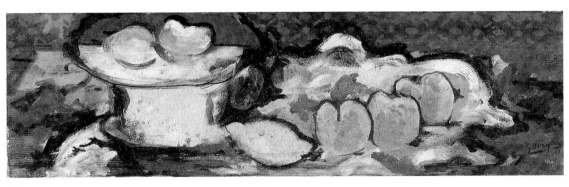

136

137

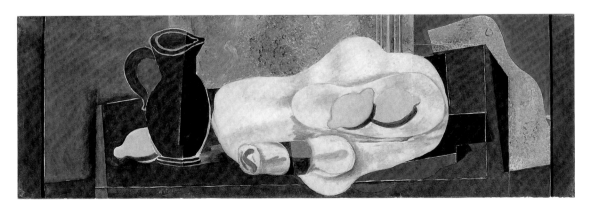

138

works do not conform exactly to our experience of the objects depicted—that they exceed the function of description and establish an independent, formal impression—reinforces the perception of the picture as an object in its own right.

Braque's still lifes of the 1920s have frequently been characterized as decorative. It is certainly true that his early experience as a decorative painter never ceased to inform his art. Patterned wallpaper, simulated wood grains, and faux-veined marble pervade his postwar works. But it is not only the presence of these decorative elements and techniques that qualifies these still lifes as decorative; it is also the cultivation of a two-dimensional lyricism within long, horizontal formats of intimate scale, perfect for enhancing living environments without commanding too much space or studied attention.

Plums, Pears, Nuts and Knife was first shown by Duncan Phillips in an exhibition titled "Intimate Decorations." Whereas the invocation of the term *decorative* in the fine arts can now imply superficiality and a lack of emotional depth, Phillips used it in a way that was common and neutral in the early twentieth century. He recognized the ability of the best artists to use decoration as a vehicle for personal expression: "Decoration is or should be an expression of the artist, his taste, his temperament, his use of, rather than his subjugation by, one of the decorative conventions."[22] The relative impersonality of Braque's earlier cubist still lifes, their subjugation of a personal sensibility to the rigors of an analytical system, was replaced in the twenties by a style that was at once distinctly his own and firmly rooted in the classicism of the French still-life tradition. Echoes of Chardin and Cézanne are unmistakable in the simple yet elegant arrangements. Braque's formats were always carefully considered. In *Pitcher, Pipe and Pear,* a rare example of the octagonal format, Braque exploited the shape of the panel to brilliant effect, establishing a correspondence between the three primary horizontal registers of the compositions and the panel's angled contours. He also rhymed the orientation of certain forms, most notably the pear and the pipe, with the panel's angled edges. The somber color scheme of this painting is characteristic of a period when Braque frequently primed canvases with saturated black grounds.

In the late twenties Braque preferred narrow horizontal canvases eminently suited for use as overmantels, suggesting that he had decorative roles in mind for these works and that the distance between fine art and interior decoration was, for a period of time, occluded.[23] The three oblong works from this period in The Phillips Collection reflect some of the ways Braque exploited this format to achieve a range of effects. In all of them the lateral dispersion of forms emphasizes the shallowness of the space they occupy, allowing the viewer's eye to delight in their surface relationships and rhythms. The manner in which Braque articulated the relationships between form, color, and texture, however, varies considerably among these three works.

Of virtually identical dimensions, *Plums, Pears, Nuts and Knife* and *Lemons, Peaches and Compotier* constitute a striking study in contrasts. Whereas the first is a work of lucid refinement, characterized by relatively crisp contours and thin washes of paint, the second presents a scene in soft focus where broad, sweeping brushstrokes create passages of thick impasto in which forms seem magically to melt into one another. Recalling discussions between Phillips and the French critic Henri Focillon in which they would compare these two works, Marjorie Phillips wrote that, despite their different preferences, they "agreed that both were little beauties and foils for each other as the artist intended."[24]

In *Lemons and Napkin Ring* virtually all sense of substance and weight has been given up in the interest of creating a controlled structure of floating, overlapping planes, a play among ovoid and rectangular forms. The still-life elements appear to be poised so precariously against the acutely tilted rectangular planes that they seem liable to slide or roll right out of the picture. Or are they weightless, pneumatic presences unaffected by the laws of gravity? The two lemons, the plate, and the napkin situated on the irregularly shaped white cloth have a particularly spectral quality. That this painting was a study for one of the four marble mosaics Braque created for Paul Rosenberg's dining room in Paris perhaps accounts in large measure for the relative spareness of its design.[25]

All of Braque's still lifes of the twenties exhibit a reformulated classicism, or neoclassicism, that was in fact characteristic of French modernist painting of this period. It was the quality of timelessness, the simultaneous expression of the new and the ancient, that Phillips found so compelling in Braque's works. About his perception of this quality in *Lemons and Napkin Ring,* Phillips wrote: "Last winter I was in my study one day absorbed in a book on archaic sculpture and primitive ornament. Friends arrived and asked to see the Braque which was then the over-mantel in the dining room. While they spoke of its curious novelty I wondered at its stately antique grandeur, wondered why it seemed so much like the constructions of antiquity that I felt no break, no interruption in passing mentally from ancient civilizations to the adventuring modern mind."[26] In many ways Braque's still lifes of this time are the perfect proof of Phillips's argument that modernist art developed through an evolutionary, not revolutionary, process.[27] Working and reworking similar subjects and compositions throughout the decade, Braque discovered a world of possibilities, an inexhaustible range of expressive nuances, through the simplest of means.

EP

139

Still Life with Grapes and Clarinet, 1927

Nature morte (à la clarinette)
Abstraction; Still Life with Grapes
Oil on canvas, 21¼ × 28¾ (53.9 × 73.0)
Signed and dated in black paint, l.r.: *G Braque/27*
Acc. no. 0219 (Valsecchi and Carrà no. 368)

The artist to Paul Rosenberg, Paris; Dr. Soubies, Paris, date unknown; Hôtel Drouot sale, Paris, June 14, 1928, to Paul Rosenberg; purchased by Reinhardt, New York; PMG purchase 1929.[28]

Still Life with Grapes and Clarinet is a splendid example of Braque's technical mastery and compositional control. Formal complexity is here distilled through elegant harmonies of color, line, and texture to produce an effect of startling clarity and consummate balance. Both its structural stability and hierarchical organization endow this work with a monumental quality belying its modest scale. It was purportedly Duncan Phillips's favorite Braque still life in the collection, and it perhaps best typifies his description of them as "works of art at once architectural and lyrical."[29]

In this work Braque revived the severe, hard-edged cubist style that had characterized his work in the years immediately preceding and following the First World War. He did not completely sacrifice the increased naturalism of the intervening years, however, and instead established a dialectic between naturalistic and more conceptual modes of representation. While he allowed certain of the depicted elements to maintain a semblance of their physical integrity, he reduced others to the more abstract quality of signs.

The work's additive, constructed quality—characteristic of what has been called "synthetic" cubism—has its roots in the principles and techniques of papier collé. Braque had made the first papier collé in 1912, when he introduced strips of simulated wood-grained wallpaper into a still-life composition. Such collage devices signify with great economy and specificity both the color and texture of an implied object while contributing formally to an independent order free of naturalistic description.

Rather than using prepared wallpaper in *Still Life with Grapes and Clarinet,* Braque painted

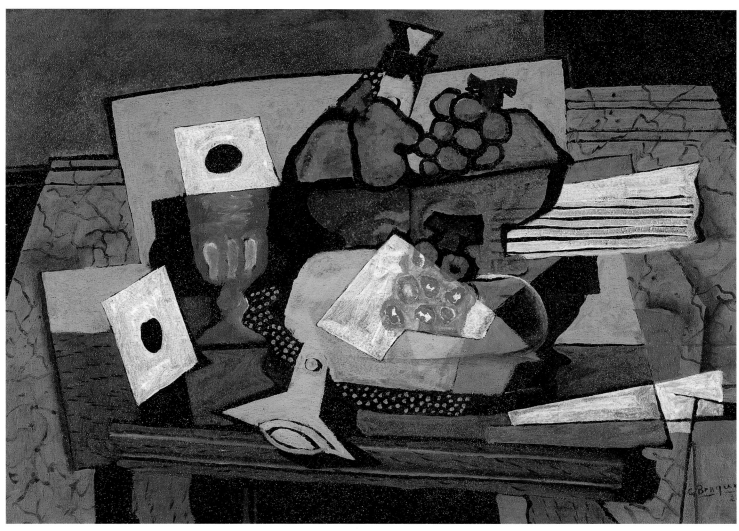

139

areas of *faux-marbre* and rich wood grain to convincing effect. The shapes of these areas are more descriptive of the actual objects to which the illusionistically painted materials correspond—namely, the wainscoting and the table—than are the papier collé strips; however, like the strips, they also function independently as abstract formal elements. The passages of pale blue, which together provide a backdrop to the centralized still-life objects, are perhaps the most highly abstracted elements of the painting. The color suggests the sky, but it remains uncertain whether we can also deduce the presence of a window through which this sky is glimpsed.

Still Life with Grapes and Clarinet is unique among Braque's paintings of the mid- to late twenties in that it reintroduces several motifs characteristic of his prewar paintings and papiers collés. The playing cards (highly abstracted aces of spades) and clarinet read like deliberate references to these earlier works, in which cards and musical instruments were among Braque's standard repertoire of subjects. The red-on-black stippling evident both toward the top of the clarinet and just above its flared base calls to mind the prewar compositions in which this mannerism first appeared. No other works from this period exhibit so many references to earlier phases of Braque's career.

Like many of Braque's paintings of the 1920s, *Still Life with Grapes and Clarinet* reveals his consistent concern for giving his canvases tactile as well as visual appeal. Whereas our eye might be confused and disturbed by the opaque rendering of the glass and compote, our sense of touch compensates, responding to the illusion of weight and solidity that opacity conveys better than translucence. The presence of the clarinet adds to the tactile dimension of the work as well. For, although schematically rendered and partially obscured, the clarinet, like all musical instruments, must be manipulated in order for it to come to life.[30] Playing cards also require hands to animate them. With so many metonymic allusions to human touch, this still life functions not as a memento mori, as so many still lifes do, but as a celebration of life, vitality, and the senses.

It was perhaps this aspect of liveliness that most attracted Duncan Phillips to this work. In a 1945 essay he wrote: "Does this sound like a complicated organization? The reply from the eye is no. The effect is of life, crackling with expanding energy through a pervasive reason."[31] To Phillips's eye, *Still Life with Grapes and Clarinet* was the quintessence of a refined and perfected cubist vocabulary. Leading up to his discussion of this work in the 1945 essay, he wrote: "Yet even in this curvilinear period which was really a new Baroque, some of the finest works were consummations of the austere experimental diagrams of

about 1912–14." The measures of these "consummations" seem to have been sensuous color and classical construction.

E P

140

The Round Table, 1929

Guéridon
Le Grand guéridon
Oil, sand, and charcoal on canvas, 57⅜ × 44¼ (145.6 × 113.8)
Signed and dated in black paint, l.r.: *G Braque/29*
Acc. no. 0217 (Valsecchi and Carrà no. 399)

The artist to Paul Rosenberg, Paris; PMG purchase 1934.[32]

141

The Washstand, 1944

La Toilette aux carreaux verts
Dressing Table with Green Squares
Oil on canvas, 63⅞ × 25⅛ (162.4 × 63.8)
Signed l.l.: *G Braque*
Acc. no. 0221

The artist until at least 1946; sold between 1946 and about 1948 to Paul Rosenberg, Paris; PMG purchase from Rosenberg, New York, 1948.[33]

The Round Table and *The Washstand,* two interiors with full-scale, object-laden tables, are exemplary works reflecting, on the one hand, Braque's tremendous artistic power in the late 1920s and, on the other, his dispirited depletion of energy during the war years. In both, however, the lessons of cubism continue to inform his calculated constructions of pictorial space.

The *guéridon,* a popular pedestal table in France, was a subject Braque turned to again and again during the 1920s. Not conceived as an actual series, the various paintings representing guéridons display a variety of modifications in style, format, and compositional elements.[34] Some were executed singly, and others were worked on in groups. At intervals throughout the decade he set the theme aside, only to return to it later. With each reprise, Braque demonstrated that in his hands the potential of any given subject was inexhaustible. As was also the case with the basket-carrier (*canephore*) and mantelpiece motifs, which Braque painted in many variations during the early and mid-twenties, the guéridon proved to be a rich vehicle for revealing the subtlety and strength of his formal explorations.

The Round Table is one of several *Guéridon* paintings executed between 1928 and 1930. In all these works, Braque focused more on the spatial setting of the table and still life than in the smaller works of the preceding years. Although the various *Guéridons* relate closely in terms of style, the Phillips painting is unique with respect to the placement of its table in a corner. This

innovation allows for a compositional format more ample in width and a pictorial structure simultaneously more complex and lucid. While the sharply inclined plane of the tabletop and the pedestal base largely obscure the actual intersection of the two walls, the vertical bifurcation of the several planes rising behind, or out of, the still-life elements evokes its presence. Nonetheless, we are not fully convinced that behind this table lies a pocket of space.

Like many of Braque's paintings of the twenties, *The Round Table* is replete with contradictory messages. Although the wainscoting's rectangular panels are angled differently on either side of the table in order to suggest a recession into space, their top edges align perfectly, as though part of a continuous plane. The sense of depth achieved by the overlapping of various still-life objects is superficial, because it is countered by the virtual absence of foreshortening. Illusionistic space is simultaneously asserted and denied. The angled knife alludes to trompe l'oeil painting in that the viewer has an impulse to grasp it; yet, because Braque has denied the viewer an illusionistic reading of this object, the urge is conceptual rather than perceptual. In addition, Braque created a sense of ambiguity through his play with white and dark contours, the exact functions of which are not always readily apparent. The fictional nature of pictorial description is intimated through the picture's pervasive paradoxes and ambiguities.

The year 1928 marked the end of a ten-year period in which Braque's palette had been dominated by dark tones of green, gray, and black. This somber color scheme gave way to an expanded range of lighter, blonder tonalities. *The Round Table* is substantially lighter than the still lifes Braque painted just a few years earlier, and thinner washes of color applied over a white particulate ground create the effect of a time-worn fresco. Combined with the composition's greater, albeit ambiguous, quality of space, the softer, more luminous colors create a mood of openness and accessibility. *The Round Table* is majestic without being formidable, tightly structured without seeming claustrophobic.

Douglas Cooper has referred to *The Round Table* as "the most complex, the most colorful, the most ornamentally enlivened and the most triumphantly successful" of all the *Guéridons* executed at this time.[35] It is certainly one of Braque's most eloquent expressions of a new classicism that takes both cubism and naturalism into account. Individual forms and planes are generated as much from the artist's mind as from the observation of actual objects. Straight and curved lines are played off one another in rhythmic counterpoint, enlivening a composition that as a whole is consummately balanced. In evoking the glories of antiquity with the

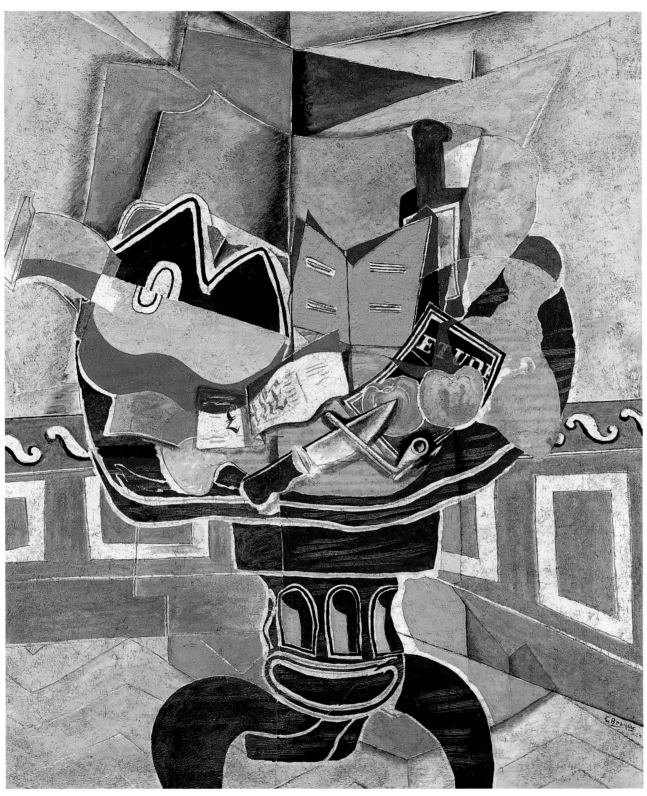

140

Doric pedestal and the classical style of the patterned wainscotting, Braque implicitly offered us a view of his reformulated style of cubism as a vital, new classicism for the contemporary era.

In contrast to the bold vision and vitality of *The Round Table,* the pictures Braque painted during the Second World War reflect a mood of pessimism and uncertainty common among those who remained in Paris during the dark days of the Nazi occupation. *The Washstand,* painted at the end of this period, exemplifies Braque's consistent focus on scenes of daily domestic routines, which, though perhaps his only source of comfort or solace, are inevitably inflected by a sense of spiritual malaise.

The thirties had by and large been a time of security and liberal experimentation for Braque, who had painted figures, landscapes, and still lifes with a vibrant palette and a fluid insouciance of line. But with the foreboding of conflict at the end of the thirties, he began to produce works that were darker and more restrained. Some of these works had an uncharacteristic iconography, perhaps symbolic of the moral and spiritual crisis at hand: skulls, rosary beads, and occasionally crosses appear in numerous still lifes painted just before and during the war.

Braque more typically relied on color and form, independent of specific motifs, to convey emotional or spiritual tone. The subjects he chose were fairly prosaic. He painted a series of kitchen tables with varying arrangements of objects, such as frying pans, coffee grinders, vegetables, fried eggs, fish, and cheese, none of which have the sensual appeal so characteristic of the objects in the prewar still lifes. Washstands with pitchers, basins, and sponges set in spartan rooms form another thematic group unique to the war years. Common to all of these paintings is a sense of austerity, monotony, and melancholy.

The Washstand is one of the concluding works in the eponymous series. Whereas the individual still-life objects are quasi-naturalistic, the overall compositional structure is based on cubist principles. The intensely vertical format, combined with the stacking of forms, works against any effect of spatial recession. Not only is the plane of the tabletop tilted upward, as in *The Round Table,* but its very definition is obscured and distorted by the checkered cloth, which seems almost to have a life of its own. The undulating gray form beneath the sponge and hairbrush (a towel? a hand mirror gone soft?) masks the true definition of the table's corner—thereby concealing an element capable of contributing to the illusion of space—while revealing its front edge. The horizontal lines beneath the window continue the lines articulating this edge, reinforcing the impression of a flattened pictorial space.

The generally grayed and muted color scheme is fairly typical for this period. Here, the colors have an earthen aspect that is punctuated by pastel shades of pink and aquamarine, somewhat leavening the mood. The repetition of soft, molten forms—from the pitcher to the sponge and brush to what appears to be a green bidet—could be seen as evocations of organic life or, to the contrary, as a dissipation of energy. Despite the firm grid of horizontals and verticals that gives the painting a certain vigor, an unmistakable sense of fatigue pervades it. Nonetheless, in comparison to pictures painted earlier in the war period, *The Washstand* reveals a renewed fluency, rigor, and assurance in Braque's handling of paint.

EP

142

The Shower, 1952

L'Ondée

Oil on canvas, 13¾ × 21½ (34.9 × 54.6)

Signed l.r.: *G Braque*

Acc. no. 0218

Purchased from the artist by Theodore Schempp and Co., New York, 1952; TPG purchase 1953.[36]

Through the analytic deconstruction and recomposition of landscape forms in his fauve-period paintings of L'Estaque—inspired by the late landscapes of Cézanne—Braque made his first advances toward developing the new pictorial language of cubism. Soon, however, his formal experimentation was focused almost exclusively on still lifes. In making still life his genre of choice for most of his career, Braque implicitly rejected what he considered to be the "visual" space of landscape, the vastness of which is beyond human comprehension; in still-life painting, however, it was possible to bring the subject within reach of the viewer.

Although he occasionally took up landscape, it was not until the 1950s and 1960s that he renewed his interest in a serious way, replacing the vibrant, emotional intensity of fauvism with the cool, more conceptual concerns of cubism.[37] As indicated by *The Shower,* Braque became more amenable to the representation of pictorial space and more accomplished at endowing his landscapes with tactile qualities.[38]

The fields of Normandy depicted here were saturated with a lifetime of memories for Braque. As a boy living in Le Havre, he rode his bicycle through them on many an adventure. Years later he chose the Norman coast over the more popular Provence as a site for a summer house. The climate and colors—cool, misty grays; deep, earthen browns; greens and ochers; and the changeable blues of storm-prone skies—were more congenial to his nature than

141

the clear weather and brilliant colors of the Mediterranean.[39]

The only sign of human presence in *The Shower* is the bicycle, which is leaning against a pair of trees. The background landscape—four principal bands of color—features a field of warm golden wheat that gives way to meadows and a distant tree line against the cool, gray-blue sky. This progression gives the sense of recession into space. An isolated rain shower, indicated by a patch of diagonal white lines, seems to be drifting in from the right. The sensuous surfaces of both the thickly textured tree trunks and the mottled wheat serve to counter this recessive effect, however, drawing our attention to the two-dimensional plane of the canvas itself and making our experience of the scene as much tactile as visual.

The sketchy quality of the bicycle suggests that it was summoned forth from memory. Even the shower has the flavor of nostalgia as it evokes the pure, cleansing properties of country rain and the innocence of youth. The

panoramic view suggests the endless expanses of sky and earth.

These late landscapes are all of small to medium scale, helping to reinforce this tactile, objectlike quality. Whereas the dimensions of *The Shower* are roughly consistent with the conventional landscape ratio of 1 to 1.7, Braque produced several landscapes that were extremely long and narrow (1 to 3.6) and thus reminiscent of his oblong still lifes of the 1920s.[40] The infinity of space is spectacularly evoked in these works, unfurling endlessly along the horizon. Although all of them lack the strict structural organization that had been crucial to his paintings for so many years, these landscapes nonetheless have a vitality all their own—one that is enhanced by Braque's reverence for the material properties of his medium and his success at making his paintings increasingly lush and expressive. Liberated from the structural confines of still lifes and other interior subjects, Braque allowed his vision to soar in these late landscapes like the grand and graceful birds that populate many of his later works.

<div align="right">EP</div>

143

The Philodendron, 1952

Le Philodendron

Oil on canvas, 51¼ × 29⅛ (130.1 × 73.9)

Signed in white paint, l.l.: *G Braque*

Acc. no. 0214

Purchased from the artist by Theodore Schempp and Co., New York, 1952; TPG purchase 1953.[41]

Painted during the period in which Braque produced his celebrated *Studio* series, *The Philodendron* shares with these works a mysterious,

almost visionary quality. The eight *Studio* paintings, produced between 1949 and 1956, are large-scale meditations on Braque's professional environment—the crucible of his creativity and, for him, a microcosm of the world—in which memories and formal inventions mingle with the actual appearance of things.[42] Despite the dense crowding of forms, the space in these works is supple and enigmatic. Because of the way the various elements freely float and interact, a sense of an all-pervasive unity is evoked.

A similar condensation of space and matter is evident in *The Philodendron,* particularly in the dark and heavily impastoed background. Curvilinear contour lines create an all-over tracery, uniting the different pictorial elements in a common web and keeping the eye focused on the surface plane. Color contrast, however, works against this effect. Here, unlike the *Studios,* the nocturnal atmosphere is relieved by vivid passages of yellow and orange that seem to surge into the viewer's space. If taken as signs of daylight's pleasures and luminous certainties, the garden chair and tabletop might be seen as offering a respite from the mystery and melancholy of night. But if the profusion of leaves is seen as a metonymic allusion to Braque's studio (photographs show that he kept many large, leafy plants there), we might instead be witnessing a metaphorical transformation of the objective, tangible world into the subjective realm of the creative imagination.[43]

The Philodendron was not the first instance in which a garden chair appeared in Braque's work. In fact, by 1952 it had become a firmly established motif. One of Braque's greatest joys after the war's end was his ability once again to frequent his house in Varengeville on the Norman coast, where he had gardens and a terrace. The

series of brightly colored, closeup, and often cropped views of single garden chairs begun in 1947 was an effective vehicle for the expression of his love of the country—and his elevated mood in general—while still qualifying as still life. Furthermore, it is hard not to see these often high-keyed, emotional paintings as echoes of the chairs van Gogh painted at Arles in the 1880s.

By integrating the garden chair (now accompanied by a table) into the studio setting, Braque gives yet another example of his lifelong preference for invention and synthesis over literal transcription. A blurring of categories is also intimated: outside/inside, night/day, reality/imagination, fact/fiction. Braque's interest in showing what he termed the "metamorphic side to reality" is equally evident, because the forms or identities of things seem to be in a state of flux.[44] Bearing in mind his belief that "no object can be tied down to one sort of reality," we are perhaps more receptive to the ambiguities of a shadow-inflected tabletop that also resembles a palette smeared with paint; a chair back that "bleeds" onto the dark background, where there may or may not be a wall lurking; and a phantasmal scallop-edged form floating against a section of vertical ropelike patterning.[45]

By the time this painting was made, Braque had taken up color lithography, a medium in which he became very accomplished during the decade. Its relevance to *The Philodendron* can be seen in the way he allowed areas of bare canvas to function as light. This technique is especially evident in the foreground, around the tabletop, carafe, and apple. But in contrast to such economy and austerity, Braque applied thick layers of paint to the background, creating tempting textures in the interest of the type of tactile space he always favored.

<div align="right">EP</div>

143

LOUIS MARCOUSSIS (1883–1941)

Born November 10, 1878, in Warsaw, Louis Casimir Ladislas Markus studied law and painting in Cracow for two years before he moved to Paris in 1903 and enrolled in the Académie Julian. Initially painting in an impressionist style, he was better known for his skills as an illustrator and by 1905 was publishing his illustrations in such journals as *L'assiette au beurre* and *La vie parisienne*. In 1910 he met Braque, Picasso, and Apollinaire; the poet suggested that he adopt the name Marcoussis after a small village in the Seine-et-Oise district. Soon Marcoussis was employing cubist principles in his paintings, and in 1912 he participated in the Section d'Or exhibition. In 1913 he married Alice Halicka, and they moved to the rue Caulaincourt, where they lived until 1939. By serving in the army during the First World War, Marcoussis became a French citizen. He continued to paint in a cubist vein throughout the 1920s and was given his first solo show in 1925 at the Galerie Pierre. His translation of cubism into graphic media was one of his most outstanding accomplishments. In the 1930s he worked with many writers and poets, including Tristan Tzara and Gérard de Nerval, making engravings to illustrate their works. In 1934 he illustrated an edition of Apollinaire's *L'alcools*. Marcoussis led a cosmopolitan life in Paris and became much sought after by the haute monde as a portrait engraver. After fleeing Paris in May 1940, he died October 22, 1941, in Cusset, near Vichy, in central France. The Phillips Collection owns two paintings by Marcoussis.

144

Painting on Glass, No. 17, 1920

Peinture sur verre, no. 17
Forms on Glass, No. 17
Oil on glass, 9¾ × 11⅝ (24.7 × 29.6) oval, with frame
Signed and dated c.l. and c.r.: *L19, 20M;* artist's inscription in graphite pencil on wood backing board, u.c.: *Louis Marcoussis/Paris 61 rue Caulaincourt/peinture sur verre/1920*
Gift from the estate of Katherine S. Dreier, 1953
Acc. no. 1261

Der Sturm Gallery, Berlin; purchased by Katherine S. Dreier ca. Oct. 1922; gift from the estate of Katherine S. Dreier 1953.[1]

Painting on Glass, No. 17 is one of nearly 112 reverse paintings on glass that Marcoussis produced between 1919 and 1928.[2] In it he combined the avant-garde language of synthetic cubism with what was primarily a folk-art tradition, thereby creating a synthesis of form and

medium that collapsed the distinction between high and low art. The special frames Marcoussis had built specifically for many of these paintings emphasized their status as objects in which an attention to material craft and elegance was of primary importance.[3]

The technique of reverse painting on glass had been practiced in Europe for hundreds of years, beginning in Italy in the thirteenth century.[4] As the center of glass production shifted to Central Europe, so too did the art of painting on glass, which in the eighteenth century became increasingly associated with the rural market for religious icons. During the second half of the nineteenth century, however, hand-produced artifacts of all kinds were eclipsed by new mass-produced items, and the art of glass painting virtually died out.[5]

A fascination with and adaptation of popular art forms was characteristic of many early twentieth-century artists. Picasso and Braque elevated the tradition of collage to the status of fine art, and German artists such as Kirchner and Nolde revived the practice of woodblock printing. Other artists working in Germany—Kandinsky, Münter, and Klee—were experimenting with reverse painting on glass as early as 1909.[6] It is possible that Marcoussis was aware of this activity through Robert Delaunay, who was exhibiting regularly with the Blaue Reiter in the years before the war. But it was not until 1919, when on a trip to his native Poland he saw many examples of reverse glass painting, that his own interest in the technique was awakened.[7]

The process calls for an ability to conceptualize in reverse an entire sequence of steps required to realize a composition. Those marks that normally would be laid down last must be put down first on the back of the glass. To facilitate this procedure Marcoussis routinely made two preparatory gouache drawings, one representing the composition as it would finally appear, the other its reverse. This second study served as the direct model for laying down the composition.[8] Precision is obviously at a premium in reverse painting on glass; it allows for no mistakes. As a master engraver, Marcoussis had the requisite discipline and sureness of hand to succeed in this alternative medium.

Marcoussis was comfortable with the idiom of synthetic cubism and remained committed to it throughout the twenties and into the thirties. In 1931 Duncan Phillips acquired an oil on canvas by the artist titled *Abstraction*, 1930 (acc. no. 1260), which depicts a dense configuration of still-life elements including a table, door, and guitar. Similarly, the composition of *Painting on Glass, No. 17* is an amalgam of various simplified

shapes and colored patterns referring to a still-life grouping. Like Braque and Picasso, Marcoussis made still-life elements his reference points, here suggesting the presence of a glass, a bottle of liqueur ("eau de vie"), fragments of wallpaper, a section of combed wood finish, and behind them a wall with wainscoting. Sharp juxtapositions of color work both to establish a visually pleasing rhythm of light and dark across the surface of the picture and to suggest a quality of spatial depth that is otherwise largely denied.

Marcoussis emphasized the constructed, fictional quality of this work by employing a frame-within-a-frame device. The still-life elements are situated within a diamond-shaped area, which is in turn framed by a blue oval ground. The heavy oval frame provides the outer limit of this piece and thus, by virtue of this succession of framing elements, has a purely pictorial status; in no way does it purport to be a window through which a different reality is glimpsed. Picasso and Braque had employed the oval format in their cubist collages as a way of disrupting expectations of traditional perspective, which is especially associated with rectangular formats. In 1920, the year Marcoussis painted this work, the oval was in fashion in the decorative arts. Considering its small scale and lyrical charm, it is easy to imagine that Marcoussis had a decorative role in mind for *Painting on Glass, No. 17*.

EP

144

ROGER DE LA FRESNAYE (1885–1925)

Roger de la Fresnaye, an aristocrat of fifteenth-century Norman lineage, was born July 11, 1885, in Le Mans. After moving to Paris in 1903, La Fresnaye studied first at the Académie Julian, then at the Ecole des Beaux-Arts. In 1905 he performed a brief period of military service, terminated by an attack of pleurisy, after which he returned to the Ecole des Beaux-Arts. Three years later he moved to the Académie Ranson, where he studied with Paul Sérusier and Maurice Denis and adopted their flat, decorative, and richly colored style. By 1911, after traveling in Italy and Germany, La Fresnaye began to paint works that exhibited clearly defined volumes and somewhat more limited colors. Having met Raymond Duchamp-Villon in 1910, he was drawn into the circle of the Puteaux artists and joined the "bataille cubiste." In the Salon des Indépendants of 1911, his painting *Le Cuirassier* was hung in a room adjoining the main cubist exhibition. While adapting many cubist methods, La Fresnaye continued to rely heavily on the examples of Cézanne and Chardin. In 1912 the artist collaborated with André Mare and Duchamp-Villon on the *Maison Cubiste* for the Salon d'Automne and participated in the Section d'Or exhibition. In April 1914 he was given his first solo show at the Galerie Levesque. Later that year La Fresnaye enlisted in the military. He drew and painted watercolors of his comrades until 1918, when he suffered a lung hemorrhage in the trenches. Severely weakened by this infirmity, La Fresnaye produced his last oil painting in 1922. He died November 27, 1925, in Grasse. The Phillips Collection owns two late drawings and one oil painting from his cubist period.

145

Emblems, 1913

La Mappemonde
Emblèmes: l'intérieur
Oil on canvas, 35 × 78¾ (88.9 × 200.0)
Unsigned
Acc. no. 1107 (Seligmann no. 169)

The artist to Georges de Miré, Paris, date unknown; purchased by Jacques Seligmann, New York, 1930; PMG purchase 1939.[1]

Emblems was one of two decorative overmantels created by La Fresnaye for André Mare's *Petit Salon,* to be exhibited at the Salon d'Automne of 1913. Its soft colors were selected to blend with the decor of the room, which had a rose damask covering on the walls.[2] The previous year La Fresnaye had collaborated with Mare, Duchamp-Villon, and other artists in the

Puteaux-based cubist circle on the provocative *Maison Cubiste,* also shown at the Salon d'Automne. The willing adaptation of cubist principles for decorative purposes was just one measure of the distance at this time between the cubism of Picasso and Braque and that of such artists as La Fresnaye.[3]

According to Duncan Phillips, what earned his admiration was precisely La Fresnaye's ability to imbue his "stately decoration[s]" with a personal sensibility attuned to the dynamism of the times. In a brief essay written on the occasion of the La Fresnaye retrospective of 1944, Phillips wrote: "While Picasso and Braque were still in the laboratory charting their challenging course and diagramming various problems of assorted shapes and textures related, with analysis or synthesis, to a field of shallow space, La Fresnaye was already free for his own personal expression, free to show how the new language of color modulations and of Cézanne's cubes, cones and cylinders, could sum up for him the chivalry of his dreams, the pageantry of a swiftly changing world which he cherished in his mind's eye."[4]

It might be said that in Phillips's estimation La Fresnaye was nearly a decade ahead of Braque, who did not "liberate himself" fully from the "laboratory" until the 1920s, when he proceeded to make "the outstanding decorations of the age."[5] Unlike Braque, however, La Fresnaye never pursued an exclusively formal approach to painting. His choice of subject matter frequently reflected traditional and nationalist values, as seen in *The Cuirassier,* 1910, *The Artillery,* 1911, and *The Fourteenth of July,* 1914. In the context of La Fresnaye's proclivity for patriotic themes and the prevailing French rhetoric attacking German barbarism, *Emblems* might well be seen as a representation of the fruits of civilization La Fresnaye deemed worth fighting for at any cost.[6]

Emblems and its companion piece, *L'Arrosoir* (*The Watering Can*), 1913, now in the collection of Mr. and Mrs. Paul Mellon, are paeans to a life at once contemplative and active.[7] Both paintings emphasize the virtues of individualism, celebrating the attributes of the scholar and of individuals who, in the spirit of Voltaire, cultivate their own gardens. These are the pursuits of the gentleman, interior and exterior activities that bespeak culture and refinement. Never averse to drawing on artistic themes or conventions from the past, La Fresnaye recalled in these works an eighteenth-century decorative tradition in which appeals to the mind and senses were emblematically evoked.[8]

In terms of its formal qualities, however,

Emblems reveals the lessons La Fresnaye had learned from the more recent art of Cézanne. Apparent here are his efforts to reconcile the depiction of volumetric form with the two-dimensionality of the picture plane. Although reducing the still life to a variety of simple geometric shapes, La Fresnaye was more relaxed and arbitrary in his approach than Picasso and Braque, who applied a rigorous system of analysis to their cubist paintings.

This less radical approach was characteristic of many artists associated with the public manifestation of cubism, and reflected La Fresnaye's carefully considered views on the the evolutionary nature of artistic progress.[9] Like Duncan Phillips, he insisted that art's own history and traditions could not be ignored in the development of contemporary art: "The continuity of art through the ages is the indispensable element without which it could not live and develop. The element of convention which succeeding generations pass down to each other acts as a gangway from one art form to the next, and helps us to get accustomed to novelties which, taken by themselves, are disconcerting."[10]

In *Emblems,* rather than using typical cubist faceting to convey the effect of viewing the books, globe, and violin from multiple vantage points, La Fresnaye maintained their integrity and legibility by situating them in a fractured field of floating abstract planes summoned from his imagination.[11] And, whereas in the cubist works of Picasso and Braque the disintegration of forms worked to blur the distinction between figure and ground, he kept the motifs centralized and deliberately distinct. The luminous color scheme also distinguishes La Fresnaye's cubism from Picasso's and Braque's.

The dominant diagonals of the composition create a pyramidal structure, lending the picture a sense of order and stability denied by its otherwise dreamy quality of forms floating in a weightless space. This paradoxical combination of compositional solidity and atmospheric levitation is present as well in La Fresnaye's *The Conquest of the Air,* also painted in 1913; it portrays the painter and his brother and refers to their passionate interest in aviation.[12] With its similar sky of disklike cumulus clouds, *Emblems* seems to celebrate not only classical knowledge but also modern technology and its ever-growing reach into exciting new dimensions.

EP

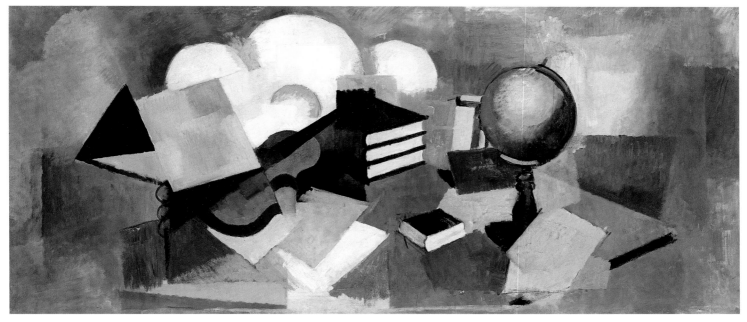

145

ALEXANDER ARCHIPENKO (1887–1964)

Alexander Archipenko was one of the twentieth century's most innovative sculptors. Born in Kiev May 30, 1887, Archipenko studied at the Kiev Art Institute between 1902 and 1905. In 1908, after several years in Moscow, he emigrated to Paris, where he quickly achieved recognition in avant-garde circles. Beginning in 1910 he exhibited regularly at the Salon des Indépendants, and by 1914 his work had appeared in vanguard shows in many major European cities and in New York, notably at the Armory Show in 1913. In 1912 he opened his own art school, participated in the celebrated Section d'Or exhibition in New York, and created his first sculpto-painting, a provocative synthesis of media that revealed his interest in and adaptation of prevailing cubist principles. After spending the war years in Nice, Archipenko moved twice—back to Paris in 1918, then to Berlin in 1921—before settling in New York in 1923. Two years earlier the Société Anonyme had given him his first one-person show in the United States. During his thirty years in America, Archipenko remained active as both a teacher and a sculptor, producing works richly informed by an expanded formal vocabulary of color, mixed materials, reflection, transparency, and motion. His experimental tendencies were applied to various graphic media as well. After more than fifty years of creative work, Archipenko died in New York February 25, 1964. The Phillips Collection owns a fine example of his sculpto-paintings, a polychrome relief of 1920, and a terra-cotta sculpture.

146

Standing Woman, 1920

Femme debout

Oil paint on gessoed papier-mâché on wood, 19¼ × 12¼ × 1⅛ (48.8 × 31.1 × 2.8)

Signed l.r.: *Archipenko;* label on reverse inscribed by artist, l.c.: *N 31. Sculpto-peinture 'Femme debout,' 1920*

Gift from estate of Katherine S. Dreier, 1953

Acc. no. 0029

The artist to Katherine S. Dreier, West Redding, Conn., ca. 1923; gift from the Dreier estate, 1953.[1]

Archipenko's innovations in the early twentieth century challenged assumptions not only about what sculpture should look like but also about what sculpture essentially is. The conventional view of sculpture as solid matter manipulated into particular forms was stood on its head by this young Ukrainian émigré, who transformed the ideas of concavity and empty space into formal principles of art making. According to

Archipenko, "The materiality of the non-existent is indeed the most vital concept."[2] The concave and the void may have had added significance for him as metaphors for the condition of creativity itself: "It is not exactly the presence of a thing but rather the absence of it that becomes the cause and impulse for creative motivation."

In sculpto-paintings such as the collection's *Standing Woman,* the principal dynamic is less emphatically one of form and space than of flatness and relief. Invented by Archipenko in 1912, sculpto-painting involves techniques and principles similar to those operative in the cubist collages and constructions of Braque and Picasso.[3] Starting with a wood support, Archipenko added to it a combination of materials, including papier-mâché, plaster, glass, metal, and occasionally mirrors. The relief was then painted and hung on a wall. *Standing Woman* is typical of the sculpto-paintings executed between 1916 and 1920, when Archipenko simplified his compositions and reduced the variety of materials employed. Works dating before 1916 tended to be more complex, having elaborate illusionistic backgrounds against which the figures were set.[4]

The sculpto-paintings confound our expectations both optically and conceptually. Optically, a vital tension is established between the tendency of the flat shapes and relief forms to cohere as a unified composition and their tendency to remain discrete. Conceptually, the boundary between painting and sculpture is blurred. The most salient characteristics of each medium are both asserted and denied: painting's illusionism and flatness are contradicted by an outward projection into real space, while sculpture's three-dimensionality is reduced to its most minimal expression, demanding to be experienced frontally rather than from multiple vantage points. Although the viewer's feet remain still, the visual experience is never static: the rhythmic juxtapositions of color and shape, and the resulting tension between a recognizable subject and the work's abstract formal qualities, make the viewing process a particularly dynamic one.

Standing Woman reflects Archipenko's abiding interest in the female figure as a subject. Like many avant-garde artists, Archipenko commingled invention and tradition in his work. Here formal experimentation is practiced on one of the most conventional thematic sites: the female body. The figure in *Standing Woman* is composed of a variety of geometric shapes—regular and irregular, flat and volumetric. The effect is paradoxical: while certain body parts are isolated and accentuated, others seem either to

blend together or to dematerialize entirely. The concave form is exploited to evoke the presence of the figure's breasts, demonstrating the uncanny ability of void to convey substance.

Color is a critical ingredient in the sculpto-paintings. Archipenko achieved a rhythmic complexity through the alternation of flat, mostly unmodulated colors that do not always conform to the shapes of the relief elements. The value of color is largely pictorial, having little to do with naturalistic description; such an approach to the application of color enhances the abstract dimensions of these works. Archipenko was highly critical of most sculptors' preference for monochromy, arguing that we experience form and color as constantly interactive: "In our daily mobile environment colors change into forms and forms into colors and there are no forms without colors; also, there are more multicolored forms than monocolored."[5] According to Archipenko, polychromy enriched the deeper resonances of the sculptural medium: "Spiritually, esthetically, emotionally, creatively and symbolically, the form-color interactions are as rich as the variation in a symphony, in which one musical phrase interfuses with another, thereby evoking multiple reaction in the individual."

As an ordered assemblage of interactive forms and colors, *Standing Woman* can be seen as a hybrid not only of sculpture and painting but also, metaphorically, of technology and nature. The precise geometric shapes of the figure's component parts have a machinelike quality associated more with robots than with humans. The gentle curves and pastel colors soften this effect, however, suggesting something more natural, even erotic. The relation of the machine to art in the industrial age was central to the thinking of many artists in the first decades of the twentieth century; Picabia, Villon, and Duchamp, among others, come to mind. Though perhaps not as blatant in their references, Archipenko's sculpto-paintings provoke thought about the automated aspects of twentieth-century life.

E P

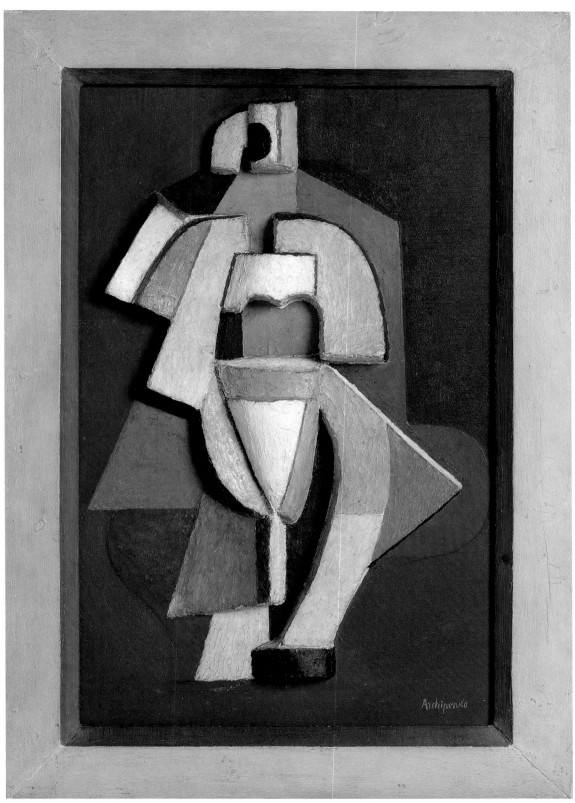

146

JUAN GRIS (1887–1927)

Juan Gris earned his reputation as a "perfect painter" by creating exquisite cubist pictures notable for their stunning precision, exact proportions, and brilliant use of color. Gris was born José Victoriano González March 23, 1887, in Madrid. He studied engineering at the Escuela de Artes y Manufacturas between 1902 and 1904, when he left to study painting with José Maria Carbonero. Initially working in the Art Nouveau style, Gris was publishing satirical drawings for books and magazines by 1906. That same year he moved to Paris; he took a studio in Montmartre in the famous Bâteau Lavoir, where he soon met Picasso and other members of the avant-garde. He continued to support himself through his drawings, which appeared in *L'assiette au beurre* and *Le cri de Paris*. In 1911 Gris produced his first cubist paintings, and by the following year he had fully developed his distinctive grid system of composition. This structure and his daring colors set Gris's paintings apart from those of Picasso and Braque. Unlike them, he submitted his work to public exhibitions; in 1912 he showed at the Salon des Indépendants and the Section d'Or. Gris's works of 1914 were almost exclusively papier collés, a medium in which he proved very deft. During the difficult years of the First World War, Gris continued to work intensely, producing some of his most glorious paintings. His first dealer, the German Daniel-Henry Kahnweiler, fled the country, but Gris gained the support of dealer Léonce Rosenberg and writer and collector Gertrude Stein. Between 1917 and 1927 his work became softer and more subdued, as his focus shifted from cubist still lifes to more classical subject matter. In 1920 Gris suffered a serious illness from which he never fully recovered, and on May 11, 1927, he died in Paris. The Phillips Collection owns two paintings by Gris.

147

Abstraction, 1915

Oil, and oil with sand, on cardboard, 11⅜ × 7¾ (28.9 × 19.6)
Signed and dated in black, u.l.: *Juan Gris 1915;* dedication inscribed, l.l.: *A mon ami André Salmon, Souvenir affectueux, Juan Gris—19*
Acc. no. 0855 (Cooper no. 133)

The artist to André Salmon, Paris 1919; PMG purchase, through John D. Graham, 1930.[1]

148

Still Life with Newspaper, 1916

Nature morte
Still Life in Black and Grey; Grey, Green, and Black; Fruit-Dish, Glass, and Lemon
Oil on canvas, 29 × 23¾ (73.6 × 60.3)
Signed and dated in black paint, l.l.: *Juan Gris/8-16*
Acc. no. 0856 (Cooper no. 188)

Léonce Rosenberg, Paris; purchased by Katherine Dreier in 1922; TPG purchase 1950.[2]

Although he did not begin to experiment with cubist principles until 1911, Gris quickly established himself, alongside Picasso and Braque, as one of cubism's most eminent exponents. There was nothing tentative about Gris's initial adoption of the radical new pictorial syntax of cubism; a sense of control and complete mastery is evident in many of his earliest works. Indeed, the rationalized order established by a grid and the systematic quality of the tonal modeling—which together would remain consistent features of Gris's cubist paintings—were present from the start.[3] His background in engineering perhaps predisposed him toward the cerebral, analytical qualities of cubism. But, for all his insistence upon rigor and rationality in his pictorial structure, Gris was romantically attached to the painting of the past and envisioned his work as an extension, rather than rupture, of a venerable artistic tradition: "I cannot break away from the Louvre. Mine is the method used by the old masters."[4] Motivated by these contradictory impulses—to make his painting at once vitally contemporary and consummately classical—Gris developed an esthetic that was both exuberant and restrained, severe and subtle, and, above all else, distinctly his own.

The two paintings by Gris in The Phillips Collection date from 1915–17, a period when his work became increasingly abstract. Having spent the better part of 1914 producing almost nothing but collages, Gris not surprisingly transposed the constructive principles of that medium to oil paintings, which he resumed making in 1915. In fact, one intriguing way of

viewing *Still Life with Newspaper* is to see it as a trompe l'oeil representation of a collage.[5] Overall, it has an additive, cut-and-paste aspect, but what most betrays the reference to collage is the "clipped" fragment of newspaper that partially reveals its title: *L'INTRANSIGEANT*. Only the sense of transparency pervading portions of the canvas makes this interpretation untenable, because opacity is so characteristic of collage.

Although they share similar qualities of abstraction, *Still Life with Newspaper* and the smaller *Abstraction* represent two different tendencies of Gris's wartime output. *Abstraction* is an example of his bright, sensuous, pointillist style, in which a delight in pattern and texture is apparent. The lush medley of vibrant colors characteristic of his prewar paintings is invoked here to stunning effect. Gris played naturalistic colors against ones that appear to be rather more arbitrarily assigned. Yet, recalling his predilection at this time for uniting indoor and outdoor views in a single plane, one is tempted to read the cerulean blue of the brick wall and the passages of brilliant green as signs of a summer sky and verdant foliage. Gris in effect sealed up with bricks the traditional "window" of representational painting in order to create a pure arrangement of flat planes, which nonetheless allude poetically to the material world. *Abstraction* is one of Gris's most tactile paintings by virtue of its section of wood-graining, the textured treatment of the brick wall, and the extremely coarse passages of off-white constituting parts of a drinking glass. An area of pointillist stippling enlivens the surface and "aerates" the dense assemblage of forms.[6]

In contrast, *Still Life with Newspaper* has an immaculately smooth finish and derives its strength from a sense of austerity and cool restraint rather than excess. The somber color scheme of black, brown, and gray creates a spectral mood reminiscent of the artist's Spanish roots. The magnificent stillness so characteristic of the seventeenth-century paintings of Francisco de Zurbarán—an artist whom Gris admired—is present in this taut arrangement of crisply contoured geometric shapes.

Gris's magisterial handling of black and white is also reminiscent of many Spanish masters. Whereas the black areas here ostensibly function as shadows of the various still-life elements, they are so flat and uniform in tone that they assume an independent value in the two-dimensional design, seeming to lie beside rather than behind the forms they echo. Subtle areas of modeling—in the stemmed fruit dish, glass, bottle, and lemon—soften the effects of the opaque and impenetrable shadows with a

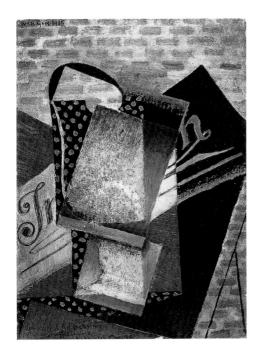

147

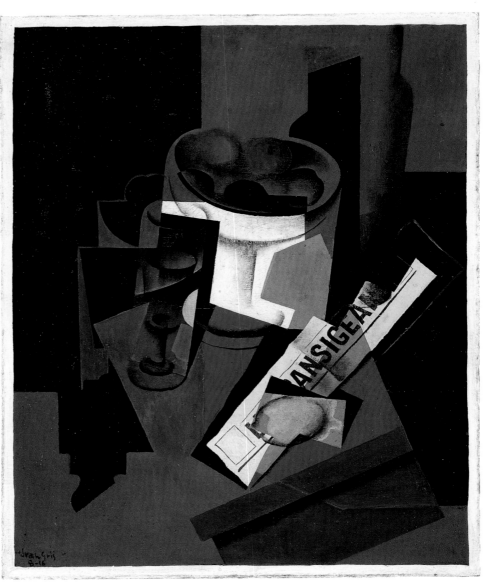

148

smoky, atmospheric quality. Finally, the power of white in this composition far exceeds the actual surface area it covers. In the central, irregular section of bright white, Gris provided a pivot around which all the other elements revolve. Because the work has no consistent external light source, the white also reads as an internal luminescence.

In the absence of any paintings by Picasso or Braque dating from the First World War or earlier, the collection's two wartime paintings by Gris have additional significance.[7] They represent what Douglas Cooper has called "essential" cubism, as opposed to the "salon" cubism practiced by artists such as Albert Gleizes and Jean Metzinger. But the appeal of Gris to Duncan Phillips probably had less to do with what he shared stylistically with Picasso and Braque than with how he differed. Contrary to the two pioneer cubists' initial preference for monochromy, Gris often employed a rich, varied, and brilliant palette. For Gris, color was a critical structural component of his compositions: "I compose with abstractions (colors) and make my adjustments when these colors have assumed the form of objects."[8] The exquisite balance of sensuous colors, simulated textures, and coolly restrained, pristine design is what gives the paintings of Juan Gris their special appeal.

EP

5 THE DREIER GIFT AND OTHER EUROPEAN MODERNISTS

ERIKA D. PASSANTINO

Just as the Armory Show of 1913 had forced the American art world to come to terms with European influences—Cézanne and Matisse in particular—certain events of the 1940s again demanded choices.[1] At stake was a reevaluation in the context of the Second World War: an acceptance or rejection of abstraction, a continued commitment to the influence of the European avant-garde, or a turn toward indigenous themes depicted in a simplified realism. Closely related to these issues was the question of whether expressionism was an integral part of the modernist mainstream or a tributary flowing chiefly through the German tradition. This debate grew into a controversy involving two museum directors with whom Duncan Phillips was closely associated. His reaction to this controversy, and an unexpected gift in 1952, bring his views into clear focus.

In the late 1920s, almost a decade after opening the Phillips Memorial Art Gallery, Phillips defined his collection as a "Museum of Modern Art and its Sources."[2] In so doing, he distilled ideas that had occupied him for some time and were to become the wellspring of his collecting. Many years later, in 1961, he wrote: "What happens in art history is not revolution but evolution. . . . Realism, Expressionism and Abstraction, they are the ancient alternatives."[3] However, his embrace of modernism had always been tempered by an abiding belief in the nobility of man and art, in the supremacy of individual expression, and in the "coming of an American renaissance."[4] Furthermore, his classic liberalism and patrician, almost Victorian, sensibilities led him to oppose both the strictures of the academic traditions and any implications of a collectivist style emerging in the context of the European avant-garde; as late as 1941 he wrote:

I have picked my way in and out of the Art movements of the 20th century with a great many mental reservations. I have selected what I like—what I understand and approve—some of Picasso—much of Braque—a few choice bits of Klee but none of Kandinsky, nothing of Futurism, nothing of Dadaism, nothing of Sur Realism nor of Purism. I have been an interested commentator about the Period and its experiments but I remain skeptical about manifestos and theories and am often as much baffled by the obscure as is the general public.[5]

Paul Klee, detail of
Tree Nursery, see cat. 159

Within this complex ideological structure, he could reconcile apparent opposites—collecting American modernist abstractions by Arthur Dove and John Marin as early as the mid-1920s but rejecting Picasso and Léger, especially, as late as the 1930s. Braque's painterly still lifes of the late 1920s were the exception, and he wrote in 1931: "Whereas an abstraction by Leger [sic] is like the machine it emulates, cold, hard, and metallic, an abstraction by Braque is like a poem in a classic form or a French prose masterpiece."[6]

Quite clearly, Phillips's collecting of European modernism centered on French art, although selectively. In contrast, the works discussed in this chapter, assembled both through purchase and gift, represent aspects of European modernism—expressionism in particular—that were partly inspired by, but flourished outside of, France. During the 1930s Phillips gained access to expressionism through Kokoschka and Klee and, in the course of the next decade, he added works by Feininger, Kandinsky, Mondrian, and Gabo. In 1952 the holdings in this area were greatly enriched by the gift of seventeen works from the estate of Katherine S. Dreier, founder and director of the stridently avant-garde Société Anonyme in New York. Today, the collection offers a limited but splendid survey of the Blaue Reiter group—Kandinsky, Marc, and Campendonk—and members of the Bauhaus studios—Klee, Feininger, and Albers. Mondrian's neo-plasticism is shown in a work of the 1920s and another from the 1940s. German dada is exemplified by Schwitters (albeit dada of his own making, which he named *Merz*). A late echo of constructivism is manifested in an ephemeral plastic and nylon sculpture by Gabo. Morandi, the solitary and meditative Italian, was a particular favorite of Phillips's because of his tensely compacted cubism, which was rendered in extraordinarily subtle color harmonies.

Phillips and Dreier met in 1941 in New York at Marjorie Phillips's Bignou Gallery opening. More than two decades had passed since each had founded a public collection centering on modern art, yet assembled from vastly different points of view. Dreier was convinced that twentieth-century man desired an art that reflected the spiritual and social aspects of a new world, a new era. She was the first American to own a work by Mondrian and the first to give Kandinsky a one-person show in the United States; she was also among the earliest to collect Archipenko, Duchamp, Max Ernst, and Léger. Her ardent belief in the cause of art was shared by Phillips, and it nurtured a fellowship that led Dreier to write him in 1949: "I wonder if you realize what [your museum] has meant in the lives of so many people throughout the United States."[7] Their correspondence also expressed a gentle competition. When Phillips informed her that his museum "has been a public gallery since its corporation in 1918," Dreier, who had believed her Société Anonyme to have been the first gallery of modern art in the country, answered: "I did not realize, until you mentioned it, that you were the very first."[8] That same year Phillips responded to Dreier's request by giving the Société one work each by Dove and Marin. The following

year he bought Gris's *Still Life with Newspaper,* 1916 (cat. no. 148), from Dreier's private collection to help her raise funds for the Société.[9]

In May 1952, shortly after Dreier's death, Marcel Duchamp requested a meeting with Phillips "in relation to Miss Dreier's private collection" and during a subsequent visit to Washington offered her personal collection as a gift from the estate.[10] Phillips later wrote to Duchamp: "I was quite overwhelmed with genuine surprise" and added that he would await the arrival of photographs "before giving you a final decision as to whether I wish all or just a selected number of the works so generously offered." Encouraged by Phillips's willingness to show "occasional exhibitions of a . . . Dreier Unit in one room," Duchamp sent photographs of forty-one major works, and Phillips selected seventeen:[11]

> Archipenko, *Standing Woman,* 1920
> Braque, *Music,* 1914
> Calder, *Mobile-Stabile,* 1948
> Campendonk, *Village Street,* ca. 1919
> Duchamp, *Small Glass,* 1918
> Duchamp-Villon, *Gallic Cock,* 1916
> Ernst, *Forest,* 1925
> Kandinsky, *Sketch for Painting with White Border,* 1913
> Klee, *Little Regatta,* 1914
> Marc, *Deer in the Forest I,* 1913
> Marcoussis, *Painting on Glass No. 17,* 1920
> Mondrian, *Painting No. 9,* 1939–42
> Pevsner, *Construction in Space,* 1929
> Rodin, *Brother and Sister,* 1890
> Schwitters, *Radiating World,* 1920, and *Tell,* ca. 1919–22
> Villon, *Abstract Composition,* 193[12]

Phillips further suggested that twelve paintings and sculptures be given to the fledgling Watkins Gallery at the American University and rejected the remaining twelve works outright. He cited lack of space, especially for sculpture, but also clearly stated his "preference to accept only such works as relate in one way or another to the whole scope and yet the very personal taste of my collection." He declined "examples of experimental creation which to me are more interesting than enjoyable" but added: "There are a few pictures which I would love to have in our collection as they are exactly what I would have eagerly bought had I seen them first. I need only mention as examples the early Braque for our Braque unit and the little Regatta of Klee for our room of Klees."[13] One important work requested by Phillips, Duchamp's *Small Glass,* never entered the Collection but went to the Museum of Modern Art after Alfred H. Barr Jr. traveled to Washington to plead for it, "not only because of its quality but also because of its significance in the Dada movement of which we have a specialized collection."[14] Phillips relin-

quished it but not the Kandinsky, Braque, and Marc that Barr had also solicited.

Since Phillips made very pointed choices in the interest of protecting his collection's unity, it is worthwhile to explore the principles that guided his selections. By 1952 he could look back on more than three decades of collecting, writing, and organizing exhibitions, and crucial to his vision was a broad interpretation of modernism that included expressionism. In fact, his interest in and understanding of expressionism had developed gradually. Early on Phillips had used the word "expression" to define impressionism.[15] By 1927, however, he entitled an exhibition that included Davies, Dove, Homer, Matisse, Tack, Utrillo, and Weber "Expressionist Painters from the Experiment Station." Now seeing the two movements' opposite ends, he wrote: "Expressionism in pictorial art aims to do for the mind what Impressionism is content to do for the eye and the visual memory. . . . The Expressionist . . . deals not in percepts but in concepts."[16]

Furthermore, in the early thirties he annotated a list of artists' names with those of Beckmann, Hofer, Kokoschka, and Marc among others as "potential additions to the collection," despite the fact that in 1927 he had characterized German art as "given to nightmare 'expressionism' and to sexual fantasies."[17] This emerging interest was finally confirmed in a 1938 letter: "Up to this time the artists of Germany and other Central European nations have been unrepresented in our Collection and we are pleased to make these purchases."[18]

It appears that in expressionism, and in Kokoschka and Klee especially, Phillips saw the potential for perpetuating two ideas that were at the heart of his liberal beliefs: the supremacy of individual expression (in other words, the artist's right to a personal style) and the continuity of representational depiction. Many years later he still insisted on the latter's viability: "Nature does not go out of date in our sensibilities! . . . Now that the image has been all but obliterated by the symbol, the critic is apt to forget that there is a dualism in art which is still as true as it ever was—the image and the symbol—the outer and the inner world."[19]

When considered in the context of national events, Phillips's view of modernism and his acceptance of expressionism must be understood against developments at two other institutions the titles of which included the words "modern art." New York's Museum of Modern Art under the direction of Alfred Barr favored European modernism, especially cubism, constructivism, and later surrealism. The Institute of Contemporary Art (ICA), originally named the Institute of Modern Art, in Boston was headed by James Plaut, a champion of expressionism.[20] In the late 1940s both men were at the center of a debate concerning modernism, and part of the discussion involved expressionism's acceptance into, or rejection from, the canon of modernism as it was understood by the American avant-garde.[21]

Boston's ICA was founded in 1935 as a branch of the New York museum. In 1948 Plaut redefined and renamed it, thereby express-

ing his wish to stress the continuity of artistic developments and distancing himself from Barr. In a published statement, "'Modern Art' and the American Public," Plaut wrote that "the [modernist] artist gradually withdrew from a common meeting-ground with the public . . . and utilized a private, often secret, language." He described modernism as "a style which . . . has become both dated and academic."[22] Barr, however, considered modernism a continuum encompassing "the more challenging, original and not yet accepted movements in philosophy, theology and the arts. . . . That is why we used the word [modern] when the Museum of Modern Art was named."[23] When Plaut later organized an exhibition that included the work of Sloan, Bellows, Kuniyoshi, and Feininger, among others, *Life* magazine printed a review, "Revolt in Boston," claiming that the museum could "no longer stomach the word 'modern.'" Barr in turn demanded that Plaut respond to the contrary, lest the article confirm the ICA's "reputation as a compliant instrument of reactionary forces."[24] In the end, a carefully worded joint statement, written by Barr in March 1950, was imposed on a reluctant Plaut.[25]

Phillips, whose own views on modernism clearly approached Plaut's, was involved in the controversy but maintained a characteristically neutral stance. On the one hand he joined twenty-four museum directors and collectors who condemned the article in *Life*. On the other, he maintained the lively exchange of exhibitions between Boston and the Phillips Memorial Gallery that had begun in 1940, when Plaut declared that he would present "contemporary art in all its aspects." Among the nine ICA exhibitions shown in Washington were retrospectives of the expressionists Rouault, Kokoschka, and Munch.[26]

As the leadership of the Museum of Modern Art solidified, expressionism clearly moved to the periphery of the "Anglo-American canonization of high modernism into which most of German and Austrian modernism simply does not fit."[27] These issues must have been a subject of discussion between Phillips and Kokoschka, one of the leading exponents of expressionism, for Phillips felt compelled to inform the artist that Barr had visited one of his exhibitions in New York.[28] In turn, Kokoschka, who had traveled to Washington during his 1948 retrospective, sent Phillips a polemic against nonobjective art, "Edvard Munch's Expressionism," inscribed with a conspiratorial message: "To Marjorie and Duncan. This essay cannot be published because it is in support of our desire to recognize and make understood to others the black magic of our times in its working, practices and doctrines[—]most cordially yours OKokoschka, Washington 1952."[29]

Clearly, as European modernism moved into the mainstream of American artistic life, Phillips looked over his shoulder at others who worked for its acceptance. Yet he clung steadfastly to his own vision developed over the years, broadening his range but never abandoning his belief in the supremacy of individual expression. In

1931, barely a year after the founding of the Museum of Modern Art, he wrote a statement that would anticipate his choices from the Dreier collection:

Our enterprise and many others such as the Barnes Foundation, Gallery of Living Art, the Museum of Modern Art, the Whitney Museum of American Art . . . the Stieglitz experiment station and, on the Pacific Coast, the Preston Harrison Collection, all are carried on in the faith that the art of today is a force, a current charged with what is most alive in the age we live in. . . . *My own special function is to find the independent artist and to stand sponsor for him against the herd mind whether it tyrannizes inside or outside of his own profession. I also pride myself on making a record of the many phases of artistic expression which are open to the modern painter.*[30]

Late in life, he expressed the same belief when he spoke in a radio address: "What I delight to collect . . . are the world's wonders of personality—not what can be put into a picture but what cannot be left out—that quintessence of self—captured in some expressive correspondence of aesthetic form."[31]

WASSILY KANDINSKY (1866–1944)

Wassily Kandinsky's thoughtful explorations of the emotional and intellectual roots of art, and his search for the abstract means to express them, revolutionized art in the early twentieth century. Kandinsky was born December 4, 1866, in Moscow, into a well-to-do family. He received a broad education in the humanities, including an 1889 expedition to study ethnography in the Vologda province of Russia. However, Kandinsky abandoned a legal career and moved to Munich in 1896 to study art. In 1901 he was a cofounder of Phalanx, an exhibition society that was active until 1904. After extensive travels in France, Italy, and Russia from 1903 to 1908, Kandinsky settled in Munich and Murnau with his companion, the painter Gabriele Münter. In 1909 he founded the Neue Künstlervereinigung but resigned in 1911 to establish the more avant-garde group Der Blaue Reiter, which grew out of his friendship with Franz Marc, Paul Klee, and August Macke. He also published his influential book, *On the Spiritual in Art,* to appear in conjunction with the first Blaue Reiter exhibition, which took place in Munich in late 1911. Kandinsky spent the First World War in Moscow, participating in the intellectual and artistic ferment of the revolution and briefly serving in an official capacity. By late 1921 he became disillusioned with the regime's arts policies and returned to Germany, joining the Weimar Bauhaus faculty in 1922. In response to the school's constructivist style, he began painting crisply delineated abstractions, which formed the basis for discussion in his 1926 book, *Point and Line to Plane.* He followed the Bauhaus to Dessau and then Berlin, but in 1933, after the Nazis came to power, he left for Paris. There he created the highly symbolic works based on biomorphic forms that were to characterize his late style. Kandinsky died in Neuilly December 13, 1944. The museum owns three oils: two early works from his Munich years and an example from his years in Paris.

149

Autumn II, 1912

Herbst II; Villa Seeburg/Spiegelung
Oil and oil washes on canvas, 23⅞ × 32½ (60.5 × 82.5)
Signed l.r.: *Kandinsky;* reverse: inscribed on stretcher, u.c. (probably by the artist): *Kandinsky herbst No 2 156. 1912*
Acc. no. 0956 (HL II and III, no. 156)

The artist to Fritz Schön, Berlin, possibly through Der Sturm Gallery, 1916, and until at least 1929; R. C. Schön, St. Augustin, Quebec, Canada, by 1942; consigned to Dominion Gallery, Montreal, by 1943; purchased by Nierendorf Galleries, New York, through S. Thalheimer, 1943; PMG purchase 1945.[1]

Kandinsky came to painting relatively late in life. He was thirty years old, and a lawyer, when he began his studies at the Munich Academy, and forty-two when his art came to full flowering in his Murnau style, named after the Bavarian village of Murnau. There, Münter had purchased a house allowing the couple to paint and entertain houseguests, among them the artists Klee, Marc, and Alexej Jawlensky.

Kandinsky's major concerns during the Murnau years were representational landscape paintings such as *Autumn II.* Aside from that, he experimented with total abstraction in two parallel themes he called "Improvisations" and "Compositions." Will Grohmann believed that these independent explorations were nevertheless "influencing each other and contrasting with each other in the most various ways."[2]

By 1912, the year *Autumn II* was created, Kandinsky had arrived at a great clarity of artistic and intellectual purpose, drawing upon his Russian heritage, his readings in theosophy, science, and politics, and, especially, on his study of recent artistic innovations in France and Germany.[3] In Kandinsky's view, representational styles as practiced by the academies and beloved by the art market had become meaningless in their materialism. He wished to restore to art its ancient redemptive purpose, expressive power, and freedom from descriptive service. He believed that art could act through its very matter—form and color—to call forth its "inner sound" just as Wagner's leitmotif characterizes an opera's hero through purely musical means. Kandinsky discussed these ideas in the *Blaue Reiter Almanac,* in his book *On the Spiritual in Art,* and in a volume of poems and woodcuts entitled *Klänge* (Sounds).[4]

Autumn II recalls the crisp light, shimmering water, and crystalline sounds of an autumn day by a mountain lake. The turreted villa by the water's edge is roughly defined by blue-green outlines. However, the mountains, trees, and their reflections are evoked by free-floating shapes and colors, and together they create "a sign language of suggestion."[5] Several other works show the distinctive diagonal thrust of the shoreline, but this painting appears to be a final resolution of the theme in that it is drawn to the foreground and extended beyond the canvas edge.[6] In some areas, thin washes of paint run together in a manner more commonly associated with watercolor technique, and occasionally the preparation layer is left exposed, further enhancing the effect of buoyancy.

Line assumes a prominent role in the double zigzag that scurries along the water's edge, pulling along colors and shapes like leaves in the wind. A calligraphic flourish, it reads as a line rather than "shore" and illustrates Kandinsky's belief that "when line is freed from delineating a thing and functions as a thing in itself, its inner sound . . . receives its full inner power."[7]

Kandinsky used the interplay of the landscape and its reflection in the water as a metaphor for the abstract and two-dimensional nature of painting, where an image is as "real" as its reflection. He believed that this new reality "will become art in the abstract sense, and will eventually achieve purely pictorial composition."[8]

The expressive qualities of *Autumn II*—transparent radiance, a joyful tenor, and a sense of fleeting melancholy—are all brought on by color. In fact, this painting is an almost perfect example of Kandinsky's ideas on the psychological and symbolic power of color. Yellow, which he saw as the complement to blue, is warm, eccentric, "like the reckless pouring out of the last forces of summer in the brilliant foliage of autumn." Blue removes itself toward the infinite, and dark blue, the predominant shade, "assumes overtones of a superhuman sorrow." Green "demands nothing, calls out to no one," and red, its complement, is used sparingly; mixed with white, as it is in *Autumn II,* it "can only be intensified." White, shown here both as bare canvas and in shaded, cloudlike wisps, "affects our psyche as a great silence, which for us is absolute."[9] In *Autumn II* the colors float on the surface, calling out to their complementing or contrasting counterparts. Forms, too, echo and reinforce each other in rhythmic sequences, and in Kandinsky's view, these harmonies are born of an inner necessity that "can only be based upon the purposeful touching of the human soul."[10] Just as he celebrated the seasons in landscapes, he also contemplated their sounds, colors, and meaning in poems:

Every autumn, the trees lose their foliage, their clothing, their finery, their body, their crown. Every autumn. And how many more? How many more autumns? Eternity? Or not? Or is it?[11]

EDP

150

Sketch I for Painting with White Border (Moscow), 1913

Entwurf I zu Bild mit weissem Rand (Moskau)
Storm; Composition-Storm
Oil on canvas, 39⅜ × 30¾ (100.0 × 78.5)
Signed l.r.: *Kandinsky;* reverse: inscribed (probably by the artist) on stretcher, u.l.: *Entwurf für Bild mit weissem Rand;* u.r.: *Kandinsky (1913)* [*MOSKA* scratched out]
Gift from the estate of Katherine S. Dreier, 1953
Acc. no. 0957 (HL II and III, no. 162)

149

150

The artist to Der Sturm Gallery, Berlin, probably 1916; purchased by Katherine S. Dreier, New York, for her personal collection, 1920; gift from the Dreier estate, 1953.[12]

Kandinsky described his native city as "'white-stone,' 'gold-crowned,' 'Mother Moscow,' . . . the tuning fork for my painting."[13] Memories of the city became powerful visions that are reflected in numerous works such as *Sketch I for Painting with White Border,* subtitled *Moscow.* It is a preparatory painting for the monumental *Painting with White Border* of the same year.[14] The Phillips version, probably the first oil sketch following at least two drawings, is vertical while later sketches and the final work are horizontal. Kandinsky wrote: "I made the first design immediately after my return from Moscow in December 1912. It was the outcome of those recent, as always extremely powerful impressions I had experienced in Moscow—or more correctly, of Moscow itself. This first design was very concise and restricted."[15]

The sketch roughly relates to the center-left half of the final painting, and although apparently abstract, the composition harbors numerous "hidden elements" that are repeated in other works, at times in representational form, at times reduced (or abstracted) to the point that they are barely recognizable except by comparison with other compositions. This reductive process was Kandinsky's way of finding an ever more distilled sign language for recurring motifs—couples in embrace, towers, riders, angels blowing trumpets—many of which alluded to Russia.[16]

Sketch I for Painting with White Border (Moscow) is rich in Russian references. In "Reminiscences," Kandinsky mentions the troika motif, here reduced to a trilobed form in the upper left corner of the painting; it is outlined in yellowish green and represents the backs of three horses. Central to the composition, however, is the hunched rider, white lance at the ready. His blue aura—the color symbolizing romantic longing ever since the era of German romanticism—designates him as the Blue Rider, the figure that gave its name to the entire movement. He appears in numerous works, ranging from a clear representation in the original edition of *Klänge* to the barely discernible curved form shown here.

For Kandinsky, the motif was dually rich because of its association with Saint George, the patron saint of Moscow. The saint's battle with the dragon appeared in icons, folk prints, and emblems, often set before views of the Kremlin; indeed, in the upper right, this painting has red and white arches that resemble those of the Kremlin cathedral. Furthermore, both in composition and coloration, Kandinsky's work evokes depictions of Saint George on icons of the sixteenth-century Novgorod School. Horizontal bands that flow through the composition suggest the icons' spatial hierarchies of the earthly, saintly, and heavenly realms. Shapes and colors—here set against black instead of the iconic gold—reinforce these parallels: the triangular hill edged in black, the vibrant reds, the whitish-green facades, and the voluptuous creamy gold shapes that hover in the foreground appear in both images.[17]

Peg Weiss has pointed out the added meaning of the rider as the shaman: "On his magic horse [the shaman] could fly above the treetops and mountains or descend to the underworld if need be."[18] He is a blend of Christian and ancient traditions that Kandinsky encountered during his ethnographic studies. Since Kandinsky's father hailed from the border between Russia and Mongolia, regions rich in shamanistic traditions, Saint George, the shaman, may well have assumed added importance to his role as the harbinger of art's new beginning.

For Kandinsky and the artists of the Blaue Reiter circle, the battle for a spiritual renewal of art took on cosmic dimensions. The rider became the symbol of their aims to defeat art's descent into materialism. In *Sketch I for Painting with White Border (Moscow)* he is attacking a crouched dragon whose many heads or claws appear before an orange-red background suggesting fire or blood.[19] Green hills rise out of the depth; in the upper right, a red circle and yellow triangle recall the shape of the trumpeting angel of the Last Judgment.[20] Kandinsky called the left side of the final painting "a battle in black and white," an apt description of the Phillips painting as well.[21] Here, a somber mood predominates; dark hues—blues, greens, and black—form the ground out of which all shapes and colors rise; white appears only in the lance, in the caps of the vaults, and in the whitish-blue aura of the rider. By scumbling and painting wet-into-wet, Kandinsky further diffused the shapes, varied their textures, and allowed thin washes to run down the canvas over other colors.[22]

The painting's mythic theme and forceful colors herald an apocalyptic upheaval, when the very earth rises, and a terrible glow emanates from the forms themselves. The valiant rider and his lance—both larger here than in the final painting—are scant match for the forces of darkness. In the final version, the white enveloping form will be the hard-earned solution of which Kandinsky spoke.[23]

In spite of such imagery, the painting is sufficiently descriptive to echo Kandinsky's memories of Moscow's hour of sunset: "The sun dissolves the whole of Moscow into a single spot, which, like a wild tuba, sets all one's soul vibrating. . . . Pink, lilac, yellow, white, blue, pistachio green, flame red houses, churches . . . the red, stiff silent ring of the Kremlin walls, and above, towering over everything, like a shout of triumph . . . the long, white graceful, serious line of the Bell Tower of Ivan the Great."[24]

Kandinsky strongly influenced Katherine Dreier's belief in the spiritual sources of abstract art. She met him at the Bauhaus in 1922 and, as an expression of her admiration, soon made him honorary vice president of the Société Anonyme. She also gave him his first one-person exhibition in America and wrote about this painting, her first purchase of a work by Kandinsky: "There are few pictures which have freed the mind from the fetters of convention more than Kandinsky's beautiful 'Painting with a White Form'. . . . Musicians as well as artists have responded to this sketch . . . [it] recalls the exuberance and richness of a Rubens."[25]

EDP

151

Succession, 1935

Aufeinanderfolge

Oil on canvas, 31⅞ × 39⅜ (81.0 × 100.1)

Signed and dated l.l.: */K 35;* reverse: inscribed on canvas: */K/No. 617/1935.*

Acc. no. 0958 (HL IV, no. 617)

The artist, Paris, to Nierendorf Galleries, New York, 1938; PMG purchase 1944.[26]

Writing in 1943, Marcel Duchamp saw Kandinsky's late work as "a clear transfer of thought on canvas." With this observation, he conveyed his understanding of Kandinsky's reformulation of pictorial space into a pure white plane upon which hover signs and symbols.[27] By contrast, Kandinsky's friend Jean Arp saw in his late work an affirmation of life and of growth: "His work is aglow with spiritual reality. . . . Things blossom, sparkle, ripple in his paintings and poems. They speak of old blood and young stones."[28]

Kandinsky's Paris work forms his third clearly defined style, as distant from the mystical Munich years as it is from his constructivist Bauhaus era.[29] When he arrived in Paris in 1933, Kandinsky was confronted by two artistic poles—the surrealism of his friends Jean Arp and Joan Miró and the increasingly ritualized geometric abstraction of the Abstraction-Création group. Furthermore, finding himself neither well known nor understood by French critics, he turned inward. The resulting works of art were pure invention, perhaps calling forth the spiritual and emotional roots first encountered on his trips to the Vologda region. Peg Weiss asserts that it had been "an experience that he ranked among the most powerful of his student days," and "with the passage of time Kandinsky's self-identification with the role of the shaman grew ever deeper."[30]

151

Succession is an example of this late burst of creative energy. At first glance, the painting recalls Kandinsky's abiding interest in natural history and scientific drawings—embryos, amoebas, and invertebrates.[31] However, closer inspection reveals fantasy creatures, shapes, and signs that dance along four horizontal fields reminiscent of musical notation. Their free-wheeling humor makes them the relatives of Miró's dog barking at the moon, Arp's embryonic sculptures, and Klee's hieroglyphics.[32] These new forms are joined by graphic elements recalling Kandinsky's book of 1926, *Point and Line to Plane*, in which he explained that the point marked repose and infinite possibilities, line implied movement, tension, and time, and the amoebalike curves illustrated "the inexhaustible variations of surfaces."[33] New also are colors of "Asiatic splendor," with delicate pastels predominating; they were methodically chosen from color bars that are integrated into the linear progression like pause signs and are reminiscent of Bauhaus color exercises.[34] Kandinsky appears to have begun by painting the outlines with a very fine brush, or in some cases with a

graphite pencil. He must have thought out colors and composition well in advance since there is little evidence of change. Finally, he filled in the remaining space with a brilliant white painted right up to the forms, reinforcing the importance of the "new space."[35] In 1935 the artist wrote: "*Empty canvas*. In appearance: truly empty, keeping silent, indifferent. . . . In reality: filled with tensions, with a thousand low voices, full of expectation." Line, point, and circle, he believed, call out: "Here I am! . . . the whole painting becomes a single 'HERE I AM!'" And he continued: "'The action' in the picture must not take place on the surface of the physical canvas, but 'somewhere' in 'illusory' space."[36]

The viewer's eye is led from left to right, and the image unfolds in sequence, as the title implies. Within its linear confines, *Succession* expresses a sense of freedom, an acceptance of organic growth. It is an expression of Kandinsky's abiding belief in the spiritual nature of evolution and the laws governing creation both in nature and in art. With these concerns he revealed his belief in the notion of materialization, according to which each instance of realization brings forth aspects of a guiding principle that manifests itself equally in the simplest cell, in a complex organism such as man, or in the process of artistic creation.[37] To express this concept, Kandinsky invented forms of notation, which he insisted were neither sign nor symbol but "concrete," the thing itself. And yet this new art, the product of reason and logic, was determined by emotion, or as Kandinsky put it, "the feelings must correct the brain."[38]

In recognizing certain similarities to Asian art, Karl Nierendorf juxtaposed *Succession* with a Chinese calligraphy in his 1943 "East-West" exhibition. Duncan Phillips, who saw the painting in New York and included it in the exhibition's Washington venue, was at first hesitant to buy it, writing to Nierendorf: "As I have so often told you, Kandinsky does not speak to me as persuasively as he does to you. I enjoyed this painting as I would enjoy a page of illuminated manuscript for its delectable ornament but that is all." In a long letter, Nierendorf explained his view of the artist's aims, and Phillips relented, making this the first Kandinsky to enter the collection.[39]

EDP

LYONEL FEININGER (1871–1956)

An American expatriate who was deeply involved with the German expressionist movement, Lyonel Feininger was born in New York July 17, 1871. His parents, who were musicians, sent him to Germany in 1887 to study music. Choosing to focus on art, however, Feininger attended a number of art schools from 1887 to 1892, including the Kunstgewerbeschule in Hamburg, the Berlin Academy, the Collège Saint-Servais in Liège, and, briefly, the Studio Schlabitz in Berlin. He then worked as a caricaturist for *Ulk, Lustige Blätter, Harper's,* and the *Chicago Tribune,* among others. He married a fellow artist, Julia Berg, in 1908. Feininger exhibited an oil at the 1910 Berlin Secession and in 1911 had six paintings in the Salon des Indépendants in Paris. He saw his first cubist works around this time and met *Die Brücke* artists the following year, when he completed his first architectural paintings. In 1913 he explored the villages of Thuringia in eastern Germany, an experience that would inspire him for the rest of his life. In 1919, after several years of exhibiting with the Blaue Reiter group and the avant-garde Der Sturm gallery in Berlin, he was appointed as the first master of the Bauhaus School at Weimar; he also oversaw the graphics workshop. In 1924, with the aid of Galka Scheyer and along with Klee, Kandinsky, and Jawlensky, he formed the exhibiting group known as the Blaue Vier (Blue Four). He remained at the Bauhaus when it relocated from Weimar to Dessau in 1926. In honor of his sixtieth birthday in 1931, the National Gallery in Berlin held his first retrospective. In March 1933 Feininger moved to Berlin. He accepted a teaching position at Mills College in California for the summer of 1936; the following year, in the face of political developments in Germany, he returned to America to teach again at Mills, and he later settled in New York. In 1944 the Museum of Modern Art gave him his second retrospective, which helped broaden his recognition in America. He died in New York January 13, 1956. The collection contains two oils by Feininger—one from his mature Bauhaus period and one from his transitional period—and a late watercolor.

152

Village, 1927

Dorf

Village Markwippach; Dorf Markwippach
Oil on canvas, 16⅞ × 28½ (42.8 × 72.4)
Signed l.r.: *Feininger;* reverse: inscribed probably by the artist on stretcher, u.c.: *Dorf;* on masking tape on stretcher, u.c.: *Lyonel Feininger/"Village"*
Acc. no. 0677 (Hess no. 282)

The artist to Buchholz Gallery, New York, after 1936; PMG purchase 1943.[1]

Introduced early in his career to cubism, futurism, and expressionism, Feininger absorbed the basic tenets of these movements and made them the underlying foundation of his style. *Village,* a mature work created during his Bauhaus period, is a summation of these experiences.[2]

Feininger often focused on architecture, which for him served as a symbol of the spirit of man. During the teens and twenties, he was especially drawn to small German villages that had maintained their medieval structure, especially those in Thuringia about which he wrote: "The villages—there must be nearly a hundred in the vicinity—are gorgeous. The architecture (you know how much I depend on it) is just to my liking. So inspiring—here and there uncommonly monumental. There are some church steeples in God-forsaken villages which belong among the most mystical achievements of so-called civilized man."[3]

The Thuringian town of Markwippach served as the inspiration for *Village.* Feininger had painted it ten years earlier, using jagged, energetic facets of yellow and blue.[4] The dominant image in that work is the medieval church, its spire reaching toward the heavens; the surrounding humble dwellings, which lean precariously as though about to tumble out of the picture plane, appear to reflect the turmoil of the war years. In the Phillips version, the cubist-derived facets of space and color evoke a mood of quietude and reflection, and Feininger chose to emphasize the village square, perhaps because of its ancient enclosed design. The work seems to illustrate his statement, "I don't paint a picture for the purpose of creating an aesthetic achievement." He added, "from deep within me arises an almost painful urge for realization of inner experiences[;] an overwhelming longing, an unearthly nostalgia overcomes me at times to bring them to light out of a long lost past. . . . Here in the Deep I am detached."[5]

The gabled dwellings in *Village* are realized as geometric shapes with subtle transitions of color, sometimes translucent, sometimes opaque. The central doorway of rich blue provides both a formal and spiritual focus to the composition, seeming to draw the viewer into the medieval town square that for Feininger represented the spiritual essence of man, his "spiritus loci."[6] Earth colors—browns and rusts—define the shifting square, and oblong planes hint at the buildings; floating mauve squares within squares, barely visible, delineate the sky; and a vertical pale-blue plane unifies the two areas. The miniature, abbreviated figure in yellow provides human scale and emphasizes the spiritual space of the painting. *Village* gives visual expression to Feininger's belief that "the strict polyphonic form of music seems to me to be the loftiest expression of our longing for supreme purity, and surely painting can be brought to the same perfection, once we have stripped off the merely objective."[7]

L B W

153

Spook I, 1940

Oil on canvas, 21 × 21 (53.3 × 53.3)
Signed l.r.: *Feininger;* reverse: inscribed probably by the artist on stretcher, u.l. to u.r.: *Lyonel Feininger 1940 "Spook" I*
Acc. no. 0676 (Hess no. 395)

The artist to Buchholz Gallery, New York; PMG purchase 1941.[8]

When Feininger returned to America in 1937, he was at first hesitant to resume painting. Overwhelmed by new sights and sounds, he preferred simply to reexperience his birthplace. As he wrote in 1937: "I am in a very unusual frame of mind, at present. Imagine the almost unprecedented home-coming of an American, after nearly 50 years entire absence (with not one visit in the intervening years!), to his native city. The changes that have taken place in that period of time are astonishing enough. . . . There is nothing that does not affect me in some way."[9] Feininger's return to painting in 1939 was noted by his wife, Julia, in her diary: "Leo paints."[10]

Not yet ready to depict the American landscape, Feininger turned to his early work for inspiration, using in *Spook I* the fairy-tale apparitions and goblinlike creatures that had populated his cartoons of the 1890s and early 1900s. His fascination with such images stemmed partly from a childhood memory of striped-suited prisoners on Blackwell Island in New York: "This made a wretched impression on me—in consequence I took to drawing ghosts for a while and this may have laid the foundation for my later work, fantastic figures and caricatures."[11] The composition is based on a tiny watercolor entitled *Little Ghosts, Friendly Ones* that he had painted to accompany an entry in a guestbook in 1922.[12] Reworking such imagery provided a period of respite and a transition into his late graphic style. Feininger later noted that "the formal treatment of these grotesque distortions served me when I turn my hand to more weighty compositions; and also, because I enjoy harking back to drolleries."[13]

152

153

Waterfront, painted two years later (acc. no. 0678), shows a reaffirmation of his creative direction. As in other late works, Feininger here provided structure solely through line in a manner reminiscent of Klee's linear approach, allowing color to float freely in fields over the picture surface. He wrote that his late work possessed "economy of means, employment of line with mere accentuation through color to sustain mood and expressive space," and observed, "I see one marked difference between early and late work: I now 'think' less, and work at times in utter unconsciousness of what may be the final achievement."[14]

Duncan Phillips, whose awareness of German expressionism grew during the mid-thirties, probably became interested in Feininger when he was represented in the 1941 Corcoran biennial exhibition.[15] Attracted to the oil painting, Phillips immediately wrote to Feininger. He also proposed holding a solo exhibition of Feininger, asking Curt Valentin of the Buchholz Gallery in New York to send seven paintings.[16] Although the exhibition never took place, Phillips purchased *Spook I* from this group and two years later acquired both *Village* and *Waterfront*. His interest in the artist continued, and in 1949 the Phillips was a venue for the Boston Institute of Contemporary Art's exhibition "Jacques Villon, Lyonel Feininger."[17]

LBW

PIET MONDRIAN (1872–1944)

Through his art and writing, Piet Mondrian gave form and word to the principles of geometric abstraction, which in turn contributed significantly to the development of the international style in art, architecture, and design. Born Pieter Cornelis Mondriaan March 7, 1872, in Amersfoort, The Netherlands, Mondrian received his early education from his father, a headmaster of a Calvinist school, and his first lessons in art from an uncle who was a painter. Mondrian's early work reflects his studies at the State Academy in Amsterdam from 1892 to 1897, as well as the influence of the Hague School—Holland's response to the French Barbizon tradition. In the first decade of the twentieth century, Mondrian turned to theosophy and neo-Platonic mysticism, which, combined with symbolist style and post-impressionist color, informed his early landscapes and flower paintings. He exhibited at the Salon des Indépendants from 1911 to 1914 and at the Cologne Sonderbund exhibition in 1912, the year he moved to Paris and changed his name to Mondrian. Confronted by cubist explorations of pictorial space, he spent the ensuing years developing these principles into his own language of abstraction. Between 1917 and 1924 he wrote for *De Stijl* magazine, which he cofounded with his friend Theo Van Doesburg. After an absence from Paris during the First World War, he returned in 1919 and achieved his classic style—neo-plasticism—which he defined in several publications between 1921 and 1923. Katherine S. Dreier visited Mondrian in 1926 and became the first American to own one of his paintings. Chiefly through her efforts, and the 1936 exhibition "Cubism and Abstract Art" at the Museum of Modern Art, Mondrian became known in America. The shadow of war forced him to move, first to London in 1938 and to New York in 1940. The impact of this city, and the esteem with which he was received, brought forth a burst of creativity that was cut short by his death February 1, 1944. The collection holds three paintings spanning the artist's career.

Throughout his life, Mondrian defined himself through his art, projecting an image carefully constructed out of his personal appearance, behavior, and the environment of his successive studios. Herbert Henkels traced this developing concept of self from the academic tradition, to a period of intense scrutiny through self-portraits, and finally to assurance found in his Paris, London, and New York years.[2]

Were it not for chance, Mondrian's earliest known self-portrait would have met its end at the hands of its youthful creator, who wanted to use it for target practice. However, his friend Albert P. van den Briel dissuaded him and asked for the painting.[3]

Although conceived as a sketch, the painting shows considerable technical refinement suggestive of the Hague School—warm tones, lively brushstrokes, sketchy dismissal of unessential areas.[4] The costume, the dress of a craftsman, not a gentleman-painter, was also carefully chosen. The vest is earth-colored and olive, the shirt the color of sand. With a sure touch, Mondrian outlined the shoulders and defined the collar. The severe, frontal pose reappears in later works, but the steady eyes and the light that descends upon the forehead like a blessing hint at later mystical concerns that would cause Mondrian to depict himself as the "initiate."[5]

According to Mondrian's friend Michel Seuphor, the artist (like so many of his contemporaries) was steeped in spiritualism around the turn of the century, a period when "his Calvinism was replaced by theosophy."[6] In years to follow, Mondrian would fashion a spiritualist belief that drew on neo-Platonic traditions, northern romanticism, and Eastern mysticism; he would study the theosophic teachings of Edouard Schuré and Madame Blavatsky, later turning to Rudolf Steiner and M. H. J. Schoenmaekers. Eventually, these ideas were absorbed into Mondrian's almost religious belief in the unity of life and art, which for Mondrian was ultimately to be found in neo-plasticism.

EDP

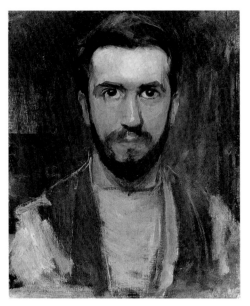

154

Mondrian's gradual embrace of pure abstraction may well have had its roots in the essentially aniconic tradition of Calvinist Protestantism; it was furthered by theosophic and neo-Platonic concepts according to which the visible world is crowded with mere incidentals—faulty particulars of a universal reality that lies beyond the grasp of our senses. For Mondrian, every work of art was a milestone toward achieving an image of this spiritual reality.[8]

Composition No. III is an example of Mondrian's classic neo-plasticism.[9] With consummate perfectionism and a limited vocabulary—black, gray, white, and three primary colors—he achieved a work of art that is at once physical and spiritual, elusive and intellectually direct, yet arrived at through intuition.

In 1946 Duncan Phillips admitted that this painting "had cast a sort of spell over me and I became converted to an artist whose style I had thought too cold and austere for my taste." Upon confirming the purchase, he wrote again: "I do not think I would find a better Mondrian, one more tonic and satisfying to one's inner need for balance and perfect relations."[10] Phillips had recognized this painting as a felicitous solution of Mondrian's precepts of neo-plasticism and of his search for the "equilibrium of *dynamic movement*" of form and color."[11]

A grid of black lines, accentuated by two

154

Self-Portrait, ca. 1900

Oil on canvas, mounted on hardboard, 20 × 15½ (50.7 × 39.3)

Unsigned; inscribed by Albert P. van den Briel with part of an Icelandic poem, l.c.

Acc. no. 1375 (Seuphor no. 1; Ottolenghi no. 42)

The artist to Albert P. van den Briel, Amsterdam, by 1902; Jon Nicholas Streep, New York, around 1950; Sidney Janis Gallery, New York, 1950; TPG purchase 1958.[1]

155

Composition No. III, 1921 or 1922; repainted 1925

Composition, 1921/Tableau III with Red, Black, Yellow, Blue and Gray; Square Composition

Oil on canvas, 19⅜ × 19⅜ (49.2 × 49.2); mount: 22⅛ × 22⅛ (56.2 × 56.2)

Signed and dated l.r.: *PM/22*[correction over *21*]*-25;* signed and dated under layer of paint, c.l.: *PM 22*

Acc. no. 1376

The artist to Margarete Dudensing, by 1942 or earlier; TPG purchase from Valentine Gallery, New York, 1946.[7]

155

axes—one vertical and one horizontal—defines the gray and white shapes as well as the fields of primary colors, red, blue, and yellow. Some of these fields are framed, others left open at the canvas edge, suggesting continuity beyond the composition. Counteracting this segmentation is a meandrous pattern—framed shapes that descend from the upper center, turn left and up again, and are terminated by the black rectangle. This motion is echoed and reinforced by the rectangles that run along the right, bottom, and left edges, ending at the white shape that appears to be a square by virtue of its missing enclosure. The red field in the upper left reverses this momentum and brings the eye to rest on the white.

The primary colors serve to heighten the complexity. While yellow and black, placed alongside each other, form the composition's focus, red and blue, by their marginal locations, establish a balance toward the periphery. Together, the shapes, lines, and colors keep the eye searching for relationships between the whole and its parts, for variations of motion and scale, and for tensions between disparate parts of the painting—a balance of apparent unequals that is Mondrian's concept of "dynamic equilibrium." A harmony analogous to music is established by the triads of black-gray-white and red-blue-yellow.

The painting's double date and the change of the earlier date from "21" to "22" raise two questions: was this work begun in 1921 or 1922, and how much of the original conception was changed in 1925 or later? The first question is complicated by Mondrian's own correction and the fact that another date, "PM 22," was recently discovered beneath layers of paint. Furthermore, the painting was listed with the double date of 1921–25 in early exhibitions.[12] The second question, the extent and exact date of later changes, is difficult to determine, but several revisions in the grid and color areas as well as the numerous layers of paint suggest that changes were made at some point.[13]

In terms of style, *Composition No. III* would bear out a first date of 1921, or shortly thereafter in early 1922. It is closely related to two 1921 works, both entitled *Composition with Red, Yellow and Blue*.[14] Discounting the later changes, comparison with these paintings reveals the great compositional harmony achieved in the Phillips work: the Rothschild painting has a vertical axis that bisects the image, its central S-

shape offering insufficient cohesion to counteract the split. The work in the Gemeentemuseum does have the central meander shape but is partitioned by lines so narrow as "to read as imposed drawing, rather than as plane connection."[15] In *Composition No. III*, these uncertainties were resolved and support Jaffé's opinion that Mondrian's works of the end of 1921 "attained a classic equilibrium and complete certitude."[16] Moreover, in the course of 1922, Mondrian became preoccupied with other issues—balancing matter and void and pitting a large white square against grids pressed to the painting's edge.

The emotional appeal of this painting, what Phillips called its "spell," lies in its expressive qualities. They are the result of a struggle for a pictorial language that could balance darkness and light, encompass esoteric mysticism, and represent spirit and matter as well as male and female principles in carefully weighed equivalents. Many years later, Mondrian summarized his artistic aims: "To create pure reality plastically, it is necessary to reduce natural forms to the *constant elements* of form and natural color to *primary color*."[17]

EDP

156

Painting No. 9, 1939–42

Composition in Black, White, Yellow and Red
Oil on canvas, 31⅛ × 29¼ (79.7 × 74.0)
Signed and dated in red paint, l.c.: *PM;* l.r.: *39/42* (first number above the second)
Gift from the estate of Katherine S. Dreier, 1953
Acc. no. 1374 (Seuphor no. 417; Ottolenghi no. 454)

The artist to Katherine S. Dreier, West Redding, Conn., probably 1942; gift from the Dreier estate, 1953.[18]

Transcendently sparse and serene, *Painting No. 9* is one of the paintings begun in London and perhaps completed or retouched in New York, as the double date implies.[19] The network of thin horizontals and verticals is carefully balanced, thus maintaining an overall unity. The ample white areas can be read as either flat surface or limitless space, and the colors, placed near the edge, draw the eye away from the center. As a result, the image hovers, as though weightless, in timeless silence and suspended energy. Katherine Dreier might have been contemplating this painting when she wrote in 1950: "Mondrian came to the philosophical conclusion that ALL IS SPACE."[20]

In its economy of means, the painting rewards Mondrian's lifelong struggle to convey the significance of pure line and color, both of which he endowed with a multiplicity of meanings. A cluster of three lines runs through the painting's center like a horizon, complemented by three verticals grouped together at the right edge. Individual verticals and horizontals balance this concentration and establish a clear "dynamic equilibrium" of line and plane, of action and repose. In using black lines that are considerably narrower than those of earlier works, Mondrian returned to compositional concerns first explored in the early 1930s, when he experimented with lines of varying widths.[21]

Mondrian believed that colors expressed spiritual light as well as emotion.[22] *Painting No. 9* combines yellow (in Mondrian's view an "inward" or spiritual color) with five small red bars (red being "outward" or worldly). In small ways he liberated them from the confines of black frames: the yellow field is left unframed at the top, and the red bars have become lines in their own right, their coarser brushwork emphasizing their special status. Visibly additive, they create a clear contrast to the large field of yellow and achieve a balance of opposites; they are like syncopated notes in the jazz compositions Mondrian loved so well and celebrated in his painting *Broadway Boogie-Woogie*.[23] Robert Welsh believes that the red bands were most likely added in New York and that the configuration of black lines may have been changed as well, creating greater tension between the voids and the tightly bundled lines.[24]

Mondrian's arrival in New York was of paramount importance to American artists, especially to the members of the Association of Abstract Artists, and, through his presence as well as his exhibitions, he helped them expand their understanding of pictorial space at a crucial time.[25] Barbara Rose summed up his legacy: "Mondrian's preoccupation with the *reality*—in a philosophical as opposed to a representational sense—of the work of art was . . . his central contribution to the formulation of the esthetic of the New York School."[26] Clement Greenberg, too, saw in Mondrian's paintings the perfection of its formalist and expressive means. In Mondrian's obituary he wrote: "His pictures . . . are no longer windows in the wall but islands radiating clarity, harmony, and grandeur—passion mastered and cooled, a difficult struggle resolved, unity imposed on diversity."[27]

EDP

PAUL KLEE (1879–1940)

Paul Klee was a painter, theorist, teacher, and musician whose introspective, cryptic, and often humorous works inspired surrealists and abstract expressionists alike. Klee was born December 18, 1879, in Münchenbuchsee, near Bern, Switzerland, the only child of musicians. After studying at the Munich Academy, Klee returned to Bern but in 1906 settled in Munich, where he took part in the activities of the emerging avant-garde, especially the Blaue Reiter group. In 1920, his career established through exhibitions and the publication of his essay "Creative Credo," Klee was invited by Walter Gropius to the Weimar Bauhaus, where he had a profound influence as teacher and artist-in-residence. He followed the Bauhaus to Dessau in 1925, sharing a duplex with Kandinsky. That same year he had his first one-artist exhibition in Paris and participated in the first surrealist show at Galerie Pierre. Klee's *Pedagogical Sketchbook,* an essay on composition, perception, and pictorial reality, was published in 1925. An inveterate traveler, he drew lasting inspiration from his early trips to Italy and Paris as well as later visits to the Mediterranean—Tunisia in 1914, Italy in the late 1920s, and Egypt in 1929. After leaving the Bauhaus in 1931, Klee taught at the Düsseldorf Academy but was forced to flee the Nazis in 1933. He traveled to Paris for a first visit with Picasso, signed a contract with Daniel-Henry Kahnweiler's Galerie Simon, and by year's end settled in Bern. From there, he watched helplessly as his works were purged from German public collections and added to the Nazis' 1937 show of "degenerate art." Deteriorating health did not diminish Klee's prolific output. He died June 29, 1940, at Muralto-Locarno. The museum owns thirteen works by Klee (one stolen in 1964 was returned in 1997).

The Klee Unit

In 1947 André Masson wrote about Klee's vision as an artist: "The beetle's graceful antenna would be enough to measure the desert, and the pollen's wake could humble the Milky Way."[1] While he would not have shared Masson's enthusiasm for the surrealist aspects of Klee's art, Duncan Phillips recognized him as "a dreamer, a poet, and a brooding rebel. . . . No art can be more personal than the art of Klee." Beginning in the early 1930s Phillips spoke passionately against "the idea that art of an age of machinery should be itself mechanical."[2] He believed that in a century shaped by technology and war, the collectivist tendencies of modernism were to be rejected, and that Klee's "private individualism" would ultimately assert itself.[3]

Klee's art grew on the fertile ground of a half-century of fundamental changes in art. He responded to the graphic elegance of Art Nouveau and the progressive ideas of the Secession; he drew inspiration from French influences such as fauvism, Delaunay, and cubism. He also lived in close proximity to expressionism, dada, and constructivism as they manifested themselves in Germany. Heir to northern romanticism's search for the "metaphors of the secrets of life," Klee became a master of line and color.[4] He exploited to the fullest the cerebral and narrative energies of the former and the emotional power of the latter; in his late work he achieved a painterly fusion of both. Klee pointed to this effort in his famous Jena lecture of 1924: "What artist would not like to live where the central organ of all space-time motion, call it brain or heart of creation as you will, activates all functions: In the womb of nature, in the primal ground of creation, where the secret key to all things lies hidden?"[5]

The Klee unit, one of the cornerstones of The Phillips Collection, was assembled between 1938 and 1948, with the exception of one early purchase in 1930. Comprising thirteen works, it represents the artist's mature oeuvre.[6] The subjects reflect Klee's far-flung interests, from contemplations of Creation in *Tree Nursery,* 1929, and *Efflorescence,* 1937 (cat. nos. 159 and 160) to his almost scientific inquiry into the pictorial laws of the two-dimensional surface in *Garden Still Life* (acc. no. 0996) and *Cathedral* (cat. no. 157), both of 1924. His love for children's art is represented by *Arrival of the Jugglers,* 1926 (acc. no. 0991). Two major works reflect his admiration for non-Western cultures: *Arab Song,* 1932, and *Picture Album,* 1937 (cat. nos. 161 and 163).

The Klee Room at The Phillips Collection has been an abiding source of inspiration to artists ever since its installation in 1938. Marc Tobey, Richard Diebenkorn, and Kenneth Noland acknowledge its importance, and Gene Davis called it "the very first influence on my work . . . a revelation."[7] Possibly these artists found in the color-soaked burlap of *Arab Song* an echo of their own enthusiasm for stained raw canvas; surely they were inspired by Klee's late "painterly drawing," the style represented by *Young Moe,* 1938 (cat. no. 164). Andrew Kagan, in assessing the importance of Klee to American artists from about 1930 on, believes that, more than his mysticism or philosophy, "Klee's most significant influence was *precisely* formal, technical, and contentual."[8]

Phillips probably came to know Klee's work through the 1930 retrospective at the Museum of Modern Art (jointly organized by Alfred H. Barr Jr. and J. B. Neumann, the first for a living European artist to be held at the recently opened museum). Phillips, a trustee, made notes in his copy of the catalogue, and two of the exhibited works eventually entered his collection: *Necropolis,* 1930, and *Land of Lemons,* 1929.[9] Furthermore, three New York dealers, J. B. Neumann, Curt Valentin, and Karl Nierendorf, represented Klee and actively competed for collectors.[10] Neumann brought more than fifty works to New York for the MOMA exhibition, and in 1938 Nierendorf announced that he had brought with him from Germany "more than one hundred new works of Paul Klee" and offered Phillips first choice.[11] By then a major contender in the market, he purchased four works in 1938 alone.

Tree Nursery, acquired in 1930, was Phillips's first work by a twentieth-century German-speaking artist. At the time, he ranked Klee somewhat tentatively among the "progressive leaders" and, referring to the playful content of some of Klee's images, wrote that Klee and Dufy "successfully bridge the chasm between Dadaism and Toyland."[12] He did not immediately appreciate Klee's theories, nor did he accept his view that the creative acts of the artist parallel those of nature. Rather, Phillips seemed to prefer James Johnson Sweeney's interpretation of the "written" character of Klee's art and quoted Herbert Read: "A world of spooks and goblins, of mathematical gnomes and musical imps, of elfish flowers and fabulous beasts: a Gothic world."[13]

Years later, when contemplating the cataclysm of the Second World War, Phillips said of Klee that his "private individualism, fervently on the side of the angels, was no doubt what seemed so dangerous to Hitler," and in his lectures he concluded: "Paul Klee builds himself a little house of art in a realm somewhere between childhood's innocence and everyman's prospect of infinity. . . . [He] believes that art is nothing if it is not personal expression—that love must come back to its vacant dwelling."[14]

EDP

157

Cathedral, 1924

Kathedrale

Watercolor and oil washes on paper mounted on cardboard and wood panel, 11⅞ × 14 (30.1 × 35.5) with original strip frame

Signed in black paint, u.l.: *Klee;* dated and numbered in black, l.l.: *1924/138;* titled in black on cardboard edge, l.r.: *Kathedrale;* reverse: Inscribed *1924/138 Kathedrale Klee.*

Acc. no. 0993 (138; A)

The artist, Weimar, until 1925; possibly consigned to Galerie Hans Goltz, Munich, 1925, to Neue Kunst Fides, Dresden, until ca. 1928, and to Galerie Alfred Flechtheim, Berlin, thereafter; PMG purchase from Nierendorf Galleries, New York, 1942 (from exhibition).[15]

158

The Way to the Citadel, 1937

Der Weg zur Stadtburg (Städtebild)

Oil on canvas mounted on cardboard, 26⅜ × 22⅜ (67.0 × 56.8)

Signed in ink, u.l.: *Klee*

Acc. no. 1001 (137; qu 17)

The artist, Bern, to Galerie Simon (Daniel-Henry Kahnweiler), Paris, on consignment 1937–38; possibly also consigned to Buchholz Galleries, New York; PMG purchase from Nierendorf Galleries, New York, 1940.[16]

Four works by Klee in the collection contain imagery derived from architecture, cities, and streets: *Cathedral* and *Garden Still Life* (acc. no. 0996), both of 1924; *Arrival of the Jugglers,* 1926 (acc. no. 0991); and *The Way to the Citadel,* 1937.[17] They reflect theories that occupied the artist during his Bauhaus tenure—a near-scientific inquiry into pictorial structure and the representation of movement and space. As a member of the faculty, he daily encountered the school's commitment to systematic design principles increasingly derived from constructivism.[18] While Klee's architectural subjects, often fantastic or ironic constructs, reveal little of this rationalist aesthetic, time and space, the factors governing the experience of architecture and music, became burning issues for him. He explored their potential for visual representation through a system of signifiers: arrows, lines, and horizontal bands that traverse the entire image.

Klee's effort to render visible the totality of architecture is clearly evident in *Cathedral.* A delicate free-hand grid evokes the ephemeral quality of ancient plans drawn by the builders of the great cathedrals. Multiple views, spatial recesses, and rhythms—both mathematical and musical—are fused into a single image implying plan and elevation simultaneously.[19] The addi-

157

tive nature of Gothic architecture is invoked by repetition. Multiple bays, windows, and crenellations move the eye along as though it were reading script; arches and rib vaults are aligned on the picture plane, subverting all illusion of perspective. Finally, at the right edge, the lines change into musical notation. This metamorphosis, so important in Klee's vision, evokes the choral harmonies to be heard within the cathedral, just as the row of trees on the left (nature's creation) conjure the verdant stillness of the cloister garden.[20]

By using white line rather than dark, Klee emphasized Gothic architecture's mystical aim to negate the earthly laws of gravity and to create light, which was equated with divine presence. Laid like a delicate scrim over the square patches of background color, the white lines are a painterly elaboration of ideas rooted in Klee's early graphics, when he experimented with a blackened piece of glass into which he drew with a needle.[21] "Hence," he wrote in his diary, "the medium is no longer the black line but the white one. The ground is not light but night; the fact that energy is the illuminating agent corresponds to the process of Nature. . . . 'Let there be light.' Thus I gradually glide into the new world of tonalities."[22]

In both *Garden Still Life* and *The Way to the Citadel,* the echoes of cubism become apparent; Jim Jordan, however, believes that Klee "used all the advanced forms of the day, without ever leaving his symbolic path to convert to their alien iconographies."[23] In the garden picture, black outlines define rectangular shapes whose shading makes them project upon, or recede into, the shallow and indeterminate pictorial

space.[24] Superimposed on this pattern are painted circles, squares, and triangles vaguely alluding to benches, bottles, stools, and tables with checkered cloths seen from above. A house, in childlike elevation, has incongruous openings and fancy ornamentation. The setting clearly speaks of the joys of the garden experienced by a modern city dweller.

By contrast, *The Way to the Citadel* has a tight, geometric structure. It is illustrated in Klee's notebooks as an example of "Succession, interpenetration or interlocking of perspectives."[25] The fine-weave canvas was prepared with a shiny, transparent size. An extremely lean oil paint, thinly applied, covers the entire surface, onto which individual color planes are added. The perimeters of these planes are actually brown underpaint left exposed and in some areas reinforced by brown or black paint.[26]

Windows, stairs, and recesses form an architectural surface that appears "real" but proves irrational and structurally impossible; all spaces are blocked, and even the windows are filled in. Six red arrows traverse the image, scampering from left to right. Their route is conceptual rather than spatial, for there is neither space for transit, nor is there an exit. Klee alluded to the arrow as a symbol of transcendence when he called it "the father of the thought" and wrote in his treatise on the arrow: "How do I expand my reach? . . . The contrast between man's ideological capacity to move at random through material and metaphysical spaces and his physical limitations, is the origin of all human tragedy."[27]

However, as so often, Klee infused his theoretical exploits with humor and images from memory. *The Way to the Citadel* recalls the

158

architecture of Italian hill towns, which he wrote about in 1902: "In Italy I first understood the architectural aspects of art—here I was in close proximity to abstract art (today I would say the constructive principles)."[28] Even the arrow has a second, lighter significance; in a 1927 letter to his wife from Corsica he described his accommodations in a small inn: "You go to your bedroom by following the arrow, up a very steep alley like those in Genoa, then around a corner, you enter the rear of the adjacent house by climbing high, very high, steps into the second floor." Finally, the work's title appears in letters from his trip to Egypt. Writing to his son, Felix, on Christmas Day, he talked about his climb to the citadel, where one enjoyed a grand view of Cairo and the pyramids in the distance.[29]

Arrival of the Jugglers, in all its playful, child-like quality, incorporates Klee's ideas about the simultaneity of space and time, here expressed through the images of the street and the parade.[30] Furthermore, time is also invoked in the simulated tattered edges and abrasions that surround the picture, giving it the appearance of an ancient object that itself has had a history aside from the scene represented. By intentionally "aging" the work, Klee gave it a cultic aura that suggests sacred tablets or ancient scrolls, thereby adding to its uniqueness.[31]

By juxtaposing village folk and circus people, Klee made poignant reference to the artist as outsider and entertainer who passes through a rigidly fixed setting—here shown in the horizontal lines that hold buildings and spectators in place—while the circus folk roam free and occupy a different spatial realm than does the audience. And yet, in Duncan Phillips's words, "whimsy and a fine sense of nonsense relieved the all-pervasive melancholy of his mind and the irony of his comments on modern man's confusions and pretensions."[32]

Both Klee and Kandinsky had been attracted to the spontaneity of children's art since their early Munich days, as attested by several illustrations in the *Blaue Reiter Almanac.* In fact, Klee might have used a child's drawing of a rider and a bicyclist parading past houses strung on a line as a model for this work.[33]

In the multitude of images shown in these works, Klee contemplated the formative energy of Creation and man's comparable efforts through art and architecture. In 1920 he wrote: "The relation of art to creation is symbolic. Art is an example, just as the earthly is an example of the cosmic. . . . A final secret stands behind all our shifting views, and the light of intellect gutters and goes out."[34]

EDP

159

Tree Nursery, 1929

Junge Pflanzung
Young Plantation
Oil on canvas with incised gesso ground, 17¼ × 20⅝ (43.9 × 52.4)
Signed and dated in black ink (incised), u.l.: *1929 Klee*
Acc. no. 1000 (98; S8)

The artist, Dessau, to Galerie Alfred Flechtheim, Berlin, on consignment 1929–30; PMG purchase through J. B. Neumann, New York, as agent, 1930.[35]

Images that reflect Klee's vision of creation and growth are richly represented in the museum's collection, and *Tree Nursery* is the most important among them. The first Klee work to be acquired by Duncan Phillips, it probably appealed to him because of its colors, texture, and "fanciful and unobtrusively artful pattern." Nevertheless, *Tree Nursery* was considered part of the "experimental laboratory of the Phillips Memorial Gallery" and kept on display for only a short time after its purchase.[36]

Tree Nursery is a clear illustration of Klee's intense studies of nature's laws governing growth and form. He believed these powers to be closely related to those of the artist, who consequently assumed a near godlike position. He wrote in his notebook: "For I was where the beginning is . . . that is tantamount to being fruitful."[37] To express these ideas, Klee employed the circle, the square, and the triangle, for he believed mathematical principles to be at the heart of all creation, containing within them countless possibilities for future growth through division, multiplication, repetition, or combination. Therefore, several such configurations are arranged on the top line of *Tree Nursery* and continue in linear progression through various stages of metamorphosis, arriving finally at the two human figures placed at the bottom right.[38] Other forms nearby are undifferentiated, suggesting future growth that could result in either plants or human figures since they all carry within them the same potential.[39]

Line determines the painting's entire compositional structure, even in the runelike signs incised into the surface. For Klee, the line, growing out of a point, symbolized growth: "The point sets itself in motion and an essential structure grows, based on figuration. . . . True essential form is a synthesis of figuration and appearance."[40]

Yet *Tree Nursery* goes beyond being an abstract illustration of nature's creative laws. Dating from the end of Klee's teaching career at the Dessau Bauhaus, it reflects his main artistic goals at the time: duplicating in art the structure of musical polyphony on the one hand, and finding means to express in pictorial terms the space-creating qualities of light and color on the

other. Both were closely connected to his search for pictorial means to express the progression of time.[41] Measured time is made visible in the painting's horizontal stripes, which are intersected vertically and horizontally in a relationship of 1:2:4—ratios that reveal parallels to musical harmony. The passage of time is further illustrated by plants that are shown at various stages of growth—small and less complex, or larger and more differentiated.[42]

Klee's other concern centered on the illusion of space created by color. The rainbow-colored ground, upon which the lines and signs are incised, extends the picture plane into the illusion of depth. The transparent colors give the image an inner light and a transcendent quality that alludes to an indeterminate future.[43] Klee was convinced that "the inner being is transparent and accented in color."[44]

Klee decentralized the composition by letting the horizontal bands run evenly over its surface and extend beyond the picture's edges. In so doing, he gave *Tree Nursery* the appearance of being a precious fragment and an emblem of history. Klee reinforced these references to a distant past by adding signs and notations reminiscent of hieroglyphs. Moreover, the scratches and incisions on the painting's uneven surface recall ancient tablets. Accordingly, *Tree Nursery* is rich in the qualities Walter Benjamin considered the essence of a painting's "aura," such as uniqueness, presence in time and space, connection to history, and, most of all, "cultic value."[45]

SabF

160

Efflorescence, 1937

Im Zeichen der Blüte
Oil on cardboard, incised, 13⅛ × 10½ (33.3 × 26.6)
Signed in black paint, u.r.: *Klee;* reverse: inscribed in red crayon u.c.: *1937/im Zeichen der Blüte*
Acc. no. 0994 (131; Qu 11)

Consigned to Galerie Simon, Paris (Daniel-Henry Kahnweiler) 1937–38; Buchholz Gallery, New York, on consignment as of 1938; PMG purchase 1938.[46]

Efflorescence celebrates nature's profusion in luscious greens, earthen browns, and glowing pink.[47] The flat composition recalls the garden designs of oriental carpets, implying a human hand imposed upon nature. Human presence is also expressed through objects: strewn about, and rendered in the manner of children's art, are a table, a chair, bowls, plates of fruit, fenced flower beds, dancing petals, bursting seeds, and exclamation marks. Extolling the joy of it all is the radiant blossom at the center, flanked on either side by a vertical bar with thorns or flames threateningly pointing at, but not touching, the flower.

159

Characteristic of Klee's late work, *Efflorescence* blends line and color on flat pictorial space. Delicate, incised lines give sharp contours to shapes otherwise vaguely suggested by color.[48] In contrast, ragged black brushstrokes delineate certain passages and geometric forms. This painterly, tactile quality is concentrated in the large flower, its bright petals and yellow center placed on a black background. Having achieved its predestined form, the blossom hovers like a vision of Goethe's *Urpflanze,* a Platonic embodiment of all natural growth, surrounded by an aura that signifies its other reality—inviolate and perfect. The threatening thorns on either side may symbolize Klee's conviction that art stands at the borderline between creation and destruction, or order and chaos.

EDP

161

Arab Song, 1932

Arabisches Lied

Oil on burlap, 35⅞ × 25⅜ (91.1 × 64.5)

Signed in apricot paint, u.r.: *Klee*

Acc. no. 0990 (283; Y3)

The artist, Düsseldorf, to Galerie Flechtheim, Berlin, on consignment 1932–33; consigned to Galerie Simon (Kahnweiler), Paris, 1934; J. B. Neumann, New York, 1934 until at least 1936; PMG purchase from Nierendorf Galleries, New York, 1940.[49]

In 1927 Klee explained his longing for "local color" experienced through travel: "This is what I search for all the time: to awaken sounds which slumber inside me, a small or large adventure in color."[50] In *Arab Song,* he found these sounds and wove them into a melody of extreme simplicity, extolled by Duncan Phillips: "With only a raw canvas stained to a few pale tones, he evoked a hot sun, desert dust, faded clothes, veiled women, an exotic plant, a romantic interpretation of North Africa."[51]

The painting is a summary of Klee's love of North Africa, first experienced in Tunisia in 1914 and reawakened in 1928 in Egypt, "his last direct contact with a continent to which he may have been related by consanguinity."[52] It is one of the large-scale works of 1932, a year that was a high point of Klee's career.[53]

In spite of its simplicity, the composition is complex and its subject ambiguous. The draped head of an Arab woman reveals only the eyes peering over a veil in a fixed, ironic gaze. A red, bulbous shape suggests the lady's nose, just as the slanted line beneath may be her mouth. However, this line could also read as a branch held between her lips. A heart-shaped form, perhaps a leaf, brings to mind the many instances in which Klee used the heart as a signifier of

amorous emotions; in Giedion-Welcker's view, it is "a dominant erotic symbol . . . a humorous summary of this dark tangle of witcheries" alluded to, but feared by the artist.[54] Like an accompanying minor chord, however, the picture also reads as a landscape—a curtained window opening onto a desert scene with a tree. The dark band of a river hovers in the distance, and the "eyes" might be hills. The viewer is given no perspectival clue, either for depth or volume, thus permitting the dual reading. Only the color planes recede or project.

The painting's burlap texture is flattened by neither paint nor brushstrokes and, having completely absorbed the very lean medium, the cloth recalls Coptic textiles or Arab gowns. The purple and pink shades evoke desert sand and the sunset's flaming glow. Faint traces of a pink and violet wash, added to the white and beige areas with the most delicate of touches, further enhance the effect of shimmering light.[55] Thin brown lines, painted free-hand with a brush, serve as demarcations between color fields and give the appearance of seams. Only the Y-shaped stem of the leaf and the stitchery on the cloth—or is it Kufic writing?—allow line its descriptive independence.

In composition, *Arab Song* is a distilled example of Klee's search for a visual analogy to music. Earlier and more complex efforts ranged from shifting horizontals of Egyptian desertscapes to works with overlapping color squares, all sug-

gesting musical polyphony.[56] By contrast, the spare means used in *Arab Song* are themselves a lesson learned from the hieroglyph, Egypt's "magnificent system of abbreviation."[57] In reducing the complexity of earlier works to a simple melody, Klee created in *Arab Song* a deeply romantic evocation, both of Egypt—its colors, stark geometry, and vast horizons—and of Tunisia, which he experienced as a young man.

By including signifiers that suggest a human figure, Klee gave the painting added meaning suggestive of youthful memories and unanswered longings. Klee's Tunisian diaries are replete with fleeting, melancholy references: his friend and traveling companion, August Macke, glimpsed a young woman and "looked moonstruck at a balcony," but Klee pulled him away. Another diary entry reads: "Once, only once, did we see a small Arab beauty." Finally, Klee recalled that on board ship in Palermo, "the eyes of a young Italian lady met mine . . . she may have been watching me. I averted my glance and searched for a spot where it was totally dark. Such eyes are quite something."[58] In his fearful sense of distance, Klee developed an "artful method of sublimating his suppressed erotic and sexual fantasies," finding solace and safety in artistic creation.[59] Will Grohmann saw in *Arab Song* a reflection of his Tunisian and Egyptian experiences: "In Tunis the Arab song had been an 'eternal rhythm,' now it is both melodic and deeply melancholy."[60]

EDP

160

161

162

Figure of the Oriental Theater, 1934

Figur des östlichen Theaters

Figure on the Oriental Stage

Oil on fabric mounted on cardboard, 20½ × 15⅝ (52.0 × 39.6)

Signed l.c.: *Klee;* reverse: inscribed on frame, u.c.: *1933* [scratched out] *1934/Figur des* [*asiatischen* scratched out] *östlichen Theaters*

Acc. no. 0995 (218; U 18)

The artist until 1938; consigned to Galerie Simon, Paris; consigned to Nierendorf Galleries, New York, 1938–42; PMG purchase 1942.[61]

In 1912 Klee's friend August Macke wrote an essay entitled "Masks." In almost hymnal fashion, he listed the artistic sources of the Blaue Reiter group: "A sunny day, a cloudy day, a Persian spear, a holy vessel, a pagan idol . . . masks and stages of the Japanese and the Greeks." He went on to stress the power of this new art: "Everywhere, forms speak in a sublime language right in the face of European aesthetics."[62] Klee's interest in non-Western theater, masks, and puppets dates to the early years of his career when, aside from merely being fascinated by carved heads and masks, he became deeply concerned about the representation of the human face. In Margaret Plant's view, his interest centered on "the mask as an accoutrement of the theatre, accomplishing the theatrical task of clarifying character."[63]

The mask's ability to conceal and reveal at the same time must have resonated in Klee's own vision of self (so often objectified in his diaries as "das Ich"). In *Figure of the Oriental Theater,* technique as well as expression brilliantly convey this duality. The whitish-green layer of paint representing the mask allows the black imprimatura to shine through numerous tiny specks that were carefully reserved in the process of painting. This technique heightens the sense of transparency and underlying darkness. Other elements, too, were reserved and later painted in, such as the large eye and the emblem on the coat. This process leaves ragged outlines that contrast sharply with the precise contours defining the figure and the small eye. Areas of red and blue are heavily impastoed, as is the brown of the hat and the half-moon shape.[64]

With this painting Klee returned to the motif of the Japanese stage, a theme he had briefly explored in 1923. Perhaps he was inspired by recent articles in the influential journal *Cahiers d'Art* that featured illustrations of Kabuki actors with whitened, stylized makeup and costumes decorated with emblems.[65] One photograph, in particular, seems to have inspired several details:

162

The actor Itzikawa's marionette, his headdress, and the circular emblems on his gown all are replicated in *Figure of the Oriental Theater* in ragged, simplified patches.

However, as so often in Klee's kaleidoscope of sources, *Figure of the Oriental Theater* has a multiplicity of meaning, at times artistic, at times political, at times deeply personal. The marionette brings to mind the many puppets Klee made for his son—characters from myth and fairy tale clad in burlap and wearing fanciful turbans and fierce stares.[66] However, the motif of the mask may have had a more ominous meaning. One of the reasons Klee had been forced to flee from Germany was his dark complexion and rumors about his mother's Near Eastern ancestry, which led the Nazis to call him a Jew. Therefore, it became important for Klee to mask his identity.[67] Indeed, the expression of this mask, its unequal eyes gazing at the viewer, its straight-lined mouth placed over a pointed chin, has the "edgy hauntedness of the large-figure paintings" and the accusatory sadness of a child.[68]

EDP

163

Picture Album, 1937

Bilderbogen

Oil on canvas, 23⅝ × 22¼ (60.0 × 56.5)

Signed in brown paint, l.l.: *Klee*

Acc. no. 0999 (133; Qu13)

Consigned to Galerie Simon, Paris, 1937 until at least 1938; Buchholz Gallery (Curt Valentin), New York, ca. 1940; sold to Mrs. Julius Wadsworth, New York, 1940; returned 1941; PMG purchase from Buchholz 1948.[69]

In 1942 Duncan Phillips quoted James Johnson Sweeney: "Klee is a painter to *be read* as well as to be looked at."[70] *Picture Album* is as mysterious and compelling as a page from a picture book (as suggested by the German title, *Bilderbogen*). Klee's "page" is a thin screen of gray-green paint that reveals figures and patterns shining through from the ground beneath. These images, as "primitive" as ancient textiles, Benin bronzes, and New Guinean shields, or as abstract and surrealist as the art of Picasso, Miró, and Max Ernst, crowd every inch of the picture. Curved lines divide the surface into fields tinted in different colors, some red, some ocher; the smaller details appear stenciled or drawn upon these planes. This manipulation of positive and negative space is reminiscent of cave paintings or blockprinted textiles.[71]

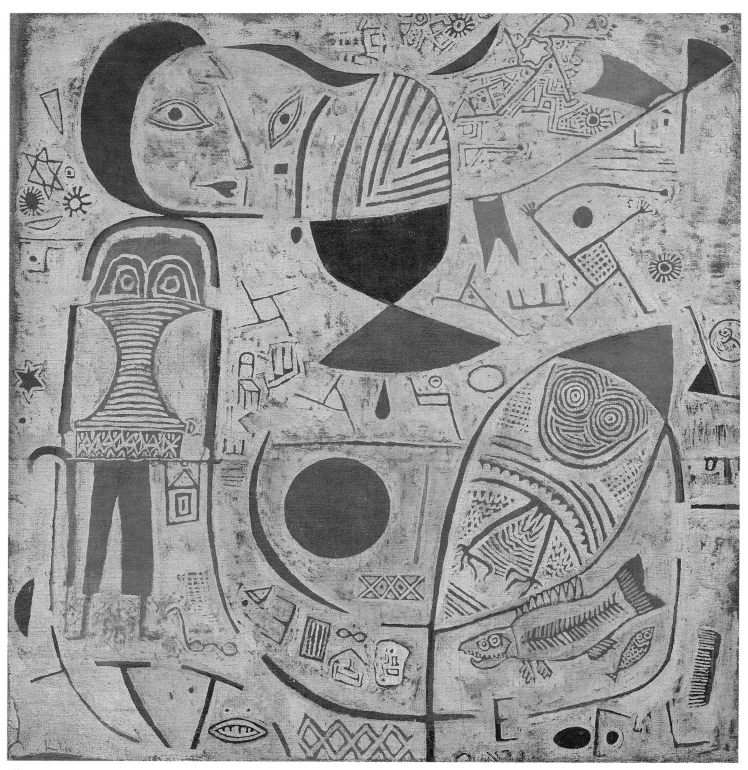

163

Three large forms dominate the composition. In the upper center is a horned head devoid of features but resembling a portrait bust. At the very center of the picture, and apparently emanating from the horned figure, is a red drop, perhaps blood, falling on a red sphere, possibly the earth. Standing at the left is a female figure, its torso resembling a memorial tablet from Papua, New Guinea.[72] The starkly profiled, crescent-shaped head has a heart-shaped mouth and one large eye which gazes disquietingly at the viewer. Curving lines extend the figure's arms and guide the viewer to a shield with demon eyes drawn as concentric rings.

Various smaller figures, symbols, and geometric shapes float in indeterminate space and crowd the stage like bit players. At the top, a detached eye floats in space, seemingly confronting the horned head at close range. Aside from its obvious relation to Picasso, this eye is a device that Klee adopted from both Christian and primitive sources; it "watches over all that is and occurs, a symbol of the Creator and the painter."[73] Gradually, numerous eyes become apparent—those of a two-eyed fish, a moon face, a shapeless creature with a large toothy mouth. Even spectacles stare in that calm, ironic gaze with which Klee himself confronted the world, as numerous photographs of him demonstrate. A perplexing array of objects—chair, comb, walking stick, and fragments of ornament—suggest a sophisticated play with the language of signs that Klee so admired in hieroglyphics and Islamic script. Here, in a single composition, he fused the "primitive" hierarchies of large and small, integrated the jumbled objects into a unified framework, and achieved a clear intellectual construct that dominates the entire image.

Klee became interested in non-Western cultures in the 1920s, a late echo of the Blaue Reiter group's fascination with the subject; he was attracted to signs, "which, when isolated are relatively neutral but when combined activate each other." In Picture Album Klee made ample use of this device, applying a variety of signifiers that recalled past and present, life and art, in a "hieroglyph of lived experience."[74] For that, the year 1937 was particularly poignant. Four years after having been forced to leave Germany, Klee found his work vilified in the "Degenerate Art" show and sold out of German public collections.[75] Seeing the artistic achievement of a generation classified as "un-Germanic," Klee may well have recalled Wilhelm Worringer's 1911 Der Sturm article on modernism and the German tradition. Worringer believed that, in order to return art to its original expressive powers, artists would need a new "way of seeing, this humble secret of the mythic effect of primitive art." He stressed that one aspect of the German

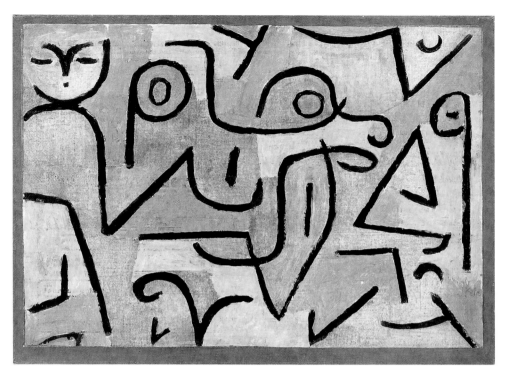

164

artistic tradition (its tragedy as well as its greatness) was a "coming to terms with other worlds of art . . . which gave [it] its own dynamic."[76] All the more painful then to find the Supreme Head of National Socialism declaring in 1937, as though referring directly to Picture Album: "It is either brazen impertinence or stupidity difficult to comprehend to confront our time of all times with works which might, perhaps, have been produced in some Stone Age ten or twenty thousand years ago."[77]

The lines of this political battle, fought on art's territory, were finally drawn on an international scale when Picasso's Guernica, a protest against the fascists' bombing of a Basque town, was displayed at the Paris exposition in June 1937. Cahiers d'Art, which had championed Picasso since the late 1920s, now thrust him in the forefront of the fight against fascism by dedicating the entire summer issue to his work. Klee could not have missed this confrontation since he, too, had been repeatedly featured in this journal.[78]

In fact, both Cahiers d'Art and Picasso resonate through Picture Album. From the classically refined female profile and the displaced eye to the horned creature, the painting evokes Picasso's female portraits of the mid-1930s, the head of the bull in Guernica, and numerous etchings depicting the confrontation of woman and beast.[79]

Aside from the inspiration derived from its

coverage of Picasso's work, Cahiers d'Art offered Klee a smorgasbord of images and signifiers in the illustrations of Benin bronzes and Neolithic rock paintings—scampering stick figures, X-ray fish, comb-shaped designs. Particularly striking are the direct quotations in Picture Album of geometric ornaments from Brazil and architectural decorations from Turkestan.[80] What better way for Klee to join Guernica's impassioned accusation in his own manner, pointing with quiet, literate wit to the power of modernism and its roots in history? Klee meets Guernica's power with a subtle suggestion of impending disaster—a single drop of blood falling on the red disk, a contemplative image of a bloodied world.

EDP

164

Young Moe, 1938

Der junge MOE

Colored paste on newspaper on burlap, 20⅞ × 27⅝ (53.1 × 70.2)

Signed in ink, l.r.: *Klee*

Acc. no. 1002 (121; J 1)

The artist, Bern, until 1940; Lily Klee to 1946; Klee-Gesellschaft, Bern, until 1948; Buchholz Gallery, New York, by 1948; PMG purchase (from exhibition) 1948.[81]

Klee frequently played a cat-and-mouse game with his audience, at once revealing and obscuring his sources. Sometimes, however, his titles

offer clues, and they are as poetic as the image itself. *Young Moe* is one of the few works in Klee's oeuvre that has a direct biographical connection. The title refers to Albert Moeschinger, professor of music theory at the conservatory of Bern from 1937 to 1943, whose nickname was "Moe." In 1935 Moeschinger dedicated three compositions for violin and piano (*Humoresken*) to Klee, who gave him two paintings in return.[82] Although recent scholarship has discounted Klee's overt use of musical concepts in the manner of Kandinsky, innumerable examples speak of the emotional and structural impetus he derived from music, most importantly its discipline and strict form; it was therefore fitting for him to create a "portrait" of a musicologist by using a vocabulary derived from music.[83]

As was typical of Klee's late work from about 1937 on, *Young Moe* achieved a monumental style through drastically reduced means—heavy black lines painted on flat fields of varying coloration. Jordan described this last flowering of creativity as "a direct equivalence to ideas and emotions [that] seems to completely bypass the whole cubistic, visual-structural tradition."[84] It

also questions the pictorial tradition according to which a subject is clearly defined against its background, ends before it approaches the margin, and is placed within clear spatial confines. Instead, Klee treated his surface as a continuum, to be extended in all directions. The viewer reads the heavy black signs, or marks, from upper left to lower right, is halted by the barely suggested face and shoulders, and then follows the line as though it were an arabesque, to the shape of a bird.[85] Curves and angles are repeated in rhythmic variation, in turn creating planes that divide the composition in harmonious sequences. These patterns introduce the element of time through their allusions to script, musical notation, or even the movements of a conductor beating time, as Klee elaborated in his notebooks.[86] The color fields beneath the marks change subtly from yellow to ocher to warm shades of brown-yellow and purplish gray; they have the emotional impact of a melody that supports, even enriches, the rhythm.

Klee noted in his oeuvre catalogue that this gouache is to be considered a sketch, implying that he intended to create a second, more defini-

tive work. Indeed, the paint seems to have been applied in rapid strokes, and the newsprint beneath the black lines is often left exposed.[87]

Jürgen Glaesemer speaks of "Klee's vision of art as a metaphor of the Creation [that] led him to the description of chaos and cosmos," with art standing at the point where chaos and cosmos meet, at the instant of their metamorphosis.[88] In *Young Moe*, forms and figures are not clearly defined; they are fragmentary and give the appearance of being shown at the very moment when they were either shattered by a powerful force or were approaching their full figuration. The artist's ultimate intention is left open.

In his late work, Klee found not only a formal balance but an integration of painterly and graphic elements as well; furthermore, he placed all artistic devices at the service of expression. The black, "written" signs, while conveying their linguistic meaning, also serve the composition. They define the color fields or use them as the surface that carries a message—an interrelationship of figure and ground, of message and embellishment, reminiscent of ancient folios of the East or of medieval manuscripts.[89]

EDP

FRANZ MARC (1880-1916)

One of the founding members of the Blaue Reiter group, Franz Marc brought to German modernism a blend of fauve color and cubist form, which he imbued with a highly personal mysticism expressed through animal imagery. Marc was born in Munich February 8, 1880, and at age twenty he abandoned his studies in theology and philosophy to pursue a career in art at the Munich Academy (1900 to 1903). After extensive travel to France, Italy, and Greece, he settled in Sindelsdorf, Upper Bavaria, in 1909. Two years later Marc briefly joined his friend Wassily Kandinsky as a member of the Neue Künstlervereinigung München (New Artists' Association, Munich). However, both artists resigned that same year and began planning the 1911 Blaue Reiter exhibition and the subsequent publication, in 1912, of the *Blaue Reiter Almanac*. That year, Marc had his first solo exhibition at the Berlin Galerie Der Sturm and later visited Robert Delaunay in Paris together with his friend August Macke. Marc's promising career ended abruptly when he volunteered for military service at the outset of the First World War; he was killed at Verdun March 4, 1916. The museum owns one painting.

165

Deer in the Forest I, 1913

Rehe im Walde I

The Deer

Oil on canvas, 39¾ × 41¼ (100.9 × 104.7)

Signed in black paint, l.r.: *M*

Gift from the estate of Katherine S. Dreier, 1953.

Acc. no. 1259 (Lankheit no. 198)

The artist's widow; lent to the Société Anonyme 1926; purchased 1927 by Katherine S. Dreier for her private collection; gift from the Dreier estate 1953.[1]

Deer in the Forest I was created at the pinnacle of Marc's tragically short career and is a masterful fusion of apparent contrasts: visions of the real and the symbolic; portents of doom and promise of redemption. By 1913 Marc had reached his mature style, painting heroic yet simplified images of animals, which he created as symbols for certain human characteristics and moral qualities.[2] He combined a fluid, symbolist-derived line with vivid colors—glowing red, blue, yellow, placed alongside their complementaries—for, like his friend Kandinsky, he believed that colors were endowed with spiritual qualities and symbolic meaning.

Gradually Marc turned to abstraction, retaining some aspects of cubism and futurism but responding more deeply to the art of Delaunay, whom he had met in 1912. Accordingly, he subsumed subject, detail, and background into an overall prismatic pattern of glowing colors. These unified compositions gave Marc's paintings added expressive power and also offered a concrete equivalent of his pantheistic belief in the unity of all creation. Both in color and form he endeavored to express his conviction that a spiritual reality lies beyond the visible world.[3]

Deer, alone or in a wooded setting, were a subject Marc first addressed around 1907. As metaphors for innocence, vulnerability, and gentleness, they became a central theme, almost an image of self.[4] In his paintings, Marc wished to express the deer's capacity for emotion, stating: "I can paint a picture: 'The Deer,' . . . However, I may also wish to paint a picture 'The Deer Feels.' How infinitely more delicate the artist's sensibilities must be to paint that!"[5]

Deer in the Forest I, seen by Mark Rosenthal as "a summation of the deer theme," combines representational and symbolic imagery that is unified through color and abstract forms.[6] Five peacefully resting animals are nestled into (and almost become part of) the ground. They are incorporated into a network of curves and diagonals that, while "uniting animal to landscape, diminishes the heroism of the animal subject" found in earlier works.[7] All trees except the one at the left are frail and painted white, thus signifying their otherworldly existence. The tree at the center, especially, with its single large leaf and a greenish-white oval in the shape of the earth radiating from behind, may well represent Goethe's *Urpflanze,* the archetypal plant that is a symbol of growth and figuration.[8] Its branches are interwoven with white swirling lines, almost arabesques, that suggest force lines, a spiritual presence, or perhaps the breeze that brings the bird, itself often depicted as a divine messenger.[9] By contrast, a green stump at the bottom right contains the movement and anchors the foreground into the darkness below.

Two sources of light heighten the sense of a meeting between natural and spiritual beings: one, originating in the lower left, washes the deer in a warm glow that underscores their physicality; the other, an icy radiance emanating from behind the central tree, illuminates the upper region. The duality of the natural and the symbolic is apparent throughout, and although in Ron Glowen's words the scene stresses "the 'virginal' innocence of the deer," the scene evokes an ominous mood:[10] pointed patches of red, yellow, and black waft between the trees like flames and smoke, closing off the view. They are encircled by areas of calm blues and whites that echo the head and wings of the bird. All other colors reappear throughout the prismatic composition.

The contrast between the threatening background and the serenity of the deer is in keeping with other works created in 1913, when Marc's animal imagery increasingly dealt with visions of destruction and rebirth.[11] *Deer in the Forest I* shares the image of the tree stump and the motif of five deer with another major work of 1913, *Fate of the Animals.*[12] The latter is based in part on a Norse myth according to which only the giant world tree, Yggdrasill, and a group of deer survive apocalyptic disaster.

Interwoven with this imagery is another theme that greatly moved Marc at the time: Gustave Flaubert's *La Légende de St. Julien l'hospitalier,* the story of a young nobleman who, in a hunting frenzy, kills a magic deer. At the moment of death, the deer predicts that the young man will murder his own parents.[13] Eventually, Julian finds redemption for this deed through suffering, compassion, and love. *Deer in the Forest I* might well illustrate the setting of this slaughter described by Flaubert: "Night was drawing on and behind the forest, through the spaces in the branches, the sky showed red like a sheet of blood."[14] Flaubert further describes a falcon, "as white as snow," the messenger of death; the sky is "almost black," and later on, "milder air had melted the hoar frost, trails of mist were swirling around."[15] Whereas Flaubert's legend stresses the bloody path to inevitable doom, *Deer in the Forest I* is more ambiguous, suggesting either the calm before the apocalypse or the renewal thereafter. Perhaps Marc saw death as a path to a spiritual life free of suffering.

Convinced that Marc should become known in America, Katherine Dreier asked her friend Heinrich Campendonk to approach the artist's widow about a purchase.[16] However, it was not until the Société Anonyme's landmark exhibition at the Brooklyn Museum in 1926 that a loan could be arranged. Although the exhibition presented works by living artists only, *Deer in the Forest I* was included as a memorial to Marc and as an expression of Dreier's deep respect for the mystical nature of his art. Duncan Phillips, by contrast, frequently hung it with works by de Staël, Knaths, and Avery, stressing the formal aspects of the painting.[17]

EDP

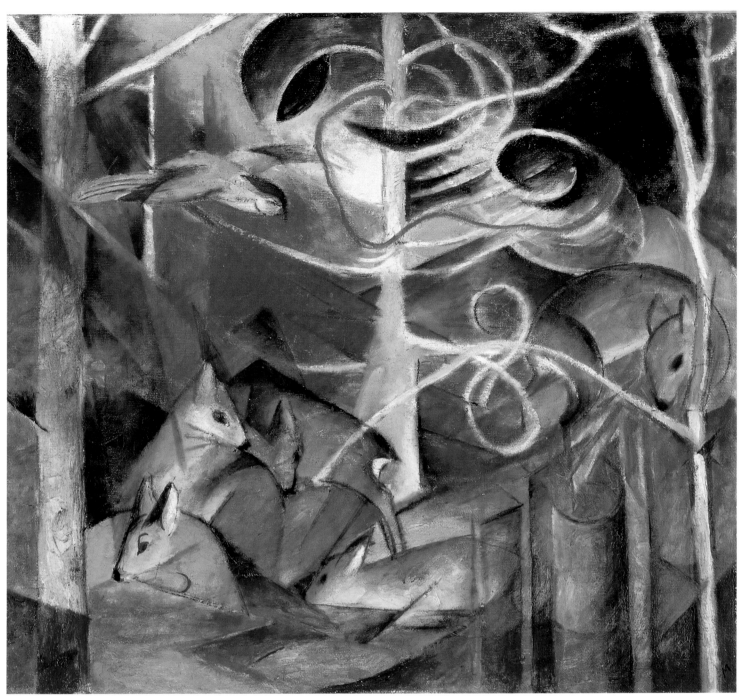

165

OSKAR KOKOSCHKA (1886–1980)

Born March 1, 1886, in rural Pöchlarn, Austria, Oskar Kokoschka received his training in the rich cultural environment of turn-of-the-century Vienna. Equally gifted as a writer, dramatist, and painter, Kokoschka burst onto the scene as an artistic enfant terrible in 1908, encouraged by the architect Adolf Loos, the composer Arnold Schönberg, and the writer Karl Kraus. By 1910 he was working for the radical journal *Der Sturm* in Berlin and had his first major exhibition in Vienna the following year. After recovering from severe wounds suffered during the First World War, Kokoschka taught at the Dresden Academy from 1917 to 1924. He spent the following decade traveling extensively, producing landscapes and city views that became the source of his renown. In 1934 Kokoschka moved to Prague, but in 1938, when his works were termed "degenerate" by the Nazis and confiscated from German public collections, he and his wife, Olda, fled to London, where he fought against fascism. His first American retrospective in 1948 was shown at The Phillips Gallery (he visited Washington on that occasion, thus initiating a long friendship with Duncan Phillips). In later years, Kokoschka was widely honored and revered as a teacher and artist. He died in Montreux, Switzerland, February 22, 1980. Two portraits, four key landscapes, and two series of lithographs comprise the Kokoschka unit at The Phillips Collection, making it one of the most comprehensive surveys of the artist's work in the United States.

The Kokoschka Unit

As was the case with Bonnard, Matisse, and numerous American artists, Kokoschka probably came to Duncan Phillips's attention at one of the Carnegie International exhibitions, which regularly included the artist's work from 1925 on. Kokoschka became widely known through the 1931 exhibition at the Museum of Modern Art, "German Painting and Sculpture," an effort of expatriate Europeans who brought with them the works by artists the Nazis had called "degenerate." Among them was the art dealer Curt Valentin, whose Buchholz Gallery introduced Kokoschka in 1938, the same year that Phillips purchased his first painting, *Prague: View from the Moldau Pier IV*, ca. 1936 (cat. no. 169). Two more acquisitions followed in 1941—the diaphanous and moving *Portrait of Lotte Franzos*, 1909, and the robust Alpine scene, *Courmayeur et les Dents des Géants*, 1927 (cat. nos. 166 and 167). Phillips broadened his holdings with the 1944 purchase of *Lac d'Annecy II*, 1930, and completed the unit in 1949 with *Lyon*, 1927 (cat.

no. 168), as well as a late portrait, *Cardinal dalla Costa*, 1948.[1]

Phillips never deaccessioned or traded paintings by Kokoschka, calling him "one of our favorite artists of the twentieth century."[2] Aside from the obvious delight he derived from the powerful colors, spirited brushwork, and impressionist echoes, Phillips considered Kokoschka the quintessential expressionist. Kokoschka himself rejected comparisons with impressionism, claiming that his was a personal, emotional response to experience. To Phillips, Kokoschka must have appeared every inch the creative individual who follows his inner voice in the face of opposition—a romantic notion that was probably at the heart of the friendship between artist and collector.

Phillips's turn toward expressionism in the course of the 1930s may have been reinforced by Sheldon Cheney, who traced its lineage from El Greco to Cézanne and Kokoschka, proclaiming that this return to "emotional expressiveness [was] a fundamental" of modern life. Herbert Read later echoed this view when he wrote in 1947, "There is no artist of the present time so near El Greco as Kokoschka."[3] These comparisons made Kokoschka a vivid example of "modern art and its sources," and Phillips eventually placed Kokoschka among "our heroes of the evolutionary progress of art."[4]

After the Second World War, Phillips wrote to Kokoschka, "We are looking forward with the most fervent interest and eagerness to an American exhibition of your paintings in our Gallery. As you may have heard from Dr. Hans Tietze, or Mr. Knize, it had been our intention to exhibit the Kokoschkas now in this country during the spring of 1947."[5] This exhibition did not take place, but Phillips participated in the 1948 tour of the large retrospective organized by James Plaut of Boston's Institute for Contemporary Art. Inspired by the tour's success, Kokoschka decided to visit Washington. Later Phillips wrote to Olda Kokoschka that during a tour of the show, Kokoschka had charmed the visitors "with his magnetic personality and his outgiving warmth of spirit." He continued that he had recently visited Kokoschka's watercolor exhibition in New York accompanied by John Marin and noted: "Alfred Barr had just been there. . . . I was told that he too was enthusiastic."[6]

Subsequent correspondence between 1949 and 1952 centers on a possible commission to paint a city view of Washington. At one point Kokoschka even suggested a family portrait, a project Phillips rejected, writing that "physically and temperamentally I am a terrible subject for a portrait painter."[7] Finally, in 1952, Kokoschka

sent Phillips a translation of his article, "Edvard Munch's Expressionism," a polemic against nonobjective art and in support of the expressive power of Munch's vision, which Kokoschka defined as "experience . . . a momentary fusion of this world and the beyond." The typed manuscript is inscribed with an almost conspiratorial, handwritten message suggesting Kokoschka's belief that expressionism lacked acceptance by critics and scholars: "To Marjorie and Duncan. This essay cannot be published because it is in support of our desire to recognize and make understood to others the black magic of our times in its working, practices and doctrines[/]most cordially yours OKokoschka, Washington 1952."[8]

Phillips and Kokoschka shared a belief in the artist as a visionary. As early as 1931 Phillips had written: "Now art, with its myriad marvels of diversity in talent and spirit should be the means of raising the banner of individualism . . . art is not authentic unless it is also an expressive creation and consequently an intimate personal message."[9]

EDP

166

Portrait of Lotte Franzos, 1909

Frau Lotte Franzos
Oil on canvas, 45¼ × 31¼ (114.9 × 79.5)
Signed in blue and brown paint, l.r.: *OK*
Acc. no. 1062 (Wingler no. 11; Winkler-Schröder no. 34)

Elisabeth Lotte Franzos, Vienna and Washington, D.C.; PMG purchase through Buchholz Gallery, New York, 1941.[10]

Graceful, brittle, and ultimately disturbing, *Portrait of Lotte Franzos* is an early example of Kokoschka's portraits. It reveals as much about the subject as it does about the painter, particularly his ardent, at times painful, relationship with women. The portrait's melancholy elegance and veiled eroticism betray the artist's debt to his mentor, Gustav Klimt. However, the psychological directness, bright colors, and incised lines emanating from the figure exhibit Kokoschka's struggle for forms of expression that reached beyond Klimt's mannered style. Kokoschka would later recall that this portrait led to new pictorial conceptions and to a departure from impressionism: "The Impressionists wouldn't have been able to do such a thing. They have an altogether different idea of light. . . . Here it is sensibility on which light impinges; it's a spiritual light."[11]

The figure is rendered in nervous contour and set in indeterminate space that denies it sta-

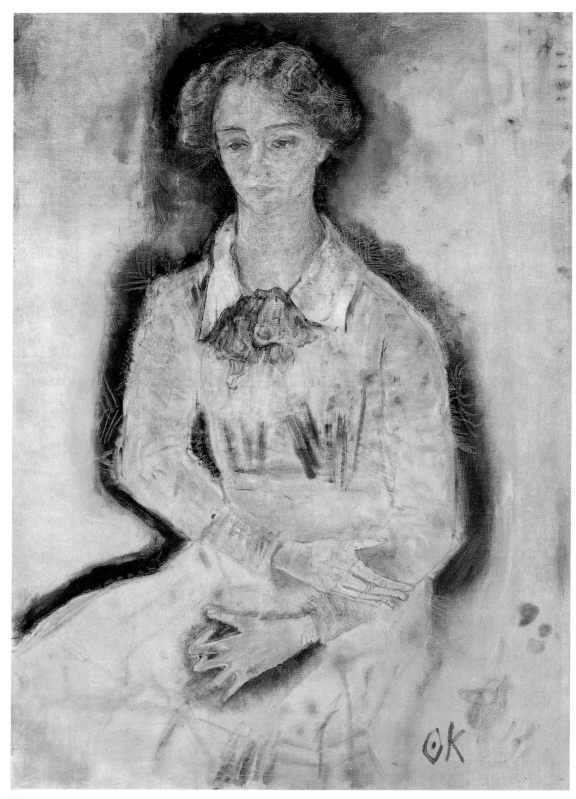

166

bility and physicality, thus heightening the sitter's frail appearance. Modeling is limited to the face. Kokoschka set the figure into a diaphanous field of pure blues, reds, and muted yellow-ochers and left large areas of the picture's gray-white ground exposed. The radiant colors, reminiscent of the fauves, also recall folk paintings of the Madonna, an Alpine tradition Kokoschka had employed but recently abandoned. The colors radiate from the figure, giving it a spiritual quality; Duncan Phillips described the effect as an "aura" upon which the "drawing stands . . . with clarity and power."[12]

The portrait's overall delicacy is disturbed by several unsettling details. Sharply incised lines (vigorously scraped with a pointed instrument) radiate like power fields from the sitter's body.[13] The tension is heightened by the sitter's cramped hands, which are crossed over her lap in a nervous and abrupt gesture adopted from Klimt. Christof Asendorf calls it an indecisive impulse, almost a convention, born of fin-de-siècle refinement.[14]

Lotte Franzos (1881–1957), the wife of a prominent attorney, was known for her progressive intellect and unusual reserve.[15] She probably commissioned her portrait in order to support the young painter, whose art, poetry, and bohemian behavior had sorely tested the patience of the Viennese bourgeoisie. Kokoschka completed the painting in late autumn 1909 before accompanying Adolf Loos to Switzerland.[16] He deeply admired, perhaps loved, his patron, for he would later recall: "I painted her like a candle flame: yellow and transparent light blue inside, and all about, outside, an aura of vivid dark blue. . . . She was all gentleness, loving kindness, understanding."[17] Franzos, however, must have expressed her displeasure, because Kokoschka wrote: "Your portrait shocked you; I saw that. Do you think that the human being stops at the neck in the effect it has on me? Hair, hands, dress, movements are all at least equally important. Please take what I say really seriously. . . . I do not paint anatomical preparations, otherwise I take it back and burn it. . . . I am very angry."[18] It is not known whether changes were made, but later correspondence and two charcoal sketches attest to continued contact. The artist's feelings for his sitter are best expressed in three designs for Franzos's *Ex libris,* ca. 1910, showing him as a mourning Orpheus accompanied by an angel and symbols of love and death.[19]

The story of Kokoschka and Lotte Franzos has a wistful postscript. Exiled from Nazi Austria, both the sitter and her portrait found a haven in Washington, D.C., where Franzos lived from 1934 until her death in 1957. On the occasion of Kokoschka's visit to the museum in 1949, Franzos's physician urged the artist to visit her;

167

she was unable to leave her hospital bed but longed to see him because "they were such close friends for years."[20]

EDP

167

Courmayeur et les Dents des Géants, 1927

Oil on canvas, 35½ × 52 (90.2 × 132.1)
Signed l.r.: *OK*
Acc. no. 1059 (Wingler no. 229; Winkler-Schröder no. 240)

Marczell von Nemes, Munich, until 1930; date of sale to Buchholz Gallery, New York, unknown; PMG purchase 1941.[21]

168

Lyon, 1927

Oil on canvas, 38½ × 51⅜ (97.8 × 130.5)
Signed l.l.: *OK*
Acc. no. 1061 (Wingler no. 232; Winkler-Schröder no. 243)

Paul Cassirer Gallery, Berlin; sold to private collector, California, 1927; TPG purchase 1949.[22]

In 1927, buoyed by recent successes, Kokoschka embarked on one of his many journeys to paint European cities and picturesque sites. Helmut Lütjens, the Amsterdam representative of Kokoschka's late dealer, Paul Cassirer, accompanied the artist and gathered the paintings created en route. According to Kokoschka's letters, *Courmayeur et les Dents des Géants* is the trip's third

work, while *Lyon* was the sixth; the former was painted between October 16 and 22, and the latter completed during the first days of December.[23]

Exhilarated by the scenery of Courmayeur, a village nestled against the Italian side of the Mont Blanc range, Kokoschka roamed the area, returning in the afternoons to paint on the balcony of his hotel room. He wrote to his mother that Mont Blanc seemed "almost close enough to be touched."[24] Indeed, the painting is rare among Kokoschka's landscapes in that the wall of mountains creates a very high horizon, and the pictorial space is densely compacted by the mountain peaks looming toward the viewer. Nonetheless, a sense of depth is established by the village in the foreground; it is the picture's focal point in keeping with the tradition of Alpine landscape painting. Working with paints that were thinned to near watercolor consistency to allow a fluid technique, Kokoschka painted large areas of sparkling blue-greens and whites, heightening and defining them with a network of swift strokes of heavier paint that remain somewhat independent of their descriptive function and yet provide compositional structure. Hans Wingler believed that "there can be no question of a conflict between the pictorial and graphic elements in the method of painting then adopted," but he asserted that over the years "the two techniques [became] fused together."[25]

With *Lyon,* Kokoschka returned to an earlier compositional scheme: the setting of a city by a

168

curving river with flocks of birds circling over-head.[26] Here he successfully integrated these ele-ments into a harmonious vision. The river Saône, with the old section of the city at its banks, sweeps around the hill crowned by Notre-Dame Fourvière. The river flows toward the south, into the picture's depth, where it will meet the Rhône, here suggested in a distant haze. The hill creates a strong diagonal axis, and the soaring birds balance the composition.

In conscious opposition to the work of the fauves and Matisse, Kokoschka affirmed his commitment to pictorial space and sweeping vis-tas. In 1950 he wrote about these efforts to Hans Wingler: "I, on the other hand, could never think in terms other than spatial . . . and in the Lyon picture I was able to arrive at an axial system which became characteristic of the new land-scapes." Kokoschka called this system a "two-focus perspective," comparing it to the focal

points of an ellipse. It allowed him to represent vistas that trail off into the distance toward two points, adding a sense of energy and movement that, in his view, reflected the motion of the uni-verse. In the same letter he stressed that this spherical system and its cosmic allusions were also expressive of his world view.[27] Edwin Lach-nit, discussing this painting, wrote that "the city appears not as an individualized topographical view, or *veduta*, but as an ideal macrocosm anal-ogous to the 'cosmic landscapes' of the sixteenth century," and he compares it to Albrecht Altdor-fer's *The Battle of Issus*, 1529, a painting that Kokoschka mentioned in his writings.[28]

Kokoschka painted the scene from an unheated attic of a house on a hill. However, the scene he saw must have differed from the one he painted, for he wrote to his family: "I am paint-ing a fine panorama picture of Lyon and [its] river, and up above are flying sea gulls . . . thick

fog for weeks and a fine rain."[29] Hence, both the glowing sky and the network of bright colors that suggests sunlight glistening on old struc-tures reflect the artist's aim to create a scene woven out of mood and personal response. Lüt-jens describes the daily, hard-fought progress on the picture: "First the general concept with short, vertical dabs of paint . . . once it appeared to be all Cézanne, the next day there was no resemblance left whatsoever; once the windows were placed precisely in the facades, the other time they were hardly recognizable. He was like a sculptor who daily checks and feels his work anew in its totality."[30]

Lyon was one of Duncan Phillips's favorite works by Kokoschka. Upon first seeing it in the 1948 retrospective, he wrote to James Plaut: "If, as you think probable, the painting is for sale, I should leave no stone unturned in my genuine desire to acquire it for the Phillips Collection."[31]

EDP

169

Prague: View from the Moldau Pier IV, 1936

Prag, Blick vom Moldauufer auf die Kleinseite und den Hradschin IV

Castle from the River, Prague

Oil on canvas, 38⅜ × 51⅜ (98.1 × 130.5)

Signed in brown paint, l.r.: *OK*

Acc. no. 1063 (Wingler no. 303; Winkler-Schröder no. 326)

Lida Palkovska, Prague; PMG purchase (from Carnegie International, Pittsburgh), 1938.[32]

169

No city other than Prague held Kokoschka's prolonged attention or was more lovingly depicted in all its splendor. For centuries it had been an intellectual center where, in the artist's words, "for the last time all Europe could meet."[33] In 1934 he moved to Prague, home of his father's family, to escape the Nazi threat. There, he married, became a citizen, and remained until 1938, when he and his wife, Olda, were forced to take refuge in England.

The crowning achievements of Kokoschka's stay in Prague were two series of views, meditations on the ancient city and its culture, created between 1935 and 1937. The first group of seven paintings depicts Prague from a variety of sites as Kokoschka explored the city. *Prague: View from the Moldau Pier IV* is part of the second series of eight works, begun after the artist had moved to his studio in a turret of Bellevue House, on the bank of the Moldau River. All represent the same vistas with slight variations to the right or left. Although Kokoschka did not record their sequence, Jan Tomeš established their lineage based on "the successive liberation of the signature, shifts in color values and the progressively free handling of the theme," calling this painting "unquestionably the finest picture in the second series."[34]

Driven perhaps by a sense of impending war, Kokoschka created broad city views bathed in a shimmering pastel glow and executed with a sure, lively touch, as though he wished to create a lasting memorial to the beloved city. Spread before the viewer are the Vltava River (the Moldau), the Charles Bridge, the Castle Hill with Saint Vitus Cathedral, and the old town, seen across the expanse of rushing water. Edith Hoffmann wrote of these paintings: "He had always moulded and kneaded the buildings under his brush, and in Prague every wall seems to be alive, every cupola to expand before the beholder's eye, every spire to rise like a flame."[35] As in *Lyon,* the flow of the river and a curving perspective animate the scene and cause the eye to retrace the view along the embankment. A weir slashes across the river forming a diagonal axis. Rapid brushwork defines the setting, and color is built up in dense, repetitive strokes out of which rise focal points such as the castle, the

bridge, and the cluster of vegetation on the left. There is evidence of graphite and charcoal underdrawing throughout; pastel might have been used to lay out the areas of color, as underdrawing, and to define compositional elements. The ground shows through in several areas, and many passages suggest that the paint was applied with a dry brush.[36] Kokoschka may have been referring to this work when he wrote in a letter: "I've already started painting a large-scale work; I hope I'm lucky with the weather so that it will be finished really soon. I'm making it purely picturesque, not topographic, and now there is a bluish-French air here by the river."[37]

The castle, ancient seat of kings, had special meaning for Kokoschka. At the time of his stay it was occupied by the first president of the Czechoslovak Republic, Thomas G. Masaryk. Kokoschka had painted his portrait just before beginning the second series of Prague views, and the two men shared a deep love of the seventeenth-century humanist and educator Johann

Amos Comenius (1592–1670), whose name Kokoschka invoked in his writings against political and intellectual totalitarianism.[38] Thus, for Kokoschka the Prague series extended beyond an artistic record of a place into an affirmation of history and intellectual life whose very existence was in danger. Writing from London in 1938, he reported to Homer Saint-Gaudens at the Carnegie Institute that he "had to fly, naked as I was born, otherwise concentration camps would have been my reward for sticking to the ideals of my beloved Masaryk which [*sic*] busts and monuments are already overturned and destroyed alike as his ideas are branded now in this country."[39]

Lida Palkovska lent *Prague: View from the Moldau Pier IV* to the 1938 Carnegie International, where Duncan Phillips saw it and sought to purchase it. She consented and ordered the proceeds sent to London, in order to help Kokoschka and his wife gain a foothold in England.

EDP

KURT SCHWITTERS (1887–1948)

An artist of staggering versatility and productivity, Kurt Schwitters celebrated in his art the seemingly meaningless fragment and random object. Out of paper and found objects he created a totality composed of the real and the imagined, as though the artist's mind were the unifying principle and the process of choice the true work of art. Born in Hannover, Germany, June 20, 1887, Schwitters attended the Dresden Academy (1909–14), briefly studied architecture, and worked in industrial design while developing his skills as an artist. In the late teens he turned from expressionist painting and rhymed poems to dadaist collage and sound poetry, both employed to gently mock bourgeois notions of beauty and propriety in art. In 1919 he published the *Merz*-poem *An Anna Blume* and soon began using the word *Merz* to signify the entire range of his artistic endeavors. Schwitters created his own version of dada art and poetry while the Berlin dada groups placed their efforts at the service of political engagement and revolution. Schwitters was a loyal member of Berlin's progressive and internationalist Galerie Der Sturm from 1918 on and remained friends with the Zurich dadaists, Dutch De Stijl artists, and Russian constructivists alike. He reflected their new ideas on art in his *Merz* magazine from 1923 to 1932. The Nazi regime forced him to leave Hannover, and he moved to Norway (1937) and later to England (1940). At each station of his exile, he built a new version of the *Merzbau,* a sculptural environment begun in his home in 1920. Only the British structure remains—but as a fragment, since work was interrupted by Schwitters's death January 8, 1948. Schwitters is represented in the collection by two early collages and two late works from his sojourns in Norway and England.

170

170

Radiating World (Merzbild 31B), 1920

Strahlen Welt

Strahlende Welt

Oil and paper collage on cardboard, 37½ × 26¼ (95.2 × 67.9)

Signed and dated l.l.: *KS 20;* reverse: inscribed in blue crayon, u.l. and u.r.: *K Schwitters/Strahlen Welt/Merzbild 31B/Juli 1920*

Gift from the estate of Katherine S. Dreier, 1953. Acc. no. 1722

Purchased 1926 from the artist through Galerie Der Sturm, Berlin; Dreier's private collection; gift from the Dreier estate 1953.[1]

Radiating World (Merzbild 31B) may well be an icon of the dada movement that flourished in Hannover around 1920 chiefly through the efforts of Kurt Schwitters. Not only does the collage declare its dada content through fragmentation, enigma, and inclusion of the printed word, but the very reason for its having been created can be considered a manifesto of the artist's beliefs.

Schwitters, who began his career as an expressionist painter and poet, turned to the Zurich dada movement around 1918. He responded to the irrationality, irony, and chance of dada, recognizing it as a revolutionary symbol of a postwar world shattered beyond reason and meaning. He coined the nonsense-word *Merz* to set his own work apart because his creative impulse was at odds with the iconoclasm advocated by the members of Berlin dada.[2] In 1924 he felt compelled to state: "I am not a Dadaist," and yet he called dada a fancy game, an amusement. Seen in this light, he was a dadaist, but one who foresaw that its old form (he called it "Dáda") had served to eradicate expressionism, whereas the new form ("Dadá") would serve constructivism and abstraction.[3]

As he abandoned expressionism, Schwitters turned from painting to collage, perhaps in response to Picasso, Braque, and Gris, or following the lead of the Italian futurists, who were frequently exhibited at Galerie Der Sturm in Berlin and had incorporated newsprint into their collages.[4] In stark contrast to his performances, where he chanted sound poems before shocked audiences, the making of a collage was a meditative, introverted activity for Schwitters. He assembled candy wrappers, tickets, and

scraps ripped from magazine pages—fragments rich in allusion and memory—and gave them new expressive power within the context of the work of art. The very process of selection made the meaningless meaningful.

Radiating World (Merzbild 31B) may be the last in a series of large early collages.[5] The German title, *Strahlen Welt,* translates more meaningfully as "World of Rays," implying cosmic bodies, modern physics, or machine-age imagery that Schwitters explored repeatedly in 1919 and 1920. His poem "Das Kreisen," written around the same time, takes up this subject and reads in part:

> Worlds hurl space.
> Thou hurlest worlds space.
> Worlds turn the new machine to thee.[6]

These themes may reflect both a postwar anxiety—a doom of cosmic proportions—and a fascination with the astounding scientific discoveries related to matter and energy that were opening up a new view of the universe.[7]

Schwitters first explored the compositional structure of *Radiating World* in a painting of 1919, *Hochgebirgsfriedhof,* an image of death and sorrow executed in explosive blood-red, fire-yellow, and black, and showing him as heir to Kandinsky and Marc.[8] In the oil, a circular form, the sun, floats in indeterminate space, and forceful rays point to the radiant center, a grave. This basic composition reappears in *Radiating World;* however, while the painting breathed pathos and personal experience, the collage turns the motif into a dada play on words: a circular globe hurls through space and various triangular shapes point into depth; exposed patches of newsprint are painted in black with cubist shadings, their haphazard jumble resembling yesterday's revolutionary poster on a Berlin wall. A chocolate wrapper and bits of wallpaper evoke the stifling delights of the bourgeoisie; numbers, tickets, and ads recall trolley rides, bureaucratic edicts, and commerce—it is a potent mix hurled into the air like confetti in a storm.

The year 1920 was crucial for Schwitters, marking his turn to abstraction—indeed, toward purely artistic concerns. He had arrived at the belief that "art is a primordial concept, exalted as the godhead, inexplicable as life itself, without definition and purpose," and he concluded that "*Merz* out of principle aims only for art."[9] The Berlin dadaists rejected these aims and turned away from Galerie Der Sturm and its journal, *Der Sturm.* They promptly refused Schwitters membership in their "Club Dada," even excluding him from their great get-

together, the so-called "Dada Conference" in Berlin, which ran from June 30 to August 25, 1920. *Radiating World* was created in July and may represent Schwitters's quietly humorous commentary on the state of Berlin dada in 1920. The triangular ray of light points to the number 825—a fragmentary postal code on a package addressed to Schwitters. To the right are the stamped, smudged words "MOUVEMENT DADA," to the left "Wertpaket" (package of high value) and "dankend erhalten" (received with thanks). In his references to dada and to Berlin, and in his compositional evocation of futurism, Schwitters quite obviously turned his back on the highly politicized dada conference and aligned himself instead with the artists of Galerie Der Sturm.

Schwitters did find a receptive audience in the circle of Katherine Dreier. Under the influence of Duchamp, and briefly Man Ray, the Société Anonyme had become a dada outpost in New York. Dreier first exhibited Schwitters in November 1920 and became the artist's lifelong friend and supporter. She especially treasured *Radiating World.* In 1921 she entered the fray between Galerie Der Sturm, members of Berlin dada, and Schwitters's position between the two. In an exhibition flyer she wrote: "The Dadas have come to town!! kurt schwitters acclaimed by the dadaists as one of their very own is the first dadaist to reach new york. DER STURM REFUSES TO CALL HIM A DADA!!" Dreier planned a one-person exhibition in 1925, which was not to be realized until 1948, when the artist's death tragically turned the retrospective into a memorial show.

EDP

171

Merz Collage—"Tell," ca. 1919–22

Watercolor and paper collage on heavy paper, 9⅝ × 6¾ (24.5 × 17.1)
Signed on mount, l.l.: *Kurt Schwitters*
Gift from the estate of Katherine S. Dreier, 1953
Acc. no. 1720

The artist to Katherine S. Dreier 1926 or 1930; gift from the Dreier estate 1953.[10]

Merz Collage—"Tell" is among the most rigidly constructed collages of Schwitters's early career, reflecting the influence of cubism, the abstract compositions of his friend Jean Arp, and Russian constructivism.[11] However, since Schwitters repeated certain formal principles at various stages of his career, the dating of this work is difficult. The absence of a *Merz* inscription suggests that *Tell* was created before 1919, when

Schwitters invented the term *Merz* and began numbering his collages, but stylistically *Tell* recalls the years around 1922, when the artist was closely connected with constructivist circles in Berlin, "a vast railroad station with refugees from Russia and Eastern Europe and visitors from the Low Countries."[12] Around 1922, too, Schwitters's friendship and close working relationship with the Russian El Lissitzky and the Dutch artist Theo Van Doesburg, cofounder of *De Stijl,* were well established.[13] By 1926, however, Schwitters had turned away from a strict constructivist vocabulary and developed what he called "the new, straightforward approach"; that year could, therefore, be considered the terminal date for works such as *Tell.*[14]

In this collage, Schwitters used the constructivists' preferred colors—red, black, and beige. He combined two vertical columns of paper, painted a glowing royal blue, with a fragment of a trolley ticket, and an aqua-colored snippet with the Gothic letters *Tell=Sch.* However, within this organized composition, in which all pieces of paper are neatly cut, he also created a "disturbance": the few horizontal elements at the bottom barely support the teetering verticals, which are pushed out of balance by a pointed shape emerging from the lower left. This motion toward the diagonal recalls constructivist conventions, though here infused with Schwitters's freewheeling humor, the imbalance calling forth a chaotic world at the brink of disaster.

The mass-produced printed word was an important part of Schwitters's collages, used at times to inject into his works some oblique autobiographical or political statements. Although the word fragment *Tell=Sch* brings to mind Wilhelm Tell, the father of Swiss independence, it derived from one of the artist's passions: chocolate (Tell-Schokolade was a brand name). Schwitters created numerous collages that include chocolate wrappers and circular candy papers, and the fragment *Tell=Sch* may well be the other half of *okolade,* which appears in the 1926 collage *Mz 26,41. okola.*[15] It would be tempting to date *Tell* from this fragment used in a dated work, were it not for the fact that Schwitters tended to save scraps of paper for later use.[16]

The surface of the collage shows traces of the thick paste applied during its creation. This residue calls attention to the physical act of pasting, which for Schwitters was an emotional reaction to experiences or events, as suggested in a letter to Dreier: "There was great joy when your telegram arrived from New York. . . . I pasted large pictures and feasted especially on sculptures."[17]

EDP

171

HEINRICH CAMPENDONK (1889–1957)

Born in Krefeld, Germany, November 3, 1889, Heinrich Campendonk studied with the Dutch artist Jan Thorn-Prikker before moving to Sindelsdorf, Bavaria, in 1911. There Campendonk was invited by Marc and Kandinsky to join the Blaue Reiter artists group, collaborated on the *Blaue Reiter Almanac,* and participated in their first exhibition in Munich in 1911. He settled in Seeshaupt, Bavaria, in 1916 and six years later returned to Krefeld, where he taught art—even teaching color theory to workers at a silk factory—before becoming a professor at the Düsseldorf Academy. Gradually, Campendonk became involved in stage design, mural painting, stained glass, and graphic arts. Dismissed by the Nazis in 1933, Campendonk left Germany in 1934 and began to teach at the Academy of Fine Arts in Amsterdam the following year. He won the grand prize for a stained-glass window at the 1937 Paris World Exposition. In 1944 Katherine Dreier appointed him Kandinsky's successor as vice president of the Société Anonyme in New York, thus adding a formal working relationship to a friendship that had begun in 1920. Campendonk died in Amsterdam May 9, 1957. The collection owns one oil painting.

172

172

Village Street, ca. 1919

Ländliche Strasse
Village Street II
Oil on canvas, 19¾ × 26¾ (50.1 × 67.9)
Unsigned
Gift from the estate of Katherine S. Dreier, 1953
Acc. no. 0266 (Firmenich no. 917)

The artist until 1924; purchased by Katherine S. Dreier for her private collection, New York; gift from the estate 1953.[1]

Campendonk's art echoes his early experiences with the Blaue Reiter and Der Sturm groups, and he recalled the years of daily contact with Kandinsky and Marc as the most wonderful of his life.[2] As their neighbor in the village of Sindelsdorf, he was exposed to cubism and futurism, to the works of Rousseau and Delaunay, and to Russian as well as Bavarian folk art. However, while Marc's animal imagery expressed an apocalyptic world view and Kandinsky's pure abstractions sought to express the spiritual unity of all the arts, Campendonk remained content to be a teller of dreamlike tales.

In *Village Street,* Campendonk employed expressionist colors and simplified forms to weave a tapestry of arcadian memory and mysticism. The Bavarian church and the houses with their lean-to sheds, gates, and fences are ren-

dered in luminous colors—red, blue, brown—that rise out of dark, indeterminate space. Chalky gray-white highlights suggest reflected moonlight. Small pine trees jot out of the rooftops. The cows seem to float as though they were part of a dream where nature and its creatures have a magical life, far from human consciousness. In writing about this painting, Katherine Dreier referred to "a new conception of space, as of a deep, liquid medium, undefined and unbounded, a dark pool, the unique source of color and indeed of being."[3]

It is difficult to establish the painting's date, partly because of conflicting records, partly because of repetitions in Campendonk's subjects and titles. Dreier suggests Campendonk may have painted it around 1919, a creative high point and a period when several similar works were painted; it was also a time when the Blaue Reiter echoes may still have been vivid.[4]

In fact, *Village Street* is an homage to the aesthetic of the *Blaue Reiter Almanac,* with direct quotations taken from its illustrations, especially two Russian folk prints of village streets with herds roaming the open spaces and pine trees sprouting from the roofs.[5] In addition, Chagall's

humorous nostalgia for village life and his blithe disregard for academic rules of perspective and scale waft through *Village Street.*[6]

Several sections of the painting reveal the artist's attempts to flatten the perspective and organize his compositions according to cubist principles. Certain areas have heavy impasto and many layers of paint; others are barely covered, allowing the canvas weave to remain visible.[7] Pentimenti show alterations made in the course of the work: the spotted cow, now looking to the left, originally had a horned head facing the viewer; trouser legs and a pair of feet appear beneath that cow's tail; the front legs of the cow on the right also show signs of changes.[8]

Upon meeting Campendonk in Bavaria in 1920, Katherine Dreier suggested exhibiting his works together with those of Klee and Kandinsky and in 1921 suggested a one-person show.[9] Neither project materialized, but she exhibited his work repeatedly and made him a member of the Société Anonyme's board of directors in 1923. Campendonk, in turn, coordinated the shipment from Germany of much of the art for Dreier's large Brooklyn exhibition of 1926 and was her contact with Maria Marc and Kandinsky.[10]

EDP

GIORGIO MORANDI (1890–1964)

Giorgio Morandi, an introspective, independent native of Bologna, is best known for his refined and subdued still lifes of bottles and containers. Born July 20, 1890, Morandi studied at that city's Accademia di Belle Arti from 1907 to 1913 and first encountered works by modern French and Italian artists at the 1909 and 1910 Venice Biennales. Although never an active partisan of the futurist movement, Morandi attended the futurist exhibition in Florence in 1914; later that year he met Umberto Boccioni and Carlo Carrà in Bologna and exhibited cubist-derived works in the "First Free Futurist Exhibition" at Galleria Sprovieri, as well as in the second exhibition of the Secession, both in Rome. Also in 1914 he began teaching drawing and printmaking in the Bologna public schools, a position he held until 1929. Morandi met de Chirico in 1919 and was later featured with Carrà and de Chirico in the avant-garde arts review *Valori Plastici*. The same year, the Galleria Giosi in Rome held his first one-person exhibition, a great success. Beginning in the 1920s and continuing until the end of his career, he participated regularly in international exhibitions such as the Venice Biennale and Rome Quadrennial, receiving numerous awards. As renowned for his etchings as for his paintings, he was awarded the position of chair of intaglio at the Bologna academy in 1930, a post he held until his retirement in 1956. Morandi's first solo exhibition in the United States took place in 1955 at the Delius Gallery in New York. In 1956 he traveled to Switzerland for his exhibition at the Winterthur Kunstmuseum, his only trip outside of Italy. Morandi died in Bologna June 18, 1964. The Phillips Collection owns two late still lifes.

173

Still Life, 1953

Oil on canvas, 8 × 15⅞ (20.4 × 40.2)
Signed in thin ocher glaze, l.r.: *Morandi*
Acc. no. 1389 (Vitali no. 872)

TPG purchase from Curt Valentin Gallery, New York, 1954.[1]

Still life was the ideal subject for Morandi, whose primary concern was to achieve a measured balance of composition and tone. Throughout his career he repeated the same motif: arrangements of objects he had in his studio—boxes, bottles, cups, vases, candlesticks. In this *Still Life* he displayed the finesse and clarity for which he was renowned. Centered on the horizontal canvas are five tightly grouped objects: in the foreground, an upright brown-and-white striped box and two rectangular bottles laid on their sides, their bottoms facing the viewer. The bottles can be perceived alternatively as one cubic entity, their ocher and brown forms bound together, or as two blocks divided by the shadow between them. In the background, a shadowy blue cylindrical vase and a white ceramic bottle with a patterned surface complete the closely knit group.[2] The lack of a horizon line focuses our attention on the objects; the shadows accentuate their volume and suggest a tabletop. Although the painting's predominant colors are shades of brown and white, Morandi further unified and added dynamism to the tonality by mixing into the background paint the ocher and blue colors of the central motif. Far from being a sterile intellectual and visual exercise, *Still Life* generates the warmth of the artist's presence through its painterly brushstrokes, which activate and surround the objects.

Morandi spent hours, even days, arranging, studying, sketching, and carefully painting his clusters of commonplace objects, transforming them into timeless "totems of poetic truth."[3] He minimized outward detail in order to emphasize the volumetric presence of the objects in space and to highlight the intricate and subtle interrelationships of proportion, color, and light. According to Andrew Forge, "it is the *interlockingness* of what fills his eye that concerns him, not the separate wholeness" of the objects.[4]

In the course of his long, productive career, Morandi was influenced minimally by the contemporary Italian avant-garde. He had little interest in the dynamic forms of the futurists and experimented only briefly with the hallucinatory imagery of the metaphysical artists, such as Carrà and de Chirico.[5] A solitary man who seldom left his native Bologna, he claimed as his foremost influences Cézanne and Seurat, and the early Italian Renaissance artists Giotto, Piero della Francesca, and Uccello, all of whom stressed balance, architectural form, and tonal relationships.

Duncan Phillips was one of many American collectors who took an interest in Morandi during the mid-1950s. Alfred H. Barr Jr., and James Thrall Soby were responsible for heightening American viewers' awareness of him in the Museum of Modern Art's "Twentieth Century Italian Art" exhibition in 1949.[6] *Still Life* was Phillips's first Morandi purchase, in 1954; three years later he held a Morandi exhibition from which he acquired a slightly earlier oil.[7] Morandi's evocation of the poetic presence of objects through painstaking arrangement and subtle tones echoed the goals of many of Phillips's favorites: Chardin, Corot, Giorgione, and Vuillard among them. His paintings also revealed a sensitive artistic temperament coupled with firm individuality, qualities that Phillips greatly respected.

GHL

173

6 THE SPIRIT OF REVOLT AND THE BEGINNING OF AMERICAN MODERNISM

DAVID W. SCOTT

It may at first seem rash to ascribe "the beginning of American modernism" to a loosely knit group of men, now regarded as relatively conservative, who exhibited together several times early in this century. Duncan Phillips himself traced the "modern" spirit to Giorgione in Europe, and to such painters as Homer, Eakins, and Ryder in America. But the "men of the rebellion," as Phillips was to term The Eight, considered together with their followers and associates, stand for the dramatic rupture that ushered in a new age—not so much because of their use of new pictorial forms (though that played its part) as because of their revolt against the National Academy of American Design and its stifling canons of taste.

This chapter includes paintings by The Eight, several of their friends and students, and a few of their artist contemporaries who, though not associated with them, shared something of their spirit and concerns. The Eight, of course, was no more than a group of friends who came together for an exhibition that originated at the Macbeth Gallery in 1908 and then went on a brief tour. Four of them (William Glackens, George Luks, Everett Shinn, and John Sloan) had worked for newspapers in Philadelphia and found themselves, with their general mentor, Robert Henri, together in New York City in the first years of the twentieth century. There they formed friendships with three very different painters—Ernest Lawson, Arthur B. Davies, and Maurice Prendergast, a Bostonian who visited New York frequently. These men constituted The Eight. In their circle were students of Henri's—George Bellows, Rockwell Kent, and Guy Pène du Bois. Associated with them, in planning exhibitions after 1908, were Walt Kuhn and Jerome Myers. Convinced individualists, they were all united in the struggle to provide exhibition opportunities for "independent" artists. The other artists of this chapter—Gifford Beal, Paul Dougherty, Robert Spencer, and Augustus Vincent Tack—went separate ways, but like the "independents" they attracted Phillips as individualists.

By and large, the innovations of these men now seem mild enough, especially as compared with contemporary European developments, but in their day the more progressive of them raised the wrath of conservative critics, and they broke significant ground in the cause of personal expression. The intolerance of the juries of the National Academy, and the near monopoly the Academy held over exhibition opportuni-

John Sloan, detail of *Six O'Clock, Winter,* see cat. 201

ties, provided the initial impetus for a revolutionary movement aimed at creating broader, more liberal occasions for display. The milestones of this movement, after the 1908 Macbeth show, were the 1910 "Exhibition of Independent Artists," the 1913 Armory Show, and the formation of the Society of Independent Artists in 1917.[1]

These artists, as a group and individually, were attacked on such scores as vulgarity and lack of finish. Luks and Sloan, especially, introduced subjects that, though seeming benign today, challenged prevailing conventions of taste and led to the soubriquet "The Ashcan School." Their paintings explored the richness and breadth of the New York scene and paved the way for far-reaching developments in American realism. Prendergast, alone of the group, experimented radically in expressive technique before 1913, but even his freest work was not exhibited with the intent to shock. His aim, and that of his associates, was to create art of increased intensity, impact, and vigor. To paint and exhibit such work called for a new freedom, and when the art establishment tried to ostracize artists seeking new expressions, the more progressive of them revolted.

If we now find particular interest in the work of these men as incipient modernists, we might at first expect that this very aspect would be highlighted in their representation in the collection that Duncan Phillips was to call "a museum of modern art and its sources."[2] That term, however, was adopted only after his full conversion to modernism in the late twenties, and the majority of his purchases of paintings by artists of this group date from the late teens and early twenties, when his taste was hardly avant-garde. And yet, as we shall see, some of his acquisitions of this period reflect a broadening of sensibility and form a bridge to his eventual appreciation of the most advanced art of his epoch.

If the works considered in this chapter culminate in the acquisitions of the twenties, they also document the formative and transitional periods in Phillips's taste and go back to his very earliest purchases, reflecting his first steps as a collector. Duncan and his brother, James, with the financial support of their father, began to purchase paintings about 1910, and in 1916 they wrote Major Phillips requesting an annual stipend so that they could regularly invest in paintings. The early records are spotty, but Duncan Phillips recalled that his first purchase was of a Lawson and a Dougherty, the first of many by these artists bought in the next dozen years.[3] By 1914 he had met Myers and Tack, both of whom became subjects of his articles soon afterward. In 1916 he acquired two works by Davies and probably two by Myers. In the same year, James sat for a portrait by Tack. It is evident that in his first five years as a collector Duncan Phillips sought out painters he could admire as individualists with a romantic bent, but not rebels in taste.[4]

The next five years, beginning in 1917, were momentous for Phillips. After joining the Century Association, he came in close contact with active and relatively liberal mid-career artists—Beal, Dougherty, Tack, and Mahonri Young. As an organizer of the Allied War Salon, he further strengthened his association with Tack and had his first experience setting up a large and broad-ranging exhibition. His collection widened to include more vigorous works by Beal, Kent, and Luks. His friend Arthur B. Davies, who was by now experimenting with cubist devices, tried vainly to induce him to appreciate abstraction. The deaths of his father and brother in 1917 and 1918 inspired him to collect seriously in their memory, and the concept of the Phillips Memorial Art Gallery was born. The years 1919 to 1921 were a time of intensive acquisition. By 1922 he possessed all his early favorites in depth, and he had added three more of The Eight (Luks, Prendergast, and Sloan), as well as two other artists of this chapter, Robert Spencer and Pène du Bois.

The paintings of Davies, Prendergast, and Tack greatly influenced Phillips at this time. With the purchase in 1922 of Tack's *Gethsemane* (acc. no. 1898), he first welcomed geometricizing abstraction into the collection, and in 1923, with Tack's breakthrough painting *Storm* (acc. no. 1933) and Davies's *Tissue Parnassian* (cat. no. 182), Phillips was well along the road to modernism. Within two years he was collecting works by Bonnard, Cézanne, and Gauguin, a prelude to his Stieglitz Group purchases of 1926.

Works by the artists of this chapter formed the cornerstone of Phillips's collection. The formal inventory of June 1921 shows that thirteen of them accounted for more than one-third of his total holdings. A sketch of a proposed museum from about this time shows the four principal rooms devoted to Davies, Prendergast, and Tack. Phillips continued collecting works by artists of the group through the twenties and more sparingly into the thirties, with a culminating commission going to Tack in 1928 for the gallery's Music Room murals.

It is significant that Phillips designated seven of the seventeen men discussed in this chapter as unit artists. He considered them to be of such significance at the time he collected them, and later when he compiled his 1952 catalogue, as to merit representation by small exhibit groups of at least five or six works.[5] These units, to this day, add much to the richness and depth of the collection. The introductory essays to units in this chapter explore, in greater depth than is possible here, the very considerable role that the individual painters played in laying the foundations of Phillips's "museum of modern art and its sources." In more ways than one, they introduced Duncan Phillips to modernism.

MAURICE PRENDERGAST (1858–1924)

Noted for his colorful, decorative scenes of out-door leisure life in Europe and North America, Maurice Prendergast was born October 10, 1858, in St. John's, Newfoundland; his family moved to Boston in 1868. From 1891 to 1894, Prendergast lived in Paris, where he studied at the Académie Julian and the atelier Colarossi (1891–93) and absorbed influences from contemporary art movements. Upon his return to the United States, he resided in Boston, sharing a studio with his brother, Charles, a decorator and framemaker. He exhibited watercolors successfully in Boston and also in New York, where he became associated with the group of artists known as The Eight. Maurice traveled to Europe in 1898–99, 1907, 1911–12, and 1914. During the teens he concentrated on oil paintings based on New England life, employing a tapestry-like manner that reflected his personal assimilation of the avant-garde styles of Cézanne and Matisse. In 1914 Prendergast moved to New York, where he enjoyed commercial success with collectors such as John Quinn and Duncan Phillips. He died February 1, 1924. The Phillips Collection owns nine oils and five watercolors by the artist.

The Prendergast Unit

In 1920, as Duncan Phillips was forming the Phillips Memorial Gallery, he began to assemble a group of paintings by Maurice Prendergast. He had already collected works by other members of The Eight—Davies, Lawson, Luks—in some quantity, and he responded to Prendergast with equal enthusiasm, finding him to be an eminently individualistic artist whose paintings were original, decorative, richly colorful, romantic without being trite, and evocative of dreams. At the end of 1921 eight Prendergasts were in the collection, and both Phillips and his new bride, Marjorie, had taken a personal interest in the painter. On a trip to New York they visited the Prendergast brothers and then invited the charmingly sensitive Maurice to lunch. When they decorated their living quarters on the third floor of the family home in Washington, they furnished one room with silvery green furniture in order to set off their Prendergasts.[1]

By the end of 1922 the gallery owned at least eleven Prendergasts, which formed one of the strongest units.[2] Phillips envisioned a very important role for this group in the planned museum building, as demonstrated by a preliminary sketch that shows a large library-gallery labeled "Prendergast."[3] During the mid-twen-ties, however, Phillips's interests widened to include many younger and more experimental artists, and he eventually abandoned the concept of permanent installations for a select group of favorites. He was to add only two more Prendergasts—relatively unconventional works—to the collection, while he deaccessioned a number of other paintings after trial periods of varying length.[4] In the end, he settled on ten examples ranging in date from the late nineties through the later teens and possibly even—in the retouching of the oil *Ponte della Paglia* (cat. no. 175)—to 1922. They may be seen as documenting at least three stages in the evolution of the artist's style over a period of some twenty-three years.

The watercolor *Pincian Hill, Rome* (cat. no. 174) and the first stage of *Ponte della Paglia* reflect the artist's early landscape approach, which favored weaving an intricate pattern from the subject at hand—animated crowds in a setting of parkland, cityscape, or seashore—and filling in the pattern with more or less spontaneous brushstrokes and washes. Prendergast showed watercolors in this style in a number of exhibitions between 1897 and 1902, achieving a considerable measure of success.

In 1907, on a trip to Paris, he was greatly stimulated by seeing Cézanne's paintings and the work of the fauves. He felt a "new impulse" that resulted in a most interesting period of expressive exploration.[5] The Phillips Collection has three pictures that relate to this stage: an oil sketch, *Luxembourg Gardens* (acc. no. 1605); a watercolor, *On the Beach* (acc. no. 1607), painted at Saint-Malo, which Prendergast visited in 1907 and 1909; and an oil, *Snow in April* (acc. no. 1611). The latter may well have been painted in 1908 following his return from France and about the time a New York critic described his work as being "like an explosion in a color factory."[6]

Five of the oils that Phillips acquired between about 1920 and 1922 form a relatively homogeneous group representative of what might be termed Prendergast's mature "tapestry style." They were probably executed between about 1914 and 1920, and unlike the early paintings there is little or no reference to a particular scene or depiction of specific details. The format is similar in each: colorful foreground figures are set against or within a shore landscape with trees; a bay is in the middle distance; and a far shore defines a high horizon. A pleasant, holiday mood is presented, but the composition serves primarily as a vehicle for the development of different color harmonies, freely built up by an elaboration of brushstrokes in dots and patches of varied hues.

Phillips made an early and substantial contribution to the literature on Prendergast in an essay that appeared in *The Arts* in March 1924, a month after the artist's death. It is based on firsthand knowledge of the man and sustained, careful study of his paintings. Prendergast's personality is well described, as are his objectives and methods as an artist. If Phillips's style is, to present-day taste, both wordy and too highly colored, a number of his conclusions were much to the point, as when he wrote that Prendergast "was so much of a purist in regard to the fusion or synthesis of the decorative and representative functions of his art of painting that he persisted in reducing his observations of the visible world and his joyous emotions in the presence of nature to a simple but beautifully organized pictorial pattern."[7] It might also be said that Phillips's writing is like Prendergast's painting in reflecting a more leisurely and glowing world, one in which people were easily delighted by decoration and allusions to tradition.

In the twenties, however, this sensibility was passing rapidly, and Phillips left a revealing record of how his own tastes and values were changing, as well. He first drafted a Prendergast essay in April 1922, shortly after meeting the painter and when he was highly enthusiastic about his work. The essay was revised for *The Arts* in 1924 and underwent further slight revision for publication in *The Enchantment of Art* in 1927. In 1922 Phillips asserted that Prendergast "painted with a brush full of colors far more beautiful and subtly related than was to be found on the palette of any painter in France."[8] Two years later he recast the sentence to omit "beautiful" (he had purchased his great Renoir in the meantime), and in 1927, having looked about even more widely, he concluded the sentence with "except possibly Pierre Bonnard."[9]

In 1922 Phillips had also characterized Prendergast as "a man of consummate genius in the use to which he puts his amazing instinct for color."[10] Six years later, in a very different vein, he concluded that the artist "was not a great pathfinder like Cézanne nor a great poet like Ryder. He was only an original, whimsical lyricist with tubes of color for his language."[11] Phillips continued to admire the artist and his painting, but with moderation, and by 1928 he was trimming back his Prendergast collection rather than adding to it.

DWS

174

Pincian Hill, Rome, 1898

Afternoon, Pincian Hill (DP)
Watercolor over graphite pencil underdrawing on paper,
21 × 27 (53.4 × 68.6)
Inscribed in black watercolor, l.r.: *Pincian Hill./Rome
1898/Prendergast.*
Acc. no. 1609 (Clark no. 748)

Montross, New York; DP purchase 1920 (from Montross
exhibition); transferred to PMG by 1924.[12]

Pincian Hill, Rome is one of three watercolors by
Prendergast that depict the same view of the fash-
ionable promenade on Rome's Monte Pincio, a
scene that attracted Prendergast during his trip to
Italy in 1898–99.[13] Carriages and well-dressed
strollers mount or descend the serpentine road-
way along the face of the hill; their movement
and the diagonals of the road are stabilized by the
row of trees and the massive horizontal brick wall
in the background. The entire composition was
carefully planned and tightly controlled. The
Phillips version relates most closely to the Terra
Museum's *Monte Pincio;* the compositions vary
only in a few small details. In fact, although Pren-
dergast painted several watercolor series around
this time, he seldom repeated a composition so
closely. His motivation is open to speculation: he
may have been responding to the request of a
patron, or perhaps he was enlarging and rework-
ing the composition in preparation for his Mac-
beth Gallery exhibition in 1900. In any case, the
subject of a colorful human parade, weaving a
pattern up the surface of the picture plane, must
have had a special appeal for him.

The Phillips watercolor is the larger and more
finished of the two, and is probably the later work.
It is executed with looser, broader brushstrokes,
and, through reduction of details and overlapping
figures, achieves greater clarity and simplicity. The
crowd in the Terra Museum's painting is more
active, and the tree trunks extending in front of
the middle wall create conflicting passages that
were avoided in *Pincian Hill, Rome.* Altogether,
the Phillips watercolor's carefully inscribed signa-
ture, outlined figures, more organized composi-
tion, and calmer handling suggest that it is a later
version based on the Terra painting.

GHL

175

Ponte della Paglia, 1898–99; completed 1922

La Ponte della Paglia, Venice
Oil on canvas, 27⅞ × 23⅛ (70.8 × 58.7); frame by Charles
Prendergast
Signed l.l.: *Prendergast*
Acc. no. 1610 (Clark no. 392)

The artist; PMAG purchase through Kraushaar, New York,
1922.[14]

Ponte della Paglia, one of Prendergast's earliest
and most delightful large oils, was extensively
repainted by the artist many years after its original
execution and thus shows with unusual clarity the
contrast between his early and late styles. Begun
during a visit to Venice in 1898–99, the painting
remained in Prendergast's possession until 1922.
At some point during this period, the tightly
painted and detailed figures and surroundings,
which are characteristic of the artist's early style,
were overpainted in the foreground and middle
distance with colorful, thick, broad brushstrokes
and heavy outlines, revealing his freely personal
adaptation of the pointillist technique.[15]

Ponte della Paglia is the only oil by Prender-
gast for which a nearly identical watercolor
exists.[16] The works share the same overall com-
position and most details. However, the water-
color's translucently toned, lightly textured
figures appear to float in airy space in marked
contrast to the oil's dark, weighty forms; ren-
dered in heavy impasto, the latter seem compara-
tively frozen within their decorative frame-
work.[17] And yet the overpainting in the oil has
unified the work into a rich tapestry of color that
would have been unattainable in watercolor.

The bright, gay crowd scene indicates the
artist's delight with his festive Venetian sur-
roundings. It also suggests the possible influence
of Vittore Carpaccio's St. Ursula series,
1490–1500, at the Venice Academy, especially a
passage in the background of the panel portray-
ing *The Return of the Ambassadors,* a dense mass
of figures receding into space over an arched
bridge. Not only does the Prendergast have a
composition similar to the panel detail, it also
adopts the warm, glowing tones of the early
Venetian work.[18] The scene of *Ponte della
Paglia*—a crowd of animated figures with color-
ful dresses and umbrellas—is typical of Pren-
dergast's work throughout his career. His
preference for festive throngs in parks and on
beaches led him to develop great variety in color
and composition within limited subject matter.

GHL

176

Fantasy, ca. 1917

Landscape with Figures; Phantasy
Oil on canvas, 22⅝ × 31⅝ (57.4 × 80.3); frame by Charles
Prendergast
Signed l.r.: *Prenderg*["ast" obscured by paint]
Acc. no. 1604 (Clark no. 416)

The artist to Daniel Gallery, New York; PMAG purchase
by 1921.[19]

177

Autumn, ca. 1917–18

Autumn Festival (DP); *Summer Festival* (DP)
Oil on canvas adhered to panel, 22½ × 32⅛ (54.5 × 81.5);
frame by Charles Prendergast
Signed l.r.: *Prendergast*
Acc. no. 1603 (Clark no. 421)

The artist to Daniel Gallery, New York; PMAG purchase
by March 1920.[20]

Autumn and *Fantasy* are fully mature oils that
display Prendergast's "daring musical genius"
with color which Phillips greatly admired.[21]
Both depict a theme that preoccupied Prender-
gast during the last decade of his career: a crowd
of people at leisure placed within an imaginary,
densely forested landscape set against a bay;
extending into the water is a promontory con-
taining a house, more people, or trees.[22]

Despite similarities in subject matter, these
works reveal wide variations in the artist's tech-
nique. The quiet, stable composition and tight,
measured brushstrokes of subdued color in *Fan-
tasy* contrast with *Autumn*'s animated scene,
which is painted with broad, expressionistic
strokes of rich tones highlighted with reds. *Fan-
tasy* is rendered as an open vista with an unin-
terrupted recession into space, while the crowd
and mass of trees in *Autumn* dominate the fore-
ground of the composition and form a screen,
obscuring the background view. *Autumn* could
be the slightly later work due to its greater free-
dom of execution and more densely packed,
tapestry-like surface. It was one of Phillips's
favorite Prendergasts, for he frequently wrote
about not only its decorative beauty but also the
spiritual response it evoked in him:

I possess a canvas by the American fantasist—an
improvisation, truly pagan . . . on the russets, purples
and orange tones of autumn orchestrated with
inexpressibly gorgeous peacock blues and greens—
which has somehow a grave dignity in the design
and spacing of the abstract figures which makes me
think of august church decorations of the best peri-
ods. The heavenly whites which Prendergast has
bestowed on some of the little figures . . . are wor-
thy to adorn frescoes presenting the most solemn
Christian stories. . . . After looking at this Autumn
Festival for long and dreamful moments, I confess
that I have fallen under a spell and experienced
ecstasy more medieval than modern.[23]

GHL

174

175

176

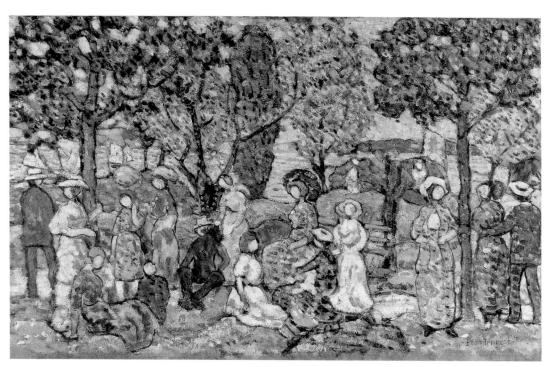

177

Arthur B. Davies straddled the boundaries between the nineteenth-century romantic tradition and early twentieth-century modernism in America. Born in Utica, New York, September 26, 1862, Davies studied with a local artist in 1877 before moving with his family to Chicago the following year. After training at the Chicago Academy of Design and the School of the Art Institute of Chicago, he worked in Mexico as a draftsman for a civil engineering firm. In 1886 he moved to New York, enrolled at the Art Students League, and contributed illustrations to *Century Magazine* and *St. Nicholas*. By 1889 he was exhibiting in Boston and New York. In 1892 Davies married a physician, Virginia Merriweather, and settled on a farm in Congers, New York. By the following year, he was commuting between the farm and a studio in New York City. The gallery owner William Macbeth became interested in his work and in 1895 arranged for Benjamin Altman to finance Davies's first trip to Italy. After his return, Davies exhibited regularly in New York and Boston. In 1905 he began leading a secret double life, living in the city with a dancer, Edna Potter, whom he married bigamously, while continuing periodically to visit his first wife and two sons at the country farm. He participated in the historic "Exhibition of Eight American Painters" at Macbeth's in 1908 and in the "Exhibition of Independent Artists" in 1910. As president of the Association of American Painters and Sculptors, Davies personally selected many of the contemporary European paintings for the 1913 Armory Show, in which six of his own works were exhibited. He was the recipient of numerous honors, among them the first Clark Prize at the Corcoran Biennial of 1916, the year Duncan Phillips began collecting his work. In 1923 Davies won first prize at the Carnegie International. In 1924 The Phillips Memorial Gallery published *Arthur B. Davies: Essays on the Man and His Art*. Toward the end of his life he spent six months each year abroad. Davies died in Florence October 24, 1928. The Phillips Collection contains twenty-eight works by Davies: sixteen oil paintings, seven pastel and chalk drawings, one watercolor, and four watercolor and gouache drawings.

The Davies Unit

Arthur B. Davies was one of the first American artists whose works Duncan Phillips collected. The subject of one of Phillips's earliest essays on American art, Davies continued to be the topic of lectures and writings throughout the 1920s, including *Arthur B. Davies: Essays on the Man and His Art* of 1924. At that time, Phillips

believed that Davies was "one of the most distinguished artists now living."[1] Because of his quiet, gentlemanly manner and wide-ranging knowledge, Davies also became a respected adviser and friend. Although Davies's star faded in the years following his death in 1928, Phillips never lost his admiration for the painter of what he called "beauty touched with strangeness."[2]

Davies held a unique and somewhat perplexing position in American art circles when Phillips met him. A rebel against the National Academy of Design and participant in The Eight exhibition, Davies had also played a key role in introducing modern European art to American audiences as chief organizer of the 1913 Armory Show. He had a devoted following of wealthy patrons, had won prestigious prizes, and was able to live solely off the sale of his work. Yet even to some of his admirers, his lyrical fantasies seemed obtuse and at odds with the abstract art he championed. Unconcerned with such contradictions, Phillips considered Davies both a "painter of dreams" and "an enchanter," and at the same time, "the antithesis of the cautious academician . . . thoroughly American and absolutely original."[3] In the teens, Davies's work appealed to Phillips because he found its traditional elements reassuring and its "modern" elements satisfying to his desire for fresh individuality.

Phillips began collecting Davies's work in 1916. One of his first purchases, *Many Waters*, 1905 (cat. no. 180), a poetic California landscape, was a personal selection using his own funds. That same year he acquired *Visions of Glory*, 1896, a romantic fantasy, using funds his father had set aside for him and his brother, James, to invest in art.[4] Phillips's enthusiasm for Davies grew into an obsession. "As soon as one fine picture by him has been acquired," he wrote, "another is desired, and this in turn whets the appetite for more until the collector enters in spite of himself into a lively competition with all the other men and women who have had the same enthralling experience."[5]

Within ten years he had assembled a unit representing nearly all phases of Davies's painting, including several examples of his emblematic interpretations of childhood. In 1920 Phillips added the early nostalgic landscape *Along the Erie Canal*, 1890 (cat. no. 178). While working closely with Davies on the preparation of the 1924 monograph, he bought several recently completed works, including *Tissue Parnassian*, ca. 1923 (cat. no. 182), which Phillips described as invoking "modern moods of wistful reverie about antique art."[6] He also persuaded Davies to create an original pastel-and-chalk

drawing for each of the first fifty copies of a limited deluxe edition of the monograph. Seven copies of this edition and their accompanying drawings came into the collection.[7] Phillips also purchased several late Italian watercolors in which Davies had returned to more direct observation of nature and revealed his mastery of the medium and considerable skill as a colorist.[8] Although Phillips did not acquire sculptures and textiles, he acknowledged the artist's facility in many media, saying that "this magician cannot touch brush to canvas, cannot take on a new medium, cannot accept the challenge of any technical adventure without creating some rare felicity of contour or some passage of enchanting color."[9]

Altogether, Phillips acquired more than thirty works by Davies, nearly all before the artist's death in 1928. Deaccessions, gifts, and exchanges eventually reduced the number of paintings and drawings to the present holding of twenty-eight.

The only examples of Davies's painting Phillips excluded from his unit were the cubist experiments made in the wake of the Armory Show. Referring in 1924 to Davies's "late and unlamented cubist preoccupation," Phillips greeted with relief the artist's return to what he called "work free from affectations and distortions and confusions."[10]

Although Davies abandoned his cubist experiments after only a few years, he remained to the end a staunch supporter of abstract art. An avid collector, he amassed an impressive body of work that included ancient artifacts along with paintings, prints, and sculptures by major European moderns, among them Cézanne, Picasso, Matisse, and Brancusi, as well as American contemporaries from both the Stieglitz circle and the realists associated with The Eight. He often steered his patrons toward contemporary European and American art and is credited with suggesting the concept for founding the Museum of Modern Art to Lillie Bliss, Abby Aldrich Rockefeller, and Mrs. Cornelius Sullivan.[11]

Davies helped educate Phillips about modern art, an education that largely took place during visits to Davies's Manhattan studio.[12] In the 1917 article and lecture "Fallacies of the New Dogmatism in Art" Phillips described one of those meetings, in which cubism was the topic, as follows: "He took my education in hand and gave me an elementary object lesson. He brought out a framed picture of a young girl playing a violin—one of the exquisite things of his early period. On the glass he marked in chalk the contour of the masses and then

removed the glass. The diagram was not unlike a Cubist masterpiece."[13]

Despite Davies's demonstration, Phillips concluded that the new movement was "sensation-seeking and hysterical." In 1917 he had not yet begun to approve of Cézanne, whom he called a "unique, but overrated painter," let alone his more radical successors.[14] However, he did share Davies's enthusiasm for two important French symbolists, Pierre Puvis de Chavannes and Odilon Redon, both of whom continued to rely on poetic allusion while exploring modern themes in their art. Works by both artists came into the collection in the early twenties while Phillips was in close contact with Davies.[15] He continued to grapple with Davies's admiration for Cézanne, however, and in his essay for the 1924 Davies monograph borrowed imagery from critic James Huneker's essay "Unicorns" in comparing Davies to Cézanne, calling them "standard bearers of opposite ideas, the lion and the unicorn of modern painting."[16] Davies was the unicorn, the mystical, delicate creature of the imagination, while Cézanne was the lion, the powerful creature of structure and visual analysis.[17] Davies's influence was undeniably one of the factors in Phillips's decision to purchase his first Cézanne in 1925, and the conversion was completed in 1929, the year after Davies's death, when Phillips bought his first postcubist Picasso, *Abstraction, Biarritz*, 1918, from the artist's estate.[18]

By this time, too, Davies the teacher had replaced Davies the artist in his patron's estimation. For the 1929 memorial exhibition, Phillips reprinted in the *Bulletin* his essay from the earlier monograph with an introduction that emphasized Davies's role as a promoter of modern art. As he explained, "Looking back on his accomplishments it seems probable that he will be considered less great as a painter than as an original artist and as a progressive leader of prestige and influence who organized and presided over the celebrated Armory Show of the new art movement in 1913, thus creating a new epoch of art in America."[19]

ET

178

Along the Erie Canal, 1890

Oil on canvas, 18⅛ × 40⅛ (46.0 × 101.9)
Signed and dated in black paint, l.l.: *A. B. Davies 1890*
Acc. no. 0434 (Czestochowski, 1979, 1 D10)

Early history unknown; PMAG purchase from Montross, New York, 1920.[20]

Davies's birthplace, Utica, New York, is located on the eastern leg of the Erie Canal, which remained a busy and important commercial inland waterway and a great source of pride for the communities it had served since its opening in 1825. This depiction of the canal and surrounding Mohawk Valley countryside has a celebratory air, suggesting a sunny, idyllic location blessed with a harmonious relationship between the land and humanity's industrious use of it. A sweeping panoramic view encompasses gently rolling hills, the canal, and an adjacent river. Three bridges cross the canal, and a cluster of large trees silhouetted against the sky dominates the center of the composition. Close scrutiny reveals many carefully rendered details, including a canal barge pulled by mules, a church steeple, a horse-drawn carriage speeding along a road, and a young girl standing on the river bank with outstretched arms waiting for a boat to reach shore. A child in the boat is also gesturing enthusiastically, suggesting a happy reunion that, in a larger sense, the artist was experiencing, as well.

Davies and his family had moved from Utica to Chicago in 1880, ten years earlier. In 1886, en route from Chicago to New York, he stopped in Cazenovia, a small resort town near Utica, to visit his teacher, Dwight Williams, and to paint. As Duncan Phillips noted in 1931, "Although Davies went forth from the special peace of the Mohawk hills and lakes and trees to his world travels . . . I know how tenderly he thought of the home of his boyhood."[21] *Along the Erie Canal* is vivid proof of that tender regard. Finished four years after his visit with Williams, it still expresses the sense of poignant and nostalgic pleasure that comes from viewing the familiar territory of one's youth through mature eyes.

A major early work, the painting was completed before Davies began adding nudes and mythological references to his landscapes. Because of its bright summer light and atmospheric effects, it has at times been labeled as impressionistic, but Davies was not as interested in French impressionist theory as others of his generation (such as J. Alden Weir). Instead, his treatment of this semipastoral location is more indebted to the Hudson River landscape tradition, tempered by the influence of the French Barbizon School.[22] At the same time, the figural element is reminiscent of both seventeenth-century Dutch painting and Currier and Ives prints. Yet the overall mood conveys more than picturesque anecdote. As Phillips observed, the painting goes beyond "the ordinary sort of naturalism" because "we cannot disengage the realism of it from the romance."[23] Filtered through childhood memories, the countryside along the Erie Canal becomes a harmonious realm of peace, prosperity, and benign nature.

ET

179

The Flood, probably 1903

Oil on canvas, 18⅛ × 30 (46.0 × 76.2)
Signed l.r.: *A. B. Davies*
Acc. no. 0440 (Czestochowski, 1979, 2 A6)

Early history unknown; PMG purchase from Macbeth, New York, 1924.[24]

The Flood, which was illustrated in the catalogue of the history-making exhibition of The Eight at the Macbeth Gallery in 1908, seems somewhat out of place alongside the urban realism for which the show became famous.[25] A small but powerful fabrication from the artist's imagination, it features two nude women, backs bent against the wind and hair flying, struggling to maintain a foothold against a roaring torrent of water. Defined with rapid brushstrokes, the swirling water and waving trees glow with luminescent color against the storm-darkened background. Critics at the time of The Eight exhibition acknowledged that Davies stood apart from urban realists like Glackens, Henri, Luks, and Sloan, calling him variously a poet, symbolist, and romantic.[26] However, what brought The Eight together at Macbeth's was not a shared choice of subject or aesthetic preference but their rebellion against the National Academy of Design and the conservative, restrictive tradition for which it stood. There is no question that Davies was a rebel, surpassing even his fellow Eight in promoting modern art in America as chief organizer of the 1913 Armory Show. Paintings such as *The Flood*, however, better illustrate his subjective mysticism than his rebellious nature.

By 1905, when *The Flood* was first shown, Davies had moved away from picturesque landscapes and lighthearted scenes of children at play to paintings with classical allusions and mythical overtones. Like the late nineteenth-century romantic Albert Pinkham Ryder, whom Davies admired and had known personally, music and literature served as inspiration for his work. Because of its dark palette, swirling forms, nudes, and raging river, *The Flood* is particularly reminiscent of Ryder's *Siegfried and the Rhine Maidens*, 1881–91.[27] Davies, who once described art as "nature seen through the prism of emotion," also admired the dark mysticism of the German romantic Arnold Böcklin and shared with the French symbolists an interest in the occult.[28] Well read and attracted to a wide variety of subjects, among them the study of comparative religion, Davies owned an early copy of James Frazer's groundbreaking anthropological study, *The Golden Bough* (1890).[29] Rather than

ET

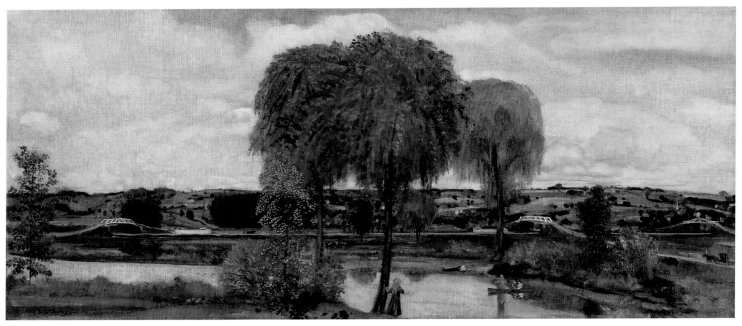

178

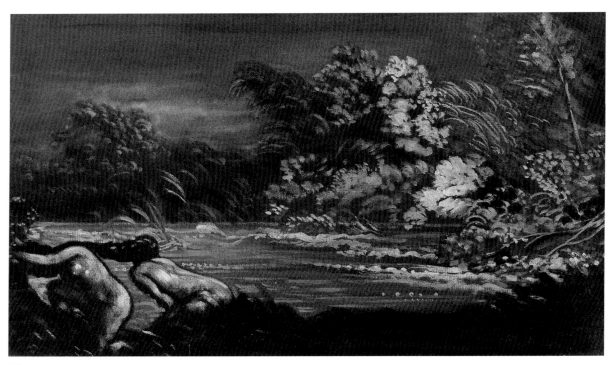

179

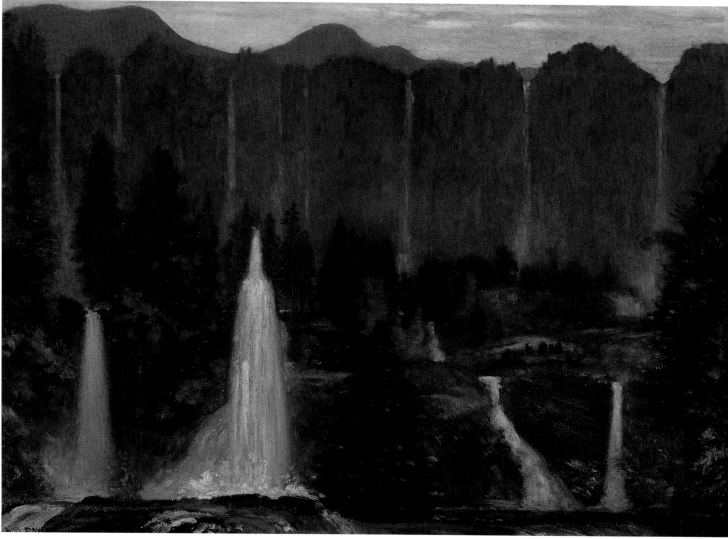

180

referring to a specific deluge such as the biblical flood, Davies's painting, in depicting frank nudity and unchecked violence, evokes the more general theme of humanity confronting nature and invokes the primeval fears and the universal power of myths discussed in *The Golden Bough*.

Although historians and critics have puzzled over the seeming disparity between Davies's role in introducing modern art at the Armory Show in 1913 and the romantic nature of his own work, he was actually ahead of his time in his assimilation of symbolist theory, and certainly in advance of the conservative circle of the National Academy of Design. *The Flood*, by evoking unbridled fear and primitive helplessness in the face of brutal nature, thus belonged in that historic exhibition of 1908 where painters in their individual ways confronted the realities, both sociological and psychological, of the new century.

ET

180

Many Waters, ca. 1905

Oil on paper adhered to canvas, 17 × 22 (43.2 × 55.9)
Signed in blue paint, l.l.: *A. B. Davies*
Acc. no. 0444 (Czestochowski, 1979, 5 E5)

Purchased by DP from Macbeth, New York, 1916; transferred to PMAG 1920.[30]

Many Waters is another work that was shown in the 1908 exhibition of The Eight. Like *The Flood*, it depicts nature in terms of powerful forces and dramatic spectacle. Because of its poetic, primitive-sounding title and its view of a dozen waterfalls spilling down from a wall of cliffs and cascading into a verdant valley, the painting seems more like a fanciful product of the artist's imagination than the record of an actual place. One writer thought it looked "like a reminiscence of the Tivoli Gardens outside Rome, transformed into something new and strange."[31]

The location, however, is Yosemite Valley, a site Davies visited in 1905 during a trip with Edna Potter across the Sierra Nevada to the Pacific Coast.

In letters to his dealer, William Macbeth, Davies wrote that he had seen enough natural wonders to "satisfy any ordinary man."[32] Some of his finest landscapes resulted from the journey. *Many Waters* is a view of the range of cliffs that, rising more than 3,000 feet, flanks the seven-mile stretch of Yosemite Valley and has a large concentration of free, leaping waterfalls.

In painting Yosemite and the Sierra Nevada, Davies followed in the footsteps of many nineteenth-century painters and photographers who had documented the natural wonders of the American West. Albert Bierstadt, George Inness, and Thomas Moran were among the major talents who visited and recorded the wonders of Yosemite in paint. It was also illustrated and discussed in travel books such as William Cullen

|81|

Bryant's hugely successful centennial publication *Picturesque America,* and featured in travelogues in popular periodicals.[33] In 1890, while working for *Century Magazine,* Davies contributed illustrations for two John Muir articles on the proposal to make Yosemite a national park.[34]

Like his predecessors, Davies stood in awe before the primordial beauty of the American landscape and saw it as an Edenic paradise. However, compared to the earlier work, which contained a wealth of descriptive detail, and to the theatrical effects of the Hudson River School tradition, *Many Waters* is more broadly painted, using blurred forms and subtle tonal modulations in a palette of soft blues. Whereas Bierstadt chose deep, tunnel-like vistas of the narrow valley, Davies viewed the escarpment head-on, thus tending to compress and flatten the pictorial space. While Moran singled out some of the most famous sites, such as Bridalveil Falls, Davies created a composite showing all of the falls, including Bridalveil, and the roaring Merced River in the foreground, even though the site offers no single vantage point where they are all visible. The result is the transformation of an already spectacular location into one of mystical dimension. As Duncan Phillips observed, "even when full of solitude, we are thrilled in such pictures as . . . *Many Waters* by a

sense of awed expectancy, thoroughly in a mood to feel that anything might happen."[35]

ET

|8|

Horses of Attica, after 1910

White Horses of Attica

Oil on canvas, 8 × 15 (20.3 × 38.1)

Signed l.l.: *A. B. Davies*

Acc. no. 0443 (Czestochowski, 1979, 2E 12)

Early history unknown; PMG purchase from Edward Duff Balken 1928.[36]

Horses of Attica, previously published as undated, was probably created after 1910, the year Davies made his first trip to Greece and southern Italy.[37] Visiting the sites of classical antiquity was especially rewarding for Davies, whose imagination had already been steeped in classical myth and lore, and it bore fruit in his art in several ways.[38] As evidenced in this work, the trip expanded the range of his landscape painting and his perception of the antique past.

The painting is small in scale but has the wide horizontal format and sweeping view preferred by Davies for his landscapes. A pastoral scene is depicted in rich, delicate pastel shades with loosely worked-in details and a dry, scrubbed-looking surface. A naked man sits on

the ground holding a staff and watching his herd of horses frolic against a backdrop of the Attic hills near Athens. To Duncan Phillips, the closely grouped, prancing poses of the horses suggested the sculptural reliefs of the Parthenon. He also saw the continuation of the long and revered pastoral landscape tradition whose roots went back to Poussin and, centuries earlier, to Virgilian Rome and Theocritan Athens: "First Poussin, then Puvis created true visions of antiquity in which the excited heroes and horses of the Parthenon frieze gallop gaily across a beach of the deep blue Mediterranean, but perhaps the most original use of the oft-recurring vision has been made by Davies in the small canvas called 'The White Horses of Attica.'"[39]

The importance of Davies's trip to Greece and Italy in reinforcing his interest in ancient myth and archaic cultures is clearly reflected in a letter he sent to his dealer, William Macbeth, in 1910 from Naples: "[The frescoes of Pompeii] are perfectly thrilling—the finest things I have ever seen—as fresh as if painted yesterday. I might say thankfully that I have been quite on the level and do feel capable of far greater expression because of my own 'entente cordiale' with Greek painters—so archaic—so great—so modern. . . . I cannot tell you how much these things mean to me."[40]

Davies's approach to antique subjects took

on a new sophistication. In another example, *Hesitation of Orestes,* ca. 1914–18 (acc. no. 0442), he approximated the earthy palette of a Greek vase. Through the stylized poses of the figures, which are set against a broadly defined hillside background, he created the effect of a flattened frieze or painted band. Davies did not present the story of Orestes as anecdotal, but rather suggested the timeless dimension of the moral dilemma of its hero through a dancelike pantomime of gesture and movement. Similarly, in *Horses of Attica,* Davies recalled antique art and motifs while evoking the universal pastoral theme of humanity in harmony with nature.

ET

182

Tissue Parnassian, by 1923

Oil and charcoal on canvas, 26 × 40 (66.0 × 101.6)
Signed l.l.: *Arthur B. Davies*
Acc. no. 0448 (Czestochowski, 1979, ZE 12)

PMG purchase from Montross, New York, 1923.[41]

182

Tissue Parnassian has an ephemeral quality, a feeling, as the title suggests, of tissuelike delicacy that derives from both the imagery and the medium (an unusual combination of oil and charcoal). The subject was loosely adapted from classical mythology. Parnassus was the Greek mountain sacred to Apollo and the Muses, and was a common metaphor in poetry. Davies depicted it as an otherworldly place high up in the rarefied atmosphere of a luminous, salmon-pink sky. The Muses—nine sister goddesses who presided over song, poetry, and the arts and sciences, and hence symbolized inspiration—assume a variety of poses and are accompanied by several other deities. Their naked figures are lithe and tall. Two Muses in the center perform a dance while the others, even those seated, have graceful, dancelike poses. Only one figure is identified by an attribute: the god Hermes bears his staff, the caduceus, a gift Apollo gave him in gratitude for inventing the lyre. Duncan Phillips saw in this painting "the divinely beautiful possibilities of the human figure, considered singly and in groups." He added, however, that "for all the seductive sensuousness," Davies's figures are not "of this earth."[42]

Davies's treatment of the figure had evolved in response to various influences. After his first trip to Italy in 1895, he painted nudes that echoed the long-limbed but full-figured ideal of Botticelli in Italianate settings reminiscent of the Venetian Renaissance. In the early 1900s, draped Renaissance madonnas and goddesses gave way to nude and partially draped figures influenced by the classicizing approach of the early French symbolist Pierre Puvis de Chavannes.[43]

Puvis's idyllic evocations of a lost golden age

and his theories of mural painting had a significant impact on Davies and many other late nineteenth-century painters, among them Davies's friend Maurice Prendergast, and even early European modernists such as Picasso.[44] *Tissue Parnassian* has the same theme as of one of Puvis's most famous mural projects, *The Sacred Grove, Beloved of the Arts and of the Muses,* which was exhibited in the 1884 Paris Salon and mounted at Lyons. A study for this mural, *The Sacred Grove,* is in The Phillips Collection (acc. no. 1619). While Puvis's classical deities are weighty and self-consciously derived from the antique, Davies's have less physicality, more animation, and fewer classical attributes. The element of stylized, dancelike motion in Davies's work can be traced to the influence of his second wife, Edna Potter, a former dancer with Isadora Duncan's troupe. Because of his interest in antiquity, Davies was naturally drawn to theories of modern dance that derived from contemporary interpretations of primitive cultures, especially those of the Hellenic world.[45]

Shortly before he painted *Tissue Parnassian,* Davies incorporated yet another element into his treatment of the figure, the theory of "inhalation." Davies, Potter, and their archaeologist-friend Gustavus Eisen claimed to have discovered the secret of the appearance of vitality in Greek art. As Eisen explained, living creatures should be represented by depicting the moment of deepest inhalation when the chest is fully

expanded. According to the theory, the effect extended to the appearance of architecture and sculpture and even to improving one's own health and vigor through deep-breathing exercises.[46] Phillips claimed to have detected the effect of inhalation in the landscape of *Tissue Parnassian* where "The trees . . . seem to breathe the life-enhancing air."[47]

Despite his preoccupation with ancient Greece, Davies was by no means tied to the tradition-bound outlook of academic art. He was, as Phillips frequently noted, a dedicated modern. The symbolist element, which appears early on in his art, was a manifestation of his modernist orientation. Like the European symbolists of his generation, among them Puvis and Redon, Davies saw art as a means to express intellectual and emotional abstractions. For a brief period after the Armory Show, in which he played such a significant role as organizer, he attempted to embrace the most radical modern styles and theories. His answer to cubism and fauvism, for example, was to superimpose brightly colored, translucent facets on his figures. Although he soon abandoned this unpopular approach, Davies retained the vivid palette, vestiges of which can still be seen in the patches of color superimposed on the figures in *Tissue Parnassian,* which Phillips described as having a "capricious modern idiom of prismatic color."[48]

ET

Robert Henri, the inspirational leader of The Eight, was born Robert Henry Cozad June 24, 1865, in Cincinnati. At an early age he moved with his family to Cozad, Nebraska, a town his father founded. After his father killed a man in self-defense, the artist assumed the name Robert Earl Henri to avoid the stigma. In 1886 Henri enrolled in the Pennsylvania Academy of Fine Arts, Philadelphia, where he studied under Thomas P. Anshutz, Thomas Eakins's former pupil and successor. He studied at the Académie Julian and the Ecole des Beaux-Arts in Paris from 1888 to 1891 but was more influenced by the Old Masters and Monet than by academic painters. In 1892 he started teaching at the Philadelphia School of Design for Women, where he gained a reputation as a vivacious and passionate teacher in the Eakins tradition and an inspiring intellectual. He soon acquired a following of emerging artists, including the Philadelphia newspaper illustrators William Glackens, George Luks, Everett Shinn, and John Sloan, the core of the group that would later form The Eight. During a trip to Europe with Glackens in 1895, he shifted away from impressionism to the realism of Hals and Velázquez. In 1900 Henri moved to New York, where he supported himself and his wife by teaching at various schools. He traveled extensively during the summers from 1906 until 1913, painting portraits in many parts of the world, including Holland, Ireland, and Spain. In 1907 Henri broke from the National Academy of Design to promote independent artists; he was the driving force behind the 1908 exhibition of The Eight and the 1910 "Exhibition of Independent Artists" in New York. While continuing to teach, he participated in progressive exhibitions in New York until his death July 12, 1929. Henri is represented in the collection by one work.

183

Dutch Girl, 1910; reworked 1913 and 1919

Little Dutch Girl (DP); *Laughing Child*

Oil on canvas, 24¼ × 20¼ (61.6 × 51.4)

Signed l.c.: *Robert Henri*

Acc. no. 0900 (Inv. no. 104 F)

The artist to Daniel Gallery, New York, 1919; PMAG purchase 1920.[1]

Henri emerged in New York at the turn of the century as an artist working in the realist tradition, combining immediacy of expression with subjects from everyday life. He had arrived at realism through the influence of Thomas Eakins and Thomas Anshutz, and his early works reflect the instantaneous working method of these masters. By the 1890s, as a result of a new appreciation of Velázquez, Eakins had synthesized "seventeenth-century Dutch and Spanish realism with American painting."[2]

In 1902, on the occasion of his first one-person show at Macbeth Galleries in New York, Henri was treated disparagingly by the more conservative critics for executing seemingly incomplete paintings, predominantly landscapes, lacking in academic finish and detail.[3] This criticism, coupled with his recent award of the silver medal for his figure paintings at the Pan-American Exposition in Buffalo, caused him to abandon landscape for portraiture. The artist was hoping for monetary success, but his good friend John Sloan noted that "the game of getting portraits to paint [was] beyond his or rather beneath his powers."[4] For models, Henri used his friends and, during the summer months, the natives of the places he visited.

Dutch Girl is representative of the many portraits Henri painted during the summers of 1907 and 1910 in Haarlem, The Netherlands. In 1907 he spotted "a little white headed, broad faced red cheeked girl of about 8" walking home from school with her two older sisters.[5] After acquiring permission from her parents to paint her portrait, he had Cornelia Elizabeth Peterson pose for him in a room of the Restaurant Brinkmann at the Grote Markt square.[6] When he returned in 1910, he painted her portrait again; *Dutch Girl* is the result of this second visit. Henri had invited other children into the studio in order to encourage Cornelia to retain an immediacy of expression, and he captured the spirited naturalness of the child rather than an exact likeness.[7] Upon Henri's return to New York in the fall, Sloan wrote of his friend's work, "The 'crop' of pictures from Holland this summer is a very fine one. Many small canvases, heads of Dutch loafers and children."[8]

The loose, painterly brushstrokes in *Dutch Girl* show Henri's indebtedness to the seventeenth-century Dutch master Hals, whose paintings he had seen in Holland. His fluid brushwork became frenetic; with short, choppy strokes, he brought forth flickering light out of dark shadow.[9] Henri trained his hand to work quickly so he could record a portrait in one sitting. Later he would tell his students, "work with great speed. . . . Finish as quickly as you can. . . . Get the greatest possibility of expression in the larger masses first. Then the features in their greatest simplicity. . . . Do it all in one sitting if you can. In one minute if you can."[10] However, Henri's record book establishes that *Dutch Girl* was repainted in May 1913 and again

Fig. 30 Robert Henri, Study for *Dutch Girl*, Robert Henri Record Books, 1885–1928, p. 104 F, Collection Janet Le Clair, Point Pleasant, New Jersey.

in April 1919 (fig. 30), prior to sending it to his dealer, Charles Daniel.[11]

Contrary to contemporary academic salon portraits, which favored a wealth of props, Henri's models were placed within a dark undefined space in the manner of Velázquez, whose integrity, dignified treatment, and somber, poignant palette Henri greatly admired. When "reproached with not adding to [his] study of these people the background of their lives," he responded that "all their lives are in their expressions, in their eyes, their movements, or they are not worth translating into art."[12] Thus, he emphasized the person, concentrating on the child's face—to him, the embodiment of her spirit.

In 1915, early in his collecting career, Duncan Phillips recognized Henri as a significant American artist of the new century and as an inspirational leader of aspiring artists.[13] Although attracted to The Eight, Phillips did not purchase a painting by Henri until 1920, a year of intense collecting prior to the opening of the Phillips Memorial Art Gallery. He evidently preferred the dark palette of the early portraits. Henri's "knack of capturing a facial expression and summing up a type," he wrote, "has been demonstrated by innumerable heads of . . . chil-

183

dren which are perhaps unimportant but very clever and pleasing."[14] Phillips divided realism into two camps: one, a triumph of technique; the other, "directness and simplicity of poetic inspiration," which he called impressionism.[15] *Dutch Girl* embodies Henri's impression of his sitter, and thus it is not surprising that Phillips responded to it. By 1928, however, Phillips believed that "Henri [was] content . . . with a rather superficial transcription of types broadly generalized," and he added none of the later works to the collection.[16]

VSB

GEORGE BENJAMIN LUKS (1866–1933)

George Luks was an artist admired for his gutsy, true-to-life depictions of modern life. Born August 13, 1866, in Williamsport, Pennsylvania, Luks studied art in brief stints in 1884 at the Pennsylvania Academy of Fine Arts in Philadelphia and in 1889 at the Staatliche Kunstakademie in Düsseldorf. Not one to adhere to a class agenda, Luks preferred to study art on his own while visiting Paris and London in 1889–90. In 1894 he began a career as a newspaper illustrator with the *Philadelphia Press*. While in Philadelphia, he became friends with William Glackens, Robert Henri, Everett Shinn, and John Sloan. By 1896 he had moved to New York to illustrate for the *New York World* and visited France in 1902–3, where he sketched in watercolor. He exhibited with The Eight in 1908 and in the Armory Show in 1913. John F. Kraushaar represented him from 1913 to 1924, succeeded by Frank Rehn from 1925 to 1933. In the early 1920s Luks made several trips to the coal region of Pennsylvania, depicting his surroundings in oils, drawings, and watercolors. After teaching at the Art Students League from 1920 to 1924, he started the George Luks School of Painting in New York. He died in New York October 29, 1933. The Phillips Collection owns five oil paintings and two watercolors by Luks.

The Luks Unit

Unable to join the armed forces during the First World War, Duncan Phillips was determined to find ways for American art and artists to serve the cause, and so he joined in organizing exhibitions, including the huge Allied War Salon of 1918, held at the American Art Galleries, New York. In general, the war-theme paintings were disappointing to critics, but Luks's *Blue Devils on Fifth Avenue*, 1918 (cat. no. 186), was a brilliant exception. Phillips bought the painting, along with Luks's *Czechoslovakian Army Entering Vladivostok, Siberia, in 1918*, 1918, and for the next decade continued to buy, borrow, trade, and return paintings as he shaped the Luks unit.[1] In the end he retained a strong group of five oils and two watercolors that reflect the variety of the artist's work over much of his career—from the time of his early, impressionist-influenced watercolor, *Verdun, France*, after 1915 (acc. no. 1225), to *Mining Village No. 3*, 1923 (acc. no. 1220), a watercolor depiction of the Pennsylvania coal mining country, the source of many compositions of the 1920s. The oil paintings have typical Luks subjects and represent the diversity of the artist's style and mood: a bold New York street scene in *Blue Devils*; the Manet-

like patterning of a figure study in the imposing *Dominican*, 1912 (cat. no. 185); the Hals-inspired bravura of *Otis Skinner as Col. Philippe Bridau*, 1919 (cat. no. 187); the humorously treated, heavily pigmented *Sulky Boy*, ca. 1908 (cat. no. 184); and the dark, ironic intimacy of *Telling Fortunes*, 1914 (acc. no. 1224), one of his humorous studies of low-life characters.

Luks was a member of the group of Philadelphia newspaper illustrators who, with Robert Henri, migrated to New York and formed the nucleus of The Eight; in their 1908 Macbeth Gallery exhibition, they became notorious for assaulting then-accepted good taste. Luks, in fact, because of his paintings of pigs and other low-life subjects, was the bad boy of the show, and Phillips, who desired to "see beautifully," would not at that time have appreciated Luks's brand of realism.[2] However, the artist's temperament was mercurial—in turn lusty, tender, brawling, and dignified—and his wit, vitality, and talent eventually attracted Phillips, who after purchasing *Blue Devils* was inspired to commission the artist to portray Otis Skinner in 1919. The Skinner portrait was an enormous success, and the next year Phillips purchased two more paintings, followed by other acquisitions over the next few years.

Although Luks was the most uneven and unpredictable of artists, his talents roused a strong if guarded enthusiasm in Phillips, whose "brief estimate" of Luks is perceptive and generous: "He is an individualist with a buoyant belief in his own genius and gusto in his copious enjoyments of his chosen subjects. The genius is unmistakable, but the gusto and self-satisfaction are not restrained by serious discipline and consequently Luks is an exasperating technician who produces two slovenly canvases for every one that is worthy of his prodigious skill. . . . When in full swing he can paint as well as Courbet, surpassing him in space composition and his rival in rich impasto, ponderable form, acceptance of life for its own sake, and bold commentary from the self-centered painter's point of view."[3]

Phillips's "estimate" appeared in 1926, and in November of that year he presented his Luks group in a small gallery exhibition of six oils, including all five in the present collection.[4] By the time of the exhibition, Phillips was becoming increasingly attracted to new movements in art, and by 1928 he had apparently stopped looking for additions to the Luks unit. There is no record of his ever having shown interest in the fresh, colorful figure studies of Luks's last phase.

DWS

184
Sulky Boy, ca. 1908
Sulking Boy
Oil on canvas, 44 × 34 (111.7 × 86.3)
Signed l.r.: *George Luks*
Acc. no. 1223

The artist; purchased by Kraushaar; sold 1920 to DP for PMAG.[5]

Sulky Boy, a portrait of Daniel Wynkoop Jr., was painted around 1908 at Cloverdale, the Wynkoop family's rented plantation near Butelow, Virginia, on the Rappahannock River.[6] The boy's father, a doctor at New York's Bellevue Hospital, had befriended Luks while treating him for alcoholism.[7] The artist visited the family at Cloverdale at least once in 1907–8 in the hope of curing his illness. The effort failed, however, when Dr. Wynkoop bought a keg of whiskey for his own consumption and Luks submitted to temptation.[8]

While at Cloverdale, Luks was photographed with the young Daniel (fig. 31), who is wearing playclothes—called "rompers"—similar to those he sports in the portrait. The child is probably depicted in the dining room of the estate. The fact that Daniel was asked to pose in one of the most formal rooms of the house may explain his tense, reticent demeanor. Or perhaps he was pouting about having to come indoors and stand still for any length of time—hence the artist's title for the painting.

Luks concentrated more on depicting the boy's mood than on the convincing representation of his surroundings. The floor slants upward far too dramatically while the folds in the tablecloth are painted with horizontal brushstrokes that break the downward flow of the fabric. Even the boy's legs are portrayed in an unsteady pose. It seems probable that Luks painted these details quickly from memory or a photograph after having depicted at least the boy's face during a sitting.

Painted not at the request of the family but on the artist's volition, the portrait, when exhibited, appealed to the critics both for its painterly qualities and for the emotions it evoked. One moved reviewer wrote, "The Sulking Boy was painted by a man who did not forget that he was a sulking boy at one time. . . . Look at the eyes of that sad little mortal." Duncan Phillips declared the work an "example of combined humour and kindliness . . . strong but not brutal. . . . Luks is seldom in this quiet mood."[9]

GHL

184

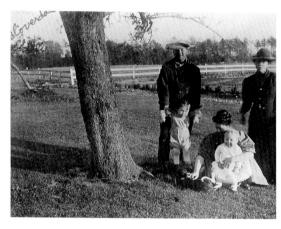

Fig. 31 George Luks, Daniel Wynkoop Jr., Mrs. Daniel Wynkoop, Gerardus Wynkoop, and a model at Cloverdale Plantation, Butelow, Virginia, ca. 1908, photograph by unknown photographer. Daniel Wynkoop Jr., Gulfport, Florida.

185

The Dominican, 1912

The Theologian
Oil on canvas, 56 × 49 (142.2 × 124.4)
Signed l.r.: *George Luks*
Acc. no. 1221

The artist; Arthur F. Egner, Newark, N.J.; purchased by Kraushaar 1919; sold 1920 to DP; transferred to PMAG 1920.[10]

When *The Dominican* was shown at Kraushaar Gallery in May 1919, an enthusiastic critic touted it as possessing "the force . . . strength of composition . . . [and] sense of tonal beauty" of Zurbarán and the "insight" of Raphael.[11] Duncan Phillips must have held similar views, for he purchased the work the following year and soon ranked it as one of the best oils in his collection.[12] However, as Phillips's interest in modern art increased, his initial enthusiasm for the painting waned. "In [Luks's] superbly plastic *The Dominican,*" he wrote in 1926, "we think perhaps just a shade too much of his aesthetic forefathers. This monk is not as inseparable from our century as many of Luks' best subjects."[13] He even turned it over to Kraushaar in the early 1930s in an attempt to have it deaccessioned, but it was returned to the Gallery by 1936 and today remains as documentation of Phillips's early collecting taste as well as Luks's artistic versatility.

The critic Frederick James Gregg identified the sitter, who was not a Dominican but George W. Maynard (1843–1923), an artist and respected member of the National Academy of Design.[14] Luks's reason for portraying Maynard as a cleric is unknown; however, it was not uncommon for him to dress his sitters in costumes that matched their demeanors.[15] He most likely intended satirical commentary on Maynard as a patriarch of the powerful, arch-conservative academy. Luks may also have been consciously emulating Old Masters like El Greco, Raphael, and Zurbarán in producing a stately, ecclesiastical portrait, intended no doubt to compare favorably with other paintings in the 1914 "Exhibition of Work by the National Association of Portrait Painters" at the Carnegie Institute.

GHL

185

186

Blue Devils on Fifth Avenue, 1918

Blue Devils Marching Up Fifth Avenue
Oil on canvas, 38⅝ × 44½ (98.2 × 113.0)
Signed l.l.: *George Luks*
Acc. no. 1219

The artist to Kraushaar, 1918; sold to DP for private collection 1918 (from Kraushaar exhibition); transferred to PMAG 1920.[16]

Duncan Phillips acquired Luks's oil *Blue Devils on Fifth Avenue* and the watercolor *Verdun* at the height of his First World War political efforts.

Verdun, painted in 1902, depicts the eventual site of a famous 1916 battle, while *Blue Devils* portrays the participation of French veterans in the Liberty Loan Drive parade in New York April 30, 1918. To the strains of the "Marseillaise," the soldiers pass by the corner of Forty-fifth Street and Fifth Avenue at about nine o'clock in the morning. Harriman National Bank and a synagogue, with flag flying, occupy one corner while Delmonico's Restaurant is situated on the other.[17]

After sketching the event on site, Luks executed this painting specifically for the Kraushaar Gallery's war exhibition the following month. He successfully adapted his characteristic sponta-

neous technique to the festive, patriotic subject. A sense of drama is created by the surge of blue-uniformed figures against the scumbled, indistinct background, which is illuminated by the morning sun streaming between the buildings. The impressionistic treatment of the figures, and the use of quick brushstrokes and bright colors, convey a vivid sense of immediacy.

Phillips believed that in *Blue Devils* Luks effectively conveyed intense "aesthetic emotion . . . a luxury of resonant color and dramatic light . . . unusual atmosphere and exciting movement," and he considered the work to be a "masterpiece of impressionistic painting, an

important canvas which would have value for its technical qualities alone." He continued his praise with patriotic zeal: "Its chief value for future generations . . . will be its record of authentic emotion at a thrilling period in history when to a great isolated peace-loving democracy the martial spirit came from the shell-scarred fields of France, and the heart of the great city beat hard with an overflow of affection for these heroes and a vague desire to emulate their example."[18]

Blue Devils was the most acclaimed painting in the Allied War Salon, which Phillips co-organized with A. E. Gallatin and others. Writing about the exhibition, Phillips revealed admiration for Luks's talent in portraying patriotic subjects: "Events of eternal consequence and incalculable importance are occurring every day and I fret to think that painters like George Luks are not there to see and to sketch them as he immortalized New York's welcome to the picturesque Blue Devils."[19]

<div style="text-align:right">GHL</div>

187

Otis Skinner as Col. Philippe Bridau, 1919

Otis Skinner as Col. Philippe Bridau in "The Honor of the Family"

Oil on canvas, 52 × 44 (132.0 × 111.7)
Signed l.l.: *George Luks*
Acc. no. 1222

Commissioned by DP; purchased 1919 through Kraushaar, New York; transferred to PMAG 1920.[20]

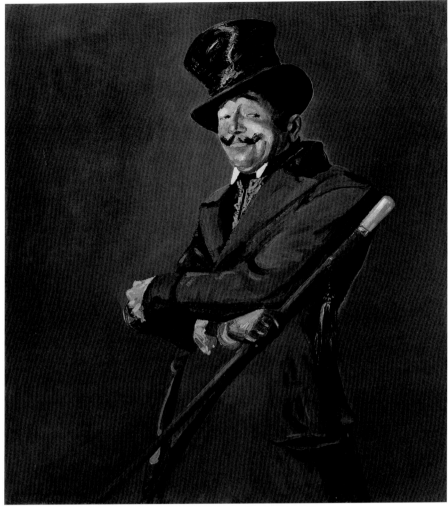

187

Luks's straightforward, spontaneous portrait of the actor Otis Skinner reveals the artist at his best in the evocation of character. He depicts Skinner as the brash, rakish Colonel Philippe Bridau, a role he played in *The Honor of the Family,* Emile Fabré's dramatic adaptation of Balzac's story "Les célibataires."[21] Famous for his impersonation of Bridau, the actor had been painted as the same character more than seven years earlier by Victor D. Hecht (1873–1931), a French-born artist. Luks may have seen this work in the catalogue for the 1912 "Exhibition of the National Association of Portrait Painters, Inc." at the Henry Reinhardt Galleries in Chicago, for his portrait bears striking similarities to Hecht's.

The posture, costume, tilted top hat, and diagonal cane are almost identical in both paintings; however, the arrogant, smug expression of Hecht's subject contrasts with the good-natured, roguish demeanor of Luks's Colonel Bridau. While Hecht depicted the actor full-length and in the act of pulling back the curtain to go on stage, Luks showed him three-quarter-length against a neutral background, removed from any descriptive context, thereby motivating the

viewer to focus on the actor's mocking gaze. Luks rivaled the seventeenth-century Dutch artist Frans Hals in his ability to capture with quick brushstrokes momentary facial expressions and poses that readily communicate personality. Duncan Phillips thought that "the portrait of Otis Skinner in the role of Colonel Philippe Bridau—a poseur and vagrant adventurer—is a design daring in color, strikingly effective in silhouette, and essentially a satire on all grandiose histrionics."[22] Luks's portrait may also be interpreted as a slight parody of Hecht's earlier effort.

An admirer of Skinner since his youth, Phillips commissioned the portrait, stating to John F. Kraushaar that he considered Luks the best man in America for the job.[23] Because Skinner was too busy for studio sittings, Phillips purchased theater tickets for the artist so that he could sketch him in performance. It was rumored that after a mere half-hour visit with

Skinner in his dressing room, and aided by a photograph, Luks painted the portrait in less than a week.[24]

In any event, it was exhibited at Kraushaar Galleries in 1919 to critical acclaim.[25] Declared by Phillips one of his best purchases of the season, the work was so popular that it was frequently requested for other exhibitions.[26] At the Art Institute of Chicago's "Thirty-third Annual Exhibition of American Oil Painting" in 1920, it won first prize, the Mr. and Mrs. Frank L. Logan Medal.

Skinner himself did not see the portrait until 1923, when it was hung at a reception in his honor at the Art Alliance in Philadelphia. A witness wrote to Phillips that Skinner "could not keep his eyes away from it, and he said when he first saw it that it was indeed a warm greeting and one of the kindest he had ever received."[27] Supposedly Skinner visited his portrait at the collection whenever he was in Washington.[28]

<div style="text-align:right">GHL</div>

JEROME MYERS (1867–1940)

Perhaps it is no surprise that Jerome Myers found spiritual kinship with the inhabitants of New York's Lower East Side, whose fragile lives he tenderly portrayed on canvas. Myers was born March 20, 1867, amid the devastation of post–Civil War Petersburg, Virginia. When his invalid mother was hospitalized in 1877, he was sent to a Methodist orphanage, where he remained until his mother recovered. At the age of twelve he left school to help support his family. In 1881 the family moved to Baltimore, and seven years later Myers began formal art training at the Cooper Union, New York, studying in the evenings and working as a sign and scene painter by day. In 1889 he enrolled in the evening class of George deForest Brush, a popular academician, at the Art Students League. A brief stay in Paris in 1896 was not to his liking, and he returned to New York after a few months. Through the artist Edward Kramer, Myers met William Macbeth, who became his first dealer and who convinced him, in 1900, to turn to oil painting. In 1905 Myers married the sculptor Ethel Klinck, then assistant director of the Chase School of Art in New York. Their daughter, Virginia, was born in 1906, and the family moved to a studio on West Twenty-third Street, across the street from their friend John Sloan. Macbeth gave Myers his first one-person show in January 1908, preceding the famous exhibition of The Eight. Myers was a force behind the independent exhibitions in New York, including the 1910 "Exhibition of Independent Artists," the 1911 exhibition "The Pastellists," and the 1913 Armory Show. In 1919 he was elected an associate member of the National Academy of Design; he became a full academician a decade later. Myers died June 29, 1940, in his Carnegie Hall studio. He is represented in The Phillips Collection by thirteen city scenes—nine paintings and four works on paper—and one 1908 pastel landscape, the gift of Marjorie Phillips in 1985.

The Myers Unit

In his depictions of New York's Lower East Side, Jerome Myers bridged the gap between romanticism and realism. With their glowing, warm colors and rich tonal effects that evoked both sentiment and charm, his paintings attracted the young Duncan Phillips, who early in his collecting career favored romantic landscapes and figure compositions, such as works by the European romantics Alexandre-Gabriel Decamps, Matthys Maris, and Adolphe Monticelli. Indeed, he considered Myers their kindred spirit in "his beautiful drawing and his rare and isolated genius for tone."[1]

Although Myers is associated with The Eight,

having adopted New York as his home, he began sketching city scenes a decade earlier than they did. Phillips believed Myers was "out of sympathy with their point of view. . . . Here is a man who is not a journalist, nor a socialist, nor a sensationalist of any sort, but a kindly observer with a passion for humanity."[2] Myers chose not to depict the harsh realities of life in the ghetto—malnourished children, child labor, horrid living conditions—in hopes of inspiring social reform. Instead, he favored portrayal of the positive side of life.

Phillips knew of Myers's work as early as 1913 when he cited him in an article entitled "The Field of Art: The City in Painting and Etching."[3] He visited Myers in his New York studio in 1916—his earliest documented visit to an American artist's studio—at which time the artist painted for him a small panel entitled *Little Mother* (acc. no. 1406).[4] In Phillips's estimation, "the theme of [this] picture is the unquenchable freshness and vividness of childhood defying envelopment in any dingy environment. . . . Myers . . . lays his emphasis [on] emotional rather than realistic or aesthetic effect."[5] *Little Mother* and *Band Concert Night* (cat. no. 189) were the first Myers paintings acquired by Phillips, and they established the tone for his Myers unit.

Of the nine paintings in the unit today, eight are genre scenes such as *Evening on the Pier*, 1921, *Waiting for the Concert*, 1921, and *Wonderland*, by 1922 (acc. nos. 1405, 1414–15). Phillips defined them as representations of "the East Side people resting after labor, delighting in their communities of race and creed, their intimacies of family life, [and] their novelties of entertainment."[6] *Market in Paris*, 1920 (acc. no. 1407), is the only painting that defies the subject matter of the grouping. Phillips usually purchased Myers's work the year it was painted, probably because, as one New York critic observed, "as a rule [Myers's] canvases are sold before they can reach a dealer's hands."[7] When in 1920 Phillips added *Field of Joy*, 1920, Myers replied, "May I say that I consider your generous appreciation of contemporary art work wholly admirable, reaching out as it does, and I am proud to be included."[8]

Phillips exhibited the Myers unit for the first time in 1926. At about that time, however, his taste began to shift toward the American modernists associated with Alfred Stieglitz. It was not until 1941, when Phillips attended the Myers memorial exhibition at the Corcoran Gallery of Art in Washington, D.C., that his interest in the artist was renewed.[9] He purchased three works on paper that recall his 1917 assessment of Myers

as "the kindly philosopher (who happens to know how to draw like a great artist)."[10] Even though Myers had passed out of fashion by the end of the 1940s, Phillips still appreciated his optimistic fantasies, and he again exhibited the unit in 1949, including his most recent purchase, *The Tambourine* of 1905 (cat. no. 188).

VSB

188

The Tambourine, 1905
East Side Picture; The Street Dance; An Appreciative Audience
Oil on canvas, 22 × 32 (55.8 × 81.2)
Signed and dated l.l.: *Jerome Myers N.Y. 1905*
Acc. no. 1413

The artist; purchased by James Speyer 1906; purchased by Macbeth, New York, at auction (James Speyer Estate sale), April 10, 1942; PMG purchase 1942.[11]

189

Band Concert Night, 1910; reworked 1916
Band Concert
Oil on cardboard, 14 × 19¼ (35.5 × 50.1)
Signed and dated l.l.: *Jerome Myers N.Y. 1910*
Acc. no. 1403

The artist to Daniel Gallery, New York, date unknown; DP purchase for his private collection by 1916; transferred to PMAG 1920.[12]

Music provided an escape from the dingy environment of tenement life for the inhabitants of the Lower East Side. On Sunday evenings the people spilled into the parks for free concerts—such as Mendelssohn's "Spring Song" and Schubert's *Unfinished* Symphony—depicted in *Band Concert Night*.[13] Similarly, when the hurdy-gurdy man played selections from *Rigoletto* and *Il Trovatore*—as portrayed in *The Tambourine*—the children's imaginations transported them, Myers wrote, "from the East Side streets to scenes at the Metropolitan Opera House."[14]

Both paintings demonstrate compositional devices that Myers regularly employed in painting crowd scenes. *The Tambourine* is set on a shallow foreground abruptly cut off by a backdrop created by a high wooden fence and red-brick building. He also used stock situations that connoted "lower class" life: gypsies performing, mother and child leaning out a window, children dancing in the street—all aspects of city life unfamiliar to the bourgeoisie. *Band Concert Night,* painted a few years after *The Tambourine,* reveals Myers's evolution as an artist. He still employed a stagelike setting but now gradually led the viewer into the background by a progres-

sion of depth-enhancing elements—a balustrade, a "wall" of spectators, and finally, darkened buildings in the distance. In both paintings, figures are painted with their torsos parallel to the picture plane, creating a closed, intimate environment. And at least two figures engage the viewer: the delicate child in the lower center of *The Tambourine* who appears to kick up her heels for the onlooker, and the child leaning against the fence in the back who seems to stare inquisitively out of the picture.

Band Concert Night is quite probably the subject explained in a 1916 letter to Phillips: "I found after a careful survey that the girl in green did not suit the picture—so I put a woman and a child in which I think harmonizes and completes the composition. I did not touch the three figures you liked but think they are set off by this arrangement."[15] Myers's "three figures" are possibly the seated women in colorful green, orange, and red blouses, highlighted by ambiguous white space, in the foreground of the picture. They are abutted by the "woman and a child" sitting on the decorative edge of the balustrade to their left.[16] Myers's rough application of paint in circular compartments allies this painting with the work of Maurice Prendergast. Indeed, Myers, who first met Prendergast in the early teens and with whom he spent many hours in Prendergast's Washington Square studio, considered him a "modest artist who fashioned the most joyous patterns of pictures our country possesses."[17]

In 1942, even though Myers was already well represented in the collection, Phillips purchased *The Tambourine,* exclaiming, "This does seem to be his masterpiece and I cannot resist it."[18] Phillips knew of the painting a quarter of a century earlier when it was in the private collection of James Speyer. Phillips cited it in an article to illustrate the artist's enthusiasm in portraying children, noting how the painting depicts "children . . . dancing to the magic music of a hand-organ. Round and round they go, swinging each other, and the swarthy grinder of tunes grins his satisfaction, while 'the good wife she throw her tambourine into the sky.'"[19] In the same article Phillips identified the sequel to this painting as *The Pursuit of Pleasure,* n.d., which presents the same children following the "hurdy-gurdy's fascination" through the streets.[20] In these works, and indeed in many others, Myers reveals his love of childhood, "especially exuberant childishness under no well-bred restraint."[21]

VSB

188

190

Night in Seward Park, 1919

Night—Bryant Park; Night, Seward Park; Seward Park
Oil on canvas, 30 × 25 (76.2 × 63.5)
Signed and dated l.r.: *Jerome Myers 1919;* reverse: signed in black ink on stretcher, u.r., *143 E. 8 St NYC/Jerome Myers;* inscribed [probably by artist] in pencil and underlined in black ink on stretcher, u.l., *Night in Seward Park NY City.*
Acc. no. 1409

The artist to Kraushaar, New York, 1919; purchased by DP for private collection 1919; transferred to PMAG 1920.[22]

At the turn of the century the great industrial boom attracted a wave of immigrants from central and southern Europe to America, and many of them settled in the Lower East Side of Manhattan. In *Night in Seward Park* Myers captures what appears to be a harmonious gathering of Jewish and Italian immigrants. He found inspiration "in this city where people of different nationalities and faiths live together in peace and harmony."[23]

This painting, however, is a more melancholic study of humanity than is typical in a Myers work. The artist portrayed not "the repose in the parks" of a happy people at the "surcease

of a great city," but the deprived and depressed, and the harsh reality of living in poverty.[24] Little joy is displayed on these people's faces, with the exception of the woman offering her baby to an elderly gentleman, no doubt the highlight of his day. In the park, named after statesman William Henry Seward (1801–1872), beggars confront people who turn their heads in disgust, an old skeletal figure hunches under his red cloak to try to keep warm, and a matriarchal figure, the anchor of the composition, stares out with indignation at the person drawing her likeness.[25]

Myers was often stylistically compared to Rembrandt. Indeed, his paintings contained textural surface quality, broken and subdued color, and homely subject matter. Myers himself acknowledged his debt to the master: "It may be that Rembrandt's Dutch courage has sustained me, even as his art has inspired me. On faith and as an atavistic liberty, I have adopted him as an exemplar."[26] Recognizing this influence, Duncan Phillips wrote that "in such a masterpiece as 'Night—Seward's Park' . . . the golden brown sensuousness of other arbitrary tonalities, and . . . the impassioned observation of the Old Testament Ghetto types, suggest that Rembrandt would have recognized a good disciple."[27]

VSB

189

190

WILLIAM J. GLACKENS (1870–1938)

William Glackens was among those members of the artists group The Eight who favored subjects depicting the more cheerful aspects of modern life. Born in Philadelphia March 13, 1870, Glackens attended Central High School with John Sloan and the collector Albert C. Barnes. In 1891 he began a career as an artist-reporter for various Philadelphia newspapers while simultaneously attending evening classes at the Pennsylvania Academy. That same year Sloan introduced him to Robert Henri, with whom Glackens shared a studio for a year and a half. After traveling to France and The Netherlands in 1895, Glackens moved to New York, where he continued working as an artist-reporter, magazine illustrator, and painter. In 1898 he accompanied the U.S. Army to Cuba to record the Spanish-American War for *McClure's* magazine. Upon his return, he met Edith Dimmock, an art student, whom he married in 1904. About that time, Glackens gave up illustration as a career in order to devote himself to painting. When the Society of American Artists merged with the National Academy of Design in 1906, Glackens became an associate of the academy (he would become a full academician in 1933). After a second trip to Europe in 1906, he began preparations for the 1908 exhibition of The Eight at Macbeth Galleries, New York. In 1912 Barnes sent him to France as his agent to purchase contemporary French paintings, including works by Cézanne, Matisse, and Renoir. Glackens served as chairman of the selection committee of American art for the Armory Show in 1913 and as first president of the Society of Independent Artists in 1917. Between 1925 and 1932 he divided his time between France and New York; thereafter he remained in America. He died in Westport, Connecticut, May 22, 1938, while visiting his good friends Charles and Eugenie Prendergast. Glackens is represented in the collection by one oil painting.

191

Bathers at Bellport, ca. 1912

Oil on canvas, 25 × 30 (63.4 × 76.0)
Signed in blue paint, l.l.: *W. Glackens*
Acc. no. 0792

The artist; consigned to Kraushaar, New York, 1925 or later; PMG purchase 1929.[1]

After nearly a decade and a half of painting in muted colors with gestural brushstrokes in the manner of Robert Henri, Glackens surprised the New York art world in 1908 with his vividly colorful entry in the winter exhibition of the National Academy of Design.[2] As the New York critic Arthur Hoeber reported, "In William Glackens's *Beach Scene* it may be said that the painter was obviously striving to get away from the conventional rendering of his confreres [The Eight]."[3] His experimentation with bright color harmonies had been encouraged by his friends Maurice Prendergast and Ernest Lawson, who were also members of The Eight, and Alfred Maurer, who had embraced fauvism in 1907. Glackens's 1912 trip to Paris, where he saw an explosion of color in the works of the impressionists, post-impressionists, and fauves, further reinforced his new direction.[4]

Glackens spent the summers of 1911 to 1916 at Bellport, Long Island, a quiet, unspoiled community that attracted artists, writers, and musicians.[5] There he painted a series of beach scenes—colorful canvases barely resembling his earlier work, which he later described as looking like "mud, life isn't like that!"[6]

During the Bellport summers Glackens painted numerous works at Great South Bay that showed his family and friends enjoying summer pleasures—the sun and the beach, sailing and swimming. In *Bathers at Bellport,* horizontal docks and sand bars bound the sparkling blue water, bright yellow-ocher and burnt sienna bathhouses contrast with crisp white sails. A visual memory of the summer of 1912, this work reveals Glackens's growing interest in impressionism. In 1913 he wrote, "Everything worth while in our [American] art is due to the influence of French art." He also noted that "Theodore Robinson, Hassam, Weir and Twachtman were the first to . . . show the influence of the French impressionists under the leadership of Monet. They brought into our art a new theory of color, a color that was honestly derived from the color of nature. . . . The impressionists introduced the light of life into our art."[7]

Bathers at Bellport is reminiscent of Monet's paintings of the 1860s in the broad and direct treatment of color, brevity of touch, and jewel-like dashes of color that denote foliage and the sun's shimmering reflection on the water.[8] However, Glackens distinguished himself from the impressionists by not allowing light to diminish the contour of an object. His close friend Everett Shinn explained, "We cannot separate the influence of [Glackens's] line, developed through his drawing, from the body of his painting. For though he used color to build form, he depended on line to give it structure."[9]

Phillips first saw *Bathers at Bellport* in 1925 at Kraushaar Gallery in New York. However, at the time he was more interested in Glackens's "recent pictures of his little daughter with her pets and toys,"[10] and he purchased *Lenna and the Rabbits,* ca. 1920.[11] When he finally acquired *Bathers at Bellport* in 1929, Phillips wrote to Kraushaar, "It is a picture which I have long admired in your gallery."[12] Glackens himself believed it was "the finest of his older pictures."[13]

VSB

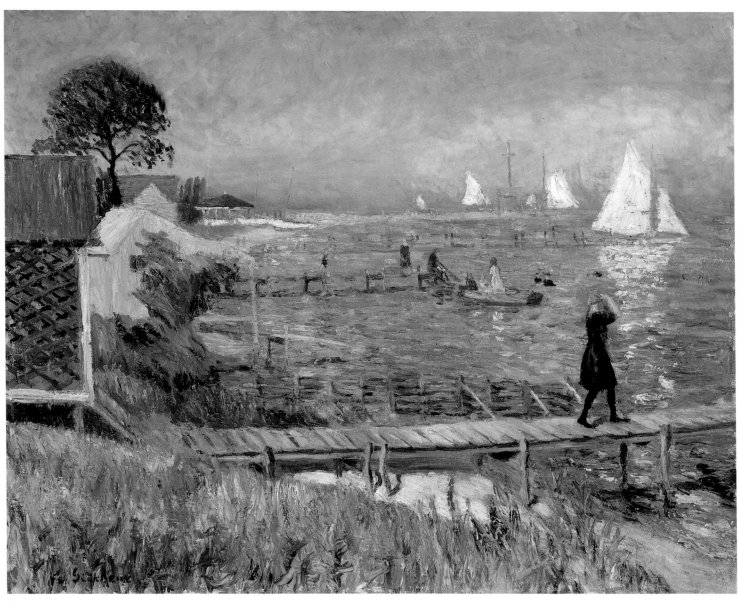

191

AUGUSTUS VINCENT TACK (1870–1949)

Born November 9, 1870, in Pittsburgh, Augustus Vincent Tack moved with his family to New York in 1883. After earning a B.A. degree from St. Francis Xavier College in Chelsea, New York, in 1890, Tack studied with H. Siddons Mowbray at the Art Students League until 1895, earning some accolades in the press for his portraits. He may also have frequented the studio of John La Farge, whose portrait he painted around 1900. Tack sojourned in France in 1893, 1895, and possibly 1896, and worked with the muralist Olivier-Luc Merson. Kraushaar Galleries in New York gave him his first one-person show in 1896, and the next year he moved to the budding artist's colony in Deerfield, Massachusetts, where he met and later married Agnes Gordon Fuller, daughter of artist George Fuller. Tack maintained a studio in New York from 1894 until the end of his life. He had frequent exhibitions at New York galleries, and from 1900 until the twenties his work was shown regularly at the Worcester Art Museum, in Carnegie International exhibitions in Pittsburgh, and at the Pennsylvania Academy of the Fine Arts in Philadelphia. He taught at the Art Students League between 1906 and 1910 and at Yale University from 1910 to 1913, earning an honorary B.F.A. at age forty-two. Around 1914–15 his work attracted the notice of Duncan Phillips, who became his close friend and chief patron. They collaborated on the organization of the Allied War Salon of 1918. Though Tack continued to produce traditional portraits and murals for the remainder of his career, his most original achievements were his semiabstract landscape paintings, many of which were inspired by photographs of the American West. These were executed almost exclusively for Phillips. From 1941 on, Tack maintained a studio in Washington, D.C., where he produced portraits of political and military leaders, including Eisenhower and Truman. He died in Deerfield, July 21, 1949. The collection contains seventy-nine works by Tack.

The Tack Unit

For Augustus Vincent Tack, perhaps more than any other artist, The Phillips Collection is both spiritual home and permanent memorial. Tack's personal history is inextricably linked with that of the museum and its founder. He counseled Duncan Phillips on purchases and participated in the administration and decoration of his fledgling museum. As Tack's foremost patron, Phillips in turn provided Tack with a commission that became the culminating statement of his career: a series of abstract paintings for the museum's North Library (known as the Music Room since 1931).[1]

When the museum opened in 1921, Phillips owned more paintings by Tack than by any other artist. The unit today spans his entire career, comprising seventy-nine works.[2] In addition, Phillips hosted more than fifteen one-person exhibitions of Tack's work between 1924 and 1958, and his paintings were displayed continuously with the permanent collection.

Sixteen years Phillips's senior, Tack held the role of close friend and seasoned aesthetic mentor, and in his work Tack strove to give pictorial form to their mutual faith in the renewing and ennobling powers of art. In 1920, at the inaugural meeting of the first board of trustees, Phillips appointed Tack vice president of the museum.[3] He also designated Tack and himself as heads of the Committee of Scope and Plan to chart the institution's direction and define its goals.[4] They expanded the group through their circle of friends—artists, dealers, and critics—and Phillips sought Tack's support in building the collection as he purchased works by diverse artists such as Ménard, Fuller, Ryder, Kent, and Twachtman.

The two men apparently first met either in the artist's studio or at the Century Association, and in Phillips's first known writing on the artist in 1914 he stated, "my earliest acquaintance with the landscapes of Augustus Tack was one of those experiences which mark an epoch in one's own mental development. . . . Some small panel-shaped canvasses—made me more or less catch my breath with delight."[5] Phillips felt an affinity for Tack's subjective explorations of nature—country fields in twilight, misty skies, and roseate mountaintops—and for a quiescent and poetic view of art that suggested a longing for transport, through painting, into imaginary realms. In his first published writing on Tack in 1916, Phillips seemed awed by the artist's eclectic broad-mindedness, which prompted in him fascination with both Japanese prints and medieval stained glass, and even "the sensational performances of Picasso." Phillips added that Tack was responsive "to the most startling revolutionary disturbances in the realms of painting and music."[6]

Around 1920 Phillips purchased a heavily impastoed religious painting, *Madonna of the Everlasting Hills*, 1913–14 (acc. no. 1906), which represents the apex of Tack's pointillist style and which was one of his most important explorations in monumental mural painting during the teens.[7] Throughout the 1920s Phillips probably aided Tack in striking out into new territory with the sonorous, heavily veiled and quasi-abstract paintings of 1922–24. They inaugurated the lower gallery, now the Music Room, thus

constituting Tack's first one-person exhibition at the museum.[8] Phillips quickly acquired four panels, trading some of Tack's earlier work back to his dealer, Kraushaar Galleries.

The period of 1922 to 1934 saw the most fruitful era of collaboration between the artist and his patron, who wrote about Tack's "inspiring dignity based . . . on the essential isolation of the true artist . . . [Tack] will stand revealed as an important pioneer into new fields of emotional expression in color and as the one creative mural painter since Puvis de Chavannes."[9] In preparation for the museum's 1922 inaugural exhibition, Tack undertook the decoration of the Main Gallery, devising an "attractive orange color scheme and surface treatment" with apricot walls muted with gray mesh.[10]

In 1923, Phillips drew a plan of his projected museum, to be built on a site overlooking the city. Tack was to decorate the hallway with "abstractions"—an evolving concept in the minds of both artist and collector bearing connotations of decoration, allegory, and the pictorial rendering of specific, immaterial ideas.[11]

By 1926 Phillips was weaving Tack into the fabric of American modernism as no other collector or critic was yet prepared to do: he exhibited *Storm* (acc. no. 1933), one of Tack's new mystical panels based on natural forms, in a group dominated by the Stieglitz circle, including O'Keeffe, Dove, and Weber. These painters were juxtaposed with Redon, whom he felt to be a guiding spirit in their attempt "to link modernity to the infinite by their inventions of new or revitalized . . . plastic expression."[12]

Tack's abstract explorations of the early 1920s culminated in the paintings for the Music Room, commissioned in 1928. Other notable works in the collection include an example of his masterful portrait style, *Portrait of Elizabeth Hudson*, 1914 (acc. no. 1922), a work that conveys a poignant mood and expresses the personality of a mutual friend of artist and patron. Furthermore, Tack's sumptuous and progressively freer handling of color and his growing mystical expression in landscapes can be traced from the early *Winter (New York in Snow)*, ca. 1900 (cat. no. 192), to a more tactile pointillism of the teens in *Madonna of the Everlasting Hills*. The turning point in Tack's abstract technique, beginning with the seminal painting *The Crowd*, 1921–22 (cat. no. 193), is carried to a new complexity in *Passacaglia*, 1922–23, and *The Voice of Many Waters*, ca. 1923–24 (cat. nos. 194 and 195). These jewel-like paintings, progressing toward a glowing opalescence of color and apparitional earth and sky forms, led ultimately to the vast panorama inspired by the American West and

by photography. Tack's apocalyptic vision of the region resulted in such pictures as *Aspiration*, 1931 (acc. no. 1871), his last painting for the Music Room. The swan song of Tack's abstract oeuvre, the modestly scaled panels here represented by *Evening*, between 1934 and 1936 (acc. no. 1893), and the last monumental painting, *Time and Timelessness*, 1943–44 (cat. no. 198), represent Tack's final investigations of an abstract idiom. In the latter part of the thirties, Phillips acquired examples of Tack's large-scale, somber paintings as typified by *Night, Amargosa Desert*, 1935.[13]

Phillips's advocacy of Tack took its boldest, most forceful form in 1930, when he threatened to resign from the board of trustees of the Museum of Modern Art if Tack's work were not represented in the 1930–31 exhibition of living Americans. Alfred Barr gracefully—and hastily—acquiesced, accepting three of Tack's Music Room decorations.[14] Furthermore, it was on Phillips's advice that in 1941 Tack moved to Washington, D.C., where, with his tireless backing, the artist secured several official portrait commissions.

Nevertheless, a shift in Phillips's attitude began to emerge. In 1930 he had defended Tack as more "genuine" a modernist than Picasso, able to "move men to ecstasy and vision through [his] divine control of the emotional potentialities of light and color."[15] In 1932 he still saw Tack's art as the "portent of the coming of something epoch-making from the East . . . an acceptance of a Universe of unceasing flux."[16] Yet the next year Phillips published an ambiguous statement that contained a clear note of disappointment: "If Tack had been painting his unique maps of . . . color for the last twenty years he would now be reaping the reward in universal acclaim for having invented a new decorative language. . . . His other researches of earlier years have not been so successful and his conservative portraits and traditional mural paintings have made him a limited reputation as an . . . eclectic painter . . . rather than as one of America's most original painters."[17] Significantly, between 1933 and 1937, when Tack had eleven solo shows at museums and galleries throughout the northeast, Phillips held no one-person exhibitions.[18] With the onset of the Second World War, he stressed Tack's affinity for Asian art: "In the midst of the most complete and terrible war of all time, at last Tack seems . . . of a prophetic timeliness," for "we have need for men who see their way around the globe and never forget the sky which arches over all men."[19]

In 1949, a few months prior to Tack's death, Phillips hosted a one-person exhibition, which

192

the artist visited. Tack was apparently viewing his most important works, the Music Room series, in situ for the last time. He later wrote to Phillips: "I came away from your exhibition . . . in a state of fervor and exaltation. . . . I can only make a feeble effort to express to you my appreciation of your recognition. . . . You have been a very great friend."[20]

Upon his death, Tack bequeathed the paintings in his possession to The Phillips Gallery. Phillips duly made the rounds of galleries, museums, and collectors to promote Tack, placing several important abstractions in museums.[21] Two years before his own death, he wrote one of his last statements on Tack's career: "The Abstractions are now in retrospect very important and it is sad that they were not appreciated during the artist's lifetime. . . . Many admirers of the Abstract Expressionists of today have noted the resemblance to Clyfford Still, and it is obvious that he was feeling his way towards that large scale color symbolism. The surface however was much more emphasized than is the fashion today and the technique was magical."[22]

LF

192

Winter (New York in Snow), ca. 1900

City in Snow
Oil on canvas, 24⅞ × 27⅞ (63.2 × 70.9)
Signed in lavender paint, l.l.: *AVGVSTVS.VINCENT.TACK.;*
inscribed on reverse: *Winter/AV Tack/939 8th Avenue/NY*
Acc. no. 1912

The artist's collection until 1949; Mrs. Agnes Gordon Tack; acquired from the estate of Agnes Gordon Tack by 1959.[23]

In the late winter of 1900, Tack wrote to his fiancée, Agnes Fuller, "We are in the midst of a blizzard in New York," and it is tempting to speculate that he depicted the storm in this painting, which shows a view from the window of his home or studio in New York.[24] Tack's view of the street from above is anchored by an oblique foreground element at the left—probably billboards seen from the back.

The painting is the sole example of an urban scene in Tack's oeuvre. Indeed, his letters are peppered with references to his aversion to the noise, crowds, and chaos of New York; it is thus no coincidence that only the softening and

enchanting effects of a blizzard could induce him to paint the city.

The free brushstrokes and decorative palette of the work suggest a date of no earlier than 1900. The tendril-like brushwork, which recalls Monet's late work, animates the surface in a dizzying mass connoting the swirling snow and dense atmosphere before a somber mass of buildings. The cool color range of blues and grays is enlivened with lavender accents, a portent of Tack's pointillist period in the teens. In style, the work invites comparison with American and French painters exploring urban themes in an impressionist idiom, and bears special affinities with Childe Hassam's winter city scenes.[25] Its theme and mood also coincide with an American revival of the tonalist style in the depiction of city views in painting and photography.[26]

LF

193

The Crowd, 1921–22

Barabbas! Barabbas!; Turmoil (DP)
Oil on canvas mounted on wallboard, 25 × 45¼ (63.5 × 116.2)
Signed in red paint, l.r.: TACK; inscribed on reverse: *The Crowd, Augustus Vincent Tack/15 Vanderbilt Ave./N.Y.*

Consigned by the artist to Kraushaar, New York, probably by 1922; on loan to Charles Downing Lay, New York, by 1930; Macbeth Gallery, New York, 1941; consigned to Nierendorf Gallery, New York, by 1943; PMG purchase (from exhibition) 1943.[27]

The Crowd, one of Tack's most dynamic, abstract compositions to this point in his career, is composed of human and landscape forms inextricably linked in swirling movement and liberated color. It forecasts the gradual suppression of the figure in favor of the landscape theme. Most significantly, the composition served as the basis for six of the paintings for the Music Room series commissioned by Duncan Phillips in 1928.[28]

To create this vortex of figures in motion, Tack drew from a myriad of sometimes unexpected sources. As early as 1899, he expressed an interest in the crowd theme, admiring in the paintings of Jean François Raffaëlli "the sense of great numbers of people and the movement of life."[29] The principal theme derives from a scriptural passage as cited in a 1941 manuscript by Tack: "The crowd preferred Barabbas to Christ. They shouted for him to be released and cried out that Christ be crucified, the choice of the mad world, and there is madness and confusion in this painting. There is the sense of turmoil and struggle."[30]

Tack apparently claimed that natural forces inspired the composition. According to Phillips, "The movement of this vast jostling crowd was inspired by wind over a tobacco field."[31] At the right side of the painting, Tack left the underdrawing exposed; this passage and recent infrared photography suggest that landscape photographs may have served as the underlying scaffolding of the composition.[32] Tack then built his figures on the directional lines indicated by these organic forms.

The painting indicates that Tack's exposure to and interest in a broad range of artistic movements is wider than has previously been thought. A characteristic love of *japoniste* design is betrayed in the two-dimensional arrangement and the ambiguous figure-ground relationships. His awareness of cubo-futurist vocabulary is suggested by his use of force lines and reductive, geometric simplification.[33] The color harmonies and rhythmic forms suggest links with the American synchromist movement spearheaded by Morgan Russell in the early teens, a connection reinforced by the fact that Tack, like Russell, borrowed from Michelangelo (here, the central figure is adapted from the ceiling of the Sistine Chapel).[34] The whole effect is undeniably reminiscent of the tangle of human limbs in such Renaissance works as Luca Signorelli's *The Damned* at Orvieto.[35]

Tack built up the picture with a collagelike combination of techniques, including stenciling, transferral of drawings or photographs, and freehand painting.[36] The sky was first painted light blue, then beige with cerulean accents over a coat of varnish. The entire work, including the aluminum-leafed frame, was distressed with rollers and cloths, conveying the antique refinement characteristic of Tack's Beaux-Arts training and his love of texture.

Tack's multiperspectival, nonhierarchical construction created a visual equivalent to anarchy and mass revolt, and carried moral undertones, especially within the biblical theme. Beginning with this painting, the rendering of order from chaos as well as the cycle of sacrifice, destruction, and ultimate redemption—central to Catholic doctrine—remain the dominant themes of Tack's abstractions for the rest of his career. The cycle itself is suggested by the figures, which on the left convey various attitudes of agitation and torment, and on the right, prayer and supplication.

Peyton Boswell, the critic for the *New York American*, singled out the work: "One of his most colorful compositions . . . a vortex of reds and blues and whirling forms which epitomize the mob spirit."[37] In a more conservative vein, another critic praised the picture as "among his best, although to some it may seem dangerously cubistic."[38]

Duncan Phillips, who came late to an acceptance of cubist painting, did not consider the work for purchase until 1941, but rather he decided on the more conventional *Gethsemane*; however, two years later he acquired it from his exhibition of Tack's work, praising it as "a powerful and personal abstraction and unique in [Tack's] own work," and a "miracle of turbulent movement."[39]

LF

194

Passacaglia, 1922–23

Oil on canvas on plywood panel, 43⅞ × 49¾ (111.6 × 126.4)
Signed l.r.: TACK
Acc. no. 1921

PMG purchase from the artist through Kraushaar, New York, 1924.[40]

195

The Voice of Many Waters, ca. 1923–24

Oil on canvas mounted on wallboard, 77¼ × 47⅞ (196.2 × 121.7)
Signed l.l.: TACK

PMG purchase from the artist through Kraushaar, New York, 1924.[41]

Tack achieved a remarkable grandeur and subtlety in the series of paintings he produced between about 1922 and 1924, as represented by these two works.[42] Their formats derive from both European and Asian decorative traditions: *Passacaglia* is a tondo and *The Voice of Many Waters* echoes Asian scroll painting on a large scale. The source for their themes is Scripture. *Passacaglia*'s biblical origins are revealed in a preparatory sketch depicting the Holy Family.[43] The subject of *The Voice of Many Waters* is from Revelation 1:12, "The voice of God is as the sound of many waters." Tack wrote later, "They may be called forms of meditation through which the mind and the heart are uplifted."[44]

Thus Tack began with New Testament subjects and gradually turned to more universal evocations of matter and spirit. "For his inspiration," wrote Duncan Phillips, "he has gone to two sources (1) the thought of the divine Nazarene, of the mighty spiritual forces created by Him to save the world from itself; (2) the majesty of high mountains in serenity and storm, the Elements which transcend time and place and speak with the voice of the Great Spirit."[45]

Tack's first view of the Rocky Mountains in the summer of 1920 indeed provided a setting majestic enough to suggest a divine realm: "We took a horseback ride of sixteen miles over a trail which led to a wonderful valley. The ground was a carpet of flowers of every variety. . . . The valley was walled in by an amphitheater of mountains as colossal as to seem an adequate setting for The Last Judge-

193

ment, glacial lakes lay like jewels on the breast of the world—malachite and jade-greens of every variation. Battlements and pinnacles of rock close to the clouds and on the mountain slopes great white glaciers seem motionless and slumbering, but terrible in their potentialities."[46] Nineteenth-century painters such as Albert Bierstadt and Thomas Moran had romanticized the Western landscape; many later artists, including Hassam, Twachtman, and Davies, sought to capture the majestic scenery of the West in highly personal terms. Tack's description in the foregoing letter, as well as the dematerialized shapes and fragmentary mountain forms of *Passacaglia* and *The Voice of Many Waters*, suggests that he, like his nineteenth-century forebears, found in the Western landscape implications of spiritual power and transcendence.

The Western terrain found its way into Tack's imagery through filtered memory and other indirect sources. Rather than sketching or painting on site, he appears to have devised his towering mountain forms and figural compositions almost wholly from forms in *The Crowd* (cat. no. 193) and an early painting of the period, *Entombment,* 1922 (acc. no. 1892). The irregular, ragged forms of both of the present paintings suggest a source in enlarged photographs of light and shadow playing over the contours of

194

195

landscape.[47] While it has been suggested that Tack made his own photographs of landscape sites, it seems more likely that his son, who had a documented interest in photography, took the pictures.[48] Tack freely rearranged, enlarged, and reconfigured the two earlier conceptions, creating the basis of a complex new imagery. For example, the gesturing figure of St. Joseph in *Entombment* reappears in the center of *Passacaglia* and even in the suspended fragmentary forms of the "landscape" in *The Voice of Many Waters*. Further, *The Crowd* serves as a model for both the craggy rocks in the foreground of *The Voice of Many Waters* and the dancing figures in *Passacaglia*.

One of Tack's freshest and most spontaneously worked creations, *Passacaglia* is titled after a medieval Italian street dance that was later adapted as a movement in baroque music. The pulsating, swirling movement is enhanced by the circular format. "The interrelation of color and form," wrote the artist, "weaves an abstraction which may be felt subconsciously if we allow the painting to lead our imaginations, as in listening to music, and by not attempting to force the identity of objective realities."[49] *Passacaglia*, along with *Canyon*, is the only work devoid of overt religious content; yet the sketch for it contains a scene from the Nativity.

Tack's startling innovations—the use of photography, the free reconfiguring of his own earlier imagery, the melding of human and landscape forms—are balanced by the singular material richness and almost effete aestheticism of his chromatic harmonies, surface treatment, mounting, and framing. He achieved a gossamer delicacy by enhancing his surfaces, scumbling them with a brush or roller, scraping back paint layers to reveal underpainting, and accenting the canvas texture. The burnishing and layering often extended to the frames.

The ambitious scale of *The Voice of Many Waters* indicates Tack's great assurance at the height of his career.[50] A triangular grassy knoll fills the left foreground, as if extending the viewer's space into the picture. A waterfall cascades from a mountain face of peaks and crags, creating, in Phillips's words, a "vision of serenity, transcending time and change."[51] The drama is emphasized by the painting's extreme vertical format.[52] Evidence has recently come to light that Tack initially created this painting as a prospective mural for the program at Nebraska's State Capitol in Lincoln (1924–28), a project to which he ultimately contributed murals in a more traditional style.[53]

The Western paintings were the focus of Tack's first solo exhibition at Phillips's museum in 1924, inaugurating the spacious lower library (now the Music Room) for public exhibitions. Phillips pronounced the show "a howling suc-

196

cess" with both press and public. "A room decorated by Tack," he wrote, "is a place where the spirits and the senses are wonderfully reconciled, and where life takes on new meanings."[54]

LF

196

Balance, 1929

Oil on canvas mounted on wallboard, 43⅝ × 35⅝ (110.8 × 90.4)

Signed l.r.: TACK

Acc. no. 1872

Commissioned by Duncan Phillips in 1928; PMG purchase 1930.[55]

197

Liberation, 1929

Oil on canvas mounted on wallboard, 47⅞ × 64¼ (121.7 × 163.2)

Signed l.l.: TACK

Acc. no. 1905

Commissioned by Duncan Phillips in 1928; PMG purchase 1930.[56]

Tack's mystical and transcendental vision reached its culmination in a cycle of thirteen paintings, including *Balance* and *Liberation,* that he created between 1928 and 1931 for the Music Room. The series forms an important chapter in the history of the museum as well as in the his-

tory of abstract painting in the United States, and the artist considered it the crowning achievement of his career.[57]

Tack's endeavors as a muralist and decorator, launched in 1900 and culminating in his murals for the Nebraska State Capitol in 1928, encouraged him to develop a muralist's conception of painting in which compositions unfold through architectural space, encompass lofty themes, and possess a monumental scale.

With their arched lunettes and gilded architectural borders, these paintings represent the final flowering of the Beaux-Arts tradition of the American Renaissance.[58] However, Tack's abstracted and fragmented forms, and his use of the Western landscape, represent a striking departure from traditional symbolism and treatment.

In 1928 Phillips realized his dream of having a room decorated by Tack, choosing the museum's lower gallery when it became clear that plans for a new building would have to be postponed. The space, which had irregular proportions, dark wainscoting, and a window transept, presented challenges to the artist. According to Phillips, the "Hall of Cosmic Conceptions" was meant to address "the mystic's sense of an all pervading God . . . seeking to create Cosmos out of Chaos."[59] Through this overarching theme, Tack synthesized a confluence of sources, including Catholic mysticism, neo-Platonism, and aesthetic formalism. The present

paintings are studies for murals that were never realized.

Both *Balance* and *Liberation* have their place within the visual and thematic scheme of the room, the former as part of the west wall, the latter intended as a lunette for one of the end walls. Their striking contrast gives evidence of Tack's sources for the series: *Balance,* the more figurative of the two, is one of five panels derived from *The Crowd* (cat. no. 193), while *Liberation* is one of the paintings inspired by photographs of a rocky desert landscape, an important source for several other works in the series.[60] Balance is the first in a central trio that includes *Order* and *Rhythm,* both 1929. The trio was to be flanked by two compositions symbolic of the limits of time and space, *Outposts of Time I* and *II,* 1929.[61]

Tack's 1930 explanatory notes on the panels outline the elements making up the progression from chaos to order: *Balance, Order,* and *Rhythm* are the "three great abstractions which concern life and art."[62] Repeating curves and complementary rhythms link the panels, underscoring their meaning.[63] Saturated primary colors and labored surface treatment are typical of this group; Tack burnished the surfaces with a roller dipped in ocher or other neutrally colored paint. To achieve additional surface effects in *Balance,* he added sand or other granular particles.

Liberation, which depicts ragged cloud forms, dizzying panoramas of cliffs, and wave patterns, suggests vast spaces and elemental forces. The painting, along with the rest of the series, is the true descendant of Tack's romantic early landscapes. The pouncing, laid on with a spiked wheel to transfer outlines, functions as an assertive part of the design and is left bare in many areas. Thus the painting has a slightly dry, formulaic appearance befitting its function as a prototype. The testimony of Tack's assistant, William Wilfred Bayne, vividly elucidates *Liberation*'s origins in photography:

On a visit to Death Valley, in the far west, [Tack] had been fascinated by the interesting patterns of light and shadow made by the sunlight falling upon the irregularities of the valley's alkaline soil. The New Year [1928] saw me engaged upon my last assignment as Mr. Tack's assistant. . . . He had taken a number of snapshots of these "abstracts" fashioned by nature's artistry, and had had a professional photographer "blow them up" to ten or fifteen times their original size. These enlargements were now turned over to me, and I spent many monotonous hours making perforated replicas of them [for pouncing]. . . . When the perforated duplicates of the photographs had been laid upon the panels the clotted contours rubbed through, my next task was to strengthen them with a fine brush. At this point Mr. Tack took over, and . . . filled in the spaces indicated . . . with various colours.[64]

197

The reverberation of Catholic mysticism in *Liberation* was Tack's culminating statement on the attainment of spiritual fulfillment. Freedom is attained through the search for moral and mental betterment in order to transcend the material world and rise toward God. The Western panorama—its grandeur, ascendancy, and vast open space—has been transformed to suggest flight to a higher realm.

The Music Room panels won Tack recognition and visibility unprecedented in his career. A selection was shown in Indianapolis in 1931, where Tack was invited to lecture on the meaning of abstraction. The reception in Washington was also favorable. "I cannot tell you how many people have simply been made over by the experience of that room," Phillips wrote Tack. "Visitors . . . become reverential and silent . . . under the influence of your art."[65] In 1934 Tack wrote to his patron: "I consider this conception my magnum opus. It may never be carried further, but it is complete. It is in a sense cosmic—a poem on Life itself."[66]

Tack's "poem," set to rich, harmonious color chords and preserved as an integral set of movable panels, remains evocative of both past art and contemporary innovation. Although never permanently installed as both artist and patron originally intended, the panels are often hung together in the room for which they were created (although the east-wall windows make a complete installation).[67] Tack's intended sequence was re-created for the 1993 retrospective.

LF

198

Time and Timelessness, 1943–44

The Spirit of Creation
Oil on canvas, 39¼ × 85¼ (99.7 × 216.5)
Signed vertically in red paint, l.l.: AVGVSTVS VINCENT TACK
Acc. no. 1935

TPG purchase from the artist 1948.[68]

In Tack's final abstract paintings in the 1930s and 1940s, he experimented with scale and mood, as reflected in *Evening,* between 1934 and 1936 (acc. no. 1893), and *Time and Timelessness* of 1943–44.[69]

Representing Tack's last innovation in an abstract style, works such as *Evening* hark back to the impressionism of his early Deerfield landscapes—both in their titles and in their soft infusions of Whistlerian tonal harmonies.[70] The delicate hues and brushwork of the sky in this painting recall tonalism and accentuate the romantic approach to nature. A halo of pink around the contour of the hill suggests dusk's lingering light, and thin veils of paint, worked wet into wet, evoke the atmospheric evanescence of early evening and the sky clearing after rain.[71] Tack approached this work with an arresting minimalism: the abbreviated telluric forms at the canvas base and the fragmentary drifting clouds at the extreme upper right subtly orient the viewer in an otherwise radically empty composition. The delicacy of treatment in the sky reinforces the lyrical approach to nature that

198

Tack preferred, even in a canvas as severely composed as *Evening*.

Time and Timelessness is a preparatory sketch for the final monumental mural work of his career, the fire curtain for George Washington University's new Lisner Auditorium.[72] Tack described to Phillips the daunting challenges of creating a work on so large a scale. "There were several moments in its genesis," he wrote, "when some obstacles seemed almost insurmountable": the location of a fireproof fabric; the decision to create the painting in fourteen separate panels; and the need for an assistant. The problem of applying a foundation of paint over such a vast area of canvas was accomplished with the novel use of a vacuum cleaner.[73]

For the composition of *Time and Timelessness* and the Lisner curtain, Tack transferred and enlarged the center-right portion of *Liberation* (cat. no. 197). The finished painting contains free, loose paint application in shades of blue and purple. A fanlike area of radiating lines at the central base in surprisingly soft, pearly tones is offset by the vibrant play of red outlines around the shapes. Pentimenti throughout the image show the removal of shapes laid in pounced lines. Numerous layers of paint in modulated tones are laid in with a large brush and in short daubs with a sponge.[74]

The sweeping forms, nacreous colors, and baroque light of *Time and Timelessness* provide a dramatic visual corollary to the central themes of the work: the nature of space and time, and the meaning of human endeavor. Tack was inspired by the book of Genesis, and by Henri Bergson's metaphors for life and human consciousness, and by natural forms, particularly properties of the spiral as revealed in scientific experimentation.[75] He later recounted the creation of *Time and Timelessness* in a testimony underscoring his eclectic sources.

When President Marvin gave me the commission . . . my mind naturally turned to the meaning of a University. How could the Vital Principle or Soul of a University be expressed abstractly? A University—the center from which springs the expansion and development of human minds reaching out far into fields of astronomical proportions as well as into the infinitesimally small ranges of microscopic discovery. To find some symbol of Creation in Eternity—or of Time in Timelessness, and of the magnificent achievement of human intelligence, made in the image and likeness of God, was the purpose and the problem. For the basic design of my composition, I decided on the spiral, one of the fundamental forms in creation. Witness the spiral nebulae which lie out in space and through which the processes of evolutionary creation are going on. . . . where the spiral crosses itself in the center of the Design a form appears which has all the aspect of a WINGED VICTORY—a triumphant and outspreading symbol of man's ever-growing achievement.[76]

A characteristic tension between the abstract and the visible worlds invites multiple readings of Tack's painting. The figurative expression—the winged victory from classical mythology—emerges from Tack's morphology based upon celestial views. The sense of a vast expanse of sky with drifting clouds spiraling upward is a contemporary resurrection of nineteenth-century heroic idealism.

LF

JOHN SLOAN (1871-1951)

A leader of The Eight, John Sloan was born August 2, 1871, in Lock Haven, Pennsylvania. Sloan grew up in Philadelphia, where he studied briefly at the Pennsylvania Academy of the Fine Arts, and in 1892 joined the art staff of the *Philadelphia Inquirer.* That year he met Robert Henri, who would become his lifelong friend and inspire him to become a painter. Among his fellow newspaper artists in Philadelphia were William Glackens, George Luks, and Everett Shinn. In 1904 Sloan and Dolly, his wife of three years, moved to New York, where he continued to work as an illustrator and became increasingly interested in depicting city life and city scenes. He participated in major exhibitions such as The Eight (1908), the Exhibition of Independent Artists (1910), the Armory Show (1913), and the first show of the Society of Independent Artists (1917). In 1910 Sloan joined the Socialist party and contributed illustrations to its publications, notably the magazine *The Masses.* With the advent of the First World War he resigned from the party. About the same time he began spending summers away from the city, first at Gloucester, Massachusetts (1914–19), and then in Santa Fe (from 1919). In 1916 he had his first one-person exhibition (at the Whitney Studio), began his association with Kraushaar Galleries, and started teaching at the Art Students League. He became president of the Society of Independent Artists in 1918, a post he held until 1944. After Dolly's death in 1943, he married his pupil and longtime friend Helen Farr. One of America's most revered artists in his later years, Sloan continued to paint and etch, and to experiment with new techniques, until his death September 7, 1951. Sloan is represented in the collection by four oil paintings and nine etchings.

The Sloan Unit

Duncan Phillips acquired three paintings by John Sloan between 1919 and 1922, the period during which he was laying the foundation for the collection of the Phillips Memorial Gallery. Phillips's taste in art at this time was liberal rather than avant-garde, and Sloan himself was a leader among the more liberal artists. But the painter, in spite of his prominence, enjoyed few sales at this period of his career, and Phillips's patronage was much appreciated, especially since the 1919 purchase, *Clown Making Up* (cat. no. 200), was the first Sloan purchased for a museum collection.

The Sloan Unit is unique among Duncan Phillips's designated units in that it has few paintings but a number of prints. In the 1952

catalogue the unit is described as containing *Clown Making Up* and, in addition, *The Wake of the Ferry II* and *Six O'Clock, Winter* (cat. nos. 199 and 201). The three paintings (the fewest in any unit) are supplemented by nine etchings. Inasmuch as Phillips seldom placed special emphasis on prints, the question follows: how did the collector view the overall significance of the artist's work?

The purchase of the three oils in 1919–22 fits well into the period when Phillips was seeking out younger and mid-career Americans whose work showed marked individuality but stopped short of abstraction. At this time Phillips purchased works by most of The Eight and by many of their students and younger associates. To be sure, Phillips tended to favor the more decorative or poetic painters—Lawson, Prendergast, and Davies—and it is significant that, of the three Sloans, two have a marked stress on sentiment or mood, while only one shows his characteristic "city-scene" realism.

The three paintings, it should be noted, date from the period 1907–12, from the year of preparation for the exhibition of The Eight to the time when Sloan began to turn from city scenes, becoming increasingly concerned with painterly problems of color and form worked out in figure studies and landscapes. In this later work, he sought to combine the formal strength of the great Western masters with a "modern" freshness and directness of approach—the very qualities Duncan Phillips himself was seeking in the twenties. But Sloan's experiments were very personal, even idiosyncratic, and did not appeal to Phillips, who in his writings of the twenties and thirties saw Sloan primarily as a satirist and illustrator whose later work was disappointing. By 1926, when Phillips published *A Collection in the Making,* his critical judgments made this clear: he characterized Sloan as "an etcher and painter whom historians of New York of the first ten years of the Twentieth Century will always turn to for direct contemporary satire as the historians of Paris of Louis Philippe and the second Empire still depend on Daumier, Guys and Gavarni. . . . It is all illustration, but if it is story telling the story at least is bound up in the method of its narration and there is not need for any text to supplement the colors and lines. . . . Sloan, during that earlier New York period, was a splendid painter and space composer. . . . His recent studies of Indians and his desert landscapes in New Mexico leave us cold."

After Phillips's graduation from Yale, he spent a number of years in New York City, absorbing the art scene there, and he had a special fondness for Sloan's etchings depicting city

life during much the same period. In fact, four of the nine prints in the Phillips Collection relate to the art or bohemian life of the city— scenes ranging from a gallery sales room to the Greenwich Village "Hell Hole." Taken as a group, Sloan's nine etchings provide a good survey of his work in the medium from 1905 through the twenties. His first important series, "The Connoisseurs," is represented by two examples; also from 1905 is the vigorous realism of *Turning Out the Light.* Other subjects range from the cityscape *Night Windows* (1910) to the figure study *Combing Her Hair* (1913), and the group concludes with *Hotel Lafayette* (1928). Only two important aspects of Sloan's work in etching are missing: the artist's warm personal portrayals of friends and family, and his monumental, Mantegnesque late nudes.

The acquisition dates of the prints are not known. They were relatively inexpensive purchases and are not listed in early inventories. Many were doubtless added to the collection in the early twenties: three are referred to, by subject, in the discussion of Sloan in *A Collection in the Making* (1926). *Hotel Lafayette,* of course, could not have been purchased before 1928, but perhaps Phillips got it in 1929, when he bought *Landscape with Cow.*

Landscape with Cow is somewhat of an anomaly both in Sloan's work and in Phillips's representation of Sloan. The collector had little enthusiasm for Sloan's landscapes in general, but he constantly searched for evidence of intrinsic nationalism in art and, especially, for indigenous Americanism. The cow painting was shown in 1931 in a small gallery exhibition of "Un-selfconscious America as a Basis for American Art." In a related essay in the 1931 *Bulletin,* Phillips noted that "the older English stock is . . . revealed by John Sloan . . . in an unusual work, an inconspicuous American landscape, just a family cow, in a shadowy rocky corner of the pasture." The *Landscape with Cow* is not one of Sloan's more successful landscapes, and although it was retained in the collection it did not make the inner circle of the 1952 unit listing. In his writings of the thirties, Phillips attempted to categorize artists and to group them by major trends. Sloan, in particular, was subjected to arbitrary categorizations. In the *Bulletin* article cited above, Sloan was identified as "best known for this caustic social satire in his etchings of New York." In a lengthy philosophical discussion of "Personality in Art: Reflections on its Suppression and the Need for its Fulfillment" (*The America Magazine of Art,* Feb. and Mar. 1935), Phillips lists, as one of the three categories of painters, "those who incline to the

concept of art as illustration or anecdotal journalistic commentary, with their pictures functioning as dull or sharp-pointed commentary in a journalistic sense . . . (Sloan is typical)." But Duncan Phillips, we may be sure, always knew that Sloan's art was more than journalism. He continued to the end of his life to exhibit the three unit oils among the highlights of his collection.

DWS

199

The Wake of the Ferry II, 1907

In the Wake of the Ferry; Wake of Ferryboat
Oil on canvas, 26 × 32 (66.0 × 81.3)
Signed and dated l.l.: *John Sloan 1907*
Acc. no. 1761 (Elzea, 1991, vol. 1, no. 83)

Consigned by the artist to Kraushaar, New York, 1916 or later; DP purchase for the private collection 1922; transferred to PMG by 1924.[1]

Sloan began painting *The Wake of the Ferry II* May 8, 1907, soon after completing arrangements for the exhibition of The Eight to be held at the Macbeth Gallery the following February. Sloan noted in his diary, "Altogether there is no lack of incentive for plenty of hard work between now and the time of the exhibition" and plunged into an exceptionally creative period, during which he emphasized scenes from city life.[2] In the final cut, *The Wake of the Ferry II* was not among the seven paintings he selected for Macbeth.

In this work, Sloan captured on canvas the boat/river theme that was so popular among the members of his circle.[3] The subject may well have been suggested by the occasions Sloan accompanied his wife, Dolly, to the Jersey City ferry on her way to Philadelphia for medical treatments.

He executed the first version, *The Wake of the Ferry I*, March 19, 1907, after returning from a ferry ride to Jersey City, and his diary records his "aimless" feeling when Dolly was away.[4] Soon after, during a quarrel with his wife, Sloan threw a rocking chair at the painting, damaging the sky area.[5] When he began *The Wake of the Ferry II* May 8, he made some changes in composition. Despite Sloan's assertion that the second version evokes "a slightly less melancholy mood," the elimination of background activity, the reduction of the palette to tonal grays, and the listless pose of the figure—who, in the first painting, is more clearly a woman—create a more somber and personal experience.[6]

The stylistic influence of Robert Henri, so pervasive in Sloan's early work, is apparent here;

the scene has been broadly conceived, spontaneously conveyed, and boldly brushed, in a limited palette of grays and near-blacks. The composition reinforces the mood; the ferry's tilted framing of the river view is arresting, and the diagonal of the wake receding into the mist reinforces the sense of loneliness and distance. In this setting, the small figure on the right, understated and half lost in shadow, becomes the essential actor in this version of Sloan's human comedy and brings into focus its melancholy expression.

Duncan Phillips admired Sloan's ability to evoke a specific mood. "Sloan, during that earlier New York period," he wrote, "was a splendid painter and space composer. He could take the ugly facts of a scene like the deck of a ferry boat on a rainy day and make his use of gray not only dramatic but infinitely subtle in its scale of 'values.'"[7] Another critic described *The Wake of the Ferry II* as "one of the few really first-rate mood paintings in early 20th-century American Art," and it has been widely recognized as such.[8] In 1949 the Cleveland Print Club asked Sloan to make an etching of it for its membership; Sloan refused, saying he did not like to reproduce early work.[9] However, when the Art Students League asked Sloan to make an etching for sale to their members, he agreed, choosing to portray "merry-making mourners on the front of a ferry boat"—*The Wake on the Ferry*—"for the amusement of collectors who could appreciate the contrast with the more romantic realism of his 1907 painting."[10] In 1971 the painting was selected by the United States Postal Service for a stamp commemorating the centennial year of Sloan's birth.

VSB

200

Clown Making Up, 1910

Old Clown Making Up (DP)
Oil on canvas, 32⅛ × 26 (81.8 × 66.0)
Signed l.r.: *John Sloan*
Acc. no. 1757 (Elzea, 1991, vol. 1, no. 166)

Consigned by the artist to Kraushaar, New York, 1916 or later; DP purchase for the private collection 1919; transferred to PMG by 1924.[11]

Sloan painted many portraits of his friends and family. *Clown Making Up*, executed relatively early in his career, is a rare example of a posed genre subject painted from a costumed professional model.[12]

The work displays the vigorous brushwork of Sloan's early style, and also reveals his intensified interest in color theory—the result of experi-

mentation with the principles of H. G. Maratta to which Robert Henri had introduced him in 1909. Sloan considered Maratta's palette "an instrument that [could] be orchestrated to build form."[13] For *Clown Making Up,* he limited the palette to the triad of purple, yellow-orange, and green.[14] The flickering candlelight casts green, not gray, shadows on the tired clown's face and garb, evidence not only of Sloan's interest in the color of shadows, but also of his use of chiaroscuro to heighten the sculptural quality of the figure. Shown within a shallow, stagelike setting, the clown is pushed to the front of the picture plane by loosely defined shapes suggesting a circus tent. Aided by Maratta's set palette, Sloan was able to work quickly and accurately.[15] He chose to depict the clown just as he was starting to apply his makeup, thus concentrating on the human being behind the facade. The painting exudes "warmth, intimacy, and truth," characteristics that have been attributed to Sloan's pre–Armory Show years, before he "became interested in 'art' more so than 'life.'"[16]

Duncan Phillips, whose early taste in art included narratives and romantic subjects, was undoubtedly attracted to the intimate quality of *Clown Making Up.* He acquired it in 1919, and later interpreted it as the depiction of a "lonely individual caught in the maelstrom—the tired old clown, who must be funny, 'making up' his haggard face by candle-light in some dusty dressing room."[17]

VSB

201

Six O'Clock, Winter, 1912

Six O'Clock; Third Avenue, Six o'clock; Six O'clock, Third Avenue; Six O'Clock Rush; Six O'Clock Evening
Oil on canvas, 26⅛ × 32 (66.3 × 81.4)
Signed in blue paint u.l.: *John Sloan*
Acc. no. 1759 (Elzea, 1991, vol. 1, no. 190)

The artist to Kraushaar, New York, 1916; DP purchase for the private collection 1922; transferred to PMG by 1924.[18]

Six O'Clock, Winter, which was painted in February 1912, falls late in the group of New York city-life scenes that Sloan executed from memory. He was beginning to place increased emphasis on formal order, and in this example he achieved unprecedented monumentality. His growing endeavor "consciously to work from plastic motives" was soon to lead him to lease his first proper studio and to paint more frequently from the nude and direct observation of nature.[19]

The subject of *Six O'Clock, Winter*—the Third Avenue "El" at the peak of the evening rush hour—reflects Sloan's ability to catch the

199

200

201

drama in everyday scenes. The carefree shop girls, clerks, and working men that form a fragile band at the bottom of the canvas seem generally happy and completely unaware of the omnipresent elevated railway looming high above them. The powerful El, creating a dark diagonal sweep across the length of the canvas, threatens to burst out of the picture frame, but it is held in check by the vertical steel posts, which are seemingly anchored in the crowd. Silhouetted against an ice-blue winter sky, the waiting train appears even more massive, if not threatening.

Sloan entered *Six O'Clock, Winter* in the 1912 Carnegie Institute annual exhibition, only to be disappointed by its rejection. He wrote in his diary, "Sad news. Is the exhibition game lost for me? Oh well, I paint them for myself."[20] Duncan Phillips acquired *Six O'Clock, Winter* from Kraushaar in 1922. Phillips, who admired the

artist's creative integrity and freedom from the whims of public taste, wrote in 1926, "We ramble with [Sloan] by day and night—to Tammany Hall—to McSorley's famous saloon—to 'arty' restaurants—to the six o'clock rush under the Sixth Avenue's L at lamp-lighting time."[21] However, Phillips's attitude toward Sloan changed in the 1930s. Writing of artists whose work he considered to be essentially journalistic, Phillips chose *Six O'Clock, Winter* to illustrate his point.[22]

VSB

ERNEST LAWSON (1873–1939)

Ernest Lawson, a member of The Eight and an exhibitor at the 1913 Armory Show, achieved early recognition with his impressionist landscape paintings but later in life experienced personal tragedy and artistic isolation. Born in Halifax, Nova Scotia, March 22, 1873, Lawson studied at the Art Students League, New York, from 1891 to 1892 and took summer classes in Cos Cob, Connecticut, under John Twachtman and Julian Alden Weir. While living in France from 1893 to 1896, Lawson briefly attended the Académie Julian and shared a Paris studio with Somerset Maugham, who used him as the model for the artist in his novel *Of Human Bondage*. A meeting with Sisley at Moret-sur-Loing confirmed Lawson's love of painting outdoors, and his first success came when two paintings were accepted by the Paris Salon in 1894. Settled in New York by 1898, Lawson concentrated on certain sites of upper Manhattan—their light, seasons, and times of day—a body of work that became the pinnacle of his career. He joined the rebellion against the National Academy of Design when his work was rejected in 1905 and, through his friend William Glackens, became a member of The Eight. His numerous awards included gold medals at the Pennsylvania Academy (1907) and Panama Pacific Exposition (1915), the Clark Prize at the Corcoran Gallery of Art (1916), and the Inness Prize and full membership in the National Academy of Design (1917). A year's stay in Spain in 1916, together with his wife and two daughters, may have been the highlight of his private life, but financial troubles and bouts of alcoholism subsequently caused him to lose his family and many patrons. Impoverished and in ill health, Lawson accepted teaching assignments in Kansas City and Colorado, finally moving to Florida in 1936, where he died of an apparent heart attack December 18, 1939, in Coral Gables. The collection holds fourteen paintings by Lawson, chiefly from the height of his career.

The Lawson Group

Early in the twentieth century, a series of events eroded the influence of the once-dominant National Academy of Design "like stormy waves beating upon the sandy shore," and Ernest Lawson's name appears repeatedly in the company of The Eight, with the Independents, and as a participant in the Armory Show.[1] While he was not truly an Ashcan artist, Lawson's subject matter—the workaday fringes of the city—made his art sufficiently progressive. Nevertheless, he may have joined the rebellion out of friendship for the other artists and out of a desire to exhibit

beyond the Academy's confines. Today, Lawson is generally viewed as an impressionist, but at the time his lonely scenes were strikingly, but acceptably, new and "exemplified modernism in American landscape."[2]

Although Duncan Phillips named Lawson a unit artist in 1924, he withheld this designation in his 1952 collection catalogue, perhaps reflecting his own turn toward modernism.[3] The fourteen Lawson paintings in the collection today include landscapes of the Washington Heights period, between 1898 and 1915, as well as scenes from his travels such as *New England Birches*, ca. 1919, *Twilight in Spain*, ca. 1916, and *Path of Sunlight, New Mexico*, ca. 1927.[4]

Lawson's early work, such as *Spring*, ca. 1900 (acc. no. 1189), has the delicate tones and melded texture of John Twachtman, his teacher. His finest mature paintings have rich colors—ranging from warm ochers and browns to cool blues and greens with touches of red—applied in myriad brushstrokes of considerable vitality. Within this intricate texture, broken color and impasto give his landscapes a certain bravura that appeared quite progressive at the time. They are often constructed of horizontal bands denoting land, water, and sky, while a delicate network of vertical lines creates foreground grasses and trees that reach past the middle ground toward a hazy horizon. At times a boat or a farmhouse provides a gentle point of focus.

Favorite among Lawson's New York subjects were the graceful bridges linking Manhattan with parts beyond; a haunting theme, they became increasingly imposing, moving from a position at middle distance, as in *High Bridge—Early Moon*, by 1910 (cat. no. 202), to the close view and high horizon of *Spring Morning*, ca. 1913, and finally to the overpowering presence of *Spring Night, Harlem River*, 1913 (cat. no. 203). A later work, *May in the Mountains*, purchased in 1919, the year it was created (cat. no. 207), allows a glimpse of Lawson's later, almost expressionistic, style.[5]

Lawson's work appears to have been an enthusiasm shared by both Duncan Phillips and his brother, James, when they first became interested in collecting. Phillips remembered *High Bridge—Early Moon* as his first purchase, made around 1912 with money from his allowance.[6] In 1915 James bought *Spring*, which was one of two paintings his young widow, Alice, gave to the museum in 1920. In a moving letter she praised Duncan for his suggestion that she donate works, calling it "a lovely idea, and one which I [am] sure would have pleased Jim more than anything else. . . . Of course, I should love to give the two Lawson pictures."[7]

In writing an essay about Lawson in 1917, Phillips followed in the footsteps of A. E. Gallatin and Guy Pène du Bois, who had both written about the artist's work as it related to French impressionism.[8] By this time Phillips knew Lawson personally, and in his essay he stresses his American sense of independence and his "subjectivity . . . which lifts him to a higher plane than the art of Claude Monet . . . [who] was only an eye, whereas Twachtman, Weir and Lawson are also temperaments." Phillips luxuriated in the "almost candied succulence to [Lawson's] glazed surfaces" and, calling him a "casual and careless Bohemian," nevertheless placed him in the context of the American tradition.[9]

Around 1922 Phillips ranked five Lawsons among eighty of his favorite paintings and proudly stated that he had bought Lawson's work "when he was comparatively unknown. Today he is regarded by the most competent critics as the greatest colorist and the greatest living landscapist and one of the most original talents America has produced."[10] In 1925 he gave him a one-person exhibition. However, the following year, while still calling Lawson "a genius," Phillips added a note of reserve: "When the world of care is too much with him he works no wonders and his pigments remain paint."[11] Phillips's next major publication, *The Artist Sees Differently* (1931), contains four illustrations of Lawson's works but no discussion of them. It will never be known whether this diminished appreciation was due to a change in taste or the artist's sad personal decline. By the early 1920s, Lawson had begun to ask Phillips for money, at one time pleading for funds to bring home the body of his daughter, who had died in Egypt.[12] Phillips wrote a consoling letter and later recommended Lawson for membership in the Century Association. In 1935 he may have been instrumental in having Lawson appointed a judge of the Washington Independents exhibition.[13] After Lawson moved to Florida, his personal and artistic life at a low ebb, he offered paintings for as little as twenty dollars each. Phillips bought several but grew weary by 1938, when he told Lawson: "Your representation is all out of proportion to the other American artists. Believe me, I wish you well."[14]

Lawson lived to see his art become outdated. While the Armory Show had proved a strong potion for Phillips, it had also displaced the men who had led the rebellion. Lawson wrote to Henri, "we are now old fogies, my dear man, with all this howling dervish mob of cubists etc. My show looks like a Philadelphia Sunday compared to the one at Montross."[15] While Phillips eventually came to terms with the advent of modernism, Lawson

changed neither style nor subject matter and found himself on the sideline of artistic developments.[16] In his early career as a collector, Phillips had seen Lawson as the embodiment of the spirit of America: independent, insisting on the artist's right to exhibit freely and paint humble, honest views along the fringes of a growing country. Soon the avant-garde ideas of other Americans (such as Dove, Hartley, and Marin) were to open new vistas for Phillips and, with a new artistic vocabulary, lead him toward abstraction.

EDP

202

High Bridge—Early Moon (DP), by 1910

Sunset, High Bridge (DP); *Early Moonlight, Harlem River*

Oil on canvas, 20 × 24 (50.3 × 60.9)

Signed l.r.: *E. Lawson*

Acc. no. 1192

DP purchase, ca. 1912; transferred to PMAG 1920.[17]

203

Spring Night, Harlem River, 1913

Moonlight, Harlem River; Summer Night Harlem River (DP); *Washington Bridge, Evening*

Oil on canvas mounted on panel, 25⅛ × 30⅛ (63.8 × 76.5)

Signed and dated in red paint, l.l.: *E. Lawson/1913*

Acc. no. 1191

Possible sale by the artist to Dr. Dohme; DP purchase through Daniel Gallery, New York, 1920; transferred to PMAG 1921.[18]

202

The motif of the bridge, while evoking the arcadian landscapes of Claude and Poussin, takes on added significance in American art as a symbol of movement and change. As cities grew, bridges were often among the first structures built, their spare designs helping to transform the face of the American landscape from rural to urban. Lawson's carefully observed paintings documenting this change were imbued with personal experience and conveyed his delight in commonplace views and objects—an old boat, a frail tree, grasses growing along the river's edge.

Two bridge scenes in the collection, dating from Lawson's Washington Heights period, show the development of his style over the years. Having left the area in 1906, when he moved to Greenwich Village, the artist often returned to paint his favorite sites until about 1916. *High Bridge—Early Moon* represents the High Bridge (1839–45), which was modeled after a Roman aqueduct and which crosses the Harlem River at 174th Street; *Spring Night, Harlem River* depicts the Washington Bridge (1888) at 181st Street.

While the delicately applied pigments and diaphanous haze of *High Bridge—Early Moon* reflect Lawson's dreamily impressionist style, the brushstrokes that define the foreground rocks introduce structural blocks hinting at his awareness of Cézanne.[19] Duncan Phillips, however, did not respond to such technical innovation but instead was attracted to the painting's emotional appeal, which at that time he considered an indispensable quality of art. One can sense his delight when he describes the painting: "an apricot gleam is reflected in the river mingling with the emerald shadows of the shore. . . . We dream and rest, thrilled yet quieted by all the color."[20]

Spring Night, Harlem River, in contrast, is unusual in the artist's oeuvre for its bold verticals and diagonals, its spatial depth and order. Among Lawson's works in the collection it is the best known and most frequently exhibited. The bridge is observed from below, against the night sky, heightening the drama and powerful impact of the huge span. Moonlight reflected on the water and on the far bank illuminate the scene. A tightly locked pattern of light and shadow runs from the foreground along the dark recesses of the bridge and continues on the dis-

tant shore; the fainter shadows echo this movement. The sharp diagonal line of the bridge creates a thrust into space that is stabilized by the four horizontal bands of land-water-land-air and the shimmering correspondence of sky and water.[21] Slender trees in the foreground invite a poignant comparison of natural and constructed forms. Lawson carefully blended his brushstrokes and defined the forms clearly, using heavy daubs of paint only in the street lamps lining the bridge. He painted two other oils of this view: *Harlem River* (n.d.), an almost identical composition, is a nocturnal scene, while *Washington Bridge, Harlem River* (ca. 1915) appears to be a daylight version and has bolder, more cursory brushwork and craggier trees.[22]

The blue and green tonalities of *Spring Night, Harlem River* and its white, pink, and gold highlights create a rich tapestry of color that undoubtedly attracted Duncan Phillips. To express how it enchanted him, he drew on his literary background: "His 'Moonlight Harlem River' is Shakespearean with its home lights and bridge lamps glimmering in a tremulous turquoise air as in some garden of romance."[23]

EDP

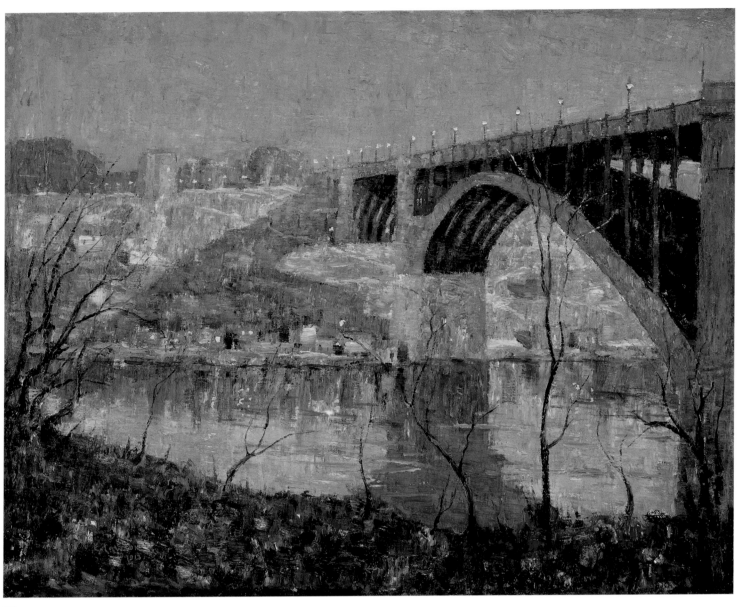

203

204

205

204

Ice in the River, ca. 1907

The River in Winter; Winter

Oil on canvas mounted on wood panel, 25 × 30
(63.5 × 76.2)

Signed l.r.: *E. Lawson*

Acc. no. 1185

The artist to Knoedler, New York, date unknown; purchased by DP 1917; transferred to PMAG 1920.[24]

205

City Suburbs, ca. 1914

Oil on canvas, 24 × 30 (60.9 × 76.1)

Signed l.r.: *E. Lawson*

Acc. no. 1183

The artist to Daniel Gallery, New York, date unknown;
PMG purchase 1922.[25]

Ice in the River and *City Suburbs,* both winter
scenes of upper Manhattan, document the once
rural setting along the Hudson and Harlem
rivers and hint at the gradual encroachment of
urban life upon the open country as New York
expanded northward. Lawson shared Twacht-
man's interest in winter scenes, especially the
effects of light on fallen snow. Blue is used
throughout, not to define sunlight and shadow
as did the impressionists, but to create form and
a vibrant surface.

Ice in the River is closely related to several
other snow scenes composed around 1907,
although it depicts a different site along the
river. Like them, it has a high horizon and
expansive view that allows the landscape to
spread before the viewer like a tapestry. It also
shares with them interwoven brushstrokes that
create the illusion of a bright haze.[26] Lawson
painted the boat and pier in dark blue, creating
the composition's focal point, which contrasts
with the wintry gray-green and cream-colored
pastel shades that dominate the background.

City Suburbs offers a view of the outskirts of
Inwood in northern Manhattan. The building
on the hill at left stands on the site of a Revolu-
tionary War fort; it was replaced by The Clois-
ters in 1930. The narrow road that crosses the
scene at a slight diagonal is Broadway. Lawson
painted this scene several times; a much larger
version of 1914 is in the Columbus Museum of
Art. The smaller dimensions of *City Suburbs* and
the inclusion of details not shown in the
Columbus painting suggest that it may have
been a study created outdoors.[27]

Four tiny laborers, possibly stone breakers,
are the focus of the composition; a quarry and a
stone-cutting mill were once located in the area.
They might also be an excavation crew because
numerous contemporary photographs show
groups of men with carts digging for Indian
artifacts and objects from the Revolutionary
War era.[28]

City Suburbs has a rich and varied palette. In
areas of exposed canvas, a thin underpaint is
visible that served to block in the composition;
after that, the artist applied heavily impastoed
paint.[29] Phillips, who had an affinity for color,
was drawn to this work; its humble theme and
undramatic setting show Lawson departing
from the picturesque subject matter of contem-
porary convention and coming as close as ever
to a true Ashcan subject. Phillips understood
this when he wrote about Lawson's "peculiar
power of finding sensuous beauty in dreary
places."[30]

MS

206

206

Approaching Storm, 1919–20

After Rain (DP)

Oil on canvas mounted on wood panel, 24¾ × 30
(62.9 × 76.2)

Signed in green paint, l.l.: *E. Lawson*

Acc. no. 1182

The artist to Milch Gallery, New York, by 1922; PMAG
purchase 1922.[31]

207

May in the Mountains (DP), 1919

Blossoms (DP?)

Oil on canvas, 25⅛ × 30 (63.8 × 76.2)

Signed and dated in red paint, l.l.: *E. Lawson/1919*

Acc. no. 1186

The artist to Daniel Gallery, New York; DP purchase 1919;
transferred to PMAG 1921.[32]

Lawson's distinctive landscape style evolved
gradually, departing from the hazy yellow-
greens and soft compositional transitions of his
Twachtman-inspired early work, such as *Spring*
(acc. no. 1189), toward the classical landscapes in
cool blues and greens of *Approaching Storm,* and
culminating in the near-expressionist style of
May in the Mountains. The artist himself would
later describe his response to color: "Color is my
specialty in art. . . . It affects me like music
affects some persons—emotionally. I like to play
with colors like a composer playing with coun-
terpoint music. It's sort of contrapuntal fashion,
and you get one effect. We don't actually copy
nature in art. Nature merely suggests something
to us, to which we add our own ideas. Impres-
sions from nature are merely jumping off points
for artistic creations."[33]

Approaching Storm represents a fresh New
England landscape bracing for a storm. The land
is shaded by heavy, romantically threatening
clouds, leaving only the middle ground bathed
in sunlight. The brushstrokes are carefully
blended, forms are well defined, and the pro-
nounced areas of light and shade, together with
the diagonal thrust of the composition, create
the illusion of spatial recession.[34]

May in the Mountains, a riotous celebration
of spring, has the tactile pigments, frantic bursts
of color, raised horizon, and psychological
intensity of a painting by van Gogh. Lawson
applied multiple layers of paint, at times rub-
bing them into the layer beneath, and forming a
built-up network of colors—yellow, white, and
grass-green; some are blended, some placed side
by side in short strokes.[35] He juxtaposed warm
and cool shades and bathed the scene in a form-
diffusing light that blurred the middle ground
under a wealth of blossoms.

The massive and craggy mountains in the
background recall Canada rather than New Eng-
land. The scene is possibly a composite created
from memories of Cornish, New Hampshire,
where Lawson and his family spent the summer
of 1919, and Nova Scotia, where the artist had an
exhibition that year.[36] It appears again in mirror
image in a much larger winter scene and in one
of Lawson's rare prints, a color monotype of
about 1920.[37]

One of the few paintings dated by the artist,
May in the Mountains was ranked sixteenth
among Duncan Phillips's eighty favorite oil
paintings in 1922, just before works by Tack and
Monet.[38] Phillips delighted in the painting,
describing it around 1924 as "an orchard of flow-
ering trees in a mountain valley where the
ecstasy is like the rhythm of the morning stars
when they sang together."[39]

EDP

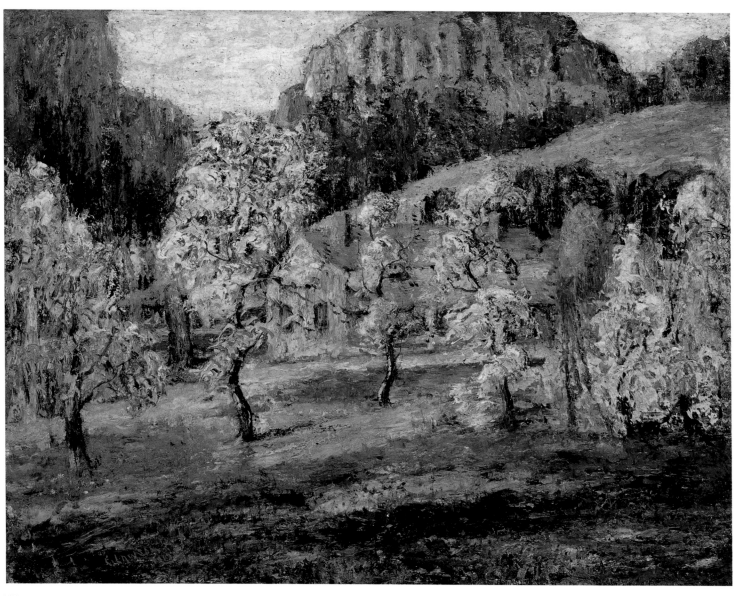

207

EVERETT SHINN (1873–1953)

A member of The Eight best known for his images of the theater, Everett Shinn was born in Woodstown, New Jersey, November 7, 1873 (not 1876 as he sometimes claimed). In 1893 Shinn enrolled in the Pennsylvania Academy of the Fine Arts, where he studied under Thomas Anshutz; he supported himself as an artist-reporter for the *Philadelphia Press,* where he became friends with William Glackens, George Luks, and John Sloan. In 1897 he moved to New York to continue his career as a newspaper and magazine illustrator; he married the Philadelphia illustrator Florence Scovel the next year. In New York, he met the architect Stanford White, for whom he later painted murals in the eighteenth-century rococo style. In 1890, shortly after his first major one-person exhibition at Boussod-Valadon and Co. in New York, Shinn and his wife traveled to England and France. Thereafter, mostly Parisian and British themes occupied him. He participated in various New York group shows, including the 1908 exhibition of The Eight at Macbeth Gallery and the 1910 Exhibition of Independent Artists, in which he included mostly theatrical scenes. In 1911, Shinn finished the mural commission for the Trenton City Hall, in which he depicted the city's two major industries, steel and pottery. A playwright and actor, Shinn turned his Waverly Place studio into a theater and founded the Waverly Street Players, which included his close friend William Glackens. Between 1911 and 1937 Shinn rarely exhibited, preferring to explore other interests, such as mural painting and working as an art director (for Goldwyn Pictures, 1917–20; Inspiration Pictures, 1920–23; and Cosmopolitan Pictures, 1923). The Ferargil Galleries, New York, began representing him in 1943. He became a member of the National Academy of Design in 1949 and was inducted into the American Academy of Arts and Letters three years later. Shinn died May 1, 1953, in New York. He is represented in the collection by one drawing.

208

Tenements at Hester Street, 1900

India ink and pastel on gray pastel paper, 8¼ × 12⅞ (21.0 × 32.7)
Signed and dated in graphite pencil, l.l.: *E. Shinn/1900*
Acc. no. 1737

Possibly collection of the artist until 1943; Ferargil Galleries, New York; PMG purchase from Ferargil exhibition 1943.[1]

Tenements at Hester Street, which in the artist's words depicted "squalid tenements, children huddled on rags on fire-escapes, [and] families side by side on a caved-in roof," is said to have inspired Mrs. J. Pierpont Morgan to open a haven for the poor on the Lower East Side of Manhattan. When Mrs. Morgan questioned whether the drawing represented truth, Shinn answered, "truth, but understated—as odor could not be given unless I dropped my drawing in refuse."[2]

Of the four Philadelphia artists who, along with their mentor Robert Henri, comprised the nucleus of The Eight, Shinn was the third to move to New York to pursue his artistic career. In 1897 he became a newspaper artist and an illustrator for books and popular magazines. He thrived on the life of the city and recorded many of its aspects. His 1900 Boussod-Valadon show consisted mostly of scenes of city life.

In 1899 Shinn began work on drawings for a book entitled *New York by Night* by William Dean Howells, a prominent novelist who sought a blend of romance and reality in his writing and "aimed at capturing the outward air of the commonplace."[3] Years later Shinn recalled that he had endeavored to show the "alternate gaiety and drabness" of New York in his illustrations.[4] *Tenements at Hester Street* is one of the works intended for this book.

To Shinn, Fifth Avenue, known for its wealthy inhabitants and beautifully kept buildings, was "artistically hopeless." He preferred the poor, dilapidated neighborhoods—the Bowery, the Gas House Section, and the Lower East Side. "The people and the buildings are complementary," he observed. "Congestion, poverty, work, avaricious landlords—a multiplicity of unavoidable conditions combined. Lines are broken here and there, buildings and odd little shops are harmonized with one another, and the ensemble speaks to any one who will stop to listen. . . . They say: 'I suffer.'"[5]

Shinn's work as a newspaper artist was a direct influence on his city scenes, a debt that Shinn himself recognized when he wrote, "The roots out of which my work has grown are undoubtedly the training I received while working on newspapers."[6] The swift execution of line and the summary treatment, nearly caricature, of the figures and buildings in *Tenements at Hester Street* indeed suggest a reporter's earnest attempt to record an incident on deadline. Shinn often worked from memory; he had a nearly photographic recall and was able to retain an "on the spot" quality while working in his studio. However, he did not show any of his city scenes in the famous exhibition of The Eight in 1908, but instead exhibited theater motifs, to which he had turned in the first decade of the new century.

In *Tenements at Hester Street,* Shinn reflected his radical sensibility in technique as well as subject matter. He may have employed his innovative manner of applying pastel in this work. He drew with pastel directly into a wet ground. When the medium struck the surface, the color disappeared, leaving behind a dark tone. As the picture dried, the original color returned, but contrary to the dustlike quality of pastel, the pigment dried hard producing brilliant color that is often mistaken for tempera, gouache, or watercolor.[7]

In the 1940s The Eight received renewed recognition by art historians, critics, and collectors. Duncan Phillips selected works for the 1941 American Federation of the Arts traveling exhibition "Men of the Rebellion: The Eight," and this process may have made him realize that Shinn was the only member of the group not represented in the collection.[8] Interestingly, Phillips purchased *Tenements at Hester Street* when Shinn's clown pictures were in greatest demand. The drawing must have appealed to him, but he may also have agreed with the general opinion that by the late 1930s and early 1940s Shinn had begun to paint for the art market. Some of Shinn's colleagues frowned upon this behavior, as evidenced by a passage in John Sloan's notes: "Shinn is now trying to echo the old self that painted city life, around the turn of the century—very thin echoes. He tells me there is a dealer in California who will take all the clowns he can make."[9] Phillips, therefore, purposely chose an early work that represented the goals of The Eight, not merely an "echo" of them.

VSB

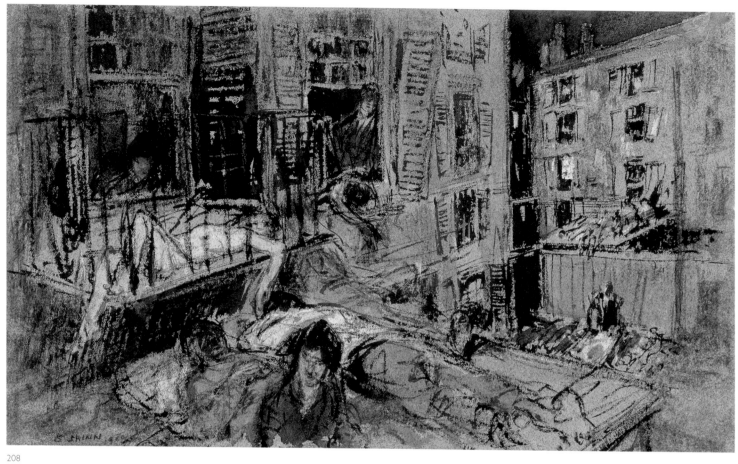

208

PAUL DOUGHERTY (1877–1947)

Born September 6, 1877, in Brooklyn, Paul Dougherty grew up expecting to inherit his father's law practice. In 1898 he graduated from the New York Law School; however, shortly after his admittance to the New York bar, he deserted law for painting. He briefly studied form and perspective with Constantine Hertzberg, and then commenced his artistic training in the museums of Europe. In 1902, while in Paris, he met and married Antje Bertha Lund, a Swedish music student, the first of his four wives. After Antje's death, he returned with their child to New York. Elected to the Society of American Artists in 1905, he enjoyed great success as a painter of marine subjects, especially at his 1907 exhibition at Macbeth Gallery in New York. In the same year he was elected to the National Academy of Design. During the teens he traveled extensively and continued to receive favorable criticism. Returning to Paris in 1920, he established a studio at 17 rue Campagne Première, which he kept in addition to his New York studio at 14 East Tenth Street until 1927. Dougherty began to develop arthritis in the late 1920s and moved to the West, living alternately in Tucson and Carmel, California, in the summer. By 1921, Duncan Phillips had acquired sixteen Dougherty works, seven of which he later deaccessioned. Dougherty died of cancer January 9, 1947, in Palm Springs. The collection includes three oils, three watercolors, and three pastels.

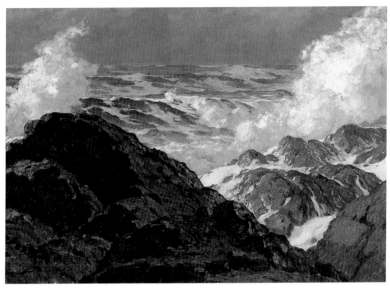

209

209

Storm Voices, 1912

Storm Voices—Coast of Maine

Oil on canvas, 36 × 48 (91.4 × 121.9)

Signed l.l.: *Paul Dougherty. 1912*

Acc. no. 0533

The artist to Macbeth, New York; purchased 1912 by Major D. C. Phillips; transferred to PMG by 1924.[1]

210

The Round of the Bay, between 1915 and 1918

Oil on canvas, 36 × 48 (91.4 × 121.9)

Signed l.l.: *Paul Dougherty*

Acc. no. 0532

Purchased by DP from the artist, New York, 1918; transferred to PMG by 1924.[2]

Early in his career, Paul Dougherty was acclaimed as "the foremost marine painter of the younger generation" for his powerful and turbulent seascapes.[3] The critic Anna Seaton-Schmidt wrote in 1910: "What exhibition of the past few years but has included in its catalogue one or more of his fascinating interpretations of the ocean's endless moods?" Consequently, Dougherty was showered with awards, and nearly every major museum in the United States acquired his canvases.[4] However, his more radical contemporaries, notably the artists who formed The Eight, did not appreciate his work or success. John Sloan, upon viewing his paintings at Macbeth Gallery, exclaimed, "The beastly daubs of Paul Dougherty, N. A. (with whom I have no acquaintance personally) are selling—five of them have been bought." Not surprisingly, when Dougherty was suggested for inclusion in the 1910 Exhibition of Independent Artists, Sloan rejected him.[5]

Dougherty's early works (1906–12) are characterized by short, choppy strokes, a muted palette of earth tones, and an emphasis on form. *Storm Voices* exemplifies this period with its waves crashing against rocks and sun-dappled spray spewing into the atmosphere. The massive rock formations in the foreground create a calm but foreboding presence in contrast to the surf's frenzied activity.

In spite of his early success, Dougherty remained open to new ideas and techniques. The greatest change in his painting occurred in the late teens in response to impressionism and fauvism.[6] In 1917 one critic remarked that his stylistic shift "has meant the voluntary departure from a safe and remunerative path and the deliberate pursuit of an idea. . . . From now on, Mr. Dougherty must

be counted as in the vanguard."[7] *The Round of the Bay*, painted in Carmel, California, is characteristic of this period. Its saturated complementary colors interact as they depict quiet, undisturbed waters, distant hills, and dense cloud formations. Although he still employed daubs of color as accents, Dougherty now defined form through broad sweeps of color, thus producing an effect of grandeur. The carefully developed composition is unified by the reiteration of shapes, for instance the way in which the bay seems to mirror the distant mountains. Regarding his work of the late teens, Dougherty declared: "What I want as I grow older is a richer and deeper interrelationship in a work of art. . . . In other words my viewpoint . . . becomes classic in that it desires . . . that the expression itself should strive toward perfection; that it should be formed as [if] it were from within, not shaped from without."[8]

After purchasing *Storm Voices* in 1912 on behalf of his father, Duncan Phillips wrote that he liked "that accent of sunlight on the spray which is so invigorating as Dougherty portrays it."[9] In 1915, after seeing a work by Dougherty in Pittsburgh, Phillips praised the painting's "great unity of mood" and its "line-color-rhythm-movement-greatness of cloud forms, wave forms, rock forms, [in which] everything is on an epic scale and at a mood of lyric ecstasy."[10] Phillips attributed Dougherty's "inspired zeal for rhythm of line and patterns of color" to the influence of Arthur B. Davies.[11] In 1921 Phillips visited the artist in his studio in New York to

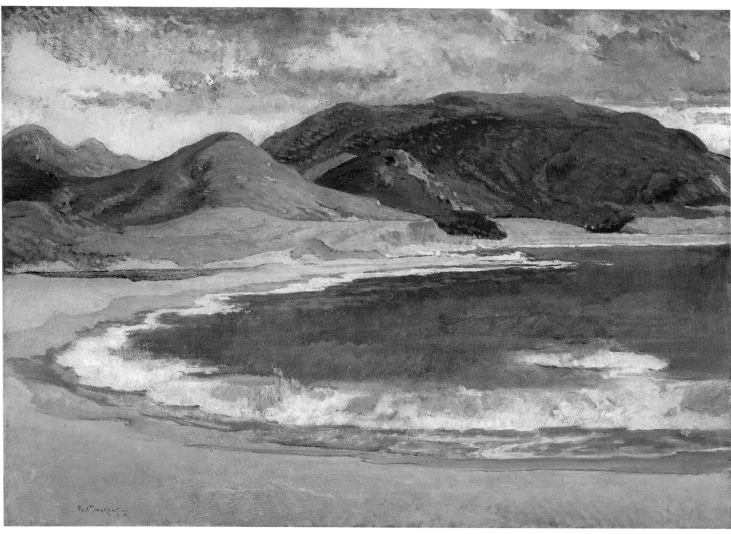

210

introduce him to his fiancée, Marjorie Acker.[12] Dougherty was a close friend of Marjorie's uncle, Gifford Beal, and a fellow member of the Century Club.[13]

Dougherty's fame as a modernist faded quickly in the 1920s as the more vigorous American painters such as Bellows, Hopper, and Kent came on the scene. In 1932 a reviewer wrote, "in those days [1907, he] was considered a mod-

ernist, an innovator; he has now for some years been regarded as a conservative, an academician."[14] In 1979 Mahonri Young wrote, "For years people had waited in line to buy [Dougherty's] pictures; then you could not give them away."[15] By 1921 Phillips had purchased his last work by Dougherty. Five years later he wrote: "[Dougherty] saw the improbability of surpassing the seascapes of his youth or of adding any-

thing to his reputation as 'the best marine painter since Winslow Homer.' . . . His habit of accurate observation, acquired from special study of waves and rocks, proved a handicap to him in attempting allegorical motifs. He decided finally that what he needed was . . . a simplicity of vision and an insistence upon volume."[16]

VSB

WALT KUHN (1877–1949)

Remembered as an early promoter of modern art in America, Walt Kuhn was broadly talented; he was not only a renowned painter, but also a cartoonist, sculptor, printmaker, writer, teacher, and producer of vaudeville shows. Born October 27, 1877, Kuhn grew up in Brooklyn, where he received his education in private schools until he was sixteen. In 1899 he ventured to San Francisco to work as a cartoonist for *Wasp*, a political and literary weekly. In 1901 Kuhn traveled to Europe to receive formal art training at the Académie Colarossi in Paris and later at the Munich Academy, where he studied under Heinrich von Zügel. Returning to New York in 1903, he established a studio in Manhattan. In 1909 he married Vera Spier of Washington, D.C., and they had one daughter, Brenda, in 1911. Kuhn helped arrange the 1910 Exhibition of Independent Artists and was a founding member and officer of the Association of American Painters and Sculptors, the organization responsible for mounting the Armory Show of 1913. Highly independent, self-critical, and somewhat irascible, Kuhn exhibited infrequently, never submitted his work to a jury, and regarded most dealers as untrustworthy. In 1910 he had his first solo show at the Madison Gallery in New York, and in 1925 he began to concentrate his efforts on painting, abandoning most of his theatrical work. He reached full maturity as an artist between 1927 and 1932. From 1930 to 1942 Kuhn was represented by the Marie Harriman Gallery, New York, and he was included in a 1930 Museum of Modern Art exhibition, thus firmly establishing his reputation. His boundless energy stimulated his creative output, which lasted until the year before his death in White Plains, New York, July 13, 1949. The collection contains six oil paintings ranging in date from about 1920 to 1944.

211

Flowers—Bouquet (Tulip Buds), between 1920 and 1923

Tulip Buds (DP)

Oil on canvas with graphite underdrawing, 9¼ × 12¼ (23.4 × 31.1)

Signed in black paint, l.r.: *Walt Kuhn*

Acc. no. 1097 (Adams no. 144)

The artist to Montross, New York, by January 1924; PMG purchase (from May Montross exhibition) 1924.[1]

Walt Kuhn's lifelong fascination with still-life subjects is reflected in *Flowers—Bouquet (Tulip Buds)*. He created his first flower painting in 1918 and made a series of them as early as 1921.[2] In

211

the Phillips canvas the simplicity of the design, the technique of laying in blocks of color, and the reduction of abstracted forms to their essential shapes are typical of Kuhn's transitional phase between 1912 and 1920. After 1912, when he traveled throughout Europe to help organize the Armory Show, the influence of Cézanne, Derain, Dufy, Pascin, and the cubists became evident.[3] Throughout the teens and early twenties Kuhn experimented with fauve colors, Cézanne's forms, and cubist space before developing a personal style in his solid, sculptural single-figure paintings.

In *Flowers—Bouquet (Tulip Buds)* Kuhn did not work directly from life as he did in later paintings. He used cut-up and reassembled scrapbook pictures as models.[4] In executing the painting, Kuhn allowed the canvas weave to become part of the composition, a method he also utilized in his mature works. His early experience as an illustrator is apparent in the calligraphic line of the underdrawing, which shows through the oil.[5]

In 1926 Duncan Phillips introduced Kuhn to the Washington public when he included *Flowers—Bouquet (Tulip Buds)* in a small group exhibition of American artists designed to "reveal the fact that drastic modifications of the cult of Cubism are being made in America." Phillips believed that artists such as Dove, Hartley, and Tack were "allied in a mutual desire to create a fresh and rhythmical language of form and color which will convey their emotions."

Phillips admired Kuhn for his lyrical use of color, writing that "the color scheme of Walt Kuhn's 'Tulip Buds' vibrates in the senses like a re-captured odor and its train of associations."[6] The following year Phillips wrote to Kuhn about this work: "I also have been anxious to meet you, chiefly because I have had so much pleasure from your little picture. . . . It hangs in my room where I see it every day. I want very much to get another, perhaps many more examples of your art which has more taste and distinction than most of the American Modernists."[7]

Phillips admired *Flowers—Bouquet (Tulip Buds)* for its "half lovable Victorian quaintness and the other half calculated Post-Impressionistic aestheticism."[8] Though he considered it important within Kuhn's oeuvre, the artist himself did not view it as a serious work. He explained, "this still life is just a slight fragment, or by-product of my work. . . . It has about the same relation to my work, as a beautiful but slight lullaby has to the symphonies of a composer."[9] Phillips responded, "If this little flower piece is not characteristic of you I am sorry for it is true that I do like it better than anything I have seen."[10] Despite their difference of opinion, Phillips and Kuhn became friends and developed similar artistic ideals and viewpoints. The Phillipses called on Kuhn in his New York studio in 1932, and the artist came to the gallery when in Washington visiting relatives.[11]

LEM

212

213

212

Girl with Mirror, 1928

Oil on canvas, 24 × 20⅛ (61.1 × 51.1)
Signed and dated in black paint, l.r.: *Walt Kuhn 1928;*
dated on tacking edge in brown paint, c.l.: *1928*
Acc. no. 1094 (Adams no. 217)

The artist on consignment to Downtown Gallery, New
York, 1929; PMG purchase 1929.[12]

213

Performer Resting, 1929

Oil on canvas, 24 × 20⅛ (61.1 × 51.1)
Signed and dated in yellow ocher paint, l.r.: *Walt Kuhn
1929*
Acc. no. 1095 (Adams no. 245)

The artist on consignment to Downtown Gallery, New
York, 1929; PMG purchase 1929.[13]

For Kuhn, the path from idea to completed can-
vas was often lengthy; numerous preparatory
drawings and sketches were executed, and cos-
tumes were sewn before he actually began paint-
ing. However, when idea and costume came
together, he would work directly from a specifi-
cally chosen model and complete the piece in a
few days. After the model had left, he added
finishing touches with delicate brushstrokes or
with the little finger of his right hand. The sig-
nature and date came last, and then Kuhn called
his wife and daughter to see "the new addition
to Walt Kuhn's family of 'painting children.'"[14]
Girl with Mirror and *Performer Resting* became
part of this "family" in the late 1920s when his
mature style was developing and becoming
articulated most clearly in his figure paintings.
The performers Dorothy Hughes and Teddy
Bergman were the models.[15] Although placed
within a shallow space, the figures do not con-
front their viewer, but occupy their own sepa-
rate world. Because they lack the simplicity,
stark contrasts, and forthrightness of Kuhn's
mature frontal images, these two works may be
seen as steps toward the monumentality of that
later style.

These two paintings were presented to the
public for the first time at the Downtown
Gallery in New York in 1929.[16] *Girl with Mirror*
was illustrated on the cover of *Art Digest* in mid-
April, and Phillips must have seen the magazine,
because he sent a telegram in early May asking
the dealer to reserve the painting for him. After
visiting the exhibition, Phillips purchased it
along with *Performer Resting,* saying he was
"glad to get Kuhn so well represented at last
and . . . I agree with those who have long pre-
dicted that he would be one of the really impor-

tant American artists."[17] Marie Harriman, Kuhn's dealer after 1930, wrote to Phillips that the artist believed the two paintings to be "very important examples of his work. . . . He [Kuhn] has found a great personal satisfaction in the thought that these paintings had been chosen by you to be part of your collection."[18]

Phillips included both works in a 1932 exhibition, Kuhn's first solo Washington show. The paintings were admired by critics for their strength of form and characterization, commenting that "Kuhn approaches real greatness . . . in the 'Girl With a Mirror.'"[19] Phillips himself observed, "Kuhn's rise to the front rank is evident enough . . . in such handsome and personal canvases as 'Girl and Mirror' and 'Performer Resting,' poised and restrained evidences of plastic power now ready for distinguished expression in the latest grand manner."[20]

LEM

214

Plumes, 1931

Show Girl with Plumes (DP)
Oil on canvas, 40 × 30 (101.7 × 76.3)
Signed and dated in black paint, l.r.: *Walt Kuhn 1931*
Acc. no. 1096 (Adams no. 276)

The artist to the Marie Harriman Gallery, New York; PMG purchase 1932.[21]

Plumes is quintessential Kuhn: a performer, shown in frontal view and wearing a slightly disillusioned expression, is placed against a simple background and depicted in bright, dissonant colors. The theme of "a routine underpaid show girl wearily crowned by a fantasy of theatrical finery" frequently recurred in Kuhn's mature oeuvre and was met with a great deal of success.[22] Painted directly from the model, Mabel Benson, in December 1931, *Plumes* was one of several canvases the artist created after a European trip that included a visit to the Prado in Madrid.[23] The architectonic, three-dimensional form, the plain background, and the black-and-white contrasts with touches of red reveal the influence of Spanish artists such as Goya and Velázquez and echo certain works by Manet that have a Spanish quality.[24] *Plumes*, as does much of Kuhn's figurative work, conveys a feeling of contained energy. The contours of the figure seem to vibrate in contrast to the seem-

ingly bored facial expression. Quiet and poised, she seems capable of movement at any moment. This tension is similar to that which Kuhn had found and admired in Archaic Greek sculpture.[25] The artist created yet another sensation of tension in the painting by confining the solid, powerful figure and the plumes closely within the boundaries of the frame.

The painting was exhibited for the first time at the Marie Harriman Gallery in January 1932. The show was a success, and *Plumes* in particular was admired for the strength and simplicity of its balance, color, and composition, although one critic dismissed it as "a decorative painting."[26] Duncan Phillips, who received a catalogue, was "especially impressed by 'Plumes.'"[27] Immediately after acquiring the painting, Phillips included it his 1932 Kuhn show. "The girl under the Plumes," he wrote, "is thoroughly disillusioned and tired of it all. She seems to sag under her magnificent head-dress and to wonder perhaps why she ever left home. That head-dress is none the less a magnificent passage of painting. The feathers are the very essence of feathers and, as texture, they are the apotheosis of pigment."[28] A sense of juxtaposition, almost contradiction, is manifested in the discordant colors and disquieting yet dignified mood of the painting, which expresses not only the feelings of the model but also the artist's response to her.

LEM

214

GIFFORD BEAL (1879–1956)

Gifford Beal, Marjorie Phillips's uncle, was born in New York, January 24, 1879. He enrolled in art classes while attending Barnard Military School, New York, and spent summers studying with William Merritt Chase in Shinnecock Hills, Long Island, a practice he continued while enrolled at Princeton University, where he graduated in 1900. His classmates included Edward Hopper and Rockwell Kent. After graduation he studied at the Art Students League with landscape and genre painter Frank V. DuMond. Success came early; the first of his many awards was the third prize at the Worcester Art Museum in 1903. In 1908 he married Maude Ramsdell of Newburgh, New York. The couple traveled through England, Scotland, and Norway, and that same year Beal became an associate of the National Academy of Design. While maintaining their home in New York, the Beals spent summers in remote areas of New England: 1920 in Maine, 1921 to 1956 in several towns in Massachusetts. He was elected to membership in the Century Association in 1913, a few years before Duncan Phillips, who became a close friend. In 1914 he was made a full member of the National Academy and was also elected president of the Art Students League, a post he held until 1929. In 1916 he accompanied his friend Paul Dougherty on a watercolor expedition through Puerto Rico and in 1919 traveled through the Bahamas and Bermuda. His first exhibition at Kraushaar Galleries in New York in 1920 was the beginning of a long personal and professional relationship that resulted in biennial exhibitions there for the rest of his career. Beal's first retrospective was held in New York at the Century Association in 1950. He died in the city of his birth February 5, 1956. He is represented in the collection by fourteen oils and nine works on paper, a cross-section of his entire career.

The Beal Unit

Gifford Beal was a somewhat younger contemporary of the artists of The Eight, who had fought to secure exhibition opportunities for themselves. By contrast, Beal had little trouble exhibiting or selling his work. His impressionist landscapes of that time, bathed in color and light and depicting the upper class enjoying everyday life in the Hudson River Valley from Newburgh to Poughkeepsie, appealed to both critics and collectors.

Gradually, as a result of his interest in contemporary developments, Beal changed subject matter and technique, moving away from the impressionistic tradition of William Merritt Chase, toward a broadly realistic depiction of

seafaring life, a popular theme of the time.[1] Earth tones, rugged brushstrokes, and simplified compositions characterize his works of mid-career. By 1940 the theater and circus, subjects that had occupied him throughout his career, had replaced the sea as Beal's main interest, and he returned to brilliant color and light effects in his treatment of these subjects.

Although Duncan Phillips knew of Beal's work in the early teens, his appreciation was probably sparked by his friendship with the artist through the Century Association, which Phillips joined in 1917.[2] In 1918 Phillips included him in the Allied War Salon, from which he acquired *Peace Celebration,* ca. 1918.[3] Phillips expressed his admiration for Beal's impressionistic work in 1921, when he described a recent purchase, *The Garden Party,* 1920: "Crowd-life at spectacular moments gives [Beal] an impressionist's pleasure in transitory effects of vibrating light and movement. . . . Of his many versions of country houses seen amid stately trees there is none in which the pigment is more jewel-like and animated by a more vivid sense of the passing moment than the 'Garden Party.'"[4]

When Beal began depicting the rugged life of New England fishermen in the early twenties, he was compared to Winslow Homer. Phillips noted "the same combination of idealism and innate simplicity."[5] In a review of Beal's work at the Washington Arts Club in 1938, Leila Mechlin acknowledged Homer's influence: "That Gifford Beal has not been influenced by Homer it would be absurd to say, but it should not be forgotten that the strength which has found expression in the works of these two artists was primarily inherent in their themes."[6] Phillips responded with enthusiasm and purchased four paintings, including two large works. By 1930, however, he had begun to trade larger paintings in the collection for smaller ones. By way of explanation, he wrote to Beal: "Most of our pictures must be seen at short range and in small rooms. I have therefore come to the decision that since the museum building project seems to recede I should not acquire many large and powerful paintings and should, if possible exchange the ones we have of that character for more intimate examples of the same artist."[7] For this reason, he traded *Swordfishermen,* ca. 1921 (which he believed "belongs in a big museum building where it can be seen from a great distance") for two smaller works.[8]

Phillips exhibited Beal as a unit for the first time in 1932, when he owned twenty-two works. He supplemented a selection of six paintings from the museum's holdings with three loans. Curiously, all nine paintings were representative

of the artist's early impressionistic period, revealing that Phillips preferred the emotional and spontaneous aspects of his early work. During this show Beal visited the Phillipses and lectured to students of the Phillips Gallery Art School.[9] Five years later Phillips held an exhibition of Beal's drawings, etchings, and lithographs to commemorate the opening of the new print rooms.[10]

In his last years, Beal found his own painting style, an expressive and energetic rendering of life—at home in New York and during his travels to exotic lands. Beal confessed to Phillips, "I am too old to do modern work. But I think I can at least keep it fresh and young looking, and even that takes energy."[11] Beal surely lived up to his resolution; vibrant color and frenetic brushstrokes dominate his later canvases. Phillips purchased his last Beal painting, *Waterfall, Haiti,* 1954, in 1955.[12] He wrote to Beal, "We are all charmed and amazed at the power and youthful gaiety of the color in the landscapes and flowers which you send for us to see. . . . Congratulations on being so continuously young at heart and vigorous in execution."[13]

V S B

215

Center Ring, 1922

Circus Ring, Little Circus Ring (DP)
Oil on canvas, 22 × 26 1/8 (55.9 × 66.3)
Signed and dated l.c.: *Gifford Beal 22*
Acc. no. 0098

The artist to Kraushaar, New York, 1922; PMG purchase 1922.[14]

Gifford Beal explored the circus theme throughout his life. "The circus has always fascinated him," his friend Mahonri Young wrote, "and by now there is a series of circus pictures of very considerable extent from his hands."[15] As Beal's son remembered, "Each year, Uncle Reynolds, my father and I would follow the circus around in the North Shore area."[16] Beal believed that it was necessary to get to know a subject well through drawing and long observation before tackling it in paint.

Center Ring received critical attention when it was shown to the Washington public for the first time in 1927.[17] One critic singled it out as "a gay and joyous canvas given with the authority of a painter who knows how to convey life with striking effect."[18] Indeed, Beal's boldly brushed color is barely contained within the scant contour lines defining the acrobats and white horses. The central group serves a dual purpose: while the act itself is exhilarating and suspense-

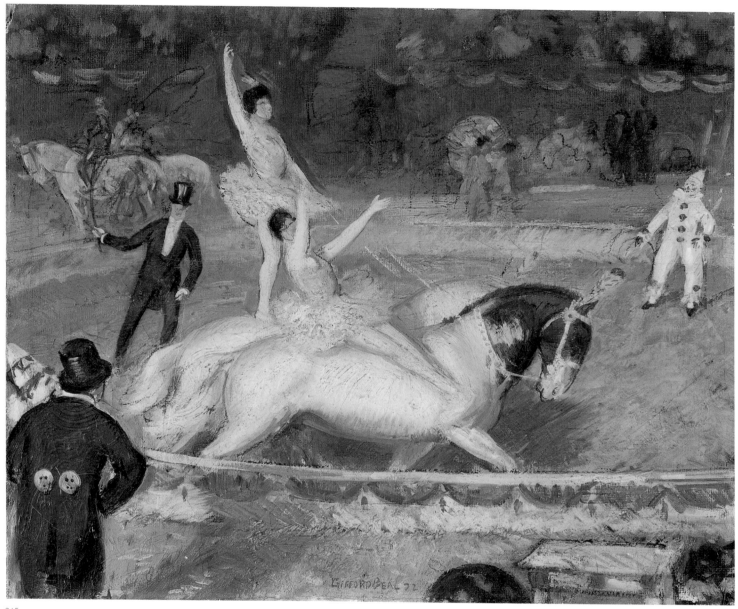

215

ful, the triangular composition nevertheless stabilizes an otherwise diagonally sweeping scene.

Beal eschewed a theoretical approach to painting, believing instead that "the better the form is understood, the better the color. . . . Each subject has a sufficient number of color tones to satisfy the most exacting painter and if it is observed long enough, it will give out a color sensation that cannot be arrived at through color systems or mental inventions."[19] Therefore, he blocked in broad areas of color, drew in the composition with a dry black brush, painted in the details, then finished with more outline.

Duncan Phillips liked to show the variation that resulted when different artists tackled the same subject. In 1932 he hung an exhibition of Beal's circus themes adjacent to a gallery of works by Walt Kuhn, noting that "from the far away and happily detached viewpoint of the spectator [Beal] has observed and studied the pictorial aspects of the performing people and animals down in the tanbark ring."[20] By contrast, Kuhn had become personally acquainted with his performers, and his works reveal the artist's interest in the human being beneath the makeup and costume.[21]

By the end of the 1930s Beal had taken a different approach to his subject. Instead of the histrionic gaiety of *Center Ring*, he now favored an American Scene realism (characterized by Rockwell Kent and Edward Hopper), as demonstrated by *Circus Ponies* (acc. no. 0076). This painting also discloses a decided assimilation of abstraction, evident through the play of line and texture on the surface, the flattening of planes, and the loose handling of the brush. *Circus Ponies* indeed anticipates Beal's mature style.

VSB

216

Carrying the Nets, 1923

Hauling Nets, Hauling the Nets
Oil on canvas, 15¾ × 31⅞ (39.9 × 81.2)
Signed and dated l.r.: *Gifford Beal 23*
Acc. no. 0094

The artist to Kraushaar, New York, 1923; PMG purchase
1923.[22]

217

The Quarryman, 1931

Oil on canvas, 18 × 24⅛ (45.6 × 61.3)
Signed in dark brown paint l.r.: *Gifford Beal*
Acc. no. 0108

The artist to Kraushaar, New York, 1931; PMG purchase
(from Kraushaar exhibition) 1931.[23]

Beal's first summer on the New England sea-
coast in 1920 exposed him to the area's rocky
terrain and its hard-working inhabitants, the
laboring men and women whose livelihood
depended on the sea. This new experience
inspired him to concentrate on subjects
exemplified by *Carrying the Nets* and *The Quar-
ryman*. Monumentality of composition, bold-
ness of touch, and muted earth tones—inspired
by his friends Rockwell Kent and George Bel-
lows—replaced the staccato, textured brush-
strokes and bright color of his earlier style.

Carrying the Nets, painted in 1923, is repre-
sentative of Beal's early treatment of the seafar-
ing theme. The artist observed the scene from a
detached point of view; like actors on a stage,
the fishermen bearing their load occupy a shal-
low space. In the classical ordering of the
figures, which are linked by the undulating mass
of the nets, Beal achieved what has been
described as "supple rhythm . . . animated by a
common impulse."[24] In the early 1920s, Duncan
Phillips recognized this quality in one of several
essays prepared for a projected publication on
contemporary American artists: "Lately [Gifford
Beal] has been painting the sea and the life and
work of fishing villages and he has passed at
times from a romantic to a classic point of
view. . . . We admire his fishermen toiling in
rhythmic unison."[25] *Carrying the Nets* recalls
two paintings in the collection by Kent: *Burial of
a Young Man*, ca. 1908–11, and *The Road Roller*,
1909 (cat. nos. 222 and 223). Certainly Phillips
saw such a connection, because he often hung
Carrying the Nets next to *The Road Roller*.

216

217

By the time he executed *The Quarryman*
nearly a decade later, Beal was no longer paint-
ing with the same sense of spectacle seen in *Car-
rying the Nets*. A solitary stonecutter, occupying
the front of the picture plane, is shown hard at
work at his everyday chores. The monumental
figure is silhouetted against a vast blue sky and
is lit dramatically from behind by intense sun-
light. Deep shadows are cast in the folds of his
garments and obscure his face; this deliberate
concealment of individuality is perhaps Beal's
way of casting the stonecutter in the role of
Everyman. Beal used the exposed ground of the
canvas as a vital tone that serves to highlight the
man's sleeve. In the bold execution and heroic
treatment of the subject, *The Quarryman* and its
companion in the collection, *The Fish Bucket*,
1924, share an affinity with American Scene
painting of the early 1930s.[26]

V S B

Robert Spencer was a founding member of the New Hope Group, a branch of American impressionism associated with the Pennsylvania School. Spencer was born December 1, 1879, in Harvard, Nebraska. His father was a Swedenborgian minister, and the family moved frequently. After studying medicine briefly, he decided to become an artist and enrolled at the National Academy of Design in New York, where he attended classes until 1901 and became a friend of Charles Rosen. From 1903 to 1905 he studied under William Merritt Chase and probably Robert Henri at the New York School of Art and then spent almost a year as a draftsman at a civil engineering firm. After living three years in the Delaware River region (where he came into contact with the landscape painters Edward Willis Redfield and William Lathrop), Spencer spent the summer of 1909 studying painting with Daniel Garber, a prominent figure among the second generation of Pennsylvania impressionists. That fall Spencer moved to New Hope, where he began to develop his own style and subject matter centered on the mill town and, from 1913 to 1915, began to achieve considerable success. In 1916 he joined forces with Rae Sloan Bredin, Morgan Colt, Garber, Lathrop, and Rosen—thus creating the New Hope Group—for mutual support and exhibition opportunities. It was at Lathrop's home that he met his future wife, Margaret Fulton, in 1914. Spencer traveled to Europe (Spain, France, and Italy) for the first time during the summer of 1925 and returned to Paris for several months in 1927. In the course of the 1920s Spencer suffered several nervous breakdowns, and July 11, 1931, he committed suicide in his studio. The collection includes eight paintings by Spencer, each representing a distinct phase of his career.

The Spencer Unit

When Robert Spencer moved to New Hope, Pennsylvania, in 1909, he quickly became a prominent figure in the art community there. The beauty and serenity of the small town, which is situated on the Pennsylvania Canal north of Philadelphia, and the fame of its notable inhabitants—namely the lauded impressionist painter Edward Redfield and the "dean" of the art colony, William Lathrop—attracted many artists to the area.[1] While members of the contemporary Boston School, led by Edmund Tarbell, favored genre and society portraits, the Pennsylvania impressionists painted the countryside surrounding the Delaware River (along the Pennsylvania–New Jersey border). As Guy Pène du Bois wrote in 1915, "If the Pennsyl-

vania painters are the democrats of our art then the Boston painters are its aristocrats."[2]

Spencer, however, differed from his fellow "democrats" by painting the everyday life of New Hope's factory and mill workers rather than uninhabited landscapes. "A landscape without a building or a figure," he explained, "is a very lonely picture to me."[3] The relationship of architecture and people to nature remained Spencer's preoccupation throughout his career. While Redfield created quick, spontaneous records of nature that followed in the tradition of Monet, Spencer followed in the realist tradition of Henri, Manet, and, ultimately, Velázquez. However, unlike his realist predecessors, Spencer did not record his impressions with great speed. He wrote: "I can't paint them 'while you wait.' . . . I have to . . . build a city of real bricks and mortar before I paint it—and the real bricks and mortar are imagination—solidified. If I were Redfield—it would be easy enough—he paints what he sees, but I first have to make what I see—so its [sic] slow, dreadfully slow."[4]

Spencer came to the fore of the New York art world in 1913, while he was painting his mill series; three years later Duncan Phillips purchased his first Spencer, End of the Day, ca. 1913, probably a work from this series.[5] This painting held special significance for Phillips, who, when faced with trading it in 1926 for a contemporary work by the artist, wrote: "I agree with you that the little early one entitled 'End of the Day' is the least important, but it has a sentiment for me as I used to be extremely fond of it at a time when we had very few pictures. It is unquestionably a poetic little scene and has a rare quality of texture."[6] Phillips particularly admired Spencer's "ability to express in pictures a significant relation of figures to landscape," and he selected him to be a member of the gallery's Committee on Scope and Plan because of their shared philosophies on art and collecting.[7] In fact, Phillips did not retain his purchases by Spencer's colleagues, Garber and Redfield.

At the time of the incorporation of the Phillips Memorial Gallery in 1921, the collection included eight paintings by Spencer: two from his early mill series, a backyard scene, a Delaware River view, and four village scenes. However, within the decade Phillips traded five of them (paintings for which Spencer had earned his reputation as the "painter of backyards") for two examples from his European period of the mid-1920s and three later works.[8]

Although Spencer never picked up a brush during his 1925 summer in Europe, he executed paintings upon his return. Works such as Ship Chandler's Row, ca. 1925, and Mountebanks and

Thieves, ca. 1925 (acc. nos. 1795 and 1792), while strongly recalling Jerome Myers and John Sloan, portray European culture and architecture—the mansard roof, spires, old brick or stone buildings. Ironically, when Pierre Bonnard was on the jury of the 1926 Carnegie International Exhibition in Pittsburgh, where Mountebanks and Thieves won third prize, he is said to have exclaimed, "Mr. Spencer . . . is in the full vigor of his talent which is great. His art does not resemble European art, a rare fact in America."[9]

In 1926, at the height of his career, Spencer stopped painting and did not execute a single work for two years. When he resumed activity in 1928 with The Seed of Revolution, 1928, he wrote to Phillips, who had expressed interest in it: "'The Seed of Revolution' is the first thing I have painted since the Biddle portrait. . . . The last two years I have literally lived in hell. . . . I am painting again with full force, cutting deeper and with a freedom from painting conventions that I never had before. . . . I dare to say what is in my mind with conviction and a free brush and palette."[10] The Seed of Revolution spawned a series of paintings depicting crowd gatherings. Indeed, Phillips recognized it as "the kind of a picture one does not forget" and as "a powerful and outstanding work."[11] Perhaps Phillips saw this painting as following in the tradition of Daumier, Delacroix, and Goya.[12] In any event, it was the last work by Spencer that he purchased during the artist's lifetime.

In the final years of his life, Spencer painted religious subjects and small genre scenes. Unable to cope with modern art or life, he wrote to Phillips a few months before his suicide: "There is a kind of inhuman quality about modern art and modern life that I cannot get the value of. . . . The Academy is dead—has always been dead. The new movement is just as dead. . . . Of course movements and academies never do produce art, but they do affect public opinion. Where are we going, and why? . . . Why turn from the corpse of the academy to the Frankenstein of today—an unloved, unlovable distorted machine."[13]

Following Spencer's death, Phillips tried to explain, and even defend, his friend's position in the history of art: "Conservative? Certainly. He could not see in the new theoretical ways, and naturally he resented a School which obscured his own predilections and purposes. Academic? Quite the reverse. He was a rebel always against the standardized and the stereotyped in art." Phillips believed "there [was] no other painter, not John Sloan or Edward Hopper, more pungently American in expression."[14]

VSB

218

218

Across the Delaware, ca. 1916

Oil on canvas, 14 × 14 (35.5 × 35.5)
Signed in blue paint, l.l.: *Robert Spencer*
Acc. no. 1789

The artist; PMAG purchase by 1921 (probably 1917).[15]

219

On the Bank, between 1928 and 1931

Oil on canvas, 14 × 12 (35.5 × 30.5)
Signed in black paint, l.r.: *Robt. Spencer*
Acc. no. 1793

The artist's estate to Ferargil Galleries, New York, 1932;
PMG purchase 1932.[16]

Between 1916 and 1920, Spencer occasionally
deviated from his depictions of working-class
life in and around New Hope to paint
panoramic views of the Delaware River, just as
his contemporaries were doing. *Across the
Delaware,* a winter landscape, considered the
"hallmark of Pennsylvania Impressionism," is
perhaps the earliest in this series. It is certainly
the earliest Spencer painting in The Phillips
Collection, and the only one without figures.[17]
Spencer concentrated only briefly on pure land-
scape and returned to scenes in which landscape
was merely a backdrop for figure compositions.

In composition and technique, *Across the
Delaware* reflects the influence of Daniel Gar-
ber's series of paintings depicting the quarries of
New Hope: square format, horizontal layering of
planes, and high horizon line designed to limit
perspective and flatten the composition.[18] Just as
Garber's *The Quarry* has the image of the quarry
reflected in the Delaware River with scintillating
touches of color, the snow-draped dwellings of
New Hope in *Across the Delaware* are mirrored
in the river. To achieve this effect, Spencer
scraped back the first layer of paint, then care-
fully placed over it thick horizontal daubs of
colors from the embankment.[19]

Spencer frequently repeated compositional
elements, and fifteen years later, in *On the Bank,*
he again divided the background into horizontal
bands but without retaining the surface texture
of the earlier work. Instead, he applied color
sparingly, thus exposing much of the canvas
weave. As in other late genre pictures, the sub-
ject of *On the Bank* is not the landscape but the
relationship between figures and landscape.

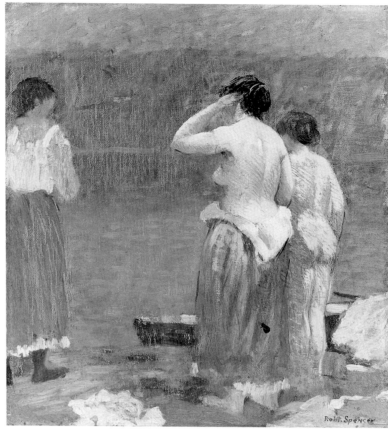

219

On the Bank was painted at a time when
Spencer was becoming discouraged with mod-
ern art. On seeing one of Matisse's "typical
women," he commented that it was "a thing of
brush strokes and intellect. . . . If Matisse and
Picasso represent life . . . the world for me is
dead!" He yearned for a "wholesome, sane and
happy trend in art."[20] Perhaps for this reason,
On the Bank recaptures nineteenth-century sen-
sitivity and subject matter, particularly the
"bather studies" of Renoir and Degas, to whom
Phillips believed Spencer owed much.[21]

Upon Spencer's death, his widow appealed to
Phillips for an exhibition of the small paintings
that Spencer had left behind in his studio. She

felt that these works, including *On the Bank* and
Woman Ironing, between 1928 and 1931, "best
truly represent his personal reactions" to mod-
ernism.[22] Phillips responded with a memorial
exhibition in the spring of 1932, postponing an
exhibition of the work of Marjorie Phillips.
(Coincidentally, Phillips believed that his wife's
art shared with Spencer an affinity for the
"French classic feeling for composition [and] an
innate American reserve.")[23] He responded
warmly to Spencer's last paintings, referring to
him as "the American Millet" and stating that in
On the Bank "there is a hint of something classic
applied to the lives of the plain people of his
own environment."[24]

VSB

220

The Evangelist, ca. 1918–19

Oil on canvas, 25 × 30 (63.4 × 76.1)
Signed l.r.: *Robert Spencer*
Acc. no. 1791

The artist to Arlington Galleries, New York, date
unknown; PMAG purchase 1920.[25]

Spencer rarely delved into his own life for sub-
ject matter. However, in *The Evangelist* he may
have summoned a childhood memory. His
father was a Swedenborgian clergyman who
often changed his parish, and this painting re-
flects the nomadic life of a clergyman who
preaches from makeshift platforms.

In the course of his career, Spencer progres-
sively deemphasized architecture and stressed
the figure.[26] In the vertical tripartite division of
The Evangelist, the platform and its inhabitants
occupy the central panel and face the viewer,
thus limiting perspective. *The Auction* (acc. no.
1790), a painting from the same period, incorpo-
rates the same compositional device. Though
not showing a central building, the composition
is like those of earlier architectural studies in
that a central rectangle closes off the center of
the canvas.

Spencer's technique changed little during the
teens, varying only in the degree of impasto. As
seen in *The Evangelist,* he blocked in areas of
color that he then scraped back to reveal the
weave of the canvas. The second layer of paint
was applied in short choppy strokes to create
texture. The color is muted and somber, befit-
ting the subject. Phillips particularly responded
to Spencer's use of color and line in *The Evange-
list,* as when he observed that "the gaunt
unlovely platform permits handsome accents of
black silvered in sunlight and contrasts delight-
fully with the pinks, grays, and whites of the vil-
lage crowd and with the lyrical light of late
afternoon on the banks of the Delaware."[27]
Exhibited twice as often as any other work by
Spencer, *The Evangelist* remained one of
Phillips's favorite paintings. He considered it to
be "a masterpiece of American genre."[28]

VSB

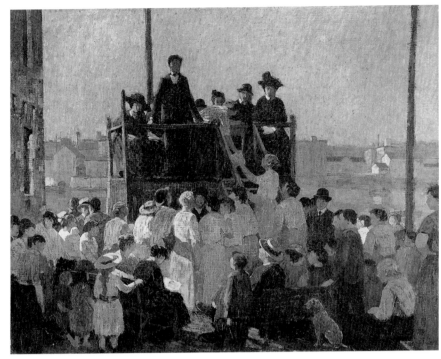

220

GEORGE BELLOWS (1882–1925)

George Wesley Bellows is best known for his scenes of urban life, sporting events, and portraits of keen insight. Bellows was born August 12, 1882, in Columbus, Ohio. After attending Ohio State University from 1901 to 1904, he enrolled in the New York School of Art, where he studied under William Merritt Chase and Robert Henri; Edward Hopper and Rockwell Kent were fellow students. While in school, he supported himself by contributing illustrations to popular magazines such as *Vanity Fair*. In 1906 he rented his own studio in New York, and two years later was awarded the Hallgarten Prize of the National Academy of Design for a landscape painting. Both the Metropolitan Museum of Art and the Pennsylvania Academy of the Fine Arts acquired his work. He was elected an associate of the National Academy of Design in 1909, the youngest member in its history, and became a full member four years later. In 1910 he married former art student Emma Story and began teaching at the Art Students League. The following year the Madison Gallery in New York gave him his first one-person exhibition. In 1913, while straddling the chasm between academic and progressive movements in art, he helped organize and contributed works to the Armory Show. Late in his career he spent summers in Maine, Rhode Island, and New Mexico, where he painted intimate portraits of his family and friends. In 1916 he began to experiment with lithography, an interest he pursued for the rest of his life. In 1922 he and his family moved to Woodstock, New York, where he lived until his death January 8, 1925. Bellows is represented in the collection by one oil painting and three lithographs.

221

Emma at a Window, 1920

Emma at the Window; Emma in Black (DP)
Oil on canvas, 41¼ × 34⅜ (104.6 × 87.3)
Signed in dark blue paint, l.l.: [*Bello*]*ws* (partly obscured)
Acc. no. 0116

The artist to Rehn, New York, 1922; PMG purchase 1924.[1]

Upon his arrival in New York in 1904, Bellows was immediately accepted by the free-spirited group of artists and critics centered around Robert Henri—members of The Eight, as well as Frank Crowninshield, Edward Hopper, Leon Kroll, Mary Fanton Roberts, and Eugene Speicher. Equally championed by the conservative arts faction, notably the National Academy of Design, Bellows maintained a curious, and perhaps enviable, position in the American art world. His expressive landscapes, urban scenes, and portraits were praised for their American temperament by both radicals and conservatives alike.

Between 1911 and 1924 Bellows painted eleven portraits of his wife, Emma Story Bellows (1884–1959).[2] The Phillips canvas is one of the last versions. Bellows created *Emma at a Window*, as well as other portraits of his friends and family, during his 1920 summer in Woodstock, New York, where he had rented a house.[3] There he became involved in the artistic community that included Henri, Kroll, and Speicher. "I enjoy the consultations," he wrote, "and believe it worth more than going off alone."[4] Attracted by the superior summer light, Bellows thereafter devoted his summers to painting in Woodstock, reserving his winters mostly for lithography and drawing in New York City.[5]

The mature portraits, such as *Emma at a Window*, reflect Bellows's admiration for the Old Masters and Thomas Eakins, as well as contemporary color theorists like Hardesty G. Maratta, Denman Ross, and Jay Hambidge.[6] By this time, too, he had abandoned the Henri-influenced impasto-laden surfaces, the frenetic brushwork, and the dark, formless backgrounds of his early portraits.[7]

Bellows painted *Emma at a Window* with thin, sleek brushstrokes and used the near complementary colors red-purple and green (pervasive in the embroidered chair and round table) for balance. A devoted and respectful husband, he placed his wife in a formal, elegant setting and gave her straight posture and a patrician expression, thus heightening her projection of dignity and strength of character.[8]

Hambidge's theory of dynamic symmetry, an American response to cubism, is also evident in this portrait.[9] Hambidge had based his theory on "that great romanticist Plato who reduced all things ultimately to ideal geometric forms in a search for the geometric soul of reality."[10] In response, Bellows composed *Emma at a Window* with horizontals, verticals, and diagonals—as seen in the window and curtains, as well as the seated figure and her arms. Only Emma's gaze breaks out of the geometrical confinement. Although Speicher claimed that Bellows "rarely allowed the system to over-assert itself," in this example Emma's arms are placed awkwardly, at right angles to each other, the result of Bellows's attempt to fit them into the formal structure.[11] In a probable preliminary drawing entitled *Study for Portrait of Emma* (fig. 32), the same ordering of the composition is observed, but delicate oriental details included in the sketch (wallpaper and a plant) were eliminated in the painting.[12] In other words, a potentially more Victorian background was exchanged for one of austere simplicity and limitless dignity.

Fig. 32 George Wesley Bellows, *Study for Portrait of Emma*, black conté crayon on gray wove paper, 12¼ × 11⅛ in., Joseph Brooks Fair Collection, 1924.510. © 1990 Art Institute of Chicago. All rights reserved.

During the mid-teens, Duncan Phillips considered Bellows "a painfully uneven performer," though he admired his transcriptions of "stark, significant reality," which he detected in *Men of the Docks*, 1913, and *Cliff Dwellers*, 1913.[13] At first, he disliked Bellows's portraits, which exhibited the technique of highlighting the face and hands, thereby reducing the illusion of volume. However, by the mid-1920s he came to appreciate the artist's "seeing the sitter in full light" and even went so far as to state that "George Bellows . . . is an American Manet in his best portraits, and *Emma in Black* is certainly one of these."[14]

V S B

221

ROCKWELL KENT (1882–1971)

The American realist Rockwell Kent was born June 21, 1882, in Tarrytown, New York. He first studied painting during the summer of 1900 under William Merritt Chase while attending the Columbia University School of Architecture. In 1904 he enrolled in the New York School of Art, where he studied under Robert Henri and Kenneth Hayes Miller. Kent's many interests—architecture, painting, illustration, carpentry, and writing—were enhanced by the widespread, often exotic, locales he visited, including Newfoundland, Alaska, Tierra del Fuego, France, Ireland, Greenland, and the Soviet Union. As he traveled, he kept journals, some of which were later published with great success. After his first one-person show at Clausen Gallery, New York, in 1907, Kent participated in most of the major progressive exhibitions of the time except the Armory Show. In 1911, while organizing an independent exhibition to be held at the Society of Beaux Arts Architects in New York, he met and became close friends with Marsden Hartley, and in 1918 Duncan Phillips began to support him with great enthusiasm. The federal Public Works Administration commissioned Kent in 1935 to paint two murals for the new post office building in Washington, D.C. Although he enjoyed acclaim as a major American artist during the 1930s, his artistic achievements were later overshadowed by his political activities. In 1960 he presented the Soviet Union with eighty of his paintings as well as a number of prints, drawings, and manuscripts, which were divided among four Soviet museums. He died March 13, 1971. The Phillips Collection owns six oil paintings, two pencil drawings, two ink drawings, one watercolor, and one electrotype.

The Kent Group

Although he was grounded in the American realist tradition, Rockwell Kent rarely painted urban scenes like his contemporaries George Bellows and John Sloan.[1] Instead he drew inspiration from nature's grandeur and humanity's relationship to its monumental forces. His early work greatly appealed to Duncan Phillips.

In 1918, the year he began to collect fervently, Phillips championed younger contemporary Americans, and Kent was one of the first. As his plans for the collection developed, Phillips intended to create a Kent unit that would include "a good example of each of . . . [his] adventures in different parts of the world," and when he projected a new museum building, it was to have included a Rockwell Kent Room.[2] By 1925 Phillips had established a "sustaining fund" for Kent: in exchange for a monthly stipend of $300, Phillips would receive first choice of two paintings per year.[3] As evidence of his growing respect for Kent, Phillips commissioned him to design the cover of the paperbound edition of his book *Collection in the Making*, which was published in 1926; however, Phillips disliked the final design and rejected it.[4] That year Kent gave the Phillips Memorial Gallery a small Marsden Hartley landscape, *Mountain Lake—Autumn*, ca. 1910 (cat. no. 239).[5] Phillips kept many artists at a distance, but his friendship with Kent was unusually close, and by 1926 they were on a first-name basis. Shortly thereafter, however, Kent "thought that the Phillips Gallery had acquired about all the Kents it ought to have," and he annulled the 1925 agreement.[6]

In addition to the six oil paintings presently in the collection, Phillips acquired and then deaccessioned six others, including *Father and Son*, 1925 (American University, Washington, D.C.), which had been commissioned soon after the birth of his son Laughlin, and *Blackhead—Monhegan*, n.d. (Colby College, Waterville, Maine), a gift from Kent at the inception of the stipend period. Eventually Phillips's enthusiasm for Kent fell off sharply, as indicated by an assessment of the artist in 1928 in which he wrote that Kent was "working too easily with a formula and what once was inspiration seems to be now stereotyped convention."[7]

VSB

222

Burial of a Young Man, ca. 1908–11

Burial; Dirge

Oil on canvas, 28⅛ × 52¼ (71.4 × 132.7)

Signed on reverse: *Rockwell Kent*

Acc. no. 0977

The artist to Macbeth Gallery, New York, 1912; DP purchase for private collection 1918; transferred to PMG by 1924.[8]

In a 1908 letter to his future wife, Rockwell Kent wrote from Monhegan Island, Maine: "I have been painting on a picture that I started last spring or rather last winter . . . of a funeral or burial at Monhegan, I have completely repainted the picture and I think it is very successful. . . . It looks to me very solemn and grand."[9] This correspondence apparently documents the inception of *Burial of a Young Man*.

The landscape in the background recalls the headlands in Kent's other Monhegan paintings, and the subject matter and composition compare with an ink wash entitled *Country Funeral*, ca. 1907, that Kent executed on Monhegan.[10] In both burial scenes figures form a shallow band resembling a frieze that stretches the length of the canvas.

The painting may have been among those finished after his return to the island in December 1910.[11] It was first exhibited in New York in April 1911 and received rave reviews. Indeed, the critic Joseph E. Chamberlin believed it was "a picture that rises to the level of genius. . . . One does not know whether one is in a world of remote antiquity or one of the ideal future."[12] Phillips, who recognized this polarity in Kent's work, stated that Kent was "at heart a Greek but with many modern complications."[13] Kent's early architectural training, which undoubtedly entailed the study of Greek and Roman monuments, may have inspired the composition of the frieze. In fact, the undulating line of the mourners' arms and hands, the presence and placement of the children, and the draped clothing suggest the processional frieze on the Augustan Ara Pacis in Rome.

When Kent first exhibited the painting, John Sloan, whose apartment was above the Kents', wrote in his diary that it was "done under the influence of [Arthur B.] Davies."[14] Sloan may have been referring to the poetic universality and vaguely Greek aspect of Davies's paintings. Phillips, who also saw an affinity with Davies, observed: "There is a sense of resignation to fate in many of Davies' pictures inspired by Greek tragedies and in Rockwell Kent's dirge of New Foundland [*sic*], entitled 'Burial of a Young Man.' In that American masterpiece we feel the inevitable working of an absolute will against which the rebellious spirit of youth is of no avail."[15]

When he purchased the somber *Burial of a Young Man* in 1918, Phillips was undoubtedly responding in part to the recent deaths of both his father and brother in the 1918 influenza epidemic, and the horrors of the First World War.[16] Phillips selected the painting for the December 1918 Allied War Salon; however, he was unable to persuade the organizing committee that it was "a powerful and by no means harmful war picture," and it was not accepted for the exhibition.[17]

VSB

223

The Road Roller, 1909

Road Breaking; Snow Roller (New Hampshire)

Oil on canvas, 34⅛ × 44¼ (86.6 × 112.3)

Signed l.r.: *Rockwell Kent 1909*

Acc. no. 0986

The artist to Daniel Gallery, New York; purchased by DP for private collection 1918; transferred to PMG by 1924.[18]

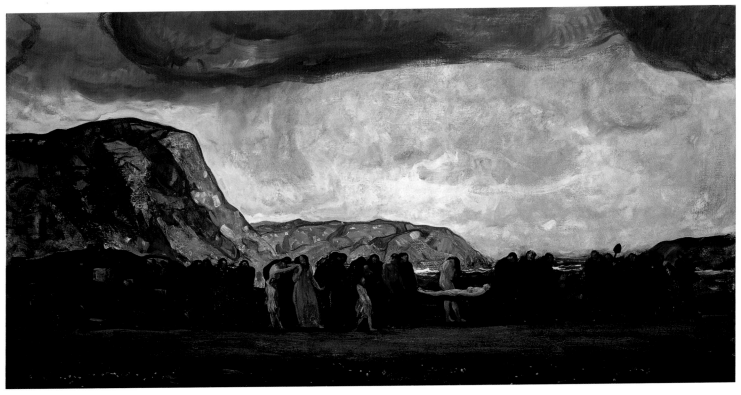

222

In the winter of 1908, while living in Dublin, New Hampshire, with his good friend Gerald Thayer, Rockwell Kent created his "best known example of that winter's work," *The Road Roller,* which depicts the Dublin Township roller packing the snow in his driveway. The large contraption, he pointed out later, "*packed,* not *cleared*" the local roads for horse-drawn sleighs.[19]

The Road Roller is one of the few works that Kent painted from a preliminary sketch (fig. 33). In the painting he drew a continuous convex curve in the lower half of the canvas, a line not fully developed in the sketch. The viewer's eye is immediately caught by the direct gaze of the dog, which anchors the curve and in turn leads to the main subject—the roller, the horses, and the men, who are trying to control the opposing forces of gravity and animal strength. Both the placement of the black-and-white collie in the foreground and the slanting shadows on the hillside establish a sense of depth. The thick impasto and fluid brushstroke enhance the drama of the subject, reflecting Kent's early training under Robert Henri.

The painting suggests a conscious effort to monumentalize the human figure. The standing men, silhouetted against a vast, threatening sky, are seen from a lower vantage point than in the sketch, thus emphasizing their height. Even

223

224

Fig. 33 Rockwell Kent, *Road Roller,* ca. 1907–9, charcoal, 7⅞ × 9⅞ in. Philadelphia Museum of Art: Purchased: The Lola Downin Peck Fund from the Carl and Laura Zigrosser Collection.

though they are overshadowed by the horses and the massive roller—both of which are shown much larger and more powerful than in the sketch—they are completely in command.

Between 1918 and 1919, Duncan Phillips selected many works by artists associated with The Eight, especially paintings that emphasized the drama of the moment and the heroism of Everyman. In Kent's work, however, he also looked for romanticism, which may explain why he considered selling *The Road Roller* in 1921; it was retained, however, and was widely exhibited in later years.[20]

VSB

224

Mountain Lake—Tierra del Fuego, between 1922 and 1925

Mountain Lake (DP)
Oil on wood panel, 15⅝ × 20⅛ (39.7 × 51.1)
Unsigned
Acc. no. 0984

The artist to DP (under stipend agreement) 1925.[21]

For Duncan Phillips, Kent's art embodied "the eager linear expression of his own abounding energy and gusto for physical adventure in wild and desolate regions," an appropriate description of the small oil panel entitled *Mountain Lake.*[22] A record of his 1922 sailing adventure to the Tierra del Fuego region of South America, it is one of many small studies that may have been executed at the site.[23] Kent described the view from his boat, which was anchored in the bay of Bahía Blanca in the Admiralty Sound: "From our anchorage at Bahia Blanca I looked across the half mile wide bay to a steep shore densely and darkly wooded with the Fuegan birch and oak. Immediately behind and far above these foothills rose lofty mountains, their lower, shaly slopes patched with scant vegetation, their upper reaches dazzling white with the past winter's snows. Our bay was terminated a mile or two away by a glacial moraine behind which rose the emerald and turquoise walls of a broad glacier and, beyond the high horizon of the glacier's plane, a few far distant, snow-clad peaks. Mostly I worked near our anchorage."[24]

In *Mountain Lake* Kent abandoned his earlier

preference for rich impasto and surface texture in favor of a thin, sleek finish. The space, arbitrarily adjusted into abstract, flat patterns, reflects a stylistic kinship with both precisionism—an American movement that was widely influential in the early 1920s—and woodblock printing.

Kent returned to New York in January 1923 with "twenty or more large Fuegan paintings to restretch and work upon, and . . . many small studies to bring to completion."[25] These works were first shown at Wildenstein Gallery, New York, in April 1925.[26] Despite positive reviews, Kent believed that "the trend toward the so-called 'modern' school had already alienated from realism many who, in the previous decade, might have been purchasers."[27] Phillips, however, greatly appreciated Kent's work and purchased *Mountain Lake* as a representation of the artist's adventures in South America, intending it for his "Rockwell Kent Room." Phillips first exhibited the painting in 1926, writing in the exhibition catalogue that "Kent [did] not need abstract vision for he moves us like mighty music with images drawn from his own romantic experience."[28]

VSB

GUY PÈNE DU BOIS (1884–1958)

In his painting and writing, Guy Pène du Bois displayed a highly personal style to express his preference for art grounded in views of everyday life. Pène du Bois was born in Brooklyn, New York, January 4, 1884, into a literary household of French descent. He showed a talent for drawing during high school and in 1899 enrolled in the New York School of Art under William Merritt Chase, later studying under Kenneth Hayes Miller and Robert Henri. Pène du Bois settled in Paris in 1905 and studied at the Académie Colarossi and in the studio of Théophile Steinlen. Following his father's death in 1906, he returned to New York to support his family. Until 1912 he was a music and art critic for the *New York American*, his father's former employer. Pène du Bois served on the publicity committee for the Armory Show in 1913 and edited a special issue of *Arts and Decoration* magazine on the show; that year he also served as assistant to the critic Royal Cortissoz. John Kraushaar became his dealer shortly after the Armory Show, a relationship that lasted more than thirty years. Pène du Bois soon became active in the Society of Independent Artists and the Whitney Studio Club, where he had his first one-person exhibition in 1918. Two years later he began teaching at the Art Students League to supplement his income. In 1921, he was invited to jury the "8th Exhibition of Oil Paintings by Contemporary American Artists" at the Corcoran Gallery of Art in Washington, D.C. From 1924 to 1930 Pène du Bois and his family lived in the French countryside, and two years after his return to New York, he founded the Guy Pène du Bois Summer School in Stonington, Connecticut. For the next twenty-one years he spent his summers there, living in New York during the winter. He was elected an associate of the National Academy of Design in 1937 and became a full academician in 1940. In 1953 he moved to Paris, but he returned to the United States in 1956 because of poor health. He died in Boston July 18, 1958. The collection owns four oils, all from his mature period, including two Parisian themes from the late 1920s.

225

225

The Arrivals, 1918 or early 1919

Two of a Kind
Oil on plywood panel, 24 × 20 (61.0 × 50.9)
Signed l.l.: *Guy Pène du Bois*
Acc. no. 0601

The artist to Kraushaar, New York, 1919; PMG purchase 1922.[1]

In 1923, Guy Pène du Bois decided to paint idealistic and decorative works that expressed the "flowing rhythms of linear design."[2] He sought the financial help of Duncan Phillips, who responded with surprise, noting that "the work by you that I know is distinguished more by its incisive and ironical commentary on life, rather bitter and disillusioned but very brilliant and sound . . . than by any far flights into the upper air of dreams and the misty region of Romance."[3]

In the early teens, Pène du Bois abandoned the style derived from his teachers Chase and Henri—a limited dark palette and quick, gestural brushstrokes—and developed the style referred to by Phillips. With the help of sleek, stylized figures, he created parodies of the upper classes of society. He received recognition in the New York art world and was praised by Phillips for his paintings of "solidly modelled figures, each one a puppet for the appreciative laughter of the worldly wise."[4] *The Arrivals* helped create this reputation.

The work is transitional in that it retains the ambiguous background occupied by sketchy figures prevalent in earlier paintings, with vaguely drawn figures that herald his mature style. It also illustrates Pène du Bois's interest in portraying people as individuals, which his daughter Yvonne noted in her biography: "[Their] environment was usually a vague blurred background from which they loomed out in bulk and space. He was not interested in landscape, architecture, interiors, perspective or abstract composition."[5]

The specific incident in *The Arrivals* is unimportant; rather, what concerned Pène du Bois was the moment of display—the woman stepping into the spotlight, both literally and socially. Her partner, whom Pène du Bois has carefully obscured in shadow, helps her remove

the fur-lined coat, revealing the long white gown and brocade necklace—all symbols of prosperity. The woman is further objectified by the vacuous expression on her face and the total lack of intimacy between her and her escort. The drama of her emergence is heightened by the sharp regression of the two male figures into the shadowy background; they serve to anchor the couple's shadow and establish depth.

Such scenes were familiar to Pène du Bois, the opera and art critic.[6] Just as his contemporaries John Sloan and Everett Shinn drew inspiration from their experiences as newspaper reporters, Pène du Bois depicted the people who frequented the opera and theater houses. The sarcasm and wit he injected into his scenes attracted Phillips, who wrote: "Du Bois is to New York what Forain is to Paris, but his wit is less caustic and his weapon blunt by comparison. Whereas Forain is passionately concerned about the immolation of the victims of lust and war, du Bois avoids drama and grimness and tolerates the wicked world with a shrug and a smile."[7]

<div style="text-align:right">V S B</div>

226

Blue Armchair, 1923

Oil on plywood panel, 25 × 20 (63.6 × 51.0)
Signed and dated in blue paint, l.r.: *Guy Pène du Bois '23*
Acc. no. 0602

The artist to Kraushaar, New York, by 1927; PMG purchase 1927.[8]

Blue Armchair, which was painted the summer of 1923 in Westport, Connecticut, captures the essence of Pène du Bois's sitter, his mistress Neely McCoy. An author and illustrator of children's books and the wife of the journalist Samuel Duff McCoy, she was approximately thirty-eight years old when *Blue Armchair* was created.[9] However, when Duncan Phillips purchased the painting from John Kraushaar in 1927, the dealer identified the sitter as the artist's daughter, Yvonne, who would have been ten years old in 1923.[10] McCoy's dark brown, bobbed hair and youthful, plump figure could have been mistaken for a teenage girl's, but her elegant hands and penetrating, unflinching gaze are those of a forthright, independent woman.

In this portrait the artist strayed from his usual portrayal of "types"—the society woman, the staunch businessman, or the wealthy dilettante—which were typically characterized by mannequin anonymity. Nevertheless, the work can be traced to the teachings of Robert Henri, who stressed the need for the artist to interpret a scene in response to his thoughts and feelings.

Although his art was grounded in realism, Pène du Bois took interpretive liberties with space and color. In *Blue Armchair* he placed a discrete diagonal form to the right of the chair in order to counterbalance the diagonal thrust of the sitter's body. The velvety stuffed armchair envelopes her rotund figure, so that her midsection is lost in an ambiguous veil of Prussian blue. McCoy's porcelain skin appears cold and lifeless.[11] To create spatial ambiguity, Pène du Bois clearly delineated the chair's front and right contours but merged the left side into the dark background, thus flattening that side of the composition. To prevent the viewer from seeing the chair in rigid perspective, he extended its top contour by adding a broad alizarin shadow.

The landscape shown in *Blue Armchair,* hanging on the wall behind the chair, was also by Pène du Bois. It offers a rare glimpse of the economy of color, line, and form that marked Pène du Bois's approach to landscape.[12]

A staunch supporter of representational painting, and a strong adversary of the avant-garde, Pène du Bois carefully chose certain modernist elements—a testament to his individualism. The saturated colors and cubist-influenced construction of space added strength and impact to his art at a time when the academic conventions seemed timid and confusing.

<div style="text-align:right">V S B</div>

227

Soldier and Peasant, 1927

Oil on panel, 21¾ × 18 (55.2 × 45.7)
Signed and dated l.l.: *Guy Pène du Bois 27*
Acc. no. 0603

The artist to Kraushaar, New York, 1927; PMG purchase 1928.[13]

In 1924, Pène du Bois launched his most productive artistic period when he left a socially active life in Westport for the small village of Garnes-par-Dampierre in France. For the first time in his life, he was able to paint free from financial worry, social obligations, and writing deadlines.[14] He painted subjects reminiscent of the society life he had left behind in America, as well as scenes from everyday life of the French people, among whom he now lived. However, he believed that "the artist begins by gathering facts. He ends by building a philosophy out of them," and in *Soldier and Peasant,* painted during this sojourn, Pène du Bois injected an ordinary scene with deeper, albeit ambiguous, meaning.[15]

By the mid-1920s, Pène du Bois had mas-

tered the depiction of psychological tension, especially tension between the sexes. The figures clearly occupy their own realm in the scene, which is divided into three distinct areas of alternating light and dark tones. The soldier leans awkwardly against the corner of a stark building, half of his body invading the space occupied by the woman (or "peasant," to use Pène du Bois's term for the local residents). The artist concealed the facial expression of both figures, inviting the viewer to imagine their relationship, if any. The lives of the villagers and soldiers at times collided, but their worlds remained separate.

Pène du Bois's mature style is also marked by the masterful integration of vibrant color, simple design, and solid form. He believed that it was "a waste of color, a miserable understanding of its properties, to make it a gossamer decoration on a good drawing."[16] By 1923 he had begun to replace the earth tones of his early works with warm hues like alizarin and ocher, and brilliant, cool blues and greens; he rarely used pure black or white. In *Soldier and Peasant* alizarin unifies the composition. It appears—placed against the warm, peach-toned wall—in the soldier's shadow and in his clothing; in the ominous passageway; and in the thin tree trunks in the distant forest. The walls suggest the burning hot sun, and the same intense light bathes the woman on the other side of the corridor. Prussian blue, the darkest tone in the composition, delineates form, which to Pène du Bois, "holds a high place among the primary considerations of realism . . . [because] form has weight; the power to occupy space, to displace light and air."[17]

The architectonic, almost stylized rendering of figures in space became a hallmark of Pène du Bois's mature style, but it puzzled purist critics, who could not justify the marriage of stylization and realism.[18] However, he defended it by quoting the nineteenth-century romantic artist Delacroix: "Nature is but a dictionary. A dictionary is not a book, it is an instrument with which to make books."[19] Hence, Pène du Bois's forms are "close to nature, [but] humanly creative," attributes the artist himself gave to the work of Cézanne, who he believed was "the apotheosis of the modern movement in art."[20]

Duncan Phillips recognized that Pène du Bois's "caustic wit" sometimes stood "in the way of his recognition as a powerful painter and space composer with all the plastic elements at his command."[21] In *Soldier and Peasant,* at least, Pène du Bois replaced his sarcasm with ambiguity and psychological tension without decreasing the effectiveness of his composition.

<div style="text-align:right">V S B</div>

226

227

7 DUNCAN PHILLIPS AND AMERICAN MODERNISM

The Continuing Legacy of the Experiment Station

WILLIAM C. AGEE

Duncan Phillips has long been acknowledged as a significant figure in the history of American modernism. But now, with the publication of this book, it is apparent that from his first acquisitions of John Marin and Arthur Dove in 1926 until his death in 1966, Phillips was an essential force. His belief in this art has lived on in the galleries of The Phillips Collection, a museum quite unlike any other in the world. Today, what remains for us is to try to put his achievement in a perspective that may enable us to understand just how profoundly he affected American avant-garde art, both then and now.

Phillips's timing was crucial. More than one critic has written that, during the period between the two world wars, America underwent a massive retreat from modernism. Phillips, however, is one good reason why we must seriously amend this view. In fact, his change in position from having a distaste for modern painting to being one of its major proponents is a signal story in the continuity of modernism in the twenties and thirties. To be sure, he was not alone. We need to remember the important collections built during the twenties by Ferdinand Howald, Katherine Dreier, Albert Barnes, and A. E. Gallatin, for example. But Phillips's involvement with American modernism was deeper and had more extensive consequences.

This commitment took many forms. Phillips bought art, he exhibited it, he wrote about it, he criticized it, he thought about it constantly, and he cared for it deeply. All this still permeates The Phillips Collection, and it is why it is the best place in the world to see American modernist art—both for the richness and depth of the collection and for its thoughtful installation in galleries appropriate for the paintings' scale.

There was, first, the indispensable material support. Dove and Stuart Davis were but two American modernists who received providential assistance through the timely acquisitions of Duncan Phillips. In 1939, for example, Davis was able to paint in a studio other than his bedroom for the first time in six years, at a time when he had no other income.[1] Further, Phillips's foresight in extending monthly stipends, against sales, to Dove, John Graham, and Marin offered crucial and continuing support when none other was forthcoming. Dove was literally saved by the stipend; in 1946, at the end of his life, he spoke movingly of this help when he wrote to Phillips:

Charles Demuth, detail of
Eggplant, see cat. 261

"You have no idea what sending on those checks means to me at this time. After fighting for an idea all your life, I realize that your backing has saved it for me and I want to thank you with all my heart and soul for what you have done. It has been marvelous."[2]

There were his acquisitions. Phillips built a collection of the best American modernists, and he built it in depth. His particular appreciation appears to have centered on the artists of the Stieglitz Circle rather than on attempting a broader view that would have encompassed all manifestations of America's emerging modernism. His commitment was—and still is—unique in America. The Phillips Collection today has 55 Doves, 36 Grahams, 28 Marins, and 14 Averys, most of them acquired by Phillips. By collecting with such concentrated focus (he seemed to take collecting as seriously as the artists took painting), Phillips demonstrated a degree of confidence and respect that Dove and Marin had seldom experienced. Many artists understood the intensity that he brought to his collecting. But others did not always appreciate this deliberate approach. The letters between Dove and Alfred Stieglitz, for example, reveal an impatience and irritation with Phillips's lengthy and painstaking considerations of Dove's paintings.[3]

Phillips could show a discerning and acute eye, at a time when few had any eye at all for American modernism, and he did not hesitate to use it. He could be painfully honest in his criticism, even to the point of suggesting that Dove crop his painting *The Bessie of New York* to eliminate the distracting human face in the tugboat, and thus to emphasize the otherwise strong passages in the painting. Dove and Stieglitz were furious, and predictably Dove refused.[4] But Phillips was right, for here and elsewhere Dove's work is often seriously flawed by this type of corny illustrating. It would be another generation before American artists could absorb relentlessly honest criticism without affront.

Duncan Phillips gave to artists what they needed most—exposure and recognition. He organized the first solo museum exhibitions for Graham, Karl Knaths, and Marin in 1929, for Dove in 1937, and for Avery in 1943. This is a remarkable record in its own right and was but one way that he was ahead of his time. Further, these exhibitions were central to his ongoing program of rotating installations and traveling exhibitions that reflected his continuing engagement and preoccupation with American artists and their work. The Phillips Collection, from the start, was anything but a storage warehouse. It was, rather, a laboratory, an "experiment station," as he himself termed it.[5] One of his invaluable principles was that works of art were dynamic and changing, not static, and were to be thought about and reevaluated constantly. They were an intrinsic part of one's life. Art would grow and evolve and change, just as one's taste and knowledge would. This was an important lesson for both the artist and the public, at a time when there were few serious proponents of this art.

Phillips established the precedent, continuing to this day, of showing American modernist works alongside European art. He saw the two as equals and as capable of coexisting in an easy, unassuming relationship. There were no false distinctions by national culture here. This was, and is, a revolutionary approach. To see American art hung with European art, with neither apology nor bravado (long the polarities of attitude that are even now its curse), is finally the best—and only—way to understand it. Experiencing American art in this way for the first time was a revelation that continues to inform the thinking of this writer. Also significant is the quality of viewing in the discrete and comfortable galleries, which provide the optimum of visual accessibility, unmatched by any other museum. This is surely one reason why the great modernist pictures of The Phillips Collection, both American and European, have had a decisive effect on so many of our greatest postwar artists—Kenneth Noland, Morris Louis, and Richard Diebenkorn among them.

The scale of the galleries enabled Phillips to install art in accordance with another of his guiding principles: art should be seen as part of a historical continuity—a crucial lesson at a time when modern art was still largely considered a radical, fringe manifestation. As a result, the collection contains certain themes that the artists and the lay public have been able to study in a sustained, focused manner. The history of visionary, poetic abstraction, including the work of Dove, Hartley, and Augustus Vincent Tack, is one such theme and is a good reason why the contemporary painter Bill Jensen has always been at home here. Another is that the collection presents a succinct history of modern color painting, from Delacroix, Renoir, and Cézanne to Matisse, Klee, Georgia O'Keeffe and Mark Rothko. This accounts in great part for the importance attached to the Phillips by Kenneth Noland, for whom going to the Phillips was "like going to church."[6]

In the collection we will see some of the best paintings by the greatest artists of American modernism. To grasp the heights reached by this movement, we really must see Marsden Hartley's *Off the Banks at Night,* 1942 (cat. no. 241), Dove's *Sand Barge,* 1930 (cat. no. 250), Marin's *Back of Bear Mountain,* 1926 (cat. no. 231), or Graham's *Blue Still Life,* 1931 (cat. no. 271). Here Phillips's taste was sure and decisive. In these paintings we find a summary of the artists' essential achievement. But what made his collection particularly fascinating was his independence of mind, which often led him to offbeat, "untypical" pictures. He understood the importance of Dove's collages and machine pictures, as well as his late work, in which he finally and consistently realized his oft-thwarted potential. These are all aspects of Dove not otherwise readily appreciated. And he saw the literally marvelous structure and handling of Graham's *Blue Bay and Interior,* 1926 (acc. no. 0813). Such works will surely warn us away from a reliance on what is popularly judged to be the "typical" painting.

Phillips's independence led him to artists of real accomplishment who had otherwise escaped the recognition they deserved. Some, like Glen O. Coleman, Knaths, and Jacob Kainen, are not

known, but they are far better painters than is currently understood. Knaths is inconsistent, but such pictures as *Maritime,* 1931 (cat. no. 279), or *Harvest,* ca. 1931–32 (cat. no. 286), are high points of American painting we would do well to study closely. Further, there are artists in the collection of whom even the most diligent revisionist historians of American modernism are unaware. It would certainly be illuminating to see, for example, more of the work of Elisabeth Clarke (1906–67), whose vibrant cubist collage *Treasure Island,* 1942 (acc. no. 0310), is remarkable.

Phillips understood and actively sought diversity, long before the public was conscious of such matters. In the late 1930s, at a time when Washington was a far more southern town in its laws and attitudes than it is today, he organized shows of black artists that included Horace Pippin, Jacob Lawrence, and Romare Bearden. He also actively acquired a large number of paintings created by women when to do so was not at all fashionable.

Duncan Phillips was human, and as with all of us, in his strength lay his weakness. His eye could be inconsistent. Not all the Doves are the best, for example, and this could also be said of the Grahams and Davises. He missed on Hartley's abstractions and ignored Max Weber's cubist pictures, concentrating instead on the dreadful late works. Morris Graves and Lee Gatch never reached the level of artistic achievement he had hoped for them, which goes to show that he was not totally immune to current critical opinion. Sometimes he struggled and vacillated, as he did with Picasso, Matisse, and O'Keeffe; although Phillips bought marvelous examples by them, one wishes he had done more. But these shortcomings take nothing away from his successes. Indeed, they make this part of the story all the more moving, and all the more significant. Our history has been indelibly marked by a man who grew as our art grew, and whose ideas are at least as valuable today as they were seventy years ago.

ALFRED STIEGLITZ (1864–1946)

Through his activities as a photographer, critic, dealer, and theorist, Alfred Stieglitz had a seminal influence on the development of modern art in America during the early twentieth century. Born January 1, 1864, in Hoboken, New Jersey, Stieglitz moved with his family to Manhattan in 1871 and to Germany in 1881. Enrolled in 1882 as a student of mechanical engineering in the Technische Hochschule in Berlin, he was first exposed to photography when he took a photochemistry course from Wilhelm Vogel in 1883. From then on he was involved with photography, first for its technical and scientific challenge, later for its artistic one. Returning with his family to America in 1890 (and marrying Emmeline Obermeyer in 1893, whom he later divorced), he became a member of and advocate for the school of pictorial photography in which photography was considered to be a legitimate form of artistic expression. In 1896 he joined the Camera Club in New York, and managed and edited *Camera Notes,* its quarterly journal. Leaving the club six years later, Stieglitz established the Photo-Secession group in 1902 and the periodical *Camera Work* in 1903. In 1905, to provide exhibition space for the group, he founded the first of his three New York galleries, the Little Galleries of the Photo-Secession, which came to be known as Gallery 291. In 1907 he began to exhibit the work of other artists, both European and American, making the gallery a fulcrum of modernism. After he closed it in 1917, he photographed extensively, and in 1922 he began his series of cloud photographs, which represented the culmination of his theories on modernism and photography. In 1924 Stieglitz married Georgia O'Keeffe, with whom he had shared a spiritual and intellectual companionship since 1916. In December 1925 he opened the Intimate Gallery; a month later Duncan Phillips purchased his first works by Dove, Marin, and O'Keeffe. In 1929 Stieglitz opened a gallery called An American Place, which he was to operate until his death. During the thirties Stieglitz photographed less, stopping altogether in 1937 owing to failing health. He died July 13, 1946, in New York. The collection contains nineteen gelatin-silver photographs of clouds by Stieglitz.

228

Equivalent, 1929

Gelatin-silver print, 4⅝ × 3⅝ (11.8 × 9.2)
Unsigned and undated
The Alfred Stieglitz Collection, gift of Georgia O'Keeffe, 1949
Acc. no. 1841 (Bry no. 167A)

The artist until 1946; Stieglitz estate until 1949; gift of Georgia O'Keeffe to TPG, 1949.[1]

In 1949 Georgia O'Keeffe honored the long friendship between Alfred Stieglitz and Duncan Phillips with a gift of nineteen photographs (acc. nos. 1833–51) from Stieglitz's series of cloud photographs (1922–35).[2] O'Keeffe accompanied the gift with the statement: "I know that I should send these to you because Stieglitz so often spoke of intending to send these himself. I think they will feel much at home with you." She thus gave recognition to the many years of association, respect, and indeed friendship between Stieglitz and Phillips.[3]

As a gallery director, Stieglitz provided emotional and intellectual sustenance to young modernists, both photographers and artists. Gallery 291 became a locus for the exchange of critical opinions and theoretical and philosophical views in the arts, while the periodical *Camera Work* became a forum for the introduction of new theories by American and European artists, critics, and writers. Phillips thought that because of their mutual devotion to modern art they were kindred spirits, "allies in the same Cause."[4] He felt that he, too, "had an 'experiment station' as well as an intimate gallery where art can be at home."[5] Stieglitz reciprocated Phillips's admiration, and was thankful for his support of the artists in his circle, especially Dove, Marin, and O'Keeffe. He wrote to Phillips in 1944: "I tell everyone that you and Mrs. Phillips . . . and all you represent are an integral part of the Place [An American Place]."[6]

Phillips also respected Stieglitz as an artist. He recognized his achievement of maintaining the realism of photography while addressing the goals of modernism, and he considered his photographs of clouds as "miracles of sensitized

individual perception and interpretation while remaining true to the medium's . . . concern with objective truth."[7] In 1934 Phillips wanted to reproduce one of Stieglitz's cloud photographs in an article he was writing for the *American Magazine of Art* that explored the unique vision of artists. Stieglitz, although thankful, refused, responding that "it would lose all its significance in reproduction."[8]

Stieglitz photographed clouds from 1922 into the thirties.[9] A symbolist aesthetic that was nourished by Kandinsky's visionary philosophy forms the theoretical basis, and he considered them "*equivalents* of . . . my most profound life experiences."[10] But, as Sarah Whitaker Peters has noted, the "greening of Stieglitz's old Symbolist concerns with the image as an equivalent for his emotional state" coincided with the arrival of O'Keeffe in his life. And for both Stieglitz and O'Keeffe, "the early Lake George years clearly unlocked new dimensions of artistic energy. . . . For a time, the physical and mystical chemistry between them—call it the spirit of 291—was like a private cult."[11]

The first group, *Music: A Sequence of Ten Cloud Photographs,* 1922, shows cloud formations over the mountainous Lake George landscape. It is assembled in a sequential, essentially narrative arrangement, in which the sky is at first calm, then dark and stormy, and finally tranquil. Stieglitz suggested in this sequence a mounting conflict and subsequent resolution and sought to evoke a corresponding emotion or reaction from the viewer. His next group, *Songs of the Sky,* 1923–24, further develops symbolist concepts. He released the clouds, which were now "way off the earth," from any reference points, especially the horizon line.[12] Stieglitz wanted the viewer to respond only to the abstract qualities of the cloud forms. Moreover, by associating these images to music in the title, he attempted to link the clouds to music, thus using music's inherently abstract nature to elicit from the viewer an appreciation for the abstract qualities of the cloud formations.[13] This synthesis of abstraction and music is underscored by his statement that he wanted the composer Ernest Bloch to exclaim upon seeing these pho-

tographs: "Music!, music! Man, why that is music. How did you ever do that?"[14]

In his next cloud photographs (1924/25–35), Stieglitz shifted more strongly toward pure abstraction by using the more modern theory of equivalence for their titles (see cat. no. 228). As Sarah Greenough notes, "The *Equivalents* are photographs of shapes that have ceded their identity, in which Stieglitz obliterated all references to reality normally found in a photograph. There is no internal evidence to locate these works either in time or place."[15] Now the abstract shapes themselves were held to be equivalent to an abstract thought or emotion.

The theory of equivalence was the subject of much discussion at Gallery 291 during the teens, and it was infused by Kandinsky's ideas, especially the belief that colors, shapes, and lines reflect the inner, often emotive "vibrations of the soul." Stieglitz echoed this idea: "I have to have experienced something that moves me and is beginning to take form within me, before I can see what are called 'shapes.' Shapes, as such, mean nothing to me unless I happen to be feeling something within, of which an *Equivalent* appears in outer form."[16]

LBW

228

JOHN MARIN (1870–1953)

John Marin, an early American modernist closely associated with Alfred Stieglitz, was born in Rutherford, New Jersey, December 23, 1870, but spent his youth in nearby Weehawken. From 1899 to 1901 Marin studied at the Pennsylvania Academy of Fine Arts under Thomas P. Anshutz and Hugh Breckenridge. After spending a few weeks in 1905 at the Art Students League in New York, Marin left for Europe. While in Paris in 1908 he met Edward Steichen, who referred his work to Alfred Stieglitz. Impressed, the gallery director visited Marin's Paris studio, and this encounter led to an exhibition at Stieglitz's Gallery 291 in New York in 1909. After Marin returned to America in 1911, he began receiving an annual stipend from Stieglitz that enabled him to concentrate on his painting. In 1913 he exhibited in the Armory Show, and in the following year he discovered the countryside and coastal areas of Maine, thereafter spending his winters in New Jersey and summers in north-eastern rural locations. After Stieglitz closed Gallery 291 in 1917, he used his influence to help Marin. The artist's first retrospective was held in 1920 at Daniel Gallery in New York; in 1925 Stieglitz included him in the exhibition of "Seven Americans" held at the Anderson Gallery, New York; and in December of that year Stieglitz opened his second establishment, the Intimate Gallery, with a retrospective of Marin's work. In early 1926 Duncan Phillips purchased his first works by Marin, and in 1929 he gave the artist his first solo museum exhibition. In 1950 he represented, along with Jackson Pollock, the United States at the Venice Biennale. Marin suffered a stroke that claimed his life October 2, 1953, at Cape Split, Maine, one of his favorite retreats. The Phillips Collection contains representative examples of every aspect of Marin's development, including sixteen watercolors, six oils, three etchings, one print, one ink on paper, one intaglio print, and one graphite drawing.

The Marin Unit

Calling him "an epigrammatic poet-painter" and an "inspired . . . wizard of watercolor," Duncan Phillips believed that John Marin was a superb American artist who was "one of the most gifted and important painters since Cézanne."[1] Phillips admired Marin's ability to capture his immediate impression of a landscape, as well as his facility for recording the syncopated rhythm of contemporary life. He considered him to be an artist of great originality, independent of artistic movements or influences, who was "too great for America alone." Phillips asserted, "The world will love him."[2]

Phillips discovered Stieglitz's Intimate Gallery by January 1926 and immediately became an avid patron of Marin, although he later recalled that his interest had been sparked much earlier.[3] Perhaps he saw Marin's work at the Daniel Gallery in 1920 or at the Montross Gallery in 1922; the latter exhibition had been particularly well received.[4] In 1926, after he purchased *Maine Islands*, 1922, and *Grey Sea*, 1924 (cat. nos. 229 and 230), Phillips collected Marin's work voraciously. Later that decade, a friendship and warm correspondence developed, especially after Marin and his wife began to visit the Phillipses sometime in 1930.[5]

Marin's work became the subject of a famous dispute between Phillips and Stieglitz. In late 1926, during a visit to Marin's second exhibition at the Intimate Gallery, the collector purchased a Marin watercolor, *Back of Bear Mountain*, 1925 (cat. no. 231), for the then-exorbitant sum of $6,000. When Stieglitz leaked the information to the press in order to generate publicity and thus boost the market value of Marin's works, Phillips was angered by the use of his name and subsequently by the numerous articles that the incident generated in newspapers and periodicals.[6] Essentially, Stieglitz and Phillips disagreed on the progression of events leading up to the purchase of the painting at the inflated price. Phillips claimed he had received three paintings for $7,000: *Sunset, Rockland County*, 1925, a gift from Stieglitz to Marjorie Phillips; *Hudson River Near Bear Mountain*, 1925 (acc. no. 1287), at a reduced price of $1,000; and *Back of Bear Mountain*, 1925, for $6,000.[7] But Stieglitz asserted that it was not until Phillips had agreed to the $6,000 price that he had reduced the price of one work and made a gift of the other.[8] The rift lasted until December 1927, when Arthur Dove, who did not want to lose Phillips's patronage, intervened.[9] Although Phillips and Stieglitz continued to respect each other's efforts to promote American modernism in the United States, the earlier warmth, trust, and camaraderie were never fully restored.[10]

With his purchase of *Maine Islands*, Phillips considered Marin a unit artist, and he wrote immediately to Stieglitz asking to see earlier, more impressionistic works. "I would like to have an exhibition of your group [Marin, Dove, O'Keeffe], or else of Marin in April," he wrote, and also stated that he wanted to "give Washington a bracing shock in the work of this stimulating creator."[11] Because Phillips regularly purchased works throughout Marin's career, the Marin unit reflects the artist's entire oeuvre and contains some of his finest oils and watercolors.[12] The earliest examples are works on paper:

one etching, *Doorway, St. Mark's, Venice*, 1907, created during his stay in Europe from 1905 to 1909, and one ink wash, *Harbor Scene*, 1905 (acc. nos. 1281 and 1286), which illustrates Marin's early emulation of Whistler. Marin's close association with Gallery 291 from 1911 to 1917, a period of great experimentation, is reflected by *Weehawken Sequence, No. 30*, ca. 1916, and *Black River Valley*, 1913 (acc. nos. 1298 and 1277). His mature style of the 1920s is represented by *Maine Islands* and *Back of Bear Mountain*. Although Phillips preferred Marin's landscapes and seascapes, he chose three New York scenes to round out his unit: a watercolor, *Street Crossing, New York*, 1928 (cat. no. 232), and two oils, *Bryant Square*, 1932, and *Pertaining to Fifth Avenue and 42nd Street*, 1933 (acc. nos. 1280 and 1291). Marin's later abstractions are also well represented in the unit by such examples as *Tunk Mountains, Autumn, Maine*, 1945, and *Blue Sea*, 1945 (cat. nos. 235 and 236). The collection includes the lyrical *Spring No. 1*, 1953 (cat. no. 237), produced shortly before Marin's death, in which he experimented with the use of line to organize the composition and activate the picture plane. One delicate drawing, *Self-Portrait* (acc. no. 1985.3.10), was so admired by Phillips that it remained in his private collection for many years, arriving finally in the museum as part of Marjorie Phillips's gift in 1985.

Over the years, Phillips wrote copiously about Marin. He admired his calligraphic line, luminous color, and ability to hint at the fleeting essence of the subject, and believed that he was one of America's finest modernists. In Phillips's estimate, Marin was both an impressionist and expressionist, because he could capture a moment and location as well as his subjective response to it.[13] For Phillips, Marin's abbreviated impressions of nature conveyed "glimpses of cosmic truth" and became "universal nature poetry."[14] Marin experimented "on the frontiers of visual consciousness," Phillips wrote, making masterful use of space, light, and the dynamics of color.[15] His works "required from the beholder an intuition . . . and an apprehension of the elemental which transcends school and dogma."[16]

LBW

229

Maine Islands, 1922

Watercolor and charcoal on off-white watercolor paper, 16⅞ × 20⅟₁₆ (42.8 × 51.0)

Signed and dated in charcoal, l.r.: *Marin/22*

Acc. no. 1288 (Reich no. 22.29)

PMG purchase 1926 from the artist through Alfred Stieglitz at the Intimate Gallery, New York.[17]

229

230

Grey Sea, 1924

The Ocean; Sea Piece
Watercolor and black chalk on off-white watercolor paper,
16½ × 20⁷⁄₁₆ (42.0 × 52.7) [irregular]
Signed and dated l.r.: *Marin 24*
Acc. no. 1285 (Reich no. 24.28)

PMG purchase 1926 from the artist through Alfred
Stieglitz at the Intimate Gallery, New York.[18]

These two watercolors of highly abstracted
seascapes reflect Marin's effort to arrive at greater
stability, simplicity, and clarity of design.
Although derived from nature, they do not
closely illustrate the actual site but instead
emphasize the expressive potential of color and
form. Marin said of his process: "The scene pro-
duced in my mind a certain grouping of colors
and form abstractions. I tried to put them on
paper and was careful not to disturb the vision by
looking either at the tree again or the paper."[19]

Maine Islands was painted from a hilltop in
Stonington Harbor, Maine, a locale Marin began
to frequent in 1920.[20] He depicted a tranquil
landscape of distant islands within a border of
strong, fragmented diagonal lines. One of his
more famous works, it was one of the first to use
the internal frame, a structural device derived
from cubism: "When I got what I wanted, I
nailed the stuff down in those frames."[21] But the
frame was not rigidly conceived, for Marin
allowed some of the scene to spill beyond its
edges. The impression of looking through a win-
dow is implied, but the disruptive diagonal lines
also suggest the idea of breaking through this
imagined barrier. The lines also serve the pur-
pose of leading the viewer's eye into the distance.

Painted two years later on Deer Isle, Maine,
Grey Sea shows the crests and waves of the
Atlantic. In a slightly earlier, directly related
watercolor entitled *Off York Island, Maine*, 1922,
Marin emphasized the frothing waves crashing
on the shoreline.[22] He developed the image fur-
ther in *Grey Sea* by capturing the underlying
rhythms and motion of the ocean. "What makes
the painted ocean look real," Marin wrote, "is
the suggestion of the motion of water—A red
ocean with motion will look more like a sea
than a patch of gray paint without movement."[23]
While this work also has an internal frame, the
effect here is quite different, because Marin
painted the frame as a simple, flat strip echoing
the rough, raw quality of the ocean.

Phillips believed that these two watercolors
well represented Marin's style, and he consid-
ered them the cornerstones of the Marin unit.
He often included one or both of them in exhi-
bitions and mentioned them in lectures. He par-
ticularly admired the movement in *Maine
Islands*, stating: "Speed. We advance upon dis-

230

tance and the oncoming rush of distance meets
and greets us. Aware of the impetuous flight of
our senses in space the clouds almost open to let
us pass through!"[24] And *Grey Sea*, which Phillips
believed was "one of the greatest watercolors
ever painted," evoked in him an emotional
response: "The element of unfathomable
Ocean . . . Surf charges over rocks . . . shot up in
a shaggy elemental explosion. The waves are
opaque, sombre and unutterably strong and
deep. . . . Weight and tragedy of the waves!
Tragic destiny of great forces wasting their
power in protest. The Infinite starts at the hori-
zon's edge and there is something inexorable in
the sky—in the straight severe line of cloud con-
trasted with the thunder and rage of the sea."[25]

L B W

231

Back of Bear Mountain, 1925

Back of Nyack, New York; Hudson Opposite Bear Mountain
Watercolor and charcoal on off-white watercolor paper, 17
× 20 (43.2 × 50.8)
Signed and dated l.l.: *Marin/25*
Acc. no. 1276 (Reich no. 25.4)

PMG purchase 1927 from the artist through Alfred
Stieglitz at the Intimate Gallery, New York.[26]

In 1925 Marin created some of his most monu-
mental and expressionistic landscapes, mature

pivotal works in his oeuvre. In Sheldon Reich's
estimate, the broadly painted forms, the tex-
tured, almost gestural brushstrokes, and the
strong linear contours of watercolors such as
Back of Bear Mountain "do not give up form of
expression . . . [but] sublimate one for the other
to achieve an expression carefully formed."[27]
Marin's interest in the underlying structure of
his subjects is evident in its clear organization,
calligraphic line, and large planes of pure,
intense colors. The energy and warmth of the
sun are evoked by the golden-yellow lines that
radiate down from the hot sphere in the upper
left.

Marin was seriously ill in 1925 and while
recuperating made four weekend trips to visit
his cousins, Lyda and Retta Currey, who were
summering in the Berkshires in Massachusetts.
It was during one of his trips north that Marin
paused in the Hudson River Valley in New York
to paint six watercolors, three in Haverstraw and
three at Bear Mountain, including *Back of Bear
Mountain* and *Hudson River Near Bear Moun-
tain*, 1925 (acc. no. 1287).[28]

When Marin exhibited these watercolors in
December of the following year at the Intimate
Gallery, they were well received by the critics.
One wrote that Marin "had nearly arrived at the
expression he seeks" and that he was "more able
to grasp his subject, analyze it and transpose its
essence with added richness." Another asserted

231

that his "exhibition . . . holds a challenge, a fulfillment and a promise."[29] When Phillips visited the exhibition he was enthralled, later stating that he had "been drinking deep of their exhilerating [*sic*] beauty and vitality."[30]

<div align="right">LBW</div>

232
Street Crossing, New York, 1928

New York; Street Crossing; New York Street Corner (DP);
New York Street Crossing; Lower New York (DP)
Watercolor, black chalk, and graphite on off-white watercolor paper, 26¼ × 21¼ (66.7 × 55.2)
Signed and dated l.r.: *Marin 28*
Acc. no. 1296 (Reich no. 28.73)

PMG purchase 1931 from the artist through Alfred Stieglitz at An American Place, New York.[31]

Marin first depicted New York in 1909–10, and it became one of his favorite themes, sharing similarities of style and purpose with futurism and Robert Delaunay's early, pre-Orphist work.[32] His images of the city personify the hurly-burly pace of urban life in twentieth-century America, as in *Street Crossing, New York,* in which fragmented, interspersed planes represent towering buildings and sketchy lines suggest objects and moving figures.

The idea that music was related to the rapid tempo of modern life was discussed at Gallery 291, and Marin may have been specifically influenced by one of his associates in Stieglitz's coterie, Henri Bergson, who wrote on this subject in "What Is the Object," published in the 1913 issue of *Camera Work*.[33] Marin himself wrote that "while these powers are at work, pushing, pulling, sideways, downwards, upwards, I can hear the sound of their strife and there is great music being played." The syncopated beat of jazz best symbolized for Marin New York's pulsating energy and became a metaphor for modern American culture in general, as expressed by his reference to "the land of Jaz [*sic*]—lights and movies—the land of money spenders."[34]

232

233

In *Street Crossing* the towering buildings are defined as a series of large cubist planes. Strong diagonal lines throughout the composition increase the feeling of movement and exhilaration. Around the subway station in the lower left, fine lines and thick slashes of paint allude to speeding cars and rapidly walking pedestrians, creating a seemingly agitated but well-organized image of urban activity. This composition has an affinity with an excerpt of a piece of free verse by Marin published in 1928:

Considering the material side of
today with its insistence
glass metals lights—building of all
kinds for all kinds of purposes with all kinds
of material—lights brilliant noises startling
and hard pace setting in all directions—
through-wires—people movements—much
hard matter.
The life of today so keyed up so
seen so seeming unreal yet so real and the eye
with so much to see and the ear to hear—
things happening most weirdly upside down—
that it's all—what is it—but the seeing eye

and the hearing ear become attuned
then comes expression
taut taut
loose and taut
electric
staccato[35]

Duncan Phillips considered Marin "a modernist in his emotional tempo" and felt that he gave "us . . . the quickened sense of our intense modern life in the midst of encircling and bewildering elements."[36]

LBW

233

Quoddy Head, Maine Coast, 1933

Quoddy Head; Maine Coast—Quoddy Head
Watercolor and black chalk on off-white watercolor paper,
15½ × 22 (39.4 × 55.8)
Signed and dated l.r.: *Marin 33*
Acc. no. 1292 (Reich no. 33.23)

PMG purchase from the artist through Alfred Stieglitz at An American Place, New York (from Studio House exhibition) 1937.[37]

234

Four-Master off the Cape—Maine Coast No. 1, 1933

Four-Master off the Cape, Maine Coast; Four Master off the Cape (DP); *Four Master No. 1, off the Cape, Maine Coast; Four Master Becalmed* (DP)
Watercolor and black chalk on off-white watercolor paper,
15½ × 21⅞ (39.4 × 55.4)
Signed and dates l.r.: *Marin 33*
Acc. no. 1283 (Reich no. 33.11)

PMG purchase 1942 (from PMG exhibition) from the artist through Alfred Stieglitz at An American Place, New York.[38]

Marin's watercolors of the thirties, like those of the previous decade, could be both expressive and contemplative, as demonstrated by *Quoddy Head, Maine Coast* and *Four-Master off the Cape—Maine Coast No. 1.*

In *Quoddy Head* Marin celebrated the rocky Maine coast, which is known for bracing winds and surging surf. The rugged, energetic quality of this watercolor perhaps resulted from his concurrent interest in the expressive possibilities of oil. Marin may have tried to emulate the impasto technique of oil in the strong, almost tactile patterns that define the rocks and waves, and the various textures created by the juxtaposing color wash and line that define the pebbles on the beach. Critics appreciated his ability to paint nature as either calm or wild, but always with a particular emphasis on the beauty of the site.

In *Four-Master off the Cape—Maine Coast No. 1* the mood is serene and romantic: the vessel calls forth visions of adventure on the high seas as it sails smoothly across the picture plane. The sense of absolute stillness and clarity recalls the work of Eugène Boudin, one of Marin's favorite artists. "Boudin is very much underrated," he wrote. "He had such an affection for boats and the beach. He put in all the lines— that's what people did in those days—but he never spoiled the essence of *boat.*"[39]

LBW

235

Tunk Mountains, Autumn, Maine, 1945

*Tunk Mountains, Maine; Tonk Mountains in the Autumn;
Tonk Mountains, Maine, In the Autumn; Tunk Mountains;
Tonk Mountains*

Oil on canvas, 25 × 30 (63.5 × 76.3)

Signed and dated l.r.: *Marin 45*

Acc. no. 1297 (Reich no. 45.43)

PMG purchase 1946 from the artist (from exhibition)
through Alfred Stieglitz at An American Place, New
York.[40]

After painting his Weehawken series from 1916
to 1918, Marin temporarily abandoned the oil
medium to focus on watercolor.[41] Although he
returned to oil during the thirties, it was not
until the forties, in works such as *Tunk Moun-
tains, Autumn, Maine,* that he fully captured its
expressive potential. Seeking to evoke the power
and expressiveness of his watercolors, he devel-
oped a more tactile, painterly approach with oil.
He interspersed strong contours and planes of
bright color with natural earth tones and inte-
grated line and color into a unified whole. In a
letter to Stieglitz in 1931, Marin commented on
how the "paint builds itself up—moulds itself—
piles itself up" and exclaimed that with oil "I
sing to the LUSTY."[42]

In the forties, critics were forced to assess his
oil compositions. Initially, they were not sup-
portive. Heavy and thickly painted, his oils
seemed to lack the spontaneity of his watercol-
ors.[43] But Marin stated that "there seems now to
me a benefit found in the . . . working of these
two" and that he could fully capture the essence
of his subject through a complete exploration of
the expressive potential of both media.[44]

Phillips's appreciation of Marin's oil paint-
ings likewise developed slowly, but by 1950 he
believed that the artist had "achieved the same
mastery and confidence in oil which is more
generally acknowledged in his water colors and
one can only regret that he did not paint more
frequently in oil during the middle years."[45]

LBW

236

Blue Sea, 1945

Sea Pieces—Maine

Watercolor, black chalk, and graphite on off-white water-
color paper, 15⅜ × 21³⁄₁₆ (39.1 × 53.9)

Signed and dated l.r.: *Marin '45*

Acc. no. 1278 (Reich no. 45.3)

PMG purchase 1946 from the artist through Alfred Stieglitz
at An American Place, New York (from exhibition).[46]

234

235

236

237

Spring No. 1, 1953

Oil on canvas, 22 × 28 (55.8 × 71.1)
Signed and dated l.r.: *Marin 53*
Acc. no. 1295 (Reich no. 53.9)

PMG purchased 1954 from Downtown Gallery, New York
(from PMG exhibition).[47]

237

Marin's late works, represented in the collection
by *Blue Sea* and *Spring No. 1*, have a lyrical, joy-
ful verve. Although he continued to be inspired
by the ocean and mountains, he modified the
dynamism of his earlier works in favor of a
lighter palette and a gentler, more sonorous
style. Phillips was drawn to these late evocations
of nature, believing that they were "as abstract
and as universal as the music of Bach."[48]

In *Blue Sea* the ocean is the sole subject; the
horizon line is high and the waves crash on a
sandy gray shore that becomes part of the painted
frame surrounding the image. In this watercolor,
Marin evoked the melodious quality of his first
landscapes, which were reflections of his enchant-
ment with Whistler's delicate style. The pleasing
shades of blue, the rhythmic horizontals of the
waves flowing toward the viewer, and the whimsi-
cally curving frame create a sense of joy and sheer
pleasure in the serene richness of the sea.

Although Marin always sought to visualize
the underlying forces of nature, his late works
show a greater interest in nature's structure.
Typical statements of his, such as "I find my
brush moving in the rhythm of wave or sail or
rock," are epitomized in *Blue Sea* by the gently
rolling waves.[49] The internal frame, which
echoes the ocean's energy, heightens this effect.
Marin laid out his credo in a letter to Phillips in
1949: "This year[']s work is . . . movements in
paint controlled by lines revealing the paths of
motion—an intention at least—to symbolize
movements of sea and sky," adding that it is "an
intention of a rhythmic-hearing-breathing."[50]

In *Spring No. 1* Marin fused line and color in
a lyrical composition painted in delicate hues
interspersed with pronounced areas of white.
The small, energetic slashes and daubs of oil dis-

persed across the canvas both define the shape
of the mountains and project a sense of nature's
energy.[51] The internal frame, which is seen
throughout Marin's oeuvre, is conspicuously
absent here; instead, he extended his lines across
the picture plane and even beyond the edge of
the canvas. In his second and even more linear
version, *Spring No. 2,* also 1953, the underlying
force of the mountain appears to be bared to the
viewer.[52]

Marin's late linear style has often been com-
pared to that of the abstract expressionists, par-
ticularly Jackson Pollock.[53] Certainly Marin was
aware of Pollock's work, which was exhibited
annually at the Betty Parsons Gallery from 1943,
and both artists participated in the 1950 Venice
Biennale. Yet their artistic aims were widely
divergent. Marin's antitheoretical approach, in

which subjects drawn from nature are depicted
in an abbreviated calligraphic style (in the belief
that "nature will see to it that the—Symbol—
persists"), differs from Pollock's subjective,
meaning-laden, gestural approach.[54] Perhaps the
formal aspects of abstract expressionism had
some effect on Marin in that he further loos-
ened his already fluid approach and sometimes
extended parts of his composition beyond the
edges of the canvas.[55] Marin may have tacitly
acknowledged this association with his late work
when he wrote to Phillips near the end of his life
that "maybe I belong with the—Notorious." He
added, "So if you could—do so—to have a
glimpse of the work of that—Notorious fellow
or myself—it might give you a—wee—Shock—
which I would hope—might have a stirring of
pleasure pinned to it."[56]

LBW

MARSDEN HARTLEY (1877–1943)

Marsden Hartley was an expressionistic painter whose broad range of subjects reflects his travels in Europe, Mexico, Bermuda, and Nova Scotia as well as his love for the rugged environment of his home state, Maine. Born January 4, 1877, in Lewiston, Maine, as Edmund Hartley, he spent his youth under the care of an aunt in Auburn. In 1893 he moved to Cleveland, Ohio, to join his father and stepmother, Martha Marsden, whose surname he would adopt in 1906. Hartley received a scholarship to the Cleveland School of Art in 1898 and demonstrated such talent that he was awarded a five-year stipend to study art in New York. From 1899 to 1900 he took classes at William Merritt Chase's New York School of Art, and he attended the National Academy of Design from 1900 to 1904, painting landscapes in Maine during the summers. Alfred Stieglitz gave Hartley his first New York solo exhibition at his Gallery 291 in 1909 and held a second successful show in 1912 that enabled Hartley to travel to Europe, where he stayed until 1915. He spent time in Paris, London, Munich, and Berlin, met many of the European modernist artists, painted abstractions, and exhibited with the Blaue Reiter group at the 1913 Herbstsalon in Berlin. Upon his return to New York, he became associated with avant-garde art circles, traveled frequently to locations such as Bermuda (1916–17), New Mexico (1918) and California (1919), and wrote critical essays, which were published in his book *Adventures in the Arts* in 1921. The same year, after auctioning 117 of his paintings at Anderson Galleries, New York, he returned to Europe, where he stayed until 1930, painting Cézanne-inspired landscapes and still lifes in France, Austria, Italy, and Germany. From 1932 to 1933, he traveled in Mexico on a Guggenheim Fellowship, followed by a one-year stay in Germany. Thereafter, except for two trips to Nova Scotia in 1935 and 1936, he lived in New York until 1937, when he had his last Stieglitz-organized exhibition and joined the dealer Hudson Walker. From then on, he made Maine his permanent home and began to create poetry and paintings inspired by its scenery. Duncan Phillips, who had sporadically bought Hartley's work, purchased six oils between 1939 and 1943. Additional financial relief came in 1941, when Walker purchased twenty-three works. Hartley died in Ellsworth, Maine, September 2, 1943. The Phillips Collection owns two early and six late oils by Hartley, all representing Maine and New England locations.

The Hartley Unit

Although Duncan Phillips never actually met Marsden Hartley, he had the impression of him as "an ardent . . . soul" with outstanding abilities as both painter and critic. He considered his paintings of Maine in particular "a personal and powerful contribution to the outstanding traditions of American art—romantic mysticism and robust realism." He also praised his book *Adventures in the Arts* (1921) for its thoughtful observations about the primitive art of the American Indian, the naive style of Henri Rousseau, and the pioneering work of Cézanne, Ryder, and Homer.[1] While Phillips viewed Hartley's critical essays as always "true to his . . . rich emotional nature," he thought the artist's work between 1910 and 1930 revealed an uncertainty of purpose.[2] He believed that Hartley's talents were diminished by an excessive intellectual aestheticism and that he produced paintings of "capricious composition and curious technical procedure."[3] For this reason Phillips did not consider Hartley a signal genius of American modernism as he did Dove and Marin.[4]

However, he agreed with other critics in greatly valuing Hartley's paintings of the scenery and images of his Maine homeland. For Phillips, these subjects "stirred [the artist's] emotions as his experiments with abstraction . . . failed to do."[5] Although Hartley's early, muted impressionistic portrayals of Maine mountainsides contrast markedly with his late, rough expressive depictions of the New England wilderness and coast, both styles reflect his strong attraction to his native surroundings, an affinity that was shared by his contemporaries Marin and O'Keeffe. Phillips asserted that Hartley's "self knowledge and his accolade would have come to him earlier had he shaped his course according to his own innermost promptings and kept close to the native forests and seacoasts of New England, following in the footsteps of Homer, Ryder and Marin."[6]

Phillips briefly owned two still lifes from Hartley's middle period, both influenced by Cézanne.[7] He exchanged them for later works after he visited a 1938 Hudson Walker Gallery exhibition of Maine paintings; he considered the works in this show to be Hartley's first truly successful paintings. In 1944 he wrote in retrospect: "Suddenly and with dramatic intensity Hartley had come into a command of composition and a sonorous eloquence of shapes, colors and textures."[8] He had five of these "powerful and personal and wholly American" paintings sent to him on approval the following year and from them acquired *Sea View, New England*, 1934 (acc. no. 0892), *Gardener's Gloves and Shears*, ca. 1937 (cat. no. 240), and *Off to the Banks*, between 1936 and 1938 (acc. no. 0891). During the next few years Phillips acquired three more New England scenes—*Wood Lot, Maine Woods*, 1939 (acc. no.

0894), *Off the Banks at Night*, 1942, and *Wild Roses*, 1942 (cat. nos. 241 and 242). In these works, he recognized the influence of Ryder's spiritualism and Homer's rugged realism and felt that Hartley had "reverted to an almost primitive Yankee saltiness."[9]

The Phillips Memorial Gallery held a retrospective of Hartley's work in 1943, shortly after the artist's death, preceding by one year the Museum of Modern Art's major Hartley exhibition.[10] Phillips hung the early Maine mountain scene *After Snow*, ca. 1908 (cat. no. 238), along with his late works, thus displaying what he considered to be the strongest periods of Hartley's artistic career. In his catalogue essay, he concluded that Hartley had "righted his course in mid-channel, after fighting through many cross-currents and had headed straight for home. In the end Hartley stands out as a profoundly, a resonantly American painter."[11]

GHL

238

After Snow, ca. 1908

Autumn Evening; After the First Snow (DP)
Oil on academy board, 12 × 12 (30.5 × 30.5)
Signed l.l.: MARSDEN HARTLE [the "Y" is hidden by paint]
Acc. no. 0887

Acquired by Duncan Phillips from Daniel Gallery, New York, by 1921 (possibly 1914).[12]

239

Mountain Lake—Autumn, ca. 1910

Autumn; Mountain Lake
Oil on academy board, 12 × 12 (30.5 × 30.5)
Signed l.c.: MARSD en Hartley; inscribed u.l. reverse: *For Rockwell/from/Marsden Hartley/Jan. 15—1912*
Gift of Rockwell Kent, 1926.
Acc. no. 0889

The artist; gift to Rockwell Kent 1912; gift to PMG 1926.[13]

After Snow and *Mountain Lake—Autumn* were executed during Hartley's earliest painting trips to Maine. The immensity of the mountains and the effect of the changing seasons on their appearance fascinated the young artist. *After Snow,* the earlier of the two, was painted in muted, dark colors with impressionistic, feathery brushstrokes; vertical trees frame the mountain and stabilize the composition. The scene is subdued in comparison to *Mountain Lake—Autumn,* which relates to Hartley's style of around 1910 when his landscapes had bright, almost fauve color and heavily textured brushstrokes that lent solidity and weight to the

scenes. In *Mountain Lake—Autumn,* he tightened the brushstrokes in a manner inspired by a Swiss impressionist that he admired, Giovanni Segantini; the artist's technique of short, closely knit strokes—called the "Segantini stitch"—enabled Hartley to use color to its fullest potential.[14] In addition, Hartley dispensed with the framing devices of his earlier Maine mountain series, thus attaining an expressive, lively effect. The painting's motif and style share many similarities with *Kezar Lake, Autumn Evening* and *Kezar Lake, Autumn Morning,* both painted around 1910, and it probably depicts the same locale and season.[15]

The inscription on *Mountain Lake—Autumn* indicates that Hartley gave it to Rockwell Kent in 1912. The two painters had become friends while exhibiting together in the 1911 "Independent Exhibition" at New York's Gallery of the Society of Beaux-Arts Architects.[16] Kent later gave the painting to Duncan Phillips, presumably in appreciation for the financial assistance he was receiving from him at the time. Phillips wrote to Kent: "The Hartley is so fine a picture that I hesitate to accept it but the reason you give is a good one namely that in our Gallery many people will enjoy it to the artist's benefit and to our mutual satisfaction."[17] Both *After Snow* and *Mountain Lake—Autumn* were among Phillips's favorites, representing to him a "brave beginning" in which the artist depicted "mountain sides . . . tapestried to the top with autumnal colors and rimmed with luminous Ryder-like cloud formations."[18]

GHL

238

240

Gardener's Gloves and Shears, ca. 1937

Oil on canvas board, 15⅞ × 20 (40.3 × 50.8)
Unsigned
Acc. no. 0888

The artist; PMG purchase 1939 (from PMG exhibition) through Hudson Walker Gallery, New York.[19]

Gardener's Gloves and Shears was probably executed in 1937, the year Hartley returned to Maine after a long absence. Stung by criticism that his work was not truly American in character because of his frequent stays abroad, Hartley was, at this point in his career, making a conscious effort to evoke the feel of his native land. The subject of this painting calls to mind an informal existence in the earthy outdoors, and he probably chose it to counter his image as a derivative sophisticate.

Despite its initial appearance as an uncomplicated composition, *Gardener's Gloves and Shears* reveals the artist's ability to create a dynamic, expressive image through direct simplicity. The magnified motifs, painted against an indistinct background, fill the picture plane; one of the shears' tips extends ever so slightly beyond the frame, giving the still life a slightly unstable air. The garden implements are painted with vigorous brushstrokes in contrasting light and dark colors, a technique that adds drama and vitality to the image.[20] The gloves seem to have a life of their own, as if they had been worn recently.

Hartley's treatment of the motif, derived in part from the influence of Ryder, is what most attracted Phillips, who had admired this painting in the 1938 Hudson Walker Gallery exhibition of Hartley's Maine paintings.[21] With this show Hartley became regarded, by Phillips as well as others, as not only a sincerely American painter but also an artist of great originality.

GHL

241

Off the Banks at Night, 1942

Off to the Banks; Off to the Banks at Night (DP)
Oil on hardboard, 30 × 40 (76.2 × 101.6)
Signed and dated: *M.H. 42*
Acc. no. 0890

The artist; PMG purchase 1943 (from PMG exhibition) through Rosenberg, New York.[22]

Hartley painted several works depicting boats on the rough ocean in emotional response to the drowning of close friends—the brothers Alty and Donny Mason—off the Nova Scotia coast in 1936. He had formed an intimate relationship with the entire Mason family while boarding with them in Nova Scotia in 1935 and 1936, and was distraught over the fateful accident. In *Northern Seascape, Off the Banks,* painted the year of the incident, two boats are adrift while ominous clouds hover overhead and waves crash against jagged rocks in the foreground.[23] The small *Off to the Banks,* between 1936 and 1938, shows a lone boat buffeted by the waves of a stormy sea. *Off the Banks at Night,* a larger version of *Northern Seascape,* is more simplified and abstracted than either of the earlier works. The clouds are consolidated into angular shapes, and the rocks resemble threatening, sharp teeth.

Throughout his career Hartley acknowledged the strong influence of Ryder, and Duncan Phillips recognized this affinity when he described his work as "Ryderesque, but in the quickened tempo of our time."[24] In *Off the Banks at Night,* Hartley, like Ryder, reduced forms to their expressive essences and heightened color contrasts, apparently striving for the most abstract, dramatic scene possible. Both of the Phillips works bear similarities in theme and appearance to Ryder's *Moonlight Marine,* 1870–80s, and *Toilers of the Sea,* early 1880s, which Hartley claimed to have studied repeat-

239

edly beginning in 1936.[25] His article on Ryder written that same year reveals his anxiety about the image of lonely boats at sea: "Will the ships ever reach a psychical, let alone a physical haven, do they not seem to be held in perpetuity to the hard business of roaming from one indifferent wave to another?"[26]

<div style="text-align: right">GHL</div>

242

Wild Roses, 1942

Oil on hardboard, 22 × 28 (55.8 × 71.1)
Unsigned
Acc. no. 0893

The artist; PMG purchase (from exhibition) through Rosenberg, New York, 1943.[27]

Executed the year before Hartley's death, *Wild Roses* at first sight appears to be an unlikely subject for him. The painting probably referred to memorial services held annually in Lunenberg, Nova Scotia, for fishermen lost at sea. During the services, funerary wreaths of roses were thrown into the ocean. In 1936 Hartley had attended such a ceremony, held to commemorate the deaths of the Mason brothers. In subsequent years he painted still lifes of these wreaths as well as bouquets of wild roses in memory of his friends.[28] Portraying the flowers in a bouquet removed the specific association with the Lunenberg service and thus placed them in a more general context. However, the images were deeply personal and poignant to Hartley as symbols of death.[29]

In *Wild Roses* the bouquet dominates its plain, brick-red background. The white paper enfolding the flowers serves as a foil for the blossoms. The dramatic color contrasts, vibrant hues, and stark simplicity of the painting contribute to its hypnotic effect.

<div style="text-align: right">GHL</div>

240

241

242

MAURICE STERNE (1878–1957)

Maurice Sterne, whose paintings reflect his extensive travels as well as various stylistic influences, was born August 8, 1878, in Memel, Latvia. After living briefly in Moscow (1885–89), the Sternes immigrated to New York. From 1894 to 1899 Sterne attended the National Academy of Design, where he met Alfred Maurer and studied briefly with Thomas Eakins. He first exhibited his work in 1902 at the Old Country Sketch Club with William J. Glackens and "Pop" (George Overbury) Hart. From 1904 to 1907 Sterne lived a bohemian life in Paris, where he first saw the art of Cézanne and other French modernists at the Salons d'Automne. He then traveled through Europe, to India and the Orient, and returned to New York in 1915. After a stormy marriage to Mabel Dodge from 1916 to 1918, he lived in one of his favorite Italian villages, Anticoli Corrado, occasionally returning to New York to teach at the Art Students League. In 1926 Scott and Fowles Gallery held an enormously successful exhibition of his work that established him as one of the foremost artists in America. Three years later, he and his second wife, Vera Segal, returned to New York, and he established an art school there in 1932. A year later, the Museum of Modern Art held Sterne's first retrospective. From 1934 to 1936 Sterne lived in San Francisco, where he taught at the California School of Fine Arts and worked on murals (installed in 1941) for the library in the Department of Justice Building in Washington, D.C. He resumed teaching in New York and in 1944 began spending his summers in Provincetown, Massachusetts. In 1945 President Truman appointed him to the National Fine Arts Commission, on which he served until 1951. Sterne died July 23, 1957, in Mount Kisco, New York. The Phillips Collection owns eight works by the artist, two from his early trip to the Orient, five 1920s Italian paintings, and one late New England seascape.

The Sterne Unit

The immigrant Maurice Sterne considered the United States his home, but his art reflects little American ambience and is distinctly international in character. His early travels from 1904 to 1915 to such varied locales as Paris, Rome, Berlin, Moscow, Greece, Egypt, India, Java, and Bali formed a taste for voyaging that persisted until the 1940s, when illness confined him to his homes in the New York area and Provincetown.[1] As a result, many of his works represent foreign peoples and imagery, his favorites being scenes of Bali and views of the Italian village Anticoli Corrado, near Rome.

The combination of Sterne's conservative training at the National Academy of Design, his appreciation of classical Greek and early Renaissance art, and his exposure to Cézanne's work in Paris resulted in a style that emphasized line, sculptural form, and compositional structure.[2] Whereas his early work (1904–15) was characterized by dense patterns and flat, cubist picture planes, his style of the 1920s and 1930s, the prime years of his career, favored simplified images with modeled forms arranged in shallow space in the manner of Cézanne. Later in life, his style became more painterly and his outlines less distinct. Although Duncan Phillips unquestionably preferred the works of the 1920s, his Sterne unit reflects the wide diversity of the artist's oeuvre. Phillips probably became aware of Sterne in New York about 1915 through an exhibition of colorful, patterned paintings of Bali.[3] Although the show enjoyed a measure of critical favor, Phillips, at the time still conservative in his tastes, was shocked and denounced Sterne's works as "pseudo-savage" creations of a "fiery revolutionist."[4] But by the mid-1920s, when Sterne had become renowned, Phillips shared in the general enthusiasm, finding exceptional promise in Sterne's new Cézanne-influenced portrayals of the statuesque inhabitants of Anticoli Corrado.

When Phillips purchased his first Sterne, *Girl with Pink Kerchief,* 1924, in 1926, he praised the artist as "one of the most important men working along original lines."[5] The same year he exhibited a selection of Sterne's Italian works from the successful 1926 show at Scott and Fowles in New York and purchased three oils—*Afternoon,* 1924 (cat. no. 244), *The Reapers,* 1925, and *Still Life,* 1925 (acc. nos. 1828–29). In appreciation, Sterne gave him an additional work, *Mother and Child,* mid-1920s (acc. no. 1827).[6] By then he had already established Sterne as a unit artist, stating that "this exhibition will give me a splendid idea of how a Sterne Room would look."[7] In an effort to educate Washingtonians about Sterne, whom he considered "one of the greatest of our contemporaries of this or any other country," Phillips wrote letters to several Washington collectors, urging them to visit the show.[8] In the catalogue, he praised the paintings as "clear conception[s] of . . . classic and universal beauty . . . wrought out of simplified form and color." He also predicted: "If the best work of Maurice Sterne during the last three years is characteristic of what we may expect from him in the future, . . . then indeed we have a great artist in our midst, an artist who will hold his own with the giants of the Early Renaissance in Italy."[9] Sterne wrote to Phillips expressing

appreciation for his statements, yet also apprehension: "Your essay . . . scared me. You expect a great deal from me. Heretofore, only one person expected that much of me—myself. . . . But it encouraged me . . . to go ahead with my work and develop."[10]

This exchange marked the beginning of a friendly, respectful relationship. Although Phillips, having apparently rescinded his earlier denunciation of Sterne's Bali paintings, purchased *Temple Feast, Bali,* 1913 (acc. no. 1830), in 1927, he did not acquire another work by him until 1946. Nevertheless, he closely followed his development, meeting the artist on several occasions and corresponding with him until his death in 1957.[11] One reason for this hiatus was Sterne's decreased output owing to teaching responsibilities, sculpture commissions, and the execution of murals for the Department of Justice. Phillips expressed disappointment in these developments, as when he wrote, "[Sterne's] great gifts as a draftsman and sculptor were so much in demand that he was being drawn away from his brushes and pigments more or less against his will."[12]

By the mid-1940s, Sterne was able to concentrate more fully on easel painting and began depicting the seascapes of Provincetown. His impressionistic portrayals of the surf reflected a dramatic change in the artist's style and were received enthusiastically in his 1947 exhibition at Wildenstein, his first solo show since 1933. As he had done twenty years earlier with the Anticoli works, Phillips displayed a selection from the New York show and purchased one, *After Rain,* 1947 (cat. no. 245), for his collection. The unit was further broadened by the addition of *Benares,* 1912 (acc. no. 1825), which he purchased in 1946. By the artist's death in 1957, Phillips had rounded out his unit by acquiring examples from almost every period of Sterne's painting career.

Phillips considered Sterne one of the foremost American disciples of Cézanne.[13] He also praised him for his effective use of decisive line, solid masses, and subtly harmonized color to give structure and monumentality to his paintings. During the late 1920s, the time of his highest hope for Sterne, he compared him to André Derain as a reconciler of classicism and modernism and a "builder in the grand manner of [his] own time." He also said that Sterne followed in the tradition of the Italian Renaissance painters, and the French artists Chardin and Corot.[14] Phillips saw in Sterne's work the ideal combination of Western, Eastern, traditional, and modern artistic influences. By the 1940s, however, Phillips's estimation of Sterne's poten-

tial as the "American Cézanne" had diminished considerably, as a result of his increasing concentration on sculpture and his new impressionistic style. Although Phillips's friendship and support remained steadfast, his praise was never again so generous and sincere as the words he published in 1932: "Of all men of art today, [Sterne] may be said to bear the most authentic stamp of that versatile and proud genius, that genius for line and mass in any medium."[15]

GHL

243

Girl with Pink Kerchief, 1924

Head of a Girl

Oil on canvas, 16¾ × 13⅞ (42.4 × 35.3)

Unsigned

Acc. no. 1826

PMG purchase 1926 from the artist (from exhibition PMG.1926.1) through Bourgeois Galleries, New York.[16]

Girl with Pink Kerchief, which depicts a resident of Anticoli Corrado, reflects Sterne's admiration of Greek art. He considered the eight months he spent in Greece in 1908 the "most formative" in his life.[17] Entranced by the "perfect, stark reality" and severe style of classical Greek sculpture such as the Delphi *Charioteer* (ca. 475–470 B.C.), Sterne allowed it to influence his work for decades thereafter.[18] Another Greek-inspired painting in The Phillips Collection is *The Reapers,* 1925, which features horizontal rows of stylized figures that appear to have been directly inspired by the friezes of the archaic Greek temples.[19]

Sterne painted many of his models in profile achieving a pronounced sculptural effect. *Girl with Pink Kerchief* and similar works such as the now missing *Profile of Asunta* stimulated his experimentation with sculpture, a medium for which he gained wide recognition.[20] Sterne admitted, "I was so much interested in form and reality that my painting was too sculptural. I insisted too much upon the representation of actual weight and volume."[21] In *Girl with Pink Kerchief,* the massive head appears to have been chiseled out of stone. It is shown in austere profile against an undefined background; the intricate curves and bone structure of the model's face are accentuated. Even the hair protruding from the scarf is rendered as thick, sculptural locks, similar to those of the Delphi charioteer. The patterned scarf provides a flattening foil that heightens the volumetric qualities of the head.

Sterne had admired early Renaissance frescoes, especially Piero della Francesca's, while

243

traveling in Italy in 1907–8, and this influence, too, seems to have found its way into *Girl with Pink Kerchief.*[22] Like Piero, Sterne used thin, fluid paint and muted color. The girl's dramatic profile and three-dimensional aspect are also reminiscent of Piero. Her face and neck appear to have been built up in layers of ivory, olive, and flesh tones which are echoed in her clothing and in the background. Large areas of off-white have been left exposed in her tunic and scarf and are highlighted with peach and pink, complementing the overall color scheme.

Duncan Phillips recognized in *Girl with Pink Kerchief,* his first Sterne acquisition, the combined influence of ancient art and "the architectonic painters of our present period."[23] One of the contemporary artists he had in mind was Derain, whose work, "derive[d] . . . directly from Egyptian plastic austerity" in "its zest for pure sculptural planes and masses."[24] Indeed, Derain's *Head of a Woman* (acc. no. 0498), which Phillips acquired a year after *Girl with Pink Kerchief,* echoes the statuesque simplicity of the Sterne.

GHL

244

Afternoon, 1924

Afternoon at Anticoli

Oil on canvas, 45¾ × 32 (116.1 × 81.2)

Signed and dated in black paint, l.r.: *Sterne/1924*

Acc. no. 1824

PMG purchase 1926 from the artist (from exhibition) through Scott and Fowles, New York.[25]

Afternoon was painted in 1924, during Sterne's most productive period in Anticoli Corrado, which "had a hold on [him] from the first time [he] saw it" in 1908.[26] "The ancient houses," he wrote, "seem to grow from the rocks and foliage of the mountain side. There is no dividing line between architecture and landscape. The people and animals live together—no dividing line between man and beast. Unity. Harmony."[27] Although one of the poorest towns in Italy, it was distinguished by inhabitants whose "statuesque carriage and noble faces" had many painters before Sterne.[28] Afternoon depicts an Anticolan woman seated on a balcony overlook-

244

245

ing the Piazza della Villa. Since Sterne's studio was located away from the city in his *castello* on a hill, the work may have been painted at the sitter's home instead. A similar painting exists of a younger girl on a balcony with a piazza view, *Peasant Girl, Anticoli*, 1922–26.[29]

The figure is depicted with incisive line and minimal detail, and is accentuated by its placement as a silhouette against the sun-filled piazza.[30] In the manner of Cézanne, Sterne has structured the mountainous landscape and buildings into layers of richly modulated greens, oranges, and browns—applied with a palette knife in some sections.[31] The frame has geometric, floral, and cherub motifs hand-painted in blue tempera, gold leaf, and brown oils over white gesso; it may have been crafted in Anticoli especially for this work because its colors complement and enhance those in the painting.

The exotic locale and the sitter's reflective expression appealed to Phillips's sense of the romantic. He described *Afternoon* as "glamorous and haunting in its sense of ancient mountains and . . . civilizations, and melancholy with the mood of the shadowed dreamer on the balcony."[32] He also told Sterne, "Your pictures are far less dependent than Gauguin's on exotic glamour, and much more important in every way."[33] He admired the painting for its compositional strength, proclaiming it "far and away the outstanding picture" in the 1926 Sterne exhibition at Scott and Fowles.[34] Sterne himself, as late as 1938, could think of no better work he had done.[35]

GHL

245

After Rain, 1947

Oil on canvas, 24⅛ × 30⅛ (61.2 × 76.3)
Signed and dated in black paint, l.r.: *Sterne 47*
Acc. no. 1823

The artist; PMG purchase 1948 (from exhibition).[36]

After Rain contrasts markedly with Sterne's works of the 1920s. He had done little easel painting since his 1933 Museum of Modern Art retrospective, and by the mid-1940s his vision had changed. While in his work of the 1920s he had emphasized structure, line, and form, by the 1940s he was stressing the effects of light on the environment, color, and the tactile quality of paint.

Sterne's summer home in Provincetown on Cape Cod, where *After Rain* was painted, provided the perfect locale for his observations reflected in this painting—an expanse of sea and a series of breakwaters jutting from the shore; two men in the foreground, their forms defined by wispy brushstrokes, rig a boat, providing a vertical counterpoint to the strong horizontals of the breakwaters and horizon line. Sterne applied the paint thickly in built-up, impastoed layers and added texture in some areas by incising the wet medium, possibly with the nub of his brush.

The final layers of paint consist of particularly fluid washes over the varied terrain of impasto, adding a glossy veneer to the scene.[37] Sterne explained in 1947: "*My* renaissance took place about three years ago. Up to that time I believed that in order to *paint* significantly all one had to do was to *see* significantly and paint as well as one knew how. Then something happened. I was too ill to work and was admiring my view from the porch; the incoming tide, the crimson and orange and gold of the sunset, the delicate nuances, the spacial volumes, when suddenly, nature ceased to be nature and became a wet painting. . . . For many, many years I tried to paint as *well* as I knew how. I stopped trying when I realized that one must paint *better* than one knows how."[38] One critic called Sterne's new work "tone paintings in which Marin and Whistler are met," and another went so far as to label him an impressionist.[39]

Phillips purchased *After Rain* from the 1948 Phillips Memorial Gallery show of Sterne's recent work, even though he was generally disappointed that Sterne had not adhered to his style of the 1920s. That he would buy a work that did not completely meet his expectations attests to his open-minded, unfailing support of one of his favorite unit artists.

GHL

ARTHUR G. DOVE (1880–1946)

Arthur Dove, whose abstractions from nature influenced many younger American artists, was born in Canandaigua, New York, August 2, 1880. Dove moved with his family in 1882 to Geneva, New York, and began experimenting with painting. Following his parents' wishes, he began prelaw study in 1901 at Cornell University. He enrolled in art courses as well, however, and after graduating in 1903 worked as an illustrator in New York. In 1904 he married his Geneva neighbor, Florence Dorsey, with whom he had a son, William, in 1910. During an eighteen-month trip to Europe (1907–9), Dove met Max Weber and Alfred Maurer, and soon after his return to New York he met Alfred Stieglitz, who was to be his dealer and adviser for the rest of his life. In 1909 he moved to Westport, Connecticut, where he painted and kept a farm. In his first solo exhibition, held at Stieglitz's Gallery 291 in 1912, Dove established himself as the most prolific and inventive artist working with abstraction in America. In 1917 he took a break from painting, resuming his career in 1921, the same year he left his wife and moved with his companion, Helen ("Reds") Torr, to a houseboat on the Harlem River. From 1924 to 1933 they lived on their sailboat, *Mona*, on Huntington Harbor near Halesite on Long Island, New York, except for the winter of 1928–29, when they served as caretakers of A. W. Pratt's waterside cottage in Noroton, Connecticut. They were married in 1932 and moved to Geneva the following year to settle Dove's family estate. Five years later, they returned to Long Island, purchasing a house in Centerport. Although diagnosed with Bright's disease, a kidney disorder, in 1939, Dove continued to paint abstractions until his death from heart failure November 22, 1946. The Phillips Collection possesses the world's largest, most representative group of works by Dove. The unit includes thirty-four oils and wax emulsions, sixteen watercolors, two collages, one gouache, and two drawings.

The Dove Unit

Arthur Dove preferred to live simply and to work quietly on a farm or boat in his native New York state. He thus appealed to Duncan Phillips as an individualist as well as an artist whose daringly abstract paintings seemed devoid of specific European influence and were not easily classified. Like other artists in Stieglitz's circle, Dove sought to represent the unseen rhythms and nuances of his environment and to record personal interpretations of nature by reducing form to its purest essence. As Phillips saw it, Dove strove "to suggest *the sense of things*—of both inert and living Elements."[1] In Dove's own words, he was "primarily . . . interested in growing ideas into realities."[2] The results were paintings in which organic shapes, undulating lines, bands of color, and glowing light evoke nature's underlying forces and the sensations Dove experienced when confronted with his environment.[3]

Although Dove had exhibited his abstractions in New York at Stieglitz's Gallery 291, in the "Forum Exhibition of Modern American Painters" held at Anderson Galleries in 1916, and in the first exhibition of the Society of Independent Artists in 1917, Phillips did not become familiar with his art until 1922.[4] By then, not only was Dove's avant-garde style fully matured and more rooted in naturalism, but Phillips was more receptive to abstract art. Indeed, Phillips admitted that his discovery of Dove increased his open-mindedness and receptivity to the formal elements of painting, thereby redirecting his collecting activity: "I then learned that I was being attracted to an artist *because* he was strictly yet sensuously visual. . . . One could not analyze him. . . . He was so whimsical that he would be embarrassing not only to the literary critics but to the painters and teachers of painting who deal in theories and group movements."[5]

The number of works in the Dove unit and its range (1925 to 1944) attest to Phillips's estimation of Dove as one of the most significant American artists of his day. He purchased his first works in 1926 and thereafter became a regular patron.[6] The relationship became more formalized in 1933 through an arrangement whereby, in exchange for a monthly stipend, Phillips received first choice from Dove's yearly exhibition at An American Place, Stieglitz's third New York gallery.[7] Although Phillips made similar arrangements with other artists from time to time, he was most constant in his support of Dove, purchasing at least two paintings every year until the artist's death.[8] Because Dove's work was never widely understood or accepted during his lifetime, he depended a great deal on Phillips's support. Marsden Hartley exaggerated pardonably when he wrote to Phillips in 1942 that "some of us who know Arthur Dove well are grateful to you for being the single person in the entire universe that likes his painting . . . for he is otherwise entirely destitute of patronage."[9] As a result of this unwavering support, the Dove unit contains examples from all phases of his mature oeuvre.[10]

The paintings Dove created during the years he lived near Halesite portray the boats, barges, and docks of Huntington Harbor as well as the effects of weather on the environment. Dove's years on the family farm in Geneva in the thirties are represented by paintings that in their rural imagery and earthy browns, moss greens, and muted ochers evoke the atmosphere of living off of the land. During his last decade, Dove painted in a freshly abstract style of crisp, bright color and spatial experimentation.

Because Dove was for the greater part of his career inspired by his surroundings, Phillips considered him "as American as Thoreau and Walt Whitman."[11] His love of nature demonstrated an earthiness and ruggedness that, in Phillips's mind, had parallels with the mysticism of Native American art, not European modernist painting, which was the primary influence of the time. Along with Ryder and Marin, Dove fit into Phillips's romantic notion of the "nature poet" who painted from instinct and was free from the bonds of established artistic movements.[12] Phillips viewed Dove's paintings as "cause for my rejoicing, as I look with alarm upon the growing standardization of art."[13]

GHL

246

Golden Storm, 1925

Storm Clouds in Gold

Oil and metallic paint on plywood panel, 18⅝ × 20½ (47.2 × 52.1)

Signed and dated in black paint on reverse, u.l.: *Golden Storm/Dove./1925.*

Acc. no. 0553 (Morgan no. 25.4)

The artist; consigned to Alfred Stieglitz (Intimate Gallery, New York); PMG purchase (from Intimate Gallery exhibition) 1926.[14]

247

Waterfall, 1925

Oil on hardboard, 10 × 8 (25.5 × 20.3)

Signed and dated on reverse, u.c.: *Water Fall/1925/Dove.*

Acc. no. 0586 (Morgan no. 25.19)

The artist; consigned to Alfred Stieglitz (Intimate Gallery, New York); PMG purchase (from Intimate Gallery exhibition) 1926.[15]

Golden Storm and *Waterfall*, executed on the artist's boat in Huntington Harbor, Long Island, are the earliest Dove paintings in the Phillips Collection and represent Dove at the beginning of his mature style. Their small scale, the result of limited working space, does not detract from their immense power. In both works Dove captured the movement of water, freezing it into abstract, timeless patterns: in *Waterfall*, the effect of water rushing and swirling over rocks;

in *Golden Storm,* choppy waves heaving under ominous billowing clouds. Their palettes are orchestrated within a narrow range of tonal values that not only emphasize form but also enhance the overall effect. The dark blues and glowing gold tones of the metallic paint in *Golden Storm* radiate an iridescent gleam reminiscent of a cloudy sky illuminated by lightning. The icy blues, grays, pinks, and whites of *Waterfall* characterize cold, clear water in its purest state.

These works, in their successful evocation of the inner vitality of nature, constitute the culmination of formative influences in Dove's development, including trends in European modernist art, especially Kandinsky's notion of spirituality and the ideals concerning individual expression espoused by Stieglitz's group. Such sources encouraged him to interpret his surroundings in an abstract style, in an effort to elicit the unseen forces they contained.

Duncan Phillips's acquisition of *Golden Storm* and *Waterfall* in 1926 represented a breakthrough for the collector in his growing acceptance of abstract form and expressive color as evocations of nature's underlying dynamism. He admired *Golden Storm* as a "symphonic tone-poem on earth shapes whirled in the maelstrom" and praised the "spacing of bright and dark accents" in *Waterfall*.[16] He compared both paintings to the art of Ryder, whom he considered Dove's "spiritual ancestor," not only in his reduction of nature's forms to their purest elements, but also in his experimental techniques and choice of medium.[17] Phillips also recognized a spiritual element in these two early works: "When there is a hint of great things going on in the mind of the artist and of his consciousness of the rhythm of the universe, abstract art ceases to be an amusement for the aesthete and becomes a divine activity."[18]

GHL

248

Goin' Fishin', 1925

Fishing Nigger; The Nigger Goes A'Fishing
Assemblage of bamboo, denim cotton, buttons, wood, and oil on wood panel, 21¼ × 25½ (54.0 × 65.4)
Unsigned
Acc. no. 0552 (Morgan no. 25.3)

The artist to the collection of Alfred Stieglitz ca. 1925; PMG purchase (from exhibition) 1937.[19]

246

249

Huntington Harbor I, 1926

Huntington Harbor; Little Sail Boat (DP); *Sailboat* (DP); *Sand, Sail and Sky* (DP)
Assemblage of canvas, oil, and sand on metal panel, 12 × 9½ (30.4 × 24.1)
Signed and dated in pencil on wood backing, reverse, u.c.: *Huntington Harbor./Dove/July 1926*
Acc. no. 0555 (Morgan no. 26.3)

The artist; consigned to Alfred Stieglitz (Intimate Gallery, New York); PMG purchase (from Intimate Gallery exhibition) 1928.[20]

Dove occasionally made collages and assemblages while living on his boat, and twenty-five are known to have been created. In *Huntington Harbor I* he used a variety of materials, such as fabric, metal, and sandpaper, and he combined bamboo, fabric, and wood in *Goin' Fishin'*. His clever, humorous technique reveals his awareness of the dadaist collages being produced in Europe and his knowledge of the American folk art revival of the 1920s (folk artists often incorporated objects from their surroundings into their work). Dove's collages and assemblages constitute a charming combination of these divergent influences.

Goin' Fishin' was interpreted by many, including Duncan Phillips, as a good-natured exposition of a Mark Twain character's fishing exploits.[21] Yet, according to Alfred Stieglitz, the work was inspired by a rumor that a black fisherman had drowned off a dock in Huntington Harbor.[22] Stieglitz elaborated: "The painting repelled me, as I would have been repelled had I suddenly come upon a black corpse floating in the water."[23] Dove, however, denied the rumor, telling his friend Elizabeth McCausland that the black man "was just sitting on [the] pier."[24] In a letter, he wrote about the rumor: "Don't know where it started—Have pulled about 14 people plus 100 cats and dogs out of the water but they were all white." He added that he considered the work "most musical." Alluding to Phillips's essay for his 1937 exhibition, Dove wrote that hearing

247

248

249

of a drowning "would probably spoil it for [him]."[25]

The sleeves of a denim shirt, representing the fisherman's attire, and a piece of dark wood from the dock form the central motif of the composition.[26] Pieces of bamboo fishing pole frame these materials in a tight semicircle. Parts of the human body are alluded to in a macabre and humorous manner by the central radiating configuration of bamboo, which may be interpreted as a skeletal hand. In addition, the cross-section of bamboo glued to the stump resembles a glassy, staring eye.[27]

In *Huntington Harbor I* Dove also employed materials directly related to the subject. However, instead of arranging the objects to obtain an abstracted image, he retained the traditional format of a seascape by representing a lone boat on the water. A piece of canvas bearing a cross-bar drawn in black designates the sail, vertical wooden strips represent masts, and sandpaper signifies the shore. Another version, *Huntington Harbor II,* 1926, depicts a similar boat even more explicitly, complete with setting sun and a wooden fence along the shoreline.[28]

Although Phillips saw *Goin' Fishin'* as early as 1926 at the Intimate Gallery, he acquired *Huntington Harbor I* first, and more readily, probably because of its more understated presence and lyrical charm. He believed that it showed "extraordinary inspiration in the use of actual wood and cloth to add tactile value and rugged reality to a lyrical impression conveyed in a few exquisite colors." But he also expressed reservations, telling Dove, "I do wish you would paint more pictures in the conventional way with brush and pigment for I think you owe it to the world to do so."[29] Nevertheless, his opinion had changed by 1935, when he wrote to Stieglitz about the "reminiscent chuckle and . . . glow of aesthetic pleasure" that he experienced every time he thought of *Goin' Fishin'*.[30] In 1937 he managed to buy it, even though it had been in Stieglitz's private collection. He had come to believe that Dove was unique in his ability to manipulate natural materials to create works, "far from the collage of the theoretical and sensation-seeking Parisians of the early cubist period."[31] Phillips's preference for Dove is made very clear in his 1937 comment, "How dated today seem those early cubist stunts by Picasso and Gris!"[32]

GHL

250

Sand Barge, 1930

Oil on cardboard, 30⅛ × 40¼ (76.5 × 102.3)
Signed in sienna paint l.r.: *Dove*
Acc. no. 0575 (Morgan no. 30.13)
The artist; consigned to Alfred Stieglitz (An American
Place, New York); PMG purchase 1931 (from An American
Place exhibition).[33]

Sand Barge was executed while Dove was resi-
dent caretaker at the Ketewomoke Yacht Club at
Huntington Harbor. He sketched from the bal-
cony of the club as barges entered the harbor
with their loads. *Red Barge* (acc. no. 0568), one
of the most naturalistic paintings by Dove in the
collection, also demonstrates his attraction to
this theme. The suggestion has been made that
Dove's companion was describing *Sand Barge*
when she wrote in her diary about a "nearly
finished . . . painting of crane, barges, and gravel.
The gravel would knock your eye out. Don't
know the name of painting yet, we'll have to
break a bottle of gin on it."[34]

　　The horizontal motif in the upper left could
be a section of the crane, or it might be inter-
preted as a boat railing or distant bridge. The
barge seems to be signified by the blue, ocher,
and gray central design. And the triangular
ground with specks of blue in the lower right
might be the sand or a representation of the
harbor's shoreline. Although inspired by an
actual scene, Dove altered and rearranged its
components to create a compelling, cohesive
abstract image.

　　It was about this time that Dove began creat-
ing oils based on the watercolors he had exe-
cuted outdoors. *Sand Barge* is one of the few
works in the Dove unit for which The Phillips
Collection also owns a preparatory watercolor,
Drawing for Sand Barge (acc. no. 0576).[35] Dove
used a pantograph to transfer the image of the
sketch to the larger scale. Whereas the tiny
watercolor has spontaneity and immediacy, the
oil has a compact design, more distinct outlines,
and greater depth of color.

　　Sand Barge received favorable critical com-
ment when it was first exhibited in 1931 at An
American Place. One reviewer stated that "one
of the most agreeable to the senses is the design
entitled 'Sand Barge,' owing to the uncommonly
harmonious coordination of line and color
which it involves."[36] Duncan Phillips was quick
to claim the painting, praising its "exhilarating
pattern" as representative of Dove's "forthright
and rugged" American temperament.[37]

　　　　　　　　　　　　　　　GHL

250

251

251

Sun Drawing Water, 1933

Oil on canvas, 24⅜ × 33⅝ (61.9 × 85.5)
Signed in dark blue-green paint, l.c.: *Dove*
Acc. no. 0582 (Morgan no. 33.4)

The artist; consigned to Alfred Stieglitz (An American Place, New York); PMG purchase (from An American Place exhibition) 1933.[38]

252

Electric Peach Orchard, 1935

Oil on canvas, 20¼ × 28 (51.3 × 71.2)
Signed in black paint, l.c.: *Dove*
Acc. no. 0549 (Morgan no. 35.11)

The artist; consigned to Alfred Stieglitz (An American Place, New York); PMG purchase (from An American Place exhibition) 1935.[39]

Sun Drawing Water and *Electric Peach Orchard* reveal Dove's attraction to the outward appearance and underlying mystery of nature. In both works, undulating lines in the sky serve as literal representations of the forces of nature, a theme that fascinated Dove throughout his life and became most visible in his art during the 1930s. His interest in giving form to the mystical attributes of the environment was encouraged by fellow artists in the Stieglitz circle and enhanced by his familiarity with theosophical writings of the late nineteenth and early twentieth centuries.[40] Although never a strong advocate of theosophy, Dove was probably drawn to the movement's use of certain forms and colors that symbolized hidden energies in nature and thus created their visual equivalents.

Sun Drawing Water was completed in two weeks during January 1933, shortly before the Doves moved to Geneva in upstate New York.[41] It appears to portray a powerful interaction between earth and sky, a symbolic representation of the evaporative effects of the sun. The water heaves in waves toward central columnar shafts, which are shot through with thin, meandering lines and soar into the sun-filled sky. Additional lines quiver horizontally across the sky, possibly alluding to the sun's all-encompassing force.[42] Dove mentioned this in a 1925 poem that revealed his outlook on nature:

> Works of nature are abstract,
> They do not lean on other things for meaning
> The sea-gull is not like the sea
> Nor the sun like the moon.
> The sun draws water from the sea
> The clouds are not like either one—
> They do not keep one form forever.
> That the mountainside looks like a face is accidental.[43]

In *Electric Peach Orchard*, which was executed in Geneva, Dove transformed a diagonal row of trees into a series of writhing forms whose branches are linked by agitated, tendril-like lines representative of electric currents. The lines not only weave throughout the tree limbs but also extend from the sky, signifying an interaction between the land and the atmosphere—perhaps the trees' absorption of light or moisture. Dove may have been influenced by P. D. Ouspensky, a popular theorist among mystical circles at the time, who believed that "electricity evidences the fourth dimension because it is physical proof of an unseen world."[44]

Another work in the Dove unit, *'Me and the Moon'* (acc. no. 0559), reflects the artist's interest in finding ways to represent cosmic powers. Furthermore, he evoked the aura of animal existence in paintings like *Cows in Pasture* (acc. no. 0548), also executed in Geneva, in which—in Phillips's words—the "slow and drowsy . . . streams of consciousness" of a group of cows are rendered in organic forms with "lazy contours." Duncan Phillips recognized Dove's philosophical attitude as a type of "primitive pantheism . . . worship of the sun and moon" in which he expounded on "the cycles of life and death in nature."[45]

GHL

253

Flour Mill II, 1938

Flour Mill; Flour Mill Abstraction No. 2; Flour Mill Abstraction
Oil and wax emulsion on canvas, 26⅛ × 16⅛ (66.3 × 41.0)
Signed in black ink, l.c.: *Dove*
Acc. no. 0551 (Morgan no. 38.5)

The artist; consigned to Alfred Stieglitz (An American Place, New York); PMG purchase (from An American Place exhibition) 1938.[46]

254

Rain or Snow, 1943

Oil and wax emulsion on canvas, 35 × 25 (88.9 × 63.5)
Signed in gray paint, l.c.: *Dove*
Acc. no. 0567 (Morgan no. 43.10)

The artist; consigned to Alfred Stieglitz (An American Place, New York); PMG purchase (from An American Place exhibition) 1943.[47]

From the late 1930s to the mid-1940s, Dove's approach became more intellectual and objective as he experimented further with abstraction and with spatial, geometric, and color relationships.[48] Although he still gained initial inspiration from nature and continued to paint in an intuitive manner, he now reduced elements to their simplest forms and stressed either flatness or spatial ambiguity. He deemphasized the descriptive details, inner energies, or poetry of the subject and focused on the arrangement of forms in space and the selection of colors, an interest made clear by his frequent use of such titles as *Pozzuoli Red; Yellow, Blue-Green and Brown*; and *Red, White and Green* (acc. nos. 0564, 0589, and 0571). His late works, expressions of pure color and form, anticipated the creations of then-emerging abstract expressionists like Gottlieb and Rothko.

In *Flour Mill II*, painted during his last months in Geneva, Dove transformed the building into a bold configuration suspended in a nondescriptive space.[49] The off-white background serves as a foil to the earthy greens, rusts, browns, and ochers of the abstraction but maintains a density and opacity—owing to the matte surface of the wax emulsion medium—that prevent it from being overpowered by the intensity of the colors.[50] Therefore, the design and its ground are treated as two presences of equal dominance on a flat surface. Duncan Phillips compared this abstract treatment of the subject to a "Chinese character" composed of "square, vibrant brushstrokes."[51]

Rain or Snow was painted five years later in Centerport while Dove was confined to his home because of deteriorating health; it may represent a winter storm that he viewed from his window. In a probable attempt to defy the two-dimensional picture plane, Dove transformed the painting itself into a window by applying aluminum strips to either side of the canvas. Within this framework, luminous, transparent, and rectangular shapes suggesting clouds or large snowflakes drift and overlap in a void. Additional elements of an outdoor scene are suggested by diagonal brown strips (branches) and thin, vertical lines (streaks of rain). Beyond the framing device are bands of open space rendered in various colors and shapes. Phillips admired the painting, stating, "The space, the balance and directions are all perfect and the aesthetic joy comes from a personal experience in nature."[52]

GHL

252

253

254

ALBERT EUGENE GALLATIN (1881–1952)

A. E. Gallatin, noted for his influential collection of avant-garde art and his own abstract painting, was born July 23, 1881, in Villanova, Pennsylvania. He was descended from a distinguished family whose ancestry included Albert Gallatin, founder of New York University and secretary of the Treasury under James Madison and Thomas Jefferson. Gallatin spent the winters of his childhood in New York and eventually attended the law school of New York University, but he never completed his degree. When he was nineteen his father died, leaving him financially independent and able to pursue collecting and writing about art. His earliest acquisitions and writing focused on Aubrey Beardsley and Whistler and later expanded to include the American impressionists and The Eight. In 1918 Gallatin organized the Allied War Salon in New York with Duncan Phillips and Augustus Vincent Tack. In 1921 he joined Katherine Dreier's avant-garde Société Anonyme (but he was not an active member) and during the following decade was increasingly drawn to modernist European art, especially cubist paintings, making yearly buying trips to Paris. In 1927 he founded at New York University the Gallery of Living Art (renamed the Museum of Living Art in 1936), which was devoted exclusively to showing works by contemporary Americans and Europeans. In 1932, when Jean Hélion, founder of Abstraction-Création in Paris, became Gallatin's adviser on acquisitions, representational works were gradually deaccessioned from his collection, leaving primarily abstract paintings. In 1937 Gallatin and G. L. K. Morris founded *Plastique,* an avant-garde magazine; only five issues were published. Gallatin began to devote himself to painting in 1936 and the following year joined the American Abstract Artists group, cofounded by Charles Greene Shaw and Morris. He had his first solo show at the Passedoit Gallery, New York, in 1938. The following year, in the face of opposition from conservative faculty members and beset by financial and war-related problems, the Museum of Living Art was closed and the collection transferred to the Philadelphia Museum of Art. Gallatin died in New York June 15, 1952. The Phillips Collection owns one late abstraction by the artist.

255

Composition, 1941

Abstraction

Oil and paper collage on board, 18⅞ × 14⅜ (47.4 × 36.5)

Signed and dated in black paint on reverse, u.c.: *A. E. Gallatin/Oct. 1941*

Acc. no. 0715

PMG purchase 1945 from the artist.[1]

Although A. E. Gallatin was best known as an avant-garde collector, he painted sporadically during his career, most regularly during the later years of his life. Many of his works from the late 1920s are lost, and the bulk of his surviving oeuvre dates from the period after he joined the American Abstract Artists in 1937. The wealthy, patrician Gallatin cut an unusual figure among the younger, liberal members of this group; however, he shared their enthusiasm for avant-garde styles in art and, with fellow member G. L. K. Morris, had the advantage of being able to purchase works by the European modernists they admired.

Gallatin's late paintings reflect the ideals of his collection after he had purged it, around 1930, of representational art in favor of abstraction. Reputedly quiet and self-effacing about his own art, he considered it "an activity he engaged in to enhance his understanding of the work he collected."[2] Believing that the more separated art was from life, the more it represented aesthetic truth, he often assigned his works the nondescriptive title *Composition.*[3]

A perfectionist, Gallatin would sometimes spend years on a painting, endeavoring to achieve the ultimate in spare simplicity, crisp line, and elegant, subtle color.[4] In style, his painting was particularly indebted to synthetic cubism, a technique that appealed to his intellectual nature because of its emphasis on geometric shapes in both paintings and collages. His favorite cubist, Juan Gris, was also admired by the French abstractionist Jean Hélion, Gallatin's friend and collecting adviser, for his balancing of "the demolition of the subject and its reconstruction."[5] *Composition* typifies Gallatin's mature work, in which multitextured overlapping and intersecting forms are anchored by radiating, decorative bands against a flat background. Before painting, he made a graphite sketch on the board.[6] The linear motif in the upper left quadrant resembles Stuart Davis's geometric imagery in his *Egg Beater* series, 1927–28 (see cat. no. 282), while the patterned shapes are echoes from Picasso's and Gris's paintings as well as constructivist sculpture. The work's surface is emphasized by the central brown-paper collage element, which was covered with a fibrous substance.[7] Its texture and dark color add an element of coarseness to an otherwise pristine image in which Gallatin used his characteristic colors—grays, subdued yellows, soft blues, rusts, and ochers. This carefully constructed composition was admired by a reviewer when the work was first shown: "From its dark brown center, rough as burnt toast, to the hard, shell-like feeling of the cream white background, [*Composition*] could be a multiple source of inspiration to the enterprising designer-manufacturer."[8]

Duncan Phillips purchased *Composition* after seeing a color illustration in a contemporary publication.[9] His admiration of Gallatin had begun as early as 1914, a time when Gallatin's taste for the refined elegance of Whistler and the American impressionists and the realism of The Eight paralleled Phillips's own preferences. Gallatin's collection of the mid-1910s had appealed to Phillips because it expressed "its owner's personal taste and his sense of the kinship and the friendship of things," and it may have stimulated Phillips's own collecting ambitions.[10] Their personal contact in 1918, when they worked together on the Allied War Salon, may have further motivated Phillips to become an open-minded collector of works by contemporary, albeit relatively conservative, artists.[11] Their tastes diverged over the years, however, and it was probably more out of their long-standing, respectful friendship than enthusiasm for Gallatin's painting that Phillips purchased *Composition* in 1945. Although it was pleasing in color and design, its sleek, cerebral quality masked the personality of the painter—and personal expressiveness was a value in painting that Phillips preferred and pursued.

GHL

255

Max Weber, who helped transmit to America the knowledge of European modernist developments, was born April 18, 1881, in Bialystok, Russia (now Poland), to an Orthodox Jewish family. When he was ten, his family immigrated to Brooklyn, where in 1898 Weber enrolled at the Pratt Institute, studying under Arthur Wesley Dow. In September 1905 he traveled to Paris; he studied at the Académie Julian under Jean Paul Laurens, the Académie Colarossi, and the Académie de la Grande Chaumière. In 1908 he helped organize and participated in a small class that Matisse guided and critiqued. Weber visited the Paris Salon retrospectives of Cézanne and Gauguin (both in 1907), frequented the studios of Matisse and Picasso, visited Gertrude Stein's salon, and was a close friend of Rousseau. He exhibited his work in the Salon des Indépendants and the Salon d'Automne. In January 1909 Weber returned to New York, where a few months later he had his first solo show at Hass Gallery. His first museum exhibition was held at the Newark Museum in 1913. After a brief and turbulent association with Stieglitz at Gallery 291, he supported himself by teaching at the Clarence H. White School of Photography (1914) and later at the Art Students League (1920–21 and 1925–27). In 1916 Weber married Frances Abrams. The following year, he became the director of the Society of Independent Artists. A prolific writer, he wrote poems as well as articles and books on art theory. The Museum of Modern Art selected his work for a solo exhibition in 1930, their inaugural year. Weber was the national chairman and honorary national chairman of the American Artists' Congress from 1937 to 1940. An extensive survey of his work at the Associated American Artists Galleries in 1941 enjoyed critical and financial success. He continued to work diligently in a variety of media, including sculpture and graphic work, until his death October 4, 1961, in Great Neck, Long Island. The Phillips Collection contains works from two phases of Weber's oeuvre: three from the 1920s when he worked in a representational, monumental style and four from his later expressionistic period.

The Weber Unit

Max Weber is noted for his theoretical writings and for the works he produced during his years in Paris and the decade following his return to the United States.[1] His writings and art reflect his assimilation of the new European developments, including futurism and cubism, which Weber helped convey to America, especially during his association with Alfred Stieglitz (1909–11).[2] About 1918 Weber began gradually to modify his theoretical concerns; he abandoned his formal analysis of modernism to concentrate more on its spiritual and emotional content, which he evoked in his art by using an expressive style. "In the history of art we may find whole periods or epochs when spirit was bankrupt," Weber wrote in 1945. "The intensity of emotion and its expression varied accordingly as religious ardor, or scientific discovery, or economic principles ruled the hour."[3] Drawing many of his figural images from his ethnic heritage—half-forgotten reminiscences of his Russian-Jewish childhood that he considered spiritually significant—Weber believed that "it is the emotion, the inspiration, that stirs the individual creator, or an entire race, before its expression."[4]

To help imbue his subjects with greater spiritual and symbolic content, Weber adopted a monumental style that recalled his earliest figural works as well as Picasso's neoclassical style.[5] During the 1930s Weber employed an even more expressive approach in which he used a sketchy calligraphic line. Late in his career, he returned to greater abstraction while maintaining his linear style.

Phillips was drawn to Weber's use of color—"his passionate protests of color and form"—but believed that his compositions were "rather over-insistent in their distortions."[6] Asserting that Weber's cubist experiments during the 1910s were derivative, he preferred the later paintings. The collector first expressed interest in 1925, when he made a special point of seeing Weber's work at J. B. Neumann's New Art Circle during a visit to New York.[7] The catalyst for his attention had undoubtedly been the strong critical success of Weber's exhibition earlier that year at Neumann's. The critic Henry McBride, whom Phillips admired, had stated that Weber was "one of the best painters in the world practically going to waste among us. And nobody gives a hang. . . . The work thus ignored glowed with distinguished colour [that] was Biblical. It was vivid and rich and seemed rooted in the immemorial past."[8] Phillips purchased two paintings, only one of which, *High Noon*, 1925 (cat. no. 257), is in the collection today. Although he preferred Weber's landscapes, he purchased *Draped Head*, before 1923 (cat. no. 256), the following year, because he wanted more figural works in the collection, and perhaps also because it alluded to Weber's Jewish-Russian heritage. Regretful that he had "missed him in past years," Phillips expressed a desire to visit Weber's studio to "increase the number of pictures by which he is represented in our Collection."[9] He believed that "the assurance of Weber's brushwork and the opulent quality of his paint proclaim the hand of a master."[10]

By 1931 Phillips had added two still lifes to the Weber group, but his interest subsequently diminished, in part because of his belief that Weber was too easily influenced by "the dogma of what constitutes an authentic, orthodox modernist."[11] His interest was not rekindled until 1941, when Weber exhibited at the Associated American Artists Galleries in New York. The impetus for Phillips's renewed attention was perhaps the positive critical attention Weber received for this exhibition. He undoubtedly read favorable reviews, such as that by the critic Forbes Watson: "Max Weber is not a movement painter, but no painter made a more thorough and searching study of what was the healthy movement of modern art."[12]

Phillips purchased three works from that show: *Rabbi*, 1940, *Students of the Torah*, 1939, and *Colonial Bowl*, 1938 (acc. nos. 2063, 1064, and 2058). Inspired once again, Phillips now began to refer to his Weber holdings as a unit.[13] In 1942, after having visited the Webers in late 1941, Phillips acquired a small gouache, *Conversation*, ca. 1925–35 (acc. no. 2059).[14] The following year he added *Last Snow*, ca. 1940 (cat. no. 258), with the observation that the "Weber Unit contains only one small landscape and it is an early one."[15]

Phillips most appreciated the artist's interest in portraying Jewish subjects. He regarded Weber as "an emotional and a spiritual artist who . . . only escaped the plight of eclecticism and meek discipleship on the fortunately frequent occasions when he painted deeply sincere and pious little pictures of religious mysticism." In such works, unlike Weber's formal explorations in modernism, Phillips believed that we are "lured into the inner life" of the artist.[16]

LBW

256

Draped Head, before 1923

Head
Oil on canvas, 21⅛ × 13⅛ (53.7 × 33.4)
Signed l.r.: *Max Weber*
Acc. no. 2060

PMG purchase from the artist through J. B. Neumann's
New Art Circle, New York, 1926.[17]

Beginning around 1918 Weber explored themes
related to his Orthodox Jewish heritage. Why he
turned to religious subjects is not known. Per-
haps he was responding to the recent deaths of
his parents—his father in 1917 and his mother in
1918—and to the war, which "reaffirmed the
hyphenated American feelings of many immi-
grant groups."[18]

The following year he began to paint busts of
solitary figures set against a neutral background,
a format he continued to explore through the
remainder of his career, as seen in both *Draped
Head* and *Rabbi.* These heads were not portraits
of specific people but were, as Percy North
states, "primarily studies of form and symbols of
meditation, imagination, and creativity."[19]

A contemplative painting overlaid with mys-
tical nuances, *Draped Head* depicts a woman
wearing a plain scarf and modest garb, and
posed in a gesture of reflection. Because the sub-
ject matter and the simple composition recall
Weber's eastern European culture, it was per-
haps a visual memory of his childhood. The
model might have been Frances, his wife of just
a few years; she has been identified as the subject
of another portrait that bears a resemblance to
this figure.[20]

In *Draped Head* Weber simplified the
woman's facial structure, giving her a masklike
appearance. He reverted to the modernist,
figural style he had developed in Paris while
under the influence of Matisse and Picasso,
whose work at that time was influenced by
African and pre-Columbian art.[21] The solidity
and monumentality of the figure in *Draped
Head* also reflects his awareness of the strain of
classicism in Picasso's work, especially in the
early 1920s.[22]

Duncan Phillips probably first became aware
of *Draped Head* from an illustration accompa-
nying Henry McBride's review of Weber's 1925
exhibition at J. B. Neumann's New Art Circle,
and he purchased it the following year. He con-
sidered *Draped Head* "a little masterpiece of
tragedy. The tormented soul of a Race speaks
through this portrait which carries on the
Byzantine and El Greco traditions."[23]

LBW

256

258

257

257

High Noon, 1925

Summer Noon

Oil on canvas, 20⅛ × 24⅛ (51.1 × 61.3)

Signed l.r.: *Max Weber*

Acc. no. 2061

Consigned to New Art Circle, New York; PMG purchase (from New Art Circle exhibition) 1925.[24]

258

Last Snow, ca. 1940

After an Ice Storm

Oil on canvas, 30 × 36¼ (76.2 × 92.0)

Signed l.r.: *Max Weber*

Acc. no. 2062

Purchased from the artist through Rosenberg, New York, 1943.[25]

Weber periodically painted landscapes throughout his career. During the 1920s, in works such as *High Noon,* he concentrated on peaceful, fairly naturalistic renditions of the suburbs and farmland of Long Island and Connecticut. In 1916 he had married, and in 1921 he and his wife had purchased a home on Long Island. His interests during this period became increasingly domestic. "It seemed to me," Weber wrote of his married life, "[that] the whole world was sweetened."[26] *High Noon* conveys the stability of this period in its quiet, restful mood, which seems to praise the benefits of country living. The influence of Cézanne is apparent in the rhythmic, layered composition and the choice of colors— bright oranges, blues, and greens.[27]

By the early 1940s, however, Weber had completely abandoned his gay palette of the 1920s for a more expressive, calligraphic style that favored blue-gray tones, white, and earthy browns. Now he primarily painted winter scenes, desolate landscapes of stark trees and the naked earth deprived of vegetation. In turbulent, expressive works such as *Last Snow,* he might have been reflecting his response to the trauma of the Great Depression and the growing menace of political events in Europe, perhaps also of anti-Semitism in the United States.[28]

LBW

GASTON LACHAISE (1882–1935)

A French expatriate sculptor whose career flourished in the United States, Gaston Lachaise was born in Paris March 19, 1882, to a prominent cabinetmaker and woodcarver. Lachaise enrolled at the Ecole Bernard Palissy in 1895 and in 1898 transferred to the Académie Nationale des Beaux-Arts. After participating in the 1899 Paris Salon, he left the Académie Nationale because he felt constricted by its conventions. Around 1901, in Paris, Lachaise met Isabel Dutaud Nagle, the inspiration for his renowned figures of women (they married in 1917). A Canadian-American, Nagle returned to Boston while Lachaise remained in Paris, working in the studio of René Lalique from 1904 to 1905 in order to save for his passage to the United States. By 1906 he was working in Boston for the academic sculptor Henry Hudson Kitsen, whom he followed to New York in 1912. After one of his plaster statuettes was chosen by Arthur B. Davies for the Armory Show in 1913, Lachaise decided to concentrate on his own career, although he worked briefly as an assistant to Paul Manship. After meeting e. e. cummings in 1917, Lachaise began to frequent the intellectual circle surrounding Scofield Thayer and James Sibley Watson Jr., the editor and publisher, respectively, of the avant-garde periodical *The Dial*. His first one-person exhibition was held at the Bourgeois Gallery in 1918. He supported himself not only with portrait commissions but also with architectural decorations such as elevator doors. In 1927 Alfred Stieglitz held a show of his work at the Intimate Gallery in New York. In 1935 the Museum of Modern Art gave him his first retrospective, which received good reviews. Lachaise died of leukemia in New York October 17, 1935. The collection contains three bronze sculptures: one portrait head and two animals.

259

Head of John Marin, 1930

Bronze (cast from 1928 plaster), 14¼ × 9½ × 9¾
(36.1 × 24.1 × 24.7)
Signed and dated on back of neck: *G. Lachaise/c 1928;*
stamped below this inscription on bottom edge of neck:
ROMAN BRONZE WORKS NYC.
Acc. no. 1103

Cast in 1930 by Weyhe Gallery, New York; PMG purchase
1930.[1]

Stifled by his training at the Académie Nationale des Beaux-Arts, Gaston Lachaise briefly absorbed the avant-garde milieu of Paris before emigrating to the United States in 1905. Once in New York, he worked independently, exploring

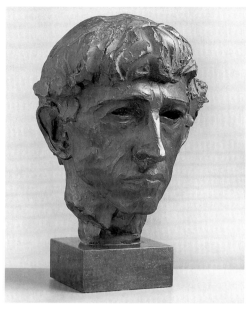

259

his own artistic vision—sculptures of the "ideal woman," a series of robust female figures inspired by his companion, Isabel Nagle. Although Lachaise considered the depiction of this ideal his raison d'être, his other sculptural achievements, most notably animals and insightful portrait busts of artists, intellectuals, and social figures, were also critically acclaimed.

Lachaise's portraits of the late 1920s, including this representation of the American artist John Marin, are among his most successful.[2] His style at this time alternated between a classical and an expressive approach in his search for "a likeness with the skin removed."[3] In his classically inspired portraits, Lachaise sought to amplify the sitter's physical and spiritual characteristics by simplifying, even eliminating, facial details.[4] In expressive works, such as the *Head of John Marin,* he favored modeling that was far more vigorous and tactile, reflecting his debt to the dynamic sculpture of Auguste Rodin, which had revolutionized French art in the late nineteenth century.[5]

Marin vividly remembered his first introduction to Lachaise in 1920: "I met Lachaise the other day—he seems to have a real big talent—He himself looks it and his work looks it."[6] Their friendship probably developed during visits to Maine, and the contact was further deepened through Alfred Stieglitz, who exhibited Lachaise's work in 1927. Marin probably sat for Lachaise later that year. In early 1928 Lachaise made one cast of the head in bronze and exhibited it at the Brummer Gallery, New York, and in

1930 the Weyhe Gallery of New York cast nine additional heads, one of which was purchased by Duncan Phillips later that year.

Lachaise did not use preliminary drawings; instead, he had numerous hour-long sittings.[7] His method was to capture a fairly realistic likeness at the first sitting, then systematically rework the portrait to achieve "a synthesis of the prevalent forces within the individual." He believed that "in this process, there is expansion for the creator."[8] He described *Head of John Marin* as "the face of a man who had suffered, sacrificed and triumphed."[9] The rough and energetic surface treatment of the bronze recalls the painter's style of slashing, thick brushstrokes.

Duncan Phillips's purchase of this head demonstrates his admiration for the sitter and perhaps also for Lachaise's ability to evoke the sitter's expressive style in the likeness. The only other sculptures by Lachaise that caught Phillips's interest were two animal figures—*Sea Lion,* 1917 (acc. no. 1105), and *Peacocks,* 1922 (acc. no. 1104)—which he purchased in 1922 during one of his frequent visits to Kraushaar Gallery in New York. Their rhythmic, undulating style and decorative qualities, reminiscent of Art Nouveau, derive from Lachaise's experiences in the studios of René Lalique and Paul Manship.[10] He stated: "On certain occasions I have made use of animals . . . to translate spiritual forces."[11] Lachaise did not, however, consider them to be among his finest achievements, as he did his female figures, and excluded them from his 1935 retrospective at the Museum of Modern Art.

LBW

CHARLES DEMUTH (1883–1935)

Charles Demuth, a versatile artist who received acclaim for his cubist-derived paintings of American cityscapes as well as his sensuous, richly colored watercolors of still lifes and figure groups, was born November 8, 1883, in Lancaster, Pennsylvania. He studied at the Drexel Institute of Art (1903–5) and the Pennsylvania Academy of Fine Arts (1905–10), both in Philadelphia. From 1907 to 1908 he visited Paris, viewing many of the current avant-garde styles; during his second trip there (1912–14), he took courses at the Académie Julian, Académie Moderne, and Académie Colarossi, painting watercolors of flowers and figure groups. During his last year in Paris, he met fellow American artist Marsden Hartley, who became a close friend and mentor. After his return to the United States, Demuth divided his time between Lancaster and New York and spent many summers in Provincetown, Massachusetts. In New York he became closely associated with Alfred Stieglitz's circle of American modernists. Charles Daniel became his dealer and gave him his first one-person show in 1914. In 1917 Demuth and Hartley spent time in Bermuda with the French cubist painter Albert Gleizes. The artist's precisionist style emerged soon thereafter in watercolor, tempera, and oil depictions of his architectural surroundings. After he was diagnosed with diabetes in 1921, Demuth spent an increasing amount of time in Lancaster, painting still-life watercolors, making poster-portraits of his artist contemporaries, and creating industrial landscapes of his hometown. Stieglitz began to exhibit his works regularly in 1925. Demuth died in Lancaster October 25, 1935. The Phillips Collection owns three watercolors by the artist: two cubist-derived works representing architectural themes and one still life.

260

260

Red Chimneys, 1918

Roofs and Chimneys; Housetops
Watercolor and graphite pencil on off-white paper,
10⅛ × 14 (25.6 × 35.6)
Signed and dated in graphite pencil, l.c.: *C Demuth/1918*
Acc. no. 0496 (Farnham no. 338)

Early history unknown; Montross Gallery, New York; purchased by PMG 1925.[1]

Red Chimneys is an early example of Demuth's work in the precisionist idiom, a style characterized by shallow space, hard edges, and a tendency toward abstraction. He had been influenced by the cubists while in Paris (1912–14), as well as by the abstract art of his friends Marsden Hartley and the Frenchman Albert Gleizes, with whom he painted in 1917. For this new approach, architecture offered Demuth an exceptional opportunity for cubist interpretation, and rooftop views of New England, Lancaster, and Bermuda became favorite subjects. Despite the abstract treatment of these images, Demuth seldom strayed far from naturalistic representation. His interest in depicting both realistic detail and two-dimensional planar relationships persisted throughout his career.[2]

Painted in Provincetown, *Red Chimneys* at first glance appears to be based on a specific view of chimneys and rooftops. Closer inspection reveals that Demuth rearranged elements to create a geometric pattern.[3] The outlines of the bricks and roof tiles form a grid that unifies and flattens the image despite its periodic punctuation with white triangles defining the gables. The elongated vertical lines along the edges of the central chimney anchor the strong horizontal and diagonal bands formed by the housetops. Radiating from the middle roof are five twisted, leafy tree limbs, the only curving elements in the composition; sketchy, penciled lines define the foliage. Color is used with discrimination; the bright red of the smokestacks and the subtly variegated wash of grays, rusts, and browns in the roofs are confined to the center of the image. The minimal color and systematic, spatial organization of *Red Chimneys* became even more pronounced in Demuth's later tempera and oil paintings.

Duncan Phillips included Demuth's work in his 1926 "Exhibition of Paintings by Nine American Artists," which was an effort to make Washington aware of current progressive trends in American art. The exhibition intrigued local critics. It included many American artists never before shown in the city who painted in a cubist-influenced style "based on systematized, arbitrary arrangement" of forms.[4] Phillips displayed two works by Demuth: *Red Chimneys* and another watercolor, *Monument, Bermuda,* 1917 (acc. no. 0495), an architectural subject that is further abstracted into a multifaceted, faintly colored cubist pattern.[5] In his catalogue essay, Phillips praised Demuth's "austerity of ruled line combined with an enchanting quality of color," and in his collection catalogue of the same year he commented on Demuth's "genius for design and a consummate taste and tact" throughout his oeuvre.[6]

GHL

261

261

Eggplant, ca. 1922–23

Still Life
Watercolor over graphite pencil underdrawing on off-
white paper, 12⅛ × 18⅛ (30.6 × 45.9)
Unsigned
Acc. no. 0494 (Farnham no. 499)

Transfer from artist to Daniel Gallery, New York, by 1924;
purchased by PMG 1924.[7]

Demuth often painted watercolor still lifes of
fruits, vegetables, and flowers from the farmers'
market in Lancaster.[8] These delicately colored
depictions of nature's bounty contrast with his
cubist-influenced architectural landscapes. While
retaining his fascination for linear design,
Demuth minimized his rational, two-dimensional
approach and emphasized the sensuous nature of
the objects he represented.

Eggplants were a favorite motif from 1922 to
1927. In contrast to Demuth's early, more
baroque still lifes, this *Eggplant,* painted around
1923, is a restrained image with subdued colors
and flattened planes.[9] Demuth's flowing pencil
line defines the curves and irregularities of the
eggplant, peach, and melon, while his blotting
technique evokes their textures and the light
reflecting off of their surfaces.[10] Set upon an
abstractly rendered tabletop, the foods cast over-
lapping shadows that heighten the complexity of
the image. Subtly tinted with the soft colors of
the fruits and vegetables, these shadows, along
with the table's edges, form an abstract pattern
around the still life. Vertical lines having no
basis in reality extend from the eggplant and
counter the strong diagonal of the table. With
these devices, Demuth retained in *Eggplant*
some of his instinct for design, despite the natu-
ralistic representation of the still-life elements.

The linear qualities and the pale, translucent
color and light of *Eggplant* reveal Demuth's
enduring admiration for Cézanne's watercol-
ors.[11] The fact that his colors are cooler than the
deep, warm tones of Cézanne's caused A. E. Gal-
latin to comment that Demuth's still lifes came
"from a country whose *vin du paye* [*sic*] is iced
water."[12] Duncan Phillips believed that
Demuth's "crafty elimination and wise selection,
with ruled lines and jewelled, blotted washes"
made his watercolors "original American contri-
butions of . . . enduring quality."[13]

GHL

CHARLES SHEELER (1883–1965)

A major figure in the precisionist movement, Charles Sheeler was born July 16, 1883, in Philadelphia. He studied art from 1900 to 1906, first at the Pennsylvania School of Industrial Art, then under William Merritt Chase at the Pennsylvania Academy of the Fine Arts. He had his first one-person show in 1908 at McClees Gallery, Philadelphia. In 1912 Sheeler turned to photography with an emphasis on architecture, eventually becoming acquainted with Alfred Stieglitz's circle. He continued to paint in the 1910s, moving toward precisionism, and exhibited in New York in that style in the early 1920s. In 1917 he met and became lifelong friends of the Walter C. Arensbergs, who introduced him to Duchamp and Picabia. Sheeler's move to New York in 1919 brought him closer to the modern art scene. He joined the Downtown Gallery in 1931 and continued to live and work in New York until his death May 7, 1965. Sheeler is represented in the Phillips Collection by one oil painting.

262

Skyscrapers, 1922

Offices (DP)

Oil on canvas, 20 × 13 (50.8 × 33.0)

Signed and dated l.r.: *Sheeler 1922*

Acc. no. 1736

The artist to Daniel Gallery, New York; PMG purchase 1926.[1]

Skyscrapers, which reflects the 1920s precisionist aesthetic, is one of Sheeler's most accomplished assimilations of European modernism into his own uniquely American style. Using sharply defined contours, nonatmospheric planes of color, and intense frontal light, Sheeler conveyed to the viewer a sense of the grandeur of monumental buildings grouped together.

Sheeler's personal artistic reevaluation occurred when, after studying under Chase, he and Morton Schamberg, his close friend and fellow artist, traveled to Italy and France in 1908–9.

Upon his return to Philadelphia, Sheeler discarded the Chase-inspired spontaneous, bravura brushstrokes he had been favoring and began employing a structure—the "steel frame which would support the bricks and mortar"—reminiscent of early Italian Renaissance masters such as Piero della Francesca and Giotto and of the French modernists, notably Cézanne, Braque, and Picasso. His intent was to establish order and permanence in his work. In addition, he began "to eliminate the evidence of painting . . . and to present a design giving the least evidence of the means of accomplishment."[2] In the following decade, before his move from Philadelphia to New York in 1919, these efforts were further reinforced by his frequent visits to New York and his participation in the Armory Show (1913), the Forum exhibition (1916), and the Society of Independent Artists exhibition (1917). Sheeler wrote in retrospect that the chief value of this period was the clarification, in which Duchamp played an important role, of his "understanding of essentials and the necessity of an underlying structure."[3]

Once in New York, Sheeler imposed these ideas on a subject that was rapidly becoming an American icon: the skyscraper. Like the Pennsylvania barn, a theme he had explored in 1917 and 1918, it too was "simple and suited to its purpose."[4] In essence the skyscraper was a "ready-made" subject for Sheeler's attempt to capture the streamlined grandeur of New York.[5] The geometry of the buildings lent itself ideally to the creation of abstract designs on canvas.

Sheeler's interest in skyscraper imagery was further heightened by his collaboration with Paul Strand on the 1920 film *Manhatta,* in which they "interpreted the spirit of modern New York photographically in terms of line and mass."[6] Sheeler found one view included in the film particularly interesting—the back of the Park Row building seen from the forty-one-story Equitable Building at 120 Broadway—and he subsequently took a series of photographs of this site.[7] One photograph in particular, *New York* (fig. 34), was the source for both a pencil drawing, *New York* (fig. 35), and *Skyscrapers.*[8] Working from a photographic image freed him to "select that which [I needed] . . . to attain an intensified presentation of its essentials, through greater compactness of its formal design by precision of vision and hand."[9]

Sheeler's gradual reduction and simplification of the scene is revealed by comparing the photograph with the drawing and both with the final work. By cropping the image in the photograph, he brought the subject closer to the picture plane. In the painting, Sheeler simplified the image even further by transcribing in planes of solid color those shapes that are crucial to the overall structure of the composition. The viewer's eye is directed by the diagonal recession of obtrusive gray shadows. Intended as a unifying compositional device rather than a disclosure of time of day, these raking shadows converge on the focal point of the painting, the cubic design in the lower center of the picture. The diagonal contours of the shadows break the sweep of the otherwise predominantly vertical composition.

The dealer, Charles Daniel, introduced Duncan Phillips to Sheeler's work in 1924, stating that no complete collection of American art should omit Marin, Hartley, or Sheeler.[10] Recognizing Sheeler's contribution to the expansion of American modernism, Phillips included *Skyscrapers* in his 1926 exhibition of young American painters, which was intended to "give the people of Washington an opportunity to see and to estimate the work of some of the more advanced painters of the younger school, the school of the so-called modernists."[11] Anticipating a negative and confused reaction from the public, Phillips wrote: "Art must either be content to remain in the museum, withdrawn from the highways of our active life, or it must be insinuated somehow into the new scheme of things. The artists, for our need, must therefore find elements of beauty in the new world."[12] In *Skyscrapers* Sheeler elicited beauty from the stark reality of New York office buildings and the utilitarian aspects of industrial America.

V S B

Fig. 34 Charles Sheeler, *New York,* 1920, gelatin silver photograph, 9¹¹⁄₁₆ × 7¾ in., Museum purchase, Museum of Fine Arts, Houston.

Fig. 35 Charles Sheeler, *New York,* 1920, pencil on ivory wove paper, 19⅞ × 13 in., Gift of Friends of American Art, 1922.5552. © 1988 Art Institute of Chicago. All rights reserved.

MILTON AVERY (1885–1965)

Milton Avery created landscapes, still lifes, and figure compositions that derived their expressive power from highly abstracted, flat shapes and vivid color. Avery was born in Sand Bank (now Altmar), New York, March 7, 1885, and in 1898 moved with his family to Wilson Station, Connecticut. From 1901 to 1911 he held many mechanical and construction jobs, and he became interested in art while taking a lettering course (some time between 1905 and 1911) at the Connecticut League of Art Students in Hartford. He continued classes there until 1918, when he entered Hartford's School of the Art Society. He moved to New York in 1925 and in 1926 married Sally Michel, a fellow artist. Avery attended evening classes at the Art Students League and in 1927 started exhibiting regularly in group shows. The following year he became friends with Mark Rothko, who in 1929 introduced him to Adolph Gottlieb and Barnett Newman. From 1935 to 1943 Avery was a member of the Valentine Gallery, New York; from 1943 to 1950, the Paul Rosenberg Gallery; and from 1951, the Grace Borgenicht Gallery. In 1952 Avery took his only trip to Europe, visiting London, Paris, and the French Riviera. He spent the summers of 1957–60 in Provincetown, Massachusetts, where he became a friend of Karl Knaths. Avery suffered a heart attack in 1960; he died in New York January 3, 1965. The Phillips Collection owns eleven oils, a gouache, a watercolor, and a drawing by Avery.

The Avery Unit

Duncan Phillips noted Milton Avery's artistic promise early in the painter's career, purchasing his first work by him in 1929; however, it was not until 1942 that he judged Avery to have reached his full potential. Phillips admired his art for its striking compositions, emphatic shapes, and sensitive, lyrical colors similar to those of Matisse and Picasso. Most of all, he appreciated Avery as an independent painter who retained his individuality in subject and technique and who stood at the threshold of a new art indigenous to America.

Although rooted in the American Scene tradition, Avery's work was too abstract to assign him a place in that group; and it was too representational to belong to the nonobjective movements of the 1940s and 1950s. Avery's colorful, simplified forms and explicit yet subtly toned contours defy classification. Yet the freshness and uncomplicated nature of his images linked him with other independent American modernists, such as Arthur Dove, John Marin, and Lee Gatch.

Although Phillips never met Avery, he was aware of him as early as 1928, when Avery had his first one-person show at the Frank Rehn Gallery in New York. It is not known whether Phillips visited this exhibition; however, he made note of seeing an Avery still life inspired by Matisse and Braque in the December 1928 issue of *Creative Art*. The accompanying article stated, "We would not be surprised if Milton Avery turned into something."[1]

Phillips grew to share this sentiment, for in 1929 he purchased from the Morton Galleries *Winter Riders*, 1929 (acc. no. 0045), the first museum acquisition for Avery. Painted in a subdued palette dominated by browns, *Winter Riders* represents the artist's early style of muted color, expressive brushstrokes, and flattened forms. Although Phillips expressed some reservations about Avery's chromatic approach, he admired his flair for daring composition: "Avery has an arresting and most distinguished vision for design and he simplifies with fine significance and emphasis. Unfortunately his colors seem to me in need of clarification. They are subtle but not altogether pleasant and they seem a little murky when compared with the fine colorists in my Collection." He nevertheless added, "I . . . will keep in touch with this artist in the future."[2] Phillips may have been intrigued by a reviewer's statement that Avery's art was "dark, brusque and reminiscent . . . of Daumier," one of the collector's favorite artists.[3]

Phillips's interest in Avery resurfaced in 1942, when he bought *Harbor at Night*, 1932 (acc. no. 0038), an aerial view of Gorton's Fishery in Gloucester, Massachusetts, painted in harmonious tones of blue and green. In his works of the 1930s and early 1940s, Avery's flattened motifs had become brighter in color and more varied in texture—matte areas detailed with gestural brushstrokes and incised lines. Believing that Avery showed a great deal of promise, Phillips gave him his first one-person museum exhibition in 1943, displaying works spanning the previous decade and surveying his full range of subjects—including the artist's favorite, his daughter, March, whom he depicted frequently from her birth in 1932. *Girl Writing*, 1941, one of the works in the 1943 exhibition, and the sketch *Girl Writing*, 1941 (acc. nos. 0036 and 1988.5.1), represent nine-year-old March busily working at a table in the family's New York apartment.[4]

Phillips's views on the artist were echoed by C. Law Watkins, the museum's associate director of education, in the exhibition's catalogue essay. Watkins expressed admiration for the artist's "color-shapes on a flat rectangle of canvas."[5] Although Avery had recently been labeled an "American Fauve," Watkins detected none of the shocking color contrasts associated with fauve painting: "The color relations and contrasts are not smashing in their intensity; they are more often sensitive and subtle. Gentleness and quiet humor give grace to the boldness of the simplification and the re-formation of the objects."[6]

Although Avery was gaining favorable recognition in New York art circles at the time, Washington critics barely took note of the 1943 exhibition; one of them commented that Avery's "whimsy [was] . . . getting a bit calculated," and another appraised his work as not "'popular' painting in any sense."[7] Despite such comments, Phillips remained supportive—"I do not want to lose this opportunity of giving recognition and encouragement to Avery and adding to his representation in the collection"—and purchased five works from the 1943 show.[8] His continuing interest in this period is demonstrated by his purchase in 1956 of the oil *Trees*, 1936 (acc. no. 0044).

Phillips continued to admire Avery even as his style became increasingly abstract during the 1950s, earning him high praise from most critics. By 1965 Phillips had acquired three late works, the subdued 1954 gouache *Morning Landscape* (acc. no. 0040), the vividly colored *March on the Balcony*, 1952 (cat. no. 264), and the boldly simplified *Black Sea*, 1959 (cat. no. 265), thereby rounding out the unit as a survey of the high points of Avery's career.

GHL

263

Pine Cones, 1940

Oil on canvas, 28 × 36 (71.1 × 91.4)
Signed in black paint, l.l.: *Milton Avery*
Acc. no. 0041

Valentine Gallery, New York; purchased 1943 (from PMG exhibition).[9]

This still life was inspired by pine cones that the Averys had brought home as mementos of their 1940 summer spent in Rawsonville, Vermont. This was a transitional period for Avery, who was experimenting with perspective and scale and using a wide range of colors and textures.

The table and wood flooring in *Pine Cones* are depicted in dramatic, distorted perspective, which pushes them toward the picture plane and produces an airless, claustrophobic effect. At the same time the placement of the table pulls the composition to the left, but this movement is stabilized by the horizontal orientation and rightward extension of the oversized bowl that holds the pine cones. The naturalistic,

263

three-dimensional treatment of the bowl and cones contrasts significantly with the flatness of the table, wall, and floor; as a result the background becomes a foil to the central still-life element, which appears to be floating in its own space.

Avery added visual interest to the painting's surface by incising the outlines of the floorboards and using thick strokes of brown, rust, and green paint to highlight the ridges of the pine cones. He orchestrated the colors within a narrow range of autumnal hues, revealing his command of subtle color relationships.

Pine Cones is one of the works that Duncan Phillips purchased from his 1943 Avery exhibition. To Phillips, such paintings reflected the artist's increased confidence and exceptional talent, as well as his mastery of color and composition. Indeed, this work foreshadows the complex, vibrant paintings of Avery's mature oeuvre.

GHL

264

March on the Balcony, 1952

March at Saint-Tropez; March on Balcony
Oil on canvas, 44 × 34 (111.8 × 86.4)
Signed and dated l.l. (incised): *Milton Avery/1952;*
inscribed on canvas reverse in red crayon, u.c.: MARCH ON
BALCONY/by/*Milton Avery 1952/44 × 34*
Acc. no. 0039

The artist; TPC purchase 1961 (from exhibition) through Galerie Internationale, Washington, D.C.[10]

March on the Balcony portrays Avery's daughter (at age twenty) reading on a balcony at St. Tropez, which the Averys visited on their trip to Europe in 1952.[11] The scene was sketched in France and painted after Avery's return to New York. It represents Avery's mature style, in which the elements of the composition are depicted as flat, matte color-shapes; linear detail is minimized and brushstrokes deemphasized in order to focus on the effect of pure color.

The sun-drenched, vibrant hues of the French Riviera and the theme of the open window revealing space beyond an intimate interior had been painted earlier by French artists such as Matisse and Bonnard.[12] In Avery's version, the shutters and intricate balcony frame three sides of the scene, enclosing March in a tight foreground space, while the open window displays a flattened, stylized vista of the sea. The figure serves less as a representational element than a compositional one. Therefore, the accurate recording of her features was not essential; spare, incised lines alone define her eyes and mouth.

March on the Balcony is especially arresting for its Matisse-like contrasts of color: free and arbitrary in the depiction of March's face as dark red; her hair, which Avery usually painted brown, as bright yellow; the balcony as green; and the shutters as purple and blue. The dark, intense colors suggest shade and emphasize the cool interior, while the bleached, subtle tones of the sea and landscape beyond evoke airiness and sunshine.

HL

264

265

Black Sea, 1959

Oil on canvas, 50 × 67¼ (127.0 × 172.2)
Signed and dated in graphite l.l.: *Milton Avery 1959;*
inscribed on canvas reverse in blue paint, u.r.: *"BLACK*
SEA"/by/Milton Avery/50 × 58/1959
Acc. no. 0035

Estate of the artist; TPC purchase 1965 (from exhibition)
through Richard Gray Gallery, Chicago.[13]

Avery started experimenting with large-scale
canvases in 1957. The increase in scale gave his
simplified color masses overwhelming impact.
This new development, apparent in *Black Sea,*
was applauded by Clement Greenberg, who
stated that the change indicated "a new and
more magnificent flowering of [Avery's] art."[14]

Black Sea, a depiction of an ebbing wave at
the Provincetown beach, represents Avery at his
most abstract.[15] Over the years he had painted
numerous scenes, many containing figures, of
New England beaches; in the late 1950s, however,
he began to reduce detail and emphasize formal
aspects to such a degree that the elements
became ambiguous, appearing on the one hand
nonobjective and on the other starkly represen-
tational. The total lack of descriptive detail in
Black Sea places it out of context and renders it
an almost iconic representation of surf. The bold
contrast of the black wave with the huge expanse
of flesh-colored sand creates one of Avery's most
striking and monumental paintings.

GHL

265

JOHN D. GRAHAM (1887–1961)

John Graham was a figure of seminal influence in the early years of American modernism, both as an artist and as a connoisseur. Born Ivan Gratianovitch Dombrowski, January 8, 1887, in Kiev, Graham fought in the Russian Revolution on the side of the czar and fled to the United States in 1920. Once in New York, he carefully hid behind a kaleidoscope of fact and myth. In 1923 Graham was enrolled at the Art Students League, working briefly as an assistant to John Sloan, and in 1925 he participated in the "Tenth Whitney Annual Exhibition." That year he moved to Baltimore with the painter Elinor Gibson, the first of his two American wives. (Before moving to the United States, he had been married twice in Russia.) In Baltimore he established contact with Duncan Phillips, who gave him his first one-person museum exhibition in 1929. Soon Graham was living and working in both New York and Paris, becoming a catalyst in the transmittal of European modernism to America. Stuart Davis, Dorothy Dehner, Arshile Gorky, Adolph Gottlieb, and David Smith were his friends, as were Katherine S. Dreier, Willem de Kooning, and Jackson Pollock in later years. Graham's book *System and Dialectics of Art* (1937) is often credited with having influenced the development of abstract expressionism. Late in life, financially secure but isolated from the art world because of his highly personal style, Graham retreated into meditation and yoga while carrying on intense correspondence with devoted women friends, Andy Warhol's movie star Ultra Violet and the artist Françoise Gilot among them. Graham died in London June 27, 1961. The Phillips Collection provides a survey of Graham's early works: twenty-eight oils, one gouache, one lithograph, and six drawings, two of them from the last decade of his life.

The Graham Group

Throughout his adult life, John Graham retained the air of the Russian émigré officer of noble descent.[1] His bearing, his classical education, and his passionate commitment to art— Duncan Phillips called it his "ambition for martyrdom"—gave him an aura of Old World romance and mystery.

It is not known how, and when, the dashing artist and the patrician patron first met, but in the earliest known letter of January 19, 1927, Phillips refers to Graham's recent visit. The majority of works were acquired during the late 1920s and early 1930s, except for the purchase of six paintings in 1933, when the Depression had caused Graham to suffer severe setbacks.[2] Phillips bought *Blue Still Life* (cat. no. 271) in 1942. The group was enriched by two late drawings, given by the artist in 1955, and several recent gifts.[3]

The correspondence between Phillips and Graham is of particular importance because it suggests that the change in Graham's style in the 1940s, while it appeared to be sudden and "radical," was actually the result of ideas nurtured for many years.[4] As early as 1927 Graham sent Phillips a two-page manuscript, "Few Disconnected Thoughts on Painting," which uses the dialectic format and includes several points published in *System and Dialectics of Art*. Graham's ideas presage the abstract expressionists' concern for the process of painting and its expressive qualities; it also introduces two of his growing preoccupations: a mystical, meditative involvement with his subject and a highly refined line. "Painting is essentially an abstract process," he wrote. "Great works of art stir one . . . not by literary means, but by velocity of brush, intensity of drawing, precision of form, vibration of surfaces."[5]

While in the early years of their friendship Phillips did not shy away from suggesting that Graham revise paintings, he became a steadfast supporter, giving him a one-person exhibition in 1929 and defending him against Lloyd Goodrich's negative review of his New York exhibition.[6] In turn, Graham acted as Phillips's agent and presented him with a subscription to *Cahiers d'art* and in 1929 with Jean Cocteau's book on de Chirico.[7] Phillips responded with continued support and instances of rare candor, even confiding his own desire for artistic expression in 1933: "I thank you for the far too complimentary references to my own work. I have a passion no doubt not only for art but for humanity and for the expression of varied personalities. I wish I could do more in creative way[s] myself for I feel very strongly the creative impulse."[8]

In his struggle for a personal style, Graham saw Picasso as both a challenge and a threat, emulating him during the 1920s, attacking him by the mid-1940s. In 1928 Graham bragged that Picasso had visited his Paris studio and in 1931 described him as "by far the greatest painter of our generation . . . all painting after Picasso is *after* Picasso."[9] In about 1946, however, neglected by galleries and alienated from most of his friends, Graham wrote a stinging rejection of Picasso, calling his work a hoax and "a great international money-making intrigue."[10]

In 1934, poor, divorced, and living in self-imposed isolation in a Russian monastery in New York, Graham experienced a crisis: his application for work under the WPA required a more conservative style than he preferred, and he also feared that his modernist efforts had not succeeded. He wrote to Phillips: "I see now that you were right when you advised me to paint in accordance to my gift [and] not to strain towards something that is not my nature . . . to follow the legitimate course of development and if it eventually would lead to abstraction it will do gradually, legitimately."[11] In 1935, in one of his last acts on behalf of Graham—a recommendation for a fellowship—Phillips expressed the belief that his true art was yet to emerge. A Guggenheim grant, he wrote, "would enable him to pursue his historical research into ancient and exotic sources and to paint under their influence would bring him finally to consummation."[12] This letter foreshadows Graham's mature style, as expressed by the figure compositions reminiscent of the Italian Renaissance and of Ingres. These works would fly in the face of both academic and modernist currents. For reasons unknown, Phillips gradually lost interest in Graham's art, and the correspondence all but ceased for almost twenty years.

With a loan request in 1954, Graham resumed his correspondence; the following year, he sent two drawings as gifts and explained his new work. Phillips reacted cordially: "I often think of you and wonder what you are doing. . . . These drawings give a splendid idea of your present direction, a merging of Leonardo and Ingres with modern geometrical experimentation."[13]

As early as 1932, Phillips had anticipated Graham's importance when he wrote that "painters like . . . Graham bring to us alien points of view and exotic manners of expression, but they, too, make up part of the New America."[14] In his broad acceptance, Phillips confirmed the belief of his early years of collecting that an American renaissance would grow out of diversity: "Not only does America inherit the arts of all nations and of all ages, but rich should be the harvesting and exquisite the flowering."[15]

EDP

266

Blue Bay, 1927

Oil on canvas, 8⅝ × 15⅞ (21.9 × 40.3)

Unsigned

Acc. no. 0812

Commissioned by Duncan Phillips; PMG purchase 1927.[16]

267

The Lonely Road, 1928

Parc Montsouris

Oil on canvas, 21¼ × 15 (55.2 × 38.1)

Signed and dated l.l.: *Graham 728;* inscribed in red chalk,
u.c.: GRAHAM; and in oil, l.c.: *21;* reverse (on strainer top):
Graham 450/(Road thru the/Forest) The Lonely Road

Acc. no. 0822

PMG purchase from the artist 1929.[17]

268

Palermo, 1928

Landscape and Houses

Oil on canvas, 15¾ × 19¾ (40.0 × 50.1)

Signed and dated in oil, l.l.: *Graham/928*

Acc. no. 0826

PMG purchase from the artist 1928.[18]

266

267

Graham's early landscapes were especially
favored by Duncan Phillips.[19] They recall the
classically inspired modernism of postwar Paris,
especially Derain's, and reflect Graham's study
of Cézanne. *The Lonely Road* shows these influ-
ences, and *Palermo* confirms Graham's growing
artistic command.

Blue Bay, on the other hand, was a commis-
sion from Phillips. In January 1927 he asked about
Graham's progress on the painting, which was
based on the view through the window shown in
Blue Bay and Interior, 1926 (acc. no. 0813). Dis-
pleased with Graham's first effort, Phillips gave
instructions that suggest he wished to pick up the
brush himself: "It should be lighter in
color . . . under the dark blue there should be a
passage scumble of yellow-green, just a hint of
this tone worked into the blue at the horizon's
edge."[20] The final work is significant for its matte,
almost transparent paint and its abstract forms,
which undulate into the distance and yet read as
flat patterns on the picture plane. The composi-
tion has a certain similarity to paintings by Dove
and Kent that Phillips had recently acquired and

may have shown to Graham.[21] Phillips must have
been pleased, for he included *Blue Bay* in an
"experiment station" exhibition he was organiz-
ing for the Baltimore Museum of Art.[22]

The Lonely Road is the only early landscape
that held its attraction for Phillips, and he
included it in the 1952 collection catalogue. It

was created in Paris at the height of Graham's
enthusiasm for Cézanne and Derain.[23] In con-
trast to similar paintings by those two artists,
Graham's work shows the scene at closer range,
resulting in a somewhat stiff composition that is
less compact and focused than Cézanne's, but
endowed with more power than Derain's.

268

Phillips, who venerated Derain, purchased several of Graham's street and park scenes, although he also asked for landscapes that were "more original and less School of Derain."[24]

Palermo, which resembles a stage set, depicts a view of the Mediterranean as seen between two rows of houses. A lantern and a huge overhanging tree limb partially obscure the view of the water. The painting gains a sense of monumentality from the massiveness of the walls, which are punctuated by tiny dark windows and doors. It is a silent, static scene that hovers somewhere between landscape and abstraction. After a trip to Italy, Graham informed Phillips that he had "always wanted to paint Italian landscape. . . . In my imagination it blends in soft colors and cubical forms. But reality—was disappointing."[25] Nevertheless, this work was an early success and was reproduced both in Waldemar George's monograph and on the cover of the catalogue for Graham's one-person show at the Phillips Memorial Gallery. Phillips wrote to Graham: "I find in [*Palermo*] all the strength of the modern movement combined with a richness and subtlety of tone and poetry of light. These last elements are too often overlooked by the Moderns in their search for form and formal relations."[26]

EDP

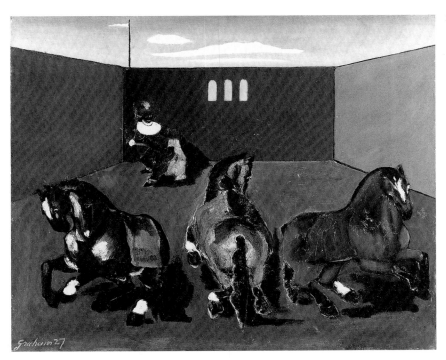

269

269

Mysteria 2, 1927

Heavy Horses; Harlequin and Heavy Horses

Oil on canvas, 18⅛ × 22 (46.0 × 55.8)

Signed and dated in oil, l.l.: *Graham 27;* inscribed on reverse, probably by the artist (now covered by aluminum backing): *Graham/Mysteria 2.*

Acc. no. 0825

Acquired from the artist 1927.[27]

270

Portrait of Elinor Gibson, 1930

Portrait d'Elinor Gibson

Oil on canvas, 28⅛ × 22 (71.4 × 55.8)

Signature and date incised u.r.: *Graham/930;* inscribed in blue paint across canvas reverse: PORTRAI[T]/d'Elinor/Gibson, over earlier inscription in black: *Graham.*

Acc. no. 0829

PMG purchase from the artist 1930.[28]

Enigma was a favored concept of the surrealists, who saw it as the poetic evocation of the mystery of reality and time; it was also the foundation of Giorgio de Chirico's "metaphysical" paintings, whose dreamlike ambiguity and heightened perspective are reflected in three of Graham's paintings, *Mysteria 2* among them.[29]

While he was generally ambivalent about surrealism, calling it a "literary art movement that spread to painting . . . troubling but frail," Graham cherished the evocative quality of enigma, terming it "only a symbol of deity and deity is only a symbol of continuity or life eternal."[30]

In *Mysteria 2,* an unabashed homage to de Chirico, a harlequin is commanding three massive horses into a dressage pattern on a tightly constricted stage set, complete with flagpole, pennant, and luminous sky. The triad motif is repeated in the walls, the arched windows, and the clouds, giving the image a frozen and slightly disturbing symmetry. Graham, who had been a cavalry officer in Russia, collected photographs of equestrian statues and incorporated horses in many of his compositions.[31] Clearly, the horse had personal significance for him beyond being the ancient symbol of physical power and the attribute of rulers.

In his catalogue for the 1929 one-person show, Duncan Phillips called Graham's dependence on de Chirico a passing fancy but also made one of the first written references to the artist's interest in analytical psychology: "The incongruous and madly fantastic vision delights him. . . . It makes him aware of a subconscious life which he venerates as a mysterious essence of reality."[32]

Elinor Gibson, Graham's third wife and a painter in her own right, may have had the most stabilizing influence on his chaotic life and temperament.[33] In 1923, shortly after meeting Gibson, Graham published a poem addressed to her:

> I miss
> you Miss
> Slim
> Queen
> Semiramis. Wild in despair
> I wish toss myself to your eyes
> From the distance of a HUNDRED
> AND EIGHTY EIGHT miles.[34]

Portrait of Elinor Gibson dates from the latter years of their marriage, which lasted from 1924 to 1934. In March 1930, Phillips wrote to Graham that he would keep the "portrait of your wife which seems to me the best you have done of her."[35] However, the painting is dated September 1930, when Graham was living in Paris. It is possible that he had taken it with him in order to rework it after Phillips's purchase. Indeed, traces of an earlier composition appear underneath the finished work.

The strong light falling across the face creates a sharply delineated half-mask, almost an abstract shape. While painterly and representational, the portrait hints at Picasso's compositions of the 1920s in which figural representation is interwoven with shapes and lines that overlap, creating complex studies of figure-ground relationships.[36] It is also reminiscent of Arshile Gorky's figure compositions of the early 1930s.

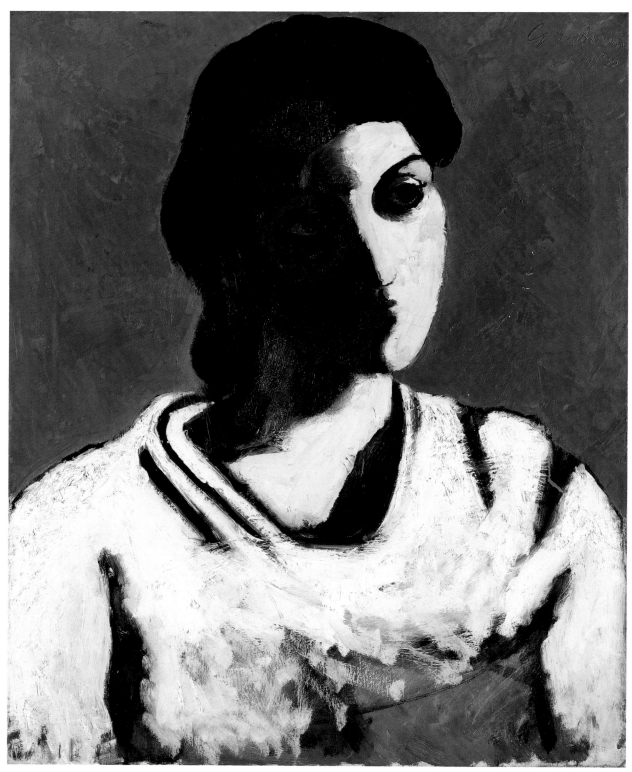

270

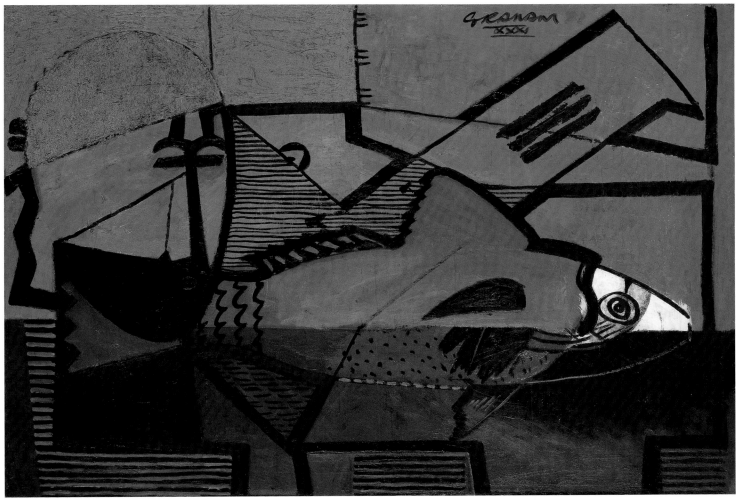

271

The close working relationship between Graham and Gorky is suggested by a 1931 letter from Graham to Phillips: "I have not been painting very much—whatever I paint now is only figures. Stuart Davis, Gorky and myself have formed a group and something original purely American is coming out from under our brushes."[37] The lyrical, melancholy tone expressed in *Portrait of Elinor Gibson* is unusual in Graham's often detached and theoretical work and conveys the sitter's gentle dignity as well as the painter's deep affection for her.

EDP

271

Blue Still Life, 1931

Blue Abstraction

Oil on canvas, 25⅝ × 36⅛ (65.1 × 91.7)

Signed and dated in oil, u.r.: GRAHAM/XXXI; inscribed on reverse: GRAHAM BLUE STILL-LIFE/XXXI/1931; [WOMAN/READI/WITH A/BOOK, crossed out].

Acc. no. 0811

The artist to Boyer Galleries, New York, by 1939; Richard Pousette-Dart, New York, by 1942; PMG purchase (through Graham) 1942.[38]

In 1929 Duncan Phillips wrote about Graham's search for an abstract style: "What appeals to Graham in Post-Cubist inventions is a ferment of ideas with a mystical undercurrent, a vague desire for a plastic art of dynamic universal appeal and therefore abstract as music is abstract and impersonal like mathematics."[39] These concerns found mature expression in *Blue Still Life,* justly considered one of Graham's most important works of the period. He knew he had arrived at a balance between compositional experimentation and enigmatic symbolism when he described the painting to Phillips as a "composition of form and design independent of composition of objects; composition of color independent of the two previous ones and composition of substance or mattiere independent of the three preceding. . . . My large blue painting has an interesting attitude—(perverse,

perhaps, but everything great has a tinge of [that] . . .) the heavy line does not follow the object all the way but leaves it barely started and turns backward each time just to make its own composition."[40] Phillips rejected it, writing on March 14, 1931: "I don't see how I could possibly use it. . . . Our collection is not quite so radical as that, not even my experiment station." The painting's colors, two horizontal bands of blue and dark gray, are indeed independent of subject or form, and dark lines serve at times to outline objects or to divide the surface into geometric planes. Placed on a table are a sculpture of a human head and a large fish, possibly a belated nod to de Chirico's painting *The Fatal Temple,* which has similar subjects.[41] The fish's head, painted a stark white, is the powerful focal point of the composition; otherwise, its form is simplified, lacking all definition in the dorsal fin (though faint lines are visible in the impastoed areas).[42] The sculpture resembles an African head that appears in a photo showing Graham in his studio.[43]

Around 1930, led perhaps by Stuart Davis—who had painted his remarkable *Egg Beater* series the winter of 1928–29 (cat. no. 282)—Graham, Gorky, and Davis began painting still lifes that explored the use of dark outlines, angular shapes, and flat surfaces. They were emulating Picasso, whose works they had seen in *Cahiers d'art*.[44] In spite of its obvious search for abstraction, however, *Blue Still Life* is more representational than similar efforts by Gorky or Davis. In his letter to Phillips, Graham deflected any comparison with Picasso: "While Picasso's painting is analytical mine is synthetic; while his, from emotional manipulations slides into an intellectual statement, mine starts-out with an intellectual concept and accumulates emotional values on the way to its realization."[45]

Many years later, in 1942, Phillips saw the painting at the Golden Gate Exposition and asked to add it to a loan show of American paintings, "a very personal selection."[46] Graham answered that it was now owned by a young artist, Richard Pousette-Dart, and he arranged for Phillips's purchase of the painting. In a letter Graham wrote that Pousette-Dart "calls it a Feat of God a sort of Hermetic arcana Selestia [*sic*]."[47] While "Hermetic arcana" alludes perhaps to the fact that Graham based this painting's diagonals, proportions, and spatial divisions on the Golden Section (considered a divine proportion in mystic circles), it points generally to his increasing fascination with occult mysticism, Christian symbolism, and neo-Platonic thought—ideas that were later to absorb him to the point of obsession.[48]

EDP

272

Aurea Mediocritas, 1954

Blue and red ballpoint pen, heightened with white pastel and red pencil on vellum placed over gray paper, 16¾ × 13¾ (42.7 × 35.0)
Signed, dated, and titled, l.l.: *STELLAPOLARIS/IOANNUS MSD/LIV/AUREA MEDIOCRITAS*
Gift of the artist, 1955.
Acc. no. 0808

The artist to Duncan and Marjorie Phillips as a gift to the museum, 1955.[49]

Late in life, Graham described his artistic pantheon: "I would say that for painting, Raphael is the greatest . . . for composition, Paolo Uccello. For metaphysics, it's Leonardo . . . for pure power, Cimabue."[50] These preferences are reflected in *Aurea Mediocritas* (which means Golden Section) and *Quibeneamat Benecastigat* (acc. no. 0830), drawings that belong to two separate series derived from revered photographs. Obsessively refined through many stages of stencil transfers and tracings, they reveal Gra-

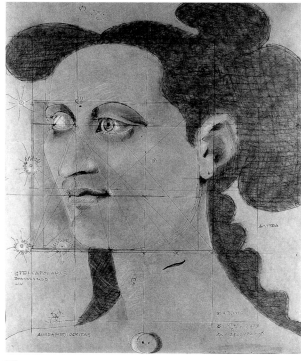

272

ham's enthusiasm for Ingres's elegant line, sinuous edges, and delicate shading.[51] Both images are drawn with a delicate touch, and much of their meaning and visual complexity derives from inscriptions that were added as though they were incantations or secret messages.[52]

The drawings show wall-eyed women whose wounds and transported stares recall idols or even objects of sadistic ritual. The earlier work is stark and cerebral, the later alluring and dangerous. Responding to a friendly inquiry by Phillips, Graham explained: "I gave up abstract painting for it being limited and superficial. . . . So called 'modern art' is inspired by the primitive art, consequently not civilized, hence no art at all. . . . Aurea mediocritas, the golden section, is the aim of civilization. . . . I like Raffael [*sic*] . . . because he plans above good and evil, way up in the frozen zone, in cruel indifference."[53]

The serial nature and photographic origin of Graham's late art have been studied in detail.[54] The three-quarter view and fanciful hair of *Aurea Mediocritas* may have their source in a photograph of a young woman inscribed "Ebreni, my first bride."[55] The head in the drawing is locked into space by a pencil grid reminiscent of the studies of Ingres or Leonardo. However, this grid, which deliberately asserts the

two-dimensional surface of the drawing, may also allude to Mondrian and thus address the issue of pictorial space as it was being discussed by artists of the mid-1940s. Rosalind Krauss described Mondrian's use of the grid as a "transfer in which nothing changes place. The physical qualities of the surface . . . are mapped onto the aesthetic dimensions of the same surface."[56]

When he gave these drawings to the Phillipses, Graham felt the need to explain *Aurea Mediocritas:* "The squares and triangles, in the face, are aimed at solving the problem of the Golden Section or Aurea Mediocritas. . . . There are records of three attempts: Vitruvius—the human body squared and encircled; Leonardo—the squaring of the profile; Ingres—full face and hands in a rare drawing of which I have a photograph."[57]

In his last known letter to Phillips, Graham wrote that "there is no true knowledge without Divine Grace," and he invited Phillips to see his work at the Stable Gallery in New York, "mostly dangerous women, cross- or wall-eyed, bleeding from many wounds . . . (blood has great esoteric meaning in ceremonial magie [*sic*]) . . . also horses, apocalyptic, like Don Giovanni of Mozart, based on gnostic wisdom of early philosophers."[58]

EDP

Georgia Totto O'Keeffe, a member of Alfred Stieglitz's circle of American modernists, was born November 15, 1887, in Sun Prairie, Wisconsin. O'Keeffe moved east with her family, where she graduated from the Chatham Episcopal Institute, Virginia, in 1905. That fall, at the age of seventeen, she entered the School of the Art Institute of Chicago, but because of illness she did not return the following year. In 1907 she moved to New York to study for one year at the Art Students League, then returned to Chicago in 1908, where she worked until 1910 as a free-lance commercial artist with two fashion houses. After teaching briefly, she spent the summer of 1912 at the University of Virginia, studying under Alon Bement, who taught principles of composition and introduced her to the theories of Arthur Wesley Dow. After two years of teaching in Amarillo, Texas, she entered Teachers College at Columbia University in New York City, to study directly under Dow for a year. In January 1916, while teaching at Columbia College, South Carolina, a friend, Anita Pollitzer, brought her charcoal drawings to the attention of the photographer and impresario Alfred Stieglitz, who exhibited them in the late spring in New York at Gallery 291. That same year she accepted a teaching position at West Texas State Normal College in Canyon. By June 1918 she had joined Stieglitz in New York; they married in 1924. As they divided their time between New York City and Lake George in upstate New York, Stieglitz's summer retreat, the couple experienced a period of intense creativity, producing some of their greatest works. In 1929 O'Keeffe began to travel to the American Southwest, and she eventually established a home in New Mexico. In 1934 the Metropolitan Museum of Art purchased its first O'Keeffe painting, and many exhibitions and honorary degrees from colleges and universities soon followed. In 1940 she purchased a house in New Mexico at Ghost Ranch. Several retrospectives were held, including one at the Art Institute of Chicago in 1943 and another in 1946 at the Museum of Modern Art, New York. After Stieglitz's death in 1946, O'Keeffe moved permanently to New Mexico. In 1973 she met Juan Hamilton, who became her companion. O'Keeffe painted and traveled extensively until her death in Santa Fe March 6, 1986. The Phillips Collection owns six paintings by the artist.

273

My Shanty, Lake George, 1922

The Shanty; My Shanty

Oil on canvas, 20 × 27⅛ (50.9 × 68.8)

Unsigned

Acc. no. 1448

PMG purchase from the artist (from PMG exhibition) through Stieglitz at the Intimate Gallery, New York, 1926.[1]

My Shanty is similar to O'Keeffe's other Lake George landscapes of the early to mid-1920s in its vocabulary of simplified forms, precise edges, and repeated horizontals.[2] The farm building, which served as the artist's studio, is solid and clearly defined, painted with what one contemporary critic described as "a clean dagger that pierces neatly."[3] O'Keeffe's precision-like depiction of the shanty is confounded by the diffuse rendering of pink and orange wildflowers and verdant trees and grass, as well as the curving sweep of the blue-toned hills and clouds overhead. Although it is a seemingly literal depiction of the building, this painting forbids classification as simply representational or precisionist. It illustrates O'Keeffe's tendency to overlay objective fact with spiritual and symbolic meanings.

Sarah Whitaker Peters compares *My Shanty* to Stieglitz's photograph of his family farmhouse, *Music: A Sequence of Ten Cloud Photographs, No. I,* 1922.[4] Both works reflect "instance[s] when these artists made objective fact coincide with their secret spiritual intentions."[5] In both, it is the end of the building's gable roof that is visible, thus emphasizing the triangular aspect of the structure.[6] She asserts that this compositional choice derived in part from the theories of Kandinsky, who identified the triangle as a symbol of the soul.[7]

Another comparison, that of *My Shanty* to Stieglitz's portrait of his darkroom in *Little House,* ca. 1933, is also illuminating.[8] Both are symbolic portraits of their creators, and, as such, each image reflects O'Keeffe's and Stieglitz's temperament as well as artistic intent. By including in the print's composition his own shadow in the act of photographing his studio, Stieglitz makes a direct reference to his artistic self while also providing an homage to the photographic process.[9] O'Keeffe, on the other hand, presents herself obliquely, alluding to her intended meanings with her characteristic emphasis on a deeper, almost occult level of understanding, "a beyond which is within."[10] The open doors to the structure make the viewer aware of the interior even as they deny access, and the white window frame and muntin become the focal point. The only area of intense brightness, the hovering window functions in symbolist fashion as an eye to her soul, which is both revealed and obscured.[11] Underscoring this interpretation is the importance of white to both O'Keeffe and Stieglitz. They shared a symbolist understanding of white and frequently invoked it—O'Keeffe in her painting and Stieglitz in his writing and photography—to refer to ideas, events, and people.[12] As Stieglitz expressed in a 1923 letter, "Georgia is a wonder. . . . If there ever is a whiteness she is that."[13]

The acquisition of her own studio was important to O'Keeffe, whose need for privacy was constantly challenged by the lively but demanding Stieglitz family, who congregated at Lake George every summer. In 1920 she recruited help to reconstruct the building, and of this venture Stieglitz wrote: "There was an old shanty on the place.—It has been going to pieces—was half dismantled. . . . Georgia has always had her eye on it." He added, "Within a few days, with virtually no outlay—doors and hinges salvaged from—or in old barns, old windows fished out of old woodpiles etc. etc., Georgia had her dream in concrete form—."[14] O'Keeffe herself described it years later: "You got to the farmhouse by walking through the grounds of the big house and then up a steep hill. Beyond that, going on for about five minutes, you got to the shanty—an old building where I worked summers." She recalled, "My hands were photographed . . . by the shanty window."[15]

My Shanty was one of three O'Keeffe works that Duncan Phillips had in his collection in 1926.[16] He was drawn to its "atmosphere of portentous solitude" and "stark expression of a sombre Celtic mood," a characterization that O'Keeffe later discounted.[17] As she recalled, she had painted *My Shanty* in response to the criticism of the men in Stieglitz's circle—Dove, Marin, Demuth, Hartley, and the photographer Paul Strand. "The clean, clear colors [of the shanty] were in my head, but one day as I looked at the brown burned wood of the Shanty I thought, 'I can paint one of those dismal-colored paintings like the men,'" recalled O'Keeffe. "I think just for fun I will try—all low-toned and dreary with the tree beside the door." She went on to say, "In my next show 'The Shanty' went up," adding in an ironic tone, "The men seemed to approve of it. They seemed to think that maybe I was beginning to paint."[18]

LBW

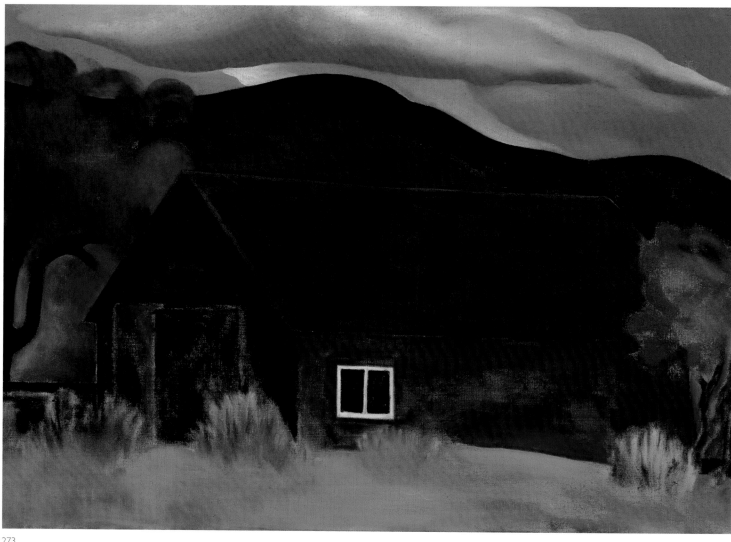

273

274

Pattern of Leaves, 1923

*Leaves; Leaf Motif; Leaf Motif No. I; Oak Leaf; Oak Leaves;
Autumn Leaf, Oak*

Oil on canvas, 22⅛ × 18⅛ (56.2 × 46.0)

Unsigned

Acc. no. 1447

PMG purchase from the artist through Stieglitz at the
Intimate Gallery, New York, 1926.[19]

Falling within the early period of O'Keeffe's
explorations with enlargement, both *Pattern of
Leaves* and *Large Dark Red Leaves on White,* 1925
(acc. no 1446), depict fragments of nature
magnified and cropped until they fill the con-

fines of the canvas. The result of O'Keeffe's dis-
passionate observation, the subjects are at once
coolly distant and psychologically intense.

As a significant, early statement in her
emerging style, *Pattern of Leaves* reflects the crux
of O'Keeffe's art: the fusion of objectivity and
abstraction as a means of expressing her inner
emotions.[20] "It is surprising to me to see how
many people separate the objective from the
abstract," stated O'Keeffe. "Objective painting is
not good painting unless it is good in the
abstract sense. A hill or tree cannot make a good
painting just because it is a hill or a tree. It is
lines and colors put together so that they say
something. For me that is the very basis of
painting. The abstraction is often the most

definite form for the intangible thing in myself
that I can only clarify in paint."[21]

The central maple leaf in *Pattern of Leaves* is
positioned diagonally across other layered
leaves, their silvery gray, white, and light green
hues creating an ambiguous space. The red of
the leaf is offset by the pale background; how-
ever, a glimpse of yellow through a tear in the
leaf pierces the carefully detailed surface. Partic-
ularly poignant is the jagged rip against the
grain of growth. O'Keeffe often used fissures and
tears in her leaf and flower compositions, both
as an effective formal device and as veiled refer-
ences to events in her life or her state of mind.[22]

The sources of this characteristic style are
diverse, although they are most closely linked to

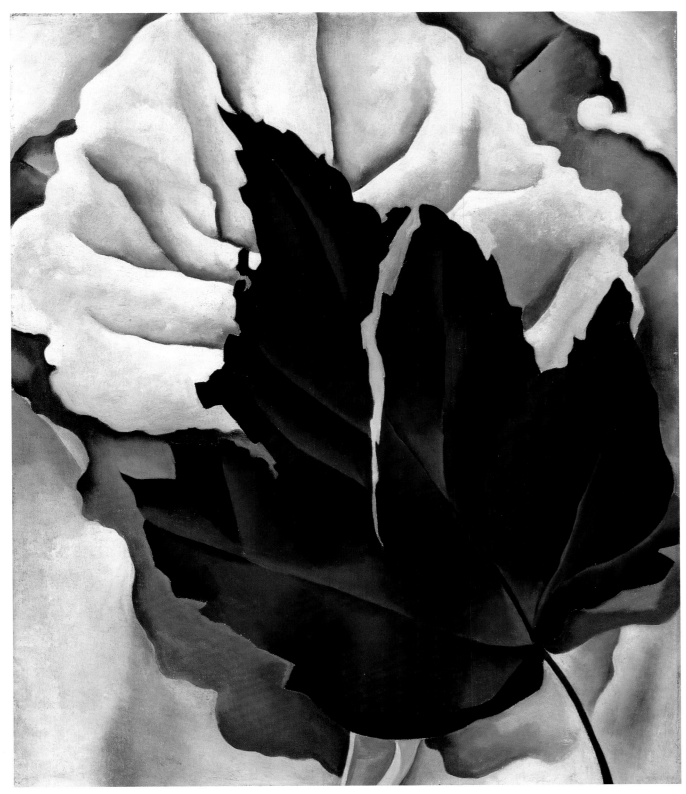

her training in the Fenollosa-Dow system, first under Alon Bement at the University of Virginia, then under Arthur Wesley Dow himself; she taught the system to her own students.[23] The exercises Dow gave his students—such as "to take a maple leaf and fit it into a seven-inch square in various ways"—provided a framework for O'Keeffe's approach to composition throughout her career. Her mature style reaffirmed, as Sarah Whitaker Peters writes, "Dow's old teaching that the essence of an object lies in its shape."[24] Indeed, according to Peters, *Pattern of Leaves* may have been partially inspired by one of Dow's exercises, which he published in his book *Composition,* because the various leaves detailed in the exercise bear a striking resemblance to the layered leaves in O'Keeffe's painting.[25] Even though she tended to veil her artistic sources, O'Keeffe herself admitted that "it was Arthur Dow who affected my start, who helped me to find something of my own," adding that "this man had one dominating idea: to fill a space in a beautiful way—and that interested me." She concluded, "By this time I had a technique for handling oil and watercolor easily: Dow gave me something to do with it."[26]

O'Keeffe's art may also have been nourished by art nouveau, whose imaginative designs and emphasis on the fecund qualities of nature could have provided the foundation for her association of abstraction with creativity. Art nouveau may have also facilitated her choice of leaves as a subject, because of their numerous veins and essential flatness.[27] Likewise, Arthur Dove's biomorphic pastel *Based on Leaf Forms and Spaces* may have inspired her.[28]

Because of their cropping and fragmentation, O'Keeffe's enlarged compositions also reflect the impact of photography. O'Keeffe had turned to photography for new subject matter as well as fresh methods of conceptually approaching her art. By 1919 she had begun to develop a synthesis of painting and photography, arriving at the style of objective abstraction characterized by *Pattern of Leaves.* Her enlarged images are often associated with the photographer Paul Strand, who had photographed bowls and porch shadows set in isolation as early as 1916 (images that she had seen). Yet the source for her change of style and motifs can also be found closer to home—her own experiences as the subject of Stieglitz's camera.[29] O'Keeffe was profoundly affected by his portraits of her, which focused not only on her face but also on her hands, torso, and other parts of her body.[30] As Stieglitz noted that year, "G. has not done much painting. She is doing a heap of thinking—my photography and manner of working are affecting her."[31]

Duncan Phillips considered O'Keeffe "a technician of compelling fascination, especially in her flower and leaf abstractions." In 1926 he

described *Pattern of Leaves* as her "best vein of clear-eyed concentration on a detail from Nature's sorcery."[32]

LBW

275

Red Hills, Lake George, 1927

The Red Hills with Sun; The Red Hills and Sun; Red Hills in the Sun; The Red Hills and the Sun, Lake George

Oil on canvas, 27 × 32 (68.7 × 81.4)

Signed and dated in reverse u.c.: *Georgia O'Keeffe/Sept. 1927*

Acc. no. 1450

The artist; sold to Richard D. Brixey of Bedford Hills, New York; bequeathed to MOMA 1943; traded to An American Place, 1945; PMG purchase 1945.[33]

With its brilliant color, dramatic luminosity, and simplified forms, *Red Hills, Lake George* typifies the distinctive approach to landscape painting of the Stieglitz circle. Within O'Keeffe's oeuvre this is a transitional work, presaging the stark drama of her New Mexico landscapes, while also paying homage to her earlier experiences out West and at Lake George.

O'Keeffe tended to allow memory images to emerge years later, recombined and reinterpreted in a fully realized composition.[34] This predilection was even noted by a contemporary critic, Henry McBride, who wrote in 1928 that "she got the theme [for *Red Hills*] in Texas."[35] Indeed, her memories of her years teaching in Texas, as well as a brief but memorable trip to New Mexico in 1917, seem to have informed this striking composition. O'Keeffe had recently been reminded of the stark beauty of the West by the reminiscences of Rebecca and Paul Strand, who had traveled to Taos, New Mexico, during the summer of 1926, as well as by her friendship with Mabel Dodge Luhan, who had established a residence there.[36]

But the stunning red in this painting surely also derives from her specific memories of autumn sunsets at Lake George. "Alfred just called me to look out the front window," wrote O'Keeffe in 1923. "The mountain on the other side of the lake is a dark burning red—The light trees in spots—each tree seems almost as clear as the leaves on the poplar trees and a little grey cloud is lying along the top of the mountain—it is wonderfully clear—deep burning color—and the near yellow trees—I wish you could see it."[37]

Red Hills, Lake George reflects O'Keeffe's careful study of Kandinsky's treatise *On the Spiritual in Art.*[38] Her experiences with symbolism would have made her receptive to Kandinsky's theories, certainly more so than his compositions, but his ideas on color and form and their symbolic and spiritual meanings are transformed into her own set of beliefs. In many

ways, *Red Hills* almost appears to be a paean to Kandinsky. The red plain in the foreground appears solid and limitless, recalling Kandinsky's description: "Red . . . reveals, for all its energy and intensity, a powerful note of immense, almost purposeful strength. In this burning, glowing character . . . we find, so to speak, a kind of masculine maturity."[39] The brilliant color is confined, whereas, conversely, the rainbow-hued sun radiates outward in soft, concentric waves of yellow, blue, and shades of lilac detailed with pliant brushwork; but the sun burns most intensely at its core of white, Kandinsky's color of joy and purity. This white core also functions as a moment of stillness and silence in the midst of the radiating colors, as expressed in this assertion by Kandinsky: "White has the sound as of a silence that suddenly becomes comprehensible . . . the nothingness that exists before the beginning, before birth."[40] As McBride keenly observed in his review, O'Keeffe was "not so much interested in facts as in the extraordinary relationships that may be established between facts."[41]

Scholars have noted that O'Keeffe was aware of Max Weber's essay in *Camera Work* in which he theorized about a fourth dimension, infinity, which he "described as the consciousness of a great and overwhelming sense of space-magnitude in all directions at one time."[42] O'Keeffe's few statements embody these ideas: "When I stand alone with the earth and sky feeling of something in me going off in every direction into the unknown of infinity means more to me than any thing any organized religion gives me."[43] Weber's theories—that the ideal, or visionary, has definite form and that thought is matter—reaffirmed Kandinsky's concepts. And for O'Keeffe, both of these notions would have produced a firm, imaginative basis for the blending of spirit and matter in *Red Hills, Lake George.* As O'Keeffe put it, "You paint *from* your subject, not what you see."[44]

Red Hills is unusual in O'Keeffe's pre–New Mexico work for its emphasis on the sky, which fills two-thirds of the canvas. Indeed, O'Keeffe and Stieglitz had staked out their domains early on—sky for him, earth for her—and these designations may have functioned as symbols of masculinity and femininity.[45] It is tempting to speculate whether the wide sky in *Red Hills* reflected the great changes going on in her life and in their relationship.[46] She had been gradually distancing herself from Stieglitz and the concerns of his gallery, a process that led her to a trip west in 1929 and that culminated in annual excursions for the remainder of their marriage. The expansive sky and western-appearing terrain may have been her bid for freedom in the constricting worlds of the city and of marriage.[47]

In 1926, the year before *Red Hills, Lake*

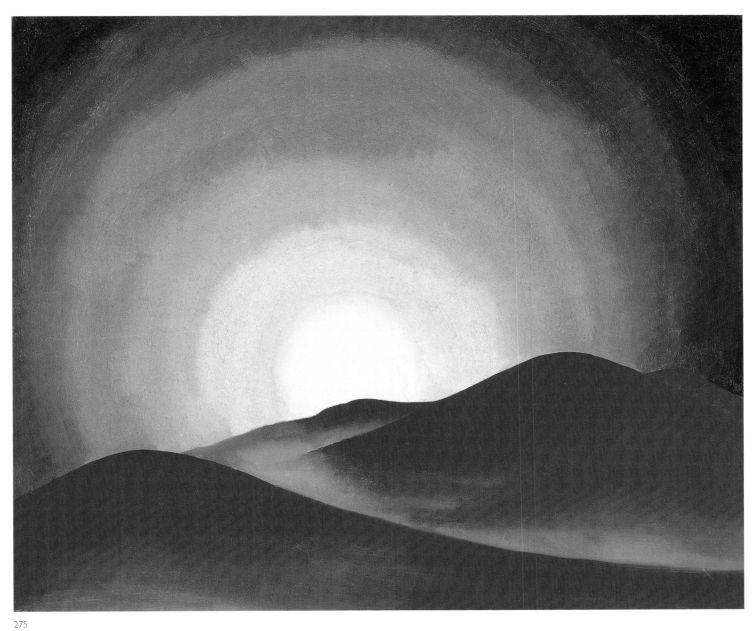

275

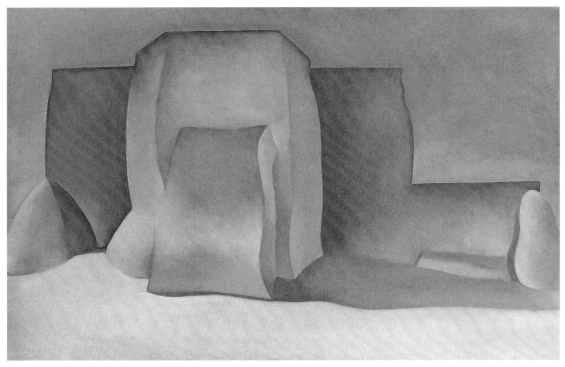

276

George was painted, Duncan Phillips had already listed O'Keeffe among a group of visionary artists who "have had one aim in common—to link modernity to the infinite by their command of rhythm and by their inventions of new or revitalized instruments of plastic expression."[48] In Phillips's estimate, she joined in the search for underlying mystical qualities, which the early American modernists believed dwelled in nature, and with them had begun exploring landscape imagery as a vehicle for self-expression.

LBW

276

Ranchos Church, No. II, N.M., 1929

Ranchos Church; Ranchos Church, No. II; Ranchos Church, Taos

Oil on canvas, 24⅛ × 36⅛ (61.3 × 91.7)

Unsigned

Acc. no. 1449

PMG purchase from the artist through Stieglitz at An American Place, New York, 1930.[49]

Ranchos Church, No. II, N.M. and *From the White Place* (acc. no. 1445) represent two important aspects of O'Keeffe's oeuvre after her discovery of New Mexico: indigenous architecture and the monumental desert landscape. In *Ranchos Church* the same appreciation of architecture and its organic relation to the landscape visible in *My Shanty, Lake George* (cat. no. 273) reappears with more determination and greater strength. As O'Keeffe grew closer to the desert landscape, she began to feel inhibited by the landscape of the Eastern United States. "I feel smothered with green," she wrote about Lake George in 1931. "I do not work. . . . I walk much and endure the green."[50]

Founded in 1710 and dedicated to Saint Francis of Assisi, the adobe church of Ranchos de Taos has a massive squared apse ideally suited to O'Keeffe's reductive approach. She chose to represent the church as a swelling form undifferentiated from the landscape, thus creating an image of timelessness and universality. The church rises against a brilliant, azure sky, unbroken by bird or cloud. A silver aura surrounds the building, softening the brittle effect of the sky.[51]

Ranchos Church is the second in a series begun during the artist's visit to Taos in the summer of 1929. Of eight known paintings, all but one depicts the rear view.[52] O'Keeffe would commonly focus on a single subject. "I have a single-track mind," she declared. "I work on an idea for a long time. It's like getting acquainted with a person, and I don't get acquainted easily."[53]

Other versions evoke mood and emotional state through variations in the composition: the angle of viewpoint, varying treatments of the sky and the contours of the church, and tonal changes in her palette. One of her 1930 versions, which is now in the Metropolitan Museum of Art, has a viewpoint similar to that of the Phillips painting, but O'Keeffe eliminated the foreground of sand and patterned the sky with clouds.[54] Although the canvas size of the two paintings is identical, the church fills the confines of the 1930 composition even more and appears to merge with the sky as well as the ground.

By her own confession, O'Keeffe was not the only artist to discover Ranchos Church.[55] In 1931 Paul Strand photographed it from the same perspective.[56] A comparison of Phillips's *Ranchos Church* with Strand's photograph illustrates O'Keeffe's spare approach. She gave the church a dynamic quality not evident in the realistically rendered photograph by exaggerating the contours of the building, eliminating extraneous detail, subtly varying the color in order to evoke the sensual gradations of light, and making imaginative adjustments to shapes and contours. The comparison with the photograph, taken two years after O'Keeffe painted the Phillips version, offers further insight into the complex interrelationship between O'Keeffe's work and photography and reminds us that her form of abstraction was likewise influential on photographers.[57]

LBW

KARL KNATHS (1891–1971)

Karl Knaths, an early modernist who worked in a cubist idiom, was born Otto G. Knaths, October 21, 1891, in Eau Claire, Wisconsin, but spent his youth in Portage, Wisconsin. In 1912 Knaths enrolled at the Art Institute of Chicago, graduating in 1916. While a student, he won numerous awards and visited the Armory Show in 1913. After a brief stay in New York in 1919, he became a lifelong resident of Provincetown, Massachusetts. He married Helen Weinrich, a pianist, in 1922, and they lived together with her sister, Agnes. He exhibited regularly with the Provincetown Art Association. In 1927 Knaths and a group of modern artists broke with the association and began to present the Provincetown Modern Art exhibitions. Knaths visited New York frequently, participating in the 1921 Society of Independent Artists exhibition and Katherine Dreier's 1926 Société Anonyme exhibition in Brooklyn. His first one-person exhibition was held at The Phillips Gallery in 1929, followed by one at the Daniel Gallery, New York, in 1930. As an artist for the WPA (1934–35), he created two murals for Falmouth High School. His major dealers were the Daniel Gallery (1922–30), the Downtown Gallery (1930–ca. 1933), J. B. Neumann's New Art Circle (ca. 1934–45), and A. P. Rosenberg and Co., Inc. (1945–71). From 1938 to 1945 Knaths taught an annual six-week course in the spring at the Phillips Gallery Art School, and from 1943 to 1945 a summer course at Bennington College in Vermont. Knaths lectured at Black Mountain College in North Carolina in 1944 and at the Skowhegan School of Painting and Sculpture in Maine in 1948. In 1951 the Art Institute of Chicago presented him with an honorary Doctor of Fine Arts degree, just one of many awards that he received between 1928 and 1971. He died from a stroke March 10, 1971, in Hyannis, Massachusetts. The Phillips Collection contains works representative of Knaths's entire oeuvre; it comprises thirty-five oils, four watercolors, four woodcuts, three collages, and one lithograph.

The Knaths Unit

In 1926, when he acquired his first painting by Karl Knaths, Duncan Phillips was purchasing works by American modernists at an astonishing rate.[1] Phillips already considered artists such as Avery, Dove, and Marin to be heralds of modern art in America whose individuality was not subsumed by their adherence to abstraction, and he came to regard Knaths as a member of this esteemed group.

With the purchase of *Geranium in Night Window,* 1922 (cat. no. 277), in 1926, Phillips initiated a patronage that would last until his death in 1966.[2] He bought, traded, borrowed, and exhibited over the years, until he had assembled the largest and most representative collection of works by Knaths.

Although as a teacher and lecturer he maintained connections with other artists and arts organizations, Knaths worked independently and developed a highly original style. During the twenties he was influenced by the modern European masters, including Cézanne, Braque, and Matisse, as well as contemporary Americans, such as Yasuo Kuniyoshi and Stuart Davis. In this early work he explored the expressive use of color and space, as seen in paintings like *Geranium in Night Window* and *Cock and Glove,* 1927–28 (cat. no. 278).

During the thirties Knaths developed a cubist style characterized by expressive line and the careful arrangement of color and plane—well represented in The Phillips Collection unit by *Harvest,* ca. 1931–32 (cat. no. 280), *Moonlight, Harbor Town,* 1938, and the late work *Shacks,* 1964 (acc. nos. 1033 and 1045). It was this signature style that Phillips had in mind when he praised Knaths's ability to create "humanizing abstraction" and "to keep the essence of life and the character of objects in [his] forms even when they go into the fascinating realm of creative design."[3]

By 1942, it was Phillips's judgment that Knaths had absorbed the luminism of the "best French painting from Chardin and Cézanne to Bonnard and Braque" and had transformed it into a uniquely American idiom. "Knaths is both a luminist and a genuine American," he wrote, "for, with his light-enchanted colors, he conveys an intimate interest in his Cape Cod environment with a special fondness for farmyard cocks, lilac bushes, and certain familiar objects in his house or studio . . . the shapes of which he likes to use again and again for his creative purposes."[4]

The relationship between artist and collector lasted for more than thirty-five years. Their first contact was in the form of a letter from Phillips, who at first assumed the role of mentor but later came to consider Knaths as a friend and colleague.[5] That Phillips believed fervently in Knaths's abilities was demonstrated not only by his acquisitions but also by the numerous essays he wrote on his art.[6] He considered Knaths a unit artist by 1929 when he decided "to have a small room devoted to Knaths," and later that year he gave him his first solo exhibition (which provided the occasion for their first meeting).[7] The show was well received in Washington, one critic prophesying that "if he lives up to the promises in this exhibit he will be one of the foremost of the younger American painters."[8] Phillips purchased five works from the exhibition, and he further expressed his own admiration by writing to Knaths: "Congratulations on the sustained and distinguished beauty of practically all the pictures you sent me for our exhibition. They are light in touch and high in key."[9] The friendship deepened in 1938, when Phillips asked Knaths to lecture at the Phillips Gallery Art School. Knaths returned regularly until 1945, in the process influencing many artists in the Washington area, such as Ben Summerford (see cat. no. 401).[10]

Phillips often referred to Knaths as a "poet of painting." His lyricism, he believed, "is due to subtle relations which are reasoned and yet more or less unconsciously achieved." As an expression of his enduring respect and admiration, Phillips observed that Knaths's "felicities of touch and taste and his harmonies of color . . . are full of the happy accidents of genius."[11]

LBW

277

Geranium in Night Window, 1922

Geranium; Geranium in Window (DP); *Geranium Pot at Night Window* (DP); *Geranium at Night Window* (DP)

Oil on canvas, 24 × 20 (60.9 × 50.8)

Signed in gold paint, l.r.: KNATHS

Acc. no. 1026

Artist to Daniel Gallery, New York, by 1924; PMG purchase 1926.[12]

Geranium in Night Window shows Knaths's early style when he was absorbing influences from European modernism but not yet working in the cubist manner characteristic of his mature style.[13] It is a vigorous work in its own right, and Knaths's personal vision is apparent in the expressive use of color to elucidate the mystical qualities of nature.

Knaths created tension in this work by distorting perspective, perhaps in emulation of Matisse.[14] He combined flat decorative elements (such as the broad contours of the leaves and the daubs of paint forming the curtain design) with cool planes of color receding into space (such as the shelf supporting the plant). The spatial depth implied by the window's niche is contradicted by the curtains, which hang parallel to the picture plane. Certain evocative qualities are reminiscent of Chagall, of whose works Knaths was also aware in the early twenties.[15] The shelf cloth's myriad floating dots and the window's muntins, which form a cross that

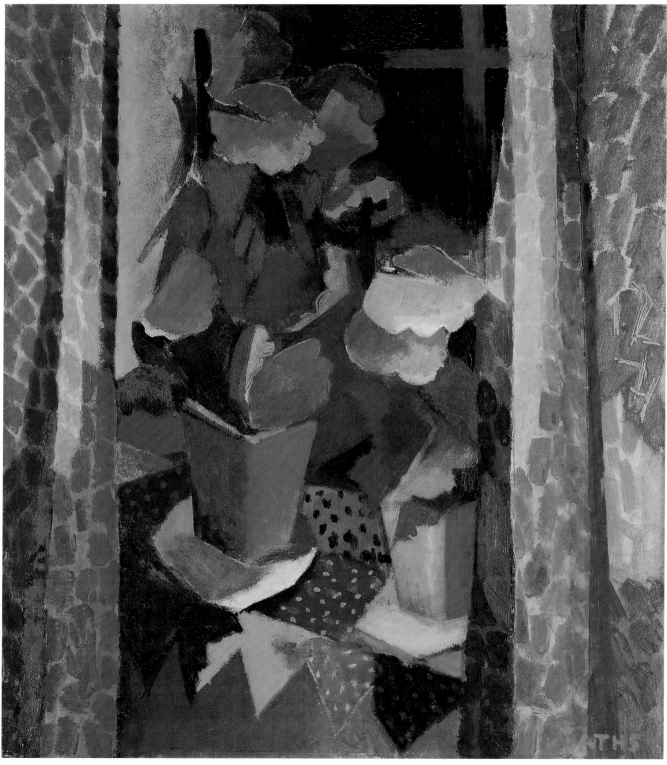

277

floats against the deep-purple night sky, help to generate an aura of mystery that recalls Chagall's dreamlike nocturnal images.

Knaths was first introduced to European modernism when he was a guard for the Chicago venue of the 1913 Armory Show. By his own admission, he was confused by the exhibition's "radical" art, especially the work of Matisse, but was immediately awed by Cézanne.[16] After moving to Provincetown, Knaths gained greater familiarity with the European avant-garde through the influence of his future wife, Helen Weinrich, and her sister, Agnes.[17] But he never visited Europe, stating that in his younger years "Paris was for me like a distant dream." He added, "I was very shy and could certainly not have had the courage to approach men like Picasso, Matisse, and Braque."[18] An avid reader on philosophy, art, and art theory, he also visited numerous New York galleries and museums in the early twenties. Knaths quickly learned to combine the expressive qualities of color with his new understanding of pictorial space.

Phillips most admired the lyrical qualities of Knaths's paintings. About *Geranium in Night Window* he wrote: "This exceptionally promising canvas reveals a delightful sense of color relations and a developed knowledge of what happens to colors under a flickering play of light."[19]

LBW

278

Cock and Glove, ca. 1927–28

Cock

Oil on canvas, 36 × 26 (91.4 × 66.0)

Signed l.r.: KNATHS

Acc. no. 1013

Artist to Daniel Gallery, New York, by 1928; PMG purchase, 1929.[20]

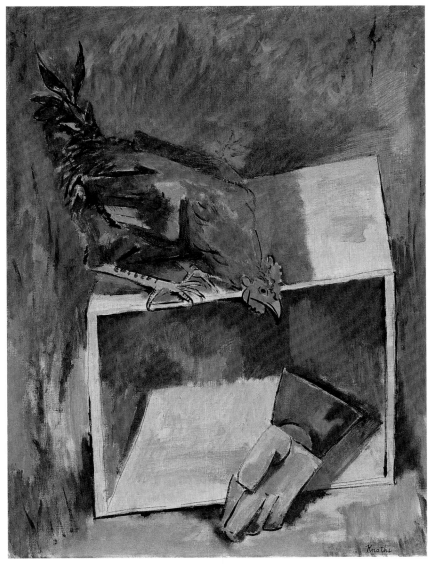

278

In *Cock and Glove,* Knaths investigated the spatial possibilities that stem from an odd placement of objects: a rooster atop a box looks at a farmer's glove, which appears to be inside the box as well as parallel to the picture plane. The box interior is also spatially ambiguous: while the warm tones defining the sides appear flat, the cool shades of the bottom recede into space. Even the perspective of the setting is distorted, seen here as flat in the lower left but receding in the upper right.

The concept for this composition may have resulted from an actual incident involving a rooster about to pounce on a farmer's glove. Knaths perhaps also intended the glove to be a metaphor for the American farmer. The curious juxtaposition, however, may simply reflect his interest in the somewhat surreal art of Kuniyoshi, whose work (which also includes the subject of roosters) he is known to have seen at the Daniel Gallery.[21]

Phillips, who referred to Knaths's "rooster complex," was particularly fond of *Cock and Glove.*[22] This enthusiasm was shared by Alfred Barr, who, when organizing his 1930 show of contemporary American art for the Museum of Modern Art, asked to borrow the painting: "I should like to have the Rooster with a glove or whatever that delightful composition is called. It seems to me [to be] one of Knaths's most interesting paintings."[23]

Phillips applauded the artist's interest in farmyard subjects, because he considered it a uniquely American orientation. But he also saw in this work a connection to the Far East in its "exercise in the elimination of non-essentials."[24]

LBW

279

Maritime, 1931

Oil on canvas, 40 × 32 (101.6 × 81.2)

Signed and dated in black paint, l.r.: *Knaths '31*

Acc. no. 1032

The artist; on consignment to Downtown Gallery, New York, 1931; PMG purchase 1931.[25]

Maritime represents Knaths's progression toward greater abstraction in the course of the 1930s. When the work was first exhibited at the Downtown Gallery in 1931, Ralph Flint, critic for *Art News,* wrote that Knaths's new abstractions were "freshly minted patterns savoring of salty inspiration."[26] Duncan Phillips, who became interested in acquiring this painting on the basis of glowing reviews, borrowed *Maritime* and sev-

eral others for his own 1931 show of recent works by Knaths. He was "delighted with these pictures," feeling that "they represented an advance" over earlier creations.[27]

Maritime is a fragmented evocation of a day's sail. The various components of the boat—stern, jib, sheets, mainsail, and deck—are abstracted and dispersed throughout the composition, reinforcing the sense of flatness. Knaths employed pristine, elegant lines to separate the planes of color, to partially frame the composition, and to designate the objects. The general effect is a tightly structured image that elicits a mood of distilled tranquillity.

With these spare elements, Knaths may have been referring to a temporal progression through a day of sailing. The upper and lower halves of the composition are each divided into three planes of color: the lower half with a central plane of pale coral, framed on either side by bands of deep blue, a reference perhaps to the deck of the boat surrounded by the ocean; the upper with golden yellow, rich coral, and clear blue apparently depicting the morning, evening, and daytime skies. The effect is enhanced by delicate associations, such as the placement of the boat's stern within the plane of color representing the evening sunset, reinforcing the notion of day's end.

Although the concept for this painting seems fresh and unusual, it nevertheless reveals the influence of Stuart Davis. Not only were they both represented by the Downtown Gallery, but in 1930, following his return from France, Davis spent some time in Provincetown.[28] In its spare abstraction, *Maritime* has the same flat, linear emphasis of Davis's *Egg Beater No. 4*, 1928 (cat. no. 282). Just as Davis broke down the components of an egg beater, electric fan, and rubber glove, Knaths separated the parts of a boat.

LBW

279

280

Harvest, ca. 1932–33

Oil on canvas, 40 × 48 (101.6 × 121.9)

Signed l.r.: *Karl Knaths*

Acc. no. 1029

The artist; PMG purchase (from the Corcoran Biennial) 1935.

Knaths's mature oeuvre, which is characterized by the preeminence of line as conveyed in a highly personalized cubist idiom, found early expression in *Harvest* and continued throughout his career in works such as *Bennington Crock,* 1944, and *Shacks,* 1964 (acc. nos. 1009 and 1045). This signature style is the result of his early interest in the distinctive manner of Matisse, as well as the cubist masters Picasso, Gris, and especially Braque. Phillips applauded

Knaths's synthesis of these influences and, calling him "the American Braque," went on to say that "he has a similar plastic lyricism of soundly organized lines and tasteful, exquisitely related colors."[29] In his estimate, Knaths "fills a given space with an order in which lyric and logic are almost as indivisible as in Braque."[30]

In *Harvest* Knaths used line descriptively to define volume as well as space. Thick black lines outline the brightly colored still-life objects—the pumpkin, the turkey, and the barrel of apples—and also selectively indicate spatial recession, as in the floorboards. Textural effects are also evident, in the spotted breast of the bird and the gridlike pattern designating the corncob kernels.

Phillips considered *Harvest* to be Knaths's masterpiece. After seeing it in two major exhibitions, he wrote to the artist, "I am more than ever impressed and charmed by your canvas entitled 'Harvest' which is now at the Corcoran Biennial."[31] He regarded Knaths "at his best as a colorist" and appreciated his unique cubist vocabulary, which in *Harvest* has the

"effect . . . of a spacious room flooded with light and of reality electrified through rhythmical relations rather than objectified through realistic details."[32]

LBW

281

Frightened Deer in Moonlight, ca. 1932

Deer in Moonlight; Frightened Deer

Oil on canvas, 35⅞ × 48 (91.1 × 121.9)

Signed l.r.: *Karl Knaths*

Acc. no. 1022

PMG purchase from the artist, 1937.[33]

Knaths first conceived of the motif of deer in a landscape around the late 1910s and early 1920s.[34] He was inspired at that time by the countryside around Chicago and later Provincetown, and rhapsodized in his diaries about the wilderness and the cosmos. On daily walks he sought his own private equivalent of Thoreau's Walden Pond, a locale that would serve as the perfect inspiration for his art.[35]

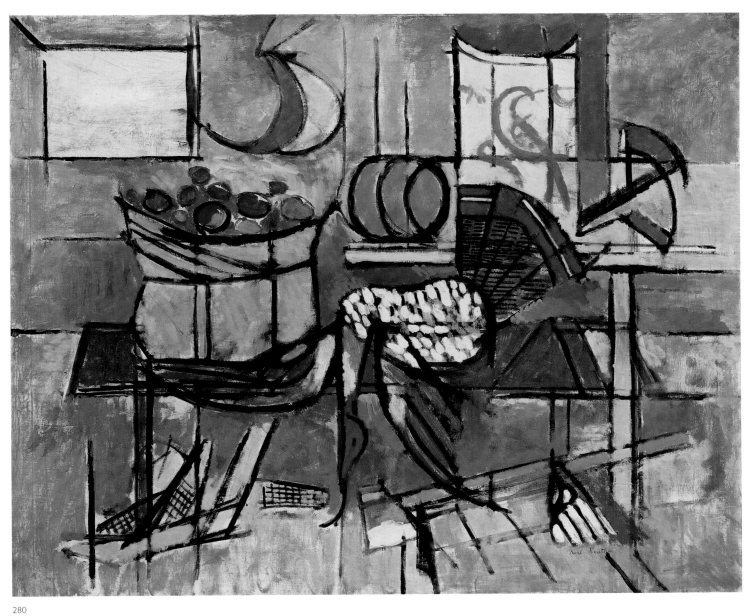

280

281

Having read Thoreau and Swedenborg as a young man and Emerson and Blake in middle age, Knaths fervently believed in the spiritual qualities of the woodlands and wildlife around him. He remained drawn to nature's mysteries throughout his life and held true to his belief that nature was the source of all art.[36] Phillips recognized this aspect of Knaths's work and included him in an exhibition of American artists who he felt shared affinities with the French symbolist Redon. They drew "from depths of spiritual experience," Phillips stated, and were, like Redon, "lonely souls seeking to commune with their kind through the mystic channels of aesthetic suggestion."[37]

Both *Frightened Deer* and *Deer in Sunset,* 1946 (acc. no. 1017), reflect Knaths's elaborate system of composing the image and selecting a color scheme. Although his theories on color and design probably originated in his student years in the 1910s, it was not until the early 1930s

that he devised a system of relating spatial proportions and color values mathematically, using music theory as a model.[38] Such a method is illustrated in both of these paintings. Each shows traces of a grid painted directly on the canvas.[39] Knaths then drew a rough sketch and measured the spaces between the various elements in the composition. From this calculation he determined the ratio between these spaces and the color values to establish his palette.[40] Despite his strict methodology, however, he maintained that whereas "I do keep to proportions and do not mix between colors . . . things happen on the canvas—colors get blended— shine through—are pushed into." He added that "systems are only bricks and lumber—of themselves they cannot encompass the immeasurable spiritual qualities that go into a successful picture. The unlooked for things that happen in the process of work are the important ones."[41]

Phillips greatly admired these paintings for

their combination of abstracted landscape and expressive color and tonal values. In *Frightened Deer* Knaths integrated rich blues and purples with a darkly calligraphic line to create a poetic image. Phillips described the setting: "The air of witchery pervading a night of frosty silence is captured by the moon-chilled colors. How this hush is broken is told by the nervous zigzags of the brush. We can all but hear the crackling sounds which have frightened the wild creatures of the wood."[42]

In the later painting, *Deer in Sunset,* browns, greens, and golds dominate. An awareness of Far Eastern art, which Knaths knew from his student years in Chicago, is reflected here in the low sun, sloping hillside, and carefully placed flock of birds. The expressive line that delineates the deer in the earlier work is now virtually the only element defining the shape of the animals, which are camouflaged within the foliage and thus fused with their environment.

LBW

STUART DAVIS (1892–1964)

One of America's strongest advocates of abstract art during the first half of the twentieth century, Stuart Davis was born in Philadelphia December 7, 1892, to Edward Wyatt Davis, art editor of the *Philadelphia Press,* and Helen Stuart Foulke Davis, a sculptor. In 1901 the family moved to East Orange, New Jersey. Stimulated by an artistic environment at home, Davis left high school in 1909 to attend the Robert Henri School of Art in New York until 1912. The following year he exhibited at the Armory Show. Between 1912 and 1916, while supporting himself as an illustrator for several magazines, including the socialist journal *The Masses,* Davis began experimenting with cubist abstraction. In 1917 he had his first solo exhibition at the Sheridan Square Gallery in New York and participated in the "First Annual Exhibition of the Society of Independent Artists." His first solo museum exhibition occurred in 1925 at the Newark Museum. The following year he was included in the "International Exhibition of Modern Art Arranged by the Société Anonyme for The Brooklyn Museum." In 1927 his abstract style reached its culmination in his *Egg Beater* series; the same year, Edith Halpert of the Downtown Gallery became his dealer. From 1928 to 1929 Davis lived in Paris, where he painted cafés and street scenes and executed lithographs of his paintings. During this sojourn in Paris he married fellow American Bessie Chosak (who died in 1932). Upon his return to the United States in 1929, he moved to Greenwich Village and spent most of his summers in Gloucester, Massachusetts. From 1931 to 1932, Davis taught at New York's Art Students League. He was a muralist for the Public Works Art Project from 1933 to 1939. His involvement with artists' rights movements resulted in his being elected president of the Artists' Union in the mid-1930s and national chairman of the American Artists' Congress in 1937. In 1938 he married Roselle Springer, his companion since 1934. In his mature years Davis taught at New York's New School for Social Research (1940–50) and at Yale University (1951). Davis died June 24, 1964, in New York. The Phillips Collection owns five oils and two lithographs by Davis, all early works.

282

Egg Beater No. 4, 1928

Egg Beater No. 1

Oil on canvas, 27⅛ × 38¼ (68.7 × 97.2)

Signed in brown paint u.r.: *stuart davis*

Acc. no. 0470

PMG purchase 1939 from the artist.[1]

Egg Beater No. 4 is the final work of Davis's well-known *Egg Beater* series of 1927–28, which was his effort to arrive at an original abstract style.[2] This endeavor had been fueled as early as 1913 when he admired the works of Cézanne, Léger, and Picasso at the Armory Show.[3] Davis purposely chose unrelated objects—egg beater, electric fan, and rubber glove—so that he could concentrate on relationships of color, shape, and space. As he explained in 1941: "This [series] was a great advance over my previous work from the standpoint of structural integration. The individual objects in the still life were visualized, not in their isolated internal aspects, but as part of a larger system of spatial relations and unity. They included transposition of sizes, shapes, and colors, and were carried out in awareness of the logic of the three-dimensional color-space of the canvas."[4]

When viewed in sequence, the *Egg Beater* compositions become progressively more two-dimensional and closely integrated. In the first two works, depth is suggested by forms that either float within undefined space or firmly inhabit an interior.[5] In the Phillips work and *Egg Beater No. 3,* the space is more ambiguous. The shapes appear to be interlocked and integrated onto a flat surface, yet they also allude to "interior and cityscape spaces."[6] For example, the angled line on the left of *Egg Beater No. 4* may be interpreted as the edge of the studio wall, while the white lines against the dark background along the top edge of the painting resemble building tops against the night sky.

Egg Beater No. 4 was one of two works from the series that Davis took with him in 1928 to Paris.[7] According to Davis, Léger admired them and "said they showed a concept of space similar to his latest development."[8] When Duncan Phillips purchased the painting in 1939, Davis told him that this *Egg Beater* "represents the best example of this series which enabled me to realize certain structural principals [*sic*] that I have continued to use ever since."[9]

GHL

283

Blue Café, 1928

Oil on canvas, 18⅛ × 21⅝ (40.6 × 55.0)

Signed on building, u.r.: *stuart davis;* inscribed in black paint on stretcher, u.r.: *paris 1928*

Acc. no. 0467

Downtown Gallery, New York; PMG purchase 1930.[10]

During his year in Paris (1928–29), Davis executed several works depicting streets and buildings that became Duncan Phillips's favorite creations by the artist. At the urging of John Graham, Phillips visited "Hotels and Cafés," the Downtown Gallery's 1930 exhibition of Davis's Paris work, and purchased *Blue Café,* his first painting by the artist.[11] Within a year he had acquired three more works from the Paris period, *Corner Café,* 1930, and two lithographs, *Place des Vosges,* 1928, and *Place Pasdeloup No. 2,* 1929 (acc. nos. 0469, 0471–72). Not only did they revive Phillips's favorable memories of his own frequent trips to Paris; they also struck him as lively, provocative improvisations of "linear perspectives and color schemes . . . [which] reveal a kinship to the . . . virtuoso Picasso."[12] He considered them lighthearted and straightforward as well as sophisticated, and believed that they indicated the influence of European modernists like Rousseau, Matisse, de Chirico, and Braque.[13]

Indeed, both *Blue Café* and *Corner Café* are flattened in a manner reminiscent of the cubists, are rendered with the simplicity and pure color of Rousseau and Matisse, and are imbued with an isolated atmosphere not unlike that of de Chirico's lonely, dreamlike cityscapes. Davis imposed flat, abstract planes of brilliant color and texture on realistic representations of the city's streets and buildings, evoking the nature of the brightly painted stucco walls of Paris.

In *Blue Café* Davis painted a frame around the image and suspended the motifs against a background of solid pink, emphasizing the two-dimensional picture plane.[14] He transformed the curls of smoke rising from the chimney into taut, compressed curves. In the sky a schematic musical staff, on which is superimposed either the number 8 or a bass clef, adds mystery to the scene and further emphasizes the sense of two-dimensionality.[15] The compression of space and geometrization of detail are carried even further in Davis's lithograph after the painting, discussed above.

In contrast to the extreme objectivity of the

282

Egg Beater series of the previous two years, the Paris works retain the identity and buoyant atmosphere of their subject. They attest to Davis's love for the city: "Paris was old-fashioned, but modern as well. . . . There was so much of the past and the immediate present brought together on one plane that nothing seemed left to be desired. There was a timelessness about the place that was conducive to the kind of contemplation essential to art. And the scale of the architecture was human."[16]

GHL

284

Still Life with Saw, 1930

Mandolin with Saw; Mandolin and Saw

Oil on canvas, 26 × 34 (66.0 × 86.3)

Signed u.r.: *Stuart Davis;* inscribed in black paint on stretcher, u.c.: *still life with saw stuart davis april 1930*

Acc. no. 0473

Downtown Gallery, New York; PMG purchase 1946.[17]

After he returned from his 1928–29 Paris sojourn, Davis painted several scenes in which Parisian and American imagery was juxtaposed against an undefined background. In *Still Life with Saw*, one of these works, a large mandolin is suspended against an ambiguous setting in the company of workman's tools: a handsaw, a length of rope, and a pair of tongs.[18] Spatial ambiguity is created by the white lines in the background, which may be interpreted as either a horizon line or a table edge. The mysterious symbols throughout the painting and the stark contrast between a musical instrument suitable for an elegant drawing room and rugged implements used for manual labor, render it one of the artist's most surreal, enigmatic works.

Surrealism's interest in the artistic unconscious held little appeal for Davis, whose foremost concern was the intellectualization of color and design. As Karen Wilkin has observed, Davis did, however, admire the Spanish surrealist Joan Miró for "his clarity and abstractness."[19] The cryptic configurations in Miró's paintings

probably attracted him in his search for sophisticated formal patterns, while Miró's depiction of apparently unrelated objects appealed to his sense of the absurd. Certain characteristics of *Still Life with Saw*, such as its opaque, brown background, the arrow, and the mandolin handle transformed into an arm, may have been inspired by Miró paintings that Davis could have seen, like *Dutch Interior I,* 1928.[20] The twisted, frayed rope in *Still Life with Saw* is also reminiscent of Miró's collage *Spanish Dancer,* 1928.[21] An even more striking comparison can be made with Arthur Dove's collage *Rope, Chiffon and Iron,* 1926.[22] Davis's work appears to be an interpretation of Dove's assemblage, which also includes a frayed rope, in addition to bent and twisted metal similar to the green tongs in *Still Life with Saw.*

By emphasizing the scale of the mandolin, yet having the title allude to the less prominent saw, Davis might have been making a tongue-in-cheek allusion to the comment by the formalist art critic Clive Bell in 1913 that a person with no

283

284

sense of aesthetics has "no faculty for distinguishing a work of art from a handsaw" and "is apt to rear up a pyramid of irrefragable argument on the hypothesis that a handsaw is a work of art" (hence the pyramid in the background of the painting).[23] Perhaps Davis was seeking to debunk such an assumption, which by 1930 was dated in light of postdada developments in art. The fact that the saw is given equal billing with the mandolin and even appears to threaten it with its emphatic jagged teeth possibly reflects the artist's opinion that utilitarian, everyday objects are as worthy of representation as traditionally used cubist motifs.

In *Still Life with Saw,* Davis altered motifs and techniques from surrealism, which at the time was at the height of its influence in Paris, and he employed them in a concrete way that fit his personal theme and message. The painting contrasts significantly in purpose and intent with *Egg Beater No. 4* of just three years earlier. While in that work the objects' identities are totally subsumed into an abstract composition, those in *Still Life with Saw* are readily recognizable, even highlighted in their individuality. Such demonstrations of Davis's artistic agility and clever nature, coupled with his struggle to maintain his originality in the face of European art movements, were appreciated by Duncan Phillips. As he wrote in the essay "Modern Wit in Two-Dimensional Design," which accompanied his 1931 exhibition of the same title, "No one can say that [Davis] is not strikingly a man of his time and . . . of witty ideas on his own account."[24]

GHL

ALEXANDER CALDER (1898–1976)

Alexander Calder originated the mobile, a type of sculpture that incorporates the qualities of time and motion. Born July 22, 1898, in the Philadelphia suburb of Lawnton, Calder was a third-generation descendant of a family of artists. After graduating from the Stevens Institute of Technology in 1919 with a degree in mechanical engineering, "Sandy" (as he was known by his friends) held down various jobs before entering the Art Students League of New York in 1923. At first a painter, he studied under Thomas Hart Benton, George Luks, Kenneth Hayes Miller, and John Sloan, and was a classmate of John Graham. He exhibited paintings for the first time in 1926 at the Artist's Gallery in New York. In June of that year he moved to Paris, but he periodically returned to the United States. By 1928 Calder was exhibiting his wire sculptures both in the United States and in France and was giving "performances" of his *Circus*, an entourage of wire animals and figures. In 1929 he had a solo show of his large-scale wire constructions at Galerie Billiet-Pierre Vorms, and in 1931 he exhibited his first abstract sculptures at Galerie Percier. That year he also joined Abstraction-Création, a loose confederation of artists that included Piet Mondrian, Theo Van Doesburg, and Jean Hélion. Calder exhibited his mobiles for the first time at Galerie Vignon in 1932. In 1933 Calder returned to the United States and purchased a home in Roxbury, Connecticut. His mobiles were exhibited in August of that year at the Berkshire Museum in Pittsfield, Massachusetts. In 1953 he purchased a home in Saché, France. While dividing his time between Roxbury and Saché, Calder produced a considerable opus of works in a wide variety of media. His work was exhibited in several large retrospectives at the Solomon R. Guggenheim Museum, New York (1964), the Musée National d'Art Moderne, Paris (1965), the Museum of Contemporary Art, Chicago (1974), and the Whitney Museum of American Art, New York (1976). Calder died in New York November 11, 1976, soon after the opening of this last retrospective, which he had personally installed. The Phillips Collection includes one mobile, one standing mobile, and one suspended sculpture made of tin cans.

285

Untitled, 1948

Mobile; Helicoidal Mobile-Stabile; Mobile-Stabile
Painted sheet metal and wire, 26 × 26 × 5½
(66.5 × 66.5 × 13.9)
Unsigned
Gift from the estate of Katherine S. Dreier, 1953
Acc. no. 0257

Collection of the artist; purchased by Katherine S. Dreier, Connecticut; gift from Dreier's estate, 1953.[1]

An active participant in the avant-garde milieu of Paris between the two world wars, Calder had a wide circle of friends and colleagues. He met many of them through performances of his *Circus* in the late twenties and through his membership from 1931 in the Abstraction-Création group, which espoused diverse multinational trends in abstract art. In response to these influences, Calder created his first abstract wire sculptures by the spring of 1931. They were followed by motorized sculptures, then stabiles, which he exhibited in Paris in 1932. In 1933, in a statement for his Berkshire Museum exhibition, which included his mobiles, Calder posed the question, "Why not plastic forms in motion?" He added, "Just as one can compose colors or forms, so one can compose motions."[2]

Calder considered the catalyst for his creation of kinetic sculpture, especially the mobile, to have been a 1930 visit to Mondrian's studio, where he was drawn to boards that Mondrian had painted red, blue, yellow, black, and white and had tacked on a pristine white wall. Calder remembered wanting to make them "oscillate in different directions at different amplitudes."[3] But he was also undoubtedly influenced by the constructivist theories on kinetic art, particularly those of Moholy-Nagy, which he would have easily understood given his early training as a mechanical engineer.[4]

Untitled probably dates from 1948, for it displays a more careful arrangement of forms and a more sophisticated design than those found in earlier mobiles. Initially Calder worked primarily with wooden spheres and painted wire, usually favoring an open tripod base for his standing mobiles.[5] By the forties he preferred a

planar tripod base, using painted wire only as the connector between the mobile elements and the base.

Several mobile-stabiles that resemble the Phillips work were made by the artist in the late forties. *Red, White, Blue, and Black,* 1948, is a large-scale sculpture that has a similar pierced form but is otherwise more complex; more attention has been paid to the numerous suspended elements and to the curving base, which is punctuated by a hole near the tip.[6] Interestingly, Katherine Dreier's papers have the drawing for *Red, White, Blue, and Black.* Perhaps her acquisition of the Phillips sculpture reflected her appreciation for this type of design.[7]

In subject and inspiration, Calder's early mobiles had cosmological reference and significance. He was fascinated by recent developments in astronomy. "From the beginning of my abstract work," he stated, "I felt there was no better model for me to choose than the Universe."[8] In the Phillips work, a later realization of these early mobiles, the yellow campanulate form perhaps refers to the sun. The flat discs attached to the elegantly curving, twisting wire may allude to planets, each on a different axis and rotation. Their orbits provide the basis for the mobile's kinetic function.

The derivation of the alternate title, *Helicoidal Mobile-Stabile,* which was probably established while this work was in Katherine Dreier's collection, is not known. Moreover, how it relates to the Phillips mobile is enigmatic. One is tempted to pose the idea that the title alludes to the kinetic paths traced out by the mobile's elements as well as the shape of the space those paths inscribe, which, although not a clearly defined flattened spiral, is nonetheless complex. Whatever the title's purpose, however, the kinetic function of the sculpture illustrates Calder's words: "How does art come into being? Out of volumes, motion, spaces carved out within the surrounding space, the universe. . . . None of this is fixed. . . . Thus, they reveal not only isolated moments, but a physical law or variation among the elements of life. Not extractions, but abstractions. Abstractions which resemble no living thing except by their manner of reacting."[9]

LBW

286

286

Only Only Bird, 1951

Tin cans and wire, 11 × 17 × 39 (27.9 × 43.2 × 99.05)
Unsigned and undated
Acc. no. 0258

Collection of the artist; given in 1965 to Jean Davidson,
Saché, France; TPC purchase (from exhibition) 1966.[10]

During the early fifties, while producing some of
his most monumental large-scale commissions,
Calder began to create a flock of smaller-sized
bird sculptures constructed out of tin cans that
were designed to be hung from the ceiling, thus
swaying and rotating with each breeze.[11] Whim-
sical yet highly sophisticated, these birds recall
Calder's work as a young American artist in
Paris from 1926 to the mid-thirties, when his
toys, wire portraits, sculptures, and especially
tiny circus figures were considered serious artis-
tic expressions by the avant-garde, helping to
legitimize Calder as an artist of great daring and
ingenuity.[12]

Calder remembers that while in Paris he saw
on an island in the Seine "birds with long slen-
der tails and a red disk about two inches in
diameter on the end." He considered them to be
"right up [his] alley."[13] Certainly, his interest in
birds is already apparent in his early career:
included among the first sculptures he created
in the late twenties are small toy birds, often on
wheels, made out of twisted wire and household
items.[14] Conceived in the irreverent, humorous
spirit of the dadaists, these small objects repre-
sented a distinct departure from the representa-
tional paintings he had been making under the
influence of his Art Students League training.[15]

The *Only Only Bird* is made out of coffee
cans. Calder ingeniously cut and assembled the
body so that at the rear of the bird, just under
the tail feathers, the printed legend on one of
the cans is visible: "ONLY Aborns dares reveal its
complete blend because Aborns uses ONLY high-
est priced premium coffee *and nothing* else!"
Calder created another version of the Phillips
work, which has on occasion also been called

Only Only Bird, 1951.[16] The same type of can was
used to form the body as well as the wing and
tail feathers, and the legend is similarly visible
beneath the tail feathers, but the conception for
the two birds is otherwise quite different.

Marjorie Phillips had long been entranced by
a color photograph of the 1952 *Only Only Bird*
and desired to have it in her 1966 exhibition,
Birds in Contemporary Art. When Calder's son-
in-law, Jean Davidson, wrote to her giving per-
mission, he stated that the "'Only Only Bird' will
fly faster, sing louder, than other birds in your
show—it's no addition but the centerpiece! . . .
Place all other birds at *his feet!*"[17] Marjorie
Phillips not only published it on the cover of the
catalogue, but she also purchased it for the per-
manent collection. She admired Calder's whim-
sical ingenuity, stating that "in bird *sculpture,*
more imaginative daring conceptions and mate-
rials have been used than in any previous age.
Calder's most delightful vigorous 'Only Only
Bird' is developed from a tin can."[18]

LBW

LEE GATCH (1902–68)

Born in Benton Heights, Maryland, September 10, 1902, Lee Gatch began his formal artistic training in 1921 at the Maryland Institute of Fine Arts in Baltimore, where he studied with Leon Kroll and John Sloan; he graduated with a traveling scholarship to the American School at Fontainebleau, France. Dissatisfied with the classes there, Gatch relocated to Paris, where he studied at the Académie Moderne with Moise Kisling and André Lhote, a cubist academician. When he returned to the United States in 1925, Gatch rented a studio in New York. His first one-person show was held in 1932 at J. B. Neumann's New Art Circle. Gatch spent the summer of 1935 at Yaddo, an artists' colony in Saratoga Springs, New York, with the painter Elsie Driggs, whom he had met in 1933; the couple married in December and eventually moved to a secluded house in Lambertville, New Jersey, where Gatch resided for the rest of his life. Duncan Phillips purchased a Gatch painting in 1941 and gave the artist his first one-person museum exhibition in 1946. His ensuing purchases of fifteen works established him as Gatch's foremost patron. Gatch continued to have exhibitions throughout the 1940s and 1950s and was represented at the Venice Biennale in 1950 and 1956. He won the Joseph E. Temple Gold Medal in the Second Biennial of American Painting and Sculpture at the Detroit Institute of Arts in 1959 and received first prize in the Corcoran Biennial in 1961. The American Academy of Arts and Letters awarded Gatch a grant in 1965, and inducted him into the academy the following year. Gatch continued to work steadily until his death in Trenton, New Jersey, November 10, 1968. He is represented in the collection by a group of sixteen works illustrating the range of his development from 1926 to 1965.

The Gatch Unit

Lee Gatch, whose American training with Leon Kroll and John Sloan emphasized both naturalism and design, was equally receptive during his 1924–25 stay in Paris to the instruction of the French modernists André Lhote and Moise Kisling. Like his contemporaries Avery, Dove, and Knaths, he strove throughout his career to maintain an individual style based on the American representational tradition while reaching beyond appearances to find inner meaning through design and color. He asserted, "With a complete belief that the true path of art is abstract, but owning that nature should never be deserted, I set myself the task to reconcile these two. The ultimate purity of technique without the loss of the spiritual and the sensuous."[1] The landscape of western New Jersey on the Delaware River provided his source of subject matter during most of his adult life; he interpreted these themes in various ways, concentrating on formal, and sometimes expressive, aspects.

Although Gatch began exhibiting his works in New York in the late 1920s, he was still relatively unknown in 1941 when Duncan Phillips saw his first Gatch painting, *Highlanders*, 1933 (acc. no. 0717), at J. B. Neumann's New Art Circle. A work that combined abstraction and representation, the oil struck Phillips with its "distinguished originality," and his ensuing purchase of it made the Phillips Memorial Gallery one of the first museums to acquire a painting by Gatch.[2] Two years later, after Phillips had bought three additional Gatch works, the artist wrote to his dealer, "It's wonderful and quite thrilling. I am beginning to think of Phillips as my Fairy Godmother. Nothing could be better for us than to have a man like that really interested in us and constantly so."[3]

Phillips expressed his support even further in 1946 when his museum became the first to give Gatch a one-person exhibition.[4] In 1949, when Phillips was invited by Robert Goldwater, editor of *Magazine of Art,* to write an article on an American painter of his choice, he selected Gatch. His resulting text was so favorable that Gatch wrote, "The power and the sensitivity of the writing indicates [*sic*] hours of real toil. . . . It will unquestionably be the greatest help and assistance in the future."[5] Designated a unit artist by 1952, Gatch was further endorsed in 1953 when Phillips announced his intention to purchase two Gatch paintings annually, an arrangement that Gatch stated gave him "security of mind for which I can't tell you how grateful I am."[6] However, the purchase plan proved to be irregular and short-lived, in part because the steady rise in popularity of Gatch's works assured him of sufficient sales to other patrons. In 1954 Phillips bought *Flyway* (acc. no. 0723) and *Snowpatch,* and two years later he made his last Gatch acquisitions, *Bird in Hand,* 1955, and *Night Fishing,* 1956 (acc. no. 0718 and cat. no. 289).[7] Phillips's fifteen-year support of the artist resulted in a collection representing the range of Gatch's development from 1933 to 1956.[8] The additional gifts to the museum, after Phillips's death, of a late canvas collage, *Game Tapestry,* 1965, and two oils, *Untitled,* 1926, and *Home of the Hawk,* 1948, further broadened the unit.[9]

The Gatch unit is particularly strong in early works. *Untitled,* 1926, *Highlanders,* 1933, and *City at Evening,* 1933 (cat. no. 287), typify the decade following his return from Paris, when Gatch emphasized contrasts of light and dark and combined naturalistic forms with cubist structure. Works from the 1940s, such as *Three Candidates for Election,* 1948 (acc. no. 0728), and *Industrial Night,* 1948 (cat. no. 288), reflect Gatch's growing interest in abstraction and his exploration of color as an expressive and unifying element. The unit includes a smaller number of works of the 1950s, such as *Bird in Hand* and *Night Fishing,* which are more symbolic and abstract, and juxtapose flat pattern and suggested depth. Although the artist continued to develop in the late 1950s and 1960s, creating increasingly experimental works that incorporate pieces of canvas and stone as collage elements, Phillips responded most positively to the sensuous color and evocative subjects of his earlier paintings, which he considered "not too abstract" but "warm in color."[10]

Phillips classified Gatch with Davies, Demuth, Prendergast, and Twachtman as American artists who, "short of eclecticism, were very curious about what was going on abroad and eager to see what was in circulation which they could use and transform to their own purpose."[11] In Gatch's oeuvre he recognized the influence of the cubists supplemented by the decorative patterning of the French Nabis artists Bonnard and Vuillard. His sensitivity to color may have been stimulated by Bonnard and Derain, and his inclination for fantasy sparked by Klee, whose paintings he surely saw at J. B. Neumann's New Art Circle. Phillips believed that Gatch combined these various stimulants into a personal style. About his complex, vibrant, poetic abstractions, Gatch wrote: "For me art should not be too cerebal [*sic*]. It is for rejoicing. As long as it bears the stamp of personality; that it communicates and the over all image is an aesthetic entity, I will have fulfilled the eternal plea, 'Art for Heaven's Sake.'"[12]

JBG AND GHL

287

City at Evening, 1933
The City
Oil on canvas, 18 × 25 (46.0 × 63.5)
Signed in black paint, l.l.: GATCH
Acc. no. 0721

PMG purchase 1943 from the artist through J. B. Neumann, New York.[13]

City at Evening, a depiction of Paris at nightfall, typifies Gatch's development following his year-long sojourn in the European capital from 1924 to 1925. The view of buildings and bridges along the Seine is transformed into a bold pattern of forceful horizontals, repeated simplified shapes, and light and dark contrasts. Brightly lit streets slash through the shadowy atmosphere and intersect to form a trapezoid that recedes into the background. The surrounding darkness is peppered with glistening lights and illuminated facades, adding lively definition to the environment. Although design and light/dark contrasts were Gatch's chief concerns, the painting's muted palette of blue-greens and pinks reveals a heightened sensitivity to color variation that would characterize his later work.

Duncan Phillips believed that "the 'cubic discipline' . . . served Gatch well as a basis for the poetic expression of heightened consciousness and evocative suggestion."[14] For him, the romantic atmosphere of a nocturnal Paris was successfully evoked in the "tall houses [which] gleam like old ivory at lamp-lighting time and carry down the afterglow from the turquoise river and sky, these lights balancing perfectly the bronze and black tones of the surrounding nightfall."[15] *City at Evening* formed an effective contrast to the collection's sunlight-filled *Highlanders,* painted the same year, in which "we feel the rhythm of the march so insistently that we hardly see the men in the imminence of their arrival, in the clangor and shock of their fanfare which the colors symbolize."[16] Phillips considered both works, with their "calligraphy [and] cubist stylization," to be "masterpieces" of the artist's early oeuvre.[17]

JBG

288

Industrial Night, 1948
Oil on canvas, 17⅞ × 39⅞ (45.4 × 101.3); frame by the artist: 24¼ × 47 (61.6 × 119.4)
Signed in black, l.r.: GATCH
Acc. no. 0724

PMG purchase 1949 from the artist through J. B. Neumann, New York.[18]

287

Industrial Night, a nighttime view of the Pennsylvania shore from New Jersey, demonstrates Gatch's ability, at the height of his mature style, to transform a mundane vista through decorative pattern and luminous color.[19] A bridge crossing the Delaware River creates a dramatic arc defined by bold curves and repeated triangles that recede into depth. Oil refineries stud the horizon and are transformed into a series of triangles mirrored in the expanse of water; they contrast strikingly with the wooden rectangles that compose the painting's frame, which Gatch himself made.[20] Gatch's sense of design, the importance of which was communicated to him nearly twenty-five years earlier by his teacher John Sloan, reached full maturity in this painting.

Gatch manipulated patches of luminous color in *Industrial Night* to create a flat, decorative surface while simultaneously generating a sense of depth by juxtaposing bright oranges and yellows in the foreground against receding blue tones. The illusion of space and movement is reinforced by the diagonals of the bridge, which rapidly draw the viewer's eye to the opposite shore. Duncan Phillips emphasized this sensation in his description of the painting: "Driving with him over elliptical curves, along gleaming tracks, through an *Industrial Night* of sapphire and gold, azure and vermilion, we are

asked to note by the way the crescent moon in the pale water, but more particularly to observe those curves in contrast to the vertical and pyramidal lines of oil wells on the dark shore and the diagonals of the drawbridge to which all curves lead."[21]

JBG

289

Night Fishing, 1956
Oil on canvas, 32 × 48 (81.2 × 121.9)
Signed in black paint, l.r.: GATCH
Acc. no. 0725

TPG purchase 1956 from the artist through Grace Borgenicht Gallery, New York.[22]

In *Night Fishing* Gatch pays homage to Picasso's 1939 painting *Night Fishing at Antibes.*[23] Picasso's work had been inspired by Mediterranean fishermen using acetylene lamps to attract their catch, a nocturnal activity Gatch might have observed on the Delaware River near his home. Although the two works share a similar theme and display each artist's fascination with the treatment of space and the abstract, formal qualities of the object, Gatch reinterpreted the scene according to his own sense of simplified design. He explained: "I have great faith in the

288

289

object and in vision. Faith in the object is to me the lesson that Picasso recites over and over. The object, I believe, can still give aesthetic birth and there is still much for the artist to discover and create from it."[24]

Gatch turned the sails of the fishing boats into a rhythmic pattern of blue and brown triangles, fragmented the river into colorful shapes, and transformed the night sky into a backdrop of floating black rectangles that enclose the activity of the scene. Suspended in the sky are a plate of speared fish, a lamp, and an angel-like bird, all motifs derived from the Picasso painting. Gatch's space is a series of overlapping planes emphasizing the flatness of the picture plane and reinforcing the decorative quality of the composition. While Gatch was concerned with structure and design, he never embraced pure abstraction. He believed that "reality in painting is so fascinating that it is hard to abandon its charms that are so apparent and within our realm of expression."[25]

The variations of texture are striking in *Night Fishing*. Gatch created the illusion of depth by contrasting the heavy impasto of the figures with the thin washes of the background. He worked the areas of thick paint with a palette knife, creating raised patterns that foreshadow his experimentation with canvas collage in the late 1950s. The painting's tonality, reminiscent of Braque's earthy palette, is dominated by the gray and black of the background, but passages of trademark oranges and blues energize the composition.

Duncan Phillips was immediately taken with *Night Fishing,* as he revealed in a letter to Max Kahn of the Grace Borgenicht Gallery: "We hope . . . that you will keep under reservation to us the *Night Fishing* by Gatch. He is so well represented in our Collection that we must be careful from now on only to get the pictures which make a special appeal. However, we do lack examples as strong as *Night Fishing*."[26] Phillips acquired the painting five days later, indicating that he considered *Night Fishing* a powerful example of Gatch's "distinguished originality."[27]

J B G

RALSTON CRAWFORD (1906–78)

George Ralston Crawford, who created images of the American industrial landscape in a precisionist style, was born in Saint Catharines, Ontario, near Niagara Falls, September 25, 1906; his family moved to Buffalo in 1910. After working several years as a sailor, Crawford turned to art, studying between 1927 and 1932 at the Otis Art Institute in Los Angeles; the Pennsylvania Academy of the Fine Arts; the Barnes Foundation, Merion, Pennsylvania; and the Hugh Breckenridge School, East Gloucester, Massachusetts. Crawford traveled in Europe in 1932–33, and in 1933 attended Columbia University. He had his first one-person show in 1934 at the Maryland Institute of Art, Baltimore. Fascinated with rural architectural forms, he returned that year to Pennsylvania to paint, living in Chadds Ford and Exton until 1939. After a series of teaching positions, including jobs at the Cincinnati Art Academy (1940–41) and the Albright Art School in Buffalo (1941–42), Crawford joined the army and was stationed first in Washington, D.C., then in China, Burma, and India. In 1946 he was sent by *Fortune* magazine to witness the atomic-bomb test at Bikini Atoll. An inveterate wanderer, Crawford traveled extensively in the United States and Europe to paint, produce lithographs, lecture, and teach. In 1950 he made the first of many trips to New Orleans, where he began to photograph black jazz musicians. Crawford died April 27, 1978, in Houston, but was buried in his beloved New Orleans. The Phillips Collection contains one oil, three lithographs, two watercolors, and one pastel.

290

290

Boat and Grain Elevators, No. 2, 1941–42

Oil on hardboard, 20⅛ × 16 (51.1 × 40.6)

Signed l.l.: *Crawford;* reverse: probable artist's inscription on hardboard in fading graphite, u.c. to u.r.: *B at Grain/— a o s #2/Crawford.*

Acc. no. 0346

The artist to the Whyte Bookstore and Gallery, Washington, D.C., by 1943; PMG purchase 1943.[1]

During the early thirties, at a time when many American artists were turning away from the wave of modernism that had swept the country since the early teens, Crawford appropriated the precisionist style to create smoothly painted, planar paintings of subjects specifically associated with America, such as skyscrapers, industrial structures, and machinery.[2] The Phillips Collection's *Boat and Grain Elevators, No. 2,* which idealizes the industrial landscape, is one of Crawford's last precisionist explorations. His later compositions depict a machine aesthetic in an increasingly fragmented, hard-edged style that perhaps results from his disillusionment with America's Second World War technology.[3]

Crawford's interest in docks, shipyards, bridges, and grain elevators stems from his childhood, which was spent near lakes Erie and Ontario. He later remarked on "how deeply the vital and most vividly recalled experience is identified with these lakes, these boats."[4] His exposure to the precisionist art of Demuth and, especially, Sheeler, while a student at the Barnes Foundation from 1927 to 1930, further fueled his interest in industrial subjects.[5]

Crawford was often drawn to rural locales, in this case an area with grain elevators on a river. Although the exact site of *Boat and Grain Elevators, No. 2* has not been identified, it was probably located near the port of Buffalo, because it depicts an ocean-going merchant steamer rather than a flat riverboat. Two other paintings of grain elevators exist, but only one of them, *Boat and Grain Elevators, 1942,* may depict the same site, although from a different angle.[6] Crawford often painted several versions of the same subject, progressively distilling the essential forms. In the Phillips painting he eliminated details, focusing instead on the "blank center" of the elevators, the central image in the composition.[7] To increase the two-dimensional effect even further and render the subject even more universal, Crawford simplified the various elements into broad, flat planes of color.

Although Duncan Phillips viewed precisionism as a movement uniquely American, he was not emotionally drawn to it. He failed to appreciate the precisionists' view of industrial subjects as symbols of order and reason and as part of America's cultural heritage.[8] In Phillips's estimate, this avenue in American art was "appropriate to a materialistic and mechanistic civilization in which the individual seems doomed to serve only a functional purpose."[9] He believed, however, that Crawford had great potential as an artist, and purchased *Boat and Grain Elevators, No. 2* for his "encouragement collection" of work by developing artists. By the late fifties, however, he considered it part of the permanent collection.[10] During that decade Phillips gained renewed interest in Crawford's work, and he purchased three lithographs from his mature period.

LBW

8 THE AMERICAN SCENE

Realism and Social Concern

RICHARD L. RUBENFELD

As a collector, critic, and museum director, Duncan Phillips supported contemporary American art without promoting a particular style or focus. During the first meeting of the Phillips Memorial Art Gallery trustees, he stated: "Our most enthusiastic purpose will be to reveal the richness of the Art created in our United States, to stimulate our native artists and afford them inspiration. . . . We must specialize in painting, more particularly in modern painting, and it will be our pleasure to show how our American artists maintain their equality with, if not indeed their superiority to, their better known foreign contemporaries."[1]

Although he provided patronage for his American contemporaries, Phillips was not blindly nationalistic, asserting in 1926, "I am not a propagandist and believe that all beauty is not confined to one school."[2] His growing admiration for French modernism and desire to be independent of prevailing critical attitudes tempered the support he gave to American art. In his essay for the 1927 exhibition "Leaders of French Art Today," Phillips stated, "I have been looking over the living Frenchmen and selecting examples of their work. . . . And I am sobered into a renewed respect for the apparently continuous mastery exercised by the French in the plastic arts."[3]

Rejecting the subjectivity and abstraction of European modernism and celebrating American experiences in a way that was understandable to ordinary people, painters in the United States during the late 1920s and the 1930s focused on the American scene. Phillips continued to educate the American public about the art produced at home and to show its relationship to international work. In 1929 he commented: "I am pained by talk of aggressive nationalism among the [American] artists because I am convinced of the underlying truth of a creative, constructive brotherhood of artists all over the world."[4] Impatient with critics who wanted American art to be sentimental, obvious, or propagandistic, Phillips railed against those who promoted work solely on the basis of its native content or accessibility to uneducated viewers, saying in 1935 that "to the average person and to such self-selected representatives of the popular attitude toward art as Thomas Craven, what is called 'the aesthetic' dwindles into unimportance, withdrawn as it seems to be into its forbidding self, when the artist no longer performs a

Jacob Lawrence, detail of *The Migration of the Negro*, panel 57, see cat. 321

practical social service such as religious education or the stimulation of racial, regional, or class consciousness."[5]

Phillips learned to recognize the potential of both realism and abstraction, writing in 1935 that "theoretical abstraction is never wholly artificial and localized realism is never altogether superficial, if thereby a sensitive and creative individual has found and fulfilled himself."[6] He believed that the collector should seek different viewpoints: "Ours is a many-minded world, and in almost every age— certainly in our own—art is many-minded too. Our concern should be to give those many minds a chance by not encouraging the moulding of a mass-mind. . . . In our search for the best of every kind of painting an attitude of reflective, sceptical, critical, but always sympathetic and unprejudiced observation has an advantage over the attitude of a pledged person, pledged to see or to think in some collective way."[7]

Phillips's willingness to endorse American work, while falling short of the chauvinist attitude of the art critic Thomas Craven, nevertheless led to concrete activities on behalf of artists in this country. True to his word, he collected American works and featured them prominently in exhibitions at the gallery. He disliked being involved with politics in art; however, for many years he was active in the American Federation of Arts (AFA), joining the organization in 1915 and serving at different times on the board of directors and the executive committee.[8] The group organized traveling exhibitions of American work, lobbied on behalf of the establishment of a national art gallery, published the *American Magazine of Art,* and by the early 1930s supported a federally funded program to decorate public buildings. Because the group was sometimes dominated by conservative artists, Phillips's affiliation with it was not always harmonious. Valuing his independence, he attempted to resign from the board of directors twice in 1926, writing on March 17, "I no longer believe that you would like to see the Federation's policy made more liberal and less dogmatic."[9] He could also, however, be vehement in his support of the group. A year earlier, he had defended it after reading Forbes Watson's negative comments on the quality of works in AFA traveling shows: "I know that it is doing splendid educational work with its traveling exhibitions. . . . The making of exhibition units representative of all that is best in every phase of American art for the benefit of the outlying sections of our country would be extremely valuable in stimulating national rather than provincial interests in things artistic and also in stirring local creative efforts."[10] By 1930 exhibitions of art from the Phillips Memorial Gallery, organized by AFA, began to tour the nation.

Phillips was also a major player in the Public Works of Art Project (PWAP), the first national art program under the Roosevelt administration, serving in 1933–34 as chairman of Regional Committee No. 4, which was responsible for the District of Columbia,

Maryland, and Virginia. Organized by Edward Bruce in December 1933, PWAP put 3,750 American artists to work in sixteen national regions in 1934. The project, concentrating on American subjects, commissioned easel paintings and murals in public buildings. Although PWAP ended on April 28, 1934, in its organization and goals it paved the way for future New Deal art programs. Marjorie Phillips remembered that her husband "was of two minds about PWAP. He felt that although some good talents were turned up, there was a good deal of mediocrity, too. . . . On the whole, however, he believed that government aid at that time did much more good than harm."[11] Phillips helped organize a large exhibition of works by PWAP participants at the Corcoran Gallery of Art, in Washington, D.C., that opened April 24, 1934. Additional exhibitions of federally funded art were shown at the Phillips Memorial Gallery in 1935, 1936, and 1939.[12]

The American realist art that Phillips collected from the 1920s through the 1940s is significant in quality and variety. Avoiding American Scene paintings that promulgated a narrow and essentially false view of life, he refused to restrict himself to artists who were well known or who participated in AFA exhibitions and the New Deal art programs. Instead, Phillips responded to art on the basis of genuine experience, choosing works by artists such as Burchfield, Hopper, and Weston in which the emphasis was on spirit instead of appearance or anecdote. Phillips admired the sensitive psychological portraits of Bernstein, Chapin, and the Soyer brothers but was also intrigued by the formal experimentation of Friedman and the technical mastery of Karfiol. He valued painters like Bishop, Crite, and Lawrence for their ability to capture aspects of contemporary life and history that were overlooked by more mainstream artists, and social realists like Gropper and Shahn who addressed topical issues in a dramatic, imaginative manner. For Phillips, the best American work was made by artists who sought their own solutions instead of following trends or European models, a trait he had already discerned in the works of Homer, Eakins, and Ryder. In 1932 he wrote that "those of us who collect American paintings, not just because they are American, but because they are good and often great . . . are impatient for the day when European critics will wake up to [the] fact that we have an ever increasing number of original artists busily at work. . . . These inventive American Artists are inheritors of the pioneer minds and the simple, grand sincerities of Homer and Eakins. But a few of them also draw upon the imagination and pictorial invention of America's greatest artist, Albert P. Ryder. . . . It is Ryder's romanticism based upon realism, his universality inherent in local and personal experience and imaginative adventure, his self-reliance and initiative, which seems to me expressive of our American character at its best, and its ideal of independence and progressive experiment."[13]

ARNOLD FRIEDMAN (1874–1946)

Arnold Friedman was born February 23, 1874, to Hungarian Jewish immigrants in New York City.[1] At an early age Friedman helped support his widowed mother and four siblings by working in the Produce Exchange, and at age seventeen he abandoned preliminary law studies at City College to begin a thirty-year career in the post office. In 1905 he started taking evening classes at the Art Students League, studying under Robert Henri for three years. In Paris, in 1908, Friedman met Renée Keller, whom he later married, and initiated his own study of French modernism—particularly impressionism and post-impressionism—which profoundly affected his painting. Formal qualities took precedence over verisimilitude and anecdote in Friedman's art, which became increasingly complex; agitated surfaces coalesced into sparkling patterns of rich color. Employment in the post office removed him from mainstream activities in the art world, but he was not completely isolated, serving as a charter member of the Society of Independent Artists. Before retiring from the Postal Service in 1933, Friedman had several one-person shows and participated in many group exhibitions. After his retirement he devoted full time to his art, winning WPA competitions for murals in post offices in Orange, Virginia; Kingstree, South Carolina; and Warrenton, Georgia. Friedman died in Queens, New York, December 29, 1946. Three of his oil paintings are in The Phillips Collection.

291

The Brown Derby, ca. 1936–40

Man at Race Track
Oil on canvas, 30¼ × 24⅛ (76.6 × 61.3)
Signed in red paint, l.r.: *FRIEDMAN;* artist's inscription on reverse: *HOW CAN THIS BE GOOD?/NO MEXICAN OR FRENCHMAN/HAS DONE IT YET–!*
Acc. no. 0699

PMG purchase from Arnold Friedman, 1940.[2]

Portraits were common subjects for Friedman, who was an inveterate observer of people. Family, friends, or clients at the post office inspired paintings, done from sketches or memory in his studio in Corona, New York. William Schack remembered: "Though he called many of his figures portraits, Friedman was interested in producing not a likeness, but a design."[3] Similarly, the painter's daughter, Elizabeth, recalled the transformation of the portraits from literal works to paintings based primarily upon his feeling for color.[4]

The Brown Derby is visually compelling yet deceptively simple. A middle-aged man wearing a derby, his darkened eyes suggesting he is deep in thought, leans on a railing. The painting's title could refer either to the hat that the man wears or to a horse race. The relationship between the man and the figures on the broad expanse of grass in the distance is unclear, but the hand up against his face also seems to gesture toward the equestrians.

Prolonged scrutiny reveals the painting's subtleties and energy. The nearly symmetrical composition, established spatially by three distinct horizontal bands, is very stable. The figure is central and the largest element, yet the painting deviates from strict symmetry by virtue of the man's gaze and almost imperceptible turn, as well as the placement of the equestrians in the upper right background. Deep space is implied, but the work appears flat owing to the very limited modeling and the compression of the figure into the foreground. The middle distance is curiously empty. Isolated areas of impasto, produced by a loaded brush, create unpredictable visual and tactile effects.[5] Line is similarly variable. In some areas, such as the face, hat, and raised hand, lines establish contours; elsewhere

the artist toned back the contour lines with white paint, making them less prominent or invisible.

Friedman claimed that "color in painting is the very heart-beat," and it resonates in *The Brown Derby.*[6] As in the painting of Cézanne, color is inseparable from form. The depth and harmony of color evoke a warm, hazy day. Green, the artist's favorite color, dominates, appearing here most prominently in the grassy field behind the man.[7] The sienna derby and warm fleshtones intensify the greens. The grays of the man's suit and jacket, close in value to the green field, further unite the figure and setting.

The identity of the man in *The Brown Derby* is not known. An undated pencil drawing, however, is certainly the study for the figure.[8] The drawing shows no setting; it is more angular, and the placement of the left hand differs, but the general position of the figure corresponds to the pose in the oil painting. By adding a setting, Friedman may have wished to amplify his portrait both formally and expressively.

Inscriptions on backs of paintings are common in Friedman's later works, constituting what Schack referred to as his "journals."[9] If the visual communication is essentially aesthetic, the inscriptions reveal the artist's state of mind. In them Friedman railed against the insularity of the American art world, the narrow-minded attitudes of jurors, and his own obscurity. On the back of *The Brown Derby,* Friedman ironically questioned the acceptance of his artwork by alluding to the pervasive influence of contemporary French and Mexican painting.

Given the emphasis on texture and varied technique, it is likely that *The Brown Derby* was painted during the later 1930s or near the date of the Federal Works Agency exhibition in 1940. Clement Greenberg's comments on the growing purity of Friedman's paintings are appropriate to *The Brown Derby:* "The significance of his pictures is largely embodied in the physical reality of their color and design. . . . He was very careful to make his pictures nothing else but easel pictures, in which both the motif taken from nature and the decorative elements are subordinated to the fact that the easel picture is an object hung on a wall to attract and hold our eyes in a special, dramatic way."[10]

RR

291

KENNETH HAYES MILLER (1876–1952)

An influential teacher of numerous artists represented in The Phillips Collection, including Marjorie Phillips, George Bellows, and Yasuo Kuniyoshi, Kenneth Hayes Miller was born at the Oneida Community in Kenwood, New York, March 11, 1876. When the community dissolved in 1880, his family moved to New York City, where he attended the Horace Mann School. In 1892 Miller enrolled in painting and drawing classes at the Art Students League and studied under Kenyon Cox, Frank Vincent DuMond, and H. Siddons Mowbray, among others. In 1897 he studied with William Merritt Chase at the New York School of Art, where he became an instructor in 1899. He traveled to Europe, for the the first time, in 1900. After the disbandment of the New York School of Art in 1911, Miller began teaching at the Art Students League, where he remained for nearly the rest of his life. He exhibited four works in the 1913 Armory Show and had his first one-person exhibition in 1916 at the Macbeth Gallery, New York. He was represented by the Montross Gallery during the 1920s and by the Rehn Gallery from 1929 to 1935. In 1929 he was included in the Museum of Modern Art's first exhibition of works by American artists, "Paintings by Nineteen Living Americans." He became an associate of the National Academy of Design in 1942, an academician two years later, and a member of the National Institute of Arts and Letters in 1947. Miller died in New York January 1, 1952. He is represented by two early paintings and three mature paintings.

292

Portrait of Albert Pinkham Ryder, 1913

Oil on canvas, 24⅛ × 20⅛ (61.3 × 51.2)

Signed and dated in brown paint, u.r.: *Hayes Miller—1913*

Acc. no. 1357

PMG purchase from the artist 1926.[1]

A supporter of modern art during the early years of the twentieth century, Kenneth Hayes Miller believed that the 1913 Armory Show had a "broadening influence" on American artists and that "art can really be free here now." However, he himself was unaffected by the artistic upheaval, stating that "the town is full of Cubist and Futurist exhibitions now—they hold the center of the stage. . . . I like the things, . . . but don't believe all [artists] need to follow."[2] Miller's own style harks back to the grand tradition, to Renaissance order, clarity, volume, and weight. He believed that Delacroix's "painting proved . . . it was possible to bridge the gulf between the old masters and moderns, and that

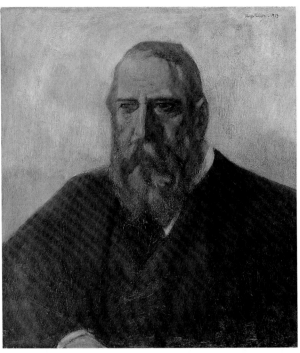

292

is what I have been trying to do ever since—both in my painting and teaching."[3]

Miller also regarded Albert Pinkham Ryder, the single most important influence on his early style (1900–18), as a successor to the Renaissance masters, stating that Ryder "groped among the plastic fundamentals until he unearthed the foundation on which Giorgione and Titian built."[4] After seeing Ryder's romantic, visionary canvases during the 1900s, Miller sought out the artist, and a close friendship ensued.[5] Miller revered Ryder both as a spiritual and an artistic mentor.[6] *Portrait of Albert Pinkham Ryder,* painted during Ryder's final years, extols the man and his art.

Miller greatly admired Ryder's ability to achieve monumentality in his forms, an effect he captured in this portrait of a dignified and impressive gentleman, portrayed in Ryder's own dark-gray palette and planar modeling technique. The figure is painted with alternating opaque light and transparent dark layers, for Miller believed that the contrasting layers create a "dramatic pressure for modeling figures."[7] In direct opposition to the teachings of his colleague Robert Henri, who stressed spontaneity in painting, Miller taught: "The medium of oil painting is more monumental than any other

because it is the only one that is both transparent and opaque. Watercolor is only transparent, tempera only opaque, but oil can be both. Therefore completely opaque use of oils as in 'direct painting' is a waste of their great potential force."[8]

Duncan Phillips began collecting Miller's work in early 1925, through the Montross Gallery, the same year he began to champion Bonnard and Cézanne.[9] Undoubtedly the artist and collector knew each other through Marjorie Phillips.[10] Upon seeing *Portrait of Albert Pinkham Ryder* in Miller's New York studio in 1926, Phillips wrote to the artist: "The Ryder portrait we certainly need and I would like to illustrate it in our Handbook."[11] Phillips appreciated this portrait not only for its intrinsic qualities but also because it is "a great portrait of a very great man and should be acquired for our Ryder Room."[12] Miller concurred, considering it to be "for external and for implicit reasons probably the most unique piece among all the canvases [I have] done."[13] In 1928 Phillips purchased *The Shoppers,* 1920 (acc. no. 1358), an example of Miller's mature period, beginning about 1918, when he became interested in "mankind in the mass."[14]

VSB

DAVID BURLIUK (1882–1967)

An artist of protean ambition and energy, David Burliuk was born July 22, 1882, in Riabushkin, near Kharkov, Ukraine, the son of an estate manager who worked in many parts of Russia. With his brother, Vladimir, Burliuk studied art in Odessa, Munich, and Paris and favored experimental art over traditional forms. The brothers participated in the first Blaue Reiter show in Munich, 1911–12, and later exhibited with Der Sturm in Berlin. Before the Russian Revolution, David Burliuk was also active as a painter, poet, and publisher in radical art groups in Moscow and Saint Petersburg. His reputation was solidified in 1913–14, when, along with his protégé, Vladimir Mayakovsky, he popularized futurism in performances and lectures held across Russia. When the economic and political situation worsened following the Revolution, Burliuk, his wife, and their two sons made their way through Siberia in 1919; they lived in Japan for two years before emigrating to the United States. In New York City by 1922, Burliuk lived there and on Long Island for the next forty-five years. He traveled extensively and worked in many styles simultaneously, becoming known through exhibitions at the Société Anonyme and the Whitney Studio Club. His later career is documented fully in *Color and Rhyme,* a lengthy newsletter published irregularly by his family between 1930 and 1966. He died in Southampton, New York, on January 15, 1967. Ten oil paintings and one copy of Katherine Dreier's book on Burliuk, with two drawings by the artist, are in The Phillips Collection.

The Burliuk Unit

David Burliuk's art is an impassioned response to the world, often stretching acceptable limits of visual communication. His artistic credo embraced all possibilities: "Art must never be narrower than life or narrower than anything one is able to imagine."[1] In a tribute to Burliuk, Raphael Soyer emphasized the strength of his friend's commitment: "I can only say how deeply I sense in Burliuk's art his one-ness with the visual world. . . . His landscapes of earth, water, flowers, sky are bursting with vitality, exuberance and elemental force. Scattered all over them are people, horses, cows, in many colors, without perspective, without logic. But strangely, the effect is one of joy and life."[2]

Burliuk's art was a reflection of both his dramatic life and his commitment to finding the most effective means of sharing an experience. In his essay for the *Blaue Reiter Almanac* he claimed that "remaining completely realistic in art is unthinkable. In art everything is more or

less realistic. But it is impossible to found a school on the 'more-or-less' principles. . . . Becoming absorbed in an experience leads me to creative activity."[3] Yet Burliuk's support of progressive art also had its limits. Although he experimented with different materials, often adding foreign matter to pigments, he vehemently rejected Vladimir Tatlin's assertion that painting no longer had meaning.[4]

Probably introduced to Burliuk's art by John Graham, or through Société Anonyme exhibitions, Duncan Phillips began buying his paintings in 1929. He completed the unit a decade later, the same year as Burliuk's solo exhibition at the Phillips Memorial Gallery.[5] Phillips's catalogue essay suggests why he was attracted to Burliuk's work. Identifying Burliuk as a pioneer of European modernism, he accepted the artist's many contradictions because he remained himself, despite the great problems of assimilation into American culture: "By turns eclectic and primitive, theoretical and infantile, he is both versatile and unchangeable, a chameleon in reflecting the color of his immediate surroundings but a folk painter fundamentally of persistent provincial integrity."[6]

The Burliuk unit, while not representing all his styles, nevertheless reveals the essential variety of Burliuk's art. With the exception of one work, *On the Road,* ca. 1920 (cat. no. 293), all were made after he moved to the United States. Despite the variance in style and technique, expressionism is an ongoing trend in the paintings. In each work, Burliuk responded emotionally to the materiality of his medium, asserting rhythmical and tactile effects. *In Gloucester,* an oil from 1928 (acc. no. 0248), portrays the New England port in a primitive, charming way. Sparkling touches of rich colors—mostly oranges and greens—enliven its predominantly earth-tone palette. The coarse burlap surface and varying levels of impasto suggest a sense of history, yet the figures are shown with great vitality. Phillips was attracted to Burliuk's attempts to show American subjects but considered his "gnome-like little people out of fairy tales" and "his attempts to be one of us . . . always quaint and touching rather than successful."[7] *Shells and Plant,* painted in 1932 (acc. no. 0253), looks microcosmic and monumental at the same time. Its naïve treatment of nature, its broad, flat brushstrokes, and its spatial ambiguity recall the work of Louis Eilshemius, an artist Burliuk and Phillips greatly admired (see cat. nos. 86–89). In contrast, *Flowers in Blue Pitcher,* an oil painting from 1934 (acc. no. 0247), is more sophisticated. Richly impressionistic, its active brushwork and broken

color are given cohesiveness by the geometry inherent in its composition. Of the Burliuk paintings in The Phillips Collection, it most clearly reveals the artist's joyful vision.

The vitality of these paintings is central to Burliuk's oeuvre. He explained: "A painting is the result of a movement. To be dead is to be immobile in the meadows of eternity. Drawings or paintings are seismographic recordings. They express psychological cataclysms; eruptions of emotions, different passions, because only souls of academicians are mournful and sleepy as swamps. Then again, real life and real creations are symbolically so near to the revolving convulsions of tigers. . . . To create means to jump . . . to beat and to bite everybody who prefers the tranquility of a cemetery."[8]

R R

293

On the Road, ca. 1920

Peasant's Cart; Peasants and Cart
Oil on burlap, 33½ × 47¾ (85.1 × 121.5)
Signed l.l.: *Burliuk*

PMG purchase from Boyer Gallery, New York, 1939.[9]

Immediate in its impact and slow to reveal all of its stylistic complexities, *On the Road* is one of Burliuk's most memorable canvases. Its uncluttered composition, focusing on a peasant couple leading a horse and wagon down a road, provides a basic appeal to human emotion rather than to the intellect.

The painting derived from Burliuk's investigations of neo-primitivism, a style he first explored between 1905 and 1911.[10] The neo-primitivists, including Burliuk, his brother, Vladimir, and Mikhail Larionov, sought to make art that was easily accessible to ordinary people and stripped their paintings of specific narratives, moralistic lessons, and illusory effects. Subjects were shown in a naïve, childlike manner reminiscent of folk art. Scenes of peasant life and portraits of workers implied that the strength of Russia rested in its people and their relationship to the land. Ultimately, however, what was done to the subject, rather than the subject itself, became the major thrust in Burliuk's neo-primitivism. In this context, the primary content of *On the Road* is its technique. Burliuk, like other neo-primitivists, used intense color, distorted human proportions, and kept the important details near the picture plane. However, he eschewed the flat areas of color favored by the group, squeezing paint directly from the tube to energize the surface.

Though intermittent, the thick, highly tex-

tured impasto is forceful. Burliuk believed that tactile effects, and the visual sensations derived from them, were major components in the expressiveness of a picture; yet characteristically, textures in his art vary considerably, sometimes within the same painting. As he explained in his article "Surfaceology," a broad range of textures should be explored: "Visual topography is the appreciation of paintings from the point of view of the characteristics of their surfaces. The surfaces of my paintings are: laminated, soft, glossy, glassy . . . flat and dull, smooth, even and mossy, dead, sandy . . . mountainous, rocky, craterformed [sic], thorny, prickly, camel-backed, et cetera. In my works you find every kind of a surface one is able to imagine or to meet in the labrinths [sic] of life."[11] The coarse burlap of *On the Road*, visible in some areas, is totally obscured elsewhere. Impasto is wildly uneven, permanently warping the picture's surface and enhancing the scene's energy.

The action in *On the Road* is staged in the foreground, and the space is flattened. Burliuk generally avoided overlapping, thereby giving visual weight to each component. The distant farm buildings at the right, near the most textured area, shift the balance of an otherwise symmetrical composition, adding tension to keep the eye moving. The heaviness of the paint suggests the enormity of the peasants' burden and helps to underscore their ties to the earth. The highest area of impasto, built up of wax and paint and jutting out several inches from the surface, appears near the windmill in the background, to the right.[12] As a result, this area is a looming presence, a source of tension that is not dependent on the imagery. Yet the complex swirls of paint and exuberant surfaces of color convey the boundless energy and resiliency of the land and those who live off of it. Duncan Phillips realized how essential Burliuk's style was in conveying meaning in the painting and thought *On the Road* was the quintessential Burliuk work: "The artist in his passion about his subject must symbolize the massive, overhanging meaning of The Soil for those who toil in it. To do this he builds out from the surface of his canvas in great mounds, tempting our hands to feel its roughness. The colors of this fascinating picture are like a song of elementary pride and joy in elemental things."[13]

RR

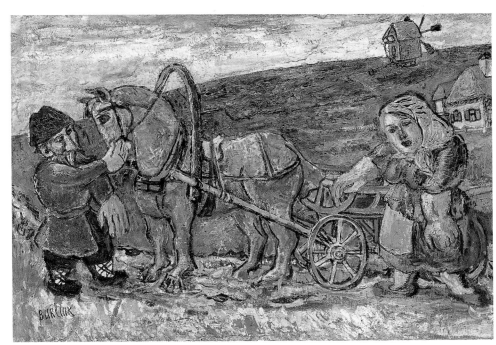

293

294

Farm at Bear Mountain, 1925

Slopes of Bear Mountain (DP)
Oil on burlap, 18 × 12⅞ (46 × 32.7)
Signed and dated l.r.: *Burliuk 1925*
Acc. no. 0254

Purchased from the artist through John Graham 1929.[14]

Having painted landscapes since childhood, David Burliuk learned to look beyond the obvious, to discover the true character of a place. Burliuk might alter specific details, including scale and the arrangement of natural forms, to enhance a painting's impact, but he would not approach his subject with an *a priori* interpretation or formula. His landscapes, often painted outdoors, capture fleeting effects of light and atmosphere and, more important, are infused with feeling.

Farm at Bear Mountain is a depiction of an upstate New York landmark that was within easy traveling distance for the artist. Besides the painting's title, Burliuk left no information about the site or his experiences there; yet the intensity of his response to the place is unmistakable.

Farm at Bear Mountain is vigorously expressionistic. Painted with rhythmical strokes, wiry lines, and strong colors, it is a paean to nature in late summer. The work seems to radiate heat and light. Its predominantly verdant palette is evocative of a summer with plenty of sun and rain. Everything appears lush; the corn is high and the trees are full. While warm highlights on the foliage and rooftops of farm buildings capture the effects of the sun, deeper greens and blues, found in the denser areas of trees, suggest the fresh, cool air of the shade. The painting's vertical format, denying the viewer a panoramic vista, accentuates the steep mountainside behind the farm. While Burliuk made the scene appealing, he also underscored its remoteness. The buildings are in the distance, and the road at the bottom of the painting is a barrier preventing the viewer from getting too close. At this point in his life, living in a Bronx tenement, Burliuk was probably nostalgic for his rural homeland.

When the painting was reproduced in *Art and Understanding*, a brief explanation of the work, possibly by Duncan Phillips, captured its robust essence: "The influence of Van Gogh is evident but the method and the blues and yellow-greens saturated in sunlight are used in a powerfully personal manner by this temperamental Russian. The entire landscape is steeped in an atmosphere of excitement."[15] For the viewer, the vitality of *Farm at Bear Mountain* is contagious.

RR

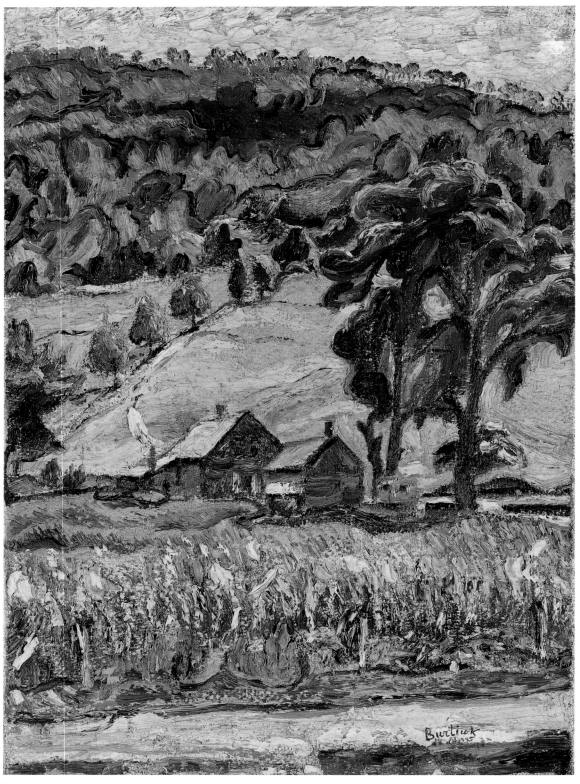

294

EDWARD HOPPER (1882–1967)

Edward Hopper's enigmatic depictions of America are indelibly etched in the memories of those who have viewed his work. Born in Nyack, New York, July 22, 1882, Hopper showed early promise in art and was encouraged by his parents to pursue a career in illustration. With their emphasis on truthful, contemporary subjects, his teachers Robert Henri and Kenneth Hayes Miller at the New York School of Art were essential to Hopper's development as a realist. Hopper made three prolonged visits to Paris between 1906 and 1910; yet, aside from an interest in impressionism, he was not attracted to modern art. Although he sold his first oil painting in the Armory Show in 1913, he was forced to continue with commercial illustration. His first one-person exhibition was at the Whitney Studio Club seven years later. Acclaim came with his solo show at the Frank K. M. Rehn Gallery in 1924, the same year he married the painter Josephine Nivison. Hopper's life and art were remarkably consistent over the next four decades. Living frugally in Greenwich Village and New England, he worked slowly, synthesizing and distilling his observations of contemporary life into hauntingly familiar scenes. Hopper died in New York May 15, 1967. Two oils and a watercolor are in The Phillips Collection.

295
Sunday, 1926

Sunday on Main Street; Sunday, Main Street; Sunday Afternoon
Oil on canvas, 29 × 34 (73.6 × 86.3)
Signed l.r.: *Edward Hopper*
Acc. no. 0925 (Levin no. 0-247)

PMG purchase from the artist through Frank K. M. Rehn, New York, 1926.[1]

Sunday is characteristic of Hopper's vision of twentieth-century America. Seemingly prosaic, it has unexpected resonance, showing the significant rather than the beautiful. The interplay between particular and generalized components, an ongoing aspect of Hopper's oeuvre, contributes to the work's vitality, making it at once familiar and unfamiliar.

Executed on the eve of the Depression, images such as those in this painting gave visual form to prevailing states of mind in the United States. Hopper's most influential teacher, Robert Henri, had already explored subjects inspired by contemporary native experiences, but Hopper's work is altogether sharper and tougher than Henri's. Finding most American Scene art sentimental and obvious, Hopper disliked being identified as a proponent of the movement.

By the 1920s, however, his art dealt exclusively with American subjects.

Hopper's work revealed the essential isolation of people in the twentieth century and their troubled relationships with the environment. He acknowledged that "great art is the outward expression of an inner life of an artist," but much of the tension conveyed by a Hopper picture is the result of the conflicts between the artist's idea and observations.[2] "I look all the time for something that suggests something to me. . . . The more you put on canvas the more you lose control of the thought. I've never been able to paint what I set out to paint."[3]

Sunday depicts a spare Hoboken street.[4] In the foreground, a solitary, middle-aged shopkeeper sits on a sunlit curb, smoking a cigar. Behind him is a row of old wooden buildings, their darkened and shaded windows suggesting stores that are closed for the day. Oblivious to the viewer's gaze, the man seems remote and passive, as if he were seen from across the street. His relationship to the buildings is uncertain. There is a strong sense of sunlight, but it is curiously unwarming. Devoid of energy and drama, *Sunday* conveys inertia and boredom.

According to Charles Burchfield, Hopper's art has "such a complete verity that you can read into his interpretations . . . any human implications you wish."[5] This has been the case for *Sunday*. When the work was first shown in New York in 1926, a critic for the *Brooklyn Daily Eagle* saw it as a manifestation of national character.[6] Robert Hobbs explored the work's contradictions more fully, seeing the buildings as a demonstration of "the unrelenting march of progress" and the figure as being "tied to the nineteenth century architecture . . . and ideals." He interpreted the painting "as a pleasant scene of a middle-aged man puffing on a cigar and enjoying the sunlight or . . . a picture that presents indirectly the unprosperous side of the 1920s."[7]

Duncan Phillips was the first to point to contrasting content in the work: "The grim scene is just as we remember it, only more so. The light conveys the emotion which is a blend of pleasure and depression—pleasure in the way the notes of yellow, blue-green, gray-violet and tobacco-brown take on a rich intensity in the clear air—and depression induced by this same light and these same colors as we sense them through the boredom of the solitary sitter on the curb. . . . Hopper defies our preconceptions of the picturesque and unflinchingly accepts the challenge of American subjects which seem almost too far beyond the scope even of the realistic artist's alchemy."[8]

RR

296
Approaching a City, 1946

Oil on canvas, 27⅛ × 36 (68.9 × 91.4)
Signed l.r.: *Edward Hopper*
Acc. no. 0923 (Levin no. O-332)

PMG purchase from the artist through Frank K. M. Rehn, New York, 1947.[9]

Travel is a recurring theme in Hopper's art. His early trips to Europe, many journeys through New England, and holidays in the South and in Mexico provided motifs for artworks such as *St. Francis' Towers, Santa Fe* (acc. no. 0924), a subtly luminescent watercolor acquired by Phillips in 1926.[10] But, while Hopper made studies and watercolors away from home, he found it difficult to show the picturesque. Actively seeking commonplace subjects, he often gave more significance to the journey than the destination. "To me," Hopper wrote, "the most important thing is the sense of going on."[11]

Hopper's most effective travel pieces are joyless, as if experienced by a commuter. Places travelers use regularly—train stations, bridges, and hotels—are purged of anything too specific or inviting. Revealing the essentials of a scene, Hopper convinces the viewer to see it truthfully, as if it were for the first time.

Approaching a City depicts an arrested moment on a trip: a wide-angle view of railroad tracks and an underpass. A massive wall separates the foreground from apartment buildings in the distance, contributing to the sense of isolation. The painting contrasts the boredom of the setting with the uncertainty of what lies beyond the dark tunnel. Presumably at the front of the train, the viewer is on the threshold of an event, but characteristically Hopper did not reveal what lay ahead. Referring to this work, the painter said he wanted to evoke the "interest, curiosity, fear" one experiences when entering or leaving a city.[12]

Several earlier works from 1906 on explore the theme of an interrupted journey, including a train station and tunnel, revealing how the artist's ideas evolved from an illustrative to a haunting painting.[13] The deserted platform, darkened train, and distant buildings of *Dawn in Pennsylvania,* an oil from 1942, predict the stark impersonality of the Phillips work, but the setting is more static.[14] In contrast, the study for *Approaching a City* (fig. 36) is vigorously sketched, suggesting the rushing movement of a train.[15] By widening the view in the finished painting, Hopper provoked the sensation of the train's deceleration as it reached the outskirts of a city. He also provided the viewer with more

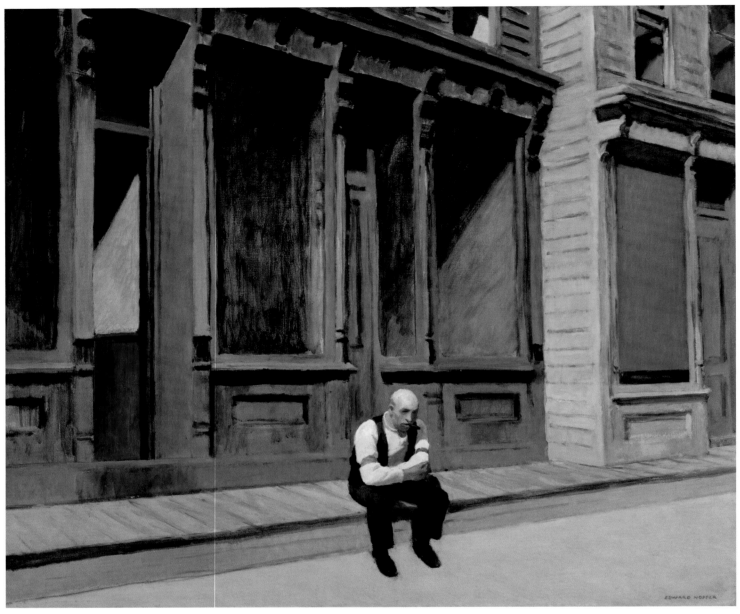

295

time to explore the bleak setting and prepare for what is beyond the tunnel.

Ultimately, *Approaching a City* conveys a paradox of contemporary life. The unseen traveler is in a curious limbo between city and country. The railroad made faraway places accessible to ordinary people, but it also made those places less distinctive. Hopper, by asserting the anonymity of the place and not revealing the train's destination, suggests a future that is both predictable and unknown.

RR

Fig. 36 Edward Hopper, *Approaching a City*, 1946, conté on paper, 15 1/16 × 22 1/8 in., Collection of Whitney Museum of American Art, New York; Bequest of Josephene N. Hopper, 70.869.

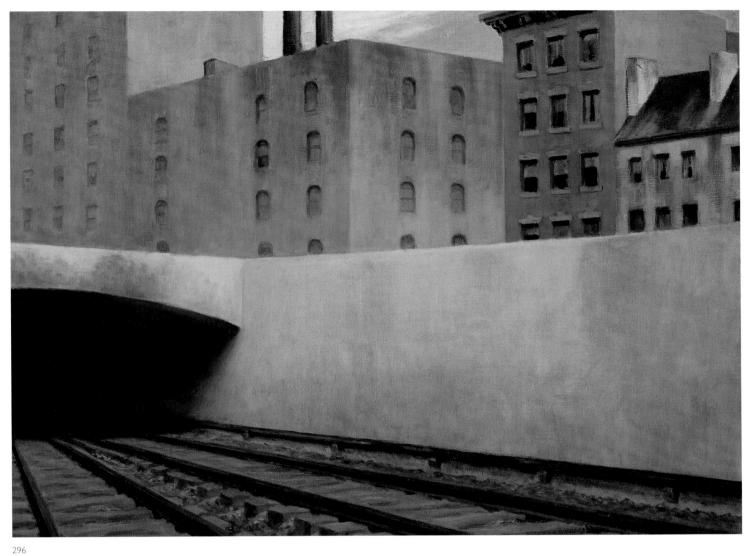

296

JAMES ORMSBEE CHAPIN (1887-1975)

James Ormsbee Chapin, born in West Orange, New Jersey, July 9, 1887, is best remembered for his revealing psychological portraits of American workers, performers, and athletes. Chapin's talent was revealed early, but his parents wanted him to pursue a career in business. He left school at age sixteen to help support his family, working as a bank runner in New York. He attended evening life-drawing sessions at Cooper Union and George Bridgman's anatomy classes at the Art Students League. A cousin generously financed two years of additional schooling at the Royal Academy of Art in Antwerp, where Chapin won a gold medal for drawing. After his return to New York in 1912, Chapin worked as a commercial artist and illustrator, experimenting on his own with modernism. Encouraged by Robert Frost to be true to himself, Chapin left the city in 1924 to live and paint on the Marvin farm near Stillwater, New Jersey. The subtle realism of the Marvin works brought him acclaim and patronage. Exhibiting portraits and genre scenes regularly, Chapin also taught at the Pennsylvania Academy of Fine Arts and received a WPA commission for a mural for the post office in Glen Ridge, New Jersey. He died in Toronto, July 12, 1975. The Phillips Collection owns one oil and one watercolor.

297

297

Emmett Marvin, Farmer, 1925

Oil on canvas, 35 × 29 (88.9 × 73.6)
Signed and dated u.l.: *JAMES CHAPIN—25*
Acc. no. 0291

The artist to the New Gallery, New York, 1925; sold to Sidney Osborne, New York, 1926; returned to the New Gallery, 1926; PMG purchase 1926.[1]

Chapin was a man of the people who celebrated the diversity of American experience by depicting individuals at work, rest, and play. Wary of groups and trends in the art world, he valued his independence, stating, "I am of a tradition but not of a school, and I should like to be counted, if at all, among those aspiring to affirm life and the brotherhood of man in common experience."[2]

He associated with few painters, claiming, "I have tried to live as much of my life as I could among other kinds of people, away from the studio, feeling that I'd like to keep the studio for a proving ground and workshop."[3] Chapin was not a loner, however, and he gave Robert Frost credit for inspiring him to set personal priorities.[4]

In 1924 Chapin was at a crossroads in his career. The previous year, his solo exhibition at the New Gallery had gained him recognition for his abstract paintings, but he did not like being indebted to European trends.[5] In demand for his illustrations and commercial art, he had little time for personal work. He was also in poor health and tired of New York. Hoping to discover his roots in New Jersey, Chapin got off the train at Stillwater because he liked the name of the town. Nearby, he rented a small log cabin on the Marvin farm for four dollars a month. How long he stayed there is not certain, but over the next several years he painted some of his most memorable canvases.[6]

Chapin got to know the Marvin family well. With few amenities and no farm machinery, the family led an active but frugal life. Guarded at first, they eventually grew comfortable with the painter and, after he got them a still to make their own whiskey, they agreed to pose for him.

Disarmingly direct, *Emmett Marvin, Farmer* was Chapin's first major work from this period; it was also his first picture purchased for a museum.[7] Emmett Marvin, centrally placed and dressed in his work clothes, sits quietly in a spare interior, the few objects near him alluding to his austere life. Drawings from the Marvin period reveal how carefully Chapin studied details of his subjects before incorporating them into his paintings.[8] Chapin's technique of applying pigment in patchy strokes, reminiscent of Cézanne's brushwork, gently animates the portrait. The unassertive palette, primarily pale blues and browns, helps convey the ordinariness of the subject.

Appearing both alert and cautious, Marvin looks directly at the viewer. He is unemotional; his introverted personality is subtly revealed by his gaze, posture, and folded hands. Chapin wrote that Marvin "was in some ways a thoughtful man with a touch of the poet in his speech. In other ways he was a frustrated and dangerous one, especially when drunk on home made whiskey."[9]

Like many of the other Marvin works, this painting was greatly admired in its time. In a letter to George Hellman in 1926, Duncan Phillips called it "a human document," writing two years later that it was "a serious tribute to a sterling American type."[10] Grant Wood later pronounced Chapin's Marvin paintings to be "among the best things in American art, strong and solid as boulders."[11] In 1975 Chapin recalled Marvin's reaction to the work: "As they stood looking, Emmet [*sic*] turned to his cousin, and his face shining said, 'And he did it all with a leedle broosh.' He so yearned to share with his cousin the wonder of it. The wonder seemed to have little or no reference to 'art' or to the painting itself. . . . It seemed to be celebrating that marvelous subtle and potent structure which is the human hand."[12]

RR

HENRY VARNUM POOR (1887–1970)

Henry Varnum Poor was born September 30, 1887, in Chapman, Kansas.[1] As a boy, Poor showed an aptitude for drawing and self-reliance as well as a strong interest in nature. He received a bachelor's degree in art from Stanford University before going to Europe in 1910. His London sojourn was particularly significant for his development as an artist; there he worked under Walter Sickert and visited the Grafton Gallery exhibition "Manet and the Post-Impressionists." French modernism had such an impact on Poor that he moved to Paris, studying at the Académie Julian for five months. After he returned to the United States, he had a diverse career. Although Poor considered his primary field to be painting, he first gained fame as a ceramist and worked successfully as an architect, designer, furniture maker, sculptor, muralist, author, illustrator, and educator. Self-taught in many of these disciplines, Poor created art that was close to nature, instinctive, vigorous, and well crafted. He was a founder of the American Designers Gallery in New York and the Skowhegan School of Painting and Sculpture in Maine. Among the first ten artists to receive federal funding for murals, Poor painted frescoes at the Departments of Justice and the Interior in Washington, D.C. Their success led to commissions for the Land Grant Frescoes at Pennsylvania State University. Poor died December 8, 1970, in New City, New York. The Phillips Collection has one oil painting and two watercolors.

298
Dead Crow, ca. 1943
Oil on hardboard, 15⅞ × 20 (40.3 × 50.8)
Signed u.l.: *H V Poor*
Acc. no. 1601

PMG purchase from Rehn Gallery, New York, 1944.[2]

Truly a Renaissance man in his range of interests and accomplishments, Henry Varnum Poor was a passionate individual in love with life. He claimed that "the only message that I may have is that I find the world exciting and beautiful."[3] Indeed, his interest in nature was long-standing.

Reminiscing about his early life in Kansas, Poor stated, "I think my strongest inclination was to be a naturalist. I knew every bird and insect and made collections of them. I remember summers of plowing on the upper prairie land, feeling the black, sandy earth between my bare toes. . . . It was a friendly world in which we grew up . . . loving every bit of the familiar earth and its even more familiar creatures."[4]

Poor linked nature to art. Animals, plants and landscapes are common images in his drawings, paintings, and ceramics; his depiction of these subjects, however, transcends mere description. In his drawing class with Sickert and his independent study of modern art, he learned to capture the essential spirit of a subject.[5] He wrote: "It takes many years of painting to arrive at the understanding of where and how the re-creation of nature in painting departs from nature and follows painting."[6]

Dead Crow is disarmingly direct and intense. The bird is a looming presence that fills much of the picture space, underscoring the drama of the moment and the pathos of the *memento mori* theme. Poor was not preoccupied by death, but he probably accepted it as part of the natural cycle. Freed from the anecdotal qualities present in much of his work from the 1930s and 1940s, this painting shows death with dignity. The theme might have been inspired by the loss of life in the Second World War or by Poor's awareness of his own mortality. Poor was active in the War Artists' Unit around the time *Dead Crow* was painted, but it is not known whether he executed the work at home in the Hudson River Valley, in New York, or in Alaska, where he was stationed for six months in 1943. Crows, moreover, interested him and he may have known that a crow can symbolize death, mourning, and misfortune.[7] In 1920, when he built his home in New City, the abundance of crows in the area led him to name his residence "Crow House."[8]

The central image and symmetry contribute to the iconic quality of *Dead Crow,* yet the artist's energetic technique vitalizes the work. With both ends of a brush and a palette knife, Poor worked *alla prima* on the unprimed hardboard. Painterly brushstrokes, augmented by

impasto built up unevenly with a palette knife, convey urgency.[9] An arc, created by the process of *sgraffito* (scratching into the paint with a brush handle) and by applying paint and scraping it with a palette knife simultaneously, extends from the top of the back wing to the left claw, further animating the surface.[10] The bird is almost encircled by the arc in a manner reminiscent of images in circular format on Poor's plates and bowls. Functioning like a lens or a gunsight, the arc also helps the viewer focus on the crow.

Space and color contribute to the impact of the subject. Depth is limited because the crow is close to the picture plane, but the layered shapes in the bird's body and background—reminiscent of the stacking of cut paper or cloth in cubist collage—is compelling in its own right. The bird, slightly foreshortened, appears less upright than the arc and the rest of the painted surface, adding tension to the painting. Frequently combining vantage points in his art, Poor wrote, "I often like to stand very close to my subject and try to get in the painting the sensation of interlacing planes, which you get most strongly by shifting your point of view."[11] The palette, limited to black, grays, and earth colors, evokes the bleakness of death. The interplay between the dark grays and blacks of the bird and the brighter umbers of the background provides a dramatic contrast, but the red hardboard intermittently showing through the paint contributes to the picture's immediacy. Its warmth suggests that the bird's death was recent.

Duncan Phillips admired Poor's art and bought several works in 1938.[12] Studies for Poor's mural *The Conservation of American Wildlife,* commissioned in 1938 by the Treasury Department for the Department of Interior building, were shown at the Phillips Memorial Gallery in 1939.[13] Moreover, Phillips's interest in the subject and theme of *Dead Crow* is supported by three similar paintings in the collection—Ryder's *Dead Bird,* Soutine's *The Pheasant,* and Graves's *Wounded Gull* (cat. nos. 71, 124, and 364).

RR

298

YASUO KUNIYOSHI (1889–1953)

Yasuo Kuniyoshi combined elements from his Japanese heritage with the naturalistic tradition of American painting to create distinctly individual paintings. Born September 1, 1889, in Okayama, Japan, Kuniyoshi came to the United States in 1906. After working odd jobs on the West Coast, he moved to New York in 1910 and took classes with Kenneth Hayes Miller at the Art Students League from 1916 to 1920. There he met Alexander Brook, Reginald Marsh, Peggy Bacon, and Katherine Schmidt; he was married to Schmidt from 1919 to 1932. Hamilton Easter Field, editor of *The Arts,* became his supporter and offered him places to live—in Ogunquit, Maine, during the summer and Brooklyn in the winter. Kuniyoshi periodically exhibited with the Society of Independent Artists and had his first one-person show at the Daniel Gallery in 1922. After traveling to Europe in 1925 and 1928, he began teaching at the Art Students League in 1933. Kuniyoshi wed his second wife, Sara Mazo, in 1935, the same year he became one of the founding members of the American Artists Congress. He served as the first president of the Artists Equity from 1947 to 1951; received the first one-person show of a living artist at the Whitney Museum of American Art in 1948; and exhibited at the 26th Venice Biennale in 1952. Kuniyoshi died in New York May 14, 1953. The Phillips Collection owns five works by Kuniyoshi: two oil paintings, and three lithographs dating from the 1930s.

299

Maine Family, ca. 1922–23

The Farmer's Family

Oil on canvas, 30¼ × 24⅛ (76.7 × 61.3)

Unsigned; inscribed in black paint, u.r. stretcher: MAINE FAMILY; bears inscription l.c. stretcher: *Katherine Schmidt;* bears inscription u.r. frame reverse: *June 26*

Acc. no. 1100

The Downtown Gallery, New York; PMG purchase 1940.[1]

Kuniyoshi painted *Maine Family* during one of the summers he spent in Ogunquit, Maine, in the 1920s. An early work, it reflects the simultaneous influences of both the Western modernist idioms and his Japanese artistic heritage.[2] The distortions of scale and perspective resemble a child's generic depiction of family members in front of their house, complete with front walk, tree, and "pet"—in this case a toy horse. The background buildings, which are represented as simplified rectangles and triangles of color, reflect the artist's exposure to cubist painting. In contrast, the figures, although curiously angular and possessing Kuniyoshi's characteristic almond-shaped eyes and unnaturally pointed feet, are given bodies that exist as three-dimensional entities in space.

Comparison of the painting and its drawing suggests that Kuniyoshi added the figure of the girl in the oil as an afterthought. Her startlingly pale visage gives her an otherworldly quality that contrasts with the earthiness of the other figures in the scene. Kuniyoshi's inspiration for this approach was possibly based on memory portraits in nineteenth-century American folk art. This style, which experienced a revival during the 1920s and 1930s, greatly interested Kuniyoshi.[3] Certainly the influence of folk art, as well as naïve styles in modern painting, like those of Henri Rousseau, Marc Chagall, and Heinrich Campendonk, can be detected in Kuniyoshi's handling of the composition and details in *Maine Family.*[4] The curious omission of a man from the "family" group and the odd juxtaposition of the formally attired woman with the diaper-clad baby add to the unconventional air. The possibility that *The Farmer's Family* was an alternate title for the painting is supported by the artist's careful inclusion of the farm buildings in the background. Kuniyoshi's whimsical, Bruegel-like mode of representing New England farm life during this period struck some critics as amusing when they viewed his works in the 1922 one-person show at the Daniel Gallery. The artist, however, emphatically denied any humorous intention.[5]

In 1928, twelve years before Duncan Phillips acquired *Maine Family,* his first work by the artist, he recognized Kuniyoshi as a serious painter who beautifully combined Japanese and American artistic tendencies. He admired the oriental quality of the artist's "confident calligraphy, . . . stylistic brush writing, . . . and . . . arbitrary color chord of ivory and ebony and lacquer red," which appeared throughout Kuniyoshi's oeuvre, as well as the "plasticity" and "vital" evocation of "the inner truth" that Phillips believed he had acquired from Western art. To Phillips, Kuniyoshi's painting represented a "new idiom of quaint pictorial expression."[6]

GHL

299

300

Thinking Ahead, 1945

Oil on canvas, 16 × 12 (40.6 × 30.4)

Signed u.r.: *Kuniyoshi;* signed c.l. stretcher: KUNIYOSHI

Acc. no. 1101

The Downtown Gallery, New York; PMG purchase 1946.[7]

During the war years, when *Thinking Ahead* was executed, Kuniyoshi's paintings attained their greatest poignancy. The melancholic atmosphere of the Phillips work is defined by the woman's contemplative countenance, which dominates the canvas. Her solemn expression is accentuated by her distracted, lowered eyes, tilted head, and expressive, attenuated fingers, which rest upon her forehead and temple, as well as by the sweeping strokes of cold gray and somber rust in her clothing and desolate surroundings. The image of a woman's draped head set against a backdrop of forbidding sky or deserted landscape recurs in Kuniyoshi's work at the time.[8]

Painted by Kuniyoshi more than twenty years after *Maine Family, Thinking Ahead* reflects, in its more fully realized forms and atmospheric landscape, the increased influence on the Japanese expatriate of naturalist tendencies that characterized much of American art in the 1930s and early 1940s. Kuniyoshi did not, however, merely replicate appearances in his paintings; he generalized and altered reality, sometimes adding surrealist elements, in order to express his personal vision. In *Thinking Ahead* an oriental quality is retained in the sketchy lines, which dissolve the figure into its surroundings and create rhythmic unity through sensitively harmonized gray and brown brushstrokes.

Kuniyoshi's work of this period, for which he received much acclaim, was characterized by images of beautiful women posed in various states of reverie. A source of influence for these introspective women was Jules Pascin (1885–1930), who sensitively depicted listless, sultry Parisian prostitutes.[9] Initially, in the early 1930s, Kuniyoshi's women appeared predominantly sensual, but, as the Second World War neared, their expressions became increasingly depressed and full of malaise. The artist's works at this time, the most difficult in his life, could often be dismal and pessimistic, revealing the depth of his concern for human hardship.[10]

GHL

300

THERESA BERNSTEIN (B. 1890)

Theresa Bernstein has created art for almost a century. Born in Philadelphia in 1890 to Jewish immigrants, Bernstein drew and painted as a child, later attending lectures at the Pennsylvania Academy of Fine Arts and receiving a degree at the Philadelphia School of Design for Women. After moving to New York City with her family, she studied briefly with William Merritt Chase at the Art Students League in 1914. Although familiar with modern art through her attendance at the Armory Show in 1913 and two visits to Europe, Bernstein chose a humanistic emphasis for her work. Her first solo exhibition was at the Milch Gallery in 1919, the year she married the artist William Meyerowitz. The couple showed regularly and taught etching and painting privately in New York and Gloucester, Massachusetts. Bernstein painted WPA murals for the post office in Manheim, Pennsylvania, and the Treasury Department in Washington, D.C., and was a charter member of the New York Society for Women Artists. Following her husband's death in 1981, Bernstein became an author. Two of her paintings are in The Phillips Collection.

301

Girlhood, 1921

Oil on canvas, 29 × 35⅛ (73.7 × 89.1)
Signed and dated u.r.: *T. Bernstein 21*
Acc. no. 0129

Purchased from the artist, through the Corcoran Gallery of Art, Washington, D.C., 1924.[1]

Throughout her career Theresa Bernstein has been attracted to humanity. Recurring subjects in her art—portraits, parades, and working women—are truthful in spirit, not verisimilitude. "People," she remarked, "represent the essence for me."[2] Her work stems from her sensitivity to character and cumulative experiences, not experimentation for its own sake or predetermined solutions. Bernstein's subjects and nontheoretical approach are akin to, but not dependent on, those of her contemporaries in the Ashcan School.

Bernstein was active in women artists' organizations and was a chronicler of the suffrage movement. As an exhibiting artist, she received excellent reviews and found major patronage. Nevertheless, Seidler Ramirez wrote, "She was perpetually overlooked. She knew all the important painters, but she chose to be a wife, and to make her husband's life as comfortable as possible."[3] Throughout her career, she advanced William Meyerowitz's art over her own.

Bernstein portrays women with dignity, individuality, and an intimation of their goals and potential accomplishments. Characteristic of her portraits from the 1920s, *Girlhood* is an image of Meyerowitz's younger sister, Minna. A talented pianist, Minna, along with her four siblings and mother, was financially dependent on William and Theresa in 1921. The work was painted during the summer of 1921 in Folly Cove, Massachusetts, near Gloucester, where the Meyerowitzes were the guests of their close friend, Ellen Day Hale, daughter of author Edward Everett Hale.[4] While visiting her brother and his wife, Minna

posed in a stone studio near the Hale home, her hands placed near three peaches. The fruit, wrote Bernstein, signified "the three stages of life—youth, development and maturity. The green peach, the partly blooming peach and the fully ripened peach represented the full cycle of the fruit's ripening."[5]

Seemingly casual in execution, the painting is carefully constructed with brushwork and line. Patches of paint—mostly muted pinks, browns, and greens—establish the figure spatially in a manner reminiscent of Cézanne's architectonic strokes. Intermittent lines give clarity to specific passages in the face and hands but also imply animation. Bernstein did not freeze the image, believing that "the important thing is to maintain the vivacity of your first impression."[6]

Bernstein characterized her sister-in-law with tenderness. Lost in thought, Minna gazes dreamily to the right. She appears to be at a crossroads in life. Leaning on the model's stand and touching the green peach, she seems curiously reticent, as if afraid to make the next move. Bernstein explained her objective in portraiture: "To paint a good portrait . . . you have to love people. . . . But you have to look beyond the fleeting expression. . . . You have to make the sitter forget that he's posing. I like to talk with him or her. . . . Many painters try to get the expression first; then they keep on painting and spoil everything. I save the expression for the very end—when I *know* the person."[7]

In Washington, D.C., in 1924 to paint a portrait of a friend, Bernstein attended the opening of the Corcoran Gallery's "Ninth Exhibition of Contemporary American Oil Paintings," in which *Girlhood* was displayed. She fondly recalled that the first people to greet her were "a gentleman and a lady," who inquired about the work. Not catching their names, Bernstein learned the next morning that she had met Duncan and Marjorie Phillips and that they had just purchased *Girlhood* for "the most modern gallery in Washington."[8]

RR

301

CHARLES EPHRAIM BURCHFIELD (1893–1967)

Charles Burchfield was born in Ashtabula Harbor, Ohio, on April 9, 1893, and moved to Salem, Ohio, five years later, with his widowed mother and five siblings. Burchfield developed his passions for nature and art early in life, exploring Salem's woodlands and becoming absorbed in the transcendentalist writings of John Burroughs and Henry David Thoreau. Between 1912 and 1916 he studied at the Cleveland School of Art, where Henry G. Keller advised him to seek personally meaningful subjects. He won a scholarship to the National Academy of Design in New York in 1916 but, after one day of classes, felt stifled and soon returned to Salem. Unlike many of his American contemporaries, Burchfield did not travel abroad or depend upon other paintings for inspiration. Hypersensitive to nature's varying moods as well as his own, he found his subjects in the countryside and towns near home. Burchfield left Salem permanently in 1921 to take a job in Buffalo, New York, as a wallpaper designer for M. H. Birge and Sons. He married Bertha L. Kenreich the following year and with her raised five children in a modest home in Gardenville, a Buffalo suburb. Although his moody watercolors of Ohio and upstate New York brought him acclaim in solo exhibitions at the Kevorkian and Montross Galleries in New York, it was not until he became affiliated with the Frank K. M. Rehn Galleries in 1929 that he was able to support his family through his fine art. Burchfield died in West Seneca, New York, on January 10, 1967. Ten works are in the collection.

The Burchfield Unit

Working primarily in watercolor, Charles Burchfield created visual poetry, discovering beauty in unexpected places. He responded to things he knew well and attempted to convey more than just visual impressions. Edward Hopper recognized his friend's gift for capturing what artists generally overlooked: "As is usually the case when one meets such intimate interpretations of the common phases of existence and of nature's more commonly encountered moods, one wonders why it had not been done before, since it reveals what so many had had at heart and had always seen, but considered unworthy to be dignified by art."[1] Burchfield's work often had a haunted quality, vividly characterized by Margaret Breuning as "something that lies on the edge of the cryptic and occult, a fringe of the never-never of experience."[2]

Burchfield attempted to be true to nature's underlying laws, even in moments of wildest fantasy. He wrote, "I am one who finds himself in an incredibly interesting world, and my chief concern is to record as many of my impressions as possible, in the simplest and most forthright manner. In short, life with all that the word implies is of first importance to me. . . . The artist must come to nature, not with a ready-made formula, but in humble reverence to learn. The work of an artist is superior to the surface appearance of nature, but not its basic laws."[3]

Burchfield sought enlightenment directly, claiming in 1917 that "the key to the universe is by personal experience not through the medium of another no matter how great he is."[4] Yet Burchfield was no cultural naif. Even though he would be unaware of contemporary developments in European and American painting until after he reached his own artistic maturity, as a student he was knowledgeable about Chinese and Japanese art and experimented with art nouveau. He was also attracted to Hindu mythology, Nietzsche's philosophy, and Vachel Lindsay's poetry. Later, congruent with his art's shift to realism, he read the works of Willa Cather and Sherwood Anderson. Music was a lifelong passion. Burchfield admired the emotional intensity of Mozart, Beethoven, and Sibelius and the exotic spectacle of Russian ballet. Burchfield was an independent thinker. His early attempts to communicate synaesthetic experiences, as Nancy Beardsley Ketchiff observed, have an affinity with paintings by Kandinsky and Dove.[5]

Burchfield had three distinct stylistic periods. Examples from each period are in The Phillips Collection, but seven of the ten paintings were created before he moved to Buffalo in 1921. Duncan Phillips identified these early works as "Burchfield's personal discovery of an ancient language of descriptive design very different from imitative illusion."[6] Childlike in their immediacy, they portray Salem and its environs energetically, with an emphasis on pattern and two-dimensional effect. In them, Burchfield responded sensitively to light, weather, and noise. The earliest, *Moonlight Over the Arbor*, painted in 1916 (acc. no. 0239), is evocative of a summer night. The only implication of movement, perhaps leaves rustling in a light breeze, comes from the foliage's rhythmical brushwork. A transitional work, *Rainy Night*, painted in 1918 (acc. no. 0236), is reminiscent of the well-known *Church Bells Ringing, Rainy Winter Night*, a watercolor from the previous year.[7] Its dull palette is the essence of dreariness. Although its shift from nature to man-made structures previews the imagery of Burchfield's next period, its

expressionism is characteristic of his early art.

In his middle period (1921–43), Burchfield concentrated on the towns, cities, and industrial areas of Ohio and New York. The paintings from this period brought him fame. Critics identified Burchfield with the American Scene painters, a label he disliked intensely. Asserting that he was not attracted to these subjects because of nationalistic pride, Burchfield remarked, "The scene itself has never been [the] main motive that impelled me to paint."[8] The two examples in the collection, *Cabin in Noon Sunlight*, 1925 (acc. no. 0234), and *Ohio River Shanty*, 1930 (acc. no. 0235), rely more on the actual appearance of the subjects than had the paintings of the early period. In these works Burchfield emphasized descriptive qualities, such as the buildings' weathered clapboards, and used perspective to portray depth. Mood remained important, but Burchfield held back his own emotions to let those implied by the subjects reveal themselves.

His late paintings, produced after 1943, return to multisensory effects, expressionism, and fantasy, but are executed in a more monumental and solid way. Although *Sultry Afternoon*, 1944 (cat. no. 305), does not exploit fantasy, the surety of its execution and suggestion of insect sounds in the distant bushes elicit a strong emotional response.

When and where Duncan Phillips first saw the work of Charles Burchfield is not known, but in March 1926 he was advised to go to the Burchfield exhibition at the Montross Gallery in New York.[9] Later that year Phillips purchased *Cabin in Noon Sunlight* from Montross. In 1932 he called Burchfield an American original, who "continues to be inherently dramatic as he tells with inimitable originality about our small town avenues and their houses of ludicrous charm, or of our ramshackle cross-road settlements, unutterable in their mud puddles and general squalor."[10] The next year, in the exhibition "Freshness of Vision in Painting," he elaborated on Burchfield's early accomplishments: "He was, in his technic, both daring and deliberate, both whimsical and precise. When he wished he could conjure up the essence of a scene indoors or out."[11] Phillips's admiration was implicit in his correspondence with the artist that same year: "I have never had the pleasure of meeting you but I feel that I know you through your very expressive art."[12] Although Burchfield visited Washington, D.C., to serve on a watercolor jury for an exhibition at the Phillips Memorial Gallery, it is not documented whether he ever met his patron.[13]

RR

302

Woman in Doorway, 1917

Portrait Study in Doorway; In the Doorway
Gouache on canvas adhered to cardboard, 25 × 30 (63.5 × 76.2)
Signed and dated l.r.: *C. Burchfield 1917*
Acc. no. 0241 (Trovato no. 244)

Estate of the artist's mother, Alice Murphy Burchfield;
PMG purchase from the artist through Rehn Gallery, New York, 1933.[14]

Woman in Doorway, a portrait of the artist's mother, is both unusual for Burchfield and entirely in keeping with the prevailing spirit of his work. Not known as a portraitist, Burchfield usually only implied the presence of people or showed them distantly through windows or doorways.[15] He painted his mother inside her six-room frame house in Salem, where he was raised. While the interior view is unusual, the emotionally charged setting and the sense of space as an extension of the people who lived there were typical of his art. Although many paintings from 1917 were sketched first in pencil, this work was drawn almost entirely with the brush.[16]

Woman in Doorway was created in what Burchfield later referred to as his "golden year." The painting was one of his attempts to recapture the moods and experiences of childhood.[17] Recently returned from his aborted attempt to study art in New York, Burchfield was welcomed by his family. He later described his joy to be back in Salem: "Surrounded by the familiar scenes of my boyhood, there gradually evolved the idea of re-creating impressions of that period, the appearance of houses, the feelings of woods and fields, memories of seasonal impressions, etc. I took no interest in what was going on in the outside world, either artistic or political: lived the life indeed of an artist hermit. This was perhaps the happiest period of my art life."[18] In this context, the painting may be understood as a loving tribute to his mother and home.

Woman in Doorway is related to several works from 1917 that show solitary, elderly women inside their homes or in their gardens. Closest to the Phillips example are another painting inspired by his mother, *Portrait Study,* and *Portrait of My Aunt Emily,* a work Phillips included in his first one-person show for Burchfield.[19] The portraits suspend time as a means to hold on to cherished memories. Other paintings of women, executed at the same time, are morbid and expressionistic, such as *Garden of Memories.* Burchfield's description of this

302

work matched his gothic treatment of the subject, which is the antithesis of what is seen in *Woman in Doorway:* "Crabbed old age sits in front of her black doorway, without hope for the future. . . . The romantic autumn moon rises just the same."[20]

Alice Murphy Burchfield, although she knew little about art, was very supportive of her son's decision to become an artist. Reminiscing about his upbringing in 1928, Burchfield wrote: "The history of art is full of examples of artists who followed their careers in spite of the handicap of unsympathetic or hostile parents or family, but . . . there was nothing of that sort in my case. There is something greatly heroic, I think, about the struggle that was made by my mother and older brothers and sisters, following the death of my father."[21] Burchfield had a good relationship with his mother. Around the time he painted this picture, he wrote in his journal, "I believe my mother is a genius."[22]

In *Woman in Doorway,* Alice Burchfield seems to be a protective presence, the essence of stability and patience, but Burchfield claimed that his painting was "not an attempt to produce

a 'bona fide' portrait, but merely a study of a mood in which the figure is simply one of many objects."[23] The work is effective in its unidealized treatment of realistic domestic details. Dressed in a plain white dress, his mother is a commanding but protective presence in a house that appears worn and cluttered. To compensate for her relatively small size, Burchfield sketched her with thick, gestural strokes, accentuating her foreshortened lap with thick, white paint. The interior is plausible as a place where a large family was raised. The furnishings look both modest and comfortable. In contrast to the ordinary details of the setting, however, the organic patterning of the wallpaper, particularly above the doorway, adds drama to the scene.

Duncan Phillips admired the painting greatly and saw it as predicting the artist's later interests: "How well Burchfield remembered his Mother sitting in her rocking chair in the open doorway between the living room and the back room which was always kept half dark and cool! That back room was a symbol of something in America he knew only too well. This early view of a phase of the small town was to be prophetic

303

of what he was to do professionally and as a specialist later on. The human interest of this transitional picture proved the turning point of his career—committing him to a serious mission of leading the way to . . . 'the American Scene' in art."[24] In 1940, when Burchfield finally saw the painting at the Phillips Memorial Gallery, he responded emotionally: "I saw with a pang, my study of Mother in the Doorway."[25]

<div align="right">RR</div>

303

Road and Sky, 1917

Decorative Landscape

Watercolor, ink, and gouache on paper, 17½ × 21½ (43.1 × 54.6)

Signed and dated l.r.: *Chas. Burchfield/1917*

Acc. no. 0237 (Trovato no. 374)

PMG purchase from Rehn 1930.[26]

Road and Sky is painted in the fluid, rhythmical style that is characteristic of Burchfield's landscapes of 1917. At this point in his career he was still drawing compositions in graphite before painting. After applying watercolor washes, he added contrast and luminosity by using opaque black ink for the shadowy parts of the trees and passages of white gouache for highlights in the grass.[27]

This seemingly mundane view of a country road and trees, though devoid of any obvious activity or drama, is mysterious in its impact and hypnotic in its suggestion of life beyond the visible. What Burchfield wrote in his journal around the time he painted this work indicates that he was making a concerted effort to let his subjects reveal their own personalities: "Complete subjugation to Nature. If you would be a poet, express the poetry of Nature. Do not invent a quasi poetry & try to twist the facts of Nature around to it."[28]

The title of the painting is curious because it is what is between road and sky that holds the greatest interest. The trees are painted mostly in green, buoyant shapes, which imply growth and lushness. Sounds are also invoked in this area of the picture. The curving lines that emanate from the bottom of the trees in the copse to the left, as well as those that spring from the tops of the trees near the horizon, are visualizations of the noises of crickets and cicadas. Other sensations are suggested, too. The curved V forms in the grass can be interpreted as shorthand notations for the flight of insects. The broad curves of the sky, painted while the paper was very wet, are the embodiment of the sweltering heat and humidity of an Ohio summer. This sensitivity to weather conditions was a recurrent trait, as Burchfield recalled in 1952: "I've been interested in weather since I was a little kid. When I was in

304

third grade, at the end of each day, I'd write down on my mother's big calendar what kind of weather we had that day."[29]

Road and Sky places the emphasis on emotion rather than decorative effects. The beautiful organic curves and patterns, which had their basis in the artist's personal exploration of Oriental art and art nouveau at the Cleveland School of Art, are less important individually than they are in the totality of the painting. Both languid and bouncy, they evoke the effects of a lazy day when flights of fancy and a desire to be elsewhere are commonplace. The call of nature is alluring but also elusive. The painting is redolent with a sense of anticipation, but what waits beyond the horizon is not revealed.

<div align="right">RR</div>

304

Barn, 1917

Barn Landscape

Watercolor, ink, and graphite on paper, 14 × 20 1/16 (35.5 × 51.0)

Signed and dated l.r.: *Chas. Burchfield—1917*

Acc. no. 0232 (Trovato no. 344)

PMG purchase from Rehn 1931.[30]

In 1917 Burchfield began to expand on the imagery that he had been favoring, turning his attention to the buildings around him, to what Hopper characterized in Burchfield's work as

"our native architecture with its hideous beauty."[31] Whether he painted storefronts, houses, or utilitarian structures, he attempted to suggest something about the people who used them. The buildings were often brought to life by exaggerating key features.

Barn was inspired by a building Burchfield saw one day while traveling along Painter Road in Salem, just west of Bentley's Woods, where he found motifs for many paintings. One of his first works to feature a barn, a characteristic subject in his middle period, the picture is eerie in its silence.[32] Although the time of year was not recorded, on the basis of the clear light and golden furrows of the plowed field to the left, the scene appears to depict a warm, sunny day in late spring or early summer. Within the barn a piece of farm machinery, a flat, light shape, stands out in the darkness. Perhaps the plow used to work the nearby fields, it is a ghostly presence that haunts the barn's interior.

Like *Road and Sky, Barn* is characteristic of Burchfield's 1917 style. It relies on a graphite underdrawing and builds the composition with supple washes of color. Selected details—the interior of the barn, some wild grass near the building, and the area under the eaves—are executed in ink to accentuate their contrast with the other forms. Unlike *Road and Sky,* however, there is a greater emphasis on local color and no enhancement with gouache.

In contrast to *The Old Barn,* a watercolor

from 1918, this painting is remarkably restrained in its respect for the actual appearance of the building.[33] Rather than transforming the barn's facade into an animated face made up of windows and doorways, Burchfield relied more on composition and fine detail to convey the character of the place. Because the composition is nearly symmetrical, with its main motif close to the center, the painting appears very still. It is enlivened subtly by features of the building. The barn appears rickety but alive. Its doors hang crookedly, and light passes through the planks of its back wall. In addition, the roof curls near the sides, probably the result of its exposure to the elements. In contrast, the landscape details, glowing with light and color, convey renewal. The sky, painted in pale, gently arching streaks on a very wet surface, suggests rising humid air and a gradual clearing of the weather.

Like *Woman in Doorway, Barn* presages the realism that would dominate Burchfield's art in the 1920s and 1930s. It is a manifestation of his quest to show beauty and life in unexpected places.

RR

305

Sultry Afternoon, 1944

Watercolor, ink, and gouache on illustration board, 28⁵/₁₆ × 22¹⁵/₁₆ (73.5 × 58.2)

Signed and dated with monogram, l.r.: *CEB/1944*

Acc. no. 0238 (Trovato no. 981)

PMG purchase from Rehn 1945.[34]

Sultry Afternoon was inspired by Burchfield's experiences on a hot, humid day just south of Hamburg, New York, near New Oregon Road.[35] It was painted in his late style, which was a conscious reaction to the realist work that brought him fame. After 1943 Burchfield attempted to revive the sense of wonder he had had for the world in his childhood and early works. His late art, built also upon the events and accomplishments of his middle years, grew in breadth and complexity. He sought a visual counterpart in nature to paint, or he created a synthesis of an event based on earlier incidents. Burchfield explained: "I would like a painting of mine, if done in mid-July, to express mid-July. I have a preconceived idea of what I want to say. . . . I may make a sketch of nothing but that. Then I'll go out and paint the landscape with that idea—perhaps even change the form of things so that they'll fit."[36] As Burchfield's art evolved, his adulation for nature and assertion of the importance of personal experience deepened.

In his journal entry for August 3, 1944, Burchfield commented on his activities at the site that inspired the picture: "On a 'bearded' hillside all afternoon painting. Afterwards I stripped to the waist and lay in the sun for awhile. Then I took my outfit to the car, and taking my lunch basket went back up on the hillside. The slightest movement made me drip with sweat."[37]

The moisture and heat in the work, conveyed primarily by the tropical palette and light saturated sky, are almost palpable. The back lighting makes the atmosphere seem heavy. The leaves of the closest tree are painted in curious radiating patterns that suggest light flickering through the treetop. The painting pulsates with other energy too. The sprouting curves of the foreground tree, echoed in many places in the composition, suggest growth. The patterns in the leaves of that tree also serve as visual shorthand for the shrill calls of birds. Moreover, the rhythmical, flickering strokes hovering above a distant wall of trees and bushes suggest that insects swarm and sing there.

While its subject is close in spirit to early works, such as *Road and Sky,* stylistically *Sultry Afternoon* is more ambitious. The asymmetrical composition, dominated by ascending curving lines and shapes, is dynamic. Revealed primarily by the tree in the foreground, nature appears monumental. All landscape details are shown with a great sense of weight and in deep space. The palette, unified by grayish greens and browns, offers a full tonal range but is boldly enlivened by unexpectedly vibrant areas of electric green, Hansa yellow, and ultramarine blue. Burchfield was in full control of his brushwork, which is marked by tremendous diversity, a kind of personal calligraphy mutating to express different aspects of the subject.

In *Sultry Afternoon* Burchfield vividly captured the essence of a time and place but, more important, conveyed his emotional response to them. His desire to understand nature in all its guises, even those experienced in discomfort, was a reflection of his deeply rooted spirituality.

RR

305

MARJORIE ACKER PHILLIPS (1894–1985)

Marjorie Acker, born October 25, 1894, while her family was visiting relatives in Bourbon, Indiana, started drawing seriously at the age of five. She was encouraged by her maternal uncles, the painters Gifford and Reynolds Beal, to become an artist. By 1918 she was commuting from the family home in Ossining-on-the-Hudson to New York City, taking classes at the Art Students League under Boardman Robinson and Kenneth Hayes Miller. Acker also regularly visited the commercial galleries, the Metropolitan Museum of Art, and the Société Anonyme. When she met Duncan Phillips in New York in January 1921 during the Century Club exhibition of his collection, she recognized that Duncan and she were kindred spirits. They married later that year. She became associate director of the new Phillips Memorial Art Gallery in 1925, a position she held for the next forty-one years. Remaining active as a painter, she was, in every sense of the word, Duncan Phillips's partner, helping to select works for the museum and organizing exhibitions. Following his death in 1966, she was director of The Phillips Collection for six years. She died in Washington, D.C., June 19, 1985. Sixty oils and two watercolors are in The Phillips Collection.

Fig. 37 Marjorie Phillips, 1940, F. Vogel.

The Marjorie Phillips Unit

Of all the artists represented in The Phillips Collection, probably none had as pervasive an influence on Duncan Phillips and on the shaping of the museum as Marjorie Acker Phillips. Her significance goes beyond her contribution as a painter of works in the collection (fig. 37). When reminiscing about her life, she characterized herself as a "prestidigitator," whose "days were spent juggling different roles: painting in the mornings; running the house; being a mother; fulfilling social responsibilities . . . and after Duncan's death . . . running the gallery."[1]

Laughlin Phillips astutely identified the symbiotic nature of his parents' relationship: "He was the extraordinarily articulate amateur of art who believed that an artist's unique vision can and should enrich our lives. She was the practicing artist who gave form to this ideal. Their tastes and sensitivities and judgments about art were developed together, and embodied in the Phillips Collection."[2] Although the full degree of Marjorie Phillips's influence on her husband is difficult to assess, she undoubtedly helped him gain insight into the artistic process and shift his emphasis from maintaining a memorial gallery in honor of his father and brother to building a vital museum committed to the contemporary world and the art of both men and women.

When she first met Duncan Phillips, she was struck by the similarity of their response to paintings and by "the great importance we both attached to art in life."[3] After their marriage, with his full support, she reserved time for painting, a daily activity for more than seventy years. Her paintings were gentle impressions of the people, places, and things she knew well, but in her increasingly demanding schedule they were also havens for her creative spirit. She exhibited them regularly in solo and group shows at The Phillips Collection.[4]

Always attentive to his wife's painting, Duncan Phillips admired the way she translated the charm of her first impression into the finished work. Building a unit collection of her paintings gave him the opportunity to concentrate more fully on their evolution. On many occasions he wrote glowingly of her achievements, such as in 1926: "Marjorie Phillips has the unmistakable style of the born painter. Although her art is delightfully young, she already reveals qualities we associate with maturity—a tempered glow of spirit and a sensitive but never sentimental transcript of the joy of life into the poetry of design."[5] In 1948 he declared, "Poet painters are rare. This art is compounded of much that the tormented world cannot do without," and seven

years later he compared her to Corot, characterizing her as "an artist of that same reassuring integrity . . . for whom the visible world exists. She sings its praise."[6]

Undoubtedly affected by Duncan Phillips's strong ideas about art, Marjorie Phillips nevertheless worked to maintain her independence in the studio. Her painting had its roots in her upbringing and art education. Although their father, a chemical engineer, objected to art as a career for a woman, the Acker children were exposed to the humanities at an early age and encouraged by their mother to make art. Among Marjorie's earliest memories were her visits every summer to her grandparents' estate, Wilellyn, near Newburgh, New York, where Gifford and Reynolds Beal shared a studio: "Oh, the tubes of paint and the palettes. The canvases. The dedication to art . . . the feeling of the importance of art! I must have had the same feeling in me, to respond so strongly."[7] She reacted positively to her uncles' genteel impressionism and by age eleven was painting pleasurable scenes of her family and life at Hudson-at-Ossining. Gifford Beal, then president of the Art Students League, encouraged Marjorie and her sister, Eleanor, to take classes at the school when they were in their early twenties. So that their ailing mother would

have help in caring for her younger children, the sisters took turns attending, each going one year at a time.

At the Art Students League, Marjorie was impressed by the professionalism of Kenneth Hayes Miller but found Boardman Robinson to be the more effective teacher. In particular, she was affected by his theory of "rhythmic continuity" and strove for such an overall pattern in each of her works to direct the eye's movement within it. Her visits to Europe, especially to France with Duncan Phillips in 1923, sharpened her awareness of the possibilities inherent in impressionism and post-impressionism. The growing emphasis in her work on structure and rich color was sparked, in part, by her careful study of the paintings of Cézanne, Renoir, and Bonnard.

Despite some variance in style, Phillips's works were consistent in emphasis over her long career: "I decided to paint the celebration of the wonder of the world. I didn't want to paint depressing pictures. There were so many depressing things; so many self-conscious, forced, foolish things. That's why my paintings are all on the cheerful side—I felt it was needed."[8]

Broken color and delicate brushwork are characteristic of early works, such as *The Hudson at Ossining*, ca. 1920 (acc. no. 1508), an oil purchased by Duncan Phillips two days after his introduction to Marjorie. It reveals an ongoing trait of her work: the exploitation of spatial effects to convey a feeling of intimacy. Despite its expansive scope and aerial vantage point, the space does not appear vast. The subdued, light colors effectively convey the tranquil riverside hamlet near her childhood home as the morning mist rises. In addition, the shared axes of the buildings in the middle distance and the design's clear basis in geometry— reminiscent of effects found in Cézanne's depictions of L'Estaque— give the scene stability.

Later works use a brighter, purer palette and stress the picture plane. *Nasturtiums*, 1951 (acc. no. 1518), is immediate in impact and modest in imagery. Rich color and active brushstrokes, reminiscent of the lyrical impressionism of Bonnard, enliven the subject. Nothing distracts the viewer from enjoying the simple white vase's bounty of orange blossoms. Intimacy is achieved by the still life being in near proximity to the viewer, a quality shared by *The Big Pear*, 1955 (acc. no. 1491). In the later painting, directional brushwork pulls the eye into the distance only to be countered by the back of a book. The success of this painting is dependent upon spatial ambiguity, not verisimilitude, a demonstration of Phillips's wish to make the painting aesthetically provocative. Adding this "strong

dissonant note" to the composition, she recalled, gave her "strange delight."[9]

On many occasions, Duncan Phillips acknowledged Marjorie's ongoing role in helping to shape his thoughts and run the museum. In his preface to *The Artist Sees Differently*, he described her: "A true and a subtle artist herself she is a sensitive and a generous judge of the merits and intentions of other artists. Naturally my own critical estimates are compared with hers and I gain immeasurably through my consultations of her mind and eye."[10] Twenty-four years later, he wrote that "she has responded with me to all that is good in this thrilling period of artistic adventures, with keen appreciation of the additions to the painter's potentialities and resources. . . . One of her many rare qualities as an artist and as an appreciator is that she keeps her creative and her critical faculties separate and independent and yet cooperative."[11]

As associate director of the museum, Marjorie Phillips's responsibilities varied, but she traveled with Duncan Phillips to meet artists and dealers and to select works for purchase, helped plan the schedule of gallery activities, and was hostess in official functions. She served as curator for many small exhibitions, held in the galleries known as the Print Rooms. After her husband's death, she followed his wishes and assumed the position of director. Her executive duties expanding, she also organized important shows, such as the museum's first outdoor sculpture exhibition in 1966, featuring the work of Penalba, Giacometti, and others. She was most proud of the 1971 show that brought to a close her curatorial career and celebrated the fiftieth anniversary of The Phillips Collection—a landmark international exhibition of eighty-three Cézanne paintings that traveled to Boston and Chicago. In 1970 her private remembrances, *Duncan Phillips and His Collection*, were published.

Marjorie Phillips continued to place great importance on her work. True to character, in 1972, when she resigned as director, it was to devote more time to her painting. *Marjorie Phillips and Her Paintings*, her personal memoirs and commentary on her art, was completed a short time before her death.

R R

306

Nuns on the Roof, 1922

Morning Light—New York

Oil on canvas, 24¼ × 22⅛ (61.5 × 56.1)

Signed l. r.: *MARJORIE PHILLIPS*

Acc. no. 1523

Gift of the artist 1984.[12]

Early in 1922, not long after their marriage, Duncan and Marjorie Phillips stayed briefly in New York City in a Park Avenue residence owned by Leila and Lister Carlisle, Duncan's cousin and her husband, who were spending the winter months in Florida. The trip, Marjorie Phillips recalled, was "a happy interlude," an opportunity to mix business with pleasure.[13] Not yet encumbered by the demands of the newly opened gallery or children, the Phillipses took advantage of the excellent location of their temporary home by attending art shows and visiting friends. While Duncan Phillips concentrated on his writing and held meetings of the Committee on Scope and Planning, Marjorie painted the city from different windows in the apartment. Choosing to work early in the morning, a lifelong preference, she caught the city in quiet moments. As a visitor to New York, she saw it primarily as a source of visual pleasure. In particular, Phillips was fascinated by distant rooftops and plant-filled windows.

Nuns on the Roof presents an unexpected vista, a contrast between a monumental setting and an ordinary yet inexplicable moment: a chance view of nuns taking the morning air on the roof of an austere building, its arched windows suggesting a convent. Everything in the painting is seen from a distance. The light, most brilliant on the buildings just beyond the occupied rooftop, gives the scene a feeling of fresh, chilly weather, an effect reinforced by puffs of steam emerging from chimneys. Although the restrained, chalky palette and the subtly impastoed surfaces of faraway buildings contribute to the setting's grandeur, the private moment of a group of women oblivious to the painter's gaze is what captures the viewer's attention. Their faces, generalized by the light and distance, do not reveal what they are feeling. Enjoying a private time of her own, Phillips presented her subject with detachment as an anomaly in the heart of a busy city.

R R

307

Rue de la Boëtie, 1923

Oil on canvas board, 9 × 11⅞ (22.9 × 30.2)

Unsigned and undated

Acc. no. 1537

Acquired by 1924.[14]

Rue de la Boëtie was painted in Paris in June 1923 while the Phillipses were staying with their infant daughter, Mary Marjorie, and her nurse at the Hôtel Le Gallais, near the Champs-Elysées. After residing at the hotel for a short

306

time, they moved to a quieter location, the Trianon Palace Hotel in Versailles, so that Mary Marjorie could spend more time outdoors.[15] Although the highlight of their two-month stay in Europe was seeing Renoir's *Luncheon of the Boating Party* at Joseph Durand-Ruel's home (see cat. no. 50), Phillips had vivid memories of making her own picture at Le Gallais: "I used to be charmed at watching the traffic on the Rue de la Boëtie. . . . I remember how noisy the traffic was in those days, with the horns tooting and the horses clattering by."[16]

Like *Nuns on the Roof, Rue de la Boëtie* is a vignette of city life seen through a window. Executed mainly with a palette knife, it is also reminiscent of Parisian subjects from the 1890s by Pissarro, such as those of the Place du Havre and the Avenue de l'Opéra, which were executed from elevated vantage points in hotels. Marjorie Phillips also might have been influenced by Bonnard's early views of the city, such as *Narrow Street in Paris,* ca. 1897, purchased by the museum in 1938 (see cat. no. 98). Though simpler on a formal level than the works of these painters, Phillips's work is similar in spirit. Fine detail is sacrificed to suggest the passage of time. Choosing a viewpoint somewhat lower than those favored by Pissarro, Phillips used fewer diagonals and applied her paint vigorously and with variety. The massing of strong horizontals and verticals in the setting conveys stately order, in contrast to the sketchy brushwork that implies the movement of vehicles and pedestrians on the rue de la Boëtie and the residential block perpendicular to it. The picture's horizontal format contributes to the effect of the flow of traffic on the street, which is seen in the painting's lowest third. Phillips's use of color is impressionistic, but she does not place the emphasis on optical mixing. Instead, loose touches of paint, often bright reds and whites, vitalize the palette of pale blues, greens, and grays, creating the effect of sparkling sunlight and also reinforcing the sense of movement.

RR

308

Night Baseball, 1951

Oil on canvas, 24¼ × 36 (61.5 × 91.4)

Signed and dated l.l.: *Marjorie Phillips '51*

Acc. no. 1521

Gift of the artist, 1951 or 1952.[17]

Night Baseball, Marjorie Phillips's best known painting, was inspired by a game she saw in 1951 at Griffith Stadium in Washington, D.C. Introduced to baseball by her husband, she grew to appreciate the sport, and it became a family pastime, a chance to spend time with one another away from the official functions of the museum

307

and their busy social life. Marjorie remembered Duncan's enthusiasm for the sport, his passion for the Washington Senators: "He and our son Laughlin shared much baseball talk following the games, discussing box scores and the records of individual players with devout interest. Laughlin and I enjoyed going with Duncan to many games at the colorful old Griffith Stadium."[18]

During the games, Marjorie Phillips made small pencil sketches of the grandstands, playing field, and players, some of which were used as details in paintings. The sport provided subjects for several oil paintings. Closest to *Night Baseball* is *Base Ball,* shown in a Studio House exhibition in February 1934 and admired by the critic Leila Mechlin for its balance of delicacy, subtle feeling, and virility.[19] A less energetic scene inspired by a game played in daylight, it nevertheless anticipated the composition, setting, and imagery of *Night Baseball.*

In the 1951 picture, Phillips showed a night game between the Senators and the New York Yankees from the family's box seats behind the first-base dugout. The moment she chose is dramatic. With the Senators in the field, the pitcher is about to throw the ball. At bat is the great outfielder Joe DiMaggio, playing in his final season. His characteristic wide-open stance makes him the only recognizable person in the composition, but the other figures, based on careful observation, are equally believable. Tension and concentration are implicit in their poses, notably in the pitcher ready to release the ball and the plate umpire bending forward to call the pitch. Everyone is poised, ready to move in an instant. A drooping banner on a flagpole on the grandstand contributes to the effect of the

frozen moment. By not revealing the outcome of the event, Phillips kept it alive. As M. Therese Southgate wrote, "She leaves us at the moment of highest potential, when anything and everything, even dreams, are still possible."[20]

The drama of the moment is carried through on a formal level as well. All major compositional lines emanate from the batter, the focal point in the lower left of the composition. The large grandstand tames the space, directing the eye to grasp the more important details on the diamond. Because no figures overlap on the playing field, the anticipation of the moment is heightened, allowing the viewer to study each player separately. In addition, Phillips contrasted the artificially illuminated ballpark with the dark sky. As a result, time is strangely indeterminate; it seems to be both day and night. The interplay of the rich blue-violet sky and light-green field, moreover, recalls the brilliant coloristic qualities of Bonnard's works but also helps underscore the beauty of this suspended moment.

Given the subject's general appeal, the painting's popularity is easy to understand. Marjorie Phillips found it curious that baseball was not a major subject in painting for a society obsessed with the game: "It is surprising how few American artists have painted our national sport—when you think of Spanish artists' absorption with bull fighting, Degas' great horse racing canvases and the absorption with . . . equestrian subjects, by the British."[21] Along with Thomas Eakins, Fletcher Martin, and Arnold Friedman, she succeeded in capturing the emotional impact of the game.

RR

308

HAROLD WESTON (1894–1972)

Harold Weston, born to an affluent family in Merion, Pennsylvania, February 14, 1894, was stimulated by his mother's love of music and his father's leadership in the Philadelphia Society of Ethical Culture to become active in art and public service. Despite an early bout with polio, Weston led a full life, graduating magna cum laude with a fine arts degree from Harvard University. During the First World War he did relief work and was a painter for the British Mesopotamia Expeditionary Force. After traveling extensively, he returned home and built a primitive studio in Saint Huberts in the Adirondacks. Weston painted in isolation for three years, developing a personal expressionist style. He had his first solo show at the Montross Gallery in New York in 1922 and for the next eighteen years exhibited widely. His murals for the Procurement Division of the Treasury Department in Washington, D.C., completed in 1938, brought additional recognition. During the next decade, humanitarian activities took precedence over making art. Weston created the civilian organization Food For Freedom and, as its director, lobbied for American involvement in the United Nations Relief and Rehabilitation Administration. From 1955 to 1965 he urged government support for the arts and helped plan the National Foundation of the Arts and Humanities. In his last paintings, *The Stone Series,* inspired by fourteen stones from the Gaspé Peninsula, he experimented with abstraction. Weston died in New York City April 10, 1972. Twenty-seven works are in The Phillips Collection.

The Weston Unit

In *The Artist Sees Differently,* Duncan Phillips wrote at length about an artist whose work he had been collecting for three years: "There is a young American painter who stirs in me the hope for a re-birth on this new soil of something that was not lost to the art of painting with the passing of Vincent van Gogh. It is something earthy and rugged and at the same time of a lyric poignancy, something unguardedly and tactlessly frank yet tenderly humane. I am thinking of Harold Weston."[1] The amassing of a large body of Weston's work for the gallery coincided with the development of a close friendship between patron and artist.[2]

They met in April 1930, two years after *The New Stove,* 1926 (cat. no. 309), was purchased. Weston traveled alone from New York to see his first one-person exhibition at the Phillips Memorial Gallery. Correspondence between the artist and the Phillipses after the visit reveals

their growing friendship and Duncan Phillips's belief in the quality of Weston's art. On May 1, 1930, Phillips told the painter he would "gladly write to any dealer telling of my interest in your work and my expectation of getting more of it."[3] Weston was invited to speak about color at the gallery on January 15, 1931, and on January 7, 1932, presented another lecture, entitled "Beyond the Known, the Artist's Abnormality of Vision."[4] In the 1930s Phillips gave Weston four solo exhibitions; following Weston's death in 1972, his final series was exhibited at The Phillips Collection.[5] The momentum of their early association continued over the years. The Phillipses visited with the Westons in New York City, and, while Weston was making his sketches for Treasury Department murals in 1936, he and his wife, Faith, lived with the Phillipses. Faith Weston recalled: "They insisted that we stay with them until the entire plan for the mural was finally approved."[6]

The Weston unit is extensive, encompassing most of the major stylistic phases and subjects he explored in a career more than a half-century long. Though many works were purchased by Phillips, others became part of the collection after his death or through donations from the artist's family and the Montross Gallery. Twenty paintings were in the collection by 1940.

Although Weston's style changed, he continually tried to capture the emotional essence of experiences. In 1939 he wrote: "I have most wanted to express through painting . . . what I feel in relation to what I know best, am a part of and feel most vitally. It is an attempt to get into paint whatever I may feel at the time significant about existence, not visual reality."[7]

An early work, *Persian Afternoon,* 1918 (acc. no. 2114), from Weston's Middle Eastern sojourn, glows gently with hues evocative of lapis lazuli and coral. In contrast, *Winds, Upper Ausable Lake,* an oil from 1922 (acc. no. 2123), was executed in isolation in Saint Huberts in Weston's early expressionist style. Boldly simplified, the painting has exaggerated rhythms and economical imagery that reveal an affinity with Marsden Hartley's art. Both works were included in Weston's debut exhibition at the Montross Gallery.

By the late 1920s, human imagery had become prominent in Weston's paintings. The artist showed people privately, often oblivious to being observed. Faith Weston posed for the figure in *Loneliness* (acc. no. 2109), an undated oil purchased in 1930, which Phillips said "seems big in the dignity it gives to the depiction of an all too familiar moment of tragic loneliness."[8]

Though Weston was not chosen to execute

murals for the Customs House in Philadelphia, his sketches for the project helped him get the commission for the Treasury Department murals. Phillips bought *Auto Body Press,* a Customs House mural study in gouache from 1935 (acc. no. 2101), based on Weston's observations at the Budd Manufacturing Company in Philadelphia. The complex composition, unified by strong rhythms and vibrant color, portrays American industry convincingly and with great dignity. Phillips was also attracted to Weston's studies of light in the Adirondacks. *Garages,* a gouache from 1932 (acc. no. 2105), has the luminosity of fresh, clean snow and morning light. *Going Home,* a gouache painted six years later (acc. no. 2106), captures the wintry appearance of the buildings of Marvin's Garage, near Saint Huberts, as seen through a windshield and illuminated by headlights.[9]

The Phillips Collection has two late works by Weston. *Aegean Summer,* 1958–60 (acc. no. 2098), is a transitional work that reveals his movement toward abstraction. Calligraphic lines capture the essence of glistening light on the waves, while intense, nonassociative colors contribute a feeling of fantasy. Painted in gouache in 1968, *Stone Series #17: Blue Beyond Blues* (acc. no. 2102), from Weston's last series, is microcosmic and energetic. A visual vortex of interlocking spirals, in gradation from deep to light blues, transcends the visible, evoking infinity.

These paintings are imbued with sympathy and reverence for their subjects, an ongoing trait of Weston's work. As Duncan Phillips observed, "Working alone in the Adirondacks he seems to have absorbed some elemental endurance and glad acceptance of life as 'just the right stuff to try the soul's strength on.' . . . It is his belief that [with] love . . . and the courage of the commonplace the artist can make art out of the most intimate and obscure personal experience."[10]

R R

309

The New Stove, 1926

Oil on canvas, 21⅝ × 15 (55.0 × 38.0)

Initialed l.r.: *W*

Acc. no. 2112

PMG purchase from Montross Gallery, New York, 1928.[11]

The New Stove was painted in Saint Martin d'Arrosa, a town in the French Pyrenees Mountains where Harold and Faith Weston rented the first floor of a stone farmhouse that had been remodeled last in 1732. The building sheltered sheep below the living quarters and had an

eleven-century chapel situated in the rear. Its terrace provided a dramatic view of Costa Buona, a tall mountain peak, and the Spanish frontier.[12] They lived there from 1926 until 1930, renting a studio in Paris for a few months each year. Although recovering from kidney surgery, Weston characterized his stay in France as "a period of very intense painting and etching as well as much mountain climbing of nearby peaks up to 9,000 feet."[13] In addition, two of their children were born in France.

Recalling that when they arrived Faith had to cook on the hearth, Weston said, "It was even more primitive living than at Saint Huberts."[14] A stove undoubtedly made life easier, so he celebrated its arrival by painting it.[15] Weston associated stoves with happy memories and comfort. Earlier, his obsession with painting Faith in the nude, not long after their marriage, took the form of a ritual in their Adirondack home, and a stove was a prominent player in these sessions. Faith Weston remembered: "We would get the pot-bellied stove hot enough so that I could bear removing my clothes and for most of the morning and into the afternoon until the daylight faded we worked. He painted and I posed. It was our regular regimen."[16] *Freedom in the Wilds,* a book by Weston, contains a photograph and fond reminiscences of that stove in Saint Huberts as well as a photograph and description of an old coal-burning laundry stove from a nearby home.[17]

In *The New Stove,* an ordinary room is infused wih quiet magic. Only the stove and a small pile of kindling occupy the space, yet the room seems more intimate than spartan. Unlike the earth colors prominent in his Adirondack paintings, the palette of this work is rich. Deep blues on the stove are offset by nearby areas of salmon orange and yellow. Light pouring through the window is captured by occasional daubs of pale yellow, green, and pink. Accentuated by the gray walls bordering the alcove, the hills and foliage seen through the window look radiant. Weston's technique in this picture is looser than in previous works. Working *alla prima,* he drew the contours of his forms with sketchy, dark lines and varied brushwork. Weston softened some lines by scribbling intermittently in the wet paint with the brush handle.[18] By leaving areas of canvas exposed, he achieved a halo effect around some forms, suggesting pristine morning light. The intimacy of the interior is contrasted with the grandeur of nature, partly glimpsed through the window.

The prominent window, heightened colors, varied brushstrokes, and areas of exposed canvas are reminiscent of Matisse, whose work Weston probably saw in Paris. Yet the humble domestic subject is a reflection of the profound influence of Weston's new environment: "The

309

important factor was that it was a primitive, timeless sort of existence during America's prosperity, free from the impatient tempo of American life. It let my work mature uninfluenced by any urge for success or reaction to critical comment. My form and color became tempered by the Pyrenees—the massive stone walls of our house, the stark life of the peasants about us. How much, I only realized after we returned to America."[19]

The New Stove was the first work by Weston to be purchased for the Phillips Memorial Gallery. The Westons learned who bought it while they were still in France. Faith Weston remembered: "When we heard from Montross that it had been sold, we were very excited because Duncan's reputation as a very perceptive connoisseur was outstanding. From then on, Duncan became an important patron."[20]

RR

310

Dos Passos Reading, 1933

Oil on canvas, 22 × 16 (56.0 × 40.8)

Signed in painting-within-painting, u.r.: WESTON [combination print and cursive]

Acc. no. 2104

PMG purchase from the artist 1933.[21]

Harold Weston and John Dos Passos, classmates at Harvard, became close friends. They saw each other erratically because, as Faith Weston recalled, "Dos always flitted in and out . . . he never seemed to stay very long in any one spot!"[22] Dos Passos was a very reluctant subject for a portrait, telling Weston that "the human face in general was hardly worth looking at and he didn't relish having his put under lengthy scrutiny."[23]

By the time Dos Passos agreed to sit for a portrait, he was living near Weston's Washing-

310

ton Square studio in New York. He arrived at the studio one winter day, ostensibly to pose. Weston described the humorous incident in *Freedom in the Wilds:* "I like to paint people in some pose that is completely natural to them. Dos asked if I minded his reading a book but the word reading was hardly appropriate. Perhaps due to his nervousness at even this degree of 'posing,' he seemed to devour the book a page a minute until it was finished. Then he confessed, he just couldn't sit still. By then I'd gotten a few things jotted down on a canvas in charcoal. Dos pleaded with me that I should go on with the painting alone which I agreed to do."[24]

Eventually enticing Dos Passos by keeping his favorite Cuban cigarettes around the studio, Weston got the author to visit every few days for several weeks. Weston kept the visits casual, talking with Dos Passos and observing him carefully, but painting only after his friend left. As a result of these sessions, he painted two portraits of Dos Passos simultaneously, both executed vigorously with bright colors, textured brushwork, and sinuous outlines in a manner reminiscent of van Gogh's late style.[25]

Dos Passos Reading was begun during the first session. In it, Dos Passos is reading a book, which he holds close to his face in a manner that suggests nearsightedness. Eye contact is not established. In each picture, Weston employed one of his favorite compositional devices—showing a painting within a painting and including his signature within it. The small painting within the Phillips work is a depiction of an actual work, *Profile,* from 1931.[26] While the lines and shapes within the small picture work formally to echo the curves of the sitter, the small picture may also signify the link between the visual arts and literature; it may also evoke the presence of the artist or allude to the relationship between artist and writer.

Dos Passos Reading effectively conveys the sitter's tension by subtle oppositions. The contours and brushwork of his body curve forcefully, implying motion, yet his posture seems stiff. Sitting with hunched shoulders and bowed head, he appears to be in an uncomfortable position, in contrast to the graceful, reclining pose of the figure seen in the painting on the wall. The background, a bright yellow, is more assertive than Dos Passos, who is dressed in restrained grays and blue; the very active brushstrokes on his hands and face, however, intensify his presence.

RR

311

311

Adirondacks in Autumn, 1948

Gouache on colored paper, 19⅞ × 25½ (50.5 × 64.8)
Signed and dated, l.l.: WESTON '48
Acc. no. 2097

Acquired probably by 1949.[27]

Adirondacks in Autumn celebrates nature's vast beauty and is a manifestation of Harold Weston's joy at being able to paint. Saint Huberts and the Adirondack wilderness were a continual source of renewal for the painter, providing him a chance to center himself in nature and to put things in perspective. After the United States entered the Second World War, he spent very little time in his mountain home and gave up painting entirely in order to help victims of war. After a hiatus of five years, he returned to art. In a letter to Duncan Phillips from Saint Huberts written on December 28, 1947, he exclaimed, "I am so happy to be painting again."[28]

Painted near the artist's camp, *Adirondacks in Autumn* depicts Upper Ausable Lake as seen from Sawtooth Mountain. Weston's description of Indian summer in the Adirondacks in *Freedom in the Wilds* matches the scene: "The Adirondacks usually go through a period in late autumn when the weather becomes balmy and sunny, a prelude of calm before the winter storms . . . when the mountains are bare of leaves while patches of gold and red cling still in the hollows, a time of relaxation and peaceful beauty."[29] Brittle, bare trees in the foreground evoke winter, but the distant hills and river valley bask in the glow of summer.

Stylistically, Weston's paintings of the late 1940s continue in the direction of his work of a decade earlier. As a result of his mural commissions, Weston's art became highly realistic and complex. Although he still responded emotionally to his subjects, he placed a new emphasis on local color and sharply focused, highly detailed forms occupying deep space. *Adirondacks in Autumn* is painted with a loaded, dry brush in gouache on dark gray paper, revealing Weston's preference for a colored surface.[30]

Adirondacks in Autumn recalls nineteenth-century American romantic art. The panoramic vista, with framing trees and a river weaving through the mountains, is reminiscent of compositions by Thomas Cole and other artists of the Hudson River school. Moreover, the painting's glowing light and crystalline focus are akin to the luminist effects of John Kensett and Martin Johnson Heade around 1860. Weston shared with these artists an intense reverence for nature and the desire to portray it in its varying moods.

Though Weston used these words to describe his art in 1922, they are equally applicable to *Adirondacks in Autumn:* "In the eternal hills the sublime epic of nature was unrolling the same as ever. It seemed to overshadow and engulf the petty affairs of men—or rather, I'll say, absorb and interpret them. So I have set up my studio at the foot of old friendly looming Giant Mountain and there, winter and summer, I keep painting away at my serial picture-song. It is a hymn to the endless glory of God."[31]

RR

PEPPINO MANGRAVITE (1896–1978)

Peppino Mangravite created poetic works based upon personal experience and observation filtered through his romantic sensibility; his paintings dealt more with mood and sensuous effects than with description. Mangravite was born June 28, 1896, on Lipari, an island north of Sicily, where his father, a naval officer, was stationed. As a child, he began a traditional Italian art education in Carrara. Mangravite and his family later emigrated to the United States, but the painter returned to Italy and then studied briefly in Paris. Back in New York in 1914, Mangravite took classes at the Cooper Union Art School, but in 1917 he transferred to the Art Students League, where he worked under Robert Henri. His paintings were exhibited widely, and he was the recipient of a number of awards, including Guggenheim Fellowships in 1932 and 1935. Mangravite was active in New Deal art programs, executing murals for the Department of Labor in Washington, D.C., and for post offices in Hempstead, New York, and Atlantic City, New Jersey. He was prominent as an art teacher at many institutions—including Sarah Lawrence College and Columbia University—and regularly contributed reviews and articles to art journals. He died in Cornwall, Connecticut, October 2, 1978. The Phillips Collection owns four oil paintings.

312

Political Exiles, ca. 1928

Exiles (DP); *Exile; Political Exile*

Oil on canvas, 24 × 28 (61.0 × 51.1)

Unsigned and undated

Acc. no. 1256

PMG purchase from Dudensing Galleries, New York, 1928.[1]

Political Exiles had tremendous personal significance for Mangravite. Prompted by childhood experiences on Lipari, it was a response to prolonged periods of seclusion, displacement, and limited freedom.

At the beginning of the century, Lipari was the location of a penal colony, where the artist's father supervised political prisoners.[2] The rugged beauty of the island, about twenty-five miles off the coast of Sicily, clearly had its impact on young Mangravite, who was also charmed by its identification in mythology as Hephaestus's home.[3] Mangravite, asserting his freedom from family and authority, openly associated with the prisoners, enjoying the opportunity to converse with independent thinkers. One of them gave him his first art lessons, and art later became the means to escape his restricted environment when Mangravite went to Carrara to study.[4] Although he moved to New York with his family in 1912, he soon returned to Europe to study art. When war broke out in Europe in 1914, he returned to the United States at his father's insistence.[5] Perhaps owing to Henri's influence at the Art Students League, he chose themes for his works that were heartfelt and based upon his experiences.

Political Exiles seethes with urgency and commitment. Its concentration on people ostracized for their political beliefs transcends the personal and is an early manifestation of Mangravite's interest in human rights and nonconformity.

The rhythmic brushwork, uneven impasto, and rich nonassociative colors convey the violent surf, ripping wind, and hot sun. The hilltop citadel and the armed guard policing the beach are looming presences that elicit a sense of claustrophobia. The viewer's attention is directed toward the foreground and middle distance, where three prisoners are isolated physically and psychologically; they seem small and vulnerable. Toward the center of the composition, a man sits humbly before a low wall near a modest building, perhaps his home. His face partly in shadow, he appears dazed and immobilized. At the lower right, another prisoner, his back to the viewer, watches furtively. His position below the side of a bridge is not visible to the other men; however, his freedom seems thwarted by the wall he faces as well as by the picture edge. The most prominent figure is a man, apparently a political exile, who stands quietly on the bridge. His face is masklike, but his downcast eyes suggest he has escaped the pressures of his confinement through the activity of his mind. His spirit is not broken. The bridge supports him both symbolically and physically and seems to provide a way out of the composition.

As a teacher, Mangravite promoted the liberal arts as essentials of civilization when they stemmed from authentic impulses, rather than fashionable theories and trends. In 1952 he said, "In philosophy, religion, and the arts we pass on . . . the heritage of the best that men have thought and said and felt, in order that that generation in turn may base its thinking on human problems that have proved eternal."[6] Yet individuality had to be tempered by being responsive to the spiritual needs of society.[7] Such an attitude, he felt, had special significance to the American artist, who was often misunderstood by society and pressured to conform: "If the mind and spirit which guide his work are not moulded, by his interest and honesty, to a detached comprehension of the natural intercourse of his whole environment, locality and environment will have no meaning for him. . . . So this talk about 'going American' and 'working in locale,' is a mawkish idealism which smacks of the axiom that, in trying to become something, one becomes nothing."[8]

Political Exiles anticipated social-realist art of the 1930s in its exposure of political repression and its emphatic belief in the power of the human mind to overcome societal pressures. The painting's spirited theme clearly impressed Duncan Phillips: "Mangravite has made an expressionist composition worthy of the influence of Greco, a work that is passionate in the mood conveyed through the dynamic intensity of its color and form."[9]

RR

312

WILLIAM GROPPER (1897–1977)

313

Born December 3, 1897, in New York City into a Romanian Jewish family, William Gropper grew up in the city's Lower East Side. As a youth he assisted his mother, a seamstress, by transporting bundles of cloth between the sweatshops and their tenement home, and at age fourteen he left school to work in a clothing store. Drawing was his only release, and at age nineteen he won a scholarship to the National Academy of Design; but he quickly tired of working from plaster casts and turned to the life drawing classes of Robert Henri and George Bellows at the Ferrer School. The art of Goya and Daumier made an indelible impression on Gropper, who became convinced that art should be humanistic and honest. His bold cartoons of the 1920s appeared in publications like the *New Masses* and *Rebel Worker*. His activities as a labor organizer and three visits to the Soviet Union further contributed to his growing reputation as a radical. By the later 1930s, however, Gropper was also known for his oil paintings and murals. His drawings of the Grand Coulee and Boulder (Hoover) dams, funded by a Guggenheim Fellowship in 1937, evolved into a monumental mural, *The Construction of a Dam,* at the U.S. Department of the Interior, Washington, D.C. Blacklisted by the House Un-American Activities Committee in 1953, Gropper retaliated by producing a vitriolic series of fifty lithographs, *Caprichos,* based on the hearings. He died in Great Neck, New York, January 4, 1977. One oil painting is in The Phillips Collection.

313

Minorities, 1938 or 1939

Refugees

Oil on canvas, 17⅞ × 30⅛ (45.4 × 76.4)

Signed in creamy tan paint, l.r.: *GROPPER*

Acc. no. 0863

PMG purchase from the artist through A.C.A. Gallery, New York, 1940.[1]

Compelled by the plight of the common man, Gropper created art that was both topical and universal. His sympathy for the masses can be traced to early experiences in the Lower East Side of Manhattan, "an amazing social laboratory in which at the expense of thousands of lives, politicians earned their spurs, racketeers learned their professions, and the human organisms' endurance was tested in the face of exploitation, poverty, and disease."[2] Gropper agreed with his teachers, Henri and Bellows, that art should be truthful to the human condition: "I began to realize that you don't paint with color—you paint with conviction, freedom, love, and heartaches—with what you have. The other end is the technique, the equipment with which you convey that."[3]

Bruegel, Goya, and Daumier were among the artists who had the strongest impact on Gropper's social conscience, and like Daumier he first gained fame as a cartoonist. By 1936 Gropper's first solo exhibition, at A.C.A. Gallery, brought him recognition for his paintings as well. He felt his art could inspire people to be more compassionate and to fight for change: "I'm from the old school, defending the under-dog. Maybe because I've been an under-dog or still am."[4]

Gropper's social-realist paintings are simple, bold, and vigorous. Active lines, distorted forms, energetic brushwork, and expressive color give them a sense of modernism's immediacy, but aesthetic issues were secondary to thematic concerns. Often creating variations on a theme, Gropper generalized and exaggerated details to make his works universal and dramatic. Louis Lozowick contended that "once Gropper is seized with a subject he holds on relentlessly; he pursues it through many transformations, modifies it, varies it, reshuffles the props and the characters, invents new combinations."[5]

Minorities was probably inspired by the Spanish Civil War.[6] Plainly dressed and carrying few possessions, four people and a horse travel through harsh terrain. The impact of their weary but determined postures is exacerbated by the lack of shelter. The landscape is devoid of life. A craggy peak, backlit, provides a mysterious detail. Both threatening and inspiring, it is either an obstacle to the refugees' progress or a manifestation of their determination. The sickly palette of greens, blues, and browns underscores the inhospitable nature of the setting. To accentuate the poignancy of their trek, Gropper contrasted the stillness of the setting with the movement of the figures. Their rhythmic placement, reminiscent of a frieze, carries the viewer's eyes across the picture, and the lateral arrangement of the refugees, directional brushstrokes, and assertive curving lines support this motion.

The title suggests that the people in the painting have been displaced by intolerance and persecution. A threat is implied but not seen. The war in Spain had profoundly affected the leftists of the art world, including Gropper, who dedicated a 1937 exhibition "to the defenders of Spanish democracy."[7] Cécile Whiting perceptively connected Gropper's use of the refugee theme to both the Flight into Egypt in Christian iconography and secular images of wandering peasants, such as Goya's *Winter,* 1786–87 (Prado). Gropper sanctified the fate of these victims, conveying "one more historical instance of humble people fated to wander."[8] With this powerful work, he made distant events accessible for ordinary Americans, for whom the painting would be prophetic. As the world plummeted into war, the situation depicted in *Minorities* became all too familiar.

RR

BEN SHAHN (1898–1969)

Ben Shahn's exposure to art and politics was long-standing. The son of a wood carver and a potter, he was born September 12, 1898, in Kovno, Lithuania, then part of Russia. His father's anti-czarist activities forced the family to emigrate to the United States in 1906, where Shahn grew up in a working-class Jewish neighborhood in Brooklyn. Drawing constantly, he became an apprentice in a Manhattan lithographic firm for a dollar a week, finishing high school at night and later taking classes at New York University, City College of New York, and the National Academy of Design. Shahn saw his art as a means to combat injustice and raise social awareness. He had his first solo exhibition at the Downtown Gallery in 1930 and became famous two years later for his paintings inspired by the trial and execution of Sacco and Vanzetti. Diego Rivera, an admirer, invited him to assist with painting the controversial murals in Rockefeller Center's RCA Building. Responding strongly to the public nature of this art form, Shahn created other murals, notably those in the Bronx Central Annex Post Office (a collaboration with his second wife, Bernarda Bryson) and the Federal Security Building in Washington, D.C. A painter and photographer for the Farm Security Administration between 1935 and 1938, and later known for his illustrations and prints, Shahn was proficient in many styles. He was also active politically, serving on the city council in Roosevelt, New Jersey, between 1945 and 1948. He died in New York March 14, 1969. Two paintings and four drawings are in The Phillips Collection.

314
Still Music, 1948

Silent Music
Casein on fabric mounted on plywood panel, 48 × 83½ (121.9 × 212.0)
Signed l.r.: *Ben Shahn*
Acc. no. 1731

PMG purchase from the Downtown Gallery, New York, 1949.[1]

Wanting to create more personal, less polemical works, Ben Shahn in the late 1940s moved away from the social realism that had brought him recognition. He responded pleasurably to the "qualities of people" and "the mood of life and places," hoping to find images that would communicate on many levels. He also believed that "the incidental items of reality remain without value . . . until they are symbolized, recreated, and imbued with value. The potato field and the auto repair shop remain without quality . . . until they are turned into literature by a Faulkner or a Steinbeck or a Thomas Wolfe or into art by a Van Gogh."[2]

A poetic conjuring of an unseen presence, *Still Music* is reminiscent of Paul Klee's art, which Shahn admired. The angular, brittle lines recall Klee's automatist drawings, as do the musical theme and the emphasis on the subject's essence. Shahn recognized the relationship between Klee's intent and his own: "More than anyone else he reaffirms an old heresy of my own—that form is merely the shape taken by content. Where content is highly subjective and highly personal *new forms* will emerge."[3]

Still Music also demonstrates what James Thrall Soby identified as the "interchangeability" of Shahn's art.[4] An image having its basis in

an illustration might evolve into a painting or print, or vice versa. This painting followed a series of drawings, commissioned in 1948 by CBS, for a radio network brochure. *The Empty Studio,* one of the published drawings, is very close in imagery and composition to the Phillips work, but its caption, the illustration's inspiration, conveyed a specific commercial message.[5] The painting and a very similar serigraph from 1950, *Silent Music,* omit the caption.[6] Shahn saw no conflict between his commercial work and fine art, claiming, "I never let out a thing until I'd be as happy with it hanging in a museum or reproduced in a daily newspaper. I don't care where."[7]

Without the caption, the viewer must ponder why no performers are shown. Some interpretations emphasize the painting's innate musical qualities. Its rhythmical deployment of straight lines, flat shapes, and dots is reminiscent of musical notation. The patchy brushstrokes covering the picture surface glow faintly with prismatic color, echoing, perhaps, the sounds of earlier performances. Duncan Phillips believed the work revealed the "vibrations of music one senses during the intermission in a concert."[8] Shahn felt "the emotion conveyed by great symphonic music happens to be expressed in semi-mathematical acoustical intervals and this cannot be transposed in terms of ninety portraits or caricatures of performers."[9] On the other hand, economic causes might explain the musicians' absence. Shahn jokingly suggested the reason for the empty seats by calling the work "Local 802 on Strike!"[10] A later writer saw the work as "an appropriate artistic comment . . . related to financial struggles affecting musical education."[11]

RR

314

RAPHAEL SOYER (1899–1987)

Raphael Soyer was born December 25, 1899, in Borisoglebsk, Russia, into a large, impoverished Jewish family. Artistic and intellectual pursuits were encouraged by his father, a Hebrew teacher and writer, whose liberal ideas and popularity among students led to trouble with provincial authorities. Denied their Russian residence permit, the Soyers moved to the United States in 1912, finally settling in the Bronx, New York. Raphael, his twin brother, Moses, and his younger brother, Isaac, eventually became successful artists, but they rarely studied or worked together as adults. Raphael left school at age sixteen to help support the family; he attended free classes at the Cooper Union and the National Academy of Design. Guy Pène du Bois, later his teacher at the Art Students League, recognized the young artist's promise and introduced him to Charles Daniel, who gave Soyer his first solo exhibition in 1929. Soyer was already known for his sensitive portrayal of New Yorkers observed near his studio in Manhattan's Lower East Side when he joined the WPA Federal Art Project. Working primarily in oil and lithography, he also taught at the Art Students League and, along with Moses Soyer, painted murals for the post office in Kingsessing, Pennsylvania. A cofounder of the short-lived *Reality* magazine, Soyer was an ardent champion of realism at a time when abstract expressionism dominated the American art scene. He died in New York November 4, 1987. One oil is in The Phillips Collection.

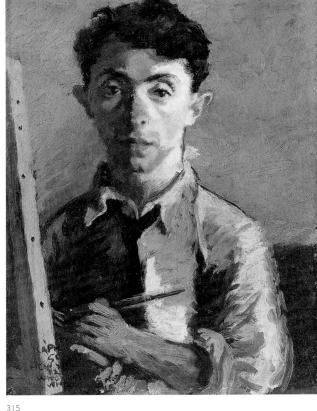

315

315

Self-Portrait, ca. 1927

Oil on wood panel, 11⅛ × 8½ (28.3 × 21)
Signed and inscribed, l.l.: RAPHAEL SOYER/NEW YORK/PAINTER/WHO IS SLEEPY/WHEN HE IS NOT/PAINT-ING; on reverse is another portrait of a man with two inscriptions: at left: ZITTER/BY/RAPHAEL/SOYER/1927; and lower section: *Chanatt* [?] *Zitter/Chanan* [?] *Zitter*/by Raphael Raphael [*sic*] Soyer June/1927.
Acc. no. 1643

PMG purchase from the artist through Valentine Gallery, New York, 1934.[1]

Although he is identified as a social realist because of his interest in the common man, Raphael Soyer, in contrast to many of his contemporaries, avoided subjects that were overtly critical of society. Like his brothers, Moses and Isaac, he searched for beauty in his life and in the people he met. Soyer never accepted commissions for portraits, because he was concerned with the private person rather than the public facade.

Committed to portraying the effects of the modern world on the human psyche, Soyer felt part of the grand tradition of the humanistic arts. He was drawn to the psychologically penetrating work of Chekhov and Dostoevsky, which he read in his youth, and to realism in painting: "My art is representational by choice. . . . I consider myself a modern artist . . . because I am influenced by the thoughts, the life and the aesthetics of our time. I am also an inheritor of many great painters who preceded me and made tradition living, on-going and ever renewable like nature itself."[2] The artists he emulated—Rembrandt, Degas, and Eakins—were also dedicated to showing their times truthfully and placed great value on artistic integrity. Delving deeply in their portraits, they emphasized inner character over status and physical beauty. Soyer's many self-portraits, like those of Rembrandt, whom he greatly admired, give testimony to a remarkably consistent artistic vision.

Despite his commitment to showing real life, Soyer recognized the introspective nature of his work: "It's always self-portraiture, always autobi-ographic. . . . Your work is what you are. . . . It's impossible to escape oneself. You are yourself, no matter what."[3] He did many self-portraits, and he often appeared as a spectator in his genre scenes, his presence validating the significance of the depicted events.

Self-Portrait is more subtly executed than the portrait that is found on the panel's reverse.[4] The painting intimately conveys Soyer's romantic view of himself as a sensitive, vigilant worker. The gentle light, sketchy drawing, and muted palette seem appropriate for this thoughtful, introverted image. Soyer presented himself alone, sleeves rolled up, and brush in hand, doing what he most loved. His expression is both alert and weary, more like a gaze into a mirror than a social encounter. His tousled hair, heavy eyelids, and rumpled shirt suggest that he has been painting for a long time. Supporting this interpretation is the inscription, which humorously alludes to Soyer's dedication to painting. Ever hoping to capture some meaningful but evanescent detail, he fights sleep and continues to work.

RR

HOBSON PITTMAN (1900–1972)

Born January 14, 1900, in Epworth, North Carolina, Hobson Pittman grew up on a plantation in Tarboro. Pittman took classes nearby at the Rouse Art School, but after his mother's death he left North Carolina permanently, settling in 1918 near his sister's home in Pennsylvania. When she died not long after his arrival, Pittman returned to school. He studied at Pennsylvania State University, the Carnegie Institute of Technology, and Columbia University before having his first solo show in 1928 at the Edward Side Gallery in Philadelphia. By the 1930s he was known nationally. Although he sought inspiration through travel and personal study of the work of the Old Masters, Pittman is best remembered for dreamy interiors and landscapes based on his youth in the South. He became an art educator in 1932, teaching the summer painting course at Penn State for the next thirty-three years as well as classes at the Pennsylvania Academy of the Fine Arts by 1949. A dedicated teacher, he encouraged individuality in his students and provided them with a solid foundation in both traditional and modern art. He died May 5, 1972, in Bryn Mawr, Pennsylvania. Two of his oils, one watercolor, and a pastel are in The Phillips Collection.

316

316

Nine P.M., ca. 1939

Nine O'Clock

Oil on canvas, 16 × 22⅜ (40.8 × 56.8)

Signed l.l.: *Hobson Pittman*

Acc. no. 1577

PMG purchase from the artist through the Walker Gallery, New York, 1939.[1]

In an age when nostalgia is too often sentimental or merchandised, it is surprising how strongly Hobson Pittman's works evoke pure feelings for a bygone era. Having been raised in a large, rambling plantation house with high ceilings and floor-length windows and filled with Victorian furniture, Pittman often painted scenes reminiscent of such places. He wrote, "I have always been interested in painting things of the past, things I loved and still do. Things I feel and understand."[2]

Pittman's atmospheric interiors are imbued with what one critic described as "the sense of presence withdrawn but briefly."[3] The inhabitants of the rooms, usually women, are curiously passive, as if they were controlled by the place or people once living there. Such imagery has also been associated with a collective identity prevalent in southern art and has been described by

Rick Stewart as an attempt "to re-capture an other-worldly Southern past that perhaps exists only in fiction."[4]

Nine P.M. is a response to something recalled for its familiarity, not its uniqueness. Pittman remembered "how the beds in these North Carolina homes were pulled out in the middle of the rooms on hot, summer nights. . . . I recall with what fascination, at an early age, I watched my sisters and my aunts strolling around the bedrooms in their long, white night gowns."[5]

The mood in *Nine P.M.* is one of quiet anticipation. The painting shows a woman sitting on a bed in a sparsely decorated room. A window provides a view of a building with a tower, its clock reading nine o'clock. The curtain, pulled to one side, captures the moonlight flooding into the room. Near the bed is an empty chair. The bedroom's sole decoration is an oval portrait, hanging on the wall near the window. Dwarfed by the enormous bed and by the vast interior space, the woman looks through the window or toward the portrait or chair, but clearly she is under the spell of one or the other.

The bedroom and its furniture have more presence than the figure, revealing Pittman's fascination for interior spaces. The artist wrote, "Rooms are wonder for me—I like rooms and doors and windows—Mystery shrouds them all—mystery not revealed or explained."[6]

Pittman plays the certainty of the hour against the feeling of suspended time, underscoring the painting's equivocal meaning. Dan Miller identified the bed as a continuing symbol in Pittman's art of birth, dream, and regeneration, as "a beginning and an ending, an emergence into the stream of life and a going home."[7] *Nine P.M.* has many possible interpretations. Pittman made his painting memorable by allowing the viewers to reach their own conclusions.

Duncan Phillips responded strongly to Pittman's art and eventually got to know the painter. He once described Pittman as "one of our best American painters . . . a genial kindly humanist whose poetic nostalgic landscapes and interiors have already won for him a high professional standing."[8]

RR

For more than sixty years, Isabel Bishop attempted to capture the pace of modern life. Born March 3, 1902, into a middle-class family in Cincinnati, Bishop spent an isolated, lonely childhood in Detroit, where her father held several teaching jobs and her mother worked on an English translation of Dante's *Inferno*. She grew accustomed to observing the world around her and developed an interest in drawing. At sixteen Bishop enrolled in the School of Applied Design for Women in New York, planning to train for a career in commercial art. Profiting from the curriculum's emphasis on drawing and impressed by the avant-garde work she saw at the Société Anonyme, she changed her direction; she was not satisfied, however, with her experiments with abstract form. At the Art Students League, Bishop studied under Kenneth Hayes Miller and Guy Pène du Bois. There she was inspired to create figure compositions based on real life, applying aesthetic principles derived from Renaissance and baroque art. Although she taught at the Art Students League and Skowhegan School of Painting and Sculpture, in Maine, and received a Treasury Department commission for a mural for the post office in New Lexington, Ohio, she is best known for sensitive images of people observed near her studio in Union Square. Bishop died February 19, 1988, in New York. The Phillips Collection owns one painting.

317

Lunch Counter, ca. 1940

Lunch Hour

Oil, egg tempera and pencil on hardboard, 23 × 14 (58.3 × 35.6)

Unsigned and undated

Acc. no. 0139

PMG purchase from Midtown Galleries, New York, 1941 (from Corcoran exhibition).[1]

Inspired by women observed at a snack bar in or near Union Square, *Lunch Counter* is one of many versions of the subject in Bishop's oeuvre. At once familiar and elusive, the scene is imbued with a sense of reality by the quotidian details and subtle technique. Two young women—office or shop workers, judging from their attire—pause briefly for lunch at a type of fast-food establishment still common in New York. Standing instead of sitting, they concentrate on eating rather than visiting and are oblivious to the gaze of the viewer. In contrast to domestic genre images common in American art since the mid-nineteenth century, these women are part of the work force outside the home. Bishop stated in 1936 that there was a great discrepancy between contemporary women and their depictions in art: "Traditionally, we show silly people in silly clothes, and the housewife with her hair done up and in a gingham apron. But that is an anachronism. It isn't true of the modern world."[2]

Ellen Wiley Todd interpreted *Lunch Counter* and other images by Bishop as embodiments of middle-class values, in accord with prevailing attitudes for working women during the 1930s: "Bishop's pictures constructed an ideal of a modest, deferential office worker, effectively avoiding any expression of the less desirable material circumstances that frequently beset the typical office worker's life."[3] Yet Bishop hoped to convey through her elusive technique her subjects' potential for overcoming class and gender restrictions: "The people are identifiable in their relation to society, but there is the implication of unfixity. The idea of mobility means a potential for change. This I consider an outstanding characteristic of American life."[4]

Bishop wanted to capture a particular moment, but not in a manner that would freeze the scene. Impressed by how life was conveyed by the implied animation of forms in the art of Rubens and other baroque masters, she began with sketches done on location or from reconstructed scenes in her studio. Before painting a picture, she would gauge the effectiveness of a composition by preparing an etching or aquatint. *Lunch Counter*, an etching from 1940, is a reverse image of the painting in The Phillips Collection, which anticipates it in all details except for the mottled effects of light and color in the background.[5] If she believed a motif could be carried further, Bishop would transform her impressions into a painting of egg tempera and oil glazes on a brown gessoed surface, in which flickering patches of color and varied brushwork, evocative of the ambience of the city, augmented the details conveyed by broken line. No attempt was made to show all aspects of a scene or to finish a painting in a traditional manner, because Bishop believed that incompleteness could suggest the passage of time.[6]

In *Lunch Counter* it is impossible to separate the lines and areas of color from the picture surface. The colors, tempered by the background tone, are hazy yet intermittently luminous. However casual or simple the scene seems, it typifies the action of the subject and its continuity in time. Bishop acknowledged her wish to assert the temporality of her subjects: "I try to limit content, to limit everything, in order to get down to something in my work. . . . I struggle for months and months to make it look as momentary as it really is."[7]

R R

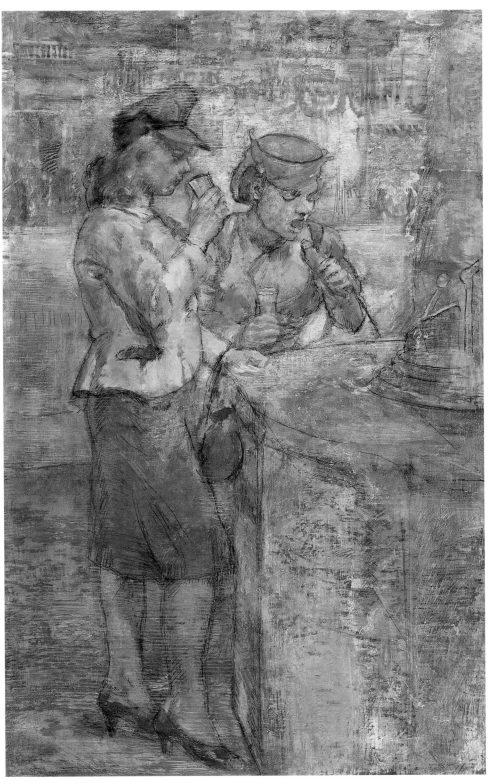

317

ALLAN ROHAN CRITE (B. 1910)

Allan Rohan Crite has had a varied, extensive career as a painter, draftsman, printmaker, author, librarian, and publisher. Born March 20, 1910, in Plainfield, New Jersey, of African, Indian, and European ancestry, Crite has spent most of his life in Boston.[1] At an early age his mother encouraged him to draw and paint. He took art classes at the Museum of Fine Arts and the Massachusetts School of Art, and business classes at Boston University. Later he focused on history and the natural sciences, receiving a bachelor's degree from Harvard University in 1968. He was awarded honorary doctorates in a range of disciplines: from Suffolk University (1979), Emmanuel College, Boston (1983), the Massachusetts College of Art (1988), and the General Theological Seminary (1994). During the 1930s Crite worked under the auspices of the PWAP and the WPA, and in the early 1940s he began a thirty-year career as a technical illustrator for the Department of the Navy. A visual chronicler of life in Boston, he is active in the Episcopal Church and is a prolific creator of liturgical art. He is on the advisory board of the National Center of Afro-American Artists, Boston, and is an author and illustrator. Crite has completed work on *The River of Human Sexuality (6,000,000 Years),* a symbolic pictorial essay containing 265 original pen and ink drawings. Crite currently resides in the Roxbury section of Boston. The Phillips Collection owns one painting by Crite.

318

Parade on Hammond Street, 1935

Parade; I Love a Parade
Oil on canvas board, 18 × 24 (45.7 × 61.0)
Signed and dated in black paint, l.l.: *Allan Rohan Crite ARC June 1935;* inscribed on reverse in black paint: *A Parade on Hammond Street Allan Rohan Crite June 1935.*
Acc. no. 0351

PMG purchase from Downtown Gallery, New York, 1942.[2]

Parade on Hammond Street, executed from memory in June 1935, was inspired by a parade the artist witnessed near his residence in Roxbury. Painted in predominantly warm, vibrant colors, this urban genre scene focuses on the neighborhood's extensive African-American community. It is characteristic of Crite's early work in its documentary emphasis, fine detail, and celebratory tone.[3]

A procession of musicians is led by a tall man wearing a high plumed hat and holding a baton. The performers wear blue-and-white uniforms and march before an appreciative audience of men, women, and children standing on the sidewalk adjacent to the street and peering from the windows of red-brick buildings in the background. The artist recalled: "The parade was one of those district conventions of the Elks, a fraternal order, and the parade was a feature of the festivities. They would be at times on a Sunday preceding a service at one of the local churches. It was a festive affair and everyone [was] in the Sunday best of attire."[4]

Crite's long-standing interest in chronicling the urban scene reveals his desire to depict black people as ordinary citizens rather than as southern sharecroppers or Harlem jazz musicians, images that were becoming stereotypical by the 1930s. On a wall of Crite's studio are neighborhood pictures he made as a child. The painter explained: "I was interested in the urban scene from day one. . . . I used to hear a whole lot about the Negro question. That's the way you discussed things in those days. . . . I had the sort of simple-minded idea that you spend so much time talking about the Negro question or any other kind of social question, you forget you are talking about people."[5] Crite frequently taps history and autobiography to connect people of color and himself to a larger context: "In the case of the American Negro his activities in the fine arts must serve a double purpose: for he must make the rest of the United States aware of his offerings: and therein have his contribution enrich the cultural life of the nation: and also he must awake his own people to the needs of the fine arts: so that they too may take part in these activities as portions of their daily living."[6]

The figures in *Parade on Hammond Street* are individualized in appearance as well as clothing. Men and women converse with one another, enjoying the fresh air and the opportunity for socializing. Entranced by the music and rhythmic movement of the marchers, children hover near the curb or lean out of windows. Crite painstakingly reconstructed the settings of his works to ground them in reality and to make the images accessible to the viewer. The neighborhood shown here has been dramatically altered by urban renewal, so his meticulous rendition of the brick buildings documents the place as well as the event.

The emphasis on fine detail is in part a manifestation of Crite's ongoing study of Flemish Late Gothic art, yet a number of the children were painted *alla prima.*[7] Variance of brushwork and scumbling, along with the rich color, animate the surface of the painting. Even though he was aware of modernism, Crite chose a representational style because it was natural to him and appropriate to his form of communication. "I'm a storyteller, telling a story of people," he said, "and I started out with my own people in the immediate sense, like the neighborhood, and people in a general sense when I make a neighborhood out of the whole world."[8]

RR

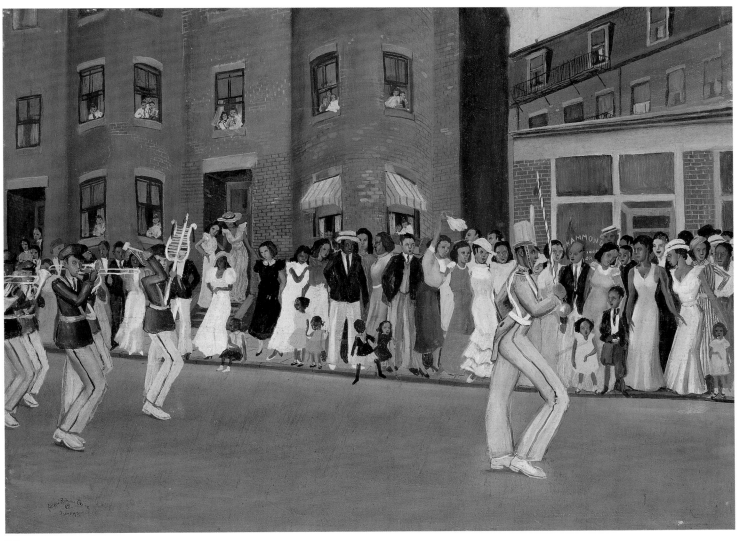

318

JACOB LAWRENCE (B. 1917)

A celebrated chronicler of African-American experience and history, Jacob Lawrence was born in Atlantic City September 7, 1917, to a couple who had moved north to find a better life. After their parents separated, Lawrence and two younger siblings lived in settlement houses and foster homes in Philadelphia until their mother could support them in New York. As a teenager, he benefited from the Harlem Renaissance's cultural fervor, studying under Charles Alston and later winning a scholarship to the American Artists School. In 1938 Lawrence had his first solo exhibition at the Harlem YMCA and started working in the easel painting division of the WPA Federal Art Project. He married the painter Gwendolyn Clarine Knight in 1941, the same year *The Migration of the Negro* series had its debut at the Downtown Gallery. The first artist of color to be represented by a major New York gallery, Lawrence was active as both a painter and an art educator. He taught at Black Mountain College in North Carolina in 1946, and later at the Skowhegan School of Painting and Sculpture in Maine and the New School for Social Research in New York. In 1971 Lawrence became a professor of painting at the University of Washington in Seattle. In recent years he has also become known for his serigraphs and illustrations. Thirty tempera panels, one half of the series *The Migration of the Negro,* two screen prints, a silkscreen, and a lithograph are in The Phillips Collection.

319, 320, 321

The Migration of the Negro, 1940–41

Three paintings from a series of sixty works.

319. Panel 3: "In every town Negroes were leaving by the hundreds to go North and enter into Northern industry." Acc. no. 1153

320. Panel 51: "In many cities in the North where the Negroes had been overcrowded in their own living quarters they attempted to spread out. This resulted in many of the race riots and the bombing of Negro homes." Acc. no. 1177

321. Panel 57: "The female worker was also one of the last groups to leave the South." Acc. no. 1180

Casein tempera on hardboard; each panel is 12 × 18 (30.5 × 45.7)

Unsigned

Acc. nos. 1152–1181

PMG purchase from the Downtown Gallery, New York, 1942.[1]

In a century when painting has shifted away from narrative, Lawrence is a master storyteller, bringing to life important historical events by drawing upon his emotional responses to them. Profoundly affected by the Harlem Renaissance of the 1920s and 1930s, he was first exposed to art in a day-care program at the Utopia House, where classes were taught by Charles Alston, later his mentor at the Harlem Art Workshop. Dissatisfied with the limited curriculum in the New York public schools, Lawrence attended lectures on black culture and exhibitions of African art at the 135th Street Public Library, the intellectual hub of the community. Lawrence's mother had hoped he would choose a career in civil service, but members of the creative community, including the poet Claude McKay and the sculptor Augusta Savage, encouraged him to become an artist.[2]

When Lawrence began painting *The Migration of the Negro* in 1940, it was his most ambitious project to date, amplifying his earlier genre scenes and historical series on Toussaint L'Ouverture, Frederick Douglass, and Harriet Tubman. Broad in scope and dramatic in exposition, this depiction of blacks moving to the North to find jobs, better housing, and freedom from oppression was a subject he associated with his parents. The artist recalled hearing how newly arrived families would receive a helping hand: "The people in the neighborhood would collect clothes for these newcomers and pick out coals that hadn't completely burned in the furnace to get them started."[3]

Funded by the Rosenwald Foundation, Lawrence began to research the subject in 1939 at the 135th Street Public Library. After many months of reading and taking notes, he made sketches for the series.[4] Gwendolyn Clarine Knight, his future wife, helped him identify memorable scenes and assisted in gessoing the panels and writing the inscriptions. Enthralled by fourteenth- and fifteenth-century Italian paintings at the Metropolitan Museum of Art, Lawrence used their medium—tempera—with a craftsman's mastery. To keep the colors consistent, he placed the panels side by side and painted each hue onto all the panels before going on to the next color. Perhaps it was this approach that resulted in a sense of collective unity, even though each panel can stand on its own.

Searing in their immediacy, the works show only essential imagery. Flattened, angular forms, strong diagonals, and contrasts of light and shadow contribute to the dynamism of the series. Although Lawrence used a limited palette, he arranged colorful focal points to direct the viewer's attention. Some pictures are self-contained; others are more expansive. As the narrative unfolds, from image to image, the vantage

319

point, compositions, and details change—in a manner reminiscent of a film. In some panels, figures dominate; in others, the setting propels the story. The people are not individualized; rather, they represent collective characteristics. However, Lawrence never lost sight of the human drama. Talking about his work in general, he said, "The human subject is the most important thing. My work is abstract in the sense of having been designed and composed, but it is not abstract in the sense of having no human content."[5]

Lawrence varied his emphasis to reveal the depth of the story. Motion and anticipation are dramatically conveyed in Panel 3, where the pyramid of people, gazing beyond the picture's edge, forcefully echoes the arrangement of the flying birds. The empty space connotes an unknown future. In contrast, the nightmarish scene in Panel 51 reduces the human presence to a few silhouettes in the windows of burning buildings, an indication that the migrants did not always find a better life. Panel 57, in its central monumental form, eloquently captures the dignity of the working woman.

Public acceptance of *The Migration of the Negro* has been strong since the series was first shown, demonstrating the continuing relevance of its theme. A seminal work in twentieth-century art, it was a manifestation of Lawrence's ethnic pride and his desire to reveal events that he felt should be known: "It was . . . so much a part of my life. I became conscious of these things when I was eight or nine years old, and this consciousness remained, and this is what you see in the *Migrations*."[6]

RR

320

57

SARAH WILSON

In *Leaders of French Art Today,* a Phillips Memorial Gallery exhibition catalogue of 1927, Duncan Phillips wrote of his wish that the lead in painting might pass from France to the United States.[1] Phillips's collection prior to the Second World War recognized both the Parisian dominance of modern art and the Francophilia of his aesthetic mentors, Roger Fry and Clive Bell.[2] In the postwar period his wish was fulfilled; New York became the new center of the art world. Yet France itself did not acknowledge this loss of hegemony until the early 1960s, and the Old Master concept as applied to French modernism still dominated those American "connoisseurs of pleasure" (Bell's phrase) who were continuing to build up European collections. In this context, carefully selected post-1945 works were seen in terms of continuity with late nineteenth- and early twentieth-century French masterpieces. While British art had to define its specific contribution against this dominance, the English critical tradition and early twentieth-century notions of taste were formative for both American collections and aesthetic approaches.[3]

The tendency to classify modern-art movements into pre- and post-1945 sections does an injustice to major modernists who had influential late careers or an immediate posthumous influence. Phillips's statement in 1940 that the veteran Georges Rouault was the "greatest artist now living," the exhibition (from Boston) of Jacques Villon with Lyonel Feininger in late 1949, and the Klee retrospective of that year were far more characteristic of period taste than the work of Nicolas de Staël at the same time.[4] The Villon purchase *The Grain Does Not Die,* 1947 (cat. no. 129), is, while elegiac, a reference to André Gide's novel *Si le grain ne meurt,* 1920, and a reminder of how influential figures of the Third Republic still ruled life and letters in postwar France.

Moreover, the contemporary political climate should not be ignored. Phillips ended the introduction to his 1952 catalogue with words fraught with Cold War tensions: "As we move into a future menaced by evil forces of tyranny and total war we must cling to our faith in art as the symbol of the creative life and as the stronghold of the free and aspiring individual."[5] While in 1929 Phillips had confidently selected as his favorites—"Despiau in sculpture and Derain and Braque in painting"—by 1945 Despiau and Derain were

Nicolas de Staël, detail of
Fugue, see cat. 343

anathema in France, both charged with collaboration with the Nazis. Derain was unjustly accused, by hearsay, prior to deacquisition by the Museum of Modern Art in New York.[6] Picasso—the greatest of the modernists, conspicuously absent except for a work of 1901 in Phillips's magnificently illustrated 1952 catalogue—was perhaps Europe's most famous Communist at the time, internationally associated through his dove emblems with the Comintern-backed World Peace movement. There was also a growing FBI file on his activities.

Phillips's taste in postwar French and British art was both enlightened and quite orthodox. His choices among School of Paris artists could well be compared with those of another "passionate acquirer," the Londoner Sir Robert Sainsbury. However, Sainsbury was not preoccupied, as was Phillips, with simultaneously developing holdings of American art. Yet differences of accent do not detract from an underlying similarity between the two men's aesthetic choices: Sainsbury collected Fautrier rather than de Staël, Léon Zack rather than Manessier, for example, and ventured further into the postwar sculptural field, adding to Giacometti the works of Germaine Richier and César in the 1960s.[7]

Although, along with Giacometti, the French painter Jean Dubuffet was assiduously marketed in America by the Pierre Matisse Gallery, initially earning the praises of Clement Greenberg, his impastoed graffiti held no appeal for Phillips, nor would the Scandinavian "vandalism" of an Asger Jorn or the "charlatanism" of an Yves Klein in the 1960s. Retrospectively, these three artists may be considered the most important European figures of the period, besides the more accessible Giacometti, Moore, and Bacon, but this opinion is at odds with the aesthetic judgment and exhibition policies of key curators or collectors at the time. The anti-art strategies exemplified by Dubuffet, Jorn, and Klein, which initially seemed shocking and brutal, have been incorporated retrospectively into the very tradition of *belle peinture* that they were trying to flout.[8]

Phillips's 1952 catalogue was subtitled *A Museum of Modern Art and Its Sources,* but the patrician ethos of opening one's house to visitors "welcomed to feel at home with the pictures" in the "unpretentious domestic setting" Phillips reemphasized in 1952 was totally at odds with the sources of the Museum of Modern Art in New York. There "the modern" entailed an acknowledgment of radical precursors, such as the Bauhaus pioneers in Germany; the impersonal white spaces and the emphasis in some 1930s exhibitions on industrial design expressed an attitude toward democracy in the machine age quite different from Phillips's philanthropic and educational purposes.[9]

The key distinction between pre- and post-1945 modernist painting was finally one of scale not style, a scale that suited the spaces and cultural imperatives of the Museum of Modern Art in the 1950s. The new American painting declared a definitive break with the small easel painting that looked so inviting in the Phillips interior. As cultural objects, domestic easel paintings were linked not only to a tradition of modern connoisseurship and social distinction but also to a contemplative "possession" through seeing totally at odds with the visual demands of a Pollock drip painting.

In France, still living through a period of ruin, austerity, and reconstruction, there were few commissions for large-scale decorations.[10] The reestablishment of Paris as a cultural metropolis and center for luxury goods was almost immediate in contrast to the slow process of economic and technological rebirth. European artists in general kept to a collectible easel size, and Phillips certainly chose some very small-scale examples of their work.

To look at the collection itself, it is perhaps appropriate to begin with Alfred Manessier, a lyrical abstractionist who provides a link between the aesthetic philosophy of Phillips during the war and his postwar School of Paris choices. Manessier had attended the 1930s lectures of Henri Focillon, the French medievalist whose *Life of Forms,* published in translation in America in 1942, was quoted with reverence by Phillips in the 1952 catalogue.[11] In Focillon the "significant form" principles of the Bloomsbury aestheticians Fry and Bell shift to an account in which the chronological development of styles retrospectively acquires its own urgency and life force, an *élan vital* and pregnant sense of *durée* (the passage of time). This approach fused evolutionist notions with the philosophy of Henri Bergson. Bergson died in Paris in 1943; he was officially honored after the war and had a great impact on painters like Manessier and Jean Bazaine who belonged to a predominantly Catholic grouping known as "young painters of the French tradition," prominent during the Occupation. As late as 1963 Manessier's mature style in *From the Depths of Darkness* (cat. no. 338) shows form in flux and chaos. Brighter passages offer a "fiat lux" to the tragic, Gethsemane-inspired title. As with El Greco, whose light and forms inspired Manessier in Spain, spiritual darkness is modulated with faith and hope.

Manessier and his fellow artists were all indebted to the cubist grid or armature and fauvist and impressionist color. This heritage was adopted by many of the new or returning members of the School of Paris. Landscape motifs and a palette inherited from impressionism and plein-air painting are exemplified by *Stones,* 1950 (cat. no. 335), a work of the Portuguese artist Maria Helena Vieira da Silva. It employs the *taches,* or small blocks of color, characteristic of a broad spectrum of School of Paris artists. Her *Easels* of 1961 (cat. no. 336) is fundamentally metonymic, evoking the long tradition of artists' studio paintings. Yet by repeating and compressing the motif, she created a sense of anguish and potential loss of individuality so characteristic of the postwar existentialist climate in Paris, echoed, for example, in the small, multiple-figure sculptures of Giacometti.[12]

The referential nature of Vieira da Silva's abstractions and their illuminating titles, which point the viewer toward a figurative reading of marks and surfaces, contrast with the work of Pierre Soulages. His strongly constructed gestures nonetheless evoke the starkness

and heat of his southern background, as in *July 10, 1950* (cat. no. 345). A looser abstraction that would be baptized *la peinture informelle* (informal painting) appeared immediately after the war with the work of the German exile Wols. His first oil paintings, exhibited at the Galerie René Drouin in 1947, had a galvanizing effect on the young Georges Mathieu, who saw "forty masterpieces. Each one more shattering, more tortured, bloodier than the next."[13] Wols's art was linked with marginality, exile, and despair—he was the perfect existentialist painter for the philosopher Jean-Paul Sartre. Yet his ethos of gestural painting, once appropriated by Mathieu, became open to increasingly nationalist, indeed Royalist, readings. While the dark background swatches of paint in *Simon, Comte de Crépy,* 1959 (fig. 38), have a somber strength, the lighter *écriture,* or writing in paint, hovers between an evocation of oriental calligraphy and the flourishes of a *paraphe* (the ornate endpiece to the French noble-man's official signature). Mathieu's *paraphes* would find their way eventually onto the sword of the Académie Française, Sèvres porce-lain, minted medallions, and the ten-franc piece.[14]

Yet, ironically, it was Mathieu, the most Americanist as well as orientalist of the French school, who would introduce artists from the United States to France: "Confronted Vehemences," organized with Michel Tapié at the Galerie Nina Dausset in 1951, showed the French and Americans together, preceding Pollock's first one-man show at the Studio Fachetti in Paris, held in 1952. Mathieu's paint-ing exemplified a characteristically "French" 1950s style. His was a major success story involving an increasing number of official com-missions. In this light he may be seen as the successor to Raoul Dufy in the 1930s; but as with Dufy, posterity has not been kind.

Mathieu described the period 1945–51 in Paris as "the anti-geometric offensive," referring to a spectrum of abstract geomet-ric artists, including such figures as Victor Vasarely, who despite local prestige did not reach collectors abroad like Sainsbury and Phillips. These artists had their own salons, galleries, critics; and as with the lyrical or gestural abstractionists, or those linked with the abstract representation of landscape (*paysagisme abstrait*), com-mercial success was linked to the evolution of a recognizable sig-nature style.[15] Subgroupings within the School of Paris could be defined by nationality as well as style; thus Nicolas de Staël, as a Russian, could be linked with the icon-inspired Serge Poliakoff and the more lyrical André Lanskoy. Yet de Staël is paradoxically the most "French" of artists: his roots may be seen to lie in the tender touch and palette of Chardin as much as in Piranesi or the Dutch landscapists. While his return to figuration was considered a betrayal by some abstractionists in the factional art world I describe, he was promoted with success in Paris and London and became a legendary figure, whose reputation peaked after his unexpected suicide in 1955. In contrast to Mathieu, de Staël has emerged as perhaps the most exemplary painter of the postwar School of Paris, vindicating Phillips's early confidence and his de

Fig. 38 Georges Mathieu, *Simon, Comte de Crépy,* 1959, oil on canvas, 38 × 64 in., The Phillips Collection, Washington, D.C., acc. no. 1302.

Staël unit. Following major retrospectives in Paris, London, and more recently Saint-Paul-de-Vence and Madrid, de Staël's exhibi-tion at the Phillips in 1990 revealed a stature that is only now beginning to be perceived by American art historians.[16]

De Staël's strength was his acute sense of the phenomenology of painting as an activity, the play between the perception of sur-face, *matière,* and residual representation, the meaning of percep-tion, and our "seeing in" to a picture. This sense of fascination and unease was reciprocated by Maurice Merleau-Ponty. The philoso-pher's focus, one could argue, moved like de Staël's from the still life and the body (*Phenomenology of Perception,* 1945) to a broader con-sideration of light and landscape (*The Eye and the Spirit,* 1961) in the same Provence where Cézanne had worked and where de Staël painted in his last few years just prior to his death.[17]

The French minister of culture, André Malraux, who visited The Phillips Collection in 1961 (including the new Annex), would have found himself at home with Phillips's taste, although Malraux's personal enthusiasms for Jean Fautrier, Dubuffet, and primitive and Asiatic sculpture were not in evidence. Both the modern American and British collections seemed provincial to Malraux at the time; yet the pronouncements of this politically powerful aesthete had lit-tle impact after the 1960s and the change of sensibilities in Europe as well as America.[18]

The "provinciality" of the British collection as it appeared to Malraux raises complex questions about the status of postwar Britain, geographically and culturally poised between France and America. The climate in 1961 was very different from that of 1946, when Phillips had welcomed Sir Kenneth Clark to Washington and, thanks to Clark's lecture *Romantic Painting in Contemporary British Art,* proceeded to purchase English neo-romantics.

Clark, the commissioning *éminence grise* of the War Artists' Advisory Committee during the war and director of the National

Gallery, was a connoisseur, aesthete, and patrician formed by the same values as Phillips. He would have been shocked to see the patriotism, individualism, and deeply literary values of the neo-romantic movement he sponsored retrospectively classed as part of an "aesthetic of decline." But such it was. The claustrophobic world of Bloomsbury in the 1920s and 1930s (its country-house weekends reflected in both the antiquarianism and the landscape paintings of a Paul Nash, for example) gave way during the war to the elegy and the nostalgia of a darker neo-romanticism that emerged as the whole country seemed to be under threat. The heritage of ancient castle and chapel settings, so redolent of a literary "Gothick," was fused in the work of John Piper with a topographical tradition now transfigured by visions of bomb damage (*Wall at Mulcheny Abbey,* 1941, and *Farmyard Chapel, Bodinnick,* 1943, cat. nos. 330–31). The introspective atmosphere and the images of ruin anticipated the decline of Britain's political and economic importance, her loss of empire in the 1950s.[19]

The British modernists Ben Nicholson and Barbara Hepworth departed to the artists' colony at St. Ives in Cornwall during the war and continued an idyllic existence; the purity of their compositions—filled with the colors and rhythms of landscape and seascape—was altered only by the appearance of a patriotic Union Jack mug in a still life or the white and blue paint with red strings of an abstract sculpture. The constructivist artist Naum Gabo spent a happy period with the Nicholsons in St. Ives before emigrating to America.[20] While both neo-romantic and St. Ives traditions continued in Britain after the war, a new Mediterranean territory was sought after 1946 by artists like Graham Sutherland. Simultaneously, the influence of the School of Paris on British painters reasserted itself, beginning with the great Picasso and Matisse exhibition at the Victoria and Albert Museum in 1946. The contrast between Keith Vaughan's two works in The Phillips Collection, *Yorkshire Farmhouse,* 1945, and *Farm in Berkshire,* 1956 (cat. nos. 339–40), is exemplary. The first small gouache, worked with ink, graphite, and charcoal on paper, is rich with a sense of place, the romantic *genius loci* of time and tradition, exemplified by shadowy figures who signify the passing of generations. The later painting, so similar in subject matter, has fallen completely under the spell of de Staël, who exhibited in London in 1952 at the Matthiesen Gallery and at Tooth's and the Whitechapel Art Gallery in 1956 (a major retrospective). Anecdote disappears from Vaughan's second farmhouse: geometric blocks of color are applied with a palette knife, and the legibility of the motif is itself a product of horizontals, verticals, and diagonals, so that the phenomenological play between surface and representation is overwhelmingly present.

The innately cosmopolitan Francis Bacon responded to the existentialist mood of postwar Paris with his tortured figure paintings. Yet *Figure in a Landscape,* late 1952, a man squatting in a dry savannah, is one of the most polite of Bacon's works, perfect for Phillips's Washington guests, until the realization dawns that the figure is defecating. One is back with the coordinates of "Birth, copulation and death" in T. S. Eliot's poem "Sweeney Agonistes," which was so important for the artist.

Neither second-generation St. Ives's artists nor those of the School of London, such as Frank Auerbach, Lucian Freud, Leon Kossof, and David Bomberg, working in the 1950s (aggressively marketed in the 1980s and fashionably attached to Bacon), appeared in Phillips's British collection. Yet this collection was typical of the taste of its time.[21]

The juxtaposition of contemporary British works and French masterpieces of the nineteenth and early twentieth centuries, similar to Phillips's policy, was part of the visible aesthetic of certain London galleries, such as Alex Reid and Lefevre. It has been demonstrated, moreover, that this strategy was not only a means of familiarizing new developments but also the way in which more avant-garde galleries like Gimpel Fils actually subsidized exhibitions of avant-garde work: contemporary abstractionists from Paris or young British artists.[22]

It was the Redfern that held the landmark exhibition "Nine Abstract Artists" in January 1955. This movement of British constructionists, which produced major figures of the postwar period like Victor Pasmore, passed Phillips by, as did the British artists associated with the Redfern show "Metavisual, Tachiste, Abstract" of 1957, organized by the artist Patrick Heron.[23] Heron's *The Changing Forms of Art,* published in 1955, maps the changes in British taste after neo-romanticism, yet prior to the impact of abstract expressionism during the later 1950s. With the arrival of American art in Britain, the School of Paris focus for British artists shifted completely; such major venues as the Whitechapel Art Gallery and finally the Tate Gallery followed suit.[24]

Duncan Phillips's artistic affinities, shared with figures like Kenneth Clark (and indeed André Malraux) were a product of a belief in beauty and "the power to see beautifully," linking modern art to a notion of heritage, continuity, and high purpose—"the antiquity of modern ideas . . . the modernity of some of the old masters," as Phillips expressed it.[25] A direct line may be drawn between the evolution of a formalist aesthetic through Fry and Clark to American critics like Clement Greenberg, and the expansion of Phillips's collection largely in the late 1950s and 1960s to include the abstract expressionists was a natural development. Yet both Phillips and Clark as critics and patrons would balk at the introduction of mass cultural values with Pop Art, which appeared in the late 1950s in both England and America.[26]

Phillips's collection of European and British art after the Second World War enshrines beliefs that were shared by the modernist artists of the early and mid-twentieth century, beliefs that passed into American art through the strength of the great nineteenth- and twentieth-century collections in the United States: from Monet to

Pollock, from Matisse to Motherwell, from late Bonnard to Sam Francis and Diebenkorn. At this revisionist moment in art-historical studies of the later twentieth century, Phillips's pioneering exposure of postwar European art in the United States must be acknowledged: the first museum solo shows given to Moore (1946), Nicholson (1951), Vaughan (1951), de Staël (1952), Poliakoff (1959), Vieira da Silva (1961), and Manessier (1964), and other exhibitions, such as the Giacometti retrospective of 1963, that were landmarks in their time. The quality of this area of the collection and its expansion with the acquisition of recent British and School of Paris works by artists like John Walker should provoke a reassessment of the postwar European artistic contribution and its continuing strength.

JACK B. YEATS (1871–1957)

Regarded as the greatest Irish painter of the twentieth century, as well as an accomplished playwright, poet, and novelist, Jack B. Yeats was born August 29, 1871, in London, where his father, the Irish portrait painter John Butler Yeats, had gone to attract clients. The poet William Butler Yeats was his brother. After spending a rather isolated youth with his grandparents in Sligo, Ireland, Yeats returned with his family to London in 1887 and enrolled in Westminster School, where he studied drawing, illustration, and watercolor. During the 1890s he became known as a master illustrator, most notably of two books by his close friend J. M. Synge, *The Aran Islands* (1907) and *Wicklow, West Kerry and Connemara* (1911). In 1898, the year following his marriage to Mary Cottenham White (Cottie), he visited Venice. From 1899 on he exhibited at the annual exhibition of the Royal Hibernian Academy, Dublin. He began painting regularly in oils about 1905. In 1910 Yeats moved to Greystones, County Wicklow, and in 1917 to Dublin, where he remained for the rest of his life, occasionally visiting the Continent and the United States. Five of his oils and one watercolor were included in the celebrated Armory Show of 1913. In 1940 he joined the Victor Waddington Galleries in Dublin. A decade later the French invested him as an officer of the Legion of Honor. In 1951 a major retrospective of his work traveled through the United States and Canada. Yeats died in Dublin March 28, 1957. He is represented in the collection by two late oil paintings.

322

The Wounded Actor, 1950–51

Oil on canvas, 36¼ × 48 (92.0 × 122.0)
Incised l.r.: *Jack B. Yeats*
Acc. no. 2140 (Pyle 2, no. 1072)

TPG purchase 1952 from the artist through the Victor Waddington Galleries, Dublin (out of retrospective exhibition).[1]

John Butler Yeats said, "I shall be known, one day, as the father of a painter," referring to his son Jack.[2] History, however, has proven otherwise: he is instead better known as the father of the Nobel Prize-winning poet William Butler Yeats, his eldest son. In his homeland of Ireland, though, Jack B. Yeats is regarded as the greatest Irish painter to have emerged in the twentieth century. Content to remain a "local hero," Yeats did not receive international recognition until late in life, due in part to his tendency to isolate himself and his unwillingness to have his work reproduced.[3] The 1951 North American tour caused great excitement among collectors, artists, and the public. Yeats was recognized as Ireland's quintessential twentieth-century expressionist, the counterpart to England's Walter Sickert and Austria's Oskar Kokoschka, both of whom were his friends.

Like many of his American contemporaries, among them William Glackens, Everett Shinn, and John Sloan, Yeats began his artistic career as an illustrator, recording scenes of life around him.[4] By 1905 he had begun painting in oil. In their emphasis on line and flat color, his early oils resembled his black-and-white illustrations. By the mid-1920s, the outline had vanished and was replaced by highly expressive brushwork and a rich palette. Years later, Yeats remarked: "I believe that the painter always begins by expressing himself with line—that is, by the most obvious means; then he becomes aware that line, once so necessary, is in fact hemming him in, and as soon as he feels strong enough, he breaks out of its confines."[5] By the 1950s, as seen here in *The Wounded Actor,* Yeats's subjects were often buried under a thick layer of frenetic brushwork and dense impasto.

A playwright, poet, and novelist as well as a painter, Yeats emphasized the narrative in his paintings. Although he believed that an artist should paint incidents drawn from personal experience, he also felt that the picture should

ultimately be the result of what he called a "half-memory," one that was "stimulated and transcended by the imagination."[6] In consequence, the boundary between literature and painting is obscured in *The Wounded Actor.* In later years he derived his subjects from sketches and memories of Ireland—scenes of the circus, horseracing, and the theater, among others.

The Wounded Actor is a composite of scenes from several plays Yeats had seen during his lifetime. In his youth he had been fascinated with melodrama, especially the work of the playwright Dion Boucicault.[7] In Boucicault's *The Shaughraun* (first performed in 1874), Conn the Shaughraun is wounded, and in *The Colleen Bawn* (1860), Danny Manny is injured and dies. *The Wounded Actor* does not replicate either scene but draws on their emotions and dramatic impact, which, in the painting, are heightened by the landscape and the processional down the steep mountainside to the sea below. A foreshadowing of the continuation of life is symbolized by the child in the foreground, at whom the wounded actor gazes.[8]

Yeats and his work were first introduced to America in 1904 with a one-person exhibition at the Clausen Gallery in New York. Despite the support of the American collector John Quinn, the American public reacted with indifference.[9] Yeats did not have another solo exhibition in New York until 1932. A critic echoed the skeptical response: "I question seriously the advisability of being so generous with his pigments."[10]

Duncan Phillips did not become aware of Yeats until 1946, when James Johnson Sweeney of the Museum of Modern Art sent him an illustrated exhibition catalogue of Yeats's work and a biography.[11] But it was not until the 1951 tour that Phillips came to appreciate fully the artist's work.[12] From that show, he purchased the two Yeats paintings in the collection, *The Wounded Actor* and *After-Dinner Coffee in a City,* 1950, one of Yeats's characteristic street scenes.[13] In Phillips's estimate, *The Wounded Actor* represented "a moment of glory near the summit of a mountain of achievement to which the actor never quite attained and from which he retreated rather splendidly." The collector admired the paint-laden, emotive work, stating that Yeats was "in the great line of the Expressionists, a family of painters which are especially congenial to this collection."[14]

VSB

PAUL NASH (1889–1946)

Paul Nash brought English landscape painting into the twentieth century, blending European modernism with the native romantic tradition. Born in London May 11, 1889, to a well-to-do family with agrarian ancestry, Nash had a childhood that was deeply troubled by the mental illness of his mother, who died when he was twenty-one. He found refuge in nature, a lasting communion that would leave a permanent mark upon his work. A gifted writer, Nash also produced poetry, art reviews, and a memoir. He began drawing in 1903 and enrolled in the Chelsea Polytechnic at age seventeen. In 1910 Nash briefly attended the Slade School of Fine Art, where he became friends with fellow student Ben Nicholson, and struggled with figure drawing. His fervent pursuit of landscape drawing earned him his first one-person show at the Carfax Gallery in 1912, and the advocacy of Roger Fry (with whom he later broke). During the First World War, Nash enlisted in an artist's regiment, recording the destruction on the Western front, work that brought him a mural commission from the Imperial War Museum in London. After the war, sojourns in Dymchurch, Kent, inspired a series of seascapes, and these explorations, along with projects in theater design, occupied him until the mid-1920s, when a sudden collapse forced him to rest. He toured extensively in Europe, and exposure to the Old Masters as well as to post-impressionism and cubism was reflected in works of greater monumentality and abstraction. Although his health began to deteriorate, Nash remained active, launching Unit One, a circle of artists including Barbara Hepworth, Nicholson, and Moore, in 1933. He also took up photography and became involved in the surrealist movement in 1936. Nash was commissioned to record the destruction in the Second World War, and his already substantial reputation culminated in the early 1940s with the publication of Herbert Read's monograph and his first retrospective. Shortly thereafter, Nash declined rapidly and died July 11, 1946. The Phillips Collection owns one oil painting.

Fig. 39 Paul Nash, *The Sea,* photograph of early state. Tate Gallery Archive, Paul Nash Photographs.

323

The Sea, 1923

Oil on canvas, 22 × 35 (55.8 × 88.9)
Signed and dated in black paint, l.r.: *Paul Nash/1923*
Gift in memory of Elizabeth Baldwin Demarest, 1939
Acc. no. 1416 (Causey no. 385)

Purchased from the artist by Edwin Duff Balken, Pittsburgh (from Carnegie International Exhibition, 1929); Elizabeth B. Demarest, Pittsburgh and Norfolk, Conn.; bequeathed to Glendinning Keeble; gift to PMG 1939.[1]

Nash's reconciliation of the English *genius loci* with a modernist devotion to formal harmonies has earned him recent reevaluation as a major figure in British painting.[2] While Nash was recuperating on the Channel coast of England after the First World War, he produced a series of silver-toned seascapes remarkable for their austerity and essentialized form. *The Sea* reflects his resolution of the aesthetic and philosophical concerns of his Dymchurch years. The pallor and skeletal structure of this painting seem to echo the "convalescent" mood of British art in the early 1920s when artists were eschewing the radical Continental movements while absorbing their classicism. Herbert Read has also pointed to the affinities of Nash's landscapes with the British watercolor tradition, as well as with the cubist and futurist movements.[3]

Nash's deeply rooted romantic vision precluded an approach to painting as a purely formalist exercise. Accordingly, the confrontation of land and ocean in this painting becomes a reflection of an inner state, a symbolic drama of opposing forces, and thus the continuation of Nash's wartime motifs.[4] In the meeting of turbulent ocean and unyielding barrier can also be sensed an underlying sexual tension, as well as a profound confrontation of natural and man-made forces. Further, Nash's lifelong concern with an underlying vital power, "that remote and immaterial force . . . which is dangerous and may be beyond control," seems embodied in this painting's tensile imagery.[5] In style it points to Nash's dilemma as an English artist: wishing faithfully to represent the stark beauty and severe mood of the Dymchurch coast in the native tradition, he also desired to reckon with its underlying geometry, as prescribed by Cézanne and the cubists.[6]

"Marsh or shore, each is fascinating," wrote Nash of the area in 1921, referring to the concrete sea wall and Romney Marsh to its north; in 1923 he referred to it as "this strange coast," perhaps in response to his intense absorption with the shore's barren "featurelessness."[7] In the present canvas, Nash enhanced the drama of the scene with a sharply diagonal viewpoint; the exaggerated height of the roiling breakers, shown at the viewer's eye level, renders the triangular sea wall and strip of grass defenseless. A striking tautness derives from its multiplicity of boundaries—between the sea and the wall, the horizon and the water, the cloud masses and the clear sky—borders reinforced by the picture edges, which seem to enhance the sense of the ocean's swelling mass. Each element is stripped

323

of detail, but the severity is somewhat alleviated by the calligraphic play of the waves, whose crosshatching and rather wooden articulation relate the painting to Nash's engravings and woodcuts. Reminiscent of Celtic linearity as well as Art Deco curvature, the waves, along with the sunbeams breaking through the clouds, create a rhythmic effect that highlights Nash's sensitivity to repeating patterns.[8] His wan palette, imbued with "a peculiar bright delicacy . . . somewhat cold but radiant and sharp in key," is subjugated to the composition.[9] Nash's denuded vision remains a superb evocation of the chilly Kentish coast—a resolution that was not immediate, as a photograph of the painting's first state indicates: formerly, a small fence had broken the horizon

where Nash had included a clearing sky; he had also maintained a greater simplicity in the wall, the grassy area, the rays, and the sea at the lower left (fig. 39). Nash eliminated the fence but added subtle embellishments to the scene; he also covered a former signature and date, and signed the work anew.

In a 1919 review of an exhibition of British war paintings, Duncan Phillips related that while he found the artist's early painting crude and "deliberately archaic," he considered Nash's latest work to be "galvinized . . . into an intense emotion suggestive of Blake."[10] Phillips and Nash met in September 1931, when the artist was invited to be a jury member at the Carnegie International in Pittsburgh; appropriately, while

visiting The Phillips Memorial Gallery, Nash responded strongly to Ryder's seascapes, and he wrote later to Phillips of his attraction to American art.[11] Phillips had admired *The Sea* when visiting his friend Professor Elizabeth Demarest, and he accepted it into the collection in 1939, a few years before he had begun to assemble in earnest his grouping of contemporary British painters into what was to become the "English Room" in the 1960s. *The Sea* was first exhibited in the museum in its 1941 display of twentieth-century British work.

LF

BEN NICHOLSON (1894–1982)

Britain's first painter to espouse an international modernist style, Ben Nicholson was born April 10, 1894, to the painters Mabel Pryde and William Nicholson. Nicholson attended London schools before receiving brief formal training at the Slade School of Fine Art in 1910–11; he would later claim that billiards and Paul Nash's friendship had more impact on his work than formal education. On one of several trips to Paris with his first wife, Winifred Dacre, Nicholson encountered a cubist work of 1915 by Picasso that had a profound effect on his style. His first one-person exhibition, in 1922, was held at the Adelphi Gallery, London. In 1924 Nicholson joined the Seven and Five Society, founded in 1919 to promote the work of a disparate group of artists; he was president from 1926 until its demise in 1935. He met Christopher Wood in 1926, and both artists pursued a primitive style reinforced by an encounter on the Cornish coast with the local fisherman painter Alfred Wallis (1855–1942) in 1928. In the 1930s, Nicholson spearheaded the promotion of nonfigurative work in Britain, in 1933 joining Nash's Unit One exhibiting group as well as Abstraction-Création in Paris. Along with the sculptor Barbara Hepworth, later his second wife, Nicholson also became part of an international group gathering in London during the thirties; this coterie included the expatriates Laszlo Moholy-Nagy, Piet Mondrian, Walter Gropius, and Naum Gabo. Nicholson's commitment to abstraction led to his 1937 coauthorship of *Circle: An International Survey of Constructivist Art,* a treatise on nonobjective art. He first exhibited in the United States in the Museum of Modern Art's 1936 "Cubism and Abstract Art," and his first solo exhibition in an American museum was held at The Phillips Gallery in 1951. Living in Cornwall from 1939 to 1958, Nicholson was a founding member of the Penwith Society of Arts. He received numerous prizes, including first prize at the 39th Carnegie International Exhibition, the Ulisse Prize at the Venice Biennale of 1954, and the first Guggenheim International Award in 1956. Further honors included the British Order of Merit in 1968 and Tate Gallery retrospectives in 1955 and 1969. Nicholson died in London February 6, 1982. He is represented in the collection by six oils.

The Nicholson Unit

A pioneer of abstraction in Britain, Ben Nicholson sought in his painting a plastic expression for an essentially lyrical, poetic vision. Nicholson's subtle palette, his repertoire of subjects often inspired by the world around him, and his

reconciliation of a Mondrian formalism with a romantic mood made it virtually inevitable that Duncan Phillips would be drawn to his mature work. Nicholson claimed that "no artist who is alive works to a theory but to an urge—the theorizing on a painting idea comes afterwards," an intuitive approach that paralleled Phillips's response to painting.[1]

Five of the collection's six works by Nicholson date to between 1940 and 1955, an era that saw the resurgence of his direct confrontation with the landscape and his striving to reconcile its color, structure, and atmosphere with the lessons of Mondrian and cubism, which had preoccupied him since the thirties; ultimately this synthesis resulted in the monolithic and expansive reliefs of his late works, such as *1966 (Zennor Quoit 2)* (cat. no. 326). The paintings in the collection show the gradual progression of Nicholson's development from the Cornwall years to his return to relief carving. Lacking are examples of his geometric abstractions of the thirties and forties; in 1951 Phillips exchanged his first purchase, *painted relief, 1940,* for *still life (winter) Nov 3-50* (acc. no. 1428), demonstrating his preference for works with more overt associations to the landscape and a greater play of color and texture.[2] Phillips also purchased, from his own exhibition, *still life + landscape (Trendrine 2) Dec 13–47* (acc. no. 1430), with which he professed to have fallen in love on sight.[3] The latter two represent Nicholson's landscape–still life genre, where natural scenery and architecture form the basis for an ongoing study of form, light, and space.

By the time of Nicholson's first New York showing at Durlacher Brothers in 1949, his radical experimentation with white reliefs was behind him, and his architectonic, richly textured still lifes were forecasting the majestic and serene reliefs of the 1950s.[4] It is not known when Phillips first encountered Nicholson's work, but in 1951, a year before the artist won the Carnegie Prize, Phillips hosted his first solo exhibition at a U.S. museum.[5]

The pair purchased in 1956 are perhaps the most spare and severe: *Feb 55 (talisman)* (cat. no. 325), one of the first works signaling Nicholson's return to relief carving, and *Still Life, March 17, 1950* (acc. no. 1427). The last two purchases comprise the earliest and latest works in the collection: the primitive and direct *St. Ives (version 2)* of 1940 (cat. no. 324) was added in 1958, and the monumental, sculptural *1966 (Zennor Quoit 2)* was the gift of Marjorie Phillips and her son, Laughlin, in memory of Duncan Phillips, in 1967.

The tradition of the "English Room" at The Phillips Collection began with a 1960 exhibition

of British works, a grouping in which Nicholson shone. One critic compared him with Henry Moore, finding the same "quality of balance and repose. . . . His cool cerebral abstractions combine delicate line with occasional representative elements, all carefully controlled and with only a quiet lyricism to save them from exercises in geometrics."[6]

L F

324

St. Ives (version 2), 1940

Oil and graphite pencil on cardboard mounted on cardboard panel, 15⅛ × 18⅛ (38.4 × 46.0)

Signed and inscribed on reverse in pencil: *Nicholson/Dunluce/Trelyon/St. Ives Cornwall/St. Ives (version 2)/Ben Nicholson 1940*

Acc. no. 1426

The artist to Reid and Lefevre, London, June 10, 1940; sold to Mrs. Blanco White [pseudonym?], London, July 5, 1940; consigned or sold to Leicester Galleries, London, by 1956; Durlacher Bros., New York; TPG purchase 1958.[7]

In the 1930s Nicholson, enthralled by Mondrian's neo-plasticism and the constructivist work of Gabo, created the rigorously pure reliefs regarded as his most original contribution to the modern movement. When the threat of war forced Nicholson and his wife Barbara Hepworth to seek refuge in Cornwall, the fervor with which he and his circle had promoted abstract art in London was largely diffused. Nicholson's confrontation with the Cornwall peninsula, renowned for its bleached light, dramatic coast, and ancient monuments, was permanently to reorient his painting.[8] While he continued to produce abstract reliefs and geometric paintings, his first decade on the southern English coast also brought a return to the landscape and still-life themes of the 1920s, a retrenchment often disparaged as a retreat from the boldness of the 1930s.

St. Ives has drawn artists since Turner, Whistler, and Sickert painted its rough coast in the nineteenth century. In the 1940s the presence of Nicholson and Hepworth brought an influx of modern painters complementing an indigenous colony of artists, giving rise to a "Cornish Renaissance."[9] Among the local artists was the self-taught painter Alfred Wallis, "discovered" by Nicholson and Christopher Wood in 1928. His naive style influenced Nicholson's 1940s work anew in such paintings as *St. Ives (version 2)* and *Trendrine (2) December 13–47* (acc. no. 1430), two compositions exploring a still life of cups and mugs before a window view.

Nicholson's return to landscape themes

324

echoed the broader neo-romantic revival over-
taking Britain; yet he sought a metaphoric
rather than descriptive evocation of the interac-
tion between himself and his surroundings—or,
in his own words, a "physical analogue," through
abstracted colors, clear, taut lines, and a direct,
simple style.[10] In his letters, he repeatedly
invoked scenes like those pictured in *St. Ives;* to
Herbert Read he wrote: "You've no idea how
lovely St. Ives looks when a low cloud comes
across the Bay and St. Ives disappears into it and
comes out again with the Atlantic horizon
beyond. The more I see of St. Ives—and this

coast and the country inland the more lovely it
seems."[11]

Nicholson's "window view" of *St. Ives* shows
the vista of the bay seen from Porthminster
Beach beyond Pednolva rocks. Several related
versions depict the same cluster of houses and
glimpse of the shoreline.[12] The present canvas
descends from illustrations intended for a chil-
dren's story, *George and Rufus,* never published.

The abbreviated still life displayed before a
distant landscape relates to the cubist work of
Braque and Gris and to the open-window theme
that had captivated twentieth-century painters

since Matisse. The formalist rigor of European
modernism informs the rendering of the vessels
and tabletop, while Nicholson's childlike treat-
ment of the hills and harbor conveys affection
for the landscape with humor and a charm
devoid of sentimentality. The jumbled, closed
sensation of the foreground may owe something
to the cramped bedroom in the St. Ives house in
which Nicholson worked; certainly the small
scale of the canvas reflects these conditions.[13]
Nicholson deemed his landscapes of the period
"potboilers," works that would sell in the reac-
tionary climate of wartime Britain.[14] Yet the

paintings, as well as his letters, indicate the sincerity of his attraction for the locale and his desire to incorporate its light and atmosphere into his work.

A cool palette serves as a backdrop for the image's scaffolding: the tensile drawing, a stylistic feature of the 1940s. Nicholson also carved into the board in the harbor area, creating an interval of "real" space, and elsewhere he incised the paint surface with his pencil—"with the paintings, I always want to cut through at some point," he wrote to Read in 1943.[15] As the still life takes on an architectural geometry, so the background houses appear less solid and substantive than the objects in the window, an interchange of characteristics that would become more sophisticated and sensual in later motifs.[16]

When first shown in London, Nicholson's work of the Cornwall phase garnered him applause among critics, who lauded his return to recognizable subject matter; one reviewer of a Reid and Lefevre exhibition of 1940 wrote: "I am glad to report that Mr. Ben Nicholson has deserted his plumbing appliances in favor of Cornish landscapes."[17] On the other side of the Atlantic, the American critic Clement Greenberg saw this preoccupation with the landscape as a threat to Nicholson's expression: "Let us hope," he wrote at the time of Durlacher's first showing in 1949, "that his partial return to nature in the last four years will not continue to thwart his talent as it now does."[18]

L F

325

Feb 55 (talisman), 1955
Oil and graphite pencil on cardboard mounted on hardboard, mounted on plywood panel, 15¼ × 19¼ (38.6 × 48.8)
Signed and dated on reverse: *Ben Nicholson/Feb 55/(talisman)*
Acc. no. 1429 (Read 2, no. 188)

The artist to Gimpel Fils, London, June 1955 (consigned but subsequently returned); the artist to Durlacher Bros., New York (on consignment?); TPG purchase (probably from exhibition) 1956.[19]

Feb 55 (talisman) bridges the transition between Nicholson's monumental still lifes of the 1950s and his gradual return to carving, in which he experimented with scale, color, and material.[20] It is a distillation of his themes—the duality of drawing and painting, the preoccupation with surface variation, and the problem of the painting as an object. These were issues first raised in the reliefs of the thirties and explored more circumspectly in the forties.

Playing with texture, Nicholson reversed the hardboard and worked on the coarse fibrous

325

backing, emphasizing its roughness by abrading his paint; he complemented the sense of coarseness by insetting a smoother panel and delicately inscribing its floating surface with a circle. He then blunted the rawness of the surface with selective varnishing and introduced trompe-l'oeil effects of real and illusory depth, bringing spatial complexity to a rare refinement: the vertical form at the right appears closer to the viewer than the slightly protruding insert because it extends vertically to the canvas's upper edge. The inset panel—the actual foreground plane—is embellished with penciled shading, suggesting a cast shadow from its lower-right edge—subtle distortions that recall the spatial tension in Cézanne's work. The pencil line, the least substantial element in the image, defines the painted areas with razor precision. The tensile forms interlock powerfully, compelling the viewer to search for a planar sequence or a vanishing point.

The forms, as well as the distribution of light, recall Nicholson's still-life and window views stripped down to essentials: the drawn circle, a plate, the right-hand vertical swath of a curtain, the rectangle at the center, a window view with distant horizon line. In fact, Nicholson believed that the imagery was interchangeable, an excuse for the pursuit of the poetic idea:

In painting a 'still-life' one takes the simple everyday forms of a bottle-mug-jug-plate on table as the basis for the expression of an idea: . . . you have in time not a still-life of objects but an equivalent . . . you eventually discard altogether the forms of even the simplest objects . . . and work out your idea, not only in free colour, but also in free form.[21]

Few painters shrugged off the distinction between abstract and objective imagery as nonchalantly; Nicholson simply sought an alternate means of creating space. The astringent colors—sharp greens and gray—suggest links with the natural world and also recall the palette of the Italian trecento.[22]

A talisman, an object with divinely protective powers, bears overtones of ritual, mysticism, and magic; it presages Nicholson's later focus on ancient monuments as a source of inspiration. The talisman motif may also point to his desire for painting to remain a viable power in daily life, a notion that the arrangement of opposing forms of this painting seems to bear out. "'Abstract art,'" Nicholson once wrote, "[is] related to the interplay of forces and therefore . . . any solution reached has a bearing on all interplay between forces."[23]

L F

326

1966 (Zennor Quoit 2), 1966

Hardboard relief with wooden collar set into shadowbox
frame, 46¹⁄₁₆ × 102¾ (117.0 × 260.8)

Signed and dated by the artist on reverse in pencil: *Ben
Nicholson/1966/(Zennor Quoit 2);* further inscribed by the
artist: *Surround T dec/yel Och/Whit[e]*

Gift of Marjorie Phillips and her son, Laughlin Phillips, in
memory of Duncan Phillips, 1967

Acc. no. 1431

Marlborough Galleries, London; gift of Marjorie and
Laughlin Phillips in memory of Duncan Phillips, 1967.

Zennor Quoit 2, serene in mood and scale,
demonstrates Nicholson's attainment of a mon-
umental and universal style in his late work, in
which he united sculpture, painting, and even
architecture.[24] The title refers to a Neolithic
gravesite set into the Cornish landscape, inland
and west of St. Ives (fig. 40); the primitive struc-
ture—evocative of sculpture, organic form, and
mysterious, sacred function—recalls Nicholson's
observation, "I feel very much at home with the
huge standing stones at Carnac in Brittany and
the quoits of W. Penwith in Cornwall in which
the sea plays a big part. There is perhaps a spe-
cial feeling of life because these are not consid-
ered 'works of art.'"[25]

Having returned to relief carving in earnest
in 1958, Nicholson set himself the problem of
maintaining delicacy of color and classical pro-
portion on a large scale; he was in his most
prolific period since the 1930s.[26] In this work,
color, shape, and scale hold the expansive forms
in balance; their sequence suggests a sweeping
landscape, as does the palette, which softens the
structure's geometry: the harmony of earth
tones of faded brown and bone white connect-
ing centrally around a "window" of cerulean
blue, breathing into the work Nicholson's
instinctive feeling for landscape and organic
form.[27]

Sparely carved on a triad of hardboard
planes, three rectangles hover within the work,
echoing the overriding horizontal format; the
challenge of its breadth was deliberately set by
the artist, who described it as: "very horizontal,
and all browns, and a mysterious blue in the
center. It's abnormally long and narrow and for
that reason exciting to try to solve it."[28]

The work was created not in Cornwall but in
Switzerland. The critic Geoffrey Grigson
described Nicholson's studio there as "more
than 1,000 feet above Lago Maggiore . . . a squar-
ish window . . . became a rectangle of unac-
countable blue . . . the curved mountains across
the lake . . . became superimpositions of a matte
blue . . . somewhere between blue and grey."

Fig. 40 Zennor Quoit, the Neolithic gravesite on the Cornish coast near St. Ives that inspired
the title of Ben Nicholson's painting. Photograph by Leslie Furth, 1992.

These could be trimmed . . . by the imagination
into straight-sided forms."[29] Indeed, the work
seems to draw inspiration from the crystalline
atmosphere and majestic forms of the moun-
tains, but the title and forms also recall the stony
Cornish coast and the sea. The artist Patrick
Heron, a close friend of Nicholson's, remem-
bered that "he was enormously nostalgic about
exactly this part of the coast [the area near Zen-
nor Quoit] while in Switzerland. . . . Ben was
always thinking about and painting this part of
Cornwall for the rest of his life."[30]

Nicholson's approach to color parallels his
sculptural treatment: "I don't call the 'carved
reliefs' 'coloured' because this conjures up an
idea of a surface colouring, whereas the colour
of stone or wood . . . runs right through the
material."[31] Yet the relief itself is a conceit, a
trompe-l'oeil effect achieved by gouging the
edges of the various forms to create an illusion
of distinct planes. Nicholson's lean, matte
medium and apparent sanding in some areas
generate a dry, subtly textured surface.[32]

That the approach has become looser and
more expansive since the 1930s is signaled in the
asymmetry of the shapes, their deliberate tilting
pitch, the imprecise angles, and the infusion of
telluric hues. Nicholson relished being physi-
cally involved with his work, and for him experi-
ence had become indistinguishable from form:

"If your idea becomes even fractionally sepa-
rated from your material, it becomes decorative
and loses its reality."[33]

This piece represents Nicholson's reconcilia-
tion of his lifelong preoccupation with both
primitive and modern expression; his intense
physical involvement in the pursuit of an anony-
mous, organic aesthetic, a classic structure, and
romantic mood; and an insistence on sculptural
rigor while preserving refinement and even deli-
cacy in an impressionistic haze. At the core of
Nicholson's achievement is this harmony of his
poetic sensibility with the integrity of his paint-
ing as object, a lesson learned from the Cornish
painter Alfred Wallis in the late 1920s and rein-
forced by European modernism. The essential
force of Nicholson's painting also embodies the
principal character of Duncan Phillips's collec-
tion, the classic and romantic sensibility consoli-
dated; the work is therefore a most fitting
tribute to the collector's memory.

LF

326

ANDRÉ MASSON (1896–1987)

As the inventor of automatic drawing, André Masson created the first lexicon of surrealist imagery, the basis of much twentieth-century abstraction. Masson was born January 4, 1896, in Ile-de-France, and the family moved to Brussels between 1903 and 1906. There, at age eleven, Masson studied at the Académie Royale and encountered the work of Delacroix and Rubens. In 1912 the influence of the symbolist poet Emile Verhaeren led him to Paris to study at the Ecole des Beaux-Arts under Paul Baudouin; he learned of the work of the cubists through reproductions. In 1914 he studied fresco in Italy. Gravely wounded in the First World War and deeply disturbed by his experiences, Masson convalesced in a mental ward. Back in Paris, around 1921, he and Miró became the core of a group of avant-garde poets and painters. Braque, Derain, Klee, Léger, and Picasso had a decisive impact on his style. Masson first experimented with automatic drawing in late 1922. His first one-person exhibition opened at Galerie Simon in Paris in 1924 and led to an invitation from Breton to join the fledgling surrealist group; he was a member until 1929, when he broke with Breton. Masson lived in Spain from 1934 until 1937. His work was first acquired by the Museum of Modern Art in New York in 1935. In 1938, having reconciled with Breton, he entered a mannequin in the "International Exhibition of Surrealism" in Paris. In 1941 he fled to the United States for the duration of the Second World War; he had contact with Calder, Gorky, Pollock, and Tanguy. Masson experienced an artistic renaissance in America, where his work influenced the abstract expressionists. He had his first significant retrospective at the Baltimore Museum of Art in 1941 as well as numerous exhibitions in New York. Upon his return to France in 1945, Masson was the subject of retrospectives and one-person exhibitions throughout Europe. He won France's National Prize for Painting in 1954, and his prodigious output earned him many honors. He died October 28, 1987, in Paris. The Phillips Collection owns one oil painting.

327

Will-o'-the-Wisp, 1942

Feux-follets
Fire Follies; Dancing Flames
Oil on canvas board, 9⅞ × 12½ (25.0 × 31.7)
Signed in red paint, l.l.: *André Masson;* titled and dated by the artist on backing reverse: *Feux-follets/-1942*
Acc. no. 1301

[Probably] the artist to Buchholz Gallery, New York; PMG purchase 1943.[1]

Duncan Phillips was an early collector of Masson's work, which is intriguing, because he had little interest in surrealism.[2] Yet the collector viewed the movement as descended from romanticism—and thus may have been attracted to Masson's excited, undulant rhythms and mystical themes. Purchased from the Masson-Klee exhibition of 1943, *Will-o'-the-Wisp* had affinities with Klee's work that may also have played a role in Phillips's enthusiasm.[3]

Masson regarded his years in America as pivotal to his development as a painter. The dominant themes of this prolific era, which he deemed his "telluric," or terrestrial, period, were natural forces, germination, and growth.[4] The charged imagery and dynamic play of the slivered lines in this work represent Masson's passionate dialogue with the natural world.

Living in the Connecticut countryside with his family, Masson was isolated in rural surroundings, unable to speak English. However, in his solitude, he developed an almost mystical communion with nature—its abundant variety and dramatic seasonal changes. The strident color and light and the uncultivated forests of New England recalled for him the terror and magnificence of the writings of Châteaubriand and the music of Wagner.

"My American painting," he later recalled, "was neatly divided into two themes: the forces that govern the universe, nature, on the one hand, and a meditation on these forces on the other. . . . The intention was distinctly metaphysical."[5] He spoke of his desire to evoke the "'presence in the air' of the Ancients," and he searched for an underlying mythology that led to his enthrallment with the Native-American past.[6]

Yet *Will-o'-the-Wisp* also draws upon French folk culture: the French title, which translates literally as "scatterbrained fire," refers to spirits emitted by the dead that hover in graveyards. It is also a metaphor for beings, passions, and sensations that are elusive, animated, colorful, and capricious—Gallic attributes embodied in Masson's apparitional visages and darting lines.[7] Probably inspired by a meditation on fire, the painting treats Masson's central themes of metamorphosis and death in a dynamic image alive with animal energy and folkloric nuance. The flickering play of calligraphic strokes and iridescent color suggests the shimmer of the spirits themselves. Each masklike specter possesses a distinct temperament conveyed by exaggerated expressions, like the humors of medieval science: one grimaces horribly, another seems to ruminate phlegmatically, and a third gapes in fear. The motif of humanoid faces emerging in flamelike strokes relates to the fully conceived portraits Masson began in 1939 and worked on in America; these include images of Leonardo, Nietzsche, and the Greek philosopher Heraclitus, whose doctrine Masson revered.

In Masson's working process, derived from automatic drawing, a design first flowed from the subconscious, spontaneous and unhindered. Only later did he interpret and embellish forms, create order, and impose a subject.[8] Despite the biomorphic linear rhythms of the fiercely glowering heads, an almost cubistic grid orders the composition. It also bears traces of the labyrinthine arrangement Masson had adopted in the 1920s, in which he had married his passionate interest in the myth of Theseus with his need to impose order on the wayward skein of lines generated in his automatic drawings. The open treatment is even looser than in similar earlier works, and its sketchy quality and glowing palette foretell the burnished highlighting of subsequent works.[9] Here Masson fused the archaic expressiveness of Klee with forms encountered in Native-American art, and the visionary intensity and radiant pastel hues may owe something to Redon, whose work Masson greatly esteemed.

Masson worked on unprimed, coarsely woven canvas, on which he applied a black layer of paint. The overall surface is matte, and the weave of the canvas is visible throughout the painting.[10] This combination of a dry-brush technique with a fluid handling of paint complements the theme of parching heat and flame. He also used the full spectrum of colors, radiant and pure, which appear particularly bright in contrast to the opaque black background: the saturated hues of the American works, Masson explained, were an attempt "to battle against the light," which he found fiercely bright.[11]

LF

327

HENRY MOORE (1898–1986)

Henry Moore is internationally renowned for sculptures of the human form that seem to evoke the modern psyche. Henry Spencer Moore was born in Castleford, Yorkshire, England, July 31, 1898, the seventh of eight children of a coal miner. Following brief service in the First World War, Moore enrolled in 1919 in the Leeds School of Art, where he was influenced by Ezra Pound's and Roger Fry's writings. He became a friend of the school's vice-chancellor, Michael Sadler, at whose home he was first exposed to modernist influences. In 1921 Moore won a scholarship to the Royal College of Art in London; he found the academic teachings stifling but necessary. He often visited the British Museum's collection of ethnographic art, which had a profound impact on him. A traveling scholarship in 1921 enabled him to tour France and Italy, where he was most impressed by Giotto, Masaccio, and Michelangelo. In 1928 he returned to London, where he became an instructor at the Royal College and had his first one-person exhibition at the Warren Gallery. The following year he married Irina Radetsky, an art student at the Royal College. He taught at the Chelsea School of Art from 1932 to 1939. He was also associated with several avant-garde organizations, including the Seven and Five Society, which he joined in 1930, and Unit One, which he cofounded in 1933 with Barbara Hepworth, Paul Nash, and Ben Nicholson. Moore participated in the seminal "International Surrealist Exhibition" in London in 1936. After his studio was bombed in 1940, he moved to Much Hadham in Hertfordshire. He spent the next two years as an official war artist, primarily sketching scenes of people huddled in the underground shelters of London. After the war, his work was exhibited internationally in numerous retrospectives, and he was awarded many honors and degrees. Moore continued to create prodigiously, both at his house in Much Hadham and his summer studio in Italy, until his death at home, August 31, 1986. He is represented in the collection by a drawing and a bronze sculpture, both dating from the forties.

328
Family Group, 1946

Bronze, 17½ × 13 × 8⅝ (44.3 × 33.2 × 22.0)
Signed on back of base, l.l.: *Moore 46*
Acc. no. 1386 (Lund Humphries no. 265)

Probably purchased from the artist by Buchholz Gallery, New York, by 1947; TPC purchase 1947.[1]

A towering figure in the flowering of the British avant-garde in the mid-twentieth century, Moore has won the public's attention with his powerful sculptured images of the archetypal woman. Sometimes she is depicted as a recumbent figure, massive yet elegant in proportion, other times, as a mother with child, the symbol of life and fertility. During the forties, Moore created a variant by adding a male figure to the composition. This family-group theme captivated him from 1944 through 1950, reflecting his preoccupation with the wholesomeness and stability of the family unit.[2]

The unspoken communion of *Family Group* was achieved not through a visual interaction of the figures but by a "lucid stillness" and inner vitality that arise from the almost hieratic frontal arrangement and simplification of the figures. The father's rectangular body with a squared chest adds a sense of broadness and depth; it also acts as a visual counterbalance to the mother's softly rounded form. The youth, sparingly modeled, stands confidently, safely ensconced between his father's bent knees, which jut forward, strong and sure, while the infant, joined with the mother's abdomen, curves upward, echoing her rounded form.

The initial conception for this group stemmed from a 1934 conversation between Moore and Henry Morris, director of education in Cambridgeshire, about a planned school, Village College, at Impington, in which the goal was a union of family and school.[3] Yet it was Moore's Second World War shelter drawings, coupled with the birth of his daughter in 1946, that were the direct catalyst for the theme.[4] He was profoundly affected by the families who managed to survive and remained intact through difficult wartime conditions.[5] Moore also derived new compositional ideas from the myriad intricate arrangements of the mingling figures in London's underground shelters. He later recalled that there were "hundreds of Henry Moore Reclining Figures stretched along the platforms."[6] The Phillips work on paper, *Figures in a Setting,* 1942 (acc. no. 1387), which was

directly influenced by his shelter drawings, reflects this new approach.[7] The two women sitting side-by-side in the lower right, one with a child standing on her lap, bear a remarkable similarity to the Phillips *Family Group.*

Moore universalized the family motif in his archetypal family groups.[8] He was "very much aware that associational, psychological factors play a large part in sculpture" and that "the meaning and significance of form itself probably depends on the countless associations of man's history."[9] In Moore's estimation, the organic shapes of his images of women "convey an idea of fruitfulness, maturity, probably because the earth, women's breasts, and most fruits are rounded."[10] Fascinated as much by what was not there as by what was, Moore found that non-space, or the void, was also highly evocative. Because it was an outgrowth of the idea of protection, which had for him "a psychological thing behind it, the mother-and-child idea perhaps," he associated the voids with "the mysterious fascination of caves in hillsides and cliffs."[11]

These archetypal nuances are clearly evident in *Family Group.* The slightly splayed legs and quadrated frame of the father suggest stability and control. His direct stare makes him the communicant with the world, and his open chest, through which viewers can see their surroundings, further unifies him with the world. The mother's hollows and curves suggest fecundity, while her oblique glance and aura of inwardness define her as the center of the family. Further enhancing this interpretation is the infant, who stares fixedly at her protruding breast, as well as the aperture in place of the other breast, because it calls forth images of vessels and shelter.

Duncan and Marjorie Phillips's interest in Moore's work coalesced in 1946 (she was especially interested in sculpture). That year they gave Moore his first museum exhibition in America, just nine months prior to his first American retrospective at the Museum of Modern Art in New York, and purchased *Figures in a Setting.*[12] Desiring a representative Moore sculpture, the Phillipses visited the Buchholz Gallery sometime in the fall of 1947 and purchased *Family Group.*[13] Usually on permanent view from 1948 to 1968, it served as the centerpiece for the British paintings in the collection, which Phillips periodically hung in the English Room. In Phillips's estimation, *Family Group* was "a very distinguished example of [a work by] one of the world's greatest sculptors."[14]

LBW

328

ALBERTO GIACOMETTI (1901–66)

Alberto Giacometti's surrealist sculptures of great originality and his later more familiar figures of elongated proportions are rivaled only by his remarkable and expressive paintings. Giacometti was born October 10, 1901, in Borgonovo, Switzerland; he and his family moved in 1904 to Stampa, Switzerland, where he spent his youth. In 1915 he enrolled in the Evangelical Secondary School in Chur, where he first studied art. In 1919 he left for Geneva to study drawing at the Ecole des Beaux-Arts and sculpture at the Ecole des Arts-Industriels. Early in 1922 he went to Paris, where he attended Antoine Bourdelle's class at the Académie de la Grande Chaumière until 1927. In the spring of that year he moved to a studio at 46 rue Hippolyte-Maindron. As a result of Bourdelle's influence, he was able to exhibit at the Salons des Tuileries from 1925 to 1927. Though Giacometti experimented with various styles during this period, he was influenced primarily by cubism and primitive art. In 1929 he met André Masson, who introduced him to other surrealists. Giacometti officially joined their group the following year. His first solo exhibition was held at Galerie Pierre Colle, Paris, in 1932, followed two years later by his first solo show in America, at the Julien Levy Gallery in New York. In 1934 Giacometti went through an abrupt change of style that resulted in his mature oeuvre. He maintained close relationships with such avant-garde intellectuals as the existentialist authors Jean-Paul Sartre and Simone de Beauvoir, the philosopher Maurice Merleau-Ponty, and the playwright Samuel Beckett. In 1948 Pierre Matisse held an exhibition of Giacometti's work in New York that was both a financial and critical success. It was followed by numerous retrospectives and worldwide renown. Giacometti died of heart failure in Chur, Switzerland, January 11, 1966, and was buried in the village of his birth. The collection owns one sculpture.

329

Monumental Head, 1960

Large Head; Grande Tête; Head on a Pedestal
Bronze, cast no. 3/6, 37½ × 11 × 10 (95.2 × 27.9 × 25.4)
with base
Signed on side of base, l.l.: *Alberto Giacometti 3/6;*
stamped on rear of base, l.r.: *Susse Fondeur, Paris*
Acc. no. 0779

Purchased in 1960 from the artist by Pierre Matisse
Gallery, New York; TPC purchase 1962.[1]

Although Giacometti's first artistic successes in the late twenties captured the spirit of French surrealism, he is nevertheless usually remembered for the sculptures he produced after the Second World War. These visionary works—primarily busts, standing women, and striding men—were characterized by their thin, elongated proportions, and they seemed to be Giacometti's personal and aesthetic response to the despair of postwar Europe. But for many they also seemed to embody the spirit of existentialism.[2] By the late fifties he had begun to increase the massiveness and surface vigor of his sculptures and to concentrate almost solely on heads. The Phillips Collection's *Monumental Head,* largely a memory portrait of the artist's brother Diego, is a transitional work leading into this final and most expressive period of Giacometti's career.

Initially Giacometti intended to include *Monumental Head* as part of a large-scale, multifigured commission for the Chase Manhattan Bank plaza in New York.[3] For this commission he drew upon his renowned *City Square,* 1948, in which three striding male figures advance upon a standing woman, but he changed the grouping to include four standing women, two striding males, and a single head of massive proportions.[4] This head was to perform the literal function of "seeing" the surrounding sculptures and human activity, as well as to serve the symbolic purpose of representing humanity's culture, both urban and artistic.[5] Although he abandoned the project, he did go on to complete the head in 1960.

Seeking an image of omnipotence, Giacometti took as his inspiration the colossal head of Constantine, ca. A.D. 330 (Palazzo dei Conservatori, Rome). The artist had always been interested in ancient and non-Western art, believing that "the truer a work is the more stylized it is."[6] The head of Constantine impressed him with its strongly frontal, hieratic design, its placement within an urban setting, and its larger-than-life eyes. While in Rome between 1959 and 1960, still involved in the ill-fated bank commission, he sketched the head, placing the accent on the eyes.[7] This emphasis was maintained in his modeling for the sculpture, where the intensity of Diego's stare is heightened by the gouged and furrowed areas representing the eyelids and the pockets under the eyes.

Giacometti was concerned with the gaze of his subjects throughout his career, and his later writings abound with references to the importance of the eyes. "The strange thing is," he wrote, "when you represent the eye precisely, you risk destroying exactly what you are after, namely the gaze. . . . In none of my sculptures since the war have I represented the eye precisely."[8]

329

Duncan and Marjorie Phillips's interest in Giacometti predated the surge of attention by American museums in the late 1960s.[9] They considered him to be "one of the most distinguished contemporary sculptors," who "found his own originality across the labyrinth of twentieth century isms." And they believed that his heads were "monumental tributes to the average man."[10]

After purchasing *Monumental Head* in 1962, the Phillipses decided to hold a major exhibition of Giacometti's work. It was organized by Marjorie Phillips, who considered it to be one of the museum's most significant shows.[11] They always kept the work on permanent view and reluctantly loaned it only once to another institution.

LBW

JOHN PIPER (1903–92)

A member of the British neo-romantic movement, which gained its greatest momentum in England during the Second World War, John Piper dedicated his life as an artist to depicting Britain's architectural heritage. Born December 13, 1903, in Epsom, Surrey, Piper attended Epsom College from 1917 to 1921. Despite his interest in art and English topography, he studied law from 1921 to 1926. Upon his father's death in 1926, he attended the Richmond School of Art for one year. In 1928, while at the Royal College of Art (1927–29), he began a career as an art critic. In 1931 he made a special trip to the south coast to visit Michael Sadler's collection of modern art. In 1934 he was elected to the Seven and Five Society and met Myfanwy Evans, who would become his second wife in 1937. Together they traveled to Paris, where they met many of the French avant-garde and published *AXIS,* a British counterpart to the magazine *Abstraction-Création.* Commissioned in 1937 to write the first of many guidebooks, Piper began to travel extensively throughout England. London Gallery, in London, gave him his first one-person show in May 1938. In 1940 he was commissioned by the War Artists' Advisory Committee, headed by Kenneth Clark, to record the destruction by bombing of the German Luftwaffe air raids, and he focused on ecclesiastical architecture. Two years later he was appointed an official war artist for the remainder of the war. His American debut was in 1948 at the Buchholz Gallery, New York; a few months later his first museum exhibition was held at The Phillips Collection, followed in 1958 by his first major retrospective, which was organized by the Arts Council Gallery, Cambridge. Piper lived and worked at Fawley Bottom near Henley-on-Thames and, in addition to painting, was avidly interested in a variety of media, including tapestry design, set design, aquatint, lithography, screenprinting, and stained glass. He died at home, June 29, 1992. The Phillips Collection contains five oils and three works on paper by him.

The Piper Unit

In the fall of 1946 Kenneth Clark delivered a lecture at The Phillips Memorial Gallery entitled "Romantic Painting in Contemporary British Art."[1] Early the following year he published an article discussing the merits of Henry Moore, Paul Nash, John Piper, and Graham Sutherland, artists whom he classified as "New Romantics" (now more commonly known as neo-romantics).[2] Considered by many to be heirs to England's eighteenth- and nineteenth-century romantic tradition, these artists shared a passion for depicting nature, particularly the British landscape. But their vision of nature had an emotionally heightened, often uneasy and anxious quality that derived partly from their individual experiences within Britain's avant-garde and partly from a general wartime anxiety.

In the months following Clark's lecture and through 1947, Duncan Phillips purchased numerous works by contemporary British artists—an early drawing by Moore and oils by Christopher Wood and Sutherland; he also acquired works by two of the precursors to the romantic tradition—J. M. W. Turner and Samuel Palmer. But Phillips's interest in Piper as a unit artist undoubtedly stemmed from Clark's lecture and article, as reflected by his comment that "Clark's enthusiasm for the artist was impressive."[3] Between February 1947 and March 1948 Phillips purchased seven works in rapid succession, followed by a one-person exhibition in spring 1948, Piper's first in a museum.[4] Phillips's first acquisition, *Russell Monuments at Strensham,* ca. 1946 (acc. no. 1568), was followed by two small oils, including *Farmyard Chapel, Bodinnick,* 1943 (cat. no. 331). In December 1947 he purchased *Bolsover Castle,* 1944 (acc. no. 1564), together with other works on paper. The following year witnessed a refinement of selection; he replaced several works on paper with one of Piper's early neo-romantic oils, *Wall at Muchelney Abbey,* 1941 (cat. no. 330), and a study entitled *Ockham Monument,* 1947 (acc. no. 1567). In 1950 Phillips rounded out the unit with a work that heralded Piper's postwar style, *Stone Gate, Portland,* 1950 (cat. no. 332), and gave him a second solo exhibition that opened in December.[5]

While part of Phillips's heightened interest in British artists was the sudden accessibility of their work following the war, his attraction may also have been due to his enduring appreciation of romantic art. Phillips, whose earliest acquisitions betrayed his romantic sensibilities and whose writings continued to laud artists who retained their individualism, surely would have appreciated Clark's view that "romantic painting, however popular, expresses the revolt of the individual" and that by reviving this tradition the artist can give full rein to his creative imagination.[6] He was probably quite receptive to Clark's creed that "the English mind is encrusted with poetical associations," which may have augmented his brief interest in neo-romantic art.[7]

Of all the neo-romantics, Piper was perhaps the most knowledgeable of England's heritage. He was a historian; an antiquarian and collector of early guidebooks of England's countryside; a critic and scholar familiar with English literature; and an artist who admired the works of William Blake, Constable, Palmer, and Turner. His interest in the topography of England dated to his childhood, when, at age twelve, he forayed into the countryside, making notes of interesting sites to visit in Surrey and Sussex. He called upon these experiences in his later work as the author of guidebooks and painter of the English landscape.

Although an active member of England's avant-garde during the thirties, Piper had become more conservative by 1936, the year he coauthored the article "England's Climate," in which he praised the eighteenth- and nineteenth-century British landscape tradition.[8] His neo-romantic style of the early forties, which reflects an abiding respect for and love of England's architecture, grew out of his burgeoning conviction that the polemics surrounding surrealism and abstraction, coupled with a nonobjective style, led to art that was sterile and far removed from life.[9] Furthermore, Piper asserted that "the looming war made the clear but closed world of abstract art untenable for me. It made the whole pattern and structure of thousands of English sites more precious as they became more likely to disappear."[10] Out of this concern, Piper developed his theory of romantic art, which he called "pleasing decay," a variant of the eighteenth-century notion of the picturesque.[11] He sought locales that nature had begun to reclaim as her own, structures that though not new were not in complete ruin but were allowed to retain their character as the inevitable decay took hold.

LBW

330

Wall at Muchelney Abbey, 1941

Muchelney Abbey

Oil on canvas mounted on plywood panel, 20⅛ × 24 (51.0 × 61.0)

Signed in black paint, l.r.: *John Piper;* reverse: inscribed (probably by the artist): *Wall at Muchelney Abbey/John Piper/1941*

Acc. no. 1571

PMG purchase from the artist through Buchholz Gallery, New York (from PMG exhibition), 1948.[12]

331

Farmyard Chapel, Bodinnick, 1943

The Church

Oil on panel, 6 × 7⅞ (15.1 × 20.1)

Signed l.r.: *John Piper*

Acc. no. 1565

PMG purchase from the artist through Buchholz Gallery, New York, 1947.[13]

330

During the early forties, when as an official war artist he was painting the devastation wrought in England by German bombing, Piper sought out rustic structures like those represented in *Wall at Muchelney Abbey* and *Farmyard Chapel, Bodinnick*.[14] Their appeal lay in the fact that they were not the "instant ruins" of war but artifacts of Britain's past.

As his love for British architecture intensified during this period, Piper was especially drawn to John Cotman, whom he believed to have been "the greatest of the later topographical and archaeological artists."[15] Piper noted Cotman's affection for ruins: "[Cotman] set out to etch 'all

the ornamented antiquities in Norfolk' in 1811. Most country churches were then at an extreme of picturesque beauty. Ready to drop like over-ripe fruit, they were in an exquisite state of decay."[16] The ruins represented in both *Wall at Muchelney Abbey* and *Farmyard Chapel, Bodinnick* serve as illustrations of Piper's words.

Painted in 1941 while Piper was visiting Somerset, *Wall at Muchelney Abbey* depicts a fifteenth-century structure on a Saxon foundation.[17] It is closely related to Piper's contemporaneous war commissions, specifically his images of Coventry Cathedral. These works recall Piper's abstract, constructivist style of the

thirties, apparent in *Wall at Muchelney Abbey* in the matte gray area in the lower left and in the large color areas defining the structure of the ruined abbey. New is the focus on varying textures, ranging from thin washes to high impasto. The dark, thick ground has a pattern of incised, fine, irregular lines in passages across the picture surface.[18] The nave in the center area has been scraped back, emphasizing the inward recession. These varying techniques evoke the weathering of stone and years of neglect.

Piper's desire to convey drama in his architectural scenes reached a new level of complexity two years later in *Farmyard Chapel, Bodinnick*. At

this time he began to paint a series of ruined barns and cottages that are similar in subject and style to *Barn with Mossy Roof,* ca. 1828, by Samuel Palmer, whose work he described as having "roofs richly clotted with decaying thatch and moss," which parallels Piper's own *Farmyard Chapel, Bodinnick.*[19] Here the ground is thick and is unevenly applied so that almost the entire surface is impastoed. Piper also incised lines in a seemingly random manner and used texture alone to describe the church emerging from its decaying environment.[20]

This small work was probably painted soon after a trip Piper made to Cornwall with Geoffrey Grigson, one of his favorite traveling companions at that time.[21] Looking specifically for holy wells and small churches, they stopped in the town of Bodinnick. Piper's diary entry may be a description of the Phillips work: "Very pale grey green in embowered surroundings. Pointed north door with Cornish spiral corbels—sienna and madder straw and dung flooring the entrance. . . . Ivy on S. side climbing to roof and bellcot. Ash trees, pale whitey-green, thistles, nettles and burdocks prone and reddening in front. Some fresh green burdock leaves in foreground. General effect white to dark grey with rich brown and grey tingeing, with dark bowering of trees and ivy. . . . Cornish drizzle now and again."[22]

LBW

331

332

Stone Gate, Portland, 1950

Oil on canvas, 47⅞ × 35⅞ (121.6 × 91.0)
Signed l.r.: *John Piper*
Acc. no. 1569

PMG purchase from the artist through Buchholz Gallery, New York, 1950.[23]

Piper's response to a place was "affected by the weather, the season and the country, but above all . . . its spirit."[24] He admired Portland (which Sir Frederick Treves called "a dismal heap of stone standing out into the sea. The island was ever windswept, barren and sour, tree-less and ill-supplied with water"), because its bleak terrain made it, in his estimate, a landscape that had great romantic possibilities as an image of melancholy and gradual decay.[25] Around 1949 to 1950 he began to interpret its environs almost exclusively, in a series of works that gained wide appreciation in America.[26]

Stone Gate, Portland reflects his fully developed postwar style, which has been described as "whole statements," a synthesis of his constructivist and later neo-romantic style.[27] In his need to rearrange the landscape "so as to make an elaborate symbol of the place; not a view, but a history," Piper began to heighten his palette and

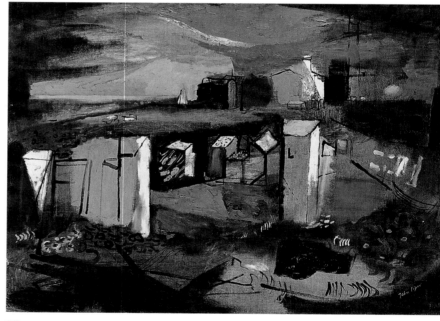

332

to employ larger planes of color.[28] Sketchy lines of black loosely define the large blocks of stone, the Portland lighthouse, and the surrounding structures. Salmons, rusts, and blue-grays are swathed across the canvas surface, independent of the objects. As in his earlier work, Piper showed an interest in texture, but he achieved it through more traditional means: the paint application ranges from thin washes to high impasto, with textured brushstrokes in certain passages and extensive use of the palette knife in others. In some areas, the weave of the canvas is visible.[29]

Stone Gate, Portland demonstrates Piper's prevailing aesthetic of "pleasing decay," which is represented by the abandoned stone blocks; surrounded by weeds, their surfaces are eroded by moss and lichen. In his Portland images, he often showed such blocks scattered throughout the landscape. Because they were used as building material, they represented the livelihood of the island, thus implying the presence of man and, by extension, his relationship to nature.[30]

LBW

GRAHAM SUTHERLAND (1903–80)

Graham Sutherland absorbed European modernist trends without compromising an English neo-romantic flair for the macabre and commitment to the natural world. Sutherland was born in London August 24, 1903, and spent a solitary childhood immersed in geology, natural history, and sketching. After a brief, unsuccessful apprenticeship in engineering, he studied at Goldsmith's College of Art from 1921 to 1926, concentrating on etching. In 1925 his first one-person print show at the Twenty-One Gallery, London, augured well, but after the market crash in 1929 his income from prints dwindled, and he turned to painting. It was the Welsh landscape that brought him his first inspiration, and the transition to painting was eased by the example of Paul Nash. In 1936 Sutherland loosely aligned himself with the surrealists, participating in their international exhibition in London. The show included works by Miró and Picasso, both of whom influenced him. In 1938 he was given his first one-person show of paintings at Rosenberg and Helft Gallery, London, and attracted the patronage of the influential art historian Kenneth Clark. During the Second World War, Sutherland was appointed an official war artist, which left its mark in a permanent penchant for morbidity. His passion for French landscape and culture led him to settle in France in 1955, but beginning in September 1950, he devoted part of each year to Venice. Branching into portraiture in 1949, Sutherland subsequently experimented with sculpture, tapestry, and lithography. He received increasingly distinguished accolades, including the Order of Merit in 1960. His work has been the subject of numerous retrospectives and monographs and has won him a particularly devoted following in Italy and Germany. A gallery dedicated to his life and work opened in Wales in 1976. Sutherland died in London February 17, 1980. The Phillips Collection owns three oil paintings by Sutherland.

333

Dark Entrance, 1959

Oil on canvas, 51¼ × 38¼ (131.4 × 97.1)
Signed in white paint, l.r.: *Sutherland;* inscribed in black paint on painting reverse, u.r.: DARK/ENTRANCE/30 vii. 59/G.S.
Acc. no. 1859 (Cooper no. 153)

The artist to Paul Rosenberg, New York, Oct. 21, 1959; PMG purchase 1959.[1]

Sutherland's often cataclysmic vision, underscored by the war, was intensified by his confrontation with Venice and inspired the brooding tone of *Dark Entrance.* The tradition of Anglo-American artists working in Italy, particularly in Venice, can be traced back to Turner, Whistler, and Sickert; Sickert's influence on Sutherland, readily acknowledged by the younger artist, is evident in the Gothic mood of this painting.[2] Sutherland's summer sojourn in June 1959 seems to have sparked this image, which was completed on July 30.[3] His scrutiny of a heron, poised at a canal watergate, echoed Matisse's and Picasso's recent concentration on bird imagery, while the cryptic gateway harkened back to one of Sutherland's earliest subjects.[4] Here the motif was recast in a picturesque recording of the city's mystery and romance; Sutherland later explained his interest in Venice as "primarily architecture—especially interiors: landing stages."[5] The motifs of the earlier *Vine Pergola* (acc. no. 1861) and the present canvas converge in the artist's fascination with isolated natural elements juxtaposed with man-made or architectural structures. The acid palette of dank blue-black and lurid orange, and Sutherland's shorthand notation of the heron's movement by an arching brushstroke off its back wing, suggest the influence of his friend Francis Bacon, while the slashing strokes imply the inspiration of Venetian painting, especially Tintoretto.[6]

When first exhibited, Phillips's last Sutherland purchase attracted notice as "a new strongly expressive canvas . . . the bird is the personification of evil . . . he leers over his wing at the spectator the very symbol of corruption and decay."[7] Its bizarre subject matter and grotesque mood were seen to "take a leaf from Bacon's book," though Sutherland himself said, "I am not conscious of a parallel with Bacon. . . . It would be totally foreign to my nature to feel an interest in decay as such. . . . I am far more interested in the structure of growth."[8] Sutherland is represented sparsely in U.S. collections, limited primarily to examples from the later 1940s; *Dark Entrance* is a rare example of his work from the 1950s.

In their obscure symbolism, hybrid style, and visionary themes, the three works by Sutherland in the collection confirm his position as "a potent influential force in English painting."[9] They are cornerstones of the English Room, where their humanist themes are mirrored in the works of Sickert, Bacon, and Moore and pay tribute to Phillips's deeply held view of the special quality of British art.

LF

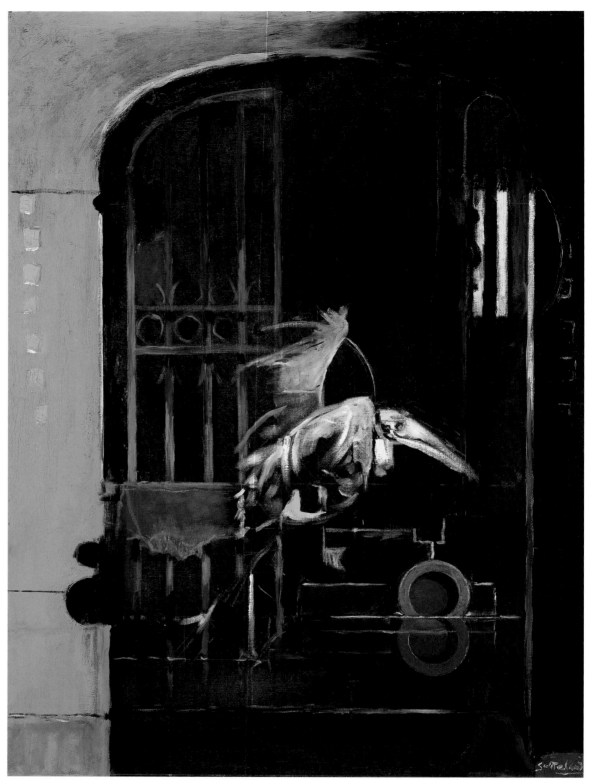

333

SERGE POLIAKOFF (1900–1969)

A second-generation painter of the School of Paris, Serge Poliakoff was born in Moscow January 8, 1900.[1] Poliakoff's father bred horses for the Imperial Russian Army, and his mother came from a family of landowners. After escaping the Russian Revolution in 1919, Poliakoff lived in Istanbul, Sofia, Belgrade, and Vienna, where he was the guitar accompanist for his aunt, Nastia Poliakoff, a well-known singer. In 1923 Poliakoff settled in Paris, but it was not until 1930 that he began to study painting seriously, joining the Académie Frochot and the Académie de la Grande Chaumière; throughout this time he continued to play the guitar in cabarets to support himself. Between 1935 and 1937 he lived in London, where he studied at the Chelsea School of Art and at the Slade and often visited the British Museum, favoring its Egyptian art. Returning to Paris in 1937, he met Kandinsky, who encouraged him and praised his work; he also became friends with Sonia and Robert Delaunay, regularly attending meetings at their home. In 1938, a turning point in his evolution, he exhibited his first abstract painting at the Galerie Le Niveau, Paris. From that year until 1945, Poliakoff exhibited yearly at the Salon des Indépendants, and in 1945 he had his first one-person show at the Galerie L'Esquisse, Paris. Two years later he received the Kandinsky Prize, presented by the artist's widow. His international reputation established, he participated in many group exhibitions throughout France and abroad, receiving his first important retrospective at Liège and Brussels in 1953. In 1959 the artist's first solo exhibition at an American museum was held at The Phillips Gallery. One-person exhibitions throughout Europe followed, including the Venice Biennale in 1962, the same year he was granted French citizenship. He died in Paris October 12, 1969. The Phillips Collection owns one painting by Poliakoff, dating from his mature period.

334

Composition, 1957

Mountains and Sky; Sky and Mountains (DP)
Tempera on plywood panel, 34⅞ × 45½ (88.6 × 115.5)
Signed and dated in cream paint, l.l.: *SErgE PoLiAKOFF 57*
Acc. no. 1596

The artist to Knoedler, New York, 1957; TPC purchase 1959.[2]

Now considered a master of the second generation of abstract painters in Paris, Poliakoff was the inheritor of both the intuitive, tactile abstraction developed by Kandinsky and the kaleidoscopic abstractions of Robert Delaunay.[3]

Furthermore, his work was distantly related to the classical color divisions of Mondrian. The search for spiritual meaning in abstract forms was certainly a vital undercurrent in the art of postwar France, and Poliakoff's jagged, flat shapes reflected cubist collage and the cutouts of Matisse, even while they harkened back to the silhouettes of Byzantine painting.[4] Poliakoff felt that after "the decay of figure painting," abstract painting was the only viable style in which to create transcendent imagery.[5]

Painted in Paris, *Composition* reflects Poliakoff's mature oeuvre of small abstract works that contain interlocking shapes vibrating with subtle, yet intense colors. These pieces often suggest organic forms, a source the artist acknowledged.[6] Because Poliakoff eschewed anecdote, he voluntarily limited himself to the tools of pure painting: color, texture, space, light, and mass. Their controlled exploration and ultimate balance were his themes.

Raised in the Russian Orthodox Church, Poliakoff's first experiences with paintings were with the sacred icons meant to be touched, kissed, and worshiped.[7] Hence the primacy of color and the spiritual aspect of his work have been seen as the product of his Russian roots, where "arts . . . derive from a certain organic unity in which all the parts were subordinate to a religious center."[8] In this tradition, the labored formal treatment is inseparable from the sacredness of the work of art. This "half-mystical, half-physical quality" stems from the concentration of both visual interest and a tensile surface integrity, features his work shares with icons as well as with Italian trecento and Flemish painting, which he also admired. The opposing forms that characterize Poliakoff's work are the concrete manifestations of his philosophy of painting: "The problem of the painter is not to insert forms in a pre-existing background, it is on the contrary, to articulate space in which forms and background will no longer be discernible, thus affirming their common genesis."[9] In *Composition* the two areas of color function as both active forms and background, a reversibility that contributes to the work's vitality.

In 1952 Poliakoff was influenced by the work of the Russian constructivist Kasimir Malevich, and the experience may have prodded him to pare down his forms. Beginning in 1957, Poliakoff also began to place increased emphasis on surface texture. According to Alexis Poliakoff, the artist's son, in its "simplicity of shapes and colours" and the "strength and importance of its material texture," *Composition* is one of only two or three paintings from 1957 that herald the compositions of 1961, "which are separated into

two main forms of two different tones."[10]

Poliakoff usually began with a charcoal drawing, and mixed his own colors. In *Composition* the highly textured surface, built up on an unprimed plywood panel, combines a granular substance and a medium of uncertain composition.[11] The colors are limited to blue and creamy white, which the artist applied wet into wet with a heavily loaded brush and a blunt tool. Despite the distinct areas of color, an electric vitality binds the painting; Poliakoff achieved this effect by underpainting each color area with traces of the contrasting color and by building up an all-over surface pattern of tactile paint. He explained that the color masses were part of his philosophy of painting: "Every form has two colors: one interior, the other exterior. The egg is white on the outside but yellow on the inside and so it is for all things."[12] This contrast, as well as the direction of the brushstrokes, which radiate out from a central point, enhance the sense of equilibrium and of a center that holds. The result is a monumental image that belies its small scale.[13]

Duncan Phillips purchased *Composition* during the apex of Poliakoff's career, two years after it was painted. To Phillips the work seemed to represent "dark blue mountains against a mackerel sky," the kind of reference to nature that Poliakoff always vigorously denied. Renaming it *Mountains and Sky,* Phillips praised its "texture and vibrant color."[14]

The painting seems inherently compatible with Phillips's earlier purchases of modernist American landscapes and studies of natural forms, as seen in the proto-abstract work of Dove, O'Keeffe, and Tack. The anchoring horizon and duality of intense tones emphasize a connection with Poliakoff's fellow Russian Rothko, whom Phillips was also acquiring in the 1950s. Phillips hung this work occasionally, usually within the context of postwar European and American abstraction.

LF

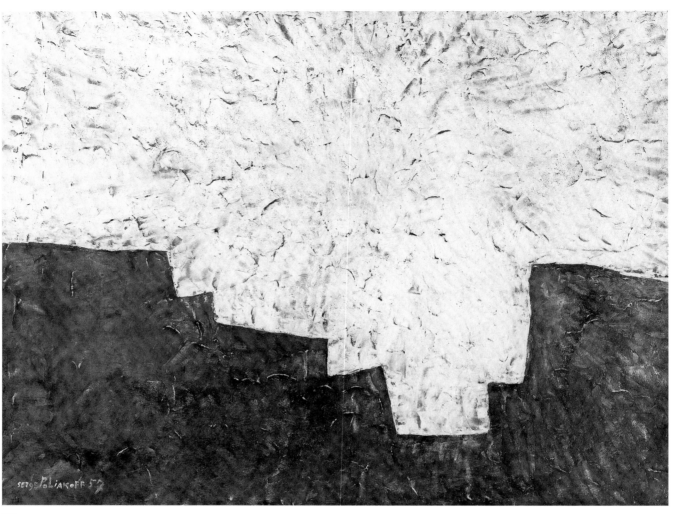

334

MARIA ELENA VIEIRA DA SILVA (1908–92)

Born in Lisbon June 13, 1908, to a cultured family, Maria Elena Vieira da Silva received a liberal education and, with her mother's encouragement, pursued an artistic vocation from age eleven. Vieira da Silva's studies in drawing, painting, and sculpture in Lisbon eventually led her to Paris, where in 1928 she entered the Académie de la Grande Chaumière; she studied there with the sculptors Emile-Antoine Bourdelle and Charles Despiau. After a trip to Italy in 1929, she abandoned sculpture and studied painting with Charles Dufresne, Othon Friesz, and Fernand Léger. She also frequented Atelier 17, the engraving workshop directed by Stanley William Hayter. In 1930, together with her husband, the Hungarian painter Arpad Szenes, Vieira da Silva went to Marseilles, where she painted numerous studies (no longer extant) inspired by the great shipping crane, developing a new, acute consciousness of line and structure that would have a major impact on her oeuvre. In 1932 she met the Parisian gallery owner Jeanne Bucher, who held Vieira da Silva's first solo exhibition in 1933. From this period came her characteristic works, in which she explored spatial relationships in multiple perspectives. With the onslaught of the Second World War, she moved with her husband to Lisbon and soon thereafter to Rio de Janeiro, where she expressed her anguish at her exile and the war in images of complex "labyrinths" or "corridors." She returned to Paris in 1947 and became a French citizen in 1956. From 1950 one-person exhibitions were held in museums and galleries all over the world. In 1988, in honor of her eightieth birthday, a major retrospective was held in Lisbon and Paris; more than thirty writers and poets contributed to the catalogue. Vieira da Silva died in Paris March 6, 1992. The Phillips Collection owns two oil paintings, and has hosted two exhibitions of her work.

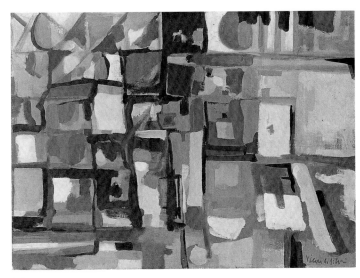

335

335
Stones, 1950

Les Rochers
Oil on canvas, 19 5/8 × 25 3/8 (29.9 × 64.5)
Signed in gray paint, l.r.: *Vieira da Silva*
Acc. no. 2004

Early history unknown; TPG purchase from Theodore Schempp, New York, 1959.[1]

336
Easels, 1960

Les Chevalets
Oil on canvas, 45¼ × 53⅞ (115.0 × 136.9)
Signed l.r.: *Vieira da Silva*
Acc. no. 2003

The artist to Knoedler and Theodore Schempp, New York, Dec. 1960; TPG purchase 1961.[2]

Because of her subtle tones and poetic themes, Vieira da Silva, along with Manessier (cat. no. 338) and de Staël (cat. nos. 341–44), is often perceived as an inheritor of the French tradition.[3] In both of these sumptuously textured canvases scattered light softens a gridlike arrangement descended from cubism and geometric abstraction. Whether Vieira da Silva contemplated nature or, more frequently, a man-made structure, her fluid, lyrical approach eclipsed her subject (fig. 41). Yet her work never broke entirely free of representation, and both of these images hover between the objective world and a prismatic, refracted abstraction.

In style *Stones* reflects the influence of the constructivist artist Joaquín Torres García of Uruguay, as well as the French artist Roger Bissière, whose studio at the Académie Ranson Vieira da Silva had frequented in 1932; like them, she keenly felt the influence of Paul Klee and divided her canvases into small geometric units, further animating them through color and the use of fanciful, deliberately primitive shapes.[4] Vieira da Silva invigorated this loose, abstract composition by scattering pastel highlights over a neutral base, which, in passages, is the unprimed canvas itself; the resulting luminosity imbues the work with a bright, joyous mood. The brushwork is broad and informal; paint was laid on spontaneously in rounded contours following the forms.[5] The accumulation of rectangles on the left side is alleviated by a perfunctory wedge of space seeking the horizon at the lower right. Guy Weelen suggests that the theme of the painting is "a meditation on the square or rectangle, their superimposition, and the architecture of the two geometric forms." The title and the image's irregular faceting, Weelen further proposes, may have been inspired by "the heaps of rocks scattered over the terrain at Sintra" in Portugal; such use of her native homeland is seen as the archetype of Vieira da Silva's recurrent use of multiple geometric shapes.[6]

The overall elegance of rhythm, color, and pattern in *Easels* is offset by the artist's unusual subject: the easel, normally a supporting backdrop, here becomes the focus and is rendered in numerous repetitions. Created a decade after *Stones,* this work signals Vieira da Silva's mastery

of her craft. The canvas is partitioned into an ethereal web through the use of refined tones, a delicate palette, and fragile brushwork built up in thin vertical strokes. The easels are presented in a shallow, compressed space, as though seen through a prism—white lines arrayed across the canvas like "a stand of birches."[7] The juxtapositions of matte and glossy passages demonstrate Vieira da Silva's sensitivity to surface texture—an emphasis further enhanced by the lack of varnish and the choice of a coarse, open-weave canvas.[8] The neutral tones and the emphasis on linear elements may have derived from her recent work in engraving. The earth-toned palette may also reflect her infatuation with Giacometti's work, though isolated areas of blue, purple, and red-browns warm the tones. The skein of lines and dim space are abruptly cut off at the right, further compressing the attenuated forms. Parallel empty rectangles crowd the canvas like a visual evocation of the painting process itself, of which Vieira da Silva said: "There are times when I start off aimlessly making tiny squares and lines out of which hundreds of things might, or might not, evolve."[9] A sense of mystery emanating from the iridescent army of easels indeed creates a haunting image of harmony and nostalgia.

The artist recently elaborated upon these ideas to Guy Weelen, who wrote: "Painted in her new studio at 34 Rue Abbé Cartou, [*Easels*] is a transposition of memories of her former studio, at Rue Saint-Jacques. She was more concerned with evoking the atmosphere, the entanglement, than with description." Weelen emphasizes that the title was given only when the painting was finished, "according to the work's composition, its color and the reverie pursued by the artist during its creation."[10] The subject suits her formal criteria in its verticality: "For me . . . there must be a vertical element rising in front of me. The painting must be tense."[11] Cerebral and unpeopled, the work excludes the human aspect of its subject, presenting instead an homage to the practical trappings of creative endeavor and its abstract potential.

Working directly on canvas, with no preconceived program or preparatory drawing, Vieira da Silva emphasized chance and indeterminacy almost as a system in itself: "It is on uncertainty that I base myself."[12] In this context the stripped, ossified image, its lack of solidity, and its sense

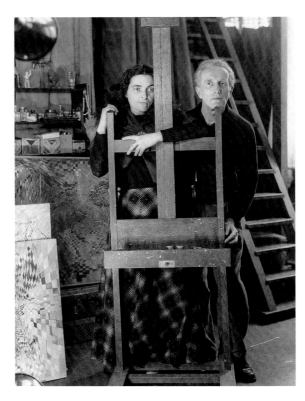

Fig. 41 Vieira da Silva and her husband, the painter Arpad Szenes, in their studio, Boulevard Saint-Jacques, Paris, ca. 1950, Collection Archives Galerie Jeanne-Bucher, Paris.

of suspended time seem to relate to the core of the artist's experience: the solitary childhood in a vast, empty house in which meaning and comfort were sought through the rigorous study of music and art.

On its first showing in Paris, *Easels* was reproduced in *Apollo* magazine to represent the artist at the height of her powers, an era in which her work has been characterized as "more neutral, more velvety than it was, more cunningly greyish in tone . . . we are here at the frontiers of weightless perfection."[13]

Duncan Phillips could have become acquainted with Vieira da Silva's work both from exhibitions in the United States and through his assiduous attention to the French art press, which regularly focused on her paintings. In keeping with his groundbreaking exhibitions of School of Paris painters, Phillips held Vieira da Silva's first solo exhibition in an American museum in 1961. His recognition of her unique contribution to European abstraction resulted in these two acquisitions in 1959 and 1961 and a showing of her work in 1963.[14] Moreover, although *Stones* and *Easels* represent distinct phases in Vieira da Silva's career, both paintings focus on two deeply personal themes that were of enduring attraction to Phillips: an abstract evocation of landscape and a studio motif.

Phillips hung the paintings, particularly *Easels,* almost constantly, grouping them with School of Paris painters and American modernists like Rouault, de Staël, Lachaise, and Tack. In the 1970s and later this grouping was broadened to include the abstract expressionists.

LF AND MJ-B

336

FRANCIS BACON (1909–92)

Francis Bacon's art combines the figurative tradition of the Old Masters with a fierce gesture and dramatic power that owe much to his often turbulent life and times. Born October 28, 1909, to English parents in Dublin, Bacon's often chaotic youth included sojourns with his maternal grandmother in her barricaded home, the revelation of his homosexuality, and his early discovery of the bohemia of Berlin and Paris. He was first inspired to paint after seeing Picasso's 1928 exhibition in Paris; his early canvases blend the Spanish master's iconography with a classic cubism in the manner of Léger. In 1933 Herbert Read reproduced his painting *Crucifixion* in his treatise on modernism, and the artist had his first gallery exhibition the next year at the Transition Gallery in London. Despite this early success, Bacon destroyed most of his work by the early 1940s. Rejected for military service, he worked in the rescue service, returning intensively to painting after the war ended. Extended trips to the Mediterranean in the late 1940s brought new light and atmosphere into his work and inspired a reverence for van Gogh. In 1948 he sold his first painting to the Museum of Modern Art in New York, a triumph that was followed by a solo exhibition there in 1953. His international reputation grew rapidly, and exhibitions were held in Paris, Italy, São Paulo, and New York, along with many London exhibitions and retrospectives, throughout the late 1950s and 1960s. The artist lived and worked in London but traveled widely. He died in Madrid April 28, 1992. The Phillips Collection owns one oil painting by Bacon.

337

Study of a Figure in a Landscape, 1952

Study of Figure in a Landscape
Oil on canvas, 78 × 54 (189.2 × 137.1)
Unsigned
Acc. no. 0046 (Alley/Rothenstein no. 47)

The artist to Hanover Gallery, London, by Dec. 1952; Durlacher Bros., New York, by late 1953; TPG purchase 1955.[1]

Bacon's abiding preoccupation with the human figure was radical in the context of postwar Europe, when abstraction dominated the art scene. Drawing on the British tradition of portraiture and the figure, especially the examples of Sickert, Sutherland, and Moore, his obsessive concentration on the theme was sparked by Picasso's monumental treatment. In raw, sometimes violent portrayals, incorporating both high art and popular imagery of modern life, Bacon conveyed the sense of displacement, alienation, and anomie of twentieth-century humanity.

The subject of Bacon's haunting image of 1952, *Study of a Figure in a Landscape,* is a naked man squatting deep in a grassy field. His crouch suggests atavistic withdrawal or predatory watchfulness. He enters our field of vision like a hallucination emerging from the gentle pastel landscape, the embodiment of human psychosis and anxiety to which Bacon habitually addressed himself.

The setting was inspired by Bacon's South African sojourns of 1950 and 1952 to visit his mother and sister. He also derived inspiration from the photographer Marius Maxwell's images, an adaptation evident in the schematicized highlights and flattened foliage, as well as the smudged flesh and tonal articulation of the figure.[2]

Bacon has said that "animal movements and human movement are continually linked in my imagery." The figure in the present work is indeed reduced to the state of a primate, assuming the position for birth, death, and defecation. The pose is a quotation from Eadweard Muybridge's nineteenth-century photographs of the human body in motion.[3] The scientific neutrality of the reference is unsettling in its banality when placed within the context of Bacon's image: arrested motion becomes autistic immobility. Intriguingly, Bacon has superimposed two positions upon the figure: in one his arms rest on extended knees in a relaxed posture, while in the other the knees (two highlighted smudges on the figure's chest) are tightly clasped in the sitter's arms. This ambiguity confounds an assessment of his nature, suggesting both fear and assurance, the role of both victim and predator.

Bacon's austere treatment is typical of the period: the unprimed canvas plays an assertive role, grounding the subtle relationships of the pastel colors—iridescent lavenders, deep green and lime, cornflower blue for the sky, and, in the figure's shadow, a burnt brown-red.[4] A sensitively applied dry brush defines the strands of grass in individual strokes; the sky area is patchily worked, perhaps rubbed, so that it echoes the treatment of the foliage—a painterly approach signaling Bacon's debt to both Degas and van Gogh, both of whom he greatly admired. Only the figure of the man is heavily impastoed, perhaps to secure his anonymity; the blurring of his contours and features conforms with Bacon's dislike of illustration or narrative.[5]

The overall lean treatment lays bare the composition's graphlike simplicity: the horizon is defined with a ruled line, and the vertical axis is likewise indicated, a foreshadowing of the arrows Bacon used in later paintings to point the way to the central image. The stippled vertical lines, too, serve as the means of removing the

picture from straightforward representation. They also recall the streaks found on film and photographs, two of Bacon's primary sources. Through his preference for glazing, Bacon also insisted on the discontinuity of the viewer's space with that of the picture.

Bacon said that he daydreamed in series of images before he began to paint, and a triad of 1952 landscape works that includes *Study of a Figure in a Landscape* may be read sequentially, like film stills: *Landscape* depicts an empty field with a central gestural scrawl vaguely echoing the present figure; the second image bears the same title and depicts an emphatic black smudge emerging from the landscape; and the present canvas reveals the figure fully materialized.[6] Perhaps never again did Bacon place his figure so deeply, so silently, and so passively within his picture. These works may relate to Bacon's own sense of crisis in approaching the human presence, the central theme of his work. While they tend to share the anonymity and anxiety of earlier paintings, the natural environment seems as alien and entrapping as the claustrophobic interiors typical of Bacon's work. Following *Study of a Figure in a Landscape,* Bacon recommitted himself to a more direct approach, animating the foreground space with figures in motion and reasserting a characteristic extreme of anguish or ecstasy.

The present painting was one of thirteen shown at Bacon's first solo exhibition in the United States in 1953, when Duncan Phillips may have first seen it; on the other hand, he may have viewed it at the Yale exhibition, where it was paired with text from T. S. Eliot's *The Cocktail Party,* one of Bacon's favorite plays.

Phillips also considered purchasing one of Bacon's famous depictions of a cardinal in late 1953, but his reticence and ultimate rejection of the piece are revealing: "There is something alien which I can not put into words even though I am profoundly impressed by the virtuosity of [Bacon's] psychological expression. . . . I hope and believe that I will find something by Bacon with less shock value, less sensationalism and an equal amount of technical skill."[7]

Exceptional in Bacon's oeuvre for its lyrical color and delicate treatment, this painting seems a suitable choice for the museum. Continuing the theme of landscape predominant in the English Room, the painting also hangs frequently with other European and American works, reflecting Bacon's international stature; it mediates between Degas's figures, van Gogh's landscapes, and the lustrous spaces of both Diebenkorn and Rothko.

LF

337

ALFRED MANESSIER (1911–93)

Alfred Manessier was born in Saint-Ouen, Picardy, in 1911 and attended school in Amiens. He did not fully immerse himself in painting until after his father's death in 1936, though while an architecture student his passion for art had led him to the Louvre to copy works by the Venetian masters and Rembrandt. He entered the atelier of Roger Bissière, a fresco painter whose work, bordering on abstraction, was greatly influenced by Klee. Manessier drew inspiration from Picasso and Braque, as well as Robert Delaunay, under whose supervision he executed decorations for a pavilion at the 1937 Exposition Universelle in Paris. Manessier passed some of the Second World War in the country near Bissière, moving back to Paris in the spring of 1941.[1] A turning point came in 1943 when he retreated to a monastery, where he underwent a spiritual awakening that permanently altered his life and work. By 1944 Manessier's imagery had become increasingly abstract, and his themes were frequently derived from sacred subjects. In 1947 his work came to the attention of Georges Rouault, who remarked on its affinity with stained glass. Manessier's first solo exhibition took place in 1949, and the next two decades brought him accolades and public recognition; he won a prize at the São Paulo Biennale in 1953, the Carnegie International first prize in 1955, and the first prize in the Venice Biennale in 1962. His first solo exhibition in a U.S. museum was held in 1964 at The Phillips Collection. These honors were followed by major retrospectives worldwide. Extensive travels, especially stays in Provence and Spain, deeply affected his oeuvre. Always active politically, Manessier turned increasingly to socially conscious themes in the late 1960s and 1970s. At eighty, Manessier felt that his work had at last come into its own. He died in Orléans, France, August 1, 1993. The Phillips Collection owns one oil painting by Manessier.

338

From the Depths of Darkness, 1963

Du Fond des ténèbres

Oil on canvas, 28¼ x 36¼ (73.0 x 92.0)

Signed and dated in red paint, l.l.: *Manessier/63;* monogram on stretcher: *Ma/63*

Acc. no. 1249 (Manessier no. H 555)

Purchase from artist through Galerie de France 1964 (from TPC exhibition).[2]

Though he began as an impressionist, Manessier was eventually influenced by Picasso, Braque, and surrealism (André Masson worked next door to his first studio). He developed a style based on gridlike compositions with cubist and surrealist underpinnings but abandoned it in favor of a flickering, luminous technique, sometimes known as abstract impressionism.[3] Freely rendered organic forms recalling crystals or cellular matter extend across the canvas in bold, electrically contrasting colors and textured brushwork.

This style is evident in *From the Depths of Darkness,* which belongs to a cycle of paintings on the Passion of Christ that occupied Manessier between 1961 and 1965. It is a meditation on a confluence of sacred themes, including the Passion, the Psalms of David, Easter, and especially Gethsemane. The title was inspired by Psalm 130: "Out of the depths have I cried unto thee, O Lord."[4] Like a closely linked work, *Study for Le Jardin des Oliviers,* 1963, it relates to the point in the Passion "when Jesus . . . is overcome with fear and dread, the moment when, although asking to be spared if possible what is awaiting him, he accept[s] it."[5] Manessier added: "It concerns a nocturnal, anguished vision—a stirring—of a still uncertain event (and could presage the . . . approaching torment of the cross). The dizziness one senses is as in a fever, at the bottom of a well."[6] For Manessier, the Passion both foretells Christ's anguish and conveys the prospect of redemption: "Possibly the shape of a cross can be made out, as though in a dream, like some as yet unreal thing: out of the depths of darkness you don't really know what you are seeing . . . and yet, in this fear, I see in my painting hope."

Manessier had concentrated on the theme of the Passion since 1948; he viewed it as the most important subject of his oeuvre and continued his exploration in his late work. The theme addressed suffering, both political and spiritual: "I did not want to make religious art into museum art, frozen art, but on the contrary to open it up to all the passions that stir us."[7] He had linked the sense of grief in the present painting to his own personal distress during this period.[8]

The work derives from natural as well as sacred motifs: Manessier's fascination with the Spanish landscape and his devout spirituality have merged here in a pantheistic approach. Manessier journeyed through Spain during the spring of 1963; his trip began in the north and culminated in the hills of Valencia. There he visited the Luchente Hermitage, where Don Alfonso Roig, a priest and professor of art history, maintained an atelier for his wide circle of artist friends. Manessier recalled, "This painting [*From the Depths of Darkness*], linked to the beginning of the 'Luchente period,' was created in Paris . . . following my first visit at Easter, 1963. . . . It was nourished by all the drawings and studies I did in that marvelous country."[9] A revelation to Manessier, Spain seemed to stir a nostalgic reaction to the Spanish Civil War, a profound admiration for both Goya and El Greco, and an attraction to the terrain, particularly that of the north.

Manessier had been especially taken "by the structure of the rocks to which Toledo clings, with the Tagus nestling in them," and the light emanating from the land. The cliff town, the narrow valley, and the Tagus River can be read in the central cleft of *From the Depths of Darkness* picked out by pooled strands of luminous paint. The silvery-blue chiaroscuro is reminiscent of El Greco's flamelike brushwork; Manessier later observed, "El Greco was everywhere in Toledo."[10] The Spanish landscape by night particularly struck the artist, who wrote: "Everything remains coloured, luminous. . . . I am speaking of a landscape put to death by the heat which is born again of the night; of colour which is not lost, which lives again as pure colour. In the North, the night is death. In Spain, its meaning changes: it is a resurrection."[11]

The suggestion of depth and space is more pronounced in *From the Depths of Darkness* and other Spanish works than elsewhere in Manessier's oeuvre, though the distinction between sky and land is, characteristically, left vague.[12] Decorative pinpoints of red punctuate the image and delineate the signature, enhancing the jewel-like glow of the surface and underscoring Manessier's place in the French tradition of *la belle peinture.*

Duncan Phillips's admiration for Manessier, whom he viewed as "one of the most important painters of the generation since 1945," seems a natural extension of his commitment to the French tradition: Manessier is often seen as continuing the lineage of Braque and Bonnard, and Phillips himself contends that he was a descendent of Rouault.[13] In planning the collection's 1964 Manessier exhibition, the Phillipses, working closely with the artist, selected examples of his most recent paintings, showcasing the new style precipitated by the Spanish period. The exhibition was well received, and one critic commented on its significance and beauty and the rarity of such an assemblage in America.[14] In praising Manessier's lyrical style and spiritual aims, Phillips quoted Marcel Brion: "His works completely realize the accord between matter and spirit, their unshakeable harmony."[15]

LF

338

KEITH VAUGHAN (1912–77)

After the human figure, landscape was Keith Vaughan's main preoccupation. He was born August 23, 1912, in Sussex, England, and, after moving to London with his family, exhibited early gifts as a draftsman at the boys' school at Christ's Hospital, where he worked under the guidance of an art tutor and the stimulus of the school's Frank Brangwyn murals. In 1931 he joined a corporate advertising agency, LINTAS, where he cultivated graphic skills; during this period he conceived works in flat, broad areas of color and also began to use photography as a source of imagery. Vaughan absorbed the criticism of Roger Fry and Clive Bell and studied the technique of Cézanne. He also acquired a passion for the ballet, whose formalized gestures entered his own paintings of figures. Not until just before the war did Vaughan devote himself exclusively to oil painting. A conscientious objector, he worked at a P.O.W. camp through most of the Second World War; there he continued sketching and began prodigious journal writing. During this period Vaughan met Graham Sutherland, who introduced him to the neo-romantic style. His first one-person exhibition was held at the Reid and Lefevre Gallery in 1944. After the war, the impact of Picasso and Matisse challenged Vaughan's romanticism. In the late forties he taught painting and continued his own education through extensive trips abroad. In 1950 he painted a mural for the "Dome of Discovery" at the 1951 Festival of Britain. A Nicolas de Staël exhibition in London had a profound influence on him, pushing his work closer to abstraction. Throughout the fifties he sought inspiration from the English and Mediterranean landscape. In 1959–60 Vaughan became painter-in-residence at Iowa University, afterward returning to London to join the faculty of the Slade School of Art. He was made Commander of the British Empire in 1965. The publication of his journal in 1966 revealed his profound intellect and terrifying solitude. On November 4, 1977, Vaughan ended his battle with cancer in suicide. The Phillips Collection possesses two gouaches and one oil painting.

339

Yorkshire Farmhouse, 1945

Gouache, ink, graphite, and possibly charcoal on paper, 11⅜ × 14⅞ (28.9 × 37.8)

Signed and dated in black ink, l. r.: *Keith Vaughan 1945;* inscribed on reverse, graphite: *Yorkshire Farmhouse (unfinished)*

Acc. no. 2000

Durlacher Brothers, Inc., New York; TPG purchase 1951.[1]

340

Farm in Berkshire, October 1956

Oil on hardboard, 18¼ × 23⅞ (46.4 × 60.6)

Signed in black paint, l.r.: *Vaughan*

Acc. no. 1998

The artist to Leicester Gallery, London; Durlacher Brothers, Inc., New York; TPG purchase from exhibition 1957.[2]

During the Second World War, Keith Vaughan was swept up in neo-romanticism, a revival of the English eighteenth-century pastoral tradition. Under this influence he cultivated a lyrical mood and delicate, illustrational technique. These qualities are reflected in *Yorkshire Farmhouse,* an early example in which a brooding spirit informs Vaughan's approach to the northern English landscape. The picture was painted during Vaughan's tour of duty in a P.O.W. camp in Malton, Yorkshire, from 1943 to 1946. Limited to drawings and gouache sketches, he produced numerous small-scale works.

A London resident all his adult life, Vaughan responded to the northern countryside both selectively and perspicaciously: while he reveled in the geologic peculiarities and the curative atmosphere of the region—"limestone, sandstone, and chalk, softer, warmer, more pastoral, a feeling of antiquity, prehistory . . . with that Spartan bareness"—he edited out all signs of war and dulled the saturated greens of summer to austere, neutral tones.[3]

The artist's description of Castle Howard, recorded in his diary, finds an echo in this painting of a much humbler Yorkshire farmhouse: "Everything seemed abandoned. . . . Everything lay in the still torpor of neglect and disintegration, as though at the bottom of the sea. The house throbbed with a honey coloured warmth as though the sun itself ran in its veins."[4] Vaughan's description of the castle continues with the desultory appearance of a girl in a school dress, a young man crossing the lawn, and a profusion of daffodils, all of which he included in the present scene. Even the curious subterranean quality of the vegetation and the murky light recall the aqueous sensation Vaughan experienced there.

The unfinished *Yorkshire Farmhouse* demonstrates Vaughan's experimental technique, his desire to capture "in lassoes of line and nets of colour" the look of figures in the landscape, and his need to exorcise his own "chronic nervous restlessness, irritation and fear."[5] Deftly creating a sense of space with a patchwork of broken planes, Vaughan implied multiple horizons and yet obscured the skyline at its expected position, at either side of the house.[6] A mood of gloom and darkness infuses the scene, and the dejected-looking house is more suggestive of humanity and personality than are the sketched-in figures.

Foliage is represented both by meandering skeins of ink, as in the ivy on the facade, and by a resist process, passed from Moore and Sutherland to Vaughan. This technique, a blend of gouache, ink, watercolor, and wax-resist, is used to great effect here, creating "texture, uncertain light and dense shadow" throughout the composition.[7] Vaughan applied wax to the surface, following it with a layer of pigment that held only in the untouched areas. The negative passage defines the tree itself, a ghostly imprint, and renders the small trees to the right a lacy filigree. Vaughan's myriad improvisations also included fingerprinting, charcoal and pencil sketching, and incising waxed passages; he also applied paint wet-into-wet to create dripping tidelines of thinned gouache.

339

One of three paintings of this subject executed in this period, *Farm in Berkshire* signals Vaughan's assimilation of Continental abstraction.[8] A 1953 exhibition of Nicolas de Staël in London galvanized and simplified his vision; he began to build up geometric forms in dense impasto with the palette knife and brush.[9] The painting's anchoring theme, the landscape, exemplifies this new technique and conveys Vaughan's continued belief that "painting fails when it loses this sense of touch with its subject . . . by casting off into the sea of pure abstraction."[10] The tight, rectilinear construction betrays a classical austerity seemingly at odds with the earlier linear rhythms; yet the critic and painter Patrick Heron emphasized the

continuity of Vaughan's style: "Underlying the linear drawing . . . Vaughan had always preserved a framework of form that was basically rectilinear. . . . He was an incipient Cubist from the start . . . so we were not taken completely by surprise when great flat sheaths of emerald green began to emerge out of the masses of his trees and to float, more or less free of one another, in space."[11] The composition bears a strong affinity with the floating planes and blocks of color with which Vaughan structured the earlier *Yorkshire Farmhouse*. The palette once again evolved from singing blues and greens still visible beneath to an earthy harmony of ocher, grays, and blacks.[12]

Seemingly indifferent to the core of Vaughan's

mature subjects, the male nude, Duncan Phillips assembled a representative group of his peopled yet melancholy landscapes with three works—one of the largest Vaughan collections in a U.S. museum.[13] Phillips hosted Vaughan's first one-person exhibition in an American museum in 1951. His partiality to Vaughan's early work sprang naturally from his interest in Sutherland, Piper, and Moore, all of whom worked within the subjective mood of British neo-romanticism. In 1957, at the height of his collecting of de Staël's work, Phillips acquired *Farm in Berkshire*.

LF

340

Nicolas de Staël, who considered himself heir to the French tradition, produced in his brief career an oeuvre of great originality and daring that influenced both his fellow compatriots and British artists. De Staël was born in Saint Petersburg, Russia, January 5, 1914 (December 23, 1913, according to the Julian calendar). In 1919 his family was forced by the Russian Revolution to emigrate to Poland. After his parents' deaths shortly thereafter, Nicolas and his two sisters were sent to Brussels to be raised by Russian expatriates, Emmanuel Fricero and his wife. He was educated in Catholic schools and later enrolled in the architecture program at the Académie Saint-Gilles-les-Bruxelles. In 1933 de Staël traveled to Holland, where he saw the works of Rembrandt and Philip de Konincks, and to Paris, where he discovered Cézanne, Matisse, Soutine, and Braque. That year he painted his first watercolors. Between 1936 and 1938 de Staël traveled through Morocco and Italy, painting portraits and landscapes. While in Morocco, he met a fellow artist, Jeannine Guillou, his companion until her death in 1946. In September 1938, after a period in Nice where he met Alberto Magnelli, Sonia Delaunay, Jean Arp, and Le Corbusier, he settled in Paris. Galerie L'Esquisse held his first one-person exhibition in 1944, and the following year he participated in the first Salon de Mai. Nine months after his marriage to Françoise Chapouton, he moved in January 1947 to a large studio at 7, rue Gauguet, where he met frequently with Braque, whose studio was nearby. In 1948 he became a French national. De Staël rediscovered his love of Dutch art in 1949 when he revisited Amsterdam, The Hague, and Brussels. A trip to England in 1950 was equally significant to his art. Between 1952 and 1953 de Staël suddenly became successful, and his reputation abroad was greatly expanded, partly through major exhibitions in London (Matthiesen's, 1952) and New York (Knoedler, 1953). In September 1954 de Staël moved to a studio in Antibes, where he committed suicide the following March. The collection contains six oils and two works on paper.

De Staël Unit

In 1950 the American dealer Theodore Schempp drove to The Phillips Collection with a group of works by Nicolas de Staël in his station wagon. De Staël was then unknown to Duncan Phillips, but he chose a small oil on canvas entitled *North*, 1949 (acc. no. 1807), thus becoming the first person to acquire the artist's work for an American museum.[1] At that time de Staël, who had begun to establish a firm reputation in his adopted France, was almost completely unknown in the United States.

Throughout the 1950s Phillips took every opportunity to exhibit de Staël's work. After including four paintings, among them his initial purchase, in a 1951 group show entitled "Advancing French Art," he organized a two-person exhibition, showing de Staël in tandem with William Congdon.[2] In 1953 de Staël enjoyed critical and financial success with a major solo exhibition at the Knoedler Gallery in New York, followed immediately by one that Phillips organized—the first in an American museum.[3]

By the end of 1953 Phillips had purchased six paintings, all of which are still in the collection. The unit represents several phases of de Staël's early mature career, from the dark *Composition*, 1948 (acc. no. 1804), with violently slashing diagonals, to *Fugue*, 1953 (cat. no. 343), a masonrylike construction of subtle shades of green and gray, to the exuberant *Musicians*, 1953 (cat. no. 344), painted after his return to figuration. Phillips was well satisfied with the group of works and later wrote, "The longer I have lived with them, the more I have enjoyed their chromatic splendour."[4] Generally, he preferred the abstract works that predated de Staël's 1953 paintings. He admired their subdued coloration and "more roughhewn, more subtle and more abstract" compositions.[5] In the works *Nocturne* (cat. no. 341), *Fugue*, and *Parc de Sceaux* (cat. no. 342), all executed between 1950 and 1952, Phillips found a "monumental architectonic grandeur," and he favorably compared de Staël's "improvising with his masonry of color shapes" to Cézanne's continual searching for both structure and rhythm.[6]

As de Staël's style evolved—his representations growing more explicit, his paint thinner, and his color ever more brilliant under the influence of the light of the Mediterranean coast— Phillips's interest declined. He believed that his de Staël unit, ranging from 1948 to 1953, represented the artist at the height of his achievement. Significantly, the work he added to the collection in 1964, a felt-tipped pen drawing, *Birds in Flight*, 1951 (acc. no. 1802), straddles the line between observation of nature and pure abstraction, allying it in character with the other purchases.[7]

In Phillips's view, even the most seemingly abstract of de Staël's compositions held the suggestion of a "real" subject, in keeping with de Staël's own aesthetic, for the artist had always insisted that his art was firmly based in nature and that he was never a pure abstractionist. "One does not begin with nothing," de Staël is reported to have said. "When Nature is not the starting point the picture is inevitably bad."[8] Phillips found in the work of de Staël a most

appealing resolution of the tension between representation and abstraction, which allowed him to discern the real-world references that had originally provided the inspiration for the paintings. And for de Staël, nature was not only a point of departure but also a milieu: "I want my painting . . . to be like a tree, like a forest. One moves from a line, from a delicate stroke, to a point, to a patch . . . just as one moves from a twig to a trunk of a tree. But everything must hold together, everything must be in place."[9]

Even though the two men never met, they shared a mutual appreciation. In return for Phillips's insightful understanding and admiration of his work, de Staël respected Phillips's highly personal approach to his collection, writing that Duncan Phillips "could never stop buying pictures whatever their price might be because he has real passion. . . . He will always buy the things which are most difficult to sell because he has true taste."[10]

LBW AND CH-H

341

Nocturne, 1950

Painting 1950
Oil on canvas, 39 × 58 (99.6 × 147.3)
Signed in white paint, l.l.: *Staël*
Acc. no. 1808 (Chastel no. 201; de Staël no. 232)

TPC purchase from the artist through Theodore Schempp & Co., New York, 1952.[11]

342

Le Parc de Sceaux, 1952

Oil on canvas, 63¾ × 44⅞ (161.9 × 113.9)
Signed in black paint, l.l.: *Staël*; canvas reverse, u.l.: *Parc/de/Sceaux*; u.r.: *Staël 1952*
Acc. no. 1810 (Chastel no. 475; de Staël no. 508)

Theodore Schempp & Co., New York; M. Knoedler & Co., Inc., New York; TPG purchase from the artist through Knoedler 1953.[12]

In 1950 de Staël, who fervently maintained that "we are continually influenced and penetrated by nature," was deeply affected by the soft light of London (which he visited in July), as well as the wide-open sky above the English countryside.[13] This visual shock, coupled with his visit to The Netherlands the previous year, further provoked his desire for a closer relationship between nature and the rhythms of color and form, a dialogue that is embraced in such works as *Nocturne* and *Le Parc de Sceaux*. "By starting with his own experience, and through the very act of creating the painting," wrote the critic

Roger van Gindertaël, "de Staël strives to abolish the distinction between the natural phenomena which inspired its creation and the finished work itself."[14]

In *Nocturne* de Staël's forms, rendered in large planes of colors in subtle harmonies and contrasts, invoke a mood of quietude. As Eliza Rathbone has observed, de Staël often pursued "form as an evocation of mood or landscape."[15] Or as de Staël related to his friend, the poet Pierre Lecuire: "You never paint what you see or think you see; you paint with a thousand vibrations the blow that struck you."[16]

The composition, though highly abstracted, does resonate as a suggestion of the last vestiges of a sunset: a dark-green hovering sphere couples with a horizontal layering of bright oranges emerging from a deep blue-black, purple gloom. The gouache study for the Phillips work, also entitled *Nocturne*, reflects only variations in hues, the sunlike form depicted instead in golden yellow.[17] The marks of de Staël's palette knife, which he began to use almost exclusively in 1949, are evident here. Thick, broad scrapings made by the edge of the knife create heavy encrustations of impasto; they are especially apparent in the three tiers of orange that provide the focus of the picture.

In contrast, *Le Parc de Sceaux* of two years later is a study of subtle variations of gray, a palette that characterizes much of de Staël's work between 1951 and 1952. Although he painted many landscapes at this time, this work differs from most in that de Staël usually favored a horizontal format to better emphasize the wide sky, the result of his attraction just two years earlier to the English landscape artists Bonington, Turner, and Constable.[18] But *Le Parc de Sceaux* has a strong, vertical design, a format that is repeated even more dramatically in two other canvases of 1952.[19]

In mid-1952 de Staël had begun to paint directly from nature, and he would leave his home each day with his artist's materials. For this composition he painted the public gardens of Parc de Sceaux, just south of Paris.[20] By gradually building up the oil—layer upon layer of large, interlocking rectangular and vertical planes of resonating grays that are offset by the sky-blue vertical plane to the right and areas of white in the center—de Staël evoked trees towering over a clearing. Patches of white suggest a small sunlit area, and a vertical shaft of blue resonates as the sky overhead. In the lower half, which alludes to the ground, a cool-red underlayer is glimpsed around edges of large gray blocks denoting the bases of the trees.[21] *Le Parc de Sceaux* recalls Lecuire's poetic description of de Staël's palette: "His greys. There would be no light in this painting, no atmosphere, no transparency, the eye would be burned in cement, no

341

air would circulate, there would be no possible happiness without these famous greys. These greys are unique in all contemporary painting. Unique in subtlety, in variety, unique in substance, in depth, unique for the multiplicity of combinations into which the painter combines them."[22]

LBW

343

Fugue, 1952

Painting, 1952

Oil on canvas, 31¼ × 39½ in. (80.6 × 100.3 cm.)

Signed in dark yellow paint, l.l.: *Staël*

Acc. no. 1809 (Chastel no. 277; de Staël no. 323)

TPG purchase from the artist through Theodore Schempp & Co., New York, 1952.[23]

Deeply aware of his growing reputation as an inheritor of the French tradition, de Staël steered carefully between the two poles of abstraction and figuration. He did not see a contradiction between the two aims; rather, he believed that in his *facture* and *matière* he had forged a new direction for young French artists and that in the process he had carved out for himself a path linking him to Braque and Matisse and through them to Cézanne and Courbet. In a letter to Lecuire, de Staël discussed his artistic purpose: "Not abstraction. Not realism. Not social art. . . . Not Dubuffesque. All of that is too Parisian for you. For me too."[24] And to his friend and writer Denys Sutton he wrote (after visiting Douglas Cooper's chateau in Castille), "These Braques are great painting just

as Uccello made great painting[,] and they acquire a mystery, a simplicity, an unprecedented strength from their kinship with painting from Corot to Cézanne."[25] Paintings like *Fugue*, composed of many luminous green-gray blocks, serve as his response to the sectarian battles between the abstract and figurative artists; it represents de Staël's most abstract and famous style, which is characterized by numerous squares applied in thick layers and in blocks reminiscent of masonry.[26]

In *Fugue* de Staël directly addressed the issue of pictorial space, which he perceived to be a key component of his work and the result of Braque's influence. The older, greatly revered French master befriended de Staël, and their friendship intensified in 1947 once de Staël had moved to a studio on rue Gauguet, near Braque's studio. At this time de Staël was painting in an abstract mode that he had first adopted in 1942 because he had been "constrained by the infinite number of other coexisting objects" and "sought to arrive at a free expression."[27] But de Staël found in Braque's example confirmation of the validity of traditional subjects, such as landscape, still life, and the figure. He also drew inspiration from Braque's rich painterly surfaces, subtle colors, and, most important, handling of abstract pictorial space. The importance of Braque to de Staël, both as a mentor within the continuity of the French tradition and as an influence on his tactile approach to space in his compositions, is clear from de Staël's comments to Theodore Schempp in 1950: "Braque came yesterday. He is very pleased with what I'm doing—it was a

342

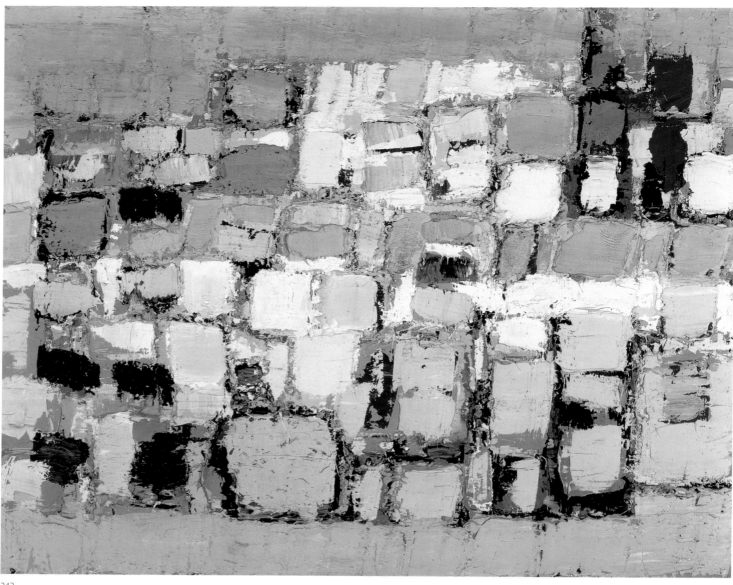

343

long, excellent visit. . . . I think one can say that my way of suggesting pictorial space is completely new; I spoke with Braque for a long time about . . . the paintings."[28]

In his early style de Staël created dense, constricted space in the tangled bars of his tightly woven compositions; gradually, he simplified his forms, making them larger and placing them in more static arrangements, until the abstract forms, built up thickly with a palette knife, take on their own character. By the early fifties when he created *Fugue*, the discrete, squarish areas of heavily layered paints had become smaller and more numerous, reminiscent of mosaics. Each tessera exudes individual characteristics while also functioning as an essential part of the overall pictorial harmony. Indeed, in the spring of 1951,

about the time he began creating works in a style similar to *Fugue*, de Staël saw in Paris an exhibition of Byzantine mosaics from Ravenna. He loved them so much that he made a special trip to see the images of Justinian while on a visit to Italy in February 1953. "Imagine," de Staël wrote to Denys Sutton, "that Françoise and I took a walk as far as Ravenna before leaving, in order to keep in our mind the pure romanesque of the mausoleum of the Galla Placidia, to eat fish and drink one of the best wines in the world."[29]

De Staël laid out his composition in *Fugue* in small squares, then repeatedly applied paint in varying colors, waiting for each layer to dry before the next application.[30] To increase surface texture, he used both a palette knife and large brush, at times using the point to dig and scrape

the surface; bits of dried paint mixed in with the wet gave the surface a granular texture. Visible in the upper register is a horizontal strip of canary yellow that emerges from around the edges of the green-gray blocks, lending vibrancy and immediate focus to the composition. Other, more subtle hues—soft orange, forest and yellowish green, and shades of muted blue—glance out from behind the blocks.

Duncan Phillips believed *Fugue* was "a great 20th century masterpiece," and he considered it evidence that de Staël "was a poet-painter and a protégé of Braque."[31] He likened it to music and considered its "structure of rhythmical repetitions with underlying counter rhythms" to be aptly expressive of a fugue pattern.[32] Of *Fugue* Phillips wrote:

This is a masterpiece of pondered construction and original craftsmanship of balanced shapes and elusive modulations within a restricted tonal scale. The brush strokes are heavily troweled irregular rectangles, large and small. They seem to build a desert city of sun-baked walls, row upon row, in an iridescent sky-blue Morocco, a memory of Staël's years in the Foreign Legion. This is like lyric poetry and like ancient music and like architecture when the planes are many-faceted in a serenity of space. The greatness of composition and conception in a painting like the *Fugue* grew in the very act of spreading the thick pigment and balancing the scale of the strokes.[33]

LBW

344

Musicians, 1953

Musiciens
Oil on canvas, 63⅞ × 45 (162.0 × 114.0)
Signed in sienna paint, l.r.: *Staël*
Acc. no. 1806 (Chastel no. 571; de Staël no. 580)

Purchased from the artist by Paul Rosenberg & Co., New York, 1953; TPG purchase 1953.[34]

Derived from a concert by the jazz musician Sidney Bechet at a club in Montparnasse, *Musicians* is among de Staël's most specific works in terms of inspiration, which even extended to the title of the first version: *The Musicians, in Memory of Sidney Bechet*, 1953.[35] De Staël's dealer, Paul Rosenberg, was so enamored of this painting that he convinced the artist to paint the work now in the Phillips.[36] Although the layout of the composition is nearly identical in both paintings, the colors vary in intensity. In the Phillips painting de Staël added as the final layer many subtle shades of gray on top of the same brilliant orange-red, blue, and navy hues that he used in the first version. This is evident, for example, in the wind instrument held by the musician on the left, as well as the bodies and faces of the musicians in the center. Moreover, the intense areas of red and yellow located behind the figures in the first version have been changed to tones of orange and yellow. The whole effect is more muted, softer.

This was not the only occasion that de Staël was inspired by music. He frequented concerts and listened to music while painting. After a memorable concert he said: "Horowitz last night . . . what an incredible phenomenon: at one point I thought the piano would hit the ceiling."[37] And just two days before his death he traveled to Paris to hear concerts of compositions by Anton Webern and Arnold Schönberg, after which he began working on two large canvases, *Le Piano*, 1955, and *Le Concert*, 1955 (the latter left unfinished). In both compositions the figures are absent, only the musical instruments remain.[38]

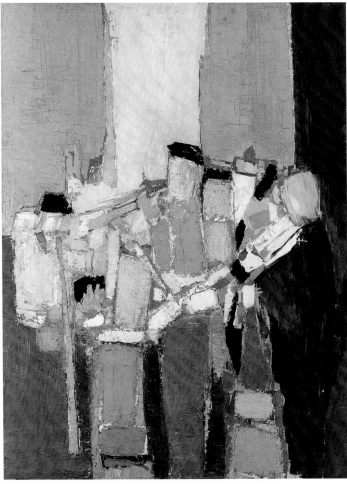

344

It was in mid-1952 that de Staël began to shift toward a more intensely chromatic palette and to choose subjects more closely affixed to their sources in the visible world. His new palette and specificity of subjects stemmed from his visit in March to a soccer match at the Parc de Princes. "Between sky and earth, on grass that is either red or blue," he wrote to the poet René Char, "there whirls a ton of muscle in complete disregard for self with, against all sensibilities, a great sense of presence. What joy! René, what joy!"[39] The Mediterranean light was another source for de Staël's chromatic interests. In the summer of 1952 he returned to the south of France for the first time since his youth. "The light here is simply dazzling," he wrote to Jacques Dubourg, adding in another letter, "I consume the color in quantity." Also that month, he wrote, "By dint of burning one's retina on the 'shattering blue,' as Char puts it, one ends up seeing the sea red and the sand violet."[40] Phillips appreciated this aspect of *Musicians*, stating that it seemed to be "like a brilliant street scene with the shadowed blue band playing their instruments under a sunlit canopy of orange and yellow."[41]

The Phillips *Musicians* retains the thick encrusted style characteristic of de Staël's previous work, such as *Fugue* and *Le Parc de Sceaux*. As Eliza Rathbone notes: "The roughness and intense physicality of the painted surface attest to a tangible sense of the artist's involvement with as much immediacy as the gesture that characterized the work of so many of de Staël's contemporaries."[42] But in terms of its color, *Musicians* heralds his fluidly painted, chromatically intense late work.

LBW

PIERRE SOULAGES (B. 1919)

One of the leading painters of French lyric abstraction, Pierre Soulages combined nuanced brushwork, subdued color, and dramatic gesture to generate some of the most striking and meditative images in the art of postwar Paris. Soulages was born December 24, 1919, in Rodez in the Auvergne. The Romanesque architecture and prehistoric stone monuments of the region had a great impact on his vision. His first exposure to modernism came in 1938, on a trip to Paris, when he attended exhibitions of the work of Cézanne and Picasso. After studying at the Ecole des Beaux-Arts in Montpellier in 1941 and working as a vineyard laborer in the same region, Soulages settled in Courbevoie, outside Paris, in 1946. He garnered a reputation, mostly among fellow artists, for his stark black-and-white paintings, which were shown at the Salon des Surindépendants in Paris. A pivotal point in his career came in 1948, when his work was shown in a German traveling exhibition and when the prominent art historian James Johnson Sweeney, a former director of painting and sculpture at the Museum of Modern Art, visited his studio. The next year his first solo exhibition in Paris was launched at the Galerie Lydia Conti, and he contributed to the Salon du Mai (as he would until 1957). International recognition followed, with acquisitions by public collections in France and abroad, one-person and group exhibitions, set-design commissions, and experimentation in new media. Honors and prizes have included the Carnegie International Prize in Pittsburgh in 1964 and the Grand Prix des Arts in Paris in 1975. Soulages's work has been the subject of numerous retrospectives throughout the world and has continued to develop, becoming more tonal, subtly textured, and varied in color. The Phillips Collection owns one oil of the 1950s.

345

July 10, 1950, 1950

le 10 Juillet 1950

Oil on canvas, 51¼ × 63⅝ (130.2 × 161.5)

Signed and dated in black paint, l.l.: *soulages 10.7.50;* and in black paint on canvas reverse, u.l.: *10 Juillet 1950/130 × 162 cm/SOULAGES/11 bis rue schoelcher/Paris 14*

Acc. no. 1774 (Encrevé, 1, no. 51)

The artist to Louis Carré and Co., Paris and New York, 1951; TPG purchase 1951.[1]

With its expansive size and somber interplay of vertical and horizontal bands, *July 10, 1950* exudes a monumental force. Exemplifying Soulages's most celebrated period, the "architectural" phase, the painting suggests beams, scaffolding, or industrial construction in a "modern treatment of chiaroscuro." Soulages himself observed of this dramatic luminosity, "If you define chiaroscuro as giving life to dark shades, then I can say yes, that does sometimes happen in some of my canvases."[2]

Dense and complex, *July 10, 1950* betrays no concentrated emotional resonance; each area of overlaying black bands, carefully positioned to create an integrated structure, seems dependent on the whole for its stability and balance. This concentration on placement is enhanced by the bands, composed in ponderous, slow strokes suggesting solidity. Soulages the "classicist" was not concerned with flamboyant gestural movement in *July 10, 1950*. Instead, he sought a serene timelessness in this painting, a quality that is often described as being at the heart of his work, his stated aim being the trapping of time.[3] Nonetheless, the image also emits a forceful dynamism: strong color contrasts suggest dense shadow and raking light; the clustered bands seem to hover in some areas and to vibrate against the light in others, "held together by tension."[4] A sense of rhythmic, sensuous play balances a note of urgency and seriousness, inveighing against the classic quietude.[5] Soulages's titles, here a record of the day the painting was finished, accent his pragmatic attitude toward each work—"at once a finished painting and . . . a stage, a moment of something more vast, which is the succession of my canvases which I cannot foresee."[6]

In an independent, craftsman's approach, Soulages often makes his own brushes and tools. In the resulting "dialogue" with his materials, he willfully restricts the role of chance to the forms and planes created by these implements.[7] The writer Roger Vailland, who observed Soulages at work, has described the artist's methods, stating that he usually executes a painting in one session.[8] Using a prepared surface—in the case of *July 10, 1950,* cream-colored—he sets down his lines in one long movement, varying the pressure and thickness of the paint, a technique evident in the scaffolding of the present work. He covers the dark bands of background color—here gray and brown—with black and then redistributes the paint in shorter "caressing" movements, using a hard-edged instrument. Matte blacks thinned with varnish contrast with glossy areas of the same color, emphasizing his desire for a richly textured surface. This fixation on surface is also enhanced by incisions made in the paint with the brush end; such labored scrapings are particularly visible in *July 10, 1950* in the central area of brown bands.

Soulages's ponderous forms and rational detachment distance him from the colorful, expressive tachists, a faction of the postwar French avant-garde whose abstract paintings are characterized by their use of decorative stains and splotches; furthermore, his formalism is diametrically opposed to the fantastic illusionism of the late surrealists. However, certain aspects of Soulages's work do reflect the artistic preoccupations of postwar Paris: his austerity of color and form, his clear rejection of academicism, and his reliance on the grid structure that had been passed down from Mondrian and the cubists. The political and aesthetic vacuum left by the war had prompted a need for alternative forms, which Soulages and others sought either in the imagery of prehistoric and primitive art or in the reflections of their own psyches.[9] His stark, totemic monochromes have been linked with the prehistoric monoliths of his region, the Auvergne; they share an anonymous style and sacred, enigmatic overtones.

Soulages is sometimes coupled with Mathieu as the first gestural painter in France; both artists stressed the action of painting (gesture) and relied not only on accident (chance) but also on control. However, Soulages desired to separate himself from gestural or expressionist painters: "I realized my painting was growing less convincing as soon as it became a sign referring . . . to a past experience of the artist of which the picture was . . . a reflection."[10]

Soulages's childhood in the Auvergne had a profound effect on his aesthetic sensibilities: his precocious eye constantly sought abstractions in his surroundings. As an adolescent, he explored the branches of trees and the spaces separating them and created drawings that demonstrated not only his fascination with spatial relationships but also his early appreciation of drawings by Rembrandt and Claude. At age fourteen Soulages decided he wanted to become a painter

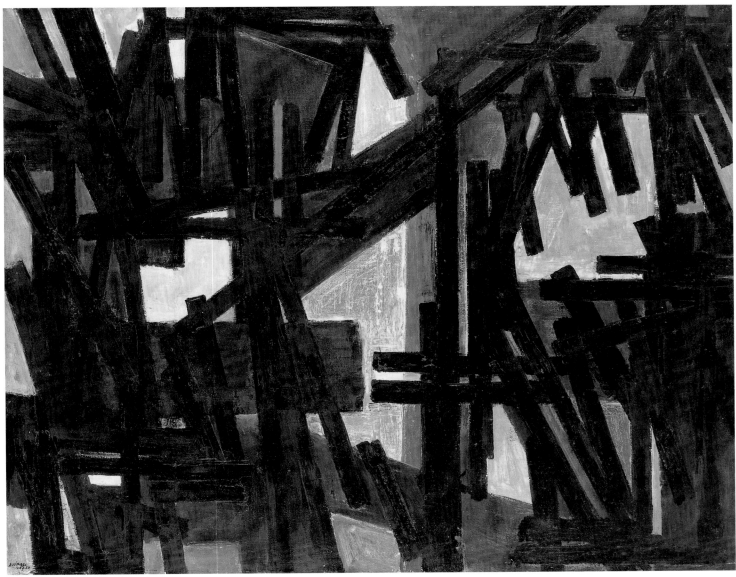

345

after a visit to Sainte Foy at Conques, a Romanesque church near his home.[11] James Johnson Sweeney's description of this church as having "sombre harmony," "eloquent intervals of clean-lined columns," and "varying tones of warm darkness cut by the narrow beams of light" seems to describe the constructs of Soulages's art as well as the church architecture.[12] In fact, Soulages even referred to Romanesque art as "at the origin of my work."[13] In his love of black, his exploration of light and space, and his sensitivity to the confines of the picture plane, Soulages seems to have followed the early Matisse, while his bold black lines may have been inspired by Picasso's work of the 1930s and 1940s.[14] Sam Hunter's description in a 1954 review could well apply to *July 10, 1950:* "Strange, smoky reflections that suggest the hallucinating light of Rembrandt or the Seicento *tenebrosi*."[15]

The American art world enthusiastically lauded Soulages in the late 1940s when Sweeney introduced the artist to the New York art audience. It was when the Louis Carré Gallery's groundbreaking exhibition "Advancing French Art," a 1951 group show that included Soulages's *July 10, 1950,* made it to the Phillips that the gallery became the first American museum to purchase Soulages's work.[16] Soulages himself visited the Phillips in 1957 and met Mrs. Phillips.[17]

July 10, 1950 hung frequently, first with other works of lyric abstraction and later in eclectic groupings of works by American and European abstract painters, such as Pollock, Rothko, de Staël, and Tack.

LF

JOHN WALKER (B. 1939)

The British painter John Walker is known for his efforts to come to terms with the figurative tradition without sacrificing his abstract vernacular. Born November 12, 1939, in Birmingham, England, Walker studied at the Birmingham College of Art from 1956 to 1960. It was at a Tate Gallery exhibition of abstract expressionists in 1959 that he was profoundly struck by Pollock's *Number 12* (now destroyed). Awarded a prize and traveling scholarship, he studied from 1961 to 1963 at the Académie de la Grande Chaumière, Paris. He then moved to London, where from 1964 to 1969 he painted while teaching at various schools. His first one-person exhibition was held at the Axiom Gallery, London, in 1967. From 1969 to 1970 he resided in New York on a Harkness Fellowship; his American debut was in New York in 1971. He was awarded numerous professorships and visiting-artist honors in England and the United States by, for example, Cooper Union, New York; Yale University, New Haven; St. Catherine's College, Oxford; and Columbia University. After several museum exhibitions, including one at The Phillips Collection in 1978, Walker moved to Australia as an artist-in-residence at Monash University in Melbourne; during this period he worked on his *Alba, Oceania,* and *Labyrinth* groups. In 1980, after a sojourn in his studio in upstate New York, he returned to Australia as an artist-in-residence at Prahan Technical College in Melbourne. In 1982, the same year the Phillips held another show of his recent work, he was appointed dean of Victoria College of Arts, Melbourne, a post he held until 1986. In 1989 he returned to Yale University as a visiting professor. He currently lives and works in Kingston, New York. The collection has six works: three acrylic and collage abstractions from the mid-seventies, two oils dating to the early eighties, and one oil on paper, a recent acquisition.

346

Roundout Alba III, 1980

Oil on canvas, 120 × 96 (304.8 × 243.8)

Signed, dated, and titled on reverse: *Walker 1980 / Roundout Alba III / oil on canvas*

Gift of the artist in memory of James McLaughlin, 1982

Acc. no. 2019

Gift of the artist through Betty Cuningham Gallery, New York, to TPC 1982.[1]

Roundout Alba III, created in 1980, is one of Walker's *Alba* paintings, which he developed from about 1979 to 1981. Characteristic of this series is the use of a single polygonal form cinched in at the "waist" and usually placed within a shallow space. The Alba shape "stands like a luminous sentinel in the richly textured gloom of the surrounding space" weighed down by "the heavy ochres, browns, greys, and crusty bituminous blacks."[2] In the Phillips work, it is painted in variations of yellow and gray and stands within a black area marked by red streaks and red underpainting that glows with fiery eruptions.

The name derives from Goya's painting of the *Duchess of Alba* of 1795. "My hero was Goya, when I was a student," recalled Walker, "and he still is."[3] Walker began to use an irregular polygonal shape without a center notch in the early sixties in a series called *Studies for Anguish,* 1964–66, which was intended as a commentary on war.[4] He has continued to explore various permutations of this shape throughout his career, adding the notch and the name in the *Alba* series. From the beginning he craved shapes that would have dignity, presence, and feelings.[5] The *Alba* paintings encompass, as Jack Flam observed, the "paradox of a form being both abstract and so very specifically tangible."[6]

In the mid-to-late seventies, when he was creating his *Numinous* series, Walker began to make direct reference to earlier masterpieces, especially those by Goya, Manet, Matisse, and Velázquez. Dore Ashton notes: "By what process, Walker seems to be asking, can a modern painter reintegrate all the traditional ways of making a canvas into an image?"[7] He saw himself as heir to great masters and as such considered his artistic mission to be the reinterpretation of the grand figural tradition, but by using the tools of abstraction. "Matisse and Picasso for example took figurative painting almost to abstraction and then they stopped," Walker stated. "I'd like to come the other way and stop, just this side of abstraction."[8]

Many aspects of *Roundout Alba III* recall traditional art, from Rembrandt to Manet. There is a baroque, theatrical ambience to the composition: strong contrasts in hue and tone, a lively painterly surface, atmospheric ambiguity, a spatial tour de force, and dramatic focus on the Alba shape itself.[9] He used materials that are suggestive of traditional approaches: he not only painted the Phillips work with rich oil but also covered the surface with a clear gel applied as if it were a translucent glaze. The effect, most evident in the center of the Alba form, is that light seems to be both reflected and absorbed, causing great surface play and vitality, which recalls any number of Old Master works.

In *Roundout Alba III* Walker has called into play the artifice of picture making—the tension between what is real and what is illusion. He placed his form within a shallow area that suggests the proscenium of a stage. The streaks of red defining this area contrast strikingly with the thick, black background, which is so allusive of shadowy space. Walker chose to leave the left side of the canvas virtually unpainted, except for a few large brushstrokes of dark paint. This area functions as a repoussoir to draw the viewer into the composition. It also serves another purpose: while we are caught up in the drama of believing the Alba shape is firmly placed in the center of a stagelike setting, Walker reminds us with the nearly bare expanse of canvas on the left that we are looking at nothing more than an artist's tools—canvas and paint. All illusion disappears. Walker believes that "air and space [are] always essential to painting," and he adds that in his work "there's always been that dilemma, that conversation between flatness and depth, the wall and the window, if you like."[10]

Drawings are a crucial part of Walker's process. As he notes, "With the drawing I'm trying to refine all the time, to refine the shapes to make them more expressive, more real, more relevant; to allow them to blossom, to have feeling."[11] Both artistic and iconographic ideas flow between his drawings and his paintings. After his famous *Blackboard* drawings, 1972–73, in which he focused on the act of drawing, Walker moved on to his closely related *Juggernaut, New York,* and *Ostracas* series, represented in the collection by three late examples.[12] These large-scale works are composed of painted canvas cut into shapes and collaged together. "I poured on chalk and dry pigment; I built up something that looked built, constructed, layered."[13] These collaged paintings and their concurrent drawings allowed Walker to focus on shape, to construct it, and to give it weight—leading eventually to the *Alba* paintings.

The Alba shape links Walker to the long-standing British romantic and figural tradition. Recently he has been associated with a group of London painters who were influenced by Francis Bacon's commitment to the figure. Many, like Walker, sought Bacon's gestural, almost violent use of paint, and their compositions, like his, encompass great drama.[14] Walker shares with the artists of this school the urge to develop a unique pictorial language, and in his case, shapes have provided the "words."[15]

LBW

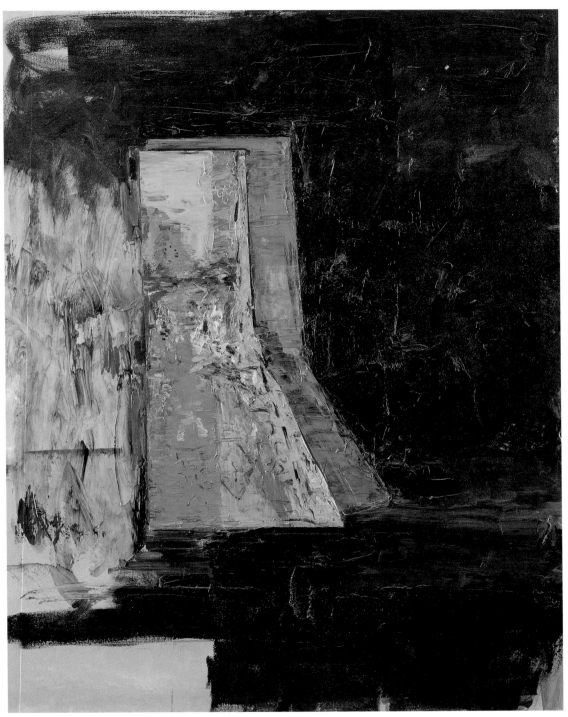

346

ELIZA E. RATHBONE

It is striking that Duncan Phillips, who in his early years reviled works in the Armory Show by giants of modernism and abstraction, was prepared in his late years to respond to a great deal that was new and abstract. He not only responded to the new painting that was emerging in and around New York in the 1940s and 1950s but also discerned and selected for his museum works of quality and distinction. The paintings and sculpture considered in this chapter were acquired between 1942 and 1974, and although the majority of them are by artists of the New York School, including those commonly referred to as abstract expressionists, the works discussed here encompass examples by artists as diverse as Morris Graves and Frank Stella. A number of these works were added to the collection by Marjorie Phillips after Duncan's death in 1966.

In general the works that Phillips chose for his museum speak to many of the aesthetic issues that had engaged him over the previous two decades. In a number of instances, Phillips acquired work produced by young artists early in their careers. (Graves was thirty-two years old and showing his work for the first time in New York, and Stamos was about twenty-seven when Phillips first acquired his work.) Phillips repeatedly demonstrated his ability to respond early and decisively to his encounter with new work at a time when the reputations of these artists had only just begun to burgeon. Nonetheless, with these new acquisitions of recent painting Phillips carried out the vision he had articulated early on: "I would create a Collection of pictures—laying every block in its place with a vision of the whole exactly as the artist builds his monument or his decoration."[1]

A champion of American art from the beginning, Phillips could only have felt thrilled—even vindicated—by the ascendance of American art after the Second World War to a status of international recognition and acclaim. As early as 1927 Phillips had expressed his passionate belief in the art produced in his native land, and his fond hopes for it, in the following terms: "I wish I could believe that it [the supremacy of American painting] is true and that the lead in painting has passed from France to the United States. Unfortunately, I cannot persuade myself that this change has come as yet."[2] He saw the work of American artists supported in an unprecedented way at home during the 1940s and by the 1950s more and more frequently

Willem de Kooning,
detail of *Asheville*, see cat. 359

presented in New York and abroad on an equal footing with the work of outstanding European counterparts. Echoing Phillips's own initiative at the Phillips Memorial Gallery in showing Europeans and Americans side by side, John Graham as early as 1942 (at McMillen, Inc., in New York) presented works by Jackson Pollock and Willem de Kooning next to examples by Picasso, Braque, and Matisse. It is possible that Graham, whom Phillips had known since the late 1920s, signaled to him the importance of some of these young Americans.

Many factors combined in the 1930s and 1940s to support American art during a period of potential adversity. The Federal Art Project of the New Deal's Works Progress Administration kept countless artists gainfully employed during the Great Depression. Many of the artists who later comprised the New York School were employed in the thirties by the WPA: de Kooning, Rothko, MacIver, Guston, Gottlieb. In spite of the highly variable quality of the work produced under the auspices of the WPA, and a general emphasis on and preference for representational work, the support was critical to sustaining and encouraging a community of artists, including some who had recently immigrated to the United States.

Phillips responded to the diverse heritage of the artists of this New York School. Whereas Tobey, Graves, and MacIver had American roots as substantial as Arthur Dove's or Marsden Hartley's, Stamos was a first-generation Greek, de Kooning was born in Rotterdam, Rothko in Dvinsk, and Okada in Yokohama. The new internationalism spawned by the political turmoil of the twentieth century and enriched by the flood of European émigrés into New York just before the Second World War brought an extraordinary wealth of knowledge and experience to the city that was destined to become the capital of the art world.

The national and geographic diversity of the artists whose reputations were established in New York City in the forties and fifties was matched by a range of styles unusually broad for any school or movement. All these artists reacted against the leaning toward representation and the narrowly defined local subject matter of 1930s regionalism. Their shared search for individual expression in a context that acknowledged international artistic developments, including abstraction and surrealism, and that was informed not only by Freudian but also by Jungian psychology, resulted in a profound belief in the necessity to express deeper universal truths in their art. These sources for the style called abstract expressionism that predominated in the late 1940s and 1950s produced an attitude and in many respects an art that could be considered fundamentally romantic. In this regard, its appeal for Duncan Phillips was perhaps inevitable.

In a surprisingly compelling way, the works that Phillips acquired during the last ten to fifteen years of his life present an extension of his ideal—both for his museum and for American art. The choices that Phillips made in postwar American art, not only of

artists to include in his collection but also of specific works to represent them, appear to be the culmination of his vision of continuity underlying modern art. In spite of the famous words referring to the abstract expressionists' rupture with tradition—"it was Pollock who broke the ice"—much of the collection that Phillips had already assembled offered a context of sources for the new American painting of the 1950s. Although Phillips basically eschewed surrealism in almost all its manifestations, and many of this movement's ideas had a profound impact on American art in the thirties and forties, the sources of abstract expressionism (and they were myriad) that appealed to Phillips most are represented here. Indeed, it may be that Phillips perceived roots farther back in Western art than did many of his contemporaries who were trying to take a stand on abstract expressionism and evaluate the new art.

The artist's search for a connection with the cosmos, for his or her place in nature and place in relation to life and death, being and nothingness, presence and absence, existed within a matrix of inquiry into the soul of man that took hold during, and in the aftermath of, the Second World War. While for certain artists, such as Morris Graves, the Orient and Zen offered a philosophical vantage point for dealing with reality, others, like Mark Tobey, formed a worldview partially informed by Zen but also based on the Baha'i World Faith which he espoused early in his career. After the Second World War many of the abstract expressionists, especially Gottlieb, Rothko, Pollock, Stamos, and Still, in search of valid subject matter found that the ancient world of myth and ritual offered insight into man's eternal quest for the meaning of existence. Rothko and Gottlieb had expressed their conviction that subject matter should be "tragic and timeless," and Gottlieb defended the new painting: "The role of the artist, of course, has always been that of image-maker. Different times require different images. Today when our aspirations have been reduced to a desperate attempt to escape from evil, and times are out of joint, our obsessive, subterranean and pictographic images are the expression of the neurosis which is our reality. To my mind certain so-called abstraction is not abstraction at all. On the contrary, it is the realism of our time."[3]

When the Museum of Modern Art launched its series of exhibitions of contemporary American art gathered from around the country in an effort to counterbalance its perceived emphasis on European moderns, one of the first of these exhibitions, "Americans 1942: 18 Artists from 9 States," included the work of Morris Graves. Graves, a mystic and a strongly individualistic artist from the Pacific Northwest, could not have catapulted to the meteoric success of his first New York exposure were it not for Dorothy Miller and this 1942 exhibition. After Alfred Barr purchased ten works from the show for the Museum of Modern Art (before the exhibition opened), Phillips made his own more gradual commitment, acquiring a total of eleven works over a period of twelve years. In 1942 his acquisition of *Surf and Bird, Chalice,* and *Eagle* (cat. nos. 362 and 365 and acc. no.

0841) gave him a core group of works that represent the fundamentals of Graves's art: nature and a personal mysticism based on Zen, expressed in muted tones of gouache on paper.

Graves's use of the bird as a metaphor for human emotion and locus of pictorial content might have struck an immediate cord with Phillips, who in 1928 had purchased the poignant and unique work by Albert Pinkham Ryder, *Dead Bird* (cat. no. 71), which elevates a lone bird to universal expression. Phillips had acquired two more Graveses and a religious work by Tobey, who was often (to his dismay) grouped with Graves as a Northwest artist at this time, before Phillips made his first purchase of work by one of the youngest of the abstract expressionists, Theodoros Stamos.

In 1949 Phillips made a considerable commitment to Stamos by immediately purchasing three paintings by the artist from Betty Parsons. Phillips's interest in Stamos's work grew into a sustained response matched only by his subsequent reaction to the work of Mark Rothko. Indeed Stamos's use of decipherable images in his work at this stage could have brought home to Phillips some of the central issues of the artist's relation to myth and nature in abstract expressionism at a time when most of the abstract expressionists were developing a more abstract style that fully emerged in the 1950s.

Of the three paintings in oil on hardboard that Phillips acquired, *Moon Chalice*, 1949 (cat. no. 376), offered a provocative alternative approach to the related work by Graves already in his collection. Whereas the Graves is distinguished by its execution in gouache, chalk, and sumi ink on rice paper, transforming the physicality of the object into an exaltation of mind over matter, pure thought over material existence, the work by Stamos evokes a physical presence, as if carved out of some ancient stone. Stamos's exploration of the relationship between nature and abstraction led in a different direction, one which he attributed to his admiration for older American modernists, including Ryder, Hartley, and Dove. So key was this relationship to Phillips that his first installation of Stamos's work was alongside paintings in the collection by Arthur Dove.[4] The following year (1950), when Phillips presented the first museum show of Stamos's work, the artist stayed with the Phillipses in Washington, thus cementing an already established basis of understanding and friendship.

On his visit to the Phillipses, Stamos made special mention to them of the work of his friend Mark Rothko, pointing out Rothko's kinship with the work of Bonnard. Although Phillips's engagement with Rothko's work was arguably his most significant encounter with the art of the New York School, it was some years before he first acquired a painting by the artist. Instead, in the early fifties he added to the collection a singular and outstanding work by de Kooning as well as an exceptional example by Gottlieb.

The circumstances of the purchase of the de Kooning are revealing. In this instance Phillips was not only fully prepared for but also inclined toward an abstract work over a figurative one. Moreover, de Kooning's roots in a European painterly tradition made his work more easily acceptable to many collectors than the work of other abstract expressionists. In preparation for an exhibition of abstract paintings, Phillips mentioned to Sidney Janis his desire to include a work by de Kooning, expressing specific interest in the "masterpiece" *Excavation,* while at the same time voicing some concern about the size of the work.[5] He acknowledged that, judging from the reproductions he had seen, he preferred "the pure abstractions in which no figures or parts of figures are to be found." Indeed, it is hard to imagine one of de Kooning's series of *Woman* paintings, on which he was working at this time, in The Phillips Collection. While *Excavation* (80 x 100 inches) was on reserve for a client of Janis's, Phillips, by exceptional good fortune, had the opportunity to borrow (and soon after buy) from Vincent Melzac *Asheville* (cat. no. 359), a work as close in spirit to *Excavation* as he could have wished for and much more easily accommodated by the galleries at Phillips's disposal at that time.

Before the Annex was built in 1960, the space typically allocated for exhibitions was a suite of rooms on the ground floor (the English basement level) of the house opening onto Q Street, rooms without very high ceilings. One of the rooms had a fireplace, further limiting the size of works that could be exhibited. The limitations of this space for showing the new American painting became increasingly apparent to Phillips, especially several years later when he wanted to exhibit a group of paintings by Rothko. In recognizing that issues of size could not be avoided in the new painting, where the easel was often cast aside in favor of the floor or the wall, the limited space available in his 1890s house could have propelled him toward his decision to construct an additional building for exhibiting his growing collection.

When purchasing *The Seer,* 1950 (cat. no. 356), by Adolph Gottlieb, Phillips did not allow size to stand in the way of selecting a large and culminating example of Gottlieb's pictographs, a series that occupied the artist throughout the 1940s. Phillips's response to the rich and subtle coloration of this work and its particular imagery might have reflected his recent and extensive engagement with the work of two artists: Klee and Avery. In the late thirties and early forties Phillips made many important additions to his collection of works by Paul Klee, building his Klee Unit into one of exceptional quality and, eventually, renown. He steadily added to it in 1939, 1940, 1941, and 1942; in 1948 he purchased from the Buchholz Gallery *Picture Album* and *Young Moe* (cat. nos. 163–64), both works that could have had significant resonance for Gottlieb.

The works of Klee, increasingly visible in New York with the arrival of such dealers as J. B. Neumann and Curt Valentin, were a major source of inspiration to American artists in the thirties and forties. Clement Greenberg wrote of the late thirties in New York, "Almost everybody, whether conscious of it or not, was learning

from Klee, who provided the best key to cubism, as a flexible, 'all-purpose' canon of style."[6] Phillips would also have recognized Klee's and Gottlieb's shared interest in a marriage of graphic and painterly methods and in a formal language indebted to myriad ancient cultures, a language evoking a timeless reality through the use of pictorial metaphor. In 1943 Phillips, who had purchased his first Avery in 1929, added five new works by the artist to his group. Avery was a friend to both Gottlieb and Rothko, and his combination of unique color harmonies and flat treatment of the picture plane had obvious relevance for Gottlieb. Moreover, just a year before *The Seer* entered his collection, Phillips purchased the only work he would ever acquire by Miró, an artist whose vision had far-reaching implications for the New York art scene of the forties and fifties.

The importance of Miró to the art of the New York School in the 1940s and 1950s can hardly be overstated. Although affiliated with the surrealists—whose movement had little appeal for Duncan Phillips—Miró evolved in the twenties a radical approach to the pictorial field that led to many later works, including his *Constellations* of 1941, that had particular relevance to artists of the New York School when they were first shown in the city in 1944.[7] Inventive and experimental, Miró's highly individual pictorial language reflected a sophisticated engagement in abstraction, and his influence on the young American painters in New York in the forties has been described as "omnipresent and pervasive."[8] One can imagine Phillips's delight in the Miró he acquired in which the red sun, the central image in landscapes by O'Keeffe and Dove already in the collection, has been wrenched from its landscape context to come into direct dialogue on the surface with a "personage" of Miró's imagination (cat. no. 123). An eye, a sun, a spiral, an arrow populate the compartments of Gottlieb's pictographs that culminate in *The Seer*.

In general Phillips favored the poetic and lyrical side of abstract expressionism over more forceful and aggressive works. He never purchased a work by Franz Kline and only later in the fifties acquired a Pollock. While not averse to depth of passion or baring of the soul, he reserved his greatest appreciation for the deeply felt but more meditative and transcendent works of Mark Rothko. Like Gottlieb, Rothko was a friend and admirer of Avery's in the thirties. He developed an early sensitivity to the resonant power of fields of color. When in the fall of 1956 Sidney Janis lent four paintings by Rothko to Phillips, he could not have foreseen the extraordinary room that would result ten years later and constitute perhaps Phillips's greatest contribution to postwar American art. In planning an exhibition for spring 1957 of Rothko, Tomlin, Gottlieb, and Okada, Phillips's first instinct was to give one of two rooms in the downstairs galleries (referred to as the Print Rooms) of the museum to Rothko's work, since, as he wrote to Janis, "I have been told that Mr. Rothko does not like to combine his work with any other painter."[9]

Rothko, in wishing for a room of his own for his art (and in the late fifties struggling over his commission for the Seagram build-ing), could hardly have come across a collector more receptive and sympathetic to the idea. It was Phillips after all who had once conceived of his museum as consisting primarily of a series of galleries each devoted to a single artist, and it was Phillips who commissioned Augustus Vincent Tack to create a series of works for the Music Room. Indeed, the spiritual nature of Tack's subject matter, even though expressed in terms that hover between abstraction and representation, and Phillips's exceptional belief in its validity not only as a work of art but also as an environment offer early evidence of Phillips's leaning toward a total experience provided by a single artist's voice. Although Phillips purchased a painting by Rothko in 1957 and mentioned to Sidney Janis his desire to acquire another in 1958, he did not add to his collection a second and third painting by the artist until 1960 in preparation for installing Gallery 3 in the New Wing. The three paintings were hung on the north, east, and south walls, and it was not until 1964 that Phillips acquired a fourth painting, *Ochre and Red on Red,* following a visit that the artist himself paid to the collection (cat. no. 354). Phillips subsequently wrote to Rothko, "I cannot tell you how much we enjoyed your visit and our talks."[10] According to the museum's hanging records, however, the room, which had remained almost unchanged from November 1960 to September 1965, was hung with the fourth painting for the first time in May 1966.

Phillips's exceptional response to Rothko's painted presences suggests the culmination of a vision that began with Giorgione, and we can only imagine that it was not simply the mystery of time and human existence binding the two disparate artists together that held him enthralled but also the sheer power of color as an expressive element. It is therefore less surprising to realize that Phillips preferred the transcendent and nongestural abstractions of Rothko over the overtly and insistently gestural works of Pollock or of Kline (best known at the time for his large black-and-white paintings). Nevertheless, a more lyrical and colorful vein of gesture in abstraction held considerable appeal for him, as evidenced by his acquisition of Tobey's *After the Imprint* in 1961 (cat. no. 347) and the more colorful paintings by Guston, Tomlin, Mitchell, and Francis.

Mitchell and Francis, both in France in the 1950s, responded with particular enthusiasm to the work of Bonnard, Matisse, and, especially in the case of Mitchell, Monet. Monet's large, late *Water Lilies* paintings commanded an unprecedented audience in the 1950s, when the family finally decided to sell a considerable number of paintings that the artist had left in his studio, and the Museum of Modern Art acquired a large painting in 1955.[11] Much bigger than the canvases that Monet was generally known for, these horizonless views of nature offered a reminder of the artist's gestures in color all over the canvas that capture light and life itself—an abstraction that was always inherent in the work of Monet. By the time Phillips acquired *August, rue Daguerre* by Joan Mitchell in 1958 (cat. no. 378), she had lived in France off and on for several years, and in the six-

ties she settled in veritable Monet country in Vétheuil. Her painting is deeply connected with landscape. Insomuch as William Seitz and Clement Greenberg were able to reassure and develop the audience for abstract expressionism by presenting the links with Monet's late work, so Phillips must have instinctively responded to the resonance in these artists' works that led them to be associated with impressionism.[12] In the case of Guston, Phillips selected a superb example from the artist's abstract work of the fifties. Guston, whose early representational work revealed an inclination toward a compression of space and emotion, expanded his sense of the possibilities in abstraction to create paintings that seem alive with light and movement. In *Native's Return* (cat. no. 368) the texture and color of the painted surface offer sheer pleasure in the medium.

Tomlin, a neighbor of Guston's in the late forties, when both artists were struggling with the direction their art would take in the ensuing decade, is represented in the collection by a work of 1940, *Still Life* (cat. no. 348), in addition to two abstractions from the fifties. This early work provides insight into the grounding in more traditional kinds of subjects that all the abstract expressionists had. When Guston was teaching in Saint Louis in the mid-1940s, it was observed that "his knowledge of Renaissance drawing, method, and structure was prodigious."[13] Indeed, one wishes that Phillips had acquired a work from the forties that might orient the viewer to Guston's middle and late periods, just as Tomlin's early painting provides a cornerstone for his great work, *No. 9* from 1952 (cat. no. 350), and insight into its composition.

Many of the abstract expressionists experienced a sense of ambiguity or one or more shifts between representational and abstract styles. Jackson Pollock, famous for his totally abstract drip paintings of 1950–51, spent most of his painting career dealing with issues of representation in his work. Richard Diebenkorn, a generation younger than Guston and Tomlin, began his career with abstractions greatly influenced by the New York School, especially Gorky and de Kooning, only to turn to a more representational mode in the 1950s when abstraction dominated the scene in New York. Still a young artist, Diebenkorn was brought to Phillips's attention by his nephew, Gifford Phillips, who had already acquired an abstract painting from 1953, *Berkeley No. I* (generously given to The Phillips Collection in 1977; cat. no. 372). Diebenkorn, whose sense of the important issues in modern painting was shaped at the collection, was of inevitable interest to the Phillipses. While his *Interior with View of the Ocean* and *Girl with Plant* (cat. nos. 373–74) are ostensibly representational works, they are deeply informed by the

artist's abstract work as well as by the abstract impulse so fundamental to the compositions of Matisse and Vuillard that he would have seen at The Phillips Collection. Diebenkorn's early exposure to Phillips's vision of modernism and his internalization of many of its principles give his work a unique place in the collection. His sense of debt to Duncan Phillips he eloquently expressed in an interview in 1982, when he said, "It was a refuge, it was a kind of sanctuary for me, and I just absorbed everything on those walls" and "Duncan Phillips's lifelong enthusiasm—indeed, his passion—went far beyond the appreciation, and study, and acquiring of paintings. An integral part of that passion was to share it—to infect others with it. This was his life—and that life was a great and profound gift to all of us."[14]

Phillips's own fascination with the tension between representation and abstraction embraced a wide range of works, executed in a variety of materials and techniques. His hesitant, and eventually restrained, response to the work of Jackson Pollock does not surprise us in a man whose interest in Picasso was highly selective and leaned toward the classic more than the orgiastic or convulsive aspect of his work, which had an even stronger influence on Pollock. Rather than avoiding Pollock's work altogether, however, Phillips selected an example as unusual as it is fitting for his collection. Always one to respond to a work for its own merit rather than looking for a "signature" piece, Phillips found in this collage by Pollock a work that in the beauty and delicacy of its calligraphy bridges the gap with Tobey and for its inventive abstraction in collage can hang with Schwitters, an artist Phillips only began to appreciate fully in the fifties. Perhaps most interesting of all, he found in Pollock's *Collage and Oil* (cat. no. 367) a work that in its palette, composition and patterning can remind us—most unexpectedly—of Vuillard.

It may be in part his decision about Pollock that allowed Phillips to choose, in the year before he died, two collages to represent the work of Robert Motherwell in the collection. For Motherwell, by contrast, collage was a central form of expression in his art for more than two decades, and Phillips came away with two examples that immediately evoke the artist's knowledge and sophistication in referencing European precedents. In spite of the fact that Picasso has often been considered the single most dominant influence on the New York School, the selection of works made by Duncan Phillips, which helps us to see kinships with many artists, both contemporary and earlier, challenges that assumption. Although not a large group, these works, to which Phillips brought an unfailing degree of commitment and selectivity, are precisely those "blocks" he put in place with "a vision of the whole."

MARK TOBEY (1890–1976)

Mark George Tobey, best known for his "white writing" style of the 1940s, was one of the most internationally respected American artists during the 1950s and 1960s. Born December 11, 1890, in Centerville, Wisconsin, Tobey was predominantly self-taught. In 1909 the family moved to Chicago, where he was employed in various jobs, including catalogue illustration at a fashion studio. In 1911 he moved to New York, finding work as an artist for *McCall's* magazine, but soon returned to Chicago, still employed as an illustrator. From 1913 to 1917 he divided his time between New York and Chicago, and he had his first one-person show of charcoal portraits in 1917 at the Knoedler Gallery. Around 1918 Tobey was introduced to the Baha'i World Faith, which changed the development of his art. In 1922 he moved to Seattle to teach art at the Cornish School. There, in 1923, he learned Chinese calligraphy from Teng Kuei, a Chinese art student at the University of Washington. For the next seven years Tobey divided his time between New York, Chicago, and Seattle, and traveled to Europe (1925–27). From 1930 to 1938 he taught at Dartington Hall in Devon, England, taking a break in 1934 to study oriental philosophy and art in China and to live in a Zen monastery in Japan. He returned to Seattle in 1938 and began working for the WPA. In 1939 Marion Willard, the New York art dealer, first saw and admired his work; in 1944 she held her first Tobey exhibition. In 1941 Tobey began lessons in piano and music theory, disciplines that greatly influenced his work. During the 1940s and 1950s his international reputation grew, and in 1954 he moved to Paris, where he stayed until 1955, the same year Jeanne Bucher held his first solo exhibition in Europe; in 1958 he became the second American, after Whistler, to win the International Grand Prize at the Venice Biennale. In 1960 Tobey moved to Basel, remaining there for the rest of his life except for summer trips to the United States. He was honored with a retrospective at the Musée des Arts Décoratifs in Paris in 1961. He died in Basel April 24, 1976. The Phillips Collection owns two paintings and four lithographs by Tobey.

347

After the Imprint, 1961

Gouache on illustration board, 39¼ × 27⅜ (99.6 × 69.5)
Signed and dated in orange gouache, l.r.: *Tobey/61*
Acc. no. 1955

TPC purchase from the artist through the Willard Gallery, New York, 1962.[1]

Like Morris Graves, Tobey occupied a place apart in the history of American abstract expressionism. His paintings revealed influences and techniques that differed significantly from those of his contemporaries Gottlieb, Pollock, Rothko, and others. In contrast to the self-involvement and angst of this group, Tobey depicted universal themes conveying hope for world unity. Painted in a delicate, linear style, his works were often inspired by contemplation of visible reality. While Tobey's separateness could be explained partially by his choice to live away from New York for most of his career, it could also be justified by his lifelong immersion in the Baha'i faith and oriental aesthetics.

Baha'i belief—that all humanity is interrelated, all religions are prophetic of a single world faith, and "ultimate reality is indivisible, and does not admit of multiplicity"—manifested itself in both the themes and the style of Tobey's art.[2] Just as his subjects were often spiritual and multifaceted, his technique revealed his focus on the unity of the image, rather than its separate parts. His mature white writing style, established in the mid-1940s and characterized by networks of white pigment painted against a dark ground, was Tobey's visual manifestation of the interrelationship of man and the universe. His white lines, a result of his experiments with Chinese calligraphy, connote vibrating movement and light; they energize and link the parts of his compositions. In his words, "White lines in movement symbolize light as a unifying idea which flows through the compartmented units of life bringing a dynamic to men's minds, ever expanding their energies toward a larger relativity."[3]

Marriage, 1945 (acc. no. 1959), was painted by Tobey at mid-career, when his work still contained motifs that were recognizable despite their abstract qualities and arrangement in flat space. In a technique related to his white writing style, he painted the forms in thin, sketchy strokes of light color upon a dark ground. *After the Imprint* was painted sixteen years later, when Tobey was an internationally acclaimed abstract artist. In this much larger work he further expanded upon his calligraphic style: energetic, enmeshed strokes of white, black, and earth tones form a dense network upon a background of muted ocher. Because of the all-over screen of interlocked brushstrokes, the painting seems to represent a minute section of the boundless cosmos, the lines visually conveying its unseen energies. The pattern is most concentrated in the lower-right quadrant, a reflection of Tobey's tendency to have a "focal nucleus" toward which the composition gravitates.[4] Nevertheless, he made "no claim to a fixed position" and elaborated, "I have sought a unified world in my paintings but have used a moveable vortex to achieve it."[5] Despite the apparent nonobjectivity and formal emphasis of *After the Imprint,* Tobey never created a painting that was not inspired by the sights and sounds of the exterior world.

Duncan Phillips's interest in Tobey was sparked as early as 1930, when he viewed his work in the Museum of Modern Art's "Painting and Sculpture by Living Americans." Nevertheless, the collector did not acquire a Tobey until 1945, most likely because the artist's work was less visible in New York from 1931 (Tobey began teaching in England then, and in 1938 he moved to Seattle) to 1944 (when Marion Willard first exhibited his paintings). Aware of Phillips's admiration of Tobey, Willard wrote to him upon the occasion of her first Tobey show, "I rarely feel as strongly about a painter."[6] Phillips purchased *Marriage* the following year, and although he was searching for another Tobey in 1955—explaining that "he is one of the best artists we have and so influential in the career of Graves"—he did not acquire *After the Imprint* until 1962, when he held a Tobey exhibition.[7] Apparently, Phillips viewed Tobey's works as essential counterparts to his larger group of Graves paintings. He detected their shared stylistic tendencies—frenetic calligraphic line and muted color—and empathized with their eternal search for a higher spiritual reality through their art.

ER AND GHL

347

A refined, subdued presence among the abstract expressionists, Bradley Walker Tomlin executed paintings that were emphatic and original in their sensitive color and compositional restraint. Born in Syracuse, New York, August 19, 1899, Tomlin became interested in art early, receiving a scholarship at age fourteen to study modeling in Hugo Gari Wagner's studio. He attended Syracuse University College of Fine Arts from 1917 to 1921, graduating with a Hiram Gee Fellowship to study for a year abroad. After working in New York as a book and magazine illustrator, Tomlin finally used his fellowship in 1923 to study in Paris at the Académie Colarossi and the Académie de la Grande Chaumière. Upon his return to New York in 1924, he continued his commercial illustrating (until 1929) and began exhibiting at the Whitney Studio Club; he received his first one-person exhibition in New York at Montross Gallery in 1926. At about this time he became friends with another artist, Frank London, with whom he shared a studio every summer in Woodstock, New York, and traveled to Europe in 1926–27. In 1929 Frank Rehn became Tomlin's dealer, and the Pennsylvania Academy of Fine Arts made the first museum purchase of a work by him. During the Depression, Tomlin began teaching for extra income, first at preparatory schools in New York, then at Sarah Lawrence College in Bronxville, New York, from 1932 to 1941. His exposure to the Museum of Modern Art's 1936–37 "Fantastic Art, Dada, and Surrealism" exhibition helped liberate his style. From 1939 to 1944 he worked in a decorative cubist mode that differed greatly from his earlier realistic technique. After London's death in 1945, Tomlin became a friend of Adolph Gottlieb and through him became associated with Motherwell, Guston, and Pollock. His art became more spontaneous and abstract as he began experimenting with automatism. At about the time he joined the Betty Parsons Gallery in 1948 or 1949, he formulated his mature style. In 1952 Tomlin suffered a heart attack, which greatly weakened him, and he died in New York May 11, 1953. The Phillips Collection owns a cubist work by the artist as well as two of his late paintings.

348

348

Still Life, 1940

The Goblet (DP)

Oil on canvas, 22⅛ × 29 (56.1 × 73.7)

Signed and dated in black paint, u.r.: *Tomlin/1940;* inscribed in pencil, stretcher reverse, u.l.: *Still Life/Bradley Walker Tomlin*

Acc. no. 1962 (Chenault no. 90)

Purchased from the artist through Rehn, New York (as *Still Life*), 1944.[1]

Still Life was painted in 1940, when Tomlin was turning away from a structured realism akin to the art of Marsden Hartley and Preston Dickinson toward a fragmented, cubist mode of expression.[2] This change was a difficult and brave one for Tomlin, who had enjoyed some critical success with his earlier work; it stemmed from his overriding desire to explore different techniques and styles, an interest that was fueled by his increased exposure to abstract styles in New York and was maintained throughout his career.[3] Tomlin's nature was that of a highly observant, methodical "gradualist," to use Duncan Phillips's term; he pondered the developments surrounding him and selectively incorporated them.[4] The many avant-garde institutions, groups, and exhibitions in New York during the late 1930s were rich sources for such a receptive artist.[5] Tomlin's activity in this milieu increased in 1941 when he became associated with the Federation of Modern Painters and Sculptors.

Cubism strongly appealed to Tomlin's controlled, rational nature—especially Picasso's and Braque's synthetic cubism, which he could view regularly at the Museum of Modern Art, the Museum of Non-Objective Painting, and, until 1942, A. E. Gallatin's Museum of Living Art at New York University. Tomlin's creations of the early 1940s masterfully interpret cubism in a fine-tuned, harmonious manner. Regularly exhibited at the Rehn Gallery as well as the Whitney and Carnegie annuals, these works won him favor with the Whitney Museum and also with such collectors as Edward Wales Root and Phillips.[6] Their subtle color and disciplined organization were to survive in his abstract, nonobjective works of the late 1940s.

Tomlin's cubism has been called "a soft elegant version recalling the subtlety of Braque, [Albert] Gleizes and [Jean] Metzinger as well as the early works of Ben Nicholson."[7] The artist's reserved, understated nature is revealed in the studied composition and intricate color of *Still*

Life, considered one of his finest cubist endeavors.[8] The tabletop still life is recognizable; however, Tomlin fragmented the image into rectangular sections of color as if he were viewing it through a kaleidoscope. He accentuated many of the sections by outlining them with incisions in the paint, and he subordinated immediate perception of the chalice, pitcher, grapes, and plums to the overall pattern. The objects and their division into panes of color especially call to mind Braque's still lifes of the 1920s, while the floating patterns are reminiscent of Alfred Maurer's still-life compositions a decade earlier.[9]

In *Still Life* Tomlin demonstrated his sensitivity to color by his manipulation of deep shades of olive, burgundy, brown, and violet. He added vivacity to the image with a shock of vivid blue in the painting's center. The minced strokes of red, green, and yellow in the left center reveal a pointillist technique that he used often during this period. Because of its carefully delineated color-shapes, *Still Life* has been compared to the overall effect of stained glass.[10]

Duncan Phillips may have first seen Tomlin's work in 1932 at the Corcoran Gallery of Art in Washington, D.C.; Phillips became familiar with it through exhibitions at the Rehn Gallery and at the annual Whitney and Carnegie exhibitions during the 1930s and early 1940s.[11] Attracted to its "rich . . . tonal subtleties," Phillips purchased *Still Life,* his first Tomlin, in 1944, although he had apparently wanted to represent him in the collection a decade earlier.[12] *Still Life* possesses the characteristics of still life that Phillips valued early in his collecting career: "not [as] . . . mere imitation of objects but [as] . . . a vehicle for personal expression" in which decorative elements unobtrusively serve as the means to achieve this goal.[13] Phillips noted that in Tomlin's "preference for Braque over Soutine . . . he was ever the musician striving to bring order out of complexity or to elaborate a simple melody with subtle variations."[14]

GHL

349

No. 8, 1952

Number 8 (Blossoms) (DP); *Blossoms* (DP); *Petals* (DP)
Oil and charcoal on canvas, 65⅞ × 47⅞ (167.4 × 121.7)
Signed and dated in black paint, u.l.: *b. tomlin/'52*
Acc. no. 1963 (Chenault no. 161)

TPG purchase from Betty Parsons Gallery, New York, 1955.[15]

350

No. 9, 1952

Oil on canvas, 84 × 79 (213.3 × 200.6)
Signed and dated in black paint, l.c.: *b. tomlin/'52*
Acc. no. 1964 (Chenault no. 149)

TPG purchase from Betty Parsons Gallery, New York, 1957.[16]

No. 8 and *No. 9,* both painted a year before Tomlin's death, are examples of the mature nonobjective, calligraphic technique for which he is best known. In 1945 his friendship with artists in the circle of Adolph Gottlieb and his subsequent immersion in the ideals of abstract expressionism freed Tomlin from his cubist style. In his characteristically earnest way, he experimented with automatism and gestural painting, enlarged his canvases, modernized his signature, assigned number titles to his paintings, and joined the avant-garde Betty Parsons Gallery.[17] Due to his tendency for contemplative restraint and perhaps because of his experience as a draftsman, Tomlin's late paintings lack the explosive quality of mainstream abstract expressionism; instead, they have a studied, rational air about them. As his friend Herbert Ferber stated, "He always depended on subtlety instead of . . . a vociferous statement."[18]

In Philip Guston's words, "Tomlin's temperament insisted on the impossible pleasure of controlling and being free at the same moment."[19] Tomlin seemed to have successfully combined these two impulses in his mature work, in which he "improvis[es] architectonic grids from free brushstrokes."[20]

No. 8 and *No. 9* represent two different working methods rather than consecutive members of a sequence. *No. 8* is a "petal painting," named as such for the resemblance of its thick, rhythmic brushstrokes to falling flower petals.[21]

Although it appears to be a spontaneous image, close observation reveals that Tomlin carefully calculated its color and organization.[22] After laying down initial color areas, he sketched a charcoal grid over the entire picture plane and then added the remaining layers of short, broad brushstrokes.[23]

No. 9, more structured in appearance, is composed of a series of linear, crisscrossed strokes—described as calligraphic by some viewers—that form a layered network against a field of variegated color.[24] The linear reticulation and its apparent migration toward the center of the image bear similarities to the work of Mondrian and Tomlin's colleague Ad Reinhardt.[25] While most of the strokes in *No. 9* are vertical or horizontal, several diagonal and semicircular touches intervene to break the repetition.

In both paintings, as is typical of his late works, Tomlin used white, or a similarly light color, for the most dominant brushstrokes, providing a gossamer, luminous effect. The muted colors—the pastel pinks, salmons, blues, grays, and lavenders of *No. 8,* and the gray, off-whites, earthy olives, and brick-reds of *No. 9*—are sporadically highlighted with blacks, which heighten the staccato rhythm of the paintings. Tomlin's color was described by admiring critics as symphonic orchestration in the spirit of Bach or Mozart.[26] His sensitivity to color was often compared to that of fellow abstract expressionist Philip Guston, with whom he frequently painted.[27]

Because of their lyricism and rational elegance, Tomlin's works were anomalies compared to the powerful, assertive creations of his colleagues. It was just such a demonstration of individuality that pleased Duncan Phillips, who marveled at Tomlin's "interplay of an ordered formalism and spontaneous, expressive gesture." He was so receptive to this new aspect of Tomlin's work that he presented his first museum solo exhibition in 1955, two years after the artist's death. He considered Tomlin's creations "classics which may outlive the more excited . . . expressionism of the more dynamic action painters."[28] To Phillips, they proved that art can be structurally sound yet simultaneously fluid and free in space, gesture, and color. In final tribute he claimed that "[Tomlin] was an individual stylist. Our age needed him."[29]

GHL

349

350

KENZO OKADA (1902-82)

The first Japanese-American artist working in the abstract expressionist style to receive international acclaim, Kenzo Okada was born the son of a wealthy industrialist in Yokohama, Japan, September 28, 1902. In 1922, upon the death of his father, who had opposed his desire to become an artist, Okada enrolled in the Tokyo Fine Arts University. In 1924 he moved to Paris, where he studied with Tsuguji Foujita and came under the influence of European modernism. He exhibited at the 1927 Salon d'Automne. That same year he returned to Japan, where he painted landscapes and figural compositions in the European tradition. In 1928 the Mitsukoshi Department Store, Tokyo, mounted his first one-person show. He was awarded a prize in 1936 from the Nikakai Group, the largest association of Japanese contemporary artists, and the following year became a lifelong member of the group. From 1940 to 1944 he taught at the School of Fine Arts, Nippon University, and was subsequently evacuated to Mori, a Takarae village in the Miyagi Prefecture. He returned to Tokyo in 1947 to teach at the Musashino Art Institute. Despite his success in Japan as a teacher and a frequently exhibited realist painter, Okada moved to New York in 1950 and began to paint abstractions. In 1953 he was given his first American one-person show at the Betty Parsons Gallery, where he continued to exhibit for the rest of his career. Although he settled in New York, Okada made frequent trips to Japan, where he died in Tokyo July 24, 1982. He is represented in the collection by three early abstractions, one a recent gift.

351

Footsteps, 1954

No. 4, 1954 (Footsteps); Footsteps (#4–1954)
Oil on canvas, 60⅜ × 69⅞ (153.5 × 177.4)
Signed in brown paint, l.l.: *Kenzo Okada*
Acc. no. 1443

Consigned by the artist to Betty Parsons Gallery, New York, 1954; consigned to Institute of Contemporary Art, Washington, D.C., 1955; PMG purchase 1956.[1]

Okada was an accomplished artist and teacher in the Western figurative tradition when in 1950 he left his homeland and immigrated to New York. Within three years, according to Gordon Washburn, he had transformed his "European landscapes and . . . pale French girls" into lyrical abstractions and had developed a new style representative of a "hybrid flower, a creation whose materials and format are Western and whose inspiration is Eastern."[2] Living in the West gave him the freedom to explore and express his feelings about Japan. As Okada recollected, "When I lived in Japan, I thought only of the West, and now that I am here I dream only of Japan."[3] His dreams became the inspiration for his abstract paintings, and *Footsteps,* painted in 1954, represents one of Okada's early forays into this new realm of expression.

Okada revealed his Asian heritage through the calm simplicity of the composition, the soft, muted palette, and the subtle allusions to nature. By balancing void against condensed weight, he realized the oriental pictorial tradition of implying vast and ambiguous space.

In keeping with the concerns of his fellow abstract expressionists, Okada drew imagery from his subconscious, allowing it to dictate his creative hand. He held no preconceived imagery for a picture and preferred "doing without knowing," in the spirit of Zen Buddhism, which emphasizes meditation. At times, however, he worked through a composition by preparing a small model, using natural elements like sticks, stones, and paper. The model would take on many different appearances as the artist manip-

ulated these elements on the paper surface to help him visualize his thoughts.[4]

In *Footsteps* the tiny daubs of gray and black paint that lead the viewer's eye into the composition, the broken, black horizontal line in the upper right, and the porous brown triangular shape in the bottom left are evocative of pebbles, rocks, and sticks. Okada's tendency to suggest landscape arises in the faint horizontal shape on the right resembling a mountain or hill, the white amorphous shapes evoking clouds, and the touches of gray in the center resembling footprints in the snow—an ephemeral suggestion for the title of this painting. Furthermore, the geometric shapes clustered to the left of the canvas conjure up houses, windows, and roofs, suggestions of man's presence in, and harmony with, nature.

Okada achieved texture in *Footsteps* by scraping back paint, painting wet-into-wet, splattering paint onto a dry surface, and using a dry brush.[5] He also rotated the canvas as he worked, as evidenced by drips of paint running in different directions. The composition is built up with thin oil washes; bare ground is exposed in some areas between forms, but most of the canvas is covered with thin scumbles and glazes. This rich, painterly play produces textures and tones akin to those found in nature.[6]

Duncan and Marjorie Phillips visited the Betty Parsons Gallery in November or December 1954 and selected three Okada paintings on approval, settling on *Number 2* (acc. no. 1444), the first Okada to enter the collection.[7] After seeing *Footsteps* at the Corcoran, Duncan Phillips was "very much tempted by the beautiful white [Okada]," but he wrote to Betty Parsons that he wanted to wait for Okada's one-person show at her gallery.[8] *Footsteps* was again exhibited at the Corcoran in the fall of 1955, on which occasion Okada visited Washington.[9] Phillips purchased it a year later. He frequently hung it with works by Tomlin and Rothko in the conviction that Okada shared similar poetic impulses with them.

V S B

351

MARK ROTHKO (1903–70)

Mark Rothko was one of the foremost members of the abstract expressionist movement, which was established after the Second World War. He was born Marcus Rothkowitz September 25, 1903, in Dvinsk, Russia. His family immigrated to Portland, Oregon, when he was still young. After early art training and two years at Yale (1921–23), Rothko settled in New York in 1925 and began study at the Art Students League under Max Weber. In 1928, at the time of his first group exhibition at Opportunity Gallery, New York, he established a close friendship with Milton Avery. In 1929 Rothko took a job teaching children part-time at the Center Academy, Brooklyn Jewish Center, a position he retained until 1952. He had his first solo show in New York in 1933 at the Contemporary Arts Gallery. In 1934 Rothko participated in the organization of the Artists' Union; he later became involved in the American Artists' Congress and the Federation of Modern Painters and Sculptors. That same year he joined the newly established Gallery Secession in New York, but in 1935 he and several other artists left it to form a loosely associated group of progressive artists called The Ten (or The Ten Who Are Nine). From 1936 to 1937 Rothko was employed by the Works Progress Administration's easel project and the next year became a U.S. citizen. During the summers of 1947 and 1949 he was a guest instructor at the California School of Fine Arts, San Francisco, on the recommendation of Clyfford Still. He also taught at Brooklyn College, the University of Colorado, Boulder, and Tulane University, and from 1958 to 1969 worked on three major commissions, monumental canvases for the Four Seasons Restaurant and Seagram Building, both in New York, and murals for the Holyoke Center, Harvard University, and the chapel at the Institute of Religion and Human Development, Houston. In 1958 he legally changed his name to Mark Rothko and in 1969 received an honorary degree of Doctor of Fine Arts from Yale University. Rothko committed suicide in his studio February 25, 1970. The Phillips Collection owns four oils on canvas, an acrylic on paper, a gouache on paper, and a watercolor and tempera on paper.

The Rothko Unit

Duncan Phillips's empathetic response to Mark Rothko's paintings revealed the collector's keen sensitivity to the overwhelming emotional impact of their color. Phillips, who had always readily responded to color as the vital visual manifestation of artistic personality, viewed Rothko's work as the most moving, penetrating statement in the medium, the culmination of the endeavors of Chardin, Delacroix, Bonnard, and Avery. Through color alone, applied in veils in an abstract composition of suspended rectangles, Rothko's work evokes strong emotions ranging from exuberance and awe to despair and anxiety, suggested by the hovering and indeterminate nature of his forms. The large canvas he consistently used after the emergence of his mature style in the late 1940s gives human scale to his work, establishing a one-on-one correspondence with the viewer and intensifying the effect of color. As a result, the paintings produce in the responsive viewer a state of spiritual or disembodied contemplation.

It is not clear exactly when Phillips became interested in Rothko. According to the artist's friend and colleague Theodoros Stamos, Phillips had not thought of collecting Rothko by 1950, when, during a stay at the Phillips's home, Stamos mentioned Rothko in relation to Bonnard: "I told him that I think its [sic] important that he get at least one [Rothko], and I told him why. I told him that he is so strongly related to Bonnard that if he looked at some black and white Bonnards he would see it clearer, and then focus on the color. We discussed that for a long time."[1] Phillips probably readily recognized that Rothko's color expanses were nondelineated and intuitively arranged within limited space in a manner similar to that of Bonnard, one of Phillips's favorite artists. By 1956 he was searching for a Rothko to purchase for his collection, and in 1957 he held his first group exhibition including the artist, from which he purchased *Green and Maroon,* 1953 (cat. no. 352), and *Mauve Intersection,* 1949.[2] Three years later he acquired *Green and Tangerine on Red,* 1956, and *Orange and Red on Red,* 1957 (cat. nos. 353 and 355), out of a one-person show at his museum. In order to select works for the 1960 show, Phillips and his wife visited the artist at his studio.[3]

Thoroughly convinced of Rothko's signal importance in the art world, Phillips began to examine the sources of the artist's intentions, even drafting some short texts, which were never published.[4] During his 1960 studio visit he asked Rothko whether color was indeed his foremost concern; Marjorie recalled that his response was simply, "No, not color but measures." Acknowledging Rothko's intellectual approach as well as his ambiguous treatment of space, Phillips commented: "Mysterious layers of paint . . . suggest depth in spite of their flat mat quality; they seem to come forward and envelop you at times."[5] Nevertheless, other writings by Phillips focus on Rothko's color and its embodiment of emotion and profound meaning:

In the soft-edged and rounded rectangles of Mark Rothko's matured style there is an enveloping magic which conveys to receptive observers a sense of being in the midst of greatness. [The colors] . . . cast a spell, lyric or tragic, which fills our existence while the moments linger. They not only pervade our consciousness but inspire contemplation. Our minds are challenged by the relativities; the relative measures of the two horizontal presences, . . . each acting on the other. . . . Color-atmosphere in painting is as old as Giovanni Bellini and his mountain backgrounds. . . . But in Rothko there is no pictorial reference at all to remembered experience. What we recall are not memories but old emotions disturbed or resolved.[6]

By 1960 Phillips was prepared to make Rothko's work a focus of installations planned for a new adjoining building to accommodate his collection, referred to as the Annex. When working on the architect's maquette, the Phillipses designated a specific room for the Rothkos. They were probably aware of Rothko's desire to have his paintings exhibited in small groups, a fact pointed out by Lawrence Alloway in 1959: "[Rothko] prefers his pictures to be hung in groups, not spaced out in conventional good hanging; their united effect stresses their environmental function."[7] The resulting room was small with gray walls, each able to accommodate one painting; the lights were kept dim to enhance the resonance of the color expanses; and chairs were added for prolonged, comfortable viewing. From the outset, the room was intended as a meditative respite, and it was even referred to by Phillips as a type of "chapel" (fig. 42).[8]

Such an idea, with its implicit understanding and appreciation of the artist's desire to have his paintings relate one-on-one to the viewer without distractions, appealed greatly to Rothko and was the first commitment to such a presentation of his work by an American museum. It lent reality to his goal expressed in 1949: "The progression of a painter's work, as it travels in time from point to point, will be toward clarity: toward the elimination of all obstacles between the painter and the idea, and between the idea and the observer."[9] Rothko took an active interest in the room, paying visits and often suggesting alterations. One such visit occurred on a snowy day in January 1961, when he was in Washington for Kennedy's inauguration; at the time the room displayed the museum's three mature oil paintings (the fourth, *Ochre and Red on Red,* 1954, cat. no. 354, was added to the group upon its purchase in 1964). Rothko expressed slight dissatisfaction with the arrangement and lighting, and the museum assistants, anxious to

Fig. 42 The Rothko Room, Goh Annex of The Phillips Collection, 1989.

accommodate him, made changes on the spot. Duncan Phillips, who had been away, returned the following week, noted the changes, and immediately had the room returned to its original installation—an action revealing the collector's consistent aesthetic preferences.[10] Nevertheless, one of Rothko's requests was granted; in order to reduce any distractions, the chairs were replaced by a single bench from the museum's sculpture court.[11]

Rothko treasured the atmosphere of the Phillips's Rothko Room, often using it as a model for future exhibitions.[12] Although the Rothko paintings in The Phillips Collection were not created to be displayed as a group, their combination in a space that has all the qualities of a sanctuary set a standard for future commissions for the artist, including those of the Holyoke Center at Harvard University, 1961–62, and the Institute of Religion and Human Development (the Rothko Chapel) in Houston, 1964–67. Of all of these installations, the Phillips room remains the only existing installation of Rothko's paintings "seen and endorsed by the artist himself."[13] The Rothko Room has remained to this day in The Phillips Collection's Annex, and it continues to engage visitors as an ideal setting in which to view Rothko's hypnotic canvases to their utmost potential.[14]

ER AND GHL

352
Green and Maroon, 1953

No. 7
Oil on canvas, 91⅛ × 54⅞ (231.3 × 139.4)
Signed and dated on reverse: *Mark Rothko / 1953*
Acc. no. 1664 (Anfam no. 491)

Purchased from the artist through Sidney Janis Gallery, New York, 1957.[15]

353
Green and Tangerine on Red, 1956

No. 16, Henna and Green, Green and Red on Tangerine
Oil on canvas, 93⅜ × 69¼ (237.9 × 175.9)
Signed and dated on reverse: *Mark Rothko / 1956*
Acc. no. 1665 (Anfam no. 562)

Purchased from the artist through Sidney Janis Gallery, New York, 1960.[16]

354
Ochre and Red on Red, 1954

The Ochre; Ochre, Red on Red
Oil on canvas, 92⅜ × 63¾ (235.3 × 162.0)
Signed on reverse: *Mark Rothko*
Acc. no. 1666 (Anfam no. 517)

Purchased from the artist through Sidney Janis Gallery, New York, 1964.[17]

355
Orange and Red on Red, 1957

Oil on canvas, 68⅞ × 66⅛ (175.0 × 168.1)
Signed and dated on reverse: *Mark Rothko / 1957*
Acc. no. 1667 (Anfam no. 599)

Purchased from the artist through Sidney Janis Gallery, New York, 1960.[18]

The four paintings by Rothko in The Phillips Collection date from the mid-1950s, the artist's mature years, when he painted scores of large canvases, which, despite a similarity in format, vary widely in mood, depending upon their color and internal proportions. Rothko abhorred being viewed as a formalist abstract artist whose foremost intent was to arrange color fields on a flat canvas; he insisted that his art concerned the distillation of human experience, both tragic and ecstatic, to its purest form. His goal was to abandon any visual obstacles detracting from the central idea. His paintings, heavy with implied content and emotional impact, ventured beyond abstract representation to become embodiments of the "human drama" itself.[19] Through their purity, their effect on the viewer became more direct and incisive.

In Rothko's compositions the rectangles and their surrounding space are given equal importance as presences. Beginning with no preconceived vision of a painting's final state, he intuitively adjusted his forms, always working with a frontal arrangement of horizontal or vertical rectangular forms. He paid close attention to their height, width, and edges, their distance from the edges of the canvas, and their interrelationships. All of his shapes have soft edges that fuse into their surrounding space. The relative dominance of the elements in the composition depends entirely on their color, which Rothko masterfully blended and layered to create varied opacity, texture, and luminosity.[20] He frequently applied paint with rags, rubbing wet colors together, so that few gestures were visible; at other times he painted with slightly built-up brushstrokes for textural variation.[21] In many cases translucent underlayers of color are visible, evoking a quality of inner light.

In *Green and Maroon* the colors are dimmed and made more dense by the underlying darker shades of blue, red, and gray; as a result a somber stillness pervades the composition. In *Ochre and Red on Red* a buoyant effect is created by the blazing yellow square, which, in comparison to the darker red of its surroundings, appears to surge out of the composition into the viewer's space. Marjorie Phillips recalled Rothko's assertion that "the striking tangerine

352

353

tone of the lower section [of *Green and Tangerine on Red*] could symbolize the normal, happier side of living; and in proportion the dark, blue-green, rectangular measure above it could stand for the black clouds or worries that always hang over us."[22] Through countless color manipulations executed on a large scale—an approach comparable to that of a composer arranging musical notes—he created powerful, timeless absolutes of human sensation ranging from exultation to torment.

Rothko's mature paintings were almost always executed on a large scale, enhancing their dramatic effect. He explained, "The reason I paint [large works] . . . is precisely because I want to be very intimate and human. To paint a small picture is to place yourself outside your experience. . . . However you paint the large picture, you are in it."[23] In a further attempt to communicate his vision effectively to the viewer, he anxiously oversaw the environment in which his paintings were shown. He preferred that they hang separately from the work of other artists in dim lighting, their large dimensions dominating the surrounding wall space—all in the endeavor to thoroughly immerse the spectator in their power. The four paintings in The Phillips Collection are exhibited in this manner, a reflection of Phillips's understanding of the artist's purpose of openly conveying his innermost experiences through his art.

ER AND GHL

354

355

ADOLPH GOTTLIEB (1903–74)

Adolph Gottlieb, long a vocal member of the American avant-garde, was born in New York March 14, 1903. After dropping out of high school in 1919, Gottlieb briefly attended the Art Students League before leaving for Europe in 1921. He traveled to Vienna, Berlin, Dresden, and Munich and took a life-drawing class at the Académie de la Grande Chaumière in Paris. Soon after his 1922 return he attended John Sloan's painting class at the Art Students League (1923–24) and forged friendships with Barnett Newman, Mark Rothko, John Graham, and Louis Schanker. In 1929 Gottlieb exhibited at the Opportunity Gallery in New York, where he met Milton Avery, his mentor during the following decade. He had his first one-person show at the Dudensing Gallery in 1930. In 1935 he became one of the founding members of The Ten, a group of artists opposed to the realism of contemporary regionalist painters. After another trip to Europe in 1935, Gottlieb worked on the Federal Arts Project in 1936–37. Politically active like many of his colleagues, he joined the Artists' Union in 1936 and became a founding member of the American Artists' Congress that same year and of the Federation of Modern Painters and Sculptors in 1940. A trip to Arizona (1937–38) and the emerging influence of surrealism in New York during the Second World War caused him to reevaluate his style, and in 1941 he began executing his pictographs. In 1947 Gottlieb joined the Kootz Gallery and began associating with Robert Motherwell and Hans Hofmann. Dividing his time between New York and Provincetown, he participated through the early 1950s in discussions and forums on American artistic developments. In his art of the 1950s and 1960s—known as *Imaginary Landscape* and *Burst*—Gottlieb indicated his increasing interest in color-field painting and abstract symbolism. His late career was highlighted by several commissions and awards, teaching in 1958 at both the Pratt Institute in Brooklyn and the University of California at Los Angeles, and his receiving a joint retrospective at the Whitney and Guggenheim in 1968. After suffering a stroke in 1971, Gottlieb died March 4, 1974, in New York. The Phillips Collection owns two works by the artist—a pictograph and a late painting.

356

The Seer, 1950

Oil on canvas, 59¾ × 71⅜ (151.7 × 181.9)

Signed l.r.: *Adolph Gottlieb;* inscribed in black paint on canvas reverse, u.l.: *"The Seer"*/ADOLPH GOTTLIEB/[hidden by stretcher] *0 × 72"/1950*

Acc. no. 0803

TPC purchase from the artist through Samuel M. Kootz Gallery, New York, 1952.[1]

357

Equinox, 1963

Oil on canvas, 90 × 84 (228.6 × 213.3)

Unsigned

Acc. no. 0802

TPC purchase from artist through Sidney Janis Gallery, New York, 1963.

Over the course of a decade, Gottlieb painted more than five hundred pictographs, which he envisioned as "archaic wall art whose meaning is lost to modern man."[2] Indeed, these paintings, with their flat grids enclosing cryptic symbols, resemble the incomprehensible picture-writing of ancient cultures.

They also represent Gottlieb's distinctive breakthrough in carrying out the overriding goal of his circle of abstract expressionists: to instill paintings with universal meaning. This concern arose from the disillusionment of the Second World War, as well as dissatisfaction with earlier artistic approaches—the intellectual, design-oriented aesthetics of the American Abstract Artists group (formed in 1936) and the insular, conservative style of the regionalist painters.[3] In an effort to reestablish the vocabulary of the modernist aesthetic, Gottlieb's group hoped to resolve "how to retain flatness in painting, without resorting to the existing forms of abstract art or . . . how to convey the presence of momentous content without using an imagery of spatial illusion."[4]

The pervasive themes of the pictographs are duality and mystery. Gottlieb strove for the tension evoked by the opposition of highly subjective content with the structured grid.[5] While he acknowledged that each symbol was "independent and occupying its own space," he added that "at the same time [each has] the proper atmosphere in which to function . . . in harmony" with the others.[6] Although he occasionally repeated motifs, he admitted, "My favorite symbols were those which I didn't understand."[7] Despite his belief that "art should communicate," he asserted, "I have no desire to communi-cate with everyone, only with those whose thoughts and feelings are related to my own."[8]

Elements of the pictographs are the result of several stimuli to which the artist was exposed during the late 1930s. Because of its geometric elements, multiple focal points, and flat picture plane, the grid format may have been inspired by the art of Uruguayan artist Joaquín Torres-Garcia or Mondrian; but the wide variation of the symbols derives from Gottlieb's fascination with the unconscious and primitive art.[9] A major influence on him was his friend and fellow artist John Graham, who published *System and Dialectics of Art* in 1937. Graham heightened Gottlieb's awareness of Jung's philosophy, which motivated him to search for content in the recurring images within the collective unconscious. The resulting subject matter was considered symbolic of "man's primitive . . . motivations," which have existed through the centuries, often in the form of myth.[10] Gottlieb gained further encouragement to tap the inner resources of his mind from exposure to Freudian psychology and the European surrealists, many of whom emigrated to America during the war years. The resulting imagery, which he arranged on canvas through free association, alludes to the hallucinatory depths of the psyche.

Gottlieb also shared with Graham a strong admiration for primitive art, as expressed in his pictographs. In the late 1930s he began to collect African art, and he regularly attended exhibitions of African, Native American, and prehistoric art at the Museum of Modern Art.[11] He viewed primitive art as the direct, trenchant expression of unknown forces and a relevant source of subject matter amidst the turmoil and injustice of world war. In 1943 he wrote: "All primitive expression reveals the immediate presence of terror and fear. . . . That these feelings are being experienced by many people throughout the world today is an unfortunate fact and to us an art that glosses over or evades these feelings is superficial and meaningless."[12]

Gottlieb emphasized the primitive content of his pictographs by using colors derived from cave painting and Native-American art—slate gray, tan, black, and clay. He "applied . . . in multiple layers, suggesting time's strata."[13] In *The Seer,* a late pictograph much larger in scale than earlier examples, Gottlieb refined the archaeological quality of the color by adding sand to the paint.[14] The boldly delineated totemic configurations make numerous references to the human body—the stick figure in the upper-right corner, the four-finger motifs along the bottom and right side, and the repeated eye motif.[15] Gottlieb

356

357

often depicted parts to represent the whole; it has therefore been stated that in his portrayal of body parts he alluded to himself and "his artistic powers." The eye, derived from surreal and primitive art and a frequent theme in his pictographs, refers to his inner vision.[16] The combination of organic imagery and graphic symbols like the triangle, circle, arrow, and ellipse reflects the increasing influence of Klee.[17]

Once he felt he had exhausted the myriad possibilities of his pictographs, Gottlieb began to simplify his symbols and composition in order to enhance his theme of universality. By the 1960s he was creating paintings like *Equinox,* in which the grid is reduced to an implied (although occasionally delineated) horizontal division that separates the image into two halves. Within each half, a few shapes—circles, squares, or calligraphic gestures—float against a field of color, vying for focal supremacy.[18]

Duncan Phillips acquired his two examples of Gottlieb's work soon after each was painted, evidence of his appreciation of his art. Although no specific reference to Gottlieb appears in Phillips's surviving writings, he could have had Gottlieb in mind when he professed in 1955, "I admire the aesthetic interpretations of the age we live in—even the symbols for the anarchy, the turmoil and the inner tensions."[19]

GHL

Seymour Lipton, one of the foremost abstract sculptors of the twentieth century, was born in New York November 6, 1903. Although interested in art and aesthetics at an early age, Lipton decided to train as a dental surgeon, completing his degree at Columbia University in 1927. Soon thereafter, however, he began experimenting with sculpture, mainly in wood. His works were first exhibited in 1933–34 at the John Reed Club in New York; his first one-person show occurred at New York's A.C.A. Gallery in 1938. In the mid-1940s Lipton began using metal because of its greater support and flexibility. He taught at the Cooper Union from 1942 to 1944 and the New School for Social Research from 1940 to 1965. Betty Parsons became his dealer in 1948 and continued to exhibit his work until 1963, when Marlborough-Gerson began to represent him. During the 1950s he began receiving major corporate commissions, including sculpture for the Inland Steel Company Building in Chicago (1957) and the IBM Watson Research Center in Yorktown Heights, New York (1961–62). In 1958 Lipton was given a one-person show at the Venice Biennale. After a successful career of awards, highly acclaimed exhibitions, and commissions, he died of bone cancer December 5, 1986, in Glen Cove, New York, on Long Island. The Phillips Collection owns a sculpture and four black crayon drawings.

358

Ancestor, 1958

Nickel-silver on monel metal, 87 × 19½ × 32 (220.9 × 49.5 × 81.2) with base
Unsigned
Acc. no. 1210

TPC purchase from the artist (from TPC exhibition) 1964.[1]

Through the medium of metal sculpture, Lipton endeavored to portray the inner complexities of the human psyche. Although his imagery was often based on visual stimuli, his expressive abstractions were never literal translations of the visible world. He altered and arranged shapes to create technically and formally sound sculptures symbolizing intangible, universal concepts absorbed from sociology, psychology, and myth. Many of his forms enclose or oppose one another in a dynamic manner that Lipton called "organicism"; the result was a "final work [that was] ambiguously unified and rich in direct and implied experience."[2] According to Albert Elsen, Lipton "discovers and invents shapes having long universal histories of identification with the tragic and heroic . . . to

which . . . other individuals will intuitively respond."[3] He gained much inspiration from primitive art because of its "more metaphysical, less representational, less realistic presentations of man about man."[4]

Ancestor, executed in mid-career, represents Lipton at the height of his powers, when his motifs were particularly refined. The work is part of the *Hero* series of the late 1950s, which was not conceived as a unit but resulted from Lipton's increasing use of vertical compositions suggestive of standing human figures, a preoccupation that began around 1956.[5] In *Ancestor,* angular, stiff shapes with threatening points and a rounded swirl of metal evoke sexual imagery alluding to reproductive organs of humans and plants, stressing the mythic sources of all life. Similar in appearance to a blooming flower with exposed stamen, the circular form protects—but at the same time reveals—an inner core that also suggests the uncovering of emotion, the inner being. Dynamic contrasts result from the juxtaposition of forms, heightening the sculpture's expressive power. In Lipton's words, the work "intrudes into the present through sharp edges and is a faceless figure like an ancestor." Elsen found that "the considerable height and generally inverted nature of *Ancestor* impart an aloofness and inscrutability that help us to comprehend the artist's selection of its title."[6]

Key to Lipton's originality was his ability to elicit mystery and vitality, and to achieve the utmost versatility, lightness, and endurance with welded sheets of metal, a method he had used since 1945 and perfected by the time he executed *Ancestor.* The monel metal of the sculpture's armature is a rust-proof, white-bronze alloy that can withstand heat, cold, and moisture. After cutting, shaping, and connecting the sheets by spot-brazing, Lipton fused a nickel-silver alloy over the surface. The intense heat from the fusing technique caused warpage of the armature, which required hammering the sculpture back into shape; the resulting textured surface "helps to give the sculpture a second poetic existence, to bring the metal to life and overcome its passive-object character."[7] Lipton then repeated the process by fusing and hammering another layer of steel on the inside of the armature.[8]

Duncan and Marjorie Phillips were two of Lipton's many admirers during the early 1960s. The sculptor invited them to his New York studio in 1963 after Marjorie suggested that The Phillips Collection host an exhibition of his work. During the visit Duncan admired many works, in particular a small sculpture entitled *The Sentinel,* which he later purchased as a birthday gift for his wife.[9] From the resulting exhibition in 1964, he pur-

358

chased *Ancestor.* Phillips, who was greatly admired by the artist, understood Lipton's goals; he described the effect of his works as "sculptural impressionism"—a term which meant, in Phillips's words, that "ideas and metaphors occur to the mind simultaneously with the impact of the form to the eye."[10] He elaborated in his catalogue essay: "The impressionism of Lipton is a quality of the volumes in light corresponding to a flash of thought."[11]

GHL

WILLEM DE KOONING (1904–97)

One of the leading figures in abstract expressionism, Willem de Kooning was born April 24, 1904, in Rotterdam. He was apprenticed in 1916 to a local commercial art and decorating firm. For the next eight years de Kooning attended night classes at the Rotterdam Academy, receiving formal training in fine and applied arts. Aspiring to become a commercial artist in the United States, he illegally entered the country August 15, 1926, at Newport News, Virginia. After settling in New York City in 1927, he soon met John Graham, Arshile Gorky, Stuart Davis, and other important avant-garde artists. In 1935, under the auspices of the WPA Federal Art Project, de Kooning was able to devote himself fully to painting for the first time, and throughout the 1930s and early 1940s he produced work in both figurative and abstract styles. His first one-person show, at the Egan Gallery in New York in the spring of 1948, featured a group of black-and-white abstractions, including *Painting*, 1948, which was purchased later that year by the Museum of Modern Art. At the Sidney Janis Gallery in 1953 de Kooning exhibited a controversial group of paintings of women, a subject that inspired him throughout his career. With the notoriety established by these provocative images and his reputation secured as a leader of abstract expressionism, he then turned to a series of works featuring the urban landscape and suburban parkways in the mid to late 1950s. While in Rome in 1969, de Kooning began experimenting with small clay sculptures; this work led to the production later that year of large-scale bronze pieces based on the figure. Since moving to East Hampton in 1963 he had been inspired primarily by the Long Island landscape, and his work had been featured in numerous national and international exhibitions. De Kooning died in East Hampton March 19, 1997. The collection contains two oils, one a later gift.

359

Asheville, 1948

Ashville

Oil and enamel on cardboard, 25⁹⁄₁₆ × 31⅞ (64.0 × 81.0)

Signed with graphite inscribed into wet paint, u.l.: *de Kooning*; inscribed on reverse: *Ashville*

Acc. no. 0484

The artist to Vincent Melzac, Washington, D.C., 1948; TPG purchase 1952.[1]

Willem de Kooning's *Asheville* takes its name from the North Carolina town near Black Mountain College where de Kooning taught in the summer of 1948.[2] A small but extremely complex work, it gathers together numerous, often oblique allusions, including references to the college and passages that recall de Kooning's early training in such crafts as marbling, wood-graining, and lettering. Other sources for the painting are the draftsmanship of Ingres, the fragmented space of cubism and collage, the random interplay of line and subject of automatism and surrealism, and, perhaps most clearly, the works of de Kooning's friend and colleague Arshile Gorky.[3]

There are four additional works entitled *Asheville*, but their relationship to the Phillips painting is, characteristically, difficult to establish.[4] In de Kooning's oeuvre the distinctions among drawings, studies, and paintings are often blurred. A constant flow and exchange of ideas and forms across different media replace the traditional academic progression from study to finished painting.[5] Although the particular role of each of these works cannot be determined, their depiction of shapes similar to those found in *Asheville* suggests that de Kooning consciously refined the seemingly random forms of the Phillips painting.

Asheville is an important example of de Kooning's intricate experiments in "collage painting" of the late 1940s, in which he used collage procedures as a source for visual ideas that he would later, often illusionistically, render in a final work free from any actual collaged elements.[6] By painting over and then removing paper templates from the surface, de Kooning created jumps and visual ruptures between passages that mimic collage.[7] Additional deceptions in *Asheville* include the illusion of a tack holding a cutout form at the upper left and a depiction of paper peeling from the surface to the left of what appears to be a mouth at the picture's center.

De Kooning further enhanced these effects by scraping down and building up the surface of the painting numerous times.[8] This layering succeeds in conflating spontaneity and measured thought, giving *Asheville* a look of immediacy and chance when de Kooning actually intensively constructed the painting over a number of months. In addition, he interspersed sinuous black lines throughout the work with a liner's brush, a tool with unusually long brush hairs traditionally used by sign painters. These gestures resemble the spontaneous, unconscious marks of psychic automatism, but upon closer inspection they reveal de Kooning's technical mastery of the brush and reflect his fascination with the precision of line as practiced by the French master Ingres.[9]

Content in *Asheville* is rendered elliptically in what de Kooning has described as a "glimpse of something, an encounter like a flash."[10] The skyline noted near the upper-center edge of the painting suggests the Blue Ridge Mountains looming over the grounds of Black Mountain College. Beneath this passage is an area of blue that may refer to Lake Eden, which was adjacent to the school. Additional iconographic fragments include eyes, hands, and a mouth, as well as a window of green, an effective foil for the dialogue between indoor and outdoor space in the picture.[11]

At the time de Kooning painted *Asheville*, a spirit of inclusiveness characterized the work of the abstract expressionists as they struggled to come to terms with the emotional legacy of the Second World War, the heritage of modernism, and the wide array of influences available to them in New York. De Kooning's response was to subject this flux of ideas and experience to an extraordinary degree of self-conscious control. His depictions of collage in *Asheville* are characteristic of a "conservativeness" that allowed him to establish a relationship with older traditions of figuration, illusion, and craft while simultaneously engaging more radical modern idioms.[12]

In 1951, in preparation for the exhibition "Painters of Expressionistic Abstractions," Duncan Phillips wrote to the New York dealer Sidney Janis about de Kooning's work, pointedly expressing a preference for "the pure abstractions in which no figures or parts of figures are to be found."[13] Following the exhibition, Phillips purchased *Asheville,* which had been lent to the show by the local collector and dealer Vincent Melzac. However, *Asheville* cannot be characterized as a "pure abstraction," and when its submerged figuration surfaced with the notorious exhibition of de Kooning's aggressively figurative paintings of women in 1953, Phillips's interest may have waned. *Asheville* was to be the only work by de Kooning Phillips purchased for the collection.

CB

359

CLYFFORD STILL (1904–80)

A vehement individualist, Clyfford Still pre-ferred to work apart from his abstract expres-sionist colleagues, limiting his participation to frequent visits to New York. Born November 30, 1904, in Grandin, North Dakota, Still spent his youth in Spokane, Washington, and on the prairies of southern Alberta, Canada, and he drew and painted from an early age. In 1925 he visited New York, briefly studying at the Art Stu-dents League. Still attended Spokane University from 1926 to 1927 and returned in 1931 with a fellowship, graduating in 1933. That fall he became a teaching fellow and then faculty mem-ber at Washington State College (now Univer-sity), Pullman, where he obtained his M.F.A. in 1935. He spent the summers of 1934 and 1935 at Yaddo, an artists' retreat in Saratoga Springs, New York. In 1941 he moved to California, where his first one-person show was held at the San Francisco Museum of Art in 1943, the same year he met Mark Rothko. Still moved that fall to Virginia to paint while teaching at Richmond Professional Institute (now Virginia Common-wealth University). After Still moved to New York in the summer of 1945, Rothko introduced him to Peggy Guggenheim, who gave him a one-person show at the Art of This Century Gallery in February 1946. That fall he moved to San Francisco to teach at the California School of Fine Arts, although he returned often to New York. His graduate painting classes became leg-endary, because of his irascible nature and con-troversial approach, and his impact on West Coast artists was great. He resigned in the fall of 1950 and returned to New York, teaching for short periods at various schools around the country. In 1961 Still bought a farm in Carroll County, near Westminster, Maryland, so he could work in seclusion; five years later he pur-chased a house in New Windsor, Maryland. In 1964 he gave thirty-one paintings to the Albright-Knox Art Gallery, Buffalo, and in 1975 gave twenty-eight works to the San Francisco Museum of Modern Art. Still received numer-ous awards and had several major exhibitions in the later years of his life. He died June 23, 1980, in Baltimore, Maryland. The collection contains one large oil from Still's early mature period.

360

1950-B, 1950

Ph-377

Oil on canvas, 84 × 67⅛ (213.4 × 171.7)

Signed and dated, l.r.: *Clyfford 1950;* inscribed on reverse, l.l.: *Clyfford/1950-B;* inscribed l.l. to l.c.: *San Francisco/Jan 10/1950*

Acc. no. 1852

Collection of the artist; sold to Marlborough-Gerson Gallery, New York, by May 1969; TPC purchase 1969 (from TPC exhibition).[1]

Despite Still's close involvement with the New York School, his participation in the develop-ment of abstract expressionism has only recently been discussed more fully.[2] Like his colleagues Rothko and Newman, the others who were often referred to as color-field painters, Still gradually purged from his painting all emblematic and ideographic imagery. In his mature work he activated his philosophical and psychological concerns in large, heavily troweled, fields of color.[3] *1950-B* is an early mature work. The field of black, painted in thick impasto, punctuated by spots of orange and indigo, serves as Still's "instrument of thought which would aid in cut-ting through all cultural opiates . . . so that a direct, immediate, and truly free vision could be achieved, and an idea revealed with clarity."[4] Probably created in January 1950, just prior to Still's return to New York from the West Coast, *1950-B* bridges his early semifigurative imagery and his emerging color-field style. Still stated that all of his paintings were in essence self-por-traits, adding, "The figure stands behind it until eventually you could say it explodes across the whole canvas."[5]

Still had established his basic themes during the forties, when he continued the investigations he had begun as a graduate student and instruc-tor at Washington State College from 1933 to 1937. It was in these early, formative years that he first came into contact with primitivism, psy-chology, anthropology, and mythology—sources that were so important to the development of abstract expressionism.[6]

Recent scholars interpret the theme of *1950-B* as the confrontation of death and life, out of which Still sought self-determination.[7] By exam-ple, he hoped to force his viewers similarly to address themselves, to question their cultural and social constraints and enlarge their defini-tion of being. Still believed the key lay in humanity's primitive past, which contained the origins of culture and the source of his psychic self. Out of the past, he could forge his own spir-itual and creative rebirth, which would serve as a paradigm for the "psychocultural" transforma-tion of contemporary society.[8] Of fundamental importance were Jung's theories, specifically those relating to the primitive mind and the col-lective unconscious as revealed by myth.[9] Equally significant to Still were recent anthropo-logical studies that explored what was then con-sidered to be the understanding of the primitive mind as reflected by myth.[10] He chiefly focused

on the discourse beyond myth—the conception by early cultures of the relationship between the world and the individual that led to the creation of myths.

Recently, *1950-B* has been aligned with the "buried sun" theme, which Still explored from the mid to late forties.[11] As David Anfam notes, these images express the cycle of death and rebirth with a circular, often orange form cou-pled with black and dark-brown shapes, seen here in the intense yellow-orange form sub-merged within the black.[12] Anfam relates the theme to the Greek myth of Persephone: in *1950-B* the black field signifies the earth, the demonic, and Demeter, the mythic Earth Mother; her daughter, Persephone, returns from the darkness bringing renewal, personified here by the buried orange circle.[13] That Still knew this particular myth was confirmed by Rothko, who recalled that Still considered many of his paintings to be extensions of the Persephone and Demeter myth, and that he believed they were "of 'the Earth, the Damned, and the Recre-ated.'"[14] Still later said, "These are not paintings in the usual sense; they are life and death merg-ing in fearful union. . . . Through them I . . . find my own revelation."[15]

Stephen Polcari also views *1950-B* as an image of regeneration, but he identifies the source of the iconography as Native-American symbols and rituals of power, which Still had learned about from local Native Americans while living in Pullman, Washington.[16] Accord-ing to Polcari, the large black field vaguely resembling a human profile is a totemic force—a shaman. This interpretation is made plausible by Still's reference to the painting as his "head" picture.[17] Moreover, Still, who saw himself as a visionary, approved of a colleague's reference to him as "a sorcerer with powerful magic. . . . Nay! An Earth Shaker."[18] The Earth Shaker, another term for shaman, is a powerful figure who expe-riences his own death and spiritual rebirth dur-ing a mysterious illness provoked by spirits.[19] In *1950-B* the totemized black field is literally fused with the muted areas of burnt sienna and earth-brown, which may represent the shaman's mate-rial and spiritual environments.[20] This work illustrates Still's statement that the "space and the figure in my canvases had been resolved into a total psychic entity . . . fusing into an instru-ment bounded only by the limits of my energy and intuition."[21]

LBW

360

LOREN MACIVER (1909-98)

Loren MacIver captured the poetic essence of her subjects through abstraction, veils of color, and subtleties of light. Born February 2, 1909, in New York, MacIver was essentially a self-taught painter, having attended classes at the Art Students League only briefly at ages ten and eleven. She married the poet Lloyd Frankenberg in 1929; from 1931 to 1941 the couple spent every summer on Cape Cod. After she received attention, some negative, for her works in the group shows at New York's Contemporary Arts Gallery in 1933 and 1934, MacIver gained the support of several collectors as well as of Alfred Stieglitz, John Sloan, and Alfred Barr. The Museum of Modern Art acquired one of her works in 1935, well before her first one-person exhibition in 1938 at Marian Willard's East River Gallery. From 1936 to 1939 she worked on the Federal Art Project of the Works Progress Administration. In 1940 Pierre Matisse became her dealer. Later in the 1940s she became involved with several commercial commissions, and she took her first trip to Europe in 1948. After a 1953 traveling retrospective of her work organized by the Whitney, MacIver returned to Europe until 1954. She spent the 1960s almost exclusively in Europe, predominantly in Paris; MacIver was one of the Americans featured in the 1962 Venice Biennale. In 1970 she returned to New York, where her paintings were exhibited by the Pierre Matisse Gallery. She died in New York, May 3, 1998. The Phillips Collection owns four paintings and one drawing by the artist.

361
New York, 1952

Oil on canvas, 45¼ × 74 (114.9 × 188)
Signed in black paint, l.l.: *MacIver*
Acc. no. 1239

Purchased from the artist through Pierre Matisse, New York, 1953.[1]

By the early 1950s MacIver was known for abstract compositions that incorporated recognizable fragments from her native New York City and European locales—"symbolic abstractions" defying categorization that captured the poetic essence of the environments they depicted.[2] In *New York* she transformed the nighttime metropolis into a magical fantasy world of shimmering color and light. Her goal was to attain the all-encompassing feel of the city, its fast pace and vitality. Buildings glow softly in the velvet blue night, forming a backdrop against which float the remaining elements of the composition. The jewel-like shapes in the lower half of the image allude to sidewalk lights above the subway, and the accordionlike form at the right portrays the subway's entrance and steps. In the center of the work is a string of miscellaneous objects—leaf, key, lobster, shoe, and hat, as well as a fantasy sun form with a birdlike face—most of them deriving from neon signs.[3] Schematic white outlines heighten their apparitional effect and emphasize their symbolic meaning for the artist. MacIver's imagery strongly resembles that of Chagall and Klee; however, although she was familiar with both artists in New York and Paris, and shared their interest in fantasy imagery, she was not directly influenced by them.[4]

The symbolic details contribute to the overall dreamlike mood that is enhanced by a subtle blending of colors and the suggestion of a soft, iridescent light. The image is composed of blue, green, and red oil paints that blend into one another with such blurred subtlety that the effect resembles pastel, a technique for which the artist was admired.[5] An earlier MacIver painting owned by Phillips, *The Window Shade* (acc. no. 1242), attains much of its appeal through similar methods. Blues and greens fuse into one another, transforming a tattered, commonplace household object into a thing of enchanting beauty. Glowing light emanates through the cracks and hole in the shade's surface, giving the image an aura of mystery. MacIver elaborated upon her tendency to find mesmerizing beauty in the most banal subjects: "Quite simple things can lead to discovery. This is what I would like to do with painting: starting with simple things, to lead the eye by various manipulations of colors, objects and tensions toward a transformation and a reward."[6]

As early as 1936 MacIver's husband, Lloyd Frankenberg, urged Duncan Phillips to consider his wife's work; however, it was not until 1949, after visiting her exhibition at the Pierre Matisse Gallery, that Phillips decided to include a MacIver painting in his collection.[7] Especially entranced with the oil *Paris,* which was purchased by the Metropolitan Museum of Art from the Matisse Gallery show, he searched for a painting similar in spirit and imagery.[8] In 1951 he mounted a solo exhibition for her at his museum, and from it he purchased *The Window Shade.* Nevertheless, he still hoped for a "landscape approaching the *Paris* in magic . . . where interest of subject matter and decorative design supplements . . . elusive lyricism."[9] His wish was fulfilled two years later with his purchase of *New York.* Phillips and his wife held another MacIver exhibition at The Phillips Collection in 1965, from which they purchased the lyrical, opalescent *Printemps.*[10] MacIver's ability to capture the spirit of her subject, as well as her keen observation and confidence with paint, made her paintings ideal, timeless candidates for Phillips's collection.

GHL

361

Morris Cole Graves, a member of a group of artists who became known as the Northwest School of Visionary Art, was born August 28, 1910, on a homestead tract in Fox Valley, Oregon. When Graves was two years old, the family moved to Seattle. The spiritual bonds to the culture and terrain of the Pacific Northwest that Graves forged as a child had a profound and lasting influence on his art. Brief service in the merchant marine at age seventeen took him to Asia. After his travels abroad, Graves received his first formal art training while in high school in Beaumont, Texas. Returning to Seattle, he began to paint full time and received regional recognition in the annual exhibitions of Northwest artists at the Seattle Art Museum. He had his first national exposure in 1942 when thirty of his paintings were included in an exhibition at the Museum of Modern Art in New York. He served in the U.S. Army from 1942 to 1943. Graves was awarded a Guggenheim Fellowship in 1946, but his intention to spend the year working and studying in Japan was thwarted by the Occupation, so he traveled to Hawaii instead. During the next six years he painted prodigiously in Seattle and made trips to Europe, Japan, and Mexico. In 1954 he settled in Ireland, living there sporadically for the next eight years. Graves experimented with three-dimensional works in the early 1960s, when he also traveled to New Zealand, Australia, India, Israel, and Greece. He returned to the United States in 1964 and established a studio on the coast of northern California, where he currently resides. The Phillips Collection owns two oils, eight gouaches, and one pencil drawing by the artist.

The Graves Unit

Duncan Phillips was first exposed to the art of Morris Graves in 1942 when he visited an exhibition at the Museum of Modern Art.[1] Response to the paintings by the unknown artist from Seattle was overwhelmingly positive, and Phillips echoed the views of many art critics: "Graves was the sensation of the show. When we discovered Graves, and he became a national celebrity, it was the immediate impact of an original genius."[2] Alfred H. Barr Jr., MOMA's director, was so taken with Graves that he purchased ten paintings for the museum before the exhibition opened to the public. Phillips acquired his first painting directly from this exhibition and went on to collect an additional nine works.[3] In 1942 he organized the first Graves show at his museum, signaling a lifelong commitment to the artist.

Phillips's support of Graves extended beyond collecting and exhibiting his paintings. He wrote several essays and articles about him and recommended him for a Guggenheim Fellowship to study in Japan, declaring, "[Morris Graves] is in my opinion the most original and inspired of all our young American painters . . . a seeker of truth, a thinker and a philosopher."[4] Graves was awarded the fellowship in 1946, but his dream of traveling to Japan to help in the postwar recovery effort was not realized because of official restrictions placed on travel between the United States and Japan. Graves remained grateful to Phillips for his support, and the two corresponded warmly, though infrequently, throughout the years. The relationship culminated in their meeting in Washington in 1963.

From the first, Phillips was drawn to the powerful emotional content and symbolic imagery of Graves's art. Although defying definitive categorization, his style was shaped by various regional and international influences. After being labeled a surrealist early in his career, Graves quickly abandoned most stylistic elements associated with surrealism. He did, however, remain committed to the surrealist credo that art should reveal the creator's subconscious and serve as a means of psychic exploration. Another major force that shaped his art was his association with Northwest artist Mark Tobey, who in turn introduced him to Zen Buddhism and other aspects of Asian culture. Zen, which offers a path to enlightenment through meditation, was of great importance to many artists in the Pacific Northwest and became a central theme in Graves's art.[5] Graves painted natural and recognizable forms that carried spiritual meaning, drawing on their potent symbolic power as well as their intrinsic beauty.

Phillips greatly admired the Asian flavor of Graves's art, believing that his style transcended cultural barriers and held a message of compassion for people of all countries. Perhaps part of Phillips's enchantment derived from the unstable world situation in the early 1940s. The relationship between East and West that Graves's art expressed must have been an inspiration to the collector, especially in view of the fact that amid the turmoil and tragedy of the Second World War, Phillips had held an abiding belief in the healing power of art. "To those of us who are deeply moved by his exquisitely sensitive symbols of birds in space," Phillips wrote, "can be felt and revered the aspiration of a rare artist to help in healing the wounds of war. He can help immediately by searching for the bond between Occidental and Oriental art to the end that one world may be realized in our time."[6]

The Graves unit is composed of paintings from the early 1940s through the mid-1950s and contains examples of the major themes—such as birds, trees, and vessels—that occupied the artist throughout his career. Phillips appears to have been particularly fond of Graves's bird paintings, because he purchased five of them for the collection. In addition, he acquired a powerful religious work, *The Chalice,* 1941 (cat. no. 365), a delicate still life, *August Still Life,* 1947, and a jewel-like painting of a pine forest, *Young Pine Forest In Bloom.* Phillips appreciated Graves's simple, emblematic subjects and the fluid and calligraphic manner in which he painted on thin rice paper, a technique that he felt emphasized the ephemeral quality of the image itself.

Graves's paintings blend harmoniously in The Phillips Collection with works by mystical artists like Mark Rothko and Mark Tobey. Unlike these abstract expressionists, however, Graves paints recognizable, mysterious images that spring from his subconscious. Whether poignant, whimsical, or serene, the paintings chosen by Phillips express with quiet beauty and conviction the artist's belief that painting connects him to the spiritual reality that lies beyond the material world.

JBG

362

Surf and Bird, ca. 1940

Bird and Surf

Gouache on paper, 26½ × 29¾ (67.3 × 75.5)

Signed l.r.: *M. Graves*

Acc. no. 0844

The artist; PMG purchase (through MOMA) 1942.[7]

363

Sanderlings, ca. 1943

Gouache on paper, 25 × 30 (63.5 × 76.2)

Unsigned; inscribed (probably by artist) in black paint, l.l.: *Sanderlings*

Acc. no. 0843

The artist to Willard Gallery, New York, 1943; PMG purchase 1944.[8]

364

Wounded Gull, 1943

Gouache on paper, 26⅜ × 30¼ (67.6 × 76.8)

Titled in graphite, l.l.: *Wounded Gull;* signed and dated in graphite, l.r.: *M. Graves/43*

Acc. no. 0847

The artist to Willard Gallery, New York, 1943; PMG purchase 1945.[9]

Surf and Bird, Sanderlings, and *Wounded Gull* reflect Graves's fascination with birds and illustrate the variety of means at his disposal for depicting them. According to Graves, the bird is often a symbol of solitude, as strikingly conveyed in his paintings of single birds surrounded by the sea or by darkness.[10] The birds appear almost human in their expression of emotion. Duncan Phillips recognized this quality, observing, "Graves is seeking . . . to symbolize the fate of man through the fate of birds."[11]

These carefully observed and rendered images, painted over the course of three years (1940–43), reflect Graves's empathetic relationship with the wildlife that inhabits the rocky coast near his home on an island in Puget Sound. Painted in gouache on thin rice paper, they appear fresh and spontaneous yet convey a sense of fragility and delicacy that reflects the transience of the subject matter. Phillips responded to Graves's choice of materials, writing: "One feels a solicitude for the survival of these rare visionary perceptions. . . . In no other medium and in no other way could this artist have expressed what he had to say about the insecurity and brevity of life and the poignant loveliness that can stir us for a second but may never return."[12]

Representative of Graves's early style, *Surf and Bird* depicts the bird in a simplified manner, painted against a relatively barren background. The image of the small creature clinging tenaciously to a lone rock in the middle of a vast expanse of water suggests that man's spirit will prevail despite the isolation and loneliness that engulf him. The white brushmarks surrounding the bird create the effect of sea foam rising in the air as waves break against the rock. The application of white paint in this manner has been related to Mark Tobey's experimentation with "white writing," a technique the Seattle artist developed out of his study of East Asian calligraphy. By contrast, Graves used this technique to produce a mystical environment for his creatures; they exist in a world that lies between the material and the ethereal.

In *Sanderlings* he has created a lively coterie of shore birds at the edge of the sea. Their forms are reduced to abbreviated brushstrokes that create an abstract pattern across the wrinkled rice paper, the birds echoing the diagonals of the waves. Black dots define the sanderlings' eyes, which appear disproportionately large in comparison to their slight bodies. In the process of capturing their characteristically intent gaze, he conveyed his fascination with the spiritual and psychological implications of sight. He achieved an extraordinarily atmospheric quality by using black washes, accentuated with white highlights, for the turbulent night sky. Like tiny specters, the birds appear to flit along the darkened beach on their delicately brushed legs and feet.

362

363

364

Wounded Gull is part of a series depicting injured sea gulls that Graves produced immediately following his honorable discharge from the army in 1943. He was drafted into military service despite his registration as a conscientious objector, and his year in the army was a devastating episode in his life. *Wounded Gull* shows an injured sea gull suffering in solitude at the ocean's edge. It is a powerful and unforgettable record of the artist's loneliness, despair, and helplessness. Graves's quick and spontaneous brushstrokes eloquently capture the agony of the bird's broken body. As Duncan Phillips observed: "He has felt vicariously the pangs of approaching death at the imagined sight of the old gull who with twisted plumage and shattered wings staggers on or sinks at last into his world of boundless sea and sky gone black."[13] Although the blood-flecked water and the bird's anguished form imply the inevitability of death, the painting suggests, through the touches of blue that define both the animal and the waves, that the gull's body will soon be enveloped by the ocean, becoming one with the life-giving elements of the earth.

JBG

365

Chalice, 1941

Chalice and Moon
Gouache, chalk, and sumi ink on paper, 27 × 30
(68.5 × 76.2)
Unsigned
Acc. no. 0840

The artist to Willard Gallery, New York, 1942; PMG purchase 1942.[14]

366

In the Night, ca. 1943
Gouache on paper, 30¼ × 26½ (76.8 × 67.3)
Unsigned; inscribed (probably by artist) in black ink, l.l.:
In the Night
Acc. no. 0842

The artist to Willard Gallery, New York, probably 1943; PMG purchase 1944.[15]

Chalice and *In the Night,* painted two years apart, exhibit strong stylistic similarities in spite of their different subject matter; especially noticeable are Graves's treatment of space and his choice of a restricted palette. The forms in both paintings seem to materialize out of velvety blackness, floating luminously against an infinite background. Like many gouaches from the late 1930s and early 1940s, these works are painted primarily in black, gray, and white.

However, *Chalice,* striking in its simplicity, is rendered in a deep red; the vessel is outlined in white, a technique that appears to push it

365

toward the viewer. The original title of the painting may have been *Chalice and Moon,* suggesting that the hypnotic sphere inside the chalice was intended to represent a celestial body. Indeed, the glowing form seems to hover in the darkness like a full moon in the night sky. *Chalice* evokes vivid associations with the eucharistic cup in the Christian tradition and the Holy Grail of medieval legends. Characterized by Jung as a creative vessel that contains the "elixir vitae," the chalice is a symbol of rebirth and life in all of its contexts.[16] Graves's fascination with the chalice may be tied to his own spiritual rebirth through Zen Buddhism. He explored the rebirth theme repeatedly during the 1930s and 1940s; in the following decades he painted other types of vessels, such as Chinese ritual bronzes and delicate glass vases.

Like the chalice, the luminous creatures populating *In the Night* float in boundless space; eerie and whimsical beings of the artist's imagination, they are rendered with delicacy and detail. Graves describes how, from his isolated coastal studio, he would listen to the night sounds in the surrounding forest: "Any sound I could hear I paid intense attention to and then quizzically and playfully tried to imagine what creatures made the sound."[17] The result is a dreamlike composition in which an immense bird's wing flutters in the darkness above a smiling, furry snail and a wary rodent. Phillips might have been referring to this painting in particular when he remarked: "As a poet-painter [Graves] haunts our minds and senses like night sounds in a great stillness."[18]

JBG

366

JACKSON POLLOCK (1912–56)

Paul Jackson Pollock, one of the most influential of the abstract expressionists, was born January 28, 1912, in Cody, Wyoming, the fifth and youngest son of impoverished farmers. Pollock grew up to be rebellious and irascible, and at the same time highly introverted and depressed; he drank excessively even as a boy. After attending the Manual Arts High School in Los Angeles for two years, Pollock enrolled at the Art Students League in New York in 1930. Until 1933 he studied with the Regionalist painter Thomas Hart Benton, whose rhythmical principles of composition lastingly influenced him. In 1937 the painter and theorist John Graham introduced Pollock to the works of Picasso and the teachings of the psychologist C. G. Jung. Under the influence of Picasso's cubo-surrealist paintings and Jung's concept of man's collective subconscious, he began to develop a new pictorial approach. Pollock's first one-person exhibition was at the Brooklyn Museum in 1935. Of greater impact was his participation in Graham's 1942 exhibition "American and French Paintings" at McMillen Inc., New York, and the ensuing year in Peggy Guggenheim's "Exhibition of Collage" at her Art of This Century Gallery, followed by a solo show there. From then on he was continuously represented by major New York galleries. In 1944 the Museum of Modern Art was the first museum to acquire one of his works. His career reached its height in the late 1940s, when he began executing his drip paintings. During this brief period Pollock avoided alcohol and lived harmoniously in his farmhouse on Long Island with his wife, the painter Lee Krasner, whom he had married in 1945. In 1950 Pollock resumed drinking, and his health and creative powers deteriorated. After 1954 he painted only sporadically. July 11, 1956, he died in a car accident. The Phillips Collection owns one collage and one oil.

367

Collage and Oil, ca. 1951

Oil, ink, gouache, and paper collage on canvas, 50 × 35 (126.9 × 88.8)

Signed in black ink, l.r.: *Jackson Pollock*

Acc. no. 1598 (O'Connor and Thaw no. 1040)

Lee Krasner Pollock; TPC purchase through Sidney Janis Gallery, New York, 1958.[1]

The name Jackson Pollock calls to mind the famous drip paintings he created between 1947 and 1950. Yet Pollock also worked with the technically less gestural collage, a medium that hardly corresponds with his image as an "action painter." He first experimented with collage in 1943 at the suggestion of Peggy Guggenheim, who invited him to participate in an international "Exhibition of Collage" at her gallery, Art of This Century; however, he only sporadically returned to collage during the following years.[2] Probably one of his last collage works, *Collage and Oil* of 1951 conveys an ambivalent balance between flatness and shallow space, and between figuration and abstraction. This ambivalence mirrors the mounting personal problems of Pollock, who for much of his life battled alcoholism and self-destructive psychological tendencies.

Pollock's development as an artist during the early 1940s was decisively influenced by John Graham, who, making frequent reference to Jung and Picasso, claimed that "primitive races and primitive genius have readier access to their unconscious mind than so-called civilized people. . . . The unconscious mind is the creative factor and the source and the storehouse of power and of all knowledge, past and future. . . . The true nature of painting . . . due to its operating space is two-dimensional."[3] Confronted with such ideas and inspired by the art of Picasso and Miró, Pollock gradually transformed his figurative language into a nonrepresentational one. By the end of the decade, he had developed an all-over, polycentric dripping technique that transformed the painting into an optical space of free-floating, variously interwoven lines of vital rhythmical energy. Thus he had found a technique that through immediate contact with the realm of the unconscious revealed the mind's collective knowledge and underlying forces: "energy and motion made visible—memories arrested in space, human needs and motives."[4]

Because Pollock's development in collage in general corresponded to his development in his oil paintings, *Collage and Oil* illustrates his situation at the beginning of the 1950s, following the immensely creative and productive period from 1947 to 1950. In 1951 he found himself torn between his artistic career and his increasingly threatening personal problems. *Collage and Oil,* like his contemporaneous works of poured black paint, represents an attempt to maintain his great achievement—the liberation of anti-illusionistic optical space—while returning to figurative motifs: haunting images emerging from his obsession with sexuality, threatening female power, male and female interdependence, and violence. This work represents his declining ability to transform his personal suffering into a universal artistic language.[5]

The surface consists of a complex and manifold interwoven structure: onto three layers of oil paint—black, pink, and earth red—Pollock adhered torn, wrinkled fragments of Japanese paper that had been previously splattered with black paint or ink and light-orange gouache. Lastly, he dripped Indian-yellow paint, or gamboge, and titanium-white gouache on the entire surface in tendrils similar to Asian calligraphy.[6] However, the torn paper fragments, shaped with figural allusions, are not evenly integrated into the painting's intended two-dimensional structure; they remain more or less separate elements occupying their own space. As a result, *Collage and Oil* appears more closely related to traditional collage patterns than to some of Pollock's other late collages.[7]

Although none of the collage elements can be precisely interpreted, the long rectangular shapes in the upper left seem to suggest two struggling human figures. These forms move within a file of shardlike fragments that appear to be falling away from the struggle. Further turmoil is suggested by the disquieting red background visible between the predominantly black collaged areas.

Duncan Phillips came to Pollock's art in the wake of general acceptance, which suggests that he was mainly interested in the artist as a central phenomenon of America's postwar art development and felt that his museum needed a representative example.[8] While holding in high esteem the meditative, transcendent approach of Rothko, Phillips probably did not respond to Pollock's disquieting expressiveness and intense psychic questioning. Yet he must have appreciated Pollock's calligraphic patterning and masterful manipulation of color in *Collage and Oil.*

SabF

367

PHILIP GUSTON (1913–80)

Philip Guston, an intense, contradictory personality associated with the New York School, was born Phillip Goldstein June 27, 1913, to Russian-Jewish immigrants in Montreal. In 1919 he and his family moved to Los Angeles, where he attended the Manual Arts High School in 1927; there he met Jackson Pollock. The same year, both were expelled, and Guston found work at odd jobs, including a stint as a Hollywood extra. A 1930 scholarship sent him to the Otis Art Institute in Los Angeles, but he left after three months and had his first solo exhibition at Stanley Rose's Bookshop in Los Angeles. In the winter of 1935–36 he moved to New York, where he worked on murals for the WPA/FAP and met de Kooning, Gorky, Stuart Davis, and others. In 1937 he married fellow artist and poet Musa McKim and changed his name to Philip Guston. From 1941 to 1945 he taught at the State University of Iowa in Iowa City, the first of many teaching positions he would hold. The Midtown Galleries held his first solo exhibition in New York in 1945. In 1947 he bought a summer home in Woodstock, New York, and became a close friend of Bradley Walker Tomlin. In 1948–49 the Prix de Rome led him to Europe for a year. His return to New York ushered in a new phase of abstract works, examples of which were exhibited in 1952 at New York's Peridot Gallery. From 1955 to 1962 Guston was represented by the Sidney Janis Gallery. After traveling to Europe in 1960, he had a major retrospective at the Guggenheim in 1962. Guston moved to Woodstock permanently in 1967 and began producing work that featured symbolism and combined elements of his previous training in cartoons and figurative painting. This work was displayed by the Marlborough Gallery from 1966 to 1972; in 1974 he joined the David McKee Gallery in New York. Guston died June 7, 1980, at his home in Woodstock. The Phillips Collection owns two oils and one acrylic on paper.

368

Native's Return, 1957

Oil on canvas, 64⅞ × 75⅞ (164.7 × 192.7)
Signed in blue paint, l.l.: *Philip Guston;* inscribed on canvas reverse, u.l.: PHILIP GUSTON/1957/65" × 76"/"NATIVE'S RETURN"
Acc. no. 0870

TPG purchase from the artist through Sidney Janis Gallery, New York, 1958.[1]

Guston, after painting in a figurative mode with political overtones for the WPA during the 1930s, strove during the following decade for the essence of form and a means of self-expression by combining cubist fragmentation with hallucinatory imagery reminiscent of Giorgio de Chirico. In the early 1950s he eliminated representation altogether and arrived at an abstract style featuring centered masses of densely packed brushstrokes whose boundaries fade and dissolve into their surrounding atmosphere. *Native's Return* is one of Guston's strongest statements in his abstract style.

Guston's conversion to abstraction came on the heels of a trip in 1948–49 to Italy, where he admired the compositional structure of paintings by his favorite Old Masters, Piero della Francesca, Masaccio, and Uccello, as well as the glowing colors and rich tonality of the Venetian painters Titian and Tiepolo.[2] From these artists he gained renewed appreciation of form and color as interacting entities within the picture plane. Through the influence of the abstract expressionist painters with whom he fraternized upon his return, he endeavored to convey through expressive abstract form and tonal color his inner conflicts, sensations, and experiences, for which he had an acute alertness and memory. According to Dore Ashton, Guston had "a deep tenderness and susceptibility to nature, his own and that of the cosmos," more so than any other abstract expressionist.[3] At this time his art was most closely related to that of his friend Bradley Walker Tomlin in its sensitivity to the wide range of expression possible through color, be it vibrant and direct or delicate and tenuous.

Guston tended to concentrate paint in the lower-center section of the canvas, partly because of his habit of working close to the picture in order to transfer his thoughts as quickly as possible. Beginning free of preconceived ideas, he viewed the act of painting as "a dialogue between [the artist] and the surface. As you work, you think and do. . . . I work to eliminate the distance between my thinking and doing."[4] Although such a method would seem to encourage speed and spontaneity, Guston's process was tortuous and time-consuming and involved many eliminations and repaintings. As Irving Sandler explained: "When Guston confronts a finished canvas, he feels he has revealed an organism that has always existed. He is surprised both at its familiarity and at its newness. . . . It is not enough to say: 'That expresses exactly how I feel'; he insists on being able to say: 'I never knew I felt like that.'"[5]

Guston's abstractions of the early 1950s were composed of shimmering clusters of feathery brushstrokes that earned him the misleading label of abstract impressionist.[6] *Native's Return* was painted in the late 1950s, when Guston's intention was to heighten the solidity and permanence of his paintings—to represent "stasis . . . in fluid space." Solid masses of thick color have been bonded together, without overlapping, inside an encasing atmosphere. Forms of violet-blue, light green, and salmon red are shot through with black paint, graying the palette and adding weightiness to the image. However, an opposing sense of transience is created by the surrounding white atmosphere, which appears to eat away slowly at the edges of the paint masses, threatening their disintegration.[7] Guston sought such duality in his abstractions—a sense of "simultaneously open and fixed, animate and inert"—as a reflection of the opposing forces within himself and in nature.[8]

Like other works of the period, the title alludes to travel.[9] Perhaps he intended to refer to his journey toward abstract expression, toward the technique that freed him to unveil in his art the most primitive nature of his being. His inner struggle on this road to self-discovery might be revealed in the many areas of built-up paint and the scraped-back pigment. Dore Ashton has observed that for Guston abstraction "was an intoxicating experience. . . . Everything was pitched to successive acts of discovery, the process itself was the voyage."[10]

Duncan Phillips purchased *Native's Return* soon after its 1958 showing at the Sidney Janis Gallery, where it received favorable comment for its power and vivid color.[11] Entranced by the painting's sensuous color, Phillips displayed it with paintings by Rothko and Tomlin; however, he noted a difference; fraught with dualities and indecision despite its lyrical color, Guston's painting derived from "immediate existential needs rather than out of ideal drives."[12]

GHL

369

The Lesson, 1975

Oil on canvas, 67¼ × 72½ (170.8 × 184.1)
Signed in red paint, l.c.: *Philip Guston*
Gift of Musa Mayer and Musa Guston, 1984.
Acc. no. 0869

The artist's estate to Musa Mayer and Musa Guston; on loan to TPC through David McKee Gallery, New York, 1981–84; gift of Musa Mayer and Musa Guston, 1984.

After receiving critical acclaim for his abstractions of the 1950s and early 1960s, Guston surprised and alarmed the art world in 1970 with his exhibition at the Marlborough Gallery of stark, cartoonlike figurative paintings. The raw, often disturbing quality of these new works came as a shock in light of his earlier fame as a

368

master of lyrical color and fluid form. He explained, "The visible world, I think, is abstract and mysterious enough."[13] His friend Willem de Kooning was one of the few who understood, saying, "What's the problem? This is all about freedom."[14]

Guston's decision to change resulted not only from his desire for new avenues of profundity and complexity but also from his innate attraction to structure in painting. Always curious, self-questioning, and wary of artistic complacency, he seemed to be seeking fresh possibilities for plumbing the depths of his psyche and interpreting his experience. And after a break from painting from 1966 to 1968, when he sketched representational subjects, his full-blown figurative style emerged. Indeed, according to Ross Feld, "He expected out of figurative work nothing less than the same mix of perplexity the abstract work provided."[15] As was the case in his abstractions, Guston arrived at a final image with few preconceived ideas and after much struggle, stating, "It's . . . totally uncontrollable, because meaning keeps shifting and so does the structure."[16] He explained: "I knew that I would need to test painting all over again in order to appease my desires for the clear and sharper enigma of solid forms in an imagined space, a world of tangible things, images, subjects, stories, like the way art always was."[17] Such comments hark back to his admiration for the art of the Italian Renaissance painters and the ambiguities of space and meaning developed by Giorgio de Chirico.

Guston considered many of his 1970s paintings to be self-portraits and comments on the artist's situation, as well as more explicit versions of his abstractions. The visual vocabulary of *The Lesson*—bald heads with bulging eyes, shoe soles, and a scratchy, barren landscape awash in pinks and grays—typifies these works. "Oh, it is all so *circular,* isn't it," Guston reflected. "The recent work makes me feel free to use whatever formal and plastic imagery and capabilities I may possess. I mean from my own past too—all the memories. Please forgive my immodest comparison, but like Babel, I want to 'paint' of things long forgotten."[18] In *The Lesson* Guston may have been alluding to childhood occurrences—for instance, the opposition of his father, an agnostic, to his enrollment in a cheder for religious instruction.[19] Or perhaps he was referring to a family disagreement, the head staring downward in the foreground representing the artist anxiously in wait for the mute head-to-head combat of the background figures

369

to cease. The bubble and work boots combine to form a visual paradox, hinting at the transience and harsh realities of life.

In an effort to heighten the direct symbolism of the objects in works like *The Lesson,* Guston stripped them of such detracting elements as calligraphic brushstrokes or pleasing color; "he pledged himself to an unlubricated approach that admitted style only as a desperate intrusion."[20] Until his death in 1980 Guston continued to discover rich possibilities in the figurative style, moving toward an increased consolidation of imagery of the kind in *Untitled,* 1980, a recent gift to The Phillips Collection.[21] Inevitable extensions of his abstractions, yet further burdened by hallucinatory starkness, these late works record Guston's continued journey into the unknown. Feld suggests that "he works . . . at making the impossible explicitly visible. What if you went to the other side of the known, and instead of discovering the sublime Null, you found *something,* lots of different somethings?"[22]

GHL

ROBERT MOTHERWELL (1915–91)

An articulate, intellectual talent among the abstract expressionists, Robert Motherwell was born January 24, 1915, in Aberdeen, Washington. While attending Stanford University (1932–37), Motherwell took his first trip to Europe. In 1937 he began graduate study in philosophy at Harvard University, and he had his first one-person exhibition at the Raymond Duncan Gallery, Paris, during his stay in Europe in 1938–39. In 1940 he studied art history with Meyer Schapiro at Columbia University. Through Schapiro he met many of the European surrealist painters and soon was devoting most of his time to painting. After settling in New York in 1941 he became associated with the group of American artists influenced by automatism—Pollock, de Kooning, William Baziotes, and Hans Hofmann—and began writing and lecturing on modern art. His first New York one-person exhibition was held in 1944 at Peggy Guggenheim's Art of This Century Gallery; that same year the Museum of Modern Art was the first museum to purchase one of his works. In 1946 he met Rothko, Barnett Newman, and Herbert Ferber and by 1949 had begun his *Elegy to the Spanish Republic* series, for which he was best known. During the 1950s and 1960s Motherwell expanded his writings on art and taught painting at several locations. In 1958 he married Helen Frankenthaler, his third wife. In 1967 he painted the first of his *Opens* paintings, which became an ongoing series in 1968. In 1971, following his divorce, he established permanent residence in Greenwich, Connecticut; two years later he married the German photographer Renate Ponsold. He continued to expand his artistic vocabulary in paintings, prints, and collages. He died July 16, 1991, in Provincetown, Massachusetts. The Phillips Collection owns two collages and one oil by the artist.

370

In White and Yellow Ochre, 1961

Oil, charcoal, ink, tempera, and paper collage on paper, 40⅞ × 27 (103.8 × 68.5)
Signed and dated in graphite, l.r.: *R Motherwell 61*
Acc. no. 1394

TPC purchase from the artist (from exhibition) through Marlborough-Gerson Gallery, New York, 1965.

371

Mail Figure, 1959

Water-based paint and paper, mailing label, and wrapping paper collage on off-white paper, 28½ × 22½ (72.4 × 57.1)
Signed and dated, u.r.: *R.M/59;* in graphite on cardboard backing, u.c.: *"MAIL FIGURE"/Robert Motherwell/1959/Falmouth, Mass.*
Acc. no. 1395

Purchased by Marjorie Phillips for personal collection from the artist (from exhibition) through Marlborough-Gerson Gallery, New York, 1965; transferred to TPC probably 1966.[1]

Motherwell underwent a period of frustration during the mid-1950s, when he seldom exhibited and destroyed many works. Between 1959 and 1961, however, he experienced a renewal of experimentation and creativity, refining his *Elegy to the Spanish Republic* series, creating a new series of oils, and executing numerous collages, including *In White and Yellow Ochre* and *Mail Figure*.

As a member of New York's abstract expressionist group from the beginning in the 1940s, Motherwell favored abstraction and automatism and considered collage as powerful a method of expression as painting. He began working in collage in 1943, gradually developing it as a medium that not only complemented but at times also directed and shaped his paintings.[2] Through collage and its combination with the paint medium, Motherwell managed to create images that were ambiguous in their expression and hence open to varied interpretations. Motherwell began a work with no preconceived subject matter, arranging and combining colors, forms, and patterns until he arrived at a composition that evoked in him a distinct sensation—be it joy, terror, mystery, or nostalgia. He strove for "a complex of qualities whose feeling is just right—veering toward the unknown and chaos, yet ordered and related in order to be apprehended."[3] Since his college days an enthusiast of nineteenth-century French symbolist poetry Motherwell had echoed the verbal imagery of Charles Baudelaire, Stéphane Mallarmé, and Paul Verlaine by carefully choosing colors and forms that most effectively evoked sensory response. In Jack Flam's view, Motherwell's art is "one of compression and condensation, of making apparently simple relationships of form and color be charged with as much feeling, and as much meaning, as possible."[4] To achieve this end, Motherwell focused upon materials that had the power to express and animate the picture plane, which he called the "void."[5] He chose colors—yellow ochers, blues, black, white, red—"that [had] rich associative meanings for him."[6]

The medium of collage, in which ready-made materials are taken out of context and placed in new, at times haphazard, association with other fragments, is particularly well suited to this method of chance association. Motherwell described the process as beginning with a "piece of paper dropped at random. . . . Then the struggle begins, and endures throughout in a state of anxiety that is ineffable, but obliquely recorded in the inner tensions of the finished canvas."[7]

Because he used materials found in his immediate surroundings—such as letters and postage stamps—he considered his collages "a kind of privately coded diary, not made with an actual autobiographical intention, but one that functions in an associative way"; in contrast, he thought of his paintings as "timeless" entities.[8]

While Motherwell's collages of the mid to late 1950s demonstrate in their richness of detail the strong influence of Picasso and Schwitters, works from around 1960, such as those in The Phillips Collection, are simpler in treatment, usually a single, centered collage motif upon a painted surface. The title *Mail Figure* makes a tongue-in-cheek allusion to the whimsical, ponderous, two-legged white shape that bears a postage stamp in its center like a name tag. Motherwell loosely affixed the white paper to a heavily painted brown ground and ripped its lower half into strips to form the figure's appendages. The collage was probably titled after its creation.

In contrast, *In White and Yellow Ochre* is a more abstract, enigmatic, and complex image. While its central motif might allude to an upright figure, elements in the upper register could be interpreted as a landscape with an implied horizon line.[9] A refined, decorative quality arises from the muted colors (predominantly ocher and white), the sparse brushstrokes and drips, and the calligraphic nature of the Cyrillic newsprint in the central fragment. Such restraint is shattered, however, by the ragged, torn edges and splattered ink spots of the newsprint motif, whose black staring eye jars the viewer into acknowledging the existence of darker portents. In Sam Hunter's view, this conflict between elegance and raw force demonstrates that Motherwell was "regulating violent gusts of native feeling by a deeply ingrained habit of civilized restraint."[10]

Duncan and Marjorie Phillips first showed their enthusiasm for Motherwell when they held a one-person exhibition of his collages in 1965. Marjorie bought *Mail Figure* from this show as her husband's Christmas present, while Duncan purchased *In White and Yellow Ochre* for the collection.[11] The sophisticated air and controlled expressiveness of *In White and Yellow Ochre* made a strong statement about the artist's temperament, a combination of reserve and expressiveness that Phillips had also hailed and valued in some of Motherwell's colleagues—Bradley Walker Tomlin and Philip Guston, in particular.

GHL

370

371

RICHARD CLIFFORD DIEBENKORN JR. (1922–93)

Richard Diebenkorn maintained his love of vivid color and structured composition in both abstract and representational modes of expression. Born in Portland, Oregon, April 22, 1922, Diebenkorn moved with his family to San Francisco in 1924. After attending Stanford University from 1940 to 1942, he joined the U.S. Marine Corps, where he concentrated on art classes. Stationed in Virginia during the winter of 1944, he used some of his leave time to visit the Phillips Gallery. In 1946 he enrolled at the California School of Fine Arts in San Francisco, where he studied with David Park. Awarded the Albert Bender grant-in-aid fellowship the same year, he lived and worked in Woodstock, New York, for nine months, visiting New York City and making many contacts. After returning to San Francisco in 1947 he was appointed to the faculty at the California School of Fine Arts, a position he held for two years; his fellow teachers included Elmer Bischoff, Edward Corbett, Hassel Smith, and Clyfford Still. Diebenkorn had his first one-person show in 1948 at the California Palace of the Legion of Honor. After receiving a degree from Stanford University in 1949, he was awarded an M.F.A. from the University of New Mexico, Albuquerque, in 1951. He briefly taught at the University of Illinois at Urbana in 1952–53, settling afterward in Berkeley. In 1952 he received his first one-person gallery show at the Paul Kantor Gallery, Los Angeles; his first New York gallery show took place at Poindexter Gallery in 1956. He taught at several California arts institutions from 1955 to 1973. While teaching at UCLA in 1967, he worked in a studio (vacated by Sam Francis) in the Ocean Park district of Santa Monica. There he created his last representational works and turned to abstraction with his *Ocean Park* paintings. In 1981 he began to concentrate on drawing. Diebenkorn died in Berkeley, California, March 30, 1993. The Phillips Collection owns four early oils by Diebenkorn, one drawing, a gift of the artist in 1990, and two acrylics on paper, gifts from the estate in 1993.

372

Berkeley No. 1, 1953

Oil on canvas, 60¼ × 52¾ (153.0 × 134.0)
Signed and dated in gray, l.l.: *RD 53;* signed in black paint on canvas reverse, u.r.: *R DIEBENKORN/BERKELEY #1*
Gift of Mr. and Mrs. Gifford Phillips, 1977
Acc. no. 0518

Mr. and Mrs. Gifford Phillips, Los Angeles, by 1960; gift to TPC 1977.[1]

Berkeley No. 1 is the first in a series of more than fifty abstractions painted by Diebenkorn between 1953 and 1955, shortly after his return to Berkeley, California. At this early point in his career, Diebenkorn, who had been painting abstractions since the mid-1940s, clung to the goal of expressive color, nonobjectivity, and flatness in his art. His interest in defining his images by color at the expense of line initially stemmed from his lifelong admiration of the works of Cézanne and Matisse, but his purely abstract, nonrepresentational mode reflected the influence of the New York abstract expressionists.[2] Diebenkorn met many of these artists when he visited New York in 1946–47 and 1953; in addition, the atmosphere at San Francisco's California School of Fine Arts during the late 1940s was dominated by the presence of Clyfford Still, who had brought from New York many of the ideals of Gorky, Rothko, and Pollock. By the early 1950s Diebenkorn's style incorporated the color expanses of Motherwell, Rothko, and Still, combined with the flesh tones and punctuated, forceful lines of de Kooning. This approach is exemplified by the *Berkeley* paintings and later became known as the "Western example" of abstract expressionism.[3]

Berkeley No. 1 is a two-dimensional abstraction composed of broad expanses of gestural color highlighted with sketchy, broken tendrils of black paint. At first glance, the composition of spattered and ripped paint appears to have been effortlessly created; however, closer examination reveals that Diebenkorn built up the surface in several layers. He strove for this reworked effect, stating that "the friction and frustration of the try itself are what generate the energy necessary to solve a painting." The paint texture of *Berkeley No. 1* varies widely from heavy impasto to thin wash.[4]

Diebenkorn's *Berkeley* works grew out of his *Albuquerque* (1950–52) and *Urbana* (1952–53) series. The works of all three series have been termed "abstract landscapes" based on their horizontal orientation, their color and light, and their resemblance to maplike aerial views.[5] However, the artist emphasized that he had not painted particular scenes.[6] While many of the *Albuquerque* paintings incorporate blacks and the opaque, muted ochers, tans, greens, and clays of the desert environment, the *Urbana* works have a lush, varied palette emblematic of the region.[7] The *Berkeley* series is characterized by intense, clear color—a reflection of the sunny, temperate California climate.

Although Diebenkorn's later *Berkeley* paintings are his most gestural and active, they stop short of the explosive effect for which abstract

expressionist painting is known. The reserved air of *Berkeley No. 1* is maintained by the tendency of the color areas to remain within discrete boundaries, despite the highly visible, frenetic, and multidirectional brushstrokes. The compositional division into three distinct tiers of color—a central band of tans, pinks, ochers, and purple sandwiched between predominantly white strips—adds to the controlled nature of the image. Although the *Berkeley* series was the closest Diebenkorn came to the abstract expressionist style, it was most important to him in arriving at his own working method, which stressed manipulation and placement of passages of pure color. This method could be adapted to several types of imagery, both abstract and representational, as Diebenkorn was to prove in later work.

GHL

373

Interior with View of the Ocean, 1957

Oil on canvas, 49½ × 57⅞ (125.5 × 146.3)
Signed and dated in blue paint, l.r.: *RD 57;* inscribed in black paint on canvas reverse, u.r.: *R DIEBENKORN/BERKELEY # 59* [painted over]/*JAN. 1955* [painted over]/*INTERIOR WITH VIEW/OF THE OCEAN/1957*
Acc. no. 0520

TPG purchase from artist through Poindexter Gallery, New York, 1958.[8]

374

Girl with Plant, 1960

Interior: Woman With Plant

Oil on canvas, 80 × 69½ (203.3 × 176.4)
Signed and dated in gray paint, l.l.: *RD 60;* inscribed in black paint on canvas reverse, u.r.: *R DIEBENKORN/GIRL WITH PLANT/1960 55*
Acc. no. 0519

TPG purchase from artist through Poindexter Gallery, New York, 1961 (possibly from exhibition).[9]

Both *Interior with View of the Ocean* and *Girl with Plant* are examples of the figurative style that occupied Diebenkorn between 1955 and 1967. Just as he reached his peak as a painter in the abstract expressionist mode, he began to believe that his abstractions were becoming too glib and "super-emotional"; as he later admitted, "I came to mistrust my desire to explode the picture and super-charge it in some way."[10] Although he continued to conceive of his paintings as abstract arrangements of form and color, he began to turn to specific objects and models found in nature, using them as sources for the observation and interpretation of spatial com-

372

position and color relationships. The limitations imposed by a concrete subject appealed to Diebenkorn's innate sense of order and control. He appreciated the conflict between reality and abstraction, stating, "I think what is more important is a feeling of strength in reserve—tension beneath calm."[11] Diebenkorn had a precedent for this change; just a few years earlier his former mentor, David Park, shocked the San Francisco art world with his first representational painting.[12]

Diebenkorn's figurative paintings, more than any others in his oeuvre, reflect his indebtedness to Matisse, whose works he had admired since the early 1940s.[13] He specified in particular The Phillips Collection's *Studio, Quai St. Michel,* 1916 (cat. no. 109), as an important influence. Diebenkorn admired the French artist for his use of flat color, manipulation of spatial tension, and willingness to expose reworkings.[14]

Interior with View of the Ocean conveys Diebenkorn's intuitive interest in underlying geometry, spatial ambiguity, and the structured balance of light and color. Although the inspiration for the image derives from reality, his foremost concern was to break the painted surface into flat color planes. The recession into depth implied by the subject—the corner of a room with large bay windows and furniture—is limited by the interlocked color areas. The inward slant of the left window is held in check by the large, blue expanse of the window view. Similarly, the recession of the road, visible through the left window, is halted by a lavender-blue strip—the ocean—which is pulled forward, flattened, and balanced by the similarly colored foreground shape. Diebenkorn schematized the light and shadows on the tabletop into triangular, rectangular, and trapezoidal shards of color—intense yellows anchored by cool blues and greens. He painted methodically in many layers, making repeated efforts to redefine the image—as is visible in the myriad transparent veils of color applied in multidirectional, gestural brushstrokes. The surface texture of *Interior with View of the Ocean* is particularly complex because it was painted over an earlier *Berkeley* abstraction.[15]

The conflict between representation and abstraction received an added psychological dimension when Diebenkorn's painting incorporated the human figure, as in *Girl with Plant.*[16] He became fascinated with the manner in which the figure and its environment interacted to create what have been termed "fields of emotional experience."[17] In his desire to evoke a pervasive mood, Diebenkorn sought to deemphasize his figures as emotional focal points by depicting them either without faces or from behind. In *Girl with Plant* the figure, her back to the viewer, seems to be embedded in the paint-

373

ing surface, as are the inanimate elements of the composition—the potted plant, chair, and window. Despite the girl's objective treatment, her presence adds a pensive, solemn air that is slightly defused by the image's vivid color. Favoring a mood of solitude in the tradition of Edward Hopper, Diebenkorn never included more than two figures in a painting.[18] The woman in *Girl with Plant* echoes the model in Matisse's *Studio, Quai St. Michel* in her solitude within an engulfing interior.

The Phillipses first became interested in Diebenkorn's figurative works at the urging of Duncan's nephew, Gifford Phillips, who in the early 1950s became one of the artist's foremost

patrons. After purchasing *Interior with View of the Ocean* in 1957, Duncan Phillips gave Diebenkorn his first East Coast solo museum show, for which Gifford Phillips wrote the catalogue. Diebenkorn represented a continuation of the tradition upon which the Phillipses' entire collection was based—that of composing images and communicating personal expression through contrasts and subtle variations of pure color, the legacy of Cézanne, Matisse, and Bonnard. Because Diebenkorn serves as one of the cornerstone artists of the collection, the choice to open the Goh Annex in 1989 with a retrospective of the artist's works on paper was an especially easy and appropriate one.[19]

GHL

374

THEODOROS STAMOS (1922–97)

The youngest of the first-generation abstract expressionists, Theodoros Stamos was born December 31, 1922, in New York to Greek immigrant parents. At thirteen Stamos received a scholarship to New York's American Artists' School, where he studied sculpture while attending high school. After dropping out of school in 1939, he held several jobs and concentrated on painting. While working in a frame shop in New York from 1941 to 1948, he met Arshile Gorky and Fernand Léger; during the early 1940s he visited An American Place, Stieglitz's gallery, where he particularly admired the work of Dove. In 1943 he met Gottlieb and Barnett Newman, with whom he shared an interest in the sciences and primitive cultures. He frequently visited New York's American Museum of Natural History. Stamos's first one-person exhibition, featuring his early biomorphic abstractions, was held at the Wakefield Gallery in 1943. In 1945 Edward Wales Root, one of his most important patrons, began purchasing his work. In 1947 he met Peggy Guggenheim, Graham, Rothko, and Tobey, the latter during a trip he took to New Mexico, California, and Seattle. He spent six months in France, Italy, and Greece with poet Robert Price in 1948–49. His first one-man museum exhibition was held at The Phillips Gallery in 1950, the same year he taught at Black Mountain College in North Carolina. In 1951 Stamos moved to East Marion, New York, where he developed an expressive color-field technique. Beginning in 1955 and for the following twenty-two years he taught at the Art Students League. From 1970 he spent part of every year on the island of Lefkada in Greece, where he started his *Infinity* series. After ending his teaching career in 1977, Stamos traveled extensively and had numerous one-person shows in New York and Europe. He died in Yiannina, Greece, February 2, 1997. The Phillips Collection owns seven oils and a gouache—all early works—by the artist.

The Stamos Unit

Theodoros Stamos was only twenty when he received his first solo exhibition in 1943 at the Wakefield Gallery in New York, and by the late 1940s he was an established member of the abstract expressionists. Stamos's interests were closely related to this circle of painters, who during the 1940s searched for profound truth and universally significant content through myth and biomorphic abstraction. The mature techniques of Stamos, Rothko, and Newman, based on expressive color fields, were subdued and tranquil in comparison to the explosive,

gestural painting of fellow abstract expressionists Pollock and de Kooning.

Stamos's work reflects a complex combination of interests: his Greek heritage, knowledge of universal myth, intense observation of nature, admiration of oriental philosophy, and a yearning to attain spiritual meaning through art. Duncan Phillips responded in a positive manner to such painters of subjective content and sensitive color. Of the abstract expressionists, Stamos and Rothko (cat. nos. 352–55) were the only ones that he chose to collect as units, an indication of his preference for artists whose works inspired spiritual contemplation.

Stamos's early attraction to myth and ancient culture was intensified by his readings of James Frazer's *The Golden Bough: A Study in Magic and Religion,* an examination of myth and primitive ritual of many cultures, which had a profound influence on many abstract expressionists as well as their precursors, such as Graham.[1] Stamos's fascination with Frazer, coupled with a fervent curiosity about nature in its many forms and derivations, led him to seek out artifacts of primitive cultures in New York museums. He identified with these objects in a "true communion" and sought to reveal, as Barbara Cavaliere writes, "the cycles and patterns of birth and death, desire and terror, the forces of flesh and spirit which man shares with all levels and species of nature."[2]

In a manner inspired by the surrealist painters, Stamos arrived at his images spontaneously, extracting elements of nature and myth from his subconscious to create abstract, biomorphic images on canvas.[3] His earliest compositions, painted in browns, greens, and golds, evoke the appearance and texture of the earth—rocks, terrain, sand, and water. The forms resemble, in some cases, fantastic amoebalike creatures and plants drifting underwater, in others, planetary bodies inhabiting otherworldly, barren terrain. Over time, the emphasis upon literal and material qualities gave way to a more ethereal interpretation of his motifs. He increased the subtleties of light and the size of the canvases; his paint application became thinner, and the color range broader. At times the gesture of his brushstroke, whether rough or delicately calligraphic, was more pronounced. However, his underlying intent remained: to excavate nature-derived images from his subconscious "to create an abstract art of universal, spiritual significance."[4]

In the late 1940s Stamos's work began to receive wide attention. Duncan Phillips was quick to take interest in the young artist, and in 1949 he purchased three biomorphic abstrac-

tions: *The Sacrifice of Kronos, No. 2,* 1948 (cat. no. 375), *World Tablet,* 1948 (acc. no. 1818), and *Moon Chalice,* 1949 (cat. no. 376). The following year he gave Stamos his first one-person museum exhibition, showing his new acquisitions with borrowed watercolors, gouaches, and oils. From this exhibition the collector acquired two gouaches, *Hard Hack* and *Mosses.*[5] Stamos visited Washington for the occasion, staying at the home of the Phillips family.[6] A mutually respectful friendship ensued, and Phillips expanded his Stamos collection in 1952 with an oil, *The Field* (acc. no. 1812), painted the same year. He held another Stamos exhibition in 1954–55, from which he purchased two larger oils, *Lupine* and *Azalea Japonica,* both painted in 1953 (acc. nos. 1811 and 1814). In his 1952 catalogue Phillips designated Stamos as one of the contemporary artists he planned to collect as a "unit," hoping to follow his development and acquire, if possible, many aspects of his oeuvre.[7] Although Phillips bought nothing more before his death in 1966, the unit of eight works remains a fine showcase of the painter's early career.

In tandem with the second Phillips exhibition of his work, Stamos delivered a lecture at the museum, "Why Nature in Art?" In this presentation he praised those American artists who conveyed emotion and spirituality through direct experience with nature, specifically the Hudson River School painters of the nineteenth century, the mystical Ryder, and the abstractionists Hartley and Dove.[8] He stated that Dove was "one of our most original painters whether he worked in a semi-abstract or in a totally abstract vein. . . . His canvases always built into beautiful compositions that at times resemble the expressive glory of Chinese calligraphic characters while never deviating from their base in a physical world. . . . Certainly, he was a true artist of the bamboo."[9]

Stamos compared these artists' meditations on nature to the manner in which oriental artists bonded with nature to create poetic, ethereal images. He respected the philosophy of Eastern art, which "teaches that things are created by the mind rather than that the mind perceives existing things—-mind is concerned with interpreting the values rather than giving the description of facts."[10] He named Pollock, Rothko, and Pacific Northwest artists Graves and Tobey as visionaries who possessed "that endemic oneness with nature" which he hoped to achieve in his own work.[11] Nevertheless, while admiring the oriental method, Stamos considered himself a painter of the Western tradition: "[I'm] not . . . an ascetic. I'm Oriental like a

Greek or Turkish rug."[12] His subject, no matter how far removed in appearance it might become from physical reality, had its origins in multiple stimulants absorbed from the real world; as Dore Ashton has written, "Each painting begins with an observed truth—the feel of the place."[13]

GHL

375

The Sacrifice of Kronos, No. 2, 1948

Oil on hardboard, 48 × 36 (121.9 × 91.4)
Signed in black paint, l.l.: *t. Stamos '48*
Acc. no. 1817

TPG purchase from the artist through Betty Parsons Gallery, New York, 1949.[14]

376

Moon Chalice, 1949

Oil on hardboard, 39¼ × 24⅜ (100.9 × 62.0)
Signed and dated in white paint, l.l.: *t. stamos '49;*
inscribed on reverse in yellow chalk, c.: *Jan 1949/t stamos/45 East 22nd st/n.y.c./"moon chalice"*
Acc. no. 1815

TPG purchase from the artist through Betty Parsons Gallery, New York, 1949.[15]

Moon Chalice and *The Sacrifice of Kronos, No. 2* depict the theme of ancient ritual that is characteristic of Stamos's work of the 1940s, when he and his contemporaries were endeavoring to "create the myth of their own time" through their art. Stamos, along with Newman, Rothko, Still, Gottlieb, and Pollock, "created works whose . . . titles, imagery, and coarse surfaces evoke the dark, totemic otherworld of subterranean ritual."[16]

The Sacrifice of Kronos, No. 2 portrays the drama and terror of the story of the Titan Cronus, who devoured his children in fear of the prophecy that one of his offspring would usurp his power. When Cronus's son Zeus was born, his mother, Rhea, wrapped a stone in clothing, and Cronus swallowed it, believing it was their son. The prophecy took its course, because Zeus eventually overthrew Cronus.[17] The painting depicts the moment of the sacrifice. Two ghost-like eyes appear in the stone, alluding to Cronus's misguided belief that it was his son he was swallowing.[18] Cronus, with gaping mouth and staring eye, appears to be crushed under the weight of the massive boulder. The theme of this ancient myth may well have been a metaphor for post–Second World War power struggles.

Moon Chalice alludes in a general sense to the mystery of myth and ritual. It depicts a goblet reminiscent of those used in sacrificial rites; a

375

glowing yellow crescent is inside.[19] Usually portrayed as a large, powerful element, this strange depiction of the moon hovering over hints of a landscape suggests that Stamos placed the world within a vessel, alluding to the metaphysical aura that encompasses the material world. In both paintings, thin, black lines illustrating natural and cosmic forces meander and streak throughout the composition. Such lines of energy reflect not only an awareness of surrealist motifs but also the influence of Dove's lines of force in his late works.

The matte paint in *The Sacrifice of Chronos, No. 2* and *Moon Chalice* evokes the roughness of ancient stone, suggesting primitive civilization. The texture is heightened by the many brush fibers that are imbedded in the oil paint. Screen-like imprints, sprayed-on paint, and incisions on

the paint surface intensify the sense of irregularity.[20] The garish, almost hallucinatory colors emphasize the supernatural qualities of the subject. The dramatic scene of Cronus devouring the rock occurs on a terra-cotta-colored field against a background of unnatural, intense blue highlighted with fluorescent greens. Similarly, in *Moon Chalice* the gray cup hovers within a ground of soft blue, black, bright green, and yellow.

These paintings, as well as *World Tablet,* 1948 (acc. no. 1818), were the first works by Stamos that Phillips purchased from Betty Parsons in 1949. Phillips recognized Stamos's spiritual and stylistic ties to Dove, and he immediately exhibited them together.[21] In Stamos he detected the legacy of Dove expressed in an individual, freshly modern manner.

GHL

376

SAM FRANCIS (1923–94)

Considered to have been the foremost expatriate American in the Paris avant-garde of the 1950s, Sam Francis was born July 25, 1923, in San Mateo, California. In 1941 Francis enrolled at the University of California, Berkeley, to study medicine, but he joined the U.S. Army Air Corps in 1943. Because of a spinal injury sustained during flight training, Francis spent most of his military life (1943–45) confined to a hospital bed. While recuperating, he began to paint in watercolors. David Park, who taught painting at the California School of Fine Arts, visited Francis in the hospital, bringing with him paintings from a local private collection, including examples by Miró, Klee, and Picasso. In 1948 Francis returned to Berkeley, where two years later he received his Master of Arts degree. He subsequently moved to Paris and enrolled briefly at the Académie Fernand Léger. Francis quickly became known in Europe; his first one-person exhibition opened in 1952 at the Galerie du Dragon, Paris, and his first museum show took place in 1955 at the Kunsthalle in Bern. Once he had become known in New York, in 1955 the Museum of Modern Art acquired *Black in Red,* Francis's first painting to enter a public collection. The following year the Museum of Modern Art included him in the seminal group exhibition "12 Americans," and he had his first one-person show in America at the Martha Jackson Gallery, New York. From 1962 Francis lived primarily in Santa Monica, while maintaining studios in Paris, Tokyo, and Bern. He owned Lapis Press, which published books by artists. Francis died in Santa Monica, California, November 4, 1994. The Phillips Collection owns one painting.

377

Blue, 1958

Oil on canvas, 48¼ × 34¼ (122.6 × 88.2)

Signed and dated on canvas reverse, u.c.: *Sam Francis/58*

Acc. no. 0698

Consigned by the artist to Martha Jackson Gallery, New York, 1958; TPG purchase 1958.[1]

In January 1958 Francis returned to Paris after a year-long world tour that took him by way of Mexico to Japan, Hong Kong, Thailand, and India. Inspired by his trip, he embarked on a prolific and successful year.[2] *Blue,* painted at this time, reflects a synthesis of his innate love for color and light and a new understanding of space and calligraphic line derived from his Asian experiences.

Francis is loosely associated with the group of second-generation abstract expressionists, who during the 1950s reacted against the first generation's "harsh, anxiety-ridden canvases" in favor of dominant color.[3] His love of color stemmed from his time in Paris, where he immersed himself in the art of Monet, Bonnard, and Matisse; however, rather than commingle figuration and color as they did, Francis created large, luminous abstractions that were intended to envelop the viewer, as in *Blue*. But this work also uses varying shades of blue to create a soft, lyrical effect. The French critic and scholar Georges Duthuit referred to this tendency in Francis's paintings as "l'abstrait chaud," to distinguish it from the cold severity of contemporary geometric abstractions.[4]

The enveloping qualities of *Blue* recall Monet's late work *Water-Lilies,* which Francis saw at the Orangerie, Paris, in 1953.[5] Francis transformed Monet's strands of clinging plant life into abstract drips and spatters that flowed downward, suggesting gravity's pull. However, he differed from the impressionists by inviting associations from the viewer in a metaphorical, not literal, sense.[6]

Francis's most radical use of space emerged after his return to Paris in 1958, when his "color areas gravitate to the extreme edges of the canvas leaving the white to function as a unified 'field,' at the same time that it suggests unlimited continuum."[7] In *Blue* the cluster of cell-like shapes, resembling a cloud, "seems to float up, across, and off the upper, right-hand corner of the field," leaving behind a limitless sea of white.[8] *Blue* shares affinities with *Tokyo Mural,* painted during his 1957 world tour, in which various blues punctuated by yellow, red, and purple create a powerful rhythmic form.[9] In the Phillips canvas the shapes have been scaled down without losing their force and presence. Green, orange, mauve, red, and yellow surface through the interstices of cobalt blue, ultramarine, and prussian blue.

When *Time* magazine touted Francis in 1956 as the "hottest American painter in Paris," his work became a revelation to artists and the public in America, and he quickly took his place among the country's leading abstract expressionists.[10] Following this trend, Duncan Phillips mounted a show of Francis's works just two years later, the artist's first major exhibition in Washington, D.C., from which *Blue* was purchased.[11] Phillips often hung *Blue* with paintings by the American artists Tomlin, Rothko, Gottlieb, and Morris Louis.

VSB

377

JOAN MITCHELL (1926–92)

Joan Mitchell, a painter whose reactions to her environment are sensitively recorded in abstract compositions of vivid, gestural color, was born in Chicago February 21, 1926. After attending the progressive Francis W. Parker School from 1930 to 1942, Mitchell entered Smith College, where she studied art for two years. From 1944 to 1947 she trained at the School of the Art Institute of Chicago. That same year she went to New York on an Edward L. Ryerson Traveling Fellowship; there she admired the paintings of Arshile Gorky and Jackson Pollock. From 1948 to 1950 she lived in Paris, where she met Philip Guston and Herbert Katzman. After her return to New York in 1950 she became friends with Franz Kline and Willem de Kooning, frequented the Cedar Tavern, and became one of the few female members of the Artists' Club. Her first solo exhibition in New York occurred in 1952 at the New Gallery; the Stable Gallery represented her from 1953. During the 1950s her abstractions received wide acclaim. In 1955 Mitchell returned to France, where she met Norman Bluhm, Francis, and Jean-Paul Riopelle. Riopelle was her companion until 1979. In 1959 after dividing her time between New York and Paris for a few years, she moved permanently to France. She worked in a studio on rue Frémicourt in Paris and in 1968 moved to an estate in Vétheuil, where she resided for the remainder of her life. Represented from 1967 by Galerie Jean Fournier, Paris, and from 1976 by Xavier Fourcade, New York, Mitchell received her first solo museum exhibition in 1972 at the Everson Museum of Art, Syracuse. In 1974 the Whitney gave her a one-person show, and in 1982 she was the first American woman to have a solo exhibition at the Musée d'Art Moderne de la Ville de Paris. Mitchell died in Paris November 1, 1992. The Phillips Collection owns an early oil by the artist.

378

August, Rue Daguerre, 1957

August Daguerre

Oil on canvas, 82 × 69 (208.2 × 175.2)

Signed in black paint, l.c.: *j. mitchell*

Acc. no. 1367

TPG purchase from the artist through Stable Gallery, New York, 1958.[1]

August, Rue Daguerre was painted in mid-career, after Mitchell had successfully assimilated the influence of gestural abstract expressionism to create a personal, poetic style. As a young adult in New York during the 1950s, she had admired the explosive canvases of de Kooning and Kline, both of whom became her friends. She integrated their energetic brushstrokes and spatial tensions with her own sense of lyrical color and infusion of bright light, which had been inspired by her favorite artists, van Gogh and Matisse.

From 1955 to 1959 Mitchell divided her time between New York and Paris, eventually settling permanently in France. As its title suggests, *August, Rue Daguerre* was painted during one of her Paris stays in 1957. In spite of its title, however, the painting is not based on a particular street view; rather, it is an interpretation of her feeling. Although her initial inspirations derived from external sources, Mitchell did not paint from specific models and views. In her efforts to promote feeling in her art, she tapped the resources of her memory. She stated, "I paint from remembered landscapes that I carry with me. . . . I could certainly never mirror nature."[2] In this manner her intent differed from that of the original abstract expressionists, who searched inward for inspiration and endeavored to communicate the profundities of the "self" or the collective subconscious. Painting "has nothing to do with me but has to do with the feeling that comes from landscape," Mitchell explained.[3] "My painting is not an allegory or a story. It is more like a poem."[4]

Equal to her desire to impart a poetic sensibility in her art was her interest in the autonomy of the painting as a composition of form, space, and color. While a feeling may have motivated her to begin a work, she eventually lost herself in the painting, becoming involved with "ambivalence of forms and space" and "color relationships to evoke an impression of light."[5] Although they appear to have been quickly executed and spontaneous, her paintings are the products of careful contemplation and studied paint application. "I want [the paintings] to hold one image," she said, "despite the activity. It's a kind of plumb line that dancers have; they have to be perfectly balanced, the more frenetic the activity is."[6]

In *August, Rue Daguerre* deep reds, blues, and browns are painted in broad, arcing strokes against a white ground. In a type of "editing" process, Mitchell applied patches of white paint over some of the colors to create spatial ambiguity. Heavy impasto in some sections reveals frequent reworkings, while spatters of paint in other areas display spontaneous paint application.[7] The varied texture and the network of bold brushstrokes in *August, Rue Daguerre* evoke the verve and energy of a bustling Paris street.

Joan Mitchell was an original talent among the nonrepresentational American artists who reached maturity during the 1950s—a group often termed the second-generation abstract expressionists. This group, which also included Helen Frankenthaler, Grace Hartigan, Alfred Leslie, and Sam Francis, was less wary of European art movements and rejected the soul-searching anguish of the older artists. While they gained inspiration from the technique of abstract expressionism, they felt free to look to their environment and other art forms as points of departure. Their paintings radiate a distinct freshness, harmony of color, and intensity of light.[8] These characteristics undoubtedly drew Duncan Phillips to Mitchell's art. He responded positively to the Francophile artist's color and light subtleties, which reveal a kinship to Matisse, van Gogh, and Bonnard, artists of paramount importance in The Phillips Collection. Had Phillips lived longer, he would have admired Mitchell's unrelenting dedication to her personal style of painting, a method she practiced to the end of her life and from which she extracted countless variations and possibilities.

GHL

378

JACK YOUNGERMAN (B. 1926)

Jack Youngerman's characteristic work is hard-edged yet lyrical; his organic shapes are painted in rich, often strongly contrasting colors. Born March 25, 1926, in Webster Groves on the outskirts of Saint Louis, Youngerman was raised in Louisville, Kentucky. In 1944, after his first year at the University of Missouri, he was drafted into the U.S. Navy and selected for officer training school at the University of North Carolina; following his tour of duty he returned to the University of Missouri, where he received his B.A. in 1947. Eligible for the G.I. Bill, he moved later that year to Paris to study at the Académie des Beaux-Arts but was more excited by avant-garde French art, frequently visiting the Salon des Réalités Nouvelles and the Salon de Mai. By 1948 he was painting on his own, studying only rarely at the Académie. He remained in Paris for nearly ten years, in 1950 marrying actress Delphine Seyrig and forging a close friendship with Ellsworth Kelly. He visited the studios and exhibitions of established artists and traveled extensively throughout Europe and the Middle East. His first one-person show was in 1951 at the Galerie Arnaud, Paris. Betty Parsons, impressed by his work during a 1956 visit to his Paris studio, pressed him to relocate to New York; he returned that December but continued to visit Paris each year. He settled in Coenties Slip, New York, an artistic community that included Kelly, Jasper Johns, Agnes Martin, and Robert Rauschenberg. His American debut was at the Betty Parsons Gallery in 1958, and he was included in the Museum of Modern Art's seminal "Sixteen Americans" exhibition the following year. In 1986 the Solomon R. Guggenheim Museum held his first retrospective. He has taught extensively: at Yale University (1974–75), Hunter College (1981–82), and currently New York University. The collection contains one acrylic from the late sixties.

379

Ultramarine Diamond, 1967

Aquamarine Diamond

Acrylic on canvas, 70⅛ × 70¼ (178.0 × 178.4)

Signed and dated on reverse, l.c.: *Youngerman/1967;* artist's inscription c. to u.r. canvas reverse: *Hang as "Diamond"/top*

Acc. no. 2148

The artist; consigned to Betty Parsons Gallery, New York, 1967; TPC purchase (from exhibition) 1968.[1]

Concerned with "the invention of form," Youngerman moved in a new direction during the 1960s, "a direction other than the past and present reigning modes of expression and constructivism in abstraction."[2] Although he was typically associated with the hard-edged school of postpainterly abstraction, he retained a lyrical quality that stemmed from his early experiences in Paris during the fifties. He merged the organic and geometric in his compositions, which he painted with hard contours, smooth, flat surfaces, and pure, unmixed colors—evoking a sense of the universal and of nature's underlying structure and laws.

Ultramarine Diamond, painted in 1967, reflects Youngerman's preoccupation with diamond-shaped canvases, which provided a transition to his circular and elliptical works of the early 1970s. Although he had "always been interested in the framing of a composition by the form of the canvas," it was not until 1967, following his reassessment of his work, that Youngerman first used the diamond shape.[3] After experimenting with ink drawings throughout 1966, he was filled with renewed enthusiasm for painting, and he wrote to his dealer, "I'm anxious to get back to my studio, and to painting again, for a long uninterrupted period."[4] The diamond canvas stimulated him both as a shape and as a container of shapes, because it generates relationships between the forms and the canvas edge and "limit[s] . . . the canvas in a satisfying way."[5] The repeating triangular and diamond forms throughout *Ultramarine Diamond* are echoed and reinforced by the diamond-shaped canvas itself. Youngerman said that "the diamond canvas *completes* the polar play that defines the painting: figure/ground, line/form, color/white, inside/outside."[6]

Seeking "a kind of marriage or welding of the shape to the surface" of the canvas, Youngerman applied numerous layers of blue acrylic to *Ultramarine Diamond,* ensuring that he retained the delicate imprint of his brush despite the hard contrast between the blue and the white forms.[7] The lush ultramarine can be read alternatively as the ground, which alludes to volume because of the modulation of tone, or to the figure forced flat by the sharp white contour.[8] This tension is repeated throughout the composition: in the center there is a dialogue between the forms and colors—the white jagged area that contains and defines the thrust and counterthrust of the blue shapes becomes a shape itself, likewise demanding the viewer's attention. As Youngerman states, "I see what you call figure-ground relationships in terms of active and passive shape. I may allow the passive surrounding shape to seep into the active shape and then in turn to become the active element itself." He concluded, "The tension caused by reversing the relationship, and making it possible to see it either way, charges it with life."[9]

In hosting an exhibition of Youngerman's work and subsequently purchasing a representative painting, Marjorie Phillips continued a long-standing tradition that she and Duncan Phillips had established over the years.[10] Choosing a painting that she believed was compatible with the collection, she hung it alongside works

by such artists as Nicolas de Staël, Morris Louis, and Clyfford Still.[11] She was attracted to Youngerman's blend of organic form and luxurious color, stating that his "edges . . . are not rigid, but have their own inner movement, delineating the satisfying measures of shapes and well related color divisions to which they give additional life."[12]

Youngerman's emphasis on form and color had its origins in several sources he experienced as a maturing artist in Paris from 1947 through 1956: the silhouettes in Arp's woodcuts, Toulouse-Lautrec's posters, nineteenth-century Japanese woodcuts, and the lyrical elegance of contemporary French artists. Yet Youngerman was most affected by Matisse's paper cutouts and ink drawings of the late 1940s.[13] He responded to "that voluptuous use of shape and of the ink. . . . The clarity of it, the starkness of it, and the voluptuousness of it." Matisse allowed him to see "shapes existing for themselves."[14]

Although nature-derived, Youngerman's shapes are not drawn from specific studies. Rather, they are reinvented from "many little drawings usually done with ink and brush," of patterns and shapes that caught his eye.[15] The forms in *Ultramarine Diamond* might originally have been inspired by the outer shell of a Japanese beetle, the pattern of a leaf, or the design of a fish's scales—but filtered through Youngerman's imagination. These shapes have abstract potential, and they are not "possessed and diminished by names and uses." Youngerman believed that "painting involves the restoring of the image to [the] original primacy" of the form.[16]

LBW

379

FRANK STELLA (B. 1936)

Dubbed by critics the "enfant terrible" of the contemporary art scene in 1959, Frank Stella has continued to challenge the boundaries of painting throughout his long and productive career. Born May 12, 1936, in Malden, Massachusetts, Stella attended Phillips Academy in Andover, Massachusetts (1950–54), where he studied under Patrick Morgan. At Princeton University he studied under William Seitz and Stephen Greene and received his A.B. in history in 1958. After graduation he established permanent residence in New York and achieved almost immediate fame with his *Black Paintings* (1958–60). In 1959 the Museum of Modern Art became the first museum to purchase a work by Stella. He married the critic and art historian Barbara Rose in 1961 (they later divorced, and in 1978 he married Harriet McGurk). The Leo Castelli Gallery, New York, held his first one-person show in 1962. He spent the following year as artist-in-residence at Dartmouth College, where he taught advanced courses in painting. The Museum of Modern Art, under William Rubin's stewardship, gave him his first retrospective in 1970. While confined to a hospital bed following a surgical complication, Stella began drawings for his *Polish Village* series (1970–74). This series was an important step toward his pivotal *Exotic Bird* series (1976–80), which has decisively shaped his recent work. The artist continues to lecture and has been awarded many honors, including the position of Charles Eliot Norton Professor of Poetry at Harvard University. "Working Space," his provocative lecture series (later published), addresses the issue of pictorial space in postmodern art. The collection has a work from the *Polish Village* series and a recently acquired print dating to 1967.

380

Pilica II, 1973

Mixed-media assemblage on wood, 110¼ × 94¼
(181.3 × 240.6)
Unsigned and undated; inscribed by artist on inner side of top section: *#36 SET #11*; inner side of section in white: *#36 SET/GROUP II* ("Group" crossed out); inner side of bottom section: *#36 SET II*
Acc. no. 1822

The artist; consigned to Lawrence Rubin Gallery, New York, 1973; TPC purchase 1974.[1]

Beginning with his seminal and highly provocative *Black Paintings* (1958–60), which served as a catalyst for the development of minimalism, Stella produced art during the sixties that epitomized his famous slogan, "What you see is what you see."[2] In the ensuing decade, however, he

changed directions, further exploring and expanding the very definition of painting, and by the late seventies he had moved away from the flat surface of the canvas into the third dimension. These pivotal, highly controversial works of the seventies—boldly colored and textured volumetric protrusions into the viewer's space that seemed to reject all the tenets of the reductive painting he had helped to establish—presaged the neo-expressionist work of the next decade.[3]

Stella first experimented with the infusion of real space in his *Polish Village* series (1970–74), to which *Pilica II* belongs, and the series provides the bridge to his later explorations.[4] In 1970, during recuperation from an illness, he made forty-two freehand drawings, forty of which provided the basis for this series. Drawing upon the interpenetrating and contrasting geometrical shapes in earlier series, Stella extended his designs into actual relief constructions.[5] The titles of the works derive from Polish synagogues that had been systematically destroyed during the Nazi occupation of Poland in the Second World War.[6]

Stella interpreted the space in this series as bas-relief; he created geometric planes in varying levels of relief and incorporated diverse hues and textures in the design. He created three versions of *Pilica*.[7] *Pilica I* has interpenetrating, hard-edge planes in various colors, materials, and textures, affixed to canvas mounted onto a solid support.[8] In the Phillips work he added bas-relief of varying levels aligned parallel to the picture plane; it is comprised of industrial materials, underscoring the idea of construction in this series—cardboard painted with commercial paint, hardboard, and particle board—as well as painted canvas, lightweight fabric, and felt. These elements were mounted onto corrugated cardboard, which was in turn mounted onto a wooden support.[9] *Pilica III* also has bas-relief, but the planes, affixed to Tri-Wall cardboard, are now tilted. Stella's hues vary in each version: the Phillips work is a subtle blend of red, white, and several shades of blue, combined with the natural tans and browns of the particle board and hardboard. Stella recalled tinkering with them, saying that they "were well designed and very tight in terms of engineering." He added, "We spent a tremendous amount of time with detail. . . . I was around all the time, so that I could adjust and readjust things, deal with every decision about tilt, angle, or surface finish."[10]

Stella's use of diverse, mostly industrial materials was new to his art. The planar design, the relief, and the components of the *Polish Village* works are reminiscent of Russian construc-

tivism, in particular Kasimir Malevich's suprematist drawings from 1916 to 1920 and Vladimir Tatlin's painted reliefs from the same period.[11] Stella noted that his own "gift for structure" as well as his "struggl[e] through the Polish pictures" enabled him to explore "the idea that paintings could be constructed, made by picture-building." This statement echoes Malevich's comment that "we see now technical means penetrating into the purely painterly picture, and these means may already be called engineering, . . . [and] 'artistic construction.'"[12]

Throughout his oeuvre, Stella's titles have consistently retained a general allusive quality.[13] Philip Leider believes that there is added significance to the titles, that "the trail of blackened synagogues commemorated in them maps out the 'Munich-Moscow axis' of Russian Constructivism."[14] William Rubin agrees and further states that the destruction of these synagogues was the destruction of the shtetl culture that produced such constructivist artists as El Lissitzky.[15] Carolyn Cohen, however, finds a close formal relationship between the manners in which the synagogues and the works in this series were constructed, an inference that is underscored by Stella's observation that he sees an analogy between the "interlockingness" of his works and of the carpentry style of the synagogues.[16] At any rate, given his statement that "the Polish series was about more than the synagogues that were destroyed," that it was "about the obliteration of an entire culture," Stella was surely also making a reference to the Holocaust, using in his constructions oblique references to shtetl architecture that alludes to the destruction both of a religion and of a way of life.[17]

LBW

11 THE PHILLIPS COLLECTION AND ART IN WASHINGTON

*Part I: Washington and Baltimore Artists
from the 1930s Through the 1950s*

BEN L. SUMMERFORD

The influence and support of Duncan and Marjorie Phillips were crucial to the development of art in the Washington area.[1] During the twenties and thirties no other individuals or institutions matched their efforts to promote contemporary art in the region, and they persisted in the decades that followed. It is clear that the Phillipses were inspired by a spirit of generosity and the simple desire to share their interests with the community at large.

The Phillips legacy took at least four forms. First and foremost was the establishment of The Phillips Memorial Art Gallery in 1920 and its enlargement in 1930. Second was the support of regional art through purchases since the early thirties. Third, and of equal importance, was the exhibiting of these purchases within the regularly changing hangings in the galleries. This policy affirmed the seriousness of intent and negated the stigma of simple philanthropy. Fourth was the establishment of a school of painting associated with the gallery (fig. 43); under the leadership of C. Law Watkins from 1930 to 1945, the school encouraged students to move unprejudiced into contemporary modes of expression without abandoning the lessons of the past.

"I saw a chance to create a beneficent force in the community where I live," Phillips wrote in 1926, "a joy giving, life enhancing influence, assisting people to see beautifully as true artists see."[2] The phrasing of this sentence is noteworthy because it clearly attached Phillips's aim for the Phillips Memorial Gallery, as it was called between 1923 and 1948, to his concern for the community, public education, and, most characteristically, the aesthetic influence of "true artists."

This emphasis on the authenticity of the artist's personal vision also characterized the management of the museum. Phillips employed artists in many positions, perhaps most notably C. Law Watkins, a friend and Yale classmate who from 1929 until his death in 1945 served as an associate director.[3] Phillips's aims for the museum were from the beginning quite precise, and in a letter inviting Watkins to join the staff he wrote that he wished to hire "a leader of men to plan and put through an educational program which will extend the benefits of the collection to a larger number of people." Phillips believed that he had to depart from the past policy of letting

Herman Maril, detail of
Waterfall No. 2, see cat. 389

his pictures speak for themselves and instead have the museum "serve a community to the utmost of its capacity."[4] In another letter he expressed this theme more eloquently: "I want the Gallery to stand for an ideal which is as big as the world and no bigger than its men and women everywhere. . . . Why should not art, which is the expressive part of man, wield some influence in molding current opinion? It's worth the experiment."[5]

One can see, therefore, that the various programs that were to follow—special exhibitions with an educational thrust, the frequent rearranging of the permanent collection, gallery lectures, publications, classes, and concerts—had a conceptual foundation: the desire to contribute to the enhancement of the public's appreciation of art.

Beginning in 1933, Phillips's role as regional chairman of the federal government's newly established Public Works of Art Project resulted in even more direct contact with artists. Clearly, this project produced long-term gains for the artists of the Washington-Baltimore area.[6] And because of his enthusiasm for all kinds of art and artists, Phillips collected more than just major works by artists whose reputations were unchallenged. Early on he distinguished paintings for the permanent collection from what, in 1944, he called the "Encouragement Collection," which consisted of works that

we purchase freely and constantly. It consists for the most part either of promising beginnings or experiments which we endorse. . . . Although our minds, like our doors, are always open, yet we must keep on questioning our choices. Incidentally we derive great satisfaction from the work of the graduates of our own art school and the painters of our own city. If the Washington-Baltimore region is better represented than any other[,] that is natural and as it should be, although we take no part in promoting group pressures and definitely do not admire an attitude among artists of self-conscious regionalism.[7]

For the Phillipses, the value of the museum to its community—and the education of this community—remained the recurrent theme.

Few purchases of Washington-Baltimore paintings were made before 1934. Thereafter, acquisitions ranged from only a few works per year to more than twenty-five. Following his inclination to concentrate on certain artists, Phillips bought numerous works by area artists like Sarah Baker, William Calfee, Bernice Cross, Margaret Gates, Robert Gates, John Gernand, Jacob Kainen, James McLaughlin, and Herman Maril.

Around the mid-thirties Phillips expanded the gallery staff. Gernand, Harold Giese, and McLaughlin were hired to fill positions of responsibility, while others were to play important roles in the conduct of the school. In succeeding years many other artists were hired in various capacities.

Marjorie Phillips remarked in her book that "one benefit to the Gallery's educational department was that when the PWAP came to an end, three of the artists whom Law Watkins had come to know

Fig. 43 Painting class, fourth-floor studio of 1600 Twenty-first Street with C. Law Watkins standing second from right, 1931–33. The room now houses the library of The Phillips Collection.

joined him as assistants in the Phillips Gallery Art School. They were Robert and Margaret Gates and [Charles] Val Clear."[8] Robert is represented in the collection by twenty-two works, Margaret by seven, and Clear by one. One of the artists employed the longest was Arthur Hall Smith, who in 1974, after fourteen years, left to take a teaching position at George Washington University; a finely realized ink-and-wash drawing by Smith entered the collection in 1964.[9]

It should be noted that all of Duncan Phillips's writing contains a sensitive regard for the particularities of an artist's vision and an uncommon ability to experience art directly without the need for historical or stylistic references. Implied in this approach is a rare trust in artists and in their art; there may lie the philosophic base for the building of this institution in concert with a loyal band of Washington artists. Their jobs in the gallery and the school were conceived in such a way as to allow for the continuance of their own careers.

When exhibiting Baltimore-Washington artists, Phillips characteristically hung their works alongside established Americans. Though such exhibitions were not comprehensive, they were inclusive enough to manifest the museum's purpose. During the years in question, the work of artists on the gallery staff was frequently hung with the collection. These artists were most notably McLaughlin, Giese, and Gernand. Artists closely associated with the school were also included. There was seldom a time when one of Cross's paintings was not shown, or almost as frequently one of Robert Gates's or Maril's.[10] From the late 1930s to the early 1960s, there were, in addition, solo exhibitions of Washington and Baltimore artists too numerous to count. Among the artists shown in these generally small individual shows were Gates, McLaughlin, Elisabeth Poe,

Cross, Watkins, and Gernand. A vivid testimonial to the policy of The Phillips Memorial Gallery comes in a 1946 review: "A surprising number of institutions devoted to promoting art have a slim record when it comes to purchase. . . . A notable exception is The Phillips Gallery, which has consistently bought paintings, particularly by artists of Washington and vicinity. The show now on view, consisting of selections from purchases made locally during the last decade, bears testimony to this policy."[11]

Responding to Phillips's specific educational interests, Watkins (alone or together with Phillips) mounted several memorable exhibitions. Each was broadly educational in nature, confirming Phillips's expressed aims and illustrating as well Watkins's strong intellectual and critical faculties—traits that made him a great and respected teacher. In 1940 Watkins formed "Emotional Design in Painting," from which came an article and a book, and the following year he organized "The Functions of Color in Painting."[12] Both exhibitions represented the museum as a place to have one's eyes opened to an understanding of artistic intention and to see beyond surface interest to an aesthetic purpose revealed by the artist in structure, color, and pattern.

Watkins shared Phillips's concern for increasing public perception and appreciation of art, and the result was the establishment of the Phillips Gallery Art School in 1930. However, because he was both an artist and teacher, Watkins was naturally drawn to a curriculum best suited to the education of the professional artist. Inevitably, a conflict arose between his educational aims and those of Phillips, whose principal educational goal was to use the collection in ways that would afford the public new insights about art. Ultimately a solution was found, and Watkins's aims furthered, through the association of the school with the Art Department of American University in Washington.

The chain of events that led to this collaboration began in 1929 when Watkins gave free informal painting lessons at the gallery. The first official term of the Phillips Gallery Art School, however, began in 1930 when Watkins assumed the post of director in charge of education. The painting studio was located on the top floor of the gallery, in a room that had been Marjorie Phillips's own studio (and is now The Phillips Collection's library). By 1931 some two hundred students were enrolled. In that year Watkins began informal Thursday-night "conferences," open to the public as well as students, in which topics ranged from "The Artist Sees Differently" to "Three Talks on Christian Religious Art" and "Influences of El Greco, Cézanne, and Van Gogh." These topics, as well as classes in drawing and painting, were announced in 1931 in a special promotional brochure formalizing the program.[13] In fact, Watkins projected a school that in its multiplicity of aims would have been difficult to sustain as an institution devoted solely to the education of professional artists.[14]

In 1932, because of the Depression, this free school was closed. In order to continue the instruction of artists in a way that would give him a chance to exercise his great resources as teacher and theoretician, Watkins independently developed Studio House at 1614 21st Street, N.W.—a new school and a commercial gallery in which both area and national artists would be shown. Although its letterhead declared that Studio House was "affiliated with the Phillips Memorial Gallery," it was not a close association. However, the Phillipses supported it through the purchase of paintings from exhibitions, and after four years of operation the school and gallery had become in large measure dependent on them.

In 1938, primarily for financial reasons, Watkins was forced to close Studio House, and the classes of the Phillips Gallery Art School were resumed on the museum premises, under his direction. Watkins's larger purpose was not to be lost, however, because in the fall of 1942 the school joined forces with American University to present a program leading to both bachelor's and master's degrees in painting. Students painted and drew at the gallery four or five mornings a week and took academic courses at the university in the afternoons. While this division of time is commonplace in universities today, it was unusual in universities in 1942. In fact, this system heralded the demise of the academies that had been the training ground of American artists since the nineteenth century. The new training ground after the Second World War was to be within institutions of higher learning like American University.

In all this Duncan Phillips played a supportive role. He lectured; he served as a thesis adviser to at least one graduate student; and in the university's announcement of the new program both he and Marjorie Phillips were listed as "administrative officers" of "career courses." After Watkins's death in 1945, the painting classes were moved to the campus of the university, and the formal association between The Phillips Memorial Gallery and American University was thus terminated. Nevertheless, the spirit of the Phillips Gallery Art School was to remain a permanent part of the university's art program through adherence to Watkins's teaching philosophy and in the selection of his associates and students to form the first faculty of the art department after his death. Calfee, one of his teaching assistants at the school, assumed the chairmanship, and Baker was one of the instructors. In 1946 Robert Gates, another former instructor at the school, joined them after serving in the U.S. Navy during the war (see cat. nos. 387–88). For Watkins, the teaching methods, or perhaps the philosophy behind them, were ingrained in a respect for tradition but with an open mind and enthusiasm for experimentation. No serious divisions were envisioned between the past and the present in art; each artist was encouraged to find his own path.

The allegiance of Washington-Baltimore artists to the Phillips was derived not just from jobs, purchase of their paintings, or exhibitions at Studio House; rather, it arose from the general sense of appreciation extended by the Phillipses to the whole community of artists. The genuine understanding of the practical and technical

problems of painting that the Phillips family possessed was an important aspect of their influence.

Marjorie Phillips, of course, was an accomplished professional painter, but the extent of practical experience that both Duncan and Laughlin Phillips had as painters is not as well known. During the summers, when the family vacationed at their home in Pennsylvania, Duncan Phillips sometimes painted in a broad post-impressionist manner quite free of adventitious influences, the more amazing since in Washington he was surrounded by masterpieces of nineteenth- and twentieth-century painting. Laughlin Phillips, like his father, did not consider himself a painter, yet he, too, especially as a young man, devoted himself seriously to painting. His work evidences an interest in, and understanding of, experimental directions taken by American artists. It is appropriate, and in a real way important, that a small group of their paintings is included in the collection (figs. 44 and 45)—"important" because these works verify the necessary search for personal experience, self-knowledge, and feeling upon which the collection as a whole rests. Laughlin Phillips's paintings were shown in solo exhibitions at the museum in 1943, 1947, and 1950, constituting a body of work of more than fifty paintings. When the works included in group shows over the years are added to this total, one can see the considerable extent of his experience. The family's competence as painters was demonstrated in 1951 when Marjorie, Duncan, and Laughlin Phillips were given an exhibition at the George Washington University library.

By now the extent of the Phillips family's contributions to the development of Washington-Baltimore art should be clear. But had there been no other service beyond formation of the museum and regular purchase of work, the Phillipses would still have played a significant role. They were virtually alone during the early years in recognizing the need for an audience for this art.

Underlying this achievement is the strength of purpose and the perceptivity of Duncan Phillips. His mind was free of cant, and he was as open to aesthetic experience as any man of his generation. Perhaps more remarkable was his sensitivity, which at times led to startling prescience. For instance, in a note scribbled on a Watkins article entitled "Pictures of People," Phillips questioned the first sentence—which included the phrase, "in these days of individualist painting and individualist criticism"—by writing: "Personally I contend that this is not a period of individualist painting and criticism but of collectivist trends which are submerging the individual." This comment was made in 1933, at a time when Phillips was among the few critics astute enough to reach such a farsighted conclusion.[15]

In short, Duncan Phillips's artistic sensibility is one of his real legacies to this region. It is found in abundance in the work he acquired, as well as in the collective experience of all the people—artists, students, average gallery goers—who have passed through the doors of The Phillips Collection during the past seven decades.

Fig. 44 Duncan Phillips, *Forest Fire,* undated, oil on canvas board, 12⅛ × 18 in., The Phillips Collection, Washington, D.C., acc. no. 1481.

Fig. 45 Laughlin Phillips, *Down Under,* ca. 1948, oil on hardboard, 24 × 33¾ in., The Phillips Collection, Washington, D.C., acc. no. 1486.

CHARLES LAW WATKINS (1886–1945)

C. Law Watkins, associate director of the newly expanded Phillips Memorial Gallery beginning in 1929 and later chairman of the American University Art Department, was born in Peckville, Pennsylvania, on February 11, 1886. A classmate of Duncan Phillips's at Yale University, Watkins graduated in 1908 and entered his father's business, the Pennsylvania Coal and Coke Company, eventually rising to the position of vice president and manager of operations. In spite of these commitments, he studied painting in Paris in the teens, and when the First World War broke out he joined the American Field Service, serving in both the French and American armies. For heroism in action he was awarded the Croix de Guerre by the French government. After the war, Watkins became increasingly aware of his true vocation as artist and writer. In 1929 he retired from the coal business and answered Phillips's call to become associate director, beginning a long career at the museum. In 1930, after organizing several exhibitions, he established the Phillips Gallery Art School at the museum and later Studio House. By 1942 the Phillips School was collaborating with American University, where Watkins headed the art department—reorganized under principles originated in the Phillips School—until his death in 1945. Watkins exhibited often in group exhibitions, both at the gallery and elsewhere. In 1939 he had a solo show at The Phillips Gallery featuring eight portraits, and following his death on March 2, 1945, a memorial exhibition of watercolors and small oil paintings was held. The Phillips Collection contains thirteen works by Watkins, including two drawings, three watercolors, and eight oil paintings.

The Watkins Group

In 1929 Duncan Phillips congratulated C. Law Watkins on his decision to retire from the coal business and offered him the position of associate director of The Phillips Memorial Gallery. Thus began an association that was to have important results not only for the museum but also for the artists of the Washington-Baltimore region. Watkins's concern for the teaching of art was almost immediately put into effect with the establishment of the Phillips Gallery School.[1] There he created an environment of serious study that offered students the freedom to experiment, buttressed by a knowledge of, and appreciation for, the lessons of the past.

Law Watkins's career was filled with writing, lecturing, and management of Studio House, with its exhibitions and school, to the point that little time was left for the development of his own painting. In the foreword to the memorial

381

exhibition of Watkins's work at The Phillips Gallery in 1945, Duncan Phillips says, "I knew him to be from our college days. . . . always an artist at heart. . . . One of the most versatile and many-sided of men, Law Watkins had an amazing capacity for pouring his strong, sensitive ardors into many interests and ambitious projects for the public good. An exacting conscience for serving others conditioned and limited his time to practice his own talents and skills. His painting became that of the broad-minded, comprehensively appreciative teacher, eager to demonstrate many different methods."[2]

Watkins's thirteen works in the collection reveal searches in several different directions; the most personal seems to have been an expressionist tendency tied to visually oriented subject matter. Rarely signed or dated, they were often acquired informally (as were many works by artists employed by the Gallery), with documentation methods that were at best inconsistent.

After his death a group of friends and former students, including Duncan and Marjorie Phillips and the faculty of American University Art Department, each gave a painting in Watkins's memory to the American University to initiate the C. Law Watkins Collection. This has since grown by gift and purchase into an important collection used for exhibit and study in the Watkins Memorial Gallery of the Art Department.

BLS

381
Vertical and Diagonal, ca. 1940

Oil on canvas board, 9⅜ × 12⅜ (23.8 × 31.3)
Unsigned
Acc. no. 2050

Acquired from the artist ca. 1940.

Watkins was acknowledged by all who knew him and worked under his instruction as a masterful teacher and theoretician, and some of his most effective painting is essentially didactic in nature, as is *Vertical and Diagonal,* probably created for teaching purposes rather than exhibition. When it is compared to Watkins's exposition motif no. 11 in *The Language of Design,* where he explains the effect of partially supported diagonals in composition, we can see it as a further experiment along this line.[3] It is a small painting in beiges and grays with no color emphasis to take away from the linear intention. Strong vertical-diagonal oppositions are set up with figures so simplified that they recall certain aspects of cubist painting. On the bottom right, a wedge representing the plane of the floor reveals the space in which the figures are set and supports their movement. The theme is austere and threatening and is a successful exploitation of a simple constructional idea.

BLS

SARAH BAKER (1899–1983)

Born in Memphis March 7, 1899, Sarah Baker grew up in Baltimore, and her intentions to be a painter were manifested while she was still in Western High School. Baker studied at the Maryland Institute of Art, enrolling there on a scholarship in 1918 and graduating in 1920. She received a three-year scholarship to attend the Pennsylvania Academy of Fine Arts (1920–23), studying with Hugh Breckenridge, Arthur Carles, and Daniel Garber. The inspiration of Carles's teaching and the excitement of the experiments of his own work were vivid and the most enduring experience of her years of study. In 1923 Baker was awarded the Emlen Cresson Scholarship for European travel by the Pennsylvania Academy; in Paris she studied with André Lhote. When she returned from France, she studied briefly at the Corcoran School of Art in 1924. She was awarded a Gold Medal by the Pennsylvania Academy in 1925, and in 1927 received a Louis Comfort Tiffany Foundation fellowship. By 1935, like many other Washington-Baltimore painters, Baker had found a niche in the Phillips Gallery Art School, and in the association with fellow local artists. Her teaching career was a meaningful one to her and an important one to her students. Between 1928 and 1948 Baker taught in several institutions simultaneously, first in Baltimore—Bryn Mawr and Saint Timothy School for Girls—and in Washington at The Phillips Gallery, American University, and Mount Vernon College. In 1946 she was chosen by William Calfee to help build the art department at the American University along the lines envisioned by C. Law Watkins, and she remained there until her retirement in 1967. A regular exhibitor in the Washington-Baltimore area, in the early 1940s she showed at the Whyte Gallery and from the 1950s at the Franz Bader Gallery, both in Washington. Baker took part in several group shows at The Phillips Collection, and she had a major retrospective there in 1977. She stopped painting in 1976 after a serious fall down a flight of stairs from which she never fully recovered. Baker died in Yonkers, New York, April 10, 1983. Her work is in the collections of the Pennsylvania Academy of Fine Arts, the Baltimore Museum of Art, the Corcoran Gallery of Art, and the Chrysler Museum, Norfolk. The Phillips Collection owns six oils and one watercolor by her.

382

382

Strawberries and Peaches, by 1939

Strawberries

Oil on canvas, 10⅛ × 12¼ (25.7 × 31.1)

Unsigned; inscribed in pencil on frame reverse (possibly by the artist), u.c. to u.r.: *SARAH BAKER / STRAWBERRIES & PEACHES*

Acc. no. 0058

The artist to Whyte Gallery, Washington, D.C., on consignment (?); PMG purchase 1939 from Whyte Gallery.[1]

Baker was essentially a post-impressionist whose primary influences were derived from French painting. She therefore often felt at loose ends in an artistic climate she characterized as having little interest in the new traditions of European painting from impressionism to cubism, and perhaps even less in the career of a young woman painter following these new directions. Her first loves were Chardin and twentieth-century French painters like Matisse. Her early work especially showed the considerable influence of Cézanne, but she developed her own identifiable style. The brushing, the directional stroking of the paint, the broken color, the particular character of the line—each of these attributes defines her individuality, and this little painting of fruit on a checked tablecloth is a typical and successful example of how she applied them to the still-life theme.

The red-checked cloth establishes the pulsating planes of this painting; line describing contour is continuously being negated by short strokes of the brush. There is the sense of the occurrence of the objects on the canvas surface, not merely their placement there. The noticeable decrease of color intensity toward the top of the picture, combined with the understated edge of the table at the bottom, provides a kind of melting pot of moving blocks of color where objects seem to be in the process of either being absorbed into or borne on the painting's surface.

BLS

383

Baker's studying with André Lhote in Paris deepened the experimental nature of her own work and allied her with the modernists throughout her career, even though the manner of her own painting was a rather broad impressionism or, at its most adventurous, recalled the reductive images of Matisse. Sometimes, as in this little still life, she attempted daring, swiftly painted statements in large, simple masses.

Baker would often find her first attempt unsuccessful, wipe it out, and start over, but not so here. *Eggplants* suggests the freshness of an artist's first few strokes on an empty canvas; it has all the vitality, spontaneity, and freedom one expects from such paintings. The purple-red and blue-purple-black eggplants sit on a plate against a brilliant alizarin background. As in other still lifes, she showed no table edge or background plane. The eggplants are seen close up, and they create a targetlike impression. The dark, harshly painted lines of the plate encircle the eggplants and effectively promote Baker's dramatic intention. Also, the dark, almost haphazard markings on the tablecloth help stabilize and situate the ground plane of the plate. It is a daring and effective painting.

BLS

MARGARET CASEY GATES (1903–89)

Margaret Gates, a native of Washington, spent her early training as an artist under C. Law Watkins at the Phillips Gallery Art School at the very beginning of its existence. It was there as well that she met the artist Robert Gates, whom she married in 1933. Together they were to play important roles in the Phillips School: she as executive secretary of Studio House, the Phillips-affiliated art school and gallery created in the 1930s by C. Law Watkins, and Robert as an instructor. Later Margaret continued in the same capacity at American University's Watkins Gallery. She worked at the Madeira School in McLean, Virginia, from the early 1950s until her retirement in 1969. Her marriage to Gates ended in divorce. From the late 1950s, Gates scarcely painted at all. In consequence her oeuvre arises mainly from the twenty-year period following the early 1930s. While her work appeared in many exhibitions of Washington artists at The Phillips Gallery and in other local group shows, her two principal solo exhibitions were at the Corcoran Gallery of Art in 1948 and a retrospective exhibition of her paintings at American University in 1981. Gates is represented in the collection by five oil paintings, one casein painting, and one watercolor.

384

384

Landscape in Colorado, 1938

Classic Landscape; Classic Landscape, Saw Mill

Oil on canvas, 16¼ × 24⅛ (41.1 × 61.2)

Unsigned; inscription in black marker on stretcher, u.c.:
Margaret Gates/ "Landscape in Colorado"

Acc. no. 0734

PMG purchase from the artist 1938.[1]

Gates was a painter of great subtlety, and her subject matter seemed as directly related to personal experience as the simplicity of her painting manner seemed tied to the emotional experience of painting. At its most acute, her delicacy of touch is reminiscent of early Corot. At any rate, in her work she sought to coalesce the quality of empathy, the condensation of visual observation, and freedom from affectation.

A modestly sized painting, *Landscape in Col-orado* is typical of Gates's work, at times recalling early Corot in its direct visual notations, subtle color, and gentle painterly surface. She played the warm beige of the sand bar and the warm gray triangle behind the three tree trunks against the blue of the mountain and the paler blue of the sky—a tactic that depends less on color than on an understanding of value relationships and tonality. The sustained interest in her painting comes from its understatement and the purity of undoctored visual sensation. There is seldom any dramatic occurrence in her work, but as in this picture there can be a rather daring scattering of dark accents—the green of the trees, the brown-blacks of their trunks, the cabin on the left, and the bold demarcation of the sand bar. Along with the warm-cool contrast of the beige and blue incidents, she added a pale silvery green that evokes the sun-drenched atmosphere of the mountains of Colorado.

BLS

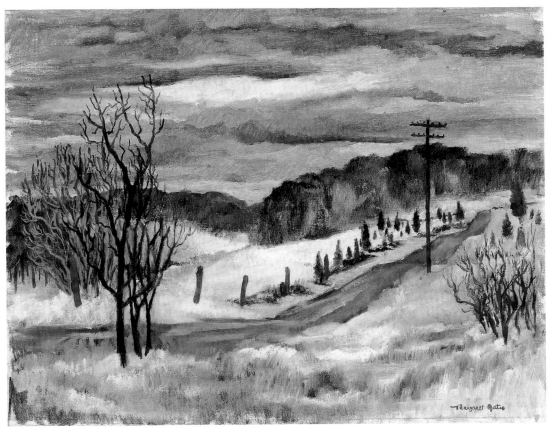

385

385

Our Road in Winter, 1944–45

Our Road in Snow
Oil on canvas board, 16 × 20 (40.6 × 50.8)
Signed in paint, l.r.: *Margaret Gates;* inscription in pencil
on frame reverse, u.l.: *Margaret Gates/Our Road in Snow*
["Winter" crossed out and "Snow" written above it]
Acc. no. 0734

Consigned by the artist to Whyte Gallery, Washington,
D.C.; PMG purchase 1946 (from exhibition).

Margaret Gates's subjects are often events or
places well known to her from daily observa-
tion. In her own particular poetry, however, they
assume a character far from mundane. This
small canvas has as its subject a road that led to
Gates's house in northern Virginia. The unity we
experience in her work arises not just from
compositional means or casual observation but
also from her depth of knowing the places she
paints.

The gray road meanders from the lower left
through broken snow fields to a midpoint along
the right side of the picture. It forms a path for
the dark accents of trees, fence posts, and tele-
phone pole. In the middle distance, dark tree
shapes hug the descending hill; behind and

beyond, the blue of the hills carries the darkness
across the central portion of the canvas. As in all
her paintings, the color is understated—whites
and steely grays, the ochers of the grass in the
snow fields, the warm darks of the trees, and, in
the heavily layered sky, a surprising touch of
pink along the horizon. The unaffected, sponta-
neous drawing is just right, and the visual
authenticity of the painting is deeply affecting.

B L S

LOÏS MAILOU JONES (1905–98)

Born in Boston November 3, 1905, Loïs Jones exemplified in her painting career the perseverance that successful artists must have or acquire. Jones's ambition to be an artist was nurtured at the High School of Practical Arts, Boston, where even as a teenager she was inspired by the reputation of Henry O. Tanner. During her high-school years she was apprenticed to the Grace Ripley Studios, where she created costume designs. In 1923 she graduated from high school, was admitted to the school of the Museum of Fine Arts in Boston, and received a scholarship for four years as a design major. While there, she won prizes for her costume and fabric designs, work she continued at the Designers Art School of Boston, while at the same time working as a free-lance designer for major textile companies. In 1928 Jones was hired by the Palmer Memorial Institute in Sedalia, North Carolina, where she established an art department. So began a teaching career that was to lead her in 1930 to Howard University in Washington, D.C., where she taught until her retirement as professor emerita in 1977. During the 1930s while teaching at Howard, she exhibited widely in group shows. In 1937 she received a fellowship to study at the Académie Julian in Paris; she returned often to France over the years. In her remarkable sixty-year career as a painter, Jones had fifty solo shows, most notably a 1973 retrospective at the Museum of Fine Arts, Boston, a one-person show at The Phillips Collection in 1979, and a comprehensive exhibition at Meridian House International in Washington in 1990. In addition, she exhibited in solo shows at the Vose Galleries in Boston, at Centre d'Art, Port-au-Prince, Haiti, and at Galerie Internationale in New York. In Paris she exhibited at the Galerie Soulages. Jones, who lived and worked in Washington, had spent time painting during summers at Martha's Vineyard and in Haiti, the native island of her late husband, the artist Louis Verginaud Pierre-Noël. She died in Washington, D.C., June 9, 1998. The Phillips Collection has two oil paintings by the artist.

386
Place du Tertre, Montmartre, Paris, 1938
Place du Tertre, Paris; La Place du Tertre à Montmartre
Oil on canvas, 18¼ × 22⅝ (46.3 × 57.4)
Signed and dated in black paint, l.r.: *Loïs M. Jones, Paris '38;* inscription in black crayon on stretcher reverse, *La Place du Tertre à Montmartre*
Acc. no. 0940

PMG purchase from the artist (from exhibition) 1944.[1]

Loïs Jones's early work is imbued with her love of France and French painting. The two paintings in The Phillips Collection, both scenes of Paris, are typical of her work at the time. In the later part of her career, however, her landscapes, still lifes, and figure paintings became more abstract and often directly related to African-American themes or African art, reflecting her heritage as an artist. She also compiled an important collection of slides of work by Haitian, African, and African-American artists, some of which were gathered on trips to Africa in 1969–70 and again in 1972.

Place du Tertre, Montmartre of 1938 represents her Paris work at its most accomplished. The influences are easy enough to read, whether we acknowledge them as those of a specific painter like Maurice Utrillo, who painted a scene at the same spot, or of the whole host of impressionists who painted the streets and parks of Paris.[2] Yet such influence does not take away from the work's effectiveness. The sidewalks, lined with buildings, café awnings, and figures, draw us by their diminishing perspective to the center of the picture. There our eye is blocked by a white building whose gable roof focuses our attention away from the street to the upper-left corner, where we find the echoing shapes of the towers of Montmartre Cathedral. Brilliant greens, reds, and blues are scattered through otherwise neutral passages, effectively directing our attention. The sharp white jacket of the waiter on the right gives a solid position from which to measure our travel within the painting. There is a brusqueness both to the color and the brushing of the paint, materially substantiating the sense of confidence the entire painting exudes.

BLS

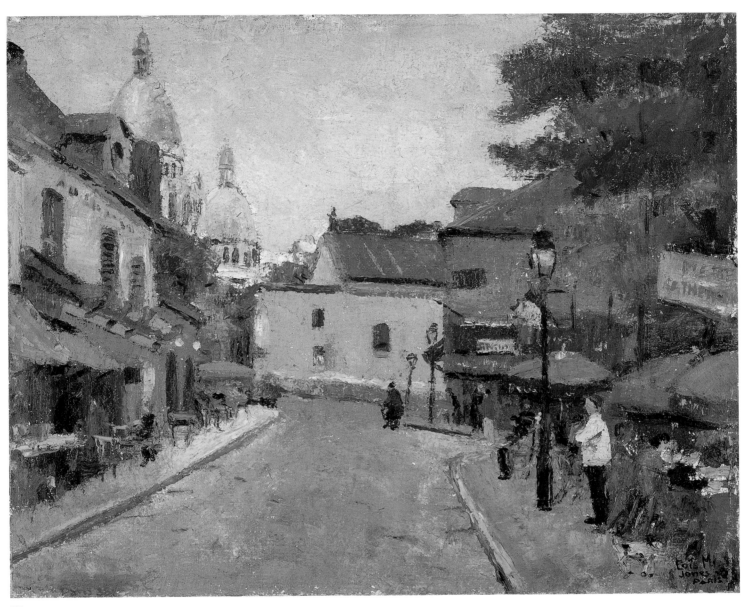

386

ROBERT FRANKLIN GATES (1906–84)

Born October 6, 1906, in Detroit, Robert Gates started to paint while still a child; his influences were John Morse and Joe Gies, Detroit painters who were friends of his grandfather's. He was always to assert in later years that he had intended to be a painter from childhood. Gates's adventuresome nature became apparent as a teenager when he ran away from home and shipped out on a Great Lakes sand barge. As punishment, he was sent to military school. Throughout his life he was to relish the experience of visiting foreign places, including Martinique and Bermuda, the Virgin Islands, Mexico, and, in later years, Iraq, where in 1966–67 he was artist-in-residence at the U.S. Embassy in Baghdad. Gates studied at the Detroit School of Arts and Crafts, moving to New York to study anatomy with George Brandt Bridgman at the Art Students League in 1929–30. By the time he was twenty-four he had moved to the Washington area, which was to be his residence for the remainder of his life. Gates studied with C. Law Watkins and in 1933 was made his assistant at the Phillips Gallery Art School. In 1942 he became a civilian technician with the U.S. Navy and spent some time in the Pacific. For his work during the war years he was awarded the Distinguished Civilian Service Citation, the highest award the navy gives to civilians. During the 1930s Gates had a number of commissions from the Section of Fine Arts of the Treasury Department, including a series of watercolors of the Virgin Islands and post office murals in Bethesda, Maryland, and Lewisburg, West Virginia. After civilian service in the U.S. Navy during the Second World War, he resumed painting and exhibiting; he had frequent one-person shows, first at the Franz Bader Gallery and later at the Jefferson Place Gallery, where he was one of the founding members. In 1946 he joined the faculty of American University, serving as chairman of the art department from 1953 until 1957. He was promoted to professor in 1964 and retired in 1975 as professor emeritus. Gates had solo shows at The Phillips (1937, 1939, 1951, and 1975), the Baltimore Museum of Art, the Corcoran Gallery of Art, and the State Gulbenkian Museum of Fine Arts, Baghdad. For many years he was married to Margaret Casey Gates, a Washington painter whose work was also collected by The Phillips Collection. At the time of his death March 11, 1984, he was married to Sarita Weekes Gates. The Phillips Collection owns twenty-two works by Robert Gates in various media.

387
Potomac River Ice Breaker, 1936
Potomac Icebreaker
Watercolor on paper, 17⅜ × 22⅛ (43.8 × 56.8)
Signed and dated in black paint, l.r.: *Robert Franklin Gates 1936*; inscription in pencil on cardboard backing: *Potomac / Ice Breaker*
Acc. no. 0748

PMG purchase from Studio House exhibition 1936.[1]

While Gates resisted its stylistic influence, he always felt that he benefited from the study of anatomy. Certainly he was one of the most accomplished draftsmen among the Washington-Baltimore painters. Gates had an illustrious exhibition career, and his work, particularly in watercolor, was much admired by Duncan Phillips, who between 1935 and 1965 acquired numerous works. In 1947, recommending Gates as a lecturer for the Michigan Water Color Society, Phillips wrote: "I think his reputation will rest upon his best watercolors which are among the best in this country."[2]

This sparkling example is one of the most arresting in Gates's entire body of work. The composition starts at the lower-left corner, where the diagonal stream of the river parts the dazzling white of the snow-covered ice. It is interrupted in the middle, below center, by the icebreaker and the superbly painted cloud of smoke rising vertically from the tugboat to the top of the image. As the diagonal river path nears the right side of the painting, it reverses direction and takes the eye back to the bridge and the spires of Georgetown University.

The quality of light and the brilliant control of *Potomac River Ice Breaker* affirm Gates's mastery of the watercolor medium. He established a warm-cool resonance by contrasting the beige-yellow to orange of the bridge and buildings with the gray of the sky, the white of the river, and the dark cool accents of the boat. The fluid calligraphy seems remarkably detailed when seen at a distance but when examined closely is reductive in the extreme—a characteristic that only a skilled draftsman and watercolorist can achieve.

BLS

388
Appalachian Landscape, 1953
Oil on hardboard, 28¼ × 36⅜ (71.7 × 92.4)
Signed and dated in paint, l.l.: *R Gates/53*; pencil inscription on frame reverse: *Robert F. Gates 1953*
Acc. no. 0737

TPG purchase from the artist 1954.[3]

When Gates returned from his civilian tour of duty in the Pacific during the Second World War, his work changed quite radically. He abandoned watercolor and began to paint first in tempera and then oil, finally settling on acrylic as his preferred medium. This was not, however, the major change, for he had always experimented with various media. The most important innovation was his steady movement toward abstraction. Various influences are apparent in this new direction, although they were absorbed in a way a younger artist could not have accomplished. One can see Marin in some pictures and Knaths in the cubist overtones, but the final result is more Gates than it is any of his influences.

An established feature of his new way of painting is apparent in *Appalachian Landscape*, where blocked planes of color move freely over the surface and indicate, in a broad way, the details of landscape. In spite of his new tendency toward abstraction, Gates remained loyal to his early manner of painting directly from observation—sometimes at the site, sometimes from drawings made there. The overall green of this landscape is interrupted by a yellow trapezoid creating a diagonal movement at the bottom right. The direction of the yellow brings the eye into the agitated central portion, where competing planes focus attention on a warm, dull-pink square whose direction is at right angles to the yellow movement. This change of direction carries the eye into the light passage in the center of the landscape and hence into the sky. All this movement backs up against a quieter and darker portion on the left and is held in check as well by the dark green on the far right. The thrust of the painting is constructional and architectonic, perhaps reflecting Gates's interest in geology, which was the other consuming passion in his life. In a 1960 interview he revealed, "I almost became a geologist instead of a painter. I still can't get through a new road cut without examining the minerals and fossils."[4]

BLS

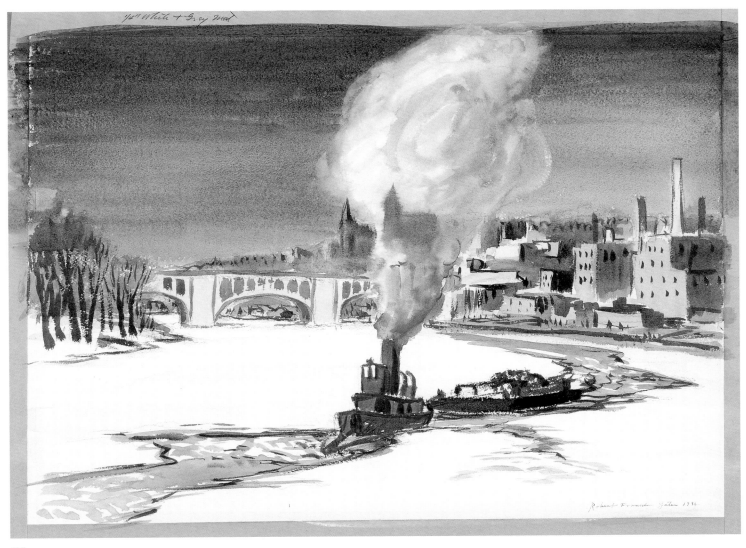

387

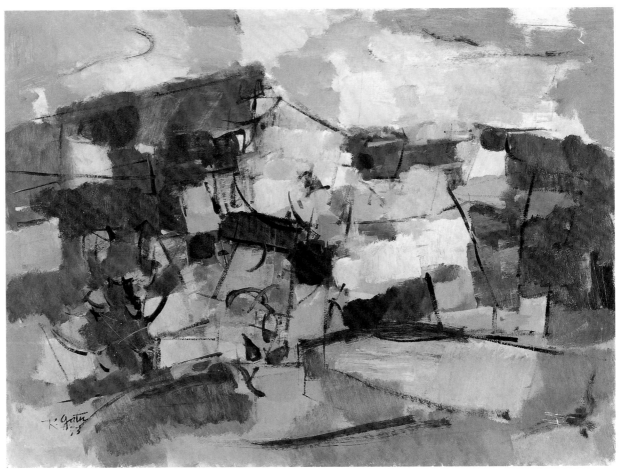

388

HERMAN MARIL (1908–86)

Herman Maril was born October 13, 1908, in Baltimore, where, with characteristic consistency, he lived all his life. Maril's training was principally at the Maryland Institute of Fine Arts in Baltimore, although, after serving in the U.S. Army during the Second World War he returned to Maryland in 1946 to continue his studies at the University of Maryland. Eventually he joined the faculty of the University's Art Department and taught there for the next thirty-one years, receiving an honorary doctorate of fine arts in 1985. Maril exhibited at the Macbeth Gallery in New York for ten years, at the Franz Bader Gallery in Washington for thirty years, and finally at the Forum Gallery in New York for almost twenty years. In all, he had more than forty solo shows, his first taking place at Howard University, Washington, D.C., in 1934. He was only twenty-six at the time but was already well known in the area. In the succeeding years his paintings were shown at numerous university and college art galleries, as well as in solo exhibitions at the Baltimore Museum of Art, the Corcoran Gallery, and the Everhart Museum in Scranton, Pennsylvania. In 1986, after painting all summer as usual in his studio in Provincetown, Massachusetts, Maril fell ill; he died in Hyannis, Massachusetts, September 6, 1986. The collection owns thirteen works by Maril, including nine oils and four works on paper.

389
Waterfall No. 2, 1945

Oil on canvas board, 18⅝ × 21⅞ (47.2 × 55.5)
Signed and dated in paint, l.r.: *HERMAN MARIL '45;* inscription in black paint on backing, u.l. to u.c.: *"Waterfall #2"/By/HERMAN MARIL/1945*
Acc. no. 1272

Purchased from the artist (from exhibition) 1945.[1]

Consistency is evident in Maril's long career as a painter, not only in the persistence of a style that hardly varied but also in the exemplary discipline of producing large numbers of paintings and of remaining loyal to the galleries that showed his work. In an amusing review of Maril's first solo exhibition in 1934, the reviewer wrote, "Twice Herman Maril, Baltimore Artist, won a 'most unpopular artist' prize at successive independent exhibits here. Although hardly crestfallen, then, over the innocuous indignity, he now has the last laugh. Mrs. Roosevelt has admired and purchased some of his work; Secretary Perkins owns two; Duncan Phillips owns several. And now Maril has a corker [of a] show at Howard University's art gallery."[2]

Phillips's interest began in the early 1930s, and Maril considered it the important first step to his eventual recognition as a painter. The first paintings in the collection date from 1934.[3] Although he never had a one-person show there, his work was often included in group exhibitions of area artists.

Maril's subject was primarily landscape. Instead of relying on immediacy of observation, he produced paintings that were condensed and purified. His subjects were scenes from the Baltimore area he knew so well, as well as Cape Cod, where he and his wife had a summer residence and studio. *Waterfall #2* has an authority and presence characteristic of Maril at his most successful. While in some of his work he had a tendency to wander indecisively to the edges of the canvas, this painting is powerfully constructed. The power builds from a series of sequential forms, each boldly outlined in black, each individual in shape, and each clear in spatial positioning. In its brusque directional painting, the waterfall is strongly conceived. Maril used this diagonal thrust again in the modulation of the sky, where the color change parallels that of the waterfall. Against this confrontation of land and sky he posed a single tree. As in most Maril paintings, the color is gentle in its contrast of hues—tawny olive greens, muted blues, and violets. The rusty red on one of the rocks emphasizes the center of the painting, thus suggesting an overall sense of balance.

BLS

390
Evening, 1954

Oil on canvas, 20 × 16 (50.8 × 40.8)
Signed in pencil, l.l.: *Herman Maril;* inscriptions in marker on frame reverse, u.l. to u.c.: *HERMAN MARIL,* and in pencil on stretcher, u.l.: *Evening*
Acc. no. 1263

TPG purchase through Franz Bader, Inc., Washington, D.C., 1954.[4]

Maril's work was being discussed as early as 1935, when Olin Dows, writing in the *American Magazine of Art,* made several interesting comments that are as true of the late work as of the early paintings about which he was writing. "His art is a curious combination of movement and repose," wrote Dows. "The subject and framework is static—very rarely does he attempt motion—yet the pictures are lively. They have a definite internal flow and rhythm that gives the spectator all the feeling of motion." He added, "Unlike many moderns who use semi-abstraction Maril always achieves mood. . . . It is clothed in a certain poetry."[5] This quiet, harmonious quality has been cited by many critics. As late as 1981 David Lawall wrote: "His art aims at a spare but vibrant calm, order and luminosity. . . . It is nature as a refuge from the multiple impingements of Modern life, a refuge, however that harbors a salutary discipline."[6]

Maril's style was set quite early in his career. He tended to depict space in simple terms and to present his subjects frontally. This lack of compositional complexity helped him to create the mood of "repose" and "calm" referred to above. This trait is exemplified in *Evening,* which is among Maril's more decorative works. The colors here are harmonious, as was typical for him. The whites of the boat and of the two sea gulls are placed in a way that does not expand the construction but instead establishes a vignette. Maril allowed the scrubbed brushing of grays and blues to wander toward the top of the painting, an event that promotes an almost dreamlike aura but leaves the composition without tension. His usual treatment of encircling most forms and colors with black line seems too heavy for the tenuousness of the mood.

BLS

389

390

WILLIAM HOWARD CALFEE (1909–95)

William H. Calfee was born February 7, 1909, in Washington, D.C. Throughout his career, Calfee expressed equal interest in painting and sculpture. From childhood, drawing was an activity he practiced as a natural form of expression; his father, Lee Price Calfee, also drew and carved in wood. At Central High School he was inspired by his art teacher, Jessie Baker. Against parental plans, Calfee decided after high school to prepare for a career as an artist and in consequence started taking classes at the Phillips Gallery Art School and the Corcoran School of Art. During this time he held a stenographic job, which allowed him to travel to France in 1932; there he entered the Ecole des Beaux-Arts and spent the year modeling in clay from life. He stayed in Europe for eighteen months, during part of which time he lived and traveled in Italy. In 1934 he enrolled at the Cranbrook Academy of Art in Bloomfield Hills, Michigan, to study with Carl Milles. Calfee began his teaching career the following year at Cumberland Homesteads, Tennessee, under the Special Skills Division of the U.S. Resettlement Administration, teaching art for children and elementary-school teachers. From 1936 through 1941 he painted eight murals in U.S. post offices in Delaware, Maryland, and Virginia. During this same period he was commissioned to make two sculptures for the U.S. Treasury Department. Calfee's first solo exhibition, in 1941 at the Whyte Gallery in Washington, included both paintings and sculptures. In 1946, following the death of C. Law Watkins, Calfee was named chairman of the American University Art Department. Having both studied with and substituted for Watkins in his classes, Calfee was able to use Watkins's ideas without negating his own talents and direction. From 1946 to 1954 he built a thriving art school based upon a sound appreciation of tradition but also open to experimentation. Calfee retired in 1954 in order to devote himself entirely to his painting and sculpture. In 1957, along with a number of his colleagues, he was one of the founders of the Jefferson Place Gallery, which was to play a significant role in the development of Washington art. Calfee died in Washington, D.C., December 3, 1995. He is represented in the collection by three paintings in oil and one in casein, as well as one bronze sculpture.

391

391

Flooded Wood, 1951

Casein on illustration board, 23⅜ × 30 (60.5 × 76.3)
Signed and dated in pen or pencil, l.l.: *Calfee / '51;*
inscribed in pencil on reverse, u.l. to u.c.: *"Flooded Wood"*
William H. Calfee
Acc. no. 0263

TPG purchase (from exhibition) 1952.[1]

The theme of this abstraction is more implied than explicit. The color is limited to black, red, white, gray, and a low-key sandy orange. Because the colors tend to be distributed rather evenly over the surface, emphasis is placed on value changes rather than color position. Calfee avoided reference to illusionistic space, subject, or color, placing major interest on the invention of shapes. In some cases the shapes are the product of accident, because they are created by a series of overlays of translucent color and line. Calfee then stressed these "found" shapes as he elaborated the surface.

To establish *Flooded Wood*'s principal architecture, Calfee used a heavy line along the top third of the painting to divide the composition horizontally. In juxtaposition, he included a series of diagonal divisions that, when they strike the horizontal, are deflected to a reverse diagonal—like reflections in water. The compartments created by these horizontal-diagonal divisions then serve as containments for a complex play with shape. While this strategy allows intense moments of value difference to occur, the painting's surface reads essentially as an all-over pattern.

BLS

JACOB KAINEN (B. 1909)

Born December 7, 1909, in Waterbury, Connecticut, Jacob Kainen moved with his parents to New York in 1918. It was in New York, in association with a score of now famous painters who were his friends—including Milton Avery, Stuart Davis, Arshile Gorky, John Graham, and David Smith—that Kainen developed as an artist. He has had a distinguished career not only as a painter and printmaker but also as a curator—overseeing prints for the U.S. National Museum from 1944 to 1966 and prints and drawings for the National Collection of Fine Arts (now NMAA) from 1966 to 1970—in which capacities he greatly enriched these collections. His many solo exhibitions include museum shows at the Corcoran Gallery of Art in 1956 and 1960 and at The Phillips Collection in 1973, 1980, and 1985. Kainen is represented in many important collections, among them the Art Institute of Chicago, the Metropolitan Museum of Art, and the National Gallery of Art. The Collection owns eight oil paintings and one print by him.

392

Only in Darkness, 1955

Oil on canvas, 34 × 44 (86.4 × 111.6)
Signed in gray-blue paint, l.c.: *Kainen*
Acc. no. 0950

TPG purchase from Franz Bader, Inc., Washington, D.C., 1958.[1]

Kainen's experiences in New York art circles in the late thirties—the experiments, the discoveries, the philosophical and aesthetic conflicts—have given flavor to his work. He was a participant at the very beginning of the maturation of American abstract painting, and while his own work at that time followed a direction more conditioned by German expressionism, its evolution has owed much to concepts shared by this group of daring New York painters. Therefore, despite the fact that Kainen has painted in Washington for almost half a century, his career and his own view of his work has seemed a part of the New York scene and more or less removed from influences shared by Washington painters associated with the Phillips School. In fact, while certain influences from the New York School—that of Gorky in particular and of abstract expressionism in general—are discernible in the body of work he has produced in Washington, the most remarkable characteristic is his distinctive handling of paint and color. His painting has gone through numerous changes, from abstract to figurative and back to an abstract direction. Yet he was not following some other artist but was instead engaged in a personally motivated search for meaning. The character of his painting has been remarkably consistent, with a flavor quite determinably its own.

This character is best expressed in Kainen's own words, describing an argument he had with Jack Tworkov in 1952. He quotes Tworkov as saying "that he would retain in a painting, any part that was expressive, regardless of whether or not it disturbed the larger design," and then he goes on to say for himself: "The whole, I argued, was the expression, and the parts were meaningless out of their context. There are good parts in bad painting, but no bad parts in good ones. Composition is expression, and every good artist creates his own order of composition, based upon his feelings. If he is dominated by his fragments the whole picture falls down and composition becomes a strait jacket. The painting is either good as a whole, as a total expression, or it is bad as a whole, and good passages cannot save it because if the conception is chaotic the painting doesn't work as an organism. . . . If it were otherwise, painting would be a simple matter."[2]

Kainen's most perceptive critics have discovered such purpose behind his paintings. Joshua C. Taylor says, "Above all . . . they are reassuring in the tranquility with which they consider the stresses and mysteries they evoke, evincing a well-considered faith in the persistent value of individual sensibility and its often tenuously maintained contact with a deeply human tradition."[3]

Kainen's *Only in Darkness* was painted in 1955, when his work continued to reflect, but not closely define, its representational and expressionist roots.[4] He has been a challenging painter, moving from subjects of working men and New York genre scenes to near abstraction, culminating in recent years with large-scale geometric abstractions that have not lost a sense of personal experimentation. *Only in Darkness* could easily have been derived from a still-life source, for it has the suggestive planar space we associate with observation, but for all that it functions, like all Kainen's paintings, as abstraction—that is to say, the expression of the whole is more important than the parts.

The central green plane holds together the many smaller incidences of color and shape, and it lends the stability of a centralized position against which the movement of color can act freely across the face of the canvas. This play of color and value provides the excitement, together with the freely disposed expressionistic gesture and the richness of the paint surface. Fragmentary colored shapes resist identification and circulate in a seemingly random way; nevertheless, they are harnessed to a strong vertical and horizontal framework, and in the end it is this stabilizing movement that provides the lasting tension. Benjamin Forgey, in a review of Kainen's exhibition at The Phillips Collection, wrote, "Kainen's paintings as a whole are very much about borderlands, emotional as well as formal. Emphatic but not excessive, together and one by one they celebrate the rigors and virtues of moderation."[5]

BLS

392

JAMES MOORE McLAUGHLIN (1909–82)

James McLaughlin was born January 4, 1909, in Louisville, Kentucky, and later moved with his family to Brownsburg, Virginia. McLaughlin lived there until his family moved to Richmond in 1926. In 1928 he enrolled in Hampden-Sydney College in Hampden-Sydney, Virginia. In 1932 he moved to Washington, where he studied painting at the Phillips Gallery Art School under C. Law Watkins and began an almost lifelong association with Duncan Phillips and the museum. In 1935 McLaughlin joined the museum staff and remained there until his death, except for several years' service in the U.S. Army during the Second World War. At first he made himself indispensable through his craftsmanship in doing installations and building frames, and in general through his skill with tools. He also became a spokesman to the public on the beauty, importance, and meaning of works in the collection. In his office, where he was ready to receive anyone interested in the collection, and on the floor of the museum itself, where he was willing to share his great knowledge of the collection, he proved his loyalty to the concepts that had given birth to the museum. He was appointed associate curator in 1972, was named acting curator in 1974, and in 1975 became curator, a position he retained until his death. McLaughlin had only eight or ten solo exhibitions during his lifetime, but his was a persistent career of almost fifty years, with a significant output of work despite his heavy museum schedule. Although he showed occasionally at Washington galleries such as the Whyte Gallery and the Agra Gallery, his most important exhibitions were the one-person shows he had at the museum in 1933, 1947, and 1953 and the retrospective after his death in 1982. McLaughlin died January 12, 1982, after a period of serious illness, during which he hardly missed a day from his duties at The Phillips. Because of his indomitably cheerful spirit and optimism, it seemed somehow very like him to have carried his load to the end. The collection contains sixteen oil paintings and one acrylic by him.

393

393

Glass, Fish and Plate, 1941–42

Oil on hardboard, 12⅝ × 21⅜ (32.0 × 54.4)
Unsigned
Acc. no. 1329

PMG purchase (from exhibition) 1942.[1]

Soon after McLaughlin joined the gallery staff, Duncan Phillips wrote to Paul Sachs, a Harvard professor, introducing him as a possible summer apprentice: "I think he is most promising material to work with and I hope that eventually he will be a good custodian and caretaker for the paintings and an intelligent guide to the visitors when they encounter pictures without previous instruction."[2] He became this and more.

McLaughlin's belief in art as a humanizing force made him a perfect liaison between artists and the gallery. His paintings reflect his modest, sincere, and kind personality. They are direct, painterly, and visually explicit depictions of the simple things he knew well and loved. On the other hand, they are never forced or intellectually pretentious. As Paul Richard noted in reviewing the 1982 retrospective: "His pictures draw as much from the history of art as they do from daily life."[3] And so they do, for his lifelong dedication to a collection he loved had so entered his own being that the obvious relationships to the painters he admired most lie lightly in his own work.

In most McLaughlin paintings, the essential structure is a simple one of horizontal and vertical divisions. In *Glass, Fish and Plate,* however, he played a series of curved shapes in opposition to the rectilinear table plane and the wall behind

it. Arising from the fruit in the plate, these shapes include the fish, the plate, the shadowed area beneath the wine glass, and the shape on the wall. A spiral motif emerges that binds all the objects of the still life together. However, this spiral does not unwittingly become an artificial device; instead, the simple authority of the basic construction—in which the red of the tomato and the wine forms a tension parallel to the table—keeps it in check. The picture is more colorful than many of McLaughlin's other paintings, and it plays off a rich thallo-green against the reds, blues, and yellow elsewhere. As is often the case in McLaughlin's work, there is more than a hint of Bernice Cross's influence (see cat. nos. 396–97).

BLS

394

Anemones and Stone, 1951

Oil on hardboard, 29½ × 21⅛ (74.8 × 53.5)
Unsigned
Acc. no. 1323

TPG purchase from the artist 1951.[4]

With the directness and simplicity that characterize all his work, McLaughlin set up this still life with the assurance of Braque. A vase of anemones, larger than life-size, is centered in the painting and is placed on a table that recedes diagonally to the left, but whose front edge maintains the horizontal. A small dish on the table contributes to the pull to the left, as do the floorboards, which run parallel to the sides of the table. McLaughlin balanced this directional tension by emphasizing, in a panel on the right,

394

another part of the room, in which a potted plant rests on a window sill. The window light and the plant suggest a movement in space away from the table and vase of anemones. This movement is accentuated by the diminution in scale between the vase of flowers and the plant. It is a simple but effective compositional device.

The color is warm and muted. The accents of color in the flowers play rhythmically against the horizontal-vertical stress. From the perspective of technique, McLaughlin's paintings are not subtle; there is, nevertheless, a subtlety of adjustment in position, color, and spatial structure that often overcomes what might otherwise be considered primitive.

<div align="right">BLS</div>

395

Dark Landscape, 1953

Oil on paper mounted on hardboard, 24⅛ × 13½ (61.2 × 34.3)
Signed in pencil on reverse, u.r.: *James McLaughlin/"Dark Landscape"*
Gift of the artist, 1953
Acc. no. 1326

Gift of James McLaughlin to Duncan Phillips 1953.[5]

This is a guileless and charming painting in which a small white house with a red roof seems measured a great distance from the large dark tree in the foreground. Indeed, the inequality in scale establishes a sense of myth or fairy tale. Against the vertical of the tree and its scattered branches and leaves, the ground undulates in broad curves and takes the eye to the very top of the picture, where the horizon is seen as another curve delineated by a white as strong as that of the house. A rich mixture of grays overlays the warm brown of the ground, making the burst of viridian leaves at the top of the painting and the white and red of the house dramatically vivid. McLaughlin used his familiar technique of applying daubs of slightly changing color over a uniform, contrasting ground. This technique gives his surfaces a rough-hewn quality entirely compatible with the work's subject and style.

<div align="right">BLS</div>

395

BERNICE CROSS (1912-96)

Bernice Cross was born in Iowa City, August 22, 1912. Cross's family moved from Iowa to New Jersey, then to Philadelphia, and finally to Wilmington, Delaware. Cross was an only child, and she spoke humorously of her alarm at first meeting James McLaughlin's large and close family at the time of their marriage. Both her parents died while she was a young woman, but her native self-sufficiency and strong individuality became manifested in both her personality and her art. Cross first studied at the Wilmington Academy of Art, where she was awarded a scholarship in 1931–32. She came to Washington in 1933 to study at the Corcoran School of Art but left in her second year to study with C. Law Watkins at the Phillips School. During the 1930s she was awarded two commissions from the Treasury Department's Section of Fine Arts: a decoration depicting the characters of Mother Goose for the Glenn Dale, Maryland, Children's Tuberculosis Sanitarium and a series of murals based on the Pinocchio story for the clinic in the Children's Hospital, Washington. No Washington artist was featured in more exhibitions at the Phillips than Cross. Between 1938 and 1953 she had six small- and full-scale solo exhibitions there, and her work was frequently included in regular museum installations. She also exhibited often in museums and galleries in Washington, including the Whyte and Franz Bader galleries and the Little Gallery in Georgetown, and she had New York shows at the Contemporary Arts and Bertha Shaefer galleries. Cross died in Bethesda, Maryland, July 23, 1996. In total, forty-two works by Cross were purchased between 1937 and 1963; the collection still has nineteen oil paintings.

396

Pansies and Pitcher, 1947–48

Oil and sand on canvas, 14 × 24 (35.5 × 60.9)
Signed and dated in black paint, l.l.: *Bernice Cross 48*
Acc. no. 0360

PMG purchase from the artist (from exhibition) 1948.[1]

Cross's well-known and admired still lifes are more symbolic than factual. She consistently used certain favored objects in situations where congruency is less important than the identity of each separate part. Each detail is realized in isolation and then surprisingly united into a whole made mysterious by the inexplicable union of objects unconditioned by one another—unconditioned, that is, except for the symbolic intention of Cross's imagination. The painter Ben-Zion wrote of her: "It is a great

relief to find in Bernice Cross an artist who is not afraid of the tyranny of subject matter and who has a deep and warm relation to life and matter. Equipped with such gifts she easily finds her symbols and the textures she introduces become an integrated part of her creation."[2]

There is always something mysterious in Cross's paintings. It may be the unusual combination of objects, or the effect of each object being seen in isolation, or the emphasis resulting in an almost anthropomorphic intensity. Such effects could destroy the unity of a picture, but they are so adroitly and subtly orchestrated by Cross that instead they evoke a life of their own. No designation seems to fit her vision; she is not a neo-primitive, for her work has no sense of the artifice of selecting a style in which to paint. She is an original, and the oddity of her vision is absorbed in the imaginative totality of her work.

Pansies and Pitcher shows a typically scattered arrangement of objects on a table within a space curiously cut off from the painting's rectangular format by sharp triangles at three corners. The effect is to dramatize the presentation, rather like a stage setting on which the curtain has just opened. The table is softly rounded at the bottom, establishing a ground for the objects. In logical compositional terms it would be hard to determine just why the arrangement is so successful. A directional tension is felt between the vase, which rests near the bottom edge of the table, and the white pitcher in the upper right. The salt shaker, lemon, and key create a sagging horizontal. Through these simple compositional decisions, Cross produced a sense of order that is emotional rather than intellectual and pays little heed to the pedantic rules of architectonic order. In this sense, her attitude is not unlike that of Bonnard or Rousseau, another great original whose painting *The Pink Candle* (acc. no. 1695) in the collection must certainly have been of some influence.

The large body of Cross's work in The Phillips Collection is varied in subject and to some extent diverse in treatment or style, and yet it is also coherent, formed by a sensibility that is original, subtle, and unmistakably her own. Critics have often spoken of the whimsy and humor of her painting. Perhaps such qualities are present in her work, but its seriousness, both in conception and execution, forbids taking it lightly.

BLS

397

Stone Angel, 1950

Oil and sand on canvas, 24 × 14⅛ (61.0 × 35.8)
Signed and dated in black paint, l.c. to l.r.: *Bernice Cross/1950;* inscription in black marker on reverse of frame, u.l. to u.r.: *STONE ANGEL*
Acc. no. 0367

TPG purchase from the artist 1950.[3]

Bernice Cross's oeuvre abounds in references to the legendary, the ancient, the mystical, the symbolic. The elements of her essentially hieratic subject matter—the angels and figure heads, the moon and sun, the queens and seers—are all a part of her imaginary world, idiosyncratic yet accessible to the viewer and often profound in their simplicity. *Stone Angel* is of this order, and like most of Cross's work, it somehow avoids sentimentality, perhaps because of its humor but more likely because of its fundamental seriousness. We are led to believe in her vision, even when it becomes fantastic or when the symbology becomes private. The stone angel depicted in this painting is poised against a rich red background as though it is about to move. The tilted column on the left and the confirming green plane on the right, behind the rail, give added life to the statue. This ability to invest life in her subjects, whatever their eccentricity, is a powerful attribute of Bernice Cross's painting. Other attributes, purely pictorial, are the beauty of the paint surfaces, which have scumbled textural interest, and of the color, which, while often somber, is never without subtlety.

BLS

396

397

JOHN GERNAND (1913–90)

John W. Gernand was born October 19, 1913, in Washington, D.C. A lifelong resident of the city, Gernand worked in various capacities at The Phillips from 1938 until his retirement in 1982; during the last ten years he served as registrar and archivist. He studied architecture at the University of Illinois, then returned to Washington, where he studied for four years at The Phillips Gallery Art School on a Marjorie Phillips Scholarship. Gernand had his first one-person exhibition at The Phillips Memorial Gallery in November 1939, with favorable reviews. This early critical success was only sporadically taken advantage of, however. In the course of his career, he exhibited infrequently and toward the end of his life, not at all. He was given two more solo exhibitions at the gallery, in 1943 and 1947, and he also exhibited occasionally at the Whyte and Franz Bader galleries in Washington. Gernand died May 15, 1990. He is represented in the collection by twelve oil paintings acquired between 1937 and 1956.

398

398

Circus, 1938

Oil on canvas, 20 × 24 (50.9 × 60.8)
Signed in brown paint, l.l.: *Gernand;* inscribed in pencil across reverse of stretcher top: *John Gernand "Circus" June 1938*
Acc. no. 0766

PMG purchase from Whyte Gallery, Washington, D.C., 1939.[1]

Both Gernand and James McLaughlin are fondly remembered by Washingtonians because they were often on duty at the front desk at the entrance to the Phillips and served as knowledgeable and enthusiastic guides to the collection. It was to these men that the success of the Phillipses' wish that the gallery be a genuinely open and residential kind of museum can be attributed in some measure, for they both brought to their jobs a devotion to the collection, to the Phillipses, and to the character that was created for the museum.

Gernand's painting centered on romantic landscape and flower studies. The gentle, sometimes waiflike forms, the subdued color, and the slightly mysterious character of his subjects found enthusiastic critical acclaim in the press.

In 1939 one critic wrote, "John Gernand is considered by many to rank first among Washington's younger painters. . . . His work is included in Phillips's permanent Collection and he is listed by Sheldon Cheny in 'America Now' as one of the nation's most promising young painter[s]."[2]

As a genre, circus paintings seldom focus, as *Circus* does, on the broad spectacle. Here it is deftly handled, and the painting sparkles with the effect of light. In fact, Gernand's surfaces always seem to emphasize a fluttering or fluctuating atmosphere, whether in themes like the circus, in landscapes, or in still lifes. The whole surface of this painting has a washed yellowish orange, which in its rubbed and reworked texture gives the effect of the changing light of a circus. The figures and other details are picked out or emphasized by line and small touches of color, but with no strong accents. A warm overall surface light deepens to a red brown in the grandstand, where rather muted reds and violets are allowed to have some emphasis. The overall warmth of the color is challenged somewhat by an earthy green below the grandstand. It is interesting to note that Sarah Baker was painting the circus at the same time, though her style was quite different from Gernand's.

BLS

MITCHELL JAMIESON (1915–76)

Mitchell Jamieson was born in Kensington, Maryland, October 27, 1915, and he lived most of his life in the Washington area. Jamieson studied at the Abbott School of Fine and Commercial Art, Washington, D.C., and later at the Corcoran School of Art and the Escuela de Bellas Artes in Mexico City. In 1935 he won a prize in the Washington Independent Artists' Exhibition; the following year he was one of six Washington-area artists represented in a national exhibition at Rockefeller Center in New York,[1] and he exhibited three paintings in The Phillips Memorial Gallery's "Second Autumn Exhibition." Jamieson participated in the U.S. Treasury Department's Section of Fine Arts projects during 1936–37, painting in Key West and the Virgin Islands. Between 1937 and 1941 he carried out numerous government mural commissions for regional post offices and the Interior Department in Washington, including a 1941 mural commemorating the celebrated concert given by Marion Anderson at the Lincoln Memorial on Easter Sunday, 1939. His fame as a young artist is further documented by a series of paintings made for the secretary of the treasury, Henry Morgenthau Jr., and for President and Mrs. Roosevelt. Jamieson was a U.S. Navy combat artist from 1942 to 1945. His skill as an illustrator attracted many government and commercial contracts after the war. In 1967 Jamieson went to Vietnam as a volunteer civilian artist for the Army Office of Military History, an experience of great consequence to his later life and work. Although Jamieson taught at a variety of schools and universities, his final teaching position at the University of Maryland lasted from 1959 to 1976. He had a notable exhibition record, which included more than thirty-five solo shows—four at the Corcoran Gallery of Art and others at art museums in Santa Barbara, Portland, Seattle, Birmingham, and Richmond. His many awards include a Bronze Star for his work as a combat artist and a Guggenheim Fellowship in 1946. He died February 4, 1976, from a self-inflicted gunshot wound. The Phillips Collection owns one casein-and-ink painting, one watercolor, and an etching by Jamieson.

399

399

Old Houses, ca. 1936

Watercolor over pencil on paper, 15½ × 20¼ (39.4 × 52.5)
Signed in black paint, l.r.: *Mitchell/Jamieson*
Acc. no. 0937

PMG purchase 1936 from Olin Dows.[2]

During the 1930s Jamieson was principally a watercolorist whose paintings revealed an uncommon facility for rendering what his eyes saw in a painterly but accurate manner. *Old Houses* was probably painted when he was in the Virgin Islands on a project for the U.S. Treasury Department's Section of Fine Arts in 1936. In a palette of dark aubergine and browns, he set up the center section like a stage flat—frontally and in conformity to a horizontal-vertical format. Light breaks across the scene as it pours in between houses on the right, creating a bold plane that isolates and at the same time drama-tizes the darkened house. The shed to the left is bathed in a soft apricot light, as is the gable end of the house. In turn, small events scattered across the image—chairs and stacked boxes, laundry drying, a man and woman—become all the more important and lend further interest in pattern and color. Control of the beautiful color and masterly technical command take this painting well beyond the realm of illustration.

Jamieson's subsequent work as a combat artist resulted in an impressive group of paintings and drawings that reveal his abilities as a draftsman and a watercolorist. His 1976 Vietnam assignment was to prove compelling, however. The war affected Jamieson deeply, and the work that came from this experience depicted with expressionist fervor the tragedy of the war. This late work was characterized as "an abrupt, indelible reminder of humankind's potential and actual inhumanity."[3]

BLS

HAROLD GIESE (1918–85)

Born in Washington, D.C., November 11, 1918, Harold Giese decided on a career as an artist while he was a student at Central High School. Upon graduation, Giese entered the Corcoran School of Art; his teacher during most of his four years there was the painter Eugene Weisz. In 1941 Giese received a scholarship from the Phillips Gallery Art School, where he studied under both C. Law Watkins and Karl Knaths. While he was studying painting, he worked at various jobs, first in the engraving department of the *Washington Post* and for about two years as a framer for the Whyte Gallery. In 1943 he joined the staff of The Phillips Memorial Gallery, where he worked until he retired in 1978. Giese's most significant body of work dates from the late 1940s and 1950s. Although he exhibited regularly in group shows of Washington artists at The Phillips, and as early as 1945 in a one-person show at the Whyte Gallery, he was otherwise an infrequent exhibitor. During the last years of his life he suffered from acute arthritis and other illnesses, and he died in Washington in 1985. Giese is represented in the collection by three oil paintings and three caseins on paper.

400

400

Ancient Meeting, 1949

Casein on paper mounted on painted board, 9½ × 12½ (24.0 × 31.5)
Signed and dated in gray paint, l.r.: *H. Giese '49;* inscribed in pencil on board reverse, u.r.: *Harold Giese/"Ancient Meeting"/casein*
Acc. no. 0781

TPG purchase from Whyte Gallery, Washington, D.C., 1950.[1]

The six Giese paintings in The Phillips Collection form a cohesive group in terms of style, and they also represent the artist's diverse subjects—figure studies, still lifes, and landscapes that sometimes have allegorical or mythic implications.

This small painting is a mood poem that derives a certain monumentality from its predominant blues and grays. The combination of the beached craft, the anchor, the outsized fish head, and the yellowish moon, which casts a yellow wake behind the boat, creates a mood heavy with allegory. Even without a key to the exact meaning of the symbols, we perceive the idea of a voyage ended, and as a result, a sense of loneliness pervades the painting.

While seeming to have been effortlessly arranged, the composition is thoughtful and effective. The parallel diagonals of the mast and the fish's mouth and gill connect the foreground and middle distance, suggesting a sense of space within the constricted format. The accent of red on the rudder sharpens the overall somber mood.

BLS

BEN L. SUMMERFORD (B. 1924)

Born in Montgomery, Alabama, February 3, 1924, Ben Summerford studied piano from age nine, and until he joined the U.S. Navy in 1943 he intended to make his career as a musician. In 1942 he entered Birmingham-Southern College on a scholarship won in statewide competition; he studied concurrently at the Birmingham Conservatory of Music, which was then associated with the college. After joining the U.S. Navy in 1943, he was commissioned an ensign in 1944 and was sent to the Naval Oriental Language School at Boulder, Colorado, where he studied Malay and graduated in 1945. Upon his release from the navy in 1946, he worked in the Office of Naval Intelligence in Washington. Having by then reassessed his career goals and decided that his interests lay entirely in art rather than music, Summerford remained in Washington and entered American University to study painting; he received a B.A. in 1948 and then enrolled in American University's Master's program. In 1949 he won a Fulbright Fellowship to France, where he stayed for the year 1949–50, studying at the Ecole des Beaux-Arts and painting in a studio in which he lived. In Paris he met Christene Morris, who was working with the Marshall Plan. They were married in 1951 after Summerford's return to American University in the fall of 1950 to assume a teaching position. He remained at the university for the next thirty-eight years. From 1957 to 1986 he was chairman of the

Department of Art, first alone and then from 1965 as one of three alternating chairmen. Summerford had sixteen solo exhibitions from 1949 to 1986, including a show at the Baltimore Museum of Art in 1951 and a twenty-year retrospective at The Phillips Collection in 1982. He showed often at the Jefferson Place Gallery, of which he was a founder, and the Franz Bader Gallery, both in Washington. He has also given many public lectures at museums, including, among others, the National Gallery and the National Museum of American Art. Summerford has often publicly acknowledged his personal and professional debt to The Phillips Collection: first as the place that introduced him to contemporary painting as well as to many Washington painters, and then as the place where he studied with Karl Knaths, who was the major influence in his early work. The collection has two works: one oil and one gouache.

401

The Blue Bottle, 1949–52

Oil on canvas, 54 × 42 (137.3 × 106.6)

Signed across top of stretcher reverse: *The Blue Bottle— Joe Summerford 1952*

Acc. no. 1856

TPG purchase out of Corcoran exhibition 1953.[1]

The work of Karl Knaths was an early and important influence on Summerford, to the point that he has referred to *The Blue Bottle* as an homage to Knaths.[2] The painting is built of contrasting horizontals and verticals that in their slight tilt create some movement in an otherwise stable composition. The light-blue central drapery, emphasized by a white triangle at its end, is pulled visually toward the center by a series of small tilted planes of brightly colored pinks. This diffusion of the vertical movement creates a change in emphasis to the horizontal plane of the table that is made more noticeable on the left by a series of planes of gray-violet and yellows. These planes lead to the conspicuous shape of the cerulean-blue bottle. The right side of the painting is quieter but provides the necessary stress on the horizontal by the inclusion of the light trapezoid behind the large transparent bottle.

The picture is constructed in a generally cubist tradition, but it depends perhaps more on color organization than planar construction for its effect. The color is a harmony of blues and browns in which the browns extend to apricot accents and the blues have several intense hues in scattered locations. The use of black line to define objects and movements is another influence from Knaths.

BLS

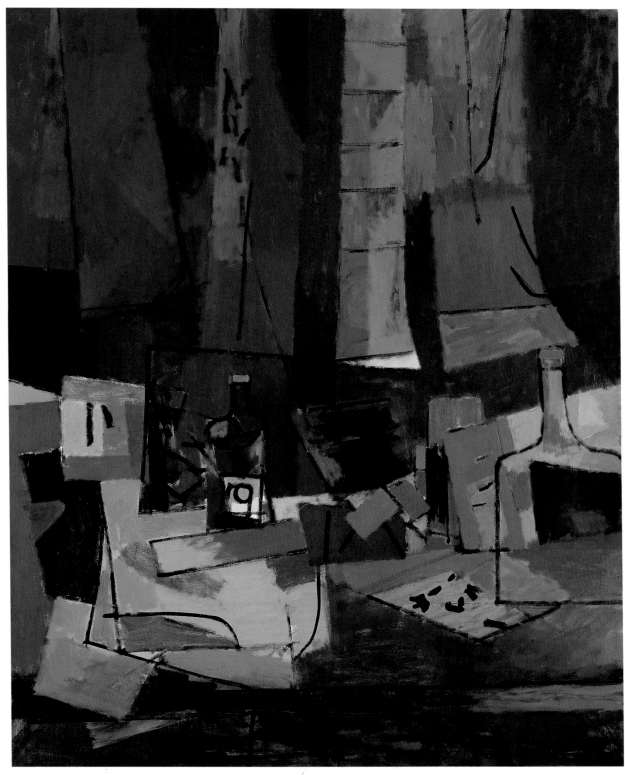

401

II THE PHILLIPS COLLECTION AND ART IN WASHINGTON

Part II: Washington Art in the 1960s and Beyond

WILLEM DE LOOPER WITH
JEFFREY HARRISON

Many institutions in Washington fostered the wealth of creativity that defined the city's artistic life during the sixties. It was a time of frenzied activity; artists shared information and argued about art, its role, its methods, its style. At The Phillips Collection, these developments found their reflection in exhibitions as well as purchases during Duncan Phillips's lifetime, but especially in the activities of Marjorie Phillips, who became the museum's director after her husband's death in 1966. It soon became apparent that she was interested in the vital contemporary art scene, including the work of local artists, many of whom had achieved some national recognition.

Within blocks of The Phillips Collection was the Washington Gallery of Modern Art (opened in 1962), where exhibitions of contemporary art of national importance took place. Even closer to the museum, in what is now the Embassy of Indonesia, was the Washington Workshop, directed by the artist Leon Berkowitz. Morris Louis was one of the teachers, and faculty and students as well as many of the artists who frequented the workshop had easy access to the paintings in The Phillips Collection.

In fact, the great colorists favored by Duncan and Marjorie Phillips—Renoir, Bonnard, Matisse, and Cézanne—served as inspiration to many, as did Klee and Rothko, both of whom were given permanent installations in separate rooms. The latter especially became a powerful magnet; among the abstract expressionists, it was Rothko to whom Phillips responded emphatically and with sustained commitment through exhibitions and purchases. Other installations had their impact as well. For example, Morris Louis and later Sam Gilliam were much taken with the paintings of Augustus Vincent Tack, whose large abstraction *Aspiration* (acc. no. 1871) dominated the new stairwell.[1]

Several exhibitions served to shape the city's emerging artistic life, including a seminal showing in 1965 of contemporary Washington-area art at the Washington Gallery of Modern Art. This event brought broader recognition to local artists including Louis, Kenneth Noland, Gene Davis, Howard Mehring, Thomas Downing, and Paul Reed. Gerald Nordland, the exhibition's organizer, coined the term "Washington Color School," which has since been both defining and misleading in its impact, because these artists did not con-

Alma Thomas, detail of
*Breeze Rustling Through Fall
Flowers,* see cat. 402

sider themselves part of a movement; rather, their close association grew out of an interest in experimental methods and techniques as well as shared experiences, especially their participation in the same galleries in Washington, the most significant being the Jefferson Place Gallery. The resulting works came to be identified as part of a national trend defined as postpainterly abstraction.[2] More national recognition came for Louis and Noland (as well as Davis a few years later) when Clement Greenberg selected their works for exhibitions in New York galleries alongside such artists as Barnett Newman and Adolph Gottlieb.[3]

The work of these Washington color artists grew out of the chromatic painting styles of Newman and Mark Rothko and owed its technique of staining to Jackson Pollock as well as Helen Frankenthaler (who also had been inspired by Pollock). It emphasized the expressive power of pure colors that interacted when they were placed adjacent to each other, without traditional drawing or value contrast. Pictorial space was flat and employed methods far removed from a traditional handling of space, especially as found in cubist painting. Color painting employed no texture to speak of, which set it apart from abstract expressionist painting with its emphasis on gesture, surface, and, often, texture. The outcome was, therefore, "optical."

In the course of the 1950s Phillips turned his attention to the artists discussed in this chapter, beginning with Noland. Two early works, *In the Garden* (cat. no. 406) and *Inside* (acc. no. 1436), related closely to the painting of Paul Klee and to the collection in general. The later purchase of a mature work by Noland, *April* (cat. no. 407), was a manifestation of the "new" abstraction—hard-edged, geometric, and unpainterly—and did not reflect Phillips's usual taste for color combined with texture. Accordingly, Phillips purchased a Louis of 1961, *Number 182* (cat. no. 403), which was not from the artist's severely geometric period. Although brilliant in color and very much an abstraction, it could nevertheless be read as a natural phenomenon—something growing, such as a plant or a tree.

Davis brought in paintings for Phillips to see, but no purchases resulted. The works by this artist now in the collection were all acquired in the 1970s and 1980s. Nor did Phillips purchase any works by Downing or Mehring, both of whom were active during the sixties and whose work was widely admired. When Marjorie Phillips became director, she showed increased interest in these painters, perhaps understanding that they were already, in a sense, part of the Phillips tradition. An accomplished painter herself, she had played an active and important role since the museum's opening, a fact often acknowledged by Duncan Phillips in words and print. And although her installations of the permanent collection did not differ significantly from those of her late husband, her acquisitions and temporary exhibitions soon carried her imprint. She began making trips to New York and regularly visited Washington's art galleries to view contemporary art. Her first purchase in 1967 was Mehring's

Interval, 1967 (cat. no. 409), followed by Sam Gilliam's *Red Petals,* 1966 (cat. no. 411), from his solo show at The Phillips Collection. In 1971 she organized a large temporary exhibition of paintings by Washington artists selected from the P Street galleries. All the works were abstract, and a number of them, such as Downing's *Dream Rate,* 1962 (cat. no. 408), and Davis's *Untitled,* 1971 (acc. no. 0463), entered the permanent collection.[4]

A "second generation" of Washington artists, including Gilliam, Willem de Looper, Alma Thomas, Berkowitz, and Jacob Kainen, pursued a course of total abstraction, absorbing the lessons taught by Pollock, Newman, and Rothko and building upon the impetus provided by the Washington color painters. This new art was discussed and treated with seriousness. A number of new galleries opened near The Phillips Collection, and they were supported by devoted collectors and local art critics. For the first time in the city's history the arts were thriving, and Washington could claim a number of nationally recognized painters.

The second-generation artists also came to the collection to see Klee, Dove, Matisse, and the Rothko Room. But it is important to remember that their conversations were about Pollock, Newman, and Frank Stella, artists working in New York and receiving great publicity in art periodicals and major traveling exhibitions.[5]

Older artists began to change as well, and by the late sixties their work, too, had become identified with color painting. Berkowitz developed a mature style of total abstraction closely related to the postpainterly, all-over color fields of Jules Olitski. In the fifties and early sixties, Kainen had painted in a figurative style inspired by his New York experiences before the advent of abstract expressionism. He, too, was inspired by the local color painting being shown at Jefferson Place Gallery, which also represented him. And so, by the time these two artists had their solo exhibitions at The Phillips Collection in 1973 and 1977, respectively, it could be argued that they, too, were second-generation color painters.[6]

Thomas was another, slightly older, local painter who was inspired by pure color painting but remained outside any group. Her work was fresh and rhythmic. Like the art of Davis, Gilliam, de Looper, and especially Mehring, hers could easily be tied to an interest in jazz and its improvisational nature.

Both Gilliam and de Looper became color-field painters soon after their art-school training at the University of Louisville, Kentucky, and American University, Washington, D.C., respectively. Their art was process-oriented; both artists laid the canvas on the floor and manipulated it—in the case of Gilliam to a radical extent in that he draped his paintings and liberated them from their support. While Gilliam painted his works unstretched, he determined their edges after completing them. De Looper, although he also manipulated the canvas and scumbled and poured paint, always worked on the stretcher because of his interest in the edge of the color field. Both artists had a particular interest in the work of Louis and Noland.

When Marjorie Phillips retired in 1972, her son, Laughlin Phillips, assumed the directorship, a tenure that spanned two decades, from 1972 to 1992. Besides continuing to add new works to the collection, Laughlin Phillips lent strong support to an active exhibition program that included the work of regional artists. Contemporary sculpture exhibitions, featuring such artists as Steven Bickley, Peter Charles, John Ferguson, Christopher Gardner, John McCarty, and Lisa Scheer, continued a tradition established by Marjorie Phillips after the Annex and Sculpture Court had made the installation of larger works of sculpture possible. Of special significance was The Phillips Collection's Giacometti exhibition of 1963.[7]

The museum also took on a new public role when it began to organize major exhibitions that subsequently went on national tours. These shows not only brought large numbers of visitors, including Washington area artists, to the museum, but also gave the museum national exposure. The first of these was "Franz Kline: The Color Abstractions," held in 1979, followed in 1981 by "Phillip Guston 1980: The Last Works," an exhibition that was selected just weeks before the artist's death. In 1982 the museum held the first exhibition of Braque's late paintings, followed in 1983 by the first major survey of Morris Graves's work since the fifties. Perhaps the most breathtaking exhibition of the eighties was "Bonnard: The Late Paintings,"

held in 1984 and organized in tandem with the Centre Pompidou in Paris. Later that year The Phillips Collection gave the English artist Howard Hodgkin his first American museum exhibition. Other important recent shows have included a 1981 retrospective of Dove's paintings, "John Graham: Artist and Avatar" in 1988, and "Nicolas de Staël in America" in 1990. These exhibitions shared one important component: they not only drew on the resources of The Phillips Collection but also reflected significant aspects of Duncan Phillips's collecting and his simultaneous concerns for local and international developments.

During this same period, Laughlin Phillips oversaw the collection's remarkable transformation from a home filled with painting to a full-fledged museum. Renovations of both the former residence and the Annex improved the galleries and enlarged the storage areas without sacrificing the museum's intimate atmosphere. Many aspects of the collection's operation were handed over to professional administrators and art historians, and yet the tradition of keeping artists on the staff and in the galleries as docents and museum assistants has been preserved, ensuring that The Phillips Collection remains a living place for both art and artists. Laughlin Phillips, who retired as director in 1992, has made sure that the "experiment station" opened to the public by his parents in 1921 will survive and flourish into the future.

Alma Thomas was a successful member of the Washington avant-garde, despite the barriers presented by her race and gender. Thomas was born September 22, 1891, in Columbus, Georgia, the eldest of four daughters of a tavern owner and his wife, a teacher. Because racial segregation effectively kept her from continuing her education, her family moved in 1907 to Washington, D.C., where she entered Armstrong Technical High School, her first exposure to formal art training. Encouraged by her mother, she took every art course she could, including mechanical drawing. After graduation, Thomas entered the Miner Teachers Normal School, specializing in kindergarten instruction. In 1921, after teaching for six years in Wilmington, Delaware, she returned to Washington to enter Howard University. Although she began as a costume-design major, her professor, James Herring, persuaded Thomas to become a student in his burgeoning art department. After graduation in 1924, she taught at Shaw Junior High School, where she remained until her retirement in 1960. In 1935 she received a master's degree in art education from Columbia University, New York. In 1943 Thomas helped Alonzo Aden found the Barnett-Aden Gallery, the site of the first exhibitions of Washington color painters, such as Gene Davis, Kenneth Noland, and Morris Louis. From 1950 to 1960 Thomas was enrolled in creative painting classes at American University, where she studied color theory under Ben L. (Joe) Summerford, Robert Gates, and Jacob Kainen. Upon retirement from teaching in 1960, Thomas devoted herself to painting full time. That year she was given her first solo show at the Dupont Theater, an art cinema. In 1972 both the Whitney Museum of American Art and the Corcoran Gallery of Art held solo exhibitions of her work. Thomas died at Howard University Hospital in Washington February 24, 1978, after undergoing aortal surgery. The Phillips Collection owns one late work by Thomas, an acrylic completed in 1968.

402

Breeze Rustling Through Fall Flowers, 1968

Acrylic on canvas, 57⅞ × 50 (147.0 × 127.1)
Signed and dated, l.r.: *AW Thomas/68;* reverse: probable artist inscriptions u.l. to u.c.: *(No 24)/"Breez Rustling through/Fall Flowers"/58 × 50 '68;* u.r.: *Alma W. Thomas;* l.l.: *Alma W. Thomas/'68*
Gift of Franz Bader, 1976
Acc. no. 1951

The artist to Franz Bader by 1976; gift of Franz Bader, Washington, D.C., 1976.[1]

Although Alma Thomas worked as a representational painter in the tradition of Cézanne and Matisse for more than twenty-five years, she changed her style late in her career under the influence of abstract expressionism and the Washington Color School. Through her association with the Barnett-Aden Gallery from 1943 to 1963 and American University from 1950 to 1960, Thomas became acquainted with the work of Gene Davis and Morris Louis, two leaders of the Washington Color School.[2] Although Thomas incorporated their powerful geometric formats, large scale, and pure colors into her abstractions, she did not appropriate their preference for unprimed, stained canvas, or the marking of edges with masking tape; instead she drew pencil lines, which are usually visible in the finished work, and retained the gesture in her brushstrokes.

In 1966, invited to hold a retrospective exhibition at Howard University, Thomas created a series entitled *Earth Paintings,* which proved to be a turning point in the development of her most recognizable style.[3] This series focused on subjects from nature, particularly wind and flowers. *Breeze Rustling Through Fall Flowers,* an early example, was inspired by "the display of azaleas at the Arboretum [the Washington, D.C., botanical gardens], the cherry blossoms, circular flower beds, the nurseries as seen from planes that are airborne, and by the foliage of trees in the fall."[4] Thomas's primary visual source was the image of a holly tree pressed against the living-room window of her Washington home. The designs formed by the leaves upon the panes, and the interrupted patterns of light and shade cast on the floor and walls of her kitchen, inspired the flickering motion of her brushstrokes. The irregular daubs of color represent "the leaves and flowers tossing in the winds as though they were dancing and singing."[5]

Breeze Rustling Through Fall Flowers is composed of a vertical grid of closely spaced stripes filled with bars of contrasting colors on a painted white ground. The acrylic paints are thinned almost to the point of transparency, retaining the luminous quality often associated with watercolor. The modulated white background serves the same function as the white of the watercolor paper that shines beneath the painted surface. Thomas sometimes produced as many as twenty watercolor studies before beginning a painting on canvas.

The power of Thomas's work lies in her uneven, irregular divisions of color, what she called her "broken image."[6] Similar to a mosaic, where each tessera is carefully placed into a larger framework, the shape and gesture of each individual daub of color create the overall pattern in the work. Thomas described paintings like *Breeze Rustling Through Fall Flowers* as "Alma's Stripes," because the brushstrokes are ordered vertically, representing the formal rows of a garden.[7] Like Gene Davis, she chose the colors of her stripes by intuition and mood. In her later *Earth* series, Thomas abandoned multicolored stripes to concentrate on the force of a single bright color on a white ground.

Breeze Rustling Through Fall Flowers was a gift in 1976 of Franz Bader, one of Washington's earliest supporters of contemporary art. Bader, who undoubtedly felt an empathy for Phillips's appreciation of art, wrote: "The beauty and informality of the Phillips Gallery has always meant very much to me. Visiting it the first week after my arrival in this country helped to form my idea of America."[8]

Throughout his writings, Duncan Phillips often extolled the artist's ability to invent color-shapes that capture the spirit of nature.[9] With its spontaneous brushstrokes of pure color and its unique interpretation of the visual appearance of nature, *Breeze Rustling Through Fall Flowers* was an appropriate addition to the collection.

SalF

402

MORRIS LOUIS (1912–62)

Morris Louis, a member of the Washington Color School, was born Morris Louis Bernstein November 28, 1912, in Baltimore, Maryland, to Russian immigrant parents. At age fifteen Louis won a four-year scholarship to the Maryland Institute of Fine and Applied Arts, graduating in 1932. He moved to New York in 1936, dropped his surname, and participated in David Siqueiros's experimental workshop. He weathered the Depression by working for the Works Progress Administration (WPA) in a representational style; in 1939 he exhibited one painting at the WPA Pavilion of the New York World's Fair. He returned to Baltimore in the early 1940s and moved in 1947 to Silver Spring, Maryland, participating in the Maryland Artists' Annual Exhibitions at the Baltimore Museum of Art. In 1952 the artist and his wife moved to Washington, D.C., and Louis secured a teaching position at the Washington Workshop Center of the Arts, where he became a friend of Kenneth Noland. In April 1953 Louis, Noland, and the critic Clement Greenberg visited New York galleries, studying works by Jackson Pollock, Franz Kline, and Helen Frankenthaler. Louis's first solo exhibition opened in 1953 upon his return to Washington, at the Workshop Art Center Gallery. The following year Greenberg included Louis in a seminal group exhibition, "Emerging Talent," at the Samuel M. Kootz Gallery in New York, which was the artist's first exposure to the New York avant-garde; it was followed in 1957 by his first New York solo show at the Martha Jackson Gallery. In 1960 André Emmerich became his dealer in the United States, and Lawrence Rubin represented him in Paris. Louis died of lung cancer September 7, 1962, at his home in Washington, D.C. The collection contains three of his *Stripe* paintings.

403

Number 182, 1961

Acrylic on unprimed canvas, 82¼ × 33¼ (208.9 × 84.4)
Unsigned
Acc. no. 1218 (Upright no. 448)

Collection of the artist until 1962; TPC purchase from the estate through André Emmerich Gallery, New York (from the Corcoran exhibition), 1963.[1]

In the fall of 1961 Louis abruptly stopped painting the series of *Unfurleds* (1960–61)—monumental works marked by banked rivulets of pure color bounding an expanse of bare white canvas—and began creating the *Stripe* paintings. *Number 182* is an early work in Louis's third and final series, in which he revived his 1960 experiments with vertical bands of pure color called *Italian Veils, Columns,* and *Twined Columns.*[2]

Louis and his Washington Color School colleagues were concerned primarily with color and the visual effects of color relationships.[3] By eliminating the trademark gesture of the abstract expressionists, they were able to assign color a preeminent role. Many of them, including Gene Davis and Kenneth Noland, explored the potential for color in the format of the stripe, but in his *Stripe* paintings, Louis created vertical bands of color abutting and overlapping each other to form a pillar of contained energy.[4] The stripes tend to move and interact with one another optically, depending upon their hue, placement, and value.

In *Number 182* the eye rests for a brief moment on the raw sienna stripe but is quickly drawn to the adjacent orange stripe, which vies for dominance: because the image is set off-center, to the right, the shared contour of the two colors actually marks the center of the canvas, while the sienna occupies the center of the pillar. These two colors are nearly identical in value, thus optically appearing on the same plane, and both stand out from their respective adjacent yellow stripes. The orange and sienna bands are flanked by greens and blues, dividing the column into three sections, separated by yellow.[5] The right side is rendered flat because the hues are close in value, while on the left, the intensely bright colors maintain their integrity.

Because Louis painted in solitude, his working methods were not known until his death, when his studio could be entered. He evidently used a nine-foot-high work stretcher to which he tacked cotton duck canvas that fell loosely to the floor.[6] From the top of the work stretcher, he poured diluted acrylic paint down the front of the canvas, possibly creasing the canvas to direct the flow.[7] The unsized and unprimed canvas soaked in the color, producing a stained effect; in essence, canvas and paint bonded to become one entity.[8] With the canvas still affixed to the work stretcher, the paint would frequently run over the top edge and onto the tacking margin, which created a cusp shape on this folded-over edge of canvas. When *Number 182* was stretched, the image was cropped through the raw sienna and cobalt-blue cusps.[9] In later *Stripe* paintings, such as The Phillips Collection's recent acquisition *Approach,* 1962 (acc. no. 1990.6.6), Louis carefully controlled the pours of paint and neatly rounded the tips.

For Louis, the final stretching of the canvas was as important as the image itself, and the height was the most important dimension; however, works were generally stretched only when they were sent to an exhibition. In the *Stripe* paintings, Louis marked stretching instructions directly on the canvas before it was rolled for storage.[10] His original intention was to cut through the painted image at both top and bottom, but Greenberg persuaded him to leave a little space of raw canvas between the image and the top of the frame.[11]

Because of their relatively small size, the *Stripe* paintings were more widely exhibited and better known than Louis's earlier series, the *Veils* and *Unfurleds.* In 1961 the André Emmerich Gallery exhibited ten *Stripe* paintings, the first major showing of this series, and nearly all were sold. The following year Emmerich sent Duncan Phillips five of Louis's *Stripe* paintings on approval, from which Phillips purchased one, *Illumination,* 1962.[12] In 1963, however, Phillips replaced *Illumination* with *Number 182.* Subsequently, he reserved the spacious third-floor gallery of his recently completed Annex for contemporary works, and *Number 182* often represented the Washington Color School.

VSB

403

GENE DAVIS (1920–85)

Gene Davis, along with Kenneth Noland, Morris Louis, Howard Mehring, Thomas Downing, and Paul Reed, was a member of the Washington Color School, a term coined by critics in the mid-sixties. Born August 22, 1920, in Washington, D.C., Davis graduated from McKinley High School in 1938 and then attended the University of Maryland and Wilson Teachers College. The drawing classes he took at McKinley were the only formal art instruction he received. From 1939 to 1968 Davis was a writer and journalist. His first job, at age nineteen, was as a sportswriter for the *Washington Daily News*. In Jacksonville, Florida, Davis was a police reporter; in New York, he worked as a copyboy and apprentice reporter for the *New York Times,* a writer for the United Press, and finally assistant editor for Popular Publications. In 1945 Davis returned to Washington as a White House correspondent for the *Transradio Press* during the late Roosevelt and early Truman years. Always fascinated by art, he began to paint seriously by 1949. He became involved with the Washington art scene in 1950, when he met the noted Washington artist and curator Jacob Kainen, who introduced him to the Washington Workshop Center of the Arts. His first two one-person shows were in 1953, at the Dupont Theater and Catholic University. During the 1950s and 1960s, Davis established important contacts with New York artists and with the influential critic Clement Greenberg, whom he first met in 1962. By 1969 a commission from the Albany South Mall in New York enabled him to paint full-time. At this time he began to teach at the Corcoran School of Art, followed by stints at American University, Skidmore College, and the University of Virginia. Davis explored variations of his signature style in painting with brief forays into other media for the remainder of his career. He died in Washington April 6, 1985. The Phillips Collection owns one early oil and five acrylics from his mature period, one of which was a gift from the estate.

404

404

Black Flowers, 1952

Oil on hardboard, 36⅛ × 24¼ (91.7 × 61.6)

Signed and dated on hardboard reverse, u.r.: *G. Davis/(1952)*

Gift of an anonymous donor, 1974

Acc. no. 0459

Collection of artist; gift of an anonymous donor 1974.[1]

405

Red Devil, 1959

Acrylic on canvas, 65¼ × 65 (165.7 × 165.1)

Signed, dated, and titled on canvas reverse, l.l.: *Red Devil (1959)/Gene Davis*

Gift of Robert Lehrman, 1982

Acc. no. 0462

Collection of artist; gift to Donald Wall, Washington, D.C., 1972; consigned to Middendorf Gallery, Washington, D.C., 1981; purchased by Robert Lehrman, Washington, D.C., July 1981; gift to TPC 1982.[2]

In reflecting on his vertical-stripe compositions, which he explored from 1958 until his death

nearly thirty years later, Davis remarked, "If I worked for 50 more years, I wouldn't exhaust the possibilities."[3] The genesis of his signature style can be seen in works like *Black Flowers,* in which a row of flowers, their stems rendered in a flat, hard-edged style, extends across the picture plane. By 1959, in *Red Devil,* Davis had ventured into his mature style, which is characterized by vertical stripes in discretely chosen hues placed edge-to-edge.

Like the other members of the Washington Color School, Davis considered color the primary element in painting.[4] In *Red Devil* he gave free rein to his intuitive sensitivity to color, exploring nuances of red and controlling the paint by confining it to the rigid geometry of the vertical stripe. Davis placed stripes of uniform width across the canvas at carefully orchestrated intervals, because he "didn't want to divert attention away from the color. If you eliminate one variable, which is the width of the stripe, then you concentrate on the color interval."[5] Surface tension is achieved through alternating stripes, one of a subtly modulated red-orange hue that hints at space beyond the picture plane,

405

and the other of an opaque red that flattens the composition. The rhythm of the image is broken by the three stripes on the far right. It is the dialogue of these yellow, blue, and green accents with the field of red that provides the subject of the picture.

Davis's mastery of color in *Red Devil* caught the attention of Clement Greenberg, the influential critic and, indeed, kingmaker of artists. In 1961 the artist wrote to Greenberg, including in his letter photographs of his work, which was then being exhibited at the Jefferson Place Gallery, noted for its support of Washington color artists. The critic replied with interest, arranging to see his paintings in October of that year. He singled out *Red Devil,* stating: "That's your key work."[6] At first Davis agreed, saying, "I am going to paint a series of about 10 paintings along the lines of the red one you seemed to like. . . . In brief, I am going to give it a whirl."[7] The resulting works share with *Red Devil* one-inch stripes in two alternating colors, the rhythm of which is broken by a few sharply contrasting colors.[8]

As Davis's style developed, however, he moved farther away from the formalist mainstream: his compositions attained a complexity only hinted at in *Red Devil* and gradually failed to affirm the inherent flatness of the painting and its ability "to impose a one-shot impression on the eye."[9] Davis came to feel that the "color painter" label did not apply to him, saying, "Actually, I am more interested in interval than color. The color becomes a means of defining interval."[10] Greenberg disliked this development and contended that Davis derived his vertical stripe from Noland and Louis, an assertion that Davis rejected, which ultimately led to a rift between them.[11]

The catalyst for Davis's first experiments with the vertical-stripe composition may have been Frank Stella's highly controversial *Black*

Paintings series, produced from 1958 to 1960.[12] These polemical, minimalist compositions were shown in 1959 at the Tibor de Nagy Gallery in New York and in the Museum of Modern Art's distinguished *Sixteen Americans* exhibition. Davis may also have been responding to Jasper Johns's *Target with Four Faces,* 1955, which was illustrated on the cover of *Art News* in 1958. Davis said of this controversial image: "Suddenly there is a totally symmetrical cliche on the cover and its presented as art—it's a bombshell. So I figured what the hell. I'll do some stripes. If he can do that, I can do stripes. So my stripes were not motivated exclusively by formal considerations."[13]

For his technique, Davis acknowledged his indebtedness to Louis and Noland, who were part of both the New York and the Washington art scenes. They transmitted the excitement and experimental nature of the New York art scene to Washington artists, particularly the new technique of staining and soaking unprimed and unsized canvas with acrylic.[14] *Red Devil* incorporates many of these new techniques.[15] The raw cotton canvas is unprimed, and the surface is soaked with diluted acrylic. Davis did not use masking tape to control the edges until later in the sixties; faint graphite lines marking the stripes are still visible in this work.[16]

Davis began to develop his idea of a single subject extended across the picture plane in a flat, hard-edged style as early as 1952. In works like *Black Flowers,* the subject, although ostensibly flowers, is the dark-green bands of color stretching vertically across the hardboard surface. Carefully placed, each long flower stem is set in isolation. The broad flat areas of white serve to unify the composition, themselves forming veritable stripes among the stems of forest green. Davis first applied a layer of green, leaving bare small circular areas at the top of the panel that he filled in with orange paint to rep-

resent the flowers; he painted a lead white across the surface and around the orange dots, leaving exposed vertical strips of green to represent the flower stems.[17]

Black Flowers most immediately derives from two of Davis's strongest early influences, Barnett Newman's "zip" paintings and Paul Klee's delicacy of line. Davis later noted that Newman's "influence on my painting is based on an early misreading of his work," adding, "When I first discovered Newman's painting in the early 1950s, I was attracted to the vertical stripes and not the color fields."[18] But Davis's burgeoning ability to integrate line and field in *Black Flowers* was also indebted to Newman's broad expanses of saturated color. As a result, Davis's classic, mature work is in essence a "field of stripes."[19]

Davis readily recalled "the influence of Paul Klee," whom he "openly imitated . . . with such paintings as *Black Flowers.*"[20] He was captivated by Klee's use of line, as in *Botanical Laboratory* (acc. no. 0992) and *Tree Nursery* (cat. no. 159), both of which were accessible to him in the Klee Room at The Phillips Collection. Klee's tree in *Botanical Laboratory* is formed by a simple black line and dots to represent the leaves. But Davis was also entranced by works like *Tree Nursery,* in which the Swiss artist delicately rendered sequential bands that "provid[ed] his atmospheric reveries with a geometric structure."[21] The undulating, tendrilous bands in *Black Flowers* illustrate Davis's controlled playfulness.

Davis considered the Klee Room highly significant to his development.[22] And, having visited the museum in the early forties, before he had begun to paint, he believed that "what constituted color in painting came directly from the French-oriented painting that Mr. Phillips seemed to be fond of."[23] Davis remained fervent in his devotion to The Phillips Collection, and he concluded that its collection played a crucial role in the emphasis on color by Washington artists.[24]

LBW

Kenneth Noland, who together with Morris Louis transmitted the energy, excitement, and innovation of the New York art scene to artists in Washington, D.C., was born in Asheville, North Carolina, April 10, 1924. Noland served in the army from 1942 to 1945 and then studied at Black Mountain College, North Carolina, from 1946 to 1948, under Ilya Bolotowsky and Josef Albers. In 1948 he traveled to Paris, where he studied under the sculptor Ossip Zadkine and had his first solo show (at the Galerie Raymond Creuze in 1949). Upon returning to America that fall, Noland moved to Washington; he spent the summer of 1950 at Black Mountain, where he met Clement Greenberg, the noted critic, who became a friend and a champion of his art. In Washington he worked first at the Institute of Contemporary Art (1949–50) and then at Catholic University of America (1951–60). From 1952 to 1956 Noland taught night classes at the Washington Workshop Center for the Arts, where he met Morris Louis. In 1954 Greenberg included him in "Emerging Talent" at the Samuel M. Kootz Gallery in New York. Noland's first one-person show in New York was held at the Tibor de Nagy Gallery in 1957. In the fall of 1961 he moved to New York. In 1963 he relocated to South Shaftesbury, Vermont; he taught at Bennington College in Vermont during the summer of 1966. He was elected to the American Academy of Arts and Letters in 1977, has served on the Board of Trustees at Bennington College since 1985, and was appointed Milton Avery Professor of Arts at Bard College in 1986. The Phillips Collection owns four works by Noland, two oils from the early fifties, one acrylic *Concentric Circle* of 1960, and an aquatint from the late seventies.

406

406

In the Garden, 1952

Oil on hardboard, 19½ × 30 (49.5 × 76.2)
Signed and titled on canvas reverse, u.l. to u.c.: [illeg.] *50 In the Garden—NOLAND*
Acc. no. 1435

TPC purchase from the artist (from exhibition) 1952.[1]

In the Garden reflects the pervasive influence on Noland of Paul Klee's late style (1937–40).[2] He had first become aware of Klee in 1948 while a student at Black Mountain College. This appreciation was strengthened in 1950 when he moved to Washington, D.C., where he spent long hours in The Phillips Collection's Klee Room, viewing such works as *Picture Album,* 1937, and *Young Moe,* 1938 (cat. nos. 163–64).[3] He was also deeply affected by the major Klee retrospective shown at The Phillips Collection in 1950.[4]

In the Garden, which is part of *The Playground* series, appears to depict a girl among motifs that evoke a playground.[5] Idiomatic signs and symbols reminiscent of Klee are placed across the surface of the painting in a seemingly random but structured formation. In the center is a figure of a girl, identified by an × on her dress and a half-moon face with one eye closed, similar to Klee's schematic delineation of the figure in *Picture Album* and the half-curve face in *Young Moe.* Acknowledging that this work "was done under the influence of Paul Klee," Noland later noted that "the problem most important to me at this time was the integrated design of symbols and color."[6]

The vibrant orange-red background, new to Noland's palette at this time, has a great deal of tonal variation, which he achieved by painting the orange-red over two layers: a gray imprimatura and a white ground.[7] This variation is particularly evident around the linear motifs, each of which has a grayish, orange-red aura. He has thus emphasized line as well as motion.

An early admirer of Noland, Duncan Phillips purchased *Inside,* 1950 (acc. no. 1436), in 1951; it was the artist's first work to enter a public collection. His interest piqued, Phillips wrote to Noland early in 1952 about an intended exhibition of Washington artists, stating that "we would like to invite you to bring in three works from which Mrs. Phillips and I could select one or more for the exhibition."[8] After choosing *In the Garden,* he purchased it for the permanent collection, perhaps because of its homage to Klee, but more likely because of Noland's subtle consonance of color and line.

407

April, 1960

Acrylic on canvas, 16 × 16 (40.7 × 40.7)

Signed and dated on tacking edge, u.r. to l.r.: *1960 Kenneth Noland 56;* titled on tacking edge, l.l.: *April*

Acc. no. 1434

The artist to Jefferson Place Gallery, Washington, D.C.; TPC purchase 1960.[9]

April belongs to Noland's highly original and startlingly direct *Concentric Circle* series (1958–63): holistic, symmetrical, and circular bands of varying colors from which energy radiates either in a rotary fashion or, as in this work, outward from the center. Noland found that the geometry of concentric circles gave him freedom, stating that "with structural considerations eliminated, I could concentrate on color. I wanted more freedom to exercise the arbitrariness of color."[10] Equally innovative is the elimination of the traditional narrative reading of a painting from left to right; instead, the viewer focuses on the center while undergoing a synoptic understanding of the image.[11]

April bridges Noland's early explorations into his *Concentric Circle* series and his late examples, which were often termed "targets." Noland began to investigate this motif in 1958;

by the first few months of 1960 he was concentrating on vibrant, energetic color, using a greater array of highly keyed hues and removing the vestiges of his gestural brushwork.[12] In the earliest works of that year, including *April,* he painted the inner rings with sharply defined contours, while he gave the outer bands softer edges, leaving the final ring of color as a softly stained halo gently flowing outward.[13] In *April* the final band in cerulean blue fills most of the composition to the edges; only the corners of the canvas are left bare. Noland sketched the circles in graphite using an object with a round edge.[14] With a brush he then soaked the pure colors into an unprimed and unsized canvas, using titanium white in the center, then yellow, permanent green, and finally various blues.[15]

Noland's development toward this series, harbingers of which are apparent in his early work, was suggested and nourished by myriad sources, one of the earliest being the art and theories of Josef Albers. He derived the idea of working in a series with a single motif to explore the expressive potential of color from Albers's *Homage to the Square* series.[16] Noland also acknowledges the influence of abstract expressionism, primarily the art of Jackson Pollock and Helen Frankenthaler. He not only adopted many of their innovative techniques but also

embraced their willingness to experiment and to approach painting in new ways.[17] He was perhaps also attracted to the immediate visual understanding of Pollock's mature, all-over paintings, stating that "the only thing to do would be to focus from the center out—it is the logical extension—almost an inevitable result."[18]

The organic qualities of the early American modernists, especially their sun imagery, may also have inspired Noland's circles. His radiating bands of color recall the life-giving force of the sun in Arthur Dove's *Me and the Moon,* 1937 (acc. no. 0559), and Georgia O'Keeffe's *Red Hills, Lake George,* 1927 (cat. no. 275); he knew both works from his visits to The Phillips Collection.[19] Noland found that the circular form satisfied new formalist concerns, while it also alluded to organic, even metaphysical, interpretations. As a dynamic shape, the circle could imply motion and life as well as eternity and organic growth, linked concepts that he drew in part from his later Hindu and Buddhist beliefs. Noland summed up his preoccupation when he said: "I knew what a circle could do. Both eyes focus on it. It stamps itself out, like a dot. This, in turn, causes one's vision to spread, as in a mandala in Tantric art."[20]

LBW

407

THOMAS DOWNING (1928–85)

Thomas Victor Downing, a Washington color artist whose work features a cool harmony of color and geometry, was born June 13, 1928, in Suffolk, Virginia. Downing received his A.B. in 1948 from Randolph-Macon College in Ashland, Virginia, and studied at the Pratt Institute, Brooklyn, from 1948 to 1950. Late in 1950, under a grant from the Virginia Museum of Fine Arts, Richmond, he traveled throughout Europe, enrolling briefly at the Académie Julian. He returned to America in July 1951, and in 1953, after serving in the army, he moved to Washington, D.C., to teach. The following year Downing enrolled in a summer course at Catholic University, where he studied under Kenneth Noland, who became a friend as well as a major influence. By 1956, he was an established member of Washington's artistic community, associating with the Washington Workshop Center for the Arts and later, beginning in 1958, with the Sculptors Studio, where he had his first solo show in 1959. He shared a studio with Howard Mehring, and in 1959 they and Betty Pajac founded the Origo, a cooperative gallery that lasted for fifteen months. He was included in several major group exhibitions throughout the sixties, including Clement Greenberg's seminal 1964 traveling show, "Post-Painterly Abstraction." As a teacher from 1965 to 1968 at the Corcoran School of Art, Downing had an impact on many Washington artists, including Sam Gilliam and Rockne Krebs. In 1971 he moved to New York to teach at the New School of Visual Art; after a brief tenure at the University of Houston in 1975, he moved to Provincetown, Massachusetts. Downing had few exhibitions during these years; several of them were in Washington: two at the Osuna Gallery (1979 and 1980) and one at The Phillips Collection (1985). He died October 20, 1985, in Provincetown. The collection has three acrylics, all variations of his circle motif.

408

Dream Rate, 1962

Acrylic on canvas, 66¾ × 66⅞ (169.5 × 169.3)
Unsigned; reverse: inscribed twice on tacking edge in yellow, u.c. and l.c.: *69 × 69 "Dream Rate";* dated on tacking edge in yellow, u.r.: *7/62*
Acc. no. 0592

Purchased from the artist by Stable Gallery, New York, probably by 1963; sold to Pyramid Gallery Ltd., Washington, D.C., 1970; TPC purchase (probably from exhibition) 1971.[1]

As a member of the Washington Color School, which was active primarily during the sixties, Thomas Downing explored the formal possibilities of color and color-space, sharing with his colleagues the belief that "the picture [should] be experienced first as a picture."[2] However, nuances of color in works like *Dream Rate* show his distinctive approach: circles of varying hues and sizes appear to float within undefined space, each set of colors existing on a different plane. The viewer is thus confronted with the paradox of an essentially flat composition that alludes to space.

Dream Rate belongs to Downing's *Grid* series (1962–63), early explorations of his circle motif, which he had originated in 1960 as a vehicle for exploring and controlling color. Downing cites Kenneth Noland's *Concentric Circle* paintings as important to his breakthrough, for they allowed him to see the "expressive potential of pure color—the necessity for a form which was simple and direct to convey it."[3] Unlike more gestural approaches, such as dripping and pouring, the strict geometry of the circle allowed him to free color from traditional associations and make it the sole subject of his compositions.

At first his circles were small dots floating across the canvas surface, but as he felt the need to assert more control, Downing established the grid structure, because it "separated the colors and allowed each one to work independently with greater clarity and intensity."[4] In *Dream Rate* he made the smallest circles an opaque pink, the medium-size ones a light blue, and the largest an intense orange-red, sienna, and medium-blue.

Downing first stenciled the circle shapes in *Dream Rate* onto unprimed, cotton duck canvas and then soaked in the color within the circles, leaving the rest of the canvas bare in order to incorporate the nubby texture of the material into the composition.[5] To Downing, "canvas is more than just a support for the paint. . . . It is also where the picture begins." By staining, he made "the paint a part of the canvas surface and not separate from it."[6] He left a few random splatters of paint, which create a sense of spontaneity at odds with the strict design.

Dream Rate assumes an almost metaphysical quality as the viewer becomes aware of, even a participant in, the illusion that the composition is merging into the surrounding space, an effect that is aided by the bare canvas extending over the edge of the stretcher. Depth is implied by the pulsing of the various colored circles, which form five planes; termed by Downing "sheets of color," these planes create the illusion of space.[7] Indeed, while the light-blue circles recede far into space, the vibrating orange-red circles almost seem to touch the viewer.

Although Downing remembered being struck by the stark nonobjectivity and infinite space of Kasimir Malevich's works, which he saw while a student at the Pratt Institute, his color choices suggest his probable awareness of Josef Albers's color theories, which he could easily have absorbed from his discussions with Noland.[8] Yet Downing considered the pulsing effect of his color-mediated space to be related to Helen Frankenthaler's and Morris Louis's approach, which he interpreted as having "the quality of openness . . . a 'breathing' kind of painting, almost pulsing.—Always in their work there is a great 'breath' to me."[9]

LBW

HOWARD MEHRING (1931–78)

Howard Mehring was the most idiosyncratic and stylistically diverse member of the Washington Color School. A native Washingtonian, Mehring was born February 19, 1931. As an art major at Wilson Teachers College he did student teaching under Leon Berkowitz; he studied painting at the Washington Workshop Center for the Arts, where he met Morris Louis and other influential members of the local art scene; and he took Kenneth Noland's design class when he received a graduate scholarship to attend Catholic University in 1953. His first solo exhibition was at the Margaret Dickey Gallery at Wilson Teachers College. In 1955, after receiving his M.F.A. from Catholic University, Mehring traveled with Noland to New York, where they visited Helen Frankenthaler's studio. An extensive series of exhibitions in Washington followed, including his first one-person show at the Jefferson Place Gallery in 1960. Between 1955 and 1964 he taught art at a variety of local institutions, including Montgomery Junior College in Takoma Park, Maryland. In 1964, as a result of the patronage of Vincent Melzac, he gave up teaching to paint full time. Also in 1964, Clement Greenberg included him in "Post-Painterly Abstraction" at the Los Angeles County Museum, which traveled extensively. In 1965 he had his first solo show in New York at A. M. Sachs Gallery. Exhibitions in New York at the Guggenheim Museum, the Jewish Museum, and the Whitney Museum followed, along with shows in Philadelphia, Madison, Wisconsin, and Munich. In 1968 or 1969 Mehring abruptly ceased painting, and for the rest of his life he made only drawings. Some of them were shown at The Phillips Collection in 1977; concurrently, the Corcoran Gallery of Art gave him a major painting retrospective. Three months later, on March 21, 1978, Mehring died of a heart attack while dining with friends in Annapolis. The Phillips Collection owns eleven works by Mehring, seven acrylics and four drawings.

409

Interval, 1967

Acrylic on canvas, 70⅞ × 84⅛ (179.9 × 213.6)
Signed, titled, and dated on canvas reverse, l.r.: *Howard Mehring/"Interval" 1967 Feb.*
Acc. no. 1345

Purchased from the artist through A. M. Sachs Gallery, New York, 1968.

Interval is one of Mehring's Z-format works from his last series of paintings.[1] Like fellow artists identified as members of the Washington Color School (a term coined by Gerald Nordland), Mehring almost always worked in series. The Z pattern of *Interval,* because of the inherent dynamism of the diagonal stroke of the letter shape, adds the consideration of lateral visual movement to the in-and-out oscillation of his previous geometric series: the inverted T-cycle of the early to mid-sixties, and before that, the squares and grids.[2]

The color in this work relies more on an analogous scheme than the earlier T-shaped format, which exhibited more or less clear-cut contrasts between nearly primary colors. In *Interval* the use of a consistently cool chroma of reds and a relatively warm chroma of blues results in an overall unity of surface that tends to act against, but does not entirely eliminate, the establishment of an ambiguous reading of pictorial geometry. A single orange-pink element serves to create the major variation within this otherwise tightly controlled environment of serene and carefully unified color modulation. Jane Livingston, in her 1977 catalogue for Mehring's last exhibition, at the Corcoran Gallery, notes that Mehring associated the colors

in this series with what he called "Renaissance color."[3] More specifically, this remark stems from his fascination with Venice and Venetian art. The city was a favorite stop in biannual trips he took to Europe from 1961 until 1976. Indeed, the close color harmonies of this particular series of paintings produce an almost atmospheric surface effect not unlike Turner's Venetian watercolors or the landscape in a Giorgione.

The appearance of variation within the whole (or within the theme) of not just this painting but the entire Z series easily bears comparison to the "cool" jazz compositions that Mehring often admitted had a profound influence on him.[4] In this painting a single color, the orange pink, provides an emphatic counterpoint over and within the underlying "atmosphere" of violet reds and blues, much as the leader in a jazz combo will "improvise" on the foundation laid by his sidemen's maintenance of a consistent beat and basic melodic line. As Mehring explained in a 1968 interview concurrent with the creation of this series, "The new work is tending to be less symmetrical and it is rhythmical in an on-beat, off-beat sense. That is about all I wish to say about my work as I feel that a conscious formalizing of concepts tends to interfere with the process of working, which is intuitive and flows from the unconscious."[5]

Interval was acquired while Marjorie Phillips was serving as director following Duncan Phillips's death. It was an appropriate addition, for Mehring's lyrical use of color, his devotion to art history, the diversity of his approach to color painting, and his lifelong dedication to Washington as a place to make art all fit assertively within Duncan Phillips's original vision and collection of art.

DT

409

WILLEM DE LOOPER (B. 1932)

Willem de Looper uses color as his primary form of expression, creating compositions that have subtle nuances and a reflective, self-contained quality. De Looper was born October 30, 1932, in The Hague, The Netherlands. In 1950 he followed his brother to America. As his family desired, he attended American University to study economics and business but later changed to art, studying under Sarah Baker, Robert Gates, and Ben (Joe) Summerford and gaining his citizenship in the interim. After receiving his B.A. in 1957, de Looper was inducted into the U.S. Army (1957–59) and was stationed in Germany. Upon his return he joined The Phillips Collection staff. In 1964 he was invited by Nesta Dorrance, director of Jefferson Place Gallery, to participate in a group exhibition, and he joined the gallery in 1965. His first solo exhibition was held there in 1966, followed by five more solo shows (1967–74). In 1969 he married Frauke Weber. Since the demise of Jefferson Place in 1974, he has been represented by various Washington galleries. In 1975 The Phillips Collection gave him a solo show. De Looper successfully combined his career as an artist with his work at the museum, becoming assistant curator in 1972, associate curator in 1974, and finally curator in 1982. In 1987 he began working as a curatorial consultant for the museum in order to give himself more time to paint. His first retrospective was held by the Northern Virginia Community College in 1975, followed three years later by one co-organized by the National Academy of Sciences and the Federal Reserve Board, and then one by the University of Maryland Art Gallery in 1996. His New York one-person-show debut was in 1979. De Looper served as curator or project director for The Phillips Collection exhibitions of Franz Kline (1979), Arthur Dove (1981), Philip Guston (1981), Morris Graves (1983), and Howard Ben Tré and William Willis (1989–90). The collection has five acrylics by de Looper, all from his period of horizontally striated compositions, and one mixed-media sketchbook, a gift from the artist.

410

Kiri Te, 1972

Acrylic on canvas, 72 × 95⅞ (182.9 × 243.5)

Signed and dated on canvas reverse, c.l.: *VI/1972/de Looper;* on stretcher, c.l.: *72 × 96 de Looper VI 1972*

Acc. no. 0490

Purchased from the artist through Jefferson Place Gallery (from exhibition) 1972.[1]

Kiri Te has a horizontally striated composition, a style de Looper explored from 1970 to 1977. The paintings from these years are characterized by subtly varied, muted colors that are swathed across the canvas in softly merging horizontal bands of acrylic. *Kiri Te* is composed of numerous bands varying in hue and width. As de Looper reminisced: "I used to pride myself that I could make endless variations of ochers, browns, and whites."[2] In later examples, he pared down the composition to just a few hues and fewer horizontals, at one point focusing on white, as in the Phillips work *Sur,* 1975 (acc. no. 0491), which is composed of wide, flat white horizontals separated at the top and bottom by misty greenish-gray bands, with thin strips of gold serving as accents.

From the beginning of his career in the early sixties, de Looper's "ideal . . . was to be an abstract painter, a nonobjective painter," and his work has continued to be process-oriented and formalist in conception. As he notes, artists of his generation were heirs to a new tradition, one in which experimental methods—staining, pouring, and the use of tools other than brushes—were favored.[3] Contributing to his emerging artistic concerns was the work of local artists identified by Gerald Nordland in 1965 as the Washington Color School, especially Kenneth Noland, Howard Mehring, and Morris Louis, and through them the biomorphic stains of Helen Frankenthaler.[4]

De Looper usually paints on an unprimed but stretched canvas that is laid on the floor, allowing him to manipulate it physically, twisting and turning it to control the flow of paint. *Kiri Te,* a rare exception, was painted upright.[5] After the initial wetting of the canvas with water and a thin wash of white acrylic, de Looper painted wet-into-wet, using rollers to layer numerous horizontals in hues of purple—violets, lavenders, mulberrys, lilacs, and magentas. Then he slowly applied, with roller and brush, horizontal layers of varying colors, beginning with a deep mulberry at the bottom and moving in sequence to a pale lilac, a sky blue, rich plum-reds and magentas in the center, ochers, a touch of sky blue and violet, permutations of earth browns, and finally subtle variations of sandy beige. Throughout the composition hints of the first layers of purple emerge, and narrow bands of gold serve as delicate flourishes of contrast. The repeated layers of lean paint render a luminescent glow and amorphous space.

During the seventies critics often connected de Looper's horizontally striated compositions to landscape, a reference he vigorously refuted in the past. Recently, however, he has admitted that a trip to the American West and Southwest in the early seventies perhaps had some formal impact on his work, because soon after he began to structure his color in loose horizontals.[6] And his palette, which he had been modifying since 1966, changed to earth tones keyed with lighter hues. The colors merging into one another in *Kiri Te* have elusive suggestions of a desert: soft pastels and whites laid over cool browns, tans, and beiges that seemingly shimmer in the heat.

De Looper does not make preliminary studies but works out his formal ideas directly on canvas in an intuitive manner. "I've always been interested in the discovery of painting," he stated, "and making a new painting will continue to be my primary starting point." He likens his approach to the improvisational nature of jazz, the strains of which serve as the backdrop to the painting process. While listening to jazz or classical music, he does not make associations but "see[s] music as a total abstraction."[7] Likewise, even though his artistic vision may be quickened by nature, it is abstract in conception. Thus, although the title *Kiri Te* derives from the name of the renowned opera singer Dame Kiri Te Kanawa, she is not the subject of the work, and the work should not be interpreted by the title. De Looper was simply intrigued by the sound of her name. "I am inspired by what I see—the gilded surface of an Italian painting, the arc of an exhaust vent outside my studio," he noted, "but these are not subjects anymore than notes on paper are music."[8]

LBW

410

Sam Gilliam's spontaneous and improvisational techniques make him one of the foremost artists to emerge from the Washington art scene. Born in Tupelo, Mississippi, in 1933, Gilliam spent his youth in Louisville, Kentucky. After receiving his B.A. from the University of Louisville in 1955, he served in the army (1956–58) and then returned to the university for his M.A. (1961). In 1962 he moved to Washington, D.C. Following an early figurative period, Gilliam began painting in an abstract idiom. In 1968 he affirmed his place among the American avant-garde with the creation of his draped works. Between 1965 and 1973 Gilliam exhibited at the Jefferson Place Gallery, where Marjorie Phillips saw *Red Petals* in 1967 and decided to host a show of his work at The Phillips Collection, his first solo museum exhibition. He has shown at various Washington galleries. Gilliam has taught art in the Washington public-school system and at the Corcoran School of Art, the Maryland Art Institute in Baltimore, the University of Maryland, and Carnegie-Mellon University in Pittsburgh. He has received a number of awards, including National Endowment for the Arts Activities Grants in 1967, 1973–75, and 1989 and a Guggenheim Memorial Foundation Fellowship in 1971, which gave Gilliam the confidence and financial independence necessary to paint full-time. In 1980 Gilliam was awarded an honorary doctorate of humane letters from the University of Louisville, followed by numerous other honors. His major commissions include works for the Atlanta airport, the Federal Building in Atlanta, and the Massachusetts Transit Authority. In 1983 Gilliam was given an extensive one-person exhibition at the Corcoran Gallery of Art in Washington, D.C., the city where he continues to live and work. The Phillips Collection owns six works by Gilliam: four acrylics on canvas and two works on paper.

411

Red Petals, 1967

Petals

Acrylic on canvas, 88 × 93 (223.5 × 236.2)

Signed, dated, and titled canvas reverse, u.c.: *Red Petals/1967/88 × 92"/Sam Gilliam*

Acc. no. 0789

TPC purchase (from exhibition) from the artist through Jefferson Place Gallery, Washington, D.C., 1967.[1]

Red Petals is among the first paintings in which Gilliam poured paint onto an unprimed and unstretched canvas, folded the canvas onto itself, suspended it, and left the paint to settle overnight, subject to the force of gravity. The next day he would sponge, daub, splatter, fold, or roll the canvas. In the case of *Red Petals,* he also restretched the canvas. Gilliam describes this delicate balance between improvisation and discipline as "a sort of accident, a part that I controlled, and then a part that I didn't control, a part that I set into motion."[2] The emotional intensity and expressionistic force of *Red Petals* partly derives from this careful manipulation and the tension between chance and control.

In *Red Petals,* nebulalike areas of deeply saturated color suggest flower petals.[3] Each nucleus of cadmium red, infused with highlights of hot coral, bleeds into black-violet stains that flow back into the cadmium before ending in feathered veils of green and yellow. Cobalt blue breaks through from beneath the reds, framed on the left by a strip of violet and yellow that recalls batik fabric. On the lower edge of the composition, splatterings of yellow and red paint seem to erupt from the unprimed canvas, balanced on the upper edge by cadmium-red, orange, and coral tones. Together, these color fields create a luminosity that pulsates from within.[4]

Although Gilliam had experimented with spontaneous methods, including staining, *Red Petals* was the first work in which he entirely abandoned sharp edges, which in earlier works he had achieved with masking tape. Now he trusted gravity to shape biomorphic rather than geometric forms.[5] Gilliam observed that "the natural environment, wind and the like, gives life to cloth. Cloth has no particular characteristic unless you give life to it."[6] He began to test different fabrics for their ability to absorb paint, and these experiments affirmed that for Gilliam at this point in his career the essential components of abstraction were color, surface, and to a lesser extent, structure.[7] He later draped the unstretched canvas, freeing his images from the narrow constraints of the picture plane, in effect creating a kind of environmental painting.[8] *Red Petals,* although ultimately mounted on a stretcher, represents Gilliam's first step toward this revolutionary reinterpretation of the role of canvas: it becomes a "medium," not the "support," and therefore is as important as acrylic or oil. Years later, by 1975, Gilliam achieved his ultimate goal—asserting the primacy of the canvas on a grand scale—in *Seahorses,* his first outdoor installation.[9]

According to Gilliam, abstraction gives him a freedom denied the realistic painter to communicate with the viewer by tapping into emotions at a deep, visceral level. "I think I'm realer than real," explains Gilliam. "If I were a musician, I'd have a louder, a more intense sound."[10] Indeed, Gilliam's improvisational technique and its emotive impact on the viewer have often been compared to jazz.[11] Although Gilliam acknowledges this influence, in particular the chromatic tonalities of John Coltrane, he cautions against isolating this quality of his work as merely an outgrowth of his African-American heritage:

I look for universal truths, not just truths that may exist in the black community. It is true, however, that in my work I try to develop a reminiscence of my past to create a sensual experience for myself as well as the viewer and to reflect creatively upon my life experience.[12]

Gilliam's relationship to the Washington Color School is equally complex. Affiliated with Morris Louis, Kenneth Noland, and Thomas Downing by region and to a certain extent by technique, his gestural handling of paint and joy of discovery also link him with abstract expressionism.[13] In 1963, shortly after arriving in Washington, Gilliam met Downing, who encouraged him to pursue the abstract idiom. He went on to study with Downing, and his early work betrays this influence. But a 1966 weekend visit to Noland's studio in South Shaftsbury, Vermont, also had a pivotal effect on Gilliam: "It was a very influential trip. . . . I realized that from the books, from seeing the pictures, I had not come to do my own work."[14] Gilliam then studied earlier contemporary masters, including Pollock, de Kooning, Hofmann, and Frankenthaler, many of whom he could see at The Phillips Collection, and he ultimately was able to arrive at his own mature style.[15] "*Petals* is . . . when I first really felt that I was getting somewhere on my own; beginning to see and unfold . . . and not to imitate all the paintings I had seen in Washington."[16]

Like other local artists of his generation, Gilliam used The Phillips Collection for study, admiring in particular the works of Rothko, MacIver, and Tack: "At that time there was no National Museum of American Art," Gilliam recalled. "The National Gallery was without the East Wing, there was no Hirshhorn and there was no place at all where one could actually see contemporary painting."[17] He credits Marjorie Phillips with expanding the exhibition possibilities for young artists in Washington during the 1960s, recalling that "The Phillips Collection did the most important thing for me that could have been done in 1967. They gave me a one-man show."[18]

KGR

411

1919

DP.1919.1* "A Group of Paintings From the Collection of our Fellow Member Duncan Phillips." Century, New York. May 18–June 5. 30 works. Partially reconstructed chklst.

1920

DP.1920.1* "Exhibition of Selected Paintings from the Collections of Mrs. D. C. Phillips and Mr. Duncan Phillips of Washington." Corcoran, Washington, D.C. Mar. 3–31. 62 works. Cat.

DP.1920.2* "A Loan Exhibition from the Duncan Phillips Collection." Knoedler, New York. Summer. 36 works. Chklst.

PMAG.1920.3* "Selected Paintings from the Phillips Memorial Art Gallery." Century, New York. Nov. 20, 1920–Jan. 5, 1921. 43 works (enlarged to 45 by Dec. 20). Cat.

1921

Phillips organized no exhibitions in 1921, spending most of his time preparing for the opening of his gallery. He showed his collection by scheduled appointment only.

1922

PMAG.1922. [Opening Exhibition]. Main Gallery. Feb. 1–opening June 1, 1922. Partially reconstructed chklst.

PMAG.1922.1* "Exhibition of Oil Paintings by American Artists Loaned by the Phillips Memorial Art Gallery, Washington, D.C." L. D. M. Sweat Memorial Art Museum, Portland, Maine. Feb. 4–15. 22 works. Cat.

PMAG.1922.2 "Second Exhibition of the Phillips Memorial Art Gallery." Main Gallery. By Nov. 22. 31 works. Chklst.

1923

During 1923 no special exhibitions were arranged, but selections from the collection remained on view. After purchasing Renoir's *Luncheon of the Boating Party* in the summer of 1923, Phillips displayed it as the highlight of an installation that autumn.

1924

PMG.1924.1 "Exhibition of Recent Decorative Paintings by Augustus Vincent Tack." Main Gallery. Mar. 26–Apr. 26. 16 works. Cat. with essay by DP.

PMG.1924.2* "Exhibition of Paintings by American Artists Lent by the Phillips Memorial Gallery." BMA, Baltimore. Nov. 6–30. 30 works. Cat.

1925

PMG.1925.1 "Paintings by Marjorie Phillips." Little Gallery. Ca. Jan. 4–17. 10 works. Chklst.

PMG.1925.2 "Water Colors by Manet, Puvis de Chavannes, Homer, La Farge, Gifford Beal and Others." Little Gallery. Ca. Jan. 17–Feb. 10. 14 works. Chklst.

PMG.1925.3 [Group Exhibition: Arthur B. Davies, Kenneth Hayes Miller and Charles Demuth]. Little Gallery. Ca. Feb. 10–Mar. 6. Partially reconstructed chklst.

PMG.1925.4 "Paintings by Ernest Lawson." Little Gallery. Ca. Mar. 6–Apr. 12. 12 works. Chklst.

PMG.1925.5 "Paintings by Childe Hassam." Little Gallery. Ca. Apr. 12–28. Partially reconstructed chklst.

PMG.1925.6 [Group Exhibition Featuring Arthur B. Davies]. Little Gallery. Apr. 28–June 1. Partially reconstructed chklst.

PMG.1925.7 [Opening Exhibition of the Season 1925–26]. By Nov. 1. Partially reconstructed chklst.

PMG.1925.8 "Exhibition of Paintings by Bernard Karfiol." Little Gallery. Dec. 12–26. 10 works. Cat. with introduction by DP.

1926

PMG.1926.1 "Exhibition of Paintings by Nine American Artists: Preston Dickinson, Stefan Hirsch, Charles Sheeler, Maurice Sterne, Vincent Canadé, William Zorach, Niles Spencer, Fiske Boyd, Charles Demuth." Little Gallery. Jan. 1–31. 16 works. Cat. with introduction by DP.

PMG.1926.2 "Exhibition of Paintings by Eleven Americans and an Important Work by Odilon Redon." Little Gallery. Feb. 1–28. 15 works. Cat. with introduction by DP.

PMG.1926.3 "Exhibition of Recent Paintings by Maurice Sterne." Little Gallery. Mar. 1–31. 9 works. Cat. with essay by DP.

PMG.1926.4 "Exhibition of Recent Paintings by Marjorie Phillips." Little Gallery. Apr. 6–May 2. 12 works. Cat. with essay by DP.

PMG.1926.5 "Intimate Impressionists: Berthe Morisot, Alfred Sisley, Pierre Bonnard, Albert André, Maurice Prendergast, Marjorie Phillips, Paul Dougherty, Samuel Halpert." Little Gallery. May 8–30. 14 works. Cat.

PMG.1926.6 "Exhibition of Paintings by George Luks." Little Gallery. Nov. 2–29. 6 works. Cat. with essay by DP.

PMG.1926.7 "Exhibition of Paintings by Jerome Myers." Little Gallery. Dec. 4–28. 9 works. Cat. with essay by DP.

1927

PMG.1927.1 "American Themes by American Painters." Little Gallery. Jan. 1–30. Partially reconstructed chklst.

PMG.1927.2a–c "Tri-Unit Exhibition of Paintings and Sculpture." Feb. 5 through April. Cat. with essay by DP.
2a "Sensibility and Simplification in Ancient Sculpture and Contemporary Painting." Main Gallery. 32 works.
2b "A Period in Art: Portraits, Ideal Heads and Figures in Praise of Girls and Women." Little Gallery. 15 works.
2c "Great Painters: Fifteenth to Twentieth Centuries." Lower Gallery. 21 works.

PMG.1927.3* "An Exhibition of Expressionist Painters from the Experiment Station of the Phillips Memorial Gallery." BMA, Baltimore. Apr. 8–May 1. 39 works. Cat. with essay by DP.

PMG.1927.4* "American Themes by American Painters Lent by the Phillips Memorial Gallery." Friends of Art, Baltimore. Apr. 12–May 3. 16 works. Cat. with essay by DP.

PMG.1927.5 "Exhibition of Recent Paintings by Marjorie Phillips." Little Gallery. May 1–31. 11 works. Cat.

PMG.1927.6 "Intimate Decorations: Chiefly Paintings of Still Life in New Manners by Matisse, Braque, Hartley, Man Ray, Kuhn, O'Keeffe, Knaths and Others." Little Gallery. Nov. 1–29. 15 works. Cat. with essay by DP.

PMG.1927.7 "Leaders of French Art To-Day: Exhibition of Characteristic Works by Matisse, Bonnard, Picasso, Vuillard, Braque, Derain, Segonzac, André, Maillol." Little Gallery. Dec. 3, 1927–Jan. 31, 1928. 14 works. Cat. with essay by DP.

1928

PMG.1928.1a–c "Tri-Unit Exhibition of Paintings and Sculpture." Feb. [?]-May 1. Cat. with essays by DP.
1a "Contemporary American Painting." Main Gallery. 38 works.
1b "American Old Masters." Little Gallery. 12 works.
1c "A Survey of French Painting from Chardin to Derain." Lower Gallery. 29 works.

PMG.1928.2* "Paintings by Maurice Prendergast Loaned by the Phillips Memorial Gallery, Washington." Friends of Art, Baltimore. Ca. Mar. 1–15. 10 works. Chklst.

PMG.1928.3 "Paintings in Water Color by Sixteen American Artists." Little Gallery. May. 16 works. Cat.

PMG.1928.4a–c "Tri-Unit Exhibition of Paintings and Sculpture." Oct. [?] 1928–Jan. [?] 1929. Cat. with essays by DP.
4a "Art is International." Main Gallery. 20 works.
4b "An International Group." Little Gallery. 14 works.
4c "Art is Symbolical." Lower Gallery. 36 works.

PMG.1928.5* "An Exhibition of Paintings Lent by the Phillips Memorial Gallery, Washington: French Paintings from Daumier to Derain and Contemporary American Paintings." Art Gallery of Toronto, Grange Park. November. 30 works. Cat.

1929

PMG.1929.1 [Watercolors by John Marin]. Little Gallery. Feb. 2–Mar. 10. Review.

PMG.1929.2 "A Retrospective Exhibition of Paintings by Arthur B. Davies." Lower Gallery Transept. Feb. 2–June 1. 19 works. Cat. with essay by DP.

PMG.1929.3 "Exhibition of Paintings by John D. Graham." Little Gallery. Mar. 11–31. 16 works. Cat. with essay by DP.

PMG.1929.4* [A Selected Group of Watercolors by Living American Artists Loaned by The Phillips Memorial Gallery]. The Providence (R.I.) Plantations Club. Mar. 17–24. Artists unknown. Review.

PMG.1929.5 "Recent Paintings by Marjorie Phillips." Little Gallery. Apr. 6–May 28. 17 works. Cat.

PMG.1929.6a–b "First Tri-Unit Exhibition of the Season of 1929–30." Cat. with essays by DP.
6a "Modern French and American Paintings." Main and Lower Galleries. Oct. [?] 1929–Feb. 9, 1930. 58 works.
6b "A Group of Water Colors by John Marin." Little Gallery. Ca. Oct.–Nov. 11 works.

PMG.1929.7 "An Exhibition of Recent Paintings by Karl Knaths." Little Gallery. Ca. Dec. 1929–Jan. 1930. 10 works. Cat.

PMG.1929.8* "Five Pictures Loaned to the Public Library by the Phillips Memorial Gallery." Central Public Library, Washington, D.C. Ca. Dec. 8–29. 5 works. Cat.

1930

PMG.1930.1a–c "Second Tri-Unit Exhibition of the Season of 1929–30." Cat. with essays by DP.
1a "Sources of Modern Art." Main Gallery. Mar. 9–[June ?]. 19 works.
1b "Decorations by Augustus Vincent Tack." Lower Gallery. Mar. 9–[June ?]. 20 works.
1c "An Exhibition of a Group of Lyric Painters." Little Gallery. Mar. 9–31. 15 works.

PMG.1930.2* [Five Pictures Loaned to the Public Library by the Phillips Memorial Gallery]. Central Public Library, Washington, D.C. By Mar. 30. 5 works. Chklst.

PMG.1930.3 "An Exhibition of Recent Paintings by Harold Weston." Little Gallery. Apr. 1–30. 12 works. Cat.

PMG.1930.4* "Exhibition of a Selected Group of Paintings from the Phillips Memorial Gallery." Century, New York. Mar. 16–31. Traveled to the Carnegie, Pittsburgh, Apr. 8–May 18; the Rochester (N.Y.) Memorial Art Gallery, June 4–Sept. 5. 22 works (43 in Rochester). Cat. with foreword by DP.

PMG.1930.5 "An Exhibition of Recent Paintings by Marjorie Phillips." Little Gallery. May 3–31. 13 works. Cat.

PMG.1930.6* "Exhibition of a Selected Group of Contemporary European Paintings from the Phillips Memorial Gallery, Washington, D.C." Syracuse (N.Y.) Museum of Fine Arts. June 3–30. Traveled to the Rochester (N.Y.) Memorial Art Gallery. July [?]–Sept. 15. 23 works. Cat. with introduction by DP.

PMG.1930.7* "Paintings from the Phillips Memorial Gallery." Los Angeles Museum Exposition Park. Traveling exhibition circulated by the AFA. 10 venues, July 21, 1930–June 28, 1931. 43 works. Cat.

PMG.1930.8 "America from Eakins to Kantor." Oct. 5, 1930–Jan. 25, 1931. 43 works (with substitutions). Cat.

PMG.1930.9 [Opening Exhibition in the Main Gallery]. Oct. 5, 1930–Jan. 25, 1931. 22 works. Cat.

PMG.1930.10 "Twelve Americans." Oct. 5, 1930–Jan. 25, 1931. 12 works. Cat.

PMG.1930.11 "Marin, Dove and Others." Oct. 5, 1930–Jan. 25, 1931. 13 works. Cat.

PMG.1930.12 "An International Group." Oct. 5, 1930–Jan. 25, 1931. 12 works. Cat.

PMG.1930.13 "Pierre Bonnard." Oct. 5, 1930–Jan. 25, 1931. 14 works. Cat.

PMG.1930.14 [Works by Augustus Vincent Tack and Charles and Maurice Prendergast]. Oct. 5, 1930–Jan. 25, 1931. 5 works. Cat.

PMG.1930.15 "Decorative Panels by Augustus Vincent Tack." Oct. 5, 1930–Jan. 25, 1931. Cat. with essay by DP.

PMG.1930.16* "A Group of Seven Modern Paintings Loaned to the Public Library of Washington by the Phillips Memorial Gallery." Central Public Library, Washington, D.C. Ca. Nov. 16, 1930–Mar. 22, 1931. 7 works. Cat.

1931

PMG.1931.1* [An Exhibition of Sixteen Paintings by Contemporary Modernists from the Phillips Memorial Gallery]. Traveling exhibition circulated by the AFA. 10 venues, Feb. 1–Sept. 30. 16 works. Chklst.

PMG.1931.2 "Modern Art and Its Sources." Feb. 2–[June?]. 17 works. Cat.

PMG.1931.3 "Romance and Satire of the Nineteenth Century." Feb. 2–[June?]. 14 works. Cat.

PMG.1931.4 "Pictorial Language of the People Direct and Spontaneous, or Stylized by Sophisticated Admirers of the Primitive." Ca. Feb. 2–Apr. 5. 9 works. Cat.

PMG.1931.5 "Twentieth Century Lyricism." Ca. Feb. 2–Apr. 5. 10 works. Cat.

PMG.1931.6 "Decorative Panels by Augustus Vincent Tack." Feb. 2–[June?]. Announcement.

PMG.1931.7 "The New Decorative Idioms in Painting." Feb. 2–[June?]. 11 works. Cat.

PMG.1931.8 "French Painting from Manet to Derain." Feb. 2–[June?]. 17 works. Cat.

PMG.1931.9 "Foreign and American Contemporaries." Feb. 2–[June?]. 10 works. Cat.

PMG.1931.10 "Memorial Exhibition of Preston Dickinson." Ca. Feb. 2–Mar. 1. 8 works. Cat.

PMG.1931.11 "Pierre Bonnard." Feb. 2–[June?]. 4 works. Cat.

PMG.1931.12 "Recent Paintings by Harold Weston." Mar. 1–31. 16 works. Cat.

PMG.1931.13 "Harold Weston." Ca. Apr. 5–May 3. 10 works. Cat.

PMG.1931.14 "Betty Lane." Ca. Apr. 5–May 3. 20 works. Cat.

PMG.1931.15 "John Marin." By Apr. 5–[June?]. 10 works. Cat.

PMG.1931.16 "Recent Paintings by Marjorie Phillips." May 3–31. 12 works. Cat.

PMG.1931.17 "Paintings by John [sic] Alden Weir and John H. Twachtman." May 3–31. 9 Works. Cat.

PMG.1931.17a* [Modern Art Loaned by the Phillips Memorial Gallery]. Public Library, Washington, D.C. By June 21. 7 works. Chklst.

PMG.1931.18* [Twenty-three Paintings from the Phillips Memorial Gallery]. Traveling exhibition circulated by the AFA. 8 venues, after Sept. 23, 1931–June 14, 1932. 23 works. Chklst.

PMG.1931.19 "Where Classic and Romantic Meet in Painting." Sept. 27, 1931–Jan. [?], 1932. 9 works. Cat. with essay by DP.

PMG.1931.20 "A Classic Cézanne with Pictures of More Personal Appeal." Sept. 27, 1931–Jan. [?], 1932. 10 works. Cat. with essay by DP.

PMG.1931.21 "Old Masters of the Nineteenth Century." Sept. 27, 1931–Jan. [?], 1932. 25 works. Cat. with essay by DP.

PMG.1931.22 "Two Decorators." Sept. 27, 1931–Jan. [?], 1932. 5 works. Cat. with essay by DP.

PMG.1931.23 "Calligraphy in Modern Occidental Art." Sept. 27, 1931–Jan. [?], 1932. 12 works. Cat.

PMG.1931.24 "Modern Wit in Two Dimensional Design." Ca. Sept. 27–Dec. 1. 12 works. Cat. with essay by DP.

PMG.1931.25 "Un-Selfconscious America." Sept. 27, 1931–Jan. [?], 1932. 14 works. Cat. with essay by DP.

PMG.1931.26 "From Palestine—to Russia—to Rome—to Paris—to New York." Sept. 27, 1931–Jan. [?], 1932. 10 works. Cat. with essay by DP.

PMG.1931.27 "A Survey of Modern Painting." Sept. 27, 1931–Jan. [?], 1932. 17 works. Cat. with essay by DP.

PMG.1931.28* "Modern Painters French and American: Fifteen Paintings by Fifteen Painters from The Phillips Memorial Gallery, Washington." Traveling exhibition circulated by the AFA. 9 venues, Oct. [?], 1931–May 28, 1932. 15 works. Chklst.

PMG.1931.29* "Modern Painting in The United States and Europe: An International Exhibition Selected from The Phillips Memorial Gallery." Traveling exhibition circulated by the AFA. 6 venues, Oct. 2, 1931–May 7, 1932. 16 works. Chklst.

PMG.1931.30* [A Small Collection of Paintings by Modern Artists Lent by the Phillips Memorial Gallery]. Central Public Library, Washington, D.C. Ca. Nov. 1, 1931–Jan. 3, 1932. Partially reconstructed chklst.

PMG.1931.31 [Gallery School Exhibition of Oil Paintings]. By Nov. 15. Partially reconstructed chklst.

PMG.1931.32 [Watercolors by Betty Lane]. By Nov. 15. Review.

PMG.1931.33 "An Exhibition of Recent Work of Karl Knaths." Dec. 1–31. 7 works. Cat. with essay by Ralph Flint.

1932

PMG.1932.1 "Calligraphic Decoration by Picasso and Karl Knaths." January. 11 works. Cat.

PMG.1932.2 "Paintings by Harold Weston: 1921–1931." January. 25 works. Cat.

PMG.1932.3 "Daumier and Ryder." Feb. [?]–Mar. [?]. 13 works. Cat.

PMG.1932.4 "Paintings by Gifford Beal." Feb. [?]–Mar. [?] 9 works. Cat. with essay.

PMG.1932.5 "Recent Paintings by Walt Kuhn." Feb. [?]–Mar. [?]. 10 works. Cat. with essay by DP.

PMG.1932.6 "An American Show of Oils and Water Colors." Feb. [?]–June [?]. 13 works. Cat.

PMG.1932.7 "American and European Abstractions." Feb. [?]–June [?]. 10 works. Cat. with essay by DP.

PMG.1932.8 "Decorations by Augustus Vincent Tack." Feb. [?]–June [?]. 16 works. Cat.

PMG.1932.9 [Group Exhibition of Oils and Watercolors]. Feb. 8–Mar. 15. 37 works. Cat.

PMG.1932.10 [Bust of George Washington by Jean-Antoine Houdon]. By Mar. 13. 1 work. Review.

PMG.1932.11 "Recent Paintings by Sewell Johnson." April. 16 works. Cat. with essay by DP.

PMG.1932.12 "Memorial Exhibition of Robert Spencer." Apr. [?]–May [?]. 11 works. Cat. with essay by DP.

PMG.1932.13 [Group Exhibition of Works by Local Painters]. Apr. 15–June 1. 50 works. Cat.

PMG.1932.14 "Retrospective Group Exhibition." May. 13 works. Cat.

PMG.1932.15* [Five Pictures Loaned to the Public Library by the Phillips Memorial Gallery]. Central Public Library, Washington, D.C. By Oct. 9. 5 works. Chklst.

PMG.1932.16* "School of Impressionism." Traveling exhibition circulated by the AFA. 4 venues, Nov. 15, 1932–Feb. 28, 1933. 24 works. Chklst.

PMG.1932.17* "Pierre Bonnard: Twelve Paintings." Smith College Museum of Art, Northampton, Mass. Nov. 19–Dec. 14. 12 works. Cat.

1933

PMG.1933.1a–c "Freshness of Vision in Painting." Nov. 5, 1933–Feb. 15, 1934. 39 works. Cat. with essays by DP.
 1a "Freshness of Vision: Classic and Romantic." 8 works.
 1b "Freshness of Vision in Painting: Where the Spirit of the Expression Invents Its Own Means: Loan Exhibition of Early Water Colors by Charles Burchfield." 23 works.
 1c "Freshness of Vision in Painting: Louis Eilshemius." 8 works.

PMG.1933.2 "Development of Modern Landscape and Still Life." Nov. 5, 1933–Feb. 15, 1934. 8 works. Cat.

PMG.1933.3 "Pierre Bonnard." Nov. 5, 1933–Feb. 15, 1934. 5 works. Cat.

PMG.1933.4 "Decorations of Augustus Vincent Tack." Nov. 5, 1933–Feb. 15, 1934. Announcement.

PMG.1933.5 "Modern Idioms—Lyrical and Impersonal." Nov. 5, 1933–Feb. 15, 1934. 9 works. Cat.

PMG.1933.6 "Pictures of People." Nov. 5, 1933–Feb. 15, 1934. 45 works. Cat.

PMG.1933.7* [Paintings by Modern French and American Artists]. Central Public Library, Washington, D.C. By Nov. 15. Review.

PMG.1933.8* [Paintings from the Phillips Memorial Gallery]. Choate School, Wallingford, Conn. Ca. Nov. 28, 1933–Jan. 11, 1934. 13 works. Chklst.

1934

PMG.1934.1 [Paintings by Marjorie Phillips]. Ca. May 12–June 1. 10 or 11 works. Chklst.

PMG.1934.2 [Recent Paintings by Eugene and Leonid Berman]. Ca. May 20–June 1. Review.

PMG.1934.3 "Cross Currents of Contemporary Paintings." By Oct. 21. Partially reconstructed chklst.

PMG.1934.4 "Exhibition of Water Colors by Charles Hopkinson." Ca. Oct. 28–Nov. 18. Partially reconstructed chklst.

1935

PMG.1935.1* "Contemporary American and European Paintings from The Phillips Memorial Gallery Selected by Mr. Phillips to Show the 'Center' of the Recent Art Movement Rather than Extreme 'Right' or 'Left'." Traveling exhibition circulated by the AFA. 12 venues, Oct. 6, 1935–Feb. 2, 1937. Partially reconstructed chklst.

PMG.1935.2 "Autumn Exhibition Selected from the Work of Artists from Washington, Virginia, Maryland." Nov. 16, 1935–Jan. 1, 1936. 125 works. Cat. with introduction by DP.

1936

PMG.1936.1* [Paintings from the Phillips Memorial Gallery]. Yale University, New Haven, Conn. Ca. Feb. 28–Mar. 27. 12 works. Chklst.

PMG.1936.2 "National Exhibition of Mural Sketches, Oil Paintings, Water Colors and Graphic Arts: Federal Art Project, Works Progress Administration." June 15–July 5. Partially reconstructed chklst.

PMG.1936.3 "Autumn Exhibition Selected from the Work of Artists from Washington, Virginia, Maryland." Nov. 21–Dec. 20. 132 works. Cat.

1937

PMG.1937.1 "An Exhibition of Drawings, Etchings and Lithographs by Gifford Beal." Jan. 2–31. 36 works. Cat.

PMG.1937.2 "An Exhibition of Drawings by American Artists of Past and Present from the Collection of John Davis Hatch, Jr." Feb. 8–28. 34 works. Cat.

PMG.1937.3 "An Exhibition of Water Colors and Drawings by Louis Eilshemius." Mar. 1–15. 34 works. Cat.

PMG.1937.4 "Retrospective Exhibition of Works in Various Media by Arthur G. Dove." Mar. 23–Apr. 18 (watercolor section closed by Apr. 15). 57 works. Cat. with essay by DP.

PMG.1937.5 [Self-Portrait by Rembrandt on Loan from the Hans Schaeffer Galleries of New York]. By Mar. 28. 1 work. Review.

PMG.1937.6 "Paintings and Sculpture Owned in Washington." Apr. 15–30. 40 works. Cat.

PMG.1937.7 "An Exhibition of Drawings by Pierre Bonnard Illustrating 'Histoires Naturelles' by Jules Renard." Apr. 15–30. Announcement.

PMG.1937.8 "An Exhibition of Drawings, Etchings and Watercolors by Reynolds Beal." May 4–18. 27 works. Cat.

PMG.1937.9 "Exhibition of Watercolor, Pen and Pencil Studies For Paintings by Robert Franklin Gates." May 4–June 15. 76 works. Chklst.

PMG.1937.10* [Paintings from the Phillips Memorial Gallery]. Hood College, Frederick, Md. May 17–22. 19 works. Chklst.

PMG.1937.11 "Drawings and Etchings by Aristide Maillol." Oct. 1–Nov. 12. Announcement.

PMG.1937.12 "Drawings by Pierre Bonnard." Oct. 1–Nov. 12. Announcement.

PMG.1937.13 "Picasso 'Bull Fight,' Dufy 'Polo,' Oils and Watercolors by Demuth, Marin, Dove, Davis, Klee and Knaths." By Oct. 1. Partially reconstructed chklst.

PMG.1937.14 "New Decorations by Augustus Vincent Tack and European and American Colorists." Ca. Oct. 1–Nov. 6. Announcement.

PMG.1937.15 "Drawings by Augustus Vincent Tack." Nov. 21, 1937–Jan. 1, 1938. Announcement.

PMG.1937.16 "Problems of Portraiture." Dec. 6, 1937–Jan. 3, 1938. Traveling exhibition organized by the PMA, Philadelphia. 2 venues, Oct. 16, 1937–Jan. 3, 1938. Ca. 60 works. Partially reconstructed chklst. Cat. with essay by E. M. Benson.

1938

PMG.1938.1 "Constantin Guys." Jan. 9–31. 40 works. Cat. with essay by DP.

PMG.1938.2 [Sketches by Karl Knaths]. Ca. Jan. 31–Feb. 20. Partially reconstructed chklst.

PMG.1938.3 "An Exhibition of Watercolors and Oils by Paul Klee." Ca. Mar. 10–Apr. 3. Partially reconstructed chklst.

PMG.1938.4 [Water Colors by Olive Rush]. Ca. Mar. 27–Apr. 10. Reviews.

PMG.1938.5 "Drawings and Cartoons by Boardman Robinson." Ca. Apr. 10–24. Partially reconstructed chklst.

PMG.1938.6 "Picasso and Marin." Apr. 10–May 1. 46 works. Cat. with essays by DP.

PMG.1938.7 "Scenes from the Italian Quarter of New York City in Water Color by Frank di Gioia." May. 16 works. Partially reconstructed chklst.

PMG.1938.8 "Paintings of Springtime by American and European Artists from the Permanent Collection." Ca. May 15–June 30. Partially reconstructed chklst.

PMG.1938.9 [An Exhibition of Water Colors from the Permanent Collection]. Ca. Oct. 1–30. Partially reconstructed chklst.

PMG.1938.10 "First National Showing and Sale of the Original Watercolors from Walt Disney's 'Snow White and the Seven Dwarfs'." Oct. 30–Nov. 26. Announcement.

PMG.1938.11 "Paintings by Bernice Cross." Nov. 20–Dec. 4. Partially reconstructed chklst.

PMG.1938.12 [Fourth Annual Christmas Sales Show by Artists of Washington, Baltimore and Vicinity]. Nov. 27–Dec. 20. Partially reconstructed chklst.

PMG.1938.13* "Thirty American Paintings By Thirty Contemporary Artists Lent by the Phillips Memorial Gallery and Circulated by The American Federation of Arts." Traveling exhibition circulated by the AFA. Undetermined number of venues, Dec. 8, 1938–May 12, 1940. 30 works. Chklst.

PMG.1938.14 [Works by Living Artists of Twelve Nations with Some Loans from the 1938 Carnegie International Exhibition]. Dec. 15, 1938–Jan. 15, 1939. Partially reconstructed chklst.

1939

PMG.1939.1 "Toulouse-Lautrec: Exhibition of Drawings, Lithographs, Posters." Jan. 1–20. Partially reconstructed chklst.

PMG.1939.2 "Margaret Fisher: Watercolors and Oils." Jan. 22–Feb. 10. 16 works. Cat.

PMG.1939.3 | "Lithographs by Vuillard and Bonnard." Jan. 22–Feb. 10. Partially reconstructed chklst.

PMG.1939.4 | "Paintings by Edouard Vuillard." Jan. 22–Feb. 22. 19 works. Cat.

PMG.1939.5 | "Mural Studies and Other Drawings for the Recently Completed Fresco 'Conservation of American Wildlife' in the Department of the Interior by Henry Varnum Poor." Feb. 12–26. Announcement.

PMG.1939.6 | "Robert F. Gates: Exhibition of Watercolors and Drawings." Feb. 12–Mar. 2. 35 works. Partially reconstructed chklst.

PMG.1939.7* | [Paintings by the Impressionists Lent by the Phillips Memorial Gallery]. Arts Club of Washington, D.C. Mar. 5–24. 18 works. Chklst.

PMG.1939.8 | "Mary Elizabeth Partridge: Exhibition of Watercolors." Mar. 5–30. 41 works. Cat.

PMG.1939.9 | "An Exhibition of Paintings by David Burliuk." Mar. 29–Apr. 13. 22 works. Cat. with essay by DP.

PMG.1939.10 | [Paintings by William Calfee]. By Apr. 2. Review.

PMG.1939.11* | "Contemporary American Paintings Lent by the Phillips Memorial Gallery, Washington." Syracuse (N.Y.) Museum of Fine Arts. April. 37 works. Cat. with foreword by DP.

PMG.1939.12 | [Recent Paintings by Marjorie Phillips and C. Law Watkins]. By Apr. 16. Announcement.

PMG.1939.13 | "Harold Weston." Apr. 16–May 7. Partially reconstructed chklst.

PMG.1939.14 | "Paintings by Henry Botkin." May 7–21. 13 works. Chklst.

PMG.1939.15 | "Landscapes of Nowhere and Everywhere by Elisabeth Poe." May 7–June 7. 56 works. Cat. with essay by C. Law Watkins.

PMG.1939.16 | "Exhibition of Paintings by Alumni of The Phillips Gallery Art School." Oct. 15–Nov. 4. 25 works. Cat. with introduction by C. Law Watkins.

PMG.1939.17 | "An Exhibition of Portraits by C. Law Watkins." Oct. 17–Nov. 6. Partially reconstructed chklst.

PMG.1939.18 | "Watercolors and Oils by John Gernand." Nov. 7–27. 33 works. Cat. with essay by John Gernand.

PMG.1939.19 | [A Small Exhibition of Works by Contemporary American Artists]. Nov. 15–Dec. 3. 17 works. Chklst.

PMG.1939.20 | [Oil Paintings by Louis Eilshemius]. Nov. 15–Dec. 5. 13 works. Chklst.

PMG.1939.21 | "Christmas Sales Exhibition: Artists of Washington, Maryland and Vicinity" [Fifth Annual]. Dec. 6–27. 88 works. Cat.

PMG.1939.22 | "Georges Braque: Retrospective Exhibition." Dec. 6, 1939–Jan. 6, 1940. Traveling exhibition organized by the Arts Club of Chicago. 3 venues, Nov. 7, 1939–Mar. 3, 1940. 55 works. Cat. with essays by DP, Henry McBride, and James Johnson Sweeney.

PMG.1939.23 | "Daumier Lithographs." Dec. 31, 1939–Jan. 25, 1940. 40 works. Announcement.

1940

PMG.1940.1 | "Paintings by Ernest Lawson" [Memorial Exhibition]. Ca. Jan. 21–Mar. 24. 10 works. Partially reconstructed chklst.

PMG.1940.2 | "More Daumier Lithographs." Jan. 28–Feb. 15. Partially reconstructed chklst.

PMG.1940.3 | "Mary Elizabeth Partridge: Watercolors." Feb. 18–Mar. 8. 35 works. Cat.

PMG.1940.4 | "Hand-Colored Etchings by Rouault Illustrating *Le Cirque*." Mar. 10–Apr. 1. Announcement.

PMG.1940.5 | "Twelve Examples of Projects Executed in the Art School in the Course of Karl Knaths." Mar. 10–Apr. 1. Announcement.

PMG.1940.6 | "Great Modern Drawings." Apr. 7–May 7. 53 works. Cat.

PMG.1940.7 | "Emotional Design in Painting." Apr. 7–May 5. Traveled to the New York World's Fair, May 11–Oct. 27. 72 works. Cat. with essay by C. Law Watkins.

PMG.1940.8 | "Photographs: Twenty Portraits of Men by Ferdinand Vogel." May 19–June 16. 20 works. Partially reconstructed chklst.

PMG.1940.9 | "Drawings and Watercolors from the Permanent Collection." May 19–June 16. Partially reconstructed chklst.

PMG.1940.10 | "An Exhibition of Recent Work by the Staff and Alumni of The Phillips Gallery Art School." Oct. 6–20. Partially reconstructed chklst.

PMG.1940.11 | "Loan Exhibition of Aquatints, Etchings and Lithographs by Goya." Oct. 22–Nov. 14. 44 works. Cat.

PMG.1940.12 | "Christmas Sales Exhibition: Artists of Washington, Maryland and Vicinity" [Sixth Annual]. Nov. 24–Dec. 27. Ca. 85 works. Cat.

PMG.1940.13 | "Georges Rouault: Retrospective Loan Exhibition." Dec. 15, 1940–Jan. 26, 1941. Traveling exhibition organized by the IMA-Boston. 3 venues, Nov. 6, 1940–Mar. 24, 1941. 79 works. Cat. with preface by James S. Plaut and introduction by Lionello Venturi.

PMG.1940.14 | "Lithographs and Etchings by Rouault." Dec. 29, 1940–Jan. 15, 1941. Announcement.

1941

PMG.1941.1* | "Paintings by Washington and Baltimore Artists." Wilmington (Del.) Museum of Art. Jan. 14–31. 27 works. Cat.

PMG.1941.2 | "Drawings and Sculpture by Henri Gaudier-Brzeska." Jan. 19–Feb. 4. 20 works. Chklst.

PMG.1941.3 | "Sixteen Gouaches by Ralph M. Rosenborg." Jan. 19–Feb. 4. 20 works. Partially reconstructed chklst.

PMG.1941.4 | "The Functions of Color in Painting: An Educational Loan Exhibition." Feb. 16–Mar. 23. 184 works. Cat. with essays by DP and C. Law Watkins.

PMG.1941.5* | [Paintings Lent by the Phillips Memorial Gallery]. Central Public Library, Washington, D.C. By Mar. 23. Partially reconstructed chklst.

PMG.1941.6 | "Gifford Beal." Apr. 6–23. 49 works. Cat.

PMG.1941.7 | "Contemporary British Paintings." Apr. 23–May 3. 75 works. Cat. with introduction by H. S. Ede.

PMG.1941.8 | [Paintings by Augustus Vincent Tack]. May 4–9. Partially reconstructed chklst.

PMG.1941.9 | "Paintings by Marjorie Phillips." May 11–June 1. Previously exhibited at Bignou Gallery, New York, Mar. 31–Apr. 18. 28 works. Cats. for both venues.

PMG.1941.10 | "Picasso: Etchings, Lithographs, Drawings." May 11–June 1. 36 works. Cat.

PMG.1941.11 | [Exhibition of Large Photographs]. Oct. 10–21. 13 works. Chklst.

PMG.1941.12 | "Oils and Watercolors" [by Students and Staff of the Phillips Gallery Art School]. Oct. 26–Nov. 10. Ca. 25 works. Partially reconstructed chklst.

PMG.1941.13 | "Prints and Drawings from the Collection." Oct. 26–Nov. 10. 21 works. Chklst.

PMG.1941.14 | [*The Three Musicians* (1921) by Pablo Picasso]. Nov. 3–Dec. 6. 1 work. Announcement.

PMG.1941.15 | "Christmas Sales Exhibition of Small Paintings and Drawings by Artists of Washington, Baltimore and Vicinity" [Seventh Annual]. Nov. 23–Dec. 26. 72 works. Cat.

1942

PMG.1942.1 | "Modern Mexican Painters." Jan. 11–Feb. 1. Traveling exhibition organized by the IMA-Boston. 6 venues, Nov. 18, 1941–July 31, 1942. 43 works. Cat. with notes by James S. Plaut and essay by MacKinley Helm.

PMG.1942.2* | [Renoir's *The Luncheon of the Boating Party*]. William Rockhill Nelson Gallery of Art and Mary Atkins Museum of Fine Arts, Kansas City, Mo. By Jan. 25. 1 work. Announcement.

PMG.1942.3* | [American Paintings Lent by the Phillips Memorial Gallery]. William Rockhill Nelson Gallery of Art and Mary Atkins Museum of Fine Arts, Kansas City, Mo. February. Partially reconstructed chklst.

PMG.1942.4 | "Exhibition of Tempera Paintings by Jacob Lawrence." Feb. 14–Mar. 3. Partially reconstructed chklst.

PMG.1942.5* | "French Paintings from the Phillips Memorial Gallery." William Rockhill Nelson Gallery of Art and Mary Atkins Museum of Fine Arts, Kansas City, Mo. Feb. 16–Mar. 1. Partially reconstructed chklst.

PMG.1942.6 | "Cross Section Number One of a Series of Specially Invited American Paintings and Water Colors with Rooms of Recent Work by Max Weber, Karl Knaths, Morris Graves." Mar. 15–April 15. 155 works. Cat.

PMG.1942.7 | "Water Colors by Elisabeth Poe." Apr. 1–26. Partially reconstructed chklst.

PMG.1942.8 | "Exhibition of Pictures by British Children—Painted Recently Under War Conditions." Apr. 25–30. Partially reconstructed chklst.

PMG.1942.9 | [Paintings by Russian-American Artists]. Ca. Apr. 26–June 21. Partially reconstructed chklst.

PMG.1942.10 | "Charles Demuth: Exhibition of Water Colors and Oil Paintings." May 3–25. 56 works. Cat.

PMG.1942.11 "Paul Klee: A Memorial Exhibition." Ca. June 14–Oct. 1. Ca. 12 works (23 after July 2). Cat. with essay by DP.

PMG.1942.12 [Paintings by Marjorie Phillips]. By June 21. Review.

PMG.1942.13 "Paintings by Robert F. Gates." Ca. Aug. 16–Sept. Partially reconstructed chklst.

PMG.1942.14* "Loan Exhibition from the Phillips Memorial Gallery." American University, Washington, D.C. Summer. 22 works. Chklst.

PMG.1942.15 "An Exhibition of Recent Work by the Staff and the Alumni of The Phillips Gallery Art School." Oct. 18–31. 40 works. Chklst.

PMG.1942.16 "Exhibition of Paintings by Sybil Bonbright." Nov. 1–13. Partially reconstructed chklst.

PMG.1942.17 [Lithographs by Honoré Daumier]. Ca. Nov. 1–15. Reviews.

PMG.1942.18 "An Exhibition of Paintings by Marc Chagall." Nov. 29, 1942–Jan. 4, 1943. 15 works. Cat.

PMG.1942.19 "Christmas Sales Exhibition of Paintings, Drawings and Sculpture by Artists of Washington, Baltimore and Vicinity" [Eighth Annual]. Nov. 29–Dec. 27. Ca. 66 works. Cat.

1943

PMG.1943.1 "Alessandro Magnasco." Jan. 17–Feb. 15. 15 works. Cat. with essay by DP.

PMG.1943.2 "Soutine." Jan. 17–Feb. 15. 23 works. Cat. with essay by DP.

PMG.1943.3 "Milton Avery." Jan. 17–Feb. 15. Previously exhibited at Valentine Gallery, New York, Nov. 30–Dec. 26, 1942. 22 works. Cat. with essay by C. Law Watkins.

PMG.1943.4 "Paul Wieghardt." Jan. 17–Feb. 15. 21 works. Cat.

PMG.1943.5 "John Gernand." Jan. 17–Feb. 15. 18 works. Cat.

PMG.1943.6 "Aspects of Contemporary Canadian Painting." Jan. 17–Feb. 15. 36 works. Cat. with essay by Bartlett H. Hayes Jr.

PMG.1943.7 [Paintings by Edward Rosenfeld]. By Feb. 21. Review.

PMG.1943.8 "Paintings by Liz Clarke." Feb. 21–Mar. 7. Previously exhibited at Bignou Gallery, New York, January. 33 works. Cat.

PMG.1943.9 "The Abstract Decorations of Augustus Vincent Tack." Feb. 21–Mar. 21. 19 works. Cat. with essay by DP.

PMG.1943.10 [Work by Pupils of Karl Knaths]. Ca. Mar. 21–28. Review.

PMG.1943.11 "Twentieth Century Drawings: A Loan Exhibition." Apr. 4–30. 42 works. Cat.

PMG.1943.12 [Paintings by Arthur G. Dove]. Apr. 4–30. Partially reconstructed chklst.

PMG.1943.13 "Student Exhibition." By May 2. Announcement.

PMG.1943.14 "Some American Drawings." May 9–28. 53 works. Cat.

PMG.1943.15 "Paintings by Frank Kleinholz." May 9–28. 11 works. Chklst.

PMG.1943.16 "Some Recent Acquisitions." By May 30. 10 works. Chklst.

PMG.1943.17 "Paintings by James McLaughlin." May 30–June 21. Ca. 20 works. Partially reconstructed chklst.

PMG.1943.18 "Paintings by Laughlin Phillips." May 30–June 21. Ca. 20 works. Partially reconstructed chklst.

PMG.1943.19 "Paintings by Abraham Rattner." Ca. June 20–28. 5 works. Reviews.

PMG.1943.20 "Drawings by Augustus John." July 4–28. Ca. 30 works. Chklst.

PMG.1943.21 "Paintings by Julio de Diego." July 4–28. Announcement.

PMG.1943.22 "John Marin: A Retrospective Loan Exhibition of Paintings." Aug. 1–Sept. 30. 20 works. Chklst.

PMG.1943.23 "Pvt. Clarence Laughlin: Creative Experiments in Photography: Old New Orleans and Other Subjects." Aug. 1–Sept. 30. Partially reconstructed chklst.

PMG.1943.24 "Paintings by Marsden Hartley." Oct. 24–Nov. 23. 29 works. Cat. with essay by DP.

PMG.1943.25 "East-West: A Parallel of Chinese and Western Art." Oct. 24–Nov. 23. 30 works. Cat. with essay by Martha Davidson.

PMG.1943.26 "Drawings and Watercolors by Mahonri Young." Oct. 24–Nov. 23. 28 works. Cat.

PMG.1943.27 "Nineteenth and Twentieth Century Prints and Drawings." Oct. 24–Nov. 23. 17 works. Cat.

PMG.1943.28 "Recent Paintings in Gouache by Morris Graves." Dec. 5–26. 19 works. Cat. with essay by DP.

PMG.1943.29 "Paintings, Sculpture and Mobiles by Max Schallinger." Dec. 5, 1943–Jan. 4, 1944. 20 works. Cat. with essay by C. Law Watkins.

PMG.1943.30 "Paintings, Prints, Drawings and Watercolors by Artists of Washington, Baltimore and Vicinity" [Ninth Annual Christmas Sales Exhibition]. Dec. 5, 1943–Jan. 4, 1944. Ca. 46 works. Cat.

1944

PMG.1944.1 "Watercolors by Milton Avery." Jan. 9–31. 17 works. Cat.

PMG.1944.2 "Contemporary European Masters." Jan. 16–Feb. 9. 21 works. Cat.

PMG.1944.3 "The Cuttoli Tapestries." Jan. 16–Feb. 9. 18 works. Cat. with essay.

PMG.1944.4 "Retrospective Exhibition of Work by Roger de la Fresnaye." Jan. 16–Feb. 15. 29 works. Cat. with essays by Germain Seligmann and DP.

PMG.1944.5 "Drawings and Prints 'From Géricault to Renoir'." Feb. 6–28. Traveling exhibition organized by Galerie St. Etienne, New York. 5 venues, Oct. 8, 1943–Apr. 29, 1944. Partially reconstructed chklst.

PMG.1944.6 "Picasso." Feb. 20–Mar. 20. 4 works. Cat. with essay by Paul Rosenberg.

PMG.1944.7 "Walt Kuhn." Feb. 27–Mar. 27. 15 works. Cat. with essay by DP.

PMG.1944.8 "Karl Knaths." Feb. 27–Mar. 27. 25 works. Cat. with essay by DP.

PMG.1944.9 "Lithographs by Oskar Kokoschka." Mar. 1–15. 20 works. Announcement.

PMG.1944.10 "Rembrandt, The Draughtsman: An Exhibition of Facsimiles." Mar. 19–Apr. 4. Announcement.

PMG.1944.11 "The American Paintings of the Phillips Collection." Apr. 9–June 18. Ca. 195 works (with substitutions; watercolor section closed May 14). Cat. with foreword by DP.

PMG.1944.12 "Modern Bookbinding by Edward McLean." May 14–30. 85 works. Chklst.

PMG.1944.13 "Paintings by Laura Douglas." May 14–30. Announcement.

PMG.1944.14 "Watercolors, Temperas and Gouaches by Washington Artists." Ca. June 25–Oct. 8. 35 works. Cat.

PMG.1944.15 "Paintings by Raoul Dufy." June 25–Oct. 18. 14 works. Chklst.

PMG.1944.16 "European Drawings." June 25–Nov. 5. 18 works. Hanging records.

PMG.1944.17 "Paintings by Arthur G. Dove." June 25–Nov. 5. 10 works. Hanging records.

PMG.1944.18 "Lithographs by Daumier." Oct. 8–29. Ca. 30 works. Announcement.

PMG.1944.19 "An Exhibition of Paintings by Bernice Cross." Nov. 5–26. 29 works. Cat.

PMG.1944.20* "Watercolors Lent by Phillips Memorial Gallery, Washington, D.C." Society of the Four Arts, Palm Beach, Fla. Dec. 8–31. 41 works. Cat.

PMG.1944.21 "Paintings by Artists of Washington, Baltimore and Vicinity" [Tenth Annual Christmas Sales Exhibition]. Dec. 10, 1944–Jan. 7, 1945. 98 works. Cat.

1945

PMG.1945.1 "Drawings and Lithographs: George Bellows." Jan. 14–Feb. 12. 50 works. Cat.

PMG.1945.2 "Eugène Delacroix: A Loan Exhibition." Jan. 14–Feb. 26. 13 works (2 from PMG). Cat. with acknowledgment by DP and essay by Georges Wildenstein.

PMG.1945.3 "Recent Paintings: Karl Knaths." Feb. 4–Mar. 9. 10 works. Hanging records.

PMG.1945.4 "Ceramics by Lea Halpern." Feb. 25–Mar. 26. 151 works. Cat. with foreword by DP and essay by Lea Halpern.

PMG.1945.5 "Paintings by Benjamin Kopman." Mar. 18–Apr. 17. 9 works. Hanging records.

PMG.1945.6 "Paintings by Pierre Bonnard." Mar. 18–Sept. 17 works. Hanging records.

PMG.1945.7 "A Loan Exhibition of Paintings by Charles W. Hutson." Apr. 1–30. 17 works. Cat. with essay by Clarence Laughlin.

PMG.1945.8 "A Group of Americans From The Collection." Apr. 1–30. 13 works. Cat.

PMG.1945.9 "Watercolors by Robert Gates and Others." Apr. 18–June 12. 12 works. Hanging records.

PMG.1945.10 "Watercolors and Small Oils by C. Law Watkins." May 6–June 10. 46 works. Cat. with essay by DP.

PMG.1945.11 "Picasso: *Musical Instruments*." Summer. 1 work. Announcement.

PMG.1945.12 "Exhibition of Monoprints by Harry Bertoia." June 10–July 31. 53 works. Announcement.

PMG.1945.13 "Rouault: Lithographs of the Circus." Aug. 5 through September. Partially reconstructed chklst.

PMG.1945.14 "Daumier: Lithographs." Aug. 5 through September. Announcement.

PMG.1945.15 "A Loan Exhibition of 52 Drawings for Ariosto's *Orlando Furioso* by Fragonard." Oct. 21–Nov. 17. 52 works. Cat. with foreword by DP.

PMG.1945.16 "Paintings by Artists of Washington, Baltimore and Vicinity"

[Eleventh Annual Christmas Sale Exhibition]. Dec. 5–27. 97 works. Cat.

1946

PMG.1946.1 "Paintings by Elisabeth Poe." Feb. 10–28. 47 works. Cat. with essay by DP.

PMG.1946.2 "Paintings by Karl Knaths." Mar. 10–31. 16 works. Chklst.

PMG.1946.3 "Objects as Subjects." Mar. 14–28. Traveling exhibition organized by MOMA. 15 venues, Oct. 28, 1945–June 12, 1947. Partially reconstructed chklst., including PMG works augmenting this showing.

PMG.1946.4 "Eilshemius." Mar. 21–Nov. 5 and Dec. 26, 1946–Feb. 3, 1947. 11 works (with substitutions). Hanging records.

PMG.1946.5 "Drawings and One Work in Sculpture by Henry Moore." Apr. 7–28. 41 works. Cat. with foreword by Geoffrey Grigson.

PMG.1946.6 "Paintings by Lee Gatch." May 12–June 3. Partially reconstructed chklst.

PMG.1946.7 "Paintings by Louis Schanker." May 12–July 31 [?]. Previously exhibited at Willard Gallery, New York, Feb. 26–Mar. 23. 18 works. Cat.

PMG.1946.8 "Woodblocks in Color: Louis Schanker." June 9–July 31. Ca. 20 works. Partially reconstructed chklst.

PMG.1946.9 "Some of the Paintings by Artists of Washington and Vicinity Purchased from the Annual Christmas Exhibitions 1935–45." Ca. Aug. 4–Oct. 27. 41 works. Hanging records.

PMG.1946.10 "Pioneers of Modern Art in America." Nov. 3–24. Traveling exhibition organized by the Whitney and circulated by the AFA. 12 venues, Apr. 9, 1946–May 30, 1947. 64 works (66 in tour). Partially reconstructed chklst. Cat. with introduction by Lloyd Goodrich.

PMG.1946.11 "A Loan Exhibition of Paintings by Christopher Wood." Dec. 1–26. 22 works. Cat. with essay by DP.

PMG.1946.12 "Three Negro Artists: Horace Pippin, Jacob Lawrence, Richmond Barthé." Dec. 14, 1946–Jan. 6, 1947. Co-organized by PMG and the Catholic Inter-Racial Council of Washington. 43 works. Cat.

1947

PMG.1947.1 "Paintings by Mary Watkins." Jan. 12–30. 29 works. Cat.

PMG.1947.2 "Exhibition of Paintings by Gifford Beal." Feb. 2–23. 32 works. Cat.

PMG.1947.3 "Paintings by Artists of Washington, Baltimore and Vicinity." Mar. 2–24. 37 works. Cat.

PMG.1947.4 "John Marin: A Retrospective Exhibition." Mar. 2–Apr. 15. Traveling exhibition organized by the IMA-Boston. 3 venues, Jan. 7, 1947–June 15, 1948. 96 works. Cat. with artist's statement and essays by MacKinley Helm and Frederick S. Wight.

PMG.1947.5 "Loan Exhibition of Drawings and Pastels by Edgar Degas." Mar. 30–Apr. 30. 36 works. Cat.

PMG.1947.6 "A Retrospective Exhibition of Paintings by Arthur G. Dove." Apr. 18–Sept. 22. 59 works. Hanging records.

PMG.1947.7 "Recent Paintings by John Gernand." May 4–26. 31 works. Cat.

PMG.1947.8 "Drawings, Prints and Small Paintings From the Collection." June 1–Sept. 22. 42 works. Hanging records.

PMG.1947.9 "Watercolors by Charles Burchfield." Sept. 28–Oct. 12. 9 works. Hanging records.

PMG.1947.10 "Watercolors by Robert F. Gates." Sept. 28–Oct. 28. 13 works. Hanging records.

PMG.1947.11 "Watercolors by Elisabeth Poe." Oct. 12–30. 18 works. Hanging records.

PMG.1947.12 "Painters of the San Francisco Bay Region." Nov. 2–Dec. 2. 34 works. Cat. with foreword by DP.

PMG.1947.13 "Early Paintings by Augustus Vincent Tack." Dec. 7, 1947–Jan. 5, 1948. 5 works. Hanging records.

PMG.1947.14 "Recent Paintings by James McLaughlin." Dec. 7, 1947–Jan. 5, 1948. 15 works. Cat.

PMG.1947.15 "Recent Paintings by Laughlin Phillips." Dec. 7, 1947–Jan. 5, 1948. 19 works. Cat.

1948

PMG.1948.1 "Exhibition of Paintings by Maurice Sterne." Jan. 11–Feb. 3. 12 works. Partially reconstructed chklst.

PMG.1948.2 "Paintings by Vaughn Flannery." Jan. 11–Feb. 3. Announcement.

PMG.1948.3 "Photographs by Clarence Laughlin." Jan. 11–Feb. 3. Announcement.

PMG.1948.4 "Lithographs by Picasso." Feb. 8–24. 26 works. Partially reconstructed chklst.

PMG.1948.4-A* "A Group of Women Painters." Centennial Club, Nashville, Tenn. Feb. 10–27. 26 works. Cat.

PMG.1948.5 "Recent Paintings by Karl Knaths." Mar. 7–Apr. 6. 12 works. Cat.

PMG.1948.6 "Recent Paintings by Bernice Cross." Mar. 7–Apr. 6. 12 works. Cat.

PMG.1948.7 "Recent Paintings by John Piper." Mar. 7–Apr. 6. 30 works. Cat.

PMG.1948.8 "Paintings by Artists of Washington, Baltimore and Vicinity." Apr. 18–May 30. 43 works. Cat.

PMG.1948.9 "Exhibition of Paintings by Marjorie Phillips." May 16–June 15. Previously exhibited at Bignou Gallery, New York, Apr. 30–May 8. 21 works. Cats. for both venues with foreword by DP.

PMG.1948.10 "Some Contemporary American Paintings from the Collection." June 13–Oct. 10. 25 works (27 after July 14). Hanging records.

PMG.1948.11 "Raoul Dufy." July 6–Dec. 7. 8 works. Hanging records.

PMG.1948.12* "Modern European Masters." University of Virginia Museum of Fine Arts, Charlottesville. Aug. 7–Oct. 4. 16 works. Cat. with notes by John Gernand.

TPG.1948.13 "Sixty Drawings by Matisse." Oct. 17–Nov. 7. Traveling exhibition circulated by the AFA. [?] venues. 60 works. Partially reconstructed chklst.

TPG.1948.14 "Oskar Kokoschka: A Retrospective Exhibition." Dec. 5, 1948–Jan. 24, 1949. Traveling exhibition organized by the ICA-Boston. 5 venues, Oct. 4, 1948–Oct. 4, 1949. Ca. 126 works. Cat. with introduction by James S. Plaut.

1949

TPG.1949.1 "Paintings by Arthur B. Davies." Jan. 29–Mar. 2. 12 works. Hanging records.

TPG.1949.2 "Paintings by Maurice Sterne." Jan. 29–Mar. 28. 8 works. Hanging records.

TPG.1949.3 "Louis Eilshemius." Jan. 29–July 8. 13 works. Hanging records.

TPG.1949.4 "John Marin." February. Announcement.

TPG.1949.5 "Color Abstractions by Augustus Vincent Tack." Feb. 1–Mar. 3. 9 works. Hanging records.

TPG.1949.6 "French Prints From Daumier to Matisse." Feb. 6–Mar. 7. 50 works. Hanging records.

TPG.1949.7 "A New Masterpiece of 1947 by Georges Braque." Ca. Feb. 20–Apr. 17. 1 work. Review.

TPG.1949.8 "Recent Paintings by Karl Knaths." Mar. 6–29. 15 works. Hanging records.

TPG.1949.9 "Paintings by Joseph Solman." Mar. 13–29. 30 works. Cat.

TPG.1949.10 "Watercolors by John Marin." Apr. 3–May 4. 29 works. Cat.

TPG.1949.11 "Paintings by Grandma Moses." May 8–June 9. 31 works. Cat.

TPG.1949.12 "Recent Paintings by Bernice Cross." June 12–July 3. 14 works. Cat.

TPG.1949.13 [Paintings by The Phillips Gallery Staff]. By June 19. Review.

TPG.1949.14 "Contemporary American and European Paintings from the Collection." Summer. Announcement.

TPG.1949.15 "Artists Look Like This: Portrait Photographs by Arnold Newman." Sept. 18–Oct. 10. Traveling exhibition organized by the Philadelphia Museum of Art. [?] venues. 30 works (49 in tour). Partially reconstructed chklst.

TPG.1949.16 "Photographs: *Equivalents* by Alfred Stieglitz." Nov. 6–29. Announcement.

TPG.1949.17 "Louisiana Plantations and Other Subjects by Clarence J. Laughlin." Nov. 6–29. Announcement.

TPG.1949.18 "Jacques Villon, Lyonel Feininger." Dec. 11, 1949–Jan. 10, 1950. Traveling exhibition organized by ICA-Boston. 4 venues, Oct. 7, 1949–May 7, 1950. 86 works. Cat. with statement by Jacques Villon and essays by George Heard Hamilton, Thomas B. Hess, and Frederick S. Wight.

1950

TPG.1950.1 "Paintings and Watercolors by Theodoros Stamos." Jan. 15–31. 25 works. Partially reconstructed chklst.

TPG.1950.2 "Paintings and Prints by Louis Schanker." Feb. 5–28. 23 works. Announcement.

TPG.1950.3 "Paintings by Laughlin Phillips." Feb. 5–28. 14 works. Chklst.

TPG.1950.4 "Paintings, Drawings, and Prints by Paul Klee from the Klee Foundation, Bern, Switzerland, with Additions from American Collections." Mar. 5–Apr. 10. Traveling exhibition organized by MOMA. 7 venues, Mar. 24, 1949–May 24, 1950. 202 works. Cat. with essay by James Thrall Soby.

TPG.1950.5 "Paintings by Artists of Washington, Baltimore and Vicinity." Apr. 15–May 16. 32 works. Partially reconstructed chklst.

TPG.1950.6 "Drawings by Virginia Patterson." May 7–22. Partially reconstructed chklst.

TPG.1950.7 "Edvard Munch." May 28–June 20. Traveling exhibition organized by the ICA-Boston. 10 venues, Apr. 19, 1950–July 15, 1951. 171 works. Cat. with introduction by Johan H. Langaard and essay by Frederick B. Deknatel.

TPG.1950.8 "Selected American Paintings from the Collection." Summer. Ca. 90 works. Partially reconstructed chklst.

TPG.1950.9 "Memorial Exhibition: Abstractions by Augustus Vincent Tack." June 25–Sept. 16. 9 works. Hanging records.

TPG.1950.10 "Prints by Five Contemporary French Masters: Dufy, Matisse, Picasso, Rouault and Jacques Villon." Oct. 1–31. 44 works. Chklst.

TPG.1950.11 "Drawings by Ben Shahn." Nov. 12–Dec. 12. 44 works. Chklst.

TPG.1950.12 "British Art: The Last Fifty Years, 1900–1950." Nov. 28–Dec. 7. Traveling exhibition organized by the English-Speaking Union of the United States. [?] venues. 48 works. Cat. with introduction by Sir Kenneth Clark and essay by Allan Nevins.

TPG.1950.13 "Paintings by John Piper." Dec. 16, 1950–Jan. 14, 1951. Partially reconstructed chklst.

TPG.1950.14 "Contemporary Ceramics." Dec. 16, 1950–Feb. 12, 1951. Partially reconstructed chklst.

1951

TPG.1951.1 "Paintings by Loren MacIver." Jan. 14–Feb. 12. 13 works. Chklst.

TPG.1951.2 "Advancing French Art." Mar. 4–25. Traveling exhibition organized by the AFA. 7 venues, tour dates [?]. 19 works (40 in other venues). Cat.

TPG.1951.3 "Paintings by Ben Nicholson." Apr. 1–30. Announcement.

TPG.1951.4 "Watercolors by Raoul Dufy: An Exhibition of His Work in the United States, 1950." May 6–June 6. Traveling exhibition organized by the artist. 7 or more venues, Jan. 18–Oct. [?], 1951. 31 works. Cat.

TPG.1951.5 "Modern French and American Paintings from the Collection." Summer. Partially reconstructed chklst.

TPG.1951.6* "Two Contemporary American Painters: John Marin and Karl Knaths." Library Gallery, Woman's College, Duke University, Durham, N.C. Summer. 34 works. Chklst.

TPG.1951.7* "A Selection of Twentieth Century European Paintings From the Phillips Collection." Person Hall Art Gallery, University of North Carolina, Chapel Hill. Ca. June 1–Aug. 31. 37 works. Chklst.

TPG.1951.8 "Paintings in Oil, Tempera and Watercolor from the Phillips Collection by Robert Gates." June 6–Aug. 12. 15 works. Hanging records.

TPG.1951.9 "Paintings by Alfred Maurer and Max Weber." June 6–Sept. 16. 11 works. Hanging records.

TPG.1951.10 "Jack B. Yeats: A First Retrospective American Exhibition." June 10–26. Traveling exhibition organized by the ICA-Boston. 7 venues, Apr. 8, 1951–June 21, 1952. 36 works. Cat. with essay by James S. Plaut.

TPG.1951.11 "Bernice Cross Retrospective." June 26–Sept. 25. 27 works. Hanging records.

TPG.1951.12 "Drawings by Alfred Maurer." Aug. 12–Sept. 16. Ca. 50 works. Hanging records.

TPG.1951.13 "Contemporary Italian Prints." Sept. 30–Oct. 30. Organized by the George Binet Print Collection, Brimfield, Mass. 53 works. Chklst.

TPG.1951.14 "Paintings by Keith Vaughan." Nov. 4–30. Announcement.

TPG.1951.15 "Paintings by James McLaughlin." Nov. 4–30. 15 works. Hanging records.

TPG.1951.16* "Paintings by Marjorie Phillips, Duncan Phillips, Laughlin Phillips." Library, George Washington University, Washington, D.C. December. 40 works. Cat.

TPG.1951.17 "Paintings by Vaclav Vytlacil." Dec. 2, 1951–Jan. 3, 1952. 10 works. Hanging records.

TPG.1951.18 "Prints and Drawings from the Permanent Collection." Dec. 2, 1951–Jan. 3, 1952. 20 works. Hanging records.

1952

TPG.1952.1 "Paintings by I. Rice Pereira." Jan. 6–28. 9 works. Partially reconstructed chklst.

TPG.1952.2 "Watercolors by John Marin." Jan. 6–28. 14 works. Hanging records.

TPG.1952.3 "Contemporary French Color Lithographs." Feb. 3–25. Organized by the George Binet Print Collection, Brimfield, Mass. 50 works. Chklst.

TPG.1952.4 "Paintings in the Collection by Bonnard." Feb. 3–Mar. 31. 18 works (19 by Mar. 16). Hanging records.

TPG.1952.5 "Painters of Expressionistic Abstractions." Mar. 16–Apr. 29. 26 works. Chklst.

TPG.1952.6 "Paintings by Karl Knaths." Apr. 3–May 30. 16 works (with substitutions). Hanging records.

TPG.1952.7 "Paintings by William Congdon, Nicolas de Staël." May 4–27. Partially reconstructed chklst.

TPG.1952.8 "An Exhibition of Paintings by a Group of Washington Artists." Summer. 28 works. Hanging records.

TPG.1952.9 "An Exhibition of Fourteen American Painters." Nov. 2–30. 29 works. Hanging records.

TPG.1952.10* "Paintings by Augustus Vincent Tack from the Phillips Collection." Library, George Washington University, Washington, D.C. December. 23 works. Chklst.

TPG.1952.11 "An Exhibition of Small Paintings by Rouault." Dec. 7, 1952–Jan. 7, 1953. Partially reconstructed chklst.

1953

TPG.1953.1 "Milton Avery." Feb. 1–23. Traveling exhibition organized by BMA. 6 venues, Dec. 9, 1952–Oct. 18, 1953. 40 works (85 at BMA). Cat. with essay by Frederick S. Wight.

TPG.1953.2 "A Small Exhibition of Abstractions from the Studio of the Late Augustus Vincent Tack." March 3–May 2. 10 works. Hanging records.

TPG.1953.3 "An Exhibition of Paintings From the Katherine S. Dreier Private Collection Bequeathed to The Phillips Collection." March 8–May 2. 17 works. Hanging records and list of gifts.

TPG.1953.4 "An Exhibition of Paintings by Nicolas de Staël." Apr. 12–May 4. 13 works. Hanging records.

TPG.1953.5 "Jack Levine." May 3–June 1. Traveling exhibition organized by ICA-Boston. 7 venues, Sept. 17, 1952–Apr. 3, 1953. 29 works. Cat. with foreword by Lloyd Goodrich and essay by Frederick S. Wight.

TPG.1953.6* [First Exhibition of Works by Arthur G. Dove from the Collection of his Friend and Patron, Duncan Phillips]. Corcoran, Washington, D.C. May 4–July 14. Organized by ICA-Boston. 22 works. Chklst.

TPG.1953.7 "Berthe Morisot and Her Circle: Paintings from the Rouart Collection, Paris." May 17–June 15. Traveling exhibition organized by the Art Gallery of Toronto (Ontario). 17 venues, Sept. 25, 1952–Oct. 10, 1954. 30 works. Cat. with introduction by Denis Rouart.

TPG.1953.8 "Joint Exhibition: Paintings by Bernice Cross and James McLaughlin." June 7–30. 32 works. Chklst.

TPG.1953.9 "Modern European and American Paintings from the Collection Including Cross Section of Contemporary Trends." June 16–Oct. 21. 21 works. Hanging records.

TPG.1953.10 "Paintings by Twachtman, Weir and Lawson." July–Oct. 21. 26 works. Hanging records.

TPG.1953.11 "A Group of Americans from the Collection." Nov. 1–30. 27 works. Hanging records.

TPG.1953.12 "A Loan Exhibition of Early Paintings by Maurice Utrillo." Dec. 6, 1953–Jan. 11, 1954. 25 works. Cat. with essay by DP.

1954

TPG.1954.1 "Some American Painters." Jan. 17–Feb. 23. 28 works. Hanging records.

TPG.1954.2 "Graham Sutherland and Henry Moore: A Loan Exhibition." Mar. 7–Apr. 6. Traveling exhibition organized by ICA-Boston. 9 venues, Apr. 2, 1953–Apr. 6, 1954. 63 works. Cat. with introduction by Frederick S. Wight and essay by Herbert Read.

TPG.1954.3 "Retrospective Exhibition of Paintings by Lee Gatch." Apr. 11–May 11. 34 works. Chklst.

TPG.1954.4 "Recent Paintings by Morris Graves." May 16–June 30. 37 works. Chklst.

TPG.1954.5 "Contemporary Eskimo Carvings." May 23–June 30. Traveling exhibition circulated by SITES. [?] venues. 130 works. Cat.

TPG.1954.6 "Americans from the Collection." Ca. July [?]–Oct. 10. 26 works. Hanging records.

TPG.1954.7 "Color Lithographs and Drawings by Bonnard, Vuillard." Ca. Oct. 10–31. Announcement.

TPG.1954.8 "Recent Paintings by Karl Knaths." Oct. 31–Nov. 30. 18 works. Hanging records.

TPG.1954.9 "Recent Work by Theodoros Stamos." Dec. 1, 1954–Jan. 3, 1955. Traveled to DeCordova and Dana Museum and Park, Lincoln, Nebr., Jan. 3–Feb. 27, 1955. 16 works. Cat. for Lincoln venue.

1955

TPG.1955.1 "Canadian Abstract Expressionist Paintings." Jan. 16–31. 15 works. Hanging records.

TPG.1955.2 "Maurice Sterne Retrospective and Recent Purchases and Loans." Feb. 7–28. 15 works. Hanging records.

TPG.1955.3* "Contemporary American Paintings from the Phillips Gallery in Washington." Library Gallery, Woman's College, Duke University, Durham, N.C. Mar. 4–31. 25 works. Chklst.

TPG.1955.4 "Loan Exhibition of Paintings by Bradley Tomlin." Mar. 6–May 3. 7 works. Announcement.

TPG.1955.5 "Abstract Expressionists from the Collection." Mar. 6–May 3. 10 works. Hanging records.

TPG.1955.6 "John Marin Memorial Exhibition." May 15–June 30. Traveling exhibition organized by UCLA Art Galleries. 9 venues, Mar. 1, 1955–July 29, 1956. 122 works. Cat. with foreword by DP, appreciations by William Carlos Williams and Dorothy Norman, and essay by Frederick S. Wight.

PMG.1955.7 "Younger New England Painters." July 10–Aug. 2. Traveling exhibition organized by ICA-Boston. 3 venues, Sept. 21, 1954–Aug. 2, 1955. Partially reconstructed chklst.

TPG.1955.8 "Roy and Marie Neuberger Collection: Modern American Painting and Sculpture." Oct. 9–31. Traveling exhibition organized by the Whitney. 7 venues, Nov. 17, 1954–Oct. 31, 1955. 50 works (100 at the Whitney). Cat. with foreword by John I. H. Baur and introduction by Marie and Roy Neuberger.

TPG.1955.9 "Some Pioneers of Modern Art." Nov. 5–Dec. 31. 32 works. Hanging records.

TPG.1955.10 "Paintings by Karl Knaths." Nov. 5, 1955–Jan. 6, 1956. 15 works. Hanging records.

1956

TPG.1956.1 "New Paintings by Karl Knaths." Jan. 8–30. 14 works. Hanging records.

TPG.1956.2 "A Loan Exhibition of Recent Work by Lee Gatch." Feb. 5–28. Partially reconstructed chklst.

TPG.1956.3 "A Group of Expressionists." Feb. 5–28. 7 works. Hanging records.

TPG.1956.4 "Watercolors by Auguste Rodin." Mar. 4–Apr. 4. Partially reconstructed chklst.

TPG.1956.5 "Drawings by Jean François Millet." Mar. 4–Apr. 4. Announcement.

TPG.1956.6 "Two Photographs by Edward Steichen of Rodin's *Balzac*." Mar. 4–Apr. 4. 2 works. Announcement.

TPG.1956.7 "Morris Graves Retrospective Exhibition." Apr. 15–May 7. Traveling exhibition organized by UCLA Art Galleries. 8 venues, Feb. 28, 1956–Mar. 10, 1957. 94 works. Cat. with foreword by John I. H. Baur, and essays by DP and Frederick S. Wight.

TPG.1956.8 "Nicolas de Staël." May 13–June 30. Traveling exhibition organized by the AFA. 8 venues, Nov. 4, 1955–Dec. 2, 1956. 22 works. Cat. with foreword by Theodore Schempp.

TPG.1956.9 "Drawings and Prints from the Collection." July [?]–Nov. 9. 40 works. Hanging records.

TPG.1956.10 "Charles Burchfield." Nov. 11–Dec. 11. Traveling exhibition organized by the Whitney. 7 venues, Jan. 11, 1956–Feb. 10, 1957. 86 works (114 at the Whitney). Cat. with essay by John I. H. Baur.

TPG.1956.11 "Loan Exhibition of Paintings by J. B. C. Corot." Dec. 16, 1956–Jan. 17, 1957. Previously exhibited at Paul Rosenberg & Co., New York, Nov. 5–Dec. 1. 16 works (32 at Rosenberg). Cat. with essay by DP.

1957

TPG.1957.1 "Collages by Kurt Schwitters." Jan. 6–Feb. 25. 33 works. Cat. with essay by C. Giedion-Welcker.

TPG.1957.2 "Paintings by Tomlin, Rothko, Okada." Jan. 6–Feb. 26. Partially reconstructed chklst.

TPG.1957.3 "Abstract Expressionists from the Collection." Mar. 3–Apr. [?]. 19 works. Hanging records.

TPG.1957.4 "Swiss Peasant Art." June 9–July 2. Traveling exhibition circulated by SITES. [?] venues. Partially reconstructed chklst.

TPG.1957.5 "Drawings from the Collection." Ca. July 15–Nov. 1. 42 works. Hanging records.

TPG.1957.6* "A Loan Exhibition from The Phillips Collection, Washington." Randolph-Macon Woman's College, Lynchburg, Va. Oct. 13–Nov. 17. 11 works. Cat.

TPG.1957.7 "Paintings by Marjorie Phillips." Nov. 1–26. 31 works. Hanging records.

TPG.1957.8 "Recent Paintings by Karl Knaths." Dec. 8, 1957–Jan. 8, 1958. Partially reconstructed chklst. Monograph with introduction by DP, appreciation by Emanuel Benson, commentary by Karl Knaths, and essay by Paul Mocsanyi.

TPG.1957.9 "Giorgio Morandi Retrospective." Dec. 15, 1957–Jan. 8, 1958. Previously exhibited at World House Galleries, New York, Nov. 5–Dec. 7. 35 works (60 at TPG). Cat. with introduction by Lionello Venturi.

1958

TPG.1958.1 "Paintings and Drawings from the Collection." Ca. Jan. 8–Apr. 1. 42 works. Hanging records.

TPG.1958.2 "Pierre Bonnard: A Small Loan Exhibition of Paintings." Jan. 12–Feb. 12. 6 works. Cat. with essay by DP.

TPG.1958.3 "Nature in Abstraction: The Relation of Abstract Painting and Sculpture to Nature in Twentieth Century American Art." Apr. 6–May 6. Traveling exhibition organized by the Whitney. 7 venues, Jan. 14, 1958–Feb. 8, 1959. 58 works. Cat. with essay by John I. H. Baur.

TPG.1958.4 "Twentieth-Century Highlights of American Painting." May 11–27. Traveling exhibition organized by the Meltzer Gallery and circulated by USIA. [?] venues. 40 works. Cat. with essay by Dorothy Adlow.

TPG.1958.5 "Paintings by Augustus Vincent Tack." Ca. June [?]–Oct. 1. 18 works. Hanging records.

TPG.1958.6 "Prints and Drawings from the Collection." Oct. 1–15. 39 works. Hanging records.

TPG.1958.7 "Paintings by Sam Francis." Oct. 19–Nov. 20. 20 works. Hanging records.

TPG.1958.8 "Arthur G. Dove." Nov. 30, 1958–Jan. 5, 1959. Traveling exhibition organized by UCLA Art Galleries. 7 venues, Sept. 30, 1958–Sept. 30, 1959. 103 works. Cat. with foreword by DP and essay by Frederick S. Wight.

1959

TPG.1959.1 "Paintings by John Ferren." Jan. 11–Feb. 9. Announcement.

TPG.1959.2 "Paintings by Olivier Debré." Jan. 11–Feb. 9. Announcement.

TPG.1959.3 "Paintings by Serge Poliakoff." Feb. 15–Mar. 10. Announcement.

TPG.1959.4 "Some Abstractions from the Collection." Mar. 15–May 4. 20 works. Hanging records.

TPG.1959.5 "Paintings by Bonnard from the Collection." Mar. 15–June [?]. 20 works. Hanging records.

TPG.1959.6 "Masterpieces of Eilshemius." May 10–June 1. Organized by and previously exhibited at the Artist's Gallery, New York, Apr. 8–30. 40 works. Cat. with contributions by Lionello Venturi, Marcel Duchamp, Lloyd Goodrich, Jean Charlot, Waldemar George, and DP.

TPG.1959.7 "European and American Contemporaries from the Collection." Summer. Announcement.

TPG.1959.8 "Recent Paintings by Marjorie Phillips." Nov. 11–Dec. 7. 23 works. Hanging records.

TPG.1959.9 "Contemporary American Watercolors and Drawings from the Edward W. Root Collection." Dec. 13, 1959–Jan. 6, 1960. Partially reconstructed chklst.

1960

TPG.1960.1 "Selections From the Edward Root Collection: The Munson-Williams-Proctor Institute, Utica, New York." Jan. 19–Feb. 9. Traveling exhibition organized by the Museum of Art, University of Michigan, and circulated by SITES. [?] venues. 47 works. Cat.

TPG.1960.2 "New Painting from Yugoslavia." Feb. 14–Mar. 7. Traveling exhibition organized by the Commission for Foreign Cultural Relations, Belgrade and circulated by the AFA. [?] venues. 54 works. Cat.

TPG.1960.3 "Sculpture Seen Anew: The Bronze Age to Brancusi: Photographs by C. J. Laughlin." Mar. 13–29. Announcement.

TPG.1960.4 "The Pottery of Bernard Leach." Apr. 3–25. Announcement and hanging records.

TPG.1960.5 "Paintings by Mark Rothko." May 4–31. 7 works. Hanging records.

TPG.1960.6 "English Paintings in the Phillips Collection." June 12–Oct. [?]. 29 works (with substitutions). Hanging records.

1961

TPG.1961.1 "The Camera as a Third Eye: Photographs by Clarence J. Laughlin." Jan. 8–24. Announcement.

TPC.1961.2 "Lee Gatch." Feb. 5–27. Traveling exhibition organized by the Whitney and circulated by the AFA. 11 venues, Feb. 3, 1960–Feb. 27, 1961. 45 works. Cat. with essay by Perry T. Rathbone.

TPC.1961.3 "Vieira da Silva." Mar. 12–Apr. 12. 25 works. Cat. with essay by Marcel Brion.

TPC.1961.4 "Drawings, Etchings, and Lithographs of Artists by Artists: A Collection Formed by Mr. James Hopkins Smith, Jr." Apr. 15–May 15. 63 works. Cat.

TPC.1961.5 "Richard Diebenkorn." May 19–June 26. 18 works. Cat. with essay by Gifford Phillips.

TPC.1961.6 "The Graphic Art of Edvard Munch." Sept. 19–Oct. 17. Traveling exhibition circulated by SITES. [?] venues. Announcement.

TPC.1961.7 "Early Paintings by Washington and Baltimore Artists in the Collection." Nov. 5–Dec. 12. 33 works. Hanging records.

TPC.1961.8 "Twentieth Century Drawings From The Museum of Modern Art." Dec. 17, 1961–Jan. 8, 1962. Traveling exhibition organized by MOMA. 16 venues, Mar. 20, 1961–Mar. 15, 1963. 45 works (85 at MOMA). Partially reconstructed chklst.

1962

TPC.1962.1 "Paintings by Josef Albers." Jan. 28–Feb. 28. 22 works. Chklst.

TPC.1962.2 "David Smith." Mar. 11–Apr. 30. Traveling exhibition organized by MOMA. 9 venues, Nov. 3, 1961–Mar. 3, 1963. 46 works. Cat.

TPC.1962.3 "Mark Tobey." May 6–July 1. 45 works. Cat.

TPC.1962.4 "Portraits of Greatness: Photographs by Yousuf Karsh." June 15–July 15. Traveling exhibition organized by the International Museum of Photography, George Eastman House, Rochester, N.Y., and circulated by SITES. [?] venues, Feb. 16, 1960–July 15, 1962. 30 works (75 at Eastman House). Partially reconstructed chklst.

TPC.1962.5 "Drawings From the Collection." Summer. 20 works. Hanging records.

TPC.1962.6 "Elements of Modern Art from the Solomon R. Guggenheim Museum." Sept. 17–Oct. 8. Traveling exhibition organized by the Guggenheim and circulated by the AFA. 16 venues, July 1, 1962–Feb. 28, 1964. 35 works. Chklst.

TPC.1962.7 "Kurt Schwitters." Nov. 4–25. Traveling exhibition organized by MOMA. 6 venues, June 19, 1962–May 20, 1963. 40 works (87 at MOMA). Cat. with essay by Walter Hopps.

TPC.1962.8 "Selection from 'The Migration of the Negro' Series by Jacob Lawrence." December. Ca. 24 works. Partially reconstructed chklst.

1963

TPC.1963.1 "Fabrics International." Jan. 3–24. Traveling exhibition organized by the Museum of Contemporary Crafts and the Philadelphia Museum College of Art, and circulated by the AFA. 8 venues, Feb. 1, 1962–Mar. 11, 1963. 159 works. Cat. with essays.

TPC.1963.2 "Alberto Giacometti: A Loan Exhibition." Feb. 7–Mar. 18. 54 works. Cat. with essay by DP.

TPC.1963.3 "Paintings from the Collection and Some Loans." Apr. 1–30. 19 works (with substitutions). Hanging records.

TPC.1963.4 "The Paintings by Jean-Paul Riopelle Exhibited at the Venice Biennale in 1962." May 12–June 17. Traveling exhibition organized by the National Gallery of Canada. 4 venues, Jan. 10–June 17. 82 works. Cat. with essays by Franco Russoli and J. Russell Harper.

TPC.1963.5 "Drawings from the Collection." Summer. Announcement.

TPC.1963.6 "A Hundred Pots by Shoji Hamada: A Loan Exhibition." Oct. 13–Nov. 18. 96 works. Cat. with foreword by MP and essay by Harold P. Stern.

TPC.1963.7 "Recent Gouaches by Vieira da Silva." Dec. 1–30. Previously exhibited at Knoedler Galleries, New York, Oct. 15–Nov. 2. 24 works. Cat. with foreword by the artist.

1964

TPC.1964.1 "Seymour Lipton: A Loan Exhibition." Jan. 12–Feb. 24. 53 works. Cat. with essays by DP and Albert Elsen.

TPC.1964.2 "Alfred Manessier: A Loan Exhibition." Mar. 14–Apr. 27. 26 works. Cat. with essay by DP and interview by Jean Clay.

TPC.1964.3 "Photographs by Cartier-Bresson: A Loan Exhibition." Apr. 5–May 5. Ca. 11 works. Cat. with artist's statement.

TPC.1964.4 "Paintings from the Fifties from The Contemporary Collection of The Museum of Art, Carnegie Institute." May 13–June 10. Traveling exhibition organized by Carnegie and circulated by the AFA. 10 venues, Apr. 1, 1964–Mar. 31, 1965. 40 works. Chklst.

TPC.1964.5 "Drawings From the Collection Including *Birds in Flight* by Nicolas de Staël." Summer. 37 works. Hanging records.

TPC.1964.6 "The Cubist Period of Jacques Lipchitz: A Loan Exhibition." Oct. 3–Nov. 17. 17 works. Cat. with essay by DP.

TPC.1964.7 "Etienne Hajdu: A Loan Exhibition." Nov. 14–Dec. 27. 30 works. Cat.

1965

TPC.1965.1 "Collages by Robert Motherwell: A Loan Exhibition." Jan. 2–Feb. 15. 30 works. Cat. with foreword by Sam Hunter.

TPC.1965.2 "A One-Painting Exhibition Loan Exhibition: *The Circus Horse,* 1946, by Pierre Bonnard." Feb. 25–Mar. 29. 1 work. Announcement.

TPC.1965.3 "Retrospective Exhibition of Paintings by Karl Knaths." Apr. 3–May 13. 29 works. Cat.

TPC.1965.4 "Milton Avery Paintings: 1941–1963." May 22–June 28. Traveling exhibition organized by MOMA. 13 venues, May 22, 1965–Dec. 11, 1966. 30 works. Cat. with essay by Alicia Legg.

TPC.1965.5 "Paintings by Marjorie Phillips: A Retrospective Exhibition." July 1–Aug. 2. Organized by the Munson-Williams-Proctor Institute (Utica, N.Y.) in cooperation with the Art Department of Hamilton College, Clinton, N.Y. 2 venues, May 2–Aug. 2. 37 works. Cat. with essay by Joseph S. Trovato.

TPC.1965.6 "Drawings from the Collection." Aug. 1–Sept. [?]. Partially reconstructed chklst.

TPC.1965.7 "Pierre Bonnard's *The Palm*." Sept. 15–Oct. 11. 1 work. Announcement.

TPC.1965.8 "Sculpture Seen Anew: The Bronze Age to Brancusi: Photographs by Clarence John Laughlin." Oct. 2–Nov. 2. Partially reconstructed chklst.

TPC.1965.9 "Paintings by Loren MacIver: A Loan Exhibition." Nov. 20, 1965–Jan. 3, 1966. Traveled to the Snite Museum of Art, University of Notre Dame, Indiana, Jan. 15–Feb. [?], 1966. 30 works. Cat. with essay by Robert M. Frash.

1966

TPC.1966.1 "Birds in Contemporary Art: A Loan Exhibition." Feb. 12–Mar. 31. 50 works. Cat. with essay by MP.

TPC.1966.2 "Paintings by Arthur Dove From the Collection." Apr. 9–May 30. 35 or 36 works. Chklst.

TPC.1966.3 "Ceramics and Graphics by Picasso." June 4–30. Traveling exhibition circulated by the AFA. [?] venues. 39 works. Chklst.

TPC.1966.4 "Drawings from the Collection." July 9–Sept. 6. 38 works. Hanging records.

TPC.1966.5 "Penalba Sculpture: A Loan Exhibition." Sept. 17–Oct. 31. 13 works. Cat. with biography by MP.

TPC.1966.6 "Sculptures and Drawings by Henry Moore." Nov. 19, 1966–Jan. 2, 1967. Traveling exhibition circulated by SITES. 12 venues, Nov. 19, 1966–June 16, 1968. 62 works. Cat.

1967

TPC.1967.1 "Paintings and Drawings by Pierre Bonnard: An Exhibition from The Phillips Collection and the Collections of Mrs. Duncan Phillips and Mr. and Mrs. Laughlin Phillips." Jan. 7–Feb. 28. 20 paintings, 14 prints and drawings. Cat. with posthumous essay by DP.

TPC.1967.2 "Kokoschka." Feb. 1–28. 19 works. Cat. with introduction by MP.

TPC.1967.3 "Recent Stabiles by Alexander Calder." Apr. 8–May 30. 7 works. Cat. with essay by MP.

TPC.1967.4 "John Marin: Paintings and Water Colors From The Phillips Collection." June 10–July 9. Previously exhibited at Knoedler Galleries, New York, May 3–26. 26 works. Cat. introduction by Lloyd Goodrich and posthumous essay by DP.

TPC.1967.5 "Prints and Drawings from the Collection." July 15–Aug. 31. 47 works. Hanging records.

TPC.1967.6 "Paintings from the Collection by Arthur G. Dove, Marsden Hartley, Alfred H. Maurer, Georgia O'Keeffe, Charles Sheeler." Sept. 2–Oct. 1. Partially reconstructed chklst.

TPC.1967.7 "Paintings by Sam Gilliam." Oct. 7–Nov. 14. 12 works. Cat.

TPC.1967.8 "Masters of Modern Italian Art From the Collection of Gianni

Mattioli." Dec. 2, 1967–Jan. 14, 1968. Traveling exhibition circulated by IEF. 7 venues, Feb. 1, 1967–Mar. 31, 1969. 104 works. Cat. with essay by Franco Russoli.

1968

TPC.1968.1 "British Drawings: The New Generation." Jan. 20–Feb. 11. Traveling exhibition circulated by MOMA. 13 venues, Oct. 8, 1967–Apr. 25, 1969. 57 works. Cat. with introduction by Jennifer Licht.

TPC.1968.2 "Art in Process: The Visual Development of a Collage." Feb. 15–Mar. 7. Traveling exhibition circulated by the AFA. 10 venues, Mar. 9, 1967–Oct. 3, 1968. 87 works. Cat. with artists' statements.

TPC.1968.3 "Drawings and Prints from the Collection." Mar. 16–Apr. 7. 21 works. Hanging records.

TPC.1968.4 "Recent Paintings and Drawings: Youngerman." Apr. 20–May 31. 46 works. Cat. with essay by MP.

TPC.1968.5 "Twentieth Century Sculpture." June 15–Sept. 30. 12 works. Cat.

TPC.1968.6 "Watercolors in The Phillips Collection." Oct. 2–Nov. 10. 41 works (with substitutions). Hanging records.

TPC.1968.7 "Julius Bissier: A Retrospective Exhibition." Nov. 21–Dec. 31. Traveling exhibition co-organized by the Guggenheim and the San Francisco Museum of Art. 5 venues, Sept. 18, 1968–June 19, 1969. 151 works. Cat. with essay by Thomas M. Messer.

1969

TPC.1969.1 "The Art of Charles Prendergast." Jan. 11–Feb. 16. Traveling exhibition organized by Boston-MFA. 3 venues, Oct. 2, 1968–Feb. 16, 1969. 81 works. Cat. with essay by Richard J. Wattenmaker.

TPC.1969.2 "Jacob Lawrence: 'The Migration of the Negro'." Feb. 1–Oct. 31. 30 works. Chklst.

TPC.1969.3* "Retrospective for a Critic: Duncan Phillips." J. Millard Tawes Fine Arts Center, University of Maryland Art Department, College Park. Feb. 12–Mar. 16. 41 works. Cat. with essay by Bess Hormats.

TPC.1969.4 "The Work of Edvard Munch from the Collection of Mr. and Mrs. Lionel C. Epstein." Mar. 15–Apr. 20. Sponsored by the Washington Print Club. 119 works. Cat. with foreword by MP and introduction by Alan M. Fern.

TPC.1969.5 "Loan Exhibition of Contemporary Paintings." May 10–June 22. 24 works. Cat.

TPC.1969.6 "Hundertwasser." July 12–Aug. 14. Traveling exhibition organized by University Art Museum, University of California, Berkeley. 7 venues, Oct. 8, 1968–Aug. 14, 1969. 80 works. Cat. with essays by Herschel Chipp, Brenda Richardson, Joachim Jean Aberbach, and Friedrich Hundertwasser.

TPC.1969.7 "Twenty Paintings by Hundertwasser Lent by Joachim Jean Aberbach and Julian J. Aberbach." Sept. 6–Dec. 9, Jan. 29–Feb. 28, 1970. 20 works. Hanging records.

TPC.1969.8 "Paintings and Graphics: John Sloan and Gifford Beal." Dec. 9, 1969–Jan. 18, 1970. 38 works. Chklst.

1970

TPC.1970.1* "Paintings From the Phillips Collection." Society of the Four Arts, Palm Beach, Fla. Feb. 7–Mar. 1. 50 works. Cat. with introduction by John Gordon.

1971

TPC.1971.1 "Puvis de Chavannes (1824–1898): Color Sketches for Murals in the Custom House at Marseilles, France." January. 2 works. Chklst.

TPC.1971.2 "Cézanne, An Exhibition in Honor of the Fiftieth Anniversary of The Phillips Collection." Feb. 28–Mar. 28. Traveling exhibition organized by AIC, Boston-MFA, and TPC. 3 venues, Feb. 28–July 3. 83 works. Cat. with introduction by John Rewald and writings by DP.

TPC.1971.3 "Memorial Exhibition of Paintings by Karl Knaths in The Phillips Collection." Apr. 18–Aug. 20 works (reduced to 17 by May 15). Hanging records.

TPC.1971.4 "Seven Loans from the Gifford and Joann Phillips Collection." May 8–June 20. 7 works. Hanging records.

TPC.1971.5 "The Paintings by Pierre Bonnard in the Collection." July 17, 1971–June 1975. 11 works (reduced to 10 by Sept. 8). Hanging records.

TPC.1971.6 "Gifford Beal: Paintings and Watercolors." Sept. 18–Oct. 31. 35 works. Cat. with essay by William R. Beal.

TPC.1971.7 "Reynolds Beal: Oils, Watercolors, Drawings, Etchings." Sept. 18–Oct. 31. Traveled to the Montclair Art Museum, N.J., Jan. 9–Feb.

13, 1972. 66 works. Cat. with foreword by MP and essays by Bob Davis and Mahonri Sharp Young.

TPC.1971.8 "Photographs by Clarence Laughlin: Victorian Chicago." Oct. 2–31. Announcement.

TPC.1971.9 "A Small Loan Exhibition of Washington Artists at The Phillips Collection." Dec. 4, 1971–Jan. 12, 1972. 40 works. Cat. with introduction by MP.

1972

TPC.1972.1 "Charles Demuth: The Mechanical Encrusted on the Living." Jan. 19–Feb. 29. Traveling exhibition organized by The Art Galleries, University of California, Santa Barbara. 4 venues, Oct. 5, 1971–Apr. 16, 1972. 118 works. Cat. with essays by David Gebhard and Phyllis Plous.

TPC.1972.2 "Contemporary Sculpture: A Loan Exhibition." Apr. 8–June 15. 14 works. Cat.

TPC.1972.3 "Paintings by Julian Alden Weir." May 6–June 8. Traveling exhibition organized by TPC. 3 venues, May 6–Oct. 5. 22 works (20 in tour). Cat. with foreword by MP, essay by Mahonri Sharp Young, and writings by DP.

TPC.1972.4 "Drawings and Prints from the Collection." July. 52 works. Hanging records.

TPC.1972.5 "Vuillard Graphics: Sixty-two Prints from the Antoine Salomon Collection." Aug. 1–27. Traveling exhibition circulated by IEF. 8 venues, Aug. 1, 1972–Oct. 15, 1973. 57 works. Chklst.

TPC.1972.6* "Augustus Vincent Tack, 1870–1949: Twenty-six Paintings from The Phillips Collection." Art Museum, University of Texas, Austin. Aug. 27–Oct. 3. Traveled to the Art Gallery, University of Maryland, College Park, Oct. 19–Nov. 19. 26 works. Cat. with essay by Eleanor Green.

TPC.1972.7 "'The Migration of the Negro' by Jacob Lawrence." Sept. 10–Oct. 23. 60 works. Announcement.

TPC.1972.8 "Second Annual Exhibition of Washington Artists: Paintings, Sculpture, Drawings and Graphics." Dec. 2–31. 30 works. Cat. with foreword by Richard Friedman.

1973

TPC.1973.1 "Bonnard: Drawings from 1893–1946." Jan. 14–Feb. 25. Traveling exhibition circulated by AFA. 9 venues, Sept. 17, 1972–Sept. 15, 1974. 114 works. Cat.

TPC.1973.2 "Watercolors by Dan Yellow Kuhne." Mar. 3–Apr. 1. 3 works. Cat. with essay by Richard Friedman.

TPC.1973.3 "Steve Szabo, Ron Stark." Apr. 7–May 1. 50 works. Cat. with artists' statements.

TPC.1973.4 "Recent Paintings by John Chapman Lewis." May 5–June 3. 16 works. Cat. with foreword by John Gernand.

TPC.1973.5 "Stoneware by Eleanor Lyman." June 9–July 8. 42 works. Cat.

TPC.1973.6 "Yuri Schwebler: Two as Three Sculptures." July 1–Sept. 30[?]. 5 works. Cat. with artist's statement.

TPC.1973.7 "Paintings by Davies and Eilshemius from the Collection." July 11–Sept. 6. 24 works. Hanging records.

TPC.1973.8 "Oils, Gouaches, Prints by Joan Miró from the Collection of Mr. and Mrs. LeRoy Makepeace, Washington, D.C." Aug. 21–Sept. 2. 10 works. Hanging records.

TPC.1973.9 "Jennie Lea Knight: Sculptures and Drawings." Sept. 8–30. 33 works. Cat. with essay by Walter Hopps.

TPC.1973.10 "Recent Paintings by Jacob Kainen." Oct. 6–28. 15 works. Cat.

TPC.1973.11* "Augustus Vincent Tack, 1870–1949: Loan Exhibition of Seventeen Abstract Paintings from the Phillips Collection, Washington, D.C." University of Rhode Island Fine Arts Center, Kingston. Oct. 9–28. 17 works. Cat. with essay by Margaret B. Sander.

TPC.1973.12 "Frank Stella." Nov. 3–Dec. 2. 5 works. Cat. with essay by Richard Friedman.

TPC.1973.13 "Edward Corbett." Dec. 8–30. 14 works. Cat.

1974

TPC.1974.1 "Arnold Kramer." Jan. 5–Feb. 3. 35 works. Cat.

TPC.1974.2 "American Impressionists in the Permanent Collection." Feb. 9–24. 24 works. Hanging records.

TPC.1974.3 "Dan Brush." Mar. 2–31. Cat. with artist's statement.

TPC.1974.4 "Karl Knaths: Five Decades of Painting." May 4–June 2. Traveling exhibition organized by the William Hayes Ackland Memorial Art Center, University of North Carolina, Chapel Hill. 6 venues, Nov.

4, 1973–July 15, 1974. 30 works (50 in tour). Cat. with essay by Charles Edward Eaton.

TPC.1974.5 "Carla Lavatelli." June 1–Sept. 15. 5 works. Cat.

TPC.1974.6 "Washington Portfolio '74: Washington Printmakers' Workshop Project." June 7–28. 10 portfolios. Cat. with foreword by Richard Friedman.

TPC.1974.7 "Emerson Woelffer." June 22–July 28. Traveling exhibition organized by Newport Harbor Art Museum, Newport Beach, Calif. 2 venues, Apr. 27–July 28. 20 works (54 at Newport Harbor). Cat. (separate catalogue published by the Newport Harbor Art Museum).

TPC.1974.8 "Tamarind: A Renaissance of Lithography." July 6–Aug. 11. Traveling exhibition circulated by IEF. 25 venues, July 15, 1971–Mar. 15, 1976. 35 works (76 in tour). Cat. with introduction by E. Maurice Bloch.

TPC.1974.9 "De Kooning: Drawings, Sculptures." Sept. 14–Oct. 27. Traveling exhibition organized by the Walker Art Center, Minneapolis. 5 venues, Mar. 10, 1974–Apr. 6, 1975. 151 works. Cat. with essays by Philip Larson and Peter Schjeldahl.

TPC.1974.10 "A Small Exhibition of Paintings by Marjorie Phillips." Oct. 25–Dec. 15. Partially reconstructed chklst.

TPC.1974.11 "French Eighteenth and Nineteenth Century Drawings." Oct. 26–Dec. 15. 19 works. Cat.

1975

TPC.1975.1 "John Flannagan: Sculpture and Works on Paper." Jan. 11–Feb. 2. Traveling exhibition circulated by IEF. 14 venues, Jan. 11, 1975–Oct. 28, 1977. 53 works. Cat. with introduction by Gene Baro.

TPC.1975.2 "Wendy V. Watriss, Frederick Baldwin." Jan. 11–Feb. 22. 46 works. Cat.

TPC.1975.3 "Willem de Looper." Mar. 1–Apr. 12. 15 works. Cat.

TPC.1975.4 "Walter Bohanan." Apr. 19–June 1. 27 works. Cat.

TPC.1975.5 "The Graphic Work of Kandinsky." May 15–June 8. Traveling exhibition organized by the Guggenheim and circulated by IEF. 12 venues, Jan. 17, 1974–Sept. 15, 1975. 75 works. Cat. with introduction by Hans K. Roethel.

TPC.1975.6 "Hilda Thorpe." June 13–July 27. 27 works. Cat.

TPC.1975.7 "Paintings by Robert Gates from the Collection." Sept. 13–Oct. 13. 21 works. Hanging records.

TPC.1975.8 "Susan Crile." Sept. 20–Nov. 2. 11 works. Cat. with introduction by Judith Goldman.

TPC.1975.9 "Paintings by Henryk Stazewski." Oct. 18–Nov. 30. 27 works. Cat. with foreword by LP and essay by Gregory Battock.

TPC.1975.10 "Eugene Rukhin: A Contemporary Russian Artist." Dec. 6, 1975–Jan. 11, 1976. Traveling exhibition organized by the North Carolina Museum of Art, Raleigh. 2 venues, Aug. 10, 1975–Jan. 11, 1976. 46 works. Cat. with essay by Ruth Mayfield.

1976

TPC.1976.1 "Arthur G. Dove: The Abstract Work." Jan. 3–Feb. 1. Co-organized by TPC and Terry Dintenfass, Inc., New York; traveled to Dintenfass Gallery Dec. 2–27, 1975. 25 works. Cat. with essay by Charles V. W. Brooks.

TPC.1976.2 "Glenn Rudolph." Jan. 3–25. 50 works. Cat. with artist's statement.

TPC.1976.3 "The Drawings of Morris Graves." Jan. 31–Mar. 7. Traveling exhibition organized by the Museum of Art, University of Oregon at Eugene, and circulated by AFA. 6 venues, Sept. 21, 1975–Sept. 12, 1976. 54 works. Cat.

TPC.1976.4 "Catherine Murphy." Feb. 14–Mar. 28. Co-organized by TPC and ICA-Boston; traveled to Boston Apr. 20–May 25, 1975. 43 works. Cat.

TPC.1976.5 "Henry Moore: Prints, 1969–1974." Apr. 3–May 2. Traveling exhibition circulated by IEF. 20 venues, Oct. 1, 1975–Apr. 30, 1978. 81 works. Cat. with introduction by David Mitchinson.

TPC.1976.6 "American Art from the Phillips Collection, Part 1." May 29–Aug. 21. 155 works. Hanging records.

TPC.1976.7 "American Art from The Phillips Collection: A Selection of Paintings 1900–1950." May 29–Sept. 5. Traveling exhibition organized by TPC. 6 venues, Sept. 28, 1975–Sept. 5, 1976. 36 works. Cat. with introduction by LP.

TPC.1976.8 "American Art from The Phillips Collection, Part 2." Sept. 4–Oct. 24. 192 works. Hanging records.

TPC.1976.9 "American Art from The Phillips Collection, Part 3." Oct. 29–Dec. 26. 140 works. Hanging records.

TPC.1976.10 "Artists on The Phillips Collection Staff." Dec. 18, 1976–Jan. 12, 1977. 42 works. Hanging records.

1977

TPC.1977.1 "The Group of Seven: Canadian Landscape Painters." Jan. 22–Feb. 20. 44 works. Cat. with foreword by LP and essay by Jeanne L. Pattison.

TPC.1977.2 "Horace Pippin." Feb. 25–Mar. 27. Traveling exhibition organized by TPC. 3 venues, Feb. 25–Sept. 5. 47 works. Cat. with essay by Romare Bearden.

TPC.1977.3 "Leon Berkowitz: Big Bend Series 1976." Apr. 2–May 1. Traveling exhibition organized by TPC. 2 venues, Apr. 2–June 24. 9 works. Cat. with foreword by James McLaughlin, introduction by Douglas Davis and Viola Herms Drath, and poem by Ida Fox.

TPC.1977.4 "The Human Form: Sculpture, Prints and Drawings: Fritz Wotruba." Apr. 23–May 22. Traveling exhibition organized by SITES. 10 venues, Apr. 23, 1977–Mar. 23, 1979. 60 works. Cat. with essay by Sareen R. Gerson.

TPC.1977.5 "Sarah Baker." May 7–29. 39 works. Cat. with essay by Ben Summerford.

TPC.1977.6 "Milton Avery, Drawings and Paintings." May 21–June 19. Traveling exhibition organized by the University of Texas Art Museum, Austin. 3 venues, Dec. 1976–June 1977. 55 works. Cat. with essay by Harvey S. Shipley Miller.

TPC.1977.7 "Clarence John Laughlin: The Transforming Eye." June 4–July 3. Traveling exhibition organized by IEF and Lunn Gallery/Graphics International, Ltd., Washington, D.C. 17 venues, Apr. 1, 1976–Nov. 15, 1979. 75 works. Cat. with essay by Fritz Grubar and artist's statement.

TPC.1977.8 "Karl Struss: Man With a Camera." July 9–31. Traveling exhibition organized by the Cranbrook Academy of Art, Bloomfield Hills, Mich. 5 venues, Jan. 13, 1976–July 31, 1977. 96 works. Cat. with essay by John Harvith and artist's memoir.

TPC.1977.9 "Alan Fenton: Washes and Drawings." Aug. 6–28. Co-organized by TPC and the University of Iowa Museum of Art, Iowa City; traveled to Iowa City Sept. 16–Oct. 30. 40 works. Cat. with introduction by Jan K. Muhlert and appreciation by Vincent Melzac.

TPC.1977.10 "Franz Bader." Sept. 3–25. 67 works. Cat. with artist's statement and introduction by Roy Slade.

TPC.1977.11 "Natalie Alper." Oct. 1–30. 16 works. Cat. with introduction by Christopher C. Cook.

TPC.1977.12 "Constance Costigan." Oct. 1–30. 7 works. Cat. with artist's statement and introduction by Lenore D. Miller.

TPC.1977.13 "Kevin MacDonald." Oct. 1–30. 14 works. Cat. with introduction by Arthur Hall Smith.

TPC.1977.14 "Stefan Hirsch." Nov. 5–Dec. 4. 36 works. Cat. with introduction by Theodore Weiss, and essays by Roy Moyer and Elsa Rogo.

TPC.1977.15 "Howard Mehring Drawings: 1975–1977." Dec. 10, 1977–Jan. 15, 1978. 4 works. Cat. with foreword by LP and essay by Andrew Hudson.

1978

TPC.1978.1 "Matt Phillips: Monotypes 1976–1977." Jan. 20–Feb. 19. Co-organized by TPC and the Des Moines Art Center, Des Moines, Iowa; traveled to Des Moines Mar. 28–Apr. 30. 25 works. Cat. with artist's statement and essay by Judith Goldman.

TPC.1978.2 "American Folk Painting: Selections from The Collection of Mr. and Mrs. William E. Wiltshire III." Feb. 25–Apr. 9. Traveling exhibition organized by the Virginia Museum of Fine Arts, Richmond, and circulated by AFA. 7 venues, Nov. 29, 1977–Apr. 22, 1979. 51 works. Cat.

TPC.1978.3 "Annette Kaplan Tapestries." Apr. 15–May 14. 24 works. Cat. with essay by Rita J. Adrosko.

TPC.1978.4 "John Walker." May 20–June 18. 20 works. Cat. with foreword by LP and essay by Andrew Forge.

TPC.1978.5 "Pottery by Vally Possony." May 20–June 18. 45 works. Cat. with artist's statement.

TPC.1978.6 "Carol Summers: Woodcuts 1951–1976." June 24–July 23. Traveling exhibition organized by the Brooklyn Museum. 4 venues, Aug. 6, 1977–Dec. 31, 1978. 58 works. Cat. with introduction by Gene Baro,

TPC.1978.7 "Recent Paintings and Serigraphs by Batuz." July 29–Aug. 27. Monograph with essays by Pietro M. Bardi, Rafael Squirru, Frank Getlein, Dieter Rante, and Joseph H. Hirshhorn.

TPC.1978.8 "Folk Art of Peru: An Exhibition of the Collection of the Honorable Antonio Lulli-Avalos." July 29–Aug. 27. Cat. with essay by Juan Manuel Ligarte Elespuru.

TPC.1978.9 "Philip C. Curtis." Sept. 2–Oct. 1. Traveling exhibition organized by the Scottsdale (Ariz.) Center for the Arts. 3 venues, Mar. [?]–Oct. 1, 1978. 43 works. Cat. with essay by Charles Parkhurst.

TPC.1978.10 "Rufino Tamayo: Fifty Years of His Painting." Oct. 7–Nov. 16. Traveling exhibition organized by TPC. 2 venues, Oct. 7, 1978–Feb. 17, 1979. 67 works. Cat. with introduction by James B. Lynch Jr.

TPC.1978.11 "Homage to Kokoschka: Prints and Drawings from the Collection of Reinhold, Count Bethusy-Huc." Dec. 2, 1978–Jan. 7, 1979. Traveling exhibition circulated by IEF. 10 venues, Dec. 2, 1978–Oct. 25, 1980. 54 works (102 works in tour). Cat.

TPC.1978.12 "Wil Brunner, Cynthia Griffith, William Ryan." Dec. 16, 1978–Jan. 17, 1979. 20 works. Cat. with foreword by LP.

1979

TPC.1979.1 "Robert Stark." Jan. 13–Feb. 10. 45 works. Cat. with introduction by Eliza Rathbone and statement by James McLaughlin.

TPC.1979.2 "Franz Kline: The Color Abstractions." Feb. 17–Apr. 8. Traveling exhibition organized by TPC. 4 venues, Feb. 17–Nov. 25. 54 works. Cat. with foreword by LP, essay by Harry F. Gaugh, and appreciation by Robert Motherwell.

TPC.1979.3 "Okada, Shinoda, and Tsutaka: Three Pioneers of Abstract Painting in Twentieth Century Japan." Apr. 14–May 26. Traveling exhibition organized by TPC. 5 venues, Apr. 14, 1979–Mar. 31, 1980. 38 works. Cat. with foreword by LP and introduction by Shuji Takashina.

TPC.1979.4 "The Phillips Collection in the Making: 1920–1930." May 5–June 10. Traveling exhibition co-organized by TPC and SITES. 10 venues, May 5, 1979–Jan. 4, 1981. 37 works. Cat. with foreword by LP and essays by Kevin Grogan, Sareen R. Gerson, and Bess Hormats.

TPC.1979.5 "From the Permanent Collection: Paintings and Watercolors by Maurice Prendergast." Summer. 9 works. Press release.

TPC.1979.6 "New American Monotypes." June 16–July 15. Traveling exhibition organized by SITES. 9 venues, Aug. 26, 1978–May 4, 1980. 70 works. Cat. with essay by Jane M. Farmer.

TPC.1979.7 "William Dole: A Retrospective Exhibition of Collages 1958–1978." July 21–Aug. 26. Traveling exhibition organized by Staempfli Gallery, New York. 5 venues, Nov. 14, 1978–Aug. 26, 1979. 71 works (77 works in tour). Cat. with introduction by Gerald Nordland.

TPC.1979.8 "Paintings and Collages by Leonard Maurer." Sept. 8–Oct. 14. Organized by the Leonard Maurer Charitable Trust. 42 works. Monograph with chklst. and essay by Ben Summerford.

TPC.1979.9 "Lois Mailou Jones: Selected Paintings and Watercolors." Oct. 2–31. 25 works. Cat. with essays by John Gernand and Kevin Grogan.

TPC.1979.10 "Ray Parker: Recent Paintings." Oct. 20–Nov. 25. 34 works. Cat. with forewords by LP and James McLaughlin, and appreciations by Barbara Rose, Vered Lieb, Diane Waldman, and Natalie Edgar.

TPC.1979.11 "Enrico Donati." Dec. 1, 1979–Jan. 6, 1980. Cat. with foreword by James McLaughlin.

1980

TPC.1980.1 "Nathan Oliveira: A Survey of Monotypes, 1973–78." Jan. 12–Feb. 24. Traveling exhibition organized by the Baxter Art Gallery, California Institute of Technology, Pasadena. 3 venues, Sept. 20, 1979–Feb. 24, 1980. 56 works. Cat. with essay by Lorenz Eitner.

TPC.1980.2 "Sam Francis: The Fifties." Mar. 1–Apr. 12. 19 works. Cat. with foreword by LP and essay by Diane W. Upright.

TPC.1980.3 "Jane Godfrey and Michael Green." Mar. 1–Apr. 12. 38 works (18 by Godfrey, 20 by Green). Cat. for each artist with foreword by LP and artist's statement.

TPC.1980.4 "Leon Spilliaert: Symbol and Expression in Twentieth Century Belgian Art." Apr. 18–June 8. Traveling exhibition organized by TPC in concert with the Belgian government and "Belgium Today," a national program in the United States honoring the 150th anniversary of Belgian independence. 2 venues, Apr. 18–Aug. 31. 57 works. Cat. with foreword by LP and Robert C. Cafritz, and essays by Frank Edebau, Patricia Farmer, and France-Claire Legrand.

TPC.1980.5 "The Watercolors of David Levine." June 13–July 20. 40 works. Cat. with essay by Ian McKibbin White.

TPC.1980.6 "Charles Rumph: Chambers." July 26–Sept. 7. Traveling exhibition organized by TPC. 2 venues, July 26–Dec. 19. 73 works. Cat. with introduction by David Tannous.

TPC.1980.7 "Joyce Tenneson." July 26–Sept. 7. 24 works. Cat. with introduction by David Tannous.

TPC.1980.8 "Helen Frankenthaler Prints: 1961–1979." Sept. 6–Oct. 19. Traveling exhibition organized by the Williams College (Williamstown, Mass.) Artist-in-Residence Program. 5 venues, Apr. 11, 1980–Nov. 8, 1981. 110 works. Cat. with essay by Thomas Krens.

TPC.1980.9 "Paintings by Judy Bass, Sherry Zvares Kasten and Ioannis Glykokokalos." Oct. 25–Dec. 7. 60 works (15 by Bass, 14 by Kasten, and 21 by Glykokokalos). Cat. for each artist with essay by David Tannous.

TPC.1980.10 "Jacob Kainen." Dec. 13, 1980–Jan. 25, 1981. 17 works. Cat. with essay by Charles Parkhurst.

1981

TPC.1981.1 "Vuillard, Drawings 1885–1930." Jan. 31–Mar. 15. Traveling exhibition circulated by AFA. 11 venues, Jan. 3, 1980–May 17, 1981. 60 works. Cat. with introduction by John Russell.

TPC.1981.2 "Two Sculptures by Ramzi Moustafa." Mar. 16–Apr. 30. Organized by TPC in conjunction with the national symposium "Egypt Today." 2 works. Cat. with essay by Ashraf Ghorbal and introduction by Janet W. Solinger.

TPC.1981.3 "Phillip Guston 1980: The Last Works." Mar. 21–May 24. Traveling exhibition organized by TPC. 3 venues, Mar. 21, 1981–Jan. 3, 1982. 31 works. Cat. with introduction by Willem de Looper and essay by Morton Feldman.

TPC.1981.4 "Arthur Dove and Duncan Phillips: Artist and Patron." June 13–Aug. 16. Traveling exhibition organized by TPC. 7 venues, June 13, 1981–Nov. 14, 1982. 79 works. Cat. with foreword by LP, posthumous essay by DP, and text by Sasha M. Newman.

TPC.1981.5* "Impressionism and the Modern Vision: Master Paintings from The Phillips Collection." Traveling exhibition organized by TPC. 5 venues, July 4, 1981–Jan. 9, 1983. 75 works. Cat. with foreword by Milton Brown, and essays by Eleanor Green and Robert Cafritz.

TPC.1981.6 "Appreciations: American Impressionist Paintings and Related Works From The Phillips Collection." Sept. 12–Nov. 29. 70 works. Cat.

TPC.1981.7 [Dufy Paintings in The Phillips Collection]. October. 9 works. Partially reconstructed chklst.

TPC.1981.8 "Dream Vision: The Work of Arthur B. Davies." Dec. 5, 1981–Feb. 7, 1982. Traveling exhibition organized by ICA-Boston. 4 venues, Mar. 17, 1981–Feb. 7, 1982. 68 works. Cat. with essays by Linda Walpert, Garnett McCoy, Elisabeth S. Sussman, and Nancy E. Miller.

TPC.1981.9 "Art From Children's Studio School." Dec. 8, 1981–Feb. 7, 1982. 60 works. Partially reconstructed chklst.

1982

TPC.1982.1 "John Walker." Feb. 13–Apr. 11. Traveling exhibition organized by TPC. 2 venues, Feb. 13–Aug. 22. 17 works (26 in tour). Cat. with essay by Jack Flam.

TPC.1982.2 "Appreciations: Louis Eilshemius." Apr. 17–May 30. 25 works. Cat. with essay by John Gernand.

TPC.1982.3 "Cita Scott." Apr. 17–May 30. 19 works. Cat. with introduction by David Schaff.

TPC.1982.4 "Margaret Olney McBride." Apr. 17–May 30. 13 works. Cat. with introduction by Ben Summerford.

TPC.1982.5* "American Impressionism and Related Works of Art from The Phillips Collection, Washington, D.C." Cheekwood Fine Arts Center, Nashville, Tenn. May 8–Sept. 5. 34 works. Cat. with essay by Sasha Newman.

TPC.1982.6* "Paintings by Marjorie Phillips." Cheekwood Fine Arts Center, Nashville, Tenn. May 8–Sept. 5. 13 works. Cat. with essay by Kevin Grogan.

TPC.1982.7 "James McLaughlin: A Retrospective Exhibition: In Memoriam." June 5–Sept. 5. 41 works. Cat. with foreword by LP, essay by Arthur Hall Smith, and appreciations by LP, John Gernand, Adelyn Bree-

TPC.1982.8 "Harold Weston: The Stone Series 1968–1972." June 5–July 18. 27 works. Cat. with essay by Sasha Newman.

skin, Abram Lerner, Susan Davis, Michael Clark, and Judy Bass.

TPC.1982.9 "The Painter and The Printer: Robert Motherwell's Graphics, 1943–1980." July 10–Aug. 29. Traveling exhibition circulated by AFA. 17 venues, Oct. 30, 1980–Apr. 29, 1984. 92 works. Cat. with catalogue raisonné by Dorothy C. Belknap, introduction by Stephanie Terenzio, artist's statement, and interviews with master printmakers.

TPC.1982.10 "Works on Paper: A Selection of Collages from The Phillips Collection." Sept. 11–Nov. 14. 14 works. Cat.

TPC.1982.11 "Appreciations: Karl Knaths." Sept. 11–Nov. 14. 24 works. Cat. with essays by John Gernand and Ben Summerford.

TPC.1982.12 "Georges Braque: The Late Paintings 1940–1963." Oct. 9–Dec. 12. Traveling exhibition organized by TPC. 4 venues, Oct. 9, 1982–Sept. 14, 1983. 49 works (46 in tour). Cat. with foreword by LP, introduction by Robert C. Cafritz, and essay by Herschel B. Chipp.

TPC.1982.13 "Ben Summerford." Dec. 18, 1982–Feb. 6, 1983. 38 works. Cat. with introduction by Willem de Looper.

1983

TPC.1983.1 "Staff Exhibition, 1982." January. 42 works. Hanging records.

TPC.1983.2* "Vilhelm Hammershøi: Painter of Stillness and Light." Feb. 16–Mar. 27. Traveling exhibition co-organized by TPC and the Danish Ministries of Foreign and Cultural Affairs in conjunction with the American cultural celebration "Scandinavia Today." 2 venues, Jan. 7–Mar. 27. 73 works. Cat. with preface by LP and essay by Thorkild Hansen.

TPC.1983.3 "Works on Paper: A Selection of American Prints and Drawings from The Phillips Collection." Mar. 15–Apr. 9. 42 works. Cat. with introduction by Judith Lyon.

TPC.1983.4 "Morris Graves: Vision of The Inner Eye." Apr. 9–May 29. Traveling exhibition organized by TPC. 6 venues, Apr. 9, 1983–Sept. 4, 1984. 132 works (137 in tour). Cat. with foreword by LP, excerpted writings by DP, and essay by Ray Kass.

TPC.1983.5* "The Enchantment of Art: Highlights from The Phillips Collection." Garfinckel's, Washington, D.C. June 17–Dec. 24. 40 works. Cat. with introduction by LP.

TPC.1983.6* "Impressionism and the Modern Vision: Master Paintings from The Phillips Collection." Nihonbashi Takashimaya Art Galleries, Tokyo. Aug. 25–Oct. 4. Traveled to Nara Prefectural Museum of Art, Oct. 9–Nov. 13. 90 works. Cat. with foreword by LP and essay by Denys Sutton.

TPC.1983.7* "American Impressionist Paintings from The Phillips Collection." Albany (Ga.) Museum of Art. Sept. 9–Oct. 25. 30 works. Chklst.

TPC.1983.8* "Abstractions from The Phillips Collection." George Mason University, Fairfax, Va. Part 1: Sept. 1, 1983–Aug. 16, 1984; part 2: Oct. 15–Nov. 13, 1984. 20 works in part 1, 18 works in part 2. Cat. with essay by Percy North.

TPC.1983.9* "Selected Works—The Phillips Gallery School." Arts Club of Washington, Washington, D.C. Oct. 22. Organized by TPC for a roundtable discussion held in conjunction with the symposium "Nineteenth-Century Washington: A City-wide Celebration." 9 works. Chklst.

TPC.1983.10* "The Intimate Scale: Paintings from The Phillips Collection." Dimock Gallery, Art Department, George Washington University, Washington, D.C. Nov. 10, 1983–Jan. 6, 1984. 28 works. Cat. with introduction by Willem de Looper and Lenore D. Miller, and essays by Lilien F. Robinson and Arthur Hall Smith.

TPC.1983.11* "Paintings and Drawings from The Phillips Collection." IBM Gallery of Science and Art, New York. Dec. 9, 1983–Jan. 21, 1984. 101 works. Cat. with essay by LP.

1984

TPC.1984.1* "Sources of the Modern Vision: A Selection of French Paintings from The Phillips Collection, Washington, D.C." Dixon Gallery and Gardens, Memphis, Tenn. Jan. 27–Mar. 25. 23 works. Cat. with essay by David Scott.

TPC.1984.2* "Jacob Lawrence: 'The Migration Series' (1940–1941)." Gallery 900, University of the District of Columbia. Feb. 2–29. 30 works. Cat. with introductory statement by LP and essay by Charles A. Young.

TPC.1984.3* "French Masterpieces from The Phillips Collection: Impressionism and Post-Impressionism." J. B. Speed Museum, Louisville, Ky. Feb. 19–Apr. 8. 16 works. Chklst.

TPC.1984.4 "Bonnard: The Late Paintings." June 9–Aug. 25. Traveling exhibition co-organized by TPC, Centre Georges Pompidou, Paris, and the Dallas Museum of Art. 3 venues, Feb. 23–Nov. 11. 61 works (59 in Paris, 57 in Dallas). Cat. with introduction by John Russell and essays by Sasha M. Newman, Steven A. Nash, Jean Clair, Antoine Terrasse, Margrit Hahnloser-Ingold, and Jean-François Chevrier.

TPC.1984.5 "Howard Hodgkin: Forty Paintings 1973–84." Oct. 11–Dec. 16. Traveling exhibition co-organized by TPC and the Whitechapel Art Gallery (London) with the support of the British Council. 4 venues, Oct. 11, 1984–Nov. 3, 1985. 49 works (50 on tour). Cat. with introduction by John McEwen and interview with the artist by David Sylvester.

TPC.1984.6 "Marjorie Phillips Ninetieth Birthday Exhibition: Paintings 1920–1977." Oct. 25–Dec. 30. 15 works. Cat. with essay by Mary E. Martin.

TPC.1984.7 "James McLaughlin Memorial Staff Show." Dec. 8, 1984–Jan. 6, 1985. 42 works. Cat.

Henceforth the annual staff show was renamed in memory of James McLaughlin, the museum's former curator.

1985

TPC.1985.1 "Kimura: Paintings and Works on Paper 1968–1984." Jan. 19–Mar. 10. 63 works. Cat. with foreword by LP, and essays by Denys Sutton and Akihiro Nanjo.

TPC.1985.2 "Appreciations: John Marin." Mar. 30–May 26. 15 works. Cat.

TPC.1985.3 "Miklos Pogany: Paintings and Works on Paper." Mar. 30–May 26. 30 works. Cat. with foreword by Willem de Looper and essay by John Yau.

TPC.1985.4 "Pioneers of American Modernism from The Phillips Collection, Washington, D.C." June 8–Sept. 8. Traveling exhibition organized by TPC. 4 venues, Aug. 26, 1984–Sept. 8, 1985. 40 works. Cat. with essay by Sasha M. Newman.

TPC.1985.5 "Thomas Downing." June 8–Sept. 8. 5 works. Cat.

TPC.1985.6 "Simon Gouverneur." June 8–Sept. 8. 16 works. Cat. with artist's statement.

TPC.1985.7 "Christopher Gardner." June 8–Sept. 8. 2 works. Cat.

TPC.1985.8* "American Impressionist Paintings from The Phillips Collection, Washington, D.C." Arkansas Art Center, Little Rock. Sept. 13–Oct. 25. Traveling exhibition organized by TPC and circulated by the Mid-America Art Alliance. 8 venues, Sept. 13, 1985–Dec. 31, 1986. 50 works. Chklst.

TPC.1985.9 "Susan Rothenberg." Sept. 21–Nov. 17. 16 works. Cat. with foreword by Willem de Looper and essay by Eliza Rathbone.

TPC.1985.10 "Peter Charles." Sept. 28, 1985–Jan. 4, 1986. 2 works (outdoor sculpture installation). Cat. with artist's statement.

TPC.1985.11 "French Drawings from The Phillips Collection." Nov. 23, 1985–Jan. 12, 1986. 47 works. Cat. with essay by Sasha M. Newman.

TPC.1985.12 "James McLaughlin Memorial Staff Show." Dec. 7, 1985–Jan. 19, 1986. 43 works. Cat.

TPC.1985.13 "Lyonel Feininger." Dec. 14, 1985–Feb. 9, 1986. Co-organized by TPC and Acquavella Galleries, New York (Oct. 15–Nov. 20). 49 works. Cat. with foreword by LP, and essays by T. Lux Feininger and Ralph F. Colin.

1986

TPC.1986.1 "James Wolfe." Jan. 25–Apr. 27. 4 works (outdoor sculpture installation). Cat.

TPC.1986.2 "Indian Art Today: Four Artists from the Chester and Davida Herwitz Family Collection." Feb. 22–Apr. 6. 59 works. Cat. with foreword by LP, and essays by Partha Mitter and David A. Herwitz.

TPC.1986.3 "The Canal: Photographs by Robert Cotton." Mar. 15–May 11. 40 works. Cat. with preface by Robert Cotton and notes by Jane Weinberger.

TPC.1986.4* "Modern American Painting from The Phillips Collection." Tucson Museum of Art. Apr. 5–May 25. 42 works. Chklst.

TPC.1986.5 "American Watercolors from The Permanent Collection." Apr. 12–May 25. 20 works. Cat.

TPC.1986.6 "Ralston Crawford." Apr. 19–May 25. Traveling exhibition organized by the Whitney. 4 venues, Oct. 3, 1985–Nov. 2, 1986. 155 works. Cat. with essay by Barbara Haskell.

TPC.1986.7 "Duncan Phillips: Centennial Exhibition." June 14–Aug. 31. 207 works. Cat. with foreword by LP, introduction by Eliza E. Rathbone, essay by Law B. Watkins, and chronology by Erika Passantino and Sarah Martin.

TPC.1986.8 "Elmer Bischoff 1947–1985." Sept. 20–Nov. 2. Traveling exhibition organized by the Laguna Art Museum, Laguna Beach, Calif. 4 venues, Dec. 5, 1985–Jan. 4, 1987. 49 works (51 in tour). Cat. with essays by Robert M. Frash and Jan Butterfield.

TPC 1986.9 "Emile Zola and the Art of His Time." Oct. 4–Nov. 9. 37 works. Cat. with introduction by Alison Hilton.

TPC.1986.10* "The Abstractions of Augustus Vincent Tack." Knoedler Galleries, New York. Nov. 5–Dec. 4. 15 works. Cat. with essay by Robert Rosenblum.

TPC.1986.11 "The Prints of the Pont-Aven School: Gauguin and His Circle in Brittany." Nov. 22, 1986–Jan. 4, 1987. Traveling exhibition organized by SITES. 11 venues, Sept. 4, 1986–June [?], 1989. 77 works. Cat. with essay by Caroline Boyle-Turner.

TPC.1986.12 "James McLaughlin Memorial Staff Show." Dec. 13, 1986–Jan. 11, 1987. 50 works. Cat.

1987

TPC.1987.1 "Leland Bell." Jan. 24–Mar. 15. 41 works. Cat. with introduction by Nicholas Fox Weber.

TPC.1987.2* "Masterpieces from the Phillips Collection." Palm Springs Desert Museum, Palm Springs, Calif. Mar. 21–May 17. Traveling exhibition organized by TPC. 2 venues, Mar. 21–Aug. 30. 50 works. Chklst.

TPC.1987.3 "Jacob Lawrence: American Painter." Apr. 4–May 31. Traveling exhibition organized by Seattle Art Museum. 6 venues, July 10, 1986–Dec. 1, 1987. 137 works (147 in tour). Cat. with essays by Ellen Harkins Wheat and Patricia Hills.

TPC.1987.4 "John Van Alstine." May 16–June 28. 3 works (outdoor sculpture installation). Cat. with introduction by Linda Johnson.

TPC.1987.5* "American Masters: Landscape Paintings from The Phillips Collection." Guild Hall Museum, East Hampton, N.Y. May 25–June 28. 20 works. Cat. with essay by Judith B. Sneddon.

TPC.1987.6 "After Matisse." June 20–Aug. 16. Traveling exhibition organized by Independent Curators, Incorporated (New York). 7 venues, Mar. 30, 1986–Feb. 7, 1988. 42 works. Cat. with essays by Tiffany Bell, Dore Ashton, and Irving Sandler.

TPC.1987.7* "Old Masters—New Visions: El Greco to Rothko from The Phillips Collection, Washington, D.C." Australian National Gallery, Canberra. Oct. 3–Dec. 6. Traveling exhibition organized by TPC. 3 venues, Oct. 3, 1987–May 1, 1988. 71 works. Cat. with foreword by LP and introduction by James Mollison, Betty Churcher, and Daniel Thomas.

TPC.1987.8 "Bill Jensen." Oct. 24–Dec. 13. Traveling exhibition organized by TPC. 2 venues, Oct. 24, 1987–Mar. 9, 1988. 29 works. Cat. with foreword by LP and essay by Eliza E. Rathbone.

TPC.1987.9* "From The Phillips Collection: A Selection of Recent Acquisitions." George Mason University, Fairfax, Va. Nov. 23–Dec. 20. 11 works. Chklst.

TPC.1987.10* "The James McLaughlin Memorial Staff Show: Artists Working at The Phillips Collection." Susan Conway Carroll Gallery, Washington, D.C. Dec. 16, 1987–Jan. 3, 1988. 46 works. Cat.

1988

TPC.1988.1 "Lee Gatch." Jan. 23–Mar. 27. 26 works. Cat. with essay by Eliza Rathbone.

TPC.1988.2 "Guillermo Roux." Feb. 6–Apr. 3. 50 works. Cat. with essays by Willem de Looper and Rafael Squirru.

TPC.1988.3 "Odilon Redon: Masterpieces from the Woodner Collection." Apr. 16–June 26. 70 works. Cat. with essay by Lawrence Gowing.

TPC.1988.4* "Master Paintings From the Phillips Collection, Washington." Hayward Gallery, London. May 19–Aug. 14. 92 works. Cat. with foreword by Joanna Drew and Catherine Lampert, preface by LP, and essay by Lawrence Gowing.

TPC.1988.5 "John Graham: Artist and Avatar." July 9–Sept. 4. Traveling exhibition organized by TPC. 5 venues, June 25, 1987–Sept. 4, 1988. 85 works. Cat. with essay by Eleanor Green.

TPC.1988.6* "American Modernism." Parrish Art Museum, Southampton, N.Y. July 16–Sept. 11, 1988. Traveling exhibition organized by TPC. 2 venues, July 16–Nov. 26. 50 works. Chklst.

TPC.1988.7* "Master Paintings from The Phillips Collection, Washington." Schirn Kunsthalle, Frankfurt. Aug. 27–Nov. 6. 92 works. Cat. with preface by Christoph Vitali, foreword by LP, and essay by Lawrence Gowing.

TPC.1988.8 "Prints: Washington." Sept. 17–Oct. 23. Jointly organized and cosponsored by TPC and the Washington Print Club. 57 works. Cat. with introduction by Willem de Looper and essays by Jack Vanderryn, Alan Fern, and Michael Mazur.

TPC.1988.9 "Places of Delight: The Pastoral Landscape." Nov. 6, 1988–Jan. 22, 1989. Organized by TPC in association with NGA and jointly exhibited in two parts. 136 works. Cat. with essays by Robert C. Cafritz, David Rosand, and Lawrence Gowing.

TPC.1988.10* "Master Paintings from The Phillips Collection, Washington." Centro de Arte Reina Sofía, Madrid. Nov. 30, 1988–Feb. 16, 1989. 93 works. Cat. with introduction by Juan Miguel Hernández León, preface by LP, and essays by Lawrence Gowing and Julián Gallego.

TPC.1988.11* "Augustus Vincent Tack: Eighteen Abstractions." Cheekwood Fine Arts Center, Nashville, Tenn. Dec. 3, 1988–Jan. 22, 1989. 19 works. Chklst.

TPC.1988.12 "The Phillips Collection: James McLaughlin Memorial Staff Show." Susan Conway Carroll Gallery, Washington, D.C. Dec. 6, 1988–Jan. 7, 1989. 49 works. Cat.

1989

TPC.1989.1* "American Modernism." Art Museum of South Texas, Corpus Christi. Jan. 12–Feb. 12. Traveling exhibition organized by TPC. 6 venues, Jan. 12, 1989–Nov. 4, 1990. 50 works. Cat. with essay by Linda L. Johnson.

TPC.1989.2 "Victor Pasmore." Feb. 4–Apr. 2. Traveling exhibition organized by the Yale Center for British Art, New Haven, Conn. 2 venues, Nov. 16, 1988–Apr. 2, 1989. 57 works. Cat. with essay by Lawrence Gowing.

TPC.1989.3 "The Return of the Master Paintings." Apr. 22–Aug. 27. 120 works. Hanging records.

TPC.1989.4 "John McCarty." Sept. 23–Dec. 3. 3 works (outdoor sculpture installation). Cat.

TPC.1989.5 "The Drawings of Richard Diebenkorn." Sept. 30–Dec. 3. Traveling exhibition organized by MOMA. 4 venues, Nov. 17, 1988–Dec. 3, 1989. 138 works (186 works in tour). Cat. with essay by John Elderfield.

TPC.1989.6 "James McLaughlin Memorial Staff Show." Dec. 9, 1989–Jan. 7, 1990. 42 works. Cat.

TPC.1989.7 "Howard Ben Tré: Contemporary Sculpture." Dec. 16, 1989–Feb. 25, 1990. Traveling exhibition organized by TPC. 4 venues, Dec. 16, 1989–Jan. 27, 1991. 33 works. Cat. with foreword by LP, introduction by Willem de Looper, and essay by Linda L. Johnson.

TPC.1989.8 "Contemporary Painting: William Willis." Dec. 16, 1989–Feb. 25, 1990. 28 works. Cat. with foreword by LP, introduction by Willem de Looper, and essay by Linda L. Johnson.

1990

TPC.1990.1 "Picasso and Gris: Loans from the Carey Walker Foundation." Jan. 20–May 6. 11 works. Cat. with text by Elizabeth Turner.

TPC.1990.2 "The Intimate Interiors of Edouard Vuillard." Feb. 17–Apr. 29. Traveling exhibition organized by the Museum of Fine Arts, Houston. 3 venues, Nov. 18, 1989–July 30, 1990. 63 works. Cat. with essay by Elizabeth Wynne Easton.

TPC.1990.3 "Dorothy Dehner." Mar. 10–May 20. 26 works. Cat. with introduction by Willem de Looper.

TPC.1990.4 "John Cage: New River Watercolors." Apr. 14–May 20. 30 works. Cat. with essays by Elizabeth Hutton Turner, John Cage, Marilyn Boyd DeReggi, and Scott Burg.

TPC.1990.5 "Steven Bickley." June 2–Aug. 26. 3 works (outdoor sculpture installation). Cat. with essay by Elizabeth Chew.

TPC.1990.6 "Nicolas de Staël in America." June 9–Sept. 9. Traveling exhibition organized by TPC. 2 venues, June 9–Dec. 31. 91 works. Cat. with essays by Eliza E. Rathbone, Nicholas Fox Weber, and John Richardson.

TPC.1990.7 "Men of the Rebellion: The Eight and Their Associates at The Phillips Collection." Sept. 22–Nov. 4. Traveling exhibition organized by TPC. 9 venues, Sept. 22, 1990–Jan. 23, 1994. 66 works. Cat. with essay by Elizabeth Hutton Turner.

TPC.1990.8 "John Ferguson." Sept. 22, 1990–Jan. 6, 1991. 3 works (outdoor sculpture installation). Cat. with artist's statement.

TPC.1990.9 "Eternal Metaphors: New Art from Italy." Nov. 17, 1990–Jan. 6, 1991. Traveling exhibition organized and circulated by Independent Curators, Incorporated (New York). 10 venues, Nov. 23, 1989–Jan. 12, 1992. 24 works. Cat. with essays by Alessandra Mammì and Susan Sollins.

TPC.1990.10 "James McLaughlin Memorial Staff Show." Dec. 15, 1990–Jan. 14, 1991. 49 works. Cat.

1991

TPC.1991.1 "Elsie Driggs: A Woman of Genius." Jan. 26–Mar. 17. Traveling exhibition organized by the New Jersey State Museum, Trenton. 2 venues, Oct. 13, 1990–Mar. 17, 1991. 59 works. Cat. with essay by Thomas C. Folk and artist's statement.

TPC.1991.2 "Dimitri Hadzi." Jan. 26–May 5. 4 works. Cat.

TPC.1991.3 "Cubism and La Section d'Or: Works on Paper and Related Paintings 1907–1922." Mar. 9–Apr. 28. Traveling exhibition organized by R. Stanley Johnson, private collector and free-lance curator. 3 venues, Mar. 9–Nov. 17, 1991. 67 works. Cat. with essay by R. Stanley Johnson.

TPC.1991.4 "Maurice Brazil Prendergast: A Retrospective Exhibition." May 18–Aug. 25. Traveling exhibition organized by Williams College Museum of Art, Williamstown, Mass. 4 venues, May 31, 1990–Aug. 25, 1991. 129 works. Cat. with essays by Nancy Mowll Mathers.

TPC.1991.5 "Peter Stevens." May 24–Sept. 22. 7 works. Cat., interview with the artist.

TPC.1991.6 "Duncan Phillips Collects: Paris between the Wars." Sept. 14, 1991–Jan. 12, 1992. Traveling exhibition organized by TPC. 5 venues, Sept. 14, 1991–Jan. 16, 1994. 49 works. Cat. with essay by Elizabeth Hutton Turner.

TPC.1991.7 "Outdoor Sculpture: Jene Highstein." Sept. 28–Feb. 2, 1992. 6 works. Cat.

TPC.1991.8* "The Aftermath of Impressionism: Selected Works from The Phillips Collection." Michael C. Carlos Museum, Emory University, Atlanta. Nov. 13–Feb. 9, 1992. 25 works. Cat. with directors' preface, foreword by Marc J. Gotlieb, and essays by Margaret Duval Shufeldt and Catherine M. Chastain.

TPC.1991.9 "James McLaughlin Memorial Staff Show." Dec. 14–Jan. 12, 1992. 52 works. Cat.

TPC.1991.10 "Works on Paper: Daumier Prints." Dec. 17–Mar. 22, 1992. 26 works. Chklst.

1992

TPC.1992.1 "Richard Pousette-Dart." Feb. 1–Apr. 26. Traveling exhibition organized by the Indianapolis Museum of Art. 4 venues, Oct. 14, 1990–Apr. 26, 1992. 65 works. Cat. with essays by Robert Hobbs and Joanne Kuebler.

TPC.1992.2 "Christopher Gardner, John McCarty, and Steven Bickley." Feb. 8–May 31. 3 works. Chklst.

TPC.1992.3 "Helene Schjerfbeck: Finland's Modernist Rediscovered." May 16–Aug. 30. Traveling exhibition organized by the Finnish National Gallery Ateneum. 2 venues, May 16, 1992–Jan. 10, 1993. 71 works. Cat. with introduction by Soili Sinisalo and essays by Salme Sarajas-Korte, Riitta Konttinen, Lena Holger, Leena Ahtola-Moorhouse, Helmiriitta, and Berndt Arell.

TPC.1992.4 "Outdoor Sculpture: Lisa Scheer." June 6–Sept. 27. 1 work. Cat.

TPC.1992.5 "Theme and Improvisation: Kandinsky and the American Avant-Garde, 1912–1950." Sept. 19–Nov. 29. Traveling exhibition organized by the Dayton (Ohio) Art Institute. 4 venues, Sept 19, 1992–Aug. 1, 1993. 85 works. Cat. with essays by Gail Levin and Marianne Lorenz.

TPC.1992.6a–c "Dialogue With Nature: Nine Contemporary Sculptors." An exhibition in 3 parts: Oct. 10, 1992–Feb. 7, 1993; Feb. 27–June 6, 1993; and June 19–Oct. 10, 1993. 23 works. Cat. with essay by Linda L. Johnson.

TPC.1992.7 "Two Lives: Georgia O'Keeffe and Alfred Stieglitz, A Conversation in Paintings and Photographs." Dec. 12, 1992–Apr. 11, 1993. Traveling exhibition organized by TPC. 4 venues, Dec. 12, 1992–Dec. 5, 1993. 97 works (110 in tour). Cat. with essays by Elizabeth Hutton Turner, Belinda Rathbone, and Roger Shattuck; and chronology by Elizabeth Chew.

TPC.1992.8 "James McLaughlin Memorial Staff Show." Collector Art Gallery and Restaurant. Dec. 16, 1992–Jan. 13, 1993. 44 works. Cat.

1993

TPC.1993.1 "Augustus Vincent Tack: Landscape of the Spirit." May 22–Aug. 22. Traveling exhibition organized by TPC. 8 venues, May 22, 1993–Oct. 22, 1995. 56 works. Cat. with preface by Eliza E. Rathbone; essays by Leslie Furth, Elizabeth V. Chew, and David W. Scott; chronology by Furth and Vivien Greene; and technical notes by Elizabeth Steele.

TPC.1993.2 "Jacob Lawrence: The Migration Series." Sept. 23, 1993–Jan. 9, 1994. Traveling exhibition organized by TPC. 9 venues, Sept. 23, 1993–Nov. 26, 1995. 60 works. Cat. with introduction by Elizabeth Hutton Turner; essays by Henry Louis Gates Jr., Lonnie G. Bunch III and Spencer R. Crew, Deborah Willis, Jeffrey C. Stewart, Diane Tepfer, Patricia Hills, and Elizabeth Steele and Susana M. Halpine; and chronology by Stephen Bennett Phillips.

TPC.1993.3 "James McLaughlin Memorial Staff Show." Dec. 4, 1993–Jan. 3, 1994. 41 works. Cat.

1994

TPC.1994.1 "Brancusi: Photographs and Sculpture." Jan. 29–Apr. 17. Traveling exhibition of photographs organized by Sidra Stich. 8 venues, Oct. 2, 1991–Apr. 17, 1994. 82 photographs (7 sculptures added for TPC venue). Cat. entitled *Brancusi: Photo Reflection* with essay by Friedrich Teja Bach.

TPC.1994.2 "The Studio of Henri Matisse." Jan. 29–Apr. 17. 2 works. Focus exhibition with *The Painter in His Studio*, winter 1916–17; Musée National d'Art Moderne, Centre Georges Pompidou, Paris.

TPC.1994.3 "Marjorie Phillips: A Centennial Celebration." Mar. 8–Nov. 13. 17 works. Chklst.

TPC.1994.4 "The Drawings of Stuart Davis: The Amazing Continuity." May 7–Aug. 28. Exhibition organized by Karen Wilkin and circulated by AFA. 7 venues, Dec. 12, 1992–Aug. 28, 1994. 91 works (5 paintings in collection added to TPC venue only). Cat. with essays by Karen Wilkin and Lewis Kachur.

TPC.1994.5 "Adolph Gottlieb Pictographs." Sept. 24, 1994–Jan. 2, 1995. Exhibition organized by Sanford Hirsch for the Adolph and Esther Gottlieb Foundation. 4 venues, Sept. 24, 1994–Jan. 28, 1996. 69 works. Cat. with essays by Sanford Hirsch, Evan Maurer, Lawrence Alloway, Linda Konheim Kramer, and Charlotta Kotik.

TPC.1994.6 "American Modernist Photography: Works from Washington Collections." Nov. 15, 1994–Mar. 26, 1995. 25 works. Chklst.

TPC.1994.7 "James McLaughlin Memorial Staff Show." Dec. 8–29. 32 works. Chklst.

1995

TPC.1995.1 "The William S. Paley Collection." Jan. 21–Mar. 26. Exhibition organized by MOMA. Cat. with foreword by Richard E. Oldenburg, preface by William Rubin, and catalogue entries by Rubin and Matthew Armstrong.

TPC.1995.2 "British Art from the Permanent Collection." Mar. 21–June 4. 20 works. Chklst.

TPC.1995.3 "Dorothea Lange, American Photographs." May 20–Aug. 27. Exhibition organized by the San Francisco Museum of Art. 6 venues, May 19, 1994–Mar. 3, 1996. 154 works. Cat. with preface by John R. Lane and essays by Sandra S. Phillips, John Szarkowski, and Therese Thau Heyman.

TPC.1995.4 "Esther Bubley." June 6–Oct. 1. 25 works. Publ. chklst.

TPC.1995.5 "In the American Grain: Arthur Dove, Marsden Hartley, John Marin, Georgia O'Keeffe, and Alfred Stieglitz." Sept. 23–Dec. 31. Traveling exhibition organized by TPC. 7 venues, Sept. 23, 1995–Apr. 27, 1997. 91 works. Cat. with essay by Elizabeth Hutton Turner, chronology by Leigh Bullard Weisblat, and correspondence selected and edited by Turner and Weisblat.

TPC.1995.6 "Willem de Looper: Sketchbooks and Works on Paper." Oct. 3, 1995–Feb. 4, 1996. 28 works. Publ. chklst. by Katherine Rothkopf.

TPC.1995.7 "James McLaughlin Memorial Staff Show." Dec. 15, 1995–Jan. 7, 1996. 38 works. Chklst.

1996

TPC.1996.1 "Weston's Westons: California and the West." Jan. 20–Mar. 31. Traveling exhibition organized by MFA, Boston. 3 venues, July 22, 1994–Mar. 31, 1996. 139 works. Cat. with foreword by Charis Wilson, introduction by Theodore E. Stebbins Jr., and essay by Karen E. Quinn.

TPC.1996.2 "Elena Prentice: The Waterworks Series." Feb. 6–June 2. 24 works. Published chklst. by Charles S. Moffett.

TPC.1996.3 "Americans in Paris: Man Ray, Gerald Murphy, Stuart Davis, Alexander Calder (1921–1931)." Apr. 27–Aug. 18. Organized by TPC on occasion of museum's seventy-fifth anniversary. 112 works. Cat. with essays by Elizabeth Hutton Turner, Elizabeth Garrity Ellis, and Guy Davenport; and chronology by Leigh Bullard Weisblat.

TPC.1996.4 "Jake Berthot: Drawing into Painting." June 4–Oct. 6. 24 works. Cat. with text by Eliza E. Rathbone.

TPC.1996.5 "Impressionists on the Seine: A Celebration of Renoir's 'Luncheon of the Boating Party.'" Sept. 21–Feb. 9. Organized by TPC on occasion of the museum's seventy-fifth anniversary. 60 works. Cat. with essays by Eliza E. Rathbone, Katherine Rothkopf, Richard Brettell, and Charles S. Moffett; the painting's history and conservation by Rathbone and Elizabeth Steele; and artist biographies by Lisa Portnoy Stein.

TPC.1996.6 "James McLaughlin Memorial Staff Show." Dec. 7–29. Held at Addison/Ripley Gallery. 61 works. Chklst.

1997

TPC.1997.1 "Spirits of the South: Selections from the Julia J. Norrell Collection." Feb. 18–June 15. 28 works. Publ. chklst. by Elizabeth Hutton Turner.

TPC.1997.2 "Pastels by Joan Mitchell." Mar. 8–June 22. 11 works. Chklst.

TPC.1997.3 "William Christenberry: The Early Years and Beyond." Mar. 22–May 25. 60 works. Book accompanying exhibition entitled *William Christenberry: The Early Years* by Richard Gruber.

TPC.1997.4 "Twentieth-Century Still-life Painting from The Phillips Collection." June 14–Aug. 31. Traveling exhibition organized by TPC. 10 venues, June 14, 1997–Nov. 17, 1999. 81 works. Cat. with essay by Stephen B. Phillips.

TPC.1997.5 "Mary Ellen Doyle: Works on Paper." June 15–Oct. 5. 20 works. Cat. with text by Charles S. Moffett.

TPC.1997.6 "Arthur Dove: A Retrospective Exhibition." Sept. 20, 1997–Jan. 4, 1998. Traveling exhibition co-organized by TPC and Addison Gallery of American Art. 4 venues, Sept. 20, 1997–Oct. 4, 1998. 79 works. Cat. with essays by Elizabeth Hutton Turner, Debra Bricker Balken, and William C. Agee.

TPC.1997.7 "Arthur Dove: Works on Paper." Oct. 7, 1997–Jan. 7, 1998. 33 works. Publ. chklst. by Elizabeth Hutton Turner.

TPC.1997.8 "James McLaughlin Staff Show." Dec. 12, 1997–Jan. 4, 1998. 37 works. Chklst.

1998

TPC.1998.1 "'The Breathing of Moments': Alfred Stieglitz at The Phillips Collection." Jan. 10–Apr. 5. 31 works. Publ. chklst. by Elizabeth Hutton Turner.

TPC.1998.2 "Consuelo Kanaga: An American Photographer." Jan. 24–Apr. 5. Traveling exhibition organized by the Brooklyn Museum. 5 venues, Jan. 23, 1998–Apr. 18, 1999. 103 works. Cat. with introduction by William Maxwell, afterword by Grace M. Mayer, essay by Barbara Head Millstein, catalogue text by Millstein and Sarah M. Lowe, and chronology by Lowe.

TPC.1998.3 "A Calder Centennial at The Phillips Collection [Part I]." Mar. 28, 1998–Jan. 23 1999. 2 works. Publ. chklst. by Elizabeth Hutton Turner.

TPC.1998.4 "The Art of Richard Diebenkorn." May 9–Aug. 16. Traveling exhibition organized by Jane Livingston for Whitney and TPC. 4 venues, Oct. 9, 1997–Jan. 19, 1999. 156 works. Cat. with essays by Jane Livingston, John Elderfield, and Ruth E. Fine.

TPC.1998.5 "Impressionists in Winter: *Effets de Neige.*" Sept. 19, 1998–Jan. 3, 1999. Traveling exhibition organized by TPC. 3 venues, Sept. 19, 1998–May 2, 1999. 63 works. Cat. with essays by Eliza E. Rathbone, Katherine Rothkopf, and Joel Isaacson; catalogue entries by Rathbone, Rothkopf, and Lisa Portnoy Stein; and weather chronology compiled by Rathbone and translated by Stein.

TPC.1998.6 "Whistler in Venice: Twenty Etchings from the Collection of C. Boyden Gray." Sept. 19, 1998–Jan. 6, 1999. 20 works. Publ. chklst. by Eliza E. Rathbone.

1999

TPC.1999.1 "Photographs from the Collection of Dr. and Mrs. Joseph Lichtenberg." Jan. 12–Apr. 25, 1999. 26 works. Publ. chklst. by Elizabeth Hutton Turner.

TPC.1999.2 "An American Century of Photography, from Dry-plate to Digital: Selections from the Hallmark Photographic Collection." Jan. 23–Mar. 28, 1999. Traveling exhibition organized by Hallmark Cards, Inc. 204 works. Cat. by Keith S. Davis, foreword by Donald J. Hall.

TPC.1999.3 "'An Adventurous Spirit': Calder at The Phillips Collection [Part II]." Jan. 23–June 8, 1999. 15 works. Cat. with essay by Elizabeth Hutton Turner, chronology by Elsa Mezvinsky Smithgall.

TPC.1999.4 "James McLaughlin Memorial Staff Show." Feb. 11–Mar. 14. 53 works. Publ. chklst.

TPC.1999.5 "Georgia O'Keeffe: The Poetry of Things." Apr. 17–July 18, 1999. Traveling exhibition organized by TPC. 4 venues, Apr. 17–May 14, 2000. 67 works. Cat. with essays by Elizabeth Hutton Turner and Marjorie B. Crozier, chronology by Elsa Mezvinsky Smithgall.

TPC.1999.6 "Judith Rothschild: An Artist's Search." May 15–Aug. 15, 1999. Traveling exhibition organized by Jack Flam for the Metropolitan Museum of Art. 31 works. Cat. with introduction and essay by Flam.

TPC.1999.7 "From Renoir to Rothko: The Eye of Duncan Phillips." Sept. 25, 1999–Jan. 23, 2000. Approx. 275 works. Exhibition organized to conincide with publication of TPC collection history and selective catalogue entitled *The Eye of Duncan Phillips: A Collection in the Making*, Erika D. Passantino, ed.

1905
"At the Opposite Ends of Art." *Yale Literary Magazine* 70 (June): 339–41.

1906
"Two Men." *Yale Literary Magazine* 71 (Feb.): 181–87.
"The People's Jester." *Yale Literary Magazine* 71 (May): 308–13.
"Corot." *Yale Literary Magazine* 72 (Nov.): 54–58.

1907
"'As if to Breathe Were Life—.'" *Yale Courant* 43 (Feb.): 354–59.
"Marie Bashirtseff." *Yale Literary Magazine* 72 (Feb.): 188–92.
"Portfolio: A Modern Wit and Sage." *Yale Literary Magazine* 72 (Feb.): 203–5.
 (Profile of Gilbert Chesterton.)
"Mona Lisa." *Yale Courant* 43 (Apr.): 563–66.
"The Need of Art at Yale." *Yale Literary Magazine* 72 (June): 355–61.
"The Problem of Art in Japan." *Yale Literary Magazine* 73 (Dec.): 94–99.

1908
"The Nature and Expression of Sentiment." *Yale Literary Magazine* 73 (Mar.): 244–52.
"Portfolio: In Austin-Dobson-Land." *Yale Literary Magazine* 73 (Mar.): 277–78.
"Portfolio: Meissonier's Napoleonic Cycle." *Yale Literary Magazine* 73 (May): 377–79.

1909
"First Love." Poem. *Forum* 41 (Apr.): 379.

1910
Unpublished Writings
"Impressionism." Outline for proposed publication. Formerly part of MS 97.
"Impressionism in Poetry and Painting." Essay. 1910–11. Formerly MS 155.

1912
"The Impressionistic Point of View." *Art and Progress* 3 (Mar.): 505–11.
"What Is Impressionism?" *Art and Progress* 3 (Sept.): 702–7.
"Sorolla, the Painter of Sunlight." *Art and Progress* 4 (Dec.): 791–97.

1913
"The Field of Art: The City in Painting and Etching." *Scribner's Magazine* 53 (Feb.):
 265–68.
"Modern Pictures in Venice." *Art and Progress* 4 (May): 953–58.
"Giorgione: The First Modern Master." *Yale Review* 2 (July): 667–80.
"Titian's Bacchanals." *Art and Progress* 5 (Nov.): 26–29.
"Revolutions and Reactions in Painting." *International Studio* 51 (Dec.): 123–29.

Unpublished Writings
[Notes on Lecture and Article]. Lecture: George Fillmore Swain, "Tendencies and
 Problems of the Present Day," presented at the convention of Civil Engineers,
 Ottawa. (Swain was president of the American Society of Civil Engineers.)
 Article: Jeremiah Jenks, "Who Earns the Money?" *Caxton* (Oct. 1913).
[Notes on Clive Bell, *Art*, New York, 1913]. Written in the book's margin between
 1913 and 1917. Formerly MS 147.

1914
E of A, 1914: *The Enchantment of Art as Part of the Enchantment of Experience*. New
 York. One draft for "Decorative Painting" formerly MS 120. (Includes some
 revisions of previously published essays.)
"A Collection of Modern Graphic Art." *Art and Progress* 5 (Feb.): 129–30. (Survey of
 Albert E. Gallatin's collection.)
[Book Review]. *The Pathos of Distance* by James Huneker. *Yale Review* 3 (Apr.): 594–96.
"Duncan Clinch Phillips, Jr." *History of the Class of 1908: Yale College*, vol. 2, edited
 by Walter G. Davis Jr., 234–35. New Haven.

Unpublished Writings
"The Fear of Seeming Afraid." Essay. Dec.
"Representative American Painters of the New Century." Introductory statement
 for book proposal. Between 1914 and 1920. Formerly MS 80.

"George Bellows." Essay. Between 1914 and 1921. Formerly MS 3.

1915
[Book Review]. *Luca Della Robbia* by Allan Marquand. *Yale Review* 4 (July): 857–59.

Unpublished Writings
"Bohemia—A State of Mind." Essay. Formerly MS 69.
"Rhythm and the Arts." Essay. Formerly MS 74.
"Makers of Memories." Story. Formerly MS 66.

1916
"The Romance of a Painter's Mind." *International Studio* 58 (Mar.): 19–24.
"Albert Ryder." *American Magazine of Art* 7 (Aug.): 387–91.
"The American Painter, Arthur B. Davies." *Art and Archaeology* 4 (Sept.): 169–77.
 File includes rough outline, formerly MS 20.
"William M. Chase." *American Magazine of Art* 8 (Dec.): 45–50.

Unpublished Writings
"Preface." Essay for proposed publication. Formerly MS 86.
"Arthur B. Davies." Essays. 4 versions. 1916–24. Formerly MSS 19, 21, 119, and 177.

1917
"George Moore." *Yale Review* 6 (Jan.): 342–57. File contains earlier, longer draft,
 formerly MS 154.
"Charles W. Hawthorne." *International Studio* 61 (Mar.): 19–24.
"What Instruction in Art Should the College A. B. Course Offer to the Future
 Writer on Art?" *American Magazine of Art* 8 (Mar.): 177–82. (Paper presented at
 the Fifth Annual Meeting of the College Art Association, Philadelphia, Univer-
 sity of Pennsylvania, Apr. 21, 1916.)
"J. Alden Weir." *American Magazine of Art* 8 (Apr.): 213–20.
"Ernest Lawson." *American Magazine of Art* 8 (May): 257–63. File contains two
 drafts for this article formerly MSS 35 and 132.
"Emil Carlsen." *International Studio* 61 (June): 105–10.
"Jerome Myers." *American Magazine of Art* 8 (Oct.): 481–85.
"Fallacies of the New Dogmatism in Art." *American Magazine of Art* 9 (pt. 1, Dec.
 1917, 43–48, (pt. 2, Jan. 1918), 101–6. Formerly MSS 75 and 76. (Paper presented
 at the 8th Annual Convention of the AFA, Washington, D.C., May 16–18; some
 versions are entitled "Modern Art" and "The New Dogmas of the Studios.")

Unpublished Writings
[Appeal for Entries]. Draft for an announcement to artists and illustrators calling
 for war pictures to be published in *Red Cross Magazine*. Nov. 23.
[Book Review]. *Whistler* by Theodore Duret. Ca. 1917.

1918
"Art and the War." *American Magazine of Art* 9 (June): 303–9. (Paper presented to
 the CAA at the Metropolitan Museum of Art, New York, Mar. 28.)
"Dwight Tryon." *American Magazine of Art* 9 (Aug.): 391–92.
"The Heroic Soul of France: Lucien Jonas' War Lithographs." *American Magazine of
 Art* 9 (Oct.): 497–503.

Unpublished Writings
"An Open Letter to American Painters." Announcement of the Allied War Salon.
"Art and the War." Text for slide lecture. (Presented to the War Work Committee of
 the AFA.)
"Permanent Hanging of Paintings." Unpubl. handwritten sheet of notes. By 1918.
 (Installation plan for private residence.)

1919
"Foreword." *Loan Exhibition of Paintings by Emil Carlsen, N.S.* Exh. cat. New York:
 Macbeth Gallery. Dec. (Reprint of "Emil Carlsen," 1917.)
"Twachtman—An Appreciation." *International Studio* 66 (Feb.): 106–7. One draft
 formerly MS 53.
"The Allied War Salon." *American Magazine of Art* 10 (Feb.): 115–23.
"A Resolution." *International Studio* 66 (Feb.): 118.

"The Official British War Pictures." *American Magazine of Art* 10 (Mar.): 155–67.

Unpublished Writings

"Albert P. Ryder." Essay. Ca. 1919. Formerly MS 50.
"J. Alden Weir." Essay. 1919–24. Formerly MS 61.
"Essays in a Time of Stress and Change." List. Ca. 1919. Formerly part of MS 97.
"List of Essays." Ca. 1919. Formerly part of MS 97.

1920

"J. Alden Weir." *Art Bulletin* 2 (June): 189–212. (Also presented to the CAA at the Cleveland Museum of Art, Apr. 1–3.)

Unpublished Writings

"Introduction to Le Sidaner-Tack Exhibition." Essay. 1920. Formerly MS 85. (Possibly intended for a catalogue of the exhibition at Kraushaar Galleries, New York.)
"15 Best Purchases of 1918–19; 15 Best Purchases Since Jan. 1920." Acquisitions list.
[Letter to Charles D. Hilles]. Oct. 18. (Hilles was president of the League of Republican Clubs.)
H of A, 1920–21: "The Herald of Art." Publication proposal. 1920–21. (Includes four drafts of the museum's holdings; subsequently published in *Inv.*, 1921.)
"Gifford Beal." Essay. Early 1920s. Formerly MS 2.

1921

Inv., 1921: *Extracts from the Minutes of First Annual Meeting of Trustees of Phillips Memorial Art Gallery*. Washington, D.C.: PMAG. (Published after July 29, 1921.)

Unpublished Writings

"To the Committee on Scope and Plan of the Phillips Memorial Art Gallery." Report. After Dec. 12. (Based on Phillips's presentation to the Dec. 12 meeting of the committee at the Coffee House Club, New York; includes condensed text of "Herald of Art," publication proposal.)
"Arthur B. Davies." Essay. 1921–22. Formerly MS 18.
[Notes on Works in Exhibition]. Written in the margin of *Art Exhibition*, exh. cat., Chappaqua, New York. (Neither the date of the sales exhibition nor the sponsoring institution is cited.)

1922

"Julian Alden Weir." In *Julian Alden Weir: An Appreciation of His Life and Works*, 3–47. Phillips Publication No. 1. New York. Previously published by J. B. Millet, ed., *Julian Alden Weir: An Appreciation of His Life and Works*, New York, Century Association, 1921. (Includes essays by Emil Carlsen, Royal Cortissoz, Childe Hassam, F. B. Millet, H. de Raasloff, Augustus Vincent Tack, and C. E. S. Wood.) Drafts formerly MS 151.
Julian Alden Weir: An Essay by Duncan Phillips. Greenwich, Conn. (Revision of "Julian Alden Weir," 1922.)
"Honoré Daumier." In *Honoré Daumier: Appreciation of his Life and Works*, 13–35. The Phillips Publication No. 2. New York. (Includes essays by Frank Jewett Mather Jr., Guy Pène du Bois, and Mahonri Young.)

Unpublished Writings

"Agenda for the Conference at 550 Park Avenue." For the Feb. 20 conference of the Committee on Scope and Plan. New York. (Meeting held at Mrs. Carlisle's residence in New York.)
"Second Exhibition of the Phillips Memorial Art Gallery." Draft for unpublished exh. cat. for PMAG.1922.2.

1923

Unpublished Writings

"Lecture on Davies." Formerly MS 17. (Presented at the Fogg Art Museum, Harvard University, Cambridge, Mass. Apr. 7. Longer version of this lecture given Apr. 30 at unknown location.)
"Purposes of the PMG." Essay. Ca. 1923.
"Arthur B. Davies." Essay. Ca. 1923. Formerly MS 22. (Text similar to that in *C in M*, 1926.)
"The Phillips Publications." Essay. 1923–24. Formerly part of MS 97.
"*Renoir* by Albert André." Translation. 1923–25. Formerly MS 81.

1924

"Foreword" and "Arthur B. Davies: Designer of Dreams." In *Arthur B. Davies: Essays on the Man and His Art*, vii–ix and 3–22. Phillips Publication No. 3. Washington, D.C. (Includes Phillips's revision of his 1923 "Lecture on Davies,"

as well as essays by Dwight Williams, Royal Cortissoz, Frank Jewett Mather Jr., Gustavus A. Eisen, and Edward Root.)
Exhibition of Recent Decorative Paintings by Augustus Vincent Tack. Exh. cat. for PMG.1924.1.
"Childe Hassam." In *"Montauk" by Childe Hassam, N.A., of the American Academy of Arts and Letters*. Exh. cat. New York: William Macbeth, Inc. Dec. 30, 1924–Jan. 19, 1925. Formerly MS 27.
"Maurice Prendergast." *Arts* 5 (Mar.): 125–31. (Many drafts for this essay are dated 1922.)
"Principles and Practices in American Art." Book review of *American Artists* by Royal Cortissoz. *Yale Review* 14 (Oct.): 165–71.

Unpublished Writings

"The Phillips Collection." Outline prepared for F. Newlin Price, "Phillips Memorial Gallery," *International Studio* 80 (Oct.): 8–18. Some drafts formerly MS 89. (Excerpts from Phillips's outline were published in Price's article.)
"Chardin." Essay. Formerly MS 9. (Handwritten version in Journal GG; sections used in essay for *E of A*, 1927.)
"Ernest Lawson." Essay. Formerly MSS 36 and 37.
"Rockwell Kent." Essay. Formerly MS 116.
"J. Alden Weir, American School, 1852–1919." Essay. Formerly MS 59.
[Arthur B. Davies]. Essay. Ca. 1924. Formerly MS 16. (Roughly resembling the 1924 monograph.)

1925

Exhibition of Paintings by Bernard Karfiol. Exh. cat. for PMG.1925.8.
"A Letter from Duncan Phillips." *Arts* 7 (June): 299–302.

Unpublished Writings

"Painters of Past and Present." Outline for proposed publication. Dated July 1. Formerly part of MS 97.
"Order of Notes and Essays." List of proposed publications. Ca. 1925–26. Formerly part of MS 97.
"John H. Twachtman." Essay. 1925. Formerly MS 54. (Text similar to that in *C in M*, 1926.)

1926

C in M, 1926: *A Collection in the Making*. Phillips Publication No. 5. New York and Washington, D.C.
Exhibition of Paintings by Nine American Artists. Exh. cat. for PMG.1926.1.
Exhibition of Paintings by Eleven Americans and an Important Work by Odilon Redon. Exh. cat. for PMG.1926.2.
Exhibition of Recent Paintings by Maurice Sterne. Exh. cat. for PMG.1926.3. (Also published, with additions, in *C in M*, 1926.)
Exhibition of Recent Paintings by Marjorie Phillips. Exh. cat. for PMG.1926.4.
Intimate Impressionists. Exh. cat. for PMG.1926.5. (Also published, with additions, in *C in M*, 1926.)
Exhibition of Paintings by George Luks. Exh. cat. for PMG.1926.6. (Also published in *C in M*, 1926.)
Exhibition of Paintings by Jerome Myers. Exh. cat. for PMG.1926.7. (Also published in *C in M*, 1926.)
"To the Editor of *The Art News*." *Art News* 24 (Feb. 13): 7.

1927

E of A, 1927: *The Enchantment of Art as Part of the Enchantment of Experience: Fifteen Years Later*. Phillips Publication No. 4. Washington, D.C. (Revision and expansion of the 1914 edition.)
Bull., 1927: *A Bulletin of the Phillips Collection Containing Catalogue and Notes of Interpretation Relating to a Tri-Unit Exhibition of Paintings and Sculpture*. Washington, D.C. Typed draft for section on Marin, formerly MS 163. (Sections of this publication served as exh. cat. for PMG.1927.2a–c.)
An Exhibition of Expressionist Painters from the Experiment Station of the PMG. Exh. cat. for PMG.1927.3. Baltimore: BMA.
Catalogue of the Exhibition of American Themes by American Painters Lent by the Phillips Memorial Gallery. Exh. cat. for PMG.1927.4. Baltimore: Friends of Art.
Intimate Decorations: Chiefly Paintings of Still Life in New Manners. Exh. cat. for PMG.1927.6.
Leaders of French Art To-Day. Exh. cat. for PMG.1927.7.
"Welcome Art Experiments." *New York Herald Tribune* (Feb. 13): sec. 3, p. 7.

Unpublished Writings

[Autobiographical Sketch]. Draft submitted for "Duncan Phillips" in *The Cyclopedia of American Biography*, vol. B. New York, 1927. Formerly MS 88.

1928

"Exhibition of Paintings by Jean Negulesco." (Possibly a draft for exh. cat., Washington, D.C.: Yorke Galleries.)

Bull., 1928: *A Bulletin of the Phillips Collection Containing Catalogue and Notes of Interpretation Relating to a Tri-Unit Exhibition of Paintings and Sculpture.* Washington, D.C. (Sections of this publication served as exh. cat. for PMG.1928.1a–c.)

Tri-Unit Exhibition of Paintings and Sculpture. Exh. cat. for PMG.1928.4a–c.

The Significance of the Duncan Phillips Collection of Pictures with a Note on Impressionism and a Few Brief Notes on Some of the Artists Represented. Exh. cat. for PMG.1928.5. (Excerpted from *C in M*, 1926.)

Mystical Crucifixion by Augustus Vincent Tack. Pamphlet. Washington, D.C.: PMG.

"Art in Washington: The Phillips Memorial Gallery." *Forerunner of the General Convention, A.D. 1928* 2 (Easter): 18–24.

"*Egyptian Stone Head*, 18th Dynasty: *The Voice of Many Waters* by Augustus Vincent Tack." *Forerunner* 2 (Easter): 24. (Revision of essay in *Bull.*, 1927.)

"Exhibitions: The Washington Independent." *Arts* 13 (Apr.): 243–44.

[Book Review]. *The A.B.C. of Aesthetics* by Leo Stein. *Yale Review* 18 (Sept.): 192–95.

"Art Is International." *Art News* 27 (Nov.): 12–14. (First published in *Tri-Unit Exhibition*, 1928.)

Unpublished Writings

"Europe in America." Essay. Formerly MS 71.

1929

"Introduction." In *American Etchers: Alfred Hutty*. Vol. 2. New York. n.p.

Bull., 1929: *A Bulletin of the Phillips Collection.* Washington, D.C. (Sections of this publication served as exh. cat. for PMG.1929.2.)

A & U, 1929: *Art and Understanding* 1 (Nov.). Washington, D.C.: PMG. (Sections of this publication served as exh. cat. for PMG.1929.6a–b; includes essays by John Galsworthy and Virgil Barker.)

Exhibition of Paintings by John D. Graham. Exh. cat. for PMG.1929.3.

CA, 1929: "The Palette Knife: A Collection Still in the Making." *Creative Art* 4 (May): 13–25.

Unpublished Writings

[Testimony on Paragraph 1704 of the Tariff Act of 1922]. Presented to the Committee on Ways and Means, House of Representatives. Feb. 23.

[Most Important Living American Artists]. List.

1930

A & U, 1930: *Art and Understanding* 2 (Mar.). Washington, D.C.: PMG. (Sections of this publication served as exh. cat. for PMG.1930.1a–c; includes essays by Charles Law Watkins, Charles Downing Lay, Ralph Flint, Henry McBride, Will Hutchins, Augustus Vincent Tack, and William M. Ivins.)

An Exhibition of a Group of Lyric Painters. Exh. cat. for PMG.1930.1c. (Also published in *Art and Understanding*, 1930.)

Exhibition of a Selected Group of Paintings from the PMG. Exh. cat. for Washington, D.C., venue of PMG.1930.4.

Exhibition of a Selected Group of Contemporary European Paintings from the Phillips Memorial Gallery, Washington, D.C. Exh. cat. for PMG.1930.6.

Important Paintings from the PMG Selected for Exhibition and Sales Through the American Federation of Arts. Exh. cat. for PMG.1930.7.

Decorative Panels by Augustus Vincent Tack. Exh. cat. for PMG.1930.15. (First published in *Art and Understanding*, 1930.)

Decorative Panels by Augustus Vincent Tack. Pamphlet. (Nearly identical to essays for PMG.1930.15 and *A & U*, 1930.)

"Modern Art, 1930." *Art News* 28 (Apr. 5): 14–16. (First published in *A & U*, 1930.)

"Free Lance Collecting." *Space* 1 (June): 7–8.

Formes, 1930: "A Collection Still in the Making." *Formes* no. 9 (Nov.): 7–9. (Revision of *Creative Art*, May 1929; includes list of proposed illustrations.)

Unpublished Writings

[Book Review]. *The Sharples: Their Portraits of George Washington and His Contemporaries, A Diary and an Account of the Life and Work of James Sharples and His Family in England and America* by Katharine McCook Knox.

[Giorgione]. Notes written in the margin of W. R. Valentiner, "Leonardo as Verrocchio's Coworker," *The Art Bulletin* 12, no. 1 (Mar. 1930): 43–89.

[List of American Artists]. Written on cover of *Paintings and Sculpture by Living Americans*, exh. cat., New York: MOMA.

[Lists of Illustrations for Handbook]. Ca. 1930. Formerly part of MS 97. (Outline for proposed publication.)

1931

ASD, 1931: *The Artist Sees Differently: Essays Based upon the Philosophy of a Collection in the Making.* 2 vols. Phillips Publication No. 6. New York and Washington, D.C. (Includes revisions of several previously published essays.)

Bull., 1931: *A Bulletin of the PMG Containing Notes of Interpretation Relating to the Various Exhibition Units.* Washington, D.C. (Sections of this publication served as exh. cat. for PMG.1931.19 through PMG.1931.27; one essay, subsequently delivered as lecture, "Modern Argument in Art and its Answer," Nov. 5, 1931, has a draft, formerly MS 77.)

[Foreword]. In *Educational Program of the Phillips Memorial Gallery.* Pamphlet. Washington, D.C.

Modern Painters, French and American: Fifteen Paintings by Fifteen Painters from the Phillips Memorial Gallery. Exh. cat. for PMG.1931.28. (First published in exh. cat. for PMG.1930.7.)

[Foreword]. In *Exhibition of Water Colors by Arthur B. Davies and Pastels by Dwight Williams.* Exh. cat. Syracuse Museum of Fine Arts. Oct.

"Important Paintings from The Phillips Memorial Gallery," *Bulletin of the Milwaukee Art Institute* (Feb. 1931): 2. (First published in exh. cat. for PMG.1930.7.)

An Exhibition of Recent Work of Karl Knaths. Exh. cat. for PMG.1931.33.

"The Artist Sees Differently." *American Magazine of Art* 22, no. 2 (Feb.): 79–82. (Also published in *ASD*, 1931.)

"Modern Art and the Museum." *American Magazine of Art* 23 (Oct.): 271–76. (Published version of a paper presented to the American Association of Museums, Pittsburgh, May.)

Unpublished Writings

"An International Exhibition." Essay for planned exh. cat. for PMG.1931.29.

"The Artist Sees Differently." Slide lecture, 12 versions. 1931–34. (One version delivered as the Trowbridge Lecture at Yale University on Mar. 20.)

1932

Phillips Memorial Gallery: Exhibitions. Exh. cat. with essays on Gifford Beal (PMG.1932.4), Walt Kuhn (PMG.1932.5), American and European abstractions (PMG.1932.7), and Robert Spencer (PMG.1932.12).

Phillips Memorial Gallery, Washington, D.C.: Special Exhibitions. Exh. cat. for Sewell Johnson (PMG.1932.11), Robert Spencer (PMG.1932.12), and Retrospective Group Exhibition (PMG.1932.14).

Appreciations by Duncan Phillips of the Decorative Panels of Augustus Vincent Tack. Pamphlet. (The essays, "Mystical Crucifixion" and "The Decorative Panels . . ." are nearly identical to the texts of *Mystical Crucifixion*, 1928, and *Decorative Panels*, 1930.)

Formes, 1932: "Original American Painting of Today." *Formes* 21 (Jan.): 197–201.

Unpublished Writings

"John Marin." Essay. Ca. 1932. Formerly MS 38. (Closely related to, but distinct from, *Formes*, 1932.)

1933

Nationalism or Peace? An Address by Duncan Phillips. Pamphlet. Washington, D.C. (Includes the supplement "A Month Later: Review of the Swift March of Events," June 20. Text was read in a lecture, May 20, before the Friends of the Women's International League for Peace and Freedom, Washington, D.C.)

Exhibitions: Phillips Memorial Gallery. Exh. cat. with essays on Charles Burchfield (PMG.1933.1b) and Louis Eilshemius (PMG.1933.1c).

Unpublished Writings

[Exhibitions for the Season of 1933–34]. Draft for exh. cat. Formerly MS 152.

1934

Unpublished Writings

[Untitled Report]. Presented to the Regional Chairmen of the Public Works of Art Project, Washington, D.C. (Meetings were held Feb. 19–21.)

[Classic or Romantic in Modern Landscape]. Paper presented at PMG, Mar. 14. (Text related to MS 103.)

[Notes on John Dewey, *Art as Experience*, New York, 1934]. Written in the book's margin. Formerly MS 64.

1935

AMA, 1935: "Personality in Art: Reflections on Its Suppression and the Present Need for Its Fulfillment." *American Magazine of Art* 28 (Feb., Mar., Apr.): 78–84, 148–55, 214–20.

"Comment and Criticism: The Rental Problem." *American Magazine of Art* 28 (Dec.): 734, 768–69. Two drafts formerly MSS 137 and 138.

Unpublished Writings

"Freshness of Vision and Spontaneity in Painting." Text for slide lecture. Ca. 1935. Formerly part of MS 178.

1936

"Albert Pinkham Ryder." In *American Art Portfolios*, 43–47. Series One. New York.

"The Leadership of Giorgione." *American Magazine of Art* 29 (May): 286–99.

Unpublished Writings

"The Expression of Personality Through Design in the Art of Painting." Slide lecture. 8 versions, ca. 1936–42. (File includes drafts on Marin, formerly MS 162; Klee, formerly MS 176; and Knaths, formerly MS 171.)

1937

The Leadership of Giorgione. Washington, D.C.

Retrospective Exhibition of Works in Various Media by Arthur G. Dove. Exh. cat. for PMG.1937.4. One draft formerly MS 12.

1938

Constantin Guys. Exh. cat. for PMG.1938.1.

[Introduction]. In *Arthur G. Dove: Exhibition of Recent Paintings.* Exh. cat., New York, An American Place. (Reprint of essay for PMG.1937.4.)

Picasso and Marin. Exh. cat. for PMG.1938.6.

Paintings and Decorative Panels by Augustus Vincent Tack. Exh. cat. Pittsfield, Mass: Berkshire Museum. August.

[Introduction]. In *John Marin: Exhibition of Oils and Water Colors.* Exh. cat. New York: An American Place. Nov. 7–Dec. 27. (First published in exh. cat. for PMG.1938.6.)

[Book Review]. *Titian: Paintings and Drawings* by Hans Tietze. *Magazine of Art* 31 (Jan.): 46, 52–53, 58.

Unpublished Writings

"Gallery Notes: International Show." Formerly MS 90. (Notes on paintings at the Carnegie International Exhibition.)

1939

An Exhibition of Paintings by David Burliuk, Russian-American Expressionist. Exh. cat. for PMG.1939.9.

Contemporary American Paintings Lent by The Phillips Memorial Gallery, Washington. Exh. cat. for PMG.1939.11. Syracuse Museum of Art.

"Georges Braque." In *Georges Braque: Retrospective Exhibition.* Exh. cat. for PMG.1939.22. (Includes essays by Henry McBride and James Johnson Sweeney; this catalogue was possibly also used at other venues.)

"The Duality of Eilshemius." *Magazine of Art* 32 (Dec.): 694–97, 724–27.

Unpublished Writings

"Preface." Draft for proposed handbook. June 20. Formerly part of MS 97.

[Exhibition of Studio House Artists]. Essay regarding Whyte Gallery showing, Mar. 6.

"Modern Art and the Museum." Essay. (Revised version of essay in *American Magazine of Art*, Oct. 1931.)

"Spontaneous Painters." Essay. Ca. 1939. Formerly MS 78.

1940

"Duncan Phillips: Art Critic and Curator." In *History of the Class of 1908: Yale College,* vol. 3, edited by Richard R. Smith, 91–93. Quarter Century Record, 1914–39. New York.

New Paintings by Washington Artists. Exh. cat. New York: Bignou Gallery. June 3–15.

Unpublished Writings

"Goya to Daumier." Notes taken during Henri Focillon's lecture at PMG. Apr. 18.

[War]. Essay. 1940–41. Formerly MS 94.

1941

Bull., 1941: *A Bulletin of the PMG.* Washington, D.C. (Based on address, "The Place of the Arts in the World Today," presented at symposium held at PMG under the auspices of the Washington Dance Association, Dec. 15, 1940.)

Paintings and Drawings by Augustus Vincent Tack. Exh. cat. New York: Macbeth Gallery. Jan. 14–Feb. 3.

The Functions of Color in Painting. Coauthored with C. Law Watkins. Exh. cat. for PMG.1941.4.

"The Place of Art in a War-Torn World." *St. Louis Post-Dispatch.* (27 Jan.): 2B. (Revision of article published in *A Bulletin of the PMG*, 1941.)

Unpublished Writings

[Letter to Henri Focillon]. Feb. 27.

"Tentative Plan for Handbook." Outline for proposed publication. Ca. 1941. Formerly part of MS 97.

"The Last War." Essay. Between 1941 and 1945. Formerly MS 98.

1942

The Nation's Great Paintings: Honoré Daumier, "The Uprising." New York. Draft formerly MS 10.

The Arts in War Time. Pamphlet. Washington, D.C.: NGA. (Also presented as a lecture to the American Association of Museums, Williamsburg, Va., May 19, 1942. A revised version, formerly MS 65, was presented on radio station WINX, Washington, D.C., May 26, and at PMG, June 10.)

Paintings by Karl Knaths. Exh. cat. Chicago: AIC. Jan. 22–Feb. 23. (Includes essays by Dudley Crafts Watson and E. M. Benson.)

Karl Knaths. Exh. cat. New York: Buchholz Gallery. Apr. 13–May 2.

Paul Klee: A Memorial Exhibition. Pamphlet accompanying exh. cat. for PMG.1942.11.

Contrasts in Impressionism: An Exhibition of Paintings by Alessandro Magnasco, Claude Monet, John Marin. Exh. cat. Baltimore: BMA. Nov. 13–Dec. 27.

"Knaths: Maturity of a Poetic American." *Art News* 41, no. 6 (May): 28–29, 40. (First published in *Paintings by Karl Knaths*, 1942.)

"The Arts in War Time." *Art News* 41 (Aug.–Sept.): 20, 45. (Text closely related to May 19 lecture to the American Association of Museums, Williamsburg, Va.)

"Letters to the Editor: Rate of Induction." *Washington Post* (21 Oct.): 6.

Unpublished Writings

"The Leadership of Giorgione." Slide lecture presented at Johns Hopkins University, Baltimore. Mar. 13. (Phillips repeated this lecture Oct. 1942 at an unknown location.)

"The Leadership of Giorgione." Slide lecture presented at the PMG. Apr. 9. (Differs from previous lecture.)

"Coalition War or Isolation War?" Essay submitted for publication to *Washington Post.* Oct. 14.

"The Arts in War Time." Slide lecture. Formerly MSS 30 and 44.

1943

The Nation's Great Paintings: Vincent Van Gogh, "Entrance to the Public Gardens in Arles." Pamphlet. New York.

Six Loan Exhibitions. Exh. cat. with essays on Alessandro Magnasco (PMG.1943.1) and Soutine (PMG.1943.2). (Includes essays by C. Law Watkins and Bartlett H. Hayes.)

Preston Dickinson: Exhibition of Paintings. Exh. cat. New York: Knoedler Galleries. Feb. 8–27. Formerly MS 15.

The Abstract Decorations of Augustus Vincent Tack. Exh. cat. for PMG.1943.9.

"Marsden Hartley." In *Four Exhibitions.* Exh. cat. for PMG.1943.24.

"Morris Graves." In *Three Loan Exhibitions.* Exh. cat. for PMG.1943.28.

Unpublished Writings

"Abraham Rattner." Draft for proposed exh. cat. Ca. 1943.

[Outline for Handbook on the Collection]. Book proposal. 1943 or later.

1944

[Foreword]. In Katherine S. Dreier, *Burliuk*, New York. (First published in exh. cat. for PMG.1939.9.)

Morris Graves: Exhibition of Recent Work. Exh. cat. New York: Willard Gallery. Jan. 11–Feb. 5. (First published in exh. cat. for PMG.1943.28.)

"Roger de la Fresnaye." In *January–February 1944.* (Sections of this publication served as exh. cat. for PMG.1944.4.)

Walt Kuhn; Karl Knaths. Exh. cat. for PMG.1944.7 and PMG.1944.8.

The American Paintings of the Phillips Collection. Exh. cat. for PMG.1944.11.

Paintings by Augustus Vincent Tack. Exh. cat. Washington, D.C.: George Washington University Library. Apr. 15–May 13. (First published in exh. cat. for PMG.1943.9.)

"Marsden Hartley." *Magazine of Art* 37 (Mar.): 82–87. Fragment of draft formerly MS 153.)

1945

The Nation's Great Paintings: Jean-Baptiste Siméon Chardin, "Bowl of Plums." Pamphlet. New York.

The Nation's Great Paintings: Georges Braque, "Still Life with Grapes." Pamphlet. New York.

C. Law Watkins, 1886–1945. Memorial pamphlet. Washington, D.C. Mar.

"Acknowledgment." In *Eugène Delacroix: A Loan Exhibition.* Exh. cat. for PMG.1945.2. (Includes essay by Georges Wildenstein.)

"Foreword." In *Ceramics by Lea Halpern.* Exh. cat. for PMG.1945.4. (Includes essay by Halpern.)

"C. Law Watkins." In *Watercolors and Small Oils by C. Law Watkins.* Exh. cat. for PMG.1945.10.

"Foreword." In *A Loan Exhibition of 52 Drawings for Ariosto's "Orlando Furioso," Fragonard.* Exh. cat. for PMG.1945.15.

Unpublished Writings

"Some Omissions and Confusions at the Sources of Art History/Omissions and Misconceptions at the Sources of Art History." 8 essays and 2 outlines.

"Freshness of Vision in Painting." Essay. Ca. 1945. Formerly part of MS 178.

"Illustrations for Gallery Picture Book." List for proposed publication. Between 1945 and 1952. Formerly part of MS 97.

1946

Paintings by Elisabeth Poe. Exh. cat. for PMG.1946.1.

A Loan Exhibition of Paintings by Christopher Wood. Exh. cat. for PMG.1946.11.

"Letters to the Editor: Big Three Conference Needed." *Washington Post* (Mar. 19): 8.

Unpublished Writings

[Letter to President Harry S. Truman]. Feb. 2. (Asking for a reevaluation of U.S. policies in view of the realities of atomic warfare.)

[Walter Lippmann's Address on Wendell Willkie]. Essay. Feb. 18.

[Letter to the Editor]. Submitted to *Washington Post.* Oct. 16. (Concerning international control of atomic energy.)

1947

[Tribute]. In *Stieglitz Memorial Portfolio, 1864–1946,* edited by Dorothy Norman. New York, 1947.

Elisabeth Poe (1888–1947): An Appreciation. Memorial pamphlet for PMG.1947.11. (First published in exh. cat. for PMG.1946.1.)

Painters of the San Francisco Bay Region. Exh. cat. for PMG.1947.12.

"Arthur G. Dove, 1880–1946." *Magazine of Art* 40 (May): 192–97.

"Georges Rouault." *Right Angle* 1 (May): 4–5.

"Henri Focillon at the Phillips Gallery: In Memoriam." *Gazette des Beaux-Arts* 26 (July–Dec. 1944 issue; publication delayed until 1947 because of Second World War): 31–34. (Phillips's contribution, dated Apr. 28, 1947, was also published as a separate pamphlet.)

"Morris Graves." *Magazine of Art* 40 (Dec.): 305–8.

Unpublished Writings

"Giorgione (Giorgio Barbarelli)." Essay.

[Economic Aid for Western Europe]. Paper presented to the United World Federalists. Ca. 1947–48. Formerly MS 108.

[Acceptance Speech]. Presented upon acceptance of honorary degree, Doctor of Humane Letters, Kenyon College, Gambier, Ohio.

1948

[Brief Note on Marin]. In E. M. Benson. *Themes and Variations in Painting and Sculpture,* 45. Exh. cat. Baltimore: BMA. Apr. 15–May 23. (First published in *Bull.,* 1927.)

"Foreword." In *Paintings by Marjorie Phillips.* Exh. cat. for PMG.1948.9. (Essay reprinted in catalogue for venue in New York: Bignou Gallery.)

Unpublished Writings

[Letter to the Editor]. Submitted to *Washington Post.* Mar. 16. (Proposals on how to thwart Communist imperialism.)

1949

"Karl Knaths, Poet of Painting." *News: The Baltimore Museum of Art* 12 (Mar.): 6–7. (Excerpted from *Paintings by Karl Knaths,* 1942.)

"The Art of Arthur G. Dove." In *New Directions in Prose and Poetry,* vol. 11, 509–12. (First published in exh. cat. for PMG.1937.4.)

"Pierre Bonnard." *Kenyon Review* 11 (Autumn): 561–66.

"Lee Gatch." *Magazine of Art* 42 (Dec.): 282–87.

Unpublished Writings

[Book Review]. *John Marin* by MacKinley Helm. (Submitted to *Saturday Review of Literature,* Jan. 27, 1949.)

"John Marin." Essay. Ca. 1949. Formerly MS 40.

1950

"Arthur Dove" and "John Marin." In Katherine S. Dreier and Marcel Duchamp, *Collection of the Société Anonyme: Museum of Modern Art, 1920,* edited by George Heard Hamilton, 11–12 and 73; New Haven. (Dove text abridged from "Arthur Dove," 1947. Reprinted in Robert L. Herbert et al., *The Société Anonyme and the Dreier Bequest at Yale University: A Catalogue Raisonné,* New Haven, 1984, 202 and 439.)

"John Marin" (translated into Italian). In *Catalogo XXV Biennale di Venezia.*

"7 Americans Open in Venice: Marin." *Art News* 49 (Summer): 21. (English version of "John Marin," 1950.)

Unpublished Writings

"John Marin." Essay. Ca. 1950. Formerly MS 39.

"Karl Knaths." Essay. After 1950. Formerly MS 29.

1952

Cat., 1952: *The Phillips Collection Catalogue: A Museum of Modern Art and Its Sources.* New York.

"Letters to the Editor: Governor or General." *Washington Post* (Nov. 3): 10.

Unpublished Writings

[Letter to Governor Adlai Stevenson]. Nov. 13. (Coauthored with Marjorie Phillips.)

[Letter to Marcel Duchamp]. July 21, 1952. (Concerning the gift from the estate of Katherine S. Dreier; handwritten draft and typed version.)

1953

"On the Art Department and Watkins Gallery." In *Fun Days.* Program pamphlet for a benefit at the Art Department, American University, Washington, D.C., May 29–30.

Loan Exhibition of Early Paintings by Maurice Utrillo. Exh. cat. for PMG.1953.12. Several drafts; one formerly MS 149.

"What Stevenson Started." *New Republic* 128 (Jan. 5): 10–11.

"The Critic: Partisan or Referee?" *Magazine of Art* 46 (Feb.): 50, 88.

"Literature and the Arts: The Gnomes and Imps of Paul Klee." Review of *Paul Klee* by Carola Giedion-Welcker. *New Republic* 128 (16 Feb.): 17–18.

Unpublished Writings

"Contemplated Publications." Outline for proposed publications. 1953–54. Formerly part of MS 97.

1954

Catholicity Does Not Mean Eclecticism: A Radio Talk by Duncan Phillips. Pamphlet. (Also published as *The Phillips Collection and Related Thoughts on Art;* originally presented as a radio talk entitled "The Pleasures of an Intimate Art Gallery," Washington, D.C., WCFM, Feb. 24).

Paintings by Robert Gates. Exh. cat. Washington, D.C.: Corcoran Gallery of Art. Apr. 30–Sept. 6.

"Foreword." In *Arthur G. Dove 1880–1946: A Retrospective Exhibition* by Alan R. Solomon. Exh. cat. Ithaca, N.Y.: Andrew Dickson White Museum of Art, Cornell University. Nov.

"A Niche for Monticelli." *Art News* 53 (Dec.): 22–23, 64–66.

1955

"Foreword." In *John Marin Memorial Exhibition* by Frederick S. Wight. Exh. cat. for TPG.1955.6.

"John Marin." In *150th Anniversary Exhibition*. Exh. cat. Philadelphia: Pennsylvania Academy of the Fine Arts. Jan. 15–Mar. 13. (First published as "7 Americans Open in Venice: Marin," 1950.)

Paintings by Marjorie Phillips. Exh. cat. Washington, D.C.: Corcoran Gallery of Art. Mar. 26–Apr. 24.

"Foreword." In *Federation of Modern Painters and Sculptors 1955–1956*. New York.

"A Critic and His Pictures," *Arts* 30 (Dec.): 27–31. (Text drawn from Phillips's writings, accompanied by illustrations of paintings in the collection.)

Unpublished Writings

[Introduction of Frederick S. Wight]. Delivered on the occasion of Wight's lecture on John Marin, May 16.

[Compilation of Essays for Proposed Publication]. Notebook containing previously published and unpublished writings. After 1955. Formerly part of MS 97.

1956

"About the Technic." In Frederick S. Wight. *Morris Graves*. Exh. cat. for TPG.1956.7. (First published in cat. for PMG.1943.28.)

Loan Exhibition of Paintings by J. B. C. Corot (1796–1875). Exh. cat. for TPG.1956.11.

Arts, 1956: "The Phillips Gallery with Commentary by Duncan Phillips." *Arts* 30 (Apr.): 30–37. One draft on Degas formerly MS 11.

Unpublished Writings

"Bradley Walker Tomlin." Essay. 1956–57. Formerly MS 52.

1957

"Introduction." In Paul Mocsanyi. *Karl Knaths*. Washington, D.C.

"Appreciation." In John I. H. Baur. *Bradley Walker Tomlin*. Exh. cat. New York: Whitney Museum of American Art, 1957–58 tour.

1958

A Loan Exhibition: Six Paintings by Bonnard. Exh. cat. for TPG.1958.2. (First published as "Pierre Bonnard," 1949.)

"Foreword." In Frederick S. Wight. *Arthur G. Dove*. Exh. cat. for TPG.1958.8.

1959

[Untitled Introduction]. To "A Thousand Years of France: An Anthology of Henri Focillon." *Art News Annual* 28 (1959): 147.

Unpublished Writings

[Acceptance Speech]. Presented on the occasion of Award of Merit bestowed by Philadelphia Museum College of Art. June 5.

"A Gallery of Modern Art and Its Sources." Text for television program produced by the Greater Washington Education Television Association; aired Oct. 16. Formerly MS 95.

[Lists of Acquisitions Since the 1952 Catalogue]. Formerly part of MS 97. (The lists name works to be illustrated in the proposed publication.)

1961
Unpublished Writings

[Letter to President Kennedy]. Oct. 3, 1961. (On the need to curtail atomic proliferation and the role of the United Nations.)

[The Phillips Collection]. Text for television program sponsored by the Junior League of Washington. Mar. 5.

[Rothko, Pollock, de Kooning, Guston, Tomlin]. Notes and Comments from the writings of Peter Selz, Robert Goldwater, and Sam Hunter. Between 1961 and 1966. Formerly MS 1.

1962
Unpublished Writings

"Karl Knaths." Essay. Ca. 1962. Formerly MS 172.

1963

Alberto Giacometti: A Loan Exhibition. Exh. cat. for TPC.1963.2.

Unpublished Writings

"Mark Rothko." Essay.

[Introduction of John Golding]. Delivered on the occasion of Golding's TPC lecture, "Guillaume Apollinaire and the Art of the 20th Century." Mar. 16.

"A Suggested Cross Section of the Collection to be Illustrated; New Acquisitions Included." List for publication proposal.

1964

Seymour Lipton: A Loan Exhibition. Exh. cat. for TPC.1964.1.

Alfred Manessier: A Loan Exhibition. Exh. cat. for TPC.1964.2.

The Cubist Period of Jacques Lipchitz: A Loan Exhibition. Exh. cat. for TPC.1964.6.

Unpublished Writings

"Mark Rothko." Essay.

1965

"Arthur Dove, 1880–1946" and "John Marin." In Adelyn Breeskin, *Roots of Abstract Art in America, 1910–1930*, 13–17 and 19–20. Exh. cat., Washington, D.C.: NCFA. Dec. 2, 1965–Jan. 6, 1966. (Abridged excerpts from "Arthur Dove," 1947, and "John Marin," in *C in M*, 1926.)

1966
Unpublished Writings

[Introduction for Proposed Supplement]. Formerly MS 159. (Revision of *Catholicity Does Not Mean Eclecticism*, 1954; intended for supplement to 1952 collection catalogue.)

1967

Paintings and Drawings by Pierre Bonnard. Exh. cat. for TPC.1967.1. (Posthumous publication of essay "Pierre Bonnard," 1949.)

"A Tribute to John Marin." In exh. cat. for TPC.1967.4. (Posthumous publication of essay first published for TPG.1955.6.)

1970

"A Statement of My Wish for the Future of the Phillips Collection." In Marjorie Phillips, *Duncan Phillips and His Collection*, 304–5. Boston, 1970. Rev. ed., New York, 1982. (Based on three drafts, one dated 1964, two from 1965.)

1972

"Introduction." In *Memorial Exhibitions: Karl Knaths, 1891–1971*, n.p. Exh. cat. New York, Paul Rosenberg & Co., Jan. 18–Feb. 19. (Posthumous publication of an earlier draft no longer extant.)

Undated Manuscripts

Gaps in the numerical sequence indicate manuscripts that have since been dated and removed to the chronological listing of published and unpublished works. Unless otherwise noted, the following manuscripts are in essay form.

MS 4. [Braque].
MS 5. [Courbet].
MS 6. [Corot].
MS 7. [Elisabeth Clark].
MS 8. [Chardin].
MS 13. [Dove].
MS 14. "Is America Neglectful of Its Native Art?"
MS 23. "El Greco."
MS 24. "Constantin Guys."
MS 25. "Notes on the Painters [John D. Graham]."
MS 26. "John D. Graham."
MS 28. [Van Gogh].
MS 31. "Kent."
MS 32. "John La Farge."
MS 33. "George B. Luks."
MS 34. "George B. Luks."
MS 41. "Adolphe Monticelli."
MS 42. "Claude Monet."
MS 43. "Jerome Myers."
MS 45. "Maurice Prendergast."
MS 46. "E. W. Redfield."
MS 47. "Renoir."
MS 48. "Renoir."
MS 49. "Albert P. Ryder."
MS 51. "Robert Spencer."
MS 55. "Augustus Vincent Tack."
MS 56. "Augustus Vincent Tack."
MS 57. [Tack].
MS 58. "Suggested Topics for Essays for American Magazine of Art." (List of proposed publications.)

MS 60. "James McNeill Whistler."
MS 62. "James McNeill Whistler."
MS 63. "Notes on [Constantin] Guys."
MS 67. "The Future of American Art."
MS 68. [Rouault].
MS 70. "A Dream."
MS 72. "The Fascination of the Orient."
MS 73. "Reflections of an Individualist."
MS 79. [Giorgione]. (Fragment).
MS 82. [America's Attitude Toward Its Native Art].
MS 83. [Untitled Essay on the Art of 1900–1930].
MS 84. [Romantic and Classic Art].
MS 87. [Individualism in Art].
MS 91. [Handwritten Revision of "Our Inclusiveness" from *C in M*, 1926]. (Includes handwritten notations by Marjorie Phillips.)
MS 92. [Notes on Jan Gordon's Publications].
MS 93. "Notes on Max Plowman's *War and Creative Impulse*."
MS 96. "To the Editor of *The Washington Post*." (U.S. and Russia conflict.)
MS 97. "Art and Democracy." Outline for proposed publication. (Portions of MS 97 have been dated; see cross-references under 1910, 1919, 1923, 1925, 1930, 1939, 1941, 1945, 1953, 1955, and 1959 in dated MSS section.)
MS 99. [Poems]. (While authorship is unknown, some are certainly by Duncan Phillips.)
MS 100. [Lists].
MS 102. [Packets of photographs on First World War-related subjects]. (Collected by Phillips to support his essays, editorials, and exhibitions.)
MS 103. [Classic or Romantic in Modern Landscape]. Lecture. (A similar version was delivered as a gallery talk Mar. 14, 1934.)
MS 104. [Notes from Ananda Coomaraswamy's *The Dance of Siva*]. (See also Journal D, 1–9.)
MS 105. [Notes from W. C. Brownell on Style].
MS 106. [Notes Entitled "Art and Life," "Art and Socialism," and "An Essay in Aesthetics" on Roger Fry, *Vision and Design,* London, 1930]. (See also Journal D, 10–18.)
MS 107. [Notes on Havelock Ellis, *Dance of Life*, Boston, 1923].
MS 109. [Outline for Essays]. (Contains references to Bonnard, Cézanne, Chardin, Corot, Courbet, Daumier, Delacroix, Degas, Eilshemius, El Greco, Goya, Manet, and Rouault.)
MS 110. "Outline of Thought—Reduced to Its Lowest Terms in *What Is the Nature of Beauty* by Henry Rutgers Marshall."
MS 111. "Jean Baptiste Camille Corot."
MS 112. [Notes on Jacques Maritain, *Georges Rouault;* Christian Zervos, *Daumier*]. (One text formerly MS 113.)
MS 114. "John Constable."
MS 115. "Homer."
MS 117. "Georges Braque."
MS 118. "Arthur B. Davies."
MS 121. "Arthur G. Dove."
MS 122. "A Note on Dove."
MS 123. "Theotokopoulos, Domenikos [El Greco]."
MS 124. "Theotokopoulos, Domenikos [El Greco]."
MS 125. [El Greco].
MS 126. "Theotokopoulos, Domenikos [El Greco]."
MS 127. [Notes on Lionello Venturi, *Giorgione*].
MS 128. "Goya."
MS 129. "Lafcadio Hearn."
MS 130. "Winslow Homer."
MS 131. "Rudyard Kipling."
MS 133. [Notes on Emerson].
MS 134. [Notes on Blake, Goethe, and Laurence Binyon]. (Two texts formerly MSS 135 and 136.)
MS 139. "Albert P. Ryder."
MS 140. "Albert P. Ryder."
MS 141. "Albert P. Ryder."
MS 142. [Ryder]. (Fragment.)
MS 143. "The Spontaneous Painters—Trained and Untrained."
MS 144. "The Mystical Decorations of Augustus Vincent Tack."
MS 145. "The Musical Abstractions of Tack."
MS 146. "The Trend of Modern Painting."
MS 148. [World Peace]. (One-page fragment.)
MS 150. "An Outline of U.S. Foreign Policy."
MS 156. "Galsworthy."

MS 157. "Marjorie Phillips."
MS 158. "Can We Isolate the Plastic Theme in Art from All Its Derivations?" (A revised version of *A Bulletin of the PMG*, "The Modern Argument in Art and Its Answer," 1931.)
MS 160. [Rouault].
MS 161. [Puvis de Chavannes].
MS 164. [Manet].
MS 165. [Delacroix].
MS 166. [Courbet].
MS 167. [Corot].
MS 168. [Cézanne].
MS 169. [Miscellaneous Notes]. (Includes fragments: brief passages on Delacroix's *Paganini;* possible lecture on Renaissance artists; Daumier; notes taken while reading a book on the Ching Dynasty; John Dewey quote (one sentence); atomic power; individualism versus the machine age; and automatism written in the margin of a page from an unidentified publication that mentions Stuart Davis's *Owh! in San Pao*, 1951.)
MS 170. [Daumier's *Two Sculptors*].
MS 173. [Revised edition of *A Collection in the Making*].
MS 174. [Eilshemius's *Van Cortland Park*].
MS 175. [Marjorie Phillips].
MS 179. [Albert P. Ryder].
MS 180. "The City in Pictures and Poetry." (See also "The Field of Art," 1913.)
MS 181. Essay in "Marjorie Phillips: Paintings of Cambria County." exh. cat., Cambria County Fair, Ebensburg, Pa., n.d. (A date has not been found for this catalogue.)

Journals

Note: There are no journals P, Q, and S. The journals are cited by their alphabetical code. This alphabetical sequence was established before the journals were dated.

Journal A. Yale University notebook, 1904–8.
Journal B. Plans and lists for the PMG, 1923–29.
Journal C. Drafts and essays for *A & U*, 1929.
Journal D. Assorted lists and notes from the writings of Ananda Coomaraswamy and Roger Fry, ca. 1923–24.
Journal E. Yale University notebook, 1904–8.
Journal F. Notes on John Millington Synge and William Shakespeare, n.d.
Journal G. Notes on Julian Alden Weir, ca. 1920.
Journal H. Critiques of theater productions from 1902–3 and 1908–9.
Journal I. Lists and plans, between 1931 and 1935. (Notes concerning future PMG publications.)
Journal J. Notes for *A & U*, 1929.
Journal K. Contains essay "Freshness of Vision in Painting," ca. 1945.
Journal L. Assorted essays relating to *E of A*, 1914.
Journal M. Essays and plans for unrealized publication on American artists, ca. 1915–20.
Journal N. Travel diary of Europe trip, 1912.
Journal O. Notes on literary works, American artists, and plans for future PMG publications, 1916–23.
Journal R. Notes on Watteau and eighteenth-century painting, n.d.
Journal T. Essays on American artists, n.d.
Journal U. Lists and notes on planned publications on American artists, ca. 1919.
Journal V. Notes for *A & U*, 1929.
Journal W. Assorted critical essays, ca. 1911–13.
Journal X. Yale University notebook, 1904–8.
Journal Y. Assorted lists, schedules, and notes for intended publications, ca. 1922–25.
Journal Z. Notes for a revised publication on Giorgione, after 1937.
Journal AA. Travel diary for Europe trip, 1913–14. (Also contains notes from reviews of *E of A*, 1914.)
Journal BB. Travel diary for Europe trip, ca. 1930–33.
Journal CC. Notes and essays for planned PMAG publications, between 1917 and ca. 1920.
Journal DD. Notes on American artists, 1921.
Journal EE. Lists and plans for future publications, ca. 1922.
Journal FF. Lists, notes, and essays on Italian Renaissance artists, n.d.
Journal GG. Lists and essays on collection artists, 1924.
Journal HH. Travel diary for Europe trip, 1912.

ENTRY CONTRIBUTORS

CB	Charles Brock		EDP	Erika D. Passantino
VSB	Virginia Speer Burden		EP	Elizabeth Peyton
SalF	Sally Faulkner		ER	Eliza Rathbone
SabF	Sabine Fischer		KGR	Katherine Grotto Revell
LF	Leslie Furth		RD-R	Raquel Da Rosa
JBG	Jennifer Burris Galen		RR	Richard Rubenfeld
PH	Pamela Hall		MS	Marcia Schifanelli
CH-H	Carolyn Halpin-Healy		DWS	David W. Scott
MJ-B	Maria Dolores Jiménez-Blanco		BLS	Ben (Joe) L. Summerford
WK	Wendy Kail		DT	Duncan Tebow
GHL	Grayson Harris Lane		ET	Elizabeth Tebow
SHL	Susan H. Libby		AV	Andrea Vagianos
LEM	Laurette E. McCarthy		LBW	Leigh Bullard Weisblat
AO	Andrew Otwell			

MUSEUM PUBLICATIONS
Frequently Cited Publications (arranged chronologically)

Early publications are cited in full in Appendix B, "Published and Unpublished Writings by Duncan Phillips."

E of A, 1914 or 1927	*The Enchantment of Art*
H of A, 1920–21	*Herald of Art*
Inv., 1921	*Extracts from the Minutes of First Annual Meeting of Trustees of Phillips Memorial Art Gallery*
C in M, 1926	*A Collection in the Making*
Bull., [date]	*Bulletins* (1927–29, 1931, 1941)
A & U, 1929 and 1930	*Art and Understanding*
CA, 1929	"The Palette Knife," *Creative Art*
Formes, 1930	"A Collection Still in the Making," *Formes*
ASD, 1931	*The Artist Sees Differently*
Formes, 1932	"Original American Painting," *Formes*
Exhibitions, [date]	*Phillips Memorial Gallery Exhibitions* (1932, 1943)
AMA, 1935	"Personality in Art," *American Magazine of Art*
Cat., 1952	*The Phillips Collection: A Museum of Modern Art and Its Sources*
Arts, 1956	"The Phillips Gallery with Commentary by Duncan Phillips," *Arts*

Later Publications

Exhibition catalogues published by the museum are cited in Appendix A, "Exhibitions at The Phillips Collection"

R for C, 1969	*Retrospective for a Critic*
MP, 1970 or 1982	Marjorie Phillips, *Duncan Phillips and His Collection*
SITES, 1979	*The Phillips Collection in the Making, 1920–1930*
MD, 1981	*Museums Discovered*
Sum. Cat., 1985	*Summary Catalogue*
MP, 1998	*Master Paintings*

FREQUENTLY CITED NAMES AND INSTITUTIONS

The following abbreviations are used throughout the book:

DP	Duncan Phillips
LP	Laughlin Phillips
MP	Marjorie Phillips

The Phillips Collection has had four changes of name:

PMAG	Phillips Memorial Art Gallery, July 1920 to May 1923
PMG	Phillips Memorial Gallery, May 1923 to October 1948
TPG	The Phillips Gallery, October 1948 to July 1961
TPC	The Phillips Collection, July 1961 to present

Other Institutions

AAA	Archives of American Art, Smithsonian Institution, Washington, D.C.
AFA	American Federation of Arts (Washington, D.C., until 1952, and New York)
AIC	Art Institute of Chicago, Chicago
BMA	Baltimore Museum of Art, Baltimore
Boston, MFA	Museum of Fine Arts, Boston
CMA	Cleveland Museum of Art, Cleveland
Carnegie	Carnegie Institute Museum of Art (1987 to present), Pittsburgh
Carnegie-DFA	Department of Fine Arts, Carnegie Institute (1896–1963)
Carnegie-MA	Museum of Art, Carnegie Institute (1963–86)
Century	The Century Association; also unofficially known as the Century Club or the Century
Corcoran	Corcoran Gallery of Art, Washington, D.C.
Guggenheim	Solomon R. Guggenheim Museum, New York
ICA, Boston	Institute of Contemporary Art, Boston
ICA, Washington	Institute of Contemporary Art, Washington, D.C.
IEF	International Exhibition Foundation, Washington, D.C.
IMA, Boston	Institute of Modern Art, Boston
Jeu de Paume	Now part of the Musée D'Orsay, Paris
LACMA	Los Angeles County Museum of Art, Los Angeles
Louvre	Musée du Louvre, Paris
Metropolitan	Metropolitan Museum of Art, New York
MOCA	Museum of Contemporary Arts, Los Angeles
MOMA	Museum of Modern Art, New York
NCFA	National Collection of Fine Arts, Washington, D.C. (now NMAA)
NGA	National Gallery of Art, Washington, D.C.
NMAA	National Museum of American Art, Washington, D.C.
Orangerie	Musée D'Orsay, Paris
Petit Palais	Musée du Petit Palais, Paris
Grand Palais	Musée du Grand Palais, Paris
PWAP	Public Works of Art Project (1933–34), Washington, D.C.
SA	Société Anonyme (now at Yale University Art Gallery, New Haven)
SA (Yale)	For citations involving the collection at Yale
São Paulo	Museo de Arte de São Paulo, Brazil
SITES	Smithsonian Institution Traveling Exhibition Service
Tate	The Tate Gallery, London
USIA	United States Information Agency, Washington, D.C.
Venice Biennale	La Biennale di Venezia
WPA	Works Progress Administration, Washington, D.C.
WPA/FAP	Works Progress Administration/Federal Art Project (1935–39), Washington, D.C.
Whitney	Whitney Museum of American Art, New York. Earlier name variations: Whitney Studio (1914–17) and Whitney Studio Club (1918–30)

NOTES AND REFERENCES

THE EVOLUTION OF A CRITIC

1. MP, 1982, 34.

2. DP, "At the Opposite Ends of Art," *Yale Literary Magazine* 70 (June 1905), 339–41.

3. DP, "Corot," *Yale Literary Magazine* 72 (Nov. 1906), 54–58.

4. DP, "Mona Lisa," *Yale Courant* 43 (Apr. 1907), 563–66; DP, "Marie Bashirtseff," *Yale Literary Magazine* 72 (Feb. 1907), 188–92.

5. DP, "The Need of Art at Yale," *Yale Literary Magazine* 72 (June 1907), 355–61.

6. DP, "The Problem of Art in Japan," *Yale Literary Magazine* 73 (Dec. 1907), 94–99.

7. DP, "The Nature and Expression of Sentiment," *Yale Literary Magazine* 73 (Mar. 1908) 244–52.

8. DP, "Portfolio: Meissonier's Napoleonic Cycle," *Yale Literary Magazine* 73 (May 1908), 377–79.

9. DP, "Duncan Clinch Phillips, Jr.," *History of the Class of 1908: Yale College,* vol. 2, ed. Walter G. Davis Jr. (New Haven, 1914), 234–35.

10. DP, "Nationality in Pictures," *E of A,* 1914, 83–87.

11. DP, "Giorgione, the First Modern Master," *Yale Review* 2 (July 1913), 670–80.

12. DP, "Giorgione," *E of A,* 1914, 242–60.

13. DP, "Revolution and Reactions in Modern Painting," *International Studio* 51 (Dec. 1913), 123–29.

14. DP, "Sorolla, the Painter of Sunlight," *Art and Progress* 4 (Dec. 1912), 791–97.

15. DP, *E of A,* 1914, 24.

16. DP, *C in M,* 1926, 32. Phillips's 1911 notes on Monet and visit to Durand-Ruel are reprinted in MP, 1982, 41. No journal of that year's trip has been found, but its occurrence is corroborated by DP in *History of the Class of 1908,* 234. For the Monet purchase, see the acquisition list, "15 Best Purchases of 1918–19; 15 Best Purchases Since Jan. 1920," n.p.

17. DP, "The Impressionistic Point of View," in *E of A,* 1914, 15–28; previously published under the same title in *Art and Progress* 3 (March 1912), 505–11.

18. DP, "The City in Painting and Etching," *E of A,* 1914, 97–110. First published as "The Field of Art: The City in Painting and Etching," *Scribner's Magazine* 53 (Feb. 1913), 265–68.

19. The "Allied War Salon" was held Dec. 9–24, 1918, at the American Art Galleries, New York. Rejected for military service because he was underweight, Phillips joined the Division of Pictorial Publicity, which was charged with inspiring artists to produce images of war. Their works were shown at the Allied War Salon. Phillips wrote several lectures and articles on the topic between 1917 and 1919. He was also to argue for the creation of an art museum as war memorial. He was unsuccessful at persuading the government to do this.

20. DP, "Modern Pictures in Venice," *Art and Progress* 4 (May 1913), 953–58; for best French artists (aside from René Ménard, he was probably referring to Lucien J. Simon and Charles Cottet), see p. 956.

21. Journal HH, 1912, n.p. (entered under July 13, 1912).

22. DP, "Revolutions and Reactions in Modern Painting," *International Studio* 51 (Dec. 1913), 123–29.

23. DP, "A Collection of Modern Graphic Art," *Art and Progress* 5 (Feb. 1914), 129–30.

24. DP, [book review], *Yale Review* 3 (Apr. 1914), 594–96.

25. DP, "William M. Chase," *American Magazine of Art* 8 (Dec. 1916), 45–50.

26. DP, "Albert Ryder," *American Magazine of Art* 7 (Aug. 1916), 387–91.

27. DP, "The Romance of a Painter's Mind," *International Studio* 58 (Mar. 1916), 19–24.

28. *Simon of Cyrene* (alt. title *The Cross Bearer*) 1913–14, National Shrine of the Immaculate Conception, Washington, D.C.

29. DP, "The American Painter, Arthur B. Davies," *Art and Archaeology* 4 (Sept. 1916), 169–77. "The wonderful room" is a reference to the music room of Lily P. Bliss.

30. DP, "Fallacies of the New Dogmatism in Art," *American Magazine of Art* 1 (Dec. 1917), 43–48; 2 (Jan. 1918), 101–6.

31. Presented at the Fifth Annual Meeting of the CAA, Philadelphia, Apr. 21, 1916. The text appeared as "What Instruction in Art Should the College A.B. Course Offer to the Future Writer on Art?" in *American Magazine of Art* 8 (Mar. 1917), 177–82. Phillips discussed the role of the critic in society, outlined a course of study, and summarized, clearly and concisely, his aesthetic credo of the time—essentially that of *The Enchantment of Art.*

32. Although not formally incorporated until July 23, 1920, the museum's beginnings are frequently dated by Phillips in 1918 (see *C in M,* 1926, 4); for the participation of his mother, Eliza Phillips, see "Washington Is to Have a New Gallery of Art," *Sunday Star,* Jan. 2, 1921.

33. Acquisitions lists before 1921 are unreliable, but the purchases were extensive; see *Inv.,* 1921. Many paintings on these early lists were later exchanged.

34. Notes on Ryder, Carlsen, and Weir in Journal CC, between 1917 and ca. 1920.

35. The Phillips dates the proposal between 1914 and 1920; formerly MS 80. On the basis of the ideas expressed in it, it can be dated more precisely to 1919. Phillips planned "A Book of Essays of Compact Criticism and Creative Interpretation on a selected number of American painters . . ." The artists include Bellows, Blakelock, Chase, Davies, Hassam, Henri, La Farge, Luks, Myers, Redfield, Ryder, Tack, and Twachtman. See also Journals CC, ca. 1919; U, ca. 1919; and M, ca. 1915–20. Research on this and other proposed publications by Phillips was carried out by Virginia Speer Burden.

36. A Harper and Brothers rejection letter dated Jan. 21, 1920, refers to Phillips's correspondence of Dec. 22, 1919, presumably the date of the proposal.

37. Journal CC, between 1917 and ca. 1920. The name was changed to Phillips Memorial Gallery in 1923.

38. The dream museum was never to be realized as a new structure, but planning continued for several years. By January 1921 Phillips had found his ideal site, a large plot fronting Connecticut Avenue, a few blocks north of the Phillips home, and he expressed the hope that the national government might purchase it for his planned gallery (writing to Charles Downing Lay, Jan. 25, 1921, Lay correspondence, TPC Archives). In June 1921 Phillips sent his newly created Committee on Scope and Plan a set of proposals for the museum and its programs, enlarging on his architectural concept (see *Inv.,* 1921). By December he had formed a Committee on Choice of Architecture, headed by William M. Kendall of the New York firm of McKim, Mead & White. He sent the members a well-considered, forward-looking museum program, emphasizing the desirability of an intimate, welcoming atmosphere. He charged the committee to give careful consideration to choice of architectural style (Notes on Committee on Choice of Architecture, part of *H of A,* 1920–21). In May 1922 McKim, Mead & White submitted plans for an Italianate building, which struck Phillips as too formal and conventional (TPC Papers, AAA, Reel 1929, #1158). In striking contrast is a sketch that Phillips later drew in a notebook (Journal B, 1923–29, 1), showing an asymmetrical plan featuring a large auditorium and libraries, together with many small galleries. For some years he continued to express hope for a new building, but he probably lacked the necessary financial resources.

39. Journal CC, 43–45.

40. DP, *H of A,* 1920, n.p.

41. *Julian Alden Weir: An Appreciation of His Life and Works,* Phillips Publications No. 1 (New York, 1922); previously published by the Century Association under the same title, J. B. Millet, ed. (New York, 1921).

42. DP, "Honoré Daumier," in *Honoré Daumier: Appreciation of His Life and Works,* Phillips Publications No. 2 (New York, 1922), 13–35.

43. "Arthur B. Davies: Designer of Dreams," in *Arthur B. Davies: Essays on the Man and His Art,* Phillips Publications No. 3 (Washington, D.C., 1924), 3–22.

44. DP, "Maurice Prendergast," *Arts* 5 (Mar. 1924), 125.

45. DP, essay for PMG.1924.1, n.p.

46. DP, "Principles and Practice in American Art," *Yale Review* (Oct. 1924), 165–71.

47. DP, *C in M,* 1926 (italics in original).

48. DP, pamphlets, both unpaginated, for exhibitions PMG.1926.1 and PMG.1926.2.

49. The exhibition of the Marin unit was part of PMG.1927.2a.

50. DP, "A Collection Still in the Making," in *CA,* 1929.

51. Although he had discussed his views on the roots of modern art from the beginning, the first instance in which Phillips used this term for the museum as a whole is in a flier, *To Our Friends and Readers,* inserted in *A & U,* 1929.

52. DP, *E of A,* 1927. See especially the new subtitle, *As Part of the Enchantment of Experience: Fifteen Years Later,* the preface, and the introduction.

53. For exhibition listings see PMG.1927.3 and PMG.1927.4.

54. Cat. for PMG.1927.6, n.p.

55. Cat. for PMG.1927.7, n.p.

56. Part of the Tri-Unit exhibition, PMG.1928.1, it had as its catalogue *Bull.,* 1928. R. H. Wilenski, *The Modern Movement in Art* (New York, 1926), was in Phillips's library.

57. PMG.1928.1b and PMG.1928.1c.

58. "Exhibition: The Washington Independents," *Arts* 13 (Apr. 1928), 243.

59. "A Letter from Duncan Phillips," *Arts* 7 (June 1925), 300.

60. PMG.1930.1a.

61. DP, *E of A*, 1927, 6.

62. In the March 1930 issue of the magazine Phillips wrote that the initial response had been most encouraging but that publication had to be temporarily discontinued to allow him to finance *The Artist Sees Differently*.

63. DP, "Art and Understanding," *A & U*, 1929, 7–16.

64. DP and C. Law Watkins, "Terms We Use in Art Criticism," *A & U*, 1930, 160–74.

65. DP, "Modern Art, 1930," *A & U*, 1930, 131–44.

66. DP, "The Artist Sees Differently," *ASD*, 1931, 3–10.

67. DP, "The Modern Argument in Art and Its Answer," *Bull.*, 1931, 37–73.

68. PMG.1933.1b.

69. DP, "Personality in Art: Reflections on Its Suppression and the Present Need for Its Fulfillment," *AMA*, Feb. 1935, 78–84.

70. John Dewey, *Art as Experience* (New York, 1934).

71. DP, "Personality in Art," *AMA*, Feb. 1935, 78–84.

72. DP, "The Expression of Personality in Art," unpubl. slide lecture, version B, ca. 1936–42.

73. DP, "Personality in Art," *AMA*, Apr. 1935, 214–20.

74. DP, *The Leadership of Giorgione* (Washington, D.C., 1937), p. 1.

75. DP, "The Place of the Arts in the World Today," *Bull.*, 1941, n.p. (based on an address, "The Place of the Arts in the World Today," presented at a symposium under the auspices of the Washington Dance Association, Dec. 15, 1940, held at PMG).

76. DP, "Rouault in America," *Bull.*, 1941, n.p; for the exhibition see PMG.1940.13.

77. DP, *Functions of Color*, PMG.1941.4, 5–50.

78. Essay for PMG.1944.11, n.p.

79. "Henri Focillon at The Phillips Gallery: In Memoriam," *Gazette des Beaux-Arts* 26 (July–Dec. 1944, pub. 1947), 31–34.

80. DP, Introduction to Cat., 1952, vii–x.

81. Ibid.

82. Phillips, recommending the artist for a Guggenheim fellowship, Nov. 1945, TPC Papers, AAA, Reel 1963, #410.

83. DP, "The Critic: Partisan or Referee," *Magazine of Art* 46 (Feb. 1953), 50, 88.

A COLLECTION IN THE MAKING

1. Undergraduate and graduate teaching in art history was professionally established in 1932 with the arrival of the French scholar Henri Focillon, who was to become one of Phillips's good friends and an enthusiastic admirer of the collection.

2. "The Need of Art at Yale," *Yale Literary Magazine* 72 (June 1907), 355–61.

3. See his report in *History of the Class of 1908: Yale College*, vol. 2, ed. Walter G. Davis Jr. (New Haven, 1914), 234–35.

4. Phillips first used this term for the museum as a whole in a flier, *To Our Friends and Readers*, inserted in *A & U*, 1929. *E of A*, 1914: Giorgione, 242–60; Tintoretto, 261–67; and Velázquez, 38–51. See also "Giorgione: The First Modern Master," *Yale Review* 2 (July 1913), 667–80. Phillips's study of Giorgione culminated in a book, *The Leadership of Giorgione* (Washington, D.C., 1937).

5. In *E of A*, 1927, "Chardin," 96–101, is dated 1915, but his first notes, in Journal HH, go back to 1912.

6. DP, "The Lyrics of Robert Bridges," *E of A*, 1927, 110–18, but dated 1913.

7. See DP, "George Moore," *Yale Review* 6 (Jan. 1917), 342–57.

8. DP, "Walter Pater," *E of A*, 1927, 103; although dated 1913, this essay does not appear in the 1914 edition of the book.

9. DP, *The Leadership of Giorgione*, 1937, 1.

10. DP to his cousin, James Laughlin, editor of the *New Directions Anthology of Contemporary Literature,* July 5, 1946; he also wrote about the inherent difference between painting and poetry.

11. DP, "Revolutions and Reactions in Painting," *International Studio* (Dec. 1913), 128–29.

12. DP, *E of A*, 1914.

13. James Phillips to Major Duncan Clinch Phillips, Jan. 6, 1916, now lost; recounted in *MP*, 1981, 54–55.

14. "15 Best Purchases of 1918–19; 15 Best Purchases Since Jan. 1920," acquisitions list, 1920.

15. DP, *C in M*, 1926, 4.

16. See *Allied War Salon,* exh. cat., American Art Galleries (New York, 1918); the exhibition was on view Dec. 9–24. See also DP, "The Allied War Salon," *American Magazine of Art* 10 (Feb. 1919), 115–23.

17. "Mrs. D. C. Phillips and Son Announce Intention of Establishing Phillips Memorial Gallery," *Washington Star*, Jan. 2, 1921.

18. DP.1919.1. See announcement and installation notes in Phillips's hand (Century Association papers, AAA, reel NCAZ, #130 and #131).

19. DP.1920.1. Eliza Phillips marked her first and only public appearance as a lender with her submission of David Cox's *Storm in the Vale of Clwyd,* 1841, to this exhibition. However, she was a generous donor to the museum until her death in late 1929.

20. Inv., 1921, 11. See PMAG.1920.3.

21. This list is published in the minutes of the First Annual Meeting of the Trustees, held on July 23, 1920. Members were invited in a letter dated May 25, and the meeting took place in New York on Dec. 12, 1921.

22. Mather's first letter, accepting his appointment to the committee, is dated Mar. 5, 1921. Phillips's last letter to Mather, dated Dec. 12, 1946, acknowledges the receipt of Mather's manuscript on George Fuller. Correspondence with the two dealers dates back to 1919. Kraushaar and Rehn were both influential during Phillips's years in New York, and Rehn in particular was a friend as well as business associate.

23. As quoted in TPC.1986.7.

24. Journal B, 1923–29, undated entry on the opening pages.

25. Although listed as part of the private collection, most of the works remained at the museum.

26. DP to Dwight Clark, July 10, 1923.

27. The sustained correspondence between Kent and Phillips illustrates the personal nature of the collector's support (see Kent, cat. nos. 222–24).

28. This association is documented by a wealth of correspondence; see discussion in Stieglitz, Marin, and Dove, cat. nos. 228, 229–37, and 246–54, respectively. For discussion of the controversy see Elizabeth Hutton Turner in TPC.1995.5, 14–25.

29. The sculptures are Emile-Antoine Bourdelle's *Virgin of Alsace*, Hunt Diederich's *Spanish Rider*, and Lachaise's *Peacocks*. He appreciated them more for their decorative character than for their form or content.

30. DP, *C in M*, 1926, 3.

31. Ibid., 35. This book was published the year before Roger Fry's *Cézanne, a Study of His Development* (London, 1927), which was the first extended analysis of Cézanne in English. See cat. nos. 38–43 for a discussion of Phillips's growing appreciation of Cézanne.

32. DP, *C in M*, 1926, 3–4.

33. See ibid., 6, for Phillips's discussion of units.

34. DP, *A & U*, 1929, 21.

35. Ibid., 78–91.

36. Graham, like several other American artists valued by Phillips, received a stipend for about two years.

37. Alfred H. Barr Jr., "American Painting," *Saturday Review of Literature* (Sept. 10, 1927), 99.

38. This was the first purchase of an Avery by any museum; by 1952 the collection owned seven Averys.

39. DP to Theodore Sizer, Oct. 19, 1932. Instead, Phillips lent ten works to Yale, eventually giving them to the university.

40. DP, "The Place of Art in a War-Torn World," *St. Louis Post Dispatch*, Jan. 27, 1941.

41. Mar. 10, 1941 (TPC Papers, AAA, Reel 1957, #0529). Phillips was a founding trustee, and his proposed gift reflected his intention to "build a bridge in [the National Gallery of Art's] collection between the Old Masters and the Moderns," as he wrote to the Bignou Gallery when making arrangements; as quoted in cat. for TPC.1986.7.

42. See comments in DP to John O'Connor, Carnegie, Nov. 3, 1938.

43. Owned by Kokoschka's mother-in-law, the painting was sent to the 1938 Carnegie International, where Phillips bought it, sending the money to Kokoschka in England (see Kokoschka, cat. no. 169).

44. In a sense, the wheel had come full circle, because Myers's *Band Concert Night* was one of his first purchases in 1910.

45. For discussion of the purchase and division of the series between Phillips and the Museum of Modern Art, see Lawrence, cat. nos. 319–21. See also the catalogue for TPC.1993.2, by Elizabeth Hutton Turner.

46. Cat., 1952, 141.

47. Ibid.

48. Journal B, 1923–29.

I. SOURCES OF MODERNISM

1. DP, *C in M*, 1926, 9. I would like to thank Raquel Da Rosa, my colleague on this project, not only for her intelligence and diligence in the preparation and writing of the catalogue entries, but also for the imagination and enthusiasm she brought to our discussions of Duncan Phillips and critical attitudes toward modernism.

2. DP, "Giorgione: The First Modern Master," *Yale Review* 2 (1913), 667–80.

3. DP, *The Leadership of Giorgione* (Washington, D.C., 1937), 1. Phillips had expressed his appreciation of Pater as the creator of "a new art, the art of imaginative criticism," in an essay of 1913, "Walter Pater," reprinted in *E of A*, 1927, 102–9.

4. *E of A*, 1927, 106.

5. DP, *C in M*, 1926, 6.

6. Ibid., 16.

7. Ibid., 17.

8. Ibid., 20.

9. Ibid., 24.

10. Ibid., 21.

11. See the concluding remarks to Phillips's introduction in *C in M*, 1926, 12–13.

GIORGIONE

1. Titles: *Vecchio con clessidra e giovane musicante,* Morassi, 1942, 159; *L'Astrologo,* Fiocco, 1948, 34; *Allegory of Time,* Berenson, 1957, 86, and Coletti, 1961, 40; *Old Man with Hourglass and a Woman Playing a Viola,* Zampetti, 1968, no. 57; *The Astrologer,* Pignatti, 1971, no. A 66; *Chronos und der geigende Engel,* Tschmelitsch, 1975, 80. Medium: Evidence of gold leaf was found on the old man's cap by Elizabeth Steele, painting conservator, per inspection May 6, 1991. Inscription: in ink on reverse by unknown hand: *Schiavone.* Provenance: Justi, 1908, 268, describes the work as "formerly in the Pulszky Collection, Budapest." According to Morassi, 1942, 159, it passed from the Pulszky collection to the St. Luke Gallery, Vienna, in 1937, and then to a private collection in Lugano. Subsequent authors have identified the latter as the Thyssen Collection. However, according to A. S. Berkes, administrative director, Sammlung Thyssen-Bornemisza to TPC, Aug. 8, 1980, the work cannot be positively identified as having been in that collection. Intent to purchase, DP to Seligmann, June 2, 1939, and payment receipt July 28, 1939.

2. Giorgione (?), *Leda and the Swan* (oil on wood panel, 12.0 × 19.0 cm.) and *Rustic Idyll* (oil on wood panel, 12.0 × 19.0 cm.); Pignatti nos. A 40 and A 41.

3. Morassi examined *The Hour Glass* at Seligmann in 1939 and identified it as an "authentic work by Giorgione." His certification, dated Jan. 17, 1939, is included in Paul M. Byk to DP, Apr. 13, 1939, Foxhall corr. "Close to Giorgione," Justi, 1908, 268; "derivate da Giorgione," Venturi, 1913, 254; "Giorgionesque," Berenson, 1957, 86; "Attributed," Zampetti, 1968, no. 57. The name Giulio Campagnola has also been proposed. See Pignatti, 1971, no. A 66, for a summary of alternative attributions in the literature up to 1971. Cited as "Circle of Giorgione" in TPC.1988.9. Sydney Freedberg to author, Dec. 16, 1991, believes it to be by the "young Titian, dating to ca. 1506."

4. Günter Bandmann, *Melancholie und Musik* (Cologne, 1960), 93. The figure has also been described as an astrologer.

5. Walter Pater, "The School of Giorgione," in *The Renaissance,* 3rd ed. (London and New York, 1888); see Walter Pater, *The Renaissance: Studies in Art and Poetry,* ed. Donald L. Hill (Berkeley, 1980), 102–22. Pater, who adhered to the view that all art aspires toward the condition of music, noted that the making and hearing of music are prominent as subjects in the School of Giorgione.

6. DP, 1942, 3–4. See also DP, "Walter Pater," *E of A,* 1927, 102–9.

7. Much of the correspondence between Phillips and Berenson is reproduced in MP, 1982, 139–63. For originals see Foxhall corr., TPC Archives.

8. DP, 1936, 298.

9. DP to Pietro Zambetti, Mar. 31, 1955: "At the time I wrote my book *The Leadership of Giorgione* I had not seen *The Hour Glass* and therefore did not venture an opinion." See also Paul M. Byk to DP, Mar. 29, 1939.

10. DP, 1942, 37–38. When the panel was offered to Phillips by Seligmann in 1939, Phillips claimed that it was stronger than the two panels in Padua and found the design worthy of the master. See DP to Seligmann, Apr. 22, 1939.

11. William E. Suida, "Giorgione in American Museums," *Art Quarterly* (summer 1956), 145–52.

12. DP, 1954, n.p.

13. DP, *The Leadership of Giorgione,* 1937, 11.

14. DP, "The Many Mindedness of Modern Painting," *A & U,* 1929, 51.

Major References

Giorgio Vasari, *Le Vite,* Florence, 1550; 2nd ed., Florence, 1568; trans. Gaston Du C. de Vere as *The Lives of the Painters, Sculptors, and Architects,* 4 vols., New York, 1977.

Ludwig Justi, *Giorgione,* 2 vols., Berlin, 1908; 3rd ed., enl., Berlin, 1936.

Lionello Venturi, *Giorgione e il Giorgionismo,* Milan, 1913.

George Martin Richter, *Giorgio da Castelfranco, Called Giorgione,* Chicago, 1937.

Antonio Morassi, *Giorgione,* Milan, 1942.

Giuseppe Fiocco, *Giorgione,* Bergamo, 1945; 2nd ed., Bergamo, 1948.

Bernard Berenson, *Italian Pictures of the Renaissance: Venetian School,* 2 vols., London, 1957.

Luigi Coletti, *All the Paintings of Giorgione,* Milan, 1955; trans. Paul Colacicchi, New York, 1961.

Pietro Zampetti, *Giorgione,* New York, 1968.

Terisio Pignatti, *Giorgione,* Venice, 1969; trans. Clovis Whitfield, New York, 1971.

Günther Tschmelitsch, *Zorzo, gennant Giorgione, Der Genius und sein Bannkreis,* Vienna, 1975.

Salvatore Settis, *La "Tempesta" interpretata: Giorgione, i committenti, il soggetto,* Turin, 1978; trans. Ellen Bianchini as *Giorgione's Tempest: Interpreting the Hidden Subject,* Chicago, 1990.

Rodolfo Pallucchini, ed., *Giorgione e l'umanesimo veneziano,* 2 vols., Florence, 1981.

Christian Hornig, *Giorgiones Spätwerk,* Munich, 1987.

Annalisa Perissa Torrini, *Giorgione: Catalogo completo dei dipinti,* Florence, 1993.

Mauro Lucco, *Giorgione,* Milan, 1995.

Jaynie Anderson, *Giorgione, the Painter of "Poetic Brevity": Including Catalogue Raisonné,* Paris, 1996.

Enrico Guidoni, *Studi su Giorgione e sulla Pittura del suo Tempo, Conferenze 1996–97,* 5 vols., Rome, 1997.

TPC Sources

DP, "Impressionism," unpubl. outline for proposed publication, 1910; formerly part of MS 97.

Journals W, ca. 1911–13; N, 1912; and HH, 1912.

DP, "Giorgione: The First Modern Master," *Yale Review* 2, July 1913, 667–80.

E of A, 1914 and 1927.

A & U, 1929.

ASD, 1931.

DP, "Freshness of Vision and Spontaneity in Painting," text for slide lecture, ca. 1935; formerly part of MS 178.

DP, "The Leadership of Giorgione," *American Magazine of Art* 29, May 1936, 286–99.

DP, "The Expression of Personality Through Design in the Art of Painting," text for slide lecture, 8 versions, ca. 1936–42.

DP, *The Leadership of Giorgione,* Washington, D.C., 1937.

Journal Z, after 1937.

DP, "The Leadership of Giorgione," text for slide lecture presented at Johns Hopkins University, Baltimore, Mar. 13, 1942.

DP, "Giorgione (Giorgio Barbarelli)," unpubl. essay, 1947.

Cat., 1952.

DP, *Catholicity Does Not Mean Eclecticism: A Radio Talk by Duncan Phillips,* pamphlet, 1954.

DP, "A Gallery of Modern Art and Its Sources," text for television program produced by the Greater Washington Education Television Association, aired Oct. 16, 1959; formerly MS 95.

MP, 1970 and 1982.

MD, 1981.

Journal FF, n.d.

MS 127.

EL GRECO (DOMENIKOS THEOTOKOPOULOS)

1. Dates: Wethey, 1962, no. 271, ca. 1600–1605; Gudiol, 1983, no. 205, 1603–7; Jonathan Brown in a letter of Mar. 22, 1994, assigns the painting to the last years of the artist's life. Titles: Spanish title per Cossío, 1972, no. 307, and Gudiol, 1971, no. 205; *St. Peter in Tears* per Wethey, 1962, no. 271. Medium: According to Elizabeth Steele (painting conservator, July 29, 1994), the painting was most likely cut on all four sides, but less so on the right. This was done some time ago, before the painting entered the collection. Therefore, the keys at the bottom and the figure of the angel on the left have been cropped. Provenance: Guillermo J. de Guillén García is from Guillermo J. de Guillén García, "Domenico Theotocópuli (El Greco)," *Revista de la asociación artística arqueológica barcelonesa* 2 (July–Aug. 1899), 242–56, and *Catálogo del Museo de Bellas Artes de Barcelona,* 1906, no. 276. Provenance: From Zuloaga to Heilbuth per Cossío, 1908, nos. 15 and 316, and Karl Madsen, *Catalogue of a Collection of Paintings (Heilbuth Collection),* 1920, no. 42. For more on the painter Ignacio Zuloaga (1870–1945), who contributed to the El Greco revival at the turn of the century, see P. Lafond, "Les 'Greco' de la Collection I. Zuloaga," *Le bulletin de l'art* 143 (June 7, 1902), 181–82. Ehrich bill of sale, Sept. 26, 1922.

2. Other versions of the subject are in the Bowes Museum (England), San Diego, Oslo, and Toledo. See Wethey, 1962, nos. 269–73.

3. José López-Rey, "Spanish Baroque: A Baroque Vision of Repentance in El Greco's 'St. Peter,'" *Art in America* 35 (1947), 313–18. For El Greco as a Counter-Reformation artist, see Jonathan Brown, "El Greco and Toledo," in Brown et al., 1982, 113–17.

4. Matt. 26:75.

5. López-Rey, 1947, 313–18. In the Oslo version the angel by an open tomb as well as the keys are intact.

6. DP, "El Greco, Cézanne, Picasso" in *A & U,* 1929, 102.

See Roger Fry's influential book *Vision and Design* (London, 1920), 138–39.

7. DP, "Arthur B. Davies: Designer of Dreams" in *Bull.*, 1929, 14.

8. DP, "Terms We Use in Art Criticism," in *A & U*, 1930, 172. At a later time, recognizing the futility of altering the traditional connotations of the term *baroque*, Phillips substituted *stylistic*; see *ASD*, 1931, 45–46.

9. See *C in M*, 1926, 6, and Brown, "El Greco and Toledo," 134–40, who considers the antinaturalistic character of El Greco's art in light of late sixteenth-century ideas about beauty. Early twentieth-century interpretations were to link El Greco's agitated style with the distortions of reality in expressionist painting.

10. DP, "Where Classic and Romantic Meet in Painting" in *Bull.*, 1931, 5. Fry expressed a similar view with respect to Cézanne. See Roger Fry, *Cézanne: A Study of His Development* (1927), Chicago, 1989, 83: "Cézanne then was a Classic artist, but perhaps all great Classics are made by the repression of a Romantic."

Major References
Manuel B. Cossío, *El Greco*, 3 vols., Madrid, 1908; rev. ed., Barcelona, 1972.
August L. Mayer, *El Greco*, Munich, 1916; rev. ed., Berlin, 1931.
Paul Guinard, *El Greco: A Biographical and Critical Study*, Barcelona, 1956.
Harold E. Wethey, *El Greco and His School*, 2 vols., Princeton, 1962.
José Gudiol, *El Greco, 1541–1614*, Barcelona, 1971; trans. Kenneth Lyons, New York, 1983.
Richard Mann, *El Greco and His Patrons*, Cambridge, 1981.
Fernando Marías and Agustín Bustamante, *Las ideas artísticas de El Greco: Commentarios a un texto inédito*, Madrid, 1981.
Jonathan Brown et al., *El Greco of Toledo*, Boston, 1982.
Jose Alvarez Lopera, *De Cean a Cossio: La Fortuna Critica del Greco en el siglo XIX*, vol. 2, Madrid, 1987.
Jose Alvarez Lopera, *El Greco: La obra esencial*, Madrid, 1993.
Fernando Marías, *El Greco: Biografia de un pintor extravagante*, Madrid, 1997.
Janis A. Tomlinson, *From El Greco to Goya: Painting in Spain, 1561–1828*, New York, 1997.

TPC Sources
Journals HH, 1912, and AA, 1913–14.
DP, "Fallacies of the New Dogmatism in Art," parts 1 and 2, *American Magazine of Art* 9, Dec. 1917, 43–48, and Jan. 1918, 101–6.
Journal GG, 1924.
DP, "The Phillips Collection," unpubl. outline prepared for F. Newlin Price, "Phillips Memorial Gallery," *International Studio* 80, Oct. 1924, 8–18; some drafts formerly MS 89.
C in M, 1926.
Bull., 1927.
DP, "Art in Washington: The Phillips Memorial Gallery," *Forerunner of the General Convention*, A.D. 1928 2, Easter 1928, 18–24.
DP, essay for PMG.1928.4a–c.
CA, 1929.
A & U, 1929 and 1930.
Bull., 1929.
Formes, 1930.

Journal BB, 1930–33.
ASD, 1931.
Bull., 1931.
DP, "Modern Art and the Museum," *American Magazine of Art* 23, no. 4, Oct. 1931, 271–76; formerly MS 77.
DP, "The Artist Sees Differently," text for slide lecture, 12 versions, 1931–34.
DP, [Classic or Romantic in Modern Landscape], paper presented at PMG, Mar. 14, 1934.
AMA, 1935.
DP, "Freshness of Vision and Spontaneity in Painting," text for slide lecture, ca. 1935; formerly part of MS 178.
DP, "The Expression of Personality Through Design in the Art of Painting," text for slide lecture, 8 versions, ca. 1936–42.
Cat., 1952.
DP, *Catholicity Does Not Mean Eclecticism: A Radio Talk by Duncan Phillips*, pamphlet, 1954.
Arts, 1956.
DP, "A Gallery of Modern Art and Its Sources," text for television program produced by the Greater Washington Education Television Association, aired Oct. 16, 1959; formerly MS 95.
MP, 1970 and 1982.
MD, 1981.
MP, 1998.
MSS 83, 109, and 125.

JEAN-BAPTISTE SIMÉON CHARDIN

1. Dates: Per Rosenberg, 1979, 135. Titles: The earliest title found for this painting is *Broc de Delft et compotier de fruits* in the 1913 Roberts sale catalogue; it is not known whether this is the original title. Georges Wildenstein in his 1933 catalogue raisonné entitles it *Dish of Plums with Peach and Delft Pitcher*. Pierre Rosenberg, in his 1979 Chardin exhibition catalogue, entitles the painting *Jatte de prunes avec une cerise, une pêche et un pot à eau (Bowl of Plums, with a Cherry, a Peach and Water Pitcher)*. Since the work's entry into the present collection in 1919, it has been referred to as *A Bowl of Plums*, possibly a Duncan Phillips title. Provenance: Bill of sale, Nov. 14, 1919. Transfer to PMG recorded in Ledger 11.

2. In Journal EE, ca. 1922, Phillips ranked *A Bowl of Plums* number thirteen out of eighty favorites; quotation from Journal B, ca. 1923–29, n.p.

3. DP, *C in M*, 1926, 17.

4. DP, 1958, n.p. (reprinted with changes from DP, 1949, 564).

5. Phillips discusses Chardin's individuality in *E of A*, 1927, 96–101.

6. An early date was also suggested by David Carritt, London, in a letter to Marjorie Phillips, July 14, 1978. Wildenstein, 1969, no. 257, suggested ca. 1756.

7. DP, 1945, n.p.

Major References
J. and Ed. de Goncourt, "Chardin," *Gazette des Beaux-Arts*, Dec. 1863, 514–33; Feb. 1864, 144–67.
Georges Wildenstein, *Chardin: Catalogue raisonné*, Zurich, 1963; rev. and enl. by Daniel Wildenstein, Oxford, 1969.
Pierre Rosenberg, *Chardin*, exh. cat., Paris, Grand Palais, 1979.
———, *Tout l'oeuvre peint de Chardin*, Paris, 1983.
Philip Consibee, *Chardin*, Lewisburg, N.J., 1986.

René Démoris, *Chardin, la chair et l'objet*, Paris, 1991.
Marianne Roland Michel, *Chardin*, London, 1996.

TPC Sources
Journal HH, 1912.
DP, "The Impressionistic Point of View," *Art and Progress* 3, Mar. 1912, 505–11.
Journal AA, 1913–14.
E of A, 1914 and 1927.
DP, "Fifteen Best Purchases of 1918–19; Fifteen Best Purchases Since Jan. 1920," unpubl. list, 1920.
H of A, 1920–21.
Inv., 1921.
Journals DD, 1921; EE, ca. 1922; B, ca. 1923–29; and GG, 1924.
DP, "Chardin," unpubl. essay, 1924; formerly MS 9.
DP, "The Phillips Collection," outline prepared for F. Newlin Price, "Phillips Memorial Gallery," *International Studio* 80, Oct. 1924, 8–18; some drafts formerly MS 89.
C in M, 1926.
DP, essay for PMG.1927.6.
Bull., 1931.
ASD, 1931.
DP, [Classic or Romantic in Modern Landscape], paper presented at PMG, Mar. 14, 1934.
AMA, 1935.
DP, "Freshness of Vision and Spontaneity in Painting," text for slide lecture, ca. 1935; formerly part of MS 178.
DP, "The Expression of Personality Through Design in the Art of Painting," text for slide lecture, 8 versions, ca. 1936–42.
DP, "Freshness of Vision in Painting," unpubl. essay, ca. 1945; formerly part of MS 178.
DP, *The Nation's Great Paintings: Jean-Baptiste Siméon Chardin, "Bowl of Plums,"* pamphlet, New York, 1945.
DP, discussion of Chardin in "Pierre Bonnard," *Kenyon Review* 11, Autumn 1949, 561–66.
Cat., 1952.
DP, *Catholicity Does Not Mean Eclecticism: A Radio Talk by Duncan Phillips*, pamphlet, 1954.
DP, "A Critic and His Pictures," *Arts* 30, Dec. 1955, 27–31.
Arts, 1956.
DP, essay for TPG.1958.2.
DP, "A Gallery of Modern Art and Its Sources," text for television program produced by the Greater Washington Education Television Association, aired Oct. 16, 1959; formerly MS 95.
MP, 1970 and 1982.
SITES, 1979.
MD, 1981.
MP, 1998.
MSS 8 and 103.

FRANCISCO JOSÉ DE GOYA

1. Dates: Ca. 1820–24 per Gassier-Wilson, 1981, no. 1641; ca. 1823–24 per Gudiol, 1971, no. 725; "latework" per Mayer, 1924, no. 66. Titles: *The Repentant Peter* per Gassier and Wilson, 1981, no. 1641; *San Pedro arrepentido* per Gudiol, 1971, no. 725. Provenance: Pidal per Madrid exhibition of 1900. Newhouse archives were inaccessible (Newhouse to TPC, June 26, 1989); original correspondence indicates that Newhouse was acting as agent for the owner, possibly the Spanish Art Gallery, London (Newhouse to DP, Dec. 8, 1936). Gauguin's *Idyll of Tahiti* traded to Newhouse in partial

payment for *The Repentant St. Peter.* Bill of sale, Dec. 18, 1936.

2. Gassier and Wilson, 1981, no. 1642.

3. The foreshortening of the figure may suggest that the painting was intended to be hung above eye level. Pentimenti in the area of the hands indicates that the fingers were shortened. Elizabeth Steele, painting conservator, Feb. 25, 1991.

4. Matt. 16:19: "And I will give unto thee the keys of the kingdom of heaven: and whatsoever thou shalt bind on earth shall be bound in heaven: and whatsoever thou shalt loose on earth shall be loosed in heaven."

5. Pérez Sanchez and Sayre, 1989, no. 123.

6. DP to Mrs. Marie Sterner, Dec. 21, 1936.

7. MS 109. Under an outline heading of "El Greco and Goya," Phillips penned: "the flame—the stone."

8. DP, "The Expression of Personality by Design in the Art of Painting," version A, Jan. 27, 1938.

9. DP, 1956, 31.

10. MP, 1982, 103. Marin to DP, Feb. 18, 1937, Foxhall corr., commented: "That Goya still haunts me."

Major References
Conde de la Viñaza, *Goya, su Tiempo, su Vida, sus Obras,* Madrid, 1887.
August L. Mayer, *Francisco de Goya,* Munich, 1923; London, 1924.
José Gudiol, *Goya 1746–1828: Biography, Analytical Study, and Catalogue of His Paintings,* 4 vols., Barcelona, 1970; trans. Kenneth Lyons, New York, 1971.
Pierre Gassier and Juliet Wilson, *The Life and Complete Work of Francisco Goya, with a Catalogue Raisonné of the Paintings, Drawings, and Engravings,* 1st English ed., New York, 1971; 2nd English ed., rev., New York, 1981.
Fred Licht, *Goya: The Origins of the Modern Temper in Art,* New York, 1979.
Angel Canellas López, ed., *Francisco de Goya: Diplomatario,* Saragossa, 1981.
Alfonso E. Pérez Sánchez and Eleanor A. Sayre, *Goya and the Spirit of Enlightenment,* exh. cat., Boston, MFA, 1989.
Janis A. Tomlinson, *Goya in the Twilight of Enlightenment,* New Haven, 1992.
Jeannine Baticle, *Goya,* Paris, 1992.
Jutta Held, ed., *Goya: Neue Forschungen, das internationale Symposium 1991 in Osnabrücke,* Berlin, 1994.
Janis A. Tomlinson, *Francesco Goya y Lucientes, 1746–1828,* London, 1994.
Jose Luis Morales y Marin, *Goya, catálogo de la pintura,* Saragossa, Spain, 1994.
Juliet Wilson-Bareau and Manuela B. Mena Marqués, *Goya: Truth and Fantasy, the Small Paintings,* exh. cat., Madrid, Museo del Prado, 1994.
Juan J. Luna, *Goya, 250 aniversario,* exh. cat., Madrid, Museo del Prado, 1996.
Janis A. Tomlinson, *From El Greco to Goya: Painting in Spain, 1561–1828,* New York, 1997.

TPC Sources
DP, "Impressionism," unpubl. outline for proposed publication, 1910; formerly part of MS 97.
Journal HH, 1912.
DP, "Revolutions and Reactions in Painting," *International Studio* 51, Dec. 1913, 123–29.
E of A, 1914 and 1927.

DP, "Fallacies of the New Dogmatism in Art," parts 1 and 2, *American Magazine of Art* 9, Dec. 1917, 43–48, and Jan. 1918, 101–6.
DP, "Art and the War," *American Magazine of Art* 9, June 1918, 303–9.
DP, essay for PMG.1928.4a–c.
Bull., 1931.
DP, "The Expression of Personality Through Design in the Art of Painting," text for slide lecture, 8 versions, ca. 1936–42.
DP, "Modern Art and the Museum," unpubl. essay, 1939.
Cat., 1952.
DP, *Catholicity Does Not Mean Eclecticism: A Radio Talk by Duncan Phillips,* pamphlet, 1954.
Arts, 1956.
DP, "A Gallery of Modern Art and Its Sources," text for television program produced by the Greater Washington Education Television Association, aired Oct. 16, 1959; formerly MS 95.
MP, 1970 and 1982.
MD, 1981.
MP, 1998.
MSS 109, 128, and 146.

JOHN CONSTABLE

1. Provenance: Per Scott and Fowles statement, May 4, 1926; Reynolds, 1984, no. 34.76; Parris and Fleming-Williams, 1991, no. 215; and Leslie Parris, deputy keeper, British Collection, Tate, to author, Aug. 13, 1992, and Oct. 22, 1992. A misidentification in the Scott and Fowles statement of May 4, 1926, led W. G. Constable, Boston exhibition of 1946, to conclude that the work was in the possession of Constable's niece, Alicia Whalley (later Alicia Webb; died ca. 1880).

2. Oil on canvas, Frick Collection, New York.

3. Constable to Fisher, Jan. 14, 1826, in *John Constable's Correspondence,* vol. 6 (1968), 212.

4. Reynolds, 1984, no. 29.55. Other versions of the composition executed during the 1830s include a watercolor in the British Museum (no. 32.17) and oils in the Victoria and Albert Museum, London (no. 34.75), Wight Art Gallery, University of California, Los Angeles (no. 34.77), and the Nationalmuseum, Stockholm (no. 34.78).

5. Ibid., 269, basing his conclusions on Constable's correspondence. See also Parris and Fleming-Williams, 1991, 375, for further discussion of this question.

6. Parris to author, Aug. 13, 1992. For more on changes in Constable's work, see Charles Rhyne, "Changes in the Appearance of Paintings by John Constable" in *Appearance, Opinion, Change: Evaluating the Look of Paintings,* Institute for Conservation (London, 1990), 72–84.

7. The reproduction in the 1917 Christie's auction catalogue and the description given in the Christie's sales catalogue of 1918 confirm the continued presence of many of these same details. The 1918 description is given in reverse; Parris to author, Jan. 2, 1992, has surmised that the Christie's cataloguer may have been looking at a reversed print. Parris (in a note of Apr. 7, 1994) believes that the architecture seen in the sepia photograph is "rather unconvincing."

8. A photograph in TPC archives, taken when the work was with Knoedler, nearly matches the work in its present state. This would suggest that some changes in the painting's appearance were brought about then.

9. Elizabeth Steele, painting conservator, Oct. 5, 1992,

and June 17, 1993. Perhaps the truth lies somewhere in between: the work may have been repainted by another hand, and subsequent attempts at cleaning may have removed not only the overpaint but also original paint, further distancing us from the artist's initial conception. Additional investigation may shed light on the actual sequence of changes.

10. Journal DD, 1921, n.p. Phillips went on to admire the manner in which Constable was able effectively to balance the classic and romantic: "Often classic in design, his art is always romantic in its apprehension of the moods of nature."

11. DP, *C in M,* 1926, 19.

Major References
Charles Robert Leslie, *Memoirs of the Life of John Constable,* London, 1843; ed. Jonathan Mayne, London, 1951.
John Constable's Correspondence, 6 vols., ed. R. B. Beckett, Ipswich, 1962–68.
John Constable's Discourses, ed. R. B. Beckett, Ipswich, 1970.
Robert Hoozee, *L'opera completa di Constable,* Milan, 1979.
Graham Reynolds, *Constable's England,* exh. cat., New York, Metropolitan, 1983.
———, *The Later Paintings and Drawings of John Constable,* 2 vols., New Haven, 1984.
Malcolm Cormack, *Constable: His Life and Work,* Cambridge, 1986.
Michael Rosenthal, *Constable,* New York, 1987.
Ian Fleming-Williams, *Constable and His Drawings,* London, 1990.
Judy Crosby Ivy, *Constable and the Critics, 1802–1837,* Woodbridge, Suffolk, 1991.
Leslie Parris and Ian Fleming-Williams, *Constable,* exh. cat., London, Tate, 1991.
Peter Bishop, *An Archetypal Constable: National Identity and the Geography of Nostalgia,* London, 1995.
Graham Reynolds, *The Early Paintings and Drawings of John Constable,* 2 vols., New Haven, 1996.

TPC Sources
DP, "Impressionism," unpubl. outline for proposed publication, 1910; formerly part of MS 97.
DP, "Impressionism in Poetry and Painting," unpubl. essay, 1910–11; formerly MS 155.
DP, "Revolutions and Reactions in Painting," *Internatioal Studio* 51, Dec. 1913, 123–29.
E of A, 1914 and 1927.
Journal DD, 1921.
C in M, 1926.
CA, 1929.
A & U, 1930.
Formes, 1930.
Bull., 1931.
ASD, 1931.
DP, [Classic or Romantic in Modern Landscape], paper presented at PMG, Mar. 14, 1934.
DP, "Modern Art and the Museum," unpubl. essay, 1939.
Cat., 1952.
DP, *Catholicity Does Not Mean Eclecticism: A Radio Talk by Duncan Phillips,* pamphlet, 1954.
Arts, 1956.
MP, 1970 and 1982.
MD, 1981.
MS 114.

JEAN-AUGUSTE-DOMINIQUE INGRES

1. Titles: Ingres did not title this painting. It has been known by different titles—all variations on "Bather" in French and English—since its first mention as *Baigneuse* in the 1862 sale catalogue of E. Blanc. The current title was first used in *MD*, 1981. Provenance: Details of Hatvany and Rosenberg transactions per letter, Alexandre Rosenberg to Mr. Jean-Flavien Lalive, May 6, 1965, a copy of which was sent to Phillips. For TPC purchase, see DP to Jean-Flavien Lalive, May 3, 1965.

2. All three paintings are in the Louvre: the *Valpinçon Bather*, 1808; *Interior of a Harem*, 1828; and *Turkish Bath*, 1859/64. Another related work is a watercolor, *Bather*, n.d., Fogg Art Museum, Cambridge, Mass. The obvious gray pentimenti that show through the two figures in the lower left suggest that Ingres may have begun this work with another idea in mind. There is other evidence to suggest that *The Small Bather* was begun as a grisaille painting; see Toussaint, 1971, 5, for a discussion of this possibility. However, sketches that would relate to a different initial conception were not revealed by infrared inspection, and further examination to prove its original state as a grisaille are required; see Elizabeth Steele, painting conservator, Nov. 12, 1991.

3. Delaborde, 1870, frequently quotes Ingres's comments about the superiority of tradition over novelty.

4. See Mayne, 1965, 84, for Baudelaire's praise of Ingres's nudes.

5. See Henry Lapauze, *Jean Briant, paysagiste (1760–1799), maître de Ingres et le paysage dans l'oeuvre de Ingres* (Paris, 1911), 46, for Ingres's comments on Watteau. See also Thibaut-Sisson, "Le paysage dans l'oeuvre de Ingres," *La renaissance de l'art français* (May 1921), 254, for further discussion of Ingres and landscape.

6. Rosenblum, [1967], 169.

7. *ASD*, 1931, 115. See *A & U*, 1930, 163, for Phillips's definitions of classicism and romanticism.

8. *Cat.*, 1952, viii. Phillips had bought his Delacroix paintings in 1922, 1940, and 1945.

9. Phillips to Sir Kenneth Clark, July 27, 1950, Foxhall corr.

10. In fact, Phillips had relegated Ingres to the "B type" of painter, stating, "[The B type] is by far the most ordinary. . . . Often they have amazing craftsmanship and in many cases original genius but the motive is lacking for emotional, humane and therefore moving expression. . . . It was so with Van Dyke [*sic*], with Boucher, with Ingres . . ." (*ASD*, 1931, 8).

Major References
Charles Blanc, *Ingres: Sa vie et ses ouvrages*, Paris, 1870.
Le Viconte Henri Delaborde, *Ingres: Sa vie, ses travaux, sa doctrine: D'après les notes manuscrites et les lettres du maître*, Paris, 1870.
Henry Lapauze, *Ingres: Sa vie et son oeuvre d'après des documents inédits*, Paris, 1911.
Georges Wildenstein, *The Paintings of Ingres*, London, 1954.
Jonathan Mayne, ed. and trans., *Art in Paris, 1845–1862: Salons and Other Exhibitions by Charles Baudelaire*, Oxford, 1965.
Robert Rosenblum, *Ingres*, New York, [1967].
Daniel Ternois and Ettore Camesasca, *Tout l'oeuvre peint d'Ingres*, Paris, 1971.
Hélène Toussaint and Suzy Delbourgo, *Le Bain Turc d'Ingres*, exh. cat., Paris, Musée du Louvre, 1971.
Patricia Condon et al., *Ingres: In Pursuit of Perfection*, exh. cat., Louisville, J. B. Speed Art Museum, 1984.
George Vigne, *Le retour a Rome de Monsieur Ingres: Dessins et peintures*, exh. cat., Villa Medicis, Rome, 1993.
———, *Ingres*, trans. John Goodman, New York, 1995.
Carol Ockman, *Ingres's Eroticized Bodies: Retracing the Serpentine Line*, New Haven, 1995.

TPC Sources
Phillips-Kenneth Clark correspondence, 1950–51, Foxhall corr.
C in M, 1926.
A & U, 1930.
ASD, 1931.
Cat., 1952.
MD, 1981.
MP, 1998.

JEAN-BAPTISTE-CAMILLE COROT

1. Titles: Per Robaut, 1905, no. 65. Inscriptions: On the stretcher is a second wax stamp: VENTE COROT (Lugt no. 460). For the stamps of the Corot sales, see Frits Lugt, *Les marques de collections de dessins et d'estampes* (Amsterdam, 1921). Provenance: Early provenance per Rosenberg bill of sale, Feb. 13, 1942. Détrimont date per Robaut, 1905, no. 65. Houghton per Cambridge exhibition of 1929. Duncan Phillips traded Matisse's painting *Plaster Figure* in partial payment for the Corot.

2. Galassi, 1991, 66. Valenciennes's theories and lessons are contained in *Elémens de perspective pratique à l'usage des artistes, suivis de réflexions et conseils à un élève sur la peinture, et particulièrement sur le genre de paysage* (Paris, 1800).

3. According to Galassi, 1991, 146, Corot's choice of motifs reflects not only the classical tradition but also a tradition of established "views," or *vedute*, often townscapes, popular since the eighteenth century. For discussion of the Farnese Gardens site, see Tinterow et al., 1996, 40–41.

4. Corot in fact intended these studies to go to the Louvre; see Toussaint, 1975, 20–21.

5. DP, *C in M*, 1926, 21.

6. Titles: Per Robaut, 1905, no. 142; Parke-Bernet sale (1945); and the American British Art Center (1946). Listed as *Civita Castellana, vue d'ensemble* in Hôtel Drouot sale of 1875. Inscriptions: On the strainer is a second wax stamp: VENTE COROT (Lugt 460). Provenance: Per Robaut, 1905, no. 142, and American British Art Center bill of sale, Nov. 6, 1946. A secondary support of linen gauze bears the stamp DETRIMONT TABLEAUX. However, it is not known whether this work was ever owned by Détrimont, who did acquire two other views of Civita Castellana at the Corot sale (part 2): nos. 296 and 297. Information regarding provenance immediately before the Parke-Bernet sale of 1945 is not available (Lynda Packard, Nineteenth Century European Paintings, Sotheby's, to author, Nov. 5, 1991).

7. It is difficult to assign specific dates to works done in and around Civita Castellana during these two trips. See André and Renée Jullien, "Les campagnes de Corot au nord de Rome (1826–1827)," *Gazette des Beaux-Arts* 99 (1982), 179–202.

8. See Galassi, 1991, 122, for a discussion of this and other principal itineraries.

9. Jullien, "Les campagnes de Corot," 190 and n. 32.

10. Titles: Per Robaut, 1905, no. 457bis. Listed as *Genzano, près du lac Nemi* in 1908 Chéramy sale. Provenance: Per Wildenstein correspondence, Mar. 1, 1955. Robaut, 1905, no. 457bis, claims the work passed from Brizard to Closel at Hôtel Drouot sale, Jan. 1886. However, it has not been possible to locate this sale (Compagnie des Commissaires Priseurs de Paris to author, July 25, 1991). Chéramy date per Paris exhibition (1889). See L. Rouart, "La collection de M. Chéramy," *Les arts* 64 (Apr. 1907), 28. Wildenstein date per Venice Biennale (1952). Phillips, writing to Wildenstein, Feb. 4, 1955, agreed to give up Cézanne's *Harvesters* in partial payment for *Genzano*.

11. See André and Renée Jullien, "Corot dans les Castelli Romani," *Gazette des Beaux-Arts* 110 (1987), 109–30. See also related drawing and discussion in Tinterow et al., 1996, 196–97.

12. An example is *Woman with Water Jar* (acc. no. 0337), acquired in 1922 and frequently exhibited and published, which appears to be a copy of a work in the Philadelphia Museum of Art (Robaut, 1905, no. 1423).

13. In "Corot," 1906, 54, Phillips wrote of Corot's romantic works: "If you love poetry you will fall easily under the spell of moist dawns and twilights in the woods, during those still hours when Nature is drowsily awakening or gently drifting into her long sleep." Fifty years later, in *Arts*, 1956, 34, he declared: "For me the great Corot was at his best in his early, sunny studies of landscape in and around Rome."

14. Ibid., 34.

Major References
Henri Dumesnil, *Corot: Souvenirs intimes*, Paris, 1875.
Alfred Robaut, *L'oeuvre de Corot, catalogue raisonné et illustré, précédé de l'histoire de Corot et de ses oeuvres, par Etienne Moreau-Nélaton*, 4 vols., Paris, 1905.
Etienne Moreau-Nélaton, *Corot raconté par lui même*, 2 vols., Paris, 1924.
Germain Bazin, *Corot*, Paris, 1942; 3rd ed. rev. and enl., Paris, 1973.
André Schoeller and Jean Dieterle, *Premier supplément à l'oeuvre de Corot par A. Robaut et Moreau-Nélaton*, Paris, 1948; *Deuxième supplément*, Paris, 1956; and Dieterle, *Corot, troisième supplément*, Paris, 1974.
André Coquis, *Corot et la critique contemporaine*, Paris, 1959.
Hélène Toussaint et al., *Hommage à Corot: Peintures et dessins de collections françaises*, exh. cat., Paris, Orangerie des Tuileries, 1975.
Jean Leymarie, *Corot*, Geneva, 1966; rev. ed., trans. Stuart Gilbert, New York, 1979.
Jean Selz, *La vie et l'oeuvre de Camille Corot*, Paris, 1988.
Alan Wintermute, ed., *Claude to Corot: The Development of Landscape Painting in France*, exh. cat., Colnaghi, New York, 1990.
Peter Galassi, *Corot in Italy*, New Haven, 1991.
Laura L. Meixner, *French Realist Painting and the Critique of American Society*, Cambridge, 1995.
Vincent Pomarède, *Corot*, Milan, 1996.
Gary Tinterow et al., *Corot*, exh. cat., New York, Metropolitan, 1996.

TPC Sources

DP, "Corot," *Yale Literary Magazine* 72, Nov. 1906, 54–58.

DP, "The Nature and Expression of Sentiment," *Yale Literary Magazine* 73, Mar. 1908, 244–52.

DP, "Impressionism in Poetry and Painting," unpubl. essay, 1910–11; formerly MS 155.

DP, "The Impressionistic Point of View," *Art and Progress* 3, Mar. 1912, 505–11.

Journal HH, 1912.

DP, "Revolutions and Reactions in Painting," *International Studio* 51, Dec. 1913, 123–29.

E of A, 1914 and 1927.

Journal GG, 1924.

DP, "The Phillips Collection," outline prepared for F. Newlin Price, "Phillips Memorial Gallery," *International Studio* 80, Oct. 1924, 8–18; some drafts formerly MS 89.

C in M, 1926.

Bull., 1928.

CA, 1929.

A & U, 1929.

Journal BB, 1930–33.

ASD, 1931.

Bull., 1931.

DP, "Modern Art and the Museum," *American Magazine of Art* 23, no. 4, Oct. 1931, 271–76.

DP, [Classic or Romantic in Modern Landscape], paper presented at PMG, Mar. 14, 1934.

DP, "Freshness of Vision and Spontaneity in Painting," text for slide lecture, ca. 1935; formerly part of MS 178.

AMA, 1935.

DP, "The Expression of Personality Through Design in the Art of Painting," text for slide lecture, 8 versions, ca. 1936–42.

DP, "Spontaneous Painters," unpubl. essay, ca. 1939; formerly MS 78.

Cat., 1952.

DP, *Catholicity Does Not Mean Eclecticism: A Radio Talk by Duncan Phillips*, pamphlet, 1954.

Arts, 1956.

DP, "A Gallery of Modern Art and Its Sources," text for television program produced by the Greater Washington Education Television Association, aired Oct. 16, 1959; formerly MS 95.

MP, 1970 and 1982.

SITES, 1979.

MD, 1981.

MP, 1998.

MSS 6, 109, 111, and 167.

FERDINAND-VICTOR-EUGÈNE DELACROIX

1. Dates: For a discussion of the painting's date, see Lee Johnson, *Eugène Delacroix, 1798–1863* (Toronto, 1962), 17, and Johnson, 1981–86, vol. 3, 65–66. Titles: Listed as *Paganini jouant du violon* for the Hermann (1879) and Chéramy sales (1908); catalogued by Johnson, 1981–86, as *Portrait of Nicolò Paganini*. Provenance: According to Robaut, 1805, 106, Delacroix seems to have painted this subject for his friend Ricourt, who was a writer and journalist, the founder of *L'artiste*, and its editor from 1831 to 1838. The provenance from Hermann to Kélékian per Johnson, 1981–86, vol. 3, 65. By the spring of 1922, Phillips had received the painting from Kraushaar per letter of Apr. 27, 1922, reel 1929, #1124. Bill of sale, Jan. 31, 1922.

2. According to Johnson, 1981–86, vol. 3, 50, *Paganini* was the only portrait Delacroix painted of a living celebrity who was not a personal friend. Paganini fos-

tered many of the colorful rumors that were widespread at the time of his Parisian debut—that he had perfected his technique while in prison (where he had been sent for murdering one of his many mistresses), that his astonishing abilities were the result of a pact he had made with the devil, that he preferred to associate with gamblers and prostitutes, and that he gave full rein to his vices. See Geraldine de Courcy, *Paganini, the Genoese*, 2 vols. (Norman, Okla., 1957). Delacroix wrote: "Painting . . . demands erudition like that of the composer, but it also demands execution like that of the violinist"; see *Journal* (Sept. 18, 1847), trans. Walter Pach, 1972, 173. See also Martin Kemp, "Ingres, Delacroix, and Paganini: Exposition and Improvisation in the Creative Process," *Arte* 9 (Aug. 1970), 49–65.

3. See de Courcy, *Paganini*, vol. 2, 14–15. Although Delacroix does not mention the 1830 concert in his journal, he later wrote that Paganini was "sans doute un homme incomparable"; see *Journal* (Jan. 15, 1856), vol. 3, 565. See also Robaut, 1885, 106, for a secondhand report of Delacroix's assessment of Paganini.

4. From Francesco Bennati, "Notice physiologique sur Paganini," *Revue de Paris* 11 (1831), 52–60, trans. Richard Smith and John Worthington in "Paganini: The Riddle and Connective Tissue," *Journal of the American Medical Association* 199, no. 11 (Mar. 13, 1967), 156–60.

5. Pierre Larousse, *Grand dictionnaire universel du XIXe siècle* (Paris, 1874), vol. 12, 19, s.v. "Paganini" (author's trans.): "Paganini avait alors quarante-sept [*sic*] ans et paraissait bien plus vieux; long et maigre, d'une pâleur cadavéreuse, avec de longs cheveux noirs battant le collet de l'habit, des bras et des doigts démesurés, sa haute taille déviée par un déhanchement qui résultait de sa pose habituelle des qu'il avait le violon à la main, la bouche profondément rentrée et sarcastique, . . . tout cet ensemble lui constituait une physionomie peu commune et en rapport, jusqu'à un certain point, avec l'originalité de son génie."

6. J. M. Schottky, *Paganinis Leben und Treiben als Künstler und als Mensch* (Prague, 1830), trans. in de Courcy, *Paganini*, vol. 1, 298–99.

7. Phillips acknowledged the "very handsome catalogue," which he "was delighted to receive," in a letter to Kélékian, Dec. 30, 1920, reel 1929, #1060. *Paganini* is reproduced in the volume.

8. DP to Kraushaar, Jan. 11, 1922, reel 1929, #1122. Although Phillips referred to three Delacroix paintings, there were actually five in the Kélékian collection, including *Paganini*.

9. Kélékian to DP, Dec. 31, 1920, reel 1929, #1061; a copy of Fry's article, "Modern Paintings in a Collection of Ancient Art," *Burlington Magazine* 37, no. 213 (Dec. 1920), 303–9, was included with the letter.

10. Hamilton Easter Field, "The Kélékian Collection," *The Arts* 2, no. 3 (Jan. 1922), 132–48. Excerpts from Fry's *Burlington Magazine* article were reprinted in this issue of *The Arts* as part of a richly illustrated editorial by Field. Although there is no direct evidence that Phillips read this article, he was familiar with the publication, contributing an article on Prendergast (Mar. 1924) and a letter to the editor (June 1935).

11. Journal B, ca. 1923–24.

12. *C in M*, 1926, 20. Phillips thus anticipated Lee Johnson's insightful description of the *Paganini* as portraying "a body that had met its soul by accident"; see Johnson, 1963, 49.

13. DP, PMG.1928.1c and 4c.

14. Titles: Delacroix referred to this painting as *Homme qui sort de la mer avec les deux chevaux* (*Journal*, Mar. 10, 1858) and later as *Chevaux sortant de la mer* (*Journal*, June 14, 1860); in 1873, Moreau catalogued it as *Chevaux sortant de l'eau* (adopted by Edwards, Faure, Laurent-Richard, and Mame in their sale catalogues); in the 1885 Paris exhibition, it was titled *Chevaux sortant du bain*; for the 1919 Cochin sale, it was listed as *Chevaux Marocains*; two labels on the back of the painting title it *Chevaux traversant la mer*; and in Phoebe Pool, *Delacroix* (London, 1969), the painting is titled *Horses Emerging from the Sea*. Provenance: On June 14, 1860, Delacroix states: "I have finished for Estienne *Chevaux que se battent dans l'écurie, Chevaux sortant de la mer, Ugolin*" (*Journal*, vol. 3, 291–92). For the Faure auction, the painting was engraved by Languillermie; reproduced in *Galerie Durand-Ruel* 1 (1873), pl. 82. That Esnault-Pelterie was the owner by 1906 is confirmed by "Collection de Madame Esnault-Pelterie," *Les arts* 54 (June 1906), n.p. The Cochin sale catalogue lists Bernheim as purchaser. Bernheim may have bought it on behalf of Staub; see Alma Jo Révy-Staub to author, May 4, 1989. Wildenstein invoice, Apr. 16, 1945.

15. The painting was probably begun by March 10, 1858; by September 5 of that year it was well advanced. On May 19, 1860, Delacroix remarked that he was working assiduously on the paintings commissioned by Estienne, and on June 14 he noted that he had finished them (for entries under these dates, see *Journal*, vol. 3, 179, 213, 291–92, and 293). During Jan.–July 1832, Delacroix was attached as a traveling companion to the diplomat Count Charles Henri Edgar de Mornay on a special goodwill mission to the Sultan of Morocco.

16. During his journey, Delacroix wrote to Bertin: "The picturesque abounds here. At every step there are pictures ready-made that would assure the fortune and the glory of twenty generations of painters"; see *Correspondance* (Apr. 2, 1832), vol. 1, 327–28. Delacroix returned to France with seven albums of notes and sketches; four were dismantled and sold when his estate was auctioned, two are now at the Louvre, and one is in Chantilly, Musée Condé.

17. *Journal*, vol. 2, 92 (author's trans.): "Je n'ai commencé à faire quelque chose de passable, dans mon voyage d'Afrique, qu'au moment où j'avais assez oublié les petits détails pour ne me rappeler dans mes tableaux que le côté frappant et poétique."

18. Perhaps, however, the coastal scene was modeled not on an African shore at all, but rather on Dieppe, a village on the English Channel that Delacroix visited frequently (late Aug.–Sept. 1851, Sept. 1852, Aug.–Sept. 1854, Oct. 1854, and July 1860). According to his *Journal*, he was painting a *View of Dieppe* at the same time he began working on *Horses* (vol. 3, 179, Mar. 10, 1858): "*La Vue de Dieppe avec l'Homme qui sort de la mer avec les deux chevaux.*" In *The Sea at Dieppe*, ca. 1852 (Louvre), an earlier painting by Delacroix, he utilized the same *repoussoir* boat; see color illus. in Serullaz, 1981, 146.

19. Delacroix's interest in depicting horses was greatly facilitated during his 1825 sojourn in England, where he lived in the home of a professional horse breeder, learned to ride, and availed himself of the magnificent models that were housed in the stables nearby. See *Correspondance*, vol. 1, 163, 166–67 (letters of June 27 and Aug. 1, 1825).

20. Frank Trapp, *The Attainment of Delacroix* (Baltimore, 1971), 17–18: "As he developed as an artist, Delacroix paid less and less attention to accuracy of anatomical structure and convincing physical movement . . . [and focused his] concentration on crucial passages at the expense of elaboration."

21. Delacroix, however, associated the horse with "unbridled strength and energy," according to John Baskett, *The Horse in Art* (Boston, 1980), 118; and horses had long been significant to Romantic iconography. They were viewed as "free, spirited, and strong" and "an animal embodiment of passion and grace," according to Trapp, *Attainment*, 139. For a general discussion, see Philippe Barbié de Préaudeau, *Le cheval arabe: Des origines à nos jours* (Paris, 1987), especially chap. 3: "Le cheval oriental au XIXe siècle."

22. Johnson, 1963, 89.

23. For a discussion of the popularity of exotic themes, see Mary Anne Stevens, ed., *The Orientalists: Delacroix to Matisse. The Allure of North Africa and the Near East* (London, 1984).

24. DP to Daniel Wildenstein, Jan. 26, 1945, and to Felix Wildenstein, Jan. 30, 1945, TPC Papers, AAA, reel 1965, #1150. On Feb. 4, 1945 (during the Delacroix exhibition), Walter Pach lectured on "Delacroix: Romantic and Classic." In 1954–55, Phillips considered deaccessioning this painting to raise money for purchasing an "Italian Corot" *(Genzano);* he eventually sold Cézanne's *Harvesters* instead. See correspondence between Dec. 1954 and Feb. 1955, especially Phillips's letter of Dec. 21, 1954, reel 1985, #1145.

25. PMG.1945.2, n. p.

26. Titles: Johnson, 1981–86, no. 342, lists the painting as *Hercules brings Alcestis back from the Underworld;* the 1905 Cronier sale catalogue lists *Hercule et Alceste;* the Kélékian auction catalogue titles it *Hercule ramenant Alceste des Enfers* and *Hercules bringing back Alcestis from Hades.* Medium: Some time ago, the painting was set into a wooden cradle for added support. Provenance: Per Johnson, 1981–86, vol. 3, 157, and Johnson to author, Nov. 4, 1988. The Cronier sale catalogue (Knoedler fiche #489, NGA) lists "G. Petit" as the purchaser of the painting. Johnson agrees that "Georges Petit almost certainly bought the picture on behalf of Chéramy at the Cronier sale, as the Meier-Graefe-Klossowski catalogue of the Chéramy collection (Munich, 1908) says that Chéramy acquired it at that sale." How the painting went from Chéramy to Schoeller in 1908 (according to newspaper accounts of the sale) and back to Chéramy in time for the estate sale in 1913 is less clear. Johnson stated: "Several pictures by Delacroix that are recorded as sold in the Chéramy sale of 1908 also turned up in the Chéramy estate sale of 1913." He "always assumed that they were bought in at the 1908 sale by agents acting for Chéramy" (quotations above per corr., Nov. 4, 1988); for a similar transaction, see *L'art décoratif* (May 1913), 241–42. Equally puzzling are the transactions between Kélékian and Durand-Ruel. The *American Art Annual* 19 (1922), 295, lists Durand-Ruel as the purchaser of the painting from the Kélékian sale, but in 1938 Kélékian exhibited the painting as part of his collection, and PMG purchased the painting from him in 1940.

27. Euripides' *Alcestis* was written in 438 B.C.

28. Delacroix was awarded several commissions to decorate public buildings. See Maurice Sérullaz, *Les peintures murales de Delacroix* (Paris, 1963). Robaut lists a preparatory oil sketch (#1140, 22 × 46 cm.; present location unknown) for the *Hercules and Alcestis* tympanum of the Hôtel de Ville.

29. The paintings were all oil on canvas. They included a central composition for the ceiling, *La Paix vient consoler les hommes et ramène l'Abondance;* eight ceiling coffers depicting various divinities considered friends of peace; and eleven lunettes dedicated to episodes from the life of Hercules, arranged in chronological order. Delacroix had begun to design the decorations by Oct. 27, 1851, and had completed them by Aug. 28, 1853, but they were not open for public view until March 1854. For the history of his progress, and a contemporary reaction, see Sérullaz, *Les peintures murales,* 129–44, and pp. 140–41 for a reprint of Théophile Gautier's article from *Moniteur universelle* (Mar. 25, 1854). Unfortunately, details of the commission are unknown; all pertinent documentation was destroyed by the fire. The extant engravings are based on drawings by Pierre Andrieu, who assisted Delacroix with the commission.

30. A black sheep was the traditional offering to Hades and Persephone, gods of the underworld.

31. *Alceste* was written in 1767, and translated into French by F. L. G. Lebland du Roullet for its Parisian debut in 1776. It was revived on Oct. 21, 1861, with revisions by Berlioz. See Alfred Loewenberg, *Annals of Opera, 1597–1940* (Totowa, N.J., 1978), 3rd ed. rev., 295–96, s.v. "Alceste."

32. Delacroix's attendance cannot be verified by his *Journal;* however, it is highly likely, given that Gluck was one of his favorite composers (see vol. 3, 221, 271) and that the performance featured the celebrated Pauline Viardot, one of his friends. Joubin's edition of Delacroix's *Journal* suggests that a sketch of *Hercule et Alceste* (Robaut no. 1140) was inspired by Viardot's performance in Gluck's *Orpheus* at the Théâtre Lyrique (see vol. 3, 278, n. 1). Trapp, 1971, 280, repeats this erroneous assertion (the sketch was painted in 1849 and the opera was performed in 1859–60), noting, however, "Delacroix's penchant for assimilating impressions from the stage [in his paintings]."

33. DP, 1913, 127.

34. MS 165.

Major References
Adolphe Moreau, *E. Delacroix et son oeuvre,* Paris, 1873.
Eugène Delacroix, *Lettres de Eugène Delacroix,* ed. Philippe Burty, Paris, 1878; 2nd ed., Paris, 1886, 2 vols.
Alfred Robaut, *L'oeuvre complet de Eugène Delacroix,* Paris, 1885; unabridged 2nd ed., New York, 1969.
Raymond Escholier, *Delacroix: Peintre, graveur, écrivain,* 3 vols., Paris, 1926–29.
Eugène Delacroix, *Journal,* ed. André Joubin, 3 vols., Paris, 1932 (selected passages edited and translated in Walter Pach, *The Journal of Eugène Delacroix,* New York, 1972).
Eugène Delacroix, *Correspondance générale d'Eugène Delacroix,* ed. André Joubin, 5 vols., Paris, 1936–38.
Eugène Delacroix, *Lettres intimes: Correspondance inédite,* ed. André Dupont, Paris, 1954.
Lee Johnson, *Delacroix,* New York, 1963.
Frank Anderson Trapp, *The Attainment of Delacroix,* Baltimore, 1971.
Maurice Sérullaz, *Eugène Delacroix,* Paris, 1981.
Lee Johnson, *The Paintings of Eugène Delacroix: A Critical Catalogue,* 4 vols., Oxford, 1981–86.
Lee Johnson, ed., *Eugène Delacroix: Further Correspondence, 1817–1863,* Oxford, 1991.
Timothy Wilson-Smith, *Delacroix: A Life,* London, 1992.
Lee Johnson, *Delacroix Pastels,* New York, 1995.
Michele Hannoosh, *Painting and the Journal of Eugène Delacroix,* Princeton, 1995.
Loys Delteil, *Delacroix: The Graphic Work: A Catalogue Raisonné,* trans. and rev. by Susan Strauber, San Francisco, 1997.

TPC Sources
DP, "Revolutions and Reactions," *International Studio* 51, Dec. 1913, 127–29.
E of A, 1914.
Journals EE, ca. 1922, and B, 1923–29.
C in M, 1926.
DP, essays for PMG.1928.1c, PMG.1928.4c, PMG.1931.21, and PMG.1931.19.
ASD, 1931.
Cat., 1952.
MP, 1998.
MSS 100, 109, and 165.

ALEXANDRE-GABRIEL DECAMPS

1. Dates: Mosby, 1977, 105–8, dates the work to ca. 1833 on the basis of style and composition, arguing that Decamps was greatly influenced by that year's Salon. Title: Listed as *Le Café turc* for the Véron sale (1858) and in Moreau, 1869, 200. Catalogue raisonné: Mosby vol. 2, no. 465. Provenance: Véron sale, per Moreau, 1869, 200, and other transactions per Williams sale (1915).

2. See Philippe Jullian, *The Orientalists: European Painters of Eastern Scenes,* trans. Helga and Dinah Harrison (Oxford, 1977), and Donald Rosenthal, *Orientalism: The Near East in French Painting, 1800–1880,* exh. cat., Memorial Art Gallery (Rochester, N.Y., 1982).

3. Mantz, 1862, 104: "il observa bien plus avec le regard qu'avec le crayon."

4. Decamps's exploration of a wide range of techniques and chemical combinations led to the darkening of many of his canvases even during his lifetime. According to the conservation report dated Mar. 25, 1987, in *Interior of a Turkish Café* the artist may have incorporated varnish into the paint.

5. Eugène Fromentin, "Une année dans le Sahel" in *Sahara et Sahel* (Paris, 1887), 244. Fromentin does not identify Decamps by name, but it is clear that he is referring to him. In *C in M,* 1926, 20, Duncan Phillips also commented briefly on this strategy: "He suggested dazzling eastern light by forcing the blackness of the adjacent shadows."

6. Fromentin, "Un été dans le Sahara," in *Sahara et Sahel,* 1887, 103–4.

7. Statement inscribed on a copy of the Williams sale catalogue, TPC Archives. Phillips acquired two other works at this sale: acc. nos. 1299 and 1385.

8. DP, "Impressionism in Prose," *E of A,* 1914, 142.

9. DP, *C in M,* 1926, 20.

10. Journal DD, 1921.

Major References
"Notice biographique de Decamps, écrite par lui-même," in Louis Désiré Véron, *Mémoires d'un*

bourgeois de Paris, vol. 4, Paris, 1857, 123–32.

Marius Chaumelin, Decamps, sa vie, son oeuvre, ses imitateurs, Marseilles, 1861.

Paul Mantz, "Decamps," Gazette des Beaux-Art 12, 1862, 97–128.

Adolphe Moreau, Decamps et son oeuvre, Paris, 1869.

Pierre du Colombier, Decamps, Paris, 1928.

Dewey F. Mosby, Alexandre-Gabriel Decamps, 1803–1860, 2 vols., New York, 1977.

David Cass and Michael Floss, Alexandre-Gabriel Decamps, 1803–1860, exh. cat., Williamstown, the Sterling and Francine Clark Art Institute, 1984.

TPC Sources
Journals W, ca. 1911–13; N, 1912; and HH, 1912.
E of A, 1914 and 1927.
H of A, 1920–21.
Inv., 1921.
Journals DD, 1921; EE, ca. 1922; and GG, 1924.
C in M, 1926.
Journals BB, 1930–33; and I, between 1931 and 1935.
Cat., 1952.
MS 72.

HONORÉ DAUMIER

1. DP to Joseph Durand-Ruel, Apr. 12, 1927. In the same letter, Phillips expressed interest in acquiring several Daumiers from the Bureau Collection. In C in M, 1926, 9, he stated, "It is my intention to continue in pursuit of great examples of his genius as a painter, a fact so long unrecognized."

2. Three other paintings were also in the collection at one time: The Reader (Maison, vol. 1, no. I-157), acquired 1927, traded to Paul Rosenberg, June 1934, for Braque's The Round Table and Sisley's Bank of the Seine; Sancho Panza (Maison, vol. 1, no. I-172); and Mountebanks Resting (Maison, vol. 1, no. II-43). The Rockets (acc. no. 0379, as "Formerly attributed to Honoré Daumier") was acquired in 1925 but is no longer believed to be by Daumier; see Maison, 1968, "Paintings reproduced by Fuchs, but not considered to be by Daumier and omitted from the present catalogue," 437–38.

3. Maison, vol. 1, no. I-163. Phillips wrote to David Finley, director of the National Gallery of Art, Mar. 10, 1941: "I would rather give a Daumier than the work of any other artist because of my deep affection and reverence for this great master." In a letter to Bignou Gallery, New York, Mar. 24, 1941, he expressed the hope that the NGA committee would accept the gift and articulated the role he anticipated it would play: "I am most anxious to help the National Gallery with this picture to build a bridge in its collection between the Old Masters and the Moderns. With such an artist they can go on to bolder and freer uses of color and form in the 19th century." The work was presented to the National Gallery immediately upon purchase in 1941.

4. Although the lithographs were collected over a period of many years, the majority of them entered the collection in two groups: Dwight Clark gave the museum a gift of sixteen works around 1934, and in 1940 fifteen lithographs were purchased from Jean Goriany.

5. DP, 1922, 30.

6. DP, "The Arts in Wartime," text for slide lecture, 1942.

7. DP, 1922, 27.

8. DP, C in M, 1926, 22.

9. DP, "The Artists Choice: Classic or Romantic" in ASD, 1931, 118.

10. DP, CA, 1929, xxi; and DP, Formes, 1930, 9.

11. DP, "Henri Focillon," 1944, 33. See also DP to Focillon, Feb. 27, 1941.

12. Maison, 1968, 7. Equally problematic is the issue of dating. Those who have attempted a chronology of his works have relied on stylistic, technical, and thematic assessments combined with limited external evidence. The Laundress of 1863 (oil on panel; Metropolitan Museum of Art, New York) is Daumier's only dated work, and fewer than ten were exhibited during his lifetime.

13. DP to Paul Sachs, Fogg Art Museum, Nov. 15, 1939. Its uneven appearance suggested to Jean Adhémar and Maison that it was finished by another hand. Phillips was supported in his assessment by scholars like Roger Fry, Julius Meier-Graefe, and Henri Focillon. In a letter to Focillon, Feb. 27, 1941, Phillips stated that he was reminded of the "skepticism about Giorgione in the early 19th century." Phillips noted that both artists left many unfinished works in their studios when they died. See also protracted correspondence from Phillips to Paul E. Cremetti, David Rosen (Walters), and René Huyghe (Louvre), among others, regarding authenticity.

14. DP, "The Arts in Wartime," text for slide lecture, 1942.

15. DP, "Modern Art and the Museum," paper presented to the Art Museum section of the American Association of Museums, Pittsburgh, May 1931, n.p.; published version in American Magazine of Art, 1931.

16. DP to Henri Focillon, Feb. 27, 1941.

17. DP, 1922, 30, illus., as L'Amateur. Today the work is in the Metropolitan Museum of Art. In International Studio 80 (Oct. 1924), 14, Phillips's aims for the gallery were similarly characterized: "This great enterprise was conceived as a bridge between folks who would not see and art, between folks who could not see and opportunity."

18. A & U, 1929, 48.

19. Title: Femme et Enfant sur un Pont, 1845–48, per Maison. Catalogued as Le Fardeau by Klossowski, 1923, no. 228 A, and as Sur un pont pendant la nuit by Fuchs, 1927, no. 68a. Provenance: Per Maison, 1968. The work was acquired at the same time as Delacroix's Paganini (cat. no. 10). Date of sale, Jan. 31, 1922, confirmed by Kraushaar statement for 1922, TPC Papers, AAA, reel 1929, #1124. See DP to Kélékian, Dec. 30, 1920, reel 1929, #1060, acknowledging receipt of catalogue, Collection Kélékian: Tableaux de l'Ecole Française Moderne (Paris, New York, and Cairo, 1920).

20. Bull., 1931, 59. For a discussion of these related scenes, see Maison, "Daumier's Painted Replicas," Gazette des Beaux-Arts 57 (May–June, 1961), 369–77. The subject was also molded in clay; see Maurice Gobin, Daumier Sculpteur (1808–1879) (Geneva, 1952), nos. 62 and 62 bis, illus. (as Le Fardeau).

21. Date: Berne exhibition (1991), no. 362, 1848–49; Adhémar, 1954, 36–37, argues for "after 1848"; Maison does not date the work and gives the title as L'Emeute; Arsène Alexandre, "An Unpublished Daumier," Burlington Magazine 44 (Mar. 1924), 143–44, believes it is a late work; Julius Meier-Graefe, "Honoré Daumier, Fifty Years After," International Studio 94 (Sept. 1929),

20–25, dates it "after 1860." Provenance: Some accounts suggest that the painting may have remained unfinished in Daumier's studio after his death; see, for example, Henri Focillon, "Visionnaires: Balzac et Daumier," reprinted from Essays in Honor of Albert Feuillerat, Yale Romantic Studies 23 (New Haven, 1943), 195–209, discussion p. 201. Fuchs, 1927, 91; Cat., 1952, 23; and Maison, 1968, list Henry Bing, Paris, as a previous owner. Paul E. Cremetti to DP, Jan. 10, 1925, stated that he thought Fiquet had purchased the painting from Blot. Cremetti's invoice of Feb. 24, 1925, states instead that the work was purchased by Fiquet in 1904 from Vigier, Paris.

22. Alexandre, "Unpublished Daumier," 143, called the work "the most important and the most impressive of those which we know or are likely to know of Daumier's."

23. DP to René Huyghe, Musée du Louvre, Mar. 20, 1940.

24. See, for example, Maison.

25. The work is entitled The Republic Nourishes and Instructs Her Children (Paris, Musée d'Orsay). Bernard Lehmann, "Daumier and the Republic," Gazette des Beaux-Arts 27 (Feb. 1945), 105–20; Marie-Claude Chaudonneret, La figure de la République: Le Concours de 1848 (Paris, 1987), 59–66.

26. Adhémar, 1954, 36–37, places these works after the 1848 revolution, when Daumier had more time to devote to painting. Other revolutionary events took place in France in 1830, 1851, and 1871. Bertrand Py, "Daumier: Peintre de la révolution de 1848," Arts Tribune (May–June 1973), 6–8, suggests that the Phillips work, along with another one in a private collection, are preparatory sketches for the destroyed version.

27. Focillon, 1943, 201.

28. DP, "Arts in Wartime," Art News, 1942, 20: "The Paris of its background might be the tragic Europe of today. . . . The leader of Daumier's picture is the eternal nomad of the questing spirit. Blind to the immediate perils of his position, haunted by his dream of the future, he is the anonymous standard bearer of innumerable battles without name. He is pure flame. Such fire will liberate and cleanse the world."

29. Focillon, 1943, 201. Adhémar, 1954, 36, suggests that the leader and his followers are singing La Marseillaise.

30. DP, The Nation's Great Paintings: Honoré Daumier, "The Uprising," 1942.

31. Title/Date: Trois avocats causant, 1855–57, per Maison; Fuchs, 1927, no. 23; and Adhémar, 1954, no. 23, who dates it 1843–46. Trois avocats per Alexandre, 1888, 375, and Klossowski, 1923, no. 122. Provenance: Geoffroy-Dechaume per Paris exhibition (1878). Henri Rouart per Alexandre, 1888, 375. Additional information provided by Melissa De Medeiros, librarian, Knoedler, to TPC, Nov. 26, 1985. Bill of sale, Nov. 11, 1920.

32. There is a related watercolor in the Sterling and Francine Clark Art Institute, Williamstown, Mass. (Maison, vol. 2, no. 604).

33. DP, 1922, 23–24.

34. Date: Per Ives et al., 1992, no. 82. Plea for the Defense was not dated by Maison in his 1968 catalogue raisonné. Title: Le défenseur per Maison and Fuchs, 1927, no. 196c; L'avocat lyrique per Klossowski, 1923, no. 124. DP to Mrs. Owen Walker, Jan. 26, 1948, titles the work Plea for the Defense. Medium: Per inspection by Sarah Bertalan, paper conservator, June 21, 1991. On

the verso is a faint pencil sketch of a standing woman in full blouse and skirt thought to be by Daumier. Provenance: see P.-André Lemoisne, "La collection de M. Alexis Rouart," *Les arts* 75 (Mar. 1908), 1–32. Henri Rouart dates per Raymond Escholier, *Daumier* (Paris, 1923), illus. opp. 108 (as *Péroraison*), and Paris exhibition (1934). Bill of sale, Nov. 15, 1937.

35. DP, 1922, 22–23.

36. See Jan Rie Kist, *Honoré Daumier, 1808–1879*, exh. cat., NGA (Washington, D.C., 1979), 14–15.

37. Title/Date: *Hercule de foire*, ca. 1865, per Maison; *Parade de saltimbanques* per Alexandre, 1888, 375, and Klossowski, 1923, no. 184. Listed as *Le lutteur* in Reid sale (1898) and as *Les lutteurs* in Desfossés sale (1899). *The Strong Man* is a Phillips title. Provenance: Aubry per Paris exhibition (1878). Additional provenance information per bill of sale, Nov. 23, 1928, and Melissa De Medeiros, librarian, Knoedler, to author, June 17, 1991. Inness's *Moonlight, Tarpon Springs*, Homer's *Cape Trinity*, and Guardi's *The Rialto Bridge, Venice* were sent to Knoedler in partial trade for *The Strong Man*.

38. Maison, vol. 2, nos. 508, 509, 514. Maison, vol. 1, II-44, mentions a related work in the Simu Museum, Bucharest, which he believes was left unfinished and completed by another hand.

39. An excellent study is Paula Hays Harper, *Daumier's Clowns: Les Saltimbanques et les Parades, New Biographical and Political Functions for a Nineteenth Century Myth* (New York, 1981); see p. 33.

40. Ibid., 164–65.

41. Title/Date: *Le Peintre devant son tableau*, "about 1870," per Maison; Klossowski, 1923, no. 391; and Adhémar, 1954, no. 153, who dates it "about 1865–68." *Daumier par lui-même* per Escholier, 1923, illus. facing 122. Provenance: Dollfus per Paris exhibition (1878). Rosenberg per Paris exhibition (1901). For provenance Reid-Burrell-Reid, see Ronald Pickvance, "Daumier in Scotland," part 1, *Scottish Art Review* 12, no. 1 (1969), 13–16, 29, and Richard Marks, *Burrell: A Portrait of a Collector* (Glasgow, 1983), 74. Information on Strauss, Reid and Lefevre, and Knoedler courtesy Melissa De Medeiros, librarian, Knoedler, to author, May 16, 1991. According to T. J. Honeyman, *Patronage and Prejudice*, W. A. Cargill Memorial Lectures in Fine Art, University of Glasgow (1968), 4, David Cargill's collection was dispersed at the beginning of the Second World War. According to Jacqueline Cartwright, Reid and Lefevre, London, to author, Aug. 13, 1991, the majority of the Cargill pictures were sold through Bignou, New York. Bill of sale, Dec. 14, 1944.

42. Title/Date: *L'atelier d'un Sculpteur*, 1870–73, per Maison; *L'atelier de Clésinger* as alternate title per Maison and Adhémar, 1954, no. 131, who dates it 1864–66. *Amateur et Sculpteur* per bill of sale; *Two Sculptors* is a Phillips title. Provenance: Uhle per Dresden exhibition (1904). Bignou to DP, Dec. 14, 1944, suggests that the work was once owned by Bignou. Phillips traded Degas's *In the Balcony* and Daumier's watercolor *Le départ du train* (Maison, vol. 2, no. 310), for the present work. Kraushaar bill of sale, Dec. 1, 1925.

43. Related versions are in the Barnes Foundation (Maison, vol. 1, no. I-220) and in the Sterling and Francine Clark Art Institute, Williamstown, Mass. (Maison, vol. 1, no. I-221). Maison rejects the view that these works are self-portraits.

44. See DP to Minnie Byers, Dec. 20, 1944.

45. For examples, see Maurice Gobin, 1952.

46. DP, *C in M*, 1926, 22, and DP, 1931–34, version B, 20.

47. Ibid.; see also DP, "The Artist Sees Differently" in *ASD*, 1931, 3–10.

Major References

Arsène Alexandre, *Honoré Daumier: L'homme et l'oeuvre*, Paris, 1888.

Erich Klossowski, *Honoré Daumier*, Munich, 1908; 3rd ed., Munich, 1923.

Eduard Fuchs, *Der Maler Daumier*, Munich, 1927; 2nd ed., with supplement, Munich, 1930.

Jean Adhémar, *Honoré Daumier*, Paris, 1954.

Oliver Larkin, *Daumier: Man of His Time*, New York, 1966.

K. E. Maison, *Honoré Daumier: Catalogue Raisonné of the Paintings, Watercolours and Drawings*, 2 vols., London, 1968.

Jean Cherpin, *L'homme Daumier*, Marseilles, 1973.

Louis Provost, *Honoré Daumier: A Thematic Guide to the Oeuvre*, ed. Elizabeth C. Childs, New York, 1989.

Bruce Laughton, *The Drawings of Daumier and Millet*, New Haven, 1991.

Colta Ives et al., *Daumier Drawings*, exh. cat., New York, Metropolitan, 1992.

Bruce Laughton, *Honoré Daumier*, New Haven, 1996.

Anette Wohlgemuth, *Honoré Daumier: Kunst im Spiegel der Karikatur von 1830 bis 1870*, Frankfurt, 1996.

TPC Sources

Journal W, ca. 1911–12.

DP, "Fallacies of the New Dogmatism in Art," parts 1 and 2, *American Magazine of Art* 9, Dec. 1917, 43–48, and Jan. 1918, 101–6; formerly MSS 75 and 76.

DP, "Art and the War," *American Magazine of Art* 9, June 1918, 303–9.

Inv., 1921.

DP, *Honoré Daumier: Appreciations of His Life and Works*, The Phillips Publications no. 2, New York, 1922.

Journals Y, ca. 1922–25; D, ca. 1923–24; and GG, 1924.

DP, "The Phillips Collection," outline prepared for F. Newlin Price, "Phillips Memorial Gallery," *International Studio* 80, Oct. 1924, 8–18; some drafts formerly MS 89.

C in M, 1926.

Bull., 1927, 1928, and 1931.

DP, "Art in Washington: The Phillips Memorial Gallery," *Forerunner of the General Convention*, A.D. 1928 2, Easter 1928, 18–24.

DP, cat. for PMG.1928.4a–c.

CA, 1929.

A & U, 1929 and 1930.

Formes, 1930.

ASD, 1931.

DP, "Modern Art and the Museum," *American Magazine of Art* 23, Oct. 1931, 271–76.

DP, "The Artist Sees Differently," text for slide lecture, 12 versions, 1931–34.

DP, [Classic or Romantic in Modern Landscape], paper presented at PMG, Mar. 14, 1934.

AMA, 1935.

DP, "Freshness of Vision and Spontaneity in Painting," text for slide lecture, ca. 1935; formerly part of MS 178.

DP, "The Expression of Personality Through Design in the Art of Painting," text for slide lecture, 8 versions, ca. 1936–42.

DP, "Goya to Daumier," notes taken during Henri Focillon's lecture at PMG, Apr. 18, 1940.

DP, *The Arts in Wartime*, pamphlet, Washington, D.C., NGA, 1942.

DP, "The Arts in Wartime," *Art News* 41, Aug.–Sept. 1942, 20, 45.

DP, "The Arts in Wartime," text for slide lecture, 1942; formerly MSS 30 and 44.

DP, *The Nation's Great Paintings: Honoré Daumier, "The Uprising,"* New York, 1942; draft formerly MS 10.

DP, "Henri Focillon at the Phillips Gallery: In Memoriam," *Gazette des Beaux-Arts* 26, July–Dec. 1944, 31–35; published 1947.

DP, "Some Omissions and Confusions at the Sources of Art History/Omissions and Misconceptions at the Sources of Art History," 8 essays and 2 outlines, 1945.

Cat., 1952.

DP, *Catholicity Does Not Mean Eclecticism: A Radio Talk by Duncan Phillips*, pamphlet, 1954.

DP, "A Critic and His Pictures," *Arts* 30, Dec. 1955: 27–31.

Arts, 1956.

DP, "A Gallery of Modern Art and Its Sources," text for television program produced by the Greater Washington Education Television Association, aired Oct. 16, 1959; formerly MS 95.

DP, untitled introduction to "A Thousand Years of France: An Anthology of Henri Focillon," *Art News Annual* 28, 1959, 147.

MP, 1970 and 1982.

SITES, 1979.

MD, 1981.

MP, 1998.

MSS 158 and 170.

GUSTAVE COURBET

1. Date: Faunce and Nochlin, 1988, no. 24, argue for date of ca. 1855 on the basis of style. Dated ca. 1850 by Fernier, 1977, no. 112. Title: Changed to *Rocks at Mouthier* in 1952 as a result of research by Gaston Delestre, curator of the Musée Gustave Courbet, Ornans, who identified the subject (Delestre to DP, Sept. 22, 1952). Listed as *Les Roches à Ornans* in Gérard sale (1905); *Le Ravin* in Hôtel Drouot sales (1908 and 1909). Provenance: Per Kraushaar to TPC, n.d. and Fernier, 1977, no. 112. Confirmation of sale, Oct. 16, 1925.

2. The long confusion about the site stems in part from the fact that Courbet often failed to assign names to his landscapes. Furthermore, some of them are in fact composed of elements from various settings. These same cliffs, for example, appear in different surroundings in Courbet, *The Rock at Hautepierre*, ca. 1869 (oil on canvas; Art Institute of Chicago); see Fernier, 1977, no. 89.

3. For more on Courbet's personal, economic, and ideological relation to the land, see Petra ten-Doesschate Chu, "It Took Millions of Years to Compose That Picture," in Faunce and Nochlin, 1988, 55–65. It has recently been argued that even those so-called realist works testifying to the industrialization of the Franche-Comté show a degree of romantic nostalgia. See Jean-Luc Mayaud, "Gustave Courbet, témoin de la proto-industrialisation?" in *Bulletin des amis de Gustave Courbet* 72 (1984), 9–35.

4. Courthion, 1948–50, vol. 1, 200: "Faites donc avec un pinceau des rochers comme celà que le temps et la pluie ont rouillés par de grandes veines du haut en bas"; trans. Chu in Faunce and Nochlin, 1988, 61.

5. DP, Journal DD, 1921, and DP, *C in M*, 1926, 23.

6. *C in M*, 1926, 24. Phillips continued to hold this view of Courbet, considering him, along with Corot, Daumier, and Delacroix, as a representative of romanticism: "Then came Courbet with his gusto for realism which converted facts into a full-flavoured romance of monumental grandeur because seen in a big, clear way"; see "A Survey of French Painting from Chardin to Derain" in *Bull.*, 1928, 17. In DP, 1954, n.p., he listed Courbet among the heroes of evolutionary change, calling him "Courbet of the romantic realism."

7. DP, 1959, 5.

8. MP, 1982, 284–85.

9. Title: Catalogued as *Marine (Méditerranée?)* in Fernier, 1977, no. 219. Provenance: Per Fernier, 1977, no. 219, and Fearon Galleries to DP, Apr. 21, 1924. Mansfield dates per New York exhibition (1919) and Fearon exhibition (1924). Bill of sale, Apr. 28, 1924.

10. Courbet commemorated his first visit by painting *The Seaside at Palavas*, 1854 (Montpellier, Musée Fabre), showing himself saluting the Mediterranean. See Philippe Bordes, *Courbet à Montpellier*, exh. cat., Musée Fabre (Montpellier, 1985), 31–34.

11. Courbet to Victor Hugo, Nov. 28, 1864, reproduced in Roger Bonniot, "Victor Hugo et Gustave Courbet. Un projet de portrait abandonné," *Gazette des Beaux-Arts* 80 (Oct. 1972), 242; see also ten-Doesschate Chu, 1992, 248–50.

Major References
Georges Riat, *Gustave Courbet*, Paris, 1906.
Pierre Courthion, *Courbet raconté par lui-même et par ses amis*, 2 vols., Geneva, 1948–50.
Jack Lindsay, *Gustave Courbet: His Life and Art*, London, 1973.
Linda Nochlin, *Gustave Courbet: A Study of Style and Society*, New York, 1976.
Robert Fernier, *La vie et l'oeuvre de Gustave Courbet: Catalogue raisonné*, 2 vols., Lausanne and Paris, 1977.
Pierre Courthion, *Tout l'oeuvre peint de Courbet*, Paris, 1987.
Sarah Faunce and Linda Nochlin, *Courbet Reconsidered*, exh. cat., New York, Brooklyn Museum, 1988.
Michael Fried, *Courbet's Realism*, Chicago, 1990.
Klaus Herding, *Courbet: To Venture Independence*, trans. John William Gabriel, New Haven, 1991.
Letters of Gustave Courbet, ed. and trans. Petra ten-Doesschate Chu, Chicago, 1992.
Sarah Faunce, *Gustave Courbet*, New York, 1993.
Raquel Da Rosa, "Still Life and the Human Subject in Mid-Nineteenth Century France," Ph.D. diss., Columbia University, 1994.
Laura L. Meixner, *French Realist Painting and the Critique of American Society*, Cambridge, 1995.
Jane Mayo Roos, *Early Impressionism and the French State, 1866–1874*, Cambridge, 1996.
James H. Rubin, *Courbet*, London, 1997.

TPC Sources
DP, "Impressionism," unpubl. outline for proposed publication, 1910; formerly part of MS 97.
DP, "Impressionism in Poetry and Painting,"

unpubl. essay, 1910–11; formerly part of MS 155.
Journal HH, 1912.
DP, "Revolutions and Reactions in Painting," *International Studio* 51, Dec. 1913, 123–29.
E of A, 1914 and 1927.
DP, "Fallacies of the New Dogmatism in Art," parts 1 and 2, *American Magazine of Art* 9, Dec. 1917, 43–48, and Jan. 1918, 101–6; formerly MSS 75 and 76.
H of A, 1920–21.
Inv., 1921.
Journals DD, 1921; D, ca. 1923–24; and GG, 1924.
DP, "The Phillips Collection," outline prepared for F. Newlin Price, "Phillips Memorial Gallery," *International Studio* 80, Oct. 1924, 8–18; some drafts formerly MS 89.
C in M, 1926.
Bull., 1928.
CA, 1929.
A & U, 1929.
Formes, 1930.
Journal BB, ca. 1930–33.
ASD, 1931.
Cat., 1952.
DP, *Catholicity Does Not Mean Eclecticism: A Radio Talk by Duncan Phillips*, pamphlet, 1954.
Arts, 1956.
DP, "A Gallery of Modern Art and Its Sources," text for a television program produced by the Greater Washington Education Television Association, aired Oct. 16, 1959; formerly MS 95.
MP, 1970 and 1982.
MD, 1981.
MP, 1998.
MSS 5, 109, and 166.

ADOLPHE MONTICELLI

1. Provenance: Per Kraushaar record book, entry Jan. 4, 1921, p. 8. Kraushaar receipt, Apr. 4, 1921.

2. See Sheon, 1978, 13–26, for a discussion of Monticelli in the context of the rococo revival of the 1830s and 1840s.

3. Phillips's acquisitions account was not always commensurate with his interests. In his catalogue of the 1915 Ichabod T. Williams sale, he listed eight works that "should have been bought," including three by Monticelli. At this sale, Phillips did acquire *Landscape with Figures* (acc. no. 1385), which he believed was by Monticelli but "restored" by Mathew Maris, when the latter was employed by the firm of Daniel Cottier, London (DP to Mr. Cailleux, July 2, 1956). Recently, Aaron Sheon has raised doubts about the work's authenticity, suggesting "School of Monticelli" (Sheon to TPC, May 2, 1986).

4. DP, *C in M*, 1926, 24–25.

5. DP, "The Decorative Imagination" in *E of A*, 1914, 192.

6. DP, *C in M*, 1926, 24. See also DP, "Watteau and His Influence on Modern Poetry" in *E of A*, 1914, 288–99.

7. Provenance: Alfred Delpiano per Marseilles exhibition of 1936. Phillips gave up Monticelli's *Midsummer* in partial trade for *Bouquet*. Bill of sale, June 13, 1961.

8. DP, 1954, 65.

9. Ibid., 64.

10. LT519, Aug. 8, 1888, in *The Complete Letters of Vincent van Gogh*, intro. by V. W. van Gogh, preface and memoir by J. van Gogh-Bonger, 3 vols. (London, 1958).

Major References
Louis Guinard, *La vie et les oeuvres de Monticelli*, Marseilles, 1891; 2nd ed. rev. and enl., Marseilles, 1931.
Aaron Sheon, "Monticelli and the Rococo Revival," Ph.D. diss., Princeton, 1966.
Guy Isnard, *Monticelli*, Geneva, 1967.
André Alauzen and Pierre Ripert, *Monticelli, sa vie et son oeuvre*, Paris, 1969.
Aaron Sheon, *Monticelli, His Contemporaries, His Influence*, exh. cat., Pittsburgh, Museum of Art, Carnegie Institute, 1978.
Sauveur Stammégna, *Catalogue des oeuvres de Monticelli*, 2 vols., Vence, 1981 and 1986.
Centre de la Vieille Charité, *Adolphe Monticelli, 1824–1886*, exh. cat., Marseille, France, 1986.
Charles and Mario Garibaldi, *Monticelli*, Geneva, 1991.

TPC Sources
DP, "Impressionism," unpubl. outline for proposed publication, 1910; formerly part of MS 97.
DP, "Impressionism in Poetry and Painting," unpubl. essay, 1910–11; formerly part of MS 155.
Journal W, ca. 1911–13.
DP, "Revolutions and Reactions in Painting," *International Studio* 51, Dec. 1913, 123–29.
E of A, 1914 and 1927.
DP, "Rhythm and the Arts," unpubl. essay, 1915; formerly MS 74.
H of A, 1920–21.
Inv., 1921.
DP, "The Phillips Collection," outline prepared for F. Newlin Price, "Phillips Memorial Gallery," *International Studio* 80, Oct. 1924, 8–18; some drafts formerly MS 89.
C in M, 1926.
Journal BB, ca. 1930–33.
Bull., 1931.
Journal I, between 1931 and 1935.
Cat., 1952.
DP, "A Niche for Monticelli," *Art News* 53, Dec. 1954, 22–23, 64–66.
MP, 1970 and 1982.
SITES, 1979.
MD, 1981.
MS 41.

PIERRE PUVIS DE CHAVANNES

1. Date: Per d'Argencourt et al., 1977, cat. no. 51. Medium: The painted brown border presumably served a function in the original presentation; analysis of Elizabeth Steele, painting conservator, June 24, 1991. Provenance: Early provenance per Durand-Ruel to DP, Dec. 23, 1920, although letters of Apr. 14, 1920, and May 16, 1923, indicate (perhaps erroneously) that Durand-Ruel purchased it from the artist. Durand-Ruel's 1894 New York exhibition indicates that this painting was loaned by Catholina Lambert. It is possible that Durand-Ruel had originally purchased the work from the artist, then had repurchased it from Lambert. Ferargil bill of sale, July 29, 1920. Listed as no. 5 in DP, "15 Best Purchases Since Jan. 1920," 1920, n.p.

2. Vachon, 1895, 33, author's trans.: "Le véritable rôle de la peinture est d'animer les murailles. A part celà, on ne devrait jamais faire de tableaux plus grands que la main."

3. See Aimée Brown Price, "The Decorative Aesthetic in the Work of Puvis de Chavannes" in d'Argencourt et al., 1977, 21–26.

4. Puvis's work for Amiens was intended to evoke the origins and essential characteristics of Picardy. For more on Puvis's tributes to particular regions in France, see Price, 1972, 81. A related easel painting, *Allegory of Autumn*, 1865 (oil on canvas), is in the Wallraf-Richartz Museum, Cologne.

5. Title: Listed as *Marseille, colonie phocéenne* in Cochin sale of 1919. Date/Provenance: Per d'Argencourt et al., 1977, cat. no. 74.

6. Title: Listed as *Marseille, porte de l'Orient* in Cochin (1919) and Goodfriend (1923) sales. The work was known in English as *Marseilles, Port of the Orient* until the Paris-Ottawa exhibition of 1977, when it was changed to *Marseilles, Gateway to the Orient*. Date/Provenance: Per d'Argencourt et al., 1977, cat. no. 75.

7. See Geneviève Drocourt, "Puvis de Chavannes et le décor de l'Escalier d'honneur du Palais Longchamps," in Henri Wytenhove and Geneviève Drocourt, *Puvis de Chavannes et le musée des Beaux-Arts de Marseilles*, exh. cat., Musée des Beaux-Arts (Marseilles, 1984), 13–50, for an examination of the Puvis paintings within the context of the staircase's decorative program.

8. Puvis's submission to Espérandieu is dated July 25, 1867. See Drocourt, "Puvis de Chavannes et le décor," 16. As was the case with the decorative scheme for Amiens, Puvis intended these works to celebrate the local history of Marseilles.

9. Puvis de Chavannes, *Massilia, Greek Colony*, 1869 (oil on canvas mounted on wall [left staircase], 4.23 × 5.65 m), and *Marseilles, Gateway to the Orient*, 1869 (oil on cavas mounted on wall [right staircase], 4.23 × 5.65 m), both in Marseilles, Musée des Beaux-Arts, Palais Longchamps.

10. D'Argencourt et al., 1977, 94.

11. Originally in Paul Guigou, *Interrupta* (Paris, 1898), 270, as quoted in Drocourt, "Puvis de Chavannes et le décor," 45.

12. Steele, June 24, 1991.

13. Castagnary, *Salons, 1857–1870* (Paris, 1890), 334–37. Following the Marseilles commission, the dramatic color contrasts were to give way to a more subdued and harmonious palette.

14. DP, *C in M*, 1926, 26.

15. DP, "A Survey of French Painting from Chardin to Derain," in *Bull.*, 1928, 17.

16. DP, "Where Classic and Romantic Meet in Painting," in *Bull.*, 1931, 6–7.

Major References

Marius Vachon, *Puvis de Chavannes*, Paris, 1895.
Arsène Alexandre, "Souvenirs sur Puvis de Chavannes," *La vie artistique*, Nov. 3, 1898, n.p.
Marius Vachon, *Un maître de ce temps: Puvis de Chavannes*, Paris, n.d. [1900].
Arsène Alexandre, *Puvis de Chavannes*, London, 1905.
Robert Goldwater, "Puvis de Chavannes: Some Reasons for a Reputation," *Art Bulletin* 28, Mar. 1946, 33–43.
Aimée Brown Price, "Puvis de Chavannes: A Study of the Easel Paintings and a Catalogue of the Painted Works," 2 vols., Ph.D. diss., Yale University, 1972.
Richard J. Wattenmaker, *Puvis de Chavannes and the Modern Tradition*, exh. cat., Toronto, Art Gallery of Ontario, 1975.

Louise d'Argencourt et al., *Puvis de Chavannes, 1824–1898*, exh. cat., Ottawa, National Gallery of Canada, 1977.
Marie-Christine Boucher, *Catalogue des dessins et peintures de Puvis de Chavannes*, exh. cat., Paris, Petit Palais, 1979.
Aimée Brown Price, *Pierre Puvis de Chavannes*, Amsterdam, exh. cat., Van Gogh Museum, 1994.
Margaret Werth, "Le Bonheur de Vivre: The Idyllic Image in French Art, 1891–1906," Ph.D. diss., Harvard University, 1994.
Jennifer L. Shaw, "Nation and Desire in the Paintings of Pierre Puvis de Chavannes, from 1870–1895," Ph.D. diss., University of California, Berkeley, 1994.
Russell T. Clement, *Four French Symbolists: A Sourcebook on Pierre Puvis de Chavannes, Gustave Moreau, Odilon Redon, and Maurice Denis*, Westport, Conn., 1996.
Brian Petrie, *Puvis de Chavannes*, ed. Simon Lee, Hants, England, 1997.

TPC Sources

DP, "Impressionism in Poetry and Painting," unpubl. essay, 1910–11; formerly MS 155.
Journal W, ca. 1911–13.
DP, "Revolutions and Reactions in Painting," *International Studio* 51, Dec. 1913, 123–29.
E of A, 1914.
DP, "15 Best Purchases of 1918–19; 15 Best Purchases Since Jan. 1920," unpubl. acquisitions list, 1920.
H of A, 1920–21.
Inv., 1921.
Journal EE, ca. 1922.
DP, "The Phillips Collection," unpubl. outline prepared for F. Newlin Price," Phillips Memorial Gallery," *International Studio* 80, Oct. 1924, 8–18; some drafts formerly MS 89.
C in M, 1926.
Bull., 1928 and 1929.
Will Hutchins, "Two Compositional Sketches by Puvis de Chavannes" in *A & U*, 1930.
Bull., 1931.
DP, "The Artist Sees Differently," unpubl. text for slide lecture, 12 versions, 1931–34.
Cat., 1952.
SITES, 1979.
MD, 1981.
MS 161.

EDOUARD MANET

1. Title: *Ballet Espagnol*, most likely the artist's title, per review, Paul Mantz, "Exposition du Boulevard des Italiens," *Gazette des Beaux-Arts* 14 (1863), 383, and catalogue of Manet's first one-person exhibition at the Place de l'Alma in May 1867. Provenance: On Durand-Ruel's ownership and private collection, see especially Lionello Venturi, *Les archives de l'impressionisme*, vol. 1 (Paris, 1939), 189–91.

2. The specific dates for the company's run at the Hippodrome are August 12 to November 2, 1862. See Tabarant, 1947, 52, as well as Elizabeth Anne McCauley, *A. A. E. Disdéri and the Carte de Visite Portrait Photograph* (New Haven, 1985), 173 and 242, n. 84, who documents the company's earlier performance that year at the Odéon on April 27, 1862. Tabarant asserts that Manet borrowed Stevens's studio because his own was too far away from the Hippodrome to be convenient and too small to accommodate the dancers and their accompanists.

3. Tabarant, 1947, 57, asserts that *Spanish Ballet* is a staged re-creation of a scene from the ballet *La Flor de Sevilla*, which was choreographed by Camprubi, and this assertion has been repeated by successive scholars. A scene from *La Flor de Sevilla* was danced by the company during the first act of *The Barber of Seville* at the Odéon on April 27, 1862, and again on August 12, 1862, at the Hippodrome. See McCauley, *Disdéri*, 173 and 242, n. 84.

4. See Hanson, 1966, 67–69. The specific Goya print related to the caped figures is pl. 19 of the *Tauromaquia*; see Cachin and Moffett, 1983, 144–45 and cat. no. 35, fig. a.

5. See John Richardson, *Edouard Manet, Paintings and Drawings* (London, 1958), 14.

6. See McCauley, *Disdéri*, 175–79.

7. The identities of the dancers are well established in the literature.

8. A drawing considered a study for this painting, *Couple Espagnol*, 1862 (black lead, 107 × 100 mm.; private collection, New York; Rouart/Wildenstein II, cat. no. 531), offers a useful comparison. Unlike the finished painting, it has the quality of a captured moment, for it depicts a male dancer in midstep, with arms open and feet apart; seated next to him is a female dancer who looks at her male partner while she rests or, perhaps, waits her turn to dance. Two other drawings related to *Spanish Ballet* are worthy of note, but their relation to the Phillips work is more ambiguous. A watercolor, *Le Ballet Espagnol*, 1862 or 1863–65 (pen and ink, watercolor, and gouache over pencil, 230 × 410 mm.; Szépmüvészeti Múzeum, Budapest; Rouart/Wildenstein II, cat. no. 533), duplicates the composition of the painting and, until recently, was considered a preparatory study for the Phillips painting. Stuckey and Wilson-Bareau, 1986, cat. no. 37, give the later date after the painting, suggesting that the watercolor may have been intended as a preparatory drawing for an etching. The second drawing, a small study of Anita Montez's slippers, simply entitled *Ballet Slippers*, ca. 1862 (watercolor over pencil, 76 × 105 mm.; Mr. and Mrs. Alex M. Lewyt, New York; Rouart/Wildenstein II, cat. no. 375), has an equally ambiguous relation to the painting. Hanson, 1966, 65, believes this drawing was probably done later as a kind of "memento" of "the excitement and charm of the Spanish dance."

9. Manet's working method in this instance underwent little alteration from start to finish. X-radiograph analysis reveals some reworking around the headpieces of the two women and the space between the feet of the figure in the lower left, but no alteration of the composition itself; see analysis by Elizabeth Steele, painting conservator, Aug. 24, 1990; reexamined Jan. 14, 1991.

10. During February–March 1863, Manet exhibited *Spanish Ballet*, along with thirteen other recent works, at the Galerie Louis Martinet in Paris. Zola's 1867 biographical and critical study of Manet referred to the "uproar" created by that exhibition, which included both "hissing and cat-calls"; he mentioned *Spanish Ballet* as one of two paintings "which put flame to the powder." See Emile Zola, "Edouard Manet," *L'artiste: Revue du XIXe siècle* (Jan. 1867), as trans. in Gronberg, 1988, 72–73. In his April 1, 1863, review, Paul Mantz criticized this painting, along with several others: "In its medley of red, blue, yellow and black," it was "colour caricatured, not colour itself." He continued,

"In short, this art may be strong and straightforward but it is not healthy." Mantz, "Exposition du Boulevard des Italiens," as trans. in Gronberg, 1988, 53.

11. McCauley, *Disdéri,* 187, 190–95.

12. Ibid., 177, and 194 for discussion of the photograph as a challenge to the conventions of Renaissance perspective.

13. DP, *C in M,* 1926, 9.

14. DP, *A & U,* 1929, 42.

15. Ibid; see also Phillips's comments in *Bull.,* 1931, 48.

16. DP, *A & U,* 1929. 43.

17. Date: Hanson, 1966, cat. no. 24, dates it ca. 1860, as does Rouart/Wildenstein II, cat. no. 454. De Leiris, 1969, cat. no. 155, says 1861. Stuckey and Wilson-Bareau, 1986, cat. no. 36, however, believe the work must date to after 1862, in part because of the form of Manet's signature on the drawing. They assign the dates of ca. 1863/1867–69? to the watercolor; the later dates are added because of the work's relation to Manet's painting *The Balcony,* 1868–69 (oil on canvas, 67¾ × 49¼ in.; Louvre, Caillebotte Bequest). Title: Manet's etching, which he derived from this watercolor, is titled *L'Enfant portant un plateau* in the exhibition of 1884, one year after his death; the title is thus probably close to the original. Some recent publications have called it *L'Enfant au plateau (Boy with a Tray);* see de Leiris, 1969, cat. no. 155, and Stuckey and Wilson-Bareau, 1986, cat. no. 36. *Boy With Fruit* per Kraushaar bill of sale, Oct. 23, 1922, and *C in M,* 1926, pl. XXXVI. Medium: Analysis per Steele, Aug. 24, 1990. Provenance: Kraushaar bill of sale, Oct. 23, 1922.

18. The usual date given for *Spanish Cavaliers* (oil on canvas, 17¾ × 10¼ in.; Musée des Beaux Arts, Lyon) is 1860–61, but Cachin and Moffett, 1983, cat. no. 2, argue that a slightly earlier date of 1859 is more accurate.

19. De Leiris, 1969, 10–11, discusses several examples of this approach in Manet's work.

20. Isaacson, 1969, cat. nos. 4 and 5, points out that the quality of the linear stroke in the drawing matches that of the etching, *L'Enfant portant un plateau (Boy Carrying a Tray),* 1861–62 (etching and aquatint, 8⅜ × 5¹¹⁄₁₆ in.; Art Institute of Chicago). Hanson, 1966, 55, sees the watercolor as a study for the etching. Harris, 1970, 92–95, and cat. no. 28, suggests that the etching may date as late as 1869 because of its similarity to the motif in Manet's 1868 painting *The Balcony,* but she believes that the figure also resembles the boy in the earlier *Spanish Cavaliers* and bears a close resemblance to the technique used in the etching of *Boy with a Sword,* which is signed and dated 1862.

21. The costume in *Boy with a Sword,* 1861 (oil on canvas, 51⅜ × 36¼ in.; Metropolitan Museum of Art), is Velázquez-inspired and identified as that of a seventeenth-century aristocratic page; Cachin and Moffett, 1983, cat. no. 14. Suzanne Leenhoff entered the Manet household in 1850 as a music teacher to Edouard and his younger brothers Eugène and Gustave. Two years later she gave birth to Léon, who lived with his maternal grandmother until her death. Manet and Suzanne delayed their marriage until after his father's death, ostensibly because the inheritance was necessary to support a family. See Adler, 1986, 229, n. 6, as well as Wilson-Bareau, 1991, 12, and Mikael Wivel, *Manet,* exh. cat., Hanne Finsen (Copenhagen, 1989), 102.

22. Léon was referred to as Suzanne's younger brother to avoid a scandal, even though she twice legally acknowledged him as her son, giving his father's name

as Koëlla. As recently as 1983 the circumstantial evidence was seen to favor Manet's paternity. See Cachin and Moffett, 1983, cat. no. 14, p. 75, for a discussion of these issues.

23. Manet never acknowledged paternity, always referring to Léon as his brother-in-law, but he always treated him like a son and in the end bequeathed him a fairly large sum in his will, naming him sole heir after Suzanne. See Wilson-Bareau, 1991, 12, and Wivel, *Manet,* 102. While discounting Manet's paternity, some recent scholars have suggested that Léon Leenhoff may have been the son of Manet's father. See Adler, 1986, 229, n. 6, and Gronberg, 1988, 11.

24. See Cachin and Moffett, 1983, cat. no. 14, p. 75, and Wivel, *Manet,* 102.

25. Hanson, 1966, 55.

26. See Rouart/Wildenstein, I, cat. no. 134.

27. See Douglas Druick and Michel Hoog, *Fantin-Latour,* exh. cat., Galeries nationales du Grand Palais and California Palace of the Legion of Honour (Paris and San Francisco, 1983), cat. no. 72.

Major References

Etienne Moreau-Nélaton, *Manet raconté par lui-même,* 2 vol., Paris, 1926.

Adolphe Tabarant, *Manet et ses oeuvres,* Paris, 1947.

Anne Coffin Hanson, *Edouard Manet, 1832–1893,* exh. cat., Philadelphia, PMA, 1966.

Alain de Leiris, *The Drawings of Edouard Manet,* Berkeley, 1969.

Joel Isaacson, *Manet and Spain: Prints and Drawings,* exh. cat., Ann Arbor, University of Michigan, 1969.

Jean C. Harris, *Edouard Manet, Graphic Works: A Definitive Catalogue Raisonné,* New York, 1970; rev. ed., Joel M. Smith, ed., San Francisco, 1990.

Denis Rouart and Daniel Wildenstein, *Edouard Manet: Catalogue Raisonné,* 2 vols., Geneva, 1975.

Françoise Cachin and Charles S. Moffett, *Manet, 1832–1883,* exh. cat., Metropolitan, New York, 1983.

Kathleen Adler, *Manet,* Oxford, 1986.

Charles F. Stuckey and Juliet Wilson-Bareau, *Edouard Manet,* exh. cat., Boston, Museum of Fine Arts, 1986.

T. A. Gronberg, ed., *Manet: A Retrospective,* New York, 1988.

Eric Darragon, *Manet,* Paris, 1991.

Juliet Wilson-Bareau, ed., *Manet By Himself,* Boston, 1991.

Henri Loyrette and Gary Tinterow, *Origins of Impressionism,* exh. cat., New York, Metropolitan, 1994.

Raquel Da Rosa, "Still Life and the Human Subject in Mid-Nineteenth Century France," Ph.D. diss., Columbia University, 1994.

Hajo Dütching, *Edouard Manet: Images of Parisian Life,* trans. Michael Robertson, Munich, 1995.

Beth Archer Brombert, *Edouard Manet: Rebel in a Frock Coat,* Boston, 1996.

Hans Korner, *Edouard Manet: Dandy, Flaneur, Maler,* Munich, 1996.

Ronald Pickvance, *Manet,* exh. cat., Martigny, Switzerland, Fondation Pierre Gianadda, 1996.

Barbara Ehrlich White, *Impressionists Side by Side: Their Friendships, Rivalries, and Artistic Exchanges,* New York, 1996.

Jane Mayo Roos, *Early Impressionism and the French State, 1866–1874,* Cambridge, 1996.

Michael Fried, *Manet's Modernism, or, the Face of Painting in the 1860s,* Chicago, 1996.

TPC Sources:
E of A, 1914 and 1927.
C in M, 1926.
Bull., 1927.
CA, 1929.
A & U, 1929.
ASD, 1931.
Bull., 1931.
DP, essay for PMG.1941.4.
Cat., 1952.
DP, *Catholicity Does Not Mean Eclecticism: A Radio Talk by Duncan Phillips,* pamphlet, 1954.
Arts, 1956.
Charles S. Moffett, cat. for TPC.1996.5.
MP, 1998.
MSS 97, 109, and 164.

HENRI FANTIN-LATOUR

1. Title: French title per Fantin-Latour, 1911, no. 187. Inscription: according to Fantin-Latour, 1911, no. 187, a second signature was added above the dedication when it was covered by a mat for the Paris exhibition of 1901. Provenance: Early provenance per Fantin-Latour, 1911, no. 187, and Druick and Hoog, 1983, no. 12, the latter erroneously citing Dwight Clark (PMG treasurer) as owner. Phillips purchases are recorded in two secondary sources: 1922 per painting file cover; 1924 per Phillips's handwritten list of works in the collection (AL1a, dated Jan. 15, 1924).

2. "Exposition de l'oeuvre de Fantin-Latour," exh. cat., Ecole Nationale Supérieure des Beaux-Arts (Paris, 1906), introduction by Léonce Bénédite, 17; as quoted in Lucie-Smith, 1977, 27.

3. Druick and Hoog, 1983, no. 84. See also Marcel Crouzet, *Un méconnu du réalisme: Duranty, 1833–1880* (Paris, 1964), 200–201.

4. Title: Catalogued by Fantin-Latour, 1911, no. 425, as *Manet dans son Atelier;* listed as *L'Atelier de Manet* for the Shoukine (1900) and Buckler (1906) sales. Provenance: Per Fantin-Latour, 1911, no. 425, and Druick and Hoog, 1983, no. 72. Christie's does not have information regarding Allard Noel (M. Jeremy Rex-Parkes, archivist, Christie's, to author, Oct. 22, 1991). Katherine Kaplan, Kraushaar, telephone conversation with author, July 31, 1992, cannot confirm ownership by Josef Stransky. The bill of sale from Kraushaar is undated, but Kraushaar to DP, July 28, 1920, acknowledges receipt of payment.

5. For examples, see Adolphe Jullien, "Fantin-Latour: Groupes et portraits d'artistes et d'hommes de lettres," *Les arts* 5, no. 53 (May 1906), 25–32. For more on images of artists' studios in the nineteenth century, see David Cass, *In the Studio: The Making of Art in Nineteenth-Century France,* exh. cat., the Sterling and Francine Clark Art Institute (Williamstown, Mass., 1981).

6. Oil on canvas; Musée d'Orsay, Paris.

7. Druick and Hoog, 1983, 207.

8. Ibid., 208.

9. Manet to Fantin, Madrid, Aug. 1865, in *Manet raconté par lui-même et par ses amis,* ed. Pierre Courthion (Geneva, 1945), 42–44.

10. The two works are Edouard Manet, *Velázquez in His Studio, Painting the Little Cavaliers,* ca. 1860 (oil on canvas; private collection), and *Spanish Gentlemen and*

a *Boy with Platter,* ca. 1860 (oil on canvas; Lyons, Musée des Beaux-Arts). See Denis Rouart and Daniel Wildenstein, *Edouard Manet: Catalogue raisonné,* 2 vols. (Lausanne, 1975), nos. 25 and 26.

11. Druick and Hoog, 1983, 208.

12. Per inspection by Elizabeth Steele, painting conservator, June 24, 1991.

13. DP to Kraushaar, Jan. 15, 1934.

14. DP, *C in M,* 1926, 30.

15. Title: French title per Fantin-Latour, 1911, no. 1103. Numerous entries in Mme Fantin-Latour's catalogue are entitled *L'aurore;* in this case, however, the English titles *Dawn* and *Spirit of Dawn* seem to have been assigned by Duncan Phillips. Listed as *Bathers in the Park* in Kraushaar sales records. Related to lithograph no. 38 in Hédiard, 1906. Provenance: Provenance and confirmation of 1919 sale per Kraushaar to TPC, n.d. Listed as no. 5, *Spirit of Dawn,* on acquisition list, "15 Best Purchases of 1918–19."

16. For example, *Sarah la Baigneuse,* a subject executed in lithography, pastel, and oil, derived from the choral work *Sara La Baigneuse* by Hector Berlioz. Berlioz in turn was inspired by Victor Hugo's poem, "Sara la Baigneuse," published in 1829 in *Les Orientales.* See Druick and Hoog, 1983, 347–48.

17. The work was paired by Phillips with another work by Fantin in the collection that was purchased the following year and given the title *Dusk* (oil on panel, 9 × 13 3/4; acc. no. 0671).

18. DP, *C in M,* 1926, 30.

19. See ibid., 1926, 30, for Phillips's comments on Fantin's "stippling" technique and its influence on later artists like Seurat and Tack.

Major References
Germain Hédiard, *Fantin-Latour, catalogue de l'oeuvre lithographique du maître,* Paris, 1906.
Adolphe Jullien, *Fantin-Latour, sa vie et ses amitiés,* Paris, 1909.
Madame Fantin-Latour, *Catalogue de l'oeuvre complet (1849–1904) de Fantin-Latour,* Paris, 1911; rpt. Amsterdam, 1969.
Frank Gibson, *The Art of Henri Fantin-Latour: His Life and Work,* London, 1924.
Gustave Kahn, *Fantin-Latour,* Paris, 1926; English ed., trans. Wilfrid Jackson, London, 1927.
Edward Lucie-Smith, *Henri Fantin-Latour,* New York, 1977.
Douglas Druick and Michel Hoog, *Fantin-Latour,* exh. cat., Ottawa, National Gallery of Canada, 1983.
Paul de Roux, *Fantin-Latour: Figures et fleurs,* Paris, 1995.
Jean-Jacques Leveque, *Henri Fantin-Latour,* Paris, 1996.

TPC Sources
DP, "15 Best Purchases of 1918–19; 15 Best Purchases Since Jan. 1920," unpubl. acquisitions list, 1920.
H of A, 1920–21.
Inv., 1921.
Journal GG, 1924.
DP, "The Phillips Collection," unpubl. outline prepared for F. Newlin Price, "Phillips Memorial Gallery," *International Studio* 80, Oct. 1924, 8–18; some drafts formerly MS 80.
C in M, 1926.
Bull., 1931.

DP, [Classic or Romantic in Modern Landscape], paper presented at PMG, Mar. 14, 1934. Cat., 1952.

2. FRANCE IN THE LATE NINETEENTH CENTURY

1. Excluding such individuals as John Quinn and Martin Reyerson, who were without ambitions to found museums of their own, the following are some of the major collectors in the United States who fit this mold: Louisine Havemeyer, who promised the major part of her unsurpassed impressionist collection to New York's Metropolitan Museum in 1919 (which entered the museum upon her death in 1929); Albert Barnes, whose Barnes Foundation (under construction since 1922), with its emphasis on modern art, opened in Merion, Pennsylvania, in 1924; Frederic Clay Bartlett, who established the Helen Birch Bartlett Memorial Collection of modern art at the Art Institute of Chicago in 1926; Claribel and Etta Cone, whose modern collection was promised as a gift to the new Baltimore Museum of Art by 1929 (although not donated until 1950); Henry Walters, also of Baltimore, who turned his family collection into a public art gallery in 1934; and Robert Sterling Clark, another of Phillips's early rivals in the impressionist and post-impressionist marketplace, who did not open his museum in Williamstown, Massachusetts, until 1955.

2. Journal HH, 1912, n.p. (entered under July 13, 1912), and "Revolutions and Reactions in Painting," *International Studio* 51 (Dec. 1913), 128.

3. Phillips's appreciation of Renoir was apparent already in 1913, when he published an article, "Revolutions and Reactions in Painting," *International Studio* 51 (Dec.), 123–29, including a reproduction of *Ball at the Moulin de la Galette* from the Caillebotte bequest to the Luxembourg Museum. One of a handful of comparably ambitious works by Renoir, *The Luncheon* was easily the most splendid and complex of three extraordinary works by the artist available from Durand-Ruel in the early 1920s (the other two sold shortly afterward to Samuel Courtauld and R. S. Clark).

4. This conversation, part of the museum's lore, is cited by Eliza Rathbone, essay for TPC.1986.7, p. 7.

5. Joachim Gasquet, *Cézanne* (Paris, 1921), 80.

6. *C in M,* 1926, 9.

7. For Mary Cassatt's frieze at the Louvre, see Paul-André Lemoisne, *Degas et son oeuvre,* 4 vols. (Paris, 1946–49); reprint ed. with supplement by Philippe Brame and Theodore Reff (New York, 1984), 302.

8. Walter Sickert, "Degas," *Burlington Magazine* 31 (July–Dec. 1917), 185.

EUGÈNE-LOUIS BOUDIN

1. Titles: French title from Schmit, 1973, 93. Inscriptions: Although the catalogue for the 1935 Chicago Boudin exhibition states that this inscription reads "Trouville," observation does not confirm this reading. Provenance: According to Phillips's list in Journal GG, 1924, *Beach at Trouville* was purchased from the Galeries Georges Petit. Earlier provenance cannot be determined because the gallery's records have been lost. Phillips's purchase is confirmed in DP to Dwight Clark, July 10, 1923, Foxhall corr.: "I paid for one little painting by Boudin $500."

2. Jean-Aubry, 1968, 50, describes Boudin's working

method at the time; reworking observed by Elizabeth Steele, painting conservator, Sept. 24, 1990.

3. See *La Plage de Trouville,* 1863 (oil on canvas, 16⅞ × 28⅜ in.; private collection; Schmit no. 273), and *L'Embarcadère et la jetée de Trouville,* 1863 (oil on panel, 13¾ × 22⅞ in.; National Gallery of Art, Washington, D.C.; Schmit no. 279).

4. *C in M,* 1926, 27. Phillips owned two additional Boudins during his collecting career: he purchased *Venice, Evening (Quai des Esclavons),* 1895 (Schmit no. 3416), in 1920. He also owned *The Beach at Trouville,* 1880 (Schmit no. 1313), from 1921 to 1930.

5. Journal DD, 1921.

Major References
Ruth L. Benjamin, *Eugène Boudin,* New York, 1937.
G. Jean-Aubry, *Eugène Boudin;* English ed., trans. Caroline Tisdall, Greenwich, Conn., 1968.
Robert Schmit, *Eugène Boudin: 1824–1898,* Paris, 1973; supplements, Paris, 1984 and 1993.
Jean Selz, *Eugène Boudin,* New York, 1982.
Laurent Manoeuvre, *Eugène Boudin, dessins,* Arcueil, 1991.
Anne-Marie Bergeret-Gourbin, *Eugène Boudin: Peintres et dessins: Catalogue raisonné, Musée Eugène Boudin, Honfleur,* Paris, 1996.

TPC Sources
H of A, 1920–21.
Inv., 1921.
Journals DD, 1921; Y, 1922–25; B, ca. 1923–29; and GG, 1924.
C in M, 1926.
ASD, 1931.
Cat., 1952.
MD, 1981.

HILAIRE-GERMAIN-EDGAR DEGAS

1. MP, 1982, 41, quotes from a journal Phillips kept during his 1911 trip to Europe; the original journal has not been found. The 1922 notation is from Journal EE, ca. 1922.

2. Oil on canvas, 14⅛ × 34½ in.; Yale University Art Gallery, New Haven; Lemoisne no. 1107.

3. The quotation is from *ASD,* 1931, 16.

4. Gift from the Bequest of June P. Carey, 1983 (acc. no. 0481). This sketch (Lemoisne supplement no. 61) is a study for Degas's 1872 oil *Dance Class at the Opera* (Paris, Musée d'Orsay; Lemoisne no. 298).

5. *Arts,* 1956, n.p.

6. Quote from *E of A,* 1914, 58.

7. MP, 1982, 41.

8. First quotation from *Arts,* 1956, n.p.; second from *E of A,* 1914, 58.

9. Phillips uses the term "emotive fragments" in MS 84, n.p.

10. Unpublished draft, MS 11, for *Arts,* 1956, n.p.

11. For the Botticelli and Holbein comparison and quotation, see *Arts,* 1956, n.p.

12. Date: The bill of sale, June 24, 1941, dates it 1868–70; Lemoisne, 1984, 188, dates the work ca. 1874. Theodore Reff to author, Mar. 25, 1989, supports a date of the late 1860s. Title: The Bignou bill of sale entitles the work *La Loge.* In a letter to Owen F. Walker, Jan. 26, 1948, Phillips asked that the title of the work be indicated as *Reflection (La Mélancolie).* The painting has been titled

Melancholy since the 1950s. Provenance: Details of the painting's early history are unknown. All information from the records of Alex Reid and Lefevre, Ltd., in correspondence with author, Apr. 25, 1989. Dates of Cargill ownership per 1931 Orangerie, 1932 Royal Academy of Arts, 1932 City of Manchester Art Gallery, and 1937 Orangerie exhibitions catalogues. Phillips gave three works in partial trade: Rouault's *Landscape with Riders,* Dufy's *The Blue Window,* and Braque's *Still Life with Pomegranate.*

13. Daniel Catton Rich, *Degas* (New York, 1976), 62.

14. According to Boggs, 1988, 146, documentation in Durand-Ruel's records indicates that Degas originally entitled one of his works *Sulking* (Metropolitan Museum of Art; Lemoisne no. 335).

15. The same chair appears in Degas's *Portrait of a Man,* ca. 1866 (oil on canvas, 33½ × 25⅝ in.; Brooklyn Museum; Lemoisne no. 145).

16. Date: Date from Lemoisne, 1984, 200. Title: French title from Lemoisne, 1984, 200. The painting is occasionally entitled *Les Femmes qui se peignent* and *La Toilette sur la plage* in exhibition catalogues; Julius Meier-Graefe in *Degas* (Munich, 1920), pl. 39, entitles it *Après le bain.* Provenance: Per Lemoisne, 1984, 200, per a Carstairs pedigree presumably sent to PMG at time of purchase, and per 1924 Galeries Georges Petit, 1931 Rosenberg, 1936 New Burlington Galleries, and 1937 Orangerie exhibition catalogues. According to the pedigree, Degas gave the work to Lerolle (1848–1929) in 1878. PMG purchase recorded in Ledger 15.

17. Boggs, 1988, 255, as translated from Reff, 1985, 110, Notebook 22 (1867–74), Bibliothèque Nationale, Carnet 8, 4.

18. Boggs, 1988, 255, suggests the influence of Botticelli's *Birth of Venus,* ca. 1482 (Uffizi Galleries, Florence), of which Degas owned a print.

19. Boggs, 1988, 373, illustrates many examples of such images by these artists, including: Cézanne's *Three Bathers,* ca. 1874–75, and Puvis de Chavannes's *Young Women by the Seashore,* 1879 (both in the Musée d'Orsay, Paris); and Renoir's *Bathers,* 1887 (Philadelphia Museum of Art).

20. MS 109, n.p.

21. This observation is made and explained in Boggs, 1988, 256.

22. In the later works, the figure's motion of combing her hair forward is made all the more sensuous by the curve of her straining spine. These three pastels are Lemoisne nos. 848 and 849, and Brame and Reff no. 115; they belong respectively to the Hermitage Museum, Saint Petersburg, the collection of Mr. and Mrs. Alfred Taubman, and the Metropolitan Museum of Art, New York, Gift of Mr. and Mrs. Nate B. Spingold, 1956. Other pastels by Degas that incorporate positions from *Women Combing Their Hair* are: *Young Woman Combing Her Hair,* ca. 1890–92, and *After the Bath, Woman Drying Her Neck,* 1898 (both Musée d'Orsay, Paris; Lemoisne nos. 930 and 1306); and *The Breakfast After the Bath,* ca. 1895 (private collection; Lemoisne no. 724).

23. Date: Lemoisne's date for this work is 1895–98; the date of ca. 1895 appears in *Sum. Cat.,* 1985. Title: The French title appears in Lemoisne, 1984, 700; the alternate title appears on the Wildenstein bill of sale, Nov. 9, 1949. Inscription: Stamp refers to 1918 sale of Degas's estate. Provenance: For the May 6, 1918, auction, see *Tableaux, Pastels et Dessins par Edgar Degas et*

provenant de son atelier, exh. cat., Galerie Georges Petit (Paris), cat. no. 255, illus. All known provenance information per letter from Joseph Baillio, Wildenstein, to author, Jan. 28, 1988; bill of sale, Nov. 9, 1949.

24. *Woman Leaving Her Bath,* 1876–77 (pastel over monotype; Musée d'Orsay, Paris; Lemoisne no. 422); a rear view is depicted in *Leaving the Bath,* 1879–80 (drypoint and aquatint, 22 states; owners of each version listed in Sue W. Reed and Barbara S. Shapiro, *Edgar Degas: The Painter as Printmaker,* exh. cat., Museum of Fine Arts [Boston, 1984], 124–32).

25. Boggs, 1988, 516.

26. See Boggs and Maheux, 1992, no. 54, for a discussion of the "preoccupation with equilibrium often encountered in Degas's late works."

27. Date: Although Lemoisne, 1984, 460, dates this work ca. 1884–88, the bill of sale dates it 1895–1900. Boggs, 1988, 588, and Theodore Reff to author, Mar. 1989, assign the date ca. 1900. Title: French title from Lemoisne, 1984, 460, and bill of sale. Provenance: For 1918 auction, see *Tableaux, Pastels et Dessins par Degas,* cat. no. 93. Subsequent ownership by Vollard, in undated notation by Phillips. For the Jan. 27, 1921, auction, see *Paintings and Pastels by the Great French Master the Late Hilaire Germain Edgar Degas Being the Private Collection of the Widely Known Antiquarian Jacques Seligmann of Paris,* exh. cat., American Art Association (New York), cat. no. 65; sold to Widener according to stockbook, AAA, reel 429, #9. For the Jan. 17, 1922, auction, see *Notable Old and Modern Paintings of Artistic Distinction: Sale from collection of Mrs. David Crocker, Charles F. Fowles (Estate), Nora Phillips, Ross Hall Maynard and Others,* exh. cat. American Art Galleries (New York), cat. no. 32. The painting was unclaimed from this sale according to AAA records. Ownership by Harriman is verified by Valentine Gallery bill of sale, Jan. 28, 1944.

28. DP, 1915, 17.

29. The pose appears in the background of *Dance Class at the Opera,* 1872 (Musée d'Orsay, Paris; Lemoisne no. 298); the image of two dancers with their legs on the bar appears in *Dancers Practicing at the Barre,* 1876–77 (Metropolitan Museum of Art, New York; Lemoisne no. 408).

30. Lemoisne nos. 808, 809, 810 (all pastels); drawings nos. 332, 262, 199.

31. *Dancers at the Barre,* ca. 1884–88 (National Gallery of Canada, Ottawa; Lemoisne no. 808), compared in Boggs, 1988, 588–89; see also pp. 481–85 for an evaluation of Degas's style at this point in his career. For discussion of how this painting represents Degas's changed artistic priorities, see Kendall, 1996, 133.

32. *Arts,* 1956, 31.

33. Ibid.

Major References
Paul-André Lemoisne, *Degas et son oeuvre,* 4 vols., Paris, 1946–49; reprint ed. with supplement by Philippe Brame and Theodore Reff, New York, 1984.

Jean Adhémar and Françoise Cachin, *Degas: The Complete Etchings, Lithographs and Monotypes,* New York, 1974.

Theodore Reff, *Degas: The Artist's Mind,* New York, 1976.

———, *The Notebooks of Edgar Degas,* 2 vols., London, 1976; 2nd ed., rev., New York, 1985.

Roy McMullen, *Degas: His Life, Times and Work,* Boston, 1984.

Richard Thomson, *The Private Degas,* exh. cat., London, Arts Council of Great Britain, 1987.

Jean Sutherland Boggs et al., *Degas,* exh. cat., New York, Metropolitan, and Ottawa, National Gallery of Canada, 1988.

Henri Loyrette, *Degas,* Paris, 1991.

Jean Sutherland Boggs and Anne Maheux, *Degas Pastels,* New York, 1992.

Richard Kendall and Griselda Pollock, eds., *Dealing with Degas: Representations of Women and the Politics of Vision,* New York, 1992.

Richard Kendall, *Degas Landscapes,* exh. cat., New York, Metropolitan, and Houston, MFA, 1994.

Barbara Ehrlich White, *Impressionists Side by Side: Their Friendships, Rivalries, and Artistic Exchanges,* New York, 1996.

Richard Kendall, *Degas: Beyond Impressionism,* exh. cat., London, National Gallery of Art, 1996.

Colta Ives et al., *The Private Collection of Edgar Degas,* exh. cat., New York, Metropolitan, 1997.

Lillian Schacherl, *Edgar Degas: Dancers and Nudes,* New York, 1997.

Richard Kendall, *Degas and the Little Dancer,* New Haven, 1998.

TPC Sources
DP, "Impressionism in Poetry and Painting," unpubl. essay, 1910–11; formerly MS 155.
DP, "What Is Impressionism?" *Art and Progress* 3, Sept. 1912, 702–7.
DP, "Revolutions and Reactions in Painting," *International Studio* 51, Dec. 1913, 123–29.
E of A, 1914 and 1927.
DP, "Rhythm and the Arts," unpubl. essay, 1915; formerly MS 74.
Journals EE, ca. 1922; and B, 1923–29.
C in M, 1926.
Bull., 1928.
Journal C, 1929.
CA, 1929.
A & U, 1929.
Formes, 1930.
Bull., 1931.
ASD, 1931.
DP, "The Artist Sees Differently," unpubl. text for slide lecture, twelve versions, 1931–34.
Cat., 1952.
DP, *Catholicity Does Not Mean Eclecticism: A Radio Talk by Duncan Phillips,* pamphlet, 1954.
Arts, 1956; one draft on Degas formerly MS 11.
MP, 1970 and 1982.
MD, 1981.
MP, 1998.
MSS 84 and 109.

PAUL CÉZANNE

1. The lithograph is *Self-Portrait,* ca. 1898 (lithograph on paper, image: 31.7 × 27.9 cm.; sheet: 55.0 × 45.4 cm.; acc. no. 0289, acquired 1949; Venturi no. 1158).

2. Journal HH, 1912, n.p. (entered under July 13, 1912).

3. DP, "Fallacies of the New Dogmatism in Art, Part II," 1918, 103.

4. DP, "Designer of Dreams," in *Arthur B. Davies, Essays on the Man and His Art* (Washington, D.C., 1924), 7–8.

5. DP to Stransky, Wildenstein, May 7, 1925.

6. The Cone sisters of Baltimore purchased *Mont*

Sainte-Victoire Seen from the Bibémus Quarry, ca. 1897, the same year; see Brenda Richardson, *Dr. Claribel and Miss Etta: The Cone Collection*, exh. cat., Baltimore Museum of Art (1985), 109–10, 175.

7. Van Gogh and Marin: *ASD*, 1931, 124 and 131. Derain and Prendergast: ibid., 69 and 104. Davies: DP, "Designer of Dreams," 8. See cat. nos. 229–37 for Marin, cat. nos. 117–18 for Derain, cat. nos. 174–77 for Prendergast, and cat. nos. 178–82 for Davies.

8. *C in M*, 1926, 9.

9. Meier-Graefe's (1867–1937) visit to America and to The Phillips Collection was arranged by Weyhe, New York (TPC Papers, AAA, reel 1937, #0592); Phillips's library included Meier-Graefe's monograph on Cézanne.

10. Rewald, 1989, 342. Phillips, along with Albert Barnes, was in the vanguard in American museums collecting Cézanne.

11. *ASD*, 1931, 77; parts of this passage appear in "El Greco, Cézanne and Picasso," *A & U*, 1929, 104.

12. Ibid., 76.

13. Roger Fry, *Cézanne: A Study of His Development* (New York, 1927).

14. *ASD*, 1931, 94.

15. *Still Life with Clock* (oil on canvas, 21¼ × 29¼ in.; private collection; Venturi no. 69).

16. Phillips's copy of *A Catalogue of A Century of Progress Exhibition of Paintings and Sculpture*, exh. cat., AIC (Chicago, 1933), has handwritten commentary on page 46. The exhibition was presented June 1–Nov. 1.

17. DP to Stransky, June 28, 1933.

18. *ASD*, 1931, 122.

19. "Paul Cézanne" in Journal GG, 1924, n.p.

20. *Harvesters* (oil on canvas; private collection, Paris), Venturi no. 1517.

21. *Arts*, 1956, 32–33.

22. John Elderfield, "Cézanne: The Lessons of the Master," *Art in America* 73 (June 1985), 90.

23. See Rewald, introduction for TPC.1971.2, which is the first scholarly evaluation of the unit. Marjorie Phillips organized the exhibition.

24. Date: The author would like to thank John Rewald for kindly making available the information from the Vollard archive and stockbooks and for providing entries from his catalogue raisonné, published posthumously in 1996 with the collaboration of Walter Feilchenfeldt and Jayne Warman. At the time of Venturi's death in 1961, Venturi's revised edition of his 1936 catalogue was with the publisher and was taken over by Rewald. In cases where these revisions differ from Rewald's catalogue, they are cited as "Venturi revised." Dates: 1878–80: Rewald, introduction for TPC.1971.2, Rewald, 1986, and Rewald, 1996; Gowing concurs, per conversation with author, Apr. 23, 1990 (hereafter: Gowing, Apr. 23, 1990). Ca. 1877: Venturi, 1936, and Venturi revised. Ca. 1880: Rivière, 1923. 1875–80: annotated photograph (no. 523) in Vollard archives. 1877: archives of Paul Rosenberg and Co., New York (correspondence with author, Mar. 1, 1991). Title: French title: possibly Vollard, 1904 Salon catalogue. Second French title: Venturi, 1936, and Rewald, 1996. Third French title: Durand-Ruel, exh. cat., 1940, *The Four Great Impressionists*. Variant: *Portrait de l'artiste par lui-même* in Vollard stockbook. Provenance: Vollard archive, photograph no. 523, stockbook

no. 4162 [A], 59 × 45. Cassirer was an intermediate owner per Venturi, 1936, and Cachin and Rishel, 1996, no. 36; Rewald, 1996, does not support this ownership. Behrens listed as owner in 1912 Saint Petersburg catalogue, no. 591, illus., and in Meier-Graefe, 1913, as well as 1920 and 1922 eds.; said to have been on loan to Kunsthalle Hamburg after Behrens's death (d. 1921?); the Kunsthalle has no record of a loan. Leo von König listed as owner in Meier-Graefe, 1923 and 1927 eds.; Venturi, 1936, lists Julius Meier-Graefe, Berlin, but there is no documentary evidence, and Rewald, 1996, refutes this ownership. Rosenberg stock no. 1940, photograph, and Mar. 13, 1928, invoice, per Elaine Rosenberg to author, Mar. 1, 1991; Wildenstein photograph file, ca. 1928 (courtesy John Rewald).

25. Rewald, 1989, 121.

26. Hugo von Tschudi was director of the Berlin National Gallery until 1908, and subsequently of Munich's Alte Pinakothek. His attempts to acquire avant-garde works resulted in his dismissal from the Berlin museum. Behrens/Tschudi anecdote: Rosenberg invoice, Mar. 13, 1928. Rewald, 1996, however, states that "according to the widow of the German painter Leo von Koenig, Meier-Graefe never owned this painting; instead, he and Koenig, who acted as Behrens's adviser, urged the latter to acquire it. When Behrens died without heirs, his widow—around 1920—presented this picture, considered the finest of the entire collection, to their lifelong friend Leo von Koenig, who was forced through financial difficulties to sell it some eight years later."

27. Meier-Graefe, 1927, 46–47.

28. Rewald, introduction for TPC.1971.2, 17. Meier-Graefe's assessment is cited by Phillips in *ASD*, 1931, 121.

29. *ASD*, 1931, 121–22.

30. Oils: *Self-Portrait*, 1879–82 (Oskar Reinhart Collection, Henry Francis Du Pont Winterthur Museum Inc.; Venturi no. 367), and *Self-Portrait*, 1877–80 (Louvre; Venturi no. 371). Drawing: *Self-Portrait*, 1880–82 (Art Institute of Chicago; Chappuis no. 614; Venturi no. 1293). Portraits of the 1870s are discussed in Cachin and Rishel, 1996, 145–50.

31. As quoted in Rewald, introduction for TPC.1971.2, 17. See alternative translation of the Rilke quote in Cachin and Rishel, 1996, no. 36, where the reader will also find other early critical responses to the painting.

32. Gowing, "Self-Consciousness in Art: Cézanne Self-Portraits," lecture delivered at TPC, Feb. 25, 1987; text in Gowing estate; cassette tape in TPC archives.

33. Venturi, 1936, 36. Author trans.: "Au milieu du désordre artiste du costume et de la chevelure, le regard de Cézanne est vif, pénétrant, sincère, sévère . . . un regard qui est le symbole de sa personnalité."

34. Quoted in Robert Kirsch, "A Cézanne Self-Portrait," *Issue: A Journal for Artists* (Spring 1986), 33. Kirsch further compares this portrait with Renaissance and baroque portraits accessible to Cézanne in Paris and Aix.

35. "Self-Consciousness in Art," n.p.; *Victor Chocquet*, 1875–76 (private collection; Venturi no. 283).

36. DP, lecture, Nov. 5, 1931, n.p.; based on *Bull.*, 1931.

37. Date: 1886–87: Rewald, introduction for TPC.1971.2; Rewald, 1996; Venturi revised; and Douglas Cooper, "Two Cézanne Exhibitions—II," *Burlington Magazine* 96 (Dec. 1954), 379. 1888: Vollard archive photograph

(no. 296) annotated by Cézanne's son, "Aix 1888." Ca. 1887: Rewald, 1986; 1885–87: Venturi, 1936. For Gowing dating see text. Title: First title: Rewald, introduction for TPC.1971.2. French title: Venturi, 1936, and Rewald, 1996. Second French title: Vollard stockbook no. 7019 [C]. Other titles include: *La Sainte Victoire*, Venturi, 1936; *Mont Sainte-Victoire with Pine Trees*, Rewald, 1989. Provenance: Vollard archive, photograph no. 296 and possibly stockbook no. 7019 [C]; transfer to Reber, May 3, 1913, per Vollard stockbook; possibly Wildenstein stock #16088 (courtesy John Rewald). In May 1925 *Mont Sainte-Victoire* was a recent Rosenberg gallery acquisition (Stransky to Phillips, May 14, 1925); Rosenberg invoice, July 6, 1925, Wildenstein acting as administrative agent (Rosenberg to author, Apr. 24, 1987). G. F. Reber was a prominent German collector who in 1918 owned fourteen Cézannes.

38. *C in M*, 1926, 11.

39. "The Artist Sees Differently," Trowbridge Lecture, Yale University, New Haven, Mar. 20, 1931, 28–29.

40. *ASD*, 1931, 124.

41. Schapiro, 1965, 74. This description accompanies a reproduction of the Courtauld version (see next note).

42. The two related versions are dated 1885–87 (Metropolitan Museum of Art; Rewald, 1996, no. 511) and ca. 1887 (Courtauld Museum, London; Rewald, 1996, no. 599). Watercolor: *La Vallée de l'Arc*, ca. 1885 (Art Institute of Chicago; Venturi no. 914, and Rewald, 1983, cat. no. 241). A drawing of a pine branch may have been used as a study for this work; see Chappuis, 1973, cat. no. 893: *Branch of a Pine Tree*, ca. 1885 (collection of Norman Schlenoff, New York). A photograph of the site is reproduced in Rewald, 1983, 143. For discussion of this series, see Cachin and Rishel, 1996, 252–65.

43. Lawrence Gowing, *Cézanne*, exh. cat., Arts Council of Great Britain (London, 1954), cat. no. 39.

44. Gowing, "Notes on the Development of Cézanne," *Burlington Magazine* 107 (June 1956), 190. Second quote in Cachin and Rishel, 1996, cat. no. 93.

45. Leila Mechlin, "Notes of Art and Artists," *Washington Star*, Dec. 27, 1925.

46. Date: 1890–93: Rewald, introduction for TPC.1971.2, Rewald, 1986, and Rewald, 1996. 1894–95: Gowing, Apr. 23, 1990. 1895–1900: Venturi, 1936. 1893–95: Venturi revised. 1885: original TPC painting file—"painted about 1885." 1895–98: Reff, 1977, 48. Title: First title: Rewald, introduction for TPC.1971.2. First French title: Venturi, 1936. First alternate title: Cat., 1952. Second alternate title: TPC.1981.5 and TPC.1983.6. Second French title: Rewald, 1996. Provenance: According to Perry B. Cott, "The Stransky Collection of Modern Art," *Worcester Art Museum Bulletin* 23 (Winter 1933), 157, *Ginger Pot* was a gift "to Monet in whose bedroom at Giverny it hung until the latter's death"; Monet ownership is also given in Venturi, 1936; Wildenstein to DP, May 10, 1939; and Rewald, 1996, who also gives Michel Monet's ownership. Bernheim-Jeune purchase, May 7, 1929, from Blanche Monet (1865–1947), widow of Monet's son, Jean (1867–1914). Sold to their Lausanne branch, Aug. 29, 1929, registration no. 25.938. However, per Rewald, 1996: Miss Monet to Georges Bernheim, Paris, and Bernheim-Jeune, Paris. Stransky purchase, Aug. 29, 1929, per Guy-Patrice Dauberville, Bernheim-Jeune and Cie, to author, Oct. 2, 1987; on loan to Worcester Art Museum from June 1, 1932 (under the title *Nature Morte*, entry no. 32.912), where, except for a 1934 loan to the Philadelphia Museum of Art, it remained until March

1936, when it was sent to the Nelson Atkins Museum of Art, Kansas City. After Stransky's death, Wildenstein received the entire collection Mar. 16, 1936, per Stephen Jareckie, Worcester Art Museum, to author, June 22 and Aug. 17, 1988; Wildenstein has no record of this work until Nov. 1936 (conversation with author, May 27, 1987). Sent on approval (along with Chardin's *Pheasant*) Feb. 25, 1939, and Phillips arranged for acquisition and gift, per Wildenstein to DP, Feb. 25 and May 3, 1939.

47. This is an extremely rare occasion on which Cézanne replicated an image in two media. Watercolors: *Pot de gingembre et fruits sur une table*, 1888–90 (Jean Dauberville, Paris; Venturi no. 1134), and *Pot de gingembre avec fruits et nappe*, 1888–90 (Christoph and Alice Bernoulli, Basel); see Rewald, 1983, cat. nos. 289, 290. Oil: *Fruits et pot de gingembre*, 1890–93 (Stiftung Langmatt Sidney and Jenny Brown, Baden, Switzerland). The Swiss version is less stably composed than the Phillips version; its closer vantage point and cluttered, almost claustrophobic arrangement suggest that it is the earlier, less resolved composition. A third oil, *Still Life of a Skull and Fruits*, 1896–98 (Barnes Foundation, Merion, Pa.; Rewald, 1996, no. 734), also contains a similar central grouping of pomegranate, cloth, and other fruits. In this work Cézanne seems to expand thematic possibilities with the inclusion of the skull. Rishel in Cachin and Rishel, 1996, 287, has reiterated the difficulty of establishing the chronology of the related still lifes.

48. Reff, 1977, 48.

49. *La Buire et la soupière*, 1888–90 (National Museum of Western Art, Tokyo; Coll. Matsukata, Tokyo; Venturi no. 848), contains a more legible example of sliced fruit, occurring here in the far right; see Rewald, 1983, cat. no. 294. Observations on technique by Steele, Dec. 3, 1990.

50. Reff, 1977, 13. Gowing, Apr. 23, 1990, cautions, however, that this work is "far from the treatment in the great still lifes of the late 1890s and early 1900s."

51. Several compositional elements point to *Boy with Skull*, 1892–93 (Barnes Foundation, Merion, Pa.; Venturi no. 679). Books also figure as a dynamic compositional element in *Portrait of Gustave Geffroy*, 1895 (Musée d'Orsay; Venturi no. 692). Props included in *Seated Woman in Blue* are the flowered cloth and a yellow book.

52. *C in M*, 1926, 9.

53. Journal Y, ca. 1922–25, n.p. The identity of this painting is not known, but it could not have been the present work, which had not yet entered Stransky's collection.

54. According to reviews, the first showing of the painting at PMG was a gallery installation that opened May 7, 1939, and included loans and permanent collection works.

55. DP to Wildenstein, Mar. 8, 1939 (TPC Papers, AAA, reel 1955, #1012).

56. Rewald, 1986, 188.

57. Cited in Charles Stuckey, ed., *Monet: A Retrospective* (New York, 1985), 248. Durand-Ruel inventoried Monet's collection in 1927. Information courtesy of Daniel Wildenstein in correspondence with author, Oct. 9, 1987.

58. Date: 1892–95: Rewald, 1989, and Rewald, 1996. 1892 or earlier: Gowing, Apr. 23, 1990 (he was reluctant to date it as late as 1895). 1885–87: Venturi, 1936, and Marie Harriman Gallery bill of sale, June 24, 1941.

1886–88: Venturi revised. Title: First title: PMG.1941.4, and Cat., 1952. French title: Venturi, 1936, and Rewald, 1996; Marie Harriman Gallery correspondence to TPC, 1939–41; and Rewald, 1996. First alternate title: Rewald, 1989. Published in *Sum. Cat.*, 1985, as *Farmhouses Near Bellevue*, mistakenly believed to have been a Rewald title. Provenance: Vollard archive, photograph no. 141; Vollard stockbook no. 3401 [A]: "Petit paysage gris d'argent, maisons dans la campagne du midi—au premier plan un pouce de terrain dans presque toute la longueur. 35 × 51 cm." (Rewald, 1996). Egisto Fabbri (1866–1933), an expatriate artist and collector, was possibly the first American to own Cézanne's work, amassing a substantial collection by the 1920s. According to Rewald, 1996, Fabbri purchased this painting from Vollard, Feb. 10, 1900, for 1,000 francs; see Vollard stockbook page reproduced in Rewald, 1996, 449. Decision to purchase, Harriman to DP, Apr. 25, 1940 (TPC Papers, AAA, reel 1953, #0907); bill of sale dated 1941.

59. *Dans la Plaine de Bellevue*, 1885–86 (Cologne, Wallraf-Richartz Museum; Rewald, 1996, no. 715). *La Plaine de Bellevue*, 1885–87 (Barnes Foundation, Merion, Pa.; Rewald, 1995, no. 716).

60. Rewald, 1986, 158–59.

61. Venturi, 1936, 55. Author trans.: "Cézanne a su tirer une fermeté, une force incroyable."

62. It is published under this title in L. H[enraux], "Une grande collection de Cézanne en Italie: La Collection Egisto Fabbri," *L'amour de l'art*, special number (Nov. 1924), 337–44, pl. 6230 (dated as 1885).

63. Gowing, 1954, entry for cat. no. 37. Gowing, Apr. 23, 1990, points out that the canvas painted in Bellevue can be contrasted with the earlier style manifested in *Mont Sainte-Victoire*.

64. Rewald, introduction to TPC.1971.2, 18.

65. Date: 1900–1902: Gowing, Apr. 23, 1990. 1902–4: Rewald, 1996. Other proposed dates hover around the 1900–1906 period (see Venturi, 1936, and Venturi revised; Reff, 1977, 204; and Gowing in Reff, 1977, 64). Differing significantly are the proposed date of 1888 in Rivière, 1923. Title: First title: Rewald, introduction for TPC.1971.2. French title: Venturi, 1936, Rewald in Reff, 1977, and Rewald, 1996. Second French title: Bernheim-Jeune records. Third French title: Rivière, 1923. Last French title: unidentified label on painting reverse. Other title: *Portrait of Madame Cézanne*, Felix Wildenstein to DP, Nov. 22, 1946. Provenance: Vollard archive, photograph no. 576; Bernheim-Jeune Stock #18668, photograph no. 6860. Pellerin to Bernheim-Jeune to Vollard transaction recorded Apr. 4, 1911 (author's conversation with Bernheim-Jeune, May 16, 1990). Credited to Wildenstein, London, in Douglas Lord, "Nineteenth-Century French Portraiture," *Burlington Magazine* 72 (June 1938), 253–63 (illus.). Bill of sale, Nov. 22, 1946.

66. John Rewald, "Homage to Paul Cézanne," exh. cat., Wildenstein (London, 1939), n.p., cat. no. 43.

67. Rewald in Reff, 1977, cat. no. 53, compares this work with *Old Woman with a Rosary*, 1895–96 (National Gallery of Art, London; Venturi no. 702).

68. For a discussion of Cézanne's achievement of mysterious and harmonious effects in this period, see Reff, 1977, 14.

69. For a discussion of the concept of time in Cézanne's paintings, see Liliane Brion-Guerry in Reff, 1977, 73–82.

70. In its earliest known reproduction in Lord, "Nineteenth-Century French Portraiture," 252, the work was captioned *The Artist's Wife*. According to Rewald in Reff, 1977, cat. no. 53, Venturi accepted this identification. Photographs of Madame Cézanne show some resemblance to this model in the heavy eyelids, downturned mouth, rounded jawline, and pensive, melancholy demeanor, which may have led to Venturi's acceptance of this identity.

71. Gowing, Apr. 23, 1990.

72. See Cachin and Rishel, 1996, cat. no. 188 (1900–1904, Hermitage Museum, Saint Petersburg, Rewald, 1996, no. 944). For discussion of Cézanne's fear of women and general isolation from the world late in life, which dictated a limited selection of models, see Rewald, 1986, 185. Although in Wildenstein, 1939, cat. no. 43, Rewald wrote that her identity was unknown, in Rewald, 1996, he likewise suggests that she might be Cézanne's housekeeper, Madame Brémond. Both Cachin (in Cachin and Rishel, 1996, no. 108) and Rewald (in Reff, 1977, 221) note that Cézanne painted his wife less and less frequently, and Rewald further states that he painted no portraits of her after 1892.

73. The existence of the pair of paintings has given rise to a fourth theory, cited in Reff, 1977, 22, that the models are Cézanne's sisters wearing identical clothing, the present canvas portraying the elder sibling. Rivière, 1923, 216, suggested that the model was the painter's maid.

74. Reff, 1977, 14 and 22.

75. Lord, "Nineteenth-Century French Portraiture," 263: "Quand la couleur est à sa richesse, la forme est à sa plénitude."

76. Date: ca. 1906: Rewald in Reff, 1977, and Rewald, 1996; 1905–6: Gowing, Apr. 23, 1990. 1902–6: Venturi, 1936. Ca. 1900: Venturi revised. 1906: Wildenstein portfolio sent at time of purchase, 1955; Reff, 1977, 28. Title: First title: Rewald in Reff, 1977. French title: Rewald, 1996. Erroneously published as *Provençal Landscape Near Les Lauves* in *Sum. Cat.*, 1985. Provenance: Cézanne estate suggested in Rewald, 1996; Vollard ownership per Venturi, 1936, and Rewald, 1996, Vollard stockbook no. 4474 "paysage. Village temps d'orage. 65 × 81"; Bernheim-Jeune ownership per Rewald, 1996; Wildenstein portfolio, 1955; painting shipped on approval, Dec. 14, 1954; decision to purchase, DP to Daniel Wildenstein, Feb. 4, 1955 (bought in partial trade for Cézanne's *The Harvesters*). According to Joseph Baillio, Wildenstein, to TPC, Mar. 26, 1980, no other early records exist.

77. Quotations from Cézanne's letters are from Rewald, 1939, 213. Cézanne's discussion of viewing the motif from different angles referred to the river of Aix but could as easily apply to the motifs visible from this studio. For discussion of this group of paintings, see Cachin and Rishel, 1996, 480–85.

78. This and the following quotations are from Rewald to TPC, Mar. 2, 1980. Rewald's photograph of the studio and the view from its terrace can be found in Reff, 1977, 95.

79. *La Terrasse du jardin des Lauves*, 1902–6 (watercolor; Mr. and Mrs. Eugene Victor Thaw, New York; Venturi no. 1072; Rewald, 1983, cat. no. 621); and *La Cathédrale d'Aix vue de l'atelier des Lauves*, 1904–6 (Alex L. Hillman Family Foundation, New York; Venturi no. 1077; Rewald, 1983, cat. no. 637).

80. Rewald in Reff, 1977, 403.

81. Rewald, 1986, 237. In 1983, 37, he notes the parallel roles of blank canvas and white paper in Cézanne's paintings.

82. As quoted in Rewald, 1986, 226.

83. Reff, 1977, 28.

84. Although Rewald, in Reff, 1977, 403, does not suggest that the colors refer to Chain d'Etoile, he observes that the pink area is the central focus.

85. DP to Wildenstein, Jan. 17, 1955.

86. Gowing, Apr. 23, 1990. For example, Reff, 1977, 45, describes the painting as unfinished. Rewald, 1996, argues that the work is in an "early stage . . . about to be born."

87. As quoted in Rewald, 1986, 237.

88. *Arts*, 1956, 32–33.

89. Ibid., 33.

Major References
Vollard Archives, Paris.
Julius Meier-Graefe, *Cézanne*, 3rd ed., Munich, 1910; 4th ed. 1913; 5th ed. 1923; English ed., London, 1927.
———, *Cézanne und sein Kreis*, Munich, 1918; 2nd ed. 1920; 3rd ed. 1922.
Georges Rivière, *Le Maître Paul Cézanne*, Paris, 1923.
Emile Bernard, *Souvenirs sur Paul Cézanne, une conversation avec Cézanne*, Paris, 1926.
Lionello Venturi, *Cézanne, son art, son oeuvre*, catalogue raisonné, 2 vols., Paris, 1936.
Ambroise Vollard, *Paul Cézanne: His Life and Art*, New York, 1937.
Meyer Schapiro, *Paul Cézanne*, New York, 1965.
Adrien Chappuis, *The Drawings of Paul Cézanne: A Catalogue Raisonné*, 2 vols., Greenwich, Conn., 1973.
Theodore Reff et al., *Cézanne: The Late Work*, ed. William Rubin, exh. cat., New York, MOMA, 1977; French ed., *Cézanne, les dernières années*, 1978.
John Rewald, *Paul Cézanne: The Watercolors, a Catalogue Raisonné*, Boston, 1983.
John Rewald, ed., *Paul Cézanne: Letters*, rev. ed., New York, 1984.
John Rewald, *Cézanne: A Biography*, rev. and enl. ed., New York, 1986; 1st ed., 1936; English ed., 1948.
Lawrence Gowing, *Cézanne: The Early Years, 1859–1872*, exh. cat., Washington, D.C., NGA, 1988.
John Rewald, *Cézanne and America: Dealers, Collectors, Artists, and Critics, 1891–1921*, Princeton, 1989.
Hajo Dütching, *Paul Cézanne, 1839–1906, Nature into Art*, Cologne, 1994.
Adriani Götz, *Cézanne Paintings*, trans. Russell Stockman, New York, 1995.
Barbara Ehrlich White, *Impressionists Side by Side: Their Friendships, Rivalries, and Artistic Exchanges*, New York, 1996.
Pavel Machotka, *Cézanne: Landscape into Art*, New Haven, 1996.
Françoise Cachin and Joseph J. Rishel, *Cézanne*, exh. cat., Philadelphia, PMA; London, Tate; and Paris, Musée d'Orsay, 1996.
John Rewald, in collaboration with Walter Feilchenfeldt and Jayne Warman, *The Paintings of Paul Cézanne: A Catalogue Raisonné*, 2 vols., New York, 1996.

TPC Sources
Journal HH, 1912.
E of A, 1914 and 1927.
Journal O, 1916–23.
DP, "Fallacies of the New Dogmatism in Art," *American Magazine of Art* 9, parts 1 and 2: Dec. 1917, Jan. 1918, 43–48, 101–6; formerly MSS 75 and 76.
Journals Y, ca. 1922–25; and GG, 1924.
C in M, 1926.
Bulls., 1927 and 1928.
Journal C, 1929.
A & U, 1929 and 1930.
ASD, 1931.
Bull., 1931.
DP, "The Artist Sees Differently," unpubl. slide lecture, 12 versions, 1931–34.
Formes, 1932.
DP, [Notes on John Dewey, *Art as Experience*, New York, 1934], written in the book's margin, 1934; formerly MS 64.
AMA, 1935.
Bull., 1941.
Cat., 1952.
DP, *Catholicity Does Not Mean Eclecticism: A Radio Talk by Duncan Phillips*, pamphlet, 1954.
DP, [Compilation of Essays for Proposed Publication], notebook containing previously published and unpublished writings, after 1955; formerly part of MS 97.
Arts, 1956.
DP, [Untitled Introduction], "A Thousand Years of France: An Anthology of Henri Focillon," *Art News Annual* 28, 1959, 147.
DP, "A Gallery of Modern Art and Its Sources," text for television program produced by the Greater Washington Education Television Association; aired Oct. 16, 1959, 11:30 A.M.; formerly MS 95.
MP, 1970 and 1982.
John Rewald, introduction to TPC.1971.2.
MD, 1981.
MP, 1998.

ALFRED SISLEY
1. The author wishes to thank Richard Shone for generously sharing his knowledge of Sisley's life and work. Information on previous owners: Correspondence between Paul Rosenberg and Josef Stransky of Wildenstein, forwarded to Phillips on May 22, 1926. Daulte, 1959, lists only Rosenberg and Phillips. Phillips to Wildenstein, Oct. 24, 1923: "Last summer I purchased . . . 'Snow at Louveciennes' from Paul Rosenberg." According to hanging records, the painting was on view by Dec. 30, 1923.

2. Cogniat, 1978, 89.

3. See Monet, *A Cart on the Snowy Road at Honfleur*, 1865 (65 × 92.5 cm.; Musée d'Orsay, Paris), in Moffett, TPC.1998.5, cat. no. 1, and *The Road in Front of the Ferme Saint-Siméon, Winter*, 1866–67 (81 × 100 cm.; Musée du Louvre, Paris, W79); for discussion see John House, *Monet: Nature into Art* (New Haven, 1986), 137.

4. Pissarro painted his first *Effet de Neige* in 1869; see *The Versailles Road at Louveciennes (Snow)*, 1869 (15⅛ × 18¼ in.; Walters Art Gallery, Baltimore), in Moffett, TPC.1998.5, cat. no. 32. *First Snow at Louveciennes*, 1871–72 (Museum of Fine Arts, Boston), is reputed to be Sisley's first snow scene at Louveciennes. Two other canvases show the alley in Voisins, near Louveciennes: *A Garden at Louveciennes*, 1873 (private collection; Daulte no. 95), a virtual companion piece showing the figure and viewpoint in the spring or summer, and *Snow at Louveciennes*, 1878 (Musée d'Orsay, Paris; Daulte no. 282). Direct inspiration for Sisley was readily available; Pissarro had created the first series focusing on one locale in different light, times of day, and seasons in 1874 at Louveciennes and in 1873–74 at Pontoise; see Brettell, 1984, 90 and 79, for reference to Louveciennes as "the cradle." See also Moffett, TPC.1998.5, cat. no. 49, for discussion of the Phillips painting.

5. Both quotes in Sisley's letter to "an unknown friend," n.d.; see Robert Goldwater and Marco Treves, eds., *Artists on Art* (New York, 1972), 308–9. Christopher Lloyd, 1985, 18, identifies the recipient of the letter as the collector and critic Adolphe Tavernier.

6. Cogniat, 1978, 58.

7. For English affinities, see ibid., 12.

8. Roger Fry, "French Art in the Nineteenth Century," *Burlington Magazine* 40 (June 15, 1922), 277.

9. Phillips purchased *Rainy Day—Moret* in 1920 and *The Banks of the Seine* in 1921.

10. *C in M*, 1931, 33.

Major References
Gustave Geffroy, *Alfred Sisley*, Les cahiers d'aujourd'hui, Paris, 1923; 2nd ed., rev., 1927.
François Daulte, *Alfred Sisley: Catalogue raisonné de l'oeuvre peint*, Lausanne, 1959.
Raymond Cogniat, *Sisley*, Paris, 1978; 2nd ed., rev., 1981.
Richard Shone, *Sisley*, Oxford, 1979.
Richard Brettell, Scott Schaefer, and Sylvie Gache-Patin, *A Day in the Country: Impressionism and the French Landscape*, exh. cat., Los Angeles, LACMA, 1984.
Christopher Lloyd, *Retrospective Alfred Sisley*, exh. cat, Tokyo, Isetan Museum of Art, 1985.
Charles S. Moffett et al., *The New Painting: Impressionism, 1874–1886*, exh. cat., Fine Arts Museums of San Francisco and Washington, D.C., NGA, 1986.
Richard Shone, *Alfred Sisley*, New York, 1992.
MaryAnne Stevens, ed., *Alfred Sisley*, exh. cat., London, Royal Academy of Art, 1992.

TPC Sources
Inv., 1921.
Journals EE, ca. 1922; and D, ca. 1923–24.
C in M, 1926.
DP, essay for PMG.1926.5.
Bulls., 1928 and 1931.
Cat., 1952.
SITES, 1979.
MD, 1981.
Eliza E. Rathbone et al., cat. for TPC.1996.5.
Charles S. Moffett et al., cat. for TPC.1998.5.
MP, 1998.

CLAUDE MONET
1. Date: No primary documentation exists from which to date this painting. Monet lived in Vétheuil from August 1878 to December 1881. Durand-Ruel to DP, May 16, 1923, recorded it as 1879; Wildenstein, 1974, cites 1880 (see also Rodolphe Walter, Wildenstein Institute, to author, Dec. 19, 1991); Charles Stuckey to author, Oct. 30, 1991, suggests 1879. Title: Secondary

titles from old labels on painting's reverse. Provenance: Early history per Durand-Ruel to DP, May 16, 1923; Drouot sale per Wildenstein, 1974, 364; PMG acquisition per DP, 1920, n.p.

2. Wildenstein, 1974, nos. 502, 508–10, and 581. He executed two other canvases from the same site but looking toward La Roche-Guyon (Wildenstein nos. 582 and 583).

3. Both quotes are from Emile Taboureux, "Claude Monet," *La vie moderne* (June 12, 1880); reprinted in Stuckey, 1985, 89–93.

4. Théodore Duret, *Le peintre Claude Monet*, 1880; essay as reprinted in Stuckey, 1985, 70–72.

5. *Bull.*, 1931, 48.

6. *C in M*, 1926, 32.

7. Quoted in MP, 1970, 41, from Phillips's 1911 travel journal; the original journal has not been located. The next day Phillips went to the Musée du Luxembourg to continue his "studies of modern French painting. First [going] to the Impressionist room to get another look at Monet and Renoir" (ibid., 42).

8. For quotes see DP, "What Is Impressionism," *Art and Progress* 3 (Sept. 1912), 707 and 706. Similar views are stated in an article in the March issue, "The Impressionistic Point of View," 505–11.

9. DP, 1942, 5–7.

10. Phillips included this painting in the acquisition list "15 Best Purchases of 1918–19," 1920, n.p. During the 1920s he acquired three more Monet paintings, which he later deaccessioned: *Nightfall, A French River* (date and location unknown; acquired 1918 or 1919, deaccessioned 1930); *Narrows of the Creuse*, 1889 (Wildenstein no. 1235, PMAG purchase by 1920, deaccessioned 1929); and *Still Life with Spanish Melon*, 1879 (Wildenstein no. 544, PMG purchase 1926, deaccessioned 1934). In 1924 Phillips wanted to purchase one other Monet painting, *Waterloo Bridge*, 1903 (Wildenstein no. 1567), but failed to come to a satisfactory arrangement.

11. DP, 1959, n.p.

12. Title/Date: First exhibited in 1898 as *Au Val-Saint-Nicolas, près Dieppe (Matin); Sur la falaise, Dieppe* was used while in Durand-Ruel family collection. Provenance: Per correspondence, Charles Durand-Ruel to Phillip Bruno, World House, Apr. 13, 1960, and Herbert Mayer, World House, to TPC, Apr. 16, 1960. Bill of sale, Oct. 30, 1959.

13. *Bull.*, 1931, 48.

14. DP to Daniel Wildenstein, Apr. 18, 1966.

15. During the 1850s and 1860s, when he became Monet's first teacher, Boudin studied Dutch landscape painting and the Barbizon School masters and was encouraged by Courbet; see Linnea S. Dietrich, *The Subjective Vision of French Impressionism*, exh. cat., Tampa Museum (1981), 12.

16. Discussed in Tucker, 1989, 214–17.

17. Ibid., 198 and 190.

18. See *Halage d'un Bateau, Honfleur*, 1864 (Wildenstein no. 37), and *La Pointe de la Hève à Marée Basse*, 1865 (Wildenstein no. 52).

19. Monet to Alice Hoschedé, Feb. 6, 1897 (Wildenstein letter no. 1367); translation per Tucker, 1989, 280, n. 12.

Major References
Gustave Geffroy, *Claude Monet, sa vie, son temps, son oeuvre*, Paris, 1924; rev. ed., *Claude Monet, sa vie, son oeuvre*, Paris, 1980.

Horace Shipp, "Monet: Lord of Light," *Apollo* 66, Oct. 1957, 67–68.

William C. Seitz, *Claude Monet*, New York, 1971.

Daniel Wildenstein, *Claude Monet: Biographie et catalogue raisonné*, 4 vols., Paris, 1974.

Steven Z. Levine, "Monet and His Critics," Ph.D. diss., New York, 1976.

Joel Isaacson, *Claude Monet: Observation and Reflection*, New York, 1978.

Andrew Forge and Robert Gordon, *Monet*, New York, 1983.

Charles F. Stuckey, ed., *Monet: A Retrospective*, New York, 1985.

Charles S. Moffett et al., *The New Painting: Impressionism, 1874–1886*, exh. cat., Fine Arts Museums of San Francisco and Washington, D.C., NGA, 1986.

Richard Kendall, ed., *Monet by Himself*, London, 1989.

Paul Hayes Tucker, *Monet in the '90s: The Series Paintings*, exh. cat., Boston, MFA, 1989.

Virginia Spate, *Claude Monet: Life and Work*, New York, 1992.

Marianne Alphant, *Claude Monet: Une vue dans le paysage*, Paris, 1993.

Steven Z. Levine, *Monet, Narcissus, and Self-Reflection: The Modernist Myth of the Self*, Chicago, 1994.

John House, *Impressions of France: Monet, Renoir, Pissarro, and Their Rivals*, exh. cat., London, South Bank Centre, 1995.

Paul Hayes Tucker, *Claude Monet: Life and Art*, New Haven, 1995.

Stephen Koja, *Monet*, exh. cat., Vienna, Österreichische Galerie im Belvedere, 1996.

Barbara Ehrlich White, *Impressionists Side by Side: Their Friendships, Rivalries, and Artistic Exchanges*, New York, 1996.

Daniel Wildenstein, *Monet, or the Triumph of Impressionism, and Catalogue Raisonné*, 4 vols., Cologne, 1996.

Carla Rachman, *Monet*, London, 1997.

Meyer Shapiro, *Impressionism: Reflections and Perceptions*, New York, 1997.

Annette Dixon et al., *Monet at Vétheuil: The Turning Point*, exh. cat., Ann Arbor, University of Michigan Museum of Art, 1998.

TPC Sources
Journals N, 1912; HH, 1912; and AA, 1913–14.
E of A, 1914 and 1927.
Journal O, 1916–23.
DP, "Fallacies of the New Dogmatism in Art," *American Magazine of Art* 9, parts 1 and 2: Dec. 1917, Jan. 1918, 43–48, 101–6.
DP, "15 Best Purchases of 1918–19; 15 Best Purchases Since Jan. 1920," 1920.
H of A, 1920–21.
Inv., 1921.
DP, "Painters of Past and Present," unpubl. outline for proposed publication, dated July 1, 1925; formerly part of MS 97.
C in M, 1926.
DP, essay for PMG.1928.5.
Bulls., 1928, 1929, and 1931.
DP, "Tentative Plan for a Handbook," outline for proposed publication, ca. 1941; formerly part of MS 97.
DP, *Contrasts in Impressionism: An Exhibition of Paintings by Alessandro Magnasco, Claude Monet,*

John Marin, exh. cat., Baltimore, BMA, 1942.
Cat., 1952.
DP, "A Gallery of Modern Art and Its Sources," text for television program produced by the Greater Washington Education Television Association; aired Oct. 16, 1959; formerly MS 95.
MP, 1970 and 1982.
SITES, 1979.
MD, 1981.
Eliza E. Rathbone et al., cat. for TPC.1996.5.
Charles S. Moffett et al., cat. for TPC.1998.5.
MP, 1998.
MS 42.

ODILON REDON
1. Date: Per John Rewald, *Odilon Redon, Gustave Moreau, Rodolphe Bresdin*, exh. cat., MOMA (New York, 1961), cat. no. 43, and supported by Roseline Bacou, conversation with Leslie Furth, 1990. This date was confirmed by Kevin Sharp, who was working on the Redon retrospective (1994) in correspondence with TPC, Feb. 10, 1993; according to Sharp, Redon began to combine floral and figural elements in 1907, producing a great number of such works through 1910 and 1911. Sharp also noted that the figure in the Phillips painting resembles the subject in *Silence*, ca. 1911 (oil on canvas; Museum of Modern Art, New York). Title: *Femme aux fleurs* appears on a 1923 Galerie E. Druet label on the painting's reverse. Phillips acquired it as *Mystery*. Provenance: Bill of sale May 1, 1925. Druet information per Wildenstein, vol. 1, 1992, no. 412; in correspondence to Phillips (Kraushaar to DP, May 8, 1926), Kraushaar states Druet acquisition as "by 1923"; see TPC Papers, AAA, reel 1933, #193 and #304.

2. Rewald, *Redon, Moreau, Bresdin*, 35, quoting Bonnard, "Homage à Redon," *La vie* (Nov. 30, 1912).

3. "Confessions of an Artist," in Redon, 1986, 24.

4. Baudelaire, *Salon de 1859*, as quoted in Berger, 1964, 28. Redon read Baudelaire's *Les fleurs du mal* at age seventeen and owned a copy of his *Curiosités esthétiques*, 1868.

5. Rewald, *Redon, Moreau, Bresdin*, 26.

6. Berger, 1964, 36.

7. DP, cat. for PMG.1928.4c, 16. Wildenstein, vol. 1, 1992, describes this work as "L'Homme—personnification de sa propre intelligence et de sa propre réflexion—s'éveille, doute, s'interroge" (Man—the personification of his own intelligence and reflection—awakens, doubts, [and] questions himself) and relates the work to *Le Silence*, no. 413 (collection of Mr. and Mrs. Alexander Lewyt, USA), in which the mysterious gesture has been transformed into one of silence.

8. Although it is not certain that *Mystery* was Redon's title for the work, he often used similar titles, for instance, *Silence; The Thought;* and *Mystic Dialogue*. The title *Mystery* could easily be applied to any of his works.

9. Redon, 1986, 84.

10. PMG.1926.2.

11. Essay for ibid., n.p.

12. *C in M*, 1926, 36.

Major References
Lettres d'Odilon Redon, 1878–1916: Publiées par sa famille, preface by Marius-Ary Leblond, Paris, 1923.
Roseline Bacou, *Odilon Redon*, 2 vols., Geneva, 1956.

Klaus Berger, *Odilon Redon: Fantasy and Color,* trans. Michael Bullock, New York, 1964.

Jean Cassou, *Odilon Redon,* Milan, 1972.

Richard Hobbs, *Odilon Redon,* London, 1977.

Odilon Redon, *To Myself: Notes on Life, Art and Artists,* comp. and trans. Mira Jacob and Jeanne L. Wasserman, New York, 1986.

Stephen F. Eisenman, *The Temptation of Saint Redon: Biography, Ideology, and Style in the "Noirs" of Odilon Redon,* Chicago, 1992.

Alec Wildenstein, *Odilon Redon: Catalogue raisonné de l'oeuvre peint et dessiné,* 3 vols., Paris, 1992–96.

Oktavia Christ, *Odilon Redon: Visionen Eines Künstlerpoeten,* Berlin, 1994.

Douglas W. Druick et al., *Odilon Redon: Prince of Dreams, 1840–1916,* exh. cat., Chicago, AIC, 1994.

Russell T. Clement, *Four French Symbolists: A Sourcebook on Pierre Puvis de Chavannes, Gustave Moreau, Odilon Redon, and Maurice Denis,* Westport, Conn., 1996.

Barbara Jean Larson, "Odilon Redon: Science and Fantasy in the 'Noirs,'" Ph.D. diss., New York University, 1996.

TPC Sources
DP, cat. for PMG.1926.2.
C in M, 1926.
E of A, 1927.
DP, cat. for PMG.1928.4c.
Bull., 1928.
A & U, 1929.
ASD, 1931.
DP and C. Law Watkins, cat. for PMG.1941.4.
Cat., 1952.
SITES, 1979.
MD, 1981.
Denys Sutton, essay for TPC.1983.6.
Cat. for TPC.1987.7.

AUGUSTE RODIN

1. Provenance: In her 1907 travel diary, under April 27, Dreier recorded a visit to Rodin's studio in the company of Edward Steichen and his wife: "Mr. and Mrs. Steichen took us to meet Rodin. Saw him at work." Although the entry does not mention a specific purchase of a Rodin sculpture, a list of expenses at the back of the diary, between entries May 10 and May 11, includes "Rodin, statue, bronze sister and child" for 2,000 francs (Katherine S. Dreier Papers, Archives of the Société Anonyme, Beinecke Rare Book and Manuscript Library, Yale University, New Haven).

2. De Caso and Sanders, 1977, 100, n. 1, discusses the mother-and-child theme, a subject popular with the public during the late nineteenth century.

3. An example is *Young Woman and Child,* 1865–70 (22 1/2 in. high); illustrated in Tancock, 1976, 234.

4. Rudenstine, 1988, 844, cites examples of the sculpture's popularity.

5. Nicole Barbier, ed., *Marbres de Rodin: Collection du Musée Rodin, Paris* (Paris, 1987), 144, and De Caso and Sanders, 1977, 103. *Galatea* (marble, 23 5/8 in. high; Musée Rodin) was first exhibited in 1889. The woman's body is a reversed, smaller version of *Study of a Seated Woman (Cybele),* 1889 (plaster, 63 1/2 in. high). The female form is also used in a sculpture for the *Gates of Hell* commission, *Shame (Absolution),* 1889–90 (bronze, 25 3/4 in. high). See Tancock, 1976, 221 and 223, for illustrations.

6. De Caso and Sanders, 1977, 103, speculate that the girl ruminates on her future maternal responsibilities.

7. See Tancock, 1976, 222–24, and Rudenstine, 1988, 843–44, for a partial list of locations of *Brother and Sister* bronze casts, as well as marble and plaster versions. This bronze is not listed.

8. Katherine Dreier to Aimée Crane, editor, Hyperion Press, Jan. 13, 1945; "H-Misc." #2, Dreier Papers.

9. Both quotes from *E of A,* 1914, 124.

10. Phillips's 1911 travel journal, excerpted in MP, 1982, 42. The original has not been located.

11. *E of A,* 1914, 123–24.

Major References
Georges Grappe, *Le Musée Rodin,* Monaco, 1944.
Albert Elsen, ed., *Auguste Rodin: Readings on His Life and Work,* Englewood Cliffs, N.J., 1965.
Ruth Butler Mirolli, "The Early Work of Rodin and Its Background," Ph.D. diss., New York University, 1966.
John L. Tancock, *The Sculpture of Auguste Rodin,* exh. cat., Philadelphia, PMA, 1976.
Jacques De Caso and Patricia B. Sanders, *Rodin's Sculpture: A Critical Study of the Spreckel's Collection: California Palace of the Legion of Honor,* San Francisco, 1977.
Ruth Butler, *Rodin in Perspective,* Englewood Cliffs, N.J., 1980.
Albert E. Elsen, ed., *Rodin Rediscovered,* exh. cat., Washington, D.C., NGA, 1981.
Alain Beausire and Hélène Pinet, *Correspondance de Rodin,* 2 vols., Paris, 1985.
Albert E. Elsen, *The Gates of Hell by Auguste Rodin,* Stanford, Calif., 1985.
Catherine Lampert, *Rodin: Sculpture and Drawings,* London, 1986.
Monique Laurent, *Rodin,* Paris, 1988.
Angelica Z. Rudenstine, *Modern Painting, Drawing and Sculpture Collected by Emily and Joseph Pulitzer, Jr.,* vol. 4, Cambridge, 1988.
Rainer Crone and Salzmann Siegfried, eds., *Rodin: Eros and Creativity,* exh. cat., Bremen, Kunsthalle, 1992.
Etienne Dujardin-Beaumetz, *Entretiens avec Rodin,* Paris, 1992.
Ruth Butler, *Rodin: The Shape of Genius,* New Haven, 1993.
Musée Goupil-Bordeaux, *Figures d'ombres: Les dessins de Auguste Rodin,* exh. cat., Bordeaux, 1996.

TPC Sources
DP, "The Impressionistic Point of View," *Art and Progress* 3, Mar. 1912, 505–11.
E of A, 1914 and 1927.
DP, "Rhythm and the Arts," unpubl. essay, 1915; formerly MS 74.
DP, "Fallacies of the New Dogmatism in Art," *American Magazine of Art,* part 2: Jan. 1918, 101–6; formerly MS 76.
ASD, 1931.
MP, 1970 and 1982.

BERTHE MORISOT

1. Date: Bataille and Wildenstein, 1961, 47, date this painting ca. 1894. Because of Morisot's style and subject in this work, Anne Higonnet agrees with this date (conversation with author, March 1991); during the early 1890s, the artist often painted girls on the verge of womanhood comparable in age to her daughter, Julie. Examples are *The Coiffure,* 1894 (oil on canvas, 21 3/8 × 18 1/8 in.; Museo Nacional de Bellas Artes, Buenos Aires), and *Cherry Tree,* 1891–92 (oil on canvas, 53 9/16 × 35 1/16 in.; private collection), both illustrated in Stuckey and Scott, 1987, pls. 103 and 89, respectively. Title: Alternate French title from Bataille and Wildenstein, 1961, 47. Provenance: Early provenance supplied by Guy-Patrice Dauberville, Bernheim-Jeune et Cie., to author, Feb. 18, 1988. Bill of sale, Nov. 30, 1925, TPC Papers, AAA, reel 1933, #242.

2. Models identified in Bataille and Wildenstein, 1961, 47. A study, *Jeune fille accoudée,* was made for the figure of Jeanne-Marie (Bataille and Wildenstein no. 363; Clairet et al., no. 367).

3. Conversation with Anne Higonnet, March 1991.

4. For an analysis, see Scott, "Morisot's Style and Technique," in Stuckey and Scott, 1987, 187–214.

5. *C in M,* 1926, 28.

6. Ibid. for quotation and for influence of Morisot on Manet. For more on this influence, see Stuckey and Scott, 1987, 81–83.

Major References
M. L. Bataille and G. Wildenstein, *Berthe Morisot: Catalogue des peintures, pastels et aquarelles,* Paris, 1961.
Jean Dominique Rey, *Berthe Morisot,* New York, 1982.
Denis Rouart, ed., *Berthe Morisot: The Correspondence with Her Family and Her Friends, Manet, Puvis de Chavannes, Degas, Monet, Renoir and Mallarmé,* trans. Betty W. Hubbard, London, 1986.
Kathleen Adler and Tamar Garb, *Berthe Morisot,* Ithaca, N.Y., 1987.
Julie Manet, *Growing Up with the Impressionists: The Diary of Julie Manet,* trans. and ed. Rosalind de Boland Roberts and Jane Roberts, London, 1987.
Charles F. Stuckey and William P. Scott, *Berthe Morisot, Impressionist,* exh. cat., South Hadley, Mass., Mount Holyoke College Art Museum, and Washington, D.C., NGA, 1987.
Chittima Amornpichetkul, "Berthe Morisot: A Study of Her Development from 1864–1886," Ph.D. diss., Brown University, 1989.
T. J. Edelstein, ed., *Perspectives on Morisot,* New York, 1990.
Anne Higonnet, *Berthe Morisot,* New York, 1990.
———, *Berthe Morisot: Images of Women,* Cambridge, Mass., 1991.
Barbara Ehrlich White, *Impressionists Side by Side: Their Friendships, Rivalries, and Artistic Exchanges,* New York, 1996.
Margaret Shennan, *Berthe Morisot: The First Lady of Impressionism,* Gloucestershire, 1996.
Alain Clairet et al., *Berthe Morisot, 1841–1895: Catalogue raisonné de l'oeuvre peint,* Montolivet, France, 1997.

TPC Sources
Journal Y, ca. 1922–25.
C in M, 1926.
DP, essay for PMG.1926.5.
DP, essay for PMG.1928.5.
A & U, 1929.
ASD, 1931.
Bull., 1931.

Cat., 1952.
MP, 1970 and 1982.
SITES, 1979.
MD, 1981.
Eliza E. Rathbone, cat. for TPC.1996.5.
MP, 1998.

PIERRE-AUGUSTE RENOIR

1. Date: Renoir began the painting in the summer of 1880, working on it over several months until its purchase by Durand-Ruel on Feb. 14, 1881. Some sources therefore date the painting 1880–81; however, 1881 is the date given by the artist with his signature. Title: Sources of alternate titles: *Déjeuner champêtre*, Durand-Ruel Archives, "livre de stock," 1880–82, pp. 33–34, #825, Dec. 10, 1881; *Les Canotiers*, Durand-Ruel Archives, "Brouillard" listing Balensi's purchase; *Un Déjeuner à Bougival*, Seventh Impressionists' Exhibition, 1882. Many variations exist in later exhibitions, reviews, and publications. The painting was titled *Le Déjeuner des canotiers* by 1917, when it was shown in Zurich. It still had that title on its arrival at The Phillips Memorial Gallery, per review, Leila Mechlin, "Notes of Art and Artists," *Sunday Star*, Dec. 30, 1923, part 2, p. 11. The title has been translated as both *Boating Party at Luncheon* and *Luncheon of the Boating Party*. Provenance: Record of first three transactions in Durand-Ruel, "livre de stock," #825 and #2290. Paul Durand-Ruel's purchase: "Journal," 1881–89, 155–56; 1891 transfer: "livre de stock," #1212. For more on Balensi and Durand-Ruel, see Anne Distel, "Renoir's Collectors: The Pâtissier, the Priest and the Prince," in House et al., 1985, 20–21. On Phillips's acquisition, see agreement of sale, July 9, 1923 (TPC Papers, AAA, reel 1929, #668–69).

2. DP to Dwight Clark, treasurer of PMG, July 10, 1923, Foxhall corr., reporting on conclusions of negotiations from Paris. Marjorie Phillips (MP, 1982, 63) remembered that, while in Paris, they were seated in view of the painting during a luncheon at the home of Joseph Durand-Ruel.

3. Phillips's negotiations with Durand-Ruel are detailed in the William H. Holston Papers, AAA, reel D-169, #1029–31. For publicity on the painting entering PMG, see Mechlin, "Notes of Art and Artists," 11, and *New York Herald*, Dec. 1, 1923, sec. 1, p. 9.

4. *Ball at the Moulin de la Galette*, 1876 (51½ × 69 in.; Musée d'Orsay, Paris). For Phillips's quote, see MP, 1982, 40–41. Although Phillips mentions a 1911 trip in *History of the Class of 1908* 2 (New Haven, 1914), 235, a journal of that trip has not been found.

5. *E of A*, 1927, 62.

6. Carey, 1980, publishes a chart outlining different opinions of the models' identities. Among the opinions noted are those of Meier-Graefe, 1912; Georges Rivière, *Renoir et ses amis* (Paris, 1921); and Renoir, 1962. The currently accepted opinion, published in House et al., 1985, is based on early records in the Durand-Ruel Archives. See also Eliza Rathbone's discussion of the various identifications in Rathbone et al., cat. for TPC.1996.5, 39–47.

7. Daulte, 1971, identifies this figure as Alphonse Fournaise Jr. and calls the man leaning against the foreground railing Alphonse Fournaise Sr., the restaurant owner.

8. For information on Samary, see Rathbone in TPC.1996.5, 45–47.

9. DP, 1959, 13.

10. MP, 1982, 65.

11. The Restaurant Fournaise has since been renovated. See Helen and Earl Abrams, "The 'Pleasantest Place' in Paris," *Art News* (Dec. 1985), 11–12, and Peter Mikelbank, "'Luncheon' Is Served," *Washington Post*, Oct. 14, 1990.

12. An analysis of the painting's composition appears in Herbert, 1988, 248–49. For discussion of the changes Renoir made to the composition, see Elizabeth Steele's technical discussion in Rathbone et al., TPC.1996.5, 221–29.

13. *E of A*, 1927, 64.

14. For an analysis of Renoir's style at this point in his career, see House et al., 1985, 220–21.

15. Phillips's quote from *C in M*, 1926, 65; House et al., 1985, 223, compares the two works.

16. This group of quotations is from *C in M*, 1926, 34.

17. Quotation from Mechlin, "Notes of Art and Artists," 11. First installation noted in DP, Journal B, 1923–29. Sisley's *Snow at Louveciennes*, 1874 (cat. no. 44); *Banks of the Seine* was later deaccessioned.

18. Quotation from *ASD*, 1931, 19. As his collecting career continued, Phillips purchased additional Renoir works: in 1940, both a late drawing, *The Judgment of Paris*, by 1908 (acc. no. 1636), and a sculpture, *Mother and Child*, 1916 (acc. no. 1638); in 1949 an etching, *The Dance in the Country*, ca. 1890 (acc. no. 1635). A lithograph, *Portrait of Rodin*, n.d. (acc. no. 1639), was purchased for the Phillipses' private collection in 1948 and given to the museum by Marjorie Phillips in 1984.

Major References
Archives, Durand-Ruel Galleries, Paris.
Julius Meier-Graefe, *Auguste Renoir*, Paris, 1912.
Albert André, *Renoir*, Paris, 1919.
Julius Meier-Graefe, *Renoir*, Leipzig, 1929.
François Daulte, *Pierre-Auguste Renoir: Watercolors, Pastels and Drawings in Colour*, London, 1959.
Jean Renoir, *Renoir, My Father*, Boston, 1962.
Barbara Ehrlich White, "An Analysis of Renoir's Development from 1877 to 1887," Ph.D. diss., Columbia University, 1965.
Linda Nochlin, *Impressionism and Post-Impressionism, 1874–1904: Sources and Documents*, Englewood Cliffs, N.J., 1966.
François Daulte, *Auguste Renoir, catalogue raisonné de l'oeuvre peint, I: Figures, 1860–1890*, Lausanne, 1971.
Barbara Ehrlich White, *Renoir, His Life, Art and Letters*, New York, 1984.
John House et al., *Renoir*, exh. cat., London, Arts Council of Great Britain; Paris, Réunion des musées nationaux; and Boston, Museum of Fine Arts, 1985.
Charles Moffett et al., *The New Painting: Impressionism, 1874–1886*, exh. cat., Fine Arts Museums of San Francisco and Washington, D.C., NGA, 1986.
Robert L. Herbert, *Impressionism: Art, Leisure, and Parisian Society*, New Haven, 1988.
Anne Elizabeth Dawson, "'Idol of the Moderns': Renoir's Critical Reception in America, 1904–1940," Ph.D. diss., Brown University, 1996.
Barbara Ehrlich White, *Impressionists Side by Side: Their Friendships, Rivalries, and Artistic Exchanges*, New York, 1996.
National Gallery of Canada, *Renoir's Portraits: Impressions of an Age*, exh. cat., Ottawa, 1997.

TPC Sources
Journals HH, 1912; O, 1916–23; and B, 1923–29.
DP, "The Phillips Publications," unpubl. essay, 1923–24; formerly part of MS 97.
DP, "*Renoir* by Albert André," unpubl. translation, 1923–25; formerly MS 81.
DP, "The Phillips Collection," outline prepared for F. Newlin Price, "Phillips Memorial Gallery," *International Studio* 80, Oct. 1924, 8–18; some drafts formerly MS 89.
Journal GG, 1924.
C in M, 1926.
E of A, 1927.
DP, "Art in Washington: The Phillips Memorial Gallery," *Forerunner of the General Convention*, A.D. 1928 2, Easter 1928, 18–24.
DP, essay for PMG.1928.4a.
Bull., 1928.
CA, 1929.
A & U, 1929 and 1930.
Formes, 1930.
Journal BB, ca. 1930–33.
ASD, 1931.
Bull., 1931.
DP, "Modern Art and the Museum," *American Magazine of Art* 23, Oct. 1931, 271–76.
DP, "The Artist Sees Differently," unpubl. text for slide lecture, 12 versions, 1931–34.
DP, [Classic or Romantic in Modern Landscape], paper presented at PMG, Mar. 14, 1934; text related to MS 103.
AMA, 1935.
DP, "The Expression of Personality Through Design in the Art of Painting," unpubl. text for slide lecture, 8 versions, ca. 1936–42.
DP, "Freshness of Vision in Painting," unpubl. essay, ca. 1945; formerly part of MS 178.
Cat., 1952.
DP, *Catholicity Does Not Mean Eclecticism: A Radio Talk by Duncan Phillips*, pamphlet, 1954.
Arts, 1956.
DP, "A Gallery of Modern Art and Its Sources," text for television program produced by the Greater Washington Education Television Association, aired Oct. 16, 1959; formerly MS 95.
MP, 1970 and 1982.
SITES, 1979.
Martha Carey, *The Luncheon of the Boating Party*, Washington, D.C., The Phillips Collection, 1980.
MD, 1981.
Eliza E. Rathbone et al., cat. for TPC.1996.5.
Charles S. Moffett et al., cat. for TPC.1998.5.
MP, 1998.
MSS nos. 47, 48, and 103.

PAUL GAUGUIN

1. Title: Paul Rosenberg to DP, Oct. 18, 1951, refers to this painting as *Ham and Onions*. Provenance: Vollard's purchase from Gauguin recorded on Rosenberg bill of sale, Jan. 21, 1952. Acquisition from Vollard and subsequent sale to Daber, Jacqueline Cartwright, Reid and Lefevre, Ltd., to author, July 28, 1987. Bignou ownership cited in Maurice Malingue, *Gauguin: Le peintre et son oeuvre* (Paris, 1948), no. 148, and Lee Van Dovski [Herbert Lewandowski], *Paul Gauguin oder die Flucht vor der Zivilisation* (Bern, 1950), no. 154. Cortot's sale to Rosenberg, courtesy of Mrs. Liliane Samuel, Paul Rosenberg and Co., to author, Nov. 3, 1987. Intent to purchase in correspondence, DP to Rosenberg, Oct. 18, 1951; bill of sale, Jan. 21, 1952.

2. Gauguin to Emile Schuffenecker, end of Feb. or early Mar. 1888; quoted in Brettell et al., 1988, 55.

3. The author wishes to thank Caroline Boyle-Turner and especially Vojtech Jirat-Wasiutynski for discussing this work in depth with her, generously sharing their knowledge on Gauguin's technique and style. For further discussion of the synthetist movement, see Boyle-Turner, 1986, 19–33, and Jirat-Wasiutynski, "Paul Gauguin's Paintings, 1886–91: Cloisonism, Synthetism and Symbolism," *RACAR* 9 (1982), 35–46.

4. Attributed to Paul Sérusier, as quoted in Brettell et al., 1988, 125.

5. Merete Bodelsen, "Gauguin's Cézannes," *Burlington Magazine* 104 (May 1962), 204–9, and "Gauguin, the Collector," *Burlington Magazine* 112 (Sept. 1970), 590–615; see p. 606 for identification of this particular work (private collection; illus. in Hoog, 1987, fig. 92).

6. As further testament to his admiration for this particular Cézanne still life, Gauguin also painted it in the background of *Portrait of a Woman, with Still Life by Cézanne,* 1890 (oil on canvas; Art Institute of Chicago, Joseph Winterbotham Collection); see Brettell et al., 1988, 193.

7. *Le Jambon* (oil on canvas; Glasgow Art Gallery and Museum, Burrell Collection). See Françoise Cachin's entry on *The Ham* in Brettell et al., 1988, 124–25. Degas purchased the Manet in June 1888 from the Hôtel Drouot, Pertuiset sale; Gauguin returned to Paris December 27 or 28, 1888. Cachin believes that Gauguin saw Manet's work at Degas's home. It is also possible that he saw it in 1884 at Manet's retrospective held at the Ecole des Beaux-Arts in January.

8. The author wishes to thank Laura A. Coyle, Princeton Ph.D. candidate, for bringing this work to her attention. See Rewald, 1978, 408–9, and Brettell et al., 1988, 189, for two other known instances of Gauguin and de Haan painting the same subject together. For discussion of Gauguin's and de Haan's collaboration in Le Pouldu, also see Robert Welsh, "Gauguin et l'auberge de Marie Henry au Pouldu," *Revue de l'art* 86 (1989), 35–43.

9. Gauguin to Schuffenecker, Aug. 14, 1888, as quoted in Jirat-Wasiutynski, "Paul Gauguin's Paintings," 41.

10. See Boyle-Turner to author, Apr. 27, 1992, and Jirat-Wasiutynski to KGR, Aug. 6, 1992. Although largely self-taught, Gauguin was clearly aware of artist's manuals of the time, many of which probably influenced his choice of materials and their technical application; see H. Travers Newton, "Observations on Gauguin's Painting Techniques and Materials" in Peres et al., 1991, 103.

11. Vojtech Jirat-Wasiutynski and Travers Newton, "Paul Gauguin's Paintings of Late 1888: Reconstructing the Artist's Aims from Technical and Documentary Evidence," *Appearance, Opinion, Change: Evaluating the Look of Paintings,* UKIC/AAH Conference, Tate Gallery, London, June 1990. See also Robert Bruce-Gardner et al., "Impressions of Change" in Courtauld Institute Galleries, *Impressionist and Post-Impressionist Masterpieces: The Courtauld Collection* (New Haven, 1987), 22–23.

12. Analyses of technique in *The Ham* by Elizabeth Steele, painting conservator, July 20, 1990; June 15 and Oct. 5, 1992. According to Carol Christensen ("The Painting Materials and Techniques of Paul Gauguin" in *Conservation Research,* monograph series 2 [Washington, D.C., 1993], 66–67 and 71–72), Gauguin pre-

ferred to avoid using impasto for textural effects, and in late 1888, while in Arles, he adopted the use of a coarse-weave canvas to add texture to the paint film. But in 1889–90 he painted on an assortment of finely woven canvases, and *The Ham* is on a moderate-to-fine-weave canvas with a white ground, the color Gauguin favored. He also preferred absorbent grounds and from 1887 consistently primed his own canvases. According to Steele, it is impossible to determine whether he did so in the Phillips work, because the tacking margins were cut when it was lined. Gauguin may have had the painting lined himself, as evidenced by the creases in the canvas and paint film visible along the top and right sides where the tacking margins were folded out prior to affixing it to a second canvas. The composition continues onto the tacking margins while the left and right sides seem to have been cut down. This may have been done by the artist to reposition the ham from the center to the lower-left quadrant of the composition. Jirat-Wasiutynski noted that the current dimensions of the canvas are nonstandard, but once the enlarged edges are subtracted, the dimensions become about 46 × 55 cm., a standard size-10 canvas (letter to KGR, Aug. 6, 1992). For sizes see David Bromford et al., "Canvases and Primings for Impressionist Paintings," in *Art in the Making: Impressionism* (New Haven, 1990), 44–46.

13. Steele, July 20, 1990, and June 15, 1992, believes that an abandoned composition may lie beneath or that the artist made revisions to the present composition; the x-radiograph of the painting, however, is inconclusive. Gauguin was known to have retouched his paintings, and there are other cases where the evidence is more visible to the eye than in the x-radiograph or infrared. See Christensen, "The Painting Materials and Techniques of Paul Gauguin," 73 and 86, and Bruce-Gardner et al., "Impressions of Change," 32–34.

14. Boyle-Turner to author, Apr. 27, 1992. See also Steele, June 15, 1992. Both Boyle-Turner and Steele state that further testing is needed. For a discussion of Gauguin's use of wax, see Christensen, "The Painting Materials and Techniques of Paul Gauguin," 81 and 92–93.

15. This work has an aqueous glue lining on which is affixed a French shipping label, dating the present lining to the 1940s or earlier. The resin varnish may have been added at the time of lining; per Steele, July 20, 1990.

16. *ASD*, 1931, 44.

17. "The Modern Argument in Art and Its Answer," text for PMG lecture, Nov. 5, 1931, n.p.; published under same title in *Bull.*, 1931, 36–73.

18. First quote in *Bull.*, 1928, 21; second in *C in M*, 1926, 36.

19. DP to Paul Rosenberg, Oct. 18, 1951. *Idyll of Tahiti* (oil on canvas; present location unknown) was sold to PMG through the Van Dyck Galleries in 1925 and traded to the Newhouse Galleries in 1936 as partial payment for Goya's *The Repentant St. Peter* (cat. no. 4).

Major References
John Rewald, *Gauguin,* Paris, 1938.
John Rewald, ed., *Paul Gauguin: Letters to Ambroise Vollard and André Fontainas,* San Francisco, 1943.
John Rewald, *Post-Impressionism from Van Gogh to Gauguin,* New York, 1956; French trans., Paris, 1961; rev. 2nd ed., New York, 1962; rev. 3rd. ed., New York, 1978.
Georges Wildenstein, *Gauguin,* catalogue raisonné, Paris, 1964.

Mark Roskill, *Van Gogh, Gauguin, and the Impressionist Circle,* Greenwich, Conn., 1970.
Vojtech Jirat-Wasiutynski, *Paul Gauguin in the Context of Symbolism,* New York, 1978.
Victor Merlhès, ed., *Correspondence de Paul Gauguin,* Paris, 1984.
Michel Hoog, *Gauguin: Life and Work,* trans. Constance Devanthéry-Lewis, New York, 1987.
Marla Prather and Charles F. Stuckey, eds., *Gauguin: A Retrospective,* New York, 1987.
Richard Brettell et al., *The Art of Paul Gauguin,* exh. cat., Washington, D.C., NGA, 1988.
Victor Merlhès, ed., *Paul Gauguin et Vincent van Gogh, 1887–1888: Lettres retrouvées, sources ignorées,* Taravao, Tahiti, 1989.
Russell T. Clement, *Paul Gauguin: A Bio-Bibliography,* New York, 1991.
Cornelia Peres et al., eds., with contributions by Mette Marie Bang et al., *A Closer Look: Technical and Art Historical Studies on Works by Van Gogh and Gauguin, Cahier Vincent,* series 3, Zwolle, Netherlands, 1991.
Bernard Denvir, *Gauguin: Letters from Brittany and the South Seas, The Search for Paradise,* New York, 1992.
Karyn Elizabeth Esielonis, "Gauguin's Tahiti: The Politics of Exoticism," Ph.D. diss., Cambridge, Harvard University, 1993.
Belinda Thomson, ed., *Gauguin by Himself,* Boston, 1993.
Arthur Ellridge, *Gauguin and the Nabis: Prophets of Modernism,* Paris, 1995.
David Sweetman, *Paul Gauguin, a Complete Life,* London, 1995.
Georg W. Koltzsch, *Paul Gauguin: Das verlorene Paradies,* exh. cat., Essen, Museum Folkwang Essen, 1998.
Ronald Pickvance, *Gauguin,* exh. cat., Martigny, Switzerland, Fondation Pierre Gianadda, 1998.

TPC Sources
"Revolutions and Reactions in Painting," *International Studio* 51, Dec. 1913, 123–29.
E of A, 1914 and 1927.
DP, "Rhythm and the Arts," unpubl. essay, 1915; formerly MS 74.
DP, "Fallacies of the New Dogmatism in Art," *American Magazine of Art* 9, parts 1 and 2: Dec. 1917, Jan. 1918, 43–48, 101–6; some drafts formerly MSS 75 and 76.
C in M, 1926.
Bull., 1928.
A & U, 1929.
DP, [Lists of Illustrations for Handbook], ca. 1930; formerly part of MS 97.
ASD, 1931.
Bull., 1931.
Journal I, between 1931 and 1935.
DP, essay for PMG.1941.4.
Cat., 1952.
DP, *Catholicity Does Not Mean Eclecticism: A Radio Talk by Duncan Phillips,* pamphlet, 1954.
Caroline Boyle-Turner, cat. for TPC.1986.11.
Charles S. Moffett et al., cat. for TPC.1998.5.
MP, 1998.

VINCENT VAN GOGH
1. Date: The author wishes to thank Ronald Pickvance for so generously sharing his expertise on van Gogh's life and work. This painting was created in October.

Hulsker, 1980, 362, gives Sept. 1888 as the date, whereas the new Hulsker, 1996, gives Oct. 25, 1888; de la Faille, 1970, 237, also cites van Gogh's September correspondence as possibly related. According to Pickvance, 1984, cat. no. 108, 182, van Gogh refers to this and several related works in a series of letters to Theo and Gauguin written between late August and October 1888; he suggests October as the month of execution, reordering the letters and reidentifying the site of the picture. Hulsker, 1996, no. 1585, concurs. Title: English title is a direct translation from the French title, per de la Faille, 1928, vol. 1, cat. no. 566, and Rosenberg records. Second French title, handwritten inventory list by Andries Bonger, "Catalogue des oeuvres de Vincent van Gogh" (unpubl. list, 1891, Van Gogh Foundation, Amsterdam), no. 102, as cited in Feilchenfeldt, 1988, 104; Bonger's lists are published (some in facsimile) in Feilchenfeldt, 1988. Second English title per early TPC history. Other titles include *L'allée de la maison de santé à Saint-Rémy* in *Théa Sternheim,* sale cat., Feb. 11, 1919, lot no. 10; *The Entrance of the Public Garden* in de la Faille, 1970, cat. no. 566; *Man Reading a Newspaper in the Public Garden* in Hulsker, 1980, cat. no. 1585; *A Lane in the Public Garden* in Hulsker, 1996, cat. no. 1585; *Entrance to the Park* in Uitert et al., 1990, 200, fig 84a; and *Promenade Under Plane Trees* in W. Scherjon and Jos. de Gruyter, *Vincent van Gogh's Great Period: Arles, St. Rémy and Auvers sur Oise* (Amsterdam, 1937), 118. Catalogue raisonné: "F" indicates de la Faille, 1970; "H," Hulsker, 1980 and 1996. Provenance: According to Feilchenfeldt, 1988, 9, "Apart from a few gifts . . . all [of van Gogh's] pictures must have been in Theo's possession and sold through him or later by Johanna." Theo died in 1891. Early transactions, including Johanna van Gogh-Bonger lists and Paul Cassirer records, per Feilchenfeldt, 1988, 104. Correspondence between author and Bernheim-Jeune, Feb. 17, 1989: Bernheim-Jeune Inventory #15.884, *L'Allée* bought from Johanna van-Gogh Bonger, Mar. 19, 1907; sold to Sternheim Oct. 3, 1908. Sternheim sale, Frederick Muller and Co., Feb. 11, 1919, lot #10, illus. Feilchenfeldt, 1988, 104, de la Faille, 1970, 633, and Musée d'Orsay, Documentaire, list ownership of Prince de Wagram (1883–1918), Paris, without dates, as do TPC records. Rosenberg stock #2375 and photograph per correspondence with TPC research office, Mar. 1, 1991. Sachs per *Art News* 2 (Nov. 9, 1929), 8. Joseph Stransky acting as agent for Wildenstein; Phillips exchanged *Women of the Fields* (F-819) in partial trade for the present work, purchased Sept. 26, 1930; see Wildenstein to TPC, Apr. 14, 1989.

2. A *toile de trente* was a standard size for French paintings of the period, usually measuring 73 × 93 cm.

3. Pickvance, 1984, 182. Dates of letters and codes follow Pickvance, 1984, 262–63 (LT: van Gogh to Theo; W: van Gogh to Wilhelmina; T: Theo to van Gogh). Letters not redated by Pickvance follow dating provided in 1978 edition of van Gogh's correspondence. The cited quotation is from LT549, Oct. 10, 1888, which is related to F-470 in de la Faille, 1970, 213; but Pickvance identifies F-470 as a painting described in mid-September and places *Entrance* almost a month later, identifying it as the one referred to in the quotation and among the finished paintings listed by van Gogh in LT552, Oct. 13, 1888. See Pickvance, 1984, cat. no. 108, and appendix I, 260–63, for justification of new sequence. Hulsker, 1996, 364, concurs that LT549 and LT552 mention the present canvas.

4. LT539, ca. Sept. 17, 1888.

5. See Pickvance, 1984, 178. According to him, the *Poet's Garden* series consists of F-1465 (drawing only; painting described in a letter to Theo, untraced), F-468, F-479, and F-485. For further discussion and alternative chronologies of the series, see Jan Hulsker, "The Poet's Garden," *Vincent* 3 (1974), 22–32; Mark Roskill, *Van Gogh and the French Paintings of the 1880s: A Catalogue Raisonné of Key Works* (Ann Arbor, 1970); Ron Johnson, "Vincent van Gogh and the Vernacular: His Southern Accent," *Arts Magazine* 52 (June 1978), 131–35; and Johnson, "Vincent van Gogh and the Vernacular: The Poet's Garden," *Arts Magazine* 53 (Feb. 1979), 98–104. The last-mentioned article theorizes that van Gogh's decorative program for the Yellow House was unified and that the *Entrance* was part of a cycle associated with Dante, whereas, according to Uitert et al., 1990, 200, *Entrance* is a pendant to *Avenue with Flowering Chestnut Trees* (F-517). Hulsker, 1996, 426, places van Gogh's paintings of the small park in the following order: cat. no. 1499 in July, cat. nos. 1578, 1613, 1585, 1601, 1615, and 1598 (in this order) in Sept.–Oct. One painting now lost is known through two drawings, cat. nos. 1583 and 1584. He concludes that only four paintings belong to the Poet's Garden series, cat. nos. 1578, the lost one, 1601, and 1615.

6. Pickvance, 1984, 178–84, discusses van Gogh's "prose" and "poem" paintings; he painted each intermittently, alternating between the right and left side of the garden.

7. According to Roland Dorn, in "Van Gogh's Concept of Decoration," International Symposium, Tokyo, 1985 (published 1988), "Van Gogh used the decorations to analyse contemporary reality in its variety, like Balzac and Zola in their series of novels, La Comédie humaine."

8. Letter LT538, ca. Sept. 17, 1888; for Daumier influence, see Pickvance, 1984, 183. Balzac: W7, Sept. 9 and 16, 1888. Pickvance, 1984, 172 and 182, identifies the works belonging to the "everyday" section of the park as F-470, F-71, F-472, and F-566 (the present work).

9. This figure reappears, with subtle variations, in several other canvases of the period. See especially F-479 and F-485.

10. LT539, ca. Sept. 17, 1888.

11. Pickvance, 1984, 183, identifies the retreating figure of the woman holding an infant as the wife of Roulin, the postal worker in Arles whose family van Gogh had befriended.

12. The poet Rainer Maria Rilke, in a brief description of the work in 1907, focused on the gashing strokes and saturated color; cited in Feilchenfeldt, 1988, 97 and 104.

13. *C in M,* 1926, 9.

14. Phillips's first van Gogh purchases were *The Fields,* 1890 (location unknown; F-812), in 1927, and *Women Walking Along the Fields,* 1890 (*Women Crossing the Fields,* Marion Koogler MacNay Art Institute, San Antonio, Texas; F-819), in 1928. The first was returned to Wildenstein in 1929, and the second was traded for the present work in 1930.

15. *A & U,* 1929, 63, and *ASD,* 1931, 124.

16. Date: This work was created in mid-December. Pickvance, 1986, 172. Title: Per de la Faille, 1970, cat. no. 658, 260. French title: De la Faille, 1928, vol. 1, cat. no. 658, 160, and Wildenstein bill of sale to Dorothy Sturges, June 2, 1930. Other titles: *Boulevard of St. Rémy,* Scherjon and de Gruyter, *Vincent van Gogh's*

Great Period, 273; *Road Menders in a Lane with Heavy Plane Trees,* Hulsker, 1980, cat. no. 1861; *Road Menders in Lane with Massive Plane Trees,* Hulsker, 1996, cat. no. 1861. A number of earlier sources identify the setting as Arles; for example, Bonger, 1891, lists the painting as no. 183, *Allée à Arles.* For Bonger list and other Arles identifications, see Feilchenfeldt, 1988, 111. Provenance: Feilchenfeldt, 1988, 111, cites the early ownership in Germany and the purchase from Johanna van Gogh-Bonger. The sale to Tschudi and subsequent ownership of Angela von Tschudi are noted in Feilchenfeldt, 1988, 19. Tschudi purchased it for the National Gallery of Berlin, but no donor could be found; following dismissal in 1908, he took it to Munich. The painting was on loan at Neue Staatsgalerie, Munich, for more than twenty years; per Wildenstein bill of sale to Dorothy Sturges, June 2, 1930. Joint ownership with Rosenberg per Wildenstein to TPC, Nov. 28, 1988.

17. According to Pickvance, 1986, cat. nos. 44 and 45, 167–72 and 308, the earlier version is *The Road Menders at Saint-Rémy,* 1889 (oil on canvas; Cleveland Museum of Art; F-657), Pickvance asserts that the present work is the "more finished" work, created in the studio, and that it was sent to Theo with a last group on Apr. 29, 1890, while the Cleveland work was sent in January (see also Pickvance, 1986, appendix II, 293–309). Scherjon and de Gruyter, *Vincent van Gogh's Great Period,* 273, also cites the Phillips version as the replica. De la Faille, 1970, cat. nos. 657 and 658, gives the reverse order, stating that the Jan. 3, 1890, shipment included the Phillips version, which therefore had to have been painted earlier. Hulsker, 1996, cat. no. 1861, concurs with Pickvance.

18. For the prototypes, as well as the motif of yellowing leaves, see Pickvance, 1986, cat. no. 45.

19. LT618, Dec. 7, 1889, and LT621, Jan. 3, 1890, respectively.

20. See Pickvance, 1896, 304, for van Gogh's preference for the Phillips picture.

21. Photograph published in Pickvance, 1986, fig. 38, 170.

22. LT594, ca. June 9, 1889, and Pickvance, 1986, 17; see Pickvance on characteristics of the Saint-Rémy period.

23. Technical observations per Elizabeth Steele, painting conservator, Dec. 4, 1990.

24. In the Cleveland version only two workers appear to the right of the trees. The vigorous crosshatching is missing, but thick brown strokes define all the shapes throughout the composition. A detailed reflection in the pool of water and a higher-keyed palette intensify the Cleveland version. This version appears rougher and less refined than the Phillips one.

25. Pickvance, 1986, cat. no. 45.

26. The drawing was created in Arles (Rijksmuseum Vincent van Gogh, Amsterdam; F-1090).

27. *ASD,* 1931, 123. For Phillips on Bonnard as the heir to van Gogh, see p. 53.

28. Ibid., 123.

29. See Peter Selz, "New Responses to Past Styles," in *German Expressionist Painting* (Berkeley, 1974), 13.

30. DP to Tim Clapp, Frick Museum, Mar. 15, 1949.

31. Date: This work was created in June. According to de la Faille, 1970, cat. no. 804, and Pickvance, 1986, cat. no. 65, van Gogh describes this work in letter W23, dated June 13, 1890. Title: Present title per de la Faille,

1970, cat. no. 804. French title: de la Faille, 1928, vol. 1, cat. no. 804. Other titles: *Wheat Field and White Country House* in Hulsker, 1980 and 1996, cat. no. 2018; *Landscape*, Knoedler photograph in Musée d'Orsay; *Landscape: a meadow at Auvers-sur-Oise with a house in the background* in Knoedler to TPC, Mar. 24, 1990. Provenance: Early history from Feilchenfeldt, 1988, 122. Knoedler Inventory #16482; London stockbook #7726, purchased in April from Caspari and sold to Kraushaar in September 1926, per Knoedler to TPC, Mar. 24, 1990. Kraushaar Inventory #20691 (as *Landscape—Auvers sur l'Oise*), sold January 1927, per Kraushaar to author, June 26, 1990. Approximate date of purchase by Sturges cited in Benjamin Sturges (nephew) to Cameron LaClair, TPC, Nov. 28, 1988. Inherited by Elizabeth Hudson. Intent to purchase April 1951; transferred to the collection 1952.

32. W23, June 13, 1890.

33. Dr. Gachet was associated with other contemporary artists, including Cézanne, Armand Guillaumin, and Camille Pissarro, upon whose recommendation van Gogh placed himself under the doctor's care. Regarding Gachet's encouragement, see LT640a, June 12, 1890. For van Gogh's oeuvre, see Pickvance, 1986, 18. One of van Gogh's etchings of Dr. Gachet is in TPC (acc. no. 0795).

34. LT635, May 20, 1890.

35. Pickvance, 1986, 18.

36. See, for example, *Wheat Field*, 1888 (oil on canvas mounted on pasteboard, 21¼ × 25⅝ in.; Rijksmuseum Vincent van Gogh, Amsterdam; F-411), and *The Field Enclosure*, 1890 (oil on canvas, 72 × 92 in.; Rijksmuseum Kröller-Müller, Otterlo, The Netherlands; F-720).

37. See Françoise Cachin et al., *Van Gogh à Paris*, exh. cat., Musée d'Orsay (Paris, 1988), 286, for a comparison of Seurat's *La Luzerne, Saint-Denis: champ de coquelicots*, ca. 1885–86 (oil on canvas; Edinburgh, National Galleries of Scotland), to van Gogh's Arles period.

38. W23, June 13, 1890.

39. Pickvance, 1986, cat no. 65, 237.

40. Compare, for example, *Wheat Fields Under Clouded Sky*, 1890 (oil on canvas; F-778), and *Crows over the Wheat Field*, 1890 (oil on canvas; F-779), both in Rijksmuseum Vincent van Gogh, Amsterdam.

41. DP to Elizabeth Hudson, Apr. 4, 1943; she had first offered it in 1943, but the transaction was not completed until 1953, per DP to Minnie Byers, Jan. 7, 1953. Phillips considered another early work in 1933, *Water Mill at Gennep*, 1884 (oil on pasteboard, 29½ × 39½ in.; New York, private collection; F-47), per Durand-Ruel to DP, Mar. 15, 1933.

Major References
Jacob Baart de la Faille, *L'oeuvre de Vincent van Gogh: Catalogue raisonné*, Paris, 4 vols., 1928; rev. ed., *The Works of Vincent van Gogh: His Paintings and Drawings*, Amsterdam, 1970.
The Complete Letters of Vincent van Gogh: With Reproductions of All the Drawings in the Correspondence, 3 vols., intro. V. W. van Gogh, preface and memoir by J. van Gogh-Bonger, London, 1958; rev. ed., Boston, 1981.
Jan Hulsker, *The Complete Van Gogh: Paintings, Drawings, Sketches*, Oxford, 1980; rev. and enl. ed., *The New Complete Van Gogh: Paintings,*

Drawings, Sketches, Amsterdam, 1996.
Ronald Pickvance, *Van Gogh in Arles*, exh. cat., New York, Metropolitan, 1984.
———, *Van Gogh at Saint-Rémy and Auvers*, exh. cat., New York, Metropolitan, 1986.
Walter Feilchenfeldt, *Vincent van Gogh and Paul Cassirer, Berlin: The Reception of Van Gogh in Germany from 1901 to 1914, Cahier Vincent*, series 2, Zwolle, Netherlands, 1988.
David Sweetman, *The Love of Many Things: A Life of Vincent van Gogh,* London, 1990.
Evert van Uitert et al., *Vincent van Gogh: Paintings*, exh. cat., Amsterdam, Rijksmuseum Vincent van Gogh, 1990.
Johannes van der Wolk et al., *Vincent van Gogh Drawings*, exh. cat., Otterlo, The Netherlands, Rijksmuseum Kröller-Müller, 1990.
J.-B. de la Faille, *Vincent van Gogh: The Complete Works on Paper, Catalogue Raisonné*, 2 vols., San Francisco, 1992.
Jean-Louis Bonnat, *Van Gogh: Ecriture de l'oeuvre*, Paris, 1994.
Paul Gachet, *Les 70 jours de van Gogh à Auvers: Essai d'éphéméride dans le décor de l'époque (20 mai–30 juillet 1890), d'après les lettres, documents, souvenirs et deductions, Auvers-sur-Oise, 1959, Saint-Ouen-l'Aumone, France, 1994.
Ronald de Leeuw, ed., *The Letters of Vincent Van Gogh,* trans. Arnold Pomerans, London, 1996.
Cornelia Homberg, *The Copy Turns Original: Vincent van Gogh and a New Approach to Traditional Art Practices,* Philadelphia, 1996.
Joseph D. Masheck, ed., *Van Gogh 100,* Westport, Conn., 1996.
Sjraar van Heugten, *Vincent van Gogh: Drawings,* 2 vols., London, 1996.
Ingo F. Walther and Rainer Metzger, *Van Gogh: The Complete Paintings,* Cologne, 1997.
Carol Zemel, *Van Gogh's Progress: Utopia, Modernity, and Late-Nineteenth-Century Art,* Berkeley, 1997.
Richard Kendall, *Van Gogh's Van Goghs: Masterpieces from the Van Gogh Museum,* exh. cat., Washington, D.C., NGA, 1998.

TPC Sources
E of A, 1914 and 1927.
DP, "Fallacies of the New Dogmatism in Art," *American Magazine of Art* 9, parts 1 and 2: Dec. 1917 and Jan. 1918, 43–48 and 101–6.
C in M, 1926.
Bull., 1928.
A & U, 1929.
ASD, 1931.
Bull., 1931.
DP, "Modern Art and the Museum," *American Magazine of Art* 23, Oct. 1931, 271–76.
DP, "The Artist Sees Differently," unpubl. text for slide lecture, 12 versions, 1931–34.
DP, [Classic or Romantic in Modern Landscape], paper presented at PMG, Mar. 14, 1934.
DP, "Freshness of Vision and Spontaneity in Painting," unpubl. text for slide lecture, ca. 1935; formerly part of MS 178.
DP, "The Expression of Personality Through Design in the Art of Painting," unpubl. text for slide lecture, 8 versions, ca. 1936–42.
DP, *The Nation's Great Paintings: Vincent van Gogh, "Entrance to the Public Gardens in Arles,"* pamphlet, New York, 1943.

DP, "Freshness of Vision and Spontaneity in Painting," essay, ca. 1945; formerly part of MS 178.
Cat., 1952.
MP, 1998.
MS 103.

GEORGES SEURAT

1. Date: Dorra and Rewald, 1959, assign the date of 1882. Herbert, 1991, 127, dates the painting 1882–83. The Bignou bill of sale, Nov. 15, 1940, and de Hauke, 1961, date it 1884. Title: The first alternate title appears in Dorra and Rewald, 1959; the second alternate title is assigned in de Hauke, 1961, and Herbert, 1991, 127. Medium: Seurat painted directly on the panel, using no ground layer. There is no indication that he reworked the composition, per Elizabeth Steele, painting conservator, Nov. 22, 1990. With cradle, the painting measures 6⅝ × 10¼ (16.8 × 26.1). Inscription: Dorra and Rewald, 1959, and de Hauke, 1961, note that a Paris dealer, Léonce Moline, applied stamps to all works from Seurat's estate that came through his gallery. According to Herbert, 1991, 128, Moline stamped a total of twenty panels (including this one) and eleven drawings. Provenance: Ownership by Madeleine Knoblock, Seurat's companion, according to Herbert, 1991, 127–28. Appert and Fénéon recorded in de Hauke, 1961, and the Bignou Gallery bill of sale, Nov. 15, 1940. The remainder of the provenance per Jacqueline Cartwright, Alex Reid and Lefevre, to author, July 28, 1987. Phillips exchanged Rouault's *Les Trois Juges* and paid an additional sum for the Seurat panel.

2. Seurat executed about twenty-five paintings and forty drawings of laborers (Herbert, 1962, 64). Daniel Catton Rich in "Seurat's Paintings," *Seurat: Paintings and Drawings,* exh. cat., AIC (Chicago, 1958), 12–13, suggests the possibility that Seurat planned to use his scenes of workers as studies for a larger composition, a project that was abandoned so he could work on his first large painting, *Bathers at Asnières,* 1883–84 (79 × 118 in.; London, National Gallery; de Hauke no. 62).

3. Courbet, *The Stone Breakers,* 1850 (Dresden, Staatliche Gemäldegalerie; destroyed). Zimmerman, 1991, 89–94, discusses in greater detail the possible effects of Courbet's *The Stone Breakers* on Seurat.

4. Sarane Alexandrian, *Seurat* (New York, 1980), 30.

5. For an explanation of Seurat's stylistic development, see Dorra and Rewald, 1959, 81–84.

6. Seurat read with great interest Charles Blanc's *Grammaire des arts du dessin, architecture, peinture* (Paris, 1867) and Ogden Rood's *Modern Chromatics* (New York, 1879, translated into French in 1881). Their influence on Seurat is discussed in Homer, 1964, and Herbert, 1991, appendixes G and K. In 1881 Seurat wrote comments about certain Delacroix paintings he had admired in Paris galleries; see Broude, 1978, 13–15, and Herbert, 1991, 395–96, for English translations.

7. Paul Signac first published the theories of the neo-impressionist movement in *D'Eugène Delacroix au néo-impressionnisme* (Paris, 1899). Seurat's ideas and theoretical sources are further clarified in Homer, 1964.

8. Phillips's comments, written on viewing Seurat's *Bathers at Asnières,* 1883–84 (London, National Gallery), are taken from his travel diary, Journal BB, ca. 1930–33. According to Albert Boime, Roger Fry first compared Seurat and Piero in *Transformations* (New York, 1926), 191; see Boime, "Seurat and Piero della Francesca," *Art Bulletin* 47 (June 1965), 265–71. Phillips owned a copy of Fry's book.

9. This drawing, *Sidewalk Show,* had previously been published as *Study for La Parade,* ca. 1887. However, recent scholarship has shown that it predates Seurat's *Parade de cirque,* 1887–88, and that it is an early exploration of the circus theme. See Herbert, 1991, 68.

10. Quote from DP, MS 83, 6. Phillips purchased another painting supposedly by Seurat, *Little Circus Camp,* in 1926 from Ferargil Gallery, New York (bill of sale, Nov. 23, 1926, TPC Papers, AAA, reel 1932, #737). After receiving a letter from Paul Signac, Feb. 12, 1929, claiming that the work was not authentic, Phillips deaccessioned it by 1931 (TPC Papers, AAA, reel 1940, #173). The painting does not appear on the list of his collection in *ASD,* 1931.

11. *Bull.,* 1927, 10–12.

Major References

Henri Dorra and John Rewald, *Seurat, l'oeuvre peint: Biographie et catalogue critique,* Paris, 1959.

C. M. de Hauke, *Seurat et son oeuvre,* 2 vols., Paris, 1961.

Robert L. Herbert, *Seurat's Drawings,* New York, 1962.

William Innes Homer, *Seurat and the Science of Painting,* Cambridge, Mass., 1964.

Norma Broude, ed., *Seurat in Perspective,* Englewood Cliffs, N.J., 1978.

Richard Thomson, *Seurat,* Oxford, 1985.

Robert L. Herbert, *Georges Seurat: 1859–1891,* exh. cat., Paris, Grand Palais, and New York, Metropolitan, 1991.

Michael Zimmerman, *Seurat and the Art Theory of His Time,* Antwerp, 1991.

Paul Smith, *Seurat and the Avant-Garde,* New Haven, 1997.

TPC Sources

DP, "Revolutions and Reactions in Painting," *International Studio* 51, Dec. 1913, 123–29.

C in M, 1926.

Bulls., 1927, 1928, and 1931.

A & U, 1930.

Journal BB, ca. 1930–33.

ASD, 1931.

DP, "The Artist Sees Differently," unpubl. text for slide lecture, 1931–34.

DP, "Freshness of Vision and Spontaneity in Painting," unpubl. text for slide lecture, ca. 1935; formerly part of MS 178.

DP, "The Expression of Personality Through Design in the Art of Painting," unpubl. text for slide lecture, 8 versions, 1936–42.

DP, "Freshness of Vision in Painting," unpubl. essay, ca. 1945; formerly part of MS 178.

Cat., 1952.

MP, 1998.

MS 83.

WALTER RICHARD SICKERT

1. Per Browse, 1960, 115, the Museum of Fine Arts, Boston, purchased a painting in 1931.

2. The other British artists are John Piper and Ben Nicholson. U.S. museums owning Sickerts include the Museum of Fine Arts, Boston; MOMA; Toledo Museum of Art; Yale Center for British Art (acquired between 1966 and 1982); and Minneapolis Institute of Fine Art. Sickert exhibited regularly in the Carnegie International beginning in the early 1920s, winning the Garden Club Prize in 1926. In 1938 a loan exhibition of

his work was held at the Arts Club of Chicago and the Carnegie Institute.

3. For *Fred Winter* and *Hudson,* see Baron, 1973, 53 and 118; for *Ludovico Magno,* Cyril Connolly, "Painting: Spring Showings," *Architectural Review* 71 (Apr. 1932), 153.

4. Phillips considered *The Studio: The Painting of a Nude,* 1906 (29½ × 19½ in.; Sands collection, England; Sotheby's, London, May 13, 1987), and he borrowed a version of *Landsdowne Crescent* on approval, according to DP to Agnew, Jan. 4, 1930.

5. DP, *ASD,* 17. Phillips placed Sickert in the company of such artists as de Chirico, Klee, and Picasso.

6. DP, 1938, 11.

7. Journal BB, ca. 1930–33.

8. Quote from *AMA,* 1935, 218. Frederick Lessore of Beaux-Arts Gallery, London, writing to Phillips, Oct. 1, 1936, suggests that Phillips was planning an article on the British artist: "When you were over here last I lent you . . . a number of photographs of pictures by Sickert for the purpose of illustrating an article that you were going to write."

9. DP, 1938, 11.

10. Oil on canvas, 40 × 41 in., acc. no. 1743, acquired 1935. The date per Wendy Baron to author, Mar. 28, 1990. It was reproduced in the *Daily Telegraph,* Nov. 6, 1934, among works created "during the past year or two." Loosely grouped under the title *Echoes,* these colorful images of romantic or historical themes were inspired by Victorian sources such as engravings and drawings.

11. DP to Ala Storey, Jan. 6, 1941. The American British Art Center was organized to promote British art in the United States during the war. Phillips was on the honorary committee beginning in 1940. The plan was for Storey, a director of the center, to "obtain a collection of about 25 paintings by Christopher Wood and . . . Sickert" and to offer Phillips first option (Storey to DP, Sept. 12, 1945).

12. For response of critics, see Shone, 1990, 8. For reassessment, see especially Morphet, 1981, 8–21.

13. Shone, 1988, 102 and 106; Shone, 1990, 8; and Morphet, 1981, 8–10. William Feaver, "Looking at Art: Walter Richard Sickert, Miss Earhart's Arrival," *Art News* (Feb. 1991), 74, also notes Sickert's lack of concern with originality.

14. Ede, 1941, n.p.

15. Alice Graeme, "Contemporary British Artists' Work on Exhibition at Phillips Gallery," *Washington Post,* Apr. 27, 1941, sec. 6, p. 6; Leila Mechlin, "Display Reflects Trend of Painting in British Isles at Start of World War," *Sunday Star,* Apr. 27, 1941, F6.

16. Title/Date: Date and alternate title, Baron, 1973, cat. no. 94. Provenance: Sickert's agents from 1926, Savile Gallery, may have purchased the work directly from the artist. *Artwork* 6 (spring 1930), 5, credits photograph "by permission of Savile Gallery." Reid and Lefevre to author, Nov. 13, 1989, confirms the purchase from Savile Gallery and sale to W. Scott and Son. Art Association of Montreal ownership, courtesy of Musée des Beaux-Arts, Montreal, corr. Aug.–Oct., 1987; accession card, no. 688, lists W. Scott and Sons as former owners. In DP to Art Association, Apr. 29, 1941, Phillips first expresses interest; the association agrees to sell July 5, 1941 (but sale date on accession card is Dec. 17, 1941).

17. Baron, 1973, 55, quoting letter to Florence Humphrey.

18. Baron and Shone, 1992, 87.

19. Winter also appears in two full-length works, both of ca. 1897–98; one an oil on canvas (18 × 14 in.; Graves Art Gallery, Sheffield, as of 1973), the other a chalk study (19 × 15 in.; Sickert Collection, Borough of Islington Libraries, London). See Alfred Thornton, *Fifty Years of the New English Art Club, 1886–1935* (London, 1935), photograph opposite p. 5. Shone, 1990, 5 and 6, notes that in this period Sickert actively sought portrait commissions and focused on friends and colleagues for subjects. Winter's probable birth date from records, St. Catherine's House, London.

20. Baron, 1973, 53.

21. For influence, see Baron, 1973, 50. A similar treatment appears in *Portrait of Israel Zangwill,* ca. 1897–98 (23½ × 20 in.; Scottish National Gallery of Modern Art, Edinburgh), and *Signor de Rossi,* 1901 (56 × 46 cm.; Hastings Museum and Art Gallery, England).

22. William Rothenstein, *Men and Memories: Reflections of William Rothenstein,* vol. 2 (New York, 1932), 7–8.

23. Shone, 1990, 16, writes that "Sickert found his neighbor amiable but talkative to the point of indiscretion."

24. DP to C. F. Martin, Art Association of Montreal, June 2, 1941.

25. Title: The French title appears on painting reverse, Agnew and Sons label. *Mushrooms:* dealer's invoice, Apr. 30, 1930, and painting file. Provenance: The painting may have remained in the artist's collection 1919–29. It was owned in half-share with Sickert's agent, Savile Gallery, along with Agnew: stock no. B 7099; purchased Oct. 14, 1929, sold to PMG Dec. 31, 1929 (corr., Thos. Agnew and Sons, May 26, 1989). DP to Agnew, Jan. 4, 1930: "I am keeping the Omelette picture."

26. Baron, 1973, 159. For other still lifes see p. 373.

27. A similar arrangement is found in Bonnard's *The Provençal Carafe,* 1912–15 (66 × 52 cm.; Hahnloser-Bühler collection, Winterthur, Switzerland). Reciprocally, Bonnard, who owned at least one painting by Sickert, painted a still life, *Nature Morte Rouge,* ca. 1939 (32 × 25½ in.; private collection), with objects arranged on two shelves, seen at an angle. For parallels to Chardin, see, for example, *Tinned Copper Pot, Pepper Box, Leek, Three Eggs, and a Casserole on a Table,* ca. 1734 (17 × 21 cm; Detroit Institute of Arts).

28. Related works: *Mushrooms* (13 × 16 in.; London, private collection) and a drawing, *Mushrooms,* (12¼ × 15½ in.; Rugby Art Gallery, England); *Take Five Eggs,* 1919 (13 × 16½ in.; Robert Emmons and descent, London).

29. Technical observations per Elizabeth Steele, painting conservator, Dec. 3, 1990.

30. Letter to Nina Hamnett, 1918, as cited in Baron, 1973, 136. In explaining his working process of 1918–19, Sickert observed, "*Perhaps . . .* you want some parts to remain tentative in the finished work"; quoted in Baron, 1973, 157.

31. [Anon.], "Exhibitions in the New York Galleries: British Artists—Thomas Agnew and Sons," *Art News* 28 (Dec. 7, 1929), 13.

32. Ralph Flint, "The Current American Art Season," *A & U,* 1930, 220. Hilton Kramer, "Walter Sickert and the

Malaise of English Painting," *New York Times*, Apr. 16, 1967.

33. As cited by Baron, 1973, 159.

34. Date: Per Wendy Baron to author, Mar. 28, 1990. Provenance: Henry Lessore to author, Feb. 24, 1989: "My father [Major Frederick Lessore, Beaux Arts Gallery] bought both paintings *Ludovico Magno* and *Porte Saint Denis* from Sickert himself in December 1931." DP to Beaux Art Gallery, Jan. 4, 1941: "We will buy [both paintings]."

35. Date: See discussion of *Ludovico Magno* in the previous note. Title: Paris, first public exhibition title, 1932 and 1933; probably not Sickert's title (Lessore to author, July 4, 1990). *Porte St. Denis, Paris:* title on dealer's invoice, Jan. 17, 1941. Provenance: See Provenance for *Ludovico Magno* in the previous note. In 1941 this work was sent to Bignou, New York, to be sold but was returned to the museum the next year; shipping record, June 29, 1941, and DP to McDonald, Bignou Gallery, Jan. 23, 1942.

36. François Blondel was the architect; the sculptural decoration was begun in 1774 by Michel Anguier.

37. Peterborough Art Gallery, England.

38. Shone, 1988, 124, referring to *Temple Bar*, ca. 1940 (27 × 30 in.; private collection, England).

39. See Steele, Dec. 3, 1990. For Sickert's use of photography see Shone, 1988, chap. 6; Morphet, 1981, 14–15; and especially Baron and Shone, 1992, 283. The Archives, Bureau des Estampes, Bibliothèque Nationale, Paris, contain no pictures of the Faubourg facade among a sampling of some two hundred images; each depiction showed a side view or the Paris facade, demonstrating the originality of Sickert's viewpoint.

40. See Hayward, in Morphet, 1981, 92. Sickert included himself in a homburg in *Self-Portrait in Grisaille*, ca. 1935 (27 × 10 in.; National Portrait Gallery, London); and in a fisherman's cap in *In the Cabin*, 1940 (17 × 31 in.; Methuen collection, Corsham Court).

41. In 1932 Ben Nicholson began to use calligraphic elements in a similar manner, after having visited the studios of Braque and Picasso.

42. From Sickert's lecture "Straws from Cumberland Market," 1923–24, in which he discussed effects he sought in painting, as quoted by Hayward, in Morphet, 1981, 11.

43. Cyril Connolly, "Spring Showings," *Architectural Review* 71 (Apr. 1932), 153.

44. Max Ernst in his 1927 oil *Vision Induced by the Nocturnal Aspect of Porte St. Denis* (65 × 81 cm; private collection) also took its textural quality as his leitmotif.

45. Sickert's probable 1930 trip to Paris per Wendy Baron, "Chronology," in Baron and Shone, 1992, 51.

46. DP to Ala Storey, Jan. 6, 1941.

Major References
W. R. Sickert collection, Islington Central Library, London.
Sickert correspondence, Tate Archives, London.
Robert Emmons, *The Life and Opinions of Walter Richard Sickert*, London, 1941.
Osbert Sitwell, ed., *A Free House! or The Artist as Craftsman Being the Writings of Walter Richard Sickert*, London, 1947.
Lillian Browse, *Sickert*, London, 1960.
Wendy Baron, *Sickert*, London, 1973.

———, "The Perversity of Walter Sickert," *Arts Magazine* 55, Sept. 1980, 125–29.
Richard Morphet et al., *Late Sickert Paintings, 1927–1942*, exh. cat., London, Arts Council of Great Britain, Hayward Gallery, 1981.
Richard Shone, *Walter Sickert*, Oxford, 1988.
Richard Shone and Penelope Curtis, *W. R. Sickert Drawings and Paintings, 1890–1942*, exh. cat., Liverpool, Tate Gallery, 1989.
Richard Shone, *From Beardsley to Beaverbrook: Portraits by Walter Richard Sickert*, exh. cat., Bath, Victoria Art Gallery, 1990.
Wendy Baron and Richard Shone, eds., *Sickert: Paintings*, exh. cat., London, Royal Academy of Arts, 1992.
Anna Gruetzner, *Walter Sickert Drawings: Theory and Practice, Word and Image*, Hants, England, 1996.

TPC Sources
A & U, 1930.
Journal BB, ca. 1930–33.
AMA, 1935.
DP, "Gallery Notes: International Show," unpubl. notes, 1938; formerly MS 90.
H. S. Ede, essay for PMG.1941.7.
Kenneth Clark, essay for TPG.1950.12.
SITES, 1979.
Stephen B. Phillips, cat. for TPC.1997.4.
MP, 1998.

EMILE-RENÉ MÉNARD

1. Date: From Kraushaar provenance records, mid-1920s. Title: *Gypsies at Sunrise:* may be a Duncan Phillips title. *Landscape with Figures, Sunrise:* Kraushaar provenance records, mid-1920s. *Gypsies at Dawn:* appears on the reverse of a photograph of the painting; may be a Duncan Phillips title. A French title is not recorded for the painting. Provenance: The painting might have been commissioned by Phillips; see entry text. Information from Kraushaar provenance records, mid-1920s. J. F. Kraushaar to DP, Jan. 11, 1921: "The large [Ménard] is in the Custom House and should be delivered this week. I hope it will come up to our expectations." The bill of sale, Jan. 16, 1921, records payment received by Kraushaar, Apr. 4, 1921, TPC Papers, AAA, reel 1929, #1062.

2. Greenspan, 1981, 30. Also see Greenspan for Ménard and contemporary developments.

3. DP, 1913, 957; illustration of painting, entitled *Landscape*, appears on p. 956. The catalogue of the Venice exhibition does not list a Ménard painting with the title *Gypsies at Sunrise* or *Landscape*. However, several titles listed refer to the themes of evening or sunset on a lake.

4. This visit is recorded at length in Journal HH, 1912, entry dated July 14, 1912. Phillips wrote, "They [the pastels] [have] entrancing beauty especially the gypsies on lakeshore (of Venice)."

5. In preparation for his essay "Bohemia—A State of Mind," 1915 (formerly MS 69), which was never published, Phillips conducted extensive research on gypsy wanderers; his notes are recorded in Journal L, ca. 1914–15. Provenance records from Kraushaar, mid-1920s, state, "The order for it was given by Mr. Phillips to Mr. J. F. Kraushaar who ordered it through Mr. J. Allard of Paris when he was there in the summer of 1920, Mr. Ménard being away in the south of France. On its completion it was sent to the C. W. Kraushaar

Art Galleries, and delivered by them to Mr. Duncan Phillips." Elizabeth Hudson, a close friend, wrote to Phillips, Mar. 1, 1921, Foxhall corr.: "I am so happy the gypsy picture is such a success—it is extraordinary how Ménard keeps documents of all his works."

6. First quotation from DP, "What Is Impressionism?," *Arts and Progress* 3 (Sept. 1912), 702; second from *E of A*, 1914, 37.

7. Journal HH, 1912, entry dated July 14, 1912.

8. The Ménard paintings that Phillips kept were seldom exhibited at the museum, a reflection of his change of taste. Only *Gypsies at Sunrise* was accessioned into the collection.

9. Journal HH, 1912, entry dated July 14, 1912.

Major References
Louis de Fourcaud, "René Ménard," *L'art et les artistes* 9, Apr.–Sept. 1909, 13–22.
Camille Mauclair, "Artistes contemporains: René Ménard," *La revue de l'art ancien et moderne* 35, Jan.–June 1914, 33–44.
Louis Aubert, "L'oeuvre de René Ménard," *La revue de Paris*, July 1, 1914, 14–42.
André Michel, *Peintures et pastels de René Ménard*, Paris, 1923.
Albert Boime, *The Academy and French Painting in the Nineteenth Century*, London, 1971.
E. R. Ménard, 1862–1930: Symbolisme Intime, exh. cat., Paris, Galerie Tanagra, 1975.
Taube G. Greenspan, "'Les Nostalgiques' Re-Examined: The Idyllic Landscape in France, 1890–1905," Ph.D. diss., City University of New York, 1981.

TPC Sources
DP, "Impressionism in Poetry and Painting," unpubl. essay, 1910–11; formerly MS 155.
Journals N, 1912; and HH, 1912.
DP, "The Impressionistic Point of View," *Art and Progress* 3, Mar. 1912, 505–11.
DP, "Modern Pictures in Venice," *Art and Progress* 4, May 1913, 953–58.
Journal AA, 1913–14.
E of A, 1914 and 1917.
DP, "15 Best Purchases of 1918–19; 15 Best Purchases Since Jan. 1920," unpubl. list, 1920.
H of A, 1920–21.
Inv., 1921.
Journals EE, ca. 1922; and B, 1923–29.
C in M, 1926.
Cat., 1952.
DP/Elizabeth Hudson letters, 1920–21, Foxhall corr.

3. THE AMERICAN VISION
The American Tradition and American Impressionism

1. *Formes*, 1932, 197.

2. *C in M*, 1926, 9.

3. Handwritten draft for "Purposes of the PMG," unpubl. essay, ca. 1923.

4. One important exception was collector Thomas B. Clarke of New Jersey, an early supporter of Homer, Inness, and Ryder, among others. Auctions of his collections beginning in 1899 brought prices comparable to foreign art. Another collector who helped increase the prestige and worth of American art was New Yorker William T. Evans. See William H. Truettner,

"William T. Evans, Collector of American Paintings," *American Art Journal* 3, no. 2 (Fall 1971), 50–71.

5. *C in M.,* 1926, 6.

6. Ibid., 3.

7. *Bull.,* 1929, 27. The Inness was actually purchased by Major Duncan Clinch Phillips in 1911 but was kept by his son and transferred to the collection in 1921.

8. Ibid., 29.

9. Ibid.

10. Ibid., 31.

11. *C in M,* 1926, 9. He expressed interest in several other paintings that never came into the collection, including a "classic figure by Abbott Thayer and a solemn landscape by Homer Martin."

12. *Bull.,* 1929, 27.

13. Alfred H. Barr Jr.'s 1930 exhibition at the Museum of Modern Art, *Winslow Homer, Albert Ryder, Thomas Eakins,* singled out the same artists that Phillips gave special praise to in his 1929 essay. For further discussion of the reappraisal of the native tradition, see Elizabeth Johns, "Histories of American Art: The Changing Quest," *Art Journal* 44 (Winter 1984), 341.

14. *Bull.,* 1928, 37.

15. Phillips also once owned a Frank Duveneck portrait, *The Music Master,* 1879 (oil on canvas, 20¾ × 16¾ in.; acquired 1927, sold 1933, present location unknown).

16. *Bull.,* 1928, 37.

GEORGE FULLER

1. Date: Exact dates for Fuller's works are difficult to determine because of lack of documentation. Stylistically, *Ideal Head* fits within his later period of activity. The 1884 Boston exhibition gives the date as 1876, whereas the 1883 Munich exhibition gives a date of 1881. Medium: The area of the face is heavily worked over with varied textures of paint and has cracks, deep holes, and depressions probably caused by the artist's applying wet paint without letting earlier layers dry sufficiently. Yellowed varnish has also darkened the painting considerably; see analysis by Elizabeth Steele, painting conservator, Aug. 3, 1990. Provenance: In the early exhibitions, this work is cited as in the collection of the artist. A label from the Boston art auction firm of Williams and Everett on the back of the painting notes that it was "[no]t for sale." A note in TPC painting file states that it was "purchased from the artist by Miss Annie Putnam, told by wife of nephew," but this information has not been verified. F. M. Weld ownership and PMG purchase per Macbeth Gallery to DP, Feb. 5, 1927, AAA, reel 2620, #0517. Although *Ideal Head* was listed in the 1927 *Bulletin* as one of the "important acquisitions of the season of 1925–26," correspondence among Phillips, Tack, and Macbeth indicates that Phillips did not actually purchase it until early 1927.

2. DP to Tack, Jan. 18, 1927, followed by a telegram. Duncan Phillips saw *Ideal Head* illustrated as the frontispiece to Millet, 1886, 42.

3. *Bull.,* 1928, 29.

4. Numerous "Ideal Heads" appear in early Fuller exhibition catalogues; many are now in private collections. Two examples in public collections are *Violet,* 1882 (oil on canvas, 27 × 22 in.; National Gallery of Art, Washington, D.C., gift of Mrs. Augustus Tack), and *Ideal Head,* n.d. (oil on canvas, 22 × 18 in.; National

Museum of American Art, Washington, D.C., gift of William T. Evans).

5. For a discussion of Fuller and French Barbizon painting, see Peter Bermingham, *American Art in the Barbizon Mood,* exh. cat., NCFA (Washington, D.C., 1975), 79–80 and 139–41.

6. Burns, 1983, 125, quotes Mariana Griswold van Rensselaer, among others, as having written (in *Century Illustrated* 27 [1883–84], 230) that "Hawthorne's name . . . is, I think, one which well suggests the quality of Mr. Fuller's art." For a discussion of the post–Civil War colonial revival, see Richard Guy Wilson, "The Presence of the Past," in *The American Renaissance, 1876–1917,* exh. cat., Brooklyn Museum (New York, 1979), 39–55.

7. An exception are his paintings of black farm workers in the South, created while accompanying his chronically ill brother on trips to Alabama in search of a cure. Quite different from the rest of his work, the southern paintings have a direct, reportorial quality and depict scenes of funerals and farming.

8. See Burns, 1989, 222, for a discussion of how *Afterglow* reflects Fuller's indebtedness to Barbizon examples.

9. Tack quotes Fuller as saying, "Every picture should have an atmosphere of its own—to be a little world by itself, back and within the frame: but there is a constant tendency to bring things forward, to make them out and to so lose breadth"; Metropolitan, 1923, 13. Fuller also studied the art theories of Joshua Reynolds and experimented with the palettes of Reynolds and Gilbert Stuart; see Burns, 1981, n. 8.

10. Millet, *Harper's New Monthly Magazine* 69 (Sept. 1884), 520; reprinted in Millet, 1886.

11. See PMG.1927.2b; quote in *Bull.,* 1927, 40.

Major References
Mariana Griswold van Rensselaer, "George Fuller," *Century Illustrated Monthly Magazine* 27, 1883–84, 230, 234.
————, *Memorial Exhibition of the Works of George Fuller,* exh. cat., Boston, Museum of Fine Arts, 1884.
Josiah B. Millet, ed., *George Fuller, His Life and Works,* Boston, 1886.
Charles DeKay, "George Fuller, Painter," *Magazine of Art* 12, Sept. 1889, 349–54.
William Howe Downes, "George Fuller's Pictures," *International Studio* 75, July 1922, 265–73.
Metropolitan, *Centennial Exhibition of the Works of George Fuller,* intro. Augustus Vincent Tack, exh. cat., New York, 1923.
William I. Homer and David M. Robb Jr., "Paintings by George Fuller in American Museums and Public Collections," *Art Quarterly* 24, Autumn 1961, 286–94.
Sarah Lea Burns, "The Poetic Mode in American Painting: George Fuller and Thomas Dewing," Ph.D. diss., University of Illinois at Urbana-Champaign, 1979.
————, "A Study of the Life and Poetic Vision of George Fuller (1822–1884)," *American Art Journal* 13, Autumn 1981, 11–37.
————, "George Fuller, the Hawthorne of Our Art," *Winterthur Portfolio* 18, Autumn 1983, 123–45.
————, *Pastoral Inventions: Rural Life in Nineteenth-Century American Art and Culture,* Philadelphia, 1989.

TPC Sources
C in M, 1926.
Bulls., 1927 and 1928.
ASD, 1931.

GEORGE INNESS

1. Title: Many of Inness's Italian landscapes were listed in these general terms in early exhibition and sales catalogues. Inscriptions: Nicolai Cikovsky Jr. believes that the date and signature are consistent with Inness's style, although he acknowledges that late in his career Inness allowed members of his family to date earlier works for him (telephone conversation with author, 1990). Provenance: Cited in Cat., 1952, 52, supported by Kraushaar sales document, n.d.; Kraushaar bill of sale, Dec. 25, 1920; bill of sale, Dec. 23, 1920, TPC Papers, AAA, reel 1929, #1059; transfer per *Inv.,* 1921.

2. Related images are as follows: *Lake Albano, Sunset,* ca. 1872 (oil on canvas, 30⅛ × 45 in.; National Gallery of Art, Washington, D.C.); *Castel Gandolfo,* 1876 (oil on canvas, 20 × 30 in.; Portland Art Museum, Oregon); and *Lake Nemi,* 1872 (oil on canvas, 30 × 45⅞ in.; Museum of Fine Arts, Boston).

3. A critic complained in 1853 that Inness's paintings were "too much like the 'old masters' for a young master"; *Knickerbocker* 42 (July 1853), 95–96.

4. Schuyler, 1878, 461.

5. Phillips, sharing the opinion of contemporary Inness scholars, declared the early works to be somewhat "commonplace and sentimental" (*C in M,* 1926, 25).

6. Ibid., 26.

7. Inness's complete reworking of a large painting in one afternoon in his studio is described in Daingerfield, 1911, 28. See also Cikovsky, 1993, 61, in which this mention of a large painting is believed to refer to the Phillips work.

8. Midway through his stay Inness had to find new financial backing because of a fire at Williams and Everett. He also became embroiled in litigation over his contract with the firm; see Inness, 1917, 81.

9. Title: The location was incorrectly listed as West Virginia in early exhibition catalogues. Provenance: Early provenance from Ireland, 1965. Ainslie purchase documented in George Ainslie to DP, Mar. 15, 1917. Listed in *Inv.,* 1921.

10. Provenance: Ault from Knoedler provenance sheet, Dec. 9, 1920. Phillips inherited this painting after the death of his father, Major D. C. Phillips; transfer per *Inv.,* 1921. In 1925 Knoedler wrote to Phillips requesting a photograph of Inness's *Moonlight, Tarpon Springs,* adding that they had sold it to Mr. D. C. Phillips in Nov. 1911 (TPC Papers, AAA, reel 1933, #196). In a letter to Knoedler dated Dec. 5, 1927, Phillips expressed interest in purchasing Whistler's *Valparaiso* and in order to do so considered selling *Moonlight, Tarpon Springs.* In a follow-up letter, Dec. 5, 1927, Phillips voiced his reluctance to part with the painting because it "has sentimental interest for me as it is one of the two pictures I have kept from my father's collection and is thus a link with the past" (TPC Papers, AAA, reel 1936, #144 and 149). He did, however, sell and subsequently reacquire the work. Knoedler bill of sale, July 19, 1939.

11. See Cikovsky, 1977, 7, for a discussion of the health issue and Inness's search for quiet, out-of-the-way places to rest.

12. Other related works are: *Moonlight in Virginia*, 1884 (oil on wood, 20 × 30 in.; Birmingham Museum of Art); *Goochland, Virginia*, 1884 (oil on wood, 16⅞ × 26 13/16 in.; University of Washington, Seattle, Horace C. Henry Collection); *March Breezes, Virginia*, 1885 (oil on canvas on panel, 20 × 30 in.; private collection); *Early Morning, Tarpon Springs*, 1892 (oil on canvas, 42 × 32 in.; Art Institute of Chicago); *Moonlight, Tarpon Springs*, 1892 (oil on canvas, 30 × 45 in.; collection of H. E. Hayes); and *A View From My Studio Window, Tarpon Springs*, 1891 (oil on canvas, 25 × 30 in.; Virginia Museum of Fine Arts, Richmond).

13. Tarpon Springs is not even listed in popular guidebooks to Florida of the period, such as George M. Barbour's *Florida for Tourists, Invalids, and Settlers*, rev. ed. (New York, 1884).

14. Inness suffered from epilepsy and, although he maintained urban studios and was active in art circles in Boston and New York, regularly sought intervals of peace and quiet as recommended by doctors. For further discussion of the health issue and his choice of Goochland, see Bullard, 1988, 32–34.

15. See Daingerfield, 1911, 28, for a discussion of Inness's improvisational approach to painting in his later years.

16. *C in M*, 1926, 26.

17. See Cikovsky, 1977, 195–203 and 319–31, for a more thorough discussion of the influence of Swedenborgianism on Inness.

18. Homer made painting trips to Florida in the early 1890s, primarily staying in Key West and the St. John's River area. Other American artists to visit in the second half of the century included Gifford, Heade, Remington, and Sargent.

19. The scene shown in this painting, which includes a few small houses, appears to be the same as that depicted in *A View From My Studio Window, Tarpon Springs*, 1891 (see n. 12 above), except that the vantage point of the present painting is further to the right.

20. *C in M*, 1926, 26

21. See Daingerfield, 1911, 25–26.

22. *C in M*, 1926, 26.

Major References
Montgomery Schuyler, "A Painter on Painting," *Harpers New Monthly Magazine* 56, Feb. 1878, 333–461.
Elliott Daingerfield, *George Inness, the Man and His Art*, New York, 1911.
George Inness Jr., *Life, Art and Letters of George Inness*, New York, 1917.
Elizabeth McCausland, *George Inness: An American Landscape Painter*, Springfield, Mass., 1946.
Leroy Ireland, *George Inness, an Illustrated Catalogue Raisonné*, Austin, Texas, 1965.
Nicolai Cikovsky Jr., *The Life and Work of George Inness*, New York, 1977.
Marjorie Darkin Arkelian and George W. Neubert, *George Inness Landscapes, His Signature Years, 1884–1894*, exh. cat., Oakland Museum, 1978.
The Cummer Gallery of Art, *George Inness in Florida, 1890–1894, and the South, 1884–1894*, exh. cat., Jacksonville, Fla., 1980.
Nicolai Cikovsky Jr. and Michael Quick, *The Life and Work of George Inness*, exh. cat., LACMA, 1985.
CeCe Bullard, "Why Not Goochland? George

Inness and Goochland County," *Goochland County Historical Society Magazine* 20, 1988, 24–35.
Nicolai Cikovsky Jr., *George Inness*, New York, 1993.
The Montclair Art Museum, *George Inness: Presence of the Unseen, A Centennial Celebration*, exh. cat., Montclair, N.J., 1994.
Leo Galileo Mazow, "George Inness: Problems in Antimodernism," Ph.D. diss., University of North Carolina at Chapel Hill, 1996.
Sarah Burns, *Inventing the Modern Artist: Art and Culture in Gilded Age America*, New Haven, 1996.

TPC Sources
DP, "Preface," unpubl. essay, 1916; formerly MS 86.
H of A, 1920–21.
Inv., 1921.
C in M, 1926.
ASD, 1931.
Cat., 1952.
MP, 1998.

JAMES ABBOTT MCNEILL WHISTLER

1. Provenance: Woakes's ownership per New Gallery exhibition catalogue; all other provenance information from Knoedler archives; transfers among Knoedler, Reinhardt, and Allen were most likely sales.

2. Whistler to Beatrix Whistler, Nov. 19, 1894, the Birnie Philip Collection, Glasgow University Library.

3. Notes of unknown authorship, Knoedler Archives, New York.

4. Extensive quotations from a letter by the sitter (who married Charles Imray Kirton of Dulwich in 1894) describing her visits to Whistler's studio (sent by Knoedler in 1920 along with the bill of sale). Information regarding the sitter's marriage courtesy of Michael Woakes in a letter of May 26, 1994.

5. Young et al., vol. 1, 1980, 174 and 175; and Anderson and Korval, 1994, 321–22.

6. Alan Cole (friend of Whistler family), diary notes, Sept. 24, 1890, letterbook 6, Glasgow University Library. Another example of this type is *The Little Red Glove*, 1896–1902 (oil on canvas, 51.3 × 31.5 cm.; Freer Gallery of Art, Smithsonian Institution, Washington, D.C.).

7. *Arrangement in Grey and Black, No 2: Portrait of Thomas Carlyle*, begun 1872 (oil on canvas; City Art Gallery, Glasgow). An unauthorized edition of *The Gentle Art of Making Enemies*, edited by Sheridan Ford, was published in Ghent in Feb. 1890, and in June Whistler's own version was published by William Heinemann, London.

8. Notes of unknown authorship, Knoedler Archives, New York.

9. Joseph Pennell to Knoedler Gallery, n.d., Knoedler Archives, New York.

10. W. J. Lampton, "Art Notes," *New York Times*, Apr. 5, 1914, sec. 3, p. 14.

11. Freer's art collection was accepted by the Smithsonian Institution in 1906 and transferred at Freer's death in 1919. Freer also collected portraits from the 1890s and, in London in 1904, he purchased Whistler's Peacock Room, which had been designed and painted by the artist. The room is now installed at the Freer. For an examination of the relationship between Freer and Whistler, see Linda Merrill, ed., *With Kindest Regards: The Correspondence of Charles Lang Freer and James*

McNeill Whistler, 1890–1903, Washington, D.C., 1995.

12. Gallatin's two critical studies on Whistler would certainly have been known to Phillips: *Notes on Some Rare Portraits of Whistler* (New York, 1916) and *Portraits of Whistler, a Critical Study and an Iconography* (New York, 1918). See also Phillips's review of Gallatin's collection, "A Collection of Graphic Art," *Art and Progress* 5 (Feb. 1914), 129–30.

13. For Phillips's endorsement of critic R. A. M. Stevenson's enthusiasm for Whistler as a modern-day proponent of Velázquezian impressionism, see his essay "Velasquez—the Enchanter of Realism," in *E of A*, 1914.

14. *C in M*, 1926, 29. Comparisons between Phillips's Whistler and those of Freer came readily to the Washington critic Ada Rainey, who wrote of *Miss Lillian Woakes*: "This is one of the finest things that Whistler has painted. It excels the heads in the Freer collection"; "French, U.S. Art Shown by Phillips," *Washington Post*, Feb. 12, 1928, S-10.

Major References
Centre for Whistler Studies, Glasgow University Library, Glasgow, Scotland.
Charles Lang Freer Papers, Freer Gallery of Art/Sackler Gallery Archives, Smithsonian Institution of Art, Washington, D.C.
Pennell Collection, Whistler Material, Library of Congress, Manuscript Division, Washington, D.C.
James Abbott McNeill Whistler, *The Gentle Art of Making Enemies*, London, 1890; enl. ed. 1892; reprint, New York, 1967; reprint, London, 1994.
Elizabeth Robins Pennell and Joseph Pennell, *The Life of James McNeill Whistler*, 5th ed., rev., Philadelphia, 1911.
Andrew McLaren Young et al., *The Paintings of James McNeill Whistler*, 2 vols., New Haven, 1980.
David Park Curry, *James McNeill Whistler at the Freer Gallery of Art*, exh. cat., Washington, D.C., Freer Gallery of Art, Smithsonian Institution, 1984.
Robert H. Getscher and Paul G. Marks, *James McNeill Whistler and John Singer Sargent*, New York, 1986.
Ruth E. Fine, ed., "James McNeill Whistler: A Reexamination," *Studies in the History of Art* 19, Center for Advanced Study in the Visual Arts Symposium Papers 6, NGA, Washington, D.C., 1987.
John Walker, *James Abbott McNeill Whistler*, Washington, D.C., 1987.
Robin Spencer, ed., *Whistler: A Retrospective*, New York, 1989.
Linda Merrill, *A Pot of Paint: Aesthetics on Trial in Whistler v Ruskin*, Washington, D.C., 1992.
Ronald Anderson and Anne Korval, *James McNeill Whistler: Beyond the Myth*, London, 1994.
Carole McNamara and John Siewart, *Whistler: Prosaic Views, Poetic Vision: Works on Paper from the University of Michigan Museum of Art*, exh. cat., Ann Arbor, 1994.
Nigel Thorpe, ed., *Whistler on Art: Selected Letters and Writings, 1849–1903, of James McNeill Whistler*, Manchester, England, 1994.
Richard Dorment and Margaret F. MacDonald, *James McNeill Whistler*, exh. cat., Tate, London, 1995.
University of Glasgow, *James McNeill Whistler, at*

the Hunterian Art Gallery: An Illustrated Guide, Scotland, 1996.

TPC Sources
Journals N and HH, 1912.
DP, "What Is Impressionism," *Art and Progress* 3, Sept. 1912, 702–7.
DP, "Revolutions and Reactions in Painting," *International Studio* 51, Dec. 1913, 123–29.
DP, "A Collection of Modern Graphic Art," *Art and Progress* 5, Feb. 1914, 129–30.
E of A, 1914 and 1927.
Journal O, 1916–23.
DP, unpubl. book review of *Whistler* by Theodore Duret, ca. 1917.
Journal U, ca. 1919.
Inv., 1921.
Journal EE, ca. 1922.
DP, "Purposes of the PMG," unpubl. essay, ca. 1923.
Journal GG, 1924.
C in M, 1926.
A & U, 1929.
ASD, 1931.
DP, essay for PMG.1944.11.
Cat., 1952.
MD, 1970 and 1981.
MP, 1998.
MSS 60 and 62.

WINSLOW HOMER

1. Abigail Booth Gerdts, CUNY, has been working on a catalogue raisonné of Homer's work. Provenance: Lloyd Goodrich saw the painting at Prout's Neck, Maine, in the summer of 1936 (CUNY/Goodrich/Whitney Record). Macbeth Stock disposition card, no. 10053, *Girl with Pitchfork*, owner: Homer estate; received Dec. 2, 1938; sold to Elizabeth Metcalf, June 1939; Macbeth Gallery Papers, AAA, reel 2822, #1064. During the Second World War, from Jan. 1942 to Jan. 1945, the painting was placed in the Phillips Academy, Addison Gallery, Andover, Mass., for safekeeping (Nicki Thiras to TPC, May 15, 1989). Sent on approval per John Nicholson to DP, Nov. 6, 1946; intent to purchase, DP to JN, Dec. 13, 1946; bill of sale, Jan. 4, 1947.

2. See chronology in Cikovsky and Kelly, 1995, 393, which states that a trip to Picardy probably occurred in late summer. Goodrich, 1944, 39, asserts that Homer "divid[ed] his time in France between Paris and the country," painting sixteen works in all; however, no trips to Picardy have been explicitly documented.

3. See Cikovsky in Cikovsky and Kelly, 1995, 33.

4. See, for example, Cikovsky in ibid., 32–33, who argues that although Homer probably would have seen the Courbet and Manet exhibitions at the Paris Exposition, and even perhaps the work of Monet, he seems to have remained relatively unaffected by these artists; rather, his interest in Barbizon and Millet's painting was reinforced by his experience at the Exposition. Cikovsky here refutes Albert Ten Eyck Gardner and others who argued for the impact on Homer of the most modern French movements. Burns, 1989, 215, contends even more strongly that the opportunity to view Barbizon pictures firsthand, especially those of Millet, was of vital importance to Homer in Paris, because what he had seen of them in America had largely been in the form of prints. For discussion of European influences, see Alexandra Murphy, "Winslow Homer, American among the Masters," in

Winslow Homer in the Clark Collection, exh. cat., Sterling and Francine Clark Art Institute (Williamstown, Mass., 1986), 7–13; Henry Adams, "Winslow Homer's 'Impressionism' and Its Relation to His Trip to France," in *Winslow Homer: A Symposium*, ed. Nicolai Cikovsky Jr., *Studies for the History of Art* 26, Center for Advanced Study in the Visual Arts, Symposium Papers 11, NGA (Washington, D.C., 1990), 61–89.

5. *The Veteran in a New Field*, 1865 (oil on canvas, 24 × 38 in.; Metropolitan Museum of Art), was painted in the United States; *Return of the Gleaner*, 1867 (oil on canvas, 24 × 18¼ in.; Strong Museum, Rochester, N.Y.), was painted in Picardy.

6. Goodrich, 1944, 33.

7. See ibid., 32, on Homer's early technique. For similarly pronounced contouring in white, see also *Amateur Musicians*, 1867 (oil on canvas; Metropolitan Museum of Art), and *Bridle Path, White Mountains*, 1868 (oil on canvas; Sterling and Francine Clark Institute, Williamstown, Mass.).

8. Robert McIntyre, director of Macbeth Gallery, New York, to Elizabeth Metcalf, Mar. 29, 1939, and Mar. 27, 1940, Macbeth Gallery Papers, AAA, reel 2610, #0767 and #0798.

9. Date: Date per Homer to Thomas Clarke, Mar. 28, 1892, and Mar. 17 and Oct. 5, 1896 (the last date per Homer Letters, AAA, reel 2814, #0617). The companion piece, *Eight Bells*, Addison Gallery of Art, Phillips Academy, Andover, Mass., is dated 1886 and is mentioned in these letters as having been completed the same month as *To the Rescue*. Title: The main title probably by DP. Sold to Clarke as *The Rescue* and first exhibited as such in 1897; Phillips ledger entry: *To the Rescue*. Provenance: Homer to Clarke, "Received Scarborough, Maine, May 6, 1897—from Thos. B. Clarke $250" (Homer Letters, AAA, reel 2814, #0618). According to H. Barbara Weinberg in her article "Thomas B. Clarke: Foremost Patron of American Art from 1872 to 1899," *American Art Journal* 8 (May 1976), 76, Clarke purchased this work in October 1896. Sale to Manson per "Thomas B. Clarke Collection," *American Art Annual* (New York, 1899), 60. Sale to Cresmer per letter to Milch, June 26, 1919, Milch Papers, AAA, box 2. Consignment per Knoedler to Dwight Clark, Dec. 15, 1926, TPC Papers, AAA, reel 1933, #[obscured]. Bill of sale, Dec. 15, 1926.

10. DP, "Paintings desired for PMG," Journal EE, ca. 1922; see also *C in M*, 1926, 9.

11. MS 130.

12. *C in M*, 1926, 31. Phillips believed that in Homer's mature period aesthetic concerns overrode those of subject matter, especially in the watercolors.

13. Oil on canvas; Addison Gallery of Art, Phillips Academy, Andover, Mass. See Homer to Thomas Clarke, Mar. 17, 1896, Homer Letters, AAA, reel 2814, #0617.

14. Homer referred to *To the Rescue* as a sketch in Homer to Thomas Clarke, Mar. 17, 1896, Homer Letters, AAA, reel 2814, #0617.

15. Homer to Clarke, Mar. 28, 1892, Homer Letters, AAA, reel 2814, #0586.

16. Homer to Clarke, Oct. 5, 1896, Homer Letters, AAA, reel 2814, #[obscured].

17. As quoted in Goodrich, 1944, 139; written late Oct.–early Nov. 1896.

18. Oil on canvas, 30 × 48 in.; Museum of Art, Carnegie Institute, Pittsburgh.

19. Henry Adams, "Mortal Themes: Winslow Homer," *Art in America* 71 (Feb. 1983), 118.

20. Oil on canvas; private collection.

21. Title: First exhibited in 1893 as *The Return at Sundown*; referred to as *Rowing Homeward* in Clarke sale, 1899; Macbeth Gallery records refer to it as *Sunlight on the Sea* (Macbeth Gallery Papers, reel 2822, #0928); first shown at TPC as *Rowing Home*. Provenance: Clarke's purchase per Weinberg, "Thomas B. Clarke," 76. Freer's purchase per "Thomas B. Clarke Collection," 60. Purchased by Freer for a friend, probably Thomas L. Manson Jr., New York, per CUNY/Goodrich/Whitney Record. Freer sale and Montross purchase per memorandum, Feb. 10, 1905, reel 1226, #176–#178, and Freer to Montross, Feb. 19, 1905, reel 1227, #240, Charles L. Freer Papers, AAA. Consignment by Weir per Robert McIntyre, Macbeth Gallery, to Weir, Dec. 4, 12, and 26, 1918, Macbeth Gallery Papers, AAA, reel 2660, #[obscured]. Phillips's intent to purchase per DP to Macbeth Gallery, Jan. 3, 1919, reel 2620, #0379; shipped immediately per Macbeth Gallery to DP, Jan. 16, 1919, reel 2662, #0386, Macbeth Gallery Papers, AAA. Transfer to PMAG, Dec. 9, 1920, per Ledger 11.

22. For Homer's Florida trips, see Cooper 1986, 13–15.

23. Homer to Clarke, Feb. 16, 1890; Homer Letters, AAA, reel 2814, #0582.

24. Weinberg, "Thomas B. Clarke," 70.

25. Homer used an Eastman Kodak no. 1 camera, a model first introduced in 1888 that produced circular images. See *Winslow Homer's Florida, 1886–1909*, exh. cat., Cummer Gallery of Art (Jacksonville, Fla., 1977), 22.

26. Watercolor; Colby College, Waterville, Maine.

27. Cooper, 1986, 161.

28. *C in M*, 1926, 9.

29. DP, exh. cat., PMG.1931.23, 16–17.

30. "Intimate Paintings Seen at Macbeth's," *New York Sun*, Dec. 16, 1918, n.p.; clipping from scrapbook, Macbeth Gallery Papers, AAA, reel NMC2, #0460.

Major References
The City University of New York/Lloyd Goodrich and Edith Havens Goodrich/Whitney Museum of American Art Record of the Works of Winslow Homer, New York.
Homer Archives, Bowdoin College Museum of Art, Brunswick, Maine.
Winslow Homer Letters 1890–1909, AAA.
William H. Downes, *The Life and Works of Winslow Homer*, New York, 1911.
Lloyd Goodrich, *Winslow Homer*, New York, 1944.
Philip Beam, *Winslow Homer at Prout's Neck*, exh. cat., Brunswick, Maine, Bowdoin College Museum of Art, 1966.
———, *Winslow Homer*, New York, 1975.
Gordon Hendricks, *The Life and Work of Winslow Homer*, New York, 1979.
Helen A. Cooper, *Winslow Homer Watercolors*, exh. cat., Washington, D.C., NGA, 1986.
Sarah Burns, *Pastoral Inventions: Rural Life in Nineteenth-Century American Art and Culture*, Philadelphia, 1989.
Philip Beam et al., *Winslow Homer in the 1890s, Prout's Neck Observed*, exh. cat., Rochester, N.Y., Memorial Art Gallery of the University of Rochester, 1990.

Nicolai Cikovsky Jr., *Winslow Homer,* New York, 1990.

David Tatham, *Homer and the Illustrated Book,* Syracuse, N.Y., 1992.

Nicolai Cikovsky, Jr., and Frank Kelly, *Winslow Homer,* exh. cat., Washington, D.C., NGA, 1995.

Sarah Burns, *Inventing the Modern Artist: Art and Culture in Gilded Age America,* New Haven, 1996.

Carl Little, *Winslow Homer: His Art, His Light, His Landscapes,* Cobb, Calif., 1997.

TPC Sources
E of A, 1914 and 1927.
DP, "Preface," unpubl. essay for proposed publication, 1916; formerly MS 86.
Journals O, 1916–23; EE, ca. 1922; and B, ca. 1923–29.
DP, "Purposes of the PMG," unpubl. essay, ca. 1923.
DP, "The Phillips Collection," unpubl. outline, 1924; formerly MS 89.
C in M, 1926.
DP, essay for PMG.1927.4.
Bulls., 1927 and 1928.
CA, 1929.
ASD, 1931.
DP, essay for PMG.1944.1.
Cat., 1952.
DP, *Catholicity Does Not Mean Eclecticism: A Radio Talk by Duncan Phillips,* pamphlet, 1954.
MP, 1998.
Journal T, n.d.
MSS 100, 115, and 130.

THOMAS EAKINS

1. Date: Goodrich, 1933, no. 263, dates this work to 1891, which most scholars accept. Goodrich, 1982, changed the date to 1890, but his research papers do not contain his reasoning (information courtesy of Darrel Sewell, PMA, in telephone conversation with author). Elizabeth Johns considers the original date more acceptable, because it was based on interviews with Eakins's associates, relatives, friends, and Susan Eakins (opinion courtesy of Elizabeth Johns in a telephone conversation with author). Provenance: Many of Eakins's portraits were uncommissioned and subsequently given to the sitter, a situation suggested here by the fact that Van Buren is listed as the lender of her portrait in the 1893 "World's Columbian Exposition" catalogue.

2. For a discussion of Eakins's late portraits, see John Wilmerding, *American Views: Essays on American Art* (Princeton, 1991), 244–63, and Homer, 1992, 223–53. The chair in this painting, found in many of his portraits, is in the Bregler-Eakins Archives.

3. These photographs, published in Gordon Hendricks, *The Photographs of Thomas Eakins* (New York, 1972), figs. 176–79, are usually assigned the same date as the painting; however, they should be dated to 1893 or later, because Van Buren is wearing a dress with large puffed sleeves that did not come into fashion until then. Opinion courtesy of Shelley Foote, Costumes Division, National Museum of American History, Smithsonian Institution, in discussion with author.

4. Scholars concur that Eakins tended to age his sitters, but the only case in which a deliberate aging has been documented is the portrait of Walter C. Bryant; see Goodrich, 1982, vol. 2, 59. See Johns, 1983, 164–68, on aging as a metaphor for motion. More recent scholar-ship has focused on the relation between Eakins's photography and painting; see Homer, 1992, 141–47, and Wilmerding, 1993, 180–91. Another print of this image is in the Bregler-Eakins Archives and was published in Foster, 1997.

5. Susan Macdowell Eakins noted that Eakins "only used a photograph when impossible to get information in the way he preferred, painting from the living and moving model" (as quoted in Homer, 1992, 141). In this case, the awkward forms beneath Van Buren's dress in the lower half of the composition may indicate that Eakins painted the passage from a draped table edge rather than from a live model. This suggests that Van Buren was not present through the entire painting process. There is no evidence of a second hand or of later additions (Elizabeth Steele, painting conservator, July 20 and Nov. 19, 1990).

6. Johns, 1983, 164.

7. Van Buren's date of birth and occupation taken from the 1880 Detroit census records. In 1886 Eakins, writing to Edward Horner Coates, director of PAFA (Sept. 12, 1886, Bregler-Eakins Archives), refers to Van Buren as "a lady of perhaps thirty years or more."

8. According to the enrollment records, Van Buren was in four one-month classes in 1884 (information courtesy of Catherine Stover, PAFA, Aug. 25, 1980). She apparently continued to receive training from Eakins at least through 1886, as suggested in Eakins's letter to Coates, where he also referred to Van Buren as a family friend (Sept. 12, 1886, Bregler-Eakins Archives). In this same letter Eakins discussed one of the incidents that further fueled the 1886 scandal; Van Buren was the student to whom Eakins demonstrated the form and function of the hip joint, using his own anatomy as a guide; see Foster and Leibold, 1989, 74 and nn. 15, 75, and 78; and Homer, 1992, 176. Van Buren remained on good terms with the Eakinses, later writing to Phillips, "As your letter gave me great pleasure I shall show it to Mrs. Eakins"; AVB to DP, Feb. 14, 1927.

9. AVB to the photographer Francis Benjamin Johnston, June 7, 1900, Johnston Collection, MS Division, Library of Congress.

10. For a brief discussion of Van Buren, see Tobey Quitslund, "Her Feminine Colleagues: Photographs and Letters Collected by Francis Benjamin Johnston," in *Women Artists in Washington Collections,* ed. Josephine Withers, exh. cat., University of Maryland (College Park, 1979), 102. For a discussion of the development of photography at the turn of the century, see William I. Homer, *Alfred Stieglitz and the Photo-Secession* (New York, 1983), 38–39, 43–48, and *Pictorial Photography in Philadelphia: The Pennsylvania Academy Salons,* exh. cat., PAFA (Philadelphia, 1984), 12–29.

11. Catalogues exist for these Salons. Van Buren received favorable mention in a review of 1900; see Charles H. Caffin, "The Philadelphia Photographic Salon," *Harper's Weekly* (Nov. 3, 1900), 1061.

12. For Van Buren's and Eakins's inclusion, see Goodrich, 1982, vol. 1, 259. For Van Buren's friendship with Watson-Schütze, see Quitslund, "Her Feminine Colleagues," 102, 140, and 142. Both Van Buren and Watson-Schütze began to work as professional photographers after 1896 and were briefly partners in a commercial photography studio.

13. See "List of Exhibitors and No. of Prints," *Diary for 1900 of Mrs. Anderson D. Johnston,* F. B. Johnston Collection, Prints and Photographs Division, Library of Congress, 6–7.

14. *C in M,* 1926, 9.

15. Mather to DP, Jan. 11, 1927. In this letter Mather responded to a letter or to an unidentified outline (both now lost) that Phillips had sent to other institutions and associates. Before 1927 the only Phillips list that includes Eakins is found in Journal B, ca. 1923–29, n.p.

16. See PMG.1927.2b. Eakins's works were still unpopular with most collectors, but Phillips was immediately interested when he first heard of the possible sale of this portrait from Charles Worcester, member of the acquisition committee for the Art Institute of Chicago; Worcester felt that the institute would not buy it because it was too sincere and realistic, hence not pleasing, for the general public; Worcester to DP, Jan. 5, 192[7].

17. DP, essay for PMG.1927.2b, 42.

18. *E of A,* 1927, 67.

Major References
Charles Bregler's Thomas Eakins Collection, Pennsylvania Academy of Fine Arts Archives, Philadelphia (cited as Bregler-Eakins Archives).
Lloyd Goodrich and Edith Havens Goodrich Papers, Whitney Museum of American Art and Philadelphia Museum of Art: Record of Works by Thomas Eakins.
Lloyd Goodrich, *Thomas Eakins: His Life and Work,* New York, 1933.
Gordon Hendricks, *The Life and Work of Thomas Eakins,* New York, 1974.
Maria Chamberlin-Hellman, "Thomas Eakins as a Teacher," Ph.D. diss., Columbia University, 1982.
Lloyd Goodrich, *Thomas Eakins,* 2 vols., Cambridge, Mass., 1982.
Elizabeth Johns, *Thomas Eakins: The Heroism of Modern Life,* Princeton, 1983.
David Lubin, *Act of Portrayal: Eakins, Sargeant, and James,* New Haven, 1985.
Elizabeth LaMotte Cates Milroy, "Thomas Eakins' Artistic Training, 1860–1870," Ph.D. diss., University of Pennsylvania, 1986.
Michael Fried, *Realism, Writing, Disfiguration on Thomas Eakins and Stephen Crane,* Chicago, 1987.
Kathleen A. Foster and Cheryl Leibold, *Writing About Eakins: The Manuscripts in Charles Bregler's Thomas Eakins Collection,* Philadelphia, 1989.
William Innes Homer, *Thomas Eakins: His Life and Art,* New York, 1992.
John Wilmerding, ed., *Thomas Eakins and the Heart of American Life,* exh. cat., London, National Portrait Gallery, 1993.
Susan Danly and Cheryl Leibold, *Eakins and the Photograph: Works by Thomas Eakins and His Circle in the Collection of the Pennsylvania Academy of Fine Arts,* Washington, D.C., 1994.
Barbara Weinberg, *Eakins and the Metropolitan,* exh. cat., New York, Metropolitan, 1994.
Elizabeth LaMotte Cates Milroy, *Guide to the Thomas Eakins Research Collection,* Philadelphia, 1995.
Martin A. Berger, "Determining Manhood: Constructions of Sexuality in the Art of Thomas Eakins," Ph.D. diss., Yale University, 1995.
Doreen Bolger and Sarah Cash, eds., *Thomas Eakins and the Swimming Picture,* exh. cat., Fort Worth, Tex., Amon Carter Museum, 1996.

Kathleen A. Foster, *Thomas Eakins Rediscovered: Charles Bregler's Thomas Eakins Collection at the Pennsylvania Academy of Fine Arts,* New Haven, 1997.

TPC Sources
Journals U, ca. 1919; B, ca. 1923–29; and GG, 1924.
C in M, 1926.
E of A, 1927.
Bull., 1927 and 1928.
A & U, 1929.
CA, 1929.
Journal V, 1929.
Formes, 1930.
DP, [Lists of illustrations for possible handbook], unpubl. list, ca. 1930; formerly part of MS 97.
ASD, 1931.
Bull., 1931.
Journal I, between 1931 and 1935.
DP, [Classic or Romantic in Modern Landscape], paper presented at PMG, Mar. 14, 1934.
DP, "The Expression of Personality Through Design in the Art of Painting," unpubl. text for slide lecture, 8 versions, ca. 1936–42.
Cat., 1952.
DP, *Catholicity Does Not Mean Eclecticism: A Radio Talk by Duncan Phillips,* pamphlet, 1954.
DP, "A Gallery of Modern Art and Its Sources," text for television program produced by the Greater Washington Education Television Association, aired Oct. 16, 1959; formerly MS 95.
MP, 1998.
MSS 100 and 158.

ALBERT PINKHAM RYDER
1. See Broun, 1989, 68–70; Homer and Goodrich, 1989, 83–87.

2. *E of A*, 1914, 198.

3. DP, 1916, 389 and 387.

4. *C in M*, 1926, 38.

5. "Ranking of Paintings in Oil" in Journal EE, ca. 1922, 3.

6. The six paintings were *Macbeth and the Witches,* early 1880s (oil on canvas mounted on wood panel, 10 × 10 in.; Art Museum, Princeton University, Gift of Alastair B. Martin); *The Barnyard,* early to mid-1870s (oil on canvas, 11⅝ × 12¼ in.; Munson-Williams-Proctor Institute Museum of Art, Utica, N.Y.); *Homeward Bound* and *Fisherman's Huts,* still in the collection; *Smuggler's Landing Place* and a version of *Sailing by Moonlight,* neither of which are in Homer and Goodrich, 1989.

7. *Fisherman's Huts* is no longer considered authentic by William Innes Homer (according to inspection, May 1988).

8. Unless noted otherwise, the dates follow Homer and Goodrich, 1989.

9. Date: Homer and Goodrich, 1989, 126. Homer, in consultation with author, May 6, 1988, based the date on the presence of a flat, Japanese style. Frederic Fairchild Sherman in "The Marines of Albert P. Ryder," *Art in America* 51 (Aug. 1963), 88, suggests "about 1890–1900." Title: Alternate title per Ryder's letter of authentication to Alexander Morten (witnessed by Kenneth Hayes Miller), Nov. 1915, as published in Homer and Goodrich, 1989, 195–96, from typed copy, AAA). Exhibited as *Moonlight on Beach* in the 1913 Armory Show. Provenance: According to Homer, May

1988, John Williams (of unknown residence) was an early owner. Phillips to Rehn, Jan. 31, 1924: "I am writing to you my understanding of our agreement concerning the great picture by Ryder entitled 'The Moonlit Cove' which I am purchasing from Mrs. Alexander Morten through you" (TPC Papers, AAA, reel 1934, #0023). Rehn bill of sale, Mar. 31, 1924.

10. Journal EE, ca. 1922.

11. Pach, 1911, 126.

12. DP, 1916, 391.

13. DP to Sherman, Dec. 18, 1920, TPC Papers, AAA, reel 1930, #1066. Rehn's response, postmarked Jan. 8, 1920, was: "Very sorry indeed you could not get the Moonlit Cove—it is the picture of Ryder's I love, and I quite agree with you as to its rank among the Ryders. . . . You should have this picture."

14. DP to Sherman, Nov. 5, 1926.

15. Observation courtesy of Homer, in consultation with author, May 1988.

16. Pène du Bois, discussing the Metropolitan retrospective, "Albert Ryder and His Pictures," *Bulletin of the Metropolitan Museum of Art* 13 (Apr. 1918), 84.

17. Sheldon Keck, "Albert P. Ryder: His Technical Procedures," in Homer and Goodrich, 1989, 177. Phillips, in correspondence with Goodyear, Jan. 8, 1938, reported "deep fissures" in the painting, and in 1940 restoration work was undertaken by Gaston Levi; see shipping record, Apr. 15, 1940. The Kecks detected oil on the canvas reverse in 1961, at which time the painting was evaluated as "acutely cracked and suffer[ing] from obscuring varnish films," per conversation report, Feb. 22, 1961; see also treatment report, Mar. 1961; Homer and Goodrich, 1989, 126; and Broun, 1989, 261.

18. Date: Per Homer and Goodrich, 1989, 34. Broun, 1989, 218, suggests late 1870s, on the basis of the symbolic, allegorical theme. Provenance: Mrs. Inglis is cited as first owner in Homer and Goodrich, 1989, 35, n. 24. Montross wrote agreeing to the price Phillips offered (Mar. 21, 1928, TPC Papers, AAA, reel 1936, #0555). Montross bill of sale, June 14, 1928; purchased together with *Resurrection.*

19. Keck, in "Albert P. Ryder: His Technical Procedures," in Homer and Goodrich, 1989, 176 and 182, believes the support to be a cigar-box lid, "stained a deep warm transparent mahogany tone." Robert Buck, in conservation report, June 4, 1974, describes the support as "brown . . . porous hardwood like walnut. Grain horizontal. Reverse grooved and rabbeted. T[op] edge decorated with gilded incised grooves."

20. DP, 1916, 390.

21. DP, essay for PMG.1928.4a–c, 10–11.

22. Bronze relief (29½ × 78¾ × 7⅞ in.; Musée des Beaux-Arts, Marseille). Ryder's image is reversed, suggesting that he may have derived the image from a print of this relief.

23. The theory that *Dead Bird* relates to Ryder's paintings of women as victim or sufferer—here symbolized by the bird—has been explored by Gaye L. Brown in "A. P. Ryder's Joan of Arc: The Damsel in Distress," *Worcester Art Museum Journal* 3 (1979–80), 37–51, 48. See also Broun, 1989, 218–19, for possible sources and parallel imagery.

24. French, 1905, 9, probably refers to Montross as the unnamed dealer who "owns three Ryders, which he keeps only to exhibit to his friends and custo-

mers. . . . These pictures are not for sale." *Dead Bird* may have been among these works.

25. Montross to DP, Nov. 21, 1927, TPC Papers, AAA, reel 1936, #0483. The early history of this painting holds that its first owner, Mrs. James Inglis, would remark when fatigued, "I feel like a dead canary" (Rosalie Warner Jones to Goodrich, Oct. 29, 1936, as cited in Homer and Goodrich 1989, 35 n. 24). This may explain why Ryder gave her this small work.

26. See also Homer and Goodrich, 1989, 35, for Ryder as anticipating Morris Graves.

27. Title: Erroneously published as *Outward Bound* in *Inv.,* 1921. Date: Per Homer and Goodrich, 1989, 74; see also p. 238: "Dates given in the recollections of Ryder's friend Captain John Robinson." Inscription: Ryder did not often sign works; however, according to Homer, May 5, 1988, the "A. P." (or "A") interlocked with the "R" of "Ryder," as well as their placement and color, are characteristic of the artist. Provenance: Gift to Robinson per Goodrich to DP, June 20, 1946. Transfer from Robinson (who kept the painting in his collection for twenty-five years) to Bromhead, an employee of Cottier's in the 1900s, documented in Bromhead to Sherman, Nov. 27, 1919. Phillips chose the present work over *The Wreck* (DP to Sherman, Dec. 29, 1920, TPC Papers, AAA, reel 1930, #1072); bill of sale, Jan. 1, 1921.

28. See Sherman, 1920, 54–55, and *ASD*, 1931, 93.

29. Bromhead to Sherman, Nov. 27, 1919. However, according to Robinson, 1925, 176, 179–87, and Goodrich, 1959, 17, Ryder sailed with him in 1887 and 1896. Sherman, 1920, 54, is more general, giving the date of voyage as "early 1890s." Ryder and the captain met through the Scottish collector and dealer Daniel Cottier, who is said to have "discovered" Ryder in 1876; see "Albert Pinkham Ryder's Beginnings," *Art in America* 9 (Apr. 1921), 122.

30. Roger B. Stein, *Seascape and the American Imagination,* exh. cat., Whitney (New York, 1975), 122.

31. *Marine,* mid-1890s (oil on wood panel, 8¾ × 17¼ in.; National Academy of Design, New York).

32. Sherman to DP, Dec. 22, 1920, TPC Papers, AAA, reel 1930, #1069.

33. *ASD*, 1931, 93.

34. Date: Homer (to TPC, Apr. 18, 1989) believes that this painting was reworked after Ryder's death, probably in or around 1924 (see discussion in text). For a discussion of dates and later reworking, see Homer and Goodrich, 1989, 138–40 and 238, who state that by 1899 the painting "was known to have been underway . . . and perhaps started earlier." Broun, 1989, 253, cites an 1899 letter from Sylvia Warner to C. E. S. Wood, indicating that Ryder sold the painting that was "only begun." Medium: The medium has not been fully analyzed and needs further research. Provenance: Sanden purchase, Homer and Goodrich, 1989, 93 n. 29, and Broun, 1989, 252–53; Homer notes that because Sanden paid Ryder a monthly stipend, he probably owned it during the artist's lifetime, although it remained in the studio. Ferargil's purchase per *Art News* 22, no. 18 (Feb. 9, 1924), 5, where it is reported that this work was one of several Ryders "on view as a loan continuously" since the memorial exhibition in spring 1918, but no documentation exists. Discussion of loan and Haverford ownership in Ferargil to DP, Feb. 8, 1940, TPC Papers, AAA, reel 1953, #0418; shown at the Haverford Club, Philadelphia, in 1930–31 (per

Haverford Library Archives). Phillips purchased it in partial trade for Ryder's *Barnyard* and the small version of *Macbeth and the Witches*; bill of sale, Mar. 28, 1940, TPC Papers, AAA, reel 1953, #0396.

35. See Elizabeth Johns, "Albert Pinkham Ryder: Some Thoughts on His Subject Matter," *Arts Magazine* 54, no. 3 (Sept. 1979), 164–71. For the more traditional view, see Richard Braddock, "The Literary World of Albert Pinkham Ryder," *Gazette des beaux-arts* 33 (Jan. 1948), 47–54.

36. Johns, "Some Thoughts," 169, emphasizes the fateful confrontation between the two forces and the moment of decision.

37. Royal Cortissoz, "American Artists at the Metropolitan Museum: An Exhibition in Memory of the Late Albert P. Ryder," *New York Tribune*, Mar. 10, 1918, revised and reprinted in "Poets in Paint, Section II, Albert P. Ryder" in *American Artists* (New York, 1923), 96–100.

38. Richard Studing, "Two American Shakespeareans in Art: Albert Pinkham Ryder and Edwin Austin Abbey," *Gazette des beaux-arts* 110 (Sept. 1987), 81. See also Braddock, "Literary World," 47–54. Broun, 1989, 253, cat. no. 35b, reproduces the German romantic painter Carl von Hafften's *Heath Scene* from Sadakichi Hartmann's *Shakespeare in Art* (Boston, 1901), citing Hartmann's claim that it served as a prototype for the artist.

39. Pach, 1911, 125–26.

40. *Macbeth and the Witches*, early 1880s.

41. Homer and Goodrich, 1989, 75; Broun, 1989, 253.

42. Ryder to Sanden, Aug. 12, 1899, as quoted in Homer and Goodrich, 1989, 197–98.

43. Charles Fitzpatrick's typed memoir, ca. 1917, forms part of the Harold O. Love Papers, AAA reel D181, #553–69. Critic Walter de Beck wrote that Ryder reclaimed the painting and "worked upon [it] until his death"; Walter de Beck, "Albert Pinkham Ryder: An Appreciation," *International Studio* 70 (Apr. 1920), xl.

44. David Erhardt et al., "Condition, Change, and Complexity: The Media of Albert Pinkham Ryder," report delivered at the annual meeting of the American Institute of Conservation (Richmond, Va., Spring 1990), 31, conclude that Ryder's techniques contributed more to deterioration than his choice of media; see also Sheldon Keck, "Albert P. Ryder: His Technical Procedures," in Homer and Goodrich, 1989, 175–84.

45. Weir observed in 1912 that "it grows darker all the time. It was once very fine"; see Dorothy Weir Young, ed., *Life and Letters of J. Alden Weir* (New Haven, 1960), 244. Ryder is even reported to have sanded the surface for further reworking (taped interview between Lloyd Goodrich and Eleanor Fink, ca. 1980, as cited by Broun, 1989, 253 n. 10). Marsden Hartley, who met the painter in 1909, remembered that the work was obscured by "surface 'scums that were added by dust and abuse,'" per Aline B. Louchheim, "Ryder: The Best American Painter's Largest Show Seen by Marsden Hartley, Walt Kuhn, Yasuo Kuniyoshi, Reginald Marsh, Kenneth Hayes Miller," *Art News* 46 (Nov. 1947), 30.

46. Anonymous review in *Arts and Decoration* 7 (May 1917), 368; Royal Cortissoz, "Poets in Paint," *American Artists* (New York, 1923), 98.

47. Homer and Goodrich, 1989, 138; quote p. 140. See also p. 246 n. 39 for an unpublished manuscript of 1929, in which Hartley described *Macbeth and the*

Witches as "better in its soiled condition . . . for restoration has prettified it out of bounds."

48. Ryder makes reference to his eye trouble in a 1905 letter cited in Brumbaugh, 1972, 364; Goodrich emphasizes it as a lifelong infirmity in Homer and Goodrich, 1959, 13. Other late works include *The Tempest*, 1890s and later, reworked after the artist's death (27¼ × 35 in.; Detroit Institute of Arts, Gift of Dexter M. Ferry Jr.); and *Desdemona*, mid-1880s to mid-1890s.

49. Ryder, 1905, 11.

Major References

Albert P. Ryder Archive, University of Delaware Library, Newark.

Charles de Kay, "A Modern Colorist: Albert Pinkham Ryder," *Century Magazine* 40, new ser. 18, June 1890, 250–59.

Joseph Lewis French, "A Painter of Dreams," *Broadway Magazine* 14, no. 6, Sept. 1905, 3–9.

Albert P. Ryder, "Paragraphs from the Studio of a Recluse," *Broadway Magazine* 14, no. 6, Sept. 1905, 10–11.

Walter Pach, "On Albert P. Ryder," *Scribner's Magazine* 49, Jan.–June 1911, 125–28.

Frank Jewett Mather Jr., "The Romantic Spirit in American Art," *Nation* 104, no. 2702, Apr. 12, 1917, 427.

Marsden Hartley, "Albert P. Ryder," *Seven Arts* 2, May 1917, 93–96.

Walter S. de Beck, "Albert Pinkham Ryder: An Appreciation," *International Studio* 70, Apr. 1920, 37–46.

Frederic Fairchild Sherman, "Unpublished Paintings by Albert Pinkham Ryder," *Art in America* 8, Apr. 1920, 129–37.

———, *Albert Pinkham Ryder*, New York, 1920.

John Robinson, "Personal Reminiscences of Albert Pinkham Ryder," *Art in America*, June 1925, 176–87.

William H. Hyde, "Albert Ryder as I Knew Him," *Arts* 16, no. 9, May 1930, 597–99.

Aline B. Louchheim, "Ryder, Seen by Marsden Hartley, Walt Kuhn, Yasuo Kuniyoshi, Reginald Marsh, Kenneth Hayes Miller," *Art News*, Nov. 1947, 29–31.

Lloyd Goodrich, *Albert Pinkham Ryder*, New York, 1959.

T. B. Brumbaugh, "Albert Pinkham Ryder to John Gellatly: A Correspondence," *Gazette des beaux-arts* 80, Dec. 1972, 361–70.

Elizabeth Broun, *Albert Pinkham Ryder*, exh. cat, Washington, D.C., NMAA, 1989.

William Innes Homer and Lloyd Goodrich, *Albert Pinkham Ryder: Painter of Dreams*, New York, 1989.

Saul E. Zalesch, "Ryder among the Writers: Friendship and Patronage in the New York Art World, 1875–1884," 2 vols., Ph.D. diss., University of Delaware, 1992.

TPC Sources
E of A, 1914.
DP, "Albert Ryder," *American Magazine of Art* 7, Aug. 1916, no. 10, 387–91.
Journals O, 1916–23, and CC, between 1917 and ca. 1920.
Inv., 1921.
Journals EE, ca. 1922; Y, ca. 1922–25; and B, 1923–29.
C in M, 1926.
E of A, 1927.
Bull., 1928.

A & U, 1930.
Journal BB, 1930–33.
ASD, 1931.
Bull., 1931.
DP, "The Artist Sees Differently," unpubl. text for slide lecture, 12 versions, 1931–34.
DP, "Freshness of Vision and Spontaneity in Painting," unpubl. text for slide lecture, ca. 1935; formerly part of MS 178.
DP, "Albert Pinkham Ryder," in *American Art Portfolios*, ser. 1, New York, 1936.
DP, "The Expression of Personality Through Design in the Art of Painting," unpubl. text for slide lecture, ca. 1936–42.
Cat., 1952.
MP, 1998.
MS 179.

WILLIAM MERRITT CHASE

1. Provenance: Inglis acquired the painting sometime after its showing in New York, 1890. The Inglis estate sold it as no. 81 at the American Art Association auction, N.Y., Jan. 29, 1919. Intent to purchase, DP to Thomas Gerrity, Knoedler, Mar. 30, 1923; Phillips immediately considered it part of his permanent collection but did not finish paying for it until 1925; see PMG to Knoedler, May 11, 1925, and Knoedler bill of sale, May 12, 1925. According to Phillips's letter to Ala Story, Nov. 7, 1964, the painting has a frame designed by the architect Stanford White.

2. Chase taught at Shinnecock during the summers of 1891 through 1902; see Pisano, 1983, 149, and Roof, 1975, 279. A landscape, *Florence*, 1907 (oil on cigar box, 6½ × 7⅞ in.; gift of Marjorie Phillips, 1985, acc. no. 1985.3.3), is an example of this later style. Painted on the lid of a cigar box that had been a gift from Julius Gerson, Chase's father-in-law, the painting was later returned with an inscription on the back: *To Mr. Julius Gerson who knows a good thing when he likes it. With best wishes, Wm. M. Chase, Florence 1907.* See Roof, 1975, 265.

3. Following his marriage in 1886, Chase displayed a keen interest in domestic life that continued throughout his career. See *Sketch—Children Playing Parlor Croquet*, ca. 1888 (oil on canvas, 31¼ × 34¼ in.; private collection). In a later painting, *Ring Toss*, ca. 1896 (oil on canvas, 40⅜ × 35⅛ in.; collection of Mr. and Mrs. Hugh Halff Jr., San Antonio), he reverted to a more traditional triangular placement of three children.

4. The chair is owned by Jackson Chase Storm, grandson of William Merritt Chase (telephone conversation with author, Apr. 30, 1990); it also appears in *Portrait of Robert Blum*, ca. 1881 (Cincinnati Art Museum), and *Meditation*, ca. 1885–86 (private collection).

5. For a description of the 1885 meeting between Chase and Whistler in London, see William M. Chase, "The Two Whistlers: Recollections of a Summer with the Great Etcher," *Century Magazine* 80 (June 1910), 219–26. Chase's interest in Japonisme may also be traced to the Tile Club, which was formed in 1877 by a group of New York artists; see Pisano, 1983, 49.

6. Atkinson in Atkinson and Cikovsky, 1987, 25.

7. For an account of Chase's and Eakins's friendship, see Lloyd Goodrich, *Thomas Eakins: His Life and Work* (New York, 1933), 97; for Eakins's photography, see William Innes Homer, *Thomas Eakins: His Life And Art* (New York, 1992), 141–53. For Muybridge, see Beaumont Newhall, *The History of Photography from 1839 to the Present* (Boston, 1982), 119–22.

8. James Carroll Beckwith (1852–1917), *Diary* (New York, 1888).

9. H. H. Arnason, *History of Modern Art,* 3rd. ed. (New York, 1986), 50.

10. Velázquez's *Las Meninas,* 1656 (Prado, Madrid), and Sargent's *The Daughters of Edward D. Boit,* 1882 (Museum of Fine Arts, Boston). For the importance of Velázquez to both Chase and Sargent, see DIA, *The Quest for Unity: American Art Between World's Fairs 1876–1893,* exh. cat. (Detroit, 1983), 95–97. Milgrome, 1969, 65, suggests that Chase saw Sargent's painting at its American debut at the St. Botolph Club in Boston in January 1888; however, because Chase showed two works at the 1883 Salon, Pisano, 1983, 63, believes it is likely that Chase, who left for Europe on June 2, would have seen it in Paris.

11. Roof, 1975, 278–79, states that Juanita Joaquina Miller (1880–1970), the daughter of the poet Joaquin Miller, was a model for this painting. See Juanita Miller, *My Father, C. H. Joaquin Miller, Poet* (Oakland, 1941). Pisano in correspondence with author, May 14, 1990, suggests that the dark-haired child may have been Hattie Chase, the artist's sister.

12. This curtain is similar to, or may be the same as, the one in the background of *Lady in Pink,* 1888 (Museum of Art, Rhode Island School of Design), which, according to the RISD museum's records and Ronald Pisano, was probably painted in Chase's studio on Tenth Street.

13. In the summer of 1912 Phillips came across Chase outside the Salon Trienniale, where Chase mistook him for one of his students (Journal HH, 1912). In Journal N, 1912, Phillips noted his intention to pay Chase a call while in New York.

14. DP, 1916, 45.

15. *Outskirts of Madrid,* 1882, was given to Yale University in 1932. Phillips's inquiries were made at the time of the Chase memorial exhibition at the Corcoran, Mar. 10–Apr. 1, 1923; see DP to Gerrity, Knoedler, Mar. 28 and Mar. 31, 1923.

16. DP, 1916, 45.

Major References

The William Merritt Chase Archives, Parrish Art Museum, Southampton, New York.

Katherine Metcalf Roof, *The Life and Art of William Merritt Chase,* New York, 1917; reprint, New York, 1975.

David Abraham Milgrome, "The Art of William Merritt Chase," Ph.D. diss., University of Pittsburgh, 1969.

Ronald G. Pisano, *A Leading Spirit in American Art: William Merritt Chase, 1849–1916,* Seattle, 1983.

William H. Gerdts, *American Impressionism,* New York, 1984.

D. Scott Atkinson and Nicolai Cikovsky Jr., *William Merritt Chase: Summers at Shinnecock, 1891–1902,* exh. cat., Washington, D.C., National Gallery of Art, 1987.

Keith L. Bryant Jr., *William Merritt Chase: A Gentle Bohemian,* Columbia, Miss., 1991.

Ronald G. Pisano and Alicia Grant Longwell, *Photographs from the William Merritt Chase Archives at the Parrish Art Museum,* exh. cat., Parrish Art Museum, Southampton, N.Y., 1992.

Barbara Dayer Gallati, *William Merritt Chase,* New York, 1995.

TPC Sources

Journals N and HH, 1912.

DP, "William M. Chase," *American Magazine of Art* 8, Dec. 1916, 45–50.

Journals DD, 1921, and EE, ca. 1922.

C in M, 1926.

Cat., 1952.

MP, 1970 and 1982.

MP, 1998.

THEODORE ROBINSON

1. Provenance: Gellatly ownership documented in Rehn to Phillips, Sept. 15, 1919, Foxhall corr.; bill of sale, Apr. 23, 1920, as *Giverny Landscape* (TPC Papers, AAA, reel 1930, #855); transfer to PMG per Journal GG. In correspondence to Knoedler, Mar. 30, 1923, Phillips offered *Giverny* and other works in trade for Chase's *Hide and Seek.*

2. Provenance: Macbeth ownership and Pratt purchase documented in Milton Brown, *The Story of the Armory Show* (New York, 1988), 310; Rehn ownership documented in Rehn Gallery Papers, AAA, Reel D-289, #347; Phillips's purchase documented in correspondence and bill of sale, Mar. 13, 1920 (Rehn Gallery Papers, AAA, reel D-289, #638–40, #647); transfer to PMG per Journal GG.

3. Gerdts, 1984, 68.

4. From *Art Amateur* (1889), as quoted in Kennedy Galleries, *Theodore Robinson, American Impressionist (1852–1896),* exh. cat. (New York, 1966), 12.

5. "The Academy of Design," *Art Amateur* 24 (Jan. 1891), 31, as quoted in Gerdts, 1984, 99.

6. Oil on canvas, 26 × 23¼ in.; Metropolitan Museum of Art, New York, Gift of George A. Hearn, 1910.

7. Gerdts, 1984, 70.

8. See Baur, "Photographic Studies," 1946, and Paine Art Center and Arboretum, 1987, for in-depth analyses of the role photography played in Robinson's figural compositions.

9. Mrs. R. J. Antes, "Artist's Biography," *Evansville [Wisc.] Review,* Feb. 4 and 11, 1943, as quoted in Baur, *Theodore Robinson,* 1946, 36.

10. Baur, "Photographic Studies," 1946, 329.

11. After Robinson's death, his niece, Mrs. C. F. Terhune, found original photographs in his studio, as cited in Baur, *Theodore Robinson,* 1946, 326; among them was the scored photograph of *Two in a Boat.*

12. Diary entry, Jan. 31, 1893. See analysis by Elizabeth Steele, painting conservator, Mar. 10, 1991.

13. Brown, *Story of the Armory Show,* 116. In 1931 Phillips discussed these four artists in "American Old Masters" in *ASD,* 1931, 103–4: "Twachtman, Weir, and Robinson were the earliest American artists who painted light and air with a science blended with sentiment." He classified Twachtman and Weir as luminists and saw Robinson and Hassam as "American editions of the French Impressionists."

14. DP to Rehn, Jan. 26, 1920, Rehn Gallery Papers, AAA, reel D-289, #640.

15. *C in M,* 1926, 39.

Major References

Theodore Robinson, Diaries, Mar. 29, 1892–Mar. 30, 1896, Frick Art Reference Library, New York.

John I. H. Baur, *Theodore Robinson, 1852–1896,* exh. cat., New York, Brooklyn Museum, 1946.

———, "Photographic Studies by an Impressionist," *Gazette des beaux-arts* 30, Oct.–Nov. 1946, 319–30.

Florence Lewison, "Theodore Robinson, America's First Impressionist," *American Artist* 27, no. 262, Feb. 1963, 40–45, 72–73.

Sona Johnston, *Theodore Robinson, 1852–1896,* exh. cat., Baltimore Museum of Art, 1973.

Eliot C. Clark, *Theodore Robinson, His Life and Art,* Chicago, 1979.

William Gerdts, *American Impressionism,* New York, 1984.

Paine Art Center and Arboretum, *The Figural Images of Theodore Robinson, American Impressionist,* exh. cat., Oshkosh, Wisc., 1987.

Richard H. Love, *Theodore Robinson: Sketchbook Drawings,* exh. cat., Chicago, R. H. Love Galleries, 1991.

TPC Sources:

DP, "Representative American Painters of the New Century," introductory statement for a book proposal, between 1914 and 1920; formerly MS 80.

"J. Alden Weir," 1919–24, formerly MS 61.

Journal U, ca. 1919.

H of A, 1920–21.

Inv., 1921.

Journals EE, ca. 1922; B, 1923–29; and GG, 1924.

DP, "Painters of Past and Present," outline for proposed publication, July 1, 1925; formerly part of MS 97.

C in M, 1926.

Journals C and V, 1929.

ASD, 1931.

Cat., 1952.

JULIAN ALDEN WEIR

1. MP, 1982, 51.

2. The circumstances and exact date of their meeting are not known. Phillips was made a member of the Century Association in 1917 but seems to have met Weir perhaps as early as 1915. Marjorie Phillips (in MP, 1982, 50–51) includes Weir as one of the friends he made there "with older members already distinguished in the field of art."

3. DP, 1917, 213.

4. DP, 1922, 26.

5. In early plans for the museum, Duncan Phillips set aside a Twachtman and a Weir room; see Journal BB and letter to Frank Rehn dated Dec. 7, 1920, Rehn Gallery Papers, AAA, reel D-289, #654.

6. For example, Weir persuaded Charles Erskine Scott Wood, a childhood friend living in Portland, Or., to purchase Ryder's *Jonah and the Whale,* 1885–ca. 1890 (National Museum of American Art); see Julian Alden Weir Papers, AAA, reel 125, #[illeg.]. Phillips in DP, 1922, 26, recounts how Weir persuaded one of his patrons to buy a Twachtman painting, which was then mistakenly hung upside down.

7. *Woman with a Parrot* (oil on canvas, 72⅞ × 30⅝ in.) and *Boy with a Sword* (oil on canvas, 51⅝ × 36¼ in.), both Metropolitan Museum of Art, gift of Erwin Davis. He also purchased works by Bastien-Lepage, Courbet, and Reynolds for Davis.

8. DP, 1922, 21. Phillips also notes that Weir wrote a chapter on his early mentor, Bastien-Lepage, in *Modern French Masters* (New York, 1896).

9. DP, 1922, 5.

10. DP, 1919–24, n.p.

11. Phillips purchased the work from "The Allied War Salon" of 1918, an exhibition he helped organize at the American Art Galleries to benefit the war effort.

12. DP, 1922, 47.

13. It was followed by books on Daumier and Davies.

14. Contributors were Emil Carlsen, Royal Cortissoz, Harald de Raasloff, Childe Hassam, Augustus Vincent Tack, and Charles Erskine Scott Wood.

15. In the preface to Young, 1971, xxvii, editor Lawrence W. Chisolm describes Phillips's 1922 memorial essay as "the best critical account of Weir's work . . . in a mood of gentle retrospection rather than in the excitement of new discovery appealing to modern sensibility. The man, his work, and his moment are kept together in a lucid analysis of Weir's 'reticent idealism,' the 'unconscious austerity' of a style of painting which matched a style of life."

16. DP, 1922, 23.

17. Phillips called *Building a Dam, Setauket* (oil on canvas, 31¼ × 40¼ in.) "a valuable painting" and a "masterpiece" that he put on the market to "finance some prospective purchases in the development of my plans for the Phillips Memorial Gallery"; letter to Samuel L. Shere, director, City Art Museum, St. Louis, Dec. 15, 1925. It was purchased by the Cleveland Museum of Art.

18. In *Formes*, 1932, 197, Phillips talks about nature being out of fashion in art but goes on to say that Twachtman, Weir, and Bonnard prove that a picture can be "light-enchanted, and even light-bewildered, without losing its well-knit pattern of abstract color relations."

19. Inscription: Early registrar's records indicate a signature in the upper right corner; however, it was not apparent during an inspection by Elizabeth Steele, painting conservator, Mar. 18, 1991. Provenance: Undocumented TPC records indicate that the work was once owned by John Gellatly, who purchased it from Knoedler. Frank Rehn purchase documented by receipt, TPC Papers, AAA, reel 1930, #867.

20. Burke, 1983, 134, 135.

21. Many members of the Society of American Artists exhibited still lifes. See William Gerdts, *Painters of the Humble Truth* (London, 1981), 28 and 219.

22. One of the U.S. suppliers of such casts, the Boston firm of P. P. Caproni and Brother, lists the della Robbia in its 1911 catalogue. In a letter to his fiancée, Anna Baker, Oct. 20, 1882, Weir noted that the Metropolitan Museum had just purchased a "della Robbia, a rare choice and work of art and possibly the most valuable possession in their collection"; Julian Alden Weir Papers, AAA, reel 125, frame #[illeg., possibly 500s]. The della Robbia in *Roses* is very similar to the right-hand portion of a *Nativity* donated to the Metropolitan by Henry G. Marquand in 1882.

23. In addition to its symbolic significance, the relief in *Roses* also reflects Weir's interest in sculpture. In Paris Weir's initial training involved sketching from plaster casts. Back in New York, he became a friend of the sculptor Olin Levi Warner, briefly tried his own hand at sculpture, and depicted sculptures in other paintings, including portraits.

24. *ASD*, 1931, 103.

25. Pinto, 1983, 12.

26. Date: Previously published as ca. 1905; the earlier date is derived from the dedication to J. Appleton Brown, who died in 1902; see following text. Titles: A metal plaque on the frame states, "*The Pasture* J. Alden Weir's Farm Near Ridgefield, Connecticut." Provenance: Possibly in the estate of J. Appleton Brown. Bill of sale, Aug. 25, 1920 (TPC Papers, AAA, reel 1930, #867).

27. Weir also owned a farm at Windham, Connecticut, which his wife, the former Anna Baker, had inherited; she died in childbirth in 1892. The Branchville farm had been given to him in trade for paintings by the collector Erwin Davis; Weir did most of his painting there.

28. DP, 1922, 11.

29. J. Alden Weir to Mr. and Mrs. Robert W. Weir, Apr. 15, 1877, as quoted in Young, 1971, 123.

30. Whistler knew the Weir family from his days at West Point. They first met in London in 1877, and Weir visited him on several subsequent occasions. See Young, 1971, 205.

31. Oil on canvas, 17⅛ × 21 in.; Wadsworth Athenaeum, Ella Gallup Sumner and Mary Catlin Sumner Collection.

32. Another, but less likely, possibility is Frank Benson, fellow member of The Ten and also a guest at Branchville. Also, in correspondence Weir sometimes addressed his older half-brother, John Ferguson Weir, as "Old Brown" (see Weir Papers, AAA, reel 125, #[illeg.; 500s]); however, it seems unlikely that he would call his brother "my good friend" in a dedication.

33. Young, 1971, 207. After Brown's sudden death in 1902, Weir organized memorial exhibitions of his work at the Century Association and in Boston, and raised money for his widow.

34. Title: In July 30, 1981, correspondence, Weir scholar Doreen Bolger Burke cites private Weir family papers that indicate the painting was sometimes known as *Two Friends*. After Phillips acquired the work in 1917, he used the title *A Girl and a Donkey*, and later *Visiting Neighbors*, by which it was known for over seventy years. Its original title was restored in 1992. Provenance: Richards ownership cited in Burke's letter, July 30, 1981, from "Records of the Paintings of J. Alden Weir" in the possession of the Weir family. Receipt is confirmed in DP to Miller, May 29, 1917, Macbeth Gallery Papers, AAA, reel 2620, #0327.

35. For a related work, see *The Donkey Ride*, ca. 1908 (oil on canvas 52 × 42 in.; collection of Charles Burlingham).

36. DP, 1922, 36.

37. Weir subsequently married his wife's sister.

38. A *New York Tribune* reviewer of the 1904 exhibition of The Ten commented that the work "would have been more engaging if the figures had been left out, but these cannot spoil the effect of light and air in the picture"; New York Public Library Art Division Papers, AAA, reel N52, #1022.

39. Gerdts, *Painters of the Humble Truth*, 74, sees the textured brushwork of Weir's late paintings as prefiguring the techniques of Maurice Prendergast and Ernest Lawson.

40. James Phillips listed as purchaser in Macbeth letter to Weir Jan. 29, 1916; Macbeth Gallery Papers, AAA, reel NMc80, #0198.

41. Clipping, "Sept. 1911 *Buffalo News*," Weir Papers, AAA, reel 70, #291.

42. Among the few other mythological subjects, *The Muse of Music*, 1881–84 (Fine Arts Museums of San Francisco), and *The Open Book*, 1891 (National Museum of American Art, Washington, D.C.), were not critical successes; see Burke, 1983, 111, and *Critic* 15 (May 2, 1891), 243.

43. DP, 1917, 213.

44. DP, 1922, 44.

45. See, for example, Ryder's *Diana's Hunt*, n.d. (oil on canvas, 18 × 14 in.; Newark Museum), and *Dancing Dryads*, before 1881 (oil on canvas, 9 × 7⅛ in.; National Museum of American Art, Washington, D.C., gift of John Gellatly).

46. In the introduction to a 1924 exhibition at Macbeth's of Hassam's paintings featuring nymphs at Montauk, Phillips wrote that it was as if he had "the eager desire to make us understand [that] the Attica of the Age of Pericles can be made to live again on the shores of North America."

47. Undated, wood engraving on tissue paper, 11¼ × 9¼ in., image 6¾ × 4⅞ in.; signed on mat in pencil l.l.: *J. Alden Weir*; inscribed l.r.: *To Mr. Duncan Phillips with my compliments.*

48. Provenance: Letter from Corcoran Director Minnigerode to Weir, dated Jan. 15, 1917, TPC Archives, mentions the sale of this painting to Duncan Phillips's father. Documentation provided by Burke from Weir records still in possession of the family.

49. DP, 1922, 39.

50. De Raasloff in DP, 1922, 90.

51. Oil on canvas, 22 × 27 in.; High Museum of Art.

52. DP, 1922, 35.

Major References
Julian Alden Weir Papers, AAA.
Metropolitan Museum of Art, *Memorial Exhibition of the Works of Julian Alden Weir*, exh. cat., New York, 1924.
American Academy of Arts and Letters, *J. Alden Weir, 1852–1919 Centennial Exhibition*, New York, 1952.
Dorothy Weir Young, ed., *The Life and Letters of J. Alden Weir*, New Haven, 1960; 2nd ed., 1971.
Doreen Bolger Burke, *J. Alden Weir: An American Impressionist*, New York, 1983.
Holly Joan Pinto, *William Cullen Bryant, The Weirs, and American Impressionism*, exh. cat., Rosyln, N.Y., Nassau County Museum of Fine Art, 1983.
Hildegard Cummings et al., *J. Alden Weir: A Place of his Own*, exh. cat., Storrs, Conn., William Benton Museum of Art, 1991.

TPC Sources
Journals O, 1916–23, and G, ca. 1920.
DP, "J. Alden Weir," *American Magazine of Art* 8, Apr. 1917, 213–20.
DP, "J. Alden Weir," unpubl. essay, 1919–24; formerly MS 61.
DP, "J. Alden Weir," *Art Bulletin* 2, June 1920, 189–212.
Inv., 1921.
DP, "Julian Alden Weir," in *Julian Alden Weir: An Appreciation of His Life and Works*, 3–47, Phillips Publication No. 1, New York, 1922; previously

published as J. B. Millet, ed., *Julian Alden Weir: An Appreciation of His Life and Works,* New York, Century Association, 1921; drafts formerly MS 151.

DP, *Julian Alden Weir: An Essay by Duncan Phillips,* Greenwich, Conn., 1922; formerly MS 59.

DP, "J. Alden Weir, American School, 1852–1919," unpubl. essay, 1924.

Journal GG, 1924.

C in M, 1926.

ASD, 1931.

DP, "Freshness of Vision and Spontaneity in Painting," unpubl. text for lecture, ca. 1935; formerly part of MS 178.

Journal BB, ca. 1930–33.

MP, 1970 and 1982.

MP et al., cat. for TPC.1972.3.

MP, 1998.

JOHN HENRY TWACHTMAN

1. Title: Early catalogues list most of the works Twachtman made on his 1895 trip to Yellowstone National Park by this general title. Provenance: *In Yellowstone Park, Yellowstone Series* (25 × 25 in.) is listed as having been purchased in 1903 by Stanford White (1853–1906) in "John H. Twachtman Sale," *American Art Annual* 4 (1903–4), 59. Ferargil bill of sale, Oct. 31, 1921.

2. In 1922 the artist's son, J. Alden Twachtman, in a letter to Edwin C. Shaw, the purchaser of one of the Yellowstone paintings, wrote that his father painted fourteen canvases in a period of ten days while in the park in the summer of 1895 (Edwin Shaw Papers, AAA, reel 1125, #795).

3. Twachtman to Wadsworth, Sept. 22, 1885; the Wadsworth Family Papers, College Libraries, State University of New York College of Arts and Science at Geneseo.

4. For a discussion of his winter scenes, see Kathleen Pyne, "Twachtman and the American Winter Landscape," in Chotner et al., 1989, 71–84. A related work is *Emerald Pool,* ca. 1895 (oil on canvas, 25¼ × 30¼ in.; Wadsworth Athenaeum, Hartford, Conn., Ella and Mary Catlin Sumner Collection).

5. For a discussion of the significance of the square format, see William H. Gerdts, "The Square Format and Proto-Modernism in American Painting," *Arts Magazine* 50 (June 1976), 70–75.

6. DP, 1919, cvi.

7. Hanging records. Monet and Twachtman were exhibited together during their lifetimes, as well. In May 1893 a Twachtman-Weir exhibition was held concurrently with a Monet-Besnard show at the American Art Galleries in New York. Critics, while generally complimentary, noted that both Weir and Twachtman had more muted palettes than the French artists; see Lisa N. Peters, "Twachtman's Greenwich Paintings: Context and Chronology," in Chotner et al., 1989, 27.

8. MP, 1982, 75.

9. Knoedler purchase and reference to estate per Melissa De Medeiros, Knoedler, to author, July 29, 1919 (stock C 4742); Macbeth bill of sale, Sept. 1919; transfer per *Inv.,* 1921.

10. For a discussion of Robinson's Giverny experience, see entry for *Two in a Boat* (cat. no. 76).

11. Oil on canvas, 21⅜ × 26⅛ in.; acc. no. 1987. The collection also contains two works on paper, *House and Tree* and *Spring* (acc. nos. 1983 and 1985).

12. Peters in Chotner et. al, 1989, 25, suggests that Twachtman's use of light color over dark underpaint came from his work with pastel on colored paper. According to Twachtman's first biographer, Clark (1924, 58), the artist would sometimes expose his canvases to the sun to dry out the excess oil in the paint and thereby create dry impastoed surfaces. Hale, 1957, 248, states that the artist's son, J. Alden Twachtman, confirmed Clark's description of technique.

13. *Bull.,* 1928, 37.

14. Friends and colleagues lamented his lack of recognition in a memorial tribute published shortly after his death; see Dewing et al., 1903, 554–57.

15. In *Bull.,* 1928, 37, Phillips explained that he was exhibiting Twachtman's work (and Prendergast's) in a room with living artists because "they are all modern in mind . . . and serve as connecting links between the past and present."

16. "To the Committee on Scope and Plan of The Phillips Memorial Art Gallery," unpubl. report, Dec. 12, 1921.

17. Title: The painting was known as *My Summer Studio* from the time it was first exhibited in 1901 until the 1920s, when Duncan Phillips changed it to *My Autumn Studio;* see Boyle, 1979, 4 and 6. Provenance: Sales per the 1903 Twachtman estate sale, held by the American Art Galleries, New York; 1907 Lotus Club; and 1919 Inglis-Morten-Lawrence Collection sale. For Phillips purchase, see Kraushaar to DP, Feb. 4, 1919, Foxhall corr., and DP to Kraushaar, Feb. 7, 1919, Kraushaar archives; transfer per *Inv.,* 1921.

18. On the basis of information and photographs in Lisa N. Peters, "Catalogue," in Hale et al., 1987, 82, the building is probably a cottage Twachtman used as a studio while staying at the Rockaway Hotel on Rocky Neck, Gloucester, where he worked into late September 1900.

19. William H. Gerdts, "John Twachtman and the Artistic Colony in Gloucester at the Turn of the Century" in Hale et al., 1987, 27–45.

20. Richard J. Boyle, "John Twachtman's Gloucester Years," in ibid., 18.

21. Gerdts, "Square Format," 70–75. Examination reveals that three of the four tacking margins are covered with paint that does not correspond to the composition in *My Autumn Studio.* Together with the pentimenti in the upper right quadrant, this evidence suggests that Twachtman painted this picture over an unfinished composition. It seems possible that the canvas was originally rectangular instead of square. See analysis by Elizabeth Steele, painting conservator, Aug. 3, 1990.

Major References
Thomas W. Dewing et al., "John H. Twachtman: An Estimation," *North American Review* 176, no. 1, Apr. 1903, 554–57.
Eliot Clark, *John Twachtman,* New York, 1924.
John Douglass Hale, "The Life and Creative Development of John H. Twachtman," 2 vols., Ph.D. diss., Ohio State University, 1957.
Cincinnati Museum of Art, *John Henry Twachtman,* exh. cat., Ohio, 1966.
Richard J. Boyle, *John Twachtman,* New York, 1979.
John Douglass Hale et al., *Twachtman in Gloucester: His Last Years, 1900–1902,* exh. cat., New York, Ira Spanierman Gallery, 1987.
Debra Chotner et al., *John Twachtman: Connecticut Landscapes,* exh. cat., Washington, D.C, NGA, 1989.
John Douglass Hale et al., *In the Sunlight: The Floral and Figurative Art of J. H. Twachtman,* exh. cat., New York, Ira Spanierman Gallery, 1989.

TPC Sources
Journal O, 1916–23.
DP, "Twachtman—an Appreciation," *International Studio* 66, Feb. 1919, 106–7; one draft formerly MS 53.
H of A, 1920–21.
Inv., 1921.
C in M, 1926.
Bull., 1928.
Journal BB, ca. 1930–33.
MP, 1998.

CHILDE HASSAM

1. Title: Numerous title variations were used in catalogue entries over the years, such as *Spring—Washington Arch, New York; The Arch, Washington Square;* and *Spring, Washington Square.* From 1950 on, the painting has been cited, with minor variations, by this title. Hirschl and Adler Gallery, New York, has been preparing a catalogue raisonné. Provenance: Receipt of payment from Macbeth, Oct. 1, 1921.

2. *Bailey's Beach—Newport,* 1901, acquired 1917, sold 1929; *The Willow Pool,* ca. 1918, acquired 1920, sold to the Sheldon Museum, University of Nebraska, 1930; *Noon on the Rocks, Cape Ann,* 1918, acquired 1922, given to Whitney Auction, 1966; *The Marshal Niel Rose,* ca. 1918, acquired 1922, sold 1929; *Fifth Avenue, May,* 1917, acquired 1920, sold 1930.

3. At the time of Hassam's death, it was predicted that his reputation would rest on his New York scenes; see Curry, 1990, 148 n. 33. Another work, acquired before 1920, was part of the Phillips family collection and was given to the museum in 1985: *Mt. Beacon at Newburgh,* 1916 (oil on wood panel, 6⅜ × 9¼ in.; gift of Marjorie Phillips, 1985, acc. no. 1985.3.21). As personal correspondence indicates, Phillips was disillusioned with Hassam partly for personal reasons, not purely because of a change in taste.

4. For example, *Columbus Avenue, Boston: Rainy Day,* 1885 (oil on canvas, 26¼ × 48¼ in.; Toledo Museum of Art).

5. For example, *Le Jour du Grand Prix,* 1887 (oil on canvas, 36 × 48 in.; New Britain Museum of American Art).

6. Mariana (Griswold) Van Rensselaer used Hassam's *Washington Arch* to illustrate an article on New York titled "Fifth Avenue" in *Century Magazine* 47, no. 25 (Nov. 1893), 5–18.

7. As quoted in Ives, 1892, 117.

8. *C in M,* 1926, 43.

9. For a history of the arch, see Paul R. Baker, *Stanny, the Gilded Life of Stanford White* (New York, 1989), 170–72.

10. Two large, discolored retouchings were discovered at the center left and right edges, just above the trees, during the painting's conservation in 1990. It was concluded that the retouchings were by the hand of the artist and reflected changes he had made in the composition; Hassam's later additions of paint have darkened. See analysis by Elizabeth Steele, painting conservator, Jan. 11, 1990.

11. As quoted in Ives, 1892, 116.

12. *C in M,* 1926, 43.

Major References
A. E. Ives, "Talks with Artists, Mr. Childe Hassam on Painting Street Scenes," *Art Amateur* 17, no. 5, Oct. 1892, 116–17.
American Academy of Arts and Letters, *Exhibition of the Works of Childe Hassam,* exh. cat., New York, 1927.
Charles E. Buckley, *Childe Hassam: A Retrospective Exhibition,* exh. cat., Washington, D.C., Corcoran, 1965.
———, *Childe Hassam, 1859–1935,* exh. cat., Tucson, University of Arizona Art Museum, 1972.
Donelson F. Hoopes, *Childe Hassam,* New York, 1979.
Susan Ilene Fort, *The Flag Paintings of Childe Hassam,* exh. cat., LACMA, 1988.
Alan Wofsy Fine Arts, *Catalogue of the Etchings and Dry-Points of Childe Hassam, N.A., of the American Academy of Arts and Letters,* San Francisco, 1989.
David Park Curry, *Childe Hassam: An Island Garden Revisited,* exh. cat., Denver Art Museum, 1990.
Susan Ilene Fort, *Childe Hassam's New York,* San Francisco, 1993.
Ulrich W. Hiesinger, *Childe Hassam,* Munich, 1994.
Guild Hall Museum, *Childe Hassam: East Hampton Summers,* exh. cat., East Hampton, New York, 1997.

TPC Sources
E of A, 1914 and 1927.
Journals U, ca. 1919; and G, ca. 1920.
H of A, 1920–21.
Inv., 1921.
Journals EE, ca. 1922; D, ca. 1923–24; and B, 1923–29.
DP, "Childe Hassam," in *'Montauk' by Childe Hassam, N.A., of the American Academy of Arts and Letters,* exh. cat., New York, William Macbeth, 1924.
C in M, 1926.
ASD, 1931.
SITES, 1979.
MP, 1998.

LOUIS MICHEL EILSHEMIUS
1. Many of his purchases were made from Valentine Dudensing, the same New York dealer who in the thirties sold him works by Bonnard, Cézanne, and Rouault.

2. Duchamp's dadaist proclivities, which included playing jokes on the public, were well known; therefore, his enthusiasm for Eilshemius aroused skepticism at the time and has subsequently troubled art historians. See Karlstrom, Washington, D.C., 1978, 13, and n. 3.

3. MS 174, n.p.

4. The two studies were *Madge in the Morning,* 1910 (acc. no. 0647), and *Veranda in Spring,* ca. 1900 (acc. no. 0658).

5. These last two works are *Adirondacks: Bridge for Fishing,* 1897 (cat. no. 87), and *Cabs for Hire,* 1909 (acc. no. 0641). Phillips never met Eilshemius but took an interest in his welfare, joining with others to help the aged and infirm artist in his last years. See DP to

Charlotte Devree, Nov. 30, 1954, and DP to William Schack, Dec. 16, 1940.

6. *The Queen's Family, Samoa,* 1908, and *Van Cortland Park,* ca. 1909, were loans from the Clark collection; present locations unknown.

7. DP, 1933, n.p.

8. DP, 1939, 694; Schack, 1939. Phillips also said that Schack did not "claim too much for him as some biographers are inclined to do for their heroes, but proposes for him a modest little room of his own among the immortals."

9. The painting of bathers, *Untitled,* 1919 (acc. no. 0657), was a gift of Margaret Hawthorn in 1984. Phillips, in general, avoided modern interpretations of nudes, perhaps a vestige of his genteel nineteenth-century upbringing. Ironically, as noted in Karlstrom, New York, 1978, 81, many of Eilshemius's nudes derive from Corot's sylvan nymphs and Courbet's robust bathers. Although most of Eilshemius's late nudes are crudely painted and shown in bizarre poses and contexts, some have an appealing exuberance and innocent charm.

10. DP, 1939, 695.

11. Karlstrom, New York, 1973, 16, describes Phillips's collection of Eilshemius as "particularly impressive."

12. Inscription: Eilshemius used this shortened spelling of his name between 1899 and 1913, per Schack, 1939, 51, 201. Provenance: Decision to purchase per DP to Kleeman, Nov. 11; final agreement Kleeman to DP, Nov. 15, 1937, TPC Papers, AAA, reel 1949, #1330 and #1332.

13. Title: The painting was called *Adirondacks* in correspondence relating to purchase. *Bridge for Fishing,* probably a Phillips title, was used from the 1930s on. Provenance: Decision to purchase, DP to Valentine Dudensing, Feb. 7, 1933, TPC Papers, AAA, reel 1944, #488–89. Also listed in Valentine Gallery statement, Feb. 1, 1935.

14. First quote DP, 1939, 725; second quote, p. 696.

15. DP, ca. 1939, n.p.

16. MS 78, n.p.

17. Title: *Apia, Samoa* is the title assigned by Henry McBride, 1926, 318, and Karlstrom, no. 161. Provenance: Valentine Gallery bill of sale, Jan. 10, 1927 (TPC Papers, reel 1933, #0354).

18. See Schack, 1939, 115–25, for an account of the trip and Eilshemius's relationship with the inhabitants.

19. In 1921 Phillips purchased one of La Farge's South Pacific watercolors, *Chiefs and Performers in War Dance, Fiji,* 1891 (acc. no. 1106).

20. In DP, ca. 1939, n.p., Phillips calls Eilshemius "the inspired child with a perpetual freshness of vision and of touch" but says that "he added in the most autographic part of his work a tendency to what is called bad taste in expression and to a juvenile drawing of the figures."

21. McBride, 1926, 319.

22. DP to Valentine Dudensing, Feb. 1933, TPC Papers, AAA, reel 1944, #0490.

23. DP, ca. 1939, n.p.

24. Inscription: Eilshemius capitalized the last "s" in some of his signatures. Provenance: Bill of sale, Mar. 4, 1932.

25. DP, 1939, 724.

26. Schack, 1939, 190.

27. Karlstrom, New York, 1978, 65.

28. Phillips compared Duchamp's discovery of Eilshemius to Picasso's discovery of Rousseau; see DP, ca. 1939, n.p.

29. Eilshemius to Peyton Boswell, Mar. 17, 1932, as cited in *Art Digest* 6 (Apr. 1, 1932), 7.

30. DP, ca. 1939, n.p.

31. DP, 1933, n.p. In addition to a deteriorating mental state, other factors may have affected Eilshemius's change in style in the second decade of the twentieth century, among them a meeting with Ryder in 1908 and his attempt to duplicate Ryder's intense expressionism. See Karlstrom, New York, 1978, 49.

32. Eilshemius was a prolific writer, but his work was generally derivative, uneven, and trite; see Schack, 1939, chap. 6.

33. DP, 1939, 724.

34. Schack, 1939, 82.

Major References
Henry McBride, "The Discovery of Louis Eilshemius," *Arts* 10, Dec. 1926, 316–20.
William Schack, *And He Sat among the Ashes,* New York, 1939.
Paul Karlstrom, "Louis Michel Eilshemius, 1864–1941: A Monograph and Catalogue of the Paintings," 2 vols., Ph.D. diss., University of California, Los Angeles, 1973.
———, *The Romanticism of Eilshemius,* exh. cat., New York, Bernard Danenberg Galleries, 1973.
———, *Louis Michel Eilshemius,* New York, 1978.
———, *Louis M. Eilshemius: Selections from the Hirshhorn Museum and Sculpture Garden,* exh. cat., Washington, D.C., 1978.
Robert L. Herbert et al., *The Société Anonyme and the Dreier Bequest at Yale University: A Catalogue Raisonné,* New Haven, 1984.
Michael Rosenfeld Gallery, *Perceivable Realities: Louis Michel Eilshemius, Morris Graves, Henry Ossawa Tanner, Pavel Tchelitchew,* exh. cat., New York, 1994.

TPC Sources
ASD, 1931.
DP, essay for PMG.1933.1c.
DP, [Classic or Romantic in Modern Landscape], paper presented at PMG, Mar. 14, 1934.
DP, "Freshness of Vision and Spontaneity in Painting," unpubl. text for slide lecture, ca. 1935; formerly part of MS 178.
DP, "The Expression of Personality Through Design in the Art of Painting," text for slide lecture, 8 versions, ca. 1936–42.
DP, "The Duality of Eilshemius," *Magazine of Art* 32, Dec. 1939, 694–97, 724–27.
DP, "Spontaneous Painters," unpubl. essay, ca. 1939; formerly MS 78.
DP, "Freshness of Vision in Painting," unpubl. essay, ca. 1945; formerly part of MS 178.
Cat., 1952.
SITES, 1979.
MD, 1981.
MSS 109, 143, and 174.

Duncan Phillips and the American Popular Tradition

1. Little Galleries of the Photo-Secession at 291 Fifth

Avenue, New York, was known as Gallery 291.

2. Duncan Phillips, perhaps taking his cue from Edith Halpert's Folk Art Gallery in New York, used the phrase "folk art" to title a 1938 exhibition arranged through Halpert at the Phillips Memorial Gallery's Studio House annex. The press release for a lecture sponsored in connection with that show, however, also used the then-more-common expressions "primitive" and "popular" interchangeably, and reviewers for both the *Washington Post* and the *Sunday Star* commented that the work on display was really too steeped in European culture to qualify as authentic folk art; see Sibilla Skidelsky, "Exhibition of 'American Folk Art' Current at Studio House in Washington," *Washington Post,* Mar. 6, 1938, and Leila Mechlin, "American Folk Art to Be Seen at Phillips Gallery Studio House," *Sunday Star,* Feb. 27, 1938.

3. Although Kane had several gallery exhibitions during his lifetime, it was not until after his death that his heirs sought a more permanent arrangement with a dealer. Valentine Dudensing, proprietor of the Valentine Gallery in New York (one of the pioneers in the promotion of folk art), took over the estate in early 1935 and remained representative until the 1950s.

4. For the quote and discussion of raising the price, see Phillips's telegram to John O'Connor, Oct. 21, 1930; other correspondence relating to the purchase are letters from O'Connor dated Oct. 20 and 21 and Dec. 8, 1930 (all Carnegie Papers, AAA).

5. About the time of this acquisition Valentine Dudensing wrote Phillips, "I am certain it [*Blowing Bubbles*] will win its way into your heart with time" (Feb. 17 [illeg.], 1938, TPC Papers, AAA, Reel 1951, #0474).

6. Otto Kallir, *Grandma Moses* (New York, 1973), no. 40: *The Old House at the Bend of the Road,* 1940 or earlier (oil on board, 10½ × 12½ in.; private collection, formerly in the collection of Duncan and Marjorie Phillips; alternately titled *The Old Home at the End of the Road*).

7. Kallir, 1973, no. 164: *Cambridge Valley,* 1942 (oil on board, 23¼ × 27 in.; private collection, courtesy of The Galerie St. Etienne, New York).

8. Selden Rodman, *Horace Pippin: A Negro Painter in America* (New York, 1947), no. 89: *Victorian Interior II,* 1945 (oil on canvas, 25¼ × 30 in.; The Metropolitan Museum of Art, New York, Arthur Hoppock Hearn Fund, Purchase 1958, acc. no. 58.26; recently retitled *Victorian Parlor II* by the owner).

9. DP to Edith Halpert, Downtown Gallery, Jan. 10, 1946.

10. DP, "Freshness of Vision and Spontaneity in Painting," text for slide lecture ca. 1935, 37; formerly part of MS 178.

11. On Dec. 13, 1939, the Downtown Gallery sent Phillips three theorem paintings on approval. Phillips elected to purchase the one described as "flower and butterfly," rendering payment for it in April 1940. In a 1935 lecture ("Freshness of Vision," 49) Phillips once noted that "there were . . . some charming fruit pieces which could hang with Braque." Judging from the context, he was probably referring to theorem still lifes.

12. It is worth noting that Phillips was primarily interested in the way images by different artists related to one another, rather than in assembling a collection of "name" artists. This is why he was not in the least perturbed when a painting he had bought as a Harnett

was reattributed to Peto.

13. DP, "Freshness of Vision," 36, and Wassily Kandinsky, "On the Problem of Form," in Herschel B. Chipp, ed., *Theories of Modern Art* (Berkeley, 1968), 161.

14. "Art for art's sake," commented Phillips, "grows out of the play instinct, and the devotees of art for art's sake were attracted to Rousseau, envious of his instinctive sense of rhythmical pattern and his freshness of vision which above all things they needed to ventilate their esoteric experiments"; DP, "Freshness of Vision," 38–39.

15. DP, "Freshness of Vision," 40.

16. It is also worth mentioning that the first significant dealers in folk art—Edith Halpert's Downtown Gallery, Otto Kallir's Galerie St. Etienne, and Valentine Dudensing's Valentine Gallery—also handled a broad array of modernism.

17. It is not clear to what extent Phillips believed that folk art could equal academic art, although the relatively limited number of folk paintings in the collection suggests that he saw the genre more as a footnote to modern art than as an end itself. His comment on the paintings of Pa Hunt—that "really they are not very good even as primitives" (letter to Karl Knaths, June 18, 1941)—indicates that he felt such works could be judged by standards other than those applicable to mainstream art.

EDWARD HICKS

1. Inscription: The inscription is now obscured by lining. Provenance: Strauss ownership per painting record in Downtown Gallery Papers, AAA, reel ND24, #0306; PMG purchase in Edith Halpert, Downtown Gallery, to DP, May 15, 1939, TPC Papers, AAA, reel 1952, #1338.

2. Hicks's poem varied slightly over the years. Although he painted it on the frames of his early versions of the subject, this particular version of the poem was found framed in Hicks's collection. He almost invariably added a verse relating Penn's treaty with the Indians to the biblical theme; see Ford, 1985, 108, for the complete poem.

3. Hicks also incorporated his features into the image of the lion; see Thomas Hicks's *Portrait of Edward Hicks,* ca. 1838 (oil on canvas, 27¼ × 22 in.; Colonial Williamsburg), illustrated in Eleanore Price Mather, "In Detail: Edward Hicks's *Peaceable Kingdom,*" *Portfolio* 2, no. 2 (Apr.–May 1980), 34–39. On Hicks's own assessment of his attributes being symbolized by the lion, see Mather and Miller, 1983, 58–69.

4. This pictorial harmony is particularly evident in the almost complete censoring of that part of the biblical text referring to "the dark hole where poisonous reptiles lay," a compositional device that tends to disrupt the visual continuity of the foreground in many other *Kingdom*s.

5. The popular sources are listed and illustrated in Ford, 1985, 190; the landscape and the Penn Treaty scene are described on pages 106 and 121.

6. See Ford, 1985, 190.

7. Phyllis Derfner, "Edward Hicks: Practical Primitivism and the 'Inner Light,'" *Art in America* (Sept.–Oct. 1975), 78.

Major References
Edward Hicks, *Memoirs of the Life and Religious Labours of Edward Hicks of Newtown, Bucks*

County, Pennsylvania; includes the diary *A Little Present for Friends and Friendly People* and *A Word of Exhortation,* Philadelphia, 1851.

Eleanore Price Mather, "A Quaker Icon: The Inner Kingdom of Edward Hicks," *Art Quarterly* 36, Spring–Summer 1973, 84–89.

David Tatham, "Edward Hicks, Elias Hicks, and John Comly: Perspectives on the Peaceable Kingdom Theme," *American Art Journal* 13, Spring 1981, 37–50.

Eleanore Price Mather and Dorothy Canning Miller, *Edward Hicks: His Peaceable Kingdoms and Other Paintings,* Newark, 1983.

Carnegie Institute, Museum of Art, *American Primitives: Hicks, Kane, Pippin,* exh. cat., Pittsburgh, 1983.

Alice Ford, *Edward Hicks: His Life and Art,* New York, 1985.

Deborah Chotner, *American Naïve Paintings: The Collection of the National Gallery of Art Systematic Catalogue,* Washington, D.C., 1992.

TPC Sources
DP, "Freshness of Vision and Spontaneity in Painting," unpubl. text for slide lecture, ca. 1935; formerly part of MS 178.
Cat., 1952.

JOHN BRADLEY

1. Inscribed Nov. 29, 1832; collection of Mr. and Mrs. Peter Tillou, William Benton Museum of Art, University of Connecticut at Storrs.

2. See Black and Feld, 1966, 502 and 505.

3. Inscription: The initials I. J. H., published in Lipman, 1945, 155, are not John Bradley's; see Black and Feld, 1966, 505. Early references to inscriptions have contributed to the misattribution. Downtown Gallery records, AAA, reel ND24, #179, read in part: "Inscribed on backing of picture: 'I.Bradley Delin Dated 1832.'" Lipman cites two signatures without indicating their exact location: "I.Bradley Delin Dated 1832" and "I.J.H. Bradley 1832." Her findings are consistent with the Downtown Gallery records, but neither source accurately cites the inscription on the painting itself. According to a note in TPC files, the painting was lined prior to acquisition (no records extant). Tucked onto the back of the canvas is an engraving of Paganini with five other musicians published in George Hart, *The Violin and Its Music* (1881). It is inscribed in pencil "I.J.H.Bradley 1832." Lipman may have interpreted this as a primary inscription, initiating the use of these initials. The addition of "Delin." to the signature was an old form of stressing authorship. Provenance: From Downtown Gallery records, AAA, ND24, #178, and Edith Halpert to DP, Mar. 3, 1938, TPC Papers, AAA, reel 1949, #0627. Paintings in the New York exhibition were for sale. Shipping notice, Feb. 14, 1938: "We understand you have purchased [*The Cellist*]."

4. Edward Alden Jewell, *New York Times,* Jan. 22, 1938, L13.

5. Downtown Gallery records; see n. 3 on provenance.

6. Lipman, 1945, 162.

7. Black and Feld, 1966, 503.

8. *Woman Before a Pianoforte,* 1831 (Hirschl and Adler, New York); signed and dated l.r.: *J. Bradley Deli N. 1831* (per telephone conversation with author, Nov. 22, 1989).

9. For discussions of the visual clues within the composition, see Smithsonian Institution costume specialist Shelly Foote and Rodris Roth, curator, Division of Domestic Life, in a meeting with Vivien Greene and conversations with author; author's interview with Gary Sturm, Music Division (both Nov. 1987). Chotner, 1992, 27, argues that the features of the three early works suggest that they were painted in Great Britain. Reference to "English school" in Mary Bartlett Cowdrey files, AAA, reel NY59–19, #415, cited in Chotner, 1992, 28.

10. Nicholas Temperley, professor of music, University of Illinois, Urbana, identified the hymn and wrote, "A hymn like this might easily have been played in a devout home setting; indeed that is the only context in which I can imagine the combination of cello and piano" (correspondence with author, Feb. 5, 1988).

11. Bradley's other portrait including a piece of sheet music is *Margaretta Bowne Crawford*, 1844–47 (Monmouth County Historical Society, Freehold, N.J.).

12. The site was identified by John C. Wittich, an expert on the city of London (correspondence with author, Dec. 29, 1987): "The court that was once sited next to the now demolished St. Mildred's Church Poultry."

Major References
Jean Lipman, "I. J. H. Bradley, Portrait Painter," *Art in America* 33, no. 3, July 1945, 154–66.
Mary Childs Black and Stuart P. Feld, "'Drawn by I. Bradley from Great Britton,'" *Antiques* 90, Oct. 1966, 502–9.
Beatrix Rumford, ed., *American Folk Portraits*, Abby Aldrich Rockefeller Folk Art Center Series, vol. 1, Boston, 1981.
Deborah Chotner, *American Naïve Paintings: The Collection of the National Gallery of Art Systematic Catalogue*, Washington, D.C., NGA., 1992.

TPC Source
Cat., 1952.

JOHN FREDERICK PETO
1. Date of Peto's death courtesy of Joy Peto Smiley, Peto's granddaughter, in correspondence with author, Oct. 31, 1990.

2. Title: *Old Time Card Rack*, the artist's title inscribed on the reverse, was revealed by Susan Corn Conway of the Washington Conservation Studio in 1980. *Old Reminiscences* appears on an Earle's Gallery label of ca. 1900–1903, also on the painting's reverse. *Old Souvenirs* (possibly by Phillips) was used briefly, but a Peto painting by this title, also signed falsely as a Harnett, is owned by the Metropolitan Museum of Art, New York. Provenance: Downtown Gallery bill of sale, May 12, 1939.

3. For a discussion of the American adaptation of this device and Peto's context, see Wilmerding, 1983, 37–55.

4. For a discussion of Peto's rack paintings and their close relationship to Harnett's, see Gerdts, 1981, 179–80.

5. In a letter dated Nov. 29, 1930 (Hughes Papers, Georgetown University), the Philadelphia art dealer G. E. Kelley offered this painting (as a Harnett) to William J. Hughes, a Washington, D.C., collector; Kelley was working as an agent for an owner identified only as a "man." Information courtesy John Davis, assistant professor of art history, Smith College.

6. Details about the painting's history at Earle's Gallery are unknown; the number on the label suggests an exhibition or an inventory number. In 1902 James S. Earle and Sons held a "retiring from business" sale, but this work was not included on the list; perhaps it had been sold or sent on consignment by that time.

7. Elmira Bier to Mildred Steinback, Frick Art Reference Library, Sept. 13, 1949.

8. Frankenstein to Elmira Bier, Aug. 27, 1948. In correspondence with the TPC staff, Sept. 6, 1980, he states that he does not know the work's early history but reaffirms his belief in Halpert's involvement.

9. Frankenstein, 1949, 40.

10. Frankenstein to Elmira Bier, quoting Sheldon Keck, Oct. 12, 1947.

11. Frankenstein, 1949, 39–40; Lloyd Goodrich, "Harnett and Peto: A Note on Style," *Art Bulletin* 31, no. 1 (Mar. 1949), 57–58.

12. John Wilmerding, "Images of Lincoln in Peto's Late Paintings," *Archives of American Art Journal* 2 (Jan. 22, 1982), 3–12; see also Wilmerding, 1983, 187, 198–204.

13. Wilmerding, 1983, 208–9.

Major References
Alfred Frankenstein, "Harnett, True and False," *Art Bulletin* 31, Mar. 1949, 38–56.
———, *After the Hunt: William Harnett and Other American Still Life Painters, 1870–1900*, rev. ed., Berkeley, 1969.
———, *The Reality of Appearance: The Trompe-L'Oeil Tradition in American Painting*, exh. cat., Washington, D.C., NGA, 1970.
William H. Gerdts, *Painters of Humble Truth: Masterpieces of American Still Life, 1801–1939*, Columbia, Mo., 1981.
John Wilmerding, *Important Information Inside: The Art of John F. Peto and the Idea of Still-Life Painting in Nineteenth Century America*, exh. cat., Washington, D.C., NGA, 1983.
Olive Bragazzi, "The Story Behind the Rediscovery of William Harnett and John Peto by Edith Halpert and Alfred Frankenstein," *American Art Journal* 16, no. 2, Spring 1984.

TPC Sources
DP, essay for PMG.1941.4.
Cat., 1952.

JOHN KANE
1. Title: Taken from an announcement (collection of the estate of John Kane) of the Twenty-ninth Carnegie International Exhibition, annotated in the artist's hand "across the stripe [*sic*]." Provenance: Apparently Phillips first saw this painting at the International. He wrote to John O'Connor: "Please send photographs of . . . the John Kane in your International Exhibition. I am waiting to hear whether our offer of $150.00 was accepted by Kane. I wanted that particular picture and hope it has not been sold elsewhere. Might give a little more if he wasn't satisfied" (Oct. 21, 1930, TPC Papers, AAA, reel 1938, #0311). O'Connor to DP, Oct. 20, (Carnegie Papers, AAA, series 3500, reel N075): "This is to confirm to you the sale of the painting *Across the Strip*. . . . [It] cannot be delivered until after close of Exhibition on Dec. 7, 1930." The painting was sent after Dec. 22, 1930.

2. Undated brochure, Carnegie Institute, Pittsburgh Room.

3. Penelope Redd, "Pittsburgh Artist, Again Honored, Calm as His Works Stir Disputes," *Pittsburgh Sun-Telegraph*, Oct. 2, 1930.

4. Kallir, 1984, n.p.

5. Kane, 1971, 78.

6. For Kane's multiple views, see Kallir, 1984, n.p., and n. 11; see Janis, 1942, 85–88, for discussion of compressed views and Kane's habit of including friends.

7. Henry McBride, *Pittsburgh Sun-Telegraph,* Nov. 21, 1930.

8. DP, 1934, n.p.

Major References
Sketches of John Kane and scrapbook, the artist's family, courtesy of Galerie St. Etienne, New York.
Sidney Janis, *They Taught Themselves: American Primitive Painters of the Twentieth Century,* New York, 1942.
John Kane, "Sky Hooks," in *John Kane, Painter,* ed. Mary McSwigan, Pittsburgh, 1971; includes "A Catalogue Raisonné of Kane's Paintings," comp. Leon Anthony Arkus.
Carnegie Institute, Museum of Art, *American Primitives: Hicks, Kane, Pippin,* exh. cat., Pittsburgh, 1983.
Jane Kallir, *John Kane: Modern America's First Folk Painter,* exh. cat., New York, Galerie St. Etienne, 1984.

TPC Sources
ASD, 1931.
DP, [Classic or Romantic in Modern Landscape], paper presented at PMG, Mar. 14, 1934.
DP, "Freshness of Vision and Spontaneity in Painting," unpubl. text for slide lecture, ca. 1935; formerly part of MS 178.
Cat., 1952.
SITES 1979.

GRANDMA MOSES (ANNA MARY ROBERTSON MOSES)
1. Title: The title's spelling per Kallir, 1946, pl. 18, showing the title in the artist's handwriting; published as *McDonnell Farm* in Kallir, 1973, no. 313. Medium: The medium, previously published as tempera, is a very thin oil that has leeched into the house-paint ground applied by the artist (Jane Kallir in a telephone conversation with research curator, June 16, 1992). The term "pressed wood" instead of hardboard was used by the gallery to describe the support (see gallery label on painting reverse).

2. Other Moses paintings inspired by nursery rhymes or popular songs include *Turkey in the Straw,* 1940 or earlier (K30); *Jack and Jill,* 1947 (K718); *Mary and Little Lamb,* 1947 (K650); and *Over the River to Grandmother's House,* about 1941 (K87).

3. Many of these traced cut-outs were found in Grandma Moses's home after her death and are preserved at the Galerie St. Etienne.

4. Moses made a preparatory sketch for this painting (collection of the Galerie St. Etienne).

5. *Washington Star,* May 15, 1949; and *Grandma Moses: Anna Mary Robertson Moses (1860–1961),* exh. cat., NGA (Washington, D.C., 1979), 15.

Major References
Otto Kallir, ed., *Grandma Moses: American Primitive,* New York, 1946.

Otto Kallir, *Grandma Moses,* New York, 1973 (cited as "K" plus catalogue raisonné number).
Jane Kallir, *Grandma Moses: The Artist Behind the Myth,* exh. cat., New York, Galerie St. Etienne, 1982.

TPC Source
Cat., 1952.

HORACE PIPPIN

1. Provenance: Bill of sale, to the Downtown Gallery, Nov. 4, 1943, Carlen Papers, AAA, reel 4173, #0954; Downtown Gallery bill of sale to PMG, also Nov. 4, 1943.

2. DP to Edith Halpert, Dec. 4, 1943, TPC Papers, AAA, reel 1960, #0159; Phillips generally took works on approval, deciding on purchase after prolonged study of the painting.

3. The author wishes to thank Judith E. Stein, adjunct curator, PAFA, for pointing out the connection to Alfred Barnes and sending the text of Pippin's letter to Robert Carlen, Feb. 1, 1943, in which he writes: "I wish that the picture I just made will be in this show. . . . The picture is the *Domino Game* so that Dr. Albert Barnes can see it. He is the main speaker at the show"; as quoted in Stein et al., 1993, 27.

4. According to Stein et al., 1993, 143 n. 9, Pippin told Carlen, his dealer, that this painting depicts a scene from his own childhood.

5. This same blouse, possibly suggesting the same woman, reappears in *Saying Prayers,* 1943 (Brandywine River Museum, Chadds Forth, Penn.).

6. Conflicting stories indicate that either Pippin's mother, who died in 1911, or his grandmother witnessed John Brown's hanging in 1859; see Rodman, 1947, 17, and Rodman and Cleaver, 1972, 28. In *Three Self-Taught Pennsylvania Artists: Hicks, Kane, Pippin,* exh. cat., Museum of Art, Carnegie Institute (Pittsburgh, 1966), n.p., it is noted that Pippin was the son of a slave; it is possible that both Pippin's mother and grandmother were born into slavery.

7. *Saying Prayers,* 1943; *Sunday Morning Breakfast,* 1943 (private collection, New York). The clock and kerosene lamp on the shelf appear in all the paintings.

8. *Saturday Night Bath,* 1945 (formerly collection of Clifford Odets, Hollywood); *Christmas Morning Breakfast,* 1945 (Cincinnati Art Museum).

9. Provenance: Purchased in partial trade for Pippin's *Victorian Interior;* see invoice, Jan. 27, 1946, and payment in DP to Edith Halpert, Downtown Gallery, Aug. 5, 1946, which occurred at the time of the settlement of Pippin's estate. The returned painting was probably *Victorian Interior II,* signed and dated Apr. 12, 1945 (Metropolitan Museum of Art, New York, Arthur Hoppock Hearn Fund, Purchase 1958); for the cataloguing of the two versions, see Rodman, 1947, 86.

10. DP to Edith Halpert, Jan. 10, 1946 (TPC Papers, AAA, reel 1962, #1356).

11. Rodman, 1947, 9–10.

12. Judith Wilson, "Scenes of War," in Stein et al., 1993, 64.

13. *The Barracks,* 1945 (oil on canvas board, 8 × 10 in.; collection of Mr. and Mrs. Daniel Dietrich II), illustrated in Rodman, 1947, 23.

14. Rodman, 1947, 3.

Major References
The Horace Pippin Papers, AAA.
Selden Rodman, *Horace Pippin: A Negro Painter in America,* New York, 1947.
Selden Rodman and Carole Cleaver, *Horace Pippin: The Artist as Black American,* New York, 1972.
Carnegie Institute, Museum of Art, *American Primitives: Hicks, Kane, Pippin,* exh. cat., Pittsburgh, 1983.
Judith E. Stein et al., *I Tell My Heart: The Art of Horace Pippin,* exh. cat., Philadelphia, PAFA, 1993.

TPC Sources
Cat., 1952.
Cat. for TPC.1977.2.
MP, 1998.

4. MODERNISM IN FRANCE

Bonnard, Matisse, and the School of Paris

1. *Bull,* 1928, 17, 19.

2. DP, "Revolutions and Reactions in Painting," *International Studio* 51 (Dec. 1913), 129.

3. *C in M,* 1926, 6.

4. Ibid., 34.

5. Guillaume Apollinaire, "Andre Derain," in *Apollinaire on Art: Essays and Reviews, 1902–1918,* ed. Leroy C. Breunig (New York, 1972), 444–46.

6. As quoted in Ingrid Rydbeck, "At Bonnard's House in Deauville," *Konstrevy* (Stockholm), no. 4 (1937), as cited in *Bonnard/Matisse: Letters Between Friends,* preface by Jean Clair, introduction and notes by Antoine Terrasse, trans. Richard Howard (New York, 1992), 20.

7. DP, "Intimate Impressionists," in cat. for PMG.1926.5, n.p.

8. DP, "Leaders of French Art Today," in cat. for PMG.1927.7, n.p.

9. Ibid.

10. Ibid. *Anemones with a Black Mirror,* 1919 (private collection; traded in 1947).

11. As quoted in Pierre Schneider, *Matisse* (New York, 1984), 502.

12. DP, "Leaders of French Art Today," n.p.

13. *A & U,* 1930, 135, 144.

14. DP, "The Functions of Color," in cat. for PMG.1941.4, 30.

15. DP to Valentine Dudensing, June 12, 1944.

16. John Russell, "Art: World's Greatest in a New York Basement," *New York Times,* Dec. 9, 1983, C26.

17. *ASD,* 1931, 128, 125.

18. DP, "Leaders of French Art Today," n.p.

19. MP, 1982, 178.

20. As quoted in Antoine Terrasse, "Bonnard's Notes," in *Bonnard: The Late Paintings* (Washington, D.C., 1984), 70.

HENRI ROUSSEAU

1. Title: First French title from 1911 exhibition, second from Grand Palais, 1984. Roch Grey, *Henri Rousseau* (Rome, 1924), has the title *On the Banks of the Seine.* Christian Zervos, *Henri Rousseau* (Paris, 1927), has the

title *Vue de l'Ile Saint-Louis.* The artist "frequently entitled his works, 'view of . . . ' with a place name" (Shattuck, 1968, 89). Provenance: For Uhde ownership, see Certigny, 1961, 399, and 1984, no. 285. Robert Delaunay credited in Uhde's 1911 monograph; Sonia Delaunay in R. Delaunay, Aug. 1, 1952, no. 1: "After the death of Rousseau, when we were selling his studio, Delaunay bought ten canvases"; for Guillaume's ownership, Certigny no. 285 cites "Photographie de Routhier No. 27 dans les Archives de Paul Guillaume (1893–1934). Ni titre ni mention. Dimensions: 41 cm × 33 cm," and gives date as 1927; Valentine Gallery lists Guillaume as former owner (Valentine Dudensing to DP, n.d.); PMG sale date recorded by Dudensing as Dec. 11, 1930. Unidentified label on painting reverse: *Ch. Pottier, Paris.*

2. Shattuck, 1968, 97. Another work, *Myself, Portrait-Landscape,* 1890 (National Gallery, Prague), shares with this painting a city scene, here shown in the background; see Shattuck et al., 1985, 38 and 106, cat. no. 5. See also pp. 234–36 for a comparison of the landscape in the two paintings.

3. *La vue de l'Ile Saint-Louis prise du Quai Henri IV,* 1909 (oil on paper laid down on canvas, 8⅝ × 11⅛ in.; private collection, Rhode Island).

4. As quoted by Rich, 1946, 58.

5. For quay wanderings and photography, see Shattuck, 1968, 48 and 100; see Certigny, 1984, 610, for a contemporary postcard of the scene.

6. Adolphe Basler, *Les albums d'art Druet Henri Rousseau,* Paris, 1930, 2 (author's trans.): "rend la mélancholie vespérale du Quai Henri IV, alors que se répondent, au-dessus du fleuve, le mât d'une péniche et la flèche élancée de Notre Dame."

7. Paris, Musée National d'Art Moderne, Centre Georges Pompidou. Delaunay owned (or might even have purchased) *Notre Dame* during the creation of *The City of Paris.* In the 1920s the Delaunays gave up their collection of Rousseaus for financial reasons. Michel Hoog, "La Ville de Paris de Robert Delaunay; Sources et développement," *La revue du Louvre* 1 (1965), 29–38. Hoog emphasizes the uncertainty of the present work's direct influence on Delaunay (correspondence with author, May 11, 1989).

8. Kandinsky wrote Delaunay complimenting him on his superb collection of Rousseaus after seeing Uhde's monograph, where *Notre Dame* is reproduced; see Shattuck et al., 1985, 69.

9. Curt Glaser, "Die XXIV. Ausstellung der Berliner Secession," *Die Kunst* (June, 1912), 420.

10. According to Carolyn Lanchner and William Rubin, "Henri Rousseau and Modernism," in Shattuck et al., 1985, 72, the image may have inspired Max Beckmann's painting *Iron Footbridge in Frankfurt,* 1922 (Düsseldorf, Kunstsammlungen Nordrhein-Westfalen).

11. Arnold Wiltz (1889–1937), *Along the Seine,* 1928 (acc. no. 2135).

12. DP, 1930, n.p.

13. Stieglitz showed Max Weber's Rousseau collection in Nov.–Dec. 1910; the painting was also included in the Armory Show of 1913. On waning influence, see Sheldon Cheney, *A Primer of Modern Art,* 10th ed., rev. (New York, 1939), 130.

Major References
Wilhelm Uhde, *Henri Rousseau,* Paris, 1911.

Philippe Soupault, *Henri Rousseau le douanier*, Paris, 1927.

Daniel Catton Rich, *Henri Rousseau*, rev. ed., exh. cat., New York, MOMA, 1946.

Robert Delaunay, "Mon ami Rousseau," *Les lettres françaises*, Aug.–Sept., 1952.

Jean Bouret, *Henri Rousseau*, Neuchâtel, 1961.

Henry Certigny, *La vérité sur le Douanier Rousseau*, Paris, 1961; supplementary eds. published ca. 1966 and 1971.

Roger Shattuck, *The Banquet Years*, New York, 1968.

Dora Vallier, *Tout l'oeuvre peint de Henri Rousseau*, Paris, 1970.

Henry Certigny, *Le douanier Rousseau et son temps: Biographie et catalogue raisonné*, 2 vols., Tokyo, 1984.

Roger Shattuck et al., *Henri Rousseau*, exh. cat.; English ed., New York, MOMA, 1985.

Henry Certigny, *Le douanier Rousseau et son temps: Catalogue raisonné*, Tokyo, 1990, supplement no. 2.

Werner Schmalenbach, *Henri Rousseau: Dreams of the Jungle*, trans. Jenny Marsh, Munich, 1998.

TPC Sources
A & U, 1930.
DP, essay for PMG.1930.8.
ASD, 1931.
DP, "Freshness of Vision and Spontaneity in Painting," text for slide lecture, ca. 1935; formerly part of MS 178.
Stephen B. Phillips, cat. for TPC.1997.4.
MP, 1998.
MS 83.

PIERRE BONNARD

1. Quote in a ca. 1964 draft of a letter to Charles Wheeler, president, Royal Academy of Arts, London. The author wishes to thank Antoine Terrasse, who has generously provided his expertise. The tireless research of Maria Dolores Jiménez-Blanco, visiting fellow at the TPC research office, is also noted with appreciation.

2. Bonnard to DP (postmarked at arrival, Aug. 7, 1931; author's trans.): "Je suis très touché de l'intérêt que vous prenez à ma peinture malgré de grands défauts que s'y trouvent—Je travaille toujours avec le souci de corriger ma manière et il ne m'est pas indifférent de savoir que certains esprits me suivent dans cet effort." Two additional letters exist, one undated, the other written Sept. 28, 1942.

3. DP, cat. for PMG.1927.7, n.p. Purchased in 1927 were *Children and Cat*, 1909, *Interior with Boy*, 1910, *The Lesson* and *Grape Harvest*, both 1926, and *Woods in Summer*, 1927.

4. DP, "Modern Art and the Museum," 1931, 276. Marjorie Phillips, whose own work shows Bonnard's influence, probably played a major role in assembling the unit. Phillips acquired *Moulin Rouge* in 1927 (1896, oil on canvas, 23¼ × 16; Wright Luddington collection, Santa Barbara, Calif.) but sold it in the early 1940s.

5. The first gallery showing in the United States, including several Phillips loans, was at de Hauke, New York, Apr. 6–28, 1928. The first one-person exhibition in an American museum was PMG.1930.13; the drawings were shown in PMG.1937.7 and PMG.1937.12 (see cat. for TPC.1984.4, 268–75).

6. Phillips, discussing his purchase of *The Palm* and *The Riviera* in *Bull.*, 1929, 31.

7. DP, 1949, 564.

8. *Bull.*, 1931, 70.

9. The four drawings are *Ants, Cows under a Tree, Grasshoppers,* and *Canaries* from Jules Renard, *Histoires naturelles* (Flammarion, Paris, 1904). The other drawing in the collection is *The Woodchopper*, ca. 1920, an illustration for André Gide's *Le Prométhée mal enchaîné*, Paris, 1920 (courtesy of Antoine Terrasse). The works from *Quelques Aspects* include the lithographs *The Square at Evening* and *Boulevard*.

10. An unidentified work, *The Nude*, appears in Ledger 15 as having been purchased in 1929; whereabouts unknown.

11. *Circus Horse* (oil on canvas, 37 × 46½ in.; private collection) was presented in "a one painting loan exhibition" (TPC.1965.2). At the end of the loan, Phillips renewed his plea (Dec. 2, 1963, and Apr. 26, 1965) but was again refused.

12. For "peintre-enfant," see Claude Roger-Marx, "Pierre Bonnard," *Les peintres français nouveau* (no. 19, 1924), 11 (freely translated and condensed in *Bull.*, 1927, 17–18).

13. Christopher Green, *Cubism and Its Enemies* (New Haven, 1987), 153, points out that the myth of cubism's collective nature was propagated by Albert Gleizes during this period, and that this movement was aligned against the supporters of Dufy, Matisse, and Bonnard. For Phillips on Bonnard's naïveté, see *C in M*, 1926, 53.

14. DP to John Walker, Harvard Society for Contemporary Art, Feb. 25, 1929, regarding "An Exhibition of The School of Paris, 1910–1928," Mar.–Apr., 1929. Phillips continued optimistically: "Bonnard and Derain will eventually outrank the fashionable celebrities Matisse and Picasso."

15. DP, "Modern Art and the Museum," 1931, 276.

16. DP, 1949, 563.

17. Date/Title: Date and French titles per Dauberville 1, no. 156; Ives et al., 1989, 124–25, date the work 1896–97. Medium: Dauberville states oil on wood; however, the wood cradling that supports the cardboard may have been added later (inspection by Elizabeth Steele, painting conservator, Aug. 1992). Provenance: Hessel ownership per Dauberville, no. 156, and Tristan Bernard, "Jos Hessel," *La Renaissance* 13 (Jan. 1930), French and English versions, pp. 2–5 (illus. as *Une Rue*). Decision to buy per DP to Carstairs, Nov. 23, 1937; bill of sale Feb. 8, 1938.

18. As cited in André Fermigier, *Pierre Bonnard* (New York, 1987), 27.

19. Ives et al., 1989, 124. The first window view appears in *Rue de Parme on Bastille Day*, 1889 (oil on canvas, 79.4 × 40.0 cm.; collection of Mr. and Mrs. Paul Mellon, Upperville, Va.).

20. Bonnard expressed this view in 1937; cited in Antoine Terrasse, "Matisse et Bonnard: 40 ans d'amitiés," *Revue de l'art* 64 (1984), 79.

21. Boyer, 1988, 1. In 1896 Bonnard designed sets and masks for Alfred Jarry's play *Ubu roi*.

22. For Bonnard's ownership of Japanese prints, see Ives, "An Art for Everyday," in Ives et al., 1989, 14–15.

23. The lithograph is no. 70 in Francis Bouvet, *Bonnard: The Complete Graphic Work* (New York, 1981), as *Street Corner Seen from Above*, 1899 (lithograph in four colors, 36.0 × 21.0 cm.). See also Ives et al., 1989, 124 (as *Narrow Street Viewed from Above*, 1896–97).

24. The triptych—*Les Ages de la Vie*, ca. 1896 (73 × 110 cm; formerly in the collection of Jos Hessel; Dauberville 1, no. 136)—depicted rue Tholozé, place Clichy, and place Pigalle. The present view is more contained and less detailed.

25. DP, 1949, 562.

26. Date: Bonnard signed the work and dated it 1910 on his visit to PMG in 1926; Dauberville's date, 1908, is deduced from style, provenance, and exhibition history. Title: Alternate French titles per Dauberville 2, 1968, cat. no. 508. Provenance: Unnamed intermediate owner (and date of 1923) from Bernheim-Jeune to DP, Oct. 31, 1925. *Early Spring*, along with *Dining Room* (*Après le dîner*) and *Woman in a Landscape* (*Paysage*), was sent on approval per shipping invoice, Nov. 24, 1925. Decision to purchase *Early Spring* and *Woman with Dog*, DP to Bernheim-Jeune, Dec. 12, 1925; bill of sale July 27, 1926.

27. Title: French titles and date per Dauberville; Salon d'Automne, 1919, dated it 1919; early TPC records erroneously date it 1911. Provenance: Bill of sale (as *La Grande Terrasse*), shipping notice, and receipt of first payment Aug. 10, 1935. This is the only Bonnard painting Phillips purchased in Paris.

28. According to Ives, "An Art for Everyday," 14, Bonnard "owned prints by Hiroshige, Toyokuni, Kunisada, and Kuniyoshi, which he tacked to his walls in Paris in the 1890s and still had on hand at his Mediterranean villa in the 1940s"; see p. 15 for Brassaï's 1946 photograph of Bonnard's Le Cannet studio, adorned with reproductions, including a Japanese print in which arabesque tree branches create an undulant surface pattern.

29. Bonnard had rented a house in Vernouillet during this period. The same garden appears in Dauberville 2, no. 504, *Après le dîner*, and no. 509, *L'Orage (Vernouillet)*, both of 1908, and no. 540, *Premier printemps*, 1909.

30. DP, PMG.1941.4, 43.

31. Bonnard's preoccupation with plastic form is evidenced by his foray into sculpture in 1906–7.

32. See, for example, *Advent of Spring (Small Fauns)*, 1909 (oil on canvas, 103 × 126 cm.; Hermitage, St. Petersburg; Dauberville 2, no. 540).

33. Watkins, 1994, 89.

34. MP, 1982, 74.

35. From 1916 to 1920 Bonnard worked on a commission of four large pastoral panels for Bernheim-Jeune, a project that may have inspired this work.

36. This complex structure reflects Bonnard's mid-decade retrenchment, when he returned to an emphasis on drawing, form, and composition in the belief that color had taken too central a place in his work.

37. This rare vignette contradicts David Sylvester's observation that "after 1905, Bonnard never painted a couple"; see "Painting of the Month—March: The Table—Pierre Bonnard," *Listener* (Mar. 15, 1962), 479.

38. James R. Mellow in "Bonnard," *Arts Magazine* 39 (Nov. 1964), 39, identified one of the artist's dominant themes as "at one pole the rank profusion of nature and at the other the rigid structuring of civilized life; the charming disorder of the garden and that rectitude with which architectural conventions structure our lives."

39. Steele, Aug. 1991.

40. Title: French title *Soleil d'avril* (possibly the artist's) and date per Dauberville. Titled *L'Eté* in Roger-Marx, *Pierre Bonnard*, 59. Phillips erroneously dated it 1922 in his *Kenyon Review* article, 1949, caption to plate following p. 566. Provenance: Early history as cited in Dauberville; Seligmann purchase from Bésnard for resale to PMG per correspondence between DP and de Hauke at Seligmann, Oct. 17 and 25, 1930.

41. See also *Fenêtre ouverte sur la Mer*, ca. 1919 (oil on canvas, 52.0 × 38.5 cm.; private collection), illus. in Raymond Cogniat, *Bonnard* (Paris, 1989), 48.

42. Quotation from Shirley Neilsen Blum, "The Open Window: A Renaissance View," in *The Window in Twentieth Century Art*, exh. cat., Neuberger Museum (Purchase, N.Y., 1986), 14; see also the essay in this catalogue by Suzanne Delehanty, "The Artist's Window," 17–28.

43. See, for example, *Dining Room in the Country*, 1913 (164.5 × 205.7 cm.; Minneapolis Institute of Arts, John R. Van Derlip Foundation); Antoine Terrasse, writing to author, Jan. 27, 1992, confirmed the location.

44. The sketch is reproduced in Jean Clair's chronology in *Pierre Bonnard*, exh. cat., Palazzo Reale (Milan, 1988), 185; no credit line is given. See Whitfield and Elderfield, 1998, cat. no. 42.

45. The artist as quoted by Antoine Terrasse, "Bonnard the Draftsman," in *Bonnard: Drawings from 1893–1946*, exh. cat., AFA (New York, 1972), n.p.

46. Cited in Michel Benedikt, "The Continuity of Pierre Bonnard," *Art News* 63 (Oct. 1964), 23.

47. Bonnard in conversation with Hans R. Hahnloser, as cited in Hahnloser's memoir, in Vaillant, 1965, 165.

48. For Bonnard's struggles with form and color, see, for example, Antoine Terrasse, "Chronology," in TPC.1984.4, 252.

49. See Matisse's *Studio, Quai Saint-Michel* (cat. no. 109).

50. DP, ca. 1936–42, version 1, 72.

51. Jean Clair, "The Adventures of the Optic Nerve," in Newman et al., 1984, 44 and 46–50, draws parallels between Bonnard and these artists. Fermigier, *Pierre Bonnard*, 35, discerns a debt to cubism in this work.

52. Title: French title from Dauberville. Titled *La Petite Fille au basset* in Germain Bazin, "II.—Bonnard," *L'amour de l'art* 14, no. 4 (Apr. 1933), 84. Provenance: Per Dauberville; decision to purchase, DP to Bernheim-Jeune, Dec. 12, 1925.

53. A related sketch appears as *Jeune Femme assise et chien*, in TPC.1984.4, 152.

54. On Bonnard's infidelity, see Margrit Hahnloser-Ingold, "Pierre Bonnard," *Du* 1 (1985), n.p., and Whitfield and Elderfield, 1998, 26 and cat. no. 43; Vaillant, 1965, 182, notes that Marthe began to suffer from mental disturbances in the 1920s. Whitfield in Whitfield and Elderfield, 1998, 26–27, discusses the sources and progression of Marthe's ill health.

55. Marthe appears in the red striped shirt in several oil paintings, including *Reine Natanson et Marthe Bonnard au corsage rouge*, 1928 (oil on canvas, 73.0 × 57.0 cm.; Musée Nationale d'Art Moderne, Centre Georges Pompidou, Paris, legacy Reine Natanson).

56. Steele, May 10, 1991.

57. *ASD*, 1931, 126.

58. Title: First French title and date per Dauberville; second French title from bill of sale and first known exhibition. Phillips erroneously titled and dated the work "*Southern France* 1928" on the painting file. Provenance: Claude Anet (pseud. for Jean Schopfer) wrote the catalogue introduction to de Hauke's 1928 exhibition and owned the picture (per catalogue) at the time. De Hauke purchase (for resale to PMG) per correspondence between de Hauke and DP, Mar.–June 1928, TPC Archives. Decision to purchase June 18, 1928; bill of sale July 3, 1928.

59. Title: French title per Dauberville and bill of sale. Provenance: Purchase agreement between de Hauke and Fénéon, May 18, 1928, at PMG behest (Seligmann papers, de Hauke foreign correspondence, Félix Fénéon folder, AAA); de Hauke bill of sale, May 30, 1928.

60. First quotation from TPC.1984.4, 251, citing Bonnard in 1944; for quote (from a 1923 letter) and general discussion of Bonnard's vantage points, see Vaillant, 1965, 183.

61. This site also appears in the drawing *L'Esterel*, ca. 1923 (16.0 × 12.5 cm.; location unknown), see Terrasse, 1988, pl. 34; and in *La Baie de Cannes*, ca. 1935 (oil on canvas, 67.0 × 53.0 cm.; private collection, Paris).

62. The exact vantage points have not been identified. According to Antoine Terrasse, Bonnard's homes in Le Cannet were Villa L'Hirondelle in 1923 and Le Rêve in 1925 and 1926. He purchased Le Bosquet in 1926 but did not move in until February 1927; correspondence with author, Jan. 26 and 27, 1992.

63. A photograph of Bonnard's studio at Le Cannet (see Watkins, 1994, 210) shows numerous images tacked to the wall, including postcards with color views of the region, as well as silver foil fragments that he may have used to study reflections (per Evelyne Pomey, caption in "Georgette Chadourne: Six Photos de Bonnard," *Cahiers du Musée d'Art Moderne* 13 [1984], 90; photo p. 92).

64. Bonnard explored the framing device of foliage throughout his career, in paintings such as *Vue Panoramique*, 1894 (31½ × 57½ in.; private collection); *Symphonie Pastorale*, 1916–20 (51⅛ × 63 in.; formerly Bernheim-Jeune, Paris); and *Bord de Seine*, ca. 1928–30 (14½ × 21 1/2 in.; collection of Walter Scharf).

65. MP, 1979, 79–80.

66. DP, PMG.1928.4a, 29.

Major References
Thadée Natanson, *Le Bonnard que je propose*, Geneva, 1951.
Annette Vaillant, *Bonnard, with a Dialogue Between Jean Cassou and Raymond Cogniat: Commentaries by Hans R. Hahnloser*, Greenwich, Conn., 1965.
Jean Dauberville and Henri Dauberville, *Bonnard: Catalogue raisonné de l'oeuvre peint*, 4 vols., Paris, 1965–74; rev. and enl. Michel Dauberville and Guy-Patrice Dauberville, Paris, 1992.
Francis Bouvet, *Bonnard: The Complete Graphic Work*, New York, 1981.
Sargy Mann, *Drawings by Bonnard*, Arts Council of Great Britain, 1984.
Philippe Néagu and Françoise Heilbrun, *Pierre Bonnard photographe*, Paris, 1987.
Patricia Eckert Boyer, ed., *The Nabis and the Parisian Avant-Garde*, exh. cat., New Brunswick, N.J., Jane Vorhees Zimmerli Art Gallery, 1988.
Antoine Terrasse, *Pierre Bonnard*, Paris, 1988.

Colta Ives et al., *Pierre Bonnard: The Graphic Art*, exh. cat., New York, Metropolitan, 1989.
Henri Matisse and Pierre Bonnard, *Correspondence, 1925–1946*, Paris, 1991.
Bonnard/Matisse: Letters Between Friends, preface by Jean Clair; introduction and notes by Antoine Terrasse; trans. Richard Howard, New York, 1992.
Monika von Hagen, ed., *Bonnard*, exh. cat., Munich, Hypo-Kulturstiftung, 1994.
Nicholas Watkins, *Bonnard*, London, 1994.
Sarah Whitfield and John Elderfield, *Pierre Bonnard*, exh. cat., London, Tate, and New York, MOMA, 1998.

TPC Sources
C in M, 1926.
Bull., 1927 and 1928.
DP, essay for PMG.1928.4a–c.
DP, "Art in Washington: The Phillips Memorial Gallery," *Forerunner of the General Convention, A.D. 1928*, no. 2, Easter 1928, 18–24.
A & U, 1929 and 1930.
Bull., 1929.
CA, 1929.
DP, "Modern Art and the Museum," *American Magazine of Art* 23, no. 4, Oct. 1931, 271–76.
ASD, 1931.
Bull., 1931.
Formes, 1932.
DP, [Classic or Romantic in Modern Landscape], paper presented at PMG, Mar. 14, 1934.
DP, "Freshness of Vision and Spontaneity in Painting," text for lecture, ca. 1935; formerly part of MS 178.
DP, "The Expression of Personality Through Design in the Art of Painting," unpubl. slide lecture, 8 versions, ca. 1936–42.
DP, essays in PMG.1941.4.
DP, "Freshness of Vision and Spontaneity in Painting," unpubl. essay, ca. 1945; formerly part of MS 178.
DP, "Pierre Bonnard," *Kenyon Review* 11, Fall 1949, 561–67 (reprinted in cats. for TPG.1958.2 and TPC.1967.1).
Cat., 1952.
MP, 1970 and 1982.
Sasha Newman et al., cat. for TPC.1984.4.
Stephen B. Phillips, cat. for TPC.1997.4.
MP, 1998.
MS 103.

EDOUARD VUILLARD

1. Duncan Phillips also owned Vuillard's *Intimacy*, ca. 1902, from 1926 to 1940, and *La Visite*, 1900, from 1943 to 1953.

2. DP, *AMA*, Apr. 1935, 218–19.

3. DP, PMG.1927.7, n.p.

4. Date: Date according to Antoine Salomon and Juliet Bareau based on location and room depicted; see Juliet Bareau to author, Nov. 6, 1988. Salomon (letter to Charles Moffett, Aug. 23, 1993) uses the title *Les Deux Tables*. Provenance: Georges Moos ownership verified by the family. According to their records, the work was sold in 1949 to a Mr. or Mrs. Colin, but this has not been verified; see Maryam Ansari to author, June 13, 1987, and Mrs. Ralph F. Colin to author, Jan. 28, 1988. Bill of sale, Mar. 24, 1954.

5. Information on the room and residence depicted in this work per Bareau to author, Nov. 6, 1988.

6. Published in facsimile ed. of Vuillard's album in Salomon and Vaillant, 1950, 5. Juliet Bareau, in a letter to the author, Nov. 6, 1987, writes that the album includes studies made in 1894 in connection with the *Jardins public* decorative panels.

7. What appear to be halos of oil paint seeping into the cardboard in sections of the image are in reality exposed areas of light brown underpainting, per Elizabeth Steele, painting conservator, Aug. 30, 1992.

8. According to Easton, TPC.1990.2, 26, Mme Vuillard was a corsetmaker; however, the artist never depicted her as such.

9. Medium: *Nurse with a Child in a Sailor Suit* is one of the relatively rare oils on cardboard that have not subsequently been mounted onto a cradled wood panel. The paint appears particularly matte because the artist used a very lean medium; see Steele, Aug. 30, 1992. Provenance: Provided by M. Knoedler and Co., 1987. Alfred Sutro was a French playwright and collector.

10. During the 1890s Vuillard created illustrations and posters for *La revue blanche*. He developed friendships with others involved with the publication, including Bonnard and Mallarmé, and absorbed some of the revolutionary cultural ideas that it advocated.

11. The Japanese print was most successfully interpreted by Bonnard, whose screen *Promenade of Nurses: Frieze of Fiacres,* 1897 (color lithograph on four panels, each 53¼ × 17¾ in.; Museum of Modern Art, New York), depicts the motif in the *japoniste* style.

12. Steele, Aug. 30, 1992.

13. Date: Date assigned by Salomon and Bareau based on the room and location depicted; see Bareau to author, Nov. 6, 1987. Title: In *Madame Vuillard lisant le journal, Rue Truffaut* the location was erroneously assigned by Salomon, 1968; in fact, the location was 342 rue Saint-Honoré. The Vuillards did not move to rue Truffaut until 1899; see Bareau to author, Nov. 6, 1987. Medium: The painting is adhered to a cradled wood panel, and the image is heavily varnished; see Steele, Sept. 21, 1990. Provenance: In Bernheim-Jeune, *Exposition Vuillard* (Nov. 1908), reprinted in Donald E. Gordon, *Modern Art Exhibitions, 1900–1916* (Munich, 1974), 286, Hessel is listed as the owner of *Femme lisant,* a fact supported by the handwritten inscription on the back of painting. Félix Fénéon is cited in provenance of the 1968 Haus der Kunst exhibition catalogue, p. 90; however, no further documentation has been found. Seligmann bill of sale, Oct. 25, 1929.

14. Date: Date assigned by Salomon and Bareau. According to Bareau (letter to author, Nov. 6, 1987), the scene represents the apartment at 28 rue Truffaut, occupied in March 1899; by 1901 the wallpaper shown here had been replaced by a different pattern. Medium: According to Steele, Aug. 30, 1992, the painting is mounted on a cradled wood panel; some elements of the composition—the door on the left, sections of the foreground table, and areas over the bureau—appear matte in comparison to the rest of the painting. Examination using ultraviolet light reveals that these matte passages are artist's retouchings, applied over a thin layer of natural resin varnish. Provenance: For Louis Bernard-Goudchaux's ownership, see Bernheim-Jeune, *Exposition Vuillard,* reprinted in Gordon, *Modern Art Exhibitions,* 286. Its purchase by Galerie Bernheim-Jeune and later by Josse Bernheim is recorded in the Bernheim-Jeune records. Jacques Seligmann is recorded in J. P. Morgan and Co. to Jacques Seligmann, Feb. 28, 1938. Bill of sale to PMG, Feb. 15, 1939.

15. Information on the rooms and residences depicted in these works per Bareau to author, Nov. 6, 1987.

Major References
Journals of Edouard Vuillard, Paris, Bibliothèque de l'Institut de France.
Claude Roger-Marx, *Vuillard et son temps,* Paris, 1945.
Jacques Salomon, *Vuillard, témoignage,* Paris, 1945.
Jacques Salomon and Annette Vaillant, *Edouard Vuillard: Cahier de dessins,* Paris, 1950.
Jacques Salomon, *Auprès de Vuillard,* Paris, 1953.
———, *Vuillard admiré,* Paris, 1961.
———, *Vuillard,* Paris, 1968.
John Russell, *Vuillard,* Greenwich, Conn., 1971.
Ann Dumas and Guy Cogeval, eds., *Vuillard,* Paris, 1990.
Kunsthaus and Galeries nationales du Grand Palais, *Nabis, 1888–1900: Bonnard, Vuillard, Maurice Denis, Vallotton,* exh. cat., Zurich and Paris, 1993.
Gloria Groom, *Edouard Vuillard, Painter-Decorator: Patrons and Projects, 1892–1912,* New Haven, 1993.

TPC Sources
DP, cat. for PMG.1927.7.
Bull., 1931.
ASD, 1931.
AMA, 1935.
Cat., 1952.
MD, 1981.
John Russell, intro. for TPC.1981.1.
Elizabeth Easton, cat. for TPC.1990.2.
MP, 1998.

HENRI MATISSE

1. DP, "Revolutions and Reactions in Painting," *E of A,* 1914, 66, adapted from the 1913 version published in *International Studio* and thus probably a reaction to Matisse's Armory Show pieces.

2. DP, *E of A,* 1927, 46 n. 1. Phillips's footnote is actually dated Nov. 1926.

3. For an overview, see Margrit Hahnloser-Ingold, "Collecting Matisses of the 1920s," NGA (Washington, D.C., 1986), 235–74. These works included three 1926 purchases: *Anemones* (unidentified) and *Girl in Chair* (location unknown), both traded in 1927 for *Anemones with a Black Mirror,* 1919 (private collection), which in turn was traded in 1947 (see DP to Dudensing, Nov. 10 and 21, 1927, and Ledger 11), and *Paysage (Path at Nice),* ca. 1918 (location unknown), traded in 1936; and *Woman at the Window* (n.d.), purchased and traded in 1928.

4. Homer Saint Gaudens, the Carnegie director, accompanied the members of the jury to the museum in late September 1930; see Saint Gaudens to DP, Sept. 10 and 16, 1930. The anecdote regarding Matisse's response to Bonnard and the American painters is from MP, 1982, 177–78.

5. This picture is known in TPC records as *Le Torse,* 1919 (Museu de Arte de São Paulo); purchased in 1934, traded in 1942. Other late acquisitions were *Le Sylphide,* 1926 (Mr. and Mrs. Peter Meltzer, New York), purchased in 1946, traded in 1947; *Arabesque* (unidentified), acquired by 1927, date of sale or trade unknown; and *The Dancer,* ca. 1920 (unidentified), purchased in 1946, traded in 1947. Differing measurements and provenances indicate that the Meltzer pic-

ture and the one known as *The Dancer* in TPC records may not have been the same.

6. DP, *ASD,* 1931, 8. Interestingly, Matisse defended himself against this appraisal, shared by other critics, in 1951: "It is said that my art comes from the intellect. That is not true. All that I have done, I have done from passion," author's trans.: "On dit que mon art vient de l'intelligence. Ce n'est pas vrai. Tout ce que j'ai fait, je l'ai fait par passion"; as quoted in Antoine Terrasse, "Matisse et Bonnard: Quarante ans d'amitié," *Revue de l'art* 64 (1984), 82.

7. In 1947, when Phillips traded *Anemones with a Black Mirror* and *The Dancer* to Pierre Matisse in exchange for Rouault's *Verlaine* (cat. no. 114), he wrote (Jan. 27, 1947), "I can let you have both these exquisite examples of your father's art since we have his acknowledged masterpiece in *The Studio, Quai Saint-Michel.*"

8. Ink on paper, acquired 1957, acc. no. 1303.

9. Date: According to Barr, 1951, 177, 191n and 529, Madame Matisse, in response to a questionnaire, said this work was created "late in 1916." The date given in Centre Georges Pompidou, 1993, cat. no. 145, 404, is end of 1916–spring 1917. Title: Pierre Matisse, bill of sale, Nov. 13, 1940, says it was "also known as *The Studio.*" *Le repos du modèle,* per "London Letter: Matisse Canvases in Soho Night Club," *Art News* 27 (Mar. 2, 1929), 25. See other alternates in exhibition catalogues. Medium: According to Sheldon and Carolyn Keck's examination (Jan. 28, 1952), before lining, an inscription on the painting's reverse in gray crayon or chalk read: *Henri Matiss* [sic] / *intérior d'atelier.* This may be the source of the notation in Galeries Georges Petit, *Henri Matisse* (Paris, 1931), cat. no. 36: "signed on back." Provenance: History per Centre Georges Pompidou, 1993, 404, 513–14, and Claude Duthuit, Paris, per conversation with author, May 9, 1990. Date of transfer from Coleman to Tennant per "London Letter," 25, where the painting is described in great detail and referred to as "the latest addition [to the Tennant collection] . . . entitled *Le repos du modèle.*" Lawrence Gowing recalled having seen the painting at Redfern Gallery, London, in the 1930s, but no records remain (conversation with author, Apr. 23, 1990). Tennant's sale of the work to Cooper, and of Cooper to Clark, per Michael Luke, *David Tennant and the Gargoyle Years* (London, 1991), 145. Bill of sale from Pierre Matisse Gallery, Nov. 13, 1940.

10. Barr, 1951, 181. Matisse's response to cubism began around 1913; see Lisa Lyons, "Matisse at Work: 1914–1917," *Arts Magazine* 49 (May 1975), 74–75.

11. On Matisse's reaction to the war, see Barr, 1951, 178.

12. Henri Matisse interview with André Verdet cited in Flam, 1988, 133.

13. Matisse had rented this studio since 1913; earlier, between 1891 and 1908, he had periodically lived in the same building.

14. See also *Lorette Reclining,* late 1916–spring 1917 (oil on canvas, 95 × 196 cm.; private collection). Barr, 1951, 191, suggests that *Studio, Quai Saint-Michel* preceded *Lorette Reclining,* but according to Centre George Pompidou, 1993, cat. no. 146, the two paintings were contemporaneous. *Etude pour "L'Atelier, Quai St. Michel,"* 1916 (collection of Charles Tomasini, Paris), is a small drawing of the studio and model that almost certainly preceded this painting; see Schneider, 1984, 438.

15. *Interior with a Goldfish Bowl,* 1914 (oil on canvas, 147.0 × 97.0 cm.; Musée National d'Art Moderne, Cen-

tre Georges Pompidou, Paris).

16. Courbet: Musée d'Orsay, Paris.

17. On Matisse's self-scrutiny, see Lawrence Gowing, *Matisse* (New York), 1979, 106–7.

18. Corot: Musée des Beaux Arts, Lyon, France. Schneider, 1984, 126, suggests the inspiration of Corot, who treated the studio theme in at least five other canvases.

19. That Matisse kept a great number of works in his studio is documented by photographs from the period. Matisse rarely included works by other artists in his paintings, with the exception of antique and primitive sculpture and textiles. The central image, because of its cylindrical top and hovering horizontal forms, may be one of his recently produced goldfish paintings.

20. In *The Red Studio* (oil on canvas, 181.0 × 219.0 cm.; Museum of Modern Art, New York, Mrs. Simon Guggenheim Fund), only the painted images and plants retain their local color; all else is flat, removed from reality, and monochromatic. Flam, 1988, 439, describes the "gaseous" quality of the wall surface.

21. Clara T. MacChesney, "A Talk with Matisse," *New York Times Magazine,* Mar. 9, 1913; reprinted in Flam, 1988, 133.

22. Observation on the atmosphere and the artist's mood from Nicholas Watkins, *Matisse* (Oxford, 1984), 138.

23. *The Painter in His Studio,* 1917 (oil on canvas, 146.5 × 97.0 cm.; Musée National d'Art Moderne, Centre Georges Pompidou, Paris). Moroccan triptych: Pushkin Museum, Moscow. See Centre Georges Pompidou, *La collection du Musée national d'art moderne* (Paris, 1987), 410.

24. It appears that Matisse altered the position, shapes, and colors of many elements. Reported in Pierre Matisse to DP, Dec. 1, 1951. Analyses confirm that reworking took place in this area, as well as in the floor and the green area below the window. Here, fast-drying paint applied over slower-drying areas created drying cracks, which reveal earlier applications of paint whose colors contrast strikingly with those visible on the surface. Textures in the paint film that do not correspond with the present image also suggest changes in, for instance, the bedspread, the area above the chair, and the hanging pictures. See technical analysis by Elizabeth Steele, painting conservator, Sept. 25, 1991, and conservation report, Sheldon and Carolyn Keck, Jan. 28, 1952.

25. "Matisse's Radio Interviews," 1942, published in Barr, 1951, 562. On Matisse's window theme, see Suzanne Delehanty, "The Artist's Window," *The Window in Twentieth-Century Art,* exh. cat., Neuberger Museum (Purchase, N.Y., 1986).

26. Barr, 1951, 191, pairs the present work with a "pendant" of the same size, *The Window,* 1916 (Detroit Institute of Arts).

27. Flam, 1986, 197–98.

28. Fry to Vanessa Bell, Dec. 14, 1921, called it one of Matisse's most beautiful works, in Denys Sutton, ed., *Letters of Roger Fry* (London, 1972), vol. 2, 518, as cited (trans. into French) in Centre Georges Pompidou, 1993, 513. Kenneth Clark, *Another Part of the Wood: A Self-Portrait* (London, 1974), 194.

29. Robert T. Buck Jr., *Richard Diebenkorn: Paintings and Drawings, 1943–1976,* exh. cat., Albright-Knox Art Gallery (Buffalo, 1976), 6.

30. For curtain and ambivalence, see Leymarie et al., 1966, 14.

31. Title: First French title possibly the artist's; the second, Schneider, 1984, 21. Provenance: Bill of sale under English title, Pierre Matisse Gallery to DP, Jan. 19, 1950.

32. The curtain itself, now in a Detroit private collection, dates to ca. 1900; it is pictured in a photograph of the artist in Vence, taken by Henri Cartier-Bresson, which is illustrated in Gérard Durozoi, *Matisse* (Paris, 1989), 30. *Interior with Window and Palm,* 1948 (private collection), uses this curtain motif. For Schneider, 1984, 650, the last series of interiors of 1946–48 culminates with the present work. The 1947 *Nature morte à la grenade* (Musée Matisse, Nice) is similar, though more exploratory. John Neff in Cowart et al., 1977, 24 and 31, observes that Matisse "succeeded in reuniting painting and drawing in masterpieces such as *Egyptian Curtain*" and cites this curtain as being among the exotic textiles he used as sources for the cutouts. Matisse wrote to the editor of *Verve,* May 9, 1948, of his "emotion before the Mediterranean springtime"; cited in Michel Anthonioz, *Album Verve* (Paris, 1987), 198. Since the summer of 1943, he had lived in a villa on the coast of southern France.

33. Gowing, *Matisse,* 181–82 and 183. According to Watkins, *Matisse,* 139, as early as 1916 Matisse "began to use a pure black as a colour of light and not as a colour of darkness," invoking the tradition of Manet.

34. Cowart et al., *Matisse Symposium* (Baltimore Museum of Art, 1976), 7, discusses this ambiguity in terms of Matisse's cutouts for *Jazz.*

35. A conservator's report, Nov. 8, 1984: "The design layer was thinly painted." A June 6, 1974, report initialed "R. M." [Ross Merrill] describes the paint as "thin dilute wash." Other observations per Steele, Dec. 3, 1991.

36. Flam in Cowart et al., 1977, 41; for Bergson's influence, see Cowart et al., *Matisse Symposium,* 9–10.

37. Cowart et al., *Matisse Symposium,* 2. The growth themes are time-honored motifs in Matisse's work; see *Red Interior,* 1908 (Hermitage, St. Petersburg), and *The Red Studio,* 1908 (The Museum of Modern Art).

38. Matisse to Louis Aragon, 1943, as cited in Cowart et al., 1977, 42.

Major References
Claude Duthuit, Matisse Archives, Paris.
Alfred Barr, *Matisse, His Art and His Public,* New York, 1951.
Jean Leymarie et al., *Henri Matisse,* exh. cat., UCLA Art Galleries, Berkeley, 1966.
Jack Flam, ed., *Matisse on Art,* New York, 1973.
Jack Cowart et al., *Henri Matisse: Paper Cut-Outs,* exh. cat., St. Louis Museum of Art, 1977.
John Elderfield, *The Drawings of Henri Matisse,* London, exh. cat., Arts Council of Great Britain, 1984.
Pierre Schneider, *Matisse,* Paris, 1984.
Jack Cowart and Dominique Fourcade, *Henri Matisse: The Early Years in Nice, 1916–1930,* exh. cat., Washington, D.C., NGA, 1986.
Jack Flam, *Matisse: The Man and His Art, 1869–1918,* Ithaca, N.Y., 1986.
Roger Benjamin, *"Notes of a Painter"; Criticism, Theory and Context, 1891–1908,* Ann Arbor, Mich., 1987.
Jack Flam, ed., *Matisse: A Retrospective,* New York, 1988.

Henri Matisse and Pierre Bonnard, *Correspondence, 1925–1946,* Paris, 1991.
Bonnard/Matisse: Letters Between Friends, preface by Jean Clair; introduction and notes by Antoine Terrasse; trans. Richard Howard, New York, 1992.
John Elderfield, *Henri Matisse: A Retrospective,* exh. cat., New York, MOMA, 1992.
Hayden Herrera, *Matisse: A Portrait,* New York, 1993.
Centre Georges Pompidou, *Henri Matisse, 1904–1917,* exh. cat., Paris, 1993.
Russell T. Clement, *Henri Matisse: A Bio-Bibliography,* Westport, Conn., 1993.
Michel Dauberville and Guy-Patrice Dauberville, *Matisse: Henri Matisse chez Bernheim-Jeune,* 2 vols., Paris, 1995.
John Elderfield, *Pleasure Painting: Matisse's Feminine Representations,* London, 1995.
Jack Flam, *Matisse on Art,* Berkeley, 1995.
Catherine Bock-Weiss, *Henri Matisse: A Guide to Research,* New York, 1996.
Claude Duthuit, ed., *Henri Matisse: Catalogue raisonné de l'oeuvre sculpté établi,* Paris, 1997.
Musei Capitolini, *Matisse: "La révélation m'est venue de l'Orient,"* exh. cat., Rome, 1997.

TPC Sources
Journal HH, 1912.
DP, "Revolutions and Reactions in Painting," *International Studio* 51, Dec. 1913, 123–29.
E of A, 1914 and 1927.
DP, "Fallacies of the New Dogmatism in Art," *American Magazine of Art* 9 (parts 1 and 2: Dec. 1917 and Jan. 1918), 43–48 and 101–6.
Journal Y, ca. 1922–25.
DP, essay for PMG.1927.7.
A & U, 1929.
DP, "Modern Art and the Museum," *American Magazine of Art* 23, no. 4, Oct. 1931, 271–76.
ASD, 1931.
Bull., 1931, "Modern Argument in Art and Its Answer."
DP, "The Artist Sees Differently," slide lecture, 12 versions, 1931–34.
AMA, 1935.
DP, "Freshness of Vision and Spontaneity in Painting," unpubl. text for slide lecture, ca. 1935; formerly part of MS 178.
DP, "Freshness of Vision in Painting," unpubl. essay, ca. 1945; formerly part of MS 178.
Cat., 1952.
MP, 1970 and 1982.
SITES, 1979.
MD, 1981.
MP, 1998.

GEORGES ROUAULT

1. Robert Speaight, "Homage to Rouault," *Dublin Review* 209 (July 1941), 63, and Soby, 1945, 6. Rouault shared this attraction with the German expressionists. Peter Selz, *German Expressionist Painting* (Berkeley, 1957), 17, contends that Grünewald's appeal lay in the fact that "his form was the vessel of his emotion, and the mastery of light, color, and line was used only for the expression of inner feeling." Clearly, Rouault would have shared this view.

2. Rouault's figures are called "Grotesques" in Venturi, 1959, 22, who borrowed the title from a 1917 series of prints that Rouault created as a critique of French bourgeois society. Venturi suggests that in contrast to

the "arrogance or superiority so common to caricature," Rouault's figures represent the artist's sarcastic outbursts against "the vices and vileness of society" with "equanimity."

3. By 1930, however, Rouault's work was shown simultaneously at the Brummer Gallery, New York, the Art Club of Chicago, the St. George Gallery, London, and the Neumann Gallery, Munich.

4. DP, in *Bull.*, 1931, 49. This is an interesting comment, given Rouault's own statement that his grandfather's prints by Daumier were among his first significant artistic experiences. His admiration for Rembrandt is also well documented.

5. DP, "Rouault in America," in *Bull.*, 1941, n.p.

6. *Three Judges* was sold in 1940 to Bignou Gallery, New York, in exchange for Seurat's *The Stone Breakers*. *Bouquet No. 1* (acc. no. 1670) and *Bouquet No. 2* (acc. no. 1671). The other two purchases were *Afterglow, Galilee* and *Yellow Christ*.

7. Two other works were purchased in 1930: *The Tragedian* and *Landscape with Rider*, deaccessioned in 1933 and 1941, respectively. Recently added to the collection is *Femme de profil*, acc. no. 1989.10.1.

8. *Cirque de l'étoile filante* (acc. nos. 1678–1693); *Self-Portrait* (acc. no. 1674).

9. Soby, 1945, 28, wrote of Rouault: "The rage of his early period (1903–1906) has abated almost entirely; the melancholy of his middle years (1915–1918) has lifted." TPC records date *Afterglow, Galilee* to "before 1930," but Isabelle Rouault, in Dorival and Rouault, 1988, vol. 2, 126, dates it to 1939. The luminous sky and rich variety of colors would support the later date, whereas the dramatic intensity, created through the variance of tones, could support the earlier. *Tragic Landscape*, 1930, was originally entitled *Landscape*, but Phillips renamed it in order to stress its somber mood.

10. Two additional, unidentified purchases in 1954 were subsequently traded or sold, although when and to whom is not documented.

11. Mar. 31, 1953.

12. DP, 1947, 5.

13. Medium: Rouault often worked on paper, which was generally mounted on canvas when the work was completed. In 1976 a sketch was found on the reverse. Gustav Berger, the conservator, identified it as the mirror image of "a cancelled plate of [Rouault's] *Miserere et guerre* series, #174"; see correspondence, Berger to James McLaughlin, TPC, Nov. 15, 1976. The paper was removed from the canvas and mounted on a transparent lining to show the sketch on the reverse; Berger invoice, Jan. 4, 1977. Inscription: The signature of the sketch on the reverse is now covered by the new liner; see Berger report, Jan. 2, 1977. Provenance: According to TPC records, Pierre Matisse "only remembers buying the painting from 'someone in Paris'" (possibly Ambroise Vollard). The Matisse archives record Phillips's purchase during the gallery's Rouault exhibition under the title *Les Clowns*, on Nov. 16, 1933 (Margaret V. Loudon to author, Dec. 19, 1989).

14. Like Degas, Renoir, Seurat, and Toulouse-Lautrec, Rouault frequented the Cirque Fernando, Nouveau Cirque, Cirque d'hiver, and Cirque de Paris into his adult years. See Dorival and Rouault, 1988, vol. 1, 183.

15. Dorival and Rouault, 1988, vol. 1, 40.

16. *Ecuyères* is the French term for equestriennes, a frequent subject in Rouault's art.

17. Venturi, 1959, 14, observes that Rouault's use of black "to express his moods of anger and revolt" set his work apart from the fauves: "More than twenty years had to elapse before the full beauty of his colors blazed out." Soby, 1945, 25, draws attention to Rouault's work as a printmaker and his indebtedness to "an appreciation of Byzantine enamels, Roman mosaics and Coptic tapestries" in his work from 1929 to 1939.

18. For example, *Three Clowns*, 1917 (collection of Joseph Pulitzer Jr., St. Louis), and *Three Judges*, 1913 (gouache and oil on cardboard, 29⅞ × 41⅜ in.; Museum of Modern Art, New York, Sam A. Lewisohn Bequest, 17.52), share this structure. In a letter to Karl Nierendorf, June 21, 1939, presumably responding to an offer, Phillips expressed his preference for *Circus Trio*: "We have a three figure composition which is finer than your *Three Judges*."

19. Dorival and Rouault, 1988, vol. 1, 107. This combination of characters may have its roots in the commedia dell'arte, possibly representing Pulcinella supported by two circus women (see Isabelle Rouault, the artist's daughter, conversation with Laughlin Phillips, June 19, 1990); the painting itself, however, does not offer sufficient iconographic clues.

20. Published by Ambroise Vollard in 1938; Phillips purchased a nearly complete set the following year through Pierre Matisse (no. 38/250). The volume includes sixteen of his seventeen etchings and aquatints, and eighty-two black-and-white woodcuts, as well as text by the artist (acc. nos. 1678–1693).

21. DP, "Rouault in America."

22. Watteau, *Pierrot* (generally called *Gilles*), between 1715 and 1721 (oil on canvas, 72⅝ × 58⅞ in.; Musée du Louvre, Paris). This painting has inspired generations of poets, writers, and painters with its "poignant and awkward" figure "cut off from the world surrounding him, . . . isolated and alone." Margaret Morgan Grasselli and Pierre Rosenberg, *Watteau, 1684–1721*, exh. cat., NGA (Washington, D.C., 1984), no. 69, 429–34.

23. Title: Published as *Christ et le docteur* and dated 1937 in Dorival and Rouault, 1988, no. 1548, and in Courthion, 1962. TPC records indicate "before 1937." In translating the title, Phillips first named the work *Christ and the Pharisee*, then settled on *Christ and the High Priest*. Provenance: Bignou letter, July 10, 1940, and bill of sale, July 8 (as *Christ et le Docteur*). Courthion, 1962, 465, claims that the work was formerly in the Vollard collection.

24. Dorival, in Dorival and Rouault, 1988, vol. 1, 289, comments that "it was to the court of Pontius Pilate that Rouault had gone to recognize Jesus, mocked by the soldiery and martyred by it." In the Bible, the word *doctor* refers to a man of learning. In this picture, the yarmulke worn by the doctor identifies him as a Jewish teacher, which would confirm Phillips's original title, *Christ and the Pharisee*.

25. Dorival in Dorival and Rouault, 1988, vol. 2, 18, sees these framing devices as decorative arches that recall Gothic decor.

26. The same almond-shaped face and penetrating gaze were inspired by Byzantine wall paintings and mosaics.

27. AS to GR, Dec. 19, 1923, in Rouault and Suarès, 1983, 86.

28. Rouault once remarked: "What we are here for is to create beautiful or expressive form. Controversy, criti

cism, negations of every sort—secular or sacred—are beside the point"; from *Art présent* (Paris, 1945), as cited in Courthion, 1962, 240.

29. DP, *Christ and the High Priest*, 1941, n.p.

30. Ibid. As early as 1905, the influence of Cézanne was noted; Louis Vauxcelles, *Gil Blas* (Oct. 17, 1905), in his review of the Salon d'Automne of that year, wrote: "Among the numerous realists inspired by Cézanne, M. Rouault stands out as a sort of dark lyricist" (cited in Courthion, 1962, 106). Rouault first saw Cézanne's work at the Universal Exposition of 1900, then in 1901 and 1902 at the Salon des Indépendants, in 1903 at the Salon d'Automne, and in 1907 at posthumous Cézanne retrospective exhibitions; per Dorival and Rouault, vol. 1, 1988, 20.

31. Title: Sold under the title *Yellow Christ*; the painting was renamed *Still Waters* by Phillips. Provenance: Matisse purchased the work (as *Yellow Christ*) directly from the artist; see bill of sale June 15, 1939.

32. *Yellow Christ*, 1889 (oil on canvas; Albright-Knox Art Gallery, Buffalo). For Rouault's comments, see Courthion, 1962, 74 and 376, and Dorival and Rouault, 1988, vol. 1, 353.

33. GR to AS (letter 46, Oct. 23, 1913), as cited in Rouault and Suarès, 1983, 49. Rouault also wrote: "Landscapes . . . are my stepping-stones on which I shall re-establish myself"; and later: "My ever more loving precise observation of nature will lead me to an art more alive." (letter 56, Feb. 2, 1914, 57).

34. Letter 129, May 21, 1922, in Rouault and Suarès, 1983, 82.

35. See Courthion 1962, 106.

36. *The Poor Fisherman*, 1881 (oil on canvas, 155.0 × 192.5 cm.; Musée du Louvre, Paris). The similarity of *Yellow Christ* to works by Gauguin and Puvis is curious, in light of the rivalry between Puvis and Moreau in the Parisian art world of the 1880s, and Rouault's affiliation with Moreau's atelier rather than the synthetist or neotraditionalist school.

37. DP, in *Bull.*, 1931, 49–50.

38. Title: *Verlaine à la Vierge* per Dorival and Rouault, 1988, no. 2169. Phillips, in a letter to Matisse of Jan. 21, 1947, referred to the painting as *Grand Portrait d'Homme (Verlaine)* (TPC Papers, AAA, reel 1967, #1258). Matisse responding to Phillips, Feb. 20, 1947, used the same title to differentiate the work from a true portrait and also stated that "the name 'Verlaine' is painted by Rouault himself on the stretcher, under the black paint"; now obscured by the painting's backing. Inscription: For many years Rouault's studio was in the home of his dealer, Ambroise Vollard. At the time of Vollard's accidental death on July 22, 1939, the house and studio were sealed while the estate was being settled. Of the more than eight hundred works the artist had kept in his studio because he considered them unfinished, about one hundred were sold by Vollard's heirs. In 1946 Rouault filed suit for breach of contract, which was resolved in his favor on Mar. 19, 1947. Isabelle Rouault, believing that *Verlaine* was among the paintings left in the studio, placed it with the "Unfinished Paintings" having a "doubtful signature" (Dorival and Rouault, 1988, no. 2169). She declared that the artist considered this work to be in need of some retouching (stated also in correspondence with Laughlin Phillips, Sept. 10, 1987, and June 27, 1990). Mme Rouault believes that the unfinished portion is the area of the Madonna and Child (conver

sation with Laughlin Phillips, June 19, 1990). Indeed, although the painting was previously published as a signed work, a conservator's examination (Elizabeth Steele, July 23, 1990) revealed instead faint indications of what could be a monogram, partly obscured by upper layers of paint; it is impossible to determine whether it is a true monogram or simply brushmarks. Provenance: The painting was shipped to Phillips on Jan. 23, 1947. Early records give provenance as "Ambroise Vollard, Paris." In a letter to Matisse, Feb. 17, 1947 (TPC papers, AAA, reel 1967, #1269), Phillips asked whether he had purchased the painting from Vollard's estate or directly from the artist. On Feb. 20, 1947, Matisse replied that the picture came from the "estate of Vollard"; however, current gallery records indicate a purchase from Gallery Pétridès (Matisse correspondence, Nov. 21, 1989), perhaps acting as agent for Matisse or for Vollard's heirs.

39. The two series of lithographs are: *Verlaine (d'après le masque mortuaire)*, three studies after the poet's death mask, 1926–28; *Verlaine*, five studies, nine states, 1926–1933 (Chapon and Rouault, 1978, nos. 361 and 362). For profile studies in oil, see Dorival and Rouault, 1988, vol. 2, nos. 2543–2546.

40. DP, 1947, 5.

41. DP to Matisse, Feb. 17, 1947.

Major References
Georges Rouault, *Cirque de l'étoile filante*, Paris, 1938.
James Thrall Soby, *Georges Rouault: Paintings and Prints*, New York, 1945.
Jacques Maritain, *Georges Rouault*, New York, 1954.
Lionello Venturi, *Rouault*, trans. James Emmons, Geneva, 1959.
Pierre Courthion, *Georges Rouault*, New York, 1962.
François Chapon and Isabelle Rouault, *Rouault l'oeuvre gravé*, 2 vols., Monte Carlo, 1978.
Danielle Molinari, *Georges Rouault*, Paris, 1983.
Georges Rouault and André Suarès, *Georges Rouault–André Suarès Correspondance, 1911–1939*, trans. Alice B. Low-Beer, Devon, 1983.
Bernard Dorival and Isabelle Rouault, *Rouault l'oeuvre peint*, 2 vols., Monte Carlo, 1988.
Fabrice Hergott, ed., *Rouault: Première période, 1903–1920*, exh. cat., Paris, Centre Georges Pompidou, Musée National d'Art Moderne, 1992.
Fabrice Hergott, *Georges Rouault: The Early Years, 1903–1920*, exh. cat., London, Royal Academy of Arts, 1993.
Stephan Koja, *Georges Rouault: Malerei und Graphik*, Munich, 1993.
Carolin Bahr, *Religiöse Malerei im 20. Jahrhundert: am Beispiel der religiosen Bildauffassung im gemalten Werk von Georges Rouault (1871–1958)*, Stuttgart, 1996.
Museo d'arte moderna, *Georges Rouault, 1871–1958*, exh. cat., Lugano, 1997.

TPC Sources
C in M, 1926.
ASD, 1931.
Bull., 1931.
DP, "Christ and the High Priest," in *The Nation's Great Paintings*, New York, 1941.
Bull., 1941.
DP, "Georges Rouault," *Right Angle* 1, no. 3, May 1947.

Cat., 1952.
MP, 1970 and 1982.
MD, 1981.
Stephen B. Phillips, cat. for TPC.1997.4.
MP, 1998.
MSS 68, 109, 112, and 160.

RAOUL DUFY
1. Date: Guillon-Laffaille, 1982, vol. 2, dated it as "ca. 1924." However, in a letter of May 22, 1990, to the author, she suggests ca. 1932, citing a related drawing, *La Salle de l'Opéra*, which she dates to 1932; the drawing is illustrated in Jacques de Laprade, *Raoul Dufy*, exh. cat., Galerie d'Estampes (Paris, 1942), 27. Antoinette Rezé-Huré to author, Mar. 26, 1992, points to a second related drawing of the Paris Opera interior, *L'escalier de l'Opéra (un jour de gala)*, ca. 1934–35 (50 × 65.5 cm.; legacy of Mme Dufy, Musée National d'Art Moderne, Paris). Title: French title per Guillon-Laffaille, 1982; second English title per early PMG label on reverse. Medium: Per analysis of Sarah Bertalan, paper conservator, June 17, 1991. Provenance: Nierendorf bill of sale, July 20, 1939, TPC Papers, AAA, reel 1954, #0722.

2. Dufy's enthusiasm for *Luxe, calme et volupté* (oil on canvas, 98.5 × 118.5 cm.; Musée d'Orsay, Paris), is recorded in Robertson et al., 1983, 2.

3. According to the conductor Charles Munch, as cited in ibid., 31, Dufy attended concerts "every week of his life in the early years."

4. DP, *A & U*, 1930, 188.

5. DP and C. Law Watkins, essay for TPC.1941.4, 30.

6. *Hôtel Sube*, 1926 (21¼ × 25⅝ in.; acc. no. 0611; Laffaille, vol. 2, no. 495). Dufy's graphic work is represented with the 1943 Jean Goriany gift of the drawing *Portrait of Fleuret*, ca. 1920 (acc. no. 0615). The collection's earliest example of Dufy, it pictures Fernand Fleuret, a friend and writer.

7. MP, 1982, 175. Dufy accompanied Homer Saint-Gaudens, director of the Carnegie Museum of Art, on the standard trip for foreign jurors of the Carnegie International to Washington and New York.

8. DP to Valentine Dudensing, June 12, 1944.

9. Florence S. Berryman, "Phillips Gallery Presents Paintings by Raoul Dufy and Arthur G. Dove," *Sunday Star*, July 2, 1944, B6. See also Jane Watson, "Dufy's Works Hold Rare Charm at Phillips," *Washington Post*, July 2, 1944, B8.

10. "Watercolors by Raoul Dufy: An Exhibition of His Work in the United States, 1950" was mounted by Dufy in gratitude to the Arthritis and Rheumatism Foundation for the recovery of the use of his hands through cortisone treatment; it was organized by the Carré Gallery, New York, and traveled as well to Pittsburgh, Chicago, Richmond, and Milwaukee.

11. Title: First French title per Laffaille, 1976, no. 1184; second French title from 1936 Paris exhibition and Bignou bill of sale, Apr. 6, 1944. Inscription: Illegible traces of a second signature and date appear above the present inscription; they are partially covered by paint. Provenance: Bill of sale, July 6, 1944, TPC Papers, AAA, reel 1962, #0263. Dufy had a contract with Etienne Bignou beginning in 1929; see Robertson et al., 1983, 5.

12. "Most successful," Perez-Tibi, 1989, 245. Two untraced versions are known only through reproductions, one of which can be seen in "Hedendaagsche Fransche Kunst," exh. cat., Gemeentemuseum (The

Hague, 1936), cat. no. 37; this work was originally thought to be the Phillips version, but compositional differences indicate that it is not. This conclusion is confirmed by Steele's analysis, May 9, 1991, and by Guillon-Laffaille to author, May 22, 1990. In addition, a "replica" was reproduced in *L'amour d'art* 16 (June 1935), 200. This may be a third version. The variants are: 1939, Collection P. Bérès, France; ca. 1940, Museum of Modern Art, Tokyo; 1935–1952, Musée Nationale d'Art Moderne, Centre Pompidou, Paris.

13. According to Perez-Tibi, 1989, 245, the pictures are, right, top: *Homage to Claude Lorrain*, 1927; center: *Boathouse on the Marne*, 1921; bottom: *Homage to Mozart*, 1934; far left: lithograph of *The Large Bather*, and what appears to be a flower painting. Above these are four sketches of boats. A photograph of the studio is reproduced in George Besson, *Dufy* (Paris, 1953), 68.

14. See Matisse's *Studio Quai Saint-Michel* (cat. no. 109). The left passage of Dufy's *Artist's Studio* has been compared with Matisse's *Porte fenêtre à Collioure*, 1905 (Mr. and Mrs. John Hay Whitney, New York), in Antoinette Rezé-Huré, *La collection du Musée National d'art moderne* (Paris, 1986), 197.

15. Analysis per Steele, May 13, 1991.

16. Fanny Guillon-Laffaille in Schulmann, 1997, 125. Also see *Venus and the Lute Player*, n.d. (New York, Metropolitan, acc. no. 36.29), erroneously cited as a work in the Prado in Martha Davidson, "View of Raoul Dufy, Modern Rococo Master," *Art News* 36 (Mar. 26, 1938), 19.

17. Davidson, "View of Dufy," 19.

18. "Lefevre Galleries: M. Raoul Dufy's Artistic Entertainment," *Times*, London, July 11, 1936, 12e; Jane Watson Crane, "Phillips Is a Living Art Center: Roomful of Dufys," *Washington Post*, Aug. 22, 1948.

Major References
Pierre Courthion, *Raoul Dufy*, Paris, 1928.
———, *Raoul Dufy*, Geneva, 1951.
Alfred Werner, *Raoul Dufy*, New York, 1970.
Jacques Lassaigne, *Dufy*, Geneva, 1972.
Maurice Laffaille, *Raoul Dufy: Catalogue raisonné de l'oeuvre peint*, 4 vols., Geneva, 1972, 1973, 1976, 1977.
Antoinette Rezé-Huré, "Les dessins de Raoul Dufy," 2 vols., Ph.D. diss., Sorbonne, Université de Paris, 1978.
Fanny Guillon-Laffaille, *Raoul Dufy: Catalogue raisonné des aquarelles, gouaches et pastels*, 2 vols., Paris, 1981, 1982.
Bryan Robertson et al., *Raoul Dufy*, exh. cat., London, Hayward Gallery, 1983.
Dora Perez-Tibi, *Dufy*, Paris, 1989.
Raoul Dufy, *Correspondances*, Paris, 1991.
Fanny Guillon-Laffaille, *Raoul Dufy: Catalogue raisonné des dessins*, Paris, 1991.
Accademia di Francia, *Raoul Dufy: Le peintre, la décoration et la mode des années, 1920–1930*, exh. cat., Rome, 1995.
Jean Forneris, *Raoul Dufy, 1877–1953*, exh. cat., Vienna, Kunsthaus Wien, 1996.
Didier Schulmann, *Raoul: Séries et séries noires*, exh. cat., Martigny, Switzerland, Fondation Pierre Gianadda, 1997.

TPC Sources
ASD, 1931.
DP, "The Expression of Personality Through

Design in the Art of Painting," slide lecture, 8 versions, ca. 1936–42.

DP and C. Law Watkins, essay for PMG.1941.4.

Cat., 1952.

SITES, 1979.

MD, 1981.

MP, 1982.

Jan Lancaster, *Raoul Dufy,* Washington, D.C., TPC, 1983.

ANDRÉ DERAIN

1. Date: Robert Stoppenbach, who worked with Michel Kellermann on the catalogue raisonné, proposes 1924–1928 on the basis of style; conversation with author, Sept. 20, 1990. Kellermann, 1996, dates it to 1926–27. Provenance: De Hauke bill of sale, Oct. 26, 1928, as *Mano, la danseuse.*

2. See John Elderfield, *The "Wild Beasts," Fauvism and Its Affinities,* exh. cat., MOMA (New York, 1976), 34–35, 124; Judith Cousin's chronology in William Rubin, *Picasso and Braque: Pioneering Cubism,* exh. cat., MOMA (New York, 1989), 342, gives summer 1906 as the time when Derain and Matisse each acquired African masks; Michel Kellermann et al., *André Derain,* exh. cat., Galerie des Beaux-Arts (Nantes, 1976), 35, give 1904 for Derain's discovery of masks. Picasso himself erroneously credited Derain with introducing him to African art; see William Rubin, *Cézanne: The Late Work,* exh. cat., MOMA (New York, 1977), 157.

3. See, for example, André Breton, "Inspiration to Order," *Le surréalisme au service de la révolution* (1930), reprinted in *The Autobiography of Surrealism,* ed. Marcel Jean (New York, 1980), 271. Derain executed wood engravings for Apollinaire's *L'enchanteur pourrissant* (Paris, 1909) and drawings for Breton's *Mont-de-Piété* (Paris, 1916).

4. Though created concurrently with a series of dancers, *Mano, the Dancer* stands apart in that it more closely resembles portraiture; see Malcolm Vaughn, *Derain* (New York, 1941), 74, for Derain's 1925–28 work depicting dancers.

5. Diaghilev commissioned sets for his 1919 *La boutique fantasque,* and Count Etienne de Beaumont invited Derain to design sets for Erik Satie's *Jack in the Box* of 1926.

6. Cited from the Derain manuscript "Les rythmes" in Salomon, 1980, 352 (author's trans.): "Le théâtre est la manifestation d'un archétype humain qui tient de l'individu ou acteur et de tous les individus ou spectateurs. . . . La création d'un type surhumain est suprême fin de l'art." Salomon dates the text to after 1920, but Warren, 1978, 96, dates it to "in or after the twenties."

7. Per Stoppenbach, Sept. 20, 1990.

8. See Gaston Diehl, *Derain* (New York, 1964), 63–64, for the influence of lithography on Derain's painting.

9. Salomon, 1980, 346 (author's trans.): "Le vrai sujet du tableau est-il [*sic*] de créer la lumière, seule matière de la peinture."

10. DP, in *ASD,* 1931, 17.

11. The review, as well as Phillips's immediate purchase and Pach letter, is cited by him in *Bull.,* 1929, 31 and 32.

12. See Phillips's comparison of the two artists in *ASD,* 1931, 71–72. It is noteworthy that both the subject and the unsentimental approach of Kuhn in the collection's *Plumes,* 1931 (cat. no. 214), have arresting paral-

lels to Derain's *Mano.* Kuhn's efforts at the Armory Show probably prompted early U.S. purchases; see *Southern France* (cat. no. 118).

13. *A & U,* 1929, 82. It was sent first to the Pierre Rosenberg Gallery, New York, and then to Pierre F. Nesi, Hollywood, Calif., on Aug. 20, 1943. It was returned in November, per shipping records.

14. DP, in *ASD,* 1931, 51, and DP, PMG.1927.7. Derain had purchased four Renoir studies in 1923.

15. Date: PMG records give the date as 1927. Stoppenbach, Sept. 20, 1990, proposes 1925–27 on the basis of style; also "Reinhardt Shows French Art," *Art News* 26 (Nov. 5, 1927), 2, observes it to be "a [product] of the last two years." Title: The bill of sale indicates *Landscape—in Southern France,* painted in 1925. The alternate title is from the painting file. On its first known publication in the United States, *Art News* 26 (Nov. 5, 1927), it was captioned *Landscape.* Provenance: Reinhardt bill of sale, Nov. 21, 1927, stock #1417: "The above painting was purchased by us from a French dealer who bought it directly from Derain." Stoppenbach, Sept. 20, 1990, believes that the painting was imported by a dealer other than Paul Guillaume, who did not appreciate Derain's landscapes until later.

16. Picasso's Ingres-like portraits and cubist works are contemporaneous.

17. The other two views are: *Landscape, Southern France,* ca. 1927 (Museum of Fine Arts, Boston, bequest of John T. Spaulding), and *Landscape with Olive Trees,* ca. 1930 (National Museum, Belgrade, Serbia). Stoppenbach, Sept. 20, 1990, cites Derain's continual shifts between tight and more fluid compositions as an obstacle to determining the chronological sequence of these works.

18. See discussion in Cowling and Mundy, 1990, 92–93. For Derain compared with Corot and Cézanne, see *A & U,* 1929, 81 and 85. For Derain's intermittent criticism of Cézanne, see Salomon, 1980, 344–45, 362, and Warren, 1978, 106.

19. For a detailed discussion of the pastoral theme and its roots in the Venetian Renaissance school, and of the French tradition, see Cowling and Mundy, 1990, 12–21. Puvis de Chavannes was also an important precursor to twentieth-century classicism. Green, 1987, 123, cites André Salmon, who traced the revival to the seminal work of Cézanne and to the revival of El Greco and French classicism in the eighteenth and nineteenth centuries.

20. The predominance of the sky could be the result of the work's being painted while unstretched, then selectively framed or cut down; see analysis by Elizabeth Steele, painting conservator, Dec. 4, 1990. According to Stoppenbach, Sept. 30, 1990, Derain often worked on unstretched canvas tacked to the wall and stretched the painting only after its completion.

21. Observations per Steele, Dec. 4, 1990.

22. Marya Mannes, "André Derain—Thoughtful Painter," *International Studio* 94 (Nov. 1929), 28.

23. DP, in *A & U,* 1929, 78.

24. The earliest evidence of Phillips's interest in Derain is a notation in Journal Y (ca. 1922–25) reminding him to view the Derain paintings at Kraushaar Gallery, New York, but his first impressions were unfavorable; for this earlier attitude and his transition to "dazzling executant with his brush," see *A & U,* 1929, 78. The Yale University Art Gallery was given a Derain in 1920 by Katherine S. Dreier, and the Detroit Institute of Art

was the first American museum to purchase a Derain, in 1923. The Art Institute of Chicago was given several Derain paintings in 1926; they are part of the Helen Birch Bartlett Memorial Collection.

25. Quoted by DP in his essay "Derain and the New Dignity in Painting," which first appeared in *A & U,* 1929, 78–91, and was reprinted in *ASD,* 1931, 67–72.

26. DP, in *Bull.,* 1928, 23.

Major References

Derain's unpublished manuscript material, Bibliothèque Doucet, Paris.

Derain correspondence, Daniel Henry Kahnweiler, Galerie Louis Leiris, Paris.

Daniel Henry Kahnweiler, *André Derain,* Leipzig, 1920.

Elie Faure, *André Derain,* Paris, 1923.

André Salmon, *André Derain,* Paris, 1924.

Roger Brielle et al., "Pour ou contre André Derain," *Les chroniques du jour,* no. 8, Jan. 1931 (special issue).

Georges Hilaire, *Derain,* Geneva, 1959.

Leland Bell, "The Case for Derain as an Immortal," *Art News* 59, May 1960, 25–27 and 61–63.

Jean Leymarie, *André Derain,* exh. cat., Paris, Grand Palais, 1977 (including text of articles by Guillaume Apollinaire, 1916; André Breton, 1924; and Alberto Giacometti, 1957).

Rosanna Warren, "A Metaphysic of Painting: The Notes of André Derain," *Georgia Review,* Spring 1978, 94–112.

Gabrielle Salomon, ed., "André Derain: Notes sur la peinture," *Cahiers du Musée d'Art Moderne,* no. 5, 1980, 343–61.

Michael Parke-Taylor, *André Derain in North American Collections,* exh. cat., Regina, Canada, Norman Mackenzie Art Gallery, 1982.

Christopher Green, *Cubism and Its Enemies: Modern Movements and Reaction in French Art, 1916–1928,* New Haven, 1987.

Kenneth Silver, *Esprit de Corps: The Art of the Parisian Avant-Garde and the First World War, 1914–1925,* London, 1989.

Elizabeth Cowling and Jennifer Mundy, *On Classic Ground: Picasso, Léger, de Chirico, and the New Classicism, 1910–1930,* exh. cat., London, Tate Gallery, 1990.

Jane Lee, *André Derain,* exh. cat., Oxford, Museum of Modern Art, 1990.

Michel Hoog, *Un certain Derain,* exh. cat., Paris, Musée de l'Orangerie, 1991.

Michel Kellermann, *André Derain: Catalogue raisonné de l'oeuvre peint,* 2 vols., Paris, 1992 and 1996.

André Derain, *Lettres à Vlaminck: Suivies de la correspondance de guerre,* Paris, 1994.

Musée d'Art Moderne de la Ville de Paris, *André Derain: Le peintre de "trouble moderne,"* exh. cat., Paris, 1994.

TPC Sources

Journal Y, ca. 1922–25.

DP, essay for PMG.1927.7.

Bull., 1928.

A & U, 1929.

"Modern Art and the Museum," *American Magazine of Art* 22, no. 2, Feb. 1931, 271–76.

Bull., 1931.

ASD, 1931.

MAURICE UTRILLO

1. Title/Date: French title and date from Pétridès. Schempp bill of sale, Feb. 19, 1940, and Cat., 1952, give the date as 1910. Fabris, 1982, 162, observes that the version now in the Kunsthaus Zurich was part of "that series of cathedrals which the artist began in the summer of 1909." Inscription: According to Alain Buquet in Fabris, 1982, 143–57, the elements of Utrillo's signature were separated with periods before 1920; here, however, commas are inserted. The loops of the *l*'s are not as pronounced as in signatures throughout Utrillo's career, raising the possibility that his mother, Suzanne Valadon, may have signed this canvas (her initial is included). Provenance: From 1909 to 1914 Louis Libaude took on most of Utrillo's paintings. Defrenne was listed as owner in the 1936 exhibition at The Hague; Schempp wrote Phillips, Sept. 24, 1939, wishing to show him French paintings "I just brought back from France." Received on approval before Nov. 6; decision to purchase Nov. 30, 1939; Schempp bill of sale, Feb. 19, 1940. Numerous sales between 1913 and 1929, listed in Fabris, 1982, 195–97, mention both *Place du Tertre* and *Abbey of Saint-Denis*, but multiple versions of both preclude identification.

2. Title/Date/Provenance: The painting is not listed in Pétridès. Title, date, and provenance per bill of sale, Nov. 12, 1953, Jacques Lindon, Stock #JV480. The Tate Gallery dates its *Place du Tertre* ca. 1910, as cited in Ronald Alley, *Catalogue of the Tate Gallery's Collection of Modern Art* (London, 1981), 735. Inscription: See inscription note for *Abbey of Saint-Denis* (note 1, above) for explanation of the initial *V*. A cradle is adhered to the cardboard reverse, and a quarter-inch of wood is visible on the four sides.

3. Related views include *Place du Tertre*, ca. 1910 (London, Tate Gallery); *Place du Tertre*, ca. 1909 (Albright-Knox Art Gallery, Buffalo); and two versions of *Basilique de Saint-Denis*, both dated ca. 1908 (Kunsthaus Zurich and Norton Simon Museum of Art, Los Angeles). According to Alley, *Tate Catalogue*, 735, Utrillo worked from postcards after 1909, but corresponding views have not been found.

4. *Tertre* means "small hill."

5. Vlaminck quoted in J.-P. Crespelle, *Utrillo Eglises* (Paris, 1960), n.p. (author trans.: " . . . l'amour de la créature montant vers le créateur").

6. David W. Scott, essay for TPC.1984.1, 12. See also Fabris, 1982, 162, who describes the technical aspects of *Basilique de Saint-Denis,* now in the Zurich Kunsthaus. Technical observations by Elizabeth Steele, painting conservator, Dec. 4, 1990.

7. DP, 1953, n.p.

8. According to Warnod, 1983, 50, Utrillo mixed plaster with his pigments to "salve his thirst for truth." Courthion, 1948, 7, describes Utrillo as a mason. A thorough analysis of media, needed to determine if oil is mixed with other substances, has not yet been done.

9. On the influence of Sisley and Pissarro, see Albert Flament, *Exposition d'oeuvres de Maurice Utrillo*, exh. cat., Galerie Le Poutre (Paris, 1919), n.p., and Alfred Werner, "Maurice Utrillo: 1883–1955," *Arts* 30 (Dec. 1955), 31.

10. Courthion, 1948, 7.

11. Between 1926 and 1944 Phillips considered or purchased three other Utrillo scenes. *Suburbs in Snow* is listed under the "Important Acquisitions of the Season of 1925–26" in *Bull.*, 1927, 55 (present location unknown; illustrated as *Effet de Neige* without date in Hamilton Easter Field, "The Kelekian Collection," *Arts* 2, no. 3 [Dec. 1921], 132). John Graham may have played a role, because Phillips wrote to him on Oct. 15, 1928, referring to "pictures by Derain and Utrillo which, at your request, were sent to your Gallery from Paris by [the dealer] Zborowski." The paintings were not identified.

12. See correspondence regarding the show, John Rewald to DP, Oct. 21, and DP to Rewald, Oct. 26, 1953.

13. DP, 1953, n.p. Critic Leslie Judd Porter wrote, "It is seldom that one sees as many paintings of the best period of Utrillo"; "Art in Washington: Utrillo and Marin; a Yule Show," *Washington Post*, Dec. 6, 1953, 15L.

Major References
Georges Tabarant, *Utrillo*, Paris, 1926.
Francis Carco, *Maurice Utrillo*, Paris, 1928.
Pierre Courthion, *Utrillo*, Lausanne, 1948.
Paul Pétridès, *L'oeuvre complet de Maurice Utrillo*, 5 vols., Paris, 1959–74.
Alfred Werner, *Utrillo*, New York, 1981.
Jean Fabris, *Utrillo: Sa vie, son oeuvre*, Paris, 1982.
———, *Maurice Utrillo*, Paris, 1992.
———, *Maurice Utrillo*, exh. cat., Padua, Palazzo Zabarella, 1997.

TPC Sources
Bull., 1927.
ASD, 1931.
Cat., 1952.
DP, essay for TPG.1953.12.
SITES, 1979.

AMEDEO MODIGLIANI

1. An almost identical portrait, *Elena*, 1917, Parisot no. 6/1917 (46 × 33 cm; private collection, Paris), is signed and dated. On Apr. 26, 1926, this second version was sold at a Hotel Drouot auction to a private collector, M. Saint, Paris, per Malcolm Gee, *Dealers, Critics and Collectors of Modern Painting: Aspects of the Parisian Art Market Between 1910 and 1930* (New York, 1981), 176. Title: First alternate title from early records; other two alternate titles in Pfannstiel, 1956. The death certificate states "Hélène Joséphine Bernier Povolozky," the spelling corresponding to that used for the name of the gallery in Paris. Provenance: Povolozky ownership per Pfannstiel, 1956, no. 189; confirmed also by Giselle Tubert, Mme Povolozky's neighbor in Paris, and her great-niece, Françoise Choppin (meetings with author, Nov. 7 and Dec. 13, 1989). Pierre Matisse's stockbooks reflect a 1948 purchase from Maurice Laffaille (Maria-Gaetana Matisse to TPC, Mar. 28, 1989). According to Mme Laffaille, however, this transaction was not recorded in the Laffaille archives (conversation with author, June 13, 1989). Pierre Matisse recalls in a letter to Elmira Bier, Dec. 22, 1949: "I acquired it in Paris in 1947, [and it] was not brought into this country until last spring." Parisot, vol. 2, no. 7/1917, erroneously lists the Phillips painting as "private collection," with The Phillips Gallery as part of its history. Horizontal cracks indicate that the painting was rolled at some point (Elizabeth Steele, painting conservator, Dec. 3, 1991). Bill of sale, Dec. 15, 1949.

2. All biographical details on Hélène Povolozky, and description of her appearance, per Giselle Tubert and Françoise Choppin.

3. Lipchitz, 1952, 27; statement by Modigliani to Léopold Survage, as quoted in Lanthemann, 1970, 81.

4. Jean Cocteau, *Modigliani* (London, 1950), n.p.

5. Although there is no documentation that Modigliani sought inspiration in such imagery, his extensive travels in Italy and acquaintance with Paris collections must have exposed him to these traditions. He could also have been inspired by the severe "neo-Renaissance" portraits by his fellow Italian and contemporary Gino Severini, such as *Portrait of Jeanne*, 1916 (private collection), which was exhibited in Paris in 1916. Severini depicted his wife in a classically simplified composition strikingly similar to Modigliani's portrait, at the very least demonstrating the commonality of their sources.

6. *MD*, 1981, 118. The stark background is almost identical to that in another portrait, *Elvira au col blanc*, 1917 (private collection).

7. See Mann, 1980, 100, for a discussion of Modigliani's emphasis on eyes in portraits.

8. Pfannstiel, 1956, 104, observes that features in some of Modigliani's portraits appear to be rendered from different viewpoints, but he does not discuss the issue in relation to this work.

9. Steele, Dec. 3, 1991.

10. Mann, 1980, 166. Several contemporary portraits show similar androgyny, a sexual ambivalence that may have been the artist's "silent dialogue" between his own masculine and feminine sides.

Major References
Modigliani archives, Musée Montmartre, Paris, and Livorno, Italy.
Jacques Lipchitz, *Amedeo Modigliani*, New York, 1952.
Arthur Pfannstiel, *Modigliani et son oeuvre, étude critique et catalogue raisonné*, Paris, 1956.
Jean Modigliani, *Modigliani: Man and Myth*, New York, 1958.
Ambrogio Ceroni, *Amedeo Modigliani*, Monographies des artistes italiens modernes no. 8, Milan, 1965.
Joseph Lanthemann, *Modigliani, 1884–1920: Catalogue raisonné: Sa vie, son oeuvre complète, son art*, Barcelona, 1970.
Carol Mann, *Modigliani*, New York, 1980.
Daniel Marchesseau, Bernadette Contensou, and J. M. G. Le Clezio, *Amedeo Modigliani, 1884–1920*, exh. cat., Paris, Musée d'Art Moderne de la Ville de Paris, 1981.
Douglas Hall, *Modigliani*, Oxford, 1984.
Théo Castieau-Barrielle, *La vie et l'oeuvre de Amedeo Modigliani*, Paris, 1987.
Werner Schmalenbach, *Amedeo Modigliani: Malerei, Sculpturen, Zeichnungen*, exh. cat., Kunstsammlung Nordrhein-Westfalen and Kunsthaus Zurich, 1990.
June Rose, *Modigliani: The Pure Bohemian*, London, 1990.
Fondation Pierre Gianadda, *Modigliani*, exh. cat., Martigny, Switzerland, 1990.
Christian Parisot, *Modigliani: Catalogue raisonné*, 2 vols., Livorno, 1990–91.
Osvaldo Patani, *Amedeo Modigliani: Catalogo generale*, Milan, 1991.
Noel Alexandre, *The Unknown Modigliani: Unpublished Papers, Documents, and Drawings from the Former Collection of Paul Alexandre*, exh. cat., London, Royal Academy of Arts, 1994.

Osvaldo Patani, *Amedeo Modigliani: Catalogo generale, disegni, 1906–1920,* Milan, 1994.

TPC Sources
MD, 1981.
MP, 1998.

MARC CHAGALL

1. Date: Per Pierre Matisse bill of sale and Meyer, 1964, no. 671. Provenance: Bill of sale, Nov. 11, 1942. Purchased along with *Village Street,* 1937–40, out of the Pierre Matisse 1942 exhibition, per Maria-Gaetana Matisse to TPC, May 1, 1989. At the same time, Phillips considered another work, *The Clown's Dream,* 1937–38 (private collection, United States), which was shown, along with *Village Street* and *The Dream,* in PMG.1942.18; see Pierre Matisse to DP, Oct. 31, 1942. According to Compton, 1985, 216, Chagall "was allowed to bring all the canvasses from his studio" with him to the United States; *The Dream* was almost certainly among these.

2. Meyer, 1964, 426 and 429, remarks on the "greater density" and "coherent construction" evident in Chagall's work of the period.

3. Chagall and his family left Paris for the Loire valley in the summer of 1939 and remained there until early in 1940, when they took refuge further south, in the Provençal town of Gordes.

4. Rembrandt, *The Jewish Bride,* 1662 (Rijksmuseum, Amsterdam).

5. Werner, 1970, 58, believes that the small building may derive from a photograph or print of Rachel's Tomb, a small structure in Palestine where infertile Jewish women have historically prayed "for relief from their childlessness." Chagall knew of this tomb, painting it in 1931 while on a trip to this area; *Rachel's Tomb* (oil on canvas, 28¾ × 36¼ in.; private collection, Paris). In other canvases of the 1930s, however, the same hilltop shrine is crowned with a cross and becomes the village church of Vitebsk; see, for example, *In the Night,* 1943 (oil on canvas, 18¼ × 20¼ in.; Brooklyn Museum, New York, Louis E. Stern Bequest). Chagall borrowed regularly from New Testament imagery and on several occasions even painted the crucifixion.

6. The same word appears in *The Flying Carriage,* 1913 (oil on canvas, 42 × 47¼ in.; Solomon R. Guggenheim Museum, New York, 49.1212), where the building is the focal point of the landscape.

7. Werner, 1970, 58, suggests that "Laz" is an abbreviation for hospital, "Lazarett."

8. Chagall resisted precise symbolic or literary interpretation of his work; in 1944 he defined a picture as "a plane surface covered with representations of objects—beasts, birds, or humans—in a certain order in which anecdotal illustrational logic has no importance." Yet he would acknowledge the intense spiritual element in his work, describing it as "the pictorial expression of the images which haunt me," as quoted in Kamenskii, 1989, 307.

9. Sweeney, 1946, 61.

10. Analysis of technique per Elizabeth Steele, painting conservator, Dec. 3, 1990. The plastic efficacy of gouache is pointed out in Meyer, 1964, 424. He added that Chagall had focused on gouache in 1911–14 and 1926–30, marking the present period as the third era in which the medium was used in major works. Jean Leymarie deemed gouache and black-and-white wash drawing Chagall's most successful media; see Leymarie, *Marc Chagall: Works on Paper, Selected Masterpieces,* exh. cat., Guggenheim (New York, 1975), 7.

11. According to Venturi, 1956, 80, Chagall did not begin to gain favor with the American public until 1945 or 1946. Paul Reinhardt held the first one-person gallery exhibition in America in 1926. An important group show at MOMA, "Fantastic Art, Dada, Surrealism," in 1936–37, represented Chagall's earlier work. In early 1945, the Institute of Modern Art, Boston, held a Soutine/Chagall show that Phillips's show, PMG.1942.18, anticipated.

Major References
Lionello Venturi, *Marc Chagall,* New York, 1945.
James Johnson Sweeney, *Marc Chagall,* exh. cat., New York, MOMA, 1946.
Marc Chagall, *My Life,* New York, 1960.
Franz Meyer, *Marc Chagall: Life and Work,* New York, 1964.
Alfred Werner, *Chagall Watercolors and Gouaches,* New York, 1970.
Charles Sorlier, ed., *Chagall by Chagall,* New York, 1979.
Susan Compton, *Chagall,* exh. cat., London, Royal Academy of Art, 1985.
Aleksandr Abramovich Kamenskii, *Chagall: The Russian Years, 1907–1922,* New York, 1989.
Susan Compton, *Marc Chagall: My Life—My Dream,* Munich, 1990.
Fondazione Antonio Mazzotta, *Marc Chagall: Il Teatro dei Sogni,* exh. cat., Milan, 1994.
Jacob Baal-Teshuva, ed., *Chagall: A Retrospective,* New York, 1995.
Patrick Cramer, *Marc Chagall: The Illustrated Books, Catalogue Raisonné,* Geneva, 1995.

TPC Source
Cat., 1952.

JOAN MIRÓ

1. Date: Dupin, 1962, no. 720, lists date as Mar. 20, 1948. Inscription: This inscription was covered by lining in 1976; a photograph is attached to cardboard backing. Provenance: Phillips expressed interest in a letter to Matisse, Feb. 13, 1951; on Mar. 12, 1951, Matisse refers to it as "the painting you acquired recently." Matisse label on reverse: St.2364.

2. See Soby, 1959, 58, for a discussion of Miró's Catalan roots.

3. Miró as quoted in interviews, Rowell, 1986, 204 and 207; also see p. 207 for the importance of cubism. Roland Penrose underscores the influence of the surrealist poets on Miró in "Enchantment and Revolution—Joan Miró," *Artforum* 22 (Nov. 1983), 55–59, quotation from p. 56.

4. In a letter to the Geneva-based publisher Gérard Cramer, June 10, 1948, Miró referred to a March 1947 project to illustrate an edition of Eluard's collected poems; as cited in Rowell, 1986, 214.

5. See especially *The Red Sun Gnaws at the Spider,* painted Apr. 2, 1948 (Stephen Hahn Inc., New York). Miró's notations, "Poetic text with titles of paintings of 1948," includes his poem that gave this work its title: "au fond du coquillage / ce soleil rouge / le soleil rouge rouge l'araignée" (Miró Archives, 1948); see Haenlein, 1989, cat. no. 59.

6. In a Francis Lee interview for the winter 1947–48 issue of *Possibilities,* Miró spoke of his admiration for the "energy and vitality" of American painters; as cited in Rowell, 1986, 202–5 and James Johnson Sweeney interview, p. 209.

7. Dupin, 1962, 388. Miró claimed that in this era he worked on several canvases at once, and months elapsed between sessions on a particular work; it is not known if the March 20 date given for *The Red Sun* marks the day of completion or the date the work was executed in toto.

8. Notes on medium and technique per Elizabeth Steele, painting conservator, Aug. 23, 1992.

9. Sweeney interview in Rowell, 1986, 210.

10. Dupin, 1962, 388.

11. Both citations are from a radio interview with Georges Charbonnier, Jan. 1951, as cited in Rowell, 1986, 223.

12. Raynal quoted in Dupin, 1962, 392.

13. DP to Pierre Matisse, Feb. 13, 1951.

Major References
Joan Miró Archives, Fundació Joan Miró, Barcelona.
James Thrall Soby, *Joan Miró,* New York, 1959.
Jacques Dupin, *Joan Miró: Life and Work,* English ed., New York, 1962.
William Rubin, *Miró in the Collection of the Museum of Modern Art,* New York, 1973.
Gäetan Picon, *Joan Miró, Catalan Notebooks,* New York, 1977.
Centre Georges Pompidou, *Dessins de Miró provenant de l'atelier de l'artiste et de la Fondation Joan Miró de Barcelone,* exh. cat., Paris, 1978.
Barbara Rose et al., *Miró in America,* exh. cat., Houston, MFA, 1982.
Margit Rowell, ed., *Joan Miró, Selected Writings and Interviews,* Boston, 1986.
Carl Haenlein, *Joan Miró: Arbeiten auf Papier, 1901–1977,* exh. cat., Hannover, Kestner-Gesellschaft, 1989.
Victoria Combalia, *El descubrimiento de Miró: Miró y sus criticoes, 1918–1929,* Barcelona, 1990.
Carolyn Lanchner, *Joan Miró,* exh. cat., New York, MOMA, 1993.
Julio Ollero, ed., *Joan Miró, 1893–1993,* exh. cat., Barcelona, Fundació Joan Miró, 1993.
Departamento de Cultura, Generalitat de Catalunya, *Memòria Any Miró 1993,* Barcelona, 1994.
Haus der Kunst, *Elan Vital, oder das Auge des Eros,* exh. cat., Munich, 1994.

TPC Source
MP, 1998.

CHAIM SOUTINE

1. Date: Per Tuchman et al., 1993, vol. 1, no. 112; 1926–27 in the chronology in Güse, 1981, 116: "1926[:] . . . still lifes of dead animals, fowl, and rabbits." Dunow, 1981, pl. 131, gives date as "ca. 1926." The date in TPC records was 1936, amended to ca. 1925 by 1966. Provenance: Early history per Maurice Laffaille to TPC, n.d. [Autumn 1980] and June 12, 1980. Consignment per label identified as such by Pierre Matisse to author, Feb. 21, 1987. Although earlier records suggest possible ownership by Henri Matisse or Patricia Matisse, the gallery is certain that these records are in error; Maria-Gaetana Matisse to author, June 5, 1987. Sent on approval, Pierre Matisse to DP, Nov. 29, 1950; bill of sale, Mar. 16, 1951.

2. Florence Berryman, *Sunday Star,* Feb. 7, 1943.

3. DP, draft for text on "Dynamic Color" in PMG.1941, n.p. From 1945 to 1971, The Phillips Collection owned a fifth work by Soutine, *Gorge du Loup,* n.d. (24¾ × 33½ in.; Scottish National Gallery of Modern Art).

4. Soutine traveled frequently in this period, to Le Blanc and Indre, locales not far from Paris, and moved his home twice within Paris. It has not been conclusively established where he painted these still lifes.

5. Two of them are similarly dated: *Pheasant,* ca. 1926, Tuchman et al., 1993, vol. 1, no. 113 (oil on canvas, 27 × 100 cm.; collection of Dr. Lucien Kleman, Paris), and *Le Faisan Mort,* 1926–27, Tuchman et al., 1993, vol. 1, no. 111 (oil on canvas, 50 × 70 cm.; formerly collection of Charles Im Obersteg, Geneva). Dunow, 1983, 11, asserts that Soutine painted at least twenty pictures in a two-year period (1925–27).

6. Dunow in Güse, 1981, 92.

7. For a discussion of Soutine's sources, see Dunow in Güse, 1981, 83–91.

8. Tuchman, 1968, 13. He notes (p. 15) that "Soutine's notorious habit of leaving dead flesh to rot for days is a flagrant (though perhaps unconscious) violation of Jewish kosher law which requires cleanliness and hasty consumption of killed animals."

9. Dunow in Güse, 1981, 89.

10. Ibid., 92.

11. Date: Tuchman et al., 1993, vol. 2, no. 165, dates the work to ca. 1937. The date in the 1940 Carstairs exhibition and in early TPC records is 1939, changed in 1950 to 1937. Title: First shown as *Profile.* Medium: This painting had apparently undergone extreme "abuse in its early existence." It also was cut down and restretched. See conservation report by Sheldon Keck and Caroline Keck, Oct. 1967. Provenance: Madeleine Castaing identified this painting as one that she sold to Roland Balay at Carroll Carstairs; per telephone conversation with Balay, who spoke with Castaing, Aug. 7, 1987. She gave no date for this transaction. Bill of sale, Apr. 9, 1943.

12. Garde, 1973, 53 (author's trans.): "Cette toile exécutée avec brio (en un après-midi, si je ne me trompe) montre Mme Tennent de profil. . . . Il [le portrait] fait aujourd'hui partie des collections de la Phillips Gallery." The history of Dr. Tennent's treatment appears in chap. 4, "Maladie," 47–54, in Garde, 1973. Soutine renamed his mistress Mlle Garde; see Leymarie in Castaing and Leymarie, 1964, 33.

13. Ada Rainey, "Varied Group at Phillips Gallery," *Washington Post,* Jan. 24, 1943.

14. Phillips stated, "At some future time, we hope to be in the position to get just such an important figure by the artist as your delightful *Petit Pâtissier,*" 1918–19 (Portland Art Museum, Portland, Oregon); DP to Carroll Carstairs, June 1, 1940.

15. DP to Carstairs, Feb. 23, 1943.

16. Tuchman, 1968, 47.

17. Leymarie in Castaing and Leymarie, 1964, 3. Soutine's interest in Greek sculpture dated from as early as 1929.

18. Tuchman in Güse, 1981, 68.

19. Dunow, 1981, 283. Dunow has more recently cited this painting as an example of the strength and elegance of Soutine's late work; see Dunow in Kleeblatt and Silver, 1998, 142.

20. Date: Per Tuchman et al., 1993, vol. 1, no. 166;

Carstairs exhibition, 1940, and chronology in Güse, 1982, 118, give a 1939 date. Castaing dates the work to 1938 (per Castaing's handwritten annotation on reverse of study photograph, returned to author through the courtesy of Roland Balay). Title: *Paysage d'automne,* the first known French title, was published in the catalogue for the 1940 Carstairs exhibition. *Windy Day* is probably a Phillips title. Provenance: Before Carroll Carstairs, the provenance is uncertain. Roland Balay states that he purchased works from Soutine in France for the gallery, but he does not remember the particular paintings or the dates of acquisition; per telephone conversation with Balay, Aug. 7, 1987. Bill of sale, Apr. 9, 1943.

21. Date: Per Tuchman et al., 1993, vol. 1, no. 174; Carstairs exhibition, 1940, and chronology in Güse, 1982, 118, give a 1939 date. Provenance: DP to Carstairs, Apr. 10, 1940: "Kind of you to ask me to your exhibition. . . . Hope to come next week."; DP to Carstairs, June 1, 1940: "I have hung the two paintings by Soutine and decided I prefer the smaller one." Invoice after sale of traded works, Apr. 22, 1941.

22. Garde, 1973, 74 (author's trans.): "La route qui conduit à l'Isle-sur-Serein était alors plantée de grands peupliers. . . . Soutine fit de cette route plusieurs tableaux. C'est l'un d'eux que la Phillips Gallery à Washington a intitulé: *Windy day, Auxerre* (*Jour de vent à Auxerre*); en réalité c'est la route . . . qu'il a peint sous un ciel d'orage."

23. The original French title, *Paysage d'automne,* implies that *Windy Day, Auxerre* was painted in the fall of 1939, but it is not known whether this original French title was given by the artist himself.

24. Garde, 1973, 75-76: " . . . s'éfforçant de découvrir entre les lignes le secret d'un avenir proche et chargé de ménaces."

25. Ibid. Dunow, 1981, 78, notes Soutine's awareness of and interest in world events during this period.

26. *Group of Trees at Civry* is presently in the Art Collection Trust, Basel. Its status as a sketch was proposed by Esti Dunow in telephone conversation with author, Aug. 1987.

27. Jeanette Lowe, "The New and the Old Soutine," *Art News* 38 (Apr. 20, 1940), 11.

28. Dunow, 1981, 145-51.

29. Phillips purchased the landscape with children as *Return from School After the Storm* but showed it for the first time at PMG as *Children Before a Storm.* His title changes often reflected his personal and romantic interpretation of a painting's subject and mood, and this change—enhancing the relevance of the image and underscoring the premonitory quality—seems to be no exception.

30. Dunow, 1983, 9.

Major References
Marcellin Castaing and Jean Leymarie, *Soutine,* New York, 1964.
Maurice Tuchman, *Chaim Soutine (1893–1943),* exh. cat., Los Angeles, LACMA, 1968.
Mlle Garde [Gerda Groth], *Mes années avec Soutine,* ed. Jacques Suffel, Paris, 1973.
Esti Dunow, "Chaim Soutine, 1893–1943," 2 vols., Ph.D diss., New York University, 1981.
Ernst-Gerhard Güse, ed., *Chaim Soutine (1893–1943),* exh. cat., London, Arts Council of Great Britain, 1981.

Esti Dunow, *Soutine (1893–1943),* exh. cat., New York, Galleri Bellman, 1983.
Maurice Tuchman et al., *Chaim Soutine (1893–1943): Catalogue Raisonné,* 2 vols., Cologne, 1993.
Museo d'Arte Moderna, *Chaim Soutine,* exh. cat., Milan, 1995.
Norman L. Kleeblatt and Kenneth E. Silver, *An Expressionist in Paris: The Paintings of Chaim Soutine,* exh. cat., New York, Jewish Museum, 1998.

TPC Sources
DP, essay for PMG.1943.2.
Cat., 1952.
MD, 1981.
DP and C. Law Watkins, essays for PMG.1941.4.
Stephen B. Phillips, cat. for TPC.1997.4.
MP, 1998.

Braque, Picasso, and Other Cubists

1. DP, "Nationality in Pictures" (1913), in *E of A,* 1914, 87–88.

2. DP, *Leaders of French Art Today,* cat. for PMG.1927.7, n.p.

3. Ibid.

4. Ibid.

5. Ibid.

6. DP, "A Survey of French Painting from Chardin to Derain," in *Bull.,* 1928, 19.

7. DP, "El Greco—Cézanne—Picasso," in *A & U,* 1929, 96.

8. *ASD,* 1931, 3.

9. DP, "The Many Mindedness of Modern Painting," in *A & U,* 1929, 60.

10. Ibid., 50.

11. See my discussion of this and the following issues in *Esprit de Corps: The Art of the Parisian Avant-Garde and the First World War, 1914–1924* (Princeton, 1989).

12. Ibid., 251 and 424.

13. DP, "Modern Art, 1930," *Art News* 28 (Apr. 5, 1930), 139.

14. *ASD,* 1931, 4–5.

15. DP, "El Greco—Cézanne—Picasso," 104.

16. DP, "Many Mindedness," 50.

17. DP, "Modern Art, 1930," 138.

18. *ASD,* 1931, 5.

19. *AMA,* 1935, 82–83.

20. DP, "Modern Art, 1930," 139.

21. *Three Musicians,* 1921 (oil on canvas, 29 × 87¾ in.; New York, Museum of Modern Art, Mrs. Simon Guggenheim Fund).

22. DP, "Modern Art, 1930," 143.

23. DP, "Many Mindedness," 58.

24. *ASD,* 1931, 7.

25. DP, "El Greco—Cézanne—Picasso," 99 and 104.

26. DP, *Leaders of French Art Today,* n.p.

27. DP, "A Survey of French Painting," 11.

28. *AMA,* 1935, 153.

29. DP, *Intimate Decorations: Still Life in New Manners,* cat. for PMG.1927.6, n.p.

30. First quote, "Many Mindedness," 57; second, "Modern Art, 1930," 140.

31. DP, *The Nation's Great Paintings: Georges Braque, "Still Life with Grapes,"* pamphlet (New York, 1945), n.p.

32. *AMA,* 1935, 152–53.

JACQUES VILLON [GASTON DUCHAMP]

1. Provenance: Pach to DP, Jan. 27, 1933, states that he had acquired this painting "from Villon's studio during the war" nearly twenty years earlier. In a letter to Maniere Dawson, Nov. 20, 1916 (Walter Pach Papers, AAA, reel 64, #0890), Pach wrote that he had been in Europe in the fall of 1914. Brummer Gallery bill of sale, Apr. 12, 1928. Ledger 15, June 14, 1928.

2. Susan Grace in Robbins, 1976, 79.

3. Alphonse Daudet, *Jack,* vol. 2, trans. Marian McIntyre (Boston, 1960), 30, as quoted in Robbins, 1976, 79.

4. Provenance: Louis Carré bill of sale, May 10, 1949. Ledger 15, May 19, 1949 (as *Le Grain ne meurt*).

5. Villon, quoted in Cabanne, 1976, 205.

6. Walter Pach believed that Villon's title derived from a verse in the New Testament: "Except a corn of wheat fall onto the ground and die, it abideth alone; but if it die, it bringeth forth much fruit" (John 12:24); as cited by Maria Shreve Simpson in Robbins, 1976, 170.

7. Simpson in Robbins, 1976, 170.

8. Romy Golan has written about a trend following the First World War in which a return-to-the-land theme played an important role not only in sociopolitical and economic discourses, but in artistic ones as well; see Golan's "A Moralized Landscape: The Organic Image of France Between the Two World Wars," Ph.D. diss., Courtauld Institute of Art, 1989. A similar trend seems to have developed during and following the Second World War: Braque, de Staël, and Villon returned to the landscape genre, and such artists as Fautier made works with organic imagery and thick, textured, telluric surfaces.

9. For a thorough discussion of this phenomenon, see T. J. Clark's chapter "The Environs of Paris" in *The Painting of Modern Life: Paris in the Art of Manet and His Followers* (Princeton, 1984), 147–204.

10. Oil on canvas, 54.9 × 38.1 cm.; gift from the estate of Katherine S. Dreier, 1953.

11. DP to Louis Carré, Villon's dealer, Apr. 15, 1949.

12. DP to Marcel Duchamp, Oct. 10, 1956.

Major References
Paul Eluard and René-Jean, *Jacques Villon ou l'art glorieux,* Paris, 1948.
Jacqueline Auberty and Charles Pérussaux, *Jacques Villon, catalogue de son oeuvre gravé,* Paris, 1950.
Dora Vallier, *Jacques Villon: Oeuvres de 1897 à 1956,* Paris, 1957.
Jacques Villon, Raymond Duchamp-Villon, Marcel Duchamp, exh. cat., New York, Guggenheim; Houston, MFA, 1957.
Raymond Cogniat, *Villon, peintures,* Paris, 1963.
Abbé Maurice Morel et al., *Souvenir de Jacques Villon,* Paris, 1963.
Pierre Cabanne, *Les frères Duchamp,* Neuchâtel, 1975; English ed., Boston, 1976.
Daniel Robbins, ed., *Jacques Villon,* exh. cat., Cambridge, Mass., Fogg Art Museum, 1976.
Roland Pressat, ed., *Jacques Villon, l'oeuvre gravé:*

Exposition autour d'une collection, exh. cat., Gravelines, Musée du dessin et de l'estampe originale; Lyon, Musée de l'imprimerie et de la Banque-Lyon, 1989.
Musée Camredon, *Jacques Villon,* exh. cat., L'Islesur-la-Sorgue, 1992.
Musée du Québec, *Jacques Villon: La donation Charles S. N. Pavent,* exh. cat., Quebec, 1992.
Detroit Institute of Arts, *Jacques Villon: Printmaker,* exh. cat., Detroit, 1995.

TPC Sources
Cat., 1952.
MD, 1981.

RAYMOND DUCHAMP-VILLON

1. Dreier purchased the relief through the American Art Association Sale, 1927, no. 705.

2. Zilczer, 1983, 140; for further discussion, see also Zilczer, 1980, 9–20.

3. The *Maison Cubiste* was presented at the Salon d'Automne in Paris in 1912. See discussion on pp. 197–207 in Jeffrey Weiss, *The Popular Culture of Modern Art: Picasso, Duchamp, and Avant-Gardism,* New Haven, 1994.

4. Zilczer, 1983, 140, has pointed out the resemblance of the relief to the composition of the program cover for the inaugural production of Edmond Rostand's play *Chantecler,* which took place Feb. 7, 1910.

5. Duchamp-Villon to Pach, Jan. 5, 1917, as quoted in translation in Zilczer, 1980, 20.

6. Katherine Dreier, who learned of Duchamp-Villon through his brother Marcel Duchamp, acquired *Gallic Cock* and several more of his works (including *Cat,* bequeathed to the Guggenheim Museum) upon the sale of Quinn's estate in 1927.

7. Judith Zilczer, *"The Noble Buyer:" John Quinn, Patron of the Avant-Garde,* exh. cat., Hirshhorn Museum and Sculpture Garden (Washington, D.C., 1978), 44.

8. Kenneth E. Silver, *Esprit de Corps: The Art of the Parisian Avant-Garde and the First World War, 1914–1925* (Princeton, 1989), 299–300.

9. Ibid., 300.

Major References
Walter Pach, *Raymond Duchamp-Villon, sculpteur, 1876–1918,* Paris, 1924.
Jacques Villon, Raymond Duchamp-Villon, Marcel Duchamp, exh. cat., New York, Guggenheim; Houston, MFA, 1957.
Albert Elsen, "The Sculpture of Duchamp-Villon," *Artforum* 6, Oct. 1967, 19–25.
George Heard Hamilton and William C. Agee, *Raymond Duchamp-Villon,* exh. cat., New York, Knoedler, 1967.
Pierre Cabanne, *Les frères Duchamp,* Neuchâtel, 1975; English ed., Boston, 1976.
Judith Zilczer, "Raymond Duchamp-Villon, Pioneer of Modern Sculpture," *Philadelphia Museum of Art Bulletin* 76, Fall 1980, 3–24.
———, "In the Face of War: The Last Works of Raymond Duchamp-Villon," *Art Bulletin* 65, Mar. 1983, 138–44.

PABLO PICASSO

1. Title: *Le Tub* probably by the artist; *The Blue Room* probably by Duncan Phillips; *La Toilette* on Wildenstein

bill of sale, Sept. 27, 1927; *Early Morning* by Phillips, used before 1939. Provenance: Uhde recounts in his book *Picasso et la tradition française: Notes sur la peinture actuelle* (Paris, 1928), 19, his purchase of this painting more than twenty years earlier from a mattress maker who sold works by young unknown artists on the side; correspondence with Alex Reid and Lefevre, Ltd., London, fall 1980; Wildenstein bill of sale, Sept. 27, 1927 (TPC Papers, AAA, reel 1938, #0509).

2. Félicien Fagus, "L'invasion espagnole," *La revue blanche* 25, 464–65, as quoted in translation in Rubin, 1980, 29.

3. See The Phillips Collection's *After the Bath,* ca. 1895 (cat. no. 36).

4. In, for example, *The Old Guitarist,* 1903 (Art Institute of Chicago), and *Woman Ironing,* 1904 (Solomon R. Guggenheim Museum, New York), Picasso employed the same slumped position, head parallel to the ground, and evoked a similar sense of disaffection and spiritual malaise.

5. Beneath this painting's lush and generous surface, however, lies evidence of how Picasso economized: texture in the paint film that does not correspond to the composition indicates that he painted this picture over an earlier one. Infrared reflectography and x-radiography indicate that this composition lies over what appears to be a portrait of a man. Examination by Anne Hoenigswald, conservator at NGA, Washington, D.C., Feb. 1998.

6. *A & U,* 1929, 105.

7. *Family of Saltimbanques,* 1905, reproduced in *Dial* 85 (Oct. 1928), is now in the collection of the National Gallery of Art, Washington, D.C.

8. DP to Josef Stransky, Wildenstein, New York, Oct. 16, 1928 (TPC Papers, AAA, reel 1937, #0653).

9. Picasso's *Still Life with Portrait* remains in the private collection of the Phillips family.

10. Provenance: In 1905 Picasso sold a group of sculptures to Vollard, who had them cast in bronze; see Alan Bowness, "Picasso's Sculpture," in Penrose and Golding, 1973, 122. A work titled *Der Pierrot* (dated 1904) appeared in a Picasso exhibition at Flechtheim's gallery in Oct. 1927; whether this is the same cast that was later purchased by Buchholz Gallery and, if so, whether Flechtheim owned this work at this time are uncertain. In a letter to Phillips dated Jan. 11, 1938, Curt Valentin (Buchholz Gallery) states that he had purchased the work from Flechtheim "some years ago"; Valentin to DP, Dec. 10, 1938, confirms receipt of payment for the work.

11. Picasso, Matisse, Boccioni, and Kirchner are among the more prominent painters who also produced noteworthy sculpture.

12. Lynne Cooke, "Paragone Rediscovered: The Painter-Sculptor in the Twentieth Century," in *The Painter-Sculptor in the Twentieth Century,* exh. cat., Whitechapel Gallery (London, 1986), 13.

13. Cooke, "Paragone Rediscovered," 13. See also *Head of a Woman,* 1950 (acc. no. 1558), which was given by Marjorie Phillips to the collection upon her retirement in 1972.

14. Lael Wertenbaker, *The World of Picasso, 1881–1973* (New York, 1967), 35–36.

15. Provenance: Valentine Gallery statement, Feb. 1, 1935, indicates that a Picasso gouache was billed to The Phillips Gallery on Sept. 20, 1930.

16. Kenneth Silver, *Esprit de Corps: The Art of the Parisian Avant-Garde and the First World War, 1914–1924* (Princeton, 1989), 298.

17. Ibid., 313.

18. Ibid., 346–49.

19. Ibid., 316.

20. John Richardson, *Pablo Picasso: Watercolors and Gouaches* (London, 1964), 10.

21. Zervos, 1932–78, vol. 4, 231–33.

22. DP to Valentine Dudensing, Feb. 1937, indicates decision to acquire this work; Dudensing to DP confirms exchange of Derain, *Still Life,* for Picasso, *Bullfight,* and Eilshemius, *Park Avenue* (TPC papers, AAA, reel 1951, #0457).

23. Picasso made eight oil paintings and several drawings and etchings of this subject during the summer of 1934; see Zervos, 1932–78, vol. 8, nos. 218–33. Like many of these paintings, The Phillips Collection's version has a sketchy, improvisatory quality, although it is less linear and dispersed in composition than some, for example, *Bullfight, August 3, 1934* (Zervos, 1932–78, vol. 8, no. 230).

24. *Guernica* is in the collection of the Reina Sofia Art Center, Madrid.

25. PMG.1941.4, cat. no. 70.

26. DP, "Gallery Notes International Show," unpubl. notes, 1938, n.p.; formerly MS 90. Also quoted in MP, 1982, 203.

Major References

Christian Zervos, *Pablo Picasso,* 33 vols., Paris, 1932–78.

Alfred H. Barr, *Picasso: Fifty Years of His Art,* New York, 1946.

Pierre Daix and Georges Boudaille, *Picasso, The Blue and Rose Periods: A Catalogue Raisonné, 1900–1906,* London, 1967 (cited as "DB").

Roland Penrose, *Picasso: His Life and Work,* New York, 1971.

Werner Spies, *Picasso Sculpture,* London, 1972.

Roland Penrose and John Golding, eds., *Picasso in Retrospect,* New York, 1973.

Jean Leymarie, *Picasso: Artist of the Century,* New York, 1977.

William Rubin, ed., *Pablo Picasso: A Retrospective,* exh. cat., New York, MOMA, 1980.

———, *Picasso and Braque: Pioneering Cubism,* exh. cat., New York, MOMA, 1989.

John Richardson, *A Life of Picasso: Vol. I, 1881–1906,* New York, 1991.

William Rubin (organizer), *Picasso and Braque, a Symposium* (proceedings of a symposium held in conjunction with the 1989 exhibition *Picasso and Braque*), New York, 1992.

Jean Sutherland Boggs, *Picasso and Things: The Still Lifes of Picasso,* exh. cat., Cleveland Museum of Art, 1992.

Pierre Daix, *Picasso: Life and Art,* trans. Olivia Emmet, New York, 1993.

Karen L. Kleinfelder, *The Artist, His Model, Her Image, His Gaze: Picasso's Pursuit of the Model,* Chicago, 1993.

Carsten-Peter Warncke, *Pablo Picasso, 1881–1973,* 2 vols., Cologne, 1993.

Jeffrey S. Weiss, *The Popular Culture of Modern Art: Picasso, Duchamp, and Avant-Gardism,* New Haven, 1994.

Pierre Daix, *Dictionnaire Picasso,* Paris, 1995.

Michael C. FitzGerald, *Making Modernism: Picasso and the Creation of the Market for Twentieth-Century Art,* New York, 1995.

Alan Wofsy Fine Arts, *Picasso's Paintings, Watercolors, Drawings, and Sculpture: A Comprehensive Illustrated Catalogue, 1885–1973,* San Francisco, 1995.

Jonathan Brown, ed., *Picasso and the Spanish Tradition,* New Haven, 1996.

Elio Grazioli, ed., *Pablo Picasso,* series *Riga* 12, Milan, 1996.

William Rubin, ed., *Picasso and Portraiture: Representation and Transformation,* exh. cat., New York, MOMA, 1996.

Anne Baldassari, *Picasso and Photography: The Dark Mirror,* trans. Deke Dusinberre, exh. cat., Boston, MFA, 1997.

TPC Sources

DP, essay for PMG.1927.7.

Bull., 1928.

CA, 1929.

A & U, 1929.

DP, essay for PMG.1938.6.

DP, "Gallery Notes International Show," unpubl. notes, 1938; formerly MS 90.

Cat., 1952.

MD, 1981.

Stephen B. Phillips, cat. for TPC.1997.4.

MP, 1998.

GEORGES BRAQUE

1. For a thorough treatment of the causes and ideological implications of the French avant-garde's stylistic retrenchment during and after the First World War, see Kenneth E. Silver's *Esprit de Corps: The Art of the Parisian Avant-Garde and the First World War, 1914–1925* (Princeton, 1989).

2. DP, "Fallacies of the New Dogmatism in Art," *American Magazine of Art* 9 (Dec. 1917); following quotes from pp. 46 and 45, respectively.

3. DP, "The Many Mindedness of Modern Painting," in *A & U,* 1929, 50–77.

4. DP, "Leaders of French Art Today," essay for PMG.1927.7, n.p.

5. DP, "George Braque," 1939, n.p.

6. DP, essay for PMG.1927.7, n.p.

7. DP, "A Survey of French Painting from Chardin to Derain," in *Bull.,* 1931, 11.

8. DP to Paul Reinhardt, Oct. 31, 1929 (TPC Papers, AAA, reel 1940, #0063).

9. DP, "George Braque," 1939, n.p.

10. The exhibition was held at the Durand-Ruel Galleries, New York, in March 1934. *The Round Table* was no. 25 in the catalogue.

11. As quoted in MP, 1982, 203.

12. *Music* (oil mixed with sawdust and black crayon on canvas, 36¼ × 23⅝ in.; private collection) was deaccessioned in 1987.

13. MP, 1982, 263–64.

14. *Pewter Pot and Plate of Fruit,* oil on canvas, 13¾ × 25½; gift of Gertrude Dunn Davis; acc. no. 1990.1.1.

15. DP, "George Braque," 1939, n.p.

16. Date: Dated 1924 in Worms de Romilly, vol. 1924–27, 29. Title: *Pitcher, Pipe and Pear* probably by Duncan Phillips; *Poires, pommes, pipe et pot* handwritten (possibly by artist) on label on reverse; *Fruits, pot et pipe* from photo-file card at Rosenberg, New York. Provenance: Original Rosenberg ownership documented in gallery records removed to New York, and henceforth cited by photo and stock (SK) numbers: photo no. 818; no SK number. No records remain that indicate to whom these works were sold. All provenance information pertaining to ownership between Rosenberg and Phillips was obtained through correspondence with Alex Reid and Lefevre, Ltd., London (Sept. 17 and Oct. 28, 1991). Although it is considered likely that Mrs. Workman originally purchased the painting through either the Reid or Lefevre galleries, perhaps at the time of its 1924 exhibition at Reid Gallery, no documentation has been found. Kraushaar bill of sale to PMG, Feb. 1, 1929 (TPC Papers, AAA, reel 1938, #1333).

17. Title: *Plums, Pears, Nuts and Knife* and variations probably by Duncan Phillips; *Fruits et couteau* from bill of sale and gallery label on painting reverse; *Poires, pêches, verre et couteau,* Isarlov cat. no. 423; *Fruits, verre, couteau,* Worms de Romilly, vol. 1924–27, 84. Provenance: Rosenberg photo no. 1227; SK no. 4106. No documentation has been found regarding purchase or consignment between Rosenberg and Durand-Ruel, but according to Elaine Rosenberg, Rosenberg frequently made arrangements with New York dealers for sale of his pictures. On approval to PMG in April; Durand-Ruel bill of sale, Dec. 14, 1927.

18. Title: *Compotier, citron et pommes,* the earliest known French title, appears on the original Rosenberg inventory card; sold to PMG as *Still Life,* the work has since been referred to by several slightly different descriptive titles. The earliest published reference to the work as *Lemons, Peaches and Compotier* appears in Cat., 1952; *Compotier et Fruits:* Worms de Romilly, vol. 1924–27, 103. Provenance: Rosenberg photo no. 1676; SK no. 4248. Reinhardt bill of sale, Oct. 2, 1928 (TPC Papers, AAA, reel 1936, #1269).

19. Title: *Lemons and Napkin Ring* by Duncan Phillips; *Pichet, citrons, serviette sur une table,* Rosenberg inventory card. Provenance: As one of four paintings created to be translated into marble mosaics for Paul Rosenberg's dining room (letter of Nov. 14, 1975, from Alexandre Rosenberg to CMA, to which he gave *The Crystal Vase,* 1929, another of the four), *Lemons and Napkin Ring* was probably commissioned by Rosenberg (photo no. 2129; SK no. 4534). Wildenstein held this work in partial share with Rosenberg and sold it to Valentine Dudensing (both per Wildenstein records, correspondence Apr. 8, 1992). No date for the Dudensing purchase is given, but because another record indicates that Dudensing saw a Braque work referred to as *Pichet* on Jan. 9, 1930, and because a work titled *Pichet, Citrons et Serviette* appeared in a Valentine Gallery show that opened Feb. 17, 1930, it seems safe to assume that Dudensing purchased it sometime between these two dates. Valentine Gallery bill of sale to PMG, Mar. 27, 1931.

20. Georges Braque, *Cahier de Georges Braque, 1917–1947,* English trans. Bernard Frechtman (Paris, 1948), 4: "Réalité. Ce n'est pas assez de faire voir ce qu'on peint. Il faut encore le faire toucher."

21. Georges Braque, "Pensées et réflexions sur la peinture," *Nord-Sud,* no. 10 (Dec. 1917), as quoted in translation by Cooper, 1972, 33.

22. DP, essay PMG.1927.6, n.p.

23. Gabriel P. Weisberg in *Burraku Ten = Georges Braque,* exh. cat., Isetan Museum of Art (Tokyo, 1988), 23.

24. MP, 1982, 192. The Phillips has another related still life, *Lemons and Oysters,* 1927 (oil on canvas, 10¾ × 13¾ in.; acc. no. 0211), acquired in 1927.

25. For a discussion of the original preparatory role of this work, see note 19 above.

26. DP, "The Modern Argument in Art and Its Answer," in *Bull.,* 1931, 45.

27. In *ASD,* 1931, 47, Phillips wrote: "Modernist art is not a revolution. It has evolved, like every other period, in a logical and gradual way. Its roots are deep in the remote past. Not since antiquity have the artists been so disciplined in theory to conform to the philosophy, the science, the tempo, and the very textures of the world around them."

28. Title: Per Cat., 1952; *Nature morte (à la clarinette),* Worms de Romilly, vol. 1924–27, 98. Provenance: Rosenberg photo no. 1858; SK no. 4363. Dr. Soubies's ownership and Rosenberg's second purchase indicated by Hôtel Drouot sale; see Malcolm Gee, *Dealers, Critics and Collectors of Modern Painting: Aspects of the Parisian Art Market Between 1910 and 1930* (New York, 1981), 158 and 160. Decision to purchase for PMG made by Dec. 4, 1929 (DP to Reinhardt, TPC Papers, AAA, reel 1940, #73). Payment made in 1930 and 1931.

29. DP, 1945, n.p.; in MP, 1982, 193, Marjorie Phillips remembers that this was one of her husband's favorites.

30. In a 1958 interview with John Richardson, "Braque Discussing His Art," *Réalités* 93 (Aug.), 26, Braque had this to say about the role of musical instruments in his paintings: "Now musical instruments have this advantage over other still-life objects, that they are animated by touch. You must know yourself how people always feel tempted to pluck the strings of a guitar or mandolin; I should like them to have the same urge to touch the objects when they look at one of my paintings."

31. DP, 1945, n.p.

32. Title: Per 1934 Durand-Ruel exhibition; *Guéridon* from Rosenberg inventory card and Isarlov, 1932, no. 494; *Le Grand Guéridon* from Worms de Romilly, vol. 1928–35, 22. Provenance: Rosenberg photo no. 2368; SK no. 4585. Phillips acquired *The Round Table* by trading two paintings for it: Daumier's *The Reader* and Sisley's *Bords de la Seine.* In a letter of Apr. 28, 1934, Rosenberg confirmed this exchange (TPC papers, AAA, reel 1945, #0788).

33. Date: Discrepancies in dating: Rosenberg label on reverse of original frame states date as 1945; Worms de Romilly, vol. 1942–47, 70, gives 1942–44. Title: Per Duncan Phillips; *La Toilette aux carreaux verts* from inscription on stretcher, possibly in artist's hand; *Dressing Table with Green Squares* from 1946 Tate exhibition catalogue of Picasso. Provenance: Tate Gallery exhibition label on reverse of painting indicates that Braque still owned the work in 1946. Rosenberg purchased it between that year and 1948, when it was sold to PMG. Paul Rosenberg to DP, July 22, 1948, refers to an enclosed invoice (no longer extant). Ledger 15, Sept. 30, 1946.

34. Cooper, 1972, 25.

35. Ibid., 62.

36. Title: *Ondée:* Worms de Romilly, vol. 1948–57, 59. Provenance: The bill of sale, Mar. 20, 1953, states that Schempp purchased the work directly from the artist.

37. At the end of the 1920s Braque flirted briefly with landscapes and seascapes, but he tended to conceive these works as still lifes or stage sets rather than open, expansive vistas.

38. Robert Cafritz has suggested that the example of Nicolas de Staël, a painter of abstract landscapes who was a friend and neighbor of Braque's, may have inspired Braque to explore the potential for "tactile immediacy" in landscape painting (Cafritz, 1982, 14).

39. Chipp, TPC.1982.13, 29.

40. Ibid., 29.

41. On bill of sale, Mar. 20, 1953, Schempp indicated that the work was purchased directly from the artist.

42. Richardson, "Braque Discussing His Art," 25.

43. Chipp, TPC.1982.13, 27.

44. Richardson, "Braque Discussing His Art," 30.

45. Ibid., 30.

Major References
Georges Isarlov, *Georges Braque,* Paris, 1932.
Cahiers d'art, nos. 1–2, Paris, 1933 (issue devoted to Braque).
Henry R. Hope, *Georges Braque,* exh. cat., New York, MOMA, 1949.
John Russell, *Georges Braque,* London, 1959.
Nicole Worms de Romilly (née Mangin), *Catalogue de l'oeuvre de Georges Braque: 1916–1957,* 6 vols., Paris, 1959–1973.
Francis Ponge et al., *Georges Braque,* Paris, 1971; English ed., New York, 1978.
Marco Valsecchi and Massimo Carrà, *L'opera completa di Braque, 1908–1929, dalla composizione cubista al recupera dell'oggetto,* Milan, 1971; French ed., Paris, 1973.
Douglas Cooper, *Braque: The Great Years,* exh. cat., Chicago, AIC, 1972.
Raymond Cogniat, *Georges Braque,* Paris, 1976; English ed., New York, 1980.
Nicole Worms de Romilly (née Mangin) and Jean Laude, *Braque: Le cubisme, 1907–1914,* Paris, 1982.
Serge Fauchereau, *Braque,* New York, 1987.
Jean Leymarie, ed., *Georges Braque,* exh. cat., New York, Guggenheim, 1988.
Bernard Zurcher, *Georges Braque, vie et oeuvre,* Fribourg, Switzerland, 1988; English ed., New York, 1988.
William S. Rubin, *Picasso and Braque: Pioneering Cubism,* exh. cat., New York, MOMA, 1989.
William Rubin (organizer), *Picasso and Braque, a Symposium* (proceedings of a symposium held in conjunction with the 1989 exhibition *Picasso and Braque*), New York, 1992.
Jean-Louis Prat, *G. Braque,* exh. cat., Martigny, Switzerland, Fondation Pierre Gianadda, 1992.
Russell T. Clement, *Georges Braque: A Bio-Bibliography,* Westport, Conn., 1994.
Fondation Maeght, *Georges Braque: Retrospective,* exh. cat., Saint-Paul, 1994.
Jean Leymarie, *Braque: Les ateliers,* Aix-en-Provence, 1995.
John Golding, *Braque: The Late Works,* exh. cat., London, Royal Academy of Arts, 1997.

TPC Sources
DP, essay for PMG.1927.6.
DP, essay for PMG.1927.7.
Bull., 1928.

CA, 1929.
A & U, 1929 and 1930.
ASD, 1931.
Bull., 1931.
DP, Henry McBride, and James Johnson Sweeney, essays for PMG.1939.22.
DP, *The Nation's Great Paintings: Georges Braque, "Still Life with Grapes,"* pamphlet, New York, 1945.
Cat., 1952.
MP, 1970 and 1982.
MD, 1981.
Robert C. Cafritz, *Georges Braque,* Washington, D.C., The Phillips Collection, 1982.
Herschel B. Chipp, essay for TPC.1982.13.
Stephen B. Phillips, cat. for TPC.1997.4.
MP, 1998.
MSS 4 and 117.

LOUIS MARCOUSSIS
1. Title: Original French title from handwritten inscription (possibly artist's) on reverse. Provenance: Label on l.l. painting reverse suggests that it was either owned by or consigned to Der Sturm Gallery in Berlin and then sold ("Kunstaustellung Der Sturm, Leitung: Herwarth Walden, Berlin"). Dreier purchased a Marcoussis painting on glass from Der Sturm Gallery ca. Oct. 1922, as per Bohan correspondence, Mar. 28, 1980.

2. Lefranchis, 1961, 84.

3. Daniel Robbins, "Louis Marcoussis," in Robert L. Herbert et al., eds., *The Société Anonyme and the Dreier Bequest: A Catalogue Raisonné* (New Haven, 1984), 436.

4. Mildred Lee Ward, *Reverse Paintings on Glass,* exh. cat., Helen Foresman Spencer Museum of Art, University of Kansas (Lawrence, 1978), 14.

5. See discussion in ibid., 15 and 24.

6. Peter Selz, *German Expressionist Painting* (Berkeley, 1957), 183.

7. Robbins, "Louis Marcoussis," 436.

8. Lefranchis, 1961, 84.

Major References
Louis Achel, "Louis Marcoussis," *Cahiers d'art* 1, July 1926, 141–44.
E. Tériade et al., *Marcoussis,* special issue of *Sélection,* no. 7, June 1929.
Jean Cassou, *Marcoussis,* exh. cat., Cologne, Kunstverein, 1960.
Jean Lefranchis, *Marcoussis: Sa vie, son oeuvre,* Paris, 1961.
Louis Marcoussis, exh. cat., Paris, Musée National d'Art Moderne, 1964.
Jean Cassou and Gaston Bachelard, *Marcoussis, l'ami des poètes,* exh. cat., Le Havre, 1966.
Solange Milet, *Louis Marcoussis: Catalogue raisonné de l'oeuvre gravé,* Copenhagen, 1991.

TPC Sources
ASD, 1931.
Cat., 1952.

ROGER DE LA FRESNAYE
1. Provenance: Georges de Miré's ownership per Seligman, 1969; stock list of Paintings and Pastels, book no. 1, Jacques Seligmann papers, AAA, storage container no. 41. Bill of sale, July 27, 1939.

2. Seligman, 1969, 74.

3. For a detailed discussion and interpretation of the role of cubist artists in the decorative arts at this time, see Nancy J. Troy, *Modernism and the Decorative Arts: Art Nouveau to Le Corbusier* (New Haven, 1991), 79–96.

4. DP, 1944, n.p.

5. DP, 1945, n.p.

6. For a discussion of La Fresnaye's prewar use of cubist principles for patriotic purposes, see Kenneth E. Silver, *The Art of the Parisian Avant-Garde and the First World War, 1914–1925* (Princeton, 1989), 49–50.

7. Seligman, 1969, 75.

8. Richard V. West, *Painters of the Section d'Or: The Alternatives to Cubism*, exh. cat., Albright-Knox Art Gallery (Buffalo, 1967), 28.

9. Picasso and Braque were not participating in either salons or group exhibitions at this time. The general public's knowledge of cubism, therefore, came exclusively from the works of artists such as Gleizes, Metzinger, Le Fauconnier, and La Fresnaye, who showed together in several Salons des Indépendants and in special group exhibitions such as "La Section d'Or" of 1912.

10. La Fresnaye, "On Imitation in Painting and Sculpture," in *La grande revue*, no. 14 (July 25, 1913); reprinted in translation in Seligman, 1969, 775.

11. Seligman, 1969, 38.

12. George Heard Hamilton, *Painting and Sculpture in Europe, 1880–1940* (New York, 1983), 260–61.

Major References
Roger Allard, *R. de la Fresnaye*, Paris, 1922.
E. Nebelthau, *Roger de la Fresnaye*, Brussels, 1935.
Raymond Cogniat and Waldemar George, *Oeuvre complète de Roger de la Fresnaye*, vol. 1, Paris, 1950 (vol. 2 never published).
René Gaffé, *Roger de la Fresnaye*, Brussels, 1956.
Robert Mead Murdock, "Elements of Style and Iconography in the Work of Roger de La Fresnaye, 1910–1914," M.A. thesis, Yale University, 1965.
Germain Seligman, *Roger de la Fresnaye* (with catalogue raisonné), Paris, 1969; English ed., New York, 1969.
Bernard Dorival et al., *Roger de la Fresnaye*, exh. cat., Saint-Tropez, Musée de l'Annonciade, 1983.

TPC Sources
ASD, 1931.
DP, essay for PMG.1944.4.
DP, *The Nation's Great Paintings: Georges Braque, "Still Life with Grapes,"* pamphlet, New York, 1945.
Cat., 1952.
MD, 1981.
Stephen B. Phillips, cat. for TPC.1997.4.

ALEXANDER ARCHIPENKO

1. Date: In Archipenko, 1960, the artist erroneously dates this work to 1919. Both the artist's inscription on the reverse and the original handwritten list of works shipped for Archipenko's New York show in 1921 indicate 1920 as the date. Provenance: Although this work was sent to Katherine Dreier in late 1920 or early 1921 for the Archipenko exhibition and was subsequently retained, there is no record of purchase from this time. Dreier may have made an arrangement with Archipenko sometime after his arrival in this country in the spring of 1923; see Ruth L. Bohan, Société

Anonyme Collection, Yale University, to TPC, Mar. 14, 1980.

2. This and the following quote from Archipenko, "The Concave and Void," in Archipenko, 1960, reprinted in Karshan, 1969, 21 and 22, respectively.

3. Although Archipenko claims to have created his first sculpto-painting in 1912 (Archipenko, 1960, 41), the earliest surviving example dates from 1914 (Michaelson, 1977, 127).

4. Michaelson, 1977, 136.

5. This and the following quote from Archipenko, "Polychrome Manifesto," in Archipenko, 1960, reprinted in Karshan, 1969, 23.

Major References
Katherine S. Dreier Papers, Archives of the Société Anonyme, Beinecke Rare Book and Manuscript Library, Yale University.
Theodor Däubler et al., *Archipenko-Album*, Potsdam, 1921.
Ivan Goll, *Archipenko, an Appreciation*, New York, 1921.
Hans Hildebrandt, *Alexander Archipenko*, Berlin, 1923.
Alexander Archipenko, *Archipenko: Fifty Creative Years, 1908–1958*, New York, 1960.
Donald H. Karshan, ed., *Archipenko: International Visionary*, exh. cat., Washington, D.C., SITES, 1969.
———, *Archipenko: The Sculpture and Graphic Art, Including a Print Catalogue Raisonné*, Tübingen, 1974.
Katherine J. Michaelson, *Archipenko: A Study of the Early Works, 1908–1920*, New York, 1977.
Katherine J. Michaelson and Nehama Guralnik, *Alexander Archipenko: A Centennial Tribute*, exh. cat., Washington, D.C., NGA, 1986.
Anette Barthe, *Alexander Archipenkos plastisches Oeuvre*, New York, 1997.

TPC Source
MD, 1981.

JUAN GRIS

1. DP to Graham, Feb. 6, 1930, states that payment was enclosed (TPC Papers, AAA, reel 1937, #0811).

2. Title: *Still Life with Newspaper* probably by Phillips; *Nature morte*, Léonce Rosenberg bill of sale, Nov. 23, 1922; *Still Life in Black and Grey* and *Grey, Green and Black* used by Katherine Dreier; *Fruit-Dish, Glass, and Lemon*, Rosenthal, 1983. Provenance: Rosenberg (Galerie L'Effort Moderne) bill of sale dated Nov. 23, 1922, Dreier Papers, Beinecke Rare Book and Manuscript Library, Yale University; Dreier's decision to sell was based on the need to meet expenses incurred by the dissolution of the Société Anonyme in April 1950 (letters to DP from Marcel Duchamp, July 24, 1950, and Katherine Dreier, Oct. 5, 1950, TPC Papers, AAA, reel 1973, #1102 and #1124); after receiving the painting for consideration on Aug. 4, 1950 (TPC shipping records), Phillips expressed intent to buy in a letter to Dreier, Oct. 11, 1950; payment was received Apr. 2, 1951 (Dreier Papers, Yale University).

3. Kenneth E. Silver, "Eminence Gris," *Art in America* 72 (May 1984), 153–54.

4. Kahnweiler, 1969, 138 (untitled biography, signed "Vauvrecy").

5. MD, 1981, 92.

6. Rosenthal, 1983, 78.

7. In a letter to Katherine Dreier, Oct. 11, 1950, in which he states his intent to buy *Still Life with Newspaper*, Phillips wrote: "We lack any important examples of early Cubism and this will fill the gap very nicely."

8. From a statement by Gris quoted by Amédée Ozenfant in *L'esprit nouveau*, no. 5 (1921); reprinted in Kahnweiler, 1969, 193.

Major References
Daniel-Henry Kahnweiler, *Juan Gris: Sa vie, son oeuvre, et ses écrits*, Paris, 1946; English ed., New York, 1947; rev. English ed., 1969.
Douglas Cooper, ed. and trans., *Letters of Juan Gris, 1913–1927* (collected by D. H. Kahnweiler), London, 1956.
James Thrall Soby, *Juan Gris*, exh. cat., New York, MOMA, 1958.
Michèle Richet et al., *Juan Gris*, exh. cat., Paris, Orangerie, 1974.
Juan Antonio Gaya-Nuño, *Juan Gris*, trans. K. Lyons, Boston, 1975.
Douglas Cooper, *Juan Gris: Catalogue raisonné de l'oeuvre peint établi avec la collaboration de Margaret Potter*, 2 vols., Paris, 1977.
Mark Rosenthal, *Juan Gris*, exh. cat., Berkeley, University Art Museum, University of California, 1983.
Gary Tinterow, ed., *Juan Gris: 1887–1927*, exh. cat., Madrid, Biblioteca Nationale, 1985.
Juan Antonio Gaya-Nuño, *Juan Gris*, trans. Kenneth Lyons, New York, 1986.
Christopher Green, *Juan Gris*, exh. cat., London, Whitechapel Art Gallery, 1992.

TPC Sources
ASD, 1931.
Cat., 1952.
MD, 1981.
Stephen B. Phillips, cat. for TPC.1997.4.
MP, 1998.

5. THE DREIER GIFT AND OTHER EUROPEAN MODERNISTS

1. The author wishes to thank Elizabeth Prelinger, associate professor of fine arts, Georgetown University, for reading this chapter in manuscript; her suggestions were invaluable and greatly improved the final version. Thanks also to Joan Kadonoff, who assisted with the research on Duncan Phillips and expressionism.

2. The subtitle "Museum of Modern Art and Its Sources" first appears on a leaflet enclosed in *A & U*, 1929, perhaps in response to the founding of the Museum of Modern Art, whose board of trustees he joined in Oct. 1929; he had been recommended by Abby Aldrich Rockefeller (letter to A. Conger Goodyear, July 31, 1929, A. Conger Goodyear Papers, vol. 1, Rockefeller Archive Center; courtesy Rona Roob, archivist, MOMA).

3. [The Phillips Collection], text for a television program sponsored by the Junior League of Washington, D.C., Mar. 5, 1961.

4. For the renaissance idea, see *E of A*, 1914, 95.

5. DP to Theodore Sizer, director, Yale University Art Gallery, Nov. 16, 1941, declining an invitation to lecture at the celebration of the gift of Katherine S. Dreier's Société Anonyme collection to Yale.

6. "Modern Art and the Museum," *American Magazine of Art* 23 (Oct. 1931), 274. See also "Modern Art, 1930," *A & U*, 1930, 131–44.

7. Dreier to DP, Feb. 15, 1949. Correspondence and records were gathered from Foxhall correspondence, TPC files, and microfilm. On their meeting, see MP, 1982, 246–48.

8. DP to Dreier, Feb. 23, 1949; response, Feb. 25. Although founded in 1918, the museum was not incorporated until July 23, 1920; the Société Anonyme, Inc., was incorporated on Apr. 29 with Duchamp as president and Man Ray as secretary; Dreier added the subtitle "Museum of Modern Art, 1920," and two years later made Kandinsky an honorary vice president. See Robert L. Herbert et al., *The Société Anonyme and the Dreier Bequest at Yale University: A Catalogue Raisonné* (New Haven, 1984), 751–53.

9. Herbert et al. 1984, entries for Dove's *Barnyard Fantasy*, 1935, and Marin's *Landscape*, ca. 1940, discuss the gifts and reprint Phillips's essays; the Phillipses also gave Marjorie's *Landscape with Buzzard*, 1948. Earlier, Phillips had written a foreword to Dreier's book, *Burliuk* (New York, 1944).

10. Duchamp, who had often acted on Dreier's behalf, wrote to Phillips May 7, 1952, without mentioning Dreier's death. Phillips's answer May 8 suggests that he was not aware of it, for he wrote that he was reluctant to buy additional works from her.

11. All quotes from Phillips to Duchamp, May 19, 1952; it appears that Duchamp had visited Phillips on May 15 (see Phillips's telegram, May 13). Since Dreier had not mentioned this gift in her will, it is to be assumed that the decision was made by Duchamp, one of her three executors. Herbert et al. 1984, 28–32, discuss Dreier's unsuccessful efforts in 1939 to give her Connecticut home (and the private collection it contained) to Yale as a country museum; her wish to have her collection join the Arensberg Collection at the Philadelphia Museum had also ended in failure. Forty-one photographs, labeled in Duchamp's handwriting, were discovered in the TPC Archives.

12. For works not discussed in this chapter, see: Rodin (cat. no. 48); Archipenko, Duchamp-Villon, Marcoussis, Villon (cat. nos. 128, 129, 130, 144, 146); Calder (cat. nos. 285, 286). No longer in the collection are Braque's *Music* (deaccessioned, private collection); Duchamp's *Small Glass*, exchanged for Werner Drewes, *Composition in Green*, 1935 (acc. no. 0597); and Ernst, *Forest* (deaccessioned). Pevsner's relief construction on vitreous black panel (35⅜ × 23½ × 7¾ in.; signed and dated; acc. no. 1478) shares the fate of many of the artist's works in that the plastic has deteriorated badly.

13. All quotations, DP to Duchamp, n.d. [July 25, 1952, per Duchamp's response July 30]. The letter includes two lists, one for the museum and one for the American University, the latter including two sculptures by Brancusi and one by Lehmbruck; the selections for the university were eventually replaced (per Duchamp's letter of conveyance, Jan. 22, 1953). For Phillips's relationship to the American University, see Summerford's essay in this volume, pp. 607–10. Among the rejected works were *In the Garden* by Léger; abstractions by Kandinsky, El Lissitzky, Buchheister, and Stuckenberg; a Calder stabile; and two works each by Klee and Schwitters.

14. Barr to Duchamp, Nov. 17, 1952, reporting on his visit to Washington (copy sent to Phillips). The work's full title is *To Be Looked At (From the Other Side of the Glass) with One Eye, Close To, for Almost an Hour*, 1918

(oil paint, silver leaf, lead wire, and magnifying lens on glass, 19½ × 15⅜ in.; the Museum of Modern Art, Katherine S. Dreier Bequest, 150.53), also called *The Small Glass*; Barr calls it *Disturbed Balance* in his letter.

15. "The concise expression, through concrete symbols or suggestions, of single, personal impressions," in "What Impressionism in Painting Really Means," *E of A*, 1914, 37.

16. Catalogue introduction to PMG.1927.3, n.p. Phillips may have been guided by Sheldon Cheney, who traced expressionism's lineage from El Greco to Cézanne and Kokoschka, proclaiming the return to emotional expressiveness as a fundamental of modern art and life; see *A Primer of Modern Art*, 10th ed. (New York, 1939), 31. This book and the 1939 edition of Cheney's *Expressionism in Art* were in Phillips's library. For a summary of the term's changing definition, see Horst Uhr, *Masterpieces of German Expressionism at the Detroit Institute of Arts* (New York, 1982), 10.

17. "Nationality in Pictures," *E of A*, 1927, 65; for the list, "Names for Catalogue," see Journal I, between 1931 and 1935, n.p. All but Beckmann are now in the collection. Notably absent is the Dresden group Die Brücke, perhaps because of the sexual undercurrents and assertive fauvism in their work.

18. DP to John O'Connor Jr., Carnegie Institute, Nov. 3, 1938, when purchasing Kokoschka's *Prague: View from the Moldau Pier IV* (cat. no. 169) and inquiring about Karl Hofer. For a survey of the gradual acceptance of German modernism, and Hofer's role in the 1925 and 1927 Carnegie Internationals, see Penny Joy Bealle, "Obstacles and Advocates: Factors Influencing the Introduction of Modern Art from Germany to New York City, 1912–1933: Major Promoters and Exhibitions," Ph.D. diss., Cornell University, 1990, particularly 153–95.

19. *Catholicity Does Not Mean Eclecticism: A Radio Talk by Duncan Phillips*, pamphlet, 1954, n.p.

20. See Reinhold Heller, "The Expressionist Challenge," in *Dissent: The Issue of Modern Art in Boston*, exh. cat., ICA (Boston, 1985). Barr's views can be gleaned from the chart in his 1936 catalogue, *Cubism and Abstract Art*, that channeled all modernist trends into "geometrical and non-geometrical abstract art," listing expressionism as "(Abstract) Expressionism," with lines leading to nongeometric abstraction and to the Bauhaus; his essay on Kandinsky, Klee, and Marc is titled "Abstract Expressionism in Germany" (pp. 64–72). Phillips created a similar chart for the exhibition "Emotional Design in Painting" (PMG.1940.7); however, it widened the range of possibilities, showing the currents running from the past to the present and including expressionism.

21. For a summary of the controversy, seen from Barr's perspective, see Irving Sandler's introduction to *Defining Modern Art: Selected Writings of Alfred H. Barr, Jr.* (New York, 1986), 30–35; for Plaut's side, see *Dissent*, 1985, 38–45. This debate spread into politics and caused even President Truman to voice his opinions on modern art as "the vaporings of half-baked lazy people" (Sandler, *Defining Modern Art*, 30).

22. Plaut's statement, written Feb. 17, 1948, is reprinted in *Dissent*, 1985, 52–53.

23. Barr, reacting in confidential notes, cited in Sandler, *Defining Modern Art*, 32, n. 126.

24. "Revolt in Boston," *Life* (Feb. 21, 1949), 84. Barr's quote from a telegram of the same day, cited in Sandler, *Defining Modern Art*, 34.

25. On May 17, 1949, Plaut suggested a three-museum conference (Whitney, MOMA, ICA), but Barr decided on a release, "A Statement on Modern Art," signed by Plaut, Frederick S. Wight, René d'Harnoncourt, Barr, Andrew C. Ritchie, Hermon More, and Lloyd Goodrich. It read in part: "We affirm our belief in the continuing validity of what is generally known as modern art" (Sandler, *Defining Modern Art*, 34–35, and n. 138).

26. Plaut quote from a May 13, 1940, radio forum talk; see *Dissent*, 1985, 14. On the museum directors' letter to the editor, see Sandler, *Defining Modern Art*, 35, n. 137. The ICA exhibitions featured Rouault (PMG.1940.13), modern Mexican painters (PMG.1942.1), Marin (PMG.1947.4), Kokoschka (PMG.1948.14), Jacques Villon and Feininger (TPG.1949.18), Munch (TPG.1950.7), Yeats (TPG.1951.10), Sutherland and Moore (TPG.1954.2), and an exhibition entitled "Younger New England Painters" (TPG.1955.7). Only the Kokoschka and Munch exhibitions traveled to MOMA.

27. Quotation from David Bathrick and Andreas Huyssen, eds., *Modernity and the Text: Revisions of German Modernism* (New York, 1989), 3. See *Dissent*, 1985, 24 and 26, for Barr's efforts to marginalize expressionism by considering Rouault an isolated phenomenon influential only in Germany and not leading to the triumph of modernism; furthermore, he saw Matisse's expressionism as a search for decorative or dynamic—that is, formal—effects.

28. Phillips, writing to Olda Kokoschka, Mar. 1, 1949: "We went with John Marin and he was impressed with the bravura, the virtuosity, the elan. Alfred Barr had just been there the same afternoon and I was told that he too was enthusiastic."

29. Typewritten, annotated manuscript, *Edvard Munch's Expressionism*, translated from *Neue Zürcher Zeitung*, nos. 1576, 1581, 1587, 1589, July 18–20, 1952. Note also that Phillips himself painted a Munchlike work, *By the Sea*, in 1950 (acc. no. 1480), probably at the time of the Munch exhibition.

30. "A Collection Still in the Making," *ASD*, 1931, 11–12 (his italics).

31. *Catholicity Does Not Mean Eclecticism*, pamphlet, 1954, n.p.

WASSILY KANDINSKY

1. Title: The subtitle *Villa Seeburg/Spiegelung* is the artist's. *Spiegelung* (reflection) was added in Kandinsky's hand to handlist (HL III); Villa Seeburg is situated on the Staffelsee near Murnau. Catalogue raisonné: Kandinsky kept four handwritten lists of his work (translated as "handlists" and cited as HL I through IV), now in the Nina Kandinsky Archives. *Autumn II* is listed as no. 156 on HL II and HL III; see also Roethel and Benjamin, 1982, 428; a Galerie Der Sturm label on the painting's reverse includes the number 156. Provenance: Fritz Schön collection per Roethel and Benjamin, 1982, and illustration in *Cahiers d'Art* 7 (1929), 323; R. C. Schön collection per list, Sept. 1, 1942, and Schön's correspondence with Galerie Dominion, Montreal, Feb. 15, 1945; sold to Nierendorf through S. Thalheimer, Nov. 4, 1943 (courtesy Michel Moreault, Galerie Dominion Archives, Sept. 17, 1991); PMG purchase per Nierendorf to DP, May 14, 1945 (TPC Papers, AAA, reel 1964 #0532); bill of sale, June 20, 1945 (as *Autumn*).

2. Will Grohmann, *Wassily Kandinsky: Life and Work* (New York [1958]), 61.

3. See Peter Jelavich, "Munich as Cultural Center: Politics and the Arts," and Peg Weiss, "Kandinsky in Munich: Encounter and Transformations," in Guggenheim, 1982; see also Long, 1987, 38–45.

4. The almanac was first published in May 1912; *On the Spiritual in Art* in Dec. 1911 (but dated 1912). *Klänge* was probably published in 1912; see *Writings*, 1982, 291; for the correlations between colors and the sound of musical instruments, see p. 182.

5. Quote from Grohmann, *Wassily Kandinsky*, 61.

6. See two wider views, both of 1911, *Autumn I* (oil on canvas, 71 × 99 cm.; collection of Lora F. Marx, Chicago; Roethel and Benjamin, 1982, no. 381, HL 123) and *Winter II*, 1911 (oil on canvas, 67.5 × 90 cm.; private collection, Connecticut; Roethel and Benjamin, 1982, no. 380, HL 122). Each work had studies of 1910. This and subsequent observations on medium and technique per Elizabeth Steele, painting conservator, Aug. 7, 1991.

7. *Blaue Reiter Almanac*, 1974, 168. Beneath the line, the weave of the canvas is visible, presumably because Kandinsky rubbed the paint into the ground layer, thereby exposing the top threads of the canvas before painting the shoreline.

8. From *On the Spiritual in Art*, 1912, in *Writings*, 1982, 162.

9. For Kandinsky's ideas on color, see *On the Spiritual in Art*, 1912, in *Writings*, 1982, 181–85, 188. Already in its third edition by the fall of 1912, the book would have been very much on Kandinsky's mind while he was working on this painting. On later color studies at the Bauhaus, see Clark V. Poling, *Bauhaus Color*, exh. cat., High Museum of Art (Atlanta, 1975).

10. *On the Spiritual in Art*, 1912, in *Writings*, 1982, 169.

11. Excerpt from "Chalk and Soot" in *Klänge*; see *Writings*, 1982, 328. In his poetry, Kandinsky used repetition, punctuation, imagery, and disorientation in ways reminiscent of his abstract compositions.

12. Title/date: Per Roethel and Benjamin, 1982, no. 453. The painting is no. 162 on HL II and III; the subtitle *Moskau* appears on HL III and was adopted by Roethel and Benjamin, although it is scratched out on the stretcher. *Storm* and *Composition-Storm* probably from Galerie Der Sturm label, a fragment of which remains on the reverse. Provenance: In a letter to Galerie Der Sturm, Aug. 16, 1920, Dreier asked about four recent purchases, including one (unnamed) Kandinsky. See Ruth Bohan to TPC, June 27, 1980, and Katherine S. Dreier Papers, Archives of the Société Anonyme, Beinecke Rare Book and Manuscript Library, Yale University, New Haven, Conn.

13. Kandinsky, *Reminiscences/Three Pictures* (Berlin, 1913), in *Writings*, 1982, 382. The last section, p. 389, "Picture With the White Edge," mentions this sketch and describes Kandinsky's struggles for a resolution.

14. *Painting with White Border*, 1913 (oil on canvas, 55¼ × 78⅞ in.; Solomon R. Guggenheim Museum, New York). For illustrations and discussion of the probable sequence of sketches, see Rudenstine, 1976, 256–63.

15. *Three Pictures*, in *Writings*, 1982, 389. Kandinsky began his first sketches on Dec. 22, 1912; see chronology in Guggenheim, 1982, 306.

16. On the "hidden elements" subsumed in the composition, see Long, 1972, 45, where Rudolf Steiner's theosophist beliefs in "hidden and ambiguous suggestions" are credited as a source.

17. The Novgorod School was richly represented in Moscow. Compare *Saint George and the Dragon*, early sixteenth century (tempera and gold leaf on wood, 37 × 27½ in.; Menil Collection, Houston). See also Marit Werenskiold, "Kandinsky's Moscow," *Art in America* 77 (Mar. 1989), 96–111, where several illustrations show the church vaults.

18. Weiss, 1986, 53–54; for a discussion of the shamanistic imagery in Kandinsky and its roots in his early studies, see especially pp. 52–56; these convictions are hotly disputed in Hahl-Koch, 1993, 32.

19. The motif of the rider on a rearing horse, pointing his lance at a many-headed mythical monster, is the reverse of a folk sculpture illustrated in *Blaue Reiter Almanac*, 1974, 73 and 270, that was possibly part of Kandinsky's collection. For a discussion of the transformation of the image, see Peg Weiss in Guggenheim, 1982, 28–30, 77.

20. See Kandinsky's *The Last Judgment*, 1910 (oil on canvas, 125 × 73 cm.; collection of Joseph H. Hazen, New York; HL 113a), for a representational depiction of the motif.

21. *Three Pictures*, in *Writings*, 1982, 391.

22. Some areas show paint film that is unrelated to the composition, suggesting that the artist either painted over another, perhaps unfinished, composition or made major changes as he went along. This would confirm the struggle described in the text (Steele, Aug. 7, 1991).

23. *Three Pictures*, in *Writings*, 1982, 391.

24. Ibid., 360.

25. *Western Art and the New Era* (New York, 1923), 104–5; illus. p. 103.

26. Medium: *Succession* is painted on a commercially prepared canvas of French standard dimensions called *40 figure* (figure compositions). Catalogue raisonné: Roethel and Benjamin, 1984, no. 1055 (HL IV, No. 617), painted in Apr. 1935. Provenance: In a letter of Oct. 17, 1923 (Dreier Papers, Beinecke), Kandinsky mentions Nierendorf as his agent. Kandinsky's handlist contains the note "Nierendorf, NY, sept. 38," presumably the date of consignment (Jessica Boissel, Centre Pompidou, to TPC, June 23, 1992). PMG purchase out of the "East-West" exhibition (DP to Nierendorf, Dec. 13, 1943); Ledger 15, June 17, 1944.

27. Essay in Katherine S. Dreier and Marcel Duchamp, *Collection of the Société Anonyme: Museum of Modern Art 1920*, ed. George Heard Hamilton (New Haven, 1950), 2. Hans K. Roethel and Jean K. Benjamin, *Kandinsky* (New York, 1979), 120, observe that, to create this space, Kandinsky did not use "the original white of the canvas[;] but the brushstrokes with which he painted over it transformed it into a breathing white plane."

28. As quoted by Harriett Watts in "Arp, Kandinsky, and the Legacy of Jakob Böhme," *The Spiritual in Art: Abstract Painting, 1890–1985*, exh. cat. LACMA (Los Angeles, 1986), 242.

29. For a summary of this "undervalued final period," see Jeffrey Weiss, "Late Kandinsky: From Apocalypse to Perpetual Motion," *Art in America* 73, no. 9 (Sept. 1985), 118–25, and Vivian Endicott Barnett, "Kandinsky and Science: The Introduction of Biological Images in the Paris Period," in Guggenheim, 1985, 82–85, who states that Kandinsky rejected the surrealists' interest in Freud, automatism, and dreams.

30. Weiss, 1986, 43–44 and 55. For his relationship with critics and his reception in France, see Christian Derouet in *Oeuvres de Vassily Kandinsky (1866–1944): Collection du Musée National d'Art Moderne* (Paris 1984), 355–56.

31. Grohmann, *Wassily Kandinsky*, 232, places *Succession* among works with "rich arabesque forms." Barnett in Guggenheim, 1985, 73, states that "*Succession* . . . resembles the watercolor *Lines of Marks* of 1931" (HL 442) and points out parallel illustrations of fungi in a book on botany owned by Kandinsky. According to Weiss, 1986, 56, shamanistic drum imagery "may include 'fantastic' animals that . . . look like strange microscopic amoebae."

32. See, for example, Miró's *Dog Barking at the Moon*, 1926 (Philadelphia Museum of Art, A. E. Gallatin Collection), and Klee's *Tree Nursery*, 1929 (cat. no. 159).

33. *Point and Line to Plane*, 1926, in *Writings*, 1982, 603.

34. Grohmann, *Wassily Kandinsky*, 227.

35. These painted outlines look almost like halos. Kandinsky's precise approach is seen in the pinholes that were created when the circles were drawn with a compass (Steele, Aug. 7, 1991).

36. "Empty Canvas, etc," in *Writings*, 1982, 780–81, 783. Weiss, 1986, 56, sees this text as a shamanistic calling forth of images into the void.

37. In a handwritten text sent to Dreier (dated Dec. 1922, Dreier Papers, Beinecke), Kandinsky contemplated the link between the creative processes of nature and of art and man's pivotal position as both the created and creator; hence, both nature and art are ruled by immutable laws (*Gesetzmässigkeit*).

38. "The Value of a Concrete Work," 1938, in *Writings*, 1982, 820.

39. DP to Nierendorf, Dec. 13, and Nierendorf to DP, Dec. 18, 1943.

Major References
Kandinsky Handlists (cited as HL), Archives of the Estate of Nina Kandinsky, Musée Nationale d'Art Moderne, Centre Georges Pompidou, Paris.

Kandinsky Gabriele Münter Stiftung, Städtische Galerie im Lenbachhaus, Munich.

Kandinsky-Sturm Archiv, Handschriftenabteilung, Staatsbibliothek, Berlin.

Rose-Carol Washton Long, "Kandinsky and Abstraction: The Role of the Hidden Image," *Artforum* 10, no. 10, June 1972, 42–49.

Wassily Kandinsky and Franz Marc, eds., *The Blaue Reiter Almanac*, ed. Klaus Lankheit, New York, 1974.

Angelica Zander Rudenstine, *The Guggenheim Museum Collection: Paintings, 1880–1945*, 2 vols., New York, 1976.

Kandinsky in Munich, exh. cat., New York, Solomon R. Guggenheim Museum, 1982.

Kandinsky: Complete Writings on Art, ed. Kenneth C. Lindsay and Peter Vergo, 2 vols., Boston, 1982 (cited as *Writings*).

Hans K. Roethel and Jean K. Benjamin, *Kandinsky: Catalogue Raisonné of the Oil Paintings*, 2 vols., Ithaca, N.Y., 1982 and 1984.

Art Journal 43, no. 1, spring 1983, Peg Weiss, guest ed. (entire issue dedicated to Kandinsky).

Kandinsky in Paris: 1934–1944, exh. cat., New York, Solomon R. Guggenheim Museum, 1985.

Peg Weiss, "Kandinsky and 'Old Russia': An Ethnographic Exploration," *Syracuse Scholar* 7, no. 1, spring 1986, 43–62.

Rose-Carol Washton Long, "Occultism, Anarchism, and Abstraction: Kandinsky's Art of the Future," *Art Journal* 46, no. 1, spring 1987, 38–45.

Vivian Endicott Barnett, *Kandinsky Watercolors: Catalogue Raisonné*, 2 vols., Ithaca, N.Y., 1992 and 1994.

Jelena Hahl-Koch, *Kandinsky*, New York, 1993.

Annegret Hoberg, *Wassily Kandinsky and Gabriele Münter: Letters and Reminscences, 1902–1914*, Munich and New York, 1994.

Magdalena Dabrowski, *Kandinsky Compositions*, exh. cat., New York, MOMA, 1995.

Peg Weiss, *Kandinsky and Old Russia: The Artist as Ethnographer and Shaman*, New Haven, 1995.

Vivian Endicott Barnett and Josef Helfenstein, eds., *The Blue Four: Feininger, Jawlensky, Kandinsky, Paul Klee in the New World,* exh. cat., Kunstmuseum, Bern, and Kunstsammlung Nordrhein-Westfalen, Düsseldorf, 1997.

TPC Sources
Cat., 1952.
MD, 1981.
Gail Levin and Marianne Lorenz, cat. for TPC.1992.5.
MP, 1998.

LYONEL FEININGER

1. Provenance: Feininger brought much of his work to America with the help of Curt Valentin of the Buchholz Gallery. This painting was probably part of that group, because it was included in Feininger's exhibition at Mills College in 1936, just after his arrival; see Hess, 1961, 134–35 and 139. Buchholz bill of sale, Feb. 18, 1943. The Achim Moeller Fine Art Gallery in New York has been preparing a catalogue raisonné of Feininger's paintings, drawings, and watercolors.

2. Feininger was introduced to cubism in 1911 when he exhibited at the Salon des Indépendants in Paris, at which time he met Robert Delaunay. Both his and Delaunay's work were included in a 1912 exhibition at Der Sturm gallery, although Feininger did not meet the director, Herwarth Walden, until 1913.

3. Feininger to Alfred Kubin, June 15, 1913, as quoted in Ness, 1974, 40.

4. *Markwippach,* 1917 (oil on canvas; Cleveland Museum of Art; Hess no. 168, pl. 7.). In a letter to his wife, Aug. 8, 1917, Feininger notes that he and Walden chose five of his drawings for publication in *Der Sturm,* including a pen-and-ink composition entitled *Markwippach;* see Ness, 1974, 88.

5. Feininger to Julia Feininger, Aug. 2, 1927, as quoted in Ness, 1974, 156. Earlier that year Feininger wrote to his wife (Feb. 25, 1927, as quoted in Ness, 1974, 154): "I have been able to combine a strong visionary conception with technical skill in a way that has been rare lately."

6. Feininger often used blue to connote spirituality, as for example, in *Gelmeroda IX,* 1926 (oil on canvas; Museum Folkwang, Essen; Hess no. 263, pl. 16): the blue spire of the cathedral links the earthly and heavenly realms. Walter Gropius, the Bauhaus founder, also linked cathedrals with spirituality, because they were created by artists and craftsmen working together for a higher purpose. Feininger undoubtedly concurred with the theories and ideas of his Bauhaus colleagues, especially regarding color symbolism, but he, like Klee, worked intuitively, and colors had varying resonances depending upon their use.

7. Feininger to Kubin, Jan. 5, 1919, as quoted in Ness, 1974, 53.

8. Medium: Examination using infrared reflectography reveals an unfinished work that lies below *Spook I.* The earlier composition reflects an architectural landscape-type image similar in style to *Village.* Per Elizabeth Steele, conservator, June 5, 1998. Provenance: Buchholz bill of sale, May 29, 1941.

9. Feininger to Theodore Spicer-Simson, Sept. 18, 1937, as quoted in Hess, 1961, 140.

10. As quoted in Hess, 1961, 142.

11. Feininger as quoted in Alfred Barr, *Feininger, Hartley,* exh. cat., MOMA (New York, 1944), 11.

12. The guestbook belonged to Hans Hess's father; the passage reads "Gespensterchen, gutartige, den lieben Freunden ins schöne neue Stammbuch von ihrem getreuen Maler Lyonel Feininger." Author's trans.: "Ghosts, friendly ones, for the dear friends [written] into the beautiful new guestbook by their faithful artist Lyonel Feininger." See Hans Hess, *Dank in Farben: Aus dem Gästebuch Alfred und Thekla Hess* (Munich, 1977), 5.

13. The statement, dated Nov. 5, 1954, is quoted in T. Lux Feininger, *City at the Edge of the World* (Munich, 1966), 77. A related work entitled *Spook II,* 1941 (oil on canvas; destroyed; Hess no. 408), may be drawn from another image of goblinlike creatures on a stone bridge in the guestbook, but Feininger expanded the composition greatly; see Hess, *Dank in Farben,* 17.

14. Feininger to Dr. Alois Schardt, Apr. 7, 1946, as quoted in Hess, 1961, 158.

15. Phillips was interested in purchasing *Gaberndorf II,* 1924 (oil on canvas; Nelson Gallery, Atkins Museum, Kansas City; Hess no. 249, pl. 29). He may also have seen a watercolor entitled *U.V.W.* in a 1939 show at Whyte Gallery, Washington, D.C., entitled "Fantasy in American Art of the Nineteenth and Twentieth Century." There is no record of his response to the brief negative mention of Feininger by Ralph Flint in *A & U,* 1930, 192.

16. Karl Lilienfeld to DP, Mar. 31, 1941, refers to Phillips's letter to Feininger. In regards to the proposed exhibition, see Valentin to DP, Apr. 9, 1941; statement sent with shipment, Apr. 9, 1941; and Valentin to DP, May 2, 1941, TPC Papers, AAA, reel 1956, #494, #495, and #530, respectively.

17. See Plaut, foreword for TPG.1949.18.

Major References
Lyonel Feininger Papers, 1887–1939, AAA.
Busch-Reisinger Feininger Archives, Harvard University.
Lyonel Feininger Papers, Houghton Library, Harvard University.
Hans Hess, *Lyonel Feininger* (catalogue raisonné by Julia Feininger), New York, 1961.
Ernst Scheyer, *Lyonel Feininger: Caricature and Fantasy,* Detroit, 1964.
Leona Prasse, *Lyonel Feininger: A Definitive Catalogue of His Graphic Work: Etchings, Lithographs, and Woodcuts,* Cleveland, 1972.
June L. Ness, ed., *Lyonel Feininger,* New York, 1974.
Achim Moeller Fine Arts, *Feininger and Tobey: Years of Friendship, 1944–1956, The Complete Correspondence,* exh. cat., New York, 1991.
Vivian Endicott Barnett and Josef Helfenstein, eds., *The Blue Four: Feininger, Jawlensky, Kandin-*

sky, Paul Klee in the New World, exh. cat., Kunstmuseum, Bern, and Kunstsammlung Nordrhein-Westfalen, Düsseldorf, 1997.

TPC Sources
Ralph Flint, "Current American Art Season," *A & U,* 1930.
James S. Plaut, foreword for TPG.1949.18.
Cat., 1952.
T. Lux Feininger and Ralph F. Colin, essays for TPC.1985.13.

PIET MONDRIAN

1. Date: Ca. 1900 per Herbert Henkels, research curator, Gemeentemuseum, The Hague, to author, Nov. 5, 1990; van den Briel, in Tokyo Shimbun, 1987, 178, gives the date "around 1900–1902." Medium: the original fabric is of extremely light weight and has disengaged from the auxiliary support in some areas, suggesting that the artist himself mounted the cloth onto the board (Elizabeth Steele, painting conservator, Nov. 8, 1994). Inscription: Van den Briel, Mondrian's friend from about 1898 on, added part of a Dutch translation of an Icelandic poem: *Alzoo waag ik myn ikheid ter wereld te brengen—en rustig verwacht ik—want het eeuwig verjagende noodlot dwingt myn verlangen tot zeker geworden.* Author's trans.: "So I take the risk of thrusting myself into the world—and I wait calmly—for destiny, which eternally pursues us, lifts my desire to the point of complete self-confidence"; see Seuphor, 1956, 63. Provenance: Approximate date of sale to Streep courtesy of Henkels, Nov. 5, 1990; Janis acquisition per telephone conversation with Jeffrey Figley, Feb. 1, 1991; bill of sale, Jan. 2, 1958; Ledger 15, Dec. 31, 1957.

2. "Mondrian in His Studio," in Tokyo Shimbun, 1987, 165–91. Mondrian's relationship to his studios has been studied in great detail; later photographs show him dressed in suit and tie or lab coat, eschewing all hints of bohemia.

3. Van den Briel recalled that Mondrian painted it "only to solve a technical problem—that of making the sitter's eyes always meet the spectator's"; Henkels in Tokyo Shimbun, 1987, 178.

4. Pentimenti in the background (rectangular and circular shapes) suggest that the portrait was painted over another composition (Steele, Sept. 27, 1990). See Threlfall, 1988, 90, for a discussion of the academic sketch and its liberating role in the art of the Hague School.

5. See Henkels in Tokyo Shimbun, 1987, 179–80, for the photographic self-portrait of 1908 and the drawings of 1908–10; he defines two types: initiate and searcher. A photograph of 1910 (p. 181) shows the artist in meditation, wearing a similar shirt and vest.

6. Seuphor, 1956, 58; for Rudolf Steiner, founder of the German branch of theosophy (or anthroposophy), the eye was the light-absorbing vessel and light the cosmic force made visible. On Steiner's Dutch lectures in 1908, see Welsh et al., 1971, 41. Mondrian joined the Dutch Theosophical Society in 1909.

7. Date: See text. Title: *Composition No. III* is the artist's title; see Holtzman and James, 1986, fig. 173, for Mondrian's drawing of each work in the 1925 Dresden exhibition (Kühl and Kühn, "P. Mondrian, Man Ray"), where he marked this painting "No. III." Two shipping lists (one dated Dec. 20, 1926) by Sophie Küppers, organizer of the exhibition, also identify this painting

as *Komposition No. III*, as does the 1927 Mannheim catalogue (copy courtesy Joop Joosten, Leiden, corr. with author, Aug. 5, 1991, and subsequent letters). Alternate title per forthcoming catalogue raisonné by Joosten. *Square Composition* derived from Valentine Gallery shipping records, Mar. 16, 1946 (with a note "title unknown"). Dimension: Küppers's two shipping lists give the dimensions as 50 × 50 cm., suggesting that the painting's format was changed at some time. Joosten found that the frame was added later since "in 1925 Mondrian did not yet make those frames" (letter to TPC, July 27, 1981). The inside of the stretcher bar has a Valentine Gallery stamp, and another, "New York," possibly from the time of the 1942 exhibition or earlier. Inscription: See text for discussion of date. Catalogues raisonnés: not listed in Seuphor, 1956, or Ottolenghi, 1976. Provenance: The work may have been sent from London when Mondrian moved to New York; see Seuphor, 1956, 174. Joosten, Aug. 5, 1991, believes that Valentin Dudensing, the gallery's owner and the husband of Margarete, may also have acquired it in Germany since he was Mondrian's dealer beginning in 1936. TPC purchase per shipping records Mar. 16, 1946.

8. Mondrian followed Rudolf Steiner's belief that art is a metaphysical medium. He owned a copy of Steiner's lecture (Seuphor, 1956, 57) and wrote him Feb. 25, 1921, that neo-plasticity would become "the art of the near future for all true anthroposophists and theosophists." Author's trans. from Carel Blotkamp, *Mondrian en Detail* (Utrecht, 1987), 143.

9. Neo-plasticism, translated from the Dutch *nieuwe Beelding,* is more closely related to form-giving rather than plastic (or sculptural) principles.

10. DP to Valentine Dudensing, Mar. 13 and May 2, 1946.

11. *Toward the True Vision of Reality,* as cited in Holtzman and James, 1986, 339 (itals. by Mondrian).

12. See Küppers lists and 1927 Mannheim catalogue. The date was discovered by Elizabeth Steele underneath layers of paint in an infrared photograph taken Mar. 1994. Joosten, in a letter of Aug. 5, 1991, stated: "Mistakes in the first dates are not uncommon in Mondrian's double datings."

13. The painting has not been X-rayed. Steele (Nov. 8, 1994) observed that paint has been scraped away and the composition reworked by the artist in numerous places. A ridge of paint is visible on the tacking margins that is presumably the result of paint having been brushed up to and over a strip frame that would have been affixed to the center of the stretcher bar. For more detailed information, see in-house before-treatment condition report, Nov. 3, 1994. Joosten wrote (Apr. 15, 1991): "In the 1921 paintings only one or two lines, the continuing ones, touch the edges." This is still the case, but almost imperceptibly so. In a letter of Nov. 25, 1991, he returned to this issue: "I am wondering if Mondrian elongated lines . . . in 1925 . . . to incorporate the painting [into] 1925 ambiance." Robert Welsh, inspecting the painting on Feb. 26, 1991, proposed that black lines may have been removed or altered, and that the painting may have had a uniformly blue-gray coloration.

14. Collection Rothschild, New York, Ottolenghi no. 323; and Gemeentemuseum, The Hague, S. B. Slijper Collection, Ottolenghi no. 331.

15. Kermit S. Champa, *Mondrian Studies* (Chicago, 1985), 92.

16. Hans L. C. Jaffé, *Mondrian* (New York, [1970]), 134.

17. Holtzman and James, 1986, 338.

18. Title: The title derives from *No. 9* (the artist's inscription, per Joosten, Aug. 5, 1991), representing the catalogue number of the 1942 Valentine exhibition; alternate title per Ottolenghi and Seuphor. Medium: The canvas has been adhered with wax resin to hardboard backing stamped "made in USA," hence applied in New York; dimensions with added molding: 34⅝ × 32¼ (88.0 × 82.0). The canvas edge is covered with paper tape attached before final reworking or restoration; see Sheldon Keck, conservation report, Jan. and Apr. 1962, and Steele inspection, Aug. 23, 1992. Provenance: Katherine Dreier may have purchased the painting from the 1942 Valentine exhibition, because in a letter dated Feb. 19, 1942, Mondrian writes: "I am glad to hear my picture pleases you" (Dreier Papers).

19. According to Threlfall, 1988, 46, twenty-two unfinished paintings were shipped to New York. Joosten, writing to author, Aug. 5, 1991, asserts that they were completed works and were only touched up in New York.

20. Herbert et al., 1984, 479. Dreier was the first American to own a Mondrian, and this was the last of three paintings purchased for her personal collection.

21. An early painting with a narrow double line is *Composition B with Gray and Yellow,* 1932 (19⅞ × 19⅞ in.; Müller-Widmann collection, Basel; Seuphor no. 368).

22. Mondrian's interpretation of color and its sources in the teachings of Schoenmaekers and Goethe are discussed in Threlfall, 1988, 303–5 (Schoenmaekers) and 274 (for Goethe). See also Robert P. Welsh et al., 1971, 36–41.

23. *Broadway Boogie-Woogie,* 1942–43 (50 × 50 in.; The Museum of Modern Art, New York). The red bars in the Phillips painting appear to have been placed over reserved spaces, while the white was later built up in layers around them. In the lower right corner, traces of red are visible beneath the white. Inspection gives no clear indication of the stages of work done in 1939 or 1942; perhaps the painting was simply touched up after arrival in New York. Ultraviolet light reveals two types of yellow, and losses along the edges have been filled and retouched in white; this same white was used to fill cracks and touch up certain minor areas (Steele, Nov. 19, 1990).

24. Welsh, who inspected the painting on Feb. 26, 1991, noted that Mondrian was known to have carefully scraped away traces of earlier black lines, then covered the area with numerous layers of white. See also Welsh, "Landscape Into Music: Mondrian's New York Period," *Arts Magazine* 40 (Feb. 1966), 33–39.

25. Among his followers who were members of AAA were Bolotowsky (acc. nos. 0151–52), J. L. K. Morris, Harry Holtzman, Charmion von Wiegand, and A. E. Gallatin (cat. no. 255).

26. "Mondrian in New York," *Artforum* 110, no. 4 (Dec. 1971), 54.

27. "Obituary of Mondrian," in Greenberg, *Perceptions and Judgments, 1939–1944,* ed. John O'Brian (Chicago, 1986), 188.

Major References
Mondrian Archives, Gemeentemuseum, The Hague. Mondrian Records, Holtzman-Mondrian Collection, and Katherine S. Dreier Papers, Bei-

necke Rare Book and Manuscript Library, Yale University, New Haven, Conn.
James Johnson Sweeney, "Eleven Europeans in America," *Museum of Modern Art Bulletin* 13, nos. 4–5, 1946.
Hans L. C. Jaffé, *De Stijl, 1917–1931: The Dutch Contribution to Modern Art,* Amsterdam, 1956.
Michel Seuphor, *Piet Mondrian: Life and Work,* New York, 1956.
Robert P. Welsh, ed., *Piet Mondrian, 1872–1944,* exh. cat., Art Gallery of Toronto, 1966.
Robert P. Welsh et al., *Piet Mondrian, 1872–1944: Centennial Exhibition,* exh. cat., Guggenheim, New York, 1971.
Maria Grazia Ottolenghi, *Tout l'œuvre peint de Mondrian,* Paris, 1976.
Robert L. Herbert et al., *The Société Anonyme and the Dreier Bequest at Yale University: A Catalogue Raisonné,* New Haven, 1984.
Harry Holtzman and Martin S. James, eds., *The New Art—The New Life: The Complete Essays of Piet Mondrian,* Boston, 1986.
The Tokyo Shimbun, *Mondrian: From Figuration to Abstraction,* exh. cat., Tokyo, 1987.
Tim Threlfall, *Piet Mondrian: His Life's Work and Evolution, 1872 to 1944,* New York, 1988.
John Milner, *Mondrian,* London, 1992.
Carel Blotkamp, *Mondrian: The Art of Destruction,* London, 1994.
De Serge Lemoine and D'Arnauld Pierre, *Piet Mondrian and Alfred Roth: Correspondance,* Paris, 1994.
Serge Faucherau, *Mondrian and the Neo-Plasticist Utopia,* New York, 1994.
Meyer Schapiro, *Mondrian: On the Humanity of Abstract Painting,* New York, 1995.
Susanne Deicher, *Piet Mondrian: Protestantismus und Modernität,* Berlin, 1995.

TPC Sources
Cat., 1952.
MD, 1981.
MP, 1998.

PAUL KLEE

1. André Masson, "Homage to Paul Klee," *Partisan Review* (Jan.–Feb. 1947), 60. The author thanks Sabine Fischer, visiting fellow at the museum in 1990, for her thorough and imaginative scholarship reflected in this essay and in her entry on *Tree Nursery.*

2. First quotation from introduction to PMG.1942.11, n.p.; second from *ASD,* 1931, 4–5.

3. Introduction to PMG.1942.11, n.p.

4. Robert Rosenblum, *Modern Painting and the Northern Romantic Tradition: Friedrich to Rothko* (New York, 1975; repr. 1983), 154.

5. As quoted in Spiller, 1961, 93.

6. *Little Regatta* (1922; watercolor on paper, 5¾ × 9 [14.6 × 22.8], acc. no. 0998; Gift from the estate of Katherine S. Dreier) was stolen from the collection in 1963 and recovered in 1997. The author was unable to inspect the work.

7. Phillips hung Klee works in Gallery E, often with Dufy, or with Marin and Stuart Davis. After the 1942 memorial exhibition, ten works remained on display in the Drawing Room; Klee's works were first installed as a unit in the fall of 1948, and the Klee Room has been on view almost continuously since 1959. For

Klee's influence on artists of the New York School, see Kagan, 1975; see also Noland entry (cat. nos. 406, 407). Gene Davis is quoted in exh. cat. for TPC.1983.8, interview with Percy North and Jerry Clapsaddle, n.p.

8. Kagan, 1975, part 1, 55.

9. In a letter of Apr. 12, 1938, Phillips said he wanted to buy *Necropolis, Botanical Laboratory,* and *Where Lemons Grow* (listed in MOMA catalogue as *Lemon Orchard*); however, *Necropolis,* 1930 (07; collection of David Thompson, Pittsburgh), was returned on Apr. 27 in exchange for *Garden Still Life.* Three other works, *Radiating Landscape, Happy Mountain Landscape,* and *Arrow in a Garden,* were noted with prices but not acquired.

10. See Lanchner, "Klee in America," in Lanchner, 1987, 83–111.

11. Neumann's activities per Lanchner, 1987, 94. Nierendorf wrote to Phillips Sept. 26, 1938, after having written Mar. 9 that he was now Klee's sole representative in America.

12. Quotations from *ASD,* 1931, 17, and *Bull.,* 1931, 19.

13. DP, 1953, 17, citing Read's *Art Now* (New York, 1933), 142–43. Sweeney quote from *Paul Klee,* Karl Nierendorf, ed. (New York, 1941), 13.

14. Quotations from introduction to PMG.1942.11, n.p. and DP, slide lecture, version E, ca. 1936–42, n.p.

15. Inscription: Signed on a corner that is painted red to simulate a tear. Catalogue raisonné: Klee devised a numbering system according to which he recorded his annual output, but not necessarily in chronological order. The accompanying notes in the oeuvre catalogue reveal his technique, medium, and often dates as well as original titles. Information from this catalogue, cited in German for each entry hereafter, courtesy Irene Rehmann (Paul Klee-Stiftung, Kunstmuseum Bern, Feb. 22, 1991). Entry for *Cathedral: 1924/138/A/ Kathedrale/Aquarell und Öllasur/Canson & Montgolfier/gekleistert, als kleines Gemälde mit Orig. leisten gefasst.* For a summary of Klee's numbering system, see Jürgen Glaesemer, *Die farbigen Werke im Kunstmuseum Bern* (Bern, 1976), 8–9. Provenance: Provenance and consignment dates per Paul Klee-Stiftung; Nierendorf label on reverse, no. 794 (stock number?). Decision to purchase, July 28, 1942; Ledger 15, Oct. 2, 1942.

16. Medium: Several earlier records, including a conservation report (Washington Conservation Studio, July 27, 1982), list gouache or watercolor in addition to oil; the brown paint is water-sensitive but has not been analyzed and could be gouache, tempera, or a very lean oil medium (Elizabeth Steele, painting conservator, Oct. 12, 1991). Inscription: The ink signature is now very faint but is seen clearly on earlier photographs. Catalogue raisonné: Oeuvre catalogue: *1937/ qu 17/ Tafel/ der Weg zur Stadtburg (Städtebild), Ölfarben, Pappe auf Keilrahmen genagelt.* The second German title, in parentheses, was inserted by Klee at a later date. Provenance: Early provenance, including consignment to Buchholz and Nierendorf, per Paul Klee-Stiftung records. Sent on approval by Nierendorf, Nov. 16, 1940; purchase (together with *Arab Song*) per Ledger 15, June 7, 1941, as *Road to the Citadel.*

17. Another work in the collection, *Land of Lemons* (*Citronengegend*), 1929 (335; 3 H35; watercolor and gouache on paper mounted on cardboard, 9 × 12 cm.; acc. no. 0997), shows roads, cars, mountains, and clouds—recollections perhaps of travel by auto in Italy, the "Land of Lemons."

18. In 1926 Klee and Kandinsky, friends since their Blaue Reiter days, moved into a duplex in Dessau designed by Walter Gropius.

19. Numerous other works render architectural elements in "polyphonic interpenetration of plan and elevation"; they also reflect rhythm as well as Klee's principle of "dividual" and "individual" pictorial structure, as analyzed in Spiller, 1961, 237–63.

20. Rosenthal, 1981, caption opp. pl. 6, interprets Klee's highlighting of the watermark, "MONTGOLFIER," as an obvious pun referring both to the paper and to a northern Algerian town which he believes inspired this architectural vision.

21. The white paint beads up as though repelled by the surface below (Steele, Dec. 9, 1991).

22. Klee, 1957, 185; entry 632, June 1905 (author trans.): "Also: Das Mittel ist nicht mehr der schwarze Strich, sondern der weisse. Der Grund ist nicht Licht, sondern Nacht; dass die Energie eine aufhellende ist, entspricht dem Vorgang in der Natur. . . . 'Es werde Licht.' So gleite ich langsam hinüber in die neue Welt der Tonalitäten."

23. Jim M. Jordan, *Paul Klee and Cubism* (Princeton, 1984), 196.

24. Klee calls these differentiations of spatial perception "exotropic" and "endotropic" (Spiller, 1961, 50–52). For cubist *passage,* spatial transitions achieved through shading, see Jordan, 1984, xvii–xviii.

25. Spiller, 1961, 157–67; illus. p. 166.

26. Steele, Oct. 12, 1991.

27. Klee, *Pädagogisches Skizzenbuch,* 1925; reprint, New York, 1953, intro. and trans. Sibyl Moholy-Nagy (5th ed.), 1967), 54.

28. Klee, "Rückblicke," in 1957, 135; inserted as late as 1921 into his 1902 entries; see Franciscono, 1991, 7, and Werckmeister, 1989, 5–8, on Klee's revisions.

29. The citadel is mentioned in a letter of Dec. 25, 1928. Quote in Klee, 1979, n.p., Aug. 15, 1927 (author's trans.): "Schlafen geht man nach dem Pfeil ein sehr steiles genuesisches Gässchen hinauf, dann um's Eck von hinten ins Nebenhaus hohe, sehr hohe Stufen zum zweiten Stock."

30. See Spiller, 1961, 155, for Klee's drawing of an **S**-curve lined with houses to illustrate these concepts.

31. For a discussion of this work's simulated age and an interpretation in terms of Walter Benjamin's concept of the aura surrounding an original work, see Haxthausen, 1990, 8ff. Also discussed is the fact that Klee, by applying these simulations, opposed the Bauhaus practices of creating art in identical multiples in order to make it available to everyone.

32. PMG.1942.11, n.p.

33. See Wassily Kandinsky and Franz Marc, eds., *The Blaue Reiter Almanac* (Munich, 1912); reprint ed. with intro., Klaus Lankheit, ed. (New York, 1974), 108.

34. "Creative Credo" in Spiller, 1961, 79.

35. Medium: The ground's texture is intensified by brushstrokes and various impressions made while still wet; bands of color were then added using a thin, lean oil medium (Steele, Oct. 12, 1991). Inscription: A photograph of the painting's reverse, taken before its 1978 conservation, shows inscriptions: *1929 S8 "Junge Pflanzung" Klee.* Catalogue raisonné: Oeuvre catalogue: *1929/98/S.8/Gemälde/junge Pflanzung/Ölfarben/Leinw. auf Keilr. Orig.l.* Provenance: Flechtheim

bill of sale, Apr. 3, 1930 (as *Young Plantation* per gallery label on painting reverse); purchased through J. B. Neumann Living Art; Ledger 15, Aug. 15, 1930. For Klee's business relationship with Flechtheim, see Stefan Frey and Wolfgang Kersten in *Alfred Flechtheim: Sammler, Kunsthändler, Verleger,* exh. cat. (Kunstmuseum Düsseldorf, 1987), 78 and 82, n. 185.

36. Quotations from *Bull.,* 1931, 20; second quote C. Law Watkins citing Phillips in a letter to Hood College, Feb. 11, 1937. Hanging records suggest that the work was not shown between Jan. 1932 and the 1937 exhibition.

37. Klee in Spiller, 1961, 21.

38. Ibid., 1961, 257. For Johann Wolfgang von Goethe's concept of the "Urpflanze" and its relationship to this work, see Verdi, 1985, 85–86, 219–26.

39. See Klee in Spiller, 1973, 129–32.

40. Ibid., 1961, 21; Klee understood figuration to be the process of coming into being according to nature's basic laws.

41. See Christian Geelhaar, "Moderne Malerei und Musik der Klassik—eine Parallele," in *Paul Klee: Das Werk der Jahre 1919–1933. Gemälde, Handzeichnungen, Druckgraphik,* exh. cat., Kunsthalle Köln (1979), 31–43. See also Gundula Overmeyer, "Studien zur Zeitgestalt in der Malerei des 20. Jahrhunderts: Robert Delaunay—Paul Klee," Ph.D. diss. (Hildesheim, 1982).

42. See Geelhaar, 1973, 118, for characterization of the works of 1928–29, and pp. 89–96 for 1924 works showing a similar system of geometric abstraction, lines, and runelike signs. From 1926 on, these lines and signs were often scratched into wet colored ground.

43. See Klee in Spiller, 1978, 467; also Overmeyer, *Studien zur Zeitgestalt,* 1982, 233–34.

44. Klee in Spiller, 1973, 119.

45. "The Work of Art in the Age of Mechanical Reproduction" in *Walter Benjamin: Illuminations,* ed. Hannah Arendt (New York, 1969), 217–51. See also James Smith Pierce, "Pictographs, Ideograms, and Alphabets in the Work of Paul Klee," *Journal of Typographic Research* 1, no. 3 (July 1967), 219–43, and figs. 5 and 6.

46. Catalogue raisonné: Artist's oeuvre catalogue: *1937/ Tafel,/ Im Zeichen der Blüte/ Ölfarben/ Pappe auf Keilrahmen genagelt.* Literally translated, the German title means "Under the sign of bloom." Provenance: Early provenance from Paul Klee-Stiftung records; on Apr. 5, 1938, Phillips informed Nierendorf of his purchase from Buchholz; recorded in Ledger 15, June 14, 1938. Galerie Simon (no. 0826) and Buchholz (no. 979, obscured) labels on painting reverse.

47. By contrast, *Botanical Laboratory,* 1928 (131, D1; gouache, watercolor and ink on paper mounted on cardboard, 15½ × 10⅝ in.; acc. no. 0992), is a humorous evocation of scientists' efforts to analyze, measure, distill, and perhaps even duplicate creation.

48. The yellow and brown areas of paint appear to have been applied first, followed by gray, then pink, and finally green. Most shapes evolve from successive layers of paint left barely exposed. Sharp outlines are incised into these layers while still wet, possibly with a stylus or pencil, although there is little evidence of graphite in the grooves (Steele, Dec. 9, 1991, and Oct. 27, 1993).

49. Medium: The burlap is covered with a very thin white ground visible in some areas (Steele, Sept. 30, 1991). Catalogue raisonné: Oeuvre catalogue:

Arabisches Lied/ 1932/ 283 (Y3)/ Tafel/ Ölfarben/ Jute (Sackleinen) auf Keilrahmen. Provenance: A 1932 Flechtheim label is on the painting's reverse; other provenance per Paul Klee-Stiftung records. Neumann is listed as lender in the 1936 Buffalo catalogue, but the 1938 London catalogue credits Galerie Simon. PMG purchase from Nierendorf with *Way to the Citadel;* invoice Nov. 16, 1940, Ledger 15, June 7, 1941.

50. Letter to his wife, Lily, written Aug. 10, 1927, on his way to Corsica, in Klee, 1979, n.p. (author's trans.): "Colorit . . . das suche ich ja immer wieder: Klänge wecken lassen, die in mir schlummern, ein kleines oder grosses Abenteuer in Farbe."

51. Introduction to PMG.1941.4, 23.

52. Giedion-Welcker, 1952, 66–67. Will Grohmann, his friend and biographer, believed that Klee's mother came from southern France, or perhaps from North Africa. He saw the spirit of the Near East as the third determining influence on Klee's work after music and poetry; see Grohmann, *Paul Klee* (New York, [1970]), 26–27 and 380.

53. Among the large works are *Ad Parnassum* (274 X14; 39⅜ × 49⅝ in.; Society of Friends of the Kunstmuseum Bern), and *Mask of Fear,* 1932 (286; Y6; 39½ × 22½ in.; New York, the Museum of Modern Art, Nelson A. Rockefeller Fund). The latter work is closely related to *Arab Song* but differs in its palette and tense expression.

54. Giedion-Welcker, 1952, 115–18; see also Pierce, 1976, 18–19, where the heart shape, "one of Klee's favorites," is traced back to 1917, signifying both love and sorrow.

55. Observations on technique and paints, Steele, Aug. 5, 1991.

56. See the Egypt-inspired watercolor *Monument in Fertile Country,* 1929 (41, N1; 17⅞ × 12⅛ in.), and *Polyphonically Enclosed White,* 1930 (140, X10; watercolor and pen and India ink, 13⅛ × 9⅝ in.), both Kunstmuseum Bern, Paul Klee-Stiftung.

57. Giedion-Welcker, 1952, 68.

58. First two quotations, Klee, 1957, 926r (author's trans.): "Einmal äugte Ma mondsüchtig nach einem Balkon" and "Einmal, ein einziges Mal, sahen wir eine kleine arabische Schönheit"; third quotation, 926s: "Die Augen einer jungen italienischen Dame begegneten mir. . . . Sie hatte mich wohl beobachtet. Ich senkte den Blick und suchte eine Stelle auf, wo es ganz finster war. Solche Augen sind zwar nicht ohne." Klee edited his diaries around 1921, perhaps with publication in mind; see Werckmeister, 1989, 5–8, and Franciscono, 1991, 7.

59. Glaesemer in Lanchner, 1987, 78.

60. Grohmann, *Paul Klee,* 312.

61. Catalogue raisonné: Oeuvre catalogue: *1934/ 218/ (U 18)/ Tafel/ 0,52 0,395, Figur des östlichen Theaters/ Ölfarben/ Sperrholz.* Inspection by Steele, Nov. 2, 1993, revealed that the fabric is actually mounted on cardboard, not plywood, as recorded by Klee. Provenance: Early provenance from Paul Klee-Stiftung records; purchase per DP to Nierendorf, Sept. 29, and Ledger 15, Oct. 2, 1942.

62. Kandinsky and Marc, *The Blaue Reiter Almanac,* 83 and 89.

63. Margaret Plant, *Paul Klee: Figures and Faces* (London, 1978), 14. See also *Actor's Mask,* 1924 (252; oil on canvas, 14⅜ × 13¼ in.; The Museum of Modern Art, New York, The Sidney and Harriet Janis Collection Fractional Gift), and *Mask of Fear,* 1932 (286, Y6), discussed in notes to *Arab Song.*

64. Steele Oct. 7, 1991.

65. See especially A. Meysselman, "Le Théâtre Japonais," *Cahiers d'Art,* no. 8 (1928), 339–42, illus. pp. 339 and 341. Will Grohmann's article, "Paul Klee," appeared in no. 7 (1928), 295–302, with 15 illustrations. Klee's work entitled *Actor,* 1923 (27, 8¼ × 9¾ in.; private collection, Switzerland), also shows a masklike Japanese figure. Klee collected this journal; see Pierce, 1976, 220.

66. Photographs of thirty puppets are illustrated in Felix Klee, *Paul Klee: His Life and Work in Documents,* trans. Richard and Clara Winston (New York, 1962), 120–24.

67. For Klee's need to change his records regarding his mother's ancestry to avoid being considered a Jew, see Werckmeister in Lanchner, 1987, 48.

68. Mark Roskill, "Three Critical Issues in the Art of Paul Klee," *Arts Magazine* 52 (Sept. 1977), 133. A similar expression can be found on the gouache *Letter Ghost,* 1937 (13 × 19¼ in.; The Museum of Modern Art, New York, purchase 8.39).

69. Catalogue raisonné: Oeuvre catalogue: *1937/ 133/ qu13/ Tafel/ 0,59 0,56/ Ölfarben/ Leinwand auf Keilrahmen.* Buchholz Gallery label on painting reverse. The painting was lined and restretched in 1976, perhaps causing the slight increase in dimensions. Provenance: Early provenance per Paul Klee-Stiftung records; Wadsworth ownership courtesy Mrs. Wadsworth, Washington, D.C., Oct. 1991; PMG purchase, together with *Young Moe,* DP to Curt Valentin, May to June 1948; bill of sale, June 3, 1948; Ledger 15, June 12, 1948.

70. DP, in cat. for PMG.1942.11, n.p.

71. A purple-brown ground is covered with areas of orange, red, green, and ocher, ending with the final gray-green layer out of which shapes and patterns were reserved, while others were drawn with graphite or black paint (Steele, Aug. 5, 1991).

72. For a discussion of the New Guinea sources, see Pierce, 1976, 37–38, and Goldwater, 1986, 193. This picture, a near icon of modernism's enthrallment with primary cultures, is the cover illustration of the latter publication.

73. Giedion-Welcker, 1952, 127.

74. Quotes from Jean Laude, "Paul Klee" in Rubin, 1985, vol. 2, 491, and Rubin quoting Charles W. Haxthausen, p. 488. In the summer of 1937 Klee's illness went into remission and he resumed painting with renewed vigor; it is possible that the painting dates from that period.

75. See Lanchner, 1987, 54–58, and chronology; the exhibition took place in Munich in July 1937.

76. Wilhelm Worringer, "Zur Entwicklungsgeschichte der modernen Malerei," *Der Sturm* 75 (Aug. 1911), 598 (author trans.).

77. Peter Thoene, *Modern German Art* (Harmondsworth, England, 1938), 73, quoting remarks of an unnamed speaker at the inauguration of the House of German Art in Munich.

78. For a discussion, see Werckmeister in Rubin, 1985, 55–57. James S. Pierce in "Pictographs, Ideograms, and Alphabets," 220, states that, according to Felix Klee, the artist collected *Cahiers d'Art.* In a postcard, Sept. 27, 1937, Lily Klee reported to Grohmann that Klee was aware of the Paris exposition (Werckmeister in Lanchner, 1987, 62, n. 123).

79. Klee had attended Picasso's 1932 Zurich retrospec-

tive and met him in 1933. In turn, Picasso visited Klee in Nov. 1937. For the importance of Picasso to Klee's late work, see Franciscono, 1991, 290–95. See *Guernica,* 1937 (oil on canvas, 349.3 × 776.6 cm., Madrid, Museo Nacional Centro de Arte Reina Sofia), and graphic works such as *Model and Surrealist Sculpture,* 1933, and *Blind Minotaur Guided by a Little Girl in the Night,* 1934.

80. For Benin bronzes, see nos. 3–5 (1932), 197–216 (an issue dedicated almost entirely to Picasso). On cave paintings, see no. 2 (1930), 57–68, which also contains a review of Klee's work (pp. 72 and 74) with four illustrations (n.p.). Klee must have referred to no. 1 (1930), 15 and 43, as the source for several designs, such as the Turkestan pattern to the right of the bull's head and the geometric bands from Bakairi in the lower center and at the hem of the woman's dress.

81. Catalogue raisonné: Oeuvre catalogue: *1938/ 121/ J1/ Tafel/ 0,7/ 0,53/ der junge MOE (als Entwurf zu bewerten), pastose, Kleisterfarben, Jute, drüber Zeitungspapier.* The medium line gives the commonly used translation. Provenance: Provenance up to Buchholz per Paul Klee-Stiftung records. Purchased together with *Picture Album* (DP to Curt Valentin, May 3, 1948, requesting both on approval). Purchase confirmed in a letter of July 15. A partially destroyed label (formerly on the reverse) suggests that the painting was either consigned to or exhibited by Galerie Simon, Paris.

82. Information courtesy Albert Moeschinger, in a letter to Mathew Jacobson, TPC, Aug. 31, 1980.

83. For the importance of eighteenth-century music as a guiding principle for Klee's art, see Andrew Kagan, *Paul Klee: Art and Music* (Ithaca, 1983), especially the chapter "Ad Parnassum."

84. Ibid., 96, for a discussion of the musical roots of the late works. For cubism, see Jordan, *Paul Klee and Cubism,* 192.

85. A similar face appears in *Figure in the Garden,* 1937 (collection of Felix Klee); see Kagan, *Klee: Art and Music,* 134. Ann Temkin, in Lanchner, 1987, 32, calls these lines of heavy pigment and paste "marks" and attributes the monumentality of the late paintings to their direct confrontation with the viewer.

86. Spiller, 1961, 273–77; see p. 290 for Klee's notes on the variations of fragmentary arrangements and the free use of planar rhythms.

87. The burlap texture shows through the paper; the black outlines were painted first, the colors were filled in later; there is visible evidence of pencil or underdrawing. The impasto is heaviest in the sienna-colored sections, thinnest in umber areas; brushstrokes are visible (Steele, July 17, 1992). For Temkin's discussion of this technique in Klee's late work, see Lanchner, 1987, 32.

88. "Klee and German Romanticism" in Lanchner, 1987, 80.

89. For a discussion of the sacred role of the book and Klee's use of illuminated texts, see Joseph Leo Koerner, "Paul Klee and the Image of the Book" in *Paul Klee: Legends of the Sign,* Interpretations in Art, no. 1 (New York, 1991), 48–59.

Major References
Paul Klee Papers and Oeuvre Catalogue, Archives of the Paul Klee-Stiftung, Kunstmuseum Bern.
Carola Giedion-Welcker, *Paul Klee,* trans. Alexander Gode, New York, 1952.

Felix Klee, ed., *Tagebücher von Paul Klee, 1898–1918*, Cologne, 1957 (Engl. ed., *The Diaries of Paul Klee, 1898–1918*, Berkeley, 1964).

Jürg Spiller, ed., *Paul Klee Notebooks, Volume 1: The Thinking Eye*, trans. Ralph Mannheim with Charlotte Weidler and Joyce Wittenborn, London, 1961; reprint 1978; *The Nature of Nature: The Notebooks of Paul Klee, Volume 2*, trans. Heinz Norden, London, 1973.

Christian Geelhaar, *Paul Klee and the Bauhaus*, New York, 1973.

Jürgen Glaesemer, *Paul Klee: Handzeichnungen*, 3 vols., Bern, vol. 1, 1973; vol. 2, 1984; vol. 3, 1979.

———. *Paul Klee: Die Farbigen Werke im Kunstmuseum Bern*, Bern, 1976.

Andrew Kagan, "Paul Klee's Influence on American Painting: New York School," part I, *Arts Magazine* 49, no. 10 (June 1975), 54–59; part II, 51, no. 1 (Sept. 1975), 90.

James Smith Pierce, *Paul Klee and Primitive Art*, New York, 1976.

Paul Klee, *Briefe an die Familie 1893–1940*, Felix Klee, ed., 2 vols. Cologne, 1979.

William Rubin, ed., *Primitivism in Twentieth Century Art: Affinity of the Tribal and the Modern*, 2nd ed., 2 vols., exh. cat., New York, MOMA, 1985.

Richard Verdi, *Klee and Nature*, New York, 1985.

Robert Goldwater, *Primitivism in Modern Art*, enl. ed., Cambridge, Mass., 1986.

Carolyn Lanchner, ed., *Paul Klee*, exh. cat., New York, MOMA, 1987.

O. K. Werckmeister, *The Making of Paul Klee's Career, 1914–1920*, Chicago, 1989.

Charles W. Haxthausen, "Simulierte Auren: Zu Klee's Parodien uralter Artifakte," lecture, Dec. 1990, Universität Konstanz; courtesy Charles Haxthausen, in telephone conversation, 1994.

Marcel Franciscono, *Paul Klee: His Work and Thought*, Chicago, 1991.

Mark Roskill, *Klee, Kandinsky, and the Thought of Their Time: A Critical Perspective*, Urbana, Ill., 1992.

Marianne Vogel, *Zwischen Wort und Bild: das schriftliche Werk Paul Klees und die Rolle der Sprache in seinem Denken und in seiner Kunst*, Munich, 1992.

Jürgen Glaesemer, ed., *Paul Klee: Leben und Werk*, rev. ed., Stuttgart, 1995.

Vivian Endicott Barnett and Josef Helfenstein, eds., *The Blue Four: Feininger, Jawlensky, Kandinsky, Paul Klee in the New World*, exh. cat., Kunstmuseum, Bern, and Kunstsammlung Nordrhein-Westfalen, Düsseldorf, 1997.

TPC Sources
ASD, 1931.
Bull. 1931.
DP, "The Expression of Personality Through Design in the Art of Painting," unpubl. lecture, 8 versions, ca. 1936–42 (Klee mentioned in versions D through H).
DP, "Gallery Notes International Show," unpubl. notes, 1938; formerly MS 90.
DP, introduction to PMG.1941.4 and PMG.1942.11.
DP, "Literature and the Arts: The Gnomes and Imps of Paul Klee," *New Republic*, Feb. 16, 1953, 17–18.

MP, 1970 and 1982.
MD, 1981.
Mark Rosenthal, in *Paul Klee*, ed. Martha Carey, Washington, D.C., The Phillips Collection, 1981.
MP, 1998.
MSS 78, 83, 176.

FRANZ MARC

1. Date: The date was confirmed by Maria Marc, the artist's widow, prior to the 1916 exhibition (Klaus Lankheit to author, Sept. 20, 1988); early TPC records give the erroneous date of 1911. Title: *Rehe im Walde I* per Lankheit, 1970, no. 198; entitled *The Deer* in Maria Marc's contract with the Société Anonyme, Oct. 14, 1927, Dreier Papers. Provenance: For the 1926 loan to the exhibition at the Brooklyn Museum and Dreier's acquisition, see correspondence with Maria Marc, May 2 and 30, 1926, Dreier Papers. Shipped by the Dresden gallery Neue Kunst Fides.

2. For instance, the horse stood for power, the deer for vulnerability, the cow for steadfastness, and the bird for spirituality. For the sources of Marc's animal symbolism, ranging from the nineteenth century to expressionism, see Levine, 1979, 104–16, who cites apocalyptic references in Georg Heym's poetry and images of animal innocence in Georg Trakl's writings (see p. 113).

3. Discussed in Rosenthal, 1989, 25; on Marc's search for abstraction, see Schardt, 1936, 108, and Johannes Birringer, "Constructions of the Spirit: The Struggle for Transfiguration in Modern Art," *Journal of Aesthetics and Art Criticism* 48 (Winter 1983), 137–50; on pantheism, see Peter Selz, *German Expressionist Painting* (Berkeley, 1974), 307–8.

4. Kandinsky visited Marc shortly before his death and remembered Marc's herd of domesticated deer, "whom he loved as if they were his own children" (Levine, 1979, 160, citing Klaus Lankheit, ed., *Franz Marc im Urteil seiner Zeit*, Cologne, 1960, 51). Drawings and lithographs show deer in their natural settings, while the paintings have increasingly abstracted compositions; see, for instance, two works of 1912, *Deer in a Monastery Garden* (oil on canvas, 29¼ × 39¼ in.) and *Deer in the Forest II* (oil on canvas, 43¼ × 31⅞ in.), both in the Städtische Galerie im Lenbachhaus, Munich.

5. Marc, 1978, 99–100, winter 1911–12: "Ich kann ein Bild malen: 'das Reh'. . . . Ich kann aber auch ein Bild malen wollen: 'das Reh fühlt.' Wie unendlich feinere Sinne muss ein Maler haben, das zu malen!" (author's trans.).

6. Quotation from Rosenthal, 1989, 31. Inspection by Elizabeth Steele, painting conservator, Aug. 31, 1990, reveals the artist's struggle between a narrative and abstract vocabulary: brushstrokes in areas around the deer are unrelated to the overall composition, and numerous changes appear to obliterate too strong an emphasis on abstraction.

7. Ibid.

8. For a discussion of Johann Wolfgang von Goethe and the German poet's concept of the *Urpflanze*, see Robert Rosenblum, *Northern Painting and the Northern Romantic Tradition: Friedrich to Rothko*, rev. ed. (New York, 1983), 47.

9. Marc's views derived from Wilhelm Ostwald's theories on the presence of energy and the illusory nature of matter; see Rosenthal, 1979, 24.

10. Ron Glowen, "The Spiritual, Empathetic and Abstract Animal," *Vanguard* 9, nos. 5–6, (summer 1980), 18.

11. See Levine, 1979, chap. 3, "The Image of Apocalypse." This sense of imminent catastrophe may have been brought on by the threat of war or by a more personal melancholia.

12. *Fate of the Animals*, 1913 (oil on canvas, 76¾ × 103¾ in.; Öffentliche Kunstsammlung Basel, Kunstmuseum, Basel); see Levine, 1979, 79–100, for an interpretation.

13. Gustave Flaubert, "The Legend of St. Julian Hospitator," in *Three Tales*, trans. Robert Baldick (New York, 1987). Marc intended to illustrate this book, but only a tempera of 1913, *St. Julian Hospitator* (63 × 55 cm.; Solomon R. Guggenheim Museum, New York), exists.

14. Flaubert, 1987, 67. Marc spoke and wrote French; he would not have missed the double meaning of Flaubert's original *nappe de sang* (*nappe*: sheet or deer hide; *sang*: blood), giving the red background new meaning. Levine, 1979, 91, finds that *Fate of Animals*, too, reflects parts of Flaubert's text.

15. Flaubert, 1987, 63 and 65.

16. Campendonk responded on Dec. 3, 1922 (Dreier Papers).

17. Part of Journal I, between 1931 and 1935. Although he never purchased a work by Marc, Phillips did add his name in pencil to a list entitled "potential additions to collection" that also included the names of Kokoschka, Beckmann, Vlaminck, Hofer, and Munch.

Major References
Katherine S. Dreier Papers, Archives of the Société Anonyme, Beinecke Rare Book and Manuscript Library, Yale University, New Haven, Conn.
Alois Schardt, *Franz Marc*, Berlin, 1936.
August Macke and Franz Marc, *Briefwechsel*, ed. Wolfgang Macke, Cologne, 1964.
Klaus Lankheit, *Franz Marc: Katalog der Werke*, Cologne, 1970.
Wassily Kandinsky and Franz Marc, eds., *The Blaue Reiter Almanac*, ed. Klaus Lankheit, New York, 1974.
Klaus Lankheit, *Franz Marc: Sein Leben und seine Kunst*, Cologne, 1976.
Franz Marc, *Schriften*, ed. Klaus Lankheit, Cologne, 1978.
Frederick S. Levine, *The Apocalyptic Vision: The Art of Franz Marc as German Expressionism*, New York, 1979.
Marc Rosenthal et al., *Franz Marc: 1880-1916*, exh. cat., Berkeley, University Art Museum, 1979.
John F. Moffitt, "Fighting Forms: *The Fate of the Animals*, The Occultist Origins of Franz Marc's 'Farbentheorie,'" *Artibus et Historiae* 6, no. 12, 1985.
Mark Rosenthal, *Franz Marc*, Munich, 1989.
Klaus Lankheit and Uwe Steffen, eds., *Letters from the War*, trans. Liselotte Dieckmann, New York, 1992.
Erich Franz, *Franz Marc: Kräfte der Natur, Werke 1912–1915*, exh. cat., Westfalen-Lippe, Auftrag des Landschaftsverbandes and Münster, Westfälisches Landesmuseum, 1993.

TPC Sources
Journal I, between 1931 and 1935.
MD, 1981.
MP, 1998.

OSKAR KOKOSCHKA

1. *Lac d'Annecy II*, 1930 (oil on canvas, 29¼ × 39⅜ in.; acc. no. 1060, Wingler no. 250; Winkler-Schröder no. 264); *Cardinal dalla Costa*, 1948 (oil on canvas, 38⅝ × 28 1.4 in.; acc. no. 1058; Wingler no. 355; Winkler-Schröder no. 378). The collection also contains a signed edition of *King Lear*, Ganymede Original Editions, London, 1963 (Gift of William A. Graham, IV, 1979; acc. nos. 1064–1079); and five lithographs, *Manhattan* (ed. 40; Roman) published 1967 by Marlborough Gallery (Gift of Anthony Harris, New York, 1979; acc. no. 1986.7.1).

2. Letter to P. A. Ade, Haus der Kunst, Munich, Jan. 8, 1958, turning down a loan request.

3. Sheldon Cheney, *A Primer of Modern Art*, 10th ed. (New York, 1939), 31; see also pp. 3 and 28–30 for Cheney's enthusiasm for the artist; both the 1924 edition of this book and the 1939 edition of Cheney's *Expressionism in Art* (New York, 1934) were in Phillips's library. Read quote in Hoffmann, 1947, 8.

4. Cat., 1952, viii.

5. Dated Dec. 3, 1946, this is the first known letter between Phillips and Kokoschka. Valentin sent Phillips a "First List of Kokoschkas" in U.S. collections. Phillips wrote him about his exhibition plans, Feb. 21, 1947, mentioning the pressure applied on him by the artist and his friends to include recent work in European collections.

6. DP to Olda Kokoschka, Mar. 1, 1949. James Plaut announced Kokoschka's arrival in New York on Jan. 6, 1949, in a letter of the same date, offering an extension of the Washington showing in view of Kokoschka's visit. Phillips introduced Marin to Kokoschka, according to DP to Plaut, Jan. 15, 1949.

7. DP to Kokoschka, Nov. 19, 1952, Foxhall Correspondence. In 1949 Phillips tried to help Kokoschka's sister to leave Czechoslovakia, even recruiting the assistance of his friend Walter Lippmann.

8. The manuscript, "Edvard Munch's Expressionism" (TPC Archives), was translated from a series that appeared in the *Neue Zürcher Zeitung*, July 18–20, 1952. The final piece of correspondence is a 1966 note from the Kokoschkas to Marjorie Phillips on the occasion of her husband's death.

9. *ASD*, 1931, 5 and 6.

10. Date: 1909 from bill of sale, Schröder and Winkler, 1991, 58, and Winkler to author, Sept. 9, 1992; Wingler, 1958, 294, gives "summer 1908 to autumn 1909" as does Leshko, 1977, 80, perhaps based on Kokoschka's statement that Franzos was his first female sitter (Goldscheider, 1963, 14). It was definitely delivered to the patron before Jan. 28, 1910, the date of Kokoschka's letter to Franzos (*Letters*, 1992, 18). Provenance: Bill of sale, Dec. 19, 1941 (as *Mrs. E. L. Franzos*, 1909); Ledger 15, Dec. 17, 1941.

11. Quoted in Goldscheider, 1963, 14.

12. As quoted in MP, 1982, 231. Christof Asendorf in Schröder and Winkler, 1991, 14, emphasizes that Kokoschka had no use for the symbolism assigned the aura by the theosophists.

13. Conservator's inspection, Elizabeth Steele, Aug. 31, 1990. Kokoschka used these expressive touches in illustrations accompanying the published version of his first drama, *Murderer, Hope of Women*, 1908–9 (published in *Der Sturm* 20, July 14, 1910), a work of violent sexual allusions, reflecting the artist's personal turmoil.

14. For a discussion of fin-de-siècle mannerisms, see Asendorf, "'Lurching Space,'" in Schröder and Winkler, 1991, 14; compare Klimt's *Salome*, 1909 (178 × 46 cm; Venice, Galleria d'Arte Moderna), which was exhibited in Vienna in 1909.

15. For a description of Franzos, see E. H. Gombrich, *Kokoschka in His Time* (London, 1986), 22.

16. Courtesy Johann Winkler, letter to author, Sept. 9, 1992. He remained there until the following February.

17. Goldscheider, 1963, 14.

18. Kokoschka to Franzos, Jan. 28, 1910, in Kokoschka and Marnau, 1992, 18–19.

19. Two charcoal drawings in three-quarter view, ca. 1912, are entitled *Lotte Franzos* (Museum Folkwang, Essen, and Collection F. Beer-Monti, New York). The *Ex libris* are illustrated and discussed in Ivan Fenjoe, *Oskar Kokoschka: Die frühe Graphik* (Vienna, 1976), 62–64.

20. Dr. Lucille Dooley to Kokoschka, letter delivered to TPG, Jan. 5, 1949. It is not known whether a meeting ever took place.

21. Provenance: Von Nemes was an early collector of El Greco whose portrait Kokoschka painted in 1928; he died in 1930, but the Paris exhibition still listed him as owner in 1931, perhaps implying the estate. Buchholz bill of sale to PMG, Feb. 25, 1941; Ledger 15, July 1, 1941 (as *Courmayeur*, erroneously dated 1925).

22. Provenance: In 1916 Kokoschka signed a new contract with Paul Cassirer in Berlin, making him and his successors his exclusive dealers until 1931. The painting was acquired with the help of James Plaut, director, ICA, Boston, the organizer of the Kokoschka traveling exhibition; see correspondence between Phillips and Plaut, Dec. 1948 to Mar. 1949.

23. See *Briefe* 2, 1985, 163, for a letter to his mother, Romana, and his brother, Bohuslav, from Padua Oct. 7, announcing that his second painting is finished. On Oct. 15 he writes from Courmayeur: "Tomorrow I shall start to paint"; on Oct. 22 his third painting has been completed (author's trans.). From Lyon Kokoschka writes to his family that his fifth work is completed (Nov. 19), and on Nov. 23 he announces that he is painting a large new landscape, giving detailed descriptions and almost daily progress reports, often sending postcards of local views. On Dec. 8 he writes to Anna Kallin: "My picture will be completed tomorrow (!) and it took two weeks, one could see only fog, never the sun, never the moon."

24. Oct. 19(?), 1927, *Briefe* 2, 1985, 165.

25. Wingler, 1958, 55. Toward the end of his travel years (1924–1931), Kokoschka painted *Lac d'Annecy II*, 1930 (acc. no. 1060), choosing a simplified, horizontal composition seen from the edge of the lake (he had painted an earlier version in 1927).

26. Compare Kokoschka's *Monte Carlo*, 1925 (oil on canvas, 73.0 × 100.0 cm.; Musée des Beaux-Arts, Liège).

27. Quotations and discussion in a letter to Hans Wingler, Dec. 6, 1950; see *Schriften*, 1956, 433 (author's trans.).

28. Edwin Lachnit, "'Man Has Two Eyes': The City Views," in Schröder and Winkler, 1991, 30. *The Battle of Issus*, 1529 (oil on panel, 158.0 × 120.0 cm.; Alte Pinakothek, Munich).

29. Writing from Lyons, Dec. 1, 1927 (*Briefe* 2, 1985, 171).

30. Lütjens quoted in *Lyon* entry, Schröder and Winkler, 1991, 148.

31. DP to James Plaut, Jan. 4, [1949] (the letter is erroneously dated 1948 but was written in 1949 according to exhibition dates and Plaut's answer Jan. 6, 1949). A few days earlier, Dec. 3, 1948, Phillips had written, "I am positively in love with the picture."

32. Title/Date: According to Winkler (correspondence with author, Aug. 30, 1989), the painting is now believed to be the fourth work created from the studio window Kokoschka occupied beginning in June 1935. The date of 1936 is based on Winkler's dating the third version to 1936; see Schröder and Winkler, 1991, 174. Provenance: Purchased from the artist's mother-in-law; Phillips's offer to purchase, Oct. 28; Palkovska's acceptance telegram, Oct. 30; order to send payments to Kokoschka in London, Nov. 9, 1938 (Carnegie Papers, AAA, reels 107, 3500, and 3775; letters not individually marked).

33. Tate, 1986, 352, citing Kokoschka in *My Life*.

34. Both quotes in Jan Tomeš, *Oskar Kokoschka: The Artist in Prague* (London, 1967), 14.

35. Hoffmann, 1947, 218; the Phillips work is listed as No. II, p. 332.

36. Steele, Aug. 31, 1990.

37. Letter to Carl Moll, Sept. 18, 1936, cited in Tate, 1986, 352, referring to this painting as the first in the series.

38. *Thomas G. Masaryk*, 1935–36 (Museum of Art, Carnegie Institute, Pittsburgh, Patrons Art Fund, 1956). The view of Prague in the background of this painting is almost identical with the present one.

39. Kokoschka to Homer Saint-Gaudens, Nov. 16, 1938, Carnegie Papers, AAA, reel 104, no number.

Major References

Oskar Kokoschka-Dokumentation, Pöchlarn, Austria.

Edith Hoffmann, *Kokoschka: Life and Work,* London, 1947.

Oskar Kokoschka, *Schriften 1907–1955*, ed. Hans M. Wingler, Munich, 1956.

Hans. M. Wingler, *Oskar Kokoschka: The Work of the Painter,* Engl. ed., Salzburg, 1958.

Ludwig Goldscheider, *Kokoschka,* London, 1963.

Oskar Kokoschka, *My Life,* London, 1974.

Jaroslaw Leshko, "Oskar Kokoschka: Paintings, 1907–1915," Ph.D. diss., Columbia University, New York, 1977.

Oskar Kokoschka, Briefe, 4 vols., eds. Olda Kokoschka and Heinz Spielmann, Düsseldorf, 1984–88.

Tate Gallery, *Oskar Kokoschka: 1886–1980,* exh. cat., London, 1986.

Frank Whitford, *Oskar Kokoschka: A Life,* New York, 1986.

Klaus Albrecht Schröder and Johann Winkler, eds., *Oskar Kokoschka,* Engl. ed., Munich, 1991.

Olda Kokoschka and Alfred Marnau, *Oskar Kokoschka: Letters, 1905–1976,* foreword by E. H. Gombrich, London, 1992.

Jutta Hülsewig-Johnen, *Kokoschka: Emigrantenleben—Prag und London, 1934–1953,* exh. cat., Kunsthalle Bielefeld, Germany, 1994.

Véronique Mauron, *Werke der Oskar Kokoschka-Stiftung,* Mainz, 1994.

Johann Winkler and Katharina Erling, *Oskar Kokoschka: die Gemälde, 1906–1929,* Salzburg, 1995.

TPC Sources

Phillips/Kokoschka Correspondence, 1946–51, TPC

Papers, AAA, and Foxhall Correspondence.
Paul Westheim, *The Nation's Great Paintings: Oskar Kokoschka, Courmayeur,* New York, The Twin Editions, n.d. [after 1946].
Cat., 1952.
MP, 1970 and 1982.
MP, 1998.

KURT SCHWITTERS

1. Inscription/Title: Inscribed (on cardboard backing) in a signature resembling the artist's in the 1920s. *Strahlen Welt* means "world of rays." The English title, *Radiating World,* is a literal translation of *Strahlende Welt* and was introduced in 1939, perhaps by Katherine Dreier. Provenance: A Der Sturm shipping list "Exhibition Brooklyn," dated May 5, 1926, includes "*Strahlen-Welt*" (Dreier Papers).

2. The actual origin of *Merz* (it is both a fragment of "Kommerz" (commerce) and of the German verb *aus-merzen,* to eradicate) was never explained by Schwitters; see Schmalenbach, 1967, 93, and Elderfield, 1985, 90, and 35, for Schwitters's first exposure to Zurich dada through his friend Jean Arp and Galerie Der Sturm. Schwitters even signed a letter to Dreier "Kurt Merz" (Nov. 25, 1936, Dreier Papers).

3. Elderfield, 1985, 133.

4. Carlo Carrà's collage, *Portrait of Marinetti,* 1914 (27⅞ × 15⅞ in.; Milwaukee Art Museum, Gift of Friends of Art, M1982.1), bears striking similarity to *Radiating World,* especially the circular form (the face of Marinetti) and the phrase "Manifesti del Futurismo," pieced together out of newspaper text. See Schmalenbach, 1967, 111, and Elderfield, 1985, 30–33, 74, on Schwitters and futurism.

5. Schwitters began numbering his *Merz* collages in early 1919, adding the letter *B* to large works. *Merz 31B* is the *B* entry with the highest known number (see Elderfield, 1985, 390, n. 9).

6. Poem translated in Elderfield, 1985, 53; other works exploring the theme are *Das Kreisen (Revolving),* 1919 (New York, Museum of Modern Art), and *Konstruktion für edle Frauen (Construction for Noble Ladies),* 1920 (Los Angeles County Museum of Art), which contains actual toy wheels.

7. Einstein published his theory of relativity in 1918.

8. *Hochgebirgsfriedhof (Mountain Graveyard),* 1919 (oil on board mounted on cork, 36 × 28½ in.; Solomon R. Guggenheim Museum, New York, Gift of Frederick M. Stern, New York, 1962).

9. Written in 1920 but published in "Merz," *Der Ararat* 2 (1921); author's trans. from Galerie Gmurzynska, 1978, 44 and 47: "Kunst ist ein Urbegriff, erhaben wie die Gottheit unerklärlich wie das Leben, undefinierbar und zwecklos . . . Merz erstrebt aus Prinzip nur die Kunst."

10. Title: The collage bears neither a *Merz* number nor date; *Tell* may not be the artist's title. See text for discussion of the date, which may range from late 1919 to about 1926. Inscription: The graphite of the signature is completely faded; only the impression remains. An inscription on the reverse, *netto 60 M,* in German script, is most likely the artist's price notation. Provenance: This collage was not part of the 1922 shipment from Galerie Der Sturm (Dreier Papers), but may have been part of shipments in 1926 and 1930 that included numerous collages; see Herbert et al., 1984, 598.

11. See Schmalenbach, 1967, 43, for the first meeting in 1918 between Arp and Schwitters.

12. Elderfield, 1985, 122.

13. Van Doesburg and Schwitters established contact in Berlin around 1919. Lissitzky arrived from Russia in 1921 (see Elderfield, 1985, 131–32). Schwitters's enthusiasm for Russian constructivism is reflected in works named *Merz 39. russisches bild,* 1920, and *Mz 448. Moskau,* 1922 (both the Museum of Modern Art, New York, Dreier Bequest).

14. Schwitters discussed this change in a catalogue foreword dated Mar. 4, 1927, reprinted in Lach, 1981, vol. 5, 250–55; for an interpretation of this text, see Elderfield, 1985, 126–27.

15. *Mz 26,41. okola,* 1926 (6⅞ × 5⅞ in.; private collection); see Elderfield, 1985, no. 201. Type, size, and color suggest that the fragments were part of the same wrapper.

16. See also *c 40. Pink Dream (Kurt Schwitters will recite),* (acc. no. 1719), where a 1944 invitation is reused in a 1946 collage.

17. Schwitters to Dreier, Feb. 27, 1930 (Dreier Papers): "Das war eine Freude als Ihr Telegramm aus New York ankam. . . . Ich habe grosse Bilder geklebt und besonders Plastiken geschlemmt" (author's trans.). Presumably Dreier had announced her visit, since the letter also mentions an "abstract evening" Schwitters had planned for the day of her arrival.

Major References
Kurt Schwitters Archives, Hannover, Stadt-büchereien.
Schwitters/Dreier Correspondence, Katherine S. Dreier Papers, Archives of the Société Anonyme, Beinecke Rare Book and Manuscript Library, Yale University, New Haven, Conn.
Werner Schmalenbach, *Kurt Schwitters,* London, 1967.
Friedhelm Lach, ed., *Kurt Schwitters: Das literarische Werk,* 5 vols., Cologne, 1973–81.
Kurt Schwitters: Wir spielen bis uns der Tod abholt. Briefe aus fünf Jahrzehnten, ed. Ernst Nündel, Frankfurt, 1975.
Galerie Gmurzynska, *Kurt Schwitters,* exh. cat., Cologne, 1978.
Robert L. Herbert et al., *The Société Anonyme and the Dreier Bequest at Yale University: A Catalogue Raisonné,* New Haven, 1984.
John Elderfield, *Kurt Schwitters,* exh. cat., MOMA, London, 1985.
Dorothea Dietrich, "The Fragment Reformed: The Early Collages of Kurt Schwitters," Ph.D. diss., Yale University, 1986.
Werner Schmalenbach, *Kurt Schwitters,* Munich, 1991.
Dorothea Dietrich, *The Collages of Kurt Schwitters: Tradition and Innovation,* Cambridge, 1993.
Jean Christophe Bailly, *Kurt Schwitters,* Paris, 1993.
Gerhard Schaub, *Kurt Schwitters: "Bürger und Idiot,"* Berlin, 1993.
Gwendolen Webster, *Kurt Merz Schwitters: A Biographical Study,* Cardiff, Wales, 1997.

TPC Sources
MD, 1981.
MP, 1982.
MP, 1998.

HEINRICH CAMPENDONK

1. Date: A typed draft (Dreier Papers, n.d., n.p.) probably prepared for Dreier's 1950 collection catalogue describes this painting in great detail, dating it "1918–19?"; the dimensions match those of this painting. Early exhibitions give a date of 1924, the year it arrived in the United States. Firmenich, 1989, accepts 1924 but also adds a 1920 exhibition. Title: German title per Firmenich, 1989. Identified as *Village Street* on a label on the reverse. *Village Street II* in Herbert et al. 1984, 771, and Dreier to Campendonk (Feb. 7, 1927, Dreier Papers), where it is annotated "88C.P.W." to indicate the painting's location in her city residence at 88 Central Park West. *Pastoral Scene* on Marcel Duchamp's list of gifts. Provenance: Dreier purchased the painting together with other works in monthly installments 1924–27 (accounting records and letter Feb. 7, 1927, Dreier Papers).

2. Biermann, 1921, 15.

3. Typed draft, Dreier Papers.

4. Ibid. See Städtisches Kunstmuseum Bonn, 1973, 3, for an evaluation of his works around 1919.

5. For the Russian prints, see Wassily Kandinsky and Franz Marc, eds., *The Blaue Reiter Almanac,* ed. Klaus Lankheit (New York, 1974), 76 and 221. Kandinsky, in *Winter No. 2,* 1910 (Munich, Städtische Galerie im Lenbachhaus), and Klee, in his *Composition with Windows,* 1919 (Kunstmuseum Bern, Paul Klee Stiftung), also used the motif of trees on roof tops.

6. Campendonk may have known Chagall's *The Soldier Drinks,* 1911–12 (Solomon R. Guggenheim Museum, New York), held by Galerie Der Sturm, Berlin, from 1914 to 1924. Campendonk exhibited there between 1914 and 1916 and with Chagall in Hannover in 1920 (Kestner-Gesellschaft, "Neue Kunst aus Hannoverschem Privatbesitz," Jan. 8–Feb. 4).

7. See Biermann, 1921, 16, on Campendonk's cubist exercises, beginning around 1913, which he subsequently overpainted.

8. Inspected by painting conservator, Elizabeth Steele, Aug. 31, 1990, and Sept. 30, 1991.

9. Dreier to Campendonk, Nov. 6, 1920, and Feb. 6, 1921 (Dreier Papers).

10. "An International Exhibition of Modern Art Assembled by the Société Anonyme" took place at the Brooklyn Museum, Nov. 19, 1926–Jan. 9, 1927, and included approximately three hundred works from twenty-three countries.

Major References
Katherine S. Dreier Papers, Archives of the Société Anonyme, Beinecke Rare Book and Manuscript Library, Yale University, New Haven, Conn.
Georg Biermann, *Heinrich Campendonk, Junge Kunst* series, vol. 17, Leipzig, 1921.
Paul Wember, *Heinrich Campendonk,* Krefeld, 1960.
Städtisches Kunstmuseum Bonn, *Heinrich Campendonk,* exh. cat., Bonn, 1973.
Robert L. Herbert et al., *The Société Anonyme and the Dreier Bequest at Yale University: A Catalogue Raisonné,* New Haven, 1984.
Andrea F. Firmenich, *Heinrich Campendonk: Leben und expressionistisches Werk mit Werkkatalog des malerischen Oeuvres,* Recklinghausen, 1989.

GIORGIO MORANDI

1. Date: Recorded on bill of sale and in Vitali, 1983. Provenance: Bill of sale, Mar. 10, 1954.

2. Morandi often painted series of works incorporating the same objects. The Phillips Collection's still life

is most similar to *Still Life*, 1953 (oil on canvas, 30 × 45 cm.; collection of José Luis and Beatriz Plaza, Caracas; Vitali, 1983, no. 871), where two bottles stand vertically.

3. Franco Solmi, "The Art of Morandi," in Solmi et al., 1988, 12. Morandi's technique is discussed in Abramowicz, 1983, 141.

4. Soby and Forge, 1970, 9.

5. During Morandi's brief association with the futurists, his works revealed a cubist, rather than futurist, orientation (Magnani et al., 1981, 22). By the 1920s he had embarked on his own stylistic course, leaving behind the influences (around 1918–19) of de Chirico and Carrà as well.

6. Soby in Soby and Forge, 1970, 5–6, discusses his acquaintance with Morandi.

7. *Still Life*, 1950 (acc. no. 1388).

Major References
Francesco Arcangeli, *Giorgio Morandi*, Milan, 1964.
James Thrall Soby and Andrew Forge, *Giorgio Morandi*, exh. cat., London, Royal Academy of Arts, 1970.
Lamberto Vitali, *Giorgio Morandi Pittore*, 3rd ed., rev., Milan, 1970.
John Maxwell, "Morandi and His Solitary Vision," *American Artist* 42, Apr. 1978, 54–61, 125–29.
Luigi Magnani et al., *Giorgio Morandi*, exh. cat., Iowa, Des Moines Art Center, 1981.
Janet Abramowicz, "The Liberation of the Object," *Art in America*, Mar. 1983, 138–46.
Lamberto Vitali, *Morandi: Catalogo Generale*, 2 vols., 2nd ed., Milan, 1983.
Eugenio Riccòmini et al., *Morandi e il suo tempo*, exh. cat., Bologna, Galleria Comunale d'Arte Moderna, 1985.
Franco Solmi et al., *Morandi*, exh. cat., Paris, Hôtel de Ville, 1987; Engl. ed., New York, 1988.
Giuliano Briganti et al., *Giorgio Morandi: 1890–1964*, Milan, 1988 (published as catalogue for European tour, 1988–90).
Marilena Pasquali et al., *Giorgio Morandi, 1890–1990: Mostra del Centenario*, exh. cat., Bologna, Galleria Comunale d'Arte Moderna, 1990.
Ernst-Gerhard Güse and Franz Armin Morat, eds., *Giorgio Morandi: Gemälde, Aquarelle, Zeichnungen, Radierungen*, New York, 1993.
Marilena Pasquali and Lorenza Selleri, *Museo Morandi, Bologna: Il catalogo*, Milan, 1993; 2nd ed. rev. and enl., *Museo Morandi: Catalogo generale*, Bologna, 1996.
Museo Morandi, *Giorgio Morandi: Die Aquarelle*, exh. cat., Bologna, 1995.
Laura Mattioli Rossi, *Morandi ultimo: Nature morte, 1950–1964*, exh. cat., Venice, Peggy Guggenheim Collection, 1998.

TPC Sources
MP, 1970 and 1982.
MD, 1981.
Stephen B. Phillips, cat. for TPC.1997.4.
MP, 1998.

6. THE SPIRIT OF REVOLT AND THE BEGINNING OF AMERICAN MODERNISM

1. Organized by Henri, Sloan, and Walt Kuhn, "The Exhibition of Independent Artists" was the first large, unrestricted, no-jury and no-prize show in the United States. The Armory Show (short for "The International Exhibition of Modern Art") was presented under the presidency of Arthur B. Davies, with seven of The Eight among the sponsors. The Society of Independent Artists, modeled after the French Société des Artistes Indépendants, staged a large annual no-jury, no-prize exhibition from 1917 until the Second World War. Its founding president was Glackens, succeeded in 1918 by Sloan. Of the thirteen Henri circle members discussed in this chapter, all but one participated in the 1910 exhibition, eleven in the Armory Show, and eight in the first exhibitions of the Society of Independent Artists. Beal also exhibited in the Armory Show and with the Independent Artists.

2. The phrase first appeared in a flier inserted in copies of *A & U*, 1929. It became a subtitle in later references to the gallery.

3. The letter, dated Jan. 6, 1916, is no longer extant but is quoted in full in MP, 1982, 54–55. Phillips recalled his earliest purchases in an interview with Warren Unna, "Phillips Is a Hush-Hush Art Gallery," *Washington Post* (Jan. 19, 1954), A12.

4. This observation is borne out by the brothers' other American acquisitions of the time: a William Gedney Bunce, *A Group of Boats, Venice* (acc. no. 0231), and a Julian Alden Weir, *Pan and the Wolf* (cat. no. 80). Major Phillips, their father, had acquired an Irving Wiles from the Corcoran Biennial of 1910–11.

5. Lawson was represented in DP, Cat., 1952, by eleven works and Rockwell Kent by five, but neither was designated a unit artist. Their works played such an important role in the formation of the collection, however, that they are discussed in introductory essays and are designated as "group" artists.

MAURICE PRENDERGAST
1. MP, 1970, 16.

2. The museum's records regarding early purchases of Prendergast paintings are inconsistent and further confused by occasional title changes. The present account is a reasonable interpretation of available records.

3. Two sketches by Phillips are in Journal B, 1923–29, n.p.

4. The two additional watercolors are *On the Beach*, ca. 1907–10, and *Snow in April*, ca. 1907–10.

5. Maurice Prendergast to Esther Williams, Oct. 10, 1907 (from Paris), AAA, Esther Williams Papers: "I got what I came over for—a new impulse."

6. Arthur Hoeber, "Art and Artists," *Globe and Commercial Advertiser* (Feb. 5, 1908), 9.

7. DP, "Maurice Prendergast," 1924, 125.

8. DP, draft (dated Apr. 1922) for *Arts*, 1924, 7.

9. First quote from DP, "Maurice Prendergast," 1924, 127; second from *E of A*, 1927, 258.

10. DP, draft (dated Apr. 1922) for "Maurice Prendergast," 1924, 14.

11. *Bull.*, 1928, 39.

12. Title: There are other variations, none of which differs significantly from the present title. Provenance: Records are not clear as to whether Montross owned the work or acted as agent in the Phillips purchase. Bill of sale, Apr. 26, 1920. According to Phillips's notations in Journal Y, 1922–25, the watercolor was in his private collection; however, by Jan. 1924 it appeared on a list of PMG works (Journal GG, 1924).

13. The other works are *Monte Pincio*, 1898 (watercolor, 15½ × 19¾ in.; Daniel J. Terra Collection, Terra Museum of American Art, Chicago), and *Afternoon, Pincian Hill*, 1898–99 (watercolor, 15⅛ × 10⅜ in.; Honolulu Academy of Arts, Gift of Mrs. Philip E. Spalding).

14. Date: Clark et al., 1990, assigns the dates "ca. 1907–10; repainted ca. 1914–15." All TPC records, however, assign the dates "1898–99; completed 1922." This assumption is based on the fact that Prendergast visited Venice in 1898–99, and on letters that mention retouching in April 1922 without naming the specific work (Prendergast to John F. Kraushaar, Apr. 3 and 24, 1922, TPC Archives). Nevertheless, *Ponte della Paglia* clearly shows changes that prove Prendergast repainted it late in his career. Title: Per bill of sale. Provenance: Bill of sale, Apr. 1922; Ledger 11, Mar. 16, 1923.

15. A brief analysis of the overpainting is discussed in Green, 1976, 26.

16. *Ponte della Paglia*, 1898–99 (watercolor, 17 × 14⅛ in.; collection of Mr. and Mrs. Arthur G. Altschul; Clark no. 697); illustrated in color in Green, 1976, 28.

17. The watercolor and oil are compared in Margaretta M. Lovell, *Venice: The American View, 1860–1920*, exh. cat., Fine Arts Museums of San Francisco (1984), 85.

18. This influence is suggested by Rhys, 1952, 70–72.

19. Date: Clark et al., 1990, dates the work ca. 1914–15. "Ca. 1917" appears in Scott, 1980, and reflects Antoinette Kraushaar's opinion of the date upon observation of a photograph of the painting (Antoinette Kraushaar to John Gernand, Aug. 24, 1948). The partly covered signature is evidence that Prendergast reworked the painting. Title: In painting Ledger 15, Phillips wrote the title *Fantasy* next to the entry for *Landscape with Figures*. It is possible that *Landscape with Figures* is the original title of the work and that *Fantasy* is his title. Provenance: This work may have been purchased as early as 1917 according to an undated handwritten notation on the inventory record. However, it does not appear on a list of PMAG works in Phillips's unpublished *Herald of Art*, 1920–21, or on any other earlier documents. Since the painting first appears in the published June 1921 PMAG inventory, one can reasonably conclude that *Fantasy* was acquired by 1921. It was purchased from the Daniel Gallery according to an annotated list by Phillips in Journal GG, 1924.

20. Date: Clark et al., 1990, dates the work ca. 1914–15. Scott, 1980, assigns ca. 1917–18. Title: First alternate title from *Inv.*, 1921; second from DP, "Maurice Prendergast," 1924, 126. Provenance: Purchase from Daniel Gallery per inventory record; in the collection by Mar. 1920, when it was included in DP.1920.1.

21. DP, draft (dated Apr. 1922) for *The Arts*, 1924, 9.

22. Other Prendergast paintings in The Phillips Collection depict the same theme: *Picnic*, ca. 1913–16 (oil on canvas, 18 × 28¼ in.; acc. no. 1608); and *Under the Trees*, ca. 1913–15 (oil on canvas, 23⅞ × 31½ in.; acc. no. 1612).

23. DP, "Maurice Prendergast," 1924, 129; reprinted in *C in M*, 1926, 46, and *E of A*, 1927, 264.

Major References
Margaret Breuning, *Maurice Prendergast*, New York, 1931.
Hedley Howell Rhys, "Maurice Prendergast: The Sources and Development of His Style," Ph.D. diss., Harvard University, 1952.

Hedley Howell Rhys, *Maurice Prendergast: 1859–1924*, exh. cat., Boston, MFA, 1960.

Eleanor Green, *Maurice Prendergast: Art of Impulse and Color*, exh. cat., College Park, Md., University of Maryland Art Gallery, 1976.

Ellen Glavin, "Maurice Prendergast: The Development of an American Post-Impressionist 1900–1915," Ph.D. diss., Boston University, 1987.

Carol Clark et al., *Maurice Brazil Prendergast, Charles Prendergast: A Catalogue Raisonné*, Munich and Williamstown, Mass., 1990.

Elizabeth Milroy, *Painters of a New Century: The Eight and American Art*, exh. cat., Milwaukee Art Museum, 1991.

Nancy Mowll Mathews, *The Art of Charles Prendergast from the Collections of the Williams College Museum of Art and Mrs. Charles Prendergast*, exh. cat., Williamstown, Mass., Williams College Museum of Art, 1993.

Richard J. Wattenmaker, *Maurice Prendergast*, New York, 1994.

Rebecca Zurier, *Metropolitan Lives: The Ashcan Artists and Their New York*, exh. cat., Washington, D.C., NMAA, 1995.

TPC Sources

DP, "Representative American Painters of the New Century," unpubl. introductory statement for a book proposal, between 1914 and 1920; formerly MS 80.

Inv., 1921.

Journals Y, ca. 1922–25; and B, 1923–29.

DP, "Maurice Prendergast," *The Arts* 5, Mar. 1924, 125–31.

Journal GG, 1924.

C in M, 1926.

DP, "To the Editor of *The Art News*," Art News 24, Feb. 13, 1926, 7.

DP, exh. cat. for PMG.1926.5.

E of A, 1927.

Bull., 1927, 1928, and 1931.

ASD, 1931.

Formes, 1932.

Cat., 1952.

MP, 1970 and 1982.

SITES, 1979.

David Scott, *Maurice Prendergast*, Washington, D.C., TPC, 1980.

MD, 1981.

Elizabeth Hutton Turner, essay for TPC.1990.7.

Nancy Mowll Mathews, cat. for TPC.1991.4.

MP, 1998.

MS 45.

ARTHUR BOWEN DAVIES

1. *Bull.* 1928, 41.

2. Ibid.

3. *C in M*, 1926, 47.

4. *Visions of Glory*, 1896 (oil on canvas, 10¼ × 15⅞ in., acc. no. 0450). The establishment of the art acquisitions fund is discussed in MP, 1982, 54–57, quoting from a letter James Phillips wrote to his father Jan. 6, 1916.

5. DP, *Arthur B. Davies*, 1924, 15.

6. *C in M*, 1926, 47.

7. All but one of the pastels, a half-length figure, are landscapes drawn on tinted paper in delicate atmospheric strokes.

8. Duncan Phillips has been credited with urging Davies to return to painting pure landscapes; see Wright, 1978, 92.

9. DP, *Arthur B. Davies*, 1924, 3.

10. Ibid.

11. Wright, 1978, 89.

12. In a letter to Frank Jewett Mather Jr., Nov. 29, 1922, Phillips mentions several visits to Davies's studio. See also MP, 1982, 68–71.

13. DP, 1917, 45.

14. Quotes from DP, 1917, 46 and 45.

15. Redon's *Mystery* (cat. no. 47) was acquired in 1925; and Puvis's *The Wine Press* (cat. no. 25) in 1920, *Marseilles, Gateway to the Orient* and *Massilia, Greek Colony* (cat. nos. 26 and 27) in 1923, and *Sacred Grove* (acc. no. 1619) in 1922.

16. DP, *Arthur B. Davies*, 1924, 8. Huneker's essay was originally published by Charles Scribner's in 1906 and reprinted as the introduction to the 1918 Macbeth Galleries catalogue, *Loan Exhibition of Paintings, Watercolors, Drawings, Etching and Sculpture by Arthur B. Davies*.

17. Davies actually painted a work called *Unicorns*, 1906 (oil on canvas, 18¼ × 40¼ in.), which entered the collection of the Metropolitan Museum of Art with the Bliss bequest in 1931. While no record of their conversations about Cézanne survives, two letters do exist in which Phillips asks Davies for information on his art and influences, TPC Papers, AAA: Feb. 3, 1921, reel 1929, #71; May 2, 1923, reel 1929, #241. It is tempting to presume that Cézanne figured heavily in Davies's undocumented reply.

18. Rockland Center, 1977, n.p. The auction was held at the American Art Association in New York on Apr. 16 and 17, 1929. The first Cézanne purchase was *Mont Sainte-Victoire*, 1886–87 (cat. no. 39).

19. *Bull.*, 1929, 9–10.

20. Provenance: Bill of sale, Mar. 26, 1920.

21. DP, 1931, n.p.

22. According to Dwight Williams, "A Biographical Sketch," in DP, *Arthur B. Davies*, 1924, 27, Davies was particularly influenced by an 1874 exhibition in Utica of paintings by George Inness, Homer Dodge Martin, and Alexander Wyant. Phillips described *Along the Erie Canal* as being in the "style of the Hudson River men with the landscape touch of the Florentine and Flemish Primitives whose work the young American artist had just learned to love" (DP, 1916, 21).

23. DP, 1916, 21.

24. Date: The painting is dated 1903 in Cortissoz, 1931, 33, a catalogue of works compiled by the artist's widow, Dr. Virginia M. Davies. It was first exhibited in 1905. Provenance: Letter from Macbeth to DP acknowledging the sale, Oct. 8, 1924, TPC Papers, reel 1933 [# illeg.].

25. The makeup of the show changed from venue to venue. For further information on the tour of The Eight exhibition, see Judith Zilczer, "The Eight on Tour, 1908–1909," *American Art Journal* (Summer 1984), 32–48.

26. Zilczer, "Eight on Tour," 35.

27. *Siegfried and the Rhine Maidens*, 1881–91 (oil on canvas, 19⅞ × 20½ in.; National Gallery of Art, Washington, D.C., Andrew W. Mellon Collection). See Wolpert, "Symbolist Attributes in the Painting of Arthur B. Davies," in *Dream Vision*, 1981, n.p.

28. Davies quoted in Wright, 1978, 112. In a letter written in the 1890s from Europe to his dealer William Macbeth, Davies called Arnold Böcklin "the biggest man of modern Germany"; see Macbeth Papers, AAA, reel NMc6 #299 and reel D23 #88.

29. Davies named his farm in Congers, New York, the Golden Bough. (He was later to own a first edition of *Ulysses*, James Joyce's modern literary masterpiece employing mythical allusions; see Wright, 1979, 87.) For a discussion of the widespread influence of Frazer's work on modern literature and art, see John B. Vickery, *The Literary Impact of "The Golden Bough"* (Princeton, 1973).

30. Medium: According to painting conservator Elizabeth Steele, who examined the painting in the fall of 1989, Davies mixed natural resins with his oil medium, making the work very difficult to clean without causing damage. Provenance: Ledger 11.

31. Mahonri Young, *The Eight* (New York, 1973), 71.

32. Macbeth Papers, AAA, reel NMC6, #317. In another letter (#320) to Macbeth during his trip, Davies reported that he was sending back seventy panels. Among the paintings from the trip are *Lake Tahoe* (oil on panel, 5½ × 9½ in.; Oakland Museum), *Redwood Grove* (oil on canvas, 26 × 40 in.; Toledo Museum of Art), and oils in the Brooklyn Museum, *In the Sierras* (18 × 40 in.) and *A Double Realm* (15 × 29 in.).

33. William Cullen Bryant, ed., *Picturesque America*, vol. 1 (New York, 1874).

34. "The Treasures of Yosemite," *Century Magazine* 40, no. 4 (Aug. 1890), 483–500; "Features of the Proposed Yosemite National Park," 40, no. 5 (Sept. 1890), 656–67.

35. DP, *Arthur B. Davies*, 1924, 13.

36. Title: This title was used in DP, *Arthur B. Davies*, 1924, 10. A painting titled *Of the Attica Hills*, listed in the Macbeth Gallery exhibition, "Painting by Arthur B. Davies," Mar. 8–30, 1912, may be the same work, giving it a date of ca. 1910–12. Provenance: Edward Balken, acting director of the Carnegie Institute, offered *Horses of Attica* to Phillips in a letter dated Dec. 20, 1920 (TPC Papers, AAA, reel 1935, #155). The Carnegie has no record of ownership, therefore it appears to have been a private transaction.

37. Financing for the trip by Davies's patron, the typewriter magnate H. H. Benedict, was arranged by Macbeth.

38. Davies's interest in the ancient world may go back to his early childhood, which was spent in a region of New York state where towns have such names as Utica, Rome, and Ithaca, and where Greek and Roman revival architecture abounds. See Driscoll, 1979, n.p.

39. DP, *Arthur B. Davies*, 1924, 10.

40. Dec. 10, 1910; Macbeth papers, AAA, reel MC6, #324.

41. Date: According to DP, *Arthur B. Davies*, 1924, 29, *Tissue Parnassian* was "recently painted." Provenance: Bill of sale, Mar. 27, 1923.

42. DP, *Arthur B. Davies*, 1924, 20.

43. For a discussion of Davies's interest in Puvis, see Wolpert, "Symbolist Attributes in the Painting of Arthur B. Davies," in *Dream Vision*, 1981, n.p.

44. For a discussion of the wide-ranging impact of Puvis on late nineteenth- and early twentieth-century art, see Richard Wattenmaker, *Puvis and the Modern Tradition*, exh. cat., Art Gallery of Canada (1975).

45. See Elizabeth Sussman, "Rhythm and Music in the

Frieze Paintings of Arthur B. Davies," in *Dream Vision,* 1981, n.p.

46. For a discussion of inhalation, see Gustavus Eisen, "Davies Recovers the Inhalation of the Greeks," in DP, *Arthur B. Davies,* 1924, 69–78. See also Wright, 1978, 78, for a discussion of the sources of the theory of inhalation.

47. DP, *Arthur B. Davies,* 1924, 20.

48. Ibid., 10.

Major References
Frederick N. Price, *The Etchings and Lithographs of Arthur B. Davies,* New York, 1929.
Royal Cortissoz, *Arthur B. Davies,* New York, 1931.
Munson-Williams Proctor Institute, *Arthur B. Davies.* exh. cat., Utica, N.Y., 1962.
Sheldon Reich, *Arthur B. Davies, Paintings and Graphics,* exh. cat., Tucson Art Center, 1967.
Joseph S. Czestochowski, *Arthur B. Davies, A Chronological Retrospective,* exh. cat., New York, M. Knoedler & Co., 1975.
Rockland Center for the Arts, *Arthur B. Davies, Artist and Collector,* exh. cat., West Nyack, N.Y., 1977.
Brooks Wright, *The Artist and the Unicorn,* New York, 1978.
Joseph S. Czestochowski, *The Works of Arthur B. Davies,* Chicago, 1979.
John Paul Driscoll, *Works by Arthur B. Davies from the Collection of Mr. and Mrs. Herbert Brill,* exh. cat., Pennsylvania State University Museum of Art, 1979.
Stephen Prokopoff et al., *Dream Vision, The Work of Arthur B. Davies,* exh. cat., Boston, ICA, 1981.
Joseph Czestochowski, *Arthur B. Davies, A Catalogue Raisonné of the Prints,* Wilmington, Del., 1987.

TPC Sources
DP, "The American Painter, Arthur B. Davies," *Art and Archaeology* 4, Sept. 1916, 169–77; file includes rough outline, formerly MS 20.
DP, "Arthur B. Davies," unpubl. essays, 4 versions, 1916–24; formerly MSS 19, 21, 119, 177.
DP, "Fallacies of The New Dogmatism in Art," *American Magazine of Art* 9, part 2, Dec. 1917, 43–48; formerly MSS 75 and 76.
DP, "Arthur B. Davies," unpubl. essay, 1921–22; formerly MS 18.
DP, "Lecture on Davies," unpubl. text, 1923; formerly MS 17.
DP, "Arthur B. Davies," unpubl. essay, ca. 1923; formerly MS 22.
DP et al., *Arthur B. Davies: Essays on the Man and His Art,* The Phillips Publication No. 3, 1924.
DP, [Arthur B. Davies], unpubl. essay, ca. 1924; formerly MS 16.
C in M, 1926.
DP, text for PMG.1928.5.
Bull., 1928; 1929 (reprint of "Designer of Dreams," in *Arthur B. Davies,* 1924, with new introduction).
DP, [foreword], in *Exhibition of Watercolors by Arthur B. Davies and Pastels by Dwight Williams,* exh. cat., Syracuse Museum of Fine Arts, 1931.
ASD, 1931.
Cat., 1952.
MP, 1970 and 1982.
Elizabeth Hutton Turner, cat. for TPC.1990.7.

ROBERT HENRI

1. Date: Henri painted *Dutch Girl* in 1910, reworking it in May 1913 and April 1919 per notes in Henri Record

Books, 1885–1928, inv. no. 104 F. Title: *Little Dutch Girl* is probably a DP title; inscribed on the reverse: *104/ F/ Robert Henri/ Dutch Girl/ 104/ F.* The bill of sale lists it as *Dutch Girl.* Provenance: Date of transfer to Daniel per Henri record book; bill of sale, Nov. 5, 1920.

2. Homer, 1969, 83. For a discussion of the Velázquez revival see Charles Caffin, *The Story of American Painting,* New York, 1907, 238–45.

3. Homer, 1969, 108–11.

4. St. John, 1965, 117 (entry Mar. 31, 1907).

5. Henri to Sloan, July 28, 1907; John Sloan Archives, Helen Farr Sloan Library, Delaware Art Museum.

6. See Johannes Dams, son of Cornelia E. Peterson Dams, to author, Sept. 13, 1989. Henri's *Laughing Child,* 1907 (24 × 20 inches; Whitney), and *Laughing Girl,* 1910 (24¼ × 20¼ inches; Brooklyn Museum), are also portraits of Cornelia Elizabeth Peterson.

7. Henri to Samuel Buckner, president of the Milwaukee Art Institute, Feb. 15, 1916 (registrar's file documentary, Milwaukee Art Museum).

8. St. John, 1965, 473–74 (entry Nov. 6, 1910).

9. Homer, 1969, 241.

10. Henri, 1923, 26.

11. A sketch is shown in the record book with an indication that he may have retouched it in May 1913, and a specific reference to repainting in April 1919 (Henri record books, 1885–1928, 104 F).

12. Henri, 1915, 463.

13. Phillips took notes on articles he was reading in preparation for a book. In a section of Journal M (ca. 1915–20), he recorded notes on Henri while reading Hartmann, 1906, 156–83.

14. *C in M,* 1926, 49.

15. DP, "What Is Impressionism?" *Art and Progress* 3, no. 11 (Sept. 1912), 705. The contemporary critics Charles Caffin, George Moore, and R. A. M. Stevenson shared similar views.

16. *Bull.,* 1928, 45.

Major References
Robert Henri diaries, 1881–1928; record books, 1885–1928; scrapbooks, 1888–1901, Collection Janet Le Clair, New York.
Robert Henri correspondence, 1885–1929, Beinecke Rare Book and Manuscript Library, Yale University, New Haven, Conn.
Sadakichi Hartmann, "Studio Talk," *International Studio* 30, Dec. 1906, 156–83.
Robert Henri, "My People," *The Craftsman* 27, no. 5, 1915, 459–69.
William Yarrow and Louis Bouché, eds., *Robert Henri: His Life and Works,* New York, 1921.
Robert Henri, *The Art Spirit,* New York, 1923.
Helen Appleton Read, *Robert Henri,* New York, 1931.
C. Law Watkins, "Pictures of People," *American Magazine of Art* 26, no. 11, Nov. 1933, 498–510.
Bruce St. John, ed., *John Sloan's New York Scene: From the Diaries, Notes, and Correspondence, 1906–1913,* New York, 1965.
William Innes Homer, *Robert Henri and His Circle,* Ithaca, N.Y., 1969.
Bennard B. Perlman, *The Immortal Eight: American Painting from Eakins to the Armory Show, 1870–1913,* Cincinnati, 1979.
Rebecca Zurier, "Picturing the City: New York in

the Press and the Art of the Ashcan School, 1890–1917," Ph.D. diss., Yale University, 1988.
Elizabeth Milroy, *Painters of a New Century: The Eight and American Art,* exh. cat., Milwaukee Art Museum, 1991.
Bennard B. Perlman, *Robert Henri: His Life and Art,* New York, 1991.
Valerie Ann Leeds, *My People: The Portraits of Robert Henri,* exh. cat., Orlando Museum of Art, Fla., 1994.
Rebecca Zurier et al., *Metropolitan Lives: The Ashcan Artists and Their New York,* exh. cat., Washington, D.C., NMAA, 1995.
Bennard B. Perlman, ed., *Revolutionaries of Realism: The Letters of John Sloan and Robert Henri,* Princeton, N.J., 1997.

TPC Sources
DP, "Representative American Painters of the New Century," unpubl. introductory statement for book proposal, between 1914 and 1920; formerly MS 80.
Journals M, ca. 1915–20; and CC, between 1917 and ca. 1920.
H of A, 1920–21.
Inv., 1921.
C in M, 1926.
Bull., 1928.
Cat., 1952.
SITES, 1979.
Elizabeth Hutton Turner, essay for TPC.1990.7.

GEORGE BENJAMIN LUKS

1. *Czechoslovakian Army Entering Vladivostok, Siberia, in 1918,* 1918 (oil on canvas, 36½ × 53⅜ in.; Los Angeles County Museum of Art, Mr. and Mrs. William Preston Harrison Collection, 25.6.1).

2. In *C in M,* 1926, 5, Phillips wrote, "I have devoted myself to the lifelong task . . . of gradually doing my bit to train the public to see beautifully."

3. *C in M,* 1926, 50.

4. The sixth oil, *Ducks on Morris Canal,* 1920 (collection of Edward and Deborah Pollack), was acquired by Phillips in 1924 in exchange for *Czechoslovakian Army Entering Vladivostok, Siberia, in 1918;* DP to J. F. Kraushaar, Apr. 28, 1924, TPC Papers, AAA, reel 1933, #100. In 1932, in another exchange, Phillips traded *Ducks on Morris Canal* for Rouault's *Tragic Landscape,* 1930 (acc. no. 1676).

5. Date: 1910 was the date assigned to this painting in provenance information sent by Kraushaar Galleries to Phillips in the mid-1920s. Cat., 1952, dates it 1912. Daniel Wynkoop, the subject of the portrait, stated in an interview with the author, Dec. 14, 1987, that it could not have been done in 1910 because the Wynkoops lived abroad by then. Wynkoop believes that the portrait was done around 1908, when he was about three years old. Provenance: Purchase by Kraushaar recorded in provenance records. Bill of sale to Duncan Phillips, July 27, 1920, TPC Papers, AAA, reel 1929, #1033. The painting is also listed by Phillips as one of his "Fifteen Best Purchases," 1920. However, *Sulky Boy* was illustrated on the cover of *Town and Country,* Nov. 20, 1919, with the notation that it already belonged to Duncan Phillips. To further confuse the issue, a bill of sale from Kraushaar to DP, Dec. 3, 1919, lists *Sulky Boy* as a credit. Although Phillips may have had *Sulky Boy* on approval briefly in 1919, perhaps even making some payment for it, he clearly purchased the painting later, in July 1920.

6. The sitter was born Apr. 14, 1905; all information regarding this painting has been supplied by the sitter; see series of letters from Daniel Wynkoop Jr., dated Dec. 13, 1987, and Jan. 17, 1988, and a telephone conversation with GHL, Dec. 14, 1987.

7. Dr. Wynkoop had an even closer friendship with Luks's brother, Will, who ran the Northern Dispensary at Waverly Place in New York. Will named one of his children Daniel Wynkoop Luks, per Wynkoop Jr. to GHL, Dec. 13, 1987.

8. DW to GHL, Jan. 17, 1988.

9. Alfred Kreymborg, "George Luks—Painter of Souls," *New York Morning Telegraph*, Dec. 13, 1914; second quotation, Phillips in MS 33, n.p.

10. Date: Per Kraushaar provenance records. Provenance: Information from Kraushaar provenance records; bill of sale to Phillips, July 27, 1920, per TPC Papers, AAA, reel 1929, #1033. Transfer recorded in Ledger 11.

11. The exhibition was "Luks, Monticelli, Ryder" at Kraushaar May 18[?]–June 10, 1919; no catalogue has been found. Quotes from the *Brooklyn Daily Eagle*, May 18, 1919, magazine, sec. 11.

12. DP, "Ranking of Paintings in Oil," Journal EE, ca. 1922. *The Dominican* was ranked eleventh out of eighty. Elizabeth Hudson referred to the importance of *The Dominican* in a letter to Phillips, Feb. 5, 1921 (Foxhall correspondence), concerning his possible purchase of a large Ménard painting: "if you should take it—it is—like the Dominican a museum picture."

13. *C in M*, 1926, 49.

14. *New York Herald,* June 8, 1919, sec. 3, p. 5.

15. Cuba et. al., 1987, 77.

16. Date: *New York Times,* Apr. 30, 1918, 5, identifies the Blue Devils, who were to participate that day in the parade of the Third Liberty Loan Drive. Because the painting was exhibited at Kraushaar by May 27, 1918, the conclusion can be made that Luks executed the work between Apr. 30 and May 27. Provenance: Bill of sale, June 24, 1918; transfer recorded in Ledger 11.

17. Identification of the streets and buildings per provenance records sent from Kraushaar Galleries to Phillips in the mid-1920s.

18. The three quotations are from DP, 1918, 20.

19. DP, 1919, 123.

20. Provenance: Commission information from Kraushaar provenance records; bill of sale, Dec. 3, 1919. Transfer to PMAG per Ledger 11.

21. The English version of this play was written by Paul Meredith Potter. It was performed in New York, with Otis Skinner in the leading role, in 1908–9, 1919, and 1926.

22. DP, MS 33, n.p.

23. Phillips was aware of Skinner as early as 1902, when at the age of 16 he referred to the actor's superb skill in Shakespeare's *The Taming of the Shrew* (Journal H, 1902–03/1908–09). His estimation of Luks's painting ability appears in Kraushaar provenance records.

24. "Modern Old Masters at Luks Exhibition," *New York Times,* Jan. 10, 1923, 23. References to his attending the performances in SITES, 1979, 48.

25. "Luks's Portrait of Otis Skinner Shown," *New York Sun,* May 20, 1919, 6, cites it as "one of the best of [Luks's] recent works"; and the *New York Herald,* May 18, 1919,

sec. 3, p. 8, as "one of the most brilliant pieces of humorous painting that Mr. Luks has ever accomplished."

26. DP, 1920.

27. Clara Mason, employee of the Alliance, to DP, Feb. 28, 1923. The reception had taken place on Feb. 27.

28. MP, 1982, 23.

Major References
George B. Luks Papers, AAA.
Forbes Watson, "George Luks: Artist and 'Character'", *Arts,* Jan. 1935, 21–26.
William Innes Homer, *Robert Henri and His Circle,* Ithaca, N.Y., 1969.
Ralph Clayes Talcott, "The Watercolors of George Luks," M.A. thesis, Pennsylvania State University, 1970.
Bennard Perlman, *The Immortal Eight: American Painting from Eakins to the Armory Show, 1870–1913,* Cincinnati, 1979.
Stanley L. Cuba et al., *George Luks: An American Artist,* exh. cat., Wilkes-Barre, Pa., Sordoni Art Gallery, 1987.
Rebecca Zurier, "Picturing the City: New York in the Press and the Art of the Ashcan School, 1890–1917," Ph.D. diss., Yale University, 1988.
Elizabeth Milroy, *Painters of a New Century: The Eight and American Art,* exh. cat., Milwaukee Art Museum, 1991.
Nina Kasanof, "The Illustrations of Everett Shinn and George Luks," Ph.D. diss., University of Illinois at Urbana-Champaign, 1992.
Rebecca Zurier et al., *Metropolitan Lives: The Ashcan Artists and Their New York,* exh. cat., Washington, D.C., NMAA, 1995.
Owen Gallery, *George Luks: An Artistic Legacy,* exh. cat., New York, 1997.

TPC Sources
Journal H, 1902–3 and 1908–9.
DP, "Representative American Painters of the New Century," unpubl. introductory statement for book proposal, between 1914 and 1920; formerly MS 80.
E of A, 1914 and 1927.
Journal CC, between 1917 and ca. 1920.
DP, "Art and the War," unpubl. text for slide lecture, 1918.
DP, "The Allied War Salon," *American Magazine of Art* 10, Feb. 1919, 115–23.
DP, "Fifteen Best Purchases of 1918–19; Fifteen Best Purchases Since Jan. 1920," unpubl. acquisitions list, 1920.
H of A, 1920–21.
Inv., 1921.
Journals EE, ca. 1922; D, ca. 1923–24; and B, 1923–29.
DP, cat. intro., PMG.1926.6.
C in M, 1926.
DP, essay for PMG.1928.4a.
Bull., 1928.
DP, [Most Important Living American Artists], unpubl. List, 1929.
Formes, 1930.
ASD, 1931.
Formes, 1932.
Cat., 1952.
MP, 1970 and 1982.
SITES, 1979.
Elizabeth Hutton Turner, essay for TPC.1990.7.
MSS 33 and 34.

JEROME MYERS

1. DP, *C in M,* 1926, 50.

2. DP, 1917, 483.

3. *Scribner's Magazine* 53 (Feb. 1913), 265–68.

4. DP, 1917, 485. Phillips and his wife visited Myers again in his studio in 1923 (Myers to DP, Nov. 23, 1923, TPC Papers, AAA, reel 1930, #668).

5. DP, 1917, 485.

6. DP, *C in M,* 1926, 50.

7. "Jerome Myers," *Arts and Decoration* 10 (Mar. 1919), 257.

8. Myers to DP, May 12, 1920. According to museum records, Phillips exchanged *Field of Joy* in 1923 for *Little Singer,* 1923 (destroyed in railroad accident Nov. 11, 1929).

9. Ethel Myers asked Phillips to sponsor the Myers Memorial exhibition in Washington (E. Myers to DP, June 10, 1941); he declined. Phillips purchased *Street Singer,* n.d. (acc. no. 1412), *East 22nd Street, New York,* n.d. (acc. no. 1404), and *Old Quarter,* by 1919 (acc. no. 1410), from the Corcoran's "Special Exhibition of Paintings, Drawings and Etchings by Jerome Myers," Dec. 4–28, 1941.

10. DP, 1917, 485.

11. Title: Illustrated as "East Side Picture" in Charles Caffin, *The Story of American Painting* (New York, 1907), 376; illustrated as "The Street Dance" in Pène du Bois, 1914, 89; recorded as "An Appreciative Audience" on a Macbeth Gallery label on frame reverse. Provenance: According to the Whitney Museum of American Art artists' file (AAA, reel N677, #305), Speyer purchased it from the "fall National Academy exh. 1906"; Macbeth and PMG purchases documented in Robert McIntyre (of Macbeth Gallery) to DP, Apr. 11 and 25, 1942; response, June 11, 1942; bill of sale, Mar. 30, 1943.

12. Date/Medium: The reworking is corroborated in Myers to DP, May 31, 1916. Evidence of retouching after a varnish was applied is visible under ultraviolet light; it is especially apparent in the balustrade and in three of the seated figures in the lower right corner (Elizabeth Steele, painting conservator, July 27, 1990). Provenance: Daniel Gallery stamps and labels on painting reverse; recorded on Dec. 9, 1920, in Ledger 11. Marjorie Phillips recorded 1910 as the acquisition date in MP, 1982, 317; however, the Daniel Gallery did not open until Dec. 1913, and other evidence points to a 1916 acquisition date (Myers to DP, May 31, 1916).

13. Myers, 1940, 227.

14. Jerome Myers Papers as quoted in Holcomb, 1977, 91.

15. Myers to DP, May 31, 1916.

16. Brushstrokes defining mother and child do not correspond to the uppermost figure, suggesting reworking by the artist (Steele, July 27, 1990).

17. Myers, 1940, 108.

18. Documented in DP to McIntyre, June 11, 1942 (TPC Papers, AAA, reel 1959, #154).

19. DP, 1917, 484.

20. *The Pursuit of Pleasure,* n.d. (oil on canvas; location unknown), is illustrated in DP, 1917, 481; quote p. 484.

21. DP, 1917, 484.

22. Title: *Night, Seward Park* disappeared from the

record books between 1920 and 1926, during which time the title *Night—Bryant Park* appeared, probably referring to the same painting. Provenance: Bill of sale from Kraushaar, Dec. 3, 1919; transfer documented in Ledger 11 (as *Night—Bryant Park*).

23. Myers, 1940, 49.

24. Myers, 1940, 48.

25. William H. Seward is best known as the secretary of state who arranged for the United States to buy Alaska from Russia.

26. Myers, 1940, 75.

27. DP, *C in M*, 1926, 50.

Major References
Jerome Myers Papers, 1911–43, Archives of American Art, Smithsonian Institution, Washington, D.C.
Guy Pène du Bois, "Jerome Myers," *Art and Progress* 5, Jan. 1914, 89–94.
Jerome Myers, *Artist in Manhattan,* New York, 1940.
Grant Holcomb, "The Forgotten Legacy of Jerome Myers (1867–1940): Painter of New York's Lower East Side," *American Art Journal* 9, May 1977, 78–91.

TPC Sources
DP, "Representative American Painters of the New Century," unpubl. introductory statement for book proposal, between 1914 and 1920; formerly MS 80.
E of A, 1914.
Journal O, 1916–23.
DP, "Jerome Myers," *American Magazine of Art* 8, Oct. 1917, 481–85.
Journals CC, between 1917 and ca. 1920; and U, ca. 1919.
H of A, 1920–21.
Inv., 1921.
Journals EE, ca. 1922; Y, ca. 1922–25; D, ca. 1923–24; B, 1923–29; and GG, 1924.
DP, "The Phillips Collection," unpubl. outline prepared for F. Newlin Price, "Phillips Memorial Gallery," *International Studio* 80, Oct. 1924, 8–18; some drafts formerly MS 89.
DP, "Painters of Past and Present," unpubl. outline for proposed publication, July 1, 1925; formerly part of MS 97.
DP, "Order of Notes and Essays," unpubl. list of proposed publications, ca. 1925–26; formerly part of MS 97.
C in M, 1926.
DP, essay for PMG.1926.7.
ASD, 1931.
DP, "Tentative Plan for Handbook," unpubl. outline for proposed publication, ca. 1941; formerly part of MS 97.
Cat., 1952.
SITES, 1979.
Elizabeth Hutton Turner, essay for TPC.1990.7. MS 43.

WILLIAM J. GLACKENS

1. Date: Date based on a drawing in a sketchbook (collection of Ira Glackens), signed and dated "W. Glackens, Bellport, L.I. 1912" (as cited in Wattenmaker, "The Art of William Glackens," Ph.D. diss., New York University, 1972, 220). Ultraviolet examination (Elizabeth Steele, painting conservator) May 11, 1987, shows that the painting was reworked in several areas, especially the sky. Provenance: Consignment date is not recorded; it may have coincided with the one-person exhibition at Kraushaar in 1925, the year Glackens joined the gallery. PMG purchase per Kraushaar to DP, Jan. 19, 1929 (TPC Papers, AAA, reel 1938, #1324).

2. *Beach Scene, Cape Cod,* 1908 (25 × 30 in.; location unknown), was included in the "National Academy of Design Winter Exhibition, 1908," Dec. 12, 1908–Jan. 9, 1909, cat. no. 336.

3. Arthur Hoeber, "The Winter Exhibition of the National Academy of Design," *International Studio* 36 (Feb. 1909), 136.

4. Together with Maurer in Paris, Glackens visited the apartment of Gertrude and Leo Stein and combed the galleries seeking to purchase works for Albert C. Barnes.

5. Several friends visited him, including Barnes, Lawson, Prendergast, and Shinn. His friends the artists James and May Wilson Preston were also inhabitants of the island, as were the poet Dorothy Parker and the Russian-American violinist Mischa Elman; see Wattenmaker, 1988, 92, n. 11.

6. De Gregorio, 1955, 198.

7. Glackens, 1913, 159, 162.

8. For a comparison, see Monet's *The River,* 1868 (oil on canvas; Art Institute of Chicago). Renoir's influence did not manifest itself until such paintings as *Young Woman in Green,* 1915 (oil on canvas; Collection of Ira Glackens).

9. Everett Shinn, "William Glackens: As an Illustrator," *American Artist* 9, no. 9 (Nov. 1945), 37.

10. *C in M,* 1926, 52.

11. Phillips traded *Lenna and the Rabbits,* ca. 1920 (30 × 25 in.), in 1928 for another Glackens painting. *Lenna* was burned in a railroad accident that same year as it was being returned from an exhibition; see de Gregorio, 1955, 590.

12. TPC Papers, AAA, reel 1938, #1323.

13. Glackens quoted in Kraushaar to DP, Jan. 19, 1929 (reel 1938, #1324, TPC Archives).

Major References
William J. Glackens Papers, AAA.
[William Glackens], "The American Section, The National Art," *Arts and Decoration,* Mar. 1913, 159–64.
Forbes Watson, *William Glackens,* New York, 1923.
Guy Pène du Bois, *William Glackens,* New York, 1931.
Vincent J. de Gregorio, "The Life and Art of William J. Glackens," Ph.D. diss., Ohio State University, Columbus, 1955.
Ira Glackens, *William Glackens and the Ashcan Group: The Emergence of Realism in American Art,* New York, 1957; 2nd ed., rev., New York, 1983.
Richard J. Wattenmaker, "William Glackens's Beach Scenes at Bellport," *Smithsonian Studies in American Art* 2, no. 2, Spring 1988, 75–94.
Elizabeth Milroy, *Painters of a New Century: The Eight and American Art,* exh. cat., Milwaukee Art Museum, 1991.
Rebecca Zurier et al., *Metropolitan Lives: The Ashcan Artists and Their New York,* exh. cat., Washington, D.C., NMAA, 1995.
William H. Gerdts, *William Glackens,* Fort Lauderdale, Fla., 1996.

TPC Sources
Journal CC, between 1917 and ca. 1920.
C in M, 1926.
DP, "Most Important Living American Artists," unpubl. list, 1929.
ASD, 1931.
Cat., 1952.
SITES, 1979.
Elizabeth Hutton Turner, essay for TPC.1990.7.
MP, 1998.

AUGUSTUS VINCENT TACK

1. Phillips's first recorded mention of Tack occurs in Journal L, 1914. Marjorie Phillips (MP, 1982, 318) recalls this as the year of the first acquisitions. Built onto the house as a library in 1907, the Music Room has been the site of Sunday concerts since 1931.

2. Fourteen paintings are listed in Inv., 1921. In addition to later commissions and purchases, the contents of Tack's studio—studies, drawings, and portraits—were bequeathed by the artist's widow in 1959, bringing the total to some 260 works in the study and permanent collections. For discussion of Tack's technique, see Elizabeth Steele's analysis in Leslie Furth, cat. for TPC.1993.1.

3. Tack remained in this position into the early 1930s when C. Law Watkins replaced him as the artist on the board. It was Watkins rather than Tack whom Phillips asked to succeed him in the event of his death, explaining that Tack "has [his] own creative career . . . whose remaining years will be all too short a time to achieve all the important work he has in him" (DP to CLW, Mar. 10, 1929).

4. Tack was also chairman of the Committee on Interior Decoration, and sat on the committees for Drama, Music and Lectures, Memorial Donations, and Additional Financial Resources.

5. "Notes on the Art of Augustus Vincent Tack," Journal L, 1914, n.p. (though most of this journal is devoted to draft essays for *E of A,* 1914, Tack is not mentioned in the book). Phillips mentions several pictures not included in the known exhibitions of the period, suggesting either a studio visit or an untraced exhibition in New York. A member of the Century Association since 1913, Tack showed a number of moody, romantic landscapes there in 1914. Phillips did not join until 1917, when he was nominated by Tack and Samuel Parrish (Nominating Committee minutes, courtesy W. Gregory Gallagher, librarian, Century Association, New York).

6. DP, 1916, 20.

7. It is part of a series of biblical scenes executed in the early teens, possibly intended as a mural cycle for a church. According to Tack in a letter to Phillips, July 21, 1937, the other works in the series were *The Remorse of Eve,* 1913–14 (63 × 48; National Shrine of the Immaculate Conception, Washington, D.C.), *Simon of Cyrene* (61 × 48, National Shrine of the Immaculate Conception), *The Burden,* a sketch for which was at TPC, although the finished work was traded, *The Voice in the Wilderness, Earthbound,* and *The Pardon of Dismas* (locations unknown).

8. PMG.1924.1.

9. "Augustus Vincent Tack," Journal GG, 1924, n.p. In 1922 Phillips began to disseminate Tack's paintings to other institutions, giving the religious painting, *In the House of Matthew,* by 1922, to the Metropolitan Museum of Art.

10. *Washington Post*, Nov. 12, 1922, Amusements and Automobiles section, 2. Tack's other roles included representing Phillips by proxy with publishers and authors. On Mar. 20, 1924, Phillips asked Tack to oversee the drawing selection with Davies for his forthcoming monograph, writing, "I feel that your taste is sufficiently like mine to make you my personal representative" (DP, *Arthur B. Davies: Essays on the Man and His Art*, 1924).

11. The museum's floor plans are drawn on the first two pages of Journal B, 1923–24. In the space for Tack's hallway, Phillips wrote: "large abstract mural paintings set in panelled walls furniture walls everything designed and colored by the artist." Tack or Davies was to be responsible for the decoration of a vast auditorium.

12. DP, essay for PMG.1926.2, n.p.

13. *Night, Amargosa Desert*, 1935 (oil on canvas, mounted on plywood panel, 84 × 48 in., acc. no. 1913).

14. "Painting and Sculpture by Living Americans: Ninth Loan Exhibition," Oct. 5, 1930–Jan. 25, 1931, an exhibition organized annually by Barr, director of MOMA. DP to Barr, Nov. 10, 1930; Barr telegraphed back with apologies (Nov. 11, 1930), explaining that Tack's name had simply not arisen in the planning meetings.

15. DP, "Modern Art, 1930," *A & U*, 1930, 144.

16. *ASD*, 1931, 17.

17. DP, *Formes*, 1932, 197.

18. In this period, Tack had attracted the patronage of collectors such as Grenville Winthrop and Stephen Clarke. This era also coincided with the end of Tack's participation on the gallery's board. For Winthrop's friendship with Tack, see Furth chronology in cat. for TPC.1993.1, 122. Clarke owned at least two Tack paintings for a period, *Night, Amargosa Desert*, 1935 (possibly a loan from the artist; now TPC), and *Abstraction*, ca. 1934–36, now in the Telfair Academy of Arts and Sciences, Savannah, Georgia.

19. PMG.1943.9, n.p.

20. Augustus Vincent Tack to DP, Feb. 9, 1949.

21. *Epiphany*, ca. 1923, Everson Museum of Art, now lost; *Canyon*, early 1930s, Brooklyn Museum; *Dunes*, Museum of Modern Art; *Before Egypt*, ca. 1936, Whitney Museum of American Art; and *Night Clouds and Star Dust*, 1943, Metropolitan Museum of Art.

22. DP to Albert Ten Eyck Gardner, then curator of American painting, Metropolitan Museum of Art, July 22, 1964.

23. Date: Tack inscribed the painting with his studio address from 1894 through 1900, providing a terminus date. Tack himself stated that the painting was executed prior to 1905 (Tack to John W. Beatty, Mar. 22, 1910); the style appears to support that conclusion. Title: First title: artist's inscription, canvas reverse. First alternate title: Tack to Beatty, Carnegie, Mar. 19 and 22, 1910 (roll 18, file 541, Carnegie Institute Papers, AAA).

24. Below the upper paint layers lies an earlier picture; an infrared photograph reveals this earlier, perhaps unfinished work to be a portrait of a man. See conservator's inspection, Elizabeth Steele, Sept. 23, 1992. Citation from Tack's letter to Agnes Fuller, Mar. 8, 1900, Higginson-Fuller Papers, Pocumtuck Valley Memorial Association, Deerfield, Mass. Patricia Paladines, Prints and Photographs Department, New-York Historical Society (Sept. 17 and Oct. 2, 1987), pointed out that

West Eighty-second Street appeared more likely as the site than the Eighth Street studio.

25. See, for example, Hassam's *Lake Afternoon, Winter, New York*, 1900 (oil on canvas, 37¼ × 29⅛ in.; Brooklyn Museum, New York).

26. For discussion, see Donaldson F. Hoopes, *Childe Hassam* (New York, 1979), 54.

27. Date: Terminus date per first known exhibition, 1922. An earlier date is suggested by the artist's letters to John Kraushaar (Sept. 2) and Phillips (July 21, 1921) referring to several new canvases under way. Title: Per inscription on reverse; alternate title per first exhibition; second alternate probably by Phillips. Provenance: Phillips borrowed the painting from Kraushaar for PMG.1924.1. The loan to Charles Lay per DP Mar. 3 and June 24, 1930; confirmed in corr., George Lay to author, Oct. 26, 1992. Macbeth acquisition per DP to Tack, Jan. 25 and Feb. 3, 1941. However, *The Crowd* appears on a TPC shipping record for the 1941–42 Phillips Academy exhibition, indicating that it was briefly on loan to, or stored at, the museum. Nierendorf consignment per letter to DP, Feb. 2, 1943: "I have written to Tack about your interest in his painting, *Turmoil*." Payment Feb. 2, 1943, Ledger 15.

28. Known to derive from *The Crowd* are those three works with recognizable human forms, *Balance, Order*, and *Rhythm*—as well as two with concealed imagery, *Allegro* and *Andante*, and a sixth painting, known as *Orchid*, in the collection of Saville Ryan, New York.

29. Tack to Violet Fuller, Nov. 21, 1899; Tack's reference to Raffaëlli began critically but ended: "he certainly can paint a crowd of people" (Fuller-Higginson Family Papers).

30. Tack MS, 1941, 31.

31. DP to Bartlett Hayes, Dec. 5, 1941 (Archives of Andover Academy, courtesy Ruth Quattlebaum). Tack could have encountered this scene in Deerfield or in Tryon, South Carolina, where the Tacks owned a house.

32. Per Steele examination, Sept. 27, 1992, and Feb. 1993; the jagged shapes and directional lines suggesting light and shadow on a rocky landscape or windblown fields are visible in the far right, extending beneath the entire image. The Music Room panels which Tack derived from *The Crowd* bear out this source.

33. If Tack saw the Armory Show, he would have seen Marcel Duchamp's *Nude Descending A Staircase*, 1912 (58 × 35 in., Philadelphia Museum of Art).

34. Tack kept a reproduction of this figure, a *putto* under Daniel, in a scrapbook. He could have seen the 1914 synchromist exhibition in New York at the Carroll Galleries or later exhibitions, among them the "Forum Exhibition of Modern American Painters," Mar. 13, 1916, at the Anderson Galleries. Lane, 1935, 728, probably quoting the artist and writing on the related panel *Gethsemane*, suggested Borgognana's battle scenes as a possible source for Tack's imagery. See also Gail Levin, *Synchromism and American Color Abstraction: 1910–1925*, exh. cat. (New York, 1982).

35. Luca Signorelli, *Damned Consigned to Hell*, 1499–1504, fresco, San Brixio Chapel, Orvieto Cathedral, Italy. I am indebted to Elizabeth Steele for this comparison.

36. Steele, Sept. 27, 1992, notes the presence of pinholes, covered with original paint, which suggests the transfer of a design from a preparatory study to the canvas surface.

37. "Other Displays in New York Art Galleries," *New York American*, Section M, 4.

38. [Royal Cortissoz?], "Various Exhibitions in Many Galleries," *New York Herald Tribune*, Feb. 19, 1922, 5.

39. DP to Tack, Mar. 4, 1941.

40. Provenance: Kraushaar bill of sale, Apr. 15, 1924; purchased together with *Entombment* and *Magi's Journey*. Phillips traded *Mother and Child, The Burden* (*Christ Carrying the Cross*), *Sketch for Court of Romance, Chinoiserie*, and *Mountain Outposts*.

41. Date: Tack mentioned *Voice of Many Waters* in a letter of July 22, 1923 (Kraushaar Archives, New York). Phillips asked to see the *Waterfall* (*Voice of Many Waters*) "after it was finished" in order to decide whether to purchase it or *Canyon* (DP to Tack, Jan. 24, 1924). Provenance: Bill of sale, Mar. 31, 1924.

42. In the summer of 1922, when Tack wrote Kraushaar of "six canvases well under way and four more planned," he probably referred to this series. For a chronology, see Furth, cat. for TPC.1993.1, 47–49, n. 92.

43. Private collection, Deerfield, Mass.

44. Tack, "Some General Remarks About Paintings Called Abstractions," ca. 1941, typescript, written for an exhibition at the gallery in 1941–42, n.p. (Phillips Academy Archives, Andover, Massachusetts).

45. DP, essay for PMG.1924.1. In 1926 (*C in M*, 56) he referred to Tack's "revered ancestors of the age of faith . . . Giotto, Masaccio and Piero della Francesca."

46. Tack, writing from Banff, Alberta, to the critic Royal Cortissoz, Aug. 2, 1920, Beinecke Rare Book and Manuscript Library, Yale University, New Haven, Conn., as quoted in Green, 1972, 16–17.

47. Thus Tack's use of photography in the Music Room series to obtain distorted yet still nature-derived forms was preceded by these explorations in a similar vein.

48. See Green, 1972, 17, for the hypothesis that Tack used his own pictures. In 1923, Tack mentioned that his son Robert was then "photographing the Indian country," indicating that he photographed the Western countryside for his father (Tack to John Kraushaar, Apr. 30, 1923; correspondence on temporary loan to TPC).

49. Tack, "Some General Remarks About Paintings Called Abstractions."

50. Correspondence between Tack and John Kraushaar documents the progress on *The Voice of Many Waters*. On July 22, 1923, Tack wrote from Deerfield, "I am working on a canvas now which interests me very much . . . —It is in the latest manner and I think more beautiful in color and feeling than any yet. I shall call it 'The Voice of Many Waters.'"

51. Journal GG, 1924.

52. The nuanced coloring, floating forms, and compressed space echo the composition in *The Horsemen*, an Asian painting from Tack's collection.

53. Frederick C. Luebke, "The Progressive Spirit in the Nebraska Capitol: The Collaboration of Goodhue and Tack," lecture, Nov. 6, 1993, Sheldon Memorial Art Gallery and Sculpture Garden, University of Nebraska, Lincoln.

54. DP, essay for PMG.1924.1.

55. Provenance: On Dec. 28, 1928, Phillips sent Tack "the first payment for the work you are doing in preparation for the ultimate decoration of the Phillips

Memorial Gallery's art library." Tack to DP, Mar. 2, 1930, documents shipment to Phillips.

56. See note 55.

57. For a detailed discussion of the series, see Furth's essay, "Landscapes of the Mind: Augustus Vincent Tack's Decorative Panels for the Phillips Memorial Gallery," in TPC.1993.1, 81–101.

58. Both patron and artist were aware of precedents. Phillips had taken a great interest in the opening of the Freer Gallery in 1923, inviting Tack to view it with him. There they would have seen Whistler's famous Peacock Room. In 1915–16 Phillips had also been impressed by the paintings Arthur B. Davies created for the music room of Lillie P. Bliss's home in New York. The adornment of a library with murals had prominent antecedents in the Boston Public Library and the Library of Congress.

59. DP, 1932, n.p., and "The Artist Sees Differently," Trowbridge lecture, Yale University, Mar. 20, 1931, 13.

60. *Balance, Order, Rhythm, Allegro,* and *Andante* derive from *The Crowd.* A panel now in the collection of Saville Ryan, New York, known in the correspondence as *Orchid,* also derives from this work. The works from the series originating in landscape photography are: *Ecstasy, Liberation, Flight, Far Reaches,* and *Aspiration.*

61. The sequence is known from a diagram Tack drew for Phillips; see Tack to DP, Mar. 9, and DP to Tack, Oct. 29, 1930.

62. From Tack's "Note on the Decorative Panels," Jan. 31, 1931.

63. DP, "The Artist Sees Differently," 12–13.

64. William Wilfred Bayne manuscript for Nathaniel Sims, American Studies Group, 1968. The snapshots may actually have been taken by Tack's son Robert, who was interested in photography as early as 1923 as evidenced in a letter from Tack to DP in which he mentions Robert photographing the West, Apr. 30, 1923, and who had an abundance of photographic equipment when he died in 1949 (Richard Arms, nephew of Agnes Gordon Tack, interview with author, Nov. 24, 1992). The "professional" photographer who enlarged the photographs was probably Louis Dreyer of New York, whom Tack used throughout the 1920s.

65. DP to Tack, Apr. 15, 1930.

66. Tack to DP, June 22, 1937.

67. Phillips's retreat in the mid-1930s from a permanent installation of the Music Room panels was, Phillips argued, to benefit the artist, for a group of easel pictures would allow juxtapositions of Tack's work with an international group of modernists.

68. Provenance: Painting file notation: "kept for collection, April 17, 1948."

69. In 1934 Wildenstein Galleries, New York, held a retrospective of Tack's work, and among more than thirty paintings were several small related canvases he had painted recently. Not all the works listed on the checklist can be identified; however, it appears that at least five of the works exhibited were the latest small abstractions. Their titles were: *Dawn, Night, Moonlit Clouds, Glow, Winter* (no. 3), and *Afternoon.* By 1936, when Tack showed at the Deerfield Valley Arts Association, the series included *Evening.* It is not known whether the artist created these works over a two-year period or simply did not include them all in the earlier showing; see Furth, cat. for TPC.1993.1, 50–66.

70. This reminiscence is further borne out in the elegance of the frames and gesso borders, honed by the artist to delicate hues of white and gray. Hand in hand with this seeming retrenchment are the compositions themselves, whose shapes are one-to-one transfers of small areas from the cartoons or underdrawings used for the large-scale abstractions of the late 1920s and early 1930s. *Night, Amargosa Desert,* 1935, bears the same ground treatment and fabric.

71. A canvas at the Telfair Academy in Savannah, *Abstraction,* numbered 2 on its verso by the artist (possibly exhibited as *Night* or *Moonlit* in the 1934 exhibition), shows the next phase in the progression: a night sky of scattered stars and clouds edged with moonlight.

72. The curtain was commissioned in 1944 for the Lisner Auditorium, designed by the Washington architects Faulkner and Kingsbury.

73. AVT to DP, June 26, 1944. Use of the vacuum cleaner is cited by Mrs. Solton Engel, "Collection of Mrs. Zolton [*sic*] Engel," Papers of the American Studies Group, Deerfield Academy, Deerfield, Mass.

74. Steele, Feb. 1992.

75. Cloyd Marvin, in an undated letter to Nathaniel Sims of the Deerfield American Studies Group, wrote that he and Tack "ended our several meetings with [Henri] Bergson's *Creative Evolution*" (1907; first English edition, 1911).

76. Tack, "Notes on Three Paintings," exhibition checklist, ca. 1944, Special Collections, George Washington University, Washington, D.C.

Major References
Art and memorabilia from the artist's studio (including 1941 unpubl. manuscript by Tack, "Reflections on Pictures, Some Painted and Some Unpainted"), collection of Joseph Peter Spang III, Deerfield, Mass.; cited as Tack MS 1941.
Correspondence, interviews, notes, photographs, and other memorabilia compiled by the American Studies Group in 1968, Deerfield Academy Archives, Deerfield, Mass.; cited as American Studies Group.
Fuller-Higginson Family Papers, Pocumtuck Valley Memorial Association, Deerfield, Mass.
Phillips-Tack correspondence, TPC Papers, AAA and TPC Archives.
Augustus Vincent Tack and Thornton Oakley, "Two Definitions of Art," *American Magazine of Art* 21, Oct. 1930, 576–78.
Formes, 1932.
James W. Lane, "Augustus Vincent Tack," *American Magazine of Art* 28, Dec. 1935, 726–33.
Augustus Vincent Tack, "Some General Remarks About Paintings Called Abstractions," ca. 1941, unpubl. typescript, Phillips Academy Archives, Andover, Mass.
Robert Rosenblum, "Resurrecting Augustus Vincent Tack," in *The Abstractions of Augustus Vincent Tack,* exh. cat., New York, M. Knoedler & Co., 1986.
Judith Susan Isaacs, "The Abstract Paintings of Augustus Vincent Tack," Ph.D. diss., University of Delaware, 1991.

TPC Sources
Journal L, 1914.
DP, "The Romance of a Painter's Mind," *International Studio* 58, Mar. 1916, 19–24.

DP, "Introduction to Le Sidaner-Tack Exhibition," unpubl. essay, 1920; formerly MS 85.
Journals B, ca. 1923–24, and GG, 1924.
DP, cat. for PMG.1924.1.
C in M, 1926.
Bull., 1927.
DP, cat. for TPC.1928.4a–c.
DP, *Mystical Crucifixion by Augustus Vincent Tack,* pamphlet, 1928.
A & U, 1930.
DP, *Decorative Panels by Augustus Vincent Tack,* pamphlet, 1930.
ASD, 1931.
DP, *Appreciations by Duncan Phillips of the Decorative Panels of Augustus Vincent Tack,* pamphlet, 1932.
DP, *Paintings and Decorative Panels by Augustus Vincent Tack,* exh. cat., Pittsfield, Mass., Berkshire Museum, 1938.
DP, *Paintings and Drawings by Augustus Vincent Tack,* exh. cat., New York, Macbeth Gallery, 1941.
DP, essay for PMG.1943.9.
Eleanor Green, cat. for TPC.1972.6.
Leslie Furth, cat. for TPC.1993.1.
MP, 1998.
Phillips-Tack correspondence, Foxhall Correspondence.
MSS nos. 55, 56, 57, 144, and 145.

JOHN SLOAN

1. Provenance: Kraushaar became Sloan's dealer in 1916; bill of sale, Feb. 3, 1922.

2. St. John, 1965, 129 (entry May 15, 1907).

3. Many of Sloan's friends and contemporaries— William Glackens, Robert Henri, Jerome Myers, Everett Shinn, and Alfred Stieglitz—experimented with this theme during the first decade of the twentieth century. However, Sloan, instead of recording an impersonal river landscape, projected a human drama, allowing his feelings to be personified.

4. St. John, 1965, 61 (entry Aug. 28, 1906). *The Wake of the Ferry I,* 1907 (oil on canvas, 26 × 32 inches; Detroit Institute of Arts, Gift of Miss Amelia Elizabeth White). See St. John, 1965, 113 (entry Mar. 19, 1907), and 119, 127, and 156; see also Sloan, *Gist,* 1939, 209.

5. St. John, 1965, 119 (entry Apr. 5, 1907). *The Wake of the Ferry I* was repaired years later. Helen Farr Sloan has related that Eleanor Sloan, the artist's cousin, was visiting at the time; Sloan became upset when Dolly drank too much, the only occasion when he displayed this kind of temper (Helen Farr Sloan to author, Oct. 10, 1991).

6. Sloan, 1977, n.p.

7. *C in M,* 1926, 51.

8. John Canaday, "A Bright Beginning, A Long, Sad Ending," *New York Times,* Sept. 26, 1971, sec. 2, p. 25.

9. Corroborated by Helen Farr Sloan to author, Oct. 10, 1991.

10. "Chronology of John Sloan," in Sloan, 1977, n.p. *The Wake on the Ferry* (etching, 7 × 7 in. [plate]; Morse no. 313).

11. Date: Previously cited as 1909; the change is based on Sloan's diary entry of Mar. 2, 1910 (St. John, 1965, 392). Provenance: Bill of sale, June 2, 1919.

12. In his Mar. 2, 1910, diary entry, Sloan recorded the model's name as Wilson (St. John, 1965, 392; see also pp. 454, 516, 527, and 597). Wilson often posed in cos-

tume, and Sloan employed him for this painting because he felt sorry for the aging model (Helen Farr Sloan to author, Oct. 10, 1991).

13. St. John, 1965, 318. In 1905 Maratta developed a color theory based on the earlier theories of Michel-Eugène Chevreul and on his own belief in the correlation between color and music. Sloan thought that Maratta's pigments, accurately mixed from the primary colors, were much higher in quality than any others produced in the United States. Maratta manufactured his pigments until his death in 1924. See Elizabeth Armstrong Handy, "H. G. Maratta's Color Theory and its Influence on the Painters—Robert Henri, John Sloan, and George Bellows," M.A. thesis, University of Delaware, 1969.

14. For a discussion of "Color Harmony and the Use of Set Palettes," see Sloan, 1977, 128–33.

15. Sloan recorded only two sittings by Wilson (St. John, 1965, 392, entries Mar. 2 and 3, 1910).

16. Milton Brown, "The Two John Sloans," *Art News* 50 (Jan. 1952), 25–27, and 56.

17. *C in M*, 1926, 51. By 1919 Phillips had begun to purchase works intended for a museum in memory of his father and brother, who had recently died. *Clown Making Up* was considered by Phillips to be part of his museum since its acquisition in 1919. It was exhibited in 1920 as part of the public collection.

18. Date: Previously cited as ca. 1912; the change is based on four diary entries (St. John, 1965)—Feb. 10, Mar. 7 and 14, and Apr. 17, 1912—and the inscription on the painting's reverse, "*Six O'Clock* by John Sloan NYC, 1912." Title: Official title as published in 1916. Sloan refers to it as "Third Avenue, Six o'clock" (diary entry of Feb. 10, 1912) and as "Six O'clock, Third Avenue" in his entry of Feb. 12 (St. John, 1965, 601 and 602). Provenance: About 1916 Kraushaar sold five of Sloan's paintings to Arthur Egner, *Six O'Clock, Winter* among them. When the purchaser returned all but one after Sloan had received his payment, the artist settled the debt by leaving this painting in the dealer's possession (courtesy Rowland Elzea to author, Aug. 4, 1988). The bill of sale is dated Apr. 10, 1922.

19. Brooks, 1955, 123.

20. St. John, 1965, 618 (entry Apr. 17, 1912).

21. *C in M*, 1926, 51.

22. *AMA*, 1935, 80.

Major References
John Sloan Collection, Delaware Art Museum, Wilmington.
A. E. Gallatin, *John Sloan*, New York, 1925.
Guy Pène du Bois, *John Sloan*, American Artists Series, New York, 1931.
John Sloan, *Gist of Art*, New York, 1939; 3rd ed., rev., New York, 1977.
Lloyd Goodrich, *John Sloan, 1871–1951*, exh. cat., New York, Whitney, 1952.
Van Wyck Brooks, *John Sloan: A Painter's Life*, New York, 1955.
Bruce St. John, ed., *John Sloan's New York Scene: From the Diaries, Notes, and Correspondence 1906–1913*, New York, 1965.
Peter Morse, *John Sloan's Prints: A Catalogue Raisonné of the Etchings, Lithographs, and Posters*, New Haven, 1969.
David W. Scott and E. John Bullard, *John Sloan, 1871–1951*, exh. cat., Washington, D.C., NGA, 1971.

David Scott, *John Sloan*, New York, 1975.
Bennard B. Perlman, *The Immortal Eight: American Painting from Eakins to the Armory Show, 1870–1913*, Cincinnati, 1979.
Rowland Elzea, *John Sloan: Spectator of Life*, exh. cat., Wilmington, Delaware Art Museum, 1988.
Rebecca Zurier, "Picturing the City: New York in the Press and the Art of the Ashcan School, 1890–1917," Ph.D. diss., Yale University, 1988.
Elizabeth Milroy, *Painters of a New Century: The Eight and American Art*, exh. cat., Milwaukee Art Museum, 1991.
Rowland Elzea, *John Sloan's Oil Paintings: A Catalogue Raisonné*, 2 vols., Newark, Del., 1991.
Elizabeth H. Hawkes, *John Sloan's Illustrations in Magazines and Books*, Wilmington, Del., 1993.
John Loughery, *John Sloan: Painter and Rebel*, New York, 1995.
Rebecca Zurier et al., *Metropolitan Lives: The Ashcan Artists and Their New York*, exh. cat., Washington, D.C., NMAA, 1995.
Bennard B. Perlman, ed., *Revolutionaries of Realism: The Letters of John Sloan and Robert Henri*, Princeton, N.J., 1997.

TPC Sources
DP, "Representative American Painters of the New Century," unpubl. introductory statement for book proposal, between 1914 and 1920; formerly MS 80.
Journal CC, between 1917 and ca. 1920.
Inv., 1921.
Journals EE, ca. 1922; and B, ca. 1923–29.
DP, "Painters of Past and Present," unpubl. outline for proposed publication, July 1, 1925; formerly part of MS 97.
C in M, 1926.
Bull., 1928.
Ralph Flint, "Current American Art Season," *A & U*, 1930, 177–224.
Bull., 1931.
AMA, 1935.
DP, "The Expression of Personality Through Design in the Art of Painting," slide lecture, 8 versions, ca. 1936–42.
DP, "Tentative Plan for Handbook," unpubl. outline for proposed publication, ca. 1941; formerly part of MS 97.
Cat., 1952.
R of C, 1969.
SITES, 1979.
MD, 1981.
Elizabeth Hutton Turner, essay for TPC.1990.7.
MP, 1998.

ERNEST LAWSON
1. For the quotation, see Clark S. Marlor, *The Society of Independent Artists* (Park Ridge, N.J., 1984), 3. For Lawson's participation in the Armory Show, see Milton W. Brown, *The Story of the Armory Show* (New York, 1988), 236 (where he notes that Lawson "exhibited in his post-Armory landscapes a strong Cézanne influence"), and 285.

2. For Lawson's impressionism, see Gerdts, 1984, 275; quotation p. 276. See also William I. Homer, *Alfred Stieglitz and the American Avant-Garde* (Boston, 1977), 83.

3. Lawson is listed as a future unit in DP, "The Phillips Collection," 1924, 8–18.

4. The 1921 inventory includes thirteen Lawsons; some were added later, others traded or sold. The artist rarely dated his works and repeated favorite subjects; acquisition records are equally tangled since purchases were often identified only as "landscape" or "Harlem River."

5. While several paintings in the group are in good condition, others show well-known signs of overcleaning done sometime in the past with damaging results. The problems were caused by Lawson's painting over a varnish layer and perhaps building up layers of paint intermixed with natural resin varnish; he may also have used aqueous media easily disturbed by cleaning; per Elizabeth Steele, painting conservator, Oct. 1, 1990. See also Serena Urry, "When *Trees in Blossom* Becomes *Winter*: Problems in Treating a Reworked Painting by Ernest Lawson," paper presented at the American Institute of Conservation annual meeting, Richmond, Va., 1990.

6. For documentation, see entry. Jerome Myers's *Band Concert Night* (cat. no. 189), purchased in 1910, may actually have been the first acquisition.

7. Alice Conyngham Gifford Phillips to DP, Mar. 12, 1920, after her husband's death from influenza Oct. 21, 1918, one year after their marriage. The second gift remains unidentified.

8. Gallatin, 1916, 17, and Pène du Bois, 1916, 507; both made comparisons as well with van Gogh, Delacroix, and to some extent Gauguin. For the friendship between Phillips and these two men, see cat. nos. 255 and 225–227.

9. DP, 1917, 258 and 260; a critical aside, "Bohemian—hence his many crude pictures," appears only in the typed draft. Phillips and Lawson may have met at the 1916 Corcoran Gallery of Art exhibition, since the artist's name does not appear in earlier texts.

10. Ranking in DP, Journal EE, ca. 1922; quote in DP, ca. 1923, n.p.

11. *C in M*, 1926, 57, where six paintings are illustrated.

12. Lawson to DP, Apr. 14, [1924]; the year is determined through Phillips's answer, dated Apr. 19, 1924.

13. Phillips was both a board member and chairman of the exhibition's arts committee; see also Berry-Hill, 1968, 51.

14. Phillips wrote to Lawson about possible sales Dec. 21, 1937, and June 20, 1938.

15. Ira Glackens, *William Glackens and the Ashcan Group: The Emergence of Realism in Art* (New York, 1957), 184. The quote has neither the date of the letter nor that of the exhibition at Montross.

16. In a review, "Bringing an Entire Career to Life," *New York Times* (Dec. 19, 1976), D31, Hilton Kramer succinctly interpreted the current neglect of Lawson as having been caused by "no rebellion—no merit."

17. Date: Determined by Corcoran exhibition. Title: *Early Moonlight, Harlem River* in 1911 Corcoran cat.; *High Bridge—Early Moon* appears on 1920 lists, in DP.1920.1, and in the 1921 Inventory. *High Bridge—Early Morn* in Ledger 15, 1926 entry. *Sunset at High Bridge* is the title in DP, 1917, 261, and subsequent publications up to 1990. However, photographs show that the overland spans are on the Bronx side, hence a view from Manhattan to the east, making a sunset impossible (Patricia Paladines, New-York Historical Society, to author, Mar. 7, 1991). Provenance: Corcoran sales records do not list this work as having been sold out of the 1910 exhibition.

Phillips remembered this as his first purchase, ca. 1912 (correspondence with the National Gallery of Canada, Apr. 18, 1966); and Warren Unna, "Phillips Is a Hush Hush Gallery," *Washington Post* (Jan. 19, 1954), A12. Journal GG indicates purchase from Daniel Gallery, but it was not established until 1913.

18. Titles: *Spring Night, Harlem River* first appears in DP, 1917, 257, and thereafter with a few exceptions, including *Summer Night, Harlem River* in *H of A*, 1920–21; *Moonlight, Harlem River* in Inv., 1921, and old painting files; *Washington Bridge, Evening* in Price, 1930, pl. 23. Provenance: *Spring Night* appears in DP, 1920, under the section "15 Best Purchases since Jan. 1920." Charles Daniel, writing to DP, Jan. 2, 1920, refers to a painting in the collection of a Dr. Dohme that would not be available for under $3,000, the amount entered in both Ledgers 11 and 15. In March the painting was included in the exhibition DP.1920.1.

19. Because this painting was purchased before the Armory Show, Lawson may have known Cézanne's work before 1913.

20. DP, 1917, 261.

21. Thematically it resembles *The Red Bridge*, ca. 1895 (oil on canvas, 24¼ × 33¾ in.; New York, Metropolitan Museum of Art, Gift of Mrs. John A. Rutherford, 1914), painted by his friend and teacher J. Alden Weir, who in turn may have been inspired by Japanese prints; see Doreen B. Burke, *J. Alden Weir, An American Impressionist* (Cranbury, N.J., 1983), 212.

22. *Harlem River*, n.d. (oil on canvas, 25¼ × 30⅛ in.; New York, Metropolitan Museum of Art, Bequest of Miss Adelaide Milton De Groot, 1967). *Washington Bridge, Harlem River*, ca. 1915 (20⅛ × 24¹⁄₁₆ in.; Atlanta, High Museum of Art, J. J. Haverty Collection, 1949).

23. *C in M*, 1926, 57. Phillips especially prized this work, consigning it to the Colorado Springs Art Center for safekeeping during the Second World War.

24. Date: The painting probably dates from the same year as several works of a similar subject. See also Karpiscak, 1979, 23. Title: Purchased as *Ice in the River* but first exhibited as *The River in Winter*. A Macbeth Gallery label suggests that this may have been the work substituted (as *Winter*) in the remaining venues of The Eight show after Gertrude Vanderbilt Whitney purchased *Floating Ice;* however, the label could also date from the time the painting was framed there in 1919 (Macbeth to DP, May 12, 1919, Macbeth Gallery Papers, AAA, reel 2620 #386). Provenance: Knoedler bill of sale, Feb. 19, 1917; Ledger 11 and Knoedler correspondence, Dec. 9, 1920: "purchased direct from the artist."

25. Date: The previously published date, ca. 1922, was derived from the acquisition date; however, this work is closely related to a dated painting, *Hills at Inwood*, 1914 (36 × 50 in.; Columbus Museum of Art, Gift of Ferdinand Howald). Title: Per Daniel invoice, Oct. 31, 1922, recorded Ledger 11, Oct. 30, 1922; DP to Daniel, Dec. 1, 1922, requesting delivery.

26. The painting is in fine condition, a "point of departure" for the study of Lawson's early technique (Elizabeth Steele, painting conservator, Oct. 1, 1990).

27. Another Phillips painting, *Harlem Valley, Winter*, ca. 1921 (26¼ × 34¼ in.; acc. no. 1184), shows a wider view of the area.

28. See Reginald P. Bolton, *Washington Heights Manhattan: Its Eventful Past* (New York, 1924), iv.

29. It appears that attempts to clean the painting were abandoned when it became evident that layers of paint and varnish were intermixed. Varnish removal seems to have been carried out in the sky but was halted in the middle ground. Therefore, the tonal relationship between sky and land is no longer that intended by the artist (Steele, Oct. 1, 1990).

30. DP, 1917, 259.

31. Date: It appears in a handwritten note on a PMAG letter of inquiry Oct. 18, 1922 (Milch Gallery Records; per telephone conversation AAA, Mar. 1991). Title/Provenance: The title has been changed from *After Rain. Approaching Storm*, probably the artist's title, appears on the Milch Gallery bill of sale, Aug. 1, 1922 (the only Lawson purchase from that gallery), and is recorded on Ledger 15. Erroneously captioned as *Vanishing Mists* in Price, 1930, 14.

32. Title: The artist's title is unknown; listed as *Blossoms* in DP, 1920, but changed to the current title in all typed drafts of the 1921 inventory; Ledger 15 lists *Blossoms* in ink, and *May Morning* is added in pencil. Provenance: No bill of sale; acquisition per DP, 1920; annotated "Daniel" in Journal GG, 1924.

33. Quoted in Berry-Hill, 1968, 46, from a 1932 interview.

34. A similar scene, *New England Birches*, ca. 1919 (oil on plywood panel; acc. no. 1187), was purchased from Daniel around 1920.

35. The painting is a well-preserved example of Lawson's later style (Steele, Oct. 1, 1990).

36. According to A.C.A. Galleries, 1967, 7, the Lawsons summered in the company of Augustus Saint-Gaudens and Maxfield Parrish and their families.

37. *Winter*, n.d. (oil on canvas, 40 × 50 in.; Detroit Institute of Arts), and *Landscape*, ca. 1920 (monotype; Susan Sheehan Gallery, New York, as of 1989).

38. Journal EE, ca. 1922.

39. DP, ca. 1924, n.p.

Major References
Lawson-Phillips correspondence, Phillips Collection Papers, AAA.
Ernest Lawson Papers, AAA, Gift of Margaret Lawson Benscoe, 1976.
A. E. Gallatin, *Certain Contemporaries: A Set of Notes on Art Criticism*, New York, 1916.
Guy Pène du Bois, "Ernest Lawson, Optimist," *Arts and Decoration*, Sept. 1916, 505–7.
Frederick Newlin Price, "Lawson of the Crushed Jewels," *International Studio* 78, Feb. 1924, 367–70.
Frederick Newlin Price, *Ernest Lawson: Canadian American*, New York, 1930.
Guy Pène du Bois, *Ernest Lawson*, American Artists Series, New York, 1932.
National Gallery of Canada, *Ernest Lawson*, exh. cat., Ottawa, 1967.
Henry and Sidney Berry-Hill, *Ernest Lawson, American Impressionist, 1873–1939*, Leigh-on-Sea, England, 1968.
A.C.A. Galleries, *Ernest Lawson Retrospective*, exh. cat., New York, 1976.
Adeline Lee Karpiscak, *Ernest Lawson*, exh. cat., Tucson, University of Arizona Museum of Art, 1979.
William H. Gerdts, *American Impressionism*, New York, 1984.
Elizabeth Milroy, *Painters of a New Century: The Eight and American Art*, exh. cat., Milwaukee Art Museum, 1991.

TPC Sources
DP, "Representative American Painters of the New Century," unpubl. introductory statement for a book proposal, between 1914 and 1920; formerly MS 80.
Journal O, 1916–23.
DP, "Ernest Lawson," *American Magazine of Art* 8, May 1917, 257–63; file contains two drafts for this article, formerly MSS 35 and 132.
DP, "15 Best Purchases of 1918–19; 15 Best Purchases Since Jan. 1920," acquisitions list.
H of A, 1920–21.
Inv., 1921.
Journal EE, ca. 1922.
DP, "Purposes of the PMG," unpubl. essay, ca. 1923.
Journals B, 1923–29; GG, 1924.
DP, "The Phillips Collection," unpubl. outline prepared for F. Newlin Price, "Phillips Memorial Gallery," *International Studio* 80, Oct. 1924, 8–18; some drafts formerly MS 89.
DP, "Ernest Lawson," unpubl. essay, ca. 1924; formerly MSS 36 and 37.
C in M, 1926.
ASD, 1931.
Cat. 1952.
Elizabeth Turner, essay for TPC.1990.7.

EVERETT SHINN

1. Medium: Analysis by Sarah Bertalan, paper conservator, June 17, 1991. Shinn developed an innovative pastel technique that resulted in brilliant color similar in appearance to tempera rather than the delicate, dustlike surface of pastel; see discussion in text and Kent, 1945, 36. Provenance: This work probably remained in Shinn's possession until 1943, when Ferargil Galleries began to represent him; bill of sale, Feb. 8, 1943, TPC Papers, AAA, reel 1960, #814.

2. Excerpt from an undated (ca. 1952) letter Shinn wrote to James Graham; cited in Graham and Sons to DP, Mar. 12, 1953.

3. The book, however, was never published. Howells and Shinn met on at least one occasion as documented in a letter from Howells to his daughter Mildred, Mar. 5, 1900: "Mamma says I must tell you something of the young artist, Everett Shinn, who came this morning to make an appointment to pastel me. . . . He is the most unaffected charming boy I've seen in a long time"; *Life in Letters of William Dean Howells,* ed. Mildred Howells (New York, 1928), n. 17, as quoted in Kwait, 1952, n. 18. See also Louis J. Budd, "W. D. Howells' Defense of the Romance," *Journal, Modern Language Association of America* 67 (1952), 37 (Everett Shinn Papers, AAA, reel 953, #168).

4. Graham and Sons to DP, Mar. 12, 1953.

5. As quoted in Baury, 1911, 594.

6. Everett Shinn Papers, AAA, reel N107, #790, undated.

7. See Kent, 1945, 36. The paper surface is roughened to a greater extent than one finds with the application of watercolor or gouache with a brush. According to Bertalan, June 17, 1991, the rough surface may be due to the action of the pastel stick against a dampened paper surface.

8. Phillips's involvement in this exhibition is documented in correspondence between him and Helen

Cambell, AFA secretary of exhibitions, TPC Papers, reel 1952, nos. 40, 45, 46, 49–52, 55, 57. In 1940, Phillips exhibited works from his collection by The Eight and their contemporaries, Bellows, Pène du Bois, Hopper, and Myers; see hanging records.

9. Sloan's notes (ca. 1945) quoted in DeShazo, 1974, 166.

Major References
Everett Shinn Papers, AAA.
Everett Shinn Papers, Delaware Art Museum, Wilmington, Collection of Edith Kind DeShazo.
Louis Baury, "The Message of Manhattan," *Bookman* 33, no. 6, Aug. 1911, 592–601.
Norman Kent, "The Versatile Art of Everett Shinn," *American Artist*, Oct. 1945, 8–13; 35–37.
Joseph J. Kwait, "Dreiser's *The Genius* and Everett Shinn, the 'Ash-Can' Painter," *Journal, Modern Language Association of America* 67, Mar. 1952, 15–31.
Edith DeShazo, *Everett Shinn, 1876–1953: A Figure in His Time,* New York, 1974.
Rebecca Zurier, "Picturing the City: New York in the Press and the Art of the Ashcan School, 1890–1917," Ph.D. diss., Yale University, 1988.
Elizabeth Milroy, *Painters of a New Century: The Eight and American Art,* exh. cat., Milwaukee Art Museum, 1991.
Barbara C. Rand, "The Art of Everett Shinn," Ph.D. diss., University of California, Santa Barbara, 1992.
Nina Kasanof, "The Illustrations of Everett Shinn and George Luks," Ph.D. diss., University of Illinois at Urbana-Champaign, 1992.
Rebecca Zurier et al., *Metropolitan Lives: The Ashcan Artists and Their New York,* exh. cat., Washington, D.C., NMAA, 1995.

TPC Sources
DP, "A Collection of Modern Graphic Art," *Art and Progress* 5, Feb. 1914, 129–30.
MP, 1970 and 1982.
Elizabeth Hutton Turner, cat. for TPC.1990.7

PAUL DOUGHERTY

1. Provenance: Purchase from Macbeth documented in correspondence between DP and Macbeth Gallery, N.Y. (Macbeth Gallery Papers, AAA, reel 2620, nos. 297–300, 302); transfer to PMG per Journal GG.

2. Dates: The painting dates from the period between Dougherty's trip to the West Coast and the year of acquisition. In 1915 he won the gold medal at the Panama-Pacific Exposition in San Francisco and, according to Lisa Dougherty Coon, the artist's daughter, stopped in California in 1916 on his way to Asia (telephone interview with author, Aug. 23, 1989). Provenance: Purchase documented in correspondence between DP and Dougherty, 1918; transfer to PMG per Journal GG, 1924.

3. Clara Ruge, "The Tonal School," *International Studio* 37 (Jan. 1906), 66.

4. Quotation in Seaton-Schmidt, 1910, 7. For a list of museum acquisitions, see Edwin C. Shaw Papers, AAA, reel 1124, #668.

5. Bruce St. John, ed., *John Sloan's New York Scene: From the Diaries, Notes, and Correspondence, 1906–1913* (New York, 1965), 190 (entry Jan. 30, 1908); 399 (entry Mar. 15, 1910).

6. Included in the 1915 Panama-Pacific Exposition

were many French impressionist and fauve works. Dougherty perhaps visited the exhibition and may have been influenced by these entries.

7. Nelson, 1986, 34.

8. Dougherty to DP, Mar. 18, 1918.

9. DP to Mr. Miller of Macbeth Gallery, Dec. 18, 1912.

10. Journal M, ca. 1915–20.

11. Journal DD, 1921. However, Dougherty does not mention the influence of Davies in any of his writings.

12. Dougherty's studio was located at 14 East Tenth Street (per Lisa Dougherty Coon, Aug. 23, 1989). Phillips may have purchased some works during this visit.

13. Dougherty gave the Phillipses a monotype, *Seated Nude on the Shore* (location unknown), as a wedding gift.

14. Leila Mechlin, "Notes of Art and Artists," *Sunday Star,* Washington, D.C., Oct. 9, 1932, sec. 7, p. 12.

15. Mahonri Sharp Young, "The Crest of the Wave," in *Paul Dougherty: A Retrospective Exhibition,* exh. cat., Portland Museum of Art (Portland, Maine, 1979), 9.

16. C in M, 1926, 58.

Major References
Paul Dougherty and Edwin C. Shaw Papers, AAA.
Sadakichi Hartmann, "Studio Talk," *International Studio,* Dec. 1906, 156–83.
Edwin A. Rockwell, "Paul Dougherty—Painter of Marines: An Appreciation," *International Studio,* Nov. 1908, 3–9.
Anna Seaton-Schmidt, "Some American Marine Painters," *Art and Progress,* Nov. 1910, 3–8.
Mary Carroll Nelson, "Paul Dougherty, 1877–1947," *Southwest Profile,* Sept.–Oct. 1986, 33–36.

TPC Sources
DP, "Representative American Painters of the New Century," unpubl. introductory statement for book proposal, between 1914 and 1920; formerly MS 80.
Journals M, ca. 1915–20; and CC, between 1917 and 1920.
DP, "Art and the War," text for slide lecture, 1918.
Journal U, ca. 1919.
H of A, 1920–21.
Journal DD, 1921.
Inv., 1921.
Journals EE, ca. 1922; and GG, 1924.
"Painters of Past and Present," unpubl. outline for proposed publication, July 1, 1925; formerly part of MS 97.
C in M, 1926.
Cat., 1952.
Stephen B. Phillips, cat. for TPC.1997.4.

WALT KUHN

1. Date: Vera Kuhn's records in the AAA indicate that it was painted "somewhere between 1918 and 1925" (Group II, reel D242B, #0839). However, a copy of the 1944 PMG Kuhn catalogue (Walt Kuhn Papers, AAA, reel 1611, #1188), inscribed in Walt or Vera Kuhn's hand, shows the date "1918" scratched out and "1920" added next to this painting's entry. Since the painting was exhibited Jan. 5, 1924, it would most likely have been painted between 1920 and 1923. Title: First exhibited as *Flowers—Bouquet,* the title that also appears on the bill of sale. *Tulip Buds* appears on a list entitled "Paint-

ings acquired since January 1st '24" (Journal GG, 1924), a title used during most of the painting's history at the museum and entered as a second title in the artist's own catalogue. Provenance: In a letter of May 12, 1924, Phillips requested shipment of painting no. 33; the sale is also recorded in Kuhn's records.

2. For a discussion of this series and his early floral works, see Adams, 1978, 86, and Perlman, 1989, 18.

3. He would have seen avant-garde works perhaps as early as 1901, when he was a student in Paris, or on his visit there in 1904, but definitely in 1912, when he visited the Sonderbund Exhibition in Cologne and then traveled throughout Europe. Cézanne's influence remained strong throughout Kuhn's career.

4. Walt Kuhn Papers, Group II, AAA, reel D242B, #0839.

5. Per Elizabeth Steele, painting conservator, Nov. 12, 1990. Kuhn had employed this technique in *An Imaginary History of the West,* a series of landscape and figurative paintings in equally small scale created between 1918 and 1923.

6. All three quotes from DP, essay for PMG.1926.2, n.p.

7. DP to Kuhn, Jan. 17, 1927.

8. *C in M,* 1926, 64.

9. Kuhn to DP, Nov. 28, 1927. Kuhn did not consider most of the works produced before his 1925 illness to be very serious or representative pieces.

10. DP to Kuhn, Dec. 6, 1927. By this time Phillips had seen examples of Kuhn's work at J. B. Neumann's Print Room and the Grand Central Galleries, both in New York.

11. Their visit is documented in a letter, Kuhn to DP, Mar. 3, 1932; Walt Kuhn Papers, AAA, reel D344, #1268.

12. Title and date: The artist's title was *Girl with Mirror,* per Kuhn to DP, Oct. 3, 1931, and it was purchased as such (bill of sale, Oct. 1, 1929). Illustrated as *Girl and Mirror* on the cover of *Art Digest* 3 (mid-April 1929) and listed on page 6. Provenance: Consignment receipt, Downtown Gallery, Apr. 20, 1929 (Walt Kuhn Papers, AAA, reel 1610, #0067); commission and sale, June 3, 1929, #0842. Bill of sale to PMG, Oct. 1, 1929.

13. Provenance: Consignment notes list "spring 1929," Kuhn Papers AAA, reel D242B, #0236. Consigned to Downtown Gallery Apr. 20, 1929 (Kuhn Papers, reel 1610, #0067), together with *Girl with Mirror;* commission and sale to the Downtown Gallery, June 3, 1929, #0842; bill of sale to PMG, Oct. 1, 1929.

14. Vera Kuhn to Mrs. Rafael Navas, Mar. 20, 1954, Mrs. Rafael Navas Papers, AAA, reel D251, #1045.

15. Almost all of Kuhn's models, including Hughes and Bergman, were show-business people. Herbert (Teddy) Bergman was also used for *The White Clown,* 1929 (oil on canvas; National Gallery of Art, Washington, D.C.), perhaps Kuhn's best-known work, and for *Athlete,* 1929 (oil on canvas; Jewett Art Museum, Wellesley College, Mass.). Walt Kuhn Papers, Group II, AAA, reel D242A, #0974, and AAA, reel D242B, #0236.

16. The list of those who lent works included Mrs. John D. Rockefeller Jr., the Brooklyn Museum, Miss L. B. Bliss, and Dikran G. Kélékian.

17. Telegram, May 3, 1929; quotation, DP to Edith Halpert, May 23, 1929. Both paintings have a stamp on their stretcher reading May 6, 1929, the day Phillips anticipated going to the gallery.

18. Harriman to DP, Dec. 4, 1930.

19. Helen Buchalter, "Charm and Distinction Mark Re-Hanging at Phillips Gallery," *Washington Daily News,* Feb. 13, 1932, 11.

20. *A & U,* 1929, 89.

21. Title: First exhibited in 1932 as *Plumes.* Shown as *Show Girl with Plumes* in PMG.1933.6 and thereafter. Provenance: Intent to purchase, Harriman to DP, Feb. 3, 1932, and DP to Harriman, Oct. 31, 1932; bill of sale, June 18, 1936.

22. Adams, 1978, 137.

23. Mabel Benson was a regular model who often "walked in" the studio (Walt Kuhn Papers, Group II, AAA, reel D242B, #0267). In June Kuhn returned from Madrid, where he had studied several Goyas; in the remaining months of 1931, he painted twelve canvases, all but one of them figurative works; see Adams, 1978, 132–33.

24. See Adams, 1978, 6, for a discussion of the influence of Spanish works on Kuhn's style. Royal Cortissoz, in a review of the 1932 Harriman exhibition states, "He has the directness, the rude power which brings back, vaguely, the thought of Manet, but he has not the Frenchman's command over the genius of oil paint" ("The New Generation of American Painters: Its Traits Shown in Recent Works," *New York Herald Tribune,* Jan. 10, 1932).

25. Arthur B. Davies had introduced this art to Kuhn, and throughout his career Kuhn kept photos of Greek sculptures on the walls of his studio; see Adams, 1978, 31 and 118.

26. Margaret Breuning, "American Art in Local Galleries," *New York Evening Post,* Jan. 9, 1932, sec. 3, p. 3.

27. DP to Kuhn, Jan. 6, 1932. Phillips wrote to Marie Harriman on Jan. 16, requesting "a reservation [be] put on the canvas entitled *Plumes.*"

28. DP, essay for PMG.1932.5, n.p.

Major References
Walt Kuhn Papers, AAA.
Walt Kuhn Files, Fine Arts Division, New York Public Library.
Philip Rhys Adams, *Walt Kuhn, 1877–1949,* exh. cat., Cincinnati Art Museum, 1960.
———, *Walt Kuhn, Painter: His Life and Work,* Columbus, Ohio, 1978, with catalogue raisonné of oil paintings.
Bennard B. Perlman, *Walt Kuhn, 1877–1949,* exh. cat., New York, Midtown Galleries, 1989.

TPC Sources
Journal GG, 1924.
C in M, 1926.
A & U, 1929.
ASD, 1931.
DP, essay for PMG.1932.5.
Formes, 1932.
DP, essay for PMG.1944.7.
Cat., 1952.
MP, 1970 and 1982.
SITES, 1979.
Elizabeth Hutton Turner, cat. for TPC.1990.7.

GIFFORD BEAL
1. By nature receptive and curious about new developments, Beal was an associate of the painters who organized the Armory Show; he proposed two paintings for inclusion in that exhibition, but did not send them.

2. This friendship preceded his romance with Beal's niece, Marjorie Acker, whom Phillips met through Beal in 1920 and married a year later. As a wedding gift, Beal painted a *Portrait of Marjorie Phillips,* 1921 (Phillips family collection). Beal was awarded the bronze medal for his painting *The End of the Street* at the Corcoran's "Fifth Exhibition, Oil Paintings by Contemporary American Artists," Dec. 15, 1914–Jan. 24, 1915, cat. no. 47 (possibly the first time Beal was shown in Washington). Phillips cited Beal in his book proposal "Representative American Painters of the New Century," unpubl. essay, between 1914 and 1920.

3. His first known purchase of a Beal oil painting; Phillips had purchased an unknown watercolor together with Rockwell Kent's *Burial of a Young Man;* DP to Miller of Macbeth Gallery, Mar. 9, 1918, Macbeth Gallery Papers, AAA, reel 2620, nos. 357, 360–62: "I have bought a number of pictures for myself including the Kent at $420. and the Beal at $350. for which pictures I enclose [a] check for $770." *Peace Celebration* (location unknown; deaccessioned in 1930 per Ledger 15) was added to the second venue of the Allied War Salon in Jan. 1919. When Phillips purchased the painting, Kraushaar wrote, "I know that both artists [Beal and Mahonri Sharp Young] will be delighted to know that they will be represented in your collection" (Feb. 19, 1919, Foxhall corr.).

4. Journal DD, ca. 1921. Phillips purchased *The Garden Party* (acc. no. 0079) in 1920 or 1921.

5. DP, essay for PMG.1927.4, n.p.

6. Leila Mechlin, "Charming Paintings by Gifford and Reynolds Beal at Arts Club," *Evening Star,* Apr. 3, 1938, F5.

7. DP to Beal, Mar. 13, 1931, TPC Papers, AAA, reel 1941, #0013. In 1922 Phillips purchased *Swordfishermen* (traded to Kraushaar, 1931), *Fishermen Hauling Nets,* ca. 1921 (deaccessioned 1930), and *Marine,* by 1922 (location unknown). In 1923 he purchased *Carrying the Nets,* 1923.

8. *Swordfishermen,* ca. 1921 (oil on canvas; location unknown; DP to Beal, Mar. 13, 1991, TPC Papers, AAA, reel 1941, #0013; the smaller works were *The Quarryman,* 1931, and *Polka from "Die Fledermaus,"* by 1931 (acc. no. 0106).

9. Phillips wrote to Beal: "We all enjoyed every moment of your visit and not only your talks to the students but our conversations" (Feb. 29, 1932, TPC Papers, AAA, reel 1941, #0216).

10. Beal had turned to etching in the late 1920s. Over the course of a decade Phillips purchased six Beal etchings, including two impressions of *The Net Wagon,* ca. 1928 (acc. no. 0101; the other intended as a gift; DP to Kraushaar, Oct. 31, 1928, TPC Papers, AAA, reel 1936, #0224). Phillips purchased not only *Gathering Brush, Central Park,* by 1937 (acc. no. 0080), but also the thirteen preliminary sketches for the work.

11. Beal to the Phillipses, Apr. 5, 1950, Foxhall corr.

12. *Waterfall, Haiti,* 1954 (oil and egg tempera on canvas; acc. no. 0110).

13. DP to Beal, Dec. 6, 1954.

14. Title: Exhibited as *Center Ring* prior to PMG acquisition. Provenance: Phillips purchased *Center Ring* out of the 1922 Kraushaar exhibition (see Kraushaar to DP, July 5, 1922, TPC Papers, AAA, reel 1929, #1163).

15. Mahonri Sharp Young, *Gifford Beal,* exh. cat., Kraushaar (New York, 1922), n.p. *Center Ring,* a work from mid-career, was on exhibit when Young wrote this statement.

16. William Beal, "Gifford Beal (1879–1956)," essay for TPC.1971.6, n.p.

17. A later adaptation of the circus theme in the collection is *Circus Ponies,* ca. 1939 (acc. no. 0076).

18. Ada Rainey, "Independent Art Exhibit is Popular," *Washington Post,* Mar. 20, 1927, F5.

19. From a 1956 press release by Kraushaar.

20. Essay for PMG.1932.4, n.p.

21. Ada Rainey, "Phillips Gallery Shows Several Splendid Groups," *Washington Post,* Feb. 14, 1932, A5. Compare Kuhn's *Plumes,* 1931, and *Performer Resting,* 1929 (cat. nos. 214 and 213).

22. Title: *Carrying the Nets* was the title of the painting at the time of the PMG purchase. It was later confused with another painting of the same subject entitled *Fishermen Hauling Nets,* which Phillips purchased in 1922 and deaccessioned by 1930. Provenance: Kraushaar bill of sale, July 25, 1923, TPC Papers, AAA, reel 1930, #0051 (as *Carrying the Nets*).

23. Medium: Beal reworked the background figure and the hat of the central figure (per Elizabeth Steele, painting conservator, July 27, 1991). Provenance: The 1931 Beal exhibition also included *Polka from "Die Fledermaus"* (or *Scene from "Die Fledermaus"*). Both were acquired through trade for Beal's *Swordfishermen;* DP to Beal, Mar. 13, 1931, TPC Papers, AAA, reel 1941, #0013.

24. Barry Faulkner, "Commemorative Tribute to Gifford Beal," unpubl. essay, Dec. 14, 1956, TPC Archives.

25. DP, early 1920s. In 1922 Phillips planned to write a series of monographs on American artists called the *Color Series;* it was never published (Journal EE, ca. 1922).

26. *The Fish Bucket,* 1924 (acc. no. 0078).

Major References
Gifford Beal Papers, AAA.
Richard Beer, "As They Are: Disclaiming Biography," *Art News* 32, May 19, 1934, pt. 2, 11.
"His Art Was Joyful," *Art Students League News* 9, no. 3, Mar. 1956, 1–2.

TPC Sources
DP, "Representative American Painters of the New Century," unpubl. introductory statement for book proposal, between 1914 and 1920; formerly MS 80.
Journals M, ca. 1915–20; CC, between 1917 and 1920; and U, ca. 1919.
DP, "Gifford Beal," unpubl. essay, early 1920s; formerly MS 2.
H of A, 1920–21.
Inv., 1921.
Journals DD, ca. 1921; EE, ca. 1922; B, 1923–29; GG, 1924; and Y, ca. 1922–25.
DP, "The Phillips Collection," unpubl. outline prepared for F. Newlin Price, "Phillips Memorial Gallery," *International Studio* 80, Oct. 1924, 8–18; some drafts formerly MS 89.
DP, "Painters of Past and Present," outline for proposed publication, July 1, 1925; formerly part of MS 97.
C in M, 1926.
Bull., 1928.
ASD, 1931.
DP, essay for PMG.1932.4
Cat., 1952.

MP, 1970 and 1982.
SITES, 1979.

ROBERT SPENCER

1. Pène du Bois, 1915, 353. Pène du Bois touted the Pennsylvania School as "our first truly national expression"; however, he tempered his remark by adding, "though it cannot be a full expression for it is a body without a soul. It is as bare of sentiment as a court calendar." For an overview of the Pennsylvania School, see Folk, 1987. The artists associated with the school were predominantly landscapists; they were award winners at the 1915 Panama-Pacific Exposition, San Francisco; but by 1926, at the Sesqui-Centennial Exposition in Philadelphia, they were considered *retardataire*.

2. Pène du Bois, "The Boston Group of Painters," *Arts and Decoration* 5 (Oct. 1915), 458.

3. Spencer, "Biographical Sketch," AAA, reel 504, #0797.

4. Spencer to DP, Mar. 12, 1926, TPC Papers, AAA, reel 1934, #387.

5. In 1913 Spencer was awarded the second Hallgarten Prize by the National Academy of Design for his painting *The Silk Mill*, 1913 (oil on canvas, 30 × 36 in.; private collection, New York). In 1914, the Metropolitan purchased *Repairing the Bridge*, 1913 (oil on canvas, 30 × 36 in.; George A. Hearn Fund), and the National Academy of Design awarded him a gold medal for *The White Tenement*, 1913 (oil on canvas, 30 × 36¼ in.; the Brooklyn Museum, John B. Woodward Memorial Fund), inviting him to become an associate of the prestigious institution. *End of the Day*, ca. 1913 (oil on canvas; location unknown), was traded to the artist in 1926 for *Mountebanks and Thieves*, ca. 1925 (acc. no. 1792).

6. DP to Spencer, Apr. 23, 1926, TPC Papers, AAA, reel 1934, #405.

7. DP to Spencer, n.d., as quoted in DP to John Phillips, Nov. 30, 1917. For their friendship, see DP and Spencer correspondence, TPC Archives.

8. Price, 1923, 485.

9. As quoted in Spencer to DP, Nov. 1926.

10. Spencer to DP, Nov. 7, 1928. The "Biddle portrait" that Spencer refers to is *Portrait of Brenda Biddle*, 1926 (oil on canvas; Philadelphia Museum of Art).

11. DP to Spencer, Nov. 6, 1928. Two other paintings of the same theme are *The Crowding City*, ca. 1927 (oil on canvas; Delaware Art Museum), and *Mob Vengeance*, ca. 1927 (oil on canvas; location unknown).

12. Phillips may have been thinking of Daumier's *The Uprising*, 1848 or later (cat. no. 15), a painting he especially cherished. Spencer referred to Goya as an artist who had painted the same subject matter as he; see "Robert Spencer," AAA, reel 504, #796.

13. Spencer to DP, Apr. 27, 1931.

14. First part of quote from DP, essay for PMG.1931.25, 29; second part from *C in M*, 1926, 67.

15. Date: The painting is similar in style and subject matter to *Across the River*, ca. 1917 (oil on canvas, 25 × 30 in.; National Academy of Design), and *The River, March*, ca. 1918–20 (oil on canvas, 30 × 36 in.; Reading [Pa.] Public Museum and Art Gallery). It must have been completed by April 1917, in time for the New York showing. Provenance: Two early lists give the acquisition as 1917, probably from the Salmagundi exhibition, but they are not authoritative. A label from the Salmagundi sale is on the painting's

stretcher bar. It is first firmly documented in *Inv.*, 1921.

16. Provenance: Old painting files suggest that the work was acquired in trade for *Barracks;* no bill of sale has been found.

17. Quote from Gerdts, 1984, 234. Redfield, Lathrop, and Schofield became known for their winter landscapes. Other Spencer paintings in this series are *The River March* (see note 15), *The Green River*, n.d. (oil on canvas; National Academy of Design), and *River View*, ca. 1918 (oil on canvas; private collection, Connecticut). Although it is now the earliest in the collection, it was not the first painting purchased. *The End of the Day*, ca. 1913 (oil on canvas; location unknown), was acquired in 1916 and traded in 1926.

18. Daniel Garber, *The Quarry: Evening*, 1913 (oil on canvas, 50 × 60 in.; Philadelphia Museum of Art), and *The Quarry*, 1917 (oil on canvas, 50 × 60 in.; Pennsylvania Academy of Fine Arts), are two examples.

19. Folk, 1984, 59. Technique described by Elizabeth Steele, painting conservator, Jan. 25, 1991.

20. Spencer to DP, Apr. 27, 1931.

21. DP, *C in M*, 67.

22. *Woman Ironing*, between 1928 and 1931 (acc. no. 1796); Margaret Spencer to DP, Oct. 20, 1931.

23. DP, essay for PMG.1931.25, 29.

24. Both quotes from DP, essay for PMG.1932.12, n.p.

25. Provenance: Documented in DP, 1920.

26. In his earliest acclaimed paintings, such as *The White Tenement*, 1913 (oil on canvas, 30 × 36⅝ in.; Brooklyn Museum), and *Grey Mills*, ca. 1913 (oil on canvas, 30 × 36 in.; collection of Widener University, Chester, Pa.), the buildings are the focus of the painting.

27. DP, "Second Exhibition of the Phillips Memorial Art Gallery," unpubl. essay for PMAG.1922.2.

28. DP, *C in M*, 67. He also included it on his acquisition list, "Best Purchases," DP, 1920.

Major References
"Robert Spencer," De Witt, McClellan, Lockman Interviews and Biographical Sketches, AAA.
Guy Pène du Bois, "The Pennsylvania Group of Landscape Painters," *Arts and Decoration*, July 1915, 351–54.
Frederick Newlin Price, "Spencer—And Romance," *International Studio*, Mar. 1923, 485–91.
Thomas Folk, *Robert Spencer: Impressionist of Working Class Life*, exh. cat., Trenton, New Jersey State Museum, 1983.
William Gerdts, *American Impressionism*, New York, 1984.
Thomas Folk, *The Pennsylvania School of Landscape Painting: An Original American Impressionism*, exh. cat., Pennsylvania, Allentown Art Museum, 1984.
Thomas Folk and Barbara J. Mitnick, "The Pennsylvania Impressionists," *The Magazine Antiques*, July 1985, 111–17.
Thomas Folk, "The Pennsylvania School of Landscape Painting," Ph.D. diss., City University of New York, 1987.

TPC Sources
DP, "Representative American Painters of the New Century," unpubl. introductory statement for

book proposal, between 1914 and 1920; formerly MS 80.
Journal CC, between 1917 and ca. 1920.
DP, "Art and the War," *American Magazine of Art* 9, June 1918, 303–09.
Journals U, ca. 1919.
DP, "15 Best Purchases of 1918–19; 15 Best Purchases Since Jan. 1920," unpubl. acquisition list, 1920.
Inv., 1921.
DP, "To the Committee on Scope and Plan of The Phillips Memorial Art Gallery," unpubl. report, Dec. 12, 1921.
Journals EE, ca. 1922; Y, ca. 1922–25; B, ca. 1923–29; D, ca. 1923–24; and GG, 1924.
"The Phillips Collection," unpubl. outline prepared for F. Newlin Price, "Phillips Memorial Gallery," *International Studio* 80, Oct. 1924, 8–18; some drafts formerly MS 89.
DP, "Painters of Past and Present," unpubl. outline for proposed publication, July 1, 1925; formerly part of MS 97.
C in M, 1926.
ASD, 1931.
DP, essay for PMG.1932.12.
Cat., 1952.
MP, 1970 and 1982.
Elizabeth Turner, cat. for TPC.1990.7.
MS 51.

GEORGE BELLOWS

1. Date: "June 1920" is recorded in Bellows's Record Book B, 213. Title: *Emma at a Window* per Bellows's Record Book B, 213, courtesy of Jean Bellows Booth to author, Apr. 30, 1990. *Emma at the Window* per bill of sale; *Emma in Black* was a DP creation. Inscription: Only "WS" of the artist's signature is visible to the viewer. According to a conservation report, Dec. 10, 1982, "the canvas has been cut down as the painting continues on all tacking edges except the bottom. . . . The painting was removed from its stretcher and the edges moistened and weighted down to bring them back into plane with the picture." A photograph taken of the lower left side documented the signature, "Bellows." Provenance: Documented in corr. between Bellows and Frank Rehn, 1923, Rehn Gallery Papers, AAA, reel D290, #0181; PMG purchase per bill of sale, Mar. 3, 1924, TPC Papers, AAA, reel 1934, #0025.

2. *Spring Sunshine: Emma on the Porch*, 1911 (Williams College, Williamstown, Mass.); *Portrait of Emma in Night Light*, 1914 (private collection, New York); *Emma at the Piano*, 1914 (Chrysler Museum, Norfolk, Va.); *Emma in the Orchard*, 1916 (Cummer Gallery of Art, Jacksonville, Fla.); *Emma in a Purple Dress*, 1919 (Raymond and Margaret Horowitz Private Collection, New York); *Emma in Black Print*, 1919 (Museum of Fine Arts, Boston); *Emma at the Window*, 1920 (TPC); and *Emma in a Purple Dress*, 1923 (Dallas Museum of Art). In his Record Book B, Bellows recorded three portraits of Emma that he later destroyed: *Girl on a Couch*, 1911; *Emma in a Country Parlor*, 1915; and *Emma [on the Balcony]*, 1917 (Jean Bellows Booth to author, Apr. 30, 1990).

3. Bellows rented the Shotwell house in Woodstock for the summers of 1920 and 1921, and built a permanent summer home there in 1922; per Jean Bellows Booth to author, Apr. 30, 1990.

4. As quoted in Christman, 1981, 25.

5. Jean Bellows Booth, "Introduction: A Daughter Remembers George Bellows," in Jane Myers and Linda

Ayres, *George Bellows: The Artist and His Lithographs, 1916–1924* (Fort Worth, Texas, 1988), 4.

6. For an explanation of how John Sloan adopted Maratta's color theory, see *Clown Making Up* (cat. no. 200). For Ross's theory see Denman Ross, *A Theory of Pure Design; Harmony, Balance, Rhythm* (New York, 1907).

7. For example, *Portrait of My Father*, 1906 (oil on canvas, 28⅛ × 22 in.; Columbus Museum of Art), and *Paddy Flannigan*, 1908 (oil on canvas, 30 × 25 in.; Collection of Miss Julia Peck, New York).

8. For a discussion of Eakins's portraits, see cat. no. 69. The painting was executed in Bellows's studio at the Shotwell house. Emma is seated on a model stand (Jean Bellows Booth to author, Apr. 30, 1990).

9. Bellows attended Hambidge's lecture on dynamic symmetry in 1917; see Morgan, 1965, 216. Bellows wrote, "Ever since I met Mr. Hambidge and studied with him I have painted very few pictures without at the same time working on his theory"; Bellows, 1921, 7.

10. Jay Hambidge and Gove Hambidge, "The Ancestry of Cubism," *Century* (Apr. 1914), 871.

11. As quoted in Christman, 1981, 25.

12. "Study for Portrait of Emma," n.d., Art Institute of Chicago, is reproduced in *George Bellows: Paintings, Drawings, and Prints,* exh. cat., AIC (Chicago, 1946), cat. no. 90.

13. Both quotes taken from DP, between 1914 and 1921. *Men of the Docks,* 1912 (oil on canvas, 45 × 63 in.; Randolph-Macon Woman's College, Lynchburg, Va.); *Cliff Dwellers,* 1913 (oil on canvas, 39½ × 41½ in.; Los Angeles County Museum of Art).

14. DP, *Bull.,* 1931, 28; DP, *Bull.,* 1928, 43.

Major References
George Wesley Bellows Papers, Amherst College Library, Amherst, Mass.

George Bellows's Record Books, Courtesy of Jean Bellows Booth.

George Bellows, "What Dynamic Symmetry Means to Me," *American Art Student* 3, June 1921, 4–7.

Royal Cortissoz, "The Field of Art," *Scribner's* 78, Oct. 1925, 440–48.

Frank Crowninshield, "George Bellows: A Memorial Exhibition," exh. cat., New York, Metropolitan, 1925.

Emma S. Bellows, *The Paintings of George Bellows,* New York, 1929.

Peyton Boswell Jr., *George Bellows,* New York, 1942.

Frank Seiberling Jr., "George Bellows, 1882–1925: His Life and Development as an Artist," Ph.D. diss., University of Chicago, 1948.

Editor, "George W. Bellows: Painter of the American Scene," *American Society Legion of Honor Magazine* 23, no. 2, summer 1952, 171–82.

Charles H. Morgan, *George Bellows: Painter of America,* New York, 1965.

Margaret C. S. Christman, *Portraits by George Bellows,* exh. cat., Washington, D.C., NPG, 1981.

Catherine Green, "George Bellows: His Vision of America and the Response of the American People to His Vision," exh. cat., Buffalo, Albright-Knox Gallery, 1981.

Rebecca Zurier, "Picturing the City: New York in the Press and the Art of the Ashcan School, 1890–1917," Ph.D. diss., Yale University, 1988.

Elizabeth Milroy, *Painters of a New Century: The Eight and American Art,* exh. cat., Milwaukee Art Museum, 1991.

Rebecca Zurier et al., *Metropolitan Lives: The Ashcan Artists and Their New York,* exh. cat., Washington, D.C., NMAA, 1995.

David F. Setford, *George Bellows: Love of Winter,* exh. cat., West Palm Beach, Fla., Norton Museum of Art, 1997.

TPC Sources
DP, "Representative American Painters of the New Century," unpubl. introductory statement for book proposal, between 1914 and 1920; formerly MS 80.

DP, "George Bellows," unpubl. essay, between 1914 and 1921; formerly MS 3.

Journal CC, between 1917 and ca. 1920.

DP, "An Open Letter to American Painters," unpubl. announcement of the Allied War Salon, 1918.

DP, "Art and the War," unpubl. text for slide lecture, 1918.

AMA, 1919.

Journals DD, 1921; and EE, ca. 1922.

"Painters of Past and Present," unpubl. outline for proposed publication, July 1, 1925; formerly part of MS 97.

C in M, 1926.

Bull., 1927, 1928, 1931.

ASD, 1931.

Formes, 1932.

Cat., 1952.

Elizabeth Hutton Turner, cat. for TPC.1990.7.

ROCKWELL KENT
1. Phillips refers to the Kent paintings as a unit in a letter of Feb. 25, 1927 (TPC Papers, AAA, reel 1936, #0066), but, in spite of the large number of works acquired, did not designate him a unit artist in 1952.

2. The Kent Room is mentioned in his letter of Feb. 25.

3. Letter of agreement, Dwight Clark, PMG treasurer, to Kent, Jan. 14, 1924, TPC Papers, AAA, reel 1933, #0077.

4. Commission and subsequent rejection per DP to Kent, Oct. 30, 1925, and June 12, 1926, TPC Papers, AAA, reel 1933, #0230 and #0311.

5. Letter of thanks, DP to Kent, Dec. 27, 1926, TPC Papers, AAA, reel 1933, #0334.

6. Kent to DP, Jan. 12, 1927, TPC Papers, AAA, reel 1936, #0034. Kent not only was financially secure by this time but also had difficulty accepting the earlier agreement regarding Phillips's first choice (Kent to DP, Oct. 27, 1925, reel 1933, #0227).

7. DP to Leila Mechlin, Oct. 17, 1928, TPC Papers, AAA, reel 1936, #0649.

8. Date: Although Kent, 1955, 235, remembers painting this work after his return from Newfoundland, Dec. 1910, he describes it in a letter to his future wife, Kathleen Whiting, Oct. 30, 1908, mentioning that he had completely repainted a work of the previous year (Kent Papers, AAA, box 33). Kent probably set it aside, finishing it before its first exhibition in April 1911. Provenance: According to David Traxel, "Rockwell Kent: The Early Years," Ph.D. diss., University of California, Santa Cruz, 1974, 98–99, it was purchased by Macbeth in 1911; however, a Macbeth inventory card notes: "Kent, Rockwell / Burial of a Young Man / 4/3/12 to replace 'Down by the Sea' / sold to Duncan Phillips 1/14/18" (Macbeth Gallery Papers, AAA, reel 2822, #1395). Phillips purchase documented in DP to Miller

of Macbeth Gallery, Jan. 19, 1918; see Macbeth Papers, reel 2620, #349. Transfer to PMG per Journal GG (ca. 1924).

9. Kent to Kathleen Whiting, Oct. 30, 1908, Kent Papers, AAA, Box 33.

10. *Country Funeral,* ca. 1907 (Lyman Allyn Museum, New London, Conn.). A similar painting is *Blackhead, Monhegan,* ca. 1909 (34 × 44 in.; Colby College Museum of Art, Waterville, Maine, Gift of The Phillips Collection, 1964).

11. Before his December visit to Monhegan, Kent traveled to Newfoundland, seeking a potential site for a communal art school. In his 1955 autobiography, Kent attributes the inspiration for *Burial of a Young Man* to an event witnessed during the Newfoundland visit, though the evidence linking it to Monhegan appears convincing.

12. Kent, 1955, 235.

13. DP, *Bull.,* 1928, 15.

14. Bruce St. John, ed., *John Sloan's New York Scene: From the Diaries, Notes, and Correspondence, 1906–1913* (New York, 1965), 527 (entry Apr. 17, 1911).

15. DP, *Bull.,* 1931, 6.

16. Phillips's father died Sept. 1917; his brother died Oct. 1918. The two events inspired the founding of the Phillips Memorial Art Gallery.

17. DP to Miller, Mar. 14, 1918, and DP to Macbeth, May 12, 1918 (both in Macbeth Gallery Papers, AAA, reel 2620, #362 and #369).

18. Provenance: Date of transfer from artist to Daniel is unknown; date of DP acquisition from in-house records. The earliest TPC documentation appears in Ledger 11 and Journal B. Transfer to PMG per acquisition list A11a.

19. Both quotations from Kent, 1955, 166.

20. DP to Otto Bernet, American Art Association, Jan. 22, 1921 (TPC Papers, AAA, reel 1929, #066–067).

21. Date: The date suggested by Richard V. West, director of the Santa Barbara Museum of Art and a Kent scholar, in correspondence with the author, June 9, 1989. Title: In early correspondence, Kent refers to the painting as "the little panel of *Tierra del Fuego.*" However, when asking how the painting is to be paid for, Phillips calls the painting "Mountain Lake." In his response, Kent also refers to it as "Mountain Lake," suggesting that the artist agreed to Phillips's title. See correspondence, Kent to DP, Dec. 5, 1925, TPC Papers, AAA, reel 1933, #0245; DP to Kent, Mar. 27, 1926, #0289; and Kent to DP, Apr. 14, 1926, #0298.

22. DP, essay for PMG.1928.4c, 15.

23. While in Tierra del Fuego, Kent painted relatively few large canvases but many small "studies" in oil on panels (see West, 1985, 21).

24. Kent, 1955, 366. Even though Kent had painted a body of salt water, Phillips, perhaps finding a lake more romantic, titled the work *Mountain Lake.*

25. Kent, 1955, 376.

26. Kent delayed exhibiting these works until he completed a book on his Tierra del Fuego adventures, *Voyaging: Southward from the Strait of Magellan.* It is illustrated by his many sketches from the trip, but none relates directly to *Mountain Lake.*

27. For reviews, see "Art: Exhibitions of the Week," *New York Times,* Apr. 19, 1925, sec. 9, p. 11, and May 10, 1925, "Art: Exhibitions of the Week, 'Rockwell Kent,'"

sec. 8, p. 11. For Kent's belief, see Johnson, 1981, 38.

28. DP, essay for PMG.1926.2.

Major References
Rockwell Kent Papers, AAA.
Phillips-Kent Correspondence, TPC Papers, AAA.
Rockwell Kent, *Wilderness: A Journal of Quiet Adventure in Alaska*, New York, 1920.
Rockwell Kent, *Voyaging: Southward from the Strait of Magellan*, New York, 1924.
F. Newlin Price, "Phillips Memorial Gallery," *International Studio* 80, Oct. 1924, 8–18.
Rockwell Kent and Carl Zigrosser, *Rockwellkentiana*, New York, 1933.
Rockwell Kent, *It's Me O Lord: The Autobiography of Rockwell Kent*, New York, 1955.
Dan Burne Jones, *The Prints of Rockwell Kent: A Catalogue Raisonné*, Chicago and London, 1975.
Paul Cummings, *Artists in Their Own Words: Interviews*, New York, 1979.
David Traxel, *An American Saga: The Life and Times of Rockwell Kent*, New York, 1980.
Fridolf Johnson, ed., *Rockwell Kent: An Anthology of His Works*, New York, 1981.
Richard V. West, *An Enkindled Eye: The Paintings of Rockwell Kent*, exh. cat., Santa Barbara Museum of Art, 1985.
Gemey Kelly, *Rockwell Kent: The Newfoundland Work*, exh. cat., Dalhousie Art Gallery, Halifax, Nova Scotia, 1986.

TPC Sources
Journals O, 1916–23; CC, between 1917 and ca. 1919; and U, ca. 1919.
H of A, 1920–21.
Inv., 1921.
Journals EE, ca. 1922; D, 1923–24; and GG, ca. 1924.
DP, "The Phillips Collection," unpubl. outline prepared for F. Newlin Price, "Phillips Memorial Gallery," *International Studio* 80, Oct. 1924, 8–18; some drafts formerly MS 89.
DP, "Painters of Past and Present," unpubl. outline for proposed publication, July 1, 1925; formerly part of MS 97.
DP, "Order of Notes and Essays," unpubl. list of proposed publications, ca. 1925–26; formerly part of MS 97.
C in M, 1926.
Bull., 1928 and 1931.
DP, "Tentative Plan for Handbook," unpubl. outline for proposed publication, ca. 1941; formerly part of MS 97.
Cat., 1952.
SITES 1979.
Elizabeth Hutton Turner, cat. for TPC.1990.7.
MP, 1998.

GUY PÈNE DU BOIS

1. Title/Date: The range of dates is derived from Kraushaar inventory number suggesting 1918–19, and date of first exhibition (courtesy Katherine Kaplan, Kraushaar, May 14, 1991). Alternate title per label on painting reverse. Provenance: Bill of sale, Pène du Bois to Kraushaar, Sept. 3, 1919; bill of sale for PMG purchase, Apr. 4, 1922, TPC Papers, AAA, reel 1929, #1124. *The Arrivals* was the first painting by Pène du Bois that Phillips purchased.

2. DP to Pène du Bois, Apr. 12, 1923, TPC Papers, AAA, reel 1929, #233. Pène du Bois had written to DP on Apr. 6, 1923: "I have an idea for a big picture I have been

considering for a long time. . . . For me it is . . . putting down a flowing rythm [*sic*] of great dignity which has been running in my head for . . . five years. It would be carried out best in subject . . . with a collection of nudes sailing and falling in the sky or against it."

3. DP to Pène du Bois, Apr. 12, 1923. Prior to this request, they had collaborated on literary projects, and Pène du Bois had heralded the gallery in a 1921 article published in *Arts and Decorations*. That same year he favorably mentioned Marjorie Phillips in the introduction to a catalogue of a group show at Kraushaar, and in 1922 contributed to a Phillips publication on Daumier. In 1923, Pène du Bois visited the Phillipses in Washington (DP to Pène du Bois, May 21, 1923, TPC Papers, AAA, reel 1929, #252).

4. DP, *C in M*, 1926, 70.

5. Biographical notes by Yvonne Pène du Bois in *Yvonne Pène du Bois, Paintings from the Last Four Decades*, exh. cat., Graham Gallery (New York, 1985), 7.

6. In 1906, at the start of the opera season, Pène du Bois was appointed music critic for the *New York American*, and he remained there until 1912.

7. *C in M*, 1926, 70.

8. Provenance: Documented in DP to Kraushaar, Feb. 28, 1927, and Kraushaar to DP, Mar. 2 (TPC Papers, AAA, reel 1936, #0068 and #0070).

9. The sitter was identified by Yvonne Pène du Bois McKenney (letter to author, May 5, 1991).

10. Yvonne later explained that "whenever in doubt about a sitter of one of my father's paintings [Kraushaar] would say, 'It was of Yvonne'" (McKenney to author, May 20, 1991). However, early correspondence had referred to it as a portrait of Yvonne: "The . . . du Bois of Yvonne seated in a chair with the landscape background will be shipped to you either on Saturday or Monday." (Kraushaar to DP, Mar. 2, 1927, TPC Papers, reel 1936, #70).

11. The white wall was originally pale pink, which probably created a softer, warmer appearance overall. Beneath the frame rabbet are remnants of a pink glaze, which is extremely fugitive; per Elizabeth Steele, painting conservator, Mar. 10, 1991.

12. Kraushaar discouraged him from painting landscapes: "You're no good at landscape, Guy. I don't want any of them, you keep them" (McKenney quoting Kraushaar, letter to author, May 20, 1991).

13. Provenance: Bill of sale, Mar. 12, 1928, TPC Papers, AAA, reel 1936, #185.

14. Kraushaar visited Pène du Bois in Garnes and liked the artist's work so much that he advanced him money against future sales. For the artist's commercial success during the 1920s, see Jack Flam, "Guy Pène du Bois," *American Heritage* (Feb. 1989), 82.

15. Quoted in Pène du Bois, 1922, 245–46.

16. Pène du Bois, Diary, Aug. 23, 1936, as quoted by Betsy Fahlman in Corcoran, 1980, 41.

17. Baker, 1977, 11.

18. See Flam, "Guy Pène du Bois," 75.

19. Pène du Bois, 1913, 153.

20. Ibid., 154.

21. DP, essay for PMG.1928.1a, 43.

Major References
Guy Pène du Bois Papers, 1903–58, AAA.
Guy Pène du Bois Diaries, 1913–55, in possession of Willa Kim.

Guy Pène de Bois, "The Spirit and the Chronology of the Modern Movement," *Arts and Decoration* 3, no. 5, Mar. 1913, 151–54, 178.
Guy Pène de Bois, "The Duncan Phillips Collection: Modern Paintings Which Are to Be Presented to the Nation," *Arts and Decoration*, Feb. 1921, 276–77.
Guy Pène de Bois, "Guy Pène du Bois by Guy Pène du Bois," *International Studio*, June 1922, 243–46.
Richard Carl Medford, *Guy Pène du Bois*, exh. cat., Maryland, Washington County Museum of Fine Arts, 1940.
Guy Pène du Bois, *Artists Say the Silliest Things*, New York, 1940.
John Baker, "Guy Pène du Bois on Realism," *Archives of American Art Journal* 17, no. 2, 1977, 2–13.
Betsy Fahlman, *Guy Pène du Bois: Artist About Town*, exh. cat., Washington, D.C., Corcoran, 1980.
Stanley I. Grand, *Guy Pène du Bois: The Twenties at Home and Abroad*, exh. cat., Sordoni Art Gallery, Wilkes University, Wilkes-Barre, Pa., 1995.
James Graham and Sons, *Guy Pène du Bois (1884–1958): Returning to America*, exh. cat., New York, 1998.

TPC Sources
Guy Pène du Bois, "Honoré Daumier" in DP, *Honoré Daumier: Appreciations of His Life and Works*, New York, 1922.
Journals EE, ca. 1922; GG, 1924; and D, ca. 1923–24.
C in M, 1926.
ASD, 1931.
Journal I, between 1931 and 1935.
Cat., 1952.
MP, 1970 and 1982.
SITES, 1979.
Elizabeth Hutton Turner, cat. for TPC.1990.7.
MP, 1998.

7. DUNCAN PHILLIPS AND AMERICAN MODERNISM

1. See Stuart Davis to DP, Dec. 15, 1939.

2. Arthur Dove to DP, n.d. [Oct. 1946].

3. See, for example, Ann Lee Morgan, ed., *Dear Stieglitz, Dear Dove* (Newark, 1988), 193, 204, 277–78, and 310–15.

4. DP to Dove, May 3, 1933; Dove's refusal is added in a handwritten note at the bottom of his response, Dove to DP, n.d. [probably May 16–18, 1933]; both Foxhall corr. *The Bessie of New York*, assigned date 1932 (oil on canvas, 28 × 40 in.; Edward Joseph Gallagher III Memorial Collection, The Baltimore Museum of Art, 1953.5). See letters in Turner and Weisblat, TPC.1995.5, 149–53.

5. The earliest record of Phillips's use of the term is in *A Collection in the Making* in 1926, followed by the catalogue for PMG.1927.3. A similar term, "experiment laboratory," was used by Stieglitz; it possibly originated at the Bauhaus.

6. Kenneth Noland, in conversation with the author, Apr. 5, 1992.

ALFRED STIEGLITZ

1. The dates for most of the Stieglitz photographs in the collection are based on those established by the National Gallery of Art for their corresponding prints. In 1946 O'Keeffe gave the National Gallery a key set of

prints that Stieglitz had compiled; see Greenough and Hamilton, 1983, 31–32, n. 41; Greenough, 1984, 188, n. 11; and Georgia O'Keeffe, "Stieglitz: His Pictures Collected Him," *New York Times Magazine*, Dec. 11, 1949, 30. Provenance: O'Keeffe to DP, July 16, 1949, and O'Keeffe to DP and MP, Aug. 11, 1949, Foxhall corr.

2. The gift includes fourteen prints that date from 1923 to 1931 and five undated *Equivalents*. All nineteen share the same dimensions; the format (vertical or horizontal) varies. Two photographs are titled *Songs of the Sky* and seventeen *Equivalents*. Two of the undated *Equivalents* derive from the same negative, but one is printed darker and with more contrast.

3. O'Keeffe to DP and MP, Aug. 11, 1949. It is not known when Stieglitz and Phillips first met, but it was probably not until after the opening of the Intimate Gallery in late 1925, because Phillips began purchasing works by Dove, O'Keeffe, and Marin from Stieglitz in the early months of 1926.

4. DP in Norman, 1947, 11.

5. Ibid. The first recorded instance that Phillips used "experiment station"—a term probably derived from Stieglitz's "experiment laboratory"—was in 1926 in *A Collection in the Making*, and he continued to use it the following year; see "Welcome Art Experiments," *New York Herald Tribune*, Feb. 13, 1927, as well as cat. for PMG.1927.3.

6. Stieglitz to DP, July 16, 1944. Stieglitz made many comments of this nature, for example, his letter to Phillips, June 11, 1945. For more discussion of their relationship, see Turner's essay in TPC.1995.5, 14–25, and "Selected Correspondence," 111–48, 153–54, 158–65.

7. DP in Norman, 1947, 10. See also DP, 1935, 154.

8. DP to AS, Dec. 1, 1934, and AS to DP, Dec. 12, 1934. The article was probably AMA, 1935, in which Stieglitz's *Equivalents* are discussed.

9. Stieglitz was interested in the photographic potential of clouds early in his career. His mentor, Wilhelm Vogel, introduced Stieglitz to orthochromatic plates, which he had invented in 1873; they made the photographing of clouds and landscape possible on the same negative.

10. As quoted in Norman, 1973, 144. See Rosalind Krauss, "Alfred Stieglitz's 'Equivalents,'" *Arts Magazine* 54, no. 6 (Feb. 1980), 134–37, and Greenough, 1984, chapters 1 and 2. Stieglitz excerpted Kandinsky's *Über das Geistige in der Kunst* (published Dec. 1911) in the July 1912 issue of *Camera Work*.

11. Sarah Whitaker Peters, *Becoming O'Keeffe: The Early Years* (New York, 1991), 142 and 275. She believes that O'Keeffe's *My Shanty, Lake George* (cat. no. 273) was a partial catalyst, both formally and spiritually, for Stieglitz's first cloud image, *Music No. 1*, 1922 (gelatin-silver print; Museum of Fine Arts, Boston, gift of Alfred Stieglitz); see pp. 241–44. See also Greenough's comments, 1984, 176–77, on the effect that the gradually more distant relationship between O'Keeffe and Stieglitz had on the cloud photographs.

12. As described by O'Keeffe in correspondence, O'Keeffe to Anderson, n.d. [Feb. 1924], Sherwood Anderson Papers, Newberry Library, as quoted in Greenough, 1984, 156. Some images titled *Songs of the Sky*, such as the Phillips work, include the Lake George landscape and are similar in composition to earlier cloud images. Stieglitz wrote about this series to Hart Crane, Dec. 19, 1923, as quoted in Peters, 1991, 142: "I

know exactly *what* I have photographed. I know I have done something that has never been done—May be an approach occasionally [found] in music.—I also know that there is more of the really abstract in some 'representation' than in most of the dead representations of the so called abstract so fashionable now.—I have scientific proof to show the correctness of that statement."

13. In discussions at Gallery 291, music and abstract art were often equated; indeed, the abstract qualities of music were used as justification for abstraction in art; see Greenough, 1984, 47–49.

14. Stieglitz, "How I Came to Photograph Clouds," *Amateur Photographer & Photography* 56, no. 1819 (Sept. 19, 1923), 225. According to Stieglitz in this article, when Bloch saw his first group of cloud photographs, "what I said I wanted to happen happened *verbatim*."

15. Greenough and Hamilton, 1983, 24.

16. Stieglitz as quoted in Norman, "Alfred Stieglitz-Seer," *Aperture* 3 (1955), 16. Americans artists were, generally speaking, not receptive to Kandinsky's theories on a spiritual art that rejected the materialism of representation, ideas that led him to nonobjective art. For many American artists, spirituality was found in the transcendental qualities of nature, and American abstraction was often firmly rooted in nature. This point is illustrated in Stieglitz's *Equivalents*: no matter how much the cloud was abstracted, it was still clearly a facet of the natural world. See Greenough and Hamilton, 1983, 23. See also Turner's observations on Stieglitz's cloud photographs in Turner and Weisblat, TPC.1995.5, 41–44.

Major References

Alfred Stieglitz Archives, Beinecke Rare Book and Manuscript Library, Yale University, New Haven.
Alfred Stieglitz, ed., *Camera Notes*, 1897–1902.
———, ed., *Camera Work*, 1903–17.
Doris Bry, *Exhibition of Photographs by Alfred Stieglitz*, exh. cat., Washington, D.C., NGA, 1958.
Herbert J. Seligmann, *Alfred Stieglitz Talking*, New Haven, 1966.
Jonathan Green, ed., *Camera Work: A Critical Anthology*, New York, 1973.
Dorothy Norman, ed., *Alfred Stieglitz: An American Seer*, New York, 1973.
William Innes Homer, *Alfred Stieglitz and the American Avant-Garde*, Boston, 1977.
Sarah E. Greenough and Juan Hamilton, *Alfred Stieglitz: Photographs & Writings*, exh. cat., Washington, D.C., NGA, 1983.
William Innes Homer, *Alfred Stieglitz and the Photo-Secession*, New York, 1983.
Sue Davidson Lowe, *Stieglitz: A Memoir Biography*, New York, 1983.
Sarah E. Greenough, "Alfred Stieglitz's Photographs of Clouds," Ph.D. diss., University of New Mexico, 1984.
Geraldine W. Kiefer, *Alfred Stieglitz: Scientist, Photographer, and Avatar of Modernism, 1880–1913*, New York, 1991.
Christian A. Peterson, *Alfred Stieglitz's Camera Notes*, exh. cat., Minneapolis Institute of Arts, 1993.
Timothy Robert Rodgers, "Making the American Artist: John Marin, Alfred Stieglitz, and Their Critics, 1909–1936," Ph.D. diss., Brown University, 1994.

Richard Whelan, *Alfred Stieglitz: A Biography*, Boston, 1995.
J. Paul Getty Museum, *Alfred Stieglitz: Photographs from the J. Paul Getty Museum*, Malibu, Calif., 1995.
John Szarkowski, *Alfred Stieglitz at Lake George*, exh. cat., New York, MOMA, 1995.
Simone Philippi and Ute Kieseyer, eds., *Alfred Stieglitz: Camera Work, the Complete Illustrations, 1903–1917*, Cologne, 1997.

TPC Sources
Phillips-Stieglitz correspondence, 1926–46, TPC Archives.
C in M, 1926.
Ralph Flint, "Current American Art Season," *A & U*, 1930.
DP, "The Artist Sees Differently," *American Magazine of Art* 22, Feb. 1931, 271–76.
ASD, 1931.
Formes, 1932.
AMA, 1935, 148–55.
DP, "The Expression of Personality Through Design in the Art of Painting," unpubl. text for slide lecture, 8 versions, ca. 1936–42.
DP, [Tribute] in *Stieglitz Memorial Portfolio, 1864–1946*, ed. Dorothy Norman, New York, 1947.
Cat., 1952.
Elizabeth Hutton Turner, cat. for TPC.1992.7.
Elizabeth Hutton Turner and Leigh Bullard Weisblat, cat. for TPC.1995.5.
Elizabeth Hutton Turner, publ. chklst. for 1998.1.

JOHN MARIN

1. *C in M*, 1926, 59; *Bull.*, 1928, 45; and DP, "7 Americans," 1950, 21.

2. Both quotes in DP, "John Marin," ca. 1950, n.p.

3. DP to Charlotte Devree, Nov. 30, 1954.

4. Phillips may have read about Marin in A. E. Gallatin's *American Water-Colourists* (New York, 1922) or in Forbes Watson's "American Collections," *The Arts* 8 (Aug. 1925), 65–95.

5. In correspondence to the Phillipses, Apr. 9, 1930 (Foxhall corr.), Marin thanks them for their hospitality. *MP*, 1982, 98–110, relates anecdotes about Marin's visits.

6. Phillips wrote in complaint to Deoch Fulton, editor-in-chief, who in turn published his letter; see "Field Marshall Stieglitz," *Art News* (Apr. 2, 1927), 8. Phillips wrote again in complaint, this time because he had not intended his letter to be published; see *Art News* (Apr. 16, 1927), 8.

7. *Sunset, Rockland County*, a watercolor on paper, was exhibited with the collection until it became part of the family's private collection in 1952.

8. The correspondence begins with AS to DP, Dec. 5, 1926, and concludes with DP to AS, Dec. 29, 1927. Stieglitz was clearly interested in promoting Marin's watercolors. Timothy Robert Rodgers, "Alfred Stieglitz, Duncan Phillips and the '$6,000 Marin,'" *Oxford Art Journal* 15, no. 1 (1992), 54–66, discusses whether Stieglitz was trying to force up the market value of Marin's work. It was a tactic he had already employed, particularly in his efforts to raise the status of the minor arts, such as watercolor and photography. For an extensive examination of their relationship and the controversy, see Turner in TPC.1995.5, 14–25, and "Selected Correspondence," 111–49.

9. AS to DP, "Xmas morning," 1927: "Arthur Dove has seen fit to send me your letter to him. . . . I will certainly ask for your forgiveness. To this day, I fail to understand what has come between us."

10. Phillips continued to correspond with Stieglitz, although primarily with regard to acquisitions of works by Dove, Marin, and O'Keeffe. See selections of their later correspondence in Turner and Weisblat, TPC.1995.5, 153–66.

11. First quote, DP to AS, Nov. 5, 1926; second, DP to Alfred Barr Jr., Jan. 15, 1927, in reference to PMG.1927.2a., the first exhibition to include Marin.

12. The John Marin Fund was to help give Marin a steady allotment of money, although Phillips's payments were actually installments for his purchases. See Ledger 11, p. 249. Earlier correspondence and bills of sale are marked as "for John Marin Fund."

13. *E of A,* 1927, 6: "What I meant by impressionism is true to a greater extent of what is now called expressionism."

14. DP, "John Marin," ca. 1932.

15. *Bull.,* 1927, 22.

16. *A & U,* 1930, 144.

17. Inscription: Condition report, July 7, 1987, notes that on the verso are the signature and date in black watercolor: l.r., *J. Marin 22;* and u.l., *22 Looking outward from Bold Island.* However, because the inscription has been covered, it cannot be verified. Medium: Conservation inspection for all of Marin's watercolors by Sarah Bertalan, paper conservator, June 21, 1991. In general Marin did not dampen the sheet, thus enhancing his already vibrant color. Provenance: Telegram from DP, Apr. 6, 1926: "Please send both *Sea Piece* and *Maine Islands.*" Purchased by May 1926.

18. Title: Purchased as *Sea Piece* and renamed *Grey Sea* by Phillips. Reich, 1970, no. 24.28, uses *The Ocean.*

19. Marin, *American Art News* 19 (Apr. 16, 1921), 3, as quoted in Reich, 1970, 129.

20. Helm, 1948, 59, identifies the sites of both watercolors.

21. Marin as quoted in Helm, 1948, 48. Many of these quotes were from interviews with Marin.

22. *Off York Island, Maine* (17⅛ × 20⅝ in.; Philadelphia Museum of Art; Reich no. 22.84). See Reich, 1970, 145, fig. 112.

23. JM to AS, undated MS, Alfred Stieglitz Archive, Beinecke Library, Yale University, as quoted in Gray, 1970, 120.

24. *Bull.,* 1927, 35. Marin has often been given credit for this quote; however it was actually written by Phillips (along with six other brief notes on Marin watercolors in the collection). In DP to AS, Jan. 27, 1927, Phillips wrote, "I think you will like the little notes I am writing for the catalogue on each Marin of our own group. They are meant to help people see emotionally and musically instead of with the usual solicitude for literal fact." Phillips intended to republish these notes in a book of his writings; see DP, after 1955.

25. DP to Lloyd Goodrich, Dec. 30, 1944, and *Bull.,* 1927, 35–36.

26. Title: Purchased as *Back of Bear Mountain;* Reich, 1970, no. 25.4, uses *Back of Nyack, New York;* Stieglitz refers to it as *Hudson Opposite Bear Mountain* in a leaflet, Stieglitz Archives, Yale University. Provenance: Intent to purchase per AS to DP, Dec. 5, 1926, but *Hudson River* and *Back of Bear Mountain* arrived at the museum January 1927. Bill of sale June 1927.

27. Reich, 1970, 163.

28. Helm, 1948, 56.

29. "John Marin: The Intimate Gallery," *Art News* 25 (Nov. 20, 1926), 9.

30. DP to AS, Jan. 10, 1927.

31. Provenance: A notation in an old painting file may indicate that Phillips traded *New Mexico Landscape* (Reich no. 29.27) for this work. He first expressed interest in it in DP to AS, Nov. 28, 1930: "I especially hope that you can send on a loan or give me an option upon the busy New York scene." By late 1931 it was being exhibited as part of the collection.

32. Reich, "John Marin: Paintings of New York, 1912," *American Art Journal* 1 (spring 1969), 47, 49–50; Reich, 1970, 56–57; and Cassidy, 1988, 184, discuss the influence of futurism and Delaunay on Marin's style. Merrill Schleier, in *The Skyscraper in American Art 1890–1931* (Ann Arbor, Mich., 1983/86), 57, believes that Marin, who was aware of abstract art theories from numerous articles in *Camera Work,* did not need direct contact with futurism and Delaunay to arrive at his New York themes and style. There are, however, strong compositional similarities between Delaunay's Eiffel Tower series of 1910 and Marin's 1912 studies of the Woolworth Building in New York, suggesting that Marin had visual access. Reich proposes that Marin saw photographs or prints of Delaunay's series and read the futurist statements printed in the 1912 issue of *Camera Work.*

33. The relationship between music and Marin's style is explored in Cassidy, 1988, 171–209. Howard Risatti, in "Music and the Development of Abstraction in America: The Decade Surrounding the Armory Show," *Art Journal* 39 (fall 1979), 8–13, further discusses this issue.

34. Both quotes in Cassidy, 1988, 183 and 195.

35. Marin, 1928, 35.

36. *C in M,* 1926, 60.

37. Provenance: AS to DP, Mar. 2, 1937: "First of all— you may keep the two watercolors of Marin's—the 'Quoddys'—provided you have the one you don't keep in An American Place by Mar. 15." *Pearl River* and the other *Quoddy Head* were shipped Mar. 11, 1937.

38. Title: *Four-Master off the Cape, Maine Coast* is on the Stieglitz label on reverse of painting; Reich uses *Four Master No. 1, off the Cape, Maine Coast.* Provenance: In DP to AS, Apr. 11, 1942, Phillips says he wants to keep on approval two watercolors of ships. AS to DP, Apr. 24, 1942: "I'm glad you're keeping the two Marin's [*sic*] you have on exhibition now"; he was referring to *Four-Master* and *Bryant Square,* which were included in PMG.1942.6.

39. Marin as quoted in Helm, 1948, 74. The lightly penciled sails along the bottom of the composition provide an interesting juxtaposition to the old-fashioned design of the ship.

40. Title: Purchased as *Tonk Mountains;* exhibited by Stieglitz under *Tunk Mountains—Autumn—Maine;* Reich, 1970, no. 45.43, uses *Tunk Mountains, Maine.* Medium: A strong interest in texture is apparent in the range of application, from thin washes to impasto; the graphite underdrawing is visible in a few areas; per Elizabeth Steele, painting conservator, Feb. 4, 1991. Provenance: Bill of sale, Jan. 11, 1946.

41. The *Weehawken* series was not exhibited until 1950, at which time it was highly acclaimed. See also C. Law

Watkins's letter to Phillips, Apr. 2, 1932, in which he discusses Marin's comments to him about oil, adding that "he was fascinated with the medium. He felt that everything he had done so far was just experiment with the medium. If this is true, it is too bad that Stieglitz showed them so prematurely."

42. Both quotes from JM to AS, July 20, 1931, as quoted in Norman, 1949, 140.

43. See discussion of criticism in Reich, 1970, 221–22 and accompanying notes.

44. As quoted in Norman, 1949, 16. See also Marin's free verse entitled "To My Paint Children," in which he addressed this issue of oil versus watercolor; published in the catalogue for his 1938 solo exhibition at An American Place and quoted in Reich, 1970, 223.

45. DP, "7 Americans," 1950, 21.

46. Title: Exhibited and purchased as *Sea Pieces— Maine;* Phillips changed the title to *Blue Sea.* Provenance: See AS to DP, Feb. 23, 1946.

47. Medium: The ground shows through throughout the composition and there are areas of heavy impasto; per Steele, July 20, 1990. Provenance: Bill of sale, Feb. 26, 1954.

48. DP, "7 Americans," 1950, 21.

49. Marin as quoted in Cassidy, 1988, 198. For a discussion of the possible relationship between nature and music in Marin's work, see Cassidy, 1988, 196–99.

50. JM to DP, Jan. 6, 1949, Foxhall corr.

51. The ground shows through throughout the composition and there are areas of heavy impasto; per Steele, July 20, 1990.

52. *Spring No. 2,* 1953 (22 × 28 in.; the artist's estate; Reich no. 53.10).

53. Reich, 1970, 235–40; Fine, 1990, 249–82; and Cleve Gray, "John Marin: Graphic and Calligraphic," *Art News* 5 (Sept. 1972), 48–53, further discuss this issue. See also Louis Finkelstein, "Marin and De Kooning," *Magazine of Art* 43 (Oct. 1950), 202–6.

54. JM to AS, Aug. 10, 1941, as quoted in Gray, 1970, 132.

55. Marin maintained, however, that the boundary of the canvas was important: "I believe in having your picture clearly defined at the outer edges of your canvas or paper. When you come to those edges you shouldn't feel you would like to see more of the picture."; Dorothy Norman, "Conversations with Marin," *Art News* 52, no. 8 (Dec. 1953), 57.

56. JM to DP, Jan. 18, 1952, Foxhall corr.

Major References
John Marin Archives, NGA, Washington, D.C.
John Marin File, New York Public Library Papers, AAA.
John Marin Papers, AAA.
Sheldon Reich Papers on Catalogue Raisonné of John Marin, AAA.
Alfred Stieglitz Archives, Beinecke Rare Book and Manuscript Library, Yale University, New Haven.
John Marin, "John Marin, By Himself," *Creative Art,* Oct. 1928, 35–39.
MacKinley Helm, *John Marin,* Boston, 1948.
Dorothy Norman, ed., *The Selected Writings of John Marin,* New York, 1949.
Cleve Gray, ed., *John Marin by John Marin,* New York, 1970.
Sheldon Reich, *John Marin: A Stylistic Analysis and Catalogue Raisonné,* 2 vols., Tucson, 1970.

Klaus Kertess, *Marin in Oil,* exh. cat., Parrish Art Museum, Southhampton, N.Y., 1987.

Donna M. Cassidy, "The Painted Music of America in the Works of Arthur Dove, John Marin, and Joseph Stella: An Aspect of Cultural Nationalism," Ph.D. diss., Boston University, 1988.

Ruth E. Fine, *John Marin,* exh. cat., Washington, D.C., NGA, 1990.

Timothy Robert Rodgers, "Making the American Artist: John Marin, Alfred Stieglitz, and Their Critics, 1909–1936," Ph.D. diss., Brown University, 1994.

TPC Sources
Phillips-Marin Correspondence, 1930–53, Foxhall corr.

Phillips-Stieglitz Correspondence, 1926–46, TPC Archives.

C in M, 1926.

DP, essay for PMG.1927.3.

Virgil Barker, "John Marin," *Bull.,* 1927 (reprinted in *A & U,* 1929).

Bull., 1927 and 1928.

DP, "Art in Washington: The Phillips Memorial Gallery," *Forerunner of the General Convention,* A.D. 1928 2, 1928, 18–24.

CA, 1929.

Journal V, 1929.

A & U, 1929 and 1930.

Ralph Flint, "Current American Art Season," *A & U,* 1930.

Formes, 1930 and 1932.

ASD, 1931.

Bull., 1931.

DP, "Modern Art and the Museum," *American Magazine of Art* 23, no. 4, Oct. 1931, 271–76.

DP, "The Artist Sees Differently," unpubl. text for slide lecture, 12 versions, 1931–34.

Journal I, between 1931 and 1935.

DP, "John Marin," unpubl. essay, ca. 1932, formerly MS 38.

DP, "Freshness of Vision and Spontaneity in Painting," unpubl. text for slide lecture, ca. 1935; formerly part of MS 178.

DP, "The Expression of Personality Through Design in the Art of Painting," unpubl. text for slide lecture, ca. 1936–42; draft on Marin formerly MS 162.

DP, essay for PMG.1938.6.

DP, "Spontaneous Painters," unpubl. essay, ca. 1939; formerly MS 78.

DP, essay for PMG.1941.4.

DP, "The Last War," unpubl. essay, between 1941 and 1945; formerly MS 98.

DP, *Contrasts in Impressionism: An Exhibition of Paintings by Alessandro Magnasco, Claude Monet, John Marin,* exh. cat., Baltimore, BMA, 1942.

DP, [Book Review], unpubl. review of *John Marin* by MacKinley Helm, 1949.

DP, "John Marin," unpubl. essay, ca. 1949; formerly MS 40.

DP, "John Marin," in Katherine S. Dreier and Marcel Duchamp, *Collection of the Société Anonyme: Museum of Modern Art, 1920,* edited by George Heard Hamilton, New Haven, 1950, 73.

DP, "7 Americans Open in Venice: Marin," *Art News* 49, summer 1950, 21.

DP, "John Marin," unpubl. essay, ca. 1950; formerly MS 39.

Cat., 1952.

DP, *Catholicity Does Not Mean Eclecticism: A Radio Talk by Duncan Phillips,* pamphlet, 1954.

DP, Foreword, for TPG.1955.6.

DP, [Compilation of Essays for Proposed Publication], notebook containing previously published and unpublished writings, after 1955; formerly part of MS 97.

Arts, 1956.

MP, 1970 and 1982.

SITES, 1979.

MD, 1981.

Elizabeth Hutton Turner and Leigh Bullard Weisblat, cat. for TPC.1995.5.

MP, 1998.

MARSDEN HARTLEY

1. DP, 1944, 83.

2. Ibid.; quote from *C in M,* 1926, 62.

3. *C in M,* 1926, 62.

4. DP, 1944, 83.

5. *C in M,* 1926, 62.

6. DP, 1944, 83.

7. *Camellias,* ca. 1920, and *Pears and Grapes,* 1920s, current whereabouts unknown.

8. DP, 1944, 87.

9. DP, 1943, n.p.

10. New York, MOMA, "Marsden Hartley," Oct. 24, 1943-Jan. 14, 1944.

11. DP, 1943, n.p.

12. Title: The Daniel Gallery label on the painting's reverse entitles the work *Autumn Evening;* it is not known whether that is the original title. The titles *After the First Snow* and *After Snow* were probably created by Phillips; they appear often in The Phillips Collection's records. Medium: The texture of the paint film that is unrelated to the present composition suggests another image underneath (Elizabeth Steele, painting conservator, Apr. 1, 1991). Provenance: The June 1921 inventory lists *After the First Snow.* Phillips may have been referring to *After Snow* when he wrote, "I bought . . . a Marsden Hartley in 1914" in "To the Editor," 1926.

13. According to the inscription on the painting's reverse, Hartley gave this painting to Rockwell Kent Jan. 15, 1912. Gift from Kent to DP according to DP to Kent, Dec. 27, 1926.

14. Scott, 1988, 15.

15. Both paintings are oils on canvas measuring 11⅞ × 11⅞ in. and are in the Fogg Art Museum in Cambridge; they are illustrated in Caroline A. Jones, *Modern Art at Harvard* (New York and Cambridge, 1985), 43.

16. Correspondence between Hartley and Kent, dating to around 1912, can be found in the Rockwell Kent papers, AAA. No reference to this painting appears in this correspondence, however.

17. DP to Kent, Dec. 27, 1926.

18. DP, 1944, 83.

19. Provenance: The painting was sent on approval Oct. 23, 1939 (TPC Papers, reel 1955, #1076). Phillips exchanged a Hartley painting entitled *Pears and Grapes* (which had been acquired in 1929) for *Gardener's Gloves and Shears.*

20. A discussion of Hartley's style at this time can be found in Haskell, 1980, 111.

21. DP, 1944, 87.

22. Title: The painting was called *Off to the Banks* in the 1943 Rosenberg exhibition catalogue and on the bill of sale. The title *Off to the Banks at Night* seems to have been created by Phillips, possibly to distinguish it from *Off to the Banks,* between 1936 and 1938, which he had purchased in 1939. Over the years the title was shortened to *Off the Banks at Night.* Provenance: Agreement to purchase, Paul Rosenberg to DP, Nov. 27, 1943; bill of sale, June 1, payment Oct. 20, 1944.

23. *Northern Seascape, Off the Banks,* 1936 (oil on cardboard, 18⅜ × 24 in.; Milwaukee Art Museum, bequest of Max E. Friedman); illustrated in Haskell, 1980, 173.

24. DP, 1944, 86.

25. Both Ryders are at the Metropolitan Museum of Art, New York.

26. Marsden Hartley, "Albert Pinkham Ryder," 1936, as cited in Scott, 1982, 264.

27. Date: This date is recorded on the bill of sale and in the 1943 Rosenberg exhibition catalogue. Provenance: Agreement to purchase, Paul Rosenberg to DP, Nov. 27, 1943; bill of sale June 1, payment Oct. 20, 1944.

28. Ferguson, 1987, 156.

29. Ibid., 168.

Major References
Marsden Hartley Papers, Beinecke Rare Book and Manuscript Library, Yale University, New Haven.

Elizabeth McCausland Papers, AAA.

Marsden Hartley, *Adventures in the Arts,* New York, 1921.

Elizabeth McCausland, *Marsden Hartley,* Minneapolis, 1952.

Barbara Haskell, *Marsden Hartley,* exh. cat., New York, Whitney, 1980.

Gail Scott, ed., *On Art by Marsden Hartley,* New Haven, 1982.

William Innes Homer, ed., *Heart's Gate: Letters Between Marsden Hartley & Horace Traubel, 1906–1915,* Highlands, N.C., 1982.

Gerald Ferguson, ed., *Marsden Hartley and Nova Scotia,* exh. cat., Halifax, N.S., Mount Saint Vincent University Art Gallery, 1987.

Gail R. Scott, ed., *The Collected Poems of Marsden Hartley 1904–1943,* Santa Rosa, Calif., 1987.

———, *Marsden Hartley,* New York, 1988.

Townsend Ludington, *Marsden Hartley: The Biography of an American Artist,* Boston, 1992.

Jeanne Hokin, *Pinnacles & Pyramids: The Art of Marsden Hartley,* Albuquerque, N.M., 1993.

Jonathan Edman Weinberg, *Speaking for Vice: Homosexuality in the Art of Charles Demuth, Marsden Hartley, and the First American Avant-Garde,* New Haven, 1993.

Patricia McDonnell, *Dictated by Life: Marsden Hartley's German Paintings and Robert Indiana's Hartley Elegies,* exh. cat., Minneapolis, Frederick R. Weisman Art Museum, 1995.

Susan Elizabeth Ryan, ed., *Somehow a Past: The Autobiography of Marsden Hartley,* Cambridge, Mass., 1997.

TPC Sources
Inv., 1921.

C in M, 1926.

DP, cat. for PMG.1926.2.

DP, "To the Editor of *The Art News,*" *Art News,* Feb. 13, 1926, 7.

DP, cat. for PMG.1927.6.

DP, "Exhibitions: The Washington Independent," *The Arts* 13, Apr. 1928, 243–44.

DP, [Most Important Living American Artists], unpubl. list, 1929.

ASD, 1931.

DP, "An International Exhibition," unpubl. essay for planned exh. cat. for PMG.1931.29.

DP, cat. intro. to PMG.1943.24.

DP, "Marsden Hartley," *Magazine of Art* 37, Mar. 1944, 82–87.

Cat., 1952.

SITES, 1979.

Elizabeth Hutton Turner and Leigh Bullard Weisblat, cat. for TPC.1995.5.

Stephen B. Phillips, cat. for TPC.1997.4.

MP, 1998.

MAURICE STERNE

1. Sterne wrote in autobiographical notes that he left unfinished at his death in 1957, "I disliked being rooted to one place because I felt that my roots were in all of nature and that I must, therefore, explore every part of it"; as quoted in Mayerson, 1965, 84.

2. A comprehensive discussion of his outlook on Cézanne's art appears in Sterne, 1952–53.

3. New York, Berlin Photographic Company, "Drawings and Paintings by Maurice Sterne," Apr. 1915. Sterne had exhibited his paintings of Italy at the Berlin Photographic Company in 1912.

4. DP, ca. 1915, 8. Phillips might have seen Sterne's 1915 New York exhibition or might have been aware of it from illustrated reviews such as "Exhibitions in the Galleries," *Arts and Decoration* (Apr. 1915), 240.

5. DP, cat. for PMG.1926.1, n.p.

6. In his autobiographical notes written shortly before his death, Sterne said that the 1926 Scott and Fowles exhibition was his greatest success. Almost all of his paintings went to important collectors, "including that of Duncan Phillips whom I considered one of the most discriminating collectors in the United States"; Mayerson, 1965, 197.

7. DP to MS, Mar. 1, 1926. Phillips's intention during the early-to-mid-1920s was to devote rooms to works by his favorite artists; this concept evolved into his idea of unit artists.

8. Quotation from DP to C. Powell Minnegerode, Mar. 5, 1926. Phillips also wrote to Mrs. John Garrett and Mrs. Eugene Meyer on the same date, urging them to consider Sterne's work.

9. DP, cat. for PMG.1926.3, n.p. He demonstrated even more fierce advocacy of Sterne when Leila Mechlin, critic for the *Sunday Star,* depicted the artist as a radical; *Sunday Star,* Mar. 14, 1926. In protest Phillips resigned from the American Federation of Art's board of directors, on which both he and Mechlin served, stating: "Your condemnation of the conservative classic artist, Maurice Sterne, who is not a modernist but a universal artist, . . . has discouraged me. I no longer believe that you would like to see the Federation's policy made more liberal and less dogmatic"; DP to LM, Mar. 17, 1926, TPC Papers, AAA, reel 1931, #316, 317. By 1932, however, he was back on the board, according to *Minutes of Meeting of the Board of Directors: The American Federation of Arts,* Oct. 21, 1932, TPC Papers, AAA, reel 1940, #1223.

10. MS to DP, Feb. 5, 1926; the date should be Mar. 1926 because Sterne mentions in his letter Phillips's correspondence with him on Mar. 1.

11. Sterne often visited the Phillipses while serving on the National Fine Arts Commission. Sterne wrote to DP: "Those frequent trips to Washington were most fruitful to me—for they have given me the opportunity to know you and Marjorie better." (Nov. 6, 1949, Foxhall corr.).

12. *ASD*, 1931, 17.

13. *Bull.*, 1931, 43.

14. *A & U*, 1929, 86 (also *ASD*, 1931, 71).

15. *Formes*, 1932, 200.

16. Title: *Girl with Pink Kerchief,* the first published title, appears in the catalogue for the 1924 Cleveland exhibition. *Head of a Girl* appears on the bill of sale. Medium: The canvas is extremely fine weave, commonly called "handkerchief linen," per Elizabeth Steele, painting conservator, Oct. 2, 1990. Provenance: Bill of sale, Feb. 11, 1926, TPC Papers, AAA, reel 1931, #628.

17. Notes written by Sterne shortly before his death, quoted in Mayerson, 1965, 64.

18. *Charioteer,* ca. 475–470 B.C., bronze, Museum, Delphi. Quote from Sterne's autobiographical notes in Mayerson, 1965, 67.

19. In addition, *Reapers* is reminiscent of a Cézanne painting, *Harvesters,* ca. 1880 (private collection, Paris; Venturi no. 1517), owned by the museum between 1939 and 1955. As an ardent Cézanne admirer, Sterne may have viewed the painting in reproduction or in exhibitions many years before the PMG owned it.

20. *Profile of Asunta* (whereabouts unknown) was illustrated in the *Chicago Evening Post of the Art World,* July 31, 1928; it represents a middle-aged woman wearing a kerchief. Sterne's earliest sculpture is *The Bomb-Thrower,* 1910 (Metropolitan Museum of Art, New York). He completed many sculpture commissions in the 1920s and 1930s.

21. "An Hour," 1941, 8.

22. A bronzed, golden tint has resulted from yellow varnish, per Steele, Oct. 2, 1990. Sterne often referred to Piero della Francesca; see Sterne's notes in Mayerson, 1965, 176, 211.

23. DP, cat. for PMG.1926.1, n.p.

24. *Bull.*, 1927, 9 (also *ASD*, 1931, 99).

25. Medium: The painting has been removed from its original stretcher and adhered to a plywood auxiliary support with a strainer; Steele, Oct. 1, 1990. Provenance: Bill of sale, Feb. 17, 1926.

26. Notes written by Sterne shortly before his death, quoted in Mayerson, 1965, 70.

27. As quoted in Mayerson, 1965, 182; excerpted from Sterne's introduction to the catalogue for his April 1922 exhibition at Bourgeois Gallery in New York.

28. Sterne, quoted in Mayerson, 1965, 70.

29. Oil on canvas; Delaware Art Museum, gift of Helen Farr Sloan.

30. After applying a white ground layer to the canvas, Sterne loosely drew the outlines of the image in graphite; much of the underdrawing is visible in the upper right section of the painting; Steele, Oct. 1, 1990.

31. In the landscape and mountains, Sterne scraped back paint areas with a flat edge, most likely a palette knife; Steele, Oct. 1, 1990.

32. *C in M*, 1926, 61 (also cat. for PMG.1926.3).

33. DP to MS, Mar. 1, 1926.

34. DP to Martin Birnbaum, Feb. 11, 1926, TPC Papers, AAA, reel 1934, #364.

35. MS to DP, Nov. 19, 1938.

36. Provenance: DP to MS, Feb. 4, 1948: "I have practically decided on *After Rain*." Phillips enclosed payment in DP to MS, June 15, 1948.

37. Per Steele, Oct. 1, 1990.

38. Sterne, introduction, *Exhibition of Recent Paintings by Maurice Sterne,* exh. cat., Wildenstein (New York, 1947), n.p.

39. *Art News* (June 1947), 42; Lawrence Dame, "Regarding Boston," *Art Digest* (Oct. 1, 1949), 6.

Major References

Phillips-Sterne correspondence 1926–56, TPC Papers, AAA.

Horace M. Kallen, *Maurice Sterne Retrospective Exhibition: Paintings, Sculpture, Drawings,* exh. cat., New York, MOMA, 1933.

"An Hour in the Studio of Maurice Sterne," *American Artist,* Dec. 1941, 5–9.

Maurice Sterne, "Cézanne Today," *American Scholar* 22, winter 1952–53, 40–59.

Charlotte Leon Mayerson, ed., *Shadow and Light: The Life, Friends and Opinions of Maurice Sterne,* New York, 1965 (orig. ed. 1952).

Museum of Modern Art, *Three American Modernist Painters: Max Weber, Maurice Sterne, Stuart Davis,* reprint of three catalogues of exhibitions at the Museum of Modern Art, New York, 1969.

Martin S. Ackerman and Diane L. Ackerman, eds., *Maurice Sterne Drawings,* New York, 1974.

TPC Sources

DP, "Rhythm and the Arts," unpubl. essay, ca. 1915; formerly MS 74.

DP, Journal Y, 1922–25.

C in M, 1926.

DP, cats. for PMG.1926.1 and PMG.1926.3.

Bull., 1927.

DP, cat. for PMG.1927.3.

Bull., 1927.

CA, 1929.

DP, [List of Most Important Living American Artists], unpubl. list, 1929.

A & U, 1929 and 1930.

Bull., 1931.

DP, "The Artist Sees Differently," unpubl. text for slide lecture, 12 versions, 1931–34.

ASD, 1931.

Formes, 1932.

AMA, 1935.

DP, "Gallery Notes International Show" (concerning the "Carnegie International Exhibition"), unpubl., 1938; formerly MS 90.

Cat., 1952.

SITES, 1979.

Stephen B. Phillips, cat. for TPC.1997.4.

ARTHUR G. DOVE

1. *C in M*, 1926, 63.

2. AD to DP, early May 1933, Foxhall corr.

3. These endeavors had their roots in symbolist theory, which was popular in art circles during the period. Dove was certainly aware of these trends, especially through Stieglitz. In addition, Dove owned copies of books by Henri Bergson, who believed in uncovering

the "essence" of objects. Cohn, 1985, discusses in detail the effect of symbolist ideas on Dove's art.

4. DP, 1947, 194. Phillips does not state the circumstances of his discovery of Dove's work. Marsden Hartley had written about Dove in *Adventures in the Arts* (New York, 1921), which Phillips read with enthusiasm. Some of Dove's works were auctioned at New York's Anderson Galleries Feb. 1922; others were shown at the Colony Club, Apr. 1922.

5. DP, 1947, 194.

6. Phillips's interest in Dove caused a reconciliation of an eight-month rift between Phillips and Stieglitz. Beginning in April 1927, the disagreement centered on Phillips's contention that Stieglitz had misrepresented the price Phillips had paid for some works by Marin and had subsequently publicized it. Because Phillips was not speaking to Stieglitz, he felt he could not visit Dove's December 1927 exhibition at the Intimate Gallery. When Dove told Stieglitz, the latter, anxious for Dove to receive the patronage he deserved, quickly apologized to Phillips, and their business relationship continued. For details, see Turner in TPC 1995.5, 18–25, and "Selected Correspondence," 118–49.

7. Ledger 11 records regular payments from Phillips to Dove from 1933 to 1946. Morgan, 1984, 26–27, details the nature of this financial agreement, pointing out that Phillips's stipends were actually regular installments on the paintings he bought; they became philanthropic during Dove's illnesses, when he was unable to paint. In any event, Dove could not have painted regularly without Phillips's steady patronage. Other artists to whom Phillips paid stipends were Graham, Kent, and Marin.

8. Although their correspondence was extensive, Phillips and Dove met only once, at An American Place in April 1936 during Dove's yearly show. Dove wrote about it in a letter to Stieglitz, "The Phillipses were much less difficult than I expected, and we enjoyed them." (Apr. 28, 1936; quoted in Morgan, 1988, 349).

9. Hartley to DP, June 3, 1942.

10. Included are recent gifts, two watercolors and a drawing: *Bull* (acc. no. 1985.3.4); *Water Tank* (acc. no. 1985.8.1); and *Me and the Moon,* (acc. no. 1991.13.1).

11. *Formes,* 1932, 198.

12. DP, 1947, 197.

13. *Formes,* 1932, 198.

14. Title: Alternate title from 1925 exhibition listing. Medium: According to Morgan, 1984, 137, the metallic paint includes copper and gold. Provenance: Purchase from exhibition recorded in AS to DP, Feb. 1, 1926; receipt of payment mentioned in AS to DP, Mar. 9, 1926.

15. Provenance: In DP to AS, Mar. 4, 1926, payment is sent.

16. *C in M,* 1926, 63.

17. Phillips related Dove to Ryder in a letter to Dove Mar. 13, 1926. Fascinated by the metallic paint in *Golden Storm,* Phillips instructed that it always be hung opposite lights in order to create reflections. He worried, however, about the painting's longevity, bringing up the notoriously unstable nature of Ryder's canvases. In Phillips, 1947, 195, he compared its composition to Ryder's *Jonah,* late 1880s, and *Flying Dutchman,* late 1880s (both in the National Museum of

American Art, Washington, D.C.; gift of John Gellatly).

18. DP to AD, Mar. 13, 1926.

19. Date: Determined from H. T. Dove Diaries, 1923–29, AAA, reel N70/52, #100, entry dated July 21, 1925: "Arthur on '*Negro Goes Fishing.*'" The work is mentioned through Aug. 10, 1925. Title: According to Morgan, 1988, 133 (n. 3), this assemblage was first exhibited as *Fishing Nigger* and soon thereafter as *The Nigger Goes A'Fishing.* Morgan states that both Dove's son, William, and Herbert J. Seligmann, in *Alfred Stieglitz Talking: Notes on Some of his Conversations, 1925–1931* (New Haven, 1966), 18, contend that the word "nigger" was not chosen with contemptuous intentions but was most likely a reflection of an undercurrent of racist thinking at the time. Later, William Dove persuaded his father to alter the title. *Goin' Fishin'* and variations on that title were in use by the mid-1940s. Provenance: Stieglitz's ownership is established in AS to DP, Oct. 20, 1926: "The *Nigger Goes A'fishin',* which I bought, will be in the coming International show of Abstract Art to be held at the Brooklyn Museum." Phillips's purchase is recorded in DP to AS, May 6, 1937.

20. Provenance: Bill of sale, Jan. 9, 1928.

21. This interpretation appears in, among others, Phillips, 1947, 194–95; Morgan, 1984, 51; and Dorothy R. Johnson, *Arthur Dove: The Years of Collage,* exh. cat., University of Maryland (College Park, 1967), 18.

22. Seligmann, *Alfred Stieglitz Talking,* 46.

23. Ibid.

24. Dove's written notations on a manuscript by McCausland concerning his work, ca. 1937, Elizabeth McCausland Papers, AAA, reel D384b, #356.

25. Dove to McCausland, Nov. 5, 1937, Elizabeth McCausland Papers, AAA, reel D384b, #236.

26. H. T. Dove Diaries, 1923–29, reel N70/52, #100, states in the entry for July 22, 1925: "A to Huntington early, got blue shirt for negro thing."

27. Much of this interpretation is made in Johnson, *The Years of Collage,* 18.

28. Carnegie Museum of Art, Pittsburgh; see Morgan no. 26.4.

29. Both quotations from DP to AD, Jan. 21, 1928.

30. DP to AS, May 4, 1935.

31. DP to AD, June 8, 1936.

32. DP, 1937, n.p.

33. Date: Written in pencil, perhaps by the artist, on the reverse of the stretcher, u.l., is *Nov. 1930.* Provenance: DP to AS, May 9, 1931: "I . . . am keeping the . . . *Sand Barge.*"

34. H. T. Dove Diaries, 1930–39, reel 38, entry dated Aug. 22, 1930. Morgan, 1984, 183, believes that she was describing *Sand Barge.* Although this interpretation conflicts with the *Nov. 1930* inscription on the painting's stretcher, Dove may have put finishing touches on the work at the later date.

35. See Morgan, 1984, 54, for Dove's working process. Another preparatory watercolor for this work is in the collection of William Lumpkins, Santa Fe, N.M.

36. Carlyle Burrows, "News and Comment on Current Art Events," *New York Tribune,* Mar. 15, 1931.

37. DP to AS, May 9, 1931.

38. Title/Date: H. T. Dove Diaries, 1930–39, reel 38,

#443, Jan. 17, 1933: "A. started 'Sun Drawing Water'"; #450, Jan. 31, 1933: "A. finished 'Sun Drawing Water.'" Provenance: Ibid., reel 38, #497, May 26, 1933: "Duncan Phillips taking 'Sun Drawing Water.'"

39. Date: ibid., reel 39, #48, Jan. 26, 1935: "A. laid in 'Electric Orchard'"; #63, Feb. 26: "A. finished 'Peach Orchard'" Provenance: DP to AS, May 4, 1935: "send . . . Peach Orchard."

40. Cohn, 1985, 62, states that Dove was familiar with theosophical works such as Annie Besant's and C. W. Leadbeater's *Thought-Forms* (London, 1901) and the writings of Helena Blavatsky. He knew them through his reading of Kandinsky and through the Stieglitz circle. Lines of force frequently appeared in cubist, futurist, and surrealist paintings, which Dove regularly saw in New York.

41. H. T. Dove Diaries, reel 38, #443, Jan. 17, and #450, Jan. 31, 1933. A preparatory watercolor for this work is in the collection of William Lumpkins, Santa Fe, N.M.

42. Cohn, 1985, 75, indicates that Dove's interest in the attraction between sun and earth may have been sparked by romantic theory, especially that of Goethe, through Johann Eckermann's *Conversations with Goethe,* trans. S. M. Fuller (Boston, 1839).

43. Arthur Dove, "A Way to Look at Things," *Seven Americans,* exh. cat., Anderson Galleries (New York, 1925), n.p. The complete poem is cited in Newman, 1981, 28–29.

44. Cohn, 1985, 68. She cites the influence of Ouspensky's *A New Model of the Universe,* first published in 1931.

45. Quotations from DP, 1947, 195.

46. Related work: *Flour Mill I,* 1938 (18 × 12 in.; collection of Max Zurier, Palm Springs, Calif; Morgan no. 38.4), is a slightly abbreviated version of the Phillips work. Title: The word "abstraction" appears in this painting's title intermittently after Phillips's ownership. Provenance: Phillips agrees to buy the painting in DP to AS, Mar. 29, 1938.

47. Date: Arthur Dove Diaries, reel 2803, Jan. 18, 1943: "Put rain in 'Rain.' Finished." Medium: Dove used a metal leaf resembling silver in his paint along the left and right edges (Steele, May 1991). In a diary entry, Jan. 27, 1943, he refers to his use of aluminum: "Fixed patches of aluminum on 'Rain or Snow.'" Provenance: DP to AS, Apr. 10, 1943, mentions his intention to purchase.

48. Cohn, 1985, 81–85, explains Dove's concerns with geometry and space during this phase of his career. During the late 1930s and the 1940s, although he was too ill for frequent travel to New York, Dove became increasingly aware of current abstract tendencies in art through his reading of art literature. He participated in the Whitney Museum's 1935 show "Abstract Painting in America" and probably saw the catalogue for MOMA's 1936 exhibition "Cubism and Abstract Art"; see Morgan, 1984, 58–60.

49. A watercolor upon which the *Flour Mill* paintings are based is in the Phillips family collection.

50. In 1935, inspired by Max Doerner's *Materials of the Artist,* trans. Eugen Newhaus (New York, 1934), Dove began using wax emulsion; see Morgan, 1984, 89 and 91.

51. DP, 1947, 196.

52. DP to AD, Apr. 7, 1943.

Major References

Diaries of Arthur Dove and Helen Torr Dove, AAA.

Alfred Stieglitz Archives, Beinecke Rare Book and Manuscript Library, Yale University, New Haven.

Suzanne M. Mullett, "Arthur G. Dove: A Study in Contemporary Art," M.A. thesis, American University, Washington, D.C., 1944.

Ann Lee Morgan, "Toward a Definition of Early Modernism in America: A Study of Arthur G. Dove," Ph.D. diss., University of Iowa, 1973.

Barbara Haskell, *Arthur Dove*, exh. cat., San Francisco Museum of Art, 1974.

Sherrye Cohn, *Arthur Dove: Nature as Symbol,* Studies in the Fine Arts: The Avant-Garde, no. 49, Ann Arbor, 1985.

Ann Lee Morgan, *Arthur Dove: Life and Work with a Catalogue Raisonné*, Newark, 1984.

Ann Lee Morgan, ed., *Dear Stieglitz, Dear Dove,* Cranbury, N.J., 1988.

Anne Cohen de Pietro, *Arthur Dove and Helen Torr: The Huntington Years,* exh. cat., Huntington, New York, The Heckscher Museum, 1989.

TPC Sources

Phillips-Dove correspondence, 1926–46, and Phillips-Stieglitz correspondence, 1926–46, TPC Archives.

DP, cat. for PMG.1926.2.

C in M, 1926.

ASD, 1931.

DP, "The Artist Sees Differently," unpubl. text for slide lecture, 12 versions, 1931–34.

DP, cat. for PMG.1932.7.

Formes, 1932.

DP, "Freshness of Vision and Spontaneity in Painting," unpubl. text for slide lecture, ca. 1935.

DP, "The Expression of Personality through Design in the Art of Painting," unpubl. text for slide lecture, ca. 1936–42.

DP, cat. for PMG.1937.4.

DP, "Gallery Notes International Show," unpubl. essay, 1938; formerly MS 90.

DP, "Spontaneous Painters," unpubl. essay, ca. 1939; formerly MS 78.

C. Law Watkins, "Color Shapes Functioning as Symbols of Nature's Forces," essay for PMG.1941.4, pp. 35–36.

DP, "Freshness of Vision in Painting," unpubl. essay, ca. 1945; formerly part of MS 178.

DP, "Arthur G. Dove, 1880–1946," *Magazine of Art* 40 (May 1947): 192–97.

Cat., 1952.

DP, "Foreword" in Alan R. Solomon, *Arthur G. Dove 1880–1946: A Retrospective Exhibition,* exh. cat., Ithaca, N.Y., Andrew Dickson White Museum of Art, Cornell University, 1954.

Arts, 1956.

DP, "A Gallery of Modern Art and Its Sources," unpubl. text for television program produced by the Greater Washington Education Television Association, aired Oct. 16, 1959; formerly MS 95.

MP, 1970 and 1982.

SITES, 1979.

MD, 1981.

Sasha M. Newman, essay for TPC.1981.4.

Elizabeth Hutton Turner and Leigh Bullard Weisblat, cat. for TPC.1995.5.

Elizabeth Hutton Turner, et al., cat. for TPC.1997.6.

Elizabeth Hutton Turner, publ. chklst. For TPC.1997.7.

MP, 1998.

MSS 13, 121, and 122.

ALBERT EUGENE GALLATIN

1. Title: *Composition,* probably Gallatin's original title, appears in reviews: "Gallatin Exhibits," *Art Digest* (May 8, 1942), 8; and James W. Lane, "Gallatin: Pure Form and Texture," *Art News* (May 1, 1942), 25. Duncan Phillips entitled the work *Abstraction* from the beginning of his ownership of it. Provenance: Purchase documented in DP to AEG, Apr. 26, 1945, TPC Papers, AAA, reel 1963, #370.

2. Balken, 1986, 30–31.

3. Ibid., 27.

4. Shaw, 1953, 139.

5. Jean Hélion in Gallatin et al., 1936, n.p.

6. Analysis by Elizabeth Steele, painting conservator, Sept. 24, 1990.

7. Ibid.

8. Lane, "Gallatin," 33.

9. Rosamund Frost, *Contemporary Art: The March of Art From Cézanne Until Now* (New York, 1942), 188. Phillips wrote to AEG, Apr. 18, 1945, asking him to send on approval "that beautiful Abstraction which was reproduced in color in the book by Rosamund Frost" (TPC Papers, AAA, reel 1963, #364); he acquired the painting a week later.

10. DP, 1914, 129.

11. During the late 1920s and early 1930s, Gallatin's avant-garde tastes outstripped those of Phillips with his acquisitions of work by Arp, Brancusi, Gleizes, Lipchitz, Modigliani, Mondrian, and Soutine. Phillips did not share Gallatin's belief that art could be understood only by the few and that "any tactic to make art accessible was futile"; see Balken, 1986, 30.

Major References

Albert Eugene Gallatin Papers, New-York Historical Society (on microfilm at AAA).

Phillips-Gallatin Correspondence, 1918, TPC Archives.

Albert Eugene Gallatin et al., *Museum of Living Art: A. E. Gallatin Collection,* New York, 1936; 2nd ed., rev., 1940.

Geoffrey T. Hellman, "Profiles: The Medici on Washington Square," *New Yorker,* Jan. 18, 1941, 25–32.

Paintings by Gallatin, New York, 1948.

Charles G. Shaw, "Albert Eugene Gallatin: A Reminiscence," *Princeton University Library Chronicle,* spring 1953, 135–40.

Susan C. Larsen, "The American Abstract Artists Group: A History and Evaluation of Its Impact on American Art," Ph.D. diss., Northwestern University, 1975.

Mildred E. Lederman, "Albert Eugene Gallatin and His Contributions to American Twentieth-Century Art," Ph.D. diss., New York University, 1976.

Debra Bricker Balken, *Albert Eugene Gallatin and His Circle,* exh. cat., Coral Gables, Fla., Lowe Art Museum, University of Miami, 1986.

Douglas Dreishpoon, *New York Cubists: Works by A. E. Gallatin, George L. K. Morris, and Charles G. Shaw from the Thirties and Forties,* exh. cat., New York, Hirschl and Adler Galleries, 1988.

Gail B. Stavitsky, "The Development, Institutionalization, and Impact of the A. E. Gallatin Collection of Modern Art," Ph.D. diss., New York University, 1990.

TPC Sources

DP, "A Collection of Modern Graphic Art," *Art and Progress* 5, Feb. 1914, 129–30.

DP, "A Resolution," *International Studio* 66, Feb. 1919, 118.

Cat., 1952.

MAX WEBER

1. The author wishes to thank Percy North for generously sharing her knowledge of Weber's life and work, and for her aid in dating many of the Phillips works. Weber's most renowned critical essay, "The Fourth Dimension from a Plastic Point of View," published in 1910, received great attention from other artists, critics, and theorists. Indeed, Willard Bohn argues convincingly in his article, "In Pursuit of the Fourth Dimension: Guillaume Apollinaire and Max Weber," *Arts* 54 (June 1980), 166–69, that this essay influenced Apollinaire's discussion of the fourth dimension in *Les peintres cubistes,* published in 1913. For a thorough analysis of the scientific influences on this theory, see Linda Dalrymple Henderson, "A New Facet of Cubism: 'The Fourth Dimension' and 'Non-Euclidean Geometry' Reinterpreted," *Art Quarterly* 34, no. 4 (1971), 411–33.

2. *Figure Study,* 1911 (oil on canvas; Albright-Knox Art Gallery, Buffalo), represents Weber's early figural style, and his renowned *Chinese Restaurant,* 1915 (oil on canvas; Whitney Museum of American Art, New York), typifies his cubist/futurist approach during the 1910s. For a discussion of Weber's relationship with Stieglitz, see Percy North, "Turmoil at 291," *Archives of American Art Journal* 24, no. 1 (1984), 12–20; Lloyd Goodrich, "Notes on Conversation with Max Weber, June 16, 1948," unpubl. MS, p. 7, Max Weber Papers, AAA, reel NY59–8; and Stieglitz, "The Story of Weber," Feb. 22, 1923, unpubl. MS, Alfred Stieglitz Archive, Beinecke Rare Book and Manuscript Library, Yale University, New Haven. Apparently Weber and Stieglitz continued to correspond intermittently until the mid-1910s; see, for example, AS to MW, Jan. 17, 1914, Stieglitz Archive.

3. As quoted in Weber, 1945, n.p. See also Weber's 1936 article, "Distortion in Modern Art," *The League* (in Max Weber Papers, AAA, reel NY59–10, #396), in which he asserted that distortion, which he linked with expressionism, could evoke greater content in the subject.

4. Weber, 1945, n.p.

5. Weber's 1909 figures are based on Cézanne's bathers and Matisse's nudes. It was not until sometime in late 1910 that his work reflected the influence of early cubist works by Picasso and Braque, although he remembers meeting Picasso as early as 1908 in Gertrude Stein's salon. John R. Lane theorizes convincingly that Picasso's influence on Weber began following publication of Gelett Burgess, "The Wild Men of Paris," *Architectural Review* (May 1910), 400–414, in which *Les Demoiselles d'Avignon* was first introduced in the United States. See Lane, "The Sources of Max Weber's Cubism," *Art Journal* 35, no. 3 (1976), 231–36. An interesting parallel can be drawn between Weber's and Picasso's monumental nudes of the early 1920s, particularly regarding the massive hands and feet. Certainly Weber could have seen Picasso's recent work in a 1923 show at Wildenstein Gallery; see review,

"Picasso is Painting in a Classic Style," *The Art News* 22 (Nov. 1923), 1–2.

6. DP, essay for PMG.1931.26, 33, and *C in M*, 1926, 62.

7. Phillips visited New York Nov. 9–15, 1925; see Journal Y, ca. 1922–25, n.p.

8. "Modern Art," *The Dial* (Apr. 1925), 346 and 349.

9. Both quotes in DP to J. B. Neumann, Dec. 15, 1925.

10. *C in M*, 1926, 62.

11. *ASD*, 1931, 52.

12. Forbes Watson, "Max Weber—1941," *Magazine of Art* 34 (Feb. 1941), 79. Phillips's visit to the gallery is implied in his letter to Pegeen Sullivan, Associated American Artists, Nov. 6, 1941.

13. The first reference is a letter to Paul Rosenberg, Nov. 9, 1943. He was probably thinking of Weber as a potential unit when he first began collecting the artist's work in the 1920s.

14. In DP to Pegeen Sullivan, Nov. 6, 1941, Phillips states, "We look forward to our one man show of Weber in February." Although a show was never held, Phillips did include works by Weber in PMG.1942.6. In PS to DP, Nov. 12, 1941, Sullivan refers to how much she "enjoyed seeing the Webers with you in New York."

15. DP to Paul Rosenberg, Nov. 9, 1943.

16. *ASD*, 1931, 55. See also Phillips's comments in MS 83, 8–9. For an analysis of Weber's art and ethnicity, see Kleeblatt and Chevlowe, 1991, 45–48.

17. Date: MW to Leonard and Addah Van Noppen, Jan. 2, 1923, (Max Weber Papers, AAA, reel NY59–8, #207): "I have worked very hard. All summer. I made all my own frames for my pictures, which are to be exhibited at the Montross Gallery next month." *Draped Head* was included in this show, which opened the following February. The present frame for this work may be the original made by Weber. Title: McBride referred to this work as *Head* when he illustrated it in his review of Weber's show at J. B. Neumann's New Art Circle; see "Modern Art," *The Dial* (Apr. 1925), 348–49. Medium: There are strongly textured brushstrokes in the face and elsewhere that indicate Weber painted this composition over another painting, per analysis by Elizabeth Steele, painting conservator, Aug. 24, 1990. Provenance: See J. B. Neumann to DP, Sept. 28, 1926, and DP to JBN, Oct. 8.

18. Matthew Baigell, "From Hester Street to Fifty-Seventh Street: Jewish-American Artists in New York," in Kleeblatt and Chevlowe, 1991, 45. On death of father, see North, 1982, 47–49. During the early to mid-1920s, Weber was involved with a group of revolutionary Yiddish poets and writers, Di Yunge, which in 1925 established the Jewish Art Center, and between 1919 and 1925 published poems, essays, and woodcuts in the journal *Schriftn*. See Kleeblatt and Chevlowe, 1991, 42 and 200.

19. North, 1982, 34.

20. Ibid., fig. 50, *Girl with Comb*, 1919 (oil on canvas; Fine Arts Museums of San Francisco); possibly also in *Head of a Woman*, by 1930 (oil on canvas; MOMA, New York), illustrated in Max Weber Papers, AAA, reel NY59–9, #546, and the nude on the left in *Three Figures*, 1921 (oil on canvas; present location unknown), illustrated in Bernard Danenberg Galleries, *Fifty Years of Painting by Max Weber*, exh. cat. (New York, 1969), 34.

21. For example, Weber's *Figure Study*, 1911 (oil on canvas; Albright-Knox Art Gallery, Buffalo), shows the impact of Matisse's *Blue Nude*, 1907 (oil on canvas; Baltimore Museum of Art), as well as Picasso's work, such as *Les Demoiselles d'Avignon*, 1907 (oil on canvas; MOMA, New York). After returning to New York, Weber remained interested in ethnographic art and frequently visited the American Museum of Natural History's collection of Mexican and Pre-Columbian art (Goodrich, 1948, 11).

22. See, for example, Picasso's *Seated Woman*, 1920 (oil on canvas; Musée Picasso, Paris), *Head of a Woman*, 1921 (pastel on paper; Collection Beyeler, Basel), and *Maternity*, 1921 (oil on canvas; Collection Bernard Picasso, Paris); the latter two were shown in New York in Nov. 1923, per "Picasso is Painting in a Classic Style," 2.

23. *C in M*, 1926, 61.

24. Consignment suggested in JBN to DP, Dec. 12, 1925; see JBN to DP, Nov. 18, 1925, regarding New Art Circle exhibition; bill of sale, Nov. 28, 1925 (purchased as *Summer Noon*).

25. Date/Title: Percy North dates this work ca. 1940 on the basis of style, per discussion with author, Sept. 1990. Purchased as *Last Snow;* alternate title by DP. Medium: The paint application ranges from impasto to thin wash, per Steele, Aug. 24, 1990. Provenance: See Paul Rosenberg to DP, Nov. 4, 1943, and DP to PR, Dec. 23; bill of sale, June 1, 1944.

26. Weber to Leonard van Noppen, July 16, 1916, as quoted in North, 1991, 42.

27. See North, 1982, 52. Weber saw Cézanne's 1907 retrospective while in Paris.

28. On political and social changes, see Kleeblatt and Chevlowe, 1991, 49–64.

Major References
Max Weber Papers, AAA.
Max Weber, "The Fourth Dimension from a Plastic Point of View" and "Chinese Dolls and Modern Colorists," *Camera Work* 31, July 1910, 25 and 51.
———, *Essays on Art*, New York, 1916.
Alfred Barr, *Max Weber Retrospective Exhibition*, exh. cat., New York, MOMA, 1930.
Holger Cahill, *Max Weber*, exh. cat., New York, Downtown Gallery, 1930.
Max Weber, *Max Weber*, New York, 1945.
The Reminiscences of Max Weber, interview by Carol S. Gruber, Oral History Research Office, Columbia University, 1958.
Museum of Modern Art, *Three American Modernist Painters: Max Weber, Maurice Sterne, Stuart Davis,* reprint of three catalogues of exhibitions at the Museum of Modern Art, New York, 1969.
Sandra Leonard, *Henri Rousseau and Max Weber*, New York, 1970.
P. B. North, "Max Weber: The Early Paintings (1905–20)," Ph.D. diss., University of Delaware, 1974.
Daryl R. Rubenstein, *Max Weber: A Catalogue Raisonné of His Graphic Work*, Chicago, 1980.
Percy North, *Max Weber: American Modern*, exh. cat., New York, Jewish Museum, 1982.
Norman L. Kleeblatt and Susan Chevlowe, eds., *Painting a Place in America: Jewish Artists in New York, 1900–1945*, exh. cat., New York, Jewish Museum, 1991.
Percy North, *Max Weber: The Cubist Decade,* *1910–1920*, exh. cat., Atlanta, High Museum of Art, 1991.
Cynthia H. Prebus, "Transitions in American Art and Criticism: The Formative Years of Early American Modernism, 1895–1905," Ph.D. diss., Rutgers, State University of New Jersey, 1994.

TPC Sources
Journal Y, ca. 1922–25.
DP, essay for PMG.1926.2.
C in M, 1926.
DP, essay for PMG.1927.3.
A & U, 1929 and 1930.
Ralph Flint, "Current American Art Season," *A & U*, 1930.
Bull., 1930 and 1931.
DP, [Lists of Illustrations for Possible Handbook], ca. 1930.
ASD, 1931.
Journal I, between 1931 and 1935.
Formes, 1932.
DP, "Freshness of Vision and Spontaneity in Painting," unpubl. text for lecture, ca. 1935; formerly part of MS 178.
AMA, 1935.
DP, "Freshness of Vision in Painting," unpubl. essay, ca. 1945; formerly part of MS 178.
Cat., 1952.
MP, 1970.
Stephen B. Phillips, cat. for TPC.1997.4.
MS 83.

GASTON LACHAISE

1. Date/Edition: Lachaise cast and exhibited the first bronze in 1928. Through Weyhe Gallery nine more bronzes were cast in the fall of 1930, and by 1957 a total of fifteen bronzes had been cast. The sculpture does not bear markings or a cast number that would indicate its position among the 1930 casts. Provenance: Payment is noted in acquisition list EB 80. Writing to his wife, Sept. 26, 1930, Lachaise Archives, Beinecke Library, Lachaise states: "Duncan Phillips has taken the Marin portrait on approval. . . . I hope he keeps it."

2. See Marin entries, cat. nos. 229–37.

3. Lachaise, as quoted in Gerald Nordland, *Gaston Lachaise, 1882–1935: Sculpture and Drawings,* exh. cat., Los Angeles County Museum of Art (1964), n.p., n. 13. Nordland interviewed Lachaise's friends Lincoln Kirstein in 1951 and E. M. M. Warburg in 1952; they independently recall this statement by the artist.

4. Lachaise's three full-length portraits of Gregory Slader derive from the Greco-Roman tradition of the nude; see Carr and Christman, 1985, 20 and 120–23. His portrait of Lincoln Kirstein is based on a gold statuette of an Egyptian pharaoh; see Nordland, 1975, 117.

5. Nordland, 1975, 110. See also Goodall, 1969, app. 2, 685–95, for further discussion of Rodin's influence. See Rodin essay, cat. no. 48.

6. Marin to Stieglitz, Aug. 6, 1920, as quoted in Dorothy Norman, ed., *The Selected Writings of John Marin* (New York, 1949), 56.

7. For working method, see Nordland, 1964, n.p., n. 14; see also Carr and Christman, 1985, 112, for Henry McBride's remembrances of Lachaise's methods.

8. Both quotations in Lachaise, "A Comment on My Sculpture," *Massachusetts Review* 1, no. 4 (Aug. 1960), 694; originally published in *Creative Art* 3, no. 2 (Aug. 1928), 23–28.

9. GL to his wife, n.d., Beinecke Library, as quoted in Nordland, 1974, 95.

10. For further discussion of these sources, see Nordland, 1974, 10–11 and 15–16.

11. Lachaise, 1960, 694.

Major References
Gaston Lachaise Papers and Isabel Lachaise Papers, AAA.
Lachaise Archives, Collection of American Literature, Beinecke Rare Book and Manuscript Library, Yale University, New Haven.
Lincoln Kirstein, *Gaston Lachaise: Retrospective Exhibition,* exh. cat., New York, MOMA, 1935.
Donald Bannard Goodall, "Gaston Lachaise, 1882–1935," *Massachusetts Review* 1, Aug. 1960, 674–84.
———, "Gaston Lachaise, Sculptor," Ph.D. diss., Harvard University, Cambridge, Mass., 1969.
Gerald Nordland, *Gaston Lachaise: The Man and His Work,* New York, 1974.
———, "Gaston Lachaise Portrait Sculpture," *American Art Review,* Mar.–Apr. 1975, 109–18.
Patterson Sims, *Gaston Lachaise: A Concentration of Works from the Permanent Collection of the Whitney Museum of American Art,* exh. cat., New York, Whitney, 1980.
Jeanne L. Wasserman, *Three American Sculptors and the Female Nude: Lachaise, Nadelman, Archipenko,* exh. cat., Cambridge, Mass., Fogg Art Museum, Harvard University, 1980.
Carolyn Kinder Carr and Margaret C. S. Christman, *Gaston Lachaise, Portrait Sculpture,* exh. cat., Washington, D.C., NPG, 1985.

TPC Sources
Journal I, between 1931 and 1936.
Cat., 1952.
MP, 1970 and 1982.
SITES, 1979.
MD, 1981.

CHARLES DEMUTH

1. Provenance: Bill of sale, Jan. 29, 1925.

2. Milton Brown, "Cubist-Realism: An American Style," *Marsyas* 3 (1943–45), 152.

3. According to Eiseman, 1982, 51, Provincetown is the locale depicted; further, Eiseman to author, Dec. 15, 1988, noted that pitched roofs are more typical of Provincetown than Lancaster. Other Demuth watercolors of similar views are *Red Chimney,* 1920 (14 × 10¼ in.; Philadelphia Museum of Art; Farnham no. 391); *Early Houses, Provincetown,* 1918 (14 × 10 in.; Museum of Modern Art, gift of Philip L. Goodwin; Farnham no. 303); and *Houses, 1918,* 1918 (13⅜ × 9¾ in.; Columbus Museum of Art, Ferdinand Howald Collection; Farnham no. 315).

4. DP, PMG.1926.1, n.p. For reviews, see Leila Mechlin, "Notes of Art and Artists," *Sunday Star,* Jan. 17, 1926, and Ada Rainey, "Young Art Shown," *Washington Post,* Jan. 17, 1926.

5. For information on works Demuth produced during his 1917 visit to Bermuda, see Emily Farnham, "Charles Demuth's Bermuda Landscapes," *Art Journal* 25 (winter 1965–66), 130–37, as well as Eiseman, 1976, 137–75.

6. Collection catalogue is *C in M,* 1926, 64; essay, DP, PMG.1926.1, n.p.

7. Date: Farnham, 1959, 609, dates this watercolor ca. 1927, which is impossible since Phillips purchased it in

1924. Alvord Eiseman dated it ca. 1923 (letter to author, Dec. 15, 1988), stating that no *Eggplant* works were executed by Demuth before 1922. Fisk University, Nashville, Alfred Stieglitz Collection, owns a similar work, *Still Life: Eggplant,* 1922 (9¼ × 13¾ in.; Farnham no. 422 as *Eggplant and Peppers*). Title: From bill of sale; in most TPC sources, however, the watercolor is entitled *Eggplant.* Provenance: Bill of sale, Feb. 6, 1924.

8. For information on the Lancaster farmers' market, see Gerald S. Lestz, "Demuth's Lancaster," in Thomas E. Norton, ed., *Homage to Charles Demuth: Still Life Painter of Lancaster* (Ephrata, Pa., 1978), 21–32.

9. Alvord Eiseman in "Charles Demuth—A Still Life Painter in the American Tradition," in Norton, *Homage to Charles Demuth,* 42, called Demuth's early still lifes "baroque" in their "curvilinear themes of the tablecloths or napkins which weave in and out of the fruit and vegetables."

10. The fruit or vegetable in the foreground may be a melon, a peeled grapefruit, or a squash. Demuth's technique is explained in J. Ray Doyle, "Technical Page," *American Artist* (Sept. 1987), 32, 90–91.

11. Farnham, 1971, 90.

12. A. E. Gallatin, *Charles Demuth* (New York, 1927), 9.

13. Phillips, *Formes,* 1932, 200.

Major References
The Demuth Foundation, Lancaster, Pa.
Emily Edna Farnham, "Charles Demuth: His Life, Psychology, and Works," 3 vols., Ph.D. diss., Ohio State University, 1959.
———, *Charles Demuth: Behind a Laughing Mask,* Norman, Okla., 1971.
Alvord L. Eiseman, "Study of the Development of an Artist: Charles Demuth," 2 vols., Ph.D. diss., New York University, 1976.
———, *Charles Demuth,* New York, 1982.
Betsy Fahlman, *Pennsylvania Modern: Charles Demuth of Lancaster,* exh. cat., Philadelphia, Philadelphia Museum of Art, 1983.
Barbara Haskell, *Charles Demuth,* exh. cat., New York, Whitney, 1987.
Wanda Corn, *In the American Grain: The Billboard Poetics of Charles Demuth,* Vassar College, Poughkeepsie, N.Y., 1991.
Jonathan Edman Weinberg, *Speaking for Vice: Homosexuality in the Art of Charles Demuth, Marsden Hartley, and the First American Avant-Garde,* New Haven, 1993.
Robin Jaffee Frank, *Charles Demuth: Poster Portraits, 1923–1929,* exh. cat., Yale University Art Gallery, New Haven, 1994.
———, "Charles Demuth Poster Portraits: 1923–1929," Ph.D. diss., Yale University, 1995.

TPC Sources
DP, exh. cat. for PMG.1926.1.
C in M, 1926.
DP, [Most Important Living American Artists], unpubl. list, 1929.
ASD, 1931.
Formes, 1932.
Cat., 1952.
SITES, 1979.

CHARLES SHEELER

1. Title: Upon acquisition in 1926, Phillips changed the painting's name to *Offices.* Provenance: Date of trans-

fer from artist to Daniel unknown; bill of sale to PMG, Mar. 10, 1926.

2. "Autobiography," Charles Sheeler Papers, reel NSH-1, #85–86 (from which excerpts were published in Rourke, 1938).

3. "Autobiography," Charles Sheeler Papers, reel NSH-1, #75.

4. Edmund Wilson Jr., "The Aesthetic Upheaval in France: The Influence of Jazz in Paris and Americanization of French Literature and Art," *Vanity Fair* (Feb. 1922), 100.

5. Marcel Duchamp invented the concept of a "readymade" in the early 1910s. It is a commercial mass-produced object that the artist chose and designated as a work of art.

6. This statement, by an unknown author, is quoted from the advertisement "Manhattan—'The Proud and Passionate City,'" *Vanity Fair* (Apr. 1922), 51. Stills from the film, which debuted July 24, 1921, at the Rialto Theatre, were also published in this issue of *Vanity Fair.* A copy of *Manhatta* is in the Museum of Modern Art's film collection.

7. Troyen and Hirshler, 1987, 82.

8. The Phillips Collection owns a photograph of *Skyscrapers* that Sheeler took in 1922 for the purpose of record for Charles Daniel Gallery. Troyen and Hirshler erroneously attribute to Sheeler two inscriptions on the back of the photograph: *Skyscrapers by Charles Sheeler* and *Photograph by Sheeler.* They are actually in Charles Daniel's hand.

9. "Autobiography," Charles Sheeler Papers, reel NSH-1, #113.

10. See Daniel to DP, dated to July 20, 1924, on the basis of its content, TPC Papers, reel 1932, #0044.

11. Leila Mechlin, "Notes of Art and Artists," *Sunday Star,* Jan. 17, 1926. This exhibition possibly represents the first time a work by Sheeler was shown in Washington; in her review Mechlin states that six of the nine artists had not previously exhibited there.

12. DP, essay for PMG.1926.1, n.p.

Major References
Charles Sheeler Papers, AAA.
Thomas Craven, "Charles Sheeler," *Shadowland* 8, Mar. 1923, 11 and 71.
Constance Rourke, *Charles Sheeler: Artist in the American Tradition,* New York, 1938.
Lillian Dochterman, *The Quest of Charles Sheeler,* exh. cat., Iowa City, University of Iowa, 1963.
Martin Friedman, Bartlett Hayes, and Charles Millard, *Charles Sheeler,* exh. cat., Washington, D.C., NCFA, 1968.
Martin Friedman, *Charles Sheeler: Paintings, Drawings, Photographs,* New York, 1975.
Susan Fillin-Yeh, "Charles Sheeler and the Machine Age," Ph.D. diss., City University of New York, 1981.
Karen Tsujimoto, *Images of America: Precisionist Painting and Modern Photography,* exh. cat., San Francisco, Museum of Modern Art, 1982.
Carol Troyen and Erica E. Hirshler, *Charles Sheeler: Paintings and Drawings,* exh. cat., Boston, Museum of Fine Arts, 1987.
Susan Fillin-Yeh, *Charles Sheeler: American Interiors,* New York, 1987.
Erica E. Hirshler, "The 'New New York' and the Park Row Building: American Artists View an

Icon of the Modern Age," *American Art Journal* 21, winter 1989, 26–45.

Karen Lucic, "The Present and the Past in the Works of Charles Sheeler," Ph.D. diss., Yale University, 1989.

———, *Charles Sheeler and the Cult of the Machine,* Cambridge, Mass., 1991.

———, "On the Threshold: Charles Sheeler's Early Photographs," *Prospects* 20 (1995), 227–55.

Karen Lucic, *Charles Sheeler in Doylstown: American Modernism and the Pennsylvania Tradition,* exh. cat., Allentown Art Museum, Allentown, Penn., 1997.

TPC Sources
Journal Y, ca. 1922–25.
C in M, 1926.
ASD, 1931.
Bull., 1931.
Formes, 1932.
Cat., 1952.
SITES, 1979.
MP, 1998.

MILTON AVERY

1. Murdock Pemberton, review of an Opportunity Gallery (New York) group exhibition "Marin and Others," *Creative Art* 3 (Dec. 1928), 46. Phillips wrote on the painting file cover for *Winter Riders:* "A Still Life was reproduced in Creative Art with favorable notice."

2. DP to Leonora Morton, Morton Galleries, New York, Nov. 12, 1929, TPC Papers, AAA, reel 1939, #368.

3. "Noted in New York Galleries," *Parnassus* 1 (Dec. 1929), 5, as quoted in Hobbs, 1990, 47.

4. The graphite sketch reveals Avery's working method, which persisted throughout his oeuvre: after sketching scenes with penciled-in color notations, he transferred the compositions to the canvas with only slight alterations; in the oil painting, however, the swiftly executed lines of the sketch were transformed into quiet boundaries for flat planes of muted color.

5. Watkins, 1943, n.p.

6. Ibid. For "American Fauve," see Rosamund Frost, "Milton Avery: American Fauve," *Art News* 41 (Dec. 15, 1942), 28.

7. In reviewing a 1944 show of Avery's watercolors at the Phillips Memorial Gallery, the critics referred back to the 1943 show: Jane Watson, "La Fresnaye's Exhibit at Phillips Is Called Indictment of War," *Washington Post,* Jan. 23, 1944; and [Leila Mechlin], "Milton Avery Again Shows at Phillips," *Sunday Star,* Jan. 16, 1944.

8. Quote from DP to Dudensing, Feb. 12, 1943. TPC Papers, AAA, reel 1961, #[obscured]. Four works remain in the collection: *Girl Writing,* 1941, *Pine Cones,* 1940 (acc. no. 0041), *Pink Still Life,* 1938 (acc. no. 0042), and *Shells and Fishermen,* 1940 (acc. no. 0043).

9. Date: Date from Sally Avery to Elmira Bier, TPC, Aug. 12, 1964. Provenance: Purchased from PMG.1943.3, according to DP to VD, Feb. 12, 1943; bill of sale June 24, 1943. Documents in TPC Papers, AAA, reel 1961, #[obscured].

10. Title: Alternate titles are from exhibition catalogues. Written in pencil on the frame reverse, lower center, is "Red Girl." Provenance: Information from painting file. No correspondence or bill of sale have been found; acquisition date confirmed in lists AL14-AL18.

11. The location depicted was identified by Sally Avery in Jo Ann Lewis, "Sally Avery, Out of the Shadows," *Washington Post,* Mar. 5, 1988, and confirmed in a conversation with the author, May 23, 1988.

12. *March on Balcony* may be compared to Matisse's *Open Window, Collioure,* 1905 (collection of Mrs. John Hay Whitney, New York), and Bonnard's *Open Window,* 1921 (cat. no. 101).

13. Inscription: The second inscription appears to be a transcription of an artist's notation that was obscured when the painting was lined. Provenance: The painting was consigned by the artist to Richard Gray Gallery in 1964 (Barbara K. Lewis, Richard Gray Gallery, to GLH, Apr. 25 and May 10, 1988). Upon the artist's death, the work became part of his estate. The TPC purchase is documented in Waldo Rasmussen to Duncan and Marjorie Phillips, June 3, 1965: "Mr. Richard Gray . . . has officially confirmed his agreement to sell to you the Milton Avery painting, *Black Sea.*"

14. Greenberg, 1957, 45.

15. An almost identical watercolor exists entitled *Black Sea,* 1959 (21 × 30 in.; collection of Dr. and Mrs. B. Goldman, Toronto).

Major References
Milton Avery Papers, AAA
Clement Greenberg, "Milton Avery," *Arts* 32, Dec. 1957, 40–45.
Hilton Kramer, *Milton Avery,* New York and London, 1962.
Bonnie Lee Grad, *Milton Avery,* Royal Oak, Mich., 1981.
Barbara Haskell, *Milton Avery,* exh. cat., New York, Whitney, 1982.
Marla Price, "The Paintings of Milton Avery," Ph.D. diss., University of Virginia, 1982.
Burt Chernow, *The Drawings of Milton Avery,* New York, 1990.
Robert C. Hobbs, *Milton Avery,* New York, 1990.
Katonah Museum of Art, *Against the Stream: Milton Avery, Adolph Gottlieb, Mark Rothko,* exh. cat., Katonah, New York, 1994.

TPC Sources
C. Law Watkins, cat. for PMG.1943.3.
Cat. for PMG.1944.1 (no text; checklist only).
Cat., 1952.
MP, 1970 and 1982.
SITES, 1979.
MD, 1981.
Interview with Sally Avery, conducted by Fritz Jellinghouse, cassette tape, 1982.
Stephen B. Phillips, cat. for TPC.1997.4.
MP, 1998.

JOHN D. GRAHAM

1. A descendent of minor Polish nobility, Graham signed his name Dabrowski in early correspondence; his date of birth is taken from his Kiev baptismal records of 1891 (Graham Papers, AAA); under the Julian calendar his birth date was Dec. 27, 1886, which translated to Jan. 8, 1887, under the Gregorian calendar of the West.

2. Although large in number, the Graham holdings were not designated a unit by Phillips. From about 1927 to early 1930 Phillips granted Graham a monthly stipend of $200 in exchange for his choice of paintings—five works in 1927, probably six in 1928, nine in 1929, and at least eight between 1930 and 1933. The

payments (see DP to JG, Oct. 15, 1928) are recorded as purchases, all but five recorded Aug. 15, 1930, several months after Phillips's Feb. 6 letter informing him that this was "the last payment due you according to our agreement." The exact sequence of acquisitions is hard to determine, since Phillips returned some paintings but reacquired them in 1933, when Graham offered them for ten dollars each.

3. Three small sketches (acc. no. 1992.6.1–3) and a painting in 1990 were given by Marjorie Phillips in 1985. *Rue Bréa,* ca. 1928 (oil on canvas, 25 × 20½ in.; gift of Judith H. Miller, acc. no. 1990.6.1.).

4. See exhibition review, "John Graham Turns," *Art Digest* 15 (Nov. 1946), 18. See also Hayden Herrera, "John Graham: Modernist Turns Magus," *Arts Magazine* 51 (Oct. 1976), 100.

5. Manuscript sent with Graham's letter of Dec. 1, 1927; in DP to JG, May 9, 1931, Phillips made a payment and promised to publish "the art catechism or questionnaire" in a future edition of *Art and Understanding;* the manuscript was never published.

6. See text for *Blue Bay* for discussion of suggested changes. TPC files contain two letters to Goodrich, Apr. 8 and 9, 1929, about his stinging review of Graham's New York show at Dudensing Gallery; see "A Round of Galleries," *New York Times,* Apr. 7, 1929, X13. Phillips felt that the Washington exhibition was superior to that in New York.

7. On Feb. 3, 1930, Graham reported on the Stuart Davis exhibition at the Downtown Gallery: "I believe you ought to have an example of his work." Phillips bought *Blue Café* (cat. no. 283). He also bought from Graham Gris's *Abstraction* (cat. no. 147); Burliuk's *Farm at Bear Mountain,* 1925 (cat. no. 294), and *A Seagoing Street,* 1927 (acc. no. 0251); and Cocteau's *Le Mystère Laïc (Giorgio de Chirico),* ltd. ed., no. 49 (Paris, 1928), formerly in Phillips's private library.

8. DP to JG, May 23, 1933.

9. JG to DP, May 23, [1931]. Some parts of this letter made their way into Graham's book, *System and Dialectics,* 1937 (see p. 169 of 1971 ed.).

10. "The Case of Mr. Picasso," ca. 1946, MS in TPC Archives. Graham may have been emboldened by Jung's review of the 1932 Picasso exhibition in the *Neue Zürcher Zeitung,* Nov. 13, 1932, 153:2, in which he alluded to the pathological sources of his art; reprinted in C. G. Jung, "Picasso," *The Spirit in Man, Art, and Literature,* Bollingen Series 20 (Princeton, 1972), 135–41.

11. JG to DP, Mar. 19, 1934, TPC Papers, AAA, reel 1944, #790–93.

12. DP to Thomas B. Grandin, Jan. 29, 1935; the John Simon Guggenheim Memorial Foundation's records do not show that a grant was given (telephone inquiry, Apr. 8, 1992).

13. DP to JG, Apr. 1, 1955.

14. *Formes,* 1932, 200.

15. *E of A,* 1914, 96.

16. Medium: The lower canvas edge shows traces of having been cut, possibly by the artist. *Blue Bay* was painted on the reverse of an abandoned composition, traces of which remain visible along the canvas edges. A cream-colored paint was applied to the reverse of the canvas after it was stretched, evidenced by the paint traces found on the interior stretcher members and the absence of this color beneath the auxiliary

support, suggesting that Graham cut the painting down himself (Elizabeth Steele, painting conservator, Aug. 31, 1990). The painting file cover has a note in an unidentified hand giving a sense of the original dimensions: "Canvas 24 × 16 signed and dated 27 . . . cut down to 8⅜ × 15⅝ and signature cut off." Provenance: Commissioned shortly before Jan. 19; acquired by Mar. 21, 1927.

17. Title: Per artist's inscription on the canvas reverse; French title per Graham's letter, Dec. 8, [1929], "and the third is *Park Montssouri* [*sic*]" and in the caption under the illustration in George, 1929, n.p. Provenance: Graham wrote to DP, Nov. 9, [1929], that he was sending twelve paintings—nine landscapes and three figures—never shown in the United States or Paris. DP answered that he would keep "Wood Interior," among others (Nov. 30, 1929).

18. Title: Alternate title per old painting-file cover. Provenance: Part of the Oct. 14, 1928, shipment, presumably under the stipend arrangement; acknowledged by DP, Oct. 15, 1928; Ledger 15, Aug. 15, 1930.

19. In the 1929 exhibition, Phillips showed sixteen works, seven of them landscapes; thirteen are still in the collection.

20. DP to JG, Mar. 21, 1927. *Blue Bay and Interior* may have been the earliest acquisition (date unknown).

21. Dove's *Golden Storm* and *Waterfall,* both of 1925, were purchased in 1926 (see cat. nos. 246 and 247). In 1925 Phillips had acquired Kent's *Mountain Lake—Tierra del Fuego,* between 1922 and 1925 (cat. no. 224).

22. Cutting *Blue Bay* from a vertical to a horizontal format further increased its similarity to Kent's landscapes. For the Baltimore exhibition, see PMG.1927.3.

23. See especially Cézanne's *Tree-lined Path, Chantilly,* 1888 (private collection), and Derain's forest scenes painted at Martigues around 1912, such as *La Forêt* (15¾ × 18½; collection Rupf, Bern). On Aug. 9, 1928, the same year Derain won first prize at the Carnegie International, Graham reported to Phillips on Derain's works at Zborowski Gallery in Paris.

24. DP to JG, Jan. 19, 1927; other oils include *Mountain Village,* 1927 (acc. no. 0824); *Road by a River,* ca. 1927 (acc. no. 0831); and *Southern Garden,* 1929 (acc. no. 0833). For Derain's role in the 1920s, see *On Classic Ground,* exh. cat., Tate (London, 1990), 92–93.

25. JG to DP, May 24, 1928.

26. DP to JG, Oct. 15, 1928. This painting is also one of three works in the collection illustrated in Graham's *System and Dialectics,* 1971 ed.

27. Title: Phillips, writing to Graham, Jan. 21, 1928: "*Mysteria* which I call *Harlequin and Heavy Horses.*" Provenance: Entered in Ledger 15 under Jan. 31, 1928, but probably sent in 1927 under stipend agreement, since it is listed among "Acquisitions of the Season of 1926–27" in *Bull.,* 1928, 59.

28. Medium: There appears to be a full-face portrait below the present painting; it is noticeable in the strongly textured and impastoed areas of paint (Steele, Aug. 31, 1990). Provenance: According to Phillips's letter of Mar. 14, 1930, this painting was the last to be selected under the stipend agreement.

29. The other two paintings are *Woman and Two Horses,* 1925 (acc. no. 0837), and *Iron Horse,* 1927 (acc. no. 0821). Compare, for instance, de Chirico's *The Joys and Enigmas of a Strange Hour,* 1913 (oil on canvas; private collection). On Jan. 25, 1927, Graham sent Phillips three

small pencil sketches, among them *Riding School,* ca. 1926 (acc. no. 1992.6.1), which shows the harlequin in a fairy-tale, rather than a de Chirico, setting.

30. Graham, *System and Dialectics,* 1971, 115 and 144.

31. Ibid., 144, cites Paolo Uccello as the painter of "severe" horses. He also created several late drawings of himself on horseback in Uccello's manner, such as *Sum Qui Sum,* n.d. (André Emmerich Gallery, New York).

32. DP, introduction to PMG.1929.3, n.p.

33. Graham and Gibson were married from 1924 to 1934; he was notorious for his affairs and friendships with women but remained in contact with Gibson until the end of his life. At the time of their divorce, Phillips wrote only one businesslike note to Graham; possibly he was annoyed by the breakup of their marriage, for the Phillipses had been very fond of Gibson.

34. "Letter to Baltimore," in Graham's privately published book of poems, *Have It!* (New York, 1923), n. p.

35. DP to JG, Mar. 14, 1930.

36. See Picasso's *Studio with Plaster Head,* 1925 (oil on canvas), and *Seated Woman,* 1927 (oil on wood), both owned by the Museum of Modern Art, New York.

37. JG to DP, Dec. 28, [1931, date established by Graham's address]; for a discussion of their friendship, see Jim M. Jordan and Robert Goldwater, *The Paintings of Arshile Gorky: A Critical Catalogue* (New York, 1982), 38–40.

38. Title/Inscription: The title was changed in accordance with the inscriptions on the reverse, which are now obscured by lining but recorded (without giving precise location) in a 1985 conservation report. Provenance: The 1939 "Golden Gate International Exposition" catalogue lists Boyer Galleries as owners. JG to DP, Apr. 16, 1942: "I was glad to learn that you bought the Blue Still-life of mine from Richard Poucette-Dart [*sic*]." Subsequent letters suggest that Graham extracted a share of the sale price from Pousette-Dart; see especially JG to DP, Apr. 16, 1942.

39. Introduction to PMG.1929.3, n. p.

40. JG to DP, May 13 [1931; date established by Graham's address], implying that the painting and others had been sent for approval. According to his May 18 letter, Phillips returned the picture.

41. By 1927 *The Fatal Temple,* 1914 (Philadelphia Museum of Art), was in A. E. Gallatin's Museum of Living Art, New York, near Graham's residence.

42. Steele, Aug. 31, 1990.

43. See Green, essay for TPC.1988.6, 45. Graham was a recognized expert on African art.

44. Graham had introduced his friends to this journal, which in 1930 featured Picasso's *The Studio,* 1928–29 (Museum of Modern Art, New York, gift of Walter P. Chrysler, Jr.); also shown were works by Picasso with striped backgrounds, especially *Glass and Guitar,* 1922 (collection Rosengart, Lucerne); see *Cahiers d'Art,* nos. 2 and 5 (1930), n.p., respectively. These figure-ground experiments appear in Davis's *Salt Shaker* of 1931 (New York, MOMA, gift of Mrs. Edith Gregor Halpert) and Gorky's *Seated Figure Variation,* ca. 1930–31 (private collection). For a discussion, see Sandler, 1968, 50–52, where Graham's and Gorky's works are illustrated.

45. JG to DP, May 13, [1931].

46. DP to JG, Jan. 24, 1942.

47. JG to DP, Feb. 8, 1942. Pousette-Dart's painting

Untitled, Birds and Fish, 1939 (collection of the artist), shows a similar tabletop composition with a large fish at its center.

48. For a discussion of the occult sources, see Graham, *System and Dialectics,* 1971, 23, 53, and 184.

49. Inscription: Aside from astronomical and mathematical signs, the Latin inscriptions are, among others: STELLA POLARIS (the north star), AUREA MEDIOCRITAS (the Golden Section), and IOANNUS MSD (John *Magus Servus Domini*), which denotes Graham's mystical persona in the early 1940s; he used this appellation as a signature in his letter to Phillips Apr. 25, 1955 (TPC Papers, AAA, reel 1984, #0079). Provenance: JG to DP, Feb. 9, 1955: "I am sending you two of my drawings, I wish you and your wife would accept them as a sign of my gratitude for all your many kind and generous acts."

50. "Ten Artists in the Margin: John Graham," interview in *Design Quarterly* 30 (1954), 17.

51. For a discussion of the Ingres revival in the 1930s and 1940s, see Lader, 1978, 94–99.

52. For a decoding of the inscriptions on one version of *Quibeneamat . . .* see Edgerton, 1986, 65–66.

53. JG to DP, Mar. 3, 1954, Graham Papers, AAA.

54. See Edgerton, 1986, 60–68, and Henry Adams, "John Graham's *Woman in Black* and a Related Drawing: The Evolution of an Image," *Arts Magazine* 59 (May 1985), 95–97; related photographs were found among Graham's papers, now at AAA.

55. The photograph was found among the artist's documents, Graham Papers, AAA. This image grew into several works: the remote *Woman in Black,* 1943 (Carnegie Museum of Art, Pittsburgh, G. David Thompson Memorial Fund, 1969); the aristocratic *Marya,* 1944 (collection of Allan Stone, New York); and fierce variants such as the witch *Kali Yuga,* ca. 1952 (collection of Richard S. Zeisler, New York)—all illustrated in Green, cat. for TPC.1988.6, 43, 114, and 117.

56. Rosalind E. Krauss, *The Originality of the Avant-Garde and Other Myths,* 4th ed. (Cambridge, Mass., 1987), 10.

57. JG to DP, Feb. 21, 1955.

58. JG to DP, Apr. 25, 1955.

Major References
John D. Graham Papers, AAA.
Phillips-Graham correspondence, 1927–55, TPC Papers, AAA, and TPC Archives.
Waldemar George, *John D. Graham,* Paris, 1929.
André Salmon et al., *John Graham,* exh. cat., New York, Dudensing Galleries, 1929.
John Graham, "The Dialectics of Art," in William S. Rusk, ed., *Methods of Teaching the Fine Arts,* Chapel Hill, 1935.
————, "Primitive Art and Picasso," *Magazine of Art* 30, Apr. 1937, 236–39, 260.
————, *System and Dialectics of Art,* New York, 1937; rev. ed., annotated and with forewords by Dorothy Dehner and Marcia Epstein Allentuck, Baltimore, 1971.
Fairfield Porter, "John Graham: Painter as Aristocrat," *Art News* 59, Oct. 1960, 39–41, 52.
John Graham, "Excerpts From an Unfinished Manuscript Titled 'Art,'" *Art News* 60, Sept. 1961, 47–48, 58.
Irving Sandler, "John D. Graham: The Painter as Esthetician and Connoisseur," *Artforum* 7, Oct. 1968, 50–53.

Hayden Herrera, "Le Feu Ardent: John Graham's Journal," *AAA Journal*, Nov. 1976, 6–17.

Eila Kokkinen, "John Graham During the 1940s," *Arts Magazine* 51, Nov. 1976, 99–103.

Melvin P. Lader, "Graham, Gorky, de Kooning, and the 'Ingres Revival' in America," *Arts Magazine* 52, Mar. 1978, 94–99.

Anne Carnegie Edgerton, "Symbolism and Transformation in the Art of John Graham," *Arts Magazine* 60, Mar. 1986, 60–68.

TPC Sources
Bull., 1928.
DP, introduction for PMG.1929.3.
ASD, 1931.
Bull., 1931.
Formes, 1932.
DP, "Gallery Notes," unpubl., 1938; formerly MS 90.
Cat., 1952.
SITES, 1979.
Eleanor Green, cat. for TPC.1988.6.
Stephen B. Phillips, cat. for TPC.1997.4.
MSS 25 and 26.

GEORGIA O'KEEFFE

1. Title/Date: The O'Keeffe Foundation, Abiquiu, N.M., in collaboration with the National Gallery of Art, has been preparing a catalogue raisonné. Much of the documentation for these paintings comes from the Georgia O'Keeffe Artist File at the Whitney Museum of American Art, which was partially microfilmed by AAA on reel NY59–13 (hereafter cited as Whitney file, followed by the frame number). The Whitney file was compiled for the American Art Research Council, Whitney, New York, 1942–61, by Rosalind Irvine and Lloyd Goodrich, with additional research by Doris Bry, 1969–72. All research was authorized by O'Keeffe and based on her records and files. The title *The Shanty* may be by O'Keeffe, as suggested by her recollections in Whitney file, reel NY59–13, #165. *My Shanty*, used throughout the painting's history at The Phillips Collection, may also be by O'Keeffe; see Whitney file, #502. *My Shanty, Lake George* per correspondence, Alfred Stieglitz to DP, Feb. 1, 1926. Medium: The picture was painted on the reverse of an unfinished composition. The latter was larger in format and perhaps depicted a landscape as indicated by a moon or sun shape that is present. See technical analysis by Elizabeth Steele, painting conservator, Mar. 4, 1991. Provenance: Bill of sale, Mar. 15, 1926.

2. O'Keeffe was first introduced to the Lake George area in the summer of 1908 as a student at the Art Students League; she had won the Chase Still Life Scholarship to paint at the league's outdoor school in that area.

3. Alexander Brook, "February Exhibitions," *The Arts* (Feb. 1923), 132.

4. According to Peters, 1991, 241–44, Stieglitz's photograph (gelatin silver print, 7⅝ × 9⅜ in.; National Gallery of Art, Alfred Stieglitz Collection), created at the apex of a period of intense and creative collaboration, may have been inspired in part by *My Shanty*, as well as by Marsden Hartley's *The Dark Mountain*, 1909 (oil on composition board, 19¼ × 23¼ in.; Art Institute of Chicago, Alfred Stieglitz Collection).

5. Peters, 1991, 244.

6. There is some reworking around the left edge of the shanty roof where the triangular shape is formed, and

around the leaves where they overlap the mountain. Steele, Mar. 4, 1991.

7. At this time Stieglitz used the bathroom in the farmhouse as his darkroom; he did not have a proper studio until 1927, when he refurbished the Little House. On O'Keeffe's awareness of Kandinsky, see Peters, 1991, 94, 100, 168, and especially 243–44, where she makes the comparison. On this painting as a portrait of her studio, see Eldredge, 1991, 56.

8. Gelatin silver print, 9⅝ × 7⅝ in.; National Gallery of Art, Alfred Stieglitz Collection.

9. Sarah Greenough and Juan Hamilton, *Alfred Stieglitz: Photographs & Writings*, exh. cat., NGA (Washington, D. C., 1983), 231, fig. 52. Interestingly, although O'Keeffe painted Stieglitz's studio several times, *My Shanty* is the only painting of her own studio. *Spring*, which she likewise painted in 1922 (oil on canvas; collection of Gabriella Rosenbaum, Chicago), shows Stieglitz's studio set within a lush landscape of bright greens, pinks, and blues. She also painted a Rousseau-like image entitled *Little House*, 1922 (oil on canvas; private collection).

10. Peters, 1991, 76; quote stems from Claude Bragdon, who in his *Architecture and Democracy* (New York, 1918) used it to refer to the fourth dimension. Peters (p. 75) believes that O'Keeffe had intuited the metaphorical possibilities of the fourth dimension by the late 1910s.

11. Peters, 1991, 99, believes that O'Keeffe's unreal light, a light that seems to emanate from the core of the painting, may also derive from Kandinsky.

12. Peters, 1991, 67–68, believes that Stieglitz's and O'Keeffe's understanding of symbolism stems from European examples, especially Mallarmé, who regarded white as the "presence of light" and the "nothingness of truth" (p. 68). Other avenues include Stieglitz's awareness of Maeterlinck (through his fellow photographer Edward Steichen) and Whistler. Peters (p. 107–8) discusses a specific instance in which Stieglitz borrowed from Whistler's *Symphony in White, No. 1: The White Girl*, 1861–62, to create an image of a sorrowful O'Keeffe dressed in a white kimono in *Georgia O'Keeffe: A Portrait*, 1918 (palladium photograph; National Gallery of Art, Alfred Stieglitz Collection). On O'Keeffe's symbolism, also see Charles C. Eldredge, "Nature Symbolized: American Painting from Ryder to Hartley," in *The Spiritual in Art: Abstract Painting, 1890–1985*, exh. cat., Los Angeles County Museum of Art (Los Angeles, 1986), 115–16.

13. Stieglitz to Sherwood Anderson, Sept. 18, 1923, as quoted in Peters, 1991, 68. In another letter to Anderson, Nov. 28, 1923, as quoted in Greenough and Hamilton, *Alfred Stieglitz: Photographs & Writings*, 209, and discussed on p. 234, Stieglitz wrote: "White—White—White—& soft & clean—& maddening shapes—the whole world in them. And curiously enough at the post office there was an unusually big mail for me. Letters . . . all happened to be very white from very white people. Wonderful letters—several of much significance to me. It was a rare day." O'Keeffe often used white to enhance certain meanings in her compositions, such as in her flower series, among the earliest being of white in her compositions of calla lilies. Also see Sharyn R. Udall, "Beholding the Epiphanies: Mysticism and the Art of Georgia O'Keeffe" in Christopher Merrill and Ellen Bradbury, eds., *From the Faraway Nearby: Georgia O'Keeffe, as Icon* (Reading, Mass., 1992), 99–100.

14. AS to Rosenfeld, Aug. 28, 1920, as quoted in Peters, 1991, 234.

15. As quoted in Metropolitan, *Georgia O'Keeffe: A Portrait by Alfred Stieglitz* (New York, 1978), n.p.

16. He purchased *Red Canna*, 1925 (deaccessioned in 1930; 29 × 18 in.; private collection), and had on approval *Leaf Motif I*, 1924 (returned later that year; 32 × 18 in.; private collection, Minn.).

17. First quote in DP, 1926, n.p.; second in *C in M*, 1926, 66.

18. Both quotes in O'Keeffe, 1976, n.p., fig. 33. Despite her comments, O'Keeffe thought highly enough of this work that she planned to include it in color in her 1976 publication; see OK to MP, June 25, 1975, Foxhall corr., and Laurie Lisle, *Portrait of an Artist: A Biography of Georgia O'Keeffe*, Albuquerque, rev. and enl. (1986), 124–25. For a discussion of O'Keeffe and the gender aspects of her art, see Wagner, 1996, 96–103.

19. Date: Date is supported by O'Keeffe in the Whitney file, #570; she also notes that it was included in her 1924 Anderson Gallery exhibition in New York. Medium/Inscription: A notation on the stretcher reverse in an unknown hand indicates *May 1—1924*; because it includes dimensions, the notation was most likely made by a framer. On the canvas reverse is another painting with generalized forms that suggest a landscape. Steele, Mar. 4, 1991. Title: O'Keeffe approved of *Pattern of Leaves* in the Whitney file, #570. The first alternate title is from early exhibition catalogues. The second and third are erroneous versions that stemmed from a painting entitled *Leaf Motif No. I*, 1924 (oil on canvas, 32 × 18 in.; private collection, Minn.), which Phillips briefly had on approval in 1926; although he returned it to Stieglitz (see DP to AS, Mar. 30, 1926), the title *Leaf Motif* was accidentally retained in museum records as an alternate title for *Pattern of Leaves*, which had been purchased in March. *Oak Leaf* per bill of sale, Mar. 15, 1926, and Ledger 15. Phillips often referred to this work as *Oak Leaves* in correspondence, for example, DP to AS, Mar. 30, 1926, and DP to AS, Mar. 28, 1930; he also exhibited it occasionally under that title. The final alternate title is from a Stieglitz label on the reverse of the painting. The leaf in the work, however, appears to be a maple leaf. Provenance: On Mar. 30, 1926, Phillips wrote asking for the work to be shipped; according to AS to DP, Apr. 7, 1926, it had just been sent. Because the bill of sale is dated Mar. 15, 1926, Phillips probably purchased it while in New York.

20. Peters, 1991, 256, states that O'Keeffe probably began to work on leaves before flowers, and that of the nine known leaf canvases created by 1923 *Pattern of Leaves* is the largest and most experimental.

21. As quoted in O'Keeffe, 1976, n.p. Of her changing style O'Keeffe stated: "I have things in my head that are not like what anyone taught me—shapes and ideas so near to me. . . . I decided to . . . accept [them] as true to my own thinking"; as quoted in *Alfred Stieglitz Presents One Hundred Pictures, Oils, Water-Colors, Pastels, Drawings by Georgia O'Keeffe, American*, exh. cat., Anderson Galleries (New York, 1923), n.p.

22. See Robinson, 1989, 456, and Peters, 1991, 262.

23. Dow had met Ernest Fenollosa (1853–1908), an orientalist and philosopher, in 1891. He developed a series of exercises that he published in his influential book *Composition* (Boston, 1899), which formed the basis of his art curriculum. For discussion, see Peters, 1991, 82–87. For how Dow and Fenollosa affected O'Keeffe's

developing aesthetic, see Turner's essay, "The Real Meaning of Things," TPC.1999.5.

24. O'Keeffe as quoted in Eldredge, 1991, 70; second quote by Peters, 1991, 135.

25. See commentary and illustration in Peters, 1991, 262–63. Turner, in TPC.1999.5, discusses Dow's influence on O'Keeffe's approach to her subject, the process by which she made her formal choices.

26. As quoted in Katharine Kuh, *The Artist's Voice* (New York, 1960), 189 and 190.

27. Peters, 1991, 264. O'Keeffe could have become familiar with Art Nouveau's forms not only through Dow but also through her two years (1908–10) working as a commercial artist in Chicago.

28. The Dove work was reproduced in Arthur Jerome Eddy's *Cubists and Post Impressionism* (Chicago, 1914), 48–49, to which she was introduced by her teacher, Alon Bement. See O'Keeffe, 1976, n.p., and William Innes Homer, "Identifying Arthur Dove's 'The Ten Commandments,'" *American Art Journal* 12, no. 3 (summer 1980), 28.

29. For discussion, see "O'Keeffe's Encounters with Strand, Sheeler, and Steichen" in Peters, 1991, 183–221. Although O'Keeffe later disavowed the influence of photography (for example, see Kuh, *The Artist's Voice*, 191), her art and early comments suggest otherwise. She wrote, in a letter to Strand, June 3, 1917: "I believe Ive [*sic*] been looking at things and seeing them as I thought you might photograph them—Isn't that funny—making Strand photographs for myself in my head"; as quoted in Cowart et al., 1987, 161. And through Charles Sheeler she arrived at new methods for the equalizing of positive and negative space; Peters, 1991, 200–202.

30. For Stieglitz's impact on O'Keeffe, see Turner, TPC.1992.7, 84, and Peters, 1991, 227–28.

31. AS to Paul Strand, Aug. 11, 1919, as quoted in Peters, 1991, 224. Stieglitz likewise found that their collaboration was fomenting a theoretical and formal change in his photography. "I am at last photographing again. . . . It is so sharp that you can see the [pores] in a face—& yet it is abstract. . . . It is a series of about 100 pictures of one person [O'Keeffe]—head & ears—toes—hands—torsos"; AS to Sadakichi Hartmann, Apr. 27, 1919, as quoted in Greenough and Hamilton, *Alfred Stieglitz: Photographs & Writings*, 205.

32. Both quotes in *C in M*, 1926, 66.

33. Title: The official title comes from bill of sale, June 11, 1945. First exhibited as *The Red Hills with Sun*; all alternate titles from various exhibition catalogues. *The Red Hills and the Sun, Lake George* appears on a label on the reverse written in Stieglitz's hand. O'Keeffe approved of *The Red Hills and Sun*, as suggested by Whitney file, reel NY59–13, #98. Provenance: The bequest and subsequent trade by MOMA confirmed by Aileen K. Chuk, associate registrar, MOMA, to TPC, Nov. 30, 1987. PMG purchase per AS to DP, June 11, 1945, and accompanying bill of sale.

34. For example, Lisa M. Messinger has made a good case for O'Keeffe's drawing upon an Edward Weston photograph, *The Ascent of Attic Angles* (which she probably saw in late November or early December 1922), eight years later to create *Black and White, 1930* (oil on canvas; Whitney Museum of American Art). She believes that the catalyst for triggering O'Keeffe's memory was Weston's first solo show in New York in 1930. See Messinger, "Sources for O'Keeffe's Imagery,"

in Merrill and Bradbury, *From the Faraway Nearby*, 55–64.

35. Henry McBride, "Georgia O'Keeffe's Recent Work," *New York Sun*, Jan. 14, 1928.

36. Robinson, 1989, 321–24, and Lisle, *Portrait of an Artist*, 159–61. O'Keeffe stated, "If you ever go to New Mexico, it will itch you for the rest of your life"; as quoted in Eldredge, 1991, 103. She also wrote in a letter to Anita Pollitzer, Sept. 11, 1916, that "it is absurd the way I love this country [Canyon, Texas]. . . . I am loving the plains more than ever it seems—and the SKY—Anita, you've never seen such SKY—it is wonderful"; Pollitzer, 1988, 146.

37. O'Keeffe to Elizabeth Stieglitz Davidson, n.d. [Nov. 24, 1923], Stieglitz/O'Keeffe Archive, Beinecke Library, Yale University. The author wishes to thank Elizabeth Hutton Turner, curator of The Phillips Collection, for bringing this letter to her attention.

38. Although Stieglitz had published an excerpt of this treatise in the July 1912 issue of *Camera Work*, O'Keeffe had been introduced to it by her teacher Alon Bement and through Eddy's *Cubists and Post-Impressionism*. See Cowart et al., 1987, 136, and Peters, 1991, 94–95.

39. Kandinsky, *On the Spiritual in Art* (Munich, 1912), published in *Kandinsky: Complete Writings on Art*, ed. Kenneth C. Lindsay and Peter Vergo, vol. 1 (Boston, 1982), 186. Kandinsky also states (p. 163) that red is most effective if limited and set off from other colors.

40. Ibid., 185.

41. McBride, "Georgia O'Keeffe's Recent Work," 8.

42. Max Weber, "The Fourth Dimension from a Plastic Point of View," *Camera Work*, no. 31 (July 1910), 25. Maurice Tuchman notes Weber's influence on O'Keeffe in "Hidden Meanings in Abstract Art" in *The Spiritual in Art: Abstract Painting, 1890–1985*, 43. Also see Peters, 1991, 72–76. For a fuller discussion of this theory as understood by American modernists, see Linda Dalrymple Henderson, "The Fourth Dimension and Non-Euclidean Geometry in America," in *The Fourth Dimension and Non-Euclidean Geometry in Modern Art* (Princeton, 1983), 164–237.

43. O'Keeffe to William Howard Schubart, July 25, 1951, as quoted in Udall, "Beholding the Epiphanies: Mysticism and the Art of Georgia O'Keeffe," in Merrill and Bradbury, eds., *From the Faraway Nearby*, 98, n. 36.

44. As quoted in Kuh, *The Artist's Voice*, 200.

45. See Peters, 1991, 224. In a now famous letter to Sherwood Anderson, Feb. 11, 1924, O'Keeffe wrote: "His [Stieglitz's] prints of this year are all 4 by five inches all of the sky. They are . . . way off the earth. . . . Mine—My work this year is very much on the ground." As quoted in Cowart et al., 1987, 176. Also see Udall, "Beholding the Epiphanies: Mysticism and the Art of Georgia O'Keeffe" in Merrill and Bradbury, eds., *From the Faraway Nearby*, 95, 110–11.

46. The year 1927 was particularly difficult for O'Keeffe. In August she had a benign tumor removed; in November, Dorothy Norman, with whom Stieglitz was to have an affair, entered their lives at Gallery 291. Also, during the late 1920s, O'Keeffe suffered from the lack of privacy and a need for greater independence and new visual stimulants. See Robinson, 1989, 300–302, 306–8, 316–18; on pp. 384–85 she discusses the significance of illness in O'Keeffe's life and career.

47. Stieglitz, who added the words "Lake George" to the title on the American Place label on the reverse,

probably interpreted this painting as a reminiscence or perhaps even a double portrait of their relationship. "That picture has a significance to me that perhaps no other painting in the world has. Maybe I'm too personal. But no, everyone who sees it comes under its particular spell." AS to DP, June 11, 1945.

48. DP, 1926, n.p.

49. Title: O'Keeffe preferred *Ranchos Church, No. II*, but also used *Ranchos Church, Taos*, as suggested by the Whitney file, #292; confirmed by Juan Hamilton to TPC, May 11, 1987. In correspondence, Phillips and Stieglitz often erroneously referred to the Phillips version as *No. I*, but O'Keeffe's records (#292) indicate that Phillips purchased *No. II*, the title used in the first exhibition. Provenance: Shipped per AS to DP, Mar. 18, 1930, Foxhall corr.; intent to purchase, Mar. 28, 1930; letter with statement, Feb. 27, 1930 (erroneously referred to as *Ranchos Church No. I*); payment per Ledger 15, Nov. 1, 1930.

50. O'Keeffe to Russell Vernon Hunter, Aug. 1931, as quoted in Cowart et al., 1987, 204.

51. Conservation reports suggest that the artist applied two layers of blue in the sky; the first layer is so thin that the canvas threads show through (perhaps as a result of scraping back the paint). The next layer is of a less uniform, thicker blue marked by textured brushstrokes, but in some areas O'Keeffe allowed the first layer to show through. This technique is not apparent in the other O'Keeffe paintings in the collection. Steele, Mar. 4, 1991.

52. The other two in the 1929 series are *Ranchos Church No. I* (oil on canvas, 18½ × 24 in.; Norton Gallery, West Palm Beach, Fla.) and *Ranchos Church No. III* (oil on canvas, 15 × 11; private collection; also called *Fragment of Ranchos Church*). The second series, begun in 1930, was unnumbered. For the other *Ranchos Church* works, see Lisa Messinger, Metropolitan, to Jeffrey Harrison, TPC, Apr. 16, 1987; Julie Schimmel, The Peters Corporation, to TPC, Apr. 15, 1987; and Messinger, *Georgia O'Keeffe* (New York, 1988), 62–65.

53. As quoted in Kuh, *The Artist's Voice*, 191.

54. *Ranchos Church*, 1930 (oil on canvas, 24 × 36, 60.8 × 91 cm.; Metropolitan Museum of Art, Alfred Stieglitz Collection, 1961, 61.258), illustrated in Messinger, *Georgia O'Keeffe*, fig. 48.

55. Kuh, *The Artist's Voice*, 191.

56. *Church, Ranchos de Taos New Mexico*, 1931 (gelatin silver print; Southwestern Bell Corporation, Paul Strand Collection, St. Louis).

57. See Messinger, *Georgia O'Keeffe*, 38. She cites Edward Weston and Imogen Cunningham as examples of photographers whose work was influenced by O'Keeffe, and she illustrates several works by Cunningham (see figs. 25–26).

Major References
Georgia O'Keeffe Foundation, Abiquiu, N.M.
Georgia O'Keeffe Files, Whitney Museum of American Art, Library, Artists Files, New York; partially microfilmed by AAA.
Alfred Stieglitz/Georgia O'Keeffe Archive, Yale Collection of American Literature, Beinecke Rare Book and Manuscript Library, Yale University, New Haven.
Lloyd Goodrich and Doris Bry, *Georgia O'Keeffe*, exh. cat., New York, Whitney, 1970.

Georgia O'Keeffe, *Georgia O'Keeffe*, New York, 1976.

Nicholas Callaway, ed., *Georgia O'Keeffe: One Hundred Letters*, New York, 1987.

Jack Cowart et al., *Georgia O'Keeffe: Art and Letters*, exh. cat., Washington, D.C., NGA, 1987.

Anita Pollitzer, *A Woman on Paper, Georgia O'Keeffe*, New York, 1988.

Barbara Buhler Lynes, *O'Keeffe, Stieglitz, and the Critics, 1916–1929*, Ann Arbor, Mich., 1989.

Roxana Robinson, *Georgia O'Keeffe: A Life*, New York, 1989.

Anna C. Chave, "O'Keeffe and the Masculine Gaze," *Art in America* (Jan. 1990), 115–25, 177, 179.

Clive Giboire, ed., *Lovingly, Georgia: The Complete Correspondence of Georgia O'Keeffe & Anita Pollitzer*, New York, 1990.

Bram Dijkstra, *Georgia O'Keeffe: The New York Years*, New York, 1991.

Charles C. Eldredge, *Georgia O'Keeffe*, New York, 1991.

Sarah Whitaker Peters, *The Early Years: Becoming O'Keeffe*, New York, 1991.

Charles C. Eldredge, *Georgia O'Keeffe: American and Modern*, exh. cat., Fort Worth, InterCultura, and Abiquiu, Georgia O'Keeffe Foundation, 1993.

Anne Middleton Wagner, *Three Artists (Three Women): Modernism and the Art of Hesse, Krasner, and O'Keeffe*, Berkeley, 1996.

Ruth E. Fine et al., *Georgia O'Keeffe's Library*, exh. cat., New York, The Grolier Club, 1997.

Peter H. Hassrick, ed., *The Georgia O'Keeffe Museum*, Santa Fe and New York, 1997.

Bram Dijkstra, *Georgia O'Keeffe, And the Eros of Place*, Princeton, 1998.

Sharyn R. Udall, *O'Keeffe and Texas*, exh. cat., New York, Marion Koogler McNay Art Museum, 1998.

TPC Sources
C in M, 1926.
DP, essay for PMG.1926.2.
DP, essay for PMG.1928.1a.
Ralph Flint, "The Current American Art Season," *A & U*, 1930.
ASD, 1931.
DP, essay to PMG.1931.1.
Formes, 1932.
DP, [tribute], *Stieglitz Memorial Portfolio, 1864–1964*, ed. Dorothy Norman, New York, 1947.
Cat., 1952.
MP, 1970, 1982.
SITES, 1979.
MD, 1981.
Elizabeth Hutton Turner, cat. for TPC.1992.7.
Elizabeth Hutton Turner and Leigh Bullard Weisblat, cat. for TPC.1995.5.
Stephen B. Phillips, cat. for TPC.1997.4.
MP, 1998.
Elizabeth Hutton Turner, cat. for TPC.1999.5.

KARL KNATHS

1. The author wishes to thank Jean and Jim Young for their generous sharing of knowledge about Knaths's life and work.

2. Phillips may have seen Knaths's work in late 1925 during a visit to Daniel Gallery (see itinerary in Journal Y, ca. 1922–25). He made his final purchase, *Scapegoat*, 1966 (lithograph on paper; acc. no. 1042), in 1966, the year of his death.

3. Both quotations from DP to KK, Nov. 5, 1931.

4. Both quotations from "Knaths: Maturity of a Poetic American," 1942, 40.

5. In a letter to Carl [*sic*] Knaths, Feb. 18, 1929, Phillips stated, "For a long time I have meant to write to you."

6. See DP, essay for PMG.1929.7.

7. DP to Charles Daniel, Mar. 20, 1929. On visit, see KK to DP and MP, [ca. Dec.] 1929. In the course of their long association, Phillips gave Knaths fourteen one-person shows and included him in numerous group exhibitions.

8. Ada Rainey, *Washington Post*, "Art and Artists in Washington," Dec. 8, 1929.

9. DP to KK, Nov. 18, 1929. Of the five works purchased, three are still in the collection: *Bananas and Grapes*, ca. 1929 (acc. no. 1005); *Red Table*, 1930 (acc. no. 1041); and *Up Along*, ca. 1927–28 (acc. no. 1051).

10. See his lecture notes in his papers, AAA, reel 2337; for his color theory, see Young, *Ornament & Glory*, 1982, 68–71; see also his statement "An Artist on Color," in a brochure for an exhibition on color, Mar. 1–Apr. 3, 1953, Watkins Gallery, American University.

11. First quote from "Knaths: Maturity of a Poetic American," 1942, 40; next two quotes from *Karl Knaths*, 1942, n.p.

12. Title: Purchased as *Geranium*. The official title was created by Phillips, who often chose more poetic ones than Knaths had assigned. Unfortunately, in many cases Knaths's titles are not known; works were often sent from the gallery with generic titles. Medium: On the reverse is a painting of a rooster; see Elizabeth Steele, painting conservator, Aug. 24, 1990. Provenance: Joe Meierhans to KK, Jan. 26, 1924, Knaths Papers, AAA, reel 2336, #1002, refers to Knaths's painting of a "geranium" hanging at Daniel Gallery. (Meierhans was a friend and frequent correspondent of Knaths's). The painting was probably on consignment to Daniel, as suggested by JM to KK, June 1, 1929, Knaths Papers, AAA, reel 2336, #1047–1049. Bill of sale for PMG purchase, Mar. 10, 1926.

13. For a 1920 graphite drawing of a similar composition, see Young, *Knaths: 1891–1971*, 1982, cat. no. 70.

14. Knaths often used the motif of flowers in a window, which he surely derived from Matisse.

15. Knaths probably saw Chagall's work in a book entitled *Junge Kunst* (1920), which Meierhans had recommended to him; JM to KK, Jan. 26, 1924, AAA, reel 2336, #1001. "Nor did I remain wholly uninfluenced by . . . the subject matter of Chagall and Campendonk," as quoted in *Six Living American Painters*, exh. cat., BMA (Baltimore, 1939), n.p.

16. Although he did not understand Matisse's work, Knaths refused to participate in the student demonstration in which an effigy of Matisse was burned; see Goodrich interview with Knaths, Whitney Papers, AAA, reel N667, #641, and Milton W. Brown, *The Story of the Armory Show* (New York, 1988), 209–10.

17. Both women spent many years in Paris, and Agnes studied with Albert Gleizes. Knaths credits Agnes with his establishing contact with his first dealer, Charles Daniel.

18. As quoted in Goodrich, 1959, 8; statement probably made that year to Goodrich.

19. *C in M*, 1926, 73.

20. Date: JM to KK, Apr. 21, 1928, Knaths Papers, AAA, reel 2336, #1040–1043, mentions a painting of a chicken hanging at Daniel that may be a reference to this work. Title: purchased as *Cock*; official title created by Phillips.

21. See Kuniyoshi's *Cock Calling the Dawn*, 1923, illustrated in *Exhibition of American Contemporary Art*, exh. cat., The Municipal Art Gallery (Atlantic City, N. J., 1929). Daniel Gallery represented both artists, and Kuniyoshi is mentioned in JM to KK, Apr. 21, 1928, Knaths Papers, AAA, reel 2336, #1041. See also Kuniyoshi entry, cat. nos. 299–300.

22. *A & U*, 1929, 113.

23. AB to DP, Nov. 6, 1930, MOMA Archives: Department of the Registrar [MOMA Exh. #9]. The show was "Painting and Sculpture by Living Americans," Dec. 2, 1930–Jan. 20, 1931.

24. *A & U*, 1929, 113–14.

25. Provenance: Bill of sale, Dec. 16, 1931. The fact that the work was consigned is documented by an invoice, Nov. 25, 1931.

26. Ralph Flint, *Art News* 30 (Oct. 31, 1931), 8.

27. DP to Edith Halpert, Downtown Gallery, Nov. 27, 1931, and EH to DP, Nov. 28, 1931.

28. Davis included his *Still Life with Saw* (cat. no. 284) in the Provincetown annual exhibition of modern art; Knaths was a juror.

29. DP, 1950, n.p.; the word *subtly* was crossed out and replaced with *exquisitely*.

30. DP, *Paintings by Karl Knaths*, 1942, n.p.

31. DP to KK, Apr. 18, 1935.

32. DP, *Paintings by Karl Knaths*, 1942, n.p.

33. Title: Purchased as *Deer in Moonlight* but renamed to the official title by Phillips soon after acquisition. Provenance: KK to DP, Oct. 16, 1938.

34. Other related compositions are known; see *Frightened Deer*, ca. 1920 (watercolor and pencil on paper, $8\frac{1}{2} \times 5\frac{1}{2}$; collection of Jean and Jim Young, New York), and *Deer at Sunset*, 1930 (oil on paper, $7\frac{1}{2} \times 7\frac{1}{2}$; collection of Jean and Jim Young, New York), both illustrated in Young, *Ornament & Glory*, 1982, 18.

35. Knaths's diaries reveal the effect nature had on him; see his diaries, 1916–19, Knaths Papers, AAA, reel 2337.

36. See Goodrich Interview, Whitney Papers, AAA, reel N667, #626; Eaton, 1973, 35; and Young, *Ornament & Glory*, 1982, 21. As late as 1966, Knaths was rereading the philosophers Swedenborg and P. D. Ouspensky, as noted in KK to DP, Mar. 13, 1966.

37. DP, essay for PMG.1926.2, n.p. See Redon entry, cat. no. 47.

38. The origin of Knaths's color theory was probably the Ernest Fenollosa/Arthur Wesley Dow system of art education, which was derived from Dow's *Composition* (Boston, 1899), an homage to Fenollosa's ideas. This method was taught at many art schools during the early years of the twentieth century, including Knaths's alma mater, the Art Institute of Chicago. Dow's statement in his book "that space art may be called 'visual music'" (p. 3) is reminiscent of Knaths's own aims in his color and composition charts; see Marianne W. Martin, "Some American Contributions to Early Twentieth-Century Abstractions," *Arts* 54 (June 1980), 160. For one of Knaths's charts and discussion of his theories, see Young, *Ornament & Glory*, 1982, 69–71. Knaths's discussions of color, composition, and music in a series of letters written in the early 1920s reflect at least an awareness of the Fenol-

losa/Dow artistic principles; see, for example, JM to KK, Oct. 22, 1920, #294–295; KK to JM, n.d. (dated 1924 by content), #1010–1016; and KK to JM, Oct. 25, 1926, #1030–1039, all in Knaths Papers, AAA, reel 2336.

39. See analysis by Steele, Aug. 24, 1990.

40. Knaths used a manual with color chips that was based on Wilhelm Ostwald's color classification system to create his palettes. For further discussion of the manuals and system used, see Goodrich, 1959, 17–18, and Eaton, 1973, 36–37. Knaths's concept of a "set palette" recalls Denham Waldo Ross's "set palettes," which establish a harmonious relationship among value, color, and intensity. Ross's statement that "the designer must be able to think in tones, measures, and shapes precisely as the composer of music thinks in sounds of voices and instruments" closely relates to Knaths's own methodology. Knaths may have been exposed to Ross's ideas by Roger Fry's influential 1909 essay "An Essay in Aesthetics," which was published in 1920 in Fry's book *Vision and Design.* For quote and discussion of Fry and Ross, see Martin, "Some American Contributions," 162.

41. As quoted in Goodrich, 1959, 18.

42. DP, "Knaths: Maturity of a Poetic American," 1942, 40.

Major References
Phillips-Knaths correspondence, 1929–66, AAA and TPC Archives.
Karl Knaths Papers, AAA.
E. M. Benson, "Karl Knaths," *American Magazine of Art* 29, May 1936, 364–75.
Lloyd Goodrich, *Four American Expressionists: Doris Caesar, Chaim Gross, Karl Knaths, Abraham Rattner,* exh. cat., New York, Whitney, 1959.
Charles E. Eaton, *Karl Knaths: Five Decades of Painting,* exh. cat., Washington, D. C., International Exhibitions Foundation, 1973.
Jean Young and Jim Young, *Karl Knaths 1891–1971: Works on Paper,* exh. cat., Syracuse, N.Y., Everson Museum of Art, 1982.
———, *Karl Knaths: Ornament & Glory,* exh. cat., Annandale-on-Hudson, N.Y., Edith C. Blum Art Institute, 1982.

TPC Sources
C in M, 1926.
A & U, 1929.
CA, 1929.
DP, essay for PMG.1929.7.
Journal V, 1929.
Ralph Flint, "Current American Art Season," *A & U,* 1930.
DP, [Lists of Illustrations for Handbook], unpubl. lists, ca. 1930; formerly part of MS 97.
ASD, 1931.
Bull., 1931.
Journal I, between 1931 and 1935.
Formes, 1932.
DP, "The Expression of Personality Through Design in the Art of Painting," unpubl. text for slide lecture, 8 versions, ca. 1936–42.
DP, essay for PMG.1941.4.
DP, "Knaths: Maturity of a Poetic American," *Art News* 41, May 1, 1942, 28–29, 40.
DP, *Karl Knaths,* exh. cat., New York, Buchholz Gallery, 1942.
DP, *Paintings by Karl Knaths,* exh. cat., Chicago, AIC, 1942.

DP, "Karl Knaths, Poet of Painting," *News: The Baltimore Museum of Art* 12, Mar. 1949, 6–7.
DP, "Karl Knaths," unpubl. essay, after 1950; formerly MS 29.
Cat., 1952.
DP, *Catholicity Does Not Mean Eclecticism: A Radio Talk by Duncan Phillips,* pamphlet, 1954.
Paul Moscanyi, *Karl Knaths,* The Phillips Gallery, Washington, D.C., 1957.
DP, "Karl Knaths," unpubl. essay, ca. 1962.
MP, 1970 and 1982.
DP, "Introduction," *Memorial Exhibition: Karl Knaths, 1891–1971,* exh. cat., New York, Paul Rosenberg, 1972 (excerpted from earlier writings on Knaths).
Ben Summerford and John Gernand, text for TPC.1982.11.
Stephen B. Phillips, cat. for TPC.1997.4.
MP, 1998.
MS 73.

STUART DAVIS

1. Title: Until recently, this painting had been published as *Egg Beater No. 1,* an issue further confused by correspondence from Edith Halpert to Duncan Phillips, Oct. 29, 1959: "The example you own is No. 1." Davis scholars have shown, however, that this work is in fact number four in the series, as there is an artist's inscription on the preparatory drawing (pencil on paper, 15¼ × 19¼ in.; Meyer Associates, New York) which reads in full: *Stuart Davis Feb 9, 28 / Egg Beater No. 4.* See Sims et al., 1991, 188. Provenance: SD to DP, Dec. 15, 1939, TPC Papers, reel 1952, #1389: "I . . . was pleased that you decided to keep the Egg Beater."

2. The *Egg Beater* series was resumed in 1930 with *Egg Beater No. 5* (oil on canvas, 50⅛ × 32¼ in.; Museum of Modern Art, New York, Abby Aldrich Rockefeller Fund), which was painted several months after Davis's return to New York from Paris. Stylistically this later painting is much closer to French modernist still lifes of the late 1920s. In particular, it has affinities with Braque's table still-life compositions, much like *The Round Table* (cat. no. 140) in The Phillips Collection, which dates from 1929, the period when Davis was in Paris. See Sims, et al., 1991, 199–200.

3. Sweeney, 1945, 16.

4. Quotation from artist's lecture "How to Construct a Modern Easel Painting" at the New School for Social Research, New York, Dec. 17, 1941, as cited in Kelder, 1971, 99.

5. In *Egg Beater No. 1,* 1927 (oil on canvas, 29⅛ × 36 in.; Whitney Museum of American Art, New York, gift of Gertrude Vanderbilt Whitney), the elements of the composition appear to hover in a void, while in *Egg Beater No. 2,* 1928 (oil on canvas, 29¼ × 36¼ in.; collection Mr. and Mrs. James A. Fisher, Pittsburgh), they inhabit a boxlike interior; illus. in Lane, 1978, 131, 141.

6. Ibid., 105, notes that *Egg Beater No. 3,* 1928 (oil on canvas, 25 × 39 in.; Museum of Fine Arts, Boston, gift of the William H. Lane Foundation), represents the still life by day, *Egg Beater No. 4* by night.

7. A photograph of Davis in his Paris studio, 1929, published in Lewis Kachur, *Stuart Davis: An American in Paris,* exh. cat., Whitney Museum of American Art at Philip Morris (New York, 1987), 14, shows *Egg Beater No. 4* hanging on the wall behind him.

8. SD to his father, Sept. 17, 1928, as cited in Kachur, 1987, 6 (letter in collection of Earl Davis, the artist's son).

9. SD to DP, n. d. [probably Oct. 1939], TPC Papers, AAA, reel 1952, #1370.

10. Provenance: Record of payment on Nov. 1, 1930, in Ledger 15.

11. John Graham to DP, Feb. 3, 1930: "There is an interesting show of Stuart Davis on now, fine paintings, and I believe you ought to have an example of his work in your collection." For a discussion of Davis's experiences in Paris, see Turner, TPC.1996.3, 30–37, and Elizabeth Garrity Ellis in Turner, pp. 53–55, 67–68.

12. *A & U,* 1930, 143.

13. *Bull.,* 1931, 21.

14. Comparison of the sketch for *Blue Café* with the oil emphasizes Davis's gradual reduction of detail and perspective toward greater abstraction. Both the drawing and the lithograph are owned by the Amon Carter Museum, Fort Worth: *Study for Au Bon Coin,* 1928–29 (graphite on paper, 10⅜ × 8⅛ in., irreg.); *Au Bon Coin,* 1929 (lithograph, 7¹³⁄₁₆ × 9⅞ in.). They are illustrated in Jane Myers, ed., *Stuart Davis: Graphic Work and Related Paintings with a Catalogue Raisonné of Prints,* exh. cat., Amon Carter Museum (Fort Worth, 1986), 40–41.

15. Kachur, *Stuart Davis: An American in Paris,* 9.

16. Excerpted in Sweeney, 1945, 19.

17. Title: First alternate title from bill of sale. Phillips referred to this painting as *Mandolin and Saw* from the time he acquired the work. The original title is *Still Life with Saw,* according to the artist's inscription on the stretcher. Provenance: Bill of sale, Mar. 13, 1946.

18. The saw may have been manufactured by the engineering firm Cammell Laird and Company, Ltd., in Sheffield, England, since a camel was one of its trademarks. The trademark is illustrated in "British Empire Exhibition," exh. cat., Palace of Engineering (London, 1924), 44.

19. Wilkin, 1987, 174.

20. Oil on canvas, 36⅛ × 28¼ in.; Museum of Modern Art, New York. While in Paris, Davis was certainly aware of Miró's work; his *Dutch Interior I* is illustrated in E. Tériade, "Documentaire sur la Jeune Peinture: Considérations liminaires," *Cahiers d'Art* 8–9 (1929), 364, a publication that Davis probably read. Valentine Gallery in New York held a Miró show Oct. 20–Nov. 8, 1930, some months after the execution of *Still Life with Saw,* which included both of the *Dutch Interior* paintings.

21. Collection of Morton G. Neumann, Chicago; illustrated in Herta Wescher, *Collage* (New York, 1968), pl. 152.

22. Collage, 7 × 7 in.; private collection; illustrated in Ann Lee Morgan, *Arthur Dove: Life and Work with a Catalogue Raisonné* (Newark, 1984), 150; Morgan no. 26.6.

23. Clive Bell, *Art* (New York, 1913), 4.

24. *Bull.,* 1931, 21.

Major References
Stuart Davis Papers, Houghton Library, Harvard University.
Phillips-Davis correspondence, AAA and Stuart Davis Scrapbooks, AAA.
Stuart Davis, *Stuart Davis,* New York, 1945.
James Johnson Sweeney, *Stuart Davis,* exh. cat., New York, MOMA, 1945.
E. C. Goossen, *Stuart Davis,* New York, 1959.

Rudi Blesh, *Stuart Davis,* New York, 1960.

Museum of Modern Art, *Three American Modernist Painters: Max Weber, Maurice Sterne, Stuart Davis,* reprint of three exhibition catalogues at MOMA, New York, 1969.

Diane Kelder, ed., *Stuart Davis,* New York, 1971.

John R. Lane, *Stuart Davis: Art and Art Theory,* exh. cat., Brooklyn Museum, 1978.

Jane Myers, ed., *Stuart Davis: Graphic Work and Related Paintings with a Catalogue Raisonné of the Prints,* Fort Worth, Amon Carter Museum, 1986.

Karen Wilkin, *Stuart Davis,* New York, 1987.

Lowery Stokes Sims et al., *Stuart Davis: American Painter,* exh. cat., New York, Metropolitan, 1991.

Patricia Hills, *Stuart Davis,* New York, 1996.

Philip Rylands, ed., *Stuart Davis,* exh. cat., Venice, Peggy Guggenheim Collection, 1997.

TPC Sources
A & U, 1930.
DP, [List of American Artists], written on the cover of *Paintings and Sculpture by Living Americans,* exh. cat., New York, MOMA, 1930.
Formes, 1930.
ASD, 1931.
Bull., 1931.
Formes, 1932.
Cat., 1952.
MD, 1981.
Karen Wilkin and Lewis Kchur, cat. for TPC 1994.4.
Elizabeth Hutton Turner, cat. for TPC.1996.3.
Stephen B. Phillips, cat. for TPC.1997.4.
MP, 1998.

ALEXANDER CALDER

1. The author wishes to thank Joan M. Marter, professor of art history at Rutgers University, and Alexander S. C. Rower, the Alexander Calder Catalogue Raisonné project, New York City, for so generously sharing their knowledge of Calder's life and work. Title/date: Per Rower in discussion with author, Feb. 17, 1999. Calder probably never titled this work. The alternate titles were probably created by Katherine Dreier while the work was in her collection. Provenance: The date of Dreier's acquisition cannot be securely verified. The researchers of Dreier's collection at Yale University believe that she may have purchased it directly from Calder during his 1938 retrospective at the George Walter Vincent Smith Art Gallery, Springfield, Mass. (courtesy of Ruth L. Bohan, June 27, 1980). This 1938 purchase date, however, is based on Dreier's correspondence, but unfortunately the works were not listed by title; see AC to KD, Nov. 15, 1938, Beinecke Rare Book and Manuscript Library, Yale University. Moreover, the stylistic dating of this work to 1948 makes a 1938 purchase impossible.

2. Calder in Marter et al., 1979, 108, taken from a statement published in "Modern Painting and Sculpture," exh. cat., Berkshire Museum (Pittsfield, Mass., 1933).

3. AC to A. E. Gallatin, Nov. 4, 1934, in Marter, "Alexander Calder: Ambitious Young Sculptor of the 1930s," *Archives of American Art Journal* 16, no. 1 (1976), 4. In it, Calder stresses the nonobjective, kinetic aspects of his work.

4. For further discussion of the importance of constructivist theories on Calder, see Marter, "Constructivism in America: The 1930s," *Arts* 56 (June 1982),

73–80. See also Read and Martin, *Gabo: Constructions, Sculpture, Paintings, Drawings, Engravings,* Cambridge, 1957, for Gabo's constructivist writings.

5. A good example is Calder's *Object with Red Discs,* 1932 (painted sheet metal, wood, wire, and rods; collection of Mr. and Mrs. James Johnson Sweeney, New York), fig. 21 in Marter, "Alexander Calder: Cosmic Imagery and the Use of Scientific Instruments," *Arts* 53 (Oct. 1978).

6. Painted sheet metal and wire; private collection, New York; illus. in Cavandente, 1983, 199. See also *Allonge* and *Six points blancs et disque percé sur orange,* both illus. in Marchesseau, 1989, 198, and *Little Pierced Disc,* illus. in Calder, 1966, 64.

7. This drawing is in the Katherine S. Dreier Papers, Archives of the Société Anonyme, Beinecke Rare Book and Manuscript Library, Yale University, New Haven.

8. As quoted in Marter, "Alexander Calder: Cosmic Imagery," 108.

9. As quoted in Marter, "Alexander Calder: Cosmic Imagery," 109; first published in *Abstraction-Création, Art Non-Figuratif* (Paris, 1932), 6. See also Calder, "What Abstract Art Means to Me: Statements by Six American Artists," *Museum of Modern Art Bulletin* 18 (spring 1951), 8.

10. Title: Rower, in correspondence (Feb. 28, 1994) and conversation with the author (Oct. 8, 1993), believes that this work has been erroneously identified, both during its sale to the museum and in the literature, as *Le Coq de Saché* and that it is actually *Only Only Bird.* Date: Per Rower in discussion with author, Feb. 17, 1999. Provenance: In correspondence with Marjorie Phillips, Aug. 30, 1965, Calder states that Davidson will need to approve the loan to the TPC exhibition. In JD to MP, Mar. 11 and 24, 1966, the terms of the sale are discussed.

11. Examples are *Chock,* 1972 (tin can and wire, 11 × 22 in.; Whitney Museum of American Art, New York, gift of the artist), and *La Touraine,* 1965 (tin can and wire, 32 in. high; collection of Jean and Sandra Davidson, Saché, France). See Marchesseau, 1989, 149–56, for illustrations of a number of these birds.

12. For further discussion of Calder's experiences in Paris, see Elizabeth Hutton Turner, *American Artists in Paris: 1919–1929* (Ann Arbor, 1988), 145–61 and 179–83, and Turner, TPC.1996.4, 37–47. Also see Elizabeth Garrity Ellis's discussion of Calder in Turner, TPC.1996.3, 53–55, 65–67.

13. Calder, 1966, 83. In recounting his experiences in 1926, he tells this story, noting vaguely that it happened years later.

14. A bird toy of 1928 is illustrated in Lipman, 1976, 49.

15. See Marter, "Alexander Calder at the Art Students League," *American Art Review* 4 (May 1978), 54–61 and 117–18.

16. Tin cans and wire; private collection, New York; illus. in Lipman, 1976, 54.

17. JD to MP, Sept. 11, 1965.

18. MP, intro. to TPC.1966.1. Interestingly, Calder had met Marjorie when he was a child; his sister had become friends with the Acker sisters in 1910 while at the Ossining school, and both often visited the Acker home. See Hayes, 1987, 40–41.

Major References
The Alexander and Louisa Calder Foundation, New York.

Alexander and Louisa Calder Papers, AAA.

James Johnson Sweeney, *Alexander Calder,* exh. cat., New York, MOMA, 1943; rev. and enl., 1951.

H. H. Arnason and Pedro Guerrero, *Calder,* New York, 1966.

Alexander Calder, *Calder: An Autobiography with Pictures,* New York, 1966.

Joan M. Marter, "Alexander Calder: The Formative Years," Ph.D. diss., University of Delaware, 1972.

Jean Lipman, *Calder's Universe,* exh. cat., New York, Whitney, 1976.

Joan M. Marter et al. *Vanguard American Sculpture 1913–1939,* exh. cat., New Brunswick, N.J., Rutgers University, 1979.

David Bourdon, *Calder: Mobilist/Ringmaster/Innovator,* New York, 1980.

M. Cavandente, *Alexander Calder,* Milan, 1983.

Margaret Calder Hayes, *Three Alexander Calders: A Family Memoir,* New York, 1987.

Daniel Marchesseau, *Calder Intime,* exh. cat., Paris, Musée des Arts Décoratifs, 1989.

Joan M. Marter, *Alexander Calder,* Cambridge, 1992.

Louisiana Museum for Moderne Kunst, *Alexander Calder, 1898–1976,* exh. cat., Humlebaek, Denmark, 1996.

Marla Prather, *Alexander Calder: The Collection of Mr. And Mrs. Klaus G. Perls,* exh. cat., Washington, D.C., NGA, 1997.

———, *Alexander Calder, 1898–1976,* exh. cat., Washington, D.C., NGA, 1998.

TPC Sources
Cat., 1952.
MD, 1981.
MP, 1982.
Elizabeth Hutton Turner, cat. for TPC.1996.3.
Elizabeth Hutton Turner, publ. chklst. for TPC.1998.3.
Elizabeth Hutton Turner, cat. for TPC.1999.3

LEE GATCH

1. Gatch as quoted in *Lee Gatch,* exh. cat., J. B. Neumann (New York, 1937), n.p.

2. DP, 1949, 283. The Detroit Institute of Arts purchased Gatch's *Bird of Prey,* date unknown (oil on canvas, 16¼ × 20 in.), from J. B. Neumann in 1939, per Carla J. Reczek, DIA, to JLB, July 18, 1989.

3. LG to Marian Willard, Apr. 8, 1943, Gatch Papers, AAA, reel NLG-1, #226.

4. Other Gatch shows followed in 1954, 1956, 1961, and 1988. On the occasion of the 1954 show, the Gatches visited the Phillipses for the first and only time, an experience Elsie Driggs Gatch describes as memorable; EDG to Eliza Rathbone, TPC, Dec. 27, 1986.

5. LG to DP, Dec. 11, 1949, Foxhall corr.

6. LG to DP, Jan. 9, 1953, TPC Papers, AAA, reel 1980, #77.

7. *Snowpatch,* 1954 (oil on canvas; Phillips family private collection).

8. Phillips actually acquired fifteen Gatches: *Snowpatch,* 1954, was purchased in 1954 for Marjorie Phillips's private collection; *Green Landscape,* 1942 (oil on canvas; location unknown), was purchased in 1943 but deaccessioned two years later.

9. *Game Tapestry,* 1965 (oil on cardboard mounted on wood panel, 17⅞ × 21⅞ in.; acc. no. 1985.8.2), and *Home of the Hawk,* 1948 (oil on canvas, 17 × 32 in.; acc. no. 1985.8.3),

were given to the collection in 1985 by Mrs. Margaret Spanel. In 1989 Elsie Driggs Gatch gave *Untitled*, 1926 (oil on cardboard, 5⅞ × 5⅞ in.; acc. no. 1989.7.1).

10. DP to Max Kahn, Dec. 21, 1955, TPC Papers, AAA, reel 1987, #436.

11. DP, 1949, 284.

12. Gatch Notebooks, n. d., AAA, reel 1, #418. This entry can possibly be dated to 1950 on the basis of the first phrase of text, "A half century is hull down." A handwritten notation on the same page reads, "This is before the stones. I cannot give the date." Gatch began working with stone in 1961.

13. Title/Date: *City at Evening* appears in the artist's card file, Gatch Papers, AAA, reel 1128; *The City* per bill of sale. The date has been taken from Gatch's card file (Gatch Papers, AAA, reel 1128) and confirmed in LG to Elmira Bier, TPG, Sept. 29, 1949. Provenance: Bill of sale, May 7, 1943, TPC Papers, AAA, reel 1961, #0193.

14. DP, 1949, 284.

15. Ibid., 283–84.

16. Ibid., 283.

17. Ibid., 285.

18. Date: The date has been taken from Gatch's card file (Gatch Papers, AAA, reel 1128) and confirmed in LG to Elmira Bier, TPG, Sept. 29, 1949. Provenance: No bill of sale; purchased April 1949 from J. B. Neumann per painting file cover; Ledger 15 entry, June 21, 1949.

19. The image was probably painted from Lambertville, N.J., Gatch's hometown, which was located on the Delaware River.

20. For the frame, Gatch cut a weathered board into irregular shapes and stained them blue to achieve the effect of a mosaic; he formed the borders from wooden yardsticks (EDG to ER, Dec. 27, 1986).

21. DP, 1949, 286.

22. Date: The date has been taken from Gatch's card file; Gatch Papers, AAA, reel 1128. Provenance: Bill of sale, Nov. 2, 1956.

23. Painted in Antibes, France, August 1939 (oil on canvas, 81 × 136 in.; Museum of Modern Art, New York, Mrs. Simon Guggenheim Fund).

24. As quoted in Seckler, 1951, 32.

25. As quoted in Seckler, 1956, 31.

26. DP to MK, Oct. 25, 1956, TPC Papers, AAA, reel 1986, #804.

27. DP, 1949, 283.

Major References
Lee Gatch Papers, AAA.
Phillips-Gatch Correspondence, TPC Papers, AAA, and TPC Archives.
Dorothy Seckler, "Gatch Paints a Picture," *Art News* 41, Jan. 1951, 32–35.
———, "Lee Gatch," *Art in America* 44, fall 1956, 29–32, 59–60.
Martica Sawin, "Paintings of Lee Gatch," *Arts* 32, May 1958, 30–33.
Julie Weill, "Lee Gatch," *Art International* 11, May–June 1958, 29–32.
Perry T. Rathbone, *Lee Gatch,* exh. cat., New York, AFA, 1960.
Martica Sawin, *Lee Gatch,* exh. cat., New York, World House Galleries, 1960.
Adelyn D. Breeskin, *Lee Gatch 1902–1968,* exh. cat., Washington, D.C., NCFA, 1971.

Jenny Nathan Strauss, "Lee Gatch: American Artist (1902–1968)," M.A. thesis, Washington University, 1973.

TPC Sources
Phillips-Gatch correspondence, Foxhall corr.
DP, "Lee Gatch," *Magazine of Art* 42, Dec. 1949, 282–87.
Cat., 1952.
MP, 1970.
Eliza Rathbone, cat. for TPC.1988.1.
MP, 1998.

RALSTON CRAWFORD

1. Date: The date 1941–42 was probably provided by the gallery at the time of purchase. The painting was completed by June 1942, because it was exhibited at the Flint Institute of Arts in Michigan. Medium: A graphite underdrawing is visible in places surrounding the forms, such as between the sky and the grain elevators; Elizabeth Steele, painting conservator, Jan. 14, 1991. Provenance: The purchase is recorded as Sept. 17, 1943, in Ledgers 11 and 15. It is possible that Phillips first saw the painting at Whyte Gallery. No reviews have been found for a 1943 show, but a critic reviewing Whyte's 1944 exhibition of work by local artists mentions that the show had been a tradition for several years; see Florence Berryman, "Whyte Gallery Annual," *Sunday Star,* 1944. Crawford wrote to Phillips, June 29, 1943 (TPC Papers, AAA, reel 1960, #413): "It gives me great pleasure to hear that you have purchased my painting, *Boat and Grain Elevators.*"

2. See precisionist artists, Demuth, cat. nos. 260–61, and Sheeler, cat. no. 262.

3. Crawford was greatly disturbed by the destructive potential of nuclear arms; see Cowart, 1978, 14–15.

4. RC to Peggy Frank Crawford, May 12, 1949, as quoted in Haskell, 1985, 9.

5. Crawford saw these artists' work in the private collections of Earle Horter, Samuel and Vera White, and Mr. and Mrs. Maurice Speiser, all in Philadelphia. Sheeler and Crawford did not meet until the early 1940s in the Downtown Gallery, New York. Crawford's student work reflected the influence of Cézanne, whose paintings he saw at the Barnes Foundation as well as in other private collections; see Agee, 1983, 6–8, and Haskell, 1985, 14–21.

6. *Boat and Grain Elevators,* 1942 (oil on canvas; Ralston Crawford estate), illustrated in Agee, 1983, pl. 21. See also *Grain Elevators from the Bridge,* 1942 (oil on canvas; Whitney Museum of American Art, New York), and *Buffalo Grain Elevators,* 1937 (oil on canvas; National Museum of American Art, Smithsonian Institution, Washington, D.C.).

7. Cowart, 1978, 12. Crawford probably acquired his awareness of the cubist concept of blank space as the focus of a composition during his student years at the Barnes Foundation.

8. See Marianne Doezema, *American Realism and the Industrial Age,* exh. cat., CMA (Cleveland, 1980), 74–91, for the sources and meaning of precisionism.

9. DP, *Formes,* 1932, 199. In correspondence with Karl Knaths, to whom he often assumed the role of mentor, Phillips warned against "this new kind of American modernism," because "it delights in mechanical efficiency and labors long and hard on problems of linear achievement"; DP to KK, Feb. 18, 1929. At this time the term "immaculates" was used to identify the precisionists.

10. Immediately after purchase Phillips attempted to sell it in his 1943 Christmas sales exhibition. In his 1952 collection catalogue he included Crawford in the section on promising artists.

Major References
Jack Cowart, "Recent Acquisitions: *Coal Elevators* by Ralston Crawford," *Saint Louis Art Museum Bulletin,* Jan.–Mar. 1978, 10–15; includes interview with the artist.
William C. Agee, *Ralston Crawford,* New York, 1983.
The Art Gallery, University of Maryland, *Ralston Crawford: Photographs/Art and Process,* exh. cat., College Park, 1983.
Barbara Haskell, *Ralston Crawford,* exh. cat., New York, Whitney, 1985.
Laurence Miller Gallery, *Ralston Crawford: Abstracting the Vernacular,* exh. cat., New York, 1995.

TPC Sources
Cat., 1952.

8. THE AMERICAN SCENE

1. *Inv.,* 1921, 11–12. I wish to thank Allison Bishop-Rein, who so ably assisted with the research on this chapter.

2. DP, "To the Editor of *The Art News,*" *Art News* 24 (Feb. 13, 1926), 7.

3. DP, essay for PMG.1927.7, n.p.

4. *CA,* 1929, xxi.

5. *AMA,* 1935, 82.

6. Ibid., 214.

7. "Modern Art and the Museum," *American Magazine of Art* 23, no. 4 (Oct. 1931), 275.

8. According to information in the TPC Archives, Phillips became a sustaining member of the AFA in 1915, possibly beginning his first term as a director in 1922. In a letter to Forbes Watson, then editor of *The Arts,* written on Apr. 29, 1925, and included in that magazine, June 1925, 302, he indicated, "I have been for many years a director of the organization." It is not known when he joined the executive committee, but he stepped down from that position on Jan. 5, 1941, while agreeing to remain on the board of directors.

9. DP to AFA Board of Directors, Mar. 17, 1926.

10. "A Letter from Duncan Phillips," Apr. 29, 1925, *The Arts* 7 (June 1925), 302.

11. MP, 1982, 183–84.

12. PMG.1935.2 was an exhibition of work by PWAP artists in Region 4. PMG.1936.2 showed works by WPA artists, and PMG.1939.5 exhibited studies and drawings by Henry Varnum Poor for his Department of Interior mural.

13. *Formes,* 1932, 197.

ARNOLD FRIEDMAN

1. Friedman's birth date was erroneously published in many sources, variously as 1873, 1879, and 1882; it is cited correctly in David Porter, *Arnold Friedman, 1874–1946,* exh. cat., George Walter Vincent Smith Art Museum, Springfield, Mass., 1947. See also Schack, 1950, 40–46, a close friend of the artist and the best source for biographical information on him.

2. Title: Alternate title, per Ledger 15, Dec. 31, 1940.

Provenance: No bill of sale has been found, but the acquisition date of 1933 in *Sum. Cat.* is incorrect. Duncan Phillips bought *The Brown Derby* in December 1940, after having seen it in a Federal Works Agency show in Washington, D.C. See Edward Rowan to Friedman, Oct. 25, 1940, Arnold Friedman Papers, "Letters 1940" file, and corr. Friedman and Edward Bruce, Dec. 10 and 11, 1940, nos. 0861–0862, Edward Bruce Papers, AAA. Rowan and Bruce were administrators of the Section of Fine Arts for the FWA. Additional information on the sale is found in Friedman to DP, "Xmas 1940," TPC Archives; and Rowan to Friedman, Jan. 23, 1941, "Letters, 1941–1949" file, Friedman Papers.

3. Schack, 1950, 43; the article includes a number of statements by the painter. The context of the statement quoted here suggests that the author was paraphrasing the painter or recalling an earlier conversation.

4. "Arnold Friedman (1882–1946), Portraits of the Twenties," *Zabriskie Gallery Newsletter* 5, no. 6 (Fall–Winter 1983–84), 4.

5. Analysis by Elizabeth Steele, painting conservator, Apr. 29, 1991.

6. Friedman, 1935, 9.

7. Ed Wallace, "Noted Art Gallery Acquires Painting by Retired Clerk: Wins Wide Fame for Works," *Post Office Clerk*, unidentified issue from 1940, n.p., Friedman vertical file, NMAA. Wallace paraphrases an interview with Friedman, including: "Mr. Friedman . . . feels that he can give the fullest account of himself in green."

8. See *Man in Hat,* n.d. (pencil, 8¾ × 8⅛ in.; Salander-O'Reilly Galleries, New York). Michael Klein, who is preparing a monograph on Friedman, first noted the similarity.

9. Schack, 1950, 43.

10. Greenberg, 1957, n.p.

Major References
Arnold Friedman Papers, AAA.
Stephen Bourgeois, *Catalogue of Paintings by Arnold Friedman,* exh. cat., New York, Bourgeois Galleries, 1925.
Arnold Friedman, "Topsoil," *Art Digest* 9, May 1, 1935, 9.
Guy Pène du Bois, *Arnold Friedman,* exh. cat., New York, Bonestell Gallery, 1940.
William Schack, "The Ordeal of Arnold Friedman, Painter," *Commentary* 9, Jan. 1950, 40–46.
Thomas B. Hess, "Friedman's Tragedy and Triumph," *Art News* 48, Feb. 1950, 26–27; 59–60.
Clement Greenberg, *Arnold Friedman (1874–1946),* exh. cat., New York, Jewish Museum, 1950.
Walter Pach, *Arnold Friedman Lent by Sixteen Collectors,* exh. cat., New York, Marquie Gallery, 1950.
Clement Greenburg, *Arnold Friedman 1874–1946,* exh. cat., New York, Zabriskie Gallery, 1957.
Zabriskie Gallery, *Arnold Friedman, Landscapes of the Forties,* exh. cat., New York, 1980.
———, *Arnold Friedman (1882–1946), Portraits of the 1920's and 1930's,* exh. cat., New York, 1983.
William C. Agee and Lawrence B. Salander, "Arnold Friedman (1874–1946): On Our Vocabulary for His Attainments," *Arts* 61, Dec. 1986, 74–76.
Hilton Kramer, *Arnold Friedman (1874–1946),* exh. cat., New York, Salander-O'Reilly Galleries, 1986.
Clement Greenberg et al., *Arnold Friedman, The*

Last Years, exh. cat., New York, Salander-O'Reilly Galleries, 1989.

TPC Sources
Cat., 1952.
MP, 1970 and 1982.

KENNETH HAYES MILLER

1. Provenance: See Miller to DP, Nov. 16, 1926, TPC Papers, AAA, reel 1933, #985.

2. Miller quoted in McCoy, 1973, 21 and 23.

3. Art Students League, *Kenneth Hayes Miller,* exh. cat. (New York, 1949), n.p.

4. Miller quoted in Elizabeth Broun, *Albert Pinkham Ryder,* exh. cat., NMAA (Washington, D.C., 1989), 168. Miller's early Ryderesque style is exemplified in the collection by the Ryder portrait and *Apparition,* 1913 (acc. no. 1355).

5. Miller probably saw Ryder's work at the Macbeth Gallery, New York, which represented both artists' work. They met around 1910 (Broun, "Albert Pinkham Ryder," 167).

6. Miller was born into a religious commune, the Oneida Community, that instilled in its members high ethical and moral values. Ryder, a man who shunned material possessions and who lived virtually for his art, embodied these values that Miller greatly admired and strove to attain.

7. As quoted in Rothschild, 1974, 76.

8. Ibid., 73.

9. Phillips's first Miller purchases were *Consulting the Cards,* 1924 (acc. no. 1356) and *Fantasy of the Antique,* 1913 (oil on canvas, 20 × 17 in.; returned to the artist in 1926).

10. See MP entry (cat. nos. 306–8).

11. DP to Miller, Mar. 25, 1926, TPC Papers, AAA, reel 1933, #910. The "Handbook" to which Phillips refers is *C in M,* 1926.

12. DP to Miller, Apr. 7, 1926, TPC Papers, AAA, reel 1933, #920. Phillips had begun building a Ryder unit in the early 1920s (see Ryder, cat. nos. 70–73).

13. Miller to DP, Mar. 31, 1926, TPC Papers, AAA reel 1933, #911.

14. Rothschild, 1974, 39. Phillips purchased *The Shoppers,* 1920 (oil on canvas, 24⅛ × 20⅛ in.; acc. no. 1358), in 1928. Compare this painting to *Two on a Boulevard,* 1927 (oil on canvas, 21¾ × 18⅛ in.; acc. no. 0604), by Miller's former student Guy Pène du Bois; du Bois's composition and palette reflect Miller's influence.

Major References
Kenneth Hayes Miller Papers, AAA.
Lloyd Goodrich, *Kenneth Hayes Miller,* New York, 1930.
Alan Burroughs, *Kenneth Hayes Miller,* New York, 1931.
C. Law Watkins, "Pictures of People," *American Magazine of Art* 26, No. 11, Nov. 1933, 498–507.
Garnett McCoy, ed., "The Kenneth Hayes Miller Papers," *Archives of American Art Journal* 13, no. 2, 1973, 19–24.
Lincoln Rothschild, *To Keep Art Alive: The Effort of Kenneth Hayes Miller, American Painter (1876–1952),* Philadelphia, 1974.
Ellen Wiley Todd, *The "New Woman" Revised: Painting and Gender Politics on Fourteenth Street,* Berkeley, 1993.

TPC Sources
Journal U, ca. 1919.
C in M, 1926.
Cat., 1952.
MP, 1970 and 1982.

DAVID BURLIUK

1. As quoted in Dreier, 1944, 69.

2. Raphael Soyer, *Self-Revealment, A Memoir* (New York, 1967), 94. The statement, part of a longer essay, has been used in several exhibition catalogues for Burliuk since his death.

3. Burliuk, 1912, 13; reprinted, 1974, 72.

4. Dreier, 1944, 69.

5. *Farm at Bear Mountain,* the first painting to enter into the collection, was purchased from Burliuk via Graham. A letter from Graham to Phillips, Jan. 12, 1930, refers to Burliuk's intention to visit Washington to study the paintings of Marjorie Phillips, and in DB to DP, Nov. 19, 1932, TPC papers, AAA, reel 1941, #314, Burliuk wants to publish one of her pictures in his *Color and Rhyme* periodical. There is no evidence that Burliuk met the Phillipses. Burliuk's solo show was PMG.1939.9.

6. DP, essay for PMG.1939.9, n.p.

7. Ibid.

8. As quoted by Martha Davidson in *David Burliuk,* exh. cat., A.C.A. Gallery (New York, 1939), n.p.

9. Date: Executed in a style Burliuk would return to throughout his career, this work is probably one of the 150 paintings the artist brought with him to the United States in 1922. Glued to the back of the picture is a newspaper with Ukrainian text and the date 1920. Title: Although exhibited as *On the Road,* the painting has these alternate titles in some early PMG documents. Provenance: Ledger 15 documents purchase in May 1939. It is not known how long Boyer owned the work.

10. For a discussion of Burliuk's neoprimitivism, see Barron and Tuchman, 1980, 128. His *Blaue Reiter* work was neoprimitivist.

11. Burliuk, "Surfaceology," *Color and Rhyme* 17 (1947–48), n.p.

12. Analysis by Elizabeth Steele, painting conservator, Aug. 10, 1990.

13. DP, essay for PMG.1939.9, n.p.

14. Title: The official title is Burliuk's transliteration in Cyrillic letters of *Farm at Bear Mountain;* the inscription is not in either Russian or Ukrainian. The author is grateful to Mr. Boris Marchuk, Cultural Attaché, Embassy of Russia, for deciphering the inscription, Jan. 4, 1993. This work has been known by its alternate title since its purchase. Provenance: No bill of sale has been found, but acquisition record AL9, TPC Archives, indicates it was in the collection by 1929. A letter to Burliuk, including payment, was misaddressed and lost, and a second payment was sent to John Graham. Ledger 15, Mar. 14, 1930, documents it as *Landscape (Slopes of Bear Mountain).*

15. *A & U,* 1929, 61.

Major References
Burliuk Family Publications, AAA. (Includes all editions of *Color and Rhyme.*)
David Burliuk, "The 'Savages' of Russia," *Blaue Reiter Almanac* 1, 1912, 13–21; reprinted in Klaus

Lankheit, ed., *The Blaue Reiter Almanac*, New York, 1974, 72–80.

Harry Salpeter, "Burliuk: Wild Man of Art," *Esquire*, July 1939, 63–65, 142, 144–45, and 147.

Raphael Soyer and Bernard Smith, *Burliuk*, exh. cat., New York, A.C.A. Gallery, 1945.

Camilla Gray, *The Russian Experiment in Art: 1863–1922*, New York, 1962.

Alfred Werner, *David Burliuk*, exh. cat., New York, A.C.A. Gallery, 1967.

Cynthia Jaffee McCabe, *The Golden Door, Artist-Immigrants of America, 1876–1976*, exh. cat., Washington, D.C., Hirshhorn Museum and Sculpture Garden, 1976.

Stephanie Barron and Maurice Tuchman, eds., *The Avant-garde in Russia, 1910–1930: New Perspectives*, exh. cat., Los Angeles County Museum of Art, 1980.

Oles Noha, *Davyd Burliuk i mystetstvo vsesvitnoho avanhardu*, Ukraine, 1993.

Elena Basner and Nina Vasileva, *David Burliuk, 1882–1967: vystavka proizvedenii iz Gosudarstvennogo russkogo muzeia*, exh. cat., Saint Petersburg, Gosudarstvennyi russkii muzei, 1995.

TPC Sources
A & U, 1929.
DP, essay for PMG.1939.9.
Katherine S. Dreier, *Burliuk*, New York, 1944 (foreword by DP, reprinting essay for PMG.1939.9).
Cat., 1952.
MP, 1970 and 1982.
Stephen B. Phillips, cat. for TPC.1997.4.

EDWARD HOPPER

1. Titles: Used in exhibitions and TPC records. According to Levin, 1995, no. 0-247, Hopper's record book refers to this work as "Sunday—or Hoboken Façade." Provenance: Bill of sale, Apr. 3, 1926, identifies the work as *Sunday*; Ledger 15, Apr. 13, 1926, as *Sunday Afternoon*. See also Frank Rehn to DP, Apr. 3 and June 16, 1926, TPC Papers, AAA, reel 1934, nos. 157 and 169.

2. Hopper, 1953, 8.

3. Hopper quoted in Alexander Eliot, *Three Hundred Years of American Painting* (New York, 1957), 298.

4. Goodrich, 1950, 54, identified the oil's setting as Hoboken, N.J., yet also indicated that "the places given for the oils refer to the subjects, and are not necessarily where they were painted."

5. Burchfield, "Edward Hopper—Classicist," in Barr, 1933, 16.

6. "America Today," *Brooklyn Daily Eagle*, Mar. 7, 1926 (the author's name is not cited).

7. Hobbs, 1987, 79.

8. *C in M*, 1926, 69.

9. Provenance: Bill of sale, May 26, and Ledger 15, June 8, 1948; however, museum records indicate that the work was acquired by late 1947.

10. Executed in 1925, the watercolor, 13½ × 19½ in., was done on the artist's first trip southwest and was the first Hopper purchased by Phillips.

11. As quoted in William C. Seitz, "Edward Hopper," in *São Paulo 9* (Washington, D.C., 1967), 22.

12. As quoted in Goodrich, 1971, 106.

13. Predicting the imagery of the Phillips oil are *The Railroad*, 1906–7 or 1909 (conté crayon, charcoal, and wash drawing, 17¾ × 14⅞ in.); and *The Locomotive*, 1922 (etching, 13⁹⁄₁₆ × 16⅛ in.), both Bequest of Josephine N. Hopper, Whitney Museum of American Art.

14. The painting, 24½ × 44½ in., is in a private collection.

15. The conté drawing, 1946, 15¹⁄₁₆ × 22⅛ in., is also part of the Bequest of Josephine N. Hopper, Whitney Museum of American Art.

Major References
Edward Hopper Archives, Whitney Museum of American Art, New York.
Lloyd Goodrich, "The Paintings of Edward Hopper," *The Arts* 2, Mar. 1927, 134–38.
Edward Hopper, "John Sloan and the Philadelphians," *The Arts* 11, Apr. 1927, 168–78.
———, "Charles Burchfield: American," *The Arts* 14, July 1928, 5–12.
Guy Pène du Bois," "The American Paintings of Edward Hopper," *Creative Art* 8, Mar. 1931, 187–91.
Alfred H. Barr Jr., *Edward Hopper: Retrospective Exhibition*, exh. cat., New York, MOMA, 1933.
Milton Brown, "The Early Realism of Hopper and Burchfield," *College Art Journal* 7, autumn 1947, 3–11.
Charles Burchfield, "Hopper: Career of Silent Poetry," *Art News* 49, Mar. 1950, 14–17.
Edward Hopper, "Statements by Four Artists," *Reality* 1, Spring 1953, 8.
John Morse, "Interview with Edward Hopper," *Art in America* 48, Mar. 1960, 60–63.
Brian O'Doherty, "Portrait: Edward Hopper," *Art in America* 52, Dec. 1964, 68–88.
Jean Gillies Mueller, "The Timeless Space of Edward Hopper," Ph.D. diss., Northwestern University, 1971.
Lloyd Goodrich, *Edward Hopper*, New York, 1971.
Matthew Baigell, "The Silent Witness of Edward Hopper," *Arts* 49, Sept. 1974, 29–33.
Gail Levin, *Edward Hopper: The Art and Artist*, exh. cat., New York, Whitney, 1980.
———, ed., "Edward Hopper Symposium at the Whitney Museum of American Art," *Art Journal* 41, no. 2, summer 1981, 115–60.
Robert Hobbs, *Edward Hopper*, New York, 1987.
Hubert Beck, *Edward Hopper*, Hamburg, 1992.
Museum Folkwang Essen, *Edward Hopper und die Fotografie: die Wahrheit des Sichtbaren*, Essen, 1992.
Ivo Kranzfelder, *Edward Hopper, 1882–1967: Vision der Wirklichkeit*, Cologne, 1994.
Gail Levin, *Edward Hopper: A Catalogue Raisonné*, 4 vols., New York and London, 1995. (Vol. 4 is a CD-ROM version.)
———, *Edward Hopper: An Intimate Biography*, New York, 1995.
Deborah Lyons and Adam D. Weinberg, *Edward Hopper and the American Imagination*, exh. cat., New York, Whitney, 1995.
Wieland Schmied, *Edward Hopper: Portraits of America*, trans. by John William Gabriel, Munich and New York, 1995.
Deborah Lyons, *Edward Hopper: A Journal of His Work*, New York, 1997.

TPC Sources
C in M, 1926.
DP, essay for PMG.1928.5.
CA, 1929.

A & U, 1929.
ASD, 1929.
Cat., 1952.
MP, 1970 and 1982.
MP, 1998.

JAMES ORMSBEE CHAPIN

1. Provenance: See correspondence between DP and George Hellman, Nov. 8 and 16, 1926, reel 1933, #1130–1131, TPC Papers, AAA, and Nov. 17, 1926, TPC Archives. Ledgers 11 and 15, Jan. 18, 1927.

2. Chapin, undated handwritten manuscript, collection of Mary Chapin. I would like to thank Mrs. Chapin for sharing with me her memories of her husband and for many other materials. Much biographical information on Chapin came from two taped interviews with him by Mary Chapin in 1974 or 1975, "New York City" and "Rabbit Skin Glue." I am also grateful to the Chapin scholar and biographer Brenda Billingsley for her assistance in preparing this catalogue entry.

3. Chapin quoted by O'Brien, 1974, n.p. Edward Hopper and Grant Wood were among the few artists who were Chapin's friends.

4. Chapin to Mrs. Tanner, one of his patrons, Sept. 11, 1944, James Chapin Papers. The letter includes a brief autobiographical sketch.

5. See C. J. Bulliet, "Our American Cezanne Looks at Nature," *Chicago Evening Post*, Dec. 29, 1925, "Magazine of the Art World."

6. Intermittently, but for extended visits, Chapin stayed between four and five years at the Marvin farm. On the basis of a drawing of George Marvin's shoes, dated 1924 (collection of Mary Chapin), he must have gone there in 1924. During the Marvin years, the artist probably also resided in nearby High Bridge, N.J., and in Greenwich Village.

7. Chapin, in an unpublished manuscript, 1975, Chapin Papers, referred to the painting as his "first major painting there" and "first museum sale." In a letter to Elliott and Helen Chapin, Aug. 31, 1972, Chapin Papers, he called it his "first museum sale."

8. Several pencil studies from this period showing Emmett Marvin and his family are in the possession of Mary Chapin, but none relates specifically to this painting.

9. Chapin to Elliott and Helen Chapin, Aug. 31, 1972, Chapin Papers. An undated painting, *Drunken Farmer* (collection of James Chapin Jr., New York), was a response to the sitter's darker, troubled side.

10. DP to George Hellman, Nov. 16, 1926; and essay for PMG.1928.1a, 43.

11. Wood, 1940, n.p.

12. Unpublished manuscript, 1975, Chapin Papers.

Major References
James Chapin Papers, Collection of Mary Chapin, Toronto.
Kenneth Prescott Papers, AAA.
Margaret Breuning, "A Young Painter of American Labor," *International Studio* 70, Apr. 1926, 75–79.
F. L. K., "Paintings of Farm Life," *Survey Graphic*, Aug. 1928, 464–76.
Alfred H. Barr, Jr., *Painting and Sculpture by Living Americans*, exh. cat., New York, MOMA, 1930.
Grant Wood, *James Chapin*, "Sixteen Years of Painting," exh. cat., New York, Associated American Artists Galleries, 1940.

"Evening in the Studio of James Chapin," *American Artist* 5, May 1941, 4–9, 27.

Watson, Ernest W., *Twenty Painters and How They Work*, New York, 1950.

Kathryn B. Greywacz, *James Chapin, A Retrospective Exhibition of Paintings 1921–1955*, exh. cat., Trenton, New Jersey State Museum, 1955.

Maureen C. O'Brien, *James Chapin—The Marvin Years*, exh. cat., Montclair (N.J.) Art Museum, 1974.

Kenneth W. Prescott, *James Chapin*, exh. cat., Toronto, Yaneff Gallery, 1981.

TPC Sources
Journal Y, ca. 1922–25.
DP, essays for PMG.1927.1, PMG.1927.3, and PMG.1927.4.
Bull., 1928.
DP, essay for PMG.1928.5.
Formes, 1930.
ASD, 1931.
Cat., 1952.
SITES, 1979.

HENRY VARNUM POOR

1. The most recent literature cites 1887 as the year of birth for Poor. See Dickson et al., 1983, 81, for chronology.

2. Date: A PMG label on the painting reverse identifies the date as ca. 1944. Dickson et al., 1983, cat. no. 38, cites it as ca. 1943. Provenance: Bill of Sale, June 23, 1944, and Ledger 15.

3. Poor quoted in *Henry Varnum Poor, A Comprehensive Exhibition*, exh. cat., Colby College, Waterville, Me., 1961, n.p.

4. Poor quoted in Boswell, 1941, 23.

5. See Dickson et al., 1983, 10–13, for the relationship between Poor's paintings and French modernism, and in the same catalogue Jeanne Chenault Porter, 20, for a discussion of Sickert's influence.

6. Poor to Emily Genauer, May 4, 1947, reel NG 1, #420, Emily Genauer Papers, AAA.

7. See Ad de Vries, *Dictionary of Symbols and Imagery* (Amsterdam, 1974), 120.

8. Mark Simon, *Henry Varnum Poor 1887–1970* (1983), 63–70, discusses Poor's architectural work in Rockland County. Besides Crow House, Poor designed homes for his friends and neighbors, including Maxwell Anderson, Burgess Meredith, John Houseman, and Milton Caniff.

9. Elizabeth Steele, painting conservator, Apr. 29, 1991, noted the variance and energy of brushwork as well as areas of paint built up by a palette knife on an unprimed surface.

10. Porter, 1983, 9–10. Although Poor used sgraffito in his painting, like other ceramists he employed it regularly in his pottery, scratching his imagery into the wet clay with a sharp tool before adding color with oxides and glazes.

11. As quoted in Boswell, 1941, 75.

12. Ledger 15 lists five works purchased on June 14, 1938, of which four were landscapes and one was a ceramic piece. Presumably, both watercolor landscapes now in The Phillips Collection came from this purchase. A letter to Frank Rehn from E[lmira] B[ier], Mar. 12, 1951, makes reference to three ceramic pieces purchased after being shown in the "Contemporary Ceramics Exhibition," one of which was sold to a private collector. Their location is not known.

13. PMG.1939.5.

Major References
Henry Varnum Poor Papers, AAA.
Ben Hecht, "Henry Varnum Poor," *Creative Art* 8, May 1931, 364–66.
Peyton Boswell Jr., *Varnum Poor*, New York, 1941.
Rose Henderson, "Henry Varnum Poor," *Studio* 123, March 1942, 84–86.
Henry Varnum Poor, "Design: A Common Language," *Craft Horizons* 11, Aug. 1944, 8–10.
———, *An Artist Sees Alaska*, New York, 1945.
"Henry Varnum Poor Discusses Drawing," *American Artist* 10, Jan. 1946, 8–9.
Ernest W. Watson, "Henry Varnum Poor," *American Artist* 17, Mar. 1953, 26–31, 64–65.
Henry Varnum Poor, *A Book of Pottery: From Mud into Immortality*, New York, 1958.
H[arold] E. D[ickson], *The Land Grant Frescoes at the Pennsylvania State University by Henry Varnum Poor*, University Park, [1980].
Harold E. Dickson et al., *Henry Varnum Poor 1887–1970*, exh. cat., University Park, Pennsylvania State University, 1983.
Richard James Porter, "Henry Varnum Poor, 1887–1970: A Biography and Study of his Paintings," Ph.D. diss., Pennsylvania State University, 1983.
———, "The Oil Paintings of Henry Varnum Poor," *Arts* 59, June 1985, 92–96.

TPC Sources
Cat., 1952.
Stephen B. Phillips, cat. for TPC.1997.4.

YASUO KUNIYOSHI

1. Date: Susan Lubowsky (meeting with author, Mar. 1990) based the date on the painting's stylistic similarity to 1923 works, including *Boy Feeding Chickens* (oil on canvas, 73.7 × 59.7 cm.; National Museum of Modern Art, Kyoto) and *Milkmaid* (oil on canvas, 50.8 × 61 cm.; National Museum of Art, Osaka); both are illustrated in Uchiyama et al., 1989, 58–59. Lubowsky cites further confirmation from Sara Kuniyoshi, who asserts a date of 1922–23. Provenance: Bill of sale, Dec. 3, 1940, TPC Papers, AAA, reel 1953, #0040.

2. Kuniyoshi, 1945, n.p., wrote that he did not see his first Western painting—a battle scene—until he was six or seven: "Here was something that was more than decorative and dignified."

3. Susan Lubowsky in "From Naiveté to Maturity: 1906–1939," in Uchiyama et al., 1989, 24, mentions the influence of folk art on Kuniyoshi. She writes that, in Ogunquit, "Folk art, like Cubism, was 'in the air.'"

4. Goodrich, 1948, 13. Milton Brown, *American Painting from the Armory Show to the Depression* (Princeton, 1955), 157–58, discusses the influence of Chagall and Campendonk.

5. Kuniyoshi, 1945, n.p. The term "Bruegel-like" comes from Lloyd Goodrich, 1948, 13. Reviews for Kuniyoshi's 1922 show were mostly favorable; a few of them, however, like that of the *New York Times Book Review and Magazine*, Jan. 15, 1922, mentioned the humor in the artist's work. Many of the reviews can be found in the Kuniyoshi Papers, AAA.

6. DP, 1928, 243.

7. Provenance: Bill of sale, June 1, 1946, TPC Papers, AAA, reel 1966, #1299.

8. Examples are *Susanna*, 1944 (oil on canvas, 45.5 × 33 cm.; Nakano Museum, Nara), and *The Prettiest Girl in the Village*, 1946 (casein on paper, 51 × 33.5 cm.; private collection, Tokyo). They are illustrated in Uchiyama et al., 1989–90, 116–17.

9. Pascin, who lived in the United States from 1915 to 1920, was Kuniyoshi's neighbor in Brooklyn; they met in 1917. Their friendship was cemented during Kuniyoshi's 1928 trip to Paris. Alexander Brook wrote in "Yasuo Kuniyoshi—A Tribute," in Goodall et al., 1975, 54, that "Pascin was the only discernible influence" he could find in Kuniyoshi's art. Brown, *American Painting*, 158–59, discusses the extent of Pascin's influence on American artists.

10. Because he was Japanese, Kuniyoshi was placed under surveillance by the U.S. government at the start of the Second World War. For more detail on these years of the artist's life, refer to Tom Wolf, "The War Years," in Goodrich, Lubowsky, and Wolf, 1986, n.p., and Alexandra Munroe, "The War Years and Their Aftermath: 1940–53" in Uchiyama et al., 1989, 38–44.

Major References
Kuniyoshi Files, Whitney Museum of American Art Papers, AAA.
Kuniyoshi Papers, AAA.
Yasuo Kuniyoshi, *Yasuo Kuniyoshi*, New York, 1945.
Lloyd Goodrich, *Yasuo Kuniyoshi: Retrospective Exhibition*, exh. cat., New York, Whitney, 1948.
Donald B. Goodall et al., *Yasuo Kuniyoshi, 1889–1953: A Retrospective Exhibition*, exh. cat., University Art Museum, University of Texas, Austin, 1975.
Lloyd Goodrich et al., *Yasuo Kuniyoshi*, exh. cat., New York, Whitney at Philip Morris, 1986.
Takeo Uchiyama et al., *Yasuo Kuniyoshi*, exh. cat., Tokyo Metropolitan Teien Art Museum, Okayama Prefectural Museum of Art, and National Museum of Modern Art, Kyoto, 1989.
Fujie Fujikawa, "Yasuo Kuniyoshi: His Life and Art as an Issei," M.A. thesis, University of Arizona, 1990.
Richard A. Davis, *Yasuo Kuniyoshi: The Complete Graphic Work*, San Francisco, 1991.
Yasuo Kuniyoshi Museum, *Yasuo Kuniyoshi*, Okayama, 1991.
Jane Myers, *The Shores of a Dream: Yasuo Kuniyoshi's Early Work in America*, exh. cat., Fort Worth, Amon Carter Museum, 1996.

TPC Sources
DP, "Exhibitions: The Washington Independent," *The Arts* 13, Apr. 1928, 243–44.
DP, [Most Important Living American Artists], unpubl. list, 1929.
A & U, 1930.
Formes, 1932.
Cat., 1952.

THERESA BERNSTEIN

1. Provenance: Bill of sale, Feb. 4, 1924, purchased out of the Ninth Corcoran Biennial.

2. As quoted in Cohen, 1991, n.p.

3. Ramirez quoted by Hall, 1991, 61. William Meyerowitz's oil, *Fruit and Flowers* (acc. no. 1353), was acquired by 1924.

4. Theresa Bernstein to Richard Rubenfeld, May 18, 1991; May 27, 1991; and interview, June 28, 1991.

5. Bernstein to RR, May 27, 1991.

6. As quoted in Movalli, 1980, 64.

7. Ibid., 90–91.

8. Bernstein to RR, May 27, 1991.

Major References
William Meyerowitz and Theresa Bernstein Meyerowitz Papers, AAA.
Milch Galleries, *Paintings by Theresa F. Bernstein,* exh. cat., New York, 1919.
Charles Movalli, "A Conversation with William Meyerowitz and Theresa Bernstein," *American Artist* 44, Jan. 1980, 62–67, 90–92.
Theresa Bernstein Meyerowitz, *William Meyerowitz, The Artist Speaks,* Philadelphia, 1986.
Patricia M. Burnham, "Theresa Bernstein," *Woman's Art Journal* 9, fall–winter 1988–89, 22–27.
Theresa Bernstein Meyerowitz, *The Poetic Canvas,* New York, 1989.
Michele Cohen, *Echoes of New York: The Paintings of Theresa Bernstein,* exh. cat., Museum of the City of New York, 1990.
Trish Hall, "A Painter Wins a New Lease on Fame," *New York Times,* Feb. 17, 1991, "Life Style" section, 61.
Norman L. Kleeblatt and Susan Chevlowe, eds., *Painting a Place in America: Jewish Artists in New York, 1900–1945,* exh. cat., New York, Jewish Museum, 1991.
Theresa Bernstein Meyerowitz, *Journal,* New York, 1991.
——, *Israeli Journal,* New York, 1994.

TPC Sources
Journal GG, 1924.
Cat., 1952.

CHARLES EPHRAIM BURCHFIELD
1. Hopper, 1928, 5–6.

2. Margaret Breuning, "Burchfield's Recent Work," *Arts* 35 (Jan. 1961), 50.

3. Burchfield, introduction to American Artists Group, 1945, n.p.

4. Burchfield, journal entry, Nov. 1917, in Townsend, 1993, 96.

5. For additional information on Burchfield's intellectual and artistic interests, see Baur, 1956, 19–32, and Ketchiff, 1977, 1–12.

6. DP, 1936–42, 17.

7. The watercolor, 30 × 19 in., is in the Cleveland Museum of Art.

8. Burchfield to Mr. and Mrs. Edward Root, July 25, 1932, as quoted in Trovato, 1970, 10.

9. Grace Sherwood to DP, Mar. 1, 1926. Her association with Phillips is not known.

10. DP, 1932, 200.

11. DP, essay for PMG.1933.1b, n.p.

12. DP to Burchfield, Oct. 16, 1933, Foxhall corr. Two other letters from DP to Burchfield have been found: Oct. 24 and Nov. 7, 1933, also part of Foxhall corr.; they are similar in tone to the one from Oct. 16.

13. In Burchfield's journal entry, Nov. 17, 1940, Burch-

field Foundation, he commented on seeing his *Woman in Doorway* as well as the art on display: "he [Phillips] has some fine things there, but much of his collection on view leans heavily to the Da-da side." His journal entry, Nov. 18–20, 1940, Townsend, 1993, 566, suggests that he met Marjorie Phillips on his visit to Washington, D.C. Referring to his first meeting with John Marin, he wrote, "I was drawn to him very strongly (and Mrs. Phillips told me he too, liked me)." No mention was made of meeting Duncan Phillips.

14. Title: The painting is identified as *Woman in a Doorway* in Trovato, 1970, 244, with *Portrait Study in a Doorway* listed as an alternate title. The work was exhibited as *Portrait Study in Doorway* in 1930 at MOMA, and this title is on the bill of sale, Dec. 4, 1933. Whether this was Burchfield's title is not known. Provenance: Early provenance per Trovato, 1970, 56. Bill of sale, Dec. 4, 1933. Three letters from DP to Burchfield, Oct. 16, 24, and Nov. 7, 1933, Foxhall corr., show Phillips's interest in buying the work. Burchfield, whose mother died that year, was financially strapped and was reluctant to sell the painting, but in a letter to Burchfield, Dec. 5, 1933, Rehn Gallery Archives, Frank Rehn convinced him to sell it.

15. Among the very few portraits by Burchfield are *Self-Portrait,* a watercolor from 1916 (19¼ × 13⅝ in.; Charles Rand Penney collection, Lockport, N.Y.), and *Rainy Day,* from 1935 (37¼ × 31¼ in., location not known), a watercolor depicting and once owned by his son, Charles Arthur Burchfield.

16. Analysis by Elizabeth Steele, painting conservator, Aug. 17, 1990.

17. Trovato, 1970, 56. The dates included in his catalogue are based on records that Burchfield kept and a chronology of works prepared in 1942 by John W. Straus, with the assistance of the artist. Burchfield, in Steadman, 1965, 20, refers to 1917 as his "golden year."

18. Burchfield, 1928, xxvii.

19. In *Portrait Study,* also called *Posed by My Mother* and *My Mother Seated in a Darkened Room,* 1917 (watercolor, 25 × 18½ in.; Burchfield Center, Buffalo, Gift of the Retired Alumni Association, State University College at Buffalo), Burchfield chooses a closer viewpoint than that used in the Phillips work and partly engulfs the figure in shadow. *Portrait of My Aunt Emily,* 27⅜ × 18 in., was once owned by Alice Burchfield and eventually became part of the collection of Mr. and Mrs. John Clancy, in New York. Like *Woman in Doorway,* it was included in both the 1930 MOMA show and PMG.1933.1b.

20. *Garden of Memories* (25¼ × 22½ in.; Museum of Modern Art, New York, Gift of Abby Aldrich Rockefeller [by exchange], 1936). See MOMA, 1930, 12. No identification of the woman in this painting has been made. Presumably, Burchfield was using her as a personification of the season.

21. Burchfield, 1928, xxv.

22. Burchfield, journal entry, Jan. 15, 1917, Burchfield Foundation.

23. MOMA, 1930, 10; PMG.1933.1b, n.p.

24. DP, 1936–42, 17.

25. Burchfield, journal entry, Nov. 17, 1940, Burchfield Foundation.

26. Title: Alternate title also appears on American Art Research Council form, filled out Apr. 1943, TPC Archives. Medium: Steele, Aug. 17, 1990. On the reverse

of the painting is an unfinished graphite sketch of trees and meadows, similar to that depicted on the front, inscribed with color notes, numbers, and the word "Evening." Also on the reverse the date, June 19, 1917, appears upside down. Provenance: Ledger 15 lists Aug. 15, 1930. A bill of sale from Rehn, Apr. 15, 1930, for *Ohio River Shanty* and "one early watercolor by Burchfield" may be for *Road and Sky.*

27. Steele, Aug. 17, 1990.

28. Burchfield, journal entry, May 6, 1917, in Townsend, 1993, 587.

29. Burchfield quoted in Belle Krasne, "A Charles Burchfield Profile," *Art Digest* 27 (Dec. 15, 1952), 21.

30. Title: Both titles are listed in Trovato, 1970, 62. Provenance: Bill of sale, Mar. 23, 1931, yet many records, including an American Art Research Council form, filled out in May 1943, give 1930 as date of acquisition. Presumably the painting was sent to PMG in 1930, but the bill did not arrive until Mar. 1931.

31. Hopper, 1928, 7.

32. Trovato, 1970, 60 and 62. In May 1917 Burchfield painted a related work, *Empty Barn and Sheds.* Its location is not known; the watercolor was included in the Burchfield exhibition at Rehn in Nov.–Dec. 1939 and was in Burchfield's possession in 1942.

33. *The Old Barn,* 18 × 25 in., is in Kennedy Galleries, New York.

34. Inscription: Burchfield's explanation for his monogram, from a letter to John W. Straus, Mar. 11, 1942, appears in Burchfield and Jones, 1968, 16–17: "My signature is an adaptation of the Zodiac Aries . . . under which I was born. . . . I freely transcribed it . . . add three prongs to indicate my middle initial . . . and then add the other two initials." Provenance: Bill of sale, Jan. 8, 1947, documents purchase on Jan. 24, 1946; shipping records indicate, however, that the work was sent to PMG in Nov. 1945.

35. *Sultry Afternoon* file, Burchfield Foundation.

36. Burchfield as quoted in Krasne, "A Charles Burchfield Profile," 21.

37. Burchfield, journal entry, Aug. 3, 1944, Burchfield Art Center. Although it is not known for certain that the painting was started or completed that day, only one other journal entry that summer, written six days later, referred to the site. The second entry only identified where the artist painted, suggesting that it was a less significant day. It is possible that Burchfield returned there in the course of painting the picture in an attempt to freshen his memory about the site.

Major References
Journals of Charles E. Burchfield on loan from the Charles E. Burchfield Foundation to the Burchfield Art Center, Buffalo State College, Buffalo, N.Y.
Charles Burchfield Papers, AAA.
Rehn Gallery Papers, AAA.
Edward Hopper, "Charles Burchfield: American," *Arts* 14, July 1928, 5–12.
Charles Burchfield, "On the Middle Border," *Creative Art* 3, Sept. 1928, 22–32.
MOMA, *Charles Burchfield, Early Watercolors, 1916 to 1918,* exh. cat., New York, 1930.
American Artists Group, *Charles Burchfield,* New York, 1945.
John I. H. Baur, *Charles Burchfield,* exh. cat., New York, Whitney, 1956.

William E. Steadman, ed., *Charles Burchfield—His Golden Year,* exh. cat., Tucson, University of Arizona Art Gallery, 1965.

Charles Burchfield and Edith H. Jones, ed., *The Drawings of Charles Burchfield,* New York, 1968.

Joseph S. Trovato, *Charles Burchfield, Catalogue of Paintings in Public and Private Collections,* exh. cat., Utica, N.Y., Munson-Williams-Proctor Institute, 1970.

Matthew Baigell, *Charles Burchfield,* New York, 1976.

Nancy Beardsley Ketchiff, *Charles E. Burchfield at Kennedy Galleries, The Early Years 1915–1929,* exh. cat., New York, Kennedy Galleries, 1977.

———, "The Invisible Made Visible: Sound Imagery in the Early Watercolors of Charles Burchfield," Ph.D. diss., University of North Carolina, Chapel Hill, 1977.

———, *The Inlander, Life and Work of Charles Burchfield, 1893–1967,* East Brunswick, N.J., 1982.

———, *The Early Works of Charles E. Burchfield,* exh. cat., Columbus Museum of Art, Columbus, Ohio, 1987.

J. Benjamin Townsend, ed., *Charles Burchfield's Journals: The Poetry of Place,* Albany, 1993.

Nancy Weekly, *Charles E. Burchfield: The Sacred Woods,* exh. cat., Buffalo, Burchfield Art Center, 1993.

Guy Davenport, *Charles Burchfield's Seasons,* San Francisco, 1994.

Colleen Lahan Makowski, *Charles Burchfield: An Annotated Bibliography,* Lanham, Md., 1996.

Nancy Weekly, ed., *Life Cycles: The Charles E. Burchfield Collection,* Buffalo, 1996.

Nannette V. Maciejunes, *The Paintings of Charles Burchfield: North by Midwest,* exh. cat., Columbus Museum of Art, Columbus, Ohio, 1997.

TPC Sources
A & U, 1929.
ASD, 1931.
Formes, 1932.
DP, essay for PMG.1933.1b.
AMA, 1935.
DP, "The Expression of Personality Through Design in the Art of Painting," slide lecture, 8 versions, ca. 1936–42.
Cat., 1952.
MP, 1970 and 1982.
MP, 1998.

MARJORIE ACKER PHILLIPS

1. As quoted in Phillips, 1985, 18.

2. Laughlin Phillips, foreword to MP, 1982, vii.

3. MP, 1982, 5.

4. She also exhibited at such galleries as the Corcoran Gallery of Art in Washington, D.C., Durlacher Brothers in New York, and Marlborough Fine Arts in London.

5. *C in M,* 1926, 75.

6. First quote, DP, 1948, n.p.; second quote, DP, 1955, n.p.

7. Phillips, 1985, 5.

8. Ibid., 40.

9. Ibid., 76.

10. DP, preface to *ASD,* 1931, n.p.

11. DP, 1955, n.p.

12. Title: Alternate title per PMAG.1922.2. Marjorie Phillips confirmed the title as *Nuns on the Roof* in Phillips, 1985, 30.

13. How long the Phillipses stayed in New York is not clear. MP, 1982, 19, indicates one month, Phillips, 1985, 30, states two.

14. Title: Occasionally dated to 1922, according to Phillips, 1985, 32, the work was painted the following year. Provenance: The painting is listed as part of the collection in Journal GG.

15. In MP, 1982, 63, the hotel is identified as Le Gallia.

16. Phillips, 1985, 32.

17. Provenance: Recorded in acquisition list AL 6, 1951–52, and Cat., 1952.

18. MP, 1982, 189. Phillips recalled a humorous incident in the early 1930s when Duncan Phillips was given a chance to become part owner of the Washington Senators. Tongue in cheek, he agreed to buy into the team, even sell the collection if needed, on the condition that they make him playing manager at his old position at second base. "So they filed out and Duncan was left with the collection."

19. Leila Mechlin, "Notes of Art and Artists," *Sunday Star,* Feb. 11, 1934, which includes a reproduction. The location of the painting is not known. Three years earlier, a work entitled *Baseball,* possibly the same one, was included in PMG.1931.25. Besides *Night Baseball,* only one other painting of the game by Phillips is in the collection: *Giants vs. Mets,* 1964 (oil on canvas, 36¼ × 42 in.; acc. no. 1504).

20. M. Therese Southgate, "The Cover," *Journal of the American Medical Association* 261, no. 24 (June 23–30, 1989), 3500.

21. As quoted by Susan Drysdale in "Night Baseball," *Christian Science Monitor,* Oct. 9, 1971.

Major References
The Phillips Collection Papers, AAA.
Guy Pène du Bois, "Exhibition of Paintings by Marjorie Phillips," exh. cat., New York, Kraushaar, 1924.
F. Newlin Price, "Phillips Memorial Gallery," *International Studio* 80, no. 329, Oct. 1924, 8–18.
"Portrait," *Life* 38, May 23, 1955, 106.
Thomas C. Howe, "Marjorie Phillips," exh. cat., San Francisco, Palace of the Legion of Honor, 1959.
Edward W. Root Art Center, "Paintings by Marjorie Phillips," exh. cat., Clinton, N.Y., Hamilton College, 1965.
Susan Drysdale, "Marjorie Phillips," exh. cat., London, Marlborough Fine Art, 1973.
Charlotte Streifer Rubinstein, *American Women Artists,* Boston, 1982.
Marjorie Phillips, *Marjorie Phillips and her Paintings,* ed. Sylvia Partridge, New York, 1985.

TPC Sources
"The Phillips Memorial Art Gallery," 1921.
Inv., 1921.
Journals EE, ca. 1922, and GG, 1924.
C in M, 1926.
DP, essays for PMG.1926.4; PMG.1926.5; and PMG.1927.5.
Formes, 1930.
ASD, 1931.
DP, "The Expression of Personality Through Design in the Art of Painting," slide lecture, 8 versions, ca. 1936–42.
DP, essay for PMG.1948.9.
Cat., 1952.
DP, *Paintings by Marjorie Phillips,* exh. cat., Washington, D.C., Corcoran Gallery of Art, 1955.
MP, 1970 and 1982.
Marjorie Phillips, C. C. Cunningham, and Perry T. Rathbone, foreword for TPC.1971.2.
SITES, 1979.
PMG.1986.7
Stephen B. Phillips, cat. for TPC.1997.4.
MP, 1998.
MSS 157, 175, and 181.

HAROLD WESTON

1. *ASD,* 1931, 137.

2. I would like to thank Nina Foster, the artist's daughter, for her assistance in researching this essay.

3. DP to Weston, May 1, 1930, Weston Manuscript Collection, AAA, box 2, "Letters, lists, etc., 1930–33."

4. Lecture records. Handwritten notes for the second lecture are in the Weston family collection.

5. Weston's works appeared regularly in group shows. He also had solo shows at Studio House in 1936 and 1937; see Studio House exhibition history, TPC Archives.

6. Wolf, 1978, n.p.

7. Weston, 1939, 16.

8. DP, 1936–42.

9. Interview with Faith Weston by Nina and Rebecca Foster, Mar. 1, 1991.

10. DP, undated reference letter, included in letter to Weston, Mar. 29, 1939, Weston Manuscript Collection, AAA, box 2, "Letters, Lists of Paintings, etc., 1938–39." Phillips, judging from the context of the letter, wrote the reference to help Weston win a Guggenheim Fellowship, which the artist did not receive.

11. Date: A PMG label stuck to the back of the frame is dated "Oct–Nov *1926*." Information in Weston, 1971, 156, supports this date of execution. Provenance: DP to Theodore Sizer, Mar. 21, 1928, and Ledger 11, June 14, 1928.

12. Wolf, 1978, n.p.

13. Weston, 1971, 156.

14. Ibid.

15. The Phillips painting is similar to *Window in the Pyrenees,* an oil from about the same time, reproduced in Wolf, 1978, n.p., that is in the Weston family collection. In that picture, the vantage point is higher and further to the right, putting the stove in a more subordinate position.

16. Wolf, 1978, n.p.

17. Weston, 1971, 106–8, 170.

18. Analysis by Elizabeth Steele, painting conservator, July 23, 1990.

19. Weston, 1939, 19.

20. Wolf, 1978, n.p. In a letter to Theodore Sizer, Mar. 21, 1928, Phillips commented on returning to Montross Gallery to see this work, which had impressed him the previous fall: "Your letter about how much it would mean to him to make a sale at this time decided me to take this little picture."

21. Date: On canvas reverse, possibly by the artist. In a letter to Phillips, Feb. 16, 1933, TPC Papers, AAA, reel

1945, #1239, Weston wrote: "A portrait of John Dos Passos turned out well." Provenance: Correspondence relating to purchase of this work, Feb.–Dec. 1933, TPC Papers, AAA, reel 1945. DP to Weston, Dec. 4, 1933, #1311, confirms purchase. Ledger 11 documents sale on Dec. 28, 1933.

22. Wolf, 1978, n.p.

23. John Dos Passos paraphrased by Weston, 1971, 162.

24. Weston, 1971, 162–63. An abbreviated version of this story appeared in Weston, 1939, 20.

25. Weston, 1971, 163. A portrait of the author, entitled *John Dos Passos,* dated 1933, is in the University of Virginia Art Collection.

26. The painting is identified on an information sheet on Weston's works in The Phillips Collection; Nina Foster made this identification based on data taken from the artist's annotated photo albums. *Profile* is in the Weston family collection.

27. Provenance: Per AL15 and painting file, TPC Archives.

28. Weston to DP, Dec. 28, 1947, Foxhall corr.

29. Weston, 1971, 164–65.

30. Steele, July 23, 1990. According to Faith Weston (Wolf, 1978, n.p.), gouache became a major medium for Weston in the Pyrenees because paintings dried quickly and could be stored in a limited space. In the 1930s he used gouache for mural studies, such as *Auto Body Press,* and for many paintings done in upstate New York, like *Going Home.*

31. As quoted in Henry Tyrell, "A Roundabout Modernist," *New York World,* Nov. 12, 1922; cited in Jean C. Harris, "Harold Weston: The Man and his Art" in Mount Holyoke College, *Harold Weston Retrospective Exhibition,* exh. cat. (South Hadley, Mass.), 1975, 6.

Major References
Harold Weston Manuscript Collection, AAA.
Harold Weston, "Persian Caravan Sketches," *National Geographic* 39, Apr. 1921, 417–68.
Montross Gallery, *Exhibition of Paintings, Adirondack Mountains and Persia, by Harold Weston,* exh. cat., New York, 1922.
Paul Rosenfeld, "Harold Weston's Adventure," *New Republic* 65, Dec. 31, 1930, 190–91.
Lewis Mumford, "The Treasury Murals," *New Yorker* 12, Oct. 17, 1936, 70–71.
Harold Weston, "A Painter Speaks," *Magazine of Art* 32, Jan. 1939, 16–21.
———, *Freedom in the Wilds,* New York, 1971.
Frank Owen, *Harold Weston, Early Adirondack Landscapes,* exh. cat., Adirondack Center Museum, New York, 1976.
Ben Wolf, *Harold Weston Retrospective Exhibition,* exh. cat., Philadelphia Art Alliance, 1978 (includes interview with Faith Weston).
Anne Mackinnon, "A Passionate Nature: The Consummate Art of Harold Weston," *Adirondack* 25, Jan./Feb. 1994, 28–35.

TPC Sources
ASD, 1931.
Formes, 1932.
DP, "The Expression of Personality Through Design in the Art of Painting," slide lecture, 8 versions, ca. 1936–42.
Cat. 1952.
MP, 1970 and 1982.

Sasha Newmann, essay for TPC.1982.8.
Stephen B. Phillips, cat. for TPC.1997.4.

PEPPINO MANGRAVITE

1. Date: Wolff, 1982, 11, dates the work to 1928, the year it was purchased. Nonillusory space, simplified drawing, and a heightened palette are qualities found in other Mangravite works of the later 1920s. Title: Per bill of sale, Apr. 19, 1928. Listed as *Political Exiles* in the 1928 Independents exhibition catalogue. Phillips identified the work as *Exiles* in his 1928 review. Provenance: Bill of sale, Apr. 19, 1928. Ledger 11, entry June 14, 1928.

2. *American Artist,* 1941, 5.

3. Read, 1934, 13. In the correspondence and papers of Mangravite, AAA, there are numerous references to classical mythology, art, and literature, indicating the artist's ongoing fascination with the traditional culture of his homeland.

4. *American Artist,* 1941, 5. The name of the convict who served as Mangravite's first teacher is not recorded.

5. Wolff, 1982, 9.

6. Mangravite, 1952, 176.

7. *American Artist,* 1941, 8. The author commented on Mangravite's belief that an artist who remains in his ivory tower is to blame for being misunderstood by society. Only by responding to the spiritual needs of his contemporaries can he hope to contribute to the richness of life.

8. Mangravite, 1935, 202.

9. DP, 1928, 244.

Major References
Peppino Mangravite Papers, AAA.
Helen Appleton Read, "Peppino Mangravite," *Parnassus* 6, no. 2, Feb. 1934, 13–15.
Peppino Mangravite, "The American Painter and His Environment," *American Magazine of Art* 28, no. 4, Apr. 1935, 198–203.
"Peppino Mangravite—Painter," *Index of 20th-Century Artists* 3, no. 2, Nov. 1935, 191–92.
Peppino Mangravite, "Aesthetic Freedom and the Artists' Congress," *American Magazine of Art* 29, no. 4, Apr. 1936, 235–37, 273.
Donald J. Bear, "Peppino Mangravite," *Magazine of Art* 31, no. 10, Oct. 1938, 582–85, 605.
"Peppino Mangravite," *American Artist* 5, no. 4, Apr. 1941, 5–10, 30.
Peppino Mangravite, "Relation of Creative Design to an Education in the Humanities," *College Art Journal* 11, no. 3, 1952, 172–77.
Theodore F. Wolff, *Peppino Mangravite,* exh. cat., Buffalo, Burchfield Art Center, 1982.

TPC Sources
DP, "Exhibitions: The Washington Independent," *The Arts* 13, no. 4, Apr. 1928, 243–44.
ASD, 1931.
Cat., 1952.

WILLIAM GROPPER

1. Date: The painting was purchased as *Minorities,* per bill of sale, Oct. 24, 1940, and Ledger 15, and this title was used in exhibitions up to TPG.1950.8, when it was referred to as *Refugees.* A painting entitled *Refugees* was included in Gropper's 1937 show but is a different example; see Brace, 1937, 467 and 514. The work was

probably created in 1938 or 1939 for the A.C.A. Gallery show in 1939. A review, "Bold and Dramatic Compositions in New Paintings by Gropper," *Art News* 37 (Mar. 1, 1939), 14, notes that the works (including *Minorities*) were "done in the last year." Freundlich, 1968, 71, however, dates the work to 1937. Provenance: The bill of sale lists two works by Gropper: *The Pretzel Vendor* (no longer in the collection) and *Minorities.*

2. Described by his friend Louis Lozowick, 1986, 13.

3. As quoted in Freundlich, 1968, 13.

4. See Matthew Baigell, *The American Scene: American Painting in the 1930's* (New York, 1974), 55–61, and Werner, 1975, 25–27. Also, Gropper as quoted in Freundlich, 1968, 28.

5. Lozowick, 1986, 49.

6. The Spanish Civil War was the inspiration for many works by Gropper between 1937 and 1939. The author of the review, "Gropper's Left Jab," *Art Digest* 13 (Mar. 1, 1939), 13, discusses the work in the context of this war. *Refugees,* a lithograph from 1937, reproduced in *Original Etchings, Lithographs and Woodcuts Published by the American Artists Group, Inc.* (New York, 1937), 18, is a similar image with different topical significance; it shows American farmers fleeing their farm during a Dust Bowl storm.

7. J. L., "Gropper's Challenging and Powerful Style," *Art News* 35 (Mar. 20, 1937), 23.

8. Whiting, 1989, 50.

Major References
A. C. A. Gallery Papers AAA.
William Gropper Papers, AAA.
E. M. Benson, "Two Proletarian Artists: Joe Jones and Gropper," *American Magazine of Art* 29, Mar. 1936, 188–89.
Ernest Brace, "William Gropper," *Magazine of Art* 30, Aug. 1937, 467–71, 514.
Herman Baron and Joe Jones, *Gropper 1940,* exh. cat., New York, A.C.A. Gallery, 1940.
Joseph Anthony Gahn, "The America of William Gropper, Radical Cartoonist," Ph.D. diss., Syracuse University, 1966.
August L. Freundlich, *William Gropper: Retrospective,* exh. cat., Coral Gables, Fla., University of Miami, 1968.
Alfred Werner, "Ghetto Graduates," *American Art Journal* 5, Nov. 1973, 71–82.
———, "WPA and Social Realism," *Art and Artists* 10, Oct. 1975, 24–31.
Louis Lozowick, *William Gropper,* Philadelphia, 1986.
Nancy Steele Hamme, "Images of Seamstresses in the Art of William Gropper," Ph.D. diss., Binghamton, State University of New York, 1989.
Cécile Whiting, *Antifascism in American Art,* New Haven, 1989.
Emiliano Sorini, *William Gropper: Catalogue Raisonné of the Etchings,* San Francisco, 1998.

TPC Sources
Cat., 1952.
MP, 1970 and 1982.

BEN SHAHN

1. Title: TPC records and exhibition catalogues identify the work alternately as *Silent Music,* which is the title of the serigraph inspired by the painting. Emily Genauer, "Shahn's Bitterness Leavened with Wit," *Art*

Digest 24 (Nov. 12, 1949), 12, saw the work at the Downtown Gallery's Shahn exhibition and identified it as *Silent Music.* Provenance: Information in TPC Archives and records indicates that the work was acquired in Nov. 1949, presumably out of the Downtown Gallery show; Ledger 15, Oct. 6, 1950.

2. Shahn, 1951, 40–41, 131.

3. Shahn, "Aspects of the Art of Paul Klee," *Museum of Modern Art Bulletin* 17 (summer 1950), 7.

4. Soby, 1947, 3.

5. Prescott, 1973, 13. A copy of the brochure is in the New Jersey State Museum collection. Its caption refers to the broadcast's role in generating sales: "The empty studio. . . . No voice is heard now. The music is still. The studio audience has gone home. But the *work* of the broadcast has just begun. All through the week . . . *between* broadcasts . . . people everywhere are buying the things this program has asked them to buy."

6. Ibid., 13–14. The serigraph (16⅞ × 35⅛ in.; New Jersey State Museum) is identified as "undoubtedly the best known of Shahn's prints." A significant subject for the artist, he printed more than one hundred serigraphs as holiday gifts for friends.

7. From a 1965 television interview, as quoted in *Ben Shahn, Paintings and Graphics,* exh. cat., Santa Barbara Museum of Art (1967), n.p.

8. DP to Henry Rox, June 29, 1950. Genauer, "Shahn's Bitterness," 12, also suggests that the work depicts a concert intermission.

9. As quoted in Prescott, 1973, 13.

10. Ibid. In a conversation from 1968, however, published as "Interview: Ben Shahn Talks with Forrest Selvig," *Archives of American Art* 17, no. 3 (1977), 20–21, Shahn ambiguously attributed this title to both his wife and a novelist friend.

11. M. E. B., "Overtones," *Music Educators Journal* (Feb. 1977), 5.

Major References
Ben Shahn Papers, AAA.
James Thrall Soby, *Ben Shahn,* exh. cat., New York, MOMA, 1947.
Ben Shahn, "An Artist's Credo," *College Art Journal* 9, 1949, 43–45.
———, *The Shape of Content,* Cambridge, Mass., 1951.
Selden Rodman, *Ben Shahn: Portrait of the Artist as an American,* New York, 1951.
———, *Ben Shahn: His Graphic Art,* New York, 1957.
Kenneth W. Prescott, *Ben Shahn: A Retrospective Exhibition,* exh. cat., Trenton, New Jersey State Museum, 1969.
Bernarda Bryson Shahn, *Ben Shahn,* New York, 1972.
Kenneth W. Prescott, *Complete Graphic Works of Ben Shahn,* New York, 1973.
Ziva Amishai-Maisels, "Ben Shahn and the Problem of Jewish Identity," *Jewish Art* 12–13, 1987, 304–19.
Frances K. Pohl, *Ben Shahn: New Deal Artist in a Cold War Climate, 1947–1954,* Austin, Texas, 1989.
Norman L. Kleeblatt and Susan Chevlowe, eds., *Painting a Place in America: Jewish Artists in New York, 1900–1945,* exh. cat., New York, Jewish Museum, 1991.
———, *Ben Shahn,* San Francisco, 1993.
Susan H. Edwards, *Ben Shahn and the Task of Photography in Thirties America,* exh. cat., New York, Hunter College of the City University of New York, 1995.
Susan Chevlowe, *Common Man, Mythic Vision: The Paintings of Ben Shahn,* exh. cat., New York, Jewish Museum, 1998.
Howard Greenfeld, *Ben Shahn: An Artist's Life,* New York, 1998.

TPC Sources
Cat., 1952.
MP, 1970 and 1982.
Stephen B. Phillips, cat. for TPC.1997.4.

RAPHAEL SOYER

1. Date: The painting on the reverse is dated 1927. Phillips referred to the work, which he had already seen, in his letter to Valentine Dudensing, Mar. 22, 1933, TPC Papers, AAA, reel 1945, #1189. Provenance: Correspondence between Phillips and Valentine Dudensing, Mar. 22, 1933–Feb. 6, 1934, TPC Papers, AAA, reel 1945, #1173 and 1189–1208, documents Phillips's interest in the work, its loan for inclusion in PMG.1933.6, and its purchase. An undated statement of account for Phillips from Valentine Gallery, Inc., lists date of purchase as Jan. 10, 1934. Ledger 15 identifies the date as Jan. 28, 1935.

2. As quoted in Goodrich, 1972, 13.

3. As quoted in Shenker, 1973, 55.

4. The portrait on the reverse is less compelling visually and psychologically; it probably depicts C. H. Zitter, a student at the Art Students League and Educational Alliance who was a friend of Moses Soyer.

Major References
Raphael Soyer Papers, Moses Soyer Papers, and Isaac Soyer Papers, AAA.
Walter Gutman, "Raphael Soyer," *Creative Art* 6, Apr. 1930, 258–60.
American Artists Group, *Raphael Soyer,* New York, 1946.
Ernest W. Watson, "The Paintings of Raphael Soyer," *American Artist* 12, June 1948, 28–33, 64.
Raphael Soyer, *A Painter's Pilgrimage: An Account of a Journey with Drawings by the Author,* New York, 1962.
———, *Homage to Thomas Eakins, Etc.,* New York, 1966.
Lloyd Goodrich, *Raphael Soyer,* exh. cat., New York, Whitney Museum of American Art, 1967.
Raphael Soyer, *Self-Revealment: A Memoir,* New York, 1969.
———, *Raphael Soyer,* New York, 1972.
Israel Shenker, "Raphael Soyer: 'I Consider Myself a Contemporary Artist Who Describes Contemporary Life'," *Art News* 72, Nov. 1973, 54–57.
Raphael Soyer, *Diary of an Artist,* New York, 1977.
Frank Gettings, *Raphael Soyer, Sixty-five Years of Printmaking,* exh. cat., Washington, D.C., Hirshhorn Museum and Sculpture Garden, 1982.
Norman L. Kleeblatt and Susan Chevlowe, eds., *Painting a Place in America: Jewish Artists in New York, 1900–1945,* exh. cat., New York, Jewish Museum, 1991.

TPC Sources
Cat., 1952.
SITES, 1979.

HOBSON PITTMAN

1. Provenance: Acquisitions records indicate that the work entered the collection in Dec. 1939. Ledger 15 cites Feb. 1, 1940.

2. From "Drift of Consciousness Writings," undated manuscript, Hobson Pittman Papers, reel 1470, #393.

3. Unknown critic cited in *American Artist,* 1945, 8.

4. Stewart and Bundy, 1983, 131.

5. "Drift of Consciousness Writings," reel 1470, #393.

6. Ibid., #392.

7. Dan Miller, *A Portrait of Hobson Pittman: A Life in Three Acts,* 19–20. A copy of this paper, written in 1984 by a former student and close friend of the artist, is in the TPC Archives.

8. Undated reference letter by DP to the Fulbright Commission, enclosed in E[lmira] B[ier] to HP, Sept. 15, 1953. It is not known when Phillips and Pittman met, but correspondence indicates that they saw each other at exhibitions. DP to HP, undated draft in Foxhall corr., refers to a time when Phillips went to State College to present awards to Pittman's students.

Major References
Hobson Pittman Papers, AAA.
"Hobson Pittman," *American Artist* 9, Sept. 1945, 8–12.
Ben F. Williams, *Hobson Pittman,* exh. cat., Raleigh, North Carolina Museum of Art, 1963.
Evan H. Turner, *Hobson Pittman,* exh. cat., New York, Babcock Galleries, 1970.
William Hull, *The World of Hobson Pittman,* exh. cat., University Park, Pennsylvania State University, and Philadelphia, Pennsylvania Academy of the Fine Arts, 1972.
Rick Stewart and David S. Bundy, *Painting in the South: 1564–1980,* exh. cat., Richmond, Virginia Museum of Fine Arts, 1983.

TPC Sources
Cat., 1952.
MP, 1970 and 1982.

ISABEL BISHOP

1. Title/Provenance: Bill of sale, July 31, 1941, and some early records identify this work as *Lunch Hour.* Ledgers 11 and 15 list payment by Oct. 30, 1941. Sales records, Corcoran Gallery of Art Archives, indicate that *Lunch Hour* was sold from the 17th Biennial Exhibition of Contemporary American Oil Paintings to PMG.

2. As quoted in "American Painting Bought by the Metropolitan," Feb. 20, 1936, unidentified newspaper, reel NY 59–4, #933, Isabel Bishop Papers.

3. Todd, 1989, 25.

4. As quoted in Lunde, 1975, 35.

5. The etching, cat. no. 24 in Teller, 1981, is 7¼ × 3⅞ in. Printed by Bishop, it was included in *Eight Etchings I,* published in 1978 by Associated American Artists.

6. As quoted in Lunde, 1975, 43.

7. As quoted in "They Drink and Fly Away," *Time* (May 23, 1949), 63.

Major References
Isabel Bishop Papers, AAA.
Isabel Bishop, "Concerning Edges," *Magazine of Art* 38, May 1945, 168–73.

Dorothy Seckler, "Bishop Paints a Picture," *Art News* 50, Nov. 1951, 38–41, 64.

Isabel Bishop and Reginald Marsh, "Kenneth Hayes Miller," *Magazine of Art* 45, Apr. 1952, 168–71.

Isabel Bishop, "Isabel Bishop Discusses 'Genre' Drawings," *American Artist* 17, July–Aug. 1953, 46–47.

Una E. Johnson and Jo Miller, *Isabel Bishop: Prints and Drawings 1925–1964*, exh. cat., Brooklyn Museum, 1964.

Sheldon Reich, *Isabel Bishop*, exh. cat., Tucson, University of Arizona Museum of Art, 1974.

Lawrence Alloway, "Isabel Bishop: The Grand Manner and the Working Girl," *Art in America* 63, Sept.–Oct. 1975, 61–65.

Karl Lunde, *Isabel Bishop*, New York, 1975.

Susan Pirpiris Teller, *Isabel Bishop Etchings and Aquatints: catalogue raisonné*, New York, 1981; 2nd ed., 1985.

Ellen Wiley Todd, "Isabel Bishop, The Question of Difference," *Smithsonian Studies in American Art*, fall 1989, 25–41.

Helen Yglesias, *Isabel Bishop*, New York, 1989.

James M. Dennis, *Between Heaven and Hell: Union Square in the 1930s*, exh. cat., Wilkes-Barre, Pa., Sordoni Art Gallery, 1996.

TPC Sources
Cat., 1952.
MP, 1982.

ALLAN ROHAN CRITE

1. Biographical material in this section is drawn from the published material listed below as well as from an interview with Allan Rohan Crite by Richard Rubenfeld and Mark Steele held May 17, 1991, in Boston. I would like to express my gratitude to Mr. Crite for his assistance in gathering material for this catalogue. I also want to thank Ms. Jackie Cox-Crite for reading and offering comments on this text; see Jackie Cox-Crite to Charles S. Moffett, Oct. 31, 1995.

2. Title: Ledger 15 and Acquisitions Lists III refer to this painting as *Parade*. *I Love a Parade* appears on a loan form, Studio Museum in Harlem, March 3, 1982. Provenance: A bill of sale has not been found. Edith Halpert to Elmira Bier, Feb. 26, 1942, reel 1958, #896, TPC Papers, AAA, refers to a Crite work as one selected by the Phillips. It is possible that it is the same work as *Street Scene*, an oil shown in PMG.1936.2 as part of a WPA exhibition. Presumably, this work introduced Crite's art to the Phillipses. Ledger 15 and acquisition lists confirm the purchase, Oct. 9, 1942. On the painting's reverse is a sticker from Grace Horne Galleries, 71 Newbury Street, Boston, which represented Crite during the 1930s; presumably, the work was exhibited and for sale there; a note on the label suggests that it was also shown at the Rhode Island School of Design. In the interview, May 17, 1991, Crite was unable to recall how the work wound up at the Downtown Gallery, but he did recall receiving money for it.

3. *School's Out*, 1936 (oil on canvas; National Museum of American Art, Washington, D.C.), and *Tyre Jumping*, 1936 (oil on canvas; International Business Machines Corp., New York), are works close in style and emphasis that show Crite's PWAP and WPA genre imagery.

4. Crite to Janice Miller, TPC, Dec. 10, 1981.

5. Interview, May 17, 1991.

6. Lecture for Fine Art's Program Library, unspecified institution, Feb. 20, 1944, reel 3911, #515, Crite Papers, AAA.

7. Interview, May 17, 1991. The artist commented on his fascination with the art of Flemish masters such as Rogier Van Der Weyden. Crite worked from a graphite sketch on a red-veiled surface and used a rich oil medium, varied brushwork, and intermittent scumbling. Analysis by Elizabeth Steele, painting conservator, Apr. 29, 1991.

8. Interview, May 17, 1991.

Major References
Allan Rohan Crite Papers, AAA. Includes interviews with the artist by Robert Brown, Jan. 16, 1979–Oct. 22, 1980.

Allan Rohan Crite, *Were You There When They Crucified My Lord*, Cambridge, Mass., 1944.

———, *Three Spirituals from Earth to Heaven*, Cambridge, Mass., 1948.

Cedric Dover, *American Negro Art*, Greenwich, Conn., 1960; reprint, 1965.

The Evolution of Afro-American Artists: 1800–1950, exh. cat., City University of New York, Harlem Cultural Council and New York Urban League, 1967.

Theresa Dickason Cederholm, ed., *Afro-American Artists: A Bio-Bibliographical Directory*, Boston, 1973.

Ed Rader, "Crite Commits Living History to Canvas," *Boston Ledger*, Oct. 17–23, 1980, 15.

Edward J. Nygren et al., *Of Time and Place, American Figurative Art from the Corcoran Gallery*, exh. cat., Washington, D.C., SITES and Corcoran, 1981.

Leslie King Hammond, *Ritual and Myth: A Survey of African American Art*, exh. cat., New York, Studio Museum in Harlem, 1982.

Michael Rosenfeld Gallery, *African-American Art: 20th Century Masterworks*, exh. cat., New York, 1994.

JACOB LAWRENCE

1. Title: In 1993 Lawrence revised the title of the series and the narrative of the captions. His new title is *The Migration Series*. The new captions read as follows. Panel 3: "From every southern town migrants left by the hundreds to travel north." Panel 51: "African Americans seeking to find better housing attempted to move into new areas. This resulted in the bombing of their new homes." Panel 57: "The female workers were the last to arrive north." See Turner, TPC.1993.2, 165. Medium: The odd-numbered panels are in The Phillips Collection; the even-numbered ones are in the Museum of Modern Art, New York. See Elizabeth Steele's comments on Lawrence's technique in Turner, TPC.1993.2. Provenance: Bill of sale and letter from same date from Edith Halpert to DP, Feb. 21, 1942, reel 1958, #893 and 909, TPC Papers, AAA, document the sale and the splitting of the series so that both PMG and MOMA could buy half; the letter also refers to Phillips's decision to allow the works to be seen as a unit at MOMA. Entered in Ledger 15, June 23, 1942.

2. I would like to thank Jacob and Gwendolyn Lawrence for granting me an interview, Aug. 19, 1991, and for their gracious assistance in researching this series.

3. As quoted in Wheat, *Jacob Lawrence, American Painter*, 1986, 60.

4. Lawrence, Aug. 19, 1991, could not recall what happened to the sketches.

5. As quoted in Wheat, *Jacob Lawrence, American Painter*, 1986, 60.

6. Interview, Aug. 19, 1991.

Major References
Jacob Lawrence Material, George Arents Research Library, Syracuse University, New York, and University of Washington Archives, Seattle.

Jacob Lawrence Papers, AAA.

Downtown Gallery, "American Negro Art, 19th and 20th Centuries," exh. cat., New York, 1941.

Alain Locke, ". . . And the Migrants Kept Coming," *Fortune* 24, Nov. 1941, 102–9.

J. G., "Jacob Lawrence's Migrations," *Art Digest* 19, Nov. 1, 1944, 7.

Elizabeth McCausland, "Jacob Lawrence," *Magazine of Art* 38, Nov. 1945, 250–54.

Romare Bearden and Harry Henderson, *Six Black Masters of American Art*, New York, 1972.

Milton Brown, *Jacob Lawrence*, exh. cat., New York, Whitney, 1974.

David C. Driskell, *Two Centuries of Black American Art*, exh. cat., LACMA, 1976.

Milton Brown, *One Hundred Masterpieces of American Painting from Public Collections in Washington, D.C.*, Washington, D.C., 1983.

Ellen Harkins Wheat, "Jacob Lawrence," Ph.D. diss., University of Washington, 1986.

———, *Jacob Lawrence, American Painter*, exh. cat., Seattle Art Museum, 1986.

Richard Powell, *Jacob Lawrence*, New York, 1992.

Peter Nesbett, ed., *Jacob Lawrence: Thirty Years of Prints (1963–1993), A Catalogue Raisonné*, Seattle, 1994.

Townsend Wolfe, *Jacob Lawrence: Drawings, 1945 to 1996*, exh. cat., Little Rock, Arkansas Arts Center, 1997.

TPC Sources
Cat., 1952.
MP, 1970 and 1982.
Ellen Harkins Wheat and Patricia Hills, cat. for TPC.1987.3.
Elizabeth Hutton Turner, cat. for TPC.1993.2.
MP, 1998.

9. PAINTING IN EUROPE AFTER THE SECOND WORLD WAR

1. DP, cat. for PMG.1927.7.

2. Clive Bell excluded contemporary art in Germany and America from his influential publication *Since Cézanne* (London, 1922).

3. Roger Fry, for example, purchased for Pierpont Morgan and built up the Metropolitan Museum's collections in New York prior to 1910. See Virginia Woolf, *Roger Fry: A Biography* (London, 1940), chapter 6, "America," 134–48.

4. Rouault quote, cat. for PMG.1940.13, n.p. Villon-Feininger, TPG.1949.18. The Klee retrospective, PMG.1950.4, toured 1949–50 and was the second Klee show, following the memorial exhibition, PMG.1942.11. A cult of gerontocracy in Paris during the Occupation focused attention upon artists like Rouault who signified continuity and French values. The veteran Jacques Villon, Duchamp's brother, first emerged as an influential modern artist with his retro-

spective of 1943 at the Galerie Louis Carré. The mysteriously curtailed Paul Klee retrospective in Paris in 1948 had a major influence, formally speaking, on young "Painters of the French Tradition," in particular Manessier, who features in this section.

5. Cat., 1952, x.

6. Despiau lent his name to a ghosted monograph on Hitler's preferred sculptor, Arno Breker, published by Flammarion in 1942. Both he and Derain (under duress) went on the notorious artistic tour of Germany organized by the Nazis in November 1941. Picasso, president of the Front National des Arts and nominally responsible for the policy of artistic *épuration,* named Derain as a collaborator in an interview with John Groth—"Picasso 1940–1944—A Digest with Notes by Alfred H. Barr, Jr.," *Museum of Modern Art Bulletin* 12, no. 3 (1945), 4—seriously affecting Derain's image in New York after the war (thanks to Michael Parke-Taylor, Toronto, for this indication). See also Jane Lee, *Derain* (Oxford, 1991), 84–87. For Phillips's preferences, see *CA,* 1929.

7. See *The Robert and Lisa Sainsbury Collection,* 1978 (African and Oceanic art also figures prominently), and *Paris after the War, 1945–1975, Works from the Sainsbury Family Collections,* introduction by Sarah Wilson, 1989; both exh. cats., Sainsbury Centre for Visual Arts, University of East Anglia, Norwich. The Sainsburys run Britain's oldest and most prestigious supermarket chain, and the family are key patrons of the visual arts; witness the new Sainsbury wing of the National Gallery.

8. It is, moreover, ironic that Marcel Duchamp, the key historical figure for the development of art in both Europe and America in the later 1960s (with Nouveau Réalisme and Pop Art) should have worked with Phillips on the Dreier Bequest to The Phillips Gallery in 1952 in what apparently was a purely administrative capacity.

9. For the museological pedigree of MOMA, especially German influences, see Christoph Grunenberg, "The Politics of Presentation. Museums, Galleries, and Exhibitions in New York, 1929–1965," forthcoming Ph.D. diss., University of London. The initially Mondrian-inspired French geometric abstractionist Jean Hélion, acting as adviser to A. E. Gallatin in the 1930s, was able to create a far more "modernist" feel for Gallatin's Gallery of Living Art, an American private collection open to the public (acknowledgments to Arnauld Pierre's conference paper, CIHA, Berlin, 1992).

10. Political-history painters, the soon-anathematized Communist artists of postwar France like Boris Taslitzky and André Fougeron, profiting from government or party purchases, continued to produce Salon-scale works. For the official situation, see Gérard Monnier, *Des Beaux-Arts aux Arts-Plastiques* (Besançon, 1991), 231–382.

11. Cat., 1952, ix.

12. For a detailed investigation of the links between existentialism and art in postwar France, see my article "Paris Post War: In Search of the Absolute," in *Paris Post War: Art and Existentialism, 1945–1955,* exh. cat. (Tate Gallery, London, 1993).

13. See Georges Mathieu, *De la révolte à la renaissance* (Paris, 1962; 1973), 37.

14. See Dominique Quignon-Fleuret, *Mathieu* (Paris, 1973), 75, 86–87.

15. Mathieu, *De la révolte à la renaissance,* 34–74. See

also Charles Estienne, *L'art abstrait est-il un académicisme?* (Paris, 1950).

16. See TPC.1990.6.

17. See Maurice Merleau-Ponty, *La phénoménologie de la perception* (Paris, 1945); *L'oeil et l'esprit* (Paris, 1964; re-edited 1991).

18. See André Malraux, *The Voices of Silence* (New York, 1953), and *André Malraux* (Saint-Paul-de-Vence, 1973). Mme Madeleine Malraux recalled the charm and delight of her Washington visit together with the impression of "provinciality" in conversation with the author, June 1992.

19. David Mellor, ed., *A Paradise Lost: The Neo-Romantic Imagination in Britain, 1935–1955,* exh. cat., Barbican Art Gallery (London, 1987), and Virginia Button, "The Aesthetic of Decline: English Neo-Romanticism c. 1935–1956," Ph.D. diss., University of London, 1991. Neo-romanticism is situated "in the context of the contemporary debates on nationalism, 'country culture,' and defence of individualism. . . . Its moral imperative and appeal to tradition seemed to defend cultural standards against the threat of both totalitarianism and the new forms and tastes of ascendant mass culture."

20. See Benjamin D. Buchloch, "Cold War Constructivism," in *Reconstructing Modernism,* ed. Serge Guilbaut (Cambridge, Mass., 1990), 85–112. See also *St. Ives, 1939–1964: Twenty-five Years of Painting, Sculpture, and Pottery,* exh. cat., Tate Gallery (London, 1985), cat. nos. 43 and 45 (Gabo), 50 (Hepworth), and 68 (Nicholson).

21. Compare Alastair Hunter's similarly constituted collection described by Dennis Farr, *The Hunter Collection of Twentieth-Century Masters,* exh. cat., Courtauld Institute Galleries (London, 1987). Hunter was the dean of St. George's Hospital Medical School, London University. Farr concludes: "His taste may be regarded as enlightened but safe, until we remember how the fierce antagonism towards modern art in the late 1940s persisted well into the 1950s."

22. See Marcy Leavitt Bourne, "Some Aspects of Commercial Patronage, 1950–1959: Four London Galleries," M.A. thesis, Courtauld Institute of Art, University of London, 1990. This work compares the policies of the Lefevre (neo-romantics and nineteenth- and twentieth-century French art), the Redfern (second-generation neo-romantics, such as Vaughan, and modern Parisian "expressionists," such as Soutine), the Hanover Gallery (established European sculpture and Modern British), and Gimpel Fils (contemporary Parisian abstraction, young British artists).

23. See Lawrence Alloway, *Nine Abstract Artists* (London, 1954). See also Margaret Garlake, "The Relation Between Institutional Patronage and Abstract Art in Britain, c. 1945–1956," Ph.D. diss., University of London, 1987, and her forthcoming book.

24. Patrick Heron, *The Changing Forms of Art* (London, 1955). Heron's own work moved through Braque and de Staël to inspirations from Rothko and Morris Louis.

25. Both quotations from *C in M,* 1926, 4, 6.

26. See Jacqueline Falkenheim, *Roger Fry and the Beginnings of Formalist Art Criticism* (Ann Arbor, Mich., 1980). She maps Fry's formation via his Old Master training, and a sense of the morality and ethical consciousness of art inherited from nineteenth-century figures like Ruskin, concluding that Clark was Fry's natural inheritor.

JACK B. YEATS

1. Date: According to Pyle, 1992, vol. 2, no. 1072, Yeats wrote in his record book that this work was painted in "Sept. 1950," with a note added, "But with many moist points." Later he wrote "OK March 5, 1951." Because Yeats may have touched up the painting while it was being held in his studio, the date should be 1950–51. Provenance: Bill of sale, Apr. 9, 1953; painting sent to Phillips on approval at the end of the North American tour, July 1, 1952, per Waddington to DP, Mar. 21, 1953.

2. Rosenthal, 1966, 2.

3. "Ireland's Unsung Hero," *Times Saturday Review,* London, Feb. 23, 1991. Today Yeats is receiving the recognition long past due; the National Gallery of Ireland is building a Jack Yeats museum in Dublin dedicated to the artist's works and archives. Recent studies have placed Yeats within the context of other Irish writers; see, for example, Gordon S. Armstrong, *Samuel Beckett, W. B. Yeats, and Jack B. Yeats: Images and Words* (Cranbury, N.J., 1990).

4. Although Yeats's father was a good friend of John Sloan and the other New York realists, Jack Yeats did not know them and was not influenced by them.

5. John Rothenstein, "Visits to Jack Yeats," *New English Review* (July 1946), as cited in Pyle, 1970, 127.

6. Pyle, 1970, 128.

7. Dion Boucicault (1820–90) was a playwright and actor known for his romantic plays.

8. White, 1971, 156.

9. Quinn was largely responsible for bringing Yeats to America; he purchased ten of the twelve paintings sold during the Clausen exhibition. See Pyle, 1970, 82.

10. "Exhibitions in New York: Jack Yeats, Francis Chapin, Ferargil Galleries," *Art News* 30 (Mar. 5, 1932), 9.

11. Per DP to Sweeney, July 9, 1946. The biography was MacGreevy, 1945; the catalogue remained unidentified.

12. The exhibition, organized by James Plaut of the Institute of Contemporary Art, Boston, came to TPG; it followed one-person exhibitions of Kokoschka and Munch, also organized by the ICA.

13. *After-Dinner Coffee in a City,* 1950 (oil on canvas, 24 × 36 in.; acc. no. 2139).

14. Both quotes from DP to Yeats, July 23, 1951.

Major References
Thomas MacGreevy, *Jack B. Yeats: An Appreciation and an Interpretation,* Dublin, 1945.
James S. Plaut, *Jack B. Yeats, A First American Retrospective,* exh. cat., Boston, Institute of Contemporary Art, 1951.
T. G. Rosenthal, "Jack B. Yeats, 1871–1957," *The Masters 40,* Bristol, 1966.
Hilary Pyle, *Jack B. Yeats: A Biography,* London, 1970.
Martha B. Caldwell, "Jack B. Yeats, Painter of Life in the West of Ireland," Ph.D. diss., Indiana University, 1971.
James White, *Jack Yeats: A Centenary Exhibition, 1871–1957,* exh. cat., Dublin, National Gallery of Ireland, 1971.
Arnolfini, *Jack B. Yeats, The Late Paintings,* exh. cat., Bristol, 1991.
John W. Purser, *The Literary Works of Jack B. Yeats,* Gerrards Cross, Buckinghamshire, 1991.
Robin Skelton, *The Selected Writings of Jack B.*

Yeats, London, 1991.

Nora A. McGuiness, *The Literary Universe of Jack B. Yeats*, Washington, D.C., 1992.

Hilary Pyle, *Jack B. Yeats: A Catalogue Raisonné of the Oil Paintings*, 3 vols., London, 1992.

John Booth, *A Vision of Ireland: Jack B. Yeats*, Nairn, Scotland, 1993.

TPC Sources
Cat., 1952.

PAUL NASH

1. Date: The work was probably painted after July 25, 1923, the date of a contract with the Leicester Gallery in which Nash agreed to produce forty new works for the 1924 exhibition (Tate Archive, Trustees of Paul Nash). Provenance: Sale to Balken (trustee and curator of Carnegie Institute, from correspondence Oct.-Dec. 1929 (reel 75, #3500, Carnegie Papers, AAA); Balken to Demarest undocumented; Demarest to Keeble, see Bertram, 1955, 174; Keeble offered the work as a gift Mar. 6, 1939 (reel 1952, #834, AAA, TPC Papers).

2. Marina Vaizey, "Paul Nash: Places," *Green Book* 3, no. 4 (1990), 19.

3. Herbert Read, *Contemporary British Art* (London, 1964), 24. Read draws a comparison with John Cotman and Thomas Girtin; for comparison with contemporary movements, see Read, 1944, 9. For the "convalescent" mood, see Charles Harrison, *English Art and Modernism, 1900–1939* (Bloomington, Ind., 1981), 171.

4. For a discussion of Nash's expressionist tendency and the symbolism of the Dymchurch series, see Cardinal, 1989, 7, 33.

5. Nash to George Bottomley, 1910, in Causey, 1980, 6.

6. According to King, 1987, 224, Nash was the only English artist to create modern art without sacrificing native tradition.

7. Paul Nash to his brother John, May 15, 1921, as quoted in Causey, 1980, 103–05.

8. Vaizey, "Paul Nash: Places," 26, points out the Art Deco flair in Nash's work.

9. Nash's own observations on the English tradition as cited in Read, 1944, 15.

10. DP, 1919, 166. The exhibition was shown in America under the auspices of the British Ministry of Information.

11. Nash's visit to PMG per a typed agenda for Friday, Sept. 25, 1931, Carnegie Papers, no. 12, National Art Library, Victoria and Albert Museum. For Nash's interest in Ryder and American art, see Nash to DP, Nov. 1, 1931.

Major References
Manuscripts, press clippings, exhibition catalogues and ephemera, National Art Library, Victoria and Albert Museum, London.

Paul Nash Collection, Tate Gallery Archive, London.

Paul Nash, *Places*, London, 1923.

Herbert Read, *Paul Nash*, Harmondsworth, Middlesex, 1944.

Margot Eates, *Paul Nash, Paintings, Drawings and Illustrations*, London, 1948.

Paul Nash, *Outline*, London, 1949.

Claude Colleer Abbott and Anthony Bertram, eds., *Poet and Painter: Being the Correspondence between Gordon Bottomley and Paul Nash, 1910–1946*, London, 1955.

Anthony Bertram, *Paul Nash, The Portrait of an Artist*, London, 1955.

Margot Eates, *Paul Nash, Master of the Image*, London, 1973.

Andrew Causey, *Paul Nash*, Oxford, 1980.

James King, *Interior Landscapes: A Life of Paul Nash*, London, 1987.

Roger Cardinal, *The Landscape Vision of Paul Nash*, London, 1989.

TPC Sources
DP, "The Official British War Pictures," *American Magazine of Art* 10, Mar. 1919, 155–67.
Cat., 1952.

BEN NICHOLSON

1. Letter to Lillian Sommerville, Mar. 25/26, 1954, in "Extracts from Letters," Maurice de Sausmarez, ed., *Studio International*, special Nicholson issue (London, 1969), 57.

2. *painted relief, 1940* (oil on canvas, 12½ × 11⅞ in.; current location unknown). The work appears on Ledger 15 as *Composition in Relief*, entered Jan. 19, 1951, and credited per May 18, 1951, bill of sale for *still life (winter) Nov 3–50* (acc. no. 1428).

3. See TPG.1951.3. DP to Nicholson, May 17, 1951: "We have also purchased the Trendrine, Cornwall, *Still Life with Landscape* . . . which I really fell in love with at sight." Phillips also purchased a drawing of the same subject: *Trendrine. summer—47* (pencil on paper, 9 × 13⅛ in.), no longer in the collection; Durlacher bill of sale, May 7, 1951. In keeping with Nicholson's preference for capitalization and punctuation, the titles of works are cited exactly as they are inscribed on the reverse of the paintings.

4. The show was favorably received. Stuart Preston, in *Art News* 48 (Apr. 1949), 44–95, acclaimed it as "one of the main events in New York's art season."

5. See TPG.1951.3. Phillips had previously exhibited two early primitive landscapes, *Towednack* and *Pill Creek*, in TPG.1950.13. Retrospectives were held in 1952 in Minneapolis and Detroit; the Museum of Modern Art acquired a Nicholson work in 1940. At the time of the 1951 exhibition, Nicholson and Phillips corresponded briefly, although they never met.

6. Leslie Judd Ahlander, "New Trends in English Painting," *Washington Post*, July 3, 1960.

7. Medium: Nicholson also constructed a deep shadow-box frame, painted gray; the overall dimensions, including the frame, are 16⅛ × 19⅛ (40.9 × 48.6). Patrick Heron, Mar. 11, 1992, emphasized that Nicholson conceived of his constructed frames, such as those for *St. Ives* and *Talisman*, as integral parts of his painting. Catalogue raisonné: Not included in Read, 1948. Provenance: Early transactions per Alex Reid & Lefevre, Ltd. to author, Feb. 12 and Apr. 15, 1992, and telephone conversation Apr. 16, 1992; Leicester per label on reverse. Sent on approval, Mar. 7, 1958; bill of sale, Apr. 24, 1958.

8. The author wishes to express her appreciation to Patrick Heron for sharing his recollections of Ben Nicholson, and his knowledge of and passion for Cornwall. Nicholson and Hepworth stayed with the painter and writer Adrian Stokes and his family in St. Ives until just after Christmas, moving to their own house at the end of 1939.

9. Gabo stayed in Cornwall until 1946; the Nicholsons entreated Mondrian to join them, but he was a confirmed city dweller and left for New York in 1940. The area also attracted Tobey in the 1930s, Rothko in the fifties, and later Helen Frankenthaler and Larry Rivers.

10. Lewis et al., 1985, 20.

11. Nicholson to Read, n.d., as quoted in Lucy Havelock-Allan, "Ben Nicholson, 1939–ca. 1950," M.A. thesis, Courtauld Institute, London University, 1978, 58, n. 51; punctuation and syntax are the artist's.

12. The first version is probably one in a private collection that lacks the still life but depicts an almost identical landscape view: *St. Ives 1940* (oil on board, 12¼ × 15⅜; C. S. Reddihough, Yorkshire; Read, 1948, no. 113).

13. Pentimenti visible under the rich, glossy paint indicate foreground and background changes, including the enlarging and centering of the brace; analysis per Elizabeth Steele, conservator, Feb. 26, 1992.

14. Nicholson to Sir John Summerson, Feb. 3, 1944: "I've been trying to do some potboilers but they've come out rather amusing, a kind of landscape + still life combined, rather subconscious."

15. Nicholson to Read, Jan. 22, 1943, as quoted in Havelock-Allan, "Ben Nicholson, 1939–ca. 1950," 25.

16. Lewison, 1983, 19, refers to this exchange of characteristics in the two themes.

17. Raymond Mortimer, *New Statesman and Nation*, Mar. 2, 1940, 135, cited in Havelock-Allan, "Ben Nicholson, 1939-ca. 1950," 57, n. 41.

18. Clement Greenberg, *The Collected Essays and Criticism*, ed. John O'Brian, vol. 2 (Chicago, 1986), 301.

19. Title: Per bill of sale and Read, 1956, no. 118. Inscription: Artist's notation in pencil, *TOP* followed by a large arrow, appears on the board reverse, u.c. Provenance: Gimpel Fils to author, Feb. 3, 1992; Durlacher bill of sale, Dec. 14, 1956.

20. Nicholson ceased making carved reliefs in 1945, returning to the medium in earnest in 1958.

21. Ben Nicholson, "Notes on Abstract Art," *Horizon* 4 (Oct. 1941), 274.

22. Lewison, 1983, 9.

23. Nicholson, "Notes on Abstract Art," 272–73.

24. Date/Title: Both per artist's inscription on panel reverse. Medium: Marlborough label on reverse: "curved pavatex" relief; medium line per Steele, July 9, 1992. Provenance: On Dec. 17, 1970 (Tate Archive letter no. 919.78), Nicholson wrote to Geoffrey Jellicoe, "The main body of my work is clearly in relief—which I suppose are somewhere midway between ptg + sculpture—++ v. closely related to architecture."

25. From artist's statement in *Ben Nicholson*, exh. cat., Galerie Beyeler (Basel, 1968), n.p.

26. Harrison, 1969, 52. In 1965–66 Nicholson had completed a project for Kassel, *Documenta III*, constructed in cement; it was later destroyed.

27. Norbert Lynton, "A Unique Venture: The Achievement of Ben Nicholson," *Studio International* 173 (June 1967), 301, discusses the sequential nature of the piece.

28. Analysis of construction by Steele, July 9, 1992. Quote from Geoffrey Grigson, *Ben Nicholson: Twelve New Works*, exh. cat., Marlborough Fine Arts Ltd. (London, 1967), n.p. Nash, 1978, 38, observed that the subordinate forms echo the larger "parent shape" of the relief.

29. Grigson, *Ben Nicholson: Twelve New Works*, n.p.

30. Patrick Heron to author, Jan. 25, 1992; in conversation, Mar. 11, 1992, Heron related that in ca. 1965–66 he photographed the coast at Nicholson's request, sending the photographs to him in Ticino. Russell, 1969, 40, refers to the "panoramic" shapes of the late reliefs.

31. From letter to Ronald Alley, Aug. 14, 1962; cited in Harrison, 1969, 6.

32. Analysis per Steele, Feb. 26, 1992.

33. As quoted in John Russell, *Ben Nicholson*, exh. cat., Marlborough Fine Arts Ltd. (London, 1963), 8.

Major References
Ben Nicholson Collection, Tate Gallery Archive, London.
Herbert Read, ed., *Ben Nicholson, vol. 1, Paintings, Reliefs, Drawings*, London, 1948; *vol. 2, Work Since 1947*, London, 1956.
Maurice de Sausmarez, ed., "Ben Nicholson," *Studio International*, special Nicholson issue, London, 1969 (including artist's statements).
Charles Harrison, *Ben Nicholson*, exh. cat., London, Tate Gallery, 1969.
John Russell, *Ben Nicholson*, London, 1969.
Steven Nash, *Ben Nicholson: Fifty Years of His Art*, exh. cat., Buffalo, Albright-Knox Art Gallery, 1978.
Jeremy Lewison, *Ben Nicholson: The Years of Experiment, 1919–1939*, exh. cat., Cambridge, Kettle's Yard Gallery, 1983.
David Lewis et al., *St. Ives, 1939–1964: Twenty-five Years of Painting, Sculpture, and Pottery*, exh. cat., London, Tate Gallery, 1985.
Jeremy Lewison, *Ben Nicholson*, London, 1991.
———, *Ben Nicholson*, exh. cat., London, Tate, 1993.
Norbert Lynton, *Ben Nicholson*, London, 1993.

TPC Sources
Kenneth Clark, intro. for TPG.1950.12.
Cat., 1952.
Stephen B. Phillips, cat. for TPC.1997.4.
MP, 1998.

ANDRÉ MASSON

1. Title: Purchased as *Dancing Flames*. Cat., 1952, uses *Will-o'-the-wisp*, which was possibly given by Duncan Phillips. A pencil inscription on the backing and a notation in the painting file cite *Fire Follies*. Medium: Another Masson canvas, *Cat and Fish* (19 × 15 in.; date and present location unknown), had been sent on approval by Mar. 17, 1943, when Curt Valentin wrote Phillips, "I . . . hoped that you would look at the paintings by Masson again because you did not seem too sure you selected the right painting for your Gallery." Bill of sale, May 10, 1943.

2. Masson's work first appeared in the United States in A. E. Gallatin's 1930 group exhibition at the Gallery of Living Art in New York; it was also included in the "Newer Super Realism" exhibition organized by James Thrall Soby for the Wadsworth Atheneum in Hartford, Conn., the next year. Masson's first one-person exhibition in the United States was at A. P. Rosenberg Gallery, Inc., New York, in 1932. Aside from the Museum of Modern Art's 1935 purchase of a Masson, most U.S. collectors and museums began to purchase his work in the mid to late forties.

3. DP, *ASD*, 1931, 119.

4. For Masson's view of his American period, see Brownstone, 1975, 130. See Charbonnier, 1985, 126, for his description of the landscape.

5. Brownstone, 1975, 130.

6. Clébert, 1971, 71. Masson visited the Museum of the American Indian in New York in 1941.

7. Information on the French folk tradition of *feux-follets* courtesy Professor Jean-Marie Pradier, University of Paris, in correspondence with author, Mar. 16, 1991. The title's English parallel, will-o'-the-wisp, refers to flickering lights over marshland, eerie lights that, in the past, gave rise to many superstitions.

8. William Rubin, "André Masson and Twentieth-Century Painting," in Lanchner and Rubin, 1976, 21.

9. For example, see *Indian Spring*, 1942 (33 × 39 3/4 in.; collection of Mr. and Mrs. William Mazer, New York).

10. Analysis by Elizabeth Steele, conservator, Dec. 3, 1990.

11. Clébert, 1971, 72.

Major References
André Masson, *Anatomy of My Universe*, New York, 1943.
Michel Leiris, *André Masson and His Universe*, Geneva, 1947.
Gilbert Brownstone, *André Masson*, exh. cat., Milan, Galerie Schwarz, 1970.
Jean-Paul Clébert, *Mythologie d'André Masson*, Geneva, 1971.
Gilbert Brownstone, *André Masson: Vagabond du surréalisme*, Paris, 1975.
Carolyn Lanchner and William Rubin, *André Masson*, exh. cat., New York, MOMA, 1976.
Françoise Will-Levaillant, ed., *André Masson, Le rebelle du surréalisme: Ecrits*, Paris, 1976.
Deborah Rosenthal, "Interview with André Masson," *Arts Magazine* 55, Nov. 1980, 88–94.
Georges Charbonnier, *Entretiens avec André Masson*, Paris, 1985.
Hayward Gallery, *André Masson: Line Unleashed*, exh. cat., London, 1987.
Françoise Levaillant, ed., *André Masson: Les années surréalistes correspondence, 1916–1942*, Paris, 1990.
Lawrence Saphire, *André Masson: The Complete Graphic Work*, Yorktown Heights, N.Y., 1990.
Bernard Noel, *André Masson: La chair du regard*, Paris, 1993.
Dawn Ades, *André Masson*, London, 1994.

TPC Sources
Cat., 1952.

HENRY MOORE

1. Date/Edition: There are seven known casts of this version: TPC; the Hirshhorn Museum and Sculpture Garden, Washington, D.C.; Norton Gallery and School of Art, West Palm Beach, Fla.; private collection, France (courtesy of Julian Barran of Sotheby's); private collection, Japan; and two casts in the collection of Jeffrey Loria, New York (one was cast by Moore in 1969). This information courtesy of David Mitchinson, the Henry Moore Foundation, Much Hadham, July 31 and Oct. 11, 1990, and Feb. 6, 1991. The original terra-cotta is in the collection of Mary Moore (courtesy of Julie Summers, assistant curator, the Henry Moore Foundation, Apr. 3, 1991). Provenance: Curt Valentin apparently purchased Moore's work for the Buchholz Gallery; see Valentin to Moore, Mar. 27,

1948, Jane Wade Papers, AAA, reel 2322, #1013. Phillips had the sculpture sent on approval, Sept. 29, 1947, and confirmed intent to purchase, Nov. 18, 1947; TPC Papers, AAA, reel 1966, #708 and #745.

2. More than seventeen versions of this motif exist; see Sylvester, 1948, 193, nn. 51–55, for descriptions and identifications. Moore created an earlier version of this sculpture in 1945 that is smaller but virtually identical; see "(h)" in n. 51 and "after (h)" in n. 52.

3. Morris commissioned Walter Gropius to design a school at Impington and Moore to create an appropriate sculpture. Unfortunately he was unable to raise enough money to have Moore cast the sculpture on a large scale. In 1947 John Newsom, a disciple of Morris, remembered Moore's unrealized family group and commissioned it for the Barclay School, Stevenage. See Moore in David Finn, *Henry Moore, Sculpture and Environment* (New York, 1976), 263, and in James, 1966, 224–29.

4. Mary was born after sixteen years of marriage. For a facsimile of his sketchbook, see Moore, *Shelter Sketchbook* (London, 1967). For a discussion, see Wilkinson, 1977, 28–40.

5. Of his experiences as a war artist, Moore wrote, "I think I could have found purely sculptural motives only, if I'd tried to, but I wanted to accept and interpret a more 'outward' attitude"; quoted in James, 1966, 216.

6. As quoted by Carlton Lake, "Henry Moore's World," *Atlantic* 209 (Jan. 1962), 40.

7. Moore often used preliminary drawings to explore new compositions for sculpture. See Robert Melville, *Henry Moore: Sculpture and Drawings, 1921–69* (New York, 1970), fig. 323, for family-group drawings that directly relate to the Phillips sculpture.

8. The archetypal aspects have been explored extensively. See Neumann, 1959, and *The Great Mother: An Analysis of the Archetype* (New York, 1955). See also Dallaportas, 1988, for a comparison of Moore's and D. H. Lawrence's use of archetypes.

9. Neumann, 1959, 22. Moore, believing that "all art has its roots in the 'primitive,'" considered Brancusi's dictum of "truth to material" significant; as quoted in Lund Humphries, 1968, xiii. For that reason, he at first preferred to carve his sculpture but later found that metal gave him more flexibility. See Kenneth Clark, "Henry Moore's Metal Sculpture," *Magazine of Art* 44 (May 1951), 171–74, for further discussion.

10. Neumann, 1959, 58.

11. As quoted in Lake, "Henry Moore's World," 41, and Gelburd, 1987, 34.

12. Moore's first exhibition in America, and indeed his first one-person show outside of England, was in 1943 at the Buchholz Gallery, New York.

13. Valentin to DP, Sept. 23, 1947, and DP to Valentin, Sept. 29, 1947, TPC Papers, AAA, reel 1966, #706 and #708.

14. DP to Valentin, Sept. 29, 1947, TPC Papers, AAA, reel 1966, #708.

Major References
Herbert Read, *Henry Moore: Sculptor*, London, 1934.
A. D. B. Sylvester, "The Evolution of Henry Moore's Sculpture: I," and "The Evolution of Henry Moore's Sculpture: II," *Burlington Magazine* 90, July 1948, 158–65 and 189–95.

Erich Neumann, *The Archetypal World of Henry Moore,* trans. R. F. C. Hull, New York, 1959.

Herbert Read, *Henry Moore: A Study of his Life and Work,* New York, 1965.

Philip James, ed., *Henry Moore on Sculpture: A Collection of the Sculptor's Writings and Spoken Words,* London, 1966; rev. and enl., New York, 1971; New York, 1992.

David Sylvester, ed., *Sculpture and Drawings, 1921–1948: Catalogue Raisonné,* vol. 1, London, 1944 (cited by publisher's name, Lund Humphries); New York, 2nd ed., 1968.

Gerald Cramer *Henry Moore: Catalogue of Graphic Work,* 4 vols., Geneva, 1973–86.

Alan G. Wilkinson, "The Drawings of Henry Moore," Ph.D. diss., University of London, Courtauld Institute of Art, 1974.

———, *The Drawings of Henry Moore,* exh. cat., Toronto, Art Gallery of Ontario, 1977.

Christa Lichtenstern, "Henry Moore and Surrealism," *Burlington Magazine* 123, 1981, 645–58.

Edward H. Teague, *Henry Moore: Bibliography and Reproductions Index,* Jefferson, N.C., 1981.

Gail Gelburd, ed., *Mother and Child: The Art of Henry Moore,* exh. cat., Hempstead, N.Y., Hofstra University, 1987.

Roger Berthoud, *The Life of Henry Moore,* London, 1987.

Susan Compton, *Henry Moore,* New York, 1988.

Joyce Dallaportas, "D. H. Lawrence and Henry Moore: The Positive and Negative Manifestations of the Archetypal Feminine," Ph.D. diss., Syracuse University, 1988.

Henry Moore Foundation, *Henry Moore: The Human Dimension,* exh. cat., London, 1991.

David Mitchinson and Julian Stallabrass, *Henry Moore,* New York, 1992.

Henry Moore Foundation, *Henry Moore Bibliography,* ed. Alexander Davis, 5 vols., Much Hadham, England, 1992–94.

Ann Garrould, ed., *Henry Moore: Complete Drawings: 1916–83,* 5 vols., London, 1994.

Claude Allemand-Cosneau, et al., eds., *Henry Moore, From the Inside Out: Plasters, Carvings, and Drawings,* Munich, 1996.

John Hedgecoe, *A Monumental Vision: The Sculpture of Henry Moore,* New York, 1998.

TPC Sources
Geoffrey Grigson, foreword for PMG.1946.5.
Cat., 1952.
DP, "A Gallery of Modern Art and Its Sources," text for television program produced by the Greater Washington Education Television Association; aired Oct. 16, 11:30 A.M., 1959; formerly MS 95.
MP, 1970 and 1982.
MD, 1981.
David Mitchinson, intro. for TPC.1976.5.

ALBERTO GIACOMETTI

1. Title/Edition: Hohl, 1971, 185–86, believes the original title was *Head on a Pedestal,* which Giacometti assigned to a small 1959 sculpture that may have been the maquette for *Monumental Head* (illus. in Hohl, "Form and Vision," in Guggenheim, 1974, 112–13). All other title variations have been used by the Pierre Matisse Gallery. The seven casts are in the following locations: private collection, London (cast no. 0/6); the Hirshhorn Museum and Sculpture Garden, Washington, D.C. (cast no. 1/6); the

Museum of Modern Art, New York, fractional gift of David M. Solinger, New York (cast no. 2/6); TPC (cast no. 3/6); Louisiana Museum of Modern Art, Humlebaek, Denmark (cast no. 4/6); Beyeler Collection, Basel (cast no. 5/6); and Galerie Beyeler, Basel (cast no. 6/6). Special casts of this commission were made at the Fondation Maeght in 1964 for the Alberto Giacometti Foundation; for further discussion, see Rotzler, 1982. Provenance: Information courtesy of Margaret V. Loudon, estate of Pierre Matisse, June 8, 1990. Bill of sale, Dec. 20, 1962, estate of Pierre Matisse records, New York.

2. There has been much debate over the relationship between Giacometti's work and existentialism, particularly as put forth by Jean-Paul Sartre. While Simone de Beauvoir believes Sartre furthered Giacometti's development, James Lord considers Giacometti's art to have had a greater impact on Sartre's theories. The influence was probably mutual. The two shared similar concerns regarding life and expression, as well as the same general war-related and postwar stresses. Maurice Merleau-Ponty's phenomenological theories on sensory perceptions are likewise echoed in the work of Giacometti. See Fletcher, 1988, 34–37, and Hohl, 1971, 187–227, for further discussion of these issues.

3. For a more extensive discussion of the Chase Manhattan Bank commission, see Friedrich Teja Bach, "Giacometti's 'Grande Figure Abstraite' und seine Platz-Projekte," *Pantheon* 38 (July-Sept. 1980), 269–80; and Monroe Denton, "The Chase Manhattan Project," in Evans, 1984, 109–14. Gordon Bunshaft designed the Chase Manhattan Bank building and its open space with a union of monumental sculpture and modern architecture in mind. See Harriet Senie, "Studies in the Development of Urban Sculpture," Ph.D. diss., New York University, 1980, 453–56; and Evans, 1984, 110–11.

4. *City Square* (Museum of Modern Art, New York; cast no. 1/6). It is not known whether Giacometti intended to use all seven figures or how they would be placed within the Chase plaza, but he clearly meant for each sculpture to be viewed both as an individual work and as a component of a group.

5. Among his earlier attempts at multifigured compositions including a gazing head are *Composition With Three Figures and a Head,* 1950, and *The Cage,* 1950, both illustrated in Pierre Matisse Gallery, 1950, 11 and 19. Giacometti explored the concept of a gazing head as early as the late twenties.

6. As quoted in Hohl, 1971, 136. Hohl discusses the source in "Form and Vision," in Guggenheim, 1974, 32, n. 61. For a discussion of Giacometti's use of non-Western and ancient art, see Krauss, 1984, 503–33.

7. For an illustration of the drawing, see Luigi Carluccio, *Giacometti: A Sketchbook of Interpretive Drawings,* trans. Barbara Luigia La Penta (New York, 1967), no. 52.

8. As quoted in Fletcher, 1988, 45. For further discussion, see Jean Clair, "Alberto Giacometti: La pointe à l'oeil d'Alberto Giacometti," *Cahiers du Musée Nationale d'Art Moderne* 11 (1983), 64–99.

9. MOMA, New York, has the largest collection of Giacometti's surrealist sculpture, including the *Palace at 4 A.M.,* which was the first and only purchase by an American museum until 1950; other museums had joined in by the late 1960s. See Beth Alberty, "Collecting Giacometti's Sculpture: American Museums," in Evans, 1984, 97–108.

10. Both quotes in DP, TPC. 1963.2, n.p.

11. MP, 1982, 291.

Major References
Michel Leiris, "Alberto Giacometti," *Documents* 4, Sept. 1929, 209–14.

Pierre Matisse Gallery, *Exhibition of Sculptures, Paintings, Drawings,* exh. cat., New York, 1948 (includes "Letter from Alberto Giacometti").

———, *Alberto Giacometti,* exh. cat., New York, 1950 (includes "Excerpts from a Recent Letter by Alberto Giacometti . . .").

Reinhold Hohl, *Alberto Giacometti,* New York, 1971 (includes complete bibliography of Giacometti's writings and statements on pp. 311–13).

Michael F. Brenson, "The Early Work of Alberto Giacometti: 1925–1935," Ph.D. diss., Johns Hopkins University, 1974.

The Solomon R. Guggenheim Museum, *Alberto Giacometti: A Retrospective Exhibition,* exh. cat., New York, 1974.

W. Rotzler, *Die Geschichte der Alberto Giacometti-Stiftung: Eine Dokumentation,* Bern, 1982.

Tamara S. Evans, ed., *Alberto Giacometti and America,* New York, 1984.

Rosalind Krauss, "Giacometti," in *Primitivism in Twentieth-Century Art,* vol. 2, ed. William Rubin, New York, 1984, 502–33.

James Lord, *Giacometti,* New York, 1985.

Metti Megged, *Dialogue in the Void: Beckett and Giacometti,* New York, 1985.

Valerie J. Fletcher, *Alberto Giacometti, 1901–1966,* exh. cat., Washington, D.C., Hirshhorn Museum and Sculpture Garden, 1988.

Alberto Giacometti, *Ecrits,* Paris, 1990.

Giorgio Soavi, *Giacometti: La ressemblance impossible* [Resemblance defeated], Paris, 1991.

Yves Bonnefoy, *Alberto Giacometti: A Biography of His Work,* trans. Jean Stewart, Paris, 1991.

Herbert C. Lust, *Alberto Giacometti: The Complete Graphics, Catalogue Raisonné,* rev. ed., San Francisco, 1991.

Marco Belpoliti and Elio Grazioli, eds., *Alberto Giacometti,* series *Riga 1* and *Riga 11,* Milan, 1991 and 1996.

David Sylvester, *Looking at Giacometti,* London, 1994.

Angela Scheider, ed., *Alberto Giacometti: Sculpture, Paintings, Drawings,* Munich, 1994.

Toni Stooss and Patrick Elliott, *Alberto Giacometti, 1901–1966,* exh. cat., Edinburgh, National Galleries of Scotland, 1996.

TPC Sources
DP, essay for TPC.1963.2.
MP, 1970 and 1982.

JOHN PIPER

1. The author wishes to thank David F. Jenkins for generously sharing his expertise on Piper's life and work. For Clark lecture, see telegrams, n.d. and Aug. 5, 1946, reel 1962, #1176 and #1179, TPC Papers, AAA.

2. See "The New Romanticism in British Paintings," *Art News* 45 (Feb. 1947), 24–29, 56–58. Few critical examinations of this movement exist outside studies of the individual artists. For further discussion, see Yorke, 1989, Mellor, 1987, and Fischer Fine Art Limited, *The British Neo-Romantics, 1935–1950,* exh. cat. (London, 1983).

3. DP to Curt Valentin, Buchholz Gallery, Feb. 21, 1947, TPC Papers, AAA, reel 1966, #582. Valentin should also be credited with helping disseminate an awareness of contemporary British artists in America following the Second World War.

4. See PMG.1948.7. His second museum solo show was in 1949 at the Victoria and Albert Museum, London. Phillips had actually purchased nine works but deaccessioned two of them by March 1948. He did not exhibit interest in Piper's abstract work of the thirties; these works later became quite popular in England.

5. See TPG.1950.13. Phillips's renewed interest in 1950 was perhaps due to the exhibition "British Art: The Last Fifty Years, 1900–1950," for which Clark wrote the introduction; organized by the English-Speaking Union of the United States, the show was mounted at the museum (see TPG.1950.12). Works by several more British artists, including Bacon and Vaughan, were acquired at this time.

6. As quoted in Yorke, 1989, 80. Phillips never abandoned his earliest romantic leanings but submerged them within his modernist aesthetic. In exhibitions and criticism throughout his career, he consistently praised the artist as an individual, free of schools and dogmas.

7. Clark, intro. to exh. cat. for PMG.1950.12, 8. Clark had already given an expanded interpretation of the neo-romantics in "The New Romanticism," 25–26.

8. Piper and Geoffrey Grigson in Axis 7 (Autumn 1936), 5–9.

9. See Piper, "Lost, A Valuable Object" in The Painter's Object, ed. Myfanwy Piper (London, 1937), 69–73.

10. As quoted in Ingrams, 1983, 22.

11. Piper, 1942, 7.

12. Medium: Analysis by Elizabeth Steele, conservator, Oct. 9, 1990. Provenance: Bill of sale, Mar. 12, 1948, TPC Papers, reel 1966, #897. Curt Valentin of the Buchholz Gallery apparently did not purchase Piper's works outright; in a letter to Piper, Feb. 28, 1948, he wrote: "I am enclosing a list of the paintings and gouaches sold. In some instances I had to make very special prices, especially in the case of sales to museums, friends, and one dealer." Jane Wade Papers, AAA, reel 2322, #1011.

13. Title: Purchased under alternate title; it is illustrated and identified in Woods, 1955, fig. 99. Medium: Piper used a fine-weave canvas, which he adhered to a panel with a beveled edge, per Steele, Oct. 9, 1990. Provenance: Bill of sale, Jan. 28, 1948, TPC Papers, AAA, reel 1966, #840.

14. See Meirion and Susie Harries, The War Artists: British Official War Art of the Twentieth Century (London, 1983), 180–93. Piper considered his initial commissions as an official war artist "the first step on the non-abstract ladder" (p. 189).

15. Piper, 1942, 22. See his article "John Sell Cotman, 1782–1842," Architectural Review 92 (July 1942), 9–12. He arranged to see Michael Sadler's collection of Cotman watercolors in 1936.

16. Piper, 1942, 22–23.

17. Piper painted another view of the ruined abbey: Muchelney Farmyard, 1941 (oil on canvas, 20 × 24 in.; collection of Edwin Arnold, Esq.), illustrated in Woods, 1955, fig. 82.

18. Steele, Oct. 9, 1990, believes that, in order to achieve this consistent patterning, Piper pressed a fabric with a rough, hairlike nap onto the ground while still wet. Jenkins (DJ to author, Feb. 14, 1992) states that Piper often sought textural effects by "roughing up the surface" of his pictures. He also notes that Piper sometimes used plaster of paris in his grounds, which is consistent with observations of this painting.

19. Piper, 1942, 30. For an illustration, see Raymond Lister, The Paintings of Samuel Palmer (Cambridge, 1985), pl. 16. For discussion of Palmer's impact, see Yorke, 1989, 98, and Jenkins et al., 1983, 90. On Piper's series, see Ingrams, 1983, 95, and accompanying illustrations.

20. Technical analysis by Steele, Oct. 9, 1990.

21. Piper often began painting a particular subject in sketchbook size; DJ to author, Dec. 2, 1991.

22. This description of a small medieval chapel that had been turned into a cow byre is in his July 20 entry; as quoted in Ingrams, 1983, 95–96.

23. Provenance: Bill of sale, Nov. 9, 1950.

24. As quoted in Jenkins et al., 1983, 39.

25. Frederick Treves in his guidebook The Highways and Byways of Dorset, as quoted in Ingrams, 1983, 29.

26. The Portland landscapes were widely distributed in America with the aid of Curt Valentin of the Buchholz Gallery, New York.

27. Woods, 1955, 14.

28. As quoted in Jenkins et al., 1983, 122.

29. Technical analysis by Steele, Oct. 9, 1990.

30. More than a hundred quarries are dotted throughout the island. See Piper, "Portland Stone—Portland," Ambassador 6 (1954), 80–94; see also Piper's comments, as quoted in Ingrams, 1983, 29.

Major References
John Piper, *British Romantic Artists*, London, 1942.
John Betjeman, *John Piper*, Middlesex, England, 1944.
John Piper, *British Romantic Artists*, London, 1946.
———, *Buildings and Prospects*, London, 1948.
John Woods, *John Piper: Paintings, Drawings, and Theatre Designs, 1932–1954*, New York, 1955.
David Fraser Jenkins et al., *John Piper*, exh. cat., London, Tate, 1983.
Richard Ingrams, *Piper's Places*, London, 1983.
Orde Levinson, ed., *John Piper, The Complete Graphic Works: A Catalogue Raisonné, 1923–1983*, London, 1987.
David Mellor, ed., *A Paradise Lost: The Neo-Romantic Imagination in Britain, 1935–1955*, exh. cat., London, Barbican Art Gallery, 1987.
John Piper, *A Painter's Camera: Buildings and Landscapes in Britain, 1935–1985*, London, 1987.
Malcome Yorke, *The Spirit of Place: Nine Neo-Romantic Artists and Their Times*, New York, 1989.
Virginia Button, "The Aesthetic of Decline: English Neo-Romanticism, c. 1935–1956," Ph.D. diss., Courtauld Institute of Art, University of London, 1991.
David Fraser Jenkins, *John Piper: The Robert and Rena Lewin Gift to the Ashmolean Museum*, exh. cat., Oxford, Ashmolean Museum, 1992.
Orde Levinson, *Quality and Experiment: The Prints of John Piper, a Catalogue Raisonné*, London, 1996.
June Osborne, *John Piper and Stained Glass*, Stroud, Gloucestershire, 1997.

TPC Sources
DP, cat. for PMG.1948.7.
Kenneth Clark, intro. for TPG.1950.12.
Cat., 1952.
MP, 1970 and 1982.

GRAHAM SUTHERLAND
1. Provenance: Included as first in a list of paintings the artist offered to Rosenberg Sept. 28, 1959, stock #5783 (courtesy Rosenberg, corr., Mar. 1, 1991); bill of sale to TPG, Dec. 5, 1959. Sutherland was under contract to Paul Rosenberg as of 1959.

2. British artists in Venice are discussed in [Denys Sutton], "The Pleasant Place of All Festivity," Apollo 94 (Sept. 1971), 168–75. Sutherland discussed Sickert's influence with Denys Sutton in "Editorial: The Precarious Tension of Opposites," Apollo 116 (Aug. 1982), 72–74.

3. A chronology, verified by the artist, places him in Venice in June 1959, as cited in Douglas Cooper, "Exhibition of Recent Paintings by Graham Sutherland," exh. cat., Rosenberg, New York, 1964, 21; see also reverse inscription with date. Two years later, Sutherland replicated this image: Dark Entrance, 1961 (127 × 103 cm.; collection of Pier Paolo Ruggerini, Italy).

4. A gateway was also depicted in Entrance to a Lane, 1939 (23½ × 19½ in.; Tate Gallery, London).

5. As quoted in Paul Nicholls, "Interview with Graham Sutherland," Graham Sutherland, exh. cat., Galleria d'Arte Narcisco (Turin, 1976), 15–23 and 20.

6. See [Sutton], "The Pleasant Place of All Festivity," 175.

7. Leslie Judd Ahlander, "New Trends in English Painting," Washington Post, July 3, 1960, E7. Recent scholarship has assessed this era as a weaker, more derivative period in Sutherland's oeuvre; see Andrew Causey, "Formalism and the Figurative Tradition in British Painting," in Susan Compton, British Art in the Twentieth Century: The Modern Movement, exh. cat., Royal Academy (London, 1986), 23.

8. Nicholls, "Interview with Graham Sutherland," 17.

9. Burr, "Round the Galleries," 206.

Major References
Robert Melville, *The Imagery of Graham Sutherland*, London, 1950.
Douglas Cooper, *The Work of Graham Sutherland*, London, 1961.
Noel Barber, *Conversations with Painters*, London, 1964.
Francesco Arcangeli, *Graham Sutherland*, New York, 1975.
Robert Tassi, *Graham Sutherland, The Complete Graphic Work*, London, 1978.
———, *Graham Sutherland: Parafrasi della natura e altre corrispondenze*, Parma, 1979.
John Hayes, *Graham Sutherland*, Oxford, 1980.
Ronald Alley, *Graham Sutherland*, exh. cat., Tate, London, 1982.
Roger Berthoud, *Graham Sutherland*, London, 1982.
Rosalind Thuillier, *Graham Sutherland: Inspiration*, 1982.
Christopher Neve, *The Unquiet Landscape: Places and Ideas in Twentieth-Century English Painting*, London, 1990.
Gordon Cooke, *Graham Sutherland: Early Etchings*, exh. cat., London, Fine Art Society, 1993.

TPC Sources
Cat., 1952.

SERGE POLIAKOFF

1. Poliakoff's birth date, often given in the literature as Jan. 8, 1906, is corrected to Jan. 8, 1900, in E. Bénézit, *Dictionnaire des Peintres, Sculpteurs, Dessinateurs et Graveurs,* vol. 8 (Paris, 1976), 404, with the notation, "not in 1906, which is generally indicated by the artist himself"); this change is also noted in exhibition catalogues on Poliakoff.

2. Title: Probably the artist's, per bill of sale, Mar. 11, 1959, #A6641; Poliakoff titled his paintings neutrally to avoid references to the visual world. Medium: The exact composition of the paint was not analyzed; however, its formulation appears to be unique to the artist. Inspection by Elizabeth Steele, painting conservator, Oct. 24, 1991. Provenance: Knoedler ownership per correspondence, Knoedler to TPC, May 8, 1990. According to the artist's son, Alexis Poliakoff, his father had a contract with Knoedler from 1959 to 1961; AP to author, Oct. 22, 1990. The dealer Theodore Schempp owned half-shares of several artists' work with Knoedler during this period; Schempp to DP, Feb. 5, 1961. Phillips most likely saw the painting at a Knoedler hanging in early 1959; DP to Knoedler, Mar. 10, 1959.

3. Durozoi, 1984, 7, refers to Poliakoff as a "classic of the second generation." For the influence of Kandinsky, see the treatment of color areas in such works as *Improvisation 26 (Rudern),* 1912 (97 × 107.5 cm.; Städtische Galerie, Munich); and the tactile density of the surface in *Bild mit Kahn (Painting with Skiff),* 1909 (79 × 123 cm.; private collection, Sweden).

4. Julien Alvard compares them to collage in "Serge Poliakoff," *XXième siècle* 7 (June 1956), 45. Daniel Abadie refers to Matisse's cutouts in "Aux couleurs de Poliakoff," *Serge Poliakoff,* exh. cat., Christian Fayt Art Gallery (Knokke, West Flanders, 1984), n.p.

5. As cited in Galerie Melki, *Serge Poliakoff,* exh. cat. (Paris, 1975), 78.

6. John Russell, *Poliakoff,* exh. cat., Hanover Gallery (London, 1958), n.p.

7. For the reference to icons, see Russell, 1963, 10–11, 14.

8. The Russian symbolist philosopher Andrei Bely, as cited by John E. Bault, "Esoteric Culture and Russian Society," in *The Spiritual in Art: Abstract Painting, 1890–1985,* exh. cat., LACMA (1986), 168.

9. Durozoi, 1984, 13.

10. AP to author, Oct. 22 and Dec. 11, 1990.

11. Steele, Aug. 2, 1991. In 1935 Poliakoff studied the multilayered, opaque paint of the Egyptian sarcophagi in the British Museum, adapting it to his own use; see Ragon, 1956, 28.

12. As quoted in Galerie Melki, *Serge Poliakoff,* 68.

13. Franz Meyer describes Poliakoff's technique in "La technique de Serge Poliakoff," *XXième siècle* 21 (May-June 1959), 43.

14. Phillips's description of "mackerel sky" from Mar. 18, 1959, letter to Knoedler; praise of texture from DP to Knoedler, Mar. 10, 1959, in which he also wrote that "[it] should be called *Landscape* or *Mountains and Sky* as it is clearly representational." In the latter correspondence, Phillips rejected a more geometric canvas by the artist.

Major References
Michel Ragon, *Poliakoff,* Paris, 1956.
Dora Vallier, *Serge Poliakoff,* Paris, 1959.
Jean Cassou, *Serge Poliakoff,* Amriswil, 1963.
John Russell, *Serge Poliakoff: Retrospective, 1938–1963,* exh. cat., London, Whitechapel Gallery and Hanover Gallery, co-organizers, 1963.
Jean Leymarie, *Serge Poliakoff,* exh. cat., Paris, Musée National d'Art Moderne, 1970.
Giuseppe Marchiori, *Serge Poliakoff,* Paris, 1976 (with documentation from Mme Marcelle Poliakoff's scrapbooks).
Gérard Durozoi, *Poliakoff: Peintures,* Paris, 1984.
Françoise Brutsch, *Serge Poliakoff, 1900–1969,* Neuchatel, 1993.
Dina Vierny et al., *Serge Poliakoff,* exh. cat., Paris, Musée Maillol, Reunion des Musées Nationaux, 1995.

MARIA ELENA VIEIRA DA SILVA

1. Title/Date/Provenance: English title per 1961 exhibition; French title, date, and Schempp ownership per bill of sale, Schempp to DP, Apr. 17, 1959 (confirmed by Guy Weelen, Oct. 29, 1990).

2. Date: Erroneously published as 1961 in *Sum. Cat.,* 1985; reproduced in Jean Yves Mock, "Art News from Paris," *Apollo* 72 (Dec. 1960), 207. Title: French title from Paris 1960 exhibition and consignment, Knoedler to TPG, Feb. 15, 1961; confirmed by Guy Weelen to author, Oct. 11, 1990. Provenance: Consigned to TPG Feb. 15, 1961, for exhibition, per Knoedler inventory no. A 7801; sold to TPG Mar. 1961. Schempp owned the Vieira da Silvas in half-share with Knoedler; Schempp to DP, Feb. 5, 1961.

3. See Laure de Buzon-Vallet, "L'Ecole de Paris: Eléments d'une enquête," in Germaine Viatte et al., *Paris, 1937–1957,* exh. cat., Centre Georges Pompidou (Paris, 1981), 255.

4. Alberte Grynpas Nguyen, "Introduction," in Grainville, 1988, 14, refers to her interest in Klee.

5. Technical observations on both works by Elizabeth Steele, painting conservator, Dec. 10, 1991.

6. Citations from Weelen to author, Oct. 29, 1990. Architectural elements suggesting houses built up along hills may also associate the painting with the coastal region of Portugal.

7. Grainville, 1988, 114.

8. Vieira da Silva's stamp on canvas reverse, INTERDIC-TION DE VERNIR ("do not varnish"), indicates her strong preference for a matte surface.

9. Reference to the influence of Giacometti's palette in Nguyen, "Introduction," in Grainville, 1988, 14. Quotation cited in Elsa Honig Fine, *Women and Art* (London, 1978), 176.

10. Weelen to author, Oct. 11, 1990. Vieira da Silva lived at the blvd. Saint-Jacques studio from 1938 to 1939 and from 1947 to 1956.

11. As quoted in Lassaigne and Weelen, 1979, 140. Other studio themes include *Atelier, Lisbonne,* 1935 (estate of the artist), and *Atelier Boulevard St. Jacques,* 1960 (Galerie Jeanne Bucher, Paris).

12. On the lack of preparatory drawing, see Fine, *Women and Art,* 131; Vallier, 1971, 123. Author's translation: "C'est sur l'incertitude que je me base."

13. Mock, "Art News from Paris," 208.

14. The exhibition, "Recent Gouaches by Vieira da Silva," Dec. 1–30, 1963 (TPC.1963.7), was apparently a loan show from Knoedler, and it did not include the two oils in the collection.

Major References
Michel Seuphor, "Promenade autour de Vieira da Silva," *Cahiers d'art* 2, 1949.
Pierre Descargues, *Vieira da Silva,* Paris, 1949.
Dora Vallier, *Chemins d'approche: La peinture de Vieira da Silva,* Paris, 1971.
Anne Philipe, *L'éclat de la lumière: Entretiens avec Marie-Hélène Vieira da Silva et Arpad Szenes,* Paris, 1978.
Jacques Lassaigne and Guy Weelen, *Vieira da Silva,* New York, 1979.
Patrick Grainville et al., *Vieira da Silva,* exh. cat., Paris, Grand Palais, 1988.
Jean-François Jaeger and Guy Weelen, *Vieira da Silva: Monographie et catalogue raisonné,* 2 vols., Paris, 1994.
Bernard Noel, *Vieira da Silva* (interview), Creil, 1994.

TPC Sources
DP, cat. for TPC.1961.3.
MP, 1970 and 1982.
Stephen B. Phillips, cat. for TPC.1997.4.

FRANCIS BACON

1. Title/Provenance: The bill of sale, Mar. 28, 1955, an old, unidentified label on the painting's reverse, and Alley and Rothenstein, 1964, no. 47, give the title as *Study of Figure in a Landscape.* The latter's Appendix C, 270, cites the painting as one of six works photographed in December 1952. The photograph illustrated in the appendix was annotated by David Sylvester with the date "late 1952."

2. On Bacon's inspiration from Maxwell's photographs, see Davies and Yard, 1986, 32. The animals with background vegetation and savannah grasses in Maxwell's book *Stalking Big Game with a Camera in Equatorial Africa* (London, 1924), are often reincarnated in Bacon's painting. See also discussion in Centre Georges Pompidou, 1996, 111.

3. See Davies and Yard, 1986, 29. Eadweard Muybridge, *The Human Figure in Motion* (London, 1901); "Man Performing Standing Broad Jump," series 13, frame 10, pictures a man crouched frontally. Bacon included the crouching nude repeatedly during this period; its first appearance was in *Study for a Crouching Nude,* 1952 (Institute of Fine Arts, Detroit). See also David W. Boxer, "The Early Work of Francis Bacon," Ph.D. diss., Johns Hopkins University, Baltimore, 1975, 140–43.

4. Medium and technique per Elizabeth Steele, painting conservator, Dec. 10, 1990.

5. For Bacon's desire to eschew illustration and representation, see Sylvester, 1988, chapters 4 and 5, especially p. 126. In 1956–57 Bacon painted eight variations of van Gogh's *The Painter on the Road to Tarascon* of 1888 (F 448; destroyed; formerly Kaiser Friedrich Museum, Magdeburg).

6. For Bacon's comments on working in series, see Sylvester, 1988, 21–22. *Landscape,* 1952 (55 × 42¾ in.; collection of M. Meyer, Zurich); *Landscape,* 1952 (78 × 53⅞ in.; Carnegie Institute, Pittsburgh, gift of Edgar Kaufmann Jr., 56.27). The landscapes interrupt the series of heads, including those in the pope series of 1949–53, and precede Bacon's intensive concentration on

friends and lovers begun in the early 1950s. In Bacon's view, landscape ranked below both figurative painting and animal subjects in significance; when asked why he painted several landscapes in this period, Bacon replied, "Inability to do the figure," according to Sylvester, 1988, 63.

7. Phillips's handwritten list "Possible Purchases" includes the entry, "Bacon, Cardinal, 1200." The list can be dated to early Nov. 1953. Phillips had the portrait study from Durlacher and at first found it "a powerful document [that] looks very well in our Gallery"; DP to George Dix, Nov. 9, 1953. Subsequent citation in DP to Dix, Dec. 9, 1953.

Major References
Ronald Alley and John Rothenstein, *Francis Bacon,* cat. rais., London, 1964.
John Russell, *Francis Bacon,* London, 1971; 3rd ed., rev. and enl., London, 1993.
David Sylvester, *The Brutality of Fact: Interviews with Francis Bacon,* London, 1975; 3rd enl. ed., New York, 1988; 4th ed., rev., London, 1993.
Hugh M. Davies, *Francis Bacon: The Early and Middle Years, 1928–1958,* New York, 1978.
Dawn Ades et al., *Francis Bacon,* exh. cat., London, Tate, 1985.
Hugh Davies and Sally Yard, *Francis Bacon,* Modern Masters Series, New York, 1986.
Lawrence Gowing and Sam Hunter, *Francis Bacon,* exh. cat., Washington, D.C., Hirshhorn Museum and Sculpture Garden, Smithsonian Institution, 1989.
Ernst van Alphen, *Francis Bacon and the Loss of Self,* London, 1992.
Daniel Farson, *The Guilded Gutter Life of Francis Bacon,* London, 1993; New York, 1994.
Andrew Sinclair, *Francis Bacon: His Life and Violent Times,* London, 1993.
Francis Bacon in Conversation with Francis Archimbaud, London, 1993.
Michel Leiris, *Francis Bacon ou la brutalité du fait, suivi de cinq lettres inédites de Michel Leiris à Francis Bacon sur le réalisme,* Paris, 1995.
Fondation Maeght, *Bacon-Freud: Expressions,* exh. cat., Saint-Paul, 1995.
Michael Peppiatt, *Francis Bacon: Anatomy of an Enigma,* London, 1996.
Milan Kundera and France Borel, *Bacon: Portraits and Self-Portraits,* London, 1996.
Wieland Schmied, *Francis Bacon: Commitment and Conflict,* trans. John Ormrod, Munich, 1996.
Centre Georges Pompidou, *Francis Bacon,* ed. Jean-Jacques Aillagon, exh. cat., Paris, 1996.

TPC Sources
MP, 1998.

ALFRED MANESSIER

1. Biographical clarification courtesy of the artist's daughter, Christine Manessier, to author, Jan. 6, 1992.

2. Title: French title per artist's inscription on stretcher. English title provided by artist in AM to author, Nov. 25, 1990. Manessier elaborated that he wished the title to suggest "a movement of release from below upward" ("un mouvement de dégagement dans le sens du bas vers le haut"). Catalogue raisonné: The numbers refer to a forthcoming catalogue raisonné by Christine Manessier. Provenance: According to Manessier, Galerie de France, with whom he had a contract, sent the painting directly from his stu-

dio to the 1964 TPC exhibition (AM to author, Nov. 25, 1990, and Apr. 23, 1991). No bill of sale has been found; painting file gives sale as Apr. 1964, from Galerie de France, Paris.

3. The term was originally suggested by Marcel Brion, in *Art Abstrait* (Paris, 1956), according to Hodin, 1972, 7. The debate among artists in the School of Paris about the merits of figurative and abstract art often took on moral overtones. In 1956 a reviewer accused Manessier of "thinking of the charms of abstraction, whom he doesn't dare make his mistress"; author's trans. from E. Degand, *Arts* 55 (Jan. 18–24, 1956), as cited in *Paris, 1937–1957,* exh. cat., Centre Georges Pompidou (Paris, 1981), 30, n. 12.

4. Manessier also cites Psalm 88, particularly the last verse, 18–19 ("Lover and friend, hast thou put far from me, and mine acquaintance into darkness?"). AM to author, Nov. 25, 1990.

5. Encrevé, 1988, n.p. *Study for Le Jardin des Oliviers* (oil on canvas, 28¼ × 39½ in.; Snite Museum of Art, Notre Dame University, Notre Dame, Ind.). Other closely related paintings include *Le Signe et la nuit,* ca. 1963–64 (location unknown, per artist).

6. AM to author, Nov. 25, 1990.

7. From interview in Encrevé, 1988, n.p.

8. AM to author, Nov. 25, 1990.

9. Ibid.

10. From interview in Encrevé, 1988, n.p. However, Manessier later disavowed a conscious El Greco influence in this image; AM to author, Nov. 25, 1990.

11. As quoted in Hodin, 1972, 85–86.

12. Martin, 1982, 290, points out the lack of a horizon line and the blending of earth and sky in Manessier's work.

13. In the catalogue for TPC.1964.2, n.p., Phillips wrote: "Since the death of Rouault, Manessier is the leader in the field of sacred art." Like Augustus Vincent Tack, Manessier was one of the first painters to address specific sacred themes in nonrepresentational painting.

14. Frank Getlein, "Religious but Anticlerical," *New Republic* (Apr. 4, 1964), 25–26. According to Getlein, the Phillipses worked with Manessier over a two-year period to realize the exhibition.

15. DP in TPC.1964.2, n.p.

Major References
Jean-Paul Hodin, *Manessier,* New York, 1972.
Martine Martin, "Manessier: Oeuvres de 1935–1960," thesis, Université de Paris 1, U.E.R. d'Arts Plastiques, 1982.
Pierre Encrevé, *Manessier: Passion 1948–1988,* exh. cat., Lyon, l'Espace Lyonnais d'Art Contemporain, 1988 (includes Dec. 1987 interviews with the artist by Encrevé).
Galeries Nationales du Grand Palais, Réunion des Musées Nationaux, *Manessier,* exh. cat., Paris, 1991.
Musée des Beaux-Arts, *Alfred Manessier: Peintures, aquarelles, vitraux, lithographies,* exh. cat., Angers, France, 1994.

TPC Sources
DP, cat. for TPC.1964.2

KEITH VAUGHAN

1. Date: An inscription (probably the artist's) on the verso, *1 wk 3/4 May,* suggests that the painting was

worked on in May 1945. Provenance: Bill of sale from Durlacher Brothers to DP, Dec. 11, 1951.

2. Date: The painting's exact date and title are from the artist's notebooks, in the collection of John N. Ball, London (the author wishes to thank Professor Ball for discussing Vaughan and for allowing consultation of materials on the artist). A label on the panel's reverse bears the title and date in the artist's hand. Provenance: Title, date, and early history per artist's notebooks (courtesy of John Ball, London): "October 1956, Farm in Berkshire (i) 24 × 18½ 2.G. / N.Y./ . . . "; bill of sale, Oct. 24, 1957, with notation that the painting will be delivered at the close of the exhibition, Oct. 26.

3. As cited in Yorke, 1990, 86. Vaughan had been jailed for depicting a trench, perhaps leading him to avoid all references to the war (Yorke, 1990, 87).

4. Journal entry, Apr. 28, 1944, as cited in Ross, 1989, 55–56. Such local farmhouses appear repeatedly in the works of this period, as for example in *Hesselton House,* 1944 (collection of Pauline Vogelpoel, Basel).

5. As quoted in Yorke, 1990, 80. The artist considered this painting unfinished; see inscription. Vaughan's other paintings of this setting include *Yorkshire Farmhouse,* 1945 (3¼ × 5 in.; private collection, London), and *Yorkshire Farm,* which according to its owner "was a six-inch miniature sketch for the Phillips painting" (Longwell to DP, June 19, 1953; present location unknown).

6. Except where indicated, Vaughan's technique is based on an inspection by Elizabeth Steele, painting conservator, Dec. 10, 1990.

7. Yorke, 1990, 77.

8. The other works are *Farm in Berkshire (ii),* December 1956, now at Girton College, Cambridge, England, and *Landscape: Berkshire,* n.d. (50.5 × 60 cm.; Huddersfield Art Gallery, England).

9. The de Staël exhibition was held in Nov. at the Matthiesen Gallery.

10. Journal entry of Mar. 14, 1943, as cited in Yorke, 1990, 78.

11. Heron's quote from *Changing Forms of Art* (London, 1955), as cited in Yorke, 1990, 163.

12. Extensive cracking along the edges of the geometric shapes, where layers that dried at different rates were juxtaposed, indicates Vaughan's still-evolving technique (Steele, 1990).

13. Vaughan's first one-person exhibition in an English museum was held at the University of Durham's Hatton Gallery in 1956. His first one-person gallery show in the United States was held at the George Dix Gallery, New York, Feb. 9 to Mar. 13, 1948. The Phillips show (TPG.1951.14) consisted mostly of loans from Durlacher Brothers. After his Vaughan exhibition, Phillips added two more early gouaches (correspondence Durlacher Bros. to DP, Dec. 13, 1951): *Reapers,* 1945 (5 × 7 in.), and *A Walled Orchard,* 1945 (11½ × 14¼ in.); neither remains in the collection, and their current location is unknown.

Major References
Sketchbooks, journals, and other memorabilia in the collection of the executors of the Vaughan estate, London.
Bryan Robertson, *Keith Vaughan: Retrospective Exhibition,* exh. cat., London, Whitechapel Gallery, 1962.
Noel Barber, *Conversations with Painters,* London, 1964.

John Nicholas Ball et. al., *Keith Vaughan: Images of Man*, exh. cat., London, Geffrye Museum, 1981.

Bryan Robertson, *Keith Vaughan 1912–1977*, exh. cat., London, Austin/Desmond Fine Art, 1989.

Alan Ross, ed., *Keith Vaughan Journals, 1939–1977*, London, 1989.

Malcolm Yorke, *Keith Vaughan, his life and work*, London, 1990.

NICOLAS DE STAËL

1. MP, 1982, 239.

2. The group exhibition discussed, TPC.1951.2, was circulated by the AFA. The two-person show is TPC.1952.7.

3. See M. Knoedler & Co., *Nicolas de Staël*, exh. cat. (New York, 1953), held from Mar. 10 to 28, and TPC.1953.4. The selection of paintings hung at the Phillips from Apr. 12 to May 4 was not identical to that installed at Knoedler's.

4. DP to Alexandre Rosenberg, Sept. 28, 1955.

5. *Arts*, 1956, n.p.

6. Ibid.

7. Phillips added to the unit a lithograph in 1954 (acc. no. 1805), this drawing in 1964 (acc. no. 1802), and a collage in 1959 (acc. no. 1803), no longer considered authentic.

8. As quoted in Roger van Gindertaël, *Nicolas de Staël, 1914–1955*, exh. cat., MFA (Boston, 1966), n.p.

9. Ibid.

10. De Staël to Paul Rosenberg, Dec. 1, 1953, Pierpont Morgan Library Collection.

11. Title: The title was suggested by Theodore Schempp to de Staël; see Schempp to Eliza Rathbone, May 13, 1988. Provenance: Purchased together with *Fugue* in partial trade for an unidentified painting known only as *Abstraction* that Phillips had owned from January to April of 1952. Bill of sale, Apr. 24, 1952.

12. Provenance: Per Rathbone, 1990, 175. Intent to purchase in E. Coe Kerr Jr., Knoedler to DP, May 7, 1953; bill of sale, Feb. 13, 1954.

13. As quoted in Gindertaël, *Nicolas de Staël, 1914–1955*, n.p.

14. Roger van Gindertaël, *Nicolas de Staël, Peintres et sculpteurs d'aujourd'hui*, no. 3 (Paris, 1950), as quoted in Gindertaël, *Nicolas de Staël, 1914–1955*, n.p. *Nocturne* was illustrated in Gindertaël's monograph *Nicolas de Staël* (Paris, 1951), pl. 27.

15. Rathbone, 1990, 19.

16. "On ne peint jamais ce qu'on voit ou croit voir, on peint à mille vibrations le coup reçu." (author's trans.); de Staël to Pierre Lecuire, Dec. 3, 1949, in de Staël, 1966, 19.

17. *Study for Nocturne*, 1950 (india ink and gouache on paper, 9¾ × 12½ in.; private collection). See Rathbone, 1990, 19, and correspondence between Mme Françoise de Staël and Rathbone, Mar. 1 and May 3, 1988.

18. See for example *Ciel à Honfleur*, 1952 (oil on hardboard, 31¼ × 51¼ in.; private collection).

19. See *Le Parc des Princes*, 1952 (oil on canvas, 76¼ × 38⅛ in.; private collection, Paris), and *Le Lavandou*, 1952 (oil on canvas, 76½ × 38¼ in.; Collection Musée National d'Art Moderne, Paris). However, these two works also reflect de Staël's emerging preference for an intensely chromatic palette.

20. For working habits, see de Staël in *Nicolas de Staël*, exh. cat., Whitechapel Art Gallery (London, 1956), 16; Rathbone, 1990, 22, and n. 37; and Sutton, 1960, 37–38. Le Parc de Sceaux was a formal park designed by the seventeenth-century landscape architect Le Nôtre, who designed the gardens of Versailles.

21. In another painting of that year, *Ballet*, 1952–53 (oil on canvas, 86⅛ × 143¼ in.; National Gallery of Art, Washington, D.C., collection of Mr. and Mrs. Paul Mellon), de Staël used the red underlayer as a strong compositional device, by making it a thread of color running horizontally across the muted blue and gray planes.

22. Pierre Lecuire, *Voir Nicolas de Staël* (Paris, privately published, 1953), as quoted in Cooper, 1961, 36 and 49.

23. Title: The title was suggested by Schempp to de Staël; see Schempp to Rathbone, May 13, 1988. It was listed in the museum's inventory book as "Painting, 1952." Provenance: Purchased together with *Nocturne* in partial trade for an unidentified painting known only as *Abstraction* that Phillips had owned from January to April 1952. Bill of sale, Apr. 24, 1952.

24. "Pas d'abstrait. Pas de réaliste. Pas d'art social (dans ce sens). Pas dubuffesque. Trop parisien pour vous tout celà. Pour moi aussi" (author's trans.); de Staël to Lecuire, Nov. 18, 1949, in de Staël, 1966, 13.

25. De Staël to Sutton, Nov. 1953, in Chastel, 1968, 302; as quoted in Hetty Einzig, "Biographical Notes," in Tate, 1981, 171.

26. In a September 1950 letter to the critic Bernard Dorival regarding his review, de Staël thanks him for not linking him with the nonfigurative artists, whom he referred to as the "gang de l'abstraction avant"; see Rathbone, 1990, 137, and Tate, 1981, 169–70. He maintained his conviction that "All of painting has a subject whether one wishes or not" ("Toute toile a un sujet, qu'on le veuille ou non," author's trans.); de Staël to Lecuire, Dec. 3, 1949, in de Staël, 1966, 25.

27. "J'étais gêné par l'infinie multitude des autres objets coexistants. . . . J'ai cherché alors à atteindre à une expression libre" (author's trans.); as quoted in French in Cooper, 1961, 12. For a discussion of influences on his early work, see Rathbone, 1990, 15–18.

28. De Staël to Schempp, Dec. 1950, as quoted in Tate, 1981, 170. Braque, in turn, stated that "de Staël was a painter: he had a true sense of painting. . . . No matter what path he took, or might have taken, one was always sure of meeting with a painter. That is the best recommendation"; as quoted in Rathbone, 1990, 36.

29. "Figurez-vous que Françoise et moi on a fait une promenade jusqu'à Ravenne avant le départ pour bien garder dans les yeux le pur roman du Mausolée du Galla Placidia, manger du poisson et boire un des meilleurs vins du monde" (author's trans.); de Staël to Sutton, Feb. 1953, as quoted in French in Tate, 1981, 13. The Paris exhibition was held at the Musée des Monuments Français from April to June. See chronology in Rathbone, 1990, 138–39. Interestingly, in 1936, early in his career, de Staël painted icons in the Byzantine tradition.

30. This and following technical analysis per Elizabeth Steele, conservator, 1991. She notes that, because de Staël waited for each layer to dry, there are fewer problems with adhesion between the layers than in other of his works.

31. DP to Alexandre Rosenberg, Sept. 28, 1955, and *Arts*, 1956, 34. In a letter to Phillips, Aug. 7, 1955, Schempp wrote, "I thought of asking for your 'Fugue' [for an exhibition] but I remembered that it was your favorite (and rightly so)."

32. DP, 1959, n.p.

33. *Arts*, 1956, 34. De Staël was in the Foreign Legion in Tunisia from January to September 1940.

34. Provenance: Purchase in June from artist, per de Staël file, Paul Rosenberg & Co., New York. Arrived at TPG, Oct. 28, 1953, per receipt; intent to purchase, Paul Rosenberg to DP, Nov. 27, 1953; final bill of sale, Feb. 28, 1955.

35. Oil on canvas; Musée d'Art Moderne, Paris. Illustrated in color in Tate, 1981, cat. no. 77. See Rathbone, 1990, 38, n. 53.

36. See Rathbone, 1990, 33, n. 53.

37. As quoted in Anthony Bower, *Art in America* 53, no. 5 (Oct.-Nov. 1965), 84.

38. *Le Piano* (oil on canvas, 160 × 220 cm.; private collection), and *Le Concert* (oil on canvas, 350 × 600 cm.; private collection, on loan to the Musée National d'Art Moderne, Paris), illustrated in color in Fondation Maeght, 1991, cat. no. 93, and Tate, 1981, cat. no. 120, respectively. *Le Concert*, the last painting de Staël worked on, was on his easel when he committed suicide.

39. De Staël to René Char, Apr. 10, 1952, in Chastel, 1968, 188; as quoted in Rathbone, 1990, 22.

40. Three letters: "La lumière est tout simplement fulgurante ici" (author's trans.), de Staël to Jacques Dubourg, Le Lavandou, May 31, 1952; "Je consomme de la couleur en quantité" (author's trans.), Le Lavandou, June 1952; and "Et que voulez-vous si à force de flamber sa rétine sur le 'cassé-bleu' comme dit Char on finit par voir la mer en rouge et le sable violet" (as quoted in Rathbone, 1990, 29), June 1952; see Chastel, 1968, 210, 218, and 228, respectively. De Staël was also struck by the large retrospective of fauvism held at the Musée National d'Art Moderne from April to June in 1951.

41. DP to A. Rosenberg, Sept. 25, 1955.

42. Rathbone, 1990, 27.

Major References

Denys Sutton, *Nicolas de Staël,* Paris, 1959; trans. Rita Barisse, New York, 1960; includes Nicolas de Staël, "Notes on Painting."

Douglas Cooper, *De Staël,* London, 1961.

Nicolas de Staël, *Lettres de Nicolas de Staël à Pierre Lecuire,* Paris, 1966; privately published in an edition of 225.

André Chastel et al., *Nicolas de Staël,* cat. rais., Paris, 1968.

Guy Dumur, *Nicolas de Staël,* Paris, 1975; trans. Finton O'Connell, New York, 1976.

Nicolas de Staël, *Lettres de Nicolas de Staël à Jacques Dubourg,* London, 1981.

Tate Gallery, *Nicolas de Staël,* exh. cat., London, 1981.

Pierre Granville, *De Staël: Peintures,* Paris, 1984.

Dora Vallier, *Nicolas de Staël, Lumières de la Méditerranée,* exh. cat., Athens, Institut Français, 1987.

Fondation Maeght, *Nicolas de Staël: Rétrospective de l'oeuvre peint,* exh. cat., Saint Paul, 1991; Spanish edition by Museo Nacional Centro de Arte Reina Sofia.

Elena Lledo, "Nicolas de Staël and Abstraction in Postwar Paris," Ph.D. diss., Courtauld Institute of Art, University of London, 1994.

Daniel Dobbels, *Staël*, Paris, 1994.

Thomas M. Messer, *Nicolas de Staël: Retrospektive*, exh. cat., Frankfurt, Schirn Kunsthalle, 1994.

Anja Chávez, *Nicolas de Staël: Die Späten Werke*, Weimar, Germany, 1996.

Françoise de Staël, *Nicolas de Staël: Catalogue raisonné de l'oeuvre peint*, Paris, 1997; includes de Staël's correspondence in the appendix.

TPC Sources
Cat., 1952.
Arts, 1956.
DP, *Catholicity Does Not Mean Eclecticism: A Radio Talk by Duncan Phillips*, pamphlet, 1954.
Theodore Schempp, foreword in TPC.1956.8.
MP, 1970 and 1982.
DP, "A Gallery of Modern Art and Its Sources," text for television program, aired Oct. 16, 11:30 A.M., 1959.
MD, 1981.
Eliza Rathbone, cat. for TPC.1990.6
MP, 1998.

PIERRE SOULAGES

1. Date: In the 1991 questionnaire, Soulages confirmed that the painting was finished July 10, 1950, in his Paris studio on the rue Schoelcher. Title: Encrevé, 1994, no. 51, has *Peinture 130 × 162 cm, 10 Juillet 1950*. Provenance: Artist to Carré, Paris, inventory #D 1056, Aug. 30, 1990; Soulages confirmation of year of sale, Sept. 13, 1991; purchased from TPG.1951.7 exhibition.

2. Ceysson, 1980, 82.

3. Ibid., 14: "Time is trapped in the space of the canvas, and both are there, forever motionless."

4. Sweeney, 1973, 23. For Sweeney, p. 13, Soulages's classicism follows André Gide's definition: "romanticism brought under control."

5. See Clément Rosset, "L'Objet Pictural: The Art of Small Means," in *Pierre Soulages oeuvres* (Lyons, 1987), 93–94.

6. Sweeney, 1973, 6.

7. Soulages speaks of his tools and the role of chance in Ceysson, 1980, 83.

8. Roger Vailland, "Comment travaille Pierre Soulages," *L'oeil* 77 (May 1961), 43. Observations specific to *July 10, 1950* are from an examination by Elizabeth Steele, painting conservator, Dec. 10, 1990.

9. A nationalist strain was also felt during and after the Occupation, when many artists turned to the past for a tradition untainted by international influences.

10. Soulages to Bernard Ceysson in "Interview with Pierre Soulages" in Ceysson, 1980, 74.

11. Ibid., 57.

12. James Johnson Sweeney, *Soulages: Paintings Since 1963*, exh. cat., Knoedler (New York, 1968), 7. Sweeney visited Saint Foy with Soulages and remembers admiring these aspects of the architecture with him.

13. Jean Leymarie, "Soulages," *Art International* 4 (May 25, 1960), 18–25, 18.

14. Soulages remembered seeing some "impressive pictures by Matisse" in reproduction in the early 1940s; for the similarity of Picasso's and Soulages's use of black, and Soulage's much-quoted insistence that black is a color, see Ceysson, 1980, 46, 60–62.

15. "Soulages," *Arts Digest* 28 (May 1, 1954), 19. Hunter was reviewing Soulages's one-person show at the Samuel M. Kootz Gallery in New York.

16. Sweeney probably initiated the first American show in 1949 at Betty Parson's Gallery, New York. MOMA and the Guggenheim made early purchases in 1952 and 1953 (under the directorship of Sweeney), and museums and galleries in Germany and Denmark gave early attention to Soulages. The Louis Carré exhibition traveled to San Francisco, Chicago, Baltimore, Kansas City, and Bloomington after its Washington, D.C., venue. For the show's importance in introducing the American public to Soulages and postwar French painting, see Encrevé, 1994, 83.

17. TPC questionnaire, 1991.

Major References
Bernard Dorival, *Soulages*, exh. cat., Paris, Musée d'Art Moderne, 1967.
James Johnson Sweeney, *Soulages*, New York, 1973.
Michel Ragon, *Pierre Soulages*, Paris, 1974.
Bernard Ceysson, *Soulages*, New York, 1980.
Georges Duby, Pierre Encrevé, Henri Meschonnic, and Clement Rosset, *Pierre Soulages oeuvres*, exh. cat., Lyon, Musée Saint-Pierre Art Contemporain, 1987.
Bernard Ceysson, Veit Loers, and Henry-Claude Cousseau, *Pierre Soulages—40 ans de peinture*, exh. cat., Stuttgart, Fridericianum Kassel, 1989.
Michel Ragon, *Les ateliers de Soulages*, Paris, 1990.
Pierre Daix, *Pierre Soulages, l'oeuvre, 1947–1990*, Neuchatel, 1991.
Pierre Encrevé, *Soulages: L'oeuvre complet, peintures*, 2 vols., Paris, 1994.
Musée d'Art Moderne de la Ville de Paris, *Soulages: Noir lumière*, exh. cat., Paris, 1996.

TPC Sources
Cat., 1952.
MP, 1982.
TPC Questionnaire, Sept. 13, 1991.

JOHN WALKER

1. Provenance: See Betty Cuningham, Betty Cuningham Gallery, to Laughlin Phillips, July 15, 1982. In a letter to Walker, July 28, 1982, Phillips stated that this painting is "one which fits beautifully into the collection." A few years earlier, Phillips referred to the Walker holdings as an "emerging Walker unit" (LP to Mr. Scott Keep, June 28, 1978).

2. Robert Rooney, "Art: Between Wall and Window," *Melbourne Age*, 1981, NMAA vertical files.

3. As quoted in Hilton, 1972, 244. As a student, Walker copied a reproduction of this work; see Miller, 1989, 103.

4. For an illustration see Lewis, 1981, 27; this envelope-like shape is set against a loose grid in ambiguous, shallow space. See also discussion of fascination with the Second World War in Hilton, 1972, 244.

5. See Walker's comments in Hilton, 1972, 244.

6. Flam, 1982, n.p.

7. Arts Council of Great Britain, 1985, 7. The shapes in this series echo the compositions in both Goya's *Majas on a Balcony*, ca. 1800–05 (Metropolitan Museum of Art), and Manet's *The Balcony*, 1868 (Musée du Louvre, Paris); see Forge, 1978, n.p.

8. As quoted in Sweet, 1978, 26. See analysis of intent in Flam, 1982.

9. This and all other analysis of medium and technique per Elizabeth Steele, conservator, June 11, 1991.

10. As quoted in Sweet, 1978, 26.

11. Ibid., 24.

12. See, for example, *Untitled*, 1977, and *Untitled*, 1976 (both acrylic, chalk, and canvas collage on canvas; acc. nos. 2020–21) and *Ostraca II*, 1977 (acrylic, acrylic gel, and canvas collage on canvas; acc. no. 2018). The *Juggernaut* works date roughly from 1973 to around 1975. Walker began his *New York* series around 1976, and it probably includes both Phillips paintings called *Untitled*; this series led into the blue and yellow collaged works that were exhibited at The Phillips in TPC.1978.4. Walker began his *Ostraca* series around 1977. See Lewis, 1981, 29, for a discussion of these series and the problems of dating.

13. As quoted in Miller, 1989, 104, in reference to his *Juggernaut* works. He continued this technique in his *New York* and *Ostraca* paintings.

14. See Alistair Hicks, *The School of London: The Resurgence of Contemporary Painting* (Oxford, 1989), 12, 18.

15. Keith Patrick, "Romantic Roots: British Painting in the 1980s," *Modern Painters* 1 (summer 1988), 47, argues that Walker's "monolith-like Albas are timeless, weathered figures . . . romantically and spiritually charged." He goes on to discuss how many of these painters incorporated an abstract, spiritual, and meaning-laden landscape in their compositions.

Major References
Timothy Hilton, "John Walker on his Painting," *Studio International* 183, June 1972, 244–47.
Tony Godfrey and Adrian Searle, "John Walker, Interview," *Artlog* 1, 1978, 12–26.
David Sweet, "John Walker" (interview), *Artscribe*, June 1978, 21–26.
Adrian Lewis, "John Walker," *Artscribe*, Oct. 1981, 24–36.
Arts Council of Great Britain, *John Walker: Paintings from the Alba and Oceania Series, 1979–84*, introduction by Dore Ashton, exh. cat., London, Hayward Gallery, 1985.
Caroline Collier, "Romancing the Shape, Progress to Oceania," *Studio International*, Mar. 1985, 16–21.
Tate Gallery, *John Walker: Prints, 1976–84* (includes catalogue raisonné), exh. cat., London, 1985.
Nancy Miller, *Figuratively Speaking: Drawings by Seven Artists*, exh. cat., Purchase, New York, Neuberger Museum, 1989.
Dore Ashton, *John Walker: Paintings and Drawings*, exh. cat., Arts Club of Chicago, 1991.

TPC Sources
Andrew Forge, essay for TPC.1978.4.
Jack Flam, essay for TPC.1982.1.

10. AMERICAN ART AFTER THE SECOND WORLD WAR

1. *C in M*, 1926, 3–4.

2. DP, cat. for PMG 1927.7, n.p.

3. Adolph Gottlieb, *Tiger's Eye* 1, no. 2 (Dec. 1947), 43, quoted in Maurice Tuchman, *The New York School* (London, 1971), 67.

4. See DP to Stamos, 1949.

5. DP to Sidney Janis, Dec. 31, 1951.

6. Clement Greenberg, "New York Painting Only Yesterday," *Art News* 56, no. 4 (Summer 1956), 84.

7. Roland Penrose, *Miró* (London, 1970), 102.

8. William Rubin, "Arshile Gorky, Surrealism and the New American Painting," *Art International* 7, no. 2 (Feb. 1963), 27.

9. DP to Sidney Janis, Oct. 25, 1956.

10. DP to Mark Rothko, Feb. 17, 1964.

11. Michael Leja, "The Monet Revival and New York School Abstraction," in *Monet in the Twentieth Century* (London, 1998), 100: "By far the most influential and highly publicized early purchase came in the spring of 1955, when the Museum of Modern Art in New York bought a mural-sized work directly from Michel Monet."

12. See ibid., 102–03.

13. Walter Barker, quoted in Dore Ashton, *Yes, but . . . A Critical Study of Philip Guston* (New York, 1976), 72.

14. Richard Diebenkorn, transcript of 1982 interview by Fritz Jellinghouse, TPC Archives.

MARK TOBEY

1. Title: *After the Imprint* was not the artist's title, per Mark Tobey to Arthur Hall Smith, May 29, 1962 (collection of Arthur Smith, Washington, D.C.): "Marion just wrote me she was there and rode to their [the Phillipses'] house . . . that she met you and they may buy—After the Imprint—whatever that means as I didn't title it." Medium: Per Sarah Bertalan, paper conservator, June 20, 1991. Provenance: Payment recorded in "The Phillips Gallery 1962 Disbursements" and Ledger 15.

2. Seitz, 1962, 10.

3. "Some Statements by the Artist," in Jermayne MacAgy, *Retrospective Exhibition of Paintings by Mark Tobey*, exh. cat., San Francisco, California Palace of the Legion of Honor, 1951, n.p.

4. Seitz, 1962, 31.

5. Tobey, in a letter from Paris, Oct. 28, 1954, as excerpted in *Art Institute of Chicago Quarterly* 49, no. 1 (Feb. 1, 1955), 9.

6. Marion Willard to DP, Apr. 8, 1944.

7. DP to Harold Diamond, Nov. 15, 1955.

Major References
Mark Tobey Papers, AAA.
Willard Gallery Scrapbooks and William Seitz Papers, AAA.
Colette Roberts, *Tobey*, Paris, 1959.
Musée des Arts Décoratifs, *Rétrospective Mark Tobey*, exh. cat., Paris, 1961.
William C. Seitz, *Mark Tobey*, exh. cat., New York, MOMA, 1962.
Min-Chih Yao, *The Influence of Chinese and Japanese Calligraphy on Mark Tobey (1890–1976)*, Asian Libraries Series No. 23, China, 1983.
Eliza E. Rathbone, *Mark Tobey: City Paintings*, exh. cat., Washington, D.C., NGA, 1984.
Galerie Beyeler, *Mark Tobey: A Centennial Exhibition*, exh. cat., Basel, 1990.
Achim Moeller Fine Arts, *Feininger and Tobey: Years of Friendship, 1944–1956: The Complete Correspondence*, exh. cat., New York, 1991.
Yoshii Gallery, *Mark Tobey: Paintings (1920–1960)*, exh. cat., New York, 1994.
Museo Nacional Centro de Arte Reina Sofia, *Mark Tobey*, exh. cat., Madrid, 1997.

TPC Sources
Cat., 1952.
MP, 1970 and 1982.
MP, 1998.

BRADLEY WALKER TOMLIN

1. Title: Tomlin inscribed *Still Life* on the reverse of the painting; it was also entitled *Still Life* in the 1944 Rehn exhibition and on the PMG bill of sale. For most of the painting's history Phillips called it *The Goblet*. Medium: According to Elizabeth Steele, painting conservator, Sept. 28, 1990, *Still Life* was painted on commercially prepared canvas and is not varnished. The painting was adhered with wax to an aluminum hexel panel in 1984. Inscription: The inscription was obscured during conservation in 1984, when the painting was adhered with wax to an aluminum panel. Provenance: Bill of sale, May 3, 1944. Phillips saw *Still Life* before its inclusion in the 1944 Rehn exhibition and asked Rehn to reserve it for him. He purchased it after the show (DP to Frank Rehn, Jan. 3, 1944, TPC Papers, AAA, reel 1964, #1162).

2. Tomlin's early figurative work is comparable to Hartley's still lifes of the 1920s. Chenault, 1971, 18, points out its similarity to Preston Dickinson as well as Demuth and Sheeler.

3. Ibid., 32.

4. DP, between 1961 and 1966, n.p.

5. According to Chenault, 1971, 33, the Museum of Modern Art's 1936–37 exhibition "Fantastic Art, Dada, and Surrealism" had a strong impact on Tomlin.

6. The Whitney purchased its first Tomlin in 1942; Phillips and Root became important patrons of Tomlin's in 1944 and 1945, respectively. Chenault, 1971, 39–40, elaborates on Tomlin's success.

7. Chenault, 1971, 36.

8. Ibid., 59–61, notes the similarity between the Phillips work and *Still Life*, 1940 (oil on canvas, 28 × 35⅛ in.; Museum of Art, University of Iowa; Chenault no. 91).

9. Ibid., 37, citing Frances Celentano, *The Origins and Development of Abstract Expressionism in the U.S.* (New York, 1957), 73. See, for example, Braque's *Still Life with Grapes and Clarinet*, 1927 (cat. no. 139), and Maurer's *Still Life with Doily*, 1930 (acc. no. 1313). Tomlin's work of this period has also been compared to that of Karl Knaths.

10. For a discussion of Tomlin's color technique, see Chenault, 1971, 17 and 37.

11. Tomlin exhibited *Water Melon* at the Corcoran's "13th Exhibition of Contemporary American Oil Paintings," Dec. 4, 1932-Jan. 15, 1933. In addition, he included *The Painter* in the Corcoran's "14th Biennial Exhibition of Contemporary American Oil Paintings," Mar. 24-May 5, 1935.

12. Quotation from DP to Frederick S. Wight, June 8, 1956. In Journal I, between 1931 and 1935, Phillips includes Tomlin on a list of artists he would like to add to his collection. In addition, Tomlin reappears on a list of artists' names entitled "also as yet unrepresented" that Phillips handwrote into his copy of the catalogue for the Carnegie's 1943 "Painting in the United States" exhibition.

13. DP, essay for PMG.1927.6, n.p.

14. DP, 1957, 13.

15. Title: The first two alternate titles appear in TPG exhibitions; the third in DP to Frederick S. Wight,

June 8, 1956. Medium: According to Steele, Sept. 28, 1990, the canvas is unprimed and there is no varnish. Provenance: Bill of sale, July 7, 1955.

16. Provenance: Bill of sale, Jan. 21, 1957.

17. Tomlin's experimentation with automatism reflects the influence of Pollock and Motherwell; see comments by Gwen Davies and Motherwell in Crosman and Miller, 1979, 110. Chenault, 1971, 55–56, discusses Motherwell's influence on Tomlin.

18. As quoted in Crosman and Miller, 1979, 109.

19. As quoted in Baur, 1957, 9.

20. Irving Sandler, *The Triumph of American Painting* (New York, 1970), 239–44.

21. Phillips repeatedly called them "petal paintings," as, for example, in his letter to Betty Parsons, Nov. 21, 1956. Chenault, 1971, 80–81, continues the use of this term. *No. 8* is considered one of the finest of the petal paintings. However, according to Chenault, 1971, 80, Gottlieb disliked the style because of its decorative qualities.

22. Sandler, *The Triumph of American Painting*, 244.

23. Steele, Sept. 28, 1990.

24. Chenault, 1975, 22, refers to the calligraphic nature of these works.

25. See Mondrian, *Composition*, 1916, which was purchased and exhibited by the Guggenheim in 1949; illus. in Angelica Z. Rudenstine, *The Guggenheim Museum Collection: Paintings, 1880–1945*, vol. 2 (New York, 1976), 575–79.

26. Henry McBride, "Abstract Report for April," *Art News* 52 (Apr. 1953), 16, compared Tomlin's paintings to the works of Bach; Herbert Ferber in Crosman and Miller, 1979, 107, compared them to Mozart.

27. Chenault, 1975, 19.

28. Both quotes from DP, between 1961 and 1966, n.p.

29. DP, 1957, 13.

Major References
Bradley Walker Tomlin Papers, AAA.
John I. H. Baur, *Bradley Walker Tomlin*, exh. cat., New York, Whitney Museum of American Art, 1957.
Jeanne Chenault, "Bradley Walker Tomlin, Abstract Expressionist," 2 vols., Ph.D. diss., Ann Arbor, University of Michigan, 1971.
———, *Bradley Walker Tomlin: A Retrospective View*, exh. cat., Hempstead, N.Y., Emily Lowe Gallery, Hofstra University, 1975.
Christopher Crosman and Nancy E. Miller, "Speaking of Tomlin," *Art Journal* 80, Winter, 1979, 107–16.
Stephen Polcari, *Abstract Expressionism and the Modern Experience*, Cambridge, 1991.
April Kingsley, *The Turning Point: The Abstract Expressionists and the Transformation of American Art*, New York, 1992.

TPC Sources
Journal I, between 1931 and 1936.
Cat., 1952.
DP, "Bradley Walker Tomlin," unpubl. essay, 1956–57; formerly MS 52.
DP, "Appreciation," in Baur, 1957.
DP [Rothko, Pollock, de Kooning, Guston, Tomlin], notes and comments from the writings of Peter Selz, Robert Goldwater, and Sam Hunter, between 1961 and 1966; formerly MS 1.

MD, 1981.
Stephen B. Phillips, cat. for TPC.1997.4.
MP, 1998.

KENZO OKADA

1. Title: *No. 4, 1954 (Footsteps)* is the title in the Betty Parsons Gallery Papers, AAA, reel 4101, #124; *Footsteps (#4–1954)* appears on the bill of sale. Provenance: Consignment documented in Betty Parsons Gallery Papers, AAA, reel 4104, #124; ICA consignment documented in DP to Betty Parsons, Oct. 26, 1956, and bill of sale, Nov. 15, 1956.

2. Both quotes from Washburn, 1965, n.p.

3. Ibid.

4. Ibid. It is not known whether Okada made a model for *Footsteps.*

5. Per conservation inspection by Elizabeth Steele, Sept. 16, 1991.

6. Washburn, 1965, n.p.

7. The two Okadas that Phillips returned were *#2–1953* and *#1–1953,* as documented in Parsons to DP, Nov. 3 and Dec. 13, 1954, TPC Papers, AAA, reel 1985, #127 and #130. *Number 2, 1954* (acc. no. 1444).

8. Parsons to DP, Dec. 13, 1954, and DP to Parsons, Apr. 22, 1955, TPC Papers, reel 1985, #127 and #190.

9. Robert Richman, ICA, to Parsons, Sept. 21, 1955, ICA Papers, AAA, box 13.

Major References
Kenzo Okada interview with Forrest Selvig, Nov. 22, 1968, AAA.
Kenzo Okada interview in 1966 by Arlene Jacobowitz, Brooklyn Museum of Art Archives, Records of the Department of Painting and Sculpture Exhibitions, "Listening to Pictures," 1968.
Gordon Washburn, *Kenzo Okada: Paintings, 1931–1965,* exh. cat., New York, Buffalo Fine Arts Academy and Albright-Knox Art Gallery, 1965.
Mary Hale Gillman Bereday, "Japanese Artists in New York," Ph.D. diss., Columbia University, 1973.
Chisaburoh F. Yamada, ed., *Dialogue in Art: Japan and the West,* Tokyo, 1976.
Seibu Museum of Art and Asahi Shimbun, *Kenzo Okada,* exh. cat., Tokyo, 1982.
Sumio Kuwabara, "Saka to Kataru: Kenzo Okada to sono sakuhin" [Talking to the author: Kenzo Okada and his works], *Mizue (Japan)* 923 (Summer 1982), 66–81.
Marisa del Re Gallery, *Kenzo Okada,* exh. cat., New York, 1991.

TPC Sources
Shuji Takashina, cat. for TPC.1979.3.

MARK ROTHKO

1. Stamos to author, Feb. 9, 1991.

2. Sidney Janis to DP, May 8, 1956, mentions that Phillips had admired one of his Rothkos. *Mauve Intersection,* a transitional work, was sold at auction in 1971.

3. MP, 1970, 288.

4. See DP, 1963 and 1964.

5. MP, 1970, 288.

6. DP, 1964, n.p.

7. Lawrence Alloway, "The New American Painting,"

Art International 3 (1959), 23, as cited in Rathbone, 1978, 250.

8. Arthur Hall Smith interviewed by Karen Schneider, Aug. 21, 1985. Smith was on staff at The Phillips Collection when the Rothko Room first opened. On conception as "chapel," see Bonnie Clearwater, "How Rothko Looked at Rothko," *Art News* 84, no. 9 (Nov. 1, 1985), 100–03, and Nodelman, 1997, 35–39. See also Christoph Grunenberg, "Mark Rothko: Painting and Environment," M.A. thesis, Courtauld Institute of Art, University of London, 1988.

9. From statement in *Tiger's Eye* 1, no. 9 (Oct. 1949), 114.

10. Smith/Schneider interview, 1985.

11. Willem de Looper, at that time curator of The Phillips, interviewed by Karen Schneider, Aug. 21, 1985.

12. The Rothko Room served as a model for Rothko's 1961 retrospective at the Museum of Modern Art, according to Peter Selz, as cited in Barnes, 1989, 38.

13. Ibid.

14. The location of the room was slightly altered in the 1989 renovation of the Annex.

15. Provenance: Bill of sale, Feb. 12, 1957.

16. Title: First titled *No. 16,* which is probably Rothko's title per David Anfam, Rothko catalogue raisonné; according to Anfam, Rothko preferred numerical titles, but unfortunately many have not survived (per discussion with Leigh Bullard Weisblat, Feb. 14, 1995). A 1960 Sidney Janis Gallery label titles the painting *Henna and Green.* According to Mary Mulcahy Jackson, Sidney Janis Gallery (correspondence with TPC, May 1, 1986), the official title was probably given by Rothko. Provenance: Janis to DP, Apr. 20, 1960.

17. Provenance: DP to Rothko, Feb. 17, 1964.

18. Provenance: Janis to DP, Apr. 20, 1960.

19. Rothko referred to his paintings as evocations of human drama in a lecture at the Pratt Institute, 1958; see Dore Ashton, "Art: Lecture by Rothko," *New York Times* (Oct. 31, 1958), 26.

20. Michael Compton, "Mark Rothko, the Subjects of the Artist," in Tate Gallery, 1987, 53–54.

21. Analysis by Elizabeth Steele, painting conservator, Apr. 1991.

22. MP, 1970, 288.

23. Statement delivered from the floor at a symposium, "How to Combine Architecture, Painting and Sculpture," Museum of Modern Art, 1951; published in *Interiors* 110, no. 10 (May 1951), 104.

Major References
Mark Rothko Papers, AAA.
Peter Selz, *Mark Rothko,* exh. cat., New York, MOMA, 1961.
Diane Waldman, *Mark Rothko, 1903–1970: A Retrospective,* exh. cat., New York, Guggenheim, 1978; rev. ed., *Mark Rothko in New York,* 1994.
Eliza Rathbone, "Mark Rothko: The Brown and Gray Paintings," *American Art at Mid-Century: The Subjects of the Artist,* exh. cat., Washington, D.C., NGA, 1978.
Lee Seldes, *The Legacy of Mark Rothko,* New York, 1979; rev. and enl., New York, 1996.
Irving Sandler, *Mark Rothko: Paintings, 1948–1969,* exh. cat., New York, Pace Gallery, 1983.
Dore Ashton, *About Rothko,* New York, 1983.

Tate Gallery, *Mark Rothko, 1903–1970,* exh. cat., London, 1987.
Susan J. Barnes, *The Rothko Chapel: An Act of Faith,* Austin, 1989.
Anna Chave, *Mark Rothko: Subjects in Abstraction,* New Haven, 1989.
Marc Glimcher, *The Art of Mark Rothko: Into an Unknown World,* New York, 1991.
James E. B. Breslin, *Mark Rothko: A Biography,* Chicago, 1993.
David Thistlewood, ed., *American Abstract Expressionism,* in Tate Gallery Liverpool Critical Forum, vol. 1, Liverpool, U.K., 1993.
Sheldon Nodelman, *The Rothko Chapel Paintings: Origins, Structure, Meaning,* Austin, Texas, 1997.
Claude Cernuschi, *"Not an Illustration but the Equivalent": A Cognitive Approach to Abstract Expressionism,* Madison, N.J., 1997.
Jeffrey Weiss, *Mark Rothko,* exh. cat., Washington, D.C., NGA, 1998.
David Anfam, *Mark Rothko: Catalogue Raisonné,* New Haven, 1999.
David Anfam, *Mark Rothko: The Works on Canvas,* Washington, D.C., and New Haven and London, 1998.

TPC Sources
DP [Rothko, Pollock, de Kooning, Guston, Tomlin], notes and comments from the writings of Peter Selz, Robert Goldwater, and Sam Hunter, between 1961 and 1966; formerly MS 1.
DP, "Mark Rothko," unpubl. essays, 1963 and 1964.
MP, 1970 and 1982.
MD, 1981.
MP, 1998.

ADOLPH GOTTLIEB

1. Provenance: Bill of sale, Jan. 3, 1952.

2. As quoted in Alloway and MacNaughton, 1981, 33.

3. For artists in the American Abstract Artists group, see Gallatin (cat. no. 255).

4. Alloway, "Melpomene and Graffiti," *Art International* 12 (Apr. 1968), 21. The avant-garde painting of Gottlieb and Rothko puzzled E. A. Jewell of the *New York Times.* His negative review in June 1943 of the third exhibition of the Federation of Modern Painters and Sculptors sparked the controversy that led Gottlieb, Rothko, and Newman to publish a letter defending their style and subject matter; see Gottlieb and Rothko with Newman to Jewell, *New York Times,* June 3, 1943, on file at the Adolph and Esther Gottlieb Foundation Archive. It was quoted in full in E. A. Jewell, "The Realm of Art: A New Platform and Other Matters: 'Globalism' Pops Into View," *New York Times,* June 13, 1943, and is considered the first published statement of the abstract expressionists. For further discussion, see Alloway and MacNaughton, 1981, 40.

5. Alloway and MacNaughton, 1981, 30. The duality and ambiguity themes are thoroughly explored by Friedman, 1963.

6. From a statement in *Arts and Architecture* 9 (Sept. 1951), 21.

7. As quoted in Doty and Waldman, 1968, 30.

8. First quote in Maurice Tuchman, ed., *New York School: The First Generation: Paintings of the 1940s and 1950s* (Greenwich, Conn., 1965), 71. Second quote in *The New Decade,* exh. cat., Whitney (New York, 1955), 35–36.

9. Alloway and MacNaughton, 1981, 34. See also Davis, 1977, 142. These sources, as well as Wilkin, 1977, are in-depth studies of the pictographs.

10. Adolph Gottlieb and Mark Rothko, "The Portrait and the Modern Artist," typescript of radio broadcast on "Art in New York," WNYC, Oct. 13, 1943, as quoted in Alloway and MacNaughton, 1981, 170–71.

11. Gottlieb saw "African Negro Art," Mar. 18–May 19, 1935; "Prehistoric Rock Pictures in Europe and Africa," Apr. 28–May 30, 1937; and "Indian Art of the United States," Jan. 22-Apr. 27, 1941. In 1937–38 he lived in Arizona, where he was also exposed to Native-American art. See Alloway and MacNaughton, 1981, 20–21, for further discussion.

12. Gottlieb and Rothko, "The Portrait of the Modern Artist," 1943. See Alloway and MacNaughton, 1981, 171.

13. Alloway and MacNaughton, 1981, 34.

14. Berger, 1976, 115.

15. The finger motif resembles the motif appearing in a rock painting Gottlieb may have seen at MOMA's "Prehistoric Rock Pictures in Europe and Africa" (New York, 1937), illus. 130: "Group of large formlings. Makumba Cave, Chinamora Reserve, Southern Rhodesia." Wilkin, 1977, 29, views the finger symbol as a unifying serpentine element.

16. Discussion of Gottlieb's body and eye motifs in Alloway and MacNaughton, 1981, 36–37. Gottlieb saw single-eye symbols in works by Miró, Magritte, and other surrealists at MOMA's "Fantastic Art, Dada and Surrealism," 1936–37. He first used eye motifs in his early pictograph The Eyes of Oedipus, 1941 (private collection).

17. Alloway and MacNaughton, 1981, 46. See also Andrew Kagan, "Paul Klee's Influence on American Painting, Part II: New York School," Arts 50, no. 1 (Sept. 1975), 84–90.

18. See Alloway and MacNaughton, 1981, 54–62, for discussion of Gottlieb's late works.

19. DP, "Foreword," Federation of Modern Painters and Sculptors 1955–1956, exh. cat. (New York, 1955), n.p.

Major References
Adolph Gottlieb Papers, AAA.
Adolph Gottlieb Papers, Adolph and Esther Gottlieb Foundation, New York.
Martin Friedman in *Adolph Gottlieb,* exh. cat., Minneapolis, Walker Art Center, 1963.
Robert Doty and Diane Waldman, *Adolph Gottlieb,* exh. cat., New York, Whitney and Guggenheim, 1968.
Gustav A. Berger, "Unconventional Treatments for Unconventional Paintings," *Studies in Conservation* 21, 1976, 115–28.
Mary R. Davis, "The Pictographs of Adolph Gottlieb: A Synthesis of the Subjective and the Rational," *Arts* 52, Nov. 1977, 141–47.
Karen Wilkin, "Adolph Gottlieb: The Pictographs," *Art International* 21, Dec. 1977, 27–33.
Lawrence Alloway and Mary Davis MacNaughton, *Adolph Gottlieb: A Retrospective,* exh. cat., New York, Adolph and Esther Gottlieb Foundation, Inc., 1981.
Mary Davis MacNaughton, "Adolph Gottlieb," Ph.D. diss., Columbia University, New York, 1981.
Stephen Polcari, "Adolph Gottlieb's Allegorical Epic of World War II," *Art Journal* 47 (Fall 1988), 202–07.

April Kingsley, *The Turning Point: The Abstract Expressionists and the Transformation of American Art,* New York, 1992.
Michael Leja, *Reframing Abstract Expressionism: Subjectivity and Paintings in the 1940s,* New Haven, 1993.
David Thistlewood, ed., *American Abstract Expressionism,* in Tate Gallery Liverpool Critical Forum, vol. 1, Liverpool, England, 1993.
Katonah Museum of Art, *Against the Stream: Milton Avery, Adolph Gottlieb, and Mark Rothko in the 1930s,* Katonah, New York, 1994.
Ann Eden Gibson, *Abstract Expressionism: Other Politics,* New Haven, 1997.

TPC Sources
MD, 1981.
Sanford Hirsch, cat. for TPC.1994.5.
MP, 1998.

SEYMOUR LIPTON

1. Date: Per catalogue for the Venice Biennale, 1958. Provenance: Seymour Lipton to DP, Jan. 29, 1964, states: "This is to certify that *Ancestor* . . . is to be considered purchased from me privately" (Seymour Lipton Papers, AAA, reel N69–89, #412). Agreement to purchase DP to Lipton, Feb. 17, 1964.

2. Lipton, "Organicism and Nature," unpubl. essay, n.d., Whitney Museum of American Art Papers, AAA, reel N671, #618.

3. Elsen, 1970, 14.

4. Lipton, undated statement, Lipton Papers, AAA, reel 3091, #113.

5. Having worked predominantly with zoomorphic and plant forms in the previous decade, Lipton arrived at the human orientation "indirectly," when reading Joseph Campbell's *The Hero with a Thousand Faces,* which helped affirm his belief that "crucial mystery lies in man himself" (Elsen, 1961, 43).

6. Both quotes from Elsen, 1970, 51. Lipton titled his works after he created them, according to Tal Streeter, "The Sculptor's Role: An Interview with Seymour Lipton," in *Register of the Museum of Art, The University of Kansas, Lawrence,* 1962, 32.

7. Elsen, 1970, 37.

8. Ritchie, 1956–57, 15.

9. DP to Lipton, Oct. 24, 1963, Lipton Papers, AAA, reel N69–89, #404. Claire M. Hegle, TPC, to Lipton, Jan. 20, 1964, #409, indicates that Phillips purchased another sculpture for his personal collection.

10. DP to Lipton, Nov. 13, 1963, Lipton Papers, AAA, reel N69–89, #408.

11. DP, 1964, n.p.

Major References
Seymour Lipton Papers, AAA.
Andrew Carnduff Ritchie, "Seymour Lipton," *Art in America* 44, Winter 1956–57, 14–17.
Albert Elsen, "Seymour Lipton: Odyssey of the Unquiet Metaphor," *Art International* 5, Feb. 1, 1961, 38–44.
Register of the Museum of Art, The University of Kansas, Lawrence 2, no. 8, Apr. 1962, introduction by Marilyn Stokstad (entire issue dedicated to Lipton and includes a lecture by Lipton).
Albert Elsen, "Lipton's Sculpture as Portrait of the Artist," *Art Journal* 24, Winter 1964–65, 113–18.

———, *Seymour Lipton,* New York, 1970.
Harry Rand, *Seymour Lipton: Aspects of Sculpture,* exh. cat., Washington, D.C., NCFA, 1979.
Lori Ann Verderame, "The Sculpture of Seymour Lipton: Themes of Nature in the 1950s," Ph.D. diss., Pennsylvania State University, 1995.

TPC Sources
DP–Seymour Lipton correspondence, Foxhall Correspondence.
DP, cat. for TPC.1964.1.
MP, 1970 and 1982.
Interview with Seymour Lipton, conducted by Fritz Jellinghouse, cassette tape, 1982.

WILLEM DE KOONING

1. Title: Officially changed from *Ashville* in a Phillips Collection memo of Aug. 18, 1986, following a written request by de Kooning dated July 24, 1986, and accompanied by a cover letter signed by Edvard Lieber and Elaine de Kooning. "Ashville," inscribed on the back of the work, is an apparent misspelling of the North Carolina town Asheville. A change in date from 1949 to 1948 was also initiated in response to the 1986 letter. Provenance: Acquired May 2, 1952, Ledger 15. Letter of Mar. 25, 1952, from Melzac to DP with bill of sale attached.

2. Mary Emma Harris, *The Arts at Black Mountain College* (London, 1987), 146–58, gives the most complete account of the college and the 1948 summer session. See also Martin Duberman, *Black Mountain: An Exploration in Community* (London, 1972), 280–92; Pat Passlof, "1948," *Art Journal* 48, no.3 (Fall 1989), 229; and Elaine de Kooning, "De Kooning Memories," *Vogue* 173, no. 12 (Dec. 1983), 350–53, 393–94.

3. Compare de Kooning's encounter with the North Carolina landscape with the work of Arshile Gorky in Virginia and Connecticut in the early 1940s. Gorky, always acknowledged by de Kooning as an important influence, committed suicide in July 1948, during the period de Kooning was working on *Asheville.*

4. *Asheville* (sapolin, 48.3 × 61.0 cm.; Saint Louis Art Museum); *Asheville* (black enamel on paper, 20 × 30 in.; private collection); *Asheville* (oil on paper, 22 × 30 in.; private collection); *Asheville* (oil on board, 24¼ × 25⅛ in.; private collection). The works in private collections are reproduced in Yard, 1986, figs. 202–04.

5. See Thomas Hess, *Willem de Kooning Drawings* (Greenwich, Conn., 1972), 13–18, for a discussion of the role of drawings in de Kooning's working process.

6. Hess, 1959, 19, noted that *Asheville* was a depiction of the torn papers and drawings used in these procedures. For a discussion of de Kooning's collage-painting techniques, see Hess, 1968, 47, and Merkert's essay in Cummings, Merkert, and Stoullig, 1983, 125–26.

7. This method is illustrated in *Collage,* 1950 (22 × 30 in.; private collection), in which the templates are still tacked to the surface; reproduced in Hess, 1968, 69.

8. For a brief description of this process, see Elaine de Kooning, "De Kooning Memories," 394.

9. See Melvin Lader, "Graham, Gorky, De Kooning and the Ingres Revival in America," *Arts Magazine* 52, no. 7 (Mar. 1978), 94–99, for a discussion of de Kooning and Ingres.

10. As quoted in Hess, 1968, 148, excerpted from an interview with David Sylvester, 1963.

11. For an iconographic discussion of *Asheville,* see

Charles Stuckey, "Bill de Kooning and Joe Christmas," *Art in America* 68, no. 3 (Mar. 1980), 78–79. Stuckey's discussion of the motifs of fire, smoke, and ashes in *Asheville* suggests that de Kooning may have intended the title inscribed on the back of the work, "Ashville," as a pun.

12. See Polcari, 1991, 263. De Kooning's respect for craft and tradition has often been noted.

13. DP to Janis, Dec. 31, 1951. Phillips was specifically interested in *Excavation,* 1950 (Art Institute of Chicago).

Major References
Thomas Hess, *Willem de Kooning,* New York, 1959.
———, *Willem de Kooning,* exh. cat., New York, MOMA, 1968.
Harold Rosenberg, *De Kooning,* New York, 1974.
Sally Yard, *Willem de Kooning: The First Twenty-Six Years in New York, 1927–1952,* London, 1986.
Paul Cummings, Jörn Merkert, and Claire Stoullig, *Willem de Kooning: Drawings, Paintings, Sculpture,* exh. cat., New York, Whitney, 1983.
William C. Seitz, *Abstract Expressionist Painting in America,* Cambridge, Mass., 1983.
Diane Waldman, *Willem de Kooning,* New York, 1988.
Stephen Polcari, *Abstract Expressionism and the Modern Experience,* New York, 1991.
Marie-Anne Sichere et al., *Ecrits et propos, Willem de Kooning,* Paris, 1992.
Michael Leja, *Reframing Abstract Expressionism: Subjectivity and Paintings in the 1940s,* New Haven, 1993.
Charles M. Brock, "Describing Chaos: Willem de Kooning's Collage Painting *Asheville* and Its Relationship to Traditions of Description and Illusion in Western Art," M.A. thesis, University of Maryland, College Park, 1993.
David Thistlewood, ed., *American Abstract Expressionism,* in Tate Gallery Liverpool Critical Forum, vol. 1, Liverpool, U.K., 1993.
Judith Zilczer, ed., *Willem de Kooning from the Hirshhorn Museum,* exh. cat., Washington, D.C., Hirshhorn Museum and Sculpture Garden, 1993.
Michael Reuben Zakian, "Representation and Illusion in the Art of Willem de Kooning," Ph.D. diss., Rutgers, State University of New Jersey, 1994.
Marla Prather, *Willem de Kooning, Paintings,* exh. cat., Washington, D.C., NGA, 1994.
San Francisco Museum of Modern Art, *Willem de Kooning: The Late Paintings, the 1980s,* exh. cat., San Francisco, 1995.
Sally Yard, *Willem de Kooning,* New York, 1997.

TPC Sources
Cat., 1952.
MD, 1981.
MP, 1998.

CLYFFORD STILL
1. Title: Still numbered his works, at first to remove the mythic titles of his earlier work, later to catalogue his oeuvre; see his correspondence with Betty Parsons, Mar. 3, 1947, Betty Parsons Papers, artist's files, Still, AAA. Medium: Still used black pigment with varying amounts of medium, which enabled him to create strong matte and glossy contrasts in the black area. This technique also resulted in an uneven drying of the black paint; see Elizabeth Steele, painting conser-

vator, Jan. 14, 1991. Still preferred to grind his own paints and mix them with boiled linseed oil; see comments on technique in Michael Auping, "Clyfford Still and New York, The Buffalo Project," in Kellein, 1992, 41–42. Provenance: Marlborough-Gerson Gallery purchased a group of works from Still; see Kellein, 1992, 165. For TPC purchase, see correspondence with Marlborough-Gerson Gallery, May 6, 1969. Marjorie and Duncan Phillips were interested in holding a solo exhibition of his work, but it was never realized; see MP to Still, Aug. 11, 1963, Foxhall corr. Still distrusted most collectors and museums, telling his dealer in 1948, "I insist that these canvases be understood in the light of, or on the basis of, the values inherent in their creation. Since much more is involved than can be got across by merely exposing the pictures to the indoctrinated parasites"; Still to Parsons, Mar. 20, 1948, Betty Parsons Papers, artist's files, Still, AAA.

2. Still was in one sense the pathfinder, as he was the first to exhibit his color-field works; Irving Sandler, *The Triumph of American Painting: A History of Abstract Expressionism* (New York, 1970), 148.

3. Ibid., 158–74, has a good summary of Still's career; Anfam, 1990, 135–62, discusses these artists as a group.

4. Still to Gordon Smith, Jan. 1, 1959, as quoted in Albright Art Gallery, *Paintings by Clyfford Still,* exh. cat. (Buffalo, 1959), n.p.

5. As quoted in Albright, 1985, 22. For a discussion of the sublime aspects of Still's work, see Auping, "Beyond the Sublime," in Auping, 1987, 146, and Auping, "Clyfford Still and New York, The Buffalo Project," in Kellein, 1992, 39–40.

6. The complex matrix of humanistic ideas in America that provided the cultural framework of this period for artists, intellectuals, and literary figures has been explored extensively; see Michael Leja in Auping, 1987, 13–33; Anfam, 1990, 51–104; and Polcari, 1991, 3–56.

7. The author wishes to thank both David Anfam and Stephen Polcari for generously sharing their opinions on the meaning of *1950-B* and their knowledge of Still's life and work.

8. Polcari, 1991, 116. For full discussion of these ideas, see pp. 113–16.

9. For the importance of Jung, see ibid., 110–13.

10. Polcari, 1982, 22, relates Still's "content" to Lévy-Bruhl's "participation mystique," a concept that Jung shared and expanded upon. In it, primitive man, conceiving of the spiritual world as being in harmony with the material, literally fused with his spiritual environment. Anfam, 1984, 53–55, relates Still's iconography to the Cambridge School of Anthropologists, especially Jane Harrison's treatise *Themis,* which was a study of the mythopoeic patterns of early cultures.

11. Conversation with David Anfam, Mar. 28 and Apr. 15, 1991. See for example *Jamais,* 1944 (oil on canvas; Peggy Guggenheim Collection, Venice), and *Buried Sun,* 1945 (oil on canvas; collection unknown), illustrated in Marlborough-Gerson Gallery, 1969, 17.

12. Conversation with Anfam, Mar. 28, 1991. On use of black, see Auping, "Clyfford Still and New York, The Buffalo Project," in Kellein, 1992, 35–36. For color symbolism and interpretation, see Evan R. Firestone, "Color in Abstract Expressionism: Sources and Background for Meaning," and Ann Gibson, "Regression and Color in Abstract Expressionism: Barnett Newman, Mark Rothko, and Clyfford Still," both in *Arts Magazine* 55 (Mar. 1981), 140 and 144, respectively.

13. Conversation with Anfam, Mar. 28, 1991. He notes that there are many layers of meaning in Still's imagery, and he relates Still's understanding of this myth to Harrison's treatise, *Themis;* see Anfam, 1984, 64–65, nn. 70–71.

14. Rothko, introduction to catalogue for Still's 1946 exhibition at the Art of This Century Gallery, as quoted in Sandler, 1970, 167; see discussion in Anfam, 1984, 63–64. Still later rejected Rothko's statement and denied that the mythic titles for these paintings were his own, despite evidence to the contrary; see discussion in Polcari, 1991, 379, n. 22.

15. As quoted in Anfam, 1984, 194, n. 70.

16. Conversation with Polcari, Mar. 28, 1991. For discussion of Native-American sources, see Polcari, 1991, 95–103, n. 5.

17. Conversation with Polcari, Mar. 28, 1991. Ernest Briggs remembers Still's reference to this work as his "head" picture, as cited in Polcari, 1991, 109, n. 40.

18. Statement in 1947 by Clay Spohn, as cited in Buffalo Fine Arts Academy, *Clyfford Still: Thirty-three Paintings in the Albright-Knox Art Gallery,* exh. cat. (New York, 1966), 6. Also see Polcari, 1991, 95, n. 9

19. Polcari, 1991, 96.

20. In ibid., 104, he discusses the fusion of the individual with nature and its spiritual forces, apparent in *1950-B* in the figure-ground relationship.

21. As quoted in Ti-Grace Sharpless, *Clyfford Still,* exh. cat., Institute of Contemporary Art, University of Pennsylvania (Philadelphia, 1963), n.p.

Major References
Notes from interview with Still by Betty Freeman, Oct. 4, 1960, Betty Freeman Papers, AAA.
Benjamin Townsend, "An Interview with Clyfford Still," *Audit,* Winter/Spring 1961, 45–48.
———, "An Interview with Clyfford Still," *Gallery Notes* (Buffalo, Albright-Knox Gallery of Art) 22–24 (Summer 1961, 8–16.
Thomas Albright, "A Conversation with Clyfford Still," *Art News* 75, Mar. 1976, 30–35.
San Francisco Museum of Modern Art, *Clyfford Still,* exh. cat., 1976.
John O'Neill, ed., *Clyfford Still,* exh. cat., New York, Metropolitan, 1979.
Stephen Polcari, "The Intellectual Roots of Abstract Expressionism: Clyfford Still," *Art International* 25, May–June 1982, 18–35.
David A. Anfam, "Clyfford Still," Ph.D. diss., Courtauld Institute of Art, University of London, 1984.
Thomas Albright, *Art in the San Francisco Bay Area, 1945–1980,* Berkeley, 1985.
Michael Auping, *Abstract Expressionism: The Critical Developments,* exh. cat., Buffalo, Albright-Knox Art Gallery, 1987.
David Anfam, *Abstract Expressionism,* London, 1990.
Stephen Polcari, *Abstract Expressionism and the Modern Experience,* Cambridge, 1991.
Thomas Kellein, ed., *Clyfford Still, 1904–1980,* Munich, 1992; published in tandem with the exhibition "Clyfford Still: The Buffalo and San Francisco Collections."
April Kingsley, *The Turning Point: The Abstract Expressionists and the Transformation of American Art,* New York, 1992.
Susan Elise Landauer, "The Rigors of Freedom:

The San Francisco School of Abstract Expressionism," Ph.D. diss., Yale University, 1992.

David Thistlewood, ed., *American Abstract Expressionism*, in Tate Gallery Liverpool Critical Forum, vol. 1, Liverpool, U.K., 1993.

David Alfred Moos, "The Loss of Landscape in American Abstraction: The Self in Clyfford Still, Jackson Pollock, and Barnett Newman," Ph.D. diss., Columbia University, 1993.

Michael Leja, *Reframing Abstract Expressionism: Subjectivity and Paintings in the 1940s*, New Haven, 1993.

TPC Sources
MD, 1981.
MP, 1970 and 1982.
Percy North, essay for TPC.1983.8.
MP, 1998.

LOREN MACIVER

1. Provenance: The painting was shipped to Phillips in March 1953 according to Pierre Matisse to DP, Mar. 7, 1953. Although an invoice was sent to Phillips Mar. 19, 1953 (PM to DP, Mar. 19, 1953), payment was not received by Matisse until Feb. 15, 1954, per notation on bill of sale.

2. Quote from Robert Coates, "The Art Galleries," *New Yorker* (Jan. 17, 1953), 53–54.

3. Identification of some of the elements suggested in Baur, 1953, 33.

4. The comparison to Klee was mentioned by Robert Coates, "The Art Galleries," *New Yorker* (Dec. 7, 1940), 104–05, and Baur, 1953, 21. MacIver disavowed direct influence in conversation with author, Sept. 19, 1991.

5. Baur, 1953, 30. MacIver noted that she did not use pastels (conversation with author, Sept. 19, 1991).

6. As quoted in Dorothy C. Miller, ed., *Fourteen Americans*, exh. cat., MOMA (New York, 1946), 28. According to MacIver, the painting depicted the dark-green shade on the window to her fire escape in her townhouse in New York.

7. Lloyd Frankenberg to DP, Mar. 10, 1936: "William Zorach suggested I write to you using his name as introduction. He thought . . . you might like to see the work of Miss Loren MacIver, which he has seen and likes very much. . . . She has received permission from Alfred Stieglitz, John Sloan, Alfred H. Barr Jr., Karl Knaths . . . to quote them as finding great personal quality in her work."

8. *Paris*, 1949 (42 × 62 in.; Metropolitan Museum of Art). Phillips later wrote to MacIver (Jan. 22, 1951): "I almost purchased that picture [*Paris*] at sight one bitter cold day last winter but I was so chilled that I fled the Gallery promising to go back and then something came up which required my return to Washington."

9. DP to LM, Jan. 22, 1951.

10. *Printemps*, 1964 (50¼ × 77 in.; acc. no. 1240). In 1983 Robert M. Frash gave a drawing and an oil by MacIver to The Phillips Collection: *Repas*, 1963 (charcoal on paper, 29 × 41¾ in.; acc. no. 1241), and *Autour d'un Tourteau de Poitiers*, 1965 (oil on canvas, 22¼ × 24¼ in.; acc. no. 1238).

Major References
Adelyn Breeskin Papers, AAA.
Whitney Museum of American Art Papers, AAA.
John I. H. Baur, *Loren MacIver; I. Rice Pereira*, exh. cat., New York, Whitney, 1953.

Robert M. Frash, *Loren MacIver: Five Decades*, exh. cat., Newport Beach, Calif., Newport Harbor Art Museum, 1983.

Sandra Garbrecht, *Loren MacIver: The Painter and the Passing Stain of Circumstance*, Washington, D.C., 1987.

Jenni L. Schlossman, "Loren MacIver: Her Life and Work, 1930–1960," Ph.D. diss., Rutgers, State University of New Jersey, 1997.

TPC Sources
Cat., 1952.

MORRIS GRAVES

1. Thirty works by Graves were included in the exhibition "Americans 1942: 18 Artists from 9 States," organized by the Museum of Modern Art.

2. DP, 1947, 306.

3. *Winter Flower* (acc. no. 0846), the eleventh work by Graves in TPC, is a gift of Robert Miller Frash, 1983.

4. From Phillips's recommendation to the Guggenheim, Nov. 1945 (TPC Papers, AAA, reel 1963, #410).

5. Graves was also a friend of the composer John Cage and the choreographer Merce Cunningham, whose compositions transmitted Zen ideas.

6. DP to Graves, Nov. 1945, TPC Papers, AAA, reel 1963, #410.

7. Date: 1941 loan card from MOMA lists ca. 1940 as the date. Ray Kass, in the catalogue for the 1983 show, uses "ca. 1940." In any case, it had to have been painted prior to its showing at MOMA in the winter of 1941. Title: Listed as *Surf and Bird* in the 1942 MOMA exhibition, but Phillips refers to the painting as *Bird and Surf* in Apr. 11, 1942, letter to Marian Willard (TPC Papers, reel 1959, #70) and in Ledger 11. Provenance: For purchase from the MOMA exhibition see DP to Marian Willard, Apr. 11, 1942 (TPC Papers, AAA, reel 1959, #70). Payment for *Surf and Bird* is recorded in Ledger 11, May 8, 1942.

8. Provenance: Telegram from DP to Marian Willard, Dec. 28, 1943 (TPC Papers, reel 1961, #[obscured]). Ledger 11 records purchase as Jan. 14, 1944.

9. Provenance: Willard Gallery must have received *Wounded Gull* in 1943, because it was painted in the spring of 1943 and subsequently appeared in PMG.1943.28.

10. Wight, 1956, 31.

11. DP, 1947, 308.

12. DP, 1943, n.p.

13. DP, 1947, 308.

14. Title: *Chalice and Moon* appears in MOMA's records of works sent by Graves to the 1942 exhibition; no further reference to this title has been found. Provenance: In a letter dated Feb. 26, 1942, Graves informs Marian Willard that all paintings not sold through MOMA would become the property of the Willard Gallery (William R. Valentiner Papers, AAA, reel 2141, #1400).

15. Provenance: "Probably 1943" is conjectural, because no confirming records exist.

16. Carl Jung, *Psychology and Alchemy* (Princeton, 1953), 178–79.

17. As quoted in Rubin, 1974, 62.

18. DP, 1947, 308.

Major References
William R. Valentiner Papers and Willard Gallery Papers, AAA.

William R. Valentiner, "Morris Graves," *Art Quarterly* 7, no. 4, Autumn 1944, 251–56.

Kenneth Rexroth, "The Visionary Paintings of Morris Graves," *Perspectives USA* 10, Winter 1955, 58–66.

George Cohen, "The Bird Paintings of Morris Graves," *College Art Journal* 18, no. 1, Fall 1958, 3–19.

Nancy Wilson Ross, *Paintings and Drawings by Morris Graves*, exh. cat., Minnesota, St. Paul Art Center, 1963.

Ida Rubin, ed., *The Drawings of Morris Graves*, Boston, 1974.

Ron Glowen, "Morris Graves: East and West," *Art in America* 72, Sept. 1984, 188–95.

Robert McDonald, *Morris Graves: Vessels of Transformation, 1932–1986*, exh. cat., New York, Schmidt Bingham Gallery, 1990.

TPC Sources
DP–Morris Graves and DP–Marian Willard correspondence, TPC Papers, AAA, and TPC Archives.
DP, essay for PMG.1943.28.
DP, "Morris Graves," *Magazine of Art* 40, Dec. 1947, 305–08.
Cat., 1952.
Frederick S. Wight, cat. for TPG.1956.7.
MP, 1970 and 1982.
Ray Kass, cat. for TPC.1983.4.
Stephen B. Phillips, cat. for TPC.1997.4.
MP, 1998.

JACKSON POLLOCK

1. Title: Per gallery label on painting reverse and bill of sale, Sidney Janis Gallery, Oct. 25, 1958; O'Connor and Thaw, 1978, vol. 4, 117, gives no title. Date according to O'Connor and Thaw, ibid., gallery label, and bill of sale. According to O'Connor and Thaw, 114, Pollock used the same orange-and-black drawings for *Collage and Oil* as he did for *Number 2, 1951* (41 × 31 in.; Hirshhorn Museum and Sculpture Garden, Washington, D.C.). Medium: Per analysis by Elizabeth Steele, painting conservator, Nov. 26, 1990; O'Connor and Thaw, 1978, vol. 4, 117, describe the medium as rice and drawing paper, oil, white graffiti, and glue wash on canvas. Inscription: Signature partially obscured by bleeding of the ink. Provenance: According to O'Connor and Thaw, 1978, vol. 1, vii, and bill of sale, Oct. 25, 1958; consignment status verified by telephone communication with Sidney Janis Gallery, Aug. 1980.

2. Landau, 1989, 103, and O'Connor and Thaw, 1978, vol. 4, 97 and 117. The collage created for this exhibition seems to be lost; other artists included were Motherwell, Baziotes, Schwitters, Ernst, Braque, and Picasso. For listing of Pollock's collages, see O'Connor and Thaw, 1978, vol. 4, nos. 1023–41, most of which were created around the years 1943, 1948, and 1951.

3. "Primitive Art and Picasso," *Magazine of Art* 30 (Apr. 1937), 237 and 239. See also Judith Wolfe, "Jungian Aspects of Jackson Pollock's Imagery," *Artforum* 11 (Nov. 1972), 65–73.

4. Jackson Pollock in O'Connor and Thaw, 1978, vol. 4, doc. 90, 253; see also Putz, 1975, 186–206.

5. In striking contrast, Lee Krasner, who began to work with collage from 1950 on, found the medium very

fruitful (see Kuthy and Landau, 1989, 69 and 83).

6. Analysis by Steele and Sarah Bertalan, July 22, 1991. Compare the Japanese manuscript *Iseshu,* early twelfth century, illustrated in Herta Wescher, *Collage* (New York, 1968), 9.

7. Compare *Collage and Oil,* 1951 (Hirshhorn Museum and Sculpture Garden, Washington, D.C.); titled *Number 2* by O'Connor and Thaw, 1978, vol. 4, 114, no. 1039. Using fragments of the same drip paintings as *Collage and Oil* (TPC), it is much less figurative and retains an integrated sense of optical space.

8. Among Phillips's manuscripts are notes from his readings of books by scholars of the movement. They reveal his interest in coming to terms with this form of expression (see DP, between 1961 and 1966).

Major References
Francis V. O'Connor, "The Genesis of Jackson Pollock: 1912 to 1943," Ph.D. diss., Baltimore, Johns Hopkins University, 1965.
William Rubin, "Jackson Pollock and the Modern Tradition," *Artforum* 5, Feb. 1967, 14–22; Mar. 1967, 28–37; Apr. 1967, 18–31; May 1967, 28–33.
C. L. Wysuph, *Jackson Pollock: Psychoanalytic Drawings,* New York, 1970.
B. H. Friedman, *Jackson Pollock: Energy Made Visible,* New York, 1972.
Ekkehard Putz, "Jackson Pollock: Theorie und Bild," Ph.D. diss., Hildesheim, 1975.
Francis V. O'Connor and Eugene V. Thaw, *Jackson Pollock: A Catalogue Raisonné of Paintings, Drawings, and Other Works,* 4 vols., New Haven, 1978; supplement, New York, 1995.
Bernice Rose, *Jackson Pollock: Drawing into Painting,* exh. cat., New York, MOMA, 1980.
E. A. Carmean et al., *Jackson Pollock,* exh. cat., Paris, Musée National d'Art Moderne, Centre George Pompidou, 1982.
Elizabeth Frank, *Jackson Pollock,* New York 1983.
Sandor Kuthy and Ellen G. Landau, *Lee Krasner—Jackson Pollock: Künstlerpaare—Künstlerfreunde,* exh. cat., Kunstmuseum Bern, 1989.
Ellen G. Landau, *Jackson Pollock,* New York, 1989.
Steven Naifeh and Gregory White Smith, *Jackson Pollock: An American Saga,* New York, 1989.
David Anfam, *Abstract Expressionism,* London, 1990.
Erika Doss, *Benton, Pollock, and the Politics of Modernism: From Regionalism to Abstract Expressionism,* Chicago, 1991.
Stephen Polcari, *Abstract Expressionism and the Modern Experience,* Cambridge, 1991.
Claude Richard Cernuschi, *Jackson Pollock: Meaning and Significance,* New York, 1992.
David Thistlewood, ed., *American Abstract Expressionism,* in Tate Gallery Liverpool Critical Forum, vol. 1, Liverpool, U.K., 1993.
Carter Ratcliff, *The Fate of a Gesture: Jackson Pollock and Postwar American Art,* New York, 1996.
Nan Rosenthal, Katharine Baetjer, and Lisa Mintz Messinger, *The Jackson Pollock Sketchbooks in the Metropolitan Museum of Art,* 4 vols., exh. cat., Metropolitan, New York, 1997.
Claude Cernuschi, *"Not an Illustration but the Equivalent": A Cognitive Approach to Abstract Expressionism,* Madison, N.J., 1997.
Kirk Varnedoe and Pepe Karmel, *Jackson Pollock Retrospective,* New York, MOMA, 1998.

TPC Sources
DP [Rothko, Pollock, de Kooning, Guston, Tomlin], unpubl. notes and comments from the writings of Peter Selz, Robert Goldwater, and Sam Hunter, between 1961 and 1966; formerly MS 1.
MD, 1981.
MP, 1998.

PHILIP GUSTON

1. Provenance: Bill of sale, Mar. 8, 1958. Consignment to the gallery per Mary Mulcahy Jackson, Sidney Janis Gallery, to TPC, July 7, 1987.

2. Ashton, 1960, 16.

3. Dore Ashton, "The Age of Lyricism," *Arts and Architecture* 73 (Mar. 1956), 15.

4. As quoted by Guston in an interview with Harold Rosenberg in *Philip Guston: Recent Paintings and Drawings,* exh. cat., Jewish Museum (New York, 1966), cited in Ashton, 1976, 132.

5. Sandler, 1959, 65.

6. Louis Finkelstein, "New Look: Abstract Impressionism," *Art News* 60 (Mar. 1956), 36–37, 66.

7. Quote and subsequent analysis in Ashton, 1960, 50, 55.

8. Sandler, 1959, 37.

9. See *Voyage,* 1956 (oil on canvas, 72 × 76 in.; Albright-Knox Art Gallery, Buffalo); *Passage,* 1957–58 (oil on canvas, 65 × 74 in.; collection of Mrs. Dolly Bright Carter).

10. Ashton, 1976, 105.

11. See R. Warren Dash, "Philip Guston," *Arts* (Apr. 1958), 60, and Ashton, "Art," *Arts and Architecture* 75 (May 1958), 28.

12. DP, between 1961 and 1966, n.p. Phillips's notes on Guston are paraphrased from Sam Hunter, *Modern American Painting and Sculpture* (New York, 1959), 157–59.

13. "Philip Guston Talking" (edited version of a lecture delivered by the artist at the University of Minnesota, March 1978), as cited in Whitechapel Art Gallery, 1982, 52.

14. Hopkins and Feld, 1980, 14.

15. Ibid., 22.

16. Whitechapel Art Gallery, 1982, 50.

17. Ibid.

18. As quoted in Mayer, 1988, 12.

19. Ibid. Mayer discusses the trauma of Guston, at the age of ten or eleven, finding the body of his father after he had committed suicide; his interest in drawing suddenly intensified, as if, in Ross Feld's words, to draw "a distance for himself away from the family's shock and grief" (pp. 12–13).

20. Hopkins and Feld, 1980, 22.

21. Acrylic on paper, 23 × 29 in.; Gift of Musa and Tom Mayer, 1990; acc. no. 1989.8.1.

22. Hopkins and Feld, 1980, 29.

Major References
Irving Sandler, "Guston: A Long Voyage Home," *Art News* 58, Dec. 1959, 36–39, 64–65.
Dore Ashton, *Philip Guston,* New York, 1960.
H. H. Arnason, *Philip Guston,* exh. cat., New York, Guggenheim, 1962.
Dore Ashton, *Yes, But . . . A Critical Study of Philip Guston,* New York, 1976.
Roberta Smith, "The New Gustons," *Art in America,* Jan./Feb. 1978, 100–06.
Henry Hopkins and Ross Feld, *Philip Guston,* exh. cat., San Francisco Museum of Modern Art, 1980.
Whitechapel Art Gallery, *Philip Guston: Paintings, 1969–1980,* exh. cat., London, 1982.
Robert Storr, *Guston,* New York, 1986.
Magdalena Dabrowski, *The Drawings of Philip Guston,* exh. cat., New York, MOMA, 1988.
Musa Mayer, *Night Studio, A Memoir of Philip Guston,* New York, 1988.
Museum of Modern Art, *Philip Guston in the Collection of the Museum of Modern Art,* exh. cat., New York, 1992.
April Kingsley, *The Turning Point: The Abstract Expressionists and the Transformation of American Art,* New York, 1992.
David Thistlewood, ed., *American Abstract Expressionism,* in Tate Gallery Liverpool Critical Forum, vol. 1, Liverpool, U.K., 1993.
William Corbett, *Philip Guston's Late Work: A Memoir,* Cambridge, Mass., 1994.
University of Iowa Museum of Art, *Philip Guston: Working Through the Forties,* exh. cat., Iowa City, 1997.

TPC Sources
MP, 1970 and 1982.
Willem de Looper and Morton Feldman, cat. for TPC.1981.3.
MD, 1981.
DP [Rothko, Pollock, de Kooning, Guston, and Tomlin], notes and comments from the writings of Peter Selz, Robert Goldwater, and Sam Hunter, between 1961 and 1966; formerly MS 1.
MP, 1998.

ROBERT MOTHERWELL

1. Provenance: Purchased as a gift for Duncan Phillips according to MP to Stephen Weil, Marlborough-Gerson, Jan. 5, 1965. The collage presumably entered TPC at Phillips's death in 1966, but documentation concerning the transfer does not exist.

2. Motherwell stated, "Sometimes I get stuck in painting, as everybody does, and often, after shifting to collage for a time, I can resolve the painting problem when I return to it." As quoted in Barbaralee Diamonstein, *Inside New York's Art World* (New York, 1979), 248.

3. "Beyond the Aesthetic," *Design* 47 (Apr. 1946), 14–15.

4. Ashton and Flam, 1983, 19.

5. Ibid., 13.

6. For example, ocher evokes the idea of adobe houses and the terrain of northern California or Spain; blue is associated with the sea or sky; red alludes to Mexico or the painting of Matisse; see Ashton and Flam, 1983, 35, and Margaret Paul, ed., "Robert Motherwell: A Conversation at Lunch," *An Exhibition of the Work of Robert Motherwell,* exh. cat., Smith College Museum of Art (Northampton, Mass., 1963), n.p.

7. "A Process of Painting," lecture, Oct. 5, 1963, Eighth Annual Conference of the American Academy of Psychotherapists, New York; see Terenzio, 1992, 141.

8. As quoted in Ashton and Flam, 1983, 16. See also Carmean, 1972, 29, quoting his conversation with Motherwell, July 15, 1972.

9. According to Carmean, 1972, 32, Motherwell was so

inspired by the vistas of Italy during his stay there in the summer of 1960, that he executed many paintings and collages with landscape motifs during the early 1960s (*Summertime in Italy* series, early 1960s).

10. Exh. cat. for TPC.1965.1, n.p.

11. MP to Weil, Marlborough-Gerson Gallery, Jan. 5, 1965. According to MP, 1970, 299, Motherwell and his wife, Helen Frankenthaler, visited Washington, D.C., on the occasion of the exhibition.

Major References
Frank O'Hara, *Robert Motherwell, with Selections from the Artist's Writings,* exh. cat., New York, MOMA, 1965.
H. H. Arnason, "Robert Motherwell: The Years 1948 to 1965," *Art International,* Apr. 1966, 19–40.
E. A. Carmean Jr., *The Collages of Robert Motherwell: A Retrospective Exhibition,* exh. cat., Houston, MFA, 1972.
H. H. Arnason, *Robert Motherwell,* New York, 1977; rev. ed., 1982.
Dore Ashton and Jack Flam, *Robert Motherwell,* exh. cat., Buffalo, Albright-Knox Art Gallery, 1983.
William Seitz, *Abstract Expressionist Painting in America,* Cambridge, Mass., 1983.
Robert Saltonstall Mattison, *Robert Motherwell: The Formative Years,* Ann Arbor, Mich., 1987.
Marcelin Pleynet, *Robert Motherwell,* trans. Mary Ann Caws, Paris, 1989.
Jack Flam, *Robert Motherwell,* London, 1991.
Stephanie Terenzio, *The Prints of Robert Motherwell: Catalogue Raisonné, 1943–1990,* New York, 1991.
———, ed., *The Collected Writings of Robert Motherwell,* New York, 1992.
April Kingsley, *The Turning Point: The Abstract Expressionists and the Transformation of American Art,* New York, 1992.
David Thistlewood, ed., *American Abstract Expressionism,* in Tate Gallery Liverpool Critical Forum, vol. 1, Liverpool, England, 1993.
Mary Ann Caws, *Robert Motherwell: What Art Holds,* New York, 1996.
Ann Eden Gibson, *Abstract Expressionism: Other Politics,* New Haven, 1997.
David Rosand, ed., *Robert Motherwell on Paper: Drawings, Prints, Collages,* exh. cat., New York, Miriam and Ira D. Wallach Art Gallery, Columbia University, 1997.

TPC Sources
Sam Hunter, exh. cat. for TPC.1965.1.
MP, 1970 and 1982.
MD, 1981.
Interview with Robert Motherwell, conducted by Fritz Jellinghouse, cassette tape, 1982.
MP, 1998.

RICHARD CLIFFORD DIEBENKORN JR.
1. Provenance: In 1990 the collection was given *Berkeley No. 12,* 1953 (oil on canvas; gift of Judith Miller; acc. no. 1990.6.5).

2. According to Maurice Tuchman in Buck et al., 1976, 9, at CSFA, Diebenkorn admired the work of Motherwell and de Kooning through reproductions. According to Jones, 1990, 27, Diebenkorn and fellow San Francisco artists John Hultberg and Frank Lobdell

were called the Sausalito abstract expressionists as early as 1947–49.

3. Nordland, 1987, 8. See De Kooning, *Asheville,* 1948 (cat. no. 359).

4. As quoted in Hofstadter, 1987, 66. Technical analysis by Elizabeth Steele, painting conservator, Nov. 26, 1990.

5. The term *abstract landscape* was first used to describe Diebenkorn's works in *Life* magazine in 1954; see Buck et al., 1976, 23. He became interested in aerial views after a plane flight from Albuquerque to San Francisco in 1950.

6. Diebenkorn commented in 1955, "What I paint seems to pertain to landscape but I try to avoid any rationalization of this either in my painting or in later thinking about it. I'm not a landscape painter . . . or I would paint landscape directly"; as quoted in Jones, 1990, 29.

7. Diebenkorn's markedly brighter palette from 1952 on may also be the result of his having visited the 1952 Matisse retrospective at the Los Angeles County Museum of Art.

8. Inscription: The last digit of the *Berkeley* number could be 57; Jones, 1990, 172, n. 34, deciphers it as 54. Eventually, Diebenkorn assigned all three of these possible numbers to other paintings in the *Berkeley* series. See conservation report by Steele, Nov. 26, 1990. Provenance: According to Harold Fondren, Poindexter Gallery, New York, to TPC, July 30, 1987, Phillips purchased the painting from the Poindexter Gallery's 1958 one-person Diebenkorn exhibition.

9. Medium: "Girl" was painted over another work, which is illegible.

10. As quoted in Paul Mills, *Contemporary Bay Area Figurative Art,* exh. cat., Oakland Art Museum (1957), 12.

11. Ibid.

12. Park began painting representational works in 1950; however, he did not receive notoriety for this change until 1951, when he won a prize for *Kids on Bikes,* 1950 (48 × 42 in.; Regis Collection, Minneapolis), in the "Seventieth Annual Oil and Sculpture Exhibition" at the San Francisco Museum of Art. An exhibition organized by Paul Miller for the Oakland Art Museum in 1957 established the San Francisco representational artists as a group; included were Park, Diebenkorn, James Weeks, Theophilus Brown, Paul Wonner, and Bruce McGaw. See Jones, 1990, for details.

13. Matisse's influence on Diebenkorn continued in the color and design of his abstract *Ocean Park* paintings, which occupied him from 1967 until 1988.

14. Diebenkorn commented on the painting's influence on his work in the "Documentary Film on The Phillips Collection," produced by Checkerboard Film, 1986: "The painting has stuck in my head ever since I first laid eyes on it there [at The Phillips]. I've discovered pieces of that painting coming out in my own work over the years." See also Tuchman in Buck et al., 1976, 6.

15. The sweeping, textured brushstrokes of the abstraction underneath are visible on the surface of *Interior with View of the Ocean;* per Steele, Nov. 26, 1990. An inscription on the reverse is painted over: R *DIEBENKORN/ BERKELEY # 59/ JAN. 1955.* See Jones, 1990, 53 and 172, n. 34.

16. Nordland, 1987, 93.

17. Hofstadter, 1987, 64.

18. Diebenkorn's interest in Hopper began in high school and was intensified by the teachings of Daniel Mendelowitz, his instructor at Stanford in the early 1940s. Diebenkorn's earliest works have explicit associations with Hopper, according to Nordland, 1987, 11.

19. See TPC.1989.5.

Major References
Herschel Browning Chipp, "Diebenkorn Paints a Picture" *Art News* 56, May 1957, 44–47, 54–55.
Gerald Nordland, *Richard Diebenkorn,* exh. cat., Washington, D.C., Washington Gallery of Modern Art, 1964.
Robert T. Buck Jr. et al., *Richard Diebenkorn: Paintings and Drawings, 1943–1976,* exh. cat., Buffalo, Albright-Knox Art Gallery, 1976.
Jan Butterfield, *Pentimenti: Seeing and Then Seeing Again,* San Francisco, 1983.
Thomas Albright, *Art in the San Francisco Bay Area, 1945–1980,* Berkeley, 1985.
Dan Hofstadter, "Profiles: Almost Free of the Mirror," *New Yorker,* Sept. 7, 1987, 54–73.
Gerald Nordland, *Richard Diebenkorn,* New York, 1987.
Caroline A. Jones, *Bay Area Figurative Art, 1950–65,* exh. cat., San Francisco Museum of Art, 1990.
Whitechapel Art Gallery, *Richard Diebenkorn,* exh. cat., London, 1991.
Susan Elise Landauer, "The Rigors of Freedom: The San Francisco School of Abstract Expressionism," Ph.D. diss., Yale University, 1992.

TPC Sources
Gifford Phillips, cat. for TPC.1961.5.
MP, 1970 and 1982.
MD, 1981.
Interview with Richard Diebenkorn, conducted by Fritz Jellinghouse, cassette tape, 1982.
John Elderfield, cat. for TPC.1989.5.
Jane Livingston, cat. for TPC.1998.4.
MP, 1998.

THEODOROS STAMOS
1. Other influential books of the time were Lucien Lévy-Bruhl, *How Natives Think,* trans. Lilian A. Clare (New York, 1926), and Herbert Read, *Art and Society* (New York, 1936); Read extensively quoted from Lévy-Bruhl's work. For an analysis of the abstract expressionists' fascination with primitivism and myth, see Jeffrey Weiss, "Science and Primitivism: A Fearful Symmetry in the Early New York School," *Arts* 57 (Mar. 1983), 81–87.

2. First quote by Barnett Newman, essay in *Stamos,* exh. cat., Betty Parsons Gallery (New York, 1947), n.p.; second quote in Cavaliere, 1977, 105.

3. Cavaliere, 1977, offers an analysis of Stamos's technique and intention.

4. Ibid., 114.

5. Bill of sale, Feb. 15, 1950. The gouaches are no longer in the collection; current whereabouts unknown.

6. During this visit, Stamos admired in particular the family's Bonnard paintings. When he discovered that Phillips owned no works by Rothko, he urged him to consider his friend, comparing his treatment of color to that of Bonnard (Stamos to author, Feb. 9, 1991). Stamos wrote to Phillips: "It sure was swell staying with you at Dunmarlin and hope that we will soon meet again . . . warmest regards to you both, to Laugh-

lin and Bonnard" (Foxhall corr., undated [1950]).

7. Cat., 1952, 136, in the section entitled "The Collection Continued."

8. See Stamos's comments in his "Why Nature in Art?," unpubl. essay, 1954, 1, typescript of lecture courtesy of Barbara Cavaliere.

9. Ibid., 6.

10. Ibid., 1.

11. Ibid., 6.

12. Dore Ashton quoting Stamos in "About Art and Artists: First Show Here for Stamos in 3 Years," *New York Times*, Jan. 20, 1956, L21.

13. As quoted in *Stamos*, exh. cat., Camillos Kouros Gallery (New York, 1985), 5.

14. Title: *The Sacrifice of Kronos, No. 2* appears on the Betty Parsons bill of sale and was preferred by the artist. *The Sacrifice of Chronos, No. 2* appears in many TPC records. Stamos painted a *Sacrifice of Kronos, No. 1*; he is unaware of its whereabouts (Stamos to author, Feb. 24, 1991). Provenance: Bill of sale, Oct. 27, 1949, Betty Parsons Gallery Papers, AAA, reel N68–72, #327, and Elmira Bier, TPG, to Betty Parsons, Dec. 15, 1949.

15. Provenance: Bill of sale, Oct. 27, 1949, Betty Parsons Gallery Papers, AAA, reel N68–72, #327.

16. W. Jackson Rushing, "Ritual and Myth: Native American Culture and Abstract Expressionism" in *The Spiritual in Art: Abstract Painting, 1890–1985*, exh. cat., Los Angeles County Museum of Art (1986), 277.

17. Cronus, who is equated with the Roman god known as Saturn, was referred to by the artist with the Greek spelling, Kronos.

18. James Hall, *Dictionary of Subjects and Symbols in Art*, rev. ed. (New York, 1979), 273. Sir James Frazer also mentions the myth in *The Golden Bough*, abridged ed. (New York, 1950), 341. Cronus was eventually forced to disgorge the stone and five of his other children. The stone was later enshrined at Delphi. War ensued between Cronus and Zeus, and the latter emerged the victor.

19. Cavaliere, 1977, 107.

20. Analysis of technique by Elizabeth Steele, painting conservator, Feb. 11, 1991. According to Stamos to author, Feb. 24, 1991, he achieved the screenlike patterns by daubing a "tacky" paint surface with a paper towel holding the color he wanted. The "sprayed-on" effect derived from flicking the loaded brush at the canvas to splatter paint on the surface. See Stamos to author, Feb. 24, 1991.

21. DP to Stamos, Nov. 28, 1949: "The three oils are hanging together now along with paintings by Arthur Dove and I wish you could see how well they look."

Major References
Kenneth Sawyer, *Stamos*, Paris, 1960.
Ralph Pomeroy, *Stamos*, New York, 1974.
Barbara Cavaliere, "Theodoros Stamos in Perspective," *Arts* 52 (Dec. 1977), 104–15.
Sam Hunter, "Theodoros Stamos: History and Recent Paintings," *Arts* 62 (Sept. 1988), 56–59.
Stephen Polcari, *Abstract Expressionism and the Modern Experience*, Cambridge, 1991.
April Kingsley, *The Turning Point: The Abstract Expressionists and the Transformation of American Art*, New York, 1992.
Ann Eden Gibson, *Abstract Expressionism: Other Politics*, New Haven, 1997.

TPC Sources
Cat., 1952.
MP, 1982.

SAM FRANCIS

1. Provenance: Consignment established by a contract between Francis and the gallery, Martha Jackson Gallery Papers, AAA, reel D246, #552–56. Bill of sale, Nov. 24, 1958.

2. In addition to completing the three large paintings intended for the Basel Kunsthalle, known as the Basel triptych (1956–58), Francis painted fifteen other large canvases, ten small canvases, and dozens of watercolors; Betty Freeman Papers, reel 4060, #1255). He was included in eleven group shows around the world and has had four one-person exhibitions, including two at The Phillips, which in 1958 was his first in a museum (TPG.1958.7 and TPC.1980.2); Buck, 1972, 142–43. For the Basel triptych, see Selz, 1975, 56–60.

3. Robert C. Cafritz's entry in *MD*, 1981, 198. See discussion of Joan Mitchell (cat. no. 378) for more on the second-generation abstract expressionists.

4. As quoted in Upright, 1980, 10.

5. For example, Monet, *Morning*, 1916–26, four-part mural (total dimensions: 77½ × 476¾ in.; Galerie de l'Orangerie, Musée du Louvre, Paris).

6. Betty Freeman, unpubl. MSS, Freeman Papers, AAA, reel 4060, #1340.

7. Colt, 1962, n.p.

8. Cafritz, entry in *MD*, 1981, 198.

9. *Tokyo Mural*, 1957 (oil on canvas, 78 × 315 in.; Collection Sofu Teshigahara, Sogetsu School of Flower Arrangement, Tokyo).

10. "New Talent," *Time* (Jan. 16, 1956), 72. Also see Robert Elkon in cat. for TPC.1980.2, 6.

11. Francis visited the museum during the exhibition (TPG.1958.7); see Francis to DP, Dec. 5, 1958, TPC Papers, AAA, reel 1990, #1373.

Major References
Betty Freeman, "Sam Francis, Ideas and Paintings," unpubl. MS, Betty Freeman Papers, AAA.
Priscilla Colt, "The Paintings of Sam Francis," *Art Journal* 22, no. 1, Fall 1962, 2–7.
James Johnson Sweeney, *Sam Francis*, exh. cat., Houston, Museum of Fine Arts, 1967.
Robert T. Buck Jr., *Sam Francis: Paintings, 1947–1972*, exh. cat., New York, Buffalo Fine Arts Academy, 1972.
Carter Ratcliff, "Sam Francis: 'Universal Painter,'" *Art News* 71, no. 8, Dec. 1972, 56–59.
Carl Belz, "Fitting Sam Francis into History," *Art in America*, 61, no. 1, Jan.–Feb. 1973, 40–45.
Peter Selz, *Sam Francis*, New York, 1975; rev. ed., 1982.
Yves Michaud, *Sam Francis*, Paris, 1992.
Connie W. Lembark, *The Prints of Sam Francis: A Catalogue Raisonné, 1960–1990*, 2 vols., New York, 1992.
Michael David Plante, "The 'Second Occupation': American Expatriate Painters and the Reception of American Art in Paris, 1946–1958," Ph.D. diss., Brown University, 1992.
Karl Gunnar Pontus Hulten, *Sam Francis*, trans. by Stephen Locke, exh. cat., Bonn, Kunst und Austellungshalle der Bundesrepublik Deutschland, 1993.

Galerie Nationale du Jeu de Paume, *Sam Francis: Les années parisiennes, 1950–1961*, exh. cat., Paris, 1995.
Fundación Caja de Madrid, *Sam Francis: Elements and Archetypes*, exh. cat., Madrid, 1997.

TPC Sources
Cat. for TPC.1980.2.
MD, 1981.
MP, 1998.

JOAN MITCHELL

1. Title: *August Daguerre* appears on the bill of sale, May 1, 1958, and in early exhibition catalogues; it is probably a misinterpretation of the actual title. Provenance: The painting was sent on approval from the Stable Gallery April 4, 1958 (shipping notebook). A letter from Elmira Bier, TPG, to The Stable Gallery, May 6, 1958, confirms Phillips's desire to purchase the painting. The bill of sale bears the date May 1, 1958.

2. Bernstock, 1988, 31, quoting Mitchell in John I. H. Baur, *Nature in Abstraction*, exh. cat., Whitney (New York, 1958), 75.

3. As quoted in Tucker, 1974, 13.

4. As quoted in Yves Michaud, *Joan Mitchell*, exh. cat., Xavier Fourcade Gallery (New York, 1986), n.p. Mitchell, an avid reader of poetry and friend of many poets, often looked to poetry for inspiration. Many examples are discussed in Bernstock, 1988.

5. As quoted in Michaud, *Joan Mitchell*, n.p.; Bernstock, 1988, 51–52.

6. As quoted in Tucker, 1974, 8–9.

7. Technical analysis by Elizabeth Steele, painting conservator, Aug. 12, 1991.

8. Irving Sandler, "The Colonization of Gesture Painting," *The New York School: The Painters and Sculptors of the Fifties* (New York, 1978), 46–57.

Major References
Irving Sandler, "Mitchell Paints a Picture," *Art News* 56, Oct. 1957, 44–47, 69–70.
Marcia Tucker, *Joan Mitchell*, exh. cat., New York, Whitney, 1974.
Judith E. Bernstock, *Joan Mitchell*, exh. cat., Ithaca, N.Y., Herbert F. Johnson Museum of Art, Cornell University, 1988.
Michael David Plante, "The 'Second Occupation': American Expatriate Painters and the Reception of American Art in Paris, 1946–1958," Ph.D. diss., Brown University, 1992.
Michel Waldberg, *Joan Mitchell*, Paris, 1992.
Musée des Beaux-Arts de Nantes and Galerie Nationale du Jeu de Paume, *Joan Mitchell*, exh. cat., Nantes and Paris, 1994.
Klaus Kertess, *Joan Mitchell*, New York, 1997.

TPC Sources
MP, 1998.

JACK YOUNGERMAN

1. Provenance: Bill of sale, Apr. 25, 1968, Betty Parsons Papers, AAA, reel 4101, #657; consignment and sale documented in reel 4129, #913.

2. As quoted in Roberts, 1972, 7, and in correspondence to Betty Parsons, Jan. 3, 1967, Betty Parsons Papers, AAA, reel 4129, #672.

3. Correspondence with author, July 8, 1992. Youngerman's interest in the diamond-shaped canvas may also

have been stimulated by Mondrian's diamond-shaped works, which were well known in America. See E. A. Carmean Jr., *Mondrian: The Diamond Compositions,* exh. cat., NGA (Washington, 1979).

4. Youngerman to Betty Parsons, Dec. 10, 1966, Betty Parsons Papers, AAA, reel 4129, #660. In 1966 he explored new shapes in a variety of graphic media. In his interview with Rose (1966, 29), he stated that his india-ink drawings helped him to simplify and clarify his shapes; he also noted that the drawings and his use of acrylic contributed to his present style (Rose, 1966, 27).

5. As quoted in *Time* (Apr. 26, 1968), 76. See also Youngerman in Roberts, 1972, 9, on the importance of the canvas edge.

6. Artist's questionnaire and correspondence with author, July 8, 1992.

7. As quoted in Rose, 1966, 27.

8. The modulation in the blue is achieved by repeated applications of paint; in some areas it is thinly painted so that the white ground lightens the tone of the color. In other areas heavier brushstrokes are visible and create density. Technical analysis by Elizabeth Steele, paintings conservator, June 11, 1991.

9. As quoted in Rose, 1966, 29.

10. For correspondence regarding this show, see Betty Parsons to MP, July 31, 1967, reel 4129, #788; MP to Parsons, Aug. 16, 1967, reel 4129, #789; Parsons to MP, Nov. 27, 1967, reel 4129, #790; and Youngerman to MP, Mar. 20, Apr. 5, and Apr. 23, 1968.

11. See gallery hanging records from 1969 through 1975.

12. From Marjorie Phillips's draft of her text for the catalogue for TPC.1968.4.

13. According to Youngerman, as cited in Roberts, 1972, 6, he first saw the Matisse drawings in an exhibition at the Musée de l'Art Moderne in Paris. For discussion of the myriad sources, see Waldman, 1986, 11–19. Also see Stephanie Barron and Larry Rosing, "Matisse and Contemporary Art," *Arts Magazine* 49 (May 1975), 66–69. Youngerman was also influenced by several American artists: Clyfford Still's massing of form, and Georgia O'Keeffe's and Arthur Dove's biomorphism.

14. As quoted in Roberts, 1972, 6.

15. As quoted in Rose, 1966, 27. Also see statements in Roberts, 1972, 9.

16. As quoted in "Portrait: Jack Youngerman, Six India Inks," *Art in America* 56 (Sept.–Oct. 1968), 53.

Major References
Jack Youngerman Papers, AAA.
Michael Benedikt, "Youngerman: Liberty in Limits," *Art News* 64, Sept. 1965, 43–45, 54–55.
Barbara Rose, "An Interview with Jack Youngerman," *Artforum* 4, Jan. 1966, 27–30.
Daniel Catton Rich, *Paintings and Drawings by Jack Youngerman,* exh. cat., Mass., Worcester Art Museum, 1966.
Colette Roberts, "Jack Youngerman," *Archives of American Art* 12, no. 2, 1972, 3–10.
Donald B. Kuspit, "Youngerman's Gestural Emblem," *Art in America* 74, July 1986, 84–91.
Diane Waldman, *Jack Youngerman,* exh. cat., New York, Guggenheim, 1986.
John Gruen, "The Geometry of Nature and the Nature of Geometry," *Art News* 86, Feb. 1987, 86–92.

Michael David Plante, "The 'Second Occupation': American Expatriate Painters and the Reception of American Art in Paris, 1946–1958," Ph.D. diss., Brown University, 1992.
Pace Gallery, *Indiana, Kelly, Martin, Rosenquist, Youngerman at Coenties Slip,* exh. cat., New York, 1993.

TPC Sources
MP and Dale McConathy, text for TPC.1968.4.
MP, 1970 and 1982.
TPC artist's questionnaire, July 8, 1992.

FRANK STELLA

1. Title: Erroneously published and exhibited as *Pilicia II* since acquisition. Medium: A stain was removed Nov. 2, 1983; see conservation files. *Pilica II* is composed of hardboard, particle board, painted canvas, manufactured lightweight fabric, felt, and cardboard painted with commercial paint, all mounted on corrugated cardboard affixed to a wooden support; analysis per Elizabeth Steele, painting conservator, June 11, 1991. The composition is comprised of three pieces that are joined. Provenance: Per M. Knoedler to author, May 29 and June 6, 1991; bill of sale, Mar. 19, 1974. The purchase was funded by an NEA grant.

2. As quoted in Lawrence Rubin, 1986, 18.

3. See, for example, Roberta Smith, "Schnabel and Stella: Art, Myth, and Ego," *New York Times,* Dec. 6, 1987. Critics called his *Polish Village* series "relief paintings," a term that has continued to be used. Stella (in William Rubin, 1986, 20) insists that he is a painter: "Whether you call what I do painted reliefs or relief paintings doesn't seem to me to make much difference. The impulse that goes into them is pictorial." Many of the quotes by Stella in MOMA's 1970 and 1986 catalogues derive from interviews with Rubin.

4. Stella remembered feeling that he "just had to start all over again"; William Rubin, 1986, 14. Rubin (pp. 28 and 32) further notes that Stella's 1970 MOMA retrospective acted as a watershed, forcing him to examine his art in its totality. The *Polish Village* series was criticized because it lacked "tight sequential logic" and retained "nascent illusion." See Rosalind Krauss, "Stella's New Work and the Problem of Series," *Artforum* 10, no. 4 (Dec. 1971), 40–44, and William Rubin, 1986, 21–22, for a discussion of these issues. See also Elizabeth C. Baker, "Frank Stella, Revival and Relief," *Art News* 70, no. 7 (Nov. 1971), 34; Louis Finkelstein, "Seeing Stella," *Artforum* 11, no. 10 (June 1973), 67–70; and Herbert David Raymond, "The Persistence of Illusion in American Non-Referential Painting in the 1960s," Ph.D. diss., New York University, 1970, 60–77.

5. For example, his *Irregular Polygon* series, 1966–67.

6. Stella used for his titles the images in *Wooden Synagogues* by Maria and Kazimierz Piechotka, introduction by Dr. Stephen S. Kayser (Warsaw, 1959). The synagogue in the village of Pilica is illustrated on p. 37 and discussed on p. 205. A friend, the architect Richard Meier, drew Stella's attention to this book; William Rubin, 1986, 40.

7. A systematic artist, Stella had several preliminary stages; he made the original working drawing for *Pilica* in 1970, which he then transferred to graph paper in 1971. In 1973 he made a working drawing for the model, followed by three maquettes, before constructing the final works of art. *Pilica I* and all preliminary studies are in the artist's personal collection (per M.

Knoedler to author, June 6, 1991). *Pilica III* is in a private collection (105 × 96 in.), and is illustrated in color in Leider, 1978, cat. no. 9. The 1970 drawing is illustrated in Kitakyushu Municipal Museum of Art, *Frank Stella, Working Drawings, 1956–1982, from the Artist's Collection,* exh. cat. (Kitakyushu, Japan, 1982), cat. no. 55–36. All of the preliminary works were exhibited with *Pilica III* in Cohen, 1983, 11. The original drawing has "36" written on the reverse, which corresponds to the reference number written on each section of *Pilica II.*

8. For a thorough discourse on the medium and variations among the versions, see Leider, 1978, 10–12. William Rubin, 1986, 22–27, illustrates the stages of *Mogielnica,* another work from the *Polish Village* series, from the initial drawing to the fourth version.

9. Per Steele, June 11, 1991.

10. As quoted in William Rubin, 1986, 37.

11. Leider first explored this derivation in Stella's art, noting a strong general resemblance to Malevich's suprematist drawings; see illustrations in Leider, 1978, 95, 98, and 103.

12. Stella and Malevich in William Rubin, 1986, 40 and 37, respectively.

13. See Leider, 1978, 102–03.

14. Ibid., 103.

15. William Rubin, 1986, 40. El Lissitzky's illustrations for the Haggadah song "Had Gadya" were the catalyst for a series of prints that Stella created a decade later. See Leider, "Shakespearean Fish," *Art in America* 71 (Oct. 1990), 172–91.

16. As quoted in William Rubin, 1986, 40, and Leider, 1978, 103. See Cohen, 1983, 4, for her observations. Neither Leider (p. 102) nor Rubin (p. 40) believes that there is a close formal relationship between the architecture and the compositions in the *Polish Village* series.

17. As quoted in William Rubin, 1986, 40. In his *Black Paintings* he consistently alluded to death and depression. His titles for three of these paintings refer to Hitler and the "darkness" of this period. See Richardson, 1976, 24, 26, and 39.

Major References
Frank Stella, interview with Sidney Tillim, 1969, Frank Stella Papers, AAA.
Michael Fried, *Three American Painters,* exh. cat., Cambridge, Fogg Art Museum, Harvard University, 1965.
William S. Rubin, *Frank Stella,* exh. cat., New York, MOMA, 1970.
Robert Rosenblum, *Frank Stella,* London, 1971.
Carol Beth Cade, "Color in Color Field Painting: Color in the Painting of Ellsworth Kelly, Kenneth Noland, and Frank Stella," Ed.D. diss., Columbia University, 1973.
Brenda Richardson, *Frank Stella: The Black Paintings,* exh. cat., Baltimore Museum of Art, 1976.
Philip Leider, *Stella Since 1970,* exh. cat., Fort Worth Art Museum, 1978.
Richard H. Axsom, *The Prints of Frank Stella: A Catalogue Raisonné, 1967–1982,* New York, 1983.
Carolyn Cohen, *Frank Stella: Polish Wooden Synagogues, Constructions from the 1970s,* exh. cat., New York, Jewish Museum, 1983.
Frank Stella, *Working Space,* Cambridge, 1986.
Lawrence Rubin, *Frank Stella: Paintings,*

1958–1965—*Catalogue Raisonné*, New York, 1986.
William Rubin, *Frank Stella, 1970–1987*, exh. cat., New York, MOMA, 1986.
Alfred Pacquement, *Frank Stella*, Paris, 1988.
Caroline A. Jones, "Machine in the Studio: Changing Constructions of the American Artist, 1945–1968," Ph.D. diss., Stanford University, 1992.
Sidney Guberman, *Frank Stella: An Illustrated Biography*, New York, 1995.
Museo Nacional Centro de Arte Reina Sofia, *Frank Stella*, exh. cat., Madrid, 1995.

TPC Sources
Richard Friedman, text for TPC.1973.12.
MD, 1981.
Interview with Frank Stella, conducted by Fritz Jellinghaus, cassette tape, 1982.

11. THE PHILLIPS COLLECTION AND ART IN WASHINGTON

Washington and Baltimore Artists from the 1930s Through the 1950s

1. I would like to thank Maura K. Parrott, my research associate on this project, for the imagination and enthusiasm she brought to the task of gathering documentation for the entries and searching the archives for details regarding this vital, but so far untold, part of the museum's history.

2. *C in M*, 1926, 4.

3. See Watkins Unit essay, cat. no. 381.

4. DP to Watkins, Mar. 10, 1929, gallery history files, TPC Archives.

5. DP to Watkins, Mar. 20, 1929, gallery history files, TPC Archives.

6. The PWAP (Public Works of Art Project) was initiated in 1933 by the federal government under the leadership of Edward Bruce, himself a distinguished artist. The project was divided into regions, and Duncan Phillips was appointed chairman of the Washington region, which included the District of Columbia, Maryland, and Virginia. Commissions were awarded to artists for murals in public buildings (post offices, for example) and for paintings of many sorts reflecting "Life in America." The purpose of the project was to provide relief for artists suffering from the effects of the Depression.

7. Essay for PMG.1944.11, n.p.

8. MP, 1982, 184.

9. *Nocturne—The Port*, 1963 (ink and ink washes on paper; acc. no. 1762).

10. To cite some specific but typical examples from the gallery hanging records: From November 1944 to January 1945, Cross's *The Little Stove* was exhibited, followed by *Flowers in Sunlight* and *Mansion* in the same location; in Gallery A a small exhibition of watercolors by Robert Gates was displayed from April to June of that year. Maril's *Harbor Scene* and Cross's *Sunken Treasure* were shown from October to November 1945, and Gernand's *Blowing Leaves* hung in the second-floor hallway from September 1947 to January 1948.

11. Jane Watson Crane, *Washington Post*, Aug. 11, 1946.

12. PMG.1941.4; for the earlier exhibition, see PMG.1940.7 and its catalogue, which in 1946 was issued by the museum as *The Language of Design*, a memorial to Watkins. For Watkins's other publications, see entry, cat. no. 381.

13. See topics as announced in brochure entitled *Educational Program of the Phillips Memorial Gallery* (1930).

14. For example, the brochure set up six separate areas of study. The first, entitled "Selective Course," was intensive, with classes on Mondays, Wednesdays, and Fridays as well as lectures on Thursday evenings; it was planned "for the individual development of beginners or more advanced students who intend to make painting a career." The second division, entitled the "Experimental Course," was offered "for professional painters or advanced students only." The third division was termed "Amateur Sketch Class" and met twice a week. The fourth was a "Tuesday Life Class" open to both artists and students; the fifth was for artists who wished to use the studios for their own work without instruction; and the sixth was a "High School Students' Saturday Course."

15. Phillips's note, written on the manuscript of Watkins's essay entitled "Pictures of People," *American Magazine of Art* 26 (Nov. 1933), 498–510.

CHARLES LAW WATKINS

1. See pp. 608–9 for the history of the Phillips Gallery Art School and the individuals involved in founding and teaching at American University.

2. DP, essay for PMG.1945.10.

3. Watkins, *The Language of Design* (Washington, D.C., 1946), 87–90.

Major References
Charles Law Watkins, "Pictures of People," *American Magazine of Art* 26, Nov. 1933, 498–510 (in conjunction with PMG.1933.6).
Elisabeth E. Poe, "Who's Who in Washington Art Circles," *Washington Times-Herald*, Apr. 30, 1939.
C. Law Watkins, "Emotional Design in Painting," *Magazine of Art* 33, May 1940, 280–87.
———, "Art and Reality," *College Art Journal* 2, part 1, May 1943, 118–19.
Paul F. Douglas, *Exhibition of Paintings, C. Law Watkins Memorial Collection*, exh. cat., Washington, D.C., American University, Watkins Gallery, 1945.
Charles Seymour, *Exhibition of the C. Law Watkins Memorial Collection*, exh. cat., Washington, D.C., American University, Watkins Gallery, 1948.

TPC Sources
Charles Law Watkins, "Art and the Business Man," *A & U*, 1930, 149–55.
DP and C. Law Watkins, "Terms We Use in Art Criticism," *A & U*, 1930, 160–74.
C. Law Watkins, essay for PMG.1940.7.
———, essay for PMG.1941.4.
DP, essay for PMG.1945.10.
C. Law Watkins, *The Language of Design*, Washington, D.C., 1946.
MP, 1970 and 1982.

SARAH BAKER

1. Provenance: Letter of payment to Whyte Gallery, Dec. 19, 1939, reel 1955, #1124, TPC Papers, AAA; Ledger 15, Dec. 19, 1939, and Ledger 16.

2. Provenance: Per acquisition record AL15 (as *Eggplants and Pink Cloth*).

Major References
Sarah Baker Papers, AAA.
Adelyn D. Breeskin, "Sarah Baker," *Divertissements!*

Sarah Baker, exh. cat., Whyte Gallery, undated [pre-1942].
Watkins Gallery, *Sarah Baker: Paintings, 1924–1960*, exh. cat., Washington, D.C., American University, 1975.
Benjamin Forgey, "Cézanne to Dracula," *Art News* 74, Apr. 1975, 79.

TPC Sources
Sarah Baker, "Plans for Work" (personal statement on file at John Simon Guggenheim Memorial Foundation), 1946, TPC Archives.
Cat., 1952.
Ben L. Summerford et al., essays for TPC.1977.5.
Arthur Hall Smith, essay for TPC.1983.10.

MARGARET CASEY GATES

1. Date: Painted in July 1938, according to the TPC painting file cover. Title: Labels on the frame reverse and stretcher corresponding to PMG.1938.13 and PMG.1941.1 carry a second title, *Classic Landscape*. The painting file and shipping records list "Howard Univ. Gallery Ex of Wash. Paintings/Nov. Dec. 1941," but the catalogue includes only one Margaret Gates work, *Classic Landscape, Saw Mill*, as lent by the museum. No work by either title appears in the TPC deaccession files, thus all three titles may refer to the same painting.

Major References
"Robert F. Gates and Wife New Gallery Executives," *Washington Post Magazine*, Oct. 15, 1933, 11.
Jane Watson, "Individuality Marks Show at Whyte," *Washington Post*, Mar. 26, 1939.
E.E.P. [Elisabeth Poe], "Who's Who in Washington Art Circles," *Washington Times-Herald*, Dec. 18, 1939.
William Francis Walter, "Margaret Gates," in *4 One-Man Exhibitions*, exh. cat., Washington, D.C., Corcoran Gallery of Art, 1948.

TPC Sources
Cat., 1952.
MP, 1970 and 1982.

LOÏS MAILOU JONES

1. Title: *Place du Tertre, Paris* per Howard University, Boston MFA, and Morgan State College exhibitions. *La Place du Tertre à Montmartre* per inscription on stretcher reverse. The artist confirmed the title *Place du Tertre, Montmartre, Paris* in correspondence of Feb. 7, 1992. Provenance: Letter of payment to Jones, Dec. 22, 1944.

2. Maurice Utrillo, *Place du Tertre* (sometimes published as *Montmartre*), 1913 (private collection). The Phillips Collection owns *Place du Tertre*, 1911, by Utrillo; it shows the same square from a different angle (see cat. no. 120).

Major References
James A. Porter et al., *Lois Mailou Jones, Peintures 1937–51*, Tourcoing, France, 1952.
"Artist of Sunlit Canvases," *Ebony* 24, Nov. 1968, 136–41.
Howard University Art Gallery, *Lois Mailou Jones: Retrospective Exhibition—Forty Years of Painting, 1932–1972*, exh. cat., Washington, D.C., 1972.
"Lois Mailou Jones Pierre-Noel/Artist and Teacher: An Artist Acclaimed Wherever Her Sunlit Paintings Are Seen," in *Ebony Success Library*,

Nashville, 1973, 188–91.

MFA, Boston, *Reflective Moments: Lois Mailou Jones; Retrospective, 1930–1972*, exh. cat., 1973.

Betty La Duke, "Lois Mailou Jones: The Grand Dame of African-American Art," *Woman's Art Journal* 8, no. 2, Fall 1987/Winter 1988, 28–32.

Nancy G. Heller, "Lois Mailou Jones American Painter," *Museum and Arts Washington* 4, July–Aug. 1988, 42–45.

Gary A. Reynolds and Beryl J. Wright, *Against the Odds: African-American Artists and the Harmon Foundation*, exh. cat., Newark Museum, 1990.

Tritobia H. Benjamin, *The World of Loïs Mailou Jones*, exh. cat., Meridian House International, Washington, D.C., 1990.

———, "The Life and Art of Loïs Mailou Jones, American Artist," Ph.D. diss., University of Maryland, College Park, 1991.

TPC Sources
Cat., 1952.
MP, 1970 and 1982.
John Gernand and Kevin Grogan, essays for TPC.1979.9.
TPC artist's questionnaire, Feb. 1992.

ROBERT FRANKLIN GATES

1. Title: *Potomac Icebreaker* per bill of sale. *Potomac Ice-Cutter* appears on acquisition record AL10, but the work was never exhibited as such. Provenance: Studio House bill of sale, Apr. 4, 1936.

2. DP to Mary Anway, Oct. 9, 1947.

3. Provenance: Purchased after the 1954 Corcoran exhibition; per Ledger 15, Jan. 17, 1955, and Elmira Bier to Gates, Jan. 18, 1955.

4. Jean White, "Eye for Color, Rocks Add Touch to Work of Painter Robert Gates," *Washington Post*, Apr. 20, 1960.

Major References
Olin Dows, "Young Americans," *American Magazine of Art* 29, May 1936, 320–23.
Alice Graeme, "Water Colors of the Virgin Islands," *Magazine of Art* 30, May 1937, 301–05.
Howard University Gallery of Art, *An Exhibition of Watercolors by Robert F. Gates*, exh. cat., Washington, D.C., 1940.
Jane Watson Crane, "Robert F. Gates, Washington Artist," *News*, Baltimore Museum of Art, Feb. 1948, 4–5.
Leslie Judd Ahlander, "An Artist Speaks: Robert Gates," *Washington Post*, Aug. 12, 1962.
Corcoran, *Robert Gates*, exh. cat., Washington, D.C., Washington Artists Exhibition Series, no. 14, 1962.
Dorothy W. Phillips, *A Catalogue of American Paintings in the Corcoran Gallery of Art*, vol. 2, *Painters Born from 1850–1910*, Washington, D.C., 1973, 184.
Jack Rasmussen Gallery, *Watercolors of the Virgin Islands and West Virginia, 1934–1941*, exh. cat., Washington, D.C., 1980.

TPC Sources
Personal statement by the artist, 1930s.
Cat., 1952.
DP, essay for *Paintings by Robert Gates*, exh. cat., Washington, D.C., Corcoran, 1954 (includes several drafts).
MP, 1970 and 1982.

HERMAN MARIL

1. Provenance: Per acquisition record AL4, Ledger 15, Jan. 12, 1946, and TPC painting file cover.

2. Helen Buchalter, "Good Maril Art in Howard Show, Work of 'Unpopular' Artist Admired by First Lady," *Washington Daily News*, Dec. 1, 1934.

3. The first known purchase was *Harbor Scene*, 1934 (oil on canvas, 14⅛ × 22⅛ in.; acc. no. 1264); the last was *Evening* (cat. no. 390). In 1980 Franz Bader gave *Poppies*, 1978 (oil on canvas, 40 × 30 in.; acc. no. 1267), to the collection.

4. Provenance: Per acquisition records AL10 and AL16.

5. Dows, 1935, 408, 411.

6. Lawall, *Works by Herman Maril from Charlottesville Collectors*, exh. cat., Bayly Art Museum of the University of Virginia (Charlottesville, 1981), n.p. Lawall was a curator at the museum.

Major References
Maril Papers, AAA.
Olin Dows, "Herman Maril," *Art News* 28, July 1935, 406–11.
Whyte Gallery, *Paintings by Herman Maril*, exh. cat., Washington, D.C., 1940.
F. A. Whiting Jr., "Herman Maril," in *Recent Paintings by Herman Maril*, exh. cat., New York, Macbeth Gallery, 1941.
James V. Herring, *Eighth Anniversary Exhibition: Herman Maril, Paintings in Retrospect, 1931–1951*, exh. cat., Washington, D.C., Barnett Aden Gallery, 1951.
Frank Getlein, *Herman Maril*, exh. cat., Baltimore Museum of Art, 1967.
William Hauptman et al., *Herman Maril*, exh. cat., College Park, University of Maryland Art Department Gallery, 1977.
Adelyn Breeskin et al., *Works by Herman Maril, Recent Paintings*, exh. cat., Washington, D.C., Franz Bader Gallery, 1983.

TPC Sources
DP to Thomas B. Grandin, John Simon Guggenheim Memorial Foundation, Jan. 29, 1935; letter regarding Maril.
Cat., 1952.
Stephen B. Phillips, cat. for TPC.1997.4.

WILLIAM HOWARD CALFEE

1. Provenance: Ledger 15, July 1, 1952, and acquisition records AL10 and AL17.

Major References
Calfee Papers, AAA.
William H. Calfee, "Suitability and Relationships," *Magazine of Art* 34, Dec. 1941, 522–26.
Whyte Gallery, *Sculpture, Oil Paintings, Drawings by William Calfee*, exh. cat., Washington, D.C., 1941.
Centre d'Art, *Calfee*, exh. cat., Port-au-Prince, Haiti, 1949; includes essays by Calfee and Selden Rodman.
Corcoran, *A Catalogue of the Collection of American Paintings in the Corcoran Gallery of Art*, 2 vols., Washington, D.C., 1973, vol. 2, 1949–95.
Abby Wasserman, "As an artist William Calfee makes a good teacher, and vice versa," *Washington Star*, Dec. 30, 1978.
Jean Lawlor Cohen, "The Old Guard: Washington

Artists in the 1940s," *Museum and Arts Washington* 4, May/June 1988, 65–66, 68.

TPC Sources
MP, 1970 and 1982.
TPC artist's questionnaire, Sept. 1991.

JACOB KAINEN

1. Provenance: Purchase per acquisition records AL10 and AL16.

2. As quoted in Rand, 1978, 144.

3. Joshua C. Taylor, foreword for *Jacob Kainen, Recent Works*, exh. cat., Lunn Gallery/Graphic International, Ltd. (Washington, D.C., 1978), n.p.

4. The title comes from Hart Crane's *The Bridge*: "Only in darkness is thy shadow clear."

5. "Recent Jacob Kainen," *Washington Star*, Jan. 4, 1981.

Major References
Kainen Papers, AAA.
Jacob Kainen, "Memories of Arshile Gorky," *Arts Magazine* 51, Mar. 1976, 96–98.
Harry Rand, "Notes and Conversations: Jacob Kainen," *Arts Magazine* 53, Dec. 1978, 135–45.
Michael Sundell, *Jacob Kainen, Four Decades: Paintings*, New Gallery of Contemporary Art, Cleveland, 1978.
David Tannous, "Those Who Stay: Seventeen Artists—Painters, Sculptors, Photographers—Discuss the Pros and Cons of Living and Making Art in Washington," *Art in America* 66, July 1978 (Kainen on pp. 82–83).
NCFA, *Jacob Kainen, Five Decades as a Painter*, exh. cat., Washington, D.C., 1980.
Toby Thompson, "The Way of Jacob Kainen," *Washington Post Magazine*, Dec. 14, 1980, 31–33.
Jean Lawlor Cohen, "The Old Guard: Washington Artists in the 1940s," *Museum and Arts Washington* 4, May–June 1988, 55–71.
———, "The Making of the Color School Stars, 1950–1960," *Museum and Arts Washington* 4, Nov.–Dec. 1988, 55–61, 84.
Iris Krasnow, "Jacob's Ladder," *Museum and Arts Washington*, 6, Jan.-Feb. 1990, 48–56, 141, 158.
NMAA, *Jacob Kainen*, exh. cat., Washington, D.C., 1993.

TPC Sources
Cat. for TPC.1973.10.
Charles Parkhurst, essay for TPC.1980.10.
TPC artist's questionnaire, April 1992.

JAMES MOORE MCLAUGHLIN

1. Date: Museum records and cat. for TPC.1982.7 give the date of execution as 1941; acquisition record EB53 gives the date as 1942. Provenance: Purchase per acquisition record EB53 and TPC painting file cover.

2. DP to Paul Sachs, professor, Fogg Art Museum, Harvard University, June 14, 1935, TPC Papers, reel 1948, #0256.

3. Richard, 1982.

4. Medium: Erroneously published as "oil on canvas" in exhibition catalogues. Provenance: Purchase per Ledger 15 and Ledger 18, p. 121, recorded on July 25, 1951. This work was probably purchased out of exhibition.

5. Provenance: Purchase per TPC painting file cover and acquisition records AL16 and AL18; a label on the

reverse reads: *"Property of Duncan Phillips."*

Major References
Elizabeth Benson, "Two-Man Exhibition at
 Phillips," *Right Angle* 1, Jan. 1948, n.p.
Susan Davis, "The Man Who Gave Modern Art a
 'Soul,'" *Washington Post,* Jan. 19, 1982.
Joe Brown, "Paintings With Heart," *Washington
 Post,* June 5, 1982.
Paul Richard, "A Phillips Tribute to Friends,"
 Washington Post, June 14, 1982.

TPC Sources
McLaughlin-DP correspondence, during military
 service, 1942–43, TPC Papers, AAA.
Cat., 1952.
MP, 1970 and 1982.
Arthur Hall Smith et al., essays for TPC.1982.7.

BERNICE CROSS
1. Date: It is possible that Cross began the work in
1947, because it was exhibited fairly early in 1948. Both
old and new painting files, as well as Cat. 1952, state
that the work was unsigned. Cross signed the painting
some time later (per phone conversation with Martha
Carey, former research curator, Sept. 21, 1986). Prove-
nance: Record of payment in Ledger 15, May 8, 1948.

2. Bertha Shaefer Gallery, *Paintings by Bernice Cross,*
exh. cat. (New York, 1951), n.p., quoted from Ben-Zion,
Right Angle, 1949, n.p.

3. Inscription: Painting file and Cat., 1952 erroneously
list this work as being unsigned. Provenance: Per
painting file and Ledger 15, May 12, 1950.

Major References
Boyer Galleries, *Paintings, Drawings, Watercolors,
 Lithographs by Washington and Baltimore Artists,*
 exh. cat., Philadelphia, 1936.
F. A. W. Jr., "Vandalism at Glendale," *Magazine of
 Art* 30, Dec. 1937, 745–46.
"New Exhibitions of the Week," *Art News* 37, Dec.
 31, 1938, 23.
Robert M. Coates, "The Art Galleries," *New Yorker*
 14, Jan. 7, 1939, 38.
Ben-Zion, "Bernice Cross: Subject and Texture,"
 Right Angle 3, June 1949, n.p.
J. K. R., "First Show in Ten Years," *Art Digest* 23,
 May 1, 1949, 19.
Henry McBride, "Bernice Cross' Wit," *Art News* 50,
 May 1951, 46.

TPC Sources
Cat., 1952
DP and MP correspondence with Cross, 1952–62,
 Foxhall Corr.
MP, 1970 and 1982.
Interview with Bernice Cross, conducted by Ben L.
 Summerford, 1990.

JOHN GERNAND
1. Provenance: Whyte Gallery bill of sale, Apr. 15, 1939,
and payment entry May 6, 1939, in Account Book 16.

2. M.H., "WPA Gallery Opens," unidentified clipping.

Major References
Alice Graeme, "Phillips Art Gallery Shows New
 Exhibitions, John Gernand Has One-Man Show
 of Recent Work," *Washington Post,* Nov. 19, 1939.
Whyte Gallery, *Young Washington Painters: Former*

"Studio House" Exhibitors, Washington, D.C.,
 1939.
———, *New Paintings by John Gernand,* exh. cat.,
 Washington, D.C., 1943.
Florence S. Berryman, "Oils by John Gernand,"
 Sunday Star, Washington, D.C., Mar. 4, 1945.
Michael Kernan, "Return of the Native," *Washing-
 ton Post,* Jan. 21, 1983.

TPC Sources
Phillips Gallery Studio House, *John Gernand and
 Alida Conover,* exh. cat., Washington, D.C., 1938
John Gernand, essay for PMG.1939.18
DP and MP correspondence with Gernand, ca.
 1940–72, Foxhall Corr.
Cat., PMG.1943.5
Cat., PMG.1947.7
Cat., 1952
MP, 1970 and 1982

MITCHELL JAMIESON
1. "5 District Artists Show Work in New York Exhibit,"
Washington Post (May 31, 1936); actually discusses five
painters and one sculptor.

2. Provenance: Per painting file and acquisition record
AL15. Date and circumstances of transfer from artist to
Dows unknown.

3. Benjamin Forgey, "'Two Wars': Detachment vs.
Guilt" (review of Corcoran exhibition), *Washington
Star* (Dec. 28, 1979).

Major References
"5 District Artists Show Work in New York
 Exhibit," *Washington Post,* May 31, 1936.
Alice Graeme, "Watercolors of the Virgin Islands;
 Treasury Department Art Project," *Magazine of
 Art* 30, May 1937, 301–05.
Whyte Gallery, *Paintings of Mexico by Mitchell
 Jamieson,* exh. cat., Washington, D.C., 1939.
"Lieutenant Mitchell Jamieson Paints Amphibious
 Warfare," *American Artist* 8, June 1944, 14–18.
Judith Kaye Reed, "Honored by the American
 Academy," *Art Digest* 21, June 1947, 11, 22.
Henry McBride, "To dream, ay, there's the rub," *Art
 News* 52, May 1953, 50.
Corcoran, *Two Wars: Drawings by Mitchell Jamieson,*
 exh. cat., Washington, D.C., 1979.

TPC Sources
Cat., 1952

HAROLD GIESE
1. Provenance: Per painting file.

Major References
Whyte Gallery, *Paintings by Harold Giese,* exh. cat.,
 Washington, D.C., 1945.
M. de la Motte, "L'actualité artistique en Alle-
 magne," *Aujourd'hui* 10, Oct. 1967, 162.

TPC Sources
Cat., 1952.
MP, 1970 and 1982.
DP and MP correspondence with Giese, 1944–78,
 Foxhall Corr.

BEN L. SUMMERFORD
1. Date: Summerford began the painting in 1949; inter-
rupted by his year abroad on a Fulbright Scholarship,
he completed it in 1952. Summerford uses the name

"Joe" informally. Provenance: Corcoran bill of sale,
Dec. 9, 1953.

2. See Knaths entries, cat. nos. 277–81.

Major References
Baltimore Museum of Art, *Paintings by Summer-
 ford,* exh. cat., 1951.
Leslie Judd Portner, "Two Musicians," *Washington
 Post,* Sept. 27, 1953.
Leslie Judd Ahlander, "An Artist Speaks: Joe Sum-
 merford," *Washington Post,* Aug. 19, 1962.
Frank Getlein and Benjamin Forgey, "Art: The Best
 Art Faculty in Town," *Sunday Star,* Washington,
 D.C., Mar. 3, 1968.
Paul Richard, "A Search for Quality," *Washington
 Post,* Nov. 23, 1972.
———, "Of Quiet, Sunlit Scenes," *Washington
 Post,* Mar. 19, 1975.
"Franz Bader Gallery, Washington, D.C.," *Art News*
 74, Sept. 1975, 87.
Jo Ann Lewis, "Ben Summerford, Artist in Resi-
 dence," *Washington Post,* Dec. 19, 1982.
Jean Lawlor Cohen, "The Old Guard: Washington
 Artists in the 1940s," *Museum and Arts Washing-
 ton* 4, May–June 1988, 66–68.

TPC Sources
Willem de Looper and Judith Lyon, cat. for
 TPC.1982.13.

Washington Art in the 1960s and Beyond

1. See Gilliam's comments in his lecture, Feb. 27, 1992,
"Sam Gilliam: Artists Speak," cassette tape, TPC
Archives.

2. For further information on postpainterly abstrac-
tion, see Michael Auping, *Abstraction, Geometry,
Painting,* exh. cat., Albright-Knox Art Gallery (Buffalo,
1989), 54–72.

3. Greenberg introduced all three artists to the New
York art scene. In 1954 he included Louis and Noland
in "Emerging Talent" at the Samuel M. Kootz Gallery.
He helped choose the works for Louis's 1959 solo exhi-
bition at French and Co., Inc., following Newman's at
that gallery; in January 1960 Gottlieb had a solo show
there. In 1962 Greenberg helped arrange for the
Poindexter Gallery to be Davis's New York dealer, and
Davis had his first New York solo show there the fol-
lowing year; Greenberg included Davis as well as Louis
and Noland in his 1964 "Post-Painterly Abstraction"
exhibition at the Los Angeles County Museum of Art.

4. Also acquired at that time was de Looper's *Chinoise,*
1970, later returned in partial trade for his painting
Kiri Te (cat. no. 410).

5. For instance, while Tack's work—especially small,
late abstractions that bear a superficial but uncanny
resemblance to paintings by Clyfford Still—appealed
to many local artists, neither he nor his work was
commonly discussed.

6. See TPC.1973.10 and TPC.1977.3.

7. See TPC.1963.2. A showing of the Museum of Mod-
ern Art's David Smith exhibition opened the series in
1962; however, subsequent shows of works by Seymour
Lipton, Jacques Lipchitz, and Etienne Hajdu origi-
nated at the museum.

ALMA WOODSEY THOMAS
1. Provenance: Gift documented by Franz Bader to

Laughlin Phillips, May 20, 1976, and LP to FB, July 24, 1979.

2. See cat. nos. 403–05.

3. Eleanor Munro, "The Late Springtime of Alma Thomas," *Washington Post Magazine*, Apr. 15, 1979, 194.

4. Thomas as quoted in Whitney Museum, 1972, n.p.

5. Thomas in Doty, 1976, 4.

6. B[enjamin]. Forgey, "At 80, Life Can Be Beautiful," *Washington Star*, May 5, 1976.

7. As quoted in Jacqueline Trescott, "The Seasons, The Flowers, The Sea . . . All Part of Her Paintings," *Sunday Star*, Aug. 29, 1971.

8. Franz Bader to Laughlin Phillips, Dec. 24, 1985.

9. See DP, essay for PMG.1941.4, for his analysis of the role of color in painting.

Major References
Alma W. Thomas Papers, AAA, gift of J. Maurice Thomas.
David Driskell, *Alma W. Thomas, A Retrospective Exhibition (1959–1966)*, exh. cat., Washington, D.C., Gallery of Art, Howard University, 1966.
———, *Alma W. Thomas: Earth and Space Series, 1961–1971*, exh. cat., Nashville, Tennessee, Carl Van Vechten Gallery of Fine Arts, Fisk University, 1971.
———, *Alma W. Thomas Retrospective Exhibition*, exh. cat., Washington, D.C., Corcoran Gallery of Art, 1972.
Whitney Museum of American Art, *Alma W. Thomas*, exh. cat., New York, 1972.
Adolphus Ealey, *Alma W. Thomas, Recent Paintings*, exh. cat., Washington, D.C., Gallery of Art, Howard University, 1975.
Robert Doty, *Alma W. Thomas: Recent Paintings, 1975–1976*, exh. cat., New York, Martha Jackson West Gallery, 1976.
Merry Foresta, *A Life in Art: Alma Thomas, 1891–1978*, exh. cat., Washington, D.C., NMAA, 1981.

MORRIS LOUIS

1. Date: Clement Greenberg served as adviser to the Louis Estate from 1962 through 1970. Under his guidance, the Louis Estate titled, dated, stretched, and hung paintings from the estate that Louis had not done himself. The first task was to inventory and assign an estate number to all the paintings stored in Louis's home. In most cases the estate number—here, "#182"—served as the title for the newly released *Stripe* paintings (Upright, 1985, 35–38). Provenance: TPC purchase recorded in Ledger 15.

2. This series became known as the *Stripes* after Louis's death. During the artist's lifetime, Greenberg and Louis's dealers referred to the paintings as *Pillars* (Upright, 1985, 38).

3. For a discussion of Louis and the Washington Color School, see Rose, 1971. For a discussion of the validity of calling this group of artists a school, see Nordland and Scott, 1991, 9–10.

4. See cat. nos. 404–07.

5. Louis chose different blues and greens: on the left are permanent green and ultramarine blue; on the right are earth green and cobalt blue.

6. Upright, 1985, 57.

7. Louis used Bocour acrylic paints called "magna col-

ors." For a discussion of Bocour products, see Upright, 1985, 49–50.

8. The staining technique was introduced to Louis in 1953, when he, Noland, and Leon Berkowitz visited Helen Frankenthaler's studio and saw her recently completed poured stain painting *Mountains and Sea*, 1952 (86⅛ × 117¼; collection of the artist).

9. Analysis by Elizabeth Steele, painting conservator, Sept. 23, 1991.

10. According to Upright, 1985, 42, Louis marked cropping instructions on the canvas reverse; however, without removing the canvas from its stretcher, it is impossible to know whether Louis's markings exist on The Phillips's canvas.

11. For a discussion of stretching and dimensions, see Upright, 1985, 42.

12. *Illumination*, 1962 (83 × 12 in., Richard Brown Baker, New York; Upright no. 588).

Major References
Morris Louis Archives, Collection of Marcella Louis Brenner, Chevy Chase, Maryland; intended gift to AAA.
Michael Fried, *Morris Louis*, New York, 1970.
Barbara Rose, "Retrospective Notes on the Washington School" in *The Vincent Melzac Collection: Modernist American Art Featuring New York Abstract Expressionism and Washington Color Painting*, exh. cat., Washington, D.C., Corcoran, 1971.
E. A. Carmean, *Morris Louis*, exh. cat., Washington, D.C., NGA, 1976.
Diane Upright, "Morris Louis: The Mature Paintings of 1954–1962," Ph.D. diss., University of Michigan, 1976.
———, *Morris Louis, The Complete Paintings: A Catalogue Raisonné*, New York, 1985.
John Elderfield, *Morris Louis*, exh. cat., New York, MOMA, 1987.
Janet Alice Jones, "Clement Greenberg: His Critical and Personal Relationships with Jackson Pollock and Selected Post-Painterly Abstractionists," Ph.D. diss., New York University, 1988.
Padiglione d'Arte, *Morris Louis*, exh. cat., Milan, 1990.
Gerald Nordland and Sue Scott, *Washington Color Painters: The First Generation*, exh. cat., Fla., Orlando Museum of Art, 1991.
Musée de Grenoble, Réunion des Musées Nationaux, *Morris Louis*, exh. cat., Paris, 1996.
Florence Rubenfeld, *Clement Greenberg: A Life*, New York, 1997.

TPC Sources
MP, 1970 and 1982.
MD, 1981.
MP, 1998.

GENE DAVIS

1. Title: Erroneously given as *Flower Form* in Donald Wall, "Gene Davis and the Issue of Complexity," *Studio International* 180 (Nov. 1970), 188.

2. Provenance: The gift to Wall confirmed in a telephone call with Florence Davis, July 31, 1990; consignment to Middendorf and subsequent purchase by Lehrman documented in Chris Middendorf to Willem de Looper, Dec. 10, 1982; and acknowledgment of gift in de Looper to Lehrman, Dec. 22, 1982.

3. Davis in Jo Ann Lewis, "Stripes of An Artist's Life," *Washington Post*, Jan. 30, 1977, as quoted in Naifeh, 1982, 11.

4. There is debate over the validity of calling this group of artists a school. The label was not coined until 1965, in Gerald Nordland's exhibition catalogue *The Washington Color Painters* for the Washington Gallery of Modern Art, located at that time across the street from The Phillips. For discussion of this issue, see Nordland and Scott, 1991, 1–2.

5. Davis in Naifeh, 1982, 70.

6. Davis to Greenberg, July 21, 1961, and Greenberg to Davis, Aug. 5, 1961, Greenberg Papers, AAA. See the artist's reminiscences in Davis, 1978, 93–94.

7. Davis to Greenberg, Apr. 10, 1962, Greenberg Papers, AAA; they corresponded regularly from 1961 to 1967.

8. Davis to Greenberg, May 29, 1962, Greenberg Papers, AAA. Greenberg included him in his pivotal and influential 1964 show, "Post-Painterly Abstraction," which was held at the Los Angeles County Museum of Art and traveled extensively.

9. Davis in Leslie Judd Ahlander, "Art in Washington: An Artist Speaks: Gene Davis," *Washington Post*, Aug. 26, 1962, quoted in Naifeh, 1982, 70.

10. As quoted in ibid., 72. For his working method, see Davis in Gerald Nordland, "Gene Davis Paints a Picture," *Art News* 65 (Apr. 1966), 49, 61–62.

11. See Naifeh, 1982, 69–73, for further discussion. Greenberg stressed the importance of Noland and Louis to Davis's development as early as 1962, as suggested by Davis's comment in a letter to Greenberg, Sept. 19, 1962, Greenberg Papers, AAA. An insightful discussion of Davis's gradual disavowals of influence is in Sara Day, "Gene Davis: Shimmering Canvases and Stormy Echoes," *Museum and Arts Washington* (Jan./Feb. 1987), 34–35. See also Naifeh's discussion of this issue (pp. 69–70 and accompanying notes).

12. According to Ben L. (Joe) Summerford, Davis mentioned (during the installation of the artist's first solo show at the Jefferson Place Gallery) that he found these works by Stella to be exciting and that they were a point of departure for him (see notes on discussion between Summerford and author, Apr. 23, 1991). See Brenda Richardson, *Frank Stella: The Black Paintings*, exh. cat., BMA (Baltimore, 1976).

13. As quoted in Auping, 1987, 62.

14. For the importance of Noland, see Davis to Greenberg, July 21, 1961, Greenberg Papers, AAA. It was Noland who gave Davis one of his first solo shows, at Catholic University in 1953, and who privately critiqued Davis's early work.

15. Analysis of technique per Elizabeth Steele, conservator, Oct. 9, 1991.

16. Davis in Nordland, "Gene Davis Paints a Picture," 49, noted that he preferred Bocour "magna colors" (a mixture of oil and acrylic) diluted with turpentine. In his article "Random Thoughts on Art," *Art International* 15 (1971), 42, Davis stated that at first he painted his stripes freehand.

17. Steele, Oct. 9, 1991.

18. Davis in Swift, 1978–79, 8.

19. Kuspit, "A Perfect Music: Gene Davis's Stripes," in Serwer, 1987, 39.

20. As quoted in Wall, 1975, 28. See also Andrew Kagan, "Paul Klee's Influence on American Painting: New

York School," *Arts Magazine* 49 (June 1975), 54–59, and "Paul Klee's Influence on American Painting, Part II," *Arts Magazine* 50 (Sept. 1975), 84–90.

21. Naifeh, 1982, 40. Davis purchased Klee's *Piano Lamp on the Desk* in 1951.

22. Davis and his wife, Florence Davis, were sentimentally attached to The Phillips Collection, for it was in a gallery there in 1953 that they were introduced.

23. As quoted in David Tannous, "Gene Davis," *Art in America* 66 (July/Aug. 1978), 80. See also Jerry Clapsaddle and Percy North, "Dialogue: Gene Davis," Sept. 1, 1983, unpubl. MS, TPC Archives.

24. As quoted in Barbara Rose, "A Conversation with Gene Davis," *Artforum* 9 (Mar. 1971), 54. In his article "Starting Out in the '50s," *Art in America* 66 (July/Aug. 1978), 88–94, Davis discussed the importance of meeting places and collections for the contemporary Washington artists, and he named the Whyte Bookshop and Gallery, the Workshop Center for the Arts, and The Phillips Collection.

Major References
Gene Davis Papers, 1930–1984, AAA.
Gene Davis Collection, NMAA, Smithsonian Institution, Washington, D.C., gift of the estate.
Donald Wall, ed., *Gene Davis*, New York, 1975.
Gene Davis, "Starting Out in the '50s," *Art in America* 66, July/Aug. 1978, 93–94.
Mary Swift, "An Interview with Gene Davis," *Washington Review* 4, Dec. 1978–Jan. 1979, 7–9.
Gene Baro, *Gene Davis Drawings*, New York, 1982.
Steven W. Naifeh, *Gene Davis*, New York, 1982.
Jacquelyn D. Serwer, *Gene Davis: A Memorial Exhibition*, exh. cat., Washington, D.C., NMAA, 1987.
Michael Auping, *Abstraction, Geometry, Painting*, exh. cat., Albright-Knox Art Gallery, Buffalo, 1989.
Gerald Nordland and Sue Scott, *Washington Color Painters: The First Generation*, exh. cat., Orlando Museum of Art, 1991.

TPC Sources
Interview with Gene Davis, conducted by Fritz Jellinghouse, cassette tape, 1982, TPC Archives.
Percy North, essay for TPC.1983.8.

KENNETH NOLAND
1. Provenance: Payment discussed in correspondence with artist, July 2, 1952.

2. On Klee's importance to Noland's art, see Sterling, 1987, 71–78. See also Andrew Kagan, "Paul Klee's Influence on American Painting: New York School," *Arts Magazine* 49, no. 10 (June 1975), 54–59, and "Paul Klee's Influence on American Painting, Part II," *Arts Magazine* 50, no. 1 (Sept. 1975), 84–90.

3. Phillips purchased both works in 1948. On the importance of The Phillips Collection, see Sterling, 1987, 78–81, Moffett, 1977, 19–20, and Agee, 1993, 19.

4. See Sterling, 1987, 75.

5. See Noland's comments about this series in Sterling, 1987, 99; she used Noland's personnel file at Catholic University as her source; information verified by representative at Catholic University over the phone.

6. As quoted in Sterling, 1987, 98. The locations of the other *Playground* paintings are unknown.

7. Analysis by Elizabeth Steele, conservator, Apr. 8, 1991.

8. DP to Noland, May 7, 1952, TPC Papers, AAA, reel 1978, # [obscured].

9. Provenance: Payment recorded as June 30, 1960, in Ledger 15; no bill of sale has been found. Phillips probably first became interested in acquiring a *Concentric Circle* painting when he visited an exhibition of work completed by Noland in 1959 (see Alice M. Denny, director, Jefferson Place Gallery, to DP, Feb. 24, 1960). According to Noland, this work was probably painted in April 1960 (TPC questionnaire, 1991).

10. As quoted in Al McConagha, "Noland Wants His Paintings to Exist as 'Sensation,'" *Minneapolis Tribune*, Mar. 13, 1966.

11. Observation of William Rubin noted in Sterling, 1987, 243.

12. Because of its circular shape, scholars have sometimes cited Noland's *Globe*, 1956 (magna on canvas; Cornelia Langer Noland, Washington, D.C.), as a breakthrough work that led to his protocircles of 1957–58. See differing opinions in Moffett, 1977, 49; Sterling, 1987, 166–67; and Agee, 1993, 23–25.

13. See Agee, 1993, 40, for a discussion of this work and Sterling, 1987, 233–39, for a discussion of this period.

14. Waldman, 1977, 23.

15. Steele, Apr. 8, 1991. See also Paul Cummings, *Artists in Their Own Words* (New York, 1979), 145. Noland used Bocour "magna colors," a mixture of oil and acrylic, because he "could thin it, stain with it. It would keep its intensity"; Wilkin, 1990, 14.

16. See Carl Goldstein, "Teaching Modernism: What Albers Learned in the Bauhaus and Taught to Rauschenberg, Noland, and Hesse," *Arts Magazine* 54 (Dec. 1979), 108–16.

17. For a summary of the now legendary trip that Noland, Leon Berkowitz, and Louis made to Frankenthaler's studio with Clement Greenberg, see Sterling, 1987, 115–18. See also Noland's comments in Emile de Antonio and Mitch Tuchman, eds., *Painters Painting* (New York, 1984), 74–75 and 80. Frankenthaler derived her staining technique from Pollock's *Black Paintings* of 1951.

18. As quoted in Moffett, 1977, 49. Jasper Johns's seminal *Target with Four Faces*, 1958, has also been cited as a catalyst for Noland's turn to concentric circles. For a general discussion, see Carter Ratcliff, "Notes on a Transitional Period: Noland's Early Circle Paintings," *Art in America* 63 (May/June 1975), 66–67.

19. See Noland's comments in Paul Richards, "Full Circle for Noland: The Artist's Tribute to the Phillips," *Washington Post*, May 4, 1982.

20. As quoted in Wilkin, 1990, 8. The mandala is a graphic symbol, often shown as a circle, that has repeating projections of an image, much like the multiple circular bands in this series. See also Agee, 1993, 31–32.

Major References
Kenneth Noland Papers relating to David Smith, ca. 1952–84, AAA.
Kenneth Noland interviews, AAA: with Alexandra Anderson, Oct. 23, 1968; with Paul Cummings, Oct. 9–Dec. 21, 1971; and with Avis Berman, July 1–16, 1987.
Carol Beth Cade, "Color in Color Field Painting: Color in the Painting of Ellsworth Kelly, Kenneth Noland, and Frank Stella," D.Ed. diss., Columbia University, New York, 1973.

Kenworth Moffett, *Kenneth Noland*, New York, 1977.
Diane Waldman, "Color, Format and Abstract Art: An Interview with Kenneth Noland," *Art in America* 65, May/June 1977, 99–105.
———, *Kenneth Noland: A Retrospective*, exh. cat., New York, Guggenheim, 1977.
Paul Cummings, *Artists in Their Own Words: Interviews*, New York, 1979.
Susan Fischer Sterling, "Kenneth Noland's Artistic Evolution: 1946–1965," Ph.D diss., Princeton University, 1987.
Janet Alice Jones, "Clement Greenberg: His Critical and Personal Relationships with Jackson Pollock and Selected Post-Painterly Abstractionists," Ph.D. diss., New York University, 1988.
Karen Wilkin, *Kenneth Noland*, New York, 1990.
Gerald Nordland and Sue Scott, *Washington Color Painters: The First Generation*, exh. cat., Orlando Museum of Art, 1991.
Michael David Plante, "The 'Second Occupation': American Expatriate Painters and the Reception of American Art in Paris, 1946–1958," Ph.D. diss., Brown University, 1992.
William C. Agee, *Kenneth Noland: The Circle Paintings, 1956–1963*, exh. cat., Houston, Museum of Fine Arts, 1993.
Florence Rubenfeld, *Clement Greenberg: A Life*, New York, 1997.

TPC Sources
Cat. 1952.
MP, 1970 and 1982.
Interview with Kenneth Noland, conducted by Fritz Jellinghouse, cassette tape, 1982, TPC Archives.
TPC artist's questionnaire, Aug. 26, 1991.
MP, 1998.

THOMAS DOWNING
1. Medium/Inscription: The measurement in the inscription, which is larger than the measurement for the painting, probably refers to the size of the canvas when unstretched; per Elizabeth Steele, conservator, Apr. 8, 1991. The two inscriptions are identical and must have been made on the same occasion; they are mirror images, perhaps indicating that the top and bottom of the painting could be reversed. Provenance: Information courtesy of Ramon Osuna, the Osuna Gallery, Oct. 18, 1991. Eleanor Ward of the Stable Gallery bought many Downing works soon after they were painted, and she held his first solo show there in 1963. The Osuna Gallery purchased all of the Stable Gallery works by Downing when it was liquidated in 1970. According to Osuna, Marjorie Phillips personally chose this work.

2. Downing in Leslie Judd Ahlander, "An Artist Speaks: Tom Downing," *Washington Post*, Sept. 9, 1962. See Nordland and Scott, 1991, 1–2, for discussion of the Washington Color School.

3. As quoted in Norton Gallery and School of Art, 1965, 33.

4. As quoted in Nordland, 1965, 31.

5. Steele, Apr. 8, 1991.

6. Both quotes in Ahlander, "An Artist Speaks."

7. Interview with Gene Baro in Pyramid Galleries, Ltd., *Thomas Downing Paintings*, exh. cat. (Washington, D.C., 1970), n.p.

8. Legrace G. Benson citing Downing in "The Washington Scene," *Art International* 13 (Dec. 1969), 38. Noland, a teacher and friend, was introduced to Albers's theories while a student at Black Mountain College from 1946 to 1948. See Susan Fisher Sterling, "Kenneth Noland's Artistic Evolution, 1946–1965," Ph.D. diss. (Princeton University, 1987), 18–28, 107, and 147–48, and Albers, *Interaction of Color* (New Haven, 1963), 29–32, 79–80.

9. As quoted in Benson, "The Washington Scene," 38.

Major References
Thomas Downing Papers, 1946–88, AAA.
Gerald Nordland, *The Washington Color Painters,* exh. cat., Washington Gallery of Modern Art, 1965.
Norton Gallery and School of Art, *The Vincent Melzac Collection Featuring, Part One: The Washington Color Painters,* exh. cat., West Palm Beach, Fla., 1965.
La Jolla Museum of Contemporary Art, *Thomas Downing Paintings: 1962–1967,* exh. cat., 1968.
Gerald Nordland and Sue Scott, *Washington Color Painters: The First Generation,* exh. cat., Orlando Museum of Art, 1991.

TPC Sources
Cat. for TPC.1971.9.
Percy North, essay for TPC.1983.8.
Cat. for TPC.1985.5.

HOWARD MEHRING

1. See Livingston, 1977, 72.

2. The Phillips Collection has examples of several of these formats, among them: *Untitled,* ca. 1955–56 (acrylic and metallic paint on canvas; acc. no. 1346), an early poured image; *Untitled,* 1960 (acrylic on canvas; acc. no. 1347), an example of a dappled field painting; and *Untitled,* 1962 (acrylic on canvas; acc. no. 1348), a square/grid painting.

3. Livingston, 1977, 19.

4. Ibid., 14.

5. Mehring, 1968, 52.

Major References
Leslie Judd Ahlander, "An Artist Speaks: Howard Mehring," *Washington Post,* Sept. 2, 1962.
Howard Mehring, "Artists on Their Art," *Art International* 13, Mar. 1968, 52.
Jane Livingston, *Howard Mehring: A Retrospective Exhibition,* exh. cat., Washington, D.C., Corcoran, 1977.
Mary Howard Swift, "Howard William Mehring, 1931–1978: Washington Color Painter," M.A. thesis, George Washington University, Washington, D.C., 1978.

TPC Sources
MP, 1970 and 1982.

WILLEM DE LOOPER

1. Provenance: Intent to purchase in Nesta Dorrance, Jefferson Place Gallery, to Laughlin Phillips, Nov. 7, 1972. Bill of sale, Nov. 10, 1972. *Chinoise,* 1970 (collection of the artist), was traded back to de Looper in partial payment for purchase; see LP to ND, Nov. 17, 1972.

2. De Looper/Weisblat interview, TPC, 1992.

3. As quoted in Schaff, 1977, 50, and de Looper/Weisblat, 1992.

4. See Louis and Noland entries, cat. nos. 403 and 406–07, on the now legendary trip that Louis, Noland, and Leon Berkowitz made to Frankenthaler's studio; they transmitted many of the experimental methods of the New York School to the Washington area. De Looper also recalls the visual impact of Gerald Nordland's exhibition "The Washington Color Painters" at the Washington Gallery of Modern Art in 1965; de Looper/Weisblat, 1992. See also comments in Schaff, 1977, 46–48.

5. Discussion on technique per de Looper/Weisblat, 1992, and analysis of technique by Elizabeth Steele, painting conservator, June 11, 1991.

6. De Looper/Weisblat, 1992. See also Schaff, 1977, 50.

7. First quotation in Schaff, 1977, 76; second quotation and observations regarding approach to painting, especially use of titles, per de Looper/Weisblat, 1992. See also his comments to Schaff, 1977, 50: "Even when the paintings contained figurative and biological shapes, my ideal was, as it is now, to have my paintings viewed in formal terms."

8. As quoted in Jean Lawlor Cohen, *Recent Paintings,* exh. cat., B. R. Kornblatt Gallery (Washington, D.C., 1989), n.p.

Major References
Willem de Looper, interview with Ben Forgey, Jan. 26 and Feb. 29, 1992, AAA.
———, "Sky Forms," in *Art Now 74: A Celebration of the American Arts,* exh. cat., Washington, D.C., John F. Kennedy Center for the Performing Arts, 1974.
David Schaff, "An Interview with Willem de Looper," *Art International* 21, no. 6, Dec. 1977, 46–50 and 76.
———, *Willem de Looper: A Retrospective,* exh. cat., Washington, D.C., co-organized by the Federal Reserve Board and the National Academy of Sciences, 1978; additional biographical brochure published for the National Academy of Sciences venue.
Ray Kass, *Willem de Looper: Paintings from the Seventies,* exh. cat., Washington, D.C., B. R. Kornblatt Gallery, 1987.
Willem de Looper, statement in Eric Gibson, "Abstraction: After Fading in the '80s, the Non-Objective Image Re-Enters the Foreground," *Washington Times,* Dec. 15, 1991.
Ferdinand Protzman, "Galleries: Willem de Looper: An Abstract Education," *Washington Post,* Dec. 14, 1996.
Howard Risatti, *Willem de Looper: A Retrospective Exhibition, 1966–1996,* exh. cat., College Park, Md., University of Maryland Art Gallery, 1996.

TPC Sources
Cat. for TPC.1975.3.
Cat. for TPC.1983.8.
Interviews with Willem de Looper, conducted by Leigh Bullard Weisblat, Mar. 3, 1992, and by Jeffrey Harrison, May 15, 1992.
Katherine Rothkopf, publ. chklst. for TPC. 1995.6.

SAM GILLIAM

1. Provenance: Remembrances of Marjorie Phillips's interest in this work per Gilliam/Weisblat interview, TPC, 1992. Purchase out of exhibition suggested by in-house notes on exhibition catalogue and by gallery

hanging records.

2. As quoted in Gilliam/Forgey interview, AAA, 1989, 35–36. Numerous critics have commented on this quality in Gilliam's work. See Hopps, 1976, n.p.; Davies and Kloner, 1978, 2; and Campbell, 1983, 5.

3. These areas were perhaps formed as the paint pooled overnight. Gilliam usually titles his works while they are in progress or after they are completed. He views titles as an important link between an abstraction and the environment or a particular moment; per Gilliam/Weisblat, 1992.

4. Benjamin Forgey first noted the luminosity in Gilliam's work in "Sam Gilliam Bursts Forth at Phillips," *Sunday Star,* Oct. 22, 1967. Kloner, in Davies and Kloner, 1978, 18, also comments on this quality, calling Gilliam's color fields "poems of emerging light. . . . Light, then, is at the heart of his structured color."

5. Gilliam/Weisblat, 1992. On method in earlier works, see Gilliam/Forgey, 1989, 35: he applied masking tape to the canvas to create hard edges, poured paint onto the canvas, then lifted the tape while the paint was still wet to create a bleeding effect.

6. As quoted in Morrison, 1977, 5.

7. Kloner in Davies and Kloner, 1978, 15.

8. Morrison, 1985, 59.

9. See Paul Richard, "Gilliam: Artful Drapery," *Washington Post,* Apr. 28, 1975.

10. As quoted in Gilliam/Weisblat, 1992.

11. See in particular Driskell, 1987, 22, and Campbell, 1983, 9.

12. As quoted in Spellman, 1973, 332. In the Young interview, AAA, 1984, 23, Gilliam remarks: "Coltrane worked at the whole sheet, he didn't bother to stop at bars and notes and clefs and various things, he just played the whole sheet at once. I think that's very important, because the spatial and the total attitude of the picture depend upon at least the feeling of planarity that is determined by the edge as a whole."

13. Kloner in Davies and Kloner, 1978, 2.

14. Gilliam/Young, 1984, 30.

15. Gilliam/Forgey, 1989, 36.

16. As quoted in cat. for TPC.1983.8, n.p.

17. Ibid. Gilliam describes his interest in Rothko and Tack: "In 1960, the works of Rothko and Tack were special influences on my work. They were the most startling and constant resource I had. I saw the paintings many times, first trying to determine their meaning and later appreciating them as art" (Gilliam Papers, AAA, Box 2). On MacIver, Gilliam remarks, "One of the most difficult shocks for me as a painter would be to see the window shade by Loren MacIver. To see that painting is to make an immediate transport from where you are to where you should be" (as quoted in TPC.1983.8, n.p.).

18. Ibid.

Major References
Sam Gilliam Papers, 1958–89, AAA.
Sam Gilliam interview with Kenneth Young, Sept. 18, 1984, AAA.
Sam Gilliam interview with Benjamin Forgey, Nov. 4 and 11, 1989, AAA.
Robert Clarence Spellman, "A Comparative Analysis of the Characteristics of Works and Aesthetic

Philosophies of Selected Contemporary Mainstream and Blackstream Afro-American Artists," Ph.D. diss., New York University, 1973.

Walter Hopps, *Sam Gilliam: Paintings and Works on Paper,* exh. cat., Louisville, Ky., J. B. Speed Art Museum, 1976.

Keith Morrison, "Interview with Sam Gilliam," *New Art Examiner* 4, June 1977, 4–5.

Hugh M. Davies and Jay Kloner, *Sam Gilliam: Indoor and Outdoor Paintings, 1967–1978,* exh. cat., Amherst, University of Massachusetts, 1978.

John Beardsley, *Sam Gilliam,* exh. cat., Washington, D.C., Corcoran, 1983.

Mary Schmidt Campbell, *Sam Gilliam: Journey Toward Red, Black, and "D,"* exh. cat., New York, Studio Museum in Harlem, 1983.

Keith Morrison, *Art in Washington and Its Afro-American Presence: 1940–1970,* Washington, D.C., Washington Project for the Arts, 1985.

David C. Driskell, *Contemporary Visual Expressions: The Art of Sam Gilliam, Martha Jackson-Jarvis, Keith Morrison, William T. Williams,* exh. cat., Washington, D.C., Anacostia Museum, 1987.

Jane Livingston, *Sam Gilliam: Small Drape Paintings, 1970–1973,* exh. cat., Washington, D.C., Middendorf Gallery, 1990.

TPC Sources

MP, 1970 and 1982.

Interview with Sam Gilliam, conducted by Fritz Jellinghouse, audio tape, 1982, TPC Archives.

Jerry Clapsaddle and Percy North, cat., TPC.1983.8; includes interview with the artist.

Sam Gilliam, lecture for "Artists Speak" series, cassette tape, Feb. 27, 1992, TPC Archives.

Interview with Sam Gilliam, conducted by Leigh Bullard Weisblat and Hwaik Lee, audio tape, May 6, 1992, TPC Archives.

ACKNOWLEDGMENTS

Over the years we relied on numerous individuals at museums, libraries, and archives whose help was of inestimable value. In New York, our thanks go to the staff at the American Federation of Arts, particularly Eleanor C. Barefoot, Jeanne Hedstrom, Julie Min, and Robert Workman; to Lawrence Campbell at the Art Students League; Guy-Patrice Dauberville of Bernheim-Jeune and Cie, Paris; Roger Friedman and Gregory Gallagher at the Century Association; Pamela Pumplin and Helen Sanger at the Frick Art Reference Library; Melissa De Medeiros at M. Knoedler and Co., Inc., New York; Katherine Kaplan, Antoinette M. Kraushaar, and Carole Pesner at Kraushaar Galleries. In Washington, D.C., we came to appreciate the continued generosity and help provided by Arthur Breton, Liza Kirwin, and Judith Throm of the Archives of American Art, then headed by Garnett McCoy; a project such as this attests to the significance and vital importance of this institution. At the Library of Congress we thank the staff of the Newspaper Reading Room and the Prints and Photographs Division. We also thank Carolyn Backlund, Ted Dalziel, and Frances Lederer at the library of the National Gallery of Art; Pat Lynagh at the National Museum of American Art; and the staff at several divisions of the Smithsonian Institution: the National Museum of American History, the National Portrait Gallery, and the Smithsonian Institution Traveling Exhibition Service. At Yale University, New Haven, we benefited from the contributions by Mary B. Dowdle, Yale Center for British Art; Rick Hart and Patricia C. Willis, Beinecke Rare Book and Manuscript Library; and the staff of the Sterling Library.

Almost without fail those scholars and experts whom we contacted for information were generous with their advice on artists and individual works of art. The Phillips Collection is extremely grateful to the following: David Anfam, Eleanor S. Apter, Roseline Bacou, Roland Balay, John N. Ball, Vivian Endicott Barnett, Brenda Billingsley, Doreen Bolger-Burke, Constance A. Bond, Caroline Boyle-Turner, Elizabeth Broun, Jonathan Brown, Gerald Buck, Ruth Butler, Barbara Cavaliere, Nicholas Chambrel, Nicolai Cikovsky, David Park Curry, John Davis, Anne Cohen De Pietro, Esti Dunow, Alvord L. Eiseman, Lorenz Eitner, Albert E. Elsen, Douglas Farquhar, Scott R. Ferris, the late Sydney J. Freedberg, Rosel Gollek, Christopher Green, Christoph Grunenberg, Fannie Guillon-Laffaille, Jeffrey R. Hayes, Patrick Heron, Anne Higonnet, Werner Hofmann, William Innes Homer, Michel Hoog, René Hoog, Sam Hunter, David Fraser Jenkins, Vojtech Jirat-Wasiutynski, Elizabeth Johns, Lee Johnson, Joop M. Joosten, Sheldon and Carolyn Keck, Michael Kellerman, Peter Khoroche, Michael Klein, Carolyn Lanchner, Klaus Lankheit, Claude Laugier, Alain de Leiris, Henry Lessore, Gail Levin, Ira Licht, Daniel Marchesseau, Boris Marchuk, Joan Marter, Nancy Mowll Mathews, David Mitchinson, Ann Lee Morgan, Percy North, Gwendolyn Owens, Leslie Parris, Bennard Perlman, Ronald Pickvance, Ronald Pisano, Stephen Polcari, Jean-Marie Pradier, Marla Prather, Elizabeth Prelinger, Theodore Reff, Irene Rehmann, the late John Rewald and the staff of the Cézanne Catalogue Raisonné project, Timothy Robert Rodgers, Antoine Salomon, Darrel L. Sewell, Aaron Sheon, Richard Shone, Judith E. Stein, Robert Stoppenbach, Sir John Summerson, Nicholas Fox Weber, Robert M. Welsh, Richard V. West, Juliet Wilson-Bareau, Johann Winkler, and Judith Zilczer.

The Phillips Collection acknowledges the generous assistance provided by artists' families, friends, estates, archives, and foundations. Among those who shared personal reminiscences and archival records with us were the following: Sally Avery; Jean Bellows Booth; Mary Rower and Alexander S. C. Rower of the Alexander and Louisa Calder Foundation, New York; Mary Chapin; Françoise Choppin; Lisa Dougherty Coon; Allan Rohan Crite and Jackie Cox-Crite; Johanna Dams and Johannes Dams; Earl Davis; the late Dorothy Dehner; Nina Foster; Elsie Driggs Gatch; Paul Klee-Stiftung, Kunstmuseum Bern; Oskar Kokoschka-Dokumentation, Pöchlarn and Vienna; Brenda Kuhn; Sara Kuniyoshi; the Lachaise Foundation, Boston; Gwendolyn and Jacob Lawrence; Jeffrey Goodhue Legler; Sue Davidson Lowe; Alfred Manessier and Christine Manessier; Georges Mathieu; Margaret V. Loudon and Maria-Gaetana Matisse of the Pierre Matisse Foundation, New York; Loren McIver; Yvonne Pène du Bois McKenney; Theresa Bernstein Meyerowitz; Archivi Legali Amedeo Modigliani, Musée de Montmartre, Paris and Casa Natale dell'Artista, Livorno; David Mitchinson of the Henry Moore Foundation, Much Hadham, England; Eugènie Prendergast; Helen Farr Sloan; Françoise de Staël; Theodoros Stamos; Jackson Chase Storm; Daniel Wynkoop Jr.; Jean and Jim Young; and Jack Youngerman.

The staff at museums in this country and in Europe fielded seemingly endless questions and earned our enduring appreciation. We want especially to thank the following: Addison Gallery of American Art, Phillips Exeter Academy, Andover, Massachusetts; Akron Art Museum, Ohio; Albany Museum of Art, Georgia; the Albrecht-Kemper Museum of Art, St. Joseph, Missouri; Albright-Knox Art Gallery, Buffalo; Allentown Art Museum, Pennsylvania; Lyman Allyn Art Museum, New London, Connecticut; the Arkansas Arts Center, Little Rock; Art Gallery of Ontario, Toronto; the Art Institute of Chicago; Arts Club of Chicago; the Baltimore Museum of Art; Bayerische Staatsgemäldesammlungen, Munich; the Berkshire Museum, Pittsfield, Massachusetts; Boston Athenaeum; the Brooklyn Museum, New York; the Butler Institute of American Art, Youngstown, Ohio; the Carnegie Museum of Art, Pittsburgh; the Chrysler Museum, Norfolk, Virginia; Cincinnati Art Museum; City Art Gallery, Manchester, England; the Cleveland Museum of Art; Colorado Springs Fine Arts Center; Columbia Museum of Art and Gibbes Planetarium, South Carolina; the Columbus Museum of Art, Ohio; the Contemporary Arts Center, Cincinnati, Ohio; Contemporary Arts Museum, Houston; the Corcoran Gallery of Art, Washington, D.C.; Cheney Cowles Museum, Spokane, Washington; the Currier Gallery of Art, Manchester, New Hampshire; Dallas Museum of Art; Davenport Museum of Art, Iowa; Dayton Art Institute; De Cordova Museum and Sculpture Park, Lincoln, Massachusetts; Delaware Art Museum, Wilmington; the Denver Art Museum; Des Moines Art Center, Iowa; Detroit Historical Museum; the Detroit Institute of Arts; Dulin Gallery of Art, Knoxville, Tennessee; Everson Museum of Art of Syracuse and Onondaga County, New York; the Fine Arts Museums of San Francisco, M. H. de Young Memorial Museum and California Palace of the Legion of Honor; Charles and Emma Frye Art Museum, Seattle; the J. Paul Getty Museum, Malibu, California; Grand Rapids Art Museum, Michigan; the Solomon R. Guggenheim Museum, New York; Heritage Plantation of Sandwich, Massachusetts; High Museum of Art, Atlanta; Hirshhorn Museum and Sculpture Garden, Washington, D.C.; Historical Society of Pennsylvania, Philadelphia; Hungarian National Gallery, Budapest; Huntington Museum of Art, West Virginia; Indianapolis Museum of Art; the Institute of Contemporary Art, Boston; International Museum of Photography at George Eastman House, Rochester, New York; Jasper Rand Art Museum, Westfield, Massachusetts; Joslyn Art Museum, Omaha, Nebraska; Kunstmuseum, Düsseldorf; Los Angeles County Museum of Art; Charles H. MacNider Museum, Mason City, Iowa; Marion Koogler McNay Art Museum, San Antonio; Memphis Brooks Museum of Art; the Metropolitan Museum of Art, New York; Milwaukee Art Museum; the Minneapolis Institute of Arts; Mint Museum of Art, Charlotte, North Carolina; the Montclair Art Museum, New Jersey; the Montreal Museum of Fine Arts; Munson-Williams-Proctor Institute Museum of Art, Utica, New York; Musée d'Art et d'Histoire, Geneva, Switzerland; Musée de l'Orangerie, Paris; Musée de Pont-Aven, France; Musée des Beaux-Arts, Bordeaux, France; Musée d'Orsay, Paris; Musée National d'Art Moderne, Centre Georges Pompidou, Paris; Museum of Contemporary Art, San Diego; Museum of Fine Arts, Boston; the Museum of Fine Arts, Houston; Museum of Fine Arts, St. Petersburg, Florida; Museum of Fine Arts, Springfield, Massachusetts; the Museum of London; the Museum of Modern Art, New York; Museum of the City of New York; Muskegon Museum of Art, Michigan; National Academy of Design, New York; National Gallery of Art, Washington, D.C.; National Gallery of Canada, Ottawa; the Nelson-Atkins Museum of Art, Kansas City, Missouri; the Newark Museum, New Jersey; New Orleans Museum of Art; Newport Harbor Art Museum, Newport Beach, California; North Carolina Museum of Art, Raleigh; Norton Gallery and School of Art, West Palm Beach, Florida; the Oakland Museum, California; Oklahoma City Art Museum; Palais des Beaux-Arts, Société des Expositions, Brussels; Pennsylvania Academy of the Fine Arts, Philadelphia; Philadelphia Museum of Art; the Philbrook Museum of Art, Tulsa, Oklahoma; Phoenix Art Museum, Arizona; Portland Art Museum, Oregon; Portland Museum of Art, Maine; Provincetown Art Association and Museum, Massachusetts; the Queens Museum of Art, New York; John and Mable Ringling Museum of Art, Sarasota, Florida; Abby Aldrich Rockefeller Folk Art Center, Williamsburg, Virginia; Lauren Rogers Museum of Art, Laurel, Mississippi; Royal Academy of Arts, London; the Saint Louis Art Museum; San Diego Museum of Art; San Francisco Museum of Modern Art; Santa Barbara Museum of Art; Seattle Art Museum; Sierra Nevada Museum of Art, Reno; Norton Simon Museum and its predecessor, Pasadena Art Institute, California; the George Walter Vincent Smith Art Museum, Springfield, Massachusetts; Society of the Four Arts, Palm Beach, Florida; South Carolina State Museum, Columbia; J. B. Speed Art Museum, Louisville, Kentucky; Springfield Art Museum, Missouri; Städelsches Kunstinstitut und Städtische Galerie, Frankfurt; Stamford Museum and Nature Center, Connecticut; the State Museum of Pennsylvania, Harrisburg; the Strong Museum, Rochester, New York; the Szépmüvészeti Múzeum, Budapest; Tacoma Art Museum, Washington; Tate Gallery, London; the Toledo Museum of Art, Ohio; Vancouver Art Gallery, British Columbia; Victoria and Albert Museum, London; Virginia Museum of Fine Arts,

Richmond; Wadsworth Atheneum, Hartford, Connecticut; Walker Art Center, Minneapolis; Westmoreland Museum of Art, Greensburg, Pennsylvania; the White House, Washington, D.C.; Whitney Museum of American Art, New York; Winnipeg Art Gallery, Manitoba; Witte Museum, San Antonio; Worcester Art Museum, Massachusetts.

We also want to extend our thanks to the staff of libraries and archives of institutions, associations, and agencies who responded to our numerous queries, including American Academy and Institute of Arts and Letters, New York; Artcodif, Paris; Art in Embassies Program, United States Department of State, Washington, D.C.; Arts Club of Washington, D.C.; Associated American Artists, Inc., New York; Avery Architectural and Fine Arts Library, Columbia University, New York; Bodleian Library, Oxford University, England; Boston Public Library; the British Library, London; Cambridge University Library, England; Chadwick-Healey, Art Exhibition Catalogues on Microfiche, Cambridge, England; Chicago Historical Society; the Coffee House Club, New York; College Art Association of America, New York; Courtauld Institute of Art Library, University of London; Deerfield Valley Art Association, Sunderland, Massachusetts; English-Speaking Union, New York; the Gelman Library (Special Collections), George Washington University, Washington, D.C.; Greenfield Historical Society, Massachusetts; Historical Society of Pennsylvania, Philadelphia; the Houghton Library, Harvard University, Cambridge, Massachusetts; International Exhibitions Foundation, Washington, D.C.; Martin Luther King Memorial Library, Washington, D.C.; National Archives and Records Administration, San Francisco Branch; Nebraska State Historical Society, Lincoln; the Newberry Library, Chicago; the New-York Historical Society; the New York Public Library; Philadelphia Art Alliance; Pierpont-Morgan Library, New York; Enoch Pratt Free Library, Baltimore; Richland County Public Library, Columbia, South Carolina; Santa Barbara Public Library, Faulkner Memorial Art Wing; Sheffield City Libraries, England; Springfield City Library and Museum Association, Massachusetts; Staatsbibliothek Preussischer Kulturbesitz, Manuscript Division, Berlin; Union League Club, New York; United States Department of Labor, Washington, D.C.; United States Information Agency, Washington, D.C.; and University of California, Special Collections, Riverside.

Detailed information provided in the catalogue frequently came from little-known exhibition catalogues and records, documentation that was gathered with the generous cooperation of the individuals affiliated with universities and schools throughout the country, including the Ackland Art Museum, University of North Carolina, Chapel Hill; American University, Watkins Gallery, Washington, D.C.; University of Arizona Museum of Art, Tucson; Arizona State University Art Museum, Tempe; Bennington College, Vermont; Bowdoin College Museum of Art, Brunswick, Maine; University Art Museum, University of California, Berkeley; University of California at Los Angeles, Wight Art Gallery; University Art Gallery, University of California, Riverside; Choate Rosemary Hall, Archives at the Andrew Mellon Library, Wallingford, Connecticut; College of St. Benedict, Benedicta Arts Center, St. Joseph, Minnesota; College of Wooster Art Museum, Ohio; Deerfield Academy, Massachusetts; Duke University Museum of Art, Durham, North Carolina; Ecole Nationale Supérieure des Beaux-Arts, Paris; Edinboro State College, Pennsylvania; Elvehjem Museum of Art, University of Wisconsin, Madison; Fisk University Museum of Art, Nashville; the Art Museum at Florida International University, Miami; Fogg Art Museum, Harvard University, Cambridge; Gallaudet University, Washington, D.C.; Georgia Museum of Art, University of Georgia, Athens; Goucher College, Towson, Maryland; Haverford College, Pennsylvania; Hofstra Museum, Hofstra University, Hempstead, New York; Hood College, Frederick, Maryland; Hood Museum of Art, Dartmouth College, Hanover, New Hampshire; Howard University Gallery of Art, Washington, D.C.; Illinois State University, Center for Visual Arts Gallery, Normal; Indiana University Art Museum, Bloomington; Institute of Contemporary Art, University of Pennsylvania, Philadelphia; University of Iowa Museum of Art, Iowa City; Kansas City Art Institute, Missouri; Krannert Art Museum, University of Illinois, Champaign; James E. Lewis Museum of Art, Morgan State University, Baltimore; Louisiana State University School of Art, Baton Rouge; Lowe Art Museum, University of Miami, Florida; Maier Museum of Art, Randolph-Macon Woman's College, Lynchburg, Virginia; Mary Baldwin College, Department of Art, Staunton, Virginia; University of Massachusetts, Amherst; Mead Art Museum, Amherst College, Massachusetts; the University of Michigan Museum of Art, Ann Arbor; Mills College Art Gallery, Oakland, California; University Art Museum, University of Minnesota, Morris; Montana State University, Bozeman; Mount Holyoke College, South Hadley, Massachusetts; Mount St. Vincent University, Halifax, Nova Scotia; Museum of Texas, Technical University, Lubbock; University of Nebraska Art Galleries, Sheldon Memorial Art Gallery, Lincoln; Northwestern University, Evanston, Illinois; Oberlin College, Clarence Ward Art Library, Ohio; Ohio University, Athens; Phillips Exeter Academy, Andover, Massachusetts; the Art Museum, Princeton University, New Jersey; the Renaissance Society at University of Chicago; Museum of Art, Rhode Island School of Design, Providence; the University of Rochester, Memorial Art Gallery, New York; St. Paul's School, Arts Center at Hargate, Concord, New Hampshire; School of the Art Institute of Chicago; School of the Museum of Fine Arts, Boston; Skowhegan School of Painting and Sculpture, Maine; Smith College Museum of Art, Northampton, Massachusetts; the Snite Museum of Art, University of Notre Dame, Indiana; University of South Carolina, Columbia; Spencer Museum of Art, University of Kansas, Lawrence; Sweet Briar College, Virginia; Telfair Academy of Arts and Sciences, Savannah, Georgia; University of Texas at Austin, Archer M. Huntington Art Gallery; Vassar College, Frances Lehman Loeb Art Center, Poughkeepsie, New York; University of Virginia, Bayly Art Museum, Charlottesville; Wabash College, Art Department, Crawfordsville, Indiana; University of Washington, Henry Art Gallery, Seattle; Wesleyan University, Davison Art Center, Middletown, Connecticut; Wichita State University, Edwin A. Ulrich Museum of Art, Kansas; Wilkes University, Sordoni Art Gallery, Wilkes-Barre, Pennsylvania; Williams College Museum of Art, Williamstown, Massachusetts; Yale University Art Gallery and Yale University School of Art, New Haven, Connecticut; Jane Voorhees Zimmerli Art Museum, Rutgers, State University of New Jersey, New Brunswick.

The willing cooperation we received from owners and staff of the many art dealers and auction houses contacted in our research is most appreciated. We are indebted to ACA Galleries, New York; Acquavella Galleries, Inc., New York; Thomas Agnew and Son, Ltd., London; American Artists Group, Inc., New York; Art Dealers Association of America, Inc., New York; Galerie Beyeler, Basel; Grace Borgenicht Gallery, New York; Leo Castelli Gallery, Inc., New York; Ralph M. Chait Galleries, Inc., New York; Christie's, New York and London; Compagnie des Commissaires Priseurs de Paris; Paula Cooper Gallery, New York; Terry Dintenfass Gallery, New York; Fischbach Gallery, New York; Janet Fleisher Gallery, Philadelphia; the Forum Gallery, New York; Thomas Gibson Fine Art Ltd., London; Grand Central Art Galleries, Inc., New York; Richard Gray Gallery, Chicago; Sidney Janis Gallery, New York; Galerie Jeanne-Bucher, Paris; Jan Krugier Gallery, New York; Galerie Louise Leiris S.A., Paris; Albert Loeb Gallery, Paris; Marlborough Gallery, New York; David McKee Gallery, New York; Robert Miller Gallery, New York; Boris Mirski Gallery, Boston; Achim Moeller Fine Art, Ltd., New York; Newhouse Galleries, Inc., New York; Perls Galleries, New York; Gerald Peters Gallery, Santa Fe and New York; Pétridès Galerie, Paris; Poindexter Gallery, New York; Portraits, Inc., New York; Alex Reid and Lefevre, Ltd., London; Paul Rosenberg and Co., New York; Galerie St. Etienne, Paris; Salander-O'Reilly, New York; Sotheby's, Inc., New York and London; Jack Tilton Gallery, New York; Vose Galleries, Boston; E. Weyhe, New York; Wildenstein and Co., Inc., New York and London; and Richard York Gallery, New York.

Finally, heartfelt thanks to the interns who over the years assisted with the documentation of the works in the collection. Their contribution was invaluable: Jennifer Abrams, Cristina Ashjian, Beverly Balger, Brent Benjamin, Allison Bishop-Rein, Amy Jo Blumrosen, Kelly Blythin, Anne H. Britton, Charles Brock, Charmine Chen, Anne Collins, Sigrid Dirkmann, Stacy A. Donohue, Tatjana Eggert, Susanne Evers, Hayley Falk, Anoka Faruqee, Sally Faulkner, Nicole Fischer, Sabine Fischer, Clare Franklin, Jennifer Burris Galen, Suzanne Marie Gillis, Laurie Gillman, Gabrielle Goldgram, Susan Lewis Graage, Vivien Green, Cindi Gresh, Deborah Gross, Jane Gross, Sarah Handwerger, Kristin Herndon, Diana Horowitz, Maria Dolores Jiménez-Blanco, Kelley Jones, Lindsay Mace Joost, Wendy Kail, Panos Kakaviatos, Hwaik Lee, Michaela Lorenc, Laurette E. McCarthy, Kim Miller, Laura L. Muir, Andrew Otwell, Maura Parrott, Louly Peacock, Anna Proctor, Jennifer Fiona Ragheb, Katharine Grotto Revel, Sila Sayer, Brien Schiappa, Marcia Schifanelli, Claire Schlumberger, Kaarin Schnebele, Emily Scudder, Melissa Shanley, Lisa Portnoy Stein, Nick Steward, Adele Thanheiser, Joslyn Treece, Elizabeth Triplett, Kathryn Ulrich, Andrea Vagianos, Nancy Waits, Abigail Walker, Maria Weigel, Deborah White, Michelle Lee White, Lynne Woodruff, Marieka Yoder, Alexandra Zapruder.

Raoul Dufy 1935